The New York Times
Film Reviews
1991–1992

The New York Times
Film Reviews
1991–1992

Times BOOKS / GP

Times Books & Garland Publishing, Inc. / New York 1993

Copyright © 1993 The New York Times Company

Library of Congress Catalog Card Number: 70-112777

ISSN 0362-3688
ISBN 0-8240-7592-7

Manufactured in the United States of America

Contents

Foreword

In 1970, THE NEW YORK TIMES FILM REVIEWS (1913–1968) was published. It was a five-volume set, containing over 18,000 film reviews exactly as they first appeared in The Times.

The collection was accompanied by a sixth volume, an 1,100-page computer-generated index, which afforded ready access to the material by film titles, by producing and distributing companies, and by the names of all actors, directors, and other persons listed in the credits.

Further volumes appeared in 1971, 1973, 1975, 1977, 1979, 1981, 1983, 1988, 1990, and 1992 reproducing the reviews that were printed in The Times during the years 1969–1970, 1971–1972, 1973–1974, 1975–1976, 1977–1978, 1979–1980, 1981–1982, 1983–1984, 1985–1986, 1987–1988, and 1989–1990; the present volume carries the collection through 1992. The index as originally conceived was incorporated into the 1969–1970, 1971–1972, 1973–1974, 1975–1976, 1977–1978, 1979–1980, 1981–1982, 1983–1984, 1985–1986, 1987–1988, 1989–1990 volumes and the present volume.

New compilations will be published periodically to keep the collection constantly updated.

BEST FILMS

Articles listing the best and award-winning films published in The Times appear at the end of each year's reviews. These include the awards of the Academy of Motion Picture Arts and Sciences and the "best films" selections of The New York Times and the New York Film Critics Circle.

The New York Times
Film Reviews
1991

Solovki Power

Directed by Marina Goldovskaya; Miss Goldovskaya, cinematographer; produced and distributed by Mosfilm. Film Forum 1, 209 West Houston Street, Manhattan. Running time: 93 minutes. In Russian with English subtitles. This film has no rating.

By VINCENT CANBY

Marina Goldovskaya's 1988 "Solovki Power," opening today at the Film Forum, is first-rate film journalism, of historical importance for what it shows to have been and for the way it demonstrates the degree of self-examination going on within the Soviet Union now.

"Solovki Power" is a remarkable documentary about the prison camp said to have been the prototype for all of the gulags that came after, though its life was comparatively short (1923-1939).

Called a "special service camp," Solovki was on the largest island in the Solovetsky archipelago in the White Sea. Even before the Bolshevik Revolution, Solovki was well known to Russians as the site of a 15th-century monastery and, from the mid-16th century on, as a place favored by the czars for political exiles.

•

Today Solovki is something of a summertime tourist attraction. The islands are pine-covered, beautiful, suggesting the more isolated reaches of the Canadian north.

As recalled in Miss Goldovskaya's packed 93-minute report, the prison camp was something else, a brutal penal colony where ordinary criminals were the elite, and the political prisoners (writers, teachers, scientists, priests, nuns), who had been sent there to be re-educated, were at the bottom of the social scale.

The film is framed by shots of Solovki today, the remains of the prison camp and of the monastery. The heart of the film is composed of interviews with a half-dozen or so camp survivors, and some extraordinary material from an official 1928 silent documentary about the camp.

The purpose of the silent film, which features Maxim Gorky making an approving tour of the camp, was to show the public how successfully the Government was carrying out its political re-education program. The completed film, which Miss Goldovskaya found in the archives, was never released. No wonder.

•

The producers had been so successful in painting an idealized portrait of the camp (prisoners dine from full plates, at tables covered with white dinner cloths) that it was suspected that hard-pressed Soviet citizens would be outraged. The prisoners were living better than they were.

The testimony of the individual survivors is possibly even more harrowing for being delivered with the icy precision and detachment that the passage of time allows.

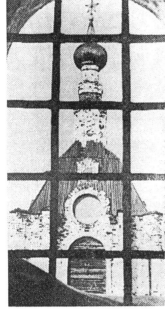

Film Forum
A scene from "Solovki Power."

One old man remembers the slaughter of 300 political prisoners on a night in 1929. Another man talks about the fury of the camp's first political prisoners when they were denied the run of the island that had been allowed the czar's political exiles.

Even the man who made the propaganda film is interviewed. He shakes his film sadly as he recalls how the film was pulled from release. "My best film," he says.

•

Miss Goldovskaya, who photographed and directed "Solovki Power," maintains her own detachment from the material. It speaks eloquently for itself

"Solovki Power" is so good that it leaves the audience wanting to know more: more about the interviewees, more about the camp (why was it shut down in 1939?) and more about its relation to the other camps and the entire Soviet penal system.

1991 Ja 2, C10:5

FILM VIEW/Caryn James

Too Oft, Fault Lies In the Stars

WHEN FRANCO ZEFFIRELLI'S MOVIE version of "Romeo and Juliet" opened in 1968, it burnished Shakespeare's good name and attracted viewers by the busload. This was documented by a New York Times reporter who interviewed a busload that had been shipped to a Manhattan theater from Peekskill Junior High. As one boy put it, "Shakespeare ain't dead when he can make pictures like that."

Well, he still ain't dead. The latest Shakespeare-Zeffirelli picture is "Hamlet," starring Mel Gibson, and like "Romeo and Juliet" it also manages to link Shakespeare and the masses without insulting either one. But while the earlier film starred the unknown actors Leonard Whiting and Olivia Hussey, because "Hamlet" has a movie star in the title role it plays with a peculiar double-edged sword.

No doubt, Mel Gibson is a great box-office draw. But audiences are understandably wary about his switch from action adventures and comic romances to one of the greatest tragedies ever written. Can the star of "Mad Max" and "Lethal Weapon" do as Hamlet advises the traveling players and let his words flow "trippingly on the tongue"? How easily can viewers get past the image of cutie-face Mel and respond to Hamlet's tortured soul? This is movie-star Shakespeare, a tough game in which fame is more often a burden than a blessing.

Mr. Gibson joins a large company of actors who have faced that problem, of course. In the last couple of years alone, Dustin Hoffman has played Shylock in London and on Broadway, and Kevin Kline has played Hamlet at the Public Theater and on public television. All sorts of Hollywood stars have done Shakespeare in Central Park, with critical reactions veering wildly. Jeff Goldblum and Michelle Pfeiffer were disastrous in "Twelfth Night" in 1989. Last summer, Denzel Washington's "Richard III" was a disappointment, while Morgan Freeman and Tracey Ullman were greeted as happy surprises in a Wild West version of "The Taming of the Shrew." There is no simple equation for predicting how stars and Shakespeare will match up.

But Mr. Zeffirelli's three Shakespearean films offer a plausible rule: when playing Shakespeare, unknowns have all the advantages. The director's low-profile "Romeo and Juliet," his 1967 "Taming of the Shrew" with Richard Burton and Elizabeth Taylor, and now "Hamlet" all suggest that the bigger the star, the harder it is for audiences to leap beyond the familiar face and persona to believe in a distant time and language.

"Romeo and Juliet" is still by far Mr. Zeffirelli's most affecting and effective film. While preserving the great beauty of its poetry, he had the savvy commercial sense to distill the story into an ultramodern question: Why must I be a star-crossed teenager in love? By casting unknowns, he allowed his actors to escape easily into their characters, and Shakespeare to became the focus of the film. Plenty of color and action help translate the play into cinematic terms: elaborate costumes, Nino Rota's lyrical music, high-action

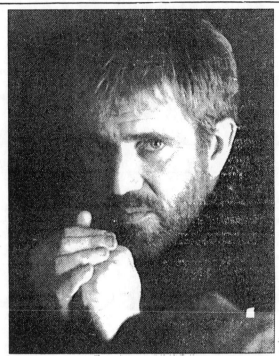

Mel Gibson in the title role of Franco Zeffirelli's "Hamlet"—an intense, restrained performance

sword fights between the Capulets and the Montagues. But the film relies on the sweet, deft performances the director elicited from his teen-age stars, who spoke Shakespeare's poetry most naturally.

Yet just one year before, Mr. Zeffirelli travestied "The Taming of the Shrew." It became a Punch-and-Judy show for Elizabeth Taylor and Richard Burton, who were then in one of their much-publicized married phases. Kate is not the most voluble or eloquent Shakespearean heroine, but neither is she the cavewoman portrayed here. Ms. Taylor howls and shrieks and snarls and grimaces more often than she resorts to the spoken word. She swings at Mr. Burton as Petruchio and literally runs from him, up on a roof. Given some lines, Ms. Taylor tries, but her readings and Mr. Burton's seem to come from different galaxies.

With his classically trained voice and diction, Mr. Burton can handle the dialogue almost too well. Full of self-absorbed flourishes, his character seems more Henry VIII than Petruchio, who slyly humiliates and therefore tames his spirited wife. Mr. Burton even resorts to wracking coughs and bits of comic business as they take their marriage vows, a scene Shakespeare never wrote.

This is movie-star Shakespeare played to the hilt, and the hints are scattered through the credits. It is "a Burton-Zeffirelli Production"; the opening credits include the line: "Elizabeth Taylor's hairstyles by Alexandre of Paris." But while this "Taming of the Shrew" strays far from its source, in one sense the slapstick star vehicle is just what the film makers wanted. It happily plays off the Burtons' real-life marriage, expecting audiences to be drawn to the spectacle

When fame 'twixt screen and viewer is interposed, oftime suffer all, including Shakespeare.

of Taylor and Burton sniping at each other as they had previously in "Who's Afraid of Virginia Woolf?" and as they were sometimes known to do in life. Shakespeare was always a high-toned source, not much more important than Alexandre and considerably less significant than the stars.

Staying in tune with a star's image was obviously never the strategy for "Hamlet"; fans of "Lethal Weapon" are not necessarily predisposed to sit through Shakespeare. Yet the film's artistic success relies on Mr. Gibson's shrewd, intelligent performance, while at times Mr. Zeffirelli seems determined to sabotage his own film by cluttering it with movie-star close-ups.

For too long in this "Hamlet," the camera emphasizes Mr. Gibson's familiar good looks, as if the director must exploit his box-office attraction.

But this strategy gives Mr. Gibson no help in establishing his character, for it lingers on the curiosity value of the star's newest look. And he needs all the help a director can give him, for audiences enter the theater loaded with petty but natural challenges to Mr. Gibson's authority.

"Isn't he too old to play Hamlet?" audiences wonder. No, as it happens, he is believably young enough to be the son of Glenn Close, who plays Gertrude. "He looks ridiculous; he's wearing bangs," say others, who have seen photographs from the film and television interviews from the movie set. In the context of "Hamlet" the modified Beatle haircut looks just fine, however goofy it may have seemed when he talked to Barbara Walters. Mr. Gibson overcomes all these obstacles, but they are obstacles that a lesser-known actor would not have had to surmount. There's no need to feel sorry for Mel Gibson, but his intense, restrained performance is all the more remarkable considering the skepticism weighing against him and the opportunities he had to play to the camera instead of to the poetry.

■

Fame is not the only route to Shakespeare, of course. Obscurity worked well for Kenneth Branagh as director and star of a vivid "Henry V." In 1989, Mr. Branagh was little known, which made his accomplished, stirring film seem all the more impressive. The question, "Who is this guy, and where did he come from?" is no advantage when it's time for producers to put up money, but it can be a great asset with audiences. Mr. Branagh even survived the inevitable comparisons with Laurence Olivier's film version of "Henry V."

Olivier himself had a different image problem. He slipped easily into the title roles of "Henry V" (1945) and "Hamlet" (1948), for he was noted as a stage actor, and among his best-known previous films were the period pieces "Wuthering Heights" and "Pride and Prejudice." For Olivier, becoming a believable Shakespearean hero was easy; the hard part came later, when he had to over-

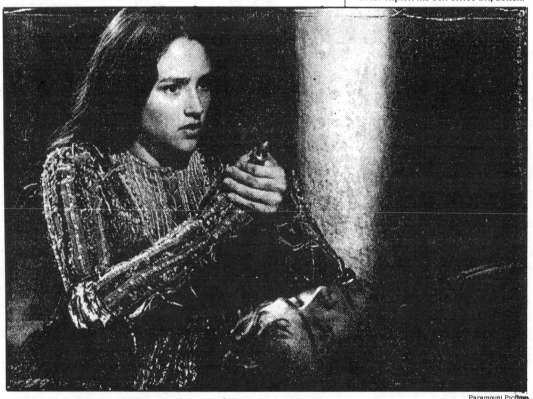

Olivia Hussey and Leonard Whiting in Franco Zeffirelli's "Romeo and Juliet"— beauty and savvy

come his pre-modern screen image to play the vaudevillian Archie Rice in "The Entertainer" (1960).

For most movie actors, though, Shakespeare is the ultimate challenge. Sometimes they serve each

When it comes to playing Shakespeare on the screen, the unknowns have all the advantages.

other well. Dustin Hoffman could not totally blend into the ensemble of "The Merchant of Venice"; he was, after all, the reason people came. But he portrayed Shylock in deeply-felt human terms, not as a star turn. His precise yet explosive manner actually seemed more effective on stage than on screen, where it sometimes threatens to call too much attention to itself. Shakespeare can lurk in the least likely places; it's encouraging to know that sometimes he hides out in Hollywood. ☐

1991 Ja 6, II:13:5

Not Without My Daughter

Directed by Brian Gilbert; written by David W. Rintels, based on the book by Betty Mahmoody with William Hoffer; director of photography, Peter Hannan; edited by Terry Rawlings; music by Jerry Goldsmith; production designer, Anthony Pratt; produced by Harry J. Ufland and Mary Jane Ufland; presented by Pathe Entertainment, Inc.; distributed by M-G-M. Running time: 117 minutes. This film is rated PG-13.

Betty	Sally Field
Moody	Alfred Molina
Mahtob	Sheila Rosenthal
Houssein	Roshan Seth
Ameh Bozorg	Mony Rey
Mohsen	Georges Corraface

By VINCENT CANBY

"Not Without My Daughter," a title that sounds like a line from a traveling salesman joke, is the first major clinker of the year. It's a seriously intended movie that goes grossly comic when it means to be most solemn. It's a tale of mother love and freedom that is both mean and narrow.

The source material is the true story of Betty Mahmoody, an American woman married to Moody, an Iranian doctor who lived in the United States for 20 years. In 1984, against her better judgment, Mrs. Mahmoody went to Iran with her husband their small daughter, Mahtob two-week visit with his fami'

Once in Teheran, Mood' or, as the movie portra' verted to his more pri' ality. Having sworn c protect his wife and see them safely k cided to remain the success of ' ni's fundame'

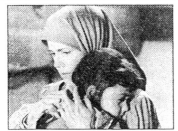

Yoni Hamenachem/MGM

Sally Field, left, as Betty Mahmoody, and Sheila Rosenthal as her daughter.

Mrs. Mahmoody was told that she could leave, but that her daughter would have to stay. As the title spells out, she would have none of this. After 18 months, she and Mahtob finally escaped with (according to the film) the help of some kindly Kurds and a rich Iranian, who talks fondly of the good old days.

"Not Without My Daughter" probably didn't set out to be biased against all things Muslim, but when such a complex, loaded subject is treated so witlessly, the effect is certainly bigoted.

The movie was written by David W. Rintels and directed by Brian Gilbert, mostly on locations in Israel. Sally Field stars as Betty who, as she plays her, is a sincerely unpleasant, rather stupid woman.

In Paris, she would be the type of tourist to insist on eating at McDonald's. In Teheran, absolutely everything earns her complacent disapproval. With just a few minor changes, "Not Without My Daughter" might have become a hilarious in-law joke.

On their arrival at the Teheran airport, Betty, Moody (Alfred Molina) and Mahtob (Sheila Rosenthal) are overwhelmed by the members of Moody's family. The in-laws descend on them like an attack force out of "Lawrence of Arabia," the harpylike women, who are dressed in blac' chadors, wailing as if for the dead

Poor Betty herself is require put on a chador. It's the na dress code. She obliges but fe pelled to ask Moody: "Ar' afraid of women's sexuali it's a different culture ' still don't understand '

•

From the time family arrive in flees, the sca' eyes with r thunderous

The o' comes ' he sw Bett str A

Lionheart

Directed by Sheldon Lettich; screenplay by Mr. Lettich and Jean-Claude Van Damme, story by Mr. Van Damme, based on a screenplay by S. N. Warren; director of photography, Robert C. New; edited by Mark Conte; music by John Scott; production designer, Gregory Pickrell; produced by Ash R. Shah and Eric Karson; released by Universal Pictures. Running time: 105 minutes. This film is rated R.

Lyon	Jean-Claude Van Damme
Joshua	Harrison Page
Cynthia	Deborah Rennard
Helene	Lisa Pelikan
Nicole	Ashley Johnson
Russell	Brian Thompson
Sgt. Hartog	Voyo
Moustafa	Michel Qissi

By JANET MASLIN

New dimensions in decadence: in "Lionheart," Jean-Claude Van Damme engages in gory clandestine street fights that are staged for the amusement of bejeweled Eurotrash. The mighty Mr. Van Damme, whose specialty is a vicious flying kick to the kidneys, can perform well under these circumstances (though perhaps not any others). But the film st exaggerates his feats with fancy e ing and overloads its soundtracl gasps, slaps and other pun sounds of battle. Using ta these, Woody Allen could ' action hero, too.

Belgium remains be' lace and waffles tha' sels-born Mr. Van ' nonetheless made years, including borg" and "Ki' memorable b ningly limit flexing, s Should a all-new mig' be r

half-dressed fight promoter who ogles Lyon outrageously even as she forces him into one gruesome slugout after another.

One fight takes place in a nearly empty swimming pool, for the delectation of giddy, bikini-clad reveler another is set in an underground rage, where one glamorous b spectator naughtily savors th of blood. It is not clear whe film is intended as critical tary on a world going t handbasket, or simply a

•

"Lionheart" is r requires accom adult guardian violence and e

Re
r

films like Luis Buñuel's classic "Olvidados" and Héctor Babenco's "Pix- | ote," the obvious ancestors of "Rodrigo D."

1991 Ja 11, C10:5

FILM VIEW/Caryn James

Frugging With Wolves

I N HIS EPIC, ENTERTAINING AND WILDLY SUCcessful "Dances With Wolves," Kevin Costner plays the most blissed-out Civil War soldier ever to face the frontier. As Lieut. John Dunbar, he is a Union officer who at first finds himself alone in Indian territory in the 1860's, and eventually "finds himself," in the 1960's sense of the term, when he adopts a Sioux identity and name, Dances With Wolves. "As I heard my Sioux name being called," he says, "I knew for the first time who I really was."

An old-fashioned frontier movie, the first film Mr. Costner has directed is also high on peace, joy and love. "Dances With Wolves" comes wrapped in a double layer of nostalgia: for the beloved long-gone westerns it evokes with great panache, and for the 1960's "make love, not war" sensibility that it clumsily lays over the genre. It offers audiences a comfortable escape into a politically correct, environmentally aware western.

This odd blend has made "Dance With Wolves" surprisingly lucrative. The film has already taken in more than $60 million at the box office and is gaining business by the week. On the strength of its success, the reissue of Michael Blake's 1988 novel, on which he based his screenplay, is the No. 1 paperback fiction book on today's New York Times best-seller list, a position it has held for several weeks.

Audiences adore this movie. They love what is best about it: high-spirited action, exotic period details, an unflag-

Kevin Costner's hit packs a double dose of nostalgia: for the 1860's and the 1960's.

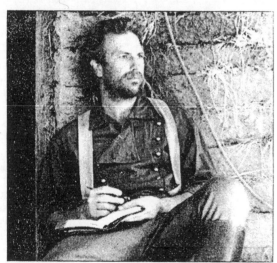

Orion Pictures

Mr. Costner as Lieut. John Dunbar of the Union Army—communing with the Maharishi?

ging narrative. Mr. Costner is not an innovative director, but he is adept at picking up where traditional westerns left off.

The scenery is expansive and gloriously photographed: a star shoots through the glittering night sky; an Indian war party rides slowly, silhouetted against a blood-red background. There are elaborate Indian costumes of feathered headdresses and layers of beads. In an eloquent scene, a white woman named Stands With a Fist, who has lived with the Sioux since childhood, haltingly recaptures her half-forgotten English language to communicate with Dunbar. Mary McDonnell as Stands With a Fist and Graham Greene as an Indian holy man named Kicking Bird give performances as graceful as any on screen at the moment. "Dances With Wolves" offers three hours of easy, intelligent escape into a familiar movie world.

Yet viewers are also seduced and reassured by what is, from a critical point of view, the film's major failing: the all too-prescient Dunbar floats through the movie like someone who is time traveling back a century. He talks like a 20th-century man. One recent audience laughed with Dunbar, not at him, when he asked his horse in a slangy tone, "What are you looking at?"

More distracting, he sees through 1960's eyes. How else to explain the cosmic consciousness that shapes his reaction to a buffalo stampede? The centerpiece of the film is an exhilarating buffalo hunt that John Ford or Howard Hawks might have been proud of. Hundreds of buffaloes race down a hill toward the camera. Now they fill the screen, flying across it. Now the camera aims at countless hooves heading in our direction. Indians on horseback ride alongside this stampeding herd, shooting spears and arrows.

In old westerns, this was macho stuff. Seen through the depressive eyes of the 1990's, it would be brutal. But when Dunbar returns to his lonely Army post after joining in the hunt, here is what he writes in his journal, what we hear in Mr. Costner's flat, gentle voice: "It seems that every day ends with a miracle here, and whatever God may be, I thank God for this day." Of the Indians, he writes: "I had never known a people so eager to laugh, so devoted to family, so dedicated to each other, and the only word that came to mind was harmony." As we hear this little meditation, Mr. Costner stands in the center of the screen surrounded by rays of golden-red light. It's as if he and the Beatles have just visited the Maharishi Mahesh Yogi.

Dunbar's historical awareness is also curiously out of place in the Old West. When he sees buffaloes that have been needlessly slaughtered, not for food but for their hides, he writes that only white men would have done such a thing, for they are "a people without value and without soul, with no regard for Sioux rights." The phrase and the notion of "Sioux rights" sit more comfortably in the 20th century than in the 19th. At the very least, such scenes make you want to ask, "Hey, how'd he know that?"

As a director, Mr. Costner clearly knew what he was about. In his introduction to "Dances With Wolves: The Illustrated Story of the Epic Film" (a companion book unexpectedly rich in details about Indian culture), he astutely calls the film "a romantic look at a terrible time in our history," one that he hoped would be "as great as the movies that shaped my love of them." It is not as great because it is not as fresh, but it is worthy of Mr. Costner's obvious affection for the movies.

In the same book, the screenwriter's 1960's jargon clangs just as badly as it does in the movie. "I love the animals with whom we share the planet," Mr. Blake writes. "I love the humbling quality of open space."

Yet together these two love-obsessed approaches work like a commercial charm. Viewers enjoy a rousing old adventure and still feel they can save the planet. By assuming the point of view of Dunbar, the good and prescient white man, "Dances With Wolves" becomes an appealing hybrid, a western without guilt. □

1991 Ja 13, II:13:5

Allen and Farrow: New Meaning for Collaboration

By VINCENT CANBY

When Sally, the cigarette girl and aspiring actress in "Radio Days," gets her big chance to play Chekhov, the broadcast is canceled minutes before air time because of the Japanese attack on Pearl Harbor.

"Who," says Sally, squeaky-voiced and much affronted, "is Pearl Harbor?"

Cecilia, the heroine of "The Purple Rose of Cairo," which is set in the depressed 1930's, is a waitress who breaks two dishes for every one she successfully delivers. Smacked with regularity by her out-of-work husband, Cecilia is Jell-O when a handsome fellow wearing a pith helmet, a character inside the movie she's watching, steps down from the screen and sweeps her out of the small-town theater.

"I just met a wonderful man," Cecilia later tells her sister. "He's fictional, but you can't have everything."

Sally and Cecilia, who inhabit universes in which the mundane and the miraculous are inextricably merged, are just two of the enchanting women that Woody Allen has written and directed for Mia Farrow since 1982.

Now it seems as if they've all been leading up to "Alice," Mr. Allen's fine new comedy about the cockeyed, herb-induced liberation of a rather solemn, inhibited Central Park West wife and mother.

•

In the world of movies, where relationships that survive more than two or three productions are rare, the collaboration of Woody Allen and Mia Farrow is both sublimely eccentric and a measure of the personal nature of Mr. Allen's cinema. "Alice" is their 11th film together, which is certainly singular and possibly unique, at least in American films.

Charlie Chaplin adored his leading ladies but was inevitably divorced from them before any sort of long-term professional relationship was established. Blake Edwards and Julie Andrews are a continuing team. Their collaborations are celebratory ("Darlin' Lili," "Victor/Victoria," "That's Life"), though not frequent.

The Allen-Farrow relationship is more like the Allen-Diane Keaton relationship, which resulted in five films and made the actress a star.

Federico Fellini's collaborations with his wife, Giulietta Masina, were rich and central to his earlier work, particularly to the matchless comedy, "Cabiria." That relationship continues to this day but, with the exception of "Ginger and Fred," offscreen.

As the Fellini films turned increasingly self-searching and self-satirizing with "La Dolce Vita" and "8½," Miss Masina became more of an unseen emotional accomplice to her husband than an actual presence in his films. She was the star and dominant figure in "Juliet of the Spirits," but the director's point of view was shifting from that of the one who is loved to that of the lover.

After "Juliet of the Spirits," the principal screen presence in the Fellini cinema is that of Marcello Mastroianni, the director's surrogate.

What the young Jean-Pierre Léaud is to François Truffaut's cycle of films about Antoine Doinel, Mr. Mastroianni is to the sometimes inspired comedies of Mr. Fellini's restless middle years.

The actor is both an idealized representation of the artist and a collaborator whose particular character and talent take the work far beyond the limits of real-life into the realm of exalting fiction.

•

The nature of such continuing collaborations between the film maker and the performer is complex and not easily analyzed even by the parties to it.

How do private feelings enrich the art or inhibit it? To what extent do the demands of the art change the direction of the private lives, sometimes, perhaps, even consume them?

The best that can be done is to chart the collaboration and describe the results.

When Mia Farrow entered the work of Woody Allen in "A Midsummer Night's Sex Comedy," she was known mainly for her delicate performance in Roman Polanski's "Rosemary's Baby." The success of that film put her in danger of becoming the screen's most formidable waif.

There's still a bit of the waif, but now there's also much, much more.

In her first Allen film, she plays Ariel Weymouth, a free spirit with some of the amiable klutziness of Annie Hall about her. Ariel looks like a golden-haired Botticelli angel, but she has a reputation as long as your arm.

In addition to the ambitious Sally and the incurably romantic Cecilia, three of the more memorable Farrow performances are the common-sensical psychiatrist, Eudora Fletcher, who successfully treats the "chameleon man" in "Zelig," Tina Vitale, the teased-blond doxy in "Broadway Danny Rose," and the unexpectedly staunch wife and mother, Hannah, in "Hannah and Her Sisters."

Just as he has shaped her career, she appears to have given direction to his. After her appearance in "A Midsummer Night's Sex Comedy," there is, among other things, a new sense of community in his work, of family and children.

This is most somberly and successfully expressed in "Hannah and Her Sisters" (which features a stunning performance by Maureen O'Sullivan, Miss Farrow's real-life mother) and most riotously in the brand-new "Alice."

It's also there in "September," about the claustrophobic relationship of a mother (incomparably played by Elaine Stritch) and her daughter (Miss Farrow), who never quite measures up.

"September" isn't Mr. Allen's most successful screenplay, but his elegant, fluid direction suggests that he might be the one to discover the screen life in Chekhov's "Seagull," with a Mme. Arkadina played by Miss Farrow.

•

Nine years ago, such a thought would have been unthinkable.

For Mr. Allen to do Chekhov, though, would be to interrupt one of the most astonishingly productive spasms of creativity in screen history. It's 21 years since "Take the Money and Run" and still he can't slow down.

Because the Allen films can now be seen to be so closely linked, each succeeding film being, in some fashion, related to the ones that have gone before, it's no longer especially productive to cite one film as better or worse than the others.

They form a continuum of a sort whose only antecedents are in the literature of the written word. Of the 20 films that Mr. Allen has written and directed to date, Miss Farrow has been associated with more than half.

She has appeared as an equal member of an ensemble acting company ("A Midsummer Night's Sex

When the one beloved becomes the one who would love.

Comedy"), sometimes as supporting player to someone else's star part (Gena Rowlands in "Another Woman"), sometimes as the star ("The Purple Rose of Cairo"), and some-

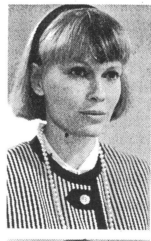

Photographs by Brian Hamill/Photoreporters

Woody Allen and Mia Farrow in some of the movies with which he has shaped her career. Clockwise from top right: "Radio Days," "Broadway Danny Rose," "The Purple Rose of Cairo" and "Alice."

times as both the star and a member of the ensemble, as in the joyous "Alice."

Concurrently the director and writer's talents (as well as his acting abilities) have flourished and matured. Mr. Allen's stand-up comedian's gift for free association, which dictated the narrative form of "Take the Money and Run," became wildly visual in the slapstick comedy of "Bananas" and "Sleeper."

Since "The Purple Rose of Cairo," his impatience with conventional narrative logic has evolved into the magic that seems to be the perfectly normal, rational order of things in "Alice."

In her search for self-fulfillment, Miss Farrow's Alice Tate levitates, becomes invisible and is able to adopt (temporarily) a different identity. The result is both moving and marvelously funny.

One of the most magical things about "Alice" is the way Mr. Allen persuades the audience to accept not only magic but also what seem to be some deeply felt observations about life.

In "September" and "Another Woman," these deeply felt observations have sometimes produced unintentional laughter. It's a risky minute in "Alice" when Miss Farrow, as a woman who worries that her children are being brought up with the wrong values, dashes off to India to work with Mother Teresa. Were the character less firmly rooted in its own reality, the movie would go sailing out the window.

It doesn't. The way in which Alice achieves salvation, which, of course, few women watching the movie can afford, is simultaneously triumphant and an unkind comment on the rich, upper-middle-class society that has bred her.

Mr. Allen has always been a first-rate satirist. One of the most caustic comments ever made in a movie about the cant of selfhood, a craze of the 1980's being carried over into the 1990's, is in "Broadway Danny Rose": the parrot who sings "I Gotta Be Me."

It's a cinch that the same parrot also knows how to be his own best friend.

If Mr. Allen believes most people to be parrots, he takes Alice Tate seriously. He believes in her and is able to give conviction to that belief through a character who is quite unlike any other in screen literature.

•

"Alice" is a personal triumph for both Mr. Allen and Miss Farrow, in part, at least, because of a fascinating shift in their professional relationship.

There had been hints of things to come in earlier films, particularly in "The Purple Rose of Cairo." The shift is manifest in "Alice" in the scene in which Alice decides to throw caution to the wind and have an extramarital affair with Joe (Joe Mantegna), a musician.

Sitting on the bed with Joe, Alice is overwhelmed by precoital guilt. She's eager to get on with it, but she talks nonstop to put it off. She says in desperation that she thinks she might be out of practice. Joe tells her to relax. "It's not like juggling."

Gently he pulls her down on the bed. With her last words, "I'm going to be going on a diet next week," it's suddenly clear that Miss Farrow is not only Mr. Allen's Giulietta Masina but also his Marcello Mastroianni.

In her, the two functions become one. She's both the one beloved and the one who would love, that is, Mr. Allen's stand-in. The collaboration is complete.

Alice Tate is her own woman, but she's also Danny Rose, Zelig and any number of other Woody Allen roles. She's a sheep in wolf's clothing.

Magic.

1991 Ja 15, C11:3

The Garden

Written and directecly by Derek Jarman; photography by Christopher Hughes and Mr. Jarman; edited by Peter Cartwright; music by Simon Fisher Turner; produced by James MacKay; production company, Basilisk, Channel Four, British Screen, ZDF, Uplink. At Film Forum 1, 209 West Houston Street. Running time: 90 minutes. This film has no rating.

WITH: Tilda Swinton, Johnny Mills, Philip MacDonald, Roger Cook, Kevin Collins, Pete Lee-Wilson, Spencer Lee and Jody Graber

By JANET MASLIN

The spirit of "The Garden," Derek Jarman's virtually wordless 90-minute assemblage of turbulent images, is a peculiar blend of reflectiveness and fury. Mr. Jarman, whose 1987 film "The Last of England" had a comparable free-associative vehemence, this time turns his thoughts to AIDS, Christianity and intolerance, combining these themes into a feverish vision of far-reaching decay.

The passion with which Mr. Jarman attempts this is not accompanied by any fondness for clarity, and so "The Garden" is as mystifying as it is intense. While its larger ideas emerge broadly and unmistakably, there is much to ponder — in, for instance, an image of the Twelve Apostles as 12 women in babushkas, sitting at a table by the seaside as they solemnly run their fingers around the edges of wine glasses to create an ominous hum.

•

"The Garden," the first of six films in the touring international series the Cutting Edge III (which can be seen at the Film Forum), returns frequently to a bitterly modified biblical motif in which Christ is replaced by two neatly dressed, sweetly smiling gay men. At first these men are seen as innocent lovers, though their bliss is intercut with the anguished cries of a Madonna-like figure whose motivation, like everything else here, is rather too widely open to interpretation.

Later, the two men are harassed and persecuted, at one point even tarred (or chocolated) and feathered by three sinister Santas who sing "God Rest Ye Merry, Gentlemen" as they sneeringly inflict pain. Eventually, the two are met en route to their own crucifixion by a tattered Mary Magdalene figure, a transvestite in long gloves and glittering gown.

•

Mr. Jarman's visual sense easily eclipses his conceptual talents. And "The Garden" has a burning, kaleidoscopic energy to compensate for the facile nature of some of its more unavoidable thoughts. In addition, it has the genuineness and pathos of Mr. Jarman's own situation: as someone who has tested HIV-positive, he reads a moving elegy to lost friends at the film's end, and consis-

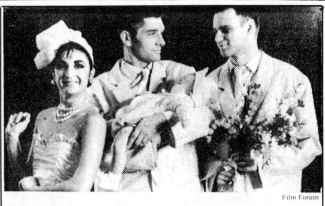

Film Forum

International Jessica Martin, Kevin Collins and Johnny Mills appear in Derek Jarman's "Garden"

tently colors these visions with the shadow of illness. One of the film's more haunting images is that of a man lying in bed at the ocean's edge, as friends raising torches dance in a circle around him.

Mr. Jarman's highly personal vision in "The Garden" also invokes imagery of a nuclear power station and a flower garden, both of which exist more or less in his own backyard. The flowers are used quite hauntingly as evocations of hope and beauty in a landscape that is otherwise so bleak.

1991 Ja 17, C16:5

Men of Respect

Written and directed by William Reilly; director of photography, Bobby Bukowski; edited by Elizabeth Kling; music by Misha Segal; production designer, William Barclay; produced by Ephraim Horowitz; released by Columbia Pictures. At Carnegie Hall Cinema, Seventh Avenue at 57th Street. Running time: 107 minutes. This film is rated R.

Mike Battaglia	John Turturro
Ruthie Battaglia	Katherine Borowitz
Bankie Como	Dennis Farina
Duffy	Peter Boyle
Lucia	Lilia Skala
Sterling	Steven Wright
Charlie D'Amico	Rod Steiger
Mal	Stanley Tucci
Don	Carl Capotorto

By JANET MASLIN

IN the 1920's it was presented disastrously, with actors (chief among them Lionel Barrymore) wearing red and silver masks, and sets that looked like abstract arches rather than the obligatory heaths and castles. In the 1930's, Orson Welles transposed it to Haiti and staged a so-called voodoo version. In the 1960's, it became a political joke on the Johnson Administration. And now "Macbeth" is a story of New York gangsters, in particular a mad-dog hoodlum (Mike Battaglia) and his ambitious, highly unscrupulous wife (Ruthie).

Only at this time of year would a film as appealingly nutty as William Reilly's

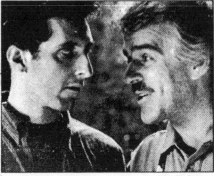

Columbia Pictures

Eccentricity and nerve — John Turturro, left, and Dennis Farina in "Men of Respect."

"Men of Respect" feel so perfectly at home. January is traditionally the burying ground for the year's most unclassifiable releases (today also brings a sweet-tempered animal saga involving man-eating wolves and a love story in which Mr. Right is a high-rolling Lithuanian-American real-estate sharpie). Even in this tumultuous atmosphere, "Men of Respect" — which opens today at the Carnegie Hall Cinema — is hard to beat when it comes to eccentricity, weird inventiveness and sheer nerve.

This is a Macbeth that begins with a shootout on City Island, that has Ruthie attempting to banish her guilt by scrubbing the bathtub, that has Mike Battaglia confusing the blood of the friend he has murdered (Bankie Como) with spilled Chianti. It's a Macbeth with a distinct sense of humor, although the essential seriousness of the venture is never compromised by Mr. Reilly's playful streak. "My son Philly in this business? Over my dead body!" declares Bankie to the witchy old woman (Lilia Skala) who tells his fortune, and of course he is proven right. "We're not outta the woods yet," says Mike Battaglia, at the point in Shakespeare's story that has Birnam Wood moving ever closer.

Mr. Reilly, 15 years ago an actor in an Off Broadway production of "Macbeth" and now this film's writer and director, is careful not to let any of this become too painful. If his goal was to make a contemporary version of this story that is effective on its own terms, then certainly he comes close. The leap from the Bard to the modern-day Mafia is in any case less farfetched than it sounds, as evidenced by the "Lear"-like overtones of Francis Ford Coppola's far more Shakespearean film "The Godfather Part III." And the potential here for wit is at least as rich as the potential for disaster.

John Turturro plays Mike Battaglia as a wild-eyed, desperate weakling, a mad-dog killer who would be at home in any modern gangster saga. Rod Steiger, wearing gold chains and a lot of carefully coiffed hair, plays the soon-to-be-dispatched Mafia don, and dispenses orders from a castle-like suburban house that makes an amusingly apt setting. The Battaglias

themselves conduct business in a dark, fortress-like Greenwich Village restaurant that has a garden, in which Ruthie eventually begins wandering nocturally with a flashlight as she tries to assuage her guilt. Mr. Reilly can allow Ruthie to wash her hands frantically in a birdbath without spoiling the mood of this enterprise.

•

As Ruthie, Katherine Borowitz — who had a brief but memorable scene in "Internal Affairs" as the impassive wife of a man hiring a killer to murder his parents — has a wry, angular look a bit like Anjelica Huston's and a similarly no-nonsense manner. She fits in well with the screenplay's hearty pragmatism, advising her husband that "in this life, there's no safe standin' still." At another point, she warns Mike about the Don, telling him, "Charlie respects the fat end of a bat, the sharp end of a stick. Charlie respects what he fears — and that ain't you." Direct, but definitely to the point.

Also in the cast are Peter Boyle, who makes a strong and chilling Duffy (the murder of this Macduff's wife and child is accomplished with a car bomb, and winds up on the front page of The Daily News). Dennis Farina makes a sturdy Bankie and eventually an eerie ghost (the apparition is filmed in gory slow motion, à la "Taxi Driver"). Stanley Tucci and Carl Capotorto play the murdered Don's two sons, formerly Malcolm and Donalbain and now Mal and Don.

Mr. Reilly's direction is muted and somber, but the film manages to be quietly outrageous all the same. From the witch's modern-sounding advice to Mike Battaglia ("You only have to be yourself"), to the satin-lined attaché case in which the murder weapon is presented, to the theatrically bad weather ("Hell of a downpour out there tonight"), this ingenious mobster "Macbeth" knows its territory, both new and o'd.

•

"Men of Respect" is rated R (Under 17 requires accompanying parent or adult guardian). It includes brief nudity and several gory episodes.

1991 Ja 18, C1:1

Rikyu

Directed by Hiroshi Teshigahara; screenplay (Japanese with English subtitles) by Genpei Akasegawa and Mr. Teshigahara, based on a book by Yaeko Nogami; photographed by Fujio Morita; music by Toru Takemitsu; produced by Yoshisuke Mae and Hiroshi Morie; released by Capitol Entertainment. At Lincoln Plaza 2, Broadway at 63d Street, in Manhattan. Running time: 116 minutes. This film has no rating.

Sen-no Rikyu Rentaro Mikuni
Hideyoshi Toyotomi Tsutomu Yamazaki
Riki .. Yoshiko Mita
Kita-no-mandokoro Kyoko Kishida
Nobunaga Oda Koshiro Matsumoto
Ieyasu Tokugawa Kichiemon Nakamura

By VINCENT CANBY

Hiroshi Teshigahara's beautiful, very fine "Rikyu" reveals itself with a cherished Japanese kind of reluctance to impose on the stranger.

The time is the late 16th century, one of the most tumultuous eras in Japanese history, when a petty warlord named Hideyoshi Toyotomi, whose mother was a peasant, fought his way up to become the most powerful man in the country.

In a series of battles and through diplomatic maneuvers, Hideyoshi defeated all rivals to unify the warring provinces into the nation that was to become modern Japan. One of his first tasks was the construction, in 1583, of the great castle that still dominates Osaka.

In addition to being a soldier and a military strategist who had world conquest in mind, Hideyoshi was also an innovative political administrator. He revised tax laws, encouraged foreign trade and instituted a series of land surveys.

•

Mindful of the unsettling results of his own ascent, he then attempted to freeze the class structure by forbidding anyone to change his occupation. Hideyoshi died in 1598 in Korea, in a campaign whose aim was the subjugation of China.

Only a few of these facts will be found in "Rikyu," whose method is indirect. It charts a time of violent change not in grand, Kurosawa-like battles and court intrigue, but in the private relationship of two remarkable men.

Though the confrontation is deadly, the film's surface is mannered, serene. It's as if "Rikyu," like its main characters, is observing the rules of a society in which gestures must never betray the appearance of equilibrium.

On one side of the struggle is Hideyoshi (Tsutomu Yamazaki), the rough, brilliant parvenu who aspires to cultural refinements suitable to his new station in life. On the other side is Sen-no Rikyu (Rentaro Mikuni), the master who is credited with having made the Japanese tea ceremony into a ritual of Zen Buddhist simplicity and intensity.

•

When the film starts, Hideyoshi has been a student of Rikyu for five years. What is called the Way of Tea is something much more complicated than handling cups, pots and heat sources without spillage. It's not to be learned in a crash course. It takes time, rather like Freudian analysis. There are no shortcuts.

As Rikyu demonstrates, the Way of Tea is a way of comprehending the universe. It informs the spirit that governs the consciousness that dictates behavior. In the course of his apprenticeship, Hideyoshi learns all of the right gestures, while refusing to deny the pre-eminence of his ambitions in the world.

A break becomes inevitable when Hideyoshi, who seeks his teacher's approval in all things, demands that Rikyu endorse the planned conquest of China. The old man politely equivocates. Hideyoshi's advisers, afraid of Rikyu's influence, scheme to have him exiled from the court.

This could be called the plot if "Rikyu" were in any way a conventional film, which it isn't. Though it is magnificent to look at, "Rikyu" proceeds with a minimum of cinematic flourishes. Everything is condensed, simplified, each sequence being utterly specific but also of general significance.

•

It's not the kind of movie with which most of us are familiar. It demands that the audience look at it with a willingness to submit to its tempo, which is measured, and to a

consideration of its concerns: art and politics, action and contemplation, flesh and spirit.

These concerns are not exactly esoteric, but their importance may seem to be.

Juzo Itami, the director of "The Funeral," "Tampopo" and "A Taxing Woman," once described the differences between Japanese and American films as reflecting the fundamental natures of the two societies. American films, he said, tend to be richer, more packed with narrative detail, in order to be comprehensible to audiences of a great variety of ethnic, economic and educational backgrounds.

"Living in Japan," he said, "is like living in a nation of twins." Because everyone shares the same cultural influences, Japanese film makers can work in a kind of shorthand. A word, a mannerism or a visual reference can carry information that would require sometimes lengthy, particular explanation in an American film.

"Rikyu" is just the sort of Japanese film Mr. Itami is talking about. Audiences in Japan come to it already familiar with Hideyoshi and the age he briefly dominated, and probably also aware of Rikyu and his fate.

As a result, the film is less a recapitulation of the story than a reconsideration of it from the vantage point of someone living through Japan's late 20th-century economic boom. "Rikyu" will demand a certain amount of devoted concentration of American moviegoers, but the rewards are there.

Mr. Teshigahara is best known in this country for his austere parable, "Woman in the Dunes," based on the Kobo Abe novel, released here in 1963. He is also a director of documentaries, including "Jose Torres" (1959), which he shot in this country, and "Antonio Gaudi" (1984).

His interests are not tied to commercial films. He is also a sculptor, ceramicist, environmental artist and flower arranger. In 1980, he succeeded his father as the grand master of the Sogetsu International School of flower arranging. That's a fairly wild background for movie making today.

Teshigahara Productions

Tsutomu Yamazaki

Yet each of these activities comes to bear at one point or another in "Rikyu." There's always an awareness of design, color, texture. There are few close-ups. Man is seen in relation to the rooms, houses, palaces or landscapes he inhabits.

What would be crises of emotion in another film are treated formally, as if in public, distant in the way of something remembered, not re-created.

The movie is very studied, and means to be. Nothing seems spontaneous, but neither is it lugubrious.

This is exemplified in the elegant performances of Mr. Yamazaki, the hip star of "The Funeral," "Tampopo" and "A Taxing Woman," and Mr. Mikuni, who is memorable as the old con artist with the Lolita complex in Mr. Itami's "Taxing Woman Returns."

In the production notes that accompany "Rikyu," Mr. Teshigahara admits to having initially had "a sense of impatience" with the tea ceremony.

He became interested in it, he says, through what he found to be the perfection of antique ceramic bowls, created to meet the requirements of the ceremony as it evolved largely through the influence of Rikyu.

His film won't send anyone out of the theater in a headlong rush to find a tea ceremony. It is a leisurely, contemplative work that is its own best, Zen-like explanation. The effect is liberating.

"Rikyu" opens today at the Lincoln Plaza 2.

1991 Ja 18, C8:1

Once Around

Directed by Lasse Hallstrom; written by Malia Scotch Marmo; director of photography, Theo van de Sande; edited by Andrew Mondshein; music by James Horner; production designer, David Gropman; produced by Amy Robinson and Griffin Dunne; released by Universal Pictures. Running time: 115 minutes. This film is rated R.

Sam Sharpe Richard Dreyfuss
Renata Bella Holly Hunter
Joe Bella Danny Aiello
Jan Bella Laura San Giacomo
Marilyn Bella Gena Rowlands
Gail Bella Roxanne Hart
Tony Bella Danton Stone
Rob .. Griffin Dunne

By JANET MASLIN

"Once Around" asks this question: Should the father of a naïve, sheltered, not very self-sufficient young woman be disturbed if she takes up with a noisy, ostentatious older man who has made far too much money hustling time-share condominiums in the tropics and whose idea of enlivening a family gathering is hiring a belly dancer? It would be a much better film than it is if it had an answer.

"Once Around" is genial, but it lacks the kind of emotional compass that ordinarily indicates to an audi-

Jim Bridges/Universal Pictures

Richard Dreyfuss as Sam Sharpe, and Holly Hunter as Renata Bella.

ence where things stand. Not until the story ends is it clear how Sam Sharpe, the tycoon and wild extrovert played by Richard Dreyfuss, is meant to be understood.

The fault is not in the characterization, since Mr. Dreyfuss, as ever, gives his all and then some. His extravagant gusto is one of the film's more enjoyable aspects. But he exists almost in a vacuum, despite the large and lively Bella family, with whom he becomes rambunctiously involved once he meets Renata (Holly Hunter), the family's desperately marriage-minded daughter. The Bellas manage to talk incessantly about Sam without saying much about how they feel.

Lasse Hallstrom's earlier film, the Swedish "My Life as a Dog," had a sweetness and whimsy that are also apparent in this one. But this director is badly out of place in Boston, where most of "Once Around" is set, and so are the actors who struggle to maintain heavy regional accents. Not much about the Bellas, their house, their squabbling or their celebrating seems truly convincing. The screenplay, by Malia Scotch Marmo, is often strenuous about the characters' earthiness, as if that somehow made them honest.

Renata Bella is first seen surviving the wedding of her sister (Laura San Giacomo) and being jilted by her own longtime beau (Griffin Dunne, who also co-produced the film with Amy Robinson). "I want to hear the exact words you use," she says, in nudging him toward possible nuptials. He succinctly replies, "I don't ever intend to marry you." This sends a weepy Renata into the bed of her hugely indulgent parents (Gena Rowlands and Danny Aiello) and later on a trip to St. Martin in hopes of taking up real estate salesmanship and drowning her sorrows.

There she meets Sam Sharpe, whose flowing white locks and banana-colored suit make him look more like Colonel Sanders than the answer to Renata's lovelorn prayers.

Nonetheless, these two are instantly united, singing "Fly Me to the Moon" together only moments after they have been introduced. Almost as quickly, they have returned to Boston, driven up to the Bella house in Sam's limousine and set about unnerving the rest of the Bellas on a full-time basis. The film makes no further attempt to flesh out Sam by explaining who Sam is, where he came from (other than Lithuania, which he mentions lovingly and often) and how he got this way.

Mr. Dreyfuss and Ms. Hunter have an easy, friendly rapport that seems destined to blossom into full-fledged movie romance someday. But so far, with "Always" and with this film, it hasn't happened. They make their way through this story cheerily but without much intensity, even though Ms. Hunter is so fiery a performer that she can seem to be laughing and crying at the same time. This kind of intensity makes the clinginess of her character that much harder to accept. It hardly helps that the screenplay calls for Mr. Dreyfuss to interrupt almost any stab at seriousness with some kind of a gag.

Mr. Aiello and Ms. Rowlands are persuasive, but they are asked to spend too much of the film reacting uncertainly to the antics of their would-be son-in-law. Only when they begin telling him off does the film cut through its own capriciousness and show a little grit.

The title refers to Sam in particular and to the film in general, at its most irritatingly antic, since Sam has a cute habit of driving around Boston's traffic circles for good luck. First he and then the film's other characters are allowed to do this enough times to make an audience dizzy.

•

"Once Around" is rated R (Under 17 requires accompanying parent or adult guardian). It includes some profanity.

1991 Ja 18, C12:4

Harshness of Soviet Life In Lungin's 'Taxi Blues'

"Taxi Blues" was shown as part of the 1990 New York Film Festival. Following are excerpts from Janet Maslin's review, which appeared in The New York Times on Oct. 1. The Russian-language film opens today at the Lincoln Plaza 1, Broadway at 63d Street in Manhattan.

From its first nighttime shot of a boisterous, glittering Moscow, Pavel Lungin's superb tragicomedy "Taxi Blues" presents a Soviet Union that is new to the screen. Even without the rollicking byplay that temporarily unites the film's two central characters, a debauched Jewish musician and a bitter, tormented, vaguely anti-Semitic cabby, "Taxi Blues" would be a haunting travelogue filled with raw, pitiless glimpses of a troubled society.

As it is, Mr. Lungin makes these insights integral to his film's remarkable character study. The story's dreamy, alcoholic intellectual and its brutish, pent-up laborer play out their

class conflicts and shared longings against a backdrop that eloquently mirrors their unhappiness, and hints at the forces behind it. The blind way in which the principals lash out at each other makes their frustration that much more wrenching in the end.

Amazingly, in view of its underlying mournfulness, "Taxi Blues" is a robust and even buoyant film. Mr. Lungin, who won the best-director prize at the 1990 Cannes film festival for this debut feature, gives his rude, sprawling film tremendous vitality. And he displays vast sympathy and affection for two small figures so thoroughly hamstrung by their own rage.

The first of these, the jazz musician nicknamed Lyosha (Pyotr Mamonov), directs his loathing primarily at himself. Lyosha is first seen messily carousing with a group of party-hopping Moscow swells, and monopolizing the services of Chlykov (Pyotr Zaichenko), a stonily impas-

MK2 Productions

Pyotr Zaichenko

sive cabby, whom Lyosha insists on patronizing.

"Honest folk with clear eyes — you're our only hope," he says soggily, in vain hopes of starting a conversation with the driver. Then a would-be compliment: "You'd thrive in sub-zero weather in Siberia without matches." Chlykov remains indifferent to his passenger's every gambit until finally, when the other passengers have trailed off, Lyosha goes too far. After a long and expensive evening, he tries to disappear without paying his fare.

At first the enraged Chlykov tries to cope with this affront the way he copes with most things: through

An intellectual and a laborer play out class conflicts.

strenuous, bullheaded exercise. It doesn't help. Chlykov winds up stalking his passenger to the jazz club where Lyosha sometimes plays, glaring suspiciously at the musicians and dancers in his path as he charges down the hallway. He confronts Lyosha, who behaves as if mornings-after like this are nothing new, and he appropriates Lyosha's saxophone as collateral.

Chlykov takes the saxophone back to the rugged, much less rarefied atmosphere in which he ordinarily lives. In the back room of a cab station, which serves as car wash, steam bath and bar (under-the-counter alcohol is ubiquitous, as is heavy drinking), he has no luck in trying to fence such a thing.

Nor is he successful at the butcher shop where his girlfriend works, a shop where the butcher warns the staff, "Don't sell all the pork." Meat is dispensed on the sly here, as part of the stream of covert business transactions that is everywhere throughout the film. Chlykov hoards automobile tires in his grimy one-room flat; used clothes are eagerly traded; vodka is sold in alleys to long lines of eager customers. The pinups seen on walls are as apt to be Mercedes-Benzes as sexy women.

Chlykov quickly decides that he would rather have the musician himself than his instrument. And so he turns Lyosha into a virtual slave. To work off the debt, Lyosha is eventually sent to work at the airport carrying

bags and put through many other humiliations.

As these two men, shackled together by circumstance, career through the film's disheveled settings, they engage in lively debate. "Even Jews sell out for booze?" asks the disbelieving Chlykov, to a Lyosha who is so desperate for a drink that he's ready to try aftershave. Lyosha replies, "You drove us to it." This kind of camaraderie, bridging vast social gaps and inchoate prejudices, is fragile at best. The film never forgets that a truce this delicate can easily crumble.

1991 Ja 18, C12:1

White Fang

Directed by Randal Kleiser; screenplay by Jeanne Rosenberg, Nick Thiel and David Fallon, based on the novel by Jack London; director of photography, Tony Pierce-Roberts; film editor, Lisa Day; music by Basil Poledouris; production designer, Michael Bolton; produced by Marykay Powell; released by Walt Disney Pictures. Running time: 104 minutes. This film is rated PG.

Alex.............................Klaus Maria Brandauer
Jack ...Ethan Hawke

By JANET MASLIN

The fluffy white bunny seen at the beginning of "White Fang" has been attacked and devoured by a wild wolf pack almost before the opening credits are over. "White Fang," adapted from Jack London's tale of a wolf-dog hybrid and his encounters with civilized man, is a scenic and enveloping nature film about a young man and his beloved pet. But it is by no means strictly a children's film, and it certainly isn't "Lassie."

The screenplay, by Jeanne Rosenberg, Nick Thiel and David Fallon, has almost nothing to do with London's novel, which has only a slender human-related story (most of the encounters are between animals) and is presented from the wolf-dog's point of view. The screenwriters have invented a seasoned gold miner named Alex (a supremely calm Klaus Maria Brandauer) and a young man named Jack (Ethan Hawke), who comes to Alaska to pick up his late father's prospecting claim.

The essence of this story is familiar: boy meets wolf, boy loses wolf and so on. But it has been filmed handsomely and energetically by Randal Kleiser, who even in "The Blue Lagoon" showed some flair for faraway places and this time makes the most of the stunning Alaskan scenery. When Jack first arrives in the Klondike, he catches sight of a "golden staircase," an endless line of miners climbing a snowy trail high up a mountain peak. The film includes many other Alaska images as striking as this.

Soon after Jack arrives, he and Alex and a grizzled fellow miner (Seymour Cassel, in a brief but memorable turn) embark on a journey into the wilderness, taking with them sled dogs and the coffin of a friend. Before this man can be buried, the expedition becomes imperiled by a couple of gruesome but rivetingly staged mishaps.

Because the film's story has been stitched together out of separate episodes, it is held together chiefly by White Fang himself. First glimpsed as a puppy, he is later found in an Indian settlement working for Gray Beaver (Pius Savage), who views

him as a resource rather than a pet. When Jack finds White Fang living under these circumstances, he is saddened but helpless to woo the animal away. Only when White Fang is sold to the evil Beauty Smith (James Remar), who means to train him as a fighter, does Jack have an opportunity to retrieve and rehabilitate his animal friend.

The film's picturesque episodes include scenes of the young White Fang exploring an ice cave, glimpses of the young wolf fishing and a wolf-versus-bear fight featuring the animal actors Jed and Bart, both of whom perform well. Among the sorts of incidental touches that help sustain interest, the film also shows how gold is mined and tested. ●

"White Fang," which is rated PG, includes simulated violence involving animal attacks.

1991 Ja 18, C16:3

The Third Animation Celebration

A series of animated features from different countries produced by Terry Thoren. Running time: 90 minutes. These films have no rating. At Angelika Film Center, Mercer and Houston Streets, Manhattan.

By STEPHEN HOLDEN

Spurred by the successes of "Who Framed Roger Rabbit," "The Little Mermaid" and "The Simpsons," as well as by rapid advances in computer technology, animated film is in a boom phase. Just how many styles of animation are available to contemporary film makers, from traditional cartoons to clay animation to computer-generated drawings, is suggested by "The Third Animation Celebration," an anthology of 25 short animated films opening today at the Angelika Film Center.

Stitched together into a crazy quilt of images and moods, the films, all of recent vintage, run from 1 to 10 minutes. Nine countries are represented, with 11 of the films from the United States. The content varies from Eastern European surrealism like the Czechoslovak film maker Jan Svankmajer's "Darkness, Light, Darkness" to inane fluff like the music video of the rock group They Might Be Giants' version of "Istanbul (Not Constantinople)."

Artistically, the program is quite uneven. At the very least, it serves as an instructive industry sampler, though too often it shows technological flash attempting to cover up a dearth of wit and ideas. The American contributions, in particular, tend to suffer from an infatuation with visual effects, along with an attitude of curdled hipness. In "Snowie and the Seven Dorps," Candy Kugel and Vincent Cafarelli's modern retelling of the Snow White fairy tale, for instance, the dwarfs are Hollywood agents with names like Sleazy, Wimpy and Later, and the narration is laced with post-Freudian psychobabble, all to little point.

Mike Wellins's and Mark Swain's spectacular-looking computer-animated journey "This Is Not Frank's Planet" floats its characters through surreal environments that have an almost photographic richness of detail, light and shadow. But its narrative is so tongue-in-cheek as to be virtually incoherent.

The best shorts are those that demonstrate a sharply defined artistic personality. Bill Plympton's two mordantly funny contributions, "The Wiseman" and "Plymptoons," have the light satiric focus of New Yorker cartoons turned into animated sequences of visual and verbal one-liners.

Amid all the frivolity, Mr. Svankmajer's disturbing seven-minute film stands in sharp, almost ludicrous contrast. From a ball of clay, augmented by such accessories as marbles and dentures, a man pieces himself together inside a miniature house. But instead of a heroic story of creation, the sketch becomes a tormented little allegory of imprisonment. Once his arms, legs, hands and feet have been attached, he finds himself permanently trapped inside the house, his body twisted in agony.

1991 Ja 18, C16:5

The End of Innocence

Directed and written by Dyan Cannon; director of photography, Alex Nepomniaschy; edited by Bruce Cannon; music by Michael Convertino; production designer, Paul Eads; produced by Thom Tyson and Vince Cannon; released by Skouras Pictures Inc. At Chelsea Cinemas, 23d Street near Seventh Avenue in Manhattan. Running time: 102 minutes. This film is rated R.

Stephanie........................Dyan Cannon
Dean...................................John Heard
Dad......................................George Coe

By STEPHEN HOLDEN

Dyan Cannon's "End of Innocence" is the latest entry in what threatens to become a full-blown movie subgenre: the rehab film. The first full-length feature to have been written and directed by Ms. Cannon, who also stars, it tells the story of Stephanie Lewis, an emotionally besieged woman who staves off her anger by popping pills and smoking pot. One evening, after her faithless boyfriend fails to show up as planned, she snaps, runs off hysterically into the rainy night and eventually ends up at a rehabilitation center.

Because of its subject matter, the rehab subgenre has almost a pre-determined dramatic structure. And "The End of Innocence," which opens today at the Chelsea Cinemas, follows it to the point of cliché. The first half of the film is a sketchy biography that shows Stephanie trying to please her repressive, loud-mouthed parents and a series of selfish lovers. The second half portrays her nervous breakdown, therapy and recovery.

"The End of Innocence" has some good performances, but it makes the mistake of being far too generalized. As written and played by Ms. Cannon, Stephanie is a psychologically wounded Everywoman whose identity never really comes into focus. Her parents, her novelist boyfriend, her doctors and fellow patients at the rehab center: all seem like stereotypes familiar from other movies and television dramas.

The film has no geographical center. Some scenes evoke cramped urban living, while others are set in suburbia. When Stephanie goes to work for her father, we are never shown what she does or what kind of business he runs. Nor are the details of her addiction adequately clarified.

The movie repeatedly falls back on visual and symbolic clichés. The

passing of time is suggested by showing Stephanie on a merry-go-round. Dream sequences are bathed in an eerie blue light. When Stephanie confides her ultimate fantasy, it is of literally being swept up by a hero riding a white stallion.

The strongest element of the movie is the rangy, full-throttle performance of Ms. Cannon, who in more than one scene must come completely unstrung. The actress has always communicated a mischievous buoyancy and willfulness that added a spark to films like "The Last of Sheila" and "Bob and Carol and Ted and Alice." Even if the character of Stephanie is only a composite personality, Ms. Cannon makes her a sympathetic and appealingly energetic one.

●

"The End of Innocence" is rated R (Under 17 requires accompanying parent or adult guardian). It includes profanity.

1991 Ja 18, C17:1

Flight of the Intruder

Directed by John Milius; screenplay by Robert Dillon and David Shaber, based on the novel by Stephen Coonts; director of photography, Fred J. Koenekamp; edited by C. Timothy O'Meara and Steve Mirkovich; music by Basil Poledouris; production designer, Jack T. Collis; produced by Mace Neufeld; released by Paramount Pictures. Running time: 115 minutes. This film is rated PG-13.

Camparelli...........................Danny Glover
Cole...................................Willem Dafoe
Jake Grafton........................Brad Johnson
Callie.............................Rosanna Arquette
Boxman................................Tom Sizemore
Cowboy Parker..............J. Kenneth Campbell
Razor...............................Jared Chandler

By VINCENT CANBY

John Milius's "Flight of the Intruder," about United States Navy pilots during the Vietnam War, works less well as an adventure movie than as a slick piece of bogus hardware.

Much care has been taken on the technology. The aerial scenes are small wonders of movie-making craft, blending actual flight material with material shot in studio mockups, with perfectly scaled miniatures and with rear projection.

These scenes, utterly impersonal, have conviction, which is just what's lacking in the film's characters and what they do. Real people can't be simulated as easily as flying machines.

The screenplay, set in 1972, is about the heroism of the carrier-based pilots and bombardiers of the Navy's A-6 Intruders, low-altitude bombers that carry no defensive armament and thus put their two-man crews at great risk.

Brad Johnson, with a jaw as strong as that of any Armani model, plays a pilot who loses his bombardier during a dangerous mission over what he sees to be worthless jungle targets. His new bombardier, a tough veteran played by Willem Dafoe, shares Mr. Johnson's sense of frustration.

Attempting to keep his men in order is Danny Glover, as their squadron leader. He has his hands full when Mr. Johnson and Mr. Dafoe take it upon themselves to bomb a missile dump in Hanoi, at that time off-limits to American aircraft.

The two men face court-martial. President Richard M. Nixon becomes the film's benign deus ex machina at

this point. More happens, but none of it any more rousing or unexpected.

Rosanna Arquette comes on briefly as a conveniently widowed young woman with whom Mr. Johnson falls in love during shore leave in the Philippines, where there's also a barroom brawl. Life aboard the carrier is enlivened by harmless boyish pranks. The movie lurches on.

The performances are adequate, but "Flight of the Intruder" is as empty as a six-pack after the Super Bowl. No issues are at stake. As portrayed here, war is unattached to the rest of the world. Like a video game, it's an end in itself, something to while away the time.

The movie's perfunctory macho posturings are neither entertaining nor instructive. They are pipe dreams.

●

"Flight of the Intruder," which has been rated PG-13 (Parents strongly cautioned), includes some vulgar language and violence.

1991 Ja 18, C19:1

Eve of Destruction

Directed by Duncan Gibbins; written by Mr. Gibbins and Yale Udoff; director of photography, Alan Hume; film editor, Caroline Biggerstaff; music by Philippe Sarde; production designer, Peter Lamont; produced by David Madden; released by Orion Pictures. Running time: 100 minutes. This film is rated R.

Jim McQuade........................Gregory Hines
Eve Simmons/ Eve VIII.....Renee Soutendijk
General Curtis.....................Michael Greene
Schneider.............................Kurt Fuller
Peter Arnold.....................John M. Jackson
Steve, the Robot...................Loren Haynes

By VINCENT CANBY

"Eve of Destruction," which opened here yesterday, is an undistinguished, barely functional action-melodrama with a body count higher than some wars.

Gregory Hines plays the role of a counterinsurgency expert, defined in the film as "the guy the Government calls in when they don't want Congress to know." His mission here is to track down and destroy a top-secret, sexy-looking robot called Eve VIII, made in the likeness and programmed with the memories of its creator, a scientist. Renee Soutendijk appears as both Eve VIII and the scientist.

The setting is San Francisco and neighboring communities where the robot runs amok after its controlling mechanism becomes locked in what the movie terms "a battlefield mode." It's a very special battlefield mode. The first thing Eve VIII does after becoming locked is to go shopping for a miniskirt and a red leather jacket.

Eve VIII then carries on a one-robot crime wave, destroying policemen, bystanders and lustful men who pick it up. The film ends in New York, where the robot has gone to be with its (the scientist's) small son.

For all of its blood and gore, the screenplay remains terribly unsure of itself. Each key line of dialogue is repeated at least twice for the benefit of those who might be either hard of hearing or intelligence-impaired.

Every member of the cast looks foolish.

"Eve of Destruction," which has been rated R (under 17 requires accompanying parent or adult guardian), features partial nudity, obscene *language and a lot of explicit mayhem.*

1991 Ja 19, 22:6

In the Movies, Class Doesn't Put Up Much of a Struggle

By BENJAMIN DeMOTT

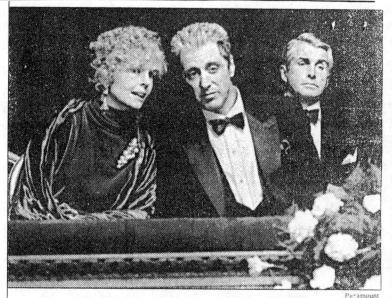

Paramount

Diane Keaton, Al Pacino and George Hamilton in "The Godfather Part III"—These days, even mobsters are struggling for social acceptance.

INCREASINGLY IN RECENT YEARS movies have been dealing with power issues and class relationships — interactions between masters and servants, executives and underlings, yuppies and waitresses, millionaires and hookers, rich aristocrats and social-nobody lawyers. Think of "Reversal of Fortune" and "The Bonfire of the Vanities." Think of "White Palace" and "Pretty Woman." Think of Michael Corleone's struggle for social acceptance in "The Godfather Part III." Think of "Working Girl," or "Driving Miss Daisy" or "Dirty Dancing." Script after script links up clout and cloutlessness, often to stunning box-office effect.

Not every movie version of the power theme speaks specifically about class relationships, and some versions are only loosely linked to social reality. The two worlds of "Edward Scissorhands," for example — hilltop mansion and tract house; solitary helpless artist versus artist-baiting mob — are derived less from everyday experience than from fairy tales, allegory and satire.

Usually, though, conventional realism is the chosen mode, and class skirmishes are sketched. The camera in "White Palace," a popular film released a few months ago,

At their worst, movies perpetuate the myth that there are no classes in America.

studies St. Louis's fancier suburbs and its rundown Dog Town; class conflict erupts at the movie's crisis point. Nora, the waitress-heroine (Susan Sarandon), listens smolderingly to her yuppie lover's upper-middle friends and relations uttering their hypocritical socio-political pieties, and explodes. Storming her way out, she cries: *"I'm working class!"*

At first glance the angry explicitness of her outcry and the movie's declaration of difference look promising. They could signify that Hollywood is reaching toward maturity, trying to teach itself and the nation how to think straight about social hierarchy — the realities of class and class power. The need for such instruction is patent. This country has an ignoble tradition of evading social facts — pretending that individual episodes of upward mobility obviate grappling with the hardening soco-economic differences in our midst. Movies that deal responsibly with class relationships could, in theory, moderate the national evasiveness.

But, regrettably, contemporary "class movies" don't deal responsibly with class. The tone of their treatment of rich and poor is new; it is harsher and meaner than that of Frank Capra's "little guy" sagas or George Cukor's social comedies or John Ford's populism that were pleasing to our parents and grandparents in the 30's, 40's and 50's.

The harsher tone, however, doesn't bespeak fundamental change. At their best, Hollywood's new-style "class movies" nod at realities of social difference — and then go on to obfuscate them. At their worst, these films are driven by near-total dedication to a scam — the maddening, dangerous deceit that there are no classes in America.

One favorite story line stresses discovery: people who think firm class lines exist come to discover, by the end of the tale, that they're mistaken; everybody's really the same.

In the 1988 blockbuster "Working Girl," Tess McGill (Melanie Griffith), initially a bottom-dog secretary-gofer, is positive she can make it to the top. But her peers in the word-processing pool regard her aspirations as foolish. They tell her, flat out, that the real world has lines and distinctions and that her daydreams of glory and business power are foolish. "I sing and dance in my underwear," says one pal, "but I'm not Madonna." The implicit message: Get real, Tess. Accept the reality of levels.

But Tess, of course, accepts no such thing. She reads W, takes classes to improve her accent, seizes her boss's office when the latter breaks her leg skiing — and winds up not only doing deals but ordering the boss (Sigourney Weaver) to get her bony bottom out of sight. What does it take to get to the top? Desire, period. Tess's desire flies her straight up to a managerial perch, allowing her to become, almost effortlessly, all she can be: no problem, few barriers, class dismissed. In the final frame the doubters in the secretarial pool acknowledge their error; they rise to applaud the heroine who proved them wrong.

A second familiar story line involves upendings: characters theoretically on the social bottom shake the cages of characters who try to use their position to humiliate those be-

By portraying upwardly mobile individuals, Hollywood avoids socio-economic differences.

low. The top dogs are so stupid they don't realize that socioeconomic power only lasts for a second and that they can be overcome by any intrepid underling.

■

Consider "Pretty Woman," the 1990 film that became one of the highest- grossing movies ever and is now near the top of video best-seller and rental charts. The would-be humiliators in this movie are snobbish salespeople on chic Rodeo Drive. Vivian (Julia Roberts), a hooker, runs afoul of them when she is sent on a shopping spree by the corporate raider (Richard Gere) who has hired her for a week. The raider wants elegance and the hooker aims to oblige

— but on her first pass at the drive she's suited up in hooker garb, and the salespeople are offended. "I don't think we have anything for you. Please leave."

Quickly the snobs are undone. The corporate raider flashes plastic and tells a shop manager that they'll be spending big and need appropriate cosseting. In minutes — through instruction in fork-tine-counting, for instance — the raider effects the few alterations of manners required to transform Vivian the street hooker into grandeur.

Regally togged, her arms filled with sleek clothes boxes, Vivian returns to the salespeople who were mean to her and sticks it to them in economic not moral terms. If they had been nice to her, they would have made a killing. ("You work on commission, don't you?")

Power is temporary and snobs are dopes — so goes the message. Ostracize a hooker in midmorning and she'll ruin you before tea. *Class dismissed.*

∎

Comparable dismissals occur in movies drawing huge audiences of high school students. They usually have plot lines showing bottom dogs gliding smoothly and painlessly to the top. In "Dirty Dancing" (1987), Patrick Swayze, playing a talented working-class dancer (he has a card in the "housepainters and plasterers union"), competes for esteem with a Yale medical school student — and wins in a breeze.

In John Hughes's "Some Kind of Wonderful" (1987) and "Pretty in Pink" (1986), working-class heroes or heroines become romantically interested in classmates who rank above them, in terms of money and status, in the school society. As the attachments develop, the poor students commence to display gifts and talents that prove them equal to or intrinsically superior to the arrogant, insecure characters in whom they've become interested.

Once the nonclass, merit-based order or hierarchy has been established, and superficial, class-based gradations have been eliminated, the poor boy or girl chooses whether to continue the relationship with the pseudo-superior as an equal or to end it. Either way, the experience bolsters the belief that, in school and out, social strata are evanescent and meaningless.

It's hardly surprising that the myth of America as a classless society emerges at its most schematic in movies aimed at relatively youthful, unsophisticated audiences. But the same impulse to paper over social differences surfaces in many more ambitious films purporting to raise subjects considered controversial by Hollywood standards (social injustice, war, the treatment of minorities).

∎

And not infrequently that impulse drives film makers — such as Francis Ford Coppola in "The Godfather Part III" and Barry Levinson in "Av-

alon" — to overplay ethnic influence and underplay class influence on character.

But what is truly striking is the array of ploys and devices by which movie makers bring off escapes from significant confrontation with class realities. The Vietnam War film "Platoon" (1986), for example, lets on at the beginning that it will show us an upper-middle white soldier learning about differences between himself and the sons of the working class who compose the majority of his comrades in arms.

But in place of the experience of learning, we're offered liberal platitudes and star turns. The hero writes his grandmother that his fellow soldiers are the salt of the earth (little corroboration supplied); the soldiers themselves — particularly the blacks among them — are brought on for a succession of amusing monologues,

following which they disappear, shipped out dead or alive; at no point is the gritty stuff of class difference even momentarily engaged.

In the much-acclaimed "Driving Miss Daisy" (1989), the early intimation is that the focus will be on relations between white employers and black servants. But almost immediately the outlines of that social difference are blurred. The white employer is Jewish and her synagogue is bombed; poor black and rich white become one, joint victims of discriminatory violence. ("You're my best friend, Hoke.") Class dismissed once more.

∎

The story is nearly the same even in those unusual movies that focus solely on minority communities. Social difference is glanced at, defined in a few snippets of dialogue — and

Vivian the hooker (Julia Roberts, right) encounters a hostile saleswoman (Dey Young) in "Pretty Woman"—Characters on the social bottom shake the cages of those who try to humiliate them.

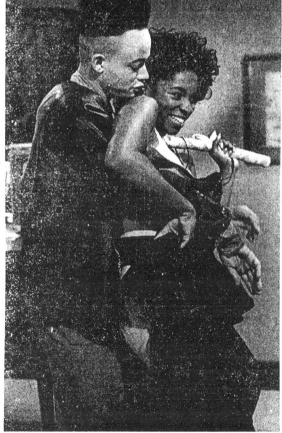

Christopher Reid and A. J. Johnson in "House Party"—Even in movies that focus solely on minority communities, social difference is glanced at and then trashed, often by means of a joke.

Johnny Depp and Winona Ryder in "Edward Scissorhands"—Some movie versions of the power theme are derived less from everyday experience than from fairy tales, allegory and satire.

then trashed, often by means of a joke. In "House Party," Reginald Hudlin's 1990 film about teen-age life, the joke is about sex. Through establishing shots and talk, two girlfriends are placed at a social distance from each other. One lives in "the projects," the other in an expensively middle-class suburban home.

The film offers a single moment of reflection on the social difference in question; a young man points out that there is plenty of space for making out in the rich girl's house, none where the projects girl lives. Yet once more, class dismissed.

■

The reason all this matters is simple. Treating class differences as totally inconsequential strengthens the national delusion that class power and position are insignificant. It encourages the middle-class — those with the clearest shot at upward mobility — to assume, wrongly, that all citizens enjoy the same freedom of movement that they enjoy. And it makes it easier for political leaders to speak as though class power had nothing to do with the inequities of life in America. ("Class is for European democracies or something else," says George Bush. "It isn't for the United States of America. We are not going to be divided by class.")

Movies that deal responsibly with class relationships might help to embolden leaders to begin talking candidly about real as opposed to phony issues of "fairness." But movies obviously can't do this as long as their makers are in terror of allowing class permanently out of the closet.

It's true that occasional moments occur when movie audiences can grasp the substantive dimensions of social difference. A person reached toward from above or below is seen to possess inner, mysterious resources (or limits) about which someone differently placed on the social scale can have no inkling, and can't conceivably lay claim.

■

There is one such moment in "Working Girl." Following orders, Tess, as secretarial underling, books her boss, Katharine Parker (Ms. Weaver), into a chalet for a ski weekend. She is helping Katharine fasten her new ski boots in the office when she is asked where in the chalet the room is located. Tess doesn't know; Katharine dials the resort and at once a flood of flawless German fills the room.

The camera angle shows us Tess's awe; we gaze up with her (from the glossy white boots that she, as footman, is buckling) to this animated, magical, Ivy-educated mistress of the world, self-transformed into Europe, performing in another language. Katharine is demonstrating quite casually that bottom dogs have no exact knowledge of what lies between them and their ideal, that top dogs possess secret skills nobody learns overnight, as in charm class, or by changing hairstyles — skills traceable to uncounted indulgent hours of tutoring, study and travel.

The bottom dog's eyes widen; a frightening truth dawns. If a talent so mesmerizing — this poured-forth foreign self — can be invisible until now, must there not be others equally well concealed? Maybe this dream to be her is foolish. What unimaginable barriers stand between me and my desire?

■

In the movie culture the answer to such questions is, of course: no real barriers, none. "Be all you can be" means, at the bottom as at the top, "Be whatever you wish," fear no obstacle, see no obstacle, there are no obstacles. "Working Girl" is, finally, a story about how ambitious working girls just can't lose — one more movie that obliterates class.

"White Palace," for all its initial explicitness about the reality of social differences, is, finally, a story asserting that such differences simply don't matter; pure passion erases them every time.

The other week Senator Daniel Patrick Moynihan told a Wall Street Journal reporter that the fundamental issue in this country is "class, not race." It's essential, he said, "to at least start thinking about it, start talking about it. Let's be honest. We're not doing that."

One reason we're not is that movies remain firmly resolved against letting us. □

1991 Ja 20, II:1:2

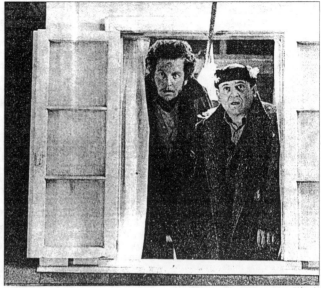

Daniel Stern and Joe Pesci as the hapless crooks in the film some viewers perceive as too violent for youngsters.

"Oh, it is," I explained. "The boy has a nice time without them. And after a while, he thinks up some great ways to outsmart the bad men who are trying to break into his house. He puts sticky stuff on the stairs, and he leaves out his toy cars for them to trip on, and he heats up the doorknobs, and he . . ."

"That sounds like what Bugs Bunny and the Road Runner do," he said. "So let's stay home and watch them instead."

■

Well, we went to see "Home Alone" anyway. And neither of us had any trouble understanding why the nation's moviegoing public has made this gleefully anarchic, warmly sentimental family comedy the runaway hit of the season. But each of us had a few small reservations. And those reservations placed us on different sides of a brand-new, media-minded generation gap.

It is deeply humiliating for anyone who once embraced Woodstock-era concepts of free expression to find himself flipping the television dial away from MTV whenever small children straggle into the room. We would all like to think we are more open-minded than that. And for anyone who grew up watching movies and saw no reason why supposedly grown-up films should be off-limits to young viewers, it's regrettable to find oneself with a newly formed double standard.

Yet developing such a standard is, for the parents of small children, as unavoidable as answering questions about Jessica Rabbit and why she looks like that. Today's films are that much more casually explicit and their violence that much more cavalier; children, for their part, are never shy about asking questions. The other three biggest children's hits of the moment — "Kindergarten Cop," "Three Men and a Little Lady" and "Look Who's Talking Too," all rated PG-13 — are apt to send parent and child home to a lively discussion about the anatomical differences between girls and boys, for example. This is a fine topic of conversation, but parents are notoriously old-fashioned about wanting to be the ones who bring it up.

The PG-rated "Home Alone" deserves credit for not harping on the possibilities for sexual snooping that become open to 8-year-old Kevin (Macaulay Culkin) once his parents leave him stranded. The film's skin-magazine reference is brief, funny, and easily missed by small children. More attention-getting are the gruesome stunts at the heart

FILM VIEW/Janet Maslin

'Home Alone': Are Its Kicks Painful for Kids?

I T'S SAD WHEN A 4-YEAR-OLD thinks you're crazy. "Let's go see a really funny movie," I said. "It's about a boy whose parents go on a long trip and forget to take him with them and leave him home alone."

"That doesn't sound funny to me," he said, with a look of deep suspicion.

of the film's uproarious climax, a series of devilish pranks staged by Kevin to foil two fabulously hapless crooks (Joe Pesci and Daniel Stern). The very awfulness of these antics — a nail through a foot, a face stamped with a red-hot iron, a character's hair burned off the top of his head — is what makes them so riotous, at least from a small child's point of view.

For an adult to object to this level of violence is to miss the pitch at which "Home Alone" actually plays. The film's practical-joke finale is so frankly cartoonish that it has the cheery unreality of a world in which all bodies are elastic, all injuries painless, all mean-spiritedness somehow in good fun —

To object to the level of violence is to miss the pitch at which this movie plays.

the world to which any child raised on movies and television is sure to feel a close connection.

That is not to say that today's children are necessarily tougher than their parents, merely that their fears lie elsewhere. Far scarier to children than the film's banana-peel war games may be the idea of being left behind by a distracted family, or the torrents of abuse heaped on Kevin by older relatives during the early scenes. The saccharine reunion at the end will not easily eradicate thoughts of Kevin's being embarrassed in front of a dozen family members. "What's a disease?" I was asked on the way home. "Why did the boy's big brother call him one?"

Still, this film's good humor overrides the brief mean-spiritedness needed to set its story in motion. The same thing happens in "Kindergarten Cop," a remarkably benign film for its star, Arnold Schwarzenegger, and an unusually coherent one for Ivan Reitman, its director. In this case, the early scenes involve three characters listed in the credits as "Street Toughs" and four "Low Lifes," not to mention a rock-and-roll-scored shootout in a drug den. This is handled briefly and bloodlessly, though, and it will make only a minimal dent on the consciousness of a child who has seen police shows on network television.

Meanwhile, the subsequent kindergarten sequences are very sweet. Mr. Schwarzenegger, with the support of three lively actresses (Linda Hunt, Penelope Ann Miller, Pamela Reed) and a pet ferret, is made to seem a friendlier figure than he has before. And Ms. Reed in particular, as a smart, feisty policewoman, offers both comic relief and a likable role model. Another refreshing touch is the film's matter-of-fact acceptance of divorce as a commonplace of modern life.

■

By far the film's most attractive touch is the cop's discovery that he likes being a teacher. By the story's end, he has decided to change careers. And he has moved into schoolteaching without even winning the lottery, which would have been a necessary last-minute plot development if this film had been made even a year or two ago. At the very least, he would have written a best seller about teaching and become an overnight celebrity. As it is, he simply learns that he likes children. That's enough. □

1991 Ja 20, II:13:1

Why Movies Are Movies And Real War Is War

By JANET MASLIN

For years we have thrilled to the movie exploits of the one-man army, the bold and celebrated fighter pilot, the anti-terrorist vigilantes who accomplish miracles while armed to the teeth. Now the consequences of all that false bravado have come home to roost.

Among the past week's many painful lessons is that real war bears scant resemblance to what we've seen in movies, especially movies of the last 10 years. If war films a generation ago emphasized patriotism, group effort and the value of individual sacrifices made for a larger cause, then those of the recent past have told a different story, a story attuned to the egotism and self-aggrandizement of the 80's. Not for nothing does "Rambo" figure in Iraqi pronouncements concerning our unreasonable notions of what combat is about.

One of the first things to become apparent over the past few days is that real war, unlike movie war, is no source of vicarious excitement. The apprehension and dread provoked by these real events have nothing to do with the suspense in which war films usually trade. What's more, a film that brings viewers to the edges of their seats generally brings those viewers back again, providing some kind of catharsis to dispel the anxiety of battle. The real thing offers no such relief.

Even the antiwar films of the post-Vietnam era, from "Apocalypse Now" to "Platoon" to "Casualties of War" to "Born on the Fourth of July," provide the kind of closure that is seldom available in real life. The characters in these films, however much they view battle as a frightening and disorienting miasma, however radically they find their thinking reordered by combat experience, still develop ways of coming to terms with this upheaval. Movie endings, in cases like these, hold forth at least the possibility of acceptance and release. Real life makes no such promises.

If the experience of war as seen on the big screen is somehow finite, the same can be said for the movie enemy's imagination. The person or power being fought in a film may embody evil, but it is usually an evil that the audience can understand. However determined the war film's villain may be to thwart its heroes' rightful interests, that villain is usually a like-minded individual in some perverse way. Even when the enemy is reduced to stereotype or sheer inscrutability, those too are somehow extensions of our own attitudes. The enemy whose aims and strategies are truly impenetrable rarely finds his way to the screen.

•

The movie enemy's game plan, even when ostensibly mysterious, is often well within our reach. The camera's selective eye and the editing process see to that. When a piece of luggage at an airport is somehow suspect, the film's having called attention to it helps clarify the situation. There is no such assistance in a world where any parked car or abandoned parcel has suddenly become an object of concern.

People in the movies talk tough when it comes to war; people who have been seen and heard in recent reportage have spoken a different language. "It's frightening and depressing," someone from Wichita told a television reporter last week, using words that would be verboten in any dramatist's version of these events. The euphemisms of the moment, like the "voluntary departure" of American civilians from Saudi Arabia, have a seriousness that makes them that much more chilling than bombastic movie talk would be.

So too do some of the most casually bizarre images of the past few days, from the gas-masked reporters and interviewees in Tel Aviv to the sight of an American servicewoman wearing combat fatigues and cradling her newborn baby. If these sights beggar the war film's ability to invent frightening and disturbing images, so does the fact that this war's first combat casualty, Navy Lieut. Comdr. Michael S. Speicher, could be seen sending a cheerful videotaped greeting to his wife and children the day after he was listed as missing in action after his plane was destroyed by an Iraqi missile.

•

What place is there, within the context of such authentic and wrenching sights, for the swaggering self-interest seen in a "Rambo" or a "Top Gun?" The latter, after all, is so insistently upbeat that its videocassette version begins with an ad in which cute, wisecracking fighter pilots banter about one another's "refreshment systems" and swig Diet Pepsi. The film itself isn't much more substantial, with its hotshot fliers taking their risks to the accompaniment of jaunty rock music (the soundtrack number about a "danger zone" is as close as anyone comes to believable peril) and endless jousting among young pilots as to who will be "the best of the best."

Aside from the foolishness of its suggestion that one can become "the best" simply by boasting about it, "Top Gun" now looks all the more objectionable for having broached such a concept of individual supremacy at all. This film's hollow showboating, and the way in which its military setting becomes nothing more than a backdrop for displaying a hero's star quality, set a standard as profoundly unhelpful as it is dishonest. Yet the

Battle writes its own story. No explanations. No promises.

attitudes exemplified here have been widespread on the screen. In "Firebirds," starring Nicolas Cage as a helicopter pilot, Mr. Cage's lone daredevil is seen grandly taking center stage in what looks like a meeting

"MAVERICK"

Paramount Pictures

Anthony Edwards, left, and Tom Cruise in "Top Gun," a war movie that emphasizes self-interest.

with the Joint Chiefs of Staff, and delivering a lot of backtalk, too.

The propagandistic combat films of World War II, like Howard Hawks's 1943 "Air Force," were in their own way just as contrived. ("I'll be back in a couple of weeks and we'll take time off for that honeymoon," says an airman, whose "routine flight" turns out to be a Dec. 7, 1941, trip to Pearl Harbor.) Yet their espousal of team effort and courageous sacrifice was a source of inspiration to many who watched them, and that inspiration had demonstrable value. Far better to believe in the power of brotherliness, dedication and forbearance than in the ability of sheer vanity and arrogance to conquer all.

•

It should be said that the "Top Gun" school of posturing does offer undeniable uplift, and that if its dauntless bravado becomes a source of strength to anyone facing the realities of war, then so much the better. A smiling soldier who in a television interview this week described his unit as "in a hurry to get in harm's way" had obviously seen a latter-day movie or two. So had the unit that had nicknamed itself "Scudbusters," or the Marine battalion setting up operations in what one called "Hard as Hell Hotel." For that matter, on the evidence of video-screen images depicting high-tech missile hits, it won't hurt pilots to have played more than their share of Nintendo.

But this much is certain: When movies finally have their chance to chronicle this new war, neither the reflexive patriotism of World War II films nor the moral ambiguity of Vietnam dramas nor the extraordinarily empty boosterism of the past few years will be adequate. A different story will have to be told.

1991 Ja 23, C11:1

The Vanishing

Directed by George Sluizer; screenplay (in Dutch with English subtitles) by Tim Krabbe, based on his novel "The Golden Egg", photography by Toni Kuhn; edited by Mr. Sluizer and Lin Friedman; music by Henny Vrienten; produced by Mr. Sluizer and Anne Lordon; presented by MGS Films. At Cinema 12, 22 East 12th Street in Manhattan. Running time: 105 minutes. This film has no rating.

Raymond Lemorne Bernard-Pierre Donnadieu
Rex Hofman Gene Bervoets
Saskia Johanna ter Steege
Lieneke Gwen Eckhaus

By JANET MASLIN

At the start of the gripping Dutch psychological thriller "The Vanishing," a crisis of confidence interrupts an otherwise sunny vacation. Rex (Gene Bervoets) and Saskia (Johanna ter Steege), a happy and attractive couple from Amsterdam, are driving along a French highway when they decide to take a detour along a scenic route. The scenery is indeed beautiful, and so mountainous that the road passes through a very long tunnel. Midway through it, in the dark, Rex and Saskia run out of gas.

This experience creates sudden panic in them both. Saskia is reminded of a nightmare vision of being encased in a golden egg and flying "all alone through space forever." Rex, who is slightly claustrophobic, reacts to being trapped with a show of anger. He stalks off and abandons Saskia in the tunnel, returning later with a can of gasoline. She is angry, but she appears to forgive him.

Afterward, having returned to the relative safety of the highway, Rex and Saskia stop at a rest area just as anyone on a road trip might. They take a break from driving, buy more gas, and relax for a while, the trouble between them evidently over. Then Saskia heads off to the service station to get each of them a cold drink. She does not come back.

"The Vanishing," directed by George Sluizer and adapted by Tim Krabbe from his novel "The Golden Egg," presents these early events with an ordinariness that proves all the more chilling in view of what follows. Mr. Sluizer, whose spooky precision of nonfiction crime writing and whose matter-of-factness makes the characters seem quite real, builds a disturbing horror story from these seemingly modest beginnings.

Abandoning Rex as he realizes that Saskia's absence is something serious, the film switches its attention to Raymond (Bernard-Pierre Donnadieu), a placid-looking French chemistry professor. He is, he tells his drab-looking wife and guileless daughters, "probably the only Frenchman who can boast of having known only one woman in his life." In addition to being given to such peculiar pronouncements, Raymond is extremely methodical about sinister things. In his car he keeps a sling, a removable cast and a bottle of a chloroformlike substance. He keeps a log of his pulse rate. He devises a formula connecting "dosage" with "minutes unconscious" and "miles."

During these scenes that actually predate the film's opening episode involving Rex and Saskia, Raymond is seen saving the life of a drowning child, who by the way is not particularly grateful. Raymond's family, watching this, decides he is a hero; Raymond himself begins to wonder whether his capacity for evil is on a par with his altruism. "Watch out for heroes: they're capable of excess," he tells his daughter.

Once Raymond is seen trying to perfect his methods of luring strange women into his car, and even practicing on one of his children, a story like this might be expected to lose its surprise value and take on a certain inevitability. Much to the credit of Mr. Sluizer and Mr. Krabbe, "The Vanishing" continues to exert its grim fascination to the very end.

Mr. Sluizer is especially effective in bringing together the two halves of this story as Rex and Raymond cross paths three years after Saskia disappears. The influence of Claude Chabrol, for whose work Mr. Sluizer has expressed admiration, is especially noticeable in the film's later stages as quiet malice and fatal curiosity become intertwined.

"The Vanishing," which opens today at the Cinema Village (formerly the Cinema Village), features effectively controlled pacing and a credible performance from Mr. Donnadieu as a man who is privately fascinated, even intellectually engaged, by the measure of his own perversity. Mr. Bervoets makes Rex a strong figure even in the face of unbearable strain. Miss ter Steege, who plays the wife of Theo van Gogh in Robert Altman's "Vincent and Theo," has a radiant, unaffected loveliness that becomes all the more touching when it is only a memory.

1991 Ja 25, C8:1

Too Much Sun

Directed by Robert Downey; screenplay by Mr. Downey, Laura Ernst and Al Schwartz from a story by Mr. Schwartz; director of photography, Robert Yeoman; edited by Joe D'Augustine; music by David Robbins; production designer, Shawn Hausman; produced by Lisa M. Hansen; presented by Cinetel Films. At Angelika Film Center, Mercer and Houston Streets in Manhattan. Running time: 100 minutes. This film is rated R.

Reed Richmond Robert Downey Jr.
O. M. Rivers Howard Duff
Susan Connor Laura Ernst
Father Seamus Kelly Jim Haynie
Sonny Rivers Eric Idle
Frank Della Rocca Jr. Ralph Macchio
Bitsy Rivers Andrea Martin
George Bianco Leo Rossi
Gracia Jennifer Rubin

By VINCENT CANBY

The place and the time are immediately identified: Los Angeles, 7 A.M. The camera pans down from a sky of pristine blue to discover a city in the grip of terminal smog.

Four bizarre-looking people are bidding emotional farewells to their overgroomed dogs, all poodles, which are going off on vacation in a van marked Poodle-Do. The two Poodle-

Do attendants wear doggie costumes and seem very sincere. .

Thus begins Robert Downey's amiable "Too Much Sun," a comedy of loosely strung together farcical situations that, played at half speed, elicit more good will than sustained laughter. It opens today at the Angelika Film Center.

The movie is very much of a piece with such earlier Downey works as "Chafed Elbows" (1967) and "No More Excuses" (1968), though hardly in the league with his classic sendup of Madison Avenue, "Putney Swope" (1969).

•

Mr. Downey is a funny man. His 60's sensibility wears well, which may say less about his sensibility than about the conforming dreariness of most humorists at work today in the mass market.

Mr. Downey's comedies reflect his funniness only in fits and starts. His "Greaser's Palace" (1972) is now a blur except for a single sequence. That's the one in which a man on crutches, who has been miraculously cured by a savior, throws away his crutches and cries with joy, "I can crawl! I can crawl!"

Maybe you have to see it.

"Too Much Sun," written by the director with Laura Ernst and Al Schwartz, is helped enormously by the burlesque clowning of Eric Idle, the comic solemnity of Howard Duff and the youthful exuberance of the director's gifted son, Robert Downey Jr.

•

They are among the principals in a story about a pair of middle-aged siblings, Sonny (Mr. Idle) and Bitsy (Andrea Martin), whose carefree homosexuality helps to send their rich old dad, O. M. Rivers (Mr. Duff), to the grave. The key word is helps.

The old man is ready to make accommodations, but his priest (Jim Haynie) isn't. Father Kelly simply withholds oxygen from his parishioner until the dying man signs a new will: unless one of the children produces an heir within 12 months, the fortune will go to the church.

It's Father Kelly who finally pulls the plug and puts the will into operation.

Both Sonny's companion, a beefy fellow named George (Leo Rossi), and Bitsy's companion, Susan (Miss Ernst), are suitably outraged that their lovers should be so compromised.

Much of the comedy, which avoids good taste like the plague, has to do with Sonny's heroic efforts to have heterosexual relations, at one point with Susan. Each partner attempts to arouse the ardor of the other by mimicking the sexual characteristics preferred by the partner. It does get complicated.

Toward the end, the screenplay picks up a few ideas from "The Importance of Being Earnest," but it's too late for "Too Much Sun" to benefit appreciably.

Mr. Idle, a first-rate performer, camps with such enthusiasm that he seems always to be going faster than the movie. Also good is Mr. Haynie, as the priest who lusts after a cardinal's red hat.

Mr. Downey Jr. plays an out-of-work actor forced to make his living by working for Ralph Macchio, a real-estate agent specializing in Soviet properties (choice sites near Chernobyl). Jennifer Rubin, an exceptionally

beautiful young woman, appears as an employee of Ecstasy Escorts.

Also worthy of note is Mr. Downey's use of Los Angeles locations. Never has that city looked quite as comically seedy while pretending to be rich and elegant.

●

"Too Much Sun," which has been rated R (Under 17 requires accompanying parent or adult guardian), including partial nudity, vulgar language and comedy routines that satirize the Roman Catholic Church and sexual behavior.

1991 Ja 25, C8:5

Critic's Choice

They stole into town seven weeks ago, won glowing reviews, then slipped away. Now the three ingenious con artists of "The Grifters" have returned for a regular New York run. The earlier weeklong engagement qualified them for Academy Award nominations, which are certainly in this film's future. Bet on that.

Among the three self-interested, beautifully played principals of Stephen Frears's film is Lily (Anjelica Huston), a hardened

Anjelica Huston stars in Stephen Frears's "Grifters."

gambler who does official business at the race track and shadier things on the side. Then there's Roy (John Cusack), the up-and-coming huckster who is Lily's son, though he hardly counts that as a stroke of good fortune. Completing the film's unstable triangle is Myra (Annette Bening), the purring bombshell who has hooked up with Roy partly for the sheer fun of getting under Lily's skin, or so it seems. Myra, as proudly duplicitous as the others, trades in a currency that is distinctly her own.

Mr. Frears's film, based on Jim Thompson's equally hard-boiled novel, sets these three schemers on a collision course, then watches their conflicting interests lead them to the brink of bloodshed.

Among the story's shocking and pitiless flare-ups are Lily's unforgettable meeting with her suspicious employer (Pat Hingle) and a final mother-son confrontation guaranteed to take the breath away. Few scenes in the annals of film noir, of which "The Grifters" is a lean and uncompromising modern example, pack a wallop to compare with this.

JANET MASLIN

1991 Ja 25, C13:1

Old Man And Nature

"A Tale of the Wind" was shown as part of the 1989 New York Film Festival. Following are excerpts from Caryn James's review, which appeared in The New York Times on Sept. 25, 1989. The film — in French with English subtitles — opens today at the Public, 425 Lafayette Street in Manhattan.

From the start of his career, in the 1920's, to his death in June 1989 at the age of 90, Joris Ivens discovered stories hidden in elegant non-narrative images. The Dutch film maker's "Rain," the 15-minute silent black-and-white film he made in 1929, is no more or less than scenes of Amsterdam's streets and canals before, during and after a rainstorm. Yet it created a miniature artistic drama of responses to nature. From a close-up of raindrops in a puddle to an overhead shot of a street blanketed with black umbrellas, its blend of lyricism, realism and wit had a huge influence on future documentary film makers.

"A Tale of the Wind" is Ivens's last film, and like so much of his work during the last 25 years, it was made in collaboration with Marceline Loridan.

Though "A Tale of the Wind" resonates with allusions to "Rain" and to several documentaries Ivens made in China, it is not a documentary. It is an autobiographical fiction starring Ivens as an old man who has spent his life trying to "tame the wind and harness the sea" by capturing them on film. It is a poetic and witty farewell, yet it also stands on its own as a hopeful commentary on the importance of art and culture.

Shot between 1984 and 1988, the film is dominated by the presence of Ivens, then in his late 80's. He is often seen sitting in a plain wooden chair in the Gobi Desert, his back to the camera. He is an isolated figure intersecting the line of the horizon where the flat blue sky meets the pale brown sand.

But just as often the camera focuses on his extraordinary face, with his old man's watery eyes framed by flowing white hair. This aged face still seems, remarkably, characterized by endless curiosity. "A Tale of the Wind," with its scenes of dreams, dramatized myths and real life, suggests the way this old man's creativity is bound to the natural landscapes, cultural images and personal memories that flow through the film.

●

In a memory, a small boy is seen next to a windmill. He climbs into a large toy plane and yells, "Mama, I'm going to fly to China." This is the

autobiographical child who will, much later, take the old man's hand and lead him away into an endless horizon.

In China, the old man stands in front of an enormous golden Buddha with a thousand hands, each with an eye in its palm. But his most important co-star and the film's most significant cultural symbol is a mischievous monkey character from the Beijing Opera. In elaborate red-and-gold face makeup and a golden costume, he scampers through the film disrupting scenes.

So when Ivens stands in a peaceful garden and tells an old Chinese man that he suffers badly from asthma — at times he cannot catch his own breath, much less the great winds of nature — the monkey causes the Chinese man to slip on a banana peel.

This monkey transports Ivens from a hospital bed into a rocket that lands in the eye of the man in the moon. That is, the old man is suddenly in a cartoonish scene from Georges Méliès's 1902 fantasy film, "Le Voyage Dans la Lune."

●

Between such fantastic scenes, there are magnificent aerial views of the Great Wall of China and of the camera crew trudging through the sand carrying their equipment, preparing to shoot the wind in the desert.

The elliptical narrative in "A Tale of the Wind" will not appeal to every taste, but this is an eloquent last word from an important artist. As he says here, "Filming the impossible is what's best in life."

1991 Ja 25, C14:6

Embrace the Stereotype; Kiss the Movie Goodbye

By CARYN JAMES

WHO IS THE MOST LUDICROUS ETHnic creation on screen right now? Is it the fanatical, small-minded Iranian or the foulmouthed, money-obsessed American or the warmhearted Italian who has to be blasted out of the family house in middle age?

The choice is tough and the possibilities more plentiful than you might think. For while some splashy current films seem teeming with cultures that range from Teheran to Boston, there is very little character lurking beneath their lazy cultural clichés. Whether the stereotypes are as innocuous as the cartoon Italians in "Once Around," as insulting as the ugly Americans in "The Russia House" or as inflammatory as the evil Iranians in "Not Without My Daughter," they are shortcuts to character that go to the heart of the films' failures.

Though "Not Without My Daughter" exploits the stereotype of the demonic Iranian, an idea with some political currency right now, it is not an exploitation film. It is, however, an utter artistic failure, and its reliance on cultural stereotypes is a major cause.

The film makes lurid use of its fact-based story: in

Beneath lazy cultural clichés, there's little character to be found.

1984 an American named Betty Mahmoody (Sally Field) travels with her Iranian-born husband, Moody (Alfred Molina), and their daughter to visit his family in Teheran. In the film's reductive approach to character and politics, rabid religious fundamentalism and social conservatism swirl through the air, and Moody catches its symptoms as easily as if he were picking up a flu germ. His promise that the family would return to Michigan in two weeks turns out to be a sham, and Betty is virtually held hostage in her in-laws' home. She and her daughter must escape illegally from what she calls "this backward, primitive country," an assessment the film supports.

She shouldn't have been surprised at her husband's deception, for on screen the portents were there all along. At first he is viewed as a sympathetic sort, telling his

small daughter that after 20 years in this country, "I'm as American as apple pie." But soon he makes a gesture that seems an evil omen in the context of this simple-minded film: He takes a sacred oath on the Koran. When a foreign religion intrudes on apple-pie America, it is a

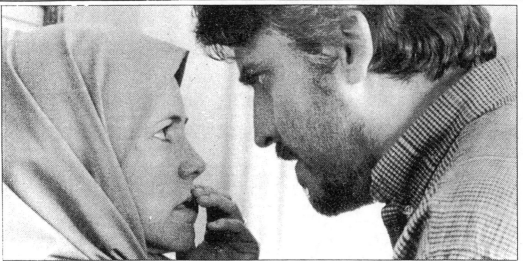

Yoni Hamenachem/Pathe Entertainment

Sally Field with Alfred Molina as her Iranian husband in "Not Without My Daughter"

Murray Close/Pathe Entertainment

Michelle Pfeiffer and Sean Connery in "The Russia House"—familiar types

clear sign of trouble in a film that clumsily uses ethnicity to outline its heroes and villain's.

"Not Without My Daughter" has gained more attention than it might have if the Middle East were not exploding. When Moody stands in his Michigan house and tells Betty that her fears are unfounded, that "we're not going to go sightseeing in the Persian Gulf or anything foolish like that," the comment reverberates more eerily than it would have a year ago.

■

But however timely it is, however scrupulous its facts, the film seems unreal because its characters are so one-dimensional, so downright scary from the start. When the Mahmoodys arrive at the Teheran airport, large images of the Ayatollah Khomeini glare down at them from billboards, and they are surrounded by black-clad women who are meant to be loving relatives, yet who descend on the family like vultures. Why the daughter, little Mahtob, goes so willingly to her aunt, who resembles a witch in a Disney cartoon, is one of the smaller questions the film raises.

■

The larger issue has to do with Moody's abrupt transformation and his secret decision, made before leaving Michigan, that he would keep his family in Iran. Whatever psychological reasons might have been behind such a move, they are not readily

Even the most repellent characters in 'The Godfather' and 'Goodfellas' are defined as individuals.

apparent in the film. Here, he seems a pure product of his culture, a mysterious, misogynistic Easterner. "Ev-

erything is so different," he says about the 10 years and the Islamic revolution that have intervened since his last visit home. Yet he adjusts in a flash. He forbids Betty to use the phone or to leave the house without him and is backed up by everyone from his family to Mahtob's teachers.

When one exceptional Iranian says of Moody's family, "They're from the provinces; they're more fanatical than most," it is a meaningless disclaimer, for the film views fanaticism as the Iranian national character. And because the people are portrayed so unrealistically, the story's valid and important social criticism — under Iranian law, Betty had no legal rights to her daughter — is reduced to melodrama and undermined as well.

At least one persistent stereotype in "Not Without My Daughter" makes for an odd, revealing parallel. There are few similarities between this film and "The Sheltering Sky," Bernardo Bertolucci's elegant, seductive, elliptical tale of Westerners wandering the through North Africa after World War II. Yet both heroines, traveling with a tribe through the desert, wake to find themselves being assaulted. In "Not Without My Daughter," Betty is saved by another tribesman, while in "The Sheltering Sky" the grief-stricken American played by Debra Winger eventually gives herself over to a mad sexual adventure and escape into a harem.

The image of the turbaned tribesman creeping over the sand to attack the American woman is part of the exoticism and danger that imbues "The Sheltering Sky"; it is a cliché, but it exists to serve the plot and the heroine's fantasies rather than to characterize an entire race. The same image is just one more nasty stereotype in "Not Without My Daughter."

Familiar types also fill "The Russia House." Though it is meant to be an up-to-the-minute glasnost-era thriller, it is filled with beleaguered Soviets and crafty Englishmen. Klaus Maria Brandauer is the dissident Soviet scientist who wants to smuggle a book manuscript out of his country and who, like Moody in "Not Without My Daughter," delivers a line that

seems overtaken by world events. "Our new people talk about openness, disarmament, peace," he says skeptically; "Words."

Michelle Pfeiffer, as the courageous Soviet woman who helps him, falls in love with Sean Connery, as the British publisher to whom she delivers the manuscript. "My life now only has room for truth," she tells him in movie-accented broken English. He replies, "You are my only country now."

You'd think the film would not have room for one more cliché, but here come the Americans. They are all C.I.A. agents who speak in schoolboy gutter language and worry that if the arms race falters, lobbyists and industrialists will take a commercial loss. "Drop it down the toilet and your guy with it" is one of the more printable lines delivered by Roy Scheider as an American agent talking to his English counterpart. If "The Russia House" had a glint of humor, the Americans would seem to be send-ups, but they're not. They are part of the neat cultural categorizing that does so much to make the story seem stultifying, to make the dazzling views of Soviet cities so much sharper than the film's chararacters.

The ethnic clichés in the new film "Once Around" are more concentrat-

ed but just as damaging to this misconceived film. Somewhere in that twilight zone where movie deals are made, someone thought it was a good idea for Lasse Hallstrom, the Swedish director of the sensitive and witty 1985 film "My Life as a Dog," to direct Holly Hunter as an Italian-American princess from Boston. If things had turned out differently, that might have seemed like a daring, imaginative move. As it happens, "Once Around" is staggeringly dull and unconvincing as both comedy and drama. Among its many problems, the synthetic Italian-Americans on screen owe far more to "Moonstruck" and Hollywood than to Naples or Sicily.

This is the kind of Italian family held together by Krazy Glue, and they work overtime to seem heartwarm-

Universal City Studios

Holly Hunter and Laura San Giacomo as sisters in "Once Around"—synthetic Italian-Americans

ing. Ms. Hunter plays Renata Bella, who is so close to her family that when her boyfriend refuses to marry her she not only goes crying to her parents, she wanders into their room at night and whines, "Can I sleep with you?" Mom scoots over closer to Dad, and Renata jumps in.

◼

The plot supposedly turns on Renata's later romance with Sam (Richard Dreyfuss), an obnoxious, wealthy salesman who makes much of his Lithuanian heritage, though being Lithuanian here means nothing more than not being Italian. He breaks the tight Bella family circle to such an extent that Ms. Hunter, in a fake-Boston accent that might have arrived via Stockholm, finally yells, "You're tearin' us apaht!"

At every turn, being Italian is meant to justify inexplicable behavior. When Sam provokes a family argument, the patriarch (Danny Aiello) orders him out of the house in what seems like a peculiar overreaction but is certainly no stranger than a woman in her 30's crawling into her parents' bed. When Renata's sister, Jan (Laura San Giacomo), gets married, she and her husband just move into her old room. Behavior like this is taken for granted as some quaint Italian tribal custom, as stereotypes replace any hint of personality or emotion.

Ms. San Giacomo might have made the main role believable, for she does a great deal with the role of the sister. There is a texture to her performance, a sense of confusion in her character that has nothing to do with her Italian name and everything to do with her acting. It helps, of course, that she has the film's most astute line: "Does anyone care that Renata's spending day and night with some bozo?" It's a more convincing assessment than the film makers intended.

But it is hard to believe that Ms. Hunter and Ms. San Giacomo are sisters, harder to believe in Renata's infantile attachment to her family, and impossible to accept an ethnic identity that is worn like an badly-tailored costume.

◼

Oddly enough, to find ethnic identities that are worn like well-tailored suits, you'd have to turn to the "Godfather" films or "Goodfellas." Though their organized crime families are more lethal than the Bellas, they are less insulting stereotypes. For even the most repellent characters in these films are defined as individuals who are partly shaped by Italian neighborhoods and backgrounds, partly shaped by their own peculiar psychologies.

It is too obvious to say that Francis Ford Coppola and Martin Scorsese capture the texture of Italian-American families more sharply than Lasse Hallstrom. What matters is that "The Godfather" and "Goodfellas" create believable ethnic characters instead of shallow ethnic types. ☐

1991 Ja 27, II:1:1

Memories of a Marriage

Directed and written by Kaspar Rostrup; based on the novel by Martha Christensen; in Danish with English subtitles; camera, Claus Loof; edited by Grete Moldrup; music by Fuzzy; produced by Lars Kolvig and Nordisk Film in cooperation with the Danish Film Institute; distributed by Pathe-Nordisk Film Distribution A/S. At Cinema 2, 60th Street and Third Avenue. Running time: 90 minutes. This film has no rating.

Karl Age	Frits Helmuth
Young Karl Age	Mikael Helmuth
Regitze	Ghita Norby
Young Regitze	Rikke Bendsen
Borge	Henning Moritzen
Young Borge	Michael Moritzen

By JANET MASLIN

In the Danish film "Memories of a Marriage" a group of friends and relatives convenes at the country cottage of Karl Age (Frits Helmuth) and his wife, Regitze (Ghita Norby), to share beer and herring and laughter. This reunion unleashes a flood of reminiscence from the principals, who recall all the stages of their many years together in a film that lasts only 90 minutes, but manages to feel as long as the couple's union.

The events seen here are rarely surprising. Karl Age and Regitze met at a dance club; each was with other friends, but they spied each other from across a crowded room. They danced together until the place was closed, the chairs were stacked on tables and all the other revelers had gone home. Even at a moment like this, "Memories of a Marriage" manages to have very little romance.

Later on Regitze's mother and Karl Age had clashes of wills, but they managed to make peace with each other. Sometimes Karl Age and Regitze quarreled; sometimes they were happy and had wonderful times with their friends, solid citizens all. Once Regitze made a lovely charitable gesture to help the poor, and Karl Age was overwhelmed with emotion. "I love you with all my heart," he said.

Based on a novel by Martha Christensen, who is identified in production notes as a "trained leisure-time teacher" as well as a writer, the film confines itself to dialogue like "What a perfect day for Regitze's summer party!" and "If only we could stretch time!" Kaspar Rostrup, who directed the film and wrote its screenplay, is no more artful when it comes to linking the various episodes together or segueing from the present to the past. The whiff of mortality that finally lends the film some pathos also rescues it from virtual paralysis.

"Memories of a Marriage," which opens today at Cinema 2, was an Oscar nominee last year and has also won many Danish prizes, mostly for its actors. The cast also includes Mikael Helmuth and Rikke Bendsen, who play the couple in their early years. All the performances are utterly sincere.

1991 Ja 28, C20:3

Wait for Me in Heaven

Directed by Antonio Mercero; script (in Spanish with English subtitles) by Horacio Valcarcel, Román Gubern and Antonio Mercero; director of photography, Manuel Rojas; edited by Rosa G. Salgado; music by Carmelo A. Bernaola; production design, Daniel Vega; distributed by M.D. Wax/Courier Films. At Film Forum, 209 West Houston Street. Running time: 108 minutes. This film has no rating.

Paulino	José Soriano
Paulino's Wife	Chus Lampreave
Minister of Propaganda	José Sazatorhil

By VINCENT CANBY

Considering the grim nature of the dictatorship of Francisco Franco and its high cost to Spain in terms of life, limb and other essentials, Antonio Mercero's "Wait for Me in Heaven" is satire of almost stupefying gentleness.

With a few small cuts, it might even have amused El Caudillo himself, a fellow who was not known for his wild and crazy sense of humor.

The 1987 Spanish comedy opens today at the Film Forum.

"Wait for Me in Heaven" (Espérame en el Cielo) is about the curious fate of Paulino Alonso (José Soriano), a short, portly middle-aged Madrid shopkeeper who sells prosthetic devices.

Paulino is Mr. Average Man. He loves his lantern-jawed wife, Emilia (Chus Lampreave), who believes in spiritualism and holds frequent seances, and his nights out at the brothel, where he's the life of the party. One day all that changes.

Paulino is kidnapped by the secret police, who, initially against his will, groom him to be Franco's stand-in. With his hair thinned, his forehead raised and a mustache pasted on, Paulino is the spitting image of the Spanish leader, who is also played by Mr. Soriano.

There are some faintly amusing scenes in which Paulino is told how to talk ("not so deep, and with more sweetness") and how to walk ("with majesty"), his chin up, his chest out and his tail tucked in.

After his wife has been informed that he has died for his country, Paulino finds himself, like Franco, with a job for life. His duties are ceremonial but, eventually, he begins to enjoy them.

●

Though the situation is made to order for mistaken-identity farce, Mr. Mercero never exploits the possibilities with any kind of gusto. Paulino, as Franco, makes one quick visit home to see Emilia, arriving in the middle of a seance, for the expected effect.

There's also a good sequence in which, at the last minute, he has to receive the Egyptian Ambassador. Not having a clue about what he should say, Paulino simply mouths bits and pieces of various inappropriate speeches he remembers from the past.

In only one sequence does the movie teeter on the edge of true farce, when both Paulino and Franco are wandering around the palace at the same time, barely missing each other and confounding servants, ministers and wife.

The movie's banal view of Franco may be intentional, but it's not really adequate. According to "Wait for Me in Heaven," the worst thing that can be said about Franco is that he was hopelessly lower middle class. His idea of a fun evening was to sit at home with his wife, staring at the radio and discussing the announcers each prefers.

A certain amount of the film's wit may be beyond the ken of the non-Spanish viewer who doesn't share an awareness of time and place. It's possible that inside jokes and references abound, the sort of things that can't be made clear by the English subtitles.

Mr. Soriano gives good, relatively subdued performances in his dual role. Almost as good are Miss Lampreave, who has appeared in several Pedro Almodóvar comedies, and José Sazatornil, who plays the comically supercilious Minister of Propaganda, who acts as Paulino's control until Paulino takes control himself.

1991 Ja 30, C10:5

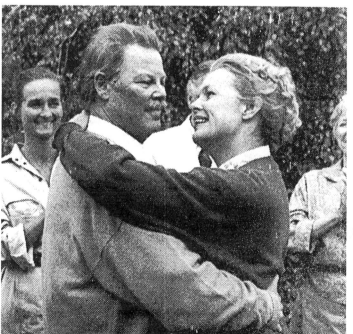

Schecter Communications

Frits Helmuth and Ghita Norby in "Memories of a Marriage."

Bertolucci's Uncut Epic Of Class and Clash

By CARYN JAMES

THE raggedy boy who catches frogs and turns them into a live, wriggling wreath on the brim of his hat is called Olmo. He will grow up to be a Communist hero played by Gérard Depardieu, dubbed into English but still a volatile presence. The boy in the elegant white suit who roughhouses with Olmo is Alfredo, the landowner's grandson. Forced to eat those frogs for dinner, to his immense credit he cannot keep them down. As an adult, Alfredo is Robert De Niro, whose American accent adds an unsettling whiff of modernism to his role as the last padrone, that their northern Italian village will know.

From their birth on the same day in 1901 to the final image of them together — hunched, white-haired men still wrestling under a tree — these two embody the endless class struggle that is the subject of Bernardo Bertolucci's 1976 film "1900." Grand and flawed, polemical yet filled with brilliant images, it has Tolstoyan ambitions and many endearing quirks.

The uncut, 5-hour-and-11-minute version of "1900" opens today at Film Forum, where it will be shown in two parts. Fittingly for a film about history, and happily for its viewers, the years have absorbed its status as a cause célèbre.

Mr. Bertolucci made "1900" right after the notorious psycho-sexual drama "Last Tango in Paris" (no longer as shocking as it was in 1973, but still one weird cookie of a movie) and a decade before his recent extravaganzas "The Last Emperor," which won the 1987 Academy Award for Best Picture, and "The Sheltering Sky," currently in theaters. "1900" was his first epic, and a peculiar paradox: a very expensive movie about the power of the working class. And it arrived in this country in 1977 amid a flurry of lawsuits, mixed reviews and charges of artistic butchery.

Paramount, the film's American distributor, had rejected Mr. Bertolucci's original five-hour version; the producer, Alberto Grimaldi, then threatened to release his own three-hour version without the director's approval. The version finally shown in theaters was a compromise, a four-hour-and-five-minute cut that Mr. Bertolucci claimed to be happy with at the time.

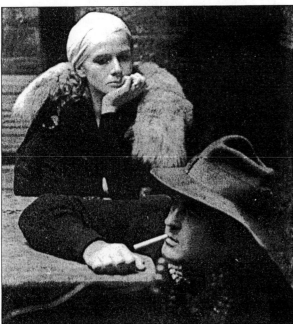

Paramount Pictures/Film Forum

Bernardo Bertolucci and Dominique Sanda during filming of "1900" — now at Film Forum.

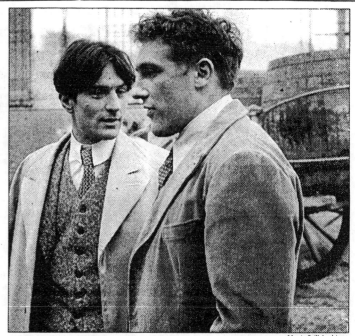

Movie Still Archives

Robert De Niro, as Alfredo, and Gérard Depardieu, as Olmo, in "1900."

Time, of course, changes everything. Mr. Bertolucci now stands by this restored version, which was recently edited and rerecorded for improved sound under the supervision of its cinematographer, Vittorio Storaro. Though the new-old "1900" includes an hour's worth of material never seen in American theaters before, these additions do not make for a radically different film. It does have more political speeches and more sex (the film proves the value of its NC-17 rating and proves that its stars did not use body doubles).

What matters more than the extra scenes is the way distance allows a new perspective on one of the more ambitious films ever made, and on the work of a director whose eloquent command of images and passion for film is beyond doubt. Today, with no need to be solemn about "1900" as endangered art, the film seems a delicious mix of idealism, beauty and sometimes laughable excess. It can be as exquisite as its opening view of misty sunlight shining through poplars, or as overwrought as Donald Sutherland, in one of the all-time bad screen performances, as a Fascist foreman named Attila. He batters a cat with his forehead early on and turns nasty after that. But however schematic its narrative and didactic its Marxist politics, "1900" remains absorbing. At every erratic turn, it demands that viewers grapple with it.

•

Part 1 is the more richly textured, the less polemical. With its affinity for nature and its lyrical scenes of Olmo and Alfredo as boys just beginning to absorb the lessons of their ancestors, it hints at idyllic possibilities.

But they are mere hints. Burt Lancaster, as Alfredo Berlinghieri, is a typically obtuse landowner who celebrates his grandson's birth by taking Champagne to the sharecroppers working his fields. "Destiny — both born on the same day," he tells Sterling Hayden as Leo Dalco, the less joyous grandfather of the illegitimate Olmo. The best Dalco can do is give his grandson a strong name that means elm tree and to teach the boy that what he owns belongs to all the

Dalcos. This proto-socialist message is not lost on Olmo, or on an audience who can do without such speeches.

At times the film resembles a pageant, its characters pulled along by a fate the film maker has decreed. Yet at its best it offers eloquent moments of individual choice. When old Berlinghieri hangs himself in the cowshed, defeated by the physical impotence that represents the failure of his class, it is a wrenching and troubling moment. Yet he has just taken a young peasant girl into the barn, and the ominous scene suggests that only his impotence saves her from being another victim of the padrones. Miraculously, Mr. Lancaster makes this unsavory old man seem pathetic and misguided.

Such complexities of character are rare in "1900." When Olmo and Alfredo turn into Mr. Depardieu and Mr. De Niro, as soldiers returning from World War I, the actors' conviction and energy make up for the characters' sparse personalities. In the script by Mr. Bertolucci, Franco Arcalli and Giuseppe Bertolucci, Olmo has virtually no inner life. Yet Mr. Depardieu conveys a sense of power that makes Olmo a convincing local hero.

•

Mr. De Niro's portrayal is the strongest because his ultramodern presence works against all expectations. Alfredo may be the watered-down last generation of feudalism, but the actor's vibrant presence suggests the tenacity of his class. Mr. Bertolucci sets up a workers' victory, but as Mr. De Niro says with chilling astuteness at the film's end, "The padrone lives."

The contrasts between the two men can be distractingly neat. Olmo falls in love with a plain schoolteacher named Anita, while Alfredo chooses a beautiful, decadent woman named Ada, played with surprising sympathy by Dominique Sanda. After Alfredo and Ada make love in a barn, carefree and slumming on the peasants' turf, Mr. Bertolucci cuts to Olmo and Anita angrily leading a funeral procession. The charred bodies of workers who died in a fire set by Fascists are carried in wagons

through the streets. It is a jarring contrast, but like so many in "1900" not an especially trenchant one.

Part 1 ends with the rise of Fascism, and Part 2 is downhill for the characters as well as the film. "Send Attila away," Olmo tells Alfredo, who has become the new padrone. But Alfredo, who has inherited his ancestral weakness, lets the warning go by. It marks a turning point, for Fascism in the person of Attila comes to dominate the film crudely. He marries Alfredo's cousin Regina, played by Laura Betti in an overblown performance that at least matches Mr. Sutherland's in pitch.

•

Yet even in its weaker parts, "1900" contains startlingly original images, whose meanings surpass description. Mr. Bertolucci is, after all, more film maker than propagandist. Ada serenely places her wedding veil on the vituperous Regina in a graceful gesture of utter contempt. In one of the film's great cathartic moments, women with pitchforks leave their haywagons and run after Attila and Regina. And on Liberation Day in 1945, workers dance under a huge canopy made of stitched-together red flags, some bearing the hammer and sickle and others simply bright peasant fabrics. It is not necessary to share Mr. Bertolucci's politics to be engaged by film making so pure and expressive.

Large-scale political films, from D. W. Griffith's "Intolerance" to Mr. Bertolucci's own "The Last Emperor," tend to lure viewers into an elegant fantasy land where the spectacle overwhelms the subject. "1900" does not seduce viewers to escape easefully into such a world. It remains a bracing anti-epic epic, feisty, challenging and all the more appealing for it.

1991 F 1, C1:1

Meet the Applegates

Directed by Michael Lehmann; written by Redbeard Simmons and Mr. Lehmann; director of photography, Mitchell Dubin; edited by Norman Hollyn; music by David Newman; production designer, Jon Hutman; produced by Denise Di Novi; released by Triton Picturescoei. Running time: 90 minutes. This film is rated R.

Dick Applegate	Ed Begley Jr.
Jane Applegate	Stockard Channing
Aunt Bea	Dabney Coleman
Johnny Applegate	Bobby Jacoby
Sally Applegate	Cami Cooper
Greg Samson	Glenn Shadix
Opal Withers	Susan Barnes
Vince Samson	Adam Biesk
Dottie	Savannah Smith Boucher

By VINCENT CANBY

By the time it finally ends, "Meet the Applegates" has the limp manner of a five-minute "Saturday Night Live" sketch that has been stretched to the length of a feature film, which is well beyond the snap-back point.

The idea is this: some ecology-minded bugs, older even than cockroaches, decide to retaliate when their Amazon jungle habitat is threatened by man.

Having the ability to mutate at will, they send off to the United States a small delegation of bugs disguised as the average American family as defined in an old Dick and Jane reading primer. Their mission is to blow up a nuclear power plant, thus to rid the

Triton Pictures

Settlers Camille Cooper, Ed Begley Jr., Stockard Channing and Bobby Jacoby star in "Meet the Applegates" as a family of Amazon arthropods who disguise themselves as the perfect American family.

world of people. Like cockroaches, these bugs can survive anything, including radiation.

The family couldn't be more average. They are Dick Applegate (Ed Begley Jr.); his wife, Jane (Stockard Channing); their teen-age daughter, Sally (Cami Cooper); younger son, Johnny (Bobby Jacoby), and a small dog named Spot. Except for their fondness for Butterfingers, you would be hard-pressed to see the insect in any of them.

•

Jane and Sally are particularly average. They are as pretty as the drawings in the Dick and Jane primer. Wearing little pink dresses with little puffed sleeves, they're average by standards about 30 years out of date, which is one of the film's sweeter conceits.

Once settled in their pretty little house in Median, Ohio, though, the Applegates and their mission begin to go to pieces. The bugs find themselves co-opted by the values they abhor.

Dick, who has a job in the local nuclear power plant, is seduced by his ever-ready secretary. Jane goes on a credit-card spending spree. Sally gets pregnant and Johnny freaks out on pot.

It's at this point that the movie becomes completely fogged. The satire of American manners is so soft that it seems that the movie is really sending up the kind of ineffectual environmentalists the Applegates represent.

That's possible but unlikely, considering the upbeat, Capra-like speech (on behalf of interspecies tolerance and the protection of the rain forests) with which the movie inches toward a long overdue conclusion.

•

"Meet the Applegates" is the second feature to be directed by Michael Lehmann, whose first film was the stylish, bitterly funny "Heathers," about one young woman's murderous

campaign to become the most popular girl in her high school class.

The screenplay for the new film, written by Redbeard Simmons and the director, isn't sharp enough. The movie wastes time and good humor showing the audience the Applegates as bugs in special makeup effects designed by Kevin Yagher.

The bug jokes are less funny than obligatory. The Applegates' neighbor is an exterminator as well as a bigot. He frightens them. Dick drools over bug pictures in Scientific American the way another man might look at Playboy. Says Jane, when her family congratulates her on the tastiness of their supper, "I happened to find some rancid trash in a dumpster behind the 7-Eleven."

The cast members aren't exactly wasted, but their possibilities are limited.

Dabney Coleman, a very funny actor with good material, turns up in drag as Aunt Bea, the queen bee of this insect clan, which otherwise doesn't have much to do with bees or bee habits.

Everything about the movie is fuzzy, not thought through, as if Mr. Lehmann had shot a first treatment instead of a finished screenplay.

"Meet the Applegates," which has been rated R (Under 17 requires accompanying parent or adult guardian), has vulgar language and partial nudity.

1991 F 1, C6:1

Popcorn

Directed by Mark Herrier; screenplay by Tod Hackett; director of photography, Ronnie Taylor; edited by Stan Cole; music by Paul J. Zaza; production designer, Peter Murton; produced by Torben Johnke, Gary Goch and Ashok Amritraj; released by Studio Three. Running time: 93 minutes. This film is rated R.

Toby	Tom Villard
Maggie	Jill Schoelen
Suzanne	Dee Wallace Stone
Dr. Mnesyne	Ray Walston
Bud	Malcolm Danare
Mark	Derek Rydall
Mr. Davis	Tony Roberts

By VINCENT CANBY

"Buy a bag ... go home in a box," reads the ad line for "Popcorn," a horror film that is less mindless than most in that it is both funny and gross.

A hideously disfigured madman runs amok backstage during an all-night movie "Horrorthon," intended to raise money for the local university's film department.

As the students attend to "Mosquito," "Attack of the Amazing Electrified Man" (shown in Shockoscope) and "The Stench" (filmed in Aroma-

Studio Three Film Corporation

Tom Villard

rama), the fiend dashes around the theater picking off victims, all, of course, innocent.

His principal target is a beautiful young student named Maggie (Jill Schoelen), a would-be screenwriter. Maggie is filled with strange forebodings as she watches scenes from the long-lost classic "Possessor," but not because she thinks it's ridiculous.

She recognizes the scenes as being those in a screenplay she is currently working on. "Oh, God, Toby," she cries out in some anxiety to her friend, "my mind is just, like, reeling!"

•

"Popcorn," written by Tod Hackett and directed by Mark Herrier, is the best spoof of its kind since "Alligator." It's especially funny when it allows the audience to see sequences from the movies-within-the-movie, each of which recalls some piece of cherished junk out of the 1950's or 60's.

"Mosquito" is about grotesque mutants that have resulted from too much A-bomb testing. At the fade-out, after the last giant mosquito has been destroyed, the heroine turns to the hero and sighs. "Mankind must ever be on the alert," she says. "I know one thing, baby," he replies with a wink. "I'm going to be watching you."

"Attack of the Amazing Electrified Man" is about a murderer who survives electrocution with the help of a crazy doctor's experiments with what he describes as "a third corpuscle," as opposed to the ordinary, run-of-the-mill red and white kinds.

Mr. Herrier and Mr. Hackett obviously have senses of humor, as do the members of the cast, which includes Tony Roberts, Tom Villard and, in a tiny role, Ray Walston. Although the film is supposed to be set in Anytown, U.S.A., it was shot in Kingston, Jamaica. There's not a beach or a palm tree in sight.

•

"Popcorn," which has been rated R (Under 17 requires accompanying parent or adult guardian), has vulgar special effects, vulgar language and simulated violence.

1991 F 1, C6:5

Book of Love

Directed by Robert Shaye; screenplay by William Kotzwinkle, based on his novel "Jack in the Box"; director of photography, Peter Deming; edited by Terry Stokes; music by Stanley Clarke; production designer, C. J. Strawn; produced by Rachel Talalay; released by New Line Cinema. Running time: 87 minutes. This film is rated PG-13.

Jack Twiller	Chris Young
Crutch Kane	Keith Coogan
Peanut	Aeryk Egan
Lily	Josie Bissett
Gina Gabooch	Tricia Leigh Fisher
Spider Bomboni	Danny Nucci
Floyd	John Cameron Mitchell
Angelo Gabooch	Beau Dremann
Adult Jack Twiller	Michael McKean

By JANET MASLIN

Robert Shaye's "Book of Love," which tells a story it says is "written in the heart of every horny teenager," is best appreciated by those with immense fondness for the embarrassments of the past. William Kotzwinkle, who has somehow fash-

ioned a straightforward screenplay from his seemingly unfilmable novel "Jack in the Box," reveres every kitschy pop-cultural artifact in the life of his hero, Jack Twiller, and delights in every wishful presexual fiasco. Under Mr. Shaye's direction, this translates as ripe middle-aged nostalgia for the kinds of pranks that barely adolescent boys play on one another at sleepaway camp.

"Book of Love," with a prologue featuring Michael McKean as a grown-up newly divorced Jack, traces the young Jack back to his first teen-age stirrings. The best of these memories share some good-natured wryness, like the sight of four boys flavoring their illicit alcoholic drinks with raisins as they vainly try to sing "Earth Angel" in tune, or a classroom scene in which it is revealed that there are, if one tries hard enough to find them, quasi-dirty parts in "Moby-Dick." One of the film's funnier moments has Jack, played affably by Chris Young, trying to impress a girl by turning himself into James Dean and rubbing his head against a wall with so much moody enthusiasm that he leaves a grease spot on the paint job.

•

Much of "Book of Love" is more gimmicky than wistful, as the film adopts Mr. Kotzwinkle's way of cramming comic-book characters, television commercials and calendar pinups into Jack's impressionable mind. So a black-and-white Charles Atlas-type body builder appears on the street to advise Jack about how to avoid having sand kicked in his face, and a calendar girl comes to life to lend him encouragement. Chaotic as such tricks were on the page, they become oddly subdued on screen and serve more to interrupt the story than to lead it anywhere.

Despite such novel touches as a father who barks insults but never pokes his head out from behind his newspaper, "Book of Love" is both visually and comically reminiscent of too many other high school stories. Even the characters are standard, from the cute and inquisitive kid brother (Aeryk Egan) to the nerdy sidekick (Keith Coogan) and bookish crony (John Cameron Mitchell) who make up Jack's immediate circle; there are also a bully (Beau Dremann), the bully's salt-of-the-earth brunette sister (Tricia Leigh Fisher) and the blond ice princess (Josie Bissett, who even looks like the young Cybill Shepherd). By now there are very deep tire tracks down this particular stretch of Memory Lane.

•

"Book of Love" is rated PG-13 (Parents strongly cautioned). It includes brief nudity and many sophomoric sexual references.

1991 F 1, C10:6

Queens Logic

Directed by Steve Rash; screenplay by Tony Spiridakis, story by Mr. Spiridakis and Joseph W. Savino; director of photography, Amir Mokri; edited by Patrick Kennedy; music supervision by Gary Goetzman and Sharon Boyle; additional music by Joe Jackson; production designer, Ed Pisoni; produced by Stuart Oken and Russ Smith; released by New Visions Pictures Production; Seven Arts Release through New Line Cinema. Running time: 153 minutes. This film is rated R.

Dennis.................................... Kevin Bacon
Carla.................................. Linda Fiorentino

New Visions Pictures

Pals Kevin Bacon, John Malkovich and Tony Spiridakis star in "Queens Logic," about a group of childhood friends from the borough.

Eliot.......................... John Malkovich
Al...................................Joe Mantegna
Ray...................................... Ken Olin
Vinny...........................Tony Spiridakis
Monte...............................Tom Waits
Patricia................................Chloe Webb
Grace........................ Jamie Lee Curtis

By JANET MASLIN

"Queens Logic" is one of those films that suppose important life decisions are best made in the company of old pals, preferably pals who have lived and loved together over a long period of time. In this and other descendants of "The Big Chill," contrivance demands that the friends reconvene on a ceremonial occasion. That event, in "Queens Logic," is the scheduled wedding of Ray (Ken Olin) and Patricia (Chloe Webb), who are acutely mismatched. These two bicker a lot, but the film's central love-hate relationship is the one between the borough of Queens and the rest of the world.

Queens itself, as embodied by the loud, hearty, toothpick-chewing Al (Joe Mantegna, happily making himself the life of the party) and all his cronies, is a safe haven with a language all its own. ("You tryina kill me, Ma?" bellows Carla, Al's unhappy wife. "G'head, g'head.") It's a place where a guy can cruise cheerfully in his convertible shouting out unsolicited advice to anyone on the street. But for Al, Queens is also a humdrum job in the fish business and a miserable mother-in-law. The rest of the world, particularly Manhattan, is where Al and the others escape to indulge their dreams of meeting more interesting women and having a wilder time.

Tony Spiridakis, who wrote the film and also plays the only group member to have gained an actual toehold in Manhattan, views the Queens side of the story too fondly to let the characters' restlessness really take root. So "Queens Logic" fans the flames of its characters' dissatisfaction only to put them out again, which makes it more tidily circular than surprising. So many longstanding problems are solved in the film's final scene that the abundance of happy pairings suggests Noah's Ark.

Queens patriotism is also reaffirmed, despite the many times the camera has gazed longingly at bridges leading elsewhere.

Luckily, "Queens Logic" has a big and eminently watchable cast, brought together for ceaseless partying and clowning. As directed by Steve Rash, who also directed "The Buddy Holly Story," the film is loosely held together by high spirits and by a terrifically upbeat, well-chosen line-up of pop songs. (The additional music by Joe Jackson is also a great help.) The film is much better off simply indulging this festive spirit than it is in getting the characters to take themselves seriously.

•

The prospective newlyweds are Ray (Mr. Olin, with a few days' perfect stubble and a heavy Queens accent) and Patricia (Ms. Webb, looking like a younger, slinkier Maureen Stapleton), an aspiring painter and a hairdresser who wants nothing more than to accommodate her future husband. "After five years of watchin' him struggle, I still believe in him even when he don't believe in himself," says Patricia, indicating that women's roles are not Mr. Spiridakis's strong suit. In a similar vein, the statuesque, deep-voiced Linda Fiorentino, as Al's angry wife, Carla, spends a long time having her hair dyed red and then presents this as a major personality change.

John Malkovich gives the film a welcome tartness as the shy, sarcastic Eliot, Al's co-worker at the fish plant and a self-described "homosexual who cannot relate to gay men." Mr. Malkovich is often droll, but Kevin Bacon, who arrives from California as the group's long-lost musician friend, is saddled with the screenplay's three most maudlin moments; still, Mr. Bacon brings the film a lot of energy. So does Jamie Lee Curtis, who appears briefly as a rich Manhattanite so carefree that she parks an unlocked red convertible sports car on the street. The singer Tom Waits also turns up, fencing jewelry and looking scary.

The film's down-to-earth quality is best expressed through Hawaiian shirts, wisecracks about domestic violence and a scene in which Patricia expresses her annoyance at Ray by flushing a toilet while he is in the shower. Its contrived side shows up most clearly in the three awkward things Mr. Bacon has to do: tell Patricia he has always loved her, tearily admit that he isn't such a big success in Hollywood after all, and regale the others with "that 'Ordinary People' song" — the Pachelbel Canon — at dawn.

•

"Queens Logic" is rated R (Under 17 requires accompanying parent or adult guardian). It includes brief nudity and rude language.

1991 F 1, C13:1

Run

Directed by Geoff Burrowes; written by Dennis Shryack and Michael Blodgett; director of photography, Bruce Surtees; film editor, Jack Hofstra; music by Phil Marshall; production designer, John Willett; produced by Raymond Wagner; distributed by Buena Vista Pictures Distribution Inc. Running time: 89 minutes. This film is rated R.

Charlie Farrow.................Patrick Dempsey
Karen Landers.........................Kelly Preston
Halloran.....................................Ken Pogue

Joseph Lederer/Hollywood Pictures
Patrick Dempsey

Denny Halloran.................... Alan C. Peterson
Sammy..James Kidnie
Marv...Sean McCann
O'Rourke.....................................Michael MacRae
Smithy..Tom McBeath
Cab Driver..................................Peter Williams

By JANET MASLIN

"Run," about a Harvard law student who falls afoul of a powerful gangster and is forced to go on the lam, is something Kafka might have thought of if Kafka had been interested in knocking off mindless television-movie scripts as a sideline.

"Run" stars Patrick Dempsey, which is a mistake right away. Mr. Dempsey, as the fleet-footed Charlie Farrow, so exaggerates the character's smirky overconfidence in the film's early scenes that the audience may later be glad to see him getting into trouble. Even then, in supposedly nerve-racking situations, Mr. Dempsey has a way of remaining uneasily on the cusp between suspense and chuckles. After a car explodes, for instance, he ducks the flying debris in a weird and unsuccessful bid for humor. Mr. Dempsey's constant mugging is especially noticeable because the rest of the casting is so bland.

As directed by Geoff Burrowes (two "Man From Snowy River" films) and co-written by Dennis Shryack and Michael Blodgett ("Cobra II," "Turner and Hooch"), "Run" takes an odd premise and hammers it into perfect predictability. Based on a news account of a visiting punk who robbed a small-town casino and met his death an hour and a half later, "Run" has been transformed into an innocent gambling-hall mix-up followed by an endless succession of breathless chase scenes.

•

Hired to drive a red Porsche convertible from Boston to Atlantic City, Charlie breaks down somewhere along the way and is led by an enterprising cabbie (Peter Williams) to a clandestine gambling establishment. There, he is picked on mercilessly by the local bully (Alan C. Peterson) until the bully lunges for him, accidentally hits his head and dies. The bully turns out to be the beloved son of the local gangland boss (Ken Pogue), who demands revenge. The screenplay also throws in a lot of corrupt policemen, who do the gangster's bidding, and a beautiful card dealer (Kelly Preston) who helps Charlie hide.

The chase scenes are comparably creative. Mr. Dempsey sprints, drives or scampers through the machinery at a bowling alley, the balloon stand and a big, sinister-looking clown' at an amusement park, the bleachers at a dog-racing track, a crowded mall (at which the fleeing, panicky extras all run in exactly the same direction) and at least two underground garages. All of this is staged to the accompaniment of loud, overbearing music in the throbbing-pulsing-drumming mode. Along the way, there are several examples of the kind of cheap, easy sadism for which a large portion of the American moviegoing public just lost its appetite.

"Run" includes exactly one funny moment, during which the escaping Harvard law student hears a particularly dire bit of news about his plight while listening to a car radio. "That's it!" he exclaims. "Now I'm gonna have to teach."

•

"Run" is rated R (Under 17 requires accompanying parent or adult guardian). It has strong language and several violent episodes.

1991 F 1, C15:1

FILM VIEW/Janet Maslin

Odd Couples Need to Be Truly Odd

MOVIE CHARACTERS OFTEN INFLUENCE each other in amazingly tidy ways. Behavioral symmetry can be a formula-loving screenwriter's best friend. Should the writer elect to take this easy way out, then the safecracker who is accidentally handcuffed to a Scout leader will have become more honest and generous before the story is over, whereas the Scout leader will have loosened up and learned to have fun. Or a prostitute (vide "Pretty Woman") will have grown more ladylike, while her businessman friend learns to be better attuned to his human side.

To some extent, we have the television sitcom to thank for this. Its writers are trained to fill 20 minutes with jokes and the last two with a little lecture, from which the viewer learns, for instance, that the prettiest girl in the eighth grade class is not necessarily the nicest person. A lecture this brief had better reduce character and motivation to the plainest

In real life, mismatched pairs aren't as evenly balanced as movies often like them to be.

possible terms. But if it's going to be oversimplified, then it had better include a sudden turnabout of some kind. Such a trick will at least create the illusion of insight or style.

Whatever the cause, current American films are filled with facile flip-flops or parallels involving characters who are linked chiefly by expediency, and often not for any better reason. The plotting that grows out of such connections may not be terribly imaginative, but at least it's easy to devise. Why stop with the patients themselves when you have, in "Awakenings," a doctor who has miraculously roused his patients from years in a statuelike state ? If you can also toss in a different kind of "awakening" for the doctor himself, as he learns to come far enough out of his shell to ask a nurse out on a date, that's icing on the cake.

The symmetrical approach isn't always this superfluous, but it does bring an obviousness to works that may already have obviousness to spare. "The Long Walk Home," a somber and estimable look at the beginnings of the civil rights movement, is committed from the outset to telling an audience things it already knows. The feeling of familiarity is only heightened by the way the narrative divides its energies between two characters, the complacent Southern housewife played by Sissy Spacek and the hard-working, uncomplaining maid played by Whoopi Goldberg.

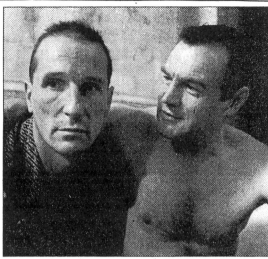

Nikolai Ejevsky/MK2 Productions

Pyotr Mamonov and Pyotr Zaichenko as the wildly unpredictable friends in "Taxi Blues"

The film could easily describe the first stirrings of social change in terms of either women. But it elects to encompass them both and to show how each one changes the other. Perhaps playing it safe in this way amounts to insurance, guaranteeing that an audience will be interested in at least one of the characters, and that change and dramatic development are built right in. But it's hardly a way to make sparks fly.

Nonetheless, it's often the method of choice. In "Mermaids," the boy-crazy adolescent mother played by Cher and her much more responsible daughter, played by Winona Ryder, have met each other halfway by the time the story ends ; the mother learns to take life more seriously while the daughter lightens up. In "Green Card," Andie MacDowell's prim botanist and Gérard Depardieu's charmingly oafish composer also take on each other's better traits, as he becomes more earnest and she more relaxed. In "The Bonfire of the Vanities," the entire character played by Bruce Willis seems to exist as a counterbalance to Tom Hanks's Sherman McCoy, who, despite Mr. Hanks's sporting performance, needed a lot more help than that.

Motivation, in films that rely on such dramatic shorthand, is never allowed to leave much to the imagination. It is not enough, in "Kindergarten Cop," to have the police detective played by Arnold Schwarzenegger find that he likes schoolteaching simply because he likes it. The screenplay must explain that he is divorced and has a child he never sees, even though neither his son nor his ex-wife has anything to do with this story.

Relying on such simple explanations can occasionally backfire, by the way, and in "Kindergarten Cop" one almost does. The police are at work trying to match up a drug-dealing husband and the wife who is hiding from him. When the screenplay has one woman saying her husband left her for a man, and the film goes out of its way to emphasize that the drug dealer is under the sway of his belittling, domineering mother, it throws a red herring at an audience that has been trained to jump to conclusions.

A significant breath of fresh air, in the midst of so much by-the-numbers character development, is the wildly unpredictable friendship to be found in "Taxi Blues," the vibrant Soviet film about a bellicose, bigoted cabbie and a sodden Jewish musician who become tied together by circumstance. The film's tremendously talented writer and director, Pavel Lungin, has described himself as influenced by American cinema, but he doesn't mean the formulaic cinema of today ; rather, it is the freewheeling, masculine buddy films of the 1970's, like "Scarecrow" and "The Last Detail" and some of John Cassavetes' work, that are echoed here.

The result, in "Taxi Blues," is excitingly unfettered by any preconception about how two people ought to affect each other. This film follows a revealing course by letting the furious culture clash that erupts between these two figures, the self-hating artist and the working stiff, take its own erratic course. Mr. Lungin has the restraint to be wise without teaching lessons. Neither of the men in "Taxi Blues," thank goodness, is a better person for having known the other. □

1991 F 3, II:13:5

21

Straight for the Heart

Directed by Lea Pool; screenplay (in French with English subtitles) by Ms. Pool and Marcel Beaulleu, adapted from the novel "Kurwenal" by Yves Navarre; photography, Pierre Mignot; edited by Michel Arcand; music by Osvaldo Montes; produced by Denise Robert and Robin Spry; an L. W. Blair Films release of a Canadian-Swiss co-production: Les Films Téléscène and Xanadu Films. At Cinema Village, Third Avenue between 12th and 13th Streets. Running time: 92 minutes. This film has no rating.

Pierre Kurwenal.....................Matthias Habich
Sarah............................Johanne-Marie Trembly
David..Michael Voita
Quentin.........................Jean François Pichette

By STEPHEN HOLDEN

Rarely has a city been filmed with such an exquisite sensitivity to the relationship among architecture, climate and the emotions as Montreal the way it is pictured in Lea Pool's visually compelling drama, "Straight for the Heart."

The moody cityscapes shown in the Swiss-Canadian film, which opened Wednesday at the Cinema Village, are more than cinematographic embellishment. They are the metaphoric core of the movie, which examines the midlife crisis of a hardened photojournalist. One day, Pierre Kurwenal (Matthias Habich) returns from an assignment in Nicaragua, where he has dispassionately photographed scenes of assassination and the murder of children, to find himself suddenly cut loose from his happy, if unorthodox, domestic life.

For 10 years, Pierre had lived in a ménage à trois with Sarah (Johanne-Marie Trembly), a violist, and David (Michael Voita), a younger man who trains dolphins. Flashbacks reveal the relationship to have been an erotically charged arrangement in which Pierre and David loved each other as freely as they loved Sarah. But as Pierre discovers, Sarah and David fell more in love with each other than with him, and she has become pregnant with David's child. After agonized individual confrontations with the two, Pierre mopes about the city, and eventually establishes a tentative relationship with Quentin (Jean

François Pichette), a deaf window washer he picks up in a bar.

Pierre also throws himself into a new project, a photojournalistic study of urban corrosion many of whose scenes incorporate surreptitious photos of the two lovers who abandoned him. As he compiles the pieces of what becomes a wall-size black-and-white mural, he gradually succumbs to a nervous breakdown.

"Straight for the Heart," which was adapted from a novel by Yves Navarre, observes the world solely through Pierre's eyes. A film of few words (they are French with English subtitles) but filled with visual poetry, it is constructed like a tone poem whose repeated images, stunningly shot by Pierre Mignot, become a psychological hall of mirrors. The opening Nicaraguan scenes in which Pierre photographs two episodes of murder are among the most recurrent visual motifs in a stream of imagery that continually punctuates the present with black-and-white flashbacks. Eventually, Pierre begins to realize that the dispassionate voyeurism he brought to his profession has begun to seep into the ménage à trois and to destroy it.

The film's weakest element is its screenplay, written by the director with Marcel Beaulleu, in which the spare dialogue is required to carry far too much weight. At a fancy dinner party where the unstable Pierre begins snapping pictures of the guests, the dinner conversation consists of portentous one-liners about art and happiness. Although the performances of the craggy-faced Mr. Habich and his co-stars have a stormy intensity, the pained, soulful eye contact can go only so far in illuminating the dynamics of a three-way relationship that remains a mystery.

By New York standards, the film's vision of urban decay is very tame. Montreal emerges as a clean, roomy city of gleaming towers and few pockets of rust. Even the graffiti on the walls that Pierre photographs in his quest for rot have a genteel, painterly beauty.

1991 F 4, C14:1

Matthias Habich in "Straight for the Heart."

Black Films: Imitation Of Life?

By VINCENT CANBY

NAOMI is a pretty little black child living in a comfortable all-black middle-class world, untouched by the poverty of the 1930's. But she is cursed.

"You're a bad girl and need to be punished," says her teacher with somewhat more vehemence than her crime would seem to warrant. Naomi has been sticking out her foot and tripping nice little girls in the schoolyard.

Niceness is something the rebellious Naomi has no interest in. For her it represents secondhand values of the most genteel and restrictive kind. "Nice children never steal, always go home and play with nice children," she is told with regularity, but Naomi is, according to her teacher, "insolent, haughty and mean."

Jimmy, Naomi's adoptive brother, tells Naomi: "You don't want to be colored. That's what's wrong."

When she is caught in a lie, her otherwise loving adoptive mother threatens Naomi with a whipping she'll never forget .

After a while, even Naomi acknowledges her own built-in rottenness. "I was a bad girl and had to be disciplined," she reports after spending eight unhappy years locked away in a convent. As someone older and wiser remarks, "There's always a reason for putting girls in convents."

Naomi's curse?

Movie Still Archives

Dorothy Dandridge and Harry Belafonte in "Carmen Jones" at the Film Forum.

Though black, her skin is so light that she can pass for white. Naomi wants to go to "the other side."

The cautionary tale of Naomi's decline, fall and suicide is the subject of the black film maker Oscar Micheaux's awkward but riveting 1938 melodrama, "God's Stepchildren."

The film, made for black audiences, is a dizzy amalgam of elements from the 1934 screen version of Fannie Hurst's novel "Imitation of Life" and Samuel Goldwyn's "These Three," the 1936 adaptation of Lillian Hellman's play "The Children's Hour." In the Micheaux movie, though, the Hellman play's hints of lesbianism are left intact, which they weren't in the Goldwyn film.

"God's Stepchildren" is just one of the cascade of highlights of Landmarks, Breakthroughs and Milestones in Black Film History, the richly detailed five-week retrospective beginning today at the Film Forum. It should be a smash. The opening program

presents a pair of all-black musicals: Otto Preminger's exuberant "Carmen Jones" (1954) and Allen Reisner's 1958 "St. Louis Blues," the life of W. C. Handy.

In addition, a retrospective titled the 1970's New Black Cinema is to begin tomorrow at the American Museum of the Moving Image in Astoria, Queens, with the showing of Gordon Parks Sr.'s "Learning Tree" (1969) and Ossie Davis's "Cotton Comes to Harlem" (1970).

Thereafter, through the end of the month, the museum will present four different black films each Saturday and Sunday, the most important being Melvin Van Peebles's seminal "Sweet Sweetback's Baadasssss Song" (1971), on Feb. 23.

•

Supplementing the Film Forum and the museum programs is Turner Network Television's current Salute to Great Black Performers, featuring a number of the films available in the other two shows, but also a number that are not.

Among the latter, the most important must be the early Ethel Waters film "On With the Show" (1929), to be broadcast on Thursday at the ungodly hour of 2:35 A.M.

The immediate peg for all of this attention is February's designation as Black History Month.

For once, such film programs do not seem to be superficial tie-ins. These black films, even when seen out of chronological order, present a remarkable and gaudy record not only of black film history, but also of American manners, the interpretation of which keeps changing and may well go on forever.

•

Only a handful of the films are notable for cinematic values, but cinematic values are beside the point. Watching these films is as addictive (and instructive) as reading old newspapers discovered by chance in the back of a closet.

"God's Stepchildren," the 1934 film version of "Imitation of Life," "Sweet Sweetback," the reverently condescending "Green Pastures" (1936) and the clear-eyed "Nothing but a Man" (1964) are reports of what happened yesterday.

As such, they are infused with an unself-conscious immediacy and honesty not available in history that has already been analyzed. These films are raw material. They don't dissemble. Even their false pieties and easy platitudes are historically important and, in the best way, entertaining.

The cinematic path to declaring that black is beautiful.

The films, most of which were made by white directors, date from the early sound era into the 1970's and embrace five main categories:

¶The "passing" films exemplified by "Imitation of Life," "God's Stepchildren," "Lost Boundaries" (1949) and "Pinky" (1949).

¶The segregated or all-black movies, including those made by Micheaux for black audiences and those produced by the Hollywood studios principally for white audiences, notably Paul Sloane's "Hearts in Dixie," 1929; King Vidor's "Hallelujah," 1929; "Green Pastures," co-directed by Marc Connelly and William Keighley; Vincente Minnelli's "Cabin in the Sky," 1943.

¶The Hollywood "problem" movies of the 1940's and 50's that try in their well-meaning, often bumbling way to call attention to racial prejudice, but nearly always by showing a single black in a uniformly white world ("Home of the Brave," 1949).

¶The "black is beautiful" movies, hints of which can be seen in Micheaux's work, but which did not really come into their own until the so-called blaxploitation films of the late 1960's and early 70's, when black audiences made their own superstars: Richard Roundtree, Pam Greer and Jim Brown, among others.

¶The exotic black film, which stands a bit outside the other categories and which includes those racially mixed-cast movies starring Paul Robeson and Josephine Baker, who were wildly praised by white critics and audiences of their day but never quite accepted into the white American mainstream.

One of the most lamentable aspects of the early films is the earnest manner with which black characters embrace the values of the dominant white culture. This is as true of the characters in Micheaux's "God's Stepchildren" as it is of those in John M. Stahl's "Imitation of Life."

•

The confusion of loyalties is particularly apparent in the films about passing for white. Though "God's Stepchildren" suggests, rather wanly, that black can be beautiful, there is also the feeling that Naomi, in wanting to pass, transgresses not just the black code but, more important, the white.

The sense of the film is that she has been especially favored by looking white and that should be reward enough for her. Micheaux's stars are usually light of skin, a tacit acceptance of white standards of beauty. Nobody yet dared to question the standards or the system itself.

In "Imitation of Life," when the light-skinned Peola, daughter of the dark-skinned Delilah, insists on passing, her distraught mammylike mother wonders where the blame lies. "It can't be the Lord's," she says. End of speculation.

The movies being shown at the Film Forum and the Museum of the Moving Image document a crucial time in movie making. They trace the steps leading to the revocation, in the 1970's, of the social contract that gave white values dominion over black. The landmarks, breakthroughs and milestones came in fits and starts, but relentlessly.

•

The all-black musicals may have been examples of glorified segregation. Yet the best of them were also more than that. "Stormy Weather," with its show-stopping performance by Ethel Waters, and "Carmen Jones," with its two equally beautiful stars, Dorothy Dandridge and Harry Belafonte, transcend their ghettos. They are joyous movies that float above the color line.

Hollywood's "problem" movies, which look fairly dated today, served notice that blacks existed as something more than happy cotton pickers (in "Hearts in Dixie"), maids, chauffeurs and handymen.

Way ahead of its time, 1964, was "Nothing but a Man," directed by Michael Roemer and written by him with Robert Young. Ivan Dixon and Abbey Lincoln give tough, moving performances as a couple making their way in a white world without

Away from the maids, chauffeurs and pieties.

apologies to anyone. No thoughts of integration for them. They demand their own lives and are willing to fight for them.

In the 1960's, as Sidney Poitier became America's first black matinee idol, it was easy to send up the seriousness with which he took his job as a credit to his race. He was an institution and often sounded like one, both in his public statements as well as in his movies.

Yet it's now possible to see that the militant black movies of the 1970's would not have been possible without the gentler Poitier films that preceded them.

Poitier was not militant, but he was a great, strong screen image. Later, when he began directing ("Buck and the Preacher," "Uptown Saturday Night"), he showed a talent for easy, unguarded, rambunctious humor missing from his more stately movies.

As important as Mr. Poitier to the evolution of black cinema is "Sweet Sweetback's Baadasssss Song." So are the dozens of schlock movies ("Blacula") and action-melodramas (the "Shaft" films) that Hollywood began to turn out as soon as it realized there was a market for them.

"Sweet Sweetback" still is not a great job of movie making, but its anger, passion, lusty comedy and commitment (which I, for one, could not see in 1971) are clearly apparent today.

Much like Mr. Poitier, Mr. Van Peebles cleared the ground for all who came after him; in particular for Spike Lee.

Hovering over the films in these retrospectives and having the effect of giving direction to the retrospectives themselves, are images from contemporary films: Mr. Lee's "Do the Right Thing," Edward Zwick's "Glory," Bruce Beresford's "Driving Miss Daisy," Keenen Ivory Wayans's "I'm Gonna Git You Sucka" and Charles Burnett's "To Sleep With Anger."

"Do the Right Thing" manages to be both militant and mainstream. "Glory" isn't perfect. Purists can object to the anachronisms spoken by the angry black Union soldier played by Denzel Washington.

Yet the entire movie is given terrible poignance by the audience's awareness of how slow the progress of the civil rights movement would be after the Civil War. That knowledge could also be called anachronistic, but it can't be denied.

"Driving Miss Daisy" makes some audiences shudder with embarrassment. But to see it as a fond recollection of a master-slave relationship is not to see the movie itself, which is about two substantial characters who do not conform to today's ideas of how whites and blacks should behave with one another.

"I'm Gonna Git You Sucka" is a wonderfully witty parody of all the "Shaft"-like films of the 1970's, conceived at a time when it is possible to send up black machismo without being called reactionary.

Equally liberating is "To Sleep With Anger," in which the members of a middle-class black American family are forced to evaluate their raw Southern heritage.

At an earlier film-making time, the subject might have been avoided as not being positive enough.

At the Film Forum, at the Museum of the Moving Image and on Turner Network Television, art and history are now colliding for sometimes astonishing results.

1991 F 8, C1:1

L.A. Story

Directed by Mick Jackson; screenplay by Steve Martin; director of photography, Andrew Dunn; edited by Richard A. Harris; music by Peter Melnick; production designer, Lawrence Miller; produced by Daniel Melnick and Michael Rachmil; released by Tri-Star. Running time: 95 minutes. This film is rated PG-13.

Harris	Steve Martin
Sara	Victoria Tennant
Roland	Richard E. Grant
Trudi	Marilu Henner
SanDee	Sarah Jessica Parker
Ariel	Susan Forristal
Frank Swan	Kevin Pollak
Morris Frost	Sam McMurray

By VINCENT CANBY

"L.A. Story," written by and starring Steve Martin, is the sort of film to which, in good conscience, you could send your aunt if she were the proverbial little old lady from Dubuque.

In fact, "L.A. Story" is ideal for anyone who avoids movies that make loud noises, go too fast or deal in smut, but who appreciates a saucy gag now and then, just as long as it's funny.

Like Mr. Martin himself, "L.A. Story" seems basically decent, intelligent and sweet. It's a fanciful romantic comedy whose wildest and craziest notion is that Los Angeles, for all of its eccentricities, is a great place to live.

You can't tell Mr. Martin or Mick Jackson, his director, anything about L.A. that they don't already know. The movie is less a narrative than an accumulation of gentle gags about smog, fads, freeways, dress, earthquakes, mating habits and trendy restaurants.

The name of the restaurant in the movie is pronounced "Leedy-O" but spelled L'Idiot. It's so exclusive that when Harris K. Telemacher (Mr. Martin) tries to make a reservation, he finds himself being questioned about his finances by the Fourth Reich Bank of Hamburg.

When first met, Harris is a professionally wacky weather forecaster on a local television station. On the sound track he confides that he is deeply unhappy, but too happy most of the time to realize it.

In the course of "L.A. Story," Harris meets and falls in love with Sara (Victoria Tennant), a beautiful, brainy young Englishwoman who shares his affection for the sun city so easily put down by others. There are also his self-absorbed, birdbrained mistress (Marilu Henner) and a pretty young thing (Sarah Jessica Parker), a free spirit who lives near the beach in Venice.

Says Harris when it's suggested that he's too old for the coltish Venice girl: "She's not so young. In four years, she'll be 27."

That is the level of Mr. Martin's humor, which has been tamed, possibly, in order not to get in the way of the movie's romantic notions. Early in the film, Harris is befriended by a freeway sign that speaks to him with its digital lettering. "Hug me," says the sign, and Harris does.

•

When Harris and Sara spend an idyllic afternoon together, the audience knows how Harris feels because he and Sara are suddenly seen to be cherub-faced youngsters.

A little bit of this goes a very long way.

Tri-Star Pictures

Victoria Tennant and Steve Martin star in "L.A. Story."

People who prefer Mr. Martin as he appeared in "Dirty Rotten Scoundrels" — that is, in a less seraphic mode — had best steer clear of "L.A. Story."

•

"L.A. Story," which has been rated PG-13 (Parents strongly cautioned), has some mildly vulgar language and one joke about breasts.

1991 F 8, C8:1

Ay, Carmela!

Directed by Carlos Saura; screenplay (in Spanish with English subtitles) by Rafael Azcona, adapted from the play "Carmela" by José Sanchís Sinisterra; director of photography, José Luis Alcaine; edited by Pablo G. Delamo; produced by Andrés Vicente Gómez; released by Prestige, a division of Miramax Films. At Lincoln Plaza, Broadway at 63d Street, Manhattan. Running time: 103 minutes. This film has no rating.

Carmela Carmen Maura
Paulino Andrés Pajares
Gustavete Gabino Diego
Lieutenant Ripamonte Maurizio di Razza
Interrogating Lieutenant Miguel A. Rellan

By JANET MASLIN

In Spain in 1938, Carmela (Carmen Maura) and Paulino (Andrés Pajares) perform their music-hall act for groups of weary Republican Army soldiers. These entertainers, purveying what they optimistically call "Tip-Top Variety," are motivat-

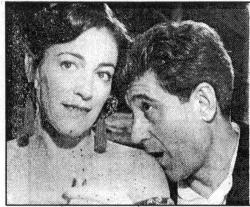

On Tour
Carmen Maura and Andrés Pajares star in "Ay, Carmela!" as cabaret performers trapped between political factions during the Spanish Civil War.

Miramax

ed by patriotism and a desire for self-preservation, though not in that order. When Carmela appears in a white toga as a symbol of the Republic, she is taking no more fervent or personal a stand than her husband does in prompting the troops to laughter by making comically rude noises. Carmela and Paulino are partisans in principle, but in fact they live mostly to entertain.

Carlos Saura's "Ay, Carmela!" is the gently stirring story of Carmela's political awakening once she, Paulino and Gustavete (Gabino Diego), the mute boy who is their third wheel, fall into enemy hands. With a nod to the humor of Ernst Lubitsch's "To Be or Not to Be," Mr. Saura's new film, which opens today at the Lincoln Plaza Cinemas, tells of theatrical performers trying to maintain their independent spirit while also placating Fascist supervisors, in this case an Italian lieutenant (Maurizio di Razza) with show-business pretensions and a soft spot for Carmela's wiles. Carmela's matronly loyalty to her husband does not mean she will stop short of much in trying to advance their cause.

Miss Maura, known in the United States for her films with Pedro Almodóvar (whose "Women on the Verge of a Nervous Breakdown" was conceived with her in mind), gives a warm, substantial and much less giddy performance this time. A generosity of spirit colors her every gesture. Not having lost her comic touch, Miss Maura is also capable of flouncing ludicrously as she struggles with the huge, impossible train of a flamenco gown, or of wiping her mouth daintily on the back of her hand after a hearty meal. ("If the Fascists always eat like this, we've lost the war," she sighs, after dining on spaghetti with Italian soldiers.) The strength and sympathy that Miss Maura embodies make Carmela a force to be reckoned with and "Ay, Carmela!" more affecting than it might otherwise have been.

•

Once Paulino, Carmela and Gustavete have been captured by Nationalist forces, they are forced into fancier footwork than anything they ever attempted on a stage. "Tell him how you trained for the priesthood," Carmela urges her husband, who is being interrogated by a Franco loyalist. Later, they try to persuade an Italian officer that a Republican flag in their possession is something they use while performing "O Sole Mio." Not surprisingly, the three performers soon find themselves treated as prisoners. But a fellow captive assures Carmela, "Don't worry, Ma'am — we who are innocent need not fear."

The film's demonstrable evidence that his words are untrue gives its lighthearted moments an underlying sobriety. From the opening theater scene, during which a ragtag performance by the variety troupe is periodically halted so that the audience can listen fearfully for war planes overhead, "Ay, Carmela!" has an undercurrent of quiet dread. The ability of the principal characters to overlook much of what is going on around them only heightens this foreboding, but Mr. Saura occasionally slips into enough sentimentality to eclipse his film's somber side. Carmela's eagerness for a church wedding to Paulino, to whom she has been married only by civil ceremony, adds more poignancy than the story otherwise needs.

Although Miss Maura takes center stage at all times, she does so thanks to indomitable vitality rather than through the efforts of Rafael Azcona (who also wrote Mr. Saura's 1973 "Cousin Anjelica," and who adapted this screenplay from a play by José Sanchís Sinisterra). Mr. Pajares, as the bumbish Paulino, makes a good foil but is inevitably secondary to his commanding co-star. Mr. Diego, who says nothing and appears always to be wincing in fear of Carmela's next ploy, manages to be both funny and heartbreaking. "Viva Mulosini," he scrawls on his little blackboard, as eager as his two partners to please their Italian captors but not as able to do it right.

1991 F 8, C8:5

Sleeping With the Enemy

Directed by Joseph Ruben; screenplay by Ronald Bass; director of photography, John W. Lindley; edited by George Bowers; music by Jerry Goldsmith; production designer, Doug Kraner; produced by Leonard Goldberg; released by 20th Century Fox. Running time: 99 minutes. This film is rated R.

Laura/Sara Julia Roberts
Martin ... Patrick Bergin
Ben ... Kevin Anderson
Chloe Elizabeth Lawrence
Fleishman Kyle Secor

By JANET MASLIN

Martin Burney (Patrick Bergin) has a successful career, an imposing glass-walled beach house and a gorgeous wife, who, at a party, wears the backless black dress that Martin recommended and smiles invitingly at him from across a crowded room. Despite this, and for reasons a film as skin-deep as "Sleeping With the Ene-

my" would never begin to explain, Martin is a bitterly unhappy man.

He demonstrates this early in the film by knocking his ravishing, compliant wife to the floor and kicking her in the stomach. Among Martin's ostensible reasons for doing this are that his wife, Laura, has talked to the man next door and that she has left the hand towels in the bathroom out of alignment.

"Sleeping With the Enemy," adapted from an appreciably more realistic novel by Nancy Price, is the fairy-tale version of how a woman like Laura Burney might make her getaway. It allows Laura a second chance (and a new name, Sara) in a small Iowa town complete with porch swings, picket fences and a conveniently unmarried nice-guy neighbor. It then casts a shadow over Laura's newfound happiness in the form of Martin himself, now eagerly on his lost wife's trail and elevated from garden-variety abusive husband to homicidal beast.

The creakiness of these developments could be noted with greater detachment were it not for one spectacular ingredient: Julia Roberts, whose very presence transforms "Sleeping With the Enemy" from a minor melodrama into an event. That is no measure of Ms. Roberts's acting ability, which remains unquantifiable, but simply an indication of how much movie-star magnetism she has to spare. Putting her in any film is tantamount to turning on a light switch.

Although it's conceivable that some day audiences may tire of Ms. Roberts's trademark mannerisms, like her way of smiling shyly with every particle of her being, that day is still far in the future. For the moment, as Laura Burney, she shines in even the most impossible situations. Even the obligatory romp montage that finds her trying on theatrical costumes — funny hats, a clown suit and so on — to the tune of Van Morrison's "Brown-Eyed Girl" manages to be likable. Count on one thumb the number of actresses who could make such an episode look more enchanting than noxious.

Joseph Ruben, whose other films include "The Stepfather" and "True Believer," has directed "Sleeping With the Enemy" with full appreciation of his leading lady's disarming beauty but less successful attention to the people and places that surround her. This strangely populated film — aside from the extras in parade and carnival scenes there are almost no secondary characters to be found — has one-note characterizations and a peculiar sparseness of detail. There is little apparent pathology to the Burney marriage. There is no air of economic or social reality. The beach resort at which the story begins has a deserted feeling, as does the Iowa town where Laura takes refuge. None of the principals have friends.

Kevin Anderson, as Laura's new neighbor, Ben, chiefly conveys patience and geniality, since the screenplay by Ronald Bass allows him little more. Mr. Bergin, who made a credible but colorless Sir Richard Burton in "Mountains of the Moon," plays this film's early scenes so tensely that it becomes difficult to believe that Laura would ever have been drawn to Martin in the first place. Only later, playing the monster at full throttle, does Mr. Bergin come into his own. One of the film's wittier touches, once Martin has arrived to stalk Laura in her new home, involves his incorrigible need to re-

arrange towel racks and grocery shelves wherever he goes.

It is at this later stage that Mr. Ruben also regains his grip, turning the film's last 20 minutes into a well-crafted, if predictable, exercise in suspense. The next film maker who finally allows a dead-looking body to remain dead will have at last infused the contemporary horror genre with an element of surprise.

•

"Sleeping With the Enemy" is rated R (Under 17 requires accompanying parent or adult guardian). It includes sexual situations and violence.

1991 F 8, C10:1

Rosencrantz and Guildenstern Are Dead

Written and directed by Tom Stoppard; director of photography, Peter Biziou; edited by Nicolas Gaster; music by Stanley Myers; production designer, Vaughan Edwards; produced by Michael Brandman and Emanuel Azenberg; released by Cinecom Entertainment Group. Running time: 118 minutes. This film is rated PG.

Rosencrantz.................................Gary Oldman
Guildenstern.......................................Tim Roth
The Player............................Richard Dreyfuss

By VINCENT CANBY

Acting on the assumption that every exit is an entrance someplace else, Tom Stoppard, the English playwright, wrote his language-giddy comedy "Rosencrantz and Guildenstern Are Dead."

The play, a hit in both London and New York in 1968, offers a cockeyed view of the events in "Hamlet" as witnessed by two characters who are as peripheral to themselves as they are to the Shakespearean text. They are expendable.

Rosencrantz and Guildenstern are Hamlet's old school chums, called to Elsinore by the King and Gertrude to try to jolly the prince out of his doldrums. They wind up infuriating everybody and, when last seen, they are escorting their friend to England at the King's command.

In the hierarchy of characters of importance, they rank somewhat above spear-carriers, more or less on a par with message-bearers.

Rosencrantz and Guildenstern exist to keep things moving, and as many productions of "Hamlet" have demonstrated (including Franco Zeffirelli's current film version), they aren't absolutely necessary for that.

Yet, when they do show up in a production, they get short shrift. They're not only uncharacterized, as Shakespeare wrote them, but they are finally hanged for their trouble, offstage.

Mr. Stoppard's idea of looking at "Hamlet" through the eyes of this pair of pale, bewildered fall guys is a promising one, which started out, apparently, as a one-act sketch. By the time he turned it into a full-length play, his thoughts had ripened, helped along, it would seem, by the work of Samuel Beckett, especially "Waiting for Godot."

In Mr. Stoppard's view, Rosencrantz and Guildenstern are two nonentities lost in time and space, victims of circumstances they never comprehend and thus are unable to escape. They arrive in Elsinore, and, in scenes incorporated from Shakespeare (totaling about 250 lines), meet the royals and eventually depart with Hamlet for England.

It is the playwright's conceit that, en route to the castle, they encounter the traveling players who later figure prominently in the original drama. It's a good thing, too, since the leader of this band, called the Player, an eloquent and ratty con artist, is the most engaging character in the Stoppard variation.

Once in Elsinore, Rosencrantz and Guildenstern move around the castle trying vainly to figure out what's going on. They are intended to recall a couple of classic burlesque buffoons, but they philosophize too much, and they aren't swatted around enough, to be very satisfying as low comedians.

Instead, they insist on talking above their station, with much time devoted to discussions of life's probabilities and purpose. The Czechoslovak-born Mr. Stoppard has an acute appreciation for the possibilities of English, which too often go unrecognized by people native to the language. He delights in sounds and meanings, in puns, in flights of words that soar and swoop as if in visual display.

On the stage, this sort of thing can be great fun, an end in itself, somewhat like music. In the more realistic medium of film, so many words can numb the eardrums and weigh upon the eyelids like old coins.

This is the effect of "Rosencrantz and Guildenstern Are Dead," the new movie, which Mr. Stoppard not only adapted but also directed.

The film looks stylish and is enthusiastically acted by Gary Oldman (Rosencrantz), Tim Roth (Guildenstern) and, in particular, Richard Dreyfuss as the Player. Although Mr. Stoppard says he has made Rosencrantz and Guildenstern more active than they were in his play, they are still feckless pawns whose word games no longer seem all that provocative or even entertaining.

These guys drone, which doesn't serve the bleaker purposes of the text. The words have the effect of absorbing all thought. The realism of the settings, including some beautiful Yugoslav scenery, also doesn't help. Rather, it calls attention to the abstract nature of the play without supporting it.

The movie has amusing moments. Nobody seems to be able to remember which man is Rosencrantz and which is Guildenstern. Even they become confused. They happen to be behind the arras when Hamlet skewers the meddlesome old Polonius. At one point Rosencrantz seems to invent the double-decker sandwich.

But the jokes are small ones, and largely academic. As happens at the opera, one usually laughs (if one laughs at all) not because something is funny, but because one has successfully recognized that it is supposed to be funny.

•

"Rosencrantz and Guildenstern Are Dead," which has been rated PG (Parental guidance suggested), has some partial nudity.

1991 F 8, C14:6

The Neverending Story II: The Next Chapter

Directed by George Miller; screenplay by Karin Howard; director of photography, David Connell; edited by Peter Hollywood; music by Robert Folk; production designers, Bob Laing and Gotz Weidner; produced by

Warner Brothers

Dieter Geissler; released by Warner Brothers. Running time: 89 minutes. This film is rated PG.

Bastian Balthazar BuxJonathan Brandis
The Childlike Empress Alexandra Johnes
Atreyu ...Kenny Morrison
Xayide...Clarissa Burt
The Father...........................John Wesley Shipp
Tri-Face...Chris Burton
NimblyMartin Umbach

Box Office Bunny

Directed by Darrell Van Citters; screenplay by Charles Carney; voices performed by Jeff Bergman; music by Hummie Mann; produced by Kathleen Helppie-Shipley; released by Warner Brothers. Running time: 5 minutes. This film is rated G.

By JANET MASLIN

The only praiseworthy attribute of "The Neverending Story II: The Next Chapter" is the wild optimism implied by its title. It was possible to see this film in near-perfect solitude at the Gemini Twin, one of the many theaters at which it opened yesterday. That suggests the saga, again adapted from Michael Ende's 1979 novel, will not be never-ending after all.

Made with great effort and no charm, this mirthless fantasy film returns its young hero, Bastian Balthazar Bux (Jonathan Brandis), to the land of Fantasia, which when first glimpsed here appears to be made entirely of cellophane. Upon closer inspection, Fantasia proves to be a weird and uncontrolled amalgam of fairy-tale styles. Among the beings seen here are claw-faced giant lobsteroids, a boyish Indian brave, a man-sized chicken, a huge and glum-looking flying hound, a talking rockpile and a lot of extras dressed as if for a Renaissance bar mitzvah in outer space. To call this overkill is to put it very mildly.

•

The plot enlists Bastian to save Fantasia from being obliterated from memory, though the case for his doing otherwise is overpowering. Along the way, the film adds ponderousness to monotony by throwing in celestial aahing on the soundtrack and mock-philosophical arguments that will bewilder children in the audience, if in fact any show up. When Bastian's father, looking for his missing son asks a bookseller whether he knows the boy, the bookseller asks quizzically, "Do we ever really *know* anybody?" The director, George Miller, does far too much to enhance the solemnity of such moments.

On the same bill and on a much lighter note, is "Box Office Bunny," a serviceable cartoon short featuring Bugs Bunny and Daffy Duck as movie patrons and a slightly less effective Elmer Fudd (the voices are by Jeff Bergman) as the manager of a 100-screen multiplex theater. They all have a chance to moonwalk their way through a rap song, and Daffy also sputters angrily about high movie ticket prices. "The price for an evening of puerile entertainment is preposterous!" he complains. There couldn't be a worse moment for bringing this up.

1991 F 9, 12:4

Larks on a String

Directed by Jiri Menzel; screenplay by Jiri Menzel and Bohumil Hrabal (in Czech with English subtitles); based on Mr. Hrabal's short-story collection "Advertisement for a House I Do Not Want to Live in Anymore"; director of photography, Jaromir Sofr; edited by Jirina Lukesova; music by Jiri Sust; production designer, Oldrich Bosak; released by International Film Exchange. Running time: 96 minutes. This film has no rating.

Pavel Hvezdar...........................Vaclav Neckar
Government Agent..............Rudolf Hrusinsky
Jitka...................................Jitka Zelenohorska

The Death of Stalinism in Bohemia

Directed by Jan Svankmajer; released by First Fun Features. Running time: 10 minutes.

By JANET MASLIN

The junk heap to which the characters of "Larks on a String" are consigned is a kind of paradise. Here, in the early 1950's, former members of Czechoslovakia's banished bourgeoisie are nominally engaged in forced labor, but in fact are free to play cards, discuss philosophy, joke sardonically about their situation and languish as they choose.

The men in this group — among them a professor who refused to destroy decadent Western literature, a saxophonist whose very instrument was considered an offense against the state and a lawyer who upheld the radical idea that a defendant ought to be allowed to plead his case — also spend a lot of time trading secret smiles and sidelong glances with a group of female prisoners nearby. The women, dressed in drably functional uniforms, nonetheless manage to look nymphlike as they laugh and frolic and hum little tunes. The setting is bleak and the season unspecified, but in spirit, it might as well be spring.

25

Film Forum

In Ruins , So-called bourgeois dissidents warm themselves at a fire in a junkyard, where the Czechoslovak authorities have sent them for re-education, in a scene from "Larks on a String."

This long-suppressed Czechoslovak film, made in 1969 by Jiri Menzel (best known for his 1966 "Closely Watched Trains"), offers a trenchant blend of playfulness and political satire. The film's blithe mood manages to accommodate the most scathing thoughts of Mr. Menzel and the writer Bohumil Hrabal, who co-wrote a screenplay based on Mr. Hrabal's stories. Visiting bureaucrats jokingly spout their rhetoric ("We'll pour our peaceful steel down the imperialist warmongers' throats — hands off Korea!") while at the same time acknowledging the real restrictiveness of the climate. The efforts of friendly officials to skirt regulations in behalf of the prisoners lead to sobering yet laughable absurdities, as when a man is allowed a proxy wedding with his fiancée's grandmother, since the fiancée herself is a prisoner.

At its considerable best, "Larks on a String," which opens today at the Film Forum, manages to be both whimsical and dark. Mr. Menzel's direction has a benign, anecdotal style that serenely embraces the full oppressiveness of the characters' situation.

•

Among the film's notably odd moments are the wedding scene, at which a shy young guard finds his silent wife looking much more captivated by the gypsy musicians who are playing than she is with him, and the peculiar consequences of this union. Also memorable are the glimpses of forbidden artifacts, like typewriters and crucifixes, being dumped on the junk heap as the principals almost casually look on. "We'll also melt them down into a new kind of people," one bureaucrat says. But the threat is so hollow it's almost amiable and complicit, which is surely one of the many reasons "Larks on a String" was so long banned.

•

On the same bill is the wonderfully apt short "The Death of Stalinism in Bohemia," by Jan Svankmajer, director of the animated, feature-length "Alice" that played at the Film Forum in 1988. This droll, breakneck satire rushes a statue of Stalin through drastic surgery, cranks out clay workers on an assembly line, only to grind them back into clay, and otherwise underscores the very same points Mr. Menzel's film has so slyly made.

1991 F 13, C14:4

The Silence of the Lambs

Directed by Jonathan Demme; screenplay by Ted Tally; director of photography, Tak Fujimoto; edited by Craig McKay; music by Howard Shore; production design, Kristi Zea; produced by Kenneth Utt, Edward Saxon and Ron Bozman; released by Orion. Running time: 120 minutes. This film is rated R.

Clarice Starling	Jodie Foster
Dr. Hannibal Lecter	Anthony Hopkins
Jack Crawford	Scott Glenn
Jame Gumb	Ted Levine
Dr. Frederick Chilton	Anthony Heald
Catherine Martin	Brooke Smith
Senator Ruth Martin	Diane Baker
Ardelia Mapp	Kasi Lemmons
Hayden Burke	Roger Corman

By VINCENT CANBY

All sorts of macabre things have gone on, and are still going on just off screen, in Jonathan Demme's swift, witty new suspense thriller, "The Silence of the Lambs."

Hannibal Lecter, a serial killer nicknamed Hannibal the Cannibal, once liked to feast on his victims, daintily, in a meal designed to complement the particular nature of the main dish. He would, for example, choose a "nice" Chianti to accompany a savory liver. A fine Bordeaux would compete.

Hannibal is a brilliant if bent psychiatrist, now under lock and key in a maximum-security facility.

Still at large, though, is a new serial killer, known as Buffalo Bill for reasons that can't be reported here. Bill's habit is to skin his victims.

At the beginning of "The Silence of the Lambs," Jack Crawford (Scott Glenn), the F.B.I.'s man in charge of Bill's case, seeks the assistance of a bright young agent, Clarice Starling (Jodie Foster).

Her assignment: to interview Hannibal Lecter (Anthony Hopkins), arouse his interest and secure his help in drawing a psychological profile of the new killer.

•

The principal concern of "The Silence of the Lambs" is the entrapment of Buffalo Bill before he can kill again. Yet the heart of the movie is the eerie and complex relationship that develops between Clarice and Hannibal during a series of prison interviews, conducted through inchthick bulletproof glass.

Hannibal, as grandly played by Mr. Hopkins, is a most seductive psychopath, a fellow who listens to the "Goldberg Variations" and can sketch the Duomo from memory. It's not his elegant tastes that attract Clarice, and certainly not his arrogant manner or his death's-head good looks. His smile is frosty, and his eyes never change expression. It's his mind that draws her to him. It pierces and surprises. Hannibal is one movie killer who is demonstrably as brilliant and wicked as he is reported to be.

In their first interview, Hannibal sizes up Clarice from her expensive bag and cheap shoes, her West Virginia accent and her furrow-browed, youthful determination not to appear intimidated. Hannibal isn't unkind to her.

He is at first skeptical and then amused. Finally he is seduced by her, at least to the extent that his egomania allows. She is flesh and blood and something more.

•

As played by Miss Foster, Clarice is as special in her way as Hannibal is in his. She is exceptionally pretty, but her appeal has more to do with her character, which is still in the process of being formed. She's unsure of herself, yet clear-headed enough to recognize her limitations.

Clarice has the charm of absolute honesty, something not often seen in movies or, for that matter, in life. She's direct, kind, always a bit on edge and eager to make her way.

When Hannibal finally agrees to help Clarice, it's with the understanding that for every bit of information he gives her, she will tell him something about herself. Because Hannibal, by nature and by profession, is an expert in prying, the questions he asks, and the answers he receives, both frighten and soothe the young woman.

For Hannibal, they are a turn-on.

Through the bulletproof glass, in dizzy succession, Hannibal and Clarice become analyst and analysand, teacher and pupil, father and daughter, lover and beloved, while always remaining cat and mouse.

•

Miss Foster, in her first role since winning an Oscar for "The Accused," and Mr. Hopkins, an actor of cool and eloquent precision, give exciting substance to the roles written by Ted Tally, who adapted the screenplay from a novel by Thomas Harris. An earlier Thomas novel, "Red Dragon," in which the homicidal doctor also appears, was the basis of the 1986 film "Manhunter."

Miss Foster and Mr. Hopkins are so good, in fact, that Clarice and Hannibal sometimes seem more important than the mechanics of "The Silence of the Lambs," which is, otherwise, committed to meeting the obligations of a suspense melodrama.

Mr. Demme meets most of these obligations with great style. The buildup to the dread Hannibal's first scene is so effective that one almost flinches when he appears. Never after that, for good reason, does Hannibal become trusted, though he is always entertaining to have around.

•

Eventually, though, the demands of the plot begin to take precedence over people and plausibility. Hannibal not only can help with the Buffalo Bill case, but he also knows who Buffalo Bill is. About halfway through, so does the audience, at which point the movie shifts to a lower, more functional gear even as the pace increases.

The screenplay, which is very effective in detailing character, is occasionally hard pressed to feed the audience enough information so that it can follow the increasingly breathless manhunt without a roadmap.

I'm told it helps if one has read the book, but reading the book shouldn't be a requirement to enjoy the film. At a crucial point the audience must also accept, as perfectly reasonable and likely, some instant surgery that allows the story to continue moving forward.

This may be hair-splitting. "The Silence of the Lambs" is not meant to be a handy home guide to do-it-yourself face liftings. Yet the movie is so persuasive most of the time that the wish is that it be perfect.

Although the continuity is sometimes unclear, the movie is clearly the work of adults. The dialogue is tough and sharp, literate without being literary.

•

Mr. Demme is a director of both humor and subtlety. The gruesome details are vivid without being exploited. He also handles the big set pieces with skill. The final confrontation between Clarice and the man she has been pursuing is a knockout — a scene set in pitch dark, with Clarice being stalked by a killer who wears night-vision glasses.

Mr. Glenn is stalwart as Clarice's F.B.I. mentor, but the role is no match for those of his two co-stars.

The good supporting cast includes Anthony Heald, as another doctor who might be as nutty as Hannibal, and Ted Levine, as a fellow who spends more time making his own clothes than is entirely healthy. Roger Corman, the self-styled king of B-

Orion

Jodie Foster as an F.B.I. agent in the film "The Silence of the Lambs."

pictures, who gave Mr. Demme his start in film making, appears briefly as the director of the F.B.I.

"The Silence of the Lambs" is pop film making of a high order. It could well be the first big hit of the year.

"The Silence of the Lambs," which has been rated R (Under 17 requires accompanying parent or adult guardian), includes some graphic still pictures of battered bodies.

1991 F 14, C17:1

Touki-Bouki

Written and directed by Djibril Diop Mambety (in French with English subtitles); director of photography, Pap Samba Sow; edited by Siro Asteni and Emma Mennenti; production design, Aziz Diop Mambety; released by Cinegrit. At the Public Theater, 425 Lafayette Street, Manhattan. Running time: 95 minutes. This film has no rating.

Mory..............................Magaye Niang
Anta.............................Marème Niang

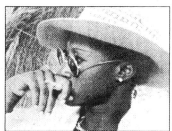

International Film Circuit

Marème Niang

"Touki-Bouki" ("Hyena's Voyage"), a 1973 Senegalese film opening today at the Public Theater, is the solemn, melancholy tale of Mory (Magaye Niang), a friendless young man with a motorbike, and Anta (Marème Niang), the young woman who loves him.

Their dream is not so much to go to Paris, that is, to be in Paris, as it is to have been in Paris and return home to be celebrated. To this end, they steal money but find that escape involves more than just the price of the tickets.

The movie, written and directed by Djibril Diop Mambety, is not always easy to follow, especially the tribal references, but it is full of local color of a sort not often seen in travelogues. Mory and Anta obtain the money to leave Dakar by crashing an afternoon pool party hosted by a rich, foppish homosexual.

Mr. Mambety mixes neo-realism and fantasy to create a mood of unease and aimless longing. The performances are good. Josephine Baker's jaunty "Paris, Paris" is heard on the sound track, both to evoke the city that Mory and Anta dream of and to call attention to a kind of sophistication forever beyond their ken.
VINCENT CANBY

1991 F 15, C10:1

King Ralph

Directed by David S. Ward; written by Mr. Ward, based on the novel "Headlong" by Emlyn Williams; director of photography, Kenneth MacMillan; edited by John Jympson; music by James Newton Howard; production designer, Simon Holland; produced by Jack Brodsky; released by Universal. Running time: 105 minutes. This film is rated PG.

Ralph...............................John Goodman
WillinghamPeter O'Toole
Graves..................................John Hurt
Miranda......................Camille Coduri
Phipps......................Richard Griffiths

By JANET MASLIN

Sure, he can play "Good Golly Miss Molly!" on the harpsichord with his feet, but can Ralph (John Goodman) really rule? That is the question asked by "King Ralph," a fictitious (needless to say) account of the first Las Vegas lounge singer — whose act includes "a tribute to the great Don Ho, the Godfather of Hawaiian soul" — to become King of England.

Greatness is thrust upon Ralph after the film's quick and promising introductory sequence shows England's entire royal family being electrocuted in the course of a group photo session. This episode, like "King Ralph" itself, is brisk, funny and admirably painless.

•

The elimination of every known Wyndham (as the royal family is called in the film) leads to herculean efforts on the part of an army of genealogists, struggling to turn up a stray heir. Even punk rockers are seen watching this undertaking avidly, with a moist eye for the sanctity of tradition.

But the news of an offspring from a tryst between an earlier monarch and Ralph's grandmother, who worked at a hotel where the king was staying, is given mixed reviews. "Well, he has his strengths and his weaknesses," the royal secretary Cedric Willingham (Peter O'Toole) is told by a tactful colleague. "You see, he's an American."

"Quickly," says a faint-looking Mr. O'Toole, who winds up playing the delectably acerbic John Gielgud role. "The strengths?"

"King Ralph," directed amiably by David S. Ward and written for the screen by him from Emlyn Williams's novel "Headlong," enthusiastically plucks Ralph from the Las Vegas dressing room he shares with Mitzi the Psychic Chimp and sets him figuratively alongside all the other great Ralphs of whom he knows: Macchio, Lauren and Kramden. The last makes the best comparison, since Mr. Goodman has gotten so much mileage out of playing the lovable slob. In "King Ralph," he does that once again, but as the story moves along he is also asked to rise to the occasion. He does this very appealingly until the screenplay finally forces him to say, "I got everythin' in the world here and nothin' I need!" to the accompaniment of sentimental strings. ("Maybe I should have *myself* beheaded," Ralph subsequently muses in his discouragement.)

"King Ralph" is better at simply contrasting Ralph with his surroundings, which is all it does at first, than at altering those surroundings to suit him. Indeed, the sight of Mr. Goodman in a kilt trying to play Frisbee with the royal corgis is worth a lot. But when Ralph begins trying to leave his mark on Buckingham Palace — "We'll put the velour industry

Frank Connor/Universal

John Goodman

on full standby," Cedric sniffs when Ralph says he might like to redecorate — the film loses a little of its spark. The sight of electric trains and pinball machines in the palace is almost overkill.

Mr. Goodman himself, simply wandering through the many great halls and formal gardens that are skillfully used to simulate his new home, is joke enough. ("Extremely nice, better than I'm used to," he admits helpfully while visiting the immense royal portrait gallery, where a likeness of a Goodman-like ancestor hangs amongst a multitude of more appropriate-looking faces.) Even when attempting to master the simplest royal nuances, like not swinging his arms when he is walking, Mr. Goodman turns his own bumbling presence into the film's best sight gag.

"King Ralph" also insists on a romantic subplot linking Ralph with a good-hearted stripper (Camille Coduri) whose presence threatens him with scandal, since her background is almost as common as his. Although Miss Coduri is engaging, the role itself is deadly, and the film slows down noticeably whenever she appears. Also in the cast are Joely Richardson, in the very strange role of a Finnish princess whom Ralph is expected to marry, and John Hurt as the conniving nobleman who will be next in line for the throne if he can ever arrange to have Ralph slip on a banana peel. Mr. Hurt brings great, lofty relish to the pronuciation of words like "usurper."

•

"King Ralph" is rated PG (Parental guidance suggested). It includes mild profanity and brief partial nudity.

1991 F 15, C10:3

Iron and Silk

Produced and directed by Shirley Sun; screenplay by Mark Salzman and Miss Sun; director of photography, James Hayman; edited by Geraldine Peroni and James Y. Kwei; music by Michael Gibbs; production designer, Calvin Tsao; released by Prestige, a division of Miramax. At the Angelika Film Center, Houston and Mercer Streets in Manhattan. Running time: 91 minutes. This film has no rating.

Mark Franklin....................Mark Salzman
Teacher Pan..........................Pan Qingfu
Teacher Hei.................Jeanette Lin Tsui
Ming..Vivian Wu
Sinbad................................Sun Xudong
Mr. Song.................................Zheng Guo

By JANET MASLIN

In order to film "Iron and Silk," Mark Salzman's account of his experiences as a teacher in China, Mr. Salzman has stepped back into his own memories to create a kind of living diary. In this film version, produced and directed by Shirley Sun, Mr. Salzman plays himself and re-enacts his experiences, a feat that would be difficult for a skilled actor and that for an amateur proves just about impossible. Mr. Salzman's eager, smiling presence gives the film a lot more gee-whiz ingenuousness than it needs.

But behind its occasionally vapid veneer, "Iron and Silk" — which opens today at the Angelika Film Center — includes a lot of interesting observations about Chinese life, observations that have a documentary-like immediacy despite the film's attempt to fictionalize them. Mr. Salzman's viewpoint eventually emerges as that of an affectionate and sharp-eyed observer.

Mr. Salzman, who is called Mark Franklin here, learned Chinese by working as a dishwasher in a Chinese restaurant and passionately watching martial-arts movies. He finally went to China as a teacher in 1982, and the film begins with him re-creating the first impressions he had on arrival. "Here I was in a country of a billion people and I didn't know a single one!" he tells himself, in a screenplay he co-wrote with Miss Sun.

•

Mark Franklin is assigned a Chinese tutor (Jeanette Lin Tsui), who is seen here registering horror at his American manners and gradually instructing him in the rituals of Chinese courtesy. He is also given the job of improving the English of a group known as "The Middle-Aged English Teachers," who had taught Russian before that was deemed politically incorrect. These teachers, who like most of the film's characters are played either by the real people Mr. Salzman knew or by eager amateurs, welcome their new instructor in a

Prestige

Instructive Mark Salzman portrays himself in "Iron and Silk," about a young American who went to China in the 1980's to teach English and learn martial arts from a master.

distinctly Chinese way. "We are sure you will be a wonderful teacher!" one of them says on the first day of class.

Mr. Salzman's best observations emerge in modest ways. When he asks his students to write essays about the happiest moments they have known, for instance, one man begins by saying, "My story's very common because I am a common man." Another tells a rapturous tale of having eaten a delicious meal of Peking duck, then confesses with some embarrassment that he did not eat the duck himself. His wife did. But she told him about it with such pleasure that he's sure it is his happiest moment all the same.

An American re-enacts his lessons in culture, love and the martial arts.

As Mark Franklin gradually acclimates himself to such attitudes, he also works his way into the good graces of a renowned martial-arts instructor, called Teacher Pan. (Mr. Salzman's real instructor, Pan Qingfu, plays himself.) The film's glimpses of young martial-arts trainees engaged in gravity-defying exercises are truly startling. There is also humor to be found in Mark's subsequent efforts to teach Pan some useful English phrases, like "Don't worry; it's just a broken arm."

•

"Iron and Silk" also attempts to convey the restrictiveness of China's social climate with a movie-perfect courtship between Mark and Ming (Vivian Wu), a young woman whose family is appalled by her interest in a Westerner. Mark's story is cut short when his interest in Ming arouses the ire of an Anti-Spiritual Pollution Campaign, after which he is made to feel distinctly unwelcome.

"Iron and Silk," filmed in the southern Chinese city of Hangzhou and made with the help of the China Co-production Film Corporation and a branch of the Beijing Film Academy, has an essential guilelessness that makes up for its initial false notes. In a particularly homey set of closing titles, Mr. Salzman explains who the film's principal figures are and what has since become of them. One makes great plum pudding. One runs a coffee shop that survived the San Francisco earthquake. One is "still singing and enjoying the decadent life of a bourgeois liberal."

1991 F 15, C12:5

Perfectly Normal

Directed by Yves Simoneau; screenplay by Eugene Lipinski and Paul Quarrington; director of photography, Alain Dostie; edited by Ronald Sanders; music by Richard Gregoire; production designer, Anne Pritchard; produced by Michael Burns; released by Four Seasons Entertainment. Running time: 104 minutes. This film is rated R.

Alonzo Turner	Robbie Coltrane
Renzo Parachi	Michael Riley
Denise	Deborah Duchene
Hopeless	Eugene Lipinski

Charlie Glesby	Kenneth Welsh
Mrs. Hathaway	Patricia Gage
Duane Bickle	Jack Nichols
Gloria	Elizabeth Harpur
Tiffany	Kristina Nicoll

By VINCENT CANBY

"Perfectly Normal," Yves Simoneau's Canadian comedy, is about a friendship that is supposed to be unlikely, though it's a staple of a certain kind of movie.

Alonzo Turner (Robbie Coltrane) is a big aggressive extrovert with no visible means of support. His past is cloudy. He lives in the present. He likes Italian opera, Italian food, women and, he emphasizes, bringing color into drab lives.

Renzo Parachi (Michael Riley) is one of those drab lives. A dark, moody, good-looking young man, he works in a brewery by day, plays goalie for the company's hockey team by night and sometimes drives a cab.

•

Since the recent death of his mother, Renzo lives alone in the roomy, rather frilly apartment they shared. He has no close friends, but dreams of building a house of his own and having a dog.

The night Renzo picks up Alonzo in his cab marks the beginning of a liberating friendship, based initially on their shared admiration for Verdi, Bellini and Puccini, among others.

Under Alonzo's guidance, the inhibited younger man falls in love with a pretty young woman, Denise (Deborah Duchene). Later he uses an unexpected inheritance to finance Alonzo's dream of an Italian restaurant, La Traviata.

Alonzo will be the chef, the waiters will dress as opera characters and Renzo and Alonzo will lip-sync favored arias in tableaux vivantes. Toward the end of the film, the once-uptight Renzo is seen in drag, lip-synching the title role of the Druid priestess in "Norma," reducing Denise and his hockey teammates to teary admiration.

It's necessary to go into this much detail about the story of "Perfectly Normal" to convey its true ghastliness.

The movie looks like the work of someone who wants to make a popular film as artily as possible. If all the slow-motion sequences in "Perfectly Normal" were played at the conventional speed, its running time might be reduced by one-third.

Mr. Simoneau, a respected Canadian film maker who is still unknown here, stuffs the movie with characters interesting only for their pallid eccentricities. Story lines are undeveloped. Gags have no pay-off. The pacing is funereal.

Everything is precious and slightly out of joint, as if Derek Jarman, the English director ("Caravaggio"), had decided to make a sitcom.

•

Though Renzo is supposed to be nerdlike, he seems to spend a vast amount of time on his appearance. He affects the unshaven look of Armani models, and wears his hair in the kind of spiky, post-punk coif favored by Peter Sellars, the opera director.

Mr. Riley could well be a fine actor, but from the contradictory signals emitted by Renzo, it's difficult to tell the difference between the performer and his role.

Mr. Coltrane, the Scottish-born English actor ("Nuns on the Run"),

gives as robust a performance as the fey dialogue allows, which is not often.

Mr. Simoneau's conceits are occasionally witty, which is not to say they're funny. The movie begins with what appears to be a parody of the opening of Franco Zeffirelli's screen version of "La Traviata," with the camera pushing its way into the apartment of Renzo's dying mother, instead of Violetta's.

There are also some decent performers in the supporting cast, particularly Kenneth Welsh, who plays Renzo's hockey coach, and Jack Nichols, as Renzo's only pal.

•

"Perfectly Normal," which has been rated R (Under 17 requires accompanying parent or adult guardian), has vulgar language and some partial nudity.

1991 F 15, C14:5

Alligator Eyes

Written and directed by John Feldman; director of photography, Todd Crockett; edited by Mr. Feldman, Cynthia Rogers and Mike Frisino; music by Sheila Silver; produced by Mr. Feldman and Ken Schwenker; released by Castle Hill. At the Quad Cinema, 13th Street, west of Fifth Avenue, Manhattan. Running time: 101 minutes. This film is rated R.

Pauline	Annabelle Larsen
Robbie	Roger Kabler
Marjorie	Mary McLain
Lance	Allen McCullough
Dr. Peterson	John MacKay

By JANET MASLIN

Standing by the side of the road, in black tights and a very short dress, is an accident waiting to happen: Pauline (Annabelle Larsen), a mysterious young woman who is beautiful, difficult and not terribly truthful about her own future plans. Pauline is also blind, which is something she neglects to mention to Robbie (Roger Kabler), Marjorie (Mary McLain)

Castle Hill Productions

Drifting Annabelle Larsen, Roger Kabler and Allen McCullough star in "Alligator Eyes," about friends who meet a mysterious blind woman while traveling from New York City to North Carolina.

and Lance (Allen McCullough), three old friends making a car trip together for nostalgia's sake.

It's just as well that Pauline keeps mum about her blindness, since discussing it might create the wrong impression. Nothing about Pauline gives her the slightest hint of helplessness, not even her inability to see keeps her from stalking off down the highway alone if she happens to lose her temper. Hardly a few moments after the others have incorporated Pauline into their vacation plans, it's clear that she is a tough customer who will be taking charge of the trip, and possibly a lot more, from that point on.

"Alligator Eyes," an ambitious first feature written and directed by John Feldman, aspires to be a kind of "Sex, Lies and Videotape" of road movies, with Pauline as the sexually challenging stranger who exposes some of the deceptions in the other characters' lives. That would be enough, but Mr. Feldman also lays on a mystery plot, a psychodrama that involves Pauline's traumatic childhood accident, her bizarre upbringing and her desire for revenge. This part of the story, while ostensibly more dramatic than the small talk, turns out to be so far-fetched that it undermines the rest of the film's more modest style.

Mr. Feldman is much better with small talk, and with establishing the casual intimacy of the three old friends. Lance and Marjorie, who were lovers a long time ago, have a vague idea of getting back together, whereas Robbie seeks to drown the sorrows of his latest disastrous romance. These three characters are quietly believable, and the film — which opens today at the Quad Cinema — has a firm grip on its audience's attention even when these travelers, roaming through various well-evoked North Carolina coastal settings, aren't doing anything more dramatic than stopping for dinner.

Even Pauline's function, that of a monkey wrench intent on disrupting as much of the others' tranquillity as possible, is effectively presented. "I think laughter is the best part of sex, don't you?" the predatory Pauline inquires of Marjorie, who is by now at a distinct sexual disadvantage.

"You're really a little too direct for me sometimes," says Marjorie, who is indeed putting it mildly.

One of the film's more interesting touches is Pauline's use of a Braille computer, from which a mechanical male voice emanates, reinforcing the sense of Pauline's alien quality. Another is the raw anger with which Ms. Larsen, as Pauline, sometimes overflows. "I don't see why I'm telling you all this," she snaps unexpectedly during one conversation. "It's none of your business; you won't get it anyway," she snaps unexpectedly during one conversation. This fury, combined with Pauline's sexual aggressiveness, gives "Alligator Eyes" a spiky intensity that is not borne out by the film's final stages but is attention getting all the same.

•

"Alligator Eyes" is rated R (Under 17 requires accompanying parent or adult guardian). It includes nudity and profanity.

1991 F 15, C15:1

Thwarted Expectations

"H-2 Worker" was shown as part of the 1990 New Directors/New Films series. Following are excerpts from Caryn James's review, which appeared in The New York Times on March 24, 1990. The film opens today at the Collective for Living Cinema, 41 White Street in Manhattan.

As black workers cut sugar cane in the 1940's, a narrator notes that these happy laborers are following the "hereditary urge to go back to the plantation." That archival clip, included in Stephanie Black's "H-2 Worker," suggests how little the plantation mentality has changed in nearly 50 years, though today the sugar-cane growers rely on Jamaicans imported to Florida for six months every year.

Ms. Black's documentary follows the men who arrive on H-2 visas, temporary permits that allow foreigners to take jobs for which employers cannot find Americans. According to the film, each year 10,000 Jamaicans respond to the promise of more money than they can make at home, and become virtual prisoners, crowded into dormitories that resemble Army barracks, paid at most $5 an hour — minus transportation and housing fees — for grueling field work.

Although Ms. Black's sympathy with the laborers is manifest, "H-2 Worker" is that rare hybrid that succeeds as both film and advocacy. The documentary's look and form is smooth and sophisticated, combining reggae music, voice-overs of letters between the Jamaicans and their families at home, interviews with the workers and with a sugar industry representative, and archival material that sets the current situation in historical context. Ms. Black is not artistically innovative, but she has mastered some fundamental rules of effective documentary film making. She assumes a calm, objective tone, allowing the visual images and interviews to speak for themselves. She lures viewers to her point of view rather than bludgeoning them.

Maryse Alberti's cinematography is a major element of the film's convincing realism. Ms. Alberti creates rich images of the men in the fields, bending to cut cane that stands taller than they do; even a glimpse suggests the strain on one's back. The dormitory, with laundry strung between the bunks, looks stark and demoralizing, but not exaggeratedly gruesome. Most important, the film never looks picturesque or condescending.

The workers are quietly angry, dignified and often resigned as they describe their thwarted expectations. One man has been returning to Florida for 14 years, suggesting the dilemma facing poor people with limited opportunities. When the workers stage a stoppage to complain about low wages, the police are brought in to remove them from the camp; within a week, 300 replacement workers are flown in from Jamaica.

"H-2 Worker" does not pretend to offer any answers, but it solidly frames issues about the economy, employment and the treatment of workers who seem just steps away from slavery.

1991 F 15, C17:1

Nothing but Trouble

Written and directed by Dan Aykroyd; director of photography, Dean Cundey; edited by James Symons and Malcolm Campbell; music by Michael Kamen; production designer, William Sandell; produced by Robert K. Weiss; released by Warner Brothers. Running time: 90 minutes. This film is rated PG-13.

Alvin Balkenheiser/Bobo Dan Aykroyd
Chris Thorne Chevy Chase
Diane Lightston Demi Moore
Sheriff Purdah/Eldona John Candy
L'il Debbull John Daveikis
Fausto .. Taylor Negron
Renalda Bertila Damas
Miss Purdah Valri Bromfield

By VINCENT CANBY

Dan Aykroyd wrote the screenplay for, co-stars in and makes his debut as a movie director with "Nothing but Trouble," a charmless feature-length joke about the world's most elaborate speed trap.

It's somewhere off the New Jersey Turnpike, at a bend in the road called Valkenvania, presided over by an ancient Justice of the Peace named Alvin Valkenheiser (Mr. Aykroyd).

The movie is about the one wild night spent in Valkenheiser's dungeons by Chevy Chase, Demi Moore and other unlucky motorists, all arrested by the Valkenvania sheriff (John Candy).

Most of the gags in the movie are visual. The J.P. lives and works in an old Gothic mansion set in the middle of a vast dump, resting atop an abandoned and burning coal mine. Yet the movie looks less funny than expensive. These sorts of sets cost a lot of money.

•

The house is full of secret doors, trap doors and hidden elevators, most of which lead eventually to the variation on a fun-house ride by which Valkenheiser gets rid of his victims.

Mr. Chase and Miss Moore spend a great deal of time being either furious or frantic. Mr. Aykroyd, who also plays his own grandson, a hairless mutant, is completely hidden under special makeup in each role. Of the stars, only John Candy is remotely comic, both as the sheriff and as Valkenheiser's large amorous granddaughter, a mechanic by trade.

Mr. Aykroyd's screenplay is an accumulation of loose narrative ends and lines that don't even cheer when they are thrown away.

The movie opened at theaters here yesterday. At the first show at the West Side Cinemas, there was virtually no laughter from beginning to end, though there may have been some silent smiles.

•

"Nothing but Trouble," which has been rated PG-13 (parents strongly cautioned), has a lot of vulgar language.

1991 F 16, 16:5

FILM VIEW/Janet Maslin

Heroines Need Guts, Not Glamour

I N "SLEEPING WITH THE ENEMY," THE GLOSSIest of several new films in which women are pursued by deadly, scarily methodical men, a wife escapes her abusive husband and begins life anew in a small Iowa town. One night, she steals apples from a tree near the cozy little cottage she has rented. She claims to have done this because she felt a late-night impulse to bake a pie. The upshot, in any case, is a dinner date with the man next door.

The heroine of the Nancy Price novel on which this film is based, also appropriates her neighbor's apples, but she is motivated by something very different: hunger. At that point, living on beans and oatmeal, she has little money, no job, a husband with a drinking problem and a long, sordid history of allowing herself to be battered by him. Compare this with her beautiful, financially secure, relatively untroubled movie counterpart, played by Julia Roberts, and you see how easily a film can trade the legitimate underpinnings of its characters' behavior for something less disturbing and easier on the eyes.

"The Silence of the Lambs," Jonathan Demme's phenomenally skillful adaptation of Thomas Harris's pulse-quickening crime novel, displays its sure sense of how to orchestrate and audience's responses by making no such deals. It introduces a wonderfully sympathetic heroine, an F.B.I. Academy student named Clarice Starling, and grounds her so firmly in the realities of her small-town past, her lingering insecurities and her fierce-determination to make good that the viewer is with her from beginning to end.

■

It is no accident that the film begins with scenes of Clarice giving herself a punishing athletic workout, or that it makes a point of showing the F.B.I. trainees' classroom exercises, in which they simulate life-threatening situations and test one another's reflexes under extreme duress. That way, when Clarice finally stands down the story's grotesque serial killer during a climactic episode guaranteed to induce a cold sweat, she and the viewer understand exactly what she has to fall back on, and how hard she has worked to attain it. Neither the film nor Mr. Harris's novel allows its heroine any unrealistic advantage in this terrifying confrontation.

The entire film would be less effective if they did. "The Silence of the Lambs" is an intricately constructed game of wits, with a credibility never at risk even while it pits the amazing forensic and deductive skills of its F.B.I. characters against the devilishness of two formidable serial killers. One psychopath, the one on the loose, brings fiendish ingenuity to a scheme that involves flaying his female victims. (Both film and novel present this clinically, with remarkably little sensationalism.)

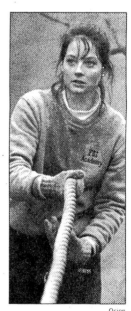

Orion

Jodie Foster in "The Silence of the Lambs"—sympathetic

The other killer, held in captivity by hospital attendants who are still afraid of him, is the cunning Dr. Hannibal Lecter, literally and figuratively a

man-eater. Lecter, played with bristling fury by Anthony Hopkins, is an established criminal genius and also a master of intimidation. The story starts off by sending Clarice Starling into the lion's den to solicit Lecter's help in catching the other killer.

There's a difference between well-motivated behavior and actions that simply look good on the screen.

The duel between Clarice and Lecter begins on her first visit to his dungeonlike lair in a hospital for the criminally insane. Lecter's tactics of behavioral one-upsmanship range from trying to embarrass Clarice sexually to commenting on her good handbag and cheap shoes, letting her know he finds this an interesting indicator of who she is and where she came from. The great strength of Jodie Foster's performance here is grounded on exactly the same uncertainties that Lecter enjoys ferreting out and toying with. Visibly nervous at first and fighting hard to control it, Ms. Foster's Clarice grows up noticeably during the course of this story.

∎

Her progress is not the story's central concern, but it is one of several beautifully sustained threads that combine to make the whole film so gripping. Condensing an intricately plotted book into a model of compression (the film's production design by Kristi Zea and its screenplay by the playwright Ted Tally capture the novel's minutiae to an astonishing degree), the film still manages to remain firmly grounded in reality. Just as surely as "Sleeping With the Enemy" turns a husband's abuse of his wife into the groundwork for a fairy tale, "The Silence of the Lambs" uses violent crime in much more pragmatic ways. One of this story's most satisfying aspects is its repeated pitting of reason against the forces of darkness, even doing this concretely during that concluding showdown scene.

Mr. Harris's three books, all built on carefully developed data and a capacity for inventing and then clinically dissecting almost unimaginable acts of horror, have yielded three crackerjack thrillers in very different styles. The chilling suspense of John Frankenheimer's "Black Sunday" (1977) could not be more unlike the sleek, sinuous evil of "Manhunter," Michael Mann's overlooked 1986 version of Mr. Harris's "Red Dragon," made in the eerily clean high-design style of Mr. Mann's "Miami Vice" television series.

Dr. Hannibal Lecter, a character in "Manhunter" as well (and played almost as scarily by Brian Cox), can be found in a gleaming white cell in an asylum that has the bold lines of a modern museum. Mr. Demme's film is by far the best of the three precisely because its ideas of evil involve the greatest and most unsettling contrasts. His Hannibal Lecter can be found in a mental hospital that looks ordinary but has lower depths as dark and frightening as Lecter himself is fastidious. The arrival of temptation, so perfectly embodied by Ms. Foster's Clarice Starling, takes this story's potential for terror to a new dimension. ▢

1991 F 17, II:11:5

Superstar: The Life and Times of Andy Warhol

Directed, written, produced and edited by Chuck Workman; director of photography Burleigh Wartes; released by Aries Films. Running time: 87 minutes. This film has no rating.

Interviews with: Viva, Dennis Hopper, Ultra Violet, Tom Wolfe, Sylvia Miles, Irving Blum, Paul Warhola, Fran Lebowitz and others

By JANET MASLIN

Why does Andy Warhol's work reveal so little about the artist? "Well there's not very much to say about me," drones Warhol, in an old interview that Chuck Workman has included in "Superstar," his witty and enterprising documentary about Warhol and his world. The film itself, which spans the same wild extremes that Warhol's life did, offers strong evidence to the contrary. It bears out the thought that Warhol, described by one of Mr. Workman's many interviewees as "this crazy peasant who somehow is the eye of the storm," was indeed a person about whom others — and he himself, in "The Andy Warhol Diaries" — could speak volumes.

Mr. Workman, using many conversations with Warhol's friends and associates, as well as frequent glimpses of his films, paintings and early advertising illustrations, has a distinct visual advantage over the artist's print biographers. He uses it well. "Superstar" displays much of the lively eccentricity that so captivated Warhol and also stops to note the artifice behind it (which is never hard to spot in any of the artist's pet luminaries). So Ultra Violet makes a point of painting her cheeks with a beet while being interviewed. And Sylvia Miles, never shy about these things, turns up wearing as much merchandise bearing the Campbell Soup logo as she can.

Putting this fully in perspective, Mr. Workman begins the film with glimpses of other media luminaries (Donald Trump, Geraldo Rivera, Jim and Tammy Bakker) beside whom Warhol's celebrity makes perfect sense. And he ends with televised scenes of stars (including Don Johnson) showing up at the artist's funeral. The film's opening montage also depicts the manufacturing of silk-screen portraits in the Warhol style, which makes artistry quite indistinguishable from merchandising.

These and other efforts to provide a context for Warhol's life and legend are deftly effective. "I couldn't believe it — I never thought he would die," says Steve Rubell.

●

Deemed "as genuine as a fingerprint" by the editors of his high school yearbook, Warhol devoted the rest of his life to proving them wrong. But the artist's cousins and brothers, who are interviewed by Mr. Workman, attest to his homey side. "When we read his philosophy, we laughed out loud because we didn't know we were so much like him," says one of Warhol's cousins. A cousin also tells of making contact with the artist's New York set when she met Calvin Klein and "asked him whether he was going to design jeans for the heavy woman, like me."

The film's glimpses of the Pittsburgh neighborhood where Warhol grew up make understandable his eagerness to escape and also his need to keep his past at a distance from his present. "I guess Andy sort of kept us away from some of the people that he had," says Paul Warhola, one of the artist's brothers, who is interviewed on a farm. Mr. Warhola adds, in the film's later segment on Warhol's love affair with the Campbell soup can, that Campbell was indeed the family's favorite brand. A spokesman for the Campbell Soup Company is more guarded, saying, "I think there were a lot of people in the company who were leery about having this kind of person involved with our brand image."

Circling carefully through the morass of opinions about Warhol's life and work, Mr. Workman interviews art dealers and critics about what, if anything, was at the core of Warhol's creativity. Irving Blum, who exhibited Warhol's work very early in the artist's career, attests to Warhol's industriousness no matter what was going on around him. Henry Geldzahler calls him "a highly intelligent blotter" with "an infinite longing for having the familiar codified in some way." Tom Wolfe describes the Warhol outlook on American culture as "Oh, it's so horrible, I love it." According to Hilton Kramer, "The statement he was making in his work was something like 'Ha, ha, ha.'"

In addressing Warhol's film work, which is shown here in snippets and at times in split-screen images, the

Aries Films

Paul Warhola

film elicits conflicting thoughts on what his directorial role actually was. Warhol himself says of film making that it's "just easier to do than painting. The camera has a motor, and you just turn it on and walk away." Dennis Hopper agrees and demonstrates his own approach to having been filmed in such a way. "He wasn't even there most of the time," says Candy Darling, one of the artist's former film stars . Warhol offers one of his own characteristic thoughts about cinema by saying that he thinks today's movie stars are more glamorous than those of the past "because you can run into them."

●

While Mr. Workman's portrait of Warhol is as vibrant (and deliberately two-dimensional) as any of the artist's celebrity images, it avoids the gaudier aspects of Warhol's life that have been so enthusiastically chronicled elsewhere. The artist's peculiar strain of voyeurism is alluded to only in an anecdote about Warhol's having been lent the original Howdy Doody doll for his series on pop-cultural myths, and having felt the need to undress it.

The gossipy revelations of Warhol's diaries are also avoided, as is the diaries' editor, Pat Hackett, whom Viva accuses of having made up the whole thing. Most of Warhol's later companions are also absent, no doubt chastened by the diaries' mean-spiritedness and notoriety. Halston is heard saying that Warhol "would go to the opening of a drawer." But beyond that, Mr. Workman is clearly more interested in Warhol as an artist and an enigma than as a fixture of New York nightlife.

"Andy's genius to me was his fingerpointing," says Dennis Hopper, who cites Marcel Duchamp's prediction that the artist of the future will merely point his finger and designate art rather than create it. "Andy made fame more famous," Fran Lebowitz observes. "Oh, I'm speechless," says Warhol himself, giving his favorite kind of answer to a direct question. Mr. Workman's fascinating portrait has the insight to reconcile these differing points of view.

1991 F 22, C8:1

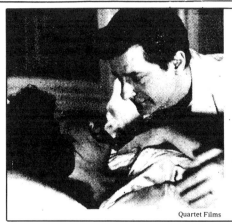

Family Money
Giancarlo Giannini, shown here with Andréa Ferréol, is the rich nephew of a roué in need of money in "The Sleazy Uncle."

Quartet Films

The Sleazy Uncle

Directed by Franco Brusati; screenplay (in Italian with English subtitles) by Leo Benvenuti, Piero De Bernardi and Mr. Brusati; story by Mr. Brusati; director of photography, Romano Albani; edited by Gianfranco Amicucci; music by Stefano Marcucci; production design by Dante Ferretti; produced by Leo Pescarolo and Guido de Laurentiis; released by Quartet Films. At the Village East Cinemas, Second Avenue and 12th Street in Manhattan. Running time: 105 minutes. This film has no rating.

Luca	Vittorio Gassman
Riccardo	Giancarlo Giannini

By JANET MASLIN

"The Sleazy Uncle" is Franco Brusati's shaggy-dog story of a gleeful, amoral reprobate who brings turmoil to the life of his complacent nephew. Luca (Vittorio Gassman), the trouble-making uncle, is first seen trying to bother schoolgirls in a movie theater, and subsequently having to be hospitalized as a result of all this excitement. Indigent as well as irrepressible, he calls upon his long-lost nephew, Riccardo (Giancarlo Giannini), who has never heard of him, to settle the bill.

The rest of the film, which attempts a lyrical mood but is more often lackadaisical, follows Luca's attempt to ruffle his strait-laced nephew's composure. He seduces the nephew's mistress (Stefania Sandrelli), laughs at the fancy gadgets in his nephew's house, and resists all efforts to live a life of greater conformity than he has known. When Riccardo straightens up Luca's colorful mess of an apartment, Luca promptly burns the place down.

Mr. Brusati, best known for his warmly sentimental "Bread and Chocolate," sometimes makes the most of Luca's humorous side, as when a man on the street comes up behind him and kicks him. Luca does not bother to turn around and look at his assailant, apparently because there are so many people who would love to kick him that it hardly matters who did the deed. Scenes like this are played lightly by both Mr. Giannini and Mr. Gassman, although the latter has by far the better role. Mr. Giannini, who himself would make a fine roué, has to work hard to play straight man in the midst of so much anarchic behavior.

The film is more successful when moving aimlessly but confidently, in the manner of a joke without a punchline, than it is in arriving at its heartstring-tugging destination, or at the insight that is supposed to make sense of Luca's seedy character. Privately, it turns out, he is an internationally respected poet known as "the most limpid voice of his generation."

Both Mr. Gassman and Mr. Brusati are a lot better at staging the old man's most outrageous antics, like his handing out blood-test certificates about himself to women at a garden party ("for your security," he explains), than they are at promulgating the idea that poetry goes hand in hand with debauchery, and is an excuse for anything.

"The Sleazy Uncle" opens today at the Village East Cinemas.

1991 F 22, C10:5

Princes in Exile

Directed by Giles Walker; screenplay by Joe Wiesenfeld, based on the novel by Mark Schreiber; director of photography, Savas Kalogeras; edited by Richard Todd; music by Normand Corbeil; production designer, Charles Dunlop; produced by John Dunning; a Cinepix/National Film Board co-production; released by Fries Entertainment. At the Gramercy, 23d Street, between Park and Lexington Avenues, in Manhattan. Running time: 103 minutes. This film is rated PG.

Ryan Rafferty	Zachary Ansley
Holly	Stacie Mistysyn
Robert	Nicholas Shields

By STEPHEN HOLDEN

"Princes in Exile," a small Canadian film directed by Giles Walker, offers a wrenching little twist on the theme of teen-agers coming of age. Its soulful 17-year-old protagonist, Ryan Rafferty (Zachary Ansley), and many of the friends he makes at a specialized summer camp, are youthful cancer patients whose chances of recovery are slim.

Suffering from a brain tumor that is in temporary remission, Ryan looks perfectly normal until he takes off his cap and reveals a shaved patch of head with an ugly bump on it. Obsessed with his condition, he indulges in morbid fantasies that he records in a journal. In a voice-over narration at the beginning of the film, he declares that his two goals for the summer are to publish his writing and to lose his virginity.

The movie, which opens today at the Gramercy theater, was made in association with the Canadian Broadcasting Corporation and the National Film Board of Canada. Although it is a fictional feature, based on a novel by Mark Schreiber, it has something of the feel of a public service documentary. In presenting its youthful characters, who share the same bunkhouse and who jokingly call themselves "princes in exile," it goes out of its way to detail the kinds of cancer from which each boy is suffering. Robert (Nicholas Shields), the camp's daredevil, who becomes Ryan's best friend, has acute lumphocytic leukemia.

Although the story of "Princes in Exile" is so cut and dried as to be predictable, Joe Wiesenfeld's simple, direct screenplay succeeds most of the time in avoiding mawkishness. What lift the film above the commonplace are the performances of the young cast. Wide-eyed, with a mixture of fear and anger that he twists into a pose of fatalistic stoicism, Mr. Ansley perfectly conveys the anguish of a young man torn between a clenched, defensive morbidity and suppressed urge to embrace life. In the movie's most amusing scene, he is induced by the head of the camp to dress in priestly garb and improvise an exorcism on a much younger boy who believes himself possessed by a demon.

The ritual is one of several incidents that help to draw Ryan out of his morbid self-preoccupation. Another rite of passage is his gradual bonding with Holly (Stacie Mistysyn), a girl who has lost part of a leg and who gently prods him into a relationship. Like Mr. Ansley, Miss Mistysyn brings just the right mixture of gravity, humor and skittishness to her role in a film that views its afflicted characters with a clear-eyed understanding and affection.

●

"Princes in Exile" is rated PG (Parental guidance suggested). It includes mild profanity.

1991 F 22, C12:5

He Said, She Said

Directed by Ken Kwapis and Marisa Silver; written by Brian Hohlfeld; director of photography, Stephen H. Burum; edited by Sidney Levin; music by Miles Goodman; production designer, Michael Corenblith; produced by Frank Mancuso Jr.; released by Paramount Pictures. Running time: 115 minutes. This film is rated PG-13.

Dan Hanson	Kevin Bacon
Lorie Bryer	Elizabeth Perkins
Wally Thurman	Nathan Lane
Mark	Anthony LaPaglia
Linda	Sharon Stone
Mr. Weller	Stanley Anderson
Cindy	Charlayne Woodard

By JANET MASLIN

On the theory that there are at least two sides to any love affair, "He Said, She Said" has come up with a good idea for poster art, if not for an entire film. The romance between two competing Baltimore journalists, Dan (Kevin Bacon) and Lorie (Elizabeth Perkins), is explained from each of their differing perspectives, his that of someone seeking to avoid serious commitment and hers largely marriage-minded. There are also references to things like a "New Republic piece on the Sandinista educational system," to prove that the film has its serious side.

The trouble is that most of the scenes are barely strong enough to hold the interest the first time, let alone on replay. We learn twice, for example, that Lorie's contact lens was stepped on when she and Dan went on their first impromptu date. And even the episodes that involve only one character, like Dan's visit to a florist who gives him advice in handling his complicated love life, seldom have much of an edge. "You know what love is?" asks the florist. "It's a time bomb waiting to go off. Believe me."

Although the principals (and the florist) discuss love so much they threaten to talk the subject to death, "He Said, She Said" rarely touches on anything romantic. It concentrates instead on the endless bickering that forms the core of Lorie and Dan's relationship, bickering that is not rendered watchable by virtue of its sounding lifelike. "I need more from you," she says at one point. "I just don't know what else I can give you," he replies. There is a lot more in Brian Hohlfeld's screenplay along these lines.

●

"He Said, She Said" was directed jointly by Ken Kwapis and Marisa Silver, who have divided up their directorial responsibilities along gender-related lines. So Mr. Kwapis's section of the film (the breezier of the two) is from Dan's perspective and includes a nightmare fantasy sequence in which a waiter tries to trick Dan into making a commitment, or possibly even marriage. Dan even imagines himself confined in an apartment he shares with Lorie by a ball and chain, while a beautiful ex-girlfriend materializes outside his window in a limousine and calls out, "You're missing the party!"

Lorie's half of the story, on the other hand, is more sincere and much more heavily fraught with émotion. The directors have done a lot to reinforce sexual stereotypes even if that was not their intention.

Mr. Bacon, by now typecast as a latter-day Peter Pan, does what he can to capture any spark of charm in the material. Ms. Perkins, who takes a much more prim approach to comedy, seldom appears as lighthearted as the story expects her to be. Sharon Stone, as the alluring ex-girlfriend

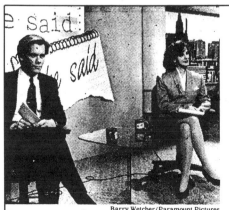

The Scoop
In "He Said, She Said," Kevin Bacon and Elizabeth Perkins are reporters who fall in love despite the fact that they can't agree on anything.

Barry Wetcher/Paramount Pictures

who wants Dan back (she also played Arnold Schwarzenegger's duplicitous wife in "Total Recall"), steals each of her scenes and makes it nearly impossible to understand why Dan and Lorie are together at all.

•

"He Said, She Said" is rated PG-13 (Parents strongly cautioned). It contains sexually suggestive situations.

1991 F 22, C17:1

Bride of Re-Animator

Directed and produced by Brian Yuzna; screenplay by Woody Keith and Rick Fry, based on H. P. Lovecraft stories; director of photography, Rick Fichter; edited by Peter Teschner; music by Richard Band; production designer, Philip Duffin; released by Troma, Inc. Running time: 95 minutes. This film is rated R.

Herbert West Jeffrey Combs
Dan Cain.................................... Bruce Abbott
Gloria Kathleen Kinmont
Lieutenant Chapham Claude Earl Jones

By VINCENT CANBY

"This is no longer about re-animating the dead," says Dr. Herbert West, a prissy, warped but brilliant scientist, at the beginning of "Bride of Re-Animator." "This is about creating new life!"

Yet it all comes down to the same thing: animating spare body parts. The doctor, who possesses the serum of life (a chartreuse liquid), thinks small as well as big.

By fusing and then animating five fingers and an eye, he creates something that looks like a really crazy spider. Later he attaches an arm to a leg, to form something that looks like a fleshy propeller. It gets out of hand.

"Bride of Re-Animator" is less a sequel to the critically praised 1985 horror film "Re-Animator" than a rehash based on the same H. P. Lovecraft stories.

Jeffrey Combs and Bruce Abbott, stars of the first film, return as the two doctors who play God, though the movie's director is Brian Yuzna, the producer of "Re-Animator." The film's special effects are good if ghoulish.

Among other things, they feature a man's re-animated severed head, to which bat wings have been attached (it flies quite well), and, at the end of the film, a man-made woman composed of parts purloined not always legally.

This unfortunate creature, built around the heart of Mr. Abbott's dead girlfriend, might only be truly welcome at an anatomy lesson.

"Bride of Re-Animator" has been rated R (Under 17 requires accompanying parent or adult guardian). There is much simulated gore and blood.

1991 F 22, C17:1

Scenes From a Mall

Directed and produced by Paul Mazursky; written by Roger L. Simon and Mr. Mazursky; director of photography, Fred Murphy; film editor, Stuart Pappé; music by Marc Shaiman; production designer, Pato Guzman; released by Touchstone Pictures. Running time: 87 minutes. This film is rated R.

Deborah.. Bette Midler
Nick.. Woody Allen

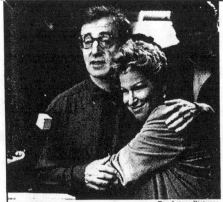

Yes, Dear?
Woody Allen and Bette Midler star in "Scenes From a Mall," about a couple who begin their 16th anniversary by shopping and end up confessing to their affairs.

Touchstone Pictures

Mime Bill Irwin
Sam... Daren Firestone
Jennifer.................................. Rebecca Nickels
Dr. Hans Clava........................ Paul Mazursky

By VINCENT CANBY

By no leap of the imagination do Woody Allen and Bette Midler seem to have been made for each other. He is a passionate skeptic, an observer. She is someone who participates with her entire being. They are pastrami on rye and a double-dip strawberry ice cream soda.

Yet by the end of "Scenes From a Mall," one of Paul Mazursky's madder and more reckless comedies, these two remarkable acting personalities appear to be a perfect match, made in Southern California if not in heaven.

They play Nick and Deborah Fifer, an ordinary middle-class Los Angeles couple of hard-won near-celebrity. They have two overly indulged children, his and hers Saabs, their own telephones (and individual beepers) and, this being the Christmas season, a plastic Santa on the roof of their house.

Nick, who wears his hair in a modest pony tail, is a lawyer who makes pots of money representing sports stars who seek lucrative product en-

Woody Allen and Bette Midler in a Mazursky comedy.

dorsements. Though he's a pussycat at home, he is, according to all reports, a killer in his profession.

Deborah is a high-profile psychiatrist who specializes in late 20th-century matrimonial problems. She's also author of the new best seller, "I Do I Do I Do," which pushes the idea that since people today live far longer than they used to, a successful marriage must be rethought, renewed and recharacterized every 10 years or so.

"Scenes From a Mall" charts Nick and Deborah's tumultuous 16th wedding anniversary, a day that starts as benignly as any other but turns hysterical and often mean in the course of what was supposed to be a quick visit to the mall.

Nick, having just been presented with his own, personalized name-on surfboard by Deborah, somehow feels compelled to blurt out that he's been having an affair. Deborah is stunned. He tells her that the affair

has ended. She wants to know when. "Yesterday," he says, "at 4:30."

From then on, "Scenes From a Mall" becomes a kind of upside-down "Scenes From a Marriage," American-style.

Nick and Deborah battle and reconcile, alternately plead with and insult each other, weep, eat Mexican food, get drunk on margaritas, negotiate divorce terms, giggle, buy clothes, celebrate over caviar and champagne, then battle again, all without ever having to be rained on or to face the sun.

In rapid, often furious and sometimes hilarious succession, they relive every infidelity, every slight, every happy moment and all of their halcyon times under the all-embracing roof of this sparkly, neon-glowing shrine to American consumerism: in the atrium, on the escalators, in the boutiques, in the restaurants and, briefly, in a movie theater showing "Salaam Bombay."

There, in the light reflected from images of street urchins, they make love as if possessed while a couple of turbanned Sikhs up front tell them to hush.

It's almost as if Mr. Mazursky were sending up the mother who tells her little boy to clean his plate because children are starving in India. Nick and Deborah aren't silly people, really, just monumentally oblivious when they think of themselves as informed.

"Scenes From a Mall" is a peculiar but, finally, very engaging comedy. Everything about it is a stretch, not the least of which is the pairing of Mr. Allen and Miss Midler.

Depending on one's allegiances, it seems at first either that Miss Midler is playing the Mia Farrow role or that Mr. Allen is standing in for Richard Dreyfuss.

Little by little, though, the stars take over their characters. They play together with a straight-on honesty that is funny because of the oddball situations, and moving for the unexpected, easy legitimacy of the performances.

Yet the screenplay, by Roger L. Simon and Mr. Mazursky, is sometimes awfully thin. The lines and situations are comic, but the script is as unstructured as a first or second draft. There is no sense of density, of secrets waiting to be exposed, preferably at the most inopportune moment.

It also puts Mr. Allen at an initial disadvantage in that the audience is never allowed to witness Nick demonstrating his reported ferocity as a wheeler-dealer.

•

It takes all of Mr. Allen's immense skill finally to give substance to the outline of this sybaritic Southern California wolf, who may not yet be able to surf though he might long to.

Mr. Mazursky's direction, especially of his two stars, is far more secure. The manner is breezy and his affection for southern California remains free of the sentimentality apparent in Steve Martin's "L.A. Story." It's a measure of Mr. Mazursky's method that he has cast the supporting roles as vividly as he has the leads.

Among the more memorable are Bill Irwin, as the mall's ubiquitous white-faced mime, who drives the nonviolent Nick to uncharacteristic action, and Mr. Mazursky himself, who appears as a slightly suspect psychiatrist.

Also to be cherished are the members of a barbershop quartet. They wander the byways of the mall singing hearty seasonal songs while the supposedly effervverscent marriage of Nick and Deborah Fifer turns into flat beer.

•

"Scenes from a Mall" has been rated R (Under 17 requires accompanying parent or adult guardian). It includes vulgar language and some mildly suggestive sexual situations.

1991 F 22, C19:1

FILM VIEW/Vincent Canby

Stanley Circles the Wolves

"I KNOW, I KNOW," SAID STANley, even before I could sit down. "You're wondering why I look so pale."

Stanley, one of the last of a dwindling breed of creative Hollywood producers, can read minds, which may be why he has more money than friends.

"Sunblock," said Stanley, "No. 32. But I still swim. I still play tennis. I still ski. Only I don't have to announce it by having a year-round tan. I've made a breakthrough: I like myself. I don't worry about image anymore."

"As long as the money rolls in."

"That helps, of course."

Aside from his uncharacteristic pallor, Stanley looked in good shape, trim of figure, freshly steamed, massaged, shaved and shiny.

Long gone was the Stanley who used to travel with a sunlamp, who in the 1970's wore tailor-made jeans, turtlenecks and suede jackets and who, in the 1980's, affected Reaganesque suits and shirts with French cuffs.

This Stanley was almost self-effacing in gray slacks, gray-and-white striped shirt and navy-blue blazer. The only unusual touch was his tie, which was of a

rich yellow satin, embroidered at the center with a pair of large dogs in a discreet embrace.

"They're not dogs," said Stanley. "They're wolves, and they're dancing."

We were having lunch at Le Cirque the day after the Oscar nominations were announced. From the moment he ordered his seltzer through the drinking of the decaf espressos, Stanley was on the offensive.

Hollywood's grand old producer feasts on the Oscar nominations.

"You can say what you like," said Stanley. "You can call me old-fashioned, maybe even sentimental, but 'Dances With Wolves' is a great picture, even if I didn't produce it myself."

That was a joke at the expense of Stanley's reputation for being a notorious egomaniac.

"It has heart," he said. "It has conscience. It's pretty. It has a buffalo stampede. In short, it's a picture all Americans can be proud of. Especially today."

"Times being what they are."

"Exactly," said Stanley. "But what you people back East don't seem to appreciate is that it's also a great art film."

"Because it has subtitles?"

"Yes," said Stanley. "Kevin [Costner] has guts. To be able to enjoy that picture, you have to be able to read English."

"Or understand Sioux."

"That's what I mean," said Stanley.

"Even so, 12 nominations?"

"It deserves every one of them."

"How will it do?"

"I predict a clean semi-sweep," said Stanley. "Best picture, best director, best screenplay, possibly even best actor." He thought a minute. "Unless people split their tickets."

"In other words?"

"If 'Wolves' receives best picture and Kevin receives best actor, people may feel inclined to vote for Marty [Martin Scorsese, "Goodfellas"] as the best director. But if they vote for Kevin as best director and best actor, they could vote for 'Goodfellas' as best picture. Am I going too fast?"

He wasn't.

"I mean," said Stanley, "that it could turn into a trade-off, which I think would be a tragedy. Don't misunderstand me. Marty is a class act, even though he keeps grinding out depressing pictures."

"They often make money, though."

"That's true," said Stanley.

"And they aren't really depressing. They're too full of life. In a serious way, they're too funny to be depressing."

"O.K., 'Goodfellas' is a fine picture, but it's not something I'd want to put my name on. I mean, isn't there enough ugliness in the world without adding to it? That's my worst fault as a three-time winner of the Irving Thalberg award for production excellence: I try to bring a little happiness into other people's lives."

■

"What about Graham Greene?"

Stanley's response was immediate.

"One of the greatest writers in the English-speaking world. I may still have something of his under option somewhere."

When I said that I meant the Graham Greene who was nominated as best supporting actor for his performance in "Dances With Wolves," Stanley assumed a pious expression.

"Do you have something against Native Americans? Are you prejudiced?"

I said that I only meant to suggest that though Mr. Greene's performance might be worthy of a special Chief Dan George award, it was not in the league with the performances of the other nominees: Joe Pesci ("Goodfellas"), Andy Garcia ("The Godfather Part III"), Bruce Davison ("Longtime Companion") and especially Al Pacino ("Dick Tracy").

"Mr. Greene is terrific," said Stanley. "Which Indian does he play?"

"The one who asks his wife, 'Has Stands With a Fist found love again?'"

Stanley admitted that this category was a tough race to call.

"If 'Dances With Wolves' receives the top awards, then there will be a need to recognize 'Goodfellas' in the supporting categories. In that case, Joe will be the favorite. Still, Pacino has never won an Oscar, and he's great in 'Dick Tracy.'"

He paused a moment.

"But then, too, there could be a lot of sentiment to give something to 'Longtime Companion,' which is not to say that Davison isn't good."

"Stanley, you're hedging."

"Yes," he said, and smiled. "Let's put it this way: My serious money is on Joe Pesci."

"What about 'Home Alone'?"

"What about it?"

"It's the biggest box-office smash of the year, and all it gets is two

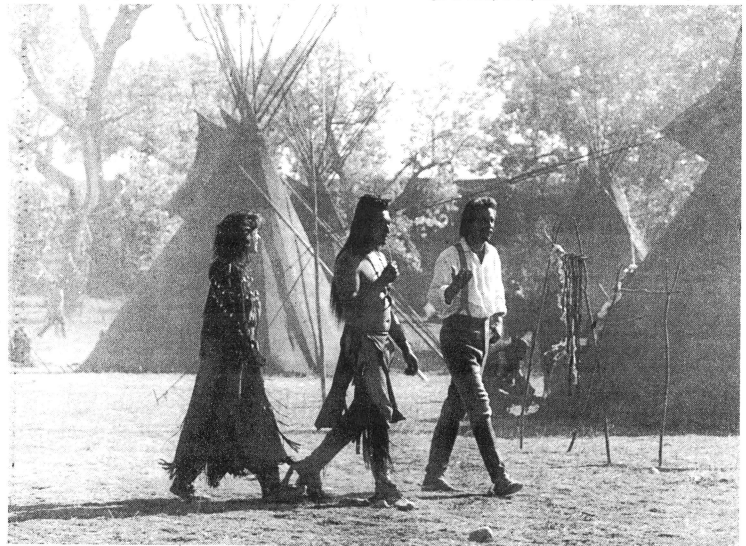

Orion Pictures

Mary McDonnell, Graham Greene and Kevin Costner in "Dances With Wolves"—"A great picture, even if I didn't produce it myself," says Stanley.

nominations, one for best score and one for best song.''

Stanley assumed his industry-spokesman, it-was-announced today manner.

''The Oscars are not about money. You seem to forget that. They are about achievement.''

'' ''Well, money is achievement, isn't it?''

''That's true,'' said Stanley. ''Yes, indeed.'' He pondered briefly. ''I think 'Home Alone' could certainly have been recognized for, say, its sound recording and set decoration, its screenplay, its direction and especially for it leading actor. Yes, I do. I think we erred.''

''Macaulay Caulkin? Have you signed him up?''

■

Stanley was patient with me. ''I'm an independent producer, not a major studio,'' he said. ''I believe in bringing talent along, but I've also found it unwise to sign a term contract with anyone who's liable to grow more than 24 inches, perpendicularly or horizontally, within the term of the aforesaid contract.''

''Is that Stanley's law?''

''You could put it that way.''

As we were waiting for dessert, I asked Stanley, who is as famous in Hollywood for his after-dinner games as for his French Impressionists, to participate in a sort of oral Rorschach test. I would read off some of this year's Oscar nominations, along with the names of some people quite mysteriously overlooked, and he

Touchstone Pictures

Al Pacino, nominated for best supporting actor for his portrayal of Big Boy Caprice in Warren Beatty's "Dick Tracy"—"Pacino has never won an Oscar, and he's great," says Hollywood's grand old producer.

Warner Brothers

Lorraine Bracco and Ray Liotta in "Goodfellas"—"Fine, but . . ."

would say the first thing that popped into his head.

''Robert De Niro, nominated best actor, 'Awakenings,' '' I said.

''Drop dead, Dustin Hoffman, 'Rain Man.' ''

''Gérard Depardieu, nominated best actor, 'Cyrano de Bergerac.' ''

''If Kevin doesn't get it, the contest is between Depardieu and Jeremy Irons, 'Reversal of Fortune.' ''

''Mia Farrow, not nominated best actress, 'Alice.' ''

''She lives in New York.''

''Julia Roberts, nominated best actress, 'Pretty Woman.' ''

''Winner,'' said Stanley.

''Wait a minute,'' I said. ''She's awfully good, but is she really a better actress than Anjelica Huston ['The Grifters'] Joanne Woodward ['Mr. and Mrs. Bridge'] or Meryl Streep ['Postcards From the Edge']?''

''I simply said 'winner,' '' said Stanley. ''This is, after all, a Cinderella business. I'd like to see her up on that stage. She's gorgeous. For heaven's sake, lighten up.''

He's got his money on Julia Roberts for best actress. 'This is, after all, a Cinderella business.'

''David Lynch, not nominated best director, 'Wild at Heart.' ''

''He's been on the cover of Time. I haven't.''

''Warren Beatty, not nominated best director, 'Dick Tracy.' ''

''Warren got an Oscar for 'Reds.' Shirley got one for 'Terms of Endearment.' That's enough for a couple of nice middle-class kids from Richmond, Va., each of whom is more talented than is absolutely necessary.''

'' 'Ghost,' nominated best picture.''

''I saw it. All I remember are the grosses.''

'' 'The Godfather Part III,' seven nominations, including best picture and best director.''

''I liked Sophia [Coppola]. She broke my heart. I mean that. Francis is a prince. He takes care of his family.''

'' 'Havana,' nominated best original score.''

''What, and nothing for its trailer?''

'' 'Hamlet,' nominated best art direction, best costume design.''

'' 'To be or not to be.' ''

''The nominees for best actress in a supporting role: Mary McDonnell, 'Dances With Wolves.' ''

''Very nice, very pretty, but no award, unless the sweep gets out of hand.''

''Diane Ladd, 'Wild at Heart.' ''

''The picture flopped.''

''Lorraine Bracco, 'Goodfellas.' ''

''Good performance, but the competition is tough.''

''Annette Bening, 'The Grifters.' ''

''Terrific. She's a possible winner, but so is Whoopi Goldberg in 'Ghost.' Whoopi has paid her dues. She remains visible even when her pictures don't. That category is a tossup.''

''O.K.,'' I said, ''this comes at you from left field: Akira Kurosawa's 'Dreams,' 'My 20th Century,' 'Sweetie.' ''

''What are they, perfumes?'' Stanley laughed and sighed his way into a pause.

''Don't look so superior,'' he said. ''I know they were on your 10-best list and haven't been heard of since. As a matter of fact, I screened each one at the house, not exactly to a full house, I admit, but I looked at them. Very interesting, but I mean, so what?''

The decaffeinated espressos arrived.

''We're talking ephemera now,'' said Stanley. ''Why not enjoy it?'' □

1991 F 24, II:11:1

FILM VIEW/Janet Maslin

L.A. Lore Delivers A Jolt

CONSIDER IT POETIC JUSTICE: THE MAN who once complained that the main cultural advantage to California living was being able to make a right turn on a red light can now be seen toting a personalized surfboard and wearing a small, discreet ponytail. Woody Allen's very presence in Paul Mazursky's ''Scenes From a Mall,'' which casts him as

a Los Angeles entertainment lawyer with a warm-up suit, car phone, long and iffy marriage to a wife who has written a self-help book, plus two teen-age children who are eager to borrow his gold card, attests to the wide world of comic possibilities inherent in culture shock — in all its many forms.

Mr. Allen's appearance in this setting is also testament to Southern California's enduring function as a target, which is the role it plays in Steve Martin's "L.A. Story." Lukewarm as Mr. Martin's satire is, it does identify Los Angeles as a place where it's possible to be fired by a person wearing a Hawaiian shirt and a baseball cap, and where an enterprising weatherman might offer a toupee report (on a windy day, he advises, "I would either stay indoors or wear a hat").

Mr. Martin's best extended gag, involving a restaurant where the staff practices "the New Cruelty" and closed-cir-

Two new movies serve up California culture shock to actors as well as audiences.

cuit video cameras pinpoint the arrival of any remotely famous person ("Voice of Donatello," says the identifying title for one new face), has an aspiring patron applying eight weeks in advance for a dinner reservation at either 5:30 or 10:30 in the evening. To do this, he must go to his bank, meet with a grave-looking restaurateur and chef, answer detailed questions about his fiscal health and give some inkling of what he hopes to order. When Mr. Martin, as a would-be patron of this desperately fashionable establishment, says he'll try the duck, he is sneeringly advised to set his sights lower. It had better be chicken.

"L.A. Story" does capture the crazy ebullience of California culture, from the bobbing, squirming, hair-tossing salesgirl (Sarah Jessica Parker) who spells her name San-DeE to the mugger who thinks he's a waiter ("Hi, my name is Bob. I'll be your robber"). It has enthusiasm for its subject, but Mr. Martin's film doesn't go much further. It lacks anything as mind-bogglingly mislocated as Mr. Allen is in "Scenes From a Mall" (or John Goodman in "King Ralph," the predictable but funny story of a baseball-jacketed American slob who becomes heir to the British throne).

Mr. Allen gives such a generous performance that he becomes convincing, but he is radically misplaced in several ways. His character's passionate defense of Southern California ("If Philip starts in on me one more time about how New York is the cultural center of the world and L.A. is a bar-

Touchstone Pictures
Woody Allen, surfer, in "Scenes From a Mall"

ren desert, I'm going to poke him in the eye.") is only the least of it. In addition to finding himself on the wrong coast, Mr. Allen is himself caught up in the culture shock of working within a comic sensibility very different from his own.

Only in a Paul Mazursky film could two long-married characters, like the couple played by Mr. Allen and Bette Midler, spend an hour and a half destroying the fundamental promises that hold them together without really changing much more than their outlook. It is in Mr. Mazursky's world, and not in Mr. Allen's, that a husband would muse about "the

secret of our longevity" and feel inclined to credit "the corniest things," like the kids and all the memories, with keeping him and his mate together.

■

As that may indicate, "Scenes From a Mall" has a world view more middle-aged than anything Mr. Allen's own films have ever embraced. Its concept of marriage, which boils down to a sexually liberated equivalent of "My wife — I think I'll keep her," would be alien to any of Mr. Allen's skittish, disengaged married characters. Mr. Mazursky is not without his quiet dismay at this, and so the film's bedroom scene between Mr. Allen and Ms. Midler suggests so much longtime familiarity that it's more than a little depressing. Ms. Midler, incidentally, is no less weirdly out of place as a popular psychologist than Mr. Allen is crying, "Ciao!"

The film's third major character, the mall itself, helps to account for the disorientation of the other two. Included within this middle-class microcosm are scraps of wildly incongruous cultural experiences that conspire, like the sushi and yogurt and Margaritas that the principals wind up having, to bring on queasiness and confusion. From the rap singers to the Christmas carolers to the models dressed in outfits of many nations and handing out free samples, this place overflows with a too-dizzying array of possibilities.

The mall becomes an apt setting for Mr. Mazursky's well-honed sense of the absurd, and so there is a Renoir mural in the yogurt parlor. And "Salaam Bombay!" looms large and incongruous on the movie screen as the feuding spouses attempt yet another of their several reconciliations. The cultural kaleidoscope in which "Scenes From a Mall" unfolds becomes the visual equivalent of the world in which this marriage has been made.

No wonder, in this overloaded environment, that both husband and wife have begun wondering whether they're kept together by anything more compelling than fear, if single, of having to "tell our life stories to total strangers two or three times a week," as Mr. Allen's character says. In this case, culture shock means chaos as well as comedy.

1991 F 24, II:11:5

Blood in the Face

Directed and produced by Anne Bohlen, Kevin Rafferty and James Ridgeway; photography by Mr. Rafferty and Sandi Sissel; edited by Mr. Rafferty; distributed by First Run Features. At Film Forum, 209 West Houston Street. Running time: 75 minutes. This film has no rating.

Interviewers: James Ridgeway, Anne Bohlen, Kevin Rafferty and Michael Moore

By VINCENT CANBY

"When you have to do the time," Bob Miles tells his audience, "don't regret the crime."

The place is the Miles farm near Cohoctah, Mich., and the occasion a small convention of far-right-thinking Americans, drawn mostly from rural areas and the ranks of urban blue-collar workers.

Between formal sessions in the barn, the attendees mill around the barnyard or sit at picnic tables. The kids play and listen and fidget. The older folk talk about the state of things now and the coming of Armageddon.

Some fellows are dressed in camouflage combat gear, others in jeans and some in the black leather associated with bike gangs that mark their territory with noise and intimidating style. Quite a few sport Nazi armbands.

The women let their men do most of the talking, though one young woman in black leather speaks for herself. Her politics would seem to be tied to her erotic impulses. Another, slightly older woman chooses her words carefully. Her husband, it seems, has been implicated in the murder of Alan Berg, the Denver talk-show host.

The down-home, avuncular-sounding Mr. Miles, called Pastor Bob Miles by his followers, knows what he's talking about when he mentions doing time. A former Grand Dragon of the Michigan Ku Klux Klan, he went to jail after being convicted of conspiracy in some school bus bombings.

The Cohoctah meeting is the centerpiece of "Blood in the Face," the riveting documentary about the radical right opening today at the Film Forum.

The film was produced and directed by Anne Bohlen (production manager of "Roger and Me"), Kevin Rafferty (co-producer and director of "The Atomic Cafe") and James Ridgeway, the Village Voice columnist and author of a new book also titled "Blood in the Face."

•

The film is neither as uproarious as "Roger and Me" nor as jazzy as "The Atomic Cafe," but it is far more insidiously spooky in its picture of the extreme right exemplified by members of the K.K.K., the Aryan Nations and the American Nazi Party, among other groups.

It is one of the points of "Blood in the Face" that most of these people see themselves as staunch, bedrock Americans, the kind almost equally beloved by Grant Wood and Norman Rockwell.

They are God-fearing, but also afraid in general. They live in a world where it's "us," meaning "pure" whites, against "them," blacks, Jews, Asiatics and southern Europeans, in a country run by Z.O.G. (the Zionist Occupation Government in Washington).

"Blood in the Face" would not agree that the extreme right is essentially harmless in its lunacies.

•

The film uses newsreel clips to recall the career of George Lincoln Rockwell, the founder and assassinated leader of the American Nazi Party in the 1950's. Rockwell's admiration for Adolf Hitler ("I'm the St. Paul to Hitler's Christ") is matched by Pastor Bob Miles, who tells his audience stoutly, "We're more Nazi than the Nazis."

The movie associates the comparatively brief career of Rockwell with that of David Duke, the Louisiana politician whose right-wing policies are seen as bringing overt racism into mainstream party politics in the South. It is the film's argument that the Duke successes in Louisiana indicate that far more people are receptive to these policies than are ever turned up in any polls.

"Blood in the Face" is full of outrageous details that are comfortingly easy to laugh at, including the warning that there are "about 35,000 Vietcong operating in the wilds of British Columbia."

There's a shot of some paramilitary right-wing shock troops attempting, unsuccessfully, to camouflage themselves in a field of goldenrod.

Pastor Bob Miles tells his audience that their cause needs the backing of scholarly works and comic books. Someone says that Rockwell was not a hate-monger, but "more of a love-monger.

"He loved white people."

As the grand finale of the Cohoctah farm convention, a couple wearing matching white K.K.K. robes are married in the light of a flaming cross.

Love's magic spell is everywhere, but hate is the spur.

The film's title is suggested by the belief, held dearly by some of these groups, that only white people can blush. For this reason, they say, the true Israelites of the Bible were "pure whites," not Jews.

The film makers use no voice-over narration. They allow people and events to speak for themselves. "Blood in the Face" is first-rate journalism.

1991 F 27, C11:1

The Doors

Directed by Oliver Stone; written by J. Randal Johnson and Mr. Stone; director of photography, Robert Richardson; edited by David Brenner and Joe Hutshing; music by the Doors; production designer, Barbara Ling; produced by Bill Graham and Sasha Harari and A. Kitman Ho; released by Tri-Star Pictures. Running time: 135 minutes. This film is rated R.

Jim Morrison	Val Kilmer
Pamela Courson	Meg Ryan
John Densmore	Kevin Dillon
Ray Manzarek	Kyle MacLachlan
Robby Krieger	Frank Whaley
Paul Rothchild	Michael Wincott
Tom Baker	Michael Madsen
Patricia Kennealy	Kathleen Quinlan
Cat	Billy Idol
Bill Siddons	Josh Evans
Engineer, last session	John Densmore
Andy Warhol	Crispin Glover
Wicca Priestess	Patricia Kennealy
Lawyer	William Kunstler

By JANET MASLIN

IN the 60's, for anyone who took the Doors half as seriously as the Doors took themselves, wide-screen musical biography was strictly for the Trapp family. It would have been unimaginable that some day movie audiences would relive the moment when the guitarist Robby Krieger (Frank Whaley) pulled a scrap of paper out of his pocket and showed it to the singer Jim Morrison (Val Kilmer) and the two other Doors, saying shyly, "I came up with somethin' ... I call it 'Light My Fire.'"

Unimaginable, perhaps — but here it is anyway: "The Doors," Oliver Stone's clamorous, reverential, much-larger-than-life portrait of the 60's most self-important rock band. Incendiary even by Mr. Stone's high standards, "The Doors" presents the group's career as a brave, visionary rise followed by a wretched slide into darkness, a slide implemented by drugs, alcohol, madness, world affairs and the demands of fame. This view is sure to arouse as strong a love-hate reaction as the Doors did themselves, but two things are certain: Mr. Stone retains his ability to grab an audience by the throat and sustain that hold for hours, without interruption. And he has succeeded in raising the dead.

Nowhere did the best and worst of the 60's collide as messily as they did in Jim Morrison, the Doors' resident sex symbol and bête noire. "It was Morrison who wrote most of the Doors' lyrics, the peculiar character of which was to reflect either an ambiguous paranoia or a quite unambiguous insistence upon the love-death as the ultimate high," wrote Joan Didion in her essay "The White Album," when the Doors were still at their peak. She also described Morrison's slow, studied way of holding a lighted match to his black

Capturing the best and worst of the 60's — Val Kilmer as the insolent, sexy and ultimately self-destructive Jim Morrison, in Oliver Stone's film "The Doors."

leather lap.

Morrison's self-destructiveness, which led to personally dangerous and professionally suicidal outbursts, was accompanied by a similarly violent streak aimed at others. In the wrong mood, he was capable of waving a knife at a friend, dragging a companion out onto a window ledge, locking a lover in a closet and then setting the door on fire, or aiming a microphone stand at an audience, javelin-style. "Why are you doing this to me?" his girlfriend Pamela (Meg Ryan) wails during one fight depicted in the movie. "Because you're in the room," Jim casually replies.

But along with this mean streak ("When I want some good pagan carnage, I put on the Doors," John Milius once said), and with the drug and alcohol use that greatly exacerbated it, came the heady idealism that accounts for part of the Doors' surprisingly long-lived popularity. (Another big factor is Morrison's untimely death, at the age of 27 in 1971, which turned his alienation, heartthrob looks and taboo-busting behavior into the makings of an updated James Dean-Elvis Presley-Lenny Bruce composite.) At his most darkly ecstatic, Morrison could invoke the liberating influences of mind-expanding drugs and literature, calling for his audience to throw off any and all life-denying constraints.

That call is heeded enthusiastically by Mr. Stone, who after "Platoon" and "Born on the Fourth of July" was

Sidney Baldwin/Tri-Star Pictures

Meg Ryan

already knee-deep in the 60's, and who now embraces the Morrison mystique hook, line and sinker. This wildly avid approach to his subject makes for some dismaying moments, especially in the film's most adulatory early stages. ("You *wrote* this? You got *more?*" asks the incredulous organist Ray Manzarek upon first hearing one of Morrison's songs.) But it is also, for the director, a source of strong and unmistakable passion. And one of the things Mr. Stone does most intoxicatingly is to set forth his enthusiasms in terms any audience will understand.

•

"The Doors" begins dangerously, with a startling but unclear prologue (it is later understood that as a boy Jim felt the soul of an Indian shaman entering his consciousness) and with unbridled excitement about the college-boy intellectual fervor that brought forth this band. In the film's opening episodes, Jim is seen courting Pam under a glorious night sky with poetry and existential small talk ("I feel most alive experiencing death, confronting pain") and wowing the impressionable Ray, a fellow student at U.C.L.A. Film School.

"It's great! It's nonlinear! It's poetry! It's everything good art stands for!" Ray exclaims after watching Jim's student film featuring Jim, a leggy blonde, a television set and images of Nazi Germany. Mr. Stone, in a goatee, is seen as the pedantic film professor in this scene, saying, "Eh, pretty pretentious there, Jim ... not easy to follow." That attitude would have been welcome in other parts of the story, but it is largely absent, which in Mr. Stone's work is unusual. The best of his other films display much more critical distance from their subjects than there is here.

Mr. Stone's other work — especially his films about the disorienting effects of wartime experience — has also packed more of a psychedelic wallop than "The Doors" does, despite the fact that psychedelia is an explicit ingredient this time. The Doors' early drug trips, especially during one long peyote-dream sequence in the desert, are fluidly and elaborately staged. Yet they are also almost redundant, so fully does the drug culture of the 60's permeate this film in every frame. Using inventive optical effects, American Indian imagery, swooping camerawork, odd angles and the dizzying motion of 30,000 extras (all told, through the film's various crowd scenes and con-

cert re-enactments), "The Doors" creates a constant buzz of lulling, mind-bending confusion. Recaptured with startling accuracy, it is the perfect visual backdrop for the Doors' rise and fall.

Prodigious research has gone into this film's minutiae (like the "Band From Venice" banner that accompanies the group's first club date on Sunset Strip), and even into its slightly fabricated episodes. (There was never a television "Light My Fire" car commercial, over which Morrison becomes infuriated in the film, but in fact his three bandmates did agree to sell the song.) But nowhere is this attention to detail more astonishing than in Mr. Kilmer's perform-

The ecstasy and the agony of Jim Morrison's mind-bending band.

ance, which is so right it goes well beyond the uncanny. Leading dauntingly with his chin, projecting sexy insolence, never losing sight of the singer's magnetism, Mr. Kilmer captures all of Morrison's reckless, insinuating appeal. "He liked to find out what the personal frontiers of the people around him were," the Doors' producer Paul Rothchild once said euphemistically, and Mr. Kilmer perfectly captures that kind of abrasive daring.

Musically, too, Mr. Kilmer is unerringly good. If anything, he sounds even more like Morrison when singing a cappella, which he does in a couple of scenes, than when his extremely serviceable new vocal renditions are integrated into pre-existing Doors recordings. Even when lip-synching expertly to the many Doors songs that are used here, Mr. Kilmer makes himself utterly convincing. Jim Morrison could sound grittier and more dangerous than this, and his stage manner was sometimes more eerily deadpan, but Mr. Kilmer expertly re-creates the essential Morrison performance style.

•

Mr. Kilmer's Jim Morrison is as comfortable demonstrating his restlessness on a small scale — stepping in front of a car on Sunset Strip, jumping boisterously onto the hood and kicking at the driver — as he is reigning over the huge concert scenes that are the film's most ambitious moments. The staging of these latter scenes courts the ridiculous (Mr. Stone insists on bringing the dancing Indian shaman in Jim's mind right onto the stage with him). But it is shockingly evocative, too. The druggy haze, the fans' ecstatic dancing, the road crew's expert intervention with groupies rushing the stage, the hail of flowers and joints thrown at the musicians, the band's utter panic over what its lead singer may choose to do next: all this chaos is re-created with frightening intensity, and with a compellingly tortured view of Morrison as both orchestrator and pawn of the surging crowd.

Some of the film's more intimate moments are just as weirdly potent, like the Thanksgiving scene chez Morrison involving acid trips, a knife fight, a showdown between Jim's two

rival girlfriends (Kathleen Quinlan is especially effective as the avowed witch in the group), and a duck dinner that gets stomped to bits in the process. The final stage of Morrison's life was never easy.

Also re-created here, with remarkable care: scenes on film stock faded to a 20-year-old orange hue, reworking real images of the Doors arriving at an airport and jokingly explaining themselves to an interviewer; Jim's deliberate, gleeful flouting of the rules of "The Ed Sullivan Show" (Mr. Kilmer does this even better than the real Morrison did), and the scary, sodden performance in Miami that put an end to Morrison's concert career. The panic of the other Doors as this last event unfolds (Kevin Dillon is especially good as the angry, uncertain drummer John Densmore) provides a striking backdrop for the sad spectacle of Morrison's dissipation. Mr. Densmore, in his memoir about the band, writes of expecting to feel that Morrison was "headed straight for a sad death in a gutter."

What ruined Jim Morrison? The film, at times, dares to make the outrageous suggestion that he died for his audience's sins, but it is possible to be haunted by "The Doors" without subscribing to that idea in the slightest. Mr. Stone is less successful in offering any final assessment of either the 60's or his hero than in bringing both back with strange and spectacular power.

•

As with any of Mr. Stone's films, the casting (here by Risa Bramon and Billy Hopkins) is unobtrusively fascinating. Crispin Glover turns up as Andy Warhol (in a New York City vignette sure to foster hopes that no one ever re-enacts the Warhol story), William Kunstler as the lawyer in Morrison's obscenity trial, and the real Patricia Kennealy (who Miss Quinlan plays so glamorously) makes a brief appearance as a middle-aged witch. Mr. Densmore turns up as a studio engineer.

Among Mr. Stone's relative stellars, Frank Whaley makes Robby Krieger quietly compelling. Michael Wincott makes the Doors' producer a knowing figure, and Josh Evans has the right brashness as the road manager stuck with the job of damage control. Miss Ryan plays Pamela in a cute, dizzy fashion that will not further Mr. Stone's reputation as a director who understands women. And she (like the other principals, in their early scenes) is saddled with a surprisingly unconvincing wig.

As photographed dynamically by Mr. Stone's usual cinematographer, Robert Richardson, "The Doors" looks spookily evocative. It sounds good, too, possibly because so many of the Doors songs on the soundtrack are heard in smaller, catchier doses than they were in their more sprawling original versions. One of Mr. Stone's most effective tricks is to fade out the sound entirely at one crucial moment, as Morrison becomes fatally out of touch with his audience.

"The Doors" concludes in Père-Lachaise cemetery in Paris, where Morrison is buried in the company of Chopin, Bizet, Molière, Balzac, Proust, Rossini and others. Even in the final analysis, Mr. Stone's film sees little irony in this. But it does explain, with captivating intensity, why Jim Morrison is the one who gets the visitors.

"The Doors" is rated R (Under 17 requires accompanying parent or adult guardian). It includes nudity, considerable profanity and drug use.

1991 Mr 1, C1:1

Shipwrecked

Directed by Nils Gaup; screenplay by Mr. Gaup, Bob Foss, Greg Dinner and Nick Thiel, based on the book "Haakon Haakonsen" by O. V. Falck-Ytter; director of photography, Erling Thurmann-Andersen; edited by Niels Pagh-Andersen; music by Patrick Doyle; production designer, Harald Agede-Nissen and Roger Cain; produced by John M. Jacobsen; released by Walt Disney Pictures. Running time: 93 minutes. This film is rated PG.

Haakon Haakonsen Stian Smestad
John Merrick Gabriel Byrne
Mary .. Louisa Haigh
Jens Trond Peter Stamso Munch

By VINCENT CANBY

Nils Gaup's "Shipwrecked," presented by Walt Disney Pictures, is the kind of innocent live-action adventure movie the Disney people used to make before they turned their attention to adult audiences.

The film is an adaptation of the Norwegian novelist O. V. Falck-Ytter's "Haakon Haakonsen," published in 1873. It should be noted that this is eight years before the appearance of the first installments of Robert Louis Stevenson's "Treasure Island," which it recalls, if dimly.

"Shipwrecked" is the story of Haakon, a young Norwegian boy who goes to sea to earn money to save the family farm. Haakon is a fairly timid fellow, but he grows up, brave and strong, in the course of his travels, which include the mishap of the title. Apparently alone on a South Sea island, Haakon builds a Robinson Crusoe-like camp, learns how to tolerate creepy-crawlies, including snakes and bats, meets a gorilla and finds a buried treasure.

Eventually, he is joined on the island by two former shipmates, Jens,

Buena Vista Pictures

Stian Smestad

a seaman, and Mary, a stowaway just about his age whom he had befriended before the fatal storm. Also lurking about is a gang of pirates.

Mr. Gaup, a Norwegian-born director and a collaborator on the screenplay, has composed the movie in such a way that it will be comprehensible to the youngest members of the audience, without scaring the wits out of them. (An earlier Gaup film, "Pathfinder," was nominated for a foreign-language Oscar in 1987.)

The Fiji Islands scenery, where much of the movie was photographed, is pretty. The gorilla is fright-free and the methods Haakon employs to protect the buried treasure are ingenious when they work. He boobytraps the

area in ways to suggest that he's seen "Home Alone," though Haakon's tricks are a lot more gentle than Macauly Culkin's.

The performances aren't great, but they have a kind of up-front sincerity to them that matches the style of the entire film. Even Merrick, the chief pirate, played by Gabriel Byrne, who threatens to do all sorts of nasty things to Haakon and his friends, is essentially benign.

"Shipwrecked," which has been rated PG (Parental guidance suggested), includes one fierce storm at sea that could possibly upset very young children.

1991 Mr 1, C6:1

The Fable of the Beautiful Pigeon Fancier

Directed by Ruy Guerra; screenplay (in Portuguese with English subtitles) by Mr. Guerra and Gabriel García Márquez, original story by Mr. García Márquez; photography by Edgar Moura; music by Egberto Gismonti; produced by João Alfredo Viegas; a Fox Lorber/Original Cinema Release. At the Public, 425 Lafayette Street in Manhattan. Running time: 75 minutes. This film has no rating.

Orestes	Ney Latorraca
Fulvia	Claudia Ohana
Orestes's Mother	Tonia Carrero
Andrea	Dina Sfat
Fulvia's Husband	Chico Díaz
Patient	Cecil Thire

By JANET MASLIN

No film maker will ever fully capture the gravity-defying magic of Gabriel García Márquez's fiction, but Ruy Guerra comes reasonably close. Mr. Guerra, who adapted his 1983 "Erendira" from a García Márquez story, has in "The Fable of the Beautiful Pigeon Fancier" collaborated with the novelist on an original screenplay and filmed it with a rueful fancifulness very like that which colors Mr. García Márquez's prose.

Originally made for television and opening today at the Public Theater, "The Fable of the Beautiful Pigeon Fancier" tells of the wealthy, foppish Don Orestes (Ney Latorraca), who lives with his mother and longs for romantic love. Vain, fastidious and given to sleeping in a hairnet, Don Orestes nonetheless dreams of escape. His mother (Tonia Carrero) has her own dreams, which prove to be prophetic for her son, who like so many of Mr. García Márquez's other characters is a hostage to preordained destiny. Don Orestes's father was, of course, Don Agamemnon.

One day at the shoreline, Don Ores-

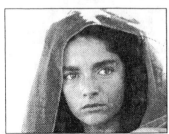
Original Cinema Release
Claudia Ohana

tes glimpses the ravishing Fulvia, a vision in a flowing white gown. As played by Claudia Ohana, the same lovely, dark-eyed actress who portrayed Mr. Guerra's Erendira, Fulvia is a figure of intoxicating innocence. Accepting a ride home from Don Orestes, she leads him to the house she shares with her white-robed baby, a horde of white messenger pigeons and a husband in white trousers who plays trombone in a marching band. From the moment he first glimpses this household, Don Orestes cannot tear himself away.

•

The film finds apt visual equivalents for Fulvia's sweet heedlessness and Don Orestes's obsession. The pigeons themselves, waddling casually through Fulvia's household, convey a peculiar tranquillity even when they become the medium through which Fulvia and Don Orestes communicate without her husband's knowledge. The Don himself, lost in his longing, stands outside on a rainy night until he loses his hair dye, emerging as a graying, desperate version of his formerly controlled self.

This story's resolution is passionate, wrenching and very much in keeping with the author's thoughts of love and doom. Despite its tragic overtones, "The Fable of the Beautiful Pigeon Fancier" has a light, soaring spirit that will be instantly recognizable to any of Mr. García Márquez's devoted readers.

1991 Mr 1, C6:4

Misplaced

Directed by Louis Yansen; script by Mr. Yansen and Thomas DeWolfe, story by Mr. Yansen; director of photography, Igor Sunara; edited by Michael Berenbaum; music by Michael Urbaniak; production designer, Beth Kuhn; produced by Lisa Zwerling; an Original Cinema Release. At the Quad Cinema, 13th Street west of Fifth Avenue, in Manhattan. Running time: 98 minutes. This film has no rating.

Jacek Nowak	John Cameron Mitchell
Zofia	Viveca Lindfors
Halina Nowak	Elzbieta Czyzev.ska
Bill	Drew Snyder
Ela	Deirdre O'Connell
David	John Christopher Jones
Mrs. Padway	Debralee Scott

By JANET MASLIN

In "Misplaced," a proud Polish woman and her teen-age son immigrate to the United States for political reasons, and rebuild their lives in an environment that is often less than friendly. Settling with relatives in Virginia, they must contend with economic hardship, lack of suitable job opportunities, loneliness, and the supercilious behavior of those not eager to make them feel welcome in a new land.

Halina Nowak (Elzbieta Czyzewska) quickly finds that her mother and half-sister cannot easily accommodate her in their small suburban house, and that after years of separation the family is less than close. ("I always wanted to bring you over, but the time just went by," says Halina's mother, played by Viveca Lindfors.) Halina and her son, Jacek (John Cameron Mitchell), move to a drab apartment and begin the difficult task of making it a home. Meanwhile, Halina also looks for a job. Though she is an accomplished lin-

guist, she can find nothing better suited to her talents than cleaning work at Voice of America headquarters.

The film — which opens today at the Quad Cinema — proceeds quietly, and without any more fire than its title suggests, to show how Halina and Jacek gradually put down roots. As directed by Louis Yansen, who makes his feature debut with this semiautobiographical story, it is often attractively sincere. The women's roles, though, are written (by Mr. Yansen and Thomas DeWolfe) as virtual catnip for any actress equipped to convey noble suffering, and both Miss Czyzewska and Miss Lindfors have many opportunities to play this to the hilt.

Miss Lindfors, in one scene, confronts street hooligans and shames them into going away. Miss Czyzewska, in another, corners two selfish yuppie women and shames *them* into giving her an audition as a Voice of America announcer. "I am just a cleaning woman, is that it?" she shouts, bristling with anger. Together with Miss Lindfors, who is also supposed to be doing work of this kind, they make the two most stately, dignified cleaning women imaginable. That may be Mr. Yansen's point, but it is overworked.

Jacek's section of the story is more easygoing. Mr. Mitchell does extremely well in conveying this high school student's shyness, intelligence and eagerness to fit in. Jacek is as obviously superior to his new surroundings as his mother is, but he is less inclined to say so, even to the teen-age girls who make fun of his loud, low-budget American clothes. Mr. Mitchell's Jacek has enough quiet dash to make those teen-age girls eventually see the error of their ways.

Mr. Yansen's direction is plain and sometimes even blunt, but he succeeds in offering a clear and affecting sense of the Nowaks' ordeal. When Jacek struggles to learn the Gettysburg Address and complains of difficulty with the word "unalienable," his mother erupts with the anger that runs tacitly throughout the story. "A word is too hard?" she cries. "You tell me what is so hard about a word!"

1991 Mr 1, C9:1

Heaven and Earth

Directed by Haruki Kadokawa; screenplay (in Japanese with English subtitles) by Toshio Kamata, Isao Yoshihara and Mr. Kadokawa; original novel by Chogoro Kaionji; cinematography, Yonezo Maeda; edited by Akira Suzuki and Robert C. Jones; music by Tetsuya Komuro; produced by Yutaka Okada; released by Triton Pictures. At the 57th Street Playhouse, 110 West 57th Street. Running time: 106 minutes. This film is rated PG-13.

Kagetora	Takaaki Enoki
Takeda	Masahiko Tsugawa
Nami	Atsuko Asano
Usami	Tsunehiko Watase
Yae	Naomi Zaizen
Kakizaki	Binpachi Ito

By VINCENT CANBY

Haruki Kadokawa's "Heaven and Earth," opening today at the 57th Street Playhouse, is an elaborate but totally weightless Japanese historical film, of less interest for what is on the screen than for how it got there. The movie looks like a wildly expensive vanity production.

The time is the 16th century, just a few decades before the events depicted in Hiroshi Teshigahara's superb "Rikyu." The story, said to be based on fact, is about the series of battles fought by two strikingly different warlords for the privilege of unifying Japan.

On one side is Kagetora, a brilliant strategist who is too humane and spiritual for his own good. He prays a lot and at one point vows to remain celibate if the gods favor him. This causes him no end of woe when he falls in love with a pretty young woman who plays the flute.

Kagetora can win battles, but he hesitates when he must put children to the sword.

•

His opponent is less squeamish. He is the older, rougher Takeda, an equally good strategist who does what's necessary to instill fear and trembling in his enemies.

According to an opening screen statement, the battles fought by Kagetora and Takeda were "destined to become a legend in both heaven and earth." That may be, but they haven't yet made a very good movie.

Mr. Kadokawa, who not only is the

Triton Pictures
Takaaki Enoki

director but also collaborated on the screenplay and is its executive producer, is not a subtle film maker.

The battle scenes were shot in Canada on the Goodstoney Indian Reserve in Morley Flats, Alberta. They are big. The production notes say they involved 3,000 extras, 4,400 spears, 5,800 swords and 16,000 feet of webbing for saber belts.

They also have been photographed and edited in such a lofty, impersonal style that it's impossible to tell who's fighting whom, or even to care. It's spectacle for its own sake.

•

This may also be the result of the tepid drama that surrounds the battles. The focus of the film is mostly on Kagetora, a melancholy warlord who is frequently discovered staring off into distances surrounded by falling leaves, sometimes by cherry blossoms.

Far more interesting than the movie is the story of Mr. Kadokawa as reported in the production notes. He is a successful publisher who became a film producer in 1976 and directed his first film in 1982. He is also said to be a Shinto priest, a noted adventurer and the author of numerous books.

He is active on Broadway, and participated in last season's production of "The Threepenny Opera" starring Sting. With James Clavell and Joe Harris, he recently presented "Shogun: The Musical."

Next year he plans to sail a replica of Columbus's flagship, the Santa Maria, on a 17,000-mile voyage from Barcelona to Japan, in honor of the 500th anniversary of Columbus's 3,000-mile voyage to America.

•

"Heaven and Earth" is rated PG-13 (Parents strongly cautioned)." It includes some violence.

1991 Mr 1, C10:4

FILM VIEW/Caryn James

'Green Card' Apes 'Pretty Woman'

"**G**REEN CARD" WAS NOT CONceived as "Daughter of 'Pretty Woman,' " though it seems that way now. Look at Gérard Depardieu holding Andie MacDowell over his shoulder in the posters and newspaper ads for "Green Card," Touchstone Pictures' current romantic comedy about a straitlaced woman and a free-spirited man. Then look at Richard Gere holding Julia Roberts in a strangely similar photograph for "Pretty Woman," Touchstone Pictures' romantic comedy about a free-spirited woman and a straitlaced man. You're not seeing double, and it's no mistake: both ads were created by the same in-house department at Touchstone, which has tried to hitch "Green Card" to the wild success of "Pretty Woman," the third highest-grossing film of last year.

"If you liked 'Pretty Woman,' give 'Green Card' a try," said Joel Siegel in his review on ABC's "Good Morning America." Touchstone featured that quote prominently in print and television ads. Picking up on the similarity, Entertainment Weekly featured Ms. MacDowell on its Jan. 18 cover next to the question: "This Year's Pretty Woman?"

∎

Touchstone refused to discuss the selling of "Green Card," a modest box-office success, but the evidence speaks for itself. It speaks to the way advertisers and audiences pigeonhole new films in terms of familiar ones — in this case to the movie's commercial advantage and the viewer's detriment.

Chronologically, the idea behind "Green Card" is too old to be the offspring of "Pretty Woman." The writer and director Peter Weir created this story about a marriage of convenience several years ago with Mr. Depardieu in mind. While waiting for the actor to finish other films, Mr. Weir went on to make his 1989 hit, "Dead Poets Society," and finally began filming "Green Card" in April 1990 — just one month after "Pretty Woman" was released.

No one had predicted that "Pretty Woman" would sell herself so well. But by the time "Green Card" opened in New York and Los Angeles last Christmas Day — overshadowed by "The Godfather Part III" and receiving both disappointed and pleasant reviews — it made sense to ride the coattails of "Pretty Woman."

There are, after all, generic similarities. Both are implausible stories of mismatched couples who are thrown together. In "Green Card," Mr. Depardieu plays an up-from-the-streets French composer who needs a green card and Ms. MacDowell, a prim New York

horticulturist who wants an apartment with a greenhouse that will be given only to a married couple. They have 48 hours to become a convincing husband and wife, hoping to dupe snoopy immigration agents by memorizing the colors of each other's toothbrushes.

"Pretty Woman," of course, perfectly fits the line in a recent "Saturday Night Live" parody of it: "The feel-good prostitute comedy of the season." Julia Roberts became a star on the strength of her performance as the wholesome streetwalker who captures the affection of a no-nonsense businessman.

Playing up the similarities to "Pretty Woman" certainly helped "Green Card" at the box office. So far, it has earned around $23 million and is playing in 757 theaters — respectable numbers, though nothing like the 1,400 theaters and $100 million grosses that signify major hits. And it seems to have peaked.

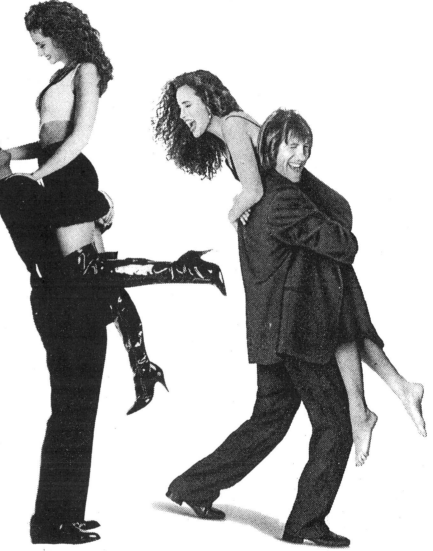

Touchstone Pictures

Nearly identical advertising promoted Richard Gere and Julia Roberts in "Pretty Woman," left, and Andie MacDowell and Gérard Depardieu in "Green Card."

Commercially, "Pretty Woman" may have turned "Green Card" into an overachiever. But the link had a hidden disadvantage. It sent viewers to the theater with false expectations, ones that obscured the quite different charms and the freshness of "Green Card." For each film relies on its own style to maneuver the on-screen lovers and the audience into place.

"Pretty Woman" is a brilliantly made commercial work. Garry Marshall's glossy Hollywood movie pushes all the right buttons

— we get safe sex, we get shopping on Rodeo Drive, we get to root for the most appealing underdog in years — yet it is so ebullient, sweet and smooth that the audience never feels manipulated.

■

To set up "Green Card" as this year's "Pretty Woman" is to prepare audiences for a glitzier, higher-energy experience than Mr. Weir's subdued film delivers. The ambiance of "Green Card" is that of a drawing-room comedy, one that takes its cue from Ms. Mac-Dowell's prissy character, Brontë Parrish. Where Julia Roberts pulls multicolored condoms out of her boots, one of the jokes of "Green Card" is that Brontë's siblings are named Colette, Austen, Lawrence and Eliot.

Marketing strategy has turned Peter Weir's romantic comedy into a wannabe.

That understated style at times makes "Green Card" seem too stiff and vacuous, as if Mr. Weir were inspired by the surface of a Jane Austen work and left out the wicked social observations. But the film is magnificently redeemed by Mr. Depardieu. As George Faure, he plays the piano like a maniac, cheerfully lies that his mother was crushed by elephants and admits in charmingly fractured, French-accented English, "I am too oaf" for Brontë.

Even more than in "Pretty Woman," the rough, illegal edges of this couple's arrangement are smoothed away. Brontë plants trees in poor neighborhoods. George's vices are drinking wine, smoking cigarettes and eating meat. No prostitutes and no sex here, not even between Brontë and her boyfriend, whom George insults by yelling, "Get out, vegetarian!"

It was a devilish deal that "Green Card" made with "Pretty Woman." For "Green Card" seems much more enjoyable on a second viewing, after the ghost of Julia Roberts in Beverly Hills had been banished. □

1991 Mr 3, II:11:1

Closet Land

Directed and written by Radha Bharadwaj; director of photography, Bill Pope; edited by Lisa Churgin; music by Richard Einhorn; production design by Eiko Ishioka; produced by Janet Meyers; released by Universal Pictures. Running time: 89 minutes. This film is rated R.

Woman Madeleine Stowe
Man .. Alan Rickman

By JANET MASLIN

Hidden away in the darkest recesses of many minds, there have doubtless lurked thoughts like those at the heart of "Closet Land," a first film written and directed by Radha Bharadwaj. Ordinarily, those thoughts escape well before reaching the feature-film stage, usually in the form of bad high-school poetry or bad one-act experimental plays.

But Miss Bharadwaj, whose film also calls to mind avant-garde department store windows and Calvin Klein's television ads, sets forth her story with no acknowledgement that it is so excruciating, obvious or small. The result is something much more remarkable for its overconfidence than in any other regard.

"Closet Land," which in practice becomes an exercise in chic sadism, is in theory an exploration of the hidden secrets of two characters, who are listed in the credits as Woman (Madeleine Stowe) and Man (Alan Rickman). He, a government interrogator in some unidentified police state, exudes distaste and wears white suspenders. She, a writer of children's stories, wears a white nightgown and is imprisoned in his cavernous office, which has freestanding columns, a marble floor and a triangular onyx piece of furniture that can function either as a desk or as an instrument of torture, depending upon the interrogator's mood.

Imagine Entertainment

Jailed Madeleine Stowe stars in "Closet Land," about the relationship between a writer of children's books and a government interrogator who considers her fanciful works subversive.

She has been abducted for questioning, we gradually learn, because her children's book "Closet Land" is thought to be subversive. It is about a little girl who is locked in a closet and invents imaginary playmates, among them a friendly rooster. Does the story have hidden meanings? Is the rooster a government agent? Was she a lonely child? "You're still lonely, aren't you?" he says. "I don't trust lonely people. Life's eternal spectators. Watching. Waiting." All of the screenplay sounds like that.

The two actors in this claustrophobic debacle are somewhat better than their material, but the material is not easily outrun. Among the welcome distractions are Eiko Ishioka's modishly austere props and costumes, which give the film a cool, peaceful aura even when the woman is being made to look ridiculous in black lingerie, pigtails and grotesque makeup, or being tortured with electric shocks to the groin.

The film's closing acknowledgments of Gandhi and Amnesty International do not bestow sufficient high seriousness on episodes like those.

"Closet Land" is rated R (Under 17 requires accompanying parent or adult guardian). It includes strong language and sexual innuendoes.

1991 Mr 7, C18:3

The Hard Way

Directed by John Badham; screenplay by Daniel Pyne and Lem Dobbs, story by Mr. Dobbs and Michael Kozoll; directors of photography, Don McAlpine and Robert Primes; edited by Frank Morriss and Tony Lombardo; music by Arthur B. Rubinstein; production design by Philip Harrison; produced by William Sackheim and Rob Cohen; released by Universal Pictures. Running time: 115 minutes. This film is rated R.

Nick Lang Michael J. Fox
John Moss James Woods
Party Crasher Stephen Lang
Susan Annabella Sciorra
Grainy John Capodice
Pooley Luis Guzman
Billy .. L. L. Cool J.
China ... Mary Mara
Captain Brix Delroy Lindo
Witherspoon Conrad Roberts
Bonnie Christina Ricci
Angie .. Penny Marshall

By VINCENT CANBY

In John Badham's high-concept new comedy, "The Hard Way," Michael J. Fox has the time of his life as a pint-size deliriously self-confident Hollywood icon for whom reality has become an abstract concept, no more easily grasped than the theory of relativity.

Mr. Fox appears as Nick Lang, the discontented but hugely popular star of adventure movies, which, from what is seen of them, look like rip-offs of Steven Spielberg's "Indiana Jones" series.

Nick is tired of making films with numbers in their titles. He says that Shakespeare never wrote "Hamlet 2" or "A Midsummer Night 3." Maybe not, says his agent, but Shakespeare did quite well with "Henry V."

Nick longs to play a tough, gritty New York cop in a new picture for which Mel Gibson is supposedly set. He wants the role so much he's ready to sacrifice his self-esteem: that is, he will test for it. In the meantime, he's off to New York to find out, firsthand, how a typical New York City detective walks, talks, thinks and breathes.

●

"The Hard Way" is about Nick's adventures with a most reluctant guru, John Moss (James Woods), a detective so hysterical by nature that it wouldn't be a surprise if he shot up a malfunctioning cigarette machine, on principle.

Though John is in the middle of a case involving a serial killer known as the Party Crasher, his superiors, mindful of the potential for favorable

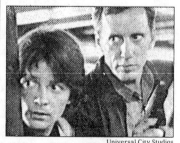

Universal City Studios

Michael J. Fox and James Woods

publicity, order him to take charge of the Hollywood visitor.

The result is "The Hard Way," written by Daniel Pyne and Lem Dobbs, and directed by Mr. Badham. It's not a perfect comedy by any means, but it is a very entertaining one.

The sensibility of "The Hard Way" is pure Hollywood. The movie is

sometimes slapdash in execution and sloppy in coherence, but it's written, directed and performed with a redeeming, self-mocking zest. "I mean it's so real," says the dazzled Nick on his first visit to the grungy precinct station, "it's like a movie!"

Nick's conversation is punctuated by the same exclamation marks used to dress up the ad blurbs for his movies.

Not the least of the film's jokes is that the reality Nick finds on the streets of Manhattan, in the lives of its police officers and in their daily routines, is just as fantastic as anything in Nick's latest movie, titled "Smoking Gun 2."

"The Hard Way" is supposed to be a buddy comedy, but Mr. Fox dominates it with a performance that would be difficult for any co-star to match.

His Nick Lang is a mixture of pious liberalism ("All my pictures are shot on biodegradable film"), naïveté

'Do I get to carry a gun?' asks Michael J. Fox's character.

("Do I get to carry a gun?") and helpful hints ("Be good to your bowels and your bowels will be good to you").

Nick also uses his acting talents in an effort to liberate John from his hangups about women. As they sit drinking in a bar, Nick initiates a psychodrama in which he assumes the role of the woman John loves, first ordering a dainty Dubonnet to get in the mood. It's one of Mr. Fox's finest moments.

Mr. Woods plays John Moss as if the fate of Western civilization depended on his energy level. He is over the top from start to finish. The intention is farcical. Yet the intensity is not much funnier than it was in his Oscar-nominated performance in "Salvador." It overwhelms the impulse to laugh.

In other respects, the movie is more appropriately larger than life. Its vision of Times Square at night, where the movie begins and ends, is far jazzier, brighter and more exuberant than Times Square ever is, even on New Year's Eve.

The serial killer, played by Stephen Lang, is a monster of no subtlety whatsoever. Penny Marshall, the actress turned director ("Awakenings"), makes a brief hilarious appearance as Nick Lang's down-to-earth Hollywood agent.

Susan, the woman in John Moss's life, would seem scarcely to exist as written, but Annabella Sciorra inhabits the role with such humor and intelligence that she gives substance to the performances around her.

The weakest sequences in "The Hard Way" are those that movie makers usually do best. The action sequences are less amusing than obligatory. The clumsiness of the final sequence, a chase atop a giant billboard in Times Square, is only emphasized by the way in which it recalls "North by Northwest" and one of Alfred Hitchcock's most enchanting conceits.

•

"The Hard Way" has been rated R (Under 17 requires accompanying parent or adult guardian). It has vulgar language and some violence.

1991 Mr 8, C8:1

La Femme Nikita

Directed and written by Luc Besson; in French with English subtitles; director of photography, Thierry Arbogast; edited by Olivier Mauffroy; music by Eric Serra; production designer, Dan Weil; released by the Samuel Goldwyn Company. Running time: 117 minutes. This film is rated R.

Nikita	Anne Parillaud
Marco	Jean-Hugues Anglade
Bob	Tcheky Karyo
Amande	Jeanne Moreau
Nikita's Friend	Jean Reno
Chief of Intelligence	Jean Bouise

By JANET MASLIN

The most popular film in France during the last 12 months has been "La Femme Nikita," a slick, calculating mixture of French contemplativeness and American flying glass. Directed by Luc Besson, whose dazzling early ingenuity (in his austere science-fiction film "Le Dernier Combat") subsequently gave way to high style and hot air (in "Subway" and "The Big Blue"), "La Femme Nikita" combines hip violence, punk anomie, lavish settings and an old-fashioned paean to the power of love.

These unlikely ingredients are held together by Mr. Besson's frankly commercial but agile direction, and by the strange and vicious Nikita (as played by the striking Anne Parillaud). Wearing chopped-off hair and a dazed expression, Nikita is first seen taking part in a drugstore robbery; more accurately, she is being dragged along for the ride. Yet for all her apparent blankness, Nikita is tough. In the aftermath of a lurid shoot-out, she emerges as the only member of her gang to have survived. And she manages to attack and

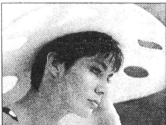

Samuel Goldwyn Company

Anne Parillaud

kill several policemen before the incident is over.

Nikita (named for an Elton John song) is sentenced to a prison term, and then behaves so badly that she is administered what seems to be a lethal injection. But she wakes up anyway, asking angrily whether she has arrived in heaven. Not really, but she has stumbled onto something almost as promising: a second chance. Nikita is told she must learn to "read, walk, talk, smile and even fight" for the sake of her country.

•

Thus begins the glamorous part of "La Femme Nikita," in which this previously unmanageable street punk is transformed into a chic, lady-like assassin. Nikita is equipped with makeup, high heels, a little black dress and pearls, and sent to work her wiles in various high-risk situations. She is given tactical advice by Jeanne Moreau, who appears briefly as a beauty consultant and tells her of "two things that have no limit: femininity and the means of taking advantage of it." Nikita is also told to "smile when you don't know something: you won't be any smarter, but it's nice for the others."

The film, like Nikita herself, becomes more conventionally sleek and less interestingly bizarre as it moves along. The latter part of the story alternates between intrigue episodes (in one, Nikita dresses up as a hotel maid to deliver a poisoned room-service meal) and scenes that reveal Nikita's softer side. It turns out, not very surprisingly, that Nikita is susceptible to love. The film supplies both Bob (Tcheky Karyo), the Government interrogator who becomes her Pygmalion, and Marco (Jean-Hugues Anglade), the charming supermarket checkout clerk who wins Nikita over while ringing up her ravioli.

Mr. Besson brings on Marco with typically broad flair. First he shows the coltish Nikita scrambling to figure out what to buy in a supermarket as she studies the other shoppers; then he makes a pleasant joke of Marco's incompetence when they meet. The ravioli dinner these two subsequently share in Nikita's unfinished apartment gracefully fades into a scene set six months later, when the place is furnished and the couple have set up housekeeping together. The smoothness with which these transitions are executed goes a long way toward making "La Femme Nikita" attractive.

•

Yet the film eventually loses sight of its heroine, and bogs down in fatuous speculation about her moral standing. She has, after all, committed various murders during the course of the story. But both Bob and Marco are willing to attach more weight to the way Nikita looks in an evening dress than to her lethal track record. Mr. Besson also betrays his initial conception of Nikita as brutal and remorseless by letting her melt into an ordinary figure, even a mundane one.

"La Femme Nikita" is best taken lightly and appreciated for the high-gloss effectiveness of Mr. Besson's methods. Among the film's most striking ingredients are the pumped-up violence of its shoot-out scenes, the sumptuous settings of a long Venetian sequence during which Nikita carries out a foreign assignment, and Miss Parillaud herself, a nimble and dangerous-looking actress with a fashion model's leggy cachet. This actress makes Nikita a femme fatale in every way.

•

"La Femme Nikita" is rated R (Under 17 requires accompanying parent or adult guardian). It includes violent episodes.

1991 Mr 8, C10:1

New Jack City

Directed by Mario Van Peebles; screenplay by Thomas Lee Wright and Barry Michael Cooper, from a story by Mr. Wright; director of photography, Francis Kenny; edited by Steven Kemper; music by Michel Colombier; production designer, Charles C. Bennett; produced by Doug McHenry and George Jackson; released by Warner Brothers. Running time: 100 minutes. This film is rated R.

Nino Brown	Wesley Snipes
Scotty Appleton	Ice-T
Pookie	Chris Rock
Nick Peretti	Judd Nelson
Detective Stone	Mario Van Peebles
Gee Money	Allen Payne
Kim Park	Russell Wong
Duh Duh Duh	Bill Nunn
Gangster	Anthony DeSando

By JANET MASLIN

The villain's prized possessions are now computer disks that hold business records of his illicit operations. But beyond that, very little has changed. The staples of the drug-lord exploitation film remain familiar, among them clanking gold jewelry, free-flowing champagne, silk suits and enough gun-toting strongmen to make the whole voyeur-tempting operation perfectly secure. It takes confidence even to revive this genre nowadays, let alone to invest it with anything new.

Fortunately, Mario Van Peebles, another actor who proves to be as comfortable behind the camera as he is in front of it, directs "New Jack City" with as much energy and flash as this film's weary formula will allow. With a title that refers to the ruthless self-interest of contemporary urban street culture, "New Jack City" tells of a seductively powerful drug kingpin named Nino Brown (Wesley Snipes) and the hipper-than-usual police operatives intent on bringing him down.

Nino Brown, modeled loosely on the notorious heroin dealer Nicky Barnes but updated to accommodate the crack trade, may be the film's liveliest creation. As played commandingly by Mr. Snipes, Nino embodies every imaginable cliché attached to underworld activity — there is even a scene in which he shakes up all of his henchmen by suddenly attacking one of them — yet still manages to seem his own man.

•

The film presses its luck when it describes Nino as being "in the tradition of Joe Kennedy," or lets him attribute his business ethics to Reaganomics and the American way. It works best when simply letting Nino revel in his megalomania, which is effectively heightened by a pious streak; he actually weeps when killing a friend in one climactic scene. The film's flamboyant portrait of Nino may be stereotypical, but Mr. Snipes makes it chilling.

Warner Brothers

Wesley Snipes

Mr. Van Peebles's direction can be overly ambitious, attempting odd angles and arty compositions, but for the most part it is efficient and unobtrusive. The film's use of once-imposing, now-crumbling New York architecture is particularly effective in underscoring the story with an air of widespread urban decay. These settings, strikingly photographed by Francis Kenny, are often quietly surprising.

Also in "New Jack City" are the rapper Ice-T, memorable as a dreadlocked undercover cop on Nino's trail; Bill Nunn, still most familiar as Radio Raheem in "Do the Right Thing," as a drug henchman with a stutter; Mr. Van Peebles himself, as a nice-guy detective; Allen Payne, as

the friend whom Nino is almost too conscience-stricken to kill, and Anthony DeSando, as a sleek Italian gangster whose attempt at antagonizing Nino costs him his ponytail. Judd Nelson, as the lone white hipster in the film's mostly black cast, starts off looking ridiculous behind a goatee, dark glasses and self-consciously dangling cigarette. Even he manages to become more or less likable before the film is over.

"New Jack City" is rated R (Under 17 requires accompanying parent or adult guardian). It includes violence, profanity and nudity.

1991 Mr 8, C15:1

Judging a Killer In the Chill Calm Of Prewar Italy

"Open Doors" was shown as part of last year's New York Film Festival. Following are excerpts from Janet Maslin's review, which appeared in The New York Times on Sept. 27. The film, in Italian with English subtitles, opens today at the Lincoln Plaza Cinema, Broadway at 63d Street in Manhattan.

At the start of the somberly handsome Italian thriller "Open Doors," a calm, neatly dressed man returns to the office from which he has recently been dismissed. He is armed with a long, sharp knife. With shocking efficiency, he quickly murders two former colleagues who were instrumental in bringing about his downfall. Moments later, after politely leaving the building, he rapes and kills his wife.

The man, Tommaso Scalia (Ennio Fantastichini), is subsequently arrested and tried for these crimes. And during the course of his trial, the sordid circumstances that drove Scalia to such desperate acts are duly revealed. But "Open Doors," unlike most other courtroom dramas, does not depend upon uncovering the truth behind a mysterious crime to hold its audience's interest. The film's true focus is the judicial process itself.

Its leading character is a dour, stately judge, Vito Di Francesco (Gian Maria Volonte), who is one of several judges charged with determining Scalia's fate. Alone among them, Di Francesco is determined to understand these violent acts born from every possible perspective. He insists on a psychiatric examination of the prisoner; he studies the accused man closely; he even pays a visit to Scalia's son. "You ask too many questions," Di Francesco is told by the chief justice on his panel.

●

Set in Palermo, Sicily, in 1937, "Open Doors" alludes only glancingly to the "difficult times" in which these events unfold. But the whole film, which has been directed with meticulous grace by Gianni Amelio, has an eerie, watchful tone. The peaceful, beautifully photographed settings in which Di Francesco is seen pondering the Scalia case are almost too serene. The film's title, equally chilling, comes from a government official's frightening re-

mark that ample use of the newly instituted capital punishment will make Palermo a place whose citizens will never need to lock their doors.

"Open Doors," a film as graceful and solemn as the judge at its center, proceeds elegantly toward an unsurprising conclusion. Its real value, however narrow, is in its haunting evocation of Palermo's deceptive calm and its contemplation of a man whose nobility and intelligence will prove to be his undoing.

1991 Mr 8, C15:1

Berlin Jerusalem

Directed by Amos Gitai; screenplay (in German with English subtitles) by Mr. Gitai and Gudie Lawaetz; photography by Henri Alekan and Nurith Aviv; edited by Luc Barnier; music by Markus Stockhausen; production manager, Laurent Truchot; produced by AGAV Films. At the Public, 425 Lafayette Street, Manhattan. Running time: 89 minutes. This film has no rating.

Else	Lisa Kreuzer
Tania	Rivka Neuman
Ludwig	Markus Stockhausen
Paul	Benjamin Levy
Editor in Berlin	Vernon Dobtcheff
Cassandra	Veronica Lazare

Because of That War

Directed and written by Orna Ben-Dor Niv; in Hebrew with English subtitles; director of photography, Oren Schmukler; edited by Rachel Yagil; music by Yehuda Poliker from his album "Ashes and Dust"; produced by Manor Productions Ltd. At the Public, 425 Lafayette Street, Manhattan. Running time: 93 minutes. This film has no rating.

WITH: Yehuda Poliker, Jaco Poliker, Yaacov Gilad and Halina Birnbaum

By VINCENT CANBY

Somewhat revisionist, second-generation views of the Israeli experience are presented by two otherwise very different films opening today at the Public Theater.

Orna Ben-Dor Niv's "Because of That War," a feature-length documentary, is about the effect of the Holocaust on the children of those who survived. Amos Gitai's "Berlin Jerusalem" is a seriously melancholy consideration of Israel's future after the realization of the Zionist dream.

In "Berlin Jerusalem," by far the more ambitious of the two, Mr. Gitai uses Expressionist techniques associated with the German cinema of the late 1920's and early 30's to tell the stories of two women who, separately, made their way to Palestine in the 30's.

They are Else Lasker-Schuler, the German poet and a member of the circle that included Wassily Kandinsky and Thomas Mann, among others, and Tania, a Russian-born revolutionary based on the real-life character of Mania Shochat.

Mr. Gitai's rigorously theatrical methods are at first off-putting, especially the tableaux vivants that feature members of the Pina Bausch dance company. In post-World War I Berlin, they move among the ruins, looking like creatures out of Georg Grosz, some saying wickedly decadent things while others parrot Marxist platitudes.

These sequences, which introduce the world-weary Else (Lisa Kreuzer), are cross-cut with sequences set in Palestine where Tania (Rivka Neuman) and her friends are trying to set up a kibbutz.

When it becomes apparent that Mr. Gitai is less concerned with conventional narrative than with presenting the interior lives of the two women, "Berlin Jerusalem" becomes a more compelling, though never less than opaque, work. It's far more interesting for what it wants to say than for how it says it.

Else is the artist. Tania is committed to political action. For each, according to Mr. Gitai, Israel represents a goal that, once it has been achieved, requires redefinition.

Tania would seek some sort of accommodation with the Arabs: "Any fool can carry a gun, but you need patience and wisdom to befriend those who hate you."

Else expresses herself more fancifully: "We need to build a Luna Park, a place of friendship for Arabs and Jews, with a roller-coaster, merry-go-round and flowers."

"Berlin Jerusalem" is an elegant-looking movie, but it often sounds and behaves like terribly high-toned Off Off Broadway theater.

●

"Because of That War" is a more straightforward work. Two youngish Israeli rock musicians, Yaacov Gilad, a composer and lyricist, and Yehuda Poliker, a composer, guitarist and singer, talk about nightmares inherited from their parents.

Mr. Poliker recalls his ambivalent feelings toward his Greek-born father, Jaco, who lost not only his first wife and child in the camps, but also 50 other members of his family.

He loves his father, he says, but he was also overwhelmed by his father's protectiveness. He lived at home until he was 30. He developed a stutter. His music both mourns the past and celebrates the resilience of the human spirit.

Supplementing Mr. Poliker's testimony is that of his father, who seems far less inhibited than his son, the performer.

Mr. Gilad remembers being terrified by his Polish-born mother's tales about life at Treblinka. His mother, Halina Birnbaum, a poet and teacher, tells the interviewer that she never thought her stories were frightening. Instead, she says, they were stories of "triumphs."

"Because of That War" is not a particularly graceful work. Scarcely any time is devoted either to Yehuda Poliker's mother or to Mr. Gilad's father. They are seen but not heard, as if the movie somehow considered them to be lesser parents than their partners.

The movie has the manner of notes set down in preparation for a film yet to be made.

1991 Mr 8, C16:6

Shadow of China

Directed by Mitsuo Yanagimachi; screenplay by Richard Maxwell and Mr. Yanagimachi, based on the novel "Snake Head" by Masaaki Nishiki; produced by Elliott Lewitt and Don Guest; released by New Line Cinema. At Angelika Film Center, Mercer and Houston Streets. Running time: 100 minutes. This film has no rating.

Henry	John Lone
Akira	Koichi Sato
Katharine	Sammi Davis
Moo-Ling	Vivian Wu
Xiao Niu	Roland Harrah 3d
Lee Hok Chow	Roy Chiao
Jameson	Constantine Gregory

By STEPHEN HOLDEN

With its spectacular harbor and a blazing nightlife that makes Times Square seem dim by comparison, Hong Kong, which is the setting for "Shadow of China," tends to upstage the most dramatic moments in the thriller by the Japanese film maker Mitsuo Yanagimachi. Hong Kong's uncertain future in its final years as a British crown colony also makes it a perfect metaphor for the life of the film's protagonist, Henry Wong (John Lone), who is a sort of Asian Jay Gatsby.

A suave multimillionaire banker with a shady past, a married English mistress (Sammi Davis) and a desire to take over Hong Kong's leading Chinese-language newspaper, Wong is a refugee from the mainland who fled with his girlfriend, Moo-Ling (Vivian Wu), during Mao Zedong's Cultural Revolution.

●

Many years later, on the fringes of an elegant private party, Wong spies his former sweetheart, now a nightclub singer, in the company of a nosy Japanese journalist, Akira (Koichi Sato), who is eager to write an article about him. They form an odd romantic triangle in which Wong secretly visits Moo-Ling while Akira sets out to uncover Wong's true identity. Further clouding the future are the student demonstrations in Beijing.

New Line Cinema

John Lone

"Shadow of China," which opens today at the Angelika Film Center, is a film of unusual thematic richness, but it is also peculiarly flat and uninvolving. The direction, which aspires toward an epic grandeur, gives many of the scenes an awkward, self-conscious staginess. And the acting is so low-key that Wong's Gatsbylike quest has little romantic resonance.

●

Mr. Lone is effective in the scenes in which he plays an unsmiling shark intent on a takeover. But except for the opening escape-from-China sequences, his scenes with Miss Wu generate no heat, and Miss Wu makes an unconvincing torch singer. If the director was reaching for a film noir iciness, he failed to capture the clenched visceral anxiety beneath the chill that would give the drama some tension. The mostly Asian actors deliver the lines clearly, but their idiomatic grasp of the language often seems shaky and leaves charged dialogue sounding too deadpan.

Where "Shadow of China" succeeds is in conveying an uneasy sense of the world shifting under people's feet. No matter how deep one's roots may go, it suggests, personal identity is ultimately conditional on the direction in which the shifting winds of history happen to be blowing.

1991 Mr 10, 58:5

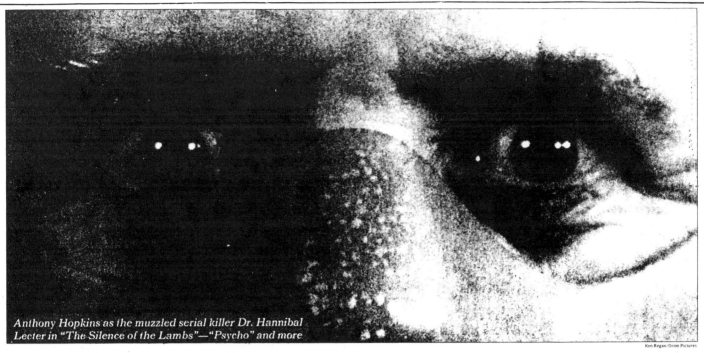

Anthony Hopkins as the muzzled serial killer Dr. Hannibal Lecter in "The Silence of the Lambs"—"Psycho" and more

Now Starring, Killers for the Chiller 90's

By CARYN JAMES

EVERY ERA GETS THE PSYCHOS IT DE-serves, at least in art. Our own violent culture has splattered us with real-life assassins and serial killers who have pervaded our consciousness through television and newspapers and left a disturbing, revealing, often entertaining legacy of fictional lunatics. The past month or so has brought three genres of highly publicized psycho-killers, each an unmistakable product of this cultural moment.

Jonathan Demme's movie "The Silence of the Lambs" is more than an artistic and commercial success. Based on mind games between a young woman F.B.I trainee and a psychiatrist who happens to be a most intelligent cannibal, it is the only film in recent memory that deserves to be compared to Alfred Hitchcock's 1960 classic, "Psycho." It is a "Psycho" for our day, intensified for a period more psychologically aware and more inured to violence.

The singing, dancing Presidential killers and wannabe killers in "Assassins," the musical by Stephen Sondheim and John Weidman that ran briefly Off Broadway, are less successful creations. But they are even more ambitious, for they embody this age's glib accommodation to violence.

And, unavoidably, there is Bret Easton Ellis's pea-brained novel "American Psycho," the book that Simon & Schuster canceled on the grounds of bad taste and that Vintage Books has just published as a controversial cause célèbre. More an up-to-the-minute media event than a novel, this story of a serial killer obsessed with designer labels should have been called "Killers Who Shop Too Much."

These varying works share an obsession with the criminal mind, perhaps a need to comprehend the cracked intelligence that seems to have a stranglehold on recent history. But they do not offer any grand social theory, or even probe the nature of criminal insanity. Instead, they act as mirrors reflecting facets of our culture's fascination and revulsion with violence.

They also define the current bounds of what an audience will endure. To watch "The Silence of the Lambs" is to be thrillingly frightened and disturbingly entertained by dancing with a criminal mind; to see "Assassins" is to be absorbed by an ambitious, intelligent failure; to read "American Psycho" is to feel like the victim of a public relations con job.

All involve voyeurism and vicarious danger, the standard lures of thrillers. In 1960, "Psycho" went as far in that direction as a "serious" film could. Yet to call "Psycho" and "The Silence of the Lambs" serious is to make them sound like pretentious psychological treatises. In fact, both are no more than escapist entertainments, brilliantly made. What sets them apart from ordinary horror films most sharply is that both engage viewers with an intelligent, if somewhat sinister, mind.

The psychos and loonies of today are perfectly cast for an age inured to intense violence.

In "Psycho," the intelligence that compels the viewer is Hitchcock's, for the onlooker never approaches Norman Bates's thoughts. Only at the end, after the knife-wielding Norman has been apprehended in his mad-mother drag, is there any hint of what is happening in his psyche.

In a scene that feels tacked on, a psychiatrist tells the other characters at length about Norman's lethal attachment to his mother. The explanation has little to do with the terrifying suspense Hitchcock has created. As the director once said, citing what he liked best about "Psycho": "The game with the audience was fascinating. I was directing the viewers. You might say I was playing them, like an organ."

'Lambs' for a Time Of Psychobabble

Audiences are tougher to play these days. So "The Silence of the Lambs" is a psycho-killer story cranked up to suit an age swamped in psychobabble and accustomed to seeing bodies explode in action-adventure movies, reading the Son of Sam's letters in the tabloids and seeing the serial killer Ted Bundy played by Mark Harmon in a television mini-series.

With its occasional glimpses of decomposing bodies, "The Silence of the Lambs" is far more graphic than "Psycho," yet it is still restrained by 1990's standards. But the most fascinating shift is the way the Demme film plays a more complicated Hitchcockian mind game, engaging viewers with several intelligences at once: those of Mr. Demme, of the F.B.I. agent and of the killer she interviews.

The film adroitly allies viewers with the perspective of Clarice Starling, the F.B.I. agent played by Jodie Foster. Starling is assigned to pick the brain of Hannibal Lecter — the imprisoned cannibal played with unnerving stares at the camera by Anthony Hopkins — in the hope that he will lead the F.B.I. to another serial killer still at work.

The Heights of Lunacy on Film

"The Cabinet of Dr. Caligari" (1919)

The granddaddy of all serial-killer movies. This German silent classic is valued for its Expressionist style, but its mad doctor is the first prominent screen psycho.

The Museum of Modern Art

"M" (1931)

Part suspense, part social allegory, "M" is Fritz Lang's masterpiece and Peter Lorre's most chilling performance, as a child murderer stalked through Germany. "I can't help myself!" he pleads.

"Psycho" (1960)

Some viewers fainted, some walked out; and the lines at the box office were endless. During the famous shower scene, the knife never touches the victim's flesh.

Movie Still Archives

"Peeping Tom" (1960)

This story of a film maker who photographs his murders was so disreputable that it nearly ended the career of the director Michael Powell ("The Red Shoes"). Now considered a tour de force.

Movie Still Archives

"A Clockwork Orange" (1971)

Stanley Kubrick's brutal film version of Anthony Burgess's futuristic novel is still controversial. Is Alex, the sadistic rapist who represents freedom, hero or antihero?

Warner Bros.

"Taxi Driver" (1976)

Martin Scorsese's film, written by Paul Schrader, brilliantly captures contemporary urban paranoia. Robert De Niro's Travis Bickle ("You talkin' to me?") became a nightmarish icon.

Columbia Pictures

"Henry: Portrait of a Serial Killer" (1990)

The distributors rejected the X-rating of the film, which helped push the Motion Picture Association of America toward its new NC-17 rating.

— Caryn James

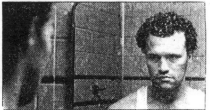

Maljack Productions

From the perspective of the smart young woman, viewers come close to the killer's thoughts but are never too attached to his demented mind. Settling into Lecter's point of view would make us murderers; much better to be the frightened, innocent heroine.

'The Silence of the Lambs,' more graphic than 'Psycho,' is still restrained by today's standards.

The perfect visual symbol for the audience's voyeuristic proximity to Lecter is the glass wall of his prison cell, a wall that makes him look like an animal on exhibit. Starling and Lecter are eye to eye while she interviews him there, yet she is physically protected. Still, his viciously manipulative mind can touch hers. He mocks her insecurities, spotting her West Virginia accent and her cheap shoes.

"Look into yourself," he practically hisses at her in his precise, snaky voice. In a lesser film, the line would be cheap psychology. Here, it is a clever clue and a cruel hoax at once. As Starling mentally spars with evil, and eventually must escape from it physically, Mr. Demme's terrified viewers tag along.

Mr. Demme and Ms. Foster have made some legitimate claims for the feminism implicit in the strong heroine's role. Gay activists have made less convincing charges that Mr. Demme exploits homophobic stereotypes: the uncaptured serial killer, though not a homosexual, is a man who wants to be a woman. Both attitudes reflect the society that shaped the film, but both are ultimately beside the point. Like "Psycho," "The Silence of the Lambs" succeeds artistically because it entangles viewers with demented individuals, not social symbols or case studies.

Not many works can achieve such a perfect, horrifying, playful balance. Some, such as the current hit movie "Sleeping With the Enemy," don't even try. Though Julia Roberts is stalked by her abusive, maniac husband, his state of mind becomes a campy joke in the film. His deranged obsession with order is expressed and summed up by neatly arranged bathroom towels and lined-up cans in the kitchen cupboard.

Why 'Henry' Is A Flawed Portrait

Not going far enough into the criminal mind is also the problem behind last year's more intelligent but over-praised film "Henry: Portrait of a Serial Killer." The film is very much a product of its time, graphic enough to push audiences to their limit. But challenging the audience's tolerance for violence is not what makes "Henry" so disturbing. The film immerses viewers in the experience of

killing, without satisfying the smallest bit of curiosity about the murderer's abnormal mind. When Henry tells of killing his abusive mother, he may well be lying, and there is no other clue to this drifter's cold, crazed behavior. Because the film offers no sense of Henry's thoughts, watching it is a grueling experience without relief or intellectual interest, as if viewers were constantly bashing their heads against Lecter's glass wall.

Yet John McNaughton directs the film with great authority and some visual flair, so "Henry" raises a troubling question: Can a flat representation of evil, one that shares the killer's perspective but does not enter his mind, be effective? Perhaps, but "Henry" isn't that film. Here the killer even enlists a friend as an accomplice, as easily as another man might get someone to buy him a drink.

'Assassins' Treads A Tightrope

The ease with which social misfits become murderers is also the most serous failing in "Assassins." With its kaleidoscopic gallery of killers from two centuries and an upbeat show-tune ending in which all nine assassins sing about their grand dreams of murder, the show walks the edge of outrageously bad taste: it treats assassins as pop icons. That is its daring and its most shocking revelation: almost three decades after President Kennedy's assassination, the nation's violent history is an acceptable subject for a musical tragicomedy.

But giving killers the star treatment denies access to the twisted thoughts that make the characters,

'Assassins' works best in scenes when the audience is drawn into the complexity of a criminal mind.

and their impact on history, so potent and intriguing. The play works best in those few scenes in which the audience feels drawn into the crazed complexity of a criminal mind. John Wilkes Booth, an elegant actor turned assassin, is the most compelling character, an attractive yet repulsive Faust who goads the others to fulfill their dreams of violence.

As Booth sings his self-justification — he had to kill Lincoln, who destroyed the country — the character of a balladeer-narrator counters with other suggestions. Maybe Lincoln died because Booth drank; the balladeer sings, or perhaps "You killed a country, John, because of bad reviews." Here Booth's fascinating, deluded mind, and the powerful force of an individual on history are presented with some sophistication for the audience to figure out.

More often, the assassins are portrayed as out-of-work social misfits who discover that America is not the land of opportunity and then find an easy way to gain attention — not a very sophisticated theory or one that has much to do with the lunatic thinking that turns losers into killers. Yet at its best "Assassins" establishes an eerie resonance between the audience's sense of history and the stage. As John Hinckley sings to his unnamed love, a picture of Jodie Foster in "Taxi Driver" is clearly visible on a table next to him. (Similarly, the image of Ms. Foster confronting a crazed criminal in "The Silence of the Lambs" comes already loaded with the audience's awareness of her unwitting role in real life as the would-be killer's inspiration.)

As the assassins gather in the Texas School Book Depository, the famous image of Lee Harvey Oswald being shot on live television is projected on a screen behind them. For all its failures, at moments like this, the musical forces audiences to recognize how violence has become an ordinary fact of life, totally absorbed by pop culture. "Assassins" returns these criminals to us in a new pop-cultural form.

'American Psycho' Goes Wrong

Though "American Psycho" also seems to address the violence of contemporary society, in fact it is too mindless to be revealing. The novel is more graphically repulsive than any paraphrase can suggest. To say that a woman is sexually tortured with a live rat, that another woman's breasts are exploded with jumper cables and that a child's throat is slit does not begin to suggest the indulgent specificity with which these deaths are related.

But, as with "Henry," violence itself does not damn the work. And unlike "Henry," "American Psycho" is both inept and pretentious, an exploitation book dressed up with an epigraph from Dostoyevsky and a title allusion to Hitchcock.

The novel attempts to depict the thoughts of a killer named Patrick Bateman. But no authorial intelligence can be spotted behind the character's craziness. Mr. Ellis wants readers to believe that cramming a dozen designer names in one sentence is the same as making a comment on consumer culture. "I have a knife with a serrated blade in the pocket of my Valentino jacket," says Bateman, as if he became a serial killer because he overused his platinum American Express card.

■

Bateman videotapes his torture and murder of women, and masturbates while watching a woman being killed with a power drill in the film "Body Double." Mr. Ellis would have us believe that those casual references amount to something more than spitting up an undigested cliché about mass media and violence. His attempt at a revelation is to make the killer write, "Some kind of existential chasm opens before me." Apparently it leads to the bank.

The high price paid for "American Psycho" (reportedly $300,000 from Simon & Schuster and an additional sum from Vintage) and the seriousness with which it has been addressed critically reveal more about consumer culture and the mass media than anything in the novel. First Simon & Schuster and then Vintage bet that the book's extreme violence would sell to a mainstream audience.

The public response is not in yet; but so far, canceling the contract was the biggest favor Simon & Schuster could have done for Mr. Ellis. The charge that Simon & Schuster censored the book got much more mileage than it deserved; the National Organization for Women's Los Angeles chapter launched a boycott of the book. The result is a steamroller of publicity that makes an amateurish work suddenly impossible to ignore.

■

Oddly, Norman Mailer in Vanity Fair and Peter Plagens in Newsweek use the same phrase in discussing "American Psycho." While panning the book, they write that it raises the ante for violence in literature. But that is a premature assessment. "American Psycho" can raise the ante only if readers and other writers accept it on its own pretentious terms, if they fall for the claim that it says something about the criminal mind. Audiences may not have got into Norman Bates's mind, but at least they knew that he, and Hitchcock, had one. It is impossible to say the same about "American Psycho."

The novel does not place readers in the position of voyeurs or of killers, but of dupes. And even in this company of high-intensity killers, that is the most disgusting feeling of all. □

1991 Mr 10, II:1:1

Paris Is Burning

Produced and directed by Jennie Livingston; cinematography by Paul Gibson; edited by Jonathan Oppenheim; co-produced by Barry Swimar; released by Off-White Productions. At Film Forum 1, 209 West Houston Street. Running time: 78 minutes. This film has no rating.
WITH: Pepper Labeija, Willi Ninja, Octavia Saint Laurent, Venus Xtravaganza and Paris Dupree

By VINCENT CANBY

It's tough enough trying to survive in our society as a black male, but "if you're black and male and gay, you have to be stronger than you can imagine."

So advised the father of one of the Harlem drag queens who are the subjects of Jennie Livingston's "Paris Is Burning," the very fine feature-length documentary opening today at the Film Forum 1.

Style is the weapon of these self-styled queens, their consorts and their entourages. Style is all-pervasive in speech, vocabulary, manner, dress and attitude. Style is a way of appearing to be "real," that is, a way of appearing to be something that, it is often apparent, one isn't.
•
"Paris Is Burning" is the name of just one of the drag balls that Miss

Film Forum

Dancing
In her prize-winning documentary, "Paris Is Burning," Jennie Livingston explores Harlem's drag balls, which can be fiercely competitive and wildly creative.

Livingston shot in the course of the film's two-year production. There are also interviews with some of the more notorious (or, as they like to describe themselves, legendary) queens whose lives Miss Livingston studies with the curiosity of a compassionate anthropologist.

Among others, there is Pepper Lebeija, who says, "I've been around now for two decades, reigning." Pepper's life, like those of most of the other people in the film, revolves around the drag balls that have much more to offer than simply the spectacle of men dressing up in women's clothes.

Drag comes in all sizes, shapes and, of course, styles. The competition for prizes is fierce in categories that go far beyond Femme Queen Realness, featuring the elaborate showgirl costumes that one usually associates with drag balls.

In the Town and Country division, contestants dress as upper-middle-class men and women as they might appear in the magazine of that name.

Other categories include Executive Realness (the costume is that of Wall Street), Military, Schoolboy/Schoolgirl and Bangee Realness. Bangee contestants adopt the look and manner of young street punks whose favorite targets are the sort of gay men who "walk the ball," that is to say, compete for prizes.
•
"Paris Is Burning" is more than spectacle, though. Miss Livingston's interviews reveal a way of living that is both highly structured and self-protective.

There is the system of "houses" to which the young men more or less apprentice themselves. The houses are associations of friends, presided over by a "mother" like Pepper Lebeija, that provide a substitute for family. Houses, says one interviewee, are gay street gangs.

Willi Ninja, the head of the House of Ninja, is a lithe, articulate young man who also happens to be a master in the art of "voguing," in which danc-

ers attempt to top each other by using gymnastics and the gestures of high-fashion models.

Associated with "voguing" is "shade," defined as the "verbal abuse, criticism and humiliation of a rival or competitor." "Throwing shade" is what they do when they do it.

This is the arcana of the drag world.
•
"Paris Is Burning" reveals the temper of that world obliquely. At the beginning of the film the drag queens talk much in the manner of would-be starlets. They tend to gush. "The balls," says Pepper Lebeija, "are our fantasies of being superstars." As the film goes on, the talk becomes more melancholy.

Carmen, a transsexual, discusses her operations. Venus Xtravaganza, who is light-skinned and blond, dreams of finding Mr. Right, who would also be rich.

Dorian Corey, a drag queen of a certain age, sits in front of a mirror applying makeup. Dorian says that once he wanted to make his mark in the world. Now he believes he will have made his mark if he just gets through it.

There is a lot of common sense and natural wit behind the role-playing. Yet there is also a terrible sadness in the testimony.

The queens knock themselves out to imitate the members of a society that will not have them.

1991 Mr 13, C13:1

Halfaouine

Written and directed by Férid Boughedir; in Arabic with English subtitles; photography by Georges Barsky; edited by Moufida Tlatli; music by Anouar Braham; produced by Ahmed Baha Eddine Attia, Eliane Stutterheim and Hassen Daldoul. At the Roy and Niuta Titus Theater 1 at the Museum of Modern Art, 11 West 53d Street, as part of the New Directors/New Films Series of the Film Society of Lincoln Center and the Department of Film of the Museum of Modern Art. Running time: 98 minutes. This film has no rating.

Noura	Sélim Boughedir
Noura's father	Mustapha Adouani
Noura's mother	Rabia Ben Abdallah
Salih	Mohamed Driss
Latifa	Hélène Catzaras
Salouha	Fatma Ben Saïdane

Dear Rosie

Directed by Peter Cattaneo. Running time: 11 minutes. This film has no rating.

L'Amour

Written and directed by Philippe Faucon; in French with English subtitles; photography by Bernard Tiphine; edited by Christian Dior; music by Benoît Schlosberg; produced by Humbert Balsan. At the Roy and Niuta Titus Theater 1 in the Museum of Modern Art, 11 West 53d Street, as part of the New Directors/New Films Series of the Film Society of Lincoln Center and the Department of Film of the Museum of Modern Art. Running time: 80 minutes. This film has no rating.

Sandrine	Laurence Kertekian
Martine	Julie Japhet
Joël	Nicolas Porte
Riri	Mathieu Bauer
Alex	Sylvain Cartigny
Paulo	Guillaume Briat

All Day and All Night
Memories From
Beale Street Musicians

Directed by Judy Peiser, Robert Gordon and Louis Guida; released by A. Center for Southern Folklore. Running time: 29 minutes. This film has no rating.

Sélim Boughedir in "Halfaouine" (Tunisia and France), in the New Directors/New Film series.

By VINCENT CANBY

THE main attraction of the annual New Directors/New Films series, sponsored by the Film Society of Lincoln Center and the film department of the Museum of Modern Art, is the opportunity to see movies without preconceptions.

That's not easy these days when the amount of time and money spent promoting a film can be as much as (and sometimes more than) the amount of time and money spent making the film. New Directors/New Films allows one to look at movies in a state of comparatively blissful innocence.

They arrive naked, without baggage, except for the blurbs within the ad that announces the series. But since the blurbs are all enthusiastic, they tend to cancel each other out. The blurbs reveal a few basic facts, but are otherwise cheerily weightless.

In this way the series allows for discovery. The audience is on its own, free of hectoring expectations.

There should be no such expectations about this year's first two presentations: Férid Boughedir's gentle "Halfaouine: Child of the Terraces" about coming of age in Tunis, and Philippe Faucon's somewhat more hip "L'Amour," a French comedy about young love and boredom in suburbia.

"Halfaouine" will be shown tonight at 6 and tomorrow at 3 P.M., and "L'Amour" at 9 tonight and at 12:15 tomorrow.

Each program is considerably enlivened by the short subject that accompanies the feature.

Preceding "Halfaouine," and having absolutely no relation to it, is Peter Cattaneo's "Dear Rosie," a very funny, deadpan, exceptionally adroit English film that tells an ironic, novel-sized tale in approximately 11 minutes of exchanged letters.

Rosie, a divorced mother, is trying to write a large, solemn piece of fiction when her agent turns her into a millionaire by publishing the diet she put together for him.

As the author of "The Armchair Slimmer," Rosie becomes a celebrity. She is mobbed at bookshops. She endorses bathroom scales and other merchandise. Then her ratty ex-husband returns and life goes from curious to worse.

Or, as her small son writes gloomily to a penpal, "My mother has written a book for fat people and we are now very rich."

"Dear Rosie" is quick and to the point. "Halfaouine" ambles, which is the appropriate gait.

The film is the story of Noura, played by Sélim Boughedir (the director's nephew), a boy not so far into puberty that he can't still accompany his mother and aunts to the women's public bathhouse.

At the beginning of "Halfaouine," Noura dreads these visits. Quite soon, though, they have become the source of erotic fantasies he can't easily disguise. One day he is tossed out of the bathhouse without ceremony. A man, at last.

This is the most dramatic event of the film, which presents a straightforward, unsentimental picture of lower-middle-class family life in Tunis. There are fetes, a series of minor crises involving Noura's aunts, a vignette about the neighborhood shoemaker (who has literary aspirations) and Noura's first successful sexual enounter.

The setting is Noura's neighborhood. The camera passes through the narrow streets, tiny shops and sidewalk cafes with the self-assurance of a resident. It sees the rest of the world as if out of the corner of the eye, as when Noura becomes a witness to a noisy political demonstration, the exact nature of which remains obscure.

Noura is a sweet-natured boy. The film that surrounds him is intentionally low-key and reticent, of more immediate interest as sociology and anthropology than as cinema, which is not to underrate the director's successfully spare style.

The world of "L'Amour" is more familiar. The film, written and directed by Mr. Faucon, suggests the sort of comedy that Eric Rohmer might make if he chose to examine the lives of a group of suburban teen-agers whose powers of introspection are severely limited.

Unlike Mr. Rohmer, though, Mr. Faucon is not especially interested in locating the remarkable within the commonplace. He seems concerned with Sandrine, Martine, Joël, Riri, Alex, Paulo and their friends just because they are so ordinary, and so soon destined to go to seed.

The time is late summer. No one within "L'Amour" appears to be aware of it, but autumn waits. Youth, so robust at the moment, will fade as the teen-agers deteriorate, eventually to become facsimiles of their tired parents.

In the course of a few weeks, Sandrine, Martine and the others pick each other up, go dancing, eat Chinese and sleep over. They fall in love and out, discuss jealousy and fidelity in passing, and fall in love again. Finally, in desperation for something different to do, some of them marry.

Not the least of the film's sad points is that, with the exception of the remarkably firm and well-proportioned Sandrine (Laurence Kertekian), these teen-agers are interchangeable. The characters are differentiated only by sex and hair color.

Whether or not this is Mr. Faucon's actual intention, it is the effect of "L'Amour," which observes its world from a rigorously maintained distance that denies both easy laughs and unearned tears.

The young actors are all persuasive, especially Miss Kertekian and Mathieu Bauer, who plays Riri, a young man made memorable by his red hair and terrible luck with women.

Sharing the bill with "L'Amour" is an exuberantly upbeat, 29-minute documentary, "All Day and All Night: Memories From Beale Street Musicians," directed by Judy Peiser, Robert Gordon and Louis Guida.

B. B. King and others recall their early days on Memphis's Beale Street, sometimes from the bandstand, sometimes directly to the camera, and sometimes sitting around a long table, eating chili at Mitchell's Domino Lounge.

Says Rufus Thomas, now of a certain age, "I told a white fella once, 'If you were black on Beale Street for one Saturday night, you'd never want to be white again.' " This rollicking film convinces.

Don't miss the short subjects.

1991 Mr 15, C1:4

Guilty by Suspicion

Written and directed by Irwin Winkler; director of photography, Michael Ballhaus; film editor, Priscilla Nedd; music by James Newton Howard; production designer, Leslie Dilley; produced by Arnon Milchan; released by Warner Brothers. Running time: 105 minutes. This film is rated PG-13.

David Merrill	Robert De Niro
Ruth Merrill	Annette Bening
Bunny Baxter	George Wendt
Dorothy Nolan	Patricia Wettig
Felix Graff	Sam Wanamaker
Paulie Merrill	Luke Edwards
Larry Nolan	Chris Cooper
Darryl F. Zanuck	Ben Piazza
Joe Lesser	Martin Scorsese

By JANET MASLIN

Humphrey Bogart is known to be a "big, big fan" of David Merrill's, since David (Robert De Niro) is a gifted new director just beginning to take on the trappings of movie royalty, circa 1951. He drives around

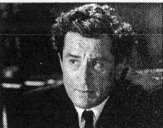

Warner Brothers Inc.

Robert De Niro

town in a sleek white convertible, and he gets a warm welcome at the Brown Derby. He is a guest in the screening room of Darryl F. Zanuck, who regards Merrill as his very special protégé; there, Zanuck confides his irritation at Howard Hawks over the rushes for Hawks's latest picture, the one with Marilyn Monroe. Merrill's talent has turned him into a legitimate insider. Hollywood hopefuls don't get much more hopeful than this.

Merrill has a new house with a sweeping view of Los Angeles. One day, early in Irwin Winkler's gripping drama "Guilty by Suspicion," he stares at that view from morning until night. The camera circles chill-

When a whispered word could make one of the 'A' crowd a pariah.

ingly around him as he makes phone call after desperate phone call, trying to rescue a career that has suddenly gone up in smoke. In the era of the Hollywood blacklist, Merrill's reluctance to clear up a few nagging questions from the House Committee on Un-American Activities is taking its toll.

●

The best thing about "Guilty By Suspicion" is that David Merrill is not martyr material. He long ago attended a couple of ban-the-bomb rallies, but he is by no means any kind of political being. What he loves best is film making, and in the course of rising to the top of his profession he has sacrificed a lot, in particular the love and company of his now-estranged wife Ruth (Annette Bening)

and their young son (Luke Edwards). Having risked so much in order to succeed, he fails to understand why he should have to give up anything more.

"Guilty by Suspicion," which views the blacklist era from the standpoint of a surprised, worried and tremendously sympathetic victim, makes the wise choice of approaching its subject without grandstanding or invective. The benefits of hindsight are never brought to bear upon David Merrill's problems. Neither he nor his friends, several of whom also fall under the shadow of Congressional scrutiny, are sure whether small compromises might not be possible, whether the chance to do valuable work should not take precedence over everything else, or whether this whole episode will even matter in 10 years' time. Merrill's having to make decisions in the dark, without an overview, makes the film that much more wrenchingly effective.

Even as he ably minimizes this story's potential for self-righteousness, Mr. Winkler creates a subtle and pervasive climate of unease. The breezy songs heard in the background — "Straighten Up and Fly Right," "I'm Just a Lucky So and So," "They Can't Take That Away From Me," "Easy Come, Easy Go" — become a deeply sardonic commentary on the main action. A grade-school performance of "Peter Pan," featuring the scene in which Peter asks the audience to create a miracle of faith on Tinkerbell's behalf, becomes equally rueful within the context of Hollywood's burgeoning anti-Communism. A merry surprise party, with F.B.I. agents examining the license plates of the parked cars, becomes a powerful hint of trouble to come.

Mr. Winkler, previously known as the producer of such films as "Raging Bull," "Rocky" and "The Right Stuff," pays especially keen attention to production values. Michael Ballhaus's vibrant cinematography and Leslie Dilley's production design both evoke the early 1950's in a deeply atmospheric but not overpowering fashion. Well-chosen background touches, like the dancers straggling across the studio lot in their "Gentlemen Prefer Blondes" costumes or the handsome fake poster for one of Merrill's hit movies, contribute to the film's overall persuasiveness.

Mr. Winkler even stages a brief takeoff on "High Noon" to represent a western that the newly disreputable Merrill is summoned to help out with, although this episode, like most of his stabs at new employment, ends in frustration. These details help the film hold its audience's interest through the full cycle of Merrill's evolution, as he trades in that sports car and finds himself literally and figuratively traveling Greyhound.

Mr. De Niro rarely takes on characters as fully rounded, or as relatively ordinary, as David Merrill. It's a long way even from the Hollywood genius Monroe Stahr, whom he played in "The Last Tycoon," to a man who can sit in his living room doing math homework with his school-age son. Yet this character's very humanity, fully captured in Mr. De Niro's fine and affecting performance, is what makes his crisis of conscience so compelling. The film's climactic scene, with the camera trained closely on the actor's face as he registers all of Merrill's conflicting emotions, manages to invest a potentially familiar event with enormous tension and surprise.

Also in the cast are George Wendt as a screenwriter who faces problems similar to Merrill's and deals with them very differently; Patricia Wettig, glaringly unconvincing as a glamorous movie star (in the film's worst-written role); Martin Scorsese, who has some lovely moments as one of Merrill's fellow directors, and of course Miss Bening, whose pert beauty perfectly exemplifies the style of the early 50's. Once again, with effortless ease, she lights up the screen.

Sam Wanamaker, once blacklisted himself, is ironically good as the studio lawyer urging Merrill to take the easy way out. These troubles, he tells Merrill, are strictly practical concerns. They're real life, and real life is about paying doctors' bills. Has Merrill ever seen anyone opening a doctor's bill on screen? The events of the blacklist, this lawyer insists, are not the stuff of which big-screen dramas are made.

"Guilty By Suspicion," a stirring and tragic evocation of terrible times, is proof otherwise.

•

"Guilty by Suspicion" is rated PG-13 (Parents strongly cautioned). It includes some strong language.

1991 Mr 15, C12:1

Robot Carnival

Animated shorts directed by Katsuhiro Otomo, Atsuko Fukushima, Kouji Morimoto, Hiroyuki Kitazume, Mao Lamdo, Hidetoshi Ohmori, Yasuomi Umetsu, Hiroyuki Kitakubo and Takashi Nakamura; directors of photography, Toshiaki Morita, K. Torigoe and Yukio Sugiyama; edited by Naotoshi Ogata, Yukiko Itoh and Nao Toyosaki. At Film Forum 2, 209 West Houston Street in Manhattan. Running time: 90 minutes. These films have no rating.

By STEPHEN HOLDEN

Japanese animated films have become enough of a cult item for the Film Forum 2 to have organized an entire three-week festival devoted to them. "Robot Carnival," which opens the festival today, is an anthology of eight short works by leading Japanese animators organized around the theme of robotics. All eight of the shorts offer a lot more visual pizzazz than Saturday-morning cartoons on television, but only two of the eight begin to transcend the genre.

Its visual flair cannot redeem a piece as trite and precious as Hiroyuki Kitazume's "Starlight Angel," a confusing kiddie soap opera in which Barbie and Ken look-alikes battle a mechanical demon. If the phosphorescent magentas that explode through Hidetoshi Ohmori's "Deprive" give his film a psychedelic glow, they don't deepen the scenario of mindless, nonstop violence.

Somewhat more palatable are Hiroyuki Kitakubo's fable "A Tale of Two Robots," which is set in the 19th century and shows some plucky children defeating a mad scientist who operates an unwieldy, old-fashioned killing machine. If there are moments of visual cleverness in Kouji Morimoto's "Franken's Gear," which focuses on the elaborate, Rube Goldberg-like machinery it takes to create a humanoid monster, it is a joke without a punch line. Takashi Nakamura's "Nightmare," a feverish dream about an immaculate city that is visited by a malevolent spidery extraterrestrial, also lacks narrative coherence.

The anthology's wittiest segment, Mao Lamdo's "Cloud," is an allegory told in line drawings, in which a cloud expands and contracts into all kinds of weather that besets a youthful android. The handsomest short, Yasuomi Umetsu's "Presence," uses Cézanne-like drawings of unusual coloristic subtlety as the backdrops for a confused "Pygmalion"-like story of an inventor and the lovelorn android he has created.

Framing the individual segments are sequences created by Atsuko Fukushima and Katsuhiro Otomo in which a giant, ominous, tanklike contraption erupts from a barren wasteland and turns into an entertainment machine.

1991 Mr 15, C14:5

Reunion

Directed by Jerry Schatzberg; written by Harold Pinter, based on the book by Fred Uhlman; director of photography, Bruno De Keyzer; music by Philippe Sarde; production designer, Alexandre Trauner; produced by Anne Francois; released by Castle Hill Productions. At the Sutton, Third Avenue at 57th Street in Manhattan. Running time: 120 minutes. This film is rated PG-13.

Henry	Jason Robards
Hans Strauss	Christien Anholt
Konradin Von Lohenburg	Samuel West
Grafin Von Lohenburg	Françoise Fabian
Lisa	Maureen Kerwin

By JANET MASLIN

"Reunion," directed by Jerry Schatzberg from a screenplay by Harold Pinter, takes an unusually luxurious view of the Holocaust, in terms of both privilege and time. The latter is what makes the vantage point of an American businessman named Henry (Jason Robards) so contemplative, since he has long since left Germany and distanced himself from the story's principal events. As "Reunion" begins, Henry is preparing for his first trip to Germany in decades and is experiencing a flood of memories that are both painful and pretty.

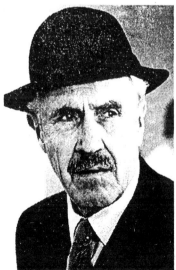

Castle Hill Productions

To the Past
Jason Robards stars in "Reunion" as a man who returns to Germany after 55 years to renew a friendship that began during the Nazi era.

The majority of the film takes place in a Germany so pleasant and rarefied that the story's characters talk and dress as if this were "Brideshead Revisited." Two English-sounding schoolboys, Hans Strauss (Christien Anholt) and Konradin Von Lohenburg (Samuel West), are seen embarking upon an enchanted friendship. Both actors look a bit mature for such innocent reverie, but they form a closeness based on idyllic travels together and the exchange of exciting ideas. "Should I read Dostoyevsky?" asks one. "You certainly should — he's tremendous," his friend replies.

The mood is blissful, but the year is 1933. And the specter of Hitler is discernible, however faintly, in the background. In the beer gardens where Hans and Konradin relax to the sound of oom-pah bands, there are occasional Hitler Youth uniforms to be seen. And on the wall of buildings there are discreet Nazi posters. But Hans's father, who fought in World War I and is proud of his Iron Cross, is sure this will not be a problem. Of German Jews, he says, "We go to synagogue on Yom Kippur and sing 'Silent Night' at Christmas." Of the German people, he says: "This is the land of Goethe, of Schiller, of Beethoven. They're not going to fall for that rubbish."

"Reunion," which opens today at the Sutton and is based on a novel by Fred Uhlman, seems at times to share Hans's father's faith in the power of good breeding and intelligence to prevail over almost anything. So much of it, while lullingly handsome and well bred, is dangerously precious, too. "You know, I don't know what we're going to do about this question of sexual desire," Konradin remarks to Hans after the two of them have accidentally spied upon young lovers in a pastoral embrace. "It's a terrible problem." The film flirts so strenuously with such tender little apercus that it jeopardizes its own seriousness sometimes.

There is a certain degree of mystery attached to Henry's trip to Germany, and to how this will connect with the story told in flashback, but that mystery is minimal. Luckily, the solemnity and weight of Mr. Robards in the role successfully camouflage the speciousness of present-day Henry as a dramatic device. Mr. Robards brings a movingly mournful air to the film's scenes of discovery, and even to a final revelation that seems pat and out of character for the person it involves.

"Reunion" is gratifying in the small ways most familiar from public-television's depictions of English upper-class behavior. The offhanded elegance of its settings, and the attractive crispness of its schoolboy manners ("Oh, he just rants and raves, doesn't he?" one of the film's cavalier young characters says about Hitler) are a major part of its gently decorative appeal.

•

"Reunion" is rated PG-13 (Parents strongly cautioned). It includes brief nudity and some harsh language.

1991 Mr 15, C16:6

Cadence

Directed by Martin Sheen; screenplay by Dennis Shryack, based on the novel "Count a Lonely Cadence" by Gordon Weaver; director of photography, Richard Leiterman; edited by Martin Hunter; music by Georges Delerue; produced by Richard Davis; released by New Line Cinema. Running time: 97 minutes. This film is rated PG-13.

Bean....................................Charlie Sheen
McKinney.................................Martin Sheen
Gessner...............................Ramon Estevez
Stokes...............................Larry Fishburne
Webb..................................Michael Beach
Lawrence..............................John Toles-Bey

By JANET MASLIN

The members of the Sheen family have grown up to be hearty and strapping, but how that happened is a mystery. It's hard to imagine any one of them asking another to pass the salt without a truckload of attitude getting in the way.

"Cadence," which is the first feature Martin Sheen has directed, allows the director and his son Charlie ample opportunity to grapple with one another, as well as with questions of racial harmony and with another of Mr. Sheen's sons, Ramon Estevez. The result is well meaning and at times even gently likable. But there is no indication that Mr. Sheen ever yelled "Cut!" when he had a chance to send one of his actors over the top.

"Cadence" begins as Pfc. Franklin F. Bean (Charlie Sheen) returns home in 1965 from an Army base in Germany to attend the funeral of his father in Montana. At the funeral, there is an open coffin. Bean staggers as he walks toward it. He weeps. He turns red. He murmurs: "I'm sorry, Dad. I'm so sorry." He places a wedding ring on his father's finger. Apparently, he loved his father very much, which is also made clear in a separate burial scene and a drunken scene, which involves slow motion and flying glass.

•

That the deceased father has little direct bearing upon the rest of the film is only the beginning of what's wrong here. At least "Cadence" becomes less overwrought when the drunken scene brings about its desired end, which is Bean getting caught by the military police and sent to a work camp for a 90-day stint. There, he is placed under the wing of the bullying Sgt. Otis McKinney, whom the senior Mr. Sheen plays jumpily as a distant, blustery relative of James Cagney. There is considerable shouting and head-butting once Bean (who misses his father) and McKinney (who neglects his own son) lock horns.

Along with the bespectacled Mr. Estevez, who gives a nicely muted performance as one of McKinney's aides, the film features Larry Fishburne as the ringleader of the all-black barracks to which Bean is assigned. This is meant to look like trouble at first, since one of his new roommates greets Bean with a taunt: "Don't you like Negroes?" Not to worry. Everyone gets along. The film's title refers to a nice Motown-style shuffle performed by Bean's barracks mates to the tune of Sam Cooke's "Chain Gang." Eventually, Bean is so well accepted that it's conceded that he has enough rhythm to join in.

The film's best scenes are its least dramatic ones, during which the inmates horse around and have a much

Republic Pictures

Maverick Charlie Sheen stars in "Cadence" as the Army private F. F. Bean, a rebel and loner who is confined to a barracks of black soldiers. His father, Martin Sheen, co-stars as a bigoted sergeant in command of a work-camp stockade; he also directed the drama.

more pleasant time than ought to be possible. John Toles-Bey and Michael Beach are particularly good as fellow inmates who never err by taking the film's melodramatic moments more seriously than they should.

•

"Cadence" is rated PG-13 (Parents strongly cautioned). It has strong language and some violence.

1991 Mr 15, C18:5

True Colors

Directed by Herbert Ross; written by Kevin Wade; director of photography, Dante Spinotti; edited by Robert Reitano and Stephen A. Rotter; music by Trevor Jones; production designer, Edward Pisoni; produced by Mr. Ross and Laurence Mark; released by Paramount Pictures. Running time: 111 minutes. This film is rated R.

Peter BurtonJohn Cusack
Tim Garrity...............................James Spader
Diana Stiles.............................Imogen Stubbs
John Palmeri..............................Mandy Patinkin
Senator Stiles...........................Richard Widmark
Joan Stiles...............................Dina Merrill
Senator Steubens.........................Philip Bosco
John Lawry...............................Paul Guilfoyle

By VINCENT CANBY

From all of the current films and television shows about the law, Hollywood producers would seem to be very high on ethics these days, though they sometimes have a very peculiar way of demonstrating it.

A case in point is Herbert Ross's "True Colors," written by Kevin Wade, which traces the friendship and careers of two young men who meet at the University of Virginia Law School in 1983.

Tim Garrity (James Spader), an emotionally secure member of the upper middle class, is true-blue, honest and straightforward, dedicated to justice as an ideal not to be tampered with.

Peter Burton (John Cusack), the product of a broken blue-collar home, is on the make. He wants to get ahead at any cost. He has even discarded a not easily pronounceable, possibly Polish surname for something more Anglo-Saxon.

•

When the opportunity is offered, Peter drops out of law school to take a job in the Washington office of a United States Senator, in order to further his own political ambitions.

Later, while the good Tim is working away anonymously in the Justice Department, Peter is wheeling and dealing in the back rooms of power.

Tim's girlfriend, the Senator's daughter, dumps him, saying, "I wouldn't be happy being basically a cop's wife." The opportunistic Peter marries her. Later he blackmails the Senator to secure his support in a race for the House of Representatives, then doublecrosses Tim in a way that jeopardizes Tim's career at Justice.

Jürgen Vollmer/Paramount

John Cusack

"True Colors" apparently thinks it is exposing the values of the greedy 1980's. Yet its own understanding of moral conduct is warped.

It asks the audience to applaud Tim's very questionable methods of dealing with his former pal. At the same time, the movie reveals a distinct, very 80's bias on behalf of the well-mannered, well-born Tim at the expense of the ambitious, self-made Peter.

•

In spite of the jazzy soundtrack score, the glitzy Washington parties and one good scene on a ski slope, "True Colors" is as bent as a somewhat questionable 19th-century platitude: "You can take the man out of the slum, but not the slum out of the man."

This may not be what Mr. Wade intended. On the basis of his screenplay for "Working Girl," his savvy, very funny satire on Wall Street manners, he is a man who knows his principles. As directed by Mr. Ross, "True Colors" is dreary, humorless, heavy-handed and self-important.

The sharp performances by Mr. Cusack and Mr. Spader brighten things a bit, as do brief appearances by Richard Widmark, Philip Bosco and Paul Guilfoyle. The other supporting actors are not seen to their advantage.

•

"True Colors," which has been rated R (Under 17 requires accompanying parent or adult guardian), includes a lot of vulgar language and some inexplicit sex scenes.

1991 Mr 15, C19:1

Class Action

Directed by Michael Apted; written by Carolyn Shelby, Christopher Ames and Samantha Shad; director of photography, Conrad L. Hall; edited by Ian Crafford; music by James Horner; production designer, Todd Hallowell; produced by Ted Field, Scott Kroopf and Robert W. Cort; released by 20th Century Fox Film Corporation. Running time: 110 minutes. This film is rated R.

Jedediah Tucker Ward..........Gene Hackman
Maggie Ward..Mary Elizabeth Mastrantonio
Michael Grazier.......................Colin Friels
Estelle Ward........................Joanna Merlin
Nick Holbrook....................Larry Fishburne
Quinn................................Donald Moffat
Pavel..................................Jan Rubes
Judge Symes...........................Matt Clark

By VINCENT CANBY

Jedediah Tucker Ward (Gene Hackman) is a brilliant San Francisco lawyer who fights for underdog causes, smallish financial returns and, on occasion, great publicity.

His daughter, Maggie (Mary Elizabeth Mastrantonio), is a brilliant San Francisco lawyer who works for an old, rich conservative firm specializing in corporate law.

In the slick, flimsy new film titled "Class Action," father and daughter meet as adversaries in the courtroom, not for laughs, as in "Adam's Rib," but for what is supposed to be human drama. Jedediah represents the plaintiff, a man badly burned in an automobile accident, and Maggie the defendant, the manufacturer of the allegedly defective automobile.

The screenplay, written by Carolyn Shelby, Christopher Ames and Samantha Shad, has the shape of something lifted from a primer on screenwriting, though there is occasional wit in the dialogue.

•

Michael Apted ("Coal Miner's Daughter," "Gorillas in the Mist") directed the work with what appears to be an unwarranted belief in its value, something that he has managed to pass on to the cast.

The performers are good. Mr. Hackman has punch and drive as the sort of public liberal who, in private, behaves like a fascist to his wife and daughter. Miss Mastrantonio is similarly strong and intelligent as a woman who appears to condone shady corporate practices, though her private morality is above reproach.

The movie looks pretty. The San Francisco scenery takes up some of the drama's slack. A couple of worthy if not wildly original points are made about corporate opportunism, but there's never a minute's doubt about what is obliged to happen next, or why.

"Class Action" won't put you to sleep. Yet it vanishes from the memory as fast as anything dreamed in the conventional manner.

•

"Class Action," which has been rated R (Under 17 requires accompanying parent or adult guardian), includes a lot of vulgar language and some sexual innuendoes.

1991 Mr 15, C20:4

Song of the Exile

Directed by Ann Hui; screenplay (in Cantonese with English subtitles) by Wu Nien-Jen; cinematographer, Chung Chi-Man; edited by Yih-Shun Huang; music by Yang Chen; produced by Deng-Fei Lin and Nai-Chung Chou; released by the Kino International Corporation. At Quad Cinema, 13th Street west of Fifth Avenue in Manhattan. Running time: 100 minutes. This film has no rating.

Aiko/Kwei Tzu Shwu-Fen Chang
Hueyin Cheung Maggie Cheung
Hueyin's Father Chi-Hung Lee
Hueyin's Grandfather Tien Feug

By JANET MASLIN

Ann Hui's delicate, finely observed "Song of the Exile" tells a tale that is at once singular and universal. The particulars of this largely autobiographical film, which opens today at the Quad Cinema, involve the marriage of a Japanese woman and a Chinese man just after the Sino-Japanese war, and the ostracism faced by the wife as she tried to make peace with her husband's relatives.

But the film's larger story is one of discovery, as the couple's Western-educated daughter returns to Hong Kong from London and resumes contact with her embittered mother. The film gently traces the rapprochement of these two, with a keen grasp of mother-daughter tensions as they might occur in any corner of the globe.

While conveying the resentment and love that govern relations between Hueyin (Maggie Cheung) and her mother, Aiko (Shwu-Fen Chang), "Song of the Exile" also offers a detailed look at life in Japan, mainland China, Hong Kong and Macao.

Kino International

Family Concerns
Shwu-Fen Chang and Maggie Cheung appear in "Song of the Exile," a film from Taiwan about the emotional and cultural gap between an English-educated Hong Kong woman and her Japanese mother.

Hueyin's relatives have at various times lived in each of these places without ever truly feeling at home. Once Hueyin gives up hope of a broadcasting career in London and returns home for her sister's wedding, she is at loggerheads with her mother almost immediately — over her hairdo for the wedding, which could become a bone of mother-daughter contention in any culture. Miss Cheung, a beautiful and demure actress, looks convincingly torn between petulance and obedience as she finally gives in to her mother's wishes, and lets herself be drawn into a furious and unaccustomed intimacy with her sole surviving parent.

Aiko, played furiously by Miss Chang, is a difficult, dissatisfied person, for reasons made clear in a series of flashbacks to Hueyin's girlhood. The child shunned her mother and insisted on being raised in Macao by grandparents, who doted on the little girl and complained cattily about Aiko's cooking. Aiko, already estranged and unhappy, never allowed this particular wound to heal.

The film's especially memorable glimpses include the sight of Aiko leaving Macao with her husband, as their daughter refuses even to wave goodbye. Later, there is a look at the teen-age Hueyin, now returned to her parents in Hong Kong and sharply critical of Aiko for being spoiled, lazy and not sufficiently maternal.

In the gentlest way imaginable, Miss Hui and the screenwriter Wu Nien-Jen allow the film's perspective to shift from Hueyin's to Aiko's, a change prompted by Aiko's impulsive wish to take her daughter on a visit to rural Japan. There, facing enormous cultural and language barriers, Hueyin begins to develop some sense of what her mother's life of displacement must have been like; at the same time, Aiko realizes how far she has traveled from what she once thought of as home. The film, after all its wandering, ultimately locates home in emotional rather than geographical terms, and gracefully binds mother and daughter in a newly discovered closeness.

Miss Hui, also the director of "Boat People," displays remarkable control of her material as she shifts between cultural and interpersonal conflicts, between the two women's varying points of view. The film's loveliest moments are those that elegantly enhance the daughter's understanding of where she fits into her mother's world.

1991 Mr 15, C21:1

A Little Stiff

Directed, written, produced and edited by Greg Watkins and Caveh Zahedi; photography by Mr. Watkins; music by Kath Bloom. At the Roy and Niuta Titus Theater 1, the Museum of Modern Art, 11 West 53d Street, as part of the New Directors/New Films Series of the Film Society of Lincoln Center and the Department of Film of the Museum of Modern Art. Running time: 86 minutes. This film has no rating.

WITH: Beat Ammon, Arnold Barkus, Alison Bradley, Leslie Copes, Erin McKim, Mike McKim, Patrick Park, David Trauberman, Mr. Watkins and Mr. Zahedi

By JANET MASLIN

He is familiar even if you've never seen him before: the lovelorn creep, the campus nuisance, the guy guaranteed to prompt elaborate shows of indifference every time he enters a room. In spite of all this, he is weirdly appealing, perhaps because his efforts to escape his own awkwardness are so clearly doomed.

As played by Caveh Zahedi, who is both the star and co-director (with Greg Watkins) of "A Little Stiff," this U.C.L.A. film student and would-be suitor becomes as funny as he is desperate. First seen talking to a long-suffering friend (played by Mr. Watkins) about his unfortunate efforts with women, Caveh (Mr. Zahedi uses his real name) embarks upon a campaign. He spies a fellow student named Erin in an elevator, makes her his target and begins doing all the wrong things either to win her over or to scare her away.

Having initially described his approach to wooing women as "do or die," Caveh starts out with research to figure out who Erin is (an art student with no known boyfriend) and where she can be found. He contrives to run into her, and does it in the clumsiest way possible, when she is with a group of friends. He engages in a flurry of demented planning, discussing strategy on the telephone as he paces frantically beside a half-dead ficus plant. He feeds nuts to a squirrel and regards that as a romantic metaphor. He tries writing a song in which "Erin" and "starin'" rhyme.

"A Little Stiff," which will be shown tonight at 9 P.M. and tomorrow at 6 P.M., unfolds in a deadpan black-and-white style that is humorously loaded with the baggage of the directors' film school education. (Both are recent alumni of the University of California at Los Angeles.) There are long shots, long takes, long pauses and many droll reminders of undergraduate excess. Caveh, for instance, enlists Erin's help as an actress in a short film he is making, which he describes as one of 26 epiphanies, one for each letter of the alphabet. Erin's film will be "E Is for Elevator," but there are also "S Is for Stranger," "K Is for Kissing" and "M Is for Maggot" — the last one capturing that "dead animal on the side of the road experience," as Caveh puts it. There is also a brief, priceless scene in which Caveh ties himself into knots trying to extract a satisfactory message from one of his dreams.

Erin herself says very little in the face of Caveh's hilariously unreasonable persistence. When she does speak, it isn't promising. She confides her desire to extract psychedelic chemicals from a certain type of frog, for instance, which leads the conversationally panicky Caveh to muse about whether each organism in the world might not have hallucinogenic properties for some other organism. "That doesn't seem statistically possible," Erin sighs, thus cutting off any further small talk.

Erin finally responds to Caveh's persistent invitations — to screenings of Bresson and Tarkovsky films — by inviting him somewhere and showing up with another suitor in tow. Caveh's efforts to wow them both by screening one of his strenuous student films (apparently a real, decade-old short film of Mr. Zahedi's) are no match for the other boyfriend's more laid-back approach. He later confides to Caveh that he and Erin are "totally in tune with each other" where their "philosophies and attitudes" are concerned, and that Erin once told him, "I just want you to play your violin while I paint."

Caveh's response to this is to accept the other boyfriend's drugs, experience a bad acid trip and then become even more unhinged when Erin refuses to offer much sympathy. She tells him little more than that she's busy and to "think positive."

"A Little Stiff" is at times more deadpan than it should be, and it might have benefited from a more forceful directorial voice. But most of it has wit, snap and a horribly clear understanding of paralyzing angst.

•

On the same bill is "Billy Turner's Secret," a half-hour short about sexual small-mindedness as demonstrated by two young black men, Billy and Rufus, who have been friends since childhood. Rufus, who expresses himself entirely through monologues steeped in raw, mindless machismo, has never stopped to notice that his friend is gay. But by the end of this raunchy light comedy (whose director, Michael Mayson, appears as Rufus), that and other lessons have been learned.

"Sometimes you just have to bust 'em in the head before they can learn anything," Billy eventually says. In this case, that's a generous and amusing epilogue.

1991 Mr 16, 16:3

Leo Sonnyboy

Directed and written by Rolf Lyssy; in German with English subtitles; photography by Hans Liechti; edited by Lilo Gerber; music by Ruedi Häusermann and Yello; produced by Edi Hubschmid. At the Roy and Niuta Titus Theater 1 at the Museum of Modern Art, 11 West 53d Street, as part of the New Directors/ New Films Series of the Film Society of Lincoln Center and the Department of Film of the Museum of Modern Art. Running time: 95 minutes. This film has no rating.

WITH: Mathias Gnädinger, Christian Kohlund, Ankie Beilke-Lau, Dieter Meier, Hilde Ziegler, Heinz Bühlmann, Peach Weber, Esther Christinat and Stephanie Glaser

By CARYN JAMES

Immigration laws have bred a strange new kind of chivalric romance, one becoming common on movie screens. In "Leo Sonnyboy," an overweight, middle-aged subway driver named Leo marries a beautiful Thai go-go dancer named Apia so she will not be deported from Switzerland.

As if that weren't enough, he really endears himself to her by catching her life-sized stuffed-animal monkey when a former roommate tosses it out a window. "That's my Sonnyboy!" Apia says of the rescued monkey, proving she's a sweet child at heart even though she is perilously close to a life of prostitution. Leo saves her from that, too, and becomes her new Sonnyboy in the process.

"Leo Sonnyboy" is "Green Card" without the glamour, "Pretty Woman" without Julia Roberts. It is pleasant, predictable and extremely slight — just the sort of movie you wouldn't expect to be in German or to be in the New Directors/New Films series, where it will be shown tonight at 6 and tomorrow at 3 P.M. at the Museum of Modern Art.

The people on screen are the only ones who will be surprised when Leo and Apia's marriage of convenience turns to love. In fact, the film is populated with characters who are obtuse in the extreme.

•

Adrian, Apia's married lover, persuades his friend Leo to help him keep his spare woman in town. He never suspects that she will fall for the laconic, soft-hearted Leo.

Though Leo lives alone, his mother keeps him attached to her apron strings and her phone line. "You have no contact with your son?" asks the inevitable immigration officer who

surprises her with the news of Leo's marriage. "Of course," she snaps, "I do his laundry."

The Swiss writer and director Rolf Lyssy handles such lame ideas with enough comic energy to keep the film alive. Leo is saved from being a pathetic sad sack by a disgruntled streak that makes him seem perfectly content to eat pre-packaged dinners in front of the television. And he turns out to be a resourceful hero, standing up to his mother, to Adrian and to a slick pimp with a small ponytail.

But this working-class romance is finally too familiar to be engaging and too antiseptic for its own good. Though Apia dances in a club called "Hot Lips," where all the other performers are topless, she manages to finish every routine with the top of her costume intact. She is, after all, the heroine Leo's mother must learn to embrace.

"Leo Sonnyboy" is preceded by a 25-minute film, "High Road, Low Road," whose bleak, worried tone could not be more different from that of the feature. This story of an adolescent brother and sister who fight and cause the family car to crash, seriously injuring their mother, displays the technical competence of the film maker, Anne Stockwell. But it is not developed enough to seem fresh — the one trait it shares with "Leo Sonnyboy."

1991 Mr 16, 16:4

The Perfect Weapon

Directed by Mark DiSalle; written by David Campbell Wilson; director of photography, Russell Carpenter; produced by Mr. DiSalle and Pierre David; released by Paramount Pictures. Running time: 90 minutes. This film is rated R.

Jeff Sanders	Jeff Speakman
Adam	John Dye
Yung	James Hong
Jennifer	Mariska Hargitay
Jimmy Ho	Dante Basco
Carl Sanders	Beau Starr
Master Lo	Seth Sakai
Tanaka	Toru Tanaka

By STEPHEN HOLDEN

In an opening sequence of "The Perfect Weapon," its star, Jeff Speakman, is shown bare-chested, kicking and whirling through karate exercises to the accompaniment Snap's hit hip-hop single, "Power." The body rhythms and moves are so similar in style to the dance routines of rap stars like M. C. Hammer that one is reminded of the forceful impact of

Paramount Pictures

For Kicks

Jeff Speakman stars in "The Perfect Weapon" as Jeff Sanders, a karate master whose quest for justice in his mentor's murder pits him against an underworld crime ring and one of the world's deadliest men.

martial arts on culture outside of the gymnasium.

"The Perfect Weapon," which opened yesterday at local theaters, is a macho fantasy of physical control, grace and invincibility in which women are all but absent. Mr. Speakman plays Jeff Sanders, a hotheaded policeman's son who does battle with the Korean mafia in Los Angeles after his father's best friend is killed for refusing to deal drugs. The plot also puts Jeff in conflict with his goody-goody brother (John Dye), who is the policeman assigned to the case.

In keeping with the genre, Mr. Speakman, who has a carefully groomed chin full of stubble throughout the film, emerges remarkably unscathed from battles in which he often floors three or four antagonists in a matter of seconds. Fighting that is as balletic and nonvisceral as the tussles portrayed in "The Perfect Weapon," which was directed by Mark DiSalle, quickly becomes a bore. By far the most gripping scene in the movie is a car chase.

1991 Mr 16, 16:5

Miramax Films

Gong Li (left), and Li Bao-Tian in Ju Dou.

the beauty that exists here only in stolen, illicit moments.

This visually stunning backdrop is one of the saving features of "Ju Dou," which opens today at the Lincoln Plaza. For though the story is filled with drama — including Ju Dou's liaison with her husband's middle-aged adopted son, the illegitimate birth of their child, a self-induced abortion, several murder attempts and two vengeful acts of arson — the film is calm, slow and dispassionate.

The director, Zhang Yimou, is a social critic who choreographs actions and images at the expense of emotions. Individual scenes jump out in brilliantly conceived moments. Beaten by her impotent husband because she has not borne a son, Ju Dou appeals to the lonely Tian Qing. When she discovers a peephole through which he watches her bathe, she is at first appalled. Later, she uses his voyeurism as a way to display the bruises that cover her body. By Western standards, it is a scene of extraordinary discretion and a mere shade of titillation. But by Chinese standards, both the character and the film are startlingly bold.

It is characteristic of Mr. Zhang's metaphorical approach that when Ju Dou and Tian Qing make love, the director cuts away to show a bolt of blood-red cloth unraveling in a vat of dye, establishing a major, recurring image. The old husband, eventually paralyzed from the waist down and reduced to crawling on the ground and propelling himself around in a bucket on wheels, will try to push Ju Dou's child into a vat. And years later the child himself, an adolescent disgusted with gossip about his mother's adultery and enraged at Tian Qing, will take his own revenge in a scene that involves the same vat of red dye associated with his conception.

All these neat images, all this obvious Oedipal wrangling, result in a film more intriguing to think and talk about than to watch. "Ju Dou" is one of the first major films to be made in the repressive, post-Tiananmen Square period by the daring group of Chinese film makers known as the Fifth Generation. Beginning his story in the 1920's and ending it in the 1930's, Mr. Zhang situates it safely in the pre-Communist period; yet his criticism of the ancient traditions that force Ju Dou to despair clearly reverberates through much of 20th-

century Chinese history. "Ju Dou" is an intellectually and artistically brave film. Asking for dramatic power and psychological depth as well may be expecting too much.

1991 Mr 17, 68:1

Legends

Directed by Ilana Bar-Din; photography by Claes Thulin; edited by Kate Amend; produced by Ms. Bar-Din. At the Roy and Niuta Titus Theater 1 at the Museum of Modern Art, 11 West 53d Street, as part of the New Directors/ New Films Series of the Film Society of Lincoln Center and he Film Department of the museum. Running time: 57 minutes. This film has no rating.

The Elvises: Jonathon Von Brana, Dave Scott, Tony Roi, Steve Person and James Rompel	
Marilyn	Susan Griffiths
Judy	Monica Maris
Sammy	Lonnie Parlor

Oreos With Attitude

Directed by Laurence Carty; a Zeitgeist Films Release. Running time: 30 minutes. This film has no rating.

By JANET MASLIN

Ilana Bar-Din, the director of "Legends," saves her scenes of a meeting of the Jonathon Von Brana Fan Club for fairly late in the film, which is a smart idea. The concept of a Jonathon Von Brana Fan Club requires leading up to. Jonathon Von Brana is not, by any reasonable standard, a famous person. He is only the tallest, cutest and generally most plausible of the several Elvis Presley impersonators connected with the Las Vegas revue of the title, a mesmerizingly sad spectacle that Ms. Bar-Din examines with tremendous verve, economy and wisdom.

"Legends" unfolds on the borderline between show business and science fiction, under the aegis of John Stuart, a Dr. Frankenstein in fringed buckskin. Mr. Stuart, the impresario behind the Legends concept, prides himself on his ability to create a new Elvis, Marilyn or Judy in a day, should there be any unwelcome displays of independence from the old ones.

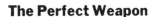

Adultery and Aftermath In a Chinese Village

"Ju Dou" was shown as part of last autumn's New York Film Festival. Following are excerpts from Caryn James's review, which appeared in The New York Times on Sept. 22, 1990. The Chinese-language film opens today at the Lincoln Plaza Cinema, Broadway at 63d Street.

•

The most dazzling element in "Ju Dou" is the everyday work of its

characters. In a Chinese village in 1920, a beautiful young woman named Ju Dou is married off to a belligerent older man who owns a factory where fabric is dyed. Though this weighty film is about the sins of the fathers, the oppression of women and passion challenging tradition, cheerful-looking banners of ruby, sapphire and topaz-colored cloth are hung to dry in the open air. They fly in the background as perpetual suggestions of

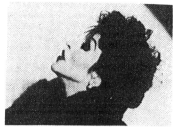

Monica Maris

Mr. Stuart has reduced impersonation to an entirely faceless ritual, one that has none of the humorous exaggeration or implied commentary that gay impersonators usually convey. Here it's strictly a job, and not a terribly demanding one (unless a performer opts for "makin' that extra step," by which Mr. Stuart means plastic surgery). Looking the part and going through a few basic moves is quite sufficient. The magic of the real Elvis, Marilyn and Judy is made that much more palpable by its total absence.

But the price of living knee-deep in the surreal can be very high, as "Legends" begins to reveal. Consider the sight of strange, lonely Jonathon Van Brana fans, whose hero is over two hours late for his appearance, prompting one to say proudly, "We're used to waitin' on Jonathon. He's worth waitin' for." This story's grotesque aspects go well beyond ordinary Las Vegas kitsch.

The film spends a lot of time with Monica Maris, who in transforming herself into Judy Garland has become a bizarrely tragic figure in her own right. Ms. Maris, obviously troubled by the strain of letting someone else take over her personality, has overreacted in frightening ways. "It's hard to explain how two people can live in a house and one person isn't even there," she says, about the house she thinks she has decorated according to Garland's standards. At other points she talks to herself in Garland's voice, and says tearfully "Sometimes I think, 'When is my life gonna come back again?'"

Ms. Bar-Din happened to be on hand for major events, including one death, one engagement, and labor disputes to make the usually smiling Mr. Stuart fighting mad. Even without these accidental extras, or without wonderful found moments (Ms. Maris to a Marilyn Monroe lookalike, with each one holding a doll-sized replica of her star: "Tell me, what's Arthur really like?"), this would be an enduringly strange and riveting film.

On the same bill in the New Directors/New Films festival, tonight at 9 and tomorrow at 6 P.M., is Laurence Carty's wickedly funny "Oreos With Attitude," about a socially ambitious black couple who decide to adopt — or "obtain," as they put it — a white child in hopes this may help them to fulfill their ambitions. But everything goes wrong: one of their new son's private-school friends, whose father is in "security," turns out to be a black child whose father is a night watchman. And when they succeed in meeting the Astors, there are surprises in store. Mr. Carty plays mercilessly with social-climbing stereotypes of all kinds.

1991 Mr 17, 68:5

FILM VIEW/Janet Maslin

Making A Living Off the Dead

I T MUST BE GERALD MELTZER'S LUCKY DAY. There he is, coaxed out of the audience and onto the stage of a Las Vegas nightclub, being personally serenaded by Marilyn Monroe. Marilyn teases open his shirt buttons to expose his undershirt, coos "My Heart Belongs to Daddy" adoringly and runs her fingers seductively through what's left of his thinning hair.

Marilyn Monroe happens to be dead, but that is only a minor inconvenience. It may even be a plus. In "Legends," a perceptive, funny and rivetingly bizarre documentary by Ilana Bar-Din that is one of the bright lights of this year's New Directors/New Films series at the Museum of Modern Art, death serves a purpose. It makes possible breakthroughs of which neither real live celebrities nor their devoted fans may have dreamed. Death becomes both tragedy and business opportunity, an overall boon.

So on the night the singer Rick Nelson dies in a plane crash, John Stuart, the impresario behind the celebrity-impersonator revue that gives "Legends" its title, a man who prides himself on the facelessness and instant replaceability of his celebrity stand-ins, is heard declaring that this terrible accident may be a cloud with a silver lining. He expects to wait until "a proper amount of respect and humility have

been given" — two and a half to three years, he figures — and then restore Rick to his fans.

"So if you happen to miss Rick Nelson, stick around and we'll bring him to you in our next chapter," Mr. Stuart promises solemnly, only moments after announcing the star's demise. Elsewhere in the film, Sammy Davis Jr. has barely expired before Mr. Stuart is coaching a whole new category of stand-ins to join forces with the Judys, Marilyns and Elvises who are already part of the act.

What is the point of this enterprise? For the stand-ins themselves, it can be ghoulish (Mr. Stuart's scarily unstable Judy Garland imagines that she shares her house with Judy's spirit and sometimes addresses remarks to Judy or to Louis B. Mayer). Or it can be pitiably naïve (one Elvis, who became so popular that he developed his own fan club, wants "to grow up and be humble and nice and sweet and rich and famous"). For Mr. Stuart himself, who likens this

Susan Griffiths as Marilyn Monroe and Jonathan Von Brana as Elvis Presley in "Legends"

form of entertainment to the moving of London Bridge to Lake Havasu City, Ariz., the point is obvious. Mr. Stuart is seen driving in his convertible, talking on his car phone and giving a tour of his expensive new Legends ranch, which he says has something to do with the American dream.

But what's in it for an audience? The point of celebrity impersonations becomes obscure when almost every aspect of the real celebrity is available for public delectation. Back in the pre-television days when heroes or other important public figures were largely unseen, it made sense for actors to bring them to the public through impersonation. But nowadays, with video images and tabloid headlines and tell-all biographies to capture the celebrity's life and work in full, the art of the stand-in serves a different purpose. It's a long way from Hal Holbrook's enduring stage show based on the life of Mark Twain, for example, to the recent television movie in which Suzanne Pleshette perfectly mimicked the throaty growl and sourpuss facial expressions of Leona Helmsley.

Today's instant celebrities need not even be deceased to be thus immortalized, but it helps. A dead star is a safe star, from the standpoint of both audience and entrepreneur. A dead star can even be marketed, like Vivien Leigh in "Gone With the Wind" or Miss Garland in "The Wizard of Oz," as a costly china figurine to be incorporated into one's very own household décor. You can put it on a pedestal, or you can smash it into a million pieces. Whatever you do, the star is now tame enough to be all yours.

■

On the evidence of stage phenomena like "Buddy" and "Beatlemania" or films like "Lenny" and "The Buddy Holly Story" and "La Bamba" and "The Doors" or even any of the myriad books that purport to invade the thoughts of well-known stars of the video age, the danger that such re-enactments will appear redundant does not ruin the fun of their

immediacy. The chance to be placed in proximity with a once-Olympian pop figure seems to be enough to attract a crowd. But how deep does this really go? How often do such efforts offer anything more than a closer look, warts and all?

Sometimes they do. "Lenny" (1974) tried to capture the explosive disparity between its hero and the culture that both admired and reviled him. And in "The Doors," an unusually colossal effort within the waxworks genre, Oliver Stone attempts to present Jim Morrison as emblematic of a turbulent, reckless, fast-changing world. Not even this pro-Morrison portrait can make the case that the singer's downfall was anything but his own fault, but his excesses are presented with frightening force. Merely watching Val Kilmer unravel, in the course of his unnervingly accurate performance, becomes an intensely evocative experience for a viewer with strong memories of Jim Morrison and his heyday.

Although 20 years have passed since Morrison's death, the film regards him at very close range. It doesn't equal the weird intimacy of "This Is Elvis," in which a voice purporting to be the late singer's offered a tour of Graceland, his Memphis house, but neither does "The Doors" view Morrison with as much bristling detachment as Mr. Stone's films usually offer. The intent appears to be resurrection rather than reassessment, but at least adulatory vision of "The Doors" isd not denatured. Jim Morrison has not joined Marilyn in running his fingers through audience members' hair. □

1991 Mr 17, II:13:5

Fallen From Heaven

Directed by Francisco J. Lombardi; screenplay (Spanish with English subtitles) by Mr. Lombardi, Giovanna Pollarolo and Augusto Cabada; photography by J. L. López Linares; edited by Alberto Arévalo; music by Alejandro Massó; production company, Tornasol Films S.A. (Spain)/Inca Films (Peru) with TVD, S.A. and Quinto Centenario. At the Roy and Niuta Titus Theater-1, 11 West 53d Street, as part of the New Directors/New Films Series of the Film Society of Lincoln Center and the Department of Film of the Museum of Modern Art. Running time: 123 minutes. This film has no rating.

Don Ventura/Humberto	Gustavo Bueno
Verónica	Marisol Palacios
Jesús	Elide Brero
Lizardo	Carlos Gassols
Meche	Delfina Paredes
Tomás	Nelson Ruiz

By CARYN JAMES

At the center of "Fallen From Heaven" is a pig as big as a cow. In most Latin-American films, the presence of such a bizarre creature would be a cue to bring on the magical realism, to make the pig fly or at least have some smart conversations. But one of the brightest touches in this alluring film from Peru is that it teeters on the brink of magic without ever resorting to impossible events. Though "Fallen From Heaven" ultimately takes the shape of a dark comic parable about life, fate and death, the route to those giant themes is wry, twisty and lighter than a pig's wings.

The episodic narrative weaves deftly among three connected sets of characters ranging across Lima's social classes: Lizardo and his wife, Jesús, an old couple bent on completing a marble mausoleum even if it means selling the family heirlooms; their former housekeeper, a blind old woman who lives in a shack with her two small grandsons, and a radio talk-show host whose on-air name is Don Ventura. He tells stories of people who conquer impossible odds and gives inspirational advice that always ends with the take-charge admonition "You are your fate."

The director, Francisco J. Lombardi, links the story's threads smoothly, without forced connections. Lizardo owns a row of houses. One tenant is Don Ventura. Another is an

Elide Brero in the film "Fallen From Heaven."

unimportant character who, instead of paying the rent, offers the old folks the pig, which they give to the blind woman.

As "Fallen From Heaven" takes us deeper into these apparently ordinary lives, the film begins to question the wisdom of Don Ventura's radio show, called "Life Lessons." The characters' circumstances grow darker and more absurd at once. Jesús prays for death, which will unite her with their dead son, while Lizardo warns: "Don't be in such a rush. We still owe money."

The old woman becomes obsessed with sending her grandsons to the local dump to collect food to fatten up the already-huge pig and will not relent even when the boys are sick and hungry.

Seen outside his darkened studio, the sanguine Don Ventura has a deeply scarred face and discovers his own melodrama when he saves a young woman from jumping off a cliff. She moves in with him, chastely, and guards some disturbing secret.

The evidence mounts that everyone is dying or wounded or helpless. And the stories eventually yield disturbing questions: Is a house in this world more important than a house in the next? Will a scarred man be repulsed by physical imperfection? How far should you go to feed a prize pig?

The plots are tied up in wickedly appropriate and unexpected ways, relying on the kinds of coincidences that only exist in parables and other life lessons. But, the film suggests, who's to say life is less strange than that?

The actors are wonderfully restrained, especially Carlos Gassols and Elide Brero, who make Lizardo and Jesús's building plans sweet and sensible. The film wanders vibrantly from a peaceful cemetery to a dump, without making a fuss about social class. That restrained manner gives "Fallen From Heaven" much of its effectiveness and its ability to sneak up on viewers with its dark little surprise endings.

Running just over two hours, the film feels about 20 minutes too long. But it is worth sitting through some redundant scenes until the story twists back on itself, livelier than ever. "Fallen From Heaven" will be shown tonight at 9 and tomorrow at 6 P.M. as part of the New Directors/ New Films series at the Museum of Modern Art. Its playful yet bleak vision is so vividly realized that Mr. Lombardi stands out as a distinctive new voice.

1991 Mr 18, C12:3

Time of the Servants

Directed and written by Irene Pavlaskova; in Czech with English subtitles; photography by S. A. Brabec; music by Jiri Vesely and Jiri Chlumecky; production company, Barrandov Film Studios. At the Roy and Niuta Titus Theater 1, 11 West 53d Street, as part of the New Directors/New Films series of the Film Society of Lincoln Center and the Department of Film of the Museum of Modern Art. Running time: 115 minutes. This film has no rating.

Dana	Ivana Chylkova
Milan	Karel Roden
Lenka	Jitka Asterova
Marek	Miroslav Etzler
Lubos	Libor Zidek
Bohunka	Eva Holubova
Hanka	Vilma Cibulkova

By JANET MASLIN

The stunning monster at the heart of "Time of the Servants," a Czechoslovak film that can be seen tonight at 9 P.M. and tomorrow at 6 P.M. as part of the New Directors/New Films series, first appears as a plain, desperately unhappy young woman. Dana (Ivana Chylkova) has just been jilted. Her friends Milan (Karel Roden) and Lenka (Jitka Asterova), a sweet and devoted couple, make the terrible mistake of offering their sympathy.

Dana accepts it — and with a vengeance. What better way to upset Malek (Miroslav Etzler), her former beau, than to show up with Milan on her arm? And why stop there? Would not Malek be devastated if he learned that Milan and Dana had married, and if someone sent him wedding photographs to prove it? Lenka and Milan aren't mad about this idea, and at the very least they think Dana ought to find some other imposter to play her groom. But Dana is, as the film's audience is beginning to learn, unnaturally persistent. "Who else can I trust but my friends?" she asks plaintively.

So a wedding is held, with Lenka waiting uneasily on the sidelines. Afterward, all is temporarily as it was before. But now Dana begins to think

that Milan might be worth keeping. Soon she has lured him into bed, betrayed her best friend, and demanded to be brought to meet Milan's mother, who instantly dislikes her. "Everyone needs love, not only those who beg for it," the mother says.

Best friends don't usually have to sacrifice a husband.

"Time of the Servants," written and directed by Irena Pavlaskova, takes off from this auspiciously evil beginning to tell the tale of Milan's ruin and Dana's bitter ascendancy. When next seen, Dana has abandoned her schoolgirl aprons for a look of chain-smoking sophistication, and has come to treat Milan — now the father of her child — with outright disdain. One day, a couple of her friends drop by just as Dana is preparing to subjugate her husband further by means of contemptuous sex. "I've just got to see to Milan," she tells the women as she disappears into the bedroom. She emerges in her bathrobe not long afterward, saying dismissively, "Well, that's that."

This grasping, magnetic, phenomenally poisonous character is intended as the centerpiece of a political parable. And indeed, if "Time of the Servants" were a film of Rainer Werner Fassbinder's, she would feel like one. As it is, Miss Pavlaskova's allusions to the state of Czechoslovak society, to a collective weakness of will and to Dana as someone who might have been helped by feminism (she dropped out of medical school to destroy Milan full time) are too unfocused to be effective. The film works best as a character study fueled by dark sensuality, and as a chilling drama in the "Bad Seed" mold.

Miss Chylkova grows and changes persuasively throughout this character's scary evolution, and she holds the interest throughout. Tall and gaunt, she makes physical intimidation a large part of Dana's power, but there is also an utter fierceness that informs her every move. This actress makes Dana's cunning persuasive even when her exploits, like the marriage proposal, come close to defying belief. "She thinks you're unattractive," she says to a man she intends to seduce. "I think you're just the opposite. So you cannot disappoint me." And he does not.

Mr. Roden is also good in the quieter role of a man who has been made to hate himself almost as much as Dana hates him, and whose last hopes for happiness have apparently been demolished. Also notable is Ms. Asterova, a gentle actress who makes Lenka comprehensible when she could easily have been nothing more than a well-meaning fool.

1991 Mr 19, C12:3

If Looks Could Kill

Directed by William Dear; screenplay by Darren Star, story by Fred Dekker; director of photography, Douglas Milsome; produced by Craig Zadan and Neil Meron; released by Warner Brothers. Running time: 89 minutes. This film is rated PG-13.

Michael Corben Richard Grieco
Ilsa Grunt.. Linda Hunt
Augustus Steranko Roger Rees
Mrs. Grober................................ Robin Bartlett
Mariska Gabrielle Anwar

By STEPHEN HOLDEN

"If Looks Could Kill," a comedy-adventure film that marks the screen debut of the television star Richard Grieco ("21 Jump Street" and "Booker"), cannot decide if it's a spoof of James Bond movies or a piece of teen-age fluff.

In the film, which opened at local theaters on Friday, Mr. Grieco plays Michael Corben, a teen-age brat who, through a ludicrous mix-up, becomes a spy for British Intelligence while embarking on a European tour with his high school French class. Equipped with such wonder toys as

Warner Brothers

Mistaken Identity

Gabrielle Anwar and Richard Grieco appear in "If Looks Could Kill," about a high school student mistaken for a top American secret agent and enmeshed in international intrigue during a French club trip to Paris.

exploding chewing gum, X-ray sunglasses and a rocket-armed sports car, Michael goes up against Augustus Steranko (Roger Rees) a financial shark with Hitlerian fantasi of reigning over a united Europe.

movie has its moments when poking fun at the clichés of James Bond films. In the most amusing, Linda Hunt does a lip-smacking caricature of Lotte Lenya in "From Russia With Love." As Ilsa Grunt, Augustus's partner in crime, Ms. Hunt goes to guttural extremes to affect a German accent while brandishing a whip whose lashes tighten like deadly claws around the necks of her enemies.

The film's fatal flaw is the charmless performance of its star, who displays so little enthusiasm that in looking for signs of life the viewer's attention is likely to drift to his weirdly

plucked Mr. Spock eyebrows. Mr. Grieco's problems can be blamed partly on the director, William Dear, who plunks him into some potentially funny situations but then leaves him stranded without a clue as to how to proceed.

•

"If Looks Could Kill" is rated PG-13 (Parents strongly cautioned). It has brief scenes of nudity.

1991 Mr 19, C12:5

Peaceful Air of the West

Directed by Silvio Soldini; screenplay (Italian with English subtitles) by Mr. Soldini and Roberto Tiraboschi; photography by Luca Bigazzi; edited by Claudio Cormio; music by Giovanni Venosta; production companies; Monogatari/PIC Film with SSR-RTSI. At the Roy and Niuta Titus Theater 1, 11 West 53d Street, as part of the New Directors/New Films series of the Film Society of Lincoln Center and the Department of Film of the Museum of Modern Art. Running time: 100 minutes. This film has no rating.

Cesare Fabrizio Bentivoglio
Irene .. Antonella Fattori
Tobia................................... Ivano Marescotti
Veronica Patrizia Piccinini
Clara.. Silli Togni
Rosa.. Olga Durano
Mario................................. Roberto Accorncrò
Cesare's Friend............................ Cesare Bocci

By JANET MASLIN

In the sly, beautifully modulated Italian film "Peaceful Air of the West," the director Silvio Soldini manipulates his characters' unspoken dreams. The principal figures, who are apparently unrelated as the film begins, are sedate young Milanese professionals with a rich supply of hidden distress but no overt awareness of their own dissatisfaction.

Demonstrating a highly developed sense of gamesmanship as well as exceptional cinematic prowess, Mr. Soldini studies them closely and searches for cracks in their composure. His film takes quiet glee in watching lives of perfect middle-class orderliness begin to unravel.

Mr. Soldini, whose direction has the cool visual meticulousness of Jean-Luc Godard's, begins by introducing separate figures and then brings them tantalizingly close together. Among the story's principals are a nurse (Patrizia Piccinini) who so fully embraces duality that she has two different names and two different hair colors during the course of the film. It is on a one-night stand, with a man later intent on finding her, that this nurse loses her datebook and provides the film with its initial momentum.

Meanwhile, a prim doctor (Ivano Marescotti) who is half of a high-powered, two-career couple (his wife pays tiresome attention to the ingredients of her healthy breakfast before breezing off to work) is quietly coming apart at the seams. "I don't want to hear about medicine at the moment," he announces at work one day, and then he stops showing up. There is a moment in their designated morning routine when he and his wife simultaneously pull their cars out of the garage and go their separate ways, but the husband begins sneaking back home. Only when he shows up in a loud shirt that offends his wife's fashion sense does she begin to notice that anything has changed.

Another of the film's characters is a translator (Antonella Fattori), recently moved to Milan from Siena, who has begun to doubt her professional competence. "I feel like dropping everything," she says, speaking for virtually everyone in the film, though few of the others have the chance to express this thought so clearly. To underscore that point, the translator's typewriter is thrown out a window and onto a busy street, where it is crushed by traffic.

Mr. Soldini, after exposing the first glimmers of such doubts, creates a series of near misses and close encounters between the principals. Various objects — the missing datebook, a lottery ticket, a tape recording — become critical in determining whether the characters' lives will truly intersect. In the end, "Peaceful Air of the West" is hampered by a reserve not unlike the characters', as Mr. Soldini limits the possibility of real change to events that are rueful and small. But the film's discretion, while finally deflating, is for the most part a source of cleverness and vigor.

"Peaceful Air of the West," a film of great deliberateness and precision, can be seen tonight at 9 and tomorrow at 6 P.M. as part of the New Directors/New Films series.

1991 Mr 20, C12:5

The Captive of the Desert

Directed by Raymond Depardon; in Toubou with English subtitles; photography by Mr. Depardon; edited by Roger Ikhlef, Camille Cotte and Pascale Charolais; music by Jean-Jacques Lemêtre; produced by Pascale Dauman and Jean-Luc Ormières. At the Roy and Niuta Titus Theater 1, 11 West 53d Street, as part of the New Directors/New Films Series of the Film Society of Lincoln Center and The Department of Film of the Museum of Modern Art. Running time: 100 minutes. This film has no rating.

WITH: Sandrine Bonnaire, Dobi Koré, Dobi Wachinké, Atchi Wahl-li, Fadi Taha, Badei Barka, Daki Koré, Isai Koré, Brahim Barkaï, Barkama Hadji, Mohamed Ixa, Hadji Azouma and Sidi Hadji Maman.

By VINCENT CANBY

A camel caravan moves across the otherwise empty desert. The pace is surprisingly brisk, in view of the heat of the white-hot sun, which also bleaches nearly all color from the world. There is purpose to the caravan. Its direction remains fixed, though without apparent guideposts.

The camels and men move single file, in silence. As the caravan passes from left to right across the screen, in middle distance, the camera stares straight ahead. It seems as disinterested as a sidelined camel chewing its cud. Camels, dark-complexioned men, more camels, more dark-complexioned men.

Bringing up the rear of the caravan is a young, very white woman wearing a dress and sandals and carrying a small tote bag over her shoulder. Two dark-complexioned men with guns follow.

•

These opening images set the tone and manner of Raymond Depardon's austere, handsome-looking French film, "The Captive of the Desert" ("La Captive du Désert"), which will be shown tonight at 9 and on Saturday at 3 P.M. as part of the New Directors/New Films series.

"The Captive of the Desert" is based on a story covered by Mr. Depardon as a photographer in 1975, when rebels in the Western Sahara held a young French woman hostage for a number of months.

The point of the film, though, which is virtually without dialogue, is less political than poetic. "The Captive of the Desert" is about man (in this case, a woman, played by the beautiful Sandrine Bonnaire) coming to some new self-realization in an alien landscape.

It's also the kind of film that one immediately accepts without question, in its poetic entirety, or resists, at first reluctantly.

Mr. Depardon does a splendid job as his own cameraman. His images have a soothing purity about them that evokes the sense of what it's like to be in a great desert. The awareness of space is liberating. The light of noon lasts throughout the day; when suddenly it's night. Dawn and dusk are instantaneous phenomena.

Sounds are heard more clearly. Their associations are sometimes unexpected. As the woman puts one foot in front of the other, there is a crunching noise, as if the sand were sugar.

The camera seems always to be at a distance, even in the occasional close-ups. It watches impassively as the woman walks, sits, eats, drinks and sleeps. One night a captor puts a blanket over her. At another time she attempts to bathe herself, but runs out of water before she has rinsed off the soap.

One watches these small details with care. There is nothing else to look at. After a while, thoughts stray. Doubts arise.

How does this woman, who has such fresh, fragile white skin, remain so impermeable to the burning rays? She has no hat, no sun block. Considerations of the universe give way to suspicions of a not especially elevating sort. The woman has the hide of a hippo.

There are vignettes that help pass the time. During an afternoon break, the woman teaches some curious nomads a song. Once she finds she can't stomach the food that's been given to her. In a momentous decision, she runs away.

Early in the film she takes from her tote bag some snapshots that would seem to indicate that she is a schoolteacher. There are also photos of a young man. Late in the film it's clear that she has passed through some crises of thought and emotion when she burns the snaps and her address book.

The end of the film, which comes none too soon, is a letdown.

"The Captive of the Desert" might be interpreted as an answer to the steamy melodrama of Bernardo Bertolucci's "Sheltering Sky." In fact, "The Captive of the Desert" is no less romantic, just less specific.

Sharing the bill with "The Captive of the Desert" is Jay Rosenblatt's 10-minute short, "Short of Breath," which may or may not tell the tale of a woman who, after the birth of her baby, jumps out a window. How the material is interpreted is left up to the audience.

"Short of Breath" is a Rorschach test with moving images instead of ink blots.

1991 Mr 21, C20:3

Teen-Age Mutant Ninja Turtles II
The Secret of the Ooze

Directed by Michael Pressman; written by Todd W. Langen, based on characters created by Kevin Eastman and Peter Laird; edited by John Wright and Steve Mirkovich; music by John Du Prez; production designer, Roy Forge Smith; produced by Thomas K. Gray, Kim Dawson and David Chan; released by New Line Cinema. Running time: 88 minutes. This film is rated PG.

April O'Neil	Paige Turco
Prof. Jordan Perry	David Warner
Michaelangelo	Michelan Sisti
Donatello	Leif Tilden
Raphael	Kenn Troum
Leonardo	Mark Caso
Splinter	Kevin Clash
Keno	Ernie Reyes Jr.
Shredder	François Chau
Tatsu	Toshishiro Obata
Rahzar	Mark Ginther
Tokka	Kurt Bryant

By JANET MASLIN

QUESTION: How many Teen-Age Mutant Ninja Turtles does it take to screw in a light bulb?

Answer: 2,869. One to change the bulb and the rest to stand by at the nearly 3,000 screens on which "Teen-Age Mutant Ninja Turtles II: The Secret of the Ooze" opens today, collecting huge amounts of money from fans obviously willing to watch the Turtles, whatever they do. Considering the runaway success of the first live-action Turtles feature, which was boring and dim, a plot maneuver like changing a light bulb would hardly be out of the question.

Luckily, this time the price of admission is, at least in psychic terms, a lot less steep. Purists may complain that the Turtles fight less, clown more and stray too far from their beloved sewers. But for anyone else these are definite improvements, as are the more varied settings, the upgrading of the Turtles' friend April O'Neil, the presence of at least one actor (David Warner) whom parents in the audience stand a chance of recognizing, and the treatment of Ninja fight scenes as the playful dance sequences that they essentially are. If the Turtles insist on remaining a mainstream

New Line Cinema

box-office attraction, at least they've now had the decency to make a mainstream movie.

There is a reasonable argument that Michaelangelo (Michelan Sisti), Donatello (Leif Tilden), Raphael (Kenn Troum) and Leonardo (Mark Caso) represent everything that has gone wrong with Western civilization. It begins with the Turtles' great love of junk food, moves on to the glee they take in garnering big tabloid headlines, and ends with the fact that they were given names from a Renaissance art book that their mentor Splinter (Kevin Clash), the world's most prominent man-sized rat, once found in a gutter.

Of course, these streaks of adolescent anarchy are also what make the Turtles so bodacious, as they themselves might put it, and such irresistible role models for anyone too small to know better. Capitalizing on their own greatest assets, the Turtles this time also throw in rap music (as represented by Vanilla Ice), references to pop luminaries like Arnold Schwarzenegger, an elaborate disco kung fu sequence, and a friendly nod to the competition. Bart Simpson's likeness is seen on a glass filled with a foul-smelling antidote to toxic waste.

This new film, dedicated to the memory of Jim Henson (whose Creature Shop provides the movie's amusing animatronic characters), finds the Turtles still camping out at the apartment of the television reporter April O'Neil. Like everything else in this second installment, April looks better, largely because she is played by a different actress (Paige Turco) and makes no attempt to resemble her earlier counterpart. The audience, however avid, is not expected to have much of an attention span.

April is still friendly and forgiving, but her patience is being tried by the skateboards, comic books, pizza cartons and other detritus strewn around her apartment by these fun-loving guests. "The *rat* is the cleanest one," she sighs, thinking of wise old Splinter, who has also moved in. Whiskery and damp-eyed as ever, he is the one exception to the now-looks-better rule.

This story, written by Todd W. Langen and directed by Michael Pressman, takes the Turtles back to their roots, which are chemical. When April reports on an attempt to move a toxic landfill, she inadvertently stumbles across the same ooze (hence the title) that transformed the Turtles from small green pets to world-famous movie stars, and onto a plot to give this forbidden substance to Shredder (François Chau), practically invisible inside a metal helmet with shingles), the boys' regular nemesis.

These developments, which have the predictable effect of making the Turtles fighting mad, also make them wistful. It's depressing, one tells Splinter, to think their special powers are no more magical than the contents of a test tube. "Do not confuse your origins with your present worth," says Splinter, ever the fortune-cookie sage. Regardless of what one thinks of his syntax, at least it's a reasonable message.

The Turtles, when not battling Shredder or providing Vanilla Ice with the basis for a rap number, kid

around in enjoyable ways. They clean April's apartment while disco dancing; they confer in football huddles; they try out new words ("Ec-lec-tic!") to replace the customary Turtle exclamation, which is "Cowabunga!" Anyone who did not know that in the first place will probably not care to find it out now.

Also in the film are a couple of cute monster mutants named Tokka and Rahzar, who started out respectively as a snapping turtle and a wolf. On the human end of the spectrum, the high-kicking Ernie Reyes Jr. does

New Line Cinema

Splinter

nicely as a pizza delivery boy who functions as the film's karate kid. They can doubtless be found soon at the toy store as well as on the screen.

●

"Teen-Age Mutant Ninja Turtles II: The Secret of the Ooze" is rated PG (Parental guidance suggested). It contains mild violence.

1991 Mr 22, C1:3

Slacker

Directed, produced and written by Richard Linklater; cameraman, Lee Daniel; edited by Scott Rhodes; production company, Detour Filmproduction; released by Orion Classics. At the Roy and Niuta Titus Theater 1, the Museum of Modern Art, 11 West 53d Street, as part of the New Directors/New Films series of the Film Society of Lincoln Center and the department of film of the Museum of Modern Art. Running time: 97 minutes. This film has no rating.

WITH: Richard Linklater, R. Basquez, J. Caggeine, J. Hockey, S. Hockey, M. James, S. Dietert, B. Boyd and others.

Aunt Hallie

Directed by Stéphen Mims; a Fanlight Productions Release. Running time: 9 minutes.

By VINCENT CANBY

The place is Austin, Tex. The time, morning, afternoon, night, and morning again.

A young fellow in a car runs over his mother and speeds off home, to wait for the police. At the scene of the accident, amid talk of calling an ambulance, a man tries to pick up a young woman jogger.

A guy sitting in a restuarant asks his friends, "Who's ever written the great work about the immense effort required *not* to create?"

A few blocks away a stoned soothsayer is revealing, though probably not for the first time, "We've been on Mars since 1962."

In another part of the city, an amateur political scientist points out with suitable gravity, "The large non-voting majority has been winning all the

elections for the last several decades."

Meanwhile, a young woman is trying to sell what she swears is Madonna's Pap smear. Apropos of an emotional breakthrough he's just had, an

A feature of non sequiturs and a 9-minute film about good manners.

intense fellow says, "I mean it's like no longer not yet."

These are just some of a hundred or so relentlessly eccentric people who amble in and out of Richard Linklater's "Slacker," a series of unconnected vignettes that open one into another somewhat in the manner of Luis Buñuel's "Phantom of Liberty."

"Slacker" will be shown today at 9 P.M. and tomorrow at 12:15 P.M. as part of the New Directors/New Films series. Sharing the program is a very special short subject, Stephen Mims's "Aunt Hallie," which belongs on everybody's list of top-10 funniest nine-minute movies ever made.

As they might say in the Deep South, which is its locale, "Aunt Hallie" is a treasure. It's a sober-faced recollection of a beloved aunt by the narrator, a benign, bearded fellow who looks a lot like Robert Benton, the writer and director.

Standing in the front yard of a large, comfortable old small-town mansion, the narrator remembers that dreadful morning many years ago when Aunt Hallie found a condom in the grass. The old lady quickly rid herself of the thing by picking it up with the handle of a rake. She later had the grass mowed to destroy all traces.

As the days, weeks and months passed, Aunt Hallie became increasingly obsessed by the thought that "the old nasty disease" carried by the thing has entered the house and, in particular, by the conviction that it had infected her.

She took to using her own plates, glasses and silverware to protect the other members of the family. Deciding that her hands were "the clearest means of contagion," she began to wear little white gloves around the house.

Good manners prevented her from wearing the gloves when she went visiting. This led to special difficulties when she was in her brother's house, where she liked to sit in a rocking chair whose seat was low and arms were high.

To get out of the chair, in ordinary circumstances, she would simply put her hands on the arms and lift herself. Not wanting to spread the contagion, though, and not wanting to make a fuss, she had to find another means by which, well, to eject.

How Aunt Hallie conquered this problem is the climax of the film, which not only is hilarious, but also contains a moral for our time. Like all good short subjects, "Aunt Hallie" is not an instant too long.

●

"Slacker" is a 14-course meal composed entirely of desserts or, more accurately, a conventional film whose narrative has been thrown out and replaced by enough bits of local color

Orion

Teresa Taylor in "Slacker."

to stock five years' worth of ordinary movies.

Some of it is very funny, including an opening sequence that features the director. The members of Mr. Linklater's cast, most of whom are nonprofessionals, are so amazingly effective that it's hard to believe they didn't make up their own lunacies.

Instead, these lunacies come from Mr. Linklater's notebook. For years he's been jotting down curious scenes he's witnessed, and swatches of mad conversations overheard, the sort that all of us try to remember but immediately forget.

Mr. Linklater apparently sees his characters (or, as he calls them, slackers) as somehow representative of our time. Yet, aside from their frequently upside-down syntax, they seem to be ageless in their oddities. That's fine.

•

Their charm and humor, however, are not inexhaustible. After a while, a certain monotony sets in, as well as desperation. It isn't easy being eccentric, and it's even more difficult to remain eccentric in the company of other eccentrics. A terrible transformation occurs: the unusual begins to look numbingly normal.

Toward the end of "Slacker," a sane voice might bring down the house, but it's not there.

1991 Mr 22, C8:1

Home Less Home

Directed and produced by Bill Brand; written by Mr. Brand and Joanna Kiernan; photography by Zoe Beloff; edited by Ms. Kiernan. At the Roy and Niuta Titus Theater 1 at the Museum of Modern Art, 11 West 53d Street, as part of the New Directors/New Films series of the Film Society of Lincoln Center and the department of film of the Museum of Modern Art. Running time: 70 minutes. This film has no rating.

WITH: Eric Booker, William Farrior, Maria Fernandez, Ronald Banes, Anthony Rose, Thomas Steed, Edward N., Deeanna Wood, Yvette Dennis and others

Blackwater Summer

Directed by Christopher Dudman. Running time: 30 minutes. This film has no rating.

By JANET MASLIN

In his documentary "Home Less Home," Bill Brand does something that should not be as unusual as it is.

He approaches homeless people with a camera crew and asks who they are, how they became homeless and what they do to survive. The answers, while not surprising, give individual faces to problems that are too easily reduced to generalities. "The American ideal of freedom and justice is out of sync with the facts," he concludes, after having amassed sad and persuasive evidence to corroborate that statement.

The testimony of many homeless people would have been a sufficiently urgent basis for any documentary film on this subject. But Mr. Brand goes further, offering a disquisition on the connections between the condition of the homeless and the consequences of studying it as a series of images. Those images, he maintains, have the effect of distancing a viewer from reality. That point may be accurate, but for a film maker it is also academic and somewhat self-defeating.

"It's not that we can't examine what it's like," Mr. Brand says of homelessness. "It's that we need to examine the sources of our imagina-

How observing can distort and make reality recede.

tion." So the film includes scenes from Preston Sturges's famous "Sullivan's Travels," in which a successful film maker (Joel McCrea) and his wisecracking companion (Veronica Lake) impersonate hobos and hitch a ride on a freight train. "This screwball comedy supports the idea that we can only understand what we experience," Mr. Brand observes.

•

The film looks back frequently to earlier images of homelessness, mostly from the Depression; there are still photographs by Walker Evans, Dorothea Lange, Berenice Abbott, Jacob Riis and many others. But these glimpses, says Mr. Brand, "help create a distance in me, so that even as I'm experiencing the present I'm imagining another place and time." Even the film's scenes of contemporary homeless people living

New Directors/New Films

Scene from "Home Less Home."

near the Port Authority Bus Terminal or in City Hall Park or at shelters around New York City take on a degree of unreality in this context. "We're so accustomed to homeless people as voiceless victims that when they speak, we no longer believe they are homeless," Mr. Brand says.

The homeless people interviewed in the film are exceptionally calm, articulate and intelligent by any standard. Even the former psychiatric patients heard here sound unusually sane. Mr. Brand maintains that the idea that many homeless people are mentally ill is one more way of oversimplifying homelessness and keeping it at a distance. He argues for a more all-embracing way of understanding homelessness, one that takes into account the interplay between unemployment, drugs, poor health care, inflated housing costs and other contributing factors.

The film's outright evidence is often more effective than its academic analysis. Mr. Brand offers cogent examples of media distortion in reporting on homelessness (as in a television account of a windshield washer who claims to make $180 on a good day), and provides facts and figures to attest to the impossibility of escaping homelessness once it has set in. Still, this bleak and disturbing film concludes on a hopeful note, as two homeless young boys eagerly discuss their ambitions. Even in this disheartening atmosphere, ideas of becoming a policeman or a rock star or a world-famous boxer are not out of the question.

•

On the same program at the New Directors/New Films series is "Blackwater Summer," Christopher Dudman's prettily executed, slightly precious account of a young girl's last carefree days during a vacation that is interrupted by family tragedy. This film's romantic seashore setting is in marked contrast to anything Mr. Brand's film contains. Both can be seen tonight at 6 and Sunday at 9 P.M. at the Museum of Modern Art.

1991 Mr 22, C8:5

Defending Your Life

Directed and written by Albert Brooks; director of photography, Allen Daviau; film editor, David Finfer; music by Michael Gore; production designer, Ida Random; produced by Michael Grillo; presented by Geffen Pictures; distributed by Warner Brothers. Running time: 110 minutes. This film is rated PG.

Daniel Miller	Albert Brooks
Julia	Meryl Streep
Bob Diamond	Rip Torn
Lena Foster	Lee Grant
Dick Stanley	Buck Henry

By JANET MASLIN

Not one theologian speculating about the next world has ever imagined a place with three championship golf courses and tour guides who encourage new arrivals to "sit back and have fun!" But then Albert Brooks, whose vision of the afterlife as a conventioneer's daydream is the basis for "Defending Your Life," is no ordinary thinker in any sphere.

Mr. Brooks, one of the screen's most attractive cranks, has concocted an incomparably paranoid scheme for determining whether one's life on earth will merit a first-rate hotel room in the great beyond. Judgment Day, presented here in the form of a

courtroom hearing enlivened by film clips of the subject's most humiliating moments, becomes a polite occasion for confirming each individual's worst self-doubts.

Within the larger context of the Brooks oeuvre, this pleasantly mortifying arrangement makes perfect sense. In the past, this writer and director has followed his most unhelpful imaginings wherever they might lead him, usually to personal and professional disaster. His 1979 "Real Life" watched a cinéma vérité film maker drive an American family crazy; his 1986 "Lost in America" showed how a successful executive could turn himself into a school crossing guard without missing a beat. The inherent (and very funny) fatalism of these works seems no less reasonable after death than it did among the living.

"Defending Your Life" takes place in a theme park-style way station for the newly departed, whose future destinations will be determined on the

Geffen

Albert Brooks in "Defending Your Life."

basis of their courtroom hearings. Mr. Brooks plays Daniel Miller, a yuppie who dies for the love of his brand-new BMW in the film's opening sequence, and who now finds himself in sugar-coated limbo. The blue skies, big smiles and perfect courtesy of Judgment City are unflagging, which, of course, makes them as faintly hellish as they are super-nice.

•

As a director, too, Mr. Brooks is in a transitional place this time, since "Defending Your Life" is a relatively elaborate and expensive production. His earlier films, no matter how much expense and professionalism went into them, always felt comfortably homemade. But the much bigger "Defending Your Life" has elaborate sets, a complicated premise and even some model and matte shots during its climactic chase scene, all of which are at odds with Mr. Brooks's fundamentally simple tactics. The role of a visitor and defendant also calls for him to be more quietly observant than usual, even though the stubborn tirade, the unreasonable argument and the suspicious rant are the best of his comic devices.

"Are floods coming? Hoover Dam broke? What do you know that I don't?" he demands of a friend in the film's opening episode, defiantly wondering why his companion drives a Jeep. This same wary attitude persists, even in muted form, after Mr.

Brooks's Daniel finds himself being processed by the orderlies, guides, check-in clerks and bellhops of the afterworld. Sure enough, he locates an element of condescension in all this friendliness, especially after his defending attorney (Rip Torn) tells him that pre-deceased earthlings are known as "littlebrains."

Even the advantages of being able to eat anything he wants without gaining weight are ruined for Daniel when he insists on sampling his lawyer's lunch. Smart people in the next world, he learns, pride themselves on being able to eat things that taste awful. The film's food jokes go on for a long time without ever really crystallizing, which is another departure from the quick, throwaway style of Mr. Brooks's past work. Many of this film's devices, including the courtroom flashbacks to Daniel's past, require a lot of set-up before they begin to move.

"Defending Your Life" also features a very flirty and charming Meryl Streep as Julia, the ideal mate whom Daniel has to die to meet. The extremely considerate Julia does all she can to shield Daniel from the fact that she has been assigned a much nicer hotel than his, and that her courtroom scenes show her rescuing children and a cat from a burning building. His show him being trounced by the schoolyard bully, caving in to pressure on the job and turning down an early opportunity to buy stock in the company that makes Casio watches.

Also in "Defending Your Life" are Lee Grant, nicely fierce as the prosecutor who plans to take Daniel apart; Buck Henry as a fill-in defender who's too casual to defend him, and a well-known actress who makes a very sporting (and uncredited) cameo appearance at the Past Lives Pavilion, where Judgment City visitors can learn about their earlier incarnations. Julia is amazed to see that she was once Prince Valiant. Daniel isn't exactly surprised to find that he was once eaten by a lion.

•

"Defending Your Life" is rated PG (Parental guidance suggested). It includes occasional off-color language.

1991 Mr 22, C12:1

Mister Johnson

Directed by Bruce Beresford; screenwriter, William Boyd, based on the novel by Joyce Cary; director of photography, Peter James; edited by Humphrey Dixon; composer, Georges Delerue; production designer, Herbert Pinter; produced by Michael Fitzgerald; released by Avenue Pictures. At 57th Street Playhouse, 110 West 57th Street in Manhattan. Running time: 100 minutes. This film is rated PG-13.

Harry Rudbeck...................Pierce Brosnan
Sargy GollupEdward Woodward
Mister Johnson.................Maynard Eziashi
Celia Rudbeck.........................Beatie Edney
The Waziri.................................Femi Fatoba
Bulteen.................................Dennis Quilley

By JANET MASLIN

When the African clerk who is the title character of "Mister Johnson" speaks of "home," he refers not to his native Nigeria but the England that looms so large in his dreams. He sings of England to fellow villagers, who are amazed at his white suit, pith helmet and European airs; he sings

to the white English colonials who preside over the region, and who consider Johnson a valuable but highly fanciful aide.

Johnson's anglophilia even extends to a love of plum pudding and a willingness to accept great abuse from English gentlemen, provided they regard him at least marginally as one of their own. Johnson's delusions contain the seeds of both humor and tragedy.

Joyce Cary, who wrote the keenly observed 1939 novel on which this film by Bruce Beresford is based, and who spent several years in the British colonial service in Nigeria, never reduced Johnson to a simple product of colonial rule. This enormously vibrant portrait of African life concentrates on its hero's endless resourcefulness and good humor. "To him

The lessons of colonialism from one native's point of view.

Africa is simply perpetual experience, exciting, amusing, alarming or delightful, which he soaks into himself through all his five senses at once, and produces again in the form of reflections, comments, songs, jokes, all in the pure Johnsonian form," Mr. Cary wrote. "Like a horse or a rose tree, he can turn the crudest and simplest form of fodder into beauty and power of his own quality."

Mr. Beresford's film acknowledges the boundless optimism of its leading character even as it watches him paint himself into a corner. Prodded by his grandiose airs into living well above his means, Johnson must fall back on a variety of half-devious ways of making ends meet. This forces him to swindle the very En-

Avenue Pictures

Maynard Eziashi as the title character in "Mister Johnson."

glishmen he admires most, although he manages even to embezzle and steal in semi-affectionate ways. But neither Johnson's chicanery nor the Englishmen's reactions are stereotypical in any way. One of the things Mr. Beresford has done best, in films like "Breaker Morant" and "Driving Miss Daisy," is to regard easily misunderstood situations in unexpectedly generous ways.

•

Mr. Beresford's film of "Mister Johnson," with a screenplay by the novelist William Boyd, takes a similarly broad view of Johnson and his world, concentrating on the elaborate

and interesting power arrangements that govern Nigerian village life, circa 1923. There is much more to local politics than mere misunderstandings between the English, whose conduct is largely unexamined, and the Africans, who know their colonial masters much better than the English know themselves. The film, which opens today at the 57th Street Playhouse, also observes the Waziri (very cannily played by Femi Fatoba), a sly local official who plays upon Johnson's indebtedness. And of course it studies Johnson himself (Maynard Eziashi), a smiling master of manipulation.

The film's main English characters are Harry Rudbeck (Pierce Brosnan), a judge who condescends to Johnson, and Sargy Gollup (Edward Woodward), a store owner who insults and beats him. "Mister Johnson" unfolds in a long-vanished world where neither of those forms of behavior is necessarily thought of as offensive, at least not in Johnson's terms. He stands his ground with both Englishmen in very peculiar ways, giving this story a singularity and insight that the film does not always fully convey. "Mister Johnson" is faithful to Mr. Cary's book, but it often stops short of the novel's real complexity, sometimes smoothing away too many rough edges.

Mr. Cary's hero was so taken with the idea of Rudbeck's new bride that he describes her rapturously to his own wife even before he has met her. The film's Johnson offers the same description, but he does it after having actually seen the bride. This kind of literalness reduces some of the story's magic to bewildering lapses at times. The film works well as far as it goes, but some of the story's emotional power is denatured or lost.

The lively Mr. Eziashi is good at conveying Johnson's charm and buoyancy, though much of the character's wiliness gets lost; Mr. Brosnan makes good use of the very bloodlessness that sometimes hampers him in more daring roles. Mr. Woodward, stiff-backed and stout, is the supreme embodiment of the kind of colonial who can heap racial abuse and imagine he is bestowing affection. "You don't know what it costs us to live here," he confides to Johnson, who sympathetically agrees.

The film, which has the red, dusty look of a rural African setting, also includes numerous flamboyant party scenes, since Johnson is an enthusiastic host and a fabled singer of chants praising either his role models or himself. He is at his most purely touching in such joyous moments, loyally celebrating English principles even as they bring about his downfall.

•

"Mister Johnson" is rated PG-13 (Parents strongly cautioned). It contains abusive language and brief nudity.

1991 Mr 22, C13:1

City Zero

Directed by Karen Shakhnazarov; screenplay (Russian with English subtitles) by Mr. Shakhnazarov and Aleksandr Borodyansky; cinematography, Nikolai Nemolyayev; music by Eduard Artemyev; Studio Mosfilm Production; an International Film Exchange release. At Angelika Film Center, Mercer and Houston Streets in Manhattan. Running time: 84 minutes. This film has no rating.

With: Leonid Filatov, Oleg Basilashvili, Vladimir Menshov, Armen Dzhigarkhanian, Yevgeny Yevstigneyev and Yelena Ardzhanik.

By CARYN JAMES

Sitting in a nearly empty hotel dining room, a baffled engineer named Aleksei watches the waiter wheel a dessert cart to his table. "I didn't order dessert," Aleksei says, but this one was custom-made: a cake that stares back at him in the precise size, shape and color of his own head, right down to the lucid, light-blue eyes. Refusing a slice of his own nose, he ignores the waiter's warning that "the chef will kill himself." Bad choice. Even as he heads for the door, Aleksei hears a shot and turns to see the insulted pastry maker keel over right in front of the happily playing band.

This is just the start of the absurd intrigue in "City Zero," a deliciously cheerful satire about the legacy of Stalin, personal identity and the political importance of rock-and-roll. "City Zero" opens today at the Angelika Film Center.

Though its plot is Kafkaesque, its setting seems closer to Lewis Carroll's Wonderland than to Moscow. Karen Shakhnazarov, the director and co-writer, establishes a tone that

Stalinism vs. rock in an intrigue of the absurd.

is eerie without being sinister, and goes on to invent a story that is comic and fluent yet full of dangerous turns.

Arriving in a small town for a simple business meeting, Aleksei gets off the train from Moscow in beautiful, misty predawn light and total isolation. When he shows up for his meeting, he finds a secretary inexplicably naked at her typewriter, behavior no one else finds strange. He and the film get off to a shaky start here, but the satire is never again so sophomoric, the tone never again so jokey and wrong.

Instead, Aleksei is confronted with the twin cake and before long by investigators who wonder about his connection to Nikolayev, the dead chef he had never seen before. Why, for instance, did the chef have a photograph of Aleksei, which was inscribed "To my dear father," and signed "Makhmud"?

Aleksei's calm, baffled demeanor in the face of what seems like a town-wide conspiracy sets the film's effective, deadpan tone. He tries to leave, only to be told at the lonely train station that all the tickets to Moscow are sold. He takes a taxi to the next town in search of another train station, and instead finds a museum whose main attractions are a Trojan

Puzzled Vladimir Menshov plays the role of a suicidal chef in "City Zero," about an engineer from Moscow stranded on a business trip in the post-glasnost Soviet Union.

International Film Exchange

sarcophagus and a rock-and-roll tribute to the first couple in town who dared dance to "Rock Around the Clock." The dancing hero, then a 27-year-old secret police lieutenant, was Nikolayev.

Soon the stranger in town is lured into its ongoing political feud, between those who live in the Stalinist past and those who are desperate to catch up with the present. "The rehabilitation of rock-and-roll is of great political significance," the mayor tells Aleksei. Just pretend you're Makhmud, suggests the friendly president of the writers' association, so the compliant newcomer helps inaugurate the Nikolayev rock-and-roll club, standing on a stage between large photographs of his beloved dead father and of Elvis. This does him no good with the public prosecutor, who believes that Nikolayev was murdered and that rock-and-roll is an American devil that will ruin the country.

Mr. Shakhnazarov is a vibrant film maker who keeps introducing new and more troubling characters without letting the film's comic energy slow down. The lithe young woman who danced so infamously with Nikolayev 30 years before (seen in a vivid flashback) shows up at Aleksei's hotel room with her grown son and a tape player. Now sad, heavy and drab, she touchingly wants to dance with Aleksei, who, she says, is so much like Nikolayev he has "kept our ideals alive."

Gradually, Aleksei is robbed of his freedom and his identity. Yet even as he struggles to reclaim them he remains a figure of fun, less a symbol of his country than a hapless hero who has fallen down a rabbit hole.

In fact, the political allegory of "City Zero" is never as heavy as its Kafkaesque hero and its rock-and-roll feud make it sound. The film works perfectly well as a fast, funny tale of mistaken identity. But it has a resonance beyond its quick wit, for the style shrewdly mirrors the subject. The tone says, "It's only rock-and-roll," but "City Zone" gleefully depicts the innocuous mask political tyranny can wear.

1991 Mr 22, C14:1

My Heroes Have Always Been Cowboys

Directed by Stuart Rosenberg; screenwriter, Joel Don Humphreys; director of photography, Bernd Heinl; edited by Dennis M. Hill; music by James Horner; produced by Martin Poll and E. K. Gaylord 2d; released by the Samuel Goldwyn Company. Running time: 96 minutes. This film is rated PG.

H. D. Dalton	Scott Glenn
Jolie Meadows	Kate Capshaw
Jesse Dalton	Ben Johnson
Cheryl Hornby	Tess Harper
Jud Meadows	Balthazar Getty
Clint Hornby	Gary Busey
Junior	Mickey Rooney
Virgil	Clarence Williams 3d

By VINCENT CANBY

"My Heroes Have Always Been Cowboys" is a folksy down-home movie about H. D. Dalton (Scott Glenn), an aging, rootless rodeo performer whose Moby-Dick is a bull named Thunderbolt.

In the opening sequence, H. D. is so rudely stomped on by Thunderbolt that he nearly loses his life. After a long hospital stay, and trussed up in a leather brace, H. D., who still walks funny, returns to his hometown in Oklahoma. Things aren't much better there.

His greedy sister (Tess Harper) and her husband (Gary Busey) have put his dear old dad (Ben Johnson) into a rest home and hope to sell the family property. Dad isn't bonkers. He's simply bored.

Even worse, H. D.'s former girlfriend (Kate Capshaw), whom he seems to have left five years before, has married, been widowed and is now bringing up a small daughter and a son who looks to be in his teens, though H. D. has never heard of him.

•

In the course of "My Heroes Have Always Been Cowboys," H. D. learns how to face his responsibilities to his family and to the woman he loves. He also decides to face Thunderbolt again at the local rodeo, called Bull-mania, to test himself as a man and to win $100,000.

Joel Don Humphreys wrote the screenplay, which includes a lot of talk about feelings and what a fellow has to do to become a man. Stuart Rosenberg ("Cool Hand Luke," "Brubaker," among others) directed it with the sort of patience that highlights every cliché.

The performances aren't bad, though they certainly aren't transforming.

The only possible reason to see the film is for its bull-riding sequences, which open and close the film. They are stunning.

•

"My Heroes Have Always Been Cowboys," which has been rated PG (Parental guidance suggested), includes some vulgar language and a sex scene that is too tasteful to be erotic.

1991 Mr 22, C14:5

Days of Being Wild

Directed and written by Wong Kar-wai; in Chinese and Tagalog with English subtitles; photography by Christopher Doyle; edited by Kai Kit-wai; music by Chan Do-ming; production designer, William Chang Suk-ping; produced by Rover Tang; production company, In Gear Film Production Company Ltd. At the Roy and Niuta Titus Theater 1, 11 West 53d Street, as part of the New Directors/New Films Series of the Film Society of Lincoln Center and the Department of Film of the Museum of Modern Art. Running time: 100 minutes. This film has no rating.

WITH: Leslie Cheung Kwok-wing, Maggie Cheung, Man-yuk, Tony Leung Chiu-wai, Karina Lau Kar-ling, Andy Lau Tak-wah, Jackie Cheung Hok-yau, Poon Dik-wah

By CARYN JAMES

"Days of Being Wild" is an elliptical melodrama, an atmospheric reverie about love and identity, delivered in the guise of a gangster film. Set in 1960, on the fringes of the Hong Hong underworld, the film crosses B-movie conventions and avant-garde jumpiness, resulting in a disquieting mix of "Hiroshima Mon Amour" and "The Big Sleep."

Its opening scenes are infused with mystery and shadowy blue light, as a man walks up to a woman he presumes to know and she makes it clear they are strangers. He suggests that she should like him for just one minute. As the days go by he increases the time limit. Soon she likes him for one hour; they become lovers; she proposes marriage and he turns her down.

This painful romance only provides the entry to the claustrophobic world of this man, a small-time gangster whose foster mother is an aging courtesan and whose sometime-mistress is a nightclub dancer. Before long the extreme lights and shadows of the early sequences give way to a bright, unforgiving look at his gritty world of rumpled beds in shabby apartments and heavily made-up women in cheap clothes.

In scenes that are sharply defined and often tangentially connected to each other, the writer and director, Wong Kar-wai, effectively lures viewers into the hero's confusion. The wildness of the title exists largely in the gangster's imagination. To him, freedom is not knowing which woman

to love. He knows himself only as a personality he wants to flee.

•

Ultimately he runs to the Philippines, rejecting both girlfriends and leaving his adopted mother to search for his natural one. He never understands how deeply each of the women left behind cares for him. For all its hard-boiled trappings, "Days of Being Wild" is ultimately about displaced emotions.

The narrative is purposefully jagged, but its jigsaw-puzzle approach comes to reflect the hero's confused state of mind more than it should. Early hints dropped about the Philippines only make sense very late in the film and the characters' backgrounds are filled in with frustrating slowness.

One obstacle is in the stilted subtitles, which suggest that much of the dialect and feel of this carefully depicted subculture might have been lost in translation. A more serious problem is that a plotless gangster story is a nearly impossible paradox to pull off, however intelligent the underpinnings of the film and however visually effective its style.

"Days of Being Wild" will be shown tonight at 9 and tomorrow at 6 P.M. as part of the New Directors/New Films series. It proves that there is life and energy left in avant-garde film making, though the demands of this movie usually outrun its rewards.

1991 Mr 23, 12:3

Cabeza de Vaca

Directed by Nicolas Echevarría; screenplay (Spanish with English subtitles) by Guillermo Sheridan and Mr. Echevarria from the book "Naufragios" by Alvar Núñez Cabeza de Vaca; photography by Guillermo Navarro; edited by Rafael Castanedo; music by Mario Lavista; produced by Rafael Cruz, Jorge Sanchez and Julia Solórzano Foppa. At the Roy and Niuta Titus Theater 1, 11 West 53d Street, as part of the New Directors/New Films Series of the Film Society of Lincoln Center and the Department of Film of the Museum of Modern Art. Running time: 111 minutes. This film has no rating.

WITH: Juan Diego, Daniel Giménez Cacho, Roberto Sosa, Carlos Castañon, Gerardo Villarreal, Roberto Cobo, José Flores, Eli Machuca "Chupadora"

New Directors/New Films

Karina Lau Kar-ling in "Days of Being Wild."

By VINCENT CANBY

Nicolas Echevarría's "Cabeza de Vaca" is a historical film that can probably be best appreciated by those who already know the story of the 16th-century Spanish explorer, Alvar Núñez Cabeza de Vaca.

The style of the Mexican film is sometimes straightforward, sometimes pagaentlike and sometimes hallucinatory. It's not especially difficult to follow, though it is less informative than evocative of times and events unknown.

The film will be shown today at 6 P.M. and tomorrow at 3 P.M. as part of the New Directors/New Films series.

Cabeza de Vaca, whose dates are approximately 1490 to 1557, was a member of an expedition that set out from Spain for the New World in 1527 under the command of Pánfilo de Narváez. After losing their ship off what is now Tampa Bay, the members of the expedition went their separate ways.

Cabeza de Vaca and a small group of men apparently sailed on a makeshift barge westward to the Texas coast, where, in 1528, they came under Indian attack. Most of the party were killed or captured.

•

This was the beginning of the remarkable overland journey for which Cabeza de Vaca is known. It ended in 1536 with his arrival at the Spanish camp at Culiacán on the Pacific coast of Mexico.

"Cabeza de Vaca" is a road movie set in a time before there were roads. In the eight years of what becomes a kind of pilgrimage, Cabeza de Vaca (Juan Diego) lives with various Indian tribes, alternately as a slave and as a shaman of great healing powers. As he teaches his captors, he is taught by them.

He is treated with harshness and contempt, then, after performing some seeming miracle, he is worshipped and set free. Sometimes he simply makes his own escape. Along the route, he meets other shipmates he thought to be dead.

Finally, like Kevin Costner in "Dances With Wolves," he learns to appreciate the sustaining mysticism of a culture that the white conquerors have sworn to stamp out.

The screenplay, by Mr. Echevarría and Guillermo Sheridan, is based on Cabeza de Vaca's own memoirs, "Los Naufragios" (The Shipwrecked Men), written in 1542.

Mr. Echevarría's previous films have all been documentaries, which is possibly the reason that "Cabeza de Vaca" is most effective when it observes people and events at an impartial remove. Yet so little attempt is made to fix time and place that confusion arises.

There seem to be mountains on the coast of Florida, and Texas would appear to be only a stone's throw from the Pacific coast of Mexico.

The tribes he meets are undifferentiated, with the exception of a stunning early adventure when he is the prisoner of a shaman and the shaman's servant, an armless dwarf who could have been imagined by Luis Buñuel.

At a couple of points Mr. Echevarría suggests that Cabeza de Vaca may have been the first white man to enjoy the mind-expanding properties of peyote and other substances natural to the Southwest.

Though Mr. Diego tends to act broadly, Cabeza de Vaca remains an unknown, chilly character. The camera does little to reflect the man's state of mind, except during what are obviously dreams, illustrated in conventional movielike ways.

"Cabeza de Vaca" is a small, generalized evocation of an epic subject.

1991 Mr 23, 12:6

The Guard

Directed by Aleksandr Rogoschkin; screenplay (Russian with English subtitles) by Ivan Loschilin; photography by Valery Martynov; edited by Tamara Denisova; production design, Aleksandr Zagoskin; production company, "Lagoda" Association, Lenfilm Studios. At the Roy and Niuta Titus Theater 1, 11 West 53d Street, as part of the New Directors/New Films series presented by the Film Society of Lincoln Center and the Department of Film of the Museum of Modern Art. Running time: 96 minutes. This film has no rating.

Paromov	Aleksei Buldakov
Andrei Iveren	Sergei Kupriyanov
Mazur	Aleksei V. Mozrun
Shlustov	Aleksandr N. Smirnov
Korchenyuk	Taras V. Denisenko
Ibragimov	Renat Ibragimov
Shyuchin	Dmitri V. Iosifov
Guards	Mikhail Kirilyuk; Andrei Serzalov

By VINCENT CANBY

The title character in "The Guard" ("Karaul"), Aleksandr Rogoschkin's dark new Soviet film, is Iveren, a young soldier who has the delicate handsomeness associated with the idealized 19th-century romantic poet. He seems, however, to live beyond hope, in self-imposed exile.

He never smiles. His soul has become clenched.

Recently assigned to a train that transports prisoners to labor camps, Iveren endures his crude new comrades with distaste. He does what they ask. Nothing more.

He finds no humor in their jokes, and refuses to cooperate in their mindless, obligatory hazing of him. In his crack-up the ferocious ordinariness of a political system is exposed.

"The Guard" will be shown today at 12:15 P.M. and tomorrow at 6 P.M. as part of the New Directors/New Films series.

•

Though the pinched, unhappy Iveren can be seen as a figure of the post-Communist imagination, his despair has its roots in pre-revolutionary Russian literature, that of Dostoyevsky among others. Yet now there is nothing grand or transforming about despair, only the fury within, which is one more toll taken.

"The Guard," written by Ivan Loschilin and directed by Mr. Rogoschkin, who was born in 1949, has the density of pent-up feelings expressed in a sudden rush, like Iveren's. Unlike Iveren, though, Mr. Rogoschkin hangs onto his wits.

The film works through its accumulation of small, precisely observed details, which at first seem as commonplace to the audience as to the soldiers. The prisoners, who are loaded aboard the train by numbers and placed in cage-like comparments, remain mostly faceless and uncharacterized.

•

It's soon apparent that this is one of Mr. Rogoschkin's methods. The guards, who are the focus of the film, are no more free than the men they are escorting. The unfortunate Iveren comes into focus only with time.

Another new soldier, a dopey fellow who is under the misapprehension that he is a singer, is initially an easier target for the other guards, especially when he entertains them with his version of "Yesterday" in English.

As the days wear on, and as the routine becomes more oppressive, the aloof Iveren attracts their attention. In cutting him down to size, the small community on the train destroys itself.

Two minor reservations: "The Guard" is too symmetrical for its own good. It has been thought through so carefully that, after a certain point, there isn't much left to surprise the audience.

Also, most of the film is shot in appropriately grainy, washed-out black-and-white. When, after a crucial event, the director switches to color, the effect is to italicize the obvious. A final sequence of dreamy desolation does not need this film-school touch.

•

Sharing the bill with "The Guard" is Geza Beremeny's Hungarian short "An Age," which reduces the history of the Hungarian People's Republic to a mocking, 14-minute montage of empty public ceremonies as recorded by official newsreels. It's clever but, after a while, too clever.

1991 Mr 24, 64:1

20th New Directors/New Films

Aleksei Buldakov, right, as the title character in "The Guard."

Julia Has Two Lovers

Directed and produced by Bashar Shbib; screenplay by Daphna Kastner and Mr. Shbib, based on an original story by Ms. Kastner; director of photography, Stephen Reizes; edited by Mr. Shbib and Dan Foegelle; music by Emilio Kauderer; released by South Gate Entertainment; presented by Oneira Pictures International. At the Village East, Second Avenue and 12th Street. Running time: 91 minutes. This film is rated R.

Julia	Daphna Kastner
Daniel	David Duchovny
Jack	David Charles
Leo	Tim Ray
Jackie	Clare Bancroft
Freddy	Martin Donovan
Ursula	Anita Olanick

By STEPHEN HOLDEN

The title character of the erotic comedy "Julia Has Two Lovers" is a restless, thirtyish writer of children's books who shares a beachside apartment in Venice, Calif., with her publisher and fiancé, Jack. Devoted but dull, Jack keeps nagging Julia to marry him but cowers in disapproval when she dons a sexy nightgown and plays come-hither games. Julia wants a lover; he wants a housekeeper.

One morning, Julia's telephone rings. Though it's a wrong number, she and the caller, Daniel, fall into an extended flirtation over their cordless phones, letting intimate confessions slip out between taking baths and showers and shooing off impromptu visitors. Julia describes a muzzy-headed philosophy that she calls "the bobby pin theory" of existence. As she explains it, it has something to do with an inability to choose between Formica patterns when shopping for kitchen counters.

•

The next day Daniel comes by for lunch, proposes marriage within minutes, and the earth moves for them. As it turns out, Prince Charming is not exactly the shrink-wrapped perfect man that he likes to pretend, and Julia is eventually forced to choose between the male equivalent of counter patterns.

"Julia Has Two Lovers," which opened yesterday at the Village East Cinemas, is largely a one-woman show. Daphna Kastner, who plays the title role, also conceived the story and wrote the screenplay with the director and producer, Bashar Shbib. Although the story suggests a soft-core fantasy, the film is really a vaguely hip, vaguely feminist reflection on the unlikelihood of romantic dreams coming true.

•

The movie's most amusing section is the extended phone call, whose dialogue has an easygoing, semi-improvisational flow. Ms. Kastner is appealing and believable as a woman whose bohemian inclinations and vestigial teen-age fantasies are momentarily realized. As Daniel, the self-styled dream lover, David Duchovny projects an agreeable, low-keyed self-assurance.

About two-thirds of the way along, the movie loses its footing and begins to lurch. By the time Daniel and Jack sit down and get drunk together, the story has lost its credibility and the talk becomes heavy-handed and faintly ridiculous. That's because "Julia Has Two Lovers" has an appealing premise but no idea of where to take it.

1991 Mr 24, 64:1

FILM VIEW/Caryn James

For Groupies Only . . .

THE NOVELIST EVE BABITZ SLEPT WITH JIM Morrison when he was still lean and beautiful, she says in this month's cover article in Esquire. Richard Goldstein, in The Village Voice, recently revisited an interview he did with Morrison more than 20 years ago. And Lisa Robinson began a column in The New York Post a few weeks ago, "I knew Jim Morrison toward the end of his life," when he was bloated and constantly drunk. So here is my own journalistic confession: I never slept with Jim Morrison, I never drank with Jim Morrison, I never saw the Doors in concert and I never even, as Oliver Stone has admitted he did, worshiped Jim Morrison from afar.

Such neutrality shouldn't be an obstacle to watching a movie, but the greatest problem among many in "The Doors," Mr. Stone's latest 60's extravaganza, is that it demands an audience already as enamored of Morrison as the director is. "You're a poet, not a rock star," Morrison's girlfriend tells him in the film. And every pseudo-poetic

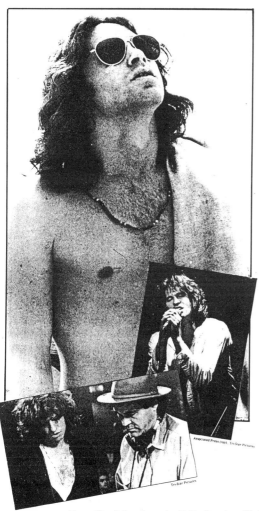

Top, Jim Morrison in 1969. Center, Val Kilmer in "The Doors." Above, Mr. Kilmer and Oliver Stone during filming

scene in "The Doors" — from the Indian shaman who enters little Jimmy Morrison's soul, to a hallucinatory peyote trip in the desert, to the final shot of Morrison's grave in Père Lachaise cemetery in Paris, alongside Oscar Wilde, Balzac and Sarah Bernhardt — declares that Mr. Stone uncritically bought into the myth of Morrison as a self-destructive genius.

That's fine; a lot of people did. But at the very least, "The Doors" needs to convey some of that idolatry to view-

With 'The Doors,' Oliver Stone demands an audience as enamored of Jim Morrison as he is.

ers for whom Morrison is nothing more than a vague memory from Top 40 radio or just another rock star who died before they were born.

Instead, the film charts Morrison's quick ascent to the rock stratosphere and his steady self-destruction from drugs and alcohol without giving a clue about whatever possessed him or his fans. Was he done in by fame or artistic frustration or some demonic gene that would have got him even if he'd turned out to be a plumber? Was it simply Morrison's sex appeal that made young women scream and tear off their clothes? Or was he, on stage, the momentary embodiment of a social and sexual freedom that owed very little to the Doors? Why is he hotter dead than alive?

These are questions that Mr. Stone is too bedazzled by Morrison to ask. No wonder so many film-goers are measuring "The Doors" against their own memories or fantasies of Morrison and the 60's. Mr. Stone creates a movie virtually inaccessible to anyone who doesn't share his assumptions. He distances viewers from his film, throwing them out on their own.

That approach, the bullying narrative surface and the hollow interior, is typical of Mr. Stone's work. He turns characters inside out, splashing their psyches across the screen with montages and quick cuts and circling cameras and extreme close-ups that are meant to mirror some internal energy but are often just dizzying. Pouring all that action onto the surface leaves nothing within the characters.

The most extreme example of Mr. Stone's hyperactivity was "Talk Radio," a nearly unwatchable 1988 film that disastrously busied up Eric Bogosian's one-set play. "Platoon," made two years earlier, was filled with blatant symbolism, including the now-famous Christlike image of Willem Dafoe dying with his arms outstretched as if on a cross. And even in Mr. Stone's most moving work, his 1989 "Born on the Fourth of July," a parade marches into the audience's face as a substitute for social context.

Leaping off the screen with relentless energy and ants-in-the-pants camerawork, "The Doors" is just Oliver Stone at his Oliver Stoniest. When Val Kilmer, as Morrison, sings the Doors' most notorious lyrics — about his desire to kill his father and sleep with his mother, the sophomoric poetry of someone who has just discovered Oedipus and Freud — Mr. Stone's camera predictably goes crazy, swirling and jumping and acting like a giant exclamation point. At its best, the film's haunted Doors music and visceral look creates the sense of being in some hypnotic trance. But by the end, audiences may feel they have been beaten over the head with a stick for two hours.

In "Born on the Fourth of July," Tom Cruise's wonderfully deep performance created the most fully developed character in any Oliver Stone film. In "The Doors," Mr. Stone also gets a first-rate performance from his star. But despite Mr. Kilmer's miraculous impersonation of Morrison, despite his shifts from a sensitive seducer to a vulgar monomaniac, he can't invent a man from a character written as a myth, with no inner life.

How, for example, did Morrison transform himself, inside and out, from a chubby college kid to a drooled-over sex symbol in the space of a year? Now *that* story would have shown myth-making in action. But Mr. Stone ignores it; he seems uninterested in any un-glamorous vision of Morrison. Even the singer's selfish, pot-bellied last days are idealized as the fall of a tragic hero.

So, what does Oliver Stone see in Jim Morrison? On the evidence of "The Doors," it must have been Morrison's way of playing an audience. He could apparently manipulate a crowd, using flash and noise and a poetic facade that masked the emptiness behind the act. Mr. Stone's film does very much the same. It is made by a Morrison groupie for other groupies, a film that leaves the rest of us locked outside wondering what the fuss is about. ☐

1991 Mr 24, II:11:1

Homemade Movie

Directed, produced, written, photographed, edited and scored by Fumiki Watanabe; cameraman, Shinji Tomita. In Japanese with English subtitles. At the Roy and Niuta Titus Theater 1, 11 West 53d Street, as part of the New Directors/New Films series of the Film Society of Lincoln Center and the Department of Film of the Museum of Modern Art. Running time: 110 minutes. This film has no rating.

Watanabe Family:
Father Fumiki Watanabe
Mother................................. Tsugiko Watanabe
Son......................................Hidefumi Mimura
The Ichihara Family:
Father..............................Isamu Shigihara
Mother..................................... Naoko Kubo
Daughter Yoko Shikami

By VINCENT CANBY

If one can believe the publicity material for the new Japanese comedy "Homemade Movie," Fumiki Watanabe has a lot in common with those American novelists whose love affairs, often with each other, are no sooner wrapped up than they appear in lightly fictionalized print.

These works settle scores, occasionally go into second printings and, in New York anyway, provide a certain amount of dim literary gossip. On the basis of "Homemade Movie," Mr. Watanabe, a tutor of high-school students as well as a film maker, is considerably more upfront.

●

His latest film, described as a "wacko family drama," is said to be based on his own real-life affair with the mother of one of his pupils, and acted by him, his wife, other family members, and even the woman with whom he had the affair.

The actors who play the woman's husband and her daughter are outsiders.

"Homemade Movie" will be shown today at 9 P.M. and tomorrow at 6 P.M. as part of the New Directors/New Films series.

"Homemade Movie" has a few genuinely lunatic moments, but it promises more wacko fun than is ever manifest on screen.

The performers appear to enjoy themselves a lot. Especially engaging is the younger Watanabe son who, at the beginning of the film, giggles helplessly every time the camera turns on him.

Mr. Watanabe plays himself with a sober face and a fine feeling for the barely acknowledged absurd. His courtship of the mother of his pupil, a girl who has absolutely no interest in higher education, is comically brisk and to the point. No words have to be spoken.

Ellipses — the things that are not seen or heard and thus must be imagined — eventually are the funniest things about "Homemade Movie."

As soon as the husband's infidelity is discovered, the film loses its momentum, becoming more and more confused and, in the way of home movies, uninflected.

It's as if the audience were expected to find it enough that Mr. Watanabe made the movie at all, having performed the duties of producer, writer, director, star, photographer and editor. There is to be no doubt that he really did all these jobs, if only because the movie picks up its pace when he is not on the screen and is able to attend to his other tasks.

●

A subplot, involving the older Watanabe son and Mr. Watanabe's pupil, is more effective than the intentionally wan relationship that causes the scandal.

The film's most rollicking moments are the family meals, including a New Year's dinner, where the actors seem to be improvising freely without having to worry about the plot, such as it is.

1991 Mr 26, C14:3

The Birthday Trip

Directed by Lone Scherfig; screenplay (Danish with English subtitles) by Peter Bay Clausen and Krzystof Kolodziejski; photography by Kim Hattensen; edited by Leif Kjeldsen; music by Anders Koppel and Michael Boesen; production design, Claus Bjerre; produced by Regner Grasten; production companies, Danish Film Studio in association with Sata Film (Warsaw) and the Trado Film Corporation. At the Roy and Niuta Titus Theater 1, 11 West 53d Street, as part of the New Directors/New Films Series of the Film Society of Lincoln Center and the Department of Film of the Museum of Modern Art. Running time: 91 minutes. This film has no rating.

Kaj.......................................Steen Svare
MagdalenaDorota Pomykala
Benny Bertel Abildgard
Kuno .. Ivan Horn
KrisserPeter Bay Clausen
Basse Michael Boesen
Alslev..................... Peter Gantzler,

By CARYN JAMES

The animated short "Land of the Snowy Mountains" is an 11-minute comic love tale about humans, animals and a unique mating game played out in an isolated shack in the Tibetan mountains. The lone land surveyor who lives in the shack has a face that looks a little like a mole's, for a very good reason. Soon a fur-covered, tailed creature arrives; she has a very similar face.

The story turns on the surprising way these two get to know each other and pull the fur over the eyes of some visiting scientists. In storybook bright planes of pastel colors, this savvy cartoon offers a wealth of wry ideas and a freshness that creates an appetite for more work by the French film maker Bernard Palacios.

"Land of the Snowy Mountains" will be shown tonight at 6 and tomorrow at 9 P.M. as part of the New Directors/New Films series. If only the feature that follows, a Danish film called "The Birthday Trip," shared a glimmer of the short's imagination. As it is, a few comic moments intrude on a storyful of clichés.

●

The premise itself is not promising. Kaj is a quiet, lonely bachelor who owns a hot dog stand in a small northern town. To celebrate his 40th birthday, four of his friends take him to Poland for what is meant to be a wild, womanizing trip. Kaj is such a movie cliché it is almost unnecessary to describe him: overweight and balding, with the kind of sweet simpering smile that is meant to suggest a good heart but usually just makes him look simple-minded.

The friends bumble their way into a tour called Contact 90, a singles group that ferries marriageable Danish men to meet lovelorn Polish women. The film's best touches are its deliberately tacky depictions of this group's banquet, an affair at which waiters double as musicians and more than one man has a flattering photo of himself in a house that smacks of middle-class newness. Why not, when the photos were taken in a furniture store?

Kaj is mistaken for a Toyota salesman named Jan, which pairs him with a quiet, lonely nurse named Magdalena, who takes him home to meet her family. Meanwhile, Kaj's drunken friends go off on their own adventures. They encounter, among other characters, an actual prostitute with a heart of gold.

The film breezes over Magdalena's desperate unhappiness, a fault that would be less conspicuous if the pathos and comedy were more distracting. But as "The Birthday Trip" moves along to its bittersweet end, it remains as ordinary and predictable as its cliché-riddled hero.

1991 Mr 26, C14:3

L'Ange

Directed by Patrick Bokanowski; music by Michele Bokanowski. Running time: 70 minutes.

Rehearsals for Extinct Anatomies

Directed by the Brothers Quay; music by Leszek Jankowski; produced by Keith Griffiths; both films distributed by First Run Features. At Film Forum 1, 209 West Houston Street. Running time: 14 minutes. These films have no rating.

By JANET MASLIN

It is indeed possible to analyze an idea to death, as is demonstrated by "L'Ange," a highly experimental film by Patrick Bokanowski that opens today at the Film Forum. It is also possible to devote wildly inappropriate degrees of effort to hair-splitting on a minuscule scale. In "L'Ange," Mr. Bokanowski devises very specific images and then repeats and dissects them, altering tiny aspects of lighting, scale and proportion each time, sometimes multiplying motion and sometimes reversing it altogether. The painterly precision with which this has been done does not mask the futility of the exercise.

One of the film's discrete, lengthy sections, which are loosely linked by cacophonous and turbulent staircase images, shows a woman dressed as in a Dutch painting, depositing a pitcher of milk on a table. A still-life bowl of fruit is on the table, and a man sits on a chair. The speed with which the woman moves, the lighting above her and even the fate of the milk are carefully regulated. Sometimes the milk spills. Sometimes it spills repeatedly. At one point a succession of falling-pitcher images is linked to form an arc. Migraine-inducing music, by the director's wife Michele Bokanowski, plays in the background. About 15 minutes go by.

●

Among the other images studied in "L'Ange" are those of multiple scholars cavorting in various permutations within a messy library; a tilted bedroom in which a man dresses himself; a bathroom in which a bather and a dog scrub furiously, and a cage in which a woman is apparently imprisoned, approached from afar by men who may be either attacking or rescuing her. Ambiguity is one critical element of Mr. Bokanowski's methods. Great patience is another.

On the same bill, fortunately, is "Rehearsals for Extinct Anatomies," a witty short film by the Brothers Quay. Combining puppets, drawings and machine parts into haunting figures, this buoyant, clever effort proves it is possible to be both cryptic and highly entertaining, despite Mr. Bokanowski's strong evidence to the contrary.

1991 Mr 27, C15:1

Film Society of Lincoln Center

A scene from "Homemade Movie," a Japanese comedy.

Outremer

Directed by Brigitte Roüan; screenplay (French with English subtitles) by Ms. Roüan, Philippe le Gay, Christian Rullier and Cédric Kahn; photography by Dominique Chapuis; edited by Yann Dedet; music by Pierre and Mathieu Foldes; produced by Serge Cohen-Solal for Paradise Productions. At the Roy and Niuta Titus Theater 1, 11 West 53d Street, as part of the New Directors/New Films Series of the Film Society of Lincoln Center and the Department of Film of the Museum of Modern Art. Running time: 98 minutes. This film has no rating.

Zon Nicole Garcia
Gritte Marianne Basler
Malène Brigitte Roüan
Paul Philippe Galland
Gildas Yann Dedet
Maxime Bruno Todeschini
Uncle Alban Pierre Doris

By STEPHEN HOLDEN

Brigitte Roüan's film "Outremer" brings a Jane Austen-like sensibility to the story of three sisters living in Algeria during the final years of French colonial rule. The movie's opening scenes, set in the late 1940's, present a romantic picture of French colonial life in the days before the nationalist uprising that eventually drove a million Europeans to leave the country. It is a vision that the director, who also co-wrote the film and who plays one of the sisters, spends the rest of the movie demol-

Film Society of Lincoln Center

Nicole Garcia, left, and Marianne Basler in "Outremer."

ishing in a story that is subtly colored with Marxist and feminist overtones.

The biggest strength of the film, which will be shown tonight at 9 and on Friday at 6 P.M. as part of the New Directors/New Films series, is its ingenious structure. One by one, the movie examines the lives of the three sisters, Zon (Nicole Garcia), Malène (Miss Roüan), and Gritte (Marianne Basler), covering the same period three times. In several sequences, the film returns to the exact time and setting of an earlier scene to reveal how one sister was an uncomprehending witness to a shattering moment in the life of another.

The technique of telling the same story three times from the beginning and each time taking it a bit further, helps Miss Roüan to demonstrate how characters with very different temperaments and personal histories share deeper similarities because of their class, sex and social conditioning.

Zon, the eldest sister, is obsessively in love with her husband, Paul (Philippe Galland), a straitlaced naval officer who goes off for long periods at sea, leaving her alone and usually pregnant. Pent-up, masochistic and devoutly religious, she is so male-dependent that after Paul is reported missing, she wishes only to die. Miss Garcia's performance, which is full of suppressed heat, is the film's most memorable.

The middle sister, Malène, is unhappily married to a rancher (Yann Dedet) who is disinterested in his property and lets his wife run things. Instead of eager to be the boss, Malène is ashamed and furious and lashes back in a devastating act of destruction. Gritte, the rebellious youngest sister, keeps postponing her marriage to an eligible young diplomat while carrying on a clandestine affair with an Algerian soldier.

●

The mood of the film is at once sensuous and detached. Until the uprisings begin, French colonial life in Algeria is depicted as a sun-drenched privileged existence in a semi-tropical paradise. In presenting her characters, the director first puts us into their shoes and then slowly draws back to observe their foolishness and cruelty with an objective eye.

The narrative rhythms of the film are nimble and the stories told glancingly, with each point made quickly and the emotional resonances left understated. The film does not want to produce tears. It is especially adept at depicting how day-to-day habits of living and personal drama can cloud political reality. At first the rebellion subtly impinges on the daily lives of people who try to ignore it. While the film portrays that sort of willful ignorance as completely understandable, it also reveals how the unthinking oppression and exploitation of the native Algerians are a product of such social and political myopia.

●

"Swimming," a confusing 12-minute film on the same program, was directed by Belinda Chayko, a 27-year-old Australian film maker who pretended to be a teen-age girl making a crude home video of her family. Toting her video camera about the house, she casually intrudes on people and captures some fragments of a drama that it is left up to the viewer to interpret.

1991 Mr 27, C15:1

The Ballad of the Sad Cafe

Directed by Simon Callow; screenplay by Michael Hirst, from the novel by Carson McCullers; photography by Walter Lassally; edited by Andrew Marcus; music by Richard Robbins; production designer, Bruno Santini; produced by Ismail Merchant; production company, Merchant Ivory Productions; an Angelika Film Release. Running time: 100 minutes. This film has no rating.

Miss Amelia Vanessa Redgrave
Marvin Macy Keith Carradine
Lymon Cork Hubbert
Willin Rod Steiger
Taylor Austin Pendleton
Mary Hale Beth Dixon
Merlie Ryan Lanny Flaherty

By VINCENT CANBY

The central figure in "The Ballad of the Sad Cafe," Simon Callow's screen adaptation of the celebrated Carson McCullers novella, is Miss Amelia (Vanessa Redgrave), a woman of most remarkable aspect. She's more than six feet tall and raw-boned, with hair cropped short like a boy's and as yellow as corn.

From the back and sometimes even from the front, Miss Amelia looks like a great but softish man as she strides about in her boots, wearing overalls of such a lovely limpid blue they seem to have been purchased pre-faded.

That is unlikely, though. The time is the depressed 1930's and the setting a tiny backwoods Southern hamlet that has yet to receive electricity.

Miss Amelia doesn't say much. She's a doer. She runs the town's general store, doctors those who come to her with their ailments and, back in the swamps, tends a still that makes the best bootleg whisky in the county.

Her manner is brusque, intimidating. She doesn't have friends. She is complete unto herself.

That is, until the fateful night when an arrogant hunchbacked dwarf comes into town and identifies himself as her Cousin Lyman, the son of Miss Amelia's mother's half-sister, Fanny, and Fanny's third husband.

Like the McCullers novella, which the film follows with fidelity, "The Ballad of the Sad Cafe" is the cautionary tale of Miss Amelia's mad, head-over-heels infatuation with Cousin Lyman (Cork Hubbert) and her terrible comeuppance when her loathed husband reappears.

●

He is Marvin Macy (Keith Carradine), in his youth the wildest boy in the county. Then he fell in love with Miss Amelia. He reformed, went to church, proposed to Miss Amelia and was accepted. On their wedding night she kicked him out of her bed and, 10 days later, out of her life.

After a career of petty crime and a spell in the penitentiary, Marvin comes home with murder in his heart.

"The Ballad of the Sad Cafe" will be shown tonight at 9 and on Saturday at 12:15 P.M. as part of the New Directors/New Films series.

From the moment Miss Amelia is discovered shelling peas, or doing some such down-home thing, and singing "Jimmy Crack Corn" in the accents of Ruritania's Deep South, "The Ballad of the Sad Cafe" is a seriously misguided hoot.

Miss Redgrave was, is and will always remain one of the greatest actresses in what's generally referred to as the English-speaking theater.

She is so great, in fact, that when she goes off the track, as she does here, she continues to barrel forward with the momentum of a transcontinental express train that will not be stopped. The spectacle takes the breath away.

"The Ballad of the Sad Cafe" is that kind of movie. It's not silly as much as it's majestically wrongheaded. It's a movie in which all options have been considered at length before the worst possible choices have been made. But then "The Ballad of the Sad Cafe" is a heartless literary work.

●

Like an oldtime movie vamp, it deceives those who love it most, especially anyone who would pick it apart to adapt it to some other form. Edward Albee attempted without success to turn it into a stage play in 1963. The novella enchants its victims and then flees in the middle of the night.

Left behind are a couple of grotesque characters, a not easily comprehended tale of three unrequited loves and a setting that is merely picturesque.

The McCullers prose is rich to the point of ripeness, but it also is so firm and precise that it beguiles. The reader's romantic imagination becomes the author's accomplice. It fills in everything that is left out.

In the easiest, most matter-of-fact manner, McCullers describes the depth of Miss Amelia's unreasonable passion for the obnoxious Lyman, Lyman's desperate obsession with the insulting Marvin, and Marvin's ha-

Merchant Ivory Productions

Vanessa Redgrave in "The Ballad of the Sad Cafe."

tred of Amelia, which is all that remains of love.

The small conceit at the heart of the novella is that, given the choice, any sane person would choose to be the lover. The role of the beloved is intolerable. To be loved, according to McCullers, is to become invisible, the creature of the beloved's fancy, unknown to oneself.

This moral is put forth by the author casually, without pretension. It is simply a part of the exposition, something that is described in passing, as if it were an aspect of the weather. In Michael Hirst's screenplay it becomes a most unlikely speech to be spoken by the country preacher.

●

"The Ballad of the Sad Cafe" cannot survive this sort of literal treatment, even though Mr. Callow has staged it with devices designed to give it a highly theatrical style. But from Miss Redgrave's mysterious accent to the extraordinary color of her hair, the movie just looks sort of loony and unreal.

The only spell it casts is one of dumbfounded disbelief. How do talented and intelligent people land so far from the mark? Possibly because they are talented and intelligent. They don't compromise. In for a penny, in for a pound.

The landscape looks like Georgia but the buildings that represent the hamlet look as if they'd been put up yesterday and quickly antiqued. The only actors who are not upstaged by the production and material are Mr. Carradine, whose role is fairly straight, and Rod Steiger, who appears briefly as the preacher.

"The Ballad of the Sad Cafe" is the first film to be directed by Mr. Callow, a fine English actor ("Mr. and Mrs. Bridge," "A Room With a View," among others) who has also directed for the stage. "The Ballad of the Sad Cafe" is not good, but it is less a disaster than a learning experience.

1991 Mr 28, C11:1

The Story of Boys and Girls

Written and directed by Pupi Avati; in Italian with English subtitles; photography by Pasquale Rachini; edited by Amedeo Salfa; music by Riz Ortolani; production designers, Daria Ganassini and Giovanna Zighetti; produced by Antonio Avati; production company, Duea Film-Unione Cinematografica in collaboration with RAI Uno; an Aries Film Release. Running time: 93 minutes. This film has no rating.

Domenico Felice Andreasi
Maria ... Angiola Baggi
Angelo .. Davide Bechini
Olimpia .. Lina Bernardi
Amelia ... Anna Bonaiuto
Baldo Massimo Bonetti
Taddeo Claudio Botosso
Valeria Valeria Bruni Tadeschi

By JANET MASLIN

"The Story of Boys and Girls," by the Italian director Pupi Avati, is an unusual selection for the New Directors/New Films festival, since Mr. Avati has been directing since 1968 and has a highly accomplished and commercial style. In this charmingly rustic drama, he tells of two families meeting on an important occasion in 1936, the sort of occasion that calls for a 20-course meal and a long, hearty celebration. The most minute details of this happy event, from the dough-kneading to the rabbit-catching, are invoked with great gusto.

●

In addition to presenting a huge meal in a warmly festive atmosphere, "The Story of Boys and

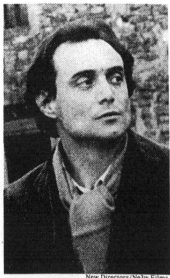

New Directors/New Films
Massimo Bonetti in a scene from "The Story of Boys and Girls."

Girls" also details the numerous domestic problems of a large and lively cast. A country girl from Emilia-Romana has become engaged to the son of a wealthy Bolognese family, and the two groups have not met prior to this celebration of the impending marriage. Aside from the initial culture shock — the upper-class family is highly discomfited when one of the bride's relatives accidentally fires his shotgun at the dinner table — this meeting also fans the flames of romance.

Mr. Avati, whose approach is humorous and evenhanded, patiently follows each and every thread of this elaborate story, and weaves them together in amusing ways. The bride-to-be's philandering father, for instance,

grieves jealously over his mistress's infidelities but then perks up at the sight of his elegant future in-law, the widowed mother of the groom. These arrangements, and many others like them, may sound hard to follow, but part of the enjoyment comes from beginning to differentiate between family members during the course of a long, agreeable visit. Be sure to have a snack before showtime. "The Story of Boys and Girls" will be shown tonight at 6 and Sunday at 3 P.M.

●

The short film on the same program is Anna Campion's "Audition," in which the director's sister Jane (herself the director of "Sweetie") plays a film maker coming to terms with her mother in the course of shooting a filmed audition in which the mother appears. The story's mother-daughter dynamics are of much greater interest than Ms. Campion's stilted, uncertain directorial technique.

1991 Mr 28, C12:1

The Comfort of Strangers

Directed by Paul Schrader; screenplay by Harold Pinter, based on the novel by Ian McEwan; director of photography, Dante Spinotti; edited by Bill Pankow; music by Angelo Badalamenti; production designer, Gianni Quaranta; produced by Angelo Rizzoli; released by Skouras Pictures. At Angelika Film Center, Mercer and Houston Streets, in Manhattan. Running time: 105 minutes. This film is rated R.

Robert Christopher Walken
Mary Natasha Richardson
Colin ... Rupert Everett
Caroline Helen Mirren

By VINCENT CANBY

Paul Schrader's "Comfort of Strangers" is about decadence in Venice, a place of long golden afternoons, steamy nights, grand palazzos, dark alleys, incredible beauty, unrecognized malignancies and, finally, death.

"The Comfort of Strangers" is too much, which is just about right for a horror film so romantic that its true nature is only revealed at the very end, when escape is no longer possible.

Harold Pinter, who adapted the screenplay from Ian McEwan's novel, has never written a film as alarmingly ghoulish as this tale of terminal love. "The Comfort of Strangers" is a Grand Guignol variation on the kind of scary Pinter play in which the menace remains discreet. Not here.

●

Two couples meet, it seems, by chance.

Mary (Natasha Richardson) and Colin (Rupert Everett) are English

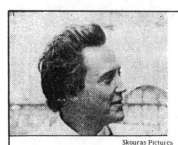

Skouras Pictures
Christopher Walken

tourists, returning to Venice where they spent an idyllic holiday four years earlier. Though they are lovers, they don't live together. They are now trying to work things out.

Mary is pretty, practical and commonsensical, the divorced mother of two children. Colin is less easily understood. He is clearly intelligent, but troubled. With his chiseled male-model good looks, he is more than handsome. He is beautiful. When he and Mary go sightseeing, he is the one whom strangers pinch.

The other couple lives in Venice. Robert (Christopher Walken) is a well-born Italian, so elegantly bred that he seems stateless. His devoted, somewhat physically impaired wife, Caroline (Helen Mirren), is Canadian, the daughter of a former ambassador to Italy.

Bad backs are not uncommon in today's society, but Caroline's is inexplicably mysterious. It comes and goes. She doesn't complain. She seems rather proud of it.

●

Robert talks too much, mostly about himself (stories no one asks to hear), mostly in English. He gives the impression that he speaks all major languages. If he is a fraud, as seems possible, he's a high-class one.

The initial meeting is casual enough. Late one night Colin and Mary become lost when they leave their hotel in search of something to eat. Robert, immaculately dressed in a white suit, finds them in a cul-de-sac and leads them to a bar.

He doesn't exactly charm them, but he is helpful. They only half listen to his stories about his family, about

A horrific comedy from Pinter and Schrader in La Serenissima

his fierce but beloved father who used to touch up his gray mustache with mascara.

Colin and Mary get quite drunk. Later they wind up lost again and sleep in an alley. The ubiquitous Robert reappears the next morning and insists they go home with him to get some much needed rest.

●

When they wake up that evening, they are in a great bedroom in a spectacular apartment with a panoramic view of Venice. But their clothes have vanished.

Robert is not around but Caroline explains pleasantly that Robert has instructed her to withhold their clothes until they agree to stay for dinner. They accept champagne as well as the rather pre-emptory invitation. That settles that. It also fixes their doom.

In spite of the rather grisly things that happen, "The Comfort of Strangers" is as much a comedy, if a melodramatic one, as a horror film. It certainly is not a tragedy. As much as Mr. Pinter's "Betrayal," it's about love and marriage and the terrible things people do to each other when the joys of intimacy have worn thin.

As it turns out, "The Comfort of Strangers" is more about the psychopathic Robert and his helplessly bewitched Caroline than it is about the conventional Colin and Mary, who become the victims of the older couple.

Yet, under the influence of Robert and Caroline, the English lovers find a renewed passion that is crazy in its intensity, and all too brief.

●

"The Comfort of Strangers" — which opens today at the Angelika Film Center — is a character piece, dressed to the nines by Armani, the Italian designer who almost qualifies as one of the film's auteurs. As photographed by Dante Spinotti and with production design by Gianni Quaranta, the movie also looks appropriately rich and, like Robert and Caroline, self-indulged.

More important, it is performed with great style by its four stars, particularly by Mr. Walken, who somehow manages to seem perfectly sane though clearly around the bend.

Miss Mirren's Caroline appears fragile but has the strength of the possessed. It's not easy playing back-up to an all-out sadist. Miss Richardson is the film's center of intelligence and Mr. Everett is its bewildered plaything.

The film goes too far from time to time (how long has it been since you saw a movie that involved drugged tea?), but that is the nature of such all-out upscale wickedness. The Pinter dialogue is a joy to listen to. It clears the brain of cobwebs. It's both witty and to the point of a narrative that builds with immense effect to its inevitable end.

As he last demonstrated with "Patty Hearst," Mr. Schrader is a director of great rigor and discipline. The movie is fascinated by the baroque behavior it observes, but without imitating it.

As in the opening of the film, when the camera moves through the empty rooms of Robert's rented apartment,

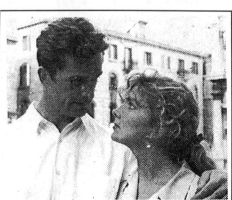

Comfy
Rupert Everett and Natasha Richardson star in Paul Schrader's "Comfort of Strangers."

Skouras Pictures

"The Comfort of Strangers" sees all but never allows itself the comfort of either easy analysis or moral judgment. That is up to the audience.

"The Comfort of Strangers" disconcerts as it entertains.

•

"The Comfort of Strangers," which has been rated R (Under 17 requires accompanying parent or adult guardian), has some erotic sex scenes as well as one act of explicit violence.

1991 Mr 29, C6:1

American Blue Note

Directed and produced by Ralph Toporoff; screenplay by Gilbert Girion; story by Mr. Toporoff and Mr. Girion; director of photography, Joey Forsyte; edited by Jack Haigis; music by Larry Schanker; production designer, Charles Lagola; presented by Panorama Entertainment. At Village East, Second Avenue and 12th Street, Manhattan. Running time: 96 minutes. This film is rated PG-13.

Jack	Peter MacNicol
Benita	Charlotte d'Amboise
Nat Joy	Sam Behrens
Lorraine	Trini Alvarado
Jerry	Carl Capotorto

By JANET MASLIN

Being realists, the five quasi-professional jazz musicians in "American Blue Note" know that they aren't going anywhere, unless it's perhaps someplace they can drive to in their own car. Transportation is often the first — and sometimes the only — concern of the Jack Solow Quintet's prospective employers. Musical ability takes a definite back seat, but somehow the group members persevere.

"American Blue Note," a debut feature by Ralph Toporoff, follows their travails with rueful amusement,

Five jazzmen bound by a love of playing.

watching from the standpoint of Jack Solow himself (Peter MacNicol), the glum-looking front man. It falls to Jack to convince potential employers that the group can play at any kind of wedding, and to keep his fellow musicians from giving up their last shreds of hope. Mr. MacNicol manages all this with a nicely pained expression and considerable comic aplomb, even when being asked to play "How Much Is That Doggie in the Window?"

The film — which opens today at the Village East — follows the musicians to various auditions and dives, always maintaining a quietly deadpan style that proves a bit too quiet in the final analysis. It has been made with affection, intelligence and an assured visual style (the lighting is particularly good), but without a lot of spark. The story's dramatic developments are relatively few, as befits a tale of struggling, good-hearted alsorans in the musical world of the early 60's, a period whose relative innocence is reflected in the characters' clean-cut style. But at times the film's deliberate mildness leaves it feeling too flat.

Fakebook Productions
Peter MacNicol

Most of the way through, "American Blue Note" manages to be warmly amusing, especially when observing the group members' various domestic problems. Jack is called on to visit an uncle who insists on settling a feud Jack knows nothing about, and an aunt who speaks in commands ("Come! Eat!"). Another group member, the comically discouraged Jerry (Carl Capotorto), must shrug off the antics of a crazy grandfather who talks back to Road Runner cartoons. In his own apartment, Jack is sometimes politely but firmly ousted so that another band member can be alone with Lorraine (Trini Alvarado), a radiant young woman who treats Jack pleasantly but with virtually no awareness of his existence.

Eventually, the beleaguered Jack tries out a hesitant courtship with a dance teacher named Benita (Charlotte d'Amboise), who seems to like him a lot. It's a good thing somebody does. Benita is the reason Jack and the others find themselves playing a jazz version of Tchaikovsky at a ballet recital performed by small children, who are as good an audience as the Jack Solow Quintet will ever find. It makes for a gently charming, suitably hangdog finale.

"American Blue Note" also includes an extended sequence in which two total strangers become part of the quintet's act and rise admirably to the occasion. The world in which this film unfolds is held together by a guileless love of music. All of its characters share this, and it's almost enough to make up for the small, wry indignities they must endure.

•

"American Blue Note" is rated PG-13 (Parents strongly cautioned). It contains mildly off-color language.

1991 Mr 29, C12:1

The British Animation Invasion

A series of 25 short animated films produced by Terry Thoren. At Cinema Village East, Second Avenue and 12th Street in Manhattan. Running time: 110 minutes. These films have no rating.

By STEPHEN HOLDEN

"The British Animation Invasion," a breathlessly paced new anthology of animated shorts from Britain, doesn't call itself an invasion for nothing.

The 110-minute program, which opens today at the Village East Theater, not only has a technological edge over other recent animated anthologies, it is also smarter and wittier. Stylistically, the 25 segments run from old-fashioned cartoons, to the computer-animated head games of

Stephen Johnson's video for Peter Gabriel's song "Sledgehammer" and the surrealism of David Anderson's "Door," which uses photographic images and elaborate models.

For all the variety on display, the anthology still has a cheeky overall tone that might be described as a cross between early John Lennon and Monty Python. The Beatles' "Yellow Submarine," after all, stands as a landmark in the history of British animated film.

•

One of the anthology's high points is Nick Park's five-and-a-half-minute "Creature Comforts," which just won the Academy Award for best animated short film. The movie, which carries a subtle animal-rights message, is set in a zoo whose discontented inhabitants — polar bears, chickens, turtles and a whiny puma — complain about their living conditions. The animals' voices are cleverly matched to sleekly designed clay figures. Without pushing the parallels too far, the film becomes a mild parable of the immigrant experience, homesickness and poverty.

Expanded Entertainment
An animated version of Shakespeare appears in "Next."

Although a majority of the work on display has a semi-hip, media-wise tone, there are some notable exceptions. Charlie Fletcher Watson's "Bluefields Express" offers a capsule history and political analysis of Nicaragua that is impressively clear for a five-and-a-half-minute short. Ian Andrew's "Dolphins" underscores animated watercolors with music by Harold Budd and Brian Eno to evoke an idyllic undersea world menaced by fishermen's nets.

The program includes an Oscar winner.

In the sheer density of its references, nothing compares to Barry Purves's "Next," in which a puppet actor performing an audition goes through the complete works of Shakespeare in just under five and a half minutes. Richard Ollive's "Night Visitors" evokes an Edwardian storybook world featuring the characters from "Peter Pan," who entice a stolid

constable on his nightly patrol to join them in Never-Never Land.

•

Several of the shorts also create fairly complex characters. Three cartoons by Candy Guard offer mordantly misanthropic studies of rude, self-centered people. Joanna Quinn's "Body Beautiful" follows the adventures of Beryl, an overweight factory worker who takes up bodybuilding, joins a competition and triumphs over her sexist male supervisor.

The biggest problem for American audiences is the thickness of the British accents in many of the shorts. The form compresses so much information into such a small space that the inability to distinguish even one or two words can seriously impede comprehension.

1991 Mr 29, C12:4

The Five Heartbeats

Directed by Robert Townsend; written by Mr. Townsend and Keenen Ivory Wayans; director of photography, Bill Dill; edited by John Carter; music by Stanley Clarke; production design, Wynn Thomas; produced by Loretha C. Jones; released by 20th Century Fox Film Corporation. Running time: 121 minutes. This film is rated R.

Duck	Robert Townsend
Eddie	Michael Wright
J.T.	Leon
Dresser	Harry J. Lennix
Choirboy	Tico Wells
Eleanor Potter	Diahann Carroll
Sarge	Harold Nicholas
Duck's baby sister	Tressa Thomas
Jimmy Potter	Chuck Patterson
Big Red	Hawthorne James

By JANET MASLIN

"I think you guys have what it takes to go all the way to the top," says the would-be manager of the Five Heartbeats, speaking in the tried-and-true idiom of the show-business success story. But "The Five Heartbeats," Robert Townsend's saga of a fast-rising rhythm-and-blues group of the 1960's, is more ambitious than most. Mr. Townsend, the director of the satirical "Hollywood Shuffle," takes on drama, romance, racism and show-business muckraking, not to mention the evolution of black music from Motown to rap.

That's a lot more than "The Five Heartbeats" can comfortably handle.

Robert Townsend celebrates black music from Motown to rap.

Its characterizations are often sketchy, its story awkwardly paced, and its dialogue much too familiar. Even the musical sequences, the very source of the Heartbeats' appeal, are not entirely convincing. But "The Five Heartbeats" also conveys an obvious love of its material and a fundamental sweetness and sincerity. Mr. Townsend's energy and enthusiasm go a long way toward making up for the film's narrative lapses.

Appearing himself in the role of Duck, the Heartbeats' resident songwriter, he frames the film in the post-

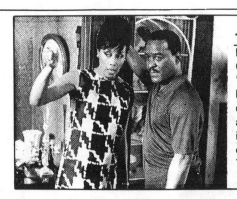

The Beats Go On
Diahann Carroll and Chuck Patterson star in "The Five Heartbeats," Robert Townsend's dramatic comedy about a singing group in the soul and disco era of the 60's and 70's.

Heartbeat present but flashes back to 1965, when the group got off the ground. First seen performing their stage act, the group's members are introduced on the run. Eddie (Michael Wright), the lead singer, is careless enough to be off playing cards when this first performance takes place. J. T. (Leon), Duck's brother, who looks a lot more like Eddie than like Duck, is a lady-killer who works the audience in search of new conquests, and always manages to find some. Duck's role is to keep a cool head and register amazement at the others' antics.

Dresser (Harry J. Lennix) is relatively down-to-earth, though less so than Choirboy (Tico Wells), a sedate minister's son. "Anthony, you disappoint me," Choirboy's father tells him, in the surprisingly clichéd style of the screenplay (by Mr. Townsend and Keenen Ivory Wayans). "You can't serve two masters."

•

The Heartbeats look and sound a shade too modern for the film's 1965 sequences, but the film follows their progress in an appealing way. After attracting the attention of Jimmy Potter (Chuck Patterson), a manager who promises to take them on despite the protests of his wife, Eleanor (the ageless Diahann Carroll), they go on to play in a talent competition, where they bring down the house. The film's audience may never be fully convinced that this could happen, since the group's singing is clearly lip-synched and its songs are ordinary at best (the film perks up noticeably whenever a real Motown record is heard in the background). Still, the big breakthrough scene has the desired effect, and the group's meteoric rise is predictably gratifying.

Mr. Townsend includes a rousing scene in which Duck's kid sister (Tressa Thomas) helps him write a song by belting out a blockbuster rendition of material he felt like throwing away. The scene is enough to convince the audience that a sixth Heartbeat has been born. But then, confusingly, the girl virtually disappears. Later on, Mr. Townsend has Duck and his brother fighting over the love of a mutual girlfriend, even though neither of them has spent any appreciable screen time in her company. Pacing is another problem, since the group takes forever to become successful and then begins a downhill slide seconds after reaching the top.

"The Five Heartbeats" becomes more compelling when it focuses on behind-the-scenes chicanery, confirming the impression that Mr. Townsend works best as a satirical observer of show-business peculiarities. The Heartbeats are courted by Big Red (Hawthorne James), who laughs and changes the subject when they ask about publishing rights to their songs. They are introduced by one record company executive to a group of blond-wigged white men in letter sweaters, who propose to do a cover version of one of their songs. They are even shown, while traveling in the South, a prospective album cover with a heart-shaped photo of a

Eli Reed

Robert Townsend

white family instead of a picture of these five black performers. The year is 1966, at the height of Motown's success, which would seem to make this even more fiscally idiotic than it is racist, but the point in general is well taken.

The film offers glancing, sometimes funny observations of the disco and funk years before arriving in the present. The film's late scenes offer a rousing promise of redemption to musicians who have taken their share of hard knocks, especially after drugs and alcohol begin to do their damage on the headstrong Eddie, whose departure from the group marks the beginning of the end.

Years after quarreling with the others, Eddie returns as a near derelict (Mr. Wright makes his dissipation look woefully convincing). He offers his services, and Duck says the others will give him a call, asking for his phone number. "I look like I got a number, man?" Eddie asks pitiably. The film is too generous to revel in this downfall, preferring instead a spirit of faith and forgiveness.

Well aware of his own place in the firmament, which remains assured despite this film's shaky moments, Mr. Townsend includes affectionate nicknames for other black film makers in his closing credits (Sidney Poitier is "The First Soldier," Charles Burnett is "The Poet"). Another fond gesture is the casting of Harold Nicholas, of the dancing Nicholas Broth-

ers, as an aging choreographer who shows the Heartbeats a thing or two. His very presence expands the range of this film's musical overview by a couple of decades.

•

"The Five Heartbeats" is rated R (Under 17 requires accompanying poarent or adult guardian). It includes profanity and brief sexual suggestiveness.

1991 Mr 29, C14:3

Twilight of the Cockroaches

Directed and written by Hiroaki Yoshida; in Japanese with English subtitles; music by Morgan Fisher; produced by Mr. Yoshida and Hidenori Taga; a Gaga Communications Presentation; a Tyo Production; a Streamline Pictures release. At Film Forum 2, 209 West Houston Street, in Manhattan. Running time: 105 minutes. This film has no rating.

Saito	Kaoru Kobayashi
Neighbor	Setsuko Karasumaru

By VINCENT CANBY

"My name is Naomi and I am 19 years old."

With that commonplace line Hiroaki Yoshida begins a rather uncommon Japanese film, "Twilight of the Cockroaches," a nervy satire that looks at the world from the point of view of cockroaches.

Naomi is a sweet virginal thing betrothed to Ichiro, a nice young cockroach who is just a little bit boring compared to Hans, a heroic warrior cockroach from another tribe.

In the film, which opens today at the Film Forum, cartoon cockroaches are seen against real backgrounds, often in the company of live actors.

The mixture of live action and animation is technically excellent, though the animated characters are not visually interesting.

Naomi and her cockroach friends look like dim fireflies in an old Silly Symphony, but that turns out to be one of the movie's many jokes within the joke: cockroaches are dopey idealizations and humans are gigantic, untrustworthy beasts.

When the film starts, Naomi, Ichiro and their friends are on the fast track, living lives of unparalleled comfort and ease in the house of a bachelor named Saito (Kaoru Kobayashi). Saito likes to eat well and never cleans up. He's a slob after any cockroach's heart.

With his apparent approval, this particular cockroach tribe has never had it so good. They have the freedom of the kitchen and the bathroom, the two most interesting rooms in the house. They don't have to go scurrying around in the dark.

They indulge themselves in broad daylight, much to the horror of one of their elders, who warns against "cavorting in the open like this."

Naomi and Ichiro are aware that other cockroach tribes are fighting for their lives. Hans tells horrifying tales of mass death and destruction abroad (in the house on the other side of the field), but no one pays attention until Saito brings home a girlfriend who is a nut about cleanliness.

Suddenly Naomi, Ichiro and their friends are confronting something more than "crushings, charrings and senseless mutilations." The girlfriend uses a bug bomb. They are confronting genocide.

The publicity material for "Twilight of the Cockroaches" describes the film as an allegory about the fate in store for affluent Japan if it doesn't meet its international responsibilities. The film may read that way in Japan. In this country, it looks somewhat darker and more muddled.

The cockroaches, who call themselves God's chosen people, speak of racial purity. Someone says, "God gave man deadly poisons so only the strongest will survive." Though I assume the film is sending up this master-race idea, it's sometimes difficult to tell, at least in the English subtitles that are provided.

Streamline Pictures

A scene from "Twilight of the Cockroaches," a Japanese comedy by Hiroaki Yoshida that is being shown at the Film Forum.

The ground-level, cockroach point-of-view photography is cleverly done, as are the sound effects. The noise of an ordinary footfall is olympian thunder to a cockroach, while the closing of a zipper cracks the ear drums.

The film's most comically subversive effect is the way it splits the loyalties of the ordinary city dweller who, outside the theater, spends far too much time attempting to outwit the dread, never-ending horde.

1991 Mr 29, C14:4

Interpretation of Dreams

Directed by Andrei Zagdansky; screenplay (in Russian with English subtitles) by Semyon Vinokur; photography by Vladimir Guyevsky; edited by Yuri Mackarov; production companies, Creative Union Chetverg Kievnauchfilm in cooperation with ORF (Austrian Television). At the Roy and Niuta Titus Theater 1, 11 West 53d Street, as part of the New Directors/ New Films Series of the Film Society of Lincoln Center and The Department of Film of the Museum of Modern Art. Running time: 50 minutes. This film has no rating.

Narrated by Sergei Yursky

Emil & Fifi

Directed, written and produced by Brett J. Love; in English, French and Czechoslovak with English subtitles; photography by Michael Siegel; editing and animation by David Hartwell. At the Roy and Niuta Titus Theater 1, 11 West 53d Street, as part of the New Directors/ New Films Series of the Film Society of Lincoln Center and the Department of Film of the Museum of Modern Art. Running time: 50 minutes. This film has no rating.

By VINCENT CANBY

Two 50-minute films, Brett J. Love's "Emil and Fifi" from the United States and Andrei Zagdansky's "Interpretation of Dreams" from the Soviet Union, make up the program that will be shown today at 6 P.M. and tomorrow at 12:15 P.M. in the New Directors/New Films series.

By far the more interesting (and more difficult) is "Interpretation of Dreams," in which an entire country is put on the couch to be analyzed by the film maker using Sigmund Freud as his guide.

Mr. Zagdansky juxtaposes quotes from Freud, which are read on the soundtrack, and the history of the Soviet Union as captured in vintage newsreels and other old films.

The tone is that of an enlightened skeptic, the manner witty. The film attempts to come to terms with a time that now seems to have been seriously neurotic, if not worse. The English subtitles fly by at a fairly relentless pace, which makes the film almost as exhausting as it is provocative.

"Emil and Fifi" is Mr. Love's somewhat naïve homage to his grandfather who, even on the evidence seen here, deserves better.

Emil Symek, who was born in Prague in 1903, now lives in placid retirement in Paris with his much younger second wife and a poodle named Fifi. His life not only spans that of his native Czechoslovakia, but also embraces its history.

Mr. Symek began as a journalist, then became a political analyst, novelist, playwright, film maker and, finally, a politician and diplomat.

As a prominent anti-Nazi, he was a minister in President Eduard Benes's exile government in London during World War II. Later he served in Paris as a representative of the Communist government of President Klement Gottwald. After a falling out with the Communists, he settled in Paris and, from 1955 to 1973, served as a consultant to the United States State Department.

Those are impressive credits, and at 87 Mr. Symek remains an impressive man, though his grandson appears to have no idea how to get through to him. The movie has the hurried manner of a term paper that must be turned in tomorrow.

As an off-screen interviewer, traipsing around Paris after Mr. Symek and Fifi, Mr. Love simply asks blunt questions that couldn't interest his grandfather less.

At one point, Mr. Love suggests that his grandfather "collaborated" with the Communists. The old man is too tired to explain the complexities of long-ago alliances. When the younger man asks him to talk about his experience as a judge, Mr. Symek turns the conversation to Mr. Love's girlfriend. Anything to stop this uninformed chatter.

In an attempt to give "Emil and Fifi" historical perspective, Mr. Love supplements the principal material, which includes home movies as well as the recent interviews, with old newsreels.

This is accompanied by soundtrack narration stuffed with lines like "the Nazi quest for power was at a fever pitch" and "war engulfed the whole of Europe."

In addition to making movies, Mr. Love teaches writing at Pepperdine University.

1991 Mr 30, 10:4

Sirup

Directed and written by Helle Ryslinge; in Danish with English subtitles; photography by Dirk Bruel; edited by Birger Moller Jensen; music by Peer Raben; produced by Per Holst. At the Roy and Niuta Titus Theater 1, 11 West 53d Street, as part of the New Directors/ New Films Series of the Film Society of Lincoln Center and the Department of Film of the Museum of Modern Art. Running time: 114 minutes. This film has no rating.

Lasse	Peter Hesse Overgaard
Ditte	Kirsten Lehfeldt
The Rack	Inger Hovmand
Jesper	Steen Svare
Pia	Pernille Hojmark-Jensen
Terje	Henrik Scheele
Goldbauer	Aage Haugland
Bente	Marianne Moritzen

By CARYN JAMES

Though it is set in Copenhagen, "Sirup" could easily take place in New York or Paris or any city with a colorful, active, acquisitive art world, anywhere creators and poseurs mingle at gallery openings and are not easy to tell apart.

Lasse Seerup, the antihero of Helle Ryslinge's generous, wry and vibrant look at that world, is a slightly scrawny but not bad-looking art-world operator. Along with some colleagues, he is part of an avant-garde cooperative, which gives him a good line of artsy patter with which to impress women. He needs those lines because he is a conspicuously talentless performance artist, who stands next to multiple video monitors, talking about destruction, a red heart painted on his bare chest. The performance has something to do with life and death.

It really has to do with Lasse's ruthless will to survive in the company of far more talented people, of course. As the writer and director sweeps through a short period in Lasse's life, she targets him and his world with an exceptionally shrewd eye, a sharp sense of the ridiculous and an understanding spirit. "Sirup" will be shown today at 3 P.M. and tomorrow night at 9 as part of the New Directors/New Films series.

The emotional center of the film is Lasse's relationship with Ditte, a woman who is smart, serious and so accomplished a painter that her breakthough seems inevitable. Lasse charms her, manages to move into her apartment and in his quiet way nearly destroys her. He is unbearably jealous when her paintings are considered for a show of Scandinavian work to be sent to New York. Ditte begins to realize she has not produced any good work since Lasse moved in.

But before she can lose him they go through infidelity, screaming-crying arguments and one scene that turns the well-balanced Ditte into a revolting drunk. Though Ditte is temporarily repulsive, Lasse emerges from the scene a true villain for what he has done to her. Taking advantage of Ditte and selling out his friends to further his ambitions, he finally turns from a pathetic failure into the artistic and emotional vampire he had always threatened to become.

John Johansen/Film Society of Lincoln Center
Kirsten Lehfeldt

Though "Sirup" is structured around Lasse and Ditte's relationship and his obsessive desire to horn in on the New York show, the most striking aspect of the film is the spirited and detailed way Miss Ryslinge establishes the art-world backdrop. From a bright-looking close-up of a dead fish in a bowl to the unobtrusive detail of crass, jeweled, Mondrian-inspired earrings worn by a wealthy art buyer, the atmosphere of "Sirup" is slightly exaggerated yet totally believable.

The cast is remarkably natural, both in the scenes of domestic warfare between Ditte and Lasse and in the episodes of group meetings and dinners, including one in which Lasse's exasperated friends mock everything from his art to his habit of bumming cigarettes. If there are occasional moments of sympathy for this obviously shallow, manipulative man, that is an impressive mark of Miss Ryslinge's breadth and understanding, for the film never endorses his behavior. In fact "Sirup" has all the visual flair, intelligence and ambition of the art world it depicts, with none of the pretension. Like Ditte, Miss Hyslinge is an artist who richly deserves a break.

1991 Mr 30, 10:4

Atlantic Rhapsody

Directed and written by Katrin Ottarsdottir; in Faroese with English subtitles; photography by Andreas Fischer-Hansen and Lars Johansson; edited by Jens Bidstrup; composer, Heoin Meitil; produced by Hugin Eide; production company, Kaleidoskop Film. At the Roy and Niuta Titus Theater 1, 11 West 53d Street, as part of the New Directors/ New Films Series of the Film Society of Lincoln Center and the Department of Film of the Museum of Modern Art. Running time: 80 minutes. This film has no rating.

WITH: Erling Eysturoy, Elin Karbech Mouritsen, Pall Danielsen, Mikkjal Helmsdal, Birita Mohr, Hjordis Heindriksdottir, Asa Lutzhoft, Sverri Egholdm, Elis Poulsen, Egi Dam

By JANET MASLIN

Katrin Ottarsdottir's "Atlantic Rhapsody: 52 Scenes From Torshavn," the first and only feature film by a director native to the Faroe Islands, is also a novelty on another score. Its narrative focus is shifted successively from one character to another, in the manner of a relay race, throughout the film's entire running time. So a scene in which people having breakfast see a fire truck out their window gives way to a scene involving the firemen; when a group of old men sitting by the harbor see a couple of young girls walk by, the camera wanders off with the girls. After the camera lurches abruptly into a hospital room to watch the birth of a baby, it shifts its attention to a maternity ward nurse and her boyfriend.

The director's ability to sustain this device at length amounts to an interesting feat of gamesmanship, and works more successfully than may sound possible. But the trick has the inherent problems of being frustratingly superficial and of leaving the film in a twilight realm of quasi fiction. Miss Ottarsdottir, in using this method to create an overview of life in the Faroese capital of Torshavn, winds up revealing very little that could not be dealt with more easily and accurately in a documentary format. The idea of using nonactors to deliver fictionalized but mundane-sounding dialogue becomes similarly distracting.

The film's portrait of Torshavn is at times mildly surprising — there is at least one Faroese disco, it turns out — and well rounded as long as it sustains its ties with reality. In its later stages, the film takes on a hint of mysticism that only adds further strain.

•

On the same program at the New Directors/New Films series, being shown tonight at 9 and tomorrow at 6 P.M., is "Theory of Achievement," a sardonic short film by Hal Hartley in which contemporary Brooklyn is presented as a spiritual equivalent to Paris in the 20's. The idea is potentially funny, what with an accordion player singing a ballad about the lottery, and lines like "we can't eat poetry" coloring the screenplay. But the film's central conceit, and its characters' efforts to reconcile artistic ambitions with humdrum reality, wear thin long before this brief satire is over.

1991 Mr 30, 11:1

Warlock

Directed and produced by Steve Miner; written by D. T. Twohy; director of photography, David Eggby; film editor, David Finfer; music by Jerry Goldsmith; production designer, Roy Forge Smith; released by Trimark Pictures. Running time: 102 minutes. This film is rated R.

Warlock...............................Julian Sands
Redferne.........................Richard E. Grant
Kassandra..............................Lori Singer
Channel..............................Mary Woronov
Chas..................................Kevin O'Brien
Mennonite............................Richard Kuss

By VINCENT CANBY

"Warlock" is a new occult melodrama that's about nothing less than the Uncreation of Man, the film's phrase, not mine. This diabolical scheme is hatched by an off-screen Satan and carried through to near-success by a warlock who aspires to become Old Scratch's son and heir.

As such nonsense goes, "Warlock" is unexpectedly entertaining, having been concocted with comic imagination by D. T. Twohy, who wrote the screenplay, and Steve Miner, the director.

The cast is headed by Lori Singer, as a hip Southern California type more comfortable in the company of surfers than satanists, and two good young English actors: Julian Sands, who plays the warlock, and Richard E. Grant, as a Bostonian so proper that he has been battling the powers of darkness since 1691, which is when the film's prologue is set.

•

Most of "Warlock" takes place in and around contemporary Los Angeles, where the warlock reappears. He is instructed by Satan to collect the three parts of his holy book in order to bring about the destruction of mankind. More need not be revealed.

Miss Singer is breezily attractive as a young woman who is cursed by the warlock to age 20 years a day. She is thus quite a sight in her leather miniskirt when she's well into her 80's. Mr. Sands and Mr. Grant are also visually arresting in 17th-century duds that look only eccentric in today's Los Angeles.

"Warlock" opened here yesterday at a number of theaters including the National, where, at the first show, the film was badly out of focus initially. Later, from time to time, the framing was off. In the final confrontation between good and evil, Mr. Sands was decapitated, not in the movie but in some mix-up in the projection booth.

•

"Warlock," which has been rated R (under 17 requires accompanying parent or adult guardian), has vulgar language and some ghastly but clearly simulated violence.

1991 Mr 30, 11:4

Career Opportunities

Directed by Bryan Gordon; written by John Hughes; director of photography, Don McAlpine; film editors, Glenn Farr and Peck Prior; music by Thomas Newman; production designer, Paul Sylbert; produced by Mr. Hughes and A. Hunt Lowry; released by Universal Pictures. Running time: 84 minutes. This film is rated PG-13.

Jim Dodge..........................Frank Whaley
Josie McClellan...............Jennifer Connelly
Nestor Pyle......................Dermot Mulroney
Gil Kinney........................Kieran Mulroney
Bud Dodge.........................John M. Jackson
Dotty Dodge..........................Jenny O'Hara
Roger Roy McClellan........Noble Willingham
Store Manager........................John Candy

By JANET MASLIN

"Career Opportunities," with a screenplay by John Hughes, calls to mind almost every good idea Mr. Hughes has ever had. Since his last good idea was the one for "Home Alone," it's not hard to see how or why this happened. At least Mr. Hughes (unlike this film's poster, which is modeled on the "Pretty Woman" ad) is content to borrow only from himself.

What would be funnier than giving a little kid the run of his family's house? "Career Opportunities," in attempting to provide a good answer to that question, gives an even bigger kid the run of a blocklong department store. The chronically unemployable Jimmy Dodge (Frank Whaley), newly fired from his job at a kennel, applies for work at an enormous store (its manager is played, in an enjoyable cameo appearance, by John Candy). Although he insists on arriving in a limousine and carrying a briefcase, Jimmy has been hired to be only the night maintenance man. On his first evening, his immediate supervisor, who is not a trusting sort, locks him in.

Jimmy himself is Mr. Hughes's Ferris Bueller without the cash, a fast-talking teen-age con man with intense delusions of grandeur. He is known, he is not happy to find out, as "the town liar." And a voluptuous beauty named Josie (Jennifer Connelly) is thought of, at least by Jimmy, as "a high-profile young ingenue." Josie, the rich, spoiled daughter of a local businessman, happens to be shoplifting in Jimmy's store. She falls asleep, and is locked in along Jimmy. So on one evening, a lot of Jimmy's dreams have a chance to come true.

Much of "Career Opportunities" is simply a chance for Jimmy and Josie to go hog-wild with all that unattended merchandise. They roller-skate through the aisles, stage a dinner party using the store's dishes and silverware, and camp out in a tent borrowed from sporting goods. When they dance romantically, they do it in front of the tropical fish, the only part of the store not brightly lit. Bryan Gordon, the film's director, comfortably adapts the live-action cartoon style of "Home Alone" to this setting and makes the shopping-romp scenes lively, although they have been edited with too much MTV-style snap.

Once Josie and Jimmy start talking, they sound the essential theme of any Hughes film: My parents (or classmates) don't understand me. They also touch on the kinds of social differences that figured in Mr. Hughes's "Some Kind of Wonderful." And there are also two bumbling crooks (Kieran and Dermot Mulroney), à la "Home Alone," thrown in for good measure. To the film's credit, it has its own personality in spite of all these obvious debts.

Mr. Whaley has to work too hard to be antic in the early, Ferris Bueller-type scenes, but he gets much better in more easygoing moments. The gorgeous Ms. Connelly is more model than actress, but by those standards she is relatively lively. The story's lovable goons carry guns and ogle Ms. Connelly very enthusiastically, which aims "Career Opportunities" at a slightly older audience than the "Home Alone" crowd.

"Career Opportunities" is rated PG-13 (Parents Strongly Cautioned). It contains includes off-color language and mild sexual suggestiveness.

1991 Mr 31, 38:1

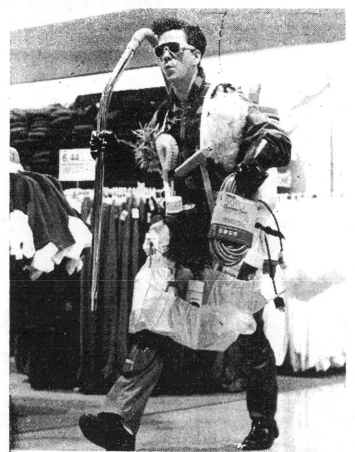

Zade Rosenthal/Universal City Studios

Frank Whaley in a scene from the movie "Career Opportunities."

Something to Do With the Wall

Directed, written, edited, photographed and produced by Marilyn Levine and Ross McElwee; released by First Run Features. At Anthology Film Archives, Second Avenue at Second Street. Running time: 88 minutes. This film has no rating.

By VINCENT CANBY

Nothing ever goes, according to schedule for Ross McElwee, which is his good fortune and ours.

Sometime in the early 1980's the North Carolina-born film maker was planning to make a documentary about Gen. William T. Sherman's devastating march to the sea in the final months of the Civil War. Mr. McElwee had the money, the research and the equipment. He was ready to go.

Then his girlfriend left him, apparently taking the muse of history with her. Mr. McElwee was bereft. For a day or two anyway, life was meaningless.

Being resilient, he eventually carried out his project, following Sherman's tracks through Georgia and the Carolinas, though he was now less interested in Sherman than in the possibility of romantic love in today's South.

The result of that journey was "Sherman's March" (1986), a wonderfully cockeyed record of Mr. McElwee's relationships with a succession of women met along the way, with occasional time out for a visit to a Civil War battlefield or monument.

•

Unforeseen circumstances also played hob with the film maker's plans in 1989 when, two days after he and Marilyn Levine had completed a film about the Berlin wall, the East Germans decided the wall was no longer necessary.

"When the wall opened up," Ms. Levine says on the sound track of their new movie, "Something to Do With the Wall," "we could hardly believe it. We now realized we had to have a new end to our film."

They certainly did. Most of the people they had interviewed in Berlin in 1986, the 25th anniversary of the wall's existence, had glumly accepted the notion that the wall would be around forever.

"Something to Do With the Wall," beginning today at Anthology Film Archives, is another blithe chapter in Mr. McElwee's continuing and extremely uncertain relationship with history. The film is not as personal as "Sherman's March," but it is reporting of a most pertinent and genially eccentric order.

It is also fitting that he should have met Ms. Levine, his co-producer, co-director and co-writer, when he was editing "Sherman's March." She is the happy offscreen ending to the exuberantly footloose odyssey remembered in the earlier film.

Together they traveled to Berlin in 1986 to make a film about the place of the wall in history, in the lives of Berliners, who had to live with the wall, and in the consciousness of Americans for whom it had become a cold war metaphor and tourist attraction.

Mr. McElwee and Ms. Levine, who is a film maker in her own right, were married in 1987. The next year they became parents of a son, Adrian, who was just 9 months old when they packed him up with their camera equipment and flew back to Berlin in 1989 to record the wall's last days.

FILM VIEW/Caryn James

'Comfort' Unsettles The Nerves

THE FIRST CHUCKLE IN "THE COMFORT OF Strangers" comes at the very start. A voice that turns out to be Christopher Walken's speaks in a mongrel-European accent that is probably, given the backdrop of Venice, meant to be Italian. "My father was a very big man," the voice says with slow solemnity. But when he gets to the line "I was his favorite," it sounds a little too much like "I was his ferret" to be taken seriously.

Something is off balance here, quite intentionally. This quirky, playful psychological thriller — the story of an ordinary English couple lured into the sumptuous home and sinister clutches of a Venetian husband and wife — is the product of a collaboration made in the Twilight Zone.

A chilling little novel by Ian McEwan became a mordant script by Harold Pinter, then a film directed by Paul Schrader, the screenwriter of "Taxi Driver." With each layer the strangeness was enhanced, culminating in the effectively bizarre performance of Mr. Walken, an actor who reaches for excess as easily as he breathes.

This is obviously not the sort of partnership that will produce smooth, seamless, reassuring movies. It is an unsettling and daring collaboration, which always risks going completely over the edge and sometimes actually goes there.

The result is a film that is easy to laugh at, instead of with, if it is taken too literally. But if viewers give themselves up to its skewed sensibility, "The Comfort of Strangers" is eerie, seductive, witty and never boring. At the very least, it is a relief from the sort of movie that controls its audience's every tear, laugh and hiccup.

When the English couple, Colin (Rupert Everett) and Mary (Natasha Richardson) stupidly leave their hotel without a map and lose themselves in the mazelike streets of Venice, they chart the twisted course of the film itself. No map, no sense of what a comedy or a thriller should be will help viewers navigate a work that defies all expectations except one: the elliptical style and the intrusion of violence on almost ordinary lives. Those elements run through the work

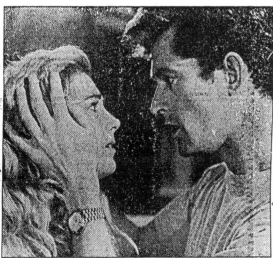

Skouras Pictures

Natasha Richardson and Rupert Everett as the English couple in "Comfort of Strangers"

of all three men, from Mr. Pinter's first play, "The Birthday Party," to Mr. McEwan's current, ironic novel, "The Innocent," to Mr. Schrader's 1988 film, "Patty Hearst."

"The Comfort of Strangers" neatly fits that pattern. Here the mysterious Robert (Mr. Walken) lurks around corners in his elegant white suit, surreptitiously photographing Colin and Mary. When he invites them, dead tired, to sleep in his guest room, they wake to find their clothes missing. Robert's wife, Caroline (Helen Mirren), later confesses that she watched them sleep naked. "I just sat on the chest for half an hour," she says as if it were ever-so-slightly peculiar.

Paul Schrader and Harold Pinter turn Ian McEwan's novel into a quirky thriller.

The film's twisty manner is best captured in a scene — present in the novel and intensified on screen — in which Robert is drinking Champagne with Colin and displaying mementos of his father. Suddenly he proves his idea of manhood by punching his guest in the stomach. Then Robert stands back, calmly lights a cigarette and winks at Colin. A punch and a wink; that's the film's style, though its creators never let on which one is coming next.

Mr. Pinter's unmistakable humor makes a major contribution to this off-balance mood. In the atmospheric, pared-down novel, Colin and Mary are lovers in romantic difficulty; on screen, they engage in the kind of Pinteresque dialogue that stretches language to the point of comic absurdity. When Mary tries to discover Colin's attitude toward her two children, it becomes a bit of business set over a tiny table in an outdoor cafe.

"Do you like children?" Mary asks.

"What do you mean, do I like children?" Colin answers.

"Do you like children?" says Mary.

"Do you mean the species as such?" says Colin, and so the conversation goes on. The actors' deadpan delivery finds the humor without denying the seriousness of the dialogue.

Yet the film also works as a psychological thriller. The shadowy look, the aura of menace and the controlled pacing recall Mr. Schrader's best work as a director, the first part of "Patty Hearst." Also starring Ms. Richardson, that work was imbued with claustrophobic light and darkness and a sense of psychic torture, which lasted until the heroine got out of her closet and the film dropped to the level of a television docudrama.

"The Comfort of Strangers" sustains its ominous mood. It creates a Venice of oppressive buildings, overdecorated interiors and deepening shadows, an off-kilter cityscape reflecting the sexual seductiveness and lethal danger that Robert and Caroline embody.

When the film loses its footing, of course, it threatens to sink into the nearest canal. Days after Colin and Mary have left their bizarre new acquaintances, they find themselves under Robert and Caroline's window. When Caroline waves them up and Colin says, "Well, she's seen us; we can't really be rude," it plays as a ludicrous lapse of good sense rather than a sendup of English politeness or as a cover for Colin and Mary's secret attraction to their sadomasochistic hosts.

That unevenness makes "The Comfort of Strangers" the sort of film audiences either love or hate. Anyone impatient with murky motivation might as well pass it by. But viewers eager for a film that gives the imagination room to breathe should welcome this perfectly bizarre collaboration. ☐

1991 Ap 7, II:13:5

Echoes of Conflict

Three films directed by Jorge Johanan Weller, Amit Goren and Gur Heller; in Hebrew with English subtitles; photography by Jorge Gurvich; distributed by Kino International. At Film Forum 1, 209 West Houston Street. Running time: 93 minutes. These films have no rating.

By JANET MASLIN

The three short Israeli films that constitute "Echoes of Conflict," the new program at the Film Forum, share the same tension and malaise. The anxiety level in each of these short dramas is unbearably high. Paranoia is everywhere, and the reactions it provokes are often trigger-happy and frightening. These stories of contemporary Israel are united by this inescapable strain and by their pessimism. None of the three film makers hold out much hope for a peaceful future.

The best film on the program is its middle selection, "The Cage" by Amit Goren. It is a black-and-white portrait of an Israeli and a Palestinian who work together in a Tel Aviv bar. They have forged a grudging, caste-conscious friendship in which the Palestinian, Yussuf, is quietly def-

erential to the loud, teasing Yoav, until Yoav's military reserve duty intervenes.

"The Cage" follows Yoav to the West Bank, where he is involved in the arrest of a suspected member of the Palestine Liberation Organization and is himself greatly changed in the process. He returns home deeply mistrustful of Yussuf, who is distantly connected to the incident and has in any case lied to his co-worker about something small. The film works best at presenting both the irrationality and the inevitability of both men's attitudes. Neither of them can escape the anger or frustration that this incident helps unleash.

•

"The Cage" has a fairly lively visual style as well as a compelling story, while the program's other two films are less accomplished. "Don't Get Involved," an exercise in extreme paranoia by Jorge Johanan Weller, tells of an Argentine émigré now living in Israel and still haunted by memories of political persecution in his native land.

Plagued by nightmares, Miguel begins to suspect that he is under official surveillance for his political activities on the Israeli left. In telling this story, Mr. Weller also offers a compelling view of his central character's family, whose responses to modern Israeli problems have been shaped by the troubles of their past, and especially of Miguel's brother, whose advice gives the film its title.

The third film, "Night Movie" by Gur Heller, finds an Israeli soldier and his young Palestinian prisoner handcuffed together in a deserted neighborhood, waiting for the soldier's colleagues to return with help. During the all-night ordeal, the man and boy develop the expected mutual understanding and are all the more shocked by the forces of bitterness and suspicion that await them at dawn. These forces, palpable in all three films in "Echoes of Conflict," have at least been documented here, even if they cannot be dispelled.

1991 Ap 10, C16:3

Korczak

Directed by Andrzej Wajda; written (in Polish with English subtitles) by Agnieszka Holland; director of photography, Robby Muller; edited by Ewa Smal; music by Wojciech Kilar; production designer, Allan Starski; produced by Regina Ziegler, Janusz Morgenstern and Daniel Toscan du Plantier; released by New Yorker Films. At Lincoln Plaza Cinema, Broadway at 63d St., in Manhattan. Running time: 113 minutes. This film has no rating.

Korczak	Wojtek Pszoniak
Stefa	Ewa Dalkowska
Heniek	Piotr Kozlowski
Estera	Marzena Trybala
Szloma	Wojcieh Klata
Abramek	Adam Siemion

By VINCENT CANBY

Much like the man it honors, Andrzej Wajda's "Korczak" maintains a steely surface tranquillity in the face of unspeakable events. From time to time, the Polish film suddenly speaks out in anger, then catches itself, as if children might be listening.

"Korczak," which opens today at the Lincoln Plaza, is a rigorously plain black-and-white movie about a remarkable, probably very complex personality.

He is Janusz Korczak (1878-1942), born Henryk Goldszmit, the Polish-Jewish doctor and educator who devoted his life to the care, study and improvement of the lot of children. In the years between the two world wars, Korczak wrote, lectured, conducted a popular radio program and sponsored a magazine put together entirely by children.

More important, he opened a home for Jewish orphans in Warsaw where he could put into practice his theories relating to children's rights. He died at Treblinka along with members of his staff and 200 children from his orphanage, which had been moved into the ghetto in 1940.

Korczak was clearly some kind of saint.

•

Mr. Wajda, being all too aware that dramatized saintliness tends to be upstaged by melodrama and sentimental speculation, has chosen to make a film so self-effacing that "Korczak" plays more like a synopsis of a life than a revelation of it.

The scale of the movie is properly small, the focus is short. In a succession of mini-tableaux, the facts of the man's life are presented without editorial comment:

New Yorker Films
Wojtek Pszoniak with an orphan.

The explanation for his adoption of the name Korczak, the loss of his job as a broadcaster in 1936 because of "pressures," his increasing difficulties in keeping up the children's home during the Nazi Occupation and, finally, his decision to remain with the children when deportation came.

Yet the modesty of Mr. Wajda's approach is more effective in theory than in practice. "Korczak" can't qualify as anti-dramatic or minimal art. It deals in generalities that are completely conventional. It looks like an authorized biography.

Korczak is played soberly by Wojtek Pszoniak, who was so fine as Robespierre in Mr. Wajda's "Danton." Korczak's only distinguishing features are his nobility and his occasional losses of temper, as when he attempts to stop a German soldier who is beating an innocent man (which, of course, amounts to more nobility).

Nobody else in the movie is characterized even to that limited extent.

What's missing from "Korczak" is a sense of the context in which it was made. Several of Mr. Wajda's earlier films have not traveled well, mostly because they have dealt with aspects of the Polish political scene that were beyond the ken of most Americans.

Something of the same sort of problem exists with "Korczak." Mr. Wajda has been quoted as saying that he wanted to make this film because "Jewish themes in Polish culture have been virtually banned for 20 years."

This must explain, in part, why he has treated the subject with such high-mindedness and reverence that "Korczak" seems to have no life of its own.

Even so, Mr. Wajda was severely criticized at last year's Cannes International Film Festival for the sequence that ends "Korczak."

In the film's first and last burst of cinematic imagination, Mr. Wajda watches the train transporting Korczak and the children to Treblinka. Suddenly the last boxcar becomes unhooked. It slows to a halt. The doors open and the children tumble out into the sunshine of an idyllic meadow. Free at last.

This dreamy, quite magical moment almost justifies the flat tone of all that has gone before. Though critics in Israel have praised the ending, others have seen it as an attempt to mitigate the horror of the "Final Solution."

Claude Lanzmann, director of the epic Holocaust film "Shoah," has questioned why "Korczak" omits any mention of passive Polish assistance to the Nazis during the occupation.

"Korczak" is not a great film, but it shouldn't be condemned for not being something else entirely.

1991 Ap 12, C8:1

Daddy Nostalgia

Directed by Bertrand Tavernier; screenplay (in French with English subtitles) by Colo Tavernier O'Hagan; director of photography, Denis Lenoir; edited by Ariane Boeglin; music by Antoine Duhamel; produced by Adolphe Viezzi; released by Avenue Pictures. At the Fine Arts Theater, 4 West 58th Street in Manhattan. Running time: 105 minutes. This film is rated PG.

Daddy	Dirk Bogarde
Caroline	Jane Birkin
Miche	Odette Laure
Juliette	Emmanuelle Bataille
Barbara	Charlotte Kady
Caroline as a child	Michele Minns

By JANET MASLIN

The silences in "Daddy Nostalgia," Bertrand Tavernier's handsomely elegiac film about the last days spent together by a father and daughter, are filled with foreboding. Tony (Dirk Bogarde) has lately been hospitalized, and the prognosis is poor. Neither he nor his daughter Caroline (Jane Birkin) speaks directly about his medical condition. Instead, as Caroline pays an extended visit to her parents on the Côte d'Azur, the conversation is sometimes oblique, sometimes painfully candid, and at other times absurdly petty. "Daddy Nostalgia" recapitulates this family's full emotional history in light of the sad circumstances that bring parents and child together one last time.

It is clear that Daddy and Caro, as they are called in the film, are exceptionally close. Not long after she arrives from Paris, Caro has begun conspiring with her father to enjoy surreptitious outings that violate the strict, joyless rules imposed by her mother (Odette Laure), whose greatest comforts in life seem to come from Roman Catholicism and Coca-Cola. As they steal away together, Caro and Daddy share dreams, memories and sometimes even flirtation. "I'd rather be your lover than your son," Daddy says drily, after Caro observes that he and his grandson resemble one another.

While it reunites its two principals, the film also touches on the events that have kept them at a distance. The urbane father long ago neglected the needs of his child; he is seen in flashback at a cocktail party, brushing aside a poem Caro offers him so he can chat with other adults instead. "Funny, I've no memory of you before you were 20," he remarks to her now. And Caro herself, whose attitude is mostly one of smiling helpfulness, occasionally reveals the raw nerves that have resulted from such treatment. "It was a beautiful, selfish life," she says bitterly to her father about his past, "and your selfish sun's going down."

"Daddy Nostalgia," which opens today at the Fine Arts Theater, has a more intimate mood and a more intrinsically emotional subject than Mr. Tavernier's films (among them, "The Clockmaker," "'Round Midnight" and "A Sunday in the Country") usually do. With a largely autobiographical screenplay by Colo Tavernier O'Hagan, the film maker's

Avenue Pictures
Dirk Bogarde

former wife and frequent collaborator, "Daddy Nostalgia" has the makings of a deeply wrenching work. In fact it remains coolly contemplative and somewhat remote, partly in deference to the "elegance and irony," as Caro puts it, that are so fundamental to Daddy's nature. Late in the film, when Daddy tells Caro (who is a screenwriter) that he imagines she will write about this some day, he tells her he could not bear to be presented in a maudlin fashion. The film's quiet detachment keeps it true to his wishes.

"The sweetness of life, my darling, is terribly perishable," says Daddy, providing the film with a motto of sorts. "Daddy Nostalgia" does what it can to capture that sweetness, traveling with Daddy and Caro around the lovely seaside village where he lives ("this seductive trap," he calls it) and to Cannes, where father and daughter share a particularly enchanting day. The film's decorousness also extends beyond the merely scenic, to the point of affecting its fundamental truthfulness.

While "Daddy Nostalgia" does more than full justice to Caro's view of her family, it is noticeably narrowed by the limitations of her perspective. Another sibling is mentioned only in passing, and neither she nor Caro's prim mother, Miche, is allowed to hold a serious claim on Daddy's affections. The marriage of Caro's parents is regarded as so hollow that Daddy and Miche, on one of the rare occasions when they are alone together, can speak only of how much they will miss Caro when she goes away.

A 'beautiful, selfish life' is recalled at its end.

While the daughter remembers her father as having once been a dashing, glamorous figure, she reveals no early memory of her mother and certainly no grasp of what kept her parents together. "I sometimes wonder if we ever had anything to talk about," the father confesses to his understanding daughter.

"Daddy, you do love her, don't you?" Caro asks about her mother in another scene. "Of course I do — why do you think I stayed with her?" is the father's not terribly convincing answer.

•

Fortunately, Miss Birkin makes Caro a more vibrant, unpredictable figure than she might have been, and the character seems less self-serving in the flesh than she might have on paper. Miss Birkin's toothy grin and her raw-boned, angular presence give the film a peculiar immediacy, and support the camera's frequent close studies of her smallest gestures.

Mr. Bogarde, who makes the father an immensely dignified and magnetic figure, beautifully captures the full range of frustration and awe that such a man might generate. "This? With this?" he exclaims contemptuously when his daughter brings him an ill-matched necktie and handkerchief to wear home from the hospital, where he has nearly died. It matters not at all that these are the precise things he has requested.

The unfortunately titled "Daddy Nostalgia" is being released in England as "These Foolish Things," from the song that colors the final days this father and daughter spend together. Mr. Tavernier has chosen the perfect musical counterpart to his film's sophisticated mixture of love and regret.

•

"Daddy Nostalgia" is rated PG (Parental guidance suggested). It includes mild profanity.

1991 Ap 12, C10:1

Impromptu

Directed by James Lapine; screenplay by Sarah Kernochan; director of photography, Bruno de Keyzer; edited by Michael Ellis; produced by Stuart Oken and Daniel A. Sherkow; a Hemdale Films Release. At the Beekman, Second Avenue and 65th Street in Manhattan. Running time: 109 minutes. This film is rated PG-13.

George Sand......................................Judy Davis
Frederic Chopin..............................Hugh Grant
Alfred de Musset.........................Mandy Patinkin
Marie d'Agoult.....................Bernadette Peters
Franz Liszt..Julian Sands
Eugène Delacroix........................Ralph Brown
Duchesse d'Antan................Emma Thompson
George Sand's Mother...............Anna Massey

By JANET MASLIN

The rustling of hoop skirts would doubtless be more evident in "Impromptu" if its heroine, George Sand (Judy Davis), did not prefer to dress as a man. As it is, this 19th-century romance achieves the usual decorousness of its genre and goes well beyond that into the realm of classical celebrity farce, whereby the great talents of Sand's day — Franz Liszt, Frederic Chopin, Eugène Delacroix and others — share endless outings, visits, duels and sexual intrigues. The film's style is so merrily and unapologetically contemporary that all of these events might easily be taking place in the present day, most likely on "Dallas."

James Lapine, the award-winning Broadway director and librettist of "Sunday in the Park With George," takes a spirited approach to his debut film, which opens today at the Beekman. His is not an attitude of undue (or even due) reverence. Handling this material playfully, he tosses together the film's artistic luminaries and allows them to indulge in outrageous antics, like the scene that finds Sand pleading for Chopin's affections and telling him she needs only a minute of his time to explain her feelings. "Very well! I'll give you exactly one minute," he says, and proceeds to play his "Minute" waltz.

Mr. Lapine, working with a screenplay by his wife, Sarah Kernochan, never leans as far toward outright farce as Ken Russell might have, but his approach brings Mr. Russell's wildly irreverent biographical films to mind. At the same time, Mr. Lapine retains a fundamental earnestness about his film's central story, which is that of the Sand-Chopin liaison and how it came about. One of the film's major difficulties is that this love affair, at least as presented here, is uneventful and of much less interest than the sideshow that surrounds it. Even the frequent assertions of Chopin's frailty seem improbable since Hugh Grant, who plays him, looks far more robust than anyone else in the cast.

Ms. Davis, a severe and pallid George Sand, is right at home with the character's boldness and less comfortable with her seductive side. But the problems of playing a woman who is addressed, variously, as "George" or "Aurore" or "Mummy" are self-evident, and Ms. Davis certainly cuts a lively figure. Her feminine opposite is embodied by Bernadette Peters, as Marie d'Agoult, Liszt's unhappy mistress and scheming, flirtatious rival for Chopin's affections. Ms. Peters's amusing slyness is accentuated by the stolidness of Julian Sands, who has the hair and accent for his role as Liszt but makes the composer something of a straight man for all of the others.

Mandy Patinkin, as Sand's spurned lover Alfred de Musset, has the film's most flamboyant role and inhabits it vigorously, declaring at one point that Sand "would drink the blood of her children from her lover's skull and not feel so much as a stomachache." Ralph Brown, in the smaller and quieter role of Delacroix, nonetheless stands out as an attentive and sardonic figure. "Go home and paint something dead," Sand barks at him at one point, sounding the film's frequent note of playful sarcasm. Sand herself is described by the sly Marie as "incurably disgusted."

Also notable is Emma Thompson as the rich ninny who proclaims herself a patroness of the arts and invites the others for a fortnight of seduction, and backbiting at her country home, greeting her precious artists with laurel wreaths as they arrive. "I have a tiny talent and an enormous amount of time," she sighs, as Delacroix gives her a painting lesson. Anna Massey, who appears fleetingly as Sand's mother, offers a demonstration of how to make an overpoweringly fine impression in only a few minutes' time.

•

"Impromptu," which has been rated PG-13 (Parents strongly cautioned), includes sexual suggestiveness and off-color language.

1991 Ap 12, C10:5

The Killer

Written and directed by John Woo; in Chinese with English subtitles; cinematography by Wong Wing Hang and Peter Pao; edited by Fan Kung Ming; music by Lowell Lowe; produced by Tsui Hark; distributed by Circle Releasing Corporation. At the Village East Cinemas, Second Avenue at 12th Street in Manhattan. Running time: 110 minutes. This film is rated R.

Jeffrey Chow...............................Chow Yun-Fat
Inspector Lee....................................Danny Lee
Jennie...Sally Yeh
Sydney Fung..Chu Kong
Sgt. Randy Chang....................Kenneth Tsang
Johnny Weng.................................Shing Fui-On

By STEPHEN HOLDEN

Balletic splatter and camp sentimentality have rarely if ever been stretched to the extremes found in John Woo's movie "The Killer." Written and directed by Hong Kong's answer to Sam Peckinpah, the action thriller arrives today at the Village East Cinemas, having already acquired a cult reputation from its showings at the Toronto and Sundance film festivals.

Alternately gripping and laughable, the movie's mixture of blood and suds suggests an unlikely fusion of "The Wild Bunch" and "Dark Victory," with other movie references thrown into the mix. The most outrageous allusion, to "Duel in the Sun," comes in the final sequence, in which blinded lovers grope toward each other through the blood-soaked dirt for a final clinch and fail to connect.

Set in contemporary Hong Kong, "The Killer" tells the story of Jeff Chow, a hired gun with a heart of gold who falls in love with a nightclub singer named Jennie, whom he has accidentally blinded during a shootout. Determined to make enough money to give up his violent ways and pay for the cornea transplants that could restore Jennie's sight, Jeff accepts one final deadly assignment. Having completed the assassination, he speeds off from the scene of a crime in a spectacular motorboat chase with the police.

The chase is the first move in an extended game of cat and mouse with his pursuer, Inspector Lee, who eventually becomes his ally when the two of them face down the entire Hong Kong underworld in an apocalyptic shootout. By that time, Jeff and Lee are calling each by their pet names, Dumbo and Mickey Mouse. The final confrontation with the mobsters who have double-crossed Jeff takes place

— where else? — in a pristine chapel filled with lighted candles, a flock of white doves and a statue of the Virgin Mary.

"The Killer" tells two love stories. The first is about Jeff and Jennie. The second is about Jeff and Lee, antagonists who reluctantly recognize each other as kindred spirits: pure souls who live by a higher code of honor than those around them. Several weepy speeches about friendship, loyalty and honor set the stage for their late-blooming bond to be tested.

The movie is the third collaboration between the director and the Asian superstar Chow Yun-Fat, who portrays Jeff. The actor glides through the role wearing an enigmatic Mona Lisa smile and gazing down at the world with a dreamy-eyed sadness. At once poetic and suave, the nearly invincible Jeff never loses his cool. Even in the shootouts, in which he is typically outnumbered 10 to 1, he gracefully brandishes two guns, casually shooting from the hip and rarely wasting a bullet, while wearing an expression of anguished sorrow.

The scenes of gore and destruction are even more spectacular than Hong Kong's fog-shrouded skyline. The director repeatedly places the viewer at the center of the crossfire and turns the gyrating camera into the next best thing to a lethal weapon.

•

"The Killer" is rated R (Under 17 requires accompanying parent or adult guardian). It includes brief nudity and extreme violence.

1991 Ap 12, C11:1

Correction

A film review of the "The Killer" in Weekend on Friday listed a rating erroneously. The movie has no rating; it is not R.

1991 Ap 18, A3:2

Class of Nuke 'Em High Part 2 Subhumanoid Meltdown

Directed by Eric Louzil; screenplay by Lloyd Kaufman, Mr. Louzil, Carl Morano, Marcus Roling, Jeffrey W. Sass and Matt Unger; director of photography, Ron Chapman; edited by Gordon Grinberg; music by Bob Mithoff; produced by Michael Herz and Mr. Kaufman; released by Troma Inc. Running time: 99 minutes. This film is rated R.

Roger Smith...............................Brick Bronsky
Professor Holt...................................Lisa Gaye
Victoria...Leesa Rowland
Yoke...Michael Kurtz
Dean Okra..Scott Resnick
Professor Jones.......................Shelby Shepard

By STEPHEN HOLDEN

Somewhere beneath the gallons of green slime spewed by mutant creatures in "Class of Nuke 'Em High Part 2: Subhumanoid Meltdown" gurgles a message: subhumans have feelings too.

The latest offering from Troma Inc. is the sequel to the independent film company's 1986 B-movie success, "Class of Nuke 'Em High." A typically loony product from the company responsible for the "Toxic Avenger" films, it conflates the esthetics of John Waters, Russ Meyer and Mad magazine into an uproarious heavy-metal vision of a civilization wallowing in man-made poison as it

might be seen through the eyes of a Teen-Age Mutant Ninja Turtle.

The setting for "Subhumanoid Meltdown" is Tromaville Tech, a New Jersey institution of lower learning nestled deep inside a nuclear power plant. In the school basement, a genetically engineered class of menials has been created by mating humans with lower life forms. Beyond a resistance to pain and an exceptional physical strength, the most salient subumanoid feature is a slurping second mouth that takes the place of a human navel.

There's only one hitch in the plan of Dean Okra (Scott Resnick), the project's evil squeaky-voiced supervisor, to use the subhumanoids for his nefarious purposes. Individual subhumanoids have begun spontaneously disintegrating into hideous heaps of flying goo in the most public places. It is up to Professor Holt (Lisa Gaye), who engineered the species, to come up with an antidote to what is called "the meltdown syndrome." That syndrome is not the only peril stalking the campus of Tromaville Tech. A curious squirrel ingests some nuclear waste and grows into a giant, rabid destroyer.

The story is narrated by Roger (Brick Bronsky), the school newspaper's musclebound ace reporter, who falls in love with Victoria (Leesa Rowland), a subhumanoid he meets in a laboratory sex experiment and teaches how to love.

"Subhumanoid Meltdown," which was directed by Eric Louzil, is as riotously energetic as it is truly tasteless. Along with the kitchen sink, it throws in just about everything that was ever sucked down the drain.

•

"Class of Nuke 'Em High Part 2: Subhumanoid Meltdown" is rated R (Under 17 requires accompanying parent or adult guardian). It has nudity and strong language.

1991 Ap 12, C13:1

Eminent Domain

Directed by John Irvin; written by Andrzej Krakowski and Richard Gregson, story by Mr. Krakowski; edited by Peter Tanner; produced by Shimon Arama; released by Triumph Releasing Corporation. Running time: 102 minutes. This film is rated PG-13.

Jozef Burski	Donald Sutherland
Mira Burski	Anne Archer
Eva	Johdi May

By JANET MASLIN

In "Eminent Domain," set in Poland in the late 1970's, Donald Sutherland plays Jozef Burski, a powerful Politburo member whose party loyalty is put to a grueling test. When first seen, he is comfortable and secure, able to trade freely in the kinds of favors and black-market benefits that accompany his position. Others refer to him admiringly as "No. 6," to indicate where he stands in the Communist political hierarchy. But one day, Burski finds his security clearance revoked and his office closed. For no apparent reason, he is stripped of his privileges and power.

The film gives Burski a smiling courtesan of a wife (Anne Archer) and a naïve, even simple-minded daughter named Eva (Jodhi May) to flesh out his story. But in fact what befalls him is never as disturbing, complicated or surprising as must have been intended. Even at its most

Kafkaesque, "Eminent Domain" is a blandly decent thriller without much flair for generating suspense. The fact that it was filmed in Warsaw with a Polish crew is of more interest than much of what constitutes its story.

The screenplay, written by Andrzej Krakowski and Richard Gregson, draws upon the experiences of Mr. Krakowski's father, a one-time Communist official who went on to head one of the state's film studios. (The latter aspect is not dealt with here.) As directed by John Irvin, whose other credits include "Turtle Diary," the film unfolds evenly but often appears to confuse drabness with dramatic value.

Mr. Sutherland's hauteur and solemnity suit this role but don't add much spark. Ms. Archer tends either to beam adoringly or dissolve into tears of grief, without much range in between. It is she who delivers some of the film's most overblown lines, as when she rages at her husband: "Everything was yours. Your car. Your apartment. Your career. Only Eva was ours. What have you done with my life? What was it all for?" The possibility of overkill is obviously there, as it is in a scene that finds Ms. Archer talking dazedly to a child's stuffed teddy bear.

The film's ending, which may well have been derived from real events, nonetheless seems improbable on the screen.

"Eminent Domain" is rated PG-13 (Parents strongly cautioned). It includes mild sexual references and violence.

1991 Ap 12, C13:4

The Object of Beauty

Directed and written by Michael Lindsay-Hogg; director of photography, David Watkin; music by Tom Bahler; production designer, Derek Dodd; produced by Jon S. Denny; presented by Avenue Pictures and BBC Films. Running time: 141 minutes. This film is rated R.

Jake	John Malkovich
Tina	Andie MacDowell
Joan	Lolita Davidovich
Jenny	Rudi Davies
Mr. Mercer	Joss Ackland
Victor Swayle	Bill Paterson
Steve	Ricci Harnett

By VINCENT CANBY

"The Object of Beauty," written and directed by Michael Lindsay-Hogg, is an enjoyably snobbish comedy about two heedless Americans living beyond their means in an elegant London hotel. It's gotten so bad for Jake (John Malkovich) and Tina (Andie MacDowell) that he crosses himself and she holds her breath as he hands his credit card to the headwaiter.

Life at the top isn't easy when there's a slight cash-flow problem.

Jake is a commodities broker whose money is tied up in a lost cocoa shipment. Tina, who is still married to someone else, has been with Jake four years. They love each other and room service and so move around the world from one hotel to the next. London is their last stop before they either split or settle down.

"The Object of Beauty" might have been practically perfect escapist entertainment if the screenplay had been as smooth as the cast. Mr. Lindsay-Hogg has written some attractive characters and a lot of bright lines,

but he needs a script doctor. He has let the plot confuse things.

This has to do with Jenny, a poor, unfortunate hearing-impaired chambermaid (Rudi Davies), who steals Tina's small Henry Moore sculpture just when Tina and Jake are going to sell it.

Tina suspects Jake of the theft. Jake suspects Tina, and the insurance company suspects them both.

Enough about the plot, except that it takes a liberal hostess's view of the lower orders. When, toward the end, Jenny is asked why she stole the Henry Moore, she writes on her little note pad, "It spoke, and I heard it." Couldn't you just die?

Yet there is real style in the performances by Mr. Malkovich and Miss MacDowell. They play and romp together with the élan of people who thoroughly enjoy what they're doing. Tina is the free spirit. Jake is conventional. "Please," he says as they consider making love, "could we do it in bed tonight?"

Don't knock small favors.

The supporting cast is headed by Joss Ackland, as the hotel's alternately nagging and unctuous manager, and a very funny Bill Paterson as Mr. Ackland's first assistant, the fellow who does the dirty work.

•

"The Object of Beauty," which has been rated R (Under 17 requires accompanying parent or adult guardian), has partial nudity and some vulgar language.

1991 Ap 12, C14:4

Out for Justice

Directed by John Flynn; written by David Lee Henry; director of photography, Ric Waite; film editor, Robert A. Ferretti; music by David Michael Frank; production designer, Gene Rudolf; produced by Steven Seagal and Arnold Kopelson; released by Warner Brothers. Running time: 90 minutes. This film is rated R.

Gino Felino	Steven Seagal
Richie Madano	William Forsythe
Ronnie Donziger	Jerry Orbach
Vicky Felino	Jo Champa

By JANET MASLIN

As a courtesy to his many fans, the ponytailed action hero Steven Seagal not only attacks sleaze but also goes out of his way to examine it. His films, the latest of which is "Out for Justice," insist on offering an up-close-

and-personal view of exactly the kinds of thugs, punks, pimps, hit men and hookers Mr. Seagal routinely finds himself up against in his sincere quest for law and order.

To this end, "Out for Justice" shows the same pimp beating up a prostitute and then being thrown by the chivalrous Mr. Seagal through automobile windshields twice before this film's opening credits are over. The audience at Loew's 84th Street yesterday, thrown into paroxysms of laughter by this and other similar maneuvers, was no doubt grateful for such close attention to detail.

It really would be unfair to take such a narrow view of Mr. Seagal's appeal. In fact, he combines street-smart swagger and a flair for wisecracks with a martial arts background and the pampered look of a Hollywood eminence, all of which makes for a lively mix. Gruesome and lurid as his films are (and this one is no slacker when it comes to vicious antics), they also have their brand of humor. "Don't be a bad guy. What you wanna shoot me for?" Mr. Seagal says sweetly to an armed man in a butcher shop, having just dispatched the man's partners with cleavers and body blows. He then lunges toward his adversary, takes the man's gun, crunches his hand, tosses the gun in a trash bin and strolls amiably out of the store.

"Out for Justice," directed by John Flynn, is the Seagal version of a Martin Scorsese film, which is to say that Mr. Seagal answers to the name of Gino and speaks in a De Niro-inspired Brooklynese. It finds him on the trail of a savage killer (made convincingly scary by William Forsythe) who has murdered one of Mr. Seagal's fellow police officers in front of the officer's wife and children, then spit on the corpse and shot it an extra time for good measure. In the course of hunting down this mad dog, Mr. Seagal has an excuse to terrorize much of Brooklyn's lowlife, and he can indeed intimidate every single person in a pool hall in an imaginative way. The biggest part of his acting responsibilities involves maintaining that scowl and pretending not to enjoy it.

The screenplay, by David Lee Henry, includes a few good rejoinders but is otherwise on the monotonous side, and a certain familiar obscenity is used as epithet, verb and modifier, suitable for any occasion.

1991 Ap 13, 12:4

FILM VIEW/Caryn James

Politics Nurtures 'Poison'

TO APPRECIATE TODD Haynes's "Poison," the brash and haunting film that has caused the latest right-wing attack on the National Endowment for the Arts, it helps to know about "Superstar: The Karen Carpenter Story." Mr. Haynes's previous, 43-minute film relies on inspired casting: the late anorexic singer, her brother, Richard, and their overbearing parents are all

played by Barbie-type dolls. There is the occasional close-up of a box of Ex-Lax and brief commentary on how the drive for perfection can lead women to starve themselves, but mostly the dolls trot around miniature sets, as the Carpenters' sunny, bland California-pop music plays in the background.

"Superstar" deftly turns the childhood game of playing Barbie into a vivid mini-drama. Sometimes it is too blunt in

James Lyons in the avant-garde film, inspired by the works of Jean Genet, that prompted an attack on the National Endowment for the Arts

criticizing the stifling 70's, when the Carpenters performed at the White House and Richard Nixon praised them as a shining example of American youth. But the work is audacious, accomplished and forever unreleasable.

Todd Haynes's iconoclastic movie has profited from right-wing venom.

Mr. Haynes never cleared the rights to use the Carpenters' music while making his small experimental film. After "Superstar" began to attract attention, Richard Carpenter made it known that he would block any theatrical release. (Men may dream of being played by Robert Redford in the movies, but who wants to be seen as Ken?)

"Superstar" became a genuine outlaw film. The 1987 work has been circulating on bootlegged videocassettes for a few years now, and it made Mr. Haynes a familiar underground favorite even before "Poison," his first feature film, won the prize for best dramatic film and prompted some walkouts during a screening at the Sundance Film Festival earlier this year.

So when "Poison" turned into a giant April Fool's joke, boomeranging to confound the purposes of the radical right, the events fit the paradoxical pattern of the 30-year-old Mr. Haynes's career so far: he is an iconoclast who has become chic.

Based on hearsay evidence and a review, the Rev. Donald Wildmon (the conservative activist who once attacked a Mighty Mouse cartoon claiming that Mighty looked as if he were snorting cocaine) said "Poison" contained "explicit porno scenes of homosexuals involved in anal sex." These are wild charges. Though one section of the film deals with a homosexual obsession, the work is neither pornographic nor shockingly explicit. The right-wing attack provoked John E. Frohnmayer, the chairman of the National Endowment, to call a news conference and defend the film in unexpectedly strong terms as a sociologically-responsible work of art.

Every major newspaper, and television programs from the "CBS Evening News" to "Entertainment Tonight," covered the fuss. When the film opened to much critical praise in New York just over a week ago, it was already famous. Not since anti-endowment forces attacked the performance artist Karen Finley last year have they done so much to push an avant-garde artist into the spotlight.

"Poison," which both parodies and challenges mainstream film making, will never be a Middle American blockbuster. It is, after all, a low-budget art film whose three interwoven stories are uneven in accomplishment. But the attention couldn't have gone to a more serious or deserving film maker.

"Poison" is at its inventive best in the section called "Horror," a black-and-white spoof of a 1950's mad-scientist movie. Dr. Thomas Graves distills "the mysteries of the sex drive"

in a bubbling teacup, accidentally drinks his concoction, and turns into a contagious leper whose kiss can kill. "Leper Sex Killer on the Loose," a tabloid headline screams, while Dr. Nancy Olson, the sweet scientist who loves Tom, is baffled by his apparent change of heart.

■

"Horror" is witty in its mock faithfulness to the genre's cheap gray look and stilted dialogue. And it becomes tragic in its obvious allusion to AIDS. Although Mr. Haynes never mentions the disease, the message is clear when Nancy's naïve romantic dreams give way to the knowledge that love equals violence and death, that the age of innocence is gone.

Though nothing else in "Poison" is as perfectly accomplished as "Horror," its theme is echoed in the other segments. The controversial section, called "Homo," is effective in a different way. Though "Poison" was inspired by the work of Jean Genet, only "Homo" has a literal connection to Genet's fictional reminiscences of his days in reform school and prison.

In "Homo," a prisoner called John Broom (Scott Renderer) becomes sexually obsessed with a fellow inmate named Jack Bolton (James Lyons). Mr. Haynes effectively creates the blue-shadowed filth and claustrophobia of the prison, which contrasts to flashbacks of the reform school, set in a lush-looking countryside, where Broom first glimpsed the object of his obsession.

"Homo" does contain a repellent scene, which is not sexually graphic or bloody, just flat-out gross. The

reform school boys spit relentlessly, for what seems like an unbearable amount of screen time, into Bolton's mouth and on his face. This is the film's true horror scene, the one that caused the walkouts at Sundance; it dares viewers to keep their eyes open.

By rubbing his audience's nose in this repulsive humiliation, Mr. Haynes pushes the boundaries of what mainstream audiences will accept. It is a misguided move, for "Homo" is more about tortured psychology than physical brutality. Even a homosexual rape, discreetly shot, emphasizes emotional rather than physical violence. But the spitting is at least an artistically honest mistake, the kind that avant-garde experiments like "Poison" are all about.

■

The film's weakest section, in fact, is the least inventive. In the fake documentary called "Hero," an abused child is accused by his mother of killing his father and flying away. Unlike "Horror," it doesn't mock its genre cleverly enough. And throughout "Poison," the transitions linking one deathly love story to the next are heavy-handed.

But Mr. Haynes's accomplishment and future are beyond doubt. Like Genet, whose release from a lifelong prison sentence was accomplished with the help of Jean-Paul Sartre and Simone de Beauvoir, Mr. Haynes has gone from being the outlaw creator of "Superstar" to being a praised film maker taken up by the intelligentsia. Soon he will probably be eminently

acceptable to the mainstream. Who knows yet whether that is Mr. Haynes's blessing or his curse? Meanwhile, there is "Poison," the most iconoclastic little film ever made popular by right-wing politics. □

1991 Ap 14, II:15:1

FILM VIEW/Janet Maslin

It's in a Box. Maybe It's a Movie.

FROM VARIETY COMES THE DISCOURAGING news that the major studios have become increasingly dependent on conventional Madison Avenue advertising tactics, the kind that tell us which toothpaste to buy. Thanks to this great breakthrough in corporate thinking, more and more films are being enthusiastically marketed as products, complete with what Variety refers to as "brand personality."

This is the quality that gives the Dick Tracy trench coat, the Dick Tracy Crimestopper Game at McDonald's and the actual "Dick Tracy" movie their supposed common ground. Brand personality originates with a film, but it need not come from character, story or any of the other things for which films used to be valued. It need only promote a particular cachet, one that can easily be transferred to products of other kinds. A brand personality is essentially just a flavor. And a film that opens in 2,000 theaters to the accompaniment of an all-out media blitz is ever less likely to have any greater long-term currency than the flavor of the month.

Popular films always generated spinoffs and souvenirs, but those were auxiliary benefits. They never threatened to become the film's primary raison d'être. Today, when a film's shelf life is shorter than ever and the costs of opening it so prohibitive, drumming up quick, momentary excitement becomes an end in itself. So a film can become a marketing triumph — on the order of "Look Who's Talking Too" — long before anyone has had time to discover that it has no more intrinsic interest than a hunk of Styrofoam. In any realm, the flavor of the month is generally more fun to contemplate than it is to taste.

■

Madison Avenue is a convenient scapegoat for this phenomenon, but we have all had a hand in it. Without the lulling convenience of home video, the movie audience would be less likely to tolerate the high-concept trash to which it is routinely subjected. Viewers who once had something at stake when chosing a film can now dispense with the commitments of waiting on line or even investing any time. If you rent something unsatisfactory, you can return it without being seriously inconvenienced. If you don't like the cable movie channel, you can flip the dial and watch something else.

Watch the rental pattern at any video store, and you quickly discover that the home video audience has an unprecedentedly high threshold of pain. Thanks to good-looking graphics and a sizable advertising budget, a film as horrible as "Closet Land" will easily find its way into the living rooms

These days, some films are peddled simply as products designed to sell other goods.

of people who never would have dreamed of going out to see it in a theater, and who would have been furious if they had. Flavor-driven marketing has long ruled the home video are-

na, where consumer choices are made on the basis of vague memories and practically no hard information. This has surely had the creeping effect of lowering the tastes and expectations of even the theatrical moviegoing crowd.

Home video has also created a greater detachment from the actual product, removing much of the urgency that might once have surrounded a theatrical opening date (and creating a second flurry of chatter once the home video release date rolls around). At Oscar time each year, in certain once-devoted sections of the moviegoing population, you are more and more likely to hear that so-and-so hasn't seen "Dances With Wolves" yet but knows somebody else who did. There is even a certain inverse status attached to boasting that you haven't seen *any* of the nominees. In this atmosphere, the flavor or image of a film threatens to supplant whatever is actually on the screen.

As flavor triumphs over content, it opens profitable new horizons, like the market for video games based on hit movies. Play "Platoon" Nintendo and you become a video G.I. marching through the jungle, fending off attackers. ("You're history!" says a title that appears if a sniper gets the best of you.) You preserve your "morale," to which a numerical value is attached, by trying not to kill innocent villagers, but if you hit six of them the game is over.

Obviously, this was not what Oliver Stone had in mind when he made "Platoon," but if that film can be turned into a game then anything can. Even the stunning production design of "Batman" can be — and has been — reduced to a row of boxy, ominous-looking urban structures: "You liked what you saw in the movie?" says the packaging for one Nintendo spinoff game. "You're gonna love what you see here."

Is it any wonder that a successfully marketed flavor can now cross almost any media barriers? A second "Teen-Age Mutant Ninja Turtles" film becomes an automatic incentive to buy more Turtle underwear. Books, toys, records and decals will not be far behind. And the popularity of movie sequels has also made it easier to recycle familiar ideas, package them according to proven formulas and count on the audience's inattention to do the rest.

So "Career Opportunities," which happens to be a disarming teen-age comedy in its own right, stays on the safe side by using a fun-couple-making-body-contact ad in the "Pretty Woman" mode and a passel of plot devices borrowed from the earlier films of its writer-producer, John Hughes. Since "John Hughes's Greatest Hits" is not a viable title, this film has its own name, but much of its individuality is overshadowed by marketing efforts to make it look like a popular product. At least the home video customers who like the looks of its advertising art six months from now won't be disappointed. They'll be getting the flavor they wanted. □

1991 Ap 14, II:15:5

Forever Mary

Directed by Marco Risi; screenplay by Sandro Petraglia and Stefano Rulli; story by Aurelio Grimaldi from his novel, "Meri per Sempre; in Italian with English subtitles; music by Giancarlo Bigazzi; produced by Claudio Bonivento; released by Cinevista. At Village East Cinemas, Second Avenue and 12th Street in Manhattan. Running time: 100 minutes. This film has no rating.

Marco Terzi..............................Michele Placido
Mary.....................................Alessandro di Sanzo
Pietro.....................................Claudio Amendola
Natale...................................Francesco Benigno

By JANET MASLIN

It stands to reason that the delinquents of Palermo, Sicily, would be unusually tough, and Marco Risi's "Forever Mary" shows them to be exactly that. Mr. Risi's film (whose sweet-sounding title character is a teen-age transvestite prostitute, formerly named Mario) takes place inside a Palermo reformatory, using a mostly nonprofessional cast of Palermo street kids to convey the bitterness and hardship of the inmates' experience.

The actors themselves, convincingly scrappy and intimidating, are the film's most startling ingredient. They remain that way even when treated as part of a fairly conventional plot. The screenplay (by Sandro Petraglia and Stefano Rulli, with a story by Aurelio Grimaldi from Mr. Grimaldi's novel), presents a good teacher (Michele Placido) who elects to enter the lion's den and take on the vast challenge of handling these unmanageable students. As such, it is on familiar ground. But the boys themselves, and even the teacher's reactions to them, remain fascinatingly unpredictable.

•

The teacher, named Marco Terzi, is a largely unexplored character. The film explains little about him beyond the facts that he has returned from Milan to his native Sicily and surprised his fellow teachers by taking on this hard-luck assignment. "You either did something stupid before or you're a reformer, in which case you're doing something stupid now," taunts one of Terzi's new students, all of whom respond mockingly to this quiet, controlled, movie-star presence in their classroom.

The boys are instantly antagonistic to Terzi, which in a Hollywood film would lead to a lot of tough talk and a string of manly confrontations. But Terzi does not approach his new assignment with an excess of machis-

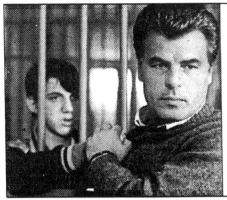

Cinevista

Compassion
Michele Placido, in foreground, stars in "Forever Mary" as a teacher who tries to protect the children in a Sicilian juvenile detention center from sadistic guards and staff.

mo. He so determinedly lets the students test the limits of their own provocativeness that the teacher allows one boy, armed with a felt-tip pen, to draw lines all over Terzi's face and hands while the teacher continues talking. When this same boy, a ringleader named Natale (Francesco Benigno), smirkingly insists on phallic references during classroom conversation, the teacher goes him one better by reading a poem containing every imaginable metaphor on the same theme.

"Forever Mary," which opens today at the Village East Cinemas, also observes the institution's dormitory rituals and the confrontations that arise among the various students. A shy new boy, seen robbing a store during the film's opening sequence, finds himself sexually accosted by Natale and protected by the stern, scary Carmelo, who later tries to make his own sexual claims on the new inmate. In this atmosphere, the seductive transvestite Mary (Alessandro di Sanzo) creates a huge stir upon arrival, and presents Terzi with one of his most significant on-the-job challenges. Terzi's response to Mary's sexual overtures is exemplary of this film's highly unusual approach to confrontational behavior.

A few brief scenes take place outside the reformatory, most of them detailing the circumstances by which these boys ran afoul of the law. These last, desperate moments of freedom have a dreamlike quality, especially in contrast to the harsh reality of life within the institution. Mr. Risi uses these outside-world scenes poignantly, to reinforce the notion of the title, which is that a person like Mary, or indeed any of the others, will remain uncategorizable and be doomed to a life in limbo. "Forever Mary" offers wrenching glimpses of what that life is like.

1991 Ap 19, C11:1

Mortal Thoughts

Directed by Alan Rudolph; written by William Reilly and Claude Kerven; director of photography, Elliot Davis; edited by Tom Walls; music by Mark Isham; production designer, Howard Cummings; produced by John Fiedler and Mark Tarlov; released by Columbia Pictures. Running time: 102 minutes. This film is rated R.

Cynthia Kellogg	Demi Moore
Joyce Urbanski	Glenne Headly
James Urbanski	Bruce Willis
Arthur Kellogg	John Pankow
Detective Woods	Harvey Keitel
Detective Nealon	Billie Neal
Cookie	Kelly Cinnante

By JANET MASLIN

Alan Rudolph is by now well established as a not-quite-established film

maker poised on the brink of a breakthrough. Each of his 12 features (among them "Welcome to L.A.," "Choose Me," "Made in Heaven" and "Remember My Name") has shown the kind of promise that makes Mr. Rudolph's audiences truly appreciative of offbeat, exploratory film making, if not wholeheartedly appreciative of the example at hand.

"Mortal Thoughts," Mr. Rudolph's latest, appears for a while to have brought its director beyond this impasse and into the realm of genre film making, the genre in this case being film noir. "Mortal Thoughts" is the story of two unhappy wives, the beauty shop in which their plans are laid, the men who do much to make these women's lives even worse than they have to be, and the way in which a convenient death solves a lot of problems all around.

Although this has all the ingredients of a dark and enjoyably sordid story, and indeed starts out as one, Mr. Rudolph's version of film noir turns out to be more like film gris. Much of it takes place in a gray area between wit and malice, and in the realm of endless, sometimes improvised small talk that winds up seeming genuinely small. Although the film's slowly unraveling mystery plot involves clever artifice and some crucial half-truths, the full truths prove no more compelling than the bogus ones. "Mortal Thoughts" has a good cast and a lot to recommend it, but what it doesn't have is the kind of dramatic payoff that makes so much extended buildup and explanation seem worthwhile.

•

"Mortal Thoughts" stars Demi Moore and Glenne Headly as two beauticians, Cynthia Kellogg and Joyce Urbanski, who work together at Joyce's Clip 'n' Dye in Bayonne, N.J., and whose friendship dates back to childhood. It begins, after brief home movies of the two as children, with the sight of Cynthia (Ms. Moore) being interrogated by two police de-

tectives (Harvey Keitel and Billie Neal) about a crime that has yet to be described. Through Cynthia's answers and recollections, the film flashes back to show the marriage of Joyce (Ms. Headly) and James Urbanski (Bruce Willis), a union that was rocky from the start. Cynthia, meanwhile, has an ill-suited husband of her own (John Pankow). Mr. Rudolph trails them all through the Urbanski nuptials and enthusiastically re-creates this large and garish party, shooting some of it in a sinister slow motion that sets the tone for what is to come.

Mr. Willis isn't around for long, but he manages, as usual, to make a big and boisterous impression. His loutish, abusive James is at least as funny as he is appalling, loping into the Clip 'n' Dye (a place that turns out to be aptly named) to scream at his wife, hand her a weirdly diapered baby and steal money out of the till. Left alone with his wife's friend Cynthia, he locks the door and attempts sexual assault, assuring Cynthia that this is what friends are for. It is small wonder that, like the philandering husband Kevin Kline played in "I Love You to Death," he becomes a prime candidate for genteelly homicidal gestures like rat poison in the sugar bowl.

•

"Mortal Thoughts" moves on to recall Alfred Hitchcock's "Strangers on a Train" when it takes James to an amusement park for the final reckoning, which occurs in the shadow of a highly photogenic Ferris wheel. Although the film has had a slightly dizzy, antic streak until this point, it becomes more serious once Joyce's threats to dispatch her husband prove to be worth taking seriously.

Ms. Headly, as Joyce, has just the right mixture of blitheness and menace, and at times Mr. Rudolph has it too. The beauty shop ambiance is droll (Kelly Cinnante has a small, funny role as a highly untalented beautician whose hairdo grows more frightening in each new scene), and the women's homicidal daydreams are entertainingly offhanded. (Joyce doesn't sound all that deadly at first, but she says she wouldn't object if a household appliance fell into James's bath water.) Ms. Moore, who has the story's most somber role, is effectively mysterious but somewhat paralyzed by an obligation to remain cryptic. Mr. Keitel, seen during endless interrogation scenes, enlivens the proceedings with such studious Jerseyisms as "terlet" (for "toilet") and "Jerce" (for "Joyce").

The screenplay, by William Reilly (who wrote and directed the recent "Men of Respect," a gangster "Macbeth") and Claude Kerven, is more successful in its small, atmospheric

touches than in creating an overall plot worthy of such an elaborate production. And Mr. Rudolph only enhances suspicions that not much is really at work here by overdirecting a car washing (great waves of water; a somber hiss on the soundtrack), a suitcase-packing (hand-held camera), the interrogation sessions (tight close-ups of the questioners' lips; close looks at the video monitor), and the announcement of a death (extravagant slow-motion swooning). Just the facts would have been fine.

•

"Mortal Thoughts" is rated R (Under 17 requires accompanying parent or adult guardian). It includes violence, profanity and sexual suggestiveness.

1991 Ap 19, C15:1

Requiem for Dominic

Directed by Robert Dornhelm; screenplay (in German with English subtitles) by Michael Kohlmeier and Felix Mitterer; photography by Hans Selikovsky; edited by Ingrid Koller and Barbara Heraut; music by Harald Kloser; produced by Norbert Blecha; released by Hemdale Film Corporation. Running time: 88 minutes. This film is rated R.

Paul	Felix Mitterer
Clara	Viktoria Schubert
Dominic	August Schmolzer
Codruta	Angelica Schutz
Antonia	Antonia Rados
Nick	Nikolas Vogel

By VINCENT CANBY

Dominic Paraschiv was a chemical engineer in Timisoara, Romania, in December 1989, at the beginning of the uprising that eventually overthrew the Communist dictatorship of Nicolae Ceausescu. Paraschiv was a Roman Catholic with well-known liberal sympathies, married, with three children.

Several days into the revolution, Paraschiv, lying naked on a hospital bed, covered only by a coarse fishnet and dying of gunshot wounds, was being exhibited on Romanian television as "the butcher of Timisoara," accused of the massacre of 80 anti-Communists.

Taking this real-life story, Robert Dornhelm has made "Requiem for Dominic," which, though set during the early weeks of the Romanian revolution, may be the first film to deal realistically with post-Communist Eastern Europe.

It probably didn't set out to do that. Yet that is the effect of this small, very good, exceptionally vivid melodrama.

•

"Requiem for Dominic" dramatizes the terrible physical, emotional and psychological toll that attends the civil chaos of such great moments in history. It's about the hangover that follows the victory celebrations, about the morning-after when nothing is as simple as it looked the night before.

Mr. Dornhelm was born in Timisoara in 1947 and at the age of 13 emigrated to Austria where he eventually became a film maker. The director, who now lives in California, had been a childhood friend of Paraschiv.

According to the film's production notes, Mr. Dornhelm returned to Romania after Paraschiv's death, determined to understand the circum-

John Clifford/Columbia Pictures

At Odds
Demi Moore stars in "Mortal Thoughts," a tale of two women whose friendship is jeopardized when one of their husbands is murdered.

stances that could have turned his old friend into "the butcher of Timisoara." "Requiem for Dominic" is both about the truth, as Mr. Dornhelm reports it, and the manner in which it is revealed.

Before Mr. Dornhelm left for Timisoara, his brother Peter gave him some advice. "Be careful," he said, "they will tell you a pack of lies. But the opposite of a lie need not be the truth."

This statement defines something of the nature of a movie that does not deal in easy answers, though it clearly has simplified some things for the purposes of drama.

•

"Requiem for Dominic" is a mystery story for adults, photographed in part in Timisoara three months after Ceausescu's downfall, when many Romanians were beginning to feel that the revolution had been betrayed.

The screenplay, written by Michael Kohlmeier and Felix Mitterer (who also plays the film's central role), is exceptionally good in that it's utterly functional. It doesn't get in the way of the complex story, nor does it attempt to smooth out the rough spots.

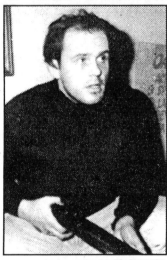

Hemdale Film Corporation

August Schmolzer

It's about Paul Weiss (Mr. Mitterer) who returns to Romania in the first exciting days of the revolution to share its triumphs with his old friend Dominic (August Schmolzer).

On his arrival in Timisoara, Paul learns that Dominic, far from being "the hero in a city of heroes" he had first been told, is the dying "terrorist" featured daily in the newspapers and on television. Dominic's co-workers have testified against him. Paul is shown the victims' bodies. Only Dominic's wife, Codruta (Angelica Schutz), maintains his innocence.

With the help of Clara (Viktoria Schubert), a young Austrian reporter who has come to Timisoara looking

The morrow of a revolution brings no easy answers.

for a nice human-interest Christmas story, Paul attempts to start his own investigation. Dominic's notoriety is such that even to seek information

about him raises questions about Paul.

The police trail him. Overworked bureaucrats, many new to their jobs, are unknowing, uncaring or incompetent. Some people simply lie. The streets outside are as chaotic as the government offices.

Nobody is sure who is working for whom or for how long. Alliances are fragile. Opportunism and fear dictate behavior. Remnants of the old security police snipe at the crowds in the main square, where the speakers come and go, it seems, around the clock.

In the hotel that is their unofficial headquarters, journalists sit around the lobby drinking, talking and trading rumors. Revolution or not, the members of the hotel band pound, pluck or saw their instruments during dinner. Life goes on.

•

In the course of his investigation Paul is jailed, released, beaten up and, at one point during a rally, loudly accused of being a member of the dread secret police, which is enough to start a riot.

The truth that emerges in bits and pieces is not neat, but it is enough to justify Paul's care and to underscore the film's post-revolutionary consciousness.

Mr. Mitterer and the other actors are all effective, as is the screenplay's fractured narrative style, which serves the facts of the film as well as their meaning.

Also enormously helpful is the way in which the remarkable material photographed during the initial Timisoara uprising is matched with new material made for the film. The film's visual authencity is stunning.

At its best, "Requiem for Dominic" suggests the moral complexity of a Graham Greene tale, coupled with the urgency of a Costa-Gavras film, though Costa-Gavras seldom deals in stories as seriously ambiguous.

•

"Requiem for Dominic," which has been rated R (Under 17 requires accompanying parent or adult guardian), has nudity and some grim newsreel material of dead bodies.

1991 Ap 19, C17:1

FILM VIEW/Caryn James

Carpe Diem Becomes Hot Advice

HERE IS THE BAD NEWS ABOUT THE AFTERlife, according to Albert Brooks: it is just as annoying as this life, at least for the first few days. There are lawyers after death and people who get better hotel rooms than you do and little old ladies on buses who talk your ear off about their pet poodles. When you die you go to Judgment City, an earthlike place where they have dead-Kiwanis meetings and stand-up comics in plaid sport jackets. They have the Weather Channel, with the Muzak version of "Misty" playing in the background.

This comically sour view of earth makes Mr. Brooks's "Defending Your Life" the most perceptive and convincing among a recent spate of carpe diem movies. Their message is as pithy as a Coke commercial — "Don't let life pass you by" — and it is powerful at the box office.

In most carpe diem movies, stars grapple with life and death in oversized terms. Robin Williams exhorts an English class of unnaturally sensitive, Shelleyan types to "seize the

Movies like 'Defending Your Life' exhort audiences to seize the day.

day!" in the maudlin 1989 hit "Dead Poets Society." Prophetic advice, for the story ends with a teen-ager's suicide. Patrick Swayze comes back from beyond the grave in "Ghost" to correct some human errors; he tells Demi Moore "I love you" and thwarts a Wall Street villain and his hired killer. And when Kevin Costner was promoting "Field of Dreams" — the 1989 film that gives his character a last chance to play baseball with his dead father — he compared it to the ultimate carpe diem movie. He called his film "the 'It's a Wonderful Life' of our generation."

That's not quite true; "It's a Wonderful Life" is the "It's a Wonderful Life" of our generation. But Mr. Costner is onto something, for "Field of Dreams" says that life is full of goodness, idealism and love after death — ideas that seem a throwback to a less cynical time.

"Defending Your Life" is savvier and, despite its white-robed characters, more realistic than most carpe diem movies because it does not depend on melodrama or old-fashioned idealism. It rests on the timely philosophy that earth is a banal place, full of nagging worries about money, marriage and social class, but you might as well make the best of it. If not, you'll just have to be reborn and do it all over again. Finally, an attitude real people can live with.

This very funny social satire is shaped by the writer and director's low-keyed persona. Instead of positing big themes about life and death, the story follows Daniel Miller, the 40-year-old advertising executive and anxious Everyman played by Mr. Brooks. His unheroic status is evident from the moment he dies in a version of a bad joke: hit by a bus while listening to Barbra Streisand singing "Something's Coming" on a CD in his new BMW.

Daniel is instantly transported to Judgment City, which sounds like hell, but is merely, as he says, a pit stop. A prosecutor, defense attorney and two judges look at scenes from his life. If he has lived too fearfully, he will be sent back to

earth; the innocent go on to a much better place.

Like any movie about the afterlife, though, Daniel's story is really about this life. The film works so well because Mr. Brooks cloaks his heavier themes in satire and exercises a shrewd impatience with clichés. "Little brains, that's what we call you folks behind your back," Daniel's defense attorney says of earthlings, who use only five percent of their brain's power, tops.

Geffen Film Company

Albert Brooks

Scenes from Daniel's past bear this out. The evidence against him runs from being bullied in the schoolyard to not buying Casio stock dirt cheap.

"There is no hell," the attorney goes on, "though I hear Los Angeles is pretty close." Daniel gives a fake, polite little smile at this shopworn L.A. joke. Recently, "Scenes From a Mall" offered dull Los Angeles jokes and "L.A. Story" offered spirited Steve Martin Los Angeles jokes, but Mr. Brooks laughs at L.A. jokes themselves.

And he mocks the media-shaped idea of a perfect life in the character of Julia, Daniel's new-found love, played by Meryl Streep. When Daniel watches a scene from her past, in which she carries her children from a burning house and then goes back for the cat, he responds with awe, "It was like watching a Mutual of Omaha commercial." The life-and-death moral issues of hell and heroism are slipped in blithely.

That unpretentious manner allows Mr. Brooks to pull off an ending of sweet, touching pathos. Daniel tells Julia, in a tone that says he is exhausted with carrying the weight of his life, "I'm just tired of being judged." Mr. Brooks taps into a fundamental feeling about modern life here. He has earned the right to do it, because the emotion has grown from the film's steadfast concern with everyday reality.

When the defense attorney advises Daniel that one should "just take the opportunities when they come," it is an offhanded statement of the carpe diem theme the film embodies without preaching. Albert Brooks shares the kind of wisdom ordinary viewers can believe. He knows that life at its best often looks like an insurance commercial, but that's no excuse not to seize those Mutual of Omaha moments. □

1991 Ap 21, II:13:5

Chameleon Street

Directed and written by Wendell B. Harris Jr.; director of photography, Daniel S. Noga; produced by Dan Lasjon. Executive producers, Helen B. Harris and Dr. Hobart Harris. Distributed by Northern Arts Entertainment. At Film Forum 1, 209 West Houston Street. Running time: 98 minutes. This film has no rating.

William Douglas Street....Wendell B. Harris Jr.
Gabrielle............................Angela Leslie
Tatiana...............................Amina Fakir

By VINCENT CANBY

At the beginning of Wendell B. Harris's serious and funny "Chameleon Street," opening today at the Film Forum, a prison doctor is analyzing Doug Street's problem: "You intuit what other people need and become that person."

Doug (played by Mr. Harris), a good-looking, mannerly young black man, intuits what the blandly self-important white doctor needs. Doug immediately becomes a receptive patient who couldn't agree more. There will be no further impersonations, for the time being anyway.

In "Chameleon Street," which he also wrote and directed, Mr. Harris demonstrates that he's a triple-threat new film maker of original and eccentric talent. In his first feature film, he also shows he understands that the compulsion to adopt alien personalities is a lot more complex than the need to please.

Mr. Harris's source material is the real-life story of William Douglas Street, who apparently had a brief but successful career as an impostor in the 1970's and 1980's. Just how closely Mr. Harris follows the facts, I've no idea. But the film is involving enough to prompt one to want to know more.

•

"Chameleon Street," which was voted the best dramatic film at the 1990 Sundance Film Festival, is both breezy and dark as it recaps Doug's quite remarkable succession of impersonations.

At one point, having passed himself off as a Harvard Medical School graduate to obtain a residency at Wayne State Medical School, he is required to perform a hysterectomy. "Lord," he says to himself at the start of the operation, "I hope my mascara doesn't run."

It doesn't. The patient survives and Doug is congratulated for the speed and efficiency of his technique.

Yet Doug has a way of accomplishing the difficult task and then being tripped up by a minor detail. To gain access to Paula McGee, the Midwestern basketball player who plays herself in the film, he takes on the identity of a magazine reporter. All goes well until someone notices that in his letter to Ms. McGee he has identified himself as a Time Magazine "wrighter."

Doug isn't stupid. He is brilliant in his improvisations, but there's always the need to self-destruct. As the

The debut of a triple threat: writer, director and actor.

film's writer and director, Mr. Harris doesn't waste time offering easy analyses of the character, which is all to the good. Instead he presents vivid incidents and details that can be explained only by a multiplicity of reasons.

•

Doug, the older son of a Detroit businessman, has grown up comparatively well-to-do. Still in his early 20's, he is on his second marriage. He is impatient to get ahead. He needs cash now, which is why, early on, he participates in an attempt to extort money from Willie Horton, the Detroit Tigers baseball star.

The plot might have succeeded (or, at least, Doug might not have been caught), if one of his cohorts hadn't signed Doug's name to the extortion note.

Doug's later impostures, including one as a French exchange student at Yale, aren't especially well planned. They just sort of happen. Once into a new life, he experiences a terrific excitement that must be due, in part, to the constant expectation of being found out.

His most magnificent obsession is his medical career. As Doug makes his hospital rounds, he's forever ducking into the men's room to look up something in one of the textbooks he carries.

He's a phenomenally quick study, though not always a thorough one. His career at Yale is cut short when it's realized that his knowledge of French is decidedly limited, though it's amazing how long he lasts by simply repeating, "J'accuse Jacques Brel. J'accuse Jacques Cousteau."

There's also the suggestion that, after establishing himself in some new role, as, say, a crackerjack lawyer for a Detroit civil rights group, Doug loses interest. He has to move on. Yet he has no identity of his own. Without a fabricated résumé, he is invisible.

Mr. Harris, who graduated from Juilliard with a B.F.A., gives an exceptionally good, quite eerie performance. He has a deep actorly voice that perfectly matches Doug's florid behavior, which, near the end, veers near the psychotic.

Mr. Harris's direction is without fancy flourishes, which also serves the subject. The film's weak link is its screenplay, which may be inhibited by the fact that "Chameleon Street" is an authorized biography, at least to the extent that the subject is still alive. For whatever reason, the continuity is unclear. Doug is always being nabbed by the police, but he is seen serving only one jail term.

Though the women in Doug's life are beautiful if shadowy presences, some of the other supporting characters are nicely realized, including his lay-about pal who, near the beginning of the film, complains about his lot in life.

"I'm a victim," the friend says with satisfaction. "For 400 years I've been conditioned to be a victim. Even my conditioning has been conditioned."

Doug Street bucks the system in his own way.

1991 Ap 24, C11:3

Film Forum

Wendell B. Harris Jr. in a scene from his "Chameleon Street."

The Two Messages of 'Spartacus'

By JANET MASLIN

Seen today, in the lovingly restored 197-minute version now playing at the Ziegfeld, the two-tiered historical pageant that is "Spartacus" says at least as much about America in the late 1950's as it does about ancient Rome.

This sword-clanking 1960 epic about a slaves' uprising was the film that took a giant step toward ending the Hollywood blacklist, since its screenwriter, Dalton Trumbo, was finally freed from the onus of working under pseudonyms and credited under his own name. That is only one of the reasons "Spartacus" has earned its place in film history. Another is that it is an early work by Stanley Kubrick, although he hardly regards this as a pet project.

Mr. Kubrick was hired only after shooting began, as a replacement for another director, Anthony Mann. He himself would probably not have devised a film including a cute goat-milking sequence and so much warm camaraderie among the rebellious slaves. Since then, Mr. Kubrick has effectively disowned "Spartacus," but his stylistic hallmarks are still occasionally discernible in the midst of all that muscle-flexing kitsch.

This is also a film whose battle scenes look as if they required the services of a real army, because they did. There were so many Roman legions on hand (as played by 5,000 Spanish soldiers) that Mr. Kubrick shot his climactic military maneuvers from half a mile away. And "Spartacus" earned another kind of distinction for having cost more ($12 million) than the studio that produced it (Universal) was actually worth. MCA bought Universal for $11,250,000 while the filming of "Spartacus" was in progress.

•

Restored under the supervision of Robert A. Harris, who also did such superb work on "Lawrence of Arabia," "Spartacus" has the kind of visual grandiosity that was much admired 30 years ago and today seems surpassingly strange. Any excuse for slaves or Romans to congregate becomes the occasion for a big, busy tableau, and some of these scenes are so dizzyingly overpopulated they suggest 3-D. (The film was actually made in Super Technirama.) In using stark angles and open space to suggest an eerie isolation, even in the midst of so much bustle, a few of these sequences offer harbingers of Mr. Kubrick's future work.

The principal casting of "Spartacus" must certainly have been right. Kirk Douglas, who played the starring role and whose company produced the film, recalls in his autobiography that there were at one time two rival Spartacus stories in the works (the other screenplay, for United Artists, was by Abraham Polonsky, another blacklisted writer). And Peter Ustinov, Laurence Olivier and Charles Laughton received copies of both scripts. "We were 3-for-3 against 0-for-3," Mr. Douglas remembers thinking, when all three actors preferred the Trumbo version (which was adapted from Howard Fast's novel). But the casting also included such notably strange choices as John Gavin, whose Julius Caesar is no match for the Roman Senate rivals played by Laughton and Olivier.

As the wildly decadent Crassus, Olivier is central to the once-deleted "snails and oysters" bath scene that makes for one of this restoration's livelier moments. (His voice has been supplied by Anthony Hopkins, who sounds distinctively like himself but expertly mimics the Olivier diction.) Making thinly veiled sexual overtures to a handsome slave (Tony Cur-

A restored film says as much about the 1950's as about antiquity.

tis, who is also described rather improbably as a "singer of songs," or poet), he frames his thoughts about sexual preference in terms of sea creatures. Censors considered this too risqué, and suggested changing the points of comparison to "artichokes and truffles," which the film makers rejected, and so the scene was deleted.

Included now, it is both valuable to the plot and comfortably attuned to the film's pervasive suggestiveness, which for a mass audience film of this scale is indeed remarkable. From the decadent rich who delight in gladiatorial fights-to-the-death to the slyly insinuating Roman senators, the privileged characters in "Spartacus" exude corruption.

•

Not so the slaves, who are noble to a one, and whose embodiment of brotherhood gives the film its ideological slant. A reaction against Hollywood's anti-Communism can be felt in the film's idealized view of these workers. But it must also be said that the wicked rich, as played by such a marvelous trio of droll, sophisticated English actors, are a lot more interesting. Mr. Ustinov, who won an Oscar for his performance as an unctuous gladiator trainer, does his best to provide entertainment "for ladies and gentlemen of quality, those who appreciate a fine kill." Olivier, in designating someone his prisoner, dryly gives the order: "Make him comfortable. Don't let him be lonely." It is he who declares, of Varinia (Jean Simmons), Spartacus's lover: "I like her. She has spirit. I'll buy her."

But it is Laughton, as the scene-stealingly cynical politician Gracchus, who has the film's best lines. "In Rome, dignity shortens life even more surely than disease," he remarks. Meeting Varinia, he casually kisses her hand and says, "So this is the woman it took Crassus eight Roman legions to conquer. I wish I had time to make your acquaintance, my dear."

Amusing at some points and laborious at others, "Spartacus" moves at the lumbering pace of the virtually extinct widescreen epic, but it eventually arrives at a tragic ending involving fierce battle, a sea of corpses and the sight of the Appian Way lined with crucified slaves. These scenes are made even more wrenching by the great tact and efficacy with which they have been restored.

1991 Ap 26, C6:4

Drowning by Numbers

Directed and written by Peter Greenaway; director of photography, Sacha Vierny; edited by John Wilson; music by Michael Nyman; produced by Kees Kasander and Denis Wigman; released by Prestige, a division of Miramax Films. Running time: 114 minutes. This film is rated R.

Cissie Colpitts 1	Joan Plowright
Cissie Colpitts 2	Juliet Stevenson
Cissie Colpitts 3	Joely Richardson
Madgett	Bernard Hill
Smut	Jason Edwards

By JANET MASLIN

The mind that embraces pure gamesmanship is rarely as fanciful as that of Peter Greenaway, who obviously plays by his own rules. Mr. Greenaway's love of puzzles, riddles, obscure references and obsessive schematization is truly astounding, but it is rarely matched by an equivalent interest in whatever has set these maneuvers in motion. He would be perfectly capable, it often seems, of staging an elaborate whodunit without bothering to determine whether anyone was ultimately to blame.

The visual appeal of Mr. Greenaway's work is unmistakable, as is the impression that something of great moment is under way. So his card castles become that much more remarkable when it becomes apparent that they are built on such thin air. This film maker's audacity, which is indeed formidable, has much more to do with testing the limits of his audience's patience, curiosity and tolerance for outrage than it does with intellectual challenge.

In Mr. Greenaway's "Drowning by Numbers," which was made in 1988 and serves as a kind of dress rehearsal for his subsequent "The Cook, the Thief, His Wife and Her Lover," there are three principal women, all of whom have the same name. Cissie Colpitts (who figured in Mr. Greenaway's 1980 film "The Falls") now spans three generations, and in each incarnation she drowns her husband, after which she mourns him briefly before going on contentedly with her life. Meanwhile, each of the numbers from 1 to 100 is seen somewhere during the course of the film, whether on a laundry mark (3) or a herring (92, 93, 94) or a dead cow (78 and 79). The names of a hundred stars are also worked into the film. So are the last words of Gainsborough, Charles II, William Pitt and Lord Nelson.

It would be unsporting and also futile to ask why, since Mr. Greenaway's intentions never reveal themselves in full. Production notes for this film include the director's eight-page, single-spaced synopsis of what transpires, yet little of this is clearer on paper than it is on screen. "Smut is perturbed by the Skipping Girl's remarks about circumcision and asks Madgett questions prompted by a painting he's found of Samson and Delilah," goes a sample development. It's not difficult to absorb such an event, and the countless others like it, without developing any larger notion of what is under way.

If Mr. Greenaway operated strictly on the level of narrative, he would have little claim to an audience's attention, but his narratives are secondary anyhow. His films are indeed visually fascinating (since the 1985 "A Zed and Two Noughts," they have been beautifully photographed by Sacha Vierny, who did so much fine work for Alain Resnais). And this one has a particularly seductive look, with a setting on the English coast and an inviting mixture of seashore and greenery. Mr. Greenaway's compositions are also hauntingly lovely even when marginally sickening, like the array of apples at the first murder scene, where insects and snails perch mysteriously amid the ripe fruit. Film-minded entomologists will note that the death's-head moth of "The Silence of the Lambs" can also be seen here, although Mr. Greenaway's film has the upper hand when it comes to bugs.

Working up to the mettle-testing extremes of "The Cook, the Thief, His Wife and Her Lover," Mr. Greenaway this time includes Smut (Jason Edwards), the small boy who counts and celebrates road kills, collects insects and becomes obsessed with the dream of circumcising himself, which indeed comes true. There are also traces of the physical disgust — the revulsion for food and flesh — and

Kirk Douglas and John Ireland leading a slave revolt in "Spartacus."

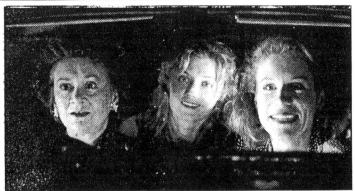

Prestige Films

From the left; Joan Plowright, Joely Richardson and Juliet Stevenson in a scene from Peter Greenaway's "Drowning by Numbers."

the free-spirited nudity that help to foster the impression of a larger honesty, though none is particularly forthcoming.

Despite that, and despite its pervasive morbidity, "Drowning by Numbers" is a much more light-hearted work than its successor. It's also a film that affords its actors better and more wry roles than Mr. Greenaway usually provides. Joan Plowright, as the senior Cissie and the one who first kills her husband, presides over the film as a droll, knowing figure and provides a deadpan delivery well suited to the film's cryptic wit. She and Juliet Stevenson, a particularly poised and acerbic Cissie 2, indeed seem cut from the same cloth.

Joely Richardson, as the youngest Cissie, is more the innocent, even though her role is largely that of a homicidal nymph. The women in the film are treated far better than the men, who include Bernard Hill as the central male figure, a coroner named Madgett whose desire for all three Cissies is only heightened by their lethal proclivities. Mr. Greenaway's brand of feminism, one of the film's few discernible constructs, brings death or bodily harm to most of his male characters.

"Drowning by Numbers" is best watched as a fable made in the manner of a latter-day and even more debauched Lewis Carroll, replete with oddly staged contests like the cricket match involving dozens of players, odd rules and abundant masks. It is also filled with gaming equipment, compulsive collections, painterly references, and a degree of intensive detail that holds the interest even when nothing else does. The film's tendency to be obscure is not helped by its soundtrack, which is occasionally muffled. But the music, composed by Michael Nyman around several bars of Mozart's Sinfonia Concertante for Violin, Viola and Orchestra, is on a par with the glowing cinematography.

•

"Drowning by Numbers" is rated R (Under 17 requires accompanying parent or adult guardian). It includes violence, considerable nudity and sexual reference.

1991 Ap 26, C8:1

Oscar

Directed by John Landis; screenplay by Michael Barrie and Jim Mulholland, based on the play by Claude Magnier; director of photography, Mac Ahlberg; edited by Dale Beldin; music by Elmer Bernstein; production designer, Bill Kenney; produced by Leslie Belzberg; released by Touchstone Pictures. Running time: 109 minutes. This film is rated PG.

Angelo (Snaps) Provolone	Sylvester Stallone
Aldo	Peter Riegert
Connie	Chazz Palminteri
Ace	Joey Travolta
Anthony Rossano	Vincent Spano
Sofia Provolone	Ornella Muti
Father Clemente	Don Ameche
Aunt Rosa	Yvonne DeCarlo
Luigi Finucci	Martin Ferrero
Guido Finucci	Harry Shearer
Theresa	Elizabeth Barondes
Oscar	Jim Mulholland
Dr. Poole	Tim Curry
Snaps's father	Kirk Douglas

By JANET MASLIN

It is no longer inconceivable that someday Sylvester Stallone will be found on network television, rolling his eyes and waving his hands at the weekly antics of a family of cute, unruly kids. In "Oscar," Mr. Stallone displays an unexpected gameness, even a flair, for the kind of broadly durable comedy that is the television sitcom's specialty. It works a lot better than might have been expected. Mr. Stallone may not be a comic genius, but he's definitely a sport.

Sam Emerson/Touchtone Pictures

Sylvester Stallone

As Snaps Provolone, a Depression-era gangster trying to transform himself into a respectable business-man, Mr. Stallone dresses nattily and rails against "the music you kids listen to today — don't think I haven't heard the lyrics to 'Minnie the Moocher'!" He tolerates the comings and goings of a crazy assortment of minor characters, all of whom arrive on his doorstep on the same morning to introduce mistaken identities, interchangeable luggage, and various other volatile elements into his formerly happy home.

The interchangeable bags, which respectively contain cash, jewels and the maid's underwear, are confused over and over again. You don't have to be a student of screwball comedy to guess which one, in a film as frenzied but fundamentally mild as this one, will be opened every time somebody boasts about the valuables inside.

John Landis's blunt but energetic direction recalls his own earlier "Trading Places," only this time it is Mr. Stallone who somehow trades places with himself. He evolves from mobster to gentleman at the behest of his dying father (a cameo by Kirk Douglas, who revives enough to give his boy a hard slap and declare "Atsa so you don't forget!"). He hires a very strange elocution coach (Tim Curry, who makes himself hilariously ghastly) so that he can learn to use words like "expeditious" in everyday conversation. He tries to be civil to his accountant (Vincent Spano) even when he learns that the accountant has been appropriating Snaps's money so that he can be rich enough to marry Snaps's daughter. He even tries to be civil about Oscar, the very minor character whose amorous behavior has helped to move the plot along, and who appears only briefly (played by Jim Mulholland, who co-wrote the screenplay with Michael Barrie) in one scene.

"Oscar" started out as a French play by Claude Magnier, but it has lost all traces of Gallic farce and has been sufficiently Americanized to include lines like "All of a sudden he's the Duke of Ellington!" and exchanges like "I'm tellin' ya a leopard don't change his stripes!" "You mean spots!" "I mean Snaps." Even when the jokes aren't far above the knock-knock level ("Angelo please, not in front of the help!" "Trust me, he's no help!") they are at least fast and furious, as befits the screwball tactic of never giving the audience time to wonder about the plot.

The casting, like the script, is much too uneven. But it's helpfully overloaded, so that a full array of comic performers runs circles around Mr. Stallone. Particularly good are Harry Shearer and Martin Ferrero as two tailors who are mistaken for hit men because their newspaper photo of a favorite client shows him shot full of holes in a "clam house slaying"; Mr. Spano as the enterprising young accountant; Elizabeth Barondes as a sweet-looking young woman who has lied her way to the center of the Provolone family, and Chazz Palminteri as the familiar dim hood who can't keep up with any of what has been going on.

Peter Riegert, as the second-in-command who spends a lot of his time polishing Snaps's silver service, provides a touch of class by behaving exactly as if he were William Demarest and this were a Preston Sturges movie, which it most emphatically is not. But not for lack of trying.

•

"Oscar" is rated PG ("Parental guidance suggested"). It includes some mildly suggestive dialogue.

1991 Ap 26, C10:5

A Kiss Before Dying

Directed and written for the screen by James Dearden; based on the novel by Ira Levin; director of photography, Mike Southon; edited by Michael Bradsell; music by Howard Shore; production designer, Jim Clay; produced by Robert Lawrence; released by Universal Pictures. Running time: 96 minutes. This film is rated R.

Young Jonathan	James Bonfanti
Lecturer	Sarah Keller
Ellen/ Dorothy Carlsson	Sean Young
Patricia Farren	Marthan Gehman
Jonathan Corliss	Matt Dillon
Thor Carlsson	Max Von Sydow
Terry Dieter	Jim Fyfe

By VINCENT CANBY

"A Kiss Before Dying," written and directed by James Dearden, who wrote "Fatal Attraction," is the entertaining if bent, almost-success story of Jonathan Corliss (Matt Dillon), a poor young man who wants to get ahead.

Jonathan, an undergraduate at the University of Pennsylvania, comes across as handsome, sincere, modest and, above all, seriously motivated. He's so seriously motivated, in fact, that in an early sequence in "A Kiss Before Dying," he doesn't hesitate to throw his fiancée down an airwell in the Philadelphia City Hall.

The young woman brings it on herself by becoming pregnant, or so Jonathan reasons. Instead of having an abortion, as he wishes, she insists that they get married, knowing full well that her father, one of the richest men in America and certainly the stuffiest, will disinherit her.

As much as Jonathan loves her, he loves her father's money more. Any such marriage would forever deny Jonathan access to the Carlsson Copper fortune. There is only one fortune, but there are two Carlsson daughters, twin sisters.

•

In adapting Ira Levin's 1953 suspense novel, first made into a film by Gerd Oswald in 1956, Mr. Dearden has updated and freely rearranged and rethought the original story. The new screenplay is both tighter and more plausible than the Levin novel, though the film's plausibility isn't exactly its strong point.

Plausibility isn't that important in a movie in which characters and performances carry such lively conviction.

As in "Drugstore Cowboy," Mr. Dillon gives a fine, easy portrayal of a young man who seems in all ways to be utterly conventional and middle-class, except for one minor flaw. Jonathan is a neat, presentable psychopathic killer.

Sean Young appears as the Carlsson twins, Dorothy, the rather tiresome and needy university student who goes plunging over the parapet on her way to the marriage bureau, and Ellen, the more interesting twin who is a social worker in Manhattan.

•

Ellen is a strong character, a match for her imperious father, Thor (Max Von Sydow), though not for the devious Jonathan. Some time after Dorothy's "suicide," which is what the police call it, Jonathan turns up in New York, with a new name, as a social worker who is as dedicated to his work as Ellen.

She finds him irresistible. He's terrific with bewildered runaways and crack addicts. On days off, he likes nothing better than to amble over to Central Park to play ball with the kids, or just laze on the grass with Ellen. Their sex life is also great.

Aware of the trauma that Dorothy's death has caused both Thor and Ellen, Jonathan works to bring father and daughter together. He's some kind of living saint, until there are hints that his interest in Ellen may not be as consuming as his interest in a corporate career with Thor.

One of the film's neatest, most evil tricks is the way in which it coaxes the audience to believe that Jonathan may not be as bad as he clearly is. The movie puts the members of the audience, who know everything, in the initially unsuspecting position of Ellen. That's not easy.

Imperiled

Sean Young and Matt Dillon play the leading roles in "A Kiss Before Dying," about a woman who marries a charming but deadly man.

Universal Pictures

The camera is not always kind to Miss Young, which is to her advantage. She often looks taut and on edge, not quite the high-fashion type seen in earlier films. She's very good, except when Mr. Dearden photographs her in close-up with one unpersuasive tear trickling down a cheek.

Mr. Dearden's screenplay is slightly more consistent than his direction of it.

There's a snappy plot twist in the film's first half that is unfortunately telegraphed. Also, in Jonathan's first scenes with Thor, he is allowed to come on so strong that the older man, as played with Mr. Von Sydow's intelligent gravity, might be expected to smell a rat.

These reservations aren't important. "A Kiss Before Dying" is not "Crime and Punishment." It is pop movie making to be enjoyed without guilt.

●

"A Kiss Before Dying," which has been rated R (Under 17 requires accompanying parent or adult guardian), includes some partial nudity and some violence.

1991 Ap 26, C12:6

Journey of Hope

Directed by Xavier Koller; screenplay (Turkish, Italian and German, with English subtitles) by Mr. Koller and Feride Çiçekoglu; director of photography, Elemer Ragalyi; edited by Galip Iyitanir; produced by Alfi Sinniger/Catpics and Peter Fueter/Condor Productions; released by Miramax Films. At 57th Street Playhouse, 110 West 57th Street in Manhattan. Ruynning time: 110 minutes. This film has no rating.

Haydar.............................. Necmettin Cobanoglu
Meryem Nur Surer
Mehmet Ali.....................................Emin Sivas
Turkmen................. Yaman Okay
Truckdriver Ramser........Mathias Gnadinger
Massimo............................Dietmar Schonherr

By VINCENT CANBY

Xavier Koller's "Journey of Hope," the Swiss film opening today at the 57th Street Playhouse, is based on the sad true story of a family of innocents and their efforts to find a new life in the economic abundance of Switzerland.

Haydar, a farmer in southeastern Turkey, sells his fields and livestock and sets out on the long journey with his wife, Meryem, and one son, Mehmet Ali, leaving behind his other children, parents, brothers and cousins.

The promised land is represented by a picture postcard featuring an idyllic Alpine view, the most prized possession of little Mehmet Ali.

The postcard is never long out of the boy's hand as they travel by bus to Istanbul, stow away on a freighter to southern Italy, hitch a ride with a kindly truck driver to the Swiss border, only to be turned back to Milan because they have no visas.

In Milan, Haydar, Meryem and Mehmet Ali entrust themselves to a sleazy bunch of international smugglers who, in exchange for Haydar's small amount of cash and a lien on his future earnings, promise to guide them over the mountains into Switzerland.

The actual cost turns out to be much higher.

●

Though "Journey of Hope" is a sincere movie with a social conscience, Mr. Koller's approach has the effect of sentimentalizing the family's problems, both in Turkey and on the road.

The opening scenes, set in rural Turkey, are so full of picturesque feasting that Haydar's desperation to leave remains mysterious. The film offers no clue why, over the years, Turkish workers have been emigrating to Western Europe in such numbers that they've become a political as well as a social issue.

The initial publicity for the film describes Haydar and his family as Turkish. More recent publicity identifies them as Kurdish, which would fit in with the part of Turkey they come from.

Yet I'm told by someone who speaks Turkish, and who has seen "Journey of Hope," that there is nothing in the film that specifically identifies the family as Kurdish. Among other things, Haydar and Meryem speak Turkish, not Kurdish, when by themselves.

The movie never calls attention to the long history of oppression suffered by the Kurdish people, which could have helped to explain the flight of Haydar and his family.

●

There is nothing outrageously wrong with "Journey of Hope." It is competent film making. It is literal and a little bit dull. The most surprising thing about it is that last month it received the Oscar as the best foreign-language film of 1990.

That says much more about the limiting manner in which the foreign-language Oscar nominees are selected, and voted upon, than it does about the quality of films produced abroad. Each country selects one film to represent it in the competition, from which a small committee picks the five final nominees.

In their journey to Hollywood, a lot of exceptionally fine movies are lost.

1991 Ap 26, C13:1

Toy Soldiers

Directed by Daniel Petrie Jr.; screenplay by Mr. Petrie and David Koepp, based on the novel by William P. Kennedy; director of photography, Thomas Burstyn; edited by Michael Kahn; music by Robert Folk; production designer, Chester Kaczenski; produced by Jack E. Freedman, Wayne S. Williams and Patricia Herskovic; released by Tri-Star Pictures. Running time: 112 minutes. This film is rated R.

Billy Tepper Sean Astin
Joey Trotta Wil Wheaton
Snuffy Bradberry Keith Coogan
Luis Cali.................................Andrew Divoff
General Kramer R. Lee Ermey
Deputy Director Brown........... Mason Adams
Headmaster................................ Denholm Elliott
Dean ParkerLouis Gossett Jr.
Ricardo Montoya George Perez
Hank Giles T. E. Russell

By JANET MASLIN

Novelty counts for a lot in a suspense film, and "Toy Soldiers" has a genuinely novel gimmick. Its setting is a boys' prep school, the kind of place that is more familiarly used as a crucible for shaping young minds and values. In this case, it becomes the serene, leafy setting for a terrorist attack.

Since the five principal boys in the story happen to be the sons of an oil company president, a Mafia don, a Congressman, the vice chairman of the Republican Party and a past president of the California Bar Association, the possibilities for mayhem are enormous. (None of the boys have mothers with careers worth mentioning, by the way.)

Never mind that none of the film's ordinary, easygoing schoolboys behave at all like the scions of prominent families, or that the long arm of coincidence gets a real workout during the course of the story. In fact, "Toy Soldiers" is a crisp, suspenseful

Tri-Star Pictures

Sean Astin

thriller well tailored to the tastes of teen-age audiences, who will doubtless appreciate such touches as the equivalent microchips found in one student's radio-controlled airplane and the chief terrorist's detonator, which is rigged to blow up the entire school.

"Toy Soldiers" has a bloody prologue in which Luis Cali (Andrew Divoff), son of a South American drug czar, shoots up a courtroom in hopes of freeing his father from United States drug charges and then tracks a Federal judge's son to the Regis School, whose students have been expelled from so many other prep schools that they have nicknamed the place "Rejects." Nonetheless, they are a plucky bunch, as is demonstrated by an early sequence that shows a few of them sneaking off to a basement hideaway to drink vodka that's disguised as mouthwash and make an illicit call to a telephone porn number. That, and the film's considerable violence, will make it unsuitable for very young children attracted by the "Toy" in the title.

Once the terrorists arrive, the boys use their knowledge of underground passages, heating ducts and so on to chart a defense plan, even marking up photographs in the school yearbook to illustrate battle plans. The director, Daniel Petrie Jr., spends enough time establishing the kids' characters and camaraderie to keep the audience interested once the action gets going.

The cast includes Sean Astin as the group's feisty ringleader, Keith Coogan as a more easygoing jokester, Denholm Elliott as the befuddled headmaster and Louis Gossett Jr. as the tough but understanding Dean. He escapes from the school long enough to meet with parents, who are outraged over the terrorist takeover, and tell them, "Please, please, let the experts handle this." The screenplay, by Mr. Petrie and David Koepp, moves fast but has its humdrum moments.

Mr. Petrie, who wrote "Beverly Hills Cop" and makes his directing debut with "Toy Soldiers" (it was his brother Donald who directed "Mystic Pizza"), gives the story as much warmth as it has suspense, but he sometimes wastes the potential for big moments. The involvement of the Mafia don, for example, produces an important plot development that is dealt with in only a perfunctory fashion. And the high-powered parents of the other boys are never brought into the story.

The boys themselves, who also include Wil Wheaton, T. E. Russell and George Perez, appear at the end for a kind of curtain call. Mr. Petrie treats "Toy Soldiers" as if it were destined to be a big hit, and he may be right.

●

'Toy Soldiers' is rated R (Under 17 requires accompanying parent or adult guardian). It includes violence, profanity and sexual references.

1991 Ap 26, C15:1

Never Leave Nevada

Directed and written by Steve Swartz; cinematographer, Lee Daniel; edited by Gordon A. Thomas; music by Ray Benson; produced by Diane Campbell; released by Cabriolet Films. At the Bleecker Street Cinema, at La Guardia Place, in Manhattan. Running time: 88 minutes. This film has no rating.

Sean KaplanSteve Swartz
Luis Ramirez............................Rodney Rincon
Betty Gurling........................Janelle Buchanan
Lou Ann Pearlstein............Katherine Catmull
Carlo Pfeffer............................Loren Loganbill

By STEPHEN HOLDEN

Midway between Death Valley and America's largest nuclear test site sits the town of Beatty (population 500), which is the setting for Steve Swartz's screwball comedy "Never Leave Nevada." Into town one day roll Sean (Mr. Swartz) and his partner, Luis (Rodney Rincon), a team of traveling salesmen with a trunkful of T-shirts bearing slogans like "Nuclear Winter Gives Me the Chills." Sean and Luis, it turns out, make their living going around the country selling these and other items at antinuclear demonstrations.

Everywhere they go, Luis is recognized as having played the Mexican Mule Boy on a vintage television series that can still be seen on the Christian Broadcasting Network. Luis's career as a child actor is one of many extraneous details in a movie

whose characters are all certifiably eccentric. Sean, for his part, recalls having blown $35,000 on a "high-concept bakery" in Los Angeles at just the moment when sweets were going out of fashion.

After drifting around Beatty and visiting a local bordello where one prostitute declares Ted Koppel to be the handsomest man in America, Sean and Luis hook up with two roommates, Betty (Janelle Buchanan) and Lou Ann (Katherine Catmull). Betty, who works in a health clinic, is married to Carlo (Loren Loganbill), who is dying of cancer and doesn't seem to mind Sean falling in love with his wife. Lou Ann deals blackjack at a local casino, prowls the highway with a gun in the middle of the night and fantasizes about being ravished by every man she meets.

"Never Leave Nevada" wants desperately to be hip in a low-key back-handed way. Mr. Swartz, who wrote, directed and stars, has a deadpan smart-aleck sensibility and a knack for writing off-kilter comic dialogue that sounds semi-improvised. Were one to take the movie more seriously than it deserves, it might be described as a dark comedy that reveals how daily life percolates along beneath a figurative mushroom cloud. The one subject that the residents of Beatty don't like to talk about is the possible effect of years of nuclear testing.

The zany chitchat and deadpan comic performances of the quartet are the best thing about the movie, which was shot in black and white for a song and has the cramped shadowy look of a 1950's military training film.

1991 Ap 28, 60:5

FILM VIEW/Janet Maslin

Seagal Packs More Than A Wallop

WE MAY AS WELL FACE THE FACT THAT our reigning action-movie star is a guy with a scowl, a ponytail and an attitude he himself has referred to (while in character, of course) as a "superior state of mind." We should also acknowledge that Steven Seagal, whose first three films have had worldwide box-office and video receipts totaling more than $200 million, and whose new "Out for Justice" was the nation's top-grossing film last week, is someone to be reckoned with.

To those who maintain a polite distance from the whole bone-crunching genre, Mr. Seagal may take a little explaining. He is big, handsome, imposing, colossally confident and not quite like any other actor who has ever made a killing, so to speak, in the action field. Only from afar would it be possible to confuse him with someone like Jean-Claude Van Damme, a more typical self-defense star and another recently arrived contender for the action crown.

■

The Belgian-born Mr. Van Damme (familiarly known as "the muscles from Brussels") doesn't say much, and he functions as a conventional slugger. In the recent "Lionheart," he played, believe it or not, a fugitive from the Foreign Legion forced to make his living by fighting in bouts staged to entertain America's idle rich. The far hipper and more exotic Mr. Seagal has even less in common with this approach to martial arts than he does with the nice-guy, sheepishly heroic Chuck Norris.

What Mr. Seagal (pronounced say-GAL) offers instead is a clever, uncategorizable hybrid of physical prowess, fortune-cookie wisdom, law-and-order politics, street-smart bravado and, above all, the confident, insouciant manner of a natural-born star. Put him in the midst of a crowded Brooklyn street scene, as "Out for Justice" does, and he can still manage to look more like a visiting dignitary than the plainclothes police officer he's supposed to be. Granted, when the

plain clothes include a gold chain, a black vest (worn sans shirt) and a black beret, inconspicuousness is probably out of the question. Ridiculousness is a better bet, but Mr. Seagal has a brash assurance that's attractive, and it extends well beyond anything a wardrobe department could devise.

Mr. Seagal's appeal also derives in part from his background, which his films reflect. "Above the Law," his first feature, began with a series of baby pictures and a biographical voice-over presenting the now-familiar facts: that he became fascinated with martial arts at an early age, that as a teen-ager he went to live in Japan, that he remained there for a long time and became a sufficiently celebrated teacher of aikido to later meet the kinds of Hollywood power brokers who might expedite his becoming an overnight movie star. The "Above the Law" sketch leaves that last part out, but it is clearly an important part of the story.

Warner Brothers
Steven Seagal in "Out for Justice"—Is he the next Arnold Schwarzenegger?

There is an element of mystery, too, since Mr. Seagal has described one of his hobbies as "organizing special investigations and security task forces to protect public figures," and since the plots of his films have often involved long time gaps and peculiar personality changes. In "Above the Law" he began as a C.I.A. operative in Vietnam and reappeared 20 years later in Chicago to expose corruption among Governmen officials. In "Marked for Death," he was transformed from a violent Federal drug agent into a simple, small-town soul. "Try to find the gentle self inside you and allow that person to come back," he was advised by the priest to whom he confessed his many sins. Of course, he was later forced to wipe out a small army of Jamaican drug dealers, just to preserve his small town's peace of mind.

In "Hard to Kill," he lost his family in a shootout and languished for seven years in a coma before waking up and falling in love with his nurse (played by Kelly LeBrock, Mr. Seagal's wife). Scenes in which he self-administered an herbal cure and acupuncture to speed the healing process undoubtedly contributed to the Seagal mystique.

There are also his teasing, mocking humor and his stylish strut, both of which presumably make Mr. Seagal's appeal to women greater than that of the usual action star. And there is the odd contrast between savagery and serenity: in "Out for Justice," he gouges one villain with a corkscrew but also befriends an abandoned puppy. Because he loves animals so very much, he feels obliged to clobber the guy who abandoned his little dog.

■

Not even Mr. Seagal's more likable qualities are apt to make him palatable to those who don't believe an argument should be settled with a meat cleaver, it's true. His primary audience remains one that would be extremely disappointed to see a Seagal film in which no one got hurt. And at present, playing a beloved neighborhood hero named Gino Felino, he may be in danger of lapsing into self-parody, since all four of his roles seem very similar despite their films' wildly disparate plots. Even his trademark nonchalance ("If I find out you lied, I'm gonna come back and kill you in your own kitchen," he remarks in "Out for Justice") is beginning to wear thin.

It doesn't have to be so. Mr. Seagal, who has expressed a desire to break out of the action genre, really does have the makings of a more versatile performer, one whose sleek good looks, celebrity manner and easy humor are more than a match for that ferocious frown. He also has an audience that will obviously follow him anywhere. And he has a role

model, if he chooses to notice it. If Arnold Schwarzenegger is possible — as a friend of small children, comic talent, romantic leading man and world's most bankable screen actor — . then Steven Seagal is possible, too. □

1991 Ap 28, II:13:5

Eating

Written, directed and edited by Henry Jaglom; director of photography, Hanania Baer; produced by Judith Wolinsky; released by Jagfilm for International Rainbow Pictures. At the Cinema Village 12th Street, 22 East 12th Street, in Manhattan. Running time: 110 minutes. This film is rated R.

Martine ... Nelly Alard
Mrs. Williams Frances Bergen
Kate .. Mary Crosby
Sadie .. Marlena Giovi
Lydia .. Marina Gregory
Jennifer Daphna Kastner
Sophie .. Gwen Welles
Jackie ... Toni Basil
Helene ... Lisa Richards

By JANET MASLIN

Of the 38 women who gather for a birthday party in Henry Jaglom's "Eating," almost none of them will touch the cake. And the few willing to do so hide out in solitary places, like the bathroom, so as to commune with dessert in perfect privacy. Food assumes near-religious importance in Mr. Jaglom's portrait of needy, anxious women who spend an entire day playing upon one another's insecurities, and waxing rhapsodic about well-remembered culinary thrills. That perfect bodies are irreconcilable with cream puffs becomes a source of genuine and amusingly well-expressed regret.

Mr. Jaglom's attitude toward his film's dizzying array of narcissists is extremely fond, which is a lot of what gives "Eating" its warmth and humor. Seen through a colder eye, the film's characters would quickly become insufferable. The subjects under discussion — the suggestion that someone might need a lower-lids eyelift, or the cry of "I hate my cheeks!" from someone else — are so relentlessly trivial that after a while they begin to take on a life of their

The snake in Eden is that perfect bodies and perfect cream puffs clash.

own. Mr. Jaglom makes no higher claims for his characters' importance, but he does claim to understand what makes them miserable, and perhaps that's enough.

The film's style is colorfully cluttered in the manner of Robert Altman (Mr. Altman's "Wedding," another party epic, comes to mind), but Mr. Jaglom seldom shapes his material quite that well. Few of the roles here are really written, or even as fully conceived as they might have been; much of the film sounds improvised and is allowed to drift. The story's ostensible focus is the 40th birthday of Helene (Lisa Richards), who faces her anxieties by curling up with a muffin and proclaiming that on her birthday she is free to eat anything she wants. A couple of other birth-

Jagfilms Inc.
Mary Crosby and Frances Bergen

days provide subsidiary interest, and an excuse to bring on several more birthday cakes.

•

As the house fills up with talkative guests and peculiar presents (Helene is given at least two things that qualify as "tools for getting out your suppressed anger"), the overheard and overlapping small talk turns to weight, men, cosmetic issues and career opportunities. A talent agent named Sadie (Marlena Giovi), celebrating her 50th birthday, talks about her younger boyfriend and nags her overweight daughter Jennifer (Daphna Kastner), while elsewhere one of Sadie's clients asks advice on how to abandon Sadie in favor of someone more powerful. "You write her a letter, you give her a present, and then you go with Sam Cohn," another actress advises this would-be deserter. "And you take me with you."

Meanwhile, Helene's supposed best friend Sophie (Gwen Welles), the film's most fully formed character and its most unremittingly nasty one, foments trouble at every possible opportunity. She concentrates particular attention on the slim, pretty Kate (Mary Crosby), who is sufficiently happy in her marriage to make the other guests wild with disbelief. Among the other principals are a French film maker (Nelly Alard) who inspires waves of resentment and admiration by looking too good in a bathing suit, and Helene's mother, who expresses shock at the silliness of much of what surrounds her. As played by the elegant Frances Bergen, this woman enchantingly recalls an age in which good sense and good form counted for at least as much as a good body. When asked to recall a favorite food, she thinks of caviar.

•

Some of the best lines in this leisurely, uneven film — which opens today at the Cinema Village 12th Street — are throwaway observations about food and all it stands for. "The last time I had sugar I ate it for five days straight," someone confesses. There are rapturous descriptions of pumpernickel bread and Canadian bacon. Composers are equated with meals (Vivaldi is thought to be like fruit salad). "I'm not really involved with food anymore — I've found a lot of distractions," says one woman in an extremely peculiar hat. "Like what?" she is asked. "Clothes, men, accessories," she answers.

"I think I'm still looking for a man who could excite me as much as a baked potato," someone else observes, summing up the film's connections between sex, love, longing and self-imposed starvation. That indeed is food for thought.

•

"Eating" is rated R (Under 17 requires accompanying parent or adult guardian.) It includes profanity and brief nudity.

1991 My 3, C8:1

China Cry

Written and directed by James F. Collier; director of photography, David Worth; edited by Duane Hartzell; music by Al Kasha and Joel Hirschhorn; production designer, Norman Baron; produced by Don LeRoy Parker; released by Penland Incorporated. At the Chelsea Cinemas, 23d Street near Seventh Avenue in Manhattan. Running time: 110 minutes. This film is rated PG-13.

Sung Neng Yee Julia Nickson-Soul
Lam Cheng Shen Russell Wong
Dr. Sung James Shigeta
Mrs. Sung France Nuyen
Colonel Cheng Philip Tan

By STEPHEN HOLDEN

"China Cry" has many of the features of a Hollywood biblical epic except that it is set in the 20th century. Instead of Romans persecuting early Christians, the villains are Communist zealots inflicting Mao Zedong's Cultural Revolution on a helpless China. The movie portrays a privileged bourgeois family under attack by Mao's Red Guards, and the brilliant, beautiful daughter, Sung Neng Yee (Julia Nickson-Soul), who eventually escapes to Hong Kong with her Prince Charming husband (Russell Wong).

TBN Films
Julia Nickson-Soul

The movie, which opens today at the Chelsea Cinemas, is an odd duck. Written and directed by James F. Collier, it is adapted from a memoir by Nora Lam. Its turning point is an old-fashioned movie miracle replete with wind, lightning and thunder. Just at the moment Sung Neng Yee faces a firing squad, a freak storm deflects the bullets and spares her. This event, which she takes to be a sign from God, restores the faith she had adopted briefly as an adolescent when attending a Christian school in pre-Communist days.

The miraculous bolt from the blue does not end Sung Neng Yee's troubles. Her lowest point arrives after her husband has safely reached Hong Kong, and she is sent to a forced labor camp while pregnant.

"China Cry" would like to be the Asian-American answer to "Ben Hur" but the tale is told too choppily to gather much momentum, and the acting is tentative. Even its carefully staged scenes of social disruption in Shanghai and of life in a forced labor camp have a curiously static feel.

Although the main character is an impossibly perfect movie heroine who should combine the misty-eyed sweetness of the 1950's Jean Simmons with the pluck (but not the meanness) of Scarlett O'Hara, Miss Nickson-Soul's portrayal of Sung Neng Yee has an unappealingly snippy edge. Mr. Wong's role is so underwritten that there is little for him to do except look moon-eyed.

•

"China Cry" is rated PG-13 (Parents strongly cautioned). It includes scenes of brutality that may frighten young children.

1991 My 3, C9:1

Truly, Madly, Deeply

Written and directed by Anthony Minghella; director of photography, Remi Adefarasin; edited by John Stothart; music by Barrington Pheloung; production designer, Barbara Gasnold; produced by Robert Cooper; released by the Samuel Goldwyn Company. At the Plaza, 42 East 58th Street in Manhattan. Running time: 107 minutes. This film has no rating.

Nina .. Juliet Stevenson
Jamie .. Alan Rickman
Sandy .. Bill Paterson
Mark Michael Maloney
Burge ... Jenny Howe

By VINCENT CANBY

At the beginning of "Truly, Madly, Deeply," Anthony Minghella's new English romantic comedy," Nina (Juliet Stevenson) is trying to put her life together after the death of her lover, Jamie. She isn't having much success.

She's moved into a shabby but frightfully picturesque north London flat that has possibilities, though in the meantime the plumbing doesn't work and the rats run free. Hovering around her, trying to cheer her up (and maybe to take Jamie's place), are her amorous super, the pest-control man, the plumber and her boss.

They're frisky and selfless, like Snow White's dwarfs. Like Snow White, Nina treats them with amusement that often seems patronizing. She can't forget her loss.

Jamie didn't die in any uncouth, melodramatic way. One day he had a sore throat. The next day he was gone. Just like that.

Theirs was a special love. They shared any number of interests. Classical music, poetry, old movies, good conversation, sex, the need for a caring Government at 10 Downing Street. Nina remembers with special poignance their intimate little musicales, Jamie on the cello, Nina at the piano.

•

As Nina, who makes a living as a translator, tells her analyst, she hears Jamie's voice everywhere, sometimes speaking to her in Spanish, though he didn't speak Spanish.

Then one evening, as she's playing the piano and weeping, Jamie (Alan Rickman) turns up, seemingly in the flesh.

Nina is ecstatic, though she realizes she may well be a figment of her imagination.

"Truly, Madly, Deeply," which opens today at the Plaza Theater, is Hollywood's "Ghost" as it might be reimagined in the positive life-affirming syntax of an ad in the personals column of The New York Review of Books. Everybody is too good to be true. Also twee.

For a while Nina and Jamie seem to be making a go of it. They sing together. They dance together. They crack little jokes. She adjusts to the fact that he's always cold: after all, he is dead.

●

When Jamie is joined by some of his pals from the other side, Nina becomes impatient. The other ghosts do nothing but sit around the front room watching "Five Graves to Cairo," "Fitzcarraldo" and other video titles that define cultural status in gentrified neighborhoods.

With a few real jokes and a lot of bogus tears, "Truly, Madly, Deeply" describes how Nina finally breaks with the past so that she can find new love with Mark (Michael Maloney). He is a social worker who has a sense of humor and a fondness for children, the disabled, good books, good music and good conversation.

Also like Nina, Mark hates racism and feels the need for a caring Government at 10 Downing Street.

●

"Truly, Madly, Deeply" should be enchanting, but it isn't. Everyone pushes too hard, especially Mr. Minghella, the writer and director. There are a few amusing lines and a lot of terrible ones, including Nina's overwrought response, early in the film, when her sister wants to borrow Jamie's cello: "It's like asking me to give you his body!"

Miss Stevenson, Mr. Rickman and Mr. Maloney, good actors all, work tirelessly on behalf of the insistently gooey and smug material. So do the rats in Nina's flat. After a while they, too, appear to favor Bach, like themselves and say yes to life.

1991 My 3, C11:1

One Good Cop

Written and directed by Heywood Gould; director of photography, Ralf Bode; edited by Richard Marks; music by David Foster and William Ross; production designer, Sandy Veneziano; produced by Laurence Mark; released by Hollywood Pictures and Buena Vista Pictures Distribution. Running time: 107 minutes. This film is rated R.

Artie Lewis	Michael Keaton
Rita Lewis	Rene Russo
Stevie Diroma	Anthony LaPaglia
Lieut. Danny Quinn	Kevin Conway
Grace	Rachel Ticotin
Beniamino	Tony Plana

By JANET MASLIN

The word "good" would not ordinarily apply to a police detective who robs, cheats and kills in the line of duty, as Artie Lewis (Michael Keaton) is seen doing in "One Good Cop." But Heywood Gould, who wrote and directed the first known Disney film (actually a release of Hollywood Pictures, a Disney subsidiary) to in-

Michael Ginsberg/Hollywood Pictures
Michael Keaton

clude a close-up of somebody who has been run through by a sword, envisions his story's hero as a latter-day ultrapractical Robin Hood.

"One Good Cop" is so confusingly edited that it takes a long time to determine whether the film maker is kidding about this. He's not. Mr. Gould, once a police reporter for The New York Post and later the man who conceived the fun-loving bartender of "Cocktail," is clearly a moralist with a mind of his own. He presents Artie Lewis's little excesses as the honest responses of a man determined to do what's best for the children in his life, even if — especially if — those children do not happen to be his own.

Early in the film, the childless Artie and his partner, Stevie (Anthony LaPaglia), a widower with three intensively cute little daughters, are seen involved in dangerous police activity, the kind that very nearly gets them killed. While the first such crisis ends relatively harmlessly, it doesn't take much foresight to anticipate the one-man-and-three-little-ladies scenario in Artie's future. The only surprise lies in how quickly everyone adapts to his or her newly altered circumstances. On the morning after they receive bad news about their father, the three little girls appear bright-eyed, bubbly and none the worse for wear.

The film further compromises its slender claim to credibility by giving Artie a sweet, gorgeous, accommodating wife (Rene Russo, the former cover girl) with whom he seems to have absolutely nothing in common. Charming scenes of their newly forged nuclear family are metronomically intercut with sleazy, frightening episodes pitting Artie against the drug-dealing scum who murdered his buddy.

●

Mr. Gould has a real flair for the latter sequences, which are genuinely suspenseful and involve such lively flourishes as biting rats and crazed crackheads. The film probably would have worked better as a straight-out thriller than it does leavened by moments of cloying domesticity.

Even Mr. Keaton, an eminently sensible and sympathetic actor, has a difficult time developing a character who is equal parts Dirty Harry and Mr. Mom. But he does bring the film a down-to-earth quality, something that its coincidence-strewn plot never seems to deserve. It doesn't help that

Mr. Gould's screenplay actually includes the line "Life ain't easy for orphans." At least Mr. Keaton is asked only to listen to this straight-faced, and not to say it.

Among the better supporting players are Tony Plana as a swaggering drug dealer and Rachel Ticotin as his smoldering sidekick, both of whom glare a great deal. Their posturing may be excessive, but it's a welcome contrast to the film's saccharine side.

●

"One Good Cop" is rated R (Under 17 requires accompanying parent or adult guardian). It includes violence and profanity.

1991 My 3, C13:1

A Rage in Harlem

Directed by Bill Duke; screenplay by John Toles-Bey and Bobby Crawford, based on the novel by Chester Himes; director of photography, Toyomichi Kurita; edited by Curtiss Clayton; music by Elmer Bernstein; production designer, Steven Legler; produced by Stephen Woolley and Kerry Boyle; released by Miramax Films. Running time: 115 minutes. This film is rated R.

Jackson	Forest Whitaker
Goldy	Gregory Hines
Imabelle	Robin Givens
Big Kathy	Zakes Mokae
Easy Money	Danny Glover
Slim	Badja Djola
Screamin' Jay Hawkins	Himself
Jodie	John Toles-Bey

By VINCENT CANBY

Bill Duke's "Rage in Harlem," adapted from a novel by Chester Himes, is a lightweight caper comedy set in 1956. Its effect, though, is to recall the early 1970's, the time of Ossie Davis's seminal "Cotton Comes to Harlem" (also based on a Himes novel) and Sidney Poitier's "Uptown Saturday Night," when black films were discovering their own comic identity.

"A Rage in Harlem" is not in a league with those two earlier films, but it's painless, occasionally funny and has a heedlessly incomprehensible plot. This has to do with a trunk of gold rocks smuggled up to Harlem by a beautiful fancy woman from Natchez named Imabelle (Robin Givens).

In attempting to unload the rocks, Imabelle meets an assortment of eccentric Harlem residents: Easy Money (Danny Glover), the mob boss; Goldy (Gregory Hines), a fellow who always forgets to pay his debts, and Big Kathy (Zakes Mokae), the transvestite madam of a local brothel.

Yet her most unlikely encounter is with Jackson (Forest Whitaker), a portly young man who wears glasses, says his prayers morning and night and works in a funeral parlor. When Imabelle seeks sanctuary, the innocent Jackson provides it and falls hopelessly in love.

●

The screenplay, by John Toles-Bey and Bobby Crawford, moves around a lot without explaining a great deal. There are two first-rate running gags.

One involves the director of the funeral parlor, an elderly fellow who sleeps on the job, always in the position of a body that's just been laid-out. The other has to do with the two portraits that hang over Jackson's bed. The first is a forbidding photograph of his mother. The second is a bland white Jesus.

Because the screenplay is so thin, the characters are revealed entirely by the actors who play them. Miss Givens does particularly well as a doxy with a heart of gold as well as a trunk full of it. She looks great and shows a real flair for absurd comedy.

●

Mr. Hines, Mr. Whitaker and Mr. Glover also are in good form, as are Badja Djola, who plays Imabelle's

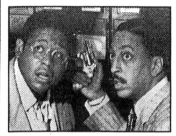

Miramax
Forest Whitaker, Gregory Hines

intimidatingly large former lover, the guy she's stolen the gold from, and Mr. Toles-Bey, who, in addition to working on the screenplay, appears as one of the bad guys.

The most entertaining moments in the movie are incidental to the main story, such as a brief but rousing performance by Screamin' Jay Hawkins at the undertakers' convention.

"A Rage in Harlem" is the first released theatrical feature to be directed by Mr. Duke, who earlier directed the television version of "A Raisin in the Sun" with Mr. Glover and Esther Rolle.

●

"A Rage in Harlem," which has been rated R (Under 17 requires accompanying parent or adult guardian), has some partial nudity, a lot of violence and some vulgar language.

1991 My 3, C14:1

Rich Girl

Directed by Joel Bender; written by Robert Elliot; director of photography, Levie Isaaks; edited by Mark Helfrich and Richard Candib; music by Jay Chattaway; production designer, Richard McGuire; produced by Micheal B. London; released by the Studio Three Film Corporation and Film West. Running time: 96 minutes. This film is rated R.

Courtney	Jill Schoelen
Rick	Don Michael Paul
Jeffrey	Sean Kanan
Rocco	Ron Karabatsos
Marvin Wells	Paul Gleason

By JANET MASLIN

Bored with privilege, Courtney Wells (Jill Schoelen) runs away from her little red sports car and her fancy wardrobe and her father's California mansion with the swimming pool. Determined to lead a more meaningful life, she finds waitressing work at a rock-and-roll club, where she can meet new people, wear a scanty outfit complete with little black ankle boots, and listen to all the loud, screamy, mediocre music her heart desires.

"Rich Girl," the listless chronicle of this transformation, commits the cardinal sin of not making Courtney's new life look like any more fun than her old one, which at least had a certain "Dynasty"-like appeal. The rock club is depressing, the clientele sleazy, and the new man in Courtney's life is a singer so slow on the uptake that he even struggles

with a line like, "Do you want me to take you home?" Don Michael Paul, who plays the singer, does elicit some admiration for wiping his brow exhaustedly after just having lip-synched his way through a song.

As directed by Joel Bender, "Rich Girl" is clumsy and colorless, with a blandly good-looking cast and a soap-opera outlook. The screenplay, by Robert Elliott, is filled with lines that might have been at least inadvertent-

ly funny if only they had been delivered with the slightest flair. Among them: "If you love that singer, you're gonna have to break up with him." "Don't ever do that again." "Well, what about Courtney's trust fund?" And: "That 'bum' was my father!"

•

"Rich Girl" is rated R. It includes profanity and sexual situations.

1991 My 4, 15:1

FILM VIEW/Caryn James

'Nikita' Needs No Words

WHEN IS A FRENCH FILM not really French? When its style is nouveau "Miami Vice," its hero is Bruce Willis with a sex change and its dialogue — in French with English subtitles — is not entirely needed in either language. Nothing is lost in translation in "La Femme Nikita," the slick, stylish, tremendously entertaining story of a bedraggled punk murderer transformed into an elegant government assassin. There is nothing *to* translate, for "Nikita" already speaks the international language of American action films, with an added soupçon of familiar French sexiness.

It is not surprising that "Nikita" is off to a wildly successful start in the United States, where it opened two months ago. It is still playing in France more than a year after its release and has done great business in England and Japan. Purists might guess that Simone Signoret and François Truffaut are spinning in their graves, but "Nikita" is that rare phenomenon, an international hit.

The reason for its success goes to the heart of current commercial movie making, for "Nikita" is an ebullient example of what can be called the kitchen-sink movie. Everything but the kitchen sink is tossed in: action, comedy, romance, suspense and a shrewd marketing campaign. "Ghost" is the kitchen-sink movie to beat them all, but the something-for-everyone approach has been adapted by Luc Besson, the 32-year-old director of "Nikita," with the unmistakable flair of a film maker raised on rock music and television.

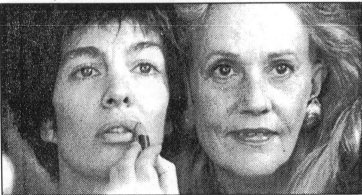

Samuel Goldwyn Company

Anne Parillaud and Jeanne Moreau in Luc Besson's film—
an international hit

The first of the many plots begins on a blue-lit night that looks and sounds like a mu-

With its style, sex and action, 'La Femme Nikita' needs no translation.

sic video. It turns out to be Nikita and her pals — including one in a leather jacket with a tic-tac-toe pattern shaved into his scalp — sauntering down the street and breaking into a pharmacy. When a shirtless guy with shoulder-length blond hair uses an ax to break the lock, he says, "J'ai zappé," translated as, "I zapped it." His nickname is Zap, which gives a pretty good idea of how well the action speaks for itself.

At this point, Nikita, played without a trace of glamour by Anne Parillaud, does not seem destined for a career as a femme fatale or a sympathetic heroine. She calmly kills a cop after a bloody shootout between the police and the burglars; it is an extremely violent scene but stylishly bathed in neon-green light. Later she stabs her interrogator with a pencil. The film is as hard-nosed and unflinching as its unrepentent heroine. Sentenced to life in prison, she is given a chance to start over as a government killer, if only she can learn how to blend into polite society. Imagine Eliza Doolittle's granddaughter made over by Don Johnson.

The hints of her fashionable future are all around her, part of the film's effective design. Nikita's mentor, Bob, has an exceptionally well-groomed stubble and well-cut clothes. Nikita's transformation is marked by changes in her tiny cell. While she is still at the rebellious stage of kicking and biting her karate teacher, she fills her room with graffiti. Of course, the bright orange circles and green slashes against a glossy white background are so vividly designed and coordinated that it seems Architectural Digest was called in to do the job.

■

Yet Mr. Besson never lets the style overwhelm the enigmatic, surprising Nikita. In a wonderfully ironic and funny touch, her transformation is aided by, of all people, Jeanne Moreau. She puts a stylish wig over Nikita's straggly hair, teaches her to use lipstick and responds to her plea, "I'm not smart," by saying, "Smile when you don't know something. You won't be any smarter, but it's nicer for others." She gives the kind of

The film reaches out to every possible audience.

advice that any Jeanne Moreau character lives by. "There are two things that have no limit," she says, "femininity and the means of taking advantage of it."

It is a remarkably generous turn by Miss Moreau, for though Nikita does become glamorous, the moral of

the story is that they don't make Frenchwomen or French movies the way they used to. Nikita is trained to shoot, not seduce. When Bob takes her for a birthday celebration at a fancy, restaurant, she blasts the place apart, dodges bullets in the kitchen and escapes down a garbage chute. This cannot have been easy to do in a tight black minidress and spike heels.

■

"La Femme Nikita" would not be a successful kitchen-sink movie without a less violent kind of action, of course. Soon Nikita is released from her prison training. She heads for the supermarket, skids down the aisles and picks up the soulful, available, good-looking cashier, who turns out to be her true love. This unbelievable but sweet comic romance gives way to some unexpected government capers and one final, complicated job that reduces Nikita to tears. In true kitchen-sink fashion, she's both tough and a crybaby.

Though the film seems to reach out to every possible audience, the Samuel Goldwyn Company marketed "La Femme Nikita" for an audience in its late teens and 20's. The invitation list for early preview screenings came from dance clubs. Few foreign films can attract this young audience, but "La Femme Nikita" did, because its American-influenced action hardly seems foreign at all.

Some phenomena will always seem inexplicably French. Mr. Besson's last film, "The Big Blue," is one of the most successful French films of all time. It has been playing in France for three straight years, but the English-language version barely touched

Samuel Goldwyn

Anne Parillaud as the assassin in "La Femme Nikita"

ground here. It has an international cast, settings that range from Peru to Sicily and a very dopey story about a diving championship and a man who leaves Rosanna Arquette for a dolphin. In attempting to make an international film, Mr. Besson made an extravagantly silly one that simply doesn't travel.

"La Femme Nikita" is far more universal. Warner Brothers is now planning to remake it, which seems a real waste of money. If they just erased the subtitles, who would notice the difference? ☐

1991 My 5, II:17:1

Herdsmen of the Sun

Directed by Werner Herzog; produced by Patrick Sandrin; released by Interama Inc. In French with English subtitles. Running time: 52 minutes. This film has no rating.

Black Water

Directed by Allen Moore; cinematographer and editor, Mr. Moore; music by Orlando Haddad; produced by Charlotte Cerf and Mr. Moore; released by First Run/Icarus Films. Running time: 28 minutes. This film has no rating.

By JANET MASLIN

Werner Herzog's fascination with the natural world at its most enduringly strange has led him to the southern Sahara for "Herdsmen of the Sun," a startling anthropological documentary about the nomadic members of the Wodaabe tribe.

In the space of only 52 minutes, Mr. Herzog examines their peculiar mating rituals, conveys a sense of their history and suggests how seriously their future is threatened. What he does most powerfully, as he has in other short documentary films (most notably "La Soufrière"), is to discover a reality more exotic and mysterious than anything a storyteller could imagine.

At the Film Forum, where audiences can watch the elaborate gay role-playing of "Paris Is Burning" in

an adjoining theater, Mr. Herzog presents an even more extravagant masquerade: that of the slender and graceful Wodaabe men, many of them seven feet tall, adorning themselves with beads and hats and blue lipstick as part of a traditional tribal celebration.

•

The preparations for this ritual can take a full day, and they involve elaborate makeup methods (including the use of toxic battery chemicals as eyeliner). This is all intended to make these men look beautiful. So are their bizarre grimaces, which Mr. Herzog explains by noting that "showing the whites of the teeth and eyeballs is considered particularly attractive."

The contestants in this tribal beauty pageant wear expressions that suggest Norma Desmond ready for her close-up at the end of "Sunset Boulevard," but among Wodaabe women the ritual has its desired effect. The man deemed most beautiful is obliged to spend the night with the woman who has selected him, and on at least one morning after (as seen in the film) the result is a proposal of marriage. "Do you love me because of my beauty or my charms?" the contest winner asks his prospective bride. "Were you told to do this, or did you do this as a personal choice?"

Whatever the answers, the Wodaabe culture is thought to date back to the Stone Age. So their methods of perpetuating the tribe must be considered a success.

But "Herdsmen of the Sun" belongs to the growing genre of ecotragedy, presenting evidence that a once-viable set of customs may now be obsolete. Practiced at following cattle (the Wodaabe can break camp in less than an hour) and wholly dependent on goods traded for cattle in the marketplace, the Wodaabe have suffered the effects of recent drought and famine and found themselves forced into city living, for which they were utterly unprepared.

"The Wodaabe in the city does not walk the sweet earth," one tribesman says solemnly in the ragged tent encampment in which he and his family have found shelter. Another tells, with an ecstasy and innocence familiar from other films of Mr. Herzog's, of looking up at the starry night sky and feeling "delirious with bliss," even under these adverse and ominous circumstances.

On the same bill is the shorter and more straightforward "Black Water," directed by Allen Moore and based on anthropological work by Charlotte Cerf, which is about the tranquil fishing village of São Braz, in Bahia, Brazil, and the effects of a paper plant that disperses toxic chemicals into its water supply, which is now sudsy and harmful to the region's once plentiful shellfish. The film's method is gentle and roundabout, quietly illustrating the villagers' utter dependence on river water for every aspect of their happiness and survival. At the film's end, a local song decries "the horror of a vain progress" and offers an affecting if predictable plea: "Send the devils away."

1991 My 8, C11:4

The Wonders of Wilder, The Movies' Master Wit

By VINCENT CANBY

IN Billy Wilder's unregenerately satiric "Ace in the Hole" (1951), Kirk Douglas gives the performance of his life as Charlie Tatum, a scrappy, none-too-ethical reporter with no fixed address. Charlie's boast is that he's been fired by newspapers with a total circulation of 11 million.

When he runs out of money while driving through Albuquerque, N.M., Charlie talks his way into a job on a local daily. For a year he goes out of his rye-soaked mind covering Rotary Club meetings and rattlesnake hunts.

Then he stumbles onto his Big Story: the predicament of a poor slob who has been trapped in a cave while scrounging for Indian relics to sell to the tourists. In less than 24 hours, Charlie has pumped up a one-day, one-paragraph, page 10 filler item into a continuing human-interest event reported in banner headlines across the country. Greed is the spur.

In the way of rampant American enterprise, Charlie has seized a business opportunity and run with it. The spectacle is harsh, funny, cruel, apt, finally disastrous: Americana on the rocks.

"Ace in the Hole," which flopped in its initial theatrical release and isn't available on video, will open a four-day run today at the Film Forum in Manhattan.

Sharing the bill is Mr. Wilder's equally stunning, equally caustic movie-about-the-movies, "Sunset Boulevard" (1950).

The presentation of these two superlative black-and-white films begins a smashing, virtually all-inclusive retrospective devoted to the work of the brightest, wittiest, most perceptive, most resourceful and most long-lived film talent of his generation.

In Billy Wilder there is the technique of Ernst

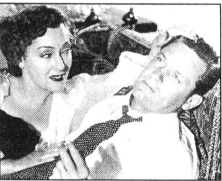

United Press International

Gloria Swanson and William Holden in Billy Wilder's 1950 "Sunset Boulevard."

Lubitsch, the Continental élan of Ferenc Molnar, the expressionism of Fritz Lang, the blithe versatility of Howard Hawks. The voice, though, which is American with a vengeance, remains singularly, triumphantly his. Mr. Wilder's films speak even when no one is talking.

The show includes 41 films and runs through June 20. It embraces the first German silents, for which Mr. Wilder wrote the screenplays, as well as his last work, the 1981 "Buddy, Buddy." In between are all of the acknowledged Wilder classics and a whole raft of films that may well be discoveries to nonbuffs.

Chief among these is the incomparable "Foreign Affair" (1948), Mr. Wilder's hilarious and savage send-up of America's military presence in the postwar occupation of Berlin. Of the entire retrospective lineup, "A Foreign Affair" is the film that one can least afford to miss.

85

Represented is the entire career of the now 85-year-old writer and director, who is as much a master of romantic comedy, melodrama, knock-about farce and straight drama as he is of hackle-raising social satire. Not since last year's Preston Sturges show, also put together by Bruce Goldstein for the Film Forum, has there been a retrospective of the depth and breadth of the Billy Wilder celebration.

•

The time is right for it.

In this era of the dimming of American mass entertainment, the Wilder films cut through the smog of mediocrity with a light that blazes. It has not always made him popular. James Agee, one of America's most astute film critics, found "A Foreign Affair" in "rotten taste." Even Charles Brackett, who wrote the screenplay with Mr. Wilder, was made uncomfortable by the film's mocking picture of bubble-headed Congressmen, of G.I.'s trading on the black market and fraternizing with the frauleins.

World War II was still too fresh to joke about, they said. Raw wounds aren't funny. Yet that's a myopic reading of "A Foreign Affair," which is probably one of the most passionate and serious films Mr. Wilder ever made.

With more eloquence and wit than any Wilder work before or since, "A Foreign Affair" expresses the film maker's profoundly mixed emotions about Berlin, where, as a young man, he'd been so invigorated and free of care, and the United States, the country that he had admired since he was a boy and that he had adopted.

Being Jewish, and having no doubt about what the Nazis were up to, Mr. Wilder fled Berlin for Paris the day after the Reichstag fire in 1933. His mother and grandmother died in Auschwitz. "A Foreign Affair" is not making casual fun of anybody. The ridicule it expresses contains the rue of Daumier.

Compare Robert Siodmak's "People on Sunday," the 1929 German silent comedy written by Mr. Wilder, with "A Foreign Affair." "People on Sunday" is a Renoiresque idyll about ordinary Berliners on their day of rest. It is sweet but unsentimental. At one point, the camera pans from a young man and woman making love on the grass to the nearby garbage dump. The Berlin of "People on Sunday" is benign. It has no thought of tomorrow.

Cut to the aerial shots that open "A Foreign Affair": postwar Berlin as seen from a plane coming in to land, block after block after block of the empty shells of burned-out buildings, once inhabited by the lovers of "People on Sunday" and Berliners like them.

The effect is harrowing. The comedy that follows is not in bad taste. It is haunted. When Jean Arthur, as a United States Congresswoman, and Marlene Dietrich, as a German cafe singer with a Nazi past, compete for the love of an opportunistic American Army officer (John Lund), it's the confrontation of the best and worst of both worlds.

•

The adjective most often applied to Mr. Wilder is "cynical," which is to confuse the film maker with his characters. Mr. Wilder and his films are anything but cynical. They are skeptical, sometimes rude, impatient with the second-rate, often amused and, from time to time, ready to believe that right will prevail.

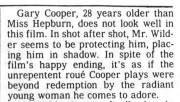

Film Forum 2

Billy Wilder

Mr. Wilder was born and raised in Austria, and served his film apprenticeship in Berlin in the late 1920's and early 30's. Yet he has been the quintessential Hollywood movie maker almost since his arrival in this country in 1934. No other European writer and director of his generation so quickly and thoroughly mastered the language and idiom of his adopted land.

To paraphrase a line from "Hold Back the Dawn" (1941), written with Mr. Brackett and directed by Mitchel Leisen, Mr. Wilder could speak English but, more importantly, he understood American. This is clear in Lubitsch's "Bluebeard's Eighth Wife" (1938), which was the first of 13 screenplays to be written by Mr. Wilder and Mr. Brackett over the next 12 years.

"Bluebeard's Eighth Wife" is inconsequential, stylized fun, but the thought and wordplay soar. They soar still higher in "Midnight" (1939), a marvelous screwball comedy with Claudette Colbert, Don Ameche and John Barrymore, directed by Mr. Leisen, a director whom Mr. Wilder came to regard with the kind of loathing reserved for the totally incompetent.

•

This was an enormously productive period for the Brackett and Wilder team. They also turned out the screenplays for the Lubitsch smash, "Ninotchka" (1939), and Hawks's "Ball of Fire" (1942), in which Barbara Stanwyck, a nightclub singer, teaches (what else?) American slang to a professor of English (Gary Cooper). In 1942, Mr. Wilder became the director as well as the co-author of all of his films. He hasn't looked back since. His initial directorial effort, "The Major and the Minor," is best remembered for being a charming romantic comedy about pedophilia, or so it seems.

Ray Milland befriends a pig-tailed 12-year-old girl on a train and finds himself drawn, quite strangely, to the child. She is actually Ginger Rogers in disguise, but he doesn't know that.

The film is clever, but is made even stranger by Miss Rogers's 12-year-old, who lisps and simpers and hangs onto a balloon in the manner of a 6-year-old. Disguises would serve the director far better in "Some Like It Hot" (1959) and "Irma la Douce" (1963).

As his own director, Mr. Wilder went on to make the best American film noir ("Double Indemnity"), the best American film satire ("A Foreign Affair"), two of the best American romantic comedies ("Sabrina," 1954, and "Love in the Afternoon," 1957), and the best American film farce ("Some Like It Hot").

•

I use these categories loosely. "Love in the Afternoon" is mainly a romantic comedy, especially as it's defined by the enchanting performance of Audrey Hepburn, who often sounds like Joan Greenwood here. Yet it is also farcical and, around the edges, very sad.

Gary Cooper, 28 years older than Miss Hepburn, does not look well in this film. In shot after shot, Mr. Wilder seems to be protecting him, placing him in shadow. In spite of the film's happy ending, it's as if the unrepentant roué Cooper plays were beyond redemption by the radiant young woman he comes to adore.

Mr. Wilder is most fondly thought of for his genre films; yet his career is also notable for the seemingly atypical one-shots.

"The Lost Weekend" (1945), with Ray Milland's great performance as an alcoholic, still pierces, though the movie threatens to turn into "Reefer Madness" every time Jane Wyman comes onscreen. She plays the kind of understanding, platitudinous fiancée who might drive any serious alcoholic more quickly to murder than abstinence.

"The Spirit of St. Louis" (1957), written with Wendell Mayes, is a long, comparatively stolid but moving appreciation of America and one of its

•

Atypical in a different way is the much maligned "Kiss Me Stupid" (1964), which was destroyed by the critics when it opened and condemned as an occasion of sin by the Roman Catholic Legion of Decency, though it has been given a G-rating for its video release.

"Kiss Me Stupid," written with I. A. L. Diamond, has a funny screenplay about small-town manners (not nice), but it was unfortunately cast. It has two stars who make it seem more sleazy than it really is. Dean Martin, playing himself, and Kim Novak, as a hooker with a runny nose, don't deliver their comic dialogue. Like blotting paper, they absorb it. They're charmless.

Yet just because they are so bad (the two other principal actors, Ray Walston and Cliff Osmond, are very good), it's possible to see Mr. Wilder's comic methods, the way he shifts expectations and turns conventions inside out. In his more successful films, one's too caught up to notice.

A retrospective of this scope encourages reappraisals. Movies that once seemed disappointing are illuminated within this context. Discoveries are to be made. Barring an unforeseen national emergency to be watched in prime time, the Film Forum is the place to be for at least two days out of each of the next six weeks.

1991 My 10, C1:1

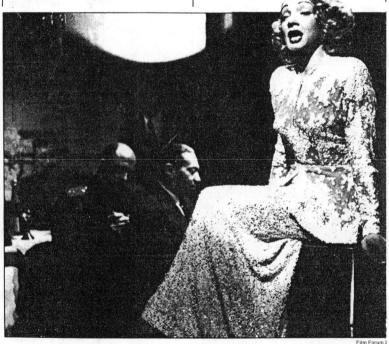

Film Forum 2

Marlene Dietrich as a nightclub singer in Billy Wilder's 1948 "A Foreign Affair" at Film Forum 2.

Truth or Dare

Directed by Alek Keshishian; directors of photography, Robert Leacock, Doug Nichol, Christophe Lazenberg, Marc Reshovsky, Daniel Pearl and Toby Phillips; produced by Ken Clawson and Jay Roewe; distributed by Miramax Films. Running time: 118 minutes. This film is rated R.

WITH: Madonna

By JANET MASLIN

MADONNA had a dream that Mikhail S. Gorbachev came to see her show. "My first reaction," she says wickedly in her new concert documentary, "Truth or Dare," "was that Warren Beatty would be so jealous that I got to meet him first!" Probably, but no doubt Mr. Beatty would understand why Madonna's star power has brought her serious attention and international renown. As the apotheosis of brilliant artifice, flagrant exhibitionism and self-conscious celebrity, Madonna has succeeded in taking on real importance. She perfectly mirrors the troubling pop-cultural climate over which she holds sway.

From that standpoint, "Truth or Dare" is at the very least a potent conversation piece. It can also be seen as a clever, brazen, spirited self-portrait, an ingeniously contrived extension of Madonna's public personality and a studied glimpse into what, in the case of most other pop luminaries, would be at least a quasi-hidden realm. In the case of Madonna, who is even filmed gossiping in the restroom and visiting her mother's grave, no such sacrosanct territory is shown to exist. Nothing is too private for Madonna to flaunt in public.

There is one notable exception. "Get out! I'm having a business talk. Goodbye!" Madonna shouts at the camera crew early in the film. But when it comes to sexual posturing or matters that might deeply embarrass friends or family members, she remains thoroughly (and often cheerfully) unfettered. True, perhaps, to the spirit of the times, "Truth or Dare" turns commerce and real intimacy into those rare subjects that are off limits, and it exhibits calculatingly full abandon about confessions of any other kind. Bear in mind, as a point of reference, that this is a film in which Mr. Beatty emerges as the voice of sanity, at least for a moment or two. Seen only briefly, as the star's companion at the time of her 1990 "Blond Ambition" tour, Mr. Beatty puts up with considerable teasing abuse ("And don't hide back there, Warren, get over here") before being dragged into Madonna's limelight. Once revealed, he looks terribly nonplused by the kind of attention to which Madonna, her assistants, her relatives and even her throat doctor are routinely subjected by the film crew. "The light's good here, don't worry," Madonna taunts her lover. But for a moment Mr. Beatty's flinching makes a lot more sense than her inexhaustible bravado.

"Truth or Dare" combines galvanizing, well-photographed color scenes of Madonna's onstage act with grainy black-and-white glimpses of her offstage one, sometimes making interesting efforts to reconcile the two. Dreading a concert date in her home city, Detroit, Madonna brings her father on stage in honor of his birthday and playfully bows down before him. Later that night, backstage, she appears unnerved by having to talk with him on a more personal basis. "Dad, you can come in, but I've got to get dressed," she says, although her black underwear has served as a costume before a concert audience of thousands. In the end, as with most of Madonna's encounters with figures from her past (as seen here), the visitor is made to look foolish and the camera has the last laugh.

"Truth or Dare," as directed proficiently and energetically by Alek Keshishian, balances the deliberate cruelty of Madonna's run-ins with the actor Kevin Costner (she puts a finger down her throat as if to gag), a childhood girlfriend ("When you see the show, you'll forgive me for not talking to you") and a brother whom she succeeds in avoiding ("Dad says he went to alcohol rehab to avoid going to jail," she says about him) with scenes intended to express her tender side. Much is made of her role as self-appointed den mother to the male dancers in her entourage, and to her insistence on a prayer before each show.

"My little babies are feeling fragile," she says of the dancers at one such session as the group is threatened with arrest on obscenity charges. Madonna is also seen briskly settling a dispute between gay dancers and the lone straight one in her entourage. She goes shopping with the whole group in tow ("Earrings don't make people look beautiful — *money* makes people look beautiful," she declares at Chanel), and she frolics in bed with each dancer individually, in a manner that seems playful but leaves no doubt as to who is the boss. While playing the game of the title, she orders two male dancers to kiss and another to expose himself, while she, in the spirit of sportsmanship, pretends to perform oral sex on a bottle of Vichy water.

●

Male pop stars are often seen demonstrating the kind of manipulative behavior and sexual intimidation that Madonna displays on such occasions. (She herself describes these male dancers' touching naïveté early in the film and is often seen playing upon it later.) Indeed, she brings to mind the Bob Dylan of the 1967 D. A. Pennebaker film "Don't Look Back" in her ability to appear elusive, dangerous, and at all times absolutely in control of those around her. Madonna obviously knows, as Mr. Dylan also must have, that the final effect of such behavior is more magnetic than it is off-putting. The image of her that emerges here, however contrived and sometimes poisonous, is in the end as seductive as she means it to be.

"Truth or Dare" makes its share of unfortunate missteps, as when it strains its ingenuousness to the breaking point by allowing a wistful Madonna to reveal the love of her life ("Sean") before what will surely be an audience of millions. She is also allowed to protest too much about the political and social seriousness of her work, and to express an improbable degree of surprise when her church-baiting show runs afoul of the Vatican. The film also falters when the performance that is under police scrutiny is so confusingly overedited that it is unclear what went on, or when Madonna's own voice-overs try too hard to graft dramatic shape onto what is essentially just a tour film.

There is also a regrettable closing montage compiling some of Madonna's various images, which is accompanied by unattributed and sometimes fatuous thoughts about her. ("I just feel like she's a little girl lost in a storm sometimes.") Yet one of the film's most sensible insights about its subject also emerges from this same series of observations. "She has a busy life," someone says. "And she's definitely on a race against time." It's a race that, as "Truth or Dare" makes evident, she will do anything to win.

●

"Truth or Dare" is rated R (Under 17 requires accompanying parent or adult guardian). It includes profanity, brief nudity and sexual suggestiveness.

1991 My 10, C1:3

Steven Meisel/Miramax

Madonna, the star of "Truth or Dare."

Strangers in Good Company

Directed by Cynthia Scott; written by Gloria Demers with Cynthia Scott, David Wilson and Sally Bochner; director of photography, David de Volpi; edited by Mr. Wilson; music by Marie Bernard; produced by Mr. Wilson; released by First Run Features/Castle Hill in association with Bedford Entertainment. At the 68th Street Playhouse, on Third Avenue, in Manhattan. Running time: 101 minutes. This film is rated PG.

Alice	Alice Diabo
Constance	Constance Garneau
Winifred	Winifred Holden
Cissy	Cissy Meddings
Catherine	Catherine Roche
Michelle	Michelle Sweeney
Beth	Beth Webber

By JANET MASLIN

The gentle Canadian film "Strangers in Good Company" feels less like a drama than a vacation, and an outstandingly tranquil vacation at that. Conceived as a kind of Outward Bound expedition for elderly women, it tells of how a group of them on a sightseeing trip becomes marooned when the tour bus breaks down. These travelers, the oldest of whom (Constance Garneau) is 92 years old, must make their way to a deserted vacation house and spend a few days together waiting until a rescue can be arranged.

The trip turns out to be a tonic. In a beautiful, pastoral setting, the women spend their time listening to bird calls, making drawings, enjoying the scenery and sharing reminiscences of their very disparate lives. Ranging in background from a sturdy, hardworking Mohawk Indian matriarch (Alice Diabo) to an elegant, very beautiful Philadelphia-born lesbian (Mary Meigs), the women are nonprofessional actresses who draw

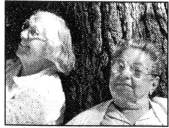

First Run Features
Cissy Meddings and Alice Diabo

heavily and eloquently upon their own lives. The film maker, Cynthia Scott (who previously directed an Academy Award-winning short film, "Flamenco at 5:15"), pauses occasionally so that the camera can gaze upon old photographs of these women with their friends and families.

Charmingly low-keyed, and directed with great patience and simplicity, "Strangers in Good Company" makes no effort to contrive much of a story. The breakdown and repair of the bus provide the film with its only real dramatic framework, but within those confines it proceeds very sweetly. The women forge friendships, share confidences, and catch fish using pantyhose for nets. "This is the way bears stun salmon — did you know that?" goes a typical observation. There is even enough good humor for a few jokes. "You never heard the one about the two old ladies who went into the woods for a tramp?" one woman asks another. "But he got away."

"Strangers in Good Company," which opens today at the 68th Street Playhouse, seems touchingly real when its characters compare anything from their medical conditions to their family hardships. Beth Webber, who is 83, reveals a poignant shyness when asked to take off the wig she always wears, and speaks with quiet grief about the death of her son. Miss Scott, who with David Wilson and Sally Bochner also shares credits on Gloria Demers's screenplay, appears to shape such moments rather than direct them, and the effect is pleasingly straightforward.

Though the film's earnestness risks becoming overwhelming ("What's it like to be a nun?" "Heavenly!") it remains modest and appealing all the way through. "Strangers in Good Company," which also features Michelle Sweeney as the group's musically talented bus driver, moves at its own slow, peaceful pace and arrives at a gratifying destination.

•

"Strangers in Good Company" is rated PG (Parental guidance suggested). It includes very mild profanity.

1991 My 10, C8:1

FX2
The Deadly Art of Illusion

Directed by Richard Franklin; written by Bill Condon; director of photography, Victor J. Kemper; edited by Andrew London; music by Lalo Schifrin; production designer, John Jay Moore; produced by Jack Wiener and Dodi Fayed; released by the Orion Pictures Corporation, Inc. Running time: 107 minutes. This film is rated PG-13.

Rollie Tyler	Bryan Brown
Leo McCarthy	Brian Dennehy
Kim Brandon	Rachel Ticotin
Liz Kennedy	Joanna Gleason
Ray Silak	Philip Bosco

By STEPHEN HOLDEN

The real star of "FX2: The Deadly Art of Illusion" isn't Bryan Brown or Brian Dennehy, who have reunited for the sequel to the 1986 sleeper hit "F/X," but a clown robot named Bluey. Bluey is an ingenious contraption created by Rollie Tyler (Mr. Brown), a retired wizard of movie special effects turned toy designer whom the police persuade to apply his skills to a case that turns out to be at least as complicated as any of his inventions.

Wearing a special "telemetry" suit connected to the robot by remote control, Rollie can make the mechanical clown duplicate his every movement right down to the twitch of a finger and the roll of an eyeball. During the movie, Bluey becomes Rollie's stand-in in brutal hand-to-hand combat, and in the final sequence, he even pilots a helicopter.

Bluey is only the most dazzling gadget in a thriller that periodically stops in its tracks so that Rollie can demonstrate his improvisatory skills at special-effects crime-busting. In the wittiest sequence, set in a deserted supermarket, popcorn, molasses and an array of aerosol products and cleaning fluids become effective weapons in a battle with a gunman who ends up with his head shrink-wrapped and stamped in the store's meat department.

As long as it is fixated on gadgetry, "FX2" is reasonably entertaining. But when the movie focuses on plot and character, it turns quite dotty in an amiable way. The story is as farfetched as it is tortuous and deals with police corruption, the theft of some priceless gold coins, relations between the Mafia and the Vatican, and a boy's computer software. It also involves two double crosses, neither of which comes as much of a surprise. At the end of the movie, loose ends are dangling everywhere.

Richard Franklin, who directed, is an adept if blunt manipulator of thrills and chills. Bill Condon's

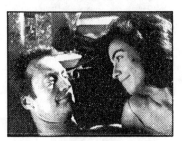

Orion Pictures
Bryan Brown and Rachel Ticotin

screenplay is extremely casual in its handling of characters, some of whom disappear two-thirds of the way into the movie.

Mr. Brown, who suggests an Australian Michael Caine in both looks and mannerisms, and Mr. Dennehy, who is very comfortable in his portrayal of a gruff old-time New York cop, make an appealing if totally unlikely pair of partners. Joanna Gleason lends a steely edge to the largely thankless role of an ambitious assistant district attorney. Rachel Ticotin, as the woman in Rollie's life, has nothing to do except be endangered.

•

"FX2: The Deadly Art of Illusion" is rated PG-13 (Parents strongly cautioned). It has violence that might scare young children.

1991 My 10, C8:5

Switch

Directed and written by Blake Edwards; director of photography, Dick Bush; edited by Robert Pergament; music by Henry Mancini; production designer, Rodger Maus; produced by Tony Adams; distributed by Warner Brothers. Running time: 102 minutes. This film is rated R.

Steve (Amanda) Brooks	Ellen Barkin
Walter	Jimmy Smits
Margo	JoBeth Williams
Shelia	Lorraine Bracco
Arnold	Tony Roberts
Steve (the man)	Perry King

By VINCENT CANBY

In the Opening sequence of "Switch," the new Blake Edwards comedy, Steve Brooks (Perry King), a serenely unaware male chauvinist pig, finds himself sharing a hot tub with three beautiful women who hate him. Just as he's warming to the situation, they drown him. Steve, who is as resilient as Rasputin, rises from the water seriously irritated. They shoot him.

In purgatory, Steve is given a second chance. Because he has been exemplary in all other ways, he will be allowed into heaven if he can find just one woman on earth who loves

him. That seems fair enough until the Devil pipes up. Steve, the Devil says, must switch sexes this trip.

When Steve awakes in his own pajamas, in his own bed, in his own adman's fancy Manhattan apartment, he is still Steve in his head, but he inhabits the body of a beautiful woman (Ellen Barkin), who comes to call herself Amanda.

At comparatively long last, "Switch" begins, though the pace never picks up.

•

"Switch" seems to be the longest comedy ever made. Like Steve's three furious killers, Mr. Edwards has trouble getting an effective hold on his subject. This may be because he's more interested in analyzing what all of this gender-bending means, in terms of male-female roleplaying, than in discovering the spontaneous humor of it.

Cinema Plus
Ellen Barkin

Almost everything that happens to Amanda is so obligatory that it plays like the inspiration of a 13-year-old. Yet Mr. Edwards is the man who made the elegant, humane and witty "Victor/Victoria" in which a woman, to get a job, masquerades as a man masquerading as a woman.

Nothing in "Switch" is that plausible or compelling. Any movie that depends on the presence of either the Devil or God is asking for trouble, and "Switch" has them both.

The Devil (Bruce Martyn Payne) is clearly English. God doesn't actually appear but is heard on the sound track in the voices of a man and a woman speaking simultaneously. Heaven is a now sort of place.

•

"Switch" just sits there. It is a drag show without the drag. It's an enlightened comedy, which, in this case, means one that's not very funny.

Amanda creates some amusement as she blackmails her principal killer, Margo (JoBeth Williams), into helping her buy a wardrobe. She then totters off to the office where she convinces her co-workers that she's Steve's half-sister and an advertising wizard.

The boss (Tony Roberts) is attracted to Amanda because of her body and the ideas he can steal from her.

Steve's best friend, Walt (Jimmy Smits), believes Amanda's story of having been reincarnated. He attempts to carry on their old buddy-buddy relationship, but sex keeps getting in the way. What's a full-time heterosexual male supposed to think when he wants to bed his oldest pal? One night Walt can't control himself.

•

Thus the chauvinist Steve learns what being a woman is all about. In time, Amanda's mind begins to change in meaningful ways. She's ecstatic when she becomes pregnant: "It's an honest-to-God miracle!" The movie's childbirth scene is as sincere as the one in last week's English

romantic comedy "Truly, Madly, Deeply."

Mr. Edwards's heart may be in the right place but his comic invention is in his shoes. An unconscionable amount of time is spent watching Amanda struggle to walk in high heels. She also smokes cigars and sits with her knees spread apart and, early on, takes pleasure in feeling her own body and in eyeing other women.

Mr. Edwards's sense of humor also appears to be hobbled by his social conscience. There's a curious and not very satisfactory episode involving Amanda and a homosexual woman, Sheila (Lorraine Bracco), from whom Amanda hopes to obtain a valuable cosmetics account.

It might be expected that the Steve side of Amanda would relish the possible encounter, but Amanda faints at the approach of the other woman. It's later explained that Steve loathed homosexuals of both sexes. Mr. Edwards handles this sequence with less tact than gingerliness.

●

"Switch" has some isolated lines that are very funny, including Margo's unprintable reply to a street demonstrator who asks her if she knows how many poor animals had to be killed to make her fur coat.

The film's principal strength is Miss Barkin. Those high-heel scenes aside, she is extraordinarily convincing and good-humored as she evokes the man inside her body, particularly in a barroom brawl that is as liberating to the audience as it is to her.

Also effective are Mr. Smits, Miss Bracco, Miss Williams and Mr. Roberts. Mr. Edwards is one of Hollywood's best farceurs, but "Switch" is inert. With luck, it will prompt discussion about role-playing, instead of the dismissive comment that it's all been said before, and better.

●

"Switch," which has been rated R (Under 17 requires accompanying parent or adult guardian), has some partial nudity and vulgar language.

1991 My 10, C13:1

Chopper Chicks in Zombietown

Directed and written by Dan Hoskins; director of photography Tom Fraser; edited by W. O. Garrett; music by Daniel Day; production designer, Rodney MacDonald; produced by Maria Snyder; released by Troma Team. At the Waverly, Third Street and Avenue of the Americas in Manhattan. Running time: 84 minutes. This film is rated R.

Dede...Jamie Rose
Rox..Catherine Carlen
T. C..Lycia Naff
Jewel...Vicki Frederick
Jojo...Kristina Loggia
Ralph Willum.......................................Don Calfa

By STEPHEN HOLDEN

From its amusing title, "Chopper Chicks in Zombietown," the newest film from Troma Inc. promises to be one of the company's typical free-for-all B-movie romps. Alas, it is not. Written and directed by Dan Hoskins, the relatively straight-faced generic hybrid of horror and biker films doesn't go nearly far enough in showing how a female motorcycle gang, aided by a local school for blind orphans, rids a tiny desert town of its exploding zombie population.

If nothing else, "Chopper Chicks," which opens today at the Waverly Theater, boasts a bizarre assortment of characters. Rox (Catherine Carlen), the fiery-eyed leader of the gang known as the Cycle Sluts, brandishes a bullwhip and straddles her chopper like a leather-clad Valkyrie. Her rebellious cohort, Dede (Jamie Rose), is a former prom queen who feels a tug toward gentility when the gang arrives in her besieged hometown.

●

The villain of the piece, Ralph Willum (Don Calfa), is a raving, homicidal mortician whose battery-powered zombies are the miserable fruits of his demented quest to create eternal life.

These lively ingredients have been mixed and matched in a remarkably unexciting way. Although Mr. Hoskins's screenplay has a few amusing jokes, the movie is seriously deficient in visual and verbal energy. Scenes seem pasted together with little sense of continuity, and the acting styles range from the

Troma Team

A scene from "Chopper Chicks in Zombietown."

cartoonishly manic to the flatly non-expressive. It all makes for a movie that is far too confusing to be much fun.

●

"Chopper Chicks in Zombietown" is rated R (Under 17 requires accompanying parent or adult guardian). It includes profanity and some violence.

1991 My 10, C15:5

Cannes Festival Opens On Somber, Soggy Note

By VINCENT CANBY

Special to The New York Times

CANNES, France, May 10 — More than 30 years ago, at an earlier Cannes Film Festival, Robert Mitchum received some unexpected publicity when a starlet with whom he was posing on the beach suddenly ripped off her bra to please the photographers.

Last night a patrician Robert Mitchum, accompanied by his two grown sons, Jim and Chris, stood on the stage of the Palais du Festival and, making a gesture that seemed to be the beginning of a priest's blessing, announced that the 44th Cannes Film Festival was officially open.

There was no danger of anyone's impulsively going topless, not just because the weather was so cold and wet. If the initial selections are

Agence France-Presse

The director Roman Polanski, left, president of this year's Cannes Film Festival jury, with the actress Whoopi Goldberg, a jury member.

an indication of things to come, the 1991 festival promises to be one of the most serious in years.

In the past, opening night selections have traditionally been big-budget crowd-pleasers, often American or, at least, films with English sound tracks shown out of the main competition to emphasize the difference between commerce and art.

Chosen to inaugurate this year's show was David Mamet's somber, brooding "Homicide" about the identity crisis of a big-city police detective who is both American and Jewish. It's a film that would very much like to be considered for the top prize.

●

Shown in competition today were two equally ambitious works of which more is certain to be heard after May 20, when the festival ends. The first is a quite remarkable new Soviet film, Karen Chakhnazarov's "Assassin of the Czar," a meditation on regicide that might not have been possible to make even two years ago. The second is Patrick Bouchitey's "Cold Moon" ("Lune Froide"), a French comedy based on two stories by Charles Bukowski, the American novelist, but played somewhat in the manner of Bertrand Blier's "Going Places." It is shot in appropriately seedy black and white and designed to affront all standards of good taste of the 1990's.

In spite of a downpour that left black ties limp and complex hair arrangements lank, the opening night gala went on as scheduled. Among the stars designed to stud the event was Gina Lollobrigida, looking as if time had stopped in the mid 1960's. She received an ovation from the sopping wet crowds outside the Palais du Festival, as did Whoopie Goldberg, a member of this year's festival jury, and Roman Polanski, the jury president.

Mr. Polanski, a first-rate newsmaker as well as a film director, is just back from the Soviet Union, where he was acting in a new movie, an experience he described to a local

Amid heavy rains, films about homicide and regicide.

reporter as "very difficult." The studio where he was working, Mosfim, he said, "is a dump." "Nothing functions. Nobody wants to work."

In the next 10 days, 21 films will be shown in the main competition, including Spike Lee's "Jungle Fever," Joel and Ethan Cohen's "Barton Fink," Irwin Winkler's "Guilty by Suspicion" and a second Soviet film, Roustam Khamdamov's "Anna Karamazova" with Jean Moreau.

Akira Kurosawa's "Rhapsody in August" will be shown on Sunday out of competition. The 81-year-old Kurosawa has arrived at the point where he doesn't have to compete. Madonna's "Truth or Dare," scheduled to be screened at 11:30 P.M. on Monday, is out of competition, which could be another way of announcing that she is beyond compare.

In addition to the main competition, there are several mini-festivals within the festival period. The one rather enigmatically called Un Certain Regard is programmed by the same people who handle the main festival,

and is regarded as the place to put those films that, for one reason or another, do not fit into the main competition. This year it will present 19 films.

•

The International Critics' Week will present an additional 15 films and the Directors' Fortnight 19. Running concurrently is the Film Market, where as many as 200 films are screened for possible purchase by distributors from around the world.

Mr. Chakhnazarov's "Assassin of the Czar" is no mere costume epic in the woozy romantic style of "Nicholas and Alexandra." It is both a mystical and psychological exploration of the murder of the Romanov family as it is remembered by Timofeyev, a patient in a Soviet mental hospital today.

The voice of a little girl named Eva has convinced Timofeyev that he is Yurovsky, the man who was in charge of the 1918 Romanov murders. Each year, on the anniversary of

A new Soviet film explores the murders of the Romanovs.

Yurovsky's death in 1938, the mental patient suffers the excruciating pains of the ulcers that killed the real-life assassin. To complicate matters a little more, the patient also remembers having assassinated Czar Alexander II in 1881.

In the most matter-of-fact sort of way, the doctor who attempts to treat the patient finds himself instead playing out a psychodrama in which he is Czar Nicholas, searching the mind of the patient-assassin for the reasons behind the murder.

The film is magnificent looking but, more important, it is acted with immense skill by Malcolm McDowell, the English actor, as Timofeyev and Yurovsky, and by Oleg Yankovsky, the Soviet actor who plays both the doctor and Czar Nicholas.

Not since reaching his mature years has Mr. McDowell, still best known for "A Clockwork Orange," given such a fine, strong, crafty performance. He is so good that he triumphs over his dubbed Russian dialogue, which has not been too carefully synchronized with his lip movements. The film was shot in two versions, Russian and English, with the Russian version shown here to qualify the production as a Russian entry.

•

Some people will probably view "Assassin of the Czar" as an example of bourgeois revisionism. It is not. It neither sentimentalizes the Romanovs nor makes beasts of their murderers. Rather, the film considers these momentous events as being part of the inevitable flow of history. The mood is sorrowful and questioning.

At the press conference following the critics' screening, Mr. Chakhnazarov said that much of the historical data in the film is based on information contained in the diaries of Yurovsky, the Czar, the Czarina and others made available only two years ago. The narrative frame is obviously fictional.

Mr. Bouchitey, known in France as an actor of great comic versatility, makes his directorial debut with

"Cold Moon," which is actually a feature-length elaboration of a 26-minute short he directed and acted in two years ago. Not for nothing is the film dedicated to Patrick Dewaere, who co-starred with Gérard Depardieu in Mr. Blier's "Going Places" and "Get Out Your Handkerchiefs."

"Cold Moon" is both abrasive and poetic, a bleakly funny tale of two layabout pals going nowhere with only the slightest awareness of what is happening to them. Simon and Dédé exist on the edge of respectability, working as infrequently as possible and borrowing money when they have to. In the sequence that gives the film its principal shock value, they steal a corpse from the morgue as a practical joke. When it turns out to be that of a pretty young woman, Simon, the less aggressive of the two, falls in love with it.

It isn't the necrophilia that causes alarm but the suggestion that in the world these men inhabit, the ideal woman is possibly a dead woman. They can only relate to an idealized inert representation. The film's implications will be debated for some time to come, not necessarily in a friendly fashion. That Mr. Bouchitey is here more persuasive as a director than as an actor has something to do with the character he plays. His Dédé is overwhelmingly oppressive, someone who is always on, always laughing at his own jokes. Dédé would be impossible to know for more than five minutes. He is thoroughly pleased by his own noisy charm, which eludes everyone except Simon, played by Jean-François Stévenin as a mild-mannered man of furious, inexpressible passions.

The French members of the audience loved it.

•

They were somewhat more reserved about "Homicide," which follows "House of Games" and "Things Change" as Mr. Mamet's third film as both the writer and the director. "Homicide" begins as a tough, bluntly funny police melodrama about Bobby Gold, a detective who specializes as a hostage negotiator.

In the course of his job, Bobby (Joe Mantegna) becomes sidetracked on a case involving an old Jewish woman who runs a pawnshop. Before he knows it Bobby finds himself dealing with a band of possible Jewish terrorists. The plot gets uncharacteristically thick for Mr. Mamet. Bobby it seems, has never felt he belonged, not as a cop, not as an American, not as a Jew. "Homicide" is about Bobby's awakening.

It's also about several different characters named Bobby Gold. The film becomes unaccountably murky as Bobby proceeds with the murder investigation. New aspects of his personality are not revealed; instead, they are arbitrarily imposed on Bobby by the writer to make his points.

The fuzziness of the character is reflected in the performance by Mr. Mantegna, who was so splendid in the two earlier Mamet films. This time the actor appears to be more bewildered by his role than laid-back in it. W. H. Macy, another Mamet regular, is fine in a much easier role that includes a short final speech containing the most pungent and moving lines Mr. Mamet has ever written.

Before the screening of "Homicide," the festival paid tribute to the 50th anniversary of Orson Welles's "Citizen Kane" by showing Welles's self-celebratory trailer for the film. He introduced all of the film's principal actors, though he himself remains an off-screen voice, sounding a lot like God, as we always think Him to be in the movies. Fascinating and right.

1991 My 11, 11:4

Sweet Talker

Directed by Michael Jenkins; screenplay by Tony Morphett; story by Bryan Brown and Mr. Morphett; director of photography Russell Boyd; edited by Neil Thumpston; music by Richard Thompson with Peter Filleul; production designer, John Stoddart; produced by Ben Gannon; released by Seven Arts through New Line Cinema. Running time: 88 minutes. This film is rated G.

Harry Reynolds	Bryan Brown
Julie McGuire	Karen Allen
David	Justin Rosniak
Bostock	Chris Haywood
Cec	Bill Kerr

By JANET MASLIN

"Sweet Talker," which opened Friday at Loew's New York Twin, is the resolutely perky story of a con man (Bryan Brown) who sets out to hoodwink the residents of a pretty Australian coastal town. His plan involves faking the discovery of a sunken galleon, building a theme park to exploit it, and turning the town into "Australia's Miami." As one character says of plans to develop tiny Beachport, "A man who owns just 1 percent of the concrete we'll pour in this place will be a millionaire."

Not surprisingly, in view of the con man's mile-wide lovable streak, there is a change of heart before the concrete mixers can do their worst. Even less surprisingly, Beachport's lone guest house is run by a plucky widow (Karen Allen) who has a cute young son (Justin Rosniak), both of whom are instrumental in making the con man come to his senses and do the right thing.

Conceived as mild family entertainment, "Sweet Talker" attempts more breeziness than humor, although the capable Mr. Brown (who conceived the story with Tony Morphett) often seems a lot wittier than his material. The film works best when sticking to improvised father-son relations between the con man and the innkeeper's son, and when appreciating the scenery of southern Australia. A sequence in which man and boy go fishing manages to do both.

Less successful are the climactic moments in which Harry, the con man, renounces the errors of his past. The screenplay (by Mr. Morphett) includes the lines "You're much better than you think you are, Harry," and "Harry, I can tolerate a lot, but don't tell me you're goin' all moral on me."

Russell Boyd's cinematography and the confident young Mr. Rosniak are appealing, as is Mr. Brown. But almost nothing that happens in "Sweet Talker," except perhaps a scene that finds Mr. Brown buried up to his neck in sand and playfully menaced by a bulldozer, will come as any kind of a surprise.

•

"Sweet Talker" is rated PG (Parental guidance suggested). It contains very gentle sexual suggestiveness and slight profanity.

1991 My 12, 42:5

Madonna and Film Enliven Cannes Festival

By VINCENT CANBY

Special to The New York Times

CANNES, France, May 14 — Unlike most successful actresses, Madonna makes no attempt to convince the public that beneath the artifice of the star she's just an ordinary woman. There is no room in her image for the commonplace. Though, by her own admission, she is neither a great singer or dancer.

Madonna is a complex and very engaging phenomenon. She is, in fact, an ordinary woman with immense humor, wit and skill, who works tirelessly to convince the world that she's a star.

That she has succeeded was demonstrated here last night when the 44th Cannes International Film Festival presented her feature-length self-portrait, "Truth or Dare," (which here is being called "In Bed With Madonna") in a special out-of-competition midnight screening at the Palais du Festival. As important as the film, which is both canny and entertaining, was the occasion, which brought this year's festival spontaneously to life for the first time.

Eddie Murphy was there wearing a cherry-red dinner jacket. Also Spike Lee wearing one of his collection of visored caps at the otherwise high-fashion event. The crowds outside the Palais were dangerously large. The gendarmes were so efficient in their crowd control that they also prevented a couple of hundred black-tie ticket holders from ever getting in.

When the film finally began, Madonna, Alek Keshishian, her director, and the other members of her party were seated in the middle of an orchestra section only part full.

•

"Truth or Dare," with its portrait of a strong, articulate woman who appears in complete command of her life, could not have been shown at a more opportune moment.

Women have not been faring well in the other festival entries.

In Patrick Bouchitey's French comedy, "Cold Moon," the object of the affections of one of the two principal male characters is a beautiful corpse stolen from the morgue. It is the film's satiric joke that, to the slob who adores her, the corpse is the perfect woman.

Marco Ferreri, the Italian director, takes an equally bleak if satiric view of the heroine of his new comedy, "Carne" ("Flesh"). Mr. Ferreri is

the man who made "La Grande Bouffe," in which a group of gourmets happily gorge themselves to death, and "The Last Woman," about a fellow who emasculates himself to prove to his demanding mistress that his passion is not entirely based on sex.

Women fare poorly. Dead is bad enough. Undead sounds worse.

Although "Carne" also is satiric, the comedy is, if possible, even less easily digestible. It's about a man who murders his mistress and when last seen is consuming her flesh broiled, baked and sautéed. Mr. Ferreri is a director of intellectual intentions, though they remain mud-

dled. The film makes much of the man's early obsession with the Christian rite of Holy Communion.

•

Even at a film festival where the self-absorption is intense, these sorts of meditations seem unnecessarily frivolous. The world has other problems that might be more profitably addressed than whether or not to serve up one's girlfriend bordelaise or nature.

The festival's most maddening, pretentious and gloomy view of women was presented in "Malina," a German film directed by Werner Schroeter, the film maker who is better known for his avant-garde work in the theater and opera.

"Malina" is an exhausting examination of the unhappy life of a successful novelist played by Isabelle Huppert, the French actress who seems to make almost as many films a year as Gérard Depardieu.

In "Malina" the Huppert character is loved by two men, but she has a

major problem: she is not sure she exists. When she is not walking around the streets, as expressionless as someone who is undead, she sometimes lectures on Wittgenstein to standing ovations. She smokes a lot and winds up immolating herself in her elegant apartment.

The film is beautiful to look at. The camera movements are graceful and seductive and finally bereft of meaning. Very quickly all thoughts stray to the location of the exit.

It was no wonder that "Truth or Dare" and Madonna herself seem so revivifying. Here is a woman who has no doubts about what she's up to. Wearing a black wig whose lacquered curls look like rolls of 35-millimeter film, she was definitely here. Therefore she exists.

•

Mr. Murphy came to Cannes not by chance, it seemed, but to lend his support to the already strong contingent of black American film makers at the festival this year. Mr. Lee's "Jungle Fever" is to be shown in competition on Thursday night. Also shown in competition was Bill Duke's

"Rage in Harlem," a lighthearted caper comedy about Harlem in the 1950's, starring Forest Whitaker, Gregory Hines and Robin Givens, all of whom are in attendance.

One of the most visible entries in the "fesitval within the festival" called "Un Certain Regard" is John Singleton's "Boyz'n the Hood." The film, about the coming of age of three young men in south central Los Angeles, is in competition for the Caméra d'Or, the best feature by a first-time director.

Eddie Murphy at Cannes.

Mr. Singleton, who is 23 years old and already has a three-film contract with Columbia Pictures, is here along with the principal members of his cast, including Ice Cube, the rap recording star.

Mr. Lee's "Do the Right Thing" was a big hit at the 1989 Cannes Festival, and some thought it deserved the top prize. With his high visibilty and way with words, he is a favorite with the press. So far he has kept a fairly low and polite profile, talking mostly about his new film about Malcolm X, which will star Denzel Washington and is to be made this year.

He could not, however, resist commenting on a statement made Sunday by Jack J. Valenti, the president of the Motion Picture Association of America. Mr. Valenti said he did not consider Mr. Lee as a black film maker, "just as a talented film maker, period."

In response, Mr. Lee told The Hollywood Reporter, the trade paper, that Mr. Valenti was talking nonsense. Color does matter, the director said, adding: "Film making to me is about culture. That's what I'm about."

"A Rage in Harlem" is a genial movie but not exactly a singular one. It would seem to be an odd festival choice except for the fact that Mr. Whitaker, who is the associate producer as well as star, won the Cannes best-actor award two years ago for his performance in Clint Eastwood's "Bird."

"A Rage in Harlem," its director and stars have been received with respect. At a news conference after his first screening, most of the questions were addressed to Mr. Duke, the director. Finally, in the way of Cannes news conferences that go on too long, a French-speaking reporter asked Ms. Givens what she thought about his impression that in the film she reminded him of Jessica Rabbit, an animated character in "Who Framed Roger Rabbit?"

Madonna and the director Alek Keshishian at screening of her new movie on Monday night at Cannes.

After the question had been translated into English, Ms. Givens thought for a moment and then said, "Wow!" This was translated back into the French as "Wow!"

1991 My 15, C11:1

Universal Studios

Annabella Sciorra and Wesley Snipes in a scene from Spike Lee's "Jungle Fever," shown at Cannes.

'Jungle Fever' Sweeps Cannes

By VINCENT CANBY

CANNES, FRANCE

FOR the first time since it began just a week ago, the 44th Cannes International Film Festival has one clearly popular favorite for the Palme d'Or, the festival's top prize. It is Spike Lee's "Jungle Fever," which was shown here on Thursday night in the presence of Mr. Lee; two of his stars, Wesley Snipes and Anthony Quinn, and Stevie Wonder, who composed the film's original music and title song.

The awards will be announced at the closing ceremonies Monday night.

Of the 20 films in competition for the Palme d'Or, only 6 are still to be screened, including the American "Barton Fink," by Joel and Ethan Coen, and the French "Van Gogh," directed by Maurice Pialat, whose "Under Satan's Sun" won the Palme d'Or in 1989.

There are no indications yet of how the jury might vote. Roman Polanski, the jury president, is known to take a dim view of the sort of arid, ambiguous studies of boredom and alienation that seem to have dominated this year's festival. There are nine other jury members but, with so little information available, Mr. Polanski's publicly stated preferences carry weight with those who would bet on the outcome.

There is also the fact that Mr. Lee's comedy-drama is a seriously conceived and executed movie that is vastly entertaining. It is the work of a young man who not only has an astonishing command of his craft, but who also is in intimate connection with the world in which he lives.

"Jungle Fever" is most easily described as an interracial love story, though that doesn't tell the half of it. The film is a vividly realized panorama of New York City urban life, as filled with character and incident as the director's earlier "Do the Right Thing."

There was some stir at the 1989 Cannes festival when "Do the Right Thing" received no awards. Should the new film take the best-picture or best-director award, no one will be able to say that the jury was attempting to make up for the earlier slight. "Jungle Fever" stands on its own. It will deserve any recognition it receives.

The pace and excitement of the festival have picked up considerably. Wednesday, the new Mel Brooks comedy, "Life Stinks," was presented as a special late-afternoon, out-of-competition screening that the French call a "Film Surprise," meaning that the title was supposed to be a secret until it appeared on the screen. Nice-Matin, however, published the news in the morning, which guaranteed a capacity audience a few hours later.

Few people appeared to be disappointed. The audience started laughing at the 20th Century Fox logo and continued throughout the rest of the movie. "Life Stinks" is close to being vintage Mel Brooks. It is also Mel Brooks in a Frank Capra mode, which in this case means that he goes for sentiment that he somehow sends up and exploits at the same time.

In "Life Stinks," Mr. Brooks appears as Goddard Bolt, one of the meanest, most avaricious billionaires America has ever produced. He is greedy, greedy, greedy. Goddard is told that to take over a coveted piece of Fort Lauderdale real estate, he will have to evict 180 elderly residents of a retirement home. His immediate response: "Fine. Do it in the middle of the night."

"Life Stinks" is about the transformation of Goddard when, to win a bet, he attempts to live by his wits on Los Angeles's Skid Row for 30 days. It is not as easy as he thought. He is beaten up. His shoes are stolen. He goes hungry. In desperation late at night, he pounds on the door of a church. Says a kindly voice within, "I'm sorry, we're closed, my son."

Susan Sarandon plays the unlikely bag lady who helps Goddard to achieve salvation. The film's highlight: a funny and surprisingly sweet musical number in a Salvation Army warehouse in which Mr. Brooks and Miss Sarandon do a song-and-dance to Cole Porter's "Easy to Love."

Without a doubt the strangest film to show up at this festival was "Pupi Avati's Bix," an Italian movie about the life of the great American jazz cornetist Bix Beiderbecke, shot largely in Iowa and Illinois with a cast of American actors, most of whom are new to the screen.

The dialogue sounds as if it's been written in Italian, and then translated into English. The very blond Bryant Weeks, who plays Bix, remains as fresh-faced as an Olympic runner, right up to the point where he's dying of alcoholism. Not even the Beiderbecke music, much of it available on old Paul Whiteman recordings, is authentic.

Mr. Lee dedicates "Jungle Fever" to Yusuf K. Hawkins, the young black man who was killed two years ago during a racial confrontation in the Bensonhurst section of Brooklyn. Though the film has nothing to do with the particulars of Mr. Hawkins's death, it is an examination of the kind of prejudice that makes possible such violence.

The film's principal characters are either blacks from Harlem or whites from Bensonhurst. At the center are a successful young black architect (Wesley Snipes), who is happily married, and the pretty, strong-minded white secretary (Annabella Sciorra), with whom he begins a casual affair. The focus of the film is so broad however, that it also encompasses the various members of both of their families and their friends.

They include white and black neighborhood toughs, crack addicts, a fundamentalist preacher, the architect's upscale black wife who is a Bloomingdale's buyer, and various Bensonhurst characters. The large, exceptionally fine supporting cast is headed by Ossie Davis, Ruby Dee, Anthony Quinn, John Turturro and Samuel L. Jackson, whose performance as a crack addict is also worthy of an award.

Mr. Lee himself appears in the small but important role as the architect's best friend.

Mr. Lee's screenplay is as triumphant as his direction of it, his Italian-American dialogue as authentic as the speech he gives his African-American characters. The film is alternately funny and harrowing, especially in two sequences that might here be called coups de cinéma. In one, a group of black women sit around attempting to console the wife of the philandering architect. They speak the truth, which is as hilarious as it is revealing.

The second sequence is a descent into hell, that is, into a Harlem crack house known as the Taj Mahal, referred to by one of its habitués as the "eighth wonder of the world." It may or may not be realistic, but it is completely plausible within the context. It's a vision of physical and spiritual desolation of near-Fellini proportions, scored, not inappropriately, by Mr. Wonder's "Livin' for the City."

It is also the sort of sequence that separates a film maker of singular talent and courage from the hacks of the commonplace.

Mr. Lee shied away from the entire drug problem in "Do the Right Thing." It is central to "Jungle Fever," to the narrative as well as to the freeze frame that ends the movie.

"Jungle Fever" is alive from its opening credits and Mr. Wonder's title song to that last haunting moment. It is almost as heavily scored as "Miss Saigon," with music heard over the dialogue as well as between the sequences. In addition to Mr. Wonder's contributions, the score also features songs by Mahalia Jackson and Frank Sinatra.

Though "Jungle Fever" is benign compared with "Do the Right Thing," it includes several explicitly violent moments. It will certainly come in for its share of debate and argument. At the news conference following the screening, one reporter who had anticipated something even more violent reminded Mr. Lee that he had promised that this new film would make "Do the Right Thing" look like "Snow White" or "Bambi."

Mr. Lee's cheerful one-word comment: "Hype."

1991 My 17, C1:1

Correction

A Critic's Notebook article in Weekend on Friday about the Cannes International Film Festival misidentified a star of "Life Stinks." She is Lesley Ann Warren, not Susan Sarandon.

1991 My 20, A3:2

Tatie Danielle

Directed by Étienne Chatiliez; written by Florence Quentin; edited by Catherine Renault; music by Gabriel Yared; production design, Geoffroy Larcher; produced by Charles Gassot; released by Prestige. In French with English subtitles. Running time: 106 minutes. This film has no rating.

Tatie Danielle	Tsilla Chelton
Catherine Billard	Catherine Jacob
Sandrine	Isabelle Nanty
Odile	Neige Dolsky
Jean-Pierre Billard	Eric Prat
Jeanne Billard	Laurence Fevrier
Madame Lafosse	Virginie Pradal

By JANET MASLIN

The milk of human kindness curdles in the veins of Tatie Danielle (Tsilla Chelton), a malicious old lady who delights in bringing tears to the eyes of those who treat her kindly. A magnificent monster, she has long since passed the point of respecting middle-class pieties. Irritable and unloved at the age of 82 (and a widow for 50 years), she has attained the freedom to say exactly what she likes, and the crueler the better. Another old woman's deferential remark, "I'll die before you," prompts Tatie Danielle to snap, "I certainly hope so."

By virtue of her age, her savings, and the blind dutifulness of her relatives, Tatie Danielle is well looked after. She is particularly comfortable in the company of those weak-willed enough to be intimidated by her mean streak. "Tatie Danielle," another sly social satire from Étienne Chatiliez (whose earlier film was "Life Is a Long Quiet River"), is as much about the old lady's willing victims as it is about her petty tyrannies. Along with the film's string of outrageous insults

Prestige Films

Tsilla Chelton

go some droll observations about how far polite society will go to avoid appearing impolite — and about how readily such acquiescence can be exploited.

Danielle, who loves sneaking sweets and reading Barbara Cartland novels, is first seen in the care of Odile (Neige Dolsky), a septuagenarian who smiles meekly at Danielle's unreasonable orders. Although Odile's efforts to plant a garden typically result in Danielle's "accidentally" stomping on her pansies, Odile refrains from fighting back until a mishap with a chandelier takes the matter out of her hands. After that, Danielle is brought to Paris by her

pleasant, fatuous-looking grandnephew Jean-Pierre Billard (Eric Prat) and his wife and children. All would like to think of themselves as the sort of people willing to help out an enfeebled old aunt.

●

"Hello, young lady," Danielle says sweetly to Jean-Pierre's longhaired, slightly effeminate teen-age son. "You *do* dye your hair?" she asks Jean-Pierre's wife, a beautician named Catherine (Catherine Jacob). The family's younger son is abandoned by auntie after a walk to the park, and the family dog is unaccountably stepped on. When the Bil-

How much will people endure to avoid being impolite?

lards offer Danielle a tour of Paris, she looks at her watch, glares suspiciously at the Arc de Triomphe and dozes off while passing other tourist highlights. "I wouldn't wish that afternoon on anyone," she later complains.

Danielle can make herself appear to be so helpless that she leaves the Billards utterly confounded. One night, as Jean-Pierre and Catherine hold a dinner party, she totters by in her nightgown, saying pitiably, "If there's something to eat I won't refuse it." She proceeds to stop conversation dead, cough and wheeze while enjoying her tea, and leave a large wet spot where she has been sitting. Tatie Danielle will even fake incontinence if it helps to make someone else's life a bit more miserable.

"Tatie Danielle" finally introduces Sandrine (Isabelle Nanty), a capable young woman who is hired to mind Danielle but becomes the first character who openly resists her. A disarming and believable rapport gradually develops between these two. Mr. Chatiliez and Florence Quentin, who wrote the screenplay, resist most opportunities to compromise Danielle's unpleasantness, but this latter part of the film risks turning sentimental. "Tatie Danielle" never comes up with a resolution that is as tough and singular as the character herself.

●

Mr. Chatiliez, a very successful director of French television commercials, has a wry appreciation for middle-class characters leading wholly unexamined lives. His films' understated humor draws upon well-observed social details, like the way the Billards and their friends feel the need to discuss Melina Mercouri's marriage to Jules Dassin when they plan a trip to Greece. The scope of Mr. Chatiliez's satire is seldom much broader than that, and in assembling a narrative he tends to move slowly. Yet the fearsome Tatie Danielle and her cowed relatives emerge from this meandering, imaginative comedy fully formed.

Miss Chelton, a French stage actress, offers a wicked yet compassionate portrait of a woman who may be an even greater enemy to herself than she is to those around her. Mixing diabolical false sweetness with incredible malice, and wearing a comparably spiteful coiffure in which gray roots demand to be noticed in

the midst of dyed brown hair, she presents a formidable set of mixed messages in every way. Miss Nanty, as the fearless Sandrine, and Miss Jacob, as the bewildered Catherine, are also memorable. It falls to Catherine to give timid voice to the Billards' terrible secret. "I think she's mean!" she and the others finally allow themselves to whisper.

It's heartening that a huge Parisian scandal erupts at one point in the story from the fact that Tatie Danielle has been left for a period of time without adequate supplies or supervision. In some cities an event like that might not even make the police blotter, let alone the nightly news.

1991 My 17, C8:1

Cassavetes, Rowlands And the Play Within

John Cassavetes's "Opening Night" was shown as part of the 1988 New York Film Festival. Following are excerpts from Janet Maslin's review, which appeared in The New York Times on Oct. 1, 1988. (Mr. Cassavetes died in 1989.) The film opens today at Cinema 1, Third Avenue at 66th Street, in Manhattan.

"Opening Night" could be described as John Cassavetes's version of "All About Eve" if Mr. Cassavetes were the sort to be strongly influenced by the work of other film makers, which he most certainly is not. Like the characters who ramble amiably through this sprawling, funny, emotionally raw 1978 film — which has a style that's of a piece with the director's other long films of the 70's, among them "Minnie and Moskowitz" (1971), "A Woman Under the Influence" (1974) and "The Killing of a Chinese Bookie" (1976) —

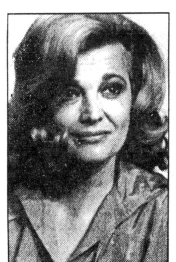

Castle Hill Productions

Gena Rowlands

Mr. Cassavetes displays a remarkably free-spirited point of view.

"Opening Night" is a reminder of what has made Mr. Cassavetes's films so appealing, and of what can make them so maddening, too. For all its length — nearly two and three-quarter hours — it's a relatively thin example of the director's work, but a mischievous and inviting one, too.

Gena Rowlands, at her most radiant, totters through the film in the role of Myrtle Gordon, a very famous actress who requires vast reserves of forbearance from anyone who's daring or foolhardy enough to try working with her. As the film begins, Myrtle is in New Haven starring in the final tryouts of a play called "The Second Woman," which is, if God is willing and Myrtle can be held in check, on its way to Broadway.

●

Overseeing the production, and collectively gnashing their teeth when they are not sweet-talking the star, are the play's seasoned director, Manny Victor (Ben Gazzara), and his playful wife (Zohra Lampert), who good-naturedly tells him, "If I had known what a boring man you were when I married you, I wouldn't have gone through all those emotional crises"; a co-star named Maurice Aarons (Mr. Cassavetes), with whom Myrtle goes back a long time; the playwright Sarah Goode (Joan Blondell), who has more reason to worry about Myrtle than anyone else, and the producer David Samuels (Paul Stewart), Sarah's husband, the one who's most apt to bring down the curtain once and for all. Second most apt, actually, since Myrtle is doing everything she can to bring on a disaster.

Miss Rowlands, as she has shown in other films directed by her husband, can be incomparably funny while coming apart at the seams. The film, which presents bits and pieces of the play in rehearsal and then gradually lets them evolve into something whole, has a lot of fun with Myrtle's improvisations onstage and their unfortunate effects on her fellow actors.

As in "All About Eve," the star's secret fear turns out to be a dread of the aging process, which in this case is the subject of the play she's trying to do; Sarah, the author, says the phrase "the second woman" refers to the person a woman becomes once the pretty, youthful side of her disappears. Myrtle has so much trouble with this idea that she hallucinates a dead fan (Laura Johnson), who has been hit by a car early in the film but returns to haunt Myrtle as a vision of her own lost youth. This device, typically for Mr. Cassavetes, is labored and attenuated but strangely touching anyhow.

When Joan Blondell was making "Opening Night" in 1977, she told an interviewer, "I couldn't tell when the actors were having a private conversation and when they were actually changing the lines of the script." The shifting-sands quality that colors Myrtle's performances onstage also extends to the actors in the film, but the cast has a vibrancy that is perhaps a byproduct of this kind of uncertainty. As always, Mr. Cassavetes, a figure of wry, unpredictable intelligence and uncertain temper, is as darkly commanding in front of the camera as he is behind it.

1991 My 17, C11:1

What About Bob?

Directed by Frank Oz; screenplay by Tom Schulman; story by Alvin Sargent and Laura Ziskin; director of photography, Michael Ballhaus; edited by Anne V. Coates; music by Miles Goodman; production designer, Les Dilley; produced by Ms. Ziskin; released by Touchstone Pictures. Running time: 97 minutes. This film is rated PG.

Bob Wiley	Bill Murray
Dr. Leo Marvin	Richard Dreyfuss
Fay Marvin	Julie Hagerty
Siggy Marvin	Charlie Korsmo
Anna Marvin	Kathryn Erbe
Mr. Guttman	Tom Aldredge
Mrs. Guttman	Susan Willis

By JANET MASLIN

On July 31, a date guaranteed to strike terror into analysands everywhere, Dr. Leo Marvin (Richard Dreyfuss) inherits a model patient. He is Bob Wiley (Bill Murray), who is polite and appreciative and likes to pay his bills ahead of time. Bob talks to himself, as well as to his goldfish. He has a set of symptoms — fear of germs, fear of elevators, fear of sleeping unless pointed in the proper direction according to a compass — that many a psychiatrist would kill to treat.

The only thing wrong with this referral, from Dr. Marvin's point of view, is Bob's whale of a dependency problem. Bob develops an instant attachment to Dr. Marvin and turns himself, as one character in "What About Bob?" puts it, into "human Krazy-Glue."

Since July 31 marks the eve of the psychiatric vacation season, and since Dr. Marvin is headed for rural New Hampshire, Bob's persistence takes on a geographic dimension. He wheedles and sneaks until he learns the doctor's address for August. Soon he is standing in the middle of a small New Hampshire village, bellowing the doctor's name and asking, "Is this a bad time?" Dr. Marvin, now busy with his wife, Fay (Julie Hagerty), and two children named Sigmund and Anna (Charlie Korsmo and Kathryn Erbe), grits his teeth and pronounces Bob's behavior "completely inappropriate," which is putting it mildly.

A happy family in a remote setting, stalked by a deranged man with an unreasonable fixation on the father: this plot would have the makings of a thriller (think of "Cape Fear") if it were not in this case played for laughs. But "What About Bob?" does work as comedy for a while, thanks to the fortuitous teaming of Mr. Dreyfuss and Mr. Murray. In terms of temperament, these two actors represent such opposite polarities (with Mr. Dreyfuss so tightly wound, and Mr. Murray ready to ooze through the floorboards) that they are automatically funny in tandem, especially when Mr. Dreyfuss does his slow burn. For half an hour, as "What About Bob?" establishes its odd-couple dynamics between Bob and the doctor, it shows a lot of promise.

But the film takes a terrible wrong turn once Bob crosses paths with the Marvin family, and the Marvins begin to realize how much they like him. Fay and the children instantly side with Bob against the pompous doctor, who has all of the psychiatrist-father's classic bad habits. ("It's as important for me to see you dive as it is for me to appear on 'Good Morning America,'" Dr. Marvin patiently tells the frazzled little Siggy, who would rather skip the diving lessons anyhow.) Very quickly, the story's emphasis on Bob's lovability becomes as annoying to the audience as

it is to Dr. Marvin, who is driven absolutely wild. Somehow, Mr. Dreyfuss maintains his sound comic timing even when Frank Oz's antic direction calls for hand-waving hysteria.

"What About Bob?" has its share of broad gags, but its screenplay (by Tom Schulman, who wrote "Dead Poets Society," with a story by Alvin Sargent and Laura Ziskin) is so seriously underplotted that its dramatic climax is the appearance of a television crew from "Good Morning America" to shoot a segment promoting Dr. Marvin's new book. Sadly, Dr. Marvin sees this as a make-or-break opportunity, and the apparent high point of his career. Predictably, Bob makes himself the main attraction, and thanks to the television escapade everyone loves him even more.

The plausibility of "What About Bob?" is not improved by fussily overdecorated sets, which contradict the idea that the Marvins are in a vacation spot in New Hampshire and suggest instead that they have won a dream house on a game show. Michael Ballhaus's cinematography is for once merely ordinary, though his glowing French Riviera scenes contributed greatly to the appeal of Mr. Oz's earlier, funnier "Dirty Rotten Scoundrels."

Mr. Korsmo, the wonderful young actor already so memorable in "Men Don't Leave" and "Dick Tracy," gives humor and dignity to little Siggy's every move. Tom Aldredge and Susan Willis have some funny moments as New Hampshire locals with an extremely low opinion of rich, visiting psychiatrists from New York.

●

"What About Bob?" is rated PG (Parental guidance suggested). It includes mild profanity.

1991 My 17, C15:1

Terror in a Texas Town

Directed by Joseph H. Lewis; written by Ben L. Perry; edited by Frank Sullivan and Stefan Arnsten; music by Gerald Fried; produced by Frank N. Seltzer; released by Swank Pictures. At the Public, 425 Lafayette Street, Manhattan. Running time: 80 minutes. This film has no rating.

George Hansen	Sterling Hayden
Ed McNeil	Sebastian Cabot
Molly	Carol Kelly
Pepe Mirada	Eugene Martin
Johnny Crale	Ned Young
Jose Mirada	Victor Millan

By STEPHEN HOLDEN

"I stay with him because as low as I am, I can turn around and see him and remember there's somebody lower," declares Molly (Carol Kelly), the tarnished girlfriend of a hired killer in "Terror in a Texas Town."

This kind of trashy B-movie dialogue runs like a thread of chewing gum through the 1958 black-and-white film, directed by Joseph H. Lewis, which opens today at the Public Theater on a double bill with the same director's 1950 cult favorite, "Gun Crazy."

Like "Gun Crazy," the more obscure "Terror in a Texas Town" has acquired a reputation in some quarters as a minor classic. Made for a song in a matter of days, it is a cut-rate "High Noon," whose final showdown pits Sterling Hayden, armed only with a harpoon, against a profes-

United Artists

Sterling Hayden

sional gunman on the main street of Prairie City, Tex.

Mr. Hayden plays George Hansen, a Swedish-American sailor who returns to his family's farm in Texas two days after his father has been slain. The murderer, Johnny Crale (Ned Young), has been hired by a ruthless land baron (Sebastian Cabot) to force the local farmers to sell him their oil-rich land. Affecting a Swedish accent on top of a monosyllabic, Gary Cooper-style delivery, Mr. Hayden seems ever-so-slightly ridiculous as the rugged personification of frontier virtue.

The movie belongs to Mr. Young. Wearing a twisted little smile throughout much of the film, he is as sardonically slithery a villain as one could expect to find in a 50's western. His every dead-eyed glance reveals a soul in the terminal stages of decay.

1991 My 17, C16:4

Dice Rules

Directed by Jay Dubin; "A Day in the Life" screenplay by Lenny Shulman, story by Andrew Dice Clay; concert material written by Mr. Clay; director of photography, Michael Negrin; edited by Mitchell Sinoway; production designer, Jane Musky; produced by Fred Silverstein; released by Seven Arts. At the Criterion, Broadway at 45th Street. Running time: 87 minutes.

By JANET MASLIN

Batting slightly higher than his previous zero on the big screen, Andrew Dice Clay can at least be seen in his natural element in "Dice Rules," which opened yesterday at the Criterion and other theaters (after having been dropped by the Loews chain.) This concert film finds him at Madison Square Garden, presiding over fist-waving, slogan-chanting fans who explode with enthusiasm every time Mr. Clay says something insulting, imbecilic or obscene (and nothing he says is otherwise). This audience even enjoys being personally insulted by Mr. Clay, for whom "Shut up, stupid" is a favorite witticism.

Women in the mostly white male audience are seen laughing uproariously at Mr. Clay's frequent references to "hooers," by which he means any woman who might date him, service him or do his laundry. "They don't just crawl to the edge of the bed until you might need them again — they're like leeches!" he complains

about women who might want to draw him into post-coital conversation.

He boasts of having given his girlfriend a broom one Christmas, and a dustpan the next. "Baby, be the pig that you are," he says, in trying to explain why he thinks women ought never to go without makeup or proper attire.

Although much of his act is given over to angry misogyny and detailed descriptions of sexual behavior, Mr. Clay also finds time to malign the handicapped, the elderly (he pretends to kick an old man), the Japanese ("they can fold a shirt, can't they?"), midgets ("What do you do when a midget is missing, put 'em on the back of a container of half-and-

Seven A

Out for Laughs The controversi comedian Andrew Dice Clay is in th spotlight again in "Dice Rules," a concert film built around two performances last year at Madison Square Garden.

half?") and even widows. "Hey, lemme ask you something — you here with anybody?" he suggests asking a good-looking widow at her husband's funeral.

At least Mr. Clay appears comfortable, which he certainly did not when attempting an acting role in "The Adventures of Ford Fairlane" last summer. The film does make apparent, if not exactly irresistible, the appeal of Mr. Clay's routine in giving cathartic voice to small-mindedness and sexual insecurity. The audience's performance, in going hog-wild over all this, is even more dismaying than the star's.

The concert seen in "Dice Rules" lasts only an hour, so the film's first half-hour, "A Day in the Life," is a series of embarrassingly amateurish skits that purport to explain who Mr. Clay is and how he got that way. Before he became fabulously cool, we learn, he was a mincing idiot in denim overalls who wore a pink apron around the house while being henpecked by a fat, grotesque, curler-wearing wife. This material more than justifies the prior reputation of this long-delayed film as unreleasable.

●

"Dice Rules" is rated NC-17. (No one under 17 admitted.) Wall-to-wall obscenity.

1991 My 18, 15:5

Stone Cold

Directed by Craig R. Baxley; written by Walter Doniger; director of photography, Alexander Gruszynski; edited by Mark Helfrich; music by Sylvester Levay; production designers, John Mansbridge and Richard Johnson; produced by Yoram Ben Ami; presented by Stone Group Pictures. Running time: 90 minutes. This film is rated R.

Joe Huff/John Stone	Brian Bosworth
Chains	Lance Henriksen
Ice	William Forsythe
Nancy	Arabella Holzbog
Lance	Sam McMurray

By STEPHEN HOLDEN

Except for his blond hair, Brian Bosworth, the football star turned movie actor who makes his film debut in "Stone Cold," is almost a dead ringer for the young Burt Reynolds. Mr. Bosworth has the same carved-in-granite facial bones, the same deep-set squint that seems directed toward a private, prehistoric memory, the same aura of suppressed intelligence struggling below the pumped-up macho facade.

In "Stone Cold," which opened yesterday at local theaters, Mr. Bosworth plays John Stone, an undercover policeman assigned to infiltrate an outlaw motorcycle gang in the Deep South. In the film's most violent sequences, the gang, which deals drugs and assassinates its opponents, roars into the Mississipi State Capitol building (actually the Arkansas State Capitol) with machine guns blazing. Its gaunt, bug-eyed leader is a creature named Chains (Lance Henriksen). He is the kind of man who, upon seeing the face of an adversary on television, promptly shoots the offending set.

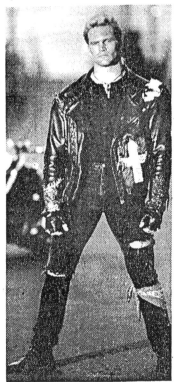

Columbia Pictures
Brian Bosworth in "Stone Cold."

"Stone Cold," which was directed by Craig R. Baxley and written by Walter Doniger, begins on a light note. In the opening scenes, Mr. Bosworth is shown making his pet reptile's breakfast — a blend of Snickers bars, potato chips, eggs, milk and Tabasco sauce. He also hangs out with his F.B.I. connection (Sam McMurray), a laughable nerd who is obsessed with germs.

But these running gags are never developed. Once the movie gets down to business, the muscle and pyrotechnics take over. The action — especially the motorcycle chases through the marble government halls — pack a fairly good visceral charge.

•

"Stone Cold" is rated R (Under 17 requires accompanying parent or adult guardian). It has nudity, strong language and violence.

1991 My 18, 16:3

Mannequin Two
On the Move

Directed by Stewart Rafill; written by Edward Rugoff, David Isaacs, Ken Levine and Betsy Israel; director of photography, Larry Pizer; edited by John Rosenberg and Joan Chapman; music by David McHugh; production designer, William J. Creber; produced by Mr. Rugoff; released by 20th Century Fox. Running time: 95 minutes. This film is rated PG.

Jessie	Kristy Swanson
Jason Williamson/ Prince William	William Ragsdale
Hollywood and Doorman	Meshach Taylor
Count Spretzle and Sorcerer	Terry Kiser
Mr. James	Stuart Pankin
Mom and Queen	Cynthia Harris

By JANET MASLIN

It comes as no disappointment that "Mannequin Two: On the Move," which was directed by Stewart Raffill and opened Friday at the Metro and other theaters, is a breezy teen-age comedy having very little to do with the earlier film for which it is named. The setting is again a Philadelphia department store (with a staff that includes Meshach Taylor as Hollywood, a very funny, very flamboyant gay "Minister of Style"), and the plot again involves a mannequin's coming to life to become one store employee's secret dream girl. Beyond that, this film has enough new characters and independent spirit to have a light, cheery style of its own.

The story's fresh-faced ingénues, Kristy Swanson and William Ragsdale, are first seen in medieval times, in a prologue set in a Bavarian kingdom called Hauptman-Koenig. The romance between a beautiful commoner named Jessie (Ms. Swanson) and Prince William (Mr. Ragsdale) is effectively quashed when the queen's forces put a curse on Jessie and turn her into an inanimate object.

A thousand years later, Jessie is a statue known as the Enchanted Peasant Girl, and she happens to be visiting Philadelphia when she crosses paths with Jason (Mr. Ragsdale), a descendant of Prince William. The film's four screenwriters deserve less credit for dreaming this up than for setting it in motion in a painless manner.

Once restored to life (thanks to the magical powers of a special necklace), Jessie wanders prettily through the modern world with Jason as her good-humored guide. "Oh, good, do they have boiled weasel?" she exclaims when he offers to take her to a fast-food restaurant. "You won't be able to tell the difference," Jason replies.

Later, in a disco, he offers her diet soda and explains that it has no calories and no caffeine. "Oh, we had something like that back home called

John Bramley/20th Century Fox
William Ragsdale in a scene from "Mannequin Two: On the Move."

water," Jessie replies. "This is easier to find," Jason says.

Also in "Mannequin Two," and helping to keep it lively, are three hunky Arnold Schwarzenegger soundalikes named Rolf, Arnold and Egon, assigned to guard Jessie as a Bavarian treasure; Andrew Hill Newman as a sheepish security guard; Stuart Pankin as the store's overbearing manager, and Mr. Taylor, who drives a fuschia cadillac and has the film's best lines. "Now, we do not fall in love with empty things unless their daddies are rich," he cautions Jason, not realizing that Jessie is flesh and blood. "And in her case her daddy's a redwood, so forget about it."

•

"Mannequin Two" is rated PG (Parental guidance suggested). It includes mild profanity.

1991 My 19, 50:3

FILM VIEW/Vincent Canby

Madonna and the Master

CANNES, France

MADONNA AND AKIRA KUROsawa: flesh and the spirit. Also, for that matter, spirit and the flesh. To be a show-business legend in your own time, you can't have one without the other. This was what film aficionados might call the subtext of the first week of the 44th Cannes Film Festival, which ends tomorrow night after 12 days of screenings.

The presence of Madonna added a lot of redeeming lunacy to this year's festival, which has been mostly serious and often lugubrious. Mr. Kurosawa, his productivity undiminished at 81, has been the festival's implacable conscience. Their work was cut out for them. The uncertainty of current business conditions and of the further economic integration of the European Community, scheduled for 1992, somewhat dampened the enthusiasm, if not the hyperbole, of the hundreds of movie traders who came to Cannes this year.

Their object: to attend the main competition, subsidiary shows and the Film Market, and to buy and sell the rights to what the trade calls "product," even though many of these haven't yet been made. This year, the still-to-be-produced category includes two big-budget productions, celebrating the 500th anniversary of Columbus's first voyage to the New World. They may or may not be what the New World needs now.

This festival definitely needed both the ephemeral razzle-dazzle created by Madonna and her entourage and the prestige conferred on it by the great Kurosawa.

Like "Rhapsody in August," the Japanese master's new work, "Madonna: Truth or Dare," Alek Keshishian's authorized documentary, now playing in New York, was shown in the main part of the festival but out of competition. It was also the week's second toughest ticket to obtain, the toughest being a ticket to the party celebrating the film's showing. Priorities tend to get confused when Madonna is around. She's not yet a cinema icon; she's a vibrant new public personality who creates the kind of excitement that helps movie makers survive.

Another sort of necessity entirely is Mr. Kurosawa, who directed his first film in 1942 and appears to be in the midst of a vigorous Golden Age. It's a measure of the true originality of "Rhapsody in August" that it has not been a major festival hit. It doesn't cater to an audience's preconceptions of the new. It's not self-consciously inventive in the way of the films of Werner Schroeter, Lars Von Trier and the other avant-garde directors who come to Cannes.

Instead, it is distilled, utterly direct, abrasive. It reflects the manner of a man who is no longer interested in superficial effects, only in expressing what is on his mind as efficiently as possible. The film is a message from a director who was born four years before the guns of August were fired in 1914. It is a report from that generation of directors who are supposed to be dead or at least retired and modestly grateful for honorary awards.

Often lugubrious, this year's festival definitely needed the pop star's pizazz and Akira Kurosawa's prestige.

Like "Akira Kurosawa's Dreams," shown out of competition at last year's Cannes festival, "Rhapsody in August" is visually splendid. Unlike "Dreams," though, it is almost willfully austere. It suggests something of the rigor of Roberto Rossellini's late films, though the two men otherwise don't have much in common. It is also a movie that could prompt righteous outrage in some quarters of the United States. At one point or another, there is something in it to offend everybody, including me. Mr. Kurosawa doesn't make it easy to accept man's higher nature, at least in part because the movie doesn't work in the way he seems to have intended.

"Rhapsody in August," adapted by the director from a Japanese novel, "Nabe-No-Naka," by Kiyoko Murata, is about the dropping of America's second atom bomb, on Aug. 9, 1945, on the city of Nagasaki. Unlike Shohei Imamura's "Black Rain" (1989), in which the effects of the Hiroshima bomb are explicitly detailed, "Rhapsody in August" avoids any attempt to recreate the spectacle of atomic holocaust.

The time is now, and the setting is an idyllic farm on the far side of the mountains outside Nagasaki. Four teen-age children have been parked for the summer with their grandmother, widowed long ago in the Nagasaki raid, while their parents go off to Hawaii to visit the grandmother's dying brother, who became rich in Hawaii as a pineapple planter.

The Hawaiian household includes the half-American children of the grandmother's dead sister. Kane, the grandmother, now mentally confused in her old age, had 10 brothers and sisters and has trouble keeping them straight, as does the audience, though that's not important.

When Kane and the children are invited to join the others in Hawaii, she refuses. She doesn't hate all Americans, she says, but she doesn't especially cherish them. Little by little, she begins to tell the children stories about the bombing. Some are grimly factual; some sound like myth.

She had a younger brother who, though not caught directly in the raid, lost all his hair from the effects of radiation. He was so embarrassed that he spent the rest of his life in his room in the farmhouse. He was a painter, but his sole subject was a large eye, which Kane describes as "the eye of the flash" they saw on the far side of the mountain on the morning of the raid.

At a key moment, Mr. Kurosawa shows the audience that eye. It is large and red and fills the sky. The effect is both shocking and magical. It's not an evil eye; neither is it good. It is a presence that hovers over their lives. The youngest grandson later sees the eye in a snake he finds in the mountain pool where Kane's bald brother used to swim at night.

Kane remembers when a skinny-legged, dwarfish creature showed up at the farmhouse, having fished her nearly drowned brother out of the mountain pool. "A kappa," she says, as if describing a village policeman, "a water spirit." According to Kane, kappas do that occasionally.

"Rhapsody in August" vividly recalls the atomic holocaust, but entirely by indirection. Though Mr. Kurosawa says he intended that the movie should be about the awakening of the children to the bomb's meaning, the children are less important to the movie than the indirectly evoked bombing itself and the vision of the apocalypse.

The children, who range in age from late to early teens, remain largely uncharacterized. At first they miss television and the other pleasures they left at home in Tokyo. They are generic children, differentiated only by age, sex and the M.I.T. and U.S.C. T-shirts they wear.

Somewhat too quickly and obligingly, they begin to explore Nagasaki on their own, looking for evidence of the Aug. 9 raid. It's as if Mr. Kurosawa didn't have time to waste in creating especially compelling children.

Yet this doesn't interfere with Mr. Kurosawa's extraordinarily heartfelt recollection of the war and what it meant to the generations that survived it. Where the film gets tricky, and even ticklish, is when Richard Gere shows up as Kane's half-American nephew from Hawaii, who has come to pay his respects to his Japanese cousins and to apologize for the war.

Mr. Gere gives a good, self-effacing performance in a role that's a little unreal. He speaks his own Japanese dialogue easily and is at the center of one of Mr. Kurosawa's most breathtaking moments.

■

During a ceremony honoring the bomb victims, the camera shifts away from the shrine to show a line of ants making a purposeful ant-line toward a rosebush. The ants climb the bushy stalk, single file, to arrive at the magnificent blood-red bloom.

This may suggest that the ants, like the bomb's victims, have found their peace. However, it is far more effective if left uninterpreted. The film is full of such moments that might have pleased Luis Buñuel.

When the movie's politics were questioned at a post-screening news conference, Mr. Kurosawa denied any intention to sidestep Japanese

Orion Classics

Sachiko Murase as Kane in Akira Kurosawa's "Rhapsody in August," shown at Cannes

responsibility for the war. "We Japanese," he said, "were also the victims of Japanese militarism." The subject of the film, he insisted, is not guilt and responsibility but the horrors of war, in particular of the bomb, which has made possible the absolute end of everything.

It is, indeed, a subject about which he has been ruminating for years, most memorably in the 1955 "I Live in Fear," about a man obsessed by atomic destruction, and the wildly garish end-of-the-world nightmare sequence in "Dreams" last year.

Later, at lunch at the Hôtel du Cap in Antibes, sitting on a sun-drenched terrace, looking at the Mediterranean, Mr. Kurosawa expressed satisfaction with the film's reception here. The film maker looks a good 10 to 15 years younger than his age and is ready for a new project.

He noted that his longtime associate, Ishiro Honda (the director of "Godzilla" and other Japanese sci-fi classics), had directed the stunning

ant sequence in "Rhapsody in August." Ants, it seems, are more difficult to direct than dogs, cats and

children. Mr. Kurosawa doesn't have the patience for it.

Nor did he have patience for several grimly insistent autograph hunters who suddenly turned up on the closely guarded hotel terrace. He signed the first sheet of a paper shoved in front of him, then erupted in the formidable style of the man who is called "sensei" ("master") on the set. It was a ferocious but short outburst, after which the appetite, the charm and the concentration returned. □

1991 My 19, II:13:1

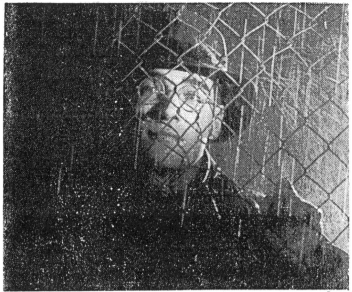

Reuters

Jean-Marc Barr in "Europa," one of the European entries most favored by the critics attending the Cannes International Film Festival.

A Day Before Cannes Awards, No Clear Winners Emerge

By VINCENT CANBY

Special to The New York Times

CANNES, France, May 19 — This afternoon, after the screening of the last 2 of the 20 films in competition at the 44th Cannes International Film Festival, the contest for the top prizes is again wide open. Odds-on favorites come and go by the hour.

On Friday, Spike Lee's "Jungle Fever" appeared to be a cinch to win either the Palme d'Or, the festival's top prize, as best picture or the award given for best director. In two days, all that has changed, although neither Mr. Lee nor his film has altered in any appreciable degree.

The winners are to be announced Monday night at the closing ceremonies in the Palais du Festival.

Two strong new contenders have come on the scene: from France, Maurice Pialat's "Van Gogh," and from the United States, Joel and Ethan Coen's "Barton Fink." Each is considered fine enough to take one of the major awards or, as local wisdom has it, to split the jury so that those awards will be given to compromise selections.

"Van Gogh" is a special favorite with French film aficionados. They see it as an attempt, both successful and overdue, to demystify the artist who was the subject of Vincente Minnelli's "Lust for Life" in 1956 and Robert Altman's "Vincent and Theo" last year.

The Pialat film is both handsome and spare. It covers the last months of the artist's life in Auvers-sur-Oise, sometime after the hysterical period in the South of France when he and Gauguin were friends and when he supposedly cut off his ear. Indicative of Mr. Pialat's approach is that Jacques Dutronc plays Van Gogh with both of his ears intact.

The film does not examine the mysteries of artistic temperament. Van Gogh is revealed through his complex love-hate relationship with his brother and sister-in-law, and through his friendships with the ordinary folk of Auvers-sur-Oise. He is no mad genius going colorfully to pieces, but a man overwhelmed by an inexpressible melancholy that may have nothing to do with Art.

Whether or not it wins a prize, "Van Gogh" would seem to be a film most likely to be invited to the New

York Film Festival in September. So is "Barton Fink," written, produced and directed by the same Coen brothers whose "Miller's Crossing" opened last year's New York festival.

•

To someone who has not been a consistent admirer of the Coens' earlier work, "Barton Fink" is a most happy surprise. Before it turns obscure, it's a hilarious, sometimes over-the-top dark comedy about Hollywood in 1941 and, in particular, a left-wing New York playwright, a self-styled friend of the common man. Although this fellow is played by John Turturro with a haircut that suggests George S. Kaufman, the character seems to be based on Clifford Odets.

For good measure, some of the Coens' satire is as good as anything written by Kaufman and Moss Hart.

A priceless pleasure is their portrait of an old-time studio boss, who manages to look like both M-G-M's Louis B. Mayer and Columbia Pictures' Harry Cohn, and who behaves with the ruthlessness of the studio boss played by Rod Steiger in the film of Odets's "Big Knife." For once such movie-buff associations add to the fun of a film.

If the Cannes jury sees fit to give an award for ensemble acting this year, the cast of "Barton Fink" would deserve it: Mr. Turturro, John Goodman, who gives the best performance of his career as a down-home insurance salesman, and Michael Lerner, who plays the studio boss.

Although the Cannes jury's members change each year, the way it does business remains pretty much the same. It seems to be a virtual Cannes policy to spread the awards around as widely as possible. It also may be a disadvantage to "Jungle Fever" and "Barton Fink" that American films have won the Palme d'Or two years in succession: Steven Soderbergh's "Sex, Lies and Videotape" in 1989 and David Lynch's "Wild at Heart" last year.

Roman Polanski, who is as familiar in Hollywood as he is in European film circles, is the president of this year's jury. The jury members are Whoopi Goldberg, the Oscar-winning American actress; Margaret Menegoz, the French producer; Natalya Negoda, the Soviet actress best known for "Little Vera"; Ferid

Boughedir, the Tunisian director; Alan Parker, the English director; Jean-Paul Rappeneau, the French writer and director whose most recent film is "Cyrano de Bergerac"; Hans-Dieter Seidel, the German film critic; Vittorio Storaro, the Italian cameraman, and Vangelis, the Greek-born composer whose score for "Chariots of Fire" won an Oscar.

Among the European entries they are considering, these are the most favored by the critics:

¶Jacques Rivette's four-hour French film, "La Belle Noiseuse," (a title for which there is said to be no accurate English equivalent), in which Michel Piccoli, as a celebrated painter, struggles to finish a grand canvas he began 10 years earlier.

¶Krzysztof Kieslowski's "The Double Life of Veronica," a French-Polish co-production, about two young women — one Polish, the other French, both played by the same actress — whose parallel lives are mystically connected.

¶Lars von Trier's "Europa," a Danish-French-German co-production, described by those who have seen it as a stunningly beautiful, very knowing, near-camp melodrama about a young American in Germany right after World War II.

"The Double Life of Veronica" and "Europa" would seem to exemplify the sort of esoteric, technically spectacular European cinema that American audiences find so easy to resist, mostly because the film makers refuse to deal in clear, straightforward narratives, paced at a speed that makes thinking impossible.

Many of these films melt the mind with boredom. But some, including "The Double Life of Veronica," enchant even as they confuse.

The European films in competition have not all been what is politely called "difficult." Daniele Luchetti's Italian satire, "Il Portaborse" ("The Porter"), is a send-up of political opportunists, accessible to all except political opportunists. Also conventional in an unembarrassed way is Maroun Bagdadi's French "Hors de Vie" ("Out of Life"), a sorrowful examination of the situation in the Middle East as reflected in the kidnapping of a French journalist in Beirut.

As the festival wound down today, order began to collapse. The woman

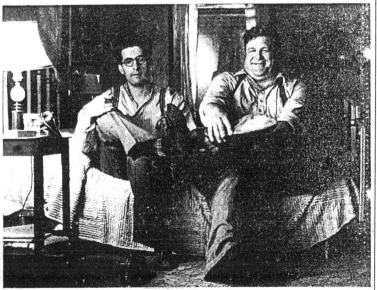

Melinda Sue Gordon/20th Century Fox

John Turturro, left, and John Goodman in "Barton Fink," which is considered a strong contender at Cannes.

who translates the French subtitles for English-speaking members of the audience (who listened through earphones) arrived at the press screening more than a half-hour late. Among those who had been left in the dark was Ms. Goldberg, the jury

member. She was polite but, she explained, after 12 days of conscientious viewing, she darn well didn't want to be disqualified from voting on the last film in the festival. Or words to that effect.

1991 My 20, C11:4

little puzzled, as if recognizing the impossibility of ever knowing the mind itself, except through books.

1991 My 21, C15:1

3 Novels Are Adapted For 'Angel at My Table'

"An Angel at My Table" was shown as part of the last year's New York Film Festival. Following are excerpts from Vincent Canby's review, which appeared in The New York Times on Oct. 4, 1990. The film opened Sunday at the Fine Arts Theater, 4 West 58th Street.

Movies about writers tend to fall to pieces when the writer starts writing, at which point there's nothing for the movie to do except hang around waiting for the writer's reviews to come in. The act of writing is private; whether done with a quill pen or a personal computer, it is singularly uninvolving to the looker-on.

The New Zealand director Jane Campion is well aware that writers writing, or even thinking about writing, look pretty silly. For the most part, she succeeds in avoiding the problem in "An Angel at My Table," a fine, rigorous adaptation of three autobiographical novels by Janet Frame, the New Zealand novelist and short-story writer.

•

In the final third of the film, when Janet (Kerry Fox) has been published and her talent recognized, it would seem that the most important moments of her life are being lived off screen. Not yet, though. In one of the film's most agonizing (and most bleakly funny) sections, the 30-ish Janet falls into an affair, her first, with a stupendously boorish American professor of history who also thinks of himself as a poet. They meet in Spain. On their first night together, Janet is thinking about sex. The poetaster is thinking about words, but with no feeling for them whatsoever.

He repeatedly interrupts their lovemaking to ask her opinion about a verse he's working on. She answers as gently as possible in the hope that he will get on with things.

It's a difficult moment. Janet's intellectual sensibility is pitted against her naked longings. It's no contest: sex triumphs over literature. Yet at the end of his holiday, when the idiot comes to say goodbye, she refuses to open the door to him.

The new film can't be casually compared with "Sweetie," Miss Campion's dense, splendidly original first feature. "An Angel at My Table" is not, strictly speaking, a movie at all. It's a television mini-series whose three parts are being shown here together, which is not the way they were designed to be seen. It's a long movie, and somewhat loose.

It also has its origins in the life, emotions and imagination of someone else, a writer of an age (Miss Frame was born in 1924) and a complexity that would seem to be utterly foreign to the young film maker.

Where "Sweetie" is a work of the film maker's imagination left to its

own devices, "An Angel at My Table" is the record of what helped to shape the imagination of the writer. The movie must pay attention to facts.

Jane Campion tells the story of a New Zealand writer.

The wonder of "An Angel at My Table" is that so much of it plays as if it had sprung from the imagination of the same young woman who made "Sweetie." About the film's Janet Frame there is always something that seems a little bit possessed. For her the world is brighter, shinier, more limpid and more dangerous than for anyone else. The film covers a great swatch of time, beginning with Janet as a little girl (played by an enchanting young actress named Alexia Keogh), and proceeding through her teen-age years (when she is played by Karen Fergusson) until she emerges in the person of Kerry Fox, who is remarkably vivid and strong as the haunted adult Janet.

Also remarkable is the casting. The three actresses blend so well into one another that the transitions are virtually unnoticeable.

Janet is one of the middle children of the six born to a railway engineer and a woman of some literary bent. It is not an especially unhappy household, though it is a strict one. Janet's older brother is epileptic. There are later misfortunes that affect Janet far more than anyone else in the family. While she is studying to be a teacher, she suffers a series of breakdowns that eventually lead to a mental hospital.

Except for the publication of a collection of her short stories and the favorable reviews it receives, she would have been lobotomized.

The movie must elide so much material that it comes as some surprise to the audience that the hospitalized Janet ever had time to write those stories. There are other narrative omissions that might not be evident to an audience watching the film in installments. For all of the casual brutality of the hospital scenes, "An Angel at My Table" seems a very gentle film about a woman of such a passionate nature. It's not easy, though, to dramatize the passion of someone who feels deeply about language, and who knows at the age of 12 or so that she wants to be a poet.

The movie records the world as Janet sees it, sometimes incredibly beautiful and as often frightening. It remains steadfastly objective and a

Straight Out of Brooklyn

Written, directed and produced by Matty Rich; director of photography, John Rosnell; edited by Jack Haigis; music by Harold Wheeler; released by the Samuel Goldwyn Company.

Ray Brown George T. Odom
Frankie Brown Ann D. Sanders
Dennis Brown Lawrence Gilliard Jr.
Carolyn Brown Barbara Sanon
Shirley Reana E. Drummond
Larry Mr. Rich
Kevin Mark Malone

By STEPHEN HOLDEN

Matty Rich's "Straight Out of Brooklyn" portrays the downfall of a black working-class family from the Red Hook section of Brooklyn in a style that used to be called kitchen-sink realism. At times gawky and plodding, the film, which represents the producing, directing and screenwriting debut of the 19-year-old Mr. Rich, also has an affecting earnestness as it explores the social and economic pressures that drive the Browns, a family of four, to self-destruct.

Ray Brown (George T. Odom), the head of the household, is an embittered gas station attendant heading into middle age. He despairs of ever doing better. Although he loves his family, his passion curdles into violence when he drinks. He storms through the family's tidy little apartment, beating up his wife, Frankie (Ann D. Sanders), smashing dishes and angrily soliloquizing to an invisible white oppressor.

Frankie, who works part time as a cleaning woman, accepts his beatings with a remarkable equanimity. Even when unable to find employment because of the bruises and welts on her face, she refuses to utter a word of criticism about her husband.

Quivering in their beds during these drunken rages are the couple's two adolescent children, Dennis (Lawrence Gilliard Jr.) and his younger sister, Carolyn (Barbara Sanon). Ray's violence stimulates fantasies of patricide in the young man, who longs to escape from the neighborhood and live in Manhattan with his girlfriend, Shirley (Reana E. Drummond).

Determined to make some quick money, the son engages his two best friends, Larry (Mr. Rich) and Kevin (Mark Malone), in a scheme to rob a low-level neighborhood drug dealer. The robbery has repercussions that go far beyond anything the young men could have imagined.

"Straight Out of Brooklyn," which opens today at the Plaza and Village East Cinemas, has a contemporary setting, but the literalness of its dialogue and its careful cinematography give it the feeling of a 1950's problem play adapted for the screen and moved up to the present. It is the kind of film in which a conversation about working-class expectations and the American dream takes place on a rooftop with the Statue of Liberty shown plainly in the background.

The Browns are portrayed as decent people who are stretched to the breaking point by forces outside their control. But beyond being sympathetic victims of hard times, racism and

the plagues of inner-city life, their characters remain unclear.

Ray is the most fully drawn, but even he is defined almost entirely by his rage. Frankie is the sort of long-suffering martyr and fortress of goodness satirized in the playwright George C. Wolfe's sketch "The Last Mama-on-the-Couch Play" from "The Colored Museum." The two children are effervescent but vague.

But if the situation is familiar almost to the point of cliché, Mr. Rich is able to squeeze some emotional juice from it. At moments, Mr. Odom's performance assumes a towering intensity. The late-night speeches he delivers to a blank wall about racism and oppression may have a clunky oratorical ring, but the actor infuses them with an angry passion that stirs the heart. Ms. Sanders's Frankie, who seems poised on the brink of tears most of the time, is entirely sympathetic. Mr. Gilliard's Dennis seems a bit too bland and callow for an inner-city youth about to pull his first robbery, but the scenes in which he goofs around with his pals have a engaging, easygoing energy. In a movie that primarily deals with society's rebuke to black male self-esteem, the daughter, Carolyn, is a strictly marginal figure.

"Straight Out of Brooklyn" is a promising film-making debut, but it is also an odd one. Where first-time directors tend to explode their feelings onto the screen nowadays, Mr. Rich's film echoes the formal, socially responsible dramas from an earlier and more emotionally temperate era of American film making.

•

"Straight Out of Brooklyn" is rated R (Under 17 requires accompanying parent or adult guardian). It includes strong language and some nudity.

1991 My 22, C11:5

The Wonderful World of Dogs

Written and directed by Mark Lewis; photography by Tony Wilson and Steve Windon; distributed by Direct Cinema. Running time: 52 minutes.

A Little Vicious

Produced and directed by Immy Humes; director of photography, Jean de Segonzac; narrated by Kevin Bacon; featuring Vicki Hearne. At Film Forum, 209 West Houston Street, Manhattan. Running time: 30 minutes. These films have no rating.

By JANET MASLIN

Film Forum, the exemplary three-screen Manhattan complex that already threatens to monopolize most of our free time (with its Billy Wilder retrospective in one theater and "Paris Is Burning" in another), has now quite literally gone to the dogs. Its third program is devoted entirely to canine attitudes, human perceptions thereof, and the distinct possibility that much of what we think of as doggie behavior is actually doggie-owner delusion on a grand scale. Pet fanciers of any kind will find this an illuminating show.

The longest and most ambitious of the program's three films is "The Wonderful World of Dogs," by the Australian director Mark Lewis, whose "Cane Toads" was such a treat. Mr. Lewis can hardly be blamed if the family dog is not quite a match for the huge, controversial,

hallucinogen-producing toads that were his earlier film's subject. As it is, he finds a lot to work with among the dogs and dog-minded people of quiet Mosman, Australia, where one

An Australian director follows up 'Cane Toads' with canines.

dog-obsessed woman has tried everything from barbecue skewers to mothballs to keep dog droppings away from the one small tree on her tiny lawn. She loudly laments the carelessness of these dogs' owners, and wonders why her neighbors resent her latest method: covering the lawn with empty plastic soda bottles to keep the dogs at bay.

In contrast to this, Mr. Lewis presents the irrepressible Fugly, who freely roams the town and makes his own leash-free visits to places like the liquor store and the gas station, where he is warmly welcomed by one and all. All except one alderman, who has made Fugly the town's reigning outlaw by making him the most frequently impounded dog in Australian history. "I didn't realize it was against the law for a dog to be a dog," Fugly's owner complains.

Mr. Lewis stages numerous re-enactments of important events in recent canine history, like the shooting of two dogs who had the poor judgment to mate on an airport runway where President Bush's plane was scheduled to land. The film also tells the story of the dog that sacrificed its life by eating poison mushrooms at a dinner party (thus saving all the human guests, who wound up having their stomachs pumped instead). The way in which another dog destroyed its owners' apartment while they were out is also faithfully re-created for the camera. Even delving into the realm of doggie dreams, Mr. Lewis presents the nightmare of Pebbles, a Chihuahua whose owner once feared it would be snatched by pelicans at the beach. Thanks to clever editing, ominous music and the skillful use of a synthetic pouch, Mr. Lewis is able to make Pebbles's presumed terror come radiantly alive on the screen.

The film's solemn moments — a scientific analysis of why dogs chase mailmen, for example — are balanced by breezier glimpses of the dog as boulevardier, roaming the streets of Mosman with a freedom that most dog owners would never understand. "The Wonderful World of Dogs," as Mr. Lewis sees it, is a wonderful place indeed.

Preceding Mr. Lewis's film on the program is "A Little Vicious," a 30-minute study by Immy Humes of the career of Bandit, who made headlines by biting several of his neighbors in Stamford, Conn. Bandit, who looks like a pit bull but is described by one mob-minded reporter as "a Staffordshire terrier with ties to the pit bull family," was deemed dangerous by local authorities and then, miraculously, saved from extinction. A dog trainer named Vicki Hearne offered to rehabilitate Bandit, and was given 90 days to do so. Ms. Hearne, believing that "dogs are made out of human language" and that "viciousness is a fairy tale," determined to make Bandit a living proof of her theoretical ideas about animal nature.

Human nature is more clearly illustrated here, in the contrast between Bandit's poor, black owners, who badly want him back, and Ms. Hearne, a white academic ready to introduce Plato and Socrates into her discussions of dog behavior. Ms. Hearne's statement that "the stuff about pit bulls is used to consolidate class and racial hostilities" is borne out by this story's outcome.

"A Little Vicious," amusingly narrated by Kevin Bacon, is a bit shapeless and overlong, but it pays rewarding attention to the little peculiarities of all concerned. Ms. Hearne, at the film's end, sings a little song she has made up about Bandit, in which "Bandit" is almost the only lyric. Lamon Redd, Bandit's original owner, complains furiously about the way he has been treated, while his daughter praises Bandit for his mercurial disposition. And the judges of the American Temperament Training Association, who hold Bandit's life in their hands, open umbrellas in his face and jump out at him wearing white sheets, in a display that says at least as much about dog-world professionals as about dogs themselves.

On the same bill, lasting only one minute, is "41 Barks," an animated film "drawn and barked by" Eli Noyes. Like the two other selections here, it's guaranteed to make an audience smile.

1991 My 23, C14:3

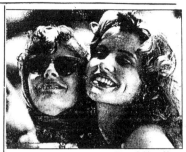

Metro Goldwyn Mayer

Susan Sarandon and Geena Davis.

Thelma and Louise

Directed by Ridley Scott; written by Callie Khouri; director of photography, Adrian Biddle; edited by Thom Noble; music by Hans Zimmer; production designer, Norris Spencer; produced by Mr. Scott and Mimi Polk. Running time. 120 minutes. This film is rated R.

Louise	Susan Sarandon
Thelma	Geena Davis
Hal	Harvey Keitel
Jimmy	Michael Madsen
Darryl	Christopher McDonald
Max	Stephen Tobolowsky
J. D.	Brad Pitt
Harlan	Timothy Carhart

By JANET MASLIN

"I DON'T remember ever feeling this awake!" exclaims one of the two freewheeling runaways of Ridley Scott's hugely appealing new road movie, as they race ecstatically across the American Southwest. Funny, sexy and quick-witted, these two desperadoes have fled the monotony of their old lives and are making up new ones on a minute-by-minute basis. Their adventures, while tinged with the fatalism that attends any crime spree, have the thrilling, life-affirming energy for which the best road movies are remembered. This time there's a difference: This story's daring anti-heroes are beautiful, interesting women.

Mr. Scott's "Thelma and Louise," with a sparkling screenplay by the first-time writer Callie Khouri, is a surprise on this and many other scores. It reveals the previously untapped talent of Mr. Scott (best known for majestically moody action films like "Alien," "Blade Runner" and "Black Rain") for exuberant comedy, and for vibrant American imagery, notwithstanding his English roots. It reimagines the buddy film with such freshness and vigor that the genre seems positively new. It discovers unexpected resources in both its stars, Susan Sarandon and Geena Davis, who are perfectly teamed as the spirited and original title characters. Ms. Sarandon, whose Louise starts out as a waitress, seems to have walked right out of her "White Palace" incarnation into something much more fulfilling. Ms. Davis may have already won an Oscar (for "The Accidental Tourist"), but for her the gorgeous, dizzy, mutable Thelma still amounts to a career-making role.

"Thelma and Louise," with a haunting dawn-to-nightfall title image that anticipates the story's trajectory, is immediately engaging. Even its relatively inauspicious opening scenes, which show the wisecracking Louise planning a weekend getaway with Thelma, a desperately bored housewife who hates her husband, Darryl (Christopher McDonald), have self-evident flair.

"Are you at work?" Thelma asks when Louise telephones her from the coffee shop where she is employed, somewhere in Arkansas. "No, I'm callin' from the Playboy Mansion," snaps Louise, who goes on to propose a fishing trip to a friend's cabin. "I still don't know how to fish," Thelma muses, nibbling on a frozen candy bar. "Neither do I, sweetie, but Darryl does it," Louise answers. "How hard could it be?"

Soon the two of them have taken off in Louise's turquoise Thunderbird convertible, with Thelma dressed for the occasion in ruffles, denim and pearls. Eager to escape her stifling home life, she has left behind a note for Darryl and borrowed a little something in return: his gun. Later that same evening, when Thelma insists on stopping at a honky-tonk bar despite Louise's protestations, the gun comes in handy. It is used, by Louise, to settle a dispute between Thelma and a would-be rapist (Timothy Carhart) in the parking lot, and it forever changes the complexion of Thelma and Louise's innocent little jaunt. From this point on, they are killers on the run.

Ms. Khouri's screenplay never begins to provide the moral justification for Louise's violent act. But it does a remarkably smooth job of making this and other outlaw gestures at least as understandable as they would be in a traditional western. It also invests them with a certain flair. When detectives investigate the slaying of this inveterate ladies' man, a local waitress says: "Has anyone asked his wife? She's the one I hope did it!" Later on, when cornering a truck driver who has pestered them

on the highway, Louise furiously asks, "Where do you get off behavin' like that with women you don't know?"

That "Thelma and Louise" is able to coax a colorful, character-building escapade out of such relatively innocuous beginnings is a tribute to the grace of all concerned, particularly the film's two stars, whose flawless teamwork makes the story gripping and believable from start to finish. On the run, Louise evolves from her former fast-talking self into a much more moving and thoughtful figure, while Thelma outgrows her initial giddy hedonism and develops real grit. Their transformation, particularly in its final stages, gives the film its rich sense of openness and possibility even as the net around Thelma and Louise closes more tightly.

Some of what Thelma learns en route comes by way of a foxy young hitchhiker named J. D. (Brad Pitt), who eradicates the memory of Darryl and also gives a memorable lesson, with the help of a hair dryer, in how to rob a convenience store. "My goodness, you're so gentlemanly about it!" exclaims Thelma. "Well now, I've always believed that if done properly, armed robbery doesn't have to be a totally unpleasant experience," J. D. says.

Like any good road movie, "Thelma and Louise" includes a number of colorful characters who wander entertainingly in and out of the principals' lives. Among them, in this film's fine cast, are Mr. Pitt, who so convincingly wows Thelma; Michael Madsen, bringing shades of Elvis Presley to the role of Louise's once foot-loose and now devoted beau, and Harvey Keitel and Stephen Tobolowsky, as two of the detectives on Thelma and Louise's trail. Mr. Keitel, in a role resembling the one he has in "Mortal Thoughts," has this time learned to say "mo-tel" in the spirit of the region, and conveys a great and touching concern for the renegades' well-being. His character alone, in a role that could have been perfunctory but is instead so full, gives an indication of how well developed this story is.

Among the film's especially memorable touches are those that establish its feminine side: the way Thelma insists on drinking her liquor from tiny bottles, or the way a weary Louise considers using lipstick after a few days in the desert but then disgustedly throws the thing away. "He's putting on his hat!" Louise confides to Thelma when a police officer stops them, which is surely not the kind of thing two male outlaws would notice. But the film's sense of freedom and excitement, as when the women exult in feeling the wind in their hair, goes well beyond sexual distinctions.

"Thelma and Louise" is greatly enhanced by a tough, galvanizing country-tinged score, and by Adrian

Biddle's glorious cinematography, which gives a physical dimension to the film's underlying thought that life can be richer than one may have previously realized. At the story's end, as Thelma and Louise make their way through Monument Valley and to the Grand Canyon, the film truly lives up to its scenery.

"I guess I've always been a little crazy, huh?" Thelma muses in this majestic setting.

"You've always been crazy," Louise acknowledges. "This is just the first chance you've ever had to really express yourself."

"Thelma and Louise" is rated R (Under 17 requires accompanying parent or adult guardian). It includes violence and strong language.

1991 My 24, C1:1

Drop Dead Fred

Directed by Ate De Jong; written by Carlos Davis and Anthony Fingleton; director of photography, Peter Deming; film editor, Marshall Harvey; music by Randy Edelman; production designer, Joseph T. Garrity; produced by Paul Webster; released by New Line Cinema. Running time: 98 minutes. This film is rated PG-13.

Elizabeth	Phoebe Cates
Drop Dead Fred	Rik Mayall
Polly	Marsha Mason
Charles	Tim Matheson
Janie	Carrie Fisher
Murray	Keith Charles
Young Elizabeth	Ashley Peldon

By STEPHEN HOLDEN

In "Drop Dead Fred," Phoebe Cates plays Elizabeth Cronin, a Minneapolis woman who is dumped by her philandering husband (Tim Matheson), loses her job as a court stenographer, and has her car and purse stolen, all in the space of an hour. Defeated, she moves in with her domineering mother (Marsha Mason), and on her first night back reunites with her imaginary childhood playmate Drop Dead Fred (Rik Mayall).

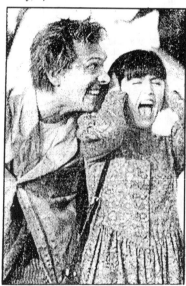

New Line Cinema

At Wit's End Rik Mayall and Phoebe Cates star in "Drop Dead Fred," about a woman whose imaginary childhood playmate reappears at a time when everything is going wrong.

A Peter Pan-like hellion with red hair, wild bloodshot eyes and a Cockney English accent, Fred was Elizabeth's partner in mischief when as a girl she prepared mud-pie banquets on the dining-room table and buried the family silver in her mother's gladiola patch. Reteamed, they pull a number of pranks, including sinking her best friend's houseboat.

"Drop Dead Fred" wants to be an offbeat cross between "Harvey" and "Beetlejuice," but it is more like a shrill, interminable episode of "I Dream of Jeannie." Sometimes the movie, which was directed by Ate De Jong, seems aimed at children, and at other times at adults. But the Freudian humor is so strained that it is difficult to imagine what grownup would put up with it.

With her wide-eyed stare and sly humor, Ms. Cates has always suggested a contemporary American "Alice in Wonderland." But her comic subtlety seems out of place in a movie where the rest of the acting is cartoonishly farcical. Mr. Mayall, the worst offender, plays Drop Dead Fred as the Jolly Green Giant gone bonkers. He is so apoplectically frenetic and unamusing that after two minutes of screen time one would like either to wring his neck or flee the theater.

"Drop Dead Fred" is rated PG-13 (Parents strongly cautioned). It includes some profanity.

1991 My 24, C8:1

Hudson Hawk

Directed by Michael Lehmann; screenplay by Steven E. de Souza and Daniel Waters, story by Bruce Willis and Robert Kraft; director of photography, Dante Spinotti; film editors, Chris Lebenzon and Michael Tronick; music by Michael Kamen and Mr. Kraft; production designer, Jack DeGovia; produced by Joel Silver; released by Tri-Star Pictures. Running time: 95 minutes. This film is rated R.

Hudson Hawk	Bruce Willis
Tommy Five-Tone	Danny Aiello
Anna Baragli	Andie MacDowell
George Kaplan	James Coburn
Darwin Mayflower	Richard E. Grant
Minerva Mayflower	Sandra Bernhard
Alfred	Donald Burton
Cesar Mario	Frank Stallone

By JANET MASLIN

Now and then, a Hollywood megabomb explodes with so much force that it actually sheds some light. "Hudson Hawk," a colossally sour and ill-conceived misfire, is at least a film from which someone may learn something, if only the hard way.

A star (Bruce Willis) out of touch with the qualities that have made him popular. A relatively new director (Michael Lehmann, who made "Heathers") who is in way over his head. And a producer (Joel Silver) who's known for vulgar hits ("48 Hours," "Die Hard" "Lethal Weapon") but this time delivers only vulgarity. These are contributing factors to the "Hudson Hawk" debacle, which is one of the very special ones, the kind that will be spoken of in the same breath with "The Bonfire of the Vanities" and "Howard the Duck." Smirky, mean-spirited cynicism is the spirit that unites all three.

Because this film has actually made its way to neighborhood theaters, it must be surmised that the above and other individuals monitored it while it was in the works. But the finished product belies that no-

Stephen Vaughan/Tri-Star Pictures

Jailbird Bruce Willis stars in "Hudson Hawk" as a cat burglar recently released from prison who is hired by a wealthy couple to steal three Da Vinci masterpieces.

tion. It's impossible to imagine anyone watching rushes of this film and walking away with the idea that things were remotely on track. Every frame of "Hudson Hawk" — even the peculiar, strained-looking photo of Mr. Willis that is used in the advertising art — spells disaster.

The opening sequence involves Leonardo da Vinci and may momentarily give the impression that you are watching the wrong film (as indeed you are). This episode, which is both jokey and confusing, gives way to a plot about the famed cat-burglar Hudson Hawk (Mr. Willis), who is, as he eventually puts it, "being blackmailed into robbing the Vatican by a psychotic American company and the C.I.A." Thrillers have no doubt been constructed out of flimsier material, but "Hudson Hawk" isn't serious about its own plot anyhow. It's more an exhaustingly whimsical farce, filled with hip asides that have no discernible point, than a story trying to command real attention.

Mr. Lehmann, who has previously shown some flair for subversive humor, this time lets each of the film's characters wander off in a different and crashingly unfunny direction. Mr. Willis, who can seem so effortlessly charming, this time is made to seem insufferably smug. (He is infinitely more appealing as a wife-beating sleaze in "Mortal Thoughts" than as this film's super-complacent hero.) Andie MacDowell is resolutely sweet in an insane role that has her making dolphin noises by the end of the film. James Coburn, as the mysterious figure who recruits Hudson Hawk, talks to four assistants who are named for candy bars. Danny Aiello, as Hudson's partner, commits heists while singing duets with Hudson (of "Side by Side" and "Swinging on a Star") in a manner that may make one long for the Sinatra rat pack, who at least did such things with good humor.

Also in the film is Sandra Bernhard, outstandingly ghastly as half of a power couple (with Richard E. Grant) intent on even more power. Frank Stallone appears briefly as a gangster to whom Mr. Willis gives "directions even your brother could understand."

What faint coherence the film has is ruined by unfunny throwaway humor, as if anyone here had wit to spare. Some of these bits have Mr. Willis pointlessly naming the playing times of familiar hit records; some refer to Nintendo; some are just plain silly, like "673 Wongs in the phone book! Hm. Helluva lot of Wong numbers!"

And some are playfully vicious, like a comical throat-stabbing or the gag that has Mr. Willis pushing a case of syringes into the face of someone who attacks him. It's only May, but that just might be the worst joke of the year.

"Hudson Hawk" is rated R (Under 17 requires accompanying parent or adult guardian). It includes violence and profanity.

1991 My 24, C8:4

Only the Lonely

Written and directed by Chris Columbus; director of photography, Julio Macat; edited by Raja Gosnell; music by Maurice Jarre; production designer, John Muto; produced by John Hughes and Hunt Lowry; released by 20 Century Fox. Running time: 120 minutes. This film is rated PG-13.

Danny	John Candy
Rose	Maureen O'Hara
Theresa	Ally Sheedy
Patrick	Kevin Dunn
Doyle	Milo O'Shea
Spats	Bert Remsen
Nick	Anthony Quinn
Sal	James Belushi
Billy	Macaulay Culkin

By JANET MASLIN

Danny Muldoon (John Candy) may not be someone only a mother could love, but he is no one's idea of a romantic leading man. And as it happens, Danny has a mother (Maureen O'Hara) who *does* love him, so much

Don Smetzer/20th Century Fox

John Candy

that it hurts. This has contributed immeasurably to Danny's isolation from other women.

"My son the anorexic!" scoffs his mother when Danny tries to lose weight by eating yogurt instead of Danish for breakfast.

"Oh, Danny! I hope you enjoyed your baseball game!" she cries weakly after falling to her death in one of Danny's morbid fantasies, this one about what would happen if he went with friends to a ball game instead of accompanying his mother to play bingo.

"Black death!" she exclaims when Danny tells her he has begun seeing a woman who is not Irish and happens to be Sicilian. Danny's mother seems to regard bigotry as a way of protecting her son even further.

"Only the Lonely," written and directed by Chris Columbus, is the

ence to share his preoccupation with the evolution of a work of art, a process that also relates to the evolution of the film itself and of the personal relationships within it.

"La Belle Noiseuse" is not a movie designed to keep the mass audience on the edge of its mass seat.

◼

"Anna Karamazova" is an introspective, sometimes utterly opaque meditation on the legacy of Stalinism. A woman (Jeanne Moreau) who is never named returns to a city (Leningrad) that is never identified after having spent years in a labor camp. She wears an impassive expression, a large 1930-ish off-the-face hat and black stiletto heels that click with inexplicable menace on cobblestones, parquet and marble. (The woman does a great deal of purposeful walking throughout the film.)

The world to which she returns is picturesquely bleak. It is garbage-littered, burned out, either dying or dead, possibly not even real, inhabited by ghouls in theatrically extravagant makeup.

Most of the film is photographed in rich, magnificent color, but stuck more or less in the center is an extended sequence shot in black and white. This seems to be out of an old silent film, except that the material is not silent.

The film never makes reference to its title, which, the publicity material explains, recalls an anecdote told by Vladimir Nabokov, who was once asked by an American student to talk about that great Russian novel "Anna Karamazov."

The language spoken in "La Belle Noiseuse" is French; in "Anna Karamazova," Russian. More significantly, both films speak a cinema language that has almost nothing to do with the language of popular movies as it has evolved in Hollywood and other movie centers around the world.

In what Hollywood calls "audience pictures," which may include those of Spike Lee and David Mamet as well as those of Steven Spielberg and John Landis, action is character.

Some films are unlike any others, and all that one can do is surrender to their allure and accept what they offer.

In the other category, action is minimal and character is elusive, sometimes created by talk, sometimes through an accumulation of surreal visual impressions. The point of the film may be wittily self-evident, as in the best work of Jacques Rivette and Eric Rohmer, but in several films shown here this year, it is revealed only in program notes furnished by the director.

These films demand that the viewer put aside ordinary expectations and attend as much to what is not on the screen as to what is there. The mind's response is more important than what happens to the emotions. Watching such films can be exhilarating or boring beyond endurance. Sometimes it's like arm wrestling with a ghost. There's nothing to grab hold of.

Some of the most arresting, most beautiful and, occasionally, most infuriating films at this year's festival speak this other language, which, when it comes out garbled, is as arcane as Old High German, though it can also be mind expanding.

◼

This was the delirious effect of 16 minutes of material from Peter Greenaway's new feature, "Prospero's Books," an adaptation of "The Tempest" in which Sir John Gielgud appears as Prospero.

"Prospero's Books" had been scheduled to compete at the festival but was withdrawn at the last minute because it couldn't be completed in time. By way of apology, Mr. Greenaway brought the film's first reel to Cannes, where it was presented at a special late-afternoon screening in the main auditorium of the Palais du Festival.

The reception was so enthusiastic that one critic suggested that Mr.

In most Hollywood films, action is character.

Greenaway should scrap the rest of the film and just release this first reel. That's not being quite fair. What we saw the other afternoon is dazzling, even to someone whose tolerance for Mr. Greenaway's films after "The Draughtsman's Contract" (1982) has not been consistently positive. It was also suggested that the 16-minute running time had something to do with the success of this special showing, though I doubt it.

The difficulty with "The Cook, the Thief, His Wife and Her Lover" (1989) and some of Mr. Greenaway's other films, loosely labeled post-modernist, has never been their exhausting length. None of these films has run much longer than "The Terminator." In fact, one of Mr. Greenaway's wittiest and most efficient films, "The Falls" (1980), runs almost three hours.

The difficulty, instead, has stemmed either from arcane reference or from an explosion of décor and color that has the effect of overwhelming the less than explosive ideas that the effects were intended to make resonant.

Mr. Greenaway is not a frivolous film maker. He doesn't shoot a lot of material with the expectation of stumbling upon a found object within. His films are planned from the first frame to the last, sometimes so carefully that his schemes are, if anything, too evident.

The material from "Prospero's Books" looked glorious even before the director stood up at a post-screening news conference to talk about what he is up to in this new work. The first reel, titled "1. The Book of Water," is clearly the opening of "The Tempest" deconstructed. Sir John, as the ancient lord of some kind of heavenly, water-soaked domain, prepares to create the world, the characters and circumstances of "The Tempest."

The images, sometimes contained within smaller frames within the film frame, are a collection of tumultuous visions, suggesting a great library of the gods as imagined by Renaissance painters; Mr. Greenaway said later that Veronese and Titian were among his models. As Shakespeare/Prospero writes the opening of the play, the great Gielgud voice is heard speaking not only Prospero's lines but also those of the other characters.

Books are seen everywhere. The text of the play is glimpsed in close-up images of old script, of writing, images that remind one of the work of Saul Steinberg, of his fondness for the orderly grace of thought systematized in print. As ideas bewitch in these scenes from "Prospero's Books," so does the beauty of the handwriting than contains those ideas.

At his news conference, Mr. Greenaway said he hoped that by keeping the text of the play intact, and that by having the presence of an actor of Sir John's classical tradition, he would gain the license to explore other ways of dealing with the play.

The director's remarks clarified what the audience saw, but much of his intent and method were already apparent.

*John Gielgud in Peter Greenaway's "Prospero's Books"—
The first 16 minutes, shown at Cannes, were dazzling.*

Reuter

Jeanne Moreau in "Anna Karamazova"—It is an introspective, sometimes utterly opaque meditation on the legacy of Stalinism.

This is not true of some of the festival's other films, for which one must use the production notes much in the way that the audience at a concert of a work by a new composer might use a musical score.

"Anna Karamazova" makes almost no sense when it is seen cold. With notes furnished by the producer, the film exemplifies the sort of personal, self-addressed cinema that one can fathom only on its own terms. Every image must be looked at in its entirety. Attention isn't guided by the editing. Logic and plausibility have no place in the narrative. The key to "Anna Karamazova" is contained in the director's biographical material. Though the film was made entirely in the country of his birth, Mr. Khamdamov is quoted as saying: "I grew up in the Soviet Union and I got nothing out of it. Everything I was taught went in one ear and out the other. It isn't easy, but I can say that during all those years anything that had to do with the Soviet Union was a void to me."

Strong words, and utterly necessary to comprehend the movie's terrifying vision.

The production notes also reveal that the black-and-white footage within "Anna Karamazova" is all that remains of the material Mr. Khamdamov shot for a 1974 production, "Slave of Love," later filmed in grand color by Nikita Mikhalkov. When the Soviet authorities found that Mr. Khamdamov wasn't shooting the screenplay they approved, they shut down his production and destroyed two-thirds of the material he had shot. He includes the remaining footage in "Anna Karamazova" more or less as a testament to his own survival. The sequence doesn't otherwise make any sense whatsoever.

Far more entertaining, but ultimately no less enigmatic, is "The Double Life of Veronica," the new film by Krzysztof Kieslowski, the Polish director whose "Short Film About Killing" was a big hit at Cannes in 1988. "The Double Life of Veronica" is about two young women, both named Veronica, one Polish, the other French, both played by the radiantly pretty Irene Jacob of France, who won the award for best actress here last week. The paths of the two Veronicas cross only once, when the Polish Veronica notes the French Veronica taking pictures of a political demonstration in Cracow. The first third of the film is about this Polish Veronica, who has been gifted with an extraordinary singing voice, which she insists on developing, although it puts a fatal strain on her heart.

The rest of the film is about the French Veronica, who is somehow aware that she is not alone, and that she has died. This Veronica also is a musician, but she abandons music to give herself to a fulfilling lover. She achieves something akin to happiness.

∎

Is "The Double Life of Veronica" really "about" something and, if so, what? I'm not at all sure; but in this case, the movie is such a magnificent visual and aural experience that conventional meaning is not terribly important. Reduced to their synopses, these other-language films are often hilarious. "The Double Life of Veronica" is not absurd. It's a most seductive though obtuse movie, photographed in ravishing color and in vividly precise images that are as evocative as fine prose. To give it a chance, to enjoy it, you have to forget all those other movies that do your thinking for you. Yet, as you surrender your autonomy and give yourself over to whatever the film has to offer, you also stand to be liberated, at least for a little while.

That's one of the ways in which art works.　□

1991 My 26, II:9:2

Soapdish

Directed by Michael Hoffman; screenplay by Robert Harling and Andrew Bergman, story by Mr. Harling; director of photography, Ueli Steiger; edited by Garth Craven; music by Alan Silvestri; produced by Aaron Spelling and Alan Greisman; released by Paramount Pictures. Running time: 100 minutes. This film is rated PG-13.

Celeste Talbert	Sally Field
Jeffrey Anderson	Kevin Kline
Rose Schwartz	Whoopi Goldberg
David Barnes	Robert Downey Jr.
Montana Moorehead	Cathy Moriarty
Lori Craven	Elisabeth Shue
Betsy Faye	Carrie Fisher
Edmund Edwards	Garry Marshall

By JANET MASLIN

Perspective in the frenetic new comedy "Soapdish" is provided by Jeffrey Anderson (Kevin Kline), a down-at-the-heels actor appearing in a dinner-theater production of "Death of a Salesman" in Opa-Locka, Fla. Dinner theater: this means Jeffrey performs in the corner of a big room that is otherwise filled with restaurant patrons, many of whom are hard of hearing. "Death of a Salesman": that means a poster touting Jeffrey's appearance as "Willie" Loman and a stage manager who insists on calling him "Mr. Loman" because she doesn't remember his real name.

Opa-Locka, Fla.: this is the sort of place to which Jeffrey has been relegated ever since he was bounced from the cast of "The Sun Also Sets" 20 years ago, having offended the popular soap opera's reigning queen, Celeste Talbert (Sally Field). Jeffrey's life in the land of dinner theater proves there really is something worse for an actor than appearing on "The Sun Also Sets," although the film's scattered, hilarious glimpses of

Where 'cheap' and 'insecure' are the nice things you can call someone.

this daytime soap offer strong evidence to the contrary.

●

"Soapdish," an uneven but often sidesplitting look at the soap opera cast and its conspiratorial backstage antics, needs Jeffrey Anderson to open up its otherwise very small world. Mostly confined to a deliberately infernolike studio set, with offices extending from its sound stage and with décor and costumes often a hellish red, it enters wholeheartedly into the iffy mental state of longtime soap opera denizens living in a weirdly elastic universe. After years of experience, the show's creative team has learned to believe that no plot development is too contrived, dishonest or counterproductive if it helps to further the private interests of at least one staff member with an ax to grind.

So it's possible for Celeste to appear on the show in a crisp polka-dot party dress while dispensing meals to the homeless in a soup kitchen and find that no one bats an eye. The staff of "The Sun Also Sets," after all, has seen its heroine in prison in another episode, clutching the bars of her cell (with a very good manicure) and declaring herself "guilty of love in the first degree!" The staff is guilty of far worse.

Bonnie Schiffman / Paramount
Kevin Kline and Sally Field

One new plot development proposed during the course of "Soapdish" involves a brain transplant performed in a restaurant. Another introduces a young woman who is mute and homeless (Elisabeth Shue, as the story's ingénue) with "a chemical imbalance," which someone refers to casually as "the Bill Styron thing."

"Soapdish," directed with good-natured zest by Michael Hoffman, has as serious a split-personality problem as any of its characters, perhaps because its screenplay is the work of Robert Harling (who wrote the story) and Andrew Bergman, two screenwriters with decidedly different comic sensibilities. The story's antic off-camera melodrama about the actors' real lives has the ring of Mr. Harling's "Steel Magnolias," and thanks to too many dread secrets it often feels like overkill; the problems between the newly reunited Celeste and Jeffrey wear thin long before Celeste climbs a fire escape to peer into Jeffrey's apartment window.

The film is funnier when sticking to its "Sun Also Sets" show-business ambiance, in scenes that are wryly uproarious in the manner of Mr. Bergman's script for "The In-Laws." A sequence in which Jeffrey, playing a doctor, proves himself totally unable to read a prompter (he declares one patient to have "a rare case of brake fluid" when he means "brain fever") is particularly amusing.

●

Mr. Kline, as in "I Love You to Death" and "A Fish Called Wanda," proves himself to be an utter delight playing a serenely fatuous ladies' man with a great flair for physical clowning. Ms. Field is more brittle as Celeste, but her shrillness makes her an entertaining fulcrum for the pandemonium that surrounds her. Whoopi Goldberg is especially deft in the small but overheated role of Rose Schwartz, the loyal writer who watches out for Celeste's best interests even when the show's quietly diabolical producer (Robert Downey Jr., wonderfully understated as the straight man) tries to turn her into the mother of her archrival. Cathy Moriarty plays this competitor in a loud, peculiar manner that makes more sense by the time the story is over.

In smaller roles are the director Garry Marshall, playing a network executive who touts "two words I like: I like the word peppy and I like the word cheap," and Carrie Fisher, seen enthusiastically interviewing bare-chested actors auditioning to play the part of a waiter with a one-line role. Kathy Najimy, holding pins between her teeth, has some funny moments as a shy costumer trying to talk Celeste into various Nolan Miller outfits, which speak a language all their own. Mr. Miller and Eugenio Zanetti, the production designer, give the film a loud, happily preposterous look that amounts to a satirical edge. Particularly nice touches in "Soapdish" include its jaunty neo-1950's title sequence, in which Ms. Goldberg's Rose takes Celeste for "a trip across the George Washington Bridge" (their code for surprise appearances at New Jersey shopping malls, where Rose pretends to be a fan and triggers a stampede of autograph seekers to bolster Celeste's wobbly ego) and Mr. Kline's explanation of why Jeffrey envisions himself as a one-man Hamlet, since he thinks all the play's action essentially takes place in Hamlet's head.

"Am I crazy?" he asks Mr. Downey, who plays the producer. "No,"

Mr. Downey assures him, without missing a beat. "That actually clears up a lot of things for me."

•

"Soapdish" is rated PG-13 (Parents strongly cautioned). It includes mild profanity and sexual references.

1991 My 31, C10:1

Everybody's Fine

Directed by Giuseppe Tornatore; original screenplay by Mr. Tornatore; co-writer, Tonino Guerra; in Italian with English subtitles; cinematographer, Blasco Giurato; edited by Mario Morra; music by Ennio Morricone; produced by Angelo Rizzoli; released by Miramax Films. At Lincoln Plaza, Broadway and 63d Street. Running time: 112 minutes. This film has no rating.

Matteo Scuro	Marcello Mastroianni
Woman on the train	Michèle Morgan
Canio	Marino Cenna
Guglielmo	Roberto Nobile
Tosca	Valeria Cavali
Norma	Norma Martelli

By VINCENT CANBY

It can be said of Giuseppe Tornatore's "Everybody's Fine" ("Stanno Tutti Bene") that it's the film that everybody who disliked his sentimental "Cinema Paradiso" was afraid he could make if he tried hard enough. It opens today at the Lincoln Plaza.

The new movie stars Marcello Mastroianni as Matteo Scuro, a willfully boring old man who sets out from his home in Sicily to visit each of his five beloved children now living in Italy. To the astonishment of only Matteo, as he dodders slowly up the boot of Italy, each child turns out to be a failure of one degree or another.

Mr. Mastroianni, that icon of the Italian cinema, is less bad than dim. His performance is obscured by some dreadful hairpieces and a pair of glasses whose lenses look as if they were chopped off the bottoms of two Coca-Cola bottles.

•

The glasses give his eyes the appearance of huge brown polka dots, and they have, I'm afraid, a point to make: Matteo has seen all, but steadfastly refuses to understand anything about his children. Nothing about the old man is credible, including his mustache.

He has two character traits intended to be endearing. He talks in long, information-filled paragraphs to his off-screen wife. When talking to someone clearly visible, he insists that the other person ask him why he believes this or that to be true.

The children are as dim as their dad, including one son, a musician, who plays the bass drum with a symphony orchestra, and a daughter who hides the fact that she has a child born out of wedlock.

•

The only halfway decent performances in the film are given by Michèle Morgan, who plays a still magnificently beautiful woman in her seventies, and Salvatore (Toto) Cascio, who overplayed the precocious little boy in "Cinema Paradiso." He appears here as one of Matteo's sons as a child. Neither Miss Morgan nor Mr. Cascio has much to do, but they seem to be alive and well. The others are zombies.

From time to time Mr. Tornatore stops everything to pay tribute to the films of Federico Fellini, which, like old Matteo and his children, he has

obviously seen without comprehending.

One sequence is set in Rimini, Mr. Fellini's birthplace and the setting for "I Vitelloni." There are also several startling visual effects that, in a Fellini film, might be showstoppers. In this dreary landscape they look as out of place as billboards in a desert.

1991 My 31, C12:6

Termini Station

Produced and directed by Allan King; written by Colleen Murphy; director of photography, Brian R. R. Hebb; edited by Gordon McClellan; music by Mychael Danna; production designer, Lillian Sarafinchan; presented by Saturday Plays. At the Bleecker Street Cinema, at La Guardia Place. Running time: 105 minutes. This film has no rating.

Molly Dushane	Colleen Dewhurst
Micheline Dushane	Megan Follows
Harvey Dushane	Gordon Clapp
Liz Dushane	Debra McGrath
Charles Marshall	Leon Pownall
Delaney	Elliott Smith

By STEPHEN HOLDEN

Kirkland Lake, the setting for "Termini Station," is a northern Ontario mining town of such unrelieved drabness that it is easy to see why the movie's characters are either on the brink of going stir-crazy, or well over the line. Under thin, distant sunlight, the streets are encrusted with a layer of dirty slush. What local action there is takes place in the vicinity of a dingy tavern populated by hard-drinking hunters and miners.

The film, which opens today at the Bleecker Street Cinema, views this world through the embittered eyes of 20-year-old Micheline Dushane (Megan Follows), and her dotty, alcoholic mother, Molly (Colleen Dewhurst). Nine years earlier, Micheline's father took her into the woods, aimed a rifle at her head and at the last moment turned the gun on himself.

•

The suicide, which is recalled in flashes, has devastated the Dushanes and left them tinged with scandal.

Northern Arts Entertainment

Outward Bound Dreams of escape preoccupy Megan Follows and Colleen Dewhurst, who portray daughter and mother in a dreary Canadian mining town.

Micheline, who hides her wounds under a veneer of tough, foul-mouthed bravado, works in a local 5-and-10, hangs out with two prostitutes, and on occasion turns tricks herself at the Greyhound station. Molly, who lives in an upstairs bedroom of her son Harvey's ugly prefabricated house, guzzles booze and listens obsessively to opera recordings. Harvey (Gordon Clapp) is a local tire dealer who wants only to forget the past, make a little money, and live a comfortable life with his meek, chirpy wife, Liz (Debra McGrath).

All the partially healed wounds of the past are suddenly reopened when Micheline learns that Molly's former lover, a Mr. Stein, has died; when she delivers the news to her mother it is received like a death blow. Slowly, Molly starts to go over the edge. One night while her son is entertaining his boss, she emerges from her lair and descends the stairs like a demented opera diva, announcing that she is going to Rome. Micheline meanwhile becomes obsessed with buying the dead man's battered old DeSoto, which she discovered at a local used-car lot priced at 10 times its actual value.

•

A story that could have been treated as a melodrama has been turned instead into a darkly amusing comedy by the writer Colleen Murphy and the producer and director Allan King. Internal family fueding has its funny side, and the film's triumphs lie in the precision of its insights into familial wounds, and resentments that can explode like dynamite. In the last third of the movie, a tragicomic portrait turns farcical as the characters frantically chase each other down the highway to Montreal.

Miss Murphy's screenplay is at once pointed in its psychological accuracy and flaky in a quasi-documentary way that gives the action an off-kilter spontaneity. When the chase is at its peak, the screenplay throws in extraneous little details — like the search for a blanket in the trunk of a car — that inject a realistic note of comic confusion.

•

As Molly, a woman of huge, pent-up passions, Ms. Dewhurst has one of the meatier roles of her career. Instead of playing the character as simply crazy, she veers between apparent irrationality and a canny knowingness to suggest how craziness can be a strategy for staying in control. Some of the actress's most telling moments are found in the burning, resentful glances she casts at her son as he trundles her off to a hospital. Like Geraldine Page in Woody Allen's "Interiors," Ms. Dewhurst communicates a deep underlying rage about physical and emotional ravages wrought by time on a proud, willful individual.

As strong as Ms. Dewhurst is, the movie ultimately belongs to Ms. Follows, whose Micheline is a fascinating mixture of street urchin, wounded child and backwater sophisticate. In a performance that is untainted by sentimentality, Ms. Follows creates an acute portrait of a smart young woman who keeps herself together by following her reckless impulses. To do anything else would be to risk coming apart.

1991 My 31, C14:5

Love Without Pity

Directed and written by Eric Rochant; in French with English subtitles; director of photography, Pierre Novion; film editor, Michele Darmon; music by Gérard Torikian; produced by Alain Rocca; released by Orion Classics. At Cinema Third Ave., at 60th St. Running time: 95 minutes. This film is rated R.

Hippo	Hippolyte Girardot
Nathalie	Mireille Perrier
Halpern	Yvan Attal
Xavier	Jean Marie Rollin
Francine	Cécile Mazan
The Mother	Aline Still
The Father	Paul Pavel

BY JANET MASLIN

The art of smoking thoughtfully is of great importance to anyone who has ever seen "Breathless," and Eric Rochant, the writer and director whose first feature film is "Love Without Pity," has undoubtedly seen it many times. His own film's disaffected romantic hero, a petulant Parisian anti-yuppie nicknamed Hippo (Hippolyte Girardot), appears to have modeled much of his own behavior on early roles played by Jean-Paul Belmondo and Gérard Depardieu, although he lacks the traffic-stopping raffishness that each of them had to spare. "You're like existentialists, but 20 years too late," an even less attractive minor figure says of Hippo and an equally sullen friend.

"Love Without Pity," which opens today at Cinema Third Avenue, begins by making no bones about its central character's unappealing qualities. Pouty and self-satisfied, living idly off the income of his drug-dealing teen-age brother, Hippo is seen watching a news report of violence in South Africa and grumbling, "Put 'em in a kettle and eat 'em all!" to no one in particular. The film may intend this as a meaningful sign of Hippo's alienation and of how far he has to go once love transforms him, but it is far from inviting. A character like Hippo, unless devastatingly attractive, can be a terrific bore.

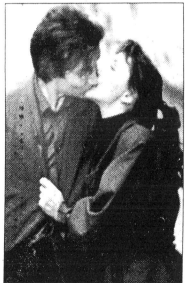

Dominique Gerard/Orion Classics

Fated Hippolyte Girardot and Mireille Perrier star in the French film "Love Without Pity" ("Une Monde Sans Pitié"), about a young man without direction in life who falls in love.

Not much more appetizing is the romantic streak that has Hippo offering world-weary come-ons to various women, like Nathalie (Mireille Perrier), who happens to be sitting in a double-parked car that blocks his own. "What's to stop us now?" Hippo asks, having climbed into the car in which Nathalie is sitting. "Everything," she replies.

"But aside from that?" Hippo continues. "Nothing," Nathalie says. Neither the film nor Mr. Girardot has enough panache to make this seem anything but labored and flat.

If the film, in watching as Hippo is transformed by his attraction to Nathalie into a slightly less petulant figure, intends him as a representative of the hip, aimless crowd that often gathers casually in his apartment, it is seldom acted with enough flair to make its point. Mr. Girardot and Ms. Perrier are adequate within the limits of their roles, but the film's minor characters (especially a nagging ex-girlfriend of Hippo's, played by Cécile Mazan) are a remarkably uninteresting bunch.

Not even Hippo's trademark philosophy ("We got nothing. All we can do is fall in love and that's worse than anything.") amounts to much of a rallying cry for either the viewer or the film's other characters, who in any case have little to do besides field Hippo's insults or mimic his boredom. The film is not helped by wan, listless cinematography or by graceless subtitles that often leave it sounding more glum than it had to.

●

"Love Without Pity" is rated R (Under 17 requires accompanying parent or adult guardian). It has profanity and sexual situations.

1991 My 31, C16:4

Ambition

Directed by Scott D. Goldstein; screenplay by Lou Diamond Phillips; director of photography, Jeff Jur; edited by Mr. Goldstein; music by Leonard Rosenman; production designer, Marek Dobrowolski; produced by Richard E. Johnson; released by Miramax Films. Running time: 100 minutes. This film is rated R.

Mitchell	Lou Diamond Phillips
Albert	Clancy Brown
Julie	Cecilia Peck
Jordan	Richard Bradford
Freddie	Willard Pugh
Mrs. Merrick	Grace Zabriskie

By JANET MASLIN

The bookstore clerk seen dusting off copies of a new nonfiction book about a mass murderer in "Ambition," which opened yesterday at the Sutton and other theaters, happens to be the mass murderer himself. It is this film's scary premise that an over-eager writer who has been unable to sell his own memoir might improve his fortunes by laying claim to a real killer as a subject — and then goading the killer into renewed violent activity, just for the sake of a more salable story.

Lou Diamond Phillips, who wrote the offbeat but sometimes overly mild screenplay, stars in "Ambition" (which was directed by Scott D. Goldstein) as a bookstore manager and aspiring author named Mitchell Osgood, who is a strenuously assimilated Filipino-American. Frustrated over his own stalled career, Mitchell decides to manipulate the fragile pysche of Albert Merrick (Clancy Brown), who has been released from

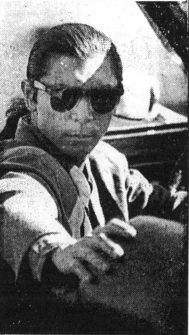

Miramax Films
Lou Diamond Phillips in "Ambition."

prison after what looks like a remarkably short stay, in view of his widely publicized murderous rampage through a crowded nightclub.

In any case, Mitchell quickly befriends Albert and offers him a job, which proves to be a good way of keeping Albert under surveillance. Mitchell does this despite the warnings of Albert's parole officer (Richard Bradford), who says, "Tell me something, Mr. Osgood: Do you think it'd be ethical for me to lead you to Merrick so you can mess around with his head?"

●

Mitchell apparently does. And he has so many thoughts of his own on this subject that he tampers with Albert's medication, arranges a traumatic reunion between Albert and his mother (Grace Zabriskie), and tries to interest Albert in Mitchell's father (Haing S. Ngor), who is very ill and has begun to get on Mitchell's nerves.

"Ambition" has enough of a film noir spirit to hold some interest, but its direction is less stylish than matter-of-fact. And Mr. Phillips's screenplay tries too hard to provide unwanted psychological insights into the characters' darker motives, which in a story like this are best left in the dark.

Mr. Phillips himself, while displaying much more range than he has been able to in desperado roles, is never so convincingly jaded or corrupt as the character he has invented for himself to play. Still, his scenes with Mr. Brown, who makes Albert a frightened, pitiable giant, have an edgy unpredictability that helps this alarming story come to life.

●

"Ambition" is rated R (Under 17 requires accompanying parent or adult guardian). It contains profanity, partial nudity and some violence.

1991 Je 1, 16:3

FILM VIEW/Caryn James

Movies Are Viewing Old Age With Some Fresh Wrinkles

FORGET THOSE CLICHÉS ABOUT apple-cheeked grannies. The little old ladies on screen today have more in common with pit bulls. Maureen O'Hara, her red hair and her temper still flaming, is so selfish, manipulative and possessive of her grown son in "Only the Lonely" that she nearly ruins his life, with behavior that ranges from insulting his Sicilian girlfriend to insisting he eat his usual Danish pastry for breakfast instead of yogurt — a cruel gesture considering he's played by John Candy and he's trying to lose weight.

The title character in "Tatie Danielle" is like the bad seed grown old. Auntie Danielle's only joy in life is thinking up new ways to torment and humiliate the kindly relatives who have taken her in. Faking incontinence is a favorite trick, though now and then she just kicks their dog. These seriocomic films seem to ask: what to do about dear old Mom? You can't live with her; you can't throw her from a train.

■

Aging fathers only seem to come off better in two current, outrageously sentimental films. Dirk Bogarde, as a dying man in his 70's, is utterly charming and attentive to his grown daughter in "Daddy Nostalgia," but he is making up for years of childhood neglect. And when Marcello Mastroianni, got up in thick glasses and a bristly white mustache, goes off to visit his five grown children in "Everybody's Fine," they are too terrified to reveal the truth about their messy lives. The audience has to wonder what kind of monstrous parent this gentle old man used to be.

This is not elder-bashing. In a slightly perverse way, it's a compliment. These films do old people the credit of treating them as individuals rather than stereotypes, of seeing them as people who were not perfect in youth or middle age and who aren't about to magically sweeten up now. They are not always likable, but they are real and are treated with as much sympathy as their frequent pigheadedness allows.

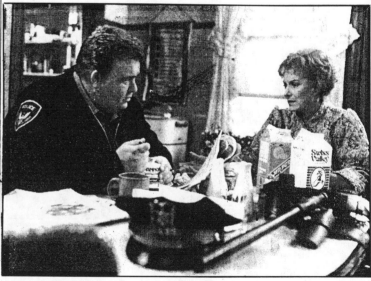

Don Smelzer/20th Century Fox
John Candy and Maureen O'Hara in "Only the Lonely"—truth and pain in the mother-son relationship

Miramax

Tsilla Chelton in "Tatie Danielle"—She's like the bad seed grown old.

Still, there is a definite current of generational conflict here, which is not surprising since three of the directors are still in their 30's: Chris Columbus, who wrote and directed "Only the Lonely," is 32; Giuseppe Tornatore, the director and co-author of "Everybody's Fine," is 34; and Etienne Chatiliez, who directed "Tatie Danielle," is 38. Bertrand Tavernier is 50, but "Daddy Nostalgia" is shaped by a similar perspective, that of adult children trying to enter the mysterious minds of their elders.

These days, grandma and grandpa are real people with real flaws.

So while old people are given center stage, these films are really exploring the barriers between the generations. The values of grown children come smashing up against those of their parents. Middle-aged people deal with the guilt-ridden question of how to care for elderly relatives. In both generations, resentment and love mingle as the films attempt to understand old age — an issue films rarely consider.

Given how emotionally fraught and complex these problems are, it makes sense that comedy and sentimentalityare the strategies for addressing them. These approaches make the characters and the serious themes easier for audiences to take.

In fact, the trailblazing film of recent generational conflict is "Throw Momma From the Train," a 1987 work directed with black comic glee by Danny DeVito. He also stars as a put-upon single man who arranges for a friend to bump off his annoying mother. Anne Ramsey's role as Momma makes her son's motivation awfully plausible. She barks orders at him, then calls him stupid and a loser. No helpless little old lady, she is a bellowing matriarch unable or unwilling — in this kind of broad comedy the difference hardly matters — to see that her son needs to be released from his slavish attachment to her apron strings. It's possible to think about murdering her because she is conceived as a cartoonish character.

It is a major step from the exaggerated Momma to Miss O'Hara's tough-minded, realistic and risky performance as Rose in "Only the Lonely." The film is billed as a comic romance, but there is much emotional truth and pain in the mother-son relationship. As Danny, a policeman trying to break free of his widowed mother so that he can marry a sweet, shy woman, Mr. Candy is extremely touching. He expertly avoids pathos and balances the comedy of Danny's thwarted courtship with his emotional strangulation.

But Rose, in the film's most daring move, is not funny at all. She comes close to being totally unlikable. As her 38-year-old son takes baby steps toward independence, her cruelty and poor-me manipulations escalate. She starts by coercing Danny into giving up tickets for a baseball game; she won't pass up one week of bingo and won't go without him. Eventually she tells Danny's girlfriend she looks like a boy and tries to get her son to move with her from Chicago to Florida. Even her priest wonders if she realizes she's living in the 20th century.

■

Mr Columbus has said he modeled Rose on Mary Kate Daniher, the character Miss O'Hara played in "The Quiet Man." But unlike Mary Kate, Rose leaves the audience guessing whether her good nature will finally poke through her defensive anger. By the time the situation explodes, it is possible to believe every word Danny yells at his mother — that she has always selfishly hurt people by blurting out insults in the name of truth. She is not excused because she is old and afraid of being alone; she is not patronized.

It might have been too much to hope that the film would avoid a contrived, melodramatic happy ending. Still, "Only the Lonely" has an emotional resonance that comes from its portrayal of a tough old woman.

"Tatie Danielle" is even less saccharine, and more savagely comic. Danielle is not just looking for attention; she seems to enjoy abandoning her sweet little grandnephew in the park. As she insists on being her vicious self, the film mocks the way we treat the elderly, as if old age were some disease that wipes out personality and will. It takes a very long time for the family to whisper incredulously among themselves, "I think she's mean," as if they were saying "Auntie is from Mars." They can't imagine that an old lady could be so purposefully vile.

The only person Danielle actually likes is Sandrine, a young woman paid to stay with her while the family is on vacation. Sandrine not only sees through and thwarts Danielle's tricks, she dares to slap her when she misbehaves and eventually leaves her on her own. The young woman's behavior is not perfect, but at least she treats Danielle like a human being instead of an age. When Sandrine leaves, Danielle reverts to behavior so bad and deceitful she ends up on the television news as an abandoned old lady. She shamelessly uses the stereotype of old age to gain sympathy, while her creators are wittily blowing that stereotype apart.

■

The clichés that female characters have left behind seem to have been picked up by men. "Daddy Nostalgia" and "Everybody's Fine" wrap their heroes in the kind of protective, parental glow ordinarily reserved for moms. "Daddy Nostalgia," from its title to its flashbacks of the school-age daughter being pushed away by her busy father, is at least honest about its intensified emotional aura and its hero's flaws, which can be forgiven but never erased.

"Everybody's Fine" is more problematic, because it raises disturbing questions almost in spite of itself. When the old man fantasizes a confrontation with his family, they appear as their childhood selves and explain that they lied because they didn't want to disappoint him. In the imaginary scene, one son says, "You always wanted us to be the best. You yelled and yelled and you hit us, remember?"

His not-so-terrible crime is having loved too much and too harshly, and his recognition of that failure makes him the hero of his own story. This mawkish approach diminishes him as an individual and allows the film to fly too quickly past the way he might have scarred his children's lives.

However sentimentalized or comically exaggerated, the attention to old people adds a rich new dimension to films. As the population ages, more older people are likely to be realistically depicted. At least one revealing portrayal has already arrived. In "Strangers in Good Company," a film by the 50-year-old Canadian director Cynthia Scott, a group of elderly women camp out together in a cabin in the woods after their bus breaks down. The largely plotless film, with nonprofessional actresses recalling their life stories for one another,

Resentment and love mingle as recent films try to understand the elderly.

sounds as if it might be hopelessly goody-goody, which it is not. The characters are strong but not super-women. They have aches and pains, broken marriages and fears about death.

The film's most conspicuous flaw, however, says much about the movies' new treatment of old people. These women never get on one another's nerves. Put any seven people together in the woods, regardless of sex or age, and someone is bound to

snap someone else's head off. It would not have made these women less likable if they had had such a normal reaction; it would have made them even more believably human. Today, old people on screen don't have to be either perfect or helpless. They get to be as flawed and as real as anyone. □

1991 Je 2, II:15:1

FILM VIEW/Janet Maslin

Is a Movie Really Awful? Let Us Count the Ways

ONE LITTLE WORD: BAD. AND yet it can mean so many different things about so many unhappy moviegoing experiences. Some bad films are merely inert; some, only disappointing. Some actively give offense; some are actively painful. The special ones make you gape with disbelief. The *really* special ones call for closing the eyes and thinking of England.

We tend to lump all bad films together, without the slightest respect for the individual differences that make them what they are. This does a disservice to all concerned. Badness deserves to be taken as seriously as merit, since the two are often integrally related. This year's dud may well hold the seeds to next year's happy comeback.

That might be true even for Andrew Dice Clay, who has made of badness a kind of cottage industry and who has exemplified it in so many different forms. "The Adventures of Ford Fairlane" (1990), Mr. Clay's stab at passing himself off as a comic actor, was a bad film to make one squirm with embarrassment, not over the raunchiness of the star's jokes but simply over the fact that they were so unfunny. It was flat, but it wasn't lively enough to raise hackles.

"Dice Rules," Mr. Clay's current concert film, gives more active offense and manages to do it in several different ways. The first half hour, a moronic series of skits in which Mr. Clay acts even more ineptly than he did the first time, never passes beyond a very primitive form of badness, that of annoying stupidity. But the concert material, which at last shows Mr. Clay in his real element, is less easily dismissed, since it presents a much more interesting shade of bad.

As is well known, Mr. Clay's stand-up act consists of putting down women, foreigners, the handicapped and total strangers in the audience who make the mistake of catching his eye. (Gay men, a frequent target for Mr. Clay, are conspicuously spared this time.) There's no question that a performance like this falls under the category of bad humor. But, as may be less well known to those who find Mr. Clay unbearable on general principles, he shows some capacity for actually being able to rise above this type of material.

■

"Dice Rules" is a miserable film, but its concert segment presents a comfortable, assured Mr. Clay who at least knows how to behave in front of a camera, and who even does some half-decent impersonations of Italian-American movie stars (he does make a passable Al Pacino). Hidden within this film's overall badness is a hint, however slight, that Mr. Clay may one day rise above his own worst instincts and develop a more legitimate appeal.

If "Dice Rules" is bad enough to make audiences bristle, the Australian "Sweet Talk-er" has badness of a more common variety, the kind to generate regret. If you blinked, you may have missed this movie, but it stars Bryan Brown as a lovable con man and Karen Allen as a pert divorcée in a small Australian coastal town. There's nothing really

We tend to lump all bad films together, but badness comes in many forms and should be taken as seriously as merit.

wrong here, except an overabundance of good spirits and squeaky-clean family fun. Material like this tends to leave a trail of good intentions and a vacuum on the screen.

"Sweet Talker" represents a familiar, old-fashioned way of being unsuccessful, since it is essentially a one-note effort. Nowadays a bad film is more apt to be confusing, thanks to the frequent tendency among screenwriters to attempt several subplots and hope at least one of them flies. That's the case with "One Good Cop," which might have worked as either a police thriller or a family drama but bogs down in its efforts to integrate two kinds of stories. In forcing its hero to commit criminal acts for the sake of the family he has newly adopted (that's an additional subplot), it ruins his credibility on both the domestic and law-enforcement fronts.

This modest kind of badness pales in the face of "Hudson Hawk," a towering catastrophe that far exceeds the usual notion of a misfire. "Hudson Hawk" is an actively bad film that insists on flaunting its mean-spiritedness at every turn. Contempt for the audience, a fairly unusual bad-movie feature, is apparent in every frame. The film feels as if it were intended as a private joke, but not even the principals appear to be having fun.

Aside from seeming to be directorially out of control — an important quality in bad films of any stripe — "Hudson Hawk" has a hostile edge. Conceived as some sort of loose sendup of the caper film, it presents Bruce Willis, usually the most affable of movie tough guys, as a self-satisfied cat burglar who condescends to everyone he meets. Most of those he encounters — Sandra Bernhard as the sneering half of a high-powered corporate couple, James Coburn as a mysterious C.I.A. mastermind, four thugs who are named after candy bars — are equally unpleasant in their own unclassifiable ways.

The director, Michael Lehmann, found subversive humor in the witheringly nasty teen-agers of "Heathers," but that was a small movie with a sustained comic tone. This is a huge, sprawling mess, and the inclusion of occasional weirdly violent outbursts — a few jokey killings, or paralyzing darts in several characters' necks — makes it that much more disheveled.

A film as stridently awful as this is a reminder that the audience plays a role in the film-making process, which is something that only the worst of bad films forget. Had five minutes' thought been given to what an audience might want to see, "Hudson Hawk" would never have been made. □

1991 Je 2, II:25:1

Begotten

Written, produced and directed by E. Elias Merhige; director of photography and film effects, Mr. Merhige; sound, Evan Albam; art direction, Harry Duggins. Produced by Theater of Material. At Film Forum 1, 209 West Houston Street. Running time: 78 minutes. This film has no rating.

God Killing Himself...............Brian Salzberg
Mother Earth..........................Donna Dempsey
Son of Earth — Flesh of Bone
 Stephen Charles Barry

By JANET MASLIN

At least in the abstract, E. Elias Merhige's wordless black-and-white film "Begotten" is an imposing work. Mr. Merhige, who is a painter and performance artist (and the founder of Theater of Material, members of which appear in the film), means to re-envision primitive myths in visceral, monstrously immediate terms. He cites as influences Bosch, Goya, Munk, Eisenstein and Buñuel, among others. He has employed such painstaking cinematographic processes in making "Begotten" that 10 hours' work have gone into rephotographing each minute of film.

"Whatever happened to Search and Discovery in the arts today?" Mr. Merhige is quoted (in production notes for his film) as asking. That's always a good question, but "Begotten" is not the answer that many viewers will have had in mind.

"Begotten," which opens today at the Film Forum 1, is considerably less intoxicating in effect than it is in theory. With characters who are identified as "God Killing Himself," "Mother Earth" and "Son of Earth — Flesh on Bone," the film attempts to recapitulate a kind of divine birth and grotesque punishment, which is executed by faceless tribesmen in primitive costume. It begins with the prolonged spectacle of a masked, gagged God Killing Himself (Brian Salzberg) slashing suicidally at his own entrails, so that abundant black glop cascades to his feet, an image in which the film revels at length. Later, surrounded by blood-spattered walls and quivering, pulsating organic matter, Mother Earth gives birth and a growling, twitching creature emerges from the ooze.

The film's grainy, flickering look lends a certain mystery to its images of agonized creatures, as do the heartbeats and sickening squishing noises heard on the soundtrack. It is a long while before these visions of suffering give way to equally impassioned images of rebirth.

Mr. Merhige's concentration, while impressive in its way, seems almost entirely self-contained, with little effort to engage an audience on even the level of myth; the film's approach is far too grotesque for that. The experience of watching "Begotten" can best be characterized as intense.

1991 Je 5, C23:1

Jungle Fever

Directed, written and produced by Spike Lee; photographed by Ernest Dickerson; edited by Sam Pollard; music by Stevie Wonder and Terence Blanchard; production design, Wynn Thomas; co-produced by Monty Ross; released by Universal Pictures. Running time: 130 minutes. This film is rated R.

Flipper Purify...........................Wesley Snipes
Angie TucciAnnabella Sciorra
Cyrus...Spike Lee
Good Reverend Dr. Purify...........Ossie Davis
Lucinda Purify......................................Ruby Dee
Gator Purify.......................Samuel L. Jackson
Drew...Lonette McKee
Paulie Carbone...........................John Turturro
Mike Tucci...................................Frank Vincent
Lou Carbone.............................Anthony Quinn
Vivian..Halle Berry
Orin Goode.....................................Tyra Ferrell
Vera..Veronica Webb
Charlie TucciDavid Dundara
James Tucci.......................Michael Imperioli
Jerry...Tim Robbins
Leslie.. Brad Dourif

By VINCENT CANBY

ARTISTS remain forever separate and unequal. There's no way to legislate parity. As a black film maker, Spike Lee has one terrific advantage over his white contemporaries who, like him, came out of film schools. He not only knows something to make movies, but he also has something to make movies about: the pluralistic American society that is not quite as perfect as it's advertised to be.

Mr. Lee's is an impatient passion. It's also something to be cherished in an art that deals mostly in anesthetics.

Further, his need to express himself enriches the uses to which he puts the purely technical aspects of a craft that, after all, can be learned by anybody, but that, in Mr. Lee's movies, look newly invented.

These are just some of the reasons "Jungle Fever," his new comedy, is so consistently invigorating, right from the jazzy, syncopated credit sequence that opens the film through the cry of despair that ends it.

Make no mistake about it, "Jungle Fever" is a comedy, a big, visually splendid, serious social comedy that embraces the sorrowful as well as the hilarious. Mr. Lee was speaking from the heart in "Do the Right Thing," and made no attempt to hide it. "Jungle Fever" is no less deeply felt, but the view is longer, the tone cooler, the command of technique so self-assured that the film can turn on a dime from tragic to the ridiculous.

"Jungle Fever" is about the world between two poles, black Harlem and the Italian-American community of Bensonhurst in Brooklyn, and about the casual love affair that attempts to bridge the gap.

The man is Flipper Purify (Wesley Snipes), a happily married, upwardly aspiring, somewhat smug black architect in an otherwise all-white midtown Manhattan firm. The woman is Angie Tucci (Annabella Sciorra), a temporary secretary from Bensonhurst, who reveals herself to be a lot brighter than the cant she talks when first assigned to Flipper.

"I like people," she says. Flipper can't believe his ears. "You like people?" Angie accepts the mockery with good humor, beginning what turns out to be a joint learning experience that is an emotional roller-coaster ride for each.

"Jungle Fever" is most easily characterized as an interracial love story, but it's also about parents and children, about families and even about entire communities. The film reaches out from Flipper and Angie to touch on the lives of nearly a dozen other characters who are important to them.

In Harlem, there are Flipper's light-skinned wife, Drew (Lonette McKee), a Bloomingdale's buyer, and his father and mother, the windy Good Reverend Dr. Purify (Ossie Davis) and his bewildered wife, Lucinda (Ruby Dee).

•

There are also Gator (Samuel L. Jackson), Flipper's older brother, a crack addict who sincerely hates to knock the heads of the elderly to feed his habit, and Vivian (Halle Berry), Gator's forever disapproving, foulmouthed companion in dope. Flipper's best friend is Cyrus (Mr. Lee), a school teacher, to whom Flipper confides about his affair with Angie. Comments Cyrus, shaking his head, "Nuclear holocaust."

Later, after Gator meets Angie, he asks Flipper if she's Jewish. Flipper says no, Italian. Gator's sad comment: "You always do things the hard way."

The Bensonhurst characters include Angie's neighborhood boyfriend, Paulie (John Turturro), who keeps house for his ill-tempered old father (Anthony Quinn) and runs the family candy store, and Angie's exuberantly bigoted brothers (David Dundara and Michael Imperioli) and her widower father (Frank Vincent).

Looking on, but comprehending only small pieces of this American mosaic, is a vivid chorus of assorted Harlem, Bensonhurst and midtown Manhattan types.

•

There are Drew's Harlem girlfriends, who gather protectively around her when word of Flipper's affair gets out. They begin by attempting to console her and wind up in a furious and funny, no-holds-barred rap session, which lays to rest the idea that Mr. Lee doesn't understand women.

In Bensonhurst there is something like the male equivalent of the women's conciousness-raising session in Harlem. The neighborhood guys get together at the candy store to make fun of the unhappy, sweet-natured Paulie for having lost his girl to a black man. The talk in the candy store is equally vicious and funny, touching on everything from blacks in professional sports ("What's left, hockey, golf?") to politics and the mayoralty of David N. Dinkins and the troubles of Marion Barry, the former Mayor of Washington.

Mr. Lee is so adept that he is able to transcend the symmetry that the narrative more or less imposes on him. When he crosscuts between Flipper's confession to Cyrus and Angie's similar confession to her two Bensonhurst girlfriends, the effect is actually greater than the sum of the two individual scenes.

One of Angie's girlfriends is compassionate and curious, the other shocked and profoundly disgusted, all the while chewing her gum. Both young women stand by her. What are friends for?

•

Not the least of these supporting characters are the two supercilious partners of Flipper's architectural firm, tiny roles played with throwaway ease by Tim Robbins and Brad Dourif.

Mr. Davis and Miss Dee are fine, though Mr. Davis's role, possibly the most difficult in the film, is not filled in. The Good Reverend Doctor is presented as an insufferably pious, scripture-quoting Baptist minister who has lost his church, for reasons that are never revealed.

Because he appears to be hipped on the subject of fornication, it seems possible that he, too, might have strayed. It could also be that he simply bored his parishioners into flight. The fuzziness is difficult to accept since the character of the Good Reverend Doctor is key to the film's most crucial confrontation.

Though Flipper Purify wanders from his beloved wife and small daughter, the character, as written by Mr. Lee, remains as idealized as something that might have been played by Sidney Poitier 20 years ago. As a result Mr. Snipes's performance seems less interesting than those of everyone around him. He looks right. He talks right, but the character is sort of dim, overprotected, instead of being the film's strong, troubled center.

There is not a bad performance in the movie, only some roles that are less showy than others. Among the more memorable performances: Mr. Turturro's, in a large role, and that of Trya Ferrell, who appears in only several scenes, as the young black woman who would introduce Mr. Turturro to another world.

In a cast of equals, Ms. Sciorra may be just a little more equal than everyone else. She shines. She glows. Her Angie is a delight, a woman of guts and humor and enormous resilience. The character, and Ms. Sciorra's performance in the role, exemplify the breadth of Mr. Lee's film making command.

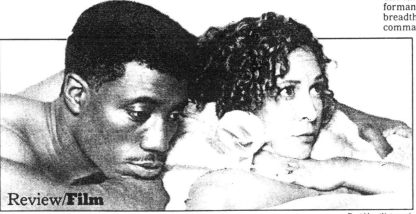

Review/Film

David Lee/Universal

Wesley Snipes as Flipper and Lonette McKee as Drew, his wife, in a scene from "Jungle Fever."

Mention should also be made of Mr. Lee's associates behind the camera, especially Ernest Dickerson, the cinematographer, and Stevie Wonder, who composed the title song and whose "Livin' for the City" scores the movie's most stunning sequence.

With "Jungle Fever," Mr. Lee joins the ranks of our best.

•

"Jungle Fever," which has been rated R (Under 17 requires accompanying parent or adult guardian), contains explicit violence, some nudity and a lot of vulgar language.

1991 Je 7, C1:2

Dark Obsession

Directed by Nicholas Broomfield; screenwriter, Tim Rose Price; cinematographer, Michael Coulter; edited by Rodney Holland; music by Stanley Myers, Richard Harvey and Hans Zimmer; production designer, Jocelyn James; produced by Tim Bevan; released by Circle Releasing. At Cinema 2, Third Avenue at 60th Street, Manhattan. Running time: 86 minutes. This film is rated NC-17.

Sir Hugo Buckton Gabriel Byrne
Lady Virginia Buckton........ Amanda Donohoe
Peter...Struan Rodger
Jamie...Douglas Hodge
Colonel.. Peter Sands
Alec.. David Delve
Jack .. Ralph Brown
Lord Crewne Michael Hordern
Lady Crewne............................... Judy Parfitt
Rebecca ... Sadie Frost

By JANET MASLIN

Rarely does a documentary film maker make the transition to fiction as adroitly as Nicholas Broomfield has in "Dark Obsession," a psychological thriller displaying a documentarian's fascination for small, telling details. Mr. Broomfield, whose earlier work includes "Soldier Girls" and "Tattooed Tears" (made in collaboration with Joan Churchill), turns this time to the world of a bony, haggard English aristocrat (Gabriel Byrne) whose bloodless manner belies a capacity for desperate jealousy, reckless behavior and worse — much worse.

Much of the film unfolds at the huge drafty ancestral hall inhabited by Sir Hugo Buckton (Mr. Byrne) and members of his complex, unhappy family. Among these are a patriarch, Lord Crewne (Michael Hordern), who resents finding his estate now open to the public ("Am I being roped off?" he asks irritably, as a servant makes arrangements for the tourists), and his supercilious wife (Judy Parfitt), who is very skilled in the ways of insulting the lovers of her two children.

Finding Jamie (Douglas Hodge), the beau of her vixenish young daughter, Rebecca (Sadie Frost), on an upstairs landing en route to the bathroom, Lady Crewne observes, "In my family, gentlemen always go to the lavatory downstairs." To a remark by her beautiful and voluptuous daughter-in-law, Virginia (Amanda Donohoe), to the effect that we all had to start somewhere, Lady Crewne icily replies: "No, my dear. Not all of us." Later, seeking some sort of rapprochment with Virginia, Lady Crewne turns even "I want you to feel that you really are a part of this family" into a remark with a cutting edge.

Mr. Broomfield, directing from a screenplay by Tim Rose Price, exposes the moral fiber of these characters by examining the consequences of a night on the town. It begins as a dinner involving Sir Hugo and several friends, members of the Queen's guard. Typically, the film presents these characters in full regalia as they toast the crown, then cuts to watch them riding piggyback on one another's shoulders in a display of passionately infantile carousing. The upshot of this merriment is that a young woman is killed in a hit-and-run accident, with Sir Hugo at the wheel.

Making sarcastic remarks, riding piggyback, killing people.

The plot, which is on the thin side, connects Sir Hugo's involvement in this crime, his lofty efforts to imagine it is someone else's problem and his conviction that he has been betrayed by his wife, who bears a resemblance to the woman hit by the car. Mr. Broomfield interweaves Sir Hugo's hot-blooded daydreams about his wife with the quiet, controlled manner in which he goes about his daily business. Explicit as these scenes are (the film has an NC-17 rating), they also convey a hint of pathos about Sir Hugo's notions of sexual abandon.

Miss Donohoe, with what Mr. Hordern's Lord Crewne refers to as her "absolutely miraculous figger," is indeed glamorous. But she is never quite as self-effacing as Virginia means to be, lending herself much more comfortably to overpowering seductiveness and menace (as she did in Ken Russell's "Lair of the White Worm"). The strong passions purportedly linking her Virginia and Mr. Byrne's brooding Hugo never fully catch fire.

But the film is best in dealing with background material anyhow, drawing the life of a wan aristocrat like Sir Hugo in precise and memorable detail. From the matter-of-fact way in which Sir Hugo acknowledges the portrait painter at work on his likeness (in officer's uniform) to the manner in which he and Virginia discuss boarding school (for their very young son), these characters display the ways in which power and weakness converge in lives of great privilege.

•

Although "Dark Obsession" — a film much more vibrant than its inert title, by the way — takes place amid the polo mallets and suits of armor found on an English country estate, it has none of the decorative allure of a Merchant-Ivory production. Mr. Broomfield prefers a more implicitly satirical style, as when the Bucktons' small son is pulled on his skateboard across the stone floor of the manor house by the family dog. An allusion to incest within Sir Hugo's family only furthers the air of genteel decadence, as do the comments of one of the Queen's guardsmen upon learning that the dead woman was Lady Castlemere's cook. "Did you ever have her cheese soufflé?" he asks dryly.

Among the smaller virtues of "Dark Obsession," which opens today at Cinema 2, are an eerie score by Hans Zimmer, a chilling performance by Struan Rodger as Sir Hugo's coldblooded business associate and the unremarked-upon inclusion of many odd bits of traditionalism that have presumably made men like Sir Hugo what they are. The family barber, for reasons that are not discussed, makes use of a lighted candle while cutting gentlemanly hair.

•

"Dark Obsession" is rated NC-17 (No children under 17 admitted). It includes nudity and sexual behavior.

1991 Je 7, C10:1

Delusion

Directed by Carl Colpaert; written by Mr. Colpaert and Kurt Voss; director of photography, Geza Sinkovics; edited by Mark Allan Kaplan; music by Barry Adamson; production designer, Ildiko Toth; produced by Daniel Hassid; presented by Cineville Inc. and Seth M. Willenson Productions. At Village East Cinemas, Second Avenue and 12th Street, Manhattan. Running time: 100 minutes. This film is rated R.

George O'Brien Jim Metzler
Patti... Jennifer Rubin
Chevy.. Kyle Secor
Larry.. Jerry Orbach
Myron Sales........................... Robert Costanzo

By JANET MASLIN

In a remarkable display of bad judgment, a bland executive named George O'Brien (Jim Metzler) stops for two hitchhikers whom anyone else would speed up to avoid. They are Chevy (Kyle Secor), a seedy criminal type who swigs Pepto-Bismol and spouts endless boring small talk and nosy questions, and Patti (Jennifer Rubin), who looks like a model but makes very little sense when she speaks. "Mm! Computers! A.T.&T., I.T.&T., you and me!" she purrs upon learning that George, at least until he became interested in "creative invoicing," was in the computer trade.

In "Delusion," a road movie about this tedious threesome, the predictable array of mind games carries George, Chevy and Patti (who always use one another's names when they speak, as if they, too, found the material stilted) to a predictable dead end. Written and directed by Carl Colpaert, a Belgian-born film maker who gives the film an in-your-face overbearing style without any particular intimacy, "Delusion" vaguely addresses corruption and greed during the course of 100 very slow and cuttable minutes.

•

The film, which opens today at the Village East Cinemas, vacillates between drabness and kitsch, with Chevy's rubber reindeer nose and antler hat (in honor of Christmas) a prime example of the latter. In one scene, Chevy stands atop a sand dune singing "La Cucaracha" while forcing George to dig a grave. Only occasionally are there signs of wit, as when Chevy says to Patti, "Mmm, what's that perfume you're wearing?" "It's to keep the flies away," she answers. "Is that right?" Chevy says. "Well, it won't work on me."

On the other hand, the screenplay also employs that old saw "It's business — it's nothing personal" to describe a killing.

Mr. Metzler, who can be quietly effective, is here mostly just quiet, which puts him in marked contrast to Mr. Secor, whose Chevy is a tireless bore. Ms. Rubin is dreamily offbeat enough to get away with some of the screenplay's whimsical excesses, which indeed require getting away with. Jerry Orbach appears briefly as a gangster who enjoys watching exercise videos and lives to regret his connection with Chevy and his involvement in the plot's central scheme. Under these circumstances, anyone would.

•

"Delusion" is rated R (Under 17 requires accompanying parent or adult guardian). It includes partial nudity and strong language.

1991 Je 7, C12:6

City Slickers

Directed by Ron Underwood; written by Lowell Ganz and Babaloo Mandel; director of photography, Dean Semler; edited by O. Nicholas Brown; production designer, Lawrence G. Paull; produced by Irby Smith; released by Castle Rock Entertainment. Running time: 107 minutes. This film is rated PG-13.

Mitch Robbins............................. Billy Crystal
Phil BerquistDaniel Stern
Ed Furillo....................................... Bruno Kirby
Barbara Robbins Patricia Wettig
Bonnie Rayburn............................ Helen Slater
Curly.. Jack Palance
Clay Stone............................ Noble Willingham
Cookie.. Tracey Walter
Barry Shalowitz............................ Josh Mostel
Ira Shalowitz David Paymer
Jeff.. Kyle Secor

By JANET MASLIN

At the New Mexico dude ranch where "City Slickers" takes place, 39-year-old men like Mitch Robbins (Billy Crystal) are a common sight. Something about the cowboy experience appeals to those who feel a creeping midlife dissatisfaction with the mundane. Mitch, who ordinarily sells advertising time for a radio station, has figured out that he's in trouble during a visit to his children's school on career day. He winds up being upstaged by a construction worker who holds the children rapt with the story of how a passer-by was crushed by a falling crane. Mitch, by comparison, winds up speaking so

Gabriel Byrne
Circle Films

Jennifer Rubin
Cineville

woefully of his job that he nearly reduces a teacher to tears.

Mitch's two best friends are similarly unsettled, since Phil (Daniel Stern) detests his wife ("If hate were people, I'd be China!" he finally screams at her), and Ed (Bruno Kirby) is a sporting-goods salesman who can't seem to grow up. "Ed, have you noticed that the older you get, the younger your girlfriends get?" Mitch asks him. "Soon you'll be dating sperm."

"Go and find your smile," Mitch's ultra-supportive wife, Barbara (Patricia Wettig), finally tells Mitch, after Ed and Phil plan the dude ranch trip as a birthday surprise. So the three old friends jump at the chance to relive what they call the "yee-haw scene" from "Red River." In addition, they share various confidences around the campfire, trade innocuous quips and flaunt a sentimental streak wide enough to drive a herd of cattle through.

•

"City Slickers," which will earn its place in the annals of wake-up-and-smell-the-roses cinema as this genre becomes increasingly popular among film makers of baby-boom age, was directed by Ron Underwood and has a screenplay by Lowell Ganz and Babaloo Mandel. Here, as in their earlier script for "Parenthood," these writers try to touch as many bases as possible without giving offense or allowing themselves to be pinned down. The result is a comedy that's cheery, earnest, harmless and almost totally lacking in bite. "City Slickers" ambles along lackadaisically, incorporating birth, death, casual wisecracks and a running gag about two ice-cream moguls who pride themselves on knowing the right flavor for any occasion. Each of these things seems to be given equal weight.

Fortunately, Mr. Crystal is an enjoyable enough comic presence to generate good will and keep the film feeling reasonably smooth. ("You're grounded, mister," he is able to say pleasantly — to a calf.) Mr. Kirby and Mr. Stern, both funny actors in roles that have been colorfully written, work well with Mr. Crystal and dis-

Bruce McBroom/Castle Rock Entertainment

Horsing Around Billy Crystal stars in "City Slickers," about three friends suffering from a midlife crisis who spend their two-week vacation driving cattle across the Southwest.

play the kind of ensemble timing that, in the absence of any larger cohesiveness, becomes essential.

•

Jack Palance, as the ranch's leathery trail boss, provides the same off-the-wall incongruity he brought to "Bagdad Cafe," as well as some unexpectedly touching moments. He remains constantly amazed at the urban types who "spend about 50 weeks a year getting knots in your rope, and you figure two weeks up here'll untie 'em for you."

Also in the cast are Helen Slater, who plays the sole female ranch guest and appears to have wandered into the wrong film; Ms. Wettig, sturdily emotional but without any trace of levity; Kyle Secor, much better as a stock villain here than as the talkative thug of another new film, "Delusion," and Josh Mostel and David Paymer, who have some funny moments as the ice-cream tycoons. Plump and unsightly, these two are represented on their ice-cream cartons by two other, much better-looking men. "If it was us," Mr. Mostel asks evenly, "could you eat?"

•

"City Slickers" is rated PG-13 (Parents strongly cautioned). It includes mild profanity and occasional kiddy-minded crude humor.

1991 Je 7, C18:5

Don't Tell Mom the Babysitter's Dead

Directed by Stephen Herek; written by Neil Landau and Tara Ison; director of photography, Tim Suhrstedt; edited by Larry Bock; music by David Newman; production designer, Stephen Marsh; produced by Robert Newmyer, Brian Reilly and Jeffrey Silver; presented by HBO in Association with Cinema Plus L.P. and Mercury/Douglas Films. Running time: 105 minutes. This film is rated PG-13.

Sue Ellen Crandell	Christina Applegate
Rose Lindsey	Joanna Cassidy
Gus Brandon	John Getz
Kenny Crandell	Keith Coogan
Bryan	Josh Charles
Walter Crandell	Robert Hy Gorman
Zach Crandell	Christopher Pettiet
Melissa Crandell	Danielle Harris

By VINCENT CANBY

"Don't Tell Mom the Baby Sitter's Dead," which is not to be confused with "Honey, I Shrunk the Kids," is a feature-length sitcom made almost painless by the first-rate farcical performances of Joanna Cassidy and John Getz.

Unfortunately, Miss Cassidy and Mr. Getz are peripheral to the main business, which is about five fairly bratty but fast-thinking children and what they do to preserve their freedom when their baby sitter drops dead.

After leaving the baby sitter's body in a trunk at the mortuary, they have to find ways of feeding themselves. Their divorced mom, off on a tour of Australia, had left all the money with the baby sitter, a terrible old crone, who apparently had it on her when the kids disposed of the body.

Sue Ellen (Christina Applegate), who at 17 is the eldest, gets a job in a tacky Los Angeles fashion house. Sue Ellen works as a high-powered businesswoman by day and plays as a birdbrained teen-ager by night. She finds it exhausting.

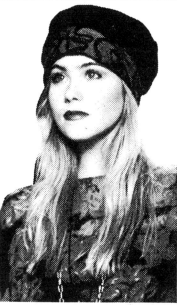

Warner Brothers

Breadwinner In "Don't Tell Mom the Babysitter's Dead," Christina Applegate portrays a rebellious teenager who grows up in a hurry when her mother takes a prolonged vacation and the elderly babysitter dies.

The good news is that she works for an intensely foolish executive, played by Miss Cassidy, who misreads Sue Ellen's every mistake as a sign of genius, and a lecherous fellow (Mr. Getz), who finds Sue Ellen's naïvité most refreshing.

Too much of the movie is about Sue Ellen's attempts to keep her job secret from her jealous boyfriend and about how the other children grow up in the course of this very long summer.

Miss Applegate is charming when the screenplay allows her to slow down. Working against her is the director, Stephen Herek, who pushes every gag so hard and fast that he seems to be keeping up with a laugh track only he can hear.

•

"Don't Tell Mom the Baby Sitter's Dead" has been rated PG-13 (Parents strongly cautioned). It includes some vulgar language.

1991 Je 7, C19:1

The Phantom Of the Opera

Videotape direction by Angel Hernandez; stage direction and choreography by Darwin Knight; book and adaptation by Bruce Falstein; music and lyrics by Lawrence Rosen and Paul Schierhorn; from Hirschfeld Productions. At the 57th Street Playhouse, 110 West 57th Street, Manhattan. Running time: 93 minutes. This film has no rating.

The Phantom	David Staller
Christine Daäe	Elizabeth Walsh
Carlotta	Beth McVey
Raoul de Chagny	Christopher Rath
Moncharmin	Darin de Paul
Richard	Richard Kinter

By STEPHEN HOLDEN

The world probably didn't need two contemporary musicals titled "The Phantom of the Opera" and based on the 1911 Gaston Leroux novel. But it has them. Now, so does New York.

The more famous of the two, the one with music by Andrew Lloyd Webber, is playing on Broadway. The other "Phantom," which opened in 1990 at the Hirschfeld Theater in Miami Beach, opened yesterday at the 57th Street Playhouse, where a videotaped live performance opens a two-week engagement. Surprise: It is not half bad.

The Miami Beach "Phantom," which was commissioned for the theater, has songs by two composers: Paul Schierhorn, who wrote the music for the 1986 Broadway show "The News," and Lawrence Rosen, whose many projects have included adapting music by Samuel Barber for the film "Platoon." The book, adapted from the novel, is by Bruce Falstein.

No chandeliers descend onto the stage in the Miami Beach "Phantom," which is far less glamorous than the Broadway production. Nor is this "Phantom" operatic in structure. The music and dialogue are crisply divided. In fact, Mr. Falstein's concise libretto makes the allegory much clearer than Mr. Lloyd Webber and Richard Stilgoe's adaptation. Mr.

David Staller in the Miami Beach "Phantom of the Opera."

Schierhorn and Mr. Rosen's songs are stylistically so alike that the score might have been composed by the same person. Their music is as unabashedly romantic as Mr. Lloyd Webber's, although the melodic edges of their songs are softer and the orchestrations more diaphanous.

•

David Staller, in the title role, is as impressive in his way as Michael Crawford was in the Lloyd Webber musical, though not as imperiously steely. His Phantom is a mad Victorian romantic who oozes a sinister charm, some of which stems from his greater vulnerability. Mr. Staller is also a superb singer whose vocalizing carries an undercurrent of feverish emotionality. As Christine, Elizabeth Walsh is warmer, both vocally and emotionally, than Sarah Brightman was on Broadway.

Unfortunately, to appreciate these virtues, one must overlook the mediocre quality of the videotape. The colors are drab and washed out; the pictorial resolution is only fair, and the sound is so thin that it borders on the atrocious. At a recent screening, the voices were slightly out of sync with the actors' lips. Although Angel Hernandez, who directed the video, used five cameras, the action still seems static, and the editing is rudimentary. Those who can see through all the technical crudeness will see a good also-ran version of a hit.

1991 Je 8, 16:1

Strip Jack Naked

Directed by Ron Peck; screenwriter, Mr. Peck with assistance from Paul Hallam; director of photography, Mr. Peck and Christopher Hughes; edited by Mr. Peck and Adrian James Carbutt; music by Mr. Carbutt; production company, BFI Productions. At the Public Theate., 425 Lafayette Street, at Astor Place. Running time: 90 minutes. This film has no rating.

WITH: John Brown, John Daimon and Nick Bolton

By STEPHEN HOLDEN

Ron Peck's "Strip Jack Naked" is an anomaly: an autobiographical film whose subject is visually absent except for an occasional fuzzy snapshot or group photo from a yearbook. Mr. Peck's physical remove from a project that includes many shots of other men, some of them naked, backhandedly underscores the themes of his film, which is a chronological narrative of growing up gay in England between 1962, when he was 14 years old, and 1990.

Until 1967, when homosexuality was decriminalized in England, being gay necessitated being invisible to the rest of society. Mr. Peck's physical absence pointedly suggests that his awakening to gay sexuality, culture and politics be taken as representing a collective experience shared by his generation.

"Strip Jack Naked," which was presented yesterday at the Biograph Cinema as part of the third annual New York International Festival of Lesbian and Gay Film and opens a weeklong run at the Public Theater today, is also a companion piece to Mr. Peck's 1978 film "Nighthawks." An exploration of gay life in London in the mid-1970's, the grainy, crudely made "Nighthawks" focused on a young teacher's nocturnal search for companionship, with much of the action centered in one dimly lighted bar.

"Nighthawks," as Mr. Peck points out, was already something of a period piece by the time it was released in 1978, four years after it was begun. By that time, the world it depicted of discreet bar cruising had already been superseded by flashier, more public gay discos.

"Strip Jack Naked," which is told clearly and methodically, begins with Mr. Peck's first adolescent crush and traces his slow, secretive, searching out of information about homosexuality in a repressive climate. He discovers important clues in an American magazine, Film and Filming, that seems to have influenced him to become a film maker. He eventually discovers a salvation of sorts in a bar that becomes the model for the club in "Nighthawks."

"Nighthawks," which the British Film Institute refused to subsidize, was financed with money that Mr. Peck raised himself by advertising in gay newspapers. Much of the casting was also done through advertising in the gay press. The experience of making it, Mr. Peck recalls, represented his final coming-out. But when the film was completed, he had nearly four hours of footage. Some of what had to be cut from "Nighthawks" is included in "Strip Jack Naked."

Visually, "Strip Jack Naked" is a shadowy, impressionistic work that blends film clips, memorabilia and photographs (Dirk Bogarde's haunted face in "Victim," a film about homosexuality and blackmail, is one of the most memorable) into a moody chronicle that changes in tone from personal memoir into a generalized history of the gay movement. The film has its polemical moments. For Mr. Peck, Britain's war with Argentina over the Falkland Islands in 1982 symbolized a chilling of Britain's social climate, as an ethic of "make love not war" gave way to the reverse.

If "Strip Jack Naked" is a film about self-affirmation, it is also permeated with the sadness of the AIDS epidemic. An early sequence remembers a colleague who appeared in "Nighthawks" and who died in 1989. But even amid the catastrophe of AIDS, Mr. Peck finds solace in the gay movement's visibility and solidarity.

1991 Je 8, 16:5

FILM VIEW/Vincent Canby

Time to Bid Adieu To the Classic French Film

PARIS

THREE AMERICAN FILM CRITics, stopping off here after the Cannes International Film Festival, rushed first not to the Louvre, the Musée d'Orsay or the Pompidou Center, but to a tiny movie theater in the Rue Champollion near the Sorbonne. The attraction: "Hellzapoppin," the manic 1941 film adaptation of the Ole Olsen-Chic Johnson Broadway show. Their explanation: you can't find "Hellzapoppin" at home.

Paris is still Paris, the greatest moviegoing city in the world, where lost movies are found even when you're not looking for them.

In this one week, Paris theaters are offering more than 350 different films, everything from "Alexander Nevsky" and "Salo, or the 120 Days of Sodom" to "Hairspray," "The Rules of the Game" and retrospectives devoted to, among others, the Central Asian cinema of the Soviet Union and Gérard Philippe.

Movie theater admissions, which plummeted in the 1980's, have started to climb back. Though the market is still dominated by Hollywood, there has been an increase in the number of French films being released.

Times seem good, but they aren't the good old days. The film world is in the midst of radical, quite heady changes, many of them originating here.

While queues are forming for the new Catherine Deneuve vehicle, "La Reine Blanche" ("The White Queen"), and Oliver Stone's "Doors," Claude Berri, the French director and producer, might be at his house in the Rue de Lille talking business on the telephone with Spike Lee in the United States. Warner Brothers, it is said, is not happy with the size of the budget Mr. Lee wants for his "Malcolm X." That extra money could be found in France.

At the same time Mr. Stone, now shooting "JFK" in America, could be conferring with

Powerful new sources of financing may alter the distinctive look of European movies.

Arnon Milchan, who is producing "JFK" with the help of a large chunk of French financing.

Movies have always been less a native folk art than a business, and how the business goes dictates the shape of the folk art. As more French money goes into films aimed at the international market, the character of French films will inevitably change.

What's happening in France today could be even more important to film makers around the world and to those of us who look at movies than the acquisition of two major Hollywood studios, Universal and Columbia, by Japanese interests.

Marin Karmitz, one of France's most outspoken and independent film producers, put it this way the other day. "It's significant," he said, "that the dominant figure at this year's Cannes Film Festival was not Fellini or Godard or Bergman, but Madonna, someone created entirely by television and video."

Mr. Karmitz was taking note of the recent emergence of two powerful new sources of film financing here. Both have their roots in television and, in one way and another, both stand to change the shape of film production not only in France and Europe, but also in Hollywood.

The newcomers are Studio Canal-Plus, the production company formed by Canal-Plus, France's hugely successful pay-television movie channel; and Ciby 2000, the production company owned by the very rich Francis Bouygues, who made his fortune in construction and is the largest shareholder in France's most popular TV station, TF-1.

Until now, Canal-Plus and TF-1 have had to scramble on the open market to acquire the films they show. Henceforth they'll have access to their own movies. New production money is welcome, but there are those who worry about the kinds of film that will be made by companies whose initial impulse is to fill their television libraries.

Further, the resources of Studio Canal-Plus and Ciby 2000 are such that, combined with those of existing production companies here, they could form the nucleus of a strong, cohesive European film-making bloc that will give American producers a run for their money. To an extent, they already have.

Ciby 2000, which is opening an office in Los Angeles this month, has signed multiple-picture deals with David Lynch, Isabelle Adjani and Pedro Almodóvar. Last week it agreed to provide 100 percent of the financing for a new Bernardo Bertolucci epic about the life of Buddha. No one is talking about the amount of money involved, but, it's assumed, Mr. Bouygues is the kind of man whose offers aren't easily ignored.

Studio Canal-Plus has been even busier. It is a production partner in two films that were highly regarded competitors at this year's Cannes festival: Krzysztof Kieslowski's "Double Life of Veronica," a French-Polish co-production, and Maurice Pialat's French film, "Van Gogh," a revisionist's view of the life of the painter.

In addition, Studio Canal-Plus has signed an agreement with Warner Brothers to make 20 films, produced by Mr. Milchan, over the next five years, one of the first of these films being "JFK," with Kevin Costner. Another is "The Mambo Kings," directed by Arnold Glimcher, who is not exactly an auteur of international repute yet, and starring Armand Assante, who is a good reliable American actor.

The company is also an investor in "Terminator 2," the Arnold Schwarzenegger movie that has become notorious for its alleged budget of $100 million.

"We have become gringos to the gringos," Mr. Karmitz said, referring to the way that American film makers are now coming to France, hats in hand, to ask for production money.

∎

Mr. Karmitz is not entirely happy about the entrance of the well-heeled television people into theatrical film production. He recalled that no television financing was available when he was seeking investors to back Claude Chabrol's screen adaptation of Gustave Flaubert's "Madame Bovary," one of France's literary treasures.

"My wife doesn't like costume pictures, and I don't either," said one man as he turned down the producer.

"Madame Bovary," with Isabelle Huppert playing Emma, is a stunning-looking production now in the eighth week of its first-run engagement in Paris. Mr. Karmitz was ultimately able to finance it by selling its distribution rights to individual countries throughout the world.

"Even," he said, "South Korea," though he was uncertain whether the attraction to the South Koreans was Flaubert or Huppert. The Samuel Goldwyn Company will be releasing the film in the United States in November.

Mr. Karmitz's point: "Madame Bovary" would never have been made had the decision been left to the television people.

Claude Berri, best known as the director of "Jean de Florette" and "Manon of the Spring," is much more optimistic. He welcomes the availability of the television money and doesn't fear that it will affect the content or look of the quintessentially French movie that he himself makes.

Among other things, he says, Studio Canal-Plus needs French films to meet the television quota, which decrees that 50 percent of all films shown be French and 10 percent European, while 40 percent is left for films from all other sources. In practice, that means 40 percent American.

Yet, in these days of multinational co-productions, it's sometimes difficult to tell whether a film is really French, German, Vietnamese, American or what-have-you. An exemplary case in point is "The Double Life of Veronica," directed by Mr. Kieslowski, who is Polish, starring Irene Jacob, who is French (and who won the best-actress prize at Cannes for her performance).

That the first third of the film was shot in Poland and the remainder in France would seem to have been dictated by the screenplay. This is about

Samuel Goldwyn Company

Jean Reno, left, and Anne Parillaud in Luc Besson's "Femme Nikita"—perhaps the prototype for the new pan-European film

the parallel lives of two young women, one Polish and one French, both played by Miss Jacob, and their mystical connection.

Yet the film's narrative shape could also have been dictated by a co-production deal in which the French partners put up two-thirds of the financing and the Polish partners one-third. In this kind of film making, the contract is the muse.

I have no idea if this was true for "The Double Life of Veronica," but the film, as intriguing as it is, looks to have been rather arbitrarily split between the Polish sequences, by far the more successful, and the long French coda. The film's feeling is far more Polish than French, though "The Double Life of Veronica" will qualify as French under the local quota rules.

The biggest danger in all of this international wheeling and dealing is that European movies, and possibly even American movies, will wind up looking stateless, that is, uncharacterized by any nationality, much like the seminal, mostly awful European co-productions of the 1960's.

This was a problem with Luc Besson's "Big Blue" ("Le Grand Bleu"), the big-budget French adventure film, shot in English, which opened the 1988 Cannes Film Festival. The movie was a grand hit in France (it's still playing here at the Grand Pavois in the Rue Lecourbe), but flopped everywhere else. That it did badly in the United States was a particular disappointment. The United States market was one of the reasons it was made with an English-language soundtrack.

Mr. Besson has apparently learned his lesson. His new French film, "La Femme Nikita," which mixes violent American action with French comedy, while all the time speaking French, is on its way to becoming a hit in its first engagements in the United States. With its spectacular gunplay, breathless pace and boutique chic, it could be the prototype for the new pan-European film, which, until now, has always been American.

For better and often for worse, the film that travels most easily from one European country to the next has been the standard Hollywood genre film, most recently the big-budget, special effects-loaded action dramas on the order of the "Die Hard" movies. While Studio Canal-Plus put money in Mr. Pialat's "Van Gogh," its hope for international success will be with "Terminator 2."

However it turns out, "Terminator 2" will be a real American action film, not some scrawny, pan-European mock-up.

∎

Two years ago, there was a rush here to shoot French films in English, to appeal not only to American audiences but also to audiences in other countries in Europe, Latin America and Asia, where English soundtracks are preferred.

That is no longer true, except for the most expensive films, including, at the moment, two films that would appear to be quintessentially French in subject matter and appeal: Jean-Jacques Annaud's "Amant" ("The Lover"), and Pierre Schoendoerffer's "Dien Bien Phu," about the collapse of French colonial power in what was then Indochina. Both films are now being shot in Vietnam.

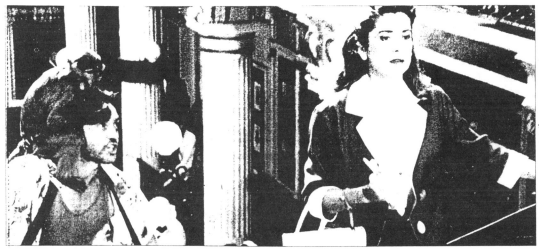

TF-1/Ciby 2000

Bernard Giraudeau and Catherine Deneuve in "La Reine Blanche" ("The White Queen")—
Lines are forming in Paris, where many of the radical, quite heady changes in the film world are originating.

In addition to directing his own films, Mr. Berri is also active as the producer of his colleagues' films, including Roman Polanski's "Tess" and, more recently, Milos Forman's "Valmont." It is Mr. Berri's company, Renne Productions, that is producing "L'Amant," a $30 million adaptation of Marguerite Duras's piercing, packed 117-page novella in which a ravaged older woman recalls her affair, at the age of 15½, with a rich 30-year-old Chinese man in Saigon.

"Dien Bien Phu," directed by the man who made the stunning "Crabe Tambour," is budgeted at a reported $25 million. In view of the fact that the average French film these days costs between $5 million and $6 million, both films might qualify as French equivalents to "Terminator 2," at least in terms of their budgets.

With or without television money, co-productions are here to stay, leading to a continuing series of oddities in the films themselves.

Karen Chakhnazarov's "Assassin of the Czar," a fascinating Anglo-Russian meditation on regicide, was shot in both Russian and English, though the version shown at Cannes was Russian in order that the film might qualify as Russian. Unfortunately, Malcolm McDowell, who gives a marvelous and mad performance as the czar's assassin, speaks no Russian, and so was quite obviously dubbed for the Cannes audience.

Marcello Mastroianni speaks dubbed Greek in Theo Angelopoulos's "Suspended Step of the Stork," which was Greece's entry at the Cannes festival, while his co-star, Jeanne Moreau, who plays the French wife of the Mastroianni character, speaks only English. This is covered at one point by having Miss Moreau say rather airily, "Oh, I never learned to speak Greek."

In the festival's Soviet-French co-production, "Anna Karamazova," Miss Moreau speaks Russian, in a voice that actually seems to be her own. There is not, however, a great deal of dialogue.

Pragmatic as always, the French have acknowledged that, in the privacy of their homes, people sometimes do things that are not entirely nice or legal. They even pirate the movies and sports events they watch on television. The solution: to charge a two-franc tax for every hour of blank tape sold.

The film portion of this fund is then divided three ways among the producers, the authors (the director, writer and composer) and the actors, according to a formula relating to the number of times a film has been telecast. Last year the kitty contained $100 million.

The French: pace setters in 1789, pace setters in 1991.

1991 Je 9, II:15:1

Robin Hood
Prince of Thieves

Directed by Kevin Reynolds; screenplay by Pen Densham and John Watson, story by Mr. Pensham; director of photography, Douglas Milsome; edited by Peter Boyle; music by Michael Kamen; production designer, John Graysmark; produced by Mr. Watson, Mr. Densham and Richard B. Lewis; released by Warner Brothers. Running time: 120 minutes. This film is rated PG-13.

Robin Hood	Kevin Costner
Azeem	Morgan Freeman
Will Scarlett	Christian Slater
Sheriff of Nottingham	Alan Rickman
Maid Marian	Mary Elizabeth Mastrantonio
Little John	Nick Brimble
Friar Tuck	Micheal McShane
Guy of Gisborne	Michael Wincott
Mortianna	Geraldine McEwan

By VINCENT CANBY

IF you let a bunch of unskilled carpenters loose in Sherwood Forest, don't be surprised if you wind up with a load of kindling.

That's about the only coherent response to Kevin Reynolds's "Robin Hood: Prince of Thieves," starring Kevin Costner as that once merry man Robin of Locksley, a k a Robin Hood.

The new movie is a mess, a big, long, joyless reconstruction of the Robin Hood legend that comes out firmly for civil rights, feminism, religious freedom and economic opportunity for all.

The screenplay was written by Pen Densham and John Watson, who also are two of the film's producers, but it sounds as if it had come from the enlightened quill of the character played by Mr. Costner in "Dances With Wolves."

It's a measure of how muddled the movie is that the only two entertaining characters are subsidiary: Robin's be-

Warner Brothers
Kevin Costner and Morgan Freeman in "Robin Hood."

loved Marian, a beautiful, intelligent strong-willed woman, played by Mary Elizabeth Mastrantonio, and the screenwriters' own invention, Azeem, a Moor, played by Morgan Freeman with a wit and humor that are otherwise not to be found in the film.

Mr. Costner and his associates seem to have approached their subject without a clear idea about the kind of movie they wanted to make. In the production notes, there are jokey references to the classic 1938 version and to the fact that Mr. Costner refused to wear the sort of green tights sported by Errol Flynn's Robin Hood.

It takes chutzpah to look down upon your betters.

Though the new "Robin Hood" observes all of the classic confrontations that keep the tale alive, the film winds up as a mixture of listless adventure, wispy comedy and what is meant to pass for social realism.

It begins in 12th-century Jerusalem where Robin, a Crusader, is a prisoner in some grungy infidel dungeon. From the looks of the fright wig Robin is wearing, he's been there 50 years, though, when he escapes, it turns out he's still a comparatively young man.

Having helped Azeem to escape, too, Robin cannot get rid of the faithful fellow, who follows him back to England where, as the Monty Python people might say, the serfs are revolting. King Richard is away and disorder reigns.

Robin's free-thinking dad (he called the Crusades "a foolish quest") is dead, killed by the evil Guy of Gisborne (Michael Wincott). The family castle has been looted and burned, the lands appropriated by the even more evil Sheriff of Nottingham (Alan Rickman).

Robin seeks sanctuary in Sherwood Forest, where he soon takes command of the band that has gathered around Little John (Nick Brimble) and Will Scarlett (Christian Slater). It is just one of the film's oddities that when Robin and Little John have their initial encounter on the bridge, Mr. Costner's Robin seems a good 20 pounds heavier than he does that same evening.

●

With or without the extra weight, Mr. Costner is the film's big problem. He plays Robin as if the character were a movie star being gracious to his fans. He is polite, but he doesn't exert himself. There's nothing wrong with his accent, which sounds plain American most of the time, only with his attitude.

This Robin Hood gives the impression of being lethargic and dull. Sometimes he may be under-acting. At other times, he seems to be doing nothing at all.

In one of the times Robin attempts to be swashbuckling, by swinging on a Sherwood Forest vine, there is no sense of thrill or dash, only the vague fear that he might fall and hurt himself. Because Mr. Costner appears to be having so little fun, the audience is allowed to grow impatient, too.

Also getting in the way of the entertainment are the movie's attempts to be relevant, as in Robin's little speech on behalf of Azeem's right to be treated like other men, or his defense of Marian's maid Fanny (Soo Druet), who asks to bear arms against the Sheriff of Nottingham. There's nothing wrong with the sentiments but, in Sherwood Forest, they look as anachronistic as Coke cans.

Even the film's politics are inconsistent. Robin's final triumph over the Sheriff of Nottingham, when the outlaws sneak into town to disrupt a hanging and stop the sheriff's marriage to Marian, is made possible only by the use of gunpowder, whose mysteries have been revealed by Azeem.

Though gunpowder, which suddenly renders the bow and arrow obsolete, is celebrated as a great step forward, it seems unlikely that the same movie makers would be equally upbeat about the introduction of a nuclear bomb. If "Robin Hood" were better, such a thought would never arise, but this film prompts such speculation.

The movie's dour production design is also a downer. The dominant colors are brown, black, olive, mousegray, which may serve realism but not the spirit of the fable. This "Robin Hood" has a dreary and haunted look.

As much as Mr. Costner underplays Robin, Mr. Rickman overplays the Sheriff of Nottingham, with results that are similarly unfortunate. He isn't funny, just an actor who is desperate to create a little screen life. Instead, he seems to be acting in another movie entirely.

The screenplay features two surprises. One is a Freudian reading of the character of Will Scarlett, and the other the appearance at the end of an unbilled star, whose well-known manner simply underscores everything that the film has been unable to achieve until that moment. It's a terrible mistake.

Note to those who care: The 1938 "Robin Hood," shot in gorgeous Technicolor, opens June 24 at the Biograph on a double bill with Richard Lester's "Robin and Marian" (1976), in which Sean Connery and Audrey Hepburn play the spirited lovers in their twilight years.

●

"Robin Hood: Prince of Thieves," which has been rated PG-13 (Some material may be inappropriate for children under 13), features some violence and partial nudity.

1991 Je 14, C1:4

Bright Angel

Directed by Michael Fields; screenplay by Richard Ford; director of photography, Elliot Davis; film editors, Melody London and Clement Barclay; music by Christopher Young; production designer, Marcia Hinds-Johnson; produced by Paige Simpson and Robert MacLean; released by Hemdale Film Corporation. Running time: 94 minutes. This film is rated R.

George	Dermot Mulroney
Lucy	Lili Taylor
Jack	Sam Shepard
Aileen	Valerie Perrine
Art	Burt Young
Bob	Bill Pullman
Claude	Benjamin Bratt
Judy	Mary Kay Place
Woody	Will Patton

By JANET MASLIN

Richard Ford's lean prose is much more cinematic on the page than it is in "Bright Angel," an elliptical, slow-moving film adapted by Mr. Ford from stories in his "Rock Springs" collection. The laconic reflectiveness of Mr. Ford's characters and the arid precision of his observations are not easily translated into visual imagery. The decaying Western scenery is here, as are some of Mr. Ford's muscular, hard-bitten characters, but what goes on beneath their opaque surfaces remains a mystery. And Mr. Ford has difficulty cobbling a coherent narrative out of what, in his original material, were essentially vignettes.

"Bright Angel," which opens today, was directed by Michael Fields, who has directed for television's "American Playhouse" series and becalms the film with a respectful, literary air. But he has also assembled the kind of varied, offbeat cast that remains surprising even when the material seems shapeless and vague. Though the story's central figure, a young man named George (Dermot Mulroney) is presented as little more than a cipher, the figures who surround him are sharply drawn.

Whether trigger-happy or wanton or merely bored, they evoke Mr. Ford's desription, in the story "Great Falls," of "just low-life, some coldness in us all, some helplessness that causes us to misunderstand life when it is pure and plain, makes our existence seem like a border between two nothings, and makes us no more or less than animals who meet on the road — watchful, unforgiving, without patience or desire." The film would

Dermot Mulroney
Hemdale Films

be vastly better if it were even once capable of summoning that sensation as lucidly as Mr. Ford captures it on the page.

●

Beginning at the start of "Great Falls," the film introduces the hesitant young George and his gaunt, taciturn father Jack (Sam Shepard), who are first seen duck hunting in the kind of scene that automatically loses some of its mystique when treated literally. Mr. Ford's dialogue, though often identical to that in the stories, is often reduced to a kind of mumbly machismo in the absence of the descriptive backdrop provided by his narrative prose.

In the first of several gun-toting confrontations here, Jack confronts Woody (Will Patton), with whom Jack's wife, Aileen (Valerie Perrine), is about to run away. After this episode, the film moves on abruptly to other matters, even though Mr. Ford's prose version of "Great Falls" re-visits Aileen later and tries to make sense of her leaving. The film works so hard at sustaining a story line that it rarely achieves the kind of closure that short fiction can provide.

Next (and with a whole set of characters from a different story, "Children"), the film finds George with his friend Claude (Benjamin Bratt), an Indian teen-ager whose father, Sherman (Alex Bulltail), has picked up a young woman drifter. She is Lucy (Lili Taylor), and she throws in her lot with George and Claude for a reckless ride from Montana to Wyoming, where she hopes to get her brother out of jail. As they travel together, during a moment of abandon, Lucy bathes in a stream and then watches as her two companions catch a fish, staring with fascination as the fish flaps helplessly on dry land. "What a surprise that must be for the fish," Lucy says. "Everything just goes crazy at once. I wonder what he thinks." Dialogue like that loses its delicacy, or perhaps takes on too much of it, when said out loud.

●

Shot in and around Billings, Mont., "Bright Angel" abounds with overwrought prairie outcasts, many of whom are much too eager to deliver the stories of their lives without having been asked. Also in the film are Burt Young and Bill Pullman as two overly colorful crooks, first seen in a house across a dirt road from a junkyard, in a living room furnished with

bar, television set, Scrabble game and almost nothing else. There are also Mary Kay Place, as George's sympathetic Aunt Judy, and Delroy Lindo as her disabled and very talkative husband, who, like several of the film's male characters, prefers to speak while waving a gun.

"Bright Angel" eventually falls into confusion, with too many isolated individuals drifting into and out of its storyline with no particular purpose. The effect is finally dilatory, since even Mr. Ford's most sharp-edged dialogue sounds aimless in this context. "Tell me something I might not know," Lucy says idly at one point. "Wish I could, I'd like that," George replies. It's a wish neither he nor anyone else here is effectively granted.

●

"Bright Angel" is rated R (Under 17 requires accompanying parent or adult guardian). It includes brief nudity and strong language.

1991 Je 14, C6:1

Forever Activists

Directed and produced by Judith Montell; photography by T. Robin Hirsh; edited by Yasha Aginsky; music by Bruce Barthol and Randy Craig; narration written by Mr. Aginsky, Phil Cousineau and Ms. Montell. Running time: 60 minutes.

A Letter to Harvey Milk

Directed, produced and written by Yariv Kohn; adapted from a short story by Leslèa Newman; distributed by Tara Releasing. Running time: 27 minutes. These films are unrated. At Bleecker Street Cinema, at La Guardia Place.

By VINCENT CANBY

In "Forever Activists," which was nominated for an Oscar this year as the best documentary feature of 1990, Judith Montell interviews seven veterans of the Abraham Lincoln Brigade, who fought for the Loyalist cause in the Spanish Civil War from 1936 until they were disbanded in 1938.

The film's point, and one not often emphasized in films about the brigade, is that for many of these men and women, the Spanish Civil War was just one of a series of continuing social struggles that gave their lives meaning. "Forever Activists" opens today at the Bleecker Street Cinema.

The scene-setting material (old newsreel clips) is familiar, but veterans' faces and their stories seem ever new and raw, even when it's apparent that the same tales have been told many times before. All of those who testify are creatures of the Great Depression, idealistic and dedicated to improving the lot of the people President Franklin D. Roosevelt addressed as his fellow Americans.

The film's highlight is a reunion of the veterans in Spain in 1986, on the 50th anniversary of the war's outbreak. It looks to have been both a picnic and a time for summing up. Yet the film's most moving moments come when the veterans recall their treatment when they went home after the war.

Passports were revoked, and for many their membership in the brigade was to cost them jobs and repu-

Tara Releasing

Old Soldiers In "Forever Activists," veterans of the Abraham Lincoln Brigade, who fought against Fascism during the Spanish Civil War in the late 1930's, are filmed during a reunion in Spain in 1986.

tations for decades to come. Most, it seems, absorbed the shocks and went on to fight on behalf of labor, civil rights and the peace movement during the Vietnam War.

●

On the same bill, but a good deal less effective, is "A Letter to Harvey Milk," Yariv Kohn's short fiction

film. It's about the friendship of a gay woman (Karen Waddell), who teaches creative writing at a California center for the elderly, and one of her students, Harry Weinberg (Irving Hoffman), a widower. The movie means well, but its characters are too politely conceived to be especially compelling.

1991 Je 14, C10:4

FILM VIEW/Janet Maslin

Lay Off 'Thelma and Louise'

BECAUSE HE DIDN'T SMILE when he said it. Because he stole, cheated or lied. Because he wasn't lucky. Because it was a good day to die —Those are traditional reasons for which characters in outlaw movies are disposed of, sometimes only in the wink of an eye. It's a list to which a new one can now be added: because he tried to rape and beat a woman whose best friend had once been the victim of a sex crime, and the best friend went berserk while watching history repeat itself. And because he was smug instead of sorry.

"Thelma and Louise," the film in which this new pretext for killing turns an Arkansas waitress and an Arkansas housewife into ebullient runaways, is obviously a crime story of a different stripe. Though it takes much of its inspiration from the road movies of 20 years ago, its style and attitudes are thoroughly up to date. Though it tells a tale of violence, its spirit could not be more benign. Though it employs certain conventions of the buddy-film genre, it feels unfamiliar in the best possible way. In viewing

Its heroines are thoroughly independent. No wonder they've ruffled a few feathers.

the desperado's life through the eyes of two suddenly adventurous women, it sees something other movies have not seen.

It also raises new hackles, having been tarred as a kind of she-"Rambo" by those who deem it mindlessly violent and uncharitable to men. The charge that this is "toxic feminism" has been leveled by sources as diverse as John Leo of U.S. News & World Report and the columnist Liz Smith. "Nobody in 'Thelma and Louise' worries about AIDS, using condoms or encountering a serial killer," Ms. Smith noted, and that's true; nobody worries about the greenhouse effect or wears seat belts, either. But what is it that really rankles about "Thelma and Louise"?

Not the violence: the amount of violence seen here is remarkably small, especially in view of the casual flare-ups with which male-oriented road movies are often loaded. Out for a weekend's fishing trip, mischievously stealing away from Thelma's husband and Louise's boyfriend, the two heroines first get into trouble in an Arkansas honky-tonk, where a man who makes a pass at Thelma mistakes her high spirits and alcoholic haze for sexual availability. This leads to the shooting incident that turns Thelma and Louise into outlaws and also gives the story its momentum. It's a legal and moral lapse, but also a plot necessity. Without events like this, the heroes of most road movies would have to pack up and go back home.

Later on, Thelma and Louise have their run-ins with a truck driver, a police officer and a storeful of customers at a grocery, none of whom is injured by their behavior. The truck driver does incur property damage, the grocery store customers are robbed, and the policeman becomes the victim of a potentially dangerous prank; but these events deserve to be seen in some kind of perspective. Last summer was the season of the

sky-high body count, with Arnold Schwarzenegger blasting his way across Mars in "Total Recall," all of whose female characters were prostitutes. In "Another 48 Hours," a buddy film tailored to more conventional tastes, Eddie Murphy and Nick Nolte killed enemy after enemy without batting an eye. So, once again, what's so egregious about "Thelma and Louise"?

■

The heroines of this story happen to look quite innocent by comparison with the road movie characters of the late 1960's and early 1970's, when the genre was in full bloom. Compared with the stoned, messianic drug dealers of "Easy Rider," who traveled the highways fueled by condescension and paranoia and took it as their sexual due to visit a whorehouse in New Orleans, Thelma (Geena Davis) and Louise (Susan Sarandon) seem infinitely more level-headed and kind. (Anyone who remembers "Easy Rider" fondly but has not watched it since its 1969 release should be reminded that Billy and Captain America visit a commune that has its own resident mime troupe, complete with stage. Timeless it's not.)

And compared with Bonnie Parker, who got a sexual thrill out of the way Clyde Barrow announced, "We rob banks" in Arthur Penn's "Bonnie and Clyde" in 1967, Thelma and Louise have no real taste for crime. Furthermore, compared with the wandering sex offenders of Bertrand Blier's "Going Places" in 1974, their feelings about the opposite sex are positively friendly. They are mobilized not by hostility or anomie but by a sudden, unexpected glimpse of what life might have been like for them without a bad marriage (Thelma's) and a dead-end job (Louise's). Their dissatisfaction with their everyday lives is something anyone in the audience will understand.

■

While it's true that criminal behavior plays a role in this story, it requires extraordinary blinders to regard "Thelma and Louise" solely as an account of antisocial depravity. Besides, criminal behavior on screen can be as well used in the service of virtue as in glorification of crime.

"The Silence of the Lambs," for example, can be seen as a grisly film, but it is much more persuasively a film in which the saving of a single life becomes all-important, in which a fundamental decency prevails. The heroism of its central character, Clarice Starling, emerges in stark relief against the horrors she has battled.

In the case of "Thelma and Louise," a violent and tragic mistake becomes the crucible in which character is formed. One of the most invigorating things about this film is the way its heroines, during the course of a few brief but wildly eventful days, crystallize their thoughts and arrive at a philosophical clarity that would have been unavailable to them in their prior lives. By the end of the film, the director Ridley Scott and the screenwriter Callie Khouri are ready to allow Thelma and Louise the opportunity to take full charge of their lives and full responsibility for their missteps, too. The film's bracing ending has a welcome toughness.

■

In fact, throughout the course of the story, Thelma and Louise have been seen learning to take charge of their own lives. And there may lie the problem: it's something that goes beyond Thelma and Louise's aggressiveness, their politics, their cavalierness about condoms (a matter not remotely addressed by the movie, by the way) or any other aspect of the film that strikes some small segment of the audience as hotheaded. It's something as simple as it is powerful: the fact that the men in this story don't really matter.

They are treated as figures in a landscape through which these characters pass, and as such they are essentially powerless. For male characters, perhaps, this is a novelty, but women in road movies have always been treated in precisely the same way.

The men in this story may be boors or charmers, but in neither case do they have much effect on what Thelma and Louise do. These women become thoroughly independent in a way that is commonplace for male movie heroes but still a novelty where

Warner Brothers

Faye Dunaway and Warren Beatty as Bonnie and Clyde—Unlike these two, Thelma and Louise have no real taste for crime.

heroines are concerned. The freedom they embrace is remarkably complete, and not even particularly sexual (sexual liberation is the one realm in which women on screen have always been free to exercise their independence). No wonder they've ruffled a few feathers.

The men in the story, ranging from Louise's conciliatory boyfriend (Michael Madsen) to a flirty young hitchhiker (Brad Pitt) and a sympathetic police detective (Harvey Keitel), do a lot to engage Thelma and Louise's respective interests, just as incidental female characters might in a movie about two footloose men. And the film draws the different ways in which Thelma and Louise each view men with particular clarity.

Louise, the older and more stern of the two, may be noticeably gun-shy as a result of her past, and she is well beyond reach of her onetime beau, even when he proposes marriage. The more sheltered Thelma is, by comparison, positively boy crazy. Having been tied to the same dull, disloyal mate since she was 14, she yearns for adventure. But if on paper this rebelliousness sounds like militancy, in effect it is played with feistiness and wry humor. When Thelma runs off, she doesn't leave an angry manifesto pinned on the wall with a dagger; she leaves a note for her husband in the microwave, together with dinner and a beer.

Consider this within the context of several other recent films that involve women who pose some kind of a threat. Anyone who doubts that style

and mood make a big difference in the way aggressive heroines are perceived might well see "La Femme Nikita," about a woman transformed from an angry, antisocial punk into a trained assassin. She might indeed seem threatening, were it not for the fact that she also learns to wear makeup and performs at least one of her violent acts wearing a little black evening dress and pearls.

The men in the movie are only figures in a landscape, essentially powerless.

The husband-killing New Jersey women in "Mortal Thoughts" are less elegant but almost as lulling, since they leaven their deadly activities with a strain of dizzy humor, and the man they kill (played by Bruce Willis) is a comical lout. In terms of misdeeds and motives, both "La Femme Nikita" and "Mortal Thoughts" are much darker than "Thelma and Louise." And in terms of antipathy toward men, Thelma and Louise can't hold a candle to the Madonna of "Truth or Dare."

But it is Thelma and Louise who tease each other about admiring the physique of that male hitchhiker, who give up all ties to home and hearth,

M·G·M

Geena Davis and Susan Sarandon as friends on the run in "Thelma and Louise"—inspired by the past, but up to date in its style and attitudes

who take issue with a truck driver who has been outstandingly rude and who otherwise exercise what in the past have been male prerogatives on the screen. The aspects of this film that have raised the greatest furor are features that would be virtually routine in a comparable movie about men.

So it requires the use of a double standard to feel that "Thelma and Louise" fails to depict exemplary behavior when the masculine road movie has never pretended to do anything of the kind. This road movie's brand of escapism offers transcendence, not instruction — and it rises above both the everyday and the limits of its genre. "Thelma and Louise" is transcendent in every way.

1991 Je 16, II:11:1

FILM VIEW/Caryn James

Writing's Wrongs Righted

WHEN FAMOUS WRITERS ARE PORtrayed on screen, their working lives seem too hard, too easy, too sententious or too silly, but rarely just right. Playing Lillian Hellman in the 1977 film "Julia," Jane Fonda becomes so frustrated that she tosses her typewriter out the window. As Isak Dinesen in "Out of Africa" in 1985, Meryl Streep entertains her dinner guests by telling eloquent stories, spinning out tales as effortlessly as if the muse were sitting on her shoulder. The all-too-prescient "Henry and June" (1990) allows Fred Ward as Henry Miller to keep insisting that no one will publish his scandalous novels. Sure, Henry.

And occasionally the act of writing descends to amazing new depths of goofiness. In the 1988 television film "Hemingway," Stacy Keach sits hunched over a table in a cafe. In a scene that goes something like this, he scribbles and says, "Isn't it fine to think so?" then furiously scratches out a word. "Isn't it *nice* to think so?" Scratch again. You can almost see the light bulb go on over his head when he finally

Screen versions of authors' lives can be goofy, but two current films stand out.

spits out, "Isn't it *pretty* to think so?" having turned the famous final line of "The Sun Also Rises" into a cheery little game of fill-in-the-blank.

Two current films offer refreshing correctives to those skewed images of writers. Jane Campion's "An Angel at My Table," based on the autobiography of the New Zealand novelist Janet Frame, is a richly realized yet understated movie that depicts a writer's sensibility forged in childhood. And in the witty, irreverent "Impromptu," directed by James Lapine, Judy Davis plays George Sand in hot pursuit of Chopin, practically strewing manscript pages of novels and memoirs in her wake. Both film makers know better than to try to turn a writer inside out and project the inner drama of composition on the screen. Instead, they create personalities that might plausibly invent novels.

"An Angel at My Table" enjoys an accidental advantage in the United States, one that it doesn't have in New Zealand: Janet Frame is relatively little known here. There is no long shadow of history looming over the film, no sense that its heroine is destined to be a writer. Janet is a character free to develop in any direction.

Originally made for Australian television, the film is divided into three long episodic parts that trace Janet from her early childhood in a poor but lively family (when she is

played by Alexia Keogh) through her 30's (played by Kerry Fox). Surprisingly, the section that reveals the most about her literary life is the first. There, she is a chubby, frizzy-haired schoolgirl in torn sweaters — a bit of a misfit — with a feel for language and a strong imagination.

Her artistic qualities are mere glimmers. She writes an ordinary little poem for school and rejects her sister's sug-

Alexia Keogh in "An Angel at My Table"

gestion that the line "the evening shadows touch the sky" must give way to the more "poetic" phrase "tint the sky." She treasures a blank copybook her father gives her, rubbing its cover the way other girls might fondle a doll. Her imagination is captivated by Grimm's fairy tales, and in one scene she and her sisters act out "The 12 Dancing Princesses" by moonlight. These are qualities that might belong to any little girl who likes to read. They are effective here because Ms. Campion and the screenwriter, Laura Jones, do not press too hard on the way they will lead to Janet's profession.

In fact, as Janet grows older, the film takes her writing more and more for granted and concentrates on other dramas. Misdiagnosed as schizophrenic, she was in a hospital for eight years and was saved from a lobotomy when a doctor noticed that her book of stories, "The Lagoon," had won a literary prize. Though writing literally rescued her, little in the film suggests how she managed to produce those stories.

As she travels to England and Spain, has her first love affair and triumphantly becomes an independent woman, she is seen writing from time to time, but the film offers no sense of her style. Yet viewers can believe that her inner literary life exists, for its birth has been so surely established.

The ultramodern zest with which George Sand and her coterie are depicted in "Impromptu" could not be more different from the calm and grace of "An Angel at My Table." Yet here, too, is a writer whose life makes the existence of her art believable. "Me? Suffer for art? You must be joking," George tells Chopin. "I suffer quite enough for life!" Her claim to just churn out pages is at least partly true, for she was a prolific and uneven author.

"Impromptu" is less about Sand's writing, though, than about social and emotional attitudes toward art. The most laughable creature is a flighty, rich duchess (Emma Thompson) who invites Sand, Chopin, Lizst and Delacroix to her country house and adorns them with laurel wreaths as they arrive, crowning them "the nobility of genius." To the artists, she represents a free vacation.

The duchess, with her shallow sense of art as social climbing, is the opposite of Sand, who falls deeply in love with Chopin before she sets eyes on him. It is enough for her to hear him playing his music through a closed door. Her intense pursuit of him has little to do with writing, except that it flows from her social rebelliousness, free imagination and total determination — the same qualities that shape her as a writer. Despite the film's comic exaggerations, it invents a George Sand whose literary life is completely credible. Did she suffer for art? Maybe. Thankfully, "Impromptu" doesn't make its audience watch that scene, and creates a more plausible writer in the process.

1991 Je 16, II:11:5

Every Other Weekend

Directed by Nicole Garcia; screenplay and dialogue (in French with English subtitles) by Ms. Garcia and Jacques Fieschi with the collaboration of Anne-Marie Étienne and Philippe le Guay; director of photography, William Lubtchansky; edited by Agnès Guillemot; music by Oswald D'Andrea; produced by Alain Sarde; an MK2 Productions USA Release. At Cinema Third Avenue, at 60th Street. Running time: 100 minutes. This film has no rating.

Camille	Nathalie Baye
Vincent	Joachim Serreau
Gaëlle	Félicie Pasotti
Adrian	Miki Manojlovic
Camille's Agent	Henri Garcin
Stéphane	Gilles Treton

By VINCENT CANBY

Nicole Garcia's "Every Other Weekend" is an elegant portrait of inarticulate decision and emotional disorder, about a woman who, having left her husband and two children to search for herself, finds no one there.

That's just one way to read the new French film, opening today at the Cinema Third Avenue. "Every Other Weekend" may also be seen as some kind of feminist statement about a woman who seeks definition no matter what the cost to herself or to those around her.

Miss Garcia, the actress ("Mon Oncle d'Amérique") who makes her feature film directorial debut here, appears to have a real gift for dealing with her performers, including two quite extraordinary child actors. The screenplay, which she wrote in collaboration with several others, is not equally sharp.

•

Camille (Nathalie Baye) is a once-popular television actress, whose face is still remembered though the name is not. She is going nowhere. Divorced from her husband, who has the custody of their children, she is now taking any assignment she can get. When the film opens, she's off to Vichy to be the emcee at a Rotary Club benefit. Because it's her weekend to have the children, she drags them along with her.

They are Vincent (Joachim Serreau), a solemn 10-year-old with a passion for astronomy, and 5-year-old Gaëlle (Félicie Pasotti), who laughs hysterically when her mother does cartwheels but feels more comfortable with the nanny she knows far better.

Camille is not an ideal mother. She apparently loves her children, but she seems to make a point of not becoming subservient to them or, for that matter, of even paying attention to them. Preoccupied by her own thoughts, she doesn't notice when Gaëlle is about to step onto the tracks at the Vichy station, or when Vincent wanders away on their arrival at the hotel.

From the minute the children join Camille, there is an extraordinary sense of dread about everything that happens. Miss Garcia effectively places the audience in the shoes of Camille's disapproving ex-husband, Adrian (Miki Manojlovic). She dares the audience to sympathize with Camille's troubled psyche, which, unfortunately, remains fuzzily understood from start to finish.

"Every Other Weekend" works not through the coherence of character development or revelation, but through the vivid detail with which Miss Garcia dramatizes the several wild days that Camille and the children share on the road, running away from both Adrian and the police.

Having left the Vichy affair in mid-performance, Camille puts the children into a rented car and takes off, seemingly determined to persuade Vincent and Gaëlle to love her even if it means killing them in the process.

She's not a good driver. She loses her purse and all her money. They spend one night sleeping on a beach, another in the car. Her casual ways scare Gaëlle and mortify Vincent, who, like most other children his age, puts great store by conventional behavior. Yet the three seem to be on the point of a new understanding when something not completely irreversible happens.

Miss Baye is excellent in a role that's both shadowy and showy. It's not by chance that her Camille is first seen in the middle of a strenuous morning workout. Her body is perfectly toned and fit, but it initially seems uninhabited.

•

Some measure of the woman within comes during the Vichy show when Camille, to the nervousness of the audience, falls into helpless giggles after mispronouncing the name of one of the Rotarians. She's full of wounded pride and arrogance. There's a comic and moving scene in which Camille roughhouses with

some children on the beach while her own children look worriedly on.

Their confidence in her, when it comes, is hard won.

The rapport between Miss Baye and young Mr. Serreau and Miss Posotti is remarkable, without an ounce of the sentimental nonsense that most directors, possibly to reassure themselves about their own happy childhoods, like to impose on such relationships in movies.

"Every Other Weekend" has the illusive manner of a fragment from some larger narrative, but it's good enough to leave you wanting to know more.

1991 Je 19, C12:3

Visitation Nathalie Baye and Felicie Pasotti portray mother and daughter in "Every Other Weekend," Nicole Garcia's drama about a divorced actress who has surrendered custody of her children to pursue her career.

MK2 Productions

The Rocketeer

Directed by Joe Johnston; screenplay by Danny Bilson and Paul De Meo, story by Mr. Bilson, Mr. De Meo and William Dear, based on the novel by Dave Stevens; director of photography, Hiro Narita; edited by Arthur Schmidt; music by James Horner; production designer, Jim Bissell; produced by Lawrence Gordon, Charles Gordon and Lloyd Levin; released by Walt Disney Pictures. Running time: 108 minutes. This film is rated PG.

Cliff	Bill Campbell
Jenny	Jennifer Connelly
Peevy	Alan Arkin
Neville Sinclair	Timothy Dalton
Eddie Valentine	Paul Sorvino
Howard Hughes	Terry O'Quinn
Fitch	Ed Lauter

By JANET MASLIN

The Saturday afternoon serials that spoke to the adventure-loving children in all of us are by now several generations away. Having inspired future film makers with their miraculous derring-do, these innocent tales of heroism have since been reconstituted as bigger, more stupendous efforts 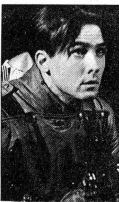 than anything their originators ever imagined. It is now possible to film a gee-whiz story with the kind of advanced technical ingenuity that would have wowed Tom Swift, but in achieving this kind of sophistication something has been lost. The heroes of tomorrow will not take their inspiration from

Bill Campbell in "The Rocketeer."

Ron Batzdorff

the movie heroics of today.

Enter "The Rocketeer," a benign adventure saga that has attractive stars, elaborate gimmicks and nice production values — everything it needs except a personality of its own. The idea of infusing this story with anything better than secondhand excitement appears to have been barely an afterthought, if indeed it occurred at all. Plenty of energy has gone into making this a bustling, visually clever film with an amusing late-1930's stylishness, but the purpose of such effort is uncertain. Something's gone wrong when the costumes and settings in a movie are substantially wittier than the people.

"The Rocketeer" is doubly nostalgic, recalling both the nice guy heroism of James Stewart in his Frank Capra roles and the buoyant cartoon vitality of Steven Spielberg's "Indiana Jones" adventures. But its fondness for both these brands of movie heroism is never more than lukewarm. Bill Campbell, as the nice young aviator who finds a streamlined backpack and becomes the flying hero of the title, is far better at affecting Mr. Stewart's look of guileless bravery than he is at displaying any independent flair. (This seems more a function of the role than of the actor's talents.) He and his co-star, Jennifer Connelly, make an exceptionally

handsome couple yet they fade into the background when they are alone together on screen.

The plot of "The Rocketeer" only heightens the uncertainty as to where this film is really aimed, since it is too

Jennifer Connelly

Ron Batzdorff

slight to engage adult audiences yet overcomplicated for children. Howard Hughes (Terry O'Quinn), the F.B.I., the Mafia and Nazi spies are all flung together in a confusing skirmish over the fate of the rocket pack; the upshot is never really in question anyhow once the rocket pack falls into the hands of Cliff Secord (Mr. Campbell), our young hero. Beginning with an airplane flight intercut with a car chase, "The Rocketeer" attempts the kind of breathless momentum that the Indiana Jones films have achieved so effortlessly, and that here is usually strained. This film's pacing is frantic without being fast.

Joe Johnston, the director of "Honey, I Shrunk the Kids," approaches this much bigger production with more good sense than inspiration,

A hero who's not just nice but who can fly, too.

which may be why it finally feels flat. Even when the sets of "The Rocketeer" are enjoyably outsized, the action within them remains inconsequential. Two of the film's major design coups, the Bulldog Cafe (a restaurant exterior resembling a bulldog) and the South Seas Club (a fancifully luxe 1930's nightclub), are themselves scene-stealingly memorable, even though the nightclub is the backdrop for an episode in which the Rocketeer whizzes crazily through its confines like an angry fly. That the hero's ability to fly becomes an occasion for slapstick does not enhance the film's overall sweep.

•

Based on a comic-book series started by Dave Stevens in 1981, and hence doubly derivative right away, the film's screenplay by Danny Bilson and Paul De Meo presents Cliff as a gung-ho flier who is the protégé of kindly, eccentric Peevy. (Even Alan Arkin, never a bland actor, is uncharacteristically colorless in this kindly grandpa role.) Thanks to the career of his gorgeous girlfriend, Jenny (Ms. Connelly), a movie extra, Cliff comes face to face with the rakish film star Neville Sinclair (Timothy Dalton), who becomes among other things his rival for Jenny's affections. Everyone in the story appears to be doing several things at once, including Paul Sorvino as a mobster with chronic indigestion. All the supporting performances have a polite denatured tone.

The battle for good and justice in "The Rocketeer" is finally waged in such unimaginative terms (despite a clever animated newsreel imagining rocket-powered enemy troops surrounding the Capitol dome) that it is

impossible to take any satisfaction in the story's ending. Cliff's good deeds never have any particular stature, even though they supposedly involve earthshaking world affairs. Within the film itself, the polarities of good and evil are too indistinct to matter. Any hint of real risk or sacrifice comes from the other, better films that are invoked.

Only the period costumes (by Marilyn Vance-Straker) and production design (by Jim Bissell) of "The Rocketeer," which are ostensibly the least original things about it, have any real flair. The film's view of swanky Hollywood is enjoyably wry, and its extravagant outfits recall movie-star glamour at its most grandiose.

The streamlined 1930's look of various props, including the Rocketeer helmet that makes Cliff look "like a hood ornament," in the words of Peevy, are equally striking. And Cliff's trademark leather jacket, which becomes a Rocketeer trademark, is a wonder. Viewers are sure to admire it. But the clothes shouldn't have to make the man.

•

"The Rocketeer" is rated PG (Parental guidance suggested). It includes mild violence.

1991 Je 21, C1:3

The Runner

Directed by Amir Naderi; written (in Farsi with English subtitles) by Mr. Naderi and Behruz Gharibpour; photography by Firouz Malekzadeh; released by International Home Cinema. At Film Forum 1, 209 West Houston Street. Running time: 94 minutes. This film has no rating.

Amiro...........................Madjid Niroumand

By STEPHEN HOLDEN

In the poignant opening scene of Amir Naderi's film "The Runner," a ragged young boy standing at the edge of a harbor waves and shouts imploringly at the silhouette of an oil tanker slipping silently through the mist. The setting is the Iranian port city of Abadan. Amiro (Madjid Niroumand), the film's subject, is a homeless 13-year-old who lives in the hulk of an abandoned ship and ekes out a living picking through garbage.

Variations of the scene recur several times in the 1985 Iranian film, which is at Film Forum 1. Amiro is as transfixed by airplanes as he is by ships and spends the few coins he is able to scrounge on aviation magazines than he cannot read. After taking himself to school where he begins learning the Farsi alphabet, he turns the letters into an incantation that he hurls to the sky with a wild, furious determination while standing on a rock surrounded by pounding surf.

•

"The Runner," which has been compared with Vittorio De Sica's "Shoeshine," François Truffaut's "400 Blows" and Héctor Babenco's "Pixote," takes its title from a ritual that is another recurrent motif. Early in the film, Amiro falls in with a pack of slightly older boys who, despite the sweltering heat, like to run races on the railroad tracks, sometimes chasing freight trains that speed away just out of reach. These increasingly frantic and surreal contests become the film's central metaphor for the survival instinct and for a driving life

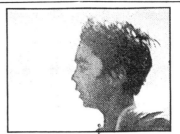
Madjid Niroumand

force that one is fairly certain will sustain Amiro despite his disadvantages. In fact, the film, which was written by Mr. Naderi and Behruz Gharibpour, was inspired by the director's childhood experiences.

Set over a period of several months in an indeterminate present, "The Runner" — in many images and few words (with confusing English subtitles) — follows Amiro's hand-to-mouth existence. From garbage scavenger he becomes a collector of floating bottles in the shark-infested harbor, an ice-water vendor, a shoeshine boy and a part-time student. A shrewd survivalist with an innate sense of justice and fair play, Amiro fights for what is rightfully his. When a man rides off on a bicycle without paying for his ice water, Amiro chases him, pulls him down and demands payment.

•

If "The Runner" is tentatively optimistic, it is also drenched in a mood of yearning lyricism. As Amiro gazes longingly into a hazy harbor sunset, the strains of Nat (King) Cole singing "Around the World" are barely audible. When his only friend departs to work on a ship, Amiro weeps. At moments like these, the film's portrayal of him as an utterly pure soul veers perilously close to sentimentality.

What keeps "The Runner" on track is the way it looks at the world through Amiro's eyes and finds beauty and wonder as well as squalor in Abadan's grimy sunsets, polluted harbor waters and dusty railroad depots. It is further anchored by the radiant performance of Madjid Niroumand, who plays Amiro without a trace of self-pity.

1991 Je 21, C5:1

A Paper Wedding

Directed by Michel Brault; screenplay (in French with English subtitles) by Jefferson Lewis, with the collaboration of Andrée Pelletier; director of photography, Sylvain Brault; edited by Jacques Gagne; produced by Aimee Danis; released by Capitol Entertainment. At Lincoln Plaza Cinema, Broadway and 63d Street. Running time: 90 minutes. This film has no rating.

Claire...........................Genevieve Bujold
Pablo...........................Manuel Aranguiz
Annie...........................Dorothée Berryman
Gaby...........................Monique Lepage
Milosh...........................Teo Spychalski

By JANET MASLIN

The French-Canadian romance "A Paper Wedding" is a more serious, less stylish version of "Green Card," another story of star-crossed strangers who meet and marry before they fall in love. Although the two films were reportedly made independently of each other, the coincidences that

link them are nothing short of amazing.

The heroines of both stories are more or less scholarly types, whereas the heroes are immigrants holding restaurant jobs. Each hero proves to be a lot more sensitive and distinguished than he initially appears. Each heroine has a suspicious erstwhile beau who resents her new situation and won't go away. Each newlymarried couple must go to elaborate lengths to hoodwink immigration authorities. Each film has its little misunderstandings about household trivia and international cuisine.

•

But the mood of "A Paper Wedding" is much more somber than that of "Green Card," in part because Claire, a professor played by Gene-

A more serious, less stylish tale of strangers who meet and marry.

vieve Bujold, begins the story seeming genuinely depressed. Nearing 40 years old, trapped in an unsatisfactory affair with a married man, she has reached the stage of quiet despair when her sister, a lawyer, requests a favor. "He's mysterious, a little sad," she says of the client she wants Claire to marry. "No, not sad, nostalgic. He's a bit of a poet." He is also a political exile, a reporter and union organizer newly arrived from a Spanish-speaking land. Pablo, played by the Chilean actor Manuel Aranguiz, even speaks poetically when talking in his sleep.

Certain as the viewer is that Pablo is the man for Claire, she herself takes a predictably long time to see the light. "A Paper Wedding," directed by Michel Brault and written by

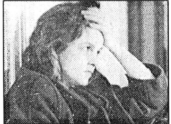
Genevieve Bujold in "A Paper Wedding."

Capitol Entertainment

Jefferson Lewis, supplies a marriage-minded mother for Claire, a few fellow countrymen for Pablo and that persistent ex-boyfriend, in efforts to forestall the inevitable moment of truth for as long as possible.

"A Paper Wedding," which opens today at Lincoln Plaza Cinema, is simply directed and holds little surprise, but it is given considerable substance by the performance of Miss Bujold, a stronger and more persuasive actress in each new role. Her Claire, fully formed yet also touchingly uncertain, is a lonely figure with a keen, cynical intelligence that contributes powerfully to her isolation. Mr. Brault's camera watches closely as her composure dissolves and she fights to preserve her dignity, all the while recognizing how badly

she needs to change. Miss Bujold renders this transformation in intricate detail.

•

This story's potential for cuteness, so fully realized in "Green Card," is confined to several scenes in which Claire and Pablo set up housekeeping and get on each other's nerves. For instance, she is unhappy when he messes up the kitchen making empanadas, which he intends as a special surprise. Miss Bujold and Mr. Aranguiz, who shares his co-star's solemnity, give even giddy moments like this a contemplative edge.

1991 Je 21, C8:1

Dying Young

Directed by Joel Schumacher; screenplay by Richard Friedenberg, based on the novel by Marti Leimbach; director of photography, Juan Ruiz Anchia; edited by Robert Brown; music by James Newton Howard; produced by Sally Field and Kevin McCormick; released by 20th Century Fox Film Corporation. Running time: 100 minutes. This film is rated R.

Hilary O'Neil	Julia Roberts
Victor Geddes	Campbell Scott
Gordon	Vincent D'Onofrio
Estelle Whittier	Colleen Dewhurst
Richard Geddes	David Selby
Mrs. O'Neil	Ellen Burstyn
Cappy	Dion Anderson

By JANET MASLIN

It takes a special kind of person to embark on a two-week trip, find a charming cottage in a romantic coastal town, set up housekeeping, make a set of new friends and show up for a Christmas party in a strapless white evening gown, something that could neither have been packed nor purchased by any reasonable means. To do this it takes a movie star of the old school, the kind whose overriding personality is never fettered by the specifics of any given role.

Julia Roberts is that kind of star, and she gets away with murder in stories that nobody else could make nearly so disarming, stories that become Julia Roberts movies no matter who else happens to be on hand. She does it again in "Dying Young," a pretty, decorative movie about messy lives and a tale best appreciated by those willing to check their taste for realism at the door.

This time Ms. Roberts appears as Hilary O'Neil, a feisty young woman who happens onto the best job opportunity since Mr. Rochester hired Jane Eyre to tutor his little ward. Disappointed in love, and not happy living with a mother (Ellen Burstyn, in a cameo appearance) who wears curlers and collects dolls, Hilary answers a newspaper ad requiring a "young attractive female only" to care for an ailing young man. Victor Geddes (Campbell Scott) turns out to be shy, debonair, mightily attractive and only minimally inconvenienced by his 10-year battle with a fatal disease.

•

"Why would you pick me?" Hilary asks him ("Dying Young" is not without its sense of humor). Perhaps it had something to do with the way she climbed adorably in a red mini-suit and high heels to the very top of Nob Hill, where Victor dwells in a mansion that is a set designer's dream. Upstairs, all is old money and wood paneling, and Victor's father (David Selby) says important-sounding things like "I'll see you in Japan."

Downstairs, where Victor lives, are sleek modern bachelor quarters replete with a curved metallic bed, in which Victor thrashes pitiably after receiving chemotherapy treatments, and a black-tiled bathroom, which still looks coolly immaculate even while Victor is getting violently sick.

The cleaned-up aspects of "Dying Young" extend beyond decoration and into the screenplay, which is by Richard Friedenberg, based on a novel by Marti Leimbach. In Ms. Leimbach's version, Victor is angry and difficult in the face of impending death, and Hilary is driven into a guilty affair with Gordon (Vincent D'Onofrio), who lives in Hull, Mass., where Hilary and Victor have hidden themselves for an extended stay.

The film, as directed by Joel Schumacher, trades in New England for picturesque Mendocino, Calif., and reduces Gordon to a minor figure who poses no threat to the lovebirds' bliss. The story's Pygmalion and Instant New Life aspects are also emphasized enough to recall "Pretty Woman" and "Sleeping With the Enemy" respectively, even though these films have nothing but Ms. Roberts in common.

•

She herself can again be found doing the kinds of fetching things that perhaps only she can handle so well. Whether coyly changing her clothes

20th Century Fox

Julia Roberts

in a Laundromat or thoughtfully stocking Victor's house with flowers, vegetables and a macrobiotic cookbook, Ms. Roberts' Hilary is frankly irresistible, even though she's also too good to be true. The story's miraculous touches — that she drives a vintage fuschia Cadillac convertible and effortlessly gives up smoking so as not to disturb Victor — make not the smallest dent in her appeal. When she promises, in one of the film's surprisingly few tearful moments, that hers will be the last face Victor ever sees, the audience can be assured that whenever he expires Victor will die a happy man.

Mr. Schumacher, directing in a seductively tactile style resembling that of Adrian Lyne, gives the film a warm glow and an abundance of elegant, otherworldly lighting (when Victor and Hilary dine at a good restaurant, the light actually emanates from under their table). Stylish flourishes are everywhere, and yet the film also manages to maintain its semblance of humanity and wit.

Much of this can be ascribed to Mr. Scott, who cuts a dashing figure and enables the coy, bashful flirtation between Victor and Hilary to be drawn out more slowly and teasingly than would otherwise have seemed possible. Also in the film, and providing a kind of grace note, is Colleen Dewhurst, Mr. Scott's mother (George C. Scott is his father), who plays a knowing Mendocino resident with a colorful past, a garden maze and an unfortunate gift for foretelling the future.

Mr. Scott's exceptional assurance and his mother's in these scenes are very much in tune.

"Dying Young" oversteps its bounds a bit when it emphasizes Victor's intellectual superiority to the point of allowing him to tutor Hilary in art history as a way of repaying her kindness, and underscores the fact that he has a doctoral thesis in the works. Still, Mr. Schumacher's use of rapturous portraits by Klimt and Rossetti is bluntly effective in underscoring the inspirational power of a beautiful artist's model. In this film he, too, has his muse.

"Dying Young" is rated R (Under 17 requires accompanying parent or adult guardian). It includes mildly off-color language and sexual situations.

1991 Je 21, C10:1

My Father's Glory

Directed by Yves Robert; screenplay (French with English subtitles) by Jérome Tonnère, Louis Nucera and Mr. Robert; cinematographer, Robert Alazraki; edited by Pierre Gillette; music by Vladimir Cosma; produced by Alain Poiré; released by Orion Classics. Running time: 110 minutes. This film is rated G. At the Fine Arts Theater, 4 W. 58th St.

Marcel	Julien Ciamaca
Joseph	Philippe Caubère
Augustine	Nathalie Roussel
Uncle Jules	Didier Pain
Aunt Rose	Thérèse Liotard

By VINCENT CANBY

Yves Robert's "My Father's Glory" ("Le Gloire de Mon Pere"), adapted from the first volume of Marcel Pagnol's memoirs of his childhood, is about a little boy named Marcel, born just before the turn of the century in a village in the south of France.

Joseph, his father, is a schoolteacher. He wears glasses, a dark suit and a spotlessly clean white shirt every day. His mother, the beautiful Augustine, is a seamstress with the manner of an angel. She seems to float, if not to fly.

To his son, Joseph is the font of all knowledge, godlike. The script in which he writes the lessons on the blackboard has a perfection that no wobbly handed child could hope to emulate. Joseph is Marcel's role model, while Augustine is the one who nourishes and comforts him.

Both are loving, kind and patient with the boy, whose only lack is that he's not yet an adult.

•

But even Marcel is remarkably patient. The process of learning about life fills him with such consistent wonder that he hasn't time to brood about the small inequities to which most children are subject.

"My Father's Glory" is a film memoir of almost dumbfounding sweetness. Yet there is also a sort of rigor about it. Because it evokes a world from which all dread has been removed, it passes beyond the sentimental into the realm of mythic happiness. It doesn't avoid or soften harsh realities: they simply don't exist.

Mr. Robert, best known here for his slapstick comedies, particularly "The Tall Blond Man With One Black Shoe," understands the extreme delicacy of material that, at any moment, could turn into hip-deep fudge. Even those of us for whom a little Pagnol goes a long way can admire the direc-

tor's tact and reserve in dramatizing an idyll that might otherwise anesthetize thought as well as immobilize movement.

"My Father's Glory" is far different from Claude Berri's recent adaptations of Pagnol's "Jean de Florette" and "Manon of the Springs." It is without any hint of melodrama, without any conventional plot, really.

Narrated by the adult Marcel (Pagnol was in his early 60's when he wrote this first volume of his memoirs), the film recalls the resolutely serene childhood of a man for whom life has obviously been very good.

Indeed, Pagnol (1895-1974) did have an extraordinary career as a playwright, novelist and film maker. His work was extremely popular. It brought him not only great financial rewards but also membership in that august group of 40 men of letters, the French Academy, which never saw fit to recognize Molière, Diderot, Balzac and Flaubert, among others.

In "My Father's Glory," Pagnol is looking back with some longing, but mostly with extreme satisfaction, which is not to be confused with smugness. He is too clever an artist for that. He recalls the courtship of his mother and father, his own birth, the birth of a younger brother, Paul, and his maiden aunt's eventual marriage.

At the age of 4 he delighted his father by being able to read, though his mother and aunt are afraid that the knowledge will drive him mad. Later, he's very pleased to figure out that babies are born through their mothers' navels. As a kind of crowning experience of a young life already filled with other crowning, if slightly lesser, experiences, there is a summer vacation in a rented villa outside Marseilles.

"Thus began the happiest days of my life," the adult Marcel says on the sound track. In the course of the summer, Marcel makes friends with a country boy, learns how to hunt and, most importantly, in one potentially terrible day, discovers that his father is the man he always knew him to be.

Philippe Caubère and Nathalie Roussel play Marcel's perfect parents with easy, unsticky authority and humor. Also very good are Thérèse Liotard and Didier Pain, as Marcel's aunt and the portly, self-satisfied civil servant she marries. Best of all is Julien Ciamaca, who appears as the 11-year-old Marcel, through whose all-trusting eyes the world is seen.

Like the adults around him, the boy never gives the impression that the events in which he finds himself are of anything less than mortal importance. He's utterly serious.

The movie also looks right; that is, idealized. Though the hills of the French Midi are serene and the hilltop towns old, everything looks spanking clean, brand-new, as it might be remembered by an old man attempting to recapture a far-off time when he, too, was new. Even the weather is unreal. At one point, the rain pours down from a sunny, cloudless sky.

"My Father's Glory," which focuses on Marcel's relationship with Joseph, opens today at the Fine Arts. It will be followed in July by "My Mother's Castle" ("Le Château de Ma Mère"), Mr. Robert's adaptation of the second volume of the memoirs. Both films have been immensely successful in France.

"My Father's Glory" is rated G (General audiences).

1991 Je 21, C10:5

When Murder Is Surreal, Corpses Don't Stay Dead

"The Golden Boat" was shown as part of the 1990 New York Film Festival. Following are excerpts from Caryn James's review, which appeared in The New York Times on Sept. 29, 1990. The film opens today at the Bleecker Street Cinema, at La Guardia Place.

"What does a real artist do when he sees blood?" asks a menacing middle-aged murderer after he has stabbed two almost-innocent bystanders in a college men's room. "He uses it," the killer says as he dips his hand into a pool of bright red goo and starts writing on the wall. He would seem truly lethal, but the corpses on the floor are fidgeting.

Many people are killed but few stay dead in "The Golden Boat," Raúl Ruiz's affectionate satire of murder mysteries, soap operas and life on the artistic fringes of downtown New York. The film, shot in lower Manhattan and featuring cameos by the directors Jim Jarmusch and Barbet Schroeder and the writer Kathy Acker, is the first English-language work by Mr. Ruiz, a prolific Chilean-born, European-based film maker.

The twisty narrative line is as smooth and nonsensical as the film's opening shot, in which the camera glides at ankle level through garbage-strewn gutters, following a trail of abandoned shoes.

Like Hansel and Gretel's trail of bread crumbs, the shoes lead a young man named Israel to a sinister older man sitting on a curb. He is Austin, who soon stabs himself in despair and has enough energy left over to kill a passerby and follow Israel home. Austin stumbles up the stairs, clutching the knife in his stomach and claiming to be the young man's father. But before long, the mystery of Austin's identity becomes more convoluted. He claims to have another son, Tony Luna (Michael Stumm), an actor on a television soap opera we glimpse now and then.

Strand Releasing

Michael Stumm in a scene from "The Golden Boat."

The show is in English, but has Hispanic actors and the overwrought drama of Mexican films and serials. More and more, the soap opera's melodrama bleeds into the "real" narrative of "The Golden Boat."

Though the lines of influence are clear — Mr. Jarmusch has called Mr. Ruiz's "On Top of the Whale" one of the best films of the 80's — audiences unfamiliar with Mr. Ruiz's work may see "The Golden Boat" as a more cockeyed surreal version of Mr. Jarmusch's deadpan stories and characters.

Mr. Ruiz and his actors, notably Michael Kirby as Austin and Kate Valk as the Mexican siren Amelia López, never let "The Golden Boat" become broadly farcical. Instead, they walk a sophisticated line between parody and homage, and end up with one of the smartest, giddiest movies around.

1991 Je 22, 12:4

FILM VIEW/Henry Louis Gates Jr.

'Jungle Fever' Charts Black Middle-Class Angst

HONEST EXPLORATIONS OF the complexities of interracial sexual attraction have not been among Hollywood's strong points. It has either been treated as bestial and demeaning, as in "The Birth of a Nation," where the fondest wish of the newly-emancipated slave was to rape a white woman, or as lurid and titillating (in "Shaft," the eponymous hero makes love to a prostitute in his shower), or almost completely sublimated (Sidney Poitier made a small fortune as

Sublimation Man, first in "A Patch of Blue" where a blind girl falls in love unwittingly with the character he plays, and then in "Guess Who's Coming to Dinner" where the character played by Katharine Houghton reveals to her mother that she and John Wade Prentiss, the doctor played by Mr. Poitier, have not yet made love "because he wouldn't." Even I, as a 16-year-old West Virginia country boy, knew *that* was a lie.

But "Guess Who's Coming to Dinner" presented a significant theme of the civil rights movement. A paragon of the race, sweet, honest, self-effacing Sidney Superman, educated at America's finest universities, is not only a doctor but a potential candidate for the Nobel Prize.

■

Prentiss was the perfect un-Negro, M.D. in hand, hair neat and closely cropped, not a trace of the plantation, or the ghetto, in his voice. This film, ironically, did more to fuel the death of the civil rights movement and the birth of black nationalism than any other — precisely because it suggested that the movement would achieve fulfillment in a new middle class, assimilated, desexualized, safe. (The sole "sexual" contact between the lead characters is one passionless American kiss, seen in a taxi's rear-view mirror.)

Spike Lee's new film "Jungle Fever," by reversing usual expectations of class status, educational background and financial stability among its black and white characters, raises hard questions about contemporary black masculinity. Flipper Purify (an architect) and Drew, his wife (a buyer at Bloomingdale's) occupy the very world to which the white ethnics of Bensonhurst (his secretary Angie's family) aspire. (When Flipper seduces Angie, in his office after hours, they traverse not just the color line, but class and economic lines as well.) While both Mr. Poitier's doctor and Mr. Snipes's architect are solidly middle class, that's where resemblances end. Mr. Snipes plays a weak and vacillating man whose reversals of fortune follow directly from flaws in his own character. There is no social determinism here; Flipper makes his bed and, quite literally, lies in it.

Mr. Lee's creation of the floundering and ineffectual Flipper Purify is a mordant commentary on the new black middle class, the post-1970's generation of buppies and wanna-bees. It also signals a recent shift in black attitudes toward social advancement. Black literature is full of characters whose greatest pride is their middle-class ancestry and whose greatest aspiration is to become even more deeply middle class. In fact, this drive for social elevation seemed to be a central trait of the culture, at least for a century.

The emergence of a new nationalist ethos in the late 60's and 70's changed that. As ghetto or street culture became romanticized, many blacks became defensive about a middle-class past or future. "Authentic" black culture, in other words, was lower-class culture, from speech and attitude to clothes and coiffure. As if to assuage guilt for having escaped, new arrivals in the black middle class, unable or unwilling to visualize themselves in their own terms, embraced the *affectations* of the ghetto, though without its pain, frustration and suffering. For one of the few times in black history, the "blackest" aspects of black culture were thought to be those least related to economic success. To be black and middle class was to betray, somehow, one's black heritage.

Meet Flipper Purify. Trying to make it "in cruel white corporate America," as he says with a facetious edge, he inherits the tensions and conflicts that have beset the black bourgeoisie since E. Franklin Frazier's scathing

David Lee/Universal Pictures

Wesley Snipes, seated above, in "Jungle Fever," and Sidney Poitier, standing at right, in "Guess Who's Coming to Dinner" are solidly middle class, but there the resemblance ends.

1953 portrait of the breed. Purify lives on a street known for generations as Striver's Row. But he is not dealing well. "I'm still pro-black," he assures his friend Cyrus, after confessing his dangerous liaison with his white secretary. What's important, however, isn't *that* Flipper sleeps with a white woman — it's *why* he sleeps with her.

"You got with me despite your family," Flipper tells Angie, breaking off the affair, but he's a little too pat to be persuasive. "You were curious about *black*." Angie is hardly the blond, blue-eyed succubus of Drew's imaginings. (Angie happens to be as dark as Drew, for one thing.) In fact, what Angie provides Flipper with is the opportunity to be "black." Flipper may fear that he's become a denatured, deracinated black yuppie, but with Angie, he can pretend to be the proverbial black buck of the American psychosexual imagination, and what he assumes to be her fantasies.

Powerless in the world of white men, he can be as black as the ace of spades in the mirror of Angie's eyes, an exotic object of sexual fascination. Or so he imagines.

Flipper Purify embodies the tensions and conflicts of the black bourgeoisie.

(That's why, when he becomes, quite simply, human to her, the magic is over for him.) Flipper's fling has everything to do with role playing and nothing to do with Angie. "Don't tell me what I feel," Angie says to him mournfully, and the line resonates.

That the Bensonhurst-bred Angie is rendered as a more sympathetic character (and, indeed, less consumed by the mystique of color) than Flipper attests to the complexity of Mr. Lee's social vision. At the same time, Flipper's ambivalent characterization captures the ambiguous position of the black middle class, at home neither among its poorer brethren nor among white middle-

class society. He is an allegorical figure of black self-alienation. Unlike Mr. Poitier's doctor, Flipper is not admirable. We do not like him, we do not aspire to emulate him, and we are not going to invite him to dinner.

If "Guess Who's Coming to Dinner" was the civil rights era's film par excellence, "Jungle Fever" may be the film that most effectively captures the marginality and assimilation of the new, young, black upper-middle class. Yes, "Jungle Fever" shows how overdetermined interracial contact is in American society. But it also shows that social categories like "black" and "white" are not mutually exclusive, either. It is saying that the supposed cultural and psychological barrier between black and white Americans — symbolized by the distance between Harlem and Bensonhurst — is just one more myth of American racism.

"Jungle Fever" illustrates that the relationship between black and white in America is one of ambivalent fascination and cultural and social interpenetration. If whites hate blacks, as one character claims, precisely because they want so desperately to be black, then it is also true that black people learned long ago to hate aspects of their cultural selves precisely because the larger society would not let them function as "white" people. But the exploitation of the white working class, and Angie's exploitation by the men in her own family, also argue strongly that society creates "niggers" even in white enclaves such as Bensonhurst. "Jungle Fever" explores the space that connects, rather than divides, black America with white. □

1991 Je 23, II:20:1

Naked Gun 2½
The Smell of Fear

Directed by David Zucker; written by Mr. Zucker and Pat Proft; director of photography, Robert Stevens; edited by James Symons and Chris Greenbury; music by Ira Newborn; production designer, John .J. Lloyd; produced by Robert K. Weiss; released by Paramount Pictures. Running time: 85 minutes. This film is rated PG-13.

Lieut. Frank Drebin..................Leslie Nielsen
Jane Spencer.........................Priscilla Presley
Ed HockenGeorge Kennedy
Nordberg.................................O. J. Simpson
Quentin HapsburgRobert Goulet
Dr. Meinheimer/Earl Hacker
 Richard Griffiths

By VINCENT CANBY

The summer is saved.

Lieut. Frank Drebin is back and Leslie Nielsen is again playing him in David Zucker's delirious new comedy, "The Naked Gun 2½: The Smell of Fear," solemnly described as 'more than a sequel."

In this follow-up to the 1988 hit "The Naked Gun: From the Files of Police Squad" the courtly, white-haired, perfectly manicured Drebin pits his cleverly concealed bewilderment against the wits of a group of greedy fuel barons determined to dictate White House energy policy.

They don't know whom they're up against in Drebin, whose fondest wish is to be known as "the environmental police detective." Drebin dreams of a world in which he can eat a sea otter without getting sick.

"The Naked Gun 2½" may not be quite as consistently funny as "Airplane!" or even "Ruthless People," which Mr. Zucker directed with his brother Jerry and Jim Abrahams, but it seems to be, after the fact. For that matter, even before the fact. The trailer for the film has been convulsing audiences here since it first appeared in theaters here a couple of months ago.

The enthusiastic Zucker, Zucker & Abrahams style of movie parody is too rarely seen to prompt much head-shaking about gags that don't work. The entire film is justified by those gags that do succeed, beginning with a pre-credit sequence that is possibly one of the most blithely hilarious six or seven minutes of film stock ever exposed to light.

The setting: the White House. The occasion: a formal dinner party given by George and Barbara Bush with, among those in attendance, Nelson and Winnie Mandela, John Sununu and Drebin, who is being honored for having shot his 1,000th drug pusher. Drebin isn't as impressed by the occasion as he is by his broiled lobster. He's hungry.

As he cracks claws and removes meat from each cranny of the sea beast, Mrs. Bush, sitting on his right, keeps being so impolitely whacked by Drebin's elbow and arm that she spends much of the meal on the floor, flat on her back, her legs in the air. Mrs. Bush, played by an amazing look alike named Margery Ross, remains smiling and gallant through each new indignity. Her husband remains thumbs up and oblivious.

If "The Naked Gun 2½" never again attains that level of inspired rudeness, it comes close many times as Drebin wanders around Washington in Mr. Nielsen's version of what might be called an informed haze. Life isn't easy at the top of one's profession.

In addition to getting to the bottom of a plot that would sabotage all anti-

Ron Phillips/Paramount
Leslie Nielsen

pollution measures, Drebin is trying to win back Jane Spencer (Priscilla Presley), who left him at the end of the first film when he was caught in a

An environmental cop seeks to make the world safe to eat sea otter.

compromising position with the Queen of England.

Their new courtship has both highs and lows and survives a bombing that destroys the offices of Jane's new boss, Dr. Meinheimer (Richard Griffith), the man responsible for a sane new energy policy. Drebin romances Jane on the dance floor and in the bedroom. Both sequences have a great deal of fun at the expense of treasured movie clichés.

"The Naked Gun 2½," identified in the opening credits as "un film de David Zucker," is best when it is casual about its narrative responsibilities. It's a marvelous grab-bag of variations on old routines, including one in which a wheelchair runs amok, and sight gags. (A nightclub called the Blue Note is decorated with large news photographs of disasters.) When Drebin and Jane ask Sam, the pianist, to play their song, it is "Ding Dong the Witch Is Dead."

•

Mr. Zucker and Pat Proft, who collaborated on the screenplay, have perfect pitch when it comes to cornball dialogue. Much of this is given to the sincerely obtuse Drebin, who likes to say such things as, "Well, the cows have come home to roost."

"The Naked Gun 2½" is the sort of film in which gags are often funny in direct relation to their obviousness, as when a policeman is asked by a young woman, who is just barely dressed, "Is this a bust?"

Undergraduate and old-time two-a-day burlesque comedy is skillfully integrated with sketches of contemporary sensibility. Look for the public service television spot promoting nuclear power that features a sweet, cuddly Old English sheepdog with two tails.

The big chase scenes are not as successful or as funny as the rest of

the film. The timing is off. Mr. Zucker and his associates are most at ease when they are scoring comic points and quickly moving on to something entirely other.

Mr. Nielsen is again splendid: a little bit pompous, immaculately groomed, but always as vulnerable as a man who is unaware that he is walking around without any trousers. Miss Presley is a winsome Juliet to his clumsy Romeo, a willing Ginger to his ardent Fred, a worldly Jane to his Tarzan. As a dedicated environmentalist, she really cares about "the end zone layer."

This time around, neither George Kennedy nor O. J. Simpson has much to do, but they do that with spirit. Robert Goulet appears as a villain, and Zsa Zsa Gabor turns up as herself, having an encounter with yet another policeman. As the First Lady, Miss Ross is so graciously stalwart that even Mrs. Bush should laugh.

Mr. Zucker apparently doesn't know when to stop. The film's printed credits, furnished to reviewers, are full of gems. Sandwiched between the Stock Librarian (Suzy Lafer) and the Choreographer (Mianda Garrison) is the Stock Answer ("I'll have it ready in the morning").

•

"The Naked Gun 2½," which is rated PG-13 ("Parents strongly cautioned"), includes some vulgar dialogue and partial nudity.

1991 Je 28, C8:1

The Reflecting Skin

Directed and written by Philip Ridley; director of photography, Dick Pope; edited by Scott Thomas; music by Nick Bicat; produced by Dominic Anciano and Ray Burdis; released by Prestige, a division of Miramax Films. Running time: 106 minutes. This film has no rating.

Cameron Dove.....................Viggo Mortensen
Dolphin Blue.........................Lindsay Duncan
Seth Dove.................................Jeremy Cooper
Ruth Dove..................................Sheila Moore
Luke Dove................................Duncan Fraser
Joshua...................................David Longworth

By VINCENT CANBY

Philip Ridley's "Reflecting Skin" is a nightmare of childhood in which everything feared is made manifest. The time is the 1950's and the place the rural American Northwest. Seth Dove is almost 9 years old.

When first seen, he and two young friends are playing a trick on Dolphin Blue, the strange young widow who lives alone in a house on the prairie. They catch a frog, inflate its stomach by blowing through a reed and, when Dolphin sees it on the road, fire at the frog with a slingshot so that it explodes in her face.

When Seth is made to apologize, the dreamy Dolphin tells the boy that she was upset only because the frog's

Miramax
Jeremy Cooper

blood spoiled her dress. In fact, she says, when she was a child she delighted in tying firecrackers to the tails of cats and in putting canaries in hot ovens to listen to them detonate.

"The Reflecting Skin" is clearly not your commonplace childhood

They're in love, but she may be a vampire: his hair is falling out.

memoir. It is part horror story, part absurdist comedy, mostly pretentious nonsense. Any movie with a character named Dolphin Blue has to be too self-importantly fey for general consumption.

•

The film is the first to be written and directed by Mr. Ridley, the Englishman who wrote the screenplay for "The Krays." He seems to have a lot on his mind, though none of it is yet sorted out. He is reported to have said that he conceived "The Reflecting Skin" at a period in his life when he was reading "Alice in Wonderland" and looking at a lot of paintings by Andrew Wyeth. You can make of that what you will.

"The Reflecting Skin" is not meant to be realistic, but it also doesn't bear interpretation. What's worse is that every now and then characters say trivial things that the audience is supposed to take as profoundly poetic insights. "Even angels lose their wings," Dolphin tells Seth at a not very gripping moment.

In the course of this one magical summer, Seth is periodically propositioned by the driver of a big black Cadillac. Two of his friends are found murdered. His father, accused of the first murder, douses himself with gasoline and burns himself up in the yard as Seth watches.

That the movie may have an all too literal subtext is suggested when Seth's beloved older brother, Cameron, comes back from the South Pacific, where he has been on duty assisting in the United States' atom-bomb tests. Cameron and Dolphin become lovers. The jealous Seth is sure that Dolphin is a vampire because Cameron's hair is falling out.

In this fashion the movie lurches on.

•

The influence of Wyeth is more apparent than that of Lewis Carroll. The movie is full of golden wheat-fields that, when they surround a desolate farm house, suggest doom somewhat too insistently. Lindsay Duncan, the English actress who plays Dolphin Blue, even has something of the rough beauty of a Wyeth model.

Jeremy Cooper, who plays Seth, and the other child actors are not great, but they are better than the adult actors, for whom there is no way to speak the dialogue without, at the same time, chewing on the scenery. The scenery is pretty but not edible.

1991 Je 28, C9:1

Europa, Europa

Directed by Agnieszka Holland; screenplay (in German and Russian with English subtitles) by Miss Holland, based on the autobiography of Solomon Perel; director of photography, Jacek Petrycki; edited by Ewa Smal and Isabelle Lorente; music by Zbigniew Preisner; released by Orion Classics. At Lincoln Plaza Cinema, Broadway and 63d Street. Running time: 115 minutes. This film is rated R.

Solomon Perel	Marco Hofschneider
Isaak	Rene Hofschneider
David	Piotr Kozlowski
Solomon's Father	Klaus Abramowsky
Solomon's Mother	Michele Gleizer
Leni	Julie Delpy

By JANET MASLIN

Running on tracks that pre-date Hitler's rise to power, the trolley car still passes through the Lodz ghetto, so its windows have been white-washed to shield the eyes of Aryan riders from unwelcome sights. But a member of Hitler Youth surreptitiously creates a peephole, and through it he glimpses a terrible vision: the abject, suffering figure of his own mother. The woman he sees — he thinks she is his mother, though he cannot be positive — moves slowly through a landscape of utter misery. Her son, a Jew who has managed to pass himself off as a Nazi hero, can do nothing to alter her fate.

At moments like this, Agnieszka Holland's "Europa, Europa," which opens today at the Lincoln Plaza Cinema, accomplishes what every film about the Holocaust seeks to achieve: It brings new immediacy to the outrage by locating specific, wrenching details that transcend cliché. Based on the memoirs of Solomon Perel, who survived the war through a variety of unusual subterfuges and is briefly seen offering a song of thanksgiving at the story's end, this film includes several remarkable episodes illustrating the strange events that shaped Mr. Perel's destiny and the full force of his terror and sorrow.

But much of the time, the truth here has a way of seeming stranger than fiction, largely because of Miss Holland's determinedly blithe directorial style. "Europa, Europa" has the pretty, sensitive look of a pastoral French romance even as it presents the most harrowing aspects of Mr. Perel's early years. Miss Holland's smooth direction is appealing and never fundamentally negates the essence of Mr. Perel's situation, but the result is a less ironic or complex film than must have been intended. The ingenuousness of the young hero, who was only a teen-ager at the time he found himself in the midst of a grave moral quandary, often feels bizarre in light of the events at hand.

•

Solly (Marco Hofschneider) comes from a close-knit family that is torn

A childhood filled with partings in 'Europa, Europa.'

apart very early in the film, leaving him to fend for himself in an increasingly dangerous world. In 1938, on the eve of Solly's bar mitzvah, his home in a German city is disrupted by a pogrom that kills his sister, an event Miss Holland presents with wrenching simplicity and tact. Soon after-

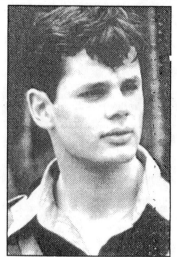
Orion Classics
Marco Hofschneider

wards, the Perels move to Lodz, Poland. But when war breaks out, the parents order their two younger sons to flee, and during the journey Solly is separated from his older brother. "Europa, Europa" is set forth as a linear, episodic story, punctuated by this and many other sad partings.

Solly makes his way east and winds up in a Soviet orphanage, where his identity as a Jew is still reasonably secure. Eminently adaptable, he learns to denounce religion as the opiate of the masses and to co-exist with Christian classmates, despite the obvious tensions in the air.

But when the orphanage is bombed — marking another sad separation, since Solly has developed ties to the beautiful Stalinist who is his teacher — Solly is again adrift, and this time he lands in the hands of Nazi soldiers. They treat him royally, partly because of his usefulness as a Russian translator and partly because of his rosy, wide-eyed good looks. Typically, when the film presents a man claiming to be Stalin's son as a Soviet prisoner whom Solly interrogates, the incident has an indefinite, fairy tale quality, although it happens to be a slightly modified version of a real event.

The fact that Solly has been circumcised, in the Jewish ceremony that is seen at the film's outset, becomes critical to his survival, since this physical evidence is the only link to his Jewish heritage. The film pays considerable attention to his efforts to avoid being caught in showers, in bathrooms, and even in a sexual situation with a fresh faced young German girl (Julie Delpy) who admires him as a German hero. "If I ever catch a Jew, I'll cut his throat," she eventually tells him, in a manner that is offhanded but nonetheless certain to wreck their budding romance.

•

Presented with his personal copy of "Mein Kampf," learning to swim in a swastika-decorated pool while wearing his army helmet and carrying his rifle, Solly eventually becomes a respected member of Hitler Youth; as such, he sits quietly through classroom lectures on how to identify Jews on sight and why "the Nordic man is the gem of this earth." The pressure of this new life eventually becomes unbearable, but Miss Holland does better at depicting the impossible aspects of Solly's outer circumstances than at probing his inner confusion.

The film's dream sequences, which involve Hitler and Stalin, are less affecting than the blunt outburst of emotion that Solly feels in the presence of his Aryan girlfriend's mother, at a moment when he simply can't stand the pressure of lying any longer. Mr. Hofschneider, whose performance is direct and impassioned as far as it goes, conveys Solly's raw panic and confusion much more effectively than the crisis of conscience that inevitably goes with them.

1991 Je 28, C10:1

Extramuros

Directed and written Miguel Picazo; based on a novel by Jesús Fernandez Santos; in Spanish with English subtitles; edited by José Luís Matesanz; music by José Nieto; produced by Antonio Martín; distributed by Frameline. At Cinema Village, Third Ave. at 13th St. Running time: 120 minutes. This film has no rating.

Sister Ana	Carmen Maura
Sister Angela	Mercedes Sampietro
Prioress	Aurora Bautista
The Guest	Assumpta Serna
The Doctor	Antonio Ferrandis

By JANET MASLIN

Directed in a composed, painterly style, Miguel Picazo's "Extramuros" is as staid as a film about the Spanish Inquisition can be. It concerns the clandestine activities of two nuns, Sister Angela (Mercedes Sampietro), and Sister Ana (Carmen Maura), who run the risk of grave punishment for their activities. Most conspicuously, the two contrive to fake stigmata on the hands of Sister Angela, whose newly found public recognition brings her convent great, unexpected fame.

Frameline
Carmen Maura

More privately, they also embark on a love affair that is presented as a series of tremulous, stagy clinches fraught with noble passion. The film's gentility in depicting this attraction is modulated by the placid sincerity of Miss Sampietro, and the always larger-than-life emotions of Miss Maura, who can bring desperate intensity to any role.

"Extramuros," which opens today at Cinema Village, is most notable for its visual style, which suggests Renaissance portraiture right down to the muted hues, the hair ornaments, and the collar ruffs. The latter articles figure in the film when the convent's newly found prestige makes it attractive to the daughter of a wealthy duke; this noblewoman (Assumpta Serna) declares her intention to take vows but undermines her seriousness by arriving with a maid who gargles perfume before spraying it dutifully onto her mistress' face. At times like this, and in detailing the internecine intrigues that threaten to destroy the convent, "Extramuros" displays a quiet intelligence that would have been accentuated by a more vigorous directorial style and a livelier, less tranquil pace.

1991 Je 28, C10:5

FILM VIEW/Janet Maslin

Big Movies, Big Bucks, Big Bombs

I N A PINCH, YOU CAN TELL A SWEEPING STORY USing not much more than basic props, but these days the pinch is obsolete. Making an ambitious film at present implies a certain contempt for cutting corners. It would be desperately unfashionable, especially during summer blockbuster season, to unleash a film that didn't do its big-budget utmost to impress. This is not without precedent in other areas. From the standpoint of size, publicity and fundamental emptiness, the Hindenburg was impressive, too.

We need not think of the Hindenburg to realize that a vast, bloated spectacle may be headed for disaster; we need only look to the screen. This summer has brought an extraordinary display of hollow pyrotechnics in slow, puffy action films that cost huge sums to make and will waste huge amounts of time. They are linked not only by a money-to-burn abandon but by a crazy incongruity between purpose and scale. When else in the history of Hollywood would it have been deemed reasonable to spend nearly $40 million on a film about firemen ("Backdraft") and upwards of $50 million on in-jokes and ill humor ("Hudson Hawk")?

Why have so many film makers lately chosen to work this way? The easy answer: Because they can. Audiences still flock to costly, heavily advertised "event" films no matter how disappointing those films turn out to be. But it would be madness to imagine that such reflexive loyalty will last forever, especially when so many other factors — shoe-box theaters, television, video — conspire to diminish the movie-going experience anyhow. There's no need to go out for indifferent entertainment when you can have it at home.

Hollywood's insistence on oversized movies as a way of asserting films' singularity might make sense, except for this: Some of these big films are the work of directors who

Tri-Star Pictures

Bruce Willis in "Hudson Hawk"—wings of lead

never mastered the basics of making small ones. Whereas the old studio system insured that a sweeping epic would at least be directed by someone of minimal proficiency, there are no such guarantees anymore. In a way, they are missed. Even old-style hackdom has advantages over the surprising ineptitude of some of this season's major releases.

Nothing about "Heathers," "Honey, I Shrunk the Kids" or "Fandango" could have indicated that these films' directors would go on to monumentally bigger things. Yet these are the directors who can be found, respectively, at the helms of "Hudson Hawk," "The Rocketeer" and "Robin Hood: Prince of Thieves," three of the summer's most lavish — and, as it turns out, leaden — efforts. Ron Underwood, who made "Tremors" and now "City Slickers," has made an equally large leap, as has Ron Howard from earlier comedies like "Splash" to the expensively incendiary "Backdraft." Not one of these directors has made a film that really required a grand scale.

Nowadays, an epic film doesn't require great breadth of outlook; it can just be certifiably important (as with "Gandhi" or "Dances With Wolves") and go on too long. Even so, the inflated solemnity of a "Robin Hood" is staggeringly extreme, especially in view of the clumsiness of the film's direction. This "Robin Hood" cannot easily be watched for the mythic heroism of its title character, which barely exists in this slow and cheerless version; but as a study in directorial blundering it holds a certain fascination. The most rudimentary aspects of film making are repeatedly bungled here.

So the director Kevin Reynolds, who did better even with the modestly stylish "Fandango" (1985), this time has his camera perpetually in the wrong place. The editing is so messy that actors are rarely allowed to complete a line on-camera, a flaw that detracts from every performance in the film. Three mediocre reaction shots are often used when one good one would do, and a lot of the sound appears to have been redubbed out of sync. Such directorial uncertainty is expensive, but it makes for fiscal extravagance that doesn't look good on screen.

What does show up is an endless array of hand-held shots where steadier ones would have been preferable; un-

sightly and uninteresting wide-angle images in place of normal ones; matching shots that don't match; shadows of Robin's arrows cast unwittingly across the face of Maid Marian; and a lot of potentially dramatic moments that are robbed of any oomph. Even the crowd-pleasing cameo appearance by a big star in the film's closing moments is diminished when the celebrity, stuck behind Robin and Marian, is obscured from view.

These are film-making fundamentals, and they are a lot more important than the period portrait of Kevin Costner, as Robin Hood, that can be seen hanging in Robin's ancestral hall. Yet much more effort appears to have gone into the latter type of detail than into the basics. In the long run, this is truly an expensive mistake.

Even if this "Robin Hood" is as sizable a hit for Mr. Costner as "Dances With Wolves" was, it will not be fondly remembered. Viewers who find themselves stranded endlessly in Sherwood Forest, or baffled by the bad jokes of "Hudson Hawk," or watching one fire too many (in Mr. Howard's skillfully filmed but shapeless "Backdraft") or mildly bored by the extended, empty heroics of "The Rocketeer" may well lose patience with all the padding and the blockbuster mentality from which it springs. Today's would-be gargantuan movies need to master a worthwhile old tactic — just cut to the chase. □

1991 Je 30, II:11:5

Terminator 2: Judgment Day

Directed and produced by James Cameron; written by Mr. Cameron and William Wisher; director of photography, Adam Greenberg; film editors, Conrad Buff, Mark Goldblatt and Richard A. Harris; music by Brad Fiedel; production designer, Joseph Nemec 3d; released by Tri-Star Pictures. Running time: 135 minutes. This film is rated R.

The Terminator	Arnold Schwarzenegger
Sarah Connor	Linda Hamilton
John Connor	Edward Furlong
T-1000	Robert Patrick
Dr. Silberman	Earl Boen
Miles Dyson	Joe Morton
Tarissa Dyson	S. Epatha Merkerson

By JANET MASLIN

Using his imagination and not much more, James Cameron devised "The Terminator," the lean, mean 1984 action film that became a classic of apocalypse-minded science fiction. What this meant, in keeping with inexorable Hollywood logic, was that Mr. Cameron would become a prime candidate for sequel sickness. He would be able to follow up his original shoestring hit with a second installment whose budget is reportedly somewhere near the $100 million mark. That figure suggests at the very least a typographical error, not to mention mistakes of a more serious kind.

Surprise. Mr. Cameron has made a swift, exciting special-effects epic that thoroughly justifies its vast expense and greatly improves upon the first film's potent but rudimentary visual style. He has also broadened his initial idea to encompass better developed characters (after all, the first Terminator was barely verbal), a livelier wit and a more ambitious, if nuttier, message.

A cautionary tale, "Terminator 2: Judgment Day" anticipates nuclear disaster in the year 1997 unless there is intervention from the forces of good, who happen to specialize in shootouts, clubbings, slammings, poundings and explosions. This tirelessly violent, ultimately exhausting film has the utter sincerity of all good science fiction, and a lot more flair than most, but it suffers from a certain confusion of purpose. In the end, it amounts to quite the pistol-packing plea for peace.

Back again is Sarah Connor (Linda Hamilton), who learned in "The Terminator" that she would some day be the mother of John Connor, a revolutionary hero in the year 2029. The first Terminator, a human-looking automaton created by all-powerful machines of the future, traveled back through time to try to prevent Sarah from living long enough to have a child. But as the new film begins, Sarah is already the mother of John (Edward Furlong), a feisty pre-teen-ager who has been brought up in foster care while Sarah was in a psychiatric hospital ("The delusional architecture is fairly unique," says a doctor who has studied Sarah's ravings, and whom Sarah has stabbed in the kneecap). This time two different Terminators have been sent back to do battle over whether Sarah and John survive into the future.

The first of these, known only as the Terminator, is familiar on two scores. At first, he has the same blank, scary demeanor that convinced the earlier film's audiences that Arnold Schwarzenegger, who continues to shine in this role, was better suited to playing a pitiless villain than a camp counselor. Later on, Mr. Schwarzenegger's Terminator develops a gruff and winning kindliness that brings to mind John Wayne, although Mr. Wayne would no doubt have been confounded by T-1000 (Robert Patrick), the rival Terminator who is the film's futuristic villain.

Expanding upon the mutable-blob effect he used in "The Abyss," Mr. Cameron presents T-1000 as a show-stopping molten metal creature capable of assuming or abandoning human form at will. Some of his tricks — like rising up out of a checkerboard-tiled floor and evolving into a steely eyed police officer without skipping a beat — are cause for applause in their own right.

•

Although this fast-paced sequel locks the Terminator and T-1000 into an extended gladiatorial duel over the fate of Sarah and her son, Sarah looks like more than a match for both of them. Vicious and feral, showing off a bodybuilder's phenomenal muscle tone, Sarah says more about Mr. Cameron's taste for ferocious heroines (Mary Elizabeth Mastrantonio was

Arnold Schwarzenegger

Tri-Star

no less abrasive in "The Abyss") than for the future state of women warriors.

The film is occasionally capable of levity at Sarah's expense, as when her son tells her to lighten up after one particularly feverish tirade, but for the most part it treats her reverently. Sarah's voice-over narration — "The future, always so clear to me, had become like a black highway at night" — could have been terminated with no loss.

Mr. Cameron, whose direction at its best has a Kubrick-like reverberant chill, only rarely lapses into such melodramatic excess. Much of "Terminator 2," especially during its gripping first hour, is taken up with tight, bravura sequences like an extended two-Terminator chase through Los Angeles, or the nuclear nightmare in which that city is incinerated before the audience's eyes.

Only later, as the fireworks become overpowering, does the film's essential craziness make itself clear. Sarah becomes racked with guilt over her attack on the family of a computer executive (Joe Morton), but not before she has fired about 500 rounds of ammunition into their living room. The Terminator, promising John that he won't kill anyone, contents himself with round after round of supposedly harmless explosions instead. The violence perpetrated by these characters means to be both constructive and exploitative, and as such it winds up thoroughly muddled. This much is clear: With friends like the Terminator, no one will ever need enemies.

•

Perhaps in a spirit of détente, Mr. Cameron (who wrote the screenplay with William Wisher) limits the story's weaponry mostly to guns, providing no technology on a par with the Terminators themselves. But this makes for inconsistencies and repetition, since the T-1000 can heal himself, albeit rather spectacularly, any time he springs a leak. It takes special tricks — like the one whereby the Terminator reduces T-1000 to brittle fragments that become liquid blobs and then reassemble and rise again — to cope with such a special fellow.

Also notable about "Terminator 2" are Mr. Schwarzenegger's perfect aplomb, Brad Fiedel's ominous music, Mr. Furlong's fine, scrappy per-

formance as the story's young hero, Ms. Hamilton's wild-eyed combativeness and the film's apt casting of Mr. Morton as a successful computer entrepreneur on whose decisions the future depends.

"It's not every day that you find out you're responsible for three billion deaths!" he exclaims, late in the story. This, in the feverish atmosphere of "Terminator 2," is what passes for a sober moment.

"Terminator 2" is rated R (Under 17 requires accompanying parent or guardian). It has a great deal of violence.

1991 Jl 3, C11:5

The Miracle

Directed and written by Neil Jordan; director of photography, Phillipe Rousselot; edited by Joke Van Wijk; music by Anne Dudley; production designer, Gemma Jackson; produced by Stephen Woolley and Redmond Morris; released by Miramax Films. At 68th Street Playhouse, at Third Avenue. Running time: 97 minutes. This film has no rating.

Renée	Beverly D'Angelo
Sam	Donal McCann
Jimmy	Niall Byrne
Rose	Lorraine Pilkington

By VINCENT CANBY

Neil Jordan, the Irish-born director, makes movies not quite like anyone else. This has already been demonstrated in "The Company of Wolves" (1985), his extravagantly decorated, sometimes funny Freudian meditation on the tale of Little Red Riding Hood, and "Mona Lisa" (1986), a shaggy-dog love story about a bigoted white hood and a beautiful black hooker.

Mr. Jordan's newest film, "The Miracle," which opens today at the 68th Street Playhouse, is many things, including an irreverent variation on the kind of mother-love drama exemplified by "Stella Dallas."

The setting is the Irish seacoast town of Bray, which is Mr. Jordan's hometown, and the child is a teen-age boy, Jimmy (Niall Byrne), an imaginative, moody fellow who lives with his alcoholic father, Sam (Donal McCann), a musician. It is summer, the days long and lazy.

Jimmy's best friend is Rose (Lorraine Pilkington), a still somewhat gawky girl whose mind, like Jimmy's, is given to romantic interpretations of the most commonplace people and events. They share a fondness for words. "Nuns-swept," says Rose as they pass a group of Roman Catholic sisters whose black robes are flapping in the wind.

•

Jimmy and Rose wander around Bray making up stories about the

people they see. Says Jimmy of a man of no distinctive qualities whatsoever, "The drabness of his life was so complete as to have its own fascination."

One day their attention is caught by a beautiful, blond, somewhat older woman (Beverly D'Angelo). To Jimmy, the woman is on the run, having murdered a lover. Rose thinks that's gauche. They follow her to the beach, and as she swims they go through her bag. The woman is surprisingly tolerant when she catches them. In the following days, Jimmy falls in love with her.

The woman turns out to be Renée, an American actress appearing in a tacky stage production of "Destry Rides Again" in the next town. She is both amused and charmed by Jimmy.

Almost immediately it's clear to the audience that Renée is aware that her relationship to Jimmy is closer than he realizes. Rose, suddenly jealous, decides to have an affair with the good-looking lug who tends the elephants at the local circus.

•

"The Miracle" not only has a dreamy style but also features dreams, which Mr. Jordan shows. They're redundant, though. Mr. Jordan so particularly evokes the minds of his characters, especially Jimmy, that the dreams have a way of interrupting the flow of the film, which is romantic and sad, sometimes a bit mawkish and sometimes very funny.

As the relationships develop between Jimmy and Renée, Jimmy and his father, and Jimmy and Rose, the narrative works as if it were being told through a series of lap-dissolves, the technique by which one image slowly fades into the next. As the audience watches, each relationship turns into something other, although the characters don't outwardly change. It is most effective:

•

So is the look of the movie, beautifully photographed by Phillipe Rousselot. Though studded with bizarre images, "The Miracle" somehow makes everything appear perfectly normal. That would include the sight of an elephant inside the church where Jimmy, at one point, has gone in search of a sign from God.

The movie's sensibility is very Roman Catholic. Possibly only an Irish film maker could conceive of a mother-son relationship of the sort that takes on such religious overtones in "The Miracle." The movie acknowledges the sacred by dramatizing the profane.

Miss D'Angelo is beautiful, mysterious and practical as Renée. Mr. McCann is also good as Jimmy's self-pitying father, although the role is not a large one.

Mr. Byrne, a rock musician, and Miss Pilkington, who had never acted

before, are especially fine. Mr. Byrne's Jimmy is a difficult mixture of naïveté, stubbornness and would-be worldliness. Miss Pilkington would be wonderful as a commonsensical Irish Juliet. She's an actress of sweet and true grit.

•

As in all of his films, Mr. Jordan sometimes pushes too hard in "The Miracle." The ending doesn't top the long buildup. Yet "The Miracle" is his most satisfactory work to date.

1991 Jl 3, C12:1

Marquis

Directed by Henri Xhonneux; written by Mr. Xhonneux and Roland Topor, based on the Marquis de Sade's "Justine"; in French with English subtitles; director of photography, Étienne Faudet; design of the original creatures and art direction by Mr. Topor; music by Reinhardt Wagner. At Film Forum 1, 209 West Houston Street. Running time: 83 minutes. This film has no rating.

By JANET MASLIN

In "Marquis," a Belgian-French film featuring actors wearing masks that suggest barnyard animals, a spaniel-faced Marquis de Sade spends much of his time discussing philosophy, morality and strategy with a baguette-size likeness of a penis, which has a mind of its own. This is no idle conceit. In the film's closing credits, the performer who supplies the voice of the penis — the character is named Colin — is given second billing.

Although the bawdy, flippant "Marquis," which opens today at Film Forum, is clearly not for everyone, it turns out to be considerably more deft than might have been expected. As directed by Henri Xhonneux, with art direction by Roland Topor, the caricaturist, "Marquis" has a consistently acerbic style and a definite viewpoint, one steeped in late 18th-century French political and literary history. (Much of the film takes place in the Bastille, where the Marquis has been imprisoned for defiling a crucifix with the perverse gusto for which he remains famous.)

•

The film is sufficiently lighthearted to make Colin a literary critic: he supervises the Marquis's writings and complains repeatedly about the overuse of verbs. In the same spirit, it names a couple of its female characters, a horse wielding a whip and a timid cow, after the de Sade heroines Juliette and Justine. It is also filled with reminders, sometimes more off-putting than clever, of why de Sade's sexual proclivities were extreme enough to warrant their own nomenclature.

Among the film's other characters, aside from the urbane, canine Marquis, are the rat who is his jailer, a camel-faced priest and a prison governor, a rooster whose facial features represent the film's brand of choppy, inconsistent caricature at its most gleefully rude. Colin himself is memorable not merely for having the temerity to play such a primary role, but also for his sympathetic facial expressions and exceptionally encouraging manner.

1991 Jl 3, C12:5

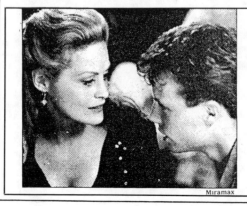

Beside the Sea
Beverly D'Angelo and Niall Byrne star in "The Miracle," about a teen-ager and the actress who appears in the Irish seaside town where he lives.

Miramax

Jimi Hendrix at the Isle of Wight

Directed by Murray Lerner; edited by Greg Sheldon; produced by Alan Douglas; an Original Cinema release. At Anthology Film Archives, Second Avenue at Second Street. Running time: 60 minutes. This film has no rating.

Bass...Billy Cox
Drums..Mitch Mitchell

By STEPHEN HOLDEN

Filmed just 18 days before his death on Sept. 18, 1970, but only recently edited into a complete film, "Jimi Hendrix at the Isle of Wight" captures a nearly hourlong set that the guitarist played before an outdoor audience estimated at half a million. But except for an opening aerial shot of the event and some chaotic backstage scenes near the beginning of the film, the camera dwells fixedly on Hendrix's face and hands as he performs with the bassist Billy Cox and the drummer Mitch Mitchell. Among the songs are "All Along the Watchtower," "Voodoo Chile," "Freedom," "Machine Gun" and "Red House."

The movie, which is at Anthology Film Archives, should certainly be of interest to Hendrix aficionados and to guitar students. But its static camera work, grainy color and muddy sound will make it tough going for everyone else. Looking for something of visual interest, one notices Hendrix's gum chewing, the quaintness of his rainbow-colored hippie attire, his slender, tapering fingers. Compared to the gladiators of contemporary arena-rock, he cut a fragile figure.

The few remarks he offers from the stage sound garbled and perfunctory. Although he seems to be concentrating on his technique, he also appears to be emotionally detached, and the static cinematography underscores a sense of his going through the motions. Even going through the motions, though, Hendrix displayed one of the most strikingly original musical personalities that rock has ever produced. Alternately sarcastic, lyrical and funny, he remains indelible, unlike those countless imitators who translated his innovations into empty pyrotechnical flash.

1991 Jl 4, C9:1

Critic's Choice

Meanest Woman

The meanest individual on screen this summer is not a half-human, half-mechanical enforcer with a penchant for shoving innocent bystanders through brick walls. No, that honor belongs to Tatie Danielle, the frail-looking old lady who is the title character of Étienne Chatiliez's wicked satire about middle-class French mores. Tatie Danielle, who lives for the glee of humiliating those weaker than she, is a sublime monster. And "Tatie Danielle" revels in her incomparable talent for giving offense.

Miramax

Tsilla Chelton, the title character in "Tatie Danielle."

Mr. Chatiliez directs in a sly, deadpan style that heightens the irascible toughness of his octogenarian heroine, a woman who will not even stop at faking incontinence as a means of making someone else feel awful. Yet Tatie Danielle's dirty tricks at the expense of her family are part of a larger picture, one that deftly describes the social climate in which this shamelessly conniving heroine works her magic. This director, whose "Life Is a Long Quiet River" was equally droll and well observed, is someone to watch. And Tatie Danielle is, too. *JANET MASLIN*

1991 Jl 5, C3:6

Problem Child 2

Directed by Brian Levant; written by Scott Alexander and Larry Karaszewski; director of photography, Peter Smokler; film editor, Lois Freeman-Fox; music by David Kitay; production designer, Maria Caso; produced by Robert Simonds; released by Universal Pictures. Running time: 91 minutes. This film is rated PG-13.

Ben Healy...John Ritter
Junior Healy.............................Michael Oliver
Big Ben Healy...............................Jack Warden
LaWanda Dumore..............Laraine Newman
Annie Young..............................Amy Yasbeck
Trixie Young............................Ivyann Schwan
Mr. Peabody.........................Gilbert Gottfried

By JANET MASLIN

Bad kids are big business, which is the only explanation for "Problem Child 2," a film angling for its share of the Bart Simpson-"Home Alone" mini-delinquent market. In this case the budding anarchist of choice is Junior (still Michael Oliver), now relocated with his father, Ben (John Ritter), to a town named Mortville and up to his same old troublemaking tricks.

Wearing his familiar malicious smirk, Junior does what he can to disrupt his father's love life by rewiring the front doorbell, so that a would-be date gets an electric shock that makes her hair stand on end. He gets even with an obnoxious neighbor by turning on the propane tanks at-

Robert de Stolfe/Universal City Studios

Ivyann Schwan as Trixie, the newest problem child.

tached to the neighbor's barbecue and blasting the man sky-high. He somehow flushes a lighted stick of dynamite down a toilet. Bathroom jokes abound. If you aren't amused by the idea of Junior's urinating into a pitcher of lemonade, or by runaway roaches in the salad greens, then you're too old for this film's brand of humor.

The same is true for those who do not relish the idea of an extended vomiting gag after Junior turns up the speed on an amusement park ride, thus making many of his acquaintances sick. Ditto the food fight that has Junior et al. flinging spaghetti and pizza in a crowded restaurant.

"Problem Child 2," which opened yesterday, is stupid but not inept. The sets and costumes are colorfully outrageous, and the cast includes various worthwhile comic actors who with any luck will find better material in their futures. Mr. Ritter remains adept at mustering sappy nice-guy excuses for the behavior of the obnoxious, not very winsome Junior; Jack Warden is the film's funniest straight man as Junior's grandfather, who is thrown out a window by his grandson and who is also yanked off the top of a bunk bed. Laraine Newman plays one of the many women throwing herself at Mr. Ritter's character, an eligible bachelor. She suffers the added indignity of being surgically altered, at Junior's behest, and given the world's biggest nose.

Food fights and bathroom jokes define the level of humor.

Also in "Problem Child 2" are Amy Yasbeck and Ivyann Schwan as a mother and daughter who are the perfect match for Ben and Junior, and Buffalo Bob Smith, who makes a cameo appearance and brings to mind the infinitely more decorous world of Howdy Doody.

"Problem Child 2" is rated PG-13 (Parents strongly cautioned). It includes rude language and many bathroom jokes.

1991 Jl 5, C6:1

'Slacker,' a Collection Of Eccentrics and Lunacies

"Slacker" was shown as part of the recent New Directors/New Films Series. Following are excerpts from Vincent Canby's review, which appeared in The New York Times on March 22, 1991. The film opens today at the Angelika Film Center, Mercer and Houston Streets.

The place is Austin, Tex. The time, morning, afternoon, night and morning again.

A young fellow in a car runs over his mother and speeds off home, to wait for the police. At the scene of the accident, amid talk of calling an ambulance, a man tries to pick up a young woman who is jogging.

A guy sitting in a restaurant asks his friends, "Who's ever written the great work about the immense effort required not to create?"

A few blocks away a stoned soothsayer is revealing, though probably not for the first time, "We've been on Mars since 1962."

These are just some of a hundred or so relentlessly eccentric people who amble in and out of Richard Linklater's "Slacker," a series of un-

Orion Classics

Hanging Out
Neo-beatnik characters living in the limbo between formal education and the real world people "Slacker," Richard Linklater's comedy.

connected vignettes that open one into another somewhat in the manner of Luis Buñuel's "Phantom of Liberty."

•

"Slacker" is a 14-course meal composed entirely of desserts or, more accurately, a conventional film whose narrative has been thrown out and replaced by enough bits of local color, to stock five years' worth of ordinary movies.

Some of it is very funny, including an opening sequence that features the director. The members of Mr. Linklater's cast, most of whom are non-professionals, are so amazingly effective that it's hard to believe they didn't make up their own lunacies.

Instead, these lunacies come from Mr. Linklater's notebook. For years he's been jotting down curious scenes he's witnessed and swatches of mad conversations overheard, the sort that all of us try to remember but immediately forget.

Mr. Linklater apparently sees his characters (or, as he calls them, slackers) as somehow representative of our time. Yet aside from their frequently upside-down syntax, they seem to be ageless in their oddities. That's fine.

Their charm and humor, however, are not inexhaustible. After a while, a certain monotony sets in, as well as desperation. It isn't easy being eccentric, and it's even more difficult to remain eccentric in the company of other eccentrics. A terrible transformation occurs: The unusual begins to look numbingly normal.

Toward the end of "Slacker," a sane voice might bring down the house, but it's not there.

1991 Jl 5, C6:5

Regarding Henry

Directed by Mike Nichols; written by Jeffrey Abrams; director of photography, Giuseppe Rotunno; edited by Sam O'Steen; music by Hans Zimmer; production designer, Tony Walton; produced by Scott Rudin and Mr. Nichols; released by Paramount Pictures. Running time: 107 minutes. This film is rated PG-13.

Henry	Harrison Ford
Sarah	Annette Bening
Rachel	Mikki Allen
Bradley	Bill Nunn
Rosella	Aida Linares
Bruce	Bruce Altman
Linda	Rebecca Miller
Charlie	Donald Moffat
Jessica	Elizabeth Wilson
Dr. Sultan	James Rebhorn
Julia	Mary Gilbert
George	John MacKay

By VINCENT CANBY

Henry Turner is a rich, successful Manhattan lawyer and a thorough sleaze ball. He speaks roughly to his little girl, but stops short of beating her when she sneezes, which may be the only decent thing that can be said for him.

He's ambitious and callous in his career. At home he's rudely outspoken, even about interior decoration. He loathes the new dining room table in his Fifth Avenue apartment, telling his wife that it looks like a turtle, which, in fact, it does.

When first seen in "Regarding Henry," the new Mike Nichols film, Henry is in court, doing what lawyers must do in movies of this sort to be rich and successful. He's defending a hospital against a malpractice suit brought by a frail man who is perma-

nently confined to a wheelchair as a result of an incorrect diagnosis. Henry wins the case and another fat fee.

•

"Regarding Henry" is not, as might be expected from Mr. Nichols, a satire about the folkways of greedy Manhattan achievers. Instead, it's that old chestnut, the second-chance movie. It's about Henry's spiritual awakening as a good man after he has been shot in the head when he walks in on a candy store holdup. He wasn't buying candy but (in spite of the Surgeon General's warning) cigarettes.

Taking this not-promising premise of Jeffrey Abrams's screenplay, Mr. Nichols has made a movie that is a good deal more tolerable than any such gimmick movie has a right to be. Make no mistake about it, "Regarding Henry" is a gimmick movie, the kind that appears to have had its genesis in a very particular, not exactly commonplace situation, for which the characters were then cut to fit — like wallpaper and as thin.

Because it's about redemption as the result of an accident, "Regarding Henry" invites the audience to enjoy a sudsy spectacle without being implicated in any disturbing way. Were Henry an alcoholic or a drug addict (he is as deeply afflicted), his salvation would be seen as too cheaply and superficially won.

Yet that perhaps is to load "Regarding Henry" with more freight than it was ever intended to carry. Here is a sentimental urban fairy tale that has been cast with actors from the A list, dressed and designed like a fashion layout and written and directed with such skill that its essential banality is often disguised.

•

Harrison Ford, who gave his best non-Indiana Jones performance in Mr. Nichols's "Working Girl," is Henry, Annette Bening is his wife, Sarah, and Mikki Allen, who has never acted before, appears as their troubled, enchantingly solemn child, Rachel.

Mr. Nichols sets up the gimmick as quickly as possible. Having established Henry as a perfectly tailored pirate and a thoughtless husband and father, the movie sends him out to his ill-fated rendezvous in the candy store. The rest of "Regarding Henry" details his lengthy recovery, first in a rehabilitation facility, then at home and, finally, back at his office.

When Henry comes out of his coma, he is a blank slate. He has no memory, power of speech or control of his limbs. He must learn to live from scratch. Aside from the scar on his forehead, he is not impaired in any unsightly way. Or, as his doctor tells Sarah at one point, "If you're going to get shot in the head, that's the way to do it."

"Regarding Henry" actually has several plots. There's the triumph over physical disability as Henry, with the help of a tough but caring therapist (Bill Nunn), learns how to talk, walk, eat, dress and tie his shoes again.

There's the re-establishment of loving relations with Sarah and Rachel, who don't know what to make of the docile, possibly brain-damaged new Henry who suddenly admires the turtle-textured dining room table.

Finally there is Henry at the office, where he finds that he has a mistress and a past as a lawyer who didn't hesitate to withhold evidence to win a case. Henry is shocked down to his toes. He doesn't like the man he once was.

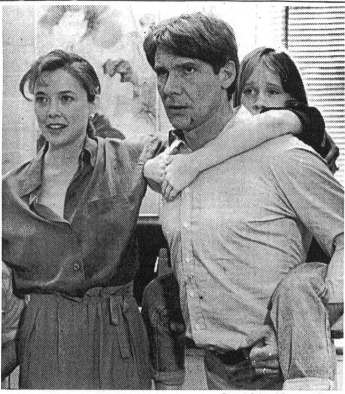

Francois Duhamel/Paramount Pictures

Annette Bening, left, Harrison Ford and Mikki Allen in a scene from the new Mike Nichols movie, "Regarding Henry."

It doesn't help the movie that Henry is less interesting as a good guy than he was as a rat, but whether this is the role or Mr. Ford's performance is unclear; maybe a combination of the two. Mr. Ford's rehabilitated Henry behaves like a cross between Tom Hanks in "Big" and Peter Sellers in "Being There," but with no sense of fun.

It's a ponderous, toned-down golly-gee-whiz performance. As the reborn Henry wanders around Manhattan, he answers a public telephone that happens to ring when he walks by. He goes to a porn movie and attends to it as if it were a training film. He buys a puppy. He's nice to doormen. He is a bore.

Definitely not a bore is Sarah who, as played by the miraculous Miss Bening, starts off as a pinched, tightly coiffed upper-middle-class Manhattan matron. As the movie progresses, she loosens up, evolving into a woman of such warmth and spirit that "Regarding Henry" seems to be more about her than about Henry.

Young Miss Allen is also surprisingly good as the forlorn little girl for whom her father's change of character is utterly bewildering. The first-rate supporting cast is headed by Mr. Nunn, Elizabeth Wilson as Henry's secretary, Rebecca Miller as the mistress and Bruce Altman as Henry's law partner.

"Regarding Henry" is a most uncharacteristic Nichols film. It is easy to take, but it succeeds neither as an all-out inspirational drama nor as a send-up of American manners. Though it looks classy and its dialogue often has bite, its center is as soft and sticky as those of the Mallomars Henry is said to adore.

By the final fadeout it seems as if Henry has been saved for a cookie.

•

"Regarding Henry," which has been rated PG-13 (Parents strongly cautioned), includes some vulgar language.

1991 Jl 10, C13:3

Boyz 'n the Hood

Directed and written by John Singleton; director of photography, Charles Mills; edited by Bruce Cannon; music by Stanley Clarke; produced by Steve Nicolaides; released by Columbia Pictures. Running time: 107 minutes. This film is rated R.

Doughboy	Ice Cube
Tre Styles	Cuba Gooding Jr.
Ricky Baker	Morris Chestnut
Furious Styles	Larry Fishburne
Reva Styles	Angela Bassett
Brandi	Nia Long
Mrs. Baker	Tyra Ferrell

By JANET MASLIN

"**B**OYZ 'N THE HOOD," John Singleton's terrifically confident first feature, places Mr. Singleton on a footing with Spike Lee as a chronicler of the frustration faced by young black men growing up in urban settings. But Mr. Single-

ton, who wrote and directed this film set in south central Los Angeles, has a distinctly Californian point of view. Unlike Mr. Lee's New York stories, which give their neighborhoods the finiteness and theatricality of stage sets, Mr. Singleton examines a more sprawling form of claustrophobia and a more adolescent angst. If Mr. Lee felt inclined to remake George Lucas's "American Graffiti" with a more fatalistic outlook and a political agenda, the results might be very much like this.

"Boyz 'n the Hood" spans seven years in the life of Tre Styles (Cuba Gooding Jr.), who in the film's first episode is seen idly discussing street crimes, and in its last is caught up in one such crime himself. Beginning with some sobering statistics detailing the homicide rate among black men in America, the film builds toward a deadly climax even while depicting its characters' best efforts to keep violence at bay.

In 'Boyz 'n the Hood,' young urban black men versus poverty and violence.

Mr. Singleton may not be saying anything new about the combined effects of poverty, drugs and aimlessness on black teen-agers. But he is saying something familiar with new dramatic force, and in ways that a wide and varied audience will understand. His film proceeds almost casually until it reaches a gut-wrenching finale, one that is all the more disturbing for the ease with which it envelops the film's principals.

In the end, "Boyz 'n the Hood" asks the all-important question of whether there is such a thing as changing one's fate. If there is — and Mr. Singleton holds out a powerful glimmer of hope in the story's closing moments — then for this film's young characters it hinges on the attitudes of their fathers. Tre is a child of divorce, but he has two parents who are devoted to him, and in particular a father who takes over his son's upbringing at a critical age. At the start of the story, when Tre is 10 years old, Furious Styles (Larry Fishburne) assumes custody of his only son, announcing that it is his responsibility to teach Tre to be a man.

Tre's mother, Reva (Angela Bassett), apparently independent and relatively successful, agrees to the change, perhaps because of the unsatisfactory way in which Tre is being reared. In his elementary school, a condescending white teacher delivers an irrelevant lecture on Pilgrims and Indians — "excuse me, the Native Americans," she wearily corrects herself — to her bored and restless black students. On the streets, Tre has learned to walk past skirmishes without even noticing them. He and his friends talk idly about street shootings, and about how bloodstains turn plasma-colored on pavement over time.

But from Tre's first day on the cozy, communal block of small houses where Tre's father lives, Furious does what he can to keep his son in line. Tre is assigned a chore when he first sets foot on his father's front lawn: "You the prince, I'm the king" is his father's joking credo. And later, even in times of crisis, Furious does a lot to sustain order. One especially gripping sequence shows Furious foiling a prowler in the house, as the camera pulls back abruptly through bullet holes in the front door.

●

Much of the conversation in "Boyz 'n the Hood" has to do with sex, and a lot of that talk is fearful. Mr. Singleton makes the connection between sex and reproduction foremost on everyone's mind, and a major factor in the destruction of these young char-

Columbia Pictures

Cuba Gooding Jr.

acters' independence. Anyone can have sex, Furious tells Tre during a lecture on the facts of life, "but only a real man can raise his children." By the time Tre and his friends are high school seniors, the football hero Ricky Baker (Morris Chestnut) is already a father, and can feel the walls closing in. Ricky's brother, Doughboy (the rapper Ice Cube), filled with scowling contempt for the neighborhood and its foibles, has opted not for early fatherhood but for a life of crime.

"Boyz 'n the Hood" — the title, about these young men and their neighborhood, comes from one of Ice Cube's records — watches Tre, Ricky and Doughboy navigate these perilous waters to the accompaniment of violent background sound. Police helicopters are such a constant presence that Brandi (Nia Long), Tre's girlfriend, who hopes to go to college, can barely get her homework done. Drive-by shootings between gang members are also part of the landscape. "Can't we have one night where there ain't no fight and nobody gets shot?" somebody finally says in frustration.

In this setting, the actors could easily disappear into speeches or stereotypes, but they don't; the film's strength is that it sustains an intimate and realistic tone. Mr. Fishburne, who is called upon to deliver several lectures, manages to do so

with enormous dignity and grace, and makes Furious a compelling role model, someone on whom the whole film easily pivots. Mr. Gooding gives Tre a gentle, impressionable quality that is most affecting. Ice Cube, who sometimes mutters too gruffly to be heard, nonetheless has a humorous delivery and a street swagger that effectively brings the neighborhood to life. The women in the film, particularly Tyra Ferrell as the exasperated mother of Doughboy and Ricky, are often feisty and vibrant but play only minor roles. As the title indicates, the climate of violence, raunch, raw nerves and and adolescent longing in which this story unfolds is very much a man's world.

●

"Boyz 'n the Hood" is rated R (Under 17 requires accompanying parent or adult guardian). It has graphic sexual references, brief nudity and violence.

1991 Jl 12, C1:1

White Dog

Directed by Samuel Fuller; screenplay by Mr. Fuller and Curtis Hanson, based on a story by Romain Gary; director of photography, Bruce Surtees; edited by Bernard Gribble; production designer, Brian Eatwell; produced by Jon Davison; released by Paramount Pictures. At Film Forum, 209 W. Houston St. Running time: 90 minutes. This film is rated PG.

Julie Sawyer	Kristy McNichol
Keys	Paul Winfield
Carruthers	Burl Ives
Roland Gray	Jameson Parker

By JANET MASLIN

"White Dog," the unreleased 1981 film about racism that opens the Film Forum's tribute to Sam Fuller, the B-movie giant, cast a long shadow before it ever saw the light of day. Long deferred in preproduction, and at various times assigned to directors as disparate and unlikely as Roman Polanski and Tony Scott, "White Dog" was made with an N.A.A.C.P. representative on the set and with threats that the film might be boycotted if and when it was ever finished.

Both Paramount Pictures, the film's distributor, and NBC, which had planned to show it on television, shied away from this controversy. So "White Dog" surfaced only briefly for test-marketing before disappearing from theatrical release. In light of the finished film, which is a fascinating oddity and as clear an indictment of racism as one might ever see, this furor seems all the more remarkable.

"White Dog" is based on a Life magazine story by Romain Gary, about a dog trained by white bigots to attack blacks (an image Mr. Gary later used as the title of his book about his marriage to Jean Seberg). It was turned by Mr. Fuller, who had had his own experiences with German-trained G.I.-hunting dogs in World War II, into the story of a young actress named Julie Sawyer (Kristy McNichol) who one dark night finds what she thinks is a lovable pet. Finding the dog hit on a road, she winds up seeking a veterinarian's help and then adopting the dog herself. Mr. Fuller's command of stark, spooky imagery is sufficiently intense to make even the visit to the vet's office an exercise in the bizarre.

Over time, it becomes apparent to both Julie and the audience that her white German shepherd has a vicious streak that is activated in the presence of any black person the dog happens to see. This first part of the film has the blunt, unnerving power of a horror story, as the dog's rampages are captured in chilling detail. A sequence in a church, where a well-dressed black man flees from the dog and takes refuge, is outstandingly ghastly.

But the film takes almost a humorous turn when Julie brings the dog to Noah's Ark, an animal-training center that trains wildlife for movie work. "I tell you what, use our panther — he's safe, and he knows every camera angle," the center's director (Burl Ives) is heard saying over the telephone. This same director throws darts at a poster of a little robot, who is undoubtedly bad for business. At Noah's Ark, the dog meets its match in a devoted animal trainer named Keys (Paul Winfield), who goes about the task of reprogramming the dog with scientific precision. Keys, who considers the dog a valuable weapon in the war against racism, insists on exposing more and more of his black skin to the animal every time he makes a suspenseful foray into the dog's cage.

"White Dog" earnestly tackles the issue of the dog's racist behavior, and even provides a surprising explanation for how the animal received its early training. And Mr. Winfield is

Paramount Pictures

The white dog

outstandingly good in turning Keys into a much more interesting character than he might have been. But much of the film's appeal lies simply in its B-style bluntness, and with its wittily obsessive attention to movie-world minutiae. Mr. Ives's character insists that as the animal trainer who handled the snakes for the movie, he helped John Wayne win his Oscar for "True Grit." Miss McNichol, when she pays a hospital visit to a fellow actress whom the dog has attacked on a movie set, brings a copy of the Truffaut-Hitchcock interview book as a present.

The scene in which this actress is attacked is both appalling and droll, since the two women are seen pretending to be touring Venice in a gondola. The dialogue: "Is that Lord Byron's house?" "I think so." "I love his poetry."

●

The screenplay for "White Dog," by Mr. Fuller and Curtis Hanson, contains much more in this B-chestnut vein. "Noah's Ark is like a laboratory that Darwin himself would go ape over," somebody says. And as befits the film's blunt, inelegant simplicity and occasional shocking tenor, there is never any mincing of words. "Do you have children?" Mr. Ives asks Miss McNichol. "When you do have them, by the time they're 25 there won't be any animals."

Bruce Surtees's cinematography, which gives a lurid, otherworldly glow to shots that seem almost to penetrate the dog's thoughts, and Ennio Morricone's eerie score contribute greatly to the enduring strangeness of "White Dog."

•

"White Dog" is rated PG (Parental guidance suggested). It includes violence.

1991 Jl 12, C8:1

See Spot. See a Lot.

The wickedest of all Disney witches sashays back to the screen today with the revival of "101 Dalmatians," the 1961 animated film that seems timely all over again. "Is there anyone in this wretched world who doesn't *live* for furs?" asks the high-fashion harridan Cruella DeVille, who kidnaps 99 meltingly cute Dalmatian puppies with the intention of turning them into wearing apparel.

Cruella's two-tone hair, cigarette holder and razor-sharp cheekbones are at least as memorable as her villainy. Even animal-rights advocates are bound to regard the red-gloved Cruella as entertainingly soigné.

"101 Dalmatians" follows Pongo and Perdita, the parents of 15 Dalmatian puppies, on a search from London to the English coun-

Disney/Buena Vista
Pongo and two of his pups.

tryside as they track down their lost offspring and dash Cruella's plans. Along the way, the film also spends time with Roger and Anita, the human couple whom the Dalmatians regard as "pets," and with many frisky little puppies, who seem to spend as much time in front of the television set as human children do. The film's satirical touches include biscuit commercials and a doggie game show.

"101 Dalmatians" isn't one of the true marvels of Disney animation; the backgrounds remain relatively static, and there are even brief moments when nothing in the frame moves at all. Nor is it a musical, since "Cruella De-Ville," Roger's teasing tribute to the fur-crazed villainess, is essentially the only song.

But this is an enjoyable G-rated children's film with a cheery, innocent spirit and a meanie to remember. Purists take note: according to Disney statistics, "101 Dalmatians" has exactly 6,469,952 spots. *JANET MASLIN*

1991 Jl 12, C8:5

Don Juan, My Love

Directed by Antonio Mercero; screenplay (Spanish with English subtitles) by Joaquin Oristrell and Mr. Mercero; director of photography, Carlos Suárez; edited by Rosa Graceli-Salgado; music by Bernardo Bonezzi; production designer, Rafael Palmero; a B.M.G. Films Production in collaboration with RTVE and Productora Andaluza de Programas; an International Film Exchange Release. At Cinema 1, Third Avenue at 60th Street, in Manhattan. Running time: 96 minutes. This film has no rating.

Don Juan/Juan Marquina
............................Juan Luis Galiardo
Dona Ines....................Maria Barranco
Ana.......................................Loles León
Vuida Prodini....................Rossy de Palma

By VINCENT CANBY

It is the conceit of "Don Juan, My Love" that, after 450 years, the legendary womanizer arises from his grave to do one good deed, thereby to escape purgatory and get on with the business of death. Antonio Mercero's new Spanish comedy opens today at Cinema 1.

Like Mr. Mercero's "Wait for Me in Heaven," in which Generalissimo Franco and his official stand-in were the central characters, "Don Juan,

International Film Exchange
Juan Luis Galiardo

My Love" is a comedy of mistaken identities.

There are the real if ghostly Don Juan, a kindly and prudish fellow, and the impossibly vain actor who happens to be starring as the Don in a new stage production in Seville. Both roles are played by Juan Luis Galiardo, a handsome, robust fellow who looks a bit like a younger road-company version of Fernando Rey.

•

The resurrected Don smiles a lot and is kindly and ever-thoughtful toward women, which is the film's basic joke. The actor who is portraying the Don in the play-within-the-film not only behaves like a pig with women, but he also turns out to be a drug smuggler.

"Don Juan, My Love" would seem to have all of the ingredients for a first-rate farce. It has a number of beautiful and passionate women, including one who talks with castanets (and whose dialogue is presented in subtitles), and a lot of bedroom doors, through which the ghostly Don walks without opening.

Yet the film lacks the feeling of mad desperation that distinguishes successful farces from those that also run from one crisis to the next. The stakes are high for the good Don, but he goes through the film so amiably and so laid back that comic confrontations prompt only occasional smiles, never belly laughs.

The members of the supporting cast are somewhat more effective, especially Loles León, as the woman with the castanets; Rossy de Palma, as an acrobat who nearly kills herself and the Don as she attempts to seduce him by doing what she does best, and María Barranco, as an actress who has been badly treated by the bogus Don.

All three will be recognized from their performances in Pedro Almodóvar's wild, funny "Women on the Verge of a Nervous Breakdown."

1991 Jl 12, C10:5

International Film Exchange
Don Juan in Purgatory
Maria Barranco plays Dona Inés in "Don Juan, My Love "

Point Break

Directed by Kathryn Bigelow; screenplay by W. Peter Iliff, story by Rick King and Mr. Iliff; director of photography, Donald Peterman; edited by Howard Smith; music by Mark Isham; production designer, Peter Jamison; produced by Peter Abrams and Robert L. Levy; released by 20th Century Fox Film Corporation. Running time: 123 minutes. This film is rated R.

Bodhi..Patrick Swayze
Johnny Utah.............................Keanu Reeves
Pappas..Gary Busey
Tyler..Lori Petty
Ben Harp...................................John McGinley
Roach.......................................James Le Gros
Nathanial.......................................John Philbin

By JANET MASLIN

"You trying to tell me the F.B.I.'s going to pay me to learn to surf?"

Yes, dude, that's exactly what his superiors are trying to tell Johnny Utah (Keanu Reeves), a clean-cut rookie officer with a secret flair for being bodacious. In "Point Break," Johnny happens to be available when a gang of bank robbers leaves behind a surfboard-wax sample (in a footprint), some beach-related toxins (in a strand of hair) and photographic evidence of a tan line (in a surveillance camera shot of one masked robber delivering a kind of humorous message by dropping his pants).

Hey, heavy evidence. This turns out to be one of those beach bum-cosmic high armed robberies with which Southern California F.B.I. agents are no doubt constantly plagued. And Johnny turns out to be the perfect candidate for the job of surfing detective. He looks good in a wet suit. He figures out how to extract information from a nice-looking female surf expert (Lori Petty). Pretty soon he is showing up at the office saying things like "Caught my first tube this morning, sir." He totes his surfboard with him to prove the point.

"Catch a wave and you're sitting on top of the world," as the Beach Boys put it in more innocent times. But the surf culture represented in "Point Break" is much more far-reaching and diffuse, in the manner of something left out too long in the sun. It is principally embodied by Bodhi (Patrick Swayze), which is short for Bodhisattva, which is Sanskrit for "being of wisdom" and therefore of no relevance here. Bodhi, who has a cult following among the kind of people who like to re-enact their finest surfing moments at parties, speaks a fluid line of Zen wavethink as he encourages acolytes to accept the water's energy and observes, "It's not tragic to die doing what you love." Among the things Bodhi loves are skydiving, extra-risky surfing and possibly even chancier pursuits.

•

Just as she did in "Blue Steel," the director Kathryn Bigelow observes the peculiar complicity that develops between a law officer and a seductive criminal. And once again Ms. Bigelow moves so fast and so far with this idea that her film (with a screenplay by W. Peter Iliff) eventually spins out of control. But "Point Break," though it's anything but watertight where plotting is concerned, again reveals Ms. Bigelow's real talents as a director of fast-paced, high-adrenaline action. Whenever the flakiness of "Point Break" threatens to become lulling, Ms. Bigelow wakes up her audience with a formidable jolt.

Among the film's especially energetic sequences are a furious two-man chase on foot through a heavily populated neighborhood, shot vigor-

Richard Foreman/20th Century Fox

Crime Nearly Pays in L.A.
Keanu Reeves plays Johnny Utah, an F.B.I. agent who goes underground to investigate a string of bank robberies in Los Angeles, in "Point Break."

ously with a hand-held camera; sustained and amazing sky-diving scenes guaranteed to make the palms sweat, and a police raid on a house that becomes a wild melee and turns a lawnmower into a potentially deadly weapon. This last episode, and others like it, prove definitively that testosterone-crazed movie violence is by no means the sole province of male directors.

Ms. Bigelow also gives many of the film's conversational scenes a crisp, punchy momentum and a lot of energy. A lot of the snap comes, surprisingly, from Mr. Reeves, who displays considerable discipline and range. He moves easily between the buttoned-down demeanor that suits a police procedural story and the loose-jointed manner of his comic roles.

•

Especially fiery and scene-stealing is Gary Busey, as the gruff Nick, Nolte-style wild man who is Johnny's F.B.I. partner and foil. Mr. Swayze, more tranquil, is best when showing off his proficiency for glamorous athletics and least good when taking the screenplay seriously. When another character says, of Mr. Swayze's Bodhi, "He's got this gift for blankness," the thought seems all too true. Mr. Iliff's screenplay includes some egregious silliness and a long string of false endings, but occasionally it sounds the kind of tough-guy note that gets one's attention. "It's been paper targets up till today, huh?" says the more experienced F.B.I. man (Mr. Busey) to the rookie (Mr. Reeves) after the latter's first kill. "It's no different, Johnny. Just a little more to clean up."

•

"Point Break" is rated R (Under 17 requires accompanying parent or adult guardian). It includes violence, profanity and nudity.

1991 Jl 12, C12:6

Shadow of the Raven

Directed and written by Hrafn Gunnlaugsson; in Icelandic with English subtitles; director of photography, Esa Vuorinen; edited by Edda Kristjansdottir; music by Hans-Erik Philip; production designer, Karl Juliusson; produced by Christer Abrahamsen; released by Cinema Art/F.I.L.M. At Cinema Village, Third Ave. between 12th and 13th Sts. Running time: 108 minutes. This film has no rating.

WITH: Reine Brynolfsson, Tinna Gunnlaugsdottir, Egill Olafsson, Helgi Skulason and Kristbjorg Kjeld

By STEPHEN HOLDEN

In the world of Hrafn Gunnlaugsson's medieval adventure film, "The Shadow of the Raven," emotions are as jagged and windblown as the spectacular Icelandic coastline where the movie was shot.

The film's star-crossed lovers, Trausti and Isold, before sealing their vows, engage in an embattled courtship in which Isold, who blames Trausti for the death of her father, repeatedly spits in his face and runs at him with a knife. The year is 1077, and Trausti, who has just returned to Iceland from a sojourn in Norway where he was infused with Christian ideology, deflects her attacks and

A swashbuckler that aspires to be something more.

wins her with his honesty and gentleness. Soon they are planning a marriage that will unite their rival neighboring clans and make them the most powerful couple in the region.

•

Gorgeously filmed in a brooding cliffside landscape of swirling mists and howling winds, "The Shadow of the Raven," which opened yesterday at the Cinema Village Third Avenue, aspires to be something more than an exotic swashbuckler. The Icelandic writer and director wants to create an epic pageant of fire and ice, passion and ritual that has as few Hollywood-style trappings as possible.

The world he evokes is one in which the discovery of a beached whale is cause for two clans to go to war over its ownership, in which stab wounds are treated with exotic ointments and red hot pokers. It is also a world in which the Christian concept of turning the other cheek is so revolutionary as to be almost practically incomprehensible. For even though Christianity has been introduced into the tribal Nordic culture and both sides have even built churches, the old ways still prevail.

Notably absent is the flowery, quasi-biblical dialogue that has been the bane of so many cinematic evocations of the distant past, not only in Hollywood but also in European films. Mr. Gunnlaugsson's characters tend to communicate very tersely, and there is a lot of glaring and primal grunting that at moments borders on the silly. There is also a great deal of violence. Many swords are hurled into many chests, and many wooden structures are set on fire with people inside. Trausti and Isold's wedding night becomes an inferno when rival conspirators torch their house and Trausti is forced to hide in a barrel of milk curd.

Reine Brynolfsson, left, and Tinna Gunnlaugsdottir starring in "The Shadow of the Raven," a medieval epic set in Iceland.

"Shadow of the Raven" has a powerful, heated performance by Tinna Gunnlaugsdottir as the tempestuous Isold, whose mother was burned as a witch and who is raising an illegitimate daughter (Klara Iris Vigfusdottir). Sune Mangs brings a glowering exuberance to the role of a grotesquely rotund bishop who schemes to undo Trausti's peaceful intentions. And Kristbjorg Kjeld, as the bishop's co-conspirator, Sigrid the Shrew, exudes

a malevolence so intense it is almost unnerving.

Reine Brynolfsson projects Trausti's faith by widening his eyes and peering solemnly into the eyes of everyone he encounters, but his portrayal is so lacking in inner fire that he is finally unconvincing as an invincible hero of truth, justice and the newly Christianized Nordic way.

1991 Jl 13, 12:1

FILM VIEW/Caryn James

A Warmer, Fuzzier Arnold

ARNOLD SCHWARZENEGGER flashed that wide, good-natured grin, but he wasn't kidding when he told David Letterman that he plays a "kinder, gentler Terminator" this time. In "Terminator 2: Judgment Day," Mr. Schwarzenegger looks like the same old villainous cyborg from "The Terminator," the 1984 film that made him a star. The original-flavor Terminator, of course, was sent back from a post-apocalyptic future to wipe out Sarah Connor before she could give birth to one of mankind's saviors. Back then he was the type of machine who murdered a couple of other Sarah Connors, just in case.

But in "Terminator 2" he saves the world without even killing anyone, takes orders from a boy, and turns out to be the most tenderhearted alien since E. T. When the first Terminator said, "I'll be back," Mr. Schwarzenegger's monotone delivery, Austrian accent and quaintly charming growl made it his signature line: "Uh'll be bek." But we never thought he'd be bek like this.

What happened? In the intervening years, Mr. Schwarzenegger transformed himself from a Hollywood joke to a likable superstar, a phenomenal

shift that resembles those Schwarzenegger biceps, once vulgarly ostentatious and now toned down to a still-powerful but socially acceptable bulk. And as pop icons do, he captures the temper of his times. The bad old Terminator reflected the heady Reagan 80's; the good new one is the perfect Bush-era Terminator, a machine as sensitive war hero.

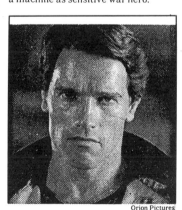

Orion Pictures

In 1984, the Terminator was murderous; now he's tender.

In 1984, the Reaganesque days of greed and bombast, Mr. Schwarzenegger was still the self-promoting and slightly ridiculous muscleman whose greatest artistic stretch had been the title role in "Conan the Barbarian." Since then he has become a symbol of all-American success, a vocal Bush Republican, chairman of the President's Council on Physical Fitness and Sports, a Kennedy in-law and an adept comedian who laughed at his own hulking image in hits like "Twins" and "Kindergarten Cop." Never mind the fact that he turned out to be a lot smarter than he seemed. Could the chairman of the President's Council on Physical Fitness and Sports go around killing innocent people on screen? The softer Schwarzenegger image seemed to demand a softer Terminator.

Very cleverly, James Cameron, who directed and co-wrote both "Terminator" movies, has used this kinder, gentler Schwarzenegger to the sequel's advantage. Like the original, "Terminator 2" has all the explosive, exhilarating action that Mr. Cameron, who also directed "Aliens," can sustain as well as anyone. Its humor is tongue-in-cheek, its special effects are capable of dazzling the most jaded moviegoer, and its reputed near-$100 million budget should be a cinch to make back.

But the film is also something more, a tricky little morality play in which the good Terminator is disguised as a biker, a bad Terminator looks like a cop, and conventional authority is undermined everywhere.

The film establishes its own moral universe, where images of good and evil are constantly shifting their meanings. Doctors and police, who don't understand that the future is at stake, become the villains who think Sarah is crazy and the heroic cyborg is a murderer.

This recasting of images is most playful when Mr. Schwarzenegger's character arrives naked from the future, walks into a bikers' bar and starts tossing tough guys around after one of them refuses to give up his clothes. The Terminator was provoked. He demanded the man's clothes calmly, and in reply got a cigar put out in his chest. No self-starting violence here.

Still, the Terminator has not yet revealed himself to be heroic, and the audience roots for him anyway — partly because he's Arnold and maybe because they've been deluged with trailers and television commercials that explain his new role: "Once he was programmed to destroy the future. Now his mission is to save it." They're rooting for an image that has been slyly transformed from bad to good even before the movie started.

It doesn't take long to discover that the Terminator is also programmed to take orders from Sarah's young son, John, the future hero he was sent to protect. Maintaining the image of "Kindergarten Cop," here Mr. Schwarzenegger plays a muscular pussycat, at the mercy of a kid. Early

on, John makes the cyborg swear to fight without killing anyone, which pretty much puts him out of business as a Terminator but makes him a more admirable warrior-hero.

If good and evil were simply reversed, "Terminator 2" would be much less twisty, less fun to follow. But though the bad Terminator sent to kill John usually looks like a clean-cut policeman, he can also change shape at will. He can diguise himself as John's foster mother, and his hands can become lethal blades, as if he were Edward Scissorhands's evil twin. And because he is technologically a more advanced machine, he makes Mr. Schwarzenegger's Terminator seem that much more fallible and human.

In fact, Sarah, a warrior herself with pumped-up muscles and nearly-shot nerves, decides that the Terminator is a great surrogate father for

The bad old Terminator reflected the heady Reagan 80's.

John. The Macho Mom is a good match for the patient, understanding Terminator Dad, who even learns

about tears. "I know now why you cry," he tells John when they part, "but it's something I can never do." The scene goes for the heart, not the wits. It doesn't quite work, but that won't stop "Terminator 2" from not crying all the way to the bank.

Creating a Terminator with a heart and a conscience, one that suits the refurbished Schwarzenegger and his era, doesn't make "Terminator 2" a politically or morally profound work. But the film astutely reads and reflects its audience and never slows down long enough to let them ponder its cultural messages. That makes it first-rate pop art, a Terminator for our times. □

1991 Jl 14, II:9:1

In "Terminator 2: Judgment Day," Edward Furlong plays John Connor and Arnold Schwarzenegger a Terminator— a machine perfect for these times

Tri-Star Pictures

FILM VIEW/Janet Maslin

In the 90's, The 80's Turn to Junk

IN "REGARDING HENRY," HARRISON FORD DOES literally what a lot of other 90's movie characters will be doing figuratively: he pauses while walking past his secretary, who is wearing a corsage, and leans over to smell the flower. As a former fast-lane champion forced by circumstance (in this case a gunshot wound inflicted by a mugger) to take a new look at his life, Mr. Ford as Henry Turner is right in tune with what is sure to be a coming cinematic vogue. He is ready to reassess the mad excesses of 80's materialism from an aggressively mellow 90's point of view.

A 1985 parody of this idea actually anticipated the real thing: in his film "Lost in America," Albert Brooks played a corporate climber who renounced the rat race, took off in search of freedom and wound up with a job as a crossing guard. (In the final analysis, this experience made a good case for corporate climbing. Mr. Brooks's character was last seen racing right back to the advertising agency he had fled.) "Regarding Henry," though very much in earnest, covers similar territory with its story of a rich and celebrated lawyer whose brain injuries derail his career and return him to a childlike naïveté.

"Regarding Henry," which was directed by Mike Nichols, can be seen as a companion piece to Mr. Nichols's earlier "Working Girl," which is only three years old but already looks like a prize piece of 80's lunacy. In that film, the thrill of business success is seen as an erotic high as Tess McGill, the secretary played by Melanie Griffith, devotes every ounce of her strength to getting ahead. What she wins through this relentless effort — an executive position, a nice office, her own secretary — is precisely what Henry Turner needs to be freed from. But as "Regarding Henry" begins, this cosseted, high-powered lawyer shows no signs of recognizing that his gilded cage has bars.

Although "Regarding Henry" has the glossy superficiality of a fairy tale, it allows Mr. Nichols almost a "Graduate"-caliber opportunity to display his skills as a social observer. The film's opening sequences capture the particulars of Henry's life with masterly precision. During a break in an important trial, in which he is defending a hospital against an elderly, incapacitated patient, he finds time to make a phone call and complain heatedly about a new dining room table. At home, he scolds his daughter self-importantly for having spilled something on his beloved piano. He and his wife, Sarah, work their way through a lavish Christmas party while laying competitive plans for a party of their own. Later, in their airily elegant apartment, Sarah is gleeful that a friend's child has been rejected by the prestigious boarding school that the Turners' daughter, Rachel, will be attending.

Shortly thereafter, the look of astonishment from Sarah (played with fluid grace by Annette Bening), as she sits in an emergency room without any certainty about her husband's future or her own, is a powerful reminder of the evanescence of an 80's-style triumph. In a flash, everything about this family's existence is called into question. "Are we going to be poor now?" Rachel asks, since the Turners have apparently been living at the outer limits of their means. The film's screenplay, by Jeffrey Abrams, who is 24 years old, is too facile to take that question very seriously or to allow much acrimony into the Turners' lives even after they are placed under enormous stress by Henry's disability. But it does raise the question of how a former legal giant, now barely competent to work behind the counter at a candy store, can possibly survive.

This film's answer is straight out of a fairy tale. It suggests that Henry will be a happier, nicer individual now that he is free to be his own man. And even if the terms whereby this is expressed are slightly childish — when Henry wanders off one afternoon, he eats a hot dog and candy, watches

Andy Schwartz/Paramount Pictures

Harrison Ford and Annette Bening in "Regarding Henry"—Excessive materialism is reassessed.

a porn film and comes home with a new puppy — the message itself gets through. As Henry, who has been kept on by his old law firm as a courtesy, begins wondering what phrases like "let's grab lunch this week" can possibly mean, the audience is liable to share his new perspective on the furious careerism of the red-suspender age.

■

Henry still wears suspenders but doesn't know how to fix them so that they don't rumple his shirt. He stays home baking cookies with his little daughter. He paints pictures, returning obsessively to the memory of something that once gave him pleasure. He likes the new dining room table. He goes to a high-powered cocktail party and chats with the waiter. He beams when his maid tells him she likes him much better now than she used to.

None of this need be especially believable to strike a nerve, especially when the memory of Mr. Nichols's "Graduate" comes to mind. It's as though the hero of that film had never rebelled in his early 20's, had taken the corporate job recommended to him and, upon reaching his 40's, suddenly panicked at how much he had lost.

The fact that both films end with their heroes disrupting staid ceremonial occasions makes for a useful comparison. "The Graduate" showed close-ups of angry faces fuming at the title character's audacity, but "Regarding Henry" carries with it no such anger. Everyone in this slick, enveloping and enormously timely film seems to understand why Henry Turner, having given so much of himself to acquisitiveness and ambition, desperately wants his soul back before it's too late. □

1991 Jl 14, II:9:5

The Famine Within

Directed, written and produced by Katherine Gilday; cinematographer, Joan Hutton; edited by Petra Valier; a Direct Cinema Ltd. release. Running time: 90 minutes.

We're Talking Vulva

Directed and produced by Tracy Traeger and Shawna Dempsey; music by Bad Tribe; a Zeitgeist Films Release. Running time: 5 minutes.

At Film Forum 1, 209 West Houston Street. These films have no rating.

By JANET MASLIN

In "The Famine Within," an eye-opening documentary about American women's collective obsession with body weight, Katherine Gilday makes a thorough and cogent case for the larger importance of this issue. "Every age has its own idea of perfect virtue for women," her film says, and it contends that our current ideal demands the triumph of will power over nature. Faith in weight loss, the

film maintains, has for many women taken on the power of religious conviction. And yet the standard to which so ·many women aspire "really has less to do with beauty than with the deep cultural meaning of body type."

Ms. Gilday's film, which opens today at the Film Forum, is an effective mixture of sobering statistics, perceptive observations and desperately sad anecdotes. Chris Alt, the heavier sister of Carol Alt, the successful model, describes seeing a photograph of Karen Carpenter in the last stages of starvation and thinking "she was very lucky." Ms. Alt recalls having "wondered how I could get that skinny without dying." Another woman remembers dieting frantically as a teen-ager because she had a chance to meet Elvis Presley in Las Vegas and· indeed being complimented by Elvis on her good looks. That accomplished, she ballooned back up to 200 pounds.

"In many respects it's a critical brain drain that we have," someone in the film observes, commenting on the amount of feminine energy and intelligence that are caught up in concern over weight loss. Various surveys cited here indicate that the majority of American women are more ·unhappy about weight than ever before, that they are happier about losing weight than about career advancement or success in love, and that they fear being fat more than they fear death.

•

Building her argument clearly and methodically, Ms. Gilday begins by examining the physical ideal that is celebrated by the media. It is radically different from the national norm. The average 5-foot-8-inch Miss America contestant weighed 132 pounds in 1954 and 117 in 1980; meanwhile, the average North American woman is about 5 feet 4 inches tall and weighs 144 pounds. The standard proportions for a good fashion model are "highly unusual among the general female population," the film tells us, as it watches models at work and remarks upon the enormous influence of the media and the fashion world. In contemplating the image of a single svelte high-fashion beauty, the film

The cost of pursuing the ideal, and how it differs from reality.

notes that "hours and hours of the collective effort of a large team go into the manufacture of the illusion."

The film moves on to consider the effects of such images on the general population. For instance, 80 percent of fourth-grade girls have already been on their first diets. It examines the aerobics craze, the stigma attached to obesity and the pathology of bulimia and anorexia. Ms. Gilday, who is as interested in the psychological and cultural aspects of such conditions as in the medical, calls upon interesting and articulate experts to provide analysis. "Sadly, the cult of the body is the only coherent philosophy of self that women are offered in this society," one says. A woman who lectures on these issues observes that when she discusses anorexia, someone in the audience usually turns up

afterward to tell her, "I wish I could have that, just for a little while.'"

The film's ultimate point, which it develops very well, is that women struggling to balance careers and families have few useful role models and are desperate for control over their lives; this may lead them· to banish the obviously feminine aspects of a full figure and emphasize the lean, masculine ideal. By dieting strenuously, one speaker says, "we are reassuring the culture that it still has the upper hand over us and over nature."

By comparison with Henry Jaglom's recent "Eating," a comic film on this subject, the speakers in "The Famine Within" sound a far more serious and less narcissistic note. The final effect of Ms. Gilday's persuasive and important film is to make the point that her subject goes far beyond vanity, and truly into matters of life and death.

•

On the same bill, and doing nothing to enhance the impact of Ms. Gilday's potent argument, is "We're Talking Vulva," a five-minute work of feminist art by Tracy Traeger and Shawna Dempsey, in which Ms. Dempsey wears a suit representing gigantic female genitalia and delivers a rap song. The lyrics, when audible, are notably lacking in wit. And anyway, it's a little early for Halloween.

1991 Jl 17, C13:1

Dead Ringer

Directed and written by Allan Nicholls, story by Mr. Nicholls, David Sonenberg and Alfred Dellentash; director of photography, Don Lenzer; edited by Norman Smith; songs by Jim Steinman; production designer, Franne Lee; produced by Mr. Dellentash and Mr. Sonenberg. At the Anthology Film Archives, Second Avenue at Second Street. Running time: 101 minutes. This film has no rating.

WITH: Meat Loaf, Josh Mostel, Fred Coffin, Alan Braunstein and Leah Ayres

By STEPHEN HOLDEN

"May I call you Meat?" asks an unctuous interviewer who pops up periodically throughout "Dead Ringer," a movie about the travails of being the rock star Meat Loaf. "Yes, if I can call you Ernie," the star replies and goes on to regale the credulous reporter with the first of several bogus stories about his past.

"Dead Ringer," which opened today at the Anthology Film Archive, was filmed in 1981 and '82 but not released commercially. It interweaves concert film of the 250-pound star with a slender story about the efforts of two brothers, one of whom bears a striking resemblance to the singer, to meet their idol.

•

Written and directed by Allan Nicholls, "Dead Ringer" aspires to be a piece of pop froth on the order of the Beatles' films but is so ineptly made that it barely makes sense. The film's one funny moment involves the brothers' attempts to adjust an unwieldy television aerial strung with pots and pans so that they can see their idol being interviewed.

The concert sequences are so jerkily edited that songs are cut off in the middle, and any sense of flow is lost. Meat Loaf himself is utterly without charm. The galumphing self-parody

he brings to his performances does not follow him off the stage. Behind the scenes, he is a grim, expressionless blob.

1991 Jl 17, C14:5

Bill and Ted's Bogus Journey

Directed by Pete Hewitt; screenwriters, Ed Solomon and Chris Matheson; cinematographer, Oliver Wood; edited by David Finfer; music by David Newman; production designer, David L. Snyder; produced by Scott Kroopf; released by Orion Pictures. Running time: 95 minutes. This film is rated PG.

Ted	Keanu Reeves
Bill	Alex Winter
Rufus	George Carlin
Death	William Sadler
De Nomolos	Joss Ackland
Captain Logan	Hal Landon Jr.
Ms. Wardroe	Pam Grier
Missy	Amy Stock-Poynton
Deputy James	Roy Brocksmith

By JANET MASLIN

Some of us were wrong in mistaking Bill (Alex Winter) and Ted (Keanu Reeves) for mere idiots the first time around. They are happy idiots, and it's the happy part that matters. Bill and Ted inhabit a hip, friendly universe where the lowliest and shaggiest of teen-agers — that would be Bill and Ted — are on an equal footing with Napoleon and Albert Einstein. This seems perfectly natural to them, as do their meetings, in "Bill and Ted's Bogus Journey," with God and the Devil. "We got totally lied to by our album covers!" complains Ted, upon catching a glimpse of the latter in hell.

It's hard not to appreciate two guys who can invest a cry of "Whoa!" with such pure ecstasy and who think that Joan of Arc is Noah's wife. It's also hard to see why the makers of the amusing but sloppy and overcomplicated "Bill and Ted's Bogus Journey" weren't content to leave well enough alone. These two unflappable teen-age heroes, played with such loose-jointed aplomb by Mr. Reeves and Mr. Winter, are most comfortable when doing little more than faking air· guitar and devastating the English language. They're at their comic best when simply playing dumb and being themselves.

But this second film, more cartoonish and confusing than "Bill and Ted's Excellent Adventure," insists on cyborgs, extraterrestrials, demonic possession, time travel, and a Father Death figure who challenges the boys to play for their lives on their own terms (that means rounds of Battleship, Twister and Clue). "You've got a lot to learn about sportsmanship," Ted solemnly tells the Grim Reaper, who has obviously met his match.

•

Death (William Sadler) turns out to be this film's funniest new character once he gives up trying to interfere with a force of nature like the Bill and Ted mind-set and settles instead on becoming a new friend. Eventually nicknamed the Duke of Spooks, Death has been taken shopping for a new scythe before the film is over, has appeared at the Pearly Gates wearing a pink ruffled apron to disguise his black robes and has revealed that he, too, like the would-be heavy-metal stars Bill and Ted, harbors show-business aspirations.

"Bill and Ted's Bogus Journey," directed by Pete Hewitt from a

screenplay by Ed Solomon and Chris Matheson, returns to a San Dimas in a California of the future, a place that in 700 years has not yet gotten over Bill and Ted's earlier time-traveling accomplishments. All would be well at Bill and Ted University (where, thanks to the magic time-traveling

Gemma Lamana/Orion Pictures

Keanu Reeves

telephone booth, Ben Franklin and Aretha Franklin can visit classes on the same day) were it not for a plot to "totally kill Bill and Ted" in 1991.

The film is breathless and confusing on this scheme and many other fine points, but the bottom line is that two evil Bill and Ted cyborgs are on the heroes' trail. Evil Bill and Evil Ted look exactly like the real things but make a clanking noise when they give each other the high-five. In trying to mow down kittens in a stolen red Porsche, for instance, they offer some idea of what the real Bill and Ted would be like if they weren't so guileless and sweet.

Once the real Bill and Ted are indeed totally dead, the film's comic-book style gets out of hand. Mr. Hewitt's idea of heaven is too much like Albert Brooks's, his hell too influenced by Tim Burton, and his ability to keep Bill and Ted on a clear course often wavers. The heaven sequence is made worthwhile, though, by Ted's breezy way of telling an unseen God: "Congratulations on Earth. It's a most excellent planet, and Bill and I enjoy it on a daily basis."

One of the film's best sequences has Bill and Ted briefly inhabiting the bodies of their fathers. ("I hope this works," says Ted. "It worked in 'The Exorcist' — I and III," Bill assures him.) At this, the two older actors, Roy Brocksmith and Hal Landon Jr., suddenly offer perfect imitations of the Bill and Ted physical style. This is the story's clearest indication that there is indeed considerable skill and method behind the Bill and Ted madness.

Also in the film are Amy Stock-Poynton, reprising her role as the much-married Missy; George Carlin, returning as Bill and Ted's mentor from the future; Joss Ackland in an incomprehensible villain's role, and a member of the group Faith No More. Anyone unfamiliar with Faith No More is not part of the film's target audience and will not enjoy the screamy heavy-metal sound track.

Pam Grier plays a part so bewildering it can't even be easily described, but she appears in the Battle of the Bands contest that represents all of Bill and Ted's dreams of success. "Maybe we oughtta get good, Ted," Bill says nervously before the contest begins. This is what Bill and Ted themselves might label a most heinous idea. Anyway, it's safe to assume they never will.

"Bill and Ted's Bogus Journey" is rated PG (Parental guidance suggested). It includes mild profanity and bloodless violence.

1991 Jl 19, C10:1

Prisoners of the Sun

Directed by Stephen Wallace; screenplay by Denis Whitburn and Brian A. Williams; director of photography, Russell Boyd; film editor, Nicholas Beauman; music by David McHugh; production designer, Bernard Hides; produced by Charles Waterstreet, Mr. Whitburn and Mr. Williams; released by Skouras Pictures. At 57th Street Playhouse, 110 West 57th Street in Manhattan. Running time: 109 minutes. This film is rated R.

Capt. Robert Cooper	Bryan Brown
Vice Adm. Baron Takahashi	George Takei
Maj. Tom Beckett	Terry O'Quinn
Maj. Frank Roberts	John Bach
Lieut. Hideo Tanaka	Toshi Shioya
Mike Sheedy	John Clarke

By CARYN JAMES

Bryan Brown is shaping up as the Australian Gene Hackman, an actor with a never-ending stream of films, most of them well beneath his talents. Mr. Brown's "FX2" and "Sweet Talker" came and went in May. His latest, "Prisoners of the Sun," opens today at the 57th Street Playhouse. It is a sincere, competent courtroom drama that never matches the demands of its historical subject.

For a few early, harrowing moments, this fictional version of real events is as disturbing as it ought to be. In historical fact, in 1942 the Japanese held 1,100 Australian soldiers in a prisoner-of-war camp on the Indonesian island of Ambon. When the camp was liberated in 1945, only 300 had survived and the Japanese were tried as war criminals.

●

"Prisoners of the Sun" begins after the war, when a group of Australian soldiers, led by Mr. Brown as the fictional Capt. Robert Cooper, forces the conquered Japanese to start digging on the island. Before long, rows of dirt-covered skulls and severed bones are lined up on the ground as the Japanese uncover a mass grave where hundreds of executed Australian soldiers were buried.

What action there is belongs to Cooper, whose job is to prosecute the war criminals. An intelligent but predictably volatile hero, he goes head-

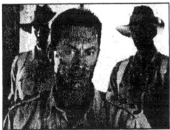

Skouras Pictures

Bryan Brown

to-head and sometimes hand-to-throat with the defendants. He begins with an aristocratic, taciturn vice admiral (played by George Takei, Mr. Sulu from "Star Trek"), who tries to pin the blame on his second-in-command, a man prone to bulldoggish growls of loyalty.

The most sympathetic defendant is a lowly boyish-looking signals officer named Tanaka, who believed in his duty and his officers and who actually turned himself in for trial. Though this Australian film goes out of its way to avoid Japan-bashing, its Western bias is uneasily revealed through Tanaka, the only "good" Japanese in it and conspicuously the only Christian one as well.

Cooper, of course, assumes that the vice admiral should be convicted for ordering the executions, but his higher-ups view the Japanese officer as a valuable pawn in reconstructing the postwar world. This bit of realpolitik appalls and astonishes Captain Cooper, who owes more than he should to Gary Cooper.

The action may take place in a thatched-roof courthouse on an Indonesian island, but the dialogue rings of familiar Hollywood melodrama. When Cooper passionately responds to the sight of Australian bodies at the grave, his commanding officer says: "The war's over. We're lawyers, not soldiers"; Cooper grunts, "Yeah," in sarcastic response. When an American Army officer advises him to let the vice admiral go, Cooper snaps back, "That's not justice: it's politics." It's also not the stuff of absorbing movie scripts, however sincerely felt.

"Prisoners of the Sun" regains its urgent, horrifying tone only when a dying Australian soldier testifies about his own brother's torture and murder. His flashbacks take the film out of the stuffy, unreal courtroom, giving it a final jolt of reality.

●

"Prisoners of the Sun" is rated R (Under 17 requires accompanying parent or adult guardian). It includes some violence.

1991 Jl 19, C12:1

Archangel

Directed, photographed and edited by Guy Maddin; screenplay by Mr. Maddin and George Toles; produced by Greg Klymkiw; a Zeitgeist Film. At Bleecker Street Cinema, at La Guardia Place, in Manhattan. Running time: 90 minutes. This film has no rating.

Lieut. John Boles	Kyle McCulloch
Veronkha	Kathy Marykuca
Philbin	Ari Cohen
Danchuk	Sarah Neville
Jannings	Michael Gottli
Geza	David Falkenberg

By STEPHEN HOLDEN

Guy Maddin's fascinating, impenetrable film "Archangel" is a tongue-in-cheek homage to the sort of drama produced in Hollywood in the twilight zone between silent and talking pictures, when sound tracks were scratchy, the dialogue minimal and titles between scenes offered portentous commentary.

Set in the city of Archangel in the Russian Arctic at the intersection of World War I and the Bolshevik Revolution, it tells the interlocking stories of Lieut. John Boles (Kyle McCulloch), a one-legged Canadian soldier, and Philbin (Ari Cohen), a Belgian aviator, both of whom suffer memory disorders brought on by mustard gas. Boles is still in love with his wife, Iris, who is dead. When he meets Veronkha (Kathy Marykuca), a Russian nurse who resembles her and who also has amnesiac tendencies, he believes he has found Iris.

Veronkha is married to Philbin, who has no clear memory of being married. Amid this confusion, she marries Boles, too. Other characters include Boles's landlady, Danchuk (Sarah Neville), her obese husband, Jannings (Michael Gottli), and their son, Geza (David Falkenberg).

●

The ludicrous story of "Archangel," which opens today at the Bleecker Street Cinema, matters

much less than the archaic style in which it is told. From its flickering, inky cinematography to its wavering late 1920's-style sound track, to Veronkha's kohl-eyed vampish look, the movie is an expert parody of a period movie style.

The deadpan tone is interrupted by moments of pure lunacy. In one scene, White Russian soldiers asleep in their trenches are invaded by rabbits. In another, Geza, who has had a stroke, is successfully treated by vigorous rubbings with a horse brush. When Jannings is knifed in the stomach by a Bolshevik soldier, he strangles his attacker with chains of link sausage that pop out of his belly.

"Archangel" is the second full-length feature by Mr. Maddin, a 34-year-old Canadian film maker from Winnipeg, who established a cult reputation with his mock Scandinavian epic, "Tales From the Gimli Hospital." "Archangel" is technically more accomplished, but also much weirder.

1991 Jl 19, C12:6

Dutch

Directed by Peter Faiman; written by John Hughes; director of photography, Charles Minsky; edited by Paul Hirsch; music by Alan Silvestri; production designer, Stan Jolley; produced by Mr. Hughes and Richard Vane; released by 20th Century Fox. Running time: 107 minutes. This film is rated PG-13.

Dutch	Ed O'Neill
Doyle	Ethan Randall
Nathalie	JoBeth Williams
Reed	Christopher McDonald
Brock	Ari Meyers
Halley	E. G. Daily

By JANET MASLIN

There's a John Candy-sized hole at the center of "Dutch," no doubt because the screenplay by John Hughes is reminiscent of his earlier "Uncle Buck," in which Mr. Candy starred. Both these films are about spoiled, affluent brats who are set straight from a no-nonsense father surrogate from the other side of the tracks. This guy is simple, direct and decent, with a habit of speaking his mind. Neither Mr. Candy's Uncle Buck nor Ed O'Neill's Dutch Dooley can be described without the use of the phrase "salt of the earth."

As is often the case in Mr. Hughes's stories, economic differences guide the plot even though the whole film (directed by Peter Faiman) has an air of economic unreality. "Dutch" has the title character taking a trip with the rich, arrogant son of his fiancée, Natalie (JoBeth Williams), engineering things so that they must travel without money, and teaching young Doyle (Ethan Randall) a few lessons in manners along the way.

Natalie is wealthy by marriage and lives in a stone mansion, whereas Dutch is in the construction business and wears a beat-up old jacket. But there doesn't seem to be much difference between them. Not even the homeless people whom Dutch and Doyle meet in a shelter — smiling kindly, to the accompaniment of choir music! — seem to be anything but middle class. The story's rich-poor disparity exists mostly so Dutch can say things like, "I don't care for caviar; I make it a rule never to eat anything a fish deposits in a river," and so the film can congratulate him repeatedly for its common sense. "You must be very proud," sneers the snotty little Doyle, when Dutch speaks of his working-class parents. "I am," Dutch piously replies.

If a film like this is to be funny at all, it had better work when the warring principals still hate each other, before the rich boy is shown to be a sweet kid and the whole story turns to mush. But "Dutch" is never more than glancingly comic, and rarely even that. Mr. O'Neill, of television's "Married ... With Children," gives a performance that's sturdy but not big or colorful enough to hold the film together. No one else in the film is as lively as that.

Mr. Faiman, who directed "Crocodile Dundee," gives this film the same kind of aimlessness without the atmosphere, and often emphasizes the screenplay's cruder side. Among its notable excesses in that department are a subplot whereby Dutch and Doyle are given a ride by two hookers while hitchhiking — when was the last time that happened in the real world? — and another involving Dutch's promise to shoot Doyle in the rump with a pellet gun. See "Dutch" only if you care whether he does.

●

"Dutch" is rated PG-13 (Parents strongly cautioned). It includes coarse language and sexual suggestiveness.

1991 Jl 19, C13:1

The Doctor

Directed by Randa Haines; written by Robert Caswell; director of photography, John Seale; edited by Bruce Green and Lisa Fruchtman; music by Michael Convertino; production designer, Ken Adam; produced by Laura Ziskin; released by Buena Vista Pictures Distribution, Inc. Running time: 123 minutes. This film is rated PG-13.

Jack	William Hurt
Anne	Christine Lahti
June	Elizabeth Perkins
Murray	Mandy Patinkin
Eli	Adam Arkin

By JANET MASLIN

William Hurt has an exceptionally wide range on the confidence scale, an ability to move from utter self-assurance to quiet terror that such superiority might crumble. He shows this off to exceptionally good effect in "The Doctor," the story of a once-impervious physician who makes a critical 90-degree shift. Dr. Jack MacKee, a prominent heart surgeon, is first seen presiding over an operating room team with the brash, cowboy arrogance of a seasoned expert. The film follows the events that leave Jack lying helpless in the same setting, about to experience a taste of his own medicine.

"The Doctor," which greatly resembles the current "Regarding Henry" in its tale of a rich, cavalier professional who is made to face his own frailty, has a more realistic outlook and a more riveting figure in its central role. Mr. Hurt, making the most of his sleek good looks and stately bearing in the film's early scenes, presents Jack MacKee as a charming, cocksure doctor who specializes not only in difficult surgical procedures but also in careful, deceptively breezy intimidation.

●

Colleagues and patients alike are thrown off-balance by Jack's mixture of false casualness, crisp professionalism and cutting wit. The film makes it clear that Jack, having spent his entire career perfecting this bedside manner, has lost track of his inner thoughts, and learned to concentrate

solely on getting the job done. "Caring's all about time," he tells someone, when discussing whether work like this ought to engage the emotions. "When you've got 30 seconds before some guy bleeds out, I'd rather cut more and care less."

"The Doctor," written by Robert Caswell (from a book by Ed Rosenbaum, M.D.) and directed by Randa Haines, opens with a quick succession of scenes that encapsulate Jack's professional life. He teases, jokes and plays rock-and-roll oldies in the operating room, setting a mood that is quickly broken when Ms. Haines offers a shot of the patient's battered face. He tells a patient who is dismayed by a new scar that she looks like a magazine centerfold, staples and all. He laughs with his wife, Anne (Christine Lahti), about an emergency call, which arrives via the car phone in his Mercedes. And he also finds after a party that he is coughing blood onto the shirt of his tuxedo.

At this, the supreme security of Mr. Hurt's beautifully precise characterization begins to fall apart. He is utterly nonplussed at the prospect of submitting to tests by a female doctor (Wendy Crewson) whose manner is every bit as briskly detached as his own. He blanches at this doctor's examination, and later rails at the hospital procedures that force him to cool his heels waiting for further treatment. He has, he finally complains to a hospital worker, been a surgeon here for 11 years. "Then you should know all about filling out forms," this worker drily replies.

"The Doctor," which is much more colorful than its weak title would suggest, takes a chillingly clinical view of the medical procedures to which Jack is subjected, once he has been found to have throat cancer. And the fear that Mr. Hurt registers in these hospital scenes is in its quiet way more affecting than the rest of the story. In addition to following the course of his sickness, the film watches Jack as he recognizes the error of his ways, reexamines his profession, owns up to the emptiness of his marriage and finds inspiration in the courage of a beautiful young woman who has a brain tumor (Elizabeth Perkins), and who suddenly becomes the only person to whom he truly feels close.

As she did in "Children of a Lesser God," Ms. Haines shows a talent for tugging at the heartstrings in unexpected ways, but her film's slowly emerging sentimental side endangers the crisp authenticity of its beginning. And the screenplay's eventual insistence on a conventional end to an otherwise unconventional story is damaging, too. So is the fact that no character here, except for Mr. Hurt's Jack, is fully formed. Even Ms. Perkins, very affecting as the fiercely independent young woman who helps Jack to locate his humanity, is given no more of a past than she has a future.

The film's best scenes, those in the hospital, deftly capture the give-and-take of doctors striving to balance seriousness and dark humor. Mandy Patinkin is especially good as the friend who is Jack's partner "until we get it right," as one of them jokes. And Adam Arkin is memorable as a younger colleague who shows his mettle when Jack is in distress. Zakes Mokae, as a radiologist, presides knowingly over the episodes that most powerfully alter Jack's character. And Ms. Crewson is especially interesting for the ambiguity of a medical manner that initially suggests cool competence, and later re-

veals to Jack everything he himself has done wrong.

Ms. Lahti, though often present, has a generic lonely-wife role and no

An illness ceases to be a clinical matter when it's your own.

real way to broaden it, just as Charlie Korsmo, as the MacKees' son, has almost nothing to do. The film's ultimate concessions to the sanctity of

family life strain credulity in a way that its clear, compelling depictions of illness do not.

The visual backdrop for "The Doctor" contributes greatly to the film's unnerving effectiveness. The costumes, especially Mr. Hurt's, evolve tellingly from high-income armor to an air of less artificiality and greater warmth. And the production design, by Ken Adam, turns the hospital into a sleek, controlled environment in which medicine appears to have triumphed over nature. "The Doctor" is a powerful reminder that it has not.

"The Doctor" is rated PG-13 (Parents strongly cautioned). It includes mild profanity and operating room scenes.

1991 Jl 24, C11:1

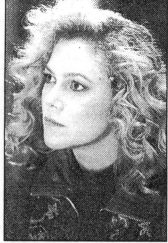

Jane O'Neal

Kathleen Turner

V. I. Warshawski

Directed by Jeff Kanew; written by Edward Taylor, David Aaron Cohen and Nick Thiel; director of photography, Jan Kiesser; edited by C. Timothy O'Meara; music by Randy Edelman; production designer, Barbara Ling; produced by Jeffrey Lurie; released by Buena Vista Pictures Distribution. Running time: 89 minutes. This film is rated R.

Vic	Kathleen Turner
Murray	Jay O. Sanders
Lieutenant Mallory	Charles Durning
Kat	Angela Goethals
Paige	Nancy Paul

By JANET MASLIN

WHEN the initials on the smoked-glass door actually mean Vicki and the shoes up on the desk are high heels, things are bound to be a little different. They certainly are for V. I. Warshawski, the latest and slinkiest of this summer's dangerous movie heroines. As the central figure in a series of detective novels by Sara Paretsky, Victoria Iphigenia Warshawski is an anomaly among private investigators, a wisecracking feminist who turns the unlikeliness of her career choice into a clear advantage. As played slyly and wittily by Kathleen Turner, she has now become as sexy as she is smart.

It's too bad that "V. I. Warshawski" is itself a lot less glamorous than Ms. Turner's performance, since the character could easily be the centerpiece of a more appealing film. Directed by Jeff Kanew ("Revenge of the Nerds," "Troop Beverly Hills") and acted by a no-star supporting cast (Charles Durning is one of the few familiar-looking actors), this film, set in Chicago, provides a cut-rate setting for a character who could just as reasonably have been given the full "Dick Tracy" treatment. Still, "V. I. Warshawski" has a breezy style and a serviceable, even surprising detective plot. And it has Ms. Turner, who makes the most of V. I. Warshawski's sardonic humor.

"You know him?" a man asks her, upon seeing the name on the office door. "I am him," Ms. Turner replies evenly. With her knack for confounding visitors and a name that often changes meaning (she says at various times that the initials are short for "Virtuous" or "Very Inquisitive") no wonder V. I. Warshawski seems like a maverick. Her private life also contributes greatly to this impression, since she and her boyfriend Murray (Jay O. Sanders) enjoy a thoroughly unconventional arrangement. When V. I., or Vic, discovers Murray in flagrante delicto with another woman, she sees this as a situation with great comic potential. And when Murray feels so inclined, he drops in at Vic's apartment without warning, which has less to do with love than logistics. Among Vic's great advantages in life is a picture window facing directly into Wrigley Field.

The apartment itself, though drably photographed, is an amusing shambles. "I'll go, uh, look for a clean

place to sit," says the sullen 13-year-old Kat Grafalk (Angela Goethals) after a brand-new suitor of Vic's has just dropped off his daughter for some unscheduled baby-sitting. Shortly thereafter, after wresting her black spangled evening dress away

A wisecracking feminist with a knack for confounding her visitors.

from this pesty teen-ager, Vic finds herself wearing the dress, a flowered bathrobe and fluffy bedroom slippers

en route with Kat to the scene of a fatal accident. "Consider that your tip," she snaps, narrowing her eyes at the cab driver who has been watching her change through his rear-view mirror.

The film, with a screenplay by Edward Taylor, David Aaron Cohen and Nick Thiel, does a lot to take the edge off Vic's feminism, which is much more strident on the page. And Ms. Turner plays Vic as such an obviously strong, self-possessed figure that the political edge of the novels would amount to a redundancy. The script does indulge in various unhelpful double-entendres, which might give Vic a trace of anti-male hostility if Ms. Turner's delivery were not so successfully droll. When a man boasts to her of his large number of sexual conquests, Vic replies, "Just can't get the hang of it, huh?"

Among the film's more enjoyable aspects, in addition to Ms. Turner's winning nonchalance and expert timing, are the rapport that develops between Vic and Kat as they join forces to investigate a crime. Ms. Goethals admirably holds her own as part of this team. And Mr. Sanders, as Murray, also has an easy rapport with Ms. Turner, although the role cries out for a star of equal magnitude. Too many of the film's other players are less colorful than the criminal misdeeds of which they are suspected.

"V. I. Warshawski," a new spin on an old formula, is also too visually drab to support Ms. Turner's performance with a production design of comparable interest. In Ms. Paretsky's version, Vic gives the standard detective's office two novel touches with a picture of the Uffizi Gallery in Florence and a poster by Georgia O'Keeffe. In the film, no one will notice what's on the wall.

"V. I. Warshawski" is rated R (Under 17 requires accompanying parent or adult guardian). It includes mild violence and profanity.

1991 Jl 26, C1:3

My Mother's Castle

Directed by Yves Robert; written (in French with English subtitles) by Jérôme Tonnere, Louis Nucera and Mr. Robert; edited by Pierre Gillette; music by Vladimir Cosma; production designer, Jacques Dugied; producced by Alain Poiré; released by Orion Classics. At the Fine Arts Theater, 4 West 58th Street in Manhattan. Running time: 98 minutes. This film is rated PG.

Joseph......................Philippe Caubère
Augustine Nathalie Roussel
Marcel.........................Julien Ciamaca
Uncle Jules.....................Didier Pain
Aunt Rose.................Thérèse Liotard

By JANET MASLIN

Whatever the interval that separates one's viewing of "My Father's Glory" from that of the equally enchanting "My Mother's Castle," it is only an intermission. This latter film, the second by Yves Robert based on the childhood memoirs of the popular French playwright and film maker Marcel Pagnol, picks up effortlessly where its predecessor left off. The hills of Provence still exert a magical attraction for the family of Marcel (Julien Ciamaca), a schoolboy who counts the days, minutes and hours that are spent away from the family's pastoral retreat. They will seem no less alluring to the viewer.

Much of the appeal of these seductively scenic films is based on pure charm, the kind of charm that means young Marcel will be taking his cod liver oil from a bottle with a lovely antique label. Thanks to the rosiness of Pagnol's boyhood memories, and to the great affection with which Mr. Robert presents them, no event of daily life is seen as too trivial to be cause for delight.

This second film, like the first, is raised to the heights of voyeuristic

Each day is a celebration, with Mother and Father making it so.

pleasure by countless family feasts, happy occasions, warm smiles and intoxicating memories. Freshly baked breads are the size of skateboards. Children always appear in crisply starched clean clothes, even in the country, and their mothers never look the least bit overworked. Marcel's father shaves outdoors, looking into a mirror hung from a tree, humming to himself as he surveys the hills of his beloved countryside. At the end of a long, dusty journey to this remote spot, a man opens an enormous chocolate Easter egg to release a white dove.

•

These films' greatest accomplishment, in light of so frankly magical a child's-eye view of the world, is that they maintain enough restraint to keep the prettiness from becoming overwhelming. In "My Mother's Castle," even more than in the earlier film, that restraint grows naturally out of the hindsight that shapes these recollections. "Such is the life of man, moments of joy obliterated by unforgettable sorrow," observes Marcel when he is seen fleetingly as a successful film maker in his 30's. "There's no need to tell children that."

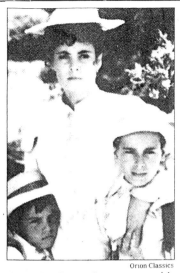

Orion Classics

Nathalie Roussel, center, with Victorien Delmare, left, and Julien Ciamaca in "My Mother's Castle."

As "My Mother's Castle" begins, Marcel catches a brief glimpse of what adult life will be like as he studies for an important school exam, and as the film proceeds he is offered other such hints of the future. He meets a beautiful little girl, holding a bouquet and wearing flowers in her hair, who says: "My name is Isabelle. I'm telling you, and you'll never forget." Isabelle, who so enchants Marcel that he sits with his face pressed against a piano as he plays, impresses him with what he thinks is her superior upbringing, and persuades him to play knight to her queen, loyal slave to her Egyptian princess. "If girls make you do that now, what'll it be in years to come?" wonders the really commanding woman in his life, his beautiful mother, Augustine (Nathalie Roussel).

"Each day saw a fresh start to the story of Augustine and her three men," says the narrator of this family drama, as the film begins to tell of how Augustine arranged for the family to spend more time in the country. As pioneering weekenders, proclaiming that "city air is poison," they use a change in the teaching schedule of Joseph (Philippe Caubère), Marcel's father, as an opportunity to travel to the country on foot each weekend.

The film dwells at length upon the difficulties of this trip, and the miraculous shortcut provided by a special key, which opens doors to the grounds of several estates. And yet the story always sustains its air of sunny unreality. The family members never really look tired, even though they appear to be carrying an entire set of dishes as part of their baggage.

"My Mother's Castle," a film that is all banquets and bouquets, concentrates as fully on life's smaller joys as on its larger ones, and does so with the kind of panache that has already charmed much of France. The abundance of fresh thyme, the jars of olive oil arranged neatly in the village market and the embroidered pillowcase from which young Marcel wakes to greet the day all contribute quietly but clearly to the film's sensual appeal. In many of these touches there is the kind of prescience that will make sound commercial sense to the comfortable contemporary audience at which the film is aimed. So Marcel's mother discovers the joy of the weekend house, to which the title refers. And Marcel's father is seen enjoying a turn-of-the-century white-wine spritzer.

"My Mother's Castle" opens today at the Fine Arts, as "My Father's Glory" moves over to the Quad.

•

"My Mother's Castle" is rated PG (Parental guidance suggested). It includes the very mildest sexual suggestiveness.

1991 Jl 26, C6:1

Trust

Written and directed by Hal Hartley; director of photography, Mike Spiller; edited by Nick Gomez; music by Phil Reed; production designer, Daniel Ouellette; produced by Bruce Weiss; released by Fine Line Features. Running time: 90 minutes. This film is rated R.

Maria Coughlin........................ Adrienne Shelly
Matthew Slaughter.............: Martin Donovan
Jean Coughlin Merritt Nelson
Jim Slaughter John MacKay
Peg Coughlin......................................Edie Falco

By CARYN JAMES

Putting on her purple lipstick one morning, a teen-ager tells her father she's pregnant. He calls her a slut, she slaps his face and the minute she stomps out the door he drops dead. Just as you were warned: if you break your father's heart, it will kill him. The situation is part nightmare, part bad joke, and the perfect deadpan way to kick off Hal Hartley's "Trust."

Mr. Hartley's two feature films — "The Unbelievable Truth" was released last year — share a droll, distinctive manner. He drops by suburban Long Island, finds a couple of young characters who have skewed but thoroughly sensible attitudes, and lets them find each other. Like the films of this 31-year-old writer and director, Mr. Hartley's characters look realistic, act cockeyed and turn out to be just right.

Maria, the pregnant teen-ager in a miniskirt and a high-school jacket, tells her boyfriend about the baby. He dumps her and goes to football practice. Back home, Maria's mother says she will never forgive her for killing her father and throws her out of the house. At the end of this luckless day, she finds shelter in an empty house and meets Matthew, potentially more lethal than she is and just the right guy to understand her.

•

When the film introduces Matthew he is so disgusted with his job at a computer factory that he puts his boss's head in a vise and walks out. Mr. Hartley's control is so sure that we instantly know Matthew has made the right choice. He may be 10 or so years older than Maria, but he is on the run from a sadistic parent himself. His father obsessively makes him clean the already spotless white bathroom. It is a true act of chivalry and self-sacrifice when Matthew takes Maria home.

Suddenly, it's a toss-up about who needs whom more. "I carry this with me at all times, just in case," Matthew says, showing Maria a hand grenade. "Are you emotionally disturbed?" she asks, cutting through politeness as if the superego had never been discovered. No, he answers. But they had been talking about how she killed her dad and thought about killing herself; he was trying to be sympathetic. Neither Maria nor Matthew is strong enough to escape

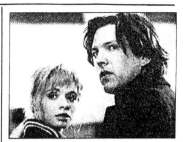

Chris Buck/Fineline Features

Adrienne Shelly, Martin Donovan

alone, but each recognizes that the other needs to be dragged out of a suffocating situation.

Though this film's tone is more sober and weightier than the black humor of "The Unbelievable Truth," Mr. Hartley has kept his sense that everyone seems screwy if you just look hard enough. As Maria and Matthew navigate toward each other, they keep bumping into characters who only seem normal.

A nurse at the abortion clinic is most sympathetic when she takes off her cap and pours a couple of glasses of Scotch for Maria and herself. Maria's sister is a flirty, gum-chomping waitress, a real type. She seems Neanderthal next to her younger sister, especially after Maria pulls back her hair, puts on her glasses and starts thinking about her life. "I am ashamed," this new Maria writes in a notebook. "I am ashamed of being young. I am ashamed of being stupid."

Surrounded by people who would agree with that wrenching self-description, she is lucky to find Matthew. As Maria says, their relationship is based on trust, admiration and respect. She is determined to convince him that those qualities add up to love, even if she has to jump off a bridge to prove it. This might be love, but not the kind usually seen on screen. At the moment they seem about to kiss, Maria pulls back and says, "Give me your hand grenade."

Adrienne Shelly, who starred as another quick-to-grow-up teen-ager in "The Unbelievable Truth," makes Maria's transformation from a smart-mouthed girl to a wise young woman both poignant and credible. Like Ms. Shelly, Martin Donovan (as Matthew) knows how to make Mr. Hartley's pared-down, stylized dialogue express the essence of his character. Though Mr. Hartley's films are richly detailed, there are no frills or grace notes. Such work risks being too blunt, but "Trust" comes through.

•

"Trust" is rated R. (Under 17 requires accompanying parent or adult guardian). It includes a little harsh language and some domestic slapping around.

1991 Jl 26, C16:5

Mobsters

Directed by Michael Karbelnikoff; written by Michael Mahern and Nicholas Kazan; director of photography, Lajos Koltai; edited by Scott Smith and Joe D'Augustine; music by Michael Small; production designer Richard Sylbert; produced by Steve Roth; released by Universal Studios. Running time: 103 minutes. This film is rated R.

Charlie (Lucky) Luciano....... Christian Slater
Frank CostelloCostas Mandylor
Bugsy Siegel.............................Richard Grieco
Meyer Lansky.......................Patrick Dempsey
Don Faranzano.....................Michael Gambon
Don Masseria............................ Anthony Quinn
Mara Motes.......................Lara Flynn Boyle

By CARYN JAMES

The idea behind "Mobsters" is so obvious, so commercial, so foolproof, such fun, that it's a wonder this film didn't turn up sooner. It's "Young Guns," but about organized crime. It's baby gangsters!

Take Lucky Luciano, Meyer Lansky, Bugsy Siegel and Frank Costello, cast hot and hunky young actors in the story of their rise to power and riches, and you've got sex, violence, money in the bank. Unless, of course, the film takes itself seriously. Then you've got "Mobsters," a surprisingly dull movie preoccupied with the knotty issue of Jewish-Italian relations.

Luciano, played with an intense stare and some authority by Christian Slater, offers this reassuring advice to Don Masseria (Anthony Quinn) as he makes his way along the buffet table at Lansky's wedding: "They've got these things called blintzes. It's like manicotti."

•

Lansky, who has the coolest head of the group, is played with understated power and intelligence by Patrick Dempsey. When Luciano heads off for a dangerous meeting with Don Faranzano (Michael Gambon), Lansky offers the benefit of his objectivity. "When it's between Italians," he warns, "one of the Italians ends up dead."

It's hard to argue with any of this, or to see much point in it, but here the

Touchstone Pictures

Historic Hood

Richard Grieco plays Bugsy Siegel in Michael Karbelnikoff's "Mobsters," which chronicles the rise of organized crime from 1917 to 1930. Also starring Christian Slater, Patrick Dempsey, Costas Mandylor, F. Murray Abraham and Anthony Quinn

Italian-Jewish alliance forged by Luciano and Lansky is given the weight of the latest Middle East peace plan. In fact, except for the way they bootleg whisky and kill people, these two are models of peace and brotherhood.

The other two mobsters are lost in the background. Richard Grieco is Bugsy Siegel, the hot-headed one who shoots first and doesn't even bother to ask questions later. As Frank Costello, Costas Mandylor looks good, says little and buys off cops.

For glamour, there are plenty of 1920's clothes and cars. For a plot, there is a rivalry between the two equally despicable dons, Masseria and Faranzano, whom Luciano and Lansky outsmart. And for absurdity, there is Lara Flynn Boyle wearing a conspicuous contemporary wig as Luciano's love interest, a chorus girl whose talk about friendship doesn't rule out languorous sex on a roulette table. The film even reveals how Charlie Luciano came to be nicknamed Lucky.

•

But for all its machine-gun hits, "Mobsters" seems to have run out of energy soon after casting. The explosive power that is usually just below the surface of Mr. Slater's characters has vanished, though this film could have used it. Mr. Dempsey is a first-rate actor who seems trapped in second-rate movies. In smaller roles, Mr. Quinn eats a lot of spaghetti and acts in a big-gestured Anthony Quinn way, and the less said about Mr. Gambon's Italian accent the better. (Well, just this one thing. He calls the gluttonous Masseria a "faht peeg" several times.)

"Mobsters" is the first feature directed by Michael Karbelnikoff, who has made commercials for such products as Levi's jeans and Coca-Cola. With that background, he must have seemed like a great choice for the kind of young, free-wheeling, swift-paced style this film needed.

Mamma mia! Go figure.

"Mobsters" is rated R (Under 17 requires accompanying parent or adult guardian). There is much violence and blood, some in stomach-churning close-up and some from far away.

1991 Jl 26, C18:4

The Dark Backward

Written and directed by Adam Rifkin; production designer, Sherman Williams; edited by Peter Schink; produced by Brad Wyman and Cassian Elwes; released by Greycat Films. At the Angelika Film Center, Houston and Mercer Streets in Manhattan. Running time: 110 minutes. This film is rated R.

Marty Malt	Judd Nelson
Gus	Bill Paxton
Jackie Chrome	Wayne Newton
Rosarita	Lara Flynn Boyle
Dr. Scurvy	James Caan
Dirk Delta	Rob Lowe

By JANET MASLIN

We have only begun to pay the price for David Lynch's immense popularity, and for the influence he no doubt exerts over a whole generation of directorial wanna-be's. If Adam Rifkin's "Dark Backward" is any indication, then aspiring young film makers in the Lynch mold can easily confuse the use of sickening grotesques and smug, simple-minded acting with the more interesting eccentricities that shape Mr. Lynch's style.

But "The Dark Backward," which opens today at the Angelika Film Center, concentrates only on stomach-turning trivia and on the kind of exaggeratedly stupid behavior that amounts to directorial condescension. Drawing on a story idea (the screenplay is by Mr. Rifkin) that is barely solid enough to sustain a brief skit, the film tells of Marty Malt (Judd Nelson), an excruciatingly shy garbage man who harbors dreams of being an excruciatingly bad stand-up comedian.

The film's nightclub scenes, in which a small, freakish audience shows no interest in laughing at Marty's awful jokes, are no less painful than the garbage-collecting sequences, in which Marty and his friend Gus (Bill Paxton) revel in every last bit of rot. One of these scenes incorporates a beautiful dead woman wrapped in plastic, possibly as a meaningless homage to "Twin Peaks."

•

The big event in "The Dark Backward" occurs when Marty notices a bump on his back, and the bump grows into an extra arm. This new appendage turns Marty into a show-business success, and turns the story into a metaphor for . . . well, for growing an extra arm. Beyond that, the film's efforts to say something about success and its capriciousness never succeed in rising above an elbow-in-the-ribs obviousness.

Mr. Nelson, who confined himself in a small, heated box in order to make sure Marty looks sweaty in the film's nightclub scenes, cannot be accused of having taken his role lightly. In fact, he gives the film's best performance, which is not to say anything pleasant about the others. The sky is the limit here when it comes to obnoxious overacting, particularly from Mr. Paxton as the accordion-playing loudmouth Gus and from the various obese or unsightly players who give the film a fun-house atmosphere without the fun. On the positive side, Lara Flynn Boyle plays a grime-caked waitress and looks beautiful in those rare scenes that show her free of dirt.

Wayne Newton, as a seedy agent, has a kind of crazy authority that makes him eminently watchable, and a wry manner suggesting that at least someone here gets the joke. Also in the film are Rob Lowe, who is deliberately made to look unattractive as a kind of witticism, and James Caan as a demented doctor.

Mr. Rifkin's direction does display, in addition to an appreciation of Mr. Lynch and perhaps John Waters, a promising eye for design and a taste for the unusual. With less noxious material and a less patronizing manner, those talents would amount to a lot more.

•

"The Dark Backward" is rated R (Under 17 requires accompanying parent or adult guardian). It includes profanity, brief nudity and general squalor.

1991 Jl 26, C18:4

Life Stinks

Directed by Mel Brooks; written by Mr. Brooks, Rudy De Luca and Steve Haberman; director of photography, Steven Poster; edited by David Rawlins; music by John Morris; production designer, Peter Larkin; produced by Mr. Brooks; released by Metro-Goldwyn-Mayer. Running time: 90 minutes. This film is rated PG-13.

Goddard Bolt	Mel Brooks
Molly	Lesley Ann Warren
Vance Crasswell	Jeffrey Tambor
Pritchard	Stuart Pankin
Sailor	Howard Morris
J. Paul Getty	Rudy De Luca
Fumes	Teddy Wilson

By JANET MASLIN

Mel Brooks's new comedy, "Life Stinks," is less downbeat than its title, but not by much. As the latest in a long line of movie millionaires (Mr. Brooks's version is a billionaire, thanks to inflation) who regain their common sense by spending time with the common folk, Mr. Brooks appears as Goddard Bolt, robber baron extraordinaire. He has a much surer sense of how to lampoon such a figure than of how to turn him into anyone nice.

So the film's opening scenes, in which Goddard displays his ruthless business tactics, show some comic promise. Told that one of his companies plans to cut down 6,000 acres of Brazilian rain forest, Goddard merely shrugs and says, "So?" At the prospect of closing down a nursing home, he advises an aide to "do it late at night." Mr. Brooks also has fun with the phallic-looking design for a new high-rise project Goddard plans for skid row, and with this entrepreneur's terrible-looking toupee, which he wears with great pride. "You look like someone who only makes $50,000 a year!" an aide exclaims in horror, once Goddard's hairpiece has been stripped away.

After Goddard makes a contrived bet with a rival tycoon (Jeffrey Tambor) and insists that he can live without money for 30 days, the film briefly finds some humor in the gutter. Mr. Brooks, in his now-tattered business suit, is seen trying to make money washing car windshields and dancing a soft-shoe. But he is also scared by rats, urinated on by a derelict, sobered by the hardships of his new acquaintances on the street and finally left damp-eyed by his more heartwarming experiences, none of

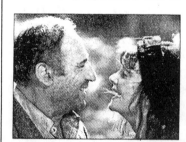

Peter Sorel/MGM

Mel Brooks, Lesley Ann Warren

which bode well for this film's comic potential. Stopped in his tracks by the essential grimness of his subject, Mr. Brooks is no longer his customary wisecracking self. He becomes subdued, compassionate and — worst of all, given that this is Mel Brooks — polite.

•

The film still occasionally finds time to be rude, but only in the most sophomoric way. One gag, involving Howard Morris as a doddering old derelict, has Mr. Brooks discreetly suggesting that Mr. Morris remove a kernel of corn from his face, and the kernel of corn stubbornly refusing to go away. Another has Mr. Brooks and Rudy De Luca (who co-wrote the screenplay with Mr. Brooks and Steve Haberman), as a bum who insists he was once richer than Goddard, slapping one another repeated-

ly in the face. Even more dispiriting than the film's silly moments are its pious ones. "Thank you, God," Goddard says at one point. "I'm sorry I didn't believe in you when I was rich."

Only at rare moments does "Life Stinks" offer much in the way of surprise or grace. Much of the latter comes from Lesley Ann Warren, playing the uncommonly beautiful bag lady with whom Goddard falls in love. Ms. Warren, sometimes energetically nutty and at one memorable instance ready to throw off her troubles and join Mr. Brooks for a movie-musical dance number, has a furious energy that too much of the film otherwise lacks. A smaller but also appealing performance comes from Teddy Wilson as a gentle wino who becomes part of Goddard Bolt's new circle of friends.

When Mr. Brooks's Goddard finally returns to the world of the wealthy, the film picks up for one amusing sequence in which he loots his own mansion of artworks. "Come on, Dr. Gachet — we're leaving!" he sniffs, with a van Gogh under his arm. Also while among the rich, Goddard interferes with a ceremonial occasion on which a toast is being made. The film at this point includes a very conspicuous plug for a brand of Champagne.

•

"Life Stinks" is rated PG-13 (Parents strongly cautioned). It includes rude language.

1991 Jl 26, C19:1

Another You

Directed by Maurice Phillips; written by Ziggy Steinberg; director of photography, Victor J. Kemper; production designer, Dennis Washington; edited by Dennis M. Hill; music by Charles Gross; produced by Mr. Steinberg; released by Tri-Star Pictures. Running time: 98 minutes. This film is rated R.
Eddie Dash Richard Pryor
George/Abe Fielding Gene Wilder
Elaine Mercedes Ruehl

By STEPHEN HOLDEN

Gene Wilder's jack-o'-lantern grin and Richard Pryor's glare of hair-raising terror have done wonders to lift many otherwise scattershot comedies above the doldrums. But bright as they are, their gifts do little to elevate "Another You," a frantically incoherent comedy that opened yesterday at local theaters

In their fourth film together, Mr. Wilder plays a pathological liar named George Washington who is discharged from a mental hospital after three years and is given an Abe Lincoln top hat as a parting gift to commemorate his hard-won honesty. Mr. Pryor is Eddie, a con man sentenced to do community service and whose first assignment is to help George make the transition from hospital to civilian life. Within minutes, they are sucked into an elaborate scam in which George is mistaken for another Abe, named Fielding, a missing billionaire beer manufacturer.

George quickly finds himself the master of a baronial Beverly Hills mansion with a hostile Great Dane and a sulky wife (Mercedes Ruehl), who accuses him of adultery. Relapsing briefly to his old ways, he convinces her to let Eddie live with them by claiming he is the heavyweight boxer Joe Frazier 40 pounds lighter after a bout with malaria. Mr. Pryor, who does not look well, virtually walks through his role.

Marcia Reed
Gene Wilder

Comedies have been known to float on even more slender and improbable premises than "Another You," if they have enough good jokes. But Ziggy Steinberg's screenplay jabbers along in ways that even Mr. Wilder, who carries the brunt of the dialogue, cannot make amusing. Mr. Pryor's role is paltry and his dialogue scant. When all else fails, he is reduced to repeating obscenities.

"Another You," which was directed by Maurice Phillips and edited by Dennis M. Hill, is so choppily put together that it has no internal momentum. Even the final scenes in which Mr. Wilder is almost turned into a beer ingredient lack punch.

1991 Jl 27, 16:3

Bikini Island

Directed by Anthony Markes; written by Emerson Bixby; director of photography, Howard Wexler; edited by Ron Resnick; music by Marc David Decker; production designer, Keith Downey; produced by Mr. Markes and Zachary Matz; released by Rocky Point Films. Running time: 85 minutes. This film is rated R.
Annie Holly Floria
Ursula Alicia Anne
Jack Denton Jackson Robinson
Brian Michael Kelly Poole
Anesa Cronin Sherry Johnson
Pat Gaston Le Gaf
Nikki Shannon Stiles
Tasha Kathleen McOsker
Frab Terry Miller
Leon Delodge Seth Thomas
Kari Cyndi Pass

By JANET MASLIN

"Bikini Island," which opened yesterday at the Village East, is a genial piece of cave art about five beautiful, absolutely brainless models who are taken to a not very nice tropical location to pose in swimsuits for a magazine. It should interest anyone who cares about such technical issues as how models play volleyball in slow motion, or how models shower.

The models are treated more or less as pets by the smug Jack Denton (Jackson Robinson), the magazine's advertising director, whose boss has sternly warned him, "I want those girls in the magazine, not in your bed!" In addition to repeatedly ignoring this order, Jack condescends to the models as a matter of course. "All

right, let's go, girls," he says wearily, herding them into a van.

But it's hard to blame him, since not one of the five women displays the intelligence of the average iguana. Sample model dialogue: "This is great — men, champagne, sun and water. I could get used to this." "So, uh, what do we do now?"

"Bikini Island" could be a lot worse, since the inevitable string of model murders (What? You thought they could do nothing but take showers for 85 minutes?) is staged without much realism or sadism, employing silly weapons like a bathroom plunger and a rattail comb. And the cheesecake is extremely benign, even relatively chaste. Sexual encounters between Jack and various models are not shown much beyond the tongue-tied proposition stage. "Well, maybe you need a massage," one model says to Jack, who has back trouble. "Well, maybe I do," he answers.

On the other hand, this film, written by Emerson Bixby and directed by Anthony Markes, makes very little of its considerable comic potential. Only when the models start mysteriously disappearing and leaving improbable farewell notes do the film makers show any signs of wit. "Sorry, Jack," one supposedly writes, after a tiff with the photo stylist. "But no way am I going to let anyone cut off my hair!"

•

"Bikini Island" is rated R. It includes partial nudity and nonstop sexual suggestiveness.

1991 Jl 27, 16:3

Hot Shots!

Directed by Jim Abrahams; written by Pat Proft and Mr. Abrahams; cinematographer, Bill Butler; edited by Jane Kursons and Eric Sears; music by Sylvester Levay; production designer, William A. Elliott; produced by Bill Badalato; released by 20th Century Fox. Running time: 85 minutes. This film is rated PG-13.
Sean "Topper" Harley Charlie Sheen
Lieut. Cmdr. Block Kevin Dunn
Kent Gregory Cary Elwes
Pete Thompson William O'Leary
Jim Pfaffenbach Jon Cryer
Ramada Valeria Golino
Admiral Benson Lloyd Bridges

By JANET MASLIN

It's heartening to know that while we sat through some of the emptiest synthetic hit movies of the 1980's, the seeds of parody were being sown. It's also nice to see that the three-headed Zucker-Abrahams-Zucker directorial entity, the one responsible for "Airplane!," has split into three fully formed talents without any apparent loss of verve.

Mr. Abrahams has directed his brazen, funny "Hot Shots!" with much the same glee that shows up in David Zucker's "Naked Gun 2½," and with a little something extra: a satirical view of other movies, one that might have been shaped by Mad magazine. When the fighter planes of "Hot Shots!" are being readied for flight, in the kind of souped-up inspirational montage that was a "Top Gun" specialty, there are suitcases to load and marshmallows to roast in the flaming engines. And when the planes, now airborne, engage in dizzying swoops and turns, watch out for Garfield dolls stuck to windshields and candy wrappers flying loose around the cockpit.

"Hot Shots!" follows the basic outline of "Top Gun," with the story of daring young Topper Harley (Charlie Sheen) and his fellow pilots, but it is more than happy to indulge in the occasional detour. Topper himself is first found living in seclusion in a tepee and using an Indian name that translates, he says sternly, as "Fluffy Bunny Feet." When he converses solemnly with an Indian elder, those viewers who ignore the subtitled dialogue will find the actors reciting the names of some of Michael Jackson's siblings, with appropriate Indian pronunciation.

•

Once Topper finds his way to the Air Force, the film has ample opportunity to cram sight gags into the corners of the frame, like the jogging recruits chanting the song "Dreidl," or the Amish extras who turn up (no doubt in honor of Kelly McGillis's performance in "Witness") in a nightclub scene. The air base also features Lloyd Bridges as the kind of officer who answers the question "How are you?" with: "Hawaii? I'm supposed to be in California."

Marsha Blackburn/Twentieth Century Fox
Lloyd Bridges in a scene from "Hot Shots!"

There is more — much more — where this came from, most of it in a slightly more movie-minded and less schoolboyish spirit than Mr. Zucker's current hit. In choosing to sustain a feature-length parody of a familiar film, Mr. Abrahams and his co-writer, Pat Proft, forfeit the chance to be as unmitigatedly manic as "The Naked Gun 2½" and risk the occasional slow spot. But they also lay the groundwork for more sustained comic caricatures.

One of the best of these involves nice, clean-cut Pete Thompson (William O'Leary), the obviously ill-fated pilot who explains sweetly that his friends call him "Dead Meat." One ominous day, he arrives at the airfield with his loving wife ("Things just couldn't be better for us," one of them says about the marriage). He also claims to have a solution to global warming and new data about President Kennedy's assassination, but explains that he'll save all that for after the flight. While it's not necessary to have seen "Top Gun" to appreciate such a scene, the memory of that film's false piety and mechanical plotting does a lot to enhance the even more false and mechanical aspects of this one.

Charlie Sheen brings just the right exaggerated seriousness to his ace pilot's role, and Cary Elwes perfectly captures the ingenue arrogance of Topper's handsome rival. Jon Cryer, as a pilot with major eyesight problems, also displays expert deadpan timing, especially when he delivers the film's most uproarious line. Valeria Golino, as the beautiful psychologist who becomes Topper's love interest and also winds up singing a torch song atop a piano à la "The Fabulous Baker Boys," is also slyly comic and a very good sport. It should be pointed out that in this film, unlike the one with Michelle Pfeiffer, the top of the grand piano on which the actress sings happens to be propped open.

Among the other satirical flourishes to be found here, interspersed at wonderfully unlikely moments, are a send-up of the ice cube-enhanced sex scene in "9½ Weeks," which in this case involves a full breakfast; a glimmer of "Marathon Man," and a montage revealing just what "Rocky," "Superman" and "Gone With the Wind" have in common. Also worth noting: a moment when saluting pilots are given the "at ease!" order and instantly assume the poses of a casual fashion layout, complete with football and flying muffler.

The credits for "Hot Shots!" include a partial brownie recipe and a few suggestions for what to do after the film is over. This is evidence that Mr. Abrahams has no idea when to stop. It is to be hoped that he never will.

•

"Hot Shots!" is rated PG-13 (Parents strongly cautioned). It includes sexual suggestiveness and mild profanity.

1991 Jl 31, C11:2

Weininger's Last Night

Directed and written by Paulus Manker; based on a play by Joshua Sobol; director of photography, Walter Kindler; edited by Igrid Koller and Marie Homolkova; produced by Veit Heiduschka; production designer, Birgit Voss; released by Cinepool. Film Forum 1, 209 West Houston Street, Manhattan. In German with English subtitles. Running time: 100 mins. This film is not rated.

Otto Weininger	Paulus Manker
Adelaide Weininger/Adele/Janitor	Hilde Sochor
Double	Josefin Platt
Leopold Weininger/Sigmund Freud	Sieghardt Rupp
Clara	Andrea Eckert
Berger	Peter Faerber

By CARYN JAMES

To watch "Weininger's Last Night" is to enter the title character's suicidal, self-hating mind. This mental dream-theater is not a pleasant place to be, but for half of the film it is an artistically arresting one. Otto Weininger was a homosexual Jewish philosopher who hated women, Jews and his own homosexuality. In Vienna in 1903, shortly after converting to Christianity, he killed himself at the age of 23 in the room where Beethoven died. On screen, the pressures of his life converge into a swirl of memory and imagination in a fluid performance-art manner that finally collapses under the weight of its own symbolism.

•

Weininger is played by Paulus Manker, who also wrote and directed the work, which opened yesterday at Film Forum. It is his version of the play "Weininger's Last Night: The Soul of a Jew," by Joshua Sobol (the author of "Ghetto," the controversial musical about the Holocaust). The film begins with a gunshot, and as the camera crouches to look out through a keyhole, the door is opened. Weininger walks in, a meek-looking, bespectacled young man with a mus-

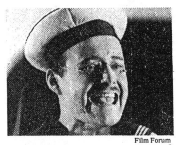

Film Forum
Paulus Manker

tache. This room becomes the landscape of Weininger's distraught mind, where figures from his past and from his imagination arrive to torment him.

There is a woman dressed as Weininger, his taunting female self. Another woman named Clara wants him to move to Palestine with her; she removes her clothes but all she gets from Weininger is a debate about the futility of Zionism. Eventually his mother arrives plucking a bloody chicken, and the adult Weininger walks aroung in a little boy's sailor suit.

Freud, the man Weininger considers his equal and archrival, also turns up and is unfortunately played by the same actor who is Weininger's father. This increasing load of symbolism obviously reflects Weininger's crazed mind. But by the time he receives a crown of thorns the film itself has gone completely over the edge.

•

At times the white sheets that cover the walls and furniture of Beethoven's room are removed to reveal theater stalls. But even when the landscape of Weininger's mind literally becomes a theater, Mr. Mankus's

visual sense remains impressive and purely cinematic. Without being fussy, he chooses some skewed, expressionistic camera angles and evokes the feeling that Weininger is about to jump out of his skin.

Mr. Mankus's ability to splash a confused psyche across the screen is, at least in part, an artistic redemption of the material. Mr. Sobol's plays have been criticized for not being equal to their self-proclaimed task of examinining anti-Semitism; that is certainly the case here. Because Weininger never grapples with his own anti-Semitism and sexual hatred — he simply spits them out — the film doesn't begin to work as a comment on its cultural moment. Mr. Mankus's intriguing artistic eye is the best justification for "Weininger's Last Night."

1991 Ag 1, C14:4

Street of No Return

Directed by Samuel Fuller; written by Jacques Bral and Mr. Fuller; director of photography, Pierre-William Glenn; music by Karl Heinz-Schafer; production designer, Mr. Bral; produced and released by Mr. Bral. At Film Forum 2, 209 West Houston Street, Manhattan. Running time: 90 minutes. This film has no rating.

Michael	Keith Carradine
Borel	Bill Duke
Celia	Valentina Vargas
Rhoda	Andrea Ferreol
Morin	Bernard Fresson

By JANET MASLIN

Samuel Fuller's "Street of No Return" was made only two years ago and has a plot incorporating rock video, but neither of those things places it firmly in the present. Hard edges, tough-guy bravado and a total inability to mince words anchor this bizarre, impassioned hybrid in the film noir past.

Based on the 1954 novel by David Goodis (whose work was also the basis for Truffaut's "Shoot the Piano Player"), the film tells of a singer who is brutally punished for loving the wrong woman, and who as a consequence falls from the peak of success to the gutter. Thanks to Mr. Fuller's directorial relentlessness, which is still very much intact, it's possible to find this tale peculiarly gripping without believing it in the slightest.

"Street of No Return," which opens today as part of the Film Forum's current Fuller retrospective, stars

A Samuel Fuller retrospective offers the premiere of his latest work.

Keith Carradine as a pop star known only as Michael. He is first seen in a state of abject decline. The film begins, with Mr. Fuller's typical bluntness, by showing a street brawl outside a liquor store, in a desolate slum where graffiti on a wall announce, "Life is beautiful." With his long gray fright wig and haunted expression, drinking spilled whisky off shards of

broken glass, Michael is very much a part of this sorry scene.

It was not always so. Once Michael was signing autographs and spending his time on a yacht, and once he wore a long metal-studded black coat for a rock video co-starring a horse and latter-day Lady Godiva. The fallen, drunken Michael, who suffers from amnesia, is somehow reminded of these glamorous days by a glimpse of a beautiful woman, whom he watches as he hides behind a pile of cartons conspicuously labeled "Milk." It would not be Mr. Fuller's style to be any subtler than that about the differences between the purity of Michael's past and the sordidness of his alcoholic haze.

•

The film flashes from its gutter scene to an intense and well-sustained romantic interlude between Michael, then at the height of his stardom, and a beautiful dancer named Celia (Valentina Vargas). They meet; sparks fly; they share a drink (Michael has water, saying of alcohol, "No, it's for losers") and go to bed, all in about two minutes time.

Mr. Fuller's pointedly abrupt direction leaves no room for small talk. But it does allow for an idyllic sexual interlude between Michael and Celia, during which he suddenly recognizes her as the model who played Lady Godiva, before everything goes wrong. Celia, it develops, is tied to a jealous real-estate tycoon who arranges for Michael to be brutally beaten and robbed of the two things he holds most dear. In addition to losing Celia, he is also wounded in the vocal cords, and he loses his voice.

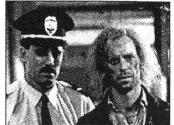

Film Forum Annex
Keith Carradine, right.

All of this action is given a bright, hard look by Mr. Fuller's direction and a distinctly hard-boiled tone by his and Jacques Bral's screenplay. "I think you mopped the floor with her face to make her stay," Mr. Carradine says bitterly at one point. "I gotta hire a private eye to find her, I'll drop you like a hot grenade," he says at another. "How long have you been a homicidal bum?" the police ask him later. For the seasoned film noir fan, this sort of thing is truly its own reward.

•

But "Street of No Return" eventually spirals into crazy excess with a long, violent, racially tense ending involving the real-estate mogul, an all-black gangster army, a jealous woman whom Michael has spurned, and a fiery police chief (Bill Duke). By the time it arrives at its sweepingly preposterous ending, the film has fallen over the edge of even film noir credibility, but it sustains its energy anyhow. Mr. Carradine's performance seems every bit as sinewy yet heartfelt as the direction, and that helps a great deal.

Mr. Fuller himself turns up in the film, but only as a shadow barking raspy orders at another character.

He can be seen more substantially in "Fuller at the Moviola," an indispensable short by André S. Labarthe in which the film maker is asked to dissect a sequence from his 1953 "Pickup on South Street," and does so with revealing and lively wit. "Always be in a position to control what you want, because you're never going to get another chance," this cigar-chomping veteran advises any up-and-coming directors who may be watching. "I love these pickpockets!" he exclaims at one point, heartily enjoying his own film clip. "This is called instinct!" he says proudly, describing a particularly good guess on the part of his cameraman. Instinct is something that Mr. Fuller, whether at his best or at his most defiantly peculiar, understands very well.

1991. Ag 2, C6:1

Doc Hollywood

Directed by Michael Caton-Jones; written by Jeffrey Price, Peter S. Seaman and Daniel Pyne; director of photography, Michael Chapman; edited by Priscilla Nedd-Friendly; music by Carter Burwell; production designer, Lawrence Miller; released by Warner Brothers. Running time: 103 mins. This film is rated PG-13.

Ben Stone	Michael J. Fox
Lou	Julie Warner
Dr. Hogue	Barnard Hughes
Hank	Woody Harrelson
Nick Nicholson	David Ogden Stiers
Lillian	Frances Sternhagen
Dr. Halberstrom	George Hamilton
Nancy Lee	Bridget Fonda
Melvin	Mel Winkler
Nurse Packer	Eyde Byrde

By JANET MASLIN

In "Doc Hollywood," Michael J. Fox plays a big-city doctor who wanders off the beaten track and right into a television sitcom, or at the very least a pilot for one. In a tiny town called Grady, famed as "the Squash Capital of the South," Mr. Fox's Ben Stone crashes cute (by driving his vintage red Porsche convertible into a judge's white picket fence) and is sentenced to stay and perform community service.

Supposedly, he is torn between a promising opportunity to perform plastic surgery on a vain Los Angeles clientele and the simpler, more immediate charms of Grady. And supposedly he has a hard time deciding what to do. But despite the prodigious efforts of the director, Michael Caton-Jones ("Scandal," "Memphis Belle"), to postpone it for as long as possible, the film's outcome is never in doubt. Anyone who has failed to notice this summer's epidemic of breast-beating among once-proud careerist yuppies has simply not been paying attention.

The town of Grady functions as an elaborate support system for Ben as he wrestles with his conscience. And Grady is a television comedy writer's dream. Funny, colorful and eccentric, it is not unlike the Alaska town that is the setting for "Northern Exposure," which really *is* a television series about a displaced big-city doctor living among a fine array of rustic oddballs. This time the setting is "hee-haw hell," as a harried Dr. Stone puts it, but the willfully offbeat feeling is much the same.

Among the residents of Grady — there is a temptation to call them "regulars," but that will probably come later — are an older, curmudgeonly doctor (Barnard Hughes), who

Michael J. Fox
Warner Brothers

resents his citified colleague but eventually comes to respect him, and a pert elderly waitress (Frances Sternhagen) who wears pigtails, makes hip wisecracks and turns up as a record-scratching D.J. at Grady's all-important Squash Festival, which Mr. Caton-Jones has done his best to transform into April in Paris. It is here, amid the fireworks and the slow-motion shots of carnival rides, that Ben becomes deeply smitten with Lou (Julie Warner), the woman who insults him constantly because she wants him to stay.

Most of the other characters are considerably less abrasive. (Ms. Warner, attractive but too much the caustic sophisticate for this country-girl role, has been given a preposterous explanation for what Lou is doing in this tiny town, and for why she happens to be the ambulance driver accompanying Dr. Stone on his rounds.) Among the others, a very breezy and personable group, are Woody Harrelson as the insurance salesman who is jealous of Lou's affections, Bridget Fonda as the much-too-friendly daughter of the mayor (David Ogden Stiers), Mel Winkler as

Another yuppie faces a career crossroads.

an especially ingratiating mechanic who can't seem to get Ben's Porsche fixed, and Eyde Byrde as a gruff, disapproving nurse. In addition to its other virtues, Grady happens to be a perfectly integrated Southern town.

Mr. Fox, blithe and funny as ever, amusingly shrugs off each new surprise the film has to offer, one of which is the pregnant woman who sees a doctor just to have him read her mail aloud. Another is George Hamilton, who turns up unexpectedly as the living embodiment of all that has been wrong with Ben's previous ambitions. ("We can squeeze one more in before lunch, don't you think?" Mr. Hamilton asks while performing plastic surgery in one of several pastel-colored operating rooms at his California clinic, each of which bears a large, flattering portrait of the doctor.) While retaining his boyish appeal, Mr. Fox also seems a

shade more substantial this time, possibly because he is seen making life-or-death decisions when not fielding comic lines.

The screenplay, by Jeffrey Price, Peter S. Seaman and Daniel Pyne, is occasionally sharp-tongued but more often pleasantly knee-deep in rustic corn. "So Doc, what do you think of our little town?" someone asks Ben soon after his arrival. "I don't know, I haven't seen all of it yet," Ben replies. "Yes, you have!" the first speaker answers. It will surprise no one that after only a few days in such a setting, Ben Stone winds up the proud owner of a pet pig.

•

"Doc Hollywood" is rated PG-13 (*Parents strongly cautioned*). *It includes one notable nude scene and occasional profanity.*

1991 Ag 2, C8:5

Voyeur

Directed and written by Alex van Warmerdam; director of photography, Marc Felperlaan; edited by Hans van Dongen; music by Vincent van Warmerdam; production designer, Harry Ammerlaan; produced by Laurens Geels, Dick Maas and Robert Swaab; released by Prestige. At the Cinema Village Third Avenue, near 12th Street, Manhattan. Running time: 100 minutes. This film is not rated.

Abel	Alex van Warmerdam
Victor	Henri Garcin
Dove	Olga Zuiderhoek
Sis	Annet Malherbe
Christine	Loes Luca

By STEPHEN HOLDEN

Abel, the protagonist of Alex van Warmerdam's Freudian comedy "Voyeur," is the ultimate passive-aggressive milquetoast with a streak of demonic mischief. At the age of 31, he has not set foot outside his parents' apartment in 10 years. Loafing about the house, Abel (Mr. van Warmerdam) spends hours peering into the windows across the street through binoculars and chasing flies with a pair of scissors. When his parents pack him off to a psychiatrist, he puts on an act and becomes a gibbering maniac. He foils the treatment of a magnetic healer by concealing a bent silver spoon in his mouth.

Abel's mother, Dove (Olga Zuderhoek), is doting and overly protective; his father, Victor (Henri Garcin), is a tyrannical business executive with a ferocious temper and a taste for voyeurism himself. At a peep show one day, Victor meets Sis (Annet Malherbe), a nonchalant exhibitionist with whom he begins a clandestine affair. It isn't long before the ferociously possessive Dove intuits

the relationship and begins ranting and raving. The situation explodes when Abel, whom Victor finally boots out of the house, is picked up on the street by Sis and taken home to be a sort of boy toy.

A mischievous passive-aggressive leaves home.

"Voyeur," which opens today at the Cinema Village Third Avenue, is a Dutch film that was a hit when it was originally released in the Netherlands in 1986 under the title "Abel." It was later chosen by a panel of Dutch critics as the country's best film of the decade. Although the film is amusing and quite stylish, its psychological canvas is narrow and, its theme surprisingly conventional. Its popularity suggests that Freudian myth exerts a greater hold on Dutch thinking than on American. It also makes one wonder whether Dutch society, so renowned for its liberated sexual attitudes, might harbor a larger-than-suspected streak of punishing Puritanism.

If "Voyeur" isn't especially kind to Abel, whom the director portrays with a sneaky, tongue-in-cheek insouciance, it is merciless to Victor, a petty tyrant and moral hypocrite, who is jealous of his son, hateful toward his wife and groveling toward his mistress. It is hard not to see him as emblematic of an urban-bourgeois hothouse where the air is very stuffy.

The film includes several funny scenes. In the most amusing, Abel's father arranges a date for him with Christine (Loes Luca), a proper young woman from Victor's amateur theater group. Before the date, Abel and his parents plan a code of elaborate signals to trigger polite conversation and dancing. But when the time comes, Abel ignores all the signals, makes fools of his parents and eventually drives Christine out of the house. The scene is a beautifully sustained exercise in the comedy of embarrassment.

The movie's surreal touches extend to the settings, all of which have a slightly artificial feel that adds to the overall aura of emotional claustrophobia. At moments the visual design recalls Alfred Hitchcock films from the 1950's like "Rear Window," in which the staginess of the setting also mirrored the psychological tensions. But with all its surreal touches, the message of "Voyeur" seems less daring than its style. That message reads: Get Dad.

1991 Ag 2, C9:1

Homeboy Alex Van Warmerdam directed and stars in "The Voyeur," about a reclusive 30-year-old who finally leaves his parents' home, only to fall in love with his father's mistress.

Prestige

Critic's Choice

Old Story With New Textures

Beverly D'Angelo

A teen-age boy is irresistibly attracted to a beautiful, mysterious older woman; the world doesn't need to hear *that* story again. But "The Miracle," the latest film by the Irish writer and director Neil Jordan, works in ways that its ancient plot doesn't begin to convey. Like Mr. Jordan's best-known film, "Mona Lisa," this one relies on the texture of complicated lives. Its fresh, enigmatic charm comes from its characters' quirky wit, the sumptuous photography of the Irish seaside town of Bray and the matter-of-fact way in which secret, tangled relationships are revealed.

The boy, Jimmy (Niall Byrne), wanders along the shore with his best friend, Rose (Lorraine Pilkington). She is a would-be writer, and one of the most appealing honest characters on screen. She tells Jimmy a few straightforward things. The older woman is not a natural blonde. She is not as young as she seems; take a look at her hands. "Yes, I'm jealous," Rose says.

The woman heading toward 40 is played by Beverly D'Angelo, still best known as Chevy Chase's wife in the National Lampoon's "Vacation" movies. Here, she gives an alluring, graceful performance as a singer and actress who rides into town with a carnival and stars in a very tacky stage version of "Destry Rides Again."

Mr. Jordan has a lot of fun sending up that carnival and the stage show and the hopeless dance band led by Jimmy's boozing father (Donal McCann). But even at its most sardonic, the film is infused with affection for these small-time talents.

"The Miracle" is colorful without being garish. It is delicate in its emotions without being the least bit restrained or genteel. The only foolish move connected with this small charmer is that it opened on the same day as "Terminator 2."
CARYN JAMES

1991 Ag 2, C11:1

Return to the Blue Lagoon

Produced and directed by William A. Graham; written by Leslie Stevens, based on the novel "The Garden of God," by Henry De Vere Stacpoole; director of photography, Robert Steadman; edited by Ronald J. Fagan; music by Basil Poledouris; production designer, Jon Dowding; released by Columbia Pictures. Running time: 98 minutes. This film is rated PG-13.

Lilli	Milla Jovovich
Richard	Brian Krause
Sarah	Lisa Pelikan
Young Lilli	Courtney Phillips
Young Richard	Garette Patrick Ratliff

By CARYN JAMES

The 1980 hit "The Blue Lagoon" was nothing more than a teen-age titillation movie, but it had a sweet, dopey simplicity. Brooke Shields and Christopher Atkins, as 19th-century orphans stranded on a tropical island, learned about sex the way Adam and Eve must have (if they had been very discreetly photographed) and still had trouble figuring out where the baby came from.

Well, that baby is back, and he is the unluckiest child on earth. Trapped in "Return to the Blue Lagoon," he is destined to replay a more complicated and even lamer version of his parents' coming of age.

At the start of this sequel, he is a 2-year-old rescued from a boat that carries his dead parents. As soon as

Avoiding sharks and cannibals takes precedence over Edenic sex.

he is saved, he is cast away again, this time sent from a cholera-ravaged ship in the care of a widow with a year-old daughter. The Pacific waves take them right back to the little boy's old home island.

It takes about 40 minutes for the mother to be written out of the script and for the children, Lilli and Richard, to reach the adolescence the film is heading toward. But this sequel is so wrong-headed that the long set-up is by far the most interesting part.

•

As the widow, Lisa Pelikan is the movie's only solid presence. She teaches the children table manners and talks about marriage. She even tells the prepubescent Lilli and Richard about sex, until it is time to explain how babies get in the mother's stomach. Then Richard, ever protective of the movie's rating, says they don't need to hear more; they've seen the iguanas do it.

When the children become adolescents, Lilli and Richard are played by Milla Jovovich and Brian Krause. To be kind, they are not great actors. And their characters are so civilized that they actually stage a wedding ceremony before their first roll in the surf.

"Return to the Blue Lagoon" is, in fact, more about escaping from sharks and avoiding the neighboring cannibals than it is about Edenic sex. This tactic makes very little sense from the teen-titillation point of view. And as an adventure, the film is even worse. The teen-age couple wind up bickering like old marrieds.

The Fijian background looks pretty, but there's no escaping the fact

Columbia Pictures
Milla Jovovich and Brian Krause

that the tropical flowers and trees seem smarter and more appealing than the people.

•

"Return to the Blue Lagoon" is rated PG-13 (Parents strongly cautioned). There is a lot of flesh but just a brief glimpse of nudity, some sexual suggestiveness but no explicit sex. Parents should be prepared, however, to explain what iguanas do.

1991 Ag 2, C12:1

Body Parts

Directed by Eric Red; written by Mr. Red and Norman Snider, based on the novel "Choice Cuts," by Boileau-Narcejac; director of photography, Theo Van de Sande; edited by Anthony Redman; music by Loek Dikker; production designer, Bill Brodie; produced by Frank Mancuso Jr.; released by Paramount Pictures. Running time: 89 mins. This film is rated R.

Chrushank	Jeff Fahey
Dr. Webb	Lindsay Duncan
Remo Lacey	Brad Dourif
Karen Chrushank	Kim Delaney
Detective Sawchuk	Zakes Mokae

By JANET MASLIN

One morning, the handsome criminal psychologist Bill Chrushank (Jeff Fahey) kisses his smiling, suburban-cute family goodbye and heads off to work. The scene is so unmitigatedly happy that the Chrushanks, at least in movie terms, might as well have bull's-eyes on their backs. Sure enough, tragedy strikes: Bill is injured in a ghastly traffic accident, and as a consequence he loses his arm. But the cool, elegant Dr. Alice Webb (Lindsay Duncan) assures him that he can have a new arm in a jiffy.

Kerry Hayes/Paramount Pictures
Brad Dourif

There's just one catch: it's an arm that will quite literally go to his head. "Body Parts," which opened yesterday and was directed by Eric Red, is the story of what happens to Bill once he recovers sufficiently from transplant surgery to begin asking some very necessary questions. The answers are worrisome. The film turns out to be a powerful warning against accepting used limbs unless you know where they've been.

At times, "Body Parts" is an intriguing sleeper, particularly when Mr. Red concentrates on the dangerous implications of Bill's new condition. The arm, Bill learns in a series of investigative scenes that Mr. Red stages with chilling clarity, formerly belonged to a deranged killer. So is it inert tissue, or does it have a mind of its own? Whenever Bill attempts to shave or touch his wife or roughhouse with his children, Mr. Red (and his co-writer Norman Snider, adapting the novel "Choice Cuts," by Boileau-Narcejac) raises the piquant possibility that the arm may act on its own. This situation is made even more interesting when someone tells Bill, "That arm can't do anything you don't want to do." Perhaps Bill's own darkest wishes will be implemented.

But too often "Body Parts" makes the mistake of opting for grisly horror effects when a less literal-minded approach would be more compelling. The film's transplant-operation scene, for instance, is filled with needless sawing and splatter. And a later scene risks pure ridiculousness in showing a man stalking around with a set of spare limbs in tow. Because of such moments, "Body Parts" has been deemed a film best not advertised in Milwaukee, where Jeffrey L. Dahmer has been much in the news.

In addition to the photogenic but stolid Mr. Fahey, the film also features Brad Dourif, who can always be counted on to sound a note of ghoulish glee. Mr. Dourif plays a painter who received the killer's other arm and now, after 25 years of painting saccharine sunsets, has a whole new career. His paintings have turned dark and violent, his prices have gone up, a newspaper (this one) has proclaimed him a "searing, original talent," and he sees no reason to question his good fortune. Still, Bill tracks him and another apparent transplant recipient, at one point telling the latter, "I know this sounds weird, but I got my arm from the same place you got your legs."

Also in the film, in addition to Ms. Duncan as one of the screen's most beautiful and assured mad doctors, is Zakes Mokae, seeming game but thoroughly misplaced as a fedora-wearing police detective. The pounding, ominous music by Loek Dikker heightens the film's eerie mood.

•

"Body Parts" is rated R (Under 17 requires accompanying parent or adult guardian). It includes brief sexual suggestiveness and considerable gore.

1991 Ag 3, 9:1

FILM VIEW/Caryn James

These Heels Aren't Made For Stompin'

Dean Williams/Hollywood Pictures

Kathleen Turner as V. I. Warshawski

THE PRIVATE INVESTIGATOR V. I. WARshawski has a pair of ruby slippers. They are beaded, sexy, red high heels Dorothy would never have dreamed of. And well beneath the movie's ho-hum plot, those shoes represent what "V. I. Warshawski" is all about. After a hard day of hunting down the scum of Chicago, V. I. puts on the red shoes, sticks out her leg and accidentally-on-purpose trips a handsome man in a bar. It's not magic, but it works.

In a wry and likable performance as the woman called Vic, Kathleen Turner's one miscalculation comes in this early scene. She doesn't toss in quite enough irony, especially when she says the right shade of lipstick and great shoes can make "a gal" feel anything is possible. Even so, it's clear that the tough but feminine V. I. has it both ways. She gets to keep her shoes and her irony too, as the film blithely uses female stereotypes to unsettle stereotypes of women.

It is a carefully calibrated balancing act whose mechanics are so obvious that "Warshawski" might serve as a guidebook: How to Create a Strong Female Character Without Offending Anyone. Each of V. I.'s powerful, traditionally unfeminine traits is offset by a softer, more conventionally feminine one. Punched in the face, she tells the thug who did it, "You know how hard it is to get blood out of cashmere?"

She has a sometime boyfriend — no strings and no loneliness. "Murray says I'm too independent," she tells a friend. But the unfaithful Murray keeps coming back, while independence evidently allows V. I. to flourish. Vic absorbs the sexy feminine stereotypes and tosses out the dull domestic ones. This is pure escapism, but it stays in touch with the images people want to escape from and the ones they fear letting go.

Like "Pretty Woman," "Warshawski" creates a fantasy woman in an ugly job and lets her come out not only smelling and looking like a rose but also seeming to empower women. On the most literal level, this doesn't add up. But "Warshawski" is one of those movies that asks you to leave your literal-mindedness and some of your common sense behind.

■

Sure, V. I. picks up a man in a bar, but she won't go beyond a kiss on the first date. She only walked into the place to chat with her girlfriend the bartender, who happened to be holding the red shoes for just such an emergency. She's upset, she tells her friend, because she had discovered Murray in bed with a redhead, so she's drinking to "Goodbye, Murray" again. All the extenuating circumstances say that Vic is a tough woman with a good girl's heart.

Most telling of all, the plot puts her in charge of a pretty, feisty girl named Kat. The girl's father was the man who had tripped on those red shoes, kissed Vic and almost instantly been murdered. (No connection, of course.) One of Kat's most important functions in the movie is to add maternal softness to Vic's character, even if it's the kind of mothering that means ordering in pizza instead of baking cookies.

Because the fearless little girl is a sort of junior V. I., she is the perfect student for Vic's philosophy. "Never underestimate a man's ability to underestimate a woman," she tells Kat after she has posed as an empty-headed Southern belle to wheedle information out of a wimpy bank clerk. Vic could be an old-fashioned femme fatale if she wanted to, this scene suggests, but she has better things to do with her brains and her acting ability. If her brain tells her it's smart to act like Scarlett O'Hara for once, that says more about society than about V. I., who appropriates the stereotype and makes fun of it at the same time.

Though the film never lets the audience forget that Vic is a woman in a man's world, Ms. Turner is so comfortable in the role that the effect is one of casual acceptance of this tough-but-feminine character. Her performance carries the film, for V. I. is far more appealing and successfully drawn than the movie she's in. The film is just a vehicle, too much like the functional but battered car the heroine drives.

Widely reported to be the beginning of a series, the film has the manner of setting up characters you'll see later. It tosses in characters from Sara Paretsky's six Warshawski novels. Bobby Mallory (Charles Durning), an old friend and police department colleague of V. I.'s father, and Lotty (Anne Pitoniak), her older friend the doctor, drop by like previews of coming attractions. The murder plot is too simple, too free of red herrings. And this is a kind of script in which a killer stops in mid-murder to announce his intention to V. I.

But if "V. I. Warshawski" doesn't pull off its feminine-but-tough act quite as breezily as "La Femme Nikita," or with as much feel for the heroine's dangerous profession, at least the film is less pretentious than its overhyped, overanalyzed sister, "Thelma and Louise." None of these films depends much on realism, but it's easier to believe in Vic's sharp tongue and red high heels than in Thelma and Louise blowing up an oil truck.

The heroes and villains aren't drawn along lines of gender in "Warshawski," where women can be just as treacherous and awful as men. That's a relief. It means men and women aren't adversaries.

Men won't have to walk out of "Warshawski" feeling attacked. And women can walk out feeling that it's perfectly possible, that it might even be a good idea, to be smart-mouthed and self-sufficient. The better men won't hate you for it, and you won't have to drive off a cliff at the end. This may be a fantasy, but as movie fantasies go it's a more effective, bracing, appealing fantasy than most. ◻

1991 Ag 4, II:7:5

Double Impact

Directed by Sheldon Lettich; written by Sheldon Lettich and Jean-Claude Van Damme; director of photography, Richard Kline; edited by Mark Conte; music by Arthur Kempel; production designer, John Jay Moore; produced by Ashok Amritraj and Mr. Van Damme; released by Columbia. Running time: 118 minutes. This film is rated R.

Chad/Alex Jean-Claude Van Damme
Katherine Wagner Sarah-Jane Varley
Paul Wagner Andy Armstrong
Nigel Griffith Alan Scarfe
Frank Avery Geoffrey Lewis

By CARYN JAMES

The martial-arts movie star Jean-Claude Van Damme has never had to act very much, even though he has starred in five money-making action films with such titles as "Bloodsport" and "Kickboxer." Being a karate-kicking fool is apparently enough. In his latest movie, "Double Impact," he plays twins. Let's just say he doesn't rival Jeremy Irons's double role in "Dead Ringers," though Mr. Van Damme's identical brothers are easier to tell apart than the Doublemint twins. One has slicked-back hair, one doesn't, which saves a lot of acting right there.

Mr. Van Damme co-wrote the script himself, although it's the kind of movie where you don't need sound to tell you what's going on. He plays Chad and Alex, born to a wealthy

contractor and his wife based in Hong Kong. When thugs murder the 6-month-old twins' parents, the boys are saved but separated. The streetwise Alex was brought up in an orphanage in Hong Kong, while the more refined Chad was brought up in France and became a martial-arts teacher in Hollywood. This accounts for the indistinguishable accents given them by the Belgian-born Mr. Van Damme. As adults, the twins are reunited in Hong Kong just in time to get back at the villains who murdered their parents.

•

What this means, of course, is that there is plenty of gunfire and karate kicks and explosives set off by remote control. Chad gets bomped in the head more often than Alex. There are some Van Damme-style showdowns with various villains, with twirls and tricks that seem to owe something to the Three Stooges. There are golden oldies like smashing someone in the head with a whisky bottle and kicking him in the crotch. As it turns out, two Jean-Claude Van Dammes are pretty much the same as one. Fans who like their action unadulterated by story, character or acting know where to find it.

•

"Double Impact" is rated R (Under 17 requires accompanying parent or adult guardian). There is nearly continuous violence, except for its one sex scene.

1991 Ag 9, C8:5

Crossing the Line

Directed by David Leland; written by Don McPherson, based on William McIlvanney's novel "The Big Man"; director of photography, Ian Wilson; edited by George Akers; music by Ennio Morricone; production designer, Caroline Amies; produced by Stephen Woolley; released by Miramax Films. Running time: 93 minutes. This film is rated R.

Danny Scoular Liam Neeson
Beth Scoular.............. Joanne Whalley-Kilmer
Matt MasonIan Bannen
Frankie ...Billy Connolly
Gordon .. Hugh Grant

By VINCENT CANBY

"Crossing the Line," David Leland's new English film, begins as a small politically aware melodrama about an unemployed (and unemployable) Scottish coal miner who is forced by circumstances to become a bare-knuckle boxer. The film ends, though, long before it's over, largely because its high-mindedness is less dramatic than anesthetizing.

Not since the screen adaptation of Clifford Odets's "Golden Boy" has there been a film about Good and Evil in which an inarticulate character talked so knowingly about principle.

"If you can't fight for the right things," says Danny Scoular (Liam Neeson), the miner, "keep your hands in your pockets."

Mr. Neeson is a big soft-spoken man with a face that seems to have been carved from magically malleable rock. He is an impressive screen presence. His Danny might well seem heroic if he were allowed to speak dialogue that sounded more spontaneous and less morally instructive.

There also is a good story buried within Don McPherson's screenplay, adapted from William McIlvanney's 1985 novel, "The Big Man." Danny is

a casualty of the bitter coal strike, which according to an opening screen credit resulted in the closing of 90 percent of all the mines in Scotland by 1989.

•

As the film opens, Danny not only has no work, but he also cannot find any because he has a prison record: he attacked a policeman during the strike. He is an easy mark when he is approached by a mysterious Mr. Mason (Ian Bannen), who is looking for a contender to fight an important big-money bare-knuckle bout in Glasgow.

In bare-knuckle fighting, which is both brutal and illegal, the contenders keep going until one of them drops, sometimes forever. It's apparently very popular in the Glasgow underworld where Mr. Mason is a powerful bookmaker. When Danny accepts the offer (he wants to prove himself a man again), his proper middle-class wife, Beth (Joanne Whalley-Kilmer), walks out, taking their two children with her.

Most of "Crossing the Line" is about Danny's training for the fight and about the consequences of the outcome. Though the big fight in any boxing film is usually a sure-fire attention grabber, no matter how bad the rest of the movie is, the one in "Crossing the Line" somehow manages to be uninvolving.

Mr. Leland's approach to the material is exemplified by his fondness for lofty overhead shots, whether the characters are seen in a life-and-death bare-knuckle bout or simply getting in and out of automobiles. It could be that he means to distance the audience from the sentimental aspects of the material, but there is also the feeling that he is condescending to it.

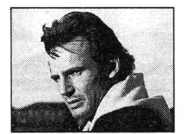

Miramax
Liam Neeson

"Crossing the Line" means to be a wicked commentary on the state of Britain under Prime Minister Margaret Thatcher and, in particular, on her handling of the coal strike. Yet the movie, while pretending to be horrified by Danny's fate, is also clearly enchanted by the pictorial possibilities it offers. The movie is pretty.

Much of the climactic fight is photographed in such lovely slow-motion that the blood and the sweat look phony, which, in turn, suggests that everything else is suspect.

"Crossing the Line" is a far cry from the gritty, idiomatic "This Sporting Life," "Saturday Night and Sunday Morning" and the other English working-class movies that made the 1960's memorable. Not helping matters is a busy, seemingly omnipresent sound track score by Ennio Morricone.

Beginning with Mr. Neeson, every member of the cast is as good as the circumstances allow.

"Crossing the Line," which has been rated R (Under 17 requires accompanying parent or adult guardian), has some vulgar language and violence.

1991 Ag 9, C11:1

Delirious

Directed by Tom Mankiewicz; written by Lawrence J. Cohen and Fred Freeman; director of photography, Robert Stevens; edited by William Gordean and Tina Hirsch; music by Cliff Eidelman; production designer, Angelo Graham; produced by Mr. Cohen, Mr. Freeman and Doug Claybourne; released by M-G-M. Running time: 135 minutes. This film is rated PG.

Jack John Candy
Louise and Janet..............Mariel Hemingway
Laura and Rachel.....................Emma Samms
Carter HedisonRaymond Burr
Blake .. Dylan Baker
Ty .. Charles Rocket
Paul and Dennis.............:............David Rasche
Lou SherwoodJerry Orbach

By JANET MASLIN

In "Delirious," John Candy plays Jack Gable, a television writer who is hit by a truck — or is it a trunk? In Jack's new situation, this is the sort of distinction about which he has to be very, very careful. Once he has been knocked unconscious, Jack leaves the world of ordinary scriptwriting and wakes up inside the very soap opera he has created. "You say you're a writer?" asks someone who was formerly one of Jack's inventions and is now one of his new friends. "Well, then write your way out."

"Delirious" is the playful story of Jack's efforts to do exactly that, and to do it in as self-serving a manner as possible. At first, he is dismayed to find himself in Ashford Falls, the sweet-looking town he formerly thought of as nothing more than a few studio sets. ("When did we build this?" he asks, surveying a hospital room that is actually attached to a whole hospital. "We're going to go way over budget!") But once he determines that the citizens of Ashford Falls will follow any directions he chooses to write for them, Jack begins to see the fun in this particular form of escapism.

The film, written by Lawrence J. Cohen and Fred Freeman and directed by Tom Mankiewicz, watches Jack fulfill some of his most gleefully far-fetched fantasies, from the chance to do a "Hi-yo, Silver!"-style exit on horseback to that of thrilling the guests at a party with his piano playing. On the latter occasion, Jack happily writes in a cheerleader who wouldn't give him the time of day in high school and a little girl who hands him a bouquet when the recital is over. "You brought tears to my eyes," one of Jack's listeners tells him. "I know," he replies.

A lot of "Delirious" is about the soap opera itself, and these scenes don't match the frenetic humor of "Soapdish." But the satirical possibilities inherent in this subject have certainly not been exhausted. And "Delirious," though uneven, does come up with some enjoyable new swipes at the same old targets.

This soap's writers have a lazy penchant for killing off characters by means of convenient brain tumors. (There have already been three such deaths this season, Jack complains to a colleague played by Jerry Orbach. "It's been a very long season," Mr. Orbach solemnly replies.) The actors

are vain and inept, the settings absurd ("Scimitar" is the name of one estate) and the dialogue laughably overheated. "Of course, you're in love with her!" one character exclaims. "She's your sister!" In this setting, no wonder that even Jack's wildest

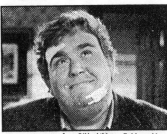

Jane O'Neal/Metro-Goldwyn-Mayer
John Candy

excesses manage to go almost unnoticed.

But there is one incident in which Jack gets drunk and produces some typos. So one of the town's leading citizens is identified as a "beloved philanthropist and well-known socialist," and a bartender is sent out for "more cold deer." The film's best comic potential lies in this aspect of the writer's nightmare. "Delirious" would have benefited from a good many more such gags.

•

The film has slow stretches, but Mr. Candy is jaunty enough to keep the mood good-humored. Also on hand are Raymond Burr and the above-mentioned prominent citizen, and Charles Rocket, very funny as his ne'er-do-well offspring. ("Can't even do that right, can you, son?" Mr. Burr says sadly, after Mr. Rocket fails to smash a priceless Chinese vase on the floor.) David Rasche is also good as the town's handsome, predictably dim doctor, and Emma Samms vamps her way through the story's femme fatale role. Mariel Hemingway is refreshingly direct as this vamp's nice-girl counterpart, a scientist with a serious interest in ants.

"Delirious" sometimes shows an unfortunate taste for morbid slapstick, as in a running gag that has Mr. Candy repeatedly knocking down or injuring Ms. Hemingway. There's also a particularly unfunny routine about a sickly young man who has developed another grim new symptom every time he's seen. A better bit of black humor concerns a cameo appearance by a television star who turns up briefly in a tuxedo before being killed off by overzealous writers. "He even looks good dead!" Mr. Candy says admiringly of the corpse.

•

"Delirious" is rated PG (parental guidance suggested). It includes mild profanity and sexual suggestiveness.

1991 Ag 9, C12:4

Blowback

Directed and written by Marc Levin; director of photography, Mark Benjamin; edited by Tim Squyres; music by Wendy Blackstone; production designer, Kosmo Vinyl; produced by Mr. Levin; released by Blowback Productions. At the Quad Cinema, 34 West 13th Street, Manhattan. Running time: 105 minutes. This film has no rating.

Owen Monroe...........................Bruce McCarty
Nancy Jones.............................. Jane Hamper
Emilio De LeonEddie Figueroa
Dr. Krack.................................. Craig Smith
Paul.. Matt Mitler
Dick Jones................................. Don Cairns

Though "Blowback" is set in Florida, the characters in this political satire exist in that border zone where real life meets its lunatic fringe. A government agent, an Oliver North mánqué, runs an Iran-contra type operation. A Cuban émigré has the goods on the conspirators who assassinated John F. Kennedy. A former drug addict named Nancy, born at the very moment of President Kennedy's death, becomes entangled with both men and eventually they all have something to do with Dr. Krack, a mad, drug-producing scientist on the Government's secret payroll.

Northern Arts Entertainment Inc.
Craig Smith as Dr. Krack.

This is potentially rich material. But "Blowback," which opens today at the Quad Cinema, demonstrates that it is easier to be inspired by political dirty dealings than to create a coherent film out of them. Written, directed and produced by Marc Levin, the film strains to be both pointed and outrageous, but comes much closer to gibberish. It has the flat look and pedestrian pace of amateur films.

Mr. Levin has been a television documentary producer for many years, and has worked with Bill Moyers on "The Secret Government," a special about the Iran-contra scandal. Truth is not always stranger than fiction, but in this case it is a lot more watchable.

CARYN JAMES

1991 Ag 9, C13:1

Pure Luck

Directed by Nadia Tass; written by Herschel Weingrod and Timothy Harris; director of photography, David Parker; production designer, Peter Wooley; edited by Billy Weber; music by Jonathan Sheffer; produced by Lance Hool and Sean Daniel. Released by Universal Pictures. Running time: 96 minutes. This film is rated PG.

Eugene Proctor	Martin Short
Ray Campanella	Danny Glover
Valerie	Sheila Kelley
Highsmith	Sam Wanamaker
Grimes	Scott Wilson
Monosoff	Harry Shearer

By CARYN JAMES

Martin Short seems to be on a mission: to save "Pure Luck" from itself. When he looks at the camera, his eyes always seem about to cross, as if he's ready to burst into his Jerry Lewis impression. When he dances, he almost leaps into his overenthusiastic nerd character, Ed Grimley. He walks through a burned-out jungle village and yells, "Anybody home?" as if he were in the suburbs. It's as if he were frantically trying to stay in character as an accident-prone accountant and at the same time inject some comic surprise into this pure-formula film. Against the odds, he makes "Pure Luck" always painless and sometimes genuinely amusing. Martin Short can do anything, it

seems, except find the right movies to star in.

•

"Pure Luck" is yet another Hollywood remake of a French comedy — a trick that pulled in so much money for "Three Men and a Baby" that everyone seems to have forgotten about Richard Pryor in "The Toy," Tom Hanks in "The Man With One Red Shoe" and Mr. Short himself in "Three Fugitives," just to mention remakes based on Francis Veber's films. "Pure Luck" is a version of another Veber film, "Le Chèvre," with Danny Glover in the Gérard Depardieu role as the straight man and Mr. Short in the bumbling role created by Pierre Richard. Like the other lame remakes, it sounds good on paper.

When a wealthy man's disaster-prone daughter disappears during a vacation in Mexico, he hires Ray Campanella (Mr. Glover) to find her. Ray fails, because he's a professional detective and therefore much too logical. But a scientist comes up with a theory: Someone just as unlucky, who attracts disaster like a magnet, might stumble onto the missing woman's path. Eugene Proctor (Mr. Short) is the kind of man who walks down the street and falls into holes. Together they take off for Mexico, with Eugene, the meek accountant, led to believe he's in charge of the search.

This is a setup for one sight gag after another, but they are announced so far ahead of time that the audience might as well be waving them in for a landing. When Mr. Short is called to the baggage-claim area at an airport, it doesn't take much to guess what's waiting for him. He drives a jeep to the edge of a cliff. A bee lands on his cheek, he announces that he's allergic to bee stings, and it's just a matter of time before the bee stings him. The form his allergic reaction takes is one of the film's few surprises (unless you've seen the trailer, which gives it away).

But Mr. Short goes on bumping into glass doors with real gusto. He is duped into an off-screen barroom fight, then crawls back to his hotel. His collapsible body saves every tired routine. And he puts on an endearing authoritative air to mask his incompetence.

Ray goes on hiding his annoyance until late in the film, when it seems that bad luck is contagious and he comes in for his share. Then Mr. Glover gets to let loose too, which seems like a tremendous relief to him and gives the film a fresh and funnier twist.

"Pure Luck" was directed by Nadia Tass, who made the small, quirky Australian films "Malcolm" and "Rikki and Pete." But this broad script leaves no room for quirks.

It does leave viewers hopeful about Mr. Short's future on the screen, though. Robin Williams, who may be Mr. Short's only equal in comic invention and mania, had his own string of failed films before he found "Good Morning, Vietnam." Martin Short can't go on stumbling through Americanized French films forever, unless he has Eugene's bad luck.

•

"Pure Luck" is rated PG (Parental guidance suggested). It includes one murder by gunshot.

1991 Ag 9, C15:1

Bingo

Directed by Matthew Robbins; written by Jim Strain; director of photography, John McPherson; edited by Maryann Brandon; music by Richard Gibbs; production designer, Mark Freeborn; produced by Thomas Baer; released by Tri-Star Pictures. Running time: 87 minutes. This film is rated PG-13.

Natalie Devlin	Cindy Williams
Hal Devlin	David Rasche
Chuckie Devlin	Robert J. Steinmiller Jr.
Chickie Devlin	David French
Lennie	Kurt Fuller
Eli	Joe Guzaldo

BY VINCENT CANBY

Bingo, the title character of Matthew Robbins's new comedy, is a reddish-colored mutt who can ride a skateboard, give artificial respiration, dial 911 and bark the square root of nine. Yet he is sometimes hopelessly dim.

Early in the film he fails to perform a simple circus trick, prompting his furious master to try to shoot him. The master's wife steps in. "Get out of here," she screams at Bingo. "Find a happy family." Bingo runs out and returns with a photograph of a family that's having fun. "Not playful happy," says the wife, who is now as impatient as her husband, "fulfilling happy."

Bingo finally gets the point and leaves. In his subsequent adventures he befriends a small boy named Chuckie, is imprisoned by a man who makes hot dogs out of dogs, finds a

The unemployed Bingo finds work licking plates clean in a restaurant.

restaurant job licking plates clean and is abducted by two inept felons.

Tri-Star Pictures
Robert Steinmiller Jr. and Bingo.

"Bingo" is a live-action film that has the manner of a cartoon. That it's never as funny as it should be isn't the fault of the human cast. Robert J. Steinmiller Jr., who plays Chuckie, and David Rasche and Cindy Williams, who play Chuckie's sometimes lunatic parents, are good farceurs.

The problem is Bingo. Is it cricket to criticize a dog? Bingo gives the sort of dog-performance that indicates he has been trained within an inch of his life. He can't relax. He never quite fits in. He seems tense even when snoozing. Though he is the center of the movie, he's not as much fun as the people around him.

The comic sensibility of Mr. Robbins, who directed the movie, and Jim Strain, the writer, comes through mostly in scenes that have nothing to do with Bingo, as when Kurt Fuller and Joe Guzaldo, as the dognappers, argue about the civil rights and responsibilities of felons.

Bring back Benji.

•

"Bingo," which has been rated PG (parental guidance suggested), includes some vulgar language and one scene in which Bingo is threatened with a nasal membrane implant.

1991 Ag 10, 9:2

FILM VIEW/Caryn James

Class Not Dismissed: Screenplays With an Attitude

"REGARDING HENRY" IS AN upper-crust snob. "The Doctor" is a middle-class professional. And "Dying Young" is blue-collar, glad-to-be-here folks. These identities have nothing to do with the movies' fictional characters, who range from petty thieves to tycoons. The films themselves exude class attitudes and personalities that ooze out from each director's stance and their scripts' tone.

Imagine these movies as people on Fifth Avenue. "Dying Young" is buying socks from a street vendor. "The Doctor" is shopping at Saks. "Regarding Henry" steps out of his limo and tosses a quarter toward a homeless person while heading to his penthouse with a view of Central Park. Whom would you most like to drop by and visit?

Mainstream movies are often considered a democratic art form, but as in any democracy, class and money lurk in the background. This is conspicuous in the summer's spate of

145

near-death movies, rife with doctors and lawyers. What professions say "class" more emphatically? And as with American democracy -- where theoretically anyone can be President, but just try to do it without money -- the ostensible message of these films is not always in sync with the underlying reality.

■

Look at the way "Regarding Henry" condescends to viewers and cows them with its pretensions and its pedigree. Directed by Mike Nichols, the film comes with built-in élan and assumes the pose of art. But the story is a shallow soap opera. Henry, the unscrupulous lawyer played by Harrison Ford, gets shot in the head, loses his memory and is a better man for it. This is simpleminded enough. (Jeffrey Abrams's script might have been written by Henry in a childish phase.)

What is worse, the film's snobbish subliminal attitude undermines its egalitarian message. The hero rejects his wealthy, socially prominent past. But the film never abandons its narrow class assumptions, even when it tries to criticize Henry's WASP-y world.

Henry can afford an expensive rehabilitation hospital, can't everyone? When his wife worries about finances, she simply trades in their palatial apartment for a town house. The film says money isn't everything, then lets the hero keep most of his money.

"Regarding Henry" aims for a basic view of life, but the "basic" people who help Henry find the noble, unsophisticated man inside himself are his young daughter and his black physical therapist, Bradley (Bill Nunn). Surely, the film doesn't mean to look down its nose at the black character any more than it

means to find its humor at the expense of the brain-damaged, but those are its unfortunate effects.

The black man is not a doctor but a therapist, and already below Henry professionally. When Henry says "Ritz," Bradley thinks he means the cracker instead of the hotel; isn't that quaint? And some humor comes from Henry picking up Bradley's streetwise jargon. "I gotta get me some of that," Bradley says about a pretty nurse, and the film's idea of a joke is for Henry to say later, in his stiff, childlike way, "You've got to get you some of that." If the film's hidden personality could talk, it would say, "Imagine, our Henry talking like a black man!"

After Henry returns home, his wife asks Bradley to come and give the patient a pep talk. The men sit at the kitchen table over a couple of beers — very expensive beers, Bradley notes — as Henry gets good advice from his simpler-but-wiser social inferior.

The film tries to be politically correct. Bradley has gone to college. And Mr. Nunn's performance is as strong and as colorblind as the script allows. But guess who's not coming to dinner? A Latino maid *serves* the family dinner and says she likes Henry better this way — now that he has lost his overeducated mind, presumably. The film has no idea it is sending such condescending messages.

"The Doctor" is more believable and less offensive, in part because Randa Haines, the director, and Robert Caswell, the writer, accept the hero's upper-middle-class life with utter self-assurance and no condescension. The film doesn't apologize for the fact that William Hurt's character, a doctor-turned-patient named Jack McKee, is a successful surgeon. In fact, "The Doctor" gains its

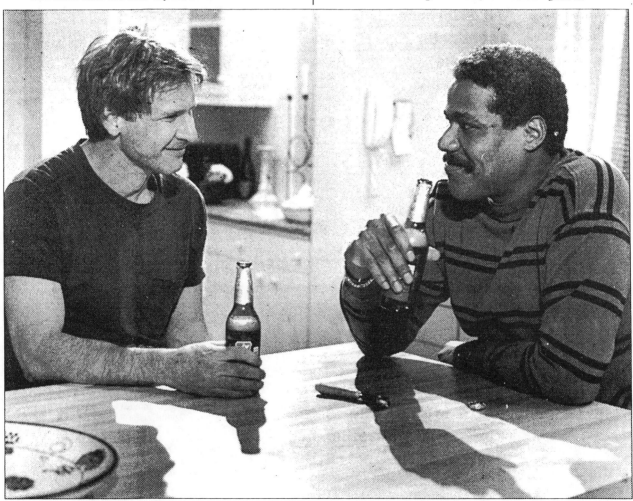

Harrison Ford and Bill Nunn in "Regarding Henry"—The movie's snobbish attitude undermines its egalitarian message.

strength from the realistic way McKee clings to his old assumptions and from Mr. Hurt's tough-minded, unsentimental performance.

When McKee becomes ill, he is irate at the way he is treated. Why does he have to fill out hospital forms, spend hours in a waiting room and put up with medical arrogance when he is a doctor? The film's least convincing idea is that he couldn't have pulled rank better than that. Still, his indignation and reluctance to change provide a dramatic edge.

And when he learns how the other half lives and realizes how callously he has treated his own patients, the film doesn't condescend to that other half. They happen to be middle class, but they deserve respect because they are human, not because the movie has some misplaced idea about noble savages. Though it has its sappy moments, "The Doctor" is infused with a fundamental human decency.

"Dying Young" is apparently about similar life-and-death issues, but in fact it is about trying to wring tears from viewers' eyes and money from their pockets. Oddly, that lack of pretension is to the credit of the film and its director, Joel Schumacher. The story seems to engage class values, with the working-class heroine (Julia Roberts) falling in love

Several recent films, rife with doctors and lawyers, exude social distinctions and assumptions that are not always in sync with reality.

with a rich, dying man. But between the lines the film says, "I'm a flat-out commercial soap opera. So what?" The movie puts on no artistic airs, just as Ms. Roberts's character puts on no social airs. ("No more art history lessons," she pleads with her lover.) But she doesn't put herself down, either. Like "Dying Young" and "The Doctor," the character simply is what she is, without regrets or excuses.

When movies seem genuinely classless, they are often innocuous, like this summer's supposedly socially aware comedies. "Doc Hollywood" might have been a comic "Regarding Henry," with an ambitious plastic surgeon discovering that people are warmer and life is better in Grady, S. C., the Squash Capital of the South. Fortunately, it avoids condescending to its small-town heroes and so is congenial if thoroughly predictable.

And Mel Brooks's "Life Stinks," in which a billionaire lives among the homeless for a month, makes little of those extremes of class. The rich man played by Mr. Brooks seems instantly comfortable among the poor and so wipes away social distinctions in a flash. The film's attitude is not defined by class but by its huge, unexpected sentimental streak.

Having a class attitude can give a film bite, even if it sometimes makes viewers want to bite back. ☐

1991 Ag 11, II:18:1

The Commitments

Directed by Alan Parker; screenplay by Dick Clement and Ian La Frenais and Roddy Doyle, from the novel by Mr. Doyle; director of photography, Gale Tattersall; edited by Gerry Hambling; production designer, Brian Morris; produced by Roger Randall-Cutler and Lynda Myers; released by 20th Century Fox. Running time: 120 minutes. This film is rated R.

Jimmy Rabbitte	Robert Arkins
Steven Clifford	Michael Aherne
Imelda Quirke	Angeline Ball
Natalie Murphy	Maria Doyle
Mickah Wallace	Dave Finnegan
Bernie McGloughlin	Bronagh Gallagher

By JANET MASLIN

"When I was studying, I used to sing hymns," the young man whispers in the confessional. "Now I'm always humming 'When a Man Loves a Woman,' by Marvin Gaye."

"Percy Sledge," the priest corrects him in "The Commitments," Alan Parker's exuberant valentine to American soul music and the impoverished Dublin teen-agers who think of it as magic. That everyone in this film, from the priest to the street kids to the father who never got over Elvis Presley, is totally obsessed with popular music is simply taken for granted. As in his earlier "Fame," Mr. Parker immerses his audience in a world in which popular art amounts to a communal high, a means of achieving identity and a great escape from the abundant problems of everyday life. As in "Fame," he does this with a mixture of annoying glibness and undeniable high-voltage style.

The sound and the setting have changed, but these two films are at heart very similar. What Mr. Parker has done, in effect, is to remake "Fame" in a different language. Once again, a taste for slickness gives his film an air of unreality for all its ostentatious grit, but once again the energy level is so pumped up that it barely matters. "The Commitments" finds Mr. Parker again doing what he does expertly: assembling a group of talented newcomers, editing snippets of their exploits into a hyperkinetic jumble, and filling the air with song.

•

The song in this case is American soul music of the 1960's, and it took more than a little nerve to devote an entire film to the efforts of an all-white band to master "In the Midnight Hour" and "Mustang Sally." Similarly, it's a stretch for this band to call itself the Commitments and claim the status of working-class heroes when they perform this music wearing evening dresses or black tie. (This is because "all the Motown brothers wore suits," as one of the wiser Commitments says. "You play better in your suit.")

Any political earnestness the film may have is limited to its glimpses of north Dublin as a claustrophobic and impoverished but friendly place, and to the speeches made by Jimmy (Robert Arkins), the budding impresario who initially assembles the band. "You're working-class, right?" he badgers one new recruit. "Your music should be about work."

Relying on a cast of vigorous and unfamiliar players (Andrew Strong, the ponytailed lead singer who does an estimable Joe Cocker imitation while performing a daunting array of soul standards, is only 16), Mr. Parker tells the slow but lively story of how the Commitments came together. There is the cute, predictable bad-audition montage; the surprisingly good singer discovered at a wedding; the times when Jimmy practices giving interviews in the shower. (Mr. Parker uses these interviews as bookends for the film, to wryly good effect.) And during all of this, there is music everywhere. Jimmy's family can even be glimpsed doing a jig to traditional Irish music while their errant son interviews potential Commitments in another part of the house.

•

Music also permeates all conversations, serving as kind of shorthand through which the characters identify one another as kindred spirits. "I'm blind without my glasses," says one. "So is Ray Charles," another replies. Someone else observes, for no pressing reason, that nothing has been the same since Roy Orbison died. A priest offers tacit encouragement when two of his parishioners sneak in to practice "A Whiter Shade of Pale" on the church organ. Lest anyone doubt that to these characters music has become a kind of religion, Jimmy's father keeps his framed portrait of Elvis just above his portrait of the Pope.

David Appleby/Beacon Communications

A scene from "The Commitments," about a Dublin group devoted to American soul music.

In this atmosphere, Mr. Parker is capable of whipping a series of quick, well-edited snippets into a happy collage of musical high spirits. The band's rehearsal of "Nowhere to Run" moves through the neighborhood n a streetcar, with the musicians, he other passengers and even people hanging laundry out on clotheslines singing along. To be sure, there i a grave risk of letting such momets go overboard, and at times Mr. Prker does: from the angelic little grls on the trolley to the twin sisters who speak in unison, the film has mre than its share of superadorabe flourishes. It would be difficult to resist the temptation to tap one's fet anyhow.

"The Commitments" becomes repetitive after a while, since so much of it is bout the group's stage show, and sine the effort to create an offstage sory never really works. The screenlay, by Dick Clemant, Ian La Frenai and Roddy Doyle, from Mr. Doyle's novel, attempts some mild intra-bnd romances and few subplots bout the characters' family lives. Among the more impressive membrs of this large group, aside from immy, are Joey (The Lips) (Johny Murphy), much older than the oters, who claims some formidable nythm-and-blues credentials; Berni (Bronagh Gallagher), a feisty yong woman who combines singing wih aking care of her youngest siblis: Imelda (Angeline Ball), the group's resident beauty queen, and Deco (Mr. Strong), whose gruff acting is as precocious as his singing.

The film's glimpses of Dublin are as effective as its score, and are made more memorable by Mr. Parker's apparent nonchalance. The sight of a dead horse, shot in a bank robbery, is one of the many street images that the film seems to notice only in passing.

•

"The Commitments" is rated R (Under 17 requires accompanying parent or adult guardian). It includes mild profanity and sexual situations.

1991 Ag 14, C11:1

In the Shadow of the Stars

Directed, produced and edited by Irving Saraf and Allie Light; cinematography by Michael Chin; music by Mozart, Puccini, Rossini, Stravinsky, Verdi and Wagner, among others; a First Run Features release. At the Film Forum, 209 West Houston Street, Manhattan. Running time: 93 minutes. This film has no rating.

With: The San Francisco Opera

By VINCENT CANBY

How many sopranos does it take to sing a high C?

This is just one of the questions, large and small, considered with enormous wit, intelligence and compassion (and occasional rue) in the very fine new documentary, "In the Shadow of the Stars," opening today at the Film Forum.

"In the Shadow of the Stars" is a consideration of lives devoted to opera or, as it's defined by one man, "a funny kind of theater that has been dead for some time."

The subjects of the film, produced, directed and edited by Irving Saraf and Allie Light, are not the internationally known stars but the members of the San Francisco Opera chorus. Not every member, but 11

men and women whose stories and personalities become particular as the film progresses, and whose bond is a shared passion that sometimes looks lunatic in this day and age.

Choristers are not to be confused with the supernumeraries sometimes hired to fill up a stage. Choristers are full-time professionals, serious hardworking artists who not only fill up a stage but also inhabit it, giving it character and texture as well as voice.

•

As in "High Fidelity," Allan Miller's equally fine documentary about the Guarneri String Quartet, the recurring theme of "In the Shadow of the Stars" is the impulse (and need) to maintain individual identity while becoming part of a unit.

Choristers are not hired by the pound or for their body types. Each must somehow contribute to the effect of, say, a roistering crowd of inebriated peasants while hanging onto his or her singularity. Life in the opera chorus is a continuing compromise, offstage as well as on.

Christine Lundquist, a soprano of striking good looks, aspires to stardom and makes ends meet by singing in the chorus. She tells the film makers of always living on the financial edge, of having no real home and of gambling all on a recent European trip that ended in disaster.

There were auditions and promises of auditions, she says, and a possible contract in Frankfurt that vanished when the opera house burned down. Toward the end of the interview, she confesses with mock weariness that men have a way of interfering with her resolve.

All of the choristers interviewed by Mr. Saraf and Ms. Light are exceptionally articulate and self-aware. "Tenors have a reputation for being high-strung and slightly stupid," says one tenor.

Frederick Matthews, a barrelchested baritone from rural North Carolina, has not abandoned his goal of a solo career and, when last seen, is about to go on stage in Costa Mesa, Calif., to sing Figaro in "The Barber of Seville."

David Burnakus is another sort entirely. He met his wife, Ruth Ann Swensen, when they were both in the chorus. She has gone on to become a soloist. He reports that he is now content to remain in the chorus and to realize his aspirations through her.

"So much of the career is not the singing," he says. Which, for him, may be another way of recognizing that so much of life is not the career.

Somewhat younger are Shelly Seitz and Karl Saarni, who met and married in the chorus, and are still in the chorus. In one of the film's sweeter, funnier scenes, they are shown in their cramped apartment singing the "Andiam" duet from "Don Giovanni" as their baby crawls around the floor, scaling pillows and other impediments to progress.

Supplementing the interviews (backstage, at home, in restaurants and, in one case, a trailer truck) are rehearsal sequences followed by shots of the rehearsed sequences as they appear in the full productions. Especially effective are the scenes from "The Rake's Progress," "Macbeth" and "La Bohème."

In a way that is close to magical, Mr. Saraf and Ms. Light have so structured "In the Shadow of the Stars" that the film audience shares the exhilaration experienced by the choristers. The music, of course, is powerful stuff, but clumsy direction and editing could have muffled it.

The movie is beautifully photographed. Michael Chin, whose credits include Wayne Wang's "Chan Is Missing" and "Dim Sum," was the principal cinematographer. After seeing "In the Shadow of the Stars," you may never again take the opera chorus for granted. You will look and listen with more care and, possibly, higher expectations.

For those who can't wait: it takes seven sopranos to sing a high C, one to sing it and six to say they could have sung it better.

Maybe you have to be a soprano.

1991 Ag 14, C15:1

On the Black Hill

Directed by Andrew Grieve; screenplay by Mr. Grieve, from the novel by Bruce Chatwin; cinematographer, Thaddeus O'Sullivan; edited by Scott Thomas; music by Robert Lockhart; produced by Jennifer Howarth; a BFI Production for Channel 4 Television in association with British Screen Finance Ltd. At the Bleecker Street Cinema, at La Guardia Place, Manhattan. Running time: 116 minutes. This film has no rating.

Benjamin Jones	Mike Gwilym
Lewis Jones	Robert Gwilym
Amos Jones	Bob Peck
Mary Jones	Gemma Jones
Sam Jones	Jack Walters
Hannah Jones	Nesta Harris
Rebecca	Lynn Gardner

By CARYN JAMES

Rainswept hills, flocks of grazing sheep, hayricks and dank cottages form the picturesque backdrop of "On the Black Hill," but this is no happy bucolic scene. The story of the Jones family, for 80 years farmers on the Welsh-English border, has such a dark psychological undercurrent that in contemporary terms they seem the ultimate dysfunctional family.

But the film, which opens today at the Bleecker Street Cinema, is deliberately traditional and backward-looking. Like the 1982 Bruce Chatwin novel, on which it is based, the movie could never have existed without Thomas Hardy. These are Hardyesque country people rooted to a natural world that is less than benevolent. They are bound to one another in relationships that are part emotional necessity, part torture. Sheepshearing is the least of their problems.

In 1895, Mary Latimer, a minister's daughter played by Gemma Jones, marries a proud, rough-mannered farmer named Amos Jones (Bob Peck). There is no question that passion as well as desperation figures into Mary's choice, and no surprise for viewers when Amos starts smashing dishes on the floor and criticizing the way his wife folds napkins as "very posh."

These characters are trapped, partly by their own choices, partly by the literary conventions the story follows slavishly. But Miss Jones makes Mary's growing unhappiness affect-

Gemma Jones

ing. As she grows to old age, her nose reddens and her face becomes gaunt, yet her eyes have an infinite capacity for disappointment. She lavishes attention on their twin sons, Benjamin and Lewis, while Amos dotes on their daughter, Rebecca.

With an unhurried pace and episodic manner, the story stops at crucial stages in the twins' lives. They are separated briefly, first by Lewis's work at a neighboring farm and later by Benjamin's service in the army. At those times, when one is hurt, the other literally bleeds. The family believes they cannot survive apart, but it is really Benjamin who cannot live without his brother. When Lewis, well into manhood, takes up with a woman for the first time, Benjamin is murderously angry. Mike and Robert Gwilym, real-life brothers seven years apart in age, deftly create Benjamin's hypersensitive nature and Lewis's frustrated resignation to bachelorhood.

The dark psychological tangle between the brothers is meant to be the film's focus, but too often the movie is distracted by its need to cram in so much family and world history. In its most overwrought scene, a feuding neighbor kills Amos's dog, which causes Amos to hit Mary with the copy of "Wuthering Heights" she is reading, which causes her to call him a "stupid fool." Amos collapses in tears, his head on the kitchen table where we see a newspaper that announces the start of World War I.

Over the years, the family nearly loses the farm; the twins discover an unknown heir and take a first airplane ride on their 80th birthday. These events are given a colorful but shallow treatment, without the psychological depth the film needs to be truly first-rate.

"On the Black Hill," directed by Andrew Grieve, was released in England in 1988. The delay in opening here may reflect its limited commercial prospects rather than its quality. There isn't much oomph in this story, not enough high drama to capture huge audiences. Instead, it resembles a sturdy, mildly engrossing "Masterpiece Theater" treatment of Hardy, without as rich a source to draw on.

1991 Ag 16, C8:1

Mystery Date

Directed by Jonathan Wacks; written by Parker Bennett and Terry Runte; director of photography, Oliver Wood; film editor, Tina Hirsch; music by John DuPrez; production designer, John Willett; produced by Cathleen Summers; released by Orion Pictures. Running time: 110 minutes. This film is rated PG-13.

Tom McHugh	Ethan Hawke
Geena Matthews	Teri Polo
Craig McHugh	Brian McNamara
Dwight	Fisher Stevens
James Lew	B. D. Wong
Sharpie	Tony Rosato
Doheny	Don Davis

By VINCENT CANBY

"Mystery Date" is an exceptionally unfunny farce about the worst night in the life of Tom McHugh (Ethan Hawke), a college student whose elder brother, Craig (Brian McNamara), arranges a blind date for Tom with the new young woman next door.

She is Geena Matthews (Teri Polo). Geena is pretty but far less mysterious than the plotting of this movie, which was written by Parker Bennett

Ethan Hawke

Orion/Bob Akester

and Terry Runte and directed by Jonathan Wacks. Craig, it seems, is not quite the paragon Tom believes him to be. He's a cheerful blackmailing scamp, playing a dangerous game with crooked cops and the members of a drug-dealing Chinese gang.

In the course of this one long night, the baffled Tom is constantly mistaken for his brother, whom he resembles not at all. He and Geena are pursued by the mad but essentially harmless driver (Fisher Stevens) of a florist's delivery truck, and the sane but lethal crooked cops and drug dealers. The body count mounts and the audience's spirits sink. Much confusion, no laughs.

•

The setting is never identified, though the film was made in that nowhere city that Vancouver, British Columbia, has come to represent for movie makers who shoot there. It looks like Anyplace, U.S.A./Canada, and thus seems to be no place.

All the performers work with enthusiasm for little effect. Among them is B. D. Wong, who plays the leader of the Chinese gang and who once won a Tony Award for his performance in "M. Butterfly." Even a good actor's life is not easy. He takes what he can get.

•

"Mystery Date," which has been rated PG-13 (Parents strongly cautioned), has some vulgar language and violence.

1991 Ag 16, C9:1

Terezin Diary

Directed and produced by Dan Weissman; screenplay by Zuzana Justman; camera, Ervin Sanders; edited by Mark Simon. A Terezin Foundation presentation in association with Visible Pictures Ltd. At the Village East Cinema, 12th Street at Second Avenue, Manhattan. Running time: 88 minutes. This film has no rating.

Narration by Eli Wallach

By VINCENT CANBY

"Terezin Diary," a new addition to the list of films about the Holocaust, documents the history of the so-called model camp established by the Nazis in 1941 at Terezin (Theresienstadt), an old fortress town near Prague.

A 1944 Nazi propaganda film, "The Führer Gives a Town to the Jews," presented the camp as an idyllic setting where children, their parents and old people could live, work and play far from the cares of a world at war. About the same time, a Red Cross team inspected the camp and gave its approval.

In fact, Terezin was a way station for inmates en route to the death camp at Auschwitz. Just before the Red Cross visited Terezin, about 7,500 prisoners were transferred to Auschwitz so the place would look less crowded.

Though Terezin may have appeared benign, at least briefly, the statistics defining its benignity freeze the mind. Of the approximately 140,000 prisoners, including 15,000 children, who passed through the camp, 33,000 died there from illness and malnutrition before reaching Auschwitz.

•

"Terezin Diary," which opens today at the Village East Cinema, begins with a reunion of the camp's survivors in Prague in 1986. The film is a plain, straightforward, chilling account in which these survivors, who were children at the time, recall their experiences.

Chief among these is Helga Kinsky, who now lives in Vienna with her daughter and grandchild. She was 12 years old at the time she was sent to Terezin in 1943, and has managed to save the diary she kept until 1944, when she was shipped off to Auschwitz. Mrs. Kinsky is a soft-spoken but strong personality who regards Terezin and Auschwitz as a kind of terrible privilege.

The Terezin experience, as evoked by Mrs. Kinsky and others, was particular for its contradictions. The place had the look of peace and order, though people were starving to death.

•

The members of Terezin's Jewish police force, who took pride in demonstrating their discipline to their Nazi keepers, were promptly dispatched to Auschwitz. Instead of admiring their precision and bearing, the Nazis saw

An idyllic town for the Jews? No, a way station to Auschwitz.

them as being the nucleus of any possible resistance.

Each story recalls similar horrors, yet each story is singular. Such is the way of Holocaust literature.

Dan Weissman produced and directed "Terezin Diary," which was conceived by Zuzana Justman, the film's executive producer and writer who herself is a Terezin survivor. Eli Wallach provides the efficient narration.

1991 Ag 16, C11:3

FILM VIEW/Caryn James

You Can't Tell a Movie By Its Trailer

MANY MONTHS AGO A BIZARRE PHENOMEnon occurred in movie theaters around the country. Audiences were shown a preview of "Hudson Hawk," and it looked as if it might be good. This can be explained easily enough in hindsight. There was no hint of the film's knotted-up, impossibly tangled plot. Sandra Bernhard wasn't glimpsed, though it turned out that she had a role so prominent and so abrasive it must have sent at least a few viewers cowering under their seats in horror. Instead, the preview offered a pleasant buddy-movie caper with Bruce Willis and Danny Aiello, a film that was actually w at its Wh en were about to jump on a high ledge, the Aiello character quoted Butch Cassidy's line to Sundance: "The fall will probably kill you." That line never made it into the final version of the film, which was released in May and became an overnight disaster. Now it looks like that missing scene was the cleverest moment of the film.

■

When this trailer was first shown, "Hudson Hawk" had not been completed. At the same time, a preview for another unfinished film was making the rounds. The trailer for "The Naked Gun 2½" is a wonderfully funny parody of "Ghost." Instead of Demi Moore and Patrick Swayze erotically molding a clay pot and falling into each other's arms miraculously clean, this is the scene as it should have been played. Leslie Nielsen and Priscilla Presley sit at the pottery wheel, so absorbed in each other that they don't notice the clay flying off the wheel, splattering them from hairline to toenails while the Righteous Brothers sing in the background. This movie, the trailer truthfully and solemnly announces, was made by the brother of the director of "Ghost."

The "Ghost" parody, created for the trailer, was never meant to be in "Naked Gun." But it worked so well that the director, David Zucker, included it in the film. "Naked Gun" turned out to be a bizarre phenomenon, too: a movie just as funny as its trailer predicted it would be.

Most moviegoers love watching trailers. Previews put in the best parts, keep out the worst and don't leave time for disappointment. But a preview is, after all, a sales pitch. So here is a consumers' guide to some current previews and the films they try to sell, each an example of a basic trailer trick.

"Pure Luck" (or, The Trailer That Gives Away All the Funny Lines):

This preview uses the most enticing and common ploy for comedies, packing in the best lines and scenes. If you've seen the trailer, you've had every laugh you're likely to have at the movie.

Martin Short is a bumbling accountant and Danny Glover a detective. Together they head to Mexico to find an accident-prone missing woman, on the theory that Mr. Short's bad luck will lead them in her direction.

So, when a bee lands on Mr. Short's cheek and he says he's allergic, no one will be surprised that he is about to be stung; when the camera closes in on Mr. Glover's shocked reaction, there should be a surprise coming. But anyone who has seen the trailer already knows that Mr. Short has suddenly blown up to blimp size, oblivious to his bursting shirt and puffed-up face. There are, truly, no laughs left out of the previews for "Pure Luck."

"Regarding Henry" (or, The Trailer That Gives Away the Ending):

This does for drama what the "Pure Luck" preview does for comedy. In fact, the trailer for "Regarding Henry" seems longer than many films. It is a mini-version of the entire movie.

Here is Harrison Ford as a big-money lawyer with slicked-back hair, here he is slowly getting his memory back

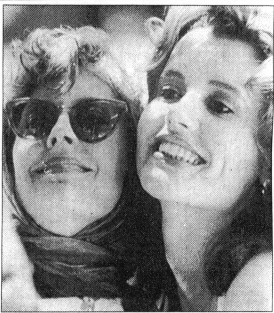

Roland Neveu/MGM-UA

A preview shot for "Thelma and Louise"—upbeat

after being shot in the head, here he is dancing around with his wife and daughter and their new puppy. If we know the happy outcome, what's left of the drama?

"The Doctor" (or, The Trailer That Gives Away the Ending *and* All the Funny Lines):

This one combines the worst features of both the "Pure Luck" and "Regarding Henry" previews. It follows the doctor played by William Hurt through every trauma, from the moment he hears, "Doctor, you have a growth," through radiation treatments and, of course, the loving emotional breakthrough when he tells his wife he needs her. And it gives away the punch lines to these comic-relief questions: "What is the difference between a catfish and a lawyer?" and "Do you know a good radiation man?"

"The Doctor" is actually a better movie than the preview suggests, though. The trailer shows one of the film's mawkish moments: Mr. Hurt swirling around, arms open wide, embracing life. The film is much tougher than that, which proves that bad trailers can happen to good movies. This supports the fundamental principle of trailer-watching: Don't even try to predict.

"Thelma and Louise" (or, The Trailer That Doesn't Tell Enough):

By now everyone must know that this well-publicized and argued-over film includes a near rape, a murder and a double suicide. But its advertising campaign portrays Susan Sarandon and Geena Davis as good old girls on the road, their crimes a h less lark. It is a truism of trailers that no one wants to s pressing movie, so the downbeat side is concealed.

The c sume s best watchwords: trailers are still fun, as long as ou Jon believe them. □

1991 Ag 18, II:11:5

Barton Fink

Directed by Joel Coen; written by Ethan Coen and Joel Coen; director of photography, Roger Deakins; edited by Roderick Jaynes; music by Carter Burwell; production designer, Dennis Gassner; produced by Ethan Coen; released by Circle Films. Running time: 117 minutes. This film is rated R.

Barton Fink	John Turturro
Charlie Meadows	John Goodman
Audrey Taylor	Judy Davis
Jack Lipnick	Michael Lerner
W. P. Mayhew	John Mahoney
Ben Geisler	Tony Shalhoub
Lou Breeze	Jon Polito
Chet	Steve Buscemi
Garland Stanford	David Warrilow

By VINCENT CANBY

Joel and Ethan Coen's "Barton Fink" looked very good at Cannes this year, where, in the first sweep ever at the film festival, it was awarded the prizes for best film, best direction and best performance by an actor. The news this morning: "Barton Fink" looks even better on home territory.

"Barton Fink" opens today at the Coronet Theater.

After three movies in which they seemed to be finding their bearings ("Blood Simple," "Raising Arizona" and "Miller's Crossing"), the Coens have at last produced an unqualified winner. Here is a fine dark comedy of flamboyant style and immense though seemingly effortless technique.

"Barton Fink" might possibly be classified as a satire on the life of the mind. There is no doubt that it is about the perils of the mind for some-

one as impressionable as Barton Fink (John Turturro). Barton is a pious, prissy New York playwright of very funny, unredeemed humorlessness, someone who has dedicated himself to creating "a living theater of, about and for the Common Man."

•

The time is the early 1940's, just before World War II, when Clifford Odets and a number of other American playwrights were still riding high on a wave of poetic proletarianism.

After having written one Broadway hit, Barton, who resembles the hero of John Lynch's "Eraserhead," goes to Hollywood to earn some big money and maybe, as he says, "to make a difference."

Barton's responsibilities to the Common Man weigh heavily on his skinny frame. He stays not at one of Los Angeles's fancier hotels but at the Earle, a downtown establishment ("For a Day or a Lifetime") whose Art Deco lobby and corridors give no hint of the Skid Row seediness of the rooms.

The Earle has a dreamlike emptiness to it when Barton arrives. His state of mind (and the things to

A satire on the life of the mind, from the "Raising Arizona" duo.

come) are hinted at when the bellboy emerges from a trap door in the floor behind the reservations desk to sign him in. Barton, who devotes himself to theater of noble purpose, has clearly landed in hell.

•

Barton's adventures in Hollywood are a series of grotesquely funny confrontations as his writer's block becomes manifest and his panic accumulates. His first assignment for Capitol Pictures is a wrestling movie "for Wally Beery."

"It's not a B picture; Capitol Pictures does not make B pictures," says Jack Lipnick (Michael Lerner), Capitol's squat, barrel-chested president,

who seems to be a cross between Harry Cohn of Columbia and Louis B. Mayer of M-G-M.

It is, of course, a B picture, and Barton hasn't a clue as to how to start. His desperation mounts.

He is befriended by another Capitol writer, W. P. Mayhew (John Mahoney). A drunken Southern novelist of Faulknerian dimensions, Mayhew calls Hollywood "the great salt lick," and is first seen from the thighs down, kneeling on a handkerchief inside a toilet stall. In as gentlemanly a way as possible, he is vomiting.

There is also Mayhew's beautiful, wise and self-assured "assistant," Audrey Taylor (Judy Davis), who is more than just a secretary or even a mistress. Her dread fate, on the night she comes to the Earle to help Barton with the Wally Beery treatment, is the center of the film's sly and elusive narrative.

More important to Barton than anyone else is Charlie Meadows (John Goodman), his next-door neighbor at the Earle. He's a big, gregarious insurance man who tells Barton, man-to-man, "You might say that I sell peace of mind."

The shirt-sleeved Charlie is actually too good to be true, but Barton doesn't notice. All he sees is the beer-belly, the sweat, the suspenders, the desperation to please. He's someone in whom Barton can confide.

"I write about people like yourself Charlie," Barton announces to his new friend. "The simple working stiff." "Well," says the pleased Charlie, "I could tell you some stories." Later, his writer's block paralyzing his work on the Wally Beery picture Barton talks to Charlie about the terrors and mysteries of the territory called the mind: "There's no road map for it."

•

Among other things, "Barton Fink" demonstrates just how fraught with danger that territory can be. It is one of the film makers' more comic conceits that Barton's socially conscious mind should be the crucible for a succession of such lurid and extravagant events.

The Coen brothers share credit for their screenplays, which are then produced by Ethan and directed by Joel. They are quoted as saying that they turned to the writing of "Barton

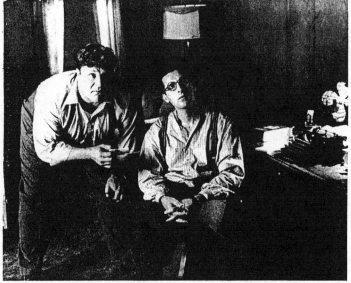

Melinda Sue Gordon/Circle Films

John Goodman, left, and John Turturro (in the title role), in a scene from "Barton Fink."

Fink" when they found themselves blocked while working on the screenplay for "Miller's Crossing." This seems completely plausible.

"Barton Fink" has the manner of a work that was written in a high old halcyon rush, of a screenplay that announced itself and took form without a lot of nervous pushing and probing to give it existence. It is seamless, packed with the sort of pertinent and priceless detail that can't be worried out of the mind piecemeal.

The dialogue from Barton's hit play, heard at the movie's beginning, is both wicked parody and pertinent to Barton's own overheated reveries.

•

The finished film, so vivid and startling, has the same coherence. The performances are virtually indistinguishable from the characters as written. It's difficult to tell where the roles leave off and the actors begin.

Mr. Turturro, the Cannes winner, is superb, but so are Mr. Goodman, Mr. Mahoney, Mr. Lerner and Ms. Davis, as well as Jon Polito, who plays Jack Lipnick's Job-like yes-man; Steve Buscemi, who plays the Earle's eerie bellboy, and David Warrilow, who turns up as Barton's New York agent. Everybody deserves mention.

Each aspect of the film fits, from the production design by Dennis Gassner to the remarkable cinematography by Roger Deakins. The Coens' screenplay is the kind that encourages and accommodates spectacular camera gestures. These include point-of-view and overhead shots and moments when the camera becomes a kind of evil companion to the disintegrating Barton.

The camera nudges Barton to expect the worst when someone knocks at the door. It points to the wall where, suddenly, for no apparent reason, the wallpaper starts curling back, exposing a lazy rivulet of viscous ooze too disgusting to identify.

After observing some furtive lovemaking, the camera sneaks away from the couple on the bed, possibly in shame, moves into the bathroom and (in effect) disappears down the drain of the basin, like a silverfish when the light goes on.

It was said by some at Cannes that "Barton Fink" is a movie for people who don't like the Coen brothers' films. Not quite true. It's a film for those who were not sure that the Coens knew what they wanted to do or had the authority to pull off a significant work.

"Barton Fink" eliminates those doubts. It's an exhilarating original.

•

"Barton Fink," which has been rated R (under 17 requires accompanying companion or adult guardian), includes some violence and vulgar language.

1991 Ag 21, C11:1

Correction

A film review yesterday about "Barton Fink" misidentified the director of the film "Eraserhead." He is David Lynch.

1991 Ag 22, A3:2

The Yen Family

Directed by Yojiri Takita; screenplay (Japanese with English subtitles) by Nobuyuki Isshiki, based on the story by Toshihiko Tani; photography by Yoichi Shiga; a Fujisankei Communications International Release. At Film Forum 1, 209 West Houston Street. Running time: 113 minutes. This film has no rating.

Noriko Kimura	Kaori Momoi
Hajime Kimura	Takeshi Kaga
Taro Kimura	Mitsunori Isaki
Terumi Kimura	Hiromi Iwasaki

By VINCENT CANBY

Japan's Age of Affluence is ridiculed with a good deal of wit in "The Yen Family," a rich and bitter satire about one suburban Tokyo family's efforts to acquire still more money, all of it in very small change.

The 1988 Japanese film is the work of Yojiri Takita, the director of a splendidly lethal sendup of television journalism, "Comic Magazine" (1986). "The Yen Family" opens today at the Film Forum 1.

The members of the Kimura clan are as tireless as they are resilient. They're also an unusually cheerful group as led by Hajime, the father, who is what the Japanese call a salaryman (office worker).

•

Noriko, the mother, starts the day by making a series of phone-sex wake-up calls. Standing in front of the stove, she pants and groans into the telephone receiver, which is awkwardly cupped between her head and shoulder. At the same time she's preparing the food for the box lunches that Hajime, their 12-year-old daughter, Terumi, and 11-year-old son, Taro, will assemble before leaving the house for work and school.

This is the Kimura catering service. There are also a newspaper delivery service (employing retired folk who travel free on public transport), a car service and any odd jobs that come up in the meantime, like drain-cleaning on weekends.

In the Kimuras' world, there is a possibility of profit in everything that has a price. The children are charged for their room and board. When Dad makes love to Mom, he must pay first. But then Mom has to reimburse Dad for her satisfaction, the cost of which is calculated according to a pedometer-like device attached to her thigh.

Yet "The Yen Family" is more than a series of very broad attacks on greed. When someone suggests to

For the Kimura family, there is a possibility of profit in everything that has a price.

Noriko that all this money-grubbing simply isn't human, she replies with the patience of someone who has thought the matter through.

"But we are human," she says. "Have you ever seen a rich monkey or a penguin in debt?"

Young Terumi, who runs a re-cycling business at school, is given a lecture by the school principal. He suggests that she should give more attention to her studies, that she

should exhibit more purity and innocence. Terumi's response: "Purity and innocence attract perverts."

The Kimuras' united front cracks when Taro, who is very small and wise for his age, expresses doubts about the family's way of life. A worried aunt and uncle send Taro a Bible in which he reads that money is the root of all evil. Nonsense, says Dad, who points out that Taro's senile grandmother has become quite reasonable since she moved in with them and became part of their work force. "There's no time for senility in the counting house," says Hajime. From his point of view that is reasonable.

Taro thinks he may not be his beloved father's son. When he asks his mother, she tells him that his real father was "Oliver Hardy, or Einstein, if you wish."

"The Yen Family" is not a homogenized film, though it is consistently imaginative. There is a ferocity to the sight gags and the slapstick that often stifles laughter, and beneath all there

Film Forum

Takeshi Kaga

is a melancholy subtext. Taro's profoundly mixed feelings about his father are shared by the film itself. Hajime is essentially a decent fellow, and doomed.

The performances are all good, but Mitsunori Isaki is remarkably effective as Taro. Nobuyuki Isshiki wrote the screenplay, based on a story by Toshihiko Tani.

1991 Ag 21, C13:1

Dead Again

Directed by Kenneth Branagh; written by Scott Frank; director of photography, Matthew F. Leonetti; edited by Peter E. Berger; music by Patrick Doyle; production designer, Tim Harvey; produced by Lindsay Doran and Charles H. Maguire; released by Paramount Pictures. Running time: 108 minutes. This film is rated R.

Roman/Mike	Kenneth Branagh
Grace/Margaret	Emma Thompson
Gray Baker	Andy Garcia
Dr. Cozy Carlisle	Robin Williams
Franklyn Madson	Derek Jacobi
Inga	Hanna Schygulla

By VINCENT CANBY

KENNETH BRANAGH is a young man in a hurry. The 30-year-old Englishman, who directed and starred in the astonishingly fine screen adaptation of "Henry V" two years ago, now makes his American film debut with the aptly titled "Dead Again."

The new film, which accepts reincarnation as a fact of this life and others, is a big, convoluted, entertainingly dizzy romantic mystery melodrama. It's also another coup de cinéma for Mr. Branagh, who directed it and stars in two roles, playing opposite Emma Thompson, his wife, who has two roles to match his.

Though "Dead Again" is very much the work of a contemporary film maker, it's also a luxuriant evocation of

Paramount/Peter Sorel

Kenneth Branagh

the sort of overripe melodramas that Warner Brothers turned out 40 years ago with Barbara Stanwyck and Humphrey Bogart in the leads.

Yet "Dead Again" doesn't reinvent a particular picture or any actual performances.

Rather, it recalls the tone of certain kinds of studio films of the 1940's and 50's and the manner in which we used to respond to them.

Audiences took them not too seriously while thoroughly enjoying their grand passions and mad motivations, having little awareness of the great craft beneath the surface sheen.

Scott Frank's original screenplay, which is packed with enough events to fuel three ordinary narratives, tells two interlocking stories. The starting point is a haunting, vaguely pre-Raphaelite beauty (Ms. Thompson) who turns up at St. Audrey's School for Boys in Los Angeles having no idea who she is.

Named Grace by Mike Church (Mr. Branagh), the private eye hired to discover her identity, the young woman is beset by dreams in which she is Margaret Strauss, who turns out to have been a real-life concert pianist. Forty years ago in Los Angeles, Margaret was murdered (brutally, of course) by her jealous husband, Roman Strauss, a musical conductor and composer (internationally known, of course).

In her dreams and in conventional flashbacks, Ms. Thompson and Mr. Branagh appear as Margaret and Roman, he with a German accent and a distinguishing mustache and goatee.

More or less orchestrating their investigations is an eccentric dealer in antiques, Madson (Derek Jacobi), who sometimes uses his powers as a hypnotist to locate art objects in a way that's not entirely ethical.

Through Madson, who, in separate sessions, is able to regress Grace and Mike to earlier lives, the events of the past swim into a focus that helps to clarify the present, which seems also about to end in another brutal murder.

Along the way, Mike enlists the help of an even more eccentric character, Dr. Cozy Carlisle, a psychiatrist stripped of his license for having had sex with his patients. This goofy role, unbilled in the screen credits, is played with genially weird intensity by Robin Williams, wearing several layers of sweaters and scarves, mostly in the supermarket meat locker where Cozy now works.

Also important to the investigation are a bad-tempered, chain-smoking newspaper reporter (Andy Garcia), who once loved Margaret and who, when last seen, is talking through a voice box, and the woman (Hanna Schygulla) who served as the housekeeper for Margaret and Roman Strauss.

Mr. Branagh doesn't exactly transform the absurdities of the story into great art, which was probably never his intention. Instead he recognizes them without condescension, turning out a most enjoyable and knowing homage to a kind of fiction that, though dead, keeps coming back.

He is sometimes hard put to cram onto the screen all of the exposition necessary to ensure that the story makes sense. Shots of newspaper headlines at the beginning are of immense help but, for the most part, he demonstrates informed, easy control of the material and the medium.

As photographed by Matthew F. Leonetti, "Dead Again" looks awfully good, with black and white for the dreams and flashbacks and soft hazy colors for the present. Patrick Doyle's score, too, is appropriately rich for a movie that is concerned, at least part of the time, with classical musicians suffering the moviegoer's idea of what the the beautiful, damned and rich must go through.

•

Mr. Branagh's performances as Mike Church, a tough, slangy American with a taste for fine furniture, and as Roman Strauss, the elegant European, make up in technical assurance and wit for what they may lack in casting. Because Mr. Branagh is not physically ideal for either role, he must work just that much harder to create the illusion of reality.

That he succeeds so well, and with such humor, would seem to be the result of sheer intelligence and, from time to time, a gesture that recalls those of the restless, ever-experimenting young Laurence Olivier.

Ms. Thompson, the vigorous and funny Princess Catherine in her husband's "Henry V," is charming as both Margaret and the befogged Grace, and her love scenes with Mr. Branagh, as Mike, have a sweetness that isn't often found in such movies.

•

Ms. Schygulla isn't on the screen long enough to call forth the personality of the woman who was virtually an icon of the cinema of Rainer Werner Fassbinder, but she gives the film style and class, as do Mr. Garcia and Mr. Williams. Mr. Jacobi is very good and straightforward in a role that might easily have been hammed up.

"Dead Again" is eventually a lot simpler than it pretends to be. The explanation of the mystery is a rather commonplace letdown, but probably nothing short of mass murder could successfully top the baroque buildup. In this way, too, the film is faithful to its antecedents, while still being a lot of fun.

•

"Dead Again," which has been rated R (Under 17 requires accompanying parent or adult guardian), includes some violence and vulgar language.

1991 Ag 23, C1:3

Defenseless

Directed by Martin Campbell; screenplay by James Hicks, from a story he co-wrote with Jeff Burkhart; director of photography, Phil Meheux; edited by Chris Wimble; music by Curt Sobel; production designer, Curtis A. Schnell; produced by Renee Missel and David Bombyk; a Seven Arts Release through New Line Cinema. Running time: 104 minutes. This film is rated R.

T. K.	Barbara Hershey
Beutel	Sam Shepard
Ellie Seldes	Mary Beth Hurt
Steven Seldes	J. T. Walsh
Janna Seldes	Kellie Overbey
Bull Dozer	Jay O. Sanders
Jack Hammer	John Kapelos
Mrs. Bodeck	Sheree North

By CARYN JAMES

When the main character of a movie is a female lawyer, you can be sure she has dangerously bad taste in men. In the slick, efficient thriller "Defenseless," the lawyer is Barbara Hershey, and the client she is fooling around with owns a building where pornographic movies are made. Steven (J. T. Walsh) claims to be innocent of any crime and ignorant of the fact that he was renting space to the creators of such films as "Nudes on the Moon." This raises the old question that drives films like "Jagged Edge": is her client really a creep?

The trick of "Defenseless" is to stick almost exclusively to the perspective of Ms. Hershey's character, whose improbable name is T. K. Katwuller. Her love affair sours fast. She knew that Steven was married, but she didn't know that his wife was her old college roommate Ellie (Mary Beth Hurt). When Ellie runs into T. K. — we're left to wonder whether it's by chance or design — she insists that the lawyer come to dinner.

•

T. K. discovers a family whose bizarre emotions are barely under wraps. Like her fluffy blond hairdo, Ellie is a little too perky and perfect-looking. Their hostile teen-age daughter, Janna, wonders out loud why her father doesn't get a more competent lawyer. T. K. can put up with a lot, but she is pushed over the brink when she hears Steven refr to Janna as Pieface, the same affectionate nickname he has called her. It is a mark of T. K.'s submerged good taste and the film's occasional wit that she never liked being called Pieface to begin with.

The director, Martin Campbell (who made the competent Gary Oldman thriller "Criminal Law"), is best in such scenes, where the characters reveal some quirks and hide others until everything seems like an ominous hint of evil.

Because, of course, a murder takes place. We know that T. K. is not the

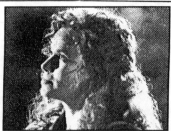

New Visions Pictures

Barbara Hershey

murderer, but she has been in a bloody fight with the victim minutes before the killing; if the police learn about it she will definitely look like the murderer. The policeman in charge of the case is Sam Shepard, playing one of his slow-talking, sharp-witted characters, so he is bound to catch on eventually.

•

Before he does, T. K. is being stalked, possibly by the killer, possibly by the deranged father of a young woman who was used for a porno film, possibly by someone else entirely. She spends an inordinate amount of time alone in parking garages and dark, dangerous neighborhoods. Mr. Campbell doesn't show much imagination here, but he brings some crispness to these stock scenes.

The plot has its weak spots. The red-herring character practically wears a sign reading Red Herring, and the film points in the general direction of the murderer early on. But the cast pulls "Defenseless" over these loopholes, bringing more fullness to the characters than the script suggests. Ms. Hurt is especially good as the socially proper, enigmatic wife.

When the truth is revealed, it seems there is a very dark side to all those nudes on the moon, and "Defenseless" turns more sordid than scary. Still, it is an effective, diverting little suspense film.

•

"Defenseless" is rated R (Under 17 requires accompanying parent or adult guardian). It includes violence and some nudity.

1991 Ag 23, C8:1

Pastime

Directed by Robin B. Armstrong; screenplay by D. M. Eyre Jr.; director of photography, Tom Richmond; edited by Mark S. Westmore; music by Lee Holdridge; production designer, David W. Ford; produced by Eric Tynan Youg and Ms. Armstrong; released by Miramax Films. At 57th Street Playhouse, 110 West 57th Street, Manhattan. Running time: 94 minutes. This film is rated PG.

Roy Dean Bream	William Russ
Tyrone Debray	Glenn Plummer
Clyde Bigby	Noble Willingham
Peter Laporte	Jeffrey Tambor
Inez Brice	Deirdre O'Connell

By CARYN JAMES

Roy Dean Bream is a 41-year-old pitcher, barely hanging on in a losing, fanless minor-league team. Roydean, as he is always called, is the kind of gung-ho guy who gives pointers to the younger players whether they want them or not. After a defeat, he walks around the locker room with unfazed enthusiasm, saying, "You can't win 'em all, cannot win them all." He has heart and soul, spunk and team spirit, and one very special pitch he calls the

Bream Dream. Get him out of here! He is every bit as annoying as his teammates think he is, though "Pastime" treats him like a candidate for sainthood.

The problem is not Roy Dean's sincerity, which might have been poignant and heroic, but the way "Pastime" embraces every baseball and movie cliché it can find. The setting is California in 1957. But the team, the Steamers, seems to have walked out of some standard Southern-movie town. There is a crusty old coach who appreciates Roy Dean's big heart, and a sweet but garish barmaid whom Roy Dean finally gets the nerve to ask out. There is, honestly, a climactic scene of a slo-mo pitch with soaring music in the background.

When a talented but shy young black pitcher named Tyrone joins the team, the other players ostracize him. Their reaction has something to do with race (though the film does nothing to fill out that theme) but much more to do with Tyrone's

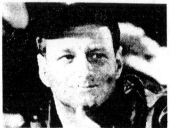

Miramax/Thomas Vozza

William Russ

friendship with Roy Dean, who chases after the new player like an overeager puppy. He buys the kid a soda and tells him about his few minutes in the major leagues, when Stan Musial hit a home run off him. Roy Dean carries around a newspaper clipping of the box score and doesn't even mind that his name is mispelled.

•

"Pastime," which opens today at the 57th Street Playhouse, is the first film directed by Robin B. Armstrong, and it includes a few promising small touches. It's amusing to see the team owner double as the hot dog vendor. And when Roy Dean (William Russ) talks about his brief time in the majors, he affectingly describes it as "just a cup of coffee." The film was called "One Cup of Coffee" when it won the Audience Award at the Sundance Film Festival in January. Under any title the film tries to push audiences' buttons, because viewers are so clearly supposed to like poor old Roy Dean, whose irritating banter is a nervous mask for his love of the game. But it's O.K. to dislike him; he is nothing like a real person.

The other Steamers are portrayed as insensitive clods who refuse to realize they'll get old, too. But on screen, it's usually better to be a clod than a walking, talking cliché.

•

"Pastime" is rated PG (Parental guidance suggested). It includes a barroom brawl and a dugout brawl.

1991 Ag 23, C13:1

FILM VIEW/Janet Maslin

Hollywood Screenwriter's Syndrome, Updated

THERE'S A BRAND-NEW NAME for an old sensation: "that Barton Fink feeling," which in the Coen brothers' current film "Barton Fink" is supposed to stand for quality but in fact comes to represent the Hollywood writer's idea of hell. Writers' purgatory .is certainly a familiar subject, especially when that purgatory has something to do with screenwriting, and when the screenwriter is seen as a lofty, literary individual who 'has temporarily agreed to abandon his principles for Hollywood's sake. But in the hands of the Coen brothers this idea takes on a haunting new life.

"The writer is king here at Capitol Pictures!" proclaims an ebullient studio head (Michael Lerner) upon meeting the self-important, newly famous playwright for whom the film is named. In one of several brilliantly nightmarish encounters he has with "'Bart" (as he insists on calling him), this studio head exemplifies every imaginable threat that the overbearing mogul can pose to the newly declawed literary lion.

■

This kingpin — a wonderful invention — outrageously flatters Barton, kisses his feet, pressures him, scares him, and always returns glowingly to the idea of "that Barton Fink feeling" as a kind of commercial badge of honor. "I guess we all have that Barton Fink feeling," he says cheerfully at their first meeting. "But since you're Barton Fink, I assume you have it in spades."

Indeed he does, by the time this fascinatingly surreal story is over. And writers have been experiencing various versions of that Barton Fink feeling since the movies began. According to Ian Hamilton, author of last year's highly entertaining "Writers in Hollywood," Cecil B. DeMille's brother William

wrote: "When I left New York for Hollywood in 1914, my friends unanimously agreed that I was committing professional hara-kiri, that I was selling my pure, white body for money, and that if my name were ever mentioned in the future it could only be . . . by people lost to all sense of shame and artistic decency." To this, a friend of Mr. DeMille's replied: "They'll pay you $25 a reel, Bill. You can do several in a day, and they'll keep your name out of it."

The sentiments expressed in that exchange have repeatedly been echoed by writers making their uneasy peace with what they perceive as the crassness of the movies. "If I had asked, they would have given me top billing," Anita Loos supposedly said of her 1916 version of "Macbeth," which was credited to William Shakespeare and Anita Loos. "A movie is never any better than the stupidest man connected with it," Ben Hecht said. Hollywood was a "dreary industrial town controlled by hoodlums of enormous wealth," according to S. J. Perelman. The vulgarity that inspired such contempt was exemplifed by David O. Selznick's wry advice to an aspiring screenwriter: "Write whatever you want as long as there's a love scene and the girl jumps in the volcano at the end."

These days there is reason to think that the writer's problem in Hollywood is less clearcut. This seems true not only in "Barton Fink," which is set in 1941, but also in the present-day "Funny for Money," last Sunday's episode in the "Naked Hollywood" series on A&E. This documentary illustrates how a writer can overcome any conscience pangs about working for the movies and only *then* realize what deep trouble he or she has fallen into.

The director Ivan Reitman is seen proudly showing off a piece of the "Kindergarten Cop" screenplay, which he has cut up, scribbled on, pasted together, and faxed back and forth among several different writing teams. Arnold Schwarzenegger, who is this series' idea of the devil incarnate, explains patiently that Mr. Reitman likes certain writers for action scenes, others for love scenes, others for cute-kid sequences, and so on. It is taken for granted that this method will produce a unified product, one that is consistent with Mr. Reitman's so-called artistic vision even if it leaves his scribes tearing out their hair.

No wonder a group of rueful writers, led hilariously by Paul Mazursky, is seen meeting for breakfast at the Farmers' Market and joking about how to beat this impossible sys-

Melinda Sue Gordon/20th Century Fox

John Turturro tries to overcome writer's block in "Barton Fink"— an enterprisingly hellish look at writing

In the hands of the Coen brothers, the notion of the lofty, literary individual who abandons his principles takes on a haunting new life.

tem. When proposing a project, Mr. Mazursky advises, mention something like "Cuckoo's Nest" in the first sentence. Say the leading man is a Nicholson-Cruise type,with Redford-Beatty looks, and promise that he isn't too handsome to be deep. Explain that the ending is "happy . . . but a little sad." Say that the film can be made for $14 million unless all the right people are available, in which case it will cost twice as much.

If this is what screenwriters endure, no wonder "Barton Fink" is the most enterprisingly hellish look at writing this side of "The Shining," with which it shares a comparably fastidious, eerie style. From the motto on Barton's hotel stationery ("A Day or a Lifetime") to the final cry of the story's rifle-toting lunatic ("I'll show you the life of the mind!"), this film is a stunning monument to literary misery. One of its most remarkable inventions is the William Faulkner look-alike who is a model of decorum in public, but from behind closed doors at the writers' building can be heard drunkenly emitting the most piteous howls.

Even he, tortured as he is, appears to have made his peace with Hollywood better than Barton ever will. Listening to one of Barton's self-righteous harangues about writing for the common man's sake, this eminent author merely shrugs. "Well, me," he says, "I just enjoy makin' things up." □

1991 Ag 25, II:16:1

The 23d International Tournée of Animation

A series of 19 animated short films from 8 countries; produced by Terry Thoren; distributed by Expanded Entertainment. At Angelika Film Center, Mercer and Houston Streets, Manhattan. Running time: 95 minutes. These films have no ratings.

By CARYN JAMES

Here is a scene you're not likely to find in a Disney movie: a chorus line of toothbrushes, wearing cheerful little skulls as heads, singing and dancing to calypso music. "I like to keep my teeth clean," takes on a loony and macabre tone when sung by animated-clay skulls lined up on a bathroom shelf, as they are in this three-minute musical, "Oral Hygiene." It is one of the cleverest, goofiest shorts in "The 23d International Tournée of Animation," an annual compilation that opens today at the Angelika Film Center.

The inspirational godfathers of this year's anthology seem to be Marcel Duchamp and David Lynch rather than Disney, for the best of the films have a dark, surreal edge. "Slow Bob in the Lower Dimensions" combines puppets, live-action film and animated objects to tell an eerie little nonsense story. Bob, played by an actor, lives in the basement, where puppet-lizards send out electrical zaps to him. He is tormented by puppet Siamese twins — dolls with blond braids and only three legs between them — who sneak up and paint him bright yellow with blue X's. "Slow Bob" was made as a pilot for MTV, which helps explain its irreverent sensibility and the fast-moving mini-form that owes so much to music videos.

•

"Gray Wolf and Red Riding Hood" is the most stunning film, an elaborate 22-minute glasnost-era musical from the Soviet Union. A retelling of the fairy tale as a political allegory, it is smart and sophisticated enough to work apart from its politics. Red Riding Hood and Granny — puppets with life-like, fluid motions — bake a "Russian pie," which they mean to send all over Europe.

It sounds dull to say that a big, bad totalitarian wolf tries to steal the pie, but imagine this slick wolf dancing down a forest path singing "Mack the Knife," or doing the soft-shoe to "Tea for Two," with new lyrics about making his own laws. That he sings in Russian, with English subtitles, adds another surreal twist. This wolf literally swallows up Disney cartoons: the Three Little Pigs and the Seven Dwarfs appear, only to be eaten. They join a spirited Soviet dentist who sings and dances in the wolf's belly.

Even the sillier films here are likely to have a sharp, satirical manner.

Expanded Entertainment
An animated-clay skull in David Fain's "Oral Hygiene."

"Fast Food Matador" is a colorful cartoon set to a Latin-beat song about a "matador from the delicatessen store." Drawn in dark silhouette, with a fashionable little ponytail, this descendent of bullfighters dodges purple, green and periwinkle-blue cars to deliver his brown bags safely across dangerous Manhattan streets.

Among such sophistication, the two shorts made for "Sesame Street" seem innocuous and out of place. The clay boy in the flying chair in "Arnold Rides a Chair" and the computer-generated lamp in "Luxo Jr." are jarring in their simplicity.

In fact, the best film *about* a child creates a wonderfully moody atmosphere that is not *for* children. In "Capital P," a bed-wetting little boy who is afraid to go to the bathroom in the middle of the night hears strange sounds and sees the hallway turn into a long, creepy, midnight-blue corridor.

Some shorts stretch far toward the avant-garde. Two Dutch-made films, "At One View" and "I Should See," combine live action, still photography and computer-generated photos with a voice-over that turns them into theoretical arguments about genre rather than works of art.

And there is a baffling work about a puppet who lassos potatoes on the range, but never mind. About a third of this collection is smashing — a high figure for an anthology — and the weaker films are painless as well as short. In fact, the one boring aspect of "The International Tournée of Animation" is its clumsy, leaden title.

1991 Ag 28, C11:1

One Hand Don't Clap

Directed and edited by Kavery Dutta; director of photography, Don Lenzer and Alicia Weber; music by various composers; produced by Ms. Dutta and Bhupender Kaul; a Rhapsody Films Presentation of a Riverfilms Production. At the Village East Cinema, Second Avenue and 12th Street. Running time: 92 minutes. This film has no rating.

WITH: Lord Kitchener, Calypso Rose, Black Stalin, David Rudder, Mighty Duke, Natasha Wilson, Lord Pretender and Growling Tiger.

By VINCENT CANBY

Kavery Dutta's "One Hand Don't Clap," opening today at the Village East Cinema, is a sweet, lilting documentary on the history and present state of calypso and its more recent spinoff, soca, defined as calypso with soul.

Ms. Dutta concentrates on two key figures: Lord Kitchener, born 70-some years ago in Trinidad as Aldwyn Roberts, who introduced calypso to London in 1948, becoming an internationally known performing artist and composer, and Calypso Rose, born in Tobago in 1940 as McCartha Sandy, who is said to be the first woman to become calypso star.

They are a most engaging pair, whether seen on screen separately or together. Lord Kitchener, a big man with a wide, toothy smile, talks easily about the Afro-Caribbean origins of calypso, what he thinks of soca and Harry Belafonte's influence on making calypso popular in the 1950's.

Calypso Rose, who looks a little like a Caribbean version of Roseanne Barr, has something of Ms. Barr's humor and, when interviewed, her self-conscious gravity.

•

Both performers, though, only really come to life when they are performing. The film carries snatches of the two singers on the soundtrack throughout the film, and some complete numbers done for the camera.

Sitting at a Trinidad racetrack, Lord Kitchener and an old pal, Lord Pretender, talk about their early days. Both express reservations about today's calypso style. Lord Pretender has no time for lyrics that don't rhyme and what he sees as the laziness of the singers, "A man sing a line, the music play five minutes."

Calypso Rose, who now lives in New York, feels strongly about the social importance of her songs, which, as she says, carry on the calypso tradition of "domestical, spiritual, economical and political" commentary. Her show-stopping moment onstage is strictly domestical. Wearing a gold lamé pants suit, she sings and shakes her way through "Solomon," a bawdy number about a man who is thoroughly no good.

Lord Kitchener's great moment arrives near the end of the film when he appears on the stage of the Calypso Revue, his club in Port of Spain, to sing and dance "Pillow Fight," which uproariously recalls another battle between the sexes.

•

"One Hand Don't Clap" uses the carnival in Trinidad as its climactic sequence, crosscutting among the various calypso events, featuring new performers, and the great Mardi Gras parade in Port of Spain.

There is one major problem for anyone whose ear is not attuned to the Caribbean accent: many of the calypso lyrics and a lot of the words in the interviews are virtually unintelligible. Reviewers were furnished with a dialogue script.

The film's title is taken from a remark made by Calypso Rose when

Expanded Entertainment
A scene from Henry Selick's film "Slow Bob in the Lower Dimensions," in "The 23d International Tournée of Animation."

she acknowledges. that without the help and advice of Lord Kitchener, she would never have reached the top. As she tells her mentor, "One hand don't clap."

1991 Ag 28, C13:1

The Festival of Animation 1991

An anthology of 16 short animated films from around the world; distributed by Mellow Madness Productions. At Cinema Village Third Avenue, between 12th and 13th Streets, Manhattan. Running time: 96 minutes. These films have no ratings.

By VINCENT CANBY

Brief comments on mundane problems and overviews of the fate of mankind are entertainingly mixed in "The Festival of Animation 1991," opening today at the Cinema Village Third Avenue.

This collection is not to be confused with "The 23d Tournée of Animation," which opened on Wednesday at the Angelika Film Center. The two shows are less competitors than extensions of each other.

It doesn't even matter that Nick Park's "Creature Comforts," which won the Oscar this year as the best animated short, was shown here in March as part of "The British Animation Invasion" at the Cinema Village East.

•

"Creature Comforts" is the brilliant centerpiece of "The Festival of Animation." If you've seen it before, you'll want to see it again. If you missed it earlier, you have a chance to catch it now.

With animated clay figures representing zoo animals, and a sound track of actual interviews with people who talk about their lives today, Mr. Park has composed a devastatingly sharp and witty portrait of Britain under Tory rule.

A Brazilian jungle cat, who speaks English rapidly but not too well, lounges on a tree trunk and complains about English food, the lack of space and the climate. He acknowledges the value of "double-glazing and heating," but he desperately longs for more meat (and fewer potatoes), for space and for truly hot weather.

A large female baboon, who genteelly removes fleas as she talks to the interviewer, also makes pointed reference to the rotten weather that doesn't allow her to get out and about as often as she likes.

A little girl, in the form of a young hippo, says with some reluctance (she doesn't want to be impolite) that the cages are rather small and, in her word, "grotty," but she looks on the bright side. She suggests that the terrapins have fairly jolly time, though a terrapi when interviewed, is as frightfully ored as all of the other creatures.

Mr. Park's so id-track dialogue is of a poignancy t t is beyond imagining by most fic n writers. Equally important is his bility to match the dialogue to cla figures that have been animated 1 enormous subtlety. A little boy r 1 polar bear, g ?s a priceless ratio- nale for zoos ai why animals are far better off inca erated than running loose in the wi

A second sh t by Mr. Park, the 12-minute "Gran Day Out," tells of the "cheese holiday". to the moon undertaken by a comfortable lower-middle-class fellow and his dog Grommet. The animation of the clay figures is very good indeed, but the script comes nowhere near the funniness of "Creature Comforts."

A number of the other shorts are unusually somber. The Russian "All Alone With Nature," by Aleksandr Fedoulor, is the sad story of a drab, commonplace office worker whose guilty passion is chewing secretly on the kind of bone favored by a pet dog. The eight-minute "Grasshoppers," by Bruno Bozzetto and Ricardo Denti of Italy, recalls the history of the civilized world as witnessed by grasshoppers.

"Mother Goose," by David Bishop, an American film maker, is a literal re-telling of the story of the three blind mice that is both somber and funny. It is also beautifully designed, mostly in black and white, the color red being used only for images of blood.

•

Bill Plympton, another American film maker, contributes what is possibly the most light-hearted film in the collection, "How to Kiss." This is an instructional film that defines and demonstrates, among other kisses, the first kiss, the suction kiss, which should not be ·undertaken casually, and the passionate kiss, which is even more dangerous.

This collection is not packed with experimental films, though "Deadsey," by David Anderson of Britain, is an adventurously eerie, seven-minute nightmare film. It mixes conventional photography with animation and video techniques to create an Edvard Munch-like vision of despair and anxiety.

Tonight and tomorrow nights the theater will present special shows at midnight and 2 A.M. in which the regular program will be supplemented by shorts that the programmers describe as "extra-twisted," which means not quite pornographic. As part of the regular program tonight, tomorrow and Sunday nights, there will also be appearances by some of the animators who have films in the collection.

1991 Ag 30, C7:1

The Pope Must Die

Directed by Peter Richardson; screenplay by Mr. Richardson and Pete Richens; director of photography, Frank Gell; edited by Katherine Wenning; production designer, John Ebden; produced by Stephen Woolley; released by Miramax Films. Running time: 87 minutes. This film is rated R.

Pope David I	Robbie Coltrane
Veronica Dante	Beverly D'Angelo
Corelli	Herbert Lom
Cardinal Rocco	Alex Rocco
Monsignor Vitchie	Paul Bartel
Carmelengo	Robert Stephens
Mother Superior	Annette Crosbie
Paulo	Salvatore Cascio

By VINCENT CANBY

The title of Peter Richardson's good-humored new English farce, "The Pope Must Die," does not refer to the incumbent Pope, who, at the start of the film, is in the process of dying, and taking his own sweet time about it.

It is a call to small arms against his successor. He is Father David Albinizi (Robbie Coltrane), an obscure, rotund, steel guitar-playing priest who, through a clerical error, is crowned

Miramax

Robbie Coltrane

Pope David I and, in a few short weeks, almost shuts down the Vatican.

After 26 days of deliberations, the members of the College of Cardinals had actually chosen the silver-haired Alfredo ("I dream in Latin") Albini, but a recording secretary with a hearing problem had understood the name to be Albinizi.

In this way Mr. Richardson, the director, and Pete Richens, with whom he wrote the screenplay, set the stage for an often rollicking comedy that lightly takes off from some of the Vatican's well-publicized real-life problems with its bank and financial partners.

•

Francis Ford Coppola's "Godfather Part III" recycled the same material for heavy melodrama. Mr. Richardson and his associates simply send up everyone in a balloon filled with the helium of laughter. The film is irreverent, boisterous and enjoyable even when the gags hang fire.

Mr. Coltrane, who played a bogus nun in "Nuns on the Run," has a classic comedy role as the bewildered Pope initially known as Father Albinizi. The country padre is the last to hear what has happened. He protests in confusion when suddenly everyone genuflects before him. An impatient old priest announces the awesome news, "Shut up, Albinizi, you've just been made Pope."

Albinizi is impressed by the grand papal apartments, by his "en suite fridge and bar," and by the balcony window in which he has only to appear to hear a roar of approval. Soon he's fitting right in. Along with everyone else, he does morning exercises with the Vatican's television fitness program: "Matthew, Mark, Luke and John, work that fat until it's gone."

When he becomes aware of the financial chicanery going on around him, he takes action. The shocked Monsignor Vitchie (Paul Bartel) cautions the new pontiff: "Papa, we're the church. We collect money. We don't give it away."

•

Mr. Coltrane is very good, but the performance is somewhat restrained by the screenplay's demand that the character ulimately be heroic. In this kind of comedy, rascality gets most of the laughs.

The biggest winners are Alex Rocco, who plays the profane wheeler-dealer cardinal in charge of the Vatican bank, and Herbert Lom as the megalomaniacal Mafia don who dreams of being Pope himself. Both actors, first-rate farceurs, are hilarious. So is Mr. Bartel as Pope David's rather prissy aide, which doesn't stop him from being a crook.

The classy cast also features Beverly D'Angelo as a woman with whom Pope David was carnally intimate before becoming a priest, Robert Stephens as the Vatican secretary of state, Annette Crosbie as a mother

superior, and even Salvatore Cascio, the little boy from "Cinema Paradiso," who gives a legitimately funny performance as an orphan.

Mention must also be made of the work by John Ebden, the production designer, who, on studio sets and locations in Yugoslavia, has whipped up an impressive, if thoroughly fake, Sistine Chapel and other Vatican landmarks.

Standing around through the early proceedings, microphone in hand, is a television reporter who, at a key moment, reminds the viewers to stay tuned to see the Pope buried live on CNN. The movie is full of such jokes. They are small, perhaps, but there are those who love them.

•

"The Pope Must Die," which has been rated R (Under 17 requires accompanying parent or adult guardian), includes some vulgar language and some obviously simulated violence.

1991 Ag 30, C10:3

Child's Play 3

Directed by Jack Bender; written by Don Mancini; director of photography, John R Leonetti; edited by Edward A. Warschilka Jr. and Scott Wallace; music by Cory Lerios; production designer, Richard Sawyer; produced by Robert Latham Brown; released by Universal Pictures. Running time: 90 minutes. This film is rated R.

Andy Barclay	Justin Whalin
De Silva	Perrey Reeves
Tyler	Jeremy Sylvers
Shelton	Travis Fine
Whitehurst	Dean Jacobson
Voice of Chucky	Brad Dourif

By CARYN JAMES

Chucky used to be such a cute little killer doll. Though he was possessed by the soul of a notorious murderer, in the original "Child's Play" he had a certain wit about him as he toddled around in his tiny red sneakers searching for victims. And even when he misbehaved, he was more likely to push pesky adults out a window rather than slit their throats with a butcher knife.

But the life of a horror hero is usually one long downward curve, and in "Child's Play 3" Chucky is simply vile. He is a little bit like Jason from "Friday the 13th" and a little bit like the Terminator from the days when he was a killing machine.

Andy Barclay, who was 6 years old in the first movie just three years ago, has grown with soap-opera speed. Now he is 16 and in military school. When Chucky returns, intending to cast his voodoo spell and throw his soul into a human body, he chooses a boy named Tyler, whom Andy has to protect.

The idea of Chucky preying on a child's innocence is a major part of the series' effectiveness, but Tyler seems too old for the part. The film never mentions his age, and everyone in the school treats him as if he were 6 or 8. But he looks more like 11 and certainly seems old enough to wonder why a doll can have a reasonably intelligent conversation. Much of Chucky's dialogue is unprintable, and Tyler doesn't think it's strange to have to tell a doll to watch his language.

The military-academy setting allows Chucky to put live ammunition in the rifles used for war games, to

Justin Whalin

Universal

take hostages, and to escape to a nearby carnival, where he hides in a dark funhouse called the "Devil's Lair." Why war games were situated so close to a carnival may be a mystery of military strategy; maybe not.

In any event, "Child's Play 3," directed by Jack Bender, misses the sharpness and dark humor that the director and co-writer Tom Holland brought to the original. Even the carnival seems bland, and the only touch of humor comes from the school barber, who takes inordinate pleasure in chopping the students' hair down to nothing. His attempt to give Chucky a regulation haircut is his last mistake.

The most intriguing part of the film is the lifelike way Chucky walks, talks and slashes. He is actually played by several mechanical dolls and is an impressive technological achievement. But advancing the state of technology is probably not what the makers of "Child's Play 3" had in mind.

•

"Child's Play 3" is rated R (Under 17 requires accompanying parent or adult guardian). It includes some bloody deaths and a lot of foul language.

1991 Ag 30, C11:3

Swan Lake: The Zone

Directed and photographed by Yuri Iliyenko; written (in Ukrainian with English subtitles) by Mr. Iliyenko and Sergei Paradzhanov, based on the stories of Mr. Paradzhanov; music by Virko Baley; released by Zeitgeist Films. At Film Forum 1, 209 West Houston Street. Running time: 96 minutes. This film has no rating.

WITH: Viktor Solovyov and Lyudmila Yefimenko

By VINCENT CANBY

Yuri Iliyenko's "Swan Lake: The Zone," which opens today at Film Forum 1, is a beautiful, dour Ukrainian film of both political and mystical import.

The story, told elliptically and with very little dialogue, is about a man who escapes from a prison camp and finds brief, brutal solace inside a battered tin monument by a highway. The monument is in the shape of a hammer and sickle. The exact meaning of the rest of the movie is not quite so clear.

The screenplay was written by Mr. Iliyenko and Sergei Paradzhanov, for whom Mr. Iliyenko photographed "Shadows of Our Forgotten Ancestors" (1964) and who seems to be the initial inspiration for Mr. Iliyenko's gorgeous imagery and almost willful taciturnity.

Both Mr. Paradzhanov and Mr. Iliyenko spent most of the 1960's and 1970's separately making movies that so offended censors that some of them have only recently been released. Mr. Paradzhanov was imprisoned on charges of homosexuality in 1974, released four and a half years later and, in the 1980's, returned to film making. He died last year.

"Swan Lake: The Zone" was made in 1990 with Ukrainian, Canadian and Swedish backing, and is yet another result of glasnost and perestroika. Reportedly based on Mr. Paradzhanov's prison experiences, the film also makes dramatic the sense of despair and hopelessness that are the roots of the feverish freedom movements in the Soviet Union today.

•

That much is certain. Much of the rest of the film is simultaneously blunt and obscure.

The prisoner (Viktor Solovyov), who is never named, is observed in the monument by a little boy whose mother (Lyudmila Yefimenko) helps to nurse the man and then falls in love with him. At one point, the man sneaks out of the monument to steal clothes from the trunk of a car. When he attempts to hitchhike to freedom, he is badly mugged by a carload of passing thugs.

Much is made of the fact that the man made his escape just three days before he was due to be released. On his return to prison, after being re-arrested, he dies, only to be resurrected on Easter Day. That's not to tell too much of the plot (there is still more to come) since it's never quite clear why anything is happening anyway.

"Swan Lake: The Zone" works principally as a poetic evocation of emotional numbness. Though the political and religious associations are sometimes vague, the movie is composed of vividly depicted, very particular events.

The individual scenes are sometimes stunning. There is a long remarkable sequence in which the escaped prisoner attempts to adapt himself to life inside the cramped space of a very drafty hammer and sickle. It has political implications, but it is also a long, wordless, agonizing demonstration of a man at odds with an eccentrically shaped environment. Politics are beside the point.

Mr. Iliyenko makes no attempt to provide narrative continuity. How the prisoner and the boy's mother become lovers is not shown and may, in fact, be a dream. Only from the program notes can one be sure that the boy is responsible for the man's recapture by the prison guards.

More important than conventional continuity are the film's big set pieces, which dot the movie like production numbers in a musical, though with somewhat different effect.

There is the comparatively convivial (and eerie) sequence in which a

Film Forum

Viktor Solovyov in Yuri Iliyenko's "Swan Lake: The Zone."

prison guard and an old woman, who seems to be an undertaker, realize that the corpse in the next room is alive. They decide to help the man recover with an impromptu blood transfusion. It is one of the film's ironies that this life-saving transfusion may be fatal.

Mr. Solovyov and Miss Yefimenko (who is married to the director in private life) serve the film by their looks and bearing. He is a man of rough, steely handsomeness, with deep-set eyes that appear to be beyond exhaustion. She has the strong, nearly perfect features of a classic Slavic beauty. To the extent that the film allows, each is an individual as well as a representation of a condition.

Mr. Iliyenko was also responsible for the cinematography, which is incredibly rich without slopping over into prettiness.

"Swan Lake: The Zone" is an odd, baffling and often arresting film.

1991 S 4, C13:1

Where

Directed, written and produced by Gabor Szabo; in Hungarian, with English subtitles; cinematography by Nyika Jancso; production design, Attila Kovacs; production company, Where Film. At Village East Cinemas, Second Avenue and 12th Street, Manhattan. Running time: 96 minutes. This film has no rating.

WITH: Miklos Acs, Renata Satler and Dennis Cornel

By VINCENT CANBY

Gabor Szabo's "Where," opening today at the Village East Cinemas, is an intense but completely inarticulate film about erotic love and platonic friendship, shot in the film maker's native Hungary and in Los Angeles, where he now lives.

In the first half of the film, which seems to be set in Budapest, a skinny young man, never named, relentlessly pursues a buxom young woman, who is also unidentified. He forces her to have sex with him in a forest, on a train, at her apartment, at his apartment, on a street corner and in an elevator.

Occasionally he beats her up. They marry. She becomes furious when he decides to divorce her and move to Los Angeles.

•

In Los Angeles, where he is a student, he begins an apparently sexless friendship with a younger Mexican fellow named Adolfo. He is as obsessed by Adolfo as he was with the young woman. Sometimes he calls Adolfo and says he wants to talk. Sometimes Adolfo calls him and says he wants to talk. They meet, but say nothing. Eventually Adolfo breaks off the relationship, such as it is.

"Where" is well photographed in black and white. The images are clear, sometimes artfully composed. The movie suggests that Mr. Szabo has seen a lot of films by Jean-Luc Godard and Jim Jarmusch without understanding any of them. More than anything else, "Where" looks like a film student's exercise.

1991 S 6, C13:1

Crooked Hearts

Directed and written by Michael Bortman, based on the novel by Robert Boswell; director of photography, Tak Fujimoto; edited by Richard Francis-Bruce; music by Mark Isham; production designer, David Brisbin; produced by Rick Stevenson, Dale Pollock and Gil Friesen; released by Metro-Goldwyn-Mayer Pictures Inc. At Loews New York Twin, Second Avenue and 66th Street, Manhattan. Running time: 112 minutes. This film is rated R.

Charley	Vincent D'Onofrio
Marriet	Jennifer Jason Leigh
Tom	Pete Berg
Edward	Peter Coyote
Ask	Noah Wyle
Jill	Cindy Pickett
Cassie	Juliette Lewis
Jenetta	Marg Helgenberger

By JANET MASLIN

If ever an entire film deserved therapeutic attention, it is "Crooked Hearts," the story of the dysfunctional Warrens and their raft of unsolvable, uninteresting family problems. Everything about the Warrens is indicative of trouble, especially the pained, halting manner in which their story is presented. One family member falls asleep at strange moments. Another carries around a list of personal guidelines (one such rule: wear white at night). A third winds up setting fire to the family homestead, which in another context might be seen as a crime. Here, it's one more cry for help.

Masking all this torment is a veneer of forced gaiety, since Edward Warren (Peter Coyote), the patriarch, traditionally welcomes each new family failure in ceremonial fashion. For instance, there are lights, streamers, a cake and a conga line to herald the news that the middle son (Pete Berg) has dropped out of college. At this particular party, there is even a banner with a fortune-cookie slogan ("You must know home to be a traveler"). To give "Crooked Hearts" the benefit of the doubt, it's at least possible that such moments worked better in Robert Boswell's 1987 novel than they could on screen.

As written and directed by Michael Bortman, who wrote a similarly strained screenplay for "The Good Mother," this film's excessive use of voice-overs and its flat, aimless dialogue turn literariness into a real liability. ("His moods had a way of surprising you," the story's narrator observes in typically unsurprising fashion. "Sometimes good, sometimes bad, and you never knew which was coming.") The narrator's ex-girlfriend, in sending him a note to explain her present situation, points out that "Everything has an explanation."

•

Mr. Bortman has also directed the actors to wring every conceivable bit of angst and indecision out of the film's dilatory plot. The actors who play Warrens — Vincent D'Onofrio as a rakish and irresponsible older brother, Noah Wyle as a wide-eyed younger one, Cindy Pickett as the plucky mother and Juliette Lewis as the teen-age daughter who keeps falling asleep — do such unanimous fretting and stalling that it's difficult to separate their contributions from Mr. Bortman's overview. Only rarely is there a burst of real emotion, and it is not always helpful. "This family is a drug and we're all junkies," Mr. D'Onofrio's character proclaims — twice.

In its search for visual novelty, the film, which opens today at Loews

MGM/Jack Roward
Peter Coyote

New York Twin, sets one scene beside the beluga whale tank at an aquarium (with Jennifer Jason Leigh as a Warren brother's date who's just crazy enough to join the family); there is also a bathtub scene in which the actors have their clothes on and an argument in a bakery that is underscored by the throwing of fresh croissants. Mr. Bortman relies on abrupt and unwarranted overhead shots whenever he is otherwise at a loss.

Tak Fujimoto's crisp cinematography and Mark Isham's lulling (though overused) music make the film look and sound better than might have been expected.

•

"Crooked Hearts" is rated R (Under 17 requires accompanying parent or adult guardian). It includes profanity, very brief nudity and sexual references.

1991 S 6, C13:1

Sex, Drugs, Rock & Roll

Directed by John McNaughton; written by Eric Bogosian; edited by Eleana Maganini; director of photography, Ernest Dickerson A.S.C.; production designer, John Arnone; produced by Frederick Zollo; released by Avenue Pictures. Running time: 99 minutes. This film is rated R.

With: Eric Bogosian.

By VINCENT CANBY

MOVIEGOERS who saw Oliver Stone's overproduced screen adaptation of Eric Bogosian's one-character play "Talk Radio" (1988) may still have only the dimmest impression of Mr. Bogosian's remarkable talents as a monologuist.

At long last those talents are now to be seen, front and center, in "Sex, Drugs, Rock & Roll," the splendid concert-film adaptation of Mr. Bogosian's one-man Off Broadway show. The film, written by Mr. Bogosian, was directed by John McNaughton, whose last work was "Henry: Portrait of a Serial Killer." The two get along just fine.

Among other things, this new one-man movie demonstrates that Mr. Bogosian can fill the big theater screen with as little effort, and as uproariously, as he does any stage.

In "Sex, Drugs, Rock & Roll," Mr. Bogosian remains alone in the camera eye, but the screen is crowded with the characters of his late 20th-century urban nightmare. Most of the time the film seems like a view of the world as it might be imagined by someone dozing in a midtown Manhattan cafeteria at 3 A.M.

Here are the junkies, the louts, the wheeler-dealers, the panhandlers and the certifiable nuts who are closest to Mr. Bogosian's heart. Just out of the camera's range, but no less vivid, are their hangers-on, their victims and their persecutors.

The world that Mr. Bogosian evokes is rife with mad conspiracies of one sort or another. There is the artist who rails against the system that collects men's minds. He fools everyone, though. "The only way to escape the system," he says, "is not to do anything."

When he wants to paint or to write, he does it in his mind, "where they can't see it."

It's also a world in which microwave ovens are ubiquitous. The artist is convinced that through some hookup of computers and microwave ovens, the population will one day be incinerated.

Between phone calls, a high-powered show-biz lawyer screams for his lunch at Diane, his offscreen secretary. Finally he buzzes Diane to say that he'll make it easy for her. "Take your hand, put it in the microwave, grill it and bring it to me."

The lawyer, one of Mr. Bogosian's most hilarious and vicious creations, browbeats an associate into dismissing a 58-year-old employee who will lose his pension and who now faces major surgery. Says the lawyer, "I'm not his doctor, Dave, I'm his boss." He reminds Dave that there are two sides to every argument: "Don't forget the human side of the equation."

The lawyer phones Yvette, his mistress, who is also a sculptor. He wants to talk about sex. When she talks about art, he becomes quickly bored. "You made a sculpture of a horse and you wrote the word 'horse' all over it?" he says, his mind wandering. "That's very conceptual, Yvette."

In the 10 sketches that make up the film, Mr. Bogosian's characters speak a language rich with clichés, in which feelings and meanings are turned inside out. A panhandler carrying a paper cup gives his spiel by rote, in a sincere but threatening monotone. An English rock star, in a television interview, gets carried away while describing the evils of drugs: "You're having such a good time, you don't know what a bad time you're having."

There is also the young man who, in a slight drawl, reveals the secret of his serenity: he is magnificently endowed. He quotes Plato to the effect that everything in the world has a perfect example on which it is modeled, then adds: "That's me. Platonic perfection."

I won't even attempt to quote from one of Mr. Bogosian's longest, most priceless sketches, which is about a bachelor party that gets out of hand. Most of it is unprintable here anyway.

"Sex, Drugs, Rock & Roll" was filmed in the course of nine performances in front of audiences at the Wilbur Theater in Boston. There are a modest set (a sort of expressionistic skeleton suggesting the city landscape) and a few essential props, but otherwise the stage is bare.

It is the perfect environment for a monologuist of Mr. Bogosian's gifts,

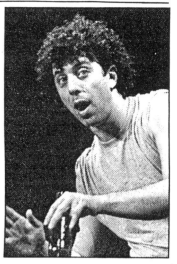

Avenue Pictures
Eric Bogosian

not the least of which is his self-effacing physical presence. I'm not sure if this is necessary, but Mr. Bogosian's real face and body seem to be singularly unmemorable, and magically adaptable, thus allowing him to disappear so completely into each succeeding character.

What he does is entirely different from Richard Pryor, who, in his one-man shows, remembers characters who are always seen through the eyes of the same narrator, that is, Mr. Pryor. Spalding Gray creates what are, in effect, spoken first-person novels.

There are only two other performers who equal Mr. Bogosian as a monologuist: Lily Tomlin, whose one-woman film "The Search for Signs of Intelligent Life in the Universe" opens here on Sept. 27, and Whoopi Goldberg, who, since moving to Hollywood, has abandoned the lonely art in favor of group efforts, often to appear underused.

Monologuists may be great character actors, but in conventional dramatic pieces, they are working at one-tenth of their potential.

This is what happened to Mr. Bogosian in Mr. Stone's inflated screen adaptation of "Talk Radio." In the stage piece, which played without an intermission, Mr. Bogosian created all of the characters. There was a unity of talent as well as of voice.

By adding supporting actors, multiple settings, fancified camera movements, flashbacks and other feeble narrative devices to the screenplay, Mr. Stone denatured Mr. Bogosian's performance and stage script.

With the exception of a few pore-tight close-ups, which are not good, Mr. McNaughton treats Mr. Bogosian and his material with the kind of cinematic reserve that serves the performance without interfering with it. No monologuist could ask for more.

•

"Sex, Drugs, Rock & Roll," which has been rated R (Under 17 requires accompanying parent or adult guardian), has a great deal of vulgar language.

1991 S 13, C1:1

Liebestraum

Directed and written by Mike Figgis; director of photography, Juan Ruiz Anchia; edited by Martin Hunter; music by Mr. Figgis; production designer, Waldemar Kalinowski; produced by Eric Fellner; released by Pathe Entertainment Inc. At Village Theater VII, Third Avenue and 11th Street, Manhattan.

Running time 105 minutes. This film is rated R.

Nick Kaminsky........................Kevin Anderson
Jane Kessler...........................Pamela Gidley
Paul Kessler...........................Bill Pullman
Mrs. Anderssen.......................Kim Novak
Sheriff Ricker.........................Graham Beckel
Barnett Ralston 4th..................Zach Grenier
Dr. Parker.............................Thomas Kopache

By JANET MASLIN

The plot of Mike Figgis's seductive "Liebestraum" is sheer madness, as crazy as the swing-time rendition of a Franz Liszt piano composition from which the film takes its title. Yet Mr. Figgis is very capable of teasing a voluptuous blend of danger and sexual possibility out of improbable raw material, as he made clear in his earlier "Stormy Monday" and "Internal Affairs."

This time, a watchful young architectural writer, a restless wife, a dying mother and a cast-iron department store become caught up in a mystery that harks back to a murder of nearly 40 years ago. As in Kenneth Branagh's current "Dead Again," the crime is born of sexual jealousy and lives on mysteriously to haunt a whole new generation. But if Mr. Figgis's film, which opens today at Village Theater VII, has an overabundance of the steaminess that is so absent from "Dead Again," it has a lot less in the way of narrative logic. The far-fetched denouement of "Dead Again" is small potatoes compared with the resolution that "Liebestraum" has in store.

Naturally enough, this story begins on a dark and stormy night. In the building that becomes the film's central metaphor, a man and woman meet for a tryst and are murdered by an intruder as the title music (with a name that translates roughly as "Dream of Love") is heard. The film's steady interweaving of sex, death and music, which reaches a wild peak in the story's closing sequences, is one of its more hauntingly effective aspects.

Many years later, Nick Kaminsky (Kevin Anderson) appears in the small town where the film began,

heading for a hospital to visit his dying mother, who gave him up as an infant and has never seen him. Ravaged and comatose, Mrs. Anderssen (Kim Novak) seems unlikely to see her son even now, but during the course of the story she rallies enough to make his acquaintance and to reveal secrets from the past. Meanwhile, Nick has also fallen under the spell of another woman: Jane Kessler (Pamela Gidley), the beautiful wife of Nick's old college friend Paul (Bill Pullman), the man who happens to be overseeing the dismantling of the handsome old department store. It is a given in Mr. Figgis's films that beautiful wives are complex, moody individuals with a habit of betraying their husbands.

Though "Liebestraum" lacks the casting electricity of the director's previous "Internal Affairs," which had Andy Garcia and Richard Gere to provide the sparks of sexual rivalry, Mr. Figgis can apparently find the smoldering side of any actor. Mr. Anderson, who made a bland nice-guy suitor in "Sleeping With the Enemy," is transformed here into a much sleeker figure. Bill Pullman, as the old friend who becomes Nick's sexual rival, is likewise given an unexpected edge. Ms. Novak, despite disheveled gray hair and shadowy makeup, looks absolutely stunning playing a character on her deathbed. It helps that Mr. Figgis can find sensuality even in the way a terminally ill woman might run her hands across her face.

Ms. Gidley, like all of Mr. Figgis's heroines, appears strong and self-possessed and still manages to seem a remarkable tease. That, of course, is the effect the film is always after. To that end, Mr. Figgis endlessly interrupts the flirtation between Nick and Jane and even goes so far as to link their incipient romance to architecture and death. Coming from a less skilled manipulator of moods, this might be more contrived, but Mr. Figgis is extremely good at what he does. Even an exchange of lines like "Would you like to see the menu?" and "I'm not hungry," when Nick talks briefly to a waitress in a restaurant, somehow resounds with an insinuating power that is best not examined too closely. There's genuine sultriness in "Liebestraum," but there's also a lot more heat than light.

●

The plot's dirty little secrets mix effectively with Mr. Figgis's own background music and with handsome camerawork by Juan Ruiz Anchia, who contributes greatly to the film's crisp yet shadowy style. The city of Binghamton, N.Y., in which this English director has found his quintessentially American architecture, has never looked better.

●

"Liebestraum" is rated R (Under 17 requires accompanying parent or adult guardian). It includes brief nudity, strong language and very frankly sexual situations.

1991 S 13, C6:1

M-G-M/Joyce Rudolph
Kevin Anderson

Blood and Concrete

Directed by Jeffrey Reiner; written and edited by Richard LaBrie and Mr. Reiner; director of photography, Declan Quinn; music by Vinny Golia; production designer, Pamela Woodbridge; produced by Mr. LaBrie; released by I.R.S. Media International. At Village East Cinemas, Second Avenue and 12th Street, Manhattan. Running time: 99 minutes. This film is rated R.

Joey Turks..............................Billy Zane
Mona.....................................Jennifer Beals
Hank Dick...............................Darren McGavin
Lance....................................James Le Gros
Bart......................................Mark Pellegrino
Spuntz...................................Nicholas Worth

By VINCENT CANBY

"Blood and Concrete," opening today at the Village East Cinemas, is a melodramatic comedy about Joey (Billy Zane), a good-looking, incompetent young Los Angeles hood, and Mona (Jennifer Beals), a sweet, vacuous, would-be rock singer, each of whom dreams of a better life.

They meet cute. Having just been stabbed by a man whose television set he was stealing, Joey runs into a cemetery to hide. Mona is sitting on the ground, burning snapshots of faithless lovers as she prepares to cut her wrists. When he collapses on top of her, she asks, "Are we dead?" He says he doesn't think so.

"Blood and Concrete" was directed by Jeffrey Reiner and written and edited by him and Richard LaBrie. The two first met 11 years ago at New York University's Tisch School of the Arts. This is a point worth noting since "Blood and Concrete" has the manner of a first feature (which it is for both) by people whose style, authority and invention don't yet match their great enthusiasm for film making.

●

"Blood and Concrete" is full of ideas and characters whose comic potential goes unrealized. At the heart of the story is a lost million-dollar stash of a new Los Angeles drug of choice. It is not only addictive, but it also has the effect of making its users helplessly amorous on the instant.

Poor Mona is an addict, but she's neither funny nor sad, just unpredictable. Among those who pursue Joey and Mona are a bumbling, over-age Los Angeles detective (Darren McGavin), a comparatively svelte, new-age type of Sidney Greenstreet villain (Nicholas Worth) and, in a new-age variation on the role that Elisha Cook Jr. once played, Mark Pellegrino as a small-brained thug recruited from Muscle Beach. James Le Gros appears as Mona's former lover, a rock musician whose normal state is hysteria.

Though the performers are all good, nothing much in the way of entertainment results. Ms. Beals, who made her debut in "Flashdance," gets to sing this time, none too spectacularly.

Watching "Blood and Concrete" is like listening to a dialect joke told by someone with a tin ear for dialects.

●

"Blood and Concrete," which has been rated R (Under 17 requires accompanying parent or adult guardian), has a lot of vulgar language and some violence.

1991 S 13, C9:1

A Matter of Degrees

Directed by W. T. Morgan; written by Randall Poster, Mr. Morgan and Jack Jason; music by various composers; produced by Roy Kissen; released by Fox/Lorber. At Village East, 11th Street at Third Avenue, Manhattan. Running time: 88 minutes. This film has no rating.

Maxwell Glass.........................Arye Gross
Kate Blum...............................Judith Hoag
Zeno......................................Tom Sizemore
Isabella Allen..........................Christina Haag
WITH: Joseph R. Paolino Jr. and John F. Kennedy Jr.

By JANET MASLIN

The Providence, R.I., that is celebrated in "A Matter of Degrees" is a geographical location, but it's mostly a state of mind. It's the undergraduate limbo enjoyed by Maxwell Glass (Arye Gross), who has just been accepted at law school but will not easily make the transition from late-1980's campus hippiedom to the corporate world. An opening montage, replete with public figures ranging from Abbie Hoffman to Ronald Reagan, reflects the confusing array of influences that have shaped Max's consciousness and left him just barely able to get out of bed in the morning. The idea of a grown-up law career seems remote at best.

"A Matter of Degrees," co-written by two Brown University alumni, Jack Mason and Randall Poster, with W. T. Morgan (who is the film's director), is extremely sympathetic to Max's predicament. So the film adopts an attitude of anti-professionalism very like its hero's, to the point where any of the normal plot contrivances that might shape Max's story become suspect. This means that "A Matter of Degrees" doesn't try very hard to tell a story. Instead, it drifts with Max from classroom to junkyard to corporate party, touching all the bases of a counterculture on the verge of extinction but still clinging to a distinctive world view. "Remember," someone remarks earnestly, "women and animals hold up two-thirds of the sky."

A remark like that transcends the limitations of campus life, but a lot of the film is more narrowly nostalgic. You may have had to be there, or at least to have spent time in a similar setting, to appreciate the film's very nonchalant approach to drama. The fact that Mr. Gross has been more at home in lovable-sidekick roles than he is as a leading man contributes further to the film's aimless feeling. The best of "A Matter of Degrees" is merely atmospheric and anecdotal. And a lot of it has the drifting feel of a good-natured anecdote without an ending.

"A Matter of Degrees," which opens today at Village East, does achieve a level of journalistic interest at times, in documenting the fact that there are courses in subjects like "Interdisciplinary Approaches to Ethnicity" and that "Ivan Boesky" can be used as a verb. Of a greedy friend who implements the corporate takeover of a once-independent college radio station, it is said, "He Ivan Boeskied it for them." The film also demonstrates, for anyone who's interested, that it's possible to make sandwiches out of white bread and undiluted canned soup.

In addition to Mr. Gross, who is amiable if not magnetic, the cast includes Tom Sizemore as Max's closest crony, Judith Hoag as his pert, feisty roommate and Christina Haag as a college temptress whose motives remain a bit more mysterious than

they have to be. Also seen briefly are Joseph R. Paolino Jr., the former Mayor of the film's beloved Providence, and John F. Kennedy Jr., who neither sings nor acts very well but can have a career in movies any time he cares to. As they used to say in Hollywood, the camera loves him.

1991 S 13, C9:4

Dogfight

Directed by Nancy Savoca; written by Bob Comfort; director of photography, Bobby Bukowski; edited by John Tintori; production designer, Lester W. Cohen; produced by Peter Newman and Richard Guay; released by Warner Brothers. At Loews Fine Arts, 58th Street, west of Fifth Avenue, Manhattan. Running time: 94 minutes. This film is rated R.

Birdlace	River Phoenix
Rose	Lili Taylor
Berzin	Richard Panebianco
Okie	Anthony Clark
Benjamin	Mitchell Whitfield
Rose Sr.	Holly Near
Marcie	E. G. Daily

By VINCENT CANBY

As her first film since her astonishingly fine debut as the director and co-writer of the independently produced (and independent-minded) "True Love," Nancy Savoca has made "Dogfight." It was not a great choice.

"Dogfight" is a wan love story about Birdlace (River Phoenix), a baby-faced marine, and Rose (Lili Taylor), the sweet spunky girl he finds in San Francisco the night before he ships out for — are you ready? — "a little country near India, called Vietnam."

Since the time is 1963, one might reasonably expect that Birdlace could assume that Rose had heard of Vietnam. Rose is not supposed to be stupid. She's a would-be folk singer who says of folk singers, "They're the ones who make things happen."

Further, since a screen card specifically sets the time as November 1963, the movie promises to make portentous connections between the young lovers and the events in a Texas city whose identity, in the spirit of Bob Comfort's coy screenplay, should not be revealed.

The dogfight of the title refers not to aerial combat but to a particularly cruel joke that Birdlace and his pals arrange as a lark for their last night Stateside. Each of the marines chips in $50 to throw a party, the high point of which is an ugly-girl contest. The marine whose date is judged to be the worst dog gets the pot.

•

One fellow finds a rather traditional American Indian squaw. Another brings a transvestite and still another a hooker without her false teeth. Birdlace finds Rose in a lunchroom run by her mother, who is played for no particular reason by Holly Near, a singer of folk songs in real life but not in this film.

Rose is a little overweight, yet she's hardly a dog as these marines use the term. The most curious thing about her is that she dresses like, and slightly resembles, Nancy Walker when Ms. Walker played Judy Garland's best friend in "Girl Crazy," though "Girl Crazy" was made in 1943, not 1963.

After thoroughly humiliating Rose at the party, Birdlace attempts to atone by taking her out to a fancy restaurant, walking around the city

Warner Brothers

Lili Taylor and River Phoenix

with her and finally going home with her. All the way. "Dogfight" ends with a beautifully staged and acted sequence that, if the rest of the movie were better, would be irresistible.

The extraordinary thing about "True Love," written by Ms. Savoca and her husband, Richard Guay, was the way in which it managed to reveal the secret lives of ordinary people without either sending up the characters or idealizing them. The authenticity of gesture and language and locale created a kind of meta-reality not seen since the early television work of Paddy Chayevsky.

"Dogfight" — which opens today at the Loews Fine Arts — seems to have no clear idea of what these ordinary people are really like. The film wants to be honest (and in its cruelties, it is), but the operative sensibility is that of a sitcom world. The characters aren't necessarily idealized, but they are flat and uninteresting. The material is lugubrious. The only seemingly spontaneous moment comes at the very end, which is too late.

The performances are neither good nor bad. The actors do what is required. That's all.

•

"Dogfight," which has been rated R (Under 17 requires accompanying parent or adult guardian), has a lot of vulgar language.

1991 S 13, C13:1

Freddy's Dead

Directed by Rachel Talalay; screenplay by Michael DeLuca, story by Ms. Talalay, based on characters created by Wes Craven; director of photography, Declan Quinn; edited by Janice Hampton; music by Brian May; production designer, C. J. Strawn; produced by Robert Shaye and Aron Warner; released by New Line Cinema. Running time: 96 minutes. This film is rated R.

Freddy Krueger	Robert Englund
Maggie	Lisa Zane
John	Shon Greenblatt
Tracy	Lezlie Deane
Carlos	Ricky Dean Logan
Spencer	Breckin Meyer
Doc	Yaphet Kotto

By JANET MASLIN

"Every town has an Elm Street!" Freddy Krueger (Robert Englund) hootingly declares in "Freddy's Dead: The Final Nightmare," a film that also begins with a quotation from Nietzsche. Has Freddy been reading his own press? Has he begun to grasp the larger implications of the "Nightmare on Elm Street" series, with its hellish dreams tailored to fit each character's individual fears? Has he grown jaded? If so, it's a lucky thing that the ending of this so-called last installment really does leave Freddy in small pieces, more or less as promised.

The "Elm Street" series, now in its sixth chapter, is apparently coming

New Line Cinema

Lisa Zane, left, as a dream therapist, with Robert Englund, as Freddy Krueger, in a scene from "Freddy's Dead: The Final Nightmare."

to a close before it runs out of gas, thus displaying the kind of class not usually found in the horror genre. No wonder: the Elm Street films have always been a cut above the competition, so to speak, with their playfully malevolent dream sequences and their mocking, ever-resourceful villain. But before mourning Freddy's demise, it might be wise to see whether "Freddy's Dead" generates as much overall interest as it did at the National Theater, where it opened to a sizable audience yesterday. Much-publicized media deaths have a way of being notoriously reversible.

•

Having resisted fire, holy water and premature burial in earlier installments, Freddy has successfully whittled the population of Springwood, U.S.A., down to a few demented adults (Roseanne and Tom Arnold make brief appearances, as does Alice Cooper) and only one teen-ager, an amnesiac known as John (Shon Greenblatt). Branching out into a shelter for wayward youngsters, Freddy seems on the verge of a whole new career. But in stalking John along with these other new victims, he runs into trouble in the form of his own long-lost child.

Attempts at a family reunion are laced with typically heavy sarcasm and culminate in a sustained, effective 3-D sequence that sends Freddy's child into Freddy's unconscious to lure him out of the world of dreams. When used to dramatic effect and in this kind of limited capacity, 3-D can actually be a treat instead of a headache.

•

Although most of the film's characters are afraid of sleep (one is heard singing "4,566 Bottles of Beer on the Wall" in an effort to resist it), they all join Freddy in fantasyland sooner or later, with results that can be ghoulishly ingenious. A deaf boy is treated

to an ear cleaning by Freddy. And a marijuana smoker finds himself drawn into psychedelic and video-game visions inside his television set. "Great graphics!" exclaims Freddy, who sits with hand controls manipulating his hapless victim as if the boy were Super Mario.

Mr. Englund, playing the Halloween favorite whom audiences love to hate, now delivers lines like this with the broadness of a latter-day Jimmy Durante. But he sustains Freddy's peculiar charm even when appearing without ghastly makeup in scenes of Freddy's early years. Also in the cast are Lisa Zane as a pretty but somewhat subdued dream therapist, Yaphet Kotto as her more dynamic coworker, Ricky Dean Logan and Breckin Meyer as potential victims, and Lezlie Deane as a teen-age athlete ready to give Freddy a taste of his own medicine. He deserves it.

•

"Freddy's Dead: The Final Nightmare" is rated R. The film includes considerable violence and strong language.

1991 S 14, 11:4

FILM VIEW/Caryn James

'Dogfight' Wears Camouflage

THERE ARE SOME UNEASY MOMENTS EARLY in "Dogfight," as the camera searches for ugly women. The director Nancy Savoca rushes into dangerous territory with a story that is a minefield of potential insults: marines, on their last night before heading out to Vietnam, stage a contest to see who can pick up the least appealing date.

The camera assumes the marines' point of view as they wander through San Francisco in 1963, when "hippie" still meant a woman whose hips were too big. To these men, ugly is a woman with a beehive hairdo, cat's-eye glasses and a very prominent nose. Ugly is a squat, round-faced American Indian with no makeup and unfashionable long braids. And in one memorable case, ugly is a woman with too much makeup and too few teeth. There seems to be something here to offend everyone, from yahoo marines to fat ladies to people with improper dental care.

But "Dogfight" turns out to be quite a subversive little film. This intelligent, affecting movie undermines its own macho premise, tosses out conventional images of beauty and turns at least one movie cliché upside down. As in "True Love," her shrewd, 1989 comedy about an Italian-American wedding, Ms. Savoca reinvents an old story and creates astonishing sympathy for characters who are making wrongheaded decisions as fast as they can.

The screenwriter, a former marine named Bob Comfort, has said that "Dogfight" is "sort of a goodbye" to friends killed in Vietnam. But what appears on screen is the rather different tale of a gentle-spirited young marine named Birdlace (River Phoenix), who is not strong or mature enough to break away from the pack. And "Dogfight" is, even more, the story of the woman he picks up, a shy, frumpy, slightly overweight teen-ager named Rose, touchingly played by Lili Taylor.

When Birdlace sees Rose in her lumpy waitress uniform, practicing the guitar in her mother's coffee shop, he thinks he has found his best shot at a winning dog. Even then, Ms. Savoca makes it clear that Rose is not ugly, just average. Her unattractiveness has more to do with the self-effacing way she holds her head down, creating a conspicuous double chin, than it does with her ordinary features. Sometimes her

Warner Brothers

Lili Taylor as Rose, the shy, frumpy, overweight teen-ager in "Dogfight"—touchingly played

Forget the marines. Nancy Savoca's movie is really about being a plain Jane.

unattractiveness appears on her face, when she holds her mouth open and looks not very smart. Part of it is simply the flipped-up 1960's hairdo that seems to belong in a museum.

But if Rose is not ugly, she is not a swan, either. She is not the conventional Hollywood Plain Jane, the stereotypical secretary with glasses and her hair in a bun, who can turn herself into a sexpot in a second.

The character's matter-of-fact plainess becomes most striking in an eloquent but apparently minor scene whose importance sneaks up on the viewer. Rose accepts Birdlace's invitation to the dogfight party and, unaware that he wants her to be ugly, goes off to try to make herself pretty. As she tries on one dress after another, it is not her imagination that makes one look too fussy, another too plain and nothing just right. Rose clumsily puts on blue eye shadow and tosses more clothes on the bed until she is nearly in tears of frustration.

This is a scene that subverts every Hollywood transformation sequence, from Janet Gaynor being made over in "A

Star Is Born" in 1937 to Julia Roberts shopping on Rodeo Drive in last year's "Pretty Woman." It is the reverse image of Natalie Wood dancing in front of her mirror, lip-synching "I Feel Pretty" in "West Side Story" (1961). Rose, it seems, will never feel pretty, and her eager, frustrated attempt to look good for Birdlace is heartbreaking.

When Rose joins Birdlace on the street, he tries to talk her out of the party; she doesn't look doggy enough anymore. She appears to be what she is, a nervous young woman who has tried extremely hard to look her best, wearing a frilly yellow party dress and a fussy barrette in her hair.

Though the film starts with Birdlace and his buddies, with this non-transformation scene Ms. Savoca deftly turns the film over to Rose. Ms. Taylor conveys Rose's loneliness and insecurity in a performance that is

As in 'True Love,' the director reinvents an old story and creates great sympathy for her characters.

free of vanity. Some actresses would have drawn attention to the fact that they were "playing plain" and would look gorgeous in the next picture. But Ms. Taylor, who was such a forceful and vibrant personality as Jojo, the reluctant bride in "Mystic Pizza" (1988), hides herself in the character. Rose's insecurity is so strongly evoked that it is even possible to

understand why, after she learns she has been entered in an ugly-contest, she accepts Birdlace's apology and agrees to go out with him on a real date. The film tries to suggest some hidden empathy between Birdlace and Rose. In fact, her decision makes sense only because we have seen how desperately lonely she is.

Rose's attitude so infuses the movie that Birdlace's friendship with the other marines and his need to brag about his mythical conquest of a beautiful older woman have the aura of a strange tribal ritual. But that ritual is obviously of deep importance to them.

"Dogfight" turns wrong at the close. Its natural dramatic end comes about 10 minutes before the movie finishes with an unfathomable epilogue. And the period setting makes the ugliness issue less volatile than it deserves to be. It is too easy to say that these "dogs" are victims of yesterday's fashion and of prehistoric, unenlightened males.

"Dogfight" is, finally, not about being a marine or being ugly — its ostensible dramatic subjects. It is about being a woman and being plain. But if Ms. Savoca had said she intended to make a movie about an insecure, ordinary woman, who would have listened? □

1991 S 15, II:13:5

Black Lizard

Directed by Kinji Fukasaku; screenplay by Masashige Narusawa (in Japanese with English subtitles), based on original novel by Edogawa Rampo; cinematographer, Hiroshi Dowaki; music by Isao Tomita; released by Cinevista. At Film Forum 1, 209 West Houston Street. Running time: 86 minutes. This film has no rating.

Black Lizard Akihiro Maruyama
Detective Akechi.......................... Isao Kimura
Jeweler .. Junya Usami
Sanaye...................................... Kikko Matsuoka
With: Yukio Mishima

By VINCENT CANBY

Kinji Fukasaku's 1968 Japanese film, "Black Lizard," can be more easily described than categorized, more easily seen than believed, and rather more easily enjoyed than common sense should allow.

Even then it's a mystery. It opens today at Film Forum 1 and may well equal the success there of "Paris Is Burning."

"Black Lizard" has the manner of a 1940's Monogram Pictures serial that has been jazzed up and reinterpreted by film makers strongly influenced by Fritz Lang and Jean Cocteau. Yet the final result also evokes "What's Up, Tiger Lily?" (1966), Woody Allen's re-edited, totally incomprehensible, English-dubbed version of a third-rate Japanese spy picture.

Here, is a tale of love, passion, greed and necrophilia in which, at one point, Japan's would-be Nobelist in literature, Yukio Mishima, appears as the perfectly embalmed image of himself. Mishima's appearance is not an inside joke.

The film, made two years before his suicide, is based, in part, on his stage adaptation of a story by a Japanese writer whose pen name was Edogawa Rampo, which is the Japanese way of pronouncing Edgar Allen Poe, transliterated back into English.

At the center of the film is Black Lizard herself, a stately queen of Tokyo crime, played more or less straight but in spectacular drag by a celebrated female impersonator, Akihiro Maruyama.

Mr. Maruyama, who changed his name to Miwa after Mishima's suicide, was the writer's discovery and his choice to star in the stage play and then in the film. Mishima was apparently fascinated by Mr. Maruyama's art, by the blurring of identities it represented and by the notion that a man, as an outsider, might somehow capture the essence of femininity more pristinely than a woman.

All of these bits and pieces of information are pertinent since, I suspect, "Black Lizard" was never intended to be simply the high camp spectacle it will be seen to be here. Exactly what it was intended to be is not clear, possibly a meditation on Japanese sexuality and movie fiction, but certainly something more than a feature-length joke.

Passion, greed, necrophilia and Yukio Mishima as himself embalmed.

In his various wigs, jewels, figure-hugging gowns and marabou feathers, Mr. Maruyama is not sending up the femme fatale as much as he is epitomizing a kind a cracked ideal. He is tall, willowy and utterly humorless, which is not to say that he isn't funny. The effect is sometimes funny, but the actor never stands apart from himself to direct the audience's attention to the parody.

•

After making "Black Lizard," Mr. Maruyama went on to have a successful career as a nightclub singer and stage actress, playing, among other roles, Queen Margaret in "Richard III," Judith Bliss in Noël Coward's "Hay Fever" and Marguerite Gautier in "La Dame aux Camélias."

Mr. Fukasaku, a director of some reputation in Japan, treats the outlandish material with the same sort of gravity, which invites audiences to make of it what they will. The movie disorients in a thoroughly modern sort of way. It never appears to seek laughter, though it is a hoot. The following is only a partial synopsis:

Black Lizard, longing to obtain a priceless diamond known as the Star of Egypt, plots to kidnap and hold for ransom the pretty young daughter of the jeweler who owns the stone.

The jeweler hires a private detective to protect his daughter. Black Lizard suddenly finds herself obsessed equally by her desire to possess the Star of Egypt, the jeweler's daughter and the private detective. Her sexual orientation is flexible and, finally, fatal.

The film's concluding sequence, which would do credit to any Saturday afternoon serial, is set on Black Lizard's private island, where she keeps her treasures, including her embalmed former lovers.

The English subtitles are suitably ornate. Black Lizard is attracted to the detective for his "deep and romantic attachment to crime." He, too, is strangely drawn to her, though when the chips are down, he resists. Says Black Lizard, "You trample cruelly on a woman's heart."

"Black Lizard" will leave you speechless. Well, almost.

1991 S 18, C13:1

Undertow

Written and directed by Thomas Mazziotti; director of photography, Kevin Lombard; production design, Michael Moran; edited by John Carter; produced by Burtt Harris and Mr. Mazziotti; released by Capstone Films. Running time: 95 minutes. This film has no rating.

Sam...Peter Dobson
Mel ... Burtt Harris
Nina .. Erica Gimpel
Marlene..Anita Gillette
William Gary Greg Mullavey
Hustler Thomas Mazziotti

There aren't enough therapists in the world to sort out the father-son problems in "Undertow," much less sort out the plot of this painfully solemn, visibly low-budget film. Mel is a convict who will be released if he goes along with an F.B.I. scheme. All he has to do is find a young man willing to be videotaped having sex with Congressman Gary, who happens to be gay and launders drug money in his spare time. The Government will take care of the blackmail.

Though Mel seems like a pretty normal guy, he decides to use his son, Sam, as the sex bait. The deal will help get the corrupt kid back on the police force. Sam isn't even homosexual, but how can he turn down the old man? Maybe this story would have worked better as satire or as tragedy. But "Undertow" gropes toward some fuzzy connection between Government corruption and the characters' willingness to sell out.

Burtt Harris, who plays Mel, has had a long career as a producer of major films, including "The Verdict." His involvement must have given this first feature by Thomas Mazziotti, the writer and director, a legitimacy that the movie itself does nothing to earn. There is no explicit sex, so "Undertow" is less lurid than it might have been. It is, however, even more ridiculous than it sounds.

CARYN JAMES

1991 S 18, C16:3

Paradise

Directed by Mary Agnes Donoghue; screenplay by Miss Donoghue; director of photography, Jerzy Zielinski; edited by Eva Gardos and Debra McDermott; music by David Newman; produced by Scott Kroopf and Patrick Palmer; production designers, Evelyn Sakash and Marcia Hinds; released by Touchstone Pictures. At Cinema 1, Third Avenue at 60th Street. Running time: 109 minutes. This film is rated PG-13.

Lily Reed...............................Melanie Griffith
Ben Reed....................................Don Johnson
Willard Young................................Elijah Wood
Billie Pike Thora Birch
Rosemary...Eve Gordon

By JANET MASLIN

The world's best-looking shrimp fisherman and its sexiest stay-at-home country wife can be found in "Paradise," a decorative American remake of the popular 1987 French film "Le Grand Chemin." Don Johnson and Melanie Griffith, playing a married couple who have grown bitter and estranged after a family tragedy, are only a part of this film's larger prettiness. There are birds; there are animals; there is swelling, sensitive music to accompany any twinge of emotion. The screenplay is equally atmospheric, filled with lines like: "Would you pick some blueberries for me? There's a trellis right by the garage."

The terrible loss that has befallen Ben Reed (Mr. Johnson) and his wife, Lily (Ms. Griffith), is set forth in similarly picturesque terms when Lily appears in her attic wearing a long white nightgown, clasping a child's jacket and looking plaintively toward the heavens. It is thus revealed that Ben and Lily have lost their young son, which makes "Paradise" a lot more wrenching than the sweet, slow-paced screenplay by Mary Agnes Donoghue (who also directed) would otherwise allow it to be.

The story is told from the standpoint of 10-year-old Willard Young (Elijah Wood), who comes to live with the Reeds in a town called Paradise after suffering a loss of his own; Willard's father has deserted his family, and the boy's mother has sent him off temporarily to be cared for by friends. Solemn and wise — and unaffectedly good, when Mr. Wood is not asked to be too precocious by the screenplay — this boy eventually helps Lily and Ben to acknowledge their unhappiness and try to face each other again.

Willard and his new friend Billie Pike (Thora Birch), a spirited 9-year-old tomboy with whom he shares many a tender moment, are pointedly natural in a way that makes the film's pastoral French origins clear. Mr. Johnson and Ms. Griffith are less constrained, although neither of them seems fully at home in the film's picture-perfect version of a rustic setting. But Ms. Griffith, though always a shade more glamorous than her character is meant to be, brings obvious and stirring emotion to Lily's attempts to express her grief. Mr. Johnson, who has the more pivotal role, brings Ben convincingly from an attitude of quiet distaste for life to a cautious renewal of hope and feeling.

Mr. Johnson, still casting around for the right kinds of movie roles, can be surprisingly effective playing simple men in plain surroundings, as he is called upon to do here. But the dialogue sometimes forces the character into undue flights of delicacy and introspection. "What's happened to me? How'd I get to be this person?" Mr. Johnson must ask late in

Cinevista/Film Forum
Akihiro Maruyama, left, and Yukio Mishima in "Black Lizard."

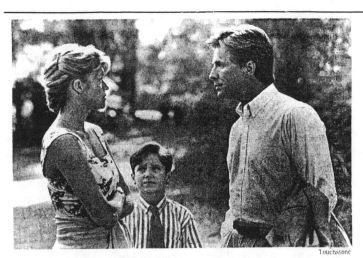

Touchstone

Melanie Griffith and Don Johnson, with Elijah Wood, in a scene from "Paradise."

the story, delivering lines that no actor could handle with equanimity. "I hate Sundays," he says bitterly, after a church service. "So dead. Dead and quiet."

Ms. Donoghue, who wrote "Beaches" along with a number of unproduced screenplays, periodically saddles her actors with dialogue that reads better than it plays. Her direction, which is mostly gentle and straightforward, also occasionally slips into moments that deny the verisimilitude of the story. At one such time, Billie and Willard sit in a tree beside a graveyard, playfully dropping worms onto the hats of mourners while a funeral service is being held. At this, the mourners and priest simply run away.

•

The sequence isn't credible, it isn't funny, and it isn't even necessary. Ms. Donaghue has simply used it as a roundabout way of positioning the children in the cemetery so that they can observe something else that occurs there, something that could have been revealed in less obvious ways. Incidentally, for some reason the film makers constructed their own rural South Carolina cemetery instead of using a real one.

•

"Paradise" is rated PG-13 (Parents strongly cautioned). It includes brief nudity and some precocious sexual curiosity on the part of the children.

1991 S 18, C16:3

The Indian Runner

Directed and written by Sean Penn; inspired by the song "Highway Patrolman" by Bruce Springsteen; director of photography, Anthony B. Richmond; edited by Jay Cassidy; music by Jack Nitzsche; production designer, Michael Haller; produced by Don Phillips; released by the Mount Film Group. Running time: 125 minutes. This film is rated R.

Joe	David Morse
Frank	Viggo Mortensen
Maria	Valeria Golino
Dorothy	Patricia Arquette
Father	Charles Bronson
Mother	Sandy Dennis

By JANET MASLIN

"Highway Patrolman," the haunting Bruce Springsteen song that Sean Penn's film "The Indian Runner" is "inspired by" (to cite the diplomatic

wording of the credits), tells of the troubled love between two brothers. Joe, the police officer of the title, struggles to reconcile his civic duty with the responsibility he feels to his kin. Frankie, Joe's violent and unpredictable brother, does nothing to make this easy. As Mr. Springsteen puts it, narrating desolately from Joe's standpoint: "I got a brother named Frankie and Frankie ain't no good."

The succinctness of that is hard to beat. Yet Mr. Penn has tried — and succeeded to a surprising degree. Devoting more than two hours to the embroidering of a five-minute song, he has reached for a ragged emotional reality that recalls the films of John Cassavetes (one of those to whom "The Indian Runner" is dedicated), and he has framed even his film's most unruly episodes with unexpected delicacy. Loose, rambling

Michael Tighe

Charles Bronson

and sometimes rudderless as it is, "The Indian Runner" has a fundamental honesty that gives it real substance.

Flirting constantly with the dangers of pure self-indulgence, Mr. Penn still manages to keep the improvisatory quality of this painful family drama from becoming overwhelming. For all its hazy excesses, the film seldom loses sight of its story's raw essence. That lies in the tensions between quiet, upright Joe Roberts (David Morse) and the mercurial Vietnam veteran Frankie (Viggo Mortensen), as well as in the backdrop of economic hardship that has shaped the lives of their parents (Charles Bronson and Sandy Dennis).

•

It can also be found in the alternating flashes of viciousness and sweetness between Frankie and his childlike girlfriend, Dorothy (Patricia Arquette), and in the fascination with which Joe observes his brother's

frightening excesses. Mr. Penn is able to identify the underlying similarities between these two brothers, despite their very different behavior, without overstating the case.

As moody and volatile as the problematic Frankie, "The Indian Runner" starts off with a killing and sustains a threat of possible violence throughout even its gentlest episodes. That threat is especially evident in the presence of Mr. Mortensen, a magnetic actor capable of both scary outbursts and eerie, reptilian calm. (Mr. Penn's own acting style is strongly echoed in this performance.) It is some measure of Mr. Mortensen's savage, mocking ferocity that in a final confrontation with Dennis Hopper, who plays a bartender given to in-your-face philosophizing, Mr. Hopper seems easily the tamer of the two.

In probing the psyche of a wounded, incorrigible loser like Frankie, Mr. Penn is not surprisingly apt to do some posturing of his own. If this film has heart, it also has attitude to spare. A man whose son has been killed bursts into an angry, defiant chorus of "John Henry"; the figure of the title (from a Plains Indian legend commingling the hunter with his prey) runs through the film in whiteface; the characters are much more apt to say things like "Hey there" than "Honey, I'm home." There are also a bearded lady, a few wellwrought montages that don't truly connect the events they encompass, a graphic childbirth sequence and an exaggerated element of country corn. "She sure could make a good apple pie," it is said of someone who has lately died.

•

Mr. Penn's direction of actors seems to have been most critical at the casting level; after that, the right people — and they are the right people — have mostly been put in place and studied with great interest by Anthony B. Richmond's adroit cinematography. Mr. Morse, as Joe, radiates stolidity, kindness and a trace of repressed yearning; Valeria Golino, as his wife, Maria, displays a lovely vitality. Ms. Arquette, with a Jean Seberg haircut and a baby-faced innocence, is a perfect visual counterpoint to the darkly menacing Mr. Mortensen.

Mr. Bronson and Ms. Dennis are unlikely but strangely effective as the dazed, determinedly polite parents who have lost their moorings. "He's a very restless boy, that Frankie," says Mr. Bronson, in what sounds like a prime example of the film's improvised style, and of its poignant understatement. "That's what got him into trouble, you know."

•

"The Indian Runner" is rated R (Under 17 requires accompanying parent or adult guardian). It includes strong language, violence and explicit scenes of childbirth.

1991 S 20, C6:1

Late for Dinner

Directed by W. D. Richter; written by Mark Andrus; director of photography, Peter Sova; edited by Richard Chew and Robert Leighton; music by David Mansfield; production designed by Lilly Kilvert; produced by Dan Lupovitz and Mr. Richter; released by Castlerock Entertainment. Running time: 89 minutes. This film is rated PG.

Willie Husband	Brian Wimmer
Frank Lovegren	Peter Berg
Joy Husband	Marcia Gay Harden
Jessica Husband	Colleen Flynn
Leland Shakes	Kyle Secor
Dr. David Arrington	Michael Beach
Bob Freeman	Peter Gallagher
Little Jessica Husband	Cassy Friel
Little Donald Freeman	Ross Malinger

By JANET MASLIN

Of all the questions to ask about a loved one, surely this is the least pressing: how would you get along if you were suddenly separated by an extra 29-year age gap? Yet this matter is central to "Late for Dinner," a time-travel story that suffers from temporal problems of its own. Arriving in the shadow of the "Back to the Future" series, this light romantic comedy adds little to what is already known about how disorienting it can be to wake up in the wrong decade. Even the obligatory Ronald Reagan double-take ("Someone shot the guy from 'Cattle Queen of Montana'?") sounds less than new.

This odd film was directed by W. D. Richter, whose even odder 1984 "The Adventures of Buckaroo Banzai" had a much more confident brand of eccentricity. Here, the burden of being heartwarming as well as funny becomes a constraint. And the humor itself is apt to show up in odd places, as in the running kidney-failure references that are actually quite important to the plot. One of the story's two heroes, the cheerfully dim-witted Frank (Peter Berg), is stuck in 1962 with the kind of kidney problems that only a 1991 kidney transplant can cure.

Castle Rock

Returning
Marcia Gay Harden and Brian Wimmer star in "Late for Dinner." W. D. Richter's romantic comedy, about two friends who try to resume their lives in 1991 after being frozen for 29 years.

The time-traveling of Frank and his brother-in-law Willie (Brian Wimmer) is also prompted by a run-in with a corrupt land developer (made very funny by Peter Gallagher). Thinking themselves crime suspects after a confrontation with him, they are eager to escape their 1962 set of problems. The screenplay, by Mark Andrus, sends them straight into the path of a cryonics expert looking for guinea pigs, and the next thing they know Willie and Frank are thawing out in the future. Once there, they marvel at things like fast food, male telephone operators and automatic teller machines ("Willie! That wall here just gave that lady money!"). They also decide that rap and heavymetal music must be playing at the wrong speed.

"Late for Dinner" builds toward a reunion between Willie and his wife, Joy (Marcia Gay Harden), not to mention the daughter (Colleen Flynn) who is now just about her father's age. The film takes a long time to reach this point, and it takes a sharp turn toward sentimentality when it finally gets there. Willie's reunion scene with his long-lost wife, touchingly acted by Mr. Wimmer and especially Ms. Harden, changes the mood significantly by giving the heartstrings an unexpected tug. It is literally at the last minute that this mild, modest film becomes anything more than slight.

•

"Late for Dinner" is rated PG (Parental guidance suggested). It includes mild profanity and sexual references.

1991 S 20, C6:5

The Fisher King

Directed by Terry Gilliam; written by Richard LaGravenese; director of photography, Roger Pratt; edited by Lesley Walker; music by George Fenton; production designer, Mel Bourne; produced by Debra Hill and Lynda Obst; released by Tri-Star Pictures. Running time: 135 minutes. This film is rated R.

Jack	Jeff Bridges
Parry	Robin Williams
Anne	Mercedes Ruehl
Lydia	Amanda Plummer
Homeless Singer	Michael Jeter

By JANET MASLIN

The cry of contrition that is sounded in "The Fisher King" can be heard long after the film is over. In bringing a jaded late-1980's celebrity to the brink of destruction and then allowing him to do penance for his cynicism, this film strikes at the heart of something disturbingly real. That, apparently, was not enough for the film makers, who have feverishly piled on elements of whimsy, mythology and romance to what was never a simple concept in the first place. The likelihood of creating an unholy mess is further heightened by the throwing in of the Holy Grail.

Yet "The Fisher King," directed by the ever-fanciful Terry Gilliam from an ingenious if loose-knit screenplay by Richard LaGravenese, is capable of great charm whenever its taste for chaos is kept in check. For every wild ride through Manhattan by an imaginary Red Knight trailing billows of flame, there is a small, comic encounter in a more down-to-earth mode.

The source of much of this appeal is obvious: the film's stars, particularly Jeff Bridges as a fallen radio star and Mercedes Ruehl as the sweetly flamboyant video-store owner who loves him, bring an emotional authenticity to material that could easily have had none. Only Robin Williams, as a gentle soul who has been left homeless and driven half-mad by grief, is allowed to chatter aimlessly, cavort naked in Central Park and generally go overboard.

•

"The Fisher King" begins stunningly well with a few glimpses of Jack Lucas (Mr. Bridges), a sleek, mean-spirited radio bully who is quite literally on top of the world. Seen in his fashionably dehumanized high-rise apartment, or in his limousine, sneering at a pandhandler from behind dark glasses, Jack is instantly emblematic of the cold-hearted excesses of his time. As the deejay sits

in his bathtub, Mr. Gilliam, working with rare restraint, and Mr. Bridges, abandoning all traces of his usually ingratiating manner, create a chillingly indelible image of Jack's spiritual emptiness. His face caked eerily with a rejuvenating cosmetic mask, Jack tries repeatedly to master the line "Hey, forgive me!" for a possible role in a television show.

Moments later, Jack's career has ended and his quest for real forgiveness has begun. A deranged caller on Jack's radio show, taking his cue from the host's insults, has committed mass murder in a yuppie bar. When Jack is next seen, three years later, he is as demoralized and barren as the mythical figure for whom the film is named. He now looks disheveled and lives listlessly with Anne Napolitano (Ms. Ruehl), who has clearly not been successful in rekindling his spirits. The only things that attract Jack's notice are unfortunate ones, like the fact that the television series that treated "Hey, forgive me!" as a comic punch line has gone on to become a hit without him.

Jack is at the end of his rope, almost literally, when he meets Parry (Mr. Williams), the colorful derelict who takes many of his cues from visions of "hundreds of the cutest little fat people floating right in front of me." Parry, who lives in a drab, industrial boiler-room setting that recalls the look of Mr. Gilliam's earlier "Brazil," turns out to be a casualty of the yuppie-bar tragedy, and as such he holds forth the possibility of Jack's redemption.

•

So Jack begins devoting himself to rehabilitating Parry, which will turn out to be a two-pronged mission. He must help Parry win the woman he loves, a shy eccentric (Amanda Plummer) who is adorable to Parry even when she accidentally drops dumplings onto her lap. And he must reclaim the Holy Grail from the place where Parry is sure, in today's world, that it must reside: a billionaire's apartment on Fifth Avenue. "Who'd think you could find anything divine on the Upper East Side?" Parry wisecracks in typically facile style.

The screenplay's enthusiasm for the mythological aspects of the story is clearly genuine, and the central myth indeed seems apt in a modern setting. But "The Fisher King" still strains to accommodate it, perhaps because so much other antic activity is allowed to swirl around on the sidelines. Even though Mel Bourne's production design fuses the modern and the medieval in fascinating ways, the narrative itself often seems confused and cluttered.

The film's flights of fancy begin to derail its story line very soon after Jack's fall from grace, and by the tale's strange and equivocal last episodes this shapelessness has become exhausting. Mr. Gilliam, though working in a much more controlled style than usual, nonetheless often chooses to sustain a funhouse atmosphere at the expense of dramatic development. What emerges, in the end, are a clever premise that has been allowed to go awry and several performances that are lively and unpredictable enough to transcend the confusion. Mr. Bridges, always a fine intuitive actor, has never displayed a greater range.

Mr. Williams, when not off on any of his various tangents, brings a disarming warmth and gentleness to the fiendishly comic Parry. Ms. Ruehl again proves herself to be a fiery comedian graced with superb timing.

Ms. Plummer gives the film's most restrained performance, which will provide some idea of the others. And Michael Jeter is heartbreakingly funny in a brief turn as a frenetic gay singer who does a mean Ethel Merman impression and also momentarily works the thought of AIDS into the film's overripe atmosphere. The best parts of "The Fisher King" and its mad, whirling vision of modern life are those that see grief lurking just beneath the surface.

•

"The Fisher King" is rated R (Under 17 requires accompanying parent or adult guardian). It includes brief nudity, off-color language and sexual references.

1991 S 20, C10:4

Rambling Rose

Directed by Martha Coolidge; screenplay by Calder Willingham, based on his book; director of photography, Johnny E. Jensen; edited by Steven Cohen; music by Elmer Bernstein; production designer, John Vallone; produced by Renny Harlin; released by Seven Arts through New Line Cinema. Running time: 112 minutes. This film is rated R.

Rose	Laura Dern
Daddy	Robert Duvall
Mother	Diane Ladd
	Lukas Haas
Willcox Hillyer	John Heard
Dr. Martinson	Kevin Conway
Dave Wilkie	Robert Burke
Doll	Lisa Jakub
Waskie	Evan Lockwood

By CARYN JAMES

Before you can get to the wry tone and strong-willed people of "Rambling Rose," you have to sit through a short corn-pone opening. In 1971, a middle-aged man drives to his hometown in Georgia. He is heading toward a flashback about the dusty old days when he was a 13-year-old called Buddy, with a life-shaping crush on a sweet but wild young woman named Rose.

As the adult Buddy Hillyer, John Heard assumes a hopeless Southern accent to say, "In deep Dixieland, the month of Octobah is almost summry," a line worth mentioning only because it so glaringly sets the wrong tone. "Rambling Rose" sounds like it will be full of molasses, but when the story moves back to 1935, it becomes honest, engaging and quite a lot like its perky, disreputable heroine.

Rose (Laura Dern) has been sent to work as the Hillyers' servant because too many men have pursued her at home. Or was it the other way around? As she approaches the yard, she manages to looks innocent, gawky and provocative with no effort at all. Her blond ringlets peek out from her close-fitting hat and her long legs are clearly visible beneath her sheer flowered dress — a dress worn, we're meant to notice, without a petticoat.

The Hillyer household is full of types, and the casting is pat. Diane Ladd is the smart but slightly loony mother, who takes off her hearing aid to work on her master's thesis for Columbia University. When Mother talks about the mystical meaning of the universe, her crusty, gentlemanly husband (Robert Duvall) says she is "lost in the fourth dimension" again. Lukas Haas plays the precocious Buddy. Along with Ms. Dern as the sexually eager young thing, the actors are superb, though they have all played these types too often for any-

Carolco

Alluring
In "Rambling Rose," Laura Dern plays a sexually free woman who moves in with a Southern family during the Depression.

one to be surprised at how good they are here.

•

Yet "Rambling Rose" always finds some fresh angle. The younger children, a girl called Doll Baby and a boy called Waski, are already shrewd enough to realize that their nicknames are ridiculous.

And when Rose becomes as drastically infatuated with Mr. Hillyer as Buddy is with Rose, the situation produces two improbably sweet and funny near-sex scenes. First Rose stops washing dishes and flings herself onto Mr. Hillyer's lap, begging to be kissed, while Buddy and Doll peek in through the kitchen door. The children don't actively take sides, but seem to be rooting for Rose. Mr. Hillyer comes to his senses and is incredulous. "A man is supposed to be a fool about this," he yells, but not women. "What are you, a nincompoop?" he asks Rose, with concern that turns fatherly.

The distraught Rose goes to Buddy's room for some innocent comfort, only to have him politely ask her to quench his sexual curiosity. While lying next to him on his bed, Rose says, "You're just a child and wouldn't understand, but that kind of thing can stir a girl up." The direction by Martha Coolidge (best known for the very different female-awakening movie "Valley Girl") and Calder Willingham's script are at their height in these delicate, hilarious episodes.

•

Soon Rose marches off to town to find a new man, with Mr. Hillyer and Buddy watching from their car. They are impressed with the speed of her success. Before long there are "scoundrels," as Mr. Hillyer puts it, fighting about her in the front yard, ruining the bushes and disrupting the family's sleep.

Some people would call Rose herself a sexual scoundrel. Mr. Hillyer is unsure, and thinks she ought to leave their house; his wife protects her. The film sides with Mother, but becomes simplistic when Rose says, "Girls don't want sex; girls want love." The aphorism is not good enough for this rich and understanding portrayal.

At the end, the film wanders off with Mother into the fourth dimension, as if all the sentimentality that had been kept on hold were flooding into the movie. But even the mawkish beginning and end cannot ruin the delicious center of "Rambling Rose." Though it is seen though the eyes of a 13-year-old, this is an uncommon coming-of-age story, one in which a whole family questions the mysteries of sex, loyalty and love.

•

"Rambling Rose" is rated R (Under 17 requires accompanying parent or adult guardian). It includes some brief, good-natured nudity.

1991 S 20, C12:4

Livin' Large

Directed by Michael Schultz; written by William M. Payne; director of photography, Peter Collister; edited by Christopher Holmes; produced by David V. Picker; released by the Samuel Goldwyn Company. Running time: 96 minutes. This film is rated R.

Dexter Jackson	T. C. Carson
Toynelle Davis	Lisa Arrindell
Kate Penndragin	Blanche Baker
Baker Moon	Nathaniel Hall
Missy Carnes	Julia Campbell

By VINCENT CANBY

Michael Schultz's "Livin' Large" is a big-beat, broad, infectiously funny comedy about the rise and fall and rise of Dexter Jackson (T. C. Carson), a young black man whose fondest wish is to make it as an anchor in the white man's world of television.

The setting is Atlanta. The time is today, and Dexter hasn't the patience to wait around for affirmative action to work. He's in a hurry. He wants the celebrity, the money and the perks now.

A graduate of the Ajax School of Broadcasting, Dexter drives a delivery truck for the Little Dog Dry Cleaners but spends most of his days goofing off with his camcorder. As luck has it in comedies of this sort, Dexter stumbles onto a breaking news story:

A Boy Scout troop leader goes berserk, having been found frequenting a pornography shop. He takes a group of scouts hostage, holes up in an office building and begins to shoot passersby, including Channel 4 Television's cityside reporter. Dexter picks up the fallen mike and runs with the story, which includes an exclusive interview with the maniacal scout master.

When Dexter arose that morning, he was an unknown. By late afternoon, he is on his way to Atlanta stardom.

"Livin' Large," written by William Mosley Payne, is Mr. Schultz's most exuberant comedy since "Car Wash." It's both a giddy Horatio Alger tale and a free-wheeling send-up of ratings-obsessed commercial television, viciously and hilariously represented in the movie by Channel 4's news director, Kate Penndragin (Blanche Baker).

Kate has a strong stomach and a nose for sensation. When, during Dexter's interview, the scout master threatened to commit suicide oncamera, it was the turned-on Kate who hoped that he would pull the trigger. At first she is Dexter's ally, assigning him the dream job of roving reporter, supported by a splashy publicity buildup.

In the course of Kate's campaign to bring out the "new" Dexter, he learns how to say "ask" instead of "ax" and allows his mini-dreadlocks to be cut. His clothes become increasingly Ivy League. He begins to call his girlfriend "Darling" instead of "Baby" and, as the ultimate sign of his achievement, he moves into a chic white-on-white apartment in a new building called Whiteyman's Towers.

"Livin' Large" is not exactly subtle, but it has the verve and the pacing of a nervy up-to-the-minute stage revue.

•

Mr. Carson, who won an Emmy for his performance in the television docudrama "Fast Break to Glory," should be one of the year's movie discoveries. He's bright, funny and, as actors say of themselves when a performance is working, centered. The role is a good one, but he gives it life and scope.

Ms. Baker, who has been around a little longer, is equally good in the best role of her movie career. Her Kate Penndragin is really impossible. In the syntax of television journalism, it can be said of Kate that she is not above stooping to anything to boost the ratings. She has a true eye for the perfectly tawdry.

Early in his Channel 4 career, Dexter annoys Kate with his stories of "social interest." At the same time, Dexter is alienating his old neighborhood pals by, among other things, exposing the near-fatal cholesterol levels served up at a neighborhood soul-food restaurant.

Says a concerned Dexter of the smiling woman who runs the place, "It's hard to believe that this little old lady is one of the killers of the ghetto."

More to Kate's taste is Dexter's handling of a story about a man who shoots up a drugstore's display of condoms. This prompts Dexter to muse on camera, "Celibacy and mental illness; is there a link?"

Little by little, Dexter also learns how to play office politics. This means seeing less of the beautiful woman he loves, Toynelle (Lisa Arrindell), and his best friend Baker (Nathaniel Hall), and more of the station's young white weather woman, Missy (Julia Campbell), a birdbrain of great ambition and no morals.

This is part of Kate's ratings plan, publicized as " 'Gone With the Wind' meets 'Superfly.' " She decides that Dexter and Missy should marry (on camera, of course) to become "the world's first married interracial anchor couple."

By that time, however, Dexter has played the office game so well that he has actually begun to turn white. Or, as Baker, the film's narrator, says, "The more polished Dexter became, the less he shined."

"Livin' Large" is a most welcome surprise — one of the best pop comedies of the season.

•

"Livin' Large," which has been rated R (Under 17 requires accompanying parent or adult guardian), has a lot of vulgar language.

1991 S 20, C15:1

The Double Life of Véronique

Directed by Krzysztof Kieslowski; screenplay (French and Polish with English subtitles) by Mr. Kieslowski and Krzysztof Piesiewicz; director of photography, Slawomir Idziak; edited by Jacques Witta; music by Zbigniew Presiner; production design, Patrice Mercier; produced by Leonardo De La Fuente; released by Miramax Films. At Alice Tully Hall, 7:45 P.M., and Avery Fisher Hall, 9 P.M., as part of the 29th New York Film Festival. Running time: 92 minutes. This film has no rating.

Véronique/Veronika	Irène Jacob
Alexandre Fabbri	Philippe Volter

By VINCENT CANBY

If one of the main purposes of the New York Film Festival is to show us what film makers around the world are up to, then Krzysztof Kieslowski's "Double Life of Véronique" is a practically perfect opening-night attraction. It exemplifies a very distinctive kind of contemporary European film.

"The Double Life of Véronique" is intellectually well bred. It bewitches the eye. It introduces a lovely new actress named Irène Jacob and, in a series of alternately haunting and opaque sequences, it examines a metaphysical equation whose symbolism and practical application would seem to be of no urgency whatsoever.

Even its auspices are significant. The film, a French-Polish co-production, was directed by Mr. Kieslowski, a Polish national. Miss Jacob, its star, is French, and it was shot in France and Poland under the sort of multinational financial arrangement that is the way of movies in what is to become the new European Community.

"The Double Life of Véronique" will be shown tonight at 7:45 at Alice Tully Hall and at 9 at Avery Fisher Hall. It will begin its regular commercial engagement in New York on Nov. 22.

•

The screenplay, written by Mr. Kieslowski with Krzysztof Piesiewicz, considers the mystical bond between two identical young women (Miss Jacob), one Polish, one French, neither of whom is aware of the other, though each has intimations of the other's existence.

The Polish Veronika is a creature of radiant life, manifest in the warmth of her friendships, in the abandon with which she makes love and especially in the passion she brings to her music when, without having trained a day, she wins a singing competition.

These are the film's provocative and mysterious initial sequences. Veronika's world is filled with images that suggest connections to an unseen order. As she runs down a street she passes a huge statue of Lenin being carted off on the back of a flatbed truck. The lawyer who comes to make her aunt's will is a dwarf.

At one point she says that she has a strange feeling she is not alone in the world. In Cracow, on the way to her music competition, she suddenly catches sight of herself, that is, of the French Véronique, who has gotten out of a tour bus to photograph a student demonstration. Veronika longs to be recognized by the other, but isn't.

•

Veronika affirms more life than her heart can sustain. She has a "condition" that Mr. Kieslowski reveals in a not-great sequence in which the poor young woman staggers, holds her hand up to her chest and breathes with difficulty. As she is sitting on a bench, attempting to pull herself together, a man walks toward her, exposing himself.

It's an unfortunately anti-climactic moment when Veronika collapses and dies in the middle of her first public concert.

This is more or less the introduction to the main body of the film, which is set in France and in which the French Véronique appears to learn instinctively from the mistakes (if that's what they are) of her Polish sister-in-spirit.

Mr. Kieslowski cuts from Veronika's funeral, shot from the point of view of the corpse, to Véronique in bed with a lover. Véronique suddenly feels grief, but for whom she knows not. She too has a heart problem. The first thing in the morning she rushes off to tell her singing coach that, henceforth, she will devote herself entirely to teaching music to grammar school students.

It's at this moment that "The Double Life of Véronique" begins to become both too literal and too fanciful, and sometimes inadvertently funny. The Polish Veronika is far more engaging than the French Véronique, who seems less a genuine character than a figure invented to finish off a theory.

Most of the French portion of the film is devoted to Véronique's courtship by a lugubriously whimsical puppeteer who woos her with anonymous midnight phone calls and audio cassettes that she deciphers as if they were clues in a game of charades.

"The Double Life of Véronique" is not characteristic of the director, whose other films are clear responses to the times in which they were created. The new movie looks downright fashionable compared with "Camera Buff," a robust if rather heavy-handed comedy presented at the 1980 New York Film Festival, and "No End," a serious consideration of political opportunism, shown here in 1986.

His "Short Film About Killing," a New York festival entry three years ago, is a stern indictment of the death-penalty. Largely unknown here but celebrated in Europe is "The Decalogue," his 10 one-hour films examining the Ten Commandments in contemporary terms.

•

"The Double Life of Véronique" is Mr. Kieslowski's most beautiful film to date but also, in its way, his most opportunistic. It has the shape of something manufactured to fit a co-production contract.

Miss Jacob, who won the Cannes prize this year for best actress, may or may not be a great actress, but she is a most engaging new screen personality and lights up the first third of the new movie as Veronika. She's also fine as Véronique, but the movie is then traveling on empty.

"The Double Life of Véronique" doesn't end. About three-quarters of the way through, it starts to dissolve, like mist, so that by the time it is actually over, the screen seems to have been blank for some time.

1991 S 20, C18:4

Toto the Hero

Directed and written (French with English subtitles) by Jaco van Dormael; cinematography by Walther van den Ende, edited by Susana Rossberg; music by Pierre van Dormael; production design, Hubert Pouille; produced by Pierre Drouot and Dany Geys. At Alice Tully Hall, as part of the 29th New York Film Festival. Running time: 90 minutes. This film has no rating.

Thomas (old man)	Michel Bouquet
Evelyne (adult)	Mireille Perrier
Thomas (adult)	Jo De Backer
Evelyne (old woman)	Gisela Uhlen
Alfred (old man)	Peter Böhlke

The Film Society of Lincoln Center

Fabienne Loriaux and Klaus Schindler as the parents of Thomas van Haserbroech, Toto, played by Thomas Godet, in "Toto the Hero."

Thomas (child)	Thomas Godet
Alice	Sandrine Blancke
Alfred (child)	Hugo Harold Harrisson
Thomas's mother	Fabienne Loriaux
Thomas's father	Klaus Schindler

By VINCENT CANBY

If "Toto the Hero" (Toto le Héros) is an indication of things to come, then Jaco van Dormael, a 34-year-old Belgian writer and director, is a bright new talent to celebrate.

The festivities begin this weekend at the New York Film Festival, which will present "Toto" tonight at 9:30 and tomorrow at 1:30 P.M.

Mr. van Dormael appears to belong to the humanist tradition of Jean Renoir and François Truffaut, but the voice and manner are his own. "Toto" is an enormously witty, bittersweet comedy that is somewhat less sentimental than your average automobile accident. It is both shocking and elegiacal.

The film has the density of a fine short story, written by a master who somehow manages to create a novel-sized world through an uncanny command of ellipsis. "Toto" is the packed, often hilarious biography of a rather commonplace old man who, on the edge of death, reviews his life with the aim of giving it point, at last.

The urgency of his desires, and the extent to which he succeeds, are the material of the film, which features three different actors as its hero, Thomas van Haserbroeck, self-nicknamed Toto.

These key players are Michel Bouquet, the venerable French star (still looking a lot like Laurence Olivier), who appears as the elderly Thomas; Jo De Backer as the lonely, pinched, 30-ish Thomas, and Thomas Godet, who carries much of the film on his scrawny shoulders as Thomas the seethingly imaginative adolescent.

Their ensemble performances blend one into another with the same grace and humor as the film's disparate parts.

In Mr. van Dormael's fine screenplay, past and present exist in continuous and crazy conjunction, much as they do in the mind, and old Thomas's mind is busier than most. Laughter and fury, fact and fantasy intertwine as the suddenly resolute fellow decides to act, thereby, possibly, to revise history.

Thomas's adolescence is seen not necessarily as it was, but as the boy perceived it to be at the time. Thus he reports on the sound track that his sister Alice, who is several years older, was conceived when his father stroked his mother's hand as his parents were bathing together. His younger brother Celestin was born in a washing machine, which probably explains to Thomas why Celestin is mentally retarded.

Though his parents are loving, the boy is convinced that he is not their child and that, in fact, he is really the son of the rich Kant family next door, whose loathed son Alfred was born on the same day. Thomas believes that he and Alfred were switched during a hospital fire.

His mother says flatly that there was never a hospital fire.

•

This does not prevent the little boy from barging in on Alfred's birthday party to demand that he be recognized as the Kants' rightful heir and, in the bargain, that he be given Alfred's birthday presents. As usually happens, his boldness earns only humiliation.

Thomas's quite ordinary childhood is suddenly turned upside-down when his father, a commercial pilot, is lost during a flight over the English Channel. Because his father was en route

to England to fetch a cargo of marmalade for Mr. Kant, Thomas has even more reason to despise Alfred and his parents.

Yet Thomas's most important relationship, and the one that shapes his deprived adulthood, is with the sweetly bossy Alice (Sandrine Blancke), whom he adores.

Alice is something of a terrorist as well as a romantic. She and Thomas play dangerous games together. When Alice becomes a young woman and threatens to leave Thomas behind in the perpetual gloom of childhood, the boy goads his sister into a terrible, irrevocable act.

These sections of the film demonstrate Mr. van Dormael's extraordinary gift for the simultaneous expression of utterly contradictory emotions. He also manages to be inside the minds of the little boy and the old man at the same time. The effect is disorienting, as melancholy as it is comic.

Emerging from this rocky adolescence, the adult Thomas is a good-looking, bespectacled near-recluse, who works 9 to 5 and avoids all entanglements. He is brought briefly back to life by an affair with a beautiful young woman (Mireille Perrier) who reminds him of Alice. Again Alfred Kant appears on the scene, unwittingly to destroy Thomas's happiness.

At the press conference after the film's preview on Thursday morning, Mr. Dormael reported that the screenplay for "Toto" took five years to write. This is evident in the packed nature of the material, but not in the breezy inevitability of the finished film.

"Toto" has the self-assurance and the gusto of something that might have been conceived in a single spasm of creativity. It flies effortlessly from one time period to another, from one mood to its opposite. It seems never to have been fiddled with, rewritten or sweated over. It is as magical, though not as innocent, as the child of a stroked hand.

1991 S 21, 11:1

Rocco and His Brothers

Directed by Luchino Visconti; screenplay (Italian with English subtitles) by Mr. Visconti, Suso Cecchi d'Amico and Vasco Pratolini, based on the novel "Il Ponte Della Ghisolfa" by Giovanni Testori; cinematography, Giuseppe Rotunno; edited by Mario Serandrei; music by Nino Rota; produced by Giuseppe Bordogni. At Alice Tully Hall, as part of the 29th New York Film Festival. Running time: 180 minutes. This film has no rating.

Rocco Parondi	Alain Delon
Simone Parondi	Renato Salvatori
Nadia	Annie Girardot
Rosaria Parondi	Katina Paxinou
Morini	Roger Hanin
Ginetta	Claudia Cardinale
Vincenzo Parondi	Spiros Focas

By VINCENT CANBY

Run, don't lope or jog, to the nearest telephone, or to Alice Tully Hall itself, to see if there are any tickets left for the 3 o'clock screening this afternoon of Luchino Visconti's "Rocco and His Brothers."

It may be your only chance to behold the 1960 Italian epic in something like its original grandeur. The New York Film Festival is presenting it just once, which is lamentable. In the come-what-may, eclectic circumstances of a festival like this one, "Rocco and His Brothers" serves as a kind of lodestar, a film that helps you keep your bearings.

It is a reminder of where films have come from and of how small and safe and self-addressed most contemporary movies are. "Rocco" is not perfect, but even when it goes over the top in its theatricality, it excites the imagination with the kind of boldness that is the only hope of the future.

"Rocco," with a good print supplied by the British Film Institute, is being shown here for the first time in its original three-hour form. When it opened in New York in 1961, the running time had been cut to 149 minutes. Later television prints had shrunk to 95 minutes.

The Film Society of Lincoln Center

Annie Girardot and Renato Salvatori in "Rocco and His Brothers."

The film is long. Yet the sense of time's passing disappears in the big enveloping narrative about the disintegration of a farm family, newly arrived in Milan from the poverty-stricken south. The film is a sort of companion piece to "La Terra Trema" (1948), Visconti's second feature, which details the hard lot of Sicilian fishermen.

•

Between 1948 and 1960 there were decisive changes in the film-making methods and manners of Visconti, an aristocrat by birth and, by choice, a committed Communist, who loftily opposed the party.

"La Terra Trema" was shot with an amateur cast. It is more easily seen as neo-realist than "Rocco," which is performed by a cast of splendid European actors and which, though utterly natural in its settings and concerns, is almost operatic in its grand emotionalism. Consistent, however, are the director's social concerns.

•

"Rocco" is about the awful inevitability of the fate (as Visconti sees it) of Rosaria Parondi (Katina Paxinou) and her five sons when they emigrate to Milan to find a better life. Vincenzo (Spiros Focas), the eldest, muddles through without too much damage. Simone (Renato Salvatori) becomes, briefly, a promising prize fighter, only to wind up as a petty crook and murderer. It is Rocco (Alain Delon), the middle son, who is both the hope of the family and its undoing.

As written, and as played by Mr. Delon, Rocco is one of the most vivid and complex characters in all of Visconti's work. His misguided saintliness, which recalls "The Idiot" of Dostoyevsky, is as responsible for the family tragedy as the system that ignores the Parondis.

Rocco falls in love with Nadia (Annie Girardot), the reformed prostitute who had earlier been Simone's mistress. In one of the toughest scenes in all film literature, the suddenly jealous Simone trails Rocco and Nadia to a meeting in a vacant lot late at night. While one of his buddies holds Rocco, Simone beats up and then rapes Nadia in front of his brother.

It is typical of the sweet, dim Rocco that he sees this as a sign of Simone's profound devotion for the unfortunate Nadia. He steps aside so that disaster may follow.

•

"Rocco" has the amplitude of detail that suggests a 19th-century novel, yet there are few digressions and Visconti does not hesitate to ignore conventions that would interrupt the film's flow. Though the film covers a period of several years, at least, the youngest Parondi son never grows an inch in his adolescence.

At this vantage point, "Rocco" looks better than ever. It does not have the historical significance of "Ossessione" (1942), Visconti's adaptation of "The Postman Always Rings Twice," which is credited with opening the way for Italian neo-realism. Yet it stands with "Senso" (1954), "White Nights" (1957) and "The Leopard" (1963) as one of this majestic director's most enduring achievements.

1991 S 21, 12:1

Amelia Lopes O'Neill

Directed by Valeria Sarmiento; written by Ms. Sarmiento and Raúl Ruiz; in Spanish with English subtitles; cinematography by Jean Penzer; edited by Rodolfo Wedeles; music by Jorge Arriagada; production design, Juan Carlos Castillo; produced by Patrick Sandrin. At Alice Tully Hall, as part of the 29th New York Film Festival. Running time: 95 minutes. This film has no rating.

Amelia	Laura del Sol
Fernando	Franco Nero
Anna	Laura Benson
Ginette	Valerie Mairesse
Igor	Sergio Hernández
Lawyer	Jaime Vadell
Fernando's Wife	Claudia di Girolamo
Journalist	Roberto Navarrete

By CARYN JAMES

If the heroine of François Truffaut's "Story of Adele H" were to pop up in a Gabriel García-Márquez novel, the result would resemble "Amelia Lopes O'Neill," a beautiful, cracked tale of romantic obsession. Though Amelia wanders the narrow, shadowy streets of Valparaíso much as Adele trekked through Nova Scotia, it makes all the difference that this story is narrated by a man out of sync with his own mirror image.

He is a magician, a thief, and our most reliable guide to the truth about Amelia and her misplaced passion. As the Chilean director Valeria Sarmiento constructs the story, every trace of melodrama is replaced by some magical portent or lunatic behavior. The enticing "Amelia Lopes O'Neill" will be shown at the New York Film Festival tonight at 6:30 and tomorrow at 9:30 P.M.

The daughter of a once-wealthy family, Amelia lives with her hysterical, invalid sister in a big, Victorian, cobalt-blue house. The magician says that the women's dead father regularly visits at 8:20 on Tuesday mornings; the house does have that haunted look about it.

One night Amelia escapes from the rain into a sleazy bar. A series of unlikely but plausible events — meeting a childhood friend who is now a stripper, being painted with make-up by this woman's daughter — allow the plain, proper Amelia to be mistaken for a whore. A doctor takes her home, pays her the next morning and apologetically says he could not have known she was a virgin. He is already married, to a dying woman, but from then on Amelia considers herself his faithful wife.

•

"You're crazy," says the stripper, and Amelia answers, "No, I'm just a faithful woman." And she is: faithful to her own crazed sensibilities, to the ideals that her father would have held her to, and most of all faithful to the obsession itself.

Miss Sarmiento wrote "Amelia" with her husband, the director Raúl Ruiz, and made it in her native Chile after a long exile in Europe. She has turned Valparaíso into a glittering, dramatic landscape that reflects the heroine's passionate grasp on life. Amelia kisses the doctor on a tall, stone stairway cast in blue shadows. She walks by the port with a dazzling night view of the sea and the shore lights. Laura del Sol as Amelia and Franco Nero as the doctor assume calm, dignified faces that the camera seems to explore.

Despite its fantastic touches – Amelia is followed by a man who is a living symbol of death – the film is far more naturalistic than Mr. Ruiz's surreal works. Yet its magical realism makes it less cogent than a film like "Adele H." Miss Sarmiento has found her own twilight zone where insane passions make sense.

The feature will be preceded by a 23-minute film, "Cairo as Told by Youssef Chahine." Mr. Chahine, an Egyptian who has been making films for 40 years, offers a contemporary view of Cairo. The mix of Pyramids and traffic jams suggests a magical realism of its own.

1991 S 21, 12:3

Adam's Rib

Directed by Vyacheslav Krishtofovich; written (in Russian with English subtitles) by Vladimir Kunin, from the book "House of Young Women" by Anatoly Kurchatkin; cinematography by Pavel Lebeshev; edited by Inna Brozhovskaya; music by Vadim Khrapachev; production designers, Sergei Khotimsky and Aleksandr Samulekin. At Alice Tully Hall, as part of the 29th New York Film Festival. Running time: 75 minutes. This film has no rating.

Nina	Inna Churikova
Lida	Svetlana Ryabova
Nastya	Masha Golubkina
Grandmother	Yelena Bogdanova
WITH: Andrei Kasyanov and Andrei Tolubeyev	

By JANET MASLIN

If ever there was a good argument for family life in close quarters it is "Adam's Rib," a wonderfully wry Soviet comedy about three generations of women living in nerve-jangling proximity to one another. Sharing a bathroom, some clothes, some onerous chores and a lot more intimacy than any of them bargained for, the heroines of this story manage to make the best of a desperately claustrophobic situation.

Presiding over it all is the silent figure of a matriarch (Yelena Bogdanova), who lies paralyzed in one corner of the apartment while her daughter and two granddaughters bustle frantically about. The director, Vyacheslav Krishtofovich, eloquently moves his film from the everyday to something much larger by beginning with this silent old woman's memories of a warm family life that is long gone.

The baby of those memories is now 49-year-old Nina (Inna Churikova), the twice-married, beleaguered, very funny mother of both Lida (Svetlana Ryabova), a beautiful office worker trapped in an unhappy affair with her boss, and Nastya (Masha Golubkina), an outspoken 15-year-old who every morning seems to have spirited away a different one of Lida's belongings. Watching these three characters ricochet wildly off one another as they prepare for work each day, arguing bitterly about whose job it is to change grandma's bedpan, is akin to observing some mad scientist's non-working model for nuclear fission.

Though this is clearly a film with universal appeal, a lot of it could take place only in the Soviet Union. Where else would a mother trying to find a little privacy and escape from her grown daughters have to schedule a rendezvous with a would-be suitor for 10 A.M., after both daughters can be counted on to have gone to work?

Even the subject of anti-Semitism, improbably enough, becomes grist for the film's sly and very Soviet humor. So does the Soviet economy, where the smaller a bathing suit is the more it costs.

The undercurrent of hardship in "Adam's Rib" makes its humor that much more welcome. Mr. Krishtofovich also underscores the essential generosity of his characters, however sorely it is often put to the test. At the

end of this small and enormously likable film, all of the women have been united in a heartening show of solidarity and in the certainty that their dynasty will endure.

•

On the same bill is the Australian "Tennis Ball," John Dobson's deadpan, darkly comic look at urban stress and the fits of pique it can provoke. A young woman dressed in T-shirt, ballet gown and hairpins refuses to relinquish the neighbor's tennis ball that has hit her in the head. Mr. Dobson, whose work recalls Jane Campion's, is able to find both distress and optimism in this unusual predicament.

"Adam's Rib" and "Tennis Ball" will be shown today at 12:30 and tomorrow at 7 P.M. as part of the New York Film Festival.

1991 S 21, 12:5

No Life King

Directed by Jun Ichikawa; screenplay by Hiroaki Jinno (Japanese with English subtitles), based on a novel by Seikou Ito; director of photography, Osamu Maruike; edited by Shigeru Okuhara; produced by Gakuto Niizu, Susumu Matsui and Takuo Murase. At Alice Tully Hall, as part of the 29th New York Film Festival. Running time: 106 minutes. This film has no rating.

Makoto Ohsawa	Ryo Takayama
Mamiko Ohsawa	Saeko Suzuki
Nobuhiko Mizuta	Neko Saito
Salaried worker	Ogato Ittsusei
Hideaki Inada	Kyusaku Shimada

By JANET MASLIN

The solemn, intent faces of the Japanese schoolboys playing video games in Jun Ichikawa's "No Life King" bespeak a new type of modern horror. Addicted to their favorite new game (from which the film takes its title), these children have become seriously estranged from the real world.

The film's constant emphasis is on the ways in which this has been allowed to happen, and on how emblematic it is of larger attitudes in a technological society. When a young boy trying to converse with his mother must compete with a home computer for her attention, it's not hard to see why the boy has retreated into his own computer-dominated world.

•

"No Life King" quietly juxtaposes the colorless, regimented reality of these boys' school with the bright, violent world that has taken over their collective imagination. The rows of soldiers arrayed before a warlord at the start of the game are even contrasted with the image of students lined up to be addressed by their principal in the schoolyard. The school authorities, well aware of the video game's addictive influence, are almost as susceptible to it as the students are. Everyone in the film spreads rumors that the game is deadly, and other superstitious notions of what its effects might be.

The impression of a desperate, misplaced yearning for spiritual life is gently but powerfully created. The antiseptic atmosphere in which students who have questions in class are expected to communicate electronically with their teacher (by typing the questions onto their computer screens) is linked unmistakably with the video game's mystical powers. The idea is plain enough, but Mr.

Ichikawa presents it with great elegance at times. When a group of boys, arguing about different game strategies, are interrupted by a girl who sits down at a piano to play "Moon River," they seem quite flabbergasted by the simplicity and sweetness of the moment.

•

Although "No Life King" is too restrained to take its premise very far, the filmmaker's concerns for a world that has lost its balance are beautifully expressed. A closing episode in which a character sees the real world with new eyes is artful enough to allow the audience to do the same.

"No Life King" will be shown today at 4 P.M. and tomorrow at 9:15 P.M. as part of the New York Film Festival. On the same bill is Kenji Larsen's "Shirt," in which a man sits at a sewing machine patiently stitching and re-stitching film stock until he has made a shirt out of celluloid. This just proves that there are many different ways to waste film.

1991 S 22, 58:5

'Showdown In Little Tokyo'

"Showdown in Little Tokyo," which opened at theaters here on Friday, is a violent but spiritless martial-arts movie about Japanese gangsters who attempt to muscle in on the Los Angeles drug trade.

To the extent that the movie equates the gangsters' efforts with those of legitimate Japanese investors in this country, "Showdown in Little Tokyo" might qualify as Japan-bashing.

Dolph Lundgren, a large man with a small-screen personality, and Brandon Lee, as the son of an American father and Japanese mother, play the policemen who kick, sock and break Asian necks on behalf of justice. The body count is huge.

•

"Showdown in Little Tokyo," which has been rated R (under 17 requires accompanying parent or adult guardian), includes a lot of blood, mayhem, vulgar language and nudity.

VINCENT CANBY

1991 S 22, 58:6

FILM VIEW/Caryn James

'The Fisher King' Is Wise Enough to Be Wacky

ACCORDING TO PARRY, A HOMEless man who once taught medieval history, the Holy Grail is "God's symbol of divine grace." Anne, a video-store owner in leopard-print leggings, thinks the Grail is "Jesus's juice glass." His answer is sacred, hers profanely cute, but together they show how "The Fisher King" pulls off its improbable success. The film carries its redemptive legend into the late 20th century with a healthy dose of irreverence.

Buried inside the film is a nightmare version of what it might have been. A television executive pitches "a weekly comedy series about the homeless" that shows them as "wacky and wise." "The Fisher King" isn't that series, but its plot is so overdone and its central idea potentially so mawkish that Terry Gilliam's film sounds as if it were from the touchy-feely school of movie making.

Jack (Jeff Bridges), a self-centered deejay, unwittingly causes a tragedy for Parry (Robin Williams), who loses his memory, his money and much of his common sense as a result. That is enough of a story, even without their unlikely love interests. Amanda Plummer is a klutz named Lydia, whom Parry worships from afar, and Mercedes Ruehl is Anne, who takes Jack in even though he has given up his career and turned into a bitter, aimless drunk. The men meet and redeem each other from their empty lives, each playing an updated version of the mythic hero who finds the Grail and saves the king. At this point, the film might have gone way over the top.

■

But Mr. Gilliam and the screenwriter, Richard LaGravenese, have discovered a wacky but wise strategy that makes "The Fisher King" an effective tale of redemption. Working against the reverent grain of the story, they use fantasy sparingly. They skirt

the simple-minded theories that the crazy are sane and the homeless are saints, and so avoid sitcom condescension.

To say the film works, of course, is to judge it by the peculiar standards of other Terry Gilliam movies. No one ever said that Mr. Gilliam's cult favorite, "Brazil," was coherent or that his notoriously over-budget "Adventures of Baron Munchausen" was even. Like those films, "The Fisher King" is a big, messy, exuberant movie that is better scene-for-scene than it is as a whole.

In fact, it resembles an upside-down version of "Monty Python and the Holy Grail," which Mr. Gilliam co-directed. The Python film was seriously irreverent, an extended joke that used the Grail as a prop. "The Fisher King" is irreverently serious, using humor and satire to make the idea of redemption palatable to a skeptical audience.

Seriousness and whimsy blend at the moment Parry enters the film. Jack — disheveled, drunk and mistaken for a homeless man — is about to be set on fire by vigilantes bent on cleaning out their neighborhood on the East Side of Manhattan. Parry, using a garbage-can lid as a shield, wearing a blanket as a cape and a woman's spangled knit cap, shoots an arrow at the attackers and saves Jack. Compare this scene with Kevin Costner's "Robin Hood," which treats the character with high seriousness, and Parry's lunatic style seems positively realistic. He is not a clinical study or a pure fantasy-figure, but a shattered man tenuously attached to the reality of New York City today.

Mr. Williams's performance, laced with satire, keeps Parry from being totally crazy, holy or wise. He believes, "I'm a knight on a special quest," but can also call himself "the janitor of God." He thinks the Grail is hidden in a tycoon's mansion, though he admits it is odd to imagine finding "anything divine on the East Side." He has constructed a shrine that places a pulp paperback novel alongside a book about the Grail. But when he and Jack find a man who has been trampled by a horse in Central Park, he insists with sudden lucidity that they have to help him. "Mother Teresa's not here; it's just us," he snaps.

Wavering back and forth from mystical visions to social satire, Mr. Williams creates a jolting but effective character. As Jack lurches along behind him, beginning a spiritual quest that he doesn't even know he's on, Mr. Bridges proves again that he is one of the strongest understated actors on screen. "The

To say this 20th-century Grail story works, of course, is to judge it by the peculiar standards of other Terry Gilliam movies.

Fisher King" itself follows Parry, as it weaves between a Manhattan that viewers recognize and a spiritual landscape that Parry allows them to see.

When viewers share his vision of the Red Knight — an apparition that seems part armored man and part tree, riding a red horse — this physical embodiment of his fears is effective because Mr. Gilliam merely drops in such fantastic touches now and then. He is shrewd enough not to let the fantasy overwhelm the story.

Once, hundreds of people waltz in Grand Central Station as Parry sees Lydia through the crowd. It is an extravagant, magical scene, and once is just enough. More would be schmaltzy, less would be mundane. By the time the Grail is brought to Parry, the object is both magical and ordinary, the perfect hybrid expression of what the film is about.

"The Fisher King" is not free of saccharine or banalities. Parry and Lydia are so well matched that they make Lancelot and Guinevere look like mortal enemies. And the story would have had a more convincing edge if some major character had been left unhappy and unredeemed. Without its risky excesses, though, "The Fisher King" might not have found its solid but mythical heart. ☐

1991 S 22, II:13:1

The Suspended Step of the Stork

Directed by Theo Angelopoulos; written (Greek with English subtitles) by Mr. Angelopoulos, Tonino Guerra, Petros Markaris and Thanassis Voltinos; cinematography by Yorgos Arvanitis and Andreas Sinanos; edited by Giannis Tsitsopoulos; music by Helena Karaindrou; production designer, Mikes Karapiperis; produced by Mr. Angelopoulos and Bruno Pesery. At Alice Tully Hall, as part of the 29th New York Film Festival. Running time: 151 minutes. This film has no rating.

The Refugee	Marcello Mastroianni
The Wife	Jeanne Moreau
The Journalist	Gregory Karr
The Young Girl	Dora Chrysikou
The Colonel	Ilias Logothetis

By CARYN JAMES

The Greek director Theo Angelopoulos is widely considered to be in the first rank of contemporary film makers. But until recently his demanding work — daring in its images, fierce in its social and political concerns, sometimes running to four hours in length — has scarcely been seen in this country outside of film festivals. Last year the Museum of Modern Art presented an Angelopoulos retrospective, and the Public Theater showed his 1988 film, "Landscape in the Mist," an elegant, brutal, masterly work about two young children searching for their nonexistent father.

His new film, "The Suspended Step of the Stork," will be shown at the New York Film Festival tonight at 6:15 and tomorrow at 9:15 P.M., offering a high-profile opportunity for Mr. Angelopoulos. Unfortunately, this is neither his best work nor the best introduction to it.

Marcello Mastroianni plays a disillusioned politician who, 10 years before the story begins, walked out of the Greek Parliament and soon disappeared entirely. Now a television reporter finds a poor, shabby man (also Mr. Mastroianni) who lives in a border town filled with refugees from many countries. Trying to discover whether this is the missing politician, the reporter brings the man's former wife, played by Jeanne Moreau, to the town.

All the elements of a first-rate Angelopoulos film are here, from the political undercurrent to the sustained long-shots that are his trademark. As the camera pans slowly along a line of abandoned railroad cars in which refugees live, the film demonstrates that few directors use wordless images as purely or effectively as Mr. Angelopoulos.

Film Society of Lincoln Center

Marcello Mastroianni in Theo Angelopoulos's new film, "The Suspended Step of the Stork."

Yet the work suffers from a major, disastrous decision. Its centerpiece is the reporter, a bland, banal character unable to offer any intriguing perspective on the politician's identity. As played by Gregory Karr, this mournful-eyed journalist dissolves suspense wherever he turns. He can turn a silent, eyes-across-the table seduction into an unintentional parody of an Angelopoulos scene. Only when the film focuses on Mr. Mastroianni, who towers over everyone else here, does it capture the mystery, ambiguity and poignancy of this man's situation, whoever he turns out to be.

There are small examples of Mr. Angelopoulos's eloquence scattered through this two-and-a-half-hour film. A long wedding scene begins with a bride and people from her half of the divided border town standing still on the river bank, as in a tableau. The scene moves slowly, without words, to the opposite bank, where the bridegroom and his neighbors appear against a delicate-looking background of trees on the horizon. Recalling "Landscape," this lyrical yet painful scene reveals Mr. Angelopoulos at his best.

But even the image that gives "The Suspended Step of the Stork" its title seems like a risk that backfires. A soldier stands on the Greek border. He holds one foot suspended in the air, looking quite like a stork (or more precisely like a flamingo) as he declares that putting his foot over the line is worth his life. The image is strained, and too typical of this uneven film.

1991 S 23, C15:1

McBain

Directed and written by James Glickenhaus; director of photography, Robert M. Baldwin Jr.; edited by Jeffrey Wolf; music by Christopher Franke; production designer, Charles C. Bennett; produced by J. Boyce Harman Jr.; released by Shapiro Glickenhaus Entertainment. Running time: 103 minutes. This film is rated R.

McBain	Christopher Walken
Christina	Maria Conchita Alonso
Frank Bruce	Michael Ironside
Eastland	Steve James
Dr. Dalton	Jay Patterson
Gill	T. G. Waites
Santos	Chick Vennera

By STEPHEN HOLDEN

James Glickenhaus's action-adventure film "McBain" might charitably be described as a contemporary historical fantasy, although lurid cartoon would be more accurate.

The title character is a Vietnam veteran who rounds up his former brothers in arms to go to Colombia and aid a people's rebellion against the Noriega-like strongman who rules the country. McBain's motives are personal. Eighteen years earlier, the rebels' leader, Santos (Chick Vennera), saved his life at a Vietcong prisoner-of-war camp. So when the slain Santos's sister Christina (Maria Conchita Alonso) calls on McBain in New York, it is understood he must drop everything, round up his old army buddies and avenge the killing.

A major obstacle is raising the $10 million necessary to carry out the operation, but that is quickly solved by kidnapping a Mafia chieftain and scaring him into depositing the money in a Swiss bank account. Moments later the rebels are armed and ready to fight, led by Christina, who wears the same grimy purple tank top throughout the movie.

"McBain" is the kind of film in which unexplained characters pop up out of the blue, then disappear just as mysteriously. The screenplay is filled with portentous exclamations like: "Let's do it! Let's go on to the palace!"

But the most ludicrous moment in the film, which finds Christopher Walken glowering embarrassedly through the thankless title performance, is the appearance of a George Bush-like President who blithely proclaims that henceforth all money will be printed on red-white-and-blue paper.

•

"McBain" is rated R (Under 17 requires accompanying parent or adult guardian). It includes strong language and scenes of torture.

1991 S 23, C15:1

Inventory

Written and directed by Krzysztof Zanussi; in Polish with English subtitles; cinematographer, Slawomir Idziak; edited by Marek Denys; music by Wojciech Kilar; production manager, Michal Szczerbic. At Alice Tully Hall, as part of the 29th New York Film Festival. Running time: 103 minutes. This film has no rating.

Julia	Krystyna Janda
Mother	Maja Komorowska
Tomek	Artur Zmijewski
WITH: Andrzej Lapicki and Artur Barcis	

By CARYN JAMES

Tomek is an idealistic young man who lives with his overprotective mother. Though he is good-looking, he seems too shy to approach a woman for a date, and it's entirely apt that we first see him getting a prescription for sleeping pills.

Julia is a woman in her 30's whose cherry-red earrings flash like a desperate symbol of hope against her haggard face. As Tomek leaves the clinic he notices Julia, who is feeling faint after having had an abortion. She is without family or friends and about to lose her apartment. So Tomek takes her back to his home, acting partly from charity and partly from a flickering attraction. How can his morally upright mother refuse to help this troubled woman? Yet how can she bear to let such a threatening creature stay?

This is the explosive situation that the Polish writer and director Krzysztof Zanussi sets up at the start of "Inventory," an intricate, small-scale work that never does explode. Though the film is true to the director's well-established style of calm, intellectual probing, it may be too placid for the powerful emotions it explores. It is best appreciated for the precise, vivid texture of its scenes rather than for its moral and psychological themes. "Inventory," the sev-

A wily woman comes between a young man and his mother.

enth Zanussi film to be included in the New York Film Festival over the years, will be shown tonight at 6:15 and Thursday at 9:15 P.M.

•

In a subtle central scene, Julia and Tomek's mother sit at the kitchen table and get to know each other. The middle-aged mother pretends not to be prying and judgmental, though the small table lamp that stands between them might as well be an inquisitor's spotlight. Julia tries not to act as defensive and dismissive as she feels.

Julia admits that she used to be a government censor, and the disapproving mother promises not to tell her son. Of course, she tells him and then Julia says she made the story up.

"For her, lying is a form of self-defense," Tomek explains to his mother, but Julia's wiliness is also Mr. Zanussi's best strategy for keeping the audience alert. At such times, "Inventory" might be a particularly dour Eric Rohmer film, filled with talk that becomes the work's strongest dramatic action.

When Tomek and Julia fall in love, the film's moral underpinnings about selfishness and sacrifice give way to more personal concerns. Yet whether the lovers will come together for good is a question without much urgency, because the three main characters remain vehicles for ideas rather than deeply formed people.

They are likely to seem more eccentric and intriguing to Americans than they must have to Polish audiences, for whom the devout Catholic son and the former censor must be more familiar, matter-of-fact types.

But even with that extra exotic twist, "Inventory" seems an intelligent exercise rather than the compelling sort of film that Mr. Zanussi is capable of making.

1991 S 24, C13:2

Jacquot de Nantes

Directed and written by Agnès Varda, (in French with English subtitles); music by Joanna Bruzdowicz; edited by Marie-Jo Audiard; directors of photography, Patrick Blossier, Agnès Godard and Georges Strouve; production designers, Robert Nardone and Oliver Radot; released by Orion Classics. At Alice Tully Hall, as part of the 29th New York Film Festival. Running time: 118 minutes. This film has no rating.

Jacquot No. 1	Philippe Maron
Jacquot No. 2	Edouard Joubeaud
Jacquot No. 3	Laurent Monnier
Marilou	Brigitte de Villepoix
Raymond	Daniel Dublet
Jacques Demy	Himself
Yvon No. 1	Clément Delaroche
Yvon No. 2	Rody Averty
Reine No. 1	Hélène Pors
Reine No. 2	Marie-Sidonie Bénoist
René No. 1	Julien Mitard
René No. 2	Jérémie Bader
Yannick No. 1	Jérémie Bernard
Yannick No. 2	Cédric Michaud
Cousin Joël	Guillaume Navaud
Geneviève	Fanny Lebreton
Bella	Edwige Dalaunay
Mr. Bonbons	Jacques Bourget
Uncle Marcel	Jean-François Lapipe
Aunt Nique	Chantal Bezias

By VINCENT CANBY

Agnès Varda, who made her first feature, "Cleo From 5 to 7," in 1961, remains one of the most long-lived, productive and difficult to categorize directors associated with France's New Wave.

Though many of her colleagues have lost their momentum or died, she continues, in part, it seems, because she has never become locked into a particular form or dominant ideology. As the years go by, her focus shifts. She lives in a present that is ever enriched by the accumulating past.

For her that past includes one of the funniest artifacts of the liberated 1960's, "Lions Love" (1969), about three upwardly mobile flower children on the loose in Hollywood, and "Daguerreotypes" (1975), a fine documentary about her friends and neighbors on a short stretch of the Rue Daguerre in Paris's 14th Arrondissement. In 1985 there was "Vagabond," her tough, compassionate fiction film about a young woman's resolute drift toward destruction.

Some Varda works have not been especially successful. "One Sings, the Other Doesn't" (1976) plays like feminist agitprop.

Yet in all of her films there is a consistent personal commitment that illuminates the material. That commitment has never been more compellingly evident than in the new "Jacquot de Nantes," which will be shown at the New York Film Festival tonight at 9:30.

"Jacquot de Nantes" is the sort of film that no one but Miss Varda would have made or, for that matter, could have made. It's neither documentary nor, in the usual sense, fiction.

It's a one-of-a-kind celebration of a very gentle man, Jacques Demy, the French film maker ("The Umbrellas of Cherbourg," among others), who died last October and who was Miss Varda's husband and the father of their son, Mathieu. The film's origins were singular.

Miss Varda said that her husband, during his illness, talked increasingly about his childhood in Nantes, about the members of his family, about growing up during the German Occupation and the struggle he had to convince his father that he should be allowed to study film making in Paris.

As Demy talked, and the anecdotes came forth, his wife suggested that he should record these stories and that, eventually, the two of them should use them as the basis for a film. He asked her to make it, refusing even to write the screenplay or any of the dialogue so the finished work would be hers.

He did oversee the production and, from time to time, briefly appears on the screen himself, looking back to the times and places of his youth, which are lovingly reconstructed by Miss Varda and lovingly acted by professionals and the people of Nantes.

The result is a film not quite like any other.

"Jacquot de Nantes" is as gentle as Demy is remembered to have been by those who knew him. In its scrubbed-clean look of a nearly trouble-free past, the film is also respectful of the physical and emotional artifice that Demy's films exalted. Neither sarcasm nor irony has any place in this world, where every particular detail is a kind of generalized ideal.

Jacquot's father, who runs a small garage, is stern but kind, even when he insists that Jacquot learn a trade instead of filling his head with movie nonsense. His mother supplements the family income as a hairdresser and is equally supportive. Jacquot never fights with his little brother. His friendships are warm. Even the war remains a benign experience.

•

Though Miss Varda uses clips from various Demy films to illustrate the ways in which the director's life directly influenced him, she has no interest in making a film scholar's associations. There is something far less parochial going on: the film mourns not only the loss of one man but also of a way of small-town French life.

At its best, "Jacquot of Nantes" has the manner of a family album. But like a family album, its interest is pretty much limited to family members, devoted friends and admirers. Those who know Demy only through his work can appreciate Miss Varda's skills, while finding it difficult to share the intensity of her emotions.

For the outsider, something vital appears to be missing. The Jacquot we see on the screen, who is played by three different boys as he grows up, is apparently so happy that his need to flee Nantes to become a film artist never seems more than an ardent whim.

The movie shows the young Jacquot falling in love with the theater, making his own puppet show and, eventually, painstakingly animating his own home movie. It prettily moves back and forth between black-and-white and color photography and, in a casual way, discovers locations in Nantes that grown-up Jacquot would later use in his movies.

Yet there is little sense of the passion that was to animate Demy; a man who, in "The Young Girls of Rochefort," could tell a story about sweet young love and a sadistic killer more or less in the same breath.

That may be asking too much. "Jacquot de Nantes" doesn't mean to be a critical evaluation, a psychological profile or a biography. It's a memoir of Demy's love affair with Nantes and with movies, by the woman who shared his life for 32 years.

1991 S 25, C16:3

The Other Eye

Written, directed and edited by Johanna Heer and Werner Schmiedel, in German with English subtitles; cinematography by Ms. Heer. At Alice Tully Hall, as part of the 29th New York Film Festival. Running time: 125 minutes. This film has no rating.

With: Rudolph S. Joseph, Anne Friedberg, Harold Nebenzal, Francis Lederer, Heide Schlüpmann, Freddy Buache, Jean Oser, Jan-Christopher Horak, Henri Alekan, Micheline Presle, Michael Pabst, Hilde Krahl, Carl Szokoll, Aglaja Schmid, Herbert G. Luft and Ronny Loewy.

By JANET MASLIN

"The Other Eye" examines the career of G. W. Pabst, the Austrian-born director who is best known for his work with Louise Brooks ("Pandora's Box," "Diary of a Lost Girl") and least well known for those films he made under the auspices of the Third Reich. This documentary by Johanna Heer and Werner Schmiedel pays particular attention to the latter chapter in Pabst's life, and to the connections between an artist's work and the political climate in which it is engendered.

Interviewing an assortment of film scholars and first-hand observers of Pabst's work, the film makers assemble a meandering but often illuminating portrait. Among those providing details of Pabst's history are Anne Friedberg of the University of California, who discusses the director's collaboration with Sigmund Freud in the 1920's on "Secrets of a Soul," a film that attempted to dramatize the process of Freudian analysis and included some remarkable dream sequences, which are glimpsed here briefly in film clips. Ms. Friedberg, in one of the film's many interesting digressions, also mentions an attempted collaboration between Freud and Samuel Goldwyn that would surely have been bizarre had it come to pass.

Francis Lederer, looking remarkably fit and vigorous here, describes his acting experiences in "Pandora's Box" with Brooks. "Naturally, it was like talking to a sphinx," he says of the actress, with whom he did not share a common language at the time. Harold Nebenzal, whose father, Seymour, was the producer of much of Pabst's best work, recalls a close friendship between the two families. The great cinematographer Henri Alekan describes Pabst's way of holding preproduction meetings and welcoming ideas from members of his cast and crew, which was unusual for its time.

The Film Society of Lincoln Center

Agnès Varda with Édouard Joubeaud, left, and Philippe Maron on the set of "Jacquot de Nantes."

The producer Rudolph S. Joseph talks of Pabst's work on "The Joyless Street" with Greta Garbo, just before she came to America. It is the film makers' pointless affectation to let the camera wander over Mr. Joseph's head to a portrait of Garbo while he speaks. They also photograph palm trees and freeways, either as an homage to Hollywood or because the person being interviewed now lives in California. Many images are also tinted or slanted, to equally vague and unhelpful effect.

The sense of Pabst that emerges from the first part of the film is often scholarly but impersonal. Much more is revealed, for instance, about his relations with a film journal that especially revered him than about what sort of character and background he brought to his work. Only when it focuses on Pabst's return to Europe, after a largely unsuccessful stint in Hollywood, does the film take on much urgency. The directors are quite clear in excoriating a director who worked under the watchful eye of Joseph Goebbels, no matter how seemingly apolitical his films may have been.

Although "The Other Eye" includes numerous clips from Pabst's films, even more would have been welcome, especially of those films whose underlying meanings are most in dispute here. Glimpses of two costume films made under the Nazi regime, "Comedians" and "Paracelsus," are intriguing but brief.

•

"For goodness' sake, I didn't think politics had anything to do with it!" exclaims the actress Hilde Krahl, who appeared as a young girl in "Comedians." But Ms. Krahl later bursts into tears, quite movingly, in describing her own remorse over having remained in Germany during the war. Pabst, it is noted, often brandished unused tickets for an ocean crossing and spoke of sudden illness and the outbreak of war to explain why he himself did not leave.

After the war, Pabst made some notable efforts to come to terms with the Nazi past; the film includes clips from "The Trial," with a scene set in a synagogue, and "The Last Ten Days," depicting Adolph Hitler in his bunker. "I believe it was a very difficult time for my father," says Michael Pabst, the director's son, with considerable understatement.

"Pabst never knew the impression it made to go back in 1939," says Jean Oser, another of the director's frequent collaborators. As the film makes clear, the director may not have understood the implications of his actions at the time, but they became unavoidable for him later.

"The Other Eye" will be shown tonight at 6:15 as part of the New York Film Festival.

1991 S 25, C17:1

The Adjuster

Written and directed by Atom Egoyan; director of photography, Paul Sarossy; edited by Susan Shipton; music by Mychael Danna; production designers, Linda Del Rosario and Richard Harris; produced by Camelia Frieberg; released by Orion Classics. At Alice Tully Hall, as part of the 29th New York Film Festival. Running time: 102 minutes. This film has no rating.

Noah	Elias Koteas
Hera	Arsinée Khanjian
Bubba	Maury Chaykin
Mimi	Gabrielle Rose
Arianne	Jennifer Dale
Bert	David Hemblen
Seta	Rose Sarkisyan
Simon	Armen Kokorian

WITH: Jacqueline Samuda, Gerard Parks, Patricia Collins, Don McKellar, John Gilbert, Stephen Ouimette, Raoul Trujillo, Tony Nardi, Paul Bettis and Frank Jefferson.

By JANET MASLIN

Atom Egoyan, the director of "The Adjuster," takes quiet glee in laying out the individual elements of his film as if they were clues in a detective story or pieces of a puzzle. Mr. Egoyan, whose earlier "Speaking Parts" and "Family Viewing" employed a similar method, finds even greater satisfaction in the off-balance, mischievously witty way in which those pieces finally fit together.

With an approach like this, it isn't likely — or even necessary — that the final effect will be as fascinating as the deadpan, perfectly controlled manner in which the film maker permits information to be released. What matters is that Mr. Egoyan directs with utter confidence in a style that grows more polished and accessible with each new effort, and is unmistakably his own.

A fire scene. A screening room. A motel. A subway car, on which a rich woman makes herself available to a sobbing and thankful derelict. A brand-new house in the absolute middle of nowhere. These are some of the ingredients with which Mr. Egoyan, in typically solemn and elliptical fashion, allows "The Adjuster" to begin. Only gradually does the connective tissue begin to appear. The screening room is where Hera (the beautiful Arsinée Khanjian, who is this director's frequent leading lady and also his wife) works as a censor. The fire scene is where her husband, Noah (Elias Koteas), the insurance adjuster of the title, comforts a new client in a manner that is not entirely reassuring. As Noah is fond of saying, "You may not feel it, but you're in a state of shock."

•

Mr. Egoyan, who wrote the screenplay, has as much fun with his dialogue as he does in naming his characters. Noah is, he says, "just sorting things out, deciding what has value and what doesn't." Hera replies: "I know what you mean. It's the same thing I do."

The process of classification, as conducted by Hera and her intensely businesslike associates, is carried to bizarre extremes. (In long shot, in a library-like setting, Hera's colleages are seen sifting gravely through enormous bins of porn.) Meanwhile, Noah goes to his own extremes in serving as a savior to those who have been figuratively cast adrift by disaster. A motel is populated solely by Noah's appreciative clients, some of whom go to extraordinary lengths to express their gratitude.

Noah makes house calls here not only for sexual purposes (at one point he discusses itemization and deductions while in the heat of passion) but also to study photographic evidence by which he reconstructs the value of his clients' past lives. "Was this a purebred?" he somberly asks two gay men who have lost their dog. "This is your bedroom?" he inquires studiously, when one of these men provocatively hands over a set of sexually explicit photographs. "These don't show too much of the background."

•

Also in the film and (it is eventually revealed) on a collision course with Noah and Hera are Bubba (Maury Chaykin) and Mimi (Gabrielle Rose), the wealthy couple who posed as derelict and dilettante on the subway and who go through numerous other dress-up games before the film is over. Bubba eventually becomes obsessed with the isolated house, as beached as the Ark, in which Noah and Hera live. "They have everything they want, or they have the means to have everything they want, but they don't know what they need," it is explained about Bubba and Mimi. "So they try different things, and this house is one of them." Having Mimi dress up as a cheerleader before a squad of utterly impassive, bored-looking football players turns out to be another.

The mournful music and the autumnal tone of "The Adjuster" allow Mr. Egoyan, a Cairo-born film maker of Armenian descent who now works in Canada, to incorporate all manner of mythological references, strange parallels and even terrible puns into the film's seemingly serious mood. "I've had people with warts covering their entire soles," says a doctor who removes one from Hera's foot. The film also pays fairly serious attention to the question of why people sing in the shower.

That substance remains secondary to intriguing style here is borne out by the film's seemingly humorous listing of alphabetical categories of censorship from A through H. In fact, these guidelines, from the Ontario Board of Classification, are real. But in the blithely skewed context of Mr. Egoyan's film, they are made to seem otherwise.

"The Adjuster" will be shown tonight at 6:15 and tomorrow at 9 P.M. as part of the New York Film Festival.

1991 S 26, C18:5

My Own Private Idaho

Directed and written by Gus Van Sant Jr.; directors of photography, Eric Alan Edwards and John Campbell; edited by Curtiss Clayton; production designer, David Brisbin; produced by Laurie Parker; released by Fine Line Features. At Alice Tully Hall, as part of the 29th New York Film Festival. Running time: 105 minutes. This film is rated R.

Mike Waters	River Phoenix
Scott Favor	Keanu Reeves
Richard Waters	James Russo
Bob Pigeon	William Richert
Gary	Rodney Harvey
Carmella	Chiara Caselli
Denise	Jessie Thomas
Digger	Mike Parker
Alena	Grace Zabriskie
Budd	Flea
Jack Favor	Tom Troupe
Hans	Udo Kier

By VINCENT CANBY

With "My Own Private Idaho," his third feature, Gus Van Sant Jr. makes a big bold leap to join Jim Jarmusch and the Coen brothers in the front ranks of America's most innovative independent film makers.

"My Own Private Idaho" is essentially a road movie that, in its subversive way, almost qualifies as a romantic comedy except that its characters are so forlorn. The film itself is invigorating — written, directed and acted with enormous insight and comic élan.

It will be presented at the New York Film Festival today at 9:15 P.M. and tomorrow at midnight and is scheduled to open its regular commercial engagement on Sunday.

Like Sam Shepard's plays, "My Own Private Idaho" is set in a contemporary American West inhabited by people who have lost touch with a past perhaps best left unexplored.

Their attempts to connect with the present are tentative, desperate and usually doomed. For most, the cost of the connection is too high, being beyond their mental and emotional means.

•

"My Own Private Idaho" is about two very different male hustlers who cross paths on Portland, Ore.'s, skid row, become close friends for a while, then separate.

Mike Waters (River Phoenix) is a good-looking, none-too-bright young fellow, the product of a dramatically dysfunctional family, whose career opportunities are affected by his narcolepsy. Mike has a terrible tendency to fall asleep, suddenly and deeply, when faced with a situation in which he can't cope.

A very different sort is Scott Favor (Keanu Reeves), who has the manners, self-assurance and handsomeness associated with an idealized preppie. He is an untroubled bisexual who operates according to a carefully planned agenda. Scott comes from a rich family and stands to inherit a fortune. His father is the Mayor of Portland.

He hustles not because he has to but to satisfy his ego, to infuriate his father and to make his own apparent salvation, when he comes into his money, just that much more dramatic. Scott is rigorous and a bit spooky in his resolve. His aim: to become a pillar of the community and maybe, some day, even mayor.

This is the frame of the movie, which Mr. Van Sant wrote and directed and which operates according to an agenda as carefully structured as Scott's, though never as baldly stated.

•

The movie opens on a stretch of two-lane blacktop highway somewhere in the vast lonely landscape of Idaho. Wearing a wool stocking cap and a wool jacket and carrying a small duffle bag, Mike Waters stands at the side of the road, at loose ends. Which way to go? As often happens at such times, Mike is overwhelmed by sleep.

The movie more or less wakes up in Seattle, where Mike is pliantly responding to a male customer. He's still without direction. There's another customer who asks him to act out an elaborate domestic fantasy. Mike docilely complies.

Moving on to Portland, he is picked up by a woman who takes him back to an imposing mansion in the suburbs. Mike: "Do you live here?" The woman: "Yes." Mike: "I don't blame you." This, however, is a somewhat different kind of job. There are already two other hustlers there. Something about the looks of the woman prompts Mike to drop into a heavy snooze again.

Though Mike and Scott have seen each other around, this is how they become pals. Scott carries the sleeping Mike out of the house, covers him with his own dark blue blazer and leaves him on the suburban lawn.

•

Back on skid row, they become something of a pair. Scott introduces Mike to an inner circle of skid row hustlers and their hangers-on. In particular, there is Bob Pigeon (William Richert), a big, fat, hard-drinking old drifter who has a fondness for young men but seldom the money to pay for them.

Bob talks grandly. Metaphors are his medium. Bob was once in love with Scott, and Scott used the older man as his teacher and protector in the demimonde. Mr. Van Sant is not

subtle about it: Bob is Falstaff to Scott's Prince Hal. There is even an elaborate variation on Shakespeare's Gadshill caper, in which Falstaff becomes the butt of Hal's carefully orchestrated joke-robbery.

Mr. Van Sant's control is such that the movie accommodates the artifice of this allusion without embarrassment and, indeed, to its own profit. Of more immediate importance to the success of the film, though, is the odd relationship between Scott and the hapless Mike.

Scott, who has nothing better to do at the moment, agrees to help Mike search for his long-lost mother, last heard from somewhere in Idaho.

•

In the course of this journey, which begins on a stolen motorcycle and is the sad lost heart of the film, the two young men move from Portland to Idaho to Italy and back to Portland, though now going their separate ways.

Like the narcoleptic Mike, the movie initially seems to be without direction. It appears to drift from one casual encounter to the next, getting what it can from the passing connections, some of them very funny, others harrowing, until time runs out. When the film abruptly reaches its end, the conclusion is seen, in hindsight, to have been inevitable from the opening frame.

"My Own Private Idaho" is as blunt, uncompromising and nonjudgmental as Mr. Van Sant's two earlier films, "Drugstore Cowboy" and "Mala Noche," but the scope is now broader and the aspirations more daring.

Too much should not be made of the free use of Falstaff, Hal and the two "Henry IV" plays. It's a nervy thing to do, and it works as far as it goes. Mr. Van Sant's evocation of the world in which Mike and Scott briefly connect is what "My Own Private Idaho" is all about.

The movie, photographed by Eric Alan Edwards and John Campbell, has a beautiful autumnal look and a way of seeming to take its time without actually wasting it.

•

The performances, especially by the two young stars, are as surprising as they are sure. Mr. Phoenix ("Dogfight") and Mr. Reeves (of the two "Bill and Ted" comedies) are very fine in what may be the two best roles they'll find in years. Roles of this density, for young actors, do not come by that often.

Mr. Richert, best known as the director of the one-of-a-kind "Winter Kills" (1976), is not fat enough to be even a weight-conscious Falstaff, but he clearly enjoys acting.

At no point in the course of the film is mention made of AIDS. The omission is so marked that it must be deliberate. It's not enough to assume that all these guys practice safe-sex because Mike is once seen carrying a condom. It could be that Mr. Van Sant means the film to be a fable set in its own privileged time.

Whatever the explanation, AIDS simply does not exist in "My Own Private Idaho."

•

"My Own Private Idaho," which has been rated R (Under 17 requires accompanying parent or adult guardian), has a lot of vulgar language, nudity and simulated sex.

1991 S 27, C5:1

Woman of the Port
(La Mujer del Puerto)

Directed by Arturo Ripstein; screenplay by Paz Alicia Garciadiego (in Spanish with English subtitles), based on a story by Guy de Maupassant; director of photography, Angel Goded; edited by Carlos Puente; music by Lucia Alvarez; production designer, Juan Jose Urbini; produced by Alien Persselin and Michael Donnelly. At Alice Tully Hall, as part of the 29th New York Film Festival. Running time: 110 minutes. This film has no rating.

Tomasa	Patricia Reyes Spindola
Carmelo	Alejandro Parodi
Perla	Evangelina Sosa
Marro	Damián Alcazar
Eneas	Ernesto Yañez
Simón	Julián Pastor
Dr. Sotero	Fernando Soler Palavicini
Rufino	Alonso Echánove
Chino	Osami Kawano
Policia	Jorge Fegan
Lola	Alejandra Montoya

By JANET MASLIN

In "Woman of the Port," the Mexican director Arturo Ripstein tells the same Guy de Maupassant story from three different viewpoints, tarting it up considerably in the process. Set in a dank, dreary brothel in a harbor town, the film begins from the perspective of Marro (Damián Alcazar), a small, glum-looking sailor. On a visit to the brothel, Marro finds himself falling in love with Perla (Evangelina Sosa), who sings onstage wearing a mermaid's tail.

Perla has also been taught by her mother, Tomasa (Patricia Reyes Spindola), and Carmelo (Alejandro Parodi), who plays piano in the club, to perform humorously in other ways that are best not described here, but are connected with Carmelo's ability to hold the note of high C.

Marro's impression of this place and its denizens emerges as fairly bold and dramatic when compared with Perla's more troubled and dejected view. As the film switches to Perla's version of these events, it takes on a slower and more hopeless tone, giving particular attention to the quarrels between Perla and her mother. Left pregnant by Marro and having attempted suicide, Perla remembers a violent argument in which her mother, brandishing a coat hanger, threatened to abort the child.

Not surprisingly, when Tomasa's story is told, the tables are turned. Tomasa sees herself as a much-abused, deeply religious woman who tries vainly to talk her daughter out of performing such a sinful act, then helps in the end because she has no choice. Tomasa also recalls Perla as an innocent toddler, whom Mr. Ripstein has the wit to dress with angel's wings for these flashback scenes.

The revelation that Perla and Marro are in fact brother and sister winds up being a good deal less shocking than might have been expected, both to them and to the narrative. Toying with both sentimentality and sordidness, Mr. Ripstein does not achieve either with great conviction. The film's approach is too abstract to convey strong emotion anyhow, but even as abstraction it remains thin. The variations among these three characters' narratives are seldom radical or revealing enough to justify the elaborateness of the endeavor.

At its better moments, Mr. Ripstein's film does take on the quality of a reverie, and the performances achieve some rueful depth. Mr. Parodi and Ms. Spindola are effective as the story's world-weary elders, and Ms. Sosa makes her voluptuousness seem affectingly bittersweet. A coda in which a presumably happier Perla, now very much pregnant, is still pro-

viding accompaniment for Carmelo's high C is perhaps meant to end the film on a fanciful and amusing note. It doesn't.

"Woman of the Port" will be shown tonight at 6:15 and tomorrow at 2:45 P.M. as part of the New York Film Festival.

1991 S 27, C5:1

The Search for Signs of Intelligent Life in the Universe

Directed and photographed by John Bailey; screenplay by Jane Wagner; produced by Paula Mazur; released by Orion Classics. At the 57th Street Playhouse, 110 West 57th Street, Manhattan. Running time: 109 minutes. This film is rated PG-13.

With: Lily Tomlin

By VINCENT CANBY

"The Search for Signs of Intelligent Life in the Universe," Jane Wagner's one-woman Broadway play written for Lily Tomlin, has now been transferred to the screen, amplified but more or less intact. Though the experience of watching it is different, the show is pretty much all there.

On the screen as on the stage, "The Search for Signs of Intelligent Life in the Universe" is a breezily convoluted, pertinent and sometimes hilarious rundown on the lives and times of a dozen characters. Mostly it's a record of how these characters have interfaced (as some of them might say) with the last 20 years of women's liberation, sexual revolution, dome houses, political commitment, having-it-all, Cuisinarts and two-timing husbands.

Up front there is Trudy, the gabby Times Square bag lady, who suspects that going crazy was the best thing that ever happened to her, though she wouldn't recommend it for everybody. Trudy is a philosopher for prime time. "Going crazy," she suggests, "could just be the evolutionary experience trying to hurry up mind expansion."

She's a "creative consultant" to a group of aliens doing research on earth, as well as the unwitting means by which all of Ms. Wagner's other characters are drawn into a single, madly coherent whole.

Lily Tomlin

The cast includes Agnus Angst, a runaway teen-ager and sometime performance artist; Kate, a rich lonely woman in need of just about anything; Brandy and Tina, Eighth Avenue hookers who are tired of being interviewed for graduate papers, and Lyn, Edie and Marge, friends from the early days of the women's movement whose early aspirations have altered, in sometimes permanent ways.

The stage presentation, directed by Ms. Wagner, looked like a model of

simplicity. In fact, it was a masterly blend of split-second sound and lighting cues, a shrewdly wise and witty text, and the grand display of Ms. Tomlin's talents, with which nothing was allowed to interfere.

Throughout the stage performance, Ms. Tomlin wore gray slacks and a blue shirt, a unisex costume that seemed to blend into the minimal set. She used only the most necessary props. This made it possible for her to bring to life, in sometimes lightning-quick succession, characters who are variously eccentric, sad, gutsy and triumphant, male as well as female.

•

Those characters are all in the film adaptation, though now, through the sometimes questionable magic of the cinema, they are frequently seen in heavy makeup and costume. Rather, Ms. Tomlin is seen in heavy makeup and costume.

The effect is not entirely successful. Ms. Tomlin is no less a wizard than she ever was, but the kind of gross makeup jobs that work in variety-show sketches don't do justice either to her talent as an actress and a monologuist or to Ms. Wagner's material.

The movie, directed and photographed by John Bailey, has trouble finding a method. It begins with the star, in the makeup of Trudy, going about her trash cans and talking to the audience as she rummages. Behind Trudy there is the theater where Lily Tomlin is starring in the show itself.

There is a cut to the stage where Ms. Tomlin is welcoming the theater audience, after which the film cuts back and forth among the characters, and back and forth between Ms. Tomlin as the stage actress in slacks and shirt, and sometimes as the characters in full figure.

•

It's a busy, breathless technique that takes the attention from the star's performance and directs it to things of peripheral interest. One enjoys not the art of the actress but, instead, judges the extent to which the makeup people have or have not succeeded in turning the actress into a teen-age girl or an old man. On the stage she didn't need help.

"The Search for Signs of Intelligent Life in the Universe," which opens today at the 57th Street Playhouse, presents a remarkable actress in a class act, but it is sometimes difficult to see her through special effects that befog.

•

"The Search for Signs of Intelligent Life in the Universe," which has been rated PG-13 (Parents strongly cautioned), includes vulgar language.

1991 S 27, C8:1

Deceived

Directed by Damian Harris; screenplay by Mary Agnes Donoghue and Derek Saunders, story by Ms. Donoghue; director of photography, Jack N. Green; film editor, Neil Travis; music by Thomas Newman; production designer, Andrew McAlpine; produced by Michael Finnell, Wendy Dozoretz and Ellen Collett; released by Touchstone Pictures. Running time: 109 minutes. This film is rated PG-13.

Adrienne	Goldie Hawn
John	John Heard
Adrienne's Mother	Beatrice Straight
Adrienne's Father	George R. Robertson
Charlotte	Robin Bartlett
Rosalie	Kate Reid

By JANET MASLIN

Goldie Hawn stalks through "Deceived" wearing a watchful scowl, which is understandable, since this story of intrigue is so strewn with incriminating evidence that there's a danger she might trip. The guilty party is obviously Jack Saunders (John Heard), the dashing, smooth-talking, slightly unsavory husband of Adrienne Saunders (Ms. Hawn), who works at art restoration when not doing amateur detective work about her spouse.

Jack's trespasses are gradually revealed during the course of the story. He has, among other things, turned up with other men's American Express receipts in his suit pockets, faked out-of-town business trips, created some confusion at the Social Security office and been very, very bad to his mother.

The director, Damian Harris, and the screenwriters, listed as Mary Agnes Donoghue and Derek Saunders, do what they can to create a swirl of Hitchcockian suspense around these events, which means that you can expect a nasty fright every time the family cat jumps out of a closet. It also means that the housekeeper in Adrienne's large, shadowy apartment has good reason to be concerned about her health. Sometimes the material lapses below even this perfunctory level, as when Adrienne actually announces, "Everything I believed in was a lie."

Not being Cary Grant, Mr. Heard is in trouble here, displaying none of the charm, devilishness or even energy to account for Jack's elaborate scheming. Ms. Hawn is better, and she holds the interest even under improbable circumstances, but she too is at a disadvantage. This role requires her to be relentlessly stern once the clues begin dropping out of Jack's pockets, and her usual ebullience is missed. Late in the film, she does have one hilariously rude moment with the

Touchstone/Rob McEwan
Goldie Hawn

oversolicitous parent of a small child.

Also in "Deceived" are Robin Bartlett, who turns up briefly but effectively as Adrienne's partner; Jan Rubes as an art expert whose work proves every bit as dangerous as the housekeeper's; Amy Wright as one of Jack's early admirers, and Kate Reid as the film's only real explanation of why Jack went bad.

•

"Deceived" is rated PG-13 (Parents strongly cautioned). It includes several violent episodes.

1991 S 27, C8:5

1,000 Pieces of Gold

Directed by Nancy Kelly; written by Anne Makepeace; director of photography, Bobby Bukowski; edited by Kenji Yamamoto; music by Gary Remal Malkin; production designer, Dan Bishop; produced by Ms. Kelly and Mr. Yamamoto; released by Greycat Films. At Angelika Film Center, Mercer and Houston Streets, Manhattan. Running time: 105 minutes. This film has no rating.

Lalu (Polly)	Rosalind Chao
Charlie	Chris Cooper
Hong King	Michael Paul Chan
Jim	Dennis Dun
Jonas	Jimmie F. Skaggs
Miles	Will Oldham
Ohio	David Hayward
Berthe	Beth Broderick

By STEPHEN HOLDEN

Lalu Nathoy, or China Polly, as she is nicknamed in "1,000 Pieces of Gold," overcomes almost as many perils as Pauline in the cool, clear-eyed historical drama that opens today at the Angelika Film Center.

As an adolescent in famine-stricken northern China in the 1880's, she is pulled out of bed one morning by her father and summarily sold to a marriage broker, who ships her across the Pacific in chains. In San Francisco, she is auctioned off to an agent (Dennis Dun) for Hong King (Michael Paul Chan), a rapaciously greedy saloonkeeper in the gold-rush mining village of Warren's Diggens, Idaho.

When Lalu violently resists Hong King's attempts to turn her into a prostitute, he forces her to be his slave. But through her toughness, pluck, intelligence and charm and the sympathetic intercession of Hong King's white business partner, Charlie Bemis (Chris Cooper), who wins her in a poker game, she pulls herself out of a seemingly hopeless situation. Eventually, she comes to love Charlie.

•

"1,000 Pieces of Gold," which is based on a true story recounted in Ruthanne Lum McCunn's 1981 book of the same name, has enough plot for three movies. But because its events are so concisely distilled, the film still has enough room left over to ground Lalu's experience securely in the context of a little-known aspect of American pioneer history.

With the discovery of gold in the West, a wave of Chinese laborers arrived to work on the railroads and in the mines. Although welcomed at first, they were soon persecuted by white laborers motivated by a combination of racism and resentment of their industriousness and their willingness to work for very low wages. Denied naturalization and the right to vote, they were eventually excluded from the United States by the Chinese Restriction Act, which Congress passed in 1882 and which ended the country's free immigration policy. Not the least of the dangers Lalu survives is a white lynching party

Bob Marshak
Rosalind Chao

that drives all the Chinese laborers out of Warren's Diggens.

"1,000 Pieces of Gold," directed by Nancy Kelly, is so straightforward in its storytelling and unfussy in its cinematography that at times it has almost a documentary feel. Although the film contains many scenes that could have been directed for excruciating suspense or for tears, its tone remains objective to the point of detachment.

That tone is set by Rosalind Chao's impressive, understated portrayal of Lalu. From the opening scenes, in which she is tearfully carted off from her family while her father turns his back and puts his hands over his ears to block out her cries, the character is revealed as a figure in a larger historical landscape.

Even in moments of terrible anguish, Ms. Chao projects the character's steely will. Threatened with rape, she wields a knife with a determination so ferocious that her captor realizes she is unsuited for prostitution. Even the least sympathetic characters are revealed as vulnerable, multi-dimensional people buffeted by forces beyond their control. The fiendish Hong King and his money-making fever are seen as just an extension of the surrounding entrepreneurial fever.

Lalu's rescuer is himself far from unblemished. A survivor of Andersonville prison, he is a hard-drinking, war-weary lost soul who swallows his feelings. Mr. Cooper's gruff, reticent performance undercuts the romantic aura of savior that clings to the most heroic secondary role in this well-made old-fashioned movie.

1991 S 27, C10:4

Necessary Roughness

Directed by Stan Dragoti; written by Rick Natkin and David Fuller; director of photography, Peter Stein; edited by John Wright and Steve Mirkovich; music by Bill Conti; production designer, Paul Peters; produced by Mace Neufeld and Robert Rehme; released by Paramount Pictures. Running time: 108 minutes. This film is rated PG-13.

Paul Blake	Scott Bakula
Coach Gennero	Hector Elizondo
Coach Rig	Robert Loggia
Suzanne Carter	Harley Jane Kozak
Dean Elias	Larry Miller
Andre Krimm	Sinbad
Lucy Draper	Kathy Ireland

By STEPHEN HOLDEN

Stan Dragoti's "Necessary Roughness" is a comedy based on the dubious assumption that the same audience that buys videotapes of sports bloopers might enjoy a film about one of the most unlikely fictional teams in the history of college football.

When the members of the Armadillos, the championship team at the fictional Texas State University, are expelled after a scandal, they are replaced by a ragtag lineup that includes a nearly middle-aged quarterback (Scott Bakula), a female place kicker (Kathy Ireland), and a wide receiver who chants "The ball is my friend! The ball is my friend!" before invariably bungling a pass.

If the movie were a farcical free-for-all ridiculing the hyper-competitive world of college football, it might be amusing. But it can never decide whether to be an athletic answer to "National Lampoon's Animal House" or icky-inspirational like "Rocky." And with a blaring score by Bill Conti, who composed the music for

"Rocky," and a sentimental subplot about the friendship between the two coaches (Hector Elizondo and Robert Loggia) who steer the Armadillos to a moment of glory, the film tilts toward the "Rocky" side.

Although the opening scenes portray the new Armadillos as a bunch of clowns, the expected pranks and comic pratfalls barely materialize. No sooner does Mr. Bakula's soulful-eyed quarterback fall in love with his journalism teacher (Harley Jane Kozak) than the film sinks into formulaic mush. The only consistent comic thread finds the comedian Larry Miller skulking around as a lecherous football-hating dean who conspires against the team. His over-the-top caricature is so out of place that it feels as if he had sneaked in unnoticed from another film.

"Necessary Roughness" is rated PG-13 (Parents strongly cautioned). It includes some strong language and mildly off-color jokes.

1991 S 27, C21:3

Prospero's Books

Directed and written by Peter Greenaway, adapted from "The Tempest" by Shakespeare; director of photography, Sacha Vierny; music by Michael Nyman; production designers, Ben van Os and Jan Roelfs; produced by Kees Kasander; released by Miramax Films. At Alice Tully Hall, as part of the 29th New York Film Festival. Running time: 129 minutes. This film has no rating.

Prospero	John Gielgud
Caliban	Michael Clark
Alonso	Michel Blanc
Gonzalo	Erland Josephson
Miranda	Isabelle Pasco
Antonio	Tom Bell
Sebastian	Kenneth Cranham
Ferdinand	Mark Rylance
Adrian	Gerard Thoolen

By VINCENT CANBY

"Knowing I lov'd my books, he furnish'd me from mine own library with volumes that I prize above my dukedom."

Thus speaks Prospero when, early in "The Tempest," he tells his daughter Miranda how they came to be living on this isolated isle. Though Prospero's dukedom was usurped by his brother, and though he and the 3½-year-old Miranda were sent into exile, all was not perfidy.

Gonzalo, an honest old counselor of Milan, saw to it that Prospero was set adrift with his books. In 12 years of exile, Prospero has used those books to assert his dominance over earth, air, fire and water, and all of the creatures therein, real and imagined. Knowledge, the accumulated learning of the known and unknown worlds since time's beginning, has given to Prospero powers whose limits even he does not fathom.

It is no accident, then, that Prospero's lines about his library are the recurring theme heard and seen throughout "Prospero's Books," Peter Greenaway's initially splendiferous and finally numbing new film phantasmagoria. It will be shown at the New York Film Festival today at 5:45 P.M. and tomorrow at 1:30 P.M. It will begin its regular commercial engagement here on Nov. 8.

•

Among other things, the movie is a kind of obsessed collector's inventory of the Renaissance world, its thought, art, architecture, religion, superstitions, music, painting and, well, anything else that might be mentioned.

Miramax Films

John Gielgud in Peter Greenaway's "Prospero's Books."

This tumultuously overpacked movie is less a screen adaptation of Shakespeare's haunting and elegiacal last play than it is a grand jumping off spot for a work that will make some people run boldly for the exits and some quite angry.

Shakespeare, possibly because he was tired and nearing the end of his rope, never got around to identifying the books Prospero took with him. Mr. Greenaway, poet that he is, supplies the information.

Some of the titles: "The Book of Water," "A Harsh Book of Geometry," "A Book of Mirrors," "A Primer of the Small Stars," "A Bestiary of Past, Present and Future Animals," and so on. Each of the books is touched on in the course of the film.

Yet film being something that moves relentlessly on at the projector's pace, "Prospero's Books" never allows the audience the time to enjoy the extraordinary breadth and depth of Mr. Greenaway's imagination. This is the movie's nearly insurmountable problem.

It is too much for mortal eye and ear. It finally swamps the mind with a nonstop succession of sounds and images that have the effect of running together in a great colorful blur.

The movie is a challenge unlike any other. It is certainly not for anyone who does not know "The Tempest" well, preferably as well as Mr. Greenaway's incomparable star, Sir John Gielgud.

Now 87, Mr. Gielgud has played Prospero four times in his stage career. The first time was in 1930 in a production in which Ralph Richardson played Caliban, though probably not with the neon-colored genitals that are a feature of this film's Caliban.

It was Mr. Greenaway's conceit, and a terrifically promising one, that in this "Tempest" Mr. Gielgud's Prospero should also be a mirror image of Shakespeare at the end of his career, with a further association

to the actor himself, nearing the end of his career as an actor.

As Mr. Greenaway pictures it, Prospero still rages over the wrongs done him by his brother Sebastian and Alonso, the King of Naples. As Prospero stands waist-deep in the water of his bathing pool, he imagines a drama in which his magic brings on the tempest that shipwrecks the conspirators on his shore.

At the same time Prospero, as Shakespeare, is writing the play's text, which is pictured in delicate Renaissance script that again calls attention to the film's concerns with thought, knowledge, books. Prospero, who is creating this fiction in his mind, speaks the lines of all of the characters as they take shape, and with the full relish and authority that only Mr. Gielgud can command.

For most of the film Mr. Gielgud is playing to himself, which might be a feast for the ears except that, much of the time, his voice is overlaid with the voice of whichever character he is playing. The result is an eerie echo effect that often renders the language incomprehensible, to say nothing about the confusion as to what, really, is going on.

Only toward the end of the film, when Prospero's forgiveness magically gives the imaginary characters life, does any one else speak his lines solo. "The Tempest" sinks amid a series of dumb-show sequences and the equivalent of cinematic footnotes.

Typical of the film's too-muchness is the largely unrecognized presence in the cast of both Michel Blanc (Alonso) and Erland Josephson (Gonzalo).

These two fine actors show up from time to time, often in processions, but without really being seen, so tremendous is the competition: the gorgeous sets; the evocations of Renaissance painting; the imperial panning shots; the explosions of magnesium; the unruly crowds of naked bodies, some less beautiful than the others, and all

that language, still beautiful but dimly heard.

Even so, I wouldn't want to miss it. Mr. Greenaway, I suspect, is some kind of genius. One day he just might expand the medium enough to accommodate all of the accumulated knowledge he wants to put in it.

1991 S 28, 9:1

A Room in Town

Directed and written by Jacques Demy (in French with English subtitles); director of photography, Jean Penzer; edited by Sabine Mamou; music by Michel Colombier; production manager, Philippe Verro; produced by Christine Gouze-Renal. At Alice Tully Hall, as part of the 29th New York Film Festival. Running time: 90 minutes. This film has no rating.

Edith Leroyer	Dominique Sanda
Margot Langlois	Danielle Darrieux
François Guilbaud	Richard Berry
Edmond Leroyer	Michel Piccoli
Violette Pelletier	Fabienne Guyon
Madame Pelletier	Anna Gaylor
Dambiel	Jean-François Stevenin
Menager	Jean-Louis Rolland
Madame Sforza	Marie-France Roussel
Chef des CRS	Georges Blaness

By VINCENT CANBY

To complement the presentation of "Jacquot of Nantes," Agnès Varda's memoir about her husband, Jacques Demy, the New York Film Festival is showing "A Room in Town" ("Une Chambre en Ville") today at 12:30 P.M.

Almost any other Demy film would have been a better choice than this sad 1982 attempt to reprise the successes of his two earlier all-singing films, "The Umbrellas of Cherbourg" (1963) and "The Young Girls of Rochefort" (1966).

As in those two films, most of the dialogue in "A Room in Town" is sung, though the music here is written by Michel Colombier, not by Michel Legrand, who wrote the far more interesting scores for "Cherbourg" and "Rochefort."

There is also little life in Demy's story, a perhaps intentionally banal romantic melodrama about life, love and death, set in Nantes in 1955 during a shipyard strike. It plays like a denatured "Carmen," complete with fortune teller.

Edith (Dominique Sanda), whose husband (Michel Piccoli) is impotent, brazenly walks the streets of Nantes wearing a mink coat with nothing underneath. One night she flashes her body in front of François (Richard Berry), a shipyard worker who cares deeply about the strike.

He sings that he has no money. She sings that she doesn't care. They go to the nearest hotel, have sex and fall in love with a passion neither ever dreamed of.

The victims of their giddiness include the sweet pregnant girlfriend of François, and Edith's short-tempered husband. By chance the workers are confronting the police just as the love story is reaching its climax. What that says about labor or about romance is anybody's guess.

It all ends tragically, though a lot of people in last week's Lincoln Center preview audience found it hilarious.

For those who know the work of Demy, who died last October, "A Room in Town" might be of some historical interest for the way it demonstrates his fondness for the same types of characters, situations and

even locations in Nantes. His zest, though, and his love of transforming artifice are nowhere to be seen.

1991 S 28, 11:5

Locked-Up Time

Directed by Sibylle Schönemann (in German with English subtitles); director of photography, Thomas Plenert; edited by Gudrun Steinbrück; music by Thomas Kahane; produced by Bernd Burkhardt and Alfred Hürmer. At Alice Tully Hall as part of the 29th New York Film Festival. Running time: 90 minutes. This film has no rating.

By CARYN JAMES

In 1984, Sibylle Schönemann and her husband, both film makers frustrated by restrictions on their work, asked the East German Government for exit visas. The next thing they knew, they had been arrested on charges that were never made clear to them. Ms. Schönemann spent a year as a political prisoner, then was put directly on a bus for the West. Her husband, who received a slightly longer sentence, and their two children were sent after her, with only a few suitcases of belongings.

"Locked-Up Time," Ms. Schönemann's extraordinary documentary about that experience, begins with another bus on the highway, but this time the director is traveling in the opposite direction. In 1990, after the Berlin Wall had come down, she returned to the East. She says she wanted to confront the past, but the film is more remarkable for the way Ms. Schönemann confronts the individuals responsible for her arrest and imprisonment. This deft and chilling film has the style of a personal excursion into history and the urgency of a moment when history is still inchoate. "Locked-Up Time" will be shown at the New York Film Festival this afternoon at 4:30.

Because it was shot in black and white, the documentary carries an aura of the past. This technique creates a strong, ironic tension. As Ms. Schönemann tracks down her prison warden, the man who interrogated her, the lawyer who failed her and the judge who convicted her, the film suggests that their experiences are far too fresh to be reacted to with anything like detachment or remorse. For them, the past is still the present.

Ms. Schönemann eases into these interviews, beginning in the yard of a woman who lives near the prison. The director climbs to the top of a tree she saw from her cell window, while the neighbor says she had no idea political prisoners were being held there.

The film maker moves on to the woman who was her jailer. Like most of those interviewed, this woman looks perfectly ordinary at first but comes to seem like a cog in an evil bureaucracy. She smiles and says she remembers Ms. Schönemann, as if they were old friends.

But when Ms. Schönemann asks why a letter from her husband was withheld for six weeks, the warden pulls a book of rules off the shelf to show that she didn't break any.

When Ms. Schönemann ambushes her interrogator as he is taking in his laundry, the man says: "I don't really have grounds for reproaching myself. I acted, I believe, lawfully, I believed."

Ms. Schönemann's method in all her interviews is to be calm and restrained rather than confrontational. She seems to want understanding,

if not an outright apology, from the people she questions That, it turns out, is asking too much too soon.

There are scenes in which Ms. Schönemann returns to her cell, but she uses re-enactments very sparingly. A close-up of her hand as she takes off a ring is a loaded image of how dehumanized she felt in prison.

Most often, she lets her questions fill in the details about what happened. Although this technique adds a bit of confusion that is intensified by the translation from German, it is an effective, nonpolemical approach that allows viewers to follow the film maker as she travels into the past. "Locked-Up Time" is an eloquent film that shows what an abstraction like "politics" did to one woman and her family.

1991 S 29, 54:3

Life on a String

Directed and written by Chen Kaige, based on a short story by Shi Tiesheng (in Chinese with English subtitles); director of photography Gu Changwei; edited by Pei Xiaonan; music by Qu Xiaosong; produced by Don Ranvaud. At Alice Tully Hall, as part of the 29th New York Film Festival. Running time: 120 minutes. This film has no rating.

The Saint .. Liu Zhongyuan
Shitou .. Huang Lei
Lanxiu ... Xu Qing
Noodleshop Owner's Wife Ma Ling
WITH: Zhang Zhenguan and Yao Jingou

By JANET MASLIN

In the imposingly beautiful but slow and cryptic Chinese film "Life on a String," a young boy is enveloped by his tutor in a magical spell. The boy is instructed to devote his life to music and told that he will be blind until the 1,000th string on his banjo breaks, an event that does not occur until the boy is a very old man.

By this time — as the film moves forward 60 years after a very brief prologue — he has become known as

the Saint (Liu Zhongyuan). And he has a disciple of his own, a young man who is as blind as the teacher. "Master! Why is empty space white?" the younger and more impatient man asks, having never fully achieved the mystical submissiveness that binds the Saint to his destiny. Both men appear torn between their desire for higher wisdom and their eagerness to see.

Beyond this, the events that occur in "Life on a String" are not easily described in anything less than the metaphorical terms in which the film maker, Chen Kaige, (working from a story by Shi Tiesheng) has conceived them. There are battles between two warring clans on the sweeping, barren plains where much of the film takes place. And these battles are influenced, even dramatically stopped, by the Saint as he sits singing on a hilltop.

There is also an enchanted noodle shop beside a waterfall, a place that proves to be a kind of way station between this world and another, to which the old man expects to go soon. Though the old man speaks often of the wonders he hopes to see, the image of a God of Death appears frequently and is linked with the idea of a larger vision.

Much of "Life on a String" is virtually silent, with the actors performing a kind of pantomime as they scramble furiously, arms waving, across the plains. Even the connection between Shitou (Huang Lei), the young protégé, and a lovely young woman called Lanxiu (Xu Qing) is expressed mostly through fervent wordless gestures. This may be just as well, since the songs and dialogue that are heard during the film do little to make it less impenetrable.

The director's ambitions here are on an epic scale, in terms of both the characters' outer lives and their spiritual progress. Slow-moving as it is, "Life on a String" regularly yields images of haunting mystery, like the sight of a radiant young woman about to disappear off a cliff or the bracing way in which a boat carrying a small

child is carried by a team of men out of a rushing river. The torch-lit gathering at which the Saint sings his final songs also achieves the kind of mystical intensity that the film maker must have intended. So does the film's last airborne image of liberation.

The Film Society of Lincoln Center

Huang Lei, left, and Liu Zhongyuan in "Life on a String."

"Life on a String" will be shown tonight at 9:30 and tomorrow at 6:15 as part of the New York Film Festival.

1991 S 29, 54:5

FILM VIEW/Janet Maslin

Pop Music as Spice: Just Be Certain To Use With Care

IN THE PAST IT MAY HAVE BEEN commonplace to walk out of films humming their theme songs, but these days an audience is more likely to be humming on the way in. Films have learned to rely on pop music for its catchiness while the credits roll, its help in glossing over continuity gaps and its effectiveness as a kind of shorthand. Music can establish mood or character in the space of only a few bars. For a film with problems, tacking on a hit record can be the aural equivalent of a Band-Aid, and an easy way out.

In almost any set of movie trailers, there's bound to be one in which a hit song is played so prominently that it becomes the tail wagging the dog. When the hit is noticeably bigger than the movie — Prince's "Delirious" or Roy Orbison's "Only the Lonely" — this tactic seems especially ill-advised. And when the hit is too familiar ("Born to Be Wild" and "Bad to the Bone" should be off limits for motorcycle movies forever after), it can create an instant sense of déjà vu. But this gambit is becoming more and more popular because it can be so powerful. In the right directorial hands, pop music becomes as central to a film as any flesh-and-blood character.

Nancy Savoca's "Dogfight," surely the only film to have accompanied a bedroom scene with Bob Dylan's raspy, acoustic "Don't Think Twice, It's All Right," makes subtle, funny use of a soundtrack that understands the characters better than they understand themselves. The score divides itself between sunny, vapid pop hits suitable to its

1963 time frame, like "Sugar Shack" and "Travelin' Man," and folk music that sounds sweetly, painfully earnest by comparison. When else has a movie heroine consoled herself by listening to Joan Baez's mournful rendition of "Silver Dagger" after a bad date?

And when else has one ever tried on dresses to a Woody Guthrie song or tried to explain "We Shall Overcome"? Ms. Savoca, who is as delicately witty about popular music as she is about tense, uneasy relations between the sexes, sets up a wall of sound behind her film's thoroughly incompatible young lovers and lets the schism between their favorite songs become a running commentary. Within the overall scheme of the film, music takes on a pivotal role.

■

Pop music has comparable importance for "The Commitments," Alan Parker's vibrant Irish valentine to American rhythm-and-blues. In addition to finding something enjoyably comic about the way every last person in the film lives and breathes music and the

way musical tastes in this atmosphere provide an ready definition of character, "The Commitments" eagerly capitalizes on the sheer entertainment value of its score. It will surprise no one that the movie's singing group has now undertaken engagements in real life, or that the film's outstanding performer, Andrew Strong, is now a prospective pop star. In this case, a symbiotic link between life and art has worked to the advantage of both.

Certainly pop music lent a lot of punch to "Thelma and Louise," and there again the music made a point. The powerhouse feminine energy of tracks by singers like Toni Childs and Charlie Sexton, or the version of Van Morrison's "Wild Night" belted out by Martha Reeves, contributed greatly to the film's breakaway spirit; in fact, just about every song on the soundtrack is a passionate embrace of freedom in one form or another. A lot of the music mixes doom with exuberance, thus enhancing the film's air of good-time characters headed for a bad-time fate. And all of it reinforces the film's wind-in-your-hair brand of exhilaration.

Ever since film makers and audiences of baby-boom age began examining their past, pop music has gone beyond amplifying a film and sometimes been central, as in "The Buddy Holly Story," "La Bamba" or "The Doors." Even the recent and forgettable "A Matter of Degrees," about college life in Providence, R.I., focused on the fight to keep a local radio station free to program its own rock-and-roll, with disk jockeys sounding the message "Rock-and-roll can save you." In last year's "Pump Up the Volume," gaining control of the airwaves was also accorded the importance of a subversive act.

■

The effort to keep pop pure and meaningful takes on a certain desperation when a jingle like "Help Me, Honda" can be heard in a car commercial, and when so many films labor to include the obligatory rock video sequence (e.g., Julia Roberts, in "Sleeping With the Enemy," trying on costumes to the irresistible strains of "Brown-Eyed Girl"). So it's all the more pleasing when pop music is used as thoughtfully in movies as it has been by directors like Martin Scorsese, Jonathan Demme and Oliver Stone, all of them outstandingly adept at creating the kind of Greek chorus that makes an audience tap its toes. In "Goodfellas" and "Born on the Fourth of July," Mr. Scorsese and Mr. Stone, respectively, created rich chronological backdrops for their stories by using the right songs. And Mr. Demme's "Something Wild" was made a lot wilder by Mr. Demme's unusually broad and buoyant musical tastes.

Sean Penn's "Indian Runner" draws on both the memory of the Bruce Springsteen song ("Highway Patrolman") on which the film is based and on several Vietnam-era hits that are used to fine, insinuating effect. Mr. Penn's only musical lapse, among otherwise sensible choices, is the use of Bob Dylan's "I Shall Be Released," as performed by the Band, over the closing credits. This is the pop equivalent of ending a film with "Amazing Grace," which has been done well (as in "Silkwood") but overdone. Music in movies shouldn't amount to a short cut; it should be shorthand. □

1991 S 29, II:15:1

The Rapture

Directed and written by Michael Tolkin; director of photography, Bojan Bazelli; edited by Suzanne Fenn; music by Thomas Newman; production designer, Robin Standefer; produced by Nick Wechsler, Nancy Tenenbaum, and Karen Koch; released by Fine Line Features. At Alice Tully Hall, as part of the 29th New York Film Festival. Running time: 102 minutes. This film is rated R.

Sharon	Mimi Rogers
Randy	David Duchovny
Vic	Patrick Bauchau
Mary	Kimberly Cullum
Sheriff Foster	Will Patton
Paula	Terri Hanauer
Henry	Dick Anthony Williams
Tommy	James Le Gros
Angie	Carole Davis
The First Boy	De Vaughn Nixon
The Older Boy	Christian Belnavis
Louis	Douglas Roberts
First Evangelist	Scott Burkholder
Second Evangelist	Vince Grant

By JANET MASLIN

By night Sharon (Mimi Rogers) leads a life of studied decadence, a response to the perfect emptiness of her days. When not tethered to her anonymous job as a telephone operator, she engages in mate-swapping sex with strangers, doing so in the impersonal confines of a friend's furniture store. "What if things go out of control?" asks a propective partner at the start of one such event. "What's control got to do with it?" Sharon tauntingly replies.

"I think he wants to know if you have any limits," suggests Vic (Patrick Bauchau), the friend who joins Sharon for these sexual adventures and whose own motives have more to do with libido than self-loathing. "I haven't found them yet," Sharon says.

But in "The Rapture," Michael Tolkin's fierce, frightening exploration of religious faith pushed to the breaking point, she finds those limits with the force of a revelation. Without warning, Sharon wakes up in the middle of the night in a frenzy of disgust. She orders a male acquaintance out of the bed she now says is unclean; she showers, flosses, changes the sheets and declares herself reborn. "I need a new direction in my life," Sharon says. "There is a God. I know it."

●

"The Player," Mr. Tolkin's scathing novel about a Hollywood executive who commits murder as a quasi-logical extension of his professional life, looks mild in comparison with what he has in mind this time. At first, that is belied by the eerily matter-of-fact manner in which he presents Sharon's conversion. Now she smiles more. She speaks of her new faith with serene self-assurance. She speaks of it so much that she begins to log seven-minute conversations with people calling her for directory assistance, which causes her supervisor to complain. "Henry, God made me an information operator for a reason," she tells him smoothly.

All of Sharon's friends marvel at this transformation, particularly Vic, who thinks at first that she must have found a new man. "Is he as bad a boy as I am?" Vic slyly inquires. "I think you should meet Him," Sharon replies. When her meaning begins to dawn on Vic, his leer evaporates and he tells Sharon to wake him when it's over.

But it doesn't end. Sharon, who always glimpsed what she thought were vague warning signs that the world was in peril, now becomes sure that Armageddon is near. And she aligns herself with a cult of like-minded individuals. All have had similar visions; all follow the teachings of a strange, oracular young boy; all wait with quiet certitude for what they know will come. In this, Mr. Tolkin is chillingly far away from the kind of movie theology that suggests the Apocalypse can be held at bay by a Terminator, that death is just a second chance, or that heaven is filled with thoughtful angels attending to the love lives of those on earth.

●

The very brazenness of his having made a mainstream film about religious faith is nothing beside the lengths to which Mr. Tolkin takes this story, once Sharon is forced to put her beliefs to what is truly the ultimate test. The last part of "The Rapture," in which Sharon's new-found complacency is undone by matters of life and death, is cinematically shocking in ways that, say, Freddy Krueger never dreamed of. Very likely many members of Mr. Tolkin's audience have not dreamed of them either.

The essence of this film's effectiveness lies there: in the fact that its deeply troubling ideas about theology are tailored to a contemporary audience, one that may be as impervious to the subject as Sharon is in the film's early scenes. "If everybody's getting this dream," she asks with representative modern cynicism, "how come it isn't on the news?"

Despite the seemingly unquestioning, even proselytizing tone of the scenes detailing Sharon's conversion, "The Rapture" succeeds in maintain-

Quest Mimi Rogers and Kimberly Cullum play mother and daughter in "The Rapture," about a troubled woman's search for spiritual fulfillment.

ing a subtle editorial distance from its subject. The immensity of that distance becomes devastatingly apparent in a tough, thoughtful ending that will not soon be forgotten.

•

All of "The Rapture" is, in its own way, as overweeningly ambitious as those visually demanding final episodes. And at times Mr. Tolkin lacks the wherewithal to realize his ideas as fully as he might have. Sharon herself, though played fervently by Ms. Rogers, is as much a theoretical construct as a flesh-and-blood individual, and her inner life in matters not linked to spirituality remains unexplored. The conspiratorial hints of a coming Apocalypse risk sounding silly when, say, whispered about during an office coffee break. The film's special effects budget does not begin to approach what would have been needed for a Hollywood-worthy climax. The flat, simple expository style is at times inadequate to the mysticism of the characters. None of this matters much in light of the fact that Mr. Tolkin has made a stark, daringly original film that viscerally demonstrates the courage of its convictions.

Also notable about "The Rapture" are David Duchovny as the slightly more dubious mate who joins Sharon in her quest for faith, Will Patton as the policeman who encounters her at a very late stage in her spiritual evolution and Kimberly Cullum as the little daughter who becomes a sweetly terrifying reflection of her parents' unwavering thoughts. "The Rapture" will be shown tonight at 9:15 and tomorrow at 6:15 as part of the New York Film Festival.

•

"The Rapture" is rated R (Under 17 requires accompanying parent of adult guardian). It includes nudity and sexual suggestiveness.

1991 S 30, C14:4

Avant-Garde Visions

OPENING THE 19TH CENTURY: 1986, directed, written and edited by Ken Jacobs; music composed by Mr. Jacobs; photography by Eugène Promio, Félix Mesgusch and Francis Doublier. Running time: 9 minutes.

THE MAKING OF "MONSTERS," directed and written by John Greyson; produced by Laurie Lynd. Running time: 35 minutes. With Stewart Arnott, Clare Coulter, David Gardner, Taborah Johnson, Ray Kahnert and Lee MacDougall.

FLAMING CREATURES, directed by Jack Smith. Running time: 45 minutes. With Francis Francine, Dolores Flores, Joel Markman and Shirley.

At Alice Tully Hall, as part of the 29th New York Film Festival.

By VINCENT CANBY

Unlike a lot of avant-garde films, which age faster than fondled gardenias, Jack Smith's "Flaming Creatures" remains as vigorously funny and innocent today as it was 29 years ago, when it outraged the censors and the police on two continents.

The 45-minute transvestite romp, one of the classics of the American film underground, is the centerpiece of "Avant-Garde Visions," a program of three films that will be shown at the New York Film Festival tonight at 9:15.

The program is a tribute to the most independent of American film makers and, specifically, to the 30th anniversary of the New American

Cinema Group and its offspring, the Film Makers' Cooperative.

The New American Cinema Group, which initially included Shirley Clark, Robert Frank and Jonas Mekas, was founded to help independent film makers secure financing and distribution. Under the direction of Mr. Mekas, the co-op agreed to distribute all films that were submitted to it.

Although Mr. Mekas has since moved on to direct Anthology Film Archives, the downtown independent film center, the co-op carries on, its only membership requirement being a movie to distribute.

The New York festival asked Smith for permission to show "Flaming Creatures" a couple of years ago. The film maker, who has since died, said that he would be delighted but that he would like to have it colorized first.

The idea of adding computerized color to the spectacularly grainy and uneven black-and-white original shocked the festival purists, although it was quite in keeping with Smith's Pop Art sensibility.

Being shown today is a black-and-white print, brand new, although you'd hardly know it. "Flaming Creatures" was never a model of technical perfection. Even when it was new, the film quality, lighting and focus were variable. It isn't always easy to see what is going on, although it is always apparent that what is going on is supposed to offend.

•

With a soundtrack composed of "Siboney," "Amapola," some rock-and-roll and one peppy song sung in Chinese, the movie is a jiggly montage of people costumed to their thrift-shop nines. They pose, dance, make mock love and, at one point, test a new "heart-shaped" lipstick.

Their sexes are never apparent until the camera closes in on a ripe, full breast or someone's shaking what looks to be an embarrassed penis. This is what caused all the fuss nearly 30 years ago, although "Flaming Creatures" is about as prurient as Ovaltine.

The film is an artfully framed and edited celebration of all that was most rude in our culture in 1962 and, even now, can upset. It exalts the camp sensibility in a way that amounts to a political statement, although Smith probably couldn't have cared less.

•

Sharing the program with "Flaming Creatures" are two new films, the nine-minute "Opening the 19th Century: 1896," by Ken Jacobs, a longtime contributor to the American avant-garde scene, and "The Making of 'Monsters,' " by John Greyson, a Canadian director.

Mr. Jacobs takes some old Lumière brothers material, including what look to be travelogue shots of Venice and Cairo, and turns it into a graceful 3-D consideration not of geography, but of the ability of film to endure and to change.

Each member of the audience is given a small piece of smoky film to hold in front of one eye while watching the screen with both eyes open. The result is the same effect as that of three-dimensional photography.

The 35-minute Greyson film is an earnest pastiche. It's a jokey mini-musical in which Bertolt Brecht, played by a catfish in a fishbowl, is supposedly directing a film about the murder of a Toronto teacher by a group of gay-bashing schoolboys. The cast also features a character called George Lucas, the music of Kurt

Weill and the voice of an actress playing someone called Lotte Lenya.

This is a very elaborate but not especially productive "distancing" device that would probably not amuse Brecht. It also calls more attention to the film maker than it does to the cause that inspired him.

Today's tribute might have been better served by any number of other choices.

1991 O 1, C13:1

La Belle Noiseuse

Directed by Jacques Rivette; screenplay (in French with English subtitles) by Pascal Bonitzer, Christine Laurent and Mr. Rivette; photography by William Lubtchansky; edited by Nicole Lubtchansky; production designer, Emmanuel de Chauvigny; produced by Pierre Grise; an MK2 Productions USA Release. At Alice Tully Hall, as part of the 29th New York Film Festival. Running time: 240 minutes. This film has no rating.

Frenhofer	Michel Piccoli
Liz	Jane Birkin
Marianne	Emmanuelle Béart
Julienne	Marianne Denicourt
Nicolas	David Bursztein
Porbus	Gilles Arbona
Painter's hand	Bernard Dufour

By VINCENT CANBY

In the South of France near Montpellier, in a magnificent old chateau slightly smaller than the Metropolitan Museum of Art, Édouard Frenhofer, a once-celebrated painter, lives in uneasy bucolic stasis with his wife, Liz, his former model.

Édouard (Michel Piccoli) has not done any work in 10 years, monumentally blocked, it seems, by love or, at least, by contentment. He eats and drinks and putters around the chateau. Liz (Jane Birkin) devotes herself to Édouard and, as a hobby, stuffs birds, sometimes members of endangered species.

Their placid existence is shattered when Édouard suddenly decides to paint again. His inspiration: a young dark-eyed beauty named Marianne (Emmanuelle Béart), the companion of Nicolas (David Bursztein), a young painter on his way up in the contemporary art world.

Nicolas has made a pilgrimage to the chateau to pay his respects to the older man. Marianne, who is not a professional model, agrees to pose for Édouard, only with reluctance. She senses something strange is going on.

What happens in the next five days, and in the four hours' running time of Jacques Rivette's "Belle Noiseuse," is intended to be nothing less than an examination of one of life's great mysteries, the artist's creative process.

•

Winner of the second prize at this year's Cannes International Film Festival, "La Belle Noiseuse" is an incredibly beautiful, roomy sort of film whose views of art reflect the tradition of what might be called academic romanticism. As in "Camille Claudel," about the storm-tossed love affair of Camille Claudel and Auguste Rodin, "La Belle Noiseuse" is convinced that no masterpiece can be created without human sacrifice.

The movie's title comes from the painting on which Édouard was working at the time he more or less drifted into temporary retirement. It was inspired by a 17th-century courtesan, Catherine Lescault, nicknamed "La Belle Noiseuse," which is translated

in the subtitles as "The Beautiful Nut." Whatever she is called, she is a woman who drives men mad.

"La Belle Noiseuse," which will be shown at the New York Film Festival today at 6 P.M. and tomorrow at 8:45 P.M., has the shapeliness of one of Eric Rohmer's high comedies, except that it is not especially funny. Though it is a comedy, it is a very solemn one. The ideas it expresses are not questioned; they're demonstrated to be given truths.

The film focuses on the four days in which Édouard and Marianne effectively collaborate to bring forth what is expected to be the older man's chef d'oeuvre. It's not an accident that Édouard's studio, the huge loft above the chateau stables, is compared to a cathedral. In this film the creative process is as sacred as it is mysterious.

It's also a total surprise to Marianne. Nicolas, after all, is a painter who works from photographs. Édouard works only from life. Stripping the initially resistant Marianne down to her glorious nakedness, he goads and bullies her into poses that cramp for long hours that exhaust.

•

As he works, first making dozens of sketches with pen and ink and charcoal before moving to his paints, the camera often spends long minutes examining the work as it progresses, the hand of Édouard being actually that of the painter Bernard Dufour.

"I don't know if Nicolas draws," says Édouard early on. "Some prefer to go straight to the canvas. A jump into the unknown."

At first difficult and quarrelsome, Marianne finds herself being drawn into what Édouard calls "the whirlwind," while both Liz and Nicolas wait with apprehension in the wings. Nicolas is jealous. Liz is not as jealous as she is fearful of the toll the experience will take on the young woman. Artists, she knows, tend to destroy everyone around them.

As he works, Édouard tells Marianne that he wants to capture "the blood, the fire, the ice, all that's inside of you." That sounds rather good, except that Mr. Rivette's camera upstages what the audience sees being done by Mr. Dufour's hand at the easel.

•

Miss Béart, as lighted and photographed by the cinematographer William Lubtchansky, looks to have been air-brushed by God. The skin textures, the line of her back, the curve of a breast and the arch of her chin, all are studied and recorded on film in such a way as to remind us why painting has gone off in so many other directions since the camera's invention. Nothing that Édouard does (or that, we see, anyway) can equal the film's reality of Marianne.

Though the concerns of "La Belle Noiseuse" are lofty, the mechanics by which it operates are conventional. Two days into their collaboration, Édouard breaks down and confesses to Marianne that he has lost his touch, saying that he can't go on. Marianne becomes a bossy muse.

It is her turn to goad him. She has not followed him into "this void," she says, to have him abandon the work unfinished. She sounds a bit like Mrs. Alexander Graham Bell telling her husband that his funny little invention really will work if he just sticks with it.

•

For a film that is so long in duration and so short on event, "La Belle Noiseuse" is remarkably easy to endure. It is as restful as a vacation in

the South of France in midsummer, when twilight seems to last to midnight, the cicadas never sleep, and meals are long, lazy and loaded with cholesterol.

Mr. Piccoli is fine as the reanimated painter, a man who is self-absorbed but, finally, not without compassion and a sense of irony. Miss Birkin plays the aging Liz somewhat in the manner of the early Mia Farrow, back in the days before Miss Farrow had been liberated from straight waifdom by Woody Allen. Liz's manners are those of a little girl but the mind is that of a woman of real substance.

Miss Béart, best known here for the title role in Claude Berri's "Manon of the Spring," is not only spectacular to look at but a most engaging actress.

Whatever you do, don't walk out on "La Belle Noiseuse" before the end. Mr. Rivette concludes with a lovely Mozartian recognition scene that is genuinely sharp and witty, and the most securely satisfying sequence in the film.

"La Belle Noiseuse" opens its commercial engagement here Friday at the Lincoln Plaza Cinemas.

1991 O 2, C17:5

Takeover

Directed and produced by Peter Kinoy and Pamela Yates; a Skylight Pictures Production. Running time: 58 minutes.

To the Moon, Alice

Directed and written by Jessie Nelson, based on a story by Lynn Sharon Schwartz; produced by Chanticleer Films; released by Fox Lorber. At Film Forum 1, 209 West Houston Street. Running time: 30 minutes. These films are not rated.

Frank.................................. Chris Cooper
Alice.................................... Karen Young
Willy................................. Max Elliot Slade
Producer............................... Julie Kavner

By CARYN JAMES

Mainstream movies like "The Fisher King" and Mel Brooks's recent "Life Stinks" approach the homeless through the comfortable lens of comedy. But the two works opening today at Film Forum are head-on views likely to make everyone feel uneasy.

"To the Moon, Alice" is a half-hour fiction about a nightmare version of the nuclear family: a homeless couple and their young son camp out by night on the set of a television sitcom. "Takeover" is an hourlong documentary about homeless people who organized and took over empty houses in eight cities on May Day 1990. Both are tough, effective complements to the growing list of commercial films on the subject.

In "Takeover," Pamela Yates and Peter Kinoy follow people who are nothing less than homeless guerrillas, bound to take back what they feel is theirs. As the film moves back and forth from Philadelphia to New York to Minneapolis and other cities, it becomes a deftly edited collage. The camera lets the homeless tell their stories, then goes along as they break padlocks, move into boarded-up houses and are sometimes arrested.

These people turn out to be an articulate group, well mixed to prove that homelessness can happen to anyone: a white husband and wife, a middle-class black widow and her son, an uneducated American Indian who is the single mother of several small children.

And they state the reasons for their actions clearly. All the houses they take are owned by the Federal Government, repossessed by the Department of Housing and Urban Development from owners who defaulted on Government-backed loans. As one single-mother in Philadelphia sees it, "This is our Government and those houses are our homes." Another woman says, "If breaking laws is what you have to do to change them, then that's what I'll do." And a man who moved from Tompkins Square Park in New York City to a vacant house says: "I'm dying on the streets. I think that should be against the law."

Despite their social diversity, these people are too much alike in one respect. All are fierce, strong, committed activists, as if the film makers didn't dare look at the homeless who are too broken or weak to take any action at all. This creates the naïve impression that determination alone will solve the problem. And though these activists are well organized in each city, the film doesn't bother to examine how these organizations came to be. But then "Takeover" is meant to be a polemical call to action, not a dispassionate study of homelessness.

Though the film is small scale, it comes with famous backers. Some of the money came from Bruce Springsteen. Some came from Michael Moore, the film director who took part of his profits from "Roger and Me" and created a foundation to offer so-called idiot grants to film makers and political groups who intend to expose idiocy.

●

"To the Moon, Alice," based on a story by Lynn Sharon Schwartz, is much gentler in tone. The plot doesn't hold up, but Karen Young and Chris Cooper richly evoke the couple's strength as well as the emotional frailty that always threatens them. Their artificial, TV-land setting brings to life the eerie, unreal sense that haunts the words of so many homeless people: "I never thought it could happen to me."

1991 O 2, C19:1

The Body Beautiful

Directed and written by Ngozi Onwurah; photography by Peter Collis; edited by Liz Webber; music by Tony Quigley; produced by Lin Solomon; a Women Make Movies Release. At Alice Tully Hall, as part of the 29th New York Film Festival. Running time: 23 minutes. This film has no rating.

WITH: Madge Onwurah, Sian Martin, Maureen Douglass and Brian Bovell.

Intimate Stranger

A film by Alan Berliner. At Alice Tully Hall, as part of the 29th New York Film Festival. Running time: 60 minutes. This film has no rating.

By JANET MASLIN

Anyone can devote an hour to the subject of his or her family's history. But few do it as entertainingly as Alan Berliner has in "Intimate Stranger," a documentary as compellingly eccentric as the man it is chiefly about. Joseph Cassuto, the film maker's grandfather, lived a restless life that made him warm friendships in some parts of the globe but left a residue of bad feeling in his Brooklyn

home. "His business was having people like him — and I never met anyone who didn't like him, outside of his immediate family," one of his children is heard saying in voice-over.

Mr. Berliner eagerly incorporates such critical voices and allows them to be heard all through the film, even when it comes to discussing whether this very project is worthwhile. "It's not going to be a 'Rain Man,' it's not going to be a 'One Flew Over the Cuckoo's Nest,'" one relative warns him at the outset.

The same skepticism greeted the prospect of Mr. Cassuto's autobiography, which he had begun at the time of his death in 1974. "My question to you is, who the hell is he to be writing an autobiography, and who the hell would be interested in it?" one of Mr. Cassuto's sons says. "When you find a person of no distinction writing about himself in the first person singular, something is cockeyed."

But Mr. Cassuto was not, on the evidence of this film, a negligible figure. He was an exceptional enigma, not least for the way he treated his family as he pursued his interests elsewhere and left his wife, daughter and 3 sons alone for 11 months out of the year. Born a Palestinian Jew and raised in Egypt, Mr. Cassuto became associated with the Alexandria office of the Japanese Cotton Trading Company and made many close Japanese friends in the years before World War II. He also married an American woman, the former Rose Honig who, according to the film, would wave the stars and stripes and sing patriotic songs to her husband during family quarrels.

The family was split in half during the war, since Rose and her two youngest children were free to return to the United States, and the others were not. When Mr. Cassuto did settle in Brooklyn after this long separation, he was visibly uneasy, as is apparent in some of the home-movie snippets that Mr. Berliner includes. "He was a nothing in America," one son says bluntly. He was also deeply grieved by news of postwar suffering in Japan, and dutifully sent parcels of food, clothing and medicine to his friends there. "It's very simple," one of them says about him in voice-over. "His heart was not American. His heart was Japanese."

So after only a year or two in Brooklyn, Mr. Cassuto returned to Japan, where he worked for the Nichimen Corporation and where he can be seen in some group photographs as the only man wearing a kimono; all his Japanese colleagues are, in business suits. In these and other photographs of Mr. Cassuto amid Japanese acquaintances, there is a remarkable air of warmth and relaxation, one that is never apparent in pictures of him on visits to Brooklyn. "When I'm looking at these pictures," one of the children says of the Japanese photographs, "it's as if I'm looking at another man and another life. That isn't my father."

Mr. Berliner succeeds in giving equal attention to all the viewpoints represented in this story, including that of his long-suffering grandmother, whom he regards as quietly heroic. "I'm not as naïve as I used to be, to believe that absence makes the heart grow fonder," she once wrote bitterly to her faraway husband. In allowing full voice to his three uncles' intense, almost comic bitterness, and to the wistful regrets that are voiced by his elegant mother, Mr. Berliner creates a rich, tumultuous portrait of family life. No matter how unusual this particular story happens to be, there is a powerful, bittersweet universality to many of the sentiments it generates.

On the same program, and in a more somber yet fanciful tone, is "The Body Beautiful," a film by Ngozi Onwurah about her mother, Madge, who appears as herself. Ms. Onwurah, played by Sian Martin, contrasts the things that make her different from her mother with those attributes that they share. In the former category, most notably, are the facts that the film maker, who is black, has a white mother, and that her mother has undergone a mastectomy, which becomes a great focus of her daughter's attention.

"The Body Beautiful," which achieves a painful honesty, and "Intimate Stranger," which somehow finds wit and understanding in the midst of pain, will be shown tonight at 6:15 as part of the New York Film Festival.

1991 O 3, C21:1

Night on Earth

Written, produced and directed by Jim Jarmusch; the French, Italian and Finnish episodes have English subtitles; photography by Frederick Elmes; edited by Jay Rabinowitz; music by Tom Waits. At Alice Tully Hall, as part of the 29th New York Film Festival. Running time: 125 minutes. This film has no rating.

Corky............................... Winona Ryder
Victoria Snelling Gena Rowlands
YoYo........................... Giancarlo Esposito
Helmut...................... Armin Mueller-Stahl
Angela............................... Rosie Perez
Driver......................... Isaach de Bankolé
Blind Woman..................... Béatrice Dalle
Driver............................ Robert Benigni
Priest.......................... Paolo Bonacelli
Mika......................... Matti Pellonpaa
First Passenger.............. Karl Vaananen
Second Passenger........... Sakari Kuosmanen
Third Passenger............... Tomi Salmela

By VINCENT CANBY

THE first image in "Night on Earth," Jim Jarmusch's delirious new comedy, is important: that of universal darkness in the center of which is a rotating sphere of brilliant blue overlaid by wisps of white.

As the camera approaches, the wisps of white turn into cloud formations so beloved by forecasters as "weather systems." Familiar oceans and seas appear, also land masses that are as yet undivided by and unclaimed for national aspiration.

Though the movie is composed of five different stories, rooted in turn in the realities of Los Angeles, New York, Paris, Rome and Helsinki, "Night on Earth" seems always to keep the alien's distance, as if part of its mind remained forever fixed in outer space.

That is the consistent, comic method of Mr. Jarmusch's films, from "Stranger Than Paradise" through "Down by Law," "Mystery Train" and now "Night on Earth," his most effervescent work to date. The movie will be shown at the New York Film Festival tonight at 9:15 and tomorrow at 12:30 P.M.

Though "Night on Earth" is exceptionally funny, it is no less bleak than those earlier movies. The often bright colors in which it has been photographed, and the laughter it prompts, are a kind of cloud cover for the film's secret nature.

In "Night on Earth" Mr. Jarmusch explores a primal urban relationship, that of man and taxi driver, in situations in which woman is sometimes man and sometimes driver. The cab itself is the world temporarily shared. It's also a distinctive cocoon (each taxi in the film has its own special purr or knock) from which one of the parties will emerge if not changed, then at least shaken up, or, in one case, no more sure where he is than when he got into the cab.

The movie opens at the Los Angeles airport on the night that Corky (Winona Ryder), a very young cabdriver with a single dream and a mouth full of bubble gum, picks up Victoria Snelling (Gena Rowlands), a chic casting agent Victoria is so high-powered that you might think her capable of raising Mars with the cordless telephone she uses.

In the course of their drive to Beverly Hills, Victoria, whom Corky sarcastically calls "Mom," admits to having night-blindness. Corky wonders if that comes with age. Something about Corky's no-nonsense hold on life inspires Victoria to think she has found a new star.

This story leads into the New York segment in which, late on a cold winter night, YoYo (Giancarlo Esposito), an exuberant, loquacious young man, is trying desperately to find a taxi that will take him from Manhattan to Brooklyn. At long last a yellow cab lurches to a halt beside him.

At the wheel is Helmut (Armin Mueller-Stahl), a smiling, suspiciously eager East German refugee who has yet to learn how to drive properly. After a couple of false starts and a lot of dickering, YoYo climbs into the driver's seat and they take off. Helmut sits beside him as the delighted passenger and student of American manners.

Among other things, Helmut is pleased that they both are wearing furry caps with long flaps to cover the ears. YoYo sees no similarity. His cap, he says, is "fresh." When Helmut introduces himself, YoYo finds his name hysterically funny.

"Helmet, helmet," he yells, "it's like calling your child Lampshade!" YoYo's gift for repartee would have been devastating in a schoolyard. Helmut, in his turn, is convulsed by YoYo's name, which the younger man doesn't think is odd at all. When YoYo calls Helmut "a clown," it turns out to be literally true. Helmut even carries his circus props with him.

In their journey toward the borough that only the dead know, they are joined by Angela (Rosie Perez), YoYo's highly opinionated sister-in-law, whom they happen to pass on a lonely East Village street. The conjunction of YoYo, Helmut and Angela is deft and hilarious, a liberating delight.

Mark Higashino

Winona Ryder

The Paris interlude is also funny but shadowed with melancholy. The night isn't going well for a handsome young cabby from the Ivory Coast (Isaach de Bankolé). He fights with, and then kicks out, two arrogant black African diplomats with the fancy manners of white colonials.

He then picks up a young blind Frenchwoman (Béatrice Dalle) who grumpily mistakes his curiosity as attempts to be patronizing. In the edgy exchanges that follow, he says he thought that blind people usually wore glasses. "I wouldn't know," she replies. "I've never seen 'blind people.' "

The truth is that the sight of her sightless eyes, freely rolling in their sockets, is as unnerving to the audience as it is to him. His questions are direct, without guile, when he brings up the subject of sex and what it must be like to make love with someone one cannot see. Even here she somehow manages to squelch him. The night ends as badly as it began.

•

It's also a rotten night for the Roman cab driver, played by the irrepressible Robert Benigni, who was one of the stars of "Down by Law." His passenger is a priest (Paolo Bonacelli), a tired old fellow who wants only a little peace and quiet, not wisecracks, nor, finally, the driver's confession.

Whether or not this confession is responsible for what happens is beside the point. The confession constitutes a psychological profile of a macho Italian male as drawn by Krafft-Ebing in collaboration with Federico Fellini and Woody Allen.

The concluding Helsinki segment is most characteristic of the spine of Mr. Jarmusch's work, best represented by "Stranger Than Paradise." This is a rueful tale for 4 A.M., about a night of drinking with the boys until you can't stand up, when your physical state has finally attained an awfulness that matches your chances in life.

Like all of the segments in the film, it's a fragment, but one that is loaded with unsentimental associations, both dour and comic.

•

With this, his fourth commercially released feature, Mr. Jarmusch again demonstrates his mastery of comedy of the oblique.

He seems to see his characters through a telescope, while attending to their talk with some kind of long-range listening device. Everything that is seen and heard is vivid and particular, but decidedly foreign. Meanings are elusive. Themes can be supplied by others.

He's also becoming an increasingly fine director of actors. The members of the cast are splendid to start with, but he pushes them to singular achievements: Ms. Rowlands, Ms. Ryder, Mr. Esposito, Mr. Mueller-Stahl, the riotous Ms. Perez, Mr. de Bankolé, Ms. Dalle and Mr. Benigni.

Two of his other major collaborators are Frederick Elmes, the cinematographer, and Tom Waits, who wrote the score. Much as jazz does, "Night on Earth" transforms the commonplace into something haunting, mysterious and newly true.

1991 O 4, C1:3

Zombie and the Ghost Train

Directed, edited and produced by Mika Kaurismaki; screenplay (in Finnish with English subtitles) by Mr. Kaurismaki, based on a story by Mr. Kaurismaki, Pauli Pentti and Sakke Jarvenpaa; photography by Olli Varja; music by Mauri Sumen. At Alice Tully Hall, as part of the 29th New York Film Festival. Running time: 88 minutes. This film has no rating.

Zombie	Silu Seppala
Marjo	Marjo Leinonen
Harri	Matti Pellonpaa
Mother	Vieno Saaristo
Father	Juhani Niemela

By JANET MASLIN

Zombie (Silu Seppala), the central figure in Mika Kaurismaki's "Zombie and the Ghost Train," really looks the part. With his pasty skin, dark-ringed eyes and matted black hair, he seems to have joined the ranks of the living dead, and so Mr. Kaurismaki does what he can to explain how Zombie got that way. This Finnish film, most of which is structured as a flashback, divides itself between observing Zombie with a cool, bemused eye and seriously contemplating the alcoholism that has contributed to his decline.

First seen living on the streets in an unspecified city (which turns out to be Istanbul), Zombie is then found six months earlier being welcomed home to Helsinki by a group of friends. He has just found his way out of the army, in a move that both the army and Zombie considered agreeable and perhaps inevitable, after Zombie expressed his unhappiness with army life by pouring turpentine into the soup while on mess duty. As an interesting footnote, the film implies that it's possible to serve in the Finnish Army with an earring and shoulder-length hair.

What Zombie has to come home to are a girlfriend, Marjo (Marjo Leinonen), who now has developed new interests; staid parents who don't look much older than their ravaged son, and a group of musician friends who specialize in American country-and-western cachet, somewhat like that which figured in "Leningrad Cowboys Go America," a film by Mr. Kaurismaki's brother Aki. This time, the very mention of the word "Mississippi" in a song lyric is meant to convey something vaguely hip and humorous that doesn't travel well beyond Finnish soil.

•

What do travel nicely are Zombie's perfectly deadpan manner and his distinctively blunt approach to solving problems; when irked by Marjo's new boyfriend, for example, Zombie simply marches up to him on the street and kicks him hard in the ankle. The tough nonchalance of this is not entirely compatible with the more maudlin voice-overs that Mr. Kaurismaki allows his hero. ("I was like a sick tree whose heart was devoured by loneliness.")

"Zombie and the Ghost Train," which takes the latter part of its title from a strange rock band that's seen but never heard, divides itself between quick, droll glimpses of Zombie's glum existence and more disturbing scenes that find him passed out in an alcoholic stupor. After the comedy begins to subside — Zombie can't keep a morgue job because he's afraid of corpses, or a construction job because he's afraid of heights — the film is left with a self-pitying and deeply self-destructive hero whom it still attempts to treat in fairly lighthearted fashion.

Mr. Kaurismaki is more successful with wry, atmospheric touches than with efforts to find emotional intensity in Zombie's plight. When Zombie's musician friends tell of a tattooed buddy who tried to hide from the sauna-loving father of his rich fiancée, for instance, the film takes on a bleak nonchalance that is appealing. It does the same when these musicians refer to a colleague as "a damn good bass player — he would have made Deep Purple, but he died last fall." Mr. Kaurismaki sometimes strains too hard for modest humor, as when he lets Zombie fall comically out of bed and onto a boiling tea kettle, but for the most part his instincts are better than that.

29th New York Film Festival

Silu Seppala

Mr. Seppala's taciturn performance as Zombie makes the character disarming no matter how little he does. But eventually the hopelessness of Zombie and his situation begins to be overpowering. By the film's end, when Zombie's devoted friend Harri (Matti Pellonpaa) has followed him to Istanbul, the film has lost much of its momentum. Harri's devotion is as hard to fathom as Zombie's misery.

On the same bill, and on a considerably cheerier note, is Lesley Ellen's 28-minute film "Tender, Slender and Tall," about the octogenarian musician Shorty Jackson and his bandmates, who now live life in the slow lane but have become able to accommodate their love of music in surprising ways. Mr. Jackson now plays music in the style of Cab Calloway and also works in a funeral home. "I always say I play 'em to death and then I bury 'em," he explains.

"Zombie and the Ghost Train" and "Tender, Slender and Tall" will be shown tonight at 6:15 and tomorrow at 9 P.M. as part of the New York Film Festival.

1991 O 4, C8:5

The Super

Directed by Rod Daniel; written by Sam Simon; director of photography, Bruce Surtees; film editor, Jack Hofstra; music by Miles Goodman; production designer, Kristi Zea; released by 20th Century Fox. Running time: 84 minutes. This film is rated R.

Louie Kritski	Joe Pesci
Big Lou Kritski	Vincent Gardenia
Naomi Bensinger	Madolyn Smith Osborne
Marlon	Rubén Blades
Heather	Stacey Travis
Irene Kritski	Carole Shelley
Leotha	Beatrice Winde

By JANET MASLIN

Drugs and danger would render "The Super" instantly unfunny, but they happen to be absent, because this is a fairy tale. It concerns Louie Kritski (Joe Pesci), a proud second-generation slumlord who subscribes to the teachings of his father, Big Lou (Vincent Gardenia). What are the three things that help a Kritski find new holdings at a good price, according to Big Lou? "Death, divorce and destitution." And what does a Kritski do with a building once he buys one? Big Lou's enthusiastic answer: "Nothing!"

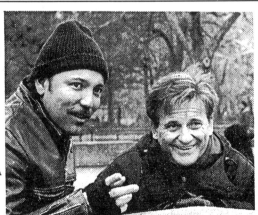

Condemned Rubén Blades and Joe Pesci star in "The Super," in which a slumlord is ordered by a court to live in one of his own tenements.

Eric Liebowitz/20th Century Fox

Raised in this great tradition, Louie is understandably surprised when his failure to maintain decent standards at his own tenement lands him in a courtroom, and then under house arrest. To the cheers of his tenants, who are black and Hispanic, the suburban-bred white Louie is sentenced to spend 120 days in his own building, in an apartment that has been advertised as a "furnished fifth-floor charmer with a view."

The appearance of this place will not be surprising, any more than what happens to Louie when he declares, "At least it's a roof over my head" and slams the door too hard. "The Super," directed by Rod Daniel, doesn't offer novelty, but it does provide lots of fun at the expense of Mr. Pesci, who makes a perfect fall guy. Smirking malevolently at his tenants even after he has received his own comeuppance, and leering so tirelessly at the housing authority lawyer in charge of his case (Madolyn Smith Osborne) that she has to hold him at arm's length while talking to him, Mr. Pesci's Louie Kritski is enjoyable precisely because he refuses to change his stripes. One waits in dread for the moment when Louie will become sweeter, kinder and more sensitive — and happily, it never really comes.

Some of the film's humor would sound racist if it were not so even-handed and if it were not delivered in such an obviously friendly way. Louie Kritski's obnoxiousness extends to wisecracks like, "If you wanna keep warm, why don't you dance?" But there's no question that those tenants — one of whom refers to Louie as "the Prince of Whiteness" — will have the last laugh. And the first and second laughs as well, since Louie is forever making himself look ridiculous. He loses the rent money to a smooth tenant (Rubén Blades) who is skilled at card tricks. And he loses it again playing in a basketball game for which he shows up wearing a Ralph Lauren logo that is almost bigger than he is. After taking a beating on the court, he asks, "You guys always play basketball and football at the same time?"

•

Mr. Daniel's direction is as snappy and broad as Louie is himself, so that Mr. Pesci has many opportunities to show off his talents for physical clowning. (At one point, while doing a double take in his suburban home, he forgets he's on an exercise machine and goes flying off his treadmill.) This is the kind of film in which even the rats have bluster: when one finally arrives in Louie's apartment, it doesn't skitter, it just stares him down. "Maybe they're avoiding your floor out of professional courtesy," one of his neighbors has previously suggested.

Aside from proving that Mr. Pesci can carry a comic lead on his own, "The Super" also shows off Mr. Blades to good advantage. It also gives Ms. Osborne an enviable straight woman's role, in which she is not expected to melt too implausibly over Louie's annoying antics. Also good are Beatrice Winde as one of Louie's more outspoken new neighbors, and Stacey Travis as the date who arrives for an evening chez Louie and delights the street crowd by leaving him flat. Particularly enjoyable is Mr. Gardenia as the incorrigible senior Kritski, who threatens to disinherit Louie if he ever fixes anything and who has a ready answer to any tenant's complaint. "A lot can happen in 120 days," he says when told he has three months to get the boiler fixed. "Like spring."

•

"The Super" is rated R (Under 17 requires accompanying parent or adult guardian). It includes rude language and sexual references.

1991 O 4, C10:1

Twenty-One

Directed by Don Boyd; screenplay by Zoe Heller and Mr. Boyd, based on a story by Mr. Boyd; director of photography, Keith Goddard; edited by David Spiers; music by Michael Berkeley; produced by Morgan Mason and John Hardy; released by Triton Pictures. Running time: 101 minutes. This film is rated R.

Katie	Patsy Kensit
Kenneth	Jack Shepherd
Jack	Patrick Ryecart
Baldie	Maynard Eziashi
Bobby	Rufus Sewell
Francesca	Sophie Thompson
Janet	Susan Wooldridge
Linda	Julia Goodman

By JANET MASLIN

Katie (Patsy Kensit), the pretty young English heroine of "Twenty-One," is enough to give youth and beauty a bad name. Wandering through London, she makes condescending observations about her friends and loved ones, observations relentlessly colored by words like "slimy" and "nauseating" and "completely cretinous." In this, Katie is presumably intended as a beacon of truth. But "Twenty-One," which begins and ends with Katie speaking directly to the camera from the toilet in her New York bathroom, in scenes that are meant to frame the London story as a flashback, has a way of confusing honesty with behavior that is merely coarse, stupid or rude.

The director, Don Boyd, and his co-screenwriter, Zoe Heller, seem to envision Katie as a much more appealing character than she turns out to be, although it would take spectacular charm to lend much gloss to Katie's adventures. She is seen wearing a white see-through dress to a wedding, then expressing surprise when the groom (Patrick Ryecart) makes a pass at her. At this, she knees him in the groin, after which she embarks on an affair with him anyhow. (Much of Katie's advice to the camera has to do with what happens "when you sleep with a creep," the one subject she knows much about.) She also flirts so brazenly with her father (Jack Shepherd) that it's remarkable incest is never added to her scorecard.

Katie is also seen pursuing a relationship with Bobby (Rufus Sewell), of whom she says, "He's a junkie, but apart from that he's a clean-living guy." She is also close to Baldie (Maynard Eziashi), a Caribbean musician, and Francesca (Sophie Thompson), who listens lasciviously to all of Katie's stories and talks with her mouth full, in keeping with the film's ideas of either frankness or humor. "Rather splendid way of finding a husband, isn't it?" Francesca says admiringly about someone who struck up a romance with the doctor she went to for an abortion.

Although no one in "Twenty-One" is the least bit likable, none of them deserve to be the target of Katie's unrelieved scorn. This smug, peevish heroine, who greets most situations with eye-rolling impatience or a disbelieving sneer, is so self-involved that she greets one character's death with a cry of "Don't do this to me!" When another confesses that he could fall deeply in love with her, Katie snaps, "Well, don't." Mr. Boyd, further extending his heroine's capacity for being unappealing, even involves her in pretentiously staged sex. Anyone who doubts that a bedroom scene can be made pretentious should think for a minute about what slow-motion photography and choral music in the background might do.

Among the actors, only the very photogenic Mr. Sewell and the gently appealing Mr. Eziashi (who starred in Bruce Beresford's "Mister Johnson") stand out. Ms. Kensit herself manages to give an impassive performance despite Katie's many mood swings and nearly constant complaints.

At the end of "Twenty-One," Katie has moved to New York and gone excessively native, with a saddle, Indian headdress, six-shooter and Monument Valley painting in her living room, and is getting ready to take Manhattan. "I love this apartment, and Central Park, and pizza, and the way everyone's so snotty on the street," she declares. In that case, she'll fit right in.

•

"Twenty-One" is rated R (Under 17 requires accompanying parent or adult guardian). It includes profanity and nudity.

1991 O 4, C10:6

The Man in the Moon

Directed by Robert Mulligan; written by Jenny Wingfield; director of photography, Freddie Francis; edited by Trudy Ship; music by James Newton Howard; production designer, Gene Callahan; produced by Mark Rydell; released by Metro-Goldwyn-Mayer. At the Loews Fine Arts, 58th Street west of Fifth Avenue, Manhattan. Running time: 99 minutes. This film is rated PG-13.

Matthew Trant	Sam Waterston
Abigail Trant	Tess Harper
Marie Foster	Gail Strickland
Dani Trant	Reese Witherspoon
Court Foster	Jason London
Maureen Trant	Emily Warfield
Billy Sanders	Bentley Mitchum

By JANET MASLIN

Everything about "The Man in the Moon," Robert Mulligan's effortlessly old-fashioned family drama set in a

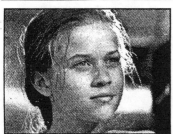

Reese Witherspoon
MGM/Elliott Marks

small Southern town, has a rosy glow. It's a reminder that Mr. Mulligan, a seasoned film maker whose credits include "To Kill a Mockingbird," "Summer of '42" and "The Other," can direct with real tenderness and without fake emotion. His latest film unfolds gently and gracefully, in a climate where the warmth isn't merely a matter of weather. Until its final reel, when it strains badly to accommodate an almost biblical stroke of retribution, "The Man in the Moon" is a small, fond film that achieves a kind of quiet perfection.

The story concerns two sisters, and Mr. Mulligan can find something evocative even in the way the elder braids the younger one's hair. The latter, 14-year-old Dani (Reese Witherspoon), is just on the verge of real beauty, while the slightly older Maureen (Emily Warfield) has already gotten there. The girls' family, which is beautifully evoked, exists at all different stages of development, from their toddler sister to their pregnant mother (Tess Harper) and the father (Sam Waterston) who is wary of his daughters' prospective suitors. In his or her own way, each member of this family longs for a boy.

When one arrives, in the form of a handsome teen-age neighbor named Court (Jason London), he affects the girls' family in powerful ways. The coltish Dani becomes smitten with Court, even though he thinks himself too grown up for her. Their meetings at a rustic swimming hole have the makings of adolescent girls' fiction at its most saccharine, but in fact these scenes have an authentic wholesomeness that's very sweet. Also remarkable is what's missing here: the sexual precocity that is the sine qua non of most current films about teen-agers. There's something refreshing and realistic in Court's anxious thought that he ought to remember how young Dani really is.

Once Court pays a visit to the girls' house and meets Maureen, the balance between the sisters shifts dramatically. The camera watches as Dani registers utter disbelief, never having thought twice about what might happen if her would-be beau met her pretty sister. In fact, the film closely observes such very small changes in its characters, and it lets them express their feelings in a decidedly down-to-earth way. "Maureen," asks Dani, "have you ever liked somebody so much that it almost made you sick?"

As written by Jenny Wingfield, "The Man in the Moon" — which opens today at the Loews Fine Arts — is simple, colorful and neatly constructed, with the occasional line of dialogue that sounds credible but still stands out. "I always knew the damn pipeline would kill him, only I thought it would be a little bit at a time," Court's mother (Gail Strickland) says of his absent father, and after that no further explanation is needed. Only when a plot impasse forces Ms. Wingfield into an event too wrenching

for this film's fairly narrow emotional range does her screenplay falter. "The Man in the Moon" is much better equipped to deal with first love and family quarrels than with matters of life and death.

Especially good here, in a role that wouldn't seem to suit him, is Mr. Waterston, who makes a stern but touching figure. (When one of Maureen's dates assures her father, "Yes sir, you don't have a thing to worry about," Mr. Waterston's patriarch replies solemnly, "Then neither will you.") The film also finds the real fondness that keeps the girls' parents together no matter how harried they are.

And it has some cozy moments between Ms. Harper and Ms. Strickland, playing neighbors and girlhood friends. Mr. Mulligan also gets an outstandingly natural performance out of Miss Witherspoon, who has no trouble carrying a lot of the film single-handedly. It falls to her to remind the audience that this story is at heart about a family, and she does.

•

"The Man in the Moon" is rated PG-13 (Parents strongly cautioned). It includes some sexual references.

1991 O 4, C13:1

Whore

Directed by Ken Russell; screenplay by Mr. Russell and Deborah Dalton, based on the play "Bondage" by David Hines; director of photography, Amir Mokri; edited by Brian Tagg; music by Michael Gibbs; production designer, Richard Lewis; produced by Dan Ireland and Ronaldo Vasconçellos; released by Trimark Pictures. Running time: 85 minutes. This film is rated NC-17.

Liz...................................Theresa Russell
BlakeBenjamin Mouton
RastaAntonio Fargas
IndianSanjay
KatieElizabeth Morehead

By VINCENT CANBY

Though the casting is not perfect, Theresa Russell, an actress with a good deal of class about her, gives a credible performance as Liz, a Los Angeles streetwalker, in "Whore," the surprisingly plain new movie by Ken Russell (who is not related to his star).

Adapted by Mr. Russell and Deborah Dalton from an English play, "Whore" is about one day in the life of the title character. Intercut with Liz's testimony, spoken directly to the camera, are flashbacks that show how she got into "the life" and how a pimp named Blake took control of her earnings.

While drinking a very dry gin martini with a maraschino cherry, Liz also remembers a few amusing clients, including an old man she used to visit in his retirement home. Mostly, though, the memories are brutal. Rapes, beatings and humiliations are Liz's lot. Says Liz of her clients: "They don't want sex. They want revenge."

For the record, Liz practices safe sex and refuses to indulge in any weird games.

The movie certainly doesn't glorify the profession. It confirms one's suspicions without adding to one's understanding. Mr. Russell treats Liz's story without any of the spectacular directorial touches for which he is known. It's difficult to tell whether this was an artistic decision or one dictated by a limited budget.

The movie looks sort of cheap. Except for Ms. Russell and Antonio Fargas, as a skid-row philosopher who befriends Liz, the cast is not great.

A scene in what is meant to be an expensive restaurant appears to have been shot in the corner of someone else's set. The dialogue in that sequence has that tinny sound that is often a feature of cheaply made porn films, those in which the actors take time out to talk. The editing is so sloppy that the film is well along before one realizes that a single day's events are the narrative frame.

"Whore" is not pornographic. It's not much of anything.

•

"Whore," which has been rated NC-17 (No one under 17 admitted), has a lot of simulated sex, graphic descriptions of sex acts and vulgar language.

1991 O 4, C15:1

Shout

Directed by Jeffrey Hornaday; written by Joe Gayton; director of photography, Robert Brinkmann; film editor, Seth Flaum; music by Randy Edelman; production designer, William F. Matthews; produced by Robert Simonds; released by Universal Pictures. Running time: 91 minutes. This film is rated PG-13.

Jack CabeJohn Travolta
Jesse Tucker.......................James Walters
Sara BenedictHeather Graham

By CARYN JAMES

No one expects or wants John Travolta to go on playing the disco king forever, but who would have thought he'd turn into Dick Clark's evil twin? In the unintentionally silly "Shout," Mr. Travolta plays a music teacher in a small Texas town in the 1950's. You can tell he's cool: he smokes, he wears a black T-shirt, he plays the harmonica and he introduces his class to what he calls rock-and-roll. Actually, the songs on the soundtrack are new and they sound more like rhythm-and-blues, but "Shout" doesn't care about fine distinctions. It cares about how hopelessly backward the townspeople are, especially the sheriff who says, "What kind of word is cool?"

The Travolta character teaches at a place called the Benedict Home for Boys, a kind of rural work camp for delinquents. But the worst thing these guys do is steal a radio tube so they

can listen to an underground deejay. "What's a deejay?" one of the boys asks. Maybe they do need help after all.

Much of the film is taken up with the predictable romance of a handsome young man named Jesse with the beautiful daughter of the evil schoolmaster, Mr. Benedict. All these characters seem to have wide, glassy eyes that make them look like extras from "The Stepford Wives." The eyes probably got that way from looking at all the big, bright orange sun that the director, Jeffrey Hornaday is addicted to. "Shout" is also the kind of film that plays inspirational music when Jesse steals the Benedict pickup truck and crashes it through the gates.

Mr. Hornaday, the choreographer of "Flashdance," has made a period piece that doesn't seem to be for anyone at all: it's too sappy for teenagers, too glitzy to be nostalgic and not even funny enough to make it a good joke.

•

"Shout" is rated PG-13 (Parents strongly cautioned). It includes a little rough language and a discreet bedroom scene.

1991 O 4, C21

Stepping Out

Directed and produced by Lewis Gilbert; screenplay by Richard Harris, based on his stage play; director of photography, Alan Hume; edited by Humphrey Dixon; music by Peter Matz; choreographer, Danny Daniels; production designer, Peter Mullins; released by Paramount Pictures. Running time: 108 minutes. This film is rated PG.

Mavis Turner...........................Liza Minnelli
Mrs. FraserShelley Winters
Geoffrey.....................................Bill Irwin
MaxineEllen Greene
VeraJulie Walters
SylviaRobyn Stevan
Lynne...............................Jane Krakowski
Andy.............................Sheila McCarthy
DorothyAndrea Martin
RoseCarol Wood
PatrickLuke Reilly

By STEPHEN HOLDEN

Liza Minnelli's radiant kewpie doll grin and hyperventilated acting style have certainly not suited every role she has portrayed in the movies, but they inject a shot of adrenaline into "Stepping Out," the film adaptation of the English playwright Richard Harris's popular boulevard comedy.

Working Theresa Russell stars in "Whore" as Liz, a prostitute in Los Angeles. Ken Russell's gritty drama, based on the David Hines play "Bondage," follows a day in the woman's life.
Trimark Pictures

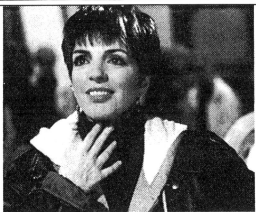

Hoofers Liza Minnelli portrays a tap dance instructor in "Stepping Out," with Shelley Winters, Ellen Greene, Bill Irwin, Julie Walters and Robyn Stevan.

Joseph Lederer/Paramount Pictures

A long-running stage hit in London, "Stepping Out" portrayed the melding of a group of disparate Londoners, mostly women from the same tap-dancing class, into an accomplished amateur chorus line. The play reached Broadway four years ago in a coolly received production directed by Tommy Tune. For the movie version, adapted by the playwright and directed by Lewis Gilbert, the setting has been shifted to Buffalo, with the role of the dance instructor Mavis, which was played on Broadway by Pamela Sousa, heavily beefed-up for Ms. Minnelli.

Ms. Minnelli's Mavis is a failed but talented Broadway hoofer whose most cherished memory was auditioning for Bob Fosse. "I didn't get the job, but I got to touch his sleeve," she recalls with wistful awe. An undeveloped, extraneous subplot follows Mavis's unwinding relationship with a sourpuss boyfriend named Patrick (Luke Reilly) who was a one-hit wonder as a rock star and whose attitude toward life is summarized by his assessment of Buffalo as "a cultural wasteland with a lot of dirty snow."

•

In an improbable scene that was apparently cooked up both to open up and Americanize the play and give Ms. Minnelli a song, the couple performs in a local country-and-western bar with Patrick playing the guitar and Mavis singing. The tune is "Mean to Me," one of the last songs one would ever expect to hear in such a setting.

But the heart of the movie consists of the classes at a church meeting hall in which Mavis molds her klutzy, quarrelsome students into a proudly synchronized tap-dancing ensemble for a charity benefit. The students represent an unlikely cross section of types from a tough-talking dress-shop proprietor (Ellen Greene), to a demure, battered wife (Sheila McCarthy), to a persnickety British matron (Julie Walters). Bill Irwin, the only man in the class, winningly plays a dramatic version of one of his clown characters, a milquetoast with a secret wellspring of macho aggression. Shelley Winters is the troupe's perpetually grumpy pianist.

Mr. Gilbert has demonstrated a knack for slick, old-fashioned comedy-drama in such previous films as "Shirley Valentine," "Educating Rita" and "Alfie." And in "Stepping Out," he manipulates the machinery with a knowing efficiency. Although the screenplay has few genuinely-funny lines, the individual cameos emerge as likable, if one-dimensional caricatures.

•

Because the movie adaptation was conceived as a star vehicle for Ms. Minnelli, the actress is given two solo dance turns, choreographed by Danny Daniels, in addition to her acting chores. Both numbers jerk the movie, which is never particularly believable, into the realm of pure show-business fantasy, while allowing the star to demonstrate real pizazz as a modern-day vaudevillian trouper.

The final number, which Ms. Minnelli introduced in her stage show last spring, is an appealingly brassy, new made-to-order song by John Kander and Fred Ebb. It puts the icing on a movie that is the contemporary equivalent of a Mickey Rooney-Judy Garland "let's put on a show" romp, seasoned with a dash of "A Chorus Line."

•

"Stepping Out" is rated PG (Parental guidance suggested). It includes mildly vulgar language.

1991 O 4, C26:4

Pictures From a Revolution

Directed and produced by Susan Meiselas, Richard P. Rogers and Alfred Guzzetti; photography, Mr. Rogers; photo animation, Patricia Kelly; music by William Eldridge and Terry Riley. At Alice Tully Hall as part of the 29th New York Film Festival. Running time: 93 minutes. This film has no rating.

By VINCENT CANBY

"Pictures From a Revolution" is a somber meditation on what sometimes looks like the futility of all social struggle. It's a report on Nicaragua today, recorded by Susan Meiselas, an American photographer who covered the Sandinista revolution, its victory and its collapse.

The film, which will be shown at the New York Film Festival today at 6:15 P.M., was jointly produced, directed and edited by Ms. Meiselas, Richard P. Rogers and Alfred Guzzetti, who also collaborated on "Risk: The Story of a Nicaraguan Family" (1984-85).

In "Pictures From a Revolution," Ms. Meiselas talks to a number of the people she photographed earlier at the height of the battle against the Somoza regime, during the early months of victory and then during the Sandinista Government's long war against the United States-backed contras.

Ms. Meiselas narrates the film and makes no secret of her own belief in the Sandinista cause: "I needed to know there was a possibility to change something." Referring to the rank-and-file urban poor and farmers who flocked to the Sandinistas, she says, "These people were willing to give their lives to a cause."

Yet she and her collaborators have made a fine film that transcends partisanship. "Pictures From a Revolution" is as much about the perspectives of history as it is about specific people in particular events.

•

Time's passage illuminates her subjects. Among them are a peasant woman photographed earlier by Miss Meiselas when the woman was burying her husband, who was killed by the Somoza regime's National Guard. Then 14, she is now in her 20's and looks to be in her 40's. She describes the man she buried as "very humble, just like that one," as she points to her second husband, a frail fellow who says nothing.

Among the people she interviews are a former member of the National Guard who later was a contra officer ("It was all for nothing. We killed for nothing. We died for nothing.") and a former member of the Sandinista Government, who says that the new leaders' social programs and the economy were crippled by outside pressures.

A farmer who fought for the revolution says: "My life hasn't changed, but my life is peaceful, without shocks. I'm no longer afraid of the National Guard." The camera catches sight of a skinny naked man walking slowly down a country road as if in a dream.

Miss Meiselas's own testimony is crucial to the film's effectiveness. She remembers that many people who worked for the Sandinista victory dropped away after victory was won: "Nothing moved fast enough. Nothing changed." One man speaks of the gulf that developed between the people who fought the war and the people who governed after the victory.

She recalls acts of heroism and moments of terrible fright. There was one time when she endangered herself and the people who were hiding her to take a picture that later turned out to convey nothing of the situation it represented.

The Nicaragua that Ms. Meiselas and her collaborators see is exhausted. She says she lost a dream, but "the Nicaraguans lost much more."

"Pictures From a Revolution" is serious and moving film reportage.

1991 O 5, 11:4

Susan Meiselas

A scene from "Pictures From a Revolution."

183

Ricochet

Directed by Russell Mulcahy; screenplay by Steven E. de Souza, story by Fred Dekker and Menno Meyjes; director of photography, Peter Levy; edited by Peter Honess; music by Alan Silvestri; produced by Joel Silver and Michael Levy; presented by HBO in association with Cinema Plus. Running time: 105 minutes. This film is rated R.

Nick Styles......................Denzel Washington
Earl Talbot Blake....................John Lithgow
Odessa...Ice T
Larry Doyle...............................Kevin Pollak
Priscilla Brimleigh...............Lindsay Wagner
Kim...Josh Evans

By JANET MASLIN

In the mean, flashy revenge thriller "Richochet," which opened yesterday at neighborhood theaters, Denzel Washington plays Nick Styles, a police officer who makes an arrest during an amusement-park shootout. This event is memorable because it leads to the incarceration of the crazed Earl Talbot Blake (John Lithgow), because it greatly advances Nick's career and because Nick contrives to do it while stripped down to his skivvies. The film, while supposedly concentrating on the war of nerves between Nick and Earl, also concocts as many excuses as possible for Mr. Washington to show off his fine physique.

As a consequence of the arrest, within the film's media-mad universe, Nick somehow becomes the most famous person in southern California. He is constantly on television. And of course Earl is constantly watching. Eventually, he stages a brutal jailbreak and returns to punish Nick for, among other things, landing himself and his happy family on the cover of a magazine called Upscale. When finally confronting Nick, Earl utters the inevitable "I'm going to do something far worse than kill you. I'm going to let you live."

•

Mr. Washington is appealing enough to get away with anything, even a plot that has him trying to build a children's center in the midst of all the story's sadism and turmoil. (The rapper Ice T is used effectively as a neighborhood drug dealer who becomes part of Nick's plans.) Mr. Lithgow is too good an actor to be relegated to the psycho beat, but he approaches his role with suitable glee. The screenplay, by Steven E. de Souza (whose credits include the "Die Hard" movies), contains many glib, obscene wisecracks, plus the misinformation that "Anna Karenina" was Tolstoy's first book.

As directed by Russell Mulcahy and overproduced by Joel Silver, "Ricochet" features a Ferris wheel, an empty swimming pool and a burning bookmobile, among other expensive touches that could easily have been dispensed with. Also in the cast are Josh Evans as Mr. Lithgow's comically slavish sidekick, and Lindsay Wagner as the kind of district attorney who strides purposefully while shaking flossy hair and wearing a nice suit.

•

"Ricochet" is rated R. (Under 17 requires accompanying parent or adult guardian.) It includes considerable violence and profanity.

1991 O 5, 12:6

Delicatessen

Directed by Jean-Pierre Jeunet and Marc Caro; screenplay (in French with English subtitles) by Mr. Jeunet, Mr. Caro and Gilles Adrien; photography by Darius Khondji; edited by Hervé Schneid; music by Carlos D'Alessio; production designer, Jean-Philippe Carp; produced by Claudie Ossard; released by Miramax Films. At Alice Tully Hall as part of the 29th New York Film Festival. Running time: 97 minutes. This film has no rating.

Louison..................................Dominique Pinon
Julie Clapet...................Marie-Laure Dougnac
The Butcher...................Jean-Claude Dreyfus
Mlle. Plusse.......................................Karin Viard
Robert Kube...Rufus
Mr. Tapioca.............................Ticky Holgado

By JANET MASLIN

In the studiously zany French fantasy film "Delicatessen," apocalyptic rubble and 1940's American kitsch make for a peculiar mix. The setting of the title is part of a half-demolished apartment house that stands amid unexplained postwar devastation, in a world where lentils have become currency and underground guerrillas called "troglodists" refer to apartment-dwellers as "surfacers." In spite of such apparent hardship, an antic spirit prevails at the apartment house in question, which is presided over by a butcher (Jean-Claude Dreyfus) with Sweeney Todd-like predilections. "I'm a butcher, but I don't mince words," he says.

Into this establishment comes Louison (Dominique Pinon), a former circus clown who would be the most eccentric person in the place if the competition were not so stiff. Also on hand are the shy, very correct Julie (Marie-Laure Dougnac), who plays the cello to accompany Louison on the musical saw; Mrs. Interligator (Sylvie Laguna), who is urged by inner voices to attempt suicide in extremely creative ways; the Kube brothers (Jacques Mathou and Rufus), who intently manufacture little cannisters that make mooing sounds, and an assortment of fellow oddballs.

As directed by Jean-Pierre Jeunet and Marc Caro, "Delicatessen" does not aspire to much more than simply flinging these characters together and intercutting their exploits in a quick, stylish fashion. The results can be weirdly hilarious, as when the sounds of Louison rhythmically rocking on creaky bedsprings (as he paints a ceiling) are allowed to permeate and co-opt every other activity going on in the house, from rug beating to knitting. They can also be frenetic and pointless, which is the case more and more frequently as the film spins out of control. Its last half-hour is devoted chiefly to letting the characters wreck the sets, and quite literally becomes a washout when the bathtub overflows.

Shot in oppressive orangey tones and sometimes taking unexpectedly grisly turns, "Delicatessen" works best when simply allowing its characters to express their strangeness. The material's fun-house atmosphere is most effectively captured in simple interludes, like Julie's rehearsed but bungled attempt to serve tea to Louison or Mrs. Interligator's unsuccessful stab at doing herself in using a lamp, a sewing machine and a length of red satin. It's worthwhile finding out how this is supposed to work, and why it doesn't.

Among the things that deserve mention in this lightweight but sometimes subversively stylish farce are its ingenious credit sequence, its lively editing by Hervé Schneid, its use of code names like Artichoke Heart and

Cordon Bleu in the guerrilla war that rages underground and its reference to a couple of odd inventions. One is a magical combination of boomerang and pocketknife, and it can work wonders. The other is a very specific sort of lie detector, and no home should be without one.

On the same bill with "Delicatessen" is "New Fangled," a delightful two-minute short by George Griffin incorporating fast, flexible imagery and smug marketing jargon. The voice-overs are as funny as the animation.

"Delicatessen" and "New Fangled" will be shown at midnight tonight as part of the New York Film Festival.

1991 O 5, 14:3

Earth Entranced

Directed and written by Glauber Rocha; in Portuguese with English subtitles; photography by Luiz Carlos Barreto; edited by Eduardo Escorel; music by Heitor Villa-Lobos and Sergio Ricardo; produced by Zelito Viana. At Alice Tully Hall as part of the 29th New York Film Festival. Running time: 110 minutes. This film has no rating.

Paulo Martins.................................Jardel Filho
Felipe Vieira....................................José Lewgoy
Sara......................................Glauce Rocha
Porfirio Diaz.................................Paulo Autran
Julio Fuentes.............................Paulo Gracindo
Silvia......................................Danuza Leão
Alvaro......................................Hugo Carvana

By VINCENT CANBY

The New York Film Festival pays tribute to Glauber Rocha (1938-1981), one of the most influential members of Brazil's Cinema Novo movement, with the showing of "Earth Entranced" ("Terra em Transe") today at 3:30 P.M.

Like the directors identified with the French New Wave, the members of the Cinema Novo, or New Cinema, were young outsiders trying to provide films of a quality and substance not available through Brazil's cinema establishment. They worked with low budgets and immense enthusiasm, and in a variety of styles. Unlike the French film makers, they were also committed to political causes.

"Earth Entranced" was made in 1966 and originally released in the United States in 1970. It is an awfully poetic but otherwise comparatively straightforward contemporary film, without the mystical and surreal evocations that mark Rocha's best-known work ("Barravento," 1961; "Black God, White Devil," 1964, and "Antônio das Mortes," 1969).

This is not to say that "Earth Entranced" is especially easy to follow, only that its subject is less parochial (and less interesting) than the films in which Rocha considers Brazil's heritage of black African voodoo and white European Roman Catholicism.

"Earth Entranced" is a most self-conscious 1960's artifact, a film about a poet and journalist who becomes a social activist, goes into politics and finds no one capable of leading the people. Although Rocha identified with the masses, the movie went over the heads of its audiences in the provinces and was called fascist by the members of the academic left. The political left praised it as revolutionary.

The hero, whose poetry is translated in some not very convincing English subtitles, first attaches himself to a senator who behaves like a demigod, and then to a populist politician who becomes a provincial governor.

Both men are more interested in their own survival than in their political responsibilities. The movie has some strikingly shot (black-and-white) images that are reminiscent of Orson Welles. It also has some spectacular colonial settings and one orgy at which the hero goes dramatically to pieces. He is too sensitive for both politics and lewd semipublic behavior.

According to a program note, "Earth Entranced" has been restored, retranslated and resubtitled through the courtesy of Martin Scorsese.

1991 O 5, 14:5

Homicide

Written and directed by David Mamet; photography by Roger Deakins; edited by Barbara Tulliver; production designer, Michael Merritt; music by Aleric Jans; produced by Michael Hausman and Edward R. Pressman. At Avery Fisher Hall to close the 29th New York Film Festival. Running time: 102 minutes. This film is rated R.

Bobby Gold..................................Joe Mantegna
Tim Sullivan...........................William H. Macy
Chava................................Natalija Nogulich
Randolph..................................Ving Rhames
Miss Klein......................Rebecca Pidgeon
Senna................................Vincent Guastaferro
Olcott................................Lionel Mark Smith
Frank................................Jack Wallace
Curren................................J. J. Johnston
Deputy Mayor Walker.................Paul Butler
Grounder.............................Colin Stinton
Benjamin.............................Adolph Mall

By VINCENT CANBY

Having written and directed "House of Games" and "Things Change," two dark, exquisitely controlled comedies, David Mamet has now made "Homicide," a police melodrama that means to be far more than a police melodrama, which is its problem.

Somewhere along the way, the movie loses its identity and becomes like Bobby Gold (Joe Mantegna), its central character — a victim of its own imperfectly realized longings.

"Homicide," which will be shown tonight at 8:30 to close the New York Film Festival, opens its commercial engagement here on Wednesday.

•

The setting is a big American city that could be Chicago, where Mr. Mamet grew up, yet there is nothing to be seen that would fix its location. This city is a generic Mamet metropolis that accommodates itself to everyday, ethnic tensions as if they were a kind of low fever, only one degree above normal but ever-present.

Bobby Gold is a tough cop who also happens to be a Jew, which, he says, is not something he thinks about. He identifies completely with the police force. Because he is Jewish in a city that was probably first dominated by the Irish, he has worked hard to be, in effect, a credit to the race he doesn't think about.

At the station house, near the beginning of "Homicide," Bobby has a vicious verbal exchange with a black superior who calls him "kike." Bobby's partner, Tim Sullivan (William H. Macy), replies in kind on behalf of his friend. These sorts of outbursts have probably happened before, but this one becomes significant for what happens later.

•

In the course of his search for a black drug pusher wanted for murder, Bobby also becomes enmeshed in the investigation of the homicide of

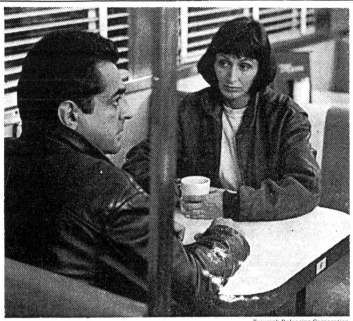

Triumph Releasing Corporation

Joe Mantegna and Natalija Nogulich in David Mamet's "Homicide."

an old Jewish woman, shot to death behind the counter of her candystore in a poor black neighborhood. The woman, it turns out, was not quite what she seemed.

The woman's roots were humble, but her family is rich and powerful. They demand special help from City Hall and they get it in the person of Bobby, who is at first skeptical about the importance of the case. He finds the members of this family exotic, slightly unreal.

They live in an elegant mansion filled with modern art, servants and an air of intrigue. In one way and another, they are constantly reminding him of their Jewishness and, in turn, reminding him of his. "You say you are a Jew," someone says to him, "but you can't read Hebrew. What are you?"

The family is convinced that there is an anti-Semitic conspiracy at work. When Bobby investigates, he begins to agree. The old woman was a member of a cabal that smuggled arms to Jews in Palestine in 1946. With a suddenness that is credible neither as drama nor as psychology, Bobby is drawn into their world. He becomes committed to it, as much to discover his own identity as to uncover the plot that threatens the family members and, through them, all Jews.

•

"Homicide," which refers to metaphorical as well as literal murder, may be Mr. Mamet's most personal and deeply felt work. It's also his most blunt and despairing. Both "House of Games" and "Things Change" deal with conspiracies of some sort. Yet the scam that is the center of this film is unconvincing.

The movie starts off in high gear. A big-city station house may be the quintessential Mamet locale, a place where every encounter is a confrontation and where all lives are lived in noisy, vulgar desperation. "Homicide" works at exactly the right pitch in these sequences, which are as hilarious as they are horrific.

Mr. Mamet's gift for language can be parodied but not equaled. He writes dialogue in such a way that every syllable is heard, and is as important to meaning as the meter in verse. "Homicide" is vivid and entertaining until poor Bobby becomes en-

trapped by his own better instincts. Then everything seems to fall apart, including Mr. Mamet's common sense.

The movie never recovers its momentum, though there is a memorable and devastating final exchange between Bobby and his pal Tim. This occurs in the course of an elaborate shoot-out that is otherwise awkwardly staged and leads up to a scene that plays as if it were a one-act stage piece.

Mr. Mantegna and Mr. Macy, members of the unofficial Mamet stock company, are fully at ease, as are all of the actors in the uproarious station-house sequences.

By the end of "Homicide," Bobby Gold is on the verge of growing up. The movie cannot learn from its mistakes; they are forever displayed within it.

•

"Homicide," which has been rated R (under 17 requires accompanying parent or adult guardian), has a lot of vulgar language and some violence.

1991 O 6, 56:1

Suburban Commando

Directed by Burt Kennedy; written by Frank Cappello; photography by Bernd Heinl; edited by Terry Stokes; production designer, Ivo Cristante; music by David Michael Frank; produced by Howard Gottfried. Presented by New Line Cinema. Running time: 85 minutes. This film is rated PG.

Shep Ramsey	Hulk Hogan
Charlie Wilcox	Christopher Lloyd
Jenny Wilcox	Shelley Duvall
Adrian Beltz	Larry Miller
General Suitor	William Ball
Margie Tanen	JoAnn Dearing
Col. Dustin McHowell	Jack Elam
Zanuck	Roy Dotrice

By STEPHEN HOLDEN

"I spend more time saving worlds than living in them; sometimes I wonder why," says Shep Ramsey, a space warrior played by the wrestling star Hulk Hogan in "Suburban Commando." It is the only moment of reflection for the gruff but kindly character whom Mr. Hogan, with his twinkly eyes and shoulder-length locks, plays like a macho Santa Claus.

"Suburban Commando," which opened yesterday at local theaters, finds Shep temporarily marooned on earth while his spacecraft is being recharged. While waiting to return to combat, he rents a room from Charlie Wilcox (Christopher Lloyd), a mild-mannered architect who lives with his wife, Jenny (Shelley Duvall), and two children in a southern California town.

The film's more amusing moments depict Shep's awkward indoctrination into the ways of suburbia. He may possess superhuman strength, but he can't last for a second on a skateboard. The first time he sees a video game being played, he assumes that an intergalactic war is actually in progress and frantically grabs the controls.

Shep's social education is sandwiched between action sequences in which he saves the universe from the monstrous intergalactic dictator General Suitor (William Ball) and then has to re-save it from the general, who has come in pursuit. Along the way, he helps Charlie prove that he is a man and not a mouse. And before returning to space, he even learns how to do somersaults on the skateboard.

Although "Suburban Commando," which was directed by Burt Kennedy and written by Frank Cappello, has little narrative continuity, it is well paced and has an amusingly sour performance by Larry Miller as the kind of boss you love to hate.

•

"Suburban Commando" is rated PG (Parental guidance suggested). It includes scenes of violence.

1991 O 6, 56:3

FILM VIEW/Caryn James

Feasting On A Festival

THE OLD MAN CHOKED ON A PIECE OF CANDY, was shot in the back, strangled by a curtain and drowned in a fountain, all in a matter of seconds. What's a coroner to do? This is a whimsical murder scene early in "Toto the Hero," the first feature by the 34-year-old Belgian director Jaco van Dormael and the most delightful surprise at this year's New York Film Festival. Any festival that includes even one discovery like "Toto" can't be all bad, and as it happens, this year's was nearly all good.

The festival closes tonight with a much grittier killing. In "Homicide," David Mamet's most ambitious and serious film yet, the murder of an elderly Jewish woman sets off an intense identity crisis for a detective who thinks of himself as a cop, not a Jew.

"Toto," which follows its imaginative hero from boyhood to a time beyond death, is an easy crowd pleaser. "Homicide" is likely to be controversial, both as a piece of film making and for the way it tackles the volatile themes of anti-Semitism and cultural identity. Together these films suggest the quality of this year's something-for-everyone selections. At the margins were the arcane and the blatantly commercial. In between were plenty of strong-flavored films that viewers were likely to love or hate — the sign of a festival willing to offer a dare.

Shakespeare Goes to the Movies

After the screening of "Prospero's Books," Peter Greenaway's loving but idiosyncratic version of "The Tempest," the director said he didn't want to disparage other Shakespeare movies. "This is *not* a Zeffirelli 'Hamlet,' " he added, without apologies to Mel Gibson.

Let's not forget that before the distributors of "The Cook, the Thief, His Wife and Her Lover" rejected its X-rating and made Mr. Greenaway a cause célèbre, he was well established as a director of challenging, art-house films.

"Prospero's Books" shows why, even though this two-hour extravaganza comes with a whiff of show biz and very effective razzle-dazzle technology. It is the most stunning film at the festival, but even at the press screening viewers were drifting out, frustrated or bored.

As Prospero, Sir John Gielgud speaks all the other voices for most of the film. He is first seen writing, and as Mr. Greenaway described this act, "Prospero's inkwell is the magician's hat out of which everything comes." That "everything" includes the plot of "The Tempest," though it is buried somewhere beneath a structure that leads viewers through each of the 24 books Prospero has taken to his island exile.

The something-for-everyone films signaled an event that was willing to offer a dare.

For all of Mr. Greenaway's love of words and devotion to the great Gielgud monologue, "Prospero's Books" is the most purely visual Shakespeare short of a mime show. Cherubic-looking little boys in red loincloths scamper around; men and women are dwarfed by the exaggerated Jacobean ruffs around their necks; in a flashback, Miranda's mother pulls off the skin of her abdomen like a living illustration of Prospero's book on birth. Up-to-the-minute technology allows Mr. Greenaway to layer his images and let them float across the screen. This is a rich, exhausting meditation on creativity. On a first viewing it is probably best to let Mr. Gielgud's voice and the visual images wash over you, without worrying too much about piecing things together.

After all that, it would have made sense if Mr. Greenaway had turned out to be some Rabelaisian wild man. But at his press conference, he spoke in a low-keyed manner and cerebral terms (well, except for the Zeffirelli line). As a visual image he was not an extravaganza at all, with his dark suit, dark shirt and neatly cropped hair. Even with his narrow red tie, he looked strait-laced enough to pass for some corporate V.P., or a living advertisement for sublimation into art.

Shakespeare also lives, incognito, in Gus Van Sant's "My Own Private Idaho," a film that takes two male hustlers — one rich, one narcoleptic — and puts them in a plot borrowed from "Henry IV, Part 1." Keanu Reeves, the wealthy young man, is the Prince Hal figure, and his Falstaff is a plump, streetwise mentor named Bob. River Phoenix, as the narcoleptic hustler, falls asleep at stressful moments. Mr. Reeves looks into the camera and talks about the direction of his life in a Shakespearean soliloquy.

The wonder is that it works as well as it does. The hustler and the Shakespeare plots collide, but at least they smash together with some explosive energy rather than a dull thud.

Viewers looking for the smooth style of Mr. Van Sant's "Drugstore Cowboy" won't find it here. But like "Prospero's Books," "My Own Private Idaho" is hugely ambitious and not like any other film. Even though its commercial release was guaranteed before it was chosen for the festival and it has received high critical praise, Mr. Van Sant's film demands a viewer's indulgence, something festival audiences are much more likely to grant than most.

Eat Your Vegetables

Though the festival may live for art and the love of film, it would die without a sense of commerce and public relations. In crass commercial terms, some films need the festival, some films the festival needs, and sometimes there is a perfect symbiosis.

The two sleepers this year were "Toto" and Viatcheslav Krichtofovitch's "Adam's Rib," a mild comedy about three generations of women in a cramped Moscow apartment. Both will be released in this country, boosted by their strong reception at the festival.

The Chilean film maker Valeria Sarmiento's "Amelia Lopes O'Neill" is an appealing magical-realist romance, and the Chinese director Chen Kaige's "Life on a String" a poetic, probably untranslatable fable about a blind musician. Because neither one evokes the easy laughter that suggests commercial prospects, they are the sort of accomplished films that need the festival most. They may, or may not, ever be shown here again.

On the other hand, there are noncommercial films to be watched not because they are good but because they are good for you. The Polish director Krzysztof Zanussi's "Inventory" and the Greek director Theo Angelopoulos's "Suspended Step of the Stork" are socially conscious minor works by major directors whose careers are worth keeping up with. Watching these films is the cinematic equivalent of eating your vegetables.

You won't find "The Suspended Step of the Stork" at your local cineplex. "The Rapture" and "My Own Private Idaho" are already there, and "Homicide" will open commercially on Wednesday, turning their festival appearances into prestigious previews. Why the festival is lending

The Film Society of Lincoln Center

Klaus Schindler and Sandrine Blancke in "Toto the Hero"—a delightful surprise at the festival

artistic legitimacy to commercial pap like "The Rapture," in which Mimi Rogers faces the apocalypse, is one of the more baffling questions of the year.

◼

But "Homicide" is the ideal quasi-commercial film for the festival. It is artistically solid yet aimed at a popular audience. The film gains prestige, the festival gains a reputation for not being snobbish, and festival viewers get the cheap thrill of feeling ahead of the game, even if only by three days.
Desperately Seeking 'Rocco'

It was nearly impossible to walk through the crowds from the sidewalk to Alice Tully Hall on the first Saturday afternoon of the festival. One young man in combat boots and a black beret held up a sign that read, "I'd love to buy your extra ticket for 'Rocco,' " while others stepped in your path and politely asked, "Do you have an extra ticket?" The sold-out showing of "Rocco and His Brothers," Luchino Visconti's 31-year-old saga of a family in Milan, had brought out these genteel ticket-mongers and given an unglamorous afternoon screening the feel of an event.

Shown in a sharp new black-and-white print and restored to its full three-hour length, "Rocco" was one of the festival's most popular attractions. And though the film holds up wonderfully, what the festival offered was something more than a chance to see a classic again. "Rocco" is, after all, available on video. But this screening was much like the festival itself: an antidote to too many rented-on-video, edited-for-television, tiny-screen film experiences. □

1991 O 6, II:13:5

The Heck With Hollywood!

Directed, photographed and produced by Doug Block; edited by Deborah Rosenberg; an Original Cinema Release. At Anthology Film Archives, Second Avenue at Second Street. Running time: 57 minutes. This film has no rating.

WITH: Ted Lichtenheld, Jennifer Fox, Gerry Cook, Charlie Schmidt, Don Moulton, Barbara Simon, Ben Barenholtz and others.

By JANET MASLIN

"The Heck With Hollywood!" by Doug Block is a prime example of the phenomenon it seeks to illustrate, that of the independently financed film whose greatest and possibly only virtue may be the enthusiasm of those who fought to get it made. Mr. Block sympathetically details the struggles of three film makers and the stumbling blocks they have encountered, from raising money to trying to find theaters where independent films are welcome. His own film, which is actually an hourlong video, opens today at the Anthology Film Archives.

A lot of what is revealed here will be of interest only to fellow would-be film makers, like the problems inherent in trying to find investors for untried talent and an iffy project. But Mr. Block, who is well attuned to the amateurish eagerness of some of his subjects, eventually moves on to the dark humor inherent in making films that may never see the light of day. The collaborators on something called "Only a Buck," who have credits like "cowriter/accountant" and "lead actor/art director," are seen joining the director, Gerry Cook, for a National Rest Stop Tour in a flamboyantly painted camper, out of which they sell videocassettes of their film "factory direct." They also give out a phone number, (800) HECK-YES, which is cute enough to land them on local news shows in the cities they visit. All that this eventually gets them is video distribution in a handful of countries, including Turkey and South Korea. This extremely limited success comes despite the film makers' vow to distributors that "we're not too fully committed to any of it — so we can take any of it out, or put any of it back in."

●

Less fortunate is Ted Lichtenheld, whose "Personal Foul" was made with money raised in Rockford, Ill., his home town, and whose main ac-

complishment, according to patrons who are interviewed on camera, is that it put Rockford on the screen. "Personal Foul" never found distribution outside of Rockford. But it and the two other films considered here will be shown Saturday afternoon starting at noon at Anthology, for the benefit of anyone whose curiosity knows no bounds.

Although Mr. Block's third subject, Jennifer Fox, garnered good reviews and various awards for her "Beirut: The Last Home Movie," the overall view of the independent film market presented here is not encouraging. Ms. Fox is seen arguing with the sales manager of Circle Releasing, her distributor, over why few theaters are available for independent features. Ben Barenholtz, the head of Circle Releasing, tells Mr. Block how hard it is to tell aspiring film makers that their work may never find an audience. "This can happen to what you're doing right now," Mr. Barenholtz says. "No one may want to see it."

Mr. Block himself has not escaped the pitfalls of obvious inexperience, as he demonstrates with shots of the white line on a highway when his subjects travel, and with interview material that is often unremarkable or flat. But he displays the kind of energy and persistence that count for a great deal in the independent film world, as "The Heck With Hollywood!" makes clear. He got this film made, and he's got it shown. That's a start.

1991 O 9, C15:1

Little Man Tate

Directed by Jodie Foster; written by Scott Frank; director of photography, Mike Southon; edited by Lynzee Klingman; music by Mark Isham; production designer Jon Hutman; produced by Scott Rudin and Peggy Rajski; released by Orion Pictures Corporation. Running time: 99 minutes. This film is rated PG.

Dede Tate	Jodie Foster
Jane Grierson	Dianne Wiest
Eddie	Harry Connick Jr.
Garth	David Pierce
Gina	Debi Mazar
Damon Wells	P. J. Ochlan
Fred Tate	Adam Hann-Byrd

By VINCENT CANBY

Fred Tate (Adam Hann-Byrd) is like any other 7-year-old. He's not especially handsome but, aside from his introspective manner, he is the kind of kid you might see in a television commercial for a ghastly new multi-colored breakfast cereal. His height is average; his face is still fleshed with baby fat.

His mind, though, is something else. It's moving at the speed of light.

Fred paints in both oils and watercolors and, at the moment, is going through a Picasso-influenced Cubist period. He plays the piano at what is said to be competition level. He takes telephones apart, not to fix them but to make them work more efficiently. As a birthday present for his mother, Dede (Jodie Foster), he writes an opera.

•

Taking the story of Dede, a militantly independent, unmarried mother, a waitress who once wanted to be a dancer, and Fred, a child prodigy hanging onto sanity as if it were a tiger's tail, Ms. Foster makes a terrifically self-assured debut as a motion-picture director with "Little Man Tate."

The material is congenial for someone as special as she is. The actress has grown up in the adult world of movies, having been first nominated for an Oscar in 1976 for "Taxi Driver," made when she was 13. Later the same year she played a femme fatale in "Bugsy Malone."

By the time she won her Oscar in 1989 for "The Accused," she had been in the business longer than most of the older people she was working with. It's now apparent that she also knows exactly what she's doing behind the camera. "Little Man Tate" is a small-scale, very engaging comedy that dares to suggest that intelligence, so often mocked in movies, can also be celebrated.

Along with his remarkable gifts, Fred has his problems, ulcers among them. When he sees a tabloid headline, "Mother Earth Meltdown," he lets out an involuntary "Oh, my God," which is both funny and, in light of his age, scary. In addition to the greenhouse effect, Fred worries about environmental pollution and the proliferation of nuclear arms.

He would also like to have someone to eat lunch with.

Fred is not exactly the most popular kid in his class. You don't make friends by knowing all the answers, either with the other students or with the teacher. The grotesquely cheerful Miss Nimvel (Celia Weston) at first thinks he's retarded, then suggests he might be able to skip elementary school entirely.

"Little Man Tate" is about the battle for Fred's future. On one side is the protective, tough-talking Dede, who doesn't want Fred turned into an exploited pint-sized freak. She tries to ignore his brilliance, while feeling her own increasing inadequacy in dealing with him.

On the other side is Jane Grierson (Dianne Wiest), a former child prodigy herself, an adult who knows the problems first-hand and who is now an educator of such children. She's still brilliant, but almost completely out of touch with real life.

When boiled down to this central conflict, and when seen in light of its resolution, "Little Man Tate" is a lot more conventional than its characters would seem to demand. The same story might well have been turned into a Movie of the Week.

Yet, as directed by Ms. Foster, the film has a kind of purity of purpose and control that is very rare in mass-market movies. It avoids a lot of sentimental nonsense. It is also

sparely (and well-) written by Scott Frank, the man who wrote the screenplay for Kenneth Branagh's "Dead Again."

"Little Man Tate" has a good deal of fun at the expense of "The Odyssey of the Mind," a sort of cross-country "mental Olympics" in which Fred participates at Jane Grierson's request. These are a series of contests at which gifted children display their skills to the amazement of academe. At one point the kids are seen trying the case of Goldilocks, charged with breaking and entering.

The movie never explores the biological roots of such special gifts, though it understands that terrible prices may have to be paid by the children themselves. This awareness gives the film its tension.

There is tension, too, in the principal women's roles. Though Ms. Wiest's Jane Grierson is initially an object of ridicule, she also knows what she's talking about in her criticism of Dede's handling of Fred.

Ms. Foster's Dede is an even more complicated character, mostly for everything that is left unexplained. Fred's father is never identified. That, says Dede, is something she doesn't talk about. It's as if she had conceived through the cooperation of an anonymous sperm donor.

Whatever the explanation, Dede is a determinedly, obsessively free spirit, fierce in her relations with everyone except Fred. She seems to be just the kind of woman who might well produce a child as singular in his way as she is in hers.

•

Ms. Foster is particularly good in her handling of young Mr. Hann-Byrd. This is not the standard American movie's kid performance. There is never that sinking feeling that he's trying to act, to give a performance as the word is understood by adult actors. Instead, he responds to the people and events around, remaining always a figure of some mystery.

Other notable members of the cast are Harry Connick Jr., as the university student who teaches Fred how to play pool; Josh Mostel, as Fred's professor of quantum physics, and George Plimpton, who appears briefly as a fatuous host of a television talk show.

"Little Man Tate" is a modest movie in the best sense. Its head is not stuffed with half-baked ambitions that cannot be realized. Like Dede, it is cool, bright, always aware of its limitations and, from time to time, unexpectedly rewarding in its turn of mind.

•

"Little Man Tate," which has been rated PG (Parental guidance suggested), has some vulgar language.

1991 O 9, C17:4

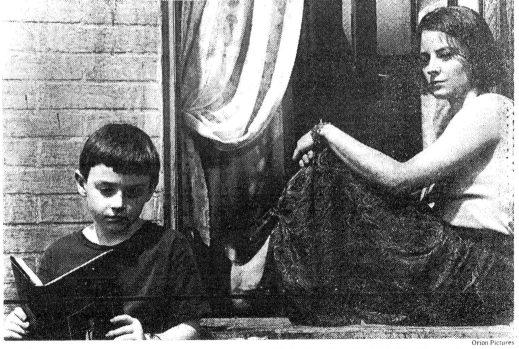

Jodie Foster and Adam Hann-Byrd in a scene from "Little Man Tate," which Ms. Foster directed.

Orion Pictures

Frankie and Johnny

Produced and directed by Garry Marshall; screenplay by Terrence McNally, based on his stage play "Frankie and Johnny in the Clair de Lune"; director of photography, Dante Spinotti; edited by Battle Davis and Jacqueline Cambas; music by Marvin Hamlisch; production designer, Albert Brenner; released by Paramount Pictures. Running time: 117 minutes. This film is rated R.

Johnny	Al Pacino
Frankie	Michelle Pfeiffer
Nick	Hector Elizondo
Cora	Kate Nelligan
Tim	Nathan Lane
Nedda	Jane Morris
Luther	Al Fann

By JANET MASLIN

"FRANKIE AND JOHNNY IN THE CLAIR DE LUNE," the one-set, two-character play by Terrence McNally, starts out where most love stories end up: in bed, with its newly united hero and heroine apparently in a position to start living happily ever after. In a more traditional play they might do that, but

Mr. McNally regards the process of finding one's knight in shining armor as a lot more problematic than it used to be.

And these days both men and women are likely to resist taking off their armor anyhow. "Are you keeping some big secret from me?" Frankie asks during the play. "It's more like I'm keeping several thousand little ones," Johnny answers.

Confined to Frankie's one-room apartment throughout the single night on which the play takes place, these two gradually fathom each other's fears. Eventually they reach a serene truce, thanks to a series of changes conveyed so quietly that even Johnny's burning himself while cooking qualifies as a significant event.

There is practically nothing in this modest situation to suggest that a big, crowded Hollywood romantic comedy could be spun out of Frankie and Johnny's mating ritual. But in the skillfully manipulative hands of Garry Marshall, who has directed from a screenplay by Mr. McNally that amounts to a complete revision, "Frankie and Johnny" has been reshaped into foolproof schmaltz. "Foolproof" is the operative word.

Mr. Marshall showed with "Pretty Woman" that he could find heart and humor in extremely unlikely places, and he shows it again with an overeager short-order cook (Al Pacino), a recalcitrant waitress (Michelle Pfeiffer) and a Greek coffee shop that houses a kind of Greek chorus. This film's determination to open up Mr. McNally's claustrophobic romance has brought forth supporting characters like Frankie's gay neighbor (Nathan Lane), her fellow waitresses (Kate Nelligan and Jane Morris) and her gruff employer (Hector Elizondo). According to production notes, this formerly spare story now features 94 characters in all.

And there are newly added events, like Frankie's bowling night and a co-worker's party, where extras ranging from punks to new immigrants and old biddies join forces to share a festive time. The effect of all this is warmly, happily seductive in time-honored sitcom fashion. Rarely has a film about loneliness been mounted with such bustling good cheer. Rarely has the story of drab lives been attended by so much color. And rarely has a tale of two misfits been played out by such obviously attractive stars.

But somehow Mr. Marshall, Mr. McNally and their superb leading actors are able to retain the intimacy of their material. They also retain the story's fundamental wariness about romance, even when everything about Ms. Pfeiffer and Mr. Pacino has the audience wondering why they don't simply fall into each other's arms. The names Frankie and Johnny gave Mr. McNally's play a sweet inevitability, an assurance that these two were fated to be together no matter how ill-suited they seemed. The movie, with this casting, needs no such guarantees. Indeed, Mr. Marshall's main challenge is to spend as much time as possible keeping Frankie and Johnny apart.

So the film takes an hour to work up to a first date, with half the staffers and patrons of the coffee shop cranning their ears every time Frankie snaps "Why do you wanna go out with me?" at the irrepressibly upbeat Johnny. Ms. Pfeiffer, despite the film's elaborate efforts to make her look drab, will never be able to ask that question in a credible way. Ms. Pfeiffer's extraordinary beauty makes her fine-tuned, deeply persuasive performance as the tough and fearful Frankie that much more surprising.

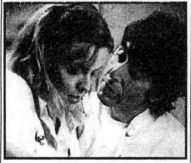

Paramount/Andrew Cooper
Michelle Pfeiffer and Al Pacino in "Frankie and Johnny."

If Mr. Marshall does well with romantic teasing, he's equally adept at making sure it pays off. When Frankie and Johnny do finally go out, there is an elaborate prelude featuring the funny, wisecracking Mr. Lane (who helps the desperately antisocial Frankie get ready and refers to Johnny as her "gentleman caller"). There is the busily staged party itself, and there is a trip to the flower market that culminates, at long last, in a kiss. Mr. Marshall's penchant for pulling out all stops on such occasions allows him to pose Frankie and Johnny next to a truck and let the truck's door fly open to reveal a sunburst of flowers at the proper moment.

"Frankie and Johnny" is not without its large share of comic overkill. Too many of the duo's most private conversations are shared by restaurant workers or patrons who happen to be hovering nearby, ready to supply a punch line. The film's sexual episodes tend to be terribly cute, with items like meat loaf and gold shoes and a pet parakeet dragged unhelpfully into the conversation. Mr. Marshall's sentimental streak also asserts itself, with montages in which the restaurant's other lonely employees are seen in their homes, accompanied by such props as a pet turtle.

•

Another peculiarity is the film's inconsistent backdrop, since the portrait of a bleak, impoverished New York becomes a lot more upscale once Frankie and Johnny begin falling in love. Then there is the sequence in which Mr. Marshall, who clearly has the most romantic view of prostitution in the movie business, shows the pre-Frankie Johnny hiring a prostitute simply to sleep next to him, fully clothed.

Mr. Pacino has not been this un-

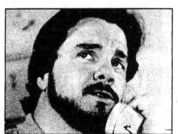

Paramount/Andrew Cooper
Nathan Lane

complicatedly appealing since his "Dog Day Afternoon" days, and he makes Johnny's endless enterprise in wooing Frankie a delight. His scenes alone with Ms. Pfeiffer have a precision and honesty that keep the film's maudlin aspects at bay. It also helps that Mr. McNally's expanded screenplay supplies so many workable one-liners, and that the supporting cast is funny and well used. Jane Morris displays flawless comic timing as the frumpiest of the waitresses, and Kate Nelligan, nearly unrecognizable, is outstandingly enjoyable as the gum-chewing, man-crazy one. "You see something cute in every guy," she is told. "I know," she beams. "I'm lucky like that."

•

"Frankie and Johnny" is rated R (Under 17 requires accompanying parent or adult guardian). It includes sexual situations and sexual references.

1991 O 11, C1:1

Lyrical Nitrate

Directed and written by Peter Delpeut; edited by Menno Boerema; produced by Suzanne Van Voorst; released by Zeitgeist Films. Running time: 75 minutes.

The Comb

Directed by the Brothers Quay, based on a fragment of text by Robert Walser; produced by Keith Griffiths; released by Zeitgeist Films. Running time: 17 minutes.

Broadway by Light

Directed and photographed by William Klein; produced by Anatole Dauman, Argos Films, Paris. Running time: 12 minutes. At Film Forum 2, 209 West Houston Street, Manhattan. These films are unrated.

By VINCENT CANBY

Peter Delpeut's "Lyrical Nitrate," opening a one-week engagement today at Film Forum 2, is an homage to the esthetics of the silent film. The 50-minute work is composed entirely of fragments of unidentified silent film stock, which were found in the attic of Jean Desmet (1875-1956), an early distributor of films in the Netherlands.

Zeitgeist Films
An image from "Lyrical Nitrate."

"Lyrical Nitrate" is the kind of homage that is best appreciated by people who are at a loss for words to express their appreciation for silent movies. As source material, Mr. Delpeut uses clips from short fiction features, documentaries, travelogues and what seem to be screen tests, many color-tinted in the manner in which they were first exhibited.

By speeding up or slowing down the rate at which the clips are projected, he effectively deconstructs the original images, removing their meanings, in order to call attention to the delicate beauty possible, it seems, only with nitrate stock. This is the highly inflammable and fragile stock on which all movies were shot until the mid-1950's.

For the convenience of those who share Mr. Delpeut's passion, "Lyrical Nitrate" is broken into segments with such lower-case titles as "passion" and "mise en scène." It is the work of a poet.

Also on the avant-garde program is "The Comb," a surreal 17-minute short by the Brothers Quay, American-born film makers who now work in England, and William Klein's "Broadway by Light," an impressionistic 11-minute color montage of Times Square signs, circa 1958.

"The Comb" is hermetic and surreal. Black-and-white images of a woman asleep are cross-cut with color images in which a child's abandoned doll, animated by the Quays' magic, moves through a dreamy, puppet theaterlike landscape, apparently in search of a comb at the top of a miniature church tower.

The colors are very beautiful (ivory, gold, tawny greens and gray) and the images often weird and striking. At the end of the film, the woman awakens into her black-and-white world and combs her hair, after which she runs a finger along the tips of the teeth of her comb. The effect is almost tactile, which for some viewers will be enough.

1991 O 11, C10:1

The Boy Who Cried Bitch

Directed by Juan José Campanella; written by Catherine May Levin; director of photography, Daniel Shulman; edited by Darren Kloomok; music by Wendy Blackstone; production designer, Nancy Deren; produced by Louis Tancredi; released by the Pilgrims 3 Corporation. At the Village East, Second Avenue and 12th Street, Manhattan. Running time: 105 minutes. This film has no rating.

Dan Love	Harley Cross
Candice Love	Karen Young
Mike Love	Jesse Bradford
Nick Love	J. D. Daniels
Jim Cutler	Gene Canfield
Jessica	Moira Kelly
Eddie	Adrien Brody
Orin Fell	Dennis Boutsikaris
Stokes	John Rothman
Richard	Samuel Wright
Dr. Habib	Kario Salem

By JANET MASLIN

"The Boy Who Cried Bitch," a more serious film than its terrible title suggests, tries to examine family dynamics between the deeply troubled 12-year-old Dan Love (Harley Cross) and his skittish, defensive mother Candice (Karen Young), who is clearly a huge part of Dan's problem. In the film's disturbing opening sequence, Candice comes home with a male friend only to have Dan and his two younger brothers pelt the stranger with dirt and address their mother as "slutbitch" and "the happy hooker," insults that soon have her retaliating in kind. Dan, who is clearly out of control and scares himself as much as he scares others, spends most of his time at a private school that keeps him out of his mother's hair.

The film, which plays like an earnest, watered-down case study, observes Dan's growing inability to get along with his peers. Violent and erratic, he finds fellowship with the school's maintenance man, Jim (Gene Canfield), a haunting Vietnam veteran who shares his back issues of Soldier of Fortune with the boy. Jim is well on his way toward child molestation when he himself shows severe signs of mental strain. The older man's crackup, eerily rendered here, prompts a similar breakdown for Dan, who is consequently moved to a private psychiatric hospital.

At the hospital, Dan makes friends with various other young patients, but eventually alienates them all. The film, which opens today at the Village East, progresses inexorably but very slowly toward a grim resolution of the mother-son conflict at the heart of the story.

●

As directed by Juan José Campanella and written by Catherine May Levin, "The Boy Who Cried Bitch" is conspicuously more soft-hearted than its subject. The film never fully enters into either Dan's furious impulses or his mother's dangerously unstable frame of mind. The boy, though played intensely and well by

Mr. Cross, never exhibits anything more surprising than textbook psychotic symptoms, and these only at well-timed intervals. Much of the time, he seems a good, misunderstood child who waves hatchets, writes on walls, rocks rhythmically and so on simply because he has problems at home.

Ms. Young has more shock value, but her character as written is brittle and repetitive. The story's mother-son friction is presented in clinical detail, but it is seldom allowed room for dramatic development. Also in the film, in helpful but ultimately ineffectual capacities, are Dennis Boutsikaris, John Rothman, Samuel Wright and Kario Salem as medical personnel doing their best to help Dan, and Moira Kelly and Adrien Brody as young patients trying very hard to be his friends.

1991 O 11, C17:1

City of Hope

Written, directed and edited by John Sayles; director of photography, Robert Richardson; music by Mason Daring; production designers, Dan Bishop and Dianna Freas; produced by Sarah Green and Maggie Renzi; released by the Samuel Goldwyn Company. Running time: 129 minutes. This film is rated R.

Nick	Vincent Spano
Joe	Tony Lo Bianco
Wynn	Joe Morton
Reesha	Angela Bassett
Carl	John Sayles
Jeanette	Gloria Foster
Asteroid	David Strathairn
O'Brien	Kevin Tighe
Angela	Barbara Williams
Pauly	Joe Grifasi
Mayor Baci	Louis Zorich
Laurie	Gina Gershon
Pina	Rose Gregorio
Professor	Bill Raymond
Former Mayor	Ray Aranha

By VINCENT CANBY

"City of Hope" is the seventh and most invigorating achievement to date by John Sayles, the godfather of independent film makers in this country. Here is a tumultuous evocation of urban America in the final decade of the 20th century, when old systems don't work, reason is in short supply, money is running out and opportunism draws more votes than equal opportunities.

"City of Hope" is as contemporary as slumlords and cut-rate appliance stores, but classic in its methods. Mr. Sayles shares Ibsen's appreciation for the ways in which the past makes a hostage of the present, as well as Arthur Miller's crazy fearlessness in writing the big melodramatic scene that often pays off.

The cast is huge, nearly three dozen featured players. Virtually every role is vividly characterized in both the writing and the performance: politicians, policemen, hoods, fixers, contractors, hard hats, muggers, do-gooders, teachers, the homeless, the overhoused. Some of them are actually trying to do the right thing.

The setting is the fictional Hudson City, N.J., whose unofficial motto is Quid Pro Quo. Hudson City is a place big enough to share the problems that face virtually every major American population center, but small enough so that each life manages in some fashion to be linked to all of the others. The degrees of separation in Hudson City are no more than two or three.

The movie begins with Nick (Vincent Spano) on an open floor of a Hudson City high-rise under construction, and ends several days later

Samuel Goldwyn

Vincent Spano

in the same spot: "City of Hope" is nothing if not symmetrical. Nick, the son of a successful contractor, is described by a pal as "the only guy stupid enough to quit a no-show job," which he is doing when first seen.

In fact, he is less stupid than terminally aimless, given to binges of alcohol and cocaine and occasional petty crime. One of these adventures, the attempted heist of Mad Anthony's television outlet, sets off the series of events that eventually involves nearly everyone in Hudson City.

Mr. Sayles's skills as both writer and director have never been more evident than they are in "City of Hope," which is shapely, theatrical and enormously skillful. It's not easy telling what initially appears to be at least five different stories at the same time.

To this end, the very wide-screen Panavision camera becomes an active presence within the film, cutting among the various narrative lines like a restless inquisitor. The camera won't be still. It pushes its way into barrooms, bedrooms, parks, patrol cars, family parties, abandoned buildings, City Hall, for reasons that appear at first to be arbitrary until, at last, the film's grand design becomes evident.

At the center of it is Mr. Spano's Nick, inarticulate but fumbling toward some truth of his own. "City of Hope" is also about his father (Tony Lo Bianco), who plays a crooked game as honestly as possible; the black councilman (Joe Morton), fighting the white majority and almost convinced that there are both a truth that is certifiable and a higher truth that is different but serves the proper ends; the divorced young mother (Barbara Williams) with whom Nick falls in love, and a white college professor (Bill Raymond), mugged in the park by two young black kids who, in turn, accuse him of having propositioned them.

There are also Hudson City's favorite disposer of stolen property (Mr. Sayles); the white mayor of Hudson City (Louis Zorich), a corrupt politician who knows that he's on the way out, and Hudson City's black former mayor (Ray Aranha) who, having broken the color bar, now spends his days playing golf.

Appearing as a kind of chorus from time to time are two busy women, shoppers who seem always on their way to someplace else, parroting all the things expected from the members of the fearful lower middle class.

"I feel like I'm living in a Charles Bronson movie," says one. "Why should anyone work," says the other, "when you can go on welfare?"

Mr. Sayles's screenplay is not exactly underwritten. Buildings are torched for profit. People are killed. Family loyalties are tested in great confrontation scenes, while love is discovered in the most unlikely encounters.

Mr. Sayles resolves some of the problems rather too easily, while other problems are simply avoided. Those are his prerogatives. There's only so much ground that even a very ambitious film can cover. Toward the end, there also are at least one or two revelations that are not entirely necessary.

The wonder is that he succeeds and convinces as often as he does. The movie sounds and looks absolutely authentic, whether it's a scene of deal making in City Hall or a young woman talking about her terrible marriage to a jealous policeman: "It was, like, I was married to the Moonies, or something."

The performances are so uniformly good that only a paid advertisement could possibly list everyone who deserves credit. In addition to those already mentioned, add the names of David Strathairn (as Hudson City's most conspicuous homeless person), Rose Gregorio as Nick's mother, Joe Grifasi as a City Hall wheeler-dealer, Gloria Foster as the mother of one of the two young muggers, Gina Gershon as Nick's sister, and Kevin Tighe as a detective on his way into politics.

Robert Richardson was the excellent cinematographer. It should also be noted that Mr. Sayles is himself fine as the Hudson City lowlife who more or less triggers all the action, and that he served as the editor of the film he wrote and directed.

"City of Hope" is a very big job well done and, I suspect, well done for a fraction of the cost of most major-company Hollywood movies.

●

"City of Hope," which has been rated R (Under 17 requires accompanying parent or adult guardian), includes vulgar language and violence.

1991 O 11, C19:1

Shattered

Written and directed by Wolfgang Petersen, based on the novel by Richard Neely; director of photography, Laszlo Kovacs; edited by Hannes Nikel and Glenn Farr; music by Alan Silvestri; production designer, Gregg Fonseca; produced by Mr. Petersen, John Davis and David Korda; released by M-G-M. Running time: 97 minutes. This film is rated R.

Dan Merrick	Tom Berenger
Gus Klein	Bob Hoskins
Judith Merrick	Greta Scacchi
Jenny Scott	Joanne Whalley-Kilmer
Jeb Scott	Corbin Bernsen
Dr. Berkus	Theodore Bikel
Nancy Mercer	Debi A. Monahan
Rudy Costa	Bert Rosario

By JANET MASLIN

The hotly coveted Nuttiest Plot of 1991 citation will almost certainly go to "Shattered," a thriller that adopts the currently popular accident-amnesia premise (e.g. "Regarding Henry") and takes it about as far as it can go. No, further. Tom Berenger plays the bewildered victim who tries to reconstruct his past and discovers

MGM/David James

Tom Berenger

what is, in films of this sort, the obvious: that he is a rich, powerful businessman with an impressive office and a very big house. "Oh wow!" he exclaims, upon being brought home to the latter.

Mr. Berenger's Dan Merrick also learns that Judith (Greta Scacchi), the loving wife helping him to regain his health, is a faithless tramp who miraculously managed not even to chip her nail polish in the car crash that robbed him of his memory. And he unearths an indescribably weird murder mystery, one that turns out to involve formaldehyde, a sunken ship and a fax machine, among other essentials. Wolfgang Petersen, who directed, maximizes the situation's lurid possibilities by returning periodically to Dan's memories of shattering car windows and sex with Judith on a beach in Mexico.

The film's chief asset is the wonderful Bob Hoskins, more or less reprising his "Who Framed Roger Rabbit" role. Mr. Hoskins plays Gus Klein, the pet-store owner who comes to Dan's attention when Dan discovers a $7,000 pet bill for the preceding year. Gus turns out to be a private investigator, and a world-weary one at that. "You spend that long peepin' through keyholes, you kinda lose confidence in the human species," he says of his career as a gumshoe.

Mr. Hoskins, sometimes surrounded by parrots and snakes and at other times sporting New York Yankees' paraphernalia, has enough fun with his role to suggest the whole film might have been better if more mischievously handled. After describing to Dan the barnyard takeover in George Orwell's "Animal Farm," he exclaims, "Boy, would I sing to see that really happen!"

Also in "Shattered," and a lot less blithe about it, are Joanne Whalley-Kilmer as Judith's equally treacherous friend, and Corbin Bernsen as her husband, Dan's friend and business partner, who keeps a drum kit in his study and tells Dan to regard his amnesia as a golden opportunity to enjoy life all over again.

•

"Shattered" is rated R (Under 17 requires accompanying parent or adult guardian). It includes nudity and profanity.

1991 O 11, C24:3

Building Bombs

Directed and produced by Susan Robinson and Mark Mori; written by Ms. Robinson, Mr. Mori and William Suchy; edited by Philip Obrecht; music by Steve Hulse; narrated by Jane Alexander. Running time: 54 minutes.

Deadly Deception

Directed and produced by Debra Chasnoff. Running time: 27 minutes.

Nukie Takes a Valium

Directed by Jonathan Amitay. Running time: 5 minutes.

Manic Denial

Directed by Hal Rucker. Running time: 11 minutes.
At the Angelika Film Center, Houston and Mercer Streets. These films are unrated.

By STEPHEN HOLDEN

When the Savannah River Plant, the nation's main installation for the manufacture of nuclear bombs, was built in the 1950's near Aiken, S. C., it was like "gold rush days," recalls a local resident in Mark Mori and Susan Robinson's frightening documentary, "Building Bombs."

Almost overnight, the population of the area grew from 13,000 to 55,000. Aiken became a thriving company town run by the Du Pont Company, which built and operated the plant until the 1980's, when it was taken over by Westinghouse.

Those rosy days are long gone. None of the plant's five reactors are operating today. It is a nuclear waste site and storage facility whose clean-up costs have been estimated at more than $30 billion.

The 54-minute film, which opened yesterday at the Angelika Film Center on a bill with three shorter films dealing with nuclear issues, offers an understated history of the plant, which is shown to be aging badly, contaminating the local ground water and threatening one of the country's largest aquifers. One of the most disturbing disclosures is that between 1955 and 1983 low-level nuclear waste from the plant was disposed of in cardboard boxes, dumped in shallow trenches and shoveled over.

•

Among those who tell their stories are Art Dexter, a retired Du Pont physicist who suffered a crisis of conscience after being shown a vault containing enough tritium to power 30,000 of the bombs dropped on Nagasaki, and William Lawless, a former engineer for nuclear waste management for the plant. While employed by the plant, Mr. Lawless filed a report on the dangers of ground water contamination from the cardboard boxes that Du Pont rejected and eventually had killed. George Couch, a maintenance mechanic at the plant for 22 years, who is now suffering from a rare blood disease, recalls the plant's lax safety procedures.

The plant's biggest defender, who cites its economic benefits to the region (14,000 jobs), is James Edwards, a former United States Secretary of Energy and a former Governor of South Carolina.

"Building Bombs" is an effective muckraking film because it doesn't scream hysterically. Its scenes covering the 1950's have a deceptively cozy, upbeat atmosphere. The recollections of former plant employees are clear and reasonable, and the narration by Jane Alexander is almost dispassionate in its coolness.

•

"Deadly Deception: General Electric, Nuclear Weapons and Our Environment," a half-hour video that is also on the bill, interweaves saccharine television advertisements for General Electric consumer products with inflammatory material about the company's operation of the Han-

ford Nuclear Reservation in Washington State and the Knolls Atomic Power Laboratory in upstate New York.

The company ran the Hanford reservation for two decades into the mid-1960's, a period in which the film alleges that those living downwind from the reservation suffered from serious radiation-induced ills. The video was produced by Infact, an organization that is pressing General Electric to get out of the nuclear weapons business, and does not present General Electric's views.

Rounding out the program are two clever, strongly polemical antinuclear cartoons. In Jonathan Amitay's "Nukie Takes a Valium," a mocking male mushroom cloud puts on drag to offer a seductive modest proposal for nuclear annihilation. Hal Rucker's "Manic Denial" is a vignette about a psychiatrist awakened to nuclear peril by the discovery of a missile weapon silo near her uncle's farm.

1991 O 12, 20:3

The Taking of Beverly Hills

Directed by Sidney J. Furie; written by Rick Natkin, David Fuller and David J. Burke; director of photography, Frank Johnson; edited by Antony Gibbs; music by Jan Hammer; production design, Peter Lamont; produced by Graham Henderson; released by Columbia Pictures. Running time: 95 minutes. This film is rated R.

Boomer Hayes	Ken Wahl
Ed Kelvin	Matt Frewer
Laura Sage	Harley Jane Kozak
Robert Masterson	Robert Davi
Oliver Varney	Lee Ving James
Benitez	Branscombe Richmond

By JANET MASLIN

Now and then a car smashes through the facade of a store like Gucci, but otherwise there's nothing fancy about "The Taking of Beverly Hills," the silly action film that opened Friday at the National and other theaters. The plot is elaborate, involving a robbery, insurance fraud, poison gas and the alphabet soup of SWAT, L.A.P.D. and E.P.A. But these elements lead to little more than violent episodes during which flying bullets, shooting flames and screeching tires are accompanied by pounding, upbeat music. There is so much of this that the credits cite an "armorer" who supplied the guns.

Ken Wahl plays Boomer Hayes, a football hero who helps to preserve what looks like Rodeo Drive and its environs (although much of the film was shot in Mexico). Mr. Wahl mumbles his way through this role and makes it easy to understand why he can more often be seen on the small screen than on the large one. Also on hand are Robert Davi as a diabolical kingpin and Harley Jane Kozak, who when cornered by him utters the memorable, "Let me get this straight — it's my wedding or my funeral, is that it?" Another heavy is played by Lee Ving James, who used not to have a last name but can always be counted on to make a good villain.

Among the minor highlights of "The Taking of Beverly Hills," which was directed by Sidney J. Furie, is the stealing of a Rolls-Royce and the use of its cut-glass decanters as firebombs. That, presumably, is intended as a form of local color.

•

"The Taking of Beverly Hills," which is rated R (Under 17 requires accompanying parent or adult guardian), includes profanity and violence.

1991 O 13, 68:5

FILM VIEW/Caryn James

Zeitgeist Isn't a Snap To Capture

"THE RAPTURE" SEEMS TO ASK: HOW CAN you love a God who allows evil in the world? But "The Rapture" really asks: What does a saved woman wear to the Apocalypse? The film is the story of a woman who trades in sex for God and is certain that His warning trumpets will sound the end of the world at any minute.

It was taken seriously enough to have been shown at the recent New York Film Festival, and most reviewers have praised its daring even when they think it ultimately fails. But the lessons it teaches are about movies, not morality. "The Rapture" tries very hard to be a Zeitgeist movie for the 90's, yet it ignores a cardinal rule. Movies that capture the spirit of the time are born, not made.

"Fatal Atttraction" was the classic Zeitgeist movie for the 1980's, a commercial suspense film that never pretended to be anything more. The screenwriter, James Dearden, and the director, Adrian Lyne, were convincing when they said they were just out to make a psychological thriller.

Everyone was surprised when the story of a married man's one-night fling with an obsessive woman took on a life

'The Rapture' serves as a lesson. Films that set out to reflect the spirit of their time are born, not made.

of its own. Suddenly it carried the weight of a cautionary tale about casual sex in the age of AIDS. If the film had tried to speak to the buried fears of the decade, it wouldn't have turned up on magazine covers. By its nature, a Zeitgeist film hits effortlessly, on an unconscious level.

"Fatal Attraction" purports to be shallow, and, in fact, works in deeper ways. "The Rapture," the first film written and directed by the novelist Michael Tolkin, purports to be deep, and is as shallow and cynical as movies get. It crams in touchstones of 90's morality, with its rejection of sex, its strong vein of fundamentalism, its aura of New Age spirituality.

"The Rapture" is hard to dismiss because it kicks around so many trendy ideas. But the film's most convincing moments come early on, before any ostensibly deep subjects have been raised. The annoying tapping noise heard at the start of the film is the sound of dozens of computer keyboards, and the eerie atmosphere comes from the track lighting in the room, filled with telephone information operators. This is where Sharon, played by Mimi Rogers, spends eight hours a day, and the place is deadening enough to send anyone in search of a little life — this life or the afterlife probably doesn't matter.

So Sharon cruises airport hotels with an urbane, devilish man named Vic. Together they pick up other couples and

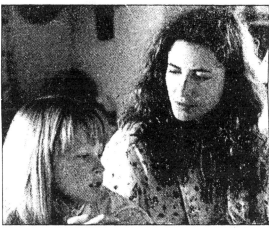

Fine Line Features

Kimberly Cullum and Mimi Rogers in "The Rapture"—as shallow and cynical as movies can get

have the kind of risky, anonymous sex that people in the 90's aren't supposed to have anymore. Here is the first of the film's slippery moves; this long stretch of sex scenes adds a voyeuristic edge but marks Sharon as a lost soul, so "The Rapture" gets to have its sex and condemn it, too. Of course, no one needs to mention AIDS, because that Zeitgeist movie has already been made.

When Sharon picks up a young man who confesses he is a murderer, he wonders, "If we weren't taught that killing is bad, would I still feel this bad?" He'll never know the answer and neither will viewers, because that is exactly the kind of question "The Rapture" never explores. But it sure sounds serious, like everything in the film.

■

When Sharon overhears portentous coffee-break conversations about "the boy and the pearl," how does she know that her co-workers are not talking about deep-sea diving? Her revelations become, not more revealing, but definitely more cinematic.

In one of her hotel encounters, she is fascinated by Vic's partner, a woman with a tattoo covering her back. On that back is a hand holding a shining pearl, and Sharon begins to

be dissatisfied with her life. Audiences sense that this is not because she wants more jewelry.

Omens litter the screen, but they are nothing more than visual effects. Sharon's major revelation comes when she tries to shoot herself. At that moment, the light turns reddish-yellow, and a giant pearl spins on the screen. Sharon wakes up at home, converted to God.

Soon she is changing her sheets at 3 A.M., kicking the murderer out of her bed and saying: "I'm tired of the pain in my life. I'm tired of feeling empty all the time." Imagine if Michael Douglas's character in "Fatal Attraction" had envisioned a giant dead rabbit and said, "I'm sorry I fooled around because I might get AIDS." The Zeitgeist wouldn't have been tapped; it would have been buried beneath pretentious symbols and literal-minded dialogue.

If "The Rapture" had invited viewers to challenge Sharon's beliefs, the film might have tickled the Zeitgeist, if not tapped into it. For quite a while Mr. Tolkin seems to be trying that, in his slick way. Sharon joins a vaguely fundamentalist church, and the film dangles the question of whether she is saved or crazy. Now *that* is a Zeitgeist question.

But when Sharon goes to the desert wearing a long, flowered dress, it turns out that God's trumpets really do sound. She is chased by apocalyptic white horses. One rider is a cloaked figure bearing a sword; another holds the scales of justice, and both ride through blue fog.

By now Sharon is usually seen with a halo of light around her head, which suggests the final message of "The Rapture": Come the Apocalypse, there will be a lot of backlighting, and all the women will wear Laura Ashley knockoffs. □

1991 O 13, II:13:5

FILM VIEW/Janet Maslin

Cute Is Out, as Odd Couples Meet in Weird Ways

IN THE RUSTIC DRAMA "PARADISE," Ben Reed (Don Johnson) tells the story of how he met Lily (Melanie Griffith), who is now his wife. It happened in their hometown, and she was the prettiest girl he had ever seen. So they fell in love.

From the standpoint of current Hollywood storytelling chic, this is just about as wrong-headed as it can be. There are several reasons: The setting is unremarkable. The characters, even though Ben is supposed to be a shrimp fisherman, are actually well matched. They are even members of the same generation. And at the time of their meeting, neither one was dead, dreaming or on another astral plane.

It would have helped enormously if one of them *had* been cosmically elsewhere, or at least if the contrivances behind their meeting had been a shade more contrived. That way, "Paradise" would have offered evidence of the desperate ingenuity that seems to be so highly prized at present. The harder a film labors to throw together characters who might otherwise be separated by time, class, race, health, personality traits or even mortality, the greater its claim to creativity. And if viewers' heads are made to spin in the process, so much the better.

Some of this strenuous inventiveness can perhaps be connected with "Ghost," the film that was unclassifiable everywhere except at the box office and left love, pottery and psychic phenomena permanently intertwined. Some of it can be seen as scary overcompensation for the all-around lack of ingenuity with which the movie business has lately been plagued. Some of it may even be worth taking seriously, insofar as it reflects a wider social fragmentation, something that has been as conspicuous lately in the ways films

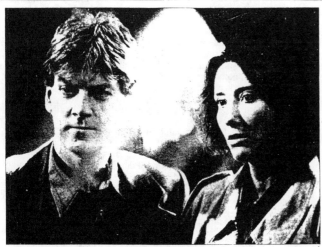

*Kenneth Branagh and Emma Thompson in "Dead Again"—
playing a bizarre couple of couples, one of them reincarnated*

are plotted as in the ways their characters cross paths. Conventional, linear modes of behavior are just as hard to find on the screen as they are in real life.

■

In any case, when it comes to the ways movie characters meet, forget about the boy next door unless he happens to be reincarnated in the form of another neighbor. And forget about the soda fountain or even the street corner as a place to make friends. Today's movie pals are more apt to make each other's acquaintance at a junk heap (as in "The Fisher King"), where one of them (Jeff Bridges) is about to be set afire by hoodlums before being miraculously rescued by the other (Robin Williams). Or they could meet as fellow street hustlers (Keanu Reeves and River Phoenix in "My Own Private Idaho") who are then thrown together when one hustler's narcoleptic seizure brings on a client's wrath.

They might even cross paths in a public toilet, where a famous writer is discovered discreetly vomiting by an admirer ("Barton Fink"). Or it could happen in a hotel room, where the sounds of one character's moans become hauntingly audible to another ("Barton Fink" again). If first encounters like this strive to assure the audience that what will follow will be no ordinary buddy-movie friendship, then they certainly succeed.

And when romance is in the air these days, the lovers' meeting is liable to be even more bizarre. Kenneth Branagh's "Dead Again" brings together an amnesiac (Emma

In today's movies, it's tough to make friends if you're not dead, dreaming or from another astral plane.

Thompson) and a private detective (Mr. Branagh), which would be film-noir ordinary if the two did not turn out to be reincarnated versions of a musician and his murdered wife. (In early versions, this was apparently more ingenuity than preview audiences would bear. Response was much more re-

spectful once flashbacks to the dead musician and his wife were switched from color to a solemn, stylized black and white.) In this case, the strangeness of the characters and their pasts acts as a smoke screen, lending mystery to a film that would often seem flat and hackneyed if it were not so doggedly confusing.

Even more mind-bendingly imaginative is the pretext for a meeting in Mike Figgis's steamy "Liebestraum," in which an architecture writer visiting his dying mother runs into the restless wife of an old friend. Should that not be sufficiently offbeat, there is the added fact that when these two begin a flirtation they become haunted by memories of a murder that took place a generation earlier, a murder in which all three — writer, friend's wife, dying mother — are ultimately shown to be involved. Once again, the strange plotting serves to conceal something, in this case Mr. Figgis's primary interest in the sultry, mock-solemn moodiness that he generates so well.

A plot like that one, however farfetched, would be even harder to orchestrate if time-traveling love affairs were not becoming so popular. But once Marty McFly was able to meet his sweetheart at different stages of her life in the "Back to the Future" movies, the genie was out of the bottle, creatively speaking. So in "Late for Dinner," a young man escaping a crime scene happens upon a cryogenics expert willing to freeze him, and the next thing he knows he has thawed out and is encountering his wife, who has become a middle-aged woman. This premise reveals much more about current Hollywood story conferences and how dumbfounding they must be than about what it would be like to find 29 extra years separating oneself from a loved one.

Even when romantic meetings strive for little more than irony, they tend to be unduly inventive these days. In "The Rapture," a couple who meet in pursuit of debased, impersonal sex wind up as devout, happily married born-again Christians. The couple in "Dogfight" meet precisely because he (River Phoenix) thinks that she (Lili Taylor) is all wrong for him and unattractive to boot. Naturally, the film's whole purpose is to reverse that assumption.

■

Introducing lovers who at first dislike each other is the oldest trick in the book (for a typically creaky example, see Michael J. Fox romance a pretty but antagonistic ambulance driver in "Doc Hollywood"). Perhaps it is in modifying this tactic that so many recent films have created wider-than-usual chasms between their characters.

Whether intimacy begins in an improbably innocent setting (a New York private school in "Alice") or even a grim one (a cancer ward in "The Doctor"), or even arrives in the potentially unremarkable form of office romance ("Jungle Fever"), it is rarely allowed to be straightforward anymore. The chillier or more difficult the relationship, the more abstract it may appear to be, and the more contemplative the film looks — within certain limits, of course. We can only wonder about the effects of letting young viewers imagine that a hostile-looking metallic Terminator from the future can turn out to be a boy's best friend.

Of course, those same viewers will soon be contemplating the love match between a pretty young woman and the horrible-looking horned monster she meets when the creature captures her father. The forthcoming "Beauty and the Beast" is a reminder that strange meetings, while newly viable, are nothing new. □

1991 O 13, II:21:1

The Cry of the Owl

Directed by Claude Chabrol; screenplay (French with English subtitles) by Mr. Chabrol and Odile Barski, based on the Patricia Highsmith novel; cinematography by Jean Rabier; music by Matthieu Chabrol; released by R5/S8. At Film Forum 1, 209 West Houston Street. Running time: 102 minutes. This film has no rating.

Robert Christophe Malavoy
Juliette ... Mathilda May
Patrick............................Jacques Penot
Véronique............................ Virginie Thevenet

By VINCENT CANBY

He is first seen only as a close-up of an eye, then as a pair of feet, finally as the shadowy shape of a Peeping Tom. A man peers through the bushes toward the lights of a house where, behind a picture window, a pretty young woman is preparing to have supper while watching television.

These initial images suggest that "The Cry of the Owl" ("Le Cri du Hibou") will be vintage Claude Chabrol, possibly even in the same romantically ruthless category with his "Femme Infidèle," "Boucher" and "Rupture." Everything appears to be as perfectly ordered as it is perverse.

The voyeur is Robert (Christophe Malavoy), the object of his attentions is Juliette (Mathilda May), whom he has been watching nightly for something close to three months. During the day he is a respectable draftsman, living in Vichy after splitting with his wife in Paris.

The melancholic Juliette, who shares the house with Patrick (Jacques Penot), her fiancé, is not unaware that she is being spied on. One night she sends Patrick out with a meat cleaver to find the prowler. No luck, though.

•

A few days later in broad daylight, when Juliette is raking leaves on the lawn, Robert presents himself to her. She senses who he is and wonders why he has been watching her with such regularity. That's not an easy question for a polite, sincere voyeur to answer, but Robert tries.

He was comforted by the sight of someone attending to the routine of commonplace existence. "You looked so self-assured," he says. She replies that looks can be deceiving. She is also intrigued. She invites him into

the house for tea and, almost on the instant, falls crazily in love with him.

As Robert says later in the film, when he has become more victim than victimizer, watching someone through a window isn't necessarily a declaration of undying love.

"The Cry of the Owl," based on a novel by Patricia Highsmith, was made in 1987 but is only now being seen in this country, opening today at Film Forum 1. The reasons for the delay are self-evident. "The Cry of the Owl" is a Chabrol film to test the patience and the theories of the French director's most abject admirers.

After the quite wonderful introductory sequences, the film's narrative goes heedlessly bonkers, playing a couple of important dirty tricks on the audience as it falls to pieces.

•

Robert is introduced as a self-confessed depressive who has spent some time in a mental hospital. This is not something he hides. He talks about it with Juliette early on. Yet it's soon apparent that he is the only sane person in the film. Why he doesn't recognize the fact is too much for plausibility to bear.

"The Cry of the Owl" is not just chilly. It is seriously irrational. Because of the way in which Mr. Chabrol manipulates the behavior of the characters to fit the story, the suspense never accumulates — it keeps running out through the holes in the bottom of the plot.

The central situation is a good one, especially when Robert and Juliette reverse roles and she becomes a most unlikely predator. Then the film's balance is thrown off by the introduction, comparatively late in the film, of Véronique (Virginie Thevenet), Robert's ex-wife, who is really the most important element in the story.

As written and directed, Véronique is a completely transparent character, whom only Robert cannot see through. His witlessness keeps the movie going, but at the expense of any interest one might have in his predicament.

The movie has an elegant surface sheen to it, largely due to the work of Jean Rabier, the cinematographer and Mr. Chabrol's longtime collaborator. The performances are good without being memorable.

Audiences are cautioned not to give away the ending. No need to worry. I couldn't remember the ending until I checked my notes.

1991 O 16, C19:1

Objects of Desire Mathilda May appears in "The Cry of the Owl" as a woman involved in a mutually obsessive relationship with a mysterious stranger.

The Wages of Fear

Directed by Henri-Georges Clouzot; screenplay (French with English subtitles) by M. G. Clouzot and Jerome Geronimi; original novel by Georges Arnaud; director of photography, Armand Thirard; edited by Henri Rust, Madeleine Gug and E. Muse; music by Georges Auric; production designer, René Renoux; produced by Louie Wipf; released by Kino International. At Film Forum 2, 209 West Houston Street, Manhattan. Running time: 148 minutes. This film has no rating.

Mario..Yves Montand
Jo..Charles Vanel
Linda..................................Vera Clouzot
Luigi....................................Folco Lulli
Bimba..............................Peter van Eyck
O'Brien..............................William Tubbs

By VINCENT CANBY

Seldom have the exquisite pain and pleasure of motion-picture suspense been mixed with quite the intoxicat-

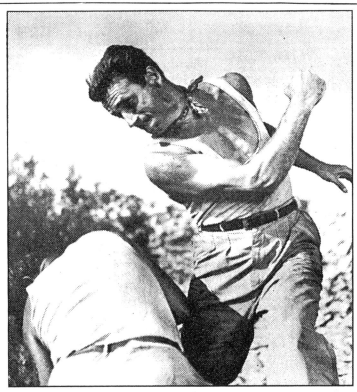

Yves Montand, right, in a scene from "The Wages of Fear."

ing effects that Henri-Georges Clouzot achieves in his 1953 classic, "The Wages of Fear" ("Le Salaire de la Peur").

The film, being released in this country for the first time in its entirety, opens today at Film Forum 2, where it may well run forever.

No other show in town can match "The Wages of Fear" for the purely gut sensations it prompts, the kind that make you laugh out loud as the heart threatens to go on permanent hold. Yet "The Wages of Fear" is a lot more than a spectacular roller-coaster ride. It's about courage as well as fear, about the impulse to persevere in the face of apparent futility.

"The Wages of Fear" is also a 1950's time capsule, the contents of which reflect French attitudes toward everything from Sartre's existentialism to America's post-World War II hegemony. No wonder that William Friedkin's 1977 remake, titled "Sorcerer," seemed so wan: it didn't have an attitude. The Clouzot original is not only one of the most breathtaking thrillers ever made but also a film that is grounded in attitude.

•

For its initial American release in 1955, the film's distributors toned down (and sometimes pared away entirely) everything they thought might offend American audiences in the Eisenhower era. The running time was thus collapsed to 105 minutes from 148, which is the version on the Film Forum screen.

The excised Clouzot attitude now looks pretty tame but, in the early 50's there were many who might have taken "The Wages of Fear" to be inflammatory.

The setting is Las Piedras, a small sun-baked village in a parched Latin American petroleum republic where the rule of law is that of the United States-owned Southern Oil Company.

SOC, as it's called, is a corporate giant that controls the lives of the peasants as well as those of the European drifters who have come to Las Piedras looking for easy money.

For all of its sincerely expressed social concerns, though, "The Wages of Fear" is far less interested in the plight of the peasants than it is in the handful of stranded Europeans, who are broke and without hope of work. For them, there is no exit.

•

This is the somber frame for the melodrama that follows when fire breaks out in an oilfield 300 miles away. The local SOC foreman seeks four volunteers to drive two trucks loaded with nitroglycerine to the oilfield.

The pay: $2,000 each, which is a fortune to these guys. It's also chicken feed in the circumstances. Ounce for ounce, the liquid nitroglycerine is far more powerful than dynamite, and it is notoriously unstable, especially when transported in ancient trucks without shock absorbers on rutted roads across rock-hard deserts, around hair-pin mountain turns and through dank, muddy jungles.

Four men accept the challenge. Mario (Yves Montand) is a cheerfully ruthless young opportunist from Corsica. Jo (Charles Vanel) is an aging Parisian con artist without a sou but with a great deal of bogus style. Luigi (Folco Lulli) is Italian, good-hearted, sentimental and devoted to Mario until Mario switches his affections to Jo. Bimba (Peter van Eyck) is German and a loner.

•

After the scene- and character-setting sequences that open the film, the last 90 minutes are devoted to this perilous journey, one of the most remarkable examples of nonstop movie wizardry ever seen. The threat of violence is so constant that fear becomes almost serene, until the violence erupts. Like Hitchcock at his

best, Clouzot manages to keep topping himself until the film's very last frame.

Like Hitchcock, too, each of the characters is fully revealed in terms of the action. There is no need for lengthy exposition or for flashbacks when the contemporary events are so vivid and rich.

Of the four drivers, Jo is both the most persuasive and most sorrowful as, in mid-trip, his nerves give out and he turns to jelly. The old fraud has lived too long not to understand the stakes. Mr. Vanel, who will be remembered as the skeptical police inspector in Hitchcock's "To Catch a Thief," gives the performance of his career.

Mr. Montand, at the beginning of his career, is splendid as the sort of guy for whom attitude is a consciously adopted style. He's all swagger and self-assurance, though still not fully formed, which is one of the reasons he attaches himself to the more worldly Jo early on. It's their relationship that gives the film its human heart.

•

It should be noted that the version of "The Wages of Fear" at the Film Forum is not actually a rediscovered one, since the complete film has always existed in France. It is, rather, the original French version equipped with new English subtitles in a pristine print.

The restored material fills in a lot of odd ellipses that existed in the 1955 American version. Time's passage has dimmed most of its political shock value. Clouzot's view of corporate America's heedlessness is less bold than can now be found on public television several times a week.

The hints of homosexuality, which were said to have been cut for the American release, are so discreet that I'm not at all sure they are really there. Maybe you have to be particularly literate in 50's film makers' shorthand to appreciate those references.

Today's audiences may also be unimpressed by Clouzot's attempt to pass off the Camargue, in southeastern France, as a Latin American petroleum republic. Even dressed up with a few palm trees and some dark-skinned extras, Las Piedras looks suspiciously like metropolitan France.

Yet these are minor reservations. "The Wages of Fear" is a big, masterly movie that works from the outside in. It joyfully scares the living hell out of you as it reveals something about the human condition.

Clouzot (1907-1977) made only 11 features, including "Le Corbeau" ("The Raven")in 1943 and "Diabolique" in 1955. It might be time for a retrospective.

1991 O 18, C8:3

Other People's Money

Directed by Norman Jewison; screenplay by Alvin Sargent, based on the play by Jerry Sterner; director of photography, Haskell Wexler; edited by Lou Lombardo; music by David Newman; production designer, Philip Rosenberg; produced by Mr. Jewison and Ric Kidney; released by Warner Brothers. Running time: 101 minutes. This film is rated R.

Lawrence Garfield Danny DeVito
Andrew (Jorgy) Jorgenson Gregory Peck
Kate Sullivan Penelope Ann Miller
Bea Sullivan Piper Laurie
William J. Coles Dean Jones
Ozzie .. Tom Aldredge
Arthur ... R. D. Call

Warner Brothers
Danny DeVito

By JANET MASLIN

The late-1980's morality play "Other People's Money" is made cuddlier by the presence of Danny DeVito, who plays the corporate raider known as Larry the Liquidator in Norman Jewison's glossy, big-hearted, determinedly Capraesque screen adaptation. Larry may say things like "I love money even more than the things it can buy," but he has a deep-down wholesomeness that makes him soft around the edges, no matter how devilish he means to be.

The film's love-hate affair with Larry does create a fine showcase for Mr. DeVito's wicked clowning. But it also reduces Larry to a minor menace. He is underhandedly charming even as he schemes to take over the New England Wire and Cable Company, an old-fashioned business with a kindly, family atmosphere. What that means, in this context, is that its managers (among them Dean Jones, convincingly tormented by the events under way) wear cardigan sweaters, even though most of them turn out to be millionaires. Gregory Peck, well used as the company's chairman and its pillar of folksy integrity, smokes a pipe.

In marked contrast to this is Kate Sullivan (Penelope Ann Miller), the daughter of one of the company's high-level executives (Piper Laurie) and the kind of high-powered lawyer who arrives for her appointments by helicopter wearing a sleek, very short outfit and a self-satisfied air. In order to bail out her mother and the other company loyalists, Kate engages Larry in a cat-and-mouse flirtation that is intended to thwart his take-over goals, or at the very least leave him powerfully distracted.

•

So Kate arrives for a putative business meeting with Larry wearing form-fitting, off-the-shoulder lace. And she opens her mouth suggestively, smiling as Larry feeds her an hors d'oeuvre, before abruptly declaring that the meeting is over and she has to go. On another occasion, Kate declares "I have a proposition for you" to Larry over the telephone in her breathiest tones. And she is seen reclining languidly in slinky white silk as she delivers this message. Let's just say this vision of how a man and a woman might conduct business together is a lot less entertaining than it would have been a week ago.

Ms. Miller flirts expertly, but she is less successful in convincing an audience that Kate might actually be smart or seasoned enough to save the day. Luckily, Mr. DeVito's Larry swoons over her so tirelessly that he helps to affirm Kate's appeal, not to mention his own. Among their more memorable encounters are one in a Japanese restaurant, where both these high-rollers turn out to have the foresight to speak Japanese, and another in which Larry explains that he is a latter-day Robin Hood. "I take from the rich and give to the middle class," he explains. "Well, the upper middle class."

•

Alvin Sargent's adaptation of Jerry Sterner's Off Broadway play culminates in a speechy but effective debate about the merits of old-fashioned business versus the corporate take-over, with references to the yen, the dollar, fiber optics and the infrastructure thrown in. This debate, while lively on its own terms and indeed effective in invoking Frank Capra's potent grandstanding, is — like the rest of the film — too genial to be hard-hitting.

" 'Other People's Money' became a cult favorite with the Wall Street crowd, including many of the corporate raider types so deftly depicted in the play," the film's production notes explain. That particular crowd may find the screen version even more agreeable.

Haskell Wexler's cinematography gives the film a warm, rosy glow that befits its references to Harry S. Truman. At least one of these is delivered amid inspirational rays of sunlight, and within close range of an American flag.

•

"Other People's Money" is rated R (Under 17 requires accompanying parent or adult guardian). It includes some sexual innuendoes.

1991 O 18, C10:3

Resident Alien

Directed, edited and produced by Jonathan Nossiter; director of photography, John R. Foster; a Greycat Films release. At Angelika Film Center, Mercer and Houston Streets, Manhattan. Running time: 85 minutes. This film has no rating.

WITH: Quentin Crisp, John Hurt, Fran Lebowitz, Holly Woodlawn and Sting.

By JANET MASLIN

Jonathan Nossiter's "Resident Alien" presents a wistful, rambling, somewhat repetitive portrait of Quentin Crisp, the octogenarian English-born man about town who has been living in New York since 1976. "I know you. You're famous!" several actors feigning ordinary-guy status say to Mr. Crisp as the film begins. In fact, he is largely famous for being famous, and he is the first to acknowledge that. "In America, the minute I was on television, everybody felt I must be somebody," he says.

In addition to watching Mr. Crisp as he wanders from art gallery to dinner party to nightclub and to various other haunts, the film considers his prominence as a prominent gay figure, in a capacity that at its best suggests Oscar Wilde. Mr. Crisp, whose painful personal history made his autobiography, "The Naked Civil Servant," so successful, delights in

Greycat Films
Quentin Crisp

affecting the manner of a sly wounded dowager (not to mention the bluish hair). And he says things like "You see, the English don't like effeminate women" in casting his sense of persecution as a gay man in dryly comic terms. But the film raises the question of whether Mr. Crisp has been helpful or hurtful to the gay rights movement in presenting his air of helplessness and victimization. "I've come to represent a sad person's view of a gay person," he says at one point. At another he observes, "I have no opinions, no voice of any kind, except the desire to please."

•

The film, which opens today at the Angelika Film Center, offers a variety of Mr. Crisp's well-honed remarks, which he tends to repeat frequently once he gets them right. ("He does that because he's worked very hard on what he has to say," one of his friends explains.) "All I can give is my infinite availability," Mr. Crisp says. And: "If we really got what we deserved, we would starve." And: "Once I'm dead I don't mind what happens — to me or to the world."

In addition to sampling Mr. Crisp's observations and watching him stage encounters with various friends (among them John Hurt and Holly Woodlawn), the film attempts an assessment of his role. "It's very easy to avoid attack by becoming the court jester — and he's the court jester of the straight world," one critic charges after Mr. Crisp has been seen appearing as a representative gay figure on a talk show. But the writer Fran Lebowitz, seen sitting at a table sipping champagne near the West Side Highway, commends Mr. Crisp's sheer talent for talk. "And since almost no one can talk anymore, you can charge people money for this," she explains.

1991 O 18, C10:6

The Borrower

Directed by John McNaughton; screenplay by Mason Nage and Richard Fire from a story by Mr. Nage; directors of photography, Julio Macat and Robert New; edited by Elena Maganini; music by Robert McNaughton and Steven A. Jones; production designer, Robert Henderson; produced by R. P. Sekon and Mr. Jones; released by Cannon Pictures. At Angelika Film Center, Mercer and Houston Streets, Manhattan. Running time: 90 minutes. This film is rated R.

Diana Pierce Rae Dawn Chong
Charles Krieger Don Gordon
Bob Laney Tom Towles
Julius Caesar Roosevelt Antonio Fargas
Connie Pam Gordon

By VINCENT CANBY

Opening tonight at the Angelika Film Center as a special midnight show (Fridays and Saturdays only) is "The Borrower," a satiric horror film directed by John McNaughton, an independent film maker on his way up in the American cinema establishment.

Mr. McNaughton's first film, the icily accomplished "Henry: Portrait of a Serial Killer," was completed in 1985 but released only last year. The director is currently represented by "Sex, Drugs, Rock & Roll," the excellent adaptation of Eric Bogosian's one-man stage piece. He is now about to direct his first big-budget Hollywood movie, "Mad Dog and Glory," starring Robert De Niro and Bill Murray, produced by Martin Scorsese.

•

"The Borrower" was turned out between "Henry" and the Bogosian film and might have been designed for midnight-only screenings. The film, alternately silly and gross on purpose, is about a space alien who is exiled to earth and must steal a series of heads from other people after his own explodes (on screen). It's a movie in which even a meal dished out to the homeless at a skid-row mission will turn the stomach.

Kevin Yagher designed the Grand Guignol makeup effects. Mason Nage and Richard Fire wrote the knowingly absurd screenplay. The deadpan cast is headed by Rae Dawn Chong, Don Gordon and Antonio Fargas.

Cannon
Tom Towles

Make special note of Pam Gordon, very funny as a weirdly enthusiastic coroner who behaves as if she had been struck by lightning as a small child.

•

This film is rated R (Under 17 requires accompanying parent or adult guardian). It includes much simulated blood and gore.

1991 O 18, C12:3

Cool as Ice

Directed by David Kellogg; written by David Stenn; director of photography, Janusz Kaminski; edited by Debra Goldfield; music by Stanley Clarke; production designer, Nina Ruscio; produced by Carolyn Pfeiffer and Lionel Wigram; released by Universal Pictures. Running time: 93 minutes. This film is rated PG.

Johnny Vanilla Ice
Kathy Kristin Minter
Gordon Winslow Michael Gross
Roscoe McCallister Sydney Lassick
Mae McCallister Dody Goodman

By STEPHEN HOLDEN

"If you ain't true to yourself, you ain't true to nobody," mumbles Johnny, a blank-faced young motorcyclist with outlaw pretensions to Kathy (Kristin Minter), his sweetheart from the right side of the tracks. Playing Johnny in "Cool as Ice," his first starring feature, the rap star Vanilla Ice wears just two expressions. One is a squinting mask upon which the right eyebrow periodically arches upward for no apparent reason. The other is the nervous, glittering smile of a shy young man who has been posed in front of the camera and told to grin and say "cheese."

When Johnny inquires about the repair of a dismembered motorcyle, he does it in hiphop grammar. "Can you put back it together with quickness?" he asks in a monotone that suggests James Dean under heavy sedation. Since the star lacks a speaking voice that carries any expression, one is left contemplating his get-up, which includes a leather jacket with "Down by Law" emblazoned on the back, black-and-white striped shorts, oversized shades, two earrings, and hair sculptured like a contour map of the Hollywood hills.

The aims of "Cool as Ice," which opened yesterday at local theaters, are modest. All it really wants to be is a hiphop answer to one of Elvis Presley's sillier vehicles. But the movie, which was directed by David Kellogg and written by David Stenn, fails to deliver an ounce of musical energy. The lifeless music and dance sequences in which the rapper performs with his crew have the feel of low-budget video clips that have been inserted almost by mistake. Far too much of the film is devoted to a preposterous story involving Kathy's father, a former policeman who is in the Government's witness protection program, and a kidnapping that is solved by guess which young rebel motorcyclist and his hiphopping friends?

•

"Cool as Ice" is rated PG (Parental guidance suggested). It has mild sexual innuendoes.

1991 O 19, 12:6

FILM VIEW/Caryn James

'Homicide': The Victims Abound

AMAN WHO HAS JUST BEEN ARRESTED FOR killing his wife and children speaks from his jail cell, his calm, polite tone coming from the depths of his craziness. "Maybe someday I could tell you the nature of evil," he offers a detective named Bobby Gold. "Would you like to know the nature of evil?"

"No, man," Gold says, " 'cause then I'd be out of a job."

He doesn't have to worry. In the America of David Mamet's "Homicide" there is plenty of evil to go around.

Gold, played with brilliant ease by Joe Mantegna, thought he could define himself by his working-class roots and his fraternity of cops rather than his Jewishness. He learns that only a slap-happy fool believes in the myth of the melting pot. In this generic American city, blacks and Jews trade ethnic slurs, and a Jewish terrorist network combats rampant neo-Nazism.

It is part of Mr. Mamet's huge ambition that he uses a pop genre to delve into these volatile, serious issues. On the most superficial level, "Homicide" is a buddy-cop-murder-mystery movie. But while Gold investigates a Jewish woman's murder, he confronts the deeper meaning of his own identity. And deeper still is the film's harsh, revisionist view of America as a land of ethnic hatred.

Artistically, this creates a risky, often dazzling blend of form and subject. Like Gold, "Homicide" is both Jewish in its personal concerns and a distinct American type. And Mr. Mamet has matured greatly as a director by realizing that genre films, products of American pop culture, can speak deeply and directly to that culture's problems.

In David Mamet's film, a slaying opens the door to a harsh vision of America.

Of course, "Homicide" also speaks the stylized language of all David Mamet works. The exchange about evil is not common in life or movies. It is typical of plays like "Glengarry Glen Ross" and Mr. Mamet's previous films, "House of Games" (1987) and "Things Change" (1988).

His dialogue, delivered relentlessly, is full of repetitions, bluntness and wit. It suits the hermetic Mamet world, which doesn't act like life but like an artificial variation on it.

In his earlier films, this approach created clever puzzles with neatly wrought endings. "Homicide" is not so perfectly wrought, but it captures urban grime, class distinctions and self-delusion more strongly. It falls apart only when Mr. Mamet retreats to a stylized motivation for his hero.

Like all good Americans, Gold believes in assimilation. Early in the film, a black city official calls Gold a disparaging ethnic name, which in turn makes Gold's Irish partner use a homosexual epithet on the black man. Gold, isolated within his community of cops, has spent a lifetime turning his back on such warning signals.

Yet when he stumbles onto the scene of the Jewish woman's murder, ethnic divisiveness is all around him. The woman owned a candy store in a once-white neighborhood that has since become black. Neighbors crowd around the scene, saying with great assurance that someone killed the old lady for the fortune hidden in her basement.

When the woman's son arrives, he turns out to be a prosperous doctor, who says, "It never stops, does it?"

"What never stops?" asks Gold, and the doctor's daughter answers, "Against the Jews." Gold thinks this is para-

Joe Mantegna as Bobby Gold, the Jewish detective

Triumph Releasing

noid. In the same way that he blocks out racial slurs among his colleagues, he ignores the black neighbors' stereotypes of the rich Jews. What's more, he resents the rich Jews, too.

Here, just when it seems that "Homicide" is about to explore black-Jewish tensions, the film twists in a different, equally unsettling direction. When the dead woman's son requests that Gold handle the murder investigation, his boss says, "The doctor wants you. You're his people." Gold answers, "I'm *his* people? I thought I was *your* people." He thinks he has nothing in common with these wealthy Jews who can pull strings. Some people would call him a cynic for believing that America is based only on money and class; Mr. Mamet goes on to show how naïve Gold is.

Reluctantly, he realizes that it never has stopped against the Jews. The old woman's family is connected to a terrorist group that fights neo-Nazism. This is the most controversial element of the film, which sets up the terrorists as heroes. But Mr. Mamet justifies his attitude by demonstrating that the Jews are not paranoid; they have lethal enemies. Hateful fliers have turned up in the neighborhood showing a huge rat wearing a yarmulke. "Crime is caused by the ghetto," it reads. "The ghetto is caused by the Jew."

■

Such bigotry is the least of the shocks to Gold's willful ignorance. While "Homicide" is trailing a murderer and then uncovering an anti-Semitic conspiracy, Mr. Mamet is also confronting American ethnic hatred.

Just where "Homicide" should be strongest, though, it turns weak. Abruptly, in a coffee-shop conversation, Gold admits he has always felt like an outsider. Now, he realizes that the Jews are his people after all. This is an epiphany willed by the writer rather than experienced by the character, and it makes the film murkier than it should have been. But Mr. Mamet succeeds in pointing out, quite emphatically when the murderer is revealed, that ethnic hatreds are not all the same and not all connected.

When the man who offered to explain evil walks by at the end of "Homicide," he is silent. Mr. Mamet has already shown the nature of evil and transformed a cop movie into a disturbing statement about American life. □

1991 O 20, II:17:5

House Party 2

Directed and produced by Doug McHenry and George Jackson; written by Rusty Cundieff and Daryl G. Nickens; based on characters created by Reginald Hudlin; director of photography, Francis Kenny; edited by Joel Goodman; music by Vassal Benford; production designer, Michelle Minch; released by New Line Cinema. Running time: 94 minutes. This film is rated R.

Professor Sinclair....... Georg Stanford Brown
Mr. Lee...Tony Burton
Sidney.................................... Tisha Campbell
Sheila..Iman
Jamal...Kamron
Zora..................................... Queen Latifah
Kid..Christopher Reid
Play..............................Christopher Martin
Dean Kramer........................ William Schallert

By VINCENT CANBY

"House Party 2" seems less like a sequel to the free-floating first film than a part of it, arbitrarily chopped off and saved for a rainy day. Though Reginald Hudlin wrote and directed the original, and though Doug McHenry and George Jackson produced and directed "House Party 2," the line separating the films is invisible.

"House Party 2" is an equally entertaining mix of comedy and music (rap and hip-hop) about the adventures of Kid (Christopher Reid), the young man with the Eraserhead hair, and his less serious pal Play (Christo-

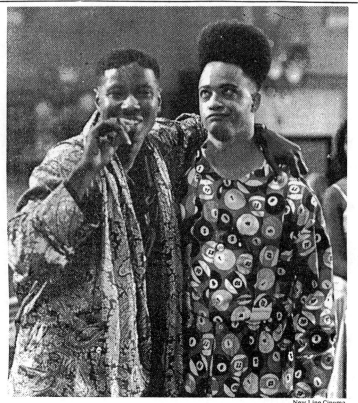

Christopher Martin, left, and Christopher Reid in "House Party 2."

New Line Cinema

pher Martin), when Kid goes off to college and Play loses Kid's tuition check. That's all there is to the story but not to the movie, which somehow makes manifest such abstractions as good humor and high spirits.

Written by Rusty Cundieff and Daryl G. Nickens, the movie centers around Kid and his encounters with teachers and fellow students at Harris University, while Play tries to make good on the lost check. The only way to recoup the money so that Kid can remain in school is, finally, a campus pajama party, the "jammie jam jam" that is to "House Party 2" what the seaside picnic was to Annette Funicello and her friends in "Beach Blanket Bingo."

•

Among the film's more notable performers are Iman, the high-fashion model, as the new-age vamp who parts Play from Kid's check; Tisha Campbell, as Kid's girlfriend, nearly lost to a campus women's movement; Queen Latifah, who is fine as an actress and sensational as a singer; Kamron, of the rap group Young Black Teen-Agers, who is very funny as Kid's blue-eyed roommate, speaking a black jargon unintelligible to anyone else.

The movie has the manner of a succession of specialty numbers, though it is far more cannily constructed than that. It moves along with the wit and pacing of a revue, its young characters somehow being both irreverent and idealized at the same time.

The casting is especially good, including the several comparatively senior members of the cast: Georg Stanford Brown, who appears as Kid's African studies professor, and Tony Burton, who plays the chef in the college dining hall as if he had been trained by General Patton. William Schallert, one of the few white actors in the movie, behaves with courage and nobility as Harris University's bewildered dean.

Whoopi Goldberg turns up several times in an unbilled cameo performance, playing the sort of joyfully ghoulish professor who haunts the imagination of every lazy student.

This is the first movie to be directed by Mr. McHenry and Mr. Jackson, who also produced "New Jack City." "House Party 2" seems to have been packaged as much as directed. However it was put together, it works.

•

"House Party 2," which has been rated R (Under 17 requires accompanying parent or adult guardian), has a lot of vulgar language and sexual innuendo.

1991 O 23, C17:1

Life Is Sweet

Written and directed by Mike Leigh; director of photography, Dick Pope; edited by Jon Gregory; music by Rachel Portman; production designer, Alison Chitty; produced by Simon Channing-Williams; released by October Films. At Angelika Film Center, Mercer and Houston Streets, Manhattan. Running time: 102 minutes. This film has no rating.

Wendy............................ Alison Steadman
Andy.......................................Jim Broadbent
Natalie..............................Claire Skinner
Nicola ...Jane Horrocks
Patsy ..Stephen Rea
Aubrey ...Timothy Spall
Nicola's lover............................. David Thewlis

By VINCENT CANBY

"Life Is Sweet," opening today at the Angelika Film Center, is a very special new English comedy by Mike Leigh, the English director whose "High Hopes," one of the hits of the 1988 New York Film Festival, revealed him to be a film maker not quite like any other.

Among other things, Mr. Leigh makes movies in which the actors participate in the creative process, discovering and refining their char-

acters in the course of long rehearsal periods. Such collaboration would have sent Hitchcock into permanent retirement.

It obviously works for Mr. Leigh, whose gently cockeyed movies are so rich with character that they seem beyond ordinary invention. His films prompt the kind of excitement that comes only when experiencing something new or, at least, something new in the context of other movies.

Like "High Hopes," an overtly political film about life in Britain under the Thatcher Government, "Life Is Sweet" is as much about a particular time and place as it is about the

Nothing goes right, or very wrong, for the family in 'Life Is Sweet.'

characters. Though virtually nothing is said about politics, "Life Is Sweet," whether consciously or not, evokes the end of the Thatcher era, before a new era has been defined, when times are neither good nor bad and life is shaped by routine.

•

Filmed entirely in the north-London suburb of Enfield, "Life Is Sweet" is a contemplative comedy about people who aren't. Chiefly it's about the members of one lower-middle-class family: Wendy (Alison Steadman), a pretty woman of early middle age who laughs too much; her husband, Andy (Jim Broadbent), a good-natured fellow and professional cook, and their red-headed twin daughters, Natalie (Claire Skinner), who has found her calling as a plumber, and Nicola (Jane Horrocks), who says she wants to "write" (but doesn't) and stays home all day.

The family lives in comparative peace in a row house that Andy has never finished off properly. The front stoop still lacks the trellis he promised to build. Yet for al fresco dining, the backyard is furnished with an umbrella table and the sort of molded plastic chairs that can be stacked easily.

•

Wendy is determinedly cheerful as she goes about her various self-assigned tasks. She works in a shop that sells children's clothes (many of them pretty ghastly) and is an enthusiastic aerobics instructor to a class of tubby little girls. She is a good wife and mother, but also an edgy one.

October Films

Jane Horrocks, left, and Alison Steadman

Money, though not a pressing problem, is ever a concern. There is also the difficulty with Nicola, who lives in a perpetual grouch. When Wendy suggests that she ought to eat something since it's lunchtime, Nicola's response is a lofty "What's lunchtime? A convention."

In the course of the several days of "Life Is Sweet," the sharp-tongued Nicola is revealed to be a secret bulimic. Her passion for chocolate also plays a part in her love life, though her boyfriend (David Thewlis) would prefer to have sex in a more conventional way.

Andy, who wants to be his own boss, takes the family savings and buys a used snack-trailer. He plans to become one of those fellows who go from neighborhood to neighborhood, ringing a bell and selling hot coffee and sandwiches. "Gilt-edged," says the man who sells the trailer. "You can't go wrong." The family members are appalled.

•

Nothing much goes right for the family, though nothing goes terribly wrong, except for their friend Aubrey (Timothy Spall). He is a cook who opens his own French restaurant, the Regret Rien. Its décor features a stuffed cat's head on the wall, a birdcage hanging from the ceiling to recall the spirit of Édith Piaf (nicknamed "the sparrow"), and candles stuck into empty wine bottles "for that bistro effect."

Several choice items on Aubrey's menu: prune quiche, boiled bacon consommé and tongue in a rhubarb hollandaise sauce.

"Life Is Sweet," a title that should not be taken as irony, demands that the audience accept its meandering manner without expectations of the big dramatic event or the boffo laugh. It is very funny, but without splitting the sides.

The film moves easily from the broad jokes about Aubrey's restaurant to Nicola's scenes of very real desperation. At the center of it all is the substantial but not simply characterized relationship between Wendy and Andy. The movie regards them fairly, at their own level, without trying to be nice to them.

"Life Is Sweet" is also an actor's field day. Miss Steadman, Mr. Broadbent, Miss Horrocks, Mr. Thewlis and the others are a joy to watch, both for the vigor of their performances and for the immense satisfaction they seem to have had in getting those characters together. "Life Is Sweet" is a movie that breathes.

1991 O 25, C10:1

La Maison Assassinée

Directed by Georges Lautner; screenplay (in French with English subtitles) by Mr. Lautner and Jacky Cukier, based on the novel by Pierre Magnan; director of photography, Yves Rodallec; film editor, Michelle David; produced by Alain Poiré; distributed by Ciné Qua Non. At Quad Cinema, 34 West 13th Street, Manhattan. Running time: 110 minutes. This film has no rating.

Séraphin Monge	Patrick Bruel
Marie Dormeur	Anne Brochet
Rose Pujol	Agnès Blanchot
Charmaine Dupin	Ingrid Held
Patrice Dupin	Yann Collette
Célestat Dormeur	Jean-Pierre Sentier
Zorme	Roger Zendly

By VINCENT CANBY

"La Maison Assassinée" ("The Murdered House"), George Lautner's French melodrama opening today at the Quad Cinema, is set in 1920 in Provence, but all similarity to Marcel Pagnol ends there.

The film is a lethargic gothic tale about Séraphin, a young man who returns to his village 24 years after all of the other members of his family were mysteriously murdered. Séraphin, 3 weeks old at the time of the massacre, was spared. Now he wants to know what happened and why.

Long-locked closets are opened, old skeletons are bared and dusty strongboxes reveal bits of enigmatic evidence. There's a crazy man in the village who is said to talk to the devil. The community's richest man keeps a pair of vicious attack dogs. An old peasant woman weeps in anticipation of dread events still to happen.

On and on it goes, but the suspense never mounts. It staggers under the weight of a large inert plot. Coincidences abound. Just as one man is about to reveal the truth early in the movie, he is accidentally killed when a wall falls.

Patrick Bruel, a big singing star in France, plays Séraphin with unsmiling earnestness. The rest of the performers are somewhat less memorable than the movie's title.

1991 O 25, C10:5

Curly Sue

Directed, written and produced by John Hughes; director of photography, Jeffrey Kimball; edited by Peck Prior and Harvey Rosenstock; music by Georges Delerue; production designer, Doug Kraner; released by Warner Brothers. Running time: 102 minutes. This film is rated PG.

Bill Dancer	James Belushi
Grey Ellison	Kelly Lynch
Curly Sue	Alisan Porter
Walker McCormick	John Getz
Bernard Oxbar	Fred Dalton Thompson
Maître d'hôtel	Cameron Thor

By JANET MASLIN

A special sound, that of palms smacking foreheads in disbelief, was heard all over Hollywood when the John Hughes production "Home Alone" emerged as last year's runaway hit. But on the evidence of his most recently released efforts, Mr. Hughes is not likely to create similar shock waves any time soon. With projects like "Career Opportunities," "Dutch" and now "Curly Sue," a film maker who had seemed uncannily well attuned to American audiences now looks badly out of touch. "Curly Sue," his film in which two derelicts win the heart of an affluent lawyer, hasn't a clue about how either half lives.

"Curly Sue," the first film Mr. Hughes has directed since "Uncle Buck" in 1989, tells of the title character (Alisan Porter), a cute, smart-alecky moppet with the voice and hairdo of a road-company Annie, and her good, decent, economically disadvantaged guardian (James Belushi). These two grime-streaked drifters, who are also con artists in the most innocent sort of way, quite literally wander into the path of the high-powered divorce lawyer Grey Ellison (Kelly Lynch) when she hits Bill with her Mercedes. Earlier, Bill has also been struck on the head by little Curly Sue, who is helping him fake this

Warner Brothers

In Hot Water
Alisan Porter, in the role of an orphan, gets a bath in "Curly Sue," John Hughes's romantic comedy about a little girl who charms her way into the life of a successful lawyer.

same accident in hopes of scrounging a free meal. Later on, Bill will be clobbered even further, whenever Mr. Hughes's screenplay looks as if it's running out of steam.

Only in a movie — and these days probably only in a Hughes movie — would the lawyer take the derelicts home, clean them up, buy them new clothes and discover they are exactly like she is, only more in touch with their feelings. Soon an immaculately groomed Bill is wearing suits and playing "You're Nobody Till Somebody Loves You" on the piano in Grey's big apartment, which has the columns-and-obelisks style of a set designer's dream.

•

And soon Curly Sue is languishing in a photogenic circular bathtub and saying things like "You got an awful lot of pillows for just one person" to Grey, whose maternal stirrings are awakened by this. When Curly Sue is afraid to sleep in her own room, Bill tells her that angels will come to the window, kiss her eyelids and give her "the sweetest, most wonderful dreams you ever had." By the time this and a lot more heart-tugging sentiment has been laid on, the film is ready to embrace a deeply conventional vision of domestic bliss.

Mr. Hughes used to make films about things he knew about (among them, "16 Candles," "Pretty in Pink," "Some Kind of Wonderful" and "Ferris Bueller's Day Off"). But "Curly Sue" has a slickness that seems deeply cynical, since not one of its characters behaves in a believable way. Though Mr. Belushi tries hard, Bill is nothing more than a too-virtuous straight man, the kind of drifter whose goal is to take his little girl to the art museum. Ms. Lynch, though a striking actress, is out of place with material this broad. Little Ms. Porter is snappish and assured, and she might have the potential of a Macaulay Culkin if the film ever allowed viewers to discover her for themselves. But it never does. This child actress's precocity is always being trumpeted, with the camera often gazing down at her big, baleful eyes.

Also in the film are John Getz as Grey's standard-issue foolish yuppie boyfriend, and Fred Dalton Thomp-

son as the fellow lawyer who delivers one of the screenplay's few memorable lines. "You keep going 190 miles an hour, you're going to hit something," he tells the workaholic Grey. Nothing else in "Curly Sue" is as sensible as that.

•

"Curly Sue" is rated PG (Parental guidance suggested). It includes rude language but no violence or sexual situations.

1991 O 25, C15:1

Notebook on Cities and Clothes

Directed and written by Wim Wenders; edited by Dominique Auvray; in English and Japanese with English subtitles; music by Laurent Petitgand; produced by Ulrich Felsberg; distributed by Connoisseur. At the Public, 425 Lafayette Street, Manhattan. Running time: 80 minutes. This film has no rating.

By JANET MASLIN

The meeting of the minds that is documented in "Notebook on Cities and Clothes," Wim Wenders's film about the Japanese fashion designer Yohji Yamamoto, began fairly inauspiciously. Mr. Wenders bought a shirt and a jacket that bore Mr. Yamamoto's label. Perhaps there was nothing cataclysmic in this, and yet it sent Mr. Wenders into a flurry of meditation and reflection, just as so many things do. "I felt protected like a knight in his armor — by what, a shirt and a jacket?" he observed. "This jacket reminded me of my childhood and my father as if the essence of this memory were tailored into it." Later on, he asked, "What did Yamamoto know about me — about everybody?"

To paraphrase Freud, sometimes a jacket is just a jacket. But not this time: Mr. Yamamoto, it turns out, is a match for Mr. Wenders when it comes to probing simple acts and objects in search of their philosophical underpinnings, no matter how small. So Mr. Yamamoto can solemnly discuss the importance of a warm coat on a cold day and can contemplate such questions as "which comes first, the touch of the material or the shape?" Mr. Wenders, who having expressed his disdain for fashion in general was commissioned by the Pompidou Center in Paris to make a film on that subject, is more than ready to respond in kind.

"Notebook on Cities and Clothes," which can be seen at the Public Theater as part of a series of Mr. Wenders's films (among them, "Paris, Texas" and "Wings of Desire"), is exactly that: a loose, journalistic exploration of its subject complete with whatever digressions happened to come to Mr. Wenders's mind. At one point in the process of filming Mr. Yamamoto in both Paris and Tokyo, the director becomes fascinated with his video camera. After a while, he winds up introducing a small, handheld video monitor (on which Mr. Yamamoto is seen talking or working) into the frame.

•

At another point, the film maker and fashion designer meet at a pool table and talk while they play. "If there is one main idea for your next show, do you have to be very secretive about it?" Mr. Wenders asks. "No," Mr. Yamamoto answers. Else-

where in the film, Mr. Wenders watches Mr. Yamamoto studying old photographs and solicits his observations. In a photograph of Jean-Paul Sartre by Henri Cartier-Bresson, Mr. Yamamoto is fascinated by the cut of Sartre's lapels.

Mr. Yamamoto is done a disservice by his own halting English and by the film maker's tendency to overlay self-important constructs onto slight situations. Still, "Notebook on Cities and Clothes" has a genuinely passionate side, thanks to the enthusiasm with which these two diverse intelligences finally connect. Mr. Wenders, comparing designing to film making, observes the staging of a fashion show and marvels touchingly at "how Yohji's tender and delicate language could survive in each of his creations." Mr. Yamamoto responds eagerly to such attention without sacrificing his own fundamental diffidence. "If you try to express something, you do it because you want to be understood," he says early in the film. "Well, sometimes I don't care if no one understands me."

"Notebook on Cities and Clothes" is considerably more interesting on clothes than on cities, and least successful in trying to make rational connections between the two. But Mr. Wenders, more a poet than a philosopher anyhow, is able to summon an eerie sense of urban dislocation with images of faceless, marching fashion mannequins dressed in Mr. Yamamoto's loose, darkly enveloping clothing. The film's ideas about fashion, transience and identity are best expressed in this simple way.

1991 O 25, C17:1

Get Back

Directed by Richard Lester; director of photography, Robert Paynter; edited by John Victor Smith; produced by Henry Thomas and Philip Knatchbull; released by Seven Arts. At the Baronet, Third Avenue at 59th Street, Manhattan. Running time: 89 minutes. This film is rated PG.

WITH: Paul McCartney, Linda McCartney, Hamish Stuart, Robbie McIntosh, Paul (Wix) Wickens and Chris Whitten

By JANET MASLIN

Paul McCartney can still do cute things with his eyebrows, and he still has the kind of hair that can be tossed. But "Get Back," the stitched-together concert film documenting Mr. McCartney's 1989-90 world tour, is enough to shake the faith of even the stauchest fan. Compiled so soullessly and arbitrarily from a variety of live shows that Mr. McCartney often appears to change outfits during the same song, "Get Back" also draws upon scrambled, incoherent news clips to bolster its performance scenes. All this is the doing of Richard Lester, who still has "Help!" and "A Hard Day's Night" to his credit but hereby forfeits any claim he ever had to being the Fifth Beatle.

It must be said, to Mr. McCartney's credit, that there are times when viewers can close their eyes and hear very solid renditions of old Beatles songs, and some of his more recent compositions sound even better. It must also be said that as soon as the eyes open there are disastrous problems. The film is desperately busy, not only in its cobbled-together musical numbers but also in the appallingly glib material that has been thrown in to accompany them. Although the

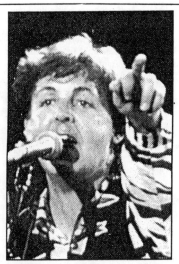

Paul McCartney

star is noticeably hoarse and off key in places, he would have come across better without these distractions.

When Mr. McCartney first makes reference to the 60's, the camera presents notable figures, including Richard Nixon, Muhammad Ali and the Beatles, as if the Beatles had to be identified or validated. After that, when Mr. McCartney launches into "The Long and Winding Road" — not everyone's idea of a 60's anthem — the film provides a thumbnail history of the Vietnam War, complete with napalm, burning villages and the Paris peace conference. Since Mr. McCartney, who used "Scrambled Eggs" as a working title for "Yesterday," never rested his popularity on his role as spokesman for a generation, this attention to world affairs seems especially ill advised.

Some of the film's other choices are so thoughtless as to border on the diabolical. "Can't Buy Me Love," though well performed here, can't help seeming inappropriate when delivered by so formidable a businessman. "I Saw Her Standing There" sounds dated enough in its reference to a 17-year-old heartbreaker, and loses all vestigial traces of romance when Mr. Lester cuts to Linda McCartney, seen thumping away dutifully at her keyboards. Mr. McCartney's decision to invoke John Lennon with a rendition of "Let It Be" is even more unfortunate, thanks to film clips from the documentary of the same name. That film was made when the Beatles could barely be coaxed into the same room with one another.

Along with the other clutter that impedes "Get Back," which opens today at the Baronet, there are silly sets (a hammer and sickle for "Back in the U.S.S.R.," the old familiar dancing-amoeba images for a mock-psychedelic number), unsightly lighting effects and audience shots that will be a deep embarrassment to all concerned. Note to die-hard rock fans of baby-boom age: never come within camera range at a live show. If you are filmed shaking your fists, mouthing lyrics, swooning idiotically or engaging in middle-aged break-dancing, you're certain to be sorry in the morning.

•

"Get Back" is rated PG (Parental guidance suggested). It includes mild profanity.

1991 O 25, C19:1

The Butcher's Wife

Directed by Terry Hughes; written by Ezra Litwak and Marjorie Schwartz; director of photography, Frank Tidy; edited by Don Cambern; music by Michael Gore; production designer, Charles Rosen; produced by Wallis Nicita and Lauren Lloyd; released by Paramount Pictures. Running time: 104 minutes. This film is rated PG-13.

Marina	Demi Moore
Alex	Jeff Daniels
Leo	George Dzundza
Stella	Mary Steenburgen
Grace	Frances McDormand
Mr. Liddle	Christopher Durang

By JANET MASLIN

A mermaid is a welcome sight in Manhattan. She really stands out in a crowd. Even a mermaid of the two-legged variety, like the beautiful seasprite played by Demi Moore in "The Butcher's Wife," is a wonder, especially if she is willing to hand out free advice to every lovelorn person she meets. There are many such people in this new-age romantic comedy, and all are enchanted by sweet, guileless Marina (Ms. Moore), with her long, flowing locks and her magical powers. Audiences will be, too.

Ordinarily a lot more hard-boiled, Ms. Moore comfortably inhabits the role of a country clairvoyant from a tiny island off the North Carolina coast. This place is presented as a rustic paradise in the film's swift, confidently staged prologue, a sequence filled with omens that persuade Marina she must fall in love with a fisherman who appears on her shores. "My Adonis, my Poseidon — no, my Zeus!" she declares to the plump, understandably perplexed Leo Lemke (George Dzundza), who happens to be a butcher from New York City. They are married that very same day and Marina immediately follows Leo home to the kind of safe, clean, neighborly Greenwich Village block that is every bit as fanciful as Marina's original home.

"What a leap I made, from my little island to his!" Marina exclaims as the film takes its first look at New York. But the transition proves to be less drastic than it could have been, since Marina retains some of her country habits, like walking barefoot and wandering around at night in a diaphanous gown. Installed in the butcher shop as her husband's partner, she immediately begins to have an effect on the neighborhood by handing out free meat to nice people, having orders prepared before anyone asks for them, and seeming to know an awful lot about the problems of everyone who comes in.

This last gift of Marina's poses particular problems for Dr. Alex Tremor (Jeff Daniels), the local psychiatrist, and such a confirmed rationalist that he wears a T-shirt quoting Plato. Dr. Tremor feels his practice slipping away under Marina's more soothing influence, and he is clearly worried. "A woman as intelligent and insightful as you doesn't need a clairvoyant to tell her how to live her life," he tells the frumpy Stella (Mary Steenburgen), a schoolmarm who has just been encouraged by Marina to try to sing like Bessie Smith. "That's why *we're* here." But Stella starts singing all the same.

"The Butcher's Wife," written by Ezra Litwak and Marjorie Schwartz and directed by Terry Hughes (one of whose principal credits is directing "The Golden Girls" on television), eventually bogs down in plot mechanics once Marina has launched her lonely neighbors on their searches for

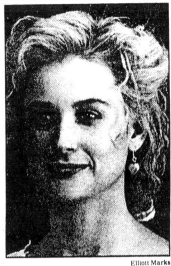
Elliott Marks

Demi Moore

one another. Too much of the film is spent matching up lovers who must almost literally get their stars uncrossed in order to find happiness. But a lot of it is enjoyably buoyant, even when it's several shades too broad. The delicately funny Ms. Steenburgen — who sings very nicely, incidentally, once she finally takes off those glasses and puts that white camellia in her hair — should not have had to grapple with an exaggerated New York accent to manage this role.

The film's earnestness about Marina's magical abilities is such that its press kit includes a four-page interview with the real psychic who helped to coach Ms. Moore. But none of that translates into anything overbearing,

From rustic paradise to a Greenwich Village butcher shop.

and most of the film sustains a light comic tone. Mr. Daniels, as the doctor who is alternately exasperated and entranced by Marina, makes himself comically and convincingly frazzled in her presence.

Mr. Dzundza is also good, especially when beaming at Ms. Steenburgen (Leo keeps a framed photo of Bessie Smith in his apartment and he, too, loves the blues). Christopher Durang appears briefly as a psychiatric patient, and in the background of one scene gets to do what many such patients have doubtless dreamed of: furtively trying on the decorative tribal mask that hangs on the doctor's wall.

Frances McDormand has some nice moments as a clothing store proprietor who has never seen a customer like the barefoot Marina with her butcher's apron and her beatific smile. Ms. Moore herself, speaking in a thick twang and wearing a wig that risks looking ridiculous, seems so utterly sure of her character that her confidence is contagious. The film gets a lot further on sheer self-assurance than on either sense or style.

"The Butcher's Wife" is helped visually by Frank Tidy's lively cinema-

tography, Charles Rosen's cosy production design, Theadora Van Runkle's soft, flowing costumes and Bald Head Island, N.C., a place that shares Marina's magical glow.

•

"The Butcher's Wife" is rated PG-13 (Parents strongly cautioned). It includes sexual references and mild profanity.

1991 O 25, C24:1

Antonia and Jane

Directed by Beeban Kidron; written by Marcy Kahan; photography by Rex Maidment; film editor, Kate Evans; music by Rachel Portman; produced by George Faber; released by Miramax Films. Running time: 77 minutes. This film has no rating.

Jane Hartman	Imelda Staunton
Antonia McGill	Saskia Reeves
Therapist	Brenda Bruce
Howard Nash	Bill Nighy
Uncle Vladimir	Alfred Marks
Young Jane	Bonnie Parker
Jeremy Woodward	Ian Redford
Norman Beer	Richard Hope

By STEPHEN HOLDEN

"Antonia and Jane" is probably the only film that will ever be made in which the English novelist Iris Murdoch plays a catalytic role without appearing or receiving a writing credit.

In the tale of a friendship between two Englishwomen — the sleek blonde Antonia McGill (Saskia Reeves) and the nerdy, owlish Jane Hartman (Imelda Staunton) — Miss Murdoch serves as an unwitting sexual guru. The weirdest of the creepy men who wind in and out of the two women's lives is one of Jane's boyfriends, a literary type named Norman (Richard Hope) who requires readings aloud from Miss Murdoch's novels before he is capable of making love. Jane happens to detest Miss Murdoch's writing, so this presents problems.

Norman is only marginally odder than the other eccentric men who straggle through the smart, amiable comedy directed by Beeban Kidron and written by Marcy Kahan. There is Howard Nash (Bill Nighy), an artist whom Jane falls in love with at an exhibition of his photographs of buttocks and whom Antonia steals from Jane and marries, to her eventual regret. There is also Jane's Uncle Vladimir (Alfred Marks), who, though Jewish, avidly admires the English fascist Sir Oswald Mosley. Finally, there is Jeremy Woodward (Ian Redford), a one-night stand of Antonia's who likes to play quiz show games while experimenting with bondage.

•

The only "normal" person in the movie is the psychotherapist (Brenda Bruce) whom Antonia and Jane each visit, unbenownst to each other, and to whom they pour out their mutual envy and fret about whether to keep their annual lunch date at a fancy restaurant. The issue of whether or not to keep that date goes to the heart of the film's biggest problem, which is based on such negative feelings.

The film traces that friendship all the way back to childhood when Antonia formed a secret society from which she immediately excluded Jane.

"Antonia and Jane" has some amusingly surreal tricks up its sleeve. When Jane reaches the depths

of despair, she watches aghast as every channel on her television set parades the sad farce of her life. Antonia's similar moment of truth is appropriately a bit more chic. While alone in a movie theater one evening, she watches in horror as the screen shows a vintage French movie from World War II in which she, Jane and Howard are characters in a melodrama about the Resistance. Although these sorts of fantastic elements are familiar from Woody Allen films, they are slipped in very deftly. Like many of Mr. Allen's films, this movie also uses voice-over narration to push along the story.

The performances of Miss Staunton and Miss Reeves have exactly the right seriously comic tone for a movie that insists on looking at the relationship lightheartedly. As much as she mopes, Miss Staunton's Jane has the light in her eyes and the secret smile of an oddball survivor. Miss Reeves is surprisingly sympathetic as an arrogant winner who gets her comeuppance.

1991 O 26, 13:1

The Hitman

Directed by Aaron Norris; written by Robert Geoffrion and Don Carmody; director of photography, João Fernandes; film editor, Jacqueline Carmody; production designer, Douglas Higgins; produced by Mr. Carmody; released by Cannon Pictures. Running time: 94 minutes. This film is rated R.

Cliff Garret	Chuck Norris
Marco Luganni	Al Waxman
André Lacombe	Marcel Sabourain
Christine De Vera	Alberta Watson
Tim	Salim Grant

By STEPHEN HOLDEN

With his shaggy, basset-hound face and an amiably paternal manner that strongly recalls Ronald Reagan, Chuck Norris is one of the screen's least likely action-movie heroes. When called upon to slaughter people, which he does every few minutes in his new film, "The Hitman," the star twinkles with the saintly equanimity of a divinely appointed executioner.

His killings are carried out with a minimum of motion and a maximum of gore. Even in scenes where he turns into a one-man army and munitions factory, he barely moves, while the bodies cascade around him. In "The Hitman," one of his victims is hung from a meat hook and then exploded. In an early scene, the star, wounded and drenched in blood from head to toe, is examined in long, loving close-ups on a hospital operating table.

"The Hitman," which was directed by Aaron Norris, the star's brother, hews to the usual Chuck Norris dramatic formula. This time he plays Cliff Garret, a New York policeman who, after being nearly killed by his corrupt partner during a sting operation, is shipped off to Seattle, where he assumes a new identity and infiltrates a drug-smuggling operation run by the local Mafia. Two rival gangs — one Iranian, the other French — are attempting to control the same territory, which makes for quite a bit of nasty ethnic baiting.

Although the movie, which opened yesterday at local theaters, has no narrative credibility, it has some creepily atmospheric scenes set in the meatpacking plant and in the idyllic Pacific Northwest landscape

where gun-toting Iranian gangsters materialize out of the winter mist.

•

"The Hitman" is rated R. It is steeped in gore.

1991 O 27, 51:5

The Architecture of Doom

Directed, written and produced by Peter Cohen; in German, with English subtitles; music by Richard Wagner and Hector Berlioz; a First Run Feature Release. At Film Forum 1, 209 West Houston Street, Manhattan. Running time: 119 minutes. This film has no rating.

Narrated by Bruno Ganz

By CARYN JAMES

It is not news that the Nazis embraced bad art, glorying in heroic statues and sentimental landscape paintings while condemning modern art as "degenerate." Josef Goebbels, the Minister for Popular Enlightenment and Propaganda, was a sometime poet and playwright, and Hitler himself was the world's most notorious failed painter. But it is a long leap from those facts to the argument put forth by the simplistic documentary "The Architecture of Doom."

Peter Cohen, a Swiss film maker, draws on a wealth of still photographs and films from the period, from kitschy floats in Nazi parades to banal portraits that Hitler kept at home. He uses this material to contend that politics offers too narrow a lens for understanding Hitler and the Holocaust; Nazism, he suggests, was a movement driven by esthetics.

In his view, "propaganda provided the outlet for Hitler's artistic ambitions," as did his designs for Nazi insignia and uniforms. A Nazi rally becomes a cast-of-thousands movie with Hitler as screenwriter and director. Hitler's power is reduced to a twisted outgrowth of his esthetic views, in which artistic ideals of purity and beauty came to include racially pure and beautiful Aryans.

This narrow thesis is far weaker than the political theories the film intends to revise. But "The Architecture of Doom," which opens today at Film Forum 1, is valuable for the archival material it preserves. Most disturbing are the glimpses of Nazi propaganda. Mr. Cohen shows how the Nazis compared the deformed faces of the mentally ill with the fragmented faces in modernist portraits, to suggest that both mentally deficient people and modern art were unfit to live. There are brief sections from "The Eternal Jew," the 1940 propaganda film that juxtaposes scenes of Polish Jews on a street with rats swarming across the movie screen.

Hitler's own paintings and drawings of houses are just as pedantic and soulless as the film says. But Mr. Cohen ignores the fact that there have been plenty of failed artists who did not become demonic megalomaniacs. "The Architecture of Doom" never questions that crazed but crucial step from artist manqué to the century's most deranged and powerful leader. It never ponders why the Germans were so susceptible to Nazism.

Mr. Cohen, who made the well-received documentary "Chaim Rumkowski and the Jews of Lodz," may be exaggerating his thesis for revisionist effect. Regardless, "The Ar-

chitecture of Doom" is so detached from historical context that it becomes dangerously facile.

1991 O 30, C14:4

Black Robe

Directed by Bruce Beresford; screenplay by Brian Moore; director of photography, Peter James; edited by Tim Wellburn; music by Georges Delerue; production designer, Herbert Pinter; produced by Robert Lantos, Stephané Reichel and Sue Milliken; released by the Samuel Goldwyn Company. Running time: 100 minutes. This film is rated R.

Father Laforgue Lothaire Bluteau
Daniel.. Aden Young
Annuka...................................... Sandrine Holt
Chomina August Schellenberg
Wife of ChominaTantoo Cardinal
Father JeromeFrank Wilson

By VINCENT CANBY

Of all the tales that make up the saga of France's 17th-century exploration and settlement of what was to be called Canada, one of the most heroic, brutal and finally disastrous is the story of the Huron Mission.

Founded and maintained by Jesuit priests at great cost in physical suffering to themselves and to the Hurons, the mission endured for two decades before it was abandoned in the early 1650's. The Jesuit plan had been to convert the stationary Huron tribes, whose members would then become missionaries to their nomadic Indian brothers.

The Hurons occupied the territories west of Lake Huron. They tolerated the proselytizing Jesuits without embracing them. They accepted the Christian faith whenever it was convenient and would later revert to their old ways.

The Jesuits developed their own tricks. They were not above surreptitiously baptizing a Huron baby while pretending to give it sips of sugared water. Epidemics, famine and wars with the Iroquois eventually brought about the end of the mission and the end of the Huron nation. Piety backfired.

This epic story provides the background for Bruce Beresford's "Black Robe," which opens today at the Beekman Theater.

"Black Robe" is no over-decorated, pumped-up boy's adventure yarn like "Dances With Wolves." It is an attempt to find the drama in the confrontation of one Jesuit priest, full of burning faith but hopelessly naïve, with both the horrors and the crude, atavistic splendors of the wilderness.

•

Young and well-born, the saintly Father Laforgue (Lothaire Bluteau) has come to New France to save the heathen and, if necessary, to become a martyr on behalf of God. His assignment: to make his way 1,500 miles west from the frontier town of Quebec to work at the newly established Huron Mission.

Most of the film is devoted to this journey, which begins with such high hopes in early autumn and ends in frozen midwinter, at what remains of the desolate mission. The film's subject is a grand one, but Mr. Beresford and Brian Moore, who adapted his own novel for the screen, never find a way to make Father Laforgue's spiritual journey as dramatic or photogenic as the physical one.

The movie was filmed entirely on spectacular Canadian locations, under weather conditions nearly as

harsh as those that faced the early Jesuit missionaries. "Black Robe" looks great. The unspoiled majestic reaches of the Saguenay River stand in beautifully for those of the St. Lawrence nearly 350 years ago.

At the start of the journey, Father Laforgue's Algonquin escorts find him a figure of ridicule. After a dwarf Indian shaman joins the party, they begin to suspect that the Jesuit is some kind of devil.

The priest's self-assurance is not helped when his young French interpreter, Daniel (Aden Young), begins an affair with the pretty daughter of an Algonquin chief, who is also in the party. Father Laforgue, it seems, is himself subject to the desires of the flesh, which the Indians around him indulge at will without embarrassment.

•

There are also a mutiny and later the party's capture and torture by a band of Iroquois. A lot happens in the course of this journey, yet none of it is especially surprising or urgent. "Black Robe" has something of the manner of a series of dioramas in a museum of natural history.

The characters, as written and performed, are perfunctory functions of the plot. Mr. Bluteau, who played the title role in "Jesus of Montreal," looks right as Father Laforgue, but the priest goes through the film simply responding to the world around him. He's a passive and rather wimpish figure instead of a heroically troubled one.

Yet "Black Robe" has its peripheral pleasures, which, because they are so seldom seen in movies, should not be underrated. It is historically authentic not only in its locations but also in the picture it gives of the conditions in which these people lived. Unlike the scenery, these conditions are not pretty.

As in "Dances With Wolves," the Indians speak their own languages, translated by English subtitles that often are better than the English dialogue spoken by the French characters. "We'll cross that bridge when we come to it," says a priest early on when discussing the journey through the virgin wilderness to the Huron Mission.

•

"Black Robe" has been rated R (Under 17 requires accompanying parent or adult guardian). It includes some violence and nudity.

1991 O 30, C15:2

Billy Bathgate

Directed by Robert Benton; screenplay by Tom Stoppard, based on the book by E. L. Doctorow; director of photography, Nestor Almendros; film editors, Alan Heim and Robert Reitano; music by Mark Isham; production designer, Patrizia Von Brandenstein; produced by Arlene Donovan and Robert F. Colesberry; released by Touchstone Pictures.

Running time: 107 minutes. This film is rated R.
Dutch Schultz.........................Dustin Hoffman
Drew Preston..........................Nicole Kidman
Billy Bathgate.................................Loren Dean
Bo WeinbergBruce Willis
Otto BermanSteven Hill
Irving.. Steve Buscemi

By VINCENT CANBY

THE people at Touchstone Pictures can relax. Their screen adaptation of E. L. Doctorow's best-selling novel "Billy Bathgate" is not the disaster that Hollywood insiders had predicted when the shooting schedule was extended, rumors of personality clashes were reported and a new ending was shot.

After all of that negative expectation, the movie is a sort of reverse letdown. It is not a disaster, but neither is it a milestone in motion-picture art.

"Billy Bathgate" is a big, generous movie entertainment of the kind that the old Hollywood studios used to manufacture without financial fuss or emotional stress. They would buy a popular novel, assign the writers, the director, the members of the cast and then shoot.

As supervised by front-office representatives, the movie was expected to synopsize the book more or less, to provide large roles for the studio's stars and not to offend any pressure groups.

The most arresting revelation offered by "Billy Bathgate" is that today a lot of hard work is required to make a film that is so perfectly homogenized, so without dangerously idiosyncratic character, that it seems almost old-fashioned. It might be easier to make a masterpiece.

A great deal of superior talent has gone into this production. Robert Benton is the director, Tom Stoppard the screenwriter and Dustin Hoffman the star, with Bruce Willis appearing in a small but showy supporting role. The movie gives prominence to two attractive newcomers, Loren Dean and Nicole Kidman, and Patrizia von Brandenstein, the production designer, has beautifully recreated the Great Depression look of mid-1930's America. Nestor Almendros was the cinematographer.

Yet the film's sensibility seems to have less to do with any of these people, or with Mr. Doctorow, than with the front-office types who shadowed its production from the original deal through the shooting, the editing, the first screenings and, finally, its release.

This is only a guess, based on the idea that movies that get wildly out of hand tend to be either more lively or far worse than "Billy Bathgate," which is altogether respectable.

The film offers an accurate recollection of the narrative line of Mr. Doctorow's expansive novel, set in 1935, about the adventures of the self-styled Billy Bathgate, a wide-eyed teen-ager from the Bronx who has the skepticism, the intellect, the luck and the nonstop gabbiness of a 20th-century Huck Finn.

It is Billy's great good fortune to witness, close up, the decline and fall of one of the legendary gangsters of his day, Arthur Flegenheimer, alias Dutch Schultz. In Mr. Doctorow's rousing mockdirge, Dutch, a lethal variation on Mark Twain's Duke (or maybe Dauphin), takes a shine to Billy, whom he praises as "a capable boy." He brings Billy into the gang and educates him in those impulsive, free-swinging gang ways that are fast going out of style as the Mafia's organization expands.

Billy sees all. He is there on the tugboat when Dutch and his boys drop a defiant Bo Weinberg overboard, Bo's feet being appropriately clad in

cement. He is instructed in the arcane mysteries of numbers by Dutch's financial wizard, Otto (Abbadabba) Berman. He is a member of Dutch's entourage when the racketeer moves to upstate New York to stand trial for income-tax evasion.

For Billy, the wonders never cease. He is at hand in the church when Dutch converts to Roman Catholicism, Lucky Luciano acting as Dutch's sponsor. He is the one who is entrusted to keep an eye on Dutch's girlfriend, the very social but nutty Drew Preston, when Dutch sends her to Saratoga Springs to sit out his trial. Billy makes mistakes along the way, none more dangerous than falling in love with Drew.

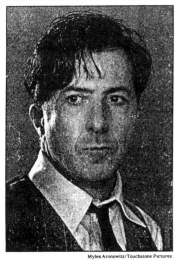

Myles Aronowitz/Touchstone Pictures

Dustin Hoffman as Dutch Schultz.

These are the novel's highlights, dutifully re-created in Mr. Stoppard's screenplay, which also preserves a lot of Mr. Doctorow's funnier lines. Gone, though, is the comic heft of the novel, Billy Bathgate's running first-person commentary that, far more than the specific events, illuminates the author's concerns with the often cockeyed meaning of the American experience.

Mr. Hoffman is fine as Dutch, the sort of man who will always look like a mug no matter how much he pays for his suits. The actor is intense, centered and absolutely straight. He dominates the movie even though it isn't his to dominate, which must have been one of the major problems facing Mr. Benton and Mr. Stoppard.

•

The novel is less about Dutch than about Billy's view of him. Dutch may be at the center of the story, but the novel is about Billy's perception of Dutch, something not easily re-created in a movie in which the star plays the secondary role and a supporting actor plays what is, in effect, the lead.

Thus the movie is always a little off balance, Dutch being a far more arresting character than Billy, who, as written and as played by Mr. Dean, is something of a cipher. It also doesn't help that Mr. Dean looks to be a bit beyond his teens, which makes his golly-gee-whiz naïveté seem more of an act than it should be.

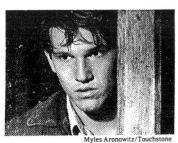

Myles Aronowitz/Touchstone

Loren Dean as Billy Bathgate

Miss Kidman is a beauty with, it seems, a sense of humor. Yet Drew Preston is a role that might have introduced a new screen personality on the riveting order of Veronica Lake or Lauren Bacall, someone who immediately registers as an original. It is that unpredictable spark that is missing from "Billy Bathgate," though Mr. Willis is lively and funny

as the doomed Bo Weinberg, and Steven Hill is exceptionally good as Otto Berman.

"Billy Bathgate" guards Mr. Doctorow's novel with care. It is enjoyable but, like the admirable son who cares too much for his poor, widowed mother, it has no real life of its own.

•

"Billy Bathgate," which has been rated R (Under 17 requires accompanying parent or adult guardian), has violence, vulgar language and partial nudity.

1991 N 1, C1:1

Lucky Star

Directed by Frank Borzage; scenario by Sonya Levien, based on the Saturday Evening Post story "Three Episodes in the Life of Timothy Osborn"; titles by Katherine Hilliker and H. H. Caldwell; photography by Chester Lyons and William Cooper Smith; film editors, Ms. Hilliker and H. H. Caldwell. At Film Forum 2, 209 West Houston Street, Manhattan. Running time: 100 minutes. This film has no rating.

Timothy Osborn	Charles Farrell
Mary Tucker	Janet Gaynor
Martin Wrenn	Guinn (Big Boy) Williams
Joe	Paul Fix
Mrs. Tucker	Hedwig Reicher
Milly	Gloria Grey
Pop Fry	Hector V. Sarno

By JANET MASLIN

Made in the days when a country gentleman could affectionately address his farm-girl sweetheart as Baa-Baa, Frank Borzage's 1929 silent film "Lucky Star" has an obvious and charming naïveté. It is also a work of remarkable sophistication, both for Mr. Borzage's highly developed storytelling skills and for the remark-

Janet Gaynor

ably genuine and touching performances he elicited from Janet Gaynor and Charles Farrell, who had great screen chemistry long before there was a name for such a thing. Think of the Film Forum's showing of a mint-condition print of "Lucky Star" with live musical accompaniment as a special presentation. Better still, think of it as a rare treat.

"Lucky Star," which was made in the brief transitional period between silent and sound films, included a few isolated and hastily added lines of dialogue when it opened "on the Broadway screen," as a 1929 review put it. But it is abundantly clear from this silent version, which was recently located in the vaults of the Netherlands Film Museum in Amsterdam, that this dialogue must have sounded superfluous, since the story unfolds so well without it.

•

The plot concerns Mary Tucker (Gaynor), a cheery, ragtag urchin

living in a very theatrical-looking countryside, and two men who eventually compete for her attentions. They are handsome, genteel Tim Osborn (Mr. Farrell) and big, strapping Martin Wrenn (Guinn (Big Boy) Williams), who are seen in a squabble provoked by Mary as they work together atop utility poles. In the midst of the fight, Tim overhears on telephone lines that war has been declared, which is indicated by a written title but is equally well signaled by the strains of "Over There" in the score. Wrenn declares: "I'm gonna join the Army. Them French girls seem mighty nice to me."

Tim's behavior is a bit more peculiar, since the last thing he does is to spank the childlike Mary for a minor transgression. "You're a cannibal and a dirty, no-good, low-down little thief," he declares. (Sometimes the written titles are priceless in their own way.) "You just wait'll I get back and see what I do to you."

•

But when Tim does return, things are different, as Mr. Borzage reveals dramatically through the use of a strategic Dutch door: the handsome, robust man waving happily at the sight of Mary is now a paraplegic confined to a wheelchair. Mary, quite undeterred by this, begins making frequent visits to Tim's lonely vine-covered cottage, and between them there arises an enchanting friendship. It is presented in the homeliest way imaginable, since one incident involves Mary's frequent habit of wiping her nose on her sleeve and Tim's fond gesture of making her a handkerchief and teaching her how to use it. At another point, he tells her of the benefits of washing one's hair in raw eggs and proceeds to give her a high-cholesterol shampoo.

Tim even tries to advance Mary's moral education, as when she shows him a party dress she has bought with cash she has hidden from her mother, known here as "the poor widow Tucker" (and played with surprising verve by Hedwig Reicher). "You're not clean if you keep money from your mother, Baa-Baa," he sternly warns the newly bathed Mary as she models the new frock. "You're filthy inside."

The mixture of Tim's paternal fondness and Mary's girlish admiration is beautifully developed by the actors and Mr. Borzage, and is allowed just as skillfully to blossom into love. Among its sweeter gestures are Tim's way of tying a ribbon in Mary's hair and his giving her a simple round bracelet. ("Gee, Tim, just like a great big wedding ring!" she exclaims.) Thanks to some fairly outrageous plot maneuvering that involves Wrenn's chicanery, Tim's courage and the obligatory dark and stormy night, Tim is ultimately allowed to demonstrate the depths of his passion in an ending that has to be seen to be believed.

•

The Film Forum is showing "Lucky Star" with two kinds of accompaniment, one by Vince Giordano

and his 11-piece Nighthawks Orchestra, the other solo piano by Steve Sterner. The full orchestra will be heard only this weekend. Either way, this is a vibrant piece of film history and an innocent delight.

1991 N 1, C8:1

Year of the Gun

Directed by John Frankenheimer; screenplay by David Ambrose, based on the book by Michael Mewshaw; photography by Blasco Giuarto; edited by Lee Percy; music by Bill Conti; production designer, Aurelio Crugnola; produced by Edward R. Pressman; released by Triumph Releasing. Running time: 111 minutes. This film is rated R.

David Raybourne	Andrew McCarthy
Lia Spinelli	Valeria Golino
Alison King	Sharon Stone
Italo Bianchi	John Pankow
Giovanni	Mattia Sbragia
Pierre Bernier	George Murcell
Round-Faced Man	Lou Castel

By JANET MASLIN

A story of political intrigue can be set almost anywhere, provided the locale is sufficiently deceit-ridden to motivate each character to do the others in. But the late-1970's Italian

Paul Ronald Pellet/Triumph

Andrew McCarthy

setting of John Frankenheimer's "Year of the Gun" is especially piquant, since it allows the story's hero, an American journalist named David Raybourne (Andrew McCarthy), to move between the angry, slogan-filled halls of an Italian university and the comfortable living quarters of Lia Spinelli (Valeria Golino), his well-heeled lover. There is also much beautiful Roman scenery to accompany the film's scenes of rioting, raids by ski-masked guerrillas and other acts of violence in the street.

The story of "Year of the Gun" unfolds briskly and methodically against this vibrant backdrop, which is as it should be from Mr. Frankenheimer, whose forte has always been the political thriller (among his credits are "Black Sunday," "The Manchurian Candidate" and "Seven Days in May"). But this film's casting problems work against the authenticity of its larger atmosphere and do a lot to trivialize the material. The smoothly unctuous Mr. McCarthy is never convincing or sympathetic as the rakish, much-in-demand American writer whose activities eventually stir the Red Brigades into a frenzy.

Rivaling him in the improbability department is tawny, glamorous Sharon Stone, who is supposed to be Alison King, a tough, world-famous photojournalist. "My job is to bring back the bad news and keep the body count," she says knowingly. Alison also leans toward remarks like, "First time I put my life on the line to get a picture was in Saigon." This latter thought is accompanied by the story of how Alison bought herself an expensive wristwatch after completing a particularly grisly assignment, which from Ms. Stone winds up sounding giddier than it should. The film's claims to political authenticity evaporate whenever it moves from background action to the behavior of its several scheming principals.

Much of the film's suspense stems from these characters' real or putative links to either the Central Intelligence Agency or the Red Brigades. And Mr. Frankenheimer duly reveals secret after secret in the process of unmasking his principals. But the plot, from a screenplay by David Ambrose based on Michael Mewshaw's book, turns out to be dizzyingly overcomplicated, and far too much of it hinges on the American journalist's supposed power to make trouble with his novel, which he says will be a "Day of the Jackal"-like mixture of real and fictitious characters. It is this journalist's advance knowledge of the plot to kidnap Aldo Moro, a former Italian Prime Minister, that makes so many waves.

●

Among the actors, only the exceptionally natural Ms. Golino seems comfortable or convincing, although John Pankow is somberly effective in the role of Italo, Lia's cousin (especially impressive in view of the fact that this actor was born in St. Louis). The seriousness of the film's other characters can perhaps be gauged by the fact that one of them is last seen wearing a New York Yankees cap in Beirut, and another winds up on the Dick Cavett show.

●

"Year of the Gun" is rated R (Under 17 requires accompanying parent or adult guardian). It includes considerable violence, brief nudity and sexual situations.

1991 N 1, C10:6

Exposure

Directed by Walter Salles Jr.; screenplay by Rubem Fonseca, from his novel; director of photography, Jose Roberto Eliezer; edited by Isabelle Rathery; music by Jurgen Kneiper and Todd Boekelheide; production design, Nico Faria and Beto Cavalcanti; produced by Alberto Flaksman; released by Miramax Films. At the Angelika Film Center, Houston and Mercer Streets, Manhattan. Running time: 100 minutes. This film is rated R.

Peter Mandrake	Peter Coyote
Hermes	Tcheky Karyo
Marie	Amanda Pays
Lima Prado	Raul Cortez
Gisela	Giulia Gam

By JANET MASLIN

In Walter Salles Jr.'s moody, ambitious "Exposure," Peter Coyote plays the world-weary photographer Peter Mandrake, a man given to Greek poetry, supersensitive reflections ("All my life my eyes have searched for something different") and slow, lingering smiles. Living temporarily in Rio de Janeiro, Mandrake is drawn into a network of violent crime once

Miramax
Amanda Pays and Peter Coyote

he determines to solve the murder of Gisela (Giulia Gam), a sweet-looking prostitute whose killer has carved his initial onto her face. Even when Mandrake finally corners this villain, the film sustains its preoccupation with art. "Don't you sign your work too, Mr. Mandrake?" the killer tauntingly inquires.

"Exposure," which opens today at the Angelika Film Center, would take the high ground more legitimately if it were not also a frequently gruesome thriller, one that vacillates oddly between studied reflectiveness and sadism. One typically unsettling episode finds Mandrake on a train, peering soulfully out the window with a woman he has just met. "This place is beautiful — it's endless," he says of the landscape. "That's exactly why I don't like it," she replies. Very quickly this exchange gives way to sex and

A photographer turns sleuth when a prostitute is killed.

then to death, two things that Mr. Salles frequently intermingles. One memorably ghoulish episode shows a man being knifed so expertly that neither of the women sleeping beside him wakes up to notice.

Mr. Salles, a Brazilian-born documentary film maker, shows off a highly developed sense of the exotic in this film, which is his debut dramatic feature. Some of it comes from the remote and picturesque Brazilian and Bolivian scenery, including some stunning desert vistas, snow-topped mountains and tiny isolated Indian villages. But much originates with the characters themselves, adapted by the screenwriter, Rubem Fonseca, from his own novel "High Art." Mandrake is at first a genuinely appealing figure, in spite of his tendency to wax ponderous when discussing photography. ("Instead of death, we deliver eternity — at least the illusion of it.") And Mr. Coyote gives a seductive performance until the film strains to turn him from a coyly passive bohemian into a man of action.

After Mandrake is wounded, he takes up the art of knife-fighting under the tutelage of the mysterious Hermes, who is played by the quietly mesmerizing actor Tcheky Karyo. "He's a 'perser,'" Mandrake explains of Hermes to the beautiful archeologist Marie (Amanda Pays), who is intermittently his lover. "It stands for 'perforate and sever,' and he's a master of the technique." Marie wisely takes this as a signal to leave Mandrake alone until he gets this particular martial art out of his system.

Mr. Salles, often an effective stylist, begins the film by pulling the camera out the window of a murder scene and backward until it offers a striking view of Rio de Janeiro; he also includes some memorable glimpses of boys attempting death-defying rides atop moving trains, in a Brazilian practice known as train-surfing. But too much of the film is given over to more blatantly sensational touches like the teaming of a giant and a dwarf, and torture episodes involving props like cockroaches and garden shears. It does not require the reflectiveness of a Peter Mandrake to wonder why a film maker of Mr. Salles's promise would resort to any of that.

●

"Exposure" is rated R (Under 17 requires accompanying parent or adult guardian). It includes considerable violence.

1991 N 1, C12:6

Iron Maze

Directed by Hiroaki Yoshida; screenplay by Tim Metcalfe, screen story by Mr. Yoshida and Mr. Metcalfe; based on the short story "In a Grove" by Ryunosuke Akutagawa; director of photography, Morio Saegusa; film editor, Bonnie Koehler; music by Stanley Myers; production design, Toby Corbett; produced by Ilona Herzberg and Hidenori Ueki; released by Castle Hill. Running time: 102 minutes. This film is rated R.

Barry	Jeff Fahey
Chris	Bridget Fonda
Sugita	Hiroaki Murakami
Jack Ruhle	J. T. Walsh
Mikey	Gabriel Damon
Mayor Peluso	John Randolph

By VINCENT CANBY

"As our financial paths intertwine," say the production notes for Hiroaki Yoshida's "Iron Maze," which is about troubled relations between Americans and Japanese, "the widening cultural gap between us stretches over a dangerous abyss."

"Iron Maze" is this week's leading entry in the looniest movie of the year sweepstakes. Using the same Ryunosuke Akutagawa story that was the basis for Akira Kurosawa's "Rashomon," Tim Metcalfe has written a screenplay of epic confusion and unintentional hilarity.

The setting is the fictional Corinth, Pa., a small, once-thriving steel town that has been bought by a Japanese entrepreneur for his son Sugita (Hiroaki Murakami) to do with what he will. When Sugita and his American wife, Chris (Bridget Fonda), arrive to take possession, the young man astonishes the locals by announcing that he is going to build an amusement park and in this way make everybody happy.

●

Sugita means well, but he doesn't understand the needs of the poverty-stricken citizens of Corinth any better than they understand him or his dream. One afternoon, Sugita is found badly battered about the head in the abandoned steel mill. What happened and why?

At this point, "Iron Maze" slips into its flashback mode. Characters are seized by flashbacks as if by some crazy new strain of chicken pox. Everybody gets flashbacks at least once, sometimes twice. It's an epidemic.

First Barry (Jeff Fahey), a young out-of-work steel worker, confesses to the attack. Then the Mayor (John

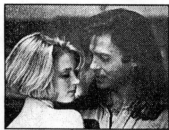

Castle Hill
Bridget Fonda and Jeff Fahey

Randolph) remembers what happened the morning of the beating. Chris tells the police that Barry raped her on the very spot where Sugita was found.

At which point Barry changes his story. Then Chris changes hers. The wounded Sugita wakes up long enough to tell his story. A separate flashback accompanies each.

The poor police chief (J. T. Walsh) doesn't know whom to believe, though the audience couldn't care less. The nature of truth is not important. In this movie, it's the little things that count, such as the scene in the abandoned steel mill in which Barry and Chris make passionate love, after which she sits up, daintily straightens her clothes and asks, "Is there a bathroom here?"

As a matter of fact, there is.

Mr. Yoshida is the man who made "Twilight of the Cockroaches" (released in New York last March), a movie that mixed live-action photography and animation in a remarkably clever way to tell an allegorical tale of great murkiness. "Iron Maze" is even murkier.

There is thunder on the soundtrack when the sun is shining, and all of the characters are seriously stupid and behave badly, though the ending is a happy one. Just what Mr. Yoshida is saying is anybody's guess. Meanwhile, the cultural gap over the dangerous abyss continues to widen.

●

"Iron Maze," which has been rated R (Under 17 requires accompanying parent or adult guardian), has some violence and vulgar language.

1991 N 1, C13:1

29th Street

Directed and written for the screen by George Gallo, based on a story by Frank Pesce and James Franciscus; director of photography, Steven Fierberg; edited by Kaja Fehr; music by William Olvis; production designer, Robert Ziembicki; produced by David Permut; released by 20th Century Fox. Running time: 101 minutes. This film is rated R.

Frank Pesce Sr.	Danny Aiello
Frank Pesce Jr.	Anthony LaPaglia
Mrs. Pesce	Lainie Kazan
Vito Pesce	Frank Pesce
Sgt. Tartaglia	Robert Forster
PHilly the Nap	Ron Karabatsos
Jimmy Vitello	Rick Aiello
Needle Nose Nipton	Paul Lazar

By JANET MASLIN

What kind of person throws snowballs at a church on Christmas Eve, especially after he's just learned his winning lottery ticket is worth more than $6 million? On the evidence of the sentimental family comedy "29th Street," about a lottery winner named Frank Pesce Jr., it's a person who connects lottery winnings with love.

The film, which greatly embroiders the story of Mr. Pesce's life, creates an O. Henry-style ending in which hitting the jackpot allows Frank to express his feelings about his big, blustery father, who happens to have a gambling problem. Doing its very best to give Mr. Pesce's story a movie gloss, the film makes sure that this all works out for the best.

Although "29th Street" takes its title from Mr. Pesce's Queens neighborhood, it was filmed in Wilmington, Del., which may offer some idea of its overall authenticity. Mr. Pesce's real story is only a loose basis for the film's warm, jokey portrait of an Italian family, which seems to be modeling its behavior on many other Italian families from many other (and often better) films. But authenticity is unimportant here anyway, and Mr. Pesce's story is hardly sacrosanct. What matters is that this film work on its own broad terms, and at times it does. Danny Aiello's broadly attention-getting performance as the domineering Frank Pesce Sr. does a lot to hold this story together.

•

Beginning with the snowball incident, "29th Street" follows Frank Jr. to police headquarters, where he tells his story to a roomful of rapt police officers. ("I got all night," one of them says, though it does happen to be Christmas Eve.) In the ensuing flashback, it is revealed that Frank has always suffered from having a lucky streak, one that works only in backhanded ways. When he dates a beautiful Puerto Rican girl and is stabbed by her brother in Spanish Harlem, for example, his good luck means that the doctor tending to his stab wound discovers a nearby tumor and removes it early enough for Frank to beat his cancer.

The film details other, comparable examples of how Frank's luck works, which makes better sense of what very nearly happens when he tries the lottery. It also observes Frank Jr.'s visit to his draft board, Frank Sr.'s attempt to grow a perfect postage-stamp lawn and various other homespun, suitably cute neighborhood scenarios. Most of this goes down easily, and the film only occasionally shows its maudlin streak. Mr. Aiello, though solidly good here, should avoid any dialogue in which he describes himself as "a dreamer."

Also in "29th Street" are Anthony LaPaglia, nicely unflappable as the young Frank, and often serving as a straight man for those around him; Lainie Kazan, talking a blue streak as Frank's zesty, blowsy mother, and the real Mr. Pesce, who plays his own brother Vito and is thoroughly comfortable on camera (since he entered the first New York State lottery in 1976, Mr. Pesce has become a character actor). The film was written and directed by George Gallo, a former screenwriter ("Midnight Run") determined to stay midway between real life and Hollywood invention.

•

The film "29th Street" is rated R (Under 17 requires accompanying parent or adult guardian). It includes considerable profanity.

1991 N 1, C14:1

Correction

A film review in Weekend on Nov. 1 about "29th Street" misidentified the locale where it was photographed. It was filmed in Wilmington, N.C., not in Wilmington, Del.

1991 N 15, A3:2

The People Under the Stairs

Directed and written by Wes Craven; director of photography, Sandi Sissel; edited by James Coblentz; music by Don Peake; production designer, Bryan Jones; produced by Marianne Maddalena and Stuart M. Besser; released by Universal Pictures. Running time: 101 minutes. This film is rated R.

Fool	Brandon Adams
Man	Everett McGill
Woman	Wendy Robie
Alice	A. J. Langer
LeRoy	Ving Rhames
Roach	Sean Whalen

By VINCENT CANBY

"The People Under the Stairs," which opened at theaters here yesterday, is an affirmative-action horror film by Wes Craven, the man who wrote and directed the first "Nightmare on Elm Street" in 1984.

Though the new movie has its share of blood and gore, it is mostly creepy and, considering the bizarre circumstances, surprisingly funny. A little boy nicknamed Fool (Brandon Adams) has greatness thrust upon him when he does battle with some bloodsucking (literally) white landlords. Fool, his dying mother and hooker-sister are about to be evicted from their black ghetto apartment.

The principal setting is the scary old house occupied by the mad real estate operators, played with thick relish by Everett McGill and Wendy Robie. They not only keep their teenage daughter (A. J. Langer) in chains, but they also have a basement full of flesh-eating ghouls, one of whom has escaped and runs around in the spaces between the walls.

Mr. Craven's screenplay manages to evoke both "Treasure Island" and "The Night of the Living Dead," and plays like a stroll through an amusement park's haunted house. It is full of peculiar noises, floors and walls that suddenly give way, things that jump out of the dark and objects of unmentionable disgustingness that sneak up from behind.

Young Mr. Adams, who was featured in Michael Jackson's "Moonwalker" video, is a small but resourceful hero. Mr. McGill and Miss Robie are also good as the fiends. It's impossible not to like fiends who, having just dispatched someone in an especially nasty way, can't contain their natural high spirits. They dance.

•

"The People Under the Stairs," which has been rated R (Under 17 requires accompanying parent or adult guardian), has a lot of vulgar language and many simulated atrocities.

1991 N 2, 17:1

Mark Fellman

Anthony LaPaglia and Danny Aiello

FILM VIEW/Caryn James

A Hole In the Heart Of 'Bathgate'

WHY DID THEY HAVE TO LOSE ABBAdabba? In the film version of "Billy Bathgate," as in the E. L. Doctorow novel on which it is based, Abbadabba Berman is a man who computes numbers magically in his head. In the real-life gangsterhood of the 1930's, this wizardry made Berman a valuable member of Dutch Schultz's gang, and turned ordinary Otto into Abbadabba, a name he reportedly liked.

This character is the solid foundation of both novel and film. The fictional Billy Bathgate (Loren Dean) idolizes the legendary Dutch Schultz (Dustin Hoffman). But when the 15-year-old Billy hooks up with the Schultz gang in its declining days, it is Abbadabba Berman who becomes his father figure. Steven Hill gives the film its richest performance as Abbadabba, who is older, wiser and as decent as a crook can be; at least he hopes that in Billy's up-and-coming generation, crime will be an accountant's business, with no need to kill.

But in transforming the novel to the screen, the accountant's colorful nickname has vanished. The gang calls him Otto, Billy calls him Mr. Berman, and the novel's narrative voice, ringing out with the magical word Abbadabba, is gone. How the film managed to lose such a perfect, lively detail goes straight to the empty space where the heart of "Billy Bathgate" ought to be.

There has been a flurry of talk about the production problems of this film, of course. It may be that the director, Robert Benton, argued with Mr. Hoffman, that the film cost $40 million, that it was re-edited and scenes were reshot a year after it was completed. But the film makers — especially Tom Stoppard, who wrote the screenplay — were defeated by a classic problem that has nothing to do with money or egos. How do you turn a literary novel into a film?

Though Billy's tale may sound as if it were made for the movies, in fact the Doctorow novel is almost as uncinematic as Proust. The story is told by Billy many years after the events, in rich, romantic language that conjures up the starry-eyed way he felt about the famous criminal and creates a tone filled with nostalgia for the boy's lost innocence.

On the page, Billy is able to call Dutch Schultz "the great gangster of my dreams," in a phrase that resonates with meaning about the allure of fame and how those dreams came to be shattered. On screen, it is a poor substitute for Billy to explain to his girlfriend: "You don't understand about Dutch Schultz. He grew up around here. He was a nobody, and look at him now." After this, viewers are still not likely to understand the romance of gangsterhood.

This is the same problem that has always made "The Great Gatsby" seem so hollow on screen, whether the hero was played by Alan Ladd in 1949 or Robert Redford in 1974. The easy part is recreating Gatsby's magnificent house and glamorous parties. The near-impossible part is capturing Nick Carraway's eloquent narrative voice, which romanticizes Gatsby with all his gangster connections. Mr. Doctorow's hero is a direct descendant of Fitzgerald's Nick. Billy's elegant literary reverie makes this novel what it is and puts film makers in a terrible bind.

The problem demands a ruthless, imaginative solution, like the one that turned Mr. Doctorow's novel "The Book of Daniel," a fictional version of how Julius and Ethel Rosenberg's children dealt with their parents' execution, into the shrewd 1983 film "Daniel." Mr. Doctorow's screenplay wisely jettisoned the novel's most basic strategy, in which Daniel comes to terms with his past by writing about it. The film, directed by Sidney Lumet, substitutes flashbacks that merge with the present to create a memory piece seen through Daniel's eyes. Occasionally, in extreme close-up, Daniel recites the definition of electrocution or some other form of execution. This literary device is the equivalent of the character's writing in the novel and the film's only wrong turn.

The film version of "Billy Bathgate" is even more ruthless in cutting out the literary language, but it finds no substitute. The screen Billy is not older and eloquent, like the novel's narrator; he is not seen struggling to make sense of the past, as Daniel does on screen. The result is a flat film. The gangster story and the coming-of-age story seem to travel on parallel courses, despite the attempt to pull them together by depicting events through Billy's eyes.

This Billy is a dull kid to whom miraculous things happen, including his affair with Schultz's rich society girlfriend (Nicole Kidman). He is constantly overshadowed by Mr. Hoffman's enigmatic, volatile Dutch Schultz.

This is not one of Mr. Hoffman's greatest performances. The low-keyed, mumbly part of Schultz's character is too muddled, so his sudden violent eruptions seem contrived. Still, the gangster plot might have worked on its own. The story moves from Bo Weinberg (Bruce Willis) being sent into the sea with his feet in a tub of cement to the big shootout from which the gang will never recover. As it is, "Billy Bathgate" is not quick or crisp enough to live as a conventional gangster movie. What's left, except the shadow of a novel that must have seemed like a good movie idea at the time?

There are things in life that don't usually pay. Crime is one, and under most circumstances comparing a movie to the novel that inspired it is another. But in this case there is no better explanation for what killed "Billy Bathgate." Like Abbadabba's name, the film's soul was misplaced during the move. ❏

1991 N 3, II:13:4

FILM VIEW/Janet Maslin

In the Recession, Sweet Are the Uses of Poverty

TIMES MAY BE TOUGH, BUT there's a place where being short of cash is actually an advantage: on the screen. Poverty as a positive cinematic character trait is enjoying a new surge of popularity, one that harks back to the Depression, when the madcap rich yearned to be free of their constraints and the poor were possessed of an automatic nobility. Today's situation may be less extreme, but there's no question that the marbled hallways of glossy 1980's films have given way to an awful lot of soiled linoleum. For a contemporary movie character looking to inspire instant trust, economic hardship is an automatic help.

This pendulum swing goes well beyond blue-collar chic and even into no-collar chic. Just as the expensive physical trappings of the pre-crisis existence of Jeff Bridges in "The Fisher King" are meant to make him seem instantly odious, the grimy simplicity of his old-overcoat phase is intended to suggest a new honesty. The even worse-dressed Robin Williams is way ahead of him where virtue is concerned, and he has the wardrobe to prove it. In this film's scheme of things, it takes old clothes to make a new man.

■

Needless to say, such ideas of morality can lend themselves to ridiculous oversimplification, to the point where neither the rich nor the poor show signs of life. In John Hughes's new film "Curly Sue," the story of two impoverished drifters who win the heart (and move into the home) of a wealthy lawyer, the drifters' ennobling poverty turns out to be so artificial that it's no more than a minor inconvenience. Even when struggling for food and covered with dirt, Bill Dancer (James Belushi) thinks of taking little Curly Sue (Alisan Porter) to an art museum, which attests to his fundamentally upscale nature. Later on, it takes hardly more than a bath and a

shopping spree to transform both Bill and Curly Sue into model middle-class citizens, at ease in a fancy restaurant and all ready for the comfortable suburban life prefigured by the film's "happy" ending.

It never occurs to Mr. Hughes, whose earlier screenplay for "Dutch" incorporated saintly, uncomplaining residents of a homeless shelter, that economic hardship may take its toll on those who suffer it, and that these problems are trivialized by being so easily solved. At least "The Super," the current comedy starring Joe Pesci as an unrepentant slumlord who gets his comeuppance by being forced to live in his own building, allows room for a little antagonism in landlord-tenant relations. Although this film courts danger by threatening to turn the landlord into someone with a conscience, it sustains its humor by leaving him mostly unrecon-

These days, villains get a fax and a limo; heroes get an old cardigan.

structed. And it allows the tenants plenty of opportunities to make their new neighbor the butt of jokes. This helps to leaven the film's blanket assumption of tenant virtue, which is so unquestioning that it threatens to turn the whole film into a fairy tale.

Even a film that attempts to address real economic problems can be diminished by such black-and-white assumptions about its characters' morality. Larry the Liquidator, the tireless corporate raider played in "Other People's Money" by Danny DeVito with his customary diabolical glee, behaves reprehensibly but emerges as nothing much worse than a lovable louse. That still leaves him looking relatively honest beside the too-good-to-be-true management team led by Gregory Peck.

As the head of a small company, the character played by Mr. Peck can hardly be considered impoverished; as it turns out, several executives of this business are even millionaires. But when the film supplies them with pipes, cardigan sweaters and other homey touches, it cloaks them in a modest economic aura and reflexively associates that climate with decency. Larry the Liquidator need not even attack these simple souls to appear villainous. One look at his fax-equipped stretch limousine parked near the drab, antiquated factory says it all.

In the present economic atmosphere, it's no wonder waitressing is the movie job of choice. As a cocktail waitress in her own "Little Man Tate," Jodie Foster is automatically assumed to be a more down-to-earth person than the rich, controlling intellectual snob embodied by Dianne Wiest, as the two women vie for the love of the title character, a reticent child prodigy. Thus the woman Ms. Wiest's plays is made to look suspect simply by her preference for discreet beige, since the waitress, in contrast, has flamboyant tastes. Even though the film ultimately supports this bias (despite its brief and fraudulent happy ending), it didn't need to stack the deck so blatantly. Providing something more complex than knee-jerk economic distinctions between these women would have made for a more interesting story.

The main problem with this reverse snobbery, though, is that it can backfire. "Frankie and Johnny," Garry Marshall's bustling adaptation of Terrence McNally's play, has exemplary performances from its two stars

and a large, funny supporting cast, giving it the tenor of a hit. But it also has an unglamorous coffee shop for a setting, plus a number of dingy apartments, a bowling alley and a locker room. Has someone overestimated audiences' new taste for realism? Probably so. "Frankie and Johnny" makes a convincing case for its characters' goodness, but it might have fared better at the box office if Mr. Marshall had moved his waitress and short-order cook to a nicer neighborhood. ☐

1991 N 3, II:22:1

Sex Icon Once, Oddity Now

By CARYN JAMES

HE wore a turban and tons of eyeshadow in "The Sheik," played a Spanish bullfighter in "Blood and Sand" and was a tango-dancing fool dressed as an Argentine gaucho in "The Four Horsemen of the Apocalypse." But when Rudolph Valentino put on a powdered wig to play an 18th-century French nobleman in "Monsieur Beaucaire," his fans rejected the film as a foppish turn in the Latin lover's steamy career. "Something has happened to the Valentino of 'The Sheik' and 'Blood and Sand,' " the movie magazine Photoplay complained in 1924. "He doesn't look a bit dangerous to women." Back in the 1920's, a girl really had to watch out for those Argentine gauchos.

Valentino is the best proof that one generation's sex symbol is another's campy curiosity. Though he was one of silent film's greatest superstars, today he would be more comfortable in a Mel Brooks parody than as People magazine's sexiest man alive. When he wasn't dancing or dueling, he acted by posing in elaborate costumes and popping open his eyes to show emotion. Love, hate, surprise, any emotion at all. Even considering that exaggerated gestures were standard in silent films, Valentino lacked subtlety.

But his image — exotic, artificial, with a splash of machismo and a whiff of androgyny — spoke to the forbidden desires of the era. His short career lasted from 1921 until his

O great lover, how can you have become a parody?

death at the age of 31 in 1926. It was a hedonistic time in Hollywood, but the actors' and film makers' licentiousness arrived on screen cloaked in conventional morality, bringing what seemed like daring sexual fantasies to Middle America. Valentino's greatest role, as icon and cultural phenomenon, is the focus of "The Valentino Cult," a series that begins

tomorrow and runs through Nov. 24 at the American Museum of the Moving Image in Astoria, Queens. Among the 12 films in the series, Valentino stars in only 4. Most feature a peculiar circle of Valentino's colleagues, all of them women. There are two films starring his one-time lover Pola Negri, three starring Alla Nazimova, the flamboyant Russian actress who encouraged his career, and several featuring stunning set designs by Natacha Rambova, Valentino's second wife. It's easier to distinguish Naz.-mova from Rambova once you know that Rambova, Mrs. Valentino, was originally named Winifred Shaughnessy and born in Salt Lake City. Like her husband, whose career she heavily influenced, Rambova knew that in the movie landscape of the 20's, an exotic image was everything.

By concentrating on less familiar films, the series creates serious omissions. Three of the movies most closely tied to the Valentino image are not included: "The Sheik" (1921), "Blood and Sand" (1922) and "Son of the Sheik" (1926). It is impossible to get a complete sense of Valentino's career or importance without them. But there are some fascinating rewards here, including the film that made Valentino a star.

He had arrived at Ellis Island from Italy in 1913, still named Rodolfo Guglielmi. He became a paid tango partner in New York dance halls and eventually made his way to Hollywood and bit parts as villains and gigolos. His career took off when he danced that tango in "Four Horsemen" in 1921.

Valentino plays Julio Desnoyers, a reluctant hero in World War I. But first, he gets to be a libertine. The son of an Argentine mother and French émigré father, Julio leaves his gaucho costume behind when the family moves from Argentina to Paris.

There, Valentino wears a tuxedo and slicked-back hair. Half-naked women pose for him in his artist's studio, he becomes an instructor at the Tango Palace, and falls in love with a beautiful young woman married to an old man. After these glamorous scenes, Julio must, of course, put on a uniform and die a hero's death. He returns as a ghost to shake his finger at the young woman and encourage her to stay true to her husband.

Silly as it sounds, "Four Horsemen" is one of the few Valentino films that has more to offer than Valentino. It was directed by Rex

Ingram and written by June Mathis, two of the most successful silent-film makers, and for its time it was an extravagant, powerful accomplishment. There are effective battle scenes and symbolic images of the four horsemen from the Book of Revelation that create a sense of helplessness in the face of war. Even the title

A mix of risqué romancer and high-minded moralist.

cards give attention to detail, with decorative drawings in the corners — liquor bottles for the libertine days or cannons for war.

As Julio, Valentino seemed to be everything women wanted: an exotic-looking playboy and a moralistic hero rolled into one. It was an image he carried for the rest of his career.

In 1921 alone, three more Valentino films were released: "The Sheik"; "The Conquering Power," a flat adaptation of Balzac's "Eugénie Grandet," with Valentino as an impoverished hero, and "Camille," updated to the 1920's.

In "Camille," Valentino co-starred with Alla Nazimova, and there he met Nastacha Rambova, who created the film's Art Nouveau sets. At the time, Valentino was trying to escape from a messy marriage of convenience to Jean Acker, a lesbian actress who was more successful than he and might have helped his career. They had married on a whim, and she had slammed the door in his face on their wedding night. As bad as Valentino's acting was, sometimes his judgment was worse.

"Camille" was the kind of literary film that the artistic Rambova thought Valentino should be making; she thought "The Sheik" was junk. It was Rambova who encouraged the disastrous "Monsieur Beaucaire." Her influence became so overwhelming — and her advice so uncommercial — that she was finally barred from the sets of Valentino's films. She then proved that love is not always the conquering power, and divorced him.

But one of the most spectacular films in "The Valentino Cult" belongs to her. "Salome" (1922) stars Alla Nazimova in a version of Oscar Wilde's play that is part dance, part theater, part time capsule. The true star is Rambova's set design, adapted from Aubrey Beardsley's illustrations for the play. She created glittering black, white and silver backdrops, a stylized cage for John the Baptist's jail, painted tights for the servants and elaborately foolish headdresses. Nazimova, the star, insisted on short-skirted costumes and a simpering acting style that makes her more flapper than femme fatale, and her dance of the seven veils has more veils than movement. Still, this period piece is weirdly intense, and it shows the artistic ambitions and pretensions of Valentino's circle.

In 1926, Valentino was in New York on a tour to promote "The Son of the Sheik" when he died. The thousands of women who screamed and fainted and streamed through Frank E. Campbell's Funeral Chapel for three days ignored the unglamorous circumstances of his death: their dashing hero had died of complications from a gastric ulcer. If he had lived, it's hard to imagine he would have aged very gracefully. But his curious legend has been preserved.

1991 N 8, C1:1

Critic's Choice

Friends Who Probably Shouldn't Be

"Antonia and Jane" is the thinking person's "Thelma and Louise." In this English female-buddy movie, frumpy Jane and fast-track Antonia have a love-hate friendship. Each envies the other and thinks her own life is a flop. This does not make them hit the road and blow up an oil truck; instead, they have an annual dinner together, fret about their relationships with men, talk to their mutual psychiatrist and indulge in the occasional self-pitying fantasy. Far from being dull, the result is funny, lively and shrewd.

Jane (Imelda Staunton), the heavy one with unstylish curls and oversize glasses, has good reasons for resenting the successful, sleek-looking Antonia (Saskia Reeves). Among other slights, Antonia has married Jane's fiancé. This would crack most friendships, but there's no underestimating Jane's self-esteem.

Meanwhile, Antonia is frazzled and bored by her supposedly glamorous life in the publishing world and envious of her friend's adventures. One year Jane might con-

vert to Buddhism and the next fall for a gentle man who happens to be an escaped convict and a pretty good cook.

Beeban Kidron's vibrant, deft direction flits back and forth between the heroines' points of view and follows them into flashbacks. Marcy Kahan's wry, sophisticated script includes just enough deadpan exaggeration. Jane wastes some time on a man who must read Iris Murdoch before sex; it takes months before she can tell him she doesn't even like Iris Murdoch. Antonia has a fling with a schoolmaster whose sexual taste runs to bondage, Shakespearean allusions and marmalade. No wonder they're depressed.

"Antonia and Jane" was made for the BBC, which explains its 77-minute length. That's scarcely longer than a single psychiatrist's session, but a lot more therapeutic.

CARYN JAMES

1991 N 8, C3:3

Small Time

Directed, written and produced by Norman Loftis; director of photography, Michael C. Miller; edited by Marc Cohen and Mr. Loftis; music by Arnold Rieber; released by Panorama Entertainment Corp. At Cinema Village on 12th, 22 East 12th Street, Manhattan. Running time: 88 minutes. This film has no rating.

Vince..........................Richard Barboza
Vicky..........................Carolyn Kinebrew
Mike..........................Scott Ferguson
Peppy..........................Keith Allen
Lieut. Gallaway..........................Robert F. Amico

By VINCENT CANBY

Norman Loftis's "Small Time," opening today at the Cinema Village on 12th, records the sad life of Vince Williams (Richard Barboza), a young Harlem thief, as he goes about his business on the streets, sidewalks and subways of Manhattan.

As much a case history as a drama, "Small Time" follows Vince as he drifts from Harlem to midtown to the Upper West Side, snatching purses, hanging out with casual friends, looking for the big payoff without ever really expecting to achieve it.

Vince is the only support for his younger brother and his distracted mother, who gave birth to him when she was 13 years old. He has a girlfriend, Vicky (Caroline Kinebrew), whom he beats just as brutally as the police beat him. Vince's journey to nowhere is interrupted from time to time by sequences in which Vicky, his mother, his grade school teacher, an arresting officer and others talk about him directly to the camera.

•

Mr. Loftis, an assistant professor of literature at the City University of New York, wrote, produced and directed "Small Time" with a lot of crude conviction and a laudable lack of sentimentality. Yet Vince, like the film itself, remains an earnest but unfulfilled fictional creation.

He's a recognizable type rather than a particular individual. He's so uncharacterized that "Small Time"

seems to be less about him than about his time and place, depicted entirely by the dim graininess of the black-and-white photography and by the impoverished landscapes through which he moves.

1991 N 8, C11:1

Strictly Business

Directed by Kevin Hooks; written by Pam Gibson and Nelson George; director of photography, Zoltan David; edited by Richard Nord; music by Michel Colombier; production designer, Ruth Ammon; produced by Andre Harrell and Ms. Gibson; released by Warner Brothers. Running time: 83 minutes. This film is rated PG-13.

Bobby..........................Tommy Davidson
Waymon..........................Joseph C. Phillips
Diedre..........................Anne Marie Johnson
David..........................David Marshall Grant
Drake..........................Jon Cypher
Monroe..........................Sam Jackson
Natalie..........................Halle Berry
Millicent..........................Kim Coles
Leroy Halloran..........................Paul Butler
Roland Halloran..........................James McDaniel
Larry..........................Paul Provenza
Sheila..........................Annie Golden
Gary..........................Sam Rockwell
Mr. Atwell..........................Ira Wheeler

By VINCENT CANBY

"Strictly Business" is an utterly joyless romantic comedy about young upwardly mobile blacks who make it big by adapting themselves to the worst values of the white establishment.

Specifically, it's about Waymon Tisdale 3d (Joseph C. Phillips), a Sidney Poitier look-alike and a hotshot member of a big midtown Manhattan real estate brokerage. Waymon wears Brooks Brothers suits and is engaged to the beautiful, equally ambitious Diedre (Anne Marie Johnson) who, though black, affects the speech of the lockjawed white upper-middle class.

Waymon's life and career threaten to go out the window when he falls in love with Natalie (Halle Berry), a pretty black promoter of fashionable downtown discos. She finds Waymon hilariously square until he enlists the aid of Bobby (Tommy Davidson), a young man in the mail room. Bobby offers to teach Waymon how to be black and hip if Waymon recommends him for the office trainee program.

"Strictly Business," directed by Kevin Hooks and written by Pam Gibson and Nelson George, is a junk bond of a movie that plays as if it had been made during the economic delirium of the Reagan era. Bobby's way of helping Waymon to find his black roots is to supervise his purchase of a flashy new wardrobe. Nothing else.

This is conciousness-raising of a

A square businessman changing clothes to change himself.

sort that Armani and even Brooks Brothers might applaud. The film has the satiric edge of a damp croissant. Its characters simply want their share of a boom that no longer exists. Instead of being funny, the movie is seriously depressing.

Warner Brothers
Tommy Davidson, left, and Joseph C. Phillips

"Strictly Business" is noteworthy only for what its cast members have done elsewhere. Ms. Berry will be remembered as the foul-mouthed junkie in Spike Lee's "Jungle Fever." Mr. Davidson is a recruit from television's "In Living Color" and Mr. Phillips comes to the big screen from "The Cosby Show."

Sam Jackson, who plays a small role as the head of the office mail room, won a special award at the Cannes International Film Festival this year for his brutally fine performance as Wesley Snipes's crack-addicted brother in "Jungle Fever."

•

"Strictly Business," which has been rated PG-13 (Parents strongly cautioned), has vulgar language and scenes of simulated sex.

1991 N 8, C13:3

All I Want for Christmas

Directed by Robert Lieberman; written by Thom Eberhardt and Richard Kramer; director of photography, Robbie Greenberg; edited by Peter E. Berger and Dean Goodhill; music by Bruce Broughton; production designer, Herman Zimmerman; produced by Marykay Powell; released by Paramount Pictures. Running time: 92 minutes. This film is rated G.

Michael O'Fallon..........................Jamey Sheridan
Catherine O'Fallon..........................Harley Jane Kozak
Ethan O'Fallon..........................Ethan Randall
Tony Boer..........................Kevin Nealon
Hallie O'Fallon..........................Thora Birch
Santa..........................Leslie Nielsen
Lillian Brooks..........................Lauren Bacall

By JANET MASLIN

It isn't believable that ruggedly handsome Michael O'Fallon (Jamey Sheridan) and his pert ex-wife, Catherine (Harley Jane Kozak), are divorced. But it's no more plausible that they were ever married in the first place. Anyway, there's not much to prevent the cute O'Fallon children, Hallie (Thora Birch) and Ethan (Ethan Randall), from engineering a Christmas Eve reunion of their parents and creating the kind of warm, festive, happy-family holiday that so often brings on clinical depression in others. But the emotions on display in the vigorously heartwarming "All I Want for Christmas" are as fake as the snow.

As directed by Robert Lieberman, who has more than 800 commercials to his credit and can now chalk up another, this film is filled with good-looking people and products that appear to have walked right out of a store. (Some of the action actually takes place in a store, with Leslie Nielsen playing a Santa Claus who is given his marching orders by the take-charge little Hallie.) Everything

seems brand new and easily replaceable, which turns the idea of an O'Fallon family tragedy into a painless problem. The kids don't have to do much more than coax their father into a suit to get him back into their mother's good graces.

•

The laughable pretext for the parents' breakup is economic. Catherine, a committed yuppie, was supposedly unable to tolerate her husband's desire to run a diner in New York City, although the downscale-chic diner op-

Santa, how about a bike, a puppy and a parental reconciliation?

eration — complete with revolving door — turns out to be something of which any yuppie would be proud. And Michael's decision to live in a loft with a pool table and a skylight does not truly bespeak an ideological rift with Catherine, even though she prefers a brownstone uptown. The diner's real purpose may be to provide an excuse to plant product plugs for soda, ketchup and ice cream prominently in the film.

•

The diner does become the setting for one of the glossily insincere episodes Mr. Lieberman favors: everybody making ice cream sundaes, doing the twist to a noisy rock song and otherwise having active, photogenic fun. In a similarly pre-fab vein, the film's opening shows Ethan rushing in late to choir practice at his prep school, nearly knocking over the minister and catching his breath winsomely just in time to belt out, "Oh, tidings of comfort and joy!"

The pretty cast performs in the kind of punchy, automatic fashion this material demands, which is to say that Ms. Kozak wears Nolan Miller's costumes well and Mr. Sheridan often flashes his sheepish grin. Ethan Randall, who also co-starred in "Dutch" this year, has a exaggeratedly naïve style that would suit any prime-time sitcom, and Amy Oberer, as his beautiful girlfriend, behaves

Panorama Entertainment

Mug Shot
Richard Barboza stars in "Small Time," Norman Loftis's portrait of a young man who survives city life through crime.

Michael Ansell/Paramount
Thora Birch

exactly like a young model struggling with her first film role. Little Thora Birch, who co-starred in "Paradise," is in a different category. She's a genuinely fresh young actress whose honest, funny manner will be in peril if she takes on more assignments like this.

Also in "All I Want For Christmas," and providing a much-needed touch of class, is Lauren Bacall, who plays Catherine's enjoyably acerbic mother and presides grandly over the

story. Ms. Bacall has some funny moments shooting conversational darts at Kevin Nealon, playing Catherine's sitting duck of a boyfriend, the obligatory BMW-driving Wall Street stiff. And Ms. Bacall's brief duet with Miss Birch, as they join forces to sing "Baby, It's Cold Outside" at a party, provides the film with a tiny oasis of charm.

1991 N 8, C14:1

The Shadows Behind 3 Sun-Drenched Colonial Lives

"Overseas" was shown as part of the 1991 New Directors/New Films series. Following are excerpts from Stephen Holden's review, which appeared in The New York Times on March 27. The French-language film opens today at the 68th Street Playhouse, at Third Avenue, in Manhattan.

Brigitte Roüan's film "Overseas" brings a Jane Austen-like sensibility to the story of three sisters living in Algeria during the final years of French colonial rule. The movie's opening scenes, set in the late 1940's, present a romantic picture of French colonial life in the days before the nationalist uprising that eventually drove a million Europeans to leave the country. It is a vision that the director, who also co-wrote the film and who plays one of the sisters, spends the rest of the movie demolishing in a story that is subtly colored with Marxist and feminist overtones.

The biggest strength of the film is its ingenious structure. One by one, the movie examines the lives of the three sisters, Zon (Nicole Garcia), Malène (Miss Roüan) and Gritte (Marianne Basler), covering the same period three times. In several sequences, the film returns to the exact time and setting of an earlier scene to reveal how one sister was an uncomprehending witness to a shattering moment in the life of another.

The technique of telling the same story three times from the beginning and each time taking it a bit further helps Miss Roüan to demonstrate how characters with very different temperaments and personal histories share deeper similarities because of their class, sex and social conditioning.

Zon, the eldest sister, is obsessively in love with her husband, Paul (Philippe Galland), a strait-laced naval officer who goes off for long periods at sea, leaving her alone and usually pregnant. Pent-up, masochistic and devoutly religious, she is so male-dependent that after Paul is reported missing, she wishes only to die. Miss Garcia's performance, which is full of suppressed heat, is the film's most memorable.

The middle sister, Malène, is unhappily married to a rancher (Yann Dedet) who is uninterested in his property and lets his wife run things. Instead of eager to be the boss, Malène is ashamed and furious and lashes back in a devastating act of destruction. Gritte, the rebellious youngest sister, keeps postponing her marriage to an eligible young diplomat while carrying on a clandestine affair with an Algerian soldier.

The mood of the film is at once sensuous and detached. Until the uprisings begin, French colonial life in Algeria is depicted as a sun-drenched privileged existence in a semitropical paradise.

The narrative rhythms of the film are nimble and the stories told glancingly, with each point made quickly and the emotional resonances left understated. It is especially adept at depicting how day-to-day habits of living and personal drama can cloud political reality. At first the rebellion subtly impinges on the daily lives of people who try to ignore it. While the film portrays that sort of willful ignorance as completely understandable, it also reveals how the unthinking oppression and exploitation of the native Algerians are a product of such social and political myopia.

1991 N 8, C25:1

FILM VIEW/Edward Rothstein

Film Scores Can Make The Innocent Ominous, The Horrific Humorous

URING THE FILMING OF "LIFEboat" (1944), Alfred Hitchcock rejected the use of background music. The characters, after all, were stranded in the middle of the

ocean on a small boat; where would the music come from?

"Ask Mr. Hitchcock to explain where the cameras come from," snapped an insulted film composer, "and I'll tell him where the music comes from."

He was right, of course: both music and cameras are instruments of illusion; they do their jobs but are rarely noticed. A film score is often thought of as a variety of Muzak with only an occasional "Lara's Theme" or "Pink Panther Theme" designed to catch the ear.

Two weeks ago, though, three performances revealed just how essential music is in our understanding of film by returning to an era when soundtracks were a novelty. First, in Avery Fisher Hall, Seiji Ozawa led the Boston Symphony Orchestra in a souped-up, rescored version of Sergei Prokofiev's music for Sergei Eisenstein's "Alexander Nevsky," as the 1938 film was shown above the players' heads, in a new print. Then, at the Metropolitan Museum of Art, Armin Brunner led an ensemble from the Orchestra of St. Luke's in three of his own scores, accompanying rarely seen silent films.

I missed "Nosferatu," but the other films were operas without songs or words — the stories of "Carmen" and "Der Rosenkavalier" told through broad, silent gestures. "Carmen," directed in 1918 by Ernst Lubitsch, was actually the 10th German silent film made about the gypsy heroine; Prosper Mérimée's tale, with its mixture of sultry seduction and bourgeois dissolution, must have been irresistible for German Expressionists.

"Der Rosenkavalier" was a more direct distillation of the opera: it was made in 1926 with the assistance of the librettist, Hugo von Hofmannsthal, who fleshed out some of the opera's characters, highlighting their social positions and pretensions. Directed by Robert Wiene (of "Dr. Caligari" fame), the film turns every encounter — Octavian's trysts, Baron Ochs's leering courtship, the Marschallin's plotting — into deliberately overwrought but witty ballets of silent-movie gesture. (Its last reel has been lost.)

The task of writing scores for these films might seem simple: just use lots of Georges Bizet and Richard Strauss. But the challenge is greater than it appears. A silent film has an intricate relationship with its accompaniment.

In the early years of film, music was often miscellaneous sonic patter, designed to hide the sound of the projector and keep the ear occupied during the artificial silence. One commentator thought it had a more significant function: to "exorcise fear" in the face of "ghostly" images on the screen.

But music was also designed to reflect those images. As early as 1908, Camille Saint-Saëns was commissioned to write a silent-movie score. Later, so were Arthur Honegger, Darius Milhaud and Dmitri Shostakovich. More commonly, an organist or a pianist would play a pastiche of suitable pieces. Supplying these players with sonic grist became a small industry. One source book from the 1920's, "Motion Picture Moods," offered pieces indexed by images they suggested. "Gruesome" was represented by a Massenet

excerpt; "railroad" was illustrated by the spinning song from Wagner's "Flying Dutchman." Eventually, compiling suitable scores became a specialized profession for the "musical illustrator."

In illustrating "Carmen," Mr. Brunner used a pre-existing score — from Bizet's opera — along with miscellaneous tidbits: a little Dvorak, a touch of Falla, some Tchaikovsky, some Rimsky-Korsakov. But for every moment of audio-visual resonance, there was another of dissonance. Bizet's music, for example, was often too conversational to suit the film's dark Expressionism and too rhythmically literal-minded to properly accompany Carmen's possessed dancing.

The task was easier in "Der Rosenkavalier," since Strauss's music is less rhetorical, and the movie was created with the music in mind. The

Harvest/Harcourt Brace Jovanovich

Part of Eisenstein's analysis of a sequence from "Alexander Nevsky," showing (1) frames from the film; (2) a diagram of Prokofiev's musical phrases, represented by letters and measure numbers; (3) a condensed musical score; (4) a diagram relating individual musical measures to film shots; (5) a sketch of the pictorial composition, and (6) a graph of the combined musical and visual profiles

score's arching lines provided the film with an elaborate sonic background of passion, nostalgia and irony. But here, too, there were distractions: Mr. Brunner's use of "Also sprach Zarathustra" as accompaniment for the Field Marshal's military victory verged on camp.

The problem is that music can be more powerful than the image it accompanies. It can turn an innocent motion ominous, make a horrific event humorous, and amplify or distort psychological and emotional effects. Music is not an accessory to an image; it can direct us to the image's heart — or overturn it completely.

■

Eisenstein was obsessed with the need for an organic unity between image and sound. Prokofiev would view a "Nevsky" scene two or three times and write music precisely coordinated with the action and the rhythm of the visual images. Eisenstein even mapped out an audio-visual score for the ice-battle, in which the profile of each image was connected with the shape of the musical phrase. He thought the chords and pulses of an individual measure could match the experience of the eye in apprehending the image; the movement of the music would match the movement of the eye.

But such literal connections are not needed. As Eisenstein knew, music's power is too great, its allusiveness too broad to be restricted by narrowly pictorial notions. Prokofiev paid exquisite attention to detail, but the overall style also has a point of view. The music for the Russian peasant army, for example, has a folk character; it is innocent and exuberant, not

full of dark dread like the themes of the Teutonic knights. The score emphasizes the ancient, national character of the tale, filtering medieval elements through 19th-century musical style.

In fact, many movies — perhaps

The music that transforms an image is also transformed in return.

most — are scored using the tonal idiom and thematic techniques derived from the music of late Romanticism. As the film historian Roy M. Prendergast has pointed out, this is no accident: much movie music is deliberately operatic, suited for novelistic narratives of passion and conflict. The Romantic musical repertory, we might also say, is cinematic.

But if music can transform or amplify an image, it is also transformed in return. Movies can constrain a composition (witness Mozart's so-called "Elvira Madigan" Concerto), but they can also reveal its implications. (Atonal music is completely acceptable for movie audiences.) This is why soundtrack recordings are popular: music is invested with the film's images. After seeing "Nevsky," I found Prokofiev's cantata based on his score much more powerful than it seemed before.

The power of images makes composers nervous. Music is constantly

straining for autonomy. The mogul Irving Thalberg once asked Arnold Schoenberg what sort of an arrangement he would desire with a movie studio. "I will write music," the composer replied, "and then you will make a motion picture to correspond with it." Imagine: a 12-tone "Fantasia." □

1991 N 10, II:13:1

Images of the World and the Inscription of War

Directed and written by Harun Farocki; presented in association with Goethe House, New York. Running time: 75 minutes.

Narrator..Cynthia Beatt

1867

Directed by Ken McMullen; produced by the Program for Art on Film. Running time: 14 minutes. Film Forum 1, 209 West Houston Street, Manhattan. These films are unrated.

By STEPHEN HOLDEN

During World War II when British pilots used aerial photography to pinpoint German bombing targets in Silesia, the Auschwitz concentration camp, which was nearby, was clearly depicted in the pictures, but nothing was done to destroy it and free its prisoners. More than 30 years after the photographs were taken, they became the objects of intense study by Central Intelligence Agency officials who used them to corroborate descriptions of the camp by its survivors.

The history of those pictures forms a central motif in "Images of the World and the Inscription of War," the elliptical cinematic essay on photographic reality by Harun Faroki, the German film maker. On the agency's blowups of those photos, the dormitories, gas chamber, crematory, paths and even the truck (disguised as a Red Cross vehicle) that delivered the poison pellets to the gas chamber have all been identified and carefully labeled.

Why, the film asks, when the existence of Auschwitz was known and the means of its destruction available, wasn't it bombed? The question is underscored when the film's narrator, Cynthia Beatt, relates the story of two men who escaped from Ausch-

Science and technology at odds with spiritual enlightenment.

witz and gave Czechoslovak authorities detailed information and drawings about the camp: they were told that nothing could be done until the war was over.

●

Although these death camp images form only one of the many leitmotifs of the film, which opens today at Film Forum 1, they give "Images of the World and the Inscription of War," an anxious moral subtext. The film also examines the history of metal pressing and the use of photography in mechanical drawing.

Pictures of Albrecht Dürer's calibrated studies of the human body are contrasted with scenes of a life-drawing class and some 1960 photographs of Algerian women who until then had concealed their faces under veils. Other scenes compare a beautician's cosmetic transformation of a woman's face into an enigmatic mask with aerial photography from World War II showing camouflaged munitions factories and airfields, along with decoy bombing targets.

●

Much is made of the fact that people have to learn how to present themselves to the camera. Among the film's most disturbing images is a picture of a beautiful woman entering Auschwitz who, despite the dire circumstances, instinctively strikes an attractive pose for the photographer: a Nazi guard.

All the themes have been woven into an austere cinematic poem in which not only the images but also repeated fragments of the narration become solemn themes in a selective technological history. While refraining from grandiose pronouncements, the film demonstrates that photographic accuracy must not be confused with objective reality.

This very dour essay also implies that science and technology may have given us miraculous ways of studying the physical world, but they haven't led the way toward a deeper spiritual enlightenment. In fact, the reverse may be true.

Ken McMullen's short film "1867," which shares the bill, is a visually arresting study of Manet's series of four paintings depicting the execution of Emperor Maximilian of México in 1867. Filmed in a single uninterrupted

shot, the 14-minute film pretends to look through the eye of the painter in his studio.

A voice-over narration imagining Manet's creative process expresses his determination to be accepted in the salon and his enthusiasm for the work of Goya, which deeply influenced him. Meditations on Maximilian's life are interwoven with the painter's reflections on how it took four attempts and one and a half years to paint a single moment. Washing through the sound track, the Adagietto from Mahler's Fifth Symphony gives the film a glossy, romantic undertone.

1991 N 13, C16:6

Cape Fear

'Directed by Martin Scorsese; screenplay by Wesley Strick, based on a screenplay by James R. Webb and the novel "The Executioners" by John D. MacDonald; director of photography, Freddie Francis; edited by Thelma Schoonmaker; music by Bernard Herrmann, adapted by Elmer Bernstein; production designer, Henry Bumstead; produced by Barbara De Fina; released by Universal Pictures. At the Coronet, Third Avenue at 59th Street, Manhattan. Running time: 123 minutes. This film is rated R.

Max Cady	Robert De Niro
Sam Bowden	Nick Nolte
Leigh Bowden	Jessica Lange
Danielle Bowden	Juliette Lewis
Claude Kersek	Joe Don Baker
Lieutenant Elgart	Robert Mitchum
Lee Heller	Gregory Peck
The Judge	Martin Balsam

By VINCENT CANBY

Film cultists, here are your hats.

Martin Scorsese's "Cape Fear," a remake of J. Lee Thompson's very popular 1962 suspense melodrama about an ex-con and the family he terrorizes, is new and improved and, from time to time, so fiendishly funny that it qualifies as a horror film.

At one point this "Cape Fear" slips in its own blood, but instead of falling on its face, it achieves a new high in audience-friendly sadism. Among the film's other double-edged virtues is the way in which it pays homage to the original while, in passing, it points out everything that's wrong with it.

One should not be too appalled by what Mr. Scorsese and his collaborators are up to here. Most remakes are of movies that have some claim to singularity. Not this one.

The best thing about the Thompson "Cape Fear" (which remains ever popular in the video market) is Robert Mitchum's bewitching, lazily menacing performance as the vengeful convict. Yet even Mr. Mitchum's evil grace as an actor cannot disguise the fact that the movie is a piece of Swiss cheese.

The 1962 "Cape Fear" is a mechanical if slick exercise in fright, the kind of film for which characters have been unashamedly bent to fit the wild events they are supposed to make credible.

•

Mr. Scorsese and Wesley Strick, who wrote the new film, closely follow the outline of the original James R. Webb screenplay. Though their "Cape Fear" is no more realistic or socially significant than Mr. Thompson's, it moves with the same merciless melodramatic momentum as Mr. Scorsese's "Goodfellas." The film is sleight of hand of high order and, at carefully calculated moments, a blunt shocker.

Unlike the original, this "Cape Fear" doesn't pretend to be a picture of paradise in peril. It is apparent from the beginning that all is not well with the members of the Bowden family. They are perfect targets for all the terrible things that happen to them — if not, to a certain extent, actually responsible for them.

The setting is a small city in the Deep South called New Essex. Sam Bowden (Nick Nolte), a successful lawyer, has a roving eye. Though he may not be unfaithful in fact, his wife, Leigh (Jessica Lange), seethes with resentment, which is all the more maddening because she still likes to sleep with him.

Whether it's love or not is difficult to tell, especially for their ripe, pretty 15-year-old daughter, Danielle (Juliette Lewis). She seems to be a naturally loving and sweet-natured child but, around her parents, she is a rude, frowning, old-for-her-age presence. Their furious fights and reconciliations lead nowhere. They also exclude her.

•

The Bowdens are on their way to being seriously dysfunctional when Max Cady (Robert De Niro), smiling, small-eyed and mean, arrives in New Essex clad in a newly paroled con's idea of sharp leisure-wear. He's a visual joke, but he drives a snappy red convertible and carries murder in his heart. On his arms, below the short sleeves of his Hawaiian shirt, are some of the tattoos he acquired during his imprisonment: names of women, Biblical quotations, doodles.

On his back, unseen most of the time, is a huge black cross from which dangle the scales of justice. Max is a zealot with a most specific mission, which is to get even with Sam Bowden. It seems that 14 years earlier, Sam, acting as Max's defense lawyer, suppressed evidence that might have cleared Max of rape and battery charges.

Sam's explanation is that the crime was so brutal, and Max so clearly psychotic, that the safety of the community justified his action. The action was also made easier by the fact that Max was then illiterate. While in prison Max not only got himself tattooed, but he also taught himself to read, starting with "Spot Goes to the

Farm" and working his way up to books on law.

Max is as clever as he is mad. He begins to haunt Sam in ways that menace but aren't legally actionable or can't be traced to him. The family dog is poisoned, though that could have been done by anybody. One of Sam's close friends is attacked but refuses to press charges. Then Max goes after the unhappy, bewildered Danielle.

Posing as her new drama teacher, he telephones Danielle and asks her to meet him the next afternoon on the stage in the school auditorium. The sequence that follows is as haunting as anything Mr. Scorsese has ever directed. It's not a chase but a seduction, the wolf coming on to Red Riding Hood with talk of Henry Miller and offers of marijuana and sympathy.

Though Danielle recognizes Max, she is willingly implicated in his scheme. It is one of Mr. De Niro's finest moments. It also reveals Miss Lewis to be a new young actress of stunning possibilities. The sequence is the heart of the movie.

"Cape Fear" goes on, relentlessly, up and over the melodramatic top in a succession of highly effective but far more conventional cat-and-mouse games, including one that recalls "Psycho." Blood flows freely, bodies accumulate in reckless numbers, while Max becomes even harder to dispatch than Rasputin.

Mr. Nolte, looking new and lean and virtually born again, and Miss Lange do very well in the not initially promising roles played by Gregory Peck and Polly Bergen in the original. Mr. Peck himself shows up to give a brief but surprisingly effective performance as Max's lawyer, a handsome, string-tied old Southern gentleman who is probably as crooked as they come.

•

Mr. Mitchum and Martin Balsam, also of the original cast, are on hand, too, in effect to bless the new venture. Freddie Francis, the gifted English cameraman who has directed his own stylish horror films ("Dr. Terror's House of Horrors"), was the cinematographer. Preserved more or less intact, though not quite as overwhelming as it once was, is Bernard Herrmann's musical score for the original film, adapted, arranged and conducted by Elmer Bernstein."

Philip Caruso/Universal Pictures

Robert De Niro, foreground, and, from left, Nick Nolte and Jessica Lange, in "Cape Fear."

Mr. Scorsese is having fun with "Cape Fear," at heart a shaggy-dog story, but he brings to it the same manic intensity and innovative techniques evident in his more solemn work. "Cape Fear" is pure make-believe. Among other things, the South it inhabits looks to be almost completely white.

Stay away if you're squeamish but, if you do, you'll miss an essential work by one of our masters, as well as two of the year's most accomplished performances, those of Mr. De Niro and Ms. Lewis.

•

"Cape Fear," which has been rated R (Under 17 requires accompanying parent or adult guardian), has a lot of violence, blood and vulgar language.

1991 N 13, C17:1

Beauty and the Beast

Directed by Gary Trousdale and Kirk Wise; animation screenplay by Linda Woolverton; original score by Alan Menken; songs by Howard Ashman and Mr. Menken; edited by John Carnochan; produced by Don Hahn. A Walt Disney film distributed by Buena Vista Pictures Distribution Inc. At Cinema 1, Third Avenue at 60th Street. Running time: 84 minutes. This film is rated G.

Voices of:

Belle	Paige O'Hara
Beast	Robby Benson
Gaston	Richard White
Lumiere	Jerry Orbach
Cogsworth	David Ogden Stiers
Mrs. Potts	Angela Lansbury
Chip	Bradley Michael Pierce

By JANET MASLIN

Two years ago Walt Disney Pictures reinvented the animated feature, not only with an eye toward pleasing children but also with an older, savvier audience in mind. Disney truly bridged a generation gap with "The Little Mermaid," bringing the genre new sophistication without sacrificing any of the delight.

It's not surprising that an attempt has been made to replicate that success with "Beauty and the Beast," a film that takes a similar view of its audience and transfers some of the earlier film's most inspired staging ideas from an underwater setting to 18th-century France. But it is a surprise, in a time of sequels and retreads, that the new film is so fresh and altogether triumphant in its own right. Lightning has definitely struck twice.

With "Beauty and the Beast," a tender, seamless and even more ambitious film than its predecessor, Disney has done something no one has done before: combine the latest computer animation techniques with the best of Broadway. Here, in the guise of furthering a children's fable, is the brand of witty, soaring musical score that is now virtually extinct on the stage. "The Little Mermaid" was similarly a showcase for the extraordinary songwriting talents of Alan Menken and Howard Ashman, but this time the music is even more central. Broadway is as vital to this film's staging and characterizations as it is to the songs themselves.

•

Since "Beauty and the Beast" is a work of Disney animation, it also has its own traditions and its own purview. No live-action musical could ever match the miracles of anthropomorphism that occur here, or the fantastically sweeping scale. Nor could a live-action work achieve this

A scene from the new Walt Disney Pictures animated film "Beauty and the Beast."

The Walt Disney Company

mixture of elaborate, painstaking technique and perfect simplicity. "Beauty and the Beast" is filled with affectionate homages to the live-action sources that have inspired it, and indeed those influences are strong. But its overriding spirit is all its own.

If this "Beauty and the Beast" is a long way from Jean Cocteau's 1947 black-and-white version, it's also a long way from the original fairy tale, which has been largely jettisoned in favor of a more timely story. This film's Beauty, called Belle, is the smartest, best-read person in a small provincial French town. As such, she is hotly pursued by Gaston, the lantern-jawed he-man who is initially the butt of the film's jokes and later becomes its villain. "The most beautiful girl in town," Gaston decides about Belle, in his booming bass tones. "That makes her the best. And don't I deserve the best?" Thoughts like that make "Beauty and the Beast" an amusingly clear product of its time.

•

Wandering through her village while reading a book, Belle becomes the focus of a spectacular opening number that captures the essence of this film's appeal. Bit by bit, the population trickles out to greet Belle and gossip about her, while she herself bemoans the small-mindedness of the place. This rousing number reaches such a flurry of musical counterpoint that it recalls sources as unlikely as "West Side Story," while the direction builds energetically from quiet beginnings to a formidable finale. The directors, Gary Trousdale and Kirk Wise, have been plucked out of relative obscurity (i.e. a short film shown at Epcot Center) in one of many remarkable casting coups here, and they acquit themselves beautifully.

So does Robby Benson, the actor chosen out of far left field to provide the voice of the Beast. Mr. Benson's usually soft timbre has been so al-

tered and amplified (by the growls of real panthers and lions) that it is virtually unrecognizable, but a crucial hint of gentleness remains. And his vocal performance, as an initially surly and frightening Beast who must be tamed by his household bric-a-brac before he can win Belle's love, is so convincing that it eradicates all memory of his mild manner.

That bric-a-brac, enchantingly cast and conceived, includes Angela Lansbury as the voice of Mrs. Potts, a kindly-teapot and the mother of a snub-nosed little cup named Chip (Bradley Michael Pierce); Jerry Orbach as the surprisingly Chevalier-like voice of Lumiere, a debonair candelabrum; David Ogden Stiers as Cogsworth, a proper English clock, and a footstool that wags its tassels and barks like a dog. All of these inventions, along with others like a dust mop with the cap and beauty mark of a French chambermaid, join forces to define the film's idea of magic, especially when at last the objects' true natures are revealed.

•

"Be Our Guest," the lavish production number that is a dry-land answer to "Under the Sea" from "The Little Mermaid," may not have the identical calypso charm, but it has just about everything else, including Busby Berkeley-style choreography carried out by dancing silverware. The jaunty Lumiere sings:

Soup du jour, hot hors d'ouevres
Why, we only live to serve
Try the gray stuff, it's delicious
Don't believe me? Ask the dishes!

This demonstrates Mr. Ashman's gifts as an outstandingly nimble lyricist. His death from AIDS in March at age 40 cut short a brilliant career, but the jubilant energy of his work will long live on.

Because of its wider ambitions, "Beauty and the Beast" is less intent on sweetness than on making its sto-

ry's central point (which is slightly undercut when the Beast is ultimately revealed to be a paragon of bland handsomeness beneath his glowering exterior). It is more darkly forbidding and at times more violent than the average animated children's fable. But it also has more to say. Belle's intelligence and bravery are

A footstool wags its tassels and barks.

as well conveyed as the fatuousness beneath Gaston's handsome exterior, all of which gives the story a modern flavor. Paige O'Hara and Richard White, supplying the voices, do wonders in bringing Belle and Gaston to life.

Gaston is the subject of another outstanding song, a musical lambasting to a tune vaguely reminiscent of "Captain Hook," from "Peter Pan." Mr. Menken's melodies, always buoyant and captivating, are familiar only in a way that bespeaks good sense and great taste. By far the songwriters' biggest triumph is the title song, which becomes even more impressive in view of the not-very-promising assignment to create a "Beauty and the Beast" theme song.

•

But the result is a glorious ballad, one that is performed in two versions, as both a top-40 style duet heard over the closing credits and a sweet, lilting solo sung by Ms. Lansbury during the film's most meltingly lovely scene. For the latter, which also shows off the film's dynamic use of computer-generated animation, the viewer would be well advised to bring a

hanky. And Mr. Menken should make room on the shelf where he keeps his Oscars.

1991 N 13, C17:4

Correction

A list of credits with a film review last Wednesday about "Beauty and the Beast," an animated feature from Walt Disney Pictures, omitted the art director. He is Brian P. McEntee.

1991 N 20, A3:1

Meeting Venus

Directed by Istvan Szabo; written by Mr. Szabo and Michael Hirst; director of photography, Lajos Koltai; edited by Jim Clark; music by Richard Wagner; production designer, Attila Kovacs; produced by David Puttnam; released by Warner Brothers. At the Fine Arts, 4 West 57th Street, Manhattan. Running time: 120 minutes. This film is rated PG-13.

Karin Anderson...............................Glenn Close
Zoltan Szanto Niels Arestrup
Von Schneider..........................Marian Labuda
Maria Krawiecki..........................Maite Nahyr
Stefano Del Sarto.......................Victor Poletti
Jorge Picabia.......................Erland Josephson
Monique Angelo...............Johanna Ter Steege
EdithDorottya Udvaros
Yvonne................................Maria de Medeiros
Role of Elisabeth....Voice of Kiri Te Kanawa

By JANET MASLIN

BEHIND the scenes in the elegant world of grand opera, there is at least as much scheming, flirting and back-stabbing as there is anywhere else. That is the message of "Meeting Venus," a thoroughly enjoyable backstage drama that also functions as a political parable, since the opera company under consideration is a hotbed of prickly national stereotypes. "This is the Opera Europa," one member of the film's large international cast explains. "Here you can be misunderstood in six different languages." There is also a seventh: the language of love.

Glenn Close, lofty and radiant as a world-famous Swedish diva, makes a perfect centerpiece for the film's romantic intrigues, which constantly threaten to upstage the production of Wagner's "Tannhäuser" that is in the works. As Karin Anderson, she makes a spectacularly nonchalant grand entrance by arriving late at the Paris opera house where rehearsals have begun and by offering genteelly effusive greetings to everyone except the conductor, Zoltan Szanto (Niels Arestrup), who gets a dirty look.

Every bit the prima donna, Karin is feeling spiteful over remarks she thinks Zoltan made regarding her age, sexual preference and general operatic talent. Zoltan, for his part, is almost too busy to notice, because he is being slyly pursued by most of the young women in the company and because he has a wife and daughter back home in Budapest. "Dear Edith, Everything moves so slowly here, apparently due to democracy," he writes in one of his

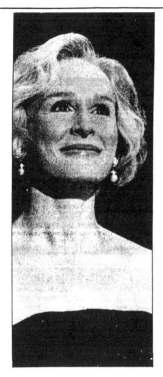

Glenn Close as Karin Anderson, a Swedish opera diva.

Niels Arestrup

Warner Brothers

national or political identity on their sleeves.

•

There are also more than enough eccentricities to go around, from the huge, amorous, spaghetti-loving diva who is Karin's co-star to the debonair, balding office assistant whose exact sex is a mystery. Mr. Szabo allows the film's many individual characters to emerge sharply, and he has assembled a remarkably well-rounded international cast. Among the more conspicuous players are Erland Josephson as the gentlemanly company director; Maria de Madeiros, who starred in "Henry and June" and flashes Zoltan her most cryptic and inviting smile, and the arresting Dutch actress Johanna Ter Steege, who starred in "The Vanishing," as a singer who fights Zoltan's favoritism toward the utterly magnetic Karin.

Ms. Close's serene, ladylike bearing is not an asset in every role, but this time it works wonderfully well, especially when combined with the avid seductiveness she brings to the character. Mr. Arestrup, at first stern and a little drab, proves to be an equally fine choice, since he moves so easily into a conductor's courtly, dedicated manner, one that easily explains his popularity with women in the company. Dorottya Udvaros, a Hungarian actress, has some powerful moments with Mr. Arestrup as Zoltan's proud, angry wife, who discovers her husband's affair and reacts with exceptional fury.

"Meeting Venus" has musical credits that are at least as critical as its dramatic ones, since much of the film's appeal lies in the musical backdrop for its story. Most notable are Kiri Te Kanawa, whose voice is heard as Karin Anderson's, and the Philharmonia Orchestra of London, which provides accompaniment. In this film's opening scenes, actors playing orchestra members are seen scratching their backs with bows and flying paper airplanes, which contributes to the air of casualness that is gradually banished as the production takes shape. By the time of the film's stirring ending, it's clear that each of these incidents, no matter how small, has played a role in shaping an opening night's triumph.

•

"Meeting Venus" is rated PG-13 (Parents strongly cautioned). It includes sexual situations.

1991 N 15, C1:3

Fist of the North Star

Directed by Toyoo Ashida; screenplay by Susumu Takahisa, based on the graphic novels by Buronson and Tetsuo Hara; dialogue written and directed by Tom Wyner; photography by Tamiyo Hosoda; music by Katsuhisa Hattori; produced by the Toei Animation Company, released by Streamline Pictures. At Cinema Village Third Avenue, near 12th Street, Manhattan. Running time: 100 minutes. This film has no rating.

Voice Cast:
Ken ... John Vickery
Julia Melodee Spivack
Raoh ... Wally Burr
Shin Michael McConnohie
Rei ... Gregory Snegoff
Bat .. Tony Oliver

By STEPHEN HOLDEN

"Fist of the North Star," a Japanese animated action-adventure film, offers one of the more brutalizing examples of a malaise that permeates pop culture: technological dazzle as a substitute for content.

Set in a postnuclear wasteland that shares some similarities with the world of "Mad Max," this "splattertoon," as its distributor calls it, purports to be a cautionary tale about the use of lethal weapons. But it is really a 100-minute orgy of blood and martial-arts violence carried on by futuristic Neanderthals so mountainously proportioned they make Arnold Schwarzenegger look like a 97-pound weakling.

•

A spinoff from an illustrated series of Japanese novels that has also produced a television series, comic books and Nintendo's Game Boy video games, "Fist of the North Star" pits Ken, a heroic martial-arts virtuoso with magical powers, against a band

The moral: There's more than one kind of lethal weapon.

of mutant giants who have captured his icky flower-child sweetheart, Julia.

What the film, which opens today at the Cinema Village Third Avenue, lacks in coherent storytelling, it partly makes up for in visual flash. Tetsuo Hara, its artistic mastermind, has created a spectacularly creepy cityscape of corpse-strewn tunnels and crumbling bombed-out skyscrapers, and the evil warriors exceed one's nightmares of heavy-metal thugs bent on pure evil.

But in its carelessly translated and poorly dubbed English adaptation,

Streamline Pictures
Ken in "Fist of the North Star"

the characters express themselves in diction so stiff that they seem ludicrously prissy. Even the obscenities sound stilted.

1991 N 15, C8:1

Revolution

Directed and written by Jeff Kahn; director of photography, Michael Stiller; edited by Chris Tellefson; music by Tom Judson; produced by Travis Preston. At the Public, 425 Lafayette Street, Manhattan. Running time: 84 minutes. This film has no rating.

Suzy .. Kimberly Flynn
Ollie Christopher Renstrom
Steve Johnny Kabalah
Billie George Osterman
Kasha Helen Schumaker
Prunievsky Travis Preston

By VINCENT CANBY

Jeff Kahn's "Revolution" is an earnest, intentionally clunky low-budget satire of Marxism as practiced by three passionate young East Villagers, who are unaware that they're at least a quarter-century out of date.

The leader of this very small ring is Ollie, who sits all day in the bathtub reading "Das Kapital." He shares his pad with Suzy, a sometime dress designer and artist who dreams of a new world order, and Steve, a rich boy and an irrepressible naif who is inclined to say such things as, "Hey, guys, when are we going to have this revolution?"

Hanging out with them, though not politically committed, is Billie, a sad, hairy fellow whose performing career as a transvestite has been cut short by the sexual revolution. The film opens today at the Public Theater.

•

At its best, "Revolution" recalls the early work of Jean-Luc Godard. There are also times when it seems to be sending up Godard's "Femme Est une Femme" and "Bande à Part," though it's difficult to tell in a film in which the line between parody and incompetence is so finely drawn. Mr. Kahn's ideas are funnier in theory than in practice.

About one-third of the film is set on the Long Island estate of Billie's rich aunt, who has asked her nephew to keep an eye on things. After several days in the lap of bourgeois luxury, the three would-be revolutionaries

The Public Theater
Kimberly Flynn

many letters home, letters that grow less and less candid as events in Paris begin to set off sparks. "I cannot mix up my work with my private life," Zoltan eventually declares during an afternoon tryst in Karin's hotel room. And both of them burst into giggles at that.

Although "Meeting Venus" which opens today at the Fine Arts and takes it title from the character in "Tannhäuser," is steeped in the refined atmosphere of grand opera, its conception of artistic ferment recalls other backstage films about other realms, like François Truffaut's "Day for Night" and Bob Fosse's "All That Jazz." The characters' various romances, rivalries and insecurities are skillfully coaxed toward a creative triumph, while the film maker also takes time to savor the human comedy at hand. Istvan Szabo, the director of "Mephisto" and "Colonel Redl," may not match Truffaut's subtle wit or Fosse's galvanizing energy, but he has a wry, bemused outlook that keeps "Meeting Venus" on track. And this film's heightened political outlook gives it an added dimension.

"Is it my face that irritates them or just the stale smell of Eastern Europe?" Zoltan wonders, as his passport is too closely examined by French officials in the film's plain, almost pedestrian opening scenes. In this way, Mr. Szabo's characters constantly combine personal and political attributes, even when — especially when — they are reduced to the level of calling one another names. Resorting to crude national stereotypes takes on the quality of caricature, as do various arguments about the fate of European Communism, arguments that inevitably go nowhere. From the company director with a Socialist past to the short, stocky Tannhäuser, who is accused of "German aggressiveness" by a colleague, those in the film wear their

spend more time discussing John McEnroe's tennis game than the politics of that bearded old German prophet.

It all ends badly, sort of, when Billie's aunt returns prematurely with her new lover, whose identity is supposed to be a comic surprise. The film is divided into chapters ("Let the Ruling Classes Tremble," "The Struggle Continues," among others), with the contemporary action punctuated by short clips from old Russian movies.

•

There are also some song-and-dance interludes, the best of which is "Death in Venice, California," sung by Suzy (Kimberly Flynn) in a manner to suggest both Lotte Lenya and Marlene Dietrich.

Mr. Kahn's first feature as the writer and director, "Revolution" is an amiable effort.

1991 N 15, C8:4

Cheap Shots

Directed and written by Jeff Ureles and Jerry Stoeffhaas; director of photography, Thom Marini; edited by Ken McIlwaine; music by Jeff Beal; production designer, Carl Zollo; produced by William Coppard, Mr. Stoeffhaas and Mr. Ureles. At Cinema 3, 2 West 59th Street, at the Plaza Hotel, Manhattan. Running time: 92 minutes. This film is rated PG-13.

Louie	Louis Zorich
Arnold	David Patrick Kelly
Dotty	Mary Louise Wilson
Jack	Michael Twaine

"Cheap Shots," opening today at Cinema 3, is a melodramatic comedy of gloomy ineptitude and amateurishness, about the owner of a run-down motor court who becomes involved in a murder plot. The film was made in Batavia, N.Y., by Jeff Ureles and Jerry Stoeffhaas. The two writers and directors are described in the publicity kit as "the resident critics for the Little Theater," a successful movie theater in Rochester. It is their first feature.

•

"Cheap Shots," which has been rated PG-13 (Parents strongly cautioned), has some vulgar language and partial nudity.

VINCENT CANBY

1991 N 15, C11:1

Hearing Voices

Directed, written and produced by Sharon Greytak; cinematographer, Doron Schlair; music, Wes York; a Phoenix International release of a Sharon Greytak production. At Village East Cinemas, Second Avenue and 12th Street, Manhattan. Running time: 87 minutes. This film has no rating.

Erika	Erika Nagy
Lee	Stephen Gatta
Michael Krieger	Tim Ahern
Carl	Michael Davenport

By JANET MASLIN

Erika (Erika Nagy), the photographer's model who is the heroine of Sharon Greytak's "Hearing Voices," has two shelves in her bathroom, one for things that make her feel beautiful and the other for those that make her feel otherwise. On the latter shelf, beneath the potions and perfumes,

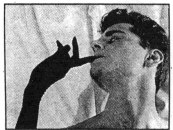
"Hearing Voices"
A scene from "Hearing Voices."

are the medical supplies Erika needs for tending to her ileostomy, which is a source of much psychic pain.

The film deals frankly with Erika's medical condition, and even more so with the problems it has created. From the vain, unpleasant boyfriend who taunts her about this intestinal bypass to the doubts Erika now feels about modeling and making herself a kind of merchandise, the film contrasts culturally acceptable notions of beauty with the disability that shapes Erika's inner life. Ms. Greytak is more successful in formulating that dichotomy than in giving Erika's private feelings much color.

The walls and settings are mostly blank in "Hearing Voices," which opens today at the Village East Cinemas. And the characters are almost equally devoid of personality. Those characters, aside from Erika, are the above-mentioned boyfriend (Michael Davenport), who is also a model and wants Erika to pose for a cigarette advertisement; her doctor (Tim Ahern), who unfeelingly uses her as an exhibit to be studied by medical students, and the doctor's more sensitive lover, Lee (Stephen Gatta), with whom Erika eventually begins an affair. The romance between this gay man and heterosexual woman is so slowly developed and talky that it never seems real, not even when the two are seen practicing very safe sex by making love with their underwear on.

Although Ms. Greytak presents her heroine's situation thoughtfully, she seldom enables Erika to speak in a lifelike way. ("He thought I'd be needy and dependent, with few options," Erika says of her former beau.) Awkward as it is in developing its characters, this somber, downbeat film becomes haunting when it silently observes Erika ceding various parts of her body — a black-gloved arm, a sturdy leg, a dispassionate face — to the fashion industry that she both needs and despises.

1991 N 15, C11:1

And You Thought Your Parents Were Weird

Directed and written by Tony Cookson; director of photography, Paul Elliott; edited by Michael Ornstein; production designer, Alexander Kicenki; produced by Just Betzer; released by Trimark Pictures. Running time: 92 minutes. This film is rated PG.

Sarah Carson	Marcia Strassman
Josh Carson	Joshua Miller
Max Carson	Edan Gross
Walter Kotzwinkle	John Quade
Steve Franklin	Sam Behrens
Voice of Matthew Carson	Alan Thicke
Alice Woods	Susan Gibney

By JANET MASLIN

The starry skies, cute prodigies and perky suburban family are redo-

lent of a Steven Spielberg movie, but even Mr. Spielberg would balk at the premise of "And You Thought Your Parents Were Weird," in which two boys invent a miraculous, E. T.-size robot. This robot, which Josh and Max Carson (Joshua Miller and Edan Gross) call Newman, is an obvious substitute for their father, who committed suicide two years earlier. That would be fine if the father did not then return to inhabit the robot's body. But he does, playing Frisbee with his sons

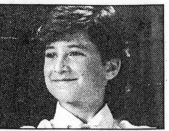
Trimark
Edan Gross

and saying things like "I've got good hands, considering they're aluminum."

The merriment in this is forced, to put it mildly. The father's tendency to wisecrack ("I've been trying to get back for a long time, but you know me with directions") borders on the bizarre. Even when he explains that the suicide was merely a fatal accident, the film never picks up much good

cheer, nor does it gain anything from weak subplots involving bullies and spies who want to steal the boys' invention. As a special nod to Bill and Ted, it is also revealed that Dad became close friends with Albert Einstein in the spirit world.

•

"And You Thought Your Parents Were Weird" has a low-budget look and a lot of strained wholesomeness, although it works best when its eccentricities are allowed to show. The hulking, shaggy-haired Mr. Miller has the manner of a real teen-ager, which sets him apart from most actors who play them on the screen. His scenes with Mr. Gross mark the film's least self-conscious moments and are a big improvement over any scenes in which live actors have to converse with the robot/Dad (which has the voice of Alan Thicke).

Marcia Strassman, looking very blond, plays the boys' mother and is actually required to dance fondly with the robot, even though it is part colander and part vacuum cleaner. This is more a display of good sportsmanship than good acting.

•

"And You Thought Your Parents Were Weird" is rated PG (Parental guidance suggested). It includes very mild profanity and sexual references.

1991 N 15, C13:1

A Collector's Inventory of the Renaissance World

"Prospero's Books" was shown as part of the 1991 New York Film Festival. Following are excerpts from Vincent Canby's review, which appeared in The New York Times on Sept. 28. The film opens today at the Angelika Film Center, Mercer and Houston Streets, in Manhattan.

"Knowing I lov'd my books, he furnish'd me from mine own library with volumes that I prize above my dukedom." Thus speaks Prospero when, early in "The Tempest," he tells his daughter, Miranda, how they came to be living on this isolated isle. Though Prospero's dukedom was usurped by his brother, and though he and the 3½-year-old Miranda were sent into exile, all was not perfidy.

Gonzalo, an honest old counselor of Milan, saw to it that Prospero was set adrift with his books. In 12 years of exile, Prospero has used those books to assert his dominance over earth, air, fire and water, and all of the creatures therein, real and imagined. Knowledge, the accumulated learning of the known and unknown worlds since time's beginning, has given to Prospero powers whose limits even he does not fathom.

It is no accident, then, that Prospero's lines about his library are the recurring theme heard and seen throughout "Prospero's Books," Peter Greenaway's initially splendiferous and finally numbing new film phantasmagoria.

Among other things, the movie is a kind of obsessed collector's inventory

Miramax
John Gielgud

of the Renaissance world, its thought, art, architecture, religion, superstitions, music, painting and, well, anything else that might be mentioned.

This tumultuously overpacked movie is less a screen adaptation of Shakespeare's haunting and elegiacal last play than it is a grand jumping off spot for a work that will make some people run boldly for the exits and some quite angry.

The movie is a challenge unlike any other. It is certainly not for anyone

who does not know "The Tempest" well, preferably as well as Mr. Greenaway's incomparable star, John Gielgud.

It was Mr. Greenaway's conceit, and a terrifically promising one, that in this "Tempest" Mr. Gielgud's Prospero should also be a mirror

Peter Greenaway pays homage to Shakespeare and to John Gielgud.

image of Shakespeare at the end of his career, with a further association to the actor himself, nearing the end of his career as an actor.

•

As Mr. Greenaway pictures it, Prospero still rages over the wrongs done him by his brother Sebastian and Alonso, the King of Naples. As Prospero stands waist-deep in the water of his bathing pool, he imagines

a drama in which his magic brings on the tempest that shipwrecks the conspirators on his shore.

At the same time Prospero, as Shakespeare, is writing the play's text, which is pictured in delicate Renaissance script that again calls attention to the film's concerns with thought, knowledge, books. Prospero, who is creating this fiction in his mind, speaks the lines of all the characters as they take shape, and with the full relish and authority that only Mr. Gielgud can command.

For most of the film, Mr. Gielgud is playing to himself, which might be a feast for the ears except that much of the time his voice is overlaid with the voice of whichever character he is playing. This results in an eerie echo effect that often renders the language incomprehensible, to say nothing about the confusion as to what, really, is going on.

Mr. Gielgud holds his own against all of the magnificent technical effects, but just barely. George Bernard Shaw wrote that "the poetry of 'The Tempest' is so magical that it would make the scenery of a modern theater ridiculous." This still is true.

1991 N 15, C15:1

FILM VIEW/Caryn James

Jesuits vs. Indians, With No Villains

"BLACK ROBE" MIGHT BE called, without a hint of disrespect, a priest-and-Indians movie. Bruce Beresford's film, about a French Jesuit missionary in 17th-century Canada, is filled with the kind of action and intensity found in old westerns. As a young priest named Laforgue makes his way from Quebec to a distant Huron Indian mission, he is aided by friendly Algonquins, abducted and tortured by Iroquois, mocked by a dwarf shaman with bright yellow paint on his face and lost in a visually magnificent and deadly cold forest.

But because this is a 1990's film, the Frenchman comes to question the righteousness of his own culture, and that is where the true, unusual power of "Black Robe" lies. Adapted by Brian Moore from his novel, the film evenhandedly depicts the integrity of the Indians and the sincerity of the Jesuits. In an era of Columbus bashing, it criticizes cultural imperialism without creating villains; it is as politically correct as "Dances With Wolves," but its hero does not experience a simple-minded conversion to Indian ways, as if he had been bumped on the head. There is much wrongheaded behavior in "Black Robe," but no evil intentions, which makes the cultural tug of war it depicts sadder and more lucid than it usually is on screen.

■

Laforgue (played by the Canadian actor Lothaire Bluteau) can be rigid and obtuse in his treatment of the Indians, but there is no doubt that his passion to baptize them is rooted in the deepest faith. He goes to Canada after seeing a priest who has been mutilated by Indians, his face scarred and an ear missing. "The savages did this," the older priest says. Laforgue sees this as a compelling reason to bring his faith to a godless people. He is willing but not eager to become a martyr.

In Canada, the Jesuit's religious rules quickly come up against the Algonquins' resistance and spiritual beliefs. All the Indians' questions about this baffling Christianity are

Samuel Goldwyn

Harrison Liu, August Schellenberg and Lothaire Bluteau in "Black Robe"—modern attitudes in 17th-century Canada

common-sensical. The film never treats them with condescension, as if their doubts were childish. It makes perfect sense when an Algonquin woman wonders whether Laforgue is a demon because black robes, as the Indians call priests, never have sex. "Why make such a promise?" the Indians ask, and they are not the first or last to do so.

But Laforgue's celibacy is based on an unshakable belief in his religion. When he happens to see the woman and his translator, a young Canadian named Daniel, making love in the woods, the priest silently watches until he cries. Later, when Laforgue flogs himself for having had impure thoughts and urges Daniel to join in this penance, the film has already shown that his reaction is not simple

'Black Robe' depicts a cultural tug of war that is sadder for being evenhanded.

self-righteousness and his vow of celibacy no easy promise to keep.

And when Laforgue tells the Algonquins that there will be no tobacco and no sex in heaven, that "you will be happy just to be with God," who can blame them for being skeptical? "Why would I go to your paradise?" an Algonquin chief asks. "Are my people there? There are only black robes."

By the time Laforgue is left to wander alone toward the Huron mission, he has come to respect the Algonquin beliefs that dreams can portend reality and that the dead can talk at night. But he never loses his sense that the Jesuits "have been sent by our God, who is the God of us all."

"Leave him alone!" an Algonquin woman cries when Laforgue offers his God's love to a dying Indian, and her plea to let the man die in peace is thoroughly sympathetic. Laforgue is exasperating in his insistence that Christianity offers the only key to heaven, but he must be respected for his motives.

The strength of Laforgue's characterization is most evident when compared to Daniel's, for the young translator is the film's least convincing figure. He instantly loses his cultural prejudices, falls in love with an Algonquin woman and tells Laforgue he should respect the Indians' belief in dreams. "Is it harder to believe that than to believe there is a paradise where we all sit around on clouds and look at God?" Daniel asks. That is the question the film asks its audience, and "Black Robe" becomes preachy when it puts those words so easily in Daniel's mouth.

Such simplicity pulls against the terrible irony at the movie's end. When Laforgue arrives at the Huron mission, he finds a community wary of conversion. If they become Christians, "We will stop being Hurons and our enemies will know our weaknesses and kill us," one of them tells Laforgue. That is precisely what happened. Though the film concludes with a group baptism and Laforgue's apparent triumph, a printed epilogue appears on screen to reveal that within 15 years the Huron tribe would be destroyed.

"Black Robe" makes its way through these moral issues with the same tough-minded determination Laforgue displays as he struggles through the woods — which sets this film apart from Mr. Beresford's glib, Oscar-winning "Driving Miss Daisy." Yet the film never turns into a series of talky set pieces. Laforgue and the Algonquin chief discuss death and paradise while captives of the Iroquois, who have just murdered a child and plan to kill the others in the morning. "If you cry out when you die, they will have your spirit," the Algonquin chief advises Laforgue. This is no abstract discussion, but one filled with urgency. "Black Robe" pulls off a nearly impossible trick, combining high drama with high ideas. □

1991 N 17, II:24:2

Uncle Moses

Directed by Sidney Goldin and Aubrey Scotto, based on the novel by Sholem Asch; in Yiddish with English subtitles; re-released by the National Center for Jewish Film. At Film Forum, 209 West Houston Street, Manhattan. Running time: 87 minutes. This film has no rating.

Uncle Moses	Maurice Schwartz
Masha	Judith Abarbanell
Charlie	Zvee Scooler
Moses' father	Rubin Goldberg
Aaron	Mark Schweid

By JANET MASLIN

Slow, deliberate and dapper, he inspires respect in some and fear in others. As the most conspicuously rich and powerful member of an immigrant community in New York City, he enjoys all the obeisance that his status demands. Sound familiar? It is, but only up to a point. "Uncle Moses," the newly restored 1932 Yiddish drama opening today at the Film Forum, is the story of a Jewish godfather, and as such it has its own distinctive flavor.

So in the obligatory big wedding scene, there are seltzer bottles on the celebrants' tables. And a young man professing love for his sweetheart is able to do so while drying dishes and speaking of Karl Marx. When the title character, a widower turned ladies' man, describes his dream of being reproached by his deceased wife, his nephew's most pertinent question is, "Did she speak Yiddish or English?" "Fifty-fifty," Uncle Moses replies.

●

"Uncle Moses," which is based on a 1918 novel by Sholem Asch (originally published in The Jewish Daily Forward in serial form), offers today's audiences a glimpse of Maurice Schwartz, who was billed as "the greatest of all Yiddish actors" in original advertising for the film. Mr. Schwartz, also described as the "Olivier of the Yiddish stage," was indeed a commanding actor, especially when playing a character as forceful as this.

Uncle Moses presides over a sweatshop in which the tailors have begun to talk of unionizing, and yet he still has the temerity to ask, "What's so terrible about working for me?" When told of gas leaks, broken windows and the absence of an oven in which his workers can cook their meals, Uncle Moses seems thoroughly unperturbed. His easy paternalism also extends to women, who generally dote on him because of his great wealth, although there is one exception. When Masha (Judith Abarbanell), the daughter of one of Uncle Moses' workers, denounces this man of means, calling him "Brute, beast, dog!," the boss falls hopelessly in love.

●

The film unfolds slowly through a series of talky, extended encounters as it follows Uncle Moses' attempts to win Masha's heart. In order to do this, he must also purchase the affections of her parents, who are easily swayed by gifts of furs, clothing and what Masha's mother calls a "grand baby" piano. On the way to an unhappy marriage, Uncle Moses finds himself changing enormously, from the physical and tonsorial alterations he affects to please Masha (the film offers a glimpse of a primitive exercise machine) to deeper changes. This godfather's spiritual progress from vain, insensitive mogul to gentler patriarch is the film's real subject.

Mr. Schwartz's performance is sometimes geared to the stage, as is

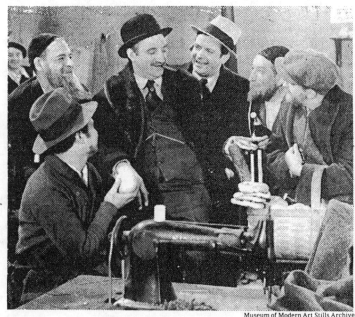

Museum of Modern Art Stills Archive

Maurice Schwartz, center, in the 1932 Yiddish film "Uncle Moses."

most of the direction by Sidney Goldin and Aubrey Scotto; characters

A sweatshop boss is reformed by love in a story by Sholem Asch.

often sit and chatter uninterrupted for long stretches of time. But Mr. Schwartz makes Uncle Moses a remarkably lifelike and immediate figure, a man whose vanity, pride and

inner doubts are as believable now as they were when the film was made. The actor's authority is unmistakable, as is the humanity that keeps "Uncle Moses" from descending into caricature.

Especially worth noting are Uncle Moses' way of managing simultaneously to bemoan and to brag about his life of luxury, the fact that signs of prosperity include a large stomach (on Uncle Moses) and the freedom to attend high school (for Masha's sibling), and of course the language. For this film's immigrant characters, "Who you think you are — Tsar Nicholas?" is an insult to remember.

1991 N 21, C18:4

The Addams Family

Directed by Barry Sonnenfeld; written by Caroline Thompson and Larry Wilson, based on the characters created by Charles Addams; director of photography, Owen Roizman; edited by Dede Allen; music by Marc Shaiman; production designer, Richard MacDonald; produced by Scott Rudin; released by Paramount Pictures. Running time: 102 minutes. This film is rated PG-13.

Morticia Addams	Anjelica Huston
Gomez Addams	Raul Julia
Uncle Fester Addams	Christopher Lloyd
Tully Alford	Dan Hedaya
Abigail Craven	Elizabeth Wilson
Granny	Judith Malina
Lurch	Carel Struycken
Thing	Christopher Hart
Wednesday Addams	Christina Ricci
Pugsley Addams	Jimmy Workman

By JANET MASLIN

EVEN those of us who have not forgotten the past seem condemned to repeat it, at least as far as American popular culture is concerned. Yesterday's com-

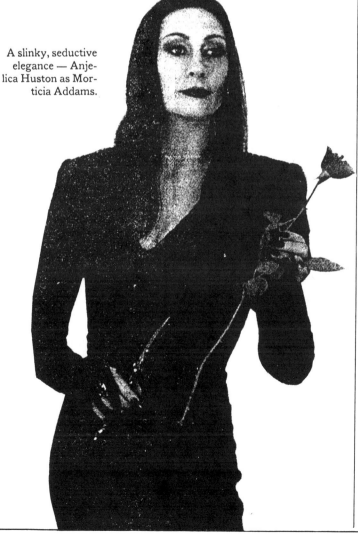

A slinky, seductive elegance — Anjelica Huston as Morticia Addams.

ic strips, television shows and B-movies simply will not die. Historians in the future are sure to wonder why so much talent, money and energy now go into preserving artifacts that once seemed so disposable, or why the original story idea has become an endangered species. But for the time being, making elaborate mountains out of vintage molehills is a favorite form of enterprise. From "Dick Tracy" to "The Jetsons" to "The Brady Bunch," no sitcom or superhero is safe from remake fever.

Still, it's amazing how much originality can sometimes be brought to bear upon projects that are in no way new. "The Addams Family," derived from the Charles Addams drawings that spawned the mid-1960's television show, is a lavish, funny revival that goes well beyond the limits of its original sources, thanks to ingenious casting, droll production design, spirited direction and dazzling camera tricks. It also has a script filled with workable one-liners and a collection of amusing props. All that's wrong is that "The Addams Family" was never conceived as a movie in the first place. No amount of cleverness can change the one-note nature of the material.

"The Addams Family" begins with the sight of Christmas carolers, then lets the camera pan upward until its finds the Addamses all set to pour a caldron of hot liquid upon these happy souls. This familiar Charles Addams image is as perfect a representation of the artist's ethos as anyone could ask for, and indeed it has the

Now snap those fingers! 'They're creepy and they're kooky . . .'

effect of Addams's drawings: dry, wicked and wholly self-contained. The film, to its credit, perfectly grasps the tone of Addams's humor and re-creates it again and again, but only in similarly isolated instances. Stringing together an assortment of these moments is no substitute for telling a story, and "The Addams Family" has virtually no story at all.

The slender plot, from a screenplay credited to Caroline Thompson and Larry Wilson, has a mother-and-son team of con artists (Elizabeth Wilson and Christopher Lloyd) scheming to steal the Addams fortune as the son impersonates Fester, the beloved long-lost brother of the Addams patriarch, Gomez (Raul Julia). Privy to this touching family reunion are the Addams children, Wednesday (Christina Ricci) and Pugsley (Jimmy Workman), who enjoy trying to harm each other in creative ways; the Granny (Judith Malina), who draws some of her cooking ideas from "Gray's Anatomy," and Lurch (Carel Struycken), who hands the children lunch bags filled with living creatures before school each day.

Of course there is also Morticia (Anjelica Huston), loving mummy extraordinaire. "Is that for your brother?" she asks Wednesday, upon catching the little girl with a carving knife. Then she takes the knife away, chiding, "I don't think so." Next, Morticia fondly hands her daughter a much bigger, meaner-looking cleaver to be used instead. In another highly characteristic moment, Morticia gazes compassionately at her husband and says, "Don't torture yourself, Gomez. That's *my* job."

Peering out regally from what is proving to be one of the great faces of the American screen, Ms. Huston makes Morticia a scene-stealing delight. She also slinks through the film conveying much of the elegance that gives the Addamses their hauteur. (The Addams brand of ghoulishness was always decidedly upper-crust; Lurch, after all, is the butler who chauffeurs the children to school.)

Paramount/Melinda Sue Gordon

Raul Julia

Among Ms. Huston's most slyly funny moments are her guided tour of the family graveyard and her visit to a school, where she offers a group of toddlers an outraged reading of "Hansel and Gretel." Morticia sees this tale as grossly unfair to the witch.

•

Ms. Huston's seductive, deadpan manner sets the tone for the rest of the film as she trades tempestuous pleasantries with the debonair Mr. Julia ("Unhappy, darling?" "Oh, yes, completely!") and instructs her children. ("What do we say?" Morticia asks when Wednesday requests salt at the dinner table. "Now!" Wednesday demands, to her mother's approval.) The children, who are particularly good and perform with just the right solemn concentration, show that they have absorbed their parents' teachings when they demand to know whether Girl Scout cookies are made from real Scouts, and when they turn a grade-school dramatic production into Grand Guignol.

Making his directorial debut, the excellent cinematographer Barry Sonnenfeld (whose credits include the Coen brothers' "Raising Arizona," "Blood Simple" and "Miller's Crossing") gives the film a visual wit to match its screenplay's ghoulish gags. Mr. Sonnenfeld's direction owes a lot to Tim Burton (of "Batman," "Beetlejuice" and "Edward Scissorhands") in its funhouse cleverness and its eagerness to rewrite the laws of nature. So Thing, formerly the half-hidden family pet, is now a lively disembodied hand (played by Christopher Hart) that skitters all over the mansion, with the camera speeding along at ground level to follow it. Very often, Mr. Sonnenfeld sends the camera hurtling off to observe what the props are doing (the bearskin rug on the floor opens its mouth and growls) before returning to the characters' own tricks.

But the film's aimlessness and repetitiveness eventually become draining. And its small touches often work better than its more elaborate ones, like an extended party sequence that seems awkward and largely unnecessary. There are also times when the minor characters' acting, like Ms. Malina's exaggerated dottiness, is just too overbearing to be fun. Owen Roizman's bright cinematography (in the midst of so much ghoulishness), Mark Shaiman's jaunty score and the presence of the rapper Hammer on the soundtrack are worth mentioning, as is a scene in which Gomez mentions wanting to watch "Gilligan's Island" on television. Someday maybe he'll see it on the big screen.

•

"The Addams Family" is rated PG-13 (Parents strongly cautioned). It includes mild profanity, brief violence and various grisly innuendoes.

1991 N 22, C1:1

For the Boys

Directed by Mark Rydell; screenplay by Marshall Brickman, Neal Jimenez and Lindy Laub, story by Mr. Jimenez and Ms. Laub; director of photography, Stephen Goldblatt; edited by Jerry Greenberg and Jere Huggins; music by Dave Grusin; production designer, Assheton Gorton; produced by Bette Midler, Bonnie Bruckheimer and Margaret South; released by 20th Century Fox Film Corporation. At the Ziegfeld, 141 West 54th Street, Manhattan. Running time: 148 minutes. This film is rated R.

20th Century Fox/François Duhamel

Bette Midler

Dixie Leonard	Bette Midler
Eddie Sparks	James Caan
Art Silver	George Segal
Shephard	Patrick O'Neal
Danny	Christopher Rydell
Jeff Brooks	Arye Gross
Loretta	Dori Brenner
Phil	Bud Yorkin
Corrine	Melissa Manchester

By JANET MASLIN

The hardest thing Bette Midler has to do in "For the Boys," the big, sweeping multi-hanky musical in which she plays a U.S.O. entertainer named Dixie Leonard, is to pretend to be shy. When in 1942 Dixie is first approached to tour with an established star named Eddie Sparks (James Caan), she is all butterflies. Can she perform before a large crowd? Will she get over her jitters? The film may dwell on these questions, but its audience knows full well that Dixie Leonard, being a lot like Ms. Midler, can bring down the house even if she's playing an open-air arena in a war zone.

That's the point, of course. "For the Boys," which is opening today at the Ziegfeld, is a custom-tailored showcase for Ms. Midler's talents, and it offers her a role in which screen character and offstage persona are powerfully intertwined. In the 1940's, a period toward which Ms. Midler has always shown an affinity, an actress with a personality this strong would always have fused her own larger-than-life image with that of whomever she was playing. Today that happens less often, but Ms. Midler has wisely taken the bull by the horns. Acting as one of her own producers, she has seen to it that "For the Boys" offers her an appealing, frank, always pivotal leading role, one that no one else could have played.

"For the Boys," directed by Mark Rydell, is at its best when concentrating on Dixie, which it does most of the time. First seen in elaborate makeup as a tough-talking, embittered old broad, she feigns infirmity but still manages to convey great reserves of grandmotherly zip. This makes a strong contrast with the film's next sequence, in which the elderly Dixie remembers her first encounter with Eddie Sparks. Looking rosy, young and vital, Ms. Midler is an instant crowd-pleaser. And when she takes the stage with Eddie and walks off with the show, she takes command of the movie as well.

•

"For the Boys" follows Eddie and Dixie through 50 years of what is essentially a rocky friendship and stormy business relationship, but not much more. This is surprising in view of the film's extravagantly romantic style and its portentous sense that some crucial development between Dixie and Eddie may be in the offing. In fact, the real emphasis is on Dixie as the mother of Danny, who is a small boy in the 1940's scenes and a soldier by the time the film gets to Vietnam. In a way, "For the Boys" makes a clever choice in presenting Ms. Midler more as a noble, long-suffering mother figure with a flair for wisecracks than as a garden-variety romantic heroine.

But even allowing for its lack of romantic chemistry (despite a fleeting one-night encounter that has Dixie back to her same old scathing remarks in the morning), the film has trouble with its central relationship, in part because James Caan never makes Eddie the magnetic figure he is supposed to be. Never credible as a famous song-and-dance man (although he displays more than enough temper and vanity for a star's role) and looking more like a world-weary carnival barker, Mr. Caan's Eddie is too easily upstaged by his partner and not enough of a foil. The screenplay, by Marshall Brickman, Neal Jimenez and Lindy Laub, never seems entirely certain of what it wants to see happening between them.

Dixie works better in big, sometimes shamelessly sentimental tableaux than she does in intimate settings anyhow. This film's most touching moments generally occur either on Christmas or when Dixie and Eddie bring their act to war-torn places, first to North Africa, where Dixie is tearfully reunited with her husband and serenades him with "Come Rain or Come Shine" before a large, appreciative military crowd.

•

Manipulative as this is, it presents Ms. Midler with some remarkable opportunities for heartstring-pulling, which she does especially well during the film's wrenching Vietnam chapter. Many other films have covered this territory, and done it better. But when Ms. Midler performs an eerily delicate, anthemlike rendition of "In My Life" to a group of soldiers who have come face-to-face with their own mortality, she adds something new. It's a moment that lingers long after the film is over.

Ms. Midler's performance, even in a role as patently flattering and theatrical as this one, has an edge of candor that keeps her seeming very real. "For the Boys" is also deft in recapitulating various cultural landmarks of its time frame, from the ways in which pinups have changed through different wars to the progress of network television and its conventions. The film's brief, sardonic looks at television are often clever, and it even attempts a scene in which Dixie champions a blacklisted associate (who has been fired while wearing a Santa Claus suit at Christmas). "Me! Who always thought Karl was the sixth Marx brother, after Zeppo!" she complains after being punished by her network for this outburst.

Also in "For the Boys" are George Segal as the uncle who helps give Dixie her start, Arye Gross as the nice young man who coaxes her onto television one last time, Dori Brenner as an early colleague and Christopher Rydell as the grown-up Danny, and such ringers as Melissa Manchester and Bud Yorkin in small roles. The cast is big and helpful, but the star is always at center stage.

•

"For the Boys" is rated R (Under 17 requires accompanying parent or adult guardian). It includes sexual innuendoes and off-color language.

1991 N 22, C12:1

My Father Is Coming

Directed and produced by Monika Treut; written (in English and German, with English subtitles) by Ms. Treut and Bruce Benderson; presented by Tara Releasing. At the Angelika Film Center, Mercer and Houston Streets, Manhattan. Running time: 82 minutes. This film has no rating.

Hans	Alfred Edel
Vicky	Shelley Kästner
Annie	Annie Sprinkle
Joe	Michael Massee
Lisa	Mary Lou Graulau
Ben	David Bronstein

By STEPHEN HOLDEN

In "My Father Is Coming," a comic fantasy by the German film maker Monika Treut, New York's Lower East Side is a cheerful cornucopia of kinkiness where genders and sexual preferences aren't simply bent — they're twisted into corkscrews.

Vicky (Shelley Kästner), the film's central character, is an out-of-work German actress who shares a Lower East Side apartment with a flamboyantly gay roommate, Ben (David Bronstein). When her stuffy Bavarian father, Hans (Alfred Edel), arrives for a visit loaded down with a wurst and a Dustbuster, Vicki, who has written home that she is married, insists that Ben pose as her husband. But the ruse is shattered when daddy catches Vicky in bed with Lisa (Mary Lou Graulau), the lesbian chef in the restaurant where Vicky is a waitress. Lisa is one of two lovers Vicky juggles indecisively. Her boyfriend, Joe (Michael Massee), is a sulkily handsome female-to-male transsexual who handles a cigarette with the intense self-consciousness of James Dean in "Rebel Without a Cause."

The film's biggest joke is that the jowly, sour-puss Hans adapts more easily to New York than his daughter does. No sooner has he arrived than he lands a fluke job in a television commercial. And while accompanying Vicky to an audition for a safe-sex porn film, he becomes instantly enamored of its director and star, Annie (the X-rated film actress and performance artist Annie Sprinkle). A twinkly fairy godmother of erotic pleasure, Ms. Sprinkle bears an eerie resemblance to Billie Burke as Glinda the Good Witch in "The Wizard of Oz." But instead of a magic wand, she brandishes an array of vibrators, harnesses and other sexual paraphernalia. It is largely through Annie's ministrations that Hans learns sexual tolerance.

"My Father Is Coming," which opens today at the Angelika Film Center, is a film whose resolutely wholesome attitude at least partly compensates for a weak screenplay, uneven performances and eccentric cinematography. It is so sweetly matter-of-fact about its characters and their tics that its tone borders on the saccharine. If everyone could take a leisurely spin through these liberated streets, the film imagines wistfully, our sexual anxieties would be allayed and all consenting adults could couple happily ever after and in any way they pleased.

Considering its subject, the movie, which is not rated, is quite demure. Its explicitness does not go beyond the soft-core.

1991 N 22, C12:5

At the Max

Creative consultant and location director, Julien Temple; concept by Michael Cohl; directors of photography, David Douglas and Andrew Kitzanuk; edited by Daniel W. Blevins; an IMAX Corporation Production. At the Beacon Theater, Broadway at 74th Street. Running time: 90 minutes. This film has no rating.

WITH: The Rolling Stones: Mick Jagger, Keith Richards, Charlie Watts, Ron Wood, Bill Wyman; Chuck Leavell; Matt Clifford; Bobby Keys; Crispin Cioe; Arno Hecht; Hollywood Paul Litteral; Bob Funk; Bernard Fowler; Lorelei McBroom; Sophia Jones.

By JANET MASLIN

What do the Rolling Stones have in common with King Kong? A lot, now that their likenesses can be seen blown up to superhuman scale on a movie screen 56 feet high. Thanks to the new process called IMAX, previously used mostly for scenes of frisking animals at places like the American Museum of Natural History, the Rolling Stones can be seen in "At the Max" towering awesomely over audiences at the Beacon Theater.

From the viewer's standpoint, this is indeed an imposing spectacle, one that gives new meaning to the title World's Biggest Rock Stars. And it's the closest the Stones' fans can get to the band without being arrested.

IMAX is still cumbersome, which means that only recently have the cameras been able to accommodate eight-minute film magazines. (Before that, it would have been impossible to make a concert film without interrupting each song.) And the film reels are so enormous that this 89-minute feature requires an intermission halfway through. More noticeable from the viewer's standpoint is the way the scale of the immense IMAX image varies with the camera's location, which can be somewhat disconcerting. The Rolling Stones can look colossal when shot from the front; the camera seems to be virtually at their feet. But in a panoramic shot of the stage taken from the side, the band suddenly becomes very small.

IMAX/BCL

n the Road Mick Jagger and eith Richards are seen in "At the ax." Julien Temple's documentary bout the Rolling Stones, filmed in IAX, covers the group's concerts in erlin, London and Turin, Italy, during 1989-90 Steel Wheels/Urban angle Tour.

At such close range, the rough edges of a performance might be expected to show up, but in the Stones' case the opposite is true. The big revelation here is the utter professionalism with which a Stones performance is staged. The viewer can see everything from the Teleprompter-like electronic device at center stage, which notes things like the song being performed and which costume Mick Jagger is supposed to be wearing, to the thoroughly practiced, even theatrical manner of Mr. Jagger's delivery. From this perspective, the audience is sure to notice that the star has become a superb athlete and that he has a great tailor.

Mr. Jagger's tendency to skip all over the stage in huge stadiums (the settings of the several shows at which this film was made) becomes a challenge for the IMAX format. And he often seems to be playing to the crowd rather than to the cameras. When two huge balloon likenesses of women appear during the band's performance of "Honky Tonk Women," for instance, it's hard to tell what Mr. Jagger is doing with the balloons until one huge foot accidentally taps him on the head; that's about all the IMAX image can fit in. Meanwhile, back at center stage, the rest of the band seems far more comfortable. Keith Richards and Ron Wood are glimpsed smiling and joking together, and Mr. Richards delivers a jubilant version of "Happy." Bill Wyman remains stolid except when Mr. Jagger tries to muss up his hair. And Charlie Watts sits sphinxlike at the drums, occasionally flashing that great, bemused grin.

•

"At the Max," with Michael Cohl billed as an executive producer and Julien Temple as its "creative consultant and location director," records the band's 1989-90 "Steel Wheels" tour in a set consisting mostly of old chestnuts. "Street Fighting Man," "Sympathy for the Devil," "Ruby Tuesday" and "Satisfaction" are all heard, along with a few newer tales like "Sad Sad Sad" and "Rock and a Hard Place." The performance, nice and loud, is almost perfunctory as the show begins, but it heats up gratifyingly as it goes along. Among the more remarkable IMAX contributions are some amazing high-contrast, stop-motion images that turn the once-psychedelic "2,000 Light Years From Home" into something resembling Pop Art, and a startling close-up of the cowbell that's used to begin "Brown Sugar." Like everything else here, it's pretty monumental.

•

"At the Max" is unrated. It includes profanity and sexual suggestiveness, of course.

1991 N 22, C15:1

An American Tail
Fievel Goes West

Directed by Phil Nibbelink and Simon Wells; screenplay by Flint Dille; story by Charles Swenson; created by David Kirschner; songs by James Horner and Will Jennings; music by Mr. Horner; produced by Steven Spielberg and Robert Watts; released by Universal Pictures. Running time: 80 minutes. This film is rated G.

Voices:
Fievel Phillip Glasser
Wylie James Stewart
Mama Erica Yohn

Universal

Fievel

Tanya Cathy Cavadini
Papa Nehemiah Persoff
Tiger Dom DeLuise
Miss Kitty Amy Irving
Cat R. Waul John Cleese
Chula Jon Lovitz

By STEPHEN HOLDEN

"An American Tail: Fievel Goes West" continues the saga of the Mousekewitzes, a plucky family of immigrant mice who, in the animated 1986 hit "An American Tail," made their way from Czarist Russia to America, naïvely believing they would find the streets paved with cheese.

The sequel finds the family living a miserable hand-to-mouth existence in a New York City tenement and longing for a better life. Young Fievel Mousekewitz, whose voice is again supplied by Phillip Glasser in a piping boyish voice, dreams of becoming a Wild West lawman like his idol, the

An animated family saga continues in the Old West.

legendary canine Wylie Burp. His sister, Tanya, yearns to be a singer.

Once again, the family is lured by false promises to pull up stakes and head west. Along with other impoverished mice, they join a cross-country migration to the frontier town of Green River. Masterminding the move is a suave, scheming feline, Cat R. Waul, who plans to ensnare the entire rodent community in a giant mousetrap. John Cleese, the voice of Cat R. Waul, gives the sales pitch just the right tone of supercilious villainy.

•

In addition to the Mouskewitz family, Tiger, the cat who is Fievel's best friend and the movie's answer to Bert Lahr's Cowardly Lion, returns from the original film, again in the voice of Dom DeLuise. In one of the sequel's wittier scenes, Fievel and Tiger, who find themselves separately stranded in the wilderness, glimpse each other but fail to connect, each believing the other to be a mirage.

When Fievel finally makes it to Green River, he meets his hero, who turns out to be a broken-down layabout. After Fievel rouses him to action, Wylie teaches the fearful Tiger how to impersonate a ferocious dog, and the three set about thwarting the mass extermination. It is left to the old sheriff, whose voice is James Stewart, to deliver the movie's fuzzy-headed homily: "You pulled me out of a gutter. Just remember, Fievel, one man's sunset is another man's dawn."

"Fievel Goes West" is not as insistent as its forerunner on being an allegory about turn-of-the-century immigrants. The film, directed by Phil Nibbelink and Simon Wells from a screenplay by Flint Dille, is really a bland, randomly connected series of adventures involving the Mouskewitz children, Tiger and his girlfriend, Miss Kitty, a sultry barroom chanteuse. While the quality of the animation is above average, the film's visualization of the American West is surprisingly dull. The movie has little narrative drive or emotional resonance, and its final action sequences seem perfunctory and tacked on.

The film features two original songs with music by James Horner and lyrics by Will Jennings. "The Girl I Left Behind," a peppy bluegrass number, is performed by Tanya in the Green River saloon, where she makes a sensational debut under the aegis of Miss Kitty. Cathy Cavadini, the voice of Tanya, also sings "Dreams to Dream," a saccharine ballad that is this film's answer to the original movie's hit song, "Somewhere Out There." It is reprised over the final credits by Linda Ronstadt.

1991 N 22, C21:1

Hearts of Darkness: A Film Maker's Apocalypse

Written and directed by Fax Bahr and George Hickenlooper; documentary footage by Eleanor Coppola; director of photography, Vittorio Storaro; edited by Michael Greer and Jay Miracle; music by Todd Boerlelheide; production designer, Dean Tavoularis; produced by George Zaloom and Les Mayfield; released by Triton Pictures. At Film Forum 3, 209 Houston Street Running time: 96 minutes. This film is rated R.
With: Francis Ford Coppola, Robert Duvall Dennis Hopper, Frederic Forrest, John Millius, Martin Sheen and others.

By JANET MASLIN

There have been few sharper portraits of the film maker as alchemist than "Hearts of Darkness: A Film Maker's Apocalypse," in which Francis Ford Coppola is seen struggling with hellish logistical problems, wildcard actors, freak accidents and other unseen demons, then ultimately pulling a miracle out of his hat. Previously seen on Showtime, "Hearts of Darkness" opens today at the Film Forum. It's well worth close scrutiny on a large screen.

The filming of Mr. Coppola's "Apocalypse Now" in the Philippines, mostly in 1977 and '78, presented rare opportunities for a journalistic fly on the wall, opportunities rendered that much more interesting when the fly

Drugs, illness, civil strife and a monsoon are part of a documentary.

turned out to be Eleanor Coppola, the director's wife. Mrs. Coppola, who earlier wrote about her experiences in an account called "Notes," shot some documentary material while the film crew was on location, and had close access to the events that

tormented her husband. She was also well acquainted with the particular brand of high-strung creative ferment that is Mr. Coppola's stock in trade, and that in the case of "Apocalypse Now" tested the limits of his capacity for courting disaster.

•

"We were in the jungle, there were too many of us, we had access to too much money, too much equipment — and little by little we went insane," Mr. Coppola is heard saying, at one of the many times either he or his wife equates the film maker's experience with the journey into spiritual torment described in Joseph Conrad's "Heart of Darkness," upon which "Apocalypse Now" was loosely based. Grandiose as that parallel may sound, this documentary by Fax Bahr and George Hickenlooper lends it credence. The cast and crew of "Apocalypse Now" clearly came apart at the seams during the 238 days of principal photography, as a result of strain, isolation, considerable drug use and, of course, the weight of Mr. Coppola's ambitions. "My greatest fear is to make a really pompous film on an important subject, and I am making it," he is overheard saying on his wife's tape recording of one of his phone calls.

Interviewed recently, Mrs. Coppola observed that the making of "Apocalypse Now" became for her husband "a metaphor for a journey into self: he has made that journey and is still making it." Fortunately, this documentary is usually a lot more specific as to just what journey the director was on, and what obstacles he faced.

Assuming control of a long-deferred project, one that had once been planned by Orson Welles (before "Citizen Kane") and that Mr. Coppola himself expected to make before "The Godfather," he declared plans for a relatively modest $13 million undertaking. Among the things that

Showtime
Francis Ford Coppola on location for filming of "Apocalypse Now."

destroyed any hope of such simplicity or economy were a major monsoon, civil unrest in the Philippines, the firing of one leading man (Harvey Keitel) and the serious heart attack suffered by his replacement (Martin Sheen), and the 11th-hour arrival of a colossally unhelpful Marlon Brando, whose haunting appearance in the finished film is revealed here as a major triumph of mind over matter.

Sitting bare-chested in the jungle, talking a mile a minute about his grand plans, Mr. Coppola was clearly as much affected by chemical influences and creative pressures as anyone in his cast or crew. A directorial command like, "Everyone land in the rice paddies and we'll have a meeting," as the Wagnerian helicopter assault on a Vietnamese village was being filmed, helps to convey the sheer unreality of the situation. So do genial claims by the screenwriter, John Milius, that the film was meant to resemble "The Odyssey," with its Playboy bunnies substituting for sirens (Mr. Coppola at times preferred to call it "The Idiodyssey"). Never being exactly sure what he was after, Mr. Coppola planned to "take John's screenplay and kind of mate it with whatever happened in the jungle."

What happened was that the actors got high and improvised endlessly. Mr. Sheen, who says he seldom touched alcohol, appeared drunk and naked in a wrenchingly painful Saigon hotel-room scene he barely remembered shooting the actors' call sheets, according to Frederick Forrest, often summoned the performers for nothing more precise than "scenes unknown." Dennis Hopper, arriving to play a photojournalist late in the film, appeared so cheerfully incoherent that the director could tease him about forgetting his lines: "It's not fair to forget 'em if you never knew 'em!"

Interspersing present-day interviews with the principals with Mrs. Coppola's on-location scenes, this film saves for last the director's most staggering challenge: figuring out what to do when Marlon Brando arrived grossly overweight (to play a version of Conrad's skeletal Kurtz), unfamiliar with "Heart of Darkness" and determined to hold up production with days' worth of discussion about his character. In desperation, Mr. Coppola is heard weighing his alternatives and finally deciding it's best simply to let Mr. Brando improvise and hope something usable will emerge.

"See, I not only have to come up with a scene, but it has to be the right shape to fit into the jigsaw puzzle," Mr. Coppola is heard saying. And astonishingly, Mr. Brando's scenes delivered exactly what the film needed, in a remarkable display of an actor's ability to achieve magical effects in purely intuitive ways.

Even allowing for the aggrandizing nature of a film largely shot by his wife, Mr. Coppola emerges from this portrait in legitimately heroic terms. He may have brought on much of the trouble and confusion, and he may not always have reacted to crises in the nicest ways ("If Marty dies I want to hear everything is O.K. until I say Marty is dead!" he exclaims, when threatened with a shutdown after Mr. Sheen's heart attack.) But he also provided the inspiration and the vision to cut through utter chaos and create perhaps a better film than the one he originally imagined. "Hearts of Darkness" shows how it was done.

1991 N 27, C9:1

My Girl

Directed by Howard Zieff; written by Laurice Elehwany; director of photography, Paul Elliot; edited by Wendy Greene Bricmont; music by James Newton Howard; production designer, Joseph T. Garrity; produced by Brian Grazer; released by Columbia Pictures. Running time: 102 minutes. This film is rated PG.

Harry Sultenfuss............................Dan Aykroyd
Shelly DeVoto........................Jamie Lee Curtis
Thomas J. Sennett........................Macaulay Culkin
Vada Sultenfuss........................Anna Chlumsky
Phil Sultenfuss........................Richard Masur
Mr. Bixler........................Griffin Dunne
Gramoo Sultenfuss........................Ann Nelson
Dr. Welty........................Peter Michael Goetz
Nurse Randall........................Jane Hallaren

By JANET MASLIN

Here are two notable facts about Macaulay Culkin, currently America's youngest movie star. One: his voice is changing, since he's now 11 years old. And two: he plays nothing more than a supporting role in "My Girl," even though the surprise success of "Home Alone" (which was released before this film began shooting) owed so much to his natural comic talent and his flair for the double-take shriek. Expecting this funny, unaffected young actor to spend most of his time on the sidelines, as the makers of "My Girl" do, is a little like trying to defy gravity — and just about as smart.

Mr. Culkin is not even the "my" in "My Girl," since the film is chiefly about the girl herself. She is Vada Sultenfuss (Anna Chlumsky), and the film's case of the cutes extends well beyond that name. Vada's father, Harry (Dan Aykroyd), is a playful mortician who kids around in the embalming room and is accused of "cremating" the food at the backyard barbecue. Harry's new assistant is Shelly DeVoto (Jamie Lee Curtis), a zany cosmetologist who assures her employer: "I promise I'll take good care of these people. They deserve it. They're dead. All they've got left is their looks." Too much of the film's wit is in this same funny-as-a-corpse vein.

There are also gags about the senility of Vada's grandmother (Ann Nelson) and the little girl's fanciful hypochondria, which has her deciding at one point that she has prostate cancer. Only slightly less ghoulish is the budding romance between Harry, who has been a widower since Vada's mother died in childbirth, and the unnaturally pert Shelly, who is supposed to be just thrilled to be taken on a date to a bingo game. Mr. Aykroyd,

looking rotund and rather hangdog, makes a very unlikely romantic lead. Ms. Curtis tries gamely but unconvincingly to appear smitten.

•

Also in the film are Griffin Dunne as the creative-writing teacher on whom Vada has a crush and Richard Masur as Harry's livelier, funnier brother. And then there's Mr. Culkin as Thomas J. Sennett, Vada's best friend. Thomas J., as he is called, is almost always second banana to the pretty, tomboyish Vada until the fateful day when he does something so foolhardy that it gets him killed. The fact that Mr. Culkin dies in this film has been widely publicized, but the circumstances are so farfetched and awful that they defy belief.

It's not hard for the maudlin "My Girl" to make its audience weepy at the sight of America's favorite kid in an open coffin. But it is difficult for this film to mix the sugary unreality of a television show with such a clumsy and manipulative morbid streak. The screenplay, by Laurice Elehwany, is a collection of loose ends bound together only by intimations of mortality and family crisis, not to mention a vague notion of Vada's coming of age. All of these matters, incidentally, are handled with infinitely more grace by another current family drama with a young tomboy as its heroine, "The Man in the Moon."

As directed by Howard Zieff, "My Girl" has a bizarrely light tone and an awkward pace, in part because it's hard for the director to keep track of the story's many half-developed subplots. The film's few laughs arise from Ms. Curtis's eagerness to put blue eye shadow on every corpse (the year is 1972, although not much about the costumes or backgrounds supports that) and Ms. Chlumsky's exaggerated bluntness. Ms. Chlumsky is a poised, lovely young actress whose competence is in a different league from Mr. Culkin's gifts as a remarkably funny Everykid. Whenever they appear together, she gets the close-ups but he steals the scene.

•

"My Girl" is rated PG (Parental guidance suggested). It includes adult sexual references, talk about puberty and numerous references to death.

1991 N 27, C15:1

Summer Love
In "My Girl," Macaulay Culkin portrays a shy youngster who befriends a precocious young tomboy (Anna Chlumsky). The film, set in the 1970's, also stars Dan Aykroyd and Jamie Lee Curtis.

Columbia Pictures

FILM VIEW/Caryn James

Reality Comes With the Popcorn

AS MACAULAY CULKIN ENTERED a theater for a preview of his new film, "My Girl," an "Entertainment Tonight" reporter asked the 11-year-old a very adult question. Should children see a film in which the beloved Macaulay Culkin dies? His predictable answer was yes, but his reason unusually commonsensical. "They ought to know it's a movie," he said with a shrug, as if only a grown-up could possibly have asked such a dimwitted question. Macaulay Culkin's is not an objective opinion, but his unaffected answer explains a lot about the popularity of the "Home Alone" hero: he reflects the attitudes of savvy 90's children.

Inside that theater, though, parents and children might have squirmed and sniffled at the funeral scene, the most upsetting in this dark, sentimental comedy about a girl's coming-of-age and her best friend's death. The Culkin character, Thomas J., was allergic to bees. He is laid out in his coffin with bee stings covering his dead little face. His friend, an 11-year-old named Vada (Anna Chlumsky), throws herself on the coffin, crying and wailing: "Where are his glasses? He can't see without his glasses."

We're a long way from the Good Ship Lollipop here, and whether that's for better or worse is a moot question. The harsh fact is that many children's movies are scrambling to keep up with what today's kids know. "My Girl," which opened Wednesday, is only a mediocre movie. You can take a 10-year-old to the film without fearing permanent damage, but don't expect it to be one of the cherished experiences of that child's life. Yet the film and the mini media flap surrounding it are important, because they focus attention on the escalating presence of death, violence and other ugly realities in children's films.

Parents will have to explain death to small children who see "My Girl." But in the last year they've already had to explain the Persian Gulf War, unless they let Peter Jennings do it for them in his Saturday-morning children's special; what the police accused Peewee Herman of doing in a pornographic-movie theater; why Magic Johnson quit playing basketball, and what it means that he has the AIDS virus. With such issues bombarding children on television and becoming topics for playground discussions, a PG movie about death doesn't seem like such a stretch.

But as films keep pace with ever more knowledgable children, parents are understandably rattled. The result has been a cock-eyed continuing debate about what is appropriate in movies for young people, a discussion that has often centered on the most visible targets, not the most logical ones. Last year, prudish op-ed writers fretted about the violence in "Home Alone" and wondered if children would be scarred for life by the idea of a family flying off to Paris, forgetting their youngest son. Children, of course, couldn't get enough of the film, a cartoonish lark that played out their fondest fantasies.

■

No one seemed nearly as worried about a film that actually did go too far. "Kindergarten Cop," the Arnold Schwarzenegger movie that was released at the same time, was sold as a benign comedy about savvy kindergarteners who are too much for their hulking new teacher, but it ended with a bloody and frightening shootout between Mr. Schwarzenegger and drug-dealing kidnappers in the school lavatory.

The year before, Disney's "Little Mermaid" was attacked for being anti-feminist

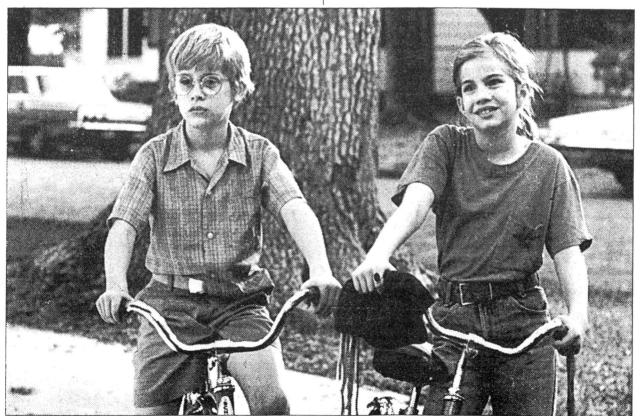

Macaulay Culkin and Anna Chlumsky in "My Girl"—Amid coffins and corpses, it's a long way from the Good Ship Lollipop.

and politically incorrect because the teen-age heroine just wants to marry the prince. She wasn't a good role model, some people complained, as if a role model with fins weren't already a little out of touch with reality.

But two other successful animated films, in the tear-jerking tradition of "Bambi," never caused a fuss. In "The Land Before Time" (1988), the baby dinosaur has to deal with the death of his mama dinosaur, whose senti-

Through death and violence, movies are keeping pace with children. Should parents be rattled?

mental, ghostly voice comes from the great beyond to comfort him. This is a film that could draw tears from a hardhearted adult. And in "All Dogs Go to Heaven" (1989), a dog is given a reprieve from death to save an orphan. ":Charlie, will I ever see you again?" the orphan asks when the dog has to go back to heaven. "Sure, sure you will, kid," says the dog with Burt Reynolds's voice, "You know goodbye isn't forever." Try explaining that concept to a 4-year-old.

This year's controversy is more legitimate, largely because "My Girl" is being marketed as a warm comedy about friendship. In fact, the film is littered with corpses. The flap began months before the movie opened. In August, Marilyn Beck revealed in her syndicated column that Macaulay Culkin dies in the film, and soon other publications picked up the story. In response, Columbia Pictures brought in child psychologists and educators to see the movie, then distributed these unpaid experts' approving remarks to the press. They praised the film's sensitivity, welcomed it as a chance for parents and children to discuss death and held it up as a relief from body-count action movies.

That is true as far as it goes, but their comments make "My Girl" sound as if it were the story of a typical girl whose best friend happens to die — exactly what the studio wants. In fact, poor Vada is Job-like in the series of deaths and emotional abandonments she faces.

Her mother died giving birth to her, so Vada feels guilty. Her father (Dan Aykroyd) is a mortician, and the regular stream of coffins in and out of the family house has made Vada a hypochondriac. Her dear Grandma came to live with the family after Vada's mother died, but she is now far into senility. And Vada's father decides to remarry. After all that, when her best friend dies it seems almost inevitable. Though "My Girl" has some sweet, coming-of-age touches — such as Vada's crush on her teacher — it is overwrought in its attention to death.

■

But television commercials cheerfully emphasize Vada and Thomas J.'s first kiss. One trailer begins with Vada's father telling his daughter not to disturb him while he's working. "I'm embalming my high school

teacher. Don't sing," he says. The trailer goes on to show Vada giving her friends a tour of empty coffins at the funeral home, but there is no hint that any of this is traumatic. A parent who hadn't happened to read about "My Girl" would have no idea that a child dies.

The film itself is more responsible than the trailer, though for every sensitive scene it also has one that gives death the Hollywood treatment. Most people are not allergic to bees, so the film wisely allows parents to tell children that a bee sting won't kill them the way it did Thomas J. No death scene is shown; Thomas J. runs off screen, pursued by a swarm of bees. But the line about his missing glasses sounds more like a bad movie than a grieving child. When Vada's father tells her that Thomas J. is dead, he never says the word death; like so many movie adults, Vada understands without being told, though children in the audience may not be so quick to grasp what is happening.

Still, "My Girl" seems enlightened next to John Hughes's "Curly Sue." This painful formula film has a Shirley Temple-like waifish heroine who belts out the national anthem at excruciating length and volume. "Curly Sue" has been a surprising commercial hit, partly because of timing — it was released when no other children's films were around — and perhaps because of its traditional appeal. "Curly Sue" is the kind of film parents think their children ought to like. The kind of films today's children usually like are not heartwarming stories about a moppet finding a mom, but black comedies where kids one-up the adults. Films of such wildly different quality as the clever "Home Alone" and the lamebrained "Problem Child" became hits by showing grown-ups at the mercy of pipsqueaks. This might mean singeing a crook's hair in "Home Alone" or, in the new "Addams Family," electrocuting your brother for fun.

No one needs to say, "Don't try this at home, kids." Who has an electric chair in the playroom, anyway, except the Addamses? This is cartoonish violence where everyone turns out O.K., electrocuted or not. Children understand that death is just a joke here. What some tone-deaf commentators ignore is the fact that the subjects of death and villainy are not disturbing; it all depends on the way they're treated.

■

In an odd turnabout, the two recent animated Disney films, "The Little Mermaid" and "Beauty and the Beast," are much less scary than the older Disney movies. Though the seawitch Ursula is evil, she isn't haunting. And except for some vicious howling wolves in the woods early in "Beauty and the Beast," there is little to frighten children. "Beauty and the Beast" proves that wholesomeness isn't impossible to find. But it is, as movies like "Curly Sue" suggest, awfully hard to pull off.

If "My Girl" makes money, the trend toward stronger, more realistic themes in children's films is likely to continue. Meanwhile, any boy or girl who watches television will be reassured that Macaulay Culkin isn't really dead. He's alive and dancing on the "My Girl" music video. And on Michael Jackson's new video, "Black or White," he does something kids can really identify with; he gives his father a hard time. He is, in fact, pretty bratty on that video, blasting Dad into outer space with giant amplifiers. He's not a hero for nothing, and while parents may think he's a rotten role model, he's the model they have to deal with.

1991 D 1, II:11:1

Kafka

Directed by Steven Soderbergh; written by Lem Dobbs; director of photography, Walt Lloyd; music by Cliff Martinez; production design, Gavin Bocquet; produced by Stuart Cornfeld and Harry Benn; released by Miramax Films. At Cinema 2, Third Avenue and 60th Street. Running time: 98 minutes. This film is rated PG-13.

Kafka	Jeremy Irons
Gabriela	Theresa Russell
Burgel	Joel Grey
Dr. Murnau	Ian Holm
Bizzlebek	Jeroen Krabbe
Inspector Grubach	Armin Mueller-Stahl
Chief Clerk	Alec Guinness
Castle Henchman	Brian Glover

By VINCENT CANBY

Steven Soderbergh's "Kafka" is a very bad well-directed movie.

The film, the director's first since making his splashy debut with "Sex, Lies and Videotape," opens a one-week engagement today at the Cinema 2 to qualify for the Academy Awards.

"Kafka" is spectacularly split. Though it is a dark, atmospheric pastiche suggested by, but not exactly based on, the life and writings of Franz Kafka, it has the blinding optimism of a sophomore who expects his five-page outline for a novel to win a National Book Award.

At the film's dualist heart is Lem Dobbs's original screenplay. Mr. Dobbs seems to be an enthusiastic if

skeptical student of, among other things, "The Trial," "Metamorphosis" and "The Castle," at least he was when the screenplay was written 10 years ago. In the belief that no Kafka novel or short story could easily be transferred to the screen, Mr. Dobbs set out to write his own Kafka-ish work, which he describes as "a fast-paced combination of thrills and comedy."

The result is the gloomy "Kafka," set in Prague in 1919, about a man named Kafka (Jeremy Irons), a distant relative of such Franz Kafka protagonists as Gregor Samsa, Joseph K. and just plain K. The fictional Kafka slaves away at a dreary job in an insurance claims office by day and, by night, writes novels and stories.

"What are you working on now?" asks a sculptor of tombstones. "Oh," says Kafka, pleased that anyone should be interested, "a story about a man who wakes up to find himself transformed into a giant insect."

When a friend disappears, Kafka sets out to search for him, only to become a victim himself. He is pursued by "them," the mostly nameless others, authority figures who represent the office in which he works, the police and even the unseen, unknown figures in the great castle that guards the city below.

•

His investigations lead him to the friend's mistress (Theresa Russell) who, in turn, introduces Kafka to a band of bomb-planting anarchists. Somehow Kafka comes into possession of his own bomb. When the friend's body turns up in the river, the police call it a suicide, which Kafka thinks unlikely.

The answers to these questions, Kafka knows, are in the castle. He vows to enter it, though no one has ever gone there and come out alive. It's at this point that Kafka meets Indiana Jones, if not in fact or style, at least in spirit.

By adding coherence and what might be called rational evil to the Kafka-ish situation, Mr. Dobbs and Mr. Soderbergh have somehow eliminated all sense of menace from the movie. One fools around with Franz Kafka's lucid prose and dread visions at one's own peril.

•

"Kafka" is opaque without ever being mysterious, frightening or suggestive of anything but movie making. Its chases through dark narrow streets don't create suspense, since nothing is at stake. Kafka is no less a cipher than those representatives of the forces that would destroy him.

It's not giving anything away to report that the movie does close on a Kafka-ish note, but it comes too late to have meaning. The same is true of the single cough that Mr. Irons suddenly coughs toward the end of the movie, a dutiful reminder of how the real Franz K. died in 1924.

The screenplay is a mess, but Mr. Soderbergh's handling of it is not at all bad. He demonstrates the kind of unflappable facility with which such old-time studio directors as Michael Curtiz and George Marshall once approached every second-rate assignment.

•

Though "Kafka" bears no resemblance to "Sex, Lies and Videotape," which was written by Mr. Soderbergh and is a contemporary comedy of real wit, the director treats the mate-

rial as if it were the real thing, that is, something by Franz K. The movie, which was shot largely in Prague, looks good.

Walt Lloyd's black-and-white cinematography recalls not only the German Expressionist cinema but also the work of Orson Welles, in particular Welles's 1963 adaptation of "The Trial," filmed in Paris's abandoned Gare d'Orsay. Whether consciously or not, Gavin Bocquet, the production designer, evokes that Belle Époque railroad station in his set for the anarchists' headquarters.

Alec Guinness, Ian Holm, Ms. Russell, Joel Grey, Armin Mueller-Stahl and the other members of the supporting cast underplay their roles with notable self-effacement. Carrying the film from start to finish is Mr. Irons, who is far darker, more intense and more latently tubercular than the screenplay ever indicates.

•

"Kafka," which is rated PG-13 (Parents strongly cautioned), would probably put a child to sleep long before a possibly scary sequence at the climax, one in which people are seen being fatally annoyed in a laboratory worthy of the mad old Dr. Frankenstein.

1991 D 4, C21:1

Pin

Directed and written by Sandor Stern; director of photography, Guy Dufaux; produced by Rene Malo; released by Transatlantic Pictures. At Film Forum 1, 209 West Houston Street, Manhattan. Running time: 102 minutes. This film has no rating.

Leon	David Hewlett
Ursula	Cyndy Preston
Dr. Linden	Terry O'Quinn
Mrs. Linden	Bronwen Mantel
Pin	Rejean Dugal

By JANET MASLIN

Dummies in horror films have a tradition of malevolent behavior, and Pin is no exception. Starting out life — if it *is* life — as a doctor's seethrough anatomical model, Pin becomes the dominant member of the doctor's repressed, unhappy family.

The doctor's son, Leon (David Hewlett), is particularly susceptible to Pin's influence, and unlike his beautiful sister, Ursula (Cyndy Preston), Leon refuses to acknowledge the dummy's inanimate nature. In "Pin," which opens today at the Film Forum, Leon's nature and Pin's eventually become hopelessly intertwined.

As written and directed by Sandor Stern, "Pin" is a cool, bloodless, well-made thriller with a taste for the quietly bizarre. The plastic furniture covers in Leon and Ursula's comfortable household are every bit as eerie as the dummy himself or the father (Terry O'Quinn), who insists on involving Pin in every intimate family event from the children's initial sex-education lecture to the abortion Ursula undergoes as a teen-ager. Eventually, Leon begins to regard Pin as his ally in protecting Ursula from the attentions of other men. And the film gives its full attention to the dangerous aspects of Leon's incestuous obsession.

•

Pin may not be directly homicidal, but he's as dangerous as an inanimate object can be. Although the viewer can never be fully sure, it

seems as though his blank, receptive facial expression is even capable of slight changes. Starting out with his internal organs visible and his overall form the color of raw liver or dried blood, Pin is eventually transformed by Leon into a true member of the family, complete with flesh-colored makeup and a suit and tie borrowed from Leon's father (who is no longer in a position to complain about his son's behavior). Although the dummy's name is ostensibly a shortened version of Pinocchio, it's the exaggeration of Leon's neat-as-a-pin fastidiousness that the name Pin calls to mind.

Mr. Stern, who has worked extensively in television and also wrote the movie "The Amityville Horror," elicits unusually lifelike performances from a cast that could easily have overplayed this family's peculiarities. Mr. O'Quinn turns the doctor into a quietly overbearing patriarch, and Mr. Hewlett makes Leon a clear consequence of his father's cold demeanor.

Ms. Preston turns Ursula into something more credible than the usual pert victim-to-be, and she becomes as substantial a figure as her scary, schizophrenic brother. Bronwen Mantel appears briefly as the mother who is responsible for those plastic furniture covers. "You know what mother's doing now?" Leon asks Ursula after Pin has implemented their mother's death. "She's vacuuming heaven."

"Pin" has been crisply photographed by Guy Dufaux using the benign blandness and dark shadows that give any good horror film its contrasts. Rejean Dugal provides Pin with his silky, lulling voice.

1991 D 4, C28:1

Cage/Cunningham

Directed and edited by Elliot Caplan; written by David Vaughan; choreography by Merce Cunningham; music by John Cage; produced by Cunningham Dance Foundation Inc. At Anthology Film Archives, 32-34 Second Avenue, at Second Street, Manhattan. Running time: 100 minutes. This film is unrated.

WITH: Merce Cunningham, John Cage, Nam June Paik, Robert Rauschenberg, Carolyn Brown, Viola Farber and others.

By STEPHEN HOLDEN

Among the tributes expressed in Elliot Caplan's beautifully filmed homage to the composer John Cage and the choreographer and dancer Merce Cunningham, the most sweeping comes from the poet and potter M. C. Richards.

Reflecting on a working relationship that has spanned half a century, during which Mr. Cage and Mr. Cunningham have fused their lives and art, Ms. Richards imagines them as two benevolent angels. In an era when many have begun to doubt whether human life will or should continue, she muses, their existence remains "an affirmation of life and ongoing working." Such words might sound grandiose when applied to other modern artists. But within Mr. Caplan's airy cinematic tribute, they resonate sweetly.

"Cage/Cunningham," which opened yesterday at Anthology Film Archives, is no more conventional than the work of the artists it celebrates. Interweaving Mr. Cage's and Mr. Cunningham's observations with

he reminiscences of their friends and collaborators, along with archival excerpts of work dating to 1944, the film erases the ordinary boundaries between life and art with the same refined casualness as that of its subjects. Merrily skipping around in time, it suggests that in some indefinable way, Mr. Cage and Mr. Cunningham have made work that transcends time, at least in the cause-and-effect sense of art-history movements and trends.

•

For both men, but especially Mr. Cage, discovering and creating music has long been part of a Zen Buddhist approach to life in which every experience involves a concentrated attention to the moment. "The sounds of Sixth Avenue are constantly surprising me and never once repeating themselves," he exults in one scene. "I'm listening as though I never heard before." He also recalls the odd circumstances that made him decide to compose. While studying music at the University of Southern California, he attended a class whose teacher declared that he would make it impossible for the students to compose. "My reaction was one of stubbornness," Mr. Cage recalls.

Mr. Cunningham relates his own revelations with the same matter-of-fact good humor. One was the application to the dance of Albert Einstein's theory that there are no fixed points in space. That meant, Mr. Cunningham recalls, that "where you are is the center," which he also realized was a Buddhist concept. Elaborated even further, it meant that he could teach himself and his dancers how to stop thinking about playing to the front of the stage. Wherever they faced was the front. Such thoughts are richly illustrated by film clips of Mr. Cunningham and his dancers leaping and mingling with an exquisite randomness.

•

Not all the talk is so enlightening. The artists Robert Rauschenberg and Jasper Johns discuss their collaborations with Mr. Cunningham, but they have little to say beyond the strictly anecdotal.

For the most part, however, the director succeeds wonderfully at bringing the spirit of work he obviously loves into his own documentary. Fragments of Mr. Cage's scores for Cunningham dances fade in and out with everyday sounds in a way that calls attention to those sounds and also reveals how the scores are really a finely attuned concentration of the everyday.

For a work exalting a 50-year collaboration, "Cage/Cunningham" shows surprisingly little direct interaction between the composer and the choreographer. The elfin Mr. Cage, who laughs easily and is shown cooking with the same enthusiasm that he expresses for the sounds of the street, seems the more accessible of the two. Mr. Cunningham, more enigmatic and feline, is shown keeping the alert, arched posture of a creature listening for a distant signal to propel him into action.

1991 D 5, C20:1

Star Trek VI
The Undiscovered Country

Directed by Nicholas Meyer; screenplay by Mr. Meyer and Denny Martin Flinn; story by Leonard Nimoy and Lawrence Konner & Mark Rosenthal, based on "Star Trek," created by Gene Roddenberry; director of photography, Hiro Narita; edited by Ronald Roose; music by Cliff Eidelman; production designer, Herman Zimmerman; produced by Ralph Winter and Steven-Charles Jaffe; released by Paramount Pictures. Running time: 110 minutes. This film is rated PG.

Kirk	William Shatner
Spock	Leonard Nimoy
McCoy	DeForest Kelley
Scotty	James Doohan
Chekov	Walter Koenig
Uhuru	Nichelle Nichols
Sulu	George Takei
Lieutenant Valeris	Kim Cattrall
General Chang	Christopher Plummer
Klingon Chancellor	David Warner
Azetbar	Rosana DeSoto
Federation President	Kurtwood Smith
Crew Member	Christian Slater

By JANET MASLIN

"IS it possible that we two, you and I, have grown so old and inflexible that we have outlived our usefulness?" Mr. Spock asks Captain Kirk in "Star Trek VI: The Undiscovered Country," the sixth and supposedly last installment in the "Star Trek" saga. It's possible, but not likely. Never mind that the crew of the starship Enterprise is supposedly only months away from mothballs as this story begins; never mind that most of the principals have reached Hairpiece Heaven. Never mind that this film, supposedly the "Star Trek" valedictory, gives fans the stars' autographs with its closing credits. The title, from "Hamlet," may refer to the afterlife, but in the words of a different poet, it ain't over till it's over.

And "Star Trek VI," directed by Nicholas Meyer, is as lively a tale as any Trekkie might want, even if it's not free-standing enough to bring in new recruits. (Anyone who thinks Klingon sounds like a new synthetic fabric need not apply.) There are no signs of waning energy here, not even in an Enterprise crew that looks ever more ready for intergalactic rocking chairs. The principals' enthusiasm for their material has never seemed to fade. If anything, that enthusiasm grows more appealingly nutty with time.

A "Star Trek" film is such a collection of wild cards that this latest one refers to Richard Nixon, Sherlock Holmes and Peter Pan, among other notables. The plot alludes to ecology, racism, the cold war, détente and Nazi Germany. William Shakespeare is a generous contributor to the screenplay, although it is credited to Mr. Meyer and Denny Martin Flinn (from a story by Leonard Nimoy and Lawrence Konner & Mark Rosenthal — punctuation theirs). In this kind of anything-goes atmosphere, creative ferment is whatever one makes of it, and the "Star Trek VI" principals have done their best to make it fun. That's no small achievement after 25 years.

They always promised to go where no man had gone before, and in a way they kept their word. The "Star Trek" films make their own rules, rules not always readily intelligible to the non-aficionado. But the heart of the matter this time is that the evil Klingons, the ridge-skulled villains who have come to

Review/Film

Aging Trekkers to the Rescue One Last Time. *Really*.

Gregory Schwartz/Paramount

TOP Twenty-five years and counting — from left: Christopher Plummer, William Shatner and De-Forest Kelley in the latest adventures of the starship Enterprise.

represent all manner of bogymen, threaten to disrupt attempts at an intergalactic peace settlement. And it falls to the Enterprise crew to put matters back on course. "Once again we have saved the world as we know it," says Captain Kirk at the conclusion of this last adventure. "And the good news is they're not going to press charges," says Dr. Leonard (Bones) McCoy (DeForest Kelley), the ship's resident cynic.

In the process of fighting a band of subversive Klingons and thwarting an assassination attempt, Kirk and Bones wind up on a snowy gulag where one of their fellow prisoners (Iman) has bright orange eyes and can perform the "Terminator 2" liquid transformation trick. They also invite a band of Klingon diplomats to dinner and drink blue ale. And there is a lethal attack in an anti-gravity zone, in which the victims emit spheres of fuchsia blood. So "Star Trek VI" is definitely colorful, but even more of its color comes from conversation, which can take some amusingly florid turns. Christopher Plummer, as the Klingon General Chang, produces a Shakespearean quote for every occasion, until Kirk grouses, "I'd give him real money if he'd just shut up." ("To be or not to be ..." Chang commences, when, of course, he meets his unfortunate end.)

As Chang, Mr. Plummer sports the furrowed head, small wisp of hair and studded eyepatch that are but a small example of the cosmetic feats attempted here. Some of the effects are garish, and not all the results have

even this much wit, but the film makers have been tireless in trying to make their otherworldly characters look strange. Whenever a skilled actor like Mr. Plummer or David Warner, who plays the Klingon Chancellor, manages to emerge from behind all this camouflage with his personality intact, it's a notable accomplishment. Among those who appear without elaborate makeup, Christian Slater has an uncredited cameo as a minor crew member and deserves some credit just for having shown up.

•

Also in "Star Trek VI" are Kim Cattrall as the sultry Vulcan who is Mr. Spock's protégée, Rosana DeSoto as the politically aware Klingon who objects vehemently to such phrases as "inalienable human rights," and Kurtwood Smith as the Federation President whose tonsorial style Confucius would have envied. Then, of course, there are the regulars, all looking pert in their vaguely military uniforms as they pursue the quest for peace. These principals, including Nichelle Nichols, James Doohan, Walter Koenig and George Takei, as well as the dependably wry William Shatner and Mr. Nimoy, are a welcome sight, especially if this really is their final bow.

But the film's production notes refer to "Star Trek's first 25 years." And the crew, however gracious, doesn't sound entirely sanguine about turning their ship over to younger, stronger replacements. Last seen bound for Never-Neverland, the Enterprise team may or may not be amenable to a curtain call. In the meantime, "Star Trek" devotees have one more fanciful chapter to this story. And they have their memories.

•

"Star Trek VI: The Undiscovered Country" is rated PG (Parental guidance suggested). It includes mild violence.

1991 D 6, C1:1

ABOVE Saving the universe — Leonard Nimoy and Kim Cattrell.

Gregory Schwartz/Paramount

George Takei

At Play in the Fields of the Lord

Directed by Héctor Babenco; screenplay by Jean-Claude Carrière and Mr. Babenco, based on the novel by Peter Matthiessen; director of photography, Lauro Escorel; edited by William Anderson; music by Zbigniew Preisner; production design, Clovis Bueno; produced by Saul Zaentz; released by Universal Pictures. Running time: 180 minutes. This film is rated R.

Lewis Moon	Tom Berenger
Leslie Huben	John Lithgow
Andy Huben	Daryl Hannah
Martin Quarrier	Aidan Quinn
Wolf	Tom Waits
Hazel Quarrier	Kathy Bates

By VINCENT CANBY

"At Play in the Fields of the Lord," Héctor Babenco's adaptation of the Peter Matthiessen novel, is a big, melancholy screen adventure, vividly realized in the jungles of Brazil, about people out of touch with one another, and at dangerous odds with a primeval world they understand not at all.

With fidelity to the book, and to the look, sound, heat and wet of the exotic locale, Mr. Babenco evokes the arrogant confusion of a small group of mismatched North Americans, caught in a brutal landscape that overwhelms them even as it's disappearing. Though the movie sometimes has trouble expressing what's on its mind, it is a rare movie in that

it has something on its mind to express.

The principal characters include a pair of mangy bush pilots, Moon (Tom Berenger) and Wolf (Tom Waits), who, low on money and gas, are stranded at a godforsaken jungle outpost, their passports and single-engine plane impounded. Wolf is a profane, hard-drinking urban lout. Moon is a moody loner, who is also half American Indian.

Also in the village, staying at the only hotel, are two youngish missionary couples, Leslie and Andy Huben (John Lithgow and Daryl Hannah) and Martin and Hazel Quarrier (Aidan Quinn and Kathy Bates) who, with their small son, have just arrived from the States.

Peter Matthiessen's novel as a big screen adventure.

The Hubens and the Quarriers share an earnest, psalm-singing, fundamentalist Christian faith. They are out to save the savages (Hazel Quarrier's term) from their Stone Age ways and from the Roman Catholic priests who, if they could, would have saved the savages first.

The screenplay, adapted by Jean-Claude Carrière and Mr. Babenco, tells several stories simultaneously. It's about Moon's reverse conversion when he leaves civilization's squalid outpost to join the Niarunas, an especially primitive Indian tribe he associates with his own North American people.

It's also about the missionaries' attempt to set up a jungle church to convert the Niaruna, about the collapse of the courage of one of the missionaries, the loss of faith of another and the madness of a third. "At Play in the Fields of the Lord" doesn't play smoothly, but it often plays well.

The film's most interesting character, acted by Mr. Quinn with a secretive kind of intelligence, is Martin Quarrier. Trapped in a marriage to a woman of small, unstable mind, Martin would honor both his marriage and his faith and becomes, almost in spite of himself, heroic.

•

Unlike the Quarriers' marriage, the Hubens' appears to be a happy one. It seems to be a true union of body, mind and spirit, but then it become apparent that Leslie Huben is the sort of man who is more skillful at public relations and moral compromises than at his work in the field. Except for the particular crisis that these missionaries must face, the Hubens' marriage would probably have been a long and satisfying one.

Though the enlightened Martin Quarrier is the center of the film, the character on whom the film rests is Moon, whose search for identity is not dramatized in any convincing way. It isn't just that the movie cannot enter Moon's thoughts. The novel has the same problem, even though Mr. Matthiessen devotes many pages to Moon's drug-induced hallucinations before he makes his big leap to freedom.

"At Play in the Fields of the Lord" looks sensationally good. There is no faking these jungle locations, wheth-

Aidan Quinn

Universal

er seen from the air, as Moon's fragile plane flies wanly into a time long past, or on the ground, where the flora can be as malignant as the fauna. A number of individual scenes stand out, including an early bar encounter of the drunken Moon with the naïve Martin Quarrier and an amused, patient Catholic priest.

Says Moon, "If the Lord made Indians the way they are, who are you to make them different?" That is the film's worthy but not exactly novel point.

•

The life at the jungle church settlement is richly realized. Yet an important scene, in which the beautiful Andy Huben goes skinny-dipping, seems wildly out of place, if only because Miss Hannah's body looks too magnificent to be entirely true in these circumstances. The scene is essential to everything that happens afterward and is taken directly from the book, but •fidelity sometimes backfires.

Mr. Lithgow and Miss Hannah, who grows more secure as an actress with every film, are fine in complex roles that are exceptionally well written. Miss Bates is splendid as a big, slow, furious and frightened woman, someone who should never have ventured south of Orlando, Fla. Mr. Berenger maintains his self-respect in sequences that often suggest the National Geographic come to life.

Though the film features a spectacular penultimate sequence, it seems not to know how to end. It sort of drifts away, perhaps trying to soften its own well-earned pessimism.

Whatever the reason, "At Play in the Fields of the Lord" leaves one a bit bemused, vaguely worrying about the fate of the rain forests and the ozone layer as the endangered Indians. To this extent, the movie can be said to engage the intellect somewhat more than the emotions.

•

"At Play in the Fields of the Lord," which has been rated R (Under 17 requires accompanying parent or adult guardian), has nudity, violence and vulgar language.

1991 D 6, C8:1

December

Directed and written by Gabe Torres; director of photography, James Glennon; edited by Rick Hinson and Carole Kravetz; music by Deborah Holland; production designer, Garreth Stover; produced by Richard C. Berman and Donald Paul Pemrick. At the Sutton, Third Avenue at 57th Street, Manhattan. Running time: 91 minutes. This film is rated PG.

Kipp Gibbs	Wil Wheaton
Stuart Brayton	Chris Young
Russell Littlejohn	Jason London
Allister Gibbs	Balthazar Getty
Tim Mitchell	Brian Krause

By JANET MASLIN

December could not be a worse time for releasing "December," a small, talky film that's sure to get lost in the holiday shuffle. But the release date was inevitable, since this film, which opens today at the Sutton, revolves around the bombing of Pearl Harbor 50 years ago and the effect of that event on five students at a boys' boarding school.

From the night they learn of the attack to the next morning, when those students who have decided to enlist board a bus taking them away from school and childhood, the film's principal characters stage a marathón debate on the meaning of war. Everything they have to say is expressed with passion, but all of it has been said before.

"This book! It made me see how crazy war is," declares Kipp Gibbs (Wil Wheaton), who has been reading "Johnny Got His Gun" (and who has just been expelled for that transgression by a book-burning headmaster). "I bet we got these Japs wrapped up by this time next year," smirks Tim Mitchell (Brian Krause), the group's smug muscleman. "I can't be what he expects me to be," says one of the others, staring at a portrait of his distinguished father. There is also the obligatory exchange: "You're talking crazy!" "For the first time in my life I'm making sense."

Gabe Torres, the film's writer and director, makes this material seem even more limited than it had to by presenting these conversations in a thoroughly stagebound style. The first scene alone is confined to a single dorm room and lasts nearly half an hour. Later on, two boys remark on how Pearl Harbor sounds like part of another world as they stand, for an awfully long time, conversing in the snow.

"I can't go halfway around the world and fight for democracy when I have my own fight right here!" Kipp finally declares, although the fight he has in mind, over the "Johnny Got His Gun" incident, hardly seems on a comparable scale. Too much of the screenplay suffers from such schoolboy overstatement. And all of the performances would have benefited by being abbreviated, since the boys are in danger of talking themselves to death long before they face the prospect of battle. Although Mr. Wheaton, as the story's principal pacifist, and the burly Mr. Krause, as a gung-ho future war hero, dominate the discussion, the three other principals are also sturdy. Balthazar Getty appears as Kipp's younger and more malleable brother, Chris Young plays the rich boy who at first thinks he can remain above the fray, and Jason London plays the most unobjectionable, least opinionated member of this little club.

•

"December" is rated PG (Parental guidance suggested). It includes mild profanity.

1991 D 6, C8:5

Convicts

Directed by Peter Masterson; written by Horton Foote, based on his play; director of photography, Toyomichi Kurita; edited by Jill Savitt; music by Peter Melnick; production designer, Dan Bishop; produced by Jonathan D. Krane and Sterling Vanwagenen;

released by MCEG. At Angelika Film Center, Mercer and Houston Streets, Manhattan. Running time: 95 minutes. This film has no rating.

Soll Gautier	Robert Duvall
Horace Robedaux	Lukas Haas
Ben Johnson	James Earl Jones
Martha Johnson	Starletta DuPois
Asa	Carlin Glynn
Leroy	Calvin Levels

By VINCENT CANBY

Horton Foote, who wrote Robert Duvall's Oscar-winning role in "Tender Mercies" (and won an Oscar for himself), provides Mr. Duvall with another big, actorly opportunity in "Convicts," opening today at the Angelika Film Center.

Soll Gautier is made to Mr. Duvall's measure. Soll is very old; the skin on his face is as tough as the hide of a hippo. He's also as mean as he is stingy, which is how he has survived. Although Soll is land-rich, he ekes out a bleak existence, using cheap convict labor to work the cane fields of his cheerless plantation on the Texas Gulf Coast.

At the film begins, on the morning of Christmas Eve in 1902, time and liquor are catching up with Soll. As on every other day of the year, he is minding his crops and the work force. He is a nonjudgmental witness as the sheriff shoots a black convict who has knifed another. Soll knows such things happen.

M.C.E.G./Ron Phillips

Robert Duvall

Yet he has intimations of his own mortality. As the day progresses, they hit him like a migraine's first stabs of pain. Soll moves in and out of reality. He's such a canny duck, though, that it's not possible to be sure he isn't being his usual rude, irascible self.

That suspicion arises when he presents Ben (James Earl Jones), who runs the plantation store, with a generous wad of Confederate money. This day, though, Soll is also seeing and hearing things, nameless black men who hide in closets waiting to assassinate him.

•

Mr. Duvall is terrific as old Soll. He is the towering figure in "Convicts," but the film is about the coming of age of 13-year-old Horace Robedaux (Lukas Haas), who sees all through clear, unsentimental eyes.

Because Horace doesn't get on with his widowed mother's new husband, he has been more or less dumped at the plantation to work at the store. His aim: to earn money to buy a tombstone for his father's grave. Like all newcomers to earthly experience, Horace is preoccupied by names and identities. Also by obligations. Soll now owes him $12.50 for six months' work.

"Convicts" is the second play in Mr. Foote's nine-play cycle, "The Orphan's Home," about four generations of the playwright's Texas fore-

bears. It's actually the third play in the cycle to be filmed. It follows "1918" (1985) and "On Valentine's Day" (1986), as well as public television's "Courtship" (1987), which deal with the adult Horace Robedaux and life in the fictional Texas town of Harrison.

•

Peter Masterson, the director of the screen adaptation of Mr. Foote's "Trip to Bountiful," directs "Convicts" in the plain, unadorned style that best suits the Foote material and doesn't upstage the performers.

Mr. Duvall is a very special actor in that he doesn't have to be noisily (or even quietly) busy to assert his control over character and the audience's attention. The camera sees everything he does, which, when one tries to describe it, seems to be nothing at all. The behavior becomes somehow riveting.

Mr. Haas, Mr. Jones and the other members of the supporting cast also serve the text. Among these are Carlin Glynn (who is married to the director), who has a fine, funny running gag of a turn as Soll's trashy, acquisitive niece (and only heir), who stops by the plantation to wish him well and to see how near to dying he might be.

•

"Convicts" is scarcely more than a fragment. Its realities are harsh, but its conflicts are muted. The dramatic line is without big conventional revelation. Yet the film creates its own elegiacal mood, which has a special poignancy when one is aware of what is to come after.

Watching Mr. Foote's memory films is like being gifted with eerie foresight, as well as with the forgiveness that only comes with time.

1991 D 6, C14:6

Young Soul Rebels

Directed by Isaac Julien; written by Paul Hallam, Derrick Saldaan McClintock and Mr. Julien; director of photography, Nina Kellgren; edited by John Wilson; music by Simon Boswell; production designer, Derek Brown; produced by Nadine Marsh-Edwards; released by Prestige, a division of Miramax Films. At Village East Cinema, Second Avenue and 12th Street, Manhattan. Running time: 94 minutes. This film has no rating.

Chris	Valentine Nonyela
Caz	Mo Sesay
Ken	Dorian Healy
Ann	Frances Barber
Tracy	Sophie Okonedo
Billibud	Jason Durr
Davis	Gary McDonald
Jill	Debra Gillett
T. J.	Shyro Chung

By STEPHEN HOLDEN

There are those who remember the summer of 1977, when punk-rock rudely exploded onto the London pop scene, as a shining moment when rock-and-roll briefly became a potent political wedge in British society. Those days when Johnny Rotten and the Sex Pistols proclaimed "Anarchy in the U.K." are fondly remembered in "Young Soul Rebels," a film by the British black independent film maker Isaac Julien. The movie's injections of racial and sexual politics suggest a crude, low-budget hybrid of "My Beautiful Laundrette" and "Pump Up the Volume."

Two years ago, Mr. Julien's cinematic meditation on the poet Langston Hughes, "Looking for Lang-

Prestige

Mo Sesay and Valentine Nonyela

ston," was shown at the New York Film Festival and caused a minor furor because of its insistence on Hughes's homosexuality. Mr. Julien's examination of the punk-rock era brings a similar racial and sexual perspective to its portrait of two friends who operate a pirate radio station out of an East End garage.

An odd couple who have known each other since childhood, Chris (Valentine Nonyela) is mulatto, slightly effeminate and heterosexual, while Caz (Mo Sesay) is black, macho and gay. Each night on their station, Soul Patrol, they broadcast the latest records by Parliament and Funkadelic and other late-1970's funk luminaries. The film's perspective on the halcyon days of punk culture is black-oriented. Chris and Caz belong to an exuberant corps of brightly attired soul brothers and sisters who share the streets with spiky-haired punks, disco-hopping gay men and ominously glowering skinheads. The film's social nexus is an interracial, omnisexual dance club called the Crypt.

•

One of the many things that the movie, which opens today at the Village East Cinema, also tries to be is a murder mystery. One night while cruising a park, T. J. (Shyro Chung), a close friend of Chris and Caz, is slashed to death. In a plot twist clumsily reminiscent of "Blow-Up," Chris visits the scene of the crime and finds the boom box T. J. was carrying when he was killed, which contains a tape of the killer's voice. It is not long before Chris is arrested for the crime and viciously interrogated by the police.

"Young Soul Rebels" is at its worst when it is trying to be a whodunit. Early in the movie, it is quite clear who the murderer is. And the moments when the film tries to build suspense are clankingly overdone. At its best, the movie lays bare the schisms in London society in scenes of the local street life, where tensions are often on the verge of erupting into violence.

The film is also at its most engaging in its portrayal of Chris and Caz as they simultaneously enter new relationships. Chris, who aspires to be a professional disk jockey, becomes involved with a sleek production assistant (Sophie Okonedo) at a commercial radio station. Caz takes up with Billibud (Jason Durr), a white punk who is helping to organize a demonstration against the Queen's Silver Jubilee celebration. The scenes of meeting and courtship capture the awkwardness and the excitement of youthful infatuation with a freshness and zest that avoids the high-gloss clichés of young love, Hollywood-style.

1991 D 6, C21:1

Let Him Have It

Directed by Peter Medak; screenplay by Neal Purvis and Robert Wade; director of photography, Oliver Stapleton; edited by Ray Lovejoy; production designer, Michael Pickwoad; produced by Luc Roeg and Robert Warr; a Fine Line Features Release. At the Plaza, 42 East 58th Street, Manhattan. Running time: 114 minutes. This film is rated R.

Derek Bentley	Chris Eccleston
Chris Craig	Paul Reynolds
William Bentley	Tom Courtenay
Fairfax	Tom Bell
Lilian Bentley	Eileen Atkins
Iris Bentley	Clare Holman
Niven Craig	Mark McGann

By JANET MASLIN

"Let him have it": those were the words that sealed the fate of Derek Bentley, the slow-witted 19-year-old who became the first man in British judicial history to be executed despite a jury's recommendation for mercy. Derek, an epileptic who had an I.Q. of 66 and a mental age of 11, was an accessory to a murder committed by Christopher Craig, his vicious and more street-wise 16-year-old friend.

The victim was a police officer. The public was outraged. The killer was too young to receive the death penalty. And Mr. Bentley made a convenient scapegoat, never offering much resistance at a trial that made no mention of his mental handicap and lasted only two days. A crucial piece of evidence was Derek's supposed cry of "Let him have it, Chris!" to his gun-wielding friend. Was Derek suggesting that Chris shoot the officer or that he hand over the gun? The meaning of the remark was never firmly established. In fact, Derek maintained that he had never said any such thing.

Public outrage and a slow-witted scapegoat.

But Peter Medak still uses "Let Him Have It" as the title of his crisp, chilling investigatory drama about the case, making the phrase relevant not only to Derek's culpability but to the climate in which he was convicted. Like "The Krays," Mr. Medak's earlier film about young criminals in postwar Britain, "Let Him Have It," which opens today at the Plaza, is as much about the pious middle-class values of that time as about the young toughs who rebelled against them.

•

"Let Him Have It," which is as eerie and meticulous as "The Krays," also has a lot to say about popular culture. Derek and Chris are seen attending a showing of "White Heat" not long before the rooftop "Chicago-style gun battle" — as a newspaper describes it — that let them cry "Top of the world, Ma!" in their own way just as James Cagney did in his. And when Derek, as a teenager who adores the popular music of the early 1950's, spies a beautiful blonde in a record store and later finds that same blonde dating a local gangster, he makes an irrefutable connection between gangland behavior and glamour.

The film proceeds with the tenacity of a case study as it moves from the wartime accident that may have affected Derek's mental abilities to his

Richard Blanshard/New Line Cinema

Chris Eccleston

disastrous school experiences. "Do you know what the magistrates asked him to do?" asks Derek's earnest, bewildered father, William (Tom Courtenay), when his son is sent home from remedial school. As is turns out, they asked him to spell. "Fluorescent, hm," William complains to a school counselor. "I can't spell it. Can you?"

The film's depiction of the Bentley family, and especially Mr. Courtenay's fine and surprising portrayal of a loving father unable to protect or control his son, does a lot to give this story its power. William, his careworn wife, Lilian (Eileen Atkins), and their daughter, Iris (Clare Holman), who helps coax the reclusive Derek out of his room and into the high-rolling atmosphere that becomes his undoing, make up an affectionate family with no real understanding of Derek's secrets. As his family sits in the living room on Sunday evening, with his father reading the newspaper and his mother darning socks, Derek is easily tempted to steal away with Chris and attempt something with a little more style.

The film's young would-be tough guys are seen in black raincoats and black felt hats, aping the style of American movies. Once the volatile Chris (Paul Reynolds) takes a liking to the shy, ungainly Derek (Chris Eccleston), he insists that Derek become part of the pack. Increasingly bewildered by their son's sharp clothes and new outlook, the Bentleys try to monitor his activities, which is made easier by the boy's own guilelessness. When Derek, who can't read, gives out stolen air force cigarettes as a gift, his father knows for sure that something is wrong.

•

While the film presents Derek as naïve, it also acknowledges his complicity in crime. He is seen delighting in the brass knuckles Chris gives him and deliberately planning to rob the local butcher, who has always treated him kindly. Mr. Medak and the screenwriters, Neal Purvis and Robert Wade, never apologize for Derek's actions, but they do differentiate them from the behavior of a calculating killer. The Bentley case, a cause célèbre in British legal history, has reportedly been reopened as a result of this film's account.

As he did in "The Krays," in which Billie Whitelaw played the loving Mother Kray who served tea to a room full of mobsters, Mr. Medak again contrasts the obliviousness and overprotectiveness of parents with the temptations faced by their children. He elicits performances that raise these attitudes well beyond the domain of easy answers. Mr. Eccleston makes Derek a sad, sweetly affecting figure who is largely a cipher. (Mr. Reynolds, as Chris, isn't magnetic enough to make Chris's hold over Derek fully convincing.) Ms.

Holman conveys a very complicated brand of sisterly love. And Mr. Courtenay is especially moving as a man overpowered by his son's problems. One remarkable scene finds Derek, in the midst of an epileptic seizure, being delivered home to a father whose fear and love for his son coalesce in that one moment.

Mr. Medak's direction veers from quiet watchfulness to sudden moments of sharp, clinical detachment. His use of abrupt overhead shots often heightens the strangeness of Derek's situation, as do the hauntingly impersonal views of row houses in Derek's neighborhood. "Let Him Have It," which has been evocatively photographed by Oliver Stapleton, finds beauty in unexpected places. One of Mr. Medak's most transcendent images is that of a hangman's noose.

•

"Let Him Have It" is rated R (Under 17 requires accompanying parent or adult guardian). It includes violence and profanity.

1991 D 6, C24:1

Rouge of the North

Directed and written by Fred Tan, adapted from the novel by Eileen Chang; in Chinese, with English subtitles; director of photography, Yang Wei-han; edited by Chen Po-wen; music by Peter Chang; production designer, Chow Chi-liang; produced by Lin Tung-fei and Chen Chun-sung; a Greycat Films release. At Cinema Village Third Avenue, at 12th Street, Manhattan. Running time: 106 minutes. This film has no rating.

Ying-ti	Hsia Wen-shi
Mr. 3	Hsu Ming
Mr. 2	Kao-Chieh
Mrs. 3	Hsiao-li
Mrs. 1	Lin Mei-ling

By JANET MASLIN

"I don't care! I can only live once!" declares the tempestuous heroine of "Rouge of the North" as she embraces the man for whom she has secretly lusted. This is soap opera, all right, but since it's set in China it has a distinctly regional flavor. This surreptitious clinch occurs in the family shrine before a large golden Buddha. The principals, related by marriage and named according to birth order in a wealthy family, are known as "Mrs. 2" and "Mr. 3." And even when they fall into each other's arms, they do so with a sense of ceremony and obligation. "We have to pay our debts to each other!" one of them breathlessly exclaims.

"Rouge of the North," which opens today at the Cinema Village Third Avenue, is based on a novel by Eileen Chang and tells of Ying-ti (Hsia Wenshi, who has the look and manner of an experienced screen star), first seen in 1910 as an orphan who abandons any hope of real love when she is forced into an arranged marriage. Only when the groom emerges from his sedan chair does Ying-ti discover that he is crippled and blind.

Hsia Wen-shi

But he is also wealthy. And Ying-ti, growing ever more ruthless, quickly accommodates herself to life as a member of his prominent Shanghai family. Mrs. 1 and Mrs. 3, her new sisters-in-law, are as catty as anything to be found on American television when they laud Ying-ti for her good luck in having a husband who is always conveniently around the house and available for mah-jongg.

The years pass. Ying-ti flirts brazenly with Mr. 3, although the film mostly retains the chasteness of a Chinese drama. Ying-ti also bears a son, loses her fortune, begins smoking opium and schemes to control her son's life. "After you marry, I'll get you a mistress," she promises him. "I won't let you down. You're my only child." One of the film's more remarkable scenes shows Ying-ti remarrying her son to a maid after his first bride turns sickly, proves infer-

tile and otherwise incurs Ying-ti's wrath. The ailing, tubercular first wife lies in her bed in the same room where the new wedding is conducted around her.

"Rouge of the North," which unfolds in a lively, decorous, slightly overheated style that reflects the influence of American television, was ably directed by Fred Tan, a Taiwan-born former film critic who later became a United States citizen and studied film making at the University of California, Los Angeles. On the evidence of this film, Tan's flair was for the commercial, but he had a keen eye for detail and showed substantial promise. It is sad to report that he died last March, at the age of 35, of hepatitis contracted two years earlier, when he returned to China during the student uprising and the violence in Tiananmen Square.

1991 D 6, C24:5

FILM VIEW/Caryn James

'Veronique': In Poetry Lies Its Key

IF "THE DOUBLE LIFE OF VERONIQUE" SEEMS ambiguous now, think about what the director wanted it to be. Krzysztof Kieslowski's original idea was to create several slightly different versions of the film, to play in different theaters. If a viewer saw "Veronique" twice at different places, the story might change like a favorite bedtime story in which a phrase is altered or a scene added or dropped with each telling. There would be no "right" way to see the film.

The idea was too impractical and expensive to be more than a thought, but the notion suggests the best way to approach the enigmatic story of a Polish woman named Veronika and a French woman named Veronique (both played by Irène Jacob). The two young women look identical, were born at the same time, never meet, yet share some not-quite-conscious affinity. They are and are not the same. Don't even attempt to resolve that paradox, and "The Double Life of Veronique" will work on its own poetic terms. Try to piece

Mirror Image
Irène Jacob and Jerzy Gudejko are in "The Double Life of Véronique," Krzysztof Kieslowski's fable about two women, one Polish, the other Parisian, who are identical in many respects but lead vastly different lives.

Miramax

the film together like a jigsaw puzzle, try to make it yield some neat message about identity, and nothing will result except frustration.

"Veronique" has recently started its commerical run after being shown at the Cannes and New York film festivals. If the film is frustrating to many viewers, it is partly because Mr. Kieslowski plays with the jigsaw-puzzle approach, creating too many parallels and coincidences, photographing too many mirrors and reflections in windows. The images are

To look for a neat message in this enigmatic story is to find only frustration.

richly beautiful, but the director sometimes seems to be scattering clues and red herrings across two countries and two lives.

The first section of the film, set in Poland, follows Veronika as she goes to visit her aunt in Cracow, wins a music contest and collapses on stage while singing. Only after her collapse does the film move on, permanently, to Veronique in Paris. She is making love, apparently content. Suddenly she feels sad, "as if I were grieving," she says. She has no conscious idea that Veronika exists, much less that something has happened to her. Still, as if she had been warned, Veronique gives up her own plans for a professional career in music and becomes a teacher.

But the film's impact does not rely on such clues linking the women; it rests on the poetic images that defy translation and that link them even more firmly than the actual clues. Veronique receives a piece of string in the mail, a mysterious gift from an admirer. It is a sign identifying the man who sent it, a puppeteer and author who has written a children's book about a shoelace.

To viewers, it is a much less literal sign, one that brings to mind the image of Veronika singing and twisting the tie-string of her music folder around her finger until the string acccidentally snaps off.

Early in the film, Veronika holds up a small, clear plastic ball with brightly colored stars inside. It is a talisman that she carries in her purse, and as she rides the train to Cracow it reflects the image of a church and the passing landscape, upside down. Veronique dreams of Veronika's landscapes, and carries an identical little ball in her purse.

Veronique even teaches her class the same choral music that Veronika sings. The piece was composed 200 years ago but discovered only recently, she tells the class. This is another of Mr. Kieslowski's tricks. The music was created by Zbigniew Preisner, who has worked on several other Kieslowski films.

The composition, brand new, only seems to carry the weight of history, just as the film only seems to carry specific clues about the themes of identity. The string does not have any allegorical meaning; neither does the star-filled plastic ball. "Veronique" is poetic in the truest sense, relying on images that can't be turned into prosaic statements without losing something of their essence. The film suggests mysterious connections of personality and emotion, but it was never meant to yield any neat, summary idea about the two women's lives.

■

Viewers are accustomed to much more certainty on screen, though. In fact, the version of "Veronique" now playing has a slightly different ending from the one released in France. There, Veronique goes to visit her father, stops some distance from the house, and puts her hand on a tree — a tentative, inexplicable image. But after that version was shown at the New York Film Festival this year, Mr. Kieslowski realized that the ambiguity made American audiences uncomfortable. So he added a scene that shows Veronique walking to the house, embracing her father, finally at home with herself and the mystery of her double existence. It is a more soothing conclusion, but it won't alter anyone's opinion of the film.

Neither would any of the other endings Mr. Kieslowski proposed when he was thinking about the many versions of "Veronique." One would have ended with the puppeteer inventing a story about identical women, a scene that now comes very near the end of the film. Another version would have sent Veronique to Cracow, where she would have caught the eye of a singer who looks almost, but not exactly,

like herself and Veronika. These many lives of Veronique would have frustrated some expectations but opened endless poetic possibilities. □

1991 D 8, II:13:4

Hook

Directed by Steven Spielberg; screenplay by Jim V. Hart and Malia Scotch Marmo, story by Mr. Hart and Nick Castle; director of photography, Dean Cundey; film editor, Michael Kahn; music by John Williams; production design, Norman Garwood; produced by Kathleen Kennedy, Frank Marshall and Gerald R. Molen; released by Tri-Star Pictures. Running time: 131 minutes. This film is rated PG.

Captain Hook Dustin Hoffman
Peter Banning/Peter Pan Robin Williams
Tinkerbell Julia Roberts
Smee ... Bob Hoskins
Granny Wendy Maggie Smith
Moira Caroline Goodall

By VINCENT CANBY

Now we know: if Michael Milken and Ivan Boesky had been less power-driven and more in touch with the child within, Wall Street would have been spared a great scandal and each man a prison term.

That is the balmy subtext of "Hook," Steven Spielberg's gargantuan, very long screen update on James M. Barrie's 1904 play, "Peter Pan," and the subsequent Barrie stories about the little boy who refused to grow up. The film is a Wall Street-size financial gamble in itself.

"Hook" cost a mint, and it shows. To be profitable, it must be all things to as many people as possible, including kids who can identify with a 40-year-old man in a midlife crisis, and 40-year-old men in midlife crises who long to fight pirates with cardboard cutlasses.

The film is too much; yet the charm of the Barrie original has not been entirely lost.

•

"Hook" has a hugely funny bravura performance by Dustin Hoffman as the vain, vile and none-too-effective Captain Hook. Wearing a large black wig in the style of England's unfortunate Charles I, Mr. Hoffman's Hook preens, walks with a dainty step, loses his temper easily and tries very hard to be bad.

Equally comic is Bob Hoskins who plays Smee, Hook's smarmy aide-de-camp and, often, his brains. This cockney Smee belongs to the great theatrical tradition of wily menservants who, like Molière's Scapin, are their masters' masters.

As Hook is racking his brains to come up with a plan to destroy Peter Pan, Smee exclaims, "I think I'm having an apostrophe!" Says Hook, "I think you mean epiphany." The plan is, in fact, a clever one.

Smee gets the words wrong and Hook is short on invention. Neither character has been tampered with to conform to late-20th-century sensibilities.

•

The other casting is also good. As the middle-aged Peter Pan, Robin Williams doesn't look entirely comfortable when he must wear the green shorts better suited to Mary Martin, but he plays the role as legitimately as possible. Julia Roberts (Tinkerbell) goes through most of the film appearing to be about seven inches tall. Even at that size, she's a sweet, light, laughing presence.

Yet "Hook" is overwhelmed by a screenplay heavy with complicated exposition, by what are, in effect, big busy nonsinging, nondancing production numbers and some contemporary cant about rearing children and the high price paid for success. The acute difficulty of having it all may be of greater urgency to Mr. Spielberg than to most of the people who will see the movie.

"Hook" is less a sequel to "Peter Pan" than a variation on it. Its conceit is that, some years after the adventures described in "Peter Pan," Peter returned from Never-Never Land to London to see his adored Wendy and fell in love with Moira, the aging Wendy's granddaughter. To be able to consummate his love, he agreed to grow up.

•

When "Hook" begins, Peter, now called Peter Banning, is a frenetic, hard-driving mergers-and-acquisitions wizard living in Southern California with Moira and their two children. In his climb to the top, he has lost touch with his true self. He's so absorbed by business that he misses his 11-year-old son's most important baseball game.

Peter has completely forgotten his earlier incarnation, which is probably just as well for his career. Not many high rollers would entrust the fate of an unfriendly corporate takeover to a fellow who has a pal named Tinkerbell and as a mortal enemy a sword-buckled pirate with a hook for a hand.

When the Banning family makes a trip to London to see the 90-year-old Granny Wendy (Maggie Smith), Peter's children are kidnapped by the vengeful Hook and taken off to Never-Never Land. There is nothing to do but go in pursuit, at which point (somewhat late) the movie really begins.

What follows is an elaborate, thoroughly Americanized version of the Barrie play, reworked so that more time is devoted to teaching Peter how to dream and fly again than to his combat with Hook. Barrie's Lost Boys, once Peter Pan's charges, now inhabit a forest paradise equipped with basketball hoops and ramps for skateboards.

The kids appear to be mostly refugees from today's urban society. They have the style of children of the television age. They indulge in cheerless food fights and their language is sitcom wise, prematurely hip. They seem to be less permanently lost than on a two-week vacation at summer camp.

Their re-education of Peter may amuse very young patrons, but they aren't an especially funny or engaging crew. The movie picks up when Peter at long last takes to the air. Mr. Williams flies well. Yet he has a problem that no legitimate theater Peter Pan faces.

When an actor onstage goes swooping aloft, even though carried by wires never entirely invisible, the audience is as much mesmerized by the mechanics of the stunt (and the thought of what might happen, heaven forbid) as by the flying's import to the play.

Because anything can be done in a movie, the flying has less emotional impact. Special effects today are commonplace.

The sequences set in the pirate's cove and aboard the pirate ship, the Jolly Roger (which never leaves the dock), are somewhat more entertaining, but the movie's obviously expensive scale inhibits the fun instead of enhancing it.

The pirates' cove is a major movie set. As seen in long shots, it looks like something from the imagination of an uncharacteristically winsome Hieronymus Bosch. The ambers, reds, browns and grays are pretty, and the eye is dazzled by the sight of so many extras, each going about a different task. It's only with difficulty that Mr. Hoffman, Mr. Hoskins and Mr. Williams dominate so much scenery. It's an exhausting labor.

•

In "Close Encounters of the Third Kind," "E.T. the Extra-Terrestrial" and "Empire of the Sun," Mr. Spielberg demonstrated that he is one of America's most able directors when it comes to handling young actors. It's a surprise then that, with one exception, the children in "Hook" are so perfunctorily cast and directed.

Only Charlie Korsmo, the boy who played Kid in "Dick Tracy," is right. His material is no better than that given the other children, but he has

So the boy grows up after all, and he turns into a Lost Man. Not end of story.

wit and emotional weight as the son whom Peter has neglected. He even holds his own with Mr. Hoffman and Mr. Hoskins, in particular, in a baseball game that Hook has arranged to win the boy's affection.

Mr. Korsmo is a real actor. So, too, are Miss Smith and Caroline Goodall, who plays Moira, though their roles are subsidiary to the décor and the other stars.

Jim V. Hart and Malia Scotch Marmo wrote the screenplay from a

Murray Close/Tri-Star Pictures
Dustin Hoffman as Captain Hook in a scene from "Hook."

screen story by Mr. Hart and Nick Castle. The biggest laugh they provide is a lawyer joke. It's probably not the writers' fault that one keeps hearing what sound like song cues, if only because the 1954 "Peter Pan" musical adaptation remains so fresh.

Perhaps one day Mr. Hoffman will get a chance to sing that show's classic "Captain Hook's Waltz," music by Jule Styne and lyrics by Betty Comden and Adolph Green. In the meantime he does very well just acting the role with brilliance, a cappella.

•

"Hook," which has been rated PG (Parental guidance suggested), has some mildly scary moments and impolite language.

1991 D 11, C17:3

Bugsy

Directed by Barry Levinson; screenplay by James Toback; director of photography, Allen Daviau; music by Ennio Morricone; production designer, Dennis Gassner; produced by Mark Johnson; released by Tri-Star Pictures. Running time: 135 minutes. This film is rated R.

Benjamin (Bugsy) Siegel....... Warren Beatty
Virginia Hill Annette Bening
Mickey Cohen Harvey Keitel
Meyer Lansky.............................Ben Kingsley
George Raft.................................Joe Mantegna
Harry Greenberg.........................Elliott Gould
Charlie (Lucky) Luciano.............Bill Graham
Esta...Wendy Phillips

By JANET MASLIN

Benjamin (Bugsy) Siegel, a true gangster Gatsby, arrived in Hollywood with a heart full of promise and a gleam in his eye. Recklessly romantic, he brought with him the first glimmer of "a Garden of Eden in the desert": a brand-new resort that would provide organized crime with a political toehold, as well as a place that would outdo even the movie capital in terms of glitter, garishness and license to indulge any whim.

Some regard the American Dream as an expression of our best vision of ourselves. Others, like the makers of the sleek, funny, vastly entertaining "Bugsy," take a less sentimental view. This film, directed by Barry Levinson and written by James Toback, regards the man who dreamed up Las Vegas as a star-struck pragmatist, a mixture of glamour and cynicism, a visionary who saw the chance to create something very like himself only much, much bigger. "Bugsy" is a smart, seductive portrait of both the man and his monument. The debonair Ben Siegel (who greatly resented any comparison to an insect) would have loved everything about it except its name.

•

Warren Beatty, who is one of the film's co-producers, has found the role of his career in this sly, evasive schemer with the manipulative instincts of a born ladies' man. When an actor as skillful as Mr. Beatty has essentially only one character in his repertory, he can indeed be glad to find that character as fully realized as Ben Siegel is here. His antecedents, in films like "Shampoo" and "McCabe and Mrs. Miller," had a similar diffident charm and a similar awareness of their own failings, but Ben Siegel is much more dangerous and vital. If this self-styled "sportsman" had not existed, Mr. Beatty would have had to make him up.

Actually, "Bugsy" does make up its hero to a certain degree. The film's rosy portrait avoids such matters as Bugsy's involvement in drug smuggling, not to mention the long, shady career enjoyed by Virginia Hill, Bugsy's lover (and by some accounts his wife), after Bugsy's messy demise. Although "Bugsy" includes deft characterizations of such mob-

Warren Beatty and Annette Bening in 'Bugsy.'

sters as Meyer Lansky (played dryly by Ben Kingsley) and Lucky Luciano (the late Bill Graham), the film greatly understates the gangland aspects of its story. No Tommy guns here: instead, the silken "Bugsy" is filled with gold lamé evening gowns, clever repartee, strawberries and Champagne. It's fitting that Ben Siegel's infatuation with the swankiest of Hollywood elegance has been incorporated into his own story.

Directing "Bugsy" with both the requisite sweep and a welcome touch of the sardonic, Mr. Levinson begins his story at a crucial juncture in Ben Siegel's life: when this Brooklyn-born killer bade farewell to his New York origins and headed west to reinvent himself in more cinematic terms. A witty prelude establishes Ben as a flirt, a clothes horse and a tease, a man capable of presenting an expensive "shirt off my back" to someone he will murder only seconds later. In Los Angeles, where he is met at a beautifully evoked Union Station by his childhood friend George Raft (Joe Mantegna), these attributes quickly take on an aspect of the dramatic, especially when coupled with Ben's natural flair. "Gangster or Star?" a newspaper headline asks about this new arrival, early in his stay.

•

Definitely a star, at least as far as "Bugsy" is concerned. The film devises a great many intoxicatingly grand gestures for its hero, including the way he first glimpses Virginia Hill across a crowded Raft movie set and simply falls into step beside her. "May I?" he asks, seeing Virginia with an unlit cigarette. "If you want any simple yes or no you're going to have to finish the question," she replies. The encounter instantly establishes Virginia as a match for this tough guy, and ends quite magically as the two stand atop a little hill, by a fake rustic bus stop on the movie set, extravagantly overdressed and enjoying each another's talent for backtalk.

In this regard, Mr. Toback's screenplay is one of the film's happiest surprises. The overheated style of his own films (among them "Fingers" and "Exposed") is apparent in the dialogue, and in such episodes as Bugsy's violently humiliating another man, then feeling ravenously hungry afterward (while Virginia finds herself sexually stimulated by Bugsy's mean streak). But Mr. Levinson's direction is so adroit and wry that such moments lose their potential for excess. Thus muted, the bravado of Mr. Toback's language becomes crisply effective, as when the widely experienced Virginia tells Ben that she's been nothing but trouble for all of the many men she knew before

Peter Sorel/Tri-Star

Ben Kingsley

him. "Good," Ben answers. "That's what they get for trying to steal my girl."

As Virginia, Annette Bening provides "Bugsy" will all the heat and chemistry that Mr. Beatty's "Dick Tracy" lacked, sauntering through her role with a sexy abandon that greatly enhances the film's allure. Only later, when Virginia becomes a pivotal figure in Ben's plans to construct a hotel (named the Flamingo, in honor of the long-legged Virginia), does Ms. Bening seem less hardboiled, complex or changeable than the woman she plays.

•

"Bugsy" pales a bit in these later sections as a consequence of its having come on like gangbusters in its opening hour. Everything the audience needs to know about Ben and Virginia is established early, and Ben himself is not fundamentally changed by the events of the story. This is limiting, but it would be more of a problem if the film's sumptuous look and Mr. Beatty's performance were not so captivating on their own.

Also in "Bugsy" are Harvey Keitel, outstandingly blunt and funny as the gangster Mickey Cohen ("You would-be smoothie!" he shouts at Bugsy); the director Richard Sarafian as one of Ben's early henchmen; Bebe Neuwirth as the Countess Dorothy di Frasso, who Ben grandly hoped would introduce him to Benito Mussolini so Ben could personally shorten World War II, and Elliott Gould as the sad-sack childhood friend whom Ben eventually executes for business reasons. Typically, the film turns this into a solitary lethal act of Bugsy's when it was more likely the work of a three-man team.

Allen Daviau's camera work and Albert Wolsky's costumes help to forge the film's high style, as does Ennio Morricone's score. But much of its élan comes from Mr. Levinson's obvious affection for the time and place that are his film's backdrop, and from the flair with which he stages even minor episodes, like the montage showing how Ben sells 900 percent of his shares in the Flamingo in order to finance his plan. Another

Others saw a scrubby nowhere. He saw Las Vegas.

memorable sequence shows Ben and Virginia slinking gracefully back and forth past a movie screen, changing from full figures to silhouettes as they stalk each another.

Only occasionally, in a sequence that shows Ben racing from gangsters to the telephone to his unhappy family on his daughter's birthday, and wearing a chef's headgear all the

while, does the film's style appear overly antic. Most of the time, its spirit is captured by the strains of "Accentuate the Positive" heard tootling in the background, and by Meyer Lansky's last words on Bugsy Siegel and Las Vegas: "He isn't even interested in money. He's interested in the idea."

•

"Bugsy" is rated R (Under 17 requires accompanying parent or adult guardian). It includes sexual suggestiveness, violence and strong language.

1991 D 13, C12:1

The Last Boy Scout

Directed by Tony Scott; screenplay by Shane Black; story by Mr. Black and Greg Hicks; director of photography, Ward Russell; film editors, Mark Goldblatt and Mark Helfrich; music by Michael Kamen; production designer, Brian Morris; produced by Joel Silver and Michael Levy; released by Warner Brothers. Running time: 105 minutes. This film is rated R.

Joe Hallenbeck Bruce Willis
Jimmy Dix................................ Damon Wayans
Sarah HallenbeckChelsea Field
Sheldon Marcone Noble Willingham
Milo..Taylor Negron
Darian Hallenbeck Danielle Harris
Cory..Halle Berry

By VINCENT CANBY

The best thing about Tony Scott's "Last Boy Scout" is the title, which refers to Joe Hallenbeck (Bruce Willis), a once-exemplary Secret Service agent who wore black suits, white shirts and narrow ties, who shaved each morning and who, in his finest moment, saved the life of a United States President.

Today Joe is history. He's a burned-out case. He is a shabby Los Angeles private eye who sleeps off his hangovers in his beat-up car. In addition to nicotine, he is hopelessly addicted to one-liners. When Mr. Big, who is about to sic his goons on Joe,

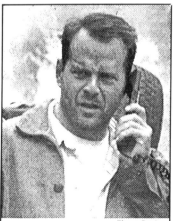

Warner Brothers

Tough Call
In "The Last Boy Scout," Bruce Willis plays a private detective who helps a former pro quarterback (Damon Wayans) clear his name of charges of drug use and gambling.

says that he would like, just once, to hear Joe scream, the response is a fast, "Play some rap music."

They don't make men like Joe anymore, but they do make screenplays like Shane Black's for "The Last Boy Scout." These would include "Lethal Weapon," for which Mr. Black wrote the screenplay, and "Lethal Weapon II," for which he wrote the first draft.

"The Last Boy Scout" is supposed to be a homage to the tough-guy detective fiction of Dashiell Hammett and Raymond Chandler; yet it plays more like a retread of the "Lethal Weapon" movies. The only things changed are the actors, the names of the characters and their professions.

•

Mr. Willis plays what is, in effect, the Mel Gibson role, though not quite as entertainingly maniacal. Damon Wayans takes over for Danny Glover of "Lethal Weapon" in a role that has been somewhat refurbished but remains essentially a voice of reason. He is Jimmy Dix, a former pro football star who, like Joe, is on the skids.

Joe's downward spiral began when a United States Senator had him fired from the service. Jimmy turned to cocaine when his wife, eight months' pregnant, was killed by a van that jumped the curb.

In Mr. Black's macho oeuvre, women either don't live long or do live badly. Joe has a wife, Sarah (Chelsea Field), but she cheats on him. He also has a 13-year-old daughter, Darian (Danielle Harris), who wears too much makeup and talks dirty. No matter that the movie acknowledges that Joe is to blame for his domestic problems. His true helpmate is Jimmy Dix.

"The Last Boy Scout" is about the ruthless attempt of the owner of a pro football team, called the Los Angeles Stallions, to secure senatorial backing for a bill to legalize gambling on sports. It's a story that, in other hands, might have made a good, tough, old-fashioned private-eye thriller.

Instead, Mr. Scott and Mr. Black have concocted another exercise in mechanical sleaze, in which narrative coherence is sacrificed on behalf of pyrotechnical special effects, mostly involving transport. When automobiles are not crashing, going over embankments or being blown up (the film's favorite mode of distressing a car), someone falls atop the rotors of a helicopter in mid-air. The body count is high.

•

Mr. Willis and Mr. Wayans have each demonstrated a knack for irreverent comedy in other vehicles — Mr. Willis in "Moonlighting" on television and in the "Die Hard" movies, Mr. Wayans on television as a regular member of the cast of "In Living Color." Yet they don't play very well together.

Joe and Jimmy meet cute and fight, then join forces to make Los Angeles safe for pro football. Their bonhomie seems forced, like the snappiness of the dialogue.

Mr. Scott ("Top Gun," "Days of Thunder") directs the film as if he were trying to win a prize for demolishing a building in record time. The opening is good: stylish video images of a night football game played in a torrential rain, climaxed by the only scene in the film that has legitimate shock. After that, the brutality and the pace don't slacken, but interest does.

The best thing in the film is Halle Berry ("Jungle Fever," "Strictly Business"), an actress who is going places. She appears briefly as cocktail waitress and stripper.

The news is not all bad for Mr. Willis. "The Last Boy Scout" is better than "Hudson Hawk."

"The Last Boy Scout," which is rated R (Under 17 requires accompanying parent or adult guardian), includes physical violence, sexual violence, foul language and partial nudity.

1991 D 13, C14:6

Critic's Choice

Experimenting Together

Elliot Caplan's "Cage/Cunningham," a 100-minute film being shown at Anthology Film Archives through Dec. 29, is a knowing — and indispensable — exploration of the lives and work of the composer John Cage and the choreographer Merce Cunningham. Mr. Caplan, resident film maker at the Cunningham Studio, draws on extensive archival material, filmed rehearsals and performances, and recent interviews with Mr. Cage, Mr. Cunningham and their colleagues.

The film, written by David Vaughan, assumes some prior knowledge of these two important experimentalists. There are gimmicks and some fatuous anecdotes, although, oddly, both enhance the film's gentle, even rhythm. What is important in this handsome collage is the sum, but what parts there are!

The philosopher M. C. Richards talks of the two as affirming angels whose work is their life style and who work "as if something extraordinary is at stake." And for all their simplicity and humor, Mr. Cage and Mr. Cunningham prove her right. There are telling comments by Robert Rauschenberg, Rudolf Nureyev, and Mr. Cage and Mr. Cunningham on their artistic discoveries over the last half-century. Frank Stella is amusing on the tiresomeness of dance. Mr. Cunningham provides what may be a key to his work in a story about his first dance teacher and her horror at seeing her young students line up neatly on the street. Mr. Cage talks of Mr. Cunningham's resting his tired feet by standing on his head.

Filmed from above in black and white, Mr. Cunningham is seen in a long-ago trudge down a street in some European city. Mr. Cage waters his plants with loving meticulousness. Mr. Cunningham whistles as he warms up at the barre on an empty stage.

"Cage/Cunningham" will be shown tonight at 9 and tomorrow and Sunday at 4 P.M. at Anthology Film Archives, 32 Second Avenue, at Second Street, Manhattan. Admission is $6. Information: (212) 505-5181.

JENNIFER DUNNING

1991 D 13, C37:1

Testimony

Directed, produced, designed, edited and co-written by Tony Palmer, from the "Memoirs of Dmitri Shostakovich," edited by Solomon Volkov; screenplay by David Rudkin; photographed by Nic Knowland. At Film Forum 1, 209 West Houston Street. Running time: 157 minutes. This film has no rating.

Shostakovich	Ben Kingsley
Stalin	Terence Rigby
Nina Shostakovich	Sherry Baines
Galya	Magdalen Asquith
Maxim	Mark Asquith

By STEPHEN HOLDEN

"Testimony," Tony Palmer's grandiose portrait of Dmitri Shostakovich, succeeds where many film biographies of composers fail; it evokes a visceral connection between musical creation and its historical moment. Periodically in the film, astutely chosen excerpts from Shostakovich's symphonies, played by the London Symphony Orchestra, underscore news film of two world wars and Stalin's purges to convey a sense of the blood-soaked stampede of European history in the first half of this century.

The 1988 film, which is having its American theatrical premiere at the Film Forum, stars a glittering-eyed Ben Kingsley as the composer, who at his death in 1975 had completed 147 works, including 15 symphonies. Shot mostly in black and white with color used sparingly for jarring dramatic effect, "Testimony" is much less a straightforward biography than an expressionistic montage that interweaves surreally imagined scenes from the composer's life with documentary film in a chronological sequence. With visual leitmotifs, the two-and-a-half-hour film also aspires to be a visual equivalent of the composer's Fifth Symphony, whose grinding, sarcastic, brass-heavy strains powerfully underscore scenes of Russian heavy industry and the gearing up of the Soviet war machine.

"Testimony" is based on the secret memoirs that Shostakovich dictated to Solomon Volkov, an expatriate Russian musicologist. Published in 1979, four years after the composer's death, the memoirs portray Shostakovich as a man who bent to the Soviet will to survive but who remained at heart a dissident. Their

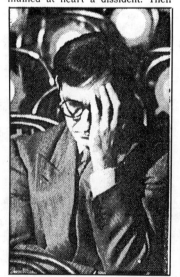

Film Forum

Recollections Ben Kingsley stars in "Testimony" as the tortured composer Dmitri Shostakovich.

authenticity was disputed by the Soviet Government. The film's central theme is Shostakovich's continuing struggle to come to terms with Stalin, with whom the composer fell out of favor in the early 1930's after his opera "Lady Macbeth of Mtsensk" was denounced. Stalin, who is portrayed by Terence Rigby as a fearsome wild boar, is shown as an isolated, shadowy giant hunched over his desk in what looks like a giant warehouse, forever checking off names on an endless list of enemies.

One of the film's most dramatic scenes shows the composer being vigorously denounced at a composers' union meeting for his "carnival squeaks," then getting up and delivering a groveling public apology. Another shows him in New York, where he was sent by the Government to attend an international peace conference, denouncing Stravinsky and other modernist composers for their formalism.

Like Ken Russell's film biographies of composers, Mr. Palmer's portrait makes everything seem a little larger than life. It also lacks Mr. Russell's prurient sense of the erotic wellsprings of creativity. Most of the scenes of Shostakovich's domestic life are clichéd portraits of tranquility amid paranoia. Some of the surreal touches are simply bizarre. What is Shostakovich's teacher, Glazunov, doing surrounded by giant alphabet blocks?

Mr. Kingsley's Shostakovich is a subtle and convincing study of a complicated man aging. And given the obstacles the composer faced, it is entirely free of self-pity. From a mousy young man with wide eyes and tight lips exuding an air of ironic detachment, he metamorphoses into a lonely, almost haunted figure whose eyes convey the same aloofness along with a terrible knowledge. The performance follows the film's view of Shostakovich as an artist who, despite capitulation to authority, never sacrificed his artistic integrity.

His music is the strongest evidence in the film to rebut those who would still argue that he became a party apparatchik pumping out officially approved bombast. Near the end of "Testimony," excerpts from a concert performance of the Symphony No. 13, Shostakovich's grim setting of Yevgeny Yevtushenko's poem "Babi Yar," are interspersed with horrific documentary scenes of concentration camps and the piled bodies of slain Russian Jews. This great late music stands up to the images.

1991 D 18, C25:1

J. F. K.

Directed by Oliver Stone; screenplay by Mr. Stone and Zachary Sklar, based on the books "On the Trail of the Assassins" by Jim Garrison and "Crossfire: The Plot That Killed Kennedy" by Jim Marrs; director of photography, Robert Richardson; edited by Joe Hutshing and Pietro Scalia; production designer, Victor Kempster; music by John Williams; produced by A. Kitman Ho and Mr. Stone. Running time: 188 minutes. This film is rated R.

Jim Garrison	Kevin Costner
Liz Garrison	Sissy Spacek
David Ferrie	Joe Pesci
Clay Shaw	Tommy Lee Jones
Lee Harvey Oswald	Gary Oldman
Lou Ivon	Jay O. Sanders
Bill Broussard	Michael Rooker
Jack Martin	Jack Lemmon
Senator Russell B. Long	Walter Matthau
Colonel X	Donald Sutherland
Willie O'Keefe	Kevin Bacon
Guy Bannister	Edward Asner
Jack Ruby	Brian Doyle Murray

By VINCENT CANBY

IN one of the dizzying barrage of images with which Oliver Stone begins "J. F. K.," President Dwight D. Eisenhower is seen on television not long before he left office in 1961. It is one of Ike's finer moments.

There he is, the former five-star general, the man who salvaged the Presidency for the Republican Party, warning the American people to beware of the military-industrial complex, a vested interest that, one might reasonably suppose, was oriented more toward the Republicans than the Democrats.

"J. F. K." goes on for another three hours or so. Yet as busy and as full of exposition as it is, it never becomes much more specific than Ike. The conspiracy that, "J. F. K." says, led to the assassination of Eisenhower's successor, John F. Kennedy, in Dallas on Nov. 22, 1963, remains far more vague than the movie pretends.

According to "J. F. K.," the conspiracy includes just about everybody up to what are called the Government's highest levels, but nobody in particular can be identified except some members of the scroungy New Orleans-Dallas-Galveston demimonde.

That the subject is hot is apparent from all the criticism the movie received even before it was completed. The ferocity of that outrage should now subside, in part because "J. F. K.," for all its sweeping innuendos and splintery music-video editing, winds up breathlessly but running in place.

The movie will continue to infuriate people who possibly know as much about the assassination as Mr. Stone does, but it also shortchanges the audience and at the end plays like a bait-and-switch scam.

"J. F. K." builds to a climactic courtroom drama, the details of which it largely avoids, to allow Kevin Costner, the film's four-square star, to deliver a sermon about America's future with an emotionalism that is completely unearned.

What the film does do effectively is to present the case for the idea that there actually was a conspiracy, rather than the lone gunman, Lee Harvey Oswald, specified by the Warren Commission report. Beyond that "J. F. K." cannot go with any assurance. This is no "All the President's Men." The only payoff is the sight of Mr. Costner with tears in his eyes.

The film's insurmountable problem is the vast amount of material it fails to make coherent sense of. Mr. Stone and Zachary Sklar, who collaborated on the screenplay, take as their starting point Jim Garrison's book, "On the Trail of the Assassins."

Mr. Garrison, played in the film by Mr. Costner, is the former New Orleans District Attorney who, five years after the assassination, unsuccessfully prosecuted Clay Shaw, a New Orleans businessman, in connection with the Kennedy murder.

To give the film something resembling conventional shape, Mr. Stone has turned Mr. Garrison into what he describes as "a Frank Capra character," that is, a plain, dedicated down-home fellow called Jim, someone who represents "the best American traditions."

Like millions of Americans, the movie's Jim admires President Kennedy and mourns him when he is murdered. But Jim also comes to see Kennedy as the 20th century's great fearless dove, whose death might be traced, if only the facts were allowed to come out, to everyone who benefited from his death. These would include corporations profiting from the Vietnam War, members of the Federal Bureau of Investigation, the Central Intelligence Agency, the Secret Service and, by clever indirection, even President Lyndon B. Johnson, Kennedy's Vice President.

Acting in concert with them or at their behest, though in ways that remain undetermined, are ultra-right-wing fanatics represented in the movie by Clay Shaw (Tommy Lee Jones), some unidentified Cuban exiles and a former F.B.I. man named Guy Bannister (Ed Asner). Also involved are various fringe types like David Ferrie (Joe Pesci), a pilot for hire; the small-time mobster Jack Ruby (Brian Doyle Murray), and Oswald (Gary Oldman), whose place in the conspiracy has become utterly mysterious by the time the movie ends.

"J. F. K." begins with a promise of intrigue and revelation, though it soon becomes clear that Mr. Stone is Fibber McGee opening the door to an overstuffed closet. He is buried under all the facts, contradictory testimony, hearsay and conjecture that he would pack into the movie.

What is fact and what isn't is not always easy to tell. Though one character is officially listed as having committed suicide, the movie allows us to see him being forced to take lethal pills. This is not speculation. Anything shown in a movie tends to be taken as truth.

The movie sees everything through the bespectacled eyes of the tireless Jim. "J. F. K." suffers with him when

the Donna Reed character, Jim's wife, Liz (Sissy Spacek), says, "Honestly, I think sometimes you care more about John Kennedy than you do your own family!"

Jim has missed a luncheon at Antoine's with Liz and the children. Some things, such as Presidential assassinations, require terrible sacrifices from those who would investigate them.

"J. F. K." is suitably aghast when Jim goes to the Lincoln Memorial in Washington to meet a man who iden-

A soundtrack layered like strudel with dialogue, music and noise.

tifies himself only as X (Donald Sutherland) but who is obviously high in the military-industrial complex. X is the one who, in a very long omnibus sort of monologue accompanied by images that jump all over the world, suggests that Jim check into the participation in the conspiracy of everyone who stood to gain from Kennedy's death.

Says Jim in his golly-gee-whiz manner, "I never realized that Kennedy was so dangerous to the Establishment!"

The movie rushes frantically on, its unsubstantiated data accumulating while Jim becomes a victim of a

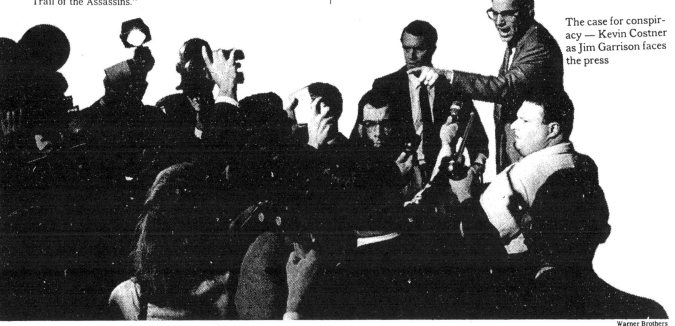

The case for conspiracy — Kevin Costner as Jim Garrison faces the press

Warner Brothers

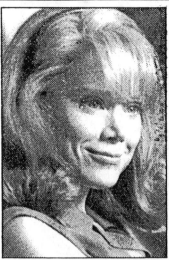

Sissy Spacek

Warner Brothers

caustic press and a vicious, self-serving Establishment. Little by little Mr. Stone seems to identify Jim with John Kennedy. When X says of the conspiracy, "It's as old as the Crucifixion," it suddenly appears that the film maker would elevate Jim and John to an even higher pantheon.

By the time "J. F. K." reaches the Clay Shaw trial, most uninformed members of the movie audience will be exhausted and bored. The movie, which is simultaneously arrogant and timorous, has been unable to separate the important material from the merely colorful. After a certain point, audience interest tunes out. It's a jumble.

"J. F. K." rivets in the manner that was intended in two sequences: its presentation of the evidence about the number of bullets fired at the Kennedy motorcade and its presentation of the so-called Zapruder film, the record of the assassination itself. But even in these latter sequences, the movie remains an undifferentiated mix of real and staged material.

Mr. Stone's hyperbolic style of film making is familiar: lots of short, often hysterical scenes tumbling one after another, backed by a soundtrack that is layered, strudel-like, with noises, dialogue, music, more noises, more dialogue. It works better in "Born on the Fourth of July" and "The Doors" than it does here, in a movie that means to be a sober reflection on history suppressed.

Some of the performances are good, all by actors who get on and off fairly fast: Mr. Jones, Mr. Pesci, Mr. Asner, Jack Lemmon (as a feckless crony of one of the New Orleans suspects) and Kevin Bacon, who plays a male hustler.

When Walter Matthau turns up for a brief, not especially rewarding turn as Senator Russell B. Long, "J. F. K." looks less as if it had been cast in the accepted way than subscribed to, like a worthy cause. The cause may well be worthy; the film fails it.

•

"J. F. K." is rated R (Under 17 requires accompanying parent or adult guardian). It has some scenes of violence and bloodshed and a good deal of vulgar language.

1991 D 20, C1:1

Father of the Bride

Directed by Charles Shyer; screenplay by Frances Goodrich and Albert Hackett, and Nancy Meyers and Mr. Shyer; director of photography, John Lindley; film editor, Richard Marks; music by Alan Silvestri; production designer, Sandy Veneziano; produced by Nancy Meyers, Carol Baum and Howard Rosenman; released by Touchstone Pictures. Running time: 101 minutes. This film is rated PG.

George Banks	Steve Martin
Nina Banks	Diane Keaton
Annie Banks	Kimberly Williams
Matty Banks	Kieran Culkin
Bryan MacKenzie	George Newbern
Franck Eggelhoffer	Martin Short
Howard Weinstein	B. D. Wong

By JANET MASLIN

Vincente Minnelli's 1950 "Father of the Bride" is an affectionate reminder of the days when parties required stiff protocol, suburban life was martini-filled and gracious, a majority of one's college classmates were likely to be married and a father was truly a patriarch, valiantly meeting the fiscal and emotional needs of everyone in his household. It's an antique with a story that doesn't quite track in a world where Mother runs a business and Daddy's little girl plays basketball.

But "Father of the Bride" has been charmingly if improbably remade, with Steve Martin as the embattled father who suffers new indignities at each stage of his daughter's wedding plans. Mr. Martin, following in the very large footsteps of Spencer Tracy, is meant to be a sturdy, houseproud businessman and the long-married, devoted father of a 22-year-old daughter. He's not believable in any of these capacities, but he can be very funny, especially when the director, Charles Shyer, gives him room to depart from Tracy's indelible performance and make the role his own.

Mr. Martin, whose presence here probably has more to do with his success in "Parenthood" than anything else, is first seen sitting in an armchair exactly as Tracy did, rubbing his sore feet and surveying the ruins of an extravagant wedding party. The film then flashes back to the point at which George Banks (Mr. Martin) and his wife, Nina (Diane Keaton), learned that their little Annie (Kimberly Williams) may be leaving the nest.

•

The nest itself has moved to southern California from a starchier East Coast setting and is now conspicuously cluttered and brand-new. There's nothing about it that looks lived in, which is in keeping with the remake's artificial flavor. Still, this house becomes an interesting echo of the earlier film's exaggeratedly gracious setting. This "Father of the Bride" is filled with evidence of how the idealized vision of American family life has changed in the last 40 years, from the fact that the cost of throwing the wedding has multiplied by nearly a hundredfold to the absence of alcohol-related humor, which was a big staple of the earlier version.

This time, when the Bankses go to meet their wealthy prospective in-laws, George doesn't drink too much and talk their ears off, as Tracy did. He experiences a sudden fit of nosiness and winds up floating in his hosts' pool, clutching their bankbook while being snarled at by their guard dogs, in a routine that is much better suited to Mr. Martin's comic talents.

Some of the new film's other efforts to broaden the story are less success-

ful, like the episode that has George going berserk in a grocery store and winding up in jail as a consequence of pre-wedding pressure. As for the wedding itself, it turns out to be overlong and anticlimactic, and it tries too hard to draw tears. The new film contains a lot more sentimental heart-to-heart talks than the earlier one did.

Mr. Martin is always the comic centerpiece of "Father of the Bride," while Ms. Keaton has been given a matronly role and much less to do. Ms. Williams, who must compete with the memory of a radiant young Elizabeth Taylor in the bride's role, does a spirited job of making the character more modern. (Ms. Taylor's most memorable line, cooing to her father about her husband-to-be's occupation: "Well, I don't know, Pops, he makes something. Does it really matter what it is?")

Kieran Culkin, playing the bride's little brother, has the same scene-stealing confidence his older brother Macaulay does. Also in the film are B. D. Wong and Martin Short as a pair of wedding consultants who are too flouncy to be entirely funny. Mr. Short, with a fussy coiffure and an indecipherable accent (he says "kek" for "cake"), strongly recalls Bronson Pinchot's hilariously bizarre art-gallery assistant in "Beverly Hills Cop."

The screenplay, credited to Frances Goodrich, Albert Hackett, Nancy Meyers and Mr. Shyer, represents recycling at its best. The material has been successfully refurbished with new jokes and new attitudes, but the earlier film's most memorable moments have been preserved. One of these finds Mr. Martin struggling to squeeze into his old suit of formal clothes just as Tracy did, although in Mr. Martin's case it's a tuxedo with a ruffled shirt, circa 1975; Tracy wore a cutaway with top hat and tails. That's the difference between the first, formal "Father of the Bride" and the new one, in which condoms and seat belts and running shoes are part of the world.

•

"Father of the Bride" is rated PG (Parental guidance suggested). It includes mild profanity.

1991 D 20, C17:1

At the Insane End Of a Twisted Road

"Golden Braid" was shown as part of the 1990 New York Film Festival. Following are excerpts from Caryn James's review, which appeared in The New York Times on Oct. 5, 1990. The film opens today at the Cinema Village, West 12th Street, near University Place, in Manhattan.

Paul Cox's "Golden Braid" is so sincere that it deserves respect, yet so precious and absurd that it's probably best to get the unintentional laughter out of the way. Bernard, a middle-aged clockmaker, is having an affair with a married Salvation Army soldier, yet feels he's cheating on her with a lovely, long golden braid he finds in an antique clock. "I wish I could take you to a restaurant, to the theater," the clockmaker tells the hair as he lies in bed and strokes his body with it. Eventually, he puts the braid in his pocket and takes it to

dinner at a Chinese restaurant. At a concert, the braid occupies the empty seat meant for the woman.

Mr. Cox, a well-regarded Australian director, recognizes that this is sick behavior and that sometimes there's no accounting for obsessions. In fact, the idea (very loosely based on a Guy de Maupassant story) lends itself perfectly to the sort of slow journey into madness that the film means to chronicle. But Mr. Cox concentrates so painstakingly on the poetic trappings of the man's behavior, and does so little to make the madness believable, that the results are simply tedious.

The cases, faces and mechanisms of clocks are all-too-artily photographed throughout the film. Bernard and his mistress sometimes make love in bed and sometimes on the stairs, but almost always in blue-shadowed light.

Chris Haywood gives a remarkably controlled, straightforward performance as Bernard. The actor never seems silly, even when going through the motions of false, rarefied cinematic madness.

1991 D 20, C20:6

High Heels

Directed and written by Pedro Almodóvar; in Spanish with English subtitles; director of photography, Alfredo Mayo; edited by Pepe Salcedo; music by Ryuichi Sakamoto; produced by Agustín Almodóvar; released by Miramax Films. Running time: 112 minutes. This film is rated R.

Rebecca	Victoria Abril
Becky Del Paramo	Marisa Paredes
Femme Lethal	Miguel Bosé

By JANET MASLIN

Pedro Almodóvar labors harder at striking a light tone than other film makers might work at a serious one. And "High Heels," the latest from the director of "Women on the Verge of a Nervous Breakdown," is very labored indeed. Combining story ele-

Miramax

Together Again In "High Heels," Victoria Abril plays the daughter of a famous diva who has an uneasy reconciliation with her mother after the two have not seen each other for 15 years.

ments worthy of Greek tragedy with the frivolous look of a fashion statement, Mr. Almodóvar sometimes achieves an arch, unpredictable narrative style but more often manufactures leaden fluff.

Unlike this director's best work, "High Heels" has no real mirth and not even enough energy to keep it lively. Even the gaudiness of Mr. Almodóvar's antic taste seems muted this time. The clothes in this film, by Chanel and Giorgio Armani, are deliberately sedate, yet they often upstage the people.

"High Heels" concerns a mother and daughter with a long, troubled history. Becky Del Páramo (Marisa Paredes), the mother, is supposedly a hugely popular singing star, although the film is never any more convincing on this point than it is about anything else. Her daughter, Rebecca (Victoria Abril, the star of Mr. Almodóvar's recent and somewhat better "Tie Me Up! Tie Me Down!"), is a Madrid television newscaster who mistrusts and resents her mother, and who has married her mother's ex-lover to prove the point.

This man's murder and the ensuing mother-daughter tensions provide the film with what would, under more conventional circumstances, be a compelling plot. But "High Heels" never takes itself seriously enough for that, since Mr. Almodóvar seems to prefer the sidelines of his own story. A jailhouse scene in which the Lycra-clad female inmates burst into song in the prison yard, for instance, has a lot more vigor than the film's endless, shapeless conversations about the mother, the daughter and the murder. The film takes another lively digression at a nightclub where Becky watches a female impersonator named Femme Lethal (Miguel Bosé, a Spanish pop star) do his Becky imitation. Femme Lethal looks a lot better doing this act than Becky does.

In his dressing room, Femme Lethal also engages in strenuously acrobatic sex with Rebecca. ("I'd like to be more than a mother to you!" he tells her, in one of the film's few flashes of wit.) This episode is then forgotten until the story's supposedly surprising conclusion. One of the problems with "High Heels" as "a tough melodrama" (in Mr. Almodóvar's own description) is that it isn't really tough, melodramatic or successfully diverting in any other way. Anyone who bothers to follow the plot will be way ahead of it most of the time.

●

"High Heels" is rated R (Under 17 requires accompanying parent or adult guardian). It includes partial nudity and sexual situations.

1991 D 20, C20:6

Rhapsody in August

Directed and written by Akira Kurosawa; in Japanese with English subtitles; based on the novel "Nabe-No-Noka," by Kiyoko Murata; cinematography by Takao Saito and Masaharu Ueda; music by Shinichiro Ikebe; produced by Hisao Kurosawa. At Lincoln Plaza, Broadway at 63d Street, Manhattan. Running time: 98 minutes. This film is rated PG.

Kane	Sachiko Murase
Tadao	Hisashi Igawa
Machiko	Narumi Kayashima
Tami	Tomoko Ohtakara
Shinjiro	Mitsunori Isaki
Yoshie	Toshie Negishi
Noboru	Choichiro Kawarasaki
Tateo	Hidetaka Yoshioka
Minako	Mie Suzuki
Clark	Richard Gere

By VINCENT CANBY

Long regarded at home and abroad as the least Japanese of great Japanese directors, in part because his work has been so widely hailed outside Japan, Akira Kurosawa has now made his most Japanese film in years and, as might be expected, he has been damned for it.

When his new "Rhapsody in August" was shown out-of-competition at this year's Cannes festival, the critics were inclined to dismiss it for the simplicity of its structure and its moralizing tone. The inference was that Mr. Kurosawa, born in 1910, was giving in to age, losing his touch.

Not so. The master is as vigorous and complex as ever, though now impatient with the world in which he has been making movies so productively since 1943.

"Rhapsody in August" will be a shock to audiences who know Mr. Kurosawa only through his recent films, the grandly spectacular "Kagemusha" (1980), "Ran" (1985) and last year's "Akira Kurosawa's Dreams."

"Rhapsody in August," opening today at the Lincoln Plaza, is something quite other.

It's a contemporary drama that is small in physical scope and apparently quite blunt about what it's up to. Though it seems to be stern, it is photographed in the bright, clear colors of youth, has moments of ravishing beauty and concludes with an image of profound lyricism. It plays as if it were a mysteriously flawed summer idyll, a pastoral into which doomy thoughts had been allowed to enter by accident.

The principal setting is a farm just over the mountains from Nagasaki where, on Aug. 9, 1945, at 11:02 A.M., the Americans dropped their second and last atomic bomb, effectively to end World War II.

Four teen-agers, two sets of first cousins, have been left with their grandmother at the farm while their parents visit the grandmother's eldest brother, in Hawaii. This fellow, whom the grandmother cannot clearly remember, migrated in 1920, stayed on to marry an American and to become rich as the owner of a pineapple plantation.

The children long to join their parents in Hawaii, but make do as best they can with the loving but eccentric old lady. No television. No washing machine. They are polite but bored. They make fun of her cooking, which seems to be mostly kidney beans boiled into mush and served with a lot of soy sauce.

In the course of the summer the children take sight-seeing trips into Nagasaki. They go to the school where their grandfather, a teacher, died in the 1945 raid. A tangle of rusted iron bars, a melted jungle gym, stands as a memorial in the schoolyard. "For most people today," says one child, speaking rather sagely for his age, "Nagasaki happened once upon a time."

Richard Gere

Orion Classics

Lasting Memories Sachiko Murase stars in "Rhapsody in August," Akira Kurosawa's drama exploring the long-term effects of war on three generations of one Japanese family.

They visit the black granite monolith that marks the spot over which the bomb was detonated. Surrounding the monolith are sculptures presented to the people of Nagasaki by virtually every developed nation in the world except the United States.

Back at the farm the grandmother tells the children stories that may or may not be true. They have the aspect of myth. There is the one about her younger brother who was once saved from drowning by a water imp. Often she talks about the war, about her brother who, after the bomb, lost his hair and stayed in his room all day drawing pictures of "the eye."

On the morning of the bomb, she says, she and her brother had been standing in the yard, looking toward the city when, suddenly, "the sky split and the eye glared through the crack." One child asks what kind of an eye it was. "The eye of the flash," she says.

Several days after the children's parents return, they receive word that their Japanese-American cousin Clark (Richard Gere) is arriving from Hawaii. It seems he has just learned that Grandmother's husband, his uncle, died in the raid. The parents fret that Clark has come to break off relations with his Japanese cousins. Says one, "American don't like to be reminded of the bomb, especially Japanese-Americans."

The children are embarrassed that their parents really are more worried about losing their contact with Clark's company than with Clark.

They are thus surprised that, when Clark arrives, he apologizes to his ancient aunt for the bomb that killed her husband.

This is the film's sticking point, a not-great dramatic moment, anyway, and one that requires Mr. Gere to be simultaneously grave, concerned and honorable. The actor does well, but it's difficult for him not to look obsequious. A lot of people at Cannes were outraged that the film makes no mention of Pearl Harbor and Japan's atrocities in China.

Good points, up to a point.

Mr. Kurosawa, not exactly a known militarist, says that he means "Rhapsody in August" to be against all war, and there are statements to the effect that during the war many people died on both sides. Yet the message does get muddled. If Clark can apologize for bombing Nagasaki, why can't Granny apologize for the raid on Pearl Harbor?

That is to miss Mr. Kurosawa's real concern. I suspect that he would admit that he doesn't know how Americans feel about the war, and that the subject is beyond his speculation. Yet he does understand the Japanese character.

He's suggesting here that if Japanese, those of the children's parents' generation, are so convinced that Americans are unforgiving, it also means that the same Japanese are equally implacable. That is the danger to which he speaks.

Though Mr. Kurosawa's most faithful audiences are abroad, "Rhapsody in August" appears to have been designed primarily for home consumption. Its concerns are domestic. It was a risky movie for him to make; but also a brave and wonderfully stubborn one.

The children are scarcely more than attractive mouthpieces. They are idealized figures. Yet the 87-year-old Sachiko Murase is very fine as the grandmother. If the others are generic, she is particular. She's a tiny, strange, unsentimental alien surrounded by the youth of her grandchildren, the cant of her own middle-aged children and her own demanding memories.

"Rhapsody in August" is didactic. But Mr. Kurosawa is such a natural film maker that even his didacticism is touched by poetry. In "Rhapsody in August" he shows us the eye of the flash.

●

"Rhapsody in August," which has been rated PG (Parental guidance suggested), has a lot of talk, translated by English subtitles, which small children will not understand.

1991 D 20, C22:4

Ted and Venus

Directed by Bud Cort; screenplay by Paul Ciotti and Mr. Cort, story by Mr. Ciotti; director of photography, Dietrich Lohmann; edited by Katina Zinner; music by David Robbins; production designer, Lynn Christopher; produced by Randolf Turrow and William Talmadge; released by Double Helix. Running time: 100 minutes. This film has no rating.

Ted Whitley	Bud Cort
Max Waters	Jim Brolin
Linda Turner	Kim Adams
Colette	Carol Kane
Gloria	Pamella D'Pella
Herb	Brian Thompson
Grace	Rhea Perlman
Mrs. Turner	Gena Rowlands
Ted's lawyer	Martin Mull
Judge H. Converse	Dr. Timothy Leary
Homeless Vietnam veteran	Woody Harrelson

By JANET MASLIN

"Ted and Venus" tells of a sadly dissipated drifter who lives in Venice, Calif., and becomes obsessed with a beautiful young woman he first glimpses on the beach. Since Ted (Bud Cort), an ex-mental patient who is an aspiring and supposedly talented poet, expresses his longing for Linda (Kim Adams) largely by means of surprise visits and obscene phone calls, it's not surprising that their relations never get past the ten-

uous stage until the film reaches its bleak finale.

Directed by Mr. Cort and based on a Southern Californian newspaper story, "Ted and Venus" seems to regard Ted as a good-hearted innocent. The audience isn't likely to share that view. Mr. Cort, still best remembered for his role as Ruth Gordon's young suitor in "Harold and Maude," directs other actors with some assurance but seems to have little idea of how he himself comes across on the screen. Alternating between wide-eyed naïveté, dopey humor (in his stridently awful poetry readings) and boozy exaggeration, he turns Ted into an unsympathetic pest and makes Linda's attempts to avoid him understandable. Indeed, when Ted first expresses his yearning for Linda, he affects a kind of dog-paddle and seems to be experiencing apoplexy rather than love.

One of the film's particularly unfortunate touches, after Linda takes legal measures to keep Ted from tackling her, is a courtroom scene in which Ted's lawyer (Martin Mull) cavalierly concocts a story of how Linda invited Ted for a walk on the beach and attempted to seduce him. The audience knows this to be a lie, and not a terribly original one at that.

•

Among the film's would-be appealing aspects are Ted's lecherous come-ons to almost any woman he meets. ("That's not a leer, honey — he always looks like that," says Jim Brolin, as Ted's unaccountably loyal friend, to Carol Kane as a giddy prostitute). Also memorable for the wrong reasons is a scene in which Ted steals a chainsaw from another lunatic, who is juggling with it, and takes the device over to Linda's apartment. There, he threatens to cut off his fingers to win her love. Mr. Cort's performance actually improves when Ted ceases to be this cute and begins looking suicidally depressed.

"Ted and Venus" has to its credit a vivid sense of the numerology, yoga classes and dulcimer lessons that col-

Rory Flynn

In Thrall Kim Adams appears in "Ted and Venus," about a poet who falls in love with a social worker in California during the Watergate affair.

or California beach life, circa 1974, when the story takes place, and an interesting cast. In addition to Mr. Brolin, who's surprisingly plausible as a jaunty, hard-drinking hipster, and Ms. Adams, gently alluring in what once would have been the Leigh Taylor-Young nubile hippie role, the film also features Gena Rowlands, who plays Linda's mother and flatly advises her daughter to get a restraining order against the obnoxious Ted. Also in the film are Woody Harrelson, obscured inside a cardboard box for his role as a homeless Vietnam veteran, Dr. Timothy Leary as a judge and Pamella D'Pella as another bad poet who is featured prominently in the locker-room shots Mr. Cort favors. It's hard to know whether these are meant to affirm Ted's lust for life or bolster his image as a creep.

•

"Ted and Venus" is rated R (Under 17 requires accompanying parent or adult guardian). It includes sexually explicit language and partial nudity.

1991 D 20, C23:1

Rush

Directed by Lili Fini Zanuck; screenplay by Pete Dexter, based on the book by Kim Wozencraft; director of photography, Kenneth MacMillan; edited by Mark Warner; music by Eric Clapton; production designer, Paul Sylbert; produced by Richard D. Zanuck; released by Metro-Goldwyn-Mayer. Running time: 120 minutes. This film is rated R.

Jim Raynor Jason Patric
Kristen Cates Jennifer Jason Leigh
Larry Dodd.................................Sam Elliott
Walker...Max Perlich
Will Gaines Gregg Allman
Willie Red Special K MoCray

By JANET MASLIN

"Rush" is the story of a dutiful rookie police officer named Kristen Cates (Jennifer Jason Leigh) who is enlisted for special hardship duty by Jim Raynor (Jason Patric), her older and more experienced partner. Kristen's new assignment is to be part of an undercover narcotics operation and pretend that she and Jim are eager to buy drugs. Jim assures her that he can show her the ropes.

It soon becomes apparent that Jim is a shade too eager to throw himself into his work. Conforming to strict police rules about drug use, he explains, can blow one's cover within the drug demimonde. So it's important to know such tricks as injecting baby laxative into a vein to simulate hard drug use, a technique Jim avidly demonstrates for his startled protégée. He also explains his reasons for circumventing departmental rules about what undercover detectives should do with drugs they buy in the line of duty. It doesn't take a new recruit of Kristen's acuity to realize that Jim has been sampling the merchandise.

But Kristen is willing to be coached and molded by the broodingly handsome Jim. "You've got to do something about your hair," he advises her. "Quit washin' it." He also tells her she'll have to learn to lie more convincingly, and it isn't long before she has mastered that particular skill. "You're not takin' your work home at night?" her police superior (Sam Elliott) asks when the formerly demure Kristen shows up looking jit-

tery and unkempt. Kristen gives him a carefully ambiguous answer.

•

"Rush" is a dark, sobering look at Jim and Kristen's spiraling decline once they are seduced by each other and by the drug culture around them. Set in a Texas town in 1974, it's particularly effective in evoking the shady characters who constitute that town's drug culture. A virtually wordless Gregg Allman, playing a suspected drug kingpin and striding ominously through the film, becomes the perfect visual artifact of the time and place this film seeks to capture. There's an outstandingly good supporting performance from Max Perlich as the nervous middleman who is forced to become Jim and Kristen's entree into drug-buying, and who somehow maintains an innocence throughout these sordid goings-on.

Directed in a terse, edgy style by Lili Fini Zanuck, "Rush" has a lot of momentum and remains disturbingly vivid as far as it goes. But Ms. Leigh and Mr. Patric, who are both persuasive, are relatively opaque actors. And there are important moments at which Pete Dexter's otherwise deft screenplay (from Kim Wozencraft's novel) doesn't give them much to say. A lot of these characters' thoughts

about their predicament never surface except in quick, frightening glimpses, some of which seem unduly abrupt. "Rush" is often more successful at being clinical than at being clear.

Taking an undercover assignment too seriously.

Eric Clapton's score is utterly apt but also overused, washing over valuable opportunities for the principals to speak. Still, Mr. Patric and Ms. Leigh are able to make Jim and Kristen as grimly memorable as the drug culture that threatens to engulf them both.

•

"Rush" is rated R (Under 17 requires accompanying parent or adult guardian). It includes profanity, drug use and sexual situations.

1991 D 22, 56:4

FILM VIEW/Caryn James

'Bugsy' Muscles In on Hollywood Glamour

D
RIVING ALONG A SUNNY, PALM-lined Hollywood street that might as well have "movie set" bannered across it, Bugsy Siegel asks his pal George Raft, "How would someone go about getting a screen test?" — as if being a gangster, a family man, a womanizer, a murderer, a snazzy dresser and a guy preoccupied with his tan weren't enough. Everyone wants to be a star.

In Warren Beatty's brilliantly seductive and funny performance, Ben Siegel is vain and violent, with a certain crackpot charm; they didn't call him Bugsy for nothing. And, as he was in real life, Bugsy is hopelessly enamored of the movies.

The enormous allure of "Bugsy" — both the character and Barry Levinson's delicious film — comes from that star-struck feel for Hollywood glamour. This killer can be a hero because the movie is about celebrity, not gangsterhood, about romance, not power; it is less about the real Bugsy than his legend. Everything about "Bugsy" embraces the stylized movie scene of the 30's and 40's, from the well-publicized love affair between Warren Beatty and his co-star, Annette Bening, to the film's tough-guy dialogue, its blatantly fake sets of nightclubs and train stations, and its absurdly compressed time scheme. Harking back to the best old Hollywood entertainments, the film shrewdly taps into the dreamy romance of the movies.

Zooming in on Bugsy's Hollywood days and his affair with the moll and sometime-starlet Virginia Hill (Ms. Bening) is only the beginning of the film's fascination with Bugsy-as-star. He meets Virginia on a movie set, where they watch George Raft (Joe Mantegna) do take after take while shooting "Manpower," until Bugsy can mouth Raft's lines.

During their first, long, more-than-suggestive conversation, Bugsy and Virginia walk along a fake road on the set. These two glamorous creatures — she is wearing a golden evening gown and he is, after all, Warren Beatty — comically flirt in front of a small-town bus stop. Their love will turn out to be real, but their arch dialogue and glass-shattering arguments will always carry a hint of movie artifice.

When Virginia stops playing hard to get, she turns up at Bugsy's house while he is watching his own, homemade screen test. Mr. Beatty, on screen in black and white, awkwardly delivers George Raft's lines, which provides the setup for one of the most sylish scenes Mr. Levinson has ever directed.

As the film of Bugsy's screen test runs out, he and Virginia kiss and are seen as silhouettes against the blank screen. It is a hugely romantic and effective moment, in part because the dialogue undercuts the sentiment. "Do you always talk this much before you *do* it?" asks the shadowy but still no-nonsense Virginia. "I only talk this much before I'm going to kill someone," says the silhouetted Bugsy, suggesting there are all kinds of sexual, emotional and actual deaths ahead of them. Bugsy and Virginia are not quite real here; they are literally absorbed into the

movie screen as if they were already legendary lovers.

"Bugsy" will return to this screen test and projector at the end. Just as the home movie marks the beginning of Bugsy's romance with Virginia, it will mark the end, with movies enveloping his story from start to finish.

In between, Bugsy's photograph appears on the society page of a newspaper under the headline "Gangster or Star?" Though he is famous as a gangster, his social star is rising, and he tries to control his image as carefully as any studio publicist could. After dancing with a countess at Ciro's nightclub, he asks a newspaper photographer to run a picture he has just taken instead of "all those sinister mug shots they always use." Even after he is arrested for murder, he sits in prison complaining that a newspaper photograph makes him look like "I've got no tan."

Here and throughout the film, Mr. Beatty handles such lines so flawlessly that their many layers are apparent. Bugsy might be displacing his worries onto a photograph, but he is also pretty upset at this bad press. He seems slightly off-kilter but never totally ridiculous — an image not far from that of most movie stars.

In fact, one of Bugsy's crackpot ideas is full of hubris but turns out to be more endear-

Tri-Star Pictures

Warren Beatty, as Bugsy Siegel, charms aristocrats portrayed by Gian-Carlo Scandiuzzi and Bebe Neuwirth.

ing than ludicrous: he hopes to personally assassinate Mussolini. "Mussolini is a dead man," he assures his friend Meyer Lansky (Ben Kingsley, an improbable choice but an impeccable foil). That Bugsy says this while wearing a funny chef's hat at home in Scarsdale makes his plan no less ambitious.

The murderous Bugsy can be a hero because Barry Levinson's movie is about celebrity, not gangsterhood, about romance, not power.

There is a touch of the movie star in all of Mr. Beatty's best roles, of course. He is expert at revealing the seductive quality, the real-life acting, that allows con men to flourish. The hairdresser in "Shampoo" and Clyde Barrow in "Bonnie and Clyde" have that in common with Bugsy.

■

But Mr. Beatty, Mr. Levinson and the screenwriter, James Toback, know better than to lean too hard on the idea of Bugsy as star or as the archetypal American dreamer — even if he does spend much of the film trying to invent Las Vegas as the crass, glitzy show-biz city we know today. "It came to me like a vision, like a religious epiphany," Bugsy says while standing in the desert and dreaming up the Flamingo Hotel. Suddenly an angry Virginia drives off, leaving him stranded in the hot sun. So much for visions and symbols.

In that respect, the film resembles the unpretentious, classic Hollywood entertainments of Bugsy's era. It took him nearly 50 years, but Bugsy is a major movie star at last. □

1991 D 22, II:22:1

FILM VIEW/Janet Maslin

'Hook' Deals Lavishly in Guilt-Edged Bonds

RARELY HAS THE HAPPY FAMily been in worse shape than it is on movie screens this holiday season. The mood may be festive, but dysfunction is everywhere. In "The Addams Family," the children are intent on killing each other, much to their parents' delight. In "The Prince of Tides," a man is forced to confront memories of a violent father and deeply dishonest mother, memories that have very nearly ruined his sister's life. In "Cape Fear," a teen-age girl is the catalyst in making her parents examine the hollowness of their marriage. And in "Bugsy," a father's efforts to celebrate his daughter's birthday are so scrambled and halfhearted that the candles on her cake burn out from sheer neglect.

There is also "My Girl," in which the heroine's mother is dead, her father is a mortician and her first little sweetheart is killed by a swarm of bees. And "All I Want for Christmas" presents a sunny look at a household disrupted (though only mildly, since the film is so toothless) by the parents' divorce.

■

All these stories have their alarming aspects as far as the family is concerned. But the season's most tear-tugging family troubles can be found in Steven Spielberg's "Hook," a film guaranteed to arouse cathartic outpourings of parental guilt. Small children are bound to find "Hook" a bit confusing, especially during the long preliminary section explaining how the stuffy mergers and acquisitions lawyer played by Robin Williams is actually Peter Pan. ("So, Peter, you've become a pirate!" the aged Wendy exclaims upon learning what Peter does for a living.) But if children aren't brought to see this film, their parents may wind up feeling conscience-stricken just for leaving them home.

"Hook" presents Peter as a comically workaholic, thoughtless father. He's the kind of man who can shriek, "Get them out of here! I'm on the phone call of my life!" when his children interrupt a business conversation. He also dispatches an aide with a video camera to his son's Little League game to film the parts (the whole game, as it turns out) that Peter himself will miss.

When Peter insists that his word is his bond, his son, Jack (the fine young actor

In Steven Spielberg's new movie, parents and children aren't exactly bathed in a warm holiday glow.

Charlie Korsmo), is quick to reply, "Yeah — junk bond!" Eventually, in one of the film's many calculating but still moving exchanges about parent-child relations, Peter's wife, Moira, declares that her husband is "not being careful" about this precious early stage in his children's lives. "And you're missing it," Moira warns.

For all its clamorous, toy-filled adventures involving the Lost Boys and Pirates of Neverland, "Hook" centers on Peter's virtually therapeutic progress with his own children. The story not only allows him to rekindle the spirit of his own childhood but also lets him acknowledge that his children are the reason he was willing to grow up at all. In one of the film's few stark, beautifully streamlined images, the film maker explains why Peter Pan chose to escape the adult world in the first place. Using just a baby carriage, a tree and Peter's mother sitting on a park bench laying plans for her son to become an important judge — and maybe "making time for marriage and a family and all that" — Mr. Spielberg establishes the elements that induced Peter to flee a dull, family-denying life.

The director makes Peter's rediscovered love of his family resoundingly clear, and indeed that love is at the heart of this story. But it would emerge more clearly if "Hook" were less contemporary and cluttered. Determined to Americanize "Peter Pan," the film loses sight of the prim English society in which the story was born (today, in America, when a grown man can happily spend his day

in sweat pants drinking beer and watching football, the idea of social repressiveness loses much of its sting). The film's multicultural pack of Lost Boys, with their urban tastes for things like skateboarding and graffiti, also denatures the original story's notion of childhood freedom. They're too tough to miss having families, and their life in Neverland cannot be much different from what it was at home. (The politically correct will note that Mr. Spielberg has dispensed with the story's stereotypical Indians, but he has not added any Lost Girls.)

"Hook" sounds another note of domestic discord with its deliciously wicked vision of Captain Hook, who takes on a stepfatherly quality once Hook starts competing with Peter for his son's affections. By trying to steal Jack's love, Hook becomes the kind of rival a real Peter Pan might develop, in his incarnation as a high-powered lawyer, if he spent so much time working that he neglected his home. "This is for all the games your Daddy missed," Hook tells Jack, staging a ballgame in which the Pirates' team really *are* pirates.

What "Hook" says about preoccupied parents and overlooked children is simple, but

Mr. Spielberg does have simplicity on his side. The best parts of "Hook" have the awe-struck exuberance to demonstrate why this film maker, so often patronized for his boyishness, has also sparked such widespread imitation. Audiences this season will have many opportunities to contemplate family life as a series of problems, but at least "Hook," in reaching for a solution, manages to be as honestly upbeat as it is sugary. However, it's hard to be fully confident that the Banning family, newly affectionate at the end of its Neverland adventure, really represents a contemporary ideal. The Addamses may just be happier. □

1991 D 22, II:23:1

Murray Close/Tri-Star Pictures

Dustin Hoffman as Hook, Charlie Korsmo as Jack, and Bob Hoskins as Smee in "Hook"—a tug of war over affections

Madame Bovary

Written and directed by Claude Chabrol, based on the novel by Gustave Flaubert, in French with English subtitles; director of photography, Jean Rabier; edited by Monique Fardoulis; music by Matthieu Charbol; produced by Marin Karmitz; released by the Samuel Goldwyn Company. Running time: 125 minutes. This film is rated PG.

Emma Bovary	Isabelle Huppert
Charles Bovary	Jean-François Balmer
Rodolphe Boulanger	Christophe Malavoy
M. Homais	Jean Yanne
Léon Dupuis	Lucas Belvaux
Lheuveux	Jean-Louis Maury
Hippolyte	Florent Gibassier
M. Rouault	Jean-Claude Bouillaud
Félicité	Sabeline Campo
Justin	Yves Verhoeven
Mother Bovary	Marie Mergey

By VINCENT CANBY

Claude Chabrol's "Madame Bovary" is a seemingly meticulous adaptation of Gustave Flaubert's ever-astonishing novel that, on its publication in 1857, was unsuccessfully prosecuted by the French Government for "immorality."

The movie looks splendid. It was filmed in Rouen and in neighboring villages and landscapes on the lower Seine. All appears to be authentic: country roads, meadows, foliage, weather, coaches, costumes, houses, even the bibelots on a mantelpiece and the circumscribed wanderings of a flock of geese in a barnyard.

Mr. Chabrol evokes the period (circa 1840) obliquely but with accuracy in the story of Emma Bovary, the provincial doctor's wife who loved with adulterous abandon and acquired material goods on credit she didn't possess. Among other things, Emma's decline and fall is a reflection on life under Louis Philippe, the stolid "citizen king", who carried an umbrella and represented bourgeois values of paralyzing mediocrity.

Yet this new "Madame Bovary," which in most other ways heeds its source material with intelligence, lacks one essential. Missing is Emma Bovary, at least an Emma Bovary whose sentimental and foolish behavior is of an obsessiveness to become genuinely tragic.

It makes no difference that the pretty, freckled, reddish-blond Isabelle Huppert, who plays Emma, appears to be too old and doesn't look at all like Flaubert's dark-haired heroine whose eyes, though brown, "seemed black under their long eyelashes."

Jennifer Jones, the Emma in Vincente Minnelli's stylish and glossy 1949 M-G-M adaptation, is virtually the image of the woman described in the novel. Yet she is somewhat too innocent to be credible. Looks are not Miss Huppert's insurmountable problem. There is something much more wrong-headed going on.

From the beginning of the film until very near the end, Miss Huppert's Emma is imperious and rather frosty, so level-headed and so in command that it seems impossible that she could mess up her life with such wanton and short-sighted thoroughness.

Her Emma moves through the film like an icon, as if she had read Flaubert's glowing reviews and accepted them as tributes to herself. She's an ice queen.

This plays havoc with the dramatic intent of most of "Madame Bovary." Though the movie is handsome, it is without life at its center until Emma's last days when her recklessness catches up with her, and when Flaubert's Emma and Miss Huppert's begin to coincide.

In all other ways, Mr. Chabrol knows what he is doing. "Madame Bovary" is painstakingly realized, moving with a gradually quickening pace that becomes a terrible unstoppable surge toward disaster at the end. But because of Miss Huppert's particular screen personality, the larger part of the film plays as if it were a stately re-enactment rather than a dramatization.

When first seen, the convent-educated Emma is the bored daughter of a well-to-do farmer. To change her lot, she accepts marriage with Charles Bovary (Charles-François Balmer), the slow-witted widower who cannot believe his good fortune.

•

Emma is an intensely sexual creature whose appetites, once aroused, are unfulfilled by her husband. Her increasing lassitude prompts Charles to move his medical practice to a somewhat larger village where Emma, still bored, begins to act out her romantic fantasies.

She makes her house into something of a small-town showplace. She borrows money in ever larger amounts and dresses in the latest fashions as reported in the popular magazines. She flirts discreetly with Léon (Lucas Belvaux), a young law clerk.

After Léon moves away, she is ready to give herself completely to Rodolphe (Christophe Malavoy), a handsome, casually aristocratic fellow who makes an initial play for her more because she is there, a fresh Alp to be scaled, than because of her innocence and charm.

Sometime after Rodolphe throws her over, Emma begins a sexual liaison in Rouen with Léon that, as described by Flaubert, remains as steamy today as it was when the French Government tried to ban the book. It is this liaison that is the beginning of the end for Emma.

•

The novel has been filmed a number of times. Jean Renoir did it in 1934 with Valentine Tessier in the title role. There was a German version in 1937, made with Nazi approval, starring the one-time Hollywood vamp Pola Negri.

The novel has a way of misleading film makers with the absolute clarity of its prose, its precise descriptions of time, place, character and behavior. It seems to be made to order for the screen.

Not so apparent, until someone of Mr. Chabrol's talents comes along, is how much of the novel exists in the voice of the author and in Emma's mind, which can't facilely be dramatized, explained or analyzed. Labels have been attached to Emma. Miss Huppert has been quoted as calling her "an idealist" and "a feminist without knowing it."

No labels are accurate, though. Emma eludes simple definition, which is why she is one of the seductive creations in modern literature.

Mr. Chabrol has now fallen into the trap. He has also been vamped by Miss Huppert. In an article in Condé Nast Traveler, Francine du Plessix Gray quotes Mr. Chabrol as saying that Miss Huppert "has the extraordinary gift of expressing things without changing her face." Yet one man's open book, to be read at will, can be another man's Sphinx, a stony face that expresses nothing.

Possibly because Mr. Chabrol feels that his star is speaking volumes, he refuses to emphasize events that are crucial in the novel, even when he uses a narrator from time to time. Charles's humiliating failure as a doctor is shown in some grisly detail, but without stressing its effect on Emma. Her increasingly muddled handling of their financial accounts remains vague.

Though the supporting actors are all good, especially Mr. Balmer and Mr. Malavoy, the roles themselves seem somehow reduced in importance. This is especially true of Homais (played by the superb Jean Yanne), the pompous, artfully ambitious pharmacist who is so important to the downfall of Emma and Charles and, indeed, to the novel.

Mr. Chabrol errs on the side of understatement. His "Madame Bovary" is not to be dismissed. It is so good in so many details that the wish is that it were better. See it. You won't be bored, but you may want to talk back to it.

•

This film is rated PG (Parental guidance suggested). It has sexual situations.

1991 D 25, 13:1

The Prince of Tides

Directed by Barbra Streisand; screenplay by Pat Conroy and Becky Johnston, based on the book by Mr. Conroy; director of photography, Stephen Goldblatt; edited by Don Zimmerman; music by James Newton Howard; production designer, Paul Sylbert; produced by Ms. Streisand and Andrew Karsch; released by Columbia Pictures. Running time: 132 minutes. This film is rated R.

Tom Wingo	Nick Nolte
Susan Lowenstein	Barbra Streisand
Sallie Wingo	Blythe Danner
Lila Wingo Newbury	Kate Nelligan
Herbert Woodruff	Jeroen Krabbé
Savannah Wingo	Melinda Dillon
Eddie Detreville	George Carlin
Bernard Woodruff	Jason Gould
Henry Wingo	Brad Sullivan
Lucy Wingo	Maggie Collier
Jennifer Wingo	Lindsay Wray
Chandler Wingo	Brandlyn Whitaker

By JANET MASLIN

Nothing about Barbra Streisand's previous acting or direction is preparation for her expert handling of "The Prince of Tides," which has been pared down from Pat Conroy's sprawling, hyperbolic novel to a film that is gratifyingly lean. Discretion and reserve are not the first qualities that come to mind about Ms. Streisand's work, yet they are very much in evidence this time. So is the frankly emotional style with which she is more often associated, a style perfectly attuned to this film's complex, stirring story. "The Prince of Tides" marks Ms. Streisand's triumphantly good job of locating that story's salient elements and making them come alive on the screen.

Everything about Mr. Conroy's overripe family saga is suffused with excess, from the author's descriptions of his characters ("The words of her poems were a most private and fragrant orchard," he writes of Savannah Wingo, the narrator Tom

Streisand casts herself against type as a restrained director.

Wingo's twin sister) to the experiences those characters share. The three Wingo children, Luke, Savannah and Tom, seem to do everything in unison, often on what are either the very best or very worst days of their lives. Feisty, brave and endlessly self-dramatizing, they have the knack of being colorful to a fault.

Their mother, Lila, who raised them idyllically on a South Carolina sea island, was both the most soothing and the most treacherous parent

Thomas Klausman/The Samuel Goldman Company

Isabelle Huppert in Claude Chabrol's "Madame Bovary."

in the world. The island itself was Paradise, then Paradise Lost. Their abusive father, Henry, cast a giant shadow over his children's lives. All of the Wingos' personal dramas are played out on this exhaustingly grand scale.

•

"The Prince of Tides" centers on the adult Tom's efforts to overcome the effects of his painful childhood and come to terms with the various women in his life. These are Lila (Kate Nelligan), now a brittle, wealthy matron; Sallie (Blythe Danner), the wife experiencing the full brunt of Tom's unhappiness; Savannah (Melinda Dillon), now a suicidally depressed New Yorker, and Dr. Susan Lowenstein (Ms. Streisand), Savannah's psychiatrist, who enlists Tom's help in treating Savannah and winds up getting to the heart of Tom's troubles, too.

One of the best things Ms. Streisand has done here is to get out of the way, so her portrayal of Dr. Lowenstein never upstages Nick Nolte's superlative Tom. "The Prince of Tides" must be Tom's story if it is to have any center, and so Ms. Streisand mostly confines herself to the role of a clever, attractive, authoritative figure on the sidelines. Later on, when Tom and the doctor do become romantically in-

volved, the film takes on a few gooey overtones, what with a too-picturesque weekend in the country, a roaring fire and so on. But by and large it does a remarkable job of maintaining its intelligence and dignity.

As envisioned by Mr. Conroy, Dr. Lowenstein's attempts to treat Tom have a coy, flirtatious ring and do a lot to undermine her professionalism. Ms. Streisand's smarter, more composed version of this character is only one of her film's notable improvements upon the novel. The screenplay, by Mr. Conroy and Becky Johnston, consistently extracts the book's best lines of dialogue and leaves the rest behind. The book may have the feel of an overwrought, melodramatic movie, but the film itself does not.

•

Long, tedious anecdotes about the Wingos' colorful exploits have been compressed into brief snippets from home movies or else simply removed. (Happily, the pet tiger that plays a role in Mr. Conroy's most traumatic episode is just about gone.) The novel's big revelations have been given different weight here, and in the film's version they make more sense. Ms. Streisand makes some especially skillful transitions in juxtaposing Tom's present and past for the audi-

ence, just as they are connected in the character's own mind.

A lot of attention has gone into keeping up both stars' appearances, and their sleek good looks give the film a romantic spirit it might otherwise lack. Ms. Streisand looks quietly, unobtrusively elegant, as do the sets representing her home and office. And Mr. Nolte comes atypically close to matinee idol status with this role. The fact that his hair has never looked quite so blond or so glossy should not detract from the fire, urgency and flawless timing that shape his performance. Mr. Nolte is every bit as good while engaging in wrenching therapeutic sessions with Dr. Lowenstein as he is in declaring in a restaurant: "God, there's nothin' sexier than a beautiful woman orderin' food in French. Now I want you to read me the whole menu."

"The Prince of Tides" has been particularly well cast, with several strongly appealing actresses in minor roles. Ms. Dillon has little to do but look traumatized; however, Ms. Danner and especially Ms. Nelligan add substantially to the film's vivid sense of Tom's life. Jeroen Krabbe plays the story's least plausible character, the world-famous violinist unhappily married to Dr. Lowenstein, and still manages to give the role

some panache. Notably good also is Jason Gould, who plays Ms. Streisand's son and very obviously *is* her son, in both appearance and manner. Mr. Gould makes this unhappy teenager a worthwhile part of the film's overall equation instead of the 'fifth wheel he easily could have been.

Contributing to the lavish tone of "The Prince of Tides" are James Newton Howard's swelling score and Stephen Goldblatt's cinematography, which visually captures the long-lost glow of childhood implicit in the story.

"The Prince of Tides" is rated R (Under 17 requires accompanying parent or adult guardian). It includes mild profanity, sexual suggestiveness and one episode of violent sexual assault.

1991 D 25, 13:3

Grand Canyon

Directed by Lawrence Kasdan; written by Mr. Kasdan and Meg Kasdan; director of photography, Owen Roizman; edited by Carol Littleton; music by James Newton Howard; production designer, Bo Welch; produced by Mr. Kasdan, Charles Okun and Michael Grillo; released by 20th Century Fox. At the Gotham Cinema, Third Avenue at 58th Street. Running time: 135 minutes. This film is rated R.

Simon	Danny Glover
Mack	Kevin Kline
Davis	Steve Martin
Claire	Mary McDonnell
Dee	Mary-Louise Parker
Jane	Alfre Woodard
Roberto	Jeremy Sisto
Deborah	Tina Lifford
Otis	Patrick Malone
The Alley Baron	Randle Mell
Vanessa	Sarah Trigger
Kelley	Destinee DeWalt

By JANET MASLIN

Mack (Kevin Kline), the central character in Lawrence Kasdan's "Grand Canyon," hauntingly describes the experience of almost being hit by a bus. He was standing on a street corner, he recalls, and was about to step off the curb without looking when a stranger pulled him back. When he thanked her, she smiled and said, "My pleasure," then disappeared. She saved Mack's life, although he never returned the favor.

The spirit of that anecdote, with its grasp of life's precariousness, its awareness of the ominous and the miraculous in everyday events, its understanding of the intricate exchanges and equations that make up our destiny, seems to be what "Grand Canyon" is after. As he did so successfully in "The Big Chill," Mr. Kasdan here uses a deceptive casualness in approaching his contemporaries' most intimate hopes and fears.

At its best, which is to say for quite a while, "Grand Canyon" is a riveting evocation of those feelings, even when dealing with such nominally ordinary matters as a bus trip to summer camp, an office lunch or a lesson on how to make a left turn in heavy traffic. For long stretches of this offbeat and innovative film, the viewer truly has no idea what will happen next and many reasons to care.

"Grand Canyon," which was written by the director and Meg Kasdan, to whom he is married, eventually pulls its punches, taking an unconvincingly beatific look at the problems and dangers that have been so persuasively outlined in what has

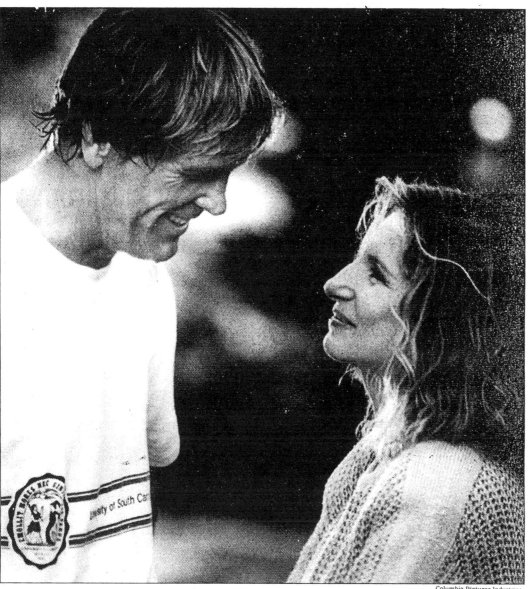

Columbia Pictures Industries

Nick Nolte and Barbra Streisand in **Ms. Streisand's new film, "The Prince of Tides."**

Kevin Kline in "Grand Canyon."

come before. But until it hits that false note, Mr. Kasdan's film is at least as fascinating as it is amorphous. Set in Los Angeles, and gliding gracefully among a representative set of characters, the film means to move through different economic strata, age groups and racial backgrounds in its search for common experience. If the ambition to do this is ultimately more impressive than the hazy, unfocused outcome, Mr. Kasdan still deserves a lot of credit for what he has tried.

•

The film begins at a Lakers game, with shots of a vigorous Magic Johnson that automatically make the film's point about the fragility of health and happiness, although they may not have been intended that way. It then follows Mack, who has been attending the game with an entertainingly crass movie producer named

The message: People are more alike than they might think.

Davis (Steve Martin), on a detour through a dangerous neighborhood. Mack gets lost, his car breaks down, and this well-heeled white lawyer is being menaced by black gang members when a black tow-truck driver named Simon (Danny Glover) shows up and saves him. This is the first of many seeming coincidences that bring the characters together.

Also in "Grand Canyon" are Mary McDonnell as Mack's compulsively well-organized wife, Claire; Mary-Louise Parker as Dee, the young secretary with whom Mack has had a brief affair; and Alfre Woodard as Jane, Dee's best friend, whom Mack eventually introduces to Simon as a way of thanking him for his original good deed. This turns out to be an intuitive masterstroke, as do many of the film's accidental meetings, but Simon still wonders about why it has happened. "Maybe we're the only two black people he ever met," he muses to Jane.

Maybe they are. Although the film intends a wide span of economic and ethnic backgrounds, all of its charac-

ters speak in the same genteel, sensitive idiom, even the homeless man who gives Claire an unexpected bit of advice about adopting a baby as she jogs past him one day. Simon's sister and her young son, who live in the midst of ghetto violence, do not sound substantially different from Mack's own prosperous white family. This may indeed be the film's very point, but it makes for a certain dramatic flatness, as does the failure of all the film's foreboding to add up to much.

In real life, too, the things one dreads most urgently may be the ones least likely to happen, and fate can be guaranteed to strike in unexpected ways. But on the screen, after generating so much tension over so many small, heavily charged incidents, this story needs a more eventful ending than the one it has.

•

Among the more startling effects Mr. Kasdan achieves here are the constantly surprising transitions that leave the story's many strands feeling woven together. In one remarkable episode, he depicts Mack's dream of flying through Los Angeles to someone else's bedroom, then lets the figure of a woman in bed become Claire, who gets up and walks into a dream of her own. On a simpler level, even the way a Lakers game being watched on television by Simon's nephew in the ghetto is shared by Mack and Claire's son in the suburbs provides a powerful contrast.

Certain images and lines of dialogue resonate well beyond the specific scenes in which they appear, like the sight of Mr. Martin's flamboyant producer bleeding and vomiting in his expensive clothes, looking frightening and abruptly human, after having been mugged for his Rolex watch. Thoughts like "Aren't you sick of trying to be in control all the time?" and "I think if you talk about stuff, maybe that takes the place of doing it" help "Grand Canyon" strike many chords to which Mr. Kasdan's contemporaries will respond.

Among the performers, Ms. Woodard stands out vibrantly despite her underwritten role, and Mr. Kline is solidly sympathetic as the story's fulcrum. Mr. Martin, who appears only briefly, delivers a scathing sendup of a familiar Hollywood type. Ms. McDonnell, looking luminous but somewhat somber, does what she can with the blandly virtuous Claire.

Mr. Glover also grapples with the excessive saintliness of his character, but he makes Simon a memorable mouthpiece for the film's ideas. It is Simon who invokes the Grand Canyon as a metaphor for those eternal verities that make one's individual worries look petty and small. That metaphor would have worked just as well if the principals didn't pile into a camper and visit the site.

•

"Grand Canyon" is rated R (Under 17 requires accompanying parent or adult guardian). It includes profanity, brief nudity and mild violence.

1991 D 25, 18:1

Until the End of the World

Directed by Wim Wenders; screenplay by Mr. Wenders and Peter Carey, based on an original idea by Mr. Wenders and Solveig Dommartin; director of photography, Robby Müller; edited by Peter Przygodda; music by Graeme Revell; production designers, Thier-

ry Flamand and Sally Campell; produced by Jonathan Taplin and Anatole Dauman; released by Warner Brothers. At the Festival, Fifth Avenue and 57th Street. Running time: 157 minutes. This film is rated R.

Sam Farber	William Hurt
Claire Tourneur	Solveig Dommartin
Eugene Fitzpatrick	Sam Neill
Dr. Farber	Max von Sydow
Edith Farber	Jeanne Moreau
Philip Winter	Rüdiger Vogler
Burt	Ernie Dingo
Chico	Chick Ortega
Raymond	Eddy Mitchell

By VINCENT CANBY

When it comes to making movies, Wim Wenders is not your average wild and crazy guy. Antic fun for its own sake is not something for which he is known. The German-born director's more recent films ("Wings of Desire," "Paris, Texas," "Hammett") have been schematic and dour, with hard surfaces encasing centers as soft as chocolate-covered cherries.

For much of its nearly three-hour running time, "Until the End of the World" is something else, a daffy, eccentric road movie that pursues its own inscrutable lighthearted logic through 15 cities in 8 countries on 4 continents.

"Until the End of the World" has less to do with Mr. Wenders's own early road movies, "Alice in the Cities" and "Kings of the Road," than it does with the kind of elegantly slapdash improvisations that Jean-Luc Godard once made with (and for) the incomparable Anna Karina. Though it is set in 1999, the movie looks like a mint-condition artifact of the 1960's.

As the film opens, a narrator informs us that an Indian nuclear satellite has swung out of orbit and threatens to crash to earth to destroy all life. The rest of the world is in a panic but, the narrator goes on, "Claire couldn't care less."

Claire (Solveig Dommartin), who sometimes wears a black wig that emphasizes her resemblance to the young Anna Karina, is waking up in a

An invocation of the movies Godard made with Anna Karina.

strange place, as has been her habit of late, this time at a chicly decadent party in Venice. On the drive back to Paris, Claire becomes the willing bag lady for a pair of loutish but gentle thieves who have just robbed a bank in Nice.

•

She agrees to transport the loot to Paris in exchange for a one-third cut. She then picks up Sam Farber (William Hurt), an American on the run, though from whom or what Claire doesn't know. Again since she couldn't care less. She's attracted to Sam for his sad eyes and his taste in music, an audio tape of songs sung by pygmy children in Cameroon.

Claire's patience is tried when Sam makes off with a large part of her money. She tells her lover, Gene (Sam Neill), a novelist based in Paris and a man whose patience is inexhaustible, that she's going after Sam.

In this fashion the chase begins: Sam, followed by Claire, followed by a bounty hunter (Sam is said to be involved in industrial espionage), a private detective, the bank robbers and Gene, who wants to protect Claire and who, in passing, provides the film's narration. Money for travel arrangements never seems to be a problem. By 1999, the recession is clearly over.

The trail leads from Paris to Lisbon, Berlin, Moscow, Beijing, Tokyo and San Francisco. It finally ends with all the characters in the Australian outback, where what amounts to another movie begins. This one involves Sam's father, Henry (Max von Sydow), a brilliant scientist, and Sam's blind mother, Edith (Jeanne Moreau).

In his underground laboratory, Henry has been perfecting a camera that will allow the blind to see. It records the impulses of a brain when it contemplates an image, then feeds those impulses into the brain of the blind person, providing the equivalent to sight. More than that, though, it's a device for "sucking out the dreams" of almost anybody.

•

It is one of Mr. Wenders's more comic conceits that Claire and the others who participate in the doctor's experiments quickly become dangerously addicted to the taped images of their dreams. They lie listlessly about the outback all day, not eating or tending to fundamental hygiene. Instead they either dream of dreams or watch those dreams on portable video monitors.

Each addict isolates himself from the others. It's the video age as a real-life nightmare. Time and the world of commonplace responsibilities have come to a halt. Only Gene continues to believe "in the magic and the healing power of the word."

There's much more to the movie, not all of it logical, much of it absurd and some of it (the last sequence, for example) funnier than even Mr. Wenders may know. The film's center is characteristically squashy.

What is appealing about "Until the End of the World" is its looseness. It appears to be composed of musiclike riffs, and with the exception of Mr. von Sydow and Miss Moreau, nobody seems to take it too seriously until the name of Greenpeace is mentioned. As often happens with Mr. Wenders, it's not always possible to tell whether he knows when he's gone over the edge.

The members of the cast are attractive and, above all, game. Shooting the film in so many far-flung locations in such a short time must have been its own nightmare. The futuristic gadgetry is kept modest in scale so the actors never have to battle the special effects.

•

"Until the End of the World" is rated R (Under 17 requires accompanying parent or adult guardian). It has some vulgar language.

1991 D 25, 18:5

The Inner Circle

Directed by Andrei Konchalovsky; written by Mr. Konchalovsky and Anatoly Usov; director of photography, Ennio Guarnieri; edited by Henry Richardson; music by Eduard Artemyev; production designer, Ezio Frigerio; produced by Claudio Bonivento; released by Columbia Pictures. At Fine Arts Theater, 4 West 58th St. Running time: 137 minutes. This film is rated PG-13.

Ivan Sanshin	Tom Hulce
Anatasiya	Lolita Davidovich
Beria	Bob Hoskins
Katya	Bess Meyer
Stalin	Aleksandr Zbruyev
Professor	Fyodor Chaliapin Jr.
General Vlasik	Oleg Tabakov
General Rumyantsev	Vsevolod Larionov
Vasily Morda	Aleksandr Garin

By STEPHEN HOLDEN

Just when the Soviet Union is coming apart, it is paradoxical that two films featuring Stalin, the personification of Soviet totalitarianism, should play in New York simultaneously. Stalin is the paranoiac center of gravity in both Andrei Konchalovsky's dark comedy "The Inner Circle," which opened today at the Loews Fine Arts, and in Ken Palmer's "Testimony," at Film Forum 1. In "The Inner Circle," the dictator, played by Aleksandr Zbruyev, is a round little demon with twinkling eyes. Terence Rigby's more ominous Stalin, in "Testimony," is a hulking, shadowy beast.

"The Inner Circle" tells the true story of Ivan Sanshin (Tom Hulce), a movie projectionist for the K.G.B. Club who on his wedding night in 1939 is routed out of his apartment and whisked into the bowels of the Kremlin. Certain he is being arrested for a minor professional mishap, he instead finds himself drafted into the job of personal projectionist for Stalin. His predecessor, he is told, died of a heart attack when yelled at.

In one of the film's whimsical juxtapositions, the first film Ivan shows the dictator is "The Great Waltz," the glossy Hollywood biography of Johann Strauss and a movie whose giddy spirits seem grotesquely incongruous given the setting.

Veering unpredictably between comedy and pathos, "The Inner Circle" is a study of prolonged political naïveté and its unhappy consequences. Long after it is clear to many in the Soviet Union that Stalin is a tyrant, Ivan remains buffoonishly idolatrous of his boss. In love with his job, he throws himself into his work with the frenzied zeal of a song-and-dance man working up new routines. When during an argument with his wife, Anastasiya (Lolita Davidovich), she asks whom he loves more, her or Stalin, he replies, "Stalin," as if no other answer could possibly be imagined. Even after German bombs have reduced his Moscow neighborhood to rubble, he remains stubbornly worshipful.

Anastasiya, who is more naïve than her husband, is emotionally unstable. She fixates her affections on the orphaned daughter of neighbors who were purged by the K.G.B. and, without telling her husband, secretly visits the little girl in the orphanage. Later, when Ivan and Anastasiya accompany Stalin and his entourage on a trip to the Ural Mountains, she lacks the wherewithal to resist the advances of the K.B.G. chief, Lavrenti P. Beria (Bob Hoskins), and her life goes into a tailspin.

"The Inner Circle" takes a remarkably lighthearted view of a world in which mortal terror pervades the most everyday interpersonal transactions. Lest they be overheard by spying neighbors, Ivan and Anatasiya bundle themselves into a wardrobe to conduct a serious conversation. The scenes in which Stalin engages a quiveringly frightened Ivan in conversation are played with an undercurrent of farce.

This air of detached gallows humor is augmented by the use of occasional snippets of narration to push the story forward and by some vaguely surreal touches, including the view from Ivan's apartment window showing cattle moving through a cityscape flecked with impossibly large drifting snowflakes. The seriocomic tone is sustained for so long that when the mood of the film suddenly turns darker and more emotional, one has to make a sudden adjustment.

Yet the film's odd shift from wryness to pathos works to its advantage. One never feels manipulated. And Mr. Hulce, who adopts a serviceable Russian accent for the role, makes the dutiful Ivan a complex character who is alternately maddening and engaging.

●

"The Inner Circle is rated PG-13 (Parents strongly cautioned). It includes mild sexual scenes.

1991 D 25, 20:1

Inspector Lavardin

Directed by Claude Chabrol; written by Dominique Roulet, based on an original idea and adaption by Mr. Chabrol and Ms. Roulet, in French with English subtitles; director of photography, Jean Rabier; edited by Monique Fardoulis and Angela Braga-Mermet; music by Matthieu Chabrol; production designer, Françoise Benoit-Fresco; produced by Martin Karmitz; released by MK 2 Productions et Films A2. At the Eighth Street Playhouse, at Avenue of the Americas. Running time: 100 minutes. This film has no rating.

Jean Lavardin	Jean Poiret
Claude Alvarez	Jean-Claude Brialy
Hélène Mons	Bernadette Lafont
Max Charnet	Jean-Luc Bideau
Raoul Mons	Jacques Dacqmine
Véronique Manguin	Hermine Clair
Marcel Vigouroux	Pierre-François Dumeniaud
Francis	Florent Gibassier
Buci	Guy Louret
Volga	Jean Depussé

By CARYN JAMES

In the long, healthy career of Claude Chabrol, from his New Wave classic "The Cousins" through his sumptuous "Madame Bovary," which opened yesterday, "Inspector Lavardin" is a trifle. But this lighthearted detective movie shows that trifling entertainments do not have to be hack work. This wily film has first-rate appeal and plays into some cherished stereotypes about the French: it is blasé, stylish, filled with effortless charm.

Though the film appeared in France in 1986, it has its United States premiere today at the Eighth Street Playhouse. The delay may reflect the film's slightness and the economics of distributing foreign films, but not its popularity abroad. This is, in fact, a sequel. The first Chabrol film to feature the urbane detective Lavardin was "Poulet au Vinaigre," which was released in France in 1985 and has yet to appear in the United States.

The plot involves a devout and wealthy Roman Catholic writer who is found murdered on a beach with the word pig written on his back. When Inspector Lavardin arrives to investigate, he discovers that the widow, Hélène, is an old flame he hasn't seen in 20 years, a well-preserved beauty of elegant style and almost catatonic personality.

She and her family seem a strange match for the religious writer. Her daughter by a previous husband is a sweet 13-year-old schoolgirl by day, a nymphet by night. Hélène's brother announces that since his wife's death he has preferred Romeos to Juliets and says, in English, that he is "the gay widower." His hobby is collecting painted glass eyeballs. Here is a classic situation: put a detective in a house where everyone has something to hide. Whether the family secrets are related to the murder is another question entirely.

●

As Lavardin, Jean Poiret has some resemblance to the middle-aged Laurence Olivier, with playful icy blue eyes and distinguished gray hair. He also has, as the final credits tell us, a wardrobe by Lanvin. Don't ask questions about detectives' salaries; doesn't everyone dress well in France? He underplays his charm as he snoops around the house and the countryside with his sidekick, whom he fondly calls Watson.

Despite such touches, there is nothing self-conscious about this cleverly sophisticated but straightforward use of the detective genre. Perhaps that is why, when the murderer is revealed, the episode is too Hitchcockian for its own good. It would take a lot more irony or homage to pull this off.

But the cast never lets the film down. Bernadette Lafont, something of a New Wave icon, looks appropriately frozen as Hélène, with her pearls and perfect blond hair and blank, lost-in-the-past expression. Jean-Claude Brialy is wonderfully ambiguous as the brother, whose increasingly obvious lies may be for good or sinister purposes. And Mr. Poiret's performance as Lavardin is wry but never mocking — just what a charming trifle needs.

1991 D 26, C13:1

Deadpan Buster in a Crazy World

By VINCENT CANBY

NEAR the middle of "Sherlock Jr.," Buster Keaton, as a movie projectionist who wants to be a detective, walks down the aisle of the theater and enters the film he's showing to save the girl on the screen. It may be the most beatifically funny and deranged sequence in all cinema as Buster, who knows only the physical laws of our world, attempts to adjust to those of movies.

Someone keeps changing the locations on him. One minute Buster is in a drawing room; a split second later he's in the Sahara. Standing on a small, isolated rock in the middle of the ocean, he dives in and lands, headfirst, in a snowbank. Buster copes. He doesn't shake his fist at the gods, question their motives or feel sorry for himself. There isn't time; it's enough just to keep up with a landscape that won't stand still.

"Sherlock Jr." (1924) shares the bill with two other magnificent Keaton comedies, "The Playhouse" (1921) and "The Navigator" (1924), as the opening program in the Film Forum's current retrospective, "The Most of Buster Keaton." You'd better rush, though. This first program continues only until Sunday.

The retrospective, which runs through Feb. 20, ranks with the Film Forum's earlier Billy Wilder show as one of New York City's major film events of the year. Included in the Keaton show are all of the incomparable silent features except "The Cameraman," which is to be screened later, in 1992.

There are also the great silent shorts, most of the sound shorts and features, plus an assortment of the later, not easily classified features and television shows Keaton continued to make right up until his death from lung cancer in 1966.

Winston Churchill was a great fan of Charlie Chaplin. Luis Buñuel was enchanted by Keaton. Admirers of these two greatest of silent-film comedians have always tended to separate themselves into Chaplin and Keaton camps, although there are a lot of crossover votes.

Both men came out of music halls and vaudeville to become cinema masters. The public Chaplin was a humanist who sought audience sympathy through identification. The Buster character remains something very different, unsentimental and a little bit aloof, a cog that has somehow been detached from life's mechanism and would desperately like to fit back in. Although Keaton's universe runs to the sound of laughter, it is spooky.

Nowhere in his work is it more spooky and hilarious than in the three remarkable films directed by Keaton in the Film Forum's opening program.

Although Keaton was born (in 1895) into an American vaudeville family and was, by his account, a part of the family act from the age of 9 months, he didn't come into his own until he discovered the movie studio. All of the ways in which he was to exploit and stretch the camera's possibilities are gloriously apparent in "Sherlock Jr.," "The Playhouse" and "The Navigator."

Like Chaplin and everyone else who came to movies from the stage, Keaton appreciated the value of the long and medium shots that allowed the audience to see him in full figure and in constant relation to his environment. Unlike Chaplin, who frequently used the close-up to milk the emotion of a moment, Keaton preferred to keep his camera at a certain distance.

It wasn't that he had esthetic reservations about close-ups, but that distance was needed if his stunningly graceful, acrobatic gags were to be properly seen. Keaton further investigated the extraordinary trickery that the camera had suddenly made available, in this way to create a reality never before possible.

In "Sherlock Jr." Keaton and his cameramen, Byron Houck and Elgin Lessley, allow the Buster character to enter the movie-within with such technical seamlessness that discus-

A retrospective demonstrates how golden were a comic's silents.

sion of the philosophical implications (the old "What is real and what is illusion?" debate) were bound to follow, though certainly not by Keaton.

René Clair called it "a kind of dramatic critique comparable to 'Six Characters in Search of an Author,' which Pirandello wrote for the stage." In Woody Allen's "Purple Rose of Cairo," the philosophical implications are translated, for great comic effect, into the dollars and cents being lost by the movie company when its juvenile star walks off the screen.

•

The four-reel "Playhouse" is remarkable. Through the use of multiple exposure techniques, Keaton plays nearly all of the roles. He is every member of the orchestra in the pit of a vaudeville theater, as well as the orchestra conductor. He is a number of the acts on the stage, including the men in a minstrel show and both dancers in a two-man team who do a soft-shoe number. He's even his own audience. In discreet drag, he looks something like Maggie Smith.

On the same program, "The Navigator" is a Keaton masterpiece in a league with "The General" (1927). The film was shot largely on the liner Buford, a real ship that was about to be scrapped. Buster and the girl he loves, two of high society's rich, spoiled playthings, find themselves alone aboard the ship, as if the last two people on earth.

Although Buster has no rivals here, true love does not immediately surface. Buster and the girl have too much trouble learning how to live like ordinary people (how to make coffee, among other things) to become romantic. Beginning with the ghostly early shipboard scenes, when neither is aware of the other's presence, the movie seems to be as concise and shapely as a sonnet, but pricelessly comic.

Also not to be missed is "The General," which will be shown Feb. 12 to 16 and is (to my way of thinking, although purists have other favorites) Keaton's chef d'oeuvre. Buster plays a mild-mannered railroad engineer who single-handedly saves the South (for a few years, anyway) during the Civil War. The film, as handsome as any black-and-white film ever made, is Keaton's most perfectly integrated as well as most visually spectacular film. The climactic collapse of a railway bridge with an engine steaming across it remains an astonishment even today.

More important, though, "The General" proceeds in a way to which today's audiences can respond without making adjustments for contemporary narrative expectations. It has a clearly defined beginning, a middle and a breathtaking chase at the end.

•

Keaton's other features have the shape of the short films. They consist of long, sometimes very funny but single-minded sequences that set the scene for the pay-off, that is, the chase that brings everything together.

In the great features, these build-ups are a joy in themselves, as in "Our Hospitality" (1923), but in "Seven Chances" (1925), in which Buster has to get married by 7 P.M. or lose a million-dollar inheritance, the build-up seems a waste of time. The pay-off, in this case the sight of thousands of desperate women, tearing through the streets of Los Angeles and its suburbs, all wearing bridal veils and all bent on marrying Buster, would be equally funny all by itself.

Never before or since has there been a comic star who was the stunt-man that Keaton was. He not only choreographed the stunts, but also performed them atop moving trains, on motorcycles, on high buildings and, in "Our Hospitality," in raging rapids and over a waterfall.

Danger is only part of the effect. The figure itself, though small, is lithe, athletic, surprisingly muscular. It has a dancer's natural sense of ease through balance. It's a part of its own world as well as a comment on it.

Keaton's career was not an especially happy one. His masterpieces, all silent films, were made within a comparatively short period, between 1920 and 1929. He had problems with women, with alcohol. He drank himself out of his contract with M-G-M in the early 1930's. Although his movies made money when the costs were kept in line, he was never a box-office attraction to rival Chaplin, to make a man like the Metro studio chief, Louis B. Mayer, kowtow to him.

His talking pictures are not great. He hated being teamed with the aggressive and pushy Jimmy Durante, although their films were very popular. He resisted the mentors who would have turned him into a sad but lovable clown. With his impassive face, he did not seek lovability. The face is resolute, seriously responsible, if often in a mad way. It also fits his body and the way it moves.

Somehow Keaton survived the Hollywood system. He despaired, but he went on, at one point as a gag writer and idea man on the M-G-M lot, where he had once been an icon. With his third wife, Eleanor, his life finally attained some tranquillity, and in his last years he received new recognition from film aficionados all over the world.

•

On the closing Film Forum program on Feb. 20 will be Keaton's strangest film, the 22-minute "Film" (1965), directed by Alan Schneider and written for Keaton by his admirer Samuel Beckett.

"Film," in which Keaton never speaks and is seen mostly from the back, is a harrowing work that seems to suggest that Buster may already be dead and is simply refusing to acknowledge the fact. Yet it is not out of place in this celebration. Keaton's genius is edged not by pity or sorrow, but by enlightened perseverance against all odds. In this way the worlds of Keaton and Beckett briefly meet.

1991 D 27, C1:1

Cinematic trickery — Buster Keaton in "Sherlock Jr."

Naked Lunch

Written and directed by David Cronenberg, based on the book by William S. Burroughs; director of photography, Peter Suschitzky; edited by Ronald Sanders; music by Howard Shore; production designer, Carol Spier; produced by Jeremy Thomas; released by 20th Century Fox. Running time: 115 minutes. This film is rated R.

Bill Lee	Peter Weller
Joan Frost and Joan Lee	Judy Davis
Tom Frost	Ian Holm
Yves Cloquet	Julian Sands
Dr. Benway	Roy Scheider
Fadela	Monique Mercure
Hank	Nicholas Campbell
Martin	Michael Zelniker

By JANET MASLIN

"**N**AKED LUNCH," adapted by the dauntless David Cronenberg from William S. Burroughs's 1959 landmark novel, represents a remarkable meeting of the minds. It's hard to imagine another film maker who could delve so deeply into the monstrousness of Mr. Burroughs's vision, in the end coming up with a bona fide monster movie of his own. Yet while Mr. Cronenberg's ingenious approach to his material matches Mr. Burroughs's flair for the grotesque, it also shares the author's perfect nonchalance and his ice-cold wit. Seldom has a film maker offered his audience a more debonair invitation to go to hell.

The director of "The Fly," "Dead Ringers" and "Scanners" will not disappoint viewers who appreciate his devilish inge-

nuity. Instead of attempting the impossible task of adapting "Naked Lunch" literally, Mr. Cronenberg has treated this disjointed, hallucinatory book as a secondary source. Concentrating instead on Mr. Burroughs himself, the drug experience that colors his writing and the agonies of the creative process, Mr. Cronenberg also devises purely metaphorical versions of the author's wild and violent sexual scenarios. The result, by turns bracing, brilliant and vile, is a screen style as audacious as Mr. Burroughs's is on the page.

"Naked Lunch" makes an instantaneous break with conventional reality in its opening moments and never looks back. Centering on the adventures of Bill Lee, played by Peter Weller as a droll, deadpan evocation of the author (Lee was the maiden name of Mr. Burroughs's mother, and William Lee his pseudonym), the film begins with smallish bugs. Then it moves on to ever more huge, horrible and intelligent ones. Bill works in New York City as an exterminator and sees even that as a metaphor. "Exterminate all rational thought: that is the conclusion I have come to," he says.

In addition to viewing his job in philosophical terms, Bill has also used it as an excuse to ingest narcotic bug powder, to which both he and his wife, Joan (Judy Davis), have become addicted. Ms. Davis, who is wonderfully dry and unflappable in two different bizarre incarnations, at first turns up barely long enough to inject bug powder intravenously and conduct a lazy affair with one of Bill's friends. "Hank and I, we're just bored," she tells Bill. "It wasn't serious."

This is enough to raise Bill's suspicions that Joan is a secret agent for an enemy spy ring, especially after a large talking beetle befriends Bill and drops that hint. Joan must be eliminated, the beetle insists, speaking from an orifice that recalls Mr. Burroughs's taste for the playfully obscene and talking in the lively, Burroughs-like idiom of Mr. Cronenberg's inventive screenplay. "It must be done this week," the insect says, "and it must be done real tasty."

So Bill and Joan perform their "William Tell act," just as Mr. Burroughs and his wife, Joan Vollmer Burroughs, did on one drunken evening in Mexico City in 1951. As Bill shoots and kills Joan, the film makes one of its many allusions to the real events of Mr. Burroughs's life. Soon afterward, he either physically or psychically flees New York for Inter-

Bugs as characters that grow, even a beetle who befriends the hero.

zone, a Tangier-like exotic setting in which the film's nightmarishness escalates to new levels (although "Naked Lunch" is so thoroughly hallucinatory that it's difficult to know exactly where its characters are, literally or figuratively). In Interzone, the suffering gets worse and the bugs get bigger as Bill attempts to write what will be "Naked Lunch," the novel.

•

On screen "Naked Lunch" recalls both "The Sheltering Sky" and "Barton Fink" in its respective evocations of the life of the literary exile and the torment of trying to write. Mr. Cronenberg's hideously clever contribution in the latter realm is the insect-cum-typewriter that supposedly assists Bill in his efforts but clearly has a mind of its own. Both the writing bug and the Mugwump, a man-sized and rather soigné strain of monster, are capable of registering their approval by oozing viscous, intoxicating substances from various parts of their anatomies. "I'd like you to meet a friend of mine," Bill is told upon encountering his first cigarette-smoking Mugwump on a bar stool in Interzone. "He specializes in sexual ambivalence."

These elements, plus a lot of attention to the addictive powers of the black meat of the giant Brazilian centipede, insure that Mr. Cronenberg's version of "Naked Lunch" is no more suitable to the fainthearted than Mr. Burroughs's was. And the film, while very different from the book, is every bit as impenetrable in its own way. By the time it reaches a repellent fever pitch, with one character literally tearing its body open to reveal someone of a different sex inside (a simple yet extravagantly weird evocation of the author's thoughts on sexual identity), "Naked Lunch" has become too stomach-turning and gone too far over the top to regain its initial aplomb. Yet for the most part this is a coolly riveting film and even a darkly entertaining one, at least for audiences with steel nerves, a predisposition toward Mr. Burroughs and a willingness to meet Mr. Cronenberg halfway.

•

The gaunt, unsmiling Mr. Weller looks exactly right and brings a perfect offhandedness to his disarming dialogue. ("You're patronizing me, boys, but I don't mind 'cause you're so sweet to me too," he tells the film's Jack Kerouac and Allen Ginsberg stand-ins.) And Ms. Davis is chillingly good as both Joan Lee and Joan Frost, a writer Bill meets with her husband in Interzone; between this and her work as the helpmate of the William Faulkner character in "Barton Fink," Ms. Davis surely qualifies as the tortured writer's Muse of the Year. Also roaming through "Naked Lunch" are Roy Scheider as the demented Dr. Benway, an odd fixture of the pharmacological strain in Mr.

Attila Dory/20th Century Fox

Battling bugs — Peter Weller.

Brian Hamill/20th Century Fox

Judy Davis

Burroughs's writing; Ian Holm as a fellow writer with a grasp of the typewriter-bug's habits, and Julian Sands as a debauched Interzone playboy.

"Stay until you finish the book, but then come back to us," Bill's friends say about his sojourn in Interzone. But if the terror so slyly and sickeningly rendered in "Naked Lunch" is representative, it's a miracle that artists ever survive the creative process to come home.

•

"Naked Lunch" is rated R (Under 17 requires accompanying parent or adult guardian). It includes oblique sexual references and occasionally gruesome special effects.

1991 D 27, C1:3

Fried Green Tomatoes

Directed by Jon Avnet; screenplay by Mr. Avnet and Fannie Flagg, based on the novel by Ms. Flagg; director of photography, Geoffrey Simpson; edited by Debra Neil; music by Thomas Newman; production designer, Barbara Ling; produced by Mr. Avnet and Jordan Kerner; released by Universal Pictures. Running time: 130 minutes. This film is rated PG-13.

Evelyn Couch	Kathy Bates
Idgie Threadgoode	Mary Stuart Masterson
Ruth Jamison	Mary-Louise Parker
Ninny Threadgoode	Jessica Tandy
Sipsey	Cicely Tyson
Buddy Threadgoode	Chris O'Donnell
Big George	Stan Shaw
Ed Couch	Gailard Sartain
Smokey Lonesome	Tim Scopt
Grady Kilgore	Gary Basaraba
Mama Threadgoode	Lois Smith

By JANET MASLIN

Two different stories are told in "Fried Green Tomatoes," tales loosely bound together by crackerbarrel feminism and antic Southern charm. The earlier and more compelling story involves two beautiful young women: Idgie Threadgoode (Mary Stuart Masterson), a tomboy and a fiercely free spirit, and the more ladylike Ruth (Mary-Louise Parker), with whom Idgie is tacitly in love.

In a series of flashbacks, the film follows Idgie and Ruth through a wide range of bittersweet events that test their loyalty to each other. In the process, it also offers a portrait of a lulling, rustic, Klan-ridden Alabama in which the characters' willful innocence often gives way to harsh racial realities.

Contrasted with this is the present-day story of Ninny Threadgoode (Jessica Tandy), an 83-year-old nursing home patient, and Evelyn Couch (Kathy Bates), who encounters Ninny by accident while on a visit to her husband's mean-tempered aunt. The reassuring Ninny and the plump, unhappily married Evelyn develop a fast friendship, one that helps Evelyn escape the blahs of her domestic life by learning to care deeply about a relative stranger. The film tries to develop some suspense around the question of how these two plots are connected, but the answer will strike no one as a surprise.

•

Based on a novel by Fannie Flagg, the comedian, and directed by Jon Avnet, "Fried Green Tomatoes" has some good performances and a measure of homespun appeal, some of which can be credited to Elizabeth McBride's gently evocative costumes and Barbara Ling's detailed production design. (When one of the principals goes on trial charged with murder, the hats of the jurors can be seen lined up on the wall in the small-town courtroom.)

One of the strongest things in the film is Ms. Masterson, a magnetic, wildly defiant actress with so much energy she often seems to be bursting

Richard Felber/Universal

Mary-Louise Parker and Mary Stuart Masterson

at the seams of her role. The film so ignores Idgie's attraction to Ruth that it would seem tepid without Ms. Masterson's furious honesty. Thanks to her, Idgie's sullenness over Ruth's marriage and her subsequent defense of Ruth against a violent husband give the two women's friendship all the depth it needs.

Ms. Tandy, appearing without makeup and looking all the more beautiful that way, gives the character of Ninny a similar kind of grit. Much broader is Ms. Bates's performance as the tubby, comical Evelyn, who borders on caricature until she develops some toughness by the end of the story. The film's overstatement is such that Evelyn has to appear in flowered frocks and stiff hairdos, nibbling candy bars and gazing longingly at her equally rotund husband, to establish the fact that she is unhappy.

•

Mr. Avnet's direction works better in the story's gentler moments than in its violent ones, which are often abruptly handled. When the serene small-town mood is ruptured by a character's being hit by a train (this happens at least once too often), Mr. Avnet has the mother of a maimed young victim smiling much too serenely a few days later. Equally abrupt is the murder episode that brings together the small town's black and white characters in an elaborate scheme. Cicely Tyson and Stan Shaw play the mother and son who are the film's principal black characters, but they are given little to say.

Equipped with a highly expendable silly streak, as in "Steel Magnolias," the film finds occasion to put Ms. Tandy in a purple wig and send Ms. Bates to a feminist consciousness-raising group, which becomes the butt of many jokes. The better parts of "Fried Green Tomatoes" have a lot more quiet dignity than that, and a lot more class.

•

"Fried Green Tomatoes" is rated PG-13 (Parents strongly cautioned). It includes sexual references and off-color language.

1991 D 27, C3:1

Talking to Strangers

Written and directed by Rob Tregenza; produced by J. K. Eareckson. At the Walter Reade Theater, 165 West 65th Street, Manhattan. Running time: 90 minutes. This film has no rating.

Jesse	Ken Gruz
General	Marvin Hunter
Red Coat	Dennis Jordan
Ms. Taylor	Caron Tate

Caron Tate and Ken Gruz

Angry Man	Brian Constantini
Manager	Bill Sanders
Priest	Henry Strozier
Water Taxi People	
Joanne Bauer, Lois Evans, Sharrie Valero, Laurie Nettles	
Slick	Richard Foster
Trigger	Linda Chambers
Potter	Sara Rush

By VINCENT CANBY

A nearly perfect antidote to today's jazzy conception of montage, seemingly designed for short attention spans, is Rob Tregenza's stylistic tour de force titled "Talking to Strangers," being shown today at the Lincoln Center Film Society's new Walter Reade Theater at 8 P.M.

The film will be presented eight more times, at different hours each day, through next Tuesday.

"Talking to Strangers" is something of a stunt, but it's a stunt pulled off by someone with a great deal of expertise. Unlike directors who simulate what is sometimes called filmmaking energy by fast cutting and abrupt juxtapositions of contradictory images and sounds, Mr. Tregenza here demonstrates how much curiosity can be aroused by a sequence that is, comparatively speaking, lazy.

The film is composed of 9 scenes, each shot in a continuous 10-minute take, by a camera that moves around and shifts its focus at will, sometimes with the beady eye of a cop on a stakeout, sometimes with the embarrassed manner of someone who wants to make a quick exit but can't.

•

The first segment plays like a textbook exercise in how to create suspense. The camera, placed high above a city street, as if on the platform of an elevated train station, studies the sidewalk traffic below, eventually becoming curious about the movements of a man with a briefcase.

The man seems distracted, unable to make up his mind what to do. He boards a bus, then gets off. He crosses the street, listens to a musician, returns to his original position. At one point he disappears around the corner, only to reappear a few minutes later around another corner.

Is he on his way to the dentist? Has he just shot his wife, been fired, lost his wallet? Is he in the middle of a breakdown? He finally leaves the scene of his indecision, without fuss. The screen goes blank as the camera eye seems to blink.

•

In the second segment the man with a briefcase, who can now be seen to be young and callow, turns up at the food kitchen of a mission for homeless men. A mission regular immediately spots him as the impostor he is. "Journalists — writers —' all noncombatants," says the older man. "If you want to do research, go to the library."

This is, in fact, just what Jesse, which is the name of the younger man, is up to. He's an artist looking for material. Once this rather large cat is out of the bag, "Talking to Strangers" loses a good deal of its kick. The problems of the artist are not terribly interesting to anyone who is not intimately connected to the artist.

In subsequent segments Jesse is bullied by a bum as he scouts locations for a jeans commercial beneath a photogenically seedy highway viaduct. He rides a ferry and encounters three women who might be nuns. In the film's funniest segment, he goes into a Roman Catholic church and, on the pretense of wanting to make a confession, tries to engage the priest in a discussion of God.

•

"Talking to Strangers" is an extended but rather amazing divertissement. Some of the segments are painfully arch. The acting is not great. Yet there seems to be a an original and witty intelligence behind the technical élan.

The Walter Reade is presenting the film as part of its "Great Beginnings" series, otherwise devoted to the first films by directors (Federico Fellini, Mike Leigh and Elia Kazan, among others) who have gone on to subsequent triumphs. This context may be freighting "Talking to Strangers" with more promises than Mr. Tregenza will ever keep.

We'll see.

1991 D 27, C12:6

The National Film Board of Canada's Animation Festival

A series of 16 animated short films; produced by Terry Thoren; released by Expanded Entertainment. At the Angelika Film Center at Mercer and Houston Streets. Running time: 87 minutes. These films have no ratings.

By STEPHEN HOLDEN

Just how thoroughly the field of animated films has been revolutionized by computer technology is suggested by the fact that only half the selections in "The National Film Board of Canada's Animation Festival" could readily be described as cartoons.

Although the festival, which opened Thursday at the Angelika Film Center, includes some lively old-fashioned funnies, its most captivating works turn crayon drawings into a sweeping visual ballet (Réal Bérard and André Leduc's "Jours de Plaine") or use unusual techniques to evoke visual depth, texture and shading.

The dark, heavily shadowed drawings in Caroline Leaf's "Two Sisters" have the look of wood cuts because many of the images were scratched directly onto 70-millimeter color frames. The 10-minute film's murky visual mood matches the elliptical Carson McCullers-like vignette about a reclusive popular author and her sister who live on a distant island. Wendy Tilby's "Strings," which uses an animation process of painting on glass, portrays the relationship between two strangers who live a floor apart in the same building and who are finally brought together by a leaky bathtub.

•

A thread of folksy nationalism also runs through the festival. Brian Duchscherer's "Balgonie Birdman" is a heavily embellished true story about a pioneering Canadian aviator. Its visual style puts modeled three-dimensional shapes in sharply edged naturalistic settings. Christopher Hinton's "Blackfly" jauntily illustrates an extended folk ballad written and sung by Wade Hemsworth about his attempts to escape a swarm of pesty insects on a trip to North Ontario.

The gorgeous "Jours de Plaine" celebrates the beauty of the Canadian prairies in mystical drawings that melt and metamorphose in sync with an appealing new-age musical score by Daniel Lavoie.

Unlike other recent collections of animated films, technological innovation does not substitute for content. Among several selections that demonstrate an edge of criticism and satire, the most succinct is Suzanne Gervais and Jacques Giraldeau's "Irises." As the colors of a painting are magically filled in, a cold, shrill auctioneer's voice is heard bidding up the price of a painting from $30 million to $54 million. What materializes in less than four minutes is a completed reproduction of van Gogh's "Irises," which was in fact sold for $53.9 million in November 1987.

1991 D 28, 9:1

242

Film/1991

BY VINCENT CANBY

Which One Is Thelma?
And Other Questions for the Ages

Most Thoughtful Civic Gesture When the gendarmes cleared the roads around Cap d'Antibes each morning so that Madonna could jog in peace while communing with nature and her entourage, which was the least they could do for the only true 1990's star to appear at the Cannes film festival.

Most Entertaining Buddy Movie Ridley Scott's ''Thelma and Louise,'' even though today you can't remember which role was played by Susan Sarandon and which by Geena Davis.

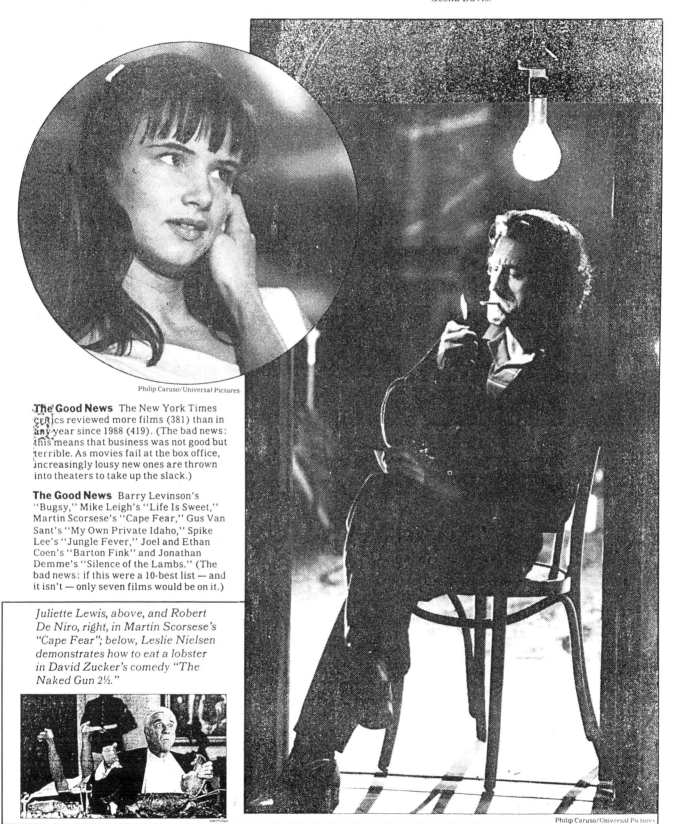

Philip Caruso/Universal Pictures

The Good News The New York Times critics reviewed more films (381) than in any year since 1988 (419). (The bad news: this means that business was not good but terrible. As movies fail at the box office, increasingly lousy new ones are thrown into theaters to take up the slack.)

The Good News Barry Levinson's ''Bugsy,'' Mike Leigh's ''Life Is Sweet,'' Martin Scorsese's ''Cape Fear,'' Gus Van Sant's ''My Own Private Idaho,'' Spike Lee's ''Jungle Fever,'' Joel and Ethan Coen's ''Barton Fink'' and Jonathan Demme's ''Silence of the Lambs.'' (The bad news: if this were a 10-best list — and it isn't — only seven films would be on it.)

Juliette Lewis, above, and Robert De Niro, right, in Martin Scorsese's "Cape Fear"; below, Leslie Nielsen demonstrates how to eat a lobster in David Zucker's comedy "The Naked Gun 2½."

Ivan Phillips

Philip Caruso/Universal Pictures

Most Memorable Sequences The crack house in "Jungle Fever," Robert De Niro's seduction of Juliette Lewis in "Cape Fear," the crashing of a house onto a two-lane blacktop in "My Own Private Idaho."

Business, Hollywood-Style Orion Pictures, which had two of the year's biggest hits, "Dances With Wolves" and "The Silence of the Lambs," went bankrupt.

New Wrinkle Movie titles that sound like the names of unisex colognes: "Exposure," "Backdraft," "Switch," "Ricochet," "Deceived," "Shattered." Forgotten.

You Always Kill the One You Love Macaulay Culkin, the nearest thing Hollywood has to a life force, was required to die in "My Girl," and Julia Roberts, God's laughing gift to romantic comedy, ministered to the terminally ill ("Dying Young").

Most Instructional Sequence Leslie Nielsen's demonstration of how to eat a lobster at a White House banquet in David Zucker's "Naked Gun 2½."

Most Notable Movie Events, Each Sponsored by a (Heaven Forbid) Not-for-Profit Institution The Film Forum's retrospectives devoted to Billy Wilder and Buster Keaton, the Public Theater's presentation of Paul Schrader's exotic "Comfort of Strangers" and the Lincoln Center Film Society's opening of its elegant new Walter Reade Theater.

Most Spectacular Modestly Budgeted Film John Sayles's "City of Hope," whose total cost was reportedly less than the pirate galleon that never leaves the dock in "Hook," which also never leaves the dock.

The Good News Though it cost between $70 million and $100 million, "Terminator 2" is said to have made a profit. (The bad news: all the money that will be spent by producers taking the same sort of gamble, only to lose the French-cuffed shirts off their investors' backs.)

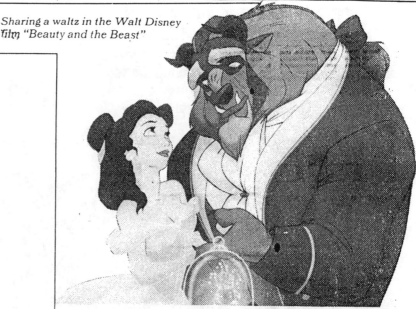

Sharing a waltz in the Walt Disney film "Beauty and the Beast"

Walt Disney Company

Belle a magic mirror, a library of her own, a romantic waltz around the ballroom and he even has a certain sex appeal — let's not say animal magnetism — that very little girls may not appreciate till they're older. This requires a stretch of the imagination, but what else is movie romance about?

Biggest Change of Heart For "Terminator 2," the bad-Arnold cyborg became a good-Arnold cyborg, but brilliant special effects kept the Schwarzenegger money rolling in. Old Terminators never say die; they just say, "No problema."

The Man Who Knew Too Much Martin Scorsese took on a remake and turned "Cape Fear" into a triumph — a stylish suspense film that is at once old-fashioned and scary, post-modern and witty. So what if De Niro has a cannibalistic moment and Nick Nolte slips in a puddle of blood? You can blink for a second.

Most Surprising Flop Don't even think "Hudson Hawk"; that's too easy. But how could "Scenes From a Mall," the dream-cast comedy with Bette Midler and Woody Allen as a battling married couple, have turned out to be more somber than "Cries and Whispers"?

Best Urban Decay and Ethnic Hatred David Mamet's "Homicide" and John Sayles's "City of Hope" won't send you out of the theater smiling, but these powerful, thoughtful views of urban America are two of the year's best films.

Most Overused Image The Indian shaman, who turns up as a ghostly figure in Oliver Stone's pretentious bore "The Doors" and in Sean Penn's pretentious but promising writing-directing debut, "The Indian Runner." There is also a dwarf shaman in Bruce Beresford's rich historical drama "Black Robe" and a passing mention in "At Play in the Fields of the Lord." This may mean nothing. But I like to think it means shamans will replace agents as the new powers in Hollywood.

Most Haunting Moment Anthony Hopkins peers out from behind his glass cage and hisses "Cla-rice" at Jodie Foster in "The Silence of the Lambs." It's on cable and video now; don't watch it alone.

BY CARYN JAMES

Beatty Redux, Poetic Infernos, And How About Those Shamans

Happiest Comeback Warren Beatty threw off Dick Tracy's ugly yellow raincoat and the career pall of "Ishtar" to come back fresher than ever. He casually ad-libbed the year's shrewdest line in "Truth or Dare," the documentary about his then-love, Madonna — "She doesn't want to live off camera" — and went on to play his most seductive character in years, the comic-romantic hero of "Bugsy."

Silliest Line "It's a living thing, Brian. It breathes, it eats and it hates." Even Robert De Niro couldn't get away with this description of a fire in "Backdraft." Let's just be grateful he stopped there. He could have gone on: "A fire sings, it dances, it calls out for Chinese food . . . "

Most Romantic Leading Man The Beast in "Beauty and the Beast," a hairy sweetheart in a burly guy's body. He gives

Orion Pictures

Jodie Foster as the F.B.I. agent Clarice Starling in Jonathan Demme's thriller "The Silence of the Lambs"

BY JANET MASLIN

Goodbye, Yuppies. Hello, Beasts. (Plus the Mellowing of Arnold)

Story of the Year A smart young woman is entrapped by a brutish male who eventually wins her respect and affection. This premise can be found in the year's two most seamlessly fine films: "The Silence of the Lambs" and "Beauty and the Beast." "Bugsy" and "Thelma and Louise" are close behind.

Endangered Species The complacent yuppie male, likely to be shot (Harrison Ford in "Regarding Henry"), felled by illness (William Hurt in "The Doctor"), sent to Neverland (Robin Williams in "Hook") or driven off a cliff (Tom Berenger in "Shattered"). California corollary: a movie producer, played by Steve Martin, mugged for his Rolex in "Grand Canyon."

Most Unforgettable Character Solomon Perel, whose stranger-than-fiction Holocaust story became the basis for "Europa, Europa."

Best Arguments for the Sequel Mentality "Hudson Hawk" ("Die Hard 3" would have been preferable). "Kafka" (ditto "Sex, Lies and Videotape 2"). ·

Memorable Malady Writer's block, turned into an even worse nightmare than it already is. Made ingeniously surreal in both "Barton Fink" and "Naked Lunch."

Most Likely to Succeed John Singleton, whose straightforward, gripping direction made a hit out of "Boyz 'N the Hood." Juliette Lewis, who provided the sexual tension in "Cape Fear." Brad Pitt, a thief and a scene stealer in "Thelma and Louise."

Worst Argument for the Sequel Mentality "Problem Child 2."

Missing in Action The adult moviegoing audience, without which films like "Frankie and Johnny," "For the Boys" and "Billy Bathgate" proved unable to fly. Should that audience continue to stay away, it can expect an upsurge of cheap thrills and teen-age dance movies on home video.

The Enemy Television. Its influence, in films from "Doc Hollywood" to "Paradise" to "All I Want for Chr: ：as" and many more, makes the big screen smaller all the time.

Sleepers "The Man in the Moon," a warm, quietly enveloping family drama. "Strangers in Good Company," about nothing more than eight old ladies and a broken-down bus. "Heart of Darkness: A Film Maker's Apocalypse," a startlingly close look at a director under fire. "My Own Private Idaho," the year's most fascinatingly idiosyncratic American film.

The End Near. Both "The Rapture," a hauntingly strange story of religious conversion, and the considerably less spiritual "Terminator 2: Judgment Day," saw Armageddon coming and showed us what it would be like.

Trick of the Year The "Terminator 2" molten-cyborg image, used to thrillingly good effect in that film and only slightly less spectacularly in "Star Trek VI," and Michael Jackson's latest video. Sure to be a fad of the future. Look for it in soda commercials by spring.

1991 D 29, II:9:1

Sundance Festival Honors Gay Film

By ALJEAN HARMETZ

PARK CITY, Utah, Jan. 25 — With less pain and more unanimity than is usual at the Sundance Film Festival, the dramatic film jury here awarded its grand prize to "Poison," a first feature by Todd Haynes, a gay film maker. "Poison," which Mr. Haynes said was inspired by the novels of Jean Genet, interweaves three stories in three different styles and time periods. In one of the stories, AIDS is handled metaphorically as the plague of a leper killer in a 1950's horror movie.

"You're all the brave ones who weathered the film," Mr. Haynes told his audience after a screening Thursday afternoon. Many in the audience had rushed out of the theater during a scene in which convicts take turns spitting into a young boy's mouth. The screenwriter-director said the subject of "Poison" was deviance, but the jury saw the more universal issue of how all cultures shame people over sex.

In contrast to the collegiality of the dramatic jury, a completely polarized documentary jury argued until 1:30 this morning before splitting its grand prize between Barbara Kopple's "American Dream," a political and social documentary about a strike at a Hormel meat-packing plant, and "Paris Is Burning," a highly wrought tale of black and Hispanic homosexuals who sit at their sewing machines making gowns to wear at Harlem drag-queen balls.

"American Dream" became the festival's first triple winner when it was also voted best documentary by the film makers themselves and by festival audiences.

Ms. Koppel's "Harlan County, U.S.A.," a 1976 documentary about the famous coal miners' strike in West Virginia, was chosen last year by the Library of Congress as one of 25 films to be placed on its Film Registry, tantamount in film terms to giving it the status of a national treasure.

The documentary jury also gave a cinematography award to David and Albert Maysles, two deans of cinéma vérité, for their "Christo in Paris," which chronicles a decadelong effort by the environmental artist Christo to wrap a Paris bridge in 44,000 feet of fabric. David Maysles died in 1987 before the film was completed.

In a festival at which the most prevalent image on the screen was urban decay and urban despair, the dramatic jury awarded a special citation to a raw, personal account of growing up in the Red Hook projects in Brooklyn. "Straight Out of Brooklyn" by Matty Rich, a 19-year-old, tells the tragic story of his aunt and uncle.

A New Award

Other dramatic jury awards went to Arthur Jafa for his cinematography on "Daughters of the Dust" and to two directors for their screenplays: Joseph B. Vasquez for "Hangin' With the Homeboys," about a night four young blacks and Puerto Ricans spend in Manhattan, and Hal Hartley for "Trust," a comedy about two losers in suburbia.

The screenplay award, which is new this year, came in response to the failure of Whit Stillman's "Metropolitan" to be recognized by last year's jury, which was hopelessly impacted. The audience award was instituted a year earlier after the jury awarded its prize to Rob Nilsson's austere "Heat and Sunlight" rather than John Waters's crowd-pleaser, "Hairspray."

This year, festival audiences voted their dramatic award to "One Cup of Coffee," a first feature by Robin Armstrong about a 41-year-old baseball pitcher who transfers both his love of the game and his best pitch to a young black pitcher.

Although "One Cup of Coffee" had acquired a distributor, Miramax, before it played here, the audience approval may have saved the film maker's vision. Mr. Armstrong has been under pressure from Miramax to recut the film to emphasize the black pitcher, played by Glenn Plummer, and to make the movie more of a civil rights story. "One Cup of Coffee," which is set in the late 1950's, is based on a screenplay written 18 years ago by David Eyre Jr., who has since written "Wolfen."

Speaking of the talent agency, Mr. Armstrong said, "When you're doing your first film, you don't call up C.A.A. and say, 'Send me your best scripts.'" He has larded his film with half a dozen real oldtime players — Duke Snider, Ernie Banks, Don Newcombe, Bill Mazeroski, Harmon Killebrew and Bob Feller.

The film makers voted their award for a dramatic film to "Privilege," a movie about women's experiences with menopause. It was written, directed, produced and edited by Yvonne Rainer.

Alberto Garcia, the competition director, said this year's juries were specifically chosen for sexual and ethnic diversity. Each jury consisted of two men and two women, and at least one member of each jury was black.

Members of the dramatic jury were Gus Van Sant, who directed "Drugstore Cowboy"; two producers, Heather Johnston and Katherine Wyler, and Karen Durbin, the arts editor of Mirabella magazine. The documentary jury consisted of the documentary film makers, Marcel Ophuls, St. Clair Bourne and Jill Godmilo, and Amy Taubin of the Village Voice.

For the last several years this festival has been seen as a spawning ground for Hollywood. Although Mr. Vasquez has been signed to a two-picture deal by New Line Cinema, which is distributing his "Hangin' With the Homeboys," it is generally agreed that the biggest beneficiary of this year's festival is not a director or writer but an actress, Patsy Kensit. Miss Kensit, who had a minor role in "Lethal Weapon II," stars as a woman who confides the details of her sexy, disorganized life to the camera in the little-liked feature "Twenty-One." Can it be long before Hollywood is knocking with major roles?

1991 Ja 26, 15:1

'Barton Fink' Wins the Top Prize And 2 Others at Cannes Festival

By VINCENT CANBY

Special to The New York Times

CANNES, France, May 20 — Joel and Ethan Coen's "Barton Fink" was awarded the Palme d'Or as best film tonight at the closing ceremonies of the 44th Cannes International Film Festival.

The American film, a dark and often hilarious satire of Hollywood set in 1941, broke several traditions observed at Cannes, where prizes usually are spread round. In addition to winning the Palme d'Or, the Coen brothers shared the festival's award as best director. John Turturro, who plays the title role, walked off with the prize as best actor.

The festival's Grand Prix, which is, in effect, the runner-up to the Palme d'Or, went to "La Belle Noiseuse," Jacques Rivette's meditative four-hour French film about an aging artist and his 10-year painter's block.

The Jury Prize, which is really the festival's third prize, was shared by two films, Lars von Trier's post-World War II melodrama, "Europa," from Denmark, and Maroun Bagdadi's "Hors de Vie" ("Out of Life"), a taut, tough, small-scale drama about the kidnapping of a French journalist in Beirut.

Irène Jacob, who is French, 25 years old and relatively new to films, was voted the best actress for her radiant performance in a dual role in "The Double Life of Veronica," Krzysztof Kieslowski's French-Polish co-production.

Early in the ceremonies at the Palais du Festival, there was a signal that Spike Lee and his "Jungle Fever" were probably going to be bypassed for the festival's top awards. This came when it was announced that a special award for a best supporting performance had been voted, and that it would go to Samuel L. Jackson, who plays a cocaine addict in "Jungle Fever."

Mr. Lee accepted the prize on behalf of Mr. Jackson, who did not attend the festival. This was the second time that a Lee film, considered by many to be a favored candidate for the Palme d'Or, lost to another American film. In 1989, Steven Soderbergh's "Sex, Lies and Videotape" won over Mr. Lee's "Do the Right Thing."

In accepting the award for his performance in the title role in "Barton Fink," Mr. Turturro, who also plays a key role in "Jungle Fever," thanked his collaborators in both films. Mr. Turturro's career owes a lot to Mr. Lee, for whom he also performed in "Do the Right Thing" and "Mo' Better Blues."

His moody, comic work in "Barton Fink" could help make him a star. He plays the title role, that of a Clifford Odets-like New York playwright who goes to Hollywood and finds himself up to his neck in a bizarre world beyond his imagination.

Some bad feeling is evident onstage as the awards are presented.

Jury Divisions

The way the principal awards were voted appears to confirm rumors that the jury members were deeply divided in their choices.

The members of the jury, including its president, Roman Polanski, were on the stage throughout the awards ceremony. Mr. Polanski, who is short, was overlooked when the emcee, the actress Carole Laure, introduced the jury to the audience.

A few minutes later, when Mr. von Trier picked up an award for the visual and aural excellence of "Europa," Mr. Polanski was not overlooked by the Danish director. Apparently in the belief that "Europa" had been voted a technical award in lieu of

Ethan and Joel Coen, left and center, directors of "Barton Fink," and John Turturro, the film's star.

anything else, the sarcastic Mr. von Trier said, speaking English, "Thanks very much to the midget, and to the rest of the jury."

Mr. Lee did not stay around to watch Ridley Scott's "Thelma and Louise," screened out of competition immediately after the awards were given. He made a quick exit from the hall and with his associates walked briskly back to the Carlton Hotel, cheered and applauded by fans along the way.

Mr. Lee was disappointed but, as he noted, it was not the first time. For the record his only comment was, "We wuz robbed," which was said with a smile.

Miss Jacob is still comparatively unknown, but her award for "The Double Life of Veronica" was not a total surprise. Though she was competing against two of France's top actresses, Isabelle Huppert and Jeanne Moreau, the roles for women in this year's films were not especial-ly challenging. These included Miss Huppert's role in "Malina," from Germany, and Miss Moreau's roles in two entries, "Anna Karamazova" from the Soviet Union and "The Suspended Step of the Stork" from Greece. "The Double Life of Veronica" also won the International Critics' Prize.

The Caméra d'Or, which is voted each year to the best first feature, was won by Jaco van Dormel's "Toto le Héros" from Belgium. Given honorable mention were Jocelyn Moorhouse's "Proof" from Australia and Deepa Mehta's "Sam and Me" from Canada.

The Palme d'Or for the best short film went to Mitko Panov's "With Hands in the Air" from Poland. The Jury Prize in the same category went to Bill Plympton's "Push Comes to Shove" from the United States.

1991 My 21, C13:2

Film Critics Honor 'Silence of Lambs'

By JANET MASLIN

"The Silence of the Lambs," the chilling tale of a brilliant psychopath and a shrewd F.B.I. trainee who joined forces to catch a serial killer, was voted the best film of 1991 by the New York Film Critics' Circle, a 25-member group representing magazine and newspaper critics from the New York area. "The Silence of the Lambs" swept the voting by winning awards for its director, Jonathan Demme, and its stars, Jodie Foster and Anthony Hopkins.

The group's best screenplay award went to "Naked Lunch," David Cronenberg's freewheeling adaptation of William S. Burroughs's novel, a film that will not open until next week. The cinematography prize went to Roger Deakins for his work on "Barton Fink," Joel and Ethan Coen's droll, nightmarish look at Hollywood in the 1940's. Judy Davis was named best supporting actress for a total of three performances in these two films. She plays two different women in the hallucinatory "Naked Lunch." Samuel L. Jackson was voted best supporting actor for his performance as a drug addict in Spike Lee's "Jungle Fever."

'Europa, Europa' a Winner

"Europa, Europa," Agnieszka Holland's film about the remarkable experiences of a real Jewish Holocaust survivor among Nazi soldiers, was voted the year's best foreign film. The group's documentary prize went to Jennie Livingston's "Paris Is Burning," which explores the competitive world of transvestite voguing and regards it as a reflection of society at large. The group voted John Singleton the year's best new director for "Boyz N the Hood," a drama about Los Angeles gang wars.

Notable among the runners-up were the supporting actresses Juliette Lewis ("Cape Fear") and Kate Nelligan ("Frankie and Johnny," "The Prince of Tides"), the supporting actor Steven Hill ("Billy Bathgate") and John Goodman ("Barton Fink"), the leading actors River Phoenix ("My Own Private Idaho") and Nick Nolte ("The Prince of Tides") and the leading actresses Geena Davis and Susan Sarandon, who followed Ms. Foster in the best actress category. In an unusual move, the group decided to vote for the stars of "Thelma and Louise" in tandem, in keeping with their close teamwork in that film.

The New York Film Critics' 57th annual awards will be presented on Jan. 12 in a ceremony at the Pegasus Room in Rockefeller Center. The group's chairman is Jami Bernard of The New York Post.

1991 D 18, C25:1

Film Critics' Award to 'Life Is Sweet'

"Life Is Sweet," Mike Leigh's gastronomic view of family life in an English suburb, was voted the best film of 1991 by the National Society of Film Critics, a 35-member group representing critics from New York, Los Angeles, Chicago and other cities. Alison Steadman and Jane Horrocks, who play a mother and daughter in the film, were voted best actress and best supporting actress, respectively. River Phoenix was voted best actor for his performance as a narcoleptic male hustler in "My Own Private Idaho," and Harvey Keitel was named best supporting actor for roles in three films: "Bugsy," "Thelma and Louise" and "Mortal Thoughts." David Cronenberg was voted both best director and best screenwriter for his adaptation of William S. Burroughs's novel "Naked Lunch."

Roger Deakins's cinematography for "Barton Fink" won the group's award in that category, and its choice for best documentary was Jennie Livingston's "Paris Is Burning." Krzysztof Kieslowski's "Double Life of Véronique" was voted the year's best foreign film.

The group elected to give a special award for best experimental film to Guy Maddin for his intricate, virtually wordless "Archangel."

1992 Ja 6, C18:1

Track Record Polishes Golden Globes' Gleam

By BERNARD WEINRAUB

Special to The New York Times

HOLLYWOOD, Jan. 19 — Barbra and Bette showed up. So did Warren and Annette. And Dustin and Kevin and Arnold and Michelle and Robin and Anjelica and Jodie and just about every other major star and powerbroker in town crammed into a hotel ballroom on Saturday night for an old-fashioned Hollywood event that was, by all accounts, the glitziest and most curious awards ceremonies of the year.

The occasion was the 49th annual Golden Globe gala, a Hollywood tradition that is now taken with considerable seriousness — tempered by plenty of private amusement and even derision — in the movie world. "Everyone is in on the joke and we're all dressed up sitting there and, like, in

Awards that were sneered at until they became an Oscar bellwether.

the middle of the dinner you always say, 'can you believe we're all here?'" said one prominent movie executive who, like numerous others, would only speak on condition of anonymity because the Golden Globes have emerged as increasingly influential on the Academy Awards.

The Golden Globes, which were televised live over TBS, are given by the Hollywood Foreign Press Association, a group whose 85 members, mostly freelancers, write for an array of overseas journals. The awards' history has been tainted by some unfortunate incidents, including a 1981 award to Pia Zadora as the newcomer of the year for her performance in the flop "Butterfly." It was revealed later that Ms. Zadora's producer (also husband), Meshulam Riklis, had flown the group to Las Vegas before the vote for a few days of fun and games.

But those embarrassing days are over, insists Philip Berk, the president of the association, who writes about Hollywood for a group of South African newspapers. "It's amazing how important we've become," he said.

Mr. Berk is absolutely right. Because the Golden Globes are awarded, quite deliberately, at the exact moment that members of the Acad-emy of Motion Picture Arts and Sciences receive their ballots for the Academy Awards — and because the Golden Globes have, especially in recent years, often tracked the Oscars — they are given enormous attention in the movie industry.

"It's *the* fore-runner of the Oscars," Peggy Siegal, a well-known public relations executive for films and stars who flew in from New York for the event, said this morning. "I mean, when 'Dances With Wolves' got three major awards last year and three standing ovations, Helen Keller could have told you that it was going to sweep the Oscars. This year, there was no clear winner. They gave something for everybody."

This year, the major winners included "Bugsy," as best picture of the year, as well as "Beauty and the Beast," as best musical (as well as two other awards) and "Europa, Europa" as best foreign film (though a German selection committee of film makers has declined to nominate it for an Oscar, because it deals with Nazi Germany during World War II). Acting awards went to Jodie Foster, for "Silence of the Lambs," Nick Nolte, for "Prince of Tides," Mercedes Ruehl and Robin Williams for "The Fisher King," Bette Midler for "For the Boys," and Jack Palance for "City Slickers." Callie Khouri won for the screenplay of "Thelma and Louise," and Oliver Stone got a prize for his direction of "J. F. K."

Because the Golden Globes give twice as many awards as the Oscars

Reuters

Bette Midler with her award as best actress for "For the Boys."

The Walt Disney Company

Walt Disney's "Beauty and the Beast" won the Golden Globe as best musical of the year.

— and distinguish between comedy-musicals and drama, and because television stars and series are also given statuettes — the evening at the Beverly Hilton is crammed with more celebrities than the Oscars, which will be awarded on March 30. The fact that the Golden Globes are presented by a such a disparate group — some of whose credentials are a litte fuzzy — is irrelevant. (The organization lists an array of publications that its members work for. But a spot check with directory assistance seeking local offices for some of the publications — Le Figaro, The London Daily Express, Femme Actuelle, The China Times — found no listings).

In some ways, studio executives say, the organization and its awards are a perfect metaphor for Hollywood, where very little endures, where careers, jobs, money, glamour and friendships are ephemeral anyway. So the Golden Globes are part and parcel of the whole environment.

"It's one of the few occasions that's like the old Hollywood, where everyone participates in a kind of silliness, where the fact that the emperor has no clothes is really irrelevant," said one major studio executive. "Unlike the academy, which is serious business, this is one of the few occasions where people actually have a good time. If you sit at a table there's often a lot of eye rolling, but who cares? In the end Hollywood lives on a social contract: you publicize me, I publicize you."

During the year, the Hollywood Foreign Press Association is treated with enormous deference — and to many free meals — by the studios that screen new movies for them and have major stars appear for unusual press conferences. We don't do hatchet jobs, and the stars like that," said Marianne Ruuth, the president, who says she writes for French and Portugese publications. "We don't scream questions. We're very well-behaved. Nobody shouts. Everyone is very pleasant."

What makes the press conferences especially unusual is that at least 15 minutes is allotted so that each member of the association can pose with the movie star. "They bring their Instamatics and line up to take pic-tures of each other posing with the star," said one studio executive. "Having scarfed down the shrimp cocktail, they'll ask Barbra or Warren some inane questions and then pose with them. They elbow each other to take pictures. It's embarrassing. It's funny. But it's all part of the game. The stars — and usually it's like pulling teeth to get them to do something — actually kind of enjoy it."

The awards ceremony, replete with screaming fans outside the hotel and beefy bodyguards, had movie stars virtually tripping over one another. In the hotel lobby, Dustin kissed Barbra and recalled that they both met in the same acting school in New York in 1960. "They used to laugh at the Golden Globes, like a joke, didn't they?" asked Mr. Hoffman. "Then they started to give the same selections as the Academy Awards."

"They've been so nice to me, they've always been so nice to me," said Ms. Streisand. Referring to her 1983 film, "Yentl," where she was ignored by the academy, Ms. Streisand said: "They gave me awards for 'Yentl. I won't forget."

As winners were announced on Saturday night, they dutifully trooped to a hotel suite to meet entertainment reporters. Surprisingly, some of the stars were surprisingly blunt.

Burt Reynolds, who won an award for his television series "Evening Shade," said his career had virtually collapsed until the show. "I felt like Betty Hutton for a while," he said. "Betty Hutton was waiting on tables. I couldn't even get a job waiting on tables. I made a lot of money, but who stayed with me? My wife and dog."

The most poignant moment after the ceremony came when a non-celebrity from New York, Sarah Gillespie, spoke simply about her brother, Howard Ashman, the lyricist and one of the creative forces behind "Beauty and the Beast." Mr. Ashman died of AIDS last March. "Howard was 40 years old," she said. "When I think of what he could have contributed, it breaks my heart."

The most candid star turned out to be Bette Midler, who acknowledged that her expensive flop, "For the Boys," left her dismayed and hurt. "It's a big, big shock," she said. "I doubt everything now. The reviews were all right. The performance at the box office was pathetic." The star said she was unsure why the movie failed, but said it could have been the recession, the marketing of the movie, the adult story.

A television reporter asked Ms. Midler what got her through this difficult period.

"What makes you think I'm through it?" she replied.

Asked if she would like to work again on a picture with Nick Nolte — whom she appeared with in "Down and Out in Beverly Hills" in 1986 — Ms. Midler replied with a shrug. "Not particularly," she said.

1992 Ja 20. C11:1

Directors Honor 'Silence of the Lambs'

By The Associated Press

The Directors Guild of America has given its award for best feature-film director to Jonathan Demme for "The Silence of the Lambs," the drama about a serial killer.

The awards were presented at a dinner Saturday at the United Nations. A companion ceremony was held in Beverly Hills, Calif.

The guild's 9,700 members chose Mr. Demme over four other directors, including Barbra Streisand, who made "The Prince of Tides." Miss Streisand, who was not nominated for an Academy Award, was the third woman ever nominated for the award.

The Directors Guild award is considered a strong indication of Academy Award potential. With only three exceptions since 1949, the winner of the Directors Guild's top prize has also been named best director at the Oscars. Last year, Kevin Costner won both awards for "Dances With Wolves." Films by the Oscar-winning directors usually win best picture as well.

This year's Oscar competition for best picture is considered one of the closest in recent years. The nominees are "The Silence of the Lambs," "Bugsy," "The Prince of Tides," "J.F.K." and "Beauty and the Beast."

Oscar voting ends on March 24. The Academy of Motion Picture Arts and Sciences will present its 64th annual awards on March 30.

1992 Mr 16, C14:5

Film Awards

The films "Thelma and Louise" and "The Silence of the Lambs" won Writers Guild of America awards for outstanding film screenplays in the 44th annual awards announced last night at the Waldorf-Astoria Hotel in New York and the Beverly Hilton Hotel in Beverly Hills, Calif.

These are the winners of this year's Writers Guild awards:

Original Screenplay: Callie Khouri, "Thelma and Louise," MGM
Adapted Screenplay: Ted Tally, "Silence of the Lambs," Orion Pictures

1992 Mr 23, C14:5

A Very Different Oscars Broadcast

By JANET MASLIN

"Young, beautiful and talented — a winning combination in any league: Daryl Hannah!" exclaimed the off-camera announcer at Monday night's 64th annual Academy Awards presentation: "Everybody's definition of class: Academy Award winner Audrey Hepburn!" "Three of Hollywood's most respected citizens: Steven Spielberg, George Lucas and Geena Davis!" Apparently nobody had notified the announcer, who provided virtually the only touches of old-style Hollywood hokum, that the game would be played a little differently this time.

Jack Palance: that's the short answer to what made Monday's uncharacteristically lively ABC telecast (produced by Gilbert Cates) a welcome departure and a winner in its own right. Of course there was nothing unusual about a best-supporting-actor award to a 72-year-old Hollywood veteran appearing in "City Slickers," the year's most lucrative sentimental comedy. However, Oscar audiences ordinarily have to wait all night for the kind of loose-cannon appearance Mr. Palance put in at the beginning of the show. And Mr. Palance's cheerfully unprintable acceptance speech, not to mention his impromptu calisthenics display, provided Billy Crystal, the program's sensationally quick-witted host, with a whole evening's worth of running gags.

"A man of few words," Mr. Crystal observed after his "City Slickers" co-

star had concluded his remarks, which did not include thank-yous to any of the film's other personnel. "Jack Palance just bungee-jumped off the Hollywood sign," he said a little while later.

"I know why I wasn't nominated; it's because I'm a woman," Mr. Crystal went on. This was only one of the

Jack Palance provided fodder for an evening of running gags.

evening's scattered references to the fact that Barbra Streisand was not nominated for best director, the first of which was in Mr. Crystal's own song medley, which has become one of the show's most delightful features. His introduction to the medley, in which he explained that the audience would be spared the obligatory splashy production number to start the show, made it that much better.

"Seven nominations on the shelf/ Did this film direct itself?" Mr. Crystal sang, imitating Ms. Streisand's "Funny Girl" musical style. When it came to "J. F. K." he crooned (to the tune of "Three Coins in the Fountain"):

"hree shots in the plaza
Who done it, Mr. Stone?
The C.I.A. or Homer Simpson?
The F.B.I. or Vic Damone?

Even better than Mr. Crystal's musical interlude was his opening monologue, which set the evening's clever and iconoclastic tone. "I remember when people used to take out *trade ads*," he said of Warren Beatty's recent high-profile extracurricular activities and their possible promotional benefits to "Bugsy." Of Oliver Stone he said, "Some say he's paranoid, but his next movie is entitled 'The *Men Who* Shot Liberty Valance.'"

"They can't afford to have another hit," he said of the financially troubled Orion Pictures, which wound up sweeping the awards with "The Silence of the Lambs." That film's Hannibal Lecter face mask provided Mr. Crystal with the perfect prop for a wicked, show-stopping entrance.

•

Appearances by Thing (the ambu-.. tory hand from "The Addams Family"), the crew of the space shuttle Atlantis and an animated Beauty and the Beast as co-presenters provided the show with some r vel touches. So did Mr. Crystal's running references to various male presenters (Kevin Costner, Nick Nolte, Patrick Swayze) as first-place winners of People magazine's annual citation as the Sexiest Man Alive. "Know who was second?" Mr. Crystal asked. "Jack Palance." In the sex-appeal category, the teaming of presenters like Antonio Banderas ("The Mambo Kings") and Sharon Stone ("Basic Instinct") showed the academy to be very much up to date.

In notably short supply was Hollywood's old guard, although Paul Newman and Elizabeth Taylor represented it radiantly when they teamed up to present the best-picture Oscar. The presenters were as current as Mike Myers and Dana Carvey of "Wayne's World," the gallant Tom Hanks, the bizarrely matched Susan Sarandon

nd Geena Davis (the latter a head and a half taller than her pregnant co-star and apparently dressed as a can-can dancer), the film makers Spike Lee and John Singleton, and the nominated mother-and-daughter co-stars Diane Ladd and Laura Dern (of "Rambling Rose"). They were "the first mother-daughter team ever nominated if you don't count Faye Dunaway in 'Chinatown,'" Mr. Crystal said. "Rent it!" he commanded, when the audience took a moment to get the joke.

The evening featured a number of touching and gracious acceptance speeches, particularly that of the great Indian director Satyajit Ray, who lay in his hospital bed in Calcutta and clutched the Oscar he received for lifetime achievement as he spoke about his award.

"This just in," Mr. Crystal said afterward, apropros of nothing. "Jack Palance has won the New York State Primary."

The screenwriter Callie Khouri said fervently, "For everyone who wanted to see a happy ending for 'Thelma and Louise,' for me this is it." Bill Lauch, an architect and the companion of the winning lyricist Howard Ashman, accepted the Oscar for the song "Beauty and the Beast" with tremendous sad dignity, noting that this was "the first Academy Award given to someone we've lost to AIDS." Jonathan Demme, stammering through impassioned thank-yous for his award as best director for "The Silence of the Lambs," remembered to single out and name some new directorial talent. Anthony Hopkins's brief remarks after accepting the Oscar as best actor were the very model of eloquent tact.

Although several of the speakers espoused causes (Richard Gere urging AIDS research, the feature-documentary winner calling for a boycott of General Electric), the evening's most radical message came from the awards themselves. In choosing "The Silence of the Lambs" and, for make-up, sound and visual effects "Terminator 2," over more comforting and conventional choices, the academy further underscored the start of Oscar's new age. Only occasionally did

The Oscar Winners

Picture: "The Silence of the Lambs"
Director: Jonathan Demme, "The Silence of the Lambs"
Actor: Anthony Hopkins, "The Silence of the Lambs"
Actress: Jodie Foster, "The Silence of the Lambs" •
Supporting Actor: Jack Palance, "City Slickers"
Supporting Actress: Mercedes Ruehl, "The Fisher King"
Original Screenplay: Callie Khouri, "Thelma and Louise"
Adapted Screenplay: Ted Tally, "The Silence of the Lambs"
Foreign Film: "Mediterraneo," Italy
Art Direction: "Bugsy"
Cinematography: "J. F. K."
Costume Design: "Bugsy"
Documentary Feature: "In the Shadow of the Stars"
Documentary Short Subject: "Deadly Deception; General Eiectric, Nuclear Weapons and Our Environment"
Film Editing: "J. F. K."
Makeup: "Terminator 2: Judgment Day"

Original Score: "Beauty and the Beast"
Original Song: "Beauty and the Beast" from "Beauty and the Beast"
Animated Short Film: "Manipulation"
Live Action Short Film: "Session Man"
Sound: "Terminator 2: Judgment Day"
Sound Effects Editing: "Terminator 2: Judgment Day"
Visual Effects: "Terminator 2: Judgment Day"
Lifetime Achievement Award: Satyajit Ray.

Irving G. Thalberg Award: Given to a film maker for the body of his work. To George Lucas.

Gordon E. Sawyer Award: For technical achievement. To Ray Harryhausen for his work in special effects.

Special Tribute: To Hal Roach, the comedy film maker, who is 100 years old.

the evening sound a nostalgically embarrassing note: when one of the editors of "J. F. K." offered a taste of what a big "J. F. K." win would have sounded like ("It's rare that a man has the courage to seek out the higher truth ..."); in a modern dance number celebrating the nominated soundtracks, and in a clumsy performance of the nominated song from "Hook" by a half-dozen young actors. "Jack Palance is the father of all those children," Mr. Crystal said.

The host's finest hour came with the kind of technical foul-up that often leaves the participants badly flustered. When the 100-year-old producer Hal Roach, speaking from the audience, expressed thanks for his honorary Oscar without realizing he had no microphone, Mr. Crystal saved the day. "I think that's fitting, because Mr. Roach started out in silent films," he said. It is to be hoped, even though Mr. Crystal insisted Jack Palance would be the show's host

next year, that he himself will be keeping up the good work.

Another valuable contribution came from Chuck Workman's witty montage, which spanned the full range of movie comedy from Chaplin and Keaton to "Home Alone." Last of all (and hardly least, from the spectators' standpoint), the clothes: Demi Moore's lace 1940's-style gown, Liza Minnelli's clinging black dress with cut-out shoulders, Daryl Hannah's black slip-like concoction, and Rebecca De Mornay's gown (no explanation necessary), made memorable impressions. Red ribbons signifying AIDS awareness were worn by most presenters. A couple of the men (like George Lucas, recipient of the Irving G. Thalberg award) wore strange shades of brown. Geena Davis, as mentioned, had the outfit for the record books. And Juliette Lewis needs hair help in a hurry.

1992 Ap 1, C15:1

Reuters

Jack Palance, winner of the best-supporting-actor award, doing a one-handed pushup after making his acceptance speech. The 72-year-old Hollywood veteran won for his performance in "City Slickers."

The New York Times
Film Reviews
1992

The Second Circle

Directed by Aleksandr Sokurov; written by Yuri Arabov; cinematography by Aleksandr Burov; edited by Raisa Lisova; music by O. Nussio; production design, Vladimir Solovyev; distributed by International Film Circuit. In Russian, with English subtitles. At the Walter Reade Theater, 165 West 65th Street. Running time: 92 minutes. This film has no rating.

WITH: Pyotr Aleksandrov, Nadezhda Rodnova, Tamara Timofeyeva and Aleksandr Bystryakov.

By CARYN JAMES

"The Second Circle" begins with a haunting, enigmatic image: a man walks along an empty, snowy road, struggling against the wind. Suddenly he bends, as if kneeling in prayer, and slowly vanishes as snow fills the screen. There is no sound except the wind, no sign of life except the radio tower that looms in the distance like a halfhearted joke about civilization.

As it turns out, this young man is heading to a Siberian village to bury his father, and the harsh, bone-chilling landscape he trudges across is the perfect introduction to this uncompromising, imagistic, masterly work by the Russian film maker Aleksandr Sokurov.

"The Second Circle," which opens today at the Walter Reade Theater at Lincoln Center, is Mr. Sokurov's most recent film, and it begins a weeklong retrospective of five works. Now 40 years old, he has been making films for a dozen years, but his early works were labeled prerevolutionary in the Soviet Union and were banned until 1987.

Though there are unmistakable traces of social conscience in the Siberian setting and extreme poverty that "The Second Circle" depicts, this is foremost a mournful human story, one that takes a harsh, unsentimental view of family relationships and death.

The unnamed young man arrives in a squalid shack where his father's corpse rests in bed, bare feet poking out from beneath the blankets. As the son attends to every detail of his father's burial, from undressing the body to haggling with the undertaker, he says very little. But Mr. Sokurov suggests much through his rich compositions; they are usually black and white and sometimes shift to scenes of clear, delicate color.

Like his mentor, Andrei Tarkovsky, Mr. Sokurov has an unshakable vision of what film art should be. He paints with light and shadow, probes emotion through action and creates a chiaroscuro film whose every scene demands the attention of a painting.

Some of these scenes have a mordant tone. Because the water pipes in the house are broken, the son and a neighbor take the father's body outside, rolling it in the snow to wash it under the bright moonlight.

Bits of the shattered family history are revealed. The son finds a doctor to come and sign the death certificate, and tells her that his father has quarreled with his entire family. We are left to guess about the circumstances, but glimpse a man whose bitterness may have led to his lonely death.

At first, the son's impassive face suggests nothing except his determination to get through a disgusting task. Eventually he drops clues about deeper emotions. He argues with the undertaker, a thoughtless woman who just wants to get on with her job. The son insists that he does not want his father cremated; he wants a white coffin instead of the cheaper red one, though he has very little money. These small gestures are all the more touching because they have struggled to the surface.

Throughout, Mr. Sokurov creates painstaking and gracefully somber portraits. When the undertaker's assistants embalm the father's body in the bedroom, they are viewed through a doorway, from another room. Clear blue light shines through the bedroom window to illuminate them, while the son sits facing the camera in the shadowy foreground. He is in the dingy room that combines bathroom and kitchen, his back to the unbearable action we see behind him.

●

Only at the end of the film does any music relieve the sound track. There is dialogue, there are appropriate sound effects, but there is no relief from this story's bleak reality.

Mr. Sokurov's approach is not easy to sustain for 90 minutes. The results are sometimes more intellectually and visually engaging than it is emotionally effective, but "The Second Circle" finally becomes a deeply sad, unsentimental experience. It becomes, in fact, a more depressing film than many viewers might wish to sit through.

Other Sokurov works in the series include "Mournful Indifference" (1983), quite loosely based on George Bernard Shaw's "Heartbreak House," and "Save and Protect" (1989), a scathing version of "Madame Bovary." Original and relentless, Mr. Sokurov makes films for an audience willing to meet him on his own exacting terms.

1992 Ja 2, C15:1

Aries Films

Margherita Buy

The Station

Directed by Sergio Rubini; screenplay (in Italian, with English subtitles) by Umberto Marion, Gianfilippo Ascione and Mr. Rubini; director of photography, Alessio Gelsini; edited by Angelo Nicolini; produced by Domenico Procacci; production company, Fandango S.r.l.; an Aries Film Release. At 68th Street Playhouse, at Third Avenue, Manhattan. Running time: 92 minutes. This film has no rating.

Domenico ..Sergio Rubini
Flavia ...Margherita Buy
Danilo ...Ennio Fantastichini

By VINCENT CANBY

"The Station" ("La Stazione"), the Italian film opening today at the 68th Street Playhouse, is a small, inoffensive comedy about Domenico, a small, inoffensive young man who works as the stationmaster near a village in the south of Italy.

One rainy night Flavia (Margherita Buy), a beautiful young woman in an evening dress, arrives at the station hoping to catch a train for Rome immediately, though there are none until morning.

In the course of this seemingly endless night, Flavia comes to realize how silly has been her life of money, parties and faithless men, and Domenico discovers resources of manhood he never knew existed. All this you know from the minute Flavia walks into the station looking damp but unmussed.

●

"The Station" is the first film to be directed by Sergio Rubini, the actor who plays Domenico and who also collaborated on the screenplay. He's somewhat more resourceful as an actor than as a director. "The Station" has moments of sweetness, as the shy, courtly stationmaster attempts to entertain his unlikely guest with his arcane knowledge of timetables.

It also has melodrama when Flavia's macho fiancé, Danilo (Ennio Fantastichini), attempts to force Flavia to return to the house party from which she fled. In the melee, the stationmaster's car is torched. Yet nothing can disguise the barrenness of the movie's imagination.

"The Station" is finally endurable only by playing it as if it were a game, by attempting to predict the next line of dialogue or the next camera position. You lose as you win.

1992 Ja 3, C6:1

N. Levitin/International Film Circuit Inc.

Pyotr Aleksandrov in "The Second Circle."

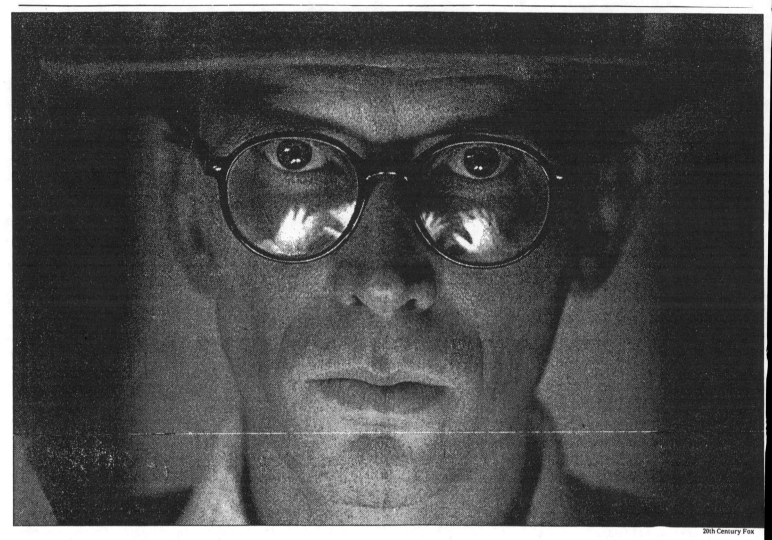

Peter Weller as the character based on William Burroughs, in David Cronenberg's film. The surreal world behind "Naked Lunch."

FILM VIEW/Caryn James

'Naked Lunch' Goes Buggy

DAVID CRONENBERG HAS A soft spot for bugs, and they've always been kind to him. His first feature was a low-budget 1975 horror movie called "Shivers," a k a "The Parasite Murders" and "They Came From Within," a grotesque little story about man-made, sexually-transmitted killer parasites. His popular breakthrough came in 1986 with his remake of "The Fly," in which a scientist played by Jeff Goldblum turned into a giant fly that drooled gallons of sickening fluid around the lab. This penchant for insects had commercial value, but it did not seem to be an artistic obsession on the order of, say, Picasso's fascination with bulls.

Who knew what David Cronenberg would one day do with a bug? In his smashingly funny and wise version of "Naked Lunch," bugs are the witty devices that bring the hero's unconscious desires to dizzying cinematic life.

The film includes Mugwumps, 6-foot-tall buggy creatures that walk, talk and secrete a highly addictive fluid. And there are the precious giant black centi-pedes, whose meat forms a mind-altering drug. Both are present in William Burroughs's hallucinatory novel of addiction, homosexuality, mind control and language games.

■

But the movie, written and directed by Mr. Cronenberg, has an even more bi-zarre central image: typewriters that turn into bossy, talking bugs. Keyboards grow out of the bugs' faces, and paper rolls out of their heads. The image is Burroughs-inspired but Cronenberg-invented, and it suggests the fearless creative leap that allowed Mr. Cronenberg to take what he needed from a plotless novel and transform it into a stylish picaresque born to be on screen.

Here a writer named Bill Lee, a figure drawn partly from Mr. Burroughs's work and partly from his life, takes orders from the overgrown bugs. Maybe they're upset that Bill is trying to kill them.

"So how is the exterminating business going, Bill?" a friend asks early in the film. As Bill Lee, Peter Weller is strik-ingly like the familiar image of William Burroughs, with his brown fedora and suit, deadpan intonation and skeletal face. Truth be told, the exterminating business (which once employed Mr. Burroughs) is not so good.

Bill gets home to find his wife, Joan (Judy Davis), with a syringe full of familiar yellow stuff. "I'm shooting up your bug powder," she explains. "It's a very literary high. It's a Kafka high. You feel like a bug." This is a peculiarly Cronenberg idea, that feeling like a bug might be so enjoyable you just can't give it up.

■

Mr. Cronenberg invents a much more crucial function for his bugs, though. Bill Lee never admits it, but viewers can see that the Mugwump and typewriter-bugs are projections of the character's imagination, ordering him to do what he secretly wants but is afraid to acknowledge. This allows Mr. Cronenberg to create a psychologically believable hero trapped in surreal events.

When Bill is arrested for drug possession, the police leave him in a room with a beetlelike bug the size of a large pizza. The bug is tastelessly comic. He asks Bill to put some drugs on his mouth, which is nothing more than a moving hole that suggests this creature has a talking rear end. (Mr. Burroughs's novel describes a man with a similarly voluble anatomy, in words still too impolite to print.)

The bug also voices ideas that Bill would never admit consciously. Claiming to be Bill's intelligence contact — he didn't even know he was a spy — the bug says that Joan is an enemy agent and orders Bill to kill her. Just as Mr. Burroughs did in life, Bill Lee later tells Joan it's time for their William Tell routine, tries to shoot a glass off her head and kills her accidentally.

That is why a Mugwump turns up in a bar and orders Bill to go on the lam to Interzone — a decadent fanta-syland based on Tangiers — to file his "reports," the writing that becomes the novel "Naked Lunch." He follows

orders, but not before picking up a used typewriter, the first to reveal its buggy essence. In Interzone, this typewriter tells him, "Homosexuality is the best all-around cover an agent ever had."

Bill has managed to get rid of his wife, write his novel and question his sexuality without taking responsibility; he can say the bugs made him do it.

It takes an insect to know the dark desires of the leading character.

Unlike the novel, the film does not make the hero blatantly homosexual. His major sexual encounter in Interzone is with Joan Frost (also played by Ms. Davis). He does, however, engage in a ménage à trois with Joan and an Arabic typewriter-bug, whose phallic parts make it indisputably male.

Mr. Cronenberg is not only having fun with these bugs; their absurdly comic presence is central to the film's tone. Where Mr. Burroughs wrote accurately that his novel had to be "brutal, obscene and disgusting," the Cronenberg "Naked Lunch" is none of those things. It is tough-minded but playful and, despite some free-flowing Mugwump fluids, surprisingly free of the grotesque. Like Terry Gilliam's "Brazil" and the Coen brothers' "Barton Fink," this is a bizarre yet accessible mainstream film.

■

Mr. Cronenberg has come far from his horror-movie days and has carried with him the dangerous, dark side of his imagination. Along with his 1988 film, "Dead Ringers," with Jeremy Irons's brilliant performance as lethal twin gynecologists, "Naked Lunch" establishes Mr. Cronenberg as one of the most brash and inspired of contemporary film makers. He proves that obsessions are an artist's best friend, whatever creepy-crawly form they may take. □

1992 Ja 5, II:13:1

Warner Brothers

Oliver Stone—a better advocate than Jim Garrison?

FILM VIEW/Janet Maslin

Oliver Stone Manipulates His Puppet

OLIVER STONE'S "J. F. K." ACHIEVES AN UNintended irony when it exhorts its audience to be suspicious of unreliable information, since the figure who emerges from this three-hour-and-eight-minute harangue as the most suspect is the film maker himself. This has nothing to do with Mr. Stone's opinions about who may have been responsible for the assassination of John Fitzgerald Kennedy, and everything to do with the way those opinions are expressed.

If there's anything that the recent firestorm of front-page news about "J. F. K." makes evident, it's that Mr. Stone is his own best invention. As a once-conservative, now-disaffected figure free to question authority and celebrate iconoclasm, he has perfected a beleaguered public posture and a raffish world-weary manner. This plays very well on talk shows and even better on the screen, where most of Mr. Stone's heroes have embodied similar attitudes in their quest for truth.

There are those who bristle at Mr. Stone's steamroller tactics no matter what topic he chooses to address. Others are willing to give the benefit of the doubt to a phenomenally talented film maker whose work makes visceral sense even when it fails to add up any other way. Being in the latter camp, I find "J. F. K." all the more troubling for its failure to match the single-minded energy of "Born on the Fourth of July" or "Platoon" or even the first half of "Wall Street." Those are works in which Mr. Stone builds up such formidable momentum that he transfixes the viewer with the sheer forcefulness of his storytelling.

"J. F. K.," which gives Mr. Stone a seemingly ideal subject for his preoccupations and talents, doesn't have any-

thing like the clarity or inexorability of these earlier films. Instead, it is facile and confusing, as if this probe of so important a chapter in American history were being conducted by MTV. Images fly by breathlessly and without identification. Composite characters are intermingled with actual ones. Real material and simulated scenes are intercut in a deliberately bewildering fashion. The camera races bewilderingly across supposedly "top secret" documents and the various charts and models being used to explain forensic evidence. Major matters and petty ones are given equal weight. Accusations are made by visual implication rather than rational deduction, as when the camera fastens on an image of Lyndon Johnson while a speaker uses the phrase "coup d'état."

Mr. Stone would say, and has said, that this amounts to creative license. And if "J. F. K." employed these tactics to tell a coherent story, he would be right, at a time when the cavalier docudrama format is widely taken for granted. But the first thing lacking in "J. F. K." is a central figure in whom the film's concerns can be unified, since Jim Garrison, the New Orleans District Attorney played by Kevin Costner, doesn't serve that purpose. As the recent furor about this film makes clear, Mr. Garrison's own conduct is too easily assailable to make him a Capraesque hero, even though Mr. Costner successfully presents him that way.

Mr. Garrison isn't specifically needed here except as a means of bringing the Kennedy assassination into focus. It is clear that Mr. Stone has re-invented Jim Garrison as a means of voicing his own ideas, and those ideas would have been expressed better without the liability of Mr. Garrison as a dramatic focus. Indeed, the film maker's sense of betrayal by his Government would offset the film's free-floating paranoia. Unlike Mr. Stone's version of Ron Kovic, who served the same purpose in "Born on the Fourth of July," Jim Garrison never becomes a flesh-and-blood character whose fate can engage the audience. And unlike Mr. Stone himself, he even lacks fire. So the film's efforts to humanize him look terribly contrived.

Mr. Stone surrounds Mr. Garrison with picturesque children, a nagging wife ("You and your Government!" exclaims poor Sissy Spacek, in one of Mr. Stone's typically paper-thin women's roles) and even Mardi Gras celebrants in an attempt to add visual interest to someone who essentially just pontificates and delivers data.

■

If this film were really about Mr. Garrison, it would be at the very least pointless and anticlimactic. But it is about the facts surrounding the Kennedy assassination, facts that could have been best articulated by Mr. Stone himself or a less controversial stand-in for the film maker. Only occasionally, in its startling re-enactments of events as formulated by the Warren Commission, re-enactments that underscore how

farfetched the commission's conclusions were, is "J. F. K." everything it should have been: disturbing, ironic, forceful and clear. As he explains the so-called magic bullet theory in the closing courtroom scene, using a pointer and a diagram to make clear the preposterousness of the hypothetical trajectory of this single bullet, Mr. Costner makes the viewer wish "J. F. K." had more pointers and more patience.

Mr. Stone's methods are usually seductive, but in the case of "J. F. K." they have a bullying effect. Without a knowledge of conspiracy theory trivia to match the director's, and without any ability to assess the film's erratic assortment of facts and fictions, the viewer is at the film maker's mercy. This is the way Mr. Stone often likes it, and audiences might like it, too, if "J. F. K." delivered the jolt that it promises. □

1992 Ja 5, II:13:5

The Hand That Rocks the Cradle

Directed by Curtis Hanson; screenplay by Amanda Silver; director of photography, Robert Elswit; film editor, John F. Link; music by Graeme Revell; production designer, Edward Pisoni; produced by David Madden; released by Touchstone Pictures. Running time: 110 minutes. THis film is rated R.

Claire	Annabella Sciorra
Peyton	Rebecca De Mornay
Michael	Matt McCoy
Solomon	Ernie Hudson
Marlene	Julianne Moore
Emma	Madeline Zima
Dr. Mott	John de Lancie

By VINCENT CANBY

The title of Curtis Hanson's "Hand That Rocks the Cradle" evokes memories of Lillian Gish and "Intolerance," while the movie itself aspires to a tradition of cinema thrills even older than D. W. Griffith's mad 1916 masterpiece.

"The Hand That Rocks the Cradle" is meant to scare audiences more or less in the way that the patrons of the early nickelodeons were frightened when they saw the image of a train rushing at them. Audiences aren't asked to think, only to react. "The Hand That Rocks the Cradle" proves again that not thinking isn't especially easy even today.

The new film is about the awful things that happen to the members of the young, upwardly mobile Bartel family when they employ the sweet, extremely blond, ravishingly beautiful Peyton Flanders (Rebecca De Mornay) as a live-in nanny for Emma (Madeline Zima), their 5-year-old daughter, and new baby boy.

Michael Bartel (Matt McCoy) is a genetic engineer. His wife, Claire (Annabella Sciorra), has such a passion for botany that she is building a full-size greenhouse in their Seattle backyard, which is why she needs a nurse for the children. What Claire and Michael fail to do is check Peyton's references.

Claire and Michael may be up on interior decoration and which French restaurant is favored this week, but they are seriously stupid in all other matters.

Right from the start the audience knows (and Claire and Michael don't) that Peyton is the deranged widow of Claire's gynecologist, who committed suicide after Claire reported him for doing unprofessional things with his fingers during a physical exam. Poor Peyton, who was herself pregnant when her husband blew his brains out, went on to have an emergency hysterectomy and to lose her sanity.

Peyton wants a family even if it isn't hers. She may be bonkers, but she is clever. She lures the baby away from Claire by breast-feeding him on the sly. She allows little Emma to stay up late watching horror films. When the handyman, Solomon (Ernie Hudson), catches her nursing the baby, she plants a pair of Emma's panties in his toolbox, thus to convince Claire that Solomon is a potential child molester.

●

Though Mr. Hanson ("Bad Influence," "The Bedroom Window") is a slick movie maker, he is not an especially persuasive one here. Don't be

'References? What references? Were we supposed to check references?'

gulled by those who would compare "The Hand That Rocks the Cradle" to "Fatal Attraction," which features three strong characters who, in one way or another, are ready to answer for their actions.

Both Ms. Sciorra and Ms. De Mornay are able actresses, but their roles, as written in Amanda Silver's screenplay, are conventions of the genre, while Mr. McCoy's Michael Bartel must be the nerd of the year. Also hilariously prissy.

Says Michael when the glowy and wet-lipped nanny makes a play for him, "Peyton, there's only one woman for me," a line that prompts unkind howls from the audience. Not even in "Thelma and Louise" are men so maligned, though, in "The Hand That Rocks the Cradle," it seems to be less a social comment than an accident of the plot and the casting.

Matthew McVay

Rebecca De Mornay, right, and Madeline Zima.

Particularly nasty is the movie's treatment of Solomon, the retarded handyman who is devoted to the Bartel family. Because he is played by the only black actor in the cast, Solomon comes across as yet another yuppie trend-setting breakthrough: a yard slave for the 1990's.

Mr. Hanson creates the occasionally effective shock effect to satisfy those who want to squeal in mock fright. More often the devices he uses are such tired tricks as the crosscutting between two sets of simultaneous, often innocent, actions to create the illusion of suspense that can't be sustained.

The movie looks as pretty as an upscale magazine layout and has one well-written supporting role, that of Marlene, a high-powered real estate agent who talks in clichés she coins herself. As played by Julianne Moore, Marlene is funny, bright and intentionally brings down the house when she advises Claire, "Never let an attractive woman occupy a power position in your home."

●

"The Hand That Rocks the Cradle," which has been rated R (Under 17 requires accompanying parent or adult guardian), has partial nudity, violence and vulgar language.

1992 Ja 10, C8:1

The End of Old Times

Directed by Jiri Menzel; screenplay (in Czech with English subtitles) by Mr. Menzel and Jiri Blazek, based on a novel by Vladislav Vancura; director of photography, Jaromir Sofr; music by Jiri Sust; produced by the Barrandov Film Studios, Prague. At the Cinema Village Third Avenue, between 12th and 13th Streets, Manhattan. Running time: 97 minutes. This film has no rating.

Duke Alexey Magalrogov	Josef Abrham
Josef Stoklasa	Marian Labuda
Bernard Spera	Jaromir Hanzlik
Mr. Pustina	Jan Hartl

By STEPHEN HOLDEN

Jiri Menzel's satirical comedy "The End of Old Times" offers some of the more sumptuous images of wining and dining to be found in a film in recent years. Set on a sprawling estate in southern Bohemia shortly after the 1918 Communist revolution in Czechoslovakia, it follows the skirmishes and intrigues of a lavish weekend hunting party given by Josef Stoklasa (Marian Labuda), a wealthy boor who has been appointed the property's official caretaker. Stoklasa is desperate to buy the estate, but has been thwarted by political rules that he hopes can be bent. One purpose of his bash is to impress the condescending neighborhood gentry.

No sooner has the celebration begun than it is crashed by an elegant, bearded stranger with twinkling eyes (Josef Abrham) who claims to be an aristocrat. At once grandiose and impudent, he patronizes the men, seduces the women and wins over the children by sliding down banisters with them. Suspicious of his lineage and envious of his charm, the men band against him and force him into a climactic duel.

"The End of Old Times," which opens today at Cinema Village Third Avenue, aspires to be something like the Czechoslovak director's answer to Jean Renoir's "Rules of the Game," seasoned with dashes of Harold Prince's "Something for Everyone" and Ingmar Bergman's "Smiles

IFEX

Looking Askance Jaromir Hanzlik and Ljoba Krbova appear in "The End of Old Times," about the escapades of a weekend hunting party on a country estate, where an uninvited guest creates havoc.

of a Summer Night." Mr. Menzel, who is best known for his 1966 film "Closely Watched Trains," is adept at sustaining a frothy, sophisticated tone that is enhanced by the film's golden-leafed autumnal setting. The mountains of cold cuts arranged on outdoor tables look as tantalizing as the steamy erotic glances exchanged by the revelers.

Yet the story, which was adapted by the director with Jiri Blazek from a novel by Vladislav Vancura, remains too mired in the petty politics of its era to transcend time and place. If the games played by the uninvited guest are diverting, the maneuvers by Stoklasa, his hot-tempered lawyer (Jan Hartl) and others to gain control of the property are too complicated and small-scale to engage much interest. And if the film is intended as a political allegory of modern Czechoslovakia, its resonance doesn't extend beyond national borders.

The one figure who does wield some symbolic weight is the enigmatic party crasher, whom Mr. Abrham portrays with a robust comic vigor. Although it is never revealed whether he is a genuine nobleman or a fake, the issue becomes irrelevant. Not just in politics but in the rest of life, the movie seems to say, you can be whatever you say you are for as long as you can get away with it.

1992 Ja 10, C12:6

256

Kuffs

Directed by Bruce A. Evans; written by Mr. Evans and Raynold Gideon; director of photography, Thomas Del Ruth; film editor, Stephen Semel; music by Harold Faltermeyer; production design, Victoria Paul and Armin Ganz; produced by Mr. Gideon; released by Universal Pictures. Running time: 100 minutes. This film is rated PG-13.

George Kuffs............................Christian Slater
Ted Bukovsky..............................Tony Goldwyn
Maya Carlton................................Milla Jovovich

By CARYN JAMES

Sometimes the best thing a movie maker can do is just go ahead and let Christian Slater smirk. Millions of teen-age girls will feel they're in heaven, and the rest of us at least won't be bored; he does smirk well. But "Kuffs" carries this to a desperate extreme. Every now and then Mr. Slater turns away from the story in this comic police-action movie and talks directly into the camera. It's no joke to say that this is the most engaging part of the film.

It takes about two seconds to figure out the target audience. At the start Mr. Slater and Milla Jovovich (last seen in "Return to the Blue Lagoon") dance around their living room to a bouncy rock-and-roll hit of a few years back, "The Future's So Bright I Gotta Wear Shades." He is wearing only sweat pants, and she is in stylish bright-colored underwear. "By the way, my name is George Kuffs," Mr. Slater tells the camera, asking that we not be too hard on him when he dumps her because she is (quite inconspicuously) pregnant.

"Kuffs" isn't going for maturity, which is fine. It's also not going for originality, which means the film comes to resemble the bastard child of "Miami Vice" and an especially bad movie-of-the-week.

Although George wants to evade responsibility, his brother tries to recruit him as a member of his Patrol Special force, a kind of private law-enforcement corps that works under the San Francisco police. "I never really saw myself as a cop," George says. "I'm more like the bad guy." Of course, he changes his mind, for a tragic reason and with tragic results for the film. As George gets good, the movie gets bad. Mr. Slater starts saying things like, "I'm only going to stick around till I clean up the neighborhood," which is apparently impossible to say with a smirk.

There is a sporadic, irreverent comic undercurrent that might have livened things up. The rookie George walks into a gun shop and says, "I'm looking for a really big gun that holds a lot of bullets." The first-time director, Bruce A. Evans, might have done better to go with that tone. As it is, he takes time bombs and exploding cars so seriously!

Somewhere, there are teen-age girls waiting for Christian Slater's every glance and teen-age boys obsessed with big guns that hold a lot of bullets. "Kuffs" is for them.

•

"Kuffs" is rated PG-13 (Parents strongly cautioned). It includes much violence and some strong language.

1992 Ja 10, C16:6

Chinese Boy Under a Spell

"Life on a String" was shown as part of the 1991 New York Film Festival. Following are excerpts from Janet Maslin's review, which appeared in The New York Times on Sept. 29. The film, in Chinese with English subtitles, opens today at the Public Theater, 425 Lafayette Street in Manhattan.

In the imposingly beautiful but slow and cryptic Chinese film "Life on a String," a young boy is enveloped by his tutor in a magical spell. The boy is instructed to devote his life to music and told that he will be blind until the 1,000th string on his banjo breaks, an event that does not occur until the boy is a very old man.

By this time — as the film moves forward 60 years after a very brief prologue — he has become known as the Saint (Liu Zhongyuan). And he has a disciple of his own, a young man who is as blind as the teacher. "Master! Why is empty space white?" the younger and more impatient man asks, having never fully achieved the mystical submissiveness that binds the Saint to his destiny. Both men appear torn between their desire for higher wisdom and their eagerness to see.

Beyond this, the events that occur in "Life on a String" are not easily described in anything less than the metaphorical terms in which the film maker, Chen Kaige (working from a story by Shi Tiesheng), has conceived them. There are battles between two warring clans on the sweeping, barren plains where much of the film takes place. And these battles are influenced, even dramatically stopped, by the Saint as he sits singing on a hilltop.

Kino International

Mythic In "Life on a String" starring Liu Zhongyuan and Huang Lei, a blind boy is promised by his master that he will someday regain his sight.

The director's ambitions here are on an epic scale, in terms of both the characters' outer lives and their spiritual progress. Slow-moving as it is, "Life on a String" regularly yields images of haunting mystery, like the sight of a radiant young woman about to disappear off a cliff, or the bracing way in which a boat carrying a small child is carried by a team of men out of a rushing river. The torch-lit gathering at which the Saint sings his final songs also achieves the kind of mystical intensity that the film maker must have intended. So does the film's last airborne image of liberation.

1992 Ja 10, C16:6

FILM VIEW/Caryn James

Almodóvar, Adrift In Sexism

I N THE ANNALS OF MOTHER-DAUGHTER RE-unions, this one should hold a special place. Becky Del Páramo, a onetime pop star, returns to Spain after 15 years abroad. She hasn't seen her daughter, Rebecca, since the girl was 12, but recently Rebecca has found a mother substitute. She stands before a poster depicting a female impersonator named Lethal, whose act is modeled on Becky at the height of her sequined and miniskirted fame. "Whenever I missed you," the grown daughter tells her mother with evident affection, "I'd go see his show." Other film makers would have given Rebecca a stepmother or puppy or at least a Barbie doll; only Pedro Almodóvar would have concocted this hilarious, unsentimental surrogate parent.

Mr. Almodóvar sustains his wry irreverence until the strained, mawkish end of "High Heels." As the story begins, Rebecca has married one of her mother's former lovers, and when the husband is murdered both women are suspects. "High Heels" is very much an Almodóvar blend: a murder mystery about mother-daughter competition and sexual ambiguity, laced with scathing touches of pop-culture insanity.

As he did in his best-known film, "Women on the Verge of a Nervous Breakdown" (1988) and his most notorious, "Tie Me Up! Tie Me Down!" (1990), Mr. Almodóvar mixes parody, satire, farce and a strong sentimental streak to create his distinctive comic tone. But if his films are so fast and funny, why do they leave such a bitter aftertaste?

As "High Heels" suggests, love-hate is the creative impulse behind Mr. Almodóvar's works. His characters seem gleefully free on screen, but his endings are contrived, declared by authorial fiat. He parodies genres from soap opera

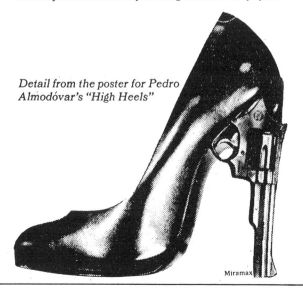

Detail from the poster for Pedro Almodóvar's "High Heels"

Miramax

to thrillers, then surrenders to them. He creates strong women characters then takes away their strength; there is a definite trace of misogyny lurking beneath his apparently fond creations of women. No wonder his effervescent films can produce a lingering headache the next day.

"High Heels" is typical of the way Mr. Almodóvar walks the line between realism and parody, creating a dead-on social world while creeping closer to melodrama. Becky exudes stage presence even while eating dinner. Rebecca is a conservative version of her glitzy mother, from the formal version of their shared name to her staid Chanel suits and her job as a television newscaster. But is Becky really a monster? Is Rebecca a bad seed?

Beneath the director's apparently fond creations of women lurks misogyny.

The soap opera elements increase when the love triangle becomes a quadrangle. After Becky, Rebecca and her husband see Lethal in performance — a perfectly choreographed spoof — the female impersonator takes Rebecca to his dressing room. "I'd like to be more than a mother to you," he says, making an unexpected but welcome pass.

Mr. Almodóvar is best at such moments, defining a cockeyed world of inexplicable but ordinary behavior. His eye for the perfect, crazy pop-cultural detail is one of his great strengths. The judge investigating the murder has a bedridden mother who keeps scrapbooks: one of Brigitte Bardot, one of Mother Teresa, one of Becky Del Páramo.

■

What the judge and Lethal have to do with the murder, which character confesses to the killing and why, are handled with Mr. Almodóvar's typical flair. But then comes the scene when Rebecca rails against her mother, "Did you see 'Autumn Sonata'? It's about a great pianist and her mediocre daughter." The reference is funny for a moment, as if "High Heels" were about to send up Bergmanesque emotions. It turns out that Mr. Almodóvar has suddenly turned serious and forgotten to warn his characters. This scene is high melodrama, and the point at which "High Heels" boomerangs and becomes sentimental. Eventually there are enough sacrifices, reconciliations, confessions and tears to fill several soap operas. The "Autumn Sonata" speech cannot justify this unexpected, serious behavior.

Similarly, the women who spend much of "Women on the Verge" ready to die for the sake of a cad are suddenly made self-sufficient at the end; this is a neat feminist twist but not a convincing one. What remains is the sense that they are frenetic and silly. Like Becky and Rebecca, they have been rescued only by the kindness of their creator. And in "Tie Me Up!," when an escaped mental patient kidnaps a woman and ties her to the bed for days, of course she falls in love with him. Mr. Almodóvar presents this as a triumph of true emotion; some things even he can't get away with.

Oddly, he is often credited with being sympathetic to women — perhaps because he gives them something interesting to do. He makes no such claims himself. He is openly homosexual and has said it is "ridiculous" to assume that gay film makers are especially insightful about women.

That is true enough, but beside the point. It is also true that his men are often egotistical, peripheral characters. The wrong-headed assumption is that Mr. Almodóvar knows and loves his female characters. In artistic terms he is like a sexist who thinks he treats women fairly, then clings tenaciously to his masculine authority. The undercurrent of sexism is directly tied to the bludgeoning control that wrecks the endings of Mr. Almodóvar's films. It is one of those pesky tendencies that can keep a very good film maker from becoming great. □

1992 Ja 12, II:11:5

35 Up

Directed and produced by Michael Apted; director of photography, George Jesse Turner; edited by Kim Horton; Samuel Goldwyn Company presents a Granada Film. At Film Forum 3, 209 West Houston Street, Manhattan. Running time: 127 minutes. This film has no rating.

WITH: Charles, Andrew, John, Peter, Neil, Suzy, Paul, Symon, Tony, Jackie, Lynn, Susan, Bruce and Nicholas

By JANET MASLIN

Michael Apted's landmark "7 Up" series, which began as an attempt to document the long-range effects of social and economic disparities among English schoolchildren of "startlingly different backgrounds," has become much, much more. These transfixing films, the latest of which is "35 Up," reveal a reality that cannot be found in nature. The series' ambitious time-lapse method, whereby subjects are revisited at regular seven-year intervals, makes possible an astonishingly intensive view of their lives and evolution. At 35, not surprisingly, many of Mr. Apted's former 7-year-olds have begun to squirm under the burden of such scrutiny.

"35 Up," which opens today at the Film Forum, finds this series growing increasingly rueful with age. Some of the participants have realized early goals, but many others see their dreams receding. Married, settled, noticeably bulkier, some sit surrounded by kitchen gadgets and family snapshots, speaking wistfully about their annual vacations. Many talk tearfully about losing their parents, as does the otherwise hardboiled Tony, who calls his mother's death "the worst moment of my life." His mother, he says, "was and still is the best girl in the world."

Tony, at 7 a scrappy kid from the East End of London, confided at 21 that his fondest dream was to have a son. Now the reality: at 35, he can be found at a crowded family dinner table, arguing with his formerly svelte wife, Debbie, about the price of sneakers for that son, who is reaching adolescence. Tony once hoped to be a jockey, but these days he is content to drive a cab and work occasionally as a movie extra. "Better to be a has-been than a never-was," he says cheerily.

●

The original "7 Up," a television film on which Mr. Apted started out as a researcher, took as its starting-off point the Jesuit maxim, "Give me a child until he is 7 and I will show you the man." Yet even as the subsequent installments sometimes affirm that thought, they also contradict it in fascinating ways. It's true that Nick, who at 7 said he hoped "to find out all about the moon and all that," anticipated his own career as a scientist; he subsequently earned his Ph.D. in physics and now teaches at the University of Wisconsin. But glimpses of Nick as a bright Yorkshire farm boy who attended a one-room schoolhouse ("If I could change the world, I'd change it into a diamond," he said at 7) don't truly prefigure his subsequent independence.

Nick alone, among the participants, criticizes the note of pessimism and passivity that runs through many of the interviews and describes it as markedly different from the mood of his American neighbors. Nick also affirms his wife's decision to remove herself from this study after "28 Up" gave total strangers the impression that theirs was an unhappy marriage. (Many of the participants discuss the

Granada Television

Lynn, one of the subjects of Michael Apted's "7 Up" series.

burden of being part of this series, which has been so widely seen in Britain that some of its subjects have received fan mail and are recognized on the street.)

Nick accepts his own obligation to Mr. Apted and this important, ever-unfolding document, but he has chosen to keep his young son away from the cameras as well. Interestingly enough, one of the few other participants to make that choice is Charles, who now works in television journalism and no doubt understands the camera's power to invite unflattering, invidious observation.

Charles was part of the first film's trio of rich boys, who were much more outlandish at 7 than they are at 35, and are well remembered for having said what John, another of the three, now calls "some shocking but

Time has been unkind to most of the subjects, and fame rather harsh.

extremely funny things in retrospect." (It was good, one of them observed, to make people pay for schooling "because if we didn't, schools would be so nasty and crowded.") One of the new film's surprises is that John, having dropped out of the series at 28, has returned for the sake of promoting a favorite charity, Friends of Bulgaria.

●

John, now a barrister, talks wryly about the effects of having "a little pill of poison" dropped into his life every seven years with a new installment of the series. But he also makes it clear, in discussing the travails of digging herbaceous borders in the garden of his country home, that not much has changed. The same is true of Suzy, an upper-class girl who had a bored composure at 7 and wears a crest on her sweater at 35. Though Suzy was in the throes of a rebellious phase at 21, she is now happily married and bringing up her children in pastoral splendor. "I can't change what I was born into," she says.

Mr. Apted's original aim was to study the effects of privilege or the lack thereof, but he leaves it to viewers to draw their own conclusions. John and Tony, for instance, may be

seen as comparably content despite the class distinctions that divide them. A more complex case is that of Bruce, who at 7 was in pre-prep boarding school speaking of becoming a missionary, and at 35 is seen sitting in language class in Bangladesh, the only adult among the students. Bruce, who carefully dodges Mr. Apted's inquiries about whether he may ever marry, lives simply in this impoverished region, and has indeed accomplished the goal he described as a child. But Mr. Apted notes bluntly: "This film is about opportunity. Do you think that you made the most of your opportunity?"

The study's most heartbreaking case of lost promise is once again Neil, who stood out so poignantly in "28 Up" that he received thousands of letters and even job offers after it was shown. Outstandingly winning and handsome at 7, Neil was by 28 a homeless derelict, mentally unstable, yet still clearly a person of exceptional intelligence and thoughtfulness. It is a vast relief, at the end of this film, to learn that he is alive and well and that Mr. Apted has even been able to find him.

•

Neil, who at 21 said, "I think I've been kicking in midair all my life," is only slightly more settled than he was before, and looks desperately uncomfortable even when filmed buying a loaf of bread. But when Mr. Apted asks whether Neil has a sense of failure, he replies, "Well, my life isn't over." Even as "35 Up" watches the walls close in around some of its participants, that remains very much the point.

The study's less obvious casualities are Jackie, Lynn and Sue, three working-class women who variously married early, became single parents, took on dead-end jobs and say they think about their lack of advantage only when Mr. Apted shows up to raise the question. And Symon, the study's only black participant, had five children and a sausage-packing job at 28 and at 35 declined to have his life held up to public exposure. Perhaps this only affirms what Mr. Apted set out to demonstrate in the first place. But this brave, demanding project has yielded much more wisdom than he or anyone else could have expected.

1992 Ja 15, C13:5

Daughters of the Dust

Written and directed by Julie Dash; director of photography, Arthur Jafa; edited by Amy Carey and Joseph Burton; music by John Barnes; production designer, Kerry Marshall; produced by Ms. Dash and Mr. Jafa; released by Kino International. At Film Forum 1, 209 West Houston Street. Running time: 113 minutes. This film has no rating.

Nana Peazant Cora Lee Day
Haagar Peazant Kaycee Moore
Eula Peazant Alva Rogers
Eli Peazant Adisa Anderson
Yellow Mary Barbara-O
Viola Cherly Lynn Bruce

By STEPHEN HOLDEN

Julie Dash's "Daughters of the Dust" is a film of spellbinding visual beauty about the Gullah people living on the Sea Islands off the South Carolina-Georgia coast at the turn of the century. More than any other group of Americans descended from West Africans, the Gullahs, through their isolation, were able to maintain African customs and rituals. Cut off from

the mainland, except by boat, they had their own patois: predominantly English but with a strong West African intonation. Most of the film's dialogue is spoken in that dialect, called Geechee, with occasional subtitles in English.

"Daughters of the Dust," which opened yesterday at Film Forum 1, focuses on the psychic and spiritual conflicts among the women of the Peazant family, a Gullah clan that makes the painful decision to migrate to the American mainland. Set on a summer day in 1902, on the eve of their departure, the film depicts an extended family picnic that is also a ritual farewell celebration attended by a photographer.

Each of the principal characters represents a different view of a family heritage that, once the Peazants have dispersed throughout the North, may not survive. Nana Peazant (Cora Lee Day), the group's 88-year-old great-grandmother and the clan's closest link to its Yoruba roots, still practices ritual magic and grieves over the demise of that tradition. Viola Peazant (Cherly Lynn Bruce) is a devout Baptist who has rejected Nana's spiritualism but who brings to her Christianity a similar fervency. Haagar (Kaycee Moore), who married into the family, disparages its African heritage as "hoodoo" and eagerly anticipates assimilation into America's middle class. Yellow Mary (Barbara-O), who has returned for the celebration, is the family pariah, shunned by the other women for being a prostitute.

The most volatile conflict is between Nana's granddaughter, Eula (Alva Rogers), who is pregnant, and her husband, Eli (Adisa Anderson), who believes the father of the child she is carrying is a white rapist. Through a ritual conducted by Nana, Eli eventually realizes that he is the father of the unborn daughter who serves as the film's occasional off-screen narrator.

Because the characters and their stories are not defined in conventional film-making terms, they are not always easy to follow. The stories, instead of being related in bite-size dramatic chunks, gradually emerge out of a broad weave in which the fabric of daily life, from food preparation to ritualized remembrance, is ultimately more significant than any of the psychological conflicts that surface.

•

With a running time of nearly two hours, "Daughters of the Dust" is a very languidly paced film that frequently stops in its tracks simply to contemplate the wild beauty of the Sea Island landscape. Even though the heat, insects and threat of yellow fever made the islands inhospitable to white settlement, the movie still portrays that environment, drenched in sea mist and strewn with palms, as a semi-tropical paradise and the Peazants as a blessed tribe whose independence and harmony with nature partly offsets the scars of having been slaves.

"Daughters of the Dust," which was made in association with the public broadcasting series "American Playhouse," is the feature film debut of Ms. Dash, who emerges as a strikingly original film maker. For all its harsh allusions to slavery and hardship, the film is an extended, wildly lyrical meditation on the power of African cultural iconography and the spiritual resilience of the generations of women who have been its custodians.

1992 Ja 16, C19:1

Juice

Directed by Ernest R. Dickerson; screenplay by Gerard Brown and Mr. Dickerson; story by Mr. Dickerson; director of photography, Larry Banks; edited by Sam Pollard and Brunilda Torres; music by Hank Shocklee and the Bomb Squad; production designer, Lester Cohen; produced by David Heyman and Neal H. Moritz and Peter Frankfurt; released by Paramount Pictures. Running time: 94 minutes. This film is rated R.

Q .. Omar Epps
Bishop Tupac Shakur
Steel Jermaine Hopkins
Raheem Khalil Kain
Yolanda: Cindy Herron
Trip Samuel L. Jackson
Ruffhouse M.C. Queen Latifah

By JANET MASLIN

Juice: it means power, nerve, street-smart bravado, and according to Ernest R. Dickerson's new film it can definitely be had in oversupply. "Juice" is the story of how four young friends from Harlem are caught up in a murderous spree after one of them decides to test the limits of his machismo. The idea may be familiar, but the execution is much better than that, thanks to natural, affecting performances from the principals and a very sharp visual style. Mr. Dickerson, whose cinematography has been the reason Spike Lee's films look so good, has a terrific eye and some juice of his own.

"Juice" begins with the innocent spectacle of Q (Omar Epps), Raheem (Khalil Kain), Steel (Jermaine Hopkins) and Bishop (Tupac Shakur) rolling out of their respective beds and heading off for school, which is a place they almost never see. Instead, they roam amiably through their neighborhood, engaging in such relatively innocent activities as shoplifting records and trading insults with rivals. Throughout this easygoing portion of the film, Mr. Dickerson (and his cinematographer, Larry Banks) gives the Harlem streets a rare crispness and clarity, and manages to position the camera in uncannily apt ways. The film's look is handsome but also claustrophobic, creating a caged feeling even in some of its outdoor scenes.

Q, who is the story's relative straight-arrow (and who can't bear his given name, Quincy, since it suggests as much), stands a better chance than his friends of breaking out. Q has talents as a disk jockey, and he dreams of winning a Mixmaster Massacre contest at a local club, for which he has earnestly practiced on two turntables with a set of records to scratch. But when the contest arrives (Queen Latifah provides a lively cameo as the mistress of ceremonies), Q's hopes are compromised by his buddies' extracurricular activities. They plan to rob a grocery store and use Q's nightclub appearance as an alibi.

The tubby, comical Steel and the earnest Raheem (who looks about 16 and already has a child) are not the instigators. The troublemaker is Bishop, for reasons that Mr. Dickerson (who wrote the screenplay) never successfully explains. Motivations are sketchy, as are the film's brief glimpses of its characters' home lives. But one thing that appears to push Bishop over the edge is watching James Cagney in "White Heat." Like many another budding gangster (the young English hoods in Peter Medak's "Let Him Have It" see "White Heat" too), he is enthralled by that film's vision of crime in terms of blazing, nihilistic glory. "That's the way to go," Bishop says, when it's top-of-the-world time.

Omar Epps Albert Watson/Paramount

"Juice" looks through Q's eyes at the temptations and trials presented in a crime-ridden atmosphere. "Pardon me for a second, I'm about to rob this place," says a friend Q has just met in a bar, as he pulls a shotgun out of his coat. (When Q declines to par-

In Harlem, young men coming of age the hard way.

ticipate and tells that to his other buddies, they tease and berate him.) In a later scene, when events have escalated to the point where Q needs a weapon, the middle-aged woman who sells him a gun sends her regards to his mother.

The film winds up taking a clear anticrime stance, and Mr. Epps ably conveys Q's trepidation about his friends' behavior. But "Juice" also revels in the flash, irreverence and tough-guy posturing to which the film's violence can ultimately be traced. (It gets a significant jolt from the score by Hank Shocklee and the Bomb Squad; Mr. Shocklee is the producer of Public Enemy and Ice Cube.) The fact that Mr. Shakur (a member of the rap group Digital Underground), as Bishop, becomes the film's most magnetic figure also undermines the story's fundamental message. It takes a final glimpse back at the four main characters in sunnier days to remind the audience just how much innocence has been lost during the course of the story.

Mr. Dickerson elicits warm, uncomplicated performances from his actors, who also include Cindy Herron as Q's older, sports-minded girlfriend and Samuel L. Jackson as Trip, a neighborhood fixture to whom Q eventually goes for help. "C'mon, Trip, you know me since I was a kid," pleads Q, who is by this point a murder suspect. "I known a lot of killers since they were kids," Trip coolly replies.

•

"Juice" is rated R (Under 17 requires accompanying parent or adult guardian). It includes profanity and violence.

1992 Ja 17, C10:1

Correction

A review in Weekend on Jan. 17 about the film "Juice" credited the screenwriters incompletely. Ernest R. Dickerson's co-writer was Gerard Brown.

1992 Ja 31, A3:2

Critic's Choice

Hellish Visions In High Style

The wickedest wit in town can be found in "Naked Lunch," David Cronenberg's ingenious adaptation of William S. Burroughs's utterly film-resistant novel. The only requirements for appreciating Mr. Cronenberg's accomplishment are a strong stomach and an interest in the Burroughs mystique.

The circumstances under which the author wrote "Naked Lunch" have been slyly worked into this film's hallucinatory look at paranoia, addiction and the hellishness of the creative process. The last, in Mr. Cronenberg's vision, is so monstrous that it actually involves monsters, albeit monsters of exceptional suaveness and insight. One such creature dispenses advice while sitting at a bar, puffing lazily on a cigarette.

Wandering through this morass, and perfectly capturing Mr. Burroughs's deadpan delivery, is an unexpectedly droll Peter Weller, who keeps his icy cool even when the story's repellent sci-fi excesses threaten to get out of hand. Judy Davis, playing two equally peculiar women (modeled on Jane Bowles, the traveler and writer, and Joan Vollmer, the wife Mr. Burroughs shot and killed while imitating William Tell), adds a great deal to the film's signature strangeness. Mr. Cronenberg ("Scanners," "The Fly," "Dead Ringers") continues to bring his demons to the screen in high style.

JANET MASLIN

1992 Ja 17, C12:6

Freejack

Directed by Geoff Murphy; screen story by Steven Pressfield and Ronald Shusett; screenplay by Mr. Pressfield, Mr. Shusett and Dan Gilroy, based on the novel "Immortality Inc." by Robert Sheckley; edited by Dennis Virkler; director of photography, Amir Mokri; music by Trevor Jones; produced by Mr. Shusett and Stuart Oken. Running ime: 115 minutes. This film is rated R.

Alex Furlong	Emilio Estevez
Vacendak	Mick Jagger
Julie	Rene Russo
McCandless	Anthony Hopkins
Michelette	Jonathan Banks
Brad Hines	David Johansen
Nun	Amanda Plummer

By JANET MASLIN

One of the few interesting notions in "Freejack" is the thought that body snatchers of the future will be forced backward in time. In the year 2009, when most of this overlong and unsightly film takes place, mind transfers are available to the rich and ailing, but pollution has made healthy bodies hard to find. So donors-to-be, like the brash young racecar driver Alex Furlong (Emilio Estevez), are rounded up from the past under the supervision of Vacendak (Mick Jagger), a bounty hunter in search of tender young flesh.

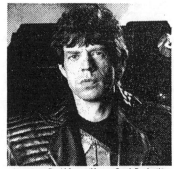

David James/Morgan Creek Productions

Mick Jagger in "Freejack."

Mr. Jagger, managing to combine a sneer and a monotone, and revealing only the occasional flash of humor, is fun to watch but lucky to have other employment. Anthony Hopkins appears only briefly (in the thankless role of the mastermind who must explain the plot's machinations) and seems to be the only real actor in the cast. Mr. Estevez and Rene Russo, who were supposedly ardent lovers in 1991 and are dramatically reunited in 2009, never set off the slightest spark. Amanda Plummer, as a gun-toting nun, delivers some unexpectedly lively lines and slugs one of the villains, but mostly seems to have wandered in from some other film.

•

"Freejack," based on Robert Sheckley's novel "Immortality Inc.," was directed colorlessly by Geoff Murphy ("Young Guns II") despite an overabundance of gimmicky details. It culminates in a computer-generated tour of one character's mind, a sequence that is of more visual interest than most of what has gone before. The film's frequently dark, grimy look and such digressions as a demonstration of how to eat river rat will appeal chiefly to those who like their science fiction on the squalid side.

•

"Freejack" is rated R (Under 17 requires accompanying parent or adult guardian). It includes a good deal of aimless, mindless violence.

1992 Ja 18, 17:5

Hear My Song

Directed by Peter Chelsom; screenplay by Mr. Chelsom and Adrian Dunbar; original story by Mr. Chelsom; director of photography, Sue Gibson; edited by Martin Walsh; music by John Altman; production designer, Caroline Hanania; produced by Alison Owen-Allen; released by Miramax Films. At the 68th Street Playhouse, on Third Avenue. Running time: 104 minutes. This film is rated R.

Josef Locke	Ned Beatty
Micky O'Neill	Adrian Dunbar
Cathleen Doyle	Shirley-Anne Field
Nancy Doyle	Tara Fitzgerald
Mr. X	William Hootkins
Benny Rose	Harold Berens
Jim Abbott	David McCallum
Fintan O'Donnell	James Nesbitt

By JANET MASLIN

The luck of the Irish is readily apparent in "Hear My Song," both in front of the camera and behind the scenes. This winning first feature by the Irish writer and director Peter Chelsom has the kind of blithe, fanciful magic that can't be achieved through skill alone.

Adrian Dunbar, Mr. Chelsom's co-screenwriter, stars in "Hear My Song" as the charming rascal Micky O'Neill, who is just barely running a nightclub in an unnamed English city. The place is on the brink of bankruptcy, and Micky's efforts to sweet-talk his landlords aren't coming to much. "There are those who find a kind of giving in their taking; that's me," he says hopefully, causing the kindly looking old ladies who own the place to curse him. Desperate measures are called for, but in this film's scheme of things, desperation and enchantment go hand in hand.

•

So Micky, who is in love with the vibrant Nancy (Tara Fitzgerald) and not very popular with her beautiful

Old wrongs are righted in a shaggy-dog tale.

mother, Cathleen (Shirley-Anne Field), decides to take a chance. He beefs up the club's bookings in search of a really big attraction, someone who will bail out the business. First he tries hiring Franc Cinatra, whose resemblance to Ol' Blue Eyes is confined entirely to his hat; then, when that doesn't work, he tries something more. Micky engages a "Mr. X" (William Hootkins), who may or may not be the famous Josef Locke, the legendary Irish tenor who left England as a tax exile. "You can't get more popular than Jo Bleedin' Locke," someone says.

When Locke disappeared in 1958, according to news reports from that time, he left behind a pedigreed Dalmatian, a Jaguar and a beauty queen. "When Jo sings, women usually weep," it is recalled about that fateful day, "but one was weeping more than most." She was Miss Dairy Goodness 1958, and it turns out that she was Cathleen, Nancy's mother. Mr. X, who gamely quotes Yeats and tries his best to sound like a mad Irish poet, may have hoodwinked Micky, but he can't fool Cathleen.

•

"Hear My Song," which opens today at the 68th Street Playhouse in Manhattan, is the shaggy-dog story of how Mickey and Josef Locke are given their respective chances to right old wrongs, once Micky has fled England and found Locke's hideout in the Irish countryside.

Much of this film recalls the work of the Scottish film maker Bill Forsyth — his "Local Hero" comes to mind particularly in the rustic Irish sequences, which look great and have a fine, whimsical flavor. Traveling in Ireland with his friend Fintan O'Donnell (James Nesbitt), who sings a breezy on-the-road duet with Micky and blames the fairies when the two of them get lost, Micky seems truly to have wandered into another world. Among the more memorable Irish episodes are those involving barroom dentistry and a moonlit scientific experiment whereby a cow nearly falls down a well.

Ned Beatty, who plays the real Josef Locke (the film is loosely based on a true story), may not be entirely comfortable lip-synching "Sorrento," but he shows his versatility and fits in admirably with the story's overall spirit. It's a spirit whereby two burly men putting up an advertising poster can break into a cheery, spontaneous little soft-shoe routine, only to find that a stranger has left a coin in one of their hats. It's an atmosphere in which everyone, no matter how gruff on the outside, is wildly romantic at heart, even the old codger who declares, "Sure I'd rather be in jail than in love again."

The film's ending errs slightly on the side of excessive sunniness, but almost all the rest of it is admirably understated. Mr. Dunbar acts ably in a furtive, beleaguered manner; his performance is good and the screenplay he co-authored (from Mr. Chelsom's original story) is even better. Miss Field is graceful and touching, and Miss Fitzgerald quite convincing as her lively daughter. Everyone in the cast, from David McCallum as a

Miramax

Tara Fitzgerald, Adrian Dunbar and Ned Beatty in "Hear My Song."

policeman who's secretly a Locke fan to Micky's two favorite henchmen and the jaunty, bemused Mr. Nesbitt, manages to combine soulfulness with sly humor.

Contributing to the film's technical finesse are a score with a swinging, big-band breeziness, and cinematography by Sue Gibson that makes the quaint, highly picturesque settings come alive. Women cinematographers are a rare breed, and this one has done a splendid job.

•

"Hear My Song" is rated R (Under 17 requires accompanying parent or adult guardian). It includes mild profanity.

1992 Ja 19, 48:1

FILM VIEW/Caryn James

Is It Time To Haul Out The Shears?

THERE ARE MOVIES THAT NEED TO BE LONG: "Greed," "The Godfather," "Gandhi" and "Gone With the Wind," just to name some G's. Frankly, I could do with a little less of Bonnie Blue Butler, Scarlett and Rhett's whiny child. But I don't have an unusually short attention span.

So when I started re-editing movies in my head this holiday season — cutting out an extra scene here, snipping at a long speech there, wondering why Tom Berenger seemed to say everything three times during the three hours of "At Play in the Fields of the Lord" — it didn't come from some frustrated urge to be a film editor or a barber or to be watching MTV. Right now there are a dozen major movies that run more than two hours each, and most feel like it.

There is an element of coincidence here, and no reason to think that the days of the average 90-minute movie are gone for good. Christmas films are traditionally among the biggest of the year, and this season was especially full of star directors with the clout to push the two-hour envelope. Is Steven Spielberg going to be asked to trim the mega-budget "Hook"? Would anyone ask Oliver Stone to cut out some of the assassination business in "J.F.K."?

Still, viewers who found themselves squirming in their seats or checking their watches were on to something. They were experiencing the effects of what some people call "the Kevin Costner Syndrome."

Because "Dances With Wolves" ran more than three hours and made a huge amount of money, producers are less skittish about long-running films than they used to be. This is nothing to be ashamed of, though several Hollywood executives refused to comment on it and one would only acknowledge the pattern off the record, as if it were a nasty secret.

But Joe Roth, the president of 20th Century Fox (whose "Grand Canyon" comes in at 2 hours 10 minutes and "For the Boys" at 2:38), said straightforwardly what others shied from admitting. "I do think it's from 'Dances With Wolves,' " he said of this mini-pattern. "Directors are less afraid to tell broad, sweeping stories, and these are first-string directors wanting to get their whole stories on screen." And, he added, except for "Hook," this season's films are for adults, who won't get restless.

When small-scale movies start creeping over two hours, though, it makes sense to ask whether the envelope is being pushed for any good reason. Almost all of this season's long films would have told their stories better — been sharper, more intriguing, more moving — if they had been tighter. Here is a seasonal catalogue of films: some are too long, some are much too long, and a couple are just right.

Movies That Should Have Been a Mini-Series, or There Is Too Much Stuff Here:

"UNTIL THE END OF THE WORLD" (2 hours 37 minutes). The first hour and a half of Wim Wenders's latest film is a stylish, breezy road movie, with William Hurt as a man on the lam chased from Paris through China to Australia, with many stops en route. Suddenly it becomes a science-fiction film about his father's invention, which transmits

Warner Brothers
Sam Neill in "Until the End of the World"—loopy

dreams. Then all the characters are in Australia waiting for nuclear apocalpyse. The longer it gets, the loopier it gets.

"J.F.K." (3 hours 8 minutes). Believe me, I'm tired of reading about it, too, but it *is* the longest. And it feels like a three-hour monologue, with Oliver Stone in your face haranguing you until you're exhausted from trying to keep it all straight: the grassy knoll and the three shots and the F.B.I. and the triangulation in Dealey Plaza. It's crammed with facts but remains curiously unemotional.

Movies That Think We Might Not Get the Point:

"THE INNER CIRCLE" (2 hours 17 minutes). At the start, Tom Hulce is a film projectionist who thinks Stalin is a hero. Two hours later, he is still a projectionist who thinks Stalin is a hero, despite many examples to the contrary. Andrei Konchalovsky's film has a slightly plodding feel that comes from waiting too long — about 15 minutes too long — for this character to snap out of it.

"AT PLAY IN THE FIELDS OF THE LORD" (3 hours). This is a story of cultural conflict in the Amazon, with selfish missionaries, good missionaries and a part-Indian mercenary who joins an embattled tribe. Still, it does not cover centuries, only months, and it might have been powerful if an hour had been cut. As it is, every character articulates his or her feelings several times, draining the film of its impact.

Movies That Need a Little Trim:

"GRAND CANYON" (2 hours 10 minutes). Too much 40-something angst and too little Steve Martin causes squirming at the two-hour mark.

"THE PRINCE OF TIDES" (2 hours 10 minutes). Just cutting out lingering shots of picturesque scenery would have helped. The mawkishness is another matter.

Movies That Don't Feel as Long as They Are:

"BUGSY" (2 hours 15 minutes). Bugsy Siegel was a smooth operator, and his film just glides along.

"FOR THE BOYS" (2 hours 38 minutes). Yes, it has to be long because Bette Midler has to flash back through three wars, but it's also lively, entertaining and it never drags.

Meanwhile, a television crew interviewed Spike Lee on the set of "Malcolm X" recently. He looked into the camera and spoke to the company producing his new film, the same one behind "J.F.K." "Warner Brothers," he said, "I don't want to hear it next year. 'J.F.K.' is three hours; this movie is going to be three hours." "Malcolm X" should take all the time it needs, as long as it's not just dancing with "J.F.K." □

1992 Ja 19, II:13:5

Adger W. Cowans/Paramount Pictures

A scene from Ernest Dickerson's "Juice." Violence in the theater lobby mirrors that on the screen.

Making a Movie Take the Rap For the Violence That It Attracts

By JANET MASLIN

The type of individual who would brandish a semi-automatic weapon at a movie theater where Ernest Dickerson's "Juice" is playing (as someone did in Commack, L.I., the other evening) is the best argument for the reasonableness of what Mr. Dickerson has to say. His film addresses the peer pressures at work on a group of Harlem high school students, one of whom eventually develops a taste for murderous mayhem and viciously attacks his friends.

The irrational bravado and macho posturing displayed by Bishop (Tupac Shakur), the film's bad-boy character, are undoubtedly shared by those gun-toting, knife-wielding moviegoers who have put "Juice" in the news. In the wake of similar violent outbreaks surrounding the openings of Mario Van Peebles's "New Jack City" and John Singleton's "Boyz N the Hood," it's not surprising to find this happening again. All these films address the frustration faced by young urban black men, and all have become lightning rods for that frustration. So bad news is being delivered, both in the lobby and on the screen.

When that happens, the messenger tends to take the blame. But can "Juice" be held accountable for the

behavior it has provoked? The film observes Bishop's actions from the viewpoint of Q (Omar Epps), who is worried and frightened by what he sees and eventually renounces the recklessness of Bishop's actions. Mr. Dickerson, who both wrote and directed the film, depicts Bishop as a loose cannon and condemns him by the time the story is over. Fundamentally, "Juice" leaves no question as to where its values lie.

•

On its surface, which involves a rap soundtrack and a fairly lighthearted attitude toward petty crime, this film says something slightly different. (So does its advertising art, which underscores Bishop's toughness, not Q's fears. Obviously, frightened young heroes don't sell tickets the way tough ones do.) Although no more exploitative than "Boyz N the Hood," which decried gang violence in South Central Los Angeles but still felt the need to depict some, "Juice" sends a mixed message just by illustrating the dangers it deplores. Like the English rock star played by Eric Bogosian in "Sex, Drugs, Rock & Roll," the one who speaks so invitingly of all the debauchery he has given up, "Juice" conveys a vivid sense of the temptations its characters try to resist.

For the portion of the audience that has created disruptions in theaters where "Juice" is playing, those

things must loom disproportionately large. Viewers who grew up heavily influenced by violent films and television shows, by rap records and MTV, are bound to have short attention spans and a taste for easy excite-

The bad news comes from real life. 'Juice' is only the messenger.

ment. They may well miss the subtlety of the antidrug attitudes of a "New Jack City" if they pay more attention to the exploitative touches — the shootouts, flashy jewelry, fast women, stacks of money and close-ups of crack vials — that help frame the message.

At a time when black American film makers have achieved new prominence, and when an important creative boom is under way among them, they can't be faulted for matching white Hollywood's standards of violence. None of these films makes

crime any more alluring than it has long been in movies about the Mafia, and none is any more violent than a vehicle for Bruce Willis or Arnold Schwarzenegger. Even by comparison with rap music video, which is currently under fire for Public Enemy's depiction of an assassination plot against state officials in Arizona (because that state has not yet endorsed Martin Luther King Day as a holiday), "Juice" seems comparatively responsible and tame.

•

But a film like this does not simply speak for itself, any more than a "J. F. K." or a "Thelma and Louise" does. Whenever a movie arrives amid a blizzard of attendant news stories, its message tends to be distorted and oversimplified, a process that in the case of "Juice" has proved more dangerous than usual. "Juice" now joins other black-oriented films that have indirectly incited their audiences to deadly violence, and the coincidence must be taken seriously. Those who distribute and advertise such films are now forced to anticipate the possibility that the film's meanings will be misunderstood.

The regrettable but necessary step of hiring extra security guards for theaters playing "Juice," an expense that will be absorbed by Paramount Pictures, introduces an air of economic reality into the problems raised by this film's release. The more responsible a distributor feels for the climate in which a film is shown, the calmer that climate is likely to be. And film makers addressing themselves to volatile viewers may wind up thinking harder about the unintended messages their work conveys. Films have every right to mirror society's troubles. They also have an obligation to avoid making those troubles any worse.

1992 Ja 22, C13:2

There's Nothing Out There

Directed and written by Rolfe Kanefsky; director of photography, Ed Hershberger; edited by Victor Kanefsky; music by Christopher Thomas; produced by Mr. Kanefsky. At Eighth Street Playhouse, at Avenue of the Americas. Running time: 90 minutes. This film has no rating.

Mike...Craig Peck
Doreen.. Wendy Bednarz
Jim ... Mark Collver
Stacy..Bonnie Bowers
Nick.. John Carhart 3d
Janet..Claudia Flores
David...Jeff Dachis

By JANET MASLIN

Mike (Craig Peck), the main character in Rolfe Kanefsky's "There's Nothing Out There," which opens today at the Eighth Street Playhouse, has seen too many horror movies. He's seen so many that he can barely go on a weekend trip to a remote house in a lonely wooded setting without getting very, very nervous.

Vacationing with three nubile young couples (among whom skinny-dipping is the sport of choice), Mike complains constantly about the sheer "Friday the 13th"-ness of the whole enterprise. "I have rented out every single horror film on videotape, and what we've just gone through is called a warning stage," he insists, when the group finds an abandoned car in the woods.

Mike also rolls his eyes in disbelief every time one of the others suggests

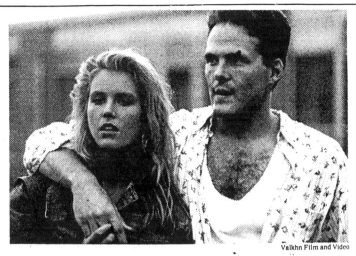

In Peril Wendy Bednarz and Mark Collver star in "There's Nothing Out There." Rolfe Kanefsky's comedic horror film — about a group of high school friends on a visit to a secluded house during spring break.

a lonely walk, midnight swim or trip to get firewood from an adjoining shed (which probably does contain an ax, after all). "Ever heard of the words foreshadowing?" he asks at one particularly ominous moment. "It's one word, Mike," a friend replies.

Mr. Kanefsky, who wrote and directed "There's Nothing Out There," has doubtless seen more than his own share of low-budget horror efforts, and has set out to give them the skewering they deserve. His intentions are good and his effects sometimes funny, but the whole film plays like exactly what it is, namely the work of a 20-year-old college student. The makings of a good satirical sketch are here, but in order to ex-

pand it to feature length Mr. Kanefsky is forced to repeat himself, overdo the silliness and rely on endless bathing scenes, for obvious reasons. The film's use of actresses dates back to times when the ability to scream while wearing a bikini was considered a form of talent.

Aside from Mr. Peck's comic timing and the cleverness of a few gags (like the sapling that shakes violently as Mike surveys the backyard), not much about the film rises above amateurishness, but Mr. Kanefsky does show energy and promise. It's easy to be well-disposed toward a horror send-up in which the answer to a question like "Where's Jim?" is, "Jim's in the other room, melting."

1992 Ja 22, C20:4

At the Sundance Film Festival, Art and Commerce Square Off

By CARYN JAMES

Special to The New York Times

PARK CITY, Utah, Jan. 22 — High-stakes Hollywood games have been played here at the Sundance Film Festival since Steven Soderbergh's "Sex, Lies and Videotape" went straight from Park City to win the grand prize at the Cannes International Film Festival three years ago. Now art and commerce battle each other here as if they were good and evil twins in a B movie. The good twin wants a happy truce, maybe some money. The bad twin wants to sell its soul and perhaps still be an artist. For film makers and others with business to do, Sundance can be nerve-racking. But for a critic, this is partly avant-garde heaven, partly a voyeuristic peek into Hollywood deal-making.

This festival of independent films, which began last Thursday, will end on Saturday with the announcement of awards for dramatic and documentary films (they must be American and are usually by unknown directors). Foreign films and those by

better-known directors are shown out of competition, and they are some of the most startling. Peter Sellars's brilliant and relentlessly uncommercial silent movie, "The Cabinet of Dr. Ramirez," is a reworked version of a film that was universally loathed when it was shown at Cannes last spring.

At the United States premiere of "Ramirez" on Monday night, Mr. Sellars, the iconoclastic opera and theater director, bounded down the aisle of the theater to introduce it. "Most Americans have been trained to think they don't get films like this," he said. "I just want to say: 'Relax! You're getting it!'" Full of energy and lacking all pretension, he added: "What's the plot? I don't know. Every time I see it there can be another plot."

It was good advice. Though "Dr. Ramirez" has only the semblance of a plot, it has the resonance of poetry and the irresistible allure of a grand, tragic ballet. Mr. Sellars translates eerie expressionistic camera angles into richly colored views of the Wall Street area. Peter Gallagher and Joan Cusack, as Wall Street execu-

tives gone financially and emotionally bankrupt, and Mikhail Baryshnikov, as an affecting and threatening homeless man, respond to the terrors of modern life: disease, violence, the inability to communicate. Though there is no dialogue, John Adams's music adds an intentionally overdramatized feel.

People trickled out of the theater throughout the 90-minute film, but Mr. Sellars said later that this was

The movies being shown range from quirky to extremely quirky.

nothing like the steady stream that walked out at Cannes, where the film was 20 minutes longer and the pace much slower. "Ramirez" does not have an American distributor, though it is one of the most audacious films to come along in years, precisely the sort of film Sundance can help to save.

The first half of the festival, which ended on Tuesday and is known as Package A for the purposes of ticket-buying, is also the more artsy part. Robert Redford and Jeremy Irons breezed in and out of town on Sunday. Mr. Irons came with Mr. Soderbergh for the regional premiere of their current film, "Kafka." Mr. Redford, whose Sundance Institute sponsors the festival, said he couldn't stay longer because he was acting in a film in Los Angeles. But despite this brief infusion of stardom, Sundance is more about films and business than about glamour.

The atmosphere was deceptively blasé. Everyone was gearing up for the last half of the festival, known to ticket buyers as Package B and to the festival staff as Attack of the Killer B's. Starting today, agents, executives and distributors overwhelmed the town, and an almost audible sense of "I'm not panicking!" was emerging among the film makers with works in competition.

Many films in the dramatic competition already have distributors. Though some film makers have come here trying to have their movies acquired, others are here to start word-

of-mouth, evaluate audience reactions and plan marketing strategies.

One of the best competition films is "Poison Ivy," directed by Katt Shea Ruben, whose previous movies were made for Roger Corman. Two of those movies will be shown at the Museum of Modern Art in Manhattan in April, which says everything about the genre she and Sundance are helping to define; it is a hybrid form that might be called the commercial art film.

"Poison Ivy" begins as a story of adolescent female friendship, with Drew Barrymore as Ivy, a sexually provocative young woman, and Sara Gilbert (the smart-mouthed younger daughter on the sitcom "Roseanne") as her tomboyish friend who may be in love with Ivy or maybe just wants to be her. Eventually this becomes a genre-bending tale of the dysfunctional family from hell, as Ms. Ruben knowingly plays off the conventions of melodrama, murder mysteries and gothic thrillers.

Though the film was made for New Line Cinema, the creators of the "Nightmare on Elm Street" series, New Line is discussing the possibility of releasing the film through its Fine Line division, which distributes more specialized art films. "Poison Ivy" walks the line between commerce

There is always mainstream potential, however.

and art so perfectly that it might be a metaphor for Sundance itself.

There is still room at this festival for nonnarrative, politically-charged films that will never make it to network television. In "The Living End," subtitled "An Irresponsible Movie by Gregg Araki," two gay men try to live with the AIDS crisis by hitting the road, literally driving away from it. Mr. Araki's film is rambling, irreverent and sexually explicit. Last year, the festival's major awards went to "Poison," whose homosexual section outraged the radical right, and "Paris Is Burning," a documentary about drag balls, so "The Living End" continues the Sundance commitment to films that live outside the mainstream.

Sara Gilbert, left, and Drew Barrymore in "Poison Ivy," an entry in the Sundance Film Festival.

But increasingly, works that seem uncommercial are arriving with some mainstream potential. Tom Kalin's "Swoon" is a lyrical, fragmented reconstruction of the notorious 1924 Leopold and Loeb murder case, in which two young men were convicted of murdering a boy. Shot in black and white, "Swoon" is esthetically very sophisticated, with an entrancing style that pulls against the themes of manipulation, homophobia and murder. It will not only be a Fine Line release, but it will also eventually turn up on PBS's "American Playhouse."

•

Other, more conventional films have arrived with major distributors as well. "Jumpin' at the Boneyard," a first film directed by Jeff Stanzler, will be released by 20th Century Fox. It is a bleak and uneven story about a New Yorker, played by the English actor Tim Roth, and his drug-addicted brother. Mr. Roth's performance is convincingly American, though it seems borrowed whole from the young Robert De Niro.

Mr. Roth gives a fresher performance in another American role here. He stars with Harvey Keitel in "Reservoir Dogs," a sometimes witty and frequently violent macho crime movie by Quentin Tarantino, a first-time director. Seven Arts, the company that was to have released the film, has almost run out of money, so "Reservoir Dogs" has become one of the more commercial films unexpectedly up for grabs.

Still to come are several out-of-competition films that have brought cachet and a higher profile to Sundance this year. Paul Schrader's "Light Sleeper," starring Willem Dafoe, will have its world premiere here on Friday. Jim Jarmusch's "Night on Earth," which was in the New York Film Festival and will be released nationally in May, will be shown Thursday evening. By Sundance standards, here come the glamour people.

1992 Ja 23, C15:4

Vintage Visconti, at Full Length

"Rocco and His Brothers" was shown as part of the 1991 New York Film Festival. Following are excerpts from Vincent Canby's review, which appeared in The New York Times on Sept. 21. The film, in Italian with English subtitles, opens today at the Public Theater, 425 Lafayette Street in Manhattan.

Luchino Visconti's 1960 Italian epic, "Rocco and His Brothers," is a reminder of where films have come from and of how small and safe and self-addressed most contemporary movies are. "Rocco" is not perfect, but even when it goes over the top in its theatricality, it excites the imagination with the kind of boldness that is the only hope of the future.

"Rocco" is being shown in its original three-hour form. When it opened in New York in 1961, the running time had been cut to 149 minutes. Later television prints had shrunk it to 95 minutes.

The film is long. Yet the sense of time's passing disappears in the big enveloping narrative about the disintegration of a farm family, newly arrived in Milan from the poverty-stricken south. The film is a sort of companion piece to "La Terra Trema" (1948), Visconti's second feature, which details the hard lot of Sicilian fishermen.

Between 1948 and 1960 there were decisive changes in the film-making methods and manners of Visconti, an aristocrat by birth and, by choice, a committed Communist who loftily opposed the party.

•

"La Terra Trema" was shot with an amateur cast. It is more easily seen as neo-realist than "Rocco," which is performed by a cast of splendid European actors and which, though utterly natural in its settings and concerns, is almost operatic in its

grand emotionalism. Consistent, however, are the director's social concerns.

"Rocco" is about the awful inevitability of the fate (as Visconti sees it) of Rosaria Parondi (Katina Paxinou) and her five sons when they immigrate to Milan to find a better life. Vincenzo (Spiros Focas), the eldest, muddles through without too much damage. Simone (Renato Salvatori) becomes, briefly, a promising prize-fighter, only to wind up as a petty crook and murderer. It is Rocco (Alain Delon), the middle son, who is both the hope of the family and its undoing.

As written, and as played by Mr. Delon, Rocco is one of the most vivid and complex characters in all of Visconti's work. His misguided saintliness, which recalls "The Idiot" of Dostoyevsky, is as responsible for the family tragedy as the system that ignores the Parondis.

Rocco falls in love with Nadia (Annie Girardot), the reformed prostitute who had earlier been Simone's mistress. In one of the toughest scenes in all film literature, the suddenly jealous Simone trails Rocco and Nadia to a meeting in a vacant lot late at night. While one of his buddies holds Rocco, Simone beats up and then rapes Nadia in front of his brother.

It is typical of the sweet, dim Rocco that he sees this as a sign of Simone's profound devotion to the unfortunate Nadia. He steps aside so that disaster may follow.

•

"Rocco" has the amplitude of detail that suggests a 19th-century novel, yet there are few digressions and Visconti does not hesitate to ignore conventions that would interrupt the film's flow. Though the film covers a period of several years, at least, the youngest Parondi son never grows an inch in his adolescence.

The film's musical score by Nino Rota, whose brassy, satiric themes and orchestrations immediately evoke the cinema of Federico Fellini, does not adequately serve Visconti's panoramic vision. But, then, something in the Verdi mode would probably be redundant.

Beginning with Mr. Delon, all of the performances are memorable. Deserving particular mention are Miss Girardot and Mr. Salvatori. Visconti even manages to channel productively the sometimes wayward energies of Miss Paxinou, who was never known to underplay even the closing of a door. Enchanting in one of her first roles is the young Claudia Cardinale, who plays Vincenzo's wife.

At this vantage point "Rocco" looks better than ever. It does not have the historical significance of "Ossessione" (1942), Visconti's adaptation of "The Postman Always Rings Twice," which is credited with opening the way for Italian neo-realism. Yet it stands with "Senso" (1954), "White Nights" (1957) and "The Leopard" (1963) as one of this majestic director's most enduring achievements.

1992 Ja 24, C8:1

In the Heat of Passion

Written, produced and directed by Rodman Flender; cinematography, Wally Psister; film editor, Patrick Rand; music by Art Wood and Ken Rarick; production designer, Hector Velez; released by Concorde Pictures. Running time: 82 minutes. This film is rated R.

Lee	Sally Kirkland
Charlie	Nick Corri
Stan	Jack Carter
Sanford	Michael Greene

By VINCENT CANBY

Since she won an Oscar nomination for her performance in "Anna" (1987), Sally Kirkland has worked tirelessly but to increasingly small effect in a series of movies whose titles, in all probability, only she remembers. Add to the list: "In the Heat of Passion."

It's about Lee (Ms. Kirkland), a sexually insatiable psychiatrist, and Charlie (Nick Corri), a good-looking young would-be actor whom she picks up at a gas station. Lee becomes something of an obsession to Charlie. Though he thinks he's in charge of their affair, it is she who calls the shots.

With a heedlessness Charlie finds intoxicating, Lee lures him into having sex in, among other places, the ladies' room of an expensive restaurant (while her husband waits outside) and her own bedroom (while her husband waits downstairs). Charlie, the poor slob, finds out too late that there is madness in her method. Also a couple of murders.

"In the Heat of Passion" was written, produced and directed by Rodman Flender. Roger Corman, the king of schlocky B movies ("Rock-and-Roll High School"), was its executive producer. The new movie is neither good enough to qualify as a psychological suspense thriller nor funny enough to be outright camp. Ms. Kirkland provides all of the spectacle, not because she is so convincing but because she seems to be so determined. She gives the impression of being an actress who will do anything to appear on the screen. The camera captures that iron will more often than a performance.

"In the Heat of Passion," which has been rated R (Under 17 requires accompanying parent or adult guardian), has simulated sex scenes, partial nudity and vulgar dialogue.

1992 Ja 24, C12:5

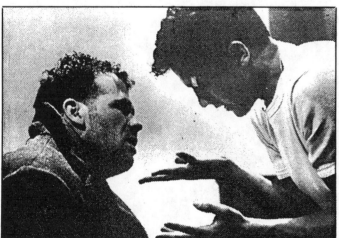

Northern Exposure Renato Salvatori and Alain Delon are seen in "Rocco and His Brothers," about a southern Italian family that moves to Milan in search of a better life.

Visconti/The Public Theater

Sally Kirkland

Love Crimes

Directed by Lizzie Borden; screenplay by Allan Moyle and Laurie Frank, based on a story by Mr. Moyle; director of photography, Jack N. Green; edited by Nicholas C. Smith and Mike Jackson; music by Graeme Revell; production designer, Armin Ganz; produced by Ms. Borden and Randy Langlais; released by Millimeter Films. Running time: 90 minutes. This film is rated R.

Dana Greenway Sean Young
David Hanover Patrick Bergin
Maria Johnson Arnetia Walker
Stanton Gray James Read
Detective Eugene Tully Ron Orbach

By JANET MASLIN

The realm of the exploitation thriller is not normally the province of feminist film makers, but in "Love Crimes" Lizzie Borden attempts some subversive inroads. She tells the story of David Hanover (Patrick Bergin), a sex offender masquerading as a famous fashion photographer, and of the efforts of an Atlanta assistant district attorney named Dana Greenway (Sean Young) to catch him at his own game.

Ordinarily this might mean a little routine voyeurism and a lot of lurid cat-and-mousing. But Ms. Borden, director of the militant 1983 "Born in Flames" and the more effective 1987 "Working Girls," tries to frame this seemingly conventional thriller in more thoughtful ways. It's unusual, when the prosecutor finally confronts the criminal, to find her asking him "Why do you hate women?" It's also unusual to find a female character asking "Do you always have to be so patronizing?" while discussing the case in bed with her boss.

"Love Crimes" ultimately does a better job of asking such questions than of providing answers. The best parts of the film are its early stages, which introduce Dana as a stern professional whose mannish wardrobe and brusque manner may conceal a few dark secrets as well as something of a kinky streak. Dana's interest in going along on a stakeout involving prostitutes, for instance, has not gone unremarked upon by her co-workers.

While a male director might stage that scene in a seductively seamy manner, Ms. Borden gives it a grotesque, slightly surreal edge, just as she makes David Hanover's violence against women more frightening and unpleasant than exciting. The film ably positions itself to explore the fine line between rape and seduction from a feminist point of view. When it develops that the man calling himself David Hanover is an imposter, for instance, Dana asks a woman who

has brought charges against him, "If he'd been the real David Hanover, would everything be all right?" And Dana herself, while repelled by David's crimes, develops a vengeful fascination with his behavior.

Provocative as it is at this point, "Love Crimes" loses momentum once Dana decides to use herself as bait and catch "David" in the act. Ms. Borden may ask interesting questions about women and pornography, but she displays little flair for the police procedural methods upon which the story (from a screenplay by Allan Moyle and Laurie Frank) later turns. At one egregious moment, after Dana has temporarily caught up with her prey, she leaves him in a car with its engine running, gets out and makes a phone call. Although a colleague (very nicely played by Arnetia Walker) tells her male colleagues that "if Dana was a man, you guys would be lining up to give her medals," that seems highly unlikely.

Ms. Young, more composed and less brittle than usual, gives a quiet performance in a role that calls for something more. Mr. Bergin, who after beating up Julia Roberts in "Sleeping With the Enemy" seems to have cornered the market on abusive-creep roles, has nothing like the bedside manner that would give David Hanover any perverse appeal, or even explain his success rate with witless victims. ("He said the pictures were for Vogue magazine!" one of them wails.) The fact that no sparks are set off between Dana and

A district attorney using herself as bait is fascinated by her suspect.

David once he imprisons her, in a critical but surprisingly suspenseless section of the film, has a lot to do with bizarre editing. Just when some sexual event between the two of them appears imminent, Dana goes abruptly from being trapped and naked in a bathtub to being dressed and wielding a gun.

> •

"Love Crimes" is rated R (Under 17 requires accompanying parent or adult guardian). It includes nudity, profanity and violence.

1992 Ja 26, 43:5

Old Movies Add To the Joy of the New

FILM VIEW/Caryn James

A MAN RUNS DOWN NARROW, shadowy, cobblestone streets, pursued by other men in long overcoats and wide-brimmed hats. Those streets are all the more sinister for their ornate, looming build-

ings, which are elegantly filmed in black and white. Our hero is investigating the mysterious death of a friend and discovers that the dead man left behind some serious political enemies as well as a beautiful lover. The hero is clearly enamored of this woman, but nothing happens between them. At the end, one question remains: Why don't they ever notice that tinkling, gypsy-sounding music in the background?

Is this "Kafka," Steven Soderbergh's mordant new film based on the writer's obsession with sinister bureaucracy and personal alienation? Or is it "The Third Man," Carol Reed's classic 1949 suspense movie, starring Joseph Cotten and Orson Welles? It is, of course, both. And just as Huck Finn once said, "You don't know me without you have read a book called 'The Adventures of Tom Sawyer,' " so Jeremy Irons as Kafka might say, "You don't know me without you have seen a movie called 'The Third Man.' "

"Kafka" has not engaged in grand theft, just grand playfulness, and it is not the only film in on the joke. When Robert De Niro yells in a sinister, singsong voice, "Come out, come out, wherever you are," in Martin Scorsese's "Cape Fear," on one level he is a crazed and vengeful ex-convict who knows that Nick Nolte is lurking behind a Dumpster. But with a tiny stretch of the imagination, he could be calling, "Come out, come out," to the ghost of Alfred Hitchcock, who lurks just about everywhere in this witty, creepy thriller — under rear windows, on the soundtrack and in the disguise of a psycho.

"Kafka" doesn't depend entirely on a viewer's knowledge of "The Third Man." And

'Kafka' and 'Cape Fear' audiences are treated like friends who share affection for and knowledge of vintage films.

"Cape Fear," which is a commercial success, is obviously appealing to an audience beyond film aficionados.

But viewers who aren't familiar with the styles, genres and movies that the directors evoke miss half the fun. These are films meant to operate on two levels: as free-standing stories and as fond allusions to movies from the past. That they were made by two of our most innovative and accomplished directors — at vastly different stages of their careers — says something about where the energy in American films is coming from.

After many triumphs, from "Mean Streets" (1973) to "Goodfellas" (1990), Mr. Scorsese is enjoying his greatest commercial success. Mr. Soderbergh, in his second film, is continuing the remarkable career that began three years ago when he won the grand prize at the Cannes International Film Festival for "Sex, Lies and Videotape." In "Kafka," he comes through with a film that is ambitious and flawed, but characteristically self-assured and original.

Both directors get much of their inspiration from films themselves, and in their latest works they treat audiences like friends who share something of the directors' affection for and knowledge of old movies.

There is no need to label this post-modernist inbreeding, but it is also more than a simple matter of old films influencing new ones, for the references operate in sophisticated ways and go beyond these two films.

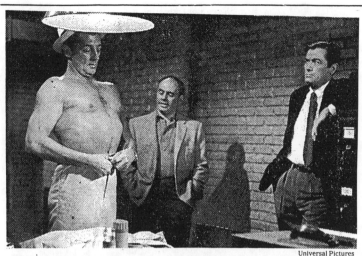

Universal Pictures

Robert Mitchum, above left, with Martin Balsam and Gregory Peck, in the 1962 film "Cape Fear," directed by J. Lee Thompson; below, Robert De Niro and Mr. Peck in the 1990 Martin Scorsese remake—infused with an awareness of movie history

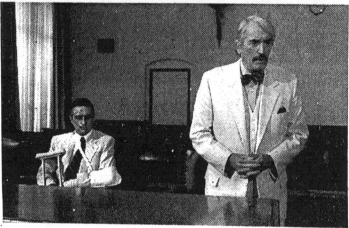

Universal City Studios

When an iconoclastic film maker like Gus Van Sant Jr., for instance, drops a tornado-swept house into the middle of a highway in "My Own Private Idaho," he is not merely influenced by "The Wizard of Oz." He creates a minor but knowing joke and a resonant image in a story about hustlers on the road. In this film, there is no place that vaguely resembles home. But while "My Own Private Idaho" offers the occasional allusion and is touched by the long shadow of Orson Welles' (whose "Chimes at Midnight" was also partly based on Shakespeare's "Henry IV"), it is not infused with the awareness of old movies in the way "Kafka" and "Cape Fear" are.

"Kafka" is not in any sense a remake of "The Third Man." It takes place in Prague rather than Vienna, is set in 1919 rather than the years after World War II, and its theme music, played on an instrument called a cimbalom, only suggests the famous zither theme of the earlier film. Lem Dobbs's screenplay is based on the ideas, and something of the life, of the historical Kafka.

But "Kafka" would be significantly different without the thematic, visual and aural resonances of "The Third Man," the haunting, tilted camera angles of German Expressionist films and commercial science-fiction and horror genres.

The chief villain in "Kafka" is named Dr. Murnau, which ironically slaps the name of the great German director F. W. Murnau onto a demonic scientist. Kafka is pursued by a raving madman who might have jumped out of a grave in a Roger Corman movie. And when Kafka follows the trail of the murderers and enters a forbidding castle, he steps into a landscape reminiscent of "Frankenstein," complete with a scientific laboratory. It has a giant microscope instead of a giant skylight, but the occupants of this castle are up to experiments every bit as dangerous as Baron von Frankenstein's.

These resonances are set up so deftly that the comic effect is to undercut any pretensions — a difficult and welcome thing to do in a film about Kafka and alienation. In fact, the cinematic in-jokes and Mr. Irons's unaffected performance are the most enjoyable aspects of "Kafka." The film's weakness is that it scarcely engages the audience on the level of suspense and human emotion — the very elements "The Third Man" used so brilliantly.

"Kafka" is very much a film lover's film, and what is on screen suggests that Mr. Soderbergh turned a problematic script, whose people never become much more than symbols, into an artistic tour de force. It helps to enter the theater with one's expectations turned upside down. "Kafka" is not a suspense film with intellectual overtones, but a cerebral film that occasionally supplies a suspenseful scene.

"Cape Fear" is more successful on both levels, for it works as an old-fashioned suspense film as well as a sophisticated movie that plays with the genres of psychological terror and horror. Though it is a remake of a 1962 movie, this version's success has less to do with the original than with Hitchcock and Freddy Krueger. Putting Gregory Peck, the the hero of the original, and Robert Mitchum, once the villain, in cameo roles that turn good and evil upside down is simply the most obvious and mildest of the film's in-jokes, quite a sweet touch in an often brutal movie.

It takes about half a minute to realize that "Cape Fear" is intentionally over the top. Bernard Herrmann's original music, reworked by Elmer Bernstein, comes on so loud and lurid that at first it seems too much. It *is* too much, offering the first clue that the film is partly a goof. The music is purposefully exaggerated to recall the mood of classic suspense films. In fact, the original music from "Cape Fear" hardly matters. It resembles many familiar scores Herrmann wrote for Hitchcock.

Throughout the rest of the film, there are slight, sometimes subtle homages to Hitchcock. Nick Nolte and Jessica Lange's bedroom overlooks the back yard, and when she peers out the window and sees the De Niro character sitting on a wall, there is a hint of "Rear Window," in which Grace Kelly and James Stewart can look out of their claustrophobic, sexually charged room to see a murderer.

There is a scene — impossible to describe fully without giving away its secret — in which one character's disguise is blatantly borrowed from "Psycho." Some viewers, in the few seconds allowed, will think, "They wouldn't dare try that." Others will not be aware of the joke, but all of them will jump at the end of the scene.

By the time of the final showdown, Mr. De Niro has become The Villain Who Wouldn't Die, part of a long tradition of unstoppable bad guys who need stakes through their hearts. As Cady relentlessly pursues the family on their houseboat, one of their attacks leaves him looking like Freddy Krueger's better-looking brother.

Getting the joke doesn't make "Cape Fear" less haunting, just haunting in a different way. On one level, the film evokes screams and fears; on another it evokes the kind of nervous laughter that says, "It's only a movie." Artistically, these two layers offer Mr. Scorsese a chance to have his commercial success and laugh at it, too.

The success of "Cape Fear" and the ambition of "Kafka" are hopeful signs of a healthy film tradition, one that acknowledges the importance and massive awareness of movies in American culture. These works don't condescend to audiences who miss their jokes, but they offer sophisticated rewards to viewers who, like the directors, have spent a good deal of their lives immersed in movies. □

1992 Ja 26, II:11:1

Color Adjustment

Directed and written by Marlon T. Riggs; videographer, Rick Butler; edited by Deborah Hoffmann; music by Mary Watkins; produced by Mr. Riggs and Vivian Kleiman. At Anthology Film Archives, Second Avenue x Second Street. Running time: 86 minutes. This film has no rating.

By JANET MASLIN

"Color Adjustment" is Marlon T. Riggs's cogent and thoughtful survey of black America as represented by American television, from the demeaning stereotypes of "Amos 'n' Andy" to the subtler, more insidious ones of "The Cosby Show." It is Mr. Riggs's well-supported opinion that today's would-be positive images of prosperous, assimilated characters are every bit as damaging as the buffoonish images of the past. Mr. Riggs also documents television's continuing identity crisis as he contrasts the idealized black figures seen on sagas and sitcoms with the harsher, angrier ones provided by the news.

In a straightforward, informative manner, Mr. Riggs elicits opinions from the stars and producers of landmark shows in black television history, pausing occasionally for a well-chosen observation from James Baldwin's writings. Each of the shows discussed here emerges as a source of both pain and pride. Diahann Carroll and Tim Reid, both of whom later starred in television series important to Mr. Riggs's argument, discuss their changing reactions to "Amos 'n' Andy," the show about which the N.A.A.C.P. said "every character is either a clown or a crook." Ms. Carroll says her family was adamant about not watching "Amos 'n' Andy," and only later could she see through the show's offensiveness and find its humor.

As the film proceeds chronologically, it also catalogues Beulah, the cheerful black servant devoted to the white family she worked for. "That was a Hollywood maid," says Esther Rolle, the star of "Good Times," of the grinning actress (Louise Beavers) who made Beulah so agreeable to white audiences. The film, which opens today at the Anthology Film Archives, devotes attention to Nat (King) Cole's variety show, which marked the first non-comedic series starring a black performer and was

canceled for lack of sponsorship after a single season. "I was very proud to see that elegant man on television," Ms. Carroll says. Meanwhile, Mr. Riggs depicts the violence over desegregation that coincided with the show's quick demise.

Ms. Carroll acknowledges that she herself was "guilty of something we had to do for survival, and that's called adjustments." Certainly she had to make compromises to star on "Julia," the 60's show in which she played a fully assimilated nurse whose race was virtually an afterthought. Mr. Riggs, who has a good ear for the idiocies of series television, extracts a brief scene featuring Julia's young son and a white boy, who exclaims, "Your mother's colored!" "Course! I'm colored, too," Julia's son replies.

"You *are*?" asks the white boy, expressing the willfully colorblind idealism that brought "Julia" and even "I Spy" (in which Bill Cosby's character was a Rhodes scholar) under attack. "These were people who could move into your neighborhood and not disturb you at all," says Dr. Henry Louis Gates Jr. of Harvard University, one of several scholars who contribute helpful commentary throughout the film.

•

"Aunt Jemima and Uncle Tom are dead, their places taken by a group of amazing, well-adjusted young men and women, ferociously literate, well-dressed and scrubbed," Mr. Baldwin wrote about such role models. The film, with narration by Ruby Dee, cites a show like "East Side, West Side," which had its share of New York City realism, as preferable to anything more self-consciously upbeat. It even admires the relative candor and familial closeness of "All in the Family," considering Archie Bunkerism a healthy antidote to the kid-gloves attitudes of other shows. "Color Adjustments" is especially interesting about "Good Times," which Mr. Riggs indicates had substance and verisimilitude until Jimmie Walker's low comedy was allowed to dominate it, and "Frank's Place," which was intelligent and forthright about the black experience and therefore didn't last.

•

"Could prime-time break the mold of comedy and still comfort white America?" Ms. Dee asks. It could and did with "Roots," which is criticized here for its placating, melodramatic style (the film clip chosen is particularly cruel) and "for transforming a national disgrace into an epic triumph of the family and the American dream." That dream, as illustrated by Mr. Riggs in scenes from sugary all-white sitcoms, has long tempted blacks with its promise of a wholesome, trouble-free world. And today, he maintains, that world is no less elusive than it was when television was new.

1992 Ja 29, C15:1

Guilty as Charged

Directed by Sam Irvin; written by Charles Gale; director of photography, Richard Michalak; edited by Kevin Tent; music by Steve Bartek; production designer, Byrnadette Di Santo; produced by Randolph Gale; I.R.S. Releasing. At Eighth Street Playhouse, at Avenue of the Americas. Running time: 95 minutes. This film has no rating.

Ben Kallin	Rod Steiger
Liz	Lauren Hutton
Kimberly	Heather Graham
Stanford	Lyman Ward
Edna	Zelda Rubinstein

By VINCENT CANBY

"Guilty as Charged," which opens today at the Eighth Street Playhouse, tries very hard to satirize moral corruption and succeeds only in being a numbingly eccentric melodrama about lawlessness and disorder.

Kallin (Rod Steiger), a rich meat packer, has taken it upon himself to execute all convicted murderers who, as he sees it, deserve the capital punishment that the state does not allow. Kallin has his own electric chair in which he dispatches his victims after a lot of sermonizing and a last supper, which may be either a Big Mac, fries and a chocolate shake or Kentucky Fried Chicken.

•

The other principal characters are a right-wing candidate for Governor (Lyman Ward), who is himself a murderer, and the candidate's world-weary wife (Lauren Hutton) who, when last seen, is carrying on the meat packer's extracurricular work.

Beyond that the story resists coherent synopsis.

The film was directed by Sam Irvin (his first feature) and written by Charles Gale. Neither they nor any members of the large cast achieve the level of wit that might qualify "Guilty as Charged" as comedy in the Swiftian mode.

1992 Ja 29, C17:1

Thank You and Good Night

Directed, written and produced by Jan Oxenberg; director of photography, John Hazard; music by Mark Suozzo; a co-production of American Playhouse Theatrical Films, POV Theatrical Films and Red Wagon Films; co-producers, Kathie Hersch and James Schamus; executive producer, Lindsay Law; an Aries Film Release. At Film Forum 1, 209 West Houston Street. Running time: 77 minutes. This film has no rating.

By STEPHEN HOLDEN

"What is this thing called death? Is it the great leveler?" "Does it give meaning and purpose to life or is it a thing to get depressed about?" "And what is eternity anyway?"

Those are only a few of the many questions posed by Scowling Jan, a cutout cartoon representation of Jan Oxenberg, the film maker, as a child in her quirky autobiographical documentary, "Thank You and Good Night."

The movie, which opened a three-week engagement today at Film Forum 1, is an aggressively perky meditation on death and dying that follows the film maker's grandmother, Mae Joffe, from the early stages of a terminal illness through her death and its effects on her Long Island family. Filmed over 12 years, "Thank You and Good Night" is an innovative blend of cinéma vérité, drama, and comic surrealism featuring cutout figures of the film maker and her grandmother along with childlike manifestations of metaphysical transformations.

•

Holding it all together is Ms. Oxenberg's calm off-screen narration, which has the chatty, almost joking tone that Woody Allen has frequently employed to address his anxiety about death, the Holocaust and other fearsome subjects. As in Mr. Allen's films, Ms. Oxenberg's seeming off-handedness helps to make a forbidding subject approachable. But the humor can go only so far in softening a vision that is sometimes quite harrowing.

The emotional core of "Thank You and Good Night" is its portrait of the reserved, lonely grandmother being filmed and interviewed as she endures the increasingly pain-racked stages of terminal cancer complicated by diabetes. To anyone who has witnessed the steady wasting away of a family member, the scenes of Mrs. Joffe's decline are likely to awaken memories whose chill no amount of comic commentary and surreal cleverness can erase. Even when the grandmother is so ill that she seems largely unaware of her surroundings, Ms. Oxenberg remains a gently persistent interrogator in search of clues to big philosophical questions. "Any messages for posterity?" she asks at one particularly agonized moment. "I

love you so much," whispers the grandmother, barely able to make a sound.

As closely as she is observed, the grandmother remains a remote, enigmatic figure, who is remembered for her gefilte fish, her marble cake and her fondness for solitaire and television game shows. In one surreal aside, Ms. Oxenberg imagines herself as a contestant on a program in which she has to answer questions about her grandmother.

•

Even among the survivors, there are disputes over what really happened. Ms. Oxenberg humorously recreates a trip she took with her grandmother to Coney Island, even though the film maker's mother, Helen, asserts that such an outing could never have taken place. Among the peripheral characters, the most vivid is Ms. Oxenberg's brother, Ricky, who bears a slight resemblance to the actor Wallace Shawn and who extemporizes about the meaning of death in amusingly earnest riddles.

An incident that resonates throughout the film and that Ms. Oxenberg skillfully uses to shape the material is the death of a younger sister who was killed as a child when she was hit by a car. Near the end of the movie, the death of the grandmother who was haunted by that accident throughout her life, seems to help the film maker come to grips with the earlier tragedy.

If "Thank You and Good Night" has a message, it is that when it comes to facing death, no matter who and how old we are, we are all as ignorant of death as the 5-year-old Scowling Jan, making faces and firing unanswerable questions into the void.

1992 Ja 29, C20:4

A scene from Jan Oxenberg's "Thank You and Good Night."

Carlo.Ontal

Voyager

Directed by Volker Schlöndorff; screenplay by Rudy Wurlitzer, based on the novel "Homo Faber," by Max Frisch; directors of photography, Yorgos Arvanitis and Pierre L'Homme; edited by Dagmar Hirtz; music by Stanley Myers; production designer, Nicos Perakis; produced by Eberhard Junkersdorf; released by Castle Hill Productions. At Lincoln Plaza, Broadway at 63d Street, Manhattan. Running time: 110 minutes. This film is rated PG-13.

Faber..............................Sam Shepard
Sabeth................................Julie Delpy
Hannah..........................Barbara Sukowa
Herbert Henke..............Dieter Kirchlechner
Charlene................................Traci Lind
Ivy........................Deborah-Lee Furness
Joachim..........................August Zirner
Kurt................................Thomas Heinze

By VINCENT CANBY

European film makers are restless these days. They are roaming the world in search of something, though exactly what remains unclear. Possibly financial backing, maybe subject matter, perhaps something to believe in.

Wim Wenders took his cast and crew through seven countries before finally settling down in Australia to conclude his enjoyably peripatetic new-age comedy, "Until the End of the World."

Volker Schlöndorff displays the same itch in his "Voyager," which was shot in Mexico, France, Italy, the United States and Greece. The new film, opening today at the Lincoln Plaza, is no less new age than Mr. Wenders's, though it considers the world in terms that evoke classic Greek tragedy rather than Jean-Luc Godard.

●

The multi-national auspices behind these films, and the variety of locations in which they were shot, appear to reflect an increasing rootlessness

Sam Shepard as a tragic figure humbled by the laws of destiny.

within the European film industry. As recent political and economic upheavals are evident in the manner in which the movies are made, the conditions are also manifest in the concerns expressed in the films themselves.

Politics and party lines are to be avoided. They may be out of date next week. In some ways, Mr. Wenders, Mr. Schlöndorff and other European film makers today appear to be as uncertain as the characters within their films.

"Voyager," directed by Mr. Schlöndorff and adapted by Rudy Wurlitzer from the 1957 Max Frisch novel, "Homo Faber," is about nothing less than fate and predestination as they operate in the curious story of Walter Faber (Sam Shepard).

The film is a modern variation on the Oedipus myth, recalled in flashbacks within flashbacks that start in June 1957, at the airport in Athens. Walter, an engineer who works with the United Nations, is a man who travels light or, as he tells someone: "Three or four days with a woman is the absolute maximum. After that I dissimulate."

Castle Hill
Sam Shepard and Julie Delpy

He recalls his student days in Switzerland, just before World War II, when he abandoned Hannah (Barbara Sukowa), his pregnant lover, to return to the United States. He had told himself that he wasn't being a cad. Hannah had promised to get an abortion and his best friend, a German student named Joachim (August Zirner), had promised to look out for her.

Some years later, in another flashback, he remembers hearing that Joachim and Hannah had married, had a child and divorced. Still later he remembers taking a ship from New York to France and meeting Sabeth (Julie Delpy), a spectacularly pretty and sweet young student with whom he falls in love, at least in part because she reminds him of Hannah.

What with all of Walter's musing on the soundtrack about probability and coincidence, the audience is alerted to the truth about Sabeth's parentage long before it dawns on Walter. He only catches on after he and Sabeth have had an idyllic motor tour across the continent, and Walter is about to deliver the young woman to her mother in Greece.

In the film's abrupt and rather brutal conclusion, the gods intervene to punish Walter for his earlier transgression. The man of technology and science is brought to heel by laws that have nothing to do with his universe.

All of this plays with a lot more intelligence than you might expect. The English dialogue often sounds as if it had been translated from something else, but there is an engaging leisureliness, almost a lassitude, about the pace that invites contemplation.

●

Walter, as played by Mr. Shepard, is seriously eccentric and self-aware: He's a character of some stature. So is Sabeth. Because Miss Delpy is a most attractive actress, the love affair takes on such weight and meaning that the inevitable revelation seems an arbitrary intrusion by a doomily schematic plot.

It also seems to be worlds away from the world in which the film was made.

"Voyager" has been handsomely photographed in all sorts of exotic locations, though it might have been just as effective if shot in two or three fewer countries. It is well acted by Mr. Shepard and Miss Delpy, and is full of moments so particular and odd that they invite belief. Yet its tale of fate and predestination seems, at last, to be not timeless but absurd.

●

"Voyager," which has been rated PG-13 (Parents Strongly Cautioned), deals with incest.

1992 Ja 31, C6:1

Shining Through

Written and directed by David Seltzer; based on the novel by Susan Isaacs; director of photography, Jan de Bont; edited by Craig McKay; music by Michael Kamen; production designer, Anthony Pratt; produced by Howard Rosenman and Carol Baum; released by 20th Century Fox in association with Peter V. Miller Investment Corp. Running time: 127 minutes. This film is rated R.

Ed Leland..........................Michael Douglas
Linda Voss........................Melanie Griffith
Franze-Otto Dietrich..................Liam Neeson
Margrete Von Eberstein....Joely Richardson
Sunflower............................John Gielgud
Andrew Berringer..................Francis Guinan

By JANET MASLIN

In the elaborate wartime drama "Shining Through," Melanie Griffith plays Linda Voss, a secretary-turned-spy who cooks her way into the heart of the Third Reich. This undoubtedly marks the first time in film history that a spy's career has been advanced by the fact that she makes great strudel.

Actually, Linda is not yet a spy at the time of the strudel incident. But she is well on her way. Hired by the formidable lawyer Ed Leland (Michael Douglas), of whom it is said that "he runs through secretaries like a bowling ball through tenpins," Linda quickly makes the right impression by raising questions about the letters Ed dictates. When he makes reference to "sea birds," Linda has a funny feeling that he means submarines. "Naturally, it set a girl's mind to wondering," she remarks in voice-over.

So Linda speaks up, expressing her suspicions in the kind of kittenish, bitsy-voiced manner that guarantees she will wind up in bed with Ed. And, thanks to this film's earnest silliness and its high-gloss Hollywood romanticism, it's also guaranteed that the bedroom scene will feature torrential rain at the window and a blazing fire in the hearth. Less predictable, perhaps, is the fact that Ed's involvement in American intelligence operations in Germany will induce Linda to try out a secret mission of her own.

The strudel, delivered fervently to Ed's door in the middle of the night, is Linda's way of assuring him that she can pass for a Nazi chef and is ready to be sent to Germany.

●

"Shining Through," written and directed by David Seltzer, is based on Susan Isaacs's better and much longer novel. In Ms. Isaacs's version, a zesty, wisecracking Linda marries her wealthy employer, John, after a torrid affair, while also attracting the eye of Ed Leland, John's partner and former father-in-law. Only after the marriage fails does Linda gravitate toward Ed and decide to take up spying, partly out of disappointment and partly as a show of real courage. Unlike the movie's cream-puff heroine, she bothers to get some O.S.S. training before taking on the job.

The film, which eliminates all this background and thus loses much of Linda's motivation, also lacks the snap and wryness of Ms. Isaacs's story. Most of its comic moments — like the point at which Linda, dismissed by one Nazi for her lousy cooking, is immediately hired by another as a nanny — appear unintentional. Even when Mr. Seltzer deliberately invokes Hollywood clichés, as he does with a "Casablanca"-style airport-runway parting between the lovers, his dialogue is a shade too sincere for ironic distance. "But Ed," wails Linda, "what's a war for if not to hold onto what we love?"

What indeed. *This* war, at least in the film's terms, is for introducing Linda to a number of glamorous Germans and making her so impress them that one declares "Mein Gott, you've got guts!" It's also for embroiling her in intrigue that eventually leaves her making a middle-of-the-night escape in cloak and evening dress, Cinderella style. The ultimate purpose of her exploits, and the device that frames the film's extended flashback, is becoming so important that she can appear, sporting a dignified hairdo and liver spots, as an honored guest on a television talk show. Heroism need no longer be its own reward.

●

"Shining Through" could easily have been more spirited. But it's still fun, in an extravagant, hopelessly retrograde fashion. Ms. Griffith's wispy working girl and Mr. Douglas's sexy, sourpuss executive both seem derived from other, better films, but they play reasonably well in this setting. However, Mr. Seltzer's insist-

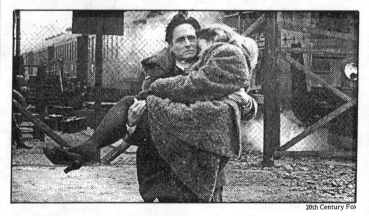
20th Century Fox

Under Cover Michael Douglas and Melanie Griffith star in "Shining Through," based on the Susan Isaacs novel about a New York secretary who persuades the officer she loves to send her into Nazi Germany.

ence on recalling other films both through Linda, who is a big movie fan, and through visual allusions almost never works to his advantage.

Brightening up the proceedings in "Shining Through" are John Gielgud as Linda's gruff, supercilious German contact; Joely Richardson as the young German society woman with whom Linda achieves a feeling of instant sisterhood, and Liam Neeson, as the unmarried Nazi officer with the bad judgment to give Linda her second job. There are also such memorable touches as Linda's effort to leave a secret message inside a fish, her uncanny good luck at negotiating padlocks and locating secret documents, and her startling discovery of Nazi regalia in an acquaintance's closet. When "Shining Through" has a bombshell to deliver, its touch is seldom light.

•

"Shining Through" is rated R (Under 17 requires accompanying parent or adult guardian). It includes brief nudity as well as some profanity and violence.

1992 Ja 31, C8:5

Alan and Naomi

Directed by Sterling VanWagenen; screenplay by Jordan Horowitz; director of photography, Paul Ryan; edited by Cari Coughlin; music by Dick Hyman; production design, George Goodridge; produced by David Anderson and Mark Balsam; released by Triton Pictures. Running time: 95 minutes. This film is rated PG.

Alan Silverman	Lukas Haas
Naomi Kirschenbaum	Vanessa Zaoui
Sol Silverman	Michael Gross
Ruth Silverman	Amy Aquino
Shaun Kelly	Kevin Connolly
Mrs. Liebman	Zohra Lampert

By JANET MASLIN

In the cloyingly sensitive "Alan and Naomi," a stickball-playing Brooklyn boy is urged by his parents to befriend a strange, troubled young girl who is a Holocaust refugee. The year is 1944, and Naomi Kirschenbaum (Vanessa Zaoui) has recently arrived from France. Still suffering the effects of her wartime experiences, Naomi "has to learn to trust again," in the words of one of the film's many meddlesome characters. So she does nothing but tear scraps of newspaper and clutch her doll, Yvette, until Alan Silverman (Lukas Haas) tries to approach her. Eventually, she will declare that "Alan makes me laugh when I'm crying inside."

This breakthrough arrives only after a long and laborious courtship stage. At first, it is only with the aid of a ventriloquist's dummy that Alan is able to engage Yvette in conversation. But after a while, Naomi is talking, too. She and Alan develop the kind of tender, budding friendship that places "Alan and Naomi" in the dread coming-of-age-film category, although it devotes equal energy to developing a kind of hothouse Brooklyn atmosphere. "Eat dat with your pickled herring!" goes one line of dialogue.

As directed by Sterling Van-Wagenen, a co-founder of the Sundance Institute, "Alan and Naomi" pays such close attention to period detail that it develops an air of unreality; the vintage cornflake boxes upstage the people. The characters themselves are often less appealing than the props anyhow. Alan's neigh-

bors are overbearing (Zohra Lampert, as the one who helps bring Alan and Naomi together, smiles unctuously at all times). And his parents make a suffocating pair. "Alan, you are my son and I am your father" begins one of the many windy speeches that Sol Silverman (Michael Gross) makes to his son. Amy Aquino, as the boy's mother, is frantically energetic but much easier to bear.

•

In any case, it's never possible to forget that these are actors making their way through a forced, fairly uneventful tale. (The screenplay, by Jordan Horowitz, is based on a 1977 novel by Myron Levoy.) Not even Mr. Haas and Miss Zaoui, playing roles that have the potential to be more natural, have much chance to break through the film's artificial mood.

Mr. Haas, whose voice is changing and who is saddled with a heavy Brooklyn accent, must hold his own not only in the doll-dummy scenes with Miss Zaoui, but in pointedly ethnic street exchanges, when his friends say things to each other like "Good night, Catholic" and "Good night, Jew." The close friendship between Alan Silverman and Shaun Kelly (Kevin Connolly) is meant to bridge any gulf of misunderstanding but, like the rest of the film, it tries too hard.

•

"Alan and Naomi" is rated PG (Parental guidance suggested). It includes mild violence.

1992 Ja 31, C8:5

Into the Sun

Directed by Fritz Kiersch; screenplay and story by John Brancato and Michael Ferris; director of photography, Steve Grass; edited by Barry Zetlin; music by Randy Miller; production designer, Gary T. New; produced by Kevin M. Kallberg and Oliver G. Hess; released by Trimark Pictures. Running time: 100 minutes. This film is rated R.

Tom Slade	Anthony Michael Hall
Capt. Paul Watkins	Michael Paré
Major Goode	Deborah Maria Moore
Mitchell Burton	Terry Kiser
Lieutenant DeCarlo	Brian Haley
Lieutenant Wolf	Michael St. Gerard
Dragon	Linden Ashby

By JANET MASLIN

Of the two subjects being lampooned in "Into the Sun" — the war in the Persian Gulf and vain, self-involved Hollywood movie stars — only one is funny. This film's portrait of Tom Slade (Anthony Michael Hall), a visiting celebrity at a military air base in Sicily, is its main comic attraction.

With his moussed hair, dark shades and ultraserious manner, Tom has arrived to study real airmen as he prepares for his latest film role, which only goes to prove that "Hot Shots!" was not the last word in flyboy satire. When shown fighter planes, Tom says dismissively: "F-14, F-16, whatever. I'm not good with numbers. I've got accountants for numbers."

When in the company of real military men, Tom watches them with near-carnivorous intensity, making them understandably nervous as he memorizes every move. And when stranded in the desert behind enemy lines, Tom manages to find a piece of his downed aircraft and use it as a sun reflector. Mr. Hall, whose earlier performances (in films like "National Lampoon's Vacation" and "Six-

teen Candles") have been much goofier, remains coolly funny and graduates to subtler forms of comedy with this role.

"Into the Sun," which takes its title from one of Tom's cornier lines of movie dialogue, is less successful in attempting a love story-action adventure-wartime humor hybrid, as Tom and the ace flier Capt. Paul Watkins (Michael Paré) are eventually stranded behind enemy lines in an unnamed Arab country. Captain Watkins, whose nickname is Shotgun ("Does it have a sexual connotation; or are you just a really good shot?" Tom solemnly asks him), makes a good foil for the Hollywood luminary, but eventually the film becomes too broad to sustain such camaraderie, or any of its novelty. When the otherwise promising screenplay, by John Brancato and Michael Ferris, turns Tom and Shotgun into hostages of clownish Arab characters, it carries a slender premise too far. Fritz Kiersch's easygoing direction also flounders when the story becomes too diffuse.

Mr. Paré, who looks like a model and sounds like a wrier version of Sylvester Stallone, makes an appropriately staunch straight man. He and Deborah Maria Moore, as the pert major who attracts both Tom and Shotgun, give the film a decorative luster it might otherwise lack. Terry Kiser has some amusing moments as the loudmouth talent manager who, asked if the "star" and "sensation" who is his client can be described as "Tom Slade, the actor," pauses nervously. He thinks that may be going too far.

"Into the Sun" is rated R (Under 17 requires accompanying parent or adult guardian). It includes profanity and sexual innuendoes.

1992 Ja 31, C10:6

Hard Promises

Directed by Martin Davidson; written by Jule Selbo; director of photography, Andrzej Bartkowiak; edited by Bonnie Koehler; music by Kenny Vance; production designer, Dan Leigh; produced by Cindy Chvatal and William Petersen; released by Columbia Pictures; presented by Stone Group Pictures. Running time: 95 minutes. This film is rated PG.

Chris	Sissy Spacek
Joey	William Petersen
Walt	Brian Kerwin
Dawn	Mare Winningham
Pinky	Jeff Perry

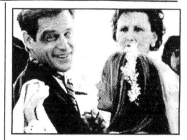

Brian Kerwin and Sissy Spacek

Chris's Mom	Ann Wedgeworth
Mrs. Bell	Lois Smith
Shelley	Amy Wright
Beth	Olivia Burnette
Stuart	Peter MacNicol

By VINCENT CANBY

"Hard Promises" is a barren little comedy that means to be romantic, set in small-town America where the lady next door bakes cookies, everybody knows everybody else and small children are full of snappy comebacks.

After a 12-year marriage, most of which he's been away, Joey (William Petersen), a good-looking, egocentric drifter, returns home in high dudgeon to stop his wife, Chris (Sissy Spacek), from marrying another man. Joey didn't know that Chris had divorced him until he received an invitation to the wedding.

For "Hard Promises" to be half as much fun as it intends to be, Joey should be a thoroughly likable scamp. For reasons that may be due to Jule Selbo's screenplay, Martin Davidson's direction or something in Mr. Petersen's screen personality, Joey is not the dreamboat the movie requires. He's a bore.

That Chris still finds him attractive reflects negatively on her, though Miss Spacek gives the character a good deal of her own charm. The movie offers a lot of running gags that walk very slowly, and small roles to a number of very good actors, including Mare Winningham, Peter MacNicol, Lois Smith, Ann Wedgeworth and Amy Wright.

In addition to being the film's co-star, Mr. Petersen is also one of its producers.

"Hard Promises" is rated PG (Parental guidance suggested). It has some vulgar language and sexually suggestive situations.

1992 Ja 31, C12:6

FILM VIEW/Janet Maslin

Yuppies Go Gracelessly Out of Style

ERE ARE TWO DIFFERENCES BETWEEN the yuppie and the dinosaur: the dinosaur took longer to become extinct. And the dinosaur probably had a larger brain. Yuppie characters in recent films have grown more and more embar-

rassing in their expensive habits, unexamined behavior and unwavering egocentricity.

The more obsolete they become, the more cringing they are apt to provoke in uncomfortably like-minded members of the movie audience.

Lawrence Kasdan, whose otherwise admirably ambitious "Grand Canyon" includes a few glaring illustrations of yuppiethink and whose "Big Chill" made the world safe for well-heeled, narcissistic characters of baby-boom age, has expressed his irritation with the much-hated Y-word.

Mr. Kasdan has also pointed out — quite correctly — that many of those who single out his films for yuppie-bashing purposes share some of his characters' concerns and attitudes, and are thus in no position to throw stones.

■

"Grand Canyon" does represent an honest, often strikingly original effort to approach the central issues of such characters' lives: mortality, social inequity, the deterioration of urban life and the slow, mounting dread that afflicts those approaching middle age. Most of the way, until it bails out with a feel-good ending, "Grand Canyon" avoids the perils of yuppie myopia in addressing those matters, but there is the occasional slip.

Mary McDonnell, as a 40-ish mother whose teen-age son has left the nest and who yearns to adopt an abandoned baby, jogs past a homeless man and imagines that he is offering magically apt advice about the baby's future.

The idea that a homeless stranger might help decide her destiny, or might be thinking about this woman's problems at all, exemplifies yuppie solipsism in all its glory.

At least, to her credit, she is contemplating a serious matter. True yuppie characters are generally more self-interested than that, which is how they come to do such stupid things. Rent out part of the newly renovated Victorian to a wealthy-looking, Porsche-driving psychopath? Melanie Griffith and Matthew Modine did exactly that in "Pacific Heights." (Mr. Modine played a manufacturer of designer kites, too.) Hire a Hollywood call girl and let her teach you a few lessons about life? "Pretty Woman" would have gone nowhere without the Richard Gere character's notable lack of intelligence in any area except entrepreneurship.

Gemma La Mana/20th Century Fox

"Grand Canyon"—illustrations of yuppiethink

But the latest example of yuppie idiocy is even more flagrant, and in its own way even more revealing. "The Hand That Rocks the Cradle," a film that means to unnerve nanny-dependent yuppie families in hair-raising new ways, cannot even set its plot in motion without bringing under fire the lives of its supposed hero and heroine. Why do Claire (played by the appealing Annabella Sciorra with a lot more common sense than the screenplay calls for) and her husband need a nanny in the first place?

Well, they have a cute school-age daughter and a brand-new baby. The husband is a genetic engineer, and Claire is rather busy in her own way, since she loves plants.

As in "Green Card," in which a heroine simulates work without appearing hard-boiled or professional about it, botany becomes the easy way out. Thus, the family's very spacious house is appointed with so many plants that it looks as if Claire, when hiring help, should have found a full-time waterer instead of Peyton (Rebecca de Mornay), the too-pretty blond nanny.

Claire tells Peyton enthusiastically that she has plans to build her own greenhouse. "And although I'll just be in the back yard, I'm anticipating being very, very busy," says Claire, leaving her newborn in Peyton's questionable care.

■

If that were not enough to damn the yuppie outlook, consider the class and racial issues that "The Hand That Rocks the Cradle" raises — or rather does *not* raise, since the film takes pains to avoid such matters.

Peyton, who has taken the job to avenge her husband's death (he was a gynecologist who committed suicide after Claire accused him of misconduct), happens to have been well-off.

So when Claire treats Peyton like a chum and not an employee, she can avoid any of the real concerns that might influence relations between a spoiled, privileged mother and the servant to whom she has entrusted her children. And when Claire, in the film's opening scene, shrieks at the sight of a black man at her kitchen window, that, too, can lose its sting.

The man, the gentle and slow-witted Solomon (Ernie Hudson), eventually becomes a beloved family retainer, although neither Claire nor her husband can recall whether the philanthropic program that sent him to work for them was called Better Day or Better Way.

Such willful ignorance is a staple of yuppie reasoning, since that group's whole tenuous life style has been built on an ability to avoid noticing the problems of others. On the movie screen, at least, such obliviousness has become dated, silly and painful to watch. It's certain that future film characters of this type will be asked to wake up and smell the coffee. And it won't be cappuccino, either. ☐

1992 F 2, II:13:5

Mississippi Masala

Directed by Mira Nair; written by Sooni Taraporevala; director of photography, Ed Lachman; edited by Roberto Silvi; music by L. Subramaniam; production designer, Mitch Epstein; produced by Michael Nozik and Ms. Nair; released by the Samuel Goldwyn Company. Running time: 118 minutes. This film is rated R.

Demetrius	Denzel Washington
Mina	Sarita Choudhury
Jay	Roshan Seth
Kinnu	Sharmila Tagore
Tyrone	Charles S. Dutton
Williben	Joe Seneca
Anil	Ranjit Chowdhry
Dexter	Tico Wells
Alicia LeShay	Natalie Oliver

By VINCENT CANBY

Near the beginning of Mira Nair's sweetly pungent new comedy, "Mississippi Masala," Mina (Sarita Choudhury) is driving a large, borrowed American automobile down a highway near Greenwood, Miss., arguing with her mother, who sits imperially in the back. Mina drives with the hapless self-assurance of someone who doesn't often get behind a wheel.

With her head turned around to answer her mother, Mina slams into the rear of the stopped van owned by Demetrius (Denzel Washington), who owns a rug-cleaning service. The van is slightly damaged, but no one is hurt. Names and addresses are exchanged. The incident is handled with comparative amiability, considering the nature of most such encounters.

It is also the first of a series of collisions by which "Mississippi Ma-

sala" vividly dramatizes the uncertain, frequently comic progress of the love affair of Mina, a spirited young Indian who has never seen India, and Demetrius, a conscientious, upwardly mobile black American who has never seen Africa.

The landscape of "Mississippi Masala" is brown and black and white. The blacks and whites have been in Greenwood for generations. The browns are newcomers. They are the Indian immigrants who have somehow found their way to Greenwood and, for reasons not entirely clear, have wound up owning most of the motels.

The Indian innkeepers are fastidious about their own manners and morals, but they are equally willing to rent rooms by the night, day or hour. It's recognized as a respectable business. Yet the so-called New South remains a network of social and cultural taboos that almost wreck the lives of Mina and Demetrius.

"Mississippi Masala" appears to have been produced on a modest (by Hollywood standards) budget, but it is a big movie in terms of talent, geography and concerns. Racism isn't the major issue, at least on the surface. Mina and Demetrius must fight the sense of cultural dislocation that, for different reasons, has become a part of the heritage of each.

"Mississippi Masala" demonstrates that the success of "Salaam Bombay!" (1988), the first collaboration of Ms. Nair, the director, and Sooni Taraporevala, her screenwriter, was not an accident. The new film has its own engagingly idiosyncratic

pace. It hurries up, dawdles and then moves on. It is full of odd characters who are not neatly explained. It is melancholy without tears.

By way of background for the contemporary story, "Mississippi Masala" opens with an extensive pre-credit sequence set in Uganda in 1972, a time of tumult, rude awakenings and "Africa for the Africans." Gen. Idi Amin has just ordered the expulsion of all Asians from his country.

•

Mina's father, Jay (Roshan Seth), a successful journalist, is seen being sent into exile with his wife Kinnu (Sharmila Tagore) and small daughter. Jay, whose family had lived in Africa for three generations, always considered himself Ugandan first, Indian second. Career, home, friends are abruptly abandoned. It is something he never quite accepts, even long after he has been working at the Monte Cristo, the Greenwood motel owned by one of his many relatives.

"Mississippi Masala" (masala being the name of a mixture of Indian spices) displays a generous kind of interest in all of the people who make up the separate worlds of Mina and Demetrius. Among others there are Demetrius's layabout brother (Tico Wells) and his father (Joe Seneca), who has survived by being mannerly in a white society.

There's also Demetrius's former girlfriend (Natalie Oliver), who is on her way up in the music world and is no longer interested in his business success. Poor Demetrius. When he finally has a word alone with her, all that he can say is: "We got some new machines. We're doing work with deep shags."

Ms. Nair is slightly more caustic about her Indian characters. They worry and bicker among themselves and work various scams, but they are energized into collective Indian outrage by the scandalous behavior of Mina and Demetrius.

•

Mr. Washington and Ms. Choudhury, whose first film this is, work

well together. He has a screen heft that gives the film its dramatic point. Her voluptuous presence defines the urgency of the love affair. In terms of wit and plain old good humor, they are each other's equals.

Mr. Seth ("Ghandi," "My Beautiful Laundrette") and the other members of the huge cast also count a lot in creating the sense of community, or lack of same, which is the heart of a film about displaced persons and reassuring emotional continuity against all odds.

•

"Mississippi Masala," which has been rated R (under 17 requires accompanying parent or adult guardian), has some sex, partial nudity and vulgar language.

1992 F 5, C15:1

Final Analysis

Directed by Phil Joanou; screenplay by Wesley Strick, story by Robert Berger and Mr. Strick; director of photography, Jordan Cronenweth; film editor, Thom Noble; music by George Fenton; production designer, Dean Tavoularis; produced by Charles Roven, Paul Junger Witt and Tony Thomas; released by Warner Brothers. Running time: 124 minutes. This film is rated R.

Isaac Barr	Richard Gere
Heather Evans	Kim Basinger
Diana Baylor	Uma Thurman
Jimmy Evans	Eric Roberts
Mike O'Brien	Paul Guilfoyle
Detective Huggins	Keith David
Alan Lowenthal	Robert Harper

By VINCENT CANBY

Phil Joanou's "Final Analysis" is an entertaining exercise in psychological suspense up to a point. Then the ghost that has been pleasurably haunting it, that of Alfred Hitchcock's "Vertigo," turns out to be an illusion, and the real villain is revealed as that implacably clear-eyed monster, demon logic.

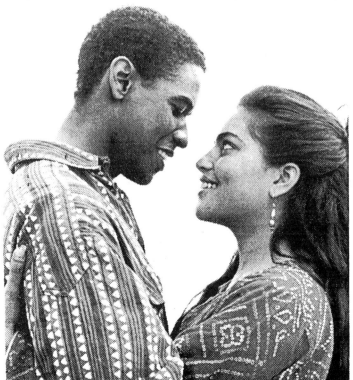

The Samuel Goldwyn Company

Denzel Washington and Sarita Choudhury in "Mississippi Masala."

It begins very well with the opening credits: lushly photographed close-ups of flowers crosscut with seemingly random objects that include the collected works of Freud, each image briefly illuminated as if by the passing sweep of a lighthouse beam.

The locale is the photogenic San Francisco we all know from movies if not life, a place where the fog rolls in on schedule and great storms materialize to score each emotional torment.

•

San Francisco is home to Isaac Barr (Richard Gere), a successful psychiatrist who is often asked to testify as an expert witness in criminal trials. Isaac is a loner absorbed

One woman's troubled psyche is explored through her sister's body.

by work. Women come and go in his life, but Freud remains constant.

When first met, Isaac is with a patient, Diana Baylor (Uma Thurman), as she tells of a recurring dream that has something to do with flower arranging. She also admits she was late for work again because she returned to her apartment eight times to make sure the pilot light had not gone out when she closed the oven door.

Diana's troubled past is dominated by memories of her drunken father and by his death in a fire for which she was blamed. She urges Isaac to talk to her sister, Heather Evans, who might be able to provide information Diana has forgotten.

One night Heather (Kim Basinger) shows up at Isaac's office. Initially seen in shadow with a halo of light around her head, Heather is a recurring dream all by herself, what with her sensational figure, her husky voice, her long blond hair and full sensuous mouth, half-open and apparently available. She is not a woman to brag about her popovers.

The steamy affair that follows does not peaceably wear itself out. There is the matter of Heather's marriage to the sadistic Jimmy Evans (Eric Roberts). When Isaac wonders why she doesn't leave him, Heather says, "You try divorcing a Greek Orthodox gangster," which Jimmy is.

•

There are also hints that Heather herself is not quite what she seems. When she drinks, she is subject to what has been diagnosed as pathological intoxication, meaning that a little wine or even some Nyquil sends her temporarily around the sanity bend. Before he can collect his wits, Isaac is involved in a murder and could become the prime suspect, his fingerprints being on the murder weapon.

The screenplay by Wesley Strick (who also wrote the remake of "Cape Fear") and Mr. Joanou's direction work increasingly less well as "Final Analysis" approaches its moment of truth, or rather, its several moments of truth. The movie attempts to top each of its revelations with still another until reason bends and interest flags.

The allusions to "Vertigo" do not help, and if unintentional, they should

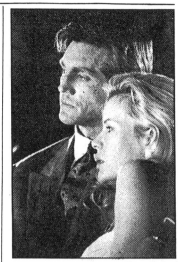

Warner Brothers'

Eric Roberts and Kim Basinger.

have been avoided. They are there in Isaac's heedless obsession with the mysterious and unreliable Heather and even in an important location, a tall phallic structure (in this case, a lighthouse) from which someone must eventually topple.

Mr. Gere and Ms. Basinger are attractive as the furious lovers, but Mr. Roberts is the film's electrical force whenever he is on screen. Ms. Thurman does well as a sort of up-scale slavey. It's not a big role, but she's around more often than Keith David, who also receives important billing though the role scarcely exists.

"Final Analysis" looks good. There is something soothing about duplicity and murder when they are set in such elegant surroundings, and when they involve people who give some semblance of being a tiny bit literate.

•

"Final Analysis" is rated R (Under 17 requires accompanying parent or adult guardian). It has partial nudity, simulated sex and vulgar language.

1992 F 7, C8:1

Medicine Man

Directed by John McTiernan; screenplay by Tom Schulman and Sally Robinson, story by Mr. Schulman; director of photography, Don McAlpine; edited by Michael R. Miller; music by Jerry Goldsmith; production designer, John Krenz Reinhart Jr.; produced by Andrew G. Vajna and Donna Dubrow; released by Buena Vista Pictures Distribution. Running time: 104 minutes. This film is rated PG-13.

Dr. Robert Campbell	Sean Connery
Dr. Rae Crane	Lorraine Bracco
Dr. Miguel Ornega	José Wilker
Tanaki	Rodolfo de Alexandre
Jahausa	Francisco Tsirene Tsere Rereme
Palala	Elias Monteiro da Silva

By JANET MASLIN

"You found the cure for cancer and all you can say is, 'I know?'" shrieks brassy Dr. Rae Crane (Lorraine Bracco) at brilliant, eccentric, pony-tailed Dr. Robert Campbell (Sean Connery). "Medicine Man," a rain forest romp about the less-than-sparkling adventures of this twosome, does indeed hinge on the discovery of an anticancer serum. But it suggests that other maladies, like cute casting and glib, wisecrack-laden writing, are beyond the reach of medical science.

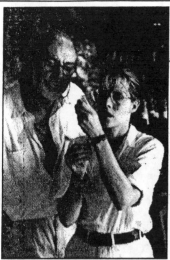

Phil Bray/Hollywood Pictures

Sean Connery and Lorraine Bracco in "Medicine Man."

"Medicine Man" transports a lot of Hollywood-style hot air to the remote jungle outpost where Dr. Campbell has accidentally stumbled upon a cancer-reversing formula. Unfortunately, he cannot duplicate that formula at will. And even more unfortunately, he now has the newly arrived Dr. Crane breathing down his neck and telling him his research is "major league." Dispatched by the pharmaceutical company sponsoring this research project, the Bronx-accented Dr. Crane is meant to seem charmingly out of place, but her charm is as elusive as the magical elixir. She complains constantly and speaks in all-too-fluent screenwriterese. (Upon arriving in the jungle: "I'm tired! I'm hungry! And I've been in these clothes for more than one dance.")

The screenplay, by Tom Schulman ("Dead Poets Society," "What About Bob?") and Sally Robinson, must have seemed a real find. After all, it combines concern for the rain forest, the aforementioned cancer cure and the kind of mock-contentious repartee that reminds some people of Tracy and Hepburn, if their memories are sufficiently short. But in this case the antagonism is as annoying as it is false, with the singsong rhythms of the most synthetic Moviespeak. "I'm not a girl!" shouts Dr. Crane when obstreperous, sexist Dr. Campbell (a trying character even for an actor as mistake-proof as Mr. Connery) calls her one. "The hell you're not!" he answers. "I'm your research assistant!" she yells back. "The hell you are!" says he.

•

"Medicine Man" was directed by John T. McTiernan ("Die Hard," "The Hunt for Red October"), who seems much more comfortable with its occasional adventure sequences than with idle banter. Unfortunately, even when the two principals are dramatically suspended high above the rain forest by ropes and pulleys, with Jerry Goldsmith's score swelling in the background, they never stop trading smart remarks. The film's scenic merits should have triumphed over that, but the cinematography by Donald McAlpine is substandard, grainy and pale. It should be noted that even after a section of the brownish rain forest has been reduced to smoking grayish rubble, Dr. Crane still has a sarcastic quip in store.

Shot in Mexico and featuring an extensive Brazilian Indian cast and crew, "Medicine Man" includes enough derring-do and jungle exotica to have appealed to children. Mr. McTiernan's insistence on using the near-naked Indians for cheesecake purposes (there are many playful shots of the rumps of Indian women as they perform various tribal rituals) greatly reduces the film's suitablility for young viewers.

•

"Medicine Man" is rated PG-13 (Parents strongly cautioned). It includes profanity and considerable nudity.

1992 F 7, C13:1

The Lunatic

Directed by Lol Creme; screenplay, based on his novel, by Anthony C. Winkler; director of photography, Richard Greatrex; edited by Michael Connell; music by Wally Badarou; produced by Paul M. Heller and John Pringle; released by Triton Pictures and presented by Island Pictures. At Cinema Village 12th Street, 22 East 12th Street, Manhattan. Running time: 93 minutes. This film is rated R.

Inga	Julie T. Wallace
Aloysius	Paul Campbell
Busha	Reggie Carter
Service	Carl Bradshaw
Linstrom	Winston Stona
Sarah	Linda Gambrill
Widow Dawkins	Rosemary Murray

By VINCENT CANBY

"The Lunatic" is a contemporary Jamaican folk tale about the life and loves of Aloysius (Paul Campbell), a tall, lanky, irrepressibly good-humored young black man who is one of nature's own.

Aloysius chats up cows and receives sage advice from the ancient tree under which he sleeps. The way to good health, the tree tells him, is through photosynthesis. Aloysius doesn't work, but makes a few pennies here and there doing odd jobs for the tourists.

Nothing surprises him, not even Inga (Julie T. Wallace), a formidable white woman who has come from Germany to learn the island ways. She is a ravaging Brünnhilde. Inga doesn't befriend Aloysius. She takes him over. In between the lessons about flora and fauna, Inga demands sex at her command. Anywhere, any time. It all ends badly for everyone except the indomitable Aloysius.

Triton Pictures

Paul Campbell

"The Lunatic," which opens today at the Cinema Village 12th Street, was adapted by Anthony C. Winkler from his own novel and is the first feature to be directed by Lol Creme, who has heretofore directed music videos.

Mr. Campbell captures the sweet exuberance of Aloysius. His performance and the island music on the sound track keep the spirits up, but everything else in the film is slightly off the mark. Inga is an oversexed but humorless revue-sketch character. Mr. Creme's direction is so uninflected that one isn't aware that a narrative has begun until the film is almost over. Too late.

•

"The Lunatic," which has been rated R (Under 17 requires accompanying parent or adult guardian), has vulgar language and simulated sex scenes.

1992 F 7, C14:5

The Restless Conscience

Directed, written and produced by Hava Kohav Beller; in English and German, with English subtitles; edited by Tonicka Janek, Juliette Weber and David Rogow; cinematographers, Volker Rodde, Martin Schaer and Gabor Bagyoni; narrated by John Dildine. At the Walter Reade Theater, 165 West 65th Street, Manhattan. Running time: 90 minutes. This film has no rating.

PRINCIPAL SUBJECTS: Julius Leber, Count Helmuth James von Moltke, Adam von Trott zu Solz, Dr. Carl Goerdeler, Count Fritz-Dietlof von der Schulenburg, Maj. Gen. Henning von Tresckow, Dietrich Bonhoeffer, Axel von dem Bussche, Ewald-Heinrich von Kleist, Dr. Hans von Dohnanyi and Col. Hans Oster

By JANET MASLIN

Among the great understatements included in "The Restless Conscience," Hava Kohav Beller's forceful and important study of anti-Hitler resistance within Nazi Germany, this one stands out: "To swim against public opinion in your own country, in the time of victory, is a difficult thing to do." The extraordinary difficulties faced by the individuals described here cannot be underestimated, nor can their courage. "I think it was a terrific loss for Germany to have killed him," it is said of one such man, by one of the many friends and colleagues and widows Ms. Beller has assembled to give testimony. The understatement with which its subjects express themselves gives this film a very special grace.

"The Restless Conscience," which opens today at the Walter Reade theater, relies on archival film clips and talking heads to reconstruct the quiet history of German resistance. It's a method that might seem arid if the subject were not so gripping or so relatively unexplored. Spanning the period from 1933 to 1945, Ms. Beller charts the diminishing hope of those Germans who initially thought the Third Reich might be assailable, only to find the possibility of resistance growing ever more remote.

•

Many of those who survived to tell their stories discuss their uneasy realization that resistance and cooperation might have to go hand in hand. "The only way to change the German Government in the period between 1933 and 1945 was with the German military and not against them," one former officer declares. "One could

only fight Hitler by remaining in the army," someone says. Ms. Beller ably records the guilt and unease of those who retained their official positions in the military or the police while still grappling with feelings of complicity, helplessness and guilt. "I think for him the worst thing was that even though he had a police job, he couldn't do anything," says a widow, recalling her husband's reaction to the anti-Semitic rampages of Kristallnacht.

Some of the most remarkable material in this film, which took Ms. Beller nine years to complete, concerns relations between the Government of Britain and the German anti-Nazi underground. The film documents instances in which emissaries emerged covertly from Germany to deliver news of anti-Hitler activities and to muster support, only to have their evidence treated skeptically by British officials. Several of the film's interviewees attest to Neville Chamberlain's and then Anthony Eden's pointed indifference to news of resistance plots against Hitler. And they speculate ruefully about what the assistance of the British Government might have meant.

•

Effective as "The Restless Conscience" is in tracing the general course of anti-Nazi activity, it is most stirring in telling the individual stories of those who formed the opposition. There is Ewald-Heinrich von Kleist, enlisted for a suicide mission to assassinate Hitler, whose father told him "a man who doesn't take such a chance will never be happy again in his life."

There is Axel von dem Bussche, once a young officer in the 9th Infantry Regiment, which the film says had more officers executed by Hitler than any other such unit in the German Army. Mr. Bussche describes his horror at witnessing a large-scale execution of civilians by the army, saying, in awkward but eloquent English, "it's a moment when the bottom of everything falls out and keeps away." There was Dietrich Bonhoeffer, a Lutheran pastor and theologian who is quoted as having said: "The more spiritual you are, the more political you must be. Only if you cry for the Jews are you permitted to sing Gregorian chants."

Many of those described here, like Bonhoeffer, sacrificed their lives for the resistance's sake, and many were apprehended after a failed plot to kill Hitler by bombing his headquarters. Ms. Beller, who also details earlier abortive schemes (like the planting of bombs in two Cognac bottles aboard Hitler's plane), includes glimpses of the August 1944 show trials in which these dignified, well-spoken resistance organizers were sentenced to death. Archival film clips, wrenchingly sad, show these heroic individuals being made to pay for having had the courage of their convictions.

In "The Restless Conscience," their voices and ideals live on.

1992 F 7, C15:1

FILM VIEW/Caryn James

Women and Sex:
A Muddle on Screen

HOW DID A DIRECTOR AS SMART as Lizzie Borden make a movie as confused as "Love Crimes"? And why isn't the film called "Sex Crimes," which is, after all, what it's about? Probably because most films about women don't know when to separate sex from love, or when to bring them together. If recent movies offer any clues to cultural standards, then that nagging good-girl/bad-girl stereotype (bad girls are sexual, while good girls are not) is alive and thriving where you least expect it.

"Love Crimes" means to be a provocative sexual thriller with a large, honest dose of political incorrectness. An assistant district attorney, played lifelessly by Sean Young, goes undercover to catch a sex criminal who is masquerading as a famous photographer. The man, who benefits on screen from Patrick Bergin's handsome looks and charm, lures women into posing nude, then has sex with them when they feel they have lost their will to resist — sometimes because he has frightened them, sometimes because he has flattered them. Emotionally, the involuntary sex is rape; legally, maybe not.

When the assistant D.A. turns herself into a decoy victim, her own dark fantasies and memories impel her more than her passion for justice. This tangle of conscious and unconscious desires might have been a complex, timely exploration of women and sex — precisely what Ms. Borden has repeatedly said she meant to create.

It didn't turn out that way, and there's no point in beating up a poor film that fails on the most commonsensical levels. The photographer's victims go running to the police,

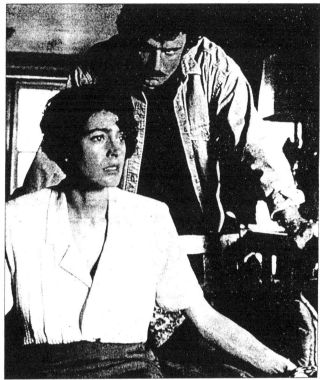

Millimeter

Sean Young and Patrick Bergin in Lizzie Borden's "Love Crimes"— Its failure points to a larger, more insidious pattern.

though their charges of violation are very hard to prove; even rape victims with strong evidence are often reluctant to press charges. Ms. Young's character looks stereotypically mannish, with her business suits and cropped, slicked-back hair, as if to set her apart from "normal" female sexuality. And she is given flashbacks to a childhood trauma that conveniently explains away her troubling sexual desires. So much for psychological depth.

■

But the failure of "Love Crimes" points to a larger, more insidious pattern: film makers are fearful of women and sex. Even those who begin their films with an unblinking, unapologetic acceptance of women's sexual desires find some cowardly way to hedge by the end. Women's sexuality is a muddle on screen, at least as confused as the highly visible real-life circumstances it mirrors, from the Anita Hill-Clarence Thomas hearings to the national debate on abortion.

Among recent films dealing with women and sex, "Rambling Rose" is the most charming; "The Rapture," the most reactionary, and "Whore," the lamest. "Love Crimes" is simply the newest and the most disappointing, given Ms. Borden's previous work — "Born in Flames" (1983), a cult film about black feminist terrorists, and "Working Girls" (1986), a smart, humanizing look at call girls.

The threat of AIDS does not seem to be a chilling factor here, for the issue is usually ignored or given a cursory disclaimer scene (Julia Roberts flashes her multicolored condoms under Richard Gere's nose in "Pretty Woman"). And the problem does not split along simple male-female lines. "Rambling Rose" is directed by a woman, Martha Coolidge, and written by a man, Calder Willingham. "Whore" is a mixture, directed by Ken Russell and adapted by Mr. Russell and Deborah Dalton from "Bondage," a play by David Hines. "Love Crimes" was written by Allan Moyle and Laurie Frank.

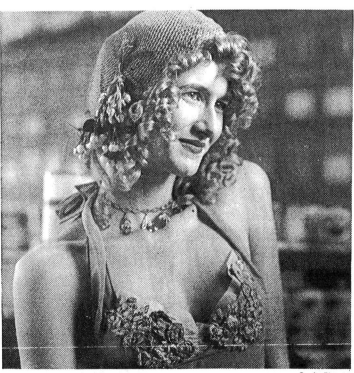

Carolco Pictures

"Rambling Rose," starring Laura Dern as a highly sexual young woman, comes close to making its case for female passion.

Instead, the confusion seems to come from the fear of violating the good-girl/bad-girl stereotype. This problem has never applied to men, of course, for whom Valentinos and Casanovas are perfectly acceptable father figures. But when movies try to explore women's sexuality, even the most intelligent film makers retreat to the safety of the madonna-whore cliché.

Film makers are confused about women's sexuality. And the women seem just as bewildered as the men.

"Rambling Rose" comes close to making its case for female passion, with Laura Dern as a highly sexual young woman who goes to work as a maid in a progressive Southern household in the 1930's. There is no doubt that she throws her body around in a desperate search for love, but it is also clear that she displays a blatant and exaggerated form of natural female desires. Diane Ladd, as the mother of the family, even offers a furious speech defending Rose when a doctor wants to perform a hysterectomy; to his archaic way of thinking, that would cure her sexual abnormality.

Yet the film insists on giving Rose this irritating, retrograde line, one that undermines the way the film has accepted, even championed, her sexuality: Rose says, "Girls don't want sex; girls want love." In real life, what girls and women want is for this not to be an either/or proposition.

But in films about women's sexuality, that is somehow a tough concept to grasp, for sex and love rarely meet. In the silly, apocalyptic movie "The Rapture," Mimi Rogers plays a telephone operator for whom promiscuous, anonymous sex is a relief from boredom. When she finds religion, she settles into marriage, motherhood and long, frumpy, flowered dresses. From bad girl to good girl in one quick costume change.

In "Whore," Theresa Russell looks into the camera and talks about life as a hooker, chomping gum and putting on a working-class accent that makes her sound as if she were doing a bad Roseanne Arnold imitation. Sex is reduced to an economic transaction, which is very much the obvious and belabored point of the film. For this character and many other women on screen, sex is either absent or loveless.

And there is little improvement in sight. Though "Fatal Attraction" has been analyzed to death in the five years since it appeared, the prototypical bad girl is still the crazed sexual predator played by Glenn Close, and the good girl is still the wife and mother who puts a knife through the other woman's heart.

The heroine who has unfortunately been left behind is one who appeared a year before "Fatal Attraction": Nola Darling in Spike Lee's "She's Gotta Have It." A woman who can't choose among her three lovers may be nobody's idea of a role model. And this 1986 film sneaked in just ahead of widespread awareness of AIDS, which is not mentioned in the movie. But while Nola would seem irresponsible now, it is important that the film never questions or challenges her sexual desire.

Mr. Lee tries to wrap things up too neatly and quickly at the end. In a sequence of events too fast to make sense, Nola is raped by one of her suitors, decides to call it a "near rape" and tells him she loves him but wants to be celibate for a while. Then in a closing monologue, she reveals that she gave up her celibacy and realized she didn't want that man after all. Dramatically, this is the weakest, most confused part of Mr. Lee's original, engaging film. But at least Nola ends by asserting her own

In dealing with women's sexuality, many directors retreat to the safety of clichés.

identity as a sexual woman. It took an iconoclast like Spike Lee to dare such an honest portrait, and few other film makers have picked up on it.

In fact, the only fully satisfying heroine currently on screen, the only woman for whom sex is neither a dirty word nor a political statement, lives far in the past. Though Emma looks a little tarty by the time she takes on her second lover in Claude Chabrol's fond adaptation of "Madame Bovary," Flaubert's heroine is not condemned for her desires. Emma Bovary's sexual passion is not separated from love, romantic fantasies or social aspirations — in short, sex is a part of her complex emotional life. Flaubert was, of course, a genius. But a woman as complete as Emma shouldn't be that hard to imagine anymore. We shouldn't have to retreat to the 19th century to find a sexual woman in films. □

1992 F 9, II:13:1

Romeo and Julia

Directed, written and produced by Kevin Kaufman; director of photography, Patrick Darrin; music by Sergei Prokofiev; associate director and editor, Peter Hammer; released by Kaufman Films. At the Quad Cinema, 13th Street, west of Fifth Avenue, Manhattan. Running time: 94 minutes. This film has no rating.

Romeo	Bob Koherr
Julia	Ivana Kane
Jake	Patrick McGuinness
Tony	Willard Morgan
Stella	Karen Porter White
Doctor Neil/Director	Donovan Dietz

By VINCENT CANBY

The title characters in "Romeo and Julia," the self-described "comedy of errors" opening today at the Quad Cinema, meet on the Brooklyn Bridge where each has come to commit suicide. The rest of the film is even worse.

Romeo (Bob Koherr), who is usually the life of any party and a great practical joker, has been told that he has AIDS. It is one of the niceties of this flat-footed film that the disease, though described, is never named. Romeo doesn't know that the diagnosis was a gag arranged by his office pals who hired an actor to pose as a doctor.

Julia (Ivana Kane), who's a lot more stupid than she looks, has also assumed that she's dying, having learned that her former boyfriend is losing weight.

Romeo and Julia exchange confidences on the bridge. He makes her laugh. She makes him happy in spite of himself. Instead of jumping, Romeo and Julia go to a fortuneteller and have dinner together; in no time at all, they are preparing to marry in Montauk.

●

Kevin Kaufman, the writer, producer and director of the film (his first theatrical feature), intends "Ro-

Ivana Kane

meo and Julia" to be life-affirming, though movies so insensitive and barren of wit tend to be depressing. They make life seem not cheap, just irrelevant.

One thing can be said for "Romeo and Julia": the physical production is slick. It has the brightly lighted, sanitized, utterly impersonal look of an industrial film that might be made in behalf of petroleum products.

1992 F 14, C6:5

Secret Friends

Written and directed by Dennis Potter; director of photography, Sue Gibson; edited by Clare Douglas; music by Nicholas Russell-Pavier; production designer, Gary Williamson; produced by Rosemarie Whitman; distributed by Briarpatch Releasing Corporation. Running time: 97 minutes. This film has no rating.

John	Alan Bates
Helen	Gina Bellman
Angela	Frances Barber
Martin	Tony Doyle
Kate	Joanna Davis
Vicar	Colin Jeavons

By VINCENT CANBY

Dennis Potter is one of the most skillful and innovative of contemporary English dramatists. With the nerviness of a stand-up comedian at a funeral, he shakes things up. He has freely reordered conventions to set new free-wheeling standards for narrative television. He has also written movies of enormous originality and feeling, most notably the screenplay for Gavin Millar's "Dreamchild" (1985).

Yet "Secret Friends," the new theatrical film he directed as well as wrote, plays as if it were a 97-minute imitation of his six-hour television classic "The Singing Detective" (1986). It has the manner of something pared down in all the wrong ways. It's an idiosyncratic work from which everything that might have been exceptional has been removed.

"Secret Friends" is short but, because it never coheres, it seems to be as long as a 640-minute mini-series.

●

Like "The Singing Detective," the film is about a man hanging onto sanity by a thread. The middle-aged John (Alan Bates) is a jealous husband to his beautiful, much younger wife, Helen (Gina Bellman), a fainthearted lover to the voracious Angela (Frances Barber) and an obsessive if successful painter of wildflowers.

He's also haunted by the morality imposed on him by a pinched religious upbringing. His father, a clergyman, had been a stern interpreter of the gospel, his mother a mute, disinterested witness to the punishments inflicted on her son. John's oversize guilts are matched only by his self-pity.

Stephen Morley

Gina Bellman and Alan Bates

That may sound familiar. John is a pallid first cousin to the grandly afflicted Philip Marlow, played by Michael Gambon with Falstaffian bra-

Drama and fantasy from the creator of 'The Singing Detective.'

vado and rage in "The Singing Detective." It isn't Mr. Bates's fault that John lacks stature. Mr. Bates can deliver invective with as much vicious, mean-spirited humor as the next man. Instead, it seems as if Mr. Potter has been parsimonious with his own gifts, also perhaps inhibited by the limited time available in the theatrical film.

The screenplay, which is said to be suggested by Mr. Potter's novel "Ticket to Ride" rather than adapted from it, again demonstrates the Potter method of jumping back and forth between past and present, between memory of what actually was and speculation on what might have been, between something that seems to be reality and paranoid fantasy.

•

Though John is in extremis from beginning to end, his major problem finally seems to be that he and the patient Helen have been enlivening their marital life by playing the sort of games suggested in best-selling sex manuals.

Their apparent favorite is one in which she is a hooker to his john. I say "apparent" because although she does show up as a hooker in his hotel room, it's not clear whether this is fact or something he has longed for. At one point she does tell him: "This is a fantasy. It's gone too far." Later she says: "I'm just tired. I'm not going to pretend anymore."

"Secret Friends" begins and ends on the train taking John to London to see a publisher. In the course of the journey, his mind races, cutting from one furious thought to the next. He becomes so disoriented that, while dining on Dover sole, he suddenly looks at the two strangers across the table and asks as politely as possible, "Am I, by any chance, with you?" It is one of the film's better moments. As John often isn't sure who he is, the rest of us aren't sure what the movie is. If it is John's voyage of self-discovery, it is a very busy but unrewarding one. Nothing Mr. Potter concocts this time supports the fury of the central character. John's childhood, seen only briefly, looks grim, but other people, including Philip Marlow, have had worse.

•

When Helen does her aerobics exercises, she plays the music too loud, which would hardly justify John's shabby treatment of her. The narrative of "Secret Friends" is so uninflected that it's not even evident just how important Angela has been as John's other woman. As the characters in his life are largely uncharacterized, so are the events that have shaped him .

Possibly Mr. Potter needs to collaborate with another director, someone who has the detached commitment to tell him when things aren't working.

The speed with which "Secret Friends" moves through John's mind doesn't allow any one character or event to dominate, not even John. The narrative remains underdeveloped.

The performances are good. Miss Bellman has a lot of the charm and the looks of Joanne Whalley, who played the nurse in "The Singing Detective." Nicholas Russell-Pavier's original songs, suggested by the sort of standards Mr. Potter usually uses, are especially enjoyable.

The title of "Secret Friends" refers to those playmates children imagine in their loneliness. John's secret friend is John himself, an unbridled John who appears from time to time to urge him on to some new childish outrage. It's not easy telling the two apart.

1992 F 14, C10:1

Wayne's World

Directed by Penelope Spheeris; written by Mike Myers and Bonnie Turner and Terry Turner, based on characters created by Mr. Myers; director of photography, Theo Van de Sande; edited by Malcolm Campbell; music by J. Peter Robinson; production designer, Gregg Fonseca; produced by Lorne Michaels; released by Paramount Pictures. Running time: 95 minutes. This film is rated PG-13.

Wayne Campbell.............................Mike Myers
Garth Algar...................................Dana Carvey
Benjamin OliverRob Lowe
CassandraTia Carrere
Noah Vanderhoff.............Brian Doyle-Murray
Stacy.......................................Lara Flynn Boyle
Alan...Michael DeLuise
Neil...Dan Bell

By JANET MASLIN

At least the world of Wayne Campbell (Mike Myers) and Garth Algar (Dana Carvey) is a cozy place. It's crammed with all the pop-cultural junk mail that helped make Wayne and Garth whatever they are today. The familiar sitcoms and advertisements and heavy-metal hits that shaped their consciousness have become, for Wayne and Garth, just so many friendly signposts on the path from one loud party to the next. As a matter of fact, these are the only signposts. Simply being able to identify them — anything from Led Zeppelin to "Laverne and Shirley," anyone from Claudia Schiffer to Dick Van Patten — is a large part of appreciating Wayne and Garth's marginal humor.

H. L. Mencken may have noted that no one ever went broke underestimating the intelligence of the American people, but not even he could have anticipated this. Like Bill and Ted, their principal rivals among screen duos who play dumb, Wayne and Garth do their best to elevate stupidity to an art form. In "Wayne's World," a feature-length spinoff of their "Saturday Night Live" routines, Wayne and Garth engage in soul-searching ("Did you ever find Bugs Bunny attractive when he put on a dress and played a girl bunny?"), pursue their hobbies (lying near an airport runway to enjoy the blast of a takeoff or landing) and use cute names (like "spew" or "hurl") for throwing up. It's hard to be this idiotic without also being at least a little bit smart.

Penelope Spheeris, who directed two lively and insightful "Decline of Western Civilization" documentaries (the first about punk rockers, the second and better one about heavy-

metal wannabes), is obviously the right person for looking on the bright side of Wayne and Garth's appeal. For instance, Ms. Spheeris understands that there's something inexplicably funny about four long-haired, partied-out dimwits crammed into a small car and lip-synching the pseudo-operatic vocals to Queen's "Bohemian Rhapsody." She knows that in Wayne's world, it would make sense for a guitar store to have a "No Stairway to Heaven" sign for customers trying out the equipment.

•

Perhaps she also realizes that Wayne and Garth can't support a feature-length movie on their own, but Ms. Spheeris does a lot to keep them busy. An uneventful screenplay (by Mr. Myers, Bonnie Turner and Terry Turner) has been embellished with as many sight gags as the traffic will bear, from Garth's collie (which wears Garth's spiky hairdo plus studded leather wristlets) to a quick "Terminator 2" joke to a guest appearance by Alice Cooper, who, of course, is one of Wayne and Garth's idols. Greeting these awestruck fans backstage after a concert, Mr. Cooper does the funniest thing he can do under the circumstances, which is to discuss the history of Milwaukee.

"Wayne's World" supposes that Wayne and Garth's late-night, public-access television show, the one they do from the sofa in Wayne's basement, is so good that a wily television executive (Rob Lowe) will scheme to exploit their commercial potential. Already straining credulity, the film does little more than steer its stars from one hangout to the next while Mr. Lowe, modeling many changes of clothes and proving himself a good comic sport, plays the heel.

Further window-dressing is provided in the form of Tia Carrere, playing a gorgeous Chinese rock-and-roll hopeful who is pursued by both the television executive and Wayne, (and who learned English, she says, from "Police Academy" movies). Ms. Carrere first appears in white shorts, stockings, garters and a white halter top cut like a modified motorcycle jacket, which should offer some idea of the film's target audience.

Also in "Wayne's World" are Brian Doyle-Murray as a potential sponsor seeking to get on the Wayne and Garth bandwagon, and Lara Flynn Boyle as the deranged beauty who won't leave Wayne alone; once again, the irresistible appeal of Wayne is overplayed. The film tends to be funny when confining itself to short sketches or dopey television-based humor, flat when pretending to be anything more.

Mr. Myers and Mr. Carvey see to it that the overconfident Wayne and the nervous, insecure Garth complement each other, even if Garth seems destined to do something truly dangerous one day. Playing with doughnuts and toothpicks in a coffee shop, he seems to be merrily imitating Norman Bates's mother.

•

"Wayne's World" is rated PG-13 (Parents strongly cautioned). It includes profanity and sexual references.

1992 F 14, C15:1

Critic's Choice

A Goodbye to Grandma

Is death anything like a long walk through the Holland Tunnel, crammed with pedestrians wearing everything from hospital gowns to black leather, all trudging to the other side? If you got in an old-fashioned rocket ship, could you fly to heaven to see your dead Grandma? These colorful fancies are played out near the end of "Thank You and Good Night," Jan Oxenberg's quirky, affectionate, part-documentary about the terminal illness and death of her grandmother and her family's reaction to those events.

The film is home-grown in the best sense: informed by the texture of family life, it is loaded with comic relief, common sense and unanswerable philosophical questions. Ms. Oxenberg wrote, produced and directed this work over 12 years, filming her mother, brother and other family members as well as herself. But her white-haired, increasingly frail grandmother is the centerpiece.

"Grandma," as Ms. Oxenberg's comfortable, Brooklyn-bred narration calls her, is feisty and straightforward about death. When she is very sick, she still has the wit to ask her granddaughter to send her royalties. "Where?" asks Ms. Oxenberg. "You have to figure that out when the time comes," says Grandma, true to her personality to the end.

Ms. Oxenberg's most effective creation is a cardboard cutout character called "Scowling Jan," herself as a little girl. Scowling Jan creates a soothing distance from the harsh documentary events. More important, she allows Ms. Oxenberg to bring up all those questions about death and the afterlife that grown-ups are supposedly too sophisticated to ask, like: "Why do people have to die, anyway?" and "Do you have to keep your same personality?"

"Thank You and Good Night," which will run at Film Forum 1 (209 West Houston Street in Manhattan) through Tuesday, becomes deeply moving about Grandma's death, but its overall tone is reflective and soothing rather than anguished. Ms. Oxenberg has created a loving, lively elegy. What more could a Grandma want, except maybe royalties?
CARYN JAMES

1992 F 14, C27:1

FILM VIEW/Vincent Canby

Onward, 'Up'-ward With Apted

THERE HAVE BEEN A NUMBER OF NOTABLE documentaries in recent years: Marcel Ophuls's "Sorrow and the Pity" and Claude Lanzmann's "Shoah," both epic in scope; Ken Burns's vast series, "The Civil War"; Errol Morris's "Thin Blue Line," about justice's miscarriage, and Michael Moore's scathingly satiric, tough and rudely biased "Roger and Me," in which a politically savvy wolf in hayseed's clothing devours General Motors down to its hubcaps.

Yet none of these has the narrative, emotional and even esthetic impact of the enchanting, singular "7 Up" films that have been made by Granada Television of England over the last 28 years, most of them directed by Michael Apted. "35 Up," the latest installment, is currently at the Film Forum and will eventually be seen on public television, but you should go now. You may want to see it twice.

Documentaries come in all sizes, shapes and concerns. Social, economic or political passions fuel the majority. Others seek to reconsider history. A smaller number examine individuals: Ross McElwee looks at his own feckless self in the very funny "Sherman's March" (1986). In "Marlene" (1986), Maximillian Schell tries to evaluate the career and private life of Marlene Dietrich while the star remains offscreen, present only as a husky, authoritarian, querulous voice.

The "7 Up" films are something quite other, an attempt to record what life in England is like, while it is being lived, in

The remarkable documentary series that has reached '35 Up' has no equal.

a series of interviews with 14 children begun in 1963 when they were 7 years old. At the time of that first film, "7 Up," directed by Paul Almond, there was no thought of pursuing the children further.

Under the direction of Mr. Apted, who was a Granada trainee in 1963 and who helped to find the subjects who would represent a cross section of English society, subsequent films have continued to track the original interviewees at seven-year intervals.

In front of our spellbound eyes, the exuberant innocence of the 7-year-olds gives way to teen-age arrogance and angst at 14, and to the expectations, some realized, some abandoned, of the 21-, 28- and 35-year-olds. England's class system shapes the films as much as it shapes the lives that the films record.

Yet the class system, and even the inescapable influence of Margaret Thatcher's Tory Government, seem increasingly less important to these lives as the subjects move toward middle age, dealing with quotidian routine, quotidian problems. The deaths of parents force several to ponder mortality. A valiant few cling to their idealism.

Though some of the material had been shown here on public television, it wasn't until 1985 and the presentation of "7 Up" and "28 Up" (which is available on video) at the New York Film Festival that this remarkable endeavor began to attract the attention it deserves. With the theatrical release of "35 Up," it is apparent that Mr. Apted and his associates are on to something that has no cinematic equivalent in longevity or scope.

It is also clear that the films, which have the manner of fiction (the material having been edited and scored to make a coherent entity), touch on the nature of fiction and the way in which it works on our sensibilities.

Granada TV

In the latest film in the series, Neil, once a bright, cheerful child, has become a melancholy drifter.

One has to go back to Oscar Lewis's books, those riveting anthropological studies of the 1960's, including "The Children of Sanchez" and "La Vida" among others, to find anything remotely similar. These films are life histories, photographed first-person novels, really, about ordinary people reported in their own words, as they see themselves (and as they would like to be seen) over a span to date of 28 years. It's as if Mike Leigh, English cinema's premier social satirist ("Life Is Sweet," "High Hopes") had become a convert of Margaret Mead.

Mr. Apted, who is his own principal interviewer, never pretends to be a fly on the wall, hoping that audiences will believe he is discovering his subjects in the midst of un-self-conscious daily routines.

The films place each person in his or her own context in brief scene-setting shots, but most of the running time is devoted to straightforward interviews. Though these are "talking heads" movies, the material is so rich in language, incidents, ideas and feelings that the effect is as indelible as that of any staged fiction.

However, something else is also at work here: for better or worse Mr. Apted's seven-year visits, and the films he makes of them, have become a part of the lives of his subjects. Some may dread their participation in the long-running project, but only 3 of the original 14 have dropped out of "35 Up."

One of those is Peter, a teacher and the son of a retired Liverpool policeman. In "28 Up" he sounded off about the educational system. "I don't want

to drag you into party politics," he told Mr. Apted, "but basically it's the most incompetent, uncaring, bloody shower we've ever had." He's now looking to enter the law.

Symon, the engaging young black man (and the sole black in the group), is in "35 Up," but only in material from the earlier films. He elected not to participate in "35 Up," for reasons never confided to Mr. Apted. When last interviewed, Symon appears to be content. He and his wife, a Jehovah's Witness, are the parents of five children.

It would also seem that the films must have changed the subjects in subtle ways. The adults are no longer quite the representative types the children were when "7 Up" was made. There is not only the notoriety, if fleeting, they receive after each seven-year telecast, but also, more importantly, the necessity at regular intervals to examine one's life in the

kind of detail otherwise demanded only on the psychiatrist's couch.

There is an eerie sequence in "21 Up" in which the subjects are seen in a screening room watching themselves in one of the movies. Some giggle, some squirm, some seem simply intent. Isadora Duncan once longed to be able to attend a "psychical cinematograph" that would be a film recording of her life. Mr. Apted's subjects have that opportunity. For each it's like drowning every seven years and having one's life flash by, but without being required to pay the ultimate price for the privilege.

■

Though all of the 7-year-olds were astonishingly articulate for their age (and were chosen to participate because of that gift), their older selves appear to be even more unusually aware of where they are in life. To this extent they are different from you and me. Not many of us are forced to examine ourselves so closely. The films may have given these kids a leg up, but then one man's leg up is another's anchor around the neck.

This might be part of the problem of Neil, the son of two suburban teachers, a bright, cheerful child when first met, a mental wreck at 28. In the course of the films Neil drifts into edgy melancholia. He is nothing if not self-aware, but his is the kind of tricky, defeating self-awareness that inhibits all action.

A drifter, last seen living in the Shetland Islands, he admits at one point that maybe his imagination does him a disservice. So vividly can he see himself becoming a successful politician, theater director or some such that the effort to attain any goal seems superfluous.

Time's passage is the most obvious subtext of the series as each film glances back to material contained in the earlier chapters. Small, undamaged, hopeful creatures acquire age lines, develop paunches, marry, have children, divorce and sometimes rue the bold self-assurance of their earlier statements. They become fixed in their emotional patterns. They adjust to new circumstances. But startling, in most cases, is the extent to which the character of the 7-year-old remains firmly inside the adult.

Thus is demonstrated the Jesuit maxim: give me the child until he is 7, and I will give you the man. In England, the class structure also helps. It limits but it also directs. It is one of the series' revelations that class attitudes and manners, which were thought to be on their way out in the 1960's, have not, in fact, much changed.

Though inevitably open-ended, each of the films is complete in itself. Each is a memory that recognizes all that has gone before.

Neil is the series' charismatic "forgotten man," so charismatic that, after the release of "28 Up," he received fan mail from people who admired his independence of spirit, his anti-establishment refusal to live the straight life of Margaret Thatcher's Britain.

Neil is the series' charismatic "forgotten man," so charismatic that, after the release of "28 Up," he re-ceived fan mail from people who admired his independence of spirit, his anti-establishment refusal to live the straight life of Margaret Thatcher's Britain.

Most of the other subjects have pretty much achieved what they wanted or (and it's not always the same thing) what they expected. There is Tony, a witty, fast-talking Dickensian cockney urchin at 7, who briefly realizes his ambition to become a jockey, goes on to become a cabdriver, to buy and sell a pub and then to raise a family, still driving his cab.

Tony seems to lead the good life. He plays golf on weekends. His youth was tough ("I seen more dinner times than dinners"), but his children have the creature comforts he was denied. Like Symon, Tony has bettered his lot without exactly moving up in the world. He is wonderfully buoyant and uncowed: "I'm as good as other people, especially in this film."

When he was in his 20's, Tony briefly studied acting with visions of a film career in mind. He didn't make it. Now, as a sort of lark and to supplement his taxi income, he works as a movie extra. It's an honor, he says, to work with a talent like Steven Spielberg.

Would Tony ever have considered show business had he not participated in these films? Sue, one of Mr. Apted's three working-class women, talks of earlier dreams of becoming a

The material of his documentary series has the indelible effect of staged fiction.

professional singer. In the Shetland Islands, Neil is seen performing in a local stage production, a pantomime of "Beauty and the Beast" and attempting to put together a group of traveling players.

Theater, if only the awareness of the celebrity that comes with it, now informs these lives.

Three of the films' more memorable characters: Nick, the Yorkshire farmer's gifted and very focused son, who grows up to go to Oxford, become a physicist and emigrate to this country, where he now teaches at the University of Wisconsin; Bruce, a solemn, handsome little boy, the son of divorced, well-to-do parents, who at 7 wants to be a missionary and at 35 is teaching in Bangladesh; and Suzy, an absolutely spotless, perfectly mannered upper-class child at 7, a painfully shy 14-year-old, a defensive, chain-smoking neurotic at 21 and, at 35, a seemingly happy and well-adjusted wife and mother who leads the good English country life.

Sue and her friends, Jackie and Lynn, say they don't envy the advantages Suzy has had. They have all had hard knocks that they have weathered with aplomb, great humor and a lot of common sense. Even the three would-be upper-class twits, John, An-drew and Charles (now a television producer and no longer a participant in the series) have turned out well.

If for nothing else, it's worth attending "35 Up" just to hear the 7-year-old John defend England's public school system: "I don't think it's a bad idea to pay for school, because if we didn't, schools would be so nasty and overcrowded." When last seen, John and his wife, the daughter of a former ambassador to Bulgaria, are raising money for needy Bulgarian causes. He's also trying to repossess some of his family's confiscated Bulgarian property.

Mr. Apted isn't an anthropologist, a sociologist or a psychologist, which may be to the advantage of these films. He's not out to prove any theories. His questions are sometimes tough, but they don't intimidate. He doesn't seek secrets. He may ask, "What do you think about sex?" but, if the interviewee begs off, he doesn't

Sara Krulwich/The New York Times

Michael Apted—rendering portraits in a style that might be called post-modernist realism.

pursue it with the tabloid journalist's severity.

The result is a series of clear-eyed portraits in a style that might be called post-modernist realism. Mr. Apted, with straight face, accepts his subject's word. He makes no value judgments, and does not analyze. He studies the surfaces of things. Though he shoots 30 feet of film for every foot finally used, the movies remain carefully collected raw material to be refined and interpreted as audiences will.

That is their fascination and their power. Second-rate fiction has a way of telling us too much, of jumping neatly to conclusions that have not been earned and that, even worse, inhibit speculation.

Mr. Apted has said that he is sorry that the films have somehow missed out on both the women's liberation movement and the sexual revolution. Yet their absence is also significant. It's an accident involved in the choice of the 14 children who participated in the first film. It's also a reminder that widely publicized movements and revolutions frequently leave masses of people untouched.

"35 Up" is not the last word on anything. Don't go to see it expecting

to find answers. Instead it raises questions about the way we think, speak, behave and look.

In the nervous, obsessive rocking movements of Neil, as he responds to Mr. Apted in front of a magnificent Scottish landscape, and in the glimpse of Bruce, such a noble soul at 14, talking about the politician's obligation to the people, "35 Up" mesmerizes in ways that few movies do. Like superior fiction, it opens private worlds. □

1992 F 16, II:13:5

Step Across the Border

Directed and written by Nicolas Humbert and Werner Penzel; camera, Oscar Salgado. Running time: 90 minutes.

WITH: Fred Frith, Joey Baron, Robert Frank, Arto Lindsay, Jonas Mekas and John Zorn.

Eye to Eye

Directed by Isabel Hegner; narrated by Jack Walls; a First Run/Icarus Films release. Running time: 18 minutes. At Film Forum, 209 West Houston Street. These films are unrated.

By STEPHEN HOLDEN

Fred Frith, the English guitarist and composer who is the subject of "Step Across the Border," is one of the more respected figures in the gray area of music where rock meets the avant-garde. A Dadaist improviser with a streak of the mystic in him, Mr. Frith, like that granddaddy of avant-gardists John Cage, finds music in everything that clanks, squeaks, rattles and hisses. He can turn just about anything lying around the house into a musical instrument. And in one sequence, he and some friends give an impromptu backyard performance of bossa nova music using rhythm instruments made of empty bottles and other household debris.

The guitarist's indomitable curiosity and playfulness inspirit the documentary by the Swiss film makers Nicolas Humber and Werner Penzel with a cheeky energy. And in their musical portrait of Mr. Frith, which opened today at Film Forum, they carry his open-ended esthetic to movie making. The result might be described as a kind of Dadaist symphony of sound and image.

Even in the film's more conventional moments, the usual niceties of documentary film making are rarely observed. Most of the musicians and commentators — and they include the musicians John Zorn and Arto Lindsay and the film makers Jonas Mekas and Robert Frank — are not clearly identified, except in the closing credits. And the film's sparse commentary is far more concerned with esthetics than with who, what, when and where.

●

In brief interviews, Mr. Frith recalls being inspired as a teen-ager by the rhythm guitar playing on the Beatles' records. He rejects self-expression as an artistic ideal and talks interestingly about performing for small audiences and waking them up to the possibilities of what music can be. Mr. Frith is also shown to be a musician whose esthetics, like Mr. Cage's, are related to environmental concerns. In one scene, he is shown standing on a rocky coastline sere-

nading flocks of seagulls that seem drawn to the birdlike sounds he is creating.

Make no mistake: Mr. Frith is no dreamy, new-age nature boy. The black-and-white movie, which was filmed on three continents, also has extended sequences of decaying urban sprawl accompanied by appropriately abrasive sounds. And the lyrics for two Frith songs suggest a core of pessimism beneath his benign, playful exterior. "Same Old Me" is an agitated litany of how boring everything is. "Too Much Too Little" laments a world in which there is "too much power and too little brains" and "the losses certainly outweigh the gains."

The Swiss film maker Isabel Hegner's "Eye to Eye," which shares the bill with "Step Across the Border," is an interview with Jack Walls, who was a frequent model for the late photographer Robert Mapplethorpe. Mr. Walls, who was filmed on the Staten Island ferry, is an insouciant showoff who frisks about in a silly leopard-skin hat and is more amused than embarrassed about a nude photo of himself aiming a gun. He also gets off a couple of amusing one-liners. When Mapplethorpe was asked about his nationality, Mr. Walls recalls, the photographer liked to reply "Catholic." To which Mr. Walls adds, "He was a very leather nun."

1992 F 19, C15:1

This Is My Life

Directed by Nora Ephron; screenplay by Nora Ephron and Delia Ephron, based on the novel by Meg Wolitzer; director of photography, Bobby Byrne; edited by Robert Reitano; music by Carly Simon; production designer, David Chapman; produced by Lynda Obst; released by 20th Century Fox. Running time: 94 minutes. This film is rated PG-13.

Dottie Ingels	Julie Kavner
Erica Ingels	Samantha Mathis
Opal Ingels	Gaby Hoffmann
Claudia Curtis	Carrie Fisher
Arnold Moss	Dan Aykroyd
Ed	Bob Nelson
Mia Jablon	Marita Geraghty
Lynn	Welker White

By JANET MASLIN

Making her directorial debut with "This Is My Life," Nora Ephron does exactly what she did on the page. She shapes every detail of this witty, picture-perfect slice of New York life to fit a single vision, one that even at its most generous and funny manages to retain a penetrating clarity. The results are a memorable portrait of Dottie Ingels (Julie Kavner), a driven, unstoppable creature who is half-mother and half-star, and a look at the problems that Dottie's career causes for her children. Despite an obvious affection for her heroine, Ms. Ephron must point out that Dottie, in hopes of someday making it to "The Tonight Show," willingly taught her young daughters to imitate Ed and Johnny.

Dottie's vague monstrousness does nothing to diminish her charm. "This Is My Life" is much too knowing about show business and ambition to regard monstrousness as a character flaw. First seen at the cosmetics counter at Macy's, where she turns every sales pitch into an opportunity to hone her comic potential, Dottie has always been ready to joke about anything, no matter how grim. Even the death of a beloved aunt becomes funny when Dottie explains that the

Kerry Hayes/20th Century Fox

Julie Kavner

deceased collapsed in her underwear in the dressing room at Loehmann's and had to be given new clothes before she could be taken away. "And when they carried Aunt Harriet out, she set off all the store alarms — really!" Dottie says.

This insistence on laughter at any cost takes a toll on the wisecracking little Opal (Gaby Hoffmann) and the seething adolescent Erica (Samantha Mathis), the two young characters who are the real heart of this story. In "This Is Your Life," the novel by Meg Wolitzer upon which Ms. Ephron and her sister Delia based their screenplay, it is Erica's point of view that predominates. That would also have helped the film, which never gets inside Dottie's thoughts (despite Ms. Kavner's unfailing warmth and sturdiness in the role) but does make her daughters' feelings utterly real. Ms. Ephron knows how to get exactly what she wants from actors, and she elicits enchanting and honest performances from the film's two young stars. As the injured, angry Erica, who eventually skewers her mother with a lacerating parody, Ms. Mathis is a particular revelation.

•

At first intrigued and delighted by their mother's show-business forays, Erica and Opal quickly see the disadvantages of their new life. In the beginning Dottie, whose idea of presenting herself interestingly is to wear polka dots, remains close to home and involves the girls in her career plans. She even brings them along as she tries to persuade agents to take her as a client. ("You know how a robber cracks open a safe?" she explains to the girls. "Well, an agent is someone who cracks open your career.") Later on, as the dots get marginally more tasteful and the jobs begin rolling in, Dottie heads for the West Coast and stays longer than anyone expected her to. "It's happening, sweethearts! It's really happening!" she says, calling long distance to plead with her daughters for more time.

The girls are left in the care of various friends, all of whom want to be stand-up comics themselves and try out cute new material around the house. This guarantees "This Is My Life" an air of blithe artificiality even when it attempts to take on the real crises caused by Dottie's success. And the screenplay, which has its own distinctive comic style but takes a lot of its best ideas from Ms. Wolitzer, conveniently ignores the possibility of Dottie's eventual failure. In the book, Dottie's dramatic rise leads to a long, painful slide into has-been status. In the film, which remains lightweight by confining itself to her uphill trajectory, the toughest thing that happens is a wrenching, passionately staged family argument that paves the way for greater understanding.

The authenticity of "This Is My Life" lies elsewhere, in the small, wry touches that are as evident here as

they are in Ms. Ephron's prose. Impeccably cast, the film offers brief but hilarious glimpses of instantly recognizable New York types, like the brittle, super-sophisticated career woman played by Carrie Fisher (a fine comic caricaturist who is funny right down to her wardrobe and her way of smoking.) Danny Zorn is precisely on target as the kind of earnest Manhattan private school student who says "muchas gracias" to the person handing him lunch in the cafeteria. Estelle Harris has a few funny moments as Aunt Harriet in her pre-Loehmann's days.

•

Dan Aykroyd, as a powerful, paper-chewing agent, has exactly the distracted manner he should, as well as an ability to argue avidly about unlikely subjects. The film is worth seeing for his denunciation of "It's a Wonderful Life" alone, or for his and Ms. Kavner's offhanded talk about the darker side of domestic bliss. "People love terrible people all the time," she observes. "That's true," he says thoughtfully. "Someone was married to Pol Pot."

"This Is My Life" has the added polish of a crisp urban look (with cinematography by Bobby Byrne) and Carly Simon's score, which is lilting, tuneful and an inspired accompaniment to this story.

"This Is My Life" is rated PG-13 (Parents strongly cautioned). It includes mild profanity.

1992 F 21, C8:1

Stop! Or My Mom Will Shoot

Directed by Roger Spottiswoode; written by Blake Snyder and William Osborne and William Davies; director of photography, Frank Tidy; edited by Mark Conte and Lois Freeman-Fox; music by Alan Silvestri; production designer, Charles Rosen; produced by Ivan Reitman, Joe Medjuck and Michael C. Gross; released by Universal Pictures. Running time: 81 minutes. This film is rated PG-13.

Joe Bomowski	Sylvester Stallone
Tutti	Estelle Getty
Gwen Harper	JoBeth Williams
Parnell	Roger Rees
Paulie	Martin Ferrero
Munroe	Gailard Sartain
Tony	John Wesley

By VINCENT CANBY

How soon we forget.

"Stop! Or My Mom Will Shoot" is a Sylvester Stallone comedy to make one yearn to relive the pleasures of "Rhinestone," in which Mr. Stallone appeared with Dolly Parton without ever seeming to be in the same frame with her. This time his co-star is Estelle Getty, the dynamite doll from television's "Golden Girls" and an actress whose presence is no more easily ignored than Miss Parton's.

Not that Mr. Stallone seems to be trying. The pint-size Miss Getty is an engaging trouper to whom he responds with suitable mock outrage, but their material is bottom-drawer. It is terrible. "Stop! Or My Mom Will Shoot" plays as if it were a pilot for a sitcom that wasn't sold in 1975.

Mr. Stallone is a tough Los Angeles police sergeant. Miss Getty is his pushy mother who comes to visit from Newark, carrying an album of his baby pictures and a suitcase full of Dole pineapple chunks.

Within one hour of her arrival, she talks a would-be suicide out of jump-

ing off a building, which prompts her son to consider jumping himself. Within 24 hours, she is baking cookies for the boys in the station house, buying an illegal gun for her son (to replace his service revolver, which she ruined by washing it in Clorox) and witnessing a shootout.

This mom is impossible without being funny. She's a recycled collection of jokes about mothers as they are conceived to be in the literature of television. Mr. Stallone plays it as straight as possible. The only other cast member worth noting is JoBeth Williams, who appears as Mr. Stallone's impatient woman friend, who is also a police lieutenant and his boss.

The contributions of Roger Spottiswoode, the director, are not to be evaluated by someone who was not on the set during the production.

•

"Stop! Or My Mom Will Shoot," which is rated PG-13 (Parents strongly cautioned), includes vulgar language.

1992 F 21, C8:5

Critics' Choice

A Film Epic On an Artist Seeking God

"Andrei Rublev" returns. The celebrated Andrei Tarkovsky epic, first reviewed when it was shown at the 1973 New York Film Festival, opens today at the Film Forum (209 West Houston Street, Manhattan) in something approximating its original form. The film, about the revered 15th-century Russian icon painter, now runs 185 minutes, compared to the 146-minute version presented at the festival.

When Tarkovsky made "Andrei Rublev," he conceived it as a boldly free-form consideration of the responsibility of the artist (any artist) to himself and to the world that gave him life. It was thus almost inevitable that the completed film would go on to illustrate everything that can happen to an artist, in this case Tarkovsky, when he refuses to mind the strictures of authoritarian rule.

"Andrei Rublev" was immediately banned, at least in part because of the troubled, pessimistic nature of its central character, its religious mysticism and the associations that could be made between the sad lot of 15th-century Russian peasants and those in the Soviet Union of the post-Nikita Khrushchev 1960's. An unauthorized print of the film was presented at the 1969 Cannes Film Festival, to enthusiastic reviews. Afterwards the censors reluctantly allowed the film to be released elsewhere.

The additional material and the passage of time have softened my original reservations. "Andrei Rublev" is still obscure, at least in part because

the subtitles, though in English, are often utterly incomprehensible. Yet even in a print not of the first quality, the film is an adventure in images of hypnotic beauty, depicting events of great thundering moral import.

Andrei Rublev (Anatoly Solonitsin) wanders across Russia, attempting to reconcile the love of God with the ignorance, brutality and injustice he sees. That he succeeds is celebrated in the final reel, when the black-and-white film turns suddenly to color to adore Rublev's masterpiece, the Old Testament Trinity, painted, it is thought, in 1411.

Tarkovsky, who died of lung cancer while in exile in Paris in 1986, made other films after "Andrei Rublev," but none as soaring and majestic.

VINCENT CANBY

1992 F 21, C10:6

Close My Eyes

Directed and written by Stephen Poliakoff; director of photography, Witold Stok; edited by Michael Parkinson; music by Michael Gibbs; production designer, Luciana Arrighi; produced by Thérèse Pickard; released by Castle Hill Productions. At the Quad Cinema, 13th Street, west of Fifth Avenue, in Manhattan. Running time: 109 minutes. This film is rated R.

Sinclair	Alan Rickman
Richard	Clive Owen
Natalie	Saskia Reeves
Colin	Karl Johnson
Jessica	Lesley Sharp
Paula	Kate Gartside
Philippa	Karen Knight

By STEPHEN HOLDEN

Contemporary London, as depicted in Stephen Poliakoff's "Close My Eyes," is gripped by a feverish malaise. Construction cranes scar the skyline for as far as the eye can see, and the weather is so hot that people have begun to mutter about the end of the world. There is also grim talk about the AIDS epidemic. And when one of the characters makes a date in the sleazier part of town, his first stop is at a vending machine dispensing condoms.

In this parched, overheated atmosphere, an incestuous affair between Natalie (Saskia Reeves), a restless young woman who drifts from job to job, and her slightly younger brother Richard (Clive Owen) almost makes sense. In a world where nature seems to have slipped out of balance, it is a way of unconsciously affirming the general state of disorder.

"Close My Eyes," which opens today at the Quad Cinema, begins with a sequence of flashbacks that reveal Natalie and Richard to be smart, attractive people who have drifted for years without a guiding focus. Natalie has always flirted recklessly with her brother, and one day a lingering kiss precipitates a ravenous mutual passion.

•

Complicating matters is the fact that Natalie has finally settled down with someone. Her husband, Sinclair (Alan Rickman), an heir to a margarine fortune, is a garrulous businessman who lives in a magnificent riverside mansion and works, as he puts it, in "trends and analysis." Although Natalie and Richard fight against their attraction, it proves overwhelm-

Castle Hill

Alan Rickman

ing. And in their clandestine rendezvous they tear at each other with the frenzy of wild animals. When Natalie finally decides to end the affair, Richard, who has given himself over completely to the relationship, begins to come apart, and an undercurrent of violence rises to the surface.

Mr. Poliakoff, a prolific English playwright whose dramas "Shout Across the River" and "American Days" have both had New York productions, has given his story a theatrical structure whose metaphors clunk a bit too heavily for the machinery not to seem overexposed. Yet the characters in the film's central triangle are drawn with an extraordinary depth and subtlety. Natalie, though beautiful and possessed of an aristocratic willfulness, is also shown to be socially and intellectually insecure. And in the company of the voluble Sinclair, who has an opinion about everything that crosses his line of vision, she is reduced to moody silences.

Richard is a brash, swinging bachelor with a social conscience, who as the affair begins, has taken a job with a regulatory agency that monitors the progress of a gargantuan development touted as "the new Venice." But as community-spirited as he is, he has as little success in forcing the unscrupulous developers to keep their word as he has in reining in his emotions once they have spun out of control. Richard's and Natalie's love scenes, and later their fight scenes, have a visceral energy that seems so spontaneous there are moments when one feels almost embarrassed to be caught watching.

Best of all is Mr. Rickman's Sinclair, who in a welcome departure from his usually sinister roles, gives the dilettantish husband many layers. Beneath a supercilious facade, he is as vulnerable as Richard. Indeed, one of the film's most striking qualities is its detailed observation of the ways in which two grown men of very different temperament become emotionally unstrung.

"Close My Eyes" is an unusually good-looking film. Witold Stok's photography gives the London suburbs a tropical lushness that is appropriate to the situation. And Michael Gibbs's throbbing semi-classical score helps keep the film's heated atmosphere well above 98.6 degrees Fahrenheit.

•

"Close My Eyes" is rated R (Under 17 requires accompanying parent or adult guardian). It includes explicit sex and nudity.

1992 F 21, C12:6

Radio Flyer

Directed by Richard Donner; written by David Mickey Evans; director of photography, Laszlo Kovacs; edited by Stuart Baird and Dallas Puett; music by Hans Zimmer; production designer, J. Michael Riva; produced by Lauren Shuler-Donner; released by Columbia Pictures. Running time: 120 minutes. This film is rated PG-13.

Mary	Lorraine Bracco
Daugherty	John Heard
The King	Adam Baldwin
Mike	Elijah Wood
Bobby	Joseph Mazzello
Geronimo Bill	Ben Johnson
Fisher	Sean Baca
Older Fisher	Robert Munic

By VINCENT CANBY

Richard Donner's "Radio Flyer" is one of those infrequent and embarrassing efforts of a perfectly adequate Hollywood director to make the kind of offbeat movie for which he has no aptitude at all. That's the only way to explain why this tale of childhood magic winds up being so bleak and gross.

"Radio Flyer" is a memory film, a story told on a sunny afternoon to two small boys to illustrate why it's important that promises be kept. By the end, though, the story can just as easily be read as a metaphor about a child's suicide, which doesn't seem to have been anybody's intention.

The main part of the film is set in the faraway 1960's, in California, where Mike (Elijah Wood), who is about 11 years old, and his younger brother, Bobby (Joseph Mazzello), have moved from the East with their recently divorced mother, Mary (Lorraine Bracco).

•

As narrated by the adult Mike, played by an unbilled Tom Hanks, young Mike and Bobby so adore their mother and so treasure her new-found happiness that they can't bring themselves to tell her the truth about the man she marries on impulse (Adam Baldwin), who likes to be called the King.

The King pleasures Mary but when she's out of the house, putting in her double shifts as a waitress, he terrorizes the boys, especially the small stoic Bobby. Coming home from work, the King likes nothing better than to sit in front of the television set, get drunk and then beat Bobby.

Mike and Bobby retreat from the real-life monster at home into their shared fantasies. Overlooking a small airport, not far from their suburban house, there is a rocky promontory they call "the wishing spot," a secret place of refuge and hope. It was very high, says Mr. Hanks on the sound track, "but just a little too far from heaven for God to hear all our wishes."

When Bobby dreams of escape by actual flight, Mike works to make that dream come true. The boys set about to build a flying machine, a great, complex, gasoline-powered Rube Goldberg contraption, the purpose of which is to loft Bobby into the air and, apparently, freedom eternal.

"Radio Flyer," which takes its title from the little red wagon that is the heart of the flying machine, is both too literal and too fanciful. There may have been a good film in David Mickey Evans's screenplay, but it's unrealized by Mr. Donner, whose best work to date has been as the director of the two cynically funny and brutal "Lethal Weapon" movies.

Dealing with this delicate material, he is like someone trying to thread a needle while wearing boxing gloves.

Most of "Radio Flyer" is photographed as if from the point of view of the two boys. The King is never seen in full face. Yet it doesn't seem as if the boys are unable to look directly at him, but only as if he has just turned away from the camera when a scene begins.

•

Because the boys would probably be able to read every expression on the King's face, the decision not to show him to the audience appears to be an ill-chosen conceit imposed on the movie by the adults in charge.

A certain amount of idealization is inevitable in a memory work, but the quality of the imagination here simply isn't good enough to support the film's poetic aspirations. Even the narrative line is murky. One walks out of the film at the end not with lifted spirits but asking what, really, was supposed to have happened.

In addition to narrating the film, Mr. Hanks appears briefly in the framing sequences. John Heard, who receives star billing after Miss Bracco, comes on several times as a benign sheriff. Miss Bracco and Mr. Baldwin are little more than figures in a landscape. The two child actors are adequate.

•

"Radio Flyer," which has been rated PG-13 (Parents strongly cautioned), has several scenes of child and animal (pet dog) abuse that could frighten small children.

1992 F 21, C16:1

Falling From Grace

Directed by John Mellencamp; written by Larry McMurtry; director of photography, Victor Hammer; edited by Dennis Virkler; production designer, George Corsillo; produced by Harry Sandler; released by Columbia Pictures. Running time: 100 minutes. This film is rated PG-13.

Bud Parks	John Mellencamp
Alice Parks	Mariel Hemingway
Speck Parks	Claude Akins
Grandpa Parks	Dub Taylor
P. J. Parks	Kay Lenz
Ramey Parks	Larry Crane

By JANET MASLIN

"Falling From Grace," directed by John Mellencamp and written by Larry McMurtry, unfolds in an invitingly familiar corner of McMurtry country, where old flames burn forever and the small town has the pow-

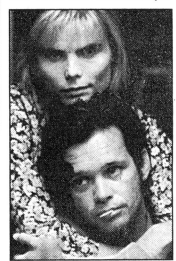

Columbia Pictures

Mariel Hemingway and John Mellencamp

er of a magnetic field. The town in this case is Doak City, somewhere near Indianapolis, and the original home of Bud Parks (Mr. Mellencamp), a big singing star.

Bud, one of Mr. McMurtry's familiar prodigal celebrities, is returning to the scene of his early experience, a scene populated by many other fixtures of Mr. McMurtry's, from the sister who sits crying quietly at her breakfast table to the rich, idle, faithless wife who declares: "Now I may not get exactly what I want, but I'm not gonna be bored. In this town, that takes a certain talent."

Once Bud is drawn back to Doak City, traveling with his young daughter and the smashing, leggy blond wife universally referred to as "that California girl" (Mariel Hemingway), he is drawn back into the past. Systematically, he pays visits to the favorite haunts and formidable figures of his early years, from the randy grandpa (Dub Taylor) to the bullying father (Claude Akins) to the old sweetheart (Kay Lenz) who still loves him after a fashion even though she happens to be married to his brother. "Well, you sure are a *nervous* adulterer," she says once they have resumed their affair, speaking with Mr. McMurtry's typical sparkling nonchalance.

•

Mr. McMurtry and Mr. Mellencamp joined forces to set "Falling From Grace" in Seymour, Ind., which in fact is Mr. Mellencamp's hometown; Mr. McMurtry visited Seymour before writing his screenplay. As a result of this and the various contributions of cast members (some, including John Prine, have supplied songs heard on the soundtrack), "Falling From Grace" has a folksy, collaborative feeling that works well with Mr. McMurtry's rue-

ful ideas about guilt, redemption and the impossibility of recapturing the past.

Mr. Mellencamp's direction, like his muted performance in the central role, reflects an affecting earnestness. The inexperience is evident as well, particularly in the film's structure as a string of two-person conversations, with Bud drifting from pool hall to fishing hole to beauty parlor and so on, searching vainly for something with which he can make contact. Even when the screenplay erupts into action, as it does occasionally, the film feels quietly static most of the time. In the end, "Falling From Grace" is more a series of separate reflections than a sustained story.

But Mr. Mellencamp does bring out the naturalness of his actors, and he has assembled a large and believable cast. Although his own performance is often passive, he is surrounded by characters who have a galvanizing effect. Chief among these are Ms. Hemingway, who brings an urgency to a role that might otherwise be merely decorative, and Mr. Akins, as the overbearing father who is most proud of his illegitimate child, and who likes to speak of parenthood in terms of fillies and sires.

Ms. Lenz, whose role most strongly recalls other McMurtry characters on screen (particularly Ellen Burstyn's Lois Farrow in "The Last Picture Show"), has this story's liveliest lines. "Speck's a force of nature," she tells an understandably troubled Bud about his father. "I just happened to lie in his path."

•

"Falling From Grace" is rated PG-13 (Parents strongly cautioned). It includes profanity and sexual situations.

1992 F 21, C16:5

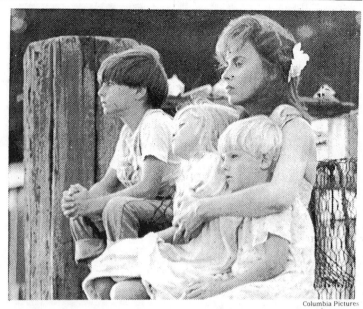

Columbia Pictures

Kate Nelligan with, from left, Grayson Fricke, Tiffany Jean Davis and Justen Woods in "The Prince of Tides"—Comforting style.

pressures, a strain that would not be entirely alleviated by motherhood or by finding Mr. Right.

One need not fully subscribe to the idea of a concerted anti-feminist wave, as detailed by Susan Faludi in her recent

The emotions of old-fashioned women's movies are back.

book "Backlash: The Undeclared War Against American Women" to see a clear pattern emerging. Women in movies, like their real counterparts, lately find themselves torn between the professional and the private, between ambition and love, between family or friendship and career advancement. And they must do what they can to achieve some sort of balance. If real women are turning out in large numbers to watch these stories, no wonder. They're being offered both glamorous escapism and a hard look in the mirror.

Unlike Thelma and Louise, who dropped right out of their everyday lives in reaction to such stress, most of this season's heroines have elected to stay and struggle. Women's pictures of the past may have emphasized the virtues of noble self-sacrifice, but in this day and age taking the "Stella Dallas" route would look absurdly self-serving. So Bette Midler, whose "For the Boys" is a marked departure from her own unlikely "Stella Dallas" remake of 1990, plays a smart, determined U.S.O. entertainer who seems to have successfully submerged all her private interests, even the raising of her young son, for the sake of her career. Unlike women's-picture heroines of the past, she does not blame herself for a family tragedy when it strikes. She does not see a cause-and-effect relationship between her desire for independence and her misfortune. Refreshing as it is, that kind of toughness hurt "For the Boys" at the box office, since it is unleavened by much

of the warm-hearted window dressing fundamental to the women's-picture ethos. Unlike many of its box-office rivals, "For the Boys" does not hinge on the idea that close family ties and emotional honesty are the only keys to a happy life.

(It should be pointed out that this domestic-minded vision is not a sexist, second-class view of feminine concerns, or at least that it's an equal-opportunity form of condescension. A number of recent films about men, from "Regarding Henry" to "The Doctor" to much of "Hook," have taken much the same attitude. Their heroes have rediscovered the values of families, leisure time and love ones after dropping out of their soulless professional lives.)

But it takes a true women's picture, like Barbra Streisand's skillful adaptation of "The Prince of Tides," to present that viewpoint with a sufficiently high gloss. Even though this

Kerry Haynes/20th Century Fox

Julie Kavner in "This Is My Life"—The heroine's goals aren't ordinary.

FILM VIEW/Janet Maslin

Get Out Your Hankies; Women's Movies Are Back

THE STATE OF MANY CURrent American films is enough to make audiences cry, which is precisely the effect intended. Strong emotions are back in style, as are tumultuous romances, family quarrels, tearful reunions and the kinds of scenery and costume that give such moments added decorative interest. There's an old-fashioned name for this set of cinematic conventions, and it's applicable even when the subject is career meltdown rather than star-crossed love. These are what were once called women's pictures, though much of the weeping is now about professional problems—and the main characters sometimes happen to be men.

Women's pictures have been out of fashion for so long that the present resurgence — with films like "Fried Green Tomatoes," "The Prince of Tides," "For the Boys," "Shining Through," "Hard Promises," "This Is My Life" and even "The Hand That Rocks the

Cradle" and the remake of "Father of the Bride" —comes as a genuine surprise. It can be ascribed in part to a widespread softening of 80's winner-take-all attitudes, with women playing more kindly, less cutthroat characters than their aggressive male forebears. There is also Hollywood's recession-minded realization that women may be worth more as ticket buyers in the audience than as bubble-brained temptresses on screen.

But perhaps the best explanation for this new round of women's pictures is a new set of problems that real women find themselves trying to cope with, problems that are easily dramatized and guaranteed to generate viewers' sympathies or even fears. Most of the heroines of these new films are fighting some sort of uphill battle for self-expression, in sharp, unsentimental ways that have not often been explored on the screen. And most are experiencing the kind of strain that has its roots in career

film, like the novel by Pat Conroy from which it is adapted, centers on a man's experience, and even though its heroine is briskly professional, its prevailing sensibility is almost stereotypically feminine.

There is the dark sexual history; there is the anguished rush of painful family memories; there is the hint of romantic tension between the crisp, attractive psychiatrist and her patient's handsome brother; and there is the consistent visual appeal of sets, costumes and landscapes to make the characters' emotional progress that much more seductive. As befits the women's-picture formula, the handsome visual style is a constant comfort, even when the content becomes particularly wrenching.

Only in its final phases, with a weekend-long romp in the country and a tearful parting, does ''The Prince of Tides'' cross the line and become a women's picture that plays to women in the traditional soapy way. Until that juncture, it does a remarkably good job of translating the women's-picture sensibility into terms that can appeal equally well to men and women. And the psychiatrist, played by Ms. Streisand, remains a much more restrained character on film than she was on the page.

■

It may be a staple of the old-fashioned women's picture that a career woman like this should secretly yearn for sexual fulfillment and escape from an unhappy marriage. But it's a staple of the newer women's picture that love should not be allowed to conquer all and that the professional woman, despite some rather glaring breaches of professional ethics, should sustain some semblance of her independence all the way through.

Universal

Kathy Bates and Jessica Tandy in "Fried Green Tomatoes"—The characters they play share a friendship forged in the shadow of another woman's inspiring example.

In ''Fried Green Tomatoes,'' the sleeper of the Christmas season and the most frankly feminist film around, a tough young heroine named Idgie Threadgoode (Mary Stuart Masterson) is seen as a figure way ahead of her time. She fights to run a business and live an iconoclastic life despite the conventional mores of her neighbors in a small Southern town. The feistiness of this struggle is bal-

anced by a funnier, more lighthearted tale of two women's friendship set in the present, a friendship forged in the shadow of Idgie's inspiring example.

While the contemporary story must strain to be charming (despite the effortless grace of Jessica Tandy as the peppery old woman who tells Idgie's story), the flashback sequences are far more riveting and unusual. Idgie's fierce devotion to her

friend Ruth Jamison (Mary-Louise Parker) suggests a powerful sexual attraction between the two young women. And if the film avoids addressing that directly, it still achieves an air of candor. Idgie is equally free-spirited in running her restaurant, or in bucking the racial attitudes that her white neighbors take for granted.

A women's picture of the past might well have lionized someone like

Keith Hamshere/20th Century Fox

Melanie Griffith in "Shining Through"—An up-to-the-minute heroine who is caught up in the chicanery of a traditional weepie.

Idgie, but not without questioning her apparent lack of husband, family or conventional happiness. (This film's footnotes in that regard are thoroughly unconvincing.) Instead, "Fried Green Tomatoes" appreciates her courage, credits her accomplishments, and understands what vast reserves of energy she must have needed to fight the status quo. Here and in "This Is My Life," Nora Ephron's film about an aspiring stand-up comedian named Dottie Ingels (Julie Kavner) and her two young daughters, it is understood that a heroine need not aim for ordinary, socially acceptable goals to feel that her ambition is legitimate.

■

Indeed, there's something frighteningly frank, in the otherwise very funny "This Is My Life," about a woman who would expect her daughters to share her elation over being flown from her New York home to California for a long absence and a chance to appear on a late-night television show. In a women's film of the past, a mother like this would have been punished mightily for leaving home for such flagrantly selfish reasons. In "This Is My Life" she is

One factor in the resurgence is a softening of 80's winner-take-all attitudes.

punished also, but by her children's indignation and her own guilty conscience rather than by any stray thunderbolt of fate. This film takes

the novel and no doubt realistic stance that her independence really is selfish, and yet is also somehow necessary to her survival.

For all its humor, which at times unduly overpowers its seriousness, "This Is My Life" is a women's picture in a tough new mold: a film about (and in this case also by) smart, interesting women willing to face up to the consequences of their ambitions and shortcomings. The women's picture is headed for new territory here. But it has not given up its toehold on the familiar turf of "Shining Through," in which a foxy legal secretary uses her linguistic and culinary skills to wow men on two continents and penetrate the heart of the Third Reich.

"Shining Through" is enough of a throwback to insist that true love come out of all this chicanery, but it also tries to affirm that its heroine has her up-to-the-minute side. When her exploits are finally presented to posterity, the appropriate setting is deemed to be a television talk show. And Mr. Right (Michael Douglas), a war hero who looks decidedly less dashing wearing glasses and a sweater than he did in uniform, has been shunted off to the sidelines.

What did he do, after all, besides look important, hold up his half of the bedroom scenes and save her life at the last minute? She was the one who turned heads, hid secret messages inside dead fish, burned the main course at an important Nazi's dinner party and escaped in the middle of the night wearing an outfit Cinderella would have killed for. In the world of the old-fashioned women's picture, those are the things worth talking about. Those are the reasons she's a star. □

1992 F 23, II:13:1

FILM VIEW/Caryn James

'Voyager': Good Crew, Slow Trip

AN OPTIMIST COULD DESCRIBE "VOYAGER" AS what might have turned out if Gary Cooper had wandered into a Bertolucci or Antonioni film. It would have been a happy if unlikely accident. Sam Shepard has never given a more complex or impressive performance than he does here, as a world traveler named Walter Faber, an iconic, Cooperesque American, tough on the outside but sensitive on the inside. Faber learns in the most painful manner that he cannot shut off his emotions or control his fate.

But let's face it: "Voyager" is also unfashionably elliptical and slow, filled with dialogue rather than blazing action. It's no mistake that the film brings to mind a dead actor and a European directorial style that was popular 20 years ago. And though "Voyager" is an English-language film, it is the kind of project that seems to have been spawned by a United

Nations committee. A French-German co-production, the film was directed by the German Volker Schlöndorff and adapted by the American Rudy Wurlitzer from the novel "Homo Faber," by the Swiss writer Max Frisch. These elements add up to a pessimist's description, sure to convince audiences that it's nap time, or at least time to rent "Terminator 2" again.

The dueling descriptions, each with its measure of truth, suggest that "Voyager" is not to everyone's taste. Yet they also point to a stylistic battle within the film itself, one that implies how perilous it is for a work to model its tone on the personality of a repressed hero.

Faber narrates the film in a series of flashbacks. He is speaking in April 1957, sitting in an airport, mourning the death of a woman whose relation to him becomes clear as he recalls the previous months. As he reconstructs his meeting with Sabeth (Julie Delpy) and their love affair, he also flashes back, in black and white, to his youth in the late 1930's.

"Voyager" is slow, stately and unruffled, even when Faber's plane crashes. That manner reflects the character, who has just described himself to his seatmate as a man who doesn't read fiction and doesn't dream, and who then calmly calculates where their plane will come down.

Though Faber insists he is a technocrat, the flashbacks to the 1930's — when he had an affair with his best friend's fiancée, who became pregnant with Faber's child but married the friend anyway — reveal that his lack of passion and imagination is a protective shield built up over the past 20 years.

Castle Hill Productions

Sam Shepard as Walter Faber in "Voyager" Tough on the outside, sensitive on the inside.

For a long while, the film manages to be livelier than its hero, largely thanks to Mr. Shepard. Though Faber is Swiss in the novel, casting Mr. Shepard and turning the character into an American was an inspired move. With his 1950's fedora and impassive face, he looks and sounds like the old-fashioned, terse masculine ideal. Still, his intense eyes and his very presence (we know, after all, that he is one of the finest playwrights of his generation) suggest more depth than Gary Cooper ever did. Sam Shepard is an intelligent icon who depicts the complex currents beneath the still surface of "Voyager." It may be a role he can do in his sleep by now; it's no less trenchant for that.

This subterranean approach to Faber's emotions works only as long as his shield of logic is in place. When he begins an affair with the much younger Sabeth and loses his steely control over his feelings, the film fails to loosen up with him. Faber never does become a wild man, but he becomes con-

Volker Schlöndorff's drama shows how perilous it is for a movie to let a repressed hero set the tone.

siderably warmer than the film.

"Voyager" maintains its cool surface long after the audience is itching for it to reflect the hero's resurfacing passion. Not long after Faber and Sabeth's affair had begun on screen, a man in the audience at one recent show said, "His

daughter, huh?'' He was picking up precisely the question the film dangles in the air at that point and doesn't answer until much later. But while "Voyager" raises the possibility of unwitting incest (Sabeth does look awfully like the woman in those flashbacks), it proceeds as if the audience weren't meant to notice. The film seems to assume that viewers are as blind to the possibility as Faber, a tactic that only makes "Voyager" seem confused.

While Faber and Sabeth are flirting on an ocean liner, driving through Italy or swimming in the Aegean, the film maintains its detached manner. "You do love me; I see it in your eyes,'' says Sabeth. "Why are you trying to hide it?" Unfortunately, Faber's back is turned to the camera. It would have helped if we had been able to see that struggle in his eyes, too, instead of having Sabeth talk about it.

When emotions explode at the end, the scene is meant to carry the weight of a long-delayed eruption. By then, however, too much tension has been sacrificed in the interest of maintaining Faber's cool manner.

Certainly, the film makers must have thought that the dialogue would be more compelling than it is, creating a lively surface. Sabeth tells Faber that in Latin his name means "forger of his own fate." Faber wonders pointedly whether life is just chance, a series of coincidences. Such dialogue hovers over "Voyager" without ever connecting to it. Faber himself, the man who regains his passion with deadly results, provides the only true interest, quite apart from the film's philosophical musings or its allusions to Greek tragedy.

Faber is a mysterious, wounded figure, whose sorrow does not seem to reflect fate, the gods or anything except itself. Despite the film's flaws, this hero manages to save "Voyager," even if he cannot save himself.

1992 F 23, II:13:5

You've Seen the Movie, Now Read the Book

By JANET MASLIN

READING the book on which a movie is based always reveals something the ordinary moviegoer wouldn't know. It may be as simple as a tip on how to prepare grits. (Fannie Flagg's "Fried Green Tomatoes at the Whistle Stop Cafe" comes with recipes, along with the news that grits keep you regular.) Or perhaps it's the fact that most of the story (i.e., the first three-quarters of Susan Isaacs's "Shining Through," or the second half of Oscar Hijuelos's Pulitzer Prize-winning novel "The Mambo Kings Play Songs of Love") never made it to the screen. It could even be the odd fact that a book (Meg Wolitzer's "This Is Your Life") en route to the movies (Nora Ephron's "This Is My Life") got a slightly different name.

Going back to the source material is a fine way of second-guessing why film makers did what they did and what they should have done instead. Whatever the literary merits of comparing a book with its screen adaptation, it does make for an irresistible sideline. After all, Monday-morning quarterbacking has as legitimate a place among moviegoers as it does anywhere else. In other words, it may not be helpful, and it's certainly not fair, but it's here to stay.

An unusually large assortment of current films have their origins in familiar fiction, albeit fiction of widely varying caliber; there's a big range between E. M. Forster and Fannie Flagg. But as any aficionado of film adaptations can point out, there is absolutely no correlation between the merit of a book and the reasonableness of what has been done to it. The best movies often come from unlikely literary sources, but whatever the original material, the film makers' ingenuity is critical. A truly inspired screen adaptation, like "The Silence of the Lambs," must capture the essence of a seemingly unfilmable story without losing any of its texture or detail.

Even in that case, reading Thomas Harris's book (published by St. Martin's) reveals the kind of deductive reasoning, forensic data and character observation that simply couldn't be compressed into two hours' screen time. And most of the time, while making its way to the screen, a book changes more drastically than that. Vital bits of information are usually altered or eliminated for the sake of the film's overall scheme. So Ms. Flagg's "Fried Green Tomatoes at the Whistle Stop Cafe," a folksy, unusual novel that provides the film version with its two-tiered structure and its odd blend of cruelty and humor, abandons a strong story about its black characters to make room for the four white women who dominate the film.

In Ms. Flagg's version (published by McGraw Hill), two of those women are clearly lovers, which makes more sense than the film's relatively indirect account. Idgie Threadgoode and Ruth Jamison, on whom the 1920's portion of the film is centered, live together openly, experience some friction over Idgie's affair with another woman, and speak of themselves as the two parents of Ruth's son. Their willingness to flout convention is thus even more impressive to Evelyn Couch, whose feminism in Ms. Flagg's present-day story is a shade stronger than it is in the movie. Evelyn's battle cry to a rude young woman whose car she wrecks — "Let's face it, honey, I'm older than you are and have more insurance than you do" — clearly comes from Ms. Flagg.

The book's ending is also different from the movie's; it never stages a sentimental reunion between the story's two present-day women, and never raises the film's suggestion that two key characters' identities are intertwined. Ninny Threadgoode, who tells Idgie's story in the film and seems actually to be Idgie by the end of it, is clearly identified as Idgie's sister-in-law on the page. A long string of newspaper clippings from Whistle Stop, Ala., has also been dropped.

As in many film adaptations, time poses a problem, and it has been drastically compressed. In Ms. Flagg's book, Idgie's trial in the murder of Ruth's husband takes place in

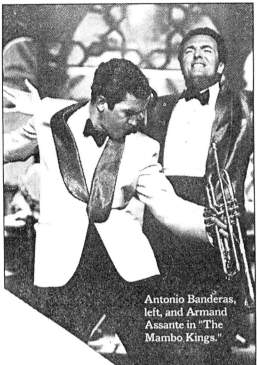

Antonio Banderas, left, and Armand Assante in "The Mambo Kings."

Kerry Hayes/20th Century Fox
Julie Kavner as Dottie Ingals, a stand-up comic, in "This Is My Life."

1955, 25 years after the crime. The movie makes no attempt to match the book's 59-year span, and so the film's trial seems to occur only a few years after the murder. A similar time problem affects "The Mambo Kings Play Songs of Love," another book narrated in flashback by an elderly contemporary character, in this case Cesar Castillo, one of the Mambo Kings of the title. The movie is much too jubilant and upbeat to make room for Cesar's long downhill slide into heavy drinking, health problems and career oblivion. Cesar's 20-year stint as a building superintendent has no place in the movie.

•

Adapting this long, crowded novel (HarperCollins) posed particular problems, since the book's period detail is so dense it sometimes calls for lengthy footnotes about Cuban-American music and culture in the early 1950's. Arne Glimcher, who directed the film, has dealt with that by letting the mambo speak for itself, loud and clear. The film version, written by Cynthia Cidre, virtually abandons all hope of capturing Mr. Hijuelos's story, instead extracting a lot of its vitality and the bare bones of a family drama. Vast amounts of family history have been dropped.

This may disappoint Mr. Hijuelos's readers, but it's almost a relief not to find the film imparting too much of a mythic dimension to Desi Arnaz, who figures prominently in the novel. Besides, the film's fiery, impassioned style — best embodied by Armand Assante doing the mambo on a nightclub dance floor — works on its own.

Noticeably missing from the film are Mr. Hijuelos's lengthy, graphic descriptions of practically every sex act in which Cesar or his brother Nestor ever participated. The film has its bedroom scenes, but they are often connected with a more generalized joie de vivre. ("I love this country!" Cesar exclaims in the midst of one heated encounter.) After all, the novel's machismo is so intense that in a scene involving Arnaz and Lucille Ball, America's favorite comedienne is described mostly as "his wife" and talks only about Cuban cooking. Only late in the story does all this begin to seem empty to Cesar, and the movie has no time for such regrets.

•

"This Is My Life" is another film that dispenses with the downbeat side of its original story, in this case the slow decline of a comedy star. The film concentrates on the meteoric rise of Dottie Engels (whose last name has been changed to Ingals) and ignores the fact that most of her jokes are about being fat. In Meg Wolitzer's book (Penguin), Erica, Dottie's older daughter, also has serious weight problems and at one point even attempts suicide, but on screen (as played by Samantha Mathis) she is attractively svelte. The film ends with Dottie still a big star, and with no suggestion that she will ever be otherwise. But the book chronicles her daughters' difficult relations with their mother and each other after they grow up, and leaves Dottie in a clinic coping with her health problems.

The film, directed and co-written by Nora Ephron, does a fine job of extracting the workable and funny aspects of this story. Some of Ms. Wolitzer's humor happens to dovetail perfectly with the director's, like her

description of T. S. Eliot night at a private school, with three little girls dressed as Hollow Men. When a book includes such funny touches, it's madness not to use them, and yet David Seltzer's film version of "Shining Through" manages to lose all the humor of Susan Isaacs's savvy novel. Even stranger than that is the film's insistence on jettisoning the most enjoyable parts of the story.

Ms. Isaacs's book (Ballantine) spends most of its time in New York City, describing the steamy affair between Linda Voss, a smart-talking legal secretary, and the handsome boss named John Berringer, whom she eventually marries. The story gets an added element of sexual tension from Edward Leland, John's dashing, prominent ex-father-in-law, when Linda also seems to catch his eye. All of this is missing from the movie, in which John and Edward have been rolled up into the same not terribly interesting character, played by Michael Douglas. The film concentrates chiefly on Linda's later adventures as a spy in Nazi Germany, but it manages to rob her of her intelligence even in that capacity. The film's Linda, played by a purring Melanie Griffith, would be incapable of the sharp, acid observations made by Ms. Isaacs's heroine.

•

Sometimes heroines do actually get smarter when they reach the screen. Dr. Susan Lowenstein, the crisp psychiatrist played by Barbra Streisand in "The Prince of Tides," is a big improvement over her coy, flirtatious counterpart in Pat Conroy's novel. In fact, this is a case in which everything about a wildly overwritten book (Bantam) has been improved by the process of condensing it into film. No movie could accommodate Mr. Conroy's incessantly purple prose. ("The music blended · and coalesced; it asked questions in phrases of honey and milk, then answered them in storm," he writes of a Vivaldi recital.)

Instead, the film version of "The Prince of Tides" extracts his best dialogue, boils down his liveliest anecdotes to their essentials and drops the extra hyperbolic touches that spoil many of his stories. In the book's pivotal episode of sexual abuse, the perpetrators wind up being mauled by a pet tiger. In the movie, fortunately, that tiger is seen in a cage and only fleetingly, during a snippet of home movies.

The worst reason for turning from a film to its book equivalent is if you simply don't know when to give up (e.g. "Wayne's World," published by Hyperion, an unfunny collection of lists and outtakes making it clear that Wayne and Garth are strictly a visual phenomenon). The best reason, as with E. M. Forster's "Where Angels Fear to Tread" (Vintage), is to return to the purely literary aspects of a story, the ones that provide its nuances and elude most film makers' grasps. At a climactic moment in "Where Angels Fear to Tread," after a terrible tragedy, the film offers a haunting tableau in which Caroline Abbott (Helena Bonham Carter) seems to be offering silent comfort to a grieving man. At this point, the film speaks powerfully, but it doesn't begin to speak like this:

"All through the day Miss Abbott had seemed to Philip like a goddess, and more than ever did she seem so now," Forster wrote of that moment. "Her eyes were open, full of infinite pity and full of majesty, as if they discerned the boundaries of sorrow,

and saw unimaginable tracts beyond. Such eyes he had seen in great pictures but never in a mortal. Her hands were folded round the sufferer, stroking him lightly, for even a goddess can do no more than that."

1992 F 28, C1:1

The Mambo Kings

Directed by Arne Glimcher; screenplay by Cynthia Cidre, based on the novel "The Mambo Kings Play Songs of Love" by Oscar Hijuelos;. director of photography, Michael Ballhaus; edited by Claire Simpson; production designer, Stuart Wurtzel; produced by Arnon Milchan and Arne Glimcher; released by Warner Brothers. Running time: 100 minutes. This film is rated R.

Cesar Castillo	Armand Assante
Nestor Castillo	Antonio Banderas
Lanna Lake	Cathy Moriarty
Delores Fuentes	Maruschka Detmers
Desi Arnaz Sr.	Desi Arnaz Jr.
Evalina Montoya	Celia Cruz
Himself	Tito Puente
María Rivera	Talisa Soto

By VINCENT CANBY

About halfway through "The Mambo Kings," the adaptation of the Pulitzer Prize-winning novel by Oscar Hijuelos, there is a brief moment in which all of the elements work as they were meant to. At a wedding reception, Celia Cruz, the veteran salsa performer who appears as a Harlem nightclub owner, can't restrain her good feelings.

Yet the Cuban-born Miss Cruz is a figure of light and shadow, a one-woman definition of chiaroscuro. Her broad smile, the lightness of her walk, the easy way she carries herself become an expression of the exuberant Latin music that is the other side of the mismatched, melancholy lives of the film's Latin exiles.

Although the sequence is a good one, it probably should have been cut and burned. It suggests everything that is otherwise missing from "The Mambo Kings," a handsome production that has been directed with no élan whatsoever by Arne Glimcher, the New York art-world figure. Mr. Glimcher, the director and founder of the Pace Gallery in Manhattan, has

Momentary good feelings in melancholy lives.

lately been dealing in movies, first as a producer ("The Good Mother," "Gorillas in the Mist") and now as a director.

There is a lot of music in "The Mambo Kings," but it seldom animates this tale of two Cuban brothers who, in 1952, come to New York to cash in on the popularity of the Latin beat. It's as if there were a terrible telephone connection between the film's vivid sound track and its tepid romantic melodrama, to which the music is supposed to give style and substance.

•

Like its title, "The Mambo Kings Play Songs of Love," the Hijuelos novel has been boiled down and unimaginatively straightened out in Cynthia Cidre's screenplay. Cesar Castillo (Armand Assante) drags his

Warner Brothers

Cathy Moriarty

younger brother, Nestor (Antonio Banderas), with him to New York after Nestor's life is threatened by the new husband of Nestor's true love, María (Talisa Soto). Nestor doesn't know this and so is resentful of his adoring older brother's high-handedness.

For Cesar, New York in the early 1950's is the promised land of beautiful easy women and the possibilities of stardom to equal Tito Puente's. He forms a band, the Mambo Kings, which earns a certain amount of success, although Cesar refuses to cooperate with the underworld characters who control the club scene. He works hard, drinks hard and takes life as it comes.

Nestor is the sad one. He plays trumpet with the Mambo Kings and composes songs for the group, working mostly on one particular number in which he remembers his lost María. In the meantime, he meets and marries a sweet, pretty Cuban woman, Delores (Maruschka Detmers).

Nestor mopes. Cesar carries on with the blond and pliant Lanna Lake (Cathy Moriarty), a good-time cigarette girl at the Palladium. Their career high point comes when Desi Arnaz (Desi Arnaz Jr.) drops into the Club Babalu one night, likes their sound and invites them to come on the "I Love Lucy" show.

This, in turn, is the most entertaining sequence in the movie, a simulation of an old telecast in which Mr. Assante and Mr. Banderas seem to be sharing the small screen with the great Lucille Ball. It's both technically expert and genuinely funny.

•

The rest of "The Mambo Kings" is an accumulation of unrealized aspirations. Mr. Assante, a good actor, seems either miscast or misdirected as the macho Cesar. He doesn't have the character's cheeky, comic, somewhat sleazy arrogance. There is no joy in either his music or his womanizing.

It's an introspective performance, as if keyed to Cesar as presented in the novel, most of which is recalled from the point of view of the sick, dying Cesar in 1980.

Mr. Banderas, whom Pedro Almodóvar has used effectively as a sex symbol in his Spanish comedies, and Miss Detmers, best remembered for Marco Bellocchio's "Devil in the Flesh," are self-effacing ciphers. Only Miss Moriarty, as Cesar's gutsy companion, is thoroughly at ease, although Miss Cruz somehow rivets attention the few times she comes onto the screen.

Mr. Glimcher has surrounded himself with a number of excellent associates, including the cinematographer Michael Ballhaus, but money cannot buy an artist's vision or a point of view. The novel's heart and soul have vanished. There are times when the director doesn't even seem

to know where to put the camera. Scenes unravel without dramatic point. No amount of breathless editing and fancy graphics can disguise the amateur nature of the enterprise.

•

"The Mambo Kings" is rated R (Under 17 requires accompanying parent or adult guardian). It includes partial nudity, simulated sex and vulgar language.

1992 F 28, C8:1

Amazon

Directed by Mika Kaurismaki; written by Mr. Kaurismaki and Richard Reitinger; director of cinematography, Timo Salminen; edited by Michael Chandler; music by Nana Vasconcelos; produced by Pentti Kouri and Mr. Kaurismaki; released by Cabriolet Films. At Angelika Film Center, Mercer and Houston Streets, Manhattan. Running time: 90 minutes. This film has no rating.

Dan	Robert Davi
Paola	Rae Dawn Chong
Kari	Kari Vaananen
Nina	Minna
Lea	Aili Sovio
Julio Cesar	Rui Polanah

By VINCENT CANBY

"Amazon," a Finnish film made in Brazil with a mostly English-language sound track, is another exotic-looking, earnestly considered plea by well-meaning outsiders to save the Amazon rain forest. It opens today at the Angelika Film Center.

The director is Mika Kaurismaki, the brother of Aki Kaurismaki, Finland's better-known director. The screenplay is by Mika Kaurismaki and Richard Reitinger, who collaborated with Wim Wenders on the script for "Wings of Desire." By any Kaurismaki standards, "Amazon" is quite conventional, though it has a nicely casual way of dealing with the clichés of the screen's pro-environment literature.

•

The story is about a Finnish bank executive who, after the death of his wife following an automobile accident, flees to Brazil with his two teenage daughters. Robbed of his financial assets on the streets of Rio, the fellow takes off with his daughters to the interior, where he suffers all sorts of indignities and has at least one epiphany. He lives with a tribe of Stone Age Indians who teach him about nature and finds love and redemption in a tiny diamond-mining village.

"Amazon" is not the most exciting movie ever made, but it doesn't push. It is laid back. The flora and fauna are interesting and the cast is attractive. The principal actors are Kari Vaananen, who plays the banker; Robert Davi as an American bush pilot who befriends the Finnish father and his daughters, and Rae Dawn Chong, who plays a Brazilian school teacher and staunch environmentalist.

The English dialogue is flat-footed. "Hope was a luxury no one could afford in the Amazon," says the sound track narrator, a character who continues to chat away long after he has died.

1992 F 28, C8:5

Under Suspicion

Written and directed by Simon Moore; director of photography, Vernon Layton; edited by Tariq Anwar; music by Christopher Gunning; production designer, Tim Hutchinson; produced by Brian Eastman; released by Columbia Pictures. At the Beekman, Second Avenue and 65th Street, Manhattan. Running time: 99 minutes. This film is rated R.

Tony	Liam Neeson
Angeline	Laura San Giacomo
Selina	Alphonsia Emmanuel
Frank	Kenneth Cranham
Hazel	Maggie O'Neill

By VINCENT CANBY

Simon Moore, an English playwright and television dramatist, makes his theatrical film debut as the writer and director of "Under Suspicion," a taut and entertaining mystery melodrama set in the English Channel resort city of Brighton in 1959.

The year is important. The death penalty was still in effect. England's divorce laws had not yet been changed, and adultery was still the favorite ground for dissolving a marriage.

All that had to be done was arrange for the husband to be surprised in bed with a woman and photographed in a facsimile of flagrante delicto. To this end, a thriving if illegal mini-industry grew up around entrepreneurs who, for a fee, would book hotel rooms for clients, supply stand-in lovers and then take the required pictures.

Such a fellow is Tony Aaron (Liam Neeson), a seedy private eye who two years earlier was asked to resign from the Brighton police force. At that time a colleague was killed when Tony was caught in serious flagrante delicto with the wife of a man he was supposed to be watching.

•

When "Under Suspicion" begins, Tony and his wife, Hazel (Maggie O'Neill), the woman with whom he was caught, are running their own divorce scam in Brighton. Thus imagine Tony's horror when, in the course of a perfectly routine business arrangement, he bursts into a hotel room to take a picture of the client with Hazel and finds them both murdered. The client's thumb has also been amputated.

•

The chief suspect is Angeline (Laura San Giacomo), the American mistress of the murdered man, a hugely successful artist. Angeline, in turn, suspects Selina (Alphonsia Emmanuel), the artist's jealous wife. Why the amputated thumb? The artist authenticated his work not by his signature but by his thumbprint.

Though recently bereaved, and not quite trusting Angeline, Tony falls into a heated affair with her. The evidence against Angeline piles up until there's a sudden break in the case that puts Tony himself under suspicion.

More cannot be said about the story except that it plays well until very close to the end. Mr. Moore is an efficient writer and director who doesn't waste time on superfluous details. He also has an excellent cast.

Mr. Neeson's Tony is an engaging second-rater who can never pass up a momentary pleasure. Miss San Giacomo is also good as a former art student who has come to enjoy life among the rich and famous. Kenneth Cranham plays Tony's pal, his mentor on the police force, who risks all to save Tony's life.

The film opens today at the Beekman.

•

"Under Suspicion" has been rated R (Under 17 requires accompanying parent or adult guardian). It includes some partial nudity, simulated sex scenes and vulgar language.

1992 F 28, C10:1

Where Angels Fear to Tread

Directed by Charles Sturridge; written by Tim Sullivan, Derek Granger and Mr. Sturridge; based on the novel by E. M. Forster; director of photography, Michael Coulter; edited by Peter Coulson; music by Rachel Portman; production designer, Simon Holland; produced by Mr. Granger; released by Fine Line Features. Running time: 113 minutes. This film is rated PG.

Caroline Abbott	Helena Bonham Carter
Harriet Herriton	Judy Davis
Phillip Herriton	Rupert Graves
Gino Carella	Giovanni Guidelli
Mrs. Herriton	Barbara Jefford
Lilia Herriton	Helen Mirren

By JANET MASLIN

E. M. Forster's characters violate all the rules of contemporary mainstream film making. Their thoughts are complicated, and not always honestly expressed. Their behavior can be misleading. Their problems are seldom resolved simply, and those resolutions that do occur are often too subtle to be dramatized with ease. Their inner natures, put through the prism of Forster's uncommon acuity, can yield startling moments of truth, and yet the process whereby those ideas are revealed is unfailingly gentle. It remains an unexpected delight that so much of this author's work has found its way to the screen.

Forster's first novel, "Where Angels Fear to Tread," is as enveloping as any of the other Forster books that have been filmed ("A Passage to India," "A Room With a View," "Maurice" and the masterpiece "Howards End," which will arrive here in a high-wattage Merchant-Ivory adaptation in two weeks' time). Its story of prim, provincial English characters who lose their bearings upon foreign soil will be instantly recognizable to admirers of Forster's work. The way the foreign land becomes a crucible for character, one in which the story's principals find themselves assessed and altered, will also have a familiar flavor.

This story's first innocent abroad is Lilia Herriton (Helen Mirren), a spirited 33-year-old widow who embarks for Italy amid the fussy ministrations of her late husband's family. After only an indecently short interval, the Herritons receive word that Lilia is engaged, allegedly to a member of the Italian nobility. Lilia's brother-in-law, Phillip Herriton (Rupert Graves), a lawyer deemed "the clever one of the family" by Forster, is dispatched to investigate. "It was the first time he had had anything to do," Forster wrote of Phillip and his mission.

Inside the walled Tuscan town of Monteriano, Phillip determines that Gino Carella (Giovanni Guidelli) happens to be the handsome 21-year-old son of an Italian dentist, and that he and Lilia are already married. This makes Phillip furious at Caroline Abbott (Helena Bonham Carter), who as Lilia's traveling companion and quasi-chaperone has failed miserably at

her appointed task. Of Caroline, Forster wrote: "She was good, quiet, dull, and amiable, and young only because she was 23. There was nothing in her appearance or manner to suggest the fire of youth."

But Caroline becomes deeply altered as this story unfolds, especially after Phillip angrily returns home to his mother (Barbara Jefford) and stern, joyless sister, Harriet (Judy Davis). Months later, back home in their suffocating village of Sawstonn, the Herritons learn that Lilia has died giving birth to Gino's son, and they determine to retrieve the baby. Phillip and Harriet return to the intoxicatingly beautiful Tuscan countryside, where they plan to introduce Gino to English ideas of right, wrong and responsibility. Much to the Herritons' surprise, both Gino and the still-present Caroline have their own ideas about those matters.

"Where Angels Fear to Tread" has been faithfully but unimaginatively directed by Charles Sturridge, whose previous credits include the listless film version of Evelyn Waugh's "Handful of Dust" and whose principal asset here is a very fine cast. The actors perform flawlessly even when the staging is too pedestrian for the ideas being expressed, and when the film's flat, uninflected style allows some of those ideas to be overlooked or thrown away.

Miss Bonham Carter in particular displays extraordinary intelligence and authority in a rewardingly delicate role. And Miss Mirren captures the streak of headstrong enthusiasm that leads Lilia to her fate. Mr. Graves finds the humanity in the dangerously fatuous Phillip, while Miss Davis turns the exaggerated shrill and repressed Harriet into a lively comic caricature. Mr. Guidelli charmingly embodies Forster's observation that "Italy is such a delightful place to live if you happen to be a man."

Mr. Sturridge's assault on his material is strictly frontal, with a screenplay (which he co-wrote with Tim Sullivan and Derek Granger) that adequately summarizes the novel but rarely approaches its depth. Although the film stumbles unimaginatively over some of Forster's more elaborate scenes (among them a carriage chase and a railway departure), and although it moves gracelessly back and forth between Italy and England, its most significant lapse is visual. Tuscany, as photographed by Michael Coulter, is never as ravishing as it deserves to be either for strictly scenic purposes or for illustrating Forster's view of Italy's magnetic allure.

Even so, the material and the performances often rise above these limitations. At its occasional best, "Where Angels Fear to Tread" even captures the transcendant aspects of Forster's tale. Outstandingly memorable is an opera-house sequence that vividly illustrates the differences between English and Italian temperaments. "These people know how to live," Phillip remarks, doubting the caliber of the production before he finds himself enjoying it thoroughly. "They'd sooner have a thing bad than not have it at all."

A stirring, reflective scene between Phillip and Caroline also stands out, in which Phillip observes: "I seem fated to pass through this life without colliding with it or moving it. I don't die. I don't fall in love. And when other people die or fall in love, they do it when I'm not there." Hearing the wistfulness and candor in this, Caro-

line offers exactly the right answer. Her reply is suffused with all the wisdom, generosity and tenderness that finally inform this story.

"Where Angels Fear to Tread" is rated PG (Parental guidance suggested). It includes one or two discreet sexual situations.

1992 F 28, C12:1

Memoirs of an Invisible Man

Directed by John Carpenter; screenplay by Robert Collector and Dana Olsen, and William Goldman, based on the book by H. F. Saint; director of photography, William A. Fraker; edited by Marion Rothman; music by Shirley Walker; production designer, Lawrence G. Paull; produced by Bruce Bodner and Dan Kolsrud; released by Warner Brothers. Running time: 99 minutes. This film is rated PG-13.

Nick Halloway	Chevy Chase
Alice Monroe	Daryl Hannah
David Jenkins	Sam Neill
George Talbot	Michael McKean
Warren Singleton	Stephen Tobolowsky
Dr. Bernard Wachs	Jim Norton

By JANET MASLIN

It is said of Nick Halloway (Chevy Chase), the title character in "Memoirs of an Invisible Man," that he "has the perfect profile: he was invisible before he was invisible." He had no particular convictions or interests beyond the mundane, and neither does this film about his adventures. As directed by John Carpenter, "Memoirs of an Invisible Man" does much more with special effects than it does with character, and even the visual tricks begin to seem commonplace when they've been repeated too often. Is it unfair to expect an invisible man to be something out of the ordinary?

True, invisible men can't do much besides spy and hide. And true, Mr. Chase is better and more substantial in this role than he has been in a long time. But "Memoirs of an Invisible Man" is bogged down by some standard-issue cloak-and-dagger shenanigans, and by the lack of much continuity or urgency from scene to scene. Each moment in Nick's newly invisible existence has been set up to allow for some new visual gimmick, not to advance his story or make it anything more than skin-deep. The story's greatest pathos emerges from the fact that Nick, hungry as he is, can't eat anything but clear foods if he wants to avoid detection.

Nick starts out as a securities analyst, the kind who's so busy and powerful that he talks business with his secretary while both of them are rushing down the hall. In this role, Mr. Chase is no less believable than Daryl Hannah is as Alice, a former lawyer turned brilliant documentary film maker. Nick and Alice are introduced at a men's club in San Francisco, where Alice is turning the dress code on its ear by wearing a very minimal gown. Dazzled by this, and by a torrid encounter with Alice in the ladies' room, Nick drinks too much and is miserably hung over the next morning. In that condition, he is too dazed to escape the mysterious, high-tech accident that renders him invisible.

One of the film's more remarkable visual accomplishents is its design for the building in which this mishap takes place. Large, jagged sectors of the building are rendered as invisible as Nick is. And the place takes on an otherworldly strangeness when it can be peered into through unexpected holes in the walls. Then there are the effects used to depict Nick's new condition, like the sight of bubble gum being unwrapped, chewed and blown by Nick's invisible mouth. Cigarette smoke can be seen going into and out of his lungs; toothpaste and foam can be seen moving somewhere near where his teeth ought to be; fire appears in his stomach when he has indigestion. When Nick runs down the street while peeling off his clothes, the clothes seem to have life and movement of their own.

These flourishes, painstakingly achieved by the magicians at Industrial Light and Magic (who covered Mr. Chase in a blue bodysuit, blacking out his eyes and teeth and tongue, to achieve some of the film's bluescreen trickery), are often more enjoyable to watch than the actors. A dull espionage plot has Sam Neill, as a corrupt C.I.A. mastermind, trying to catch Nick and turn him into a spy, which is a considerably less novel idea now than it was in H. G. Wells's day. Ms. Hannah looks great but makes a bland and none-too-clever Alice. Unlike Mr. Carpenter's enchanting "Starman," this film never generates much heat or affection between its stars.

Mr. Chase, to his credit, seems to be trying. Gone are the smirk and the flippant delivery of the past, although the pratfalls remain: this film finds endless occasions for the invisible Nick to collide with strangers on the street. This time Mr. Chase appears capable of taking himself more seriously, although it doesn't help to give him glib lines like "For years women have been telling me they can see right through me." The screenplay, by Robert Collector and Dana Olson, and William Goldman, from a novel by H. F. Saint, only occasionally shows signs of wit, as when a newly invisible Nick gives his name as Harvey.

Unlike the Invisible Man of the past, today's model wears wristbands and headbands with his sports attire; otherwise, not enough has changed. This film does generate some novelty with its scenic views of San Francisco, Salinas and the Northern California coast.

●

"Memoirs of an Invisible Man" is rated PG-13 (Parents strongly cautioned). It includes mild profanity and sexual situations.

1992 F 28, C17:1

Paper Mask

Directed by Christopher Morahan; written by John Collee; director of photography, Nat Crosby; edited by Peter Coulson; music by Richard Harvey; produced by Mr. Morahan and Sue Austen; released by Castle Hill Productions. At the Quad Cinema, 13th Street, west of Fifth Avenue, Manhattan. Running time: 105 minutes. This film is rated R.

Matthew Harris	Paul McGann
Christine Taylor	Amanda Donohoe
Dr. Mumford	Frederick Treves
Dr. Thorn	Tom Wilkinson
Celia Mumford	Barbara Leigh-Hunt
Alec Moran	Jimmy Yuill
Dr. Simon Hennessey	Dale Rapley

By JANET MASLIN

"Paper Mask," which opens today at the Quad Cinema, is the story of a medical fake whose willfulness knows no bounds. Originally a London hospital aide named Matthew Harris (Paul McGann), he takes on the identity of Dr. Simon Hennessey after Hennessey is killed in an accident. He then applies for a job at a hospital in Bristol without benefit of formal medical training, and quickly tries to achieve a minimal level of proficiency by tutoring himself. "I don't know what you see in these skinny women," says one of Matthew's friends when he finds a teaching skeleton hidden in Matthew's bed.

Bluffing his way into a privileged position — the camera lingers fondly on perks like "Doctors Only" signs in hospital parking lots — he does rather well, under the circumstances. Talent and luck are at least as important to Matthew's success as real knowledge would have been. Intuition helps, too; he is able to make a diagnosis of cirrhosis simply by spotting a bottle of liquor hidden in a patient's bed. Also immeasurably helpful is Christine Taylor (Amanda Donohoe), a smart, sexy emergency-ward nurse who seems at least as knowledgeable as most of the doctors working around her.

●

In its detailed depiction of hospital life and various medical crises, the generally engrossing "Paper Mask" has an authentic flavor. Written by John Collee, a doctor who is also a novelist and columnist, the screenplay captures the banter and bravado of young doctors, as well as the tension that would make an emergency ward such a nerve-racking place for on-the-job training. As directed by Christopher Morahan, whose credits include "Jewel in the Crown" for Grenada Television and the very funny film "Clockwise," "Paper Mask" moves briskly and does a lot to make its central character's improbable situation seem real.

But by the end of the story, in an effort to heighten this material's dramatic possibilities, Matthew's compelling mixture of sweetness and ruthlessness becomes unbalanced. Sheer ambition takes precedence, leading him to take deadly measures to hang onto his medical career. And at that point the film becomes too macabre to remain plausible. The story's last moments, however diabolical, are less interesting than the day-by-day details of Matthew's medical charade.

Mr. McGann, best known as the "I" of "Withnail and I," does a lot to make Matthew appealing, even when he is seen flushing a wristwatch engraved "Love Mom and Dad" down a toilet to dispose of his old identity. Mr. McGann so ably captures Matthew's opportunistic charm that it becomes difficult to dislike him, even when he turns out to be evil incarnate. Ms. Donohoe gives a lively, game performance and manages to look slinky even while wearing sensible shoes. Production notes point out that she has never had any interest in being a nurse.

Also in the film's solid cast of stage-trained actors are Tom Wilkinson and Frederick Treves as two senior doctors with reason to suspect the competence of "Dr. Hennessey," and Barbara Leigh-Hunt as Mr. Treves's kindly, devoted wife. Ms. Leigh-Hunt, who may be vividly remembered as a strangler's victim in Alfred Hitchcock's "Frenzy," doesn't fare much better this time around.

●

"Paper Mask" is rated R (Under 17 requires accompanying parent or adult guardian). It includes some gore, partial nudity and sexual situations.

1992 F 28, C19:1

Young Black Cinema

"Baobab," directed by Erik Knight; "Suspect," directed by Darnell Martin; "Occupational Hazard," directed by Eric Daniel; "Boss of the Ballet," directed by Lindley Farley; "Billy Turner's Secret," directed by Michael Mayson. At the Public, 425 Lafayette Street, Manhattan. Running time: 116 minutes. These films have no rating.

By STEPHEN HOLDEN

Far and away the most accomplished of the works showcased in "Young Black Cinema," a program of five short movies by black film makers that opened yesterday at the Public Theater, is Michael Mayson's "Billy Turner's Secret." The story of Rufus (Mr. Mayson), an ultra-macho ladies' man who discovers that his best friend, Billy, is gay, it offers a streetwise prescription for coping with intolerance. Rufus spews contempt and disgust at this revelation until Billy loses his temper and beats him up, and a subsequent physical attack by Billy's lover reduces Rufus to respectful contrition.

That tolerance can be enforced through physical intimidation may not be the most positive message for a film to send about human relations. But because the performances in the 25-minute vignette seem more lived than acted, Rufus's lesson in humility seems entirely believable. Mr. Mayson's streetwise dialogue and the camera's unobtrusive way of dropping in on the action enhance a brash, slice-of-life ambiance that recalls the playful Spike Lee of "She's Gotta Have It."

Although none of the program's four other offerings match Mr. Mayson's movie in deftness of pacing, each has its distinctive moments. Erik Knight's "Baobab" is an artfully edited exploration of his own racially mixed background (his mother is Norwegian, his father is from Barbados), stirring everything from old home movies to mystical shots of the Kenyan landscape into a poetically structured montage.

Eric Daniel's "Occupational Hazard" and Lindley Farley's "Boss of the Ballet" are crude but promising exercises in genre film making that take odd stylistic twists. "Occupational Hazard" tells a "Twilight Zone"-like ghost story of a teen-age boy's serial revenge from beyond the grave on the members of the clique that drove him to commit suicide. Mr. Daniel handles the teen-age horror aspects of the film smoothly, but undermines the supernatural spookiness with a garish portrait of a heartless psychiatrist (Dale Place) who so despises his patients that he fakes family emergencies in order to cut his sessions short.

"Boss of the Ballet," an absurdist caper film that seems to change in style and intention every few minutes, is the tale of two sanitation workers — a former oboist and a former ballet student — who decide to collaborate on a show. But before they can begin, the oboist must retrieve his musical instrument, which his wife gave to a neighbor. Instead of simply asking for it back, they decide to reclaim it in a ludicrously elaborate burglary.

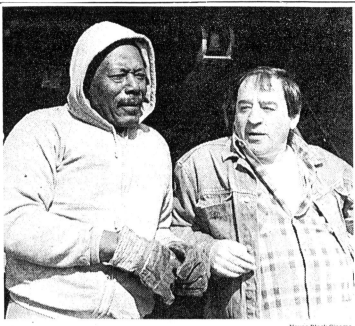

Young Black Cinema

A scene from Lindley Farley's "Boss of the Ballet."

Darnell Martin's "Suspect," the program's most sobering film, is a documentary-style vignette about racial misunderstanding. A young white woman leaving a nightclub alone drops her cigarette lighter on the street. When a young black man follows her and attempts to return it, she panics and assumes he is attacking her. The ensuing chase threatens to erupt into violence. The grainy 12-minute film distills the suspicious racial climate of New York City today. It could be a valuable teaching tool.

1992 F 29, 17:1

All Sick and Twisted Festival of Animation

A series of 17 short films; distributed by Mellow Madness Productions. At the Cinema Village Third Avenue, between 12th and 13th Streets, Manhattan. Running time: 80 minutes. These films have no rating.

By STEPHEN HOLDEN

Collectively, the 18 short films that have been stitched together for the "All Sick and Twisted Festival of Animation" are the cartoon film world's answer to anthologies like "Truly Tasteless Jokes." Here one can find everything from fornicating plastic dolls, including one of Elvis Presley (in Pierre Ayotte and Danielle Jovanovic's "Plastic Sex"), to teen-age boys in Metallica and AC/DC T-shirts gleefully playing baseball with a live frog (Mike Judge's "Frog Baseball").

Beyond a willingness to offend, one thread that runs through the midnight cult-favorite program, which moved to regular hours yesterday at the Cinema Village Third Avenue, is a tone of exuberantly defiant nihilism. That mood infuses John Magnuson's 1968 short, "Thank You Mask Man," a 10-minute cartoon created around a Lenny Bruce routine that imagines a goody-goody Lone Ranger naïvely confessing to homosexual and bestial impulses only to be jeered out of town.

Although most of the films are technically crude, there are some exceptions. "Deadsey," by the British animator David Anderson, uses computer-driven expressionistic imagery that suggests the paintings of Edvard Munch. In "Pink Komkommer," seven animators depict a series of semi-abstract erotic dreams, the most amusing of which suggest burbling, slurping Rube Goldberg contraptions made out of contorted flesh.

1992 F 29, 17:1

Mixture of Kitsch and Camp

"La Paloma" was shown as part of the 1974 New York Film Festival. Following are excerpts from Nora Sayre's review, which appeared in The New York Times on Oct. 9, 1974. The film, in German with English subtitles, opens today at the Public Theater, 425 Lafayette Street in Manhattan.

"La Paloma" by Daniel Schmid is intentionally crammed with cultural chestnuts, and also makes a heavy pass at the plots of "Camille" and "La Traviata." Kitsch and camp collide in this storm of pity and terror and wonder, which seethes with boundless love, burning glances and unfathomable revenge.

A glum nightclub singer — Ingrid Caven, who's tricked out like a caricature of Dietrich — is ailing with some nameless rot. She permits a wealthy young admirer (Peter Kern) to cosset her, cure her and finally marry her. It's repeated that she doesn't love him, but that she cherishes his passion for her. Then she falls for his best friend and wants to decamp with him; her husband selfishly refuses to finance the expedition. Therefore, she dies slowly and even

more tidily than Ali MacGraw in "Love Story."

Her deathbed wish forces her husband to exhume and dismember her three years later; the corpse chuckles as he moans while converting it into cutlets.

You can't really discuss "La Paloma" in terms of acting; the performers stalk rigidly about, exchanging long, brooding stares or significant smirks, and the result is a failed parody of the grand manner. They also speak their lines very, very slowly, as though one another's reflexes were impaired.

The ultimate astonishment is the appearance of Bulle Ogier as the husband's mother. Looking younger than her offspring, she doesn't seem to be on good terms with her cane. If only Elaine May had directed "La Paloma": the brisk deadpan delivery that she can draw out of actors might have been marvelous for this material.

1992 F 29, 17:5

The Tragedies of Bedlam In 'Titicut Follies' of 1967

"Titicut Follies" was shown as part of the 1967 New York Film Festival. It also played briefly at the Cinema Rendezvous before it was withdrawn from distribution because of court action in Massachusetts. Following are excerpts from Vincent Canby's review, which appeared in The New York Times on Oct. 4, 1967. The film opened yesterday at the Film Forum 1, 209 West Houston Street.

Movies became talkies 40 years ago, but it wasn't until recently, with the development of new, lightweight camera and sound equipment, that motion picture documentaries learned how to speak for themselves. The possibilities of this combination of the aural with the visual actuality are stunningly realized in "Titicut Follies," a calm, cool and ultimately horrifying look at conditions in the state prison for the criminally insane at Bridgewater, Mass. (Titicut, incidentally, is the Indian name for the area around Bridgewater.)

It is a small, black-and-white picture, laconic, abrasive, occasionally awkward and always compelling. Its content dictates its style, which is that of honest, thoroughly committed cinema reportage. Framed — in its opening and closing — with scenes from a desperately sad musical show put on by and for the inmates and the staff, the film observes life at Bridgewater without comment. But considering what we see, comment is hardly necessary.

We sit in as the prison psychiatrist, apparently a chain smoker, perfunctorily interviews a young man who has been committed for sexual offenses against an 11-year-old girl.

We watch as guards, who do not seem to have much fun in their lives, gently torment a mad old man named Jim.

●

Vladimir, an open-faced young paranoid, wildly argues his case before a staff meeting, and we listen to another gentleman, his eyes blazing like John Brown's, as he offers his benediction to the world in his own gibberish, punctuated occasionally with recognizable phrases: "John Kennedy ... Jesus Christ ... arrest those men!"

In one of the most moving moments of the film an old man is force-fed through a tube in his nose. The doctor stands on a chair holding the liquid while we wait for the ash on the cigarette in his mouth to fall into the container.

Intercut are shots of the same old man being laid out for burial.

There is no soundtrack narrator telling us what we should be seeing, how we should feel and, worse, what it all means. Frederick Wiseman, the director, and John Marshall, the cameraman, have instead allowed their subjects to do all the talking.

The result is an extraordinarily candid picture of a modern Bedlam, where the horrors are composed of indifference and patronizing concern. The concern of the film makers, however, and of the men who originally allowed the film to be made, is very real indeed.

1992 Mr 5, C21:3

Welles's 'Othello,' Crowned in Glory

By VINCENT CANBY

ORSON WELLES'S screen adaptation of "Othello" shared the top prize at the 1952 Cannes Film Festival with Renato Castellani's sentimental Italian comedy "Two Cents Worth of Hope," approximately four years, three Iagos and a half-dozen Desdemonas after Welles began production in Italy in the summer of 1948.

The Castellani film went on to please crowds in Europe and the United States. "Othello," which had been listed as having Moroccan nationality at Cannes, enjoyed some success in

287

Castle Hill Productions

Orson Welles and Suzanne Cloutier in the Welles version of "Othello."

Europe but pleased very few critics in this country when it opened in 1955. It came and quickly went.

For me and, I suspect, others, the Welles "Othello" existed for many years only as a cherished, eccentric but dimly recalled memory. Specific images remained vivid, as did the conviction that it ranked somewhere up there near Welles's "Citizen Kane" and "Magnificent Ambersons," though why, exactly, was unclear. With time, "Othello" became a memory of a memory.

Today, nearly 40 years after Welles's prize at Cannes, "Othello" reopens in Manhattan, at the Cinema 2, in an expertly restored print that should help to rewrite cinema history.

At 91 minutes, this black-and-white film is Shakespeare stripped down to his skivvies, without apology and with no apology needed. His majesty remains intact. More important: though it was shot in bits and pieces on two continents (sometimes with pickup crews and sometimes even without its principal actors), the film may now be seen as one of the screen's sublime achievements.

"Othello" doesn't rank below "Citizen Kane" and "The Magnificent Ambersons," but alongside them. Which film comes first, second or third is irrelevant. A case can be made for each. The good news this morning is that the Welles "Othello" is no musty old classic in need of gentle handling and explication. Like Welles, his "Othello" roars for itself. It's a great, scrappy, pugnacious entertainment that mesmerizes with its beauty and makes one laugh out loud with its audacity.

Tallulah Bankhead once said in the pre-tape era that doing a live television show was, for her, like being shot out of a cannon. The minute the show had begun, there was no turning back. The tension was great, but so was the lunatic excitement. Watching "Othello" is like taking off on a rocket from Cape Canaveral, but for the audience instead of the actors. (The actors spent much of their time on the film sitting around hotel lobbies in Europe and Africa, waiting for Welles to raise additional funds.)

It's one of the curiosities about "Othello" that a film that took so long to make, and that was shot in such financially precarious circumstances in so many locations, should play with the headlong speed of an Alpine schuss. After the grandly deliberate, Eisenstein-like images of the pre-credit sequence, the film quickly gathers such momentum that there's no stopping it until it comes back to the beginning.

"Othello" is one long flashback, mournfully framed by the funeral processions of Othello and Desdemona, and by the images of a furious, demonic Iago as he is squeezed into a small wooden cage and hauled aloft over the ramparts of Cyprus, eventually to become food for vultures. There's no nonsense in this production about what happens next. The film is a single, seamless recollection of sexual obsession, astonishment and despair.

In terms of running time, Welles's "Othello" is a tab show compared with Laurence Olivier's 166-minute 1966 screen adaptation of his National Theater production. Olivier's "Othello" is an adventurous recital accompanied by pore-tight close-ups of the theater performance. The text, though served up, is frequently upstaged. The Welles film is something else.

Welles tossed out language by the yard, rearranged scenes and added new sequences (though not new dialogue). Purists will object now as they did when the film was initially released. Yet objections are academic.

•

In his usual disarming way of calling attention to his genius by denying it, Welles once told André Bazin, the French critic, that with "Othello" he had to choose between filming a play and freely adapting Shakespeare to the cinema. "Without presuming to compare myself to Verdi," he said, "I think he gives me my best justifica-

A restored 40-year-old treasure may rewrite cinema history.

tion." Though Verdi's "Otello" could not have been written without Shakespeare, Welles said, it was "first and foremost an opera."

" 'Othello' the movie, I hope, is first and foremost a motion picture," he added.

Unlike Welles's ambitious but mixed-up, indifferently acted 1948 screen adaptation of "Macbeth," "Othello" has a magnificent screen life of its own that neutralizes even its evident faults. As fine as the restoration job is, there remain some problems with sound levels and with the synchronization of dialogue to the lip movements of the actors.

These difficulties were built into Welles's way of shooting what is called a "wild" track for the dialogue, and having the actors dub their speeches later in a studio. This allowed him to obtain the readings he wanted and, sometimes, to insert the voices of actors other than those who had played the roles. According to one report, Welles himself redubbed the lines of Robert Coote, the English actor who plays Roderigo in "Othello."

Some dialogue is still difficult to understand. The narrative line at the beginning is not clear and, of absolutely no importance whatsoever, Welles's skin tones as Othello vary throughout from a baby-faced matte-white to the kind of high-gloss swarthiness imparted by the liberal use of greasy makeup.

•

The triumph of "Othello" is Welles's mastery of a style imposed on him as a result of the film's unexpectedly attenuated shooting schedule. Bazin wrote of Welles's films that they "bear witness to both the obstinacy and the uncertainty of their author, to an extraordinary singleness of mind, and an incredible capacity for squandering and indecision." No more so than with the great "Othello."

Welles's biographers, particularly Barbara Leaming ("Orson Welles") and Frank Brady ("Citizen Welles"), and even Welles himself in his 1978 film memoir, "Filming Othello," have exhaustively and hilariously recalled the troubles that dogged the production. As backers signed on and off, Welles kept "Othello" afloat by acting in one movie after another, including "The Third Man."

His first Desdemona was Lea Padovani. Later he wanted Betsy Blair. Cecile Aubry went before the camera for a while, and was succeeded by Suzanne Cloutier, the enchanting Desdemona in the finished film.

The first Iago was an Italian actor whose name no one seems to remember. Everett Sloane, Welles's Mercury Theater colleague, took over but grew tired of the delays and departed the production. He was replaced by Micheal MacLiammoir, the co-founder of Dublin's Gate Theater and an old Welles friend.

As far as I can find out, "Othello" is the first as well as last film made by MacLiammoir who, at the age of 50, created an eerily self-possessed, unkempt, asexual Iago opposite Welles, who was then 34, big and bear-like but a remarkably passionate, seething and delicate Othello.

•

Over a two-year period, Welles shot when he had the money, then put the production on hold as he went off to act in someone else's picture. The members of the cast would come back together as they could, to Venice, Rome, Viterbo, Perugia and, for most spectacular effect, to Mogodor on the coast of Morocco, which stands in for Cyprus. The film was shot in slivers, as Mr. Brady reports in "Citizen Welles":

"When Iago steps from the portico of a church shot in Torcello, an island in the Venetian lagoon, the next image was actually filmed in a Portuguese cistern off the coast of Africa." And, "Roderigo kicks Cassio in Massaga and gets punched back in Orgete, a thousand miles away."

Welles told Bazin, "Every time you see someone with his back turned or

Castle Hills Productions

Orson Welles and Micheal MacLiammoir in "Othello."

with a hood over his head, you can be sure that it's a stand-in. I had to do everything by cross-cutting because I was never able to get Iago, Desdemona and Roderigo, etc., together at once in front of the camera."

Under such conditions, Welles was unable to exploit his fondness for long takes and the great deep-focus shots that make "Kane" and "Ambersons" memorable. Those things require money and the skill of technicians he didn't have. "Othello" is composed instead of fragments that have been magically put together to create a kind of kaleidoscopic effect, a film that is the antithesis of his two earlier masterworks.

•

In some ways "Othello" seems to anticipate the sort of editing that passes for energy in contemporary films and television commercials. The point of view constantly changes, but it never shifts without mind. Even the odd sound levels, and the sometimes distant relation between a character and his voice, suggest the disconnection that we now take for granted in music videos.

Here they work. They all contribute to the poetic unity of "Othello." They are as essential to the breathtaking finished film as the filtered exterior shots, the forest of Moorish arches through which the characters move in the interiors, and the language (yes, the language) that one seems to hear even more clearly because it doesn't swamp the screen.

"Be sure of it," Othello says to Iago. "Give me the ocular proof."

"Othello" does that and more.

It may be time now to attend to the rehabilitation of Welles's other magnificent Shakespearean variation, "Chimes at Midnight" (1966). Here the old prestidigitator makes no attempt at adapting a single play but, helping himself to portions of "Richard II," "Henry IV" (Parts I and II), "Henry V" and "The Merry Wives of Windsor," creates his own eulogy to the splendor that is Falstaff's.

1992 Mr 6, C1:3

Blame It on the Bellboy

Directed and written by Mark Herman; director of photography, Andrew Dunn; edited by Michael Ellis; music by Trevor Jones; production designer, Gemma Jackson; produced by Jennie Howarth and Steve Abbott; released by Hollywood Pictures; distributed by Buena Vista Pictures Distribution Inc. Running time: 78 minutes. This film is rated PG-13.

Melvyn Orton.............................Dudley Moore
Charlton Black (Lawton)..........Bryan Brown
Maurice Horton....................Richard Griffiths
Scarpa.....................................Andreas Katsulas
Caroline Wright............................Patsy Kensit
Rosemary Horton.................Alison Steadman
Patricia Fulford.....................Penelope Wilton
Bellboy......................................Bronson Pinchot

By JANET MASLIN

There's more method than inspired madness to "Blame It on the Bellboy," but this scenic, fast-paced farce by a first-time British director is still effervescent fun. Mark Herman, a film school graduate who both wrote and directed this comedy, has concocted a witty mistaken-identity plot and done an able job of keeping it in motion.

Bronson Pinchot, happily mangling the language as he plays the Venetian hotel employee of the title, has

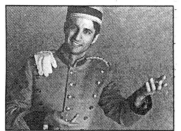

Frank Connor/Hollywood Pictures
Bronson Pinchot in "Blame It On the Bellboy."

Messrs. Horton (Richard Griffiths), Orton (Dudley Moore) and Lawton (Bryan Brown) to contend with, and pronounces all three of those names in the same way ("Or-tone"). Very quickly, the upshot is what the bellboy labels a "big misunderstood."

Naturally, each of these guests has an important envelope waiting for him when he checks into the hotel. And naturally, those envelopes wind up being scrambled. Lawton, a professional hit man, has been sent to Venice to kill an Italian mobster. Instead he is handed a photograph of a pleasant-looking Englishwoman named Patricia Fulford (Penelope Wilton), whom he mistakes for his target. Patricia's picture was intended for Horton, who has come to Venice via a dating service, and who has neglected to mention his dating plans to his wife (Alison Steadman).

Horton is accidentally given the name and address of a real estate agency whose avaricious, pretty young saleswoman (Patsy Kensit) will do anything to sell him a villa in a jiffy. Ms. Kensit is just right for all the off-color double-entendres that grow easily out of this particular mix-up. Meanwhile, Orton was supposed to be making that real estate deal, but he falls into the hands of a mobster, who eventually feels sorry for this

brow-beaten, middle-level corporate functionary. "Life is a no worth living if you living like a worm," he says sadly.

•

The cast is uniformly spirited and funny within the confines of the material, which never quite makes the leap to full-scale zaniness; there's a slightly formulaic quality to any mistaken-identity farce that culminates in mixed-up suitcases, after all. On the other hand, Mr. Herman has an authentically light touch, and his screenplay's fundamental tidiness does lead to a tying-up of all the story's loose ends. By the film's last moments, poetic justice has been meted out to all concerned. Only a final set of too-cute titles indicating the characters' fates makes this closing sequence seem overly neat.

Mr. Moore flails expertly through his role, at one point even paddling his gondola by hand in a state of wild panic. Also quite funny are Mr. Griffiths and Miss Steadman as the couple thrown by fate into an unexpected family reunion. Mr. Brown and Miss Wilton have some nice moments, once he has decided to refrain from killing her and has grown comfortable enough to complain about loneliness as an occupational hazard. "You don't meet too many people as an assassin," he says. "Not for long, anyway."

The film's use of Venice is bright, breezy and at times almost perfunctory. Happily, Mr. Herman keeps the standard-issue pigeon-in-the-piazza shots to a minimum.

•

"Blame It on the Bellboy" is rated PG-13 (Parents strongly cautioned). It includes mild profanity and sexual situations.

1992 Mr 6, C10:6

A Magical Mystery Tour of One Man's Mind, in 'Toto'

"Toto the Hero" was shown as part of the 1991 New York Film Festival. Following are excerpts from Vincent Canby's review, which appeared in The New York Times on Sept. 21. The film, in French with English subtitles, opens today at the Lincoln Plaza Cinemas, Broadway at 63d Street, in Manhattan.

If "Toto the Hero" ("Toto le Héros") is an indication of things to come, then Jaco van Dormael, a 34-year-old Belgian writer and director, is a bright new talent to celebrate.

Mr. van Dormael appears to belong to the humanist tradition of Jean Renoir and François Truffaut, but the voice and manner are his own. "Toto" is an enormously witty, bittersweet comedy that is somewhat less sentimental than your average automobile accident. It is both shocking and elegiac.

The film has the density of a fine short story, written by a master who somehow manages to create a novel-sized world through an uncanny command of ellipsis. "Toto" is the packed, often hilarious biography of a rather commonplace old man who, on the edge of death, reviews his life with the aim of giving it point, at last.

The urgency of his desires, and the extent to which he succeeds, are the material of the film, which features three different actors as its hero, Thomas van Haserbroeck, self-nicknamed Toto.

•

These key players are Michel Bouquet, the venerable French star (still looking a lot like Laurence Olivier), who appears as the elderly Thomas; Jo De Backer as the lonely, pinched, 30-ish Thomas. and Thomas Godet, who carries much of the film on his scrawny shoulders as Thomas the seethingly imaginative adolescent.

In Mr. van Dormael's fine screenplay, past and present exist in continuous and crazy conjunction, much as they do in the mind, and old Thomas's mind is busier than most. Laughter and fury, fact and fantasy intertwine as the suddenly resolute fellow decides to act and thereby, possibly, to revise history.

Thomas's adolescence is seen not necessarily as it was, but as the boy perceived it to be at the time. Thus he reports on the sound track that his sister Alice, who is several years older, was conceived when his father

stroked his mother's hand as his parents were bathing together.

Though his parents, played by Fabienne Loriaux and Klaus Schindler, are loving, the boy is convinced that he is not their child and that, in fact, he is really the son of the rich Kant family next door, whose loathed son Alfred was born on the same day. Thomas believes that he and Alfred were switched during a hospital fire.

His mother says flatly that there was never a hospital fire.

This does not prevent the little boy from barging in on Alfred's birthday party to demand that he be recognized as the Kants' rightful heir and, in the bargain, that he be given Alfred's birthday presents. As usually happens, his boldness earns only humiliation.

•

Thomas's most important relationship, and the one that shapes his deprived adulthood, is with the sweetly bossy Alice (Sandrine Blanke), whom he adores.

Alice is something of a terrorist as well as a romantic. She and Thomas play dangerous games together. When Alice becomes a young woman and threatens to leave Thomas behind in the perpetual gloom of childhood, the boy goads his sister into a terrible, irrevocable act.

Mr. van Dormael has said that the screenplay for "Toto" took five years to write. This is evident in the packed nature of the material, but not in the breezy inevitability of the finished film.

"Toto" has the self-assurance and the gusto of something that might have been conceived in a single spasm of creativity. It flies effortlessly from one time period to another, from one mood to its opposite. It seems never to have been fiddled with, rewritten or sweated over. It is as magical, though not as innocent, as the child of a stroked hand.

1992 Mr 6, C12:1

Shadow of Angels

Directed by Daniel Schmid; script (German, with English subtitles) by Mr. Schmid and Rainer Werner Fassbinder; camera, Renato Berta; edited by Ila von Hasperg; production company, Albatros Produktion München/Artcofilm SA Genève. At the Public, 425 Lafayette Street, Manhattan. Running time: 108 minutes. This film has no rating.

Lily Brest.......................................Ingrid Caven
Raoul....................Rainer Werner Fassbinder
Real Estate Promoter............Klaus Lowitsch
Mrs. Muller.......................Annemarie Duringer
Mr. Muller.....................................Adrian Hoven
Police Chief.......................................Boy Gobert

By JANET MASLIN

"Shadow of Angels," which opens today at the Public Theater, is the 1976 film version of a suicidally grim

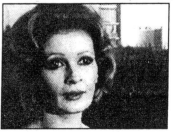

Ingrid Caven

play by Rainer Werner Fassbinder, who appears in one of its principal roles. Fassbinder plays a sad pimp who lives with an even sadder prostitute named Lily (Ingrid Caven), who is so beautiful that no man will hire her. Lily is so despondent that she strangles a kitten, which in this film's scheme of things amounts to an act of kindness. The pimp is so glum that when Lily returns home a little while later, she finds him lying on the floor, playing with the kitten's corpse.

As directed by Daniel Schmid, the Swiss-born film maker whose work is currently being featured at the Public, "Shadow of Angels" is extremely stagebound, with characters staring stonily into the distance as they recite the bitter aphorisms that constitute Fassbinder's dialogue. Some samples: "Where there is no contempt, there is no love." "Ugly persons despise the sweat on beauty's forehead." "When no one sings, silence reigns." "The thought of death makes me smile. What else can one do?"

•

Had this material been directed by Fassbinder, it might have had sufficient irony and energy to make better use of the sardonically stereotypical characters who populate the play. As it is, Mr. Schmid's flat presentation of figures like the Rich Jew (as he is always called), who eventually hires Lily to listen to his own despairing monologues, and the transvestite fascist, who is Lily's father, lacks a certain critical distance. On the other hand, there's not much to be done with scenes like one in which the transvestite, dressed for his cabaret act, and Lily, wearing bridal white, discover that the pimp, after having left Lily for a male lover, has been gravely wounded in a barroom brawl. "He'll live," Lily's father assures her. "Does he want to?" Lily inquires.

"Shadow of Angels" is of more interest as a marginal part of the Fassbinder canon than as an example of Mr. Schmid's directorial acumen. The occasional odd flourishes — freeze-frames, bits of Latin music — that break up the otherwise arid staging are not helpful.

1992 Mr 6, C15:1

Gladiator

Directed by Rowdy Herrington; screenplay by Lyle Kessler and Robert Mark Kamen, story by Djordje Milicevic and Mr. Kamen; director of photography, Tak Fujimoto; edited by Peter Zinner and Harry B. Miller 3d; music by Brad Fiedel; production esigner, Gregg Fonseca; produced by Frank Price and Steve Roth; released by Columbia Pictures. Running time: 88 minutes. This film is rated R.

Lincoln	Cuba Gooding Jr.
Tommy	James Marshall
Pappy Jack	Robert Loggia
Noah	Ossie Davis
Horn	Brian Dennehy
Miss Higgins	Francesca P. Roberts
Dawn	Cara Buono
John Riley	John Heard

By JANET MASLIN

"Gladiator" is a totally familiar new film involving boxing, gangs, high school kids, first love, corrupt businessmen, racial harmony and the importance of loyalty among friends. The mixture may be slightly unexpected, but it still manages to be predictable all the way. Only the film's resolution has any spirit or novelty, and even that goes all the way back to the Roman Colosseum.

Quicker than you can say "Spartacus," two fighters figure out that their real enemy is outside the ring.

"Gladiator" begins with the arrival of new-kid-in-school Tommy Riley (James Marshall). Tommy, who is either the strong silent type or just plain silent, encounters the usual troubles with local bullies. ("You're in my seat, boy," etc.) He has a teacher who encourages him to learn (Francesca P. Roberts). He also has a father with serious gambling debts (John Heard). And he has a talent for boxing, which is discovered by an unscrupulous talent promoter (Robert Loggia) who turns him over to a wise old trainer (Ossie Davis) and

Spartacus goes to high school, n the hood, with Rocky, on the waterfront.

also to an even more unscrupulous promoter of illicit, underground bouts (Brian Dennehy). Somewhere along the line, there is a nice girl (Cara Buono) who loves Tommy enough to try to keep him from becoming brain-dead.

The film eventually pits Tommy, who is white, against Lincoln (Cuba Gooding Jr.), who is black, even though they have developed a friendship outside the ring. The story's ending, which brings strife between these two, also reveals a newly slimmed-down Mr. Dennehy to be a wild man when he's fighting. And Mr. Dennehy has the chance to say the following: "You know why people get so excited at fights? It's the presence of death."

•

"Gladiator" is occasionally on the gory side, but most of its really painful moments are on the page. The screenplay, by Lyle Kessler and Robert Mark Kamen, is filled with dialogue that could have been written in anyone's sleep. (Nice girl: "I can't figure you out." Tommy: "Neither can I.") The direction by Rowdy Her-

Columbia Pictures
Cuba Gooding Jr., left, and James Marshall in "Gladiator."

rington ("Jack's Back") is only slightly better, and it, too, has little life of its own. The best things about the film are Tak Fujimoto's crisp cinematography, a couple of the supporting performances (Mr. Davis and Ms. Roberts are both good) and the possibility that both Mr. Marshall ("Twin Peaks") and Mr. Gooding ("Boyz N the Hood") might fare better under other circumstances. Unlike anything else about "Gladiator," they are at least relatively unknown quantities.

•

"Gladiator" is rated R (Under 17 requires accompanying parent or adult guardian). It includes profanity and violence.

1992 Mr 6, C17:1

The Lawnmower Man

Directed by Brett Leonard; screenplay by Mr. Leonard and Gimel Everett, based on a story by Stephen King; director of photography, Russell Carpenter; edited by Alan Baumgarten; production designer, Alex McDowell; produced by Mr. Everett; released by New Line Cinema. Running time: 108 minutes. This film is rated R.

Jobe Smith	Jeff Fahey
Dr. Lawrence Angelo	Pierce Brosnan
Marnie Burke	Jenny Wright
Sebastian Timms	Mark Bringleson
Terry McKeen	Geoffrey Lewis
Father McKeen	Jeremy Slate
Director	Dean Norris

By VINCENT CANBY

Technology turns mean yet again in "The Lawnmower Man," a science-fiction melodrama based on a 1975 short story by Stephen King.

The film is about Jobe (Jeff Fahey), a sweet-natured, mentally retarded young slob who, as a result of experiments with a pink serum, begins to comb his hair. He also turns into a brilliant megalomaniac. Having once been happy mowing lawns, Jobe suddenly dreams of becoming one with a main-frame computer and ruling the world.

New Line Cinema
Jeff Fahey

On his way to the top he takes time off to do ghastly things to his guardian, an old priest who used to beat him, and to the town bully, who humiliated him.

The two principal scientists are played by Pierce Brosnan, who is the good one, and Mark Bringleson, the bad one. The movie was directed by Brett Leonard and written by him and Gimel Everett.

"The Lawn Mower Man" depends mostly on a lot of colorful video-game-like special effects. They are very loud but, after a while, the noise and the lights induce a torpor that is quite soothing.

•

"The Lawnmower Man," which has been rated R (under 17 requires accompanying parent or adult guardian), has vulgar language, violence and some simulated sex.

1992 Mr 7, 20:1

Once Upon a Crime

Directed by Eugene Levy; screenplay by Charles Shyer and Nancy Meyers and Steve Kluger, based on a story by Rodolfo Sonego and a screenplay by Mr. Sonego, Giorgio Arlorio, Stefano Strucchi and Luciano Vincenzoni; director of photography, Giuseppe Rotunno; edited by Patrick Kennedy; music by Richard Gibbs; production designer, Pier Luigi Basile; produced by Dino de Laurentiis; released by M-G-M. Running time: 94 minutes. This film is rated PG.

Augie Morosco	John Candy
Neil Schwary	James Belushi
Marilyn Schwary	Cybill Shepherd
Inspector Bonnard	Giancarlo Giannini
Phoebe	Sean Young
Julian Peters	Richard Lewis
Elena Morosco	Ornella Muti
Alfonso de la Peña	George Hamilton

By JANET MASLIN

The cast of "Once Upon a Crime" performs energetically, as if the material was funny, although most of the time it is not. As a general rule, films whose plots revolve around lost dogs are apt to be short on comic inspiration, and this one is no exception.

The dog is a dachshund, and it is first found by a jilted waif named Phoebe (Sean Young) and an unsuccessful actor named Julian (Richard Lewis) in Rome. Joining forces to trade insults and collect a reward from the dog's wealthy owner, Phoebe and Julian take a train for Monte Carlo. On board, they meet Augie Morosco (John Candy), a ridiculously suave fortune-hunter who has landed a rich, gorgeous wife (Ornella Muti).

Meanwhile, the film also follows the antics of Neal (James Belushi) and Marilyn (Cybill Shepherd), a couple from Newark vacationing in Monaco. The Riviera scenery ought to look a lot more glamorous than it does.

Also involved in what turns out to be a half-humorous murder plot are Giancarlo Giannini, as the basset-eyed police investigator who is this film's answer to Inspector Clouseau, and George Hamilton as a Latin gigolo. Mr. Hamilton, whose Latin accent is a lot like his Dracula, is so tan that he looks peculiar in scenes with the other actors. It's not clear whether this effect is intentionally exaggerated or Mr. Hamilton ought to spend more time in the shade.

"Once Upon a Crime" was directed by Eugene Levy in a snappy, upbeat manner that requires the actors to give their all regardless of whether it is really required. Ms. Young is animated enough for silent comedy, and Ms. Shepherd occasionally socks Mr. Belushi in the nose with her elbow. The film grows slightly funnier as it goes along, particularly in a scene in which Mr. Giannini interrogates Mr. Candy about the dachshund's owner, who is now deceased. "A few weeks ago at the casino, you attempted to sit on her head," he says suspiciously. "She was cold and without a hat," Mr. Candy sweetly replies.

•

"Once Upon a Crime" is rated PG (Parental guidance suggested). It includes mild profanity.

1992 Mr 7, 20:4

FILM VIEW/Janet Maslin

Playing Dumb Isn't a Job For Nitwits

BEING STUPID ON THE SCREEN may look easy, but in fact it calls for skill. Unless stylized stupidity is presented properly, it runs the risk of looking dangerously like the real thing. Except for those eager to follow in the footsteps of the authentically imbecilic Ernest (of "Ernest Scared Stupid" fame), precautions are definitely in order. After all, achieving just the right degree of dimness is a delicate business. In the words of the pioneeringly stupid pseudo-rock band Spinal Tap, "It's such a fine line between stupid and clever."

It is indeed a fine line, and the 1984 film "This Is Spinal Tap" stayed on the right side of it. In the process, screen stupidity entered a new realm — of heavy-metal music, head-banging fans and all the brain damage that implies. "Spinal Tap" has paved the way for

Some movies aren't too dim to see the fine line between stupid and clever.

such arch-stupid heavy-metal devotees as Bill and Ted, the happy, time-traveling high school duo and, most recently, Wayne Campbell (Mike Myers) and Garth Algar (Dana Carvey) of "Saturday Night Live," on which these characters originated. Anyone who mistakes these two for bona fide numbskulls need only glance at last week's chart of movie grosses, where the hit film "Wayne's World," in the No. 1 spot, emerged as a true idiot's delight.

Clearly, Wayne and Garth are doing something right, even if a large segment of the population would find it alarming. They do, after all, confirm every dire assessment that Japanese Government officials have made of American youth. Wayne and Garth are lazy, uneducated, irresponsible and proud of it. But they also fit the mold of sunny, crazy-like-a-fox stupid characters who accidentally triumph over their own mindlessness and manage to take a party with them wherever they go.

When actors really master this routine (as Keanu Reeves did in two Bill and Ted films), it's easy to forget that any acting is involved. On close inspection, though, there's a lot more intelligence at work in Bill and Ted's happy-go-lucky witlessness, and in Mr. Reeves's vacant grin, than in anything as authentically dopey and one-dimensional as, say, the current "Medicine Man." In that jungle adventure, humor and perspective are entirely lacking, and the know-nothing banter is delivered in earnest. (Sean Connery: "Sweet dreams." Lorraine Bracco: "Go to hell." Mr. Connery: "Probably.") It could be argued that Bill, Ted, Wayne, Garth, et al., became what they are by listening to just this sort of conversation.

Penelope Spheeris, who directed "Wayne's World" (from the screenplay by Mr. Myers, Bonnie Turner and Terry Turner), happens to be conversant with a Wayne and Garth-like outlook. A 1988 documentary by Ms. Spheeris, "The Decline of Western Civilization Part II: The Metal Years," observed heavy-metal stars and wannabe's in their

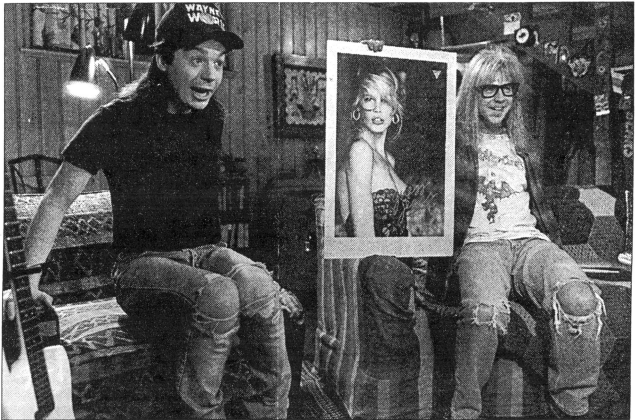

Mike Meyers and Dana Carvey, with a portrait of the model Claudia Schiffer, in "Wayne's World"—Atop the charts.

Wayne's Words

Wayne and Garth (Mike Myers and Dana Carvey), the shaggy-haired, baseball-capped, Aerosmith-T-shirted stars of "Wayne's World," first showed up on television on "Saturday Night Live." Now they're cleaning up at the box office and, believe it or not, in bookstores, where "Wayne's World: Extreme Close-up" (Hyperion) has become a best seller.

Wayne and Garth truly live in a universe of their own. It's a place where loutish immaturity is an art form, Gary Stewart's "Dream Weaver" is the ultimate love tune and intellect is a last-resort tool for attracting a foxy female. Entrée into "Wayne's World" requires a certain linguistic expertise. Here is a primer.

NOT! (adv.): Contradiction of a previous statement, as in "Madonna is my girlfriend — NOT!" Etymology: on "Saturday Night Live" in the late 70's, Bill Murray and Gilda Radner used this expression in the Todd and Lisa Loopner skits. Back then, though, no one laughed.

BABE (fem. n.): An extremely sexy woman with disproportionately large breasts and pouty lips. Preferably clad in a bikini, leather miniskirt or buckskin, with navel visible.

BABEFEST (n.): A congregation of babes.

BABELICIOUS (adj.): A compound of babe and delicious. A tasty babe.

SCHWING (exclam.): Remark conveying appreciation of a babe. (Accompanied by gesture of swinging rear end across seat of chair.)

MIRTHMOBILE (n.): Car, cruising vessel. Must be equipped with stereo to provide maximum opportunity to sing along with Queen's "Bohemian Rhapsody."

KA-CHING (onomatopoeia): The sound of a cash register, used to indicate the presence of or potential for large sums of money. Probably derived from Pink Floyd's rock staple "Money."

BABE LAIR (n.): An apartment to which males with power and money (ka-ching!) lure babes.

HURL (v.): To vomit. Also "honk" and "spew."

WE'RE NOT WORTHY! WE'RE NOT WORTHY! (idiom): "We're not deserving of such an honor." Used in moments of crisis-level ebullience, such as when Wayne and Garth are in the presence of rock gods like Aerosmith or Alice Cooper.

PARTY ON (imperative v.): Continue the festivities, at least until the movie fades to black.

— *Karen Schoemer*

natural habitats and found their aspirations to be amazingly narrow. Several of that film's musical hopefuls, whose idea of wit was a two-tone hairdo, spoke of heavy-metal stardom, involving money, celebrity and groupies, as their only goal. And when asked what they might do otherwise, a few said they would succeed or die. One subject drank himself to death during the course of the film.

■

Stupidity on that scale is riveting, but obviously it isn't funny. (Most films about exaggeratedly mindless metalheads have avoided referring directly to drugs and have treated alcohol only as an excuse for comical vomiting; real substance abuse would force audiences to take these characters seriously.) To make their audiences laugh, it is essential that Wayne and Garth or Bill and Ted appear happy at all times, except perhaps when thwarted in their efforts to land the right girl. That way, audiences can savor the enjoyable notion that being cheerfully stupid is a means of feeling carefree. The liberation of watching friends careering through a narrow, teenager-friendly universe, free to do whatever they want without consequences, is a large part of the appeal of these films.

Audiences also need assurance that such characters' mock-moronic attitudes are intentional and that the viewer is being let in on the joke. So "Wayne's World" pauses for the occasional sign of intelligent life, as when Wayne teaches himself Cantonese to converse with a beautiful Chinese-born singer, who has herself learned English by studying "Police Academy" movies. "The irony is, I feel partly responsible for her self-nullifying behavior," say the subtitles, as Wayne chatters on in Cantonese about an old girlfriend's problems. Without the occasional wink like this, "Wayne's World" would go from hip to horrifying in a hurry.

Thus assured that Wayne and Garth are more clever than they look and that they have an awfully good time doing nothing, the audience is free to enjoy touches like Wayne and Garth's trouble with numbers. In "Spinal Tap," Christopher Guest played a musician who thought an amplifier whose volume control dial went from 1 to 11 was louder than the same device with a dial calibrated to reach only 10. Along those same lines, Wayne and Garth and the crew of their amateur television show never get over the fact that professional cameramen count "5. . .4. : .3. . ." before a shot, leaving the 2 and 1 unspoken. When Wayne and Garth's crew tries this themselves, everyone nods emphatically at

the silent beats, just the way trained horses would. But these guys are smarter than Mr. Ed. And when their television show brings them a check for $5,000, they can count just fine.

1992 Mr 8, II:15:1

The Winter in Lisbon

Directed by José Antonio Zorrilla; screenplay (French with English subtitles) by Mr. Zorrilla and Mason M. Funk, based on the novel by Antonio Muñoz Molina; director of photography, Jean Francis Gondre; edited by Pablo G. del Amo; music by Dizzy Gillespie; produced by Igeldo, P.C., S.A. (Spain), Impala, S.A.-Jet Films, S.A., Sara Films (France) MGN Filmes e Espectaculos LDA (Portugal). At the Quad Cinema, 13th Street, west of Fifth Avenue. Running time: 100 minutes. This film has no rating.

Bill Swann	Dizzy Gillespie
Jim	Christian Vadim
Lucrecia	Hélène de St. Père
Floro	Eusebia Poncela
Malcolm	Fernando Guillén

By STEPHEN HOLDEN

Whenever "The Winter in Lisbon" loses its bearings, which is every few minutes, the camera pans dreamily over the Lisbon harbor at sunset while the movie's woozy theme song, "Magic Summer," trickles in the background.

The film, which is at the Quad Cinema, is a romantic thriller that wants to be a combination of "The Maltese Falcon," " 'Round Midnight" and "A Man and a Woman." In the Spanish-French-Portuguese co-production, directed by José Antonio Zorrilla, Christian Vadim plays Jim, a cadaverous young jazz pianist and

heavy smoker who falls for Lucrecia (Hélène de St. Père), a femme fatale with unsavory connections. Dizzy Gillespie plays Bill Swann, an ailing jazz trumpeter who leads the quartet in which Jim performs.

"The Winter In Lisbon," which was adapted from a novel by Antonio Muñoz Molina, is stylishly photographed, but its story makes no sense. The thriller part of the plot has something to do with gunrunning, a stolen Cézanne painting and a plot against the Portuguese Government. The musical part of the tale is a poorly reworked cliché. Mr. Gillespie plays the trumpet wonderfully, but he is miscast as a bitter expatriate American jazz legend who in the movie's most embarrassing moment stumbles through a long monologue about racism in America.

The romance between Jim and Lucrecia has its steamy moments, but their relationship is so complicated with betrayals, imagined betrayals and undeveloped subplots that it becomes simply mystifying.

There are moments early in the film when "The Winter in Lisbon" achieves its desired mood of hip, international chic. In trying to do too many things at once, the film takes that mood and tears it to shreds.

1992 Mr 9, C15:5

Howards End

Directed by James Ivory; screenplay by Ruth Prawer Jhabvala; photography, Tony Pierce-Roberts; edited by Andrew Marcus; music by Richard Robbins; production designer, Luciana Arrighi; produced by Ismail Merchant; a Sony Pictures Classics release. At Fine Arts, 4 West 58th Street, Manhattan. Running time: 145 minutes. This film is rated PG.

Ruth Wilcox	Vanessa Redgrave
Helen Schlegel	Helena Bonham Carter
Margaret Schlegel	Emma Thompson
Aunt Juley	Prunella Scales
Leonard Bast	Sam West
Henry Wilcox	Anthony Hopkins
Charles Wilcox	James Wilby
Evie Wilcox	Jemma Redgrave
Paul Wilcox	Joseph Bennett
Jacky Bast	Nicola Duffett
Miss Avery	Barbara Hicks

By VINCENT CANBY

IT'S time for legislation decreeing that no one be allowed to make a screen adaptation of a novel of any quality whatsoever if Ismail Merchant, James

Ivory and Ruth Prawer Jhabvala are available, and if they elect to do the job. Trespassers should be prosecuted, possibly condemned, sentenced to watch "Adam Bede" on "Masterpiece Theater" for five to seven years.

In case you've been living inside a pinball machine for the last several decades, Mr. Merchant, the producer; Mr. Ivory, the director, and Mrs. Jhabvala, the writer, are the team responsible for, among other films, the screen adaptations of Henry James's "Bostonians," E. M. Forster's "Room With a View" and Evan S. Connell's "Mr. and Mrs. Bridge."

They triumph again with their entertaining, richly textured film translation of Forster's fourth novel, "Howards End," opening today at the Fine Arts.

Like the novel, which was published in 1910, the film is elegant, funny and romantic. Though intensely serious in its concerns, it is as escapist as a month in an English countryside so idyllic that it probably doesn't exist.

Forster is not passé, but time has played tricks on his work. The shapeliness of his prose and his plotting still satisfies. The wit remains piercing and seemingly painless. "All men are equal," he writes in "Howards End," "all men, that is to say, who possess umbrellas."

Yet our world is now so different from Forster's that we follow the drawing-room war in "Howards End," seen in the confrontation of the two high-minded Schlegel sisters with the members of the rich, acquisitive Wilcox family, as if it were a fantastic spectacle, a time out of time.

"Howards End," set at the end of the Edwardian era, doesn't even dimly perceive World War I, to say nothing of World War II, the Holocaust, the Bomb and the possibility of the planet's extinction. The stakes being fought over in this film are high, but no one is killed, with the exception of poor Leonard Bast, and he scarcely counts (this is a Forster irony), since he is of the lower orders.

It's easy for us to shake our heads with Forster over the inequities built into England's class system, although that same system provides the stability of the structure in which such drawing-room wars can be fought. Forster was a social critic capable of savagery, but for today's film audiences, "Howards End" is so much fun that it becomes a guilty pleasure. Thank heaven for inequities.

•

Although Leonard Bast (Sam West), a rather dull bank clerk who aspires to culture, is the unwitting instrument for the story's optimistic resolution, he is at the center of the film only when he is invited to call by the brainy Margaret Schlegel (Emma Thompson) and her younger, prettier, more headstrong sister, Helen (Helena Bonham Carter).

The Schlegel sisters are well-bred, well-read, music-loving people for whom the life of the mind is as natural as fine food and drink. Their serene London existence is forever destroyed by the richer, cruder, altogether (it seems at first) more dynamic Wilcoxes, whom they have met (before the film starts) while on a holiday abroad.

Sticking to the novel with unhurried fidelity, Mrs. Jhabvala's screenplay traces Helen's brief, doomed infatuation with the younger Wilcox son, Paul (Joseph Bennett). There follows the friendship of Margaret with the otherworldly Ruth Wilcox (Vanessa Redgrave), mother of Paul and two other children and wife to Henry (Anthony Hopkins). After Ruth's death, Margaret marries Henry, whom Helen sees to be a barbarian, if a very rich one.

The war that ensues has as its main issue Henry Wilcox's high-handed treatment of the dopey Leonard Bast and Leonard's good-natured, tarty wife, Jacky (Nicola Duffett), who, it turns out, had once been Henry's mistress.

•

Standing first as décor, then as a concept, is Howards End, the Wilcox family's comfortable old country house, which Forster saw as a symbol of England. It is Forster's conceit that the house must fall if the Schlegels, the Wilcoxes and the Basts cannot somehow be reconciled within Howards End. The grace with which this is accomplished is just one of the delights of this film, which is nothing if not symmetrical.

Though full of plot, "Howards End" is a comedy of character, expertly realized in performances that match any on the screen now or in the recent past.

Ms. Thompson, who was a charming asset to "Henry V" and "Dead Again," both directed by her husband, Kenneth Branagh, comes into her own as the wise, patient Margaret Schlegel. Hers is the film's guiding performance. Ms. Thompson even manages to be beautiful while convincingly acting the role of a woman who is not supposed to be beautiful, being all teeth and solemn expressions.

The film is also a breakthrough for Ms. Bonham Carter. No more the pouty ingénue, she here gives a full-length portrait of a pretty young woman who, disappointed by life, gathers a sort of mad force as she ages and proudly assumes the role of one of society's outcasts.

Mr. Hopkins is splendid and easy as the Edwardian era's equivalent to a corporate raider, outwardly tough and willful but, at heart, almost fatally fragile. Miss Redgrave is not on the screen long, but hers is also a strong performance as a woman not quite in touch with the quotidian world. She looks grandly haggard, as she is supposed to, while her niece, Jemma Redgrave (daughter of Corin Redgrave), is very comic as her spoiled Wilcox daughter. Prunella Scales bustles through the movie as the Schlegel sisters' managerial aunt.

•

That Mr. Ivory and Mrs. Jhabvala work well together is not exactly news. What continues to astonish is Mrs. Jhabvala's magical way of putting herself in the service of another writer's work, preserving as she distills. The film unfolds chronologically. No narrator is used. Yet the Forster voice is heard in virtually every scene, chatting, being discreetly sarcastic, sometimes sounding worried and, at other times, laughing with pleasure.

Like all Merchant-Ivory productions, "Howards End" looks terrific, the colors mostly muted, the light dim. Occasionally the physical opulence does become excessive, as with the wisteria, which may be all nature's doing. Yet there is so much wisteria clinging to the roof and walls of Howards End that the place would seem in danger of collapse, no matter how the characters pair off to save England.

That's an extremely minor reservation. "Howards End" need apologize only for its bracing high spirits and the consistency of its intelligence. A great pleasure.

•

"Howards End," which has been rated PG (Parental guidance suggested), has nothing that would disturb small children, although it might bore them quickly.

1992 Mr 13, C1:3

Derrick Santini

Forster revisited: Vanessa Redgrave, left, and Barbara Hicks.

My Cousin Vinny

Directed by Jonathan Lynn; written by Dale Launer; director of photography, Peter Deming; edited by Tony Lombardo; music by Randy Edelman; production designer, Victoria Paul; produced by Mr. Launer and Paul Schiff; released by 20th Century Fox. Running time: 119 minutes. This film is rated R.

Vinny Gambini Joe Pesci
Bill Gambini Ralph Macchio
Mona Lisa Vito Marisa Tomei
Stan Rothenstein Mitchell Whitfield
Judge Chamberlain Haller Fred Gwynne
Jim Trotter III Lane Smith
John Gibbons Austin Pendleton

By VINCENT CANBY

It's easy to recommend "My Cousin Vinny" from the moment, early on, when Mona Lisa Vito (Marisa Tomei), a vivid young woman from Brooklyn with a fondness for overstated clothes, gets out of the car of her longtime fiancé, Vinny Gambini (Joe Pesci), in Wahzoo, Ala. Her first remark, uttered as a kind of informed hunch: "I bet the Chinese food in this town is terrible."

It's even easier when Vinny, a New York lawyer who passed his bar examination six weeks earlier (after six tries), starts to prepare his case, which is to defend his nephew and his nephew's pal, who have been charged with a capital offense. It is not only Vinny's first time in Alabama, but also his first time inside a courtroom as a lawyer.

•

His black leather jacket, black sweater and gold chains offend the judge (Fred Gwynne). When Vinny refers to the young defendants as "these two yutes," the judge behaves as if Vinny is speaking an especially esoteric Balkan dialect.

Twentieth Century Fox

Marisa Tomei and Joe Pesci

"My Cousin Vinny" is easily the most inventive and enjoyable American film farce in a long time, even during those extended patches when it seems to be marking time or when it continues with a running gag that can't stay the distance.

The film has a secure and sophisticated sense of what makes farce so delicious, which may not be surprising, since its credentials are about as impeccable as you can find in the peccable atmosphere of Hollywood.

It was written by Dale Launer, who wrote "Ruthless People" and "Dirty Rotten Scoundrels," and directed by Jonathan Lynn, the Englishman who wrote and directed "Nuns on the Run" and collaborated on the scripts for the English television series "Yes, Minister" and "Yes, Prime Minister." They are very funny men.

⚫

"My Cousin Vinny" takes a little while to get going. Bill Gambini (Ralph Macchio) and Stan Rothenstein (Mitchell Whitfield), a couple of innocent young New Yorkers, are driving through Alabama on their way to college when they stop at a convenience store for supplies. As a lark, Bill shoplifts a can of tunafish.

When they are stopped a short time later by the county sheriff (Bruce McGill) and hauled off to jail, Bill confesses. "Was it premeditated?" asks the sheriff. Bill says it was just a spur-of-the-moment sort of thing. Says the sheriff, "We're going to run enough electricity through you to light up Birmingham."

Bill and Stan don't know it, but they've just been booked for the murder of the convenience store operator, who was very much alive when they left him. Thus begin the succession of epic misunderstandings and the talking at cross-purposes that keep one laughing with "My Cousin Vinny" past the point of absolute necessity.

⚫

The cast is very good. Mr. Pesci, recently the embodiment of out-of-control evil in "Goodfellas" and a burglar of singular ineptitude in "Home Alone," is a puzzled delight as he attempts to gather his wits, being helped not at all by Mona Lisa's loudly articulated common sense and her ability to read law books and retain their contents.

Ms. Tomei, who appeared with Sylvester Stallone in "Oscar," gives every indication of being a fine comedian, whether towering over Mr. Pesci and trying to look small, or arguing about a leaky faucet in terms that demonstrate her knowledge of plumbing. Mona Lisa is also a first-rate auto mechanic, which comes in handy in the untying of the knotted story.

Mr. Gwynne heads the collection of fine comic actors who appear in the supporting roles: Mr. McGill; Lane

Smith as the courtly district attorney, and Austin Pendleton, who plays a sincerely motivated public defender whose only impediment is one of speech: he stutters under stress.

As sometimes happens in a farce, the characters around whom the action rages are played stoically (by Mr. Macchio and Mr. Whitfield), although their import to the proceedings is forgotten for long periods of time.

⚫

"My Cousin Vinny" is rated R (Under 17 requires accompanying parent or adult guardian). It includes much vulgar language.

1992 Mr 13, C6:1

American Me

Directed by Edward James Olmos; screenplay by Floyd Mutrux and Desmond Nakano from a story by Mr. Mutrux; director of photography, Reynaldo Villalobos; edited by Arthur R. Coburn and Richard Candib; music by Dennis Lambert and Claude Gaudette; production designer, Joe Aubel; produced by Sean Daniel, Robert M. Young and Mr. Olmos; released by Universal Pictures. Running time: 119 minutes. This film is rated R.

Santana	Edward James Olmos
J. D.	William Forsythe
Mundo	Pepe Serna
Puppet	Danny de la Paz
Julie	Evelina Fernandez
El Japo	Cary Hiroyuki Tagawa
Little Puppet	Daniel Villarreal
Pedro	Sal Lopez
Esperanza	Vira Montes

By JANET MASLIN

Edward James Olmos's "American Me" begins with a warning that the events it describes are brutal, and indeed they are. The film's views of gang violence in East Los Angeles, and of the forces that conspire to perpetuate that violence from generation to generation, are blunt enough to give it a documentary air.

But Mr. Olmos's direction, from a screenplay by Floyd Mutrux and Desmond Nakano, is dark, slow and solemn, so much so that it diverts energy from the film's fundamental frankness. Violent as it is, "American Me" is seldom dramatic enough to bring its material to life.

⚫

The story centers on Santana, played by Mr. Olmos and first seen serving a prison sentence. Flashing back to the youth of Santana's parents, the film depicts the 1943 "zoot suit" riots and shows Santana's Hispanic father being assaulted by sailors while his mother is raped. These are the first in a long, painful series of

events that steer Santana toward a life of crime.

Mr. Olmos's voice-over narration of these events happens to be in rhyme. "It was easy to blame my father for everything I did — isn't that the life of every kid?" he says about Santana's teen-age years. "Thought I knew it all," he goes on. "Ended up in juvie hall." Although the poetry sounds authentic, it's also awkward and dour, which is the whole film's overriding problem. Even allowing for the bleakness of the facts it exposes, "American Me" manages to seem unduly bleak.

"American Me" follows Santana and two buddies, J. D. (William Forsythe) and Mundo (Pepe Serna) from juvenile hall to Folsom prison, in scenes that were in fact shot at Folsom using inmates as extras. The tenor of these scenes is extremely graphic, from an episode depicting exactly how drugs are secreted by smugglers operating in an atmosphere of strip searches to the rituals that surround the inmates' murderous conspiracies against one another. Santana, who has become a hardened drug dealer, presides over these operations with Mr. Olmos's familiar dolorous, chilling calm.

⚫

The film is most compelling at these exposélike moments, and least so when it becomes needlessly derivative. In the latter category, a mafia don whose son figures in the story is shown in his garden, listening to opera and tending his roses. When the son is attacked in prison, the godfather's reaction to this news is staged in similarly predictable style. On the other hand, the attack itself, which involves a vicious anal rape, is intercut with Santana's first sexual experience with a sweet, decent young woman (Evelina Fernandez) who falls in love with him. Whatever one makes of that juxtaposition, it's not a cliché.

"American Me" eventually moves on to the dire effects of Santana's crime empire upon a new generation of Hispanic boys, whose involvement in the drug trade is blatantly depicted. The film's ability to sound a warning to other young men in similar circumstances is its most valuable aspect.

⚫

"American Me" is rated R (Under 17 requires accompanying parent or adult guardian). It includes considerable violence, profanity and sexual situations.

1992 Mr 13, C6:5

Legacy Edward James Olmos and Pepe Serna star in "Amerian Me," about violence in three generations of a Hispanic family in East Los Angeles.

Universal City Studios

Shaking the Tree

Directed by Duane Clark; written by Mr. Clark and Steven Wilde; cinematographer, Ronn Schmidt; edited by Martin L. Bernstein; music by David E. Russo; production designer, Sean Mannion; produced by Robert J. Wilson; released by Castle Hill Productions. Running time: 95 minutes. This film is rated R.

Barry	Arye Gross
John (Sully) Sullivan	Gale Hansen
Michael	Doug Savant
Terry (Duke) Keegan	Steven Wilde
Kathleen	Courteney Cox

By STEPHEN HOLDEN

A flaw at the heart of many rites-of-passage movies about groups of friends is the improbability of such cross sections of humanity ever cohering in real life.

What social or psychological glue, for instance, could have united Barry (Arye Gross), Sully (Gale Hansen), Michael (Doug Savant) and Duke (Steven Wilde), the four friends in Duane Clark's earnest little film, "Shaking the Tree"? All they have in common are age (late 20's), location (Chicago) and anxiety about the future.

Barry is a whiny, pseudo-bohemian from a rich family, with no direction, no job, no money of his own and a penchant for gambling. Sully is a self-proclaimed "heartbreaker and dealmaker" who keeps a picture of Donald Trump on his office desk and is pathologically jealous of his girlfriend's former lovers. Michael, an aspiring novelist, teaches English literature and feels trapped in his marriage to Kathleen (Courteney Cox), a lawyer who is very pregnant. Duke is a bartender and stud who had to give

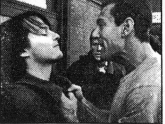

Castle Hill Productions

Gale Hansen, left, and Steven Wilde in "Shaking the Tree."

up a promising boxing career after developing an unnamed eye malady.

"Shaking the Tree," which opens today, follows the quartet's misadventures over the 1989 Christmas holidays, when each goes through an emotional crisis. Barry bets $10,000 that he doesn't have on a losing horse, and is menaced by thugs when he can't deliver the money. Sully walks out on his girlfriend. Michael contemplates an affair with a student. And Duke quits his bartending job.

Except for Duke, who has a tense Christmas reunion with his working-class alcoholic father, the characters seem detached from any background. They are more like types selected for their demographic range and forced together by a screenwriter given to putting clunky redundancies in his characters' mouths.

When, late in the movie, Barry sobs, "I'm 27 years old and I still haven't a clue what to do with my life," it is the umpteenth restatement of a theme that became cloying half an hour into the picture.

Final Approach

Directed and produced by Eric Steven Stahl; screenplay by Mr. Stahl and Gerald Laurence; film editor, Stefan Küt; music by Kirk Hunter; production designer, Ralph E. Stevic; presented by Trimark Pictures. Running time: 100 minutes. This film is rated R.

Col. Jason Halsey	James B. Sikking
Dr. Dio Gottlieb	Hector Elizondo
Casey Halsey	Madolyn Smith
General Geller	Kevin McCarthy
Brooke Halsey	Cameo Kneuer
Doug Slessinger	Wayne Duvall

By STEPHEN HOLDEN

Eric Steven Stahl's film "Final Approach" is a cinematic maze, a high-technology head trip in which the roles of director, film editor, computer animator and sound designer have blurred.

In the spectacular opening sequences, Col. Jason Halsey (James B. Sikking), a test pilot flying close to the ground over the Southwestern desert, crashes after his plane is struck by lightning. On waking, he finds himself in the spare, futuristic office of a psychiatrist (Hector Elizondo) who pelts him with questions he cannot answer since he has forgotten everything, including his own name. But slowly, through word-association games and Rorschach-style tests, his past begins to reveal itself in sudden, explosive flashes.

Tantalizing questions are raised. Is he the subject of some demonic brain transplant? Is it all a dream? Or is the psychiatrist a foreign agent intent on prying military secrets out of him? As much as possible, the film remains inside the mind of a character who is desperate for clues to his own identity and who is terrified that he has gone mad. And in its most effective moments, it produces a roller-coaster sense of mental queasiness.

•

It is no surprise to learn that Mr. Stahl, who produced, directed and co-wrote "Final Approach," comes from the world of television commercials, for the movie often has the look and sound of an MTV commercial. The entire film is structured as an extended flashback montage with a multi-layered, wraparound sound track. But for every breathtaking bit of aerial photography there is something

correspondingly banal, like the recurrent silhouette of a nude woman diving. And many of the computer-animated effects serve only as slick, superfluous visual filler.

As is often the case in films this technologically showy, the cinematic pyrotechnics also camouflage gaping holes in a story whose abrupt, unsatisfying conclusion seems borrowed from Albert Brooks's "Defending Your Life." Until that ending, however, the two leading actors play a smooth game of cat and mouse. Mr. Elizondo glides enigmatically along the line between genial and menacing, and Mr. Sikking undergoes a convincing grand mal seizure.

•

Article 99

Directed by Howard Deutch; written by Ron Cutler; director of photography, Richard Bowen; edited by Richard Halsey; music by Danny Elfman; production designer, Virginia L. Randolph; produced by Michael Gruskoff and Michael I. Levy; released by Orion Pictures. Running time: 99 minutes. This film is rated R.

Dr. Richard Sturgess	Ray Liotta
Dr. Peter Morgan	Kiefer Sutherland
Dr. Sid Handleman	Forest Whitaker
Dr. Robin Van Dorn	Lea Thompson
Dr. Rudy Bobrick	John C. McGinley
Dr. Henry Dreyfoos	John Mahoney
Luther Jerome	Keith David
Dr. Diana Walton	Kathy Baker
Sam Abrams	Eli Wallach
Amelia Sturdeyvant	Julie Bovasso
Pat Travis	Troy Evans
Nurse White	Lynne Thigpen

By JANET MASLIN

"Article 99" unfolds in that medical never-never land where rookies are brash and drive sports cars, the most irreverent doctors turn out to be the most talented, and on every gurney or behind every surgical mask there lurks a stock character with a familiar face. As directed with irrepressible pep by Howard Deutch ("Pretty in Pink," "Some Kind of Wonderful"), it has a television-series jauntiness even when addressing itself to the serious business of veterans' medical care.

The film, with a screenplay by Ron Cutler, takes place at a Veterans Administration hospital and takes its title from a fictitious regulation that might as well have been labeled Catch-22. This regulation promises veterans "full medical benefits," adding that "as the diagnosed condi-

tion cannot be specifically related to military service, treatment is not available at this time."

Fighting the good fight against this illogic is Dr. Richard Sturgess, who would be insufferably glib if he were not played with such appealing sincerity by Ray Liotta. Doing everything he can to fray the nerves of Dr. Henry Dreyfoos (John Mahoney), who sternly urges his staff to develop "the right perspective," Dr. Sturgess functions as the hospital's best-loved troublemaker and prankster. Among the stunts in which he engages is performing open-heart surgery on a prostate patient when regulations deny the patient full medical coverage for his heart trouble. "Look, we're here, he's here," he tells his operating-room staff. "Why don't we make the most of this?"

The story begins, as hokily as possible, with a Korean War veteran (Troy Evans) leaving his farmhouse in search of medical treatment. "Don't worry about anything," he tells his wife. "Uncle Sam's gonna take care of me just fine." Naturally, he becomes desperately sick while at the V.A. hospital, and Uncle Sam is no help at all. This veteran's problems are complicated by the fact that just as his heart begins to fail him, he watches a fellow veteran go berserk to the tune of "The Halls of Montezuma" and run through the hospital waving a gun. In the film's typically overheated language, this outburst is described as "a rampage."

The cast of "Article 99" includes enough familiar, energetic actors to keep the film enjoyable even when the material takes on that tabloid tone. Kathy Baker appears as Dr. Diana Walton, a psychiatrist who really cares about her patients and finds time to care about Dr. Sturgess, too. "You come tearing into my life, you make me care about what happens to you, and then you slam the door in my face!" she declares when the two of them have their obligatory spat.

Kiefer Sutherland is young Dr. Peter Morgan, new to the hospital and its scandalous practices and drawn to an elderly patient named Sam Abrams (Eli Wallach), with whom he becomes friends. Forest Whitaker, John C. McGinley and Lea Thompson are among the doctors trading operating-room taunts. Julie Bovasso (who died after filming was completed) and Lynne Thigpen are the nurses who glare suspiciously at the doctors' every move. Keith David is the hospital's resident rabble-rouser and the screenplay's most blatantly political mouthpiece. He plays a prominent role once the action, which began with that rampage, hits the same high note by culminating in a siege.

•

Shakes the Clown

Directed and written by Bobcat Goldthwait; directors of photography, Elliot Davis and Bobby Bukowski; edited by J. Kathleen Gibson; production designer, Pamela Woodbridge; produced by Ann Luly; I.R.S. Releasing Presents an I.R.S. Media Production. Running time: 83 minutes. This film is rated R.

Shakes the Clown	Bobcat Goldthwait
Judy	Julie Brown
Owen Cheese	Paul Dooley

Bobcat Goldthwait

The Unknown Woman	Florence Henderson
Binky the Clown	Tom Kenny
Mime Teacher	Robin Williams

By JANET MASLIN

As Shakes the Clown, Bobcat Goldthwait is first seen being urinated on by a small boy, after which Shakes vomits, belches, moans about his terrible hangover and prepares to face yet another day. It is difficult to imagine how the rest of Shakes's exploits could be of interest to anyone other than Mr. Goldthwait's close friends and relatives. Even they may wind up realizing that 83 minutes can be a very long time.

The best to be said about "Shakes the Clown" is that it must have sounded better on paper. As written by Mr. Goldthwait (who also directed), it takes place in an all-clown universe where the local bar is called the Twisted Balloon and where one denizen complains that another "can't even throw a pie straight." The film's nonscatological humor pretty much begins and ends with that line.

•

Shakes, an alcoholic clown, wanders through this setting with very little to do. So the screenplay gives him an archrival named Binky (Tom Kenny), a girlfriend named Judy (Julie Brown) who has a cute speech defect ("dwink" for "drink," etc.) and a boss named Owen Cheese (Paul Dooley), in whose murder Shakes is eventually implicated. The film's mood, one of vague contempt for the audience, keeps this material hovering somewhere in the realm of the half-serious.

Although it seems fleetingly possible that Shakes's alcoholism is meant to have some importance (he winds up attending an Alcoholics Anonymous meeting in full clown makeup), the film's production notes explain that this is in fact a satire on all those dramas that regard performers as tragic figures. Certainly it took impressive temerity to compare "Shakes the Clown" with either "Lenny" or "Monsieur Verdoux."

Appearing briefly and inexplicably is Robin Williams, who plays a mime and is many times funnier than anything around him. Ms. Brown's Madonna parody, "Medusa: Dare to Tell the Truth," was also infinitely better than anything she is able to do here.

"Shakes the Clown" has been photographed as poorly as it was conceived. The cinematography is so murky that a white picket fence comes out looking brown.

•

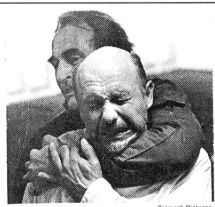

At Odds James B. Sikking, as an Air Force test pilot, confronts Hector Elizondo, as a psychiatrist, after the crash of a top-secret Stealth aircraft.

Voices From the Front

Directed, edited and produced by Robyn Hutt, Sandra Elgear and David Meieran; A Frameline release. At Film Forum 1, 209 West Houston Street. Running Time: 88 minutes. This film has no rating.

By VINCENT CANBY

The aptly titled "Voices From the Front," opening a one-week engagement today at the Film Forum, is a vivid, impassioned report on the war against AIDS as it is being fought by members of the People With AIDS Coalition, Act Up and other advocacy groups.

Robyn Hutt, Sandra Elgear and David Meiesan jointly produced, directed and edited the film, which is both a call to arms and a record of the war to date. Though the film presents statistics and personal stories that are harrowing, it has an invigorating evangelical fervor that recalls the long-lost time of militant trade unionism.

•

Among the tough and angry personal statements that open the film is one by a man who pretty much sets the tone for all that follows. "I am a person living with AIDS," he tells a responsive rally. He doesn't want to be thought of as somehow disabled or disadvantaged, he explains, but as an active member of society. "They like us as victims," he says, "but not when we speak out."

Speaking out is what "Voices From the Front" is all about. The film recalls the series of giant demonstrations in which Act Up, the P.W.A. Coalition and their associate groups participated between 1988 and 1991 to attract attention to the cause. Though mad as hell, the soldiers in this war, both women and men, are clearly channeling their emotions to do the most good. Joint action and the acknowledgment of community responsibility on a national level are the goals.

The targets of these demonstrations: the Burroughs Wellcome Company, manufacturer of the AIDS-fighting drug AZT (whose cost was cut by 20 percent after the mass rallies), the New York Stock Exchange, the Food and Drug Administration, the National Institutes of Health and Cook County Hospital in Chicago where, at the time of that demonstration, there were only 15 beds for AIDS patients, none of them for women.

"Voices From the Front" is impatient, energetic, terrifically articulate. It is also full of hope. Though its subject is grim, the film demonstrates that informed, committed citizens can indeed make a difference. There's no time for tears when there's a war to be won.

1992 Mr 18, C15:1

Idealism And Reality At Hormel

"American Dream" was shown as part of the 1990 New York Film Festival. Following are excerpts from Janet Maslin's review, which appeared in The New York Times on Oct. 6, 1990. The film is at the Angelika Film Center, 611 Broadway, at Houston Street.

Barbara Kopple is well remembered as the director of "Harlan County, U.S.A.," her outstandingly fine and troubling 1977 documentary about a strike by coal miners against a power company in eastern Kentucky. Now, in her account of another walkout, this time by factory workers at the George A. Hormel Company meatpacking plant in Austin, Minn., Ms. Kopple has found and illustrated another American tragedy.

"American Dream," her devastating look at this strike and the profound damage it left behind, begins in the mid-1980's with a matter-of-fact look at meat processors at work. It's a dirty job, but in the town of Austin it was then also a good one, paying $10.69 an hour and providing steady employment. "American Dream" is about what happened to Austin when Hormel tried to roll back those wages to $8.25. Unlike "Harlan County, U.S.A.," which observed a more violent struggle that was simpler, "American Dream" is no David and Goliath story. The David here, Local P-9 of the meatpacking division of the United Food and Commercial Workers' Union, pits itself against two Goliaths and embarks on a suicide mission. Rebelling against both Hormel and its own international parent union, Local P-9 resisted the idea of lower wages. "The unions are getting their teeth kicked in," said Jim Guyette, the local's president. He was right.

•

"American Dream" begins with Ronald Reagan, since it sees his economic policies as the root of Austin's troubles. Early in the film, workers protesting the wage cut visit the home of a Hormel executive and are asked (by a wife speaking to them through a screen door), "Why do you stay if you aren't happy?" Corporate spokesmen cite "the welfare of the long-term future of the company" to counter the workers' demands. One of Local P-9's first moves, in response to such stonewalling, is to hire Ray Rogers of Corporate Campaign Inc., a one-man army whose specialty is turning media attention into a secret weapon.

Although Mr. Rogers is a colorful figure and his tactics have an element of mischief, "American Dream" is no "Roger and Me." Ms. Kopple spends much less time questioning the behavior of Hormel's management than she does studying the terrible predicament in which it places the workers. As the protest moves inevitably toward a strike, Local P-9 meets opposition from employers, its parent union and even inside its own ranks. "That'll destroy us quicker than anything will," one union member says.

Ms. Kopple's camera observes all of this at very close range, at the kitchen tables of those who are most painfully affected. When the prospect of a strike becomes inevitable, she films two brothers who are on different sides of the dispute and agree they will not speak if one crosses the picket line. Once the strike is under way, with nonunion workers earning $10.25 an hour, she captures the misery and bewilderment of those on the picket line. "You see all these people you talk to every day, and it makes you want to cry," one picket says. Above all else, "American Dream" is about the destruction of Austin's ideals.

By the end of the film, the limb onto which P-9 has ventured has been sawed off. P-9's parent union has ousted the renegades and made its own settlement with Hormel, making no allowance for restoring jobs to those who honored the picket lines and agreeing on a $10.25 wage. It didn't take long, Ms. Kopple notes in a closing title, for Hormel to sublease the factory to a company that paid $6.50 an hour.

What hits home most powerfully in "American Dream" is the film maker's sense of how deep this damage ultimately runs. When the defeated strikers try to claim victory or when a woman tearfully packing her belongings insists, "We're not leaving, we're just taking our fight elsewhere," it's clear how crushing the full weight of this debacle will be.

1992 Mr 19, C16:6

Shadows and Fog

Written and directed by Woody Allen; director of photography, Carlo Di Palma; edited by Susan E. Morse; production designer, Santo Loquasto; produced by Helen Robin and Joseph Hartwick; Executive producers, Jack Rollins and Charles H. Joffe; released by Orion Pictures. Running time: 85 minutes. This film is rated PG-13.

Kleinman	Woody Allen
Killer	Michael Kirby
Irmy	Mia Farrow
Clown	John Malkovich
Marie	Madonna
Doctor	Donald Pleasence
Prostitutes	Lily Tomlin, Jodie Foster, Katny Bates and Anne Lange
Student Jack	John Cusack
Eve	Kate Nelligan
Magician	Kenneth Mars

By VINCENT CANBY

As Wolcott Gibbs once said to Shakespeare: Kafka, here's your hat.

That's just one of the deliciously eccentric messages being sent out by Woody Allen in his rich, not easily categorized new black-and-white comedy, "Shadows and Fog." Among other things, "Shadows and Fog" contemplates life, death, love, literature, movies, American humor in general, the gags of Bob Hope in particular, the music of Kurt Weill and the changing fashions in B.V.D.'s.

Kleinman (Mr. Allen) is a timid clerk in the kind of unidentified Middle European city once so beloved by Kafka, Kafka's imitators, the masters of the German Expressionist cinema of the 1920's and their imitators. It is always night in this closed world of miasmic fog, cobbled alleys and street lamps that shed too little light but cast photogenically deep shadows.

Authority here is absolute and inscrutable. It may be represented by the police, by angry mobs or by Kleinman's petit bourgeois employer, whom Kleinman addresses with deference. He calls him "your grace."

On this terrible night, death stalks the streets of the unidentified Middle European city, picking victims at random, strangling one fellow with piano wire, cutting another's throat ear to ear. His most heinous crime: the murder of pretty, virginal identical twins.

Kleinman remains unaware, sleeping fretfully on the second floor of a grubby little rooming house where, you can be sure, the air is heavy with the smell of yesterday's overcooked cabbage. At 2:30 A.M., there is a sudden pounding on Kleinman's door.

Testing the Limits/Film Forum

"Voices From the Front," a documentary on the AIDS epidemic, is at Film Forum I in a one-week engagement.

Miramax

Barbara Kopple's film "American Dream," which was shown at the 1990 New York Film Festival, is now at the Angelika Film Center.

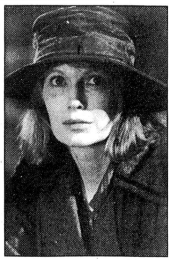

Orion Pictures

Mia Farrow.

Men wearing long overcoats and fedoras push their way in.

They say they need Kleinman's help in their search for the homicidal maniac. The exhausted fall-guy shivers in his underwear. What homicidal maniac? Don't ask so many questions, they say. They tell him he is part of their plan. What plan? There's no time to explain now, says the leader. Just get dressed and go outside. Someone will find him.

For Kleinman, it's six of one, a half-dozen of the other. If the homicidal maniac doesn't get him, the vigilantes will.

Kleinman reluctantly puts on his clothes and is leaving when confronted by his ferocious landlady. Even in the middle of the night, she is ready to pounce on Kleinman with a new proposal of marriage.

He points out that he is engaged to Eve. "She just wants you for an ornament," says the landlady. She pauses, surveys the accumulation of grim bibelots around them, and adds, "Why would you want to marry Eve when you can have half of all this?"

•

Thus begins the Passion of Kleinman, a hellish and funny succession of trials in a hostile nighttime Middle European landscape. Like "Zelig," "Shadows and Fog" is a pastiche of references to the works of others, but it's a brazen, irrepressible original in the way it uses those references. How many times did you laugh while watching Steven Soderbergh's polite and doomy "Kafka"?

Mr. Allen sends up his sources to rediscover and celebrate them. Carlo Di Palma's black-and-white cinematography recalls the glories of a technology all but forgotten today, as do Santo Loquasto's elegantly stylized studio sets, which may remind you of those in John Ford's "Informer."

Mr. Allen's screenplay is an expansion of his play "Death," included in his collection "Without Feathers," originally published by Random House. Among the characters created for the film is that of the camera, which doesn't merely record the events of this ghastly night of unreason. It is also a participant.

•

The camera has a distinct personality, rather like that of a curious, independently minded cat. It watches Kleinman with sarcastic amusement and then goes off exploring on its own.

It knows where the action is. It's privy to information that the bewildered Kleinman doesn't dream of. It anticipates events.

While Kleinman wanders the streets, the camera turns up at the circus grounds where Irmy (Mia Farrow), the sword swallower, is trying to cheer up her lover, the Clown (John Malkovich), whose performance that night wasn't well received.

Irmy doesn't help him by whining about their getting married. But she really gets under his skin when she says, in that nagging way of hers, "I think you can always tell a lot about audiences by how they respond to a good sword swallower." That's enough to send him off to the wagon of Marie (Madonna), the high-wire artist, where he's soon caught by Irmy. (The camera is already there.)

Kleinman keeps meeting people who assume he's part of the plan, but who either can't or won't tell him what his part is. There's an obsessed coroner (Donald Pleasence), impatient to perform an autopsy on the killer as part of his study of the nature of evil. Meanwhile, poor Irmy, who has run away from the circus, is befriended by a philosophical prostitute (Lily Tomlin) and taken back to the brothel for a good hot meal.

Irmy listens with fascination as the prostitutes (Ms. Tomlin, Jodie Foster, Kathy Bates, Anne Lange) talk about love, marriage and their clients. The camera, seemingly made drunk by their friendship and body warmth, swoops around the table where the prostitutes sit, peering into each face in turn as if seeing their humanity for the first time.

•

Irmy is propositioned by a customer, Student Jack (John Cusack), who offers her $700 to have sex with him. The experience forever changes Irmy's life.

Before the arrival of dawn, the original vigilante group has broken up into warring factions. The killer finds additional victims. Kleinman comes to the brothel saying that he has never before paid for sex. "You just think you haven't," says Ms. Foster. Eventually a bogus seer with a sensitive nose sniffs Kleinman and identifies him as the killer. All that and much, much more.

Mr. Allen is extravagant in his use of talent. He's now in a position to obtain the best actors available to do everything from starring and featured roles to what amount to walk-ons. Yet the strength of the film is such that recognizing, say, Kate Nelligan standing behind a window, seen briefly in long shot, does not interrupt the drama, but enriches it.

A note of caution: "Shadows and Fog" operates on its own wavelength. It is different. It should not be anticipated in the manner of other Allen films. It's unpredictable, with its own tone and rhythm, even though, like all of the director's work, it's a mixture of the sincere, the sardonic and the classically sappy. A vigilante questions Kleinman: "Are you a coward or a worm or a yellow-belly?" "No," says Kleinman, "but keep going."

•

"Shadows and Fog," which has been rated PC-13 (Parents strongly cautioned), has some sexually suggestive scenes and dialogue.

1992 Mr 20, C6:1

Basic Instinct

Directed by Paul Verhoeven; written by Joe Eszterhas; director of photography, Jan De Bont; edited by Frank J. Urioste; music by Jerry Goldsmith; production designer, Terence Marsh; costumes designed by Ellen Mirojnick; produced by Alan Marshall; released by Tri-Star. Running time: 120 minutes. This film is rated R.

Nick Curran	Michael Douglas
Catherine Tramell	Sharon Stone
Gus	George Dzundza
Hazel Dobkins	Dorothy Malone
Dr. Beth Garner	Jeanne Tripplehorn
Lieutenant Walker	Denis Arndt
Roxy	Leilani Sarelle
Andrews	Bruce A. Young

By JANET MASLIN

"Basic Instinct" begins with two naked bodies, a mirrored ceiling and an ice pick, which will be wielded in the heat of passion by an unidentified blond woman as she makes a nasty mess of her unsuspecting lover. Paul Verhoeven, whose films include lurid techno-thrillers ("Robocop" and "Total Recall") and now this red-hot, dangerously modern romance, will never be accused of not knowing how to get an audience's attention.

Whatever else Mr. Verhoeven winds up being assailed for, with a film that is as violent and misogynistic as it is sexually frank, he hasn't pulled his punches. That opening murder scene serves as warning that "Basic Instinct" is not bound by the usual rules of decorum, not even those rules that apply to homicidal psychopaths playing cat-and-mouse games with the San Francisco police. It's no wonder that when Detective Nick Curran (Michael Douglas) and his partner, Gus (George Dzundza), first interrogate the glamorous Catherine Tramell (Sharon Stone), who is the prime suspect in that ice-pick

A femme fatale ensnares Michael Douglas's character.

murder, they exchange wary glances over Catherine's absolute diffidence and superiority. Neither the detectives nor the audience has seen anything quite like Catherine before.

Or maybe they have: Madonna is an obvious model for this rich, controlling woman who turns her sexuality into a form of malice, deliberately mocking and inverting ordinary notions of heterosexual seduction. When Catherine offhandedly tells five police detectives that she has nothing to hide, she is laying down a contemptuous challenge. In an interrogation-room scene that will be remarked upon as much for its carefully built tension level as its use of nudity, Catherine is shown deliberately crossing and uncrossing her legs as a way of embarrassing her questioners, who discover that Catherine has the same disdain for underwear that she has for everything else. In this film's disturbing scheme, the power to arouse and the power to humiliate go hand in hand.

•

It is the conceit of Joe Eszterhas's enterprising screenplay, which does what it can to insert an obscene thought into every situation, that the

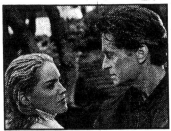

Tri-Star Pictures

Sharon Stone and Michael Douglas in "Basic Instinct."

recently reformed Nick and the reckless Catherine are two of a kind, and are thus inexorably drawn together. It is also the screenplay's idea that this is potentially dangerous to Nick's health, since Catherine, while trying to drive Nick back to his former vices (drinking, smoking, cocaine), may also be plotting his murder. An heiress with too much time on her hands, Catherine writes mystery novels with fictitious stories that have a way of coming true. Is this another of Catherine's taunts? Or is someone staging similar crimes in an attempt to frame her? The $3 million reportedly paid for Mr. Eszterhas's screenplay did not buy a coherent ending.

Mr. Verhoeven is not seriously inconvenienced by the script's inconsistencies, or even by the fact that it eventually devolves into a series of house calls. (Mr. Eszterhas seldom comes up with more interesting ways for the characters to meet.) This director's forte is slam-bang sensationalism of the sort that transcends ordinary nit-picking, and his skill is readily apparent. "Basic Instinct" transfers Mr. Verhoeven's flair for action-oriented material to the realm of Hitchcockian intrigue, and the results are viscerally effective even when they don't make sense. Drawing powerfully on the seductiveness of his actors and the intensity of their situation, Mr. Verhoeven easily suspends all disbelief.

As a hurt, embittered man drawn against his better judgment into a maelstrom of temptation, Mr. Douglas recalls Cary Grant as often as he's meant to (Mr. Verhoeven even attempts something like the sustained kissing sequence from "Notorious"). He also engages in the kinds of on-screen behavior that never would have been called for in Grant's day, and conveys emotion that goes well beyond the film's carefully choreographed sexual behavior. Mr. Douglas, whose strong and involving performance holds the film together, helps to humanize his bionically beautiful co-star. Ms. Stone delivers Catherine's most heartless dialogue with chilling verisimilitude.

•

As the other woman in Nick's life, a police psychologist who both treats him professionally and sleeps with him, Jeanne Tripplehorn makes a memorable impression in a completely impossible role. Also notable are Leilani Sarelle as Nick's main competition for Catherine's attention, and Mr. Dzundza, who is jovial and entertaining as the only quasi-normal figure in the story. A smiling Dorothy Malone turns up in a small, very peculiar role.

Frankly intent on keeping its audience entertained at all costs, "Basic Instinct" employs one dizzying car chase, some impressive California real estate, Jan De Bont's bright and

scenic cinematography, Ellen Mirojnick's series of skin-tight costumes for Ms. Stone (who at times furthers the Hitchcock motif by dressing in the Kim Novak-Tippi Hedren mode), and Jerry Goldsmith's effectively insidious score. It also incorporates four apparently homicidal women, at least three of whom are bisexual, by the time the story is over. This film is far too bizarre and singular to be construed as homophobic, but the bisexuality helps to undermine any possibility of real closeness between the story's men and women, which is apparently the point. Hostility between the sexes is an essential part of this film's AIDS-era escapism, with its suggestion that the possibility of physical violence is what gives sex its greatest element of danger.

•

"Basic Instinct" includes male and female frontal nudity, profanity, graphic sexual encounters, extreme violence, frequent obscenity, references to masturbation, voyeurism, bondage and the use of cocaine as a sexual aid. Although it was initially rated NC-17 (No one under 17 admitted), it has undergone minor alterations and is now rated R (Under 17 requires accompanying parent or adult guardian). The altering of several explicit images does not significantly change the film's overall tenor, which would seem to be exactly what the NC-17 rating was meant to designate. Haggling over details in a case like this means not seeing the forest for the trees.

1992 Mr 20, C8:1

Noises Off

Directed by Peter Bogdanovich; screenplay by Marty Kaplan, based on the play by Michael Frayn; director of photography, Tim Suhrstedt; edited by Lisa Day; music adaptations by Phil Marshall; production designer, Norman Newberry; produced by Frank Marshall; released by Touchstone Pictures. Running time: 104 minutes. This film is rated PG-13.

Dotty Otley and Mrs. Clackett
........................Carol Burnett
Lloyd Fellowes............................Michael Caine
Selsdon Mowbray and the Burglar
........................Denholm Elliott
Poppy Taylor................................Julie Hagerty
Belinda Blair and Flavia Brent
........................Marilu Henner
Tim Allgood............................Mark Linn-Baker
Frederick Dallas and Philip Brent
........................Christopher Reeve
Garry Lejune and Roger Tramplemain
........................John Ritter
Brooke Ashton and Vicki
........................Nicollette Sheridan

By VINCENT CANBY

There are a number of hefty laughs scattered throughout "Noises Off," Peter Bogdanovich's screen version of Michael Frayn's English stage farce. Yet there are nowhere near as many as the source material deserves and Mr. Bogdanovich's cast might otherwise have earned.

The play, a critical smash when it opened on Broadway in 1983, is about a group of second-rate English actors touring the provinces in a third-rate English sex comedy. The play's gimmick is that the theater audience is first introduced to the play-within-the-play, titled "Nothing On," as it falls apart during dress rehearsal. The audience next sees the play in mid-performance from backstage as the actors' so-called real lives become the hilarious and hopeless mirror images of their frantic stage lives.

For "Noises Off" to work, the theater audience must be almost as familiar with "Nothing On" as the actors are. It's also necessary that the audience knows exactly what sort of play the play-within is, and what sort of actors are performing it.

All of these things are blurred in this woozy film adaptation, written by Marty Kaplan, with the locale transposed from England to the United States. "Noises Off" is a practically perfect stage piece, constructed with such delicacy that any opportunistic adjustment can destroy it, which is what happens here.

In this film version, "Nothing On" is touring the American heartland, on its way to Broadway. It's being performed by a mostly American cast whose terrible onstage English accents would seem to indicate that they are second-raters, although very late in the movie they turn out to be (I think) first-raters, capable of winning the hearts and pocketbooks of New York audiences.

The film makers have attempted to upgrade their source material. Unfortunately, they also never allow the movie audience a chance to know "Nothing On" well enough to be entirely sure how far it's being sent up during its disastrous road tour.

Laughs do remain. Certain gags work no matter what the circumstances: men caught with their pants around their ankles, beautiful myopic blondes caught in their bras and panties, props misplaced during a performance, actors missing their cues, prompting other actors to ad-lib gloriously.

The excellent trans-Atlantic cast is headed by Michael Caine, Carol Burnett, Denholm Elliott, Christopher Reeve, John Ritter, Julie Hagerty,

The ins and outs, and ons and offs, of a play filmed.

Marilu Henner and, as the myopic blonde, Nicollette Sheridan. It is not their fault that the film does not provide them with the limited, clearly defined context so necessary to farce.

It may not even be Mr. Bogdanovich's fault. He hasn't opened up the play in any foolish way. There are even times when the camera successfully catches the tempo of the lunatic action without being overwhelmed by it. Yet too often the action and the dialogue are so fuzzily understood that the laughs are lost.

The film's problem is more basic: the attempt to Americanize a fine English farce about provincial seediness. It can't be done.

•

"Noises Off," which has been rated PG-13 (Parents strongly cautioned), has some vulgar language.

1992 Mr 20, C10:1

Critic's Choice

Works of Art About Art

Philip Haas does a rare thing: he makes elegant, quietly revelatory films about art. In the nine films to be screened in the 10-year retrospective of Mr. Haas's work this weekend and next week at the Walter Reade Theater at Lincoln Center, the 38-year-old film maker seems to possess a kind of sixth sense when it comes to capturing the experience of art — both the making and the viewing — on film.

His subjects vary tremendously in style, culture and geographical location. "The Giant Woman and the Lightning Man," which is being shown today at 3:30 P.M., is one of four extraordinary films that Mr. Haas made in conjunction with the "Magicians of the Earth" exhibition at the Pompidou Center in Paris in 1989. It shows aboriginal artists in central Australia creating a ground painting. "Seni's Children," another of the "Magicians" films, features Seni Camara, a Senegalese woman whose elaborate clay creature-sculptures have developed independently of local traditions (Sunday at 4:15).

In his 1988 film "Stones and Flies: Richard Long in the Sahara" Mr. Haas follows Mr. Long, a well-known English sculptor, as he treks across the Sahara on foot, making meditative sculptures from the desert's stones or red earth as he goes (tomorrow at 5:45 P.M.; Sunday at 2; Tuesday at 3:45). In "A Day on the Grand Canal With the Emperor of China," the film maker follows another English artist, David Hockney, as he simply stands before a table and unrolls a 17th-century Chinese scroll, discussing the differences between Eastern and Western concepts of time and space, and finding the former far superior. (This film will be shown, together with "The Singing Sculpture," today at 2, 5:45 and 7:45 P.M., and Tuesday at 6.)

Nearly all of Mr. Haas's efforts have an air of meticulousness: the images, music and words dovetail effortlessly, showing their maker to be, increasingly, an artist in his own right.

The Walter Reade Theater is at 165 West 65th Street, Manhattan. Admission is $7 ($5 for the elderly at weekday matinees). Information: (212) 875-5600. *ROBERTA SMITH*

1992 Mr 20, C14:5

Memoirs of a River

Written and directed by Judit Elek (in Hungarian with English subtitles); director of photography, Gabor Halasz; edited by Katalin Kabdebo; production designer, Andras Ozorai; produced by Gabor Hanak and Hubert Niogret; released by Quartet Films. At the Quad Cinema, 13th Street, between Fifth Avenue and the Avenue of the Americas, Manhattan. Running time: 147 minutes. This film has no rating.

Quartet Films

Pal Hetenyi, left, and Sandor Gaspar in "Memoirs of a River."

David Hersko	Sandor Gaspar
Csepkanics	Pal Hetenyi
Amsel Vogel	Franciszek Pieczka
Matej	Andras Stohl
Commissar Vay	Janos Acs
Jacob	Zoltan Mucsi
Joszef Scharf	Robert Koltay
Moric Scharf	Istvan Meszaros
Jacob	Zoltan Mucsi

By STEPHEN HOLDEN

In the opening scene of Judit Elek's film "Memoirs of a River," the peaceful existence of Jacob (Zoltan Mucsi), a Jewish shepherd, is shattered by the sounds of gunfire. Moments later, he sees a wounded young girl running in terror from armed horsemen. Fleeing into the forest, he watches as his house is burned to the ground and his sheep are set on fire.

Such images of extreme brutality erupting in lush pastoral landscapes, photographed with a mystical appreciation of their beauty, recur throughout the film, which opens today at the Quad Cinema. These juxtapositions underscore an unsettling notion that runs to the heart of the film: not even the secluded pastoral aeries of this world are safe from evil.

Set in the northeastern corner of the Austro-Hungarian Empire in what is now Hungary, "Memoirs of a River" recalls an actual incident of anti-Semitic violence in the early 1880's. The focus of the film turns out to be not Jacob the shepherd but David Hersko (Sandor Gaspar), a logger (also Jewish) whose family shelters him.

•

Soon after Jacob arrives, Hersko and his cohorts embark on a timber run that becomes a slow journey into hell. Among the grim portents they encounter is a young woman's floating corpse, which they pull ashore and bury, contrary to the orders of the local law enforcer, Commissar Vay (Janos Acs). The next day, they are arrested and charged with the woman's murder, although everything about the case, including the victim's identity, is unclear.

Although they have no evidence, the commissar and many of the townspeople believe the woman was ritually slaughtered in a Jewish temple and her blood used to make Passover bread. Employing systematic torture, the commissar sets about extracting confessions from the loggers.

"Memoirs of a River" is not an easy film to watch, but once one has adjusted to its stately pace (it runs two and a half hours), it becomes a gripping, often unsettling experience. The film gazes unflinchingly on the face of anti-Semitic hatred. And the scenes of the men's torture and their varying reactions (Hersko gives in, while most of the others resist) are not for the squeamish.

The final third of the film is devoted to the trial at which Hersko's

lawyer persuades him to tell the truth about his forced confession. Heightening the courtroom drama is the case of Rabbi Scharf (Robert Koltay), one of those accused of the murder, whose terrorized 14-year-old son, Moric (Istvan Meszaros), testifies against him.

•

"Memoirs of a River" is an oddly shaped film that begins with one character, quickly shifts its focus to another and then turns into an ensemble piece before focusing on Hersko again. Although somewhat confusing, this seemingly meandering perspective has a purpose, for it deflects easy emotional identification with any one character, no matter how powerfully dramatic the performances may be. The strongest are Mr. Acs's interrogator, a grimly self-righteous bureaucrat who harbors a secret streak of cruelty, and Mr. Koltay's rabbi, who becomes completely unstrung by his son's apparent betrayal.

If the film keeps a distance from individuals, it goes all out to convey the group's befuddlement and utter helplessness in the face of an ethnic hatred as implacable as it is irrational.

In the most disturbing sequence, the Jewish prisoners are forced to spend the night squeezed together in a chicken coop. As the disgruntled fowl squawk about their heads, one of the men suffers an attack of claustrophobic panic. Watching this horrifying outburst of fear, misery and humiliation, it is impossible not to remember how millions of Jews would suffer similar experiences, and worse, a half-century later.

1992 Mr 20, C15:1

Edward II

Directed by Derek Jarman; screenplay by Mr. Jarman, Stephen McBride and Ken Butler, based on the play by Christopher Marlowe; director of photography, Ian Wilson; edited by George Akers; music by Simon Fisher Turner; production designer, Christopher Hobbs; produced by Steve Clark-Hall and Antony Root; released by Fine Line Features. Running time: 91 minutes. This film is rated R.

Edward II	Steven Waddington
Lightborn	Kevin Collins
Gaveston	Andrew Tiernan
Spencer	John Lynch
Bishop of Winchester	Dudley Sutton
Isabella	Tilda Swinton
Kent	Jerome Flynn
Prince Edward	Jody Graber
Mortimer	Nigel Terry
Singer	Annie Lennox

By STEPHEN HOLDEN

Extravagant visual elegance and sexual politics have always formed a volatile mix in the work of the English film maker Derek Jarman. And in "Edward II," his adaptation of Christopher Marlowe's musty Elizabethan drama, the 14th-century tale of the downfall of a weak gay monarch and his unpopular companion is invested with a powerful contemporary resonance.

Although the screen adaptation remains more or less faithful to Marlowe's text, Mr. Jarman has augmented the drama with provocative visualizations of homosexual love and the persecution of gay people that infuse the play with sex, sadomasochistic violence and a hysterically pitched moral fury. Where the Marlowe play is a dog-eat-dog political allegory without heroes, the movie is

a tract against the oppression of homosexuals through the ages, filmed by a director who is himself openly gay and living with AIDS.

But if "Edward II" presents the King and his lover, Piers Gaveston, as victims of anti-gay prejudice, it hardly ennobles them. Steven Waddington's Edward is a passive, dissolute playboy who turns into a whimpering baby whenever he doesn't get what he wants. Andrew Tiernan's Gaveston is an opportunistic workingclass urchin whose surly coquettishness repels everyone except the King. The lovers, both of them redheads, blithely ignore matters of state, preferring to loll around in bed with sailors or to while away the hours watching a male stripper twirling a python around his neck.

The nobles who plot Edward's undoing are portrayed as a scheming corporate board of directors. In some scenes they are shown in period costume and in others wearing contemporary business suits. Mortimer (Nigel Terry), their leader, is a supermacho military man and practicing sadomasochist who takes a grim pleasure in personally torturing Gaveston and the lovers' friend Spencer (John Lynch), whom he addresses as "girlboy." The scenes of their torture are crosscut with shots of a clash between the police and members of the English gay-rights organization Outrage. The costuming makes explicit parallels between Mortimer and his henchmen and modern-day storm troopers.

Like Mr. Jarman's earlier films, most notably "Caravaggio," "Edward II" is a handsomely designed and dramatically lighted film in which each scene evokes a heroic canvas. Instead of flowing into one another, the events unfold as a series of self-contained tableaux whose visual imagery is often far more striking than Marlowe's poetry. The film was shot among giant stone blocks placed in sand, and this setting gives the film a look that seems more North African than English. In a strong cast, Tilda Swinton, who plays Edward's Queen, Isabella, turns in the most memorable performance, that of a love-starved woman whose iceberg exterior conceals a consuming sexual hunger.

Typically for a Jarman film, "Edward II" has elements that seem entirely gratuitous. One of the oddest touches is the out-of-the-blue appearance of the singer Annie Lennox wistfully crooning Cole Porter's "Ev'ry Time We Say Goodbye."

•

The film is suffused with sexual menace. In one scene, Gaveston inflames Isabella by whispering obscenities in her ear, then mocks her responsiveness. Mortimer, for all his straight-arrow attitudes, is shown to be a bondage enthusiast. A bishop who has persecuted Edward is tormented in a prison ritual that recalls the more fiendish fantasies of humiliation in the films of Ken Russell.

For all its fulminating about sexual hypocrisy and anti-gay violence, the film offers a few affirmative flashes. To Marlowe's retelling of Edward's execution by impalement on a red-hot poker, Mr. Jarman has appended an alternative happy ending, "Threepenny Opera"-style, in which this hideous fate is presented as a nightmare from which the imprisoned King awakens. The executioner, when he does arrive, tosses away his lethal weapon and kisses the man he was sent to kill.

Back in the castle, the King's young son, Edward III, has donned his mother's earrings and lipstick and is playing Tchaikovsky's "Dance of the Sugar Plum Fairy" on his Walkman headphones. Prancing atop a cage that imprisons his mother and Mortimer, England's future ruler personifies an androgynous spirit that will not be quenched in spite of all the forces marshaled against it.

•

"Edward II" is rated R (Under 17 requires accompanying parent or adult guardian). It includes nudity and scenes of explicit sex and torture.

1992 Mr 20, C16:3

Raise the Red Lantern

Directed by Zhang Yimou; screenplay by Ni Zhen (in Mandarin with English subtitles), based on a novel by Su Tong; director of photography, Zhao Fei; edited by Du Yuan; music by Zhao Jiping; produced by Chiu Fu-Sheng; released by Orion Classics. At the Lincoln Plaza Cinemas, Broadway at 62d Street, Manhattan. Running time: 125 minutes. This film is rated PG.

Songlian	Gong Li
Chen Zuoqian	Ma Jingwu
Meishan	He Caifei
Zhuoyun	Cao Cuifeng
Yuru	Jin Shuyuan
Yan'er	Kong Lin
Mother Song	Ding Weimin
Dr. Gao	Cui Zhihgang

By JANET MASLIN

Songlian (Gong Li), the college-educated beauty who arrives at a feudal manor house at the outset of Zhang Yimou's "Raise the Red Lantern," insists on carrying her own suitcase, which is virtually the last act of independence she will be permitted during the course of the story. Forced by her stepmother into what is essentially the life of a concubine, Songlian has agreed to become the fourth wife of a feudal patriarch, a man so regal that each of his wives presides over her own separate home.

Mr. Zhang, while acknowledging this man's importance, deliberately ignores him. "Raise the Red Lantern," a beautifully crafted and richly detailed feat of consciousness-raising and a serious drama with the verve of a good soap opera, is strictly about the women who manage to live under this arrangement. Ruled by elaborate rituals, the wives spend their days waiting to be chosen for the night by their mutual husband, whose ways of signaling his choice include assigning a special foot massage to the woman he likes best. "If you can manage to have a foot massage every day, you'll soon be running this household," wife No. 2 (Cao Cuifeng) tells the new arrival.

As in his earlier "Ju Dou" (which, like this film, was an Oscar nominee

Orion Classics
He Caife, left, and Jin Shuyuan

for best foreign film), Mr. Zhang works with an exquisite simplicity that broadens the universality of his work. Steeped as it is in the specifics of privileged life in 1920's China, "Raise the Red Lantern" is also filled with instantly familiar figures, from the gloriously malicious and spoiled wife No. 3 (He Caifei), a former opera singer who manages to play Camille whenever her husband visits his new bride, to the resentful maid (Kong Lin) who proves extremely treacherous to her new mistress.

In 1920's China, the tragedy of a victim of marital concubinage.

The film, very knowing about its characters' particular personalities and the ways they intersect, even becomes quietly comic when Mr. Zhang stages dinner scenes among the four wives, each of whom has a maid standing in silent attendance. Progressively younger and more beautiful, the wives are united in quiet resentment of the man they call "the master." Yet the situation demands that each one try her best to win his approval. From the plain, motherly wife No. 1 to the trophy types who are the most recent additions, these women reveal a lot about the man who married them, while also providing a fairly hellish vision of life without the option of divorce. Songlian, who initially views the wives' intrigue with detachment, eventually learns to assess her rivals' abilities and fight fire with fire.

Directing in a quiet, observant style, Mr. Zhang begins the film — which opens today at the Lincoln Plaza Cinemas — by introducing Songlian to the household and its customs. The title ritual, like that of the foot massage, is meant to signal the husband's nightly sexual predilection, and is performed with elaborate fanfare. On the night she arrives, the passageway to Songlian's house is lined with red lanterns as her new husband tells her "I like it bright and formal." The next morning, Songlian gazes in the mirror with a look of pure disgust and shame.

Subtly exploring the politics of power and control, "Raise the Red Lantern" traces Songlian's growing canniness once she becomes accustomed to the strictures governing her new life. It eventually becomes a tale of treachery in some quarters and solidarity in others, with a narrative that yields several surprising shifts of character. Songlian learns, among other things, not to trust her first impressions, and not to lose track of who her real enemies are.

•

Gong Li, also the star of "Ju Dou" and Mr. Zhang's "Red Sorghum," is a stunningly handsome actress of strong, stately bearing. In this role, she reveals unexpected sharpness as well as great depths of dignity and sorrow. Also fine are Ms. Cao as the wife eventually revealed to have "a Buddha's face and a scorpion's heart," and Ms. Kong as the disloyal maid whose lot is ultimately even more pitiable than her mistress's. Ms. He, as the opera singer who sets the film's tragic ending in motion,

cogently demonstrates the film's attitudes about divisiveness, solidarity and oppression.

"Raise the Red Lantern," based on a novel called "Wives and Concubines" by Su Tong, is as visually striking as it is dramatically effective. Mr. Zhang makes evocative use of clear, simple colors, from the lanterns themselves to the blue of the house's rooftops at twilight. And he captures a detailed visual sense of the rituals governing Songlian's new life. (Ceremonial black lantern covers are employed when one of the wives commits a shameful transgression.) The house itself, hauntingly photographed, becomes a perfect visual metaphor for Songlian's plight. Vast, rambling and strangely empty, it has developed the look of a prison by the film's closing moments.

•

"Raise the Red Lantern" is rated PG (Parental guidance suggested). It includes some sexual situations.

1992 Mr 20, C18:1

Proof

Written and directed by Jocelyn Moorhouse; director of photography, Martin McGrath; edited by Ken Sallows; music by Not Drowning, Waving; production designer, Patrick Reardon; produced by Lynda House; released by Fine Line Features. At the Roy and Niuta Titus Theaters in the Museum of Modern Art, 11 West 53d Street, as part of the New Directors/New Films series presented by the Film Society of Lincoln Center and the Department of Film of the Museum of Modern Art. Running time: 86 minutes. This film has no rating.

Martin	Hugo Weaving
Celia	Genevieve Picot
Andy	Russell Crowe
Mother	Heather Mitchell
Young Martin	Jeffrey Walker
Vet	Frank Gallacher
Policeman	Frankie J. Holden
Gary	Daniel Pollock
Waitress	Saskia Post
Caretaker	Cliff Ellen

By JANET MASLIN

This year's New Directors/New Films series begins exactly as it should, with the work of film makers whose utter assurance and originality prefigure a bright future. Jocelyn Moorhouse's "Proof," the opening feature, is a darkly clever Australian drama focusing on brilliant, wickedly manipulative characters whose attachment to one another is matched only by their mutual loathing.

Miss Moorhouse has just the right acid wit to make the most of such a situation. Her film is centered on Martin (Hugo Weaving), a willfully unpleasant young man who happens to be blind and happens to vent much of his hostility upon Celia (Genevieve Picot), his housekeeper. The droll Celia, whose scathing intelligence makes it clear that she is seriously underemployed, has long devoted herself to taking care of Martin, despite his abusiveness and indifference. The film initially suggests that this uneasy truce could go on indefinitely, while it also introduces the naïve, handsome young Andy (Russell Crowe), who will inadvertently throw it off balance.

Andy, a dishwasher at a restaurant, notices Martin as a patron. Martin is easy to notice. When a waitress is slow in taking his order, he pours' red wine on a tablecloth until she gets the point. And as a blind man carrying a camera, he also attracts considerable attention. Taking pictures is Martin's passion, and he enlists Andy

to, describe the photographs after they have been developed. Pictures provide the deeply suspicious Martin with proof that the world exists just as he imagines it, although he always has his doubts. "Why would I lie to you?" he remembers his mother asking when he was a small child. "Because you can," the young Martin replied.

•

Martin and Andy develop a warm friendship. Perhaps as a consequence, Martin appears even more frightened and horrified by Celia's sexual advances than he was at first. And Celia, for her part, grows more insistent upon having her revenge. Free to manipulate what Martin thinks he knows of the world, she variously tricks and blackmails the other two characters in extremely inventive ways, never forgetting her sense of humor in the process. "I don't think you realize how fond I am of you," she says one evening, having forced Martin into a sort of date at gunpoint. (He may not realize, but we do: Celia's apartment is a virtual shrine to Martin's image.) "I'm getting a fair idea," Martin says archly at this juncture.

Miss Moorhouse's direction is as crisply controlled as her characters' banter, and as quietly insidious in its own way. She allows the actors in this highly peculiar story to generate a powerful battle of nerves, yet she never allows that battle to lose the elegance and reserve that make it interesting (although the film does end on a slightly anticlimactic note). The actors, who have been very well chosen, avoid anything sentimental or easy in their characterizations.

The forbidding-looking Mr. Weaving, who resembles the writer Martin

Traffic Jam

Directed by Mitsuo Kurotsuchi; screenplay by Mr. Kurotsuchi and Mineyo Sato (in Japanese with English subtitles), director of photography, Kenji Takama; edited by Akimasa Kawashima; music by Kenny G.; production designer, Yuji Maruyama; produced by Yutaka Okada; released by Water Bearer Films Inc. At the Roy and Niuta Titus Theaters in the Museum of Modern Art as part of the New Directors/New Films series of the Film Society of Lincoln Center and the Department of Film of the Museum of Modern Art. Running time: 108 minutes. This film has no rating.

Father	Kenichi Hagiwana
Mother	Hitomi Kuroki
Son	Eiji Okada
Daughter	Misa Shimizu

By VINCENT CANBY

The expressway a few miles south of Tokyo has become a parking lot.

Amis, does nothing to make Martin conventionally ingratiating, and indeed he is not; the pathos of Martin's situation is in an odd way heightened by the character's self-defeating unpleasantness. Miss Picot, who projects the acerbically intelligent manner of the young Glenda Jackson, makes Celia someone both aware of and almost bemused by her own hopeless folly. Mr. Crowe never condescends to Andy, who is as innocent and open as he initially appears, and thus becomes catnip for the ingenious Celia. A feat of deception involving photographs taken in a park is strongly reminiscent of "Blow-Up," although this film's ominousness is less all-embracing and certainly more concrete.

On the same bill is "The Room," a delightful 12-minute fable billed as "a short film about the rest of your life." Making inventive use of special effects, the director Jeff Balsmeyer (a storyboard artist on "Big," "Alice," "Do the Right Thing" and other films) and his brother Randall, the cinematographer, show how a boy who retreats from family pressures into the welcome escapism of a fairy tale can indeed free himself from the mundane. The boy is last seen abandoning the ordinary and embarking upon a life of adventure. These film makers are off to a comparably auspicious start.

•

"Proof" and "The Room" will be shown at 6 tonight and at 3 P.M. tomorrow at the Museum of Modern Art. "Proof" will open commercially at the Angelika Film Center, 18 West Houston Street in Manhattan, on Sunday.

1992 Mr 20, C20:1

The shiny precision-built automobiles are lined up bumper to bumper as far as the eye can see. It is late afternoon on the first day of a four-day New Year's holiday, but it could be the night before Christmas.

Nothing is stirring, certainly not the traffic. The only signs of life are parents making furtive three-foot forays from their cars to the curb to allow their children to relieve themselves. Meanwhile, temperatures are rising inside the cars. Says one irate father (Kenichi Hagiwana), "Why don't Japanese complain more?"

Considering the conditions, it's something of a wonder that Mitsuo Kurotsuchi, the director, hasn't made a more brutal and scathing satire than "Traffic Jam," a sweet-natured comedy about one average Tokyo

family's doomed attempt to have a holiday.

"Traffic Jam," Mr. Kurotsuchi's second feature, will be shown at the Museum of Modern Art today at 9 P.M. as part of the New Directors/New Films series. It will be shown again tomorrow at 11:30 A.M.

•

A critic is not supposed to review the film the director elected not to make, which is very difficult in the case of "Traffic Jam," which clearly reveals the sensibility of a talented film maker. Mr. Kurotsuchi characterizes the members of this average family (Dad, Mom, Daughter and Son) with such effortless wit that his decision not to express more lethal outrage is anticlimactic. Possibly he feels it would be redundant.

Yet satire doesn't come easily to Japanese film makers. With the exception of the films of Juzo Itami ("The Funeral," "A Taxing Woman," among others), and some one-shots, including Yojiro Takita's "Comic Magazine" and Yoshimitsu Morita's "Family Game," very few Japanese films have attempted to consider the new, economically ascendant Japan in the satiric terms it might seem to invite.

As satire, "Traffic Jam" is enormously patient. Having set out from Tokyo early one morning to beat the traffic, Mr. Kurotsuchi's average family spends three days and nights on the road, driving the 300-mile route south to visit Dad's parents, who live on an island in the Inland Sea.

•

Their adventures en route are mildly diverting. At one point, Dad runs into a truck carrying pigs to market. At another point, he thinks he has found a miraculously clear, traffic-free road, only to discover that it's a speed trap. The hotels along the way are full. The first night they sleep in the car. The next night they obtain a noisy little room by paying Ritz prices. The children fidget and criticize. One gets sick. Dad and Mom (Hitomi Kuroki) fight bitterly, then declare a truce late at night as they make love on the darkened stairs of the hotel.

This is the film's defining sequence in the way it expresses the director's feelings for his characters, which take precedence over his outrage at the conditions in which they find themselves.

Late in their odyssey of gridlock and detours, Dad mocks the vision of a rich Japan. What good is being rich if this is what riches buy? If Mr. Kurotsuchi does not bear down on this notion, it could be that he feels

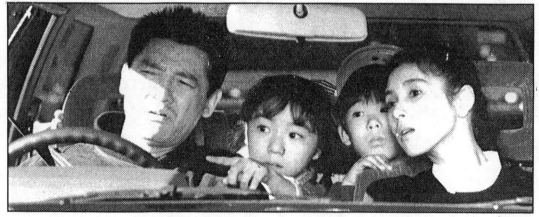

Kenichi Hagiwana and Hitomi Kuroki as the parents in "Traffic Jam."

the members of his family are far better off than they realize. He is a humanist.

"Traffic Jam" is a good-hearted film, acted with great tact and intelligence by his two leading performers, Mr. Hagiwana and Miss Kuroki.

1992 Mr 20, C20:4

Triple Bogey on a Par 5 Hole

Written and directed by Amos Poe; director of photography, Joe DeSalvo; edited by Dana Congdon; production designer, Jocelyne Beaudoin; produced by Mr. Poe and Dolly Hall. At the Walter Reade Theater, 165 West 65th Street. Running time: 88 minutes. This film has no rating.

Remy Gravelle	Eric Mitchell
Amanda Levy	Daisy Hall
Bree Levy	Angela Geothals
Satch Levy	Jesse McBride
Nina Baccardi	Alba Clemente
Steffano Baccardi	Robbie Coltrane
Stacha	Olga Bagnasco
Klutch	Phil Hoffman
Arnstein	Tom Cohen

By VINCENT CANBY

There would appear to be a great movie in the story of the three Levy children or, at least, that's what Remy Gravelle (Eric Mitchell) thinks when, like the reporter in "Citizen Kane," he begins his hunt for the Levy equivalent to Kane's Rosebud.

At the start of Amos Poe's blithely comic "Triple Bogey on a Par 5 Hole," which opens today at the Walter Reade Theater, this much is known: the Levy children live on a yacht that Robert Maxwell might have coveted and spend their days cruising up and down the Hudson and East Rivers.

The eldest, Amanda (Daisy Hall), is in her early 20's and has been writing hugely profitable best sellers since she was 13. Satch (Jesse McBride), 17, is a would-be musician who wants to open a boutique for cyclists called Everything on Wheels. Bree (Angela Goethals) is 14 and something of a philosopher. "I never learned to walk," Bree tells Remy, "but it's all right. Nobody seems to notice."

•

At the heart of their story is a singular event that made headlines everywhere. Ten years earlier their father and mother, Harry and Sally, were shot dead while committing a hold-up on a Maine golf course. Though they also robbed the occasional bank, Harry and Sally were otherwise loving, rather ordinary middle-class suburban parents. Much of the film is composed of the home movies they took of their beloved children.

When Remy presses Bree for her thoughts about Harry and Sally, she says simply, "I like to think they were just a couple of crooks with some really cute kids."

As Remy roots around in his search for screenplay material, he keeps getting sidetracked, especially by his attraction to the icy beauty, composure and mystery of Amanda, whose most recent best seller is titled "Rattle My Cage." He muses on the soundtrack, "My notes read like graffiti on clouds." Remy muses like a writer who hopes that movie audiences will someday hear him.

"Triple Bogey" is not your ordinary run-of-the-mill independently

The Film Society of Lincoln Center

Alba Clemente in the movie "Triple Bogey on a Par 5 Hole."

made movie. It's a sweetly demented original, a shaggy-dog story told with

Three siblings on a yacht. Is there a Rosebud to be discovered?

utmost gravity, with unself-conscious references to other movies. Especially striking is the cinematography by Joe DeSalvo. The film was photographed in black and white, and printed on color stock. It looks gorgeous, all deep bluish-blacks and brilliant whites, with sun-bright skies seen in those deep tones usually acquired by filters.

It is also acted with becoming ease by its cast, which includes Robbie Coltrane, the rotund English star ("Nuns on the Run," "The Pope Must Die"), who shows up briefly as a friend of the Levy family. Grandly mustachioed, with his hair dyed a patent-leather black, wearing the kind of white linen suit once favored by Sidney Greenstreet, Mr. Coltrane's Steffano Baccardi evokes primal evil, though, in fact, he's benign.

•

A series of anticlimaxes, solemnly revealed, is virtually the narrative method of "Triple Bogey," written, produced and directed by Mr. Poe with great style and consistency of wit. It is not a film to be minutely analyzed, which would destroy it faster than a pair of scissors. Its pleasures are to be found at one's own speed, without too much over-the-shoulder pointing.

Mr. Poe, who was born in Israel in 1949 and emigrated to this country eight years later, has made avant-garde films as well as more or less conventional movies. In 1984 he wrote and directed "Alphabet City" and in

1988 wrote the screenplay for "Rocket Gibraltar," the Burt Lancaster-Macauley Culkin film directed by Daniel Petrie.

He was apparently the original director of "Rocket Gibraltar," produced by Columbia, but was replaced when the costs got out of hand. Operating under his own auspices, as here, he does just fine.

1992 Mr 21, 13:4

Laws of Gravity

Written and directed by Nick Gomez; director of photography, Jean de Sagonzac; edited by Tom McArdle; production designer, Monica Bretherton; produced by Bob Gosse and Larry Meistrich. At the Roy and Niuta Titus Theaters in the Museum of Modern Art, 11 West 53d Street, as part of the New Directors/New Films series of the Film Society of Lincoln Center and the Department of Film of the Museum of Modern Art. Running time: 100 minutes. This film has no rating.

Jimmy	Peter Greene
Denise	Edie Falco
Frankie	Paul Schulzie
Tommy	Tony Fernandez
Kenny	James McCauley
Ray	Anibel Lierras
Vasquez	Miguel Sierra
Jon	Adam Trese
Celia	Arabella Field
Sal	Saul Stein

By VINCENT CANBY

Nick Gomez makes an impressive debut as the writer and director of his first feature, "Laws of Gravity," a vividly acted and extremely well pho-

Catherine McGann

Adam Trese

tographed tale of three days and nights on the Brooklyn streets. The film will be shown at the Museum of Modern Art today at 9:30 P.M. and tomorrow at 3 P.M. in the New Directors/New Films Series.

At the center of "Laws of Gravity" is the friendship of the comparatively settled Jimmy (Peter Greene), who is married and makes ends meet by petty thievery, and his sidekick, Jon (Adam Trese), a good-looking younger man with no great amount of brains and a dangerously short temper.

The film is also about Jimmy's wife, Denise (Edie Falco), who has a good deal of common sense but not much chance to exercise it, and Celia (Arabella Field), Jon's pretty girlfriend, so infatuated that she forgives him all, even after he brutally beats her. To Celia beatings are the price a woman pays to be with the man of her dreams. Such barren dreams.

The star of "Laws of Gravity" is Jean de Segonzac's remarkably sensitive hand-held camera, which attends to Jimmy, Jon, Denise and Celia like a neighborhood groupie. The camera tags along from early morning until late at night, studying them in close-up, sometimes pulling back for an appreciative medium shot.

It watches Jimmy and Jon as they steal the contents of an unlocked van. It stands by as they haggle with street-corner customers and behaves, it seems, like a lookout for cops. It hangs out with them at the corner bar. It goes along on a family picnic in the park where, not unexpectedly, there is a fight.

•

The coming together of any two or more of Mr. Gomez's characters sooner or later leads to a physical confrontation. Though their streets are open and they are nominally free, Jimmy, Jon and their friends wear the threadbare coats of caged creatures. The fights they so readily invite somehow reassure them. The fights give them identity, importance and a momentary sense of direction.

When Frankie (Paul Schulzie), an ex-con and an old neighborhood pal, arrives home driving a stolen car and carrying a load of handguns, the fights inevitably have lethal consequences.

Mr. Gomez's narrative is bleak, but it is kept in such tight focus, and dramatized with such intensity, that the effect is spellbinding even when the terrifically accomplished actors, all speaking at once, go sailing cheerfully over the top.

Attempts may be made to celebrate Mr. Gomez by comparing "Laws of Gravity" to Martin Scorsese's "Mean Streets," which would be a disservice to both. There is a certain romanticism about "Mean Streets" that is nowhere to be found in the Gomez film. The shabbiness of the lives in "Laws of Gravity" is relieved only by an awareness of the mature control of the young man who made it. Mr. Gomez was born in 1963.

1992 Mr 21, 18:1

A Heart of Glass

Written and directed by Fehmi Yasar (Turkish with English subtitles); director of photography, Erdal Kahraman; edited by Mevlut Kocak; music by Okay Temiz. At the Roy and Niuta Titus Theaters in the Museum of Modern Art, 11 West 53d Street, as part of the New Directors/New Films series of the Film Society of Lincoln Center and the Department of Film of the Museum of Modern Art. Running time: 105 minutes. This film is not rated.

Kirpi	Genco Erkal
Kiraz	Serif Sezer
Naciye	Deniz Gokcer
Sinten	Fusun Demirel
Yetim	Ersen Ersoy
Maho	Cemal San
Besir	Aytekin Ozen
Siho	Macit Sonkan

By JANET MASLIN

The rueful Turkish film "A Heart of Glass" could be called a comedy of mild manners if it was a shade less hangdog, and if it had been made with more flair. As it is, Fehmi Yasar's story of a hapless screenwriter in Istanbul, and of the unlikely adventures that lead him to rural Anatolia, is more notable for its occasional droll flourishes than for its ability to sustain interest.

"A Heart of Glass" has been directed quite confidently, as if the material had more charm than it actually does. But Mr. Yasar vacillates too unpredictably between a dryly observant tone and one that intimates real tragedy is in the offing. In the end, this mixed message, plus a number of quasi-comic allusions to film history, winds up being more than this slight tale can easily sustain. Like his protagonist, Mr. Yasar may have seen too many movies.

That protagonist is Kirpi (Genco Erkal), a.k.a. Hedgehog, a writer whose latest screenplay is rejected during one of the film's more amusing early scenes. A producer suggests that Hedgehog instead attempt a Turkish version of "The Last Emperor," an idea that is enough to send the artist home in a state of terminal writer's block. Thus unemployed, he begins to notice Kiraz, who works for Hedgehog and his wife as a cleaning woman. Hedgehog's wife, another element in her husband's movie-mad universe, dubs the voices of foreign actresses for Turkish versions of well-known films. She specializes in Marilyn Monroe, and is prone to imitating Monroe around the house.

Since his wife is so busy, Hedgehog is often alone with Kiraz (Serif Sezar), whose tyrannical old-world husband is the source of her many problems. Seeking to help her, and also somewhat desperate for material, Hedgehog begins an impromptu in-

This Turk goes home to the voice of Marilyn Monroe.

vestigation of Kiraz's life. Eventually, this leads him away from the sophistication of Istanbul — where it is possible to find a film maker lounging in a black kimono, waxing pretentious about his art — and back to the impoverished Turkish countryside, where Kiraz's relatives are ready to come to her rescue. When his efforts briefly land him in jail, Hedgehog tells the police his name is Fritz Lang.

Mr. Yasar's story is ambitious in its scope, and it offers an unusual and sometimes witty cross section of Turkish society. Certainly the film benefits from a wide range of cultural extremes: from the movie producer's secretary talking knowingly about Wittgenstein to the runaway peasant bride who dutifully disguises herself as a coffee table while hiding from the police.

Mr. Erkal's Hedgehog, though seldom sufficiently animated or compelling, does at times succeed in conveying the absurdity of what he sees through simple understatement. When, at a rug bazaar, a salesman assures him that the young girls who wove the rugs went blind in their teens — and when some of the rugs feature likenesses of Elvis and John Wayne — Hedgehog's look of resignation says enough. There is no escaping the movies.

"A Heart of Glass" will be shown tonight at 6 and tomorrow at 12:15 P.M. as part of the New Directors/New Films series.

1992 Mr 21, 18:4

Five Girls and a Rope

Directed and edited by Yeh Hung-wei; screenplay by Mr. Yeh, Lau Chia-hua and Xiao Mao, (in Mandarin with English subtitles); photography by Yang Wei-han and Lee Yi-shu; music by Zhao Jiping; produced by Tong Cun-lin; released by Tomson (HK) Films. At the Roy and Niuta Titus Theaters in the Museum of Modern Art, 11 West 53d Street, as part of the New Directors/New Films Series of the Film Society of Lincoln Center and the Department of Film of the Museum of Modern Art. Running time: 123 minutes. This film has no rating.

Mingtao	Yang Chieh-mei
Guijuan	Wang Hsiu-ling
Jinmei	Wu Pei-yu
Aiyue	Lu Yuan-chi
Hexiang	Ai Jing
Sibao	Chang Shih
The Sorceress	Chang Ying

By JANET MASLIN

On the cinematic evidence of the past week, the repressive treatment of women in China has lately generat-

ed feminist film making of remarkable cogency and power. Yeh Hung-wei's "Five Girls and a Rope," which like Zhang Yimou's current "Raise the Red Lantern" unfolds from the viewpoint of young women imprisoned by Chinese customs, is a potent and radical film with the lulling veneer of a gentle soap opera, and with a decorous style that belies its galvanizing message.

This film begins with the image of five pretty young women dressed in festive garb, and with the echo of girlish giggling. But the women are dead, having collectively hanged themselves in reaction to the conditions under which they lived. Hoping to ascend to a kind of paradise where sex roles are reversed and where they will be reunited with the souls of fellow sufferers, they have earnestly embarked upon this grim mission, which the film manages to render with unexpected sweetness. It is later revealed that even disposition of the rope is decided according to patriarchal rules in rural China. The rope will be returned to one of the girls' fathers, who grows flax.

The film, which has an astonishingly buoyant spirit despite its morbid theme, flashes back to the events that forced the five young women to choose their fate. One witnesses the ordeal of her aunt, who married into a powerful family but was subsequently displaced by her husband's concubines when she bore no child of her own. Another finds her family ready to force her into a loveless marriage, and observes the effects of such a union on her desperate sister-in-law. Yet another watches her older sister's ordeal in childbirth, and bitterly learns the value placed on a mother's life in Chinese society. These stories, told in plain fashion, show no signs of stridency. And they require no rhetoric in order to speak loud and clear.

The film's most wrenching anecdote concerns a 70-year-old grandmother who wants to celebrate her birthday with her son but is forbidden by custom from doing so. Though the grandmother yearns to sit down at a dining table with the men of her village in honor of this great occasion, women are expected to remain stand-

ing and keep their distance from the men who dine. Reduced to asking her son's permission for the special favor of being seated, she is told, "Mother, it's not very appropriate. It's not appropriate at all." Later she is filled with remorse over this incident. "I regret it so much!" she cries in heartbroken rage.

•

"Five Girls and a Rope" builds to a spiritual release when its five vibrant young heroines, filled with promise of a better world if they visit a certain mysterious garden on the Day of the Dead, decide to exercise the only freedom they really have. The presence of a smiling sorceress at this juncture of the film helps further elevate it beyond the realm of the ordinary.

"Five Girls and a Rope," an iron-fisted film with the softness of a velvet glove, can be seen tonight at 9 and tomorrow at 6 P.M. as part of the New Directors/New Films festival.

1992 Mr 22, 48:1

Mediterraneo

Directed by Gabriele Salvatores; screenplay by Vincenzo Monteleone, (in Italian with English subtitles); director of photography, Italo Pettriccione; edited by Nino Baragali; music by Giancarlo Bigazzi; produced by Gianni Minervini, Mario Cecchi Gori and Vittorio Cecchi Gori; released by Miramax Films. At the 68th Street Playhouse, at Third Avenue. Running time: 92 minutes. This film is not rated.

Sergeant Lo Russo	Diego Abatantuono
Lieut. Montini	Claudio Bigagli
Farina	Giuseppe Cederna
Noventa	Claudio Bisio
Strazzabosco	Gigio Alberti
Colosanti	Ugo Conti
Felice Munaron	Memo Dini
Libero Munaron	Vasco Mirandolo
Vasilissa	Vanna Barba
Pope	Luigi Montini
Shepherd	Irene Grazioli
Pilot	Antonio Catalina

By VINCENT CANBY

Gabriele Salvatores's "Mediterraneo" is a deliberately charming

A scene from "Five Girls and a Rope," a Taiwanese movie about the oppression of women in China.

comedy whose most daring conceit is that love, in one form and another, makes the world go around. Actually, it's somewhat better than it sounds, having the good sense not to slop over into the sentimentality that awaits it at every turn.

"Mediterraneo," the Italian nominee for this year's Oscar as the best foreign-language film, opens today at the 68th Street Playhouse.

•

The time is 1941, a year after Italy joined Germany in the war against the Allies. A small group of undisciplined Italian soldiers is dispatched to a tiny Greek island in the Aegean for four months of lookout duty. They include a young lieutenant with a passion for art, a robust sergeant who is the font of all Army knowledge, a former farmer accompanied by his beloved donkey, and other particular types.

For a while the soldiers live in edgy expectation of unforeseen calamity. There is a village on the island but no sign of people. One night they see a terrible explosion on the horizon and realize that their relief ship has been torpedoed. As if that weren't enough, the owner of the donkey goes temporarily mad when the animal is shot by accident. In a tantrum of grief the soldier destroys the group's radio. The men lose all touch with the world outside.

Only then do the islanders emerge from their hiding places. They have

been afraid that the Italians would be as vicious as the German occupiers who, when they withdrew, took all of the young island men with them. It isn't long before everyone's sunny nature appears. The Italian soldiers are absorbed into the life, heat and landscape of the idyllic island.

The local priest asks the lieutenant, a Sunday painter, to restore the murals in his church. Two soldiers, who are brothers, befriend a lovely young woman, a shepherd, who believes that three is the perfect number for an affair of pure sexual fun. The sergeant takes up folk dancing and the shyest of the soldiers falls profoundly in love with the island's single, very overworked whore.

"Mediterraneo" has all of the carefully calculated simulated innocence

'Mediterraneo' is the Italian nominee for an Academy Award.

of a Broadway musical, but, also like a Broadway musical (or at least, like a good one), it knows just how far it can go before too much becomes oppressive. The film is cannily constructed and acted with legitimate style, especially by Diego Abatan-

Toni Benetti/Miramax
Vanna Barba and Giuseppe Cederna in the movie "Mediterraneo."

tuono as the sergeant, Giuseppe Cederna as the man who falls in love with the island's most available woman and Claudio Bigagli as the lieutenant.

"Mediterraneo" is a live-action fairy tale.

1992 Mr 22, 48:4

The Puerto Rican Mambo (Not a Musical)

Produced and directed by Ben Model; written by Luis Caballero; director of photography, Rosemary Tomosky-Franco; edited by Ben Model; music by Eddie Palmieri; released by Cabriolet Films. Running time: 90 minutes. This film has no rating.

Luis Caballero	Himself
Paco	Johnny Leggs
Store clerk	Carolyn McDermott
Friend	Ben Model
Boss	Howard Arnesson
Psychiatrist	John Fulweiler
Spanish teacher	Mike Robles

By STEPHEN HOLDEN

Why are there so few Puerto Rican celebrities? Why, when Puerto Rican characters appear in films, are they usually played by non-Hispanic actors like Lou Diamond Phillips, who was born in the Philippines, or Armand Assante, who is from New York? Why are the anchors on the Spanish-language network Telemundo "whiter than Chuck Scarborough"? These are just a few of the questions posed by the stand-up comedian Luis Caballero in "The Puerto Rican Mambo (Not a Musical)."

The film, which opened on Friday at the Public Theater and moves to the Quad Cinema, 34 West 13th Street, next Friday, is a darkly comic exploration of the image of Puerto Ricans in the media and in society. One of the conclusions it draws is that a negative image of Puerto Ricans in the media contributes significantly to a generalized lack of self-esteem among Hispanic people.

The film, produced and directed by Ben Model and written by Mr. Caballero, interweaves the comedian's sarcastic monologues with sketches in the style of "Saturday Night Live," spoofing the many ways Puerto Ricans are subjected to discrimination.

•

A typical sketch finds Mr. Caballero entering a bookstore where a saleswoman asks if she can help. When he replies, "Just browsing," there is an agitated conference at the checkout counter, followed by a warning on the store's loudspeaker system that "there is a Puerto Rican browsing."

In other sketches, Mr. Caballero portrays Hispanic characters who are harassed by the police for no reason, patronized by bank tellers and assumed to be window cleaners. In the angriest sketch, he is interviewed on the street for a low-level job in the garment district and asked, "If they took Bacardi off the market, how would you deal with that?"

•

As funny and sharp as they are, Mr. Caballero's points become redundant before the 90-minute film is half over. In a sequence that is supposed to examine Hispanic behavior at the beach, the camera pans listlessly over people sprawled on the sand without making any visual point.

Padding out the film is a party scene in which the Hispanic actor and performance artist John Leguizamo

(billed as Johnny Leggs) portrays a suave, well-dressed guest who goes around asking people to guess his nationality. Everything from French to Chinese is suggested. When he tells them he is Puerto Rican, he is congratulated for not looking Hispanic.

Like everything else in the film, the joke is hammered home several times when once would have sufficed.

1992 Mr 22, 48:4

Finzan

Written, produced and directed by Cheik Oumar Sissoko; in Bambara with English subtitles; director of photography, Mr. Sissoko; edited by Ouopba Motandi; released by California Newsreel. At the Public Theater, 425 Lafayette Street. Running time: 107 minutes. This film has no rating.

Nanyuma	Diarrah Sanogo
Bala	Oumar Namory Keita
Chief	Balla Moussa Keita

By STEPHEN HOLDEN

"Finzan," the second feature film by Cheick Oumar Sissoko, a Malian director and leader in his country's democracy movement, takes place in a rural African village whose customs have changed little over the centuries. The tribal life in this grasshut community of subsistence farmers is orderly and ritualized. But it is also a place of glaring sexual inequities. The women work side by side in the fields with their husbands but share few of the men's rights and privileges. When a young woman marries, she becomes a piece of property who can be "inherited" by a male relative when her husband dies.

As remote as it is, the village is not entirely untouched by modern urban life. Enough information leaks in from the outside world to sow the seeds of a feminist rebellion. "Finzan" tells the stories of two women who go up against the prevailing customs. When Nanyuma (Diarrah Sanogo) a sturdy, stubborn field worker, is widowed, her brother-in-law Bala (Oumar Namory Keita), who is the village idiot, petitions the local chieftain for her hand. Over Nanyuma's furious objections, his request is granted, and she is forced to marry him. When she refuses to sleep with him, he attempts to rape her, and she runs away. Eventually she musters enough support from the other women to make involuntary marriage an issue that begins to divide the community.

More desperate is the predicament of Fili (uncredited in the film's production notes), a young woman who was brought up in the city and has been sent to the village by her father. It is a longstanding custom for the local women to have their clitoris removed upon reaching puberty. Outraged that female circumcision is still being carried out, Fili preaches to her friends about the cruelty and the physical dangers of the procedure. But instead of listening to her, they are shocked to discover that she has not undergone this rite of passage, and she finds herself in imminent danger of having the operation forced upon her.

"Finzan," which opened on Thursday at the Public Theater, is a passionate and convincing plea for the emancipation of African women. Beyond its political agenda, it also offers a portrait of rural African life that conveys a richly textured sense of day-to-day existence in the village.

The community is itself imperiled when a corrupt local district leader arrives with his armed guards to demand his regular payment of grain. When the villagers refuse to pay because of a drought, their chief is arrested and they unite for a sit-down demonstration in front of the district leader's office. The film's circles-within-circles picture of the impact of regional, local and personal politics on people's lives is its most impressive accomplishment.

●

The narrative aspects of the film are a bit bumpy. The movie begins by focusing on Nanyuma, then two-thirds of the way along shifts its attention to Nili, whose story is told too quickly.

Enlivening the picture is a strain of satiric slapstick that emerges in scenes in which the young men of the village play practical jokes on Bala. Portraying characters drawn from Malian street theater, they thoroughly intimidate him by hiding in the trees and pretending to be spirits with magical powers. Their funniest prank becomes an extended scatological joke.

If the film's juxtaposition of politics and vaudevillian humor seems somewhat arbitrary, the comedy helps make "Finzan" a multidimensional portrait of a community and not just a political polemic.

1992 Mr 22, 48:4

Swimming With Tears

Written and directed by Hirotaka Tashiro, (in Japanese with English subtitles); director of photography, Koichi Sakuma; edited by Masahiro Matsumura; music by Hitoshi Hashimoto; produced by Syujiro Kawakami; released by Cine Ballet. At the Roy and Niuta Titus Theaters in the Museum of Modern Art, 11 West 53d Street, as part of the New Directors/New Films Series of the Film Society of Lincoln Center and the Department of Film of the Museum of Modern Art. Running time: 104 minutes. This film has no rating.

Ryoichi Kokubu................................Shiro Sano
Asami Agawa................................Jun Togawa
Fey Yokoyama............................Ruby Moreno
Shoichi Yokoyama................Masayuki Suzuki
With: Sakae Umezu, Ken Yoshizawa, Ei Kawakami, Ritsuo Ishiyama, Tomonori Ito

Ruby Moreno in a scene from the movie "Swimming With Tears."

By JANET MASLIN

"Swimming With Tears" begins with an act of quiet rebellion, as Fey, a Filipino mail-order bride, runs away from her Japanese husband and life on his lonely farm. Escaping to Tokyo without a word of farewell or explanation, she finds work at a Chinese restaurant with a boisterous, largely American clientele. Thus transplanted, she tries her best to feel welcome in Japanese society, but the film clearly regards this as an impossible task. "Swimming With Tears" addresses itself bluntly to Japanese xenophobia by capturing the unhappiness and prejudice encountered by this gentle, accommodating foreign worker.

Fey, very much the innocent as played by Ruby Moreno, begins the story having already experienced second-class citizenship on the farm. "My only function is hard labor and sex for reproduction," she writes to her mother in the Philippines, though it was the mother who urged her to emigrate in the first place. ("Do you want to be an egg vendor like me?" Fey recalls her mother asking.) Part of the reason Fey has been sent to Japan is to find her father, a Japanese executive whom she has never met or heard from. Fey's mother, though ignored by this man, has never lost hope of attracting his attention.

●

The film, unfolding in a quiet, uncomplicated manner, offers a rude awakening on that score and many others. Fey's father becomes instrumental in a plot involving Ryoichi (Shiro Sano), a scholar studying the English Industrial Revolution, and his girlfriend, Asami (Jun Togawa), who become Fey's friends and neighbors in Tokyo. The father's efforts, mostly indirect, to harm and manipulate those looking out for his daughter's interest become representative of a greater coldness that the film ascribes to contemporary Japanese culture. Eventually, the once-hopeful Fey is forced to acknowledge the disappointment and anger she has been

made to feel. "I never hated people," she says, "but I can feel I'm gradually changing."

The film abounds with victims who can register their unhappiness only indirectly, and with oblique images meant to capture Fey's entrapment, like that of a leaf caught in a web. It works best at its most matter-of-fact.

Hirotaka Tashiro, who wrote and directed "Swimming With Tears," has a modest but effective style that succeeds in making its point. Beyond identifying the dismissiveness with which this Filipino worker is treated, Mr. Tashiro looks for explanation to many of the film's Japanese characters, and allows those characters to appear openly troubled. Shoichi (Masayuki Suzuki), the husband who sent for Fey because Japanese women are apparently not eager to marry farmers, is eventually able to acknowledge the restrictiveness and indifference that drove her away.

The scholar Ryoichi, the film's most interesting character, is seen as the victim of a terrible crime, and as a tortured man trying hard to maintain some semblance of propriety, as in a scene depicting Japanese executives attempting to manipulate Ryoichi's fortunes, or in another showing Shoichi's fellow farmers, all of whom have married Filipino women, expressing puzzlement at their wives' discontent. The film has only a few characters, but its otherwise simple narrative strains noticeably in trying to involve all of them in Fey's destiny, and in generating a reconciliation for the film's ending.

"Swimming With Tears" will be shown tonight at 6 and tomorrow at 9 P.M. as part of the New York Film Festival.

1992 Mr 22, 49:1

(Review reprinted here as it appeared originally)

FILM VIEW/Caryn James

Why Forster's Novels Have Star Quality

"**S**HE IS GOING TO MARRY someone she met in an ho*tel!*" says Mrs. Herriton, with an air of restrained alarm at the news that her widowed daughter-in-law is about to drag the family's good English name through the Italian mud. In "Where Angels Fear to Tread," this Edwardian lady sits at the dining table with her two grown children — the slightly priggish Philip and the exceedingly priggish Harriet — who are equally shocked. Lilia, it seems, is planning to marry the penniless son of an Italian village dentist, a man who is actually a dozen or so years younger than herself. She might as well have run naked through the House of Lords.

Mrs. Herriton's contemptuous tone says everything about the rigid rules of her social class, whose very existence is challenged by such passion and willfulness as Lilia's. And this compressed scene suggests why E. M. Forster's novels are so successful and alluring on screen.

His fiction captures a distant era that is enticingly, deceptively beautiful, at least for the author's leisured class. It is an easeful world of teatime discussions in sitting rooms with brocade sofas and Oriental carpets, of long walks in flowering meadows at one's country house, a world defined by order and elegance — with danger and chaos lurking in the soul of some sympathetic, explosive character. What could be more cinematic than putting an attractive, articulate rebel in a luxurious setting and letting the drama build?

Two new films based on Forster novels take full advantage of their rich sources. "Where Angels Fear to Tread," based on Forster's deft first novel, published in 1905, is a droll comedy of manners that ends in tragedy. Directed by Charles Sturridge and produced by Derek Granger (the team behind the hugely appealing "Brideshead Revisited"), this is so lavishly photographed and acted that in any other season it might be considered a small gem.

But "Where Angels Fear to Tread" has the bad luck to be appearing at the same time as the Merchant-Ivory production of "Howards

Fine Line Features/New Line Cinema

Judy Davis in "Where Angels Fear to Tread"—Forster's fiction captures a distant era that is enticingly beautiful.

End," based on Forster's 1910 masterpiece. Mingling emotional and material legacies, and contrasting pedestrian with philosophical personalities, it takes up issues commonly called unfilmable.

■

Ruth Wilcox bequeaths her house, Howards End, to Margaret Schlegel, a casual acquaintance. Margaret marries the widowed Henry Wilcox, unaware of his late wife's bequest. Meanwhile, Margaret and her sister, Helen, try to help an intelligent working-class man named Leonard Bast, with devastating consequences.

The Wilcoxes and the Schlegels are the greatest of Forster's characters, and the film that recreates them is as sumptuous, delicate and deeply intelligent as anyone could hope. "Howards End" overshadows every other Forster movie.

That is a considerable shadow to cast, for the two new films join three released in the past decade. All together, they reveal Forster's uncanny cinematic power.

He has always been fortunate in his adapters. "A Passage to India" (1984), the last film directed by David Lean, merged the extravagant Indian setting with the inner confusion of two English heroines, vividly portrayed by Dame Peggy Ashcroft and Judy Davis.

The 1985 film "A Room With a View" was, like "Howards End," written by Ruth Prawer Jhabvala, directed by James Ivory and produced by Ismail Merchant. In this delicious comedy of manners, Lucy Honeychurch (Helena Bonham Carter) is kissed by George Emerson (Julian Sands) while visiting Florence. How can she fall in love with someone so improper? Yet how can she marry the stuffy, supercilious Cecil Vyse (Daniel Day-Lewis)?

■

It is revealing that the one unsuccessful adaptation, Merchant-Ivory's 1987 film "Mau-

rice" (with a screenplay by Mr. Ivory), is based on Forster's only failed novel. Published posthumously in 1971, "Maurice" is so intent on gaining sympathy for its homosexual hero that Forster fails to give him a distinctive personality. Ultimately, the film is as flat as the discursive fiction on which it is based.

In his other novels, though, Forster displayed a genius for capturing the complex personalities expressed in the social manners of his day, and the best screen adaptations have done the same. That is not as simple as lifting the drama and the dialogue from the page. Forster's adapters have found precise visual equivalents for his descriptions and resonant bits of dialogue to take the place of his narrator's frequent lyrical and philosophical passages.

"Where Angels Fear to Tread" begins, as the novel does, at a train station, which turns out to be the crossroads in the life of the flighty Lilia (Helen Mirren). She is going abroad with her spinsterish chaperone, Caroline Abbot. Ms. Bonham Carter (who seems to be making a career out of Forster; she is also in "Howards End") is cast effectively against type as the plain Caroline. Mrs. Herriton (Barbara Jefford), Philip (Rupert Graves) and Harriet (Judy Davis in another unexpected bit of casting) are also at the station, expressing relief that the troublesome Lilia will soon be out of the country and out of their hair.

Steam from the engine clouds the scene. From then on, England is presented in crisp, sharp detail, while Italy is lushly photographed as a land of misty, mountainous landscapes and colorful opera halls. Lilia's young husband, Gino, first appears wearing a garish plaid suit that defines his good intentions and bad taste at a glance. His wardrobe says more than pages of dialogue.

Like Forster himself, the film makers are sympathetic to all their characters, even when Philip, Harriet and Caroline go to Italy to fight over the possession — and it does

seem a material possession — of an infant. The film falls short of Forster only at the end, when it glides over the chilling way that a person who caused another's death swiftly resumes normal life. Forster could be brutal about his own class.

Still, in "Where Angels Fear to Tread" and "A Room With a View," published in 1908, Forster was concerned with minor, individual rebellions. In his two great novels, the rebellions reflect a culture that was itself on the verge of disintegration.

Cinecom International Films

Julian Sands and Helena Bonham Carter in "A Room With a View"—A delicious comedy of errors full of individual rebellions.

The 1924 book "A Passage to India" sounded a prescient death knell for the Raj. "Howards End" foresaw that the leisure class would not survive World War I intact.

While the screen version of "Howards End" displays the trademark Merchant-Ivory prettiness, it has more than surface beauty. The characters embody the social elements that shaped them but remain individuals rather than symbols.

Vanessa Redgrave creates a haunting Ruth Wilcox, a woman who is meant to be both mundane (compared to the younger, better-educated Margaret) and deeply instinctive. In the film's one serious misstep, Mrs. Wilcox is made to be too cracked, too ill and disoriented, so that her legacy to Margaret might be considered a deranged deathbed wish. Forster's story depends on the fact that her extravagant gesture is the single outrageous act of this eminently wise, sensible woman's life — and therefore maybe not so outrageous after all. Still, Ms. Redgrave sets the graceful tone of an old order being passed on.

All the other actors find the right tone. As Helen, Ms. Bonham Carter projects a lethal combination of the thoughtless romantic and the fierce social reformer. But "Howards End" finally relies on the viewer's total belief in Anthony Hopkins and Emma Thompson, as Henry Wilcox and Margaret. They have the most challenging and successfully realized roles.

Mr. Hopkins gives the kind of performance that seems effortless as he makes Henry a well-meaning, blundering businessman and paterfamilias, totally unaware of his own obtuseness. It is an oddly affecting performance, one that makes viewers understand why Margaret could love him, wrongheaded though he is.

∎

Of course, Margaret has other reasons for falling in love. Her loneliness is unexpressed on screen, except for two brief, silent moments when she looks at Mr. and Mrs. Wilcox together. The visual clues to character are everywhere in "Howards End." Some are as obvious as the house itself, others as subtle as the softer, prettier clothes Margaret wears after she falls in love.

It is Margaret who connects all the characters, who tries to understand and sort out all points of view, who mingles the worlds of romanticism and realism, as Forster did himself. And the script, perhaps the best Mrs. Jhabvala has ever written, allows the film to walk that line between romanticism and realism with unfailing balance.

During one of those teatime chats Forster loved, Henry says condescendingly about Leonard, "I know the world and that type of man."

"He's not a type, he's an individual," Margaret replies. "He has a sort of romantic ambition."

"It is your view of him that is romantic," says Henry, and they are both partly right.

This brief bit of dialogue, largely invented for the film, is as true to Forster as anything he might have written himself. It cuts through pages of the novel's dialogue and exposi-

while recreating its lyrical tone. The film version is filled, end to end, with such exquisitely wrought scenes.

Early in her acquaintance with the author, Virginia Woolf wrote, "I saw Forster, who is timid as a mouse, but when he creeps out of his hole very charming." Even on the page, Forster's writing voice has a quiet composure that would make him seem an unlikely movie star. But when his stories creep out of their books and onto the screen, they are charming and cinematic after all. ☐

1992 Mr 22, II:11:1

Finding Christa

Written, produced and directed by Camille Billops and James Hatch; director of photography, Dion Hatch; edited by Paula Heredia. At the Roy and Niuta Titus Theaters in the Museum of Modern Art, 11 West 53d Street, as part of the New Directors/New Films Series of the Film Society of Lincoln Center and the Department of Film of the Museum of Modern Art. Running time: 55 minutes. This film has no rating.

With: Camille Billops, Christa Victoria, James Hatch, Margaret Liebig and others.

June Roses

Directed by Christine Noschese; screenplay by Ms. Noschese and Richard Press; director of photography, Jens Sturup; edited by Liz Gelber; music by Jeffrey Coulter; produced by Beth Taubner and Ms. Noschese. At the Roy and Niuta Titus Theaters in the Museum of Modern Art, 11 West 53d Street, as part of the New Directors/New Films Series of the Film Society of Lincoln Center and the Department of Film of the Museum of Modern Art. Running time: 43 minutes. This film has no rating.

Rosemarie	Sari Caine
Dolly	Shareen Mitchell

WITH: Chevi Colton, Lou Galiardo, Madlyn DePaolo Keller, David Kenner, David H. Kramer, Sir Ralph Lucarelli, Irma St. Paule, Daniel Tuffarelli and Samantha Tuffarelli.

By VINCENT CANBY

In 1962 Camille Billops gave up her 4-year-old daughter, Christa Victoria, for adoption. Eighteen years later, Ms. Billops, who had since married and become a painter and sculptor, was reunited with Christa.

"Finding Christa," written, produced and directed by Ms. Billops and James Hatch, is a 55-minute documentary about that reconciliation, and what a mass of fascinating contradictions it is! "Finding Christa" is forgiving but sometimes thin-skinned. Everybody talks a lot, yet certain important information is not revealed or is passed over so quickly that it seems not to matter.

The tone is loving, though behind it there is a certain chilliness. The film, full of expressions of spontaneous emotion, is terrifically artful. The title is slightly misleading. You might think that Camille, the film's major character, had gone out looking for Christa, but it was Christa who found Camille.

All of which is meant as high praise for "Finding Christa," which is a big, joyous consideration of some of the contradictions that have shaped Camille, Christa and those who are important to them. Among other things, it recognizes that nothing in life is easily categorized. Even ethnicity is blurred.

●

The light-skinned Camille describes herself as an artist who is black. Christa's father, who had dis-

Christa Victoria in her mother's documentary "Finding Christa."

appeared by the time Christa was born, was of Czechoslovak descent. The members of Camille's own family were almost militantly middle class in their values. This is one of the reasons Camille decided to leave her daughter in the Children's Home Society and seek a life of adventure and art elsewhere.

"Finding Christa" is the third film by Ms. Billops and Mr. Hatch, her husband and a professor of theater at City University of New York. Their first collaboration, "Suzanna, Suzanne," which also deals with members of her family, was a presentation of the 1983 New Directors/New Films series.

"Finding Christa" will be shown at the Museum of Modern Art today at 6 P.M. and on Thursday at 9 P.M. in the current New Directors/New Films series.

Sharing the program is Christine Noschese's "June Roses," a 43-minute fiction film about a wife and mother who, in 1952, rebels against social pressures with far less success than the irrepressible Camille.

"Finding Christa," photographed by Dion Hatch, Mr. Hatch's son from an earlier marriage, and edited by Paul Heredia, is cannily composed of contemporary interviews and a lot of wonderful old home movies. In addition to Camille, the cast of characters includes Christa's adoptive mother, Margaret Liebig, Christa's adoptive siblings, Camille's assorted aunts and uncles and cousins, and — more or less co-starring with her mother — Christa.

She is very much her mother's daughter: articulate, ambitious for her own career (as a singer and composer), seemingly delighted to discover the depth and complexity of her mother, but still somewhat troubled about her mother's decision all those years ago.

In light of the circumstances, she has been lucky. Ms. Liebig appears to be a woman any child would be exceptionally fortunate to be adopted by. She's warmhearted, witty and generous. She's even a professional singer and, at one point, lights up the film with a sweetly magical "Stormy Monday Blues."

"Finding Christa" is a densely packed amalgam of feminism, individualism, interracial relations, art and show business. Camille and Christa act out their feelings in staged sketches, including one in which Camille yodels, the exact point of which I've now forgotten.

●

The movie has the manner of an immensely convivial family reunion at which everyone talks, some people perform and others offer not always polite criticism. Why did Camille

abandon Christa the way she did, putting the child in a home instead of leaving her with the sister who was eager to care for her?

Camille offers a number of answers. She was then classified as an "unwed mother." Today she would be called a "single mother." She wanted Christa to have an entirely new life. She was also compelled to pursue her art. She says she is sorry for any pain she caused, but not sorry for the decision.

"Finding Christa" is a rich and haunting film.

Ms. Noschese's "June Roses" is a daughter's poignant recollection of her Brooklyn childhood and of her mother, Dolly (Shareen Mitchell), a woman who feels there is more to life than cleaning, cooking and attending to her husband, a union organizer.

Just what that "more" might be, Dolly does not know. Inevitably she becomes a pathetic victim of her infatuation with Art and the so-called finer things of life. "June Roses" is not sentimental, but neither is it especially moving.

1992 Mr 24, C15:3

Alex

Written and directed by Teresa Villaverde (in Portuguese, with English subtitles); director of photography, Elfi Mikesch; edited by Vasco Pimentel and Manuela Viegas; produced by Joao Pedro Bénard; released by Coralie Films. At the Roy and Niuta Titus Theaters in the Museum of Modern Art, 11 West 53d Street, as part of the New Directors/New Films Series of the Film Society of Lincoln Center and the Department of Film of the Museum of Modern Art. Running time: 118 minutes. This film has no rating.

Alex	Ricardo Colares
Manuela	Teresa Roby
Pedro	Joaquim de Almeida
Barbara	Maria de Medeiros
Mário	Vincent Gallo

By STEPHEN HOLDEN

The title character and narrator of Teresa Villaverde Cabral's first feature film, "Alex," is a morose young man (Ricardo Colares) who recounts events from his childhood in a deadened monotone. Asked in the film's opening sequence whether he remembers his parents, he answers no, even though the film turns out to be a cinematic memory play.

Set in the early 1970's, during Portugal's final years under the Salazar dictatorship, the film tells the story of how Alex's father, Pedro (Joaquim de Almeida), is reluctantly drafted to fight in the country's African colonies. At first his letters home to his adoring wife, Manuela (Teresa Roby), and son are loving. But as the months pass, they become less frequent and turn increasingly bitter and despairing. Eventually they stop coming altogether, and Pedro is presumed lost.

Although the film observes the world primarily from the confused perspective of a boy who is unable to grasp the grown-up realities of war and separation, its point of view shifts briefly from Alex to show Pedro coming back to Portugal to resume a civilian life without informing his family of his return.

When he eventually reconnects with his wife and son, he has changed from a devoted family man into a cold, moody enigma given to inexpli-

cable fits of destructive anger. There are strong hints that while abroad he participated in unspeakable atrocities, but nothing is spelled out. What psychological tension the film accumulates revolves around questions about what happened during the war, questions that remain unanswered.

The film's tone of pained solemnity suggests that "Alex" has larger ambitions than simply evoking the effects of one's man's wartime traumas. Pedro's changes of heart and his family's anguished uncertainty seem invested with historical and political resonances. The boy's refusal to acknowledge his parents at the beginning of the film could signify a nation's refusal to speak frankly about its recent history or a generation's rejection of its elders. Pedro's sneaking back into the country to stay with a close friend (Vincent Gallo) might also suggest a nation's shame over its colonialist past.

Those metaphorical possibilities are dangled throughout the film, whose ending, although melodramatic, leaves the mysteries frustratingly unresolved. From its muddy colors to the expressions of suppressed anguish on its actors' faces, "Alex" is an intriguing exercise in glumness that never states what is in the back of its mind.

The film will be shown today and tomorrow at the Museum of Modern Art as part of the New Directors/New Films series. It opens at Le Cinematographe (15 Vandam Street) on Friday.

1992 Mr 24, C15:3

Lovers

Directed by Vicente Aranda; screenplay by Alvaro Del Amo, Carlos Pérez Merinero and Mr. Aranda (in Spanish with English subtitles); director of photography, José Luis Alcaine; edited by Teresa Font; music by José Nieto; produced by Pedro Costa; released by Aries Films. At the Roy and Niuta Titus Theaters in the Museum of Modren Art, 11 West 53d Street, Marhattan, as part of the New Directors/New Films series of the Film Society of Lincoln Center and the Department of Film of the Museum of Modern Art. Running time: 103 minutes. This film has no rating.

Luisa.............................. Victoria Abril
Paco...................................Jorge Sanz
Trini................................Maribel Verdú

By VINCENT CANBY

The place is Madrid and the time the mid-1950's, when the dictatorship of Francisco Franco has imposed an anesthetizing order on Spanish life. Life seems good if not exciting. The rigid moral values of church and state are not to be questioned, certainly not by Paco, a naïve young soldier on whom fortune seems to be smiling.

At the beginning of "Lovers," Vicente Aranda's steamily entertaining new Spanish film, Paco is preparing to re-enter civilian life with far more promise than he had when, as a farm boy, he joined the army. He is engaged to the virginal Trini, who works as a maid for the family of his avuncular superior officer.

Trini is not only sweet and pretty, but she is also frugal. She has saved a sizable amount of money that will help them secure their status as shopkeepers, thus to become hard-working, productive members of the lower middle class.

The ease and speed with which this perfect future collapses is the sardonic subtext of Mr. Aranda's dark, romantic melodrama, which is said to be based on a true story and is certainly one that could never have been made as a movie in Franco's day.

"Lovers" will be shown at the Museum of Modern Art today at 9 P.M. and tomorrow at 6 P.M. as part of the New Directors/New Films series. The film is notable not for its stylistic innovations, but for the economy and wit with which Mr. Aranda evokes the temper of a society frozen in time.

Not at any point does "Lovers" appear to be overtly political. Yet it is a seriously cautionary tale.

●

"Lovers" is also extremely well acted by Jorge Sanz as Paco, Maribel Verdú as Trini, and Victoria Abril, the film's star, as the commanding, sensual and greedy Luisa. It is she who becomes the enthusiastic if completely unknowing instrument for the destruction of Paco, Trini and herself.

Luisa is a youngish widow making ends meet in whatever way she can. When Paco rents a room in her Madrid flat, supposedly counting the days until he and Trini can be married, Luisa loses no time taking him to bed. Though Paco is already impressed by Luisa's chic clothes and movie-star manners (she nibbles chocolates throughout the day and drinks ladylike nightcaps of anisette), he is almost terminally dazzled by the sexual delights to which she introduces him.

The movie suggests that Luisa must be something of an artist. She never does the same thing twice. She is tireless. She knows tricks that poor

Church, state, sexual acrobatics and a society frozen in time.

inhibited Paco would never dare to imagine. In no time at all, Paco is beginning to forget Trini. After he loses his job in a brick factory, Luisa has no trouble persuading him to participate with her and some business associates in a scam to sell a tobacco shop that is not theirs.

When Luisa's creditors start closing in on her, and when Trini becomes more and more jealous and demanding, Paco agrees to Luisa's plan to commit what becomes a far from perfect murder.

●

In addition to a first-rate narrative, "Lovers" has two central characters of some complexity. Luisa is the more dominant, showy personality, but Trini is no less important, a young woman whose mild manners hide a puritanical resolve of a ferocity to make Luisa's grand passions look petty.

In one of the film's spookier moments, Trini introduces Paco to her mother, an ancient farm woman who has evident difficulty walking. Trini

explains that many years ago her mother jumped in front of a cart after learning that Trini's father had been unfaithful. Paco's fate is sealed long before he's aware of it.

The film's manner is dispassionate. Mr. Aranda observes everything in detail, the sexual acrobatics as well as the melodrama that ends the story, but without appearing to comment on the events or to burden them with larger meanings. "Lovers" is a sophisticated, highly accomplished work.

1992 Mr 25, C18:5

The Ear

Directed by Karel Kachyna; written by Mr. Kachyna and Jan Prochazka, (in Czech with English subtitles); director of photography, Josef Illik; released by International Film Exchange. At the Film Forum, 209 West Houston Street, Manhattan. This film has no rating.

Ludvik Radoslav Brzobahaty
Anna...Jirina Bohdalova

By JANET MASLIN

The government reception that plays a central role in "The Ear," a powerful, long-suppressed Czechoslovak film made in 1969 and opening today at the Film Forum, is seen only in hindsight through the eyes of two desperate revelers. Anna (Jirina Bohdalova) and Ludvik (Radoslav Brzobahaty), a quarrelsome married couple, are first observed as they return home drunkenly, very much the worse for wear. Sporting a party hat made out of newspaper and a volatile, contentious expression, Anna is first to discover that something is amiss. The door is unlocked. The power and telephone lines are out of order. Abruptly, the evening's strained merriment looks a lot less innocent than it did before.

Ludvik, a Communist Party official during the Stalinist 1950's, has quietly learned during the course of the evening that other bureaucrats, including his own superior, have been mysteriously detained. This means that Ludvik and Anna, who have been in the midst of sniping at each other over petty domestic matters, must contemplate the possibility of a serious reversal of fortune. Anna is torn between voicing contempt for her husband and allowing that con-

tempt to be monitored by what she calls "the ear."

●

The title of this tense, expertly executed film by Karel Kachyna (with a screenplay co-written by Jan Prochazka) refers to the bugging devices that must surely have been planted in the couple's house while they were conveniently occupied at the party. Or so Anna thinks, when she shouts things like "Comrades, we're going to bed!" into an empty room. But the enormity of this situation makes the evening quickly lose any trace of black humor. And it plunges the couple into frantic attempts to reconstruct and analyze the preceding evening.

What did the visiting Soviet dignitary say besides "When there's a severe frost, can you pour concrete in your country?" What did the fellow official mean when he embraced Ludovik and whispered, "I'm only friendly with those whom they're after"? Why did the waiters confirm some guests' suspicions by not being able to identify the salmon? Could it be that they were spying on the partygoers? And were some of those partygoers being sensible or overly sensitive in refusing to discuss important matters within earshot of any of the statues?

●

"The Ear" is lent unexpected depth by the complex, changeable performances of the leading actors, who effectively transform this into a two-character hothouse drama despite the presence of various minor figures. (Almost all of the film's secondary characters appear drunk and silly, until Anna and Ludovik's retrospective view of the evening reveals how much dead-serious behavior has been masked by fake giddiness.) Miss Bohdalova in particular displays impressive range, moving from the pettiness and coquettishness of the film's early scenes to the solemnity of its later stages, and making her character's fear and anger utterly real. Mr. Kachyna's direction is remarkably agile in balancing its portrait of a marriage with the larger terrors of life in a police state.

The black-and-white cinematography of "The Ear" is unusually expressive, velvety when the film is in a party mood and subsequently much more edgy and stark. It is the perfect accompaniment to remarkable images like that of a formerly festive couple clutching silver candelabra as they hide in their bathroom, wondering whether the walls have ears.

1992 Mr 25, C18:5

Ruby

Directed by John Mackenzie; screenplay by Stephen Davis; director of photography, Phil Meheux; edited by Richard Trevor; music by John Scott; production designer, David Brisbin; produced by Sigurjon Sighvatsson and Steve Golin; released by the Triumph Releasing Corporation. Running time: 100 minutes. This film is rated R.

Jack Ruby.................................Danny Aiello
Candy CaneSherilyn Fenn
Action JacksonFrank Orsatti
HankJeffrey Nordling

Telephone Trixie......................Jane Hamilton
DiegoMaurice Benard
Joseph ValachiJoe Viterelli
Senator....................................Robert S. Telford
Santos Alicante.......................Marc Lawrence
Maxwell....................................Arliss Howard
Officer TippitDavid Duchovny
Proby..Richard Sarafian
Sam GiancanaCarmine Caridi
Lee Harvey OswaldWillie Garson
President John F. Kennedy (Las Vegas)Gerard David
President Kennedy (Dallas) ...Kevin Wiggins

By VINCENT CANBY

S if heeding the advice of Jean-Luc Godard, who once said that the best way to criticize a movie is by making another, the English di-

Triumph Releasing Corporation

An anti-hero enmeshed in conspiracies: Danny Aiello as Jack Ruby.

rector John Mackenzie and the English writer Stephen Davis have concocted "Ruby," which they candidly describe as "speculative fiction."

Unlike "J. F. K.," Oliver Stone's kaleidoscopic consideration of the various conspiracy theories surrounding President John F. Kennedy's assassination, "Ruby" looks at the events in Dallas on Nov. 22, 1963, from a rather more modest point of view, which is not to say that its imagination doesn't run amok, sometimes deliriously.

With the physically impressive Danny Aiello in the title role, "Ruby" is the story of one of American history's most infamous fringe characters, Jack Ruby, the smallish man who, on national television, shot Lee Harvey Oswald in a Dallas police station two days after Kennedy's death.

"Ruby" doesn't exactly refute "J. F. K." It seems improbable that Mr. Mackenzie and his associates could have seen the Stone film before making theirs. Yet "Ruby" pares down the size of the alleged conspiracy to somewhat more manageable proportions and never overburdens the audience with historical detail. It is an exposé cast in the form of a fever dream. It takes off from truth with the freedom of a poet obsessed with mob literature.

To this end, "Ruby" mythologizes a lot of known facts, which are then mixed with fiction to speculate in ways that suggest the movie has been sniffing glue. As crazy as it is, though, "Ruby" is almost rudely entertaining. It may also indicate that we're attending the birth of a new movie subgenre, a specific kind of film noir devoted to an event treated earlier as an occasion to prompt sorrow and conventional sentimentality.

Mr. Mackenzie, who made "The Long, Good Friday," keeps "Ruby" moving. It's unreasonably watchable from the moment its "Godfather"-like theme music is heard behind the opening credits until Jack's last defiant cry from his jail cell: "You don't own me. I'm Jack Ruby!"

Mr. Mackenzie, Mr. Davis and Mr. Aiello attempt to impose a kind of anti-heroism on the Dallas nightclub operator who, in life, was always an outsider, in part because he was Jewish and in part because he was so emotionally unreliable. History's Ruby was known as a groupie to both the mob and the Dallas police, and as a hopelessly self-serving paid informant to the Federal Bureau of Investigation. His tips to the F.B.I. were usually intended to discredit competing club operators.

●

The film's Jack is a man of psychological stature, flawed, perhaps, but wise in the world's ways and kind to hungry strippers. When he loses his temper, it is because his honor has been questioned. He mercilessly

beats up a husky rodeo rider, the husband of his star performer, Candy Cane (Sherilyn Fenn), when the husband calls Jack's Club Carousel "a sleaze pit." Says Jack with authority: "Make that the last time you take out your disappointment with life on Jack Ruby!"

Jack talks like a movie ad. Almost everything he says is punctuated by an exclamation point.

Early in the film, at the bidding of the mob, Jack flies off to Cuba to spring a Mafia big-shot from prison. When his Mafia connection orders him to shoot the man just freed, Jack refuses on principle. He shoots the connection instead. In the fictional world of "Ruby," this independent attitude apparently earns him even more mob respect.

Before long, Jack and Candy, whose relationship is platonic (Jack

explains that his mind is too full of business matters to become involved with his stars) are invited to Las Vegas, Nev., to attend a big Mafia pow-wow. Jack is both dazzled by the honor and wired by the Central Intelligence Agency. Sam Giancana and other mob leaders ask him to deliver poisoned cigars to Fidel Castro, while the C.I.A. wants Jack to shoot the Cuban leader with a Government-issue rifle.

Jack, it would seem, is some kind of home-grown James Bond.

●

It's during the Las Vegas sequences that "Ruby" really goes into orbit. As the movie pictures it, Jack sits at a table in a glitzy hotel ballroom, surrounded by more mob chieftains than have come together since Government agents made their memorable 1957 raid on the Mafia meeting in Apalachin, N.Y. Performing onstage is a singer who is meant to recall Frank Sinatra. Purely by coincidence, President Kennedy enters and sits with his party on the other side of the room. Almost immediately Candy Cane is invited to join the Kennedy table.

Miss Fenn (who played Audrey Horne on "Twin Peaks") is actually very good as platinum-blond Candy, a fictitious character that evokes several real-life women in succession. When she first meets the President, she seems to be playing a fictional counterpart to Judith Campbell Exner, whose book, "My Story," tells about her concurrent affairs with Giancana and Kennedy.

A little while later, when Candy is seen performing as a chanteuse in an elegant supper club in Washington, she is a dead ringer for Marilyn Monroe as Monroe appeared when she sang for the President at his televised birthday party. Yet being at the top is no bed of roses for poor Candy. The mob starts to lean on her to take messages to Kennedy, which she adamantly refuses. She's in love.

●

"Ruby" is not always easy to follow, especially when it comes to the Kennedy assassination, which seems to be a mob hit carried out with some sort of participation by the C.I.A. The film pretends to an unconvincing discretion as it hints that it knows even more than it can say in all decency.

Officer J. D. Tippit, the Dallas policeman allegedly shot by Oswald shortly after the Kennedy assassination, is pointedly introduced as a Club Carousel regular whose admiration for Candy might have been his undoing. Diego, the bartender at the Carousel, who is Cuban and otherwise uncharacterized, is shown entering the Texas School Book Depository Building on the morning of the assassination in the company of Oswald.

When Jack hears the news of the assassination, he weeps and moans, "Everything is connected up wrong." He vows "to blow this thing wide open," but he hits Oswald instead.

Mr. Aiello plays Jack as written, that is, with a good deal of energy and passion, though he remains a fringe character even when at the center of the frame. The supporting cast includes Marc Lawrence, who adds a rich antique sheen to the movie as the old Mafia fellow Jack frees from Castro's prison, and Arliss Howard as a vividly creepy C.I.A. agent. Miss Fenn is the movie's principal attraction, but then roles like that of Candy Cane don't come along all that often.

At the beginning of the film, she's just a cheerful, sassy, well-proportioned stripper from Rising Star, Tex. A little later she's playing the mistress of the President. Still later she could be Marilyn Monroe. The character's apotheosis is complete when, at the end, she visits Jack, a broken man, sentenced to death, in his jail cell. Grieving but dressed in haute couture, carrying herself with dignity, Candy suddenly looks like a very blond Jacqueline Kennedy.

The head spins.

●

"Ruby," which has been rated R (Under 17 requires accompanying parent or adult guardian), includes a lot of violence, vulgar language and some partial nudity.

1992 Mr 27, C1:3

Swoon

Written, directed and edited by Tom Kalin; director of photography, Ellen Kuras; music by James Bennett; production designer, Therese Déprèz; produced by Mr. Kalin and Christine Vachon; released by Fine Line Features. At the Roy and Niuta Titus Theaters in the Museum of Modern Art, 11 West 53d Street, as part of the New Directors/New Films Series of the Film Society of Lincoln Center and the department of film of the Museum of Modern Art. Running time: 90 minutes. This film has no rating.

Richard Loeb Daniel Schlachet
Nathan Leopold Jr. Craig Chester
State's Attorney Crowe................. Ron Vawter
Detective Savage....................... Michael Kirby
Doctor Bowman Michael Stumm
Germaine Reinhardt.............. Valda Z. Drabla
Susan Lurie Natalie Stanford

By JANET MASLIN

In "Swoon," his wildly audacious debut feature about the 1924 kidnapping and murder committed by Nathan (Babe) Leopold Jr. and Richard (Dickie) Loeb, Tom Kalin challenges his audience's every assumption about this story, and quite a few assumptions the viewer may never have made. Mr. Kalin's objective, dazzlingly well realized, is apparently to fracture any familiar notions and prejudices that have been incorporated into this much-studied story.

Removing all elements of the usual, and sometimes deliberately interjecting jarringly incongruous touches to disrupt the ordinary, Mr. Kalin insists that his viewers re-invent the atmosphere that contributed to this enormously public 1924 crime.

The greatest success of "Swoon" lies in its power to dismantle ideas that the film maker clearly regards as bigoted and banal. Radical in its approach to the facts (although the core elements of the case remain unaltered), this film imposes contemporary styles and attitudes upon the past. And it re-imagines its case in terms of more explicit, daring and even jaded behavior than anything of which the real Leopold and Loeb might have been capable. A film in which one kidnapper works on his ransom note while the other invites friends over for drinks is clearly well outside the bounds of run-of-the-mill amoral behavior.

In the end, "Swoon" is more successful in taking apart this particular chapter in criminal history than in reassembling it with a clear point of view. The film's most unnerving aspect, aside from its utter fearlessness in tackling this subject, is the pitiless calm with which Mr. Kalin surveys his landscape. Although "Swoon" sounds a resounding protest against

John Rowan/New Line Cinema

Daniel Schlachet in "Swoon."

the homophobic attitudes that influenced Leopold and Loeb's trial, and acknowledges the swift social changes that may have contributed to the kidnapers' behavior, its true attitude toward this duo is finally elusive. If Mr. Kalin intends a less dispassionate vision, or even a more emphatic one, it doesn't come through.

●

Shot in the hauntingly stylish manner of avant-garde advertising, the black-and-white "Swoon" is a tricky, unpredictable synthesis of the mannered and the real. Its posing flappers, floating archly past the camera in the film's opening moments, bespeak a pointed artificiality, but the passion between Leopold (Craig Chester) and Loeb (Daniel Schlachet) is urgent and real. Imagining them as ardent, contemporary lovers, Mr. Kalin has them exchanging wedding rings in the film's early moments, rings that one presents to the other with his mouth. The decision to kill a schoolboy (who is actually a relative of one of the killers) is later seen as part of this same intoxicatingly romantic spell. "Killing Bobby Franks together would join Richard and me for life," Nathan later says at his trial.

Mr. Kalin sees the crime's early stages as an unsettling blend of Nietzschean arrogance and mad love. There are languid smiles shared by Babe and Dickie as they plot the grisliest details of their scheme; there is the lazy insouciance of bodies tangled beneath white sheets. "You've just had the pleasure of shaking hands with a murderer," Dickie tells a chauffeur just after the killing. Indeed, after disposing of the boy's body, Dickie 's seen lingering at the crime scene for a casual snack.

●

The film attempts to place its characters' cavalier attitudes in a larger context, using everything from quotations from von Masoch's "Venus in Furs" to deliberate mysteries and anachronisms (a dateless newspaper, present-day clothing and hairstyles, a touch-tone phone). These methods are most effective in the film's sections dealing with the limitations of Babe's psychoanalysis, and with the trial featuring Clarence Darrow as the killers' attorney.

Mr. Kalin's single most noteworthy touch, and the one that best summarizes his methods, is the image of

Babe, Dickie and their bed in the middle of the courtroom as their homosexuality becomes an issue at the trial. Conventional thinking — circa 1924 and perhaps today as well — is seen truly to exist in a different dimension from these characters and their passion. Mr. Kalin's sense of the incongruous later follows Dickie and Babe to prison, in an ending that shares an eerie symmetry with the film's opening moments. Dickie's murder at the hands of a calm white prisoner, and the subsequent newspaper description of that prisoner as a "frenzied Negro," provides the film's ultimate assessment of the press

"Swoon" will be seen tonight at 9 and tomorrow at 3 P.M. as part of the New Directors/New Films series at the Museum of Modern Art.

1992 Mr 27, C8:1

Adorable Lies

Directed by Gerardo Chijona; screenplay by Senei Paz, based on an original idea by Mr. Chijona, (in Spanish with English subtitles); director of photography, Julio Valdés; edited by Jorge Abello; music by Edesio Alejandro and Gerardo García; produced by Evelio Delgado. At the Roy and Niuta Titus Theaters in the Museum of Modern Art, 11 West 53d Street, as part of the New Directors/New Films series of the Film Society of Lincoln Center and the department of film of the Museum of Modern Art. Running time: 100 minutes. This film has no rating.

Sissy...Isabel Santos
Jorge Luis.........................Luis Alberto García
Nancy..Mirtha Ibarra
Flora..Thaïs Valdés

By VINCENT CANBY

"Adorable Lies," Gerardo Chijona's new Cuban comedy, tries very hard to be bright and cheery, even madcap, but there is something melancholy about it. It prompts the suspicion that the director and his associates cannot themselves believe in the carefree world they want to create.

The film even seems inhibited in its subject matter, as if this gentle send-up of Cuban movie makers couldn't possibly offend anybody of authority, the characters being too peripheral to matter seriously. Chief among these are Jorge Luis, a young would-be director; Sissy, the pretty young woman he seduces by promising her a role in a nonexistent film, and Flora, Luis's jealous wife.

●

"Adorable Lies" has some amusing lines that have a film-school ring to them. "How tall do you think Jane Fonda is?" says a fellow trying out a new pickup approach. A second-rate producer, completely unaware that the preview of his latest movie has been a disaster, is magnanimous to a friend. "I haven't forgotten my promise," he says. "If my film is invited to the festival at Tashkent, I'll bring your daughter a pair of shoes."

The sad thing about "Adorable Lies" is not that the characters don't acknowledge how drab their lives are, but that the film cannot address that drabness more directly and with more freewheeling gusto.

"Adorable Lies" will be shown at the Museum of Modern Art today at 6 P.M. and tomorrow at 12:15 P.M. as part of the New Directors/New Films series.

1992 Mr 27, C8:5

Roadside Prophets

Written and directed by Abbe Wool; director of photography, Tom Richmond; edited by Nancy Richardson; music by Pray for Rain; production designer, J. Rae Fox; produced by Peter McCarthy and David Swinson; released by Fine Line Features. At the Angelika Film Center, 18 West Houston Street, Manhattan. Running time: 96 minutes. This film is rated R.

Joe Mosely...John Doe
Sam..Adam Horovitz
Salvadore.....................................Timothy Leary
Harvey...Arlo Guthrie
Caspar..John Cusack
Othello Jones.........................David Carradine
Oscar..Bill Cobbs

By STEPHEN HOLDEN

The best thing about "Roadside Prophets," a film that blatantly aspires to be a 1990's answer to "Easy Rider," is its motorcyclist's-eye-view of the desert Southwest. As Joe (John Doe) and Sam (Adam Horovitz) scour the highway for a mythical casino, they whiz through vistas more magical than any of the psychedelic visual effects in the film's 1969 forerunner.

Like "Easy Rider," "Roadside Prophets," which opens today at the Angelika Film Center, is a boys-on-bikes American odyssey drenched in an attitude of would-be hipness. Abbe Wool, who wrote and directed the film, collaborated on the screenplay for the well-regarded punk-rock movie "Sid and Nancy." The two stars of "Roadside Prophets" are each admired figures in a particular pop subgenre. Mr. Doe once led the Los Angeles post-punk rock band X, and Mr. Horovitz is a member of the rap group the Beastie Boys.

In teaming them, Ms. Wool treats them as symbolic figures in a comic allegory that pretends to explore the spiritual lineage of the 60's counterculture. Mr. Doe's character is a veteran factory worker in his late 30's who is running out of youth and hope. Mr. Horovitz's Sam, a pesky smart-aleck roughly half Joe's age, is obsessed with motorcycles and Motel 9's and carries around a stash of fireworks. Putting in tiny cameo appearances are 60's cultural figures including Arlo Guthrie and Timothy Leary.

●

Although the film's setup is promising, "Roadside Prophets" almost immediately becomes mired in pretentious symbolism and cutesy little jokes. Beginning with the electrocution of a friend of Joe's while playing a video game and ending with the pair's arrival at El Dorado, a casino in the town of Jackpot, the story's metaphors have a sledgehammer obviousness.

Along the way, Joe has a fling with an exotic dancer called Labia Mirage (Jennifer Balgobin), who later reveals her true name to be Prudence Kierkegaard. Dr. Leary woodenly

Merrick Morton/New Line Cinema

John Doe, left, and Adam Horovitz in "Roadside Prophets."

parodies himself in a routine that tries to amuse by confusing a brand name of champagne with a type of drug. Such is the film's sense of humor.

Ms. Wool's film may look good, but she doesn't know how to direct actors. Mr. Doe mumbles most of his lines, and Mr. Horovitz whines most of his. Although a friendship is supposed to develop between them, one never feels any connection. In addressing the political legacy of the 60's counterculture, the screenplay merely drops names (like Reagan and Bush) and rhetorical non sequiturs like "They're building more prisons than schools." They hit the ear and land with a lethal thud.

●

"Roadside Prophets" is rated R (Under 17 requires accompanying parent or adult guardian). It includes brief nudity and strong language.

1992 Mr 27, C10:1

The Power of One

Directed and edited by John G. Avildsen; screenplay by Robert Mark Kamen, based on a novel by Bryce Courtenay; director of photography, Dean Semler; music by Hans Zimmer; production designer, Roger Hall; produced by Arnon Milchan; released by Warner Brothers. Running time: 126 minutes. This film is rated PG-13.

P. K. (age 18)..................................Stephen Dorff
P. K. (age 12)................................Simon Fenton
P. K. (age 7)......................................Guy Witcher
Doc.................................Armin Mueller-Stahl
Headmaster.....................................John Gielgud
Geel Piet...Morgan Freeman
Maria Marais.................................Fay Masterson

By JANET MASLIN

John G. Avildsen directs the pious South African drama "The Power of One" as if it were "The Anti-Apartheid Kid," chronicling the brave attempts of a little blond, blue-eyed boy named P. K. to fight racial injustice. The battle is waged mostly in terms of toothless platitudes ("a waterfall begins with only one drop of water") and ugly encounters with racist bullies, encounters that Mr. Avildsen prefers shooting in close-up whenever possible. On the affirmative side, the boy's every triumph is accompanied by Johnny Clegg's soaring choral music (and Hans Zimmer's instrumental score).

P. K. (played by three actors of different ages, none of whom especially resemble the others) is introduced as a small, wise child during a shapeless preamble. Typically, this part of the film is edited so unemphatically that it appears to place equal emphasis on the little boy's bed-wetting and the death of his mother. It is half an hour before the excellent Morgan Freeman and Armin Mueller-Stahl enter P. K.'s story as an African prison inmate and the boy's kindly German grandfather, thus giving the film at least some reason to exist.

●

The grandfather, Doc, has been incarcerated by South African authorities for the duration of World War II, and P. K. follows him to prison. "Inside, everyone was concerned with just one thing — the outcome of the inter-prison boxing championships," P. K. says in voice-over, thereby explaining the presence of Mr. Avildsen ("Rocky" I and V, "The Karate Kid" I, II and II) in these unfamiliar waters. When an older P. K. enrolls in

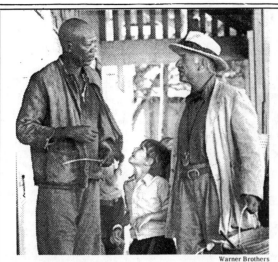

Warner Brothers

Colorblind Morgan Freeman, left, Guy Witcher and Armin Mueller-Stahl are in "The Power of One," John G. Avildsen's drama about an English boy's metamorphosis into manhood, set in South Africa during the 1930's and 40's.

high school (where the vastly over-qualified John Gielgud has been cast as his headmaster), another boxing tournament lies in store.

The film's facile treatment of racial issues 'may be enough to bring back the practice of throwing tomatoes at the screen. Huge throngs of black extras (many played by members of the Masibemunye Bulawayo Choir, a large choral group that provides much of the stirring score) are often seen responding admiringly to the overtures of a lone white boy. At one point, the adolescent P. K. (Simon Fenton) even tries to conduct their musical efforts, though he demonstrably has no talent.

When the 18-year-old P. K. (Stephen Dorff) jogs through a black township, he is treated with similar reverence. The film's black characters are even said to believe P. K. has magical powers, thanks to the hints dropped by Mr. Freeman's Geel Piet, a bald, barefoot prisoner with a disconcertingly servile manner (he refers to P. K. as "Little Boss"). Mr. Freeman's humanity and intelligence are unmistakable, as always, but not even he can rise above the wretchedness of this role. When Geel Piet is forced to eat excrement by a white prison guard, the camera zeroes in for yet another close-up image of humiliation.

"The Power of One," with a screenplay by Robert Mark Kamen based on Bryce Courtenay's novel, must surely be less obvious on the page than it is on screen. The film is often regrettably blunt, as when the story's fascist Afrikaner villains literally drink a toast to apartheid, or when P. K.'s feeble Romeo-and-Juliet romance with the daughter (Fay Masterson) of this Afrikaner family is filmed as if it were "Romeo and Juliet," balcony and all. The film's occasional jarring elements, like the presence of what looks like a nuclear power plant near a black township in the late 1940's, are a welcome diversion.

●

"The Power of One" is rated PG-13 (Parents strongly cautioned). It includes profanity and graphic violence.

1992 Mr 27, C20:5

The Cutting Edge

Directed by Paul M. Glaser; written by Tony Gilroy; director of photography, Elliot Davis; edited by Michael E. Polakow; production designer, David Gropman; music by Patrick Williams; produced by Ted Field, Karen Murphy and Robert W. Cort; released by MGM. Running time: 126 minutes. This film is rated PG.

Doug	D. B. Sweeney
Kate	Moira Kelly
Anton	Roy Dotrice
Jack	Terry O'Quinn
Hale	Dwier Brown

By STEPHEN HOLDEN

Nasty sparks fly when Doug Dorsey (D. B. Sweeney) meets Kate Moseley (Moira Kelly), his future figure-skating partner in the Winter Olympics.

"Do you soak your hands in battery acid?" sneers Kate the first time he touches her.

It is the opening salvo in a barrage of stinging insults that the spoiled, arrogant Kate flings at him in her father's private ice rink. Later, during their early practice sessions, she leaves him floundering and bruised so often that he ends up traipsing around with ice packs attached to both hips.

Compounding the pressure is the fact that Doug is desperate for the job. A hockey star whose career ended abruptly after an accident cost him some peripheral vision in one eye, he knows that his only hope for a skating career lies in forming a successful partnership with the notoriously temperamental Kate. It also

Insults and agony on the way to a figure-skating partnership.

doesn't help that his friends in his hometown, Duluth, look down their noses at figure-skating.

"Are they going to make you shave your legs?" Doug's bartending older

brother jokes when informed of his plans.

●

Their volatile relationship as Doug and Kate pursue an Olympic gold medal forms the core of "The Cutting Edge." Although the movie follows the standard Hollywood formula of pictures dealing with athletic competition, it is snappily paced and unusually well acted.

Ms. Kelly's uncompromising portrayal of a high-strung prima donna whose outrageous willfulness masks a girlish vulnerability gives the picture a big charge of energy. When Kate doesn't get her way, her eyes widen in furious disbelief and she begins spitting sarcasm so venomous it could give the stoutest heart pause. Physically she exudes the imperious self-assurance of someone who is used to being in complete control of both her own body and her environment. And when toward the end of the film, Kate begins to melt a little, Ms. Kelly makes the difficult transition from vixen to insecure crybaby entirely credible.

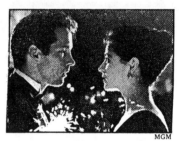

MGM

D. B. Sweeney, left, and Moira Kelly in "The Cutting Edge."

Mr. Sweeney's more subtly shaded character is a likable lug who is a lot more intelligent than the rest of the world realizes. Instead of sentimentalizing his character's underdog role in a Sylvester Stallone-like manner, he plays him as an uncomplaining jock who never raises his voice unless he has to.

"The Cutting Edge," which was directed by Paul M. Glaser, has a smooth visual polish and is crisply shot and edited. Its many close-ups of skates hissing on ice are skillfully interwoven with competitive skating sequences (using professional doubles) whose medium-intense visceral charge is effectively bolstered by a chugging pop score.

●

"The Cutting Edge," which is rated PG (Parental guidance suggested), has strong language.

1992 Mr 27, C21:1

White Men Can't Jump

Written and directed by Ron Shelton; director of photography, Russell Boyd; edited by Paul Seydor; music by Bennie Wallace; production designer, Dennis Washington; produced by Don Miller and David Lester; released by 20th Century Fox. Running time: 115 minutes. This film is rated R.

Sidney Deane	Wesley Snipes
Billy Hoyle	Woody Harrelson
Gloria Clemente	Rosie Perez
Rhonda Deane	Tyra Ferrell
Robert	Cylk Cozart
Junior	Kadeem Hardison
George	Ernest Harden Jr.

D. Stevens/20th Century Fox

Woody Harrelson

By JANET MASLIN

The torrent of your-mama comic insults heard in the basketball film "White Men Can't Jump" suggests constant antipathy among the film's racially mixed cast of characters. So does the fact that the actors are forever shoving one another's shoulders when they deliver these lines. But this film unfolds in an uncommonly sweet, harmonious climate, one in which rude remarks are the sine qua non of friendship. And that benign atmosphere becomes a large part of its charm.

As in his earlier "Bull Durham" and "Blaze," the writer and director Ron Shelton cares much more about how his characters play the game than whether they win or lose. However fundamentally aimless his gamesmanship proves to be, it does have a lot of style.

"White Men Can't Jump" begins with a basketball hustle, a routine Mr. Shelton is happy to repeat on several other occasions without worries of wearing out his audience's patience. Billy Hoyle (Woody Harrelson), who is white, wanders near the spot where an all-black group is playing basketball. Looking as inept as he can, he waits for one of the players to single him out as a loser and dare him to play.

The showboat who notices Billy this time is Sidney Deane (Wesley Snipes), a fast-talking street star who is understandably irritated when Billy turns out to be a ringer, one whose sneaky basketball bets are his principal source of income. "This is like the luck of the Irish," Billy says amiably, while scoring yet another basket. "Only I'm not Irish, so you figure it out."

Like the movie characters they are, Billy and Sidney develop a close rapport forged out of enthusiastically traded wisecracks (Sidney's friends often refer to Billy in terms of "The Brady Bunch" or "The Andy Griffith Show"). That friendship, appealingly conveyed through Mr. Snipes and Mr. Harrelson's first-rate teamwork, is really all the film is after, but Mr. Shelton has gone to some lengths to concoct a busier-looking plot.

So Billy and Sidney are seen embarking on a co-hustle in other predominantly black neighborhoods, attempting the kind of swindle that would ordinarily land both of them in the hospital, or at the very least lose them their betting cash. But in this film there is no possibility of real trouble, not even when a player named Raymond (Marques Johnson) grabs his ski mask and gun in order to raise some quick funds for betting purposes. (He winds up having to sell the gun to the convenience-store owner he tried to rob.) Much of the cheerfully lackadaisical story revolves around Billy's efforts to solve his money problems with one big score. A lot of it also concerns the woman in Billy's life, a "former disco queen,

originally from Brooklyn, N.Y.," named Gloria Clemente (Rosie Perez), who feels that it is her mission to appear on the quiz show "Jeopardy." Mr. Shelton's running "Jeopardy" gambit may be mild, but it is made to pay off, as are many of the film's smaller touches. Even Gloria's complaint when Billy brings her a drink has an echo later in the story. "If I'm thirsty, I don't want you to bring me a glass of water," says Gloria, who has had a bit too much of her consciousness raised by magazine articles. "I want you to say, 'Gloria, I too know what it means to be thirsty.'"

The story also dwells on the home life of Sidney, his wife, Rhonda (Tyra Ferrell), and his several buddies, who hang around his living room watching basketball on television when they aren't playing it themselves. A quarrel involving Billy, Gloria, Sidney and Rhonda captures the film's boisterous high spirits when it triggers mass protest from Sidney's friends, a funny and smart-talking group. They don't care who wins the argument, but they don't want anyone blocking the television screen.

Since "White Men Can't Jump" has no particular place to go, it concentrates on motor-mouthed banter, an area in which Mr. Shelton has considerable expertise. The dialogue is fast, furious and often overlapping, and the less sense it makes, the better. ("You can put a cat in the oven, but that don't make it a biscuit." "The mustard is off the hot dog, you big corn-fed mule, you.") Scattered amid all this hot air are apparently more serious attempts at folk wisdom, since the screenplay is not shy about repeating its favorite homilies. As with "Bull Durham," it's best to take each one lightly (like the idea that winning and losing are "all one big organic globule") and then move on.

•

The terrifically confident Mr. Snipes gives a funny, knowing performance with a lot of physical verve. And Mr. Harrelson (of "Cheers") further perfects the art of appearing utterly without guile. Their comic timing together shapes the film's raucous wit, and their basketball playing looks creditable, too. Ms. Perez, a tiny firecracker of an actress, avoids the cuteness in Gloria's eccentricities and turns her "Jeopardy" break into an epiphany the whole audience can share. This film proves, among other things, that a person who thinks Babe Ruth was a basketball player may be nobody's fool.

"White Men Can't Jump" opens and closes with the Venice Beach Boys, an a cappella gospel group that deserves special mention for striking a suitably mellow mood. Russell Boyd's cinematography makes the most of the film's sunny California street scenery.

•

"White Men Can't Jump" is rated R (Under 17 requires accompanying parent or adult guardian). It includes profanity, partial nudity and sexual situations.

1992 Mr 27, C22:4

Ladybugs

Directed by Sidney J. Furie; written by Curtis Burch; director of photography, Dan Burstall; edited by John W. Wheeler and Timothy N. Board; music by Richard Gibbs; production designer, Robb Wilson King; produced by Albert S. Ruddy and Andre E. Morgan; released by Paramount Pictures. Running time: 91 minutes. This film is rated PG-13.

Chester Lee	Rodney Dangerfield
Julie Benson	Jackée
Matthew/Martha	Jonathan Brandis
Bess	Ilene Graff
Kimberly Mullen	Vinessa Shaw
Dave Mullen	Tom Parks
Glynnis Mullen	Jeannetta Arnette

By VINCENT CANBY

Rodney Dangerfield was 64 years old at the time his last hit comedy, "Back to School," was released in 1986. Today he looks to be about 39, Jack Benny's favorite age, which may be why "Ladybugs" can't keep up with him. The new comedy runs as if it were composed of plastic joints and transplanted organs not in mint condition.

Looking a bit more paunchy than he did in 1986, and with his short, thinning hair colored a quite vivid gold, Mr. Dangerfield plays a salesman who, to earn a promotion, undertakes to coach the Ladybugs, a girl's soccer team, a sport about which he knows nothing. There are a few funny gags and many more bad ones, including a couple about pedophilia.

Even when the material is feeble, as it is here, Mr. Dangerfield can sometimes be funny, a gravelly-voiced comic confusion of emotional insecurities laced with aggressive tendencies. The principal members of the good supporting cast are Jackée, who plays Mr. Dangerfield's practical assistant; Ilene Graff, as his fiancée; Jonathan Brandis, as the boy he dresses in drag to help the Ladybugs on the field, and the beautiful, statuesque Vinessa Shaw, who looks a little old to be playing with the Ladybugs.

Sidney J. Furie will not be remembered for his direction of this one. Curtis Burch, who wrote the screenplay, is given a one-sentence biography in the production notes, compared with the three pages devoted to the histories of the film's two producers, its executive producer, its co-executive producer and its associate producer. The priorities are all wrong.

•

"Ladybugs," which has been rated PG-13 (parents strongly cautioned), has vulgar language and jokes.

1992 Mr 28, 17:1

Satan

Written and directed by Viktor Aristov (in Russian with English subtitles); director of photography, Yuri Voronzov; edited by J. Vigdorschik; music by Arkady Gagulaschvili; produced by Sergei Avrutin and Valentina Goroschnikova. At the Roy and Niuta Titus Theaters in the Museum of Modern Art, 11 West 53d Street, as part of the New Directors/New Films Series of the Film Society of Lincoln Center and the Department of Film of the Museum of Modern Art. Running time: 106 minutes. This film has no rating.

Vitaly	Sergei Kuprianov
Alyona	Svetlana Bragarnik
Alyona's Husband	Veniamin Malotschevski
Armen	Armen Nasikyan
Vera	Mariya Averbach
Vitaly's grandfather	Anatoly Aristov
Alyona's daughter	Zhanna Schipkova
Braut	Anna Sagalovitsch
Inna	Margarita Alekseyeva
Heinrich	Mikhail Starodubov

Film Society of Lincoln Center
Sergei Kuprianov and Svetlana Bragarnik in Viktor Aristov's "Satan."

By JANET MASLIN

In the Russian film "Satan," the devil is a delicately handsome young man whose murderous opportunism is too easy to understand. While the film registers shock at its protagonist's absolute amorality, it also presents him as part of a bitterly divided and pessimistic culture. The world of "Satan" is one in which nothing really works, and therefore anything goes. "Where's our motherland?" one character asks, looking at a map of the Soviet Union that is upside down (the film was made in 1990). "At the bottom," another character replies.

"Satan," directed with a keen eye for detail and an unnerving matter-of-factness by Viktor Aristov, tells of the impassively good-looking Vitaly (Sergei Kuprianov), who at the beginning of the film cheerfully offers a bike ride to a pre-adolescent schoolgirl with whom he is acquainted. They ride together for a while, singing, and then Vitaly pulls off into a deserted area and kills the child for no apparent reason.

Possibly more shocking than the crime is the fact that Vitaly next goes to discuss it with his grandfather, who has been a party to Vitaly's plans. Since kidnapping was the real motive, and since the little girl was the daughter of Vitaly's married lover Alyona (Svetlana Bragarnik), the grandfather understandably questions the extreme nature of Vitaly's act. Had he been in Vitaly's place, he says casually, he would only have kidnapped the child and hidden her in a shed.

•

"Satan" divides itself between the particulars of Vitaly's unsettled existence and the extreme anguish of Alyona, whose unspecified job makes her something of a Soviet V.I.P. Vitaly's nominal reason for devising his scheme has been to extort some of the cash Alyona keeps hidden in her relatively comfortable apartment. Vitaly himself lives as a boarder with a number of other people in a crowded, grimy household where there are clusters of empty liquor bottles beside mattresses on the floor. A drifter, he has been dismissed from many jobs and makes his chief occupation the manipulation and exploitation of friends.

In one memorably cold-blooded sequence, Vitaly is seen at a wedding, where he makes a ransom call to the distressed Alyona, then casually destroys the brand-new marriage by seducing the bride. Earlier in the evening, he has been seen shining his shoes with an obliging kitten, which pretty much sums up Vitaly's attitude toward other forms of life. The film observes all of this calmly, and without the overt moralizing that would reduce it to an obvious tale. Vitaly's behavior is carefully placed within the context of a society coming apart at the seams.

Although Vitaly is the film's nominal center, Alyona becomes an equally compelling figure, thanks to Miss Bragarnik's fierce and commanding performance; the scenes depicting her grief are almost unbearably painful to watch. "Satan" arrives at a remarkable resolution in a sequence that finds Alyona seeing her lover Vitaly for the first time during the story and telling him about her daughter's abduction. As she goes on, she begins to realize that she is speaking to her child's killer. The characters in Mr. Aristov's cool, clinical "Satan" find themselves face to face with the unthinkable in many ways.

•

On the same bill with "Satan" is "Meeting With Father," a less successful short, connecting a survivor of the Holocaust with the family of an elderly Ukrainian man accused of participating in war crimes against Jews. The emotions experienced by these people come through clearly, even when their words are rendered barely coherent by some very poor subtitles. The program can be seen tonight at 9 and tomorrow at 3 P.M. as part of the New Directors/New Films Festival.

1992 Mr 28, 18:1

Motorama

Directed by Barry Shils; screenplay by Joseph Minion; director of photography, Joseph Yacoe; edited by Peter Verity; music by Andy Summers; production designers, Vincent Jefferds and Cathlyn Marshall; produced by Donald P. Borchers; released by Planet Productions. At the Roy and Niuta Titus Theaters in the Museum of Modern Art, 11 West 53d Street, as part of the New Directors/New Films series of the Film Society of Lincoln Center and the Department of Film of the Museum of Modern Art. Running time: 90 minutes. This film has no rating.

Gus.........................Jordan Christopher Michael
Kidnapping Husband...................Sandy Baron
Kidnapping Wife......................Mary Woronov
Vern...Meat Loaf

By STEPHEN HOLDEN

The protagonist of "Motorama" is a plucky 10-year-old named Gus (Jordan Christopher Michael) who, after overhearing one too many parental battles, steals his father's red Mustang and hits the road. So short that he is barely able to see over the dashboard, he is nevertheless a good enough driver to hold his own on the open highway. And in his baseball cap, sweat shirt and jeans, the boy suggests a pint-size Everyman.

The film, which will be shown today and tomorrow at the Museum of Modern Art as part of the New Directors/New Films series, follows Gus's adventures across an unnamed fictional land that suggests America re-imagined as a surrealistic parlor game. As Gus eludes a nosy highway patrolman and passes signs welcoming him to states with names like Essex and Bergen, one has the sense of his proceeding from square to square on a giant game board.

Early in his travels, Gus's eye is caught by a glittering highway sign announcing a game called Motorama. All a player has to do is pick up lettered cards when buying gas at stations owned by the Chimera Oil Company. The first player to amass all eight letters in the game's title will win $500 million. The next thing we know, Gus lives for Motorama, going from station to station across the country, looking for the missing letters. By the time he has collected all eight, his hair has turned white, although he hasn't grown an inch taller.

"Motorama," directed by Barry Shils from a screenplay by Joseph Minion, is a lighthearted pop allegory about the quest for the American dream. What saves it from hopeless pretentiousness is a streak of fantastical whimsy. Gus undergoes some rites of passage that another director might have exploited for terror, but that Mr. Shils treats as comic incidents in a dreamlike odyssey. In one mishap, the boy is kidnapped by a sinister couple (Sandy Baron and Mary Waronov) who nearly put out one of his eyes.

"Motorama" wants to be a hip road-movie answer to "The Wizard of Oz," with the $500 million jackpot as the wizard and the oil company's 102-story headquarters as the Emerald City. But the film, unlike its forerunner, is thin in texture and devoid of emotional resonance. There is also too little continuity between episodes, and the picaresque minor characters seem more grotesque than sympathetic. Even Gus, though mildly engaging, evokes no compelling sense of identification. With his obsession for easy money, he is really a precocious miniature grown-up who had lost his innocence before the film began.

1992 Mr 28, 18:5

Quiet Days In August

Written, produced and directed by Pantelis Voulgaris (in Greek with English subtitles); photographed and edited by Dinos Katsouridis; music by Manos Hadjidakis. At the Roy and Niuta Titus Theaters in the Museum of Modern Art, 11 West 53d Street, as part of the New Directors/New Films Series of the Film Society of Lincoln Center and the Department of Film of the Museum of Modern Art. Running time: 108 minutes. This film has no rating.

Aleka......................................Aleka Paizi
Nikos..............................Thanassis Vengos,
Elly...................................Themis Bazaka
Marta.............................Chryssoula Diavati
Man on phone.....................Alekos Oudinotis
Woman on phone...................Irene Ingilessi
WITH: Mirka Klatzopoulou, Nina Papazafiropoulou and Irene Kourmarianou.

By JANET MASLIN

On the evidence of Pantelis Voulgaris's "Quiet Days in August," Athens in late summer is a deserted place. It is populated by moody, pensive people capable of sudden intimacies that spring up under unexpected circumstances — encounters over the telephone or on a subway car, glances through a window or across a cafe. Mr. Voulgaris's genteelly solemn film observes three isolated individuals — a banker, a widow and a retired seaman — and records the chance events that make them marginally less lonely, if only for a while.

Most of the major events in "Quiet Days in August" have the impact of a cake exchanged between neighbors, or a shy, amorous glance. Though the film is directed with taste and intelligence, its sensitivities are mostly too aching and muted to have much effect. Only in its later stages does the story become relatively eventful, and at that point it begins to feel forced. The main satisfaction in watching Mr. Voulgaris's understated film comes from the gentle elegance of his actors and the modest accuracy of his observations.

•

The film's most memorable character is Aleka (Aleka Paizi), a handsome, fine-boned elderly widow whose kindly smile belies her tacit longing. Aleka's feelings about life and love are reawakened by Elly (Themis Bazaka), a young nurse who moves into a nearby apartment. Meanwhile, the retired seaman (Thanassis Vengos) experiences a rekindling of his own romantic dreams when he feels a sudden kinship with a woman on a train, and then watches that woman unexpectedly fall into a faint. At certain moments, including these, narrative ballads are heard on the soundtrack to help voice the characters' inner thoughts.

The third figure in the story is a downcast-looking banker (Alekos Oudinotis) who engages in solemn telephone sex with an unknown woman (Irene Ingilessi) and yearns to meet her. Mr. Voulgaris's plot mechanics can be clumsy, as when the woman who faints is found to have her husband's death certificate in her pocketbook; surely there was a less contrived way of announcing her situation. But the maneuvers of the film maker all share a tacit sympathy for his middle-aged characters' various losses and burdens.

The film is worth noting for its compassion, in large matters and small. In this context, it is barely surprising when a policeman investigating a crime explains that he will be away for 10 days to help his father in the vineyard. The characters in this story, for all their private unhappiness, are exceptionally well-mannered and kind.

"Quiet Days in August" will be shown tonight at 6 and tomorrow at 9 P.M. as part of the New Directors/New Films Festival.

1992 Mr 29, 48:1

Viaduc

Directed by Danniel Danniel. At the Roy and Niuta Titus Theaters in the Museum of Modern Art, 11 West 53d Street, as part of the New Directors/New Films Series of the Film Society of Lincoln Center and the Department of Film of the Museum of Modern Art. Running time: 14 minutes. This film has no rating

Le Ciel de Paris

Directed by Michael Bena; screenplay by Isabelle Coudrier-Kleist, Cecile Var Haftig and Mr. Bena (in French with English subtitles); director of photography, Jean-Marc Fabre; edited by Catherine Schwartz; music by Jorge Arriagada; released by Sara Films. At the Roy and Niuta Titus Theaters in the Museum of Modern Art, 11 West 53d Street, as part of the New Directors/New Films Series of the Film Society of Lincoln Center and the Department of Film of the Museum of Modern Art. Running time: 90 minutes. This film has no rating.

Suzanne.............................Sandrine Bonnaire
Marc...............................Marc Fourastier
Lucien....................................Paul Blain
Clothilde.............................Evelyne Bouix
Florist...............................Tanya Lopert
Father Lucien...................Armand Delcampe
Pierre...................................Niels Dubost
Saleswoman.......................Françoise Patou
Sister Marc.....................Marie Laure Wicker
Theo.................................Pierre Amzallag

By VINCENT CANBY

Looking at "Le Ciel de Paris," a new French film by Michel Bena, one would never suspect that the world is on the point of being dangerously overpopulated. It's about emotional isolation so complete that even its contemporary Parisian settings, though filled with people, appear to be empty.

The movie looks at the lives of Suzanne (Sandrine Bonnaire) and Marc (Marc Fourastier), who share a flat but are not lovers, and Lucien (Paul Blain), whom they meet one day at a swimming pool. Very quickly it is appearent that Suzanne loves Marc, but Marc loves Lucien who loves Suzanne.

Mr. Bena doesn't attempt to make either romance or melodrama out of this situation. He observes it from a cool distance as the friends go swimming together, have dinner, sometimes attend a disco and make unsuccessful attempts at connection.

Suzanne works for a florist, Marc in a photocopy shop and Lucien for his father, who has a small printing press. The three are as alienated from their jobs as they are from one another. They are like figures in a piece of Pop art: blandly good-looking in a generic sort of way, devoid of surface idiosyncrasy though possibly seething within.

This may be exactly the effect Mr. Bena intended. How one responds to the film depends on how much one is willing to read into it. I found it humorless, self-pitying and self-important.

"Le Ciel de Paris" is Mr. Bena's first and last feature film. He died of AIDS last July.

Also on the program is "Viaduc," Danniel Danniel's 14-minute Dutch short. It's about a brief, not very revealing encounter on a train between a naïve young soldier, who knows the world by the postcards he buys in strange cities, and an older man who understands how much the soldier still has to learn.

The program will be shown at the Museum of Modern Art today at 9 P.M. and tomorrow at 6 P.M. in the New Directors/New Films series.

1992 Mr 29, 48:2

The Museum of Modern Art

A scene from Pantelis Voulgaris's "Quiet Days in August."

The Real Winners Are Often the Losers

By JANET MASLIN

THE SECOND MOST MEANingful phrase of Academy Awards night is the one that is never spoken: "And the winner *isn't*" Those words define one of Hollywood's most illustrious fraternities, the should-be list of winners who never were. The academy's capricious streak has always lent certain losers a special cachet, particularly if they were supplanted by obviously less worthy candidates. Sentimentality, shortsightedness and misguided notions of lofty art have all conspired, on various occasions, to turn the academy's goldenboy trophy into Oscar the Grouch.

Oscar has vented his crankiness at some of the most significant figures in Hollywood history. And the passage of time has regularly underscored the error of his ways. To make amends for such oversights, the academy sometimes votes special Oscars to venerable nonwinners, but the consolation prize will never be mistaken for the real thing. Oscar also-rans need not wish for the honorary awards accorded Cary Grant (1969), Orson Welles (1970), Charlie Chaplin (1971), Groucho Marx (1973), Jean Renoir, Howard Hawks (both 1974), Barbara Stanwyck (1981), Paul Newman (1985) or Myrna Loy (1990) to feel themselves in good company. They need only look at the long list of others who have been slighted by Oscar, and consider how these oversights occurred.

Tomorrow night's telecast of the 64th annual Academy Awards presentation, on ABC at 9, will find neither Martin Scorsese nor Barbra Streisand — to name but two highly visible omissions — competing for the best director award. If Mr. Scorsese never wins in that category, he will be in the same

The Oscars have eluded many greats. That doesn't make them less great.

distinguished boat as Alfred Hitchcock, Stanley Kubrick, Luis Buñuel, François Truffaut, Ernst Lubitsch, Buster Keaton, D. W. Griffith, Cecil B. DeMille, Howard Hawks and, for the time being, George Lucas.

The latest nonwinners in the best acting categories will join a pantheon including Greta Garbo, Fred Astaire, Marlene Dietrich, Clint Eastwood, Rosalind Russell, Al Pacino, Marilyn Monroe and Judy Garland (who received a special miniature Oscar in

Philip Caruso/Universal Pictures

Martin Scorsese didn't get an Oscar for "Taxi Driver" or "Goodfellas"; his work on "Cape Fear" wasn't even nominated.

Peter Francis/Camera Press

Steven Spielberg won the 1986 Irving G. Thalberg Memorial Award instead of an Oscar for his direction of "E.T." in 1982.

1939 for her work as a child star, but never a full-sized one).

To be fair, a lot of venerable Oscar losers have lost for the best possible reason: the competition was murder. It's true that "Citizen Kane" was passed over for the best picture Oscar in 1941, and that the token Oscar to Orson Welles and Herman J. Mankiewicz for their screenplay amounted to a virtual insult, since "Kane" was passed over in eight other categories. But it's also true that "Suspicion," "The Maltese Falcon," "Sergeant York" and "How Green Was My Valley" (which won) were in the running that year — and that "The Lady Eve" didn't even garner a best picture nomination.

The stakes were higher a year earlier, with 1940 best picture nonwinners including "The Philadelpia Story," "The Grapes of Wrath" and "The Great Dictator," and there was nary a best picture nomination for "His Girl Friday." (The winner was "Rebecca.") When "Gone With the Wind" won in 1939, it eclipsed "Stagecoach," "Ninotchka," "Mr. Smith Goes to Washington," "The Wizard of Oz" and "Wuthering Heights," arguably the most impressive list of also-rans in movie history. (Among the non-nominees: "Young Mr. Lincoln," "The Lady Vanishes" and "Only Angels Have Wings.") And when only 4 out of 25 nominated documentaries won Oscars in 1942 (when multiple winners were permitted), the losers had little to be sorry about. Being crowded out by worthy candidates during Hollywood's golden age was no disgrace.

More recently, the caliber of candidates has rarely been high enough to excuse Oscar's lapses on the basis of overabundant talent. So Martin Scorsese, whose nonwinner status marks one of the academy's most egregious contemporary lapses, has seen his best films eclipsed by "The Sting" (1973, the year of "Mean Streets"), "Rocky" (1976, the year of "Taxi Driver"), "Ordinary People" (1980, the year of "Raging Bull") and "Dances With Wolves" (1990, the year of "Goodfellas"). This year, his direction for "Cape Fear" wasn't even nominated. The Irving G. Thalberg Memorial Award will no doubt be in Mr. Scorsese's future if Oscar does not soon find another way to make up for this omission. (The Thalberg award is what the academy gave the nonwinner Steven Spielberg in 1986, four years after his "E.T." lost out to "Gandhi.")

■

Glaring as that omission is, it pales before the academy's treament of foreign films. In their lengthy compendium "Inside Oscar," Mason Wiley and Damien Bona make special mention of "Submitted Films Rejected by the Foreign Language Award Committee" because such significant works were overlooked. On that impressive roster: "The Seventh Seal," "Persona," "Last Year at Marienbad," "Fellini's Satyricon" and "Jonah Who Will Be 25 in the Year 2000."

Sometimes the full measure of Oscar's wrong turns can only be taken by comparing the winners with the might-have-wons. This process shows Oscar to be notoriously slow on the uptake, as when 1964's best song award went to the giddy "Chim Chim Cher-ee" from "Mary Poppins," rather than to anything by those brash young newcomers, the Beatles. All the songs on the soundtrack for "A Hard Day's Night" — including

Jim Wilson/The New York Times

George Lucas has joined Alfred Hitchcock, Stanley Kubrick and François Truffaut in never winning an Oscar for directing.

Columbia Pictures

"The Prince of Tides" was nominated for best picture but Barbra Streisand was not nominated for her direction of the movie.

"If I Fell," "And I Love Her," "Can't Buy Me Love" — were eligible, though none was nominated.

New talent and new styles are slow to make an impact among the staunchest members of the academy's rear guard, who often prefer a pointedly "serious" movie (e.g. "Chariots of Fire," "Amadeus," "The Last Emperor") to anything faster on its feet. That tendency may make for some unusual difficulties this year.

If Oscar is hoping to make the latest best picture winner a suitably dignified selection, he may wind up even grouchier than usual. Rarely have the best picture nominees, however sweeping and grand, dealt with dicier subject matter. Is a film dealing with a grisly serial killer really likely to garner the academy's highest honor? "The Silence of the Lambs" happens to be the best film nominated this year, but it would be a true movie miracle if Oscar's tastes were ready to accommodate cannibalism.

On the other hand, the frankly glamorous "Bugsy" glorifies a vicious mobster and his unscrupulous moll, and thus hardly constitutes a step toward the straight and narrow. "The Prince of Tides," another handsome contender, centers on an ugly sex crime involving homosexual rape. If "J.F.K." were to win, it would mark Oscar's first nod to a film accusing an American President of conspiracy to commit murder. Maybe Oscar will indeed show uncharacteristic grit in favoring one of these selections — or maybe he'll take the easy way out with the less toxic "Beauty and the Beast."

The nominations themselves are no indication of where academy preferences ultimately lie, especially when the results are as hard to anticipate as they are this year. Think of "The Turning Point" (1977, 11 nominations, no wins) or "The Color Purple" (1985, also 11 nominations, no wins) before betting the farm on this year's heavily nominated "Bugsy" (10 nominations) or "J.F.K." (8).

On the other hand, when a deserving film fails to be nc in the appropriate major ategory, it often winds up winning elsewhere; which may well be what happens to "Europa, Europa." Not submitted by Germany as a nominee for best foreign language film, it's likely to win for its screenplay based on material from another medium, despite some outstanding fellow nominees in that category — including screen adaptations of "The Silence of the Lambs" and "The Prince of Tides."

This year's best actor race is a tough call even by Oscar's capricious standards, because the prospective losers wield a lot of clout. Warren Beatty's impressive record as a film producer (not to mention his recent fatherhood and marriage) may establish him as a team player in Oscar's eyes, and he has also given the performance of his career. Nick Nolte has lately attracted attention as a hard-working veteran with a long string of unassumingly wonderful performances to his credit, and Oscar likes to reward a fine résumé.

But Anthony Hopkins, in a smaller role than his competitors', created the kind of characterization no viewer is liable to forget. No viewer except Oscar, that is. The early opening of "The Silence of the Lambs" last February would ordinarily hurt Mr. Hopkins's chances. His current appearance in "Howards End" may make all the difference if it refreshes Oscar's memory.

What Oscar can be counted on to remember is a hard-luck story like Bette Midler's, since Ms. Midler's

The academy's rear guard is slow to accept new styles.

ambitious performance in the big, sudsy "For the Boys" never received its box-office due. The fact that two of her fellow nominees, Geena Davis and Jodie Foster, are past winners may also help Ms. Midler (although Susan Sarandon, like Mr. Nolte, had a terrific role this year and qualifies as a trouper).

"Thelma and Louise," in which Ms. Sarandon and Ms. Davis co-starred as homicidal heroines, marks yet another challenge to Oscar's notions of respectability. Incidentally, so do "Cape Fear" and "The Fisher King," with their respective best actor nominees Robert De Niro and Robin Williams, whose tattooed sex offender and mad derelict join the gangster (Mr. Beatty), the serial killer (Mr. Hopkins) and the brutalized rape victim (Mr. Nolte) already on the list for best actor.

Among those of us who regularly lose money trying to second-guess Oscar, firm predictions are always a bad idea. But this much is certain: by the end of tomorrow's program, Oscar is sure to have vented his traditional ill humor in memorable ways. And more great losers will be added to the list. □

1992 Mr 29, II:1:1

Shadow on the Snow

Directed by Attila Janisch; screenplay by Andras Forgach, (in Hungarian with English subtitles); director of photography, Tamas Sas; edited by Anna Kornis; music by Steve Reich, Michal Oginski, Andras Szollosy, Laszio Saary and Eagles; produced by Gabor Nanak. At the Roy and Niuta Titus Theaters in the Museum of Modern Art, 11 West 53d Street, Manhattan, as part of the New Directors/New Films series of the Film Society of Lincoln Center and the department of film of the Museum of Modern Art. Running time: 76 minutes. This film has no rating.

With: Miroslaw Baka, Josef Kroner, Johanna-Kreft Baka, Zsofi Baji and Denes Ujlaki

Replay

Directed by Cameron Spencer. At the Roy and Niuta Titus Theaters in the Museum of Modren Art, 11 West 53d Street, Manhattan, as part of the New Directors/New Films series of the Film Society of Lincoln Center and the department of film of the Museum of Modern Art. Running time: 32 minutes. This film has no rating.

By STEPHEN HOLDEN

"Shadow on the Snow," the moody first feature film by Attila Janisch, a 34-year-old Hungarian director, evokes a wintry bleakness that is so concentrated it leaves a lingering chill.

Filmed in inky black-and-white, it traces the peripatetic movements of Sandor Gaspar (Miroslaw Baka), a trim young man who shuttles between a crude country cabin and a bare city apartment with his daughter, Rebecca (Zsofi Baji). From Sandor's phone calls to characters who remain mostly off screen, it is obvious that he is desperate for money. And with his sharp, vulpine features and air of generalized furtiveness, he stirs up suspicion and hostility wherever he goes. He also has a stormy relationship with a girlfriend, Agnes (Johanna-Kreft Baka), who exudes more fear than affection during their tumultuous encounters.

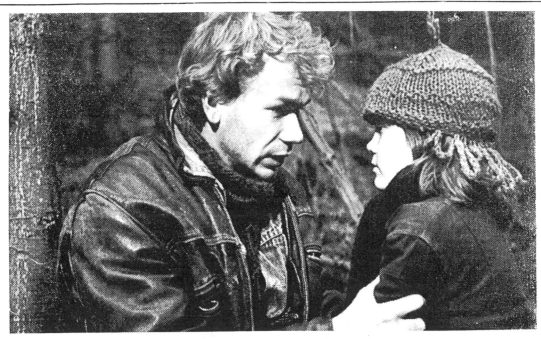

Miroslav Baka, left, and Zsofi Baji in a scene from Attila Janisch's "Shadow on the Snow."

Sandor is the sort of sullen hothead who invites trouble at every turn. And sure enough it arrives one day while he is standing in line at the post office. A robber enters the building and secures a bag of cash but in the last second stumbles and drops his booty. On an impulse, Sandor picks it up and flees conspicuously through the streets.

The rest of the film becomes a cold-eyed study of paranoia that turns into grim animal terror. After cowering in his apartment, Sandor tries to cover up the deed in a series of panicky maneuvers. But when Agnes shows him a front-page story about the crime with a drawing of his face, he flees with Rebecca to the country, where he becomes the object of a relentless manhunt.

In the fiendish ways it toys with the audience and in its icy view of the human condition, "Shadow on the Snow" has a lot in common with the early films of Roman Polanski. It is particularly adroit in its mixing of chilly soundtrack music with clinking sound effects of everyday objects filmed in close-up to evoke a jittery suspense.

•

But "Shadows on the Snow" is suffused with a desolation that runs deeper than Mr. Polanski's cynicism. Except for his attachment to his daughter, Sandor seems virtually disconnected from a world peopled with taciturn automatons, all of them potential enemies. And as played by Mr. Baka, the character exudes a certain magnetism while commanding very little sympathy. The city he inhabits is a place of sterile apartment buildings and scarred industrial wastelands. The country cabin has the cheerlessness of an army encampment before the age of electricity.

For Sandor it comes as almost a relief to find himself tracked down like an animal by gun-toting policemen. Long before he chanced onto this fugitive path, he knew the world was nothing but a desperate dog-eat-dog chase.

•

"Shadow on the Snow," which is being shown today at 6 P.M. and tomorrow at 9 P.M. at the Museum of Modern Art as part of the New Directors/New Films series, shares the program with the half-hour American film "Replay." Written and directed by Cameron Spencer, it portrays a narcissistic young video editor (Jamie Burris) who explores her budding relationship with a rock guitarist (Christopher Brown) as though it were a video to be edited. The film, which seems to have been inspired by "Sex, Lies and Videotape," has some technological flash but a weak screenplay and uneven acting.

1992 Mr 31, C16:1

On The Wing

Directed by Lisa Cupery. At the Roy and Niuta Titus Theaters in the Museum of Modern Art, 11 West 53d Street, Manhattan, as part of the New Directors/New Films series of the Film Society of Lincoln Center and the department of film of the Museum of Modern Art. Running time: 3 minutes. This film has no rating

Children Of Nature

Directed and produced by Fridrik Thor Fridriksson; screenplay by Mr. Fridriksson and Einar Mar Gudmundss, (in Icelandic with English subtitles); director of photography, Ari Kristinsson; edited by Skule Eriksen; music by Hilmar Orn Hilmarsson; released by the Icelandic Film Corporation. At the Roy and Niuta Titus Theaters in the Museum of Modren Art, 11 West 53d Street, Manhattan, as part of the New Directors/New Films series of the Film Society of Lincoln Center and the department of film of the Museum of Modern Art. Running time: 85 minutes. This film has no rating.

Geirri	Gisli Halldorsson
Stella	Sigridur Hagalin
Engeler	Bruno Ganz

By VINCENT CANBY

"Children of Nature," Fridrik Thor Fridriksson's new Icelandic film, considers death as the perfectly natural, inevitable end of the life cycle, not something to be ignored, feared or artificially staved off. The film has a narrative of sorts, but its effect is that of a documentary about an ancient ritual rediscovered.

When first seen, the widowed old Geirri is preparing to leave his farm. He sells his sheep, burns faded family photographs and takes his ancient sheep dog into a field, where he shoots and buries him. After Geirri's plans to live in the city with his married daughter do not work out, he allows himself to be placed in a retirement home, to be patronized and disciplined by the ever-smiling personnel.

Most of "Children of Nature" is about the rebellion of Geirri and Stella, a widow whom he meets at the home and who shares his impatience with this attempt, in effect, to pervert death by socializing it. One day Geirri and Stella walk out of the home, withdraw their money from the bank, steal a Jeep and start driving north.

As the Icelandic landscape becomes increasingly wild and primeval, the line between life and death gently blurs until it disappears.

"Children of Nature," a nominee for this year's Oscar as the best foreign-language film, will be shown at the Museum of Modern Art today at 6 P.M. and on Saturday at 12:15 P.M. in the New Directors/New Films series.

"Children of Nature" is an intelligent film, not easily categorized. Neither Geirri nor Stella is a character in a conventional sense. They are representations, figures in a modern myth that is dramatized in settings of spectacular, chilly beauty. Mr. Fridriksson has directed "Children of Nature" with a notable rigor, but it prompts rather more awe than passionate interest.

Sharing the program is the American "On The Wing," Lisa Cupery's three-minute, very earnest animated film celebrating the poetry of flight.

1992 Ap 2, C18:3

Hey, You Wild Geese

Written and directed by Lidiya Bobrova, (in Russian with English subtitles); director of photography, Sergei Astakhov; edited by Z. Shorokhova; released by Lenfilm Studios. At the Roy and Niuta Titus Theaters in the Museum of Modern Art, 11 West 53d Street, Manhattan, as part of the New Directors/

New Films series of the Film Society of Lincoln Center and the department of film of the Museum of Modern Art. Running time: 88 minutes. This film has no rating.

Mitka	Vyacheslav Sobolev
Petka	Yuri Bobrov
Sanka	Vasily Frolov
Raya	Galina Volkova
Dasha	Nina Usatova
Liubka	Svetlana Gaitan
Natasha	Marina Kuznetsova

By JANET MASLIN

The unremittingly bleak Russian film "Hey, You Wild Geese" takes its title from a folk song with a chorus about destiny. "Tell me my fate in the world," the lyrics ask, and the film provides grim answers for each of its principal characters.

These are Mitka, Petka and Sanka, seen as three young brothers in the film's 1950's prologue and then as weary, disappointed men in 1980, when the film's action unfolds in a rural village. The abjectness of these brothers' lives is painfully contrasted with the false merriment of the Moscow Olympics, as symbolized by that grinning Soviet mascot, Misha the Bear.

"The Muscovites' generous and hospitable hearts," as described in an Olympic newsreel that the haunted-looking, disabled Mitka (Vyacheslav Sobolev) watches wistfully, are very different from the dark, embittered spirits of those around him. "You don't love me," Mitka says to his wife, Raya (Galina Volkova), who barely makes ends meet by slaving over a sewing machine. "I do as a dog loves a stick," she replies. Life is barely better for tiny, wizened Petka (Yuri Bobrov), who has a large, overbearing wife (Nina Usatova) and distant dreams of making money through profiteering.

•

The third brother, the huge, gaunt Sanka (Vasily Frolov), is an ex-convict who has been away from his family for years and returns home during the course of the story. Sad-eyed and remote, Sanka observes his brothers' miserable lives and even rekindles some unlikely romantic sparks in one of his sisters-in-law. Sanka also befriends a village drunkard, a bedraggled young woman named Liubka (Svetlana Gaitan), who utters a cry of pure animal anguish when Sanka declines to share his liquor with her. Touched by this, he sends the young woman to a public bathhouse, buys her clean clothes and brings her home to his already unhappy family.

"Hey, You Wild Geese" (which is also translated in the film's subtitles as "Hey Goose, Wild Bird" and lacks a helpful title either way) is directed by Lidiya Bobrova in a black-and-white, slightly improvisatory style that gives it a documentary feeling. It is of more interest for the peripheral details of these characters' difficult lives — the operation of the public bathhouse or the way in which a shortage of sewing-machine needles sends Raya into utter panic — than for any sense of drama.

The film depicts an impoverished, dead-end culture in which alcohol offers the only escape and meaningful, productive labor is virtually an impossibility. Not surprisingly, Miss Bobrova's screenplay was subject to censorship in Soviet days.

"Hey, You Wild Geese" will be shown tonight at 9 as part of the New Directors/New Films series.

1992 Ap 2, C20:5

The Living End

Written, directed, photographed and edited by Gregg Araki; music by Cole Coonce; produced by Marcus Hu and Jon Gerrans. At the Roy and Niuta Titus Theaters in the Museum of Modern Art, 11 West 53d Street, Manhattan, as part of the New Directors/New Films series of the Film Society of Lincoln Center and the department of film of the Museum of Modern Art. Running time: 92 minutes. This film has no rating.

Luke	Mike Dytri
Jon	Craig Gilmore
Doctor	Mark Finch
Daisy	Mary Woronov
Fern	Johanna Went
Darcy	Darcy Marta
Peter	Scot Goetz
Ken	Bretton Vail
Barbie	Nicole Dillenberg
Twister Master	Paul Bartel
7-Eleven Couple	
	Stephen Holman and Magie Song

By JANET MASLIN

BLACK humor doesn't get much darker than "The Living End," the story of two H.I.V.-positive young men who manage to turn potential tragedy into a desperate, uproarious celebration of their newfound nihilistic freedom. Doing himself a great disservice, the writer and director Gregg Araki labels his work "an irresponsible movie" when in fact it has the power of honesty and originality, as well as the weight of legitimate frustration. Miraculously, it also has a buoyant, mischievous spirit that transcends any hint of gloom.

Working on a shoestring, Mr. Araki has made a candid, freewheeling road movie that ably represents the boom of gay-oriented talent evident in this year's New Directors/New Films series at the Museum of Modern Art (where the film will be shown today at 6 P.M. and Sunday at 9 P.M.). Among the festival's several entries with gay themes, this is easily the most uncomplicatedly entertaining.

Mr. Araki has managed to make even morbidity seem intrinsically droll, from a character's remark that this is "the first day of the rest of my life" to the slogan "Choose Death" on a bumper sticker. Suddenly, in this film's funhouse universe, even the simplest of platitudes looks mad. Normal life ceases to exist for this film's two main characters as soon as they receive their bad news. And the passion that develops between them, however playful it appears, is truly a matter of life or death.

Wearing his cinematic influences on his sleeve, Mr. Araki acknowledges film makers including Jean-Luc Godard, Andy Warhol and Derek Jarman during the course of his story, and he stages that story with a mock nonchalance reminiscent of Jim Jarmusch or Gus Van Sant. Even the offhanded "Sorry" with which a doctor tells Jon (Craig Gilmore) that he has tested H.I.V.-positive is given an absurdly downbeat, casual spin. In that context, the film's outbursts of violence

Michael Matson

Craig Gilmore, left, and Mike Dytri in "The Living End."

seem no less bizarre than its tiny proprieties. And its crime spree is presented as an understandable response to AIDS-induced rage. Like "Thelma and Louise," which it resembles on a more modest and desperate scale, "The Living End" uses crime as a way of extricating its characters from everyday society, and not as an occasion for passing moral judgment on their behavior. Getting out is what matters, not getting even.

Soon after Jon receives his diagnosis, he encounters a handsome hustler named Luke (Mike Dytri), whose more raucous exploits have been separately detailed early in the film. In a campy but crudely executed sequence, Luke is seen stealing a car from two killer lesbians (the screen does not need any more killer lesbians at the moment) and irritably throwing away their audiotapes of K. D. Lang and Michelle Shocked. He is then seen sexually involved with a man who likes to be spanked with a tennis racquet, and who insists that Luke keep score ("15-love").

Luke even witnesses a murder, an event staged with the type of cartoonish exaggeration that Mr. Araki succeeds in making unexpectedly droll. Compared with the more conventional Jon, Luke seems a real rebel, but the two soon overcome their differences to begin a fervent love affair. When they begin having sex, Jon forces himself to acknowledge his recent diagnosis, but Luke's response is typically cool. "Welcome to the club, partner," he whispers.

•

Mr. Araki gets a lot of mileage out of the cultural climate from which Jon, a film critic, has emerged. "You know what they say: those that can't do, teach; and those that can't teach get 25 cents a word to rip other people's work to shreds," he explains when Luke visits his apartment, which is filled with carefully selected movie posters. It's also said that one of the film's characters is so oversensitive he suffered a lengthy depression when Echo and the Bunnymen broke up. The film easily shifts between these sorts of dry asides (many of them shared by Jon and a woman named Darcy, his close friend) and observations of a more solemn kind. "The generation before us had all the fun," says one of the film's handsome, 20-ish heroes. "And we get to pick up the tab."

The ragged humor of "The Living End" wears thinner as the characters discuss sex, death and the afterlife, and begin to come face to face with their fate. Mr. Araki, for all his playfulness, fully grasps his heroes' situation, and he does not presume to invent an easy escape. Rudely funny as it is about most things, "The Living End" doesn't trivialize AIDS in any way. What it does instead is give vibrant, angry substance to the phrase "till death do us part."

1992 Ap 3, C1:1

The Hours and Times

Written, directed, edited and photographed by Christopher Münch; released by Antarctic Pictures. At the Roy and Niuta Titus Theaters in the Museum of Modern Art, 11 West 53d Street, as part of the New Directors/New Films series of the Film Society of Lincoln Center and the department of film of the Museum of Modern Art. Running time: 60 minutes. This film has no rating.

Brian	David Angus
John	Ian Hart
Marianne	Stephanie Pack
Quiñones	Robin McDonald
Miguel	Sergio Moreno
Mother	Unity Grimwood

By VINCENT CANBY

"The Hours and Times," written and directed by a young American named Christopher Münch, is a sharp, concise, evocative film about friendship, about its limitations and the recognition of those limitations. It

USA

David Angus, left, and Ian Hart

is novel-size yet short (60 minutes), and utterly specific. Everything superfluous has been cut away.

The film takes as its starting point the fact that in the spring of 1963 Brian Epstein, the Beatles' brilliant, troubled manager, and John Lennon, a Beatle still very much on the road to self-discovery, shared a four-day vacation in Barcelona. The Beatles had just finished a winter of touring. Beatlemania was on the cusp. That much is known. Everything else in "The Hours and Times" is fiction, though it is fiction of an unusually disciplined, sinewy sort.

It is Mr. Münch's speculation that Brian (David Angus), 29 years old and a man who has tasted every sensation except death, is hopelessly in love with John (Ian Hart), six years his junior, a working-class lad for whom a new world is about to be born.

John is impressed by Brian's upper-middle-class background, by his seeming self-assurance, his sophistication, his manners. He says he enjoys hearing about Brian's conquests, which represent a form of decadence he can admire in theory anyway. Brian sees John as a holy innocent with a Liverpool accent.

•

In the course of the four days, a mocking courtship takes place. Brian shows Barcelona to John, hovering about the younger man without aggressively imposing himself on him. John tries to fit in. When they go to a gay bar, it is John who invites a Spanish businessman to join them at their hotel, where nothing happens. Brian drinks brandy and pops pills. A telephone call from Cynthia, John's wife, draws him back to the realities of life at home. He is bored.

Torn between his own heterosexuality and his affection for Brian, John eventually attempts to please his friend, but can't go through with it. Says Brian, still mocking, "And with that, what never was is ended."

Shot in black and white, on a very small budget, "The Hours and Times" has a rigor that, in its keenness, matches Brian's merciless honesty. As played by Mr. Angus, Brian has no time for self-pity. He is doomed to comprehend too much, even to be able to stand aside and see the humor of his situation. Though Mr. Hart doesn't look especially like Lennon, he suggests all of the common sense, the impatience with cant and the sweet restlessness of the public man John was to become.

"The Hours and Times" will be shown at the Museum of Modern Art today at 9 P.M. and tomorrow at 6 P.M. in the New Directors/New Films series. It will open a one-week engagement at the Walter Reade Theater at Lincoln Center next Friday.

•

Sharing the bill with "The Hours and Times" at the Museum of Modern Art is Laurie Lynd's "R.S.V.P.," a 23-minute Canadian film about mourning. The lover, family and friends of a man who has recently died of AIDS are each moved in different ways when they hear on the radio Jessye Norman's recording of "Le Spectre de la Rose" from Berlioz's "Nuits d'Été."

The man being mourned had requested the song several weeks before his death. The film tries to do something not easily accomplished on film: to celebrate the manifold private processes of grief.

1992 Ap 3, C10:1

Thunderheart

Directed by Michael Apted; written by John Fusco; director of photography, Roger Deakins; edited by Ian Crafford; music by James Horner; production designer, Dan Bishop; produced by Robert De Niro, Jane Rosenthal and Mr. Fusco; released by Tri-Star pictures. Running time: 118 minutes. This film is rated R.

Ray Levoi	Val Kilmer
Frank Coutelle	Sam Shepard
Walter Crow Horse	Graham Greene
Jack Milton	Fred Ward
Willam Dawes	Fred Dalton Thomas
Maggie Eagle Bear	Sheila Tousey
Grandpa Sam Reaches	Chief Ted Thin Elk
Jimmy Looks Twice	John Trudell
Richard Yellow Hawk	Julius Drum
Maisy Blue Legs	Sarah Brave
Leo Fast Elk	Allan R. J. Joseph
Dennis Banks	Himself

By JANET MASLIN

The "Washington redskin" of "Thunderheart," as he is derisively called by the film's American Indian characters, is an F.B.I. agent who is sent from Washington to an Oglala Sioux reservation to investigate a crime. Raymond Levoi (Val Kilmer) does not welcome this assignment. Part Sioux himself, and too culturally assimilated to acknowledge that heritage, he resents having been selected for the job on the basis of his background. He refers contemptuously to various Indians as "Geronimo" and "Tonto" as a means of registering his unfamiliarity with their world.

But during the course of the story, Ray is freed from his high-handed superiority to Indian culture, made to understand the many problems of the violence-torn Indian community (the film is set in the late 1970's) and forced to accept his own past. "The same blood that was spilled in the grass and snow at Wounded Knee runs through your heart like a buffalo," he is told by one of the story's far more spiritually aware Indian characters.

"Thunderheart" isn't really about Ray anyhow. He provides the foreground interest for a film whose background is much more authentic and important, and much more fully realized. Michael Apted, the remarkable documentary film maker ("35 Up") whose dramatic films often have an anthropological accuracy ("Coal Miner's Daughter," "Gorillas in the Mist"), addresses himself to life on an Indian reservation with the same curiosity and intelligence he has brought to other subjects. Mr. Apted displays too much respect for his material to overdramatize it or otherwise create a Hollywood gloss.

•

Though "Thunderheart" is about a murder investigation and has the shape of a thriller, it also has a documentary's attentiveness to detail. (Prior to making this film, Mr. Apted covered similar territory when he completed "Incident at Oglala," a documentary about the American Indian rights advocate Leonard Peltier.) So the film, which deals reasonably well with the progress of Ray's spiritual awakening and with a murder plot, also dwells on many Indian customs, ceremonies and beliefs.

Filmed on the Pine Ridge Reservation in South Dakota (which is called the Bear Creek Reservation in the movie), "Thunderheart" is loosely based on violent events that took place there and elsewhere during the 1970's. The film employs many Indian actors, some of whose screen roles mirror their real lives. The fiery John Trudell, who plays an Indian activist suspected of murder in the movie, is in fact an Indian activist, as well as a poet and singer. Chief Ted Thin Elk, who plays an honored Lakota medicine man with a winning combination of courtliness and guile, is a Lakota elder himself.

A film this intent on authenticity might easily grow dull, but this one doesn't; Mr. Apted is a skillful storyteller. He gives "Thunderheart" a brisk, fact-filled exposition and a dramatic structure that builds to a strong finale, one that effectively drives the film's message home. That message concerns corruption and reform battling for supremacy within the Indian community, widespread neglect on the part of the Federal Government and the urgent need for change.

•

Sam Shepard co-stars as the sardonic, hard-boiled F.B.I. agent who shows Ray some of the ropes, though not all of them. Fred Ward appears briefly but effectively as the swaggering tribal president who is head of the reservation's most repressive faction. The film's outstanding performance comes from Graham Greene, an Oscar nominee for "Dances With Wolves," a film that looks like an utter confection beside this plainer, harder-hitting drama. In the role of a tribal police officer, serving as Ray's wry tour guide through various Indian rituals, Mr. Greene proves himself a naturally magnetic actor who deserves to be seen in other, more varied roles.

Sheila Tousey, making her film debut, conveys a quiet, stirring integrity as a schoolteacher and activist caught up in the story's violent events. "Sorry I got your family involved in this," Ray eventually tells her. "Ray, my family's been involved since Columbus landed," she replies. In paying its respects to that figurative family and its traditions, the film depicts a large ceremonial powwow, a sweat lodge ceremony and other authentic aspects of Indian life, including the rusted-out trailers and appalling medical facilities that are present-day features. The reservation is pointedly described by one character as "a third world right here in America."

Trivia buffs may note that a shot in which the camera hurtles forward across the plains and over a cliff, conveying great natural beauty and mystery, looks very like one used in "The Doors," which also starred Mr. Kilmer. That film's neo-hippie vision of American Indian mysticism could not be more different from this film's utterly serious view.

•

"Thunderheart" is rated R (Under 17 requires accompanying parent or adult guardian). It includes profanity many violent outbursts and bloodshed.

1992 Ap 3, C12:1

Rock-a-Doodle

Directed by Don Bluth; screenplay by David N. Weiss; music by Robert Folk and T. J. Kuenster; produced by Mr. Bluth, Gary Goldman and John Pomeroy; released by Samuel Goldwyn Company. Running time: 77 minutes. This film is rated G.

Featuring the voices of Glen Campbell, Christopher Plummer, Phil Harris, Sandy Duncan, Eddie Deezen, Charles Nelson Reilly, Sorrell Booke, Ellen Greene and Toby Scott Granger.

Samuel Goldwyn Company

Barnyard Gig Chanticleer, a rocking rooster, struts his stuff in Don Bluth's animated musical "Rock-a-Doodle."

By STEPHEN HOLDEN

"Rock-a-Doodle," the newest animated feature by Don Bluth, is so overzealous in its attempts at myth making that it often verges on muddle. Stuffed with enough characters and plot to fill two movies, it veers in style from a simple rustic fairy tale to an Elvis Presley parody. Right in the middle, it turns into a frenetic, nerve-jangling Saturday-morning cartoon before finally subsiding into a mood of pastoral whimsy.

The film tells the story of Edmond, a farm boy so entranced by his bedtime story about a rooster named Chanticleer that he enters the world of his storybook. The pride of the barnyard, Chanticleer and his morning crows insure that the sun will rise. One day, however, the evil Grand Duke of Owl picks a fight with him and he neglects his duties. When the sun rises anyway, the rooster is so humiliated that he quits the farm for the big city, where he becomes a rockabilly star known as the King and his red comb becomes a blob of black hair that he tosses wildly while performing.

The weather soon turns nasty, and floods threaten to destroy Edmond's farm. When the boy desperately calls out for Chanticleer, he is visited instead by the owl, who changes him from a boy into a kitten. Fearful but still determined to find the rooster, he and several animal friends ride the flood waters to the city in a toy box. When they finally locate Chanticleer, he is under the thumb of a ruthless manager who conspires with the owl to prevent a reunion.

All these adventures are recounted by Patou, a shaggy cartoon canine whose singular quirk is an inability to tie his shoes.

•

In their zest to be clever, David N. Weiss, who wrote the screenplay, and Mr. Bluth have lost sight of the essential need for simplicity in animated storytelling. The film has an army of subsidiary characters (the King's bouncers, the owl's henchmen and others) who clutter up the screen and aren't properly accounted for. Except for the rooster, the characters aren't very compelling to look at. More seriously, the film's crisscrossing stories don't mesh into a resonant fable.

The movie's values are really quite confusing. The evil owl, whose part is spoken by Christopher Plummer in a supercilious English accent, plays Bach toccatas on the organ in his lofty hideaway. This suggests that the film equates Bach with pretentiousness and evil. And the rooster, for all his sun-raising powers, is quite dumb and conceited. When it's all over and done, the only lesson learned is voiced by the old dog: "With a little help from your friends, you can do just about anything."

"Rock-a-Doodle" has some clever special effects combining live action and animation. Its songs by T. J. Kuenster are decent parodies of 1950's rock-and-roll songs, and Glen Campbell, who is the voice of Chanticleer, does a dead-on vocal impersonation of Elvis. Ellen Greene, as his sweetheart, a "pheasant showgirl" named Goldie, fruitfully applies her squeakiest "Little Shop of Horrors" voice to the role.

1992 Ap 3, C13:1

Straight Talk

Directed by Barnet Kellman; screenplay by Craig Bolotin and Patricia Resnick, based on a story by Mr. Bolotin; director of photography, Peter Sova; edited by Michael Tronick; music by Brad Fiedel and Dolly Parton; production designer, Jeffrey Townsend; produced by Robert Chartoff and Fred Berner; released by Hollywood Pictures. Running time: 88 minutes. This film is rated PG.

Shirlee	Dolly Parton
Jack	James Woods
Alan	Griffin Dunne
Steve	Michael Madsen
Lily	Deirdre O'Connell
Guy Girardi	John Sayles
Janice	Teri Hatcher
Dr. Erdman	Spalding Gray
Milo Jacoby	Jerry Orbach
Gene Perlman	Philip Bosco

By VINCENT CANBY

Perched atop her five-inch stiletto heels, the full-busted but otherwise tiny Dolly Parton towers above "Straight Talk" like a laughing colossus of Rhodes.

In the flat landscape of this new romantic comedy, no other body or thing comes up to the ankle straps of the irrepressibly positive-thinking star. She appears in virtually every scene and accompanies herself on the soundtrack almost nonstop, singing in upbeat Dolly-style a half-dozen songs she wrote for herself.

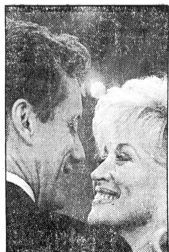

Hollywood Pictures

Dolly Parton and James Woods

She's intimidating but irresistible, which is all to the good. "Straight Talk" needs every ounce of irresistibility it can get to offset a certain predictability of formula. Ms. Parton is surrounded by a lot of talented people who seem to have been ordered not to do anything to deflect audience attention from the woman at the center of the screen. With good humor, they obey.

In "Straight Talk" Ms. Parton plays Shirlee, a Flat Rock, Ark., dance instructor who, after losing her job because she talks too much, flees to Chicago to find out who she is. Through a series of fruitful misunderstandings, Shirlee becomes the toast of the town as a psychologist who dispenses homespun wisdom on radio station WNDY.

•

Shirlee can dish it out, but she obviously doesn't listen to herself. When first met in Flat Rock, her live-in lover (Michael Madsen) is the slobbish best friend of the man she earlier married and divorced three times. In Chicago, she unknowingly falls in love with Jack (James Woods), the tough newspaper reporter who is out to expose WNDY's bogus claims that she holds a doctorate in psychology.

Like the pink Mercedes that a grateful WNDY gives to Shirlee, "Straight Talk" is an eye-catching custom-built vehicle. The role is made to Ms. Parton's measurements. When a parking attendant asks her if she is the pink Mercedes, the no-nonsense Shirlee's immediate reply is, "I'm the woman who drives the pink Mercedes."

In much the same manner, Ms. Parton drives the film.

The members of the good supporting cast include Griffin Dunne as the exuberantly ambitious manager of WNDY; Spalding Gray as a stuffy psychiatrist whom Shirlee humbles on a television talk show, and Philip Bosco playing the WNDY chief, the man who insists that the station's resident therapist have an academic degree.

•

Mr. Woods has the film's toughest role, which he plays with a kind of intense, unflappable intelligence. It can't be easy romancing a star who is as much a myth as a woman. Possibly because of her long and successful career as a singer, Ms. Parton has developed a public personality so complete that, like Mae West, she doesn't seem really to need anyone else.

Barnet Kellman's direction of the screenplay, written by Craig Bolotin and Patricia Resnick, does nothing to suggest otherwise.

•

"Straight Talk" is rated PG (parental guidance suggested). It has some mildly vulgar dialogue and situations.

1992 Ap 3, C17:1

Beethoven

Directed by Brian Levant; written by Edmond Dantes and Amy Holden Jones; director of photography, Victor J. Kemper; music by Randy Edelman; production designer, Alex Tavoularis; produced by Joe Medjuck and Michael C. Gross; released by Universal Pictures. Running time: 89 minutes. This film is rated PG.

George Newton........................ Charles Grodin
Alice Newton.................................. Bonnie Hunt
Dr. Varnick.............................Dean Jones

Bruce McBroom
Charles Grodin and St. Bernard

Ryce..............................Nicholle Tom
Ted................................Christopher Castile
Harvey..............................Oliver Platt
Brad..............................David Duchovny
Brie..............................Patricia Heaton

By JANET MASLIN

"Beethoven" is no classic, but it's a sunny, energetic children's film with a good notion of what young audiences like. That includes a gruff, lovable Dad (Charles Grodin) who takes a lot of pratfalls, a wide range of mess-minded sight gags and, of course, a shaggy dog story, complete with huge, drooling shaggy dog.

First seen as a cuter-than-cute St. Bernard puppy, the pooch of the title strays into the lives of the Newton family, who are living the 1990's equivalent of a 1950's sitcom dream. Father thinks he knows best, and he certainly thinks the house ought to be clean. So he is staunchly against keeping the puppy when it appears. His idea of a pet is a goldfish or an ant farm, not a St. Bernard.

•

Naturally, this leads to a funny montage of paw prints and puddles and glimpses of Dad angrily scrubbing the carpet while Mom (Bonnie Hunt) and three dog-loving children (Nicholle Tom, Christopher Castile and Oliver Platt) look on. Finally, the dog is allowed to stay, and named Beethoven after it barks enthusiastically during a rendition of the Fifth Symphony.

Eager to hold young viewers' attention, "Beethoven" includes two different sets of villains: dog-craving lab technicians, led by the evil veterinarian Dr. Varnick (Dean Jones); and a yuppie couple, Brad (David Duchovny) and Brie (Patricia Heaton), who are plotting to take over the air-freshener business run by George Newton (the aforementioned Dad). The last two aren't around for long, but they make fine targets for the dog's pranks, especially after they refer to George as Giorgio.

"Beethoven" depends chiefly on the dog's wide array of stunts, Mr. Grodin's even wider range of slow burns and serviceably lively direction by Brian Levant, who has definitely come a long way since "Problem Child 2." An enjoyable score by Randy Edelman consists mainly of standard-sounding movie music, but occasionally flirts with the real Beethoven for a bar or two.

"Beethoven" is rated PG (Parental guidance suggested). It includes mild profanity, slight violence and various doggie messes.

1992 Ap 3, C18:1

Steal America

Directed by Lucy Phillips; written by Ms. Phillips and Glen Scantlebury; music by Gregory Jones; produced by Liz Gazzanno; released by Tara Releasing. At the Cinema Village, Third Avenue near 12th Street, Manhattan. Running time: 82 minutes. This film has no rating.

Stella..............................Clara Bellino
Christophe..............................Charlie Homo
Maria Maddelena.............Diviana Ingravallo
Jack..............................Kevin Haley
Mickey..............................Liza Monjauze
Ace..............................Christopher Fisher
Carletta..............................Cintra Wilson
Joey..............................Sean Parke
Jeena..............................Gina Ravarra

By STEPHEN HOLDEN

Who are this country's new bohemians? "Steal America," a grainy, quintessentially bohemian-looking film, which opens today at the Cinema Village, suggests that some of them are young Europeans adrift in the North Beach district of San Francisco. Spiritual descendants of Jean Seberg's American expatriate in Jean-Luc Godard's "Breathless," they are driven by wanderlust, along with vague dreams of American-style glory that aren't likely to pan out. When not working at their boring day jobs in video stores and postcard shops, they sit around wondering where to go next and complaining about how claustrophobic they feel in San Francisco. Their romantic couplings seem more perfunctory than enthusiastic.

Early in the film, Christophe (Charlie Homo), a Frenchman who has taken a job parking cars, sullenly confides his fantasy of conquering the American Wild West in a big flashy car. Instead, he complains, here he is, eating croissants for breakfast. The movie's liveliest scene takes place when he is fired from his job, steals a customer's car and takes Stella (Clara Bellino), a Swiss cabaret singer, and her bisexual pal Maria (Diviana Ingravallo) to New Orleans. Although Christophe disappears from the film, it is revealed later that he was arrested and deported to Haiti.

•

The two women end up working in a North Beach dive called the Chi-Chi Club, where Stella sings French ballads with her band, the Flying Monkeys, and Maria delivers smutty performance-art monologues with an inflatable plastic doll. With Christophe out of the picture, Stella becomes involved with Jack (Kevin Haley), a gas-station attendant and sometime painter. She is also discovered by a pair of Japanese businessmen, who promise to book her on a cross-country tour of Japan.

Tara Releasing
Clara Bellino, left, and Diviana Ingravallo in "Steal America."

Directed by Lucy Phillips in a loose-jointed, quasi-cinéma-vérité style, "Steal America" is a messily constructed film whose soundtrack is so crude that about one-third of the dialogue is unintelligible. The best thing about the movie is the low-key acting of the four principals, who look and sound as if they had been pulled in off the street and told just to go on being themselves.

With a blurry gray look that suggests Jim Jarmusch at his crudest and an anomic attitude that echoes the mid-1960's Godard, "Steal America" evokes a downbeat cultural mood that feels a lot like real life.

1992 Ap 3, C24:5

Black Harvest

Directed and produced by Robin Anderson and Bob Connolly; director of photography, Mr. Connolly; edited by Ray Thomas, Mr. Connolly and Mr. Anderson; produced with the assistance of: the Australian Film Commission, in association with the Australian Broadcasting Commission; La Sept (France), Channel 4 (Britain) and the Institute of Papua New Guinea Studies. At the Roy and Niuta Titus Theater in the Museum of Modern Art, 11 West 53d Street, as part of the New Directors/New Films Series of the Film Society of Lincoln Center and the Department of Film of the Museum of Modern Art. Running time: 75 minutes. This film has no rating.

Natives

Directed by Jesse Lerner and Scott Sterling. At the Roy and Niuta Titus Theater in the Museum of Modern Art, 11 West 53d Street, as part of the New Directors/New Films series. Running time: 25 minutes. This film has no rating.

By STEPHEN HOLDEN

"Black Harvest," a documentary of extraordinary historical resonance, is the third film by the Australian team of Bob Connolly and Robin Anderson to study the intrusion of modern culture on the Ganiga, an aboriginal tribe in the highlands of Papua New Guinea.

A sequel to their 1989 film, "Joe Leahy's Neighbors," it focuses on the strained relationship between the Ganiga and Joe Leahy, the half-white, half-aboriginal owner of a flourishing coffee plantation built on land that was sold to him cheaply by the tribe.

The Film Society of Lincoln Center
A Papua New Guinea tribesman in a scene from "Black Harvest."

The team's 1983 film, "First Contact," told the story of the foray in the early 1900's by Joe's father into the region, which had never before been visited by whites.

The new film follows Joe's well-meaning but ultimately disastrous attempt to go into business with the Ganiga. Returning to the scene of the 1989 documentary, the film makers find that Joe and the tribe have set up what promises to be a successful co-operative coffee-growing business. Under their agreement, Joe will manage the business and reap 60 percent of the profits from his $300,000 investment, and the tribes who supply the labor will earn 40 percent. The arrangement seems to be working until world coffee prices suddenly plunge, and Joe is forced to reduce their wages.

Disgruntled and suspicious, the tribe refuses to pick the crop, even though it is the peak of the harvest. To demonstrate the urgency of the situation, Joe stages a tribal ritual depicting the death of the farm. But instead of appealing to the tribes it deeply offends them. Coincidentally, the Ganiga embark on a frivolous war with a neighboring tribe. The film's most remarkable scenes were shot in the thick of a battle waged with spears and bows and arrows. There are closeup shots of the long-term agony endured by warriors who have arrowheads lodged in their flesh. Although the arrowheads could easily be removed in a hospital, the nearest facility demands $100 in advance (money the Ganiga don't have) to treat the wounded.

As relations between Joe and the tribe deteriorate, the war drags on and he is forced to consider leaving his comfortable estate and relocating to the Australian mainland where he has a family.

"Black Harvest" is only 75 minutes long, but it is so rich that watching it feels like taking an inspired crash course in economics and cultural anthropology. The film, which takes no sides, paints Joe as a fairly sympathetic, though ultimately ambiguous, figure. A businessman who drives a tough bargain and feels so superior to the Ganiga that he won't allow them into his house, he also feels a paternalistic tie to the tribe.

The Ganiga, torn between their tribal traditions and promises of material well-being that are evident from Joe's comfortable style of living, are portrayed as deeply human but also extremely childish. There is something almost laughable in scenes of the tribe's eager waging of a war that was unprovoked and is carried on with a stubborn zeal that proves devastatingly self-destructive. The fact that its tools are spears and arrows instead of modern high-technology weaponry only points up the futility of an activity that looks as ludicrous as a children's game of cowboys and Indians except that the war paint is real and people die.

•

The film's most compelling figure is Popina, the tribal elder who is Joe's assistant and go-between with the Ganiga. After painfully wavering in his loyalty, Popina eventually sides with his people. But in his anguish he deliberately puts himself in the middle of a battle and is seriously wounded.

"Black Harvest" is all the more remarkable for not having a narrator. Letting the individuals and events speak for themselves, it presents a disquieting microcosm of civilization coming apart. Its saddest sight is the crumbling of an opportu-

nity that seemed genuinely golden and based on mutual good will. The immediate cause, the plunging of the coffee market, might just as well be an act of God, for all the influence exerted by the principal players. To the Ganiga, it is an inexplicable act of betrayal. And as their experiment in modern capitalism fails, their reversion to primitive bellicosity seems like a collective childish tantrum that is painfully easy to understand.

"Black Harvest" has performances today and tomorrow at the Museum of Modern Art as part of the New Directors/New Films series. Sharing the program is "Natives," a short documentary by Jesse Lerner and Scott Sterling about the anti-immigrant movement in San Diego. The film looks at middle-class, mostly white Americans in the San Diego area who the influx of Latin Americans across the United States-Mexico border for everything wrong with their communities. The darkest suggestions — that America should station the armed forces with machine guns at the border with orders to shoot anything that moves — reveal ugly seams of hatred and bigotry.

1992 Ap 4, 17:1

City of the Blind

Directed by Alberto Cortés; screenplay by Hermann Bellinhausen, Mr. Cortés, Paz Alicia Garcia Diego, José Agustin, Marcel Fuentes and Silvia Tomasa Rivera, (in Spanish with English subtitles); director of photography, Carlos Marcovich; edited by Rafael Castanedo; music by José Elorza. At the Roy and Niuta Titus Theaters in the Museum of Modern Art, 11 West 53d Street, as part of the New Directors/New Films Series of the Film Society of Lincoln Center and the Department of Film of the Museum of Modern Art. Running time: 87 minutes. This film has no rating.

With: Gabriela Roel, Juan Ibarra, Carmen Salinas, Fernando Balzaretti, Silva Mariscal, Claudia Fernández, Arcelia Ramirez, Verónica Merchant, Roberto Sosa, Zaide Silvia Gutiérrez, Silvana Orsatti, Blanca Guerra, Luis Felipe Tovar, Enrique Rocha, Elpidia Carrillo, Melissa, Sax (Maldita Vecindad), Rita Guerrero, Dobrina Liubomirova, Saúl Hernández (Caifanes), Macaria y Santa Sabina.

By VINCENT CANBY

"City of the Blind" ("Ciudad de Ciegos"), Alberto Cortés's new Mexican drama, is an ambitious attempt to chart the changes in a nation's social, sexual, political and economic manners from the late 1940's until today. The focus is on a single upper-middle-class Mexico City flat and the succession of people who inhabit it. Among those who come and go are a Communist revolutionary, a businessman who faces bankruptcy, assorted pairs of lovers and some punk musicians.

One astonishing sequence seems to have been lifted whole from "La Voix Humaine," the Jean Cocteau play so beloved by actresses who like to have the stage all to themselves: a distraught woman ponders suicide between telephone calls to the lover who has deserted her. The only difference is an O. Henry ending.

The idea for "City of the Blind" is somewhat more interesting than its realization by Mr. Cortés, six writers and a large cast of actors. Possibly something is lost in the not always adequate English subtitles. Possibly not. On occasion the only way to tell when one vignette has ended and another has begun is by an inventory of the furniture.

"City of the Blind" will be shown at the Museum of Modern Art today at 9 P.M. and tomorrow at 3 P.M. in the New Directors/New Films series.

1992 Ap 4, 17:5

From France, a Microcosm of Society Gone Wild

"Delicatessen" was shown as part of the 1991 New York Film Festival. Following are excerpts from Janet Maslin's review, which appeared in The New York Times on Oct. 5, 1991. The film, in French with English subtitles, opens today at the Lincoln Plaza Cinemas 1, Broadway at 63d Street.

In the studiously zany French fantasy film "Delicatessen," apocalyptic rubble and 1940's American kitsch make for a peculiar mix. The setting of the title is part of a half-demolished apartment house that stands amid unexplained postwar devastation, in a world where lentils have become currency and underground guerrillas called "troglodists" refer to apartment-dwellers as "surfacers." Despite such apparent hardship, an antic spirit prevails at the apartment house in question, which is presided over by a butcher (Jean-Claude Dreyfus) with Sweeney Todd-like predilections. "I'm a butcher, but I don't mince words," he says.

Into this establishment comes Louison (Dominique Pinon), a former circus clown who would be the most eccentric person in the place if the competition were not so stiff. Also on hand are the shy, very correct Julie (Marie-Laure Dougnac), who plays the cello to accompany Louison on the musical saw; Mrs. Interligator (Sylvie Laguna), who is urged by inner voices to attempt suicide in extremely creative ways; the Kube brothers (Jacques Mathou and Rufus), who intently manufacture little canisters that make mooing sounds, and an assortment of fellow oddballs.

As directed by Jean-Pierre Jeunet and Marc Caro, "Delicatessen" does not aspire to much more than simply flinging these characters together and intercutting their exploits in a quick, stylish fashion. The results can be weirdly hilarious, as when the sounds of Louison rhythmically rocking on creaky bedsprings (as he paints a ceiling) are allowed to permeate and co-opt every other activity going on in the house, from rug-beating to knitting. They can also be frenetic and pointless, which is the case more and more frequently as the film spins out of control. Its last half-hour is devoted chiefly to letting the characters wreck the sets, and quite literally becomes a washout when the bathtub overflows.

Shot in oppressive orangy tones and sometimes taking unexpectedly grisly turns, "Delicatessen" works best when simply allowing its characters to express their strangeness. Among the things that deserve mention in this lightweight but sometimes subversively stylish farce are its ingenious credit sequence, its lively editing by Hervé Schneid, its use of code names like Artichoke Heart and Cordon Bleu in the guerrilla war that rages underground, and its reference to a couple of odd inventions. One is a magical combination of boomerang and pocketknife, and it can work wonders. The other is a very specific sort of lie detector, and no home should be without one.

1992 Ap 5, 53:2

FILM VIEW/Caryn James

Truffaut's Passion Still Glows

WHEN FRANÇOIS TRUFFAUT WAS WORKing on his now-classic book of interviews with Alfred Hitchcock, he developed an inferiority complex. By then, in 1963, he had made "The 400 Blows," "Shoot the Piano Player" and "Jules and Jim." Still, as he wrote in a letter to his friend and

translator, Helen Scott, he had just one consolation in the shadow of Hitchcock's brilliance: "I at least am able to make the public feel sympathy for a young kid who steals everything he can get his hands on, for a selfish little coward of a piano player, for a turn-of-the-century bitch who sleeps around."

That wily Truffaut. Who else could have tossed off such a wry, astute comment, part sincere hero-worship and part deft self-promotion? Who else would have described his most emotionally engaging characters in such cool, comic terms? Jean-Pierre Léaud as the mischievous Antoine Doinel in "The 400 Blows" and Jeanne Moreau as the irresistible, destructive Catherine in "Jules and Jim" are among the truly adored screen creations of our time, though they are, as Truffaut says, a thief and a slut.

A retrospective at the Public reaffirms the brilliance of the French film maker.

In that casually self-aware remark, he defined his own brilliance. Truffaut could turn reprehensible creatures — madwomen, lotharios, murderers, crooks and a feral child — into people we love. The crazed Adele H. and the man who loved women, the bride who wore black and the wild child of Aveyron will all be on screen at the Truffaut retrospective that starts Friday at the Public Theater.

This comprehensive series includes the 21 features and two shorts Truffaut left behind when he died eight years ago, of brain cancer, at the age of 52. (Only "Une Visite," an amateur short made in 1954 and considered unwatchable by the director himself, and "Une Histoire d'Eau," a short co-directed with Jean-Luc Godard in 1958, are missing.)

Les Films du Carosse

Jean-Pierre Cargol in Truffaut's "Wild Child."

Though the series' corny title, "April in Paris," speaks to the lush, romantic surface of Truffaut's films, the best of his works are profound. "Being sentimental myself, I distrust overt sentimentality," he once said, and even his sweetest films depict an entrenched battle between romance and cold-bloodedness. For Truffaut, passion and ruthlessness are a more likely match than love and marriage.

It is no surprise that well-known works such as "Day for Night" or "The Story of Adele H." hold up over time. But anyone who thinks Truffaut is too familiar will be shocked at the strength and allure of some lesser-known films. Truffaut had his box-office bombs, but they look ravishing today.

"Les Mistons," "Mississippi Mermaid" and "Two English Girls" are pure Truffaut; "The Green Room" belongs on the short list of his masterworks, alongside "Jules and Jim" and "The 400 Blows." All share the wild beauty, the obsessiveness, the sense of delicious voyeurism that mark his best films.

■

"Les Mistons" (1958), the rarely seen 23-minute film that is his first professional work, is a revelation. This amazingly rich and self-assured debut is witty and ultimately sorrowful, encapsulating many of the qualities that would make Truffaut famous. The "mistons" of the title are five "brats" or "mischief-makers," preadolescent boys who anticipate Antoine Doinel. They become collectively enamored of Bernadette, a woman who must be around 18. We are told this by an adult voice, one of the mistons (we never learn which one) looking back at his youth.

"Too young to love Bernadette," he explains, "we decided to hate her" — which means that the mistons live for those moments when they catch Bernadette and her boyfriend kissing at the movies or in the woods, so they can create a raucous fuss and end the kiss.

The voice-over, offering an older though not always wiser view, creates a layering device Truffaut would return to throughout his career. Yet even without the narrator, we would know that Bernadette represents what he calls "a world of luminous sensuality." She first appears as a graceful vision, gliding along a road on her bicycle with her skirt flying in the wind. Even in this, his first film, Truffaut's fluid, elegant visual style was mature.

Bernadette herself, an icon of potent sexuality, looks ahead to Catherine in "Jules and Jim." And Truffaut's unsentimental but hugely empathetic observations of childhood were already in place. One day the boys play soldiers with imaginary guns; the next they sit by a tennis court, passing around a cigarette while ogling Bernadette's behind.

"Mississippi Mermaid," with Catherine Deneuve and Jean-Paul Belmondo, flopped when it was released in 1969. It is a playful yet haunting story of mail-order marriage, love, murder and rat poison — pretty much in that order. The film must have seemed mystifying to audiences, especially after the single-minded murders and the panache of Jeanne Moreau in "The Bride Wore Black," which it followed by two years. But "Mississippi Mermaid" offers the sort of glamorous, sardonic, lethal passion Truffaut could make so appealing.

Never mind why a character as rich and handsome as Mr. Belmondo would advertise for a wife; logic has little currency here. Someone as young and beautiful as Miss Deneuve answered the ad, it is revealed early on, because she is an imposter, out to get his money and maybe his life. "I can't say I'm happy with her," the Belmondo character tells a friend, "but I can't live without her." Which of Truffaut's lovers, man or woman, would fail to understand that?

"Mississippi Mermaid" is the name of the ship that carries the bride from France to Reunion Island off the African coast, but the film's French title, "La Sirène du Mississippi," evokes the siren song Truffaut creates on screen.

"Two English Girls" (1971), another commercial failure, may have suffered from viewers' assumption that it would be the flip side of "Jules and Jim." Like the earlier work, it was adapted from a novel by Henri-Pierre Roché and tells a vaguely similar story. "Jules and Jim," of course, concerns two friends who love the same woman. "Two English Girls" is about English sisters, Muriel and Anne, involved with the same Frenchman, Claude (played by Jean-Pierre Léaud). Though both stories are set at the turn of the century, their sensibilities and styles are radically different, suggesting how Truffaut was inspired by his material rather than the public's expectations.

■

"Two English Girls" has the pastoral beauty of an Impressionist landscape, and its heroines must struggle for even a taste of the free-spirited sexuality that came so naturally to Catherine. As Truffaut said, when creating the sisters he had in mind Charlotte and Emily Brontë, who were "also puritanical, romantic and rather impassioned English girls." That is a combination guaranteed to produce unhappiness, though hardly murder or suicide. Beneath its lyrical manner, "Two English Girls" is a subtle portrait of genteel people whose passions are manipulated and misdirected in every possible permutation.

Truffaut was sometimes depressed about his commercial failures but always kept his wit. " 'The Green Room' has had good notices, but from the distributors' point of view the real title ought to be 'The Empty Room'!" he said. This 1978 film may be his least typical, the farthest from the romantic wit associated with Truffaut. Based loosely on Henry James's story "The Altar of the Dead," its sympathetic antihero is Julien Davenne, played with impeccable subtlety by Truffaut himself.

Having survived World War I and lost his young wife soon after, Da-

Jean-Pierre Léaud in "The 400 Blows"—In the actor, Truffaut had the good fortune and sense to find his perfect alter ego.

venne devotes himself to her memory and that of others he has loved. He is so obsessed by the dead, so intently cut off from life, that he can share his ideas about death with a young woman named Cécilia (Nathalie Baye)

The film maker had his box-office bombs, but they look ravishing today.

yet remain blind to the fact that she loves him.

This film about honoring the dead is also about life, art and love, though Truffaut would never stoop to treating those themes in a blatant or abstract way. Instead, he captures their essence in luxurious images — of blazing candles, of the cool glass windows and doors Davenne hides behind. With his implacable, slightly pained expression and his rigidly proper bearing, Truffaut makes Davenne an affecting figure of loss and of lost opportunities. The green room itself is a shrine to the dead wife, filled with photographs, portraits and votive candles, a place that is at once soothing and disturbing.

After Davenne restores an abandoned chapel as a memorial to the dead, he guides Cécilia through it, pointing out the photographs that line

the walls. There are Henry James, Jean Cocteau, the composer Maurice Jaubert — artists precious to Truffaut —alongside the fictional dead precious to Davenne.

But the film's reviews, Truffaut complained in a letter, "went on so much about DEATH" that "the public is scared to go and see it." There's no denying that "The Green Room" is elegiac, but it is not depressing. It is as passionately felt, as exquisitely filmed and as life-affirming as anything Truffaut created.

"April in Paris" is also a feast of lighter Truffaut. Here is the entire Antoine Doinel series, from "The 400 Blows" through "Antoine and Colette" (Truffaut's 29-minute segment in the anthology film "Love at 20"), "Stolen Kisses," "Bed and Board" and "Love on the Run." Part of Truffaut's genius sprang from the good fortune and sense to have found his perfect alter ego in Mr. Léaud.

Still, nothing can match the image of Truffaut himself on screen. Playing Dr. Itard in "The Wild Child," he is wise enough to learn from his pupil. At the end of "The Green Room," he makes us mourn for Julien Davenne. But he is most impressive when he is most himself, as the film director in "Day for Night." There, Truffaut plays a man who loves movies. □

1992 Ap 5, II:17:5

Mindwalk

Directed by Bernt Capra; screenplay by Floyd Byars and Fritjof Capra, based on Mr. Capra's book "The Turning Point"; director of photography, Karl Kases; edited by Jean Claude Piroue; music by Philip Glass; produced by Adrianna A. J. Cohen; released by Triton Pictures. At the Film Forum, 209 West Houston St. Running time: 111 minutes. This film is rated PG.

Sonia Hoffman Liv Ullmann
Jack Edwards Sam Waterston
Thomas Harriman John Heard
Kit Hoffman Ione Skye
Romain Emmanuel Montes

By VINCENT CANBY

In Bernt Capra's "Mindwalk," opening today at the Film Forum, an alienated scientist (Liv Ullmann), a losing candidate for the United States Presidency (Sam Waterston), and an American poet (John Heard) who lives in self-imposed exile in France meet by chance at Mont-St.-Michel and spend the day walking and talking.

Though not exactly spontaneous and seldom witty, it is good serious talk, a sort of feature-length op-ed piece. The source material is "The Turning Point" by the director's brother, Fritjof Capra, a physicist and the author of the best seller "The Tao of Physics," which finds links between science and religious mysticism. (The Austrian-born Capra brothers are no relation to Frank Capra.)

It is Fritjof Capra's point that the Earth can be saved only by a radical rethinking of priorities. Because the universe and everything within it function according to a single system of interdependencies, he believes, a holistic approach is needed to solve all problems, from famine, overpopulation and global warming to the tired businessman's heart attack.

●

Mont-St.-Michel, a mile off the Normandy coast, is as apt a locale for the Capra brothers today as it was for Henry Adams in 1904. That was when Adams privately published his first edition of "Mont-St.-Michel and Chartres," a meditation upon the 13th century, when, as he saw it, the worship of the Virgin Mary briefly gave a transcendent unity and coherence to French life.

The ancient Benedictine abbey, founded in the eighth century, is a spectacular setting, though "Mindwalk" is less interested in scenery than in delivering ideas as efficiently and conversationally as possible. Miss Ullmann's scientist must do most of the talking while she leads the two men around the island, gently lecturing them on Descartes, Newton and the outmodedness of the mechanistic approach to science.

"Well, let's take the population problem, for example," she says by way of one preamble, or "Take Brazil. As you know they are destroying the Amazon rain forest at the rate of one football field a second."

A specialist in laser physics, she describes herself as being on "a semi-permanent sabbatical" from her post at an American university. She lost interest, she tells them, when she found her work was being "fed to the U.S. Defense Department."

She is intense, sincere and so very knowing that the politician and the poet haven't much to do except make little interjections, which allow her to catch her breath and the audience to digest her last speech. "Is that what's known as scientific thinking?" one

On an Isle Liv Ullmann co-stars with Sam Waterston and John Heard in "Mindwalk." Bernt Capra's drama is about a conversation among three people who find enlightenment and renewal at Mont-Saint-Michel in France.

man might say. Or more bluntly, "What does that mean?"

●

In the course of the day, the poet has a chance to quote Pablo Neruda. The politician, who seems less introspective than empty, invites the scientist to join his staff.

Miss Ullmann goes on dropping large thoughts. To make her point about the relative sizes of things, she says that if an orange were blown up to the size of the Earth, the atoms in it would be the size of cherries. "Wow," the poet says, "that's an image!"

Though "Mindwalk" is better read than said, it will have done its job if it stirs people whose list of unopened books reaches from here to Philadelphia.

1992 Ap 8, C17:1

Rock Soup

Produced, directed and edited by Lech Kowalski; director of photography, Doron Schlair; music by Chico Freeman; released by First Run Features. At the Film Forum, 209 West Houston Street. Running time: 81 minutes. This film has no rating.

Chico and the People

Directed by Lech Kowalski; music by Chico Freeman; released by First Run Features. At the Film Forum, 209 West Houston Street. Running time: 19 minutes. This film has no rating.

By JANET MASLIN

Why are these people smiling? It is 9 degrees above zero in Tompkins Square Park in New York City, and the street musicians seen in Lech Kowalski's short film "Chico and the People" look almost impervious to the weather. Although their breath shows up on camera and some of

them can be seen warming their hands over trash fires, a majority of the film's participants appear caught up in the jazz rhythms played by Chico Freeman and his ragged, exuberant street ensemble. The spirit of community, as captured by Mr. Kowalski in pure and wordless terms, is enough to conquer the cold.

"Chico and the People," the first part of a program opening today at the Film Forum, is an apt prelude to "Rock Soup," Mr. Kowalski's longer and angrier look at street life on the Lower East Side. Filmed principally at an outdoor soup kitchen on Ninth Street, a place first seen under a torn, dripping tarpaulin on a miserable day, the stark black-and-white "Rock Soup" gives voice to the many emotions experienced by those who go to the kitchen for meals. What is surprising in Mr. Kowalski's vision is the closeness and hope he sees binding the participants together. They would no doubt prefer to be elsewhere, but they have found the kind of sustenance that surpasses mere creature comfort.

•

Remarkably, Mr. Kowalski communicates this thought without seeming unreasonably idealistic, and without imposing his own ideas upon the participants. He simply lets them talk, and his camera captures a wide array of individuals trying to make peace with their circumstances. Without fully separating volunteers and food donors from those who use the kitchen's services, Mr. Kowalski simply captures the cooperative atmosphere of the whole enterprise and underscores how important it has become to the members of this small, embattled community. The real focus of "Rock Soup" is a neighborhood effort to close this soup kitchen down.

A long stretch of the film unfolds at a community meeting, where those who champion the kitchen come face to face with unfriendly neighbors. Civil at first, the meeting rapidly degenerates into bitterness on both sides, with the camera capturing utter contempt and indifference on the faces of those who oppose the kitchen. A plan to close down the kitchen and put up public housing is in the works, with the housing intended for the elderly and the rest of the homeless population expected to move on. Two sad footnotes to Mr. Kowalski's work: Tompkins Square Park was cleared of its homeless population after "Chico and the People" was filmed, and neither soup kitchen nor senior housing now stands on the site of "Rock Soup."

•

Although there are times when Mr. Kowalski might have questioned his subjects more directly or allowed them to speak more clearly into the camera, the film's participants speak memorably about their lives. Some talk of how they came to be homeless. ("Tell 'em about gentrification," shouts a man in chinos and a V-neck sweater. "Look, I'm wearing the costume of it.") Two men muse about the wealthy, with one wondering "What do people do with so much money?" His friend replies, "They got so much they can't even donate none."

Kalif Beacon, who runs the soup kitchen, describes his role simply: "It's easy. You cook all day and you scrounge in the streets all night. And you sleep about two or three hours in the morning." It is Mr. Beacon who provides the film with its title by explaining in effect how to make something from nothing. The film's vision of generosity, wisdom and pa-

tience is even better articulated by a man who donates food to the kitchen. "Today for you," he says. "Tomorrow for me."

Mr. Kowalski has made his forceful, revealing documentary, which is part of his longer series about the homeless, with that thought very much in mind.

1992 Ap 8, C22:3

Newsies

Directed by Kenny Ortega; written by Bob Tzudiker and Noni White; director of photography, Andrew Laszlo; edited by William Reynolds; music by Alan Menken; production designer, William Sandell; produced by Michael Finnell; released by Walt Disney Pictures. Running time: 125 minutes. This film is rated PG.

Jack Kelly	Christian Bale
David Jacobs	David Moscow
Les Jacobs	Luke Edwards
Bryan Denton	Bill Pullman
Medda Larson	Ann-Margret
Joseph Pulitzer	Robert Duvall
Racetrack	Max Casella
Crutchy	Marty Belafsky
Boots	Arvie Lowe, Jr.
Mush	Aaron Lohr
Kid Blink	Trey Parker
Spot Conlon	Gabriel Damon
Snitch	Dee Caspary
Jake	Joseph Conrad
Itey	Dominic Maldonado
Snipeshooter	Matthew Fields
Specs	Mark David

By JANET MASLIN

The premise for "Newsies," an elaborate Disney live-action musical about the New York newsboys' strike of 1899, never sounded all that promising in the first place. But this film's real trouble lies in its joyless, pointless execution. As directed by Kenny Ortega, the choreographer whose credits include many stage acts and rock videos as well as the film "Dirty Dancing," "Newsies" is a long, half-hearted romp through what is made to seem a not terribly compelling chapter in New York City's history. The story remains tedious even though Joseph Pulitzer, William Randolph Hearst and Theodore Roosevelt are all briefly on hand to give it color.

•

A score featuring music by Alan Menken and lyrics by Jack Feldman provides the film's only bright spots, but even these are bungled. Many of the musical numbers are staged so strangely that the characters, when they begin singing, appear to have taken leave of their senses. Christian Bale, as the film's hero who dreams of escaping to the Southwest, is made to sing "Santa Fe" while ambling through a dusty, too-picturesque New York street at night. The staging goes well beyond run-of-the-mill fantasy when it sends him leaping onto a horse and frolicking on a hay wagon.

Mr. Ortega, whose great strength ought to have been in handling these musical sequences, unaccountably breaks up songs with dialogue and sometimes limits a musical outburst to only a few bars; never does he allow a song-and-dance number to build to a rousing finale. The choreography, by Mr. Ortega and Peggy Holmes, is similarly strange, at one point managing to combine turn-of-the-century Irish jigs with the hip-hop moves of the present. The musical outbursts do not grow organically from the film's other action, nor do they otherwise feel authentic, since the dancing looks forced and the sound is noticeably lip-synched. Mr. Menken's music would have sounded

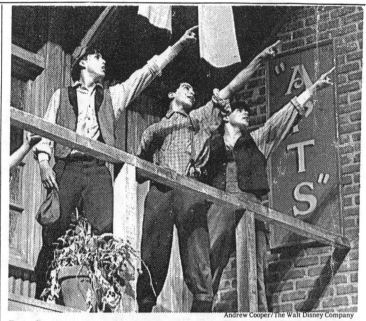

Andrew Cooper/The Walt Disney Company

Dee Caspary, left, Dominic Maldonado, center, and Joseph Conrad, three of the newsboys in Disney's new live-action musical, "Newsies."

better under almost any other circumstances than these.

•

The Welsh-born Mr. Bale, who has grown from the sweet-faced schoolboy star of "Empire of the Sun" into a strapping actor, is as hamstrung by the film's insistence on heavy New York accents as are the other young performers ("work" comes out "woik," etc.) Few of the cast members have much chance to shine, since the film's idea of charm is seriously misguided. Lovable little Crutchy (Marty Belafsky), a disabled newsboy with a heart of gold, pretty much personifies the film's would-be winsome side. Ann-Margret, done up in orange and fuchsia as a vaudeville star who looks more like a madam, particularly strains the limits of innocent fun.

Robert Duvall, hidden behind glasses and large tufts of facial hair as a cartoonishly villainous Joseph Pulitzer, looks understandably un-

comfortable in the role. ("There's lots of money down there in those streets," he tells his henchmen. "I want to know how I can get more of it — by tonight!") Only slightly better off is Bill Pullman, as the newspaper reporter who helps to champion the newsboys' strike against the Pulitzer and Hearst empires. While "Newsies" will seem dull to children and badly contrived to their parents, it is even further hurt by a fairy-tale view of labor relations. It would be hard to imagine a worse moment for a film that supposes a dispute between labor and management could be settled by a few songs.

•

"Newsies" is rated PG (Parental guidance suggested). It includes mildly rude language ("Ya lousy little shrimp!") and very faint sexual suggestiveness.

1992 Ap 8, C22:3

Down From Hopeless, to Hilarious

By VINCENT CANBY

THE English air is chill, the sky without color even when the sun is out. The wallpaper in the old council house is of a ghastly, faded busy-ness that is emphasized by the knickknacks, which include a grouping of china fawns on a table top. The recently built blocks of flats are no more cheerful. Though inhabited, they look worn out. The elevators are unreliable, like the tenants they're supposed to serve. The houses in the so-called new towns are, in fact, new but barren. Love dies quickly here.

This is what one first sees in the films of Mike Leigh: a world that is pinched and without horizons. Yet Mr. Leigh, the most innovative of contemporary English film makers, is also the most subversive. He has radically changed the socially conscious English cinema from the tradition established by the shapely,

Alison Steadman, Roger Sloman and Anthony O'Donnell in "Nuts in May" (1976).

poetic working-class films made in the 1950's and 60's by Tony Richardson, Karel Reisz and Lindsay Anderson.

Mr. Leigh's films appear to be shapeless, devoid of poetry. They are unforgiving in their portrayal of squalor. They shuffle along on tired feet, seemingly as aimless and inarticulate as their characters. Yet at some point in each of his films there comes a transforming moment when the unbearable and the hopeless fuse to create an explosion of recognition, sometimes of high, incredible hilarity.

Near the end of "Grown-Ups" (1980), four adults wrestle on the cramped stairs of a row house in Canterbury in the shadow of the cathedral. They are trying to remove an exceptionally boring woman who, in the midst of a serious breakdown, had invaded the domain of the genteel next-door neighbors and locked herself in their toilet. Everybody is screaming. Husbands are blaming wives. Neighbor would kill neighbor. The class war is at hand. Laughter suddenly erupts in the audience. It is not cruel, but the sound of a triumphant breakthrough: during the fury of the fight on the stairs, stasis has been defeated.

In the best of Mr. Leigh's work, what once was called neo-realism gives way to something on the order of magic humanism. Each of his films has its moment of truth. In the dour "Hard Labour" (1973), it comes when an exhausted charwoman, played by the great Liz Smith, who has the pointy impassive face of a saint on the facade of Chartres, confesses to her priest, hesitantly but at long last, that she can't stand to be touched by her husband.

On the other side of the screen the young priest sighs, tells her what her penance shall be and goes back to his tabloid. In a number of the other films, equally harrowing moments are side-splitting funny. They suggest that Mr. Leigh has found some kind of meta-working-class idiom, one that need not be solemn to be serious, nor frivolous to be funny.

From 1971 to 1990, Mr. Leigh made 12 films, all of which, plus a number of his shorts, will be screened in the course of the two-week retrospective, "Life Could Be Better: The Films of Mike Leigh," starting today at the Museum of Modern Art. Since most of the films were

produced for television and because legal snarls make their theatrical presentation unlikely, this may be the only opportunity to see them in such elegant circumstances.

Most Americans have come to Mike Leigh comparatively late in his career through the theatrical release of two of his most supple films, "High Hopes" (1988), about a benignly out-of-date hippie couple trying to survive in Margaret Thatcher's England, and "Life Is Sweet" (1990), which gauges the temperature in post-Thatcher England and finds it alarmingly subnormal.

Encountered separately, with long intervals between, the Leigh films are not so easily appreciated as they are in this kind of show, when the methods, manners and astonishingly rich performances in each film give resonance to all the others.

The Leigh films look different, and prompt far different responses, from earlier English working-class classics: "A Taste of Honey," "The Loneliness of the Long Distance Runner," "Saturday Night and Sunday Morning" and "This Sporting Life," movies that invite audience identification and royally reward it.

Beginning with his aptly titled "Bleak Moments" (1971), about a young woman, an accountant's clerk, whose life is dominated by her mentally retarded sister, Mr. Leigh's work is alternately diffident and cheeky. It challenges the viewer to find the way into existences so bereft that the only response is to examine the entire system. That the films themselves are not depressing or boring is a testament to their vitality and to the director's way of working.

Many of the films carry the credit "devised and directed by Mike Leigh," for the logical reason that they are devised as much as they are directed. Mr. Leigh's film-making method, an extension of practices he first used in the theater, is to work with actors over an extended period during which they agree on characters they would like to develop.

Next comes research, followed by improvisations, at first separately, then with the director and finally with the entire group, when the shape of the piece is finally arrived at. This sounds like a blueprint for disaster. In Mr. Leigh's case, it has been the genesis for a dozen remarkable features.

At their worst, they sometimes exhibit a certain predictability of pace and event. At their best, they possess a liveliness and a truth so intense that it seems unlikely their texts could ever have been written down, though by the time the work is completed, they have been. With care. Once a piece is set, Mr. Leigh doesn't allow any actorlike improvements.

Out of these collaborations have emerged seven films that should not be missed at the Modern:

"**NUTS IN MAY**" (1976), about the hilarious and appalling things that happen to Keith and Candice-Marie, a pair of terrifically self-satisfied, middle-class vegetarians still high on the love-philosophy of the 1960's, when they go on a camping trip in Dorset. Keith and Candice-Marie want to love their fellow man, but it's difficult for the loutish working-class types at the camp ground to love them back. By way of a conversational opener, Keith is likely to rattle off the names of famous vegetarians in history (Leonardo and Malcolm Muggeridge, among others). "No killer whites in our tent!" he says, meaning refined sugar and flour. In the midst of all this nature, Keith has an encounter

that forever changes him. Great performances by Roger Sloman as Keith and Alison Steadman (who is married to Mr. Leigh) as Candice-Marie.

"**THE KISS OF DEATH**" (1977), in which a tongue-tied young apprentice (David Threlfall) to an undertaker discovers the world of live young women, not entirely to his satisfaction.

"**ABIGAIL'S PARTY**" (1977), featuring Miss Steadman's horrendously funny performance as the hostess at a dainty evening party. The festivities are nearly ruined when one of the guests has the poor taste to have a heart attack on her new carpet.

"**WHO'S WHO**" (1978), in which Mr. Leigh crosscuts among the private lives of a group of employees in a London brokerage house, contrasting the terrible manners of some young upper-class twits with those of an even scarier working-class fellow who collects celebrity autographs.

"**GROWN-UPS**" (1980), about the marriage of young Dick, a dishwasher, and Mandy, a cashier, which is doomed, though not because Mandy's emotionally needy sister, Gloria, wants to live with them. Once Dick and Mandy stop sleeping together, which will happen after the first or second baby, Dick will take off.

"**HOME SWEET HOME**" (1982), which may be Mr. Leigh's funniest and most moving film. It's about the parched lives of three postmen and their wives and women friends. The unlikely Romeo of the group is Stan (Eric Richard), 42 years old, with a large hooked nose and a wife who has departed but not divorced him. Stan also has a sad 14-year-old daughter whom he leaves in an orphanage, much to the horror of the inept, pushy social services people.

"**MEANTIME**" (1983), which features a fine performance by Gary Oldman as a skinhead and which is the bleakest Leigh film since his first, "Bleak Moments." Everybody in this East London family is unemployed and on the way to becoming lastingly unemployable.

Mr. Leigh has been criticized in England for placing so much emphasis on class distinctions, which were supposed to have vanished after World War II. In Mr. Leigh's cinema, class distinctions are actual. More important, perhaps, they are also a metaphor for the great divides that separate all of us, even when class is no longer the issue. These films rivet.

1992 Ap 10, C1:2

Ferngully
The Last Rain Forest

Directed by Bill Kroyer; screenplay by Jim Cox, based on the stories of "Ferngully" by Diana Young; edited by Gillian Hutshing; music by Alan Silvestri; produced by Wayne Young and Peter Faiman; released by 20th Century Fox. Running time: 72 minutes. This film is rated G.

WITH: the voices of Tim Curry, Samantha Mathis, Christian Slater, Jonathan Ward, Robin Williams, Grace Zabriskie, Geoffrey Blake, Robert Pastorelli, Cheech Marin, Tommy Chong and Tone-Loc.

By JANET MASLIN

"Ferngully: The Last Rain Forest" bears a conspicuous resemblance to "The Little Mermaid," although it lacks that film's prodigious parent appeal. What "Ferngully" has instead are politically correct attitudes about conservation, pollution and junk food, subjects that may not be entirely riveting for children but

Into the Woods A young boy enters a magical world and must fight to save it in "Ferngully . . . The Last Rainforest."

that are ostensibly close to parental hearts. In that regard, this animated feature would be a shade more admirable if it didn't also have a coquettish, turquoise-eyed heroine who is referred to as a "bodacious babe."

An uncertain blend of sanctimonious principles and Saturday-morning cartoon esthetics, "Ferngully" tells of pert, insect-size Crysta (with the voice of Samantha Mathis), who lives in a lush, dramatically drawn rain forest that is the film's most appealing feature. Warned by her elders that she must "never, never fly above the canopy," this tiny, winged sprite goes exploring all the same. She discovers the outside world, just as Ariel the mermaid did, and becomes smitten with Zak (Jonathan Ward), a human hunk who is unfortunately engaged in razing the endangered rain forest. Crysta casts a spell on Zak, making him fairy-size, and sets out to show him the error of his ways.

This slender plot calls for a lot of padding, even though the film has only a 72-minute running time. So there is an evil woodland spirit named Hexxus (Tim Curry), who sings the praises of toxic slime. And there is Magi Lune (Grace Zabriskie), the motherly type who provides the story with its quotient of new-age spirituality. ("We tree spirits nurtured the harmony of all living things, but our closest friends were human.")

Also on hand, and providing the film with a few welcome bursts of energy, is Robin Williams, who supplies the voice of a cheerfully demented bat. Children may be puzzled by Mr. Williams's fast, throwaway impersonations of Bette Davis, John Wayne and Desi Arnaz, among others, but adults will appreciate the change of pace.

As written by Jim Cox and directed by Bill Kroyer, "Ferngully" is more run-of-the-mill than its subject matter might indicate. The main characters are disappointingly ordinary, with the exotic Crysta sounding very much like someone who spends time

at the mall. And even the film's more stellar-sounding touches, like the voices supplied by Christian Slater, Cheech Marin and Tommy Chong, or the songs by Elton John, Jimmy Webb and Jimmy Buffett, among others, tend to get lost. Even Raffi, a musical superstar for this film's small viewers, is heard only briefly before his music fades away.

1992 Ap 10, C10:5

Complex World

Written and directed by James Wolpaw; director of photography, Denis Maloney; edited by Steven Gentile; music by Steven Snyder; produced by Geoff Adams, Rich Lupo and Mr. Maloney; released by Hemdale Releasing Corporation. At the Loews 7, 11th Street at Third Avenue, Manhattan. Running time: 82 minutes. This film is rated R.

Morris Brock	Stanley Matis
Gilda	Margot Dionne
Harpo	Allen Oliver
Malcolm	Daniel Von Bargen
Alex the Janitor	Joe Klimek
Kiem	Jay Charbonneau
Jeff Burgess	Dan Welch
Hotel Waiter	Ernesto Luna
Robert Burgess	Bob Owczarek
Miriam	Dorothy Gallagher
Larry Newman	David P. B. Stevens
The Mayor	Rich Lupo
Boris Lee	Captain Lou Albano

By STEPHEN HOLDEN

Morris Brock (Stanley Matis), the narrator of James Wolpaw's maniacally zany comedy "Complex World," is a sad-sack folk singer who looks a lot like the young Woody Allen and sings his own ludicrous protest songs in a rock club in Providence, R.I., the Heartbreak Hotel. Morris does not go in for political correctness. One of the numbers he performs asks, "Why do we feed the broads when we could feed the whole damn world?" Another is a series of ranting epithets directed at the state of New Jersey. His performances invariably inspire hails of abuse and garbage.

For reasons too silly to go into, Morris also belongs to a group of political terrorists who have planted 100 pounds of plastique in the club's cellar. It is set to explode if a ransom is not paid by 1 A.M. on a certain night. Coincidentally that's the same night the mayor has paid a motorcycle gang to tear up the place.

"Complex World," which opens today at the Loews 7, unfolds as a farcical countdown toward possible catastrophe. Among the more prominent characters are Jeff Burgess (Dan Welch), the club's goofy owner, who has a metal plate in his head and refuses to take bomb threats over the phone, and Jeff's ominous father, Robert (Bob Owczarek), a former C.I.A. chief who is running for President, Robert would be only too happy to see his politically embarrassing son blown to smithereens.

●

Some of the other oddballs who pop up are a motorcycle gang leader (Captain Lou Albano) with a fixation on Stonewall Jackson, a crazy street preacher who raves about people being "fricasseed" in hell, and the members of two rock groups, the Young Adults and the Beat Legends. The Young Adults, a defunct real-life post-punk band that reunited for the movie, perform a number of amusing rock spoofs, the most hilarious of which are a funky dance number, "Do the Heimlich," and a love song, "I Married a Tree."

The Beat Legends, an imitation (and fictional) Beatles band, hang out

in the cellar of the Heartbreak Hotel, stoking themselves with marijuana, alcohol and cocaine. In the middle of their party, the phone rings and the caller identifies himself as Elvis Presley. The awestruck musicians pelt him with questions about life in heaven. Is he the fat Elvis or the thin Elvis? Where is John Lennon? Has Janis Joplin learned how to sing?

Mr. Wolpaw, who wrote and directed "Complex World," doesn't attempt to impose logic on his story. What he has created is an amiable rock-and-roll farce that has the antic spirit of a Marx Brothers comedy, spiced with enough observations of the rock life in the style of "This Is Spinal Tap" to give the movie a mild satirical bite.

As much fun as it is, the film, which was completed three years ago, already seems a little out of date. Its heart belongs to a rock-club ambiance that feels more early 80's than early 90's, and the evil candidate's warnings about a Communist conspiracy place the film's paranoid comedy in a time well before the era of Boris Yeltsin.

"Complex World" is rated R (Under 17 requires accompanying parent or adult guardian). It includes sex scenes and strong language.

1992 Ap 10, C14:5

The Player

Directed by Robert Altman; screenplay by Michael Tolkin, based on the novel by Mr. Tolkin; director of photography, Jean Lepine; edited by Geraldine Peroni; music by Thomas Newman; production designer, Stephen Altman; produced by David Brown, Nick Wechsler and Mr. Tolkin; released by Fine Line Features. Running time: 123 minutes. This film is rated R.

Griffin Mill	Tim Robbins
June Gudmundsdottir	Greta Scacchi
Walter Stuckel	Fred Ward
Detective Avery	Whoopi Goldberg
Larry Levy	Peter Gallagher
Joel Levison	Brion James
Bonnie Sherow	Cynthia Stevenson
David Kahane	Vincent D'Onofrio
Andy Civella	Dean Stockwell
Tom Oakley	Richard E. Grant
Dick Mellen	Sydney Pollack
Detective DeLongpre	Lyle Lovett
Celia	Dina Merrill

WITH: Buck Henry, Julia Roberts, Jack Lemmon, Marlee Matlin, Harry Belafonte, Anjelica Huston, Nick Nolte, Bruce Willis and others.

By VINCENT CANBY

Robert Altman has not really been away. Yet his new Hollywood satire titled "The Player" is so entertaining, so flip and so genially irreverent that it seems to announce the return of the great gregarious film maker whose "Nashville" remains one of the classics of the 1970's.

Taking Michael Tolkin's clever and knowing screenplay, which Mr. Tolkin adapted from his own novel, Mr. Altman has made the kind of "in" Hollywood film that will be comprehensible to just about anybody who goes to movies or who simply reads about them.

●

"The Player" is a Hollywood morality tale, appropriately skin-deep. It's no apocalyptic "Day of the Locust," but a send-up of Hollywood spelled out in the broad terms that can be easily understood by the deal makers at the top, men and women who are so pressed for time that they prefer their stories synopsized, orally if possible.

It is also a tale of murder and mystery, though not a murder-mystery. There's no mystery about who commits the murder, only about the circumstances that make the crime inevitable. At the film's center is the head of production at a large studio, Griffin Mill (Tim Robbins), who is first met as he listens to a series of screenplay proposals that set the movie's tone.

Among them is Buck Henry's pitch for "The Graduate, Part 2," which is the story of Ben Braddock and Elaine Robinson, who, 25 years after their elopement, are living with Mrs. Robinson. "I like it, I like it," says Griffin. Another fellow outlines a rather complicated story that Griffin tries to paraphrase: "Like 'The Gods Must Be Crazy,' except that the Coke bottle is a television actress?"

Griffin's life is precarious. Production executives have notoriously short careers at any one company. There are rumors that a new young genius named Larry Levy (Peter Gallagher) is being hired with the obvious intent of replacing him. This aggravates another situation, which, at any other time, might not have

Tim Robbins in Robert Altman's film "The Player."

come to obsess him the way it does now.

Griffin has picked up a poison-penpal. Every day or two he receives an anonymous card from someone whom he has apparently, in the jargon of American business, failed to get back to. The notes are cryptic, threatening his life. Apprehensive that he will become a laughingstock if he reports his fears, Griffin does a little detective work. He finally identifies the suspect as a screenwriter whom, indeed, he did fail to get back to.

•

When the writer turns up dead in an alley following a meeting with Griffin, the production chief becomes a suspect. What to do? Among other things, Griffin falls hopelessly in love with the writer's live-in lover. She is June Gudmundsdottir (Greta Scacchi), a painter from, she says, Iceland, which might explain her fondness for the color blue, though not for the isolated words that appear in her paintings.

"I like words and letters," she tells Griffin, "but I'm not crazy about complete sentences." It is also her opinion that her dead lover was "uniquely untalented."

In addition to its other identities, "The Player" is a love story, but one set in the very particular world of movie making, which is why Griffin is initially drawn to June as an outsider. Yet everyone seems to turn a little strange when brought into the Hollywood orbit. Among others there are the police who are investigating the writer's murder, including one cop who is a fan of "Freaks," and Detective Avery (Whoopi Goldberg), who seems to find anything Griffin says ridiculously funny.

•

If "The Player" were more plot-oriented, Detective Avery might be described as playing Police Inspector Petrovich to Griffin's Raskolnikov, but the film has no intention of replaying "Crime and Punishment" on any level. To do so would be to crack the film's completely self-absorbed, comic facade.

Indeed, there is not really that much of a story to "The Player," though it is breezy fun. The film is a grand Hollywood fresco that depicts the eccentric passion of Griffin Mill as he goes to his destiny, sometimes godlike and sometimes like a bewildered amoral pilgrim. Mr. Altman paints everything large, with lots of color and overlapping sound, whether the locale is a studio board room, a screening room, a cocktail party for the A list or a dressed-to-the-nines Hollywood gala.

The members of the huge cast seem to be having a great night out on the town. They respond with enthusiasm to Mr. Altman's generosity, whether the roles are large or small, whether they play cameos or dress-extras. In addition to Ms. Goldberg and Mr. Gallagher, the main featured actors are Fred Ward, Cynthia Stevenson, Vincent D'Onofrio, Sydney Pollack, Dean Stockwell and Richard E. Grant. Mr. Robbins and Miss Scacchi are securely funny in the central roles, though attention is often drawn from them by the dozens of "names" who come and go around them.

A few of them: Julia Roberts, Jack Lemmon, Marlee Matlin, Harry Belafonte, Anjelica Huston, Nick Nolte and Bruce Willis. Like a Renaissance master, Mr. Altman has a way of filling the frame of large crowd scenes with the faces of friends and associates who will be familiar to anyone who knows the neighborhood.

•

As a satire, "The Player" tickles. It doesn't draw blood. It says nothing about Hollywood that Hollywood insiders don't say with far more venom in their hearts. Mr. Altman's most subversive message here is not that it's possible to get away with murder in Hollywood, but that the most grievous sin, in Hollywood terms anyway, is to make a film that flops.

"The Player" looks to be a hit.

•

"The Player," which has been rated R (Under 17 requires accompanying parent or adult guardian), has partial nudity, some sex scenes and vulgar language.

1992 Ap 10, C16:1

Sleepwalkers

Directed by Mick Garris; written by Stephen King; director of photography, Rodney Charters; edited by O. Nicholas Brown; music by Nicholas Pike; production designer, John DeCuir Jr.; produced by Mark Victor, Michael Grais and Nabeel Zahid; released by Columbia Pictures. Running time: 91 minutes. This film is rated R.

Charles Brady	Brian Krause
Tanya Robertson	Mädchen Amick
Mary Brady	Alice Krige
Ira	Jim Haynie
Mrs. Robertson	Cindy Pickett
Captain Soames	Ron Perlman
Mr. Robertson	Lyman Ward
Andy Simpson	Dan Martin
Mr. Fallows	Glenn Shadix
Laurie	Cynthia Garris
Cemetery Caretaker	Stephen King

BY STEPHEN HOLDEN

Moments before she kills a policeman with a corncob snatched from a dinner plate, Mary Brady (Alice Krige), a fiend in human form, utters the only witty lines to be heard in "Stephen King's Sleepwalkers." "No vegetables, no dessert!" she growls. "Those are the rules."

Columbia Pictures

Out of This World Alice Krige stars in "Sleepwalkers" as a voracious creature who roams the earth searching for human prey necessary to sustain life.

The film, which opened today at local theaters, follows the mayhem wrought by Mary and her son Charles (Brian Krause) when they arrive in the small town of Travis, Ind. Both mother and son are Sleepwalkers, werewolflike creatures condemned to feed on the life force of beautiful young women to stay alive. They are also lovers. Before dispatching her son to find a fresh young victim, Mary entices Charles to slow dance with her to his favorite song, "Sleep Walk" (what else?), the 1959 hit by the Brooklyn guitar duo Santo and Johnny.

"Am I beautiful?" she demands. "You're always beautiful, Mother," he replies. "I'm famished," she reminds him. Pale and gaunt, with glittering eyes and a provocative swivel, Ms. Krige is an all-too-predictable Hollywood incarnation of a Freudian nightmare come to life.

Tanya Robertson (Mädchen Amick), the classmate Charles selects to be his next victim, is something of a soulmate. Since Tanya likes to photograph gravestones, what better place for a first date with Charles than the local cemetery? But in the middle of a kiss, he clenches down a bit too hard, and the perfect teen-age romance turns into horror.

The movie is filled with felines. It seems that the only things that Sleepwalkers fear are cats, which would like to tear them to pieces. That's why the Brady front yard teems with them. They are waiting for a denouement that, when it arrives, is anticlimactic.

"Sleepwalkers" is rated R (Under 17 requires accompanying parent or adult guardian). It includes scenes of nudity, sex and violence.

1992 Ap 11, 18:1

City of Joy

Directed by Roland Joffé; screenplay by Mark Medoff, based on the book by Dominique Lapierre; director of photography, Peter Biziou; edited by Gerry Hambling; music by Ennio Morricone; production designer Roy Walker; produced by Jake Eberts and Mr. Joffé; released by Tri-Star Pictures. Running time: 134 minutes. This film is rated PG-13.

Max Lowe	Patrick Swayze
Hasari Pal	Om Púri
Joan Bethel	Pauline Collins
Kamla Pal	Shabana Azmi
Amrita Pal	Ayesha Dharker
Shambu Pal	Santu Chowdhury
Manooj Pal	Imran Badsah Khan
Ashoka	Art Malik
Anouar	Nabil Shaban
Ram Chander	Debtosh Ghosh

By VINCENT CANBY

After a night of boozing and wenching in the fleshpots of old Calcutta, Max Lowe (Patrick Swayze), a once-promising young Houston heart surgeon, is viciously beaten and robbed by a gang of street thugs. Max couldn't care less. Life has lost all meaning for him.

The next morning he regains consciousness in an especially poor Calcutta quarter known as the City of Joy. He's in a primitive clinic run by Joan Bethel (Pauline Collins), a feisty, youngish, Irish-born variation on the Albanian-born Mother Teresa. When Joan tells Max the name of the place, he asks, "Is that geographical or spiritual?" Says Joan, "It depends on your point of view."

At long last, "City of Joy," Roland Joffé's self-important new film, is about to get down to its serious business, which means to be uplift but is often heartburn.

There has already been a dreamy, slow-motion pre-credit sequence set in a Houston hospital's operating room. When Max's patient, a little girl, dies during a transplant operation, the distraught surgeon floats blindly from the hospital, apparently to book the first flight to India. At some point in his life he seems to have read a paperback edition of "The Razor's Edge."

•

There has also been a sequence in which an Indian farmer, Hasari Pal (Om Puri), his wife and children leave their poverty-stricken village and head for Calcutta to find work. "Remember," says Hasari's father, "A man's journey to the end of his obligations is a very long road."

In the strange ways of fate in fiction like "City of Joy," it is Hasari who finds Max on the street and takes him to Joan's clinic, initiating a friendship between a man who has nothing but love and faith and a man who has everything except a reason to live. Standing by is the wise-cracking, saintly Joan, who sometimes talks like a self-help manual — "There are three choices in life: to run, to speculate, to commit."

"City of Joy" probably means well, but it exemplifies the worst kind of simple-minded Occidental literature, in which India exists to be a vast, teeming rehab center where emotionally troubled Americans can find themselves. Or, at least, those Americans who have the time and the money to fly off to India instead of taking a bus to a local clinic.

Mr. Joffé made his directorial debut in 1984 with "The Killing Fields," which, though large in physical scale, was also coherent. Since then it's been downhill all the way with movies of big themes and moral muddle: "The Mission," "Fat Man and Little Boy" and now "City of Joy."

•

Adapted by Mark Medoff from Dominique Lapierre's novel, "City of Joy" is phony from start to finish, though in fact it was shot mostly in Calcutta and employs a lot of Indian actors and extras. The setting is not the problem. It's the point of view, which is that of a concerned but hopelessly inept, sunny-natured tourist.

With his passport and money gone, and with nothing better to do for the time being, Max grudgingly begins to work with Joan at her City of Joy Self-Help Dispensary. He delivers the healthy baby of a grateful leper mother. He sets about to put the dispensary in order and, when he sees the people in the City of Joy being exploited by the local "godfather," he organizes their resistance.

His inspiration is Hasari, a man of incredible spirit who works, sunup to sundown, as a rickshaw man. It's not easy for Max to adjust. He misses his hamburgers. He's also impatient with the passivity of the people, who lack that good old-fashioned American get-up-and-go. Yet little by little, Max re-establishes his commitment to life, even as he witnesses terrible injustices and cruelties.

There is an attack on the local lepers orchestrated by the greedy godfather. The face of a pretty young woman is slashed with a razor (on-screen). A great monsoon flood threatens to destroy the City of Joy and everyone in it: A decent man who appears to be in the terminal stages of tuberculosis receives severe stab wounds in the stomach and is on the point of death.

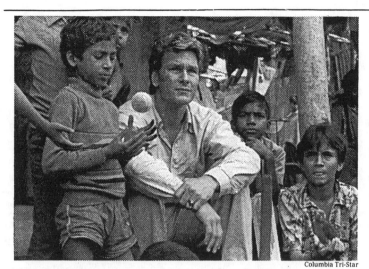

Columbia Tri-Star

Patrick Swayze in Calcutta in a scene from "City of Joy."

This would be a vision of hell in any other movie, though not in "City of Joy."

The godfather is told to cease and desist by the courts. The slashed young woman heals without scars. Nobody is lost to the flood and, when last seen, the tubercular man with the blood running out of his stomach is still walking upright.

In Mr. Joffé's view of things, Calcutta is truly a magical place: it's a city without consequences.

Some people may find this inspiriting, but to anyone who has seen Mira Nair's "Salaam Bombay!" (among other, far more honest films about India) it's more like a visit to a severely depressed Disneyland.

"City of Joy" is lightweight. Mr. Swayze has more screen heft in the title role of "Ghost" than he does here. The character, as written, is impossible. Miss Collins is similarly disadvantaged. There are times when it seems as if there's going to be a romance between Joan and Max, but, though that never happens, "City of Joy" doesn't seem more honest, only more faint of heart. It lacks the courage of its confused convictions.

•

"City of Joy," which has been rated PG-13 (Parents strongly cautioned)includes some violence and vulgar language.

1992 Ap 15, C15:1

Liquid Dreams

Directed by Mark Manos; written by Zack Davis and Mr. Manos; director of photography, Sven Kirsten; edited by Karen Joseph; music by Ed Tomney; production designer, Pam Moffat; produced by Zane W. Levitt and Diane Firestone; released by Northern Arts Entertainment. At the Eighth Street Playhouse, at Avenue of the Americas. Running time: 92 minutes. This film has no rating.

Eve Black	Candice Daly
Rodino	Richard Steinmetz
Juno	Juan Fernandez
The Major	Barry Dennen

WITH: Rohanne Descy, Rowena Guinness, Zane W. Levitt, Frankie Thorn, Tina, Denise Truscello and Tracey Walter.

The Bruce Diet

Written and directed by Jeff Baron; director of photography, John Thomas; edited by Jonathan Oppenheim; music by Franni Burke; production designer, Erik Ulfers; produced by Debra Kent and Linda Habib. At the Eighth Street Playhouse, at Avenue of the Americas. Running time: 25 minutes. This film has no rating.

Sheila	Diana Canova
Bruce	John Christopher Jones
Dr. Henderson	Sam Coppola
Jeffrey	Matthew Ryan
Receptionist	Sue Henry
First Dieter	Charlotte Leslie
Second Dieter	Carolyn Blair

By STEPHEN HOLDEN

No sooner has Eve Black (Candice Daly) arrived from Kansas to visit her sister Tina in an eerie unnamed city than she receives a brutal shock. Seconds after entering her sister's apartment in a sinister factory-like building that suggests a futuristic brothel, she discovers Tina's dead body in a bathtub.

While a sympathetic vice detective (Richard Steinmetz) looks into the case, Eve decides to remain in the creepy building, whose rooms are equipped with an elaborate video system that shows continuous soft-core pornography. As she soon learns, the videos are filmed on the premises and feature the female residents, including her dead sister. Masterminding the system, known as Neurovid, is a grim-faced former brain surgeon known only as the Major (Barry Dennen).

To pay for her room, Eve agrees to work as a taxi dancer in a club run by the Major. The job is the bottom rung of a hierarchy whose "stars" perform in the videos with a select few invited to participate in a mysterious erotic ceremony known as the Ritual. Eve quickly demonstrates her star potential.

•

With its mixture of sex, science fiction and video, "Liquid Dreams," which opens today at the Eighth Street Playhouse, lurches wildly between surreal satire and soft-core titillation without ever finding its balance. Metaphorically, the film, which was directed by Mark Manos — who wrote the screenplay with Zack Davis — suggests that the world is a whorehouse run by a mad scientist. It is hardly a fresh concept.

Although the film builds a fine menacing atmosphere, it becomes mired in poorly worked-out plot details involving the detective, and its climactic scenes collapse under ludicrous, ham-fisted dialogue. Ms. Daly, a honey-blond actress who resembles the youthful Gena Rowlands, has exactly the right look for a Neurovid ingénue but brings little passion to the role. The strongest performance belongs to Juan Fernandez, who plays the

Major's fiendish assistant, Juno, who brutalizes the women he is charged to protect.

"The Bruce Diet," the short comic horror film that opens the program, shares the jaundiced sensibility of "Liquid Dreams" and offers a few nasty laughs. Diana Canova portrays Sheila, an inveterate dieter who is unable to shed weight until a doctor introduces her to a talking guinea pig named Bruce who eats cellulite. With Bruce nibbling away at her, Sheila grows progressively more svelte while consuming as much as nine gallons of ice cream at a clip. There is a price to be paid, of course. Bruce grows into an insatiable beast who pleads day and night for Sheila to consume just one more bag of Pepperidge Farm cookies.

1992 Ap 15, C19:1

Deep Cover

Directed by Bill Duke; written by Michael Tolkin and Henry Bean; director of photography, Bojan Bazelli; edited by John Carter; produced by Pierre David and Mr. Bean; released by New Line Cinema. Running time 112 minutes. This film is rated R.

John Q. Hull	Larry Fishburne
David Jason	Jeff Goldblum
Betty McCutcheon	Victoria Dillard
Carver	Charles Martin Smith
Taft	Clarence Williams 3d
Barbosa	Gregory Sierra
Eddie	Roger Guenveur Smith
Russell Stevens Jr.	Cory Curtis
Russell Stevens Sr.	Glynn Turman

By JANET MASLIN

"I want my cake and eat it too," says one of the characters in "Deep Cover," the story of a policeman assigned to masquerade as a cocaine dealer. The film itself seemingly embraces that same thought. On the one hand an upright police thriller, "Deep Cover" is also a rapt exploration of all the vice and viciousness that make the drug kingpin's life so popular with contemporary film makers. The film's cautionary message, which is stated outright, is undercut by its fascination with seamy glamour.

At the résumé level, there are several things that raise "Deep Cover" above the ordinary. The screenplay is by Michael Tolkin and Henry Bean, who respectively wrote "The Player" and "Internal Affairs" and whose views on the subject of corruption are subversively entertaining. The director is Bill Duke, whose "Rage in Harlem" was a spirited period piece. Its stars are the quietly commanding Larry Fishburne and the wry Jeff Goldblum, who make an interestingly offbeat team. And its racial stereotypes have been reversed, since it is Mr. Goldblum, who is white, who plays the drug dealer and Mr. Fishburne who plays the cop.

Mr. Fishburne, who made such a formidable impression playing the father in "Boyz N the Hood," has what is clearly the film's central role. Indeed, "Deep Cover" is seen so purely from this black policeman's viewpoint that the story's white characters take on a cartoonish exaggeration, just as black figures in white-dominated movies sometimes do. The film's brief glimpse of a white lawyer, his pretty blond wife and their studious little daughter in an all-white suburban kitchen offers a lacerating perspective on the yuppie dream. Its white and Hispanic drug traders are drawn in similarly broad ways.

•

In contrast with this is the film's early look at little Russell Stevens Jr.

and his father (Glynn Turman) in 1972. "What you want for Christmas, boy?" asks the father, who has just snorted some white powder in front of his terrified young son and who at this point has begun waving a gun. Moments later, watching his father shot to death in a bungled liquor-store holdup, the boy finds his character being forged. Twenty years later he is a stern, solemn policeman (Mr. Fishburne). His private motto regarding drugs and alcohol is "Never have, never will."

Playing instantly on racial tensions in his film's first scene (just as he did in "A Rage in Harlem"), Mr. Duke shows Russell being recruited by an insulting white Drug Enforcement Agency operative (Charles Martin Smith) who wants him to infiltrate a vast drug cartel. "Undercover, all your faults will become virtues," the D.E.A. man says insinuatingly, referring to the fact that Russell's psychological profile is not dissimilar to a criminal's. Thus persuaded, Russell adopts the pseudonym John Q. Hull and takes up residence in a seedy Los Angeles rooming house, where the woman across the hall is soon offering to sell him her young son. Evidence of the drug culture and its ill effects is not hard to find.

If the film does a powerful job of depicting that drug culture and of demonstrating how high-level dealers keep their business associates in line, it is less successful in separating the many strands of a deeply cynical and convoluted plot. The story often loses sight of Russell/John and his gradual inner transformation. (Before the story of his drug escapade is over, he will be participating in the killing of underworld rivals, not to mention sampling the merchandise.)

•

Instead, the film pays attention to ugly encounters into which the undercover cop is reluctantly drawn, from the fatal poolroom beating of a suspected police informer to the shooting of an especially ruthless dealer. Eventually, the hero's participation in these events brings him a fancy car, new clothes and a new home, all on Government orders. "I liked being a big shot," Mr. Fishburne says hauntingly in voice-over. "Wouldn't you?"

Although "Deep Cover" stumbles over too many minor characters, it sustains interest through the contrast and camaraderie between Mr. Goldblum's lawyer, who has a get-rich-quick scheme involving detailed marketing prospectuses for drug sales, and Mr. Fishburne's once-honest cop. Also on hand are Victoria Dillard as a money-laundering art dealer with a cool, seductive manner, and Gregory Sierra and Roger Guenveur Smith as two of the story's many drug entrepreneurs. Clarence Williams 3d's earnest narcotics officer figures prominently in the film's ending but only adds to the overall confusion.

"Deep Cover" eventually degenerates into so much gratuitous violence that "kill" sounds like the most-used verb in the screenplay's last stages. The screenplay's frequent emphasis on homophobic insults is another unfortunate touch.

•

"Deep Cover" is rated R (Under 17 requires accompanying parent or adult guardian). It includes violence, profanity and sexual situations.

1992 Ap 15, C19:4

The Babe

Directed by Arthur Hiller; written and produced by John Fusco; director of photography, Haskell Wexler; edited by Robert C. Jones; music by Elmer Bernstein; production designer; James D. Vance; released by Universal Pictures. Running time: 115 minutes. This film is rated PG.

Babe Ruth	John Goodman
Claire Ruth	Kelly McGillis
Helen Ruth	Trini Alvarado
Jumpin' Joe Dugan	Bruce Boxleitner
Frazee	Peter Donat
Brother Mathis	James Cromwell
Jack Dunn	J. C. Quinn
Huggins	Joe Ragno
Guy Bush	Richard Tyson
Ping	Ralph Marrero
George Ruth Sr.	Bob Swan
Colonel Ruppert	Bernard Kates
Lou Gehrig	Michael McGrady
Brother Paul	Gene Ross
Carrigan	Danny Goldring

By JANET MASLIN

"You know, you can't put everything in a story, so I left out a few things," Babe Ruth reportedly said about his 1948 autobiography. "Maybe there should have been two books, one for kids and one for adults."

The new film about Ruth, "The Babe," has no room for separate versions. But it recounts a childlike success story at a time when adult-minded disclosures are sometimes thought to represent a deeper truth. So this film does its best to bolster the mythic Ruth naïveté, even going so far as to dress John Goodman as an oversize child for the title role and show him marveling at modern inventions (circa 1920) like the elevator. At the same time, the film also acknowledges the kinds of recreational habits that would easily have kept Babe Ruth out of public office had he lived today.

"The Babe," as genial and lumbering as the man whose story it tells, needs all the faux innocence it can muster to reconcile the extremes of Babe Ruth's career. Great effort on the part of the director Arthur Hiller and the screenwriter John Fusco has been expended to establish boyish guilelessness in the man once famed for being higher paid than the President of the United States, before that was commonplace. It took even greater effort to link that naïveté with celebrity, prehistoric baseball groupies and the Babe's habit of showing up on the playing field still soused after all-night benders.

"Ah, banana oil!" the viewer may snort at some of this (since the film relies heavily on such period locutions). But the hokum, though heavily predictable, manages to be appealing all the same. Even when riddled with the obligatory pinpricks of contemporary biography, Babe Ruth is one American hero who remains larger than life.

•

Savoring every aspect of this much-told story, the film first finds little George Herman Ruth at St. Mary's Industrial School for Boys, outside Baltimore, as it depicts events ranging from 1902 (Babe's first brush with baseball) to 1935 (his heartbreaking farewell to the game). Fans may find the film taking minor liberties along the way, but it remains true to the Horatio Alger aspects of Ruth's rise, and to his legendary generosity in public arenas, if not in private ones

First teased for his bulk (his classmates compare him to an ox and Mount Vesuvius), Ruth is quickly

Universal City Studios

Swing Time John Goodman plays Babe Ruth in "The Babe," which follows the slugger's life from his days in a boys' home through his glory years as a Yankee to the end of his career as a member of the Boston Braves.

seen silencing his critics. John Goodman, looking wildly out of place as a schoolboy newly released from St. Mary's, does his best to capture the gee-whiz boyishness of this sheltered young baseball prodigy, while the film chronicles his legendary idiosyncrasies. Dutifully noted are the huge meals, prodigious drinking and forgetfulness about names (the movie's Babe even refers to a chicken as a duck).

Occasionally, the film's way of romanticizing these matters gets out of hand, as in its depiction of how the shy Babe courted the even shyer Helen Woodford (Trini Alvarado), who became his first wife. After Helen, who was a coffee-shop waitress when Babe met her, accepts his invitation to go boating, the two quite literally go overboard; the film does, too. When the cinematic Babe proposes marriage, he does it by surprising Helen with a farm he has already bought her, which is a big departure from Ruth's own version of this story. "She used to wait on me in the mornings, and one day I said 'How about you and me gettin' married, hon?'" he wrote in his autobiography (co-written by Bob Considine). "Helen thought it over for a few minutes and said yes."

Mixing baseball scenes with glimpses of Babe's taste for night life, the film chiefly concentrates on his stellar rise and amazing baseball feats. It runs into trouble when trying to account for his decline, which is presented abruptly and with confusing lapses. The fans go from loving Ruth to throwing things at him very quickly, and not much explanation is provided for that change. The presence of Kelly McGillis, the good-time blonde to Ms. Alvarado's bashful brunette, is similarly ill-established until

Ms. McGillis's Claire Hodgeson goes on to become the slugger's second wife.

•

Mr. Goodman does his best lovable-slob turn and persuasively brings Babe Ruth to life, even lowering his voice to capture Ruth's husky tones. (A painful episode in which Ruth was treated for throat trouble with silver nitrate, which altered his voice and may have contributed to his developing throat cancer many years later, has been omitted from this doggedly sunny story.) Mr. Goodman is convincing as both the incorrigible carouser and the abandoned boy who later showed great kindness to children. And even in the film's clumsy domestic scenes he shows some spark. The film's idea of depicting Babe's restlessness in his first marriage is to show him prowling the house holding a baseball bat, telling his wife: "I got a craving, kid. Can ya understand that?"

"The Babe," set mostly in the 1920's, has an elaborate period look, but it is held together almost entirely by Mr. Goodman's performance and Ruth's penchant for miracles. When his teammate Jumpin' Joe Dugan (Bruce Boxleitner) advises Ruth to "hit 'em where they ain't," Ruth replies with classic simplicity: "Well, they ain't over the fences, so that's where I hit 'em." Warts and all, "The Babe" is aimed at anyone ready to believe in that kind of magic.

•

"The Babe" is rated PG (Parental guidance suggested). It includes profanity and sexual situations.

1992 Ap 17, C8:1

Critic's Choice

A Beauty, A Beast And a Dog That Isn't

Once there was a Beauty who arrived at a Beast's enchanted castle, only to find . . . that Jean Cocteau had got there first. Although Cocteau's 1946 version of the fairy tale begins with an appeal to "childhood simplicity," it is one of the most sophisticated and visually elegant films of all time. The mournful undertone of this tale takes it far beyond the grasp of children.

Today, Film Forum 2 (209 West Houston Street, Manhattan) begins a weeklong run of "Beauty and the Beast" and "Un Chien Andalou" (1929), Luis Buñuel and Salvador Dali's 17-minute Surreal romp. Both will be shown in gloriously fresh prints that sweep away the dust of nostalgia.

As Cocteau's Beast, Jean Marais has fangs and a wonderfully expressive fur-covered face. He pleads — in

French, of course — "Forgive me for being a beast." What could be more grown-up?

As Belle, Josette Day looks too much a pouty 1940's star, but she doesn't diminish the film's esthetic grace. She does, after all, shed a tear that turns into a diamond. The tableaux at Belle's farmhouse evoke Vermeer. At the Beast's castle, living arms reach out from the walls, holding candelabra that cast rich shadows. "Beauty and the Beast" is a haunting, original treasure.

"Un Chien Andalou" is a treasure of a weirdly different sort. This is the avant-garde masterpiece with the razor across an eyeball and dead donkeys sprawled across pianos. But Film Forum's version features music added in 1960 under Buñuel's direction. Dominated by a jaunty tango, the music makes the film's wackiness unmistakable. Its iconoclastic creators might be pleased to know that this much-studied classic is a hoot.

CARYN JAMES

1992 Ap 17, C8:6

Window Shopping

Directed by Chantal Akerman; screenplay by Ms. Akerman, Jean Gruault, Leora Barish, Henry Bean and Pascal Bonitzer (in French with English subtitles); directors of photography, Gilberto Azevedo and Luc Benhamou; edited by Francine Sandberg; music by Marc Herouet; production designer, Serge Marzolff; produced by Martine Marignac; released by World Artists. At Le Cinématographe, 15 Vandam Street, Manhattan. Running time: 96 minutes. This film has no rating.

Sylvie	Miriam Boyer
Eli	John Berry
Jeanne	Delphine Seyrig
Robert	Nicolas Tronc
Mado	Lio
Pascale	Pascale Salkin
Lili	Fanny Cottençon
Monsieur Schwartz	Charles Denner
Monsieur Jean	Jean-François Balmer

By VINCENT CANBY

In "Window Shopping," Chantal Akerman's Belgian-French co-production opening today at Le Cinématographe in Manhattan, the world is a place where the sun doesn't shine though it's always fair weather. The locale is a piece of late 20th-century environmental art, an underground shopping mall in which the air is conditioned, the temperature controlled by thermostat, and the lighting fluorescent with zingy neon accents.

Anyone familiar with the Belgian-born director's earlier films, including the chilly, severe "Jeanne Dielman" (1975) and "All Night Long" (1982), might expect "Window Shopping" to be some kind of indictment of consumer society. It may be, in its own devious way, but "Window Shopping" is more interested in the tiny problems that loom so large in the lives of the people within that society.

As if that weren't already uncharacteristic of the Akerman mode, "Window Shopping" is also a musical that recalls Jacques Demy's considerably more grandiose "Umbrellas of Cherbourg" and "Young Girls of Rochefort." Although the characters do not sing their dialogue, as in the Demy films, they don't hesitate to express themselves in song when the mood hits them.

The result is an unpretentious, absolutely charming romantic comedy-with-music, the small scale of which perfectly suits the passions of its characters.

Among these are Jeanne (Delphine Seyrig) who, with her husband, Monsieur Schwartz (Charles Denner), and son, Robert (Nicolas Trunc), runs a men's boutique; Lili (Fanny Cottençon), a femme fatale and the proprietor of a beauty salon, and Mado (Lio), a lovely innocent who works in the beauty salon and yearns for Robert, who yearns for the older, more worldly Lili.

John Berry, the American director ("He Ran All the Way," "Claudine"), who is a longtime resident of France, plays Eli, an American businessman who becomes the story's catalyst. One day, Eli wanders into the mall looking for a shave and finds Jeanne, the woman he loved 30 years before when he was a soldier stationed in France.

"Window Shopping" was made in 1986 and looks it. Beginning with the opening credits, presented against a montage of the well-shod feet of women on purposefully crisscrossing the mall's marble floor, the film is as determinedly stylish as all those magazines that came out in the mid-80's designed for up-market readers.

Seen today, in the midst of a recession, "Window Shopping" appears to be both an artifact of a bygone era and possibly something of an omen. That may not have been Miss Akerman's intention. Yet, like any work of substance, "Window Shopping" seems somehow prescient. It is so naturally accurate that the slow bust that followed the 80's boom now seems to be its subtext.

This is not to overload the movie with solemn import, only to suggest that, although the movie is a fairy tale, it is not necessarily out of touch.

•

The two parallel love triangles, involving Lili, Robert and Mado and Jeanne, Eli and Monsieur Schwartz, are worked out in a lightly satiric fashion that is enriched by Marc Herouet's romantic and comic score and Miss Akerman's lyrics, which are translated with a good deal of unexpected wit by English subtitles.

How great it is to see Seyrig looking so beautiful, so intelligent and so amused, although "Window Shopping" was one of the last films she made before her death last year. This great actress, whose first two films were Robert Frank's "Pull My Daisy" and Alain Resnais's "Last Year in Marienbad," was as much at ease in avant-garde films, including those of Miss Akerman and Marguerite Duras, as she was in François Truffaut's and Luis Buñuel's.

•

Another standout in "Window Shopping" is Miss Cottençon who, although she has made a number of films in France, will probably be new to American audiences. She's a pretty, slightly brassy comic presence as the scheming beautician who loses her heart to a man all wrong for her, at least financially.

At the end of the film, Seyrig's Jeanne comes up out of the mall into the light of the real day. The sun appears incredibly bright and warm. Until that moment, the real world has been forgotten, which is possibly just what Miss Akerman intended. "Window Shopping" is both sweet and a little spooky.

1992 Ap 17, C13:1

The Branches of the Tree

Written and directed by Satyajit Ray (in English and Bengali with English subtitles); director of photography, Barun Raha; edited by Dulal Dutt. At the Walter Reade Theater, 165 West 65th Street, Manhattan. Running time: 117 minutes. This film has no rating.

WITH: Ajit Banerjee, Maradan Banerjee, Lily Charraborty, Soumitra Chatterjee, Deepankar De, Mamata Shankar and Ranjit Mallik.

By VINCENT CANBY

Satyajit Ray's "Branches of the Tree" has the gravity if not the dramatic complexity of a play by Ibsen staged with a mortifying emphasis on the text. Sparely and rigorously directed by Mr. Ray, who also wrote the screenplay, the film is a lament for the loss of ethics in an Indian society where money increasingly dominates behavior. It opens today at the Walter Reade Theater.

The film takes place almost entirely in the house of Ananda Majunda, a self-made Bengali businessman who is respected as much for his high moral principles and many charities as for the fortune he has amassed. After Ananda suffers a heart attack on his 70th birthday, his family gathers to stand vigil.

Like Mr. Ray's screen adaptation of Ibsen's "Enemy of the People,"

which was shown at the Cannes festival in 1989, "The Branches of the Tree" might be as effective a radio play as it is a film. Nothing gets in the way of the talk, recorded as Ananda's four sons and two daughters-in-law come together in various combinations in the living room, dining room, bedrooms and, from time to time, around the dying Ananda himself.

The opportunistic eldest son is revealed to have cheated on his taxes. Disillusioned by such practices, the still idealistic youngest son has chucked the world of business to become an actor. Wandering through the film, a sort of idiot savant, is Ananda's second son, mentally impaired ever since an auto accident.

"The Branches of the Tree" is totally lacking in irony. The characters mean what they say, especially when they lie to one another. If Mr. Ray has any interest in the social forces that have shaped their manners, he makes nothing of it. Yet the members of Ananda's family, as well as the dying man, appear to be vestiges of a colonial rule so dominant that it has left them without identities.

Perhaps that is the point of the film. It's difficult to be sure. "The Branches of the Tree" is so stiff and humorless that to speculate seems almost rude.

1992 Ap 17, C15:3

uproar, and parents can count on a painless good time.

Compared with the derivative and politically correct "Ferngully: The Last Rain Forest," the saccharine "Rock-a-Doodle" and the bewilderingly misguided "Newsies," "Beethoven" is a charming anomaly. As they used to say back when Flubber was king, this one is fun for the whole family.
JANET MASLIN

1992 Ap 17. C24:5

Brain Donors

Directed by Dennis Dugan; screenplay by Pat Proft; director of photography, David M. Walsh; edited by Malcolm Campbell; music by Ira Newborn; production designer, William J. Cassidy; produced by Gil Netter and James D. Brubaker; released by Paramount Pictures. Running time: 91 minutes. This film is rated PG.

Roland Flakfizer	John Turturro
Jacques	Bob Nelson
Rocco Melonchek	Mel Smith
Lillian Oglethorpe	Nancy Marchand
Lazlo	John Savident
The Great Volare	George De La Pena
Lisa	Juli Donald
Alan	Spike Alexander

By JANET MASLIN

"Brain Donors" is a short, reasonably snappy attempt at nothing less than a present-day Marx Brothers comedy, with a cigar-waving John Turturro mugging furiously in the main role. Mr. Turturro can't beat Groucho, but he can toss off criminally bad jokes and shameless double-entendres with charming abandon. As written by Pat Proft and directed by Dennis Dugan, "Brain Donors" will stop at very little to get its laughs, and Mr. Turturro has just the right silliness for the occasion.

In this attempt to do for ballet what the real Marx Brothers did for opera, Mr. Turturro appears as Roland Flakfizer, an ambulance-chasing lawyer who's angling to control the prestigious Oglethorpe Ballet Company by sweet-talking Lillian Oglethorpe, a patron of the arts. (Nancy Marchand appropriately plays this as the Margaret Dumont role.) Flakfizer is aided in his efforts by two other stooges, Jacques (Bob Nelson) and Rocco (Mel Smith), who appear to have watched just as many vintage smart-talking slapstick comedies as he has. Together, this trio can turn the words Gorbachev, gesundheit and Baryshnikov into what sounds like an extended group sneeze.

•

"If there's anything I can ever do for you, forget it, because I don't do those kinds of things," says Roland, offering a good sample of this film's brand of humor. The gags are low and sometimes sophomoric, but they're seldom without at least some small spark of wit. Among the film's better

Doggie Antics on Film

With school vacations under way and a flood of new kiddie-minded films on the market, the question of which children's films are worth seeing takes on particular urgency. The winner this season is "Beethoven," a shaggy-dog story about a lovable St. Bernard, and a sunny, enjoyable throwback to family films of the past.

Lacking only the Flubber of vintage Disney comedies, "Beethoven" features a cute pet, a

squeaky-clean family and quaintly harmless notions of villainy. A duplicitous vet (Dean Jones) is out to kidnap the huge, drooling Beethoven and use the dog in wicked experiments, so Beethoven's loyal owners eventually must rally to his rescue. The rest of the time, this comedy concentrates on messy doggie antics and the endless pratfalls of a dog-hating Dad (played amusingly by Charles Grodin, a master of the slow burn). Kids will enjoy all the

Bruce McBroom

"Beethoven" is an amusing movie for the whole family.

Jokes, cigars and a giddy nod to the Marx Brothers.

routines is one that finds the three principals impersonating doctors, crooning things like "You say ether

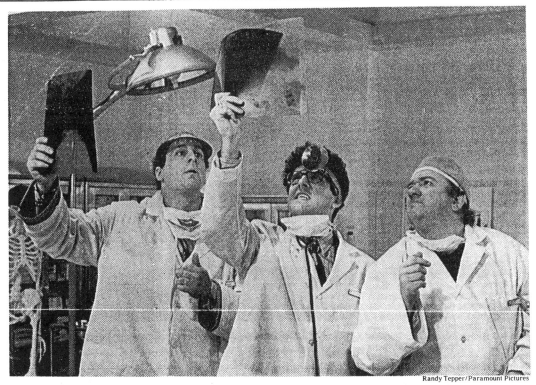

Randy Tepper/Paramount Pictures

Disguised as doctors in "Brain Donors" are, from left, Bob Nelson, John Turturro and Mel Smith.

and I say either" and wondering whether a patient's X-rays depict liver or veal.

"Brain Donors" culminates in a genuinely funny ballet sequence that finds the trio trying to disrupt a performance in progress, using the harp to slice poundcake and applying CPR to the ballerina playing the dying swan. By the time an actor in a duck suit appeared among the dancers, followed by duck hunters and a pack of hounds, the audience at Loew's 84th Street (one of the theaters where this film opened yesterday) had become giggly enough to share the film makers' idea of a mindless good time.

●

"Brain Donors" is rated PG (Parental guidance suggested). It includes many double-entendres and sexual references.

1992 Ap 18, 11:1

The Fourth Animation Celebration: The Movie

A series of animated short films; produced by Terry Thoren; released by Expanded Entertainment. At Cinema Village Third Avenue, at 13th Street, Manhattan. Running time: 90 minutes. These films have no rating.

By STEPHEN HOLDEN

Easily the most intriguing selection in "The Fourth Animation Celebration: The Movie" is "Canfilm," an 18-minute political allegory by the Bulgarian film maker Zlatin Radev. Set in a claustrophobic cardboard-box environment that suggests the miniature city of a child's nightmare, it portrays a totalitarian society whose clashing political forces are symbolized by different kinds of tin cans.

Ominous black garbage cans representing repressive police agents break down flimsy cardboard doors to arrest and escort cans of cherries

to prison. At a tumultuous tin-can rally, lids flap up and down in synchronized precision like hundreds of arms raised in a Nazi salute. In the most violent scene, cans of stewed tomatoes spurt into the forced-open mouths of the previously loyal cherry cans.

●

Filmed at expressionistic angles with a brooding musical soundtrack and chase scenes in which the camera races with the cans down cramped cardboard corridors, "Canfilm" is a tour-de-force of animated political cartooning. But because its mood is so dark, it doesn't really belong with the 16 other films packed into a program that leans heavily toward jokey comedy.

Most of the rest of the anthology, which opened yesterday at Cinema Village Third Avenue, conveys a prankish humor that in most cases is less interesting than the animated technology used to express it. Technologically, Paul DeNooijer's "Rrringg!," which is part of a three-film salute to Tex Avery, the animator who created Bugs Bunny, Daffy Duck and other legendary cartoon figures, may be the most impressive film. Combining live action, photography and drawing in wonderful ways, it portrays a young woman's desperate attempts to keep a persistent would-be visitor from entering her home.

The films have been edited together so that the transitions offer maximum stylistic contrast. This approach insures against visual monotony, but it also prevents any thematic coherence. That's why watching "The Fourth Animation Celebration: The Movie" is like sitting in a roomful of comics who are all trying to tell their favorite jokes at the same time. It is a chaos of colliding zingers that tend to cancel one another out.

1992 Ap 18, 14:3

Brenda Starr

Directed by Robert Ellis Miller; screenplay by Jenny Wolkind, Noreen Stone and James David Buchanan, based on the comic strip created by Dale Messick; director of photography, Freddie Francis; edited by Mark Melnick; music by Johnny Mandel; production designer, John J. Lloyd; produced by Myron A. Hyman; released by the Triumph Releasing Corporation. Running time: 96 minutes. This film is rated PG.

Brenda Starr	Brooke Shields
Basil St. John	Timothy Dalton
Mike Randall	Tony Peck
Libby (Lips) Lipscomb	Diana Scarwid
José	Nestor Serrano
Vladimir	Jeffrey Tambor
Luba	June Gable
Francis I. Livright	Charles Durning
Police Chief Maloney	Eddie Albert
Prof. Gerhardt Von Kreutzer	Henry Gibson
President Harry S. Truman	Ed Nelson

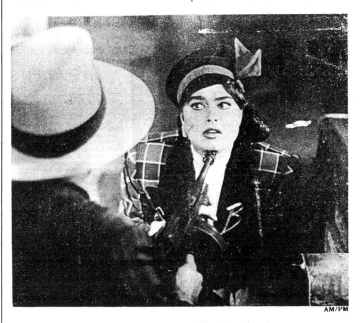

AM/PM

Brooke Shields in the title role of the film "Brenda Starr," an adaptation of the comic strip.

By JANET MASLIN

There were more than 13 stars in the flag when "Brenda Starr" was filmed (actually in 1986, but audiences may find that hard to believe). This would-be comic romp is badly dated in several conspicuous ways. Its cold war villains are embarrassingly outré (even allowing for the film's 1940's look, in keeping with the peak popularity of Brenda Starr as a comic strip heroine). And its narrow view of the comic strip's screen possibilities, in the wake of such visually

Was Brenda Starr of the comic strip jealous of the onscreen Batman?

ambitious projects as "Batman" and "Dick Tracy," is similarly outmoded.

●

Most dated of all is Brenda herself (Brooke Shields), the "girl reporter" who worries chiefly about not running her stockings or breaking her high heels and who in one scene actually uses a black patent leather handbag as a secret weapon. "I'm having a terrible time with some of these purses you're having me wear," she complains to Mike Randall (Tony Peck), the artist who draws her and who winds up as part of the film's fantasy action. "They're just too small!" (Dale Messick, who created Brenda Starr, is mentioned separately, but the use of the Mike Randall character is more confusing than helpful.)

Bob Mackie, who designed extravagantly madcap costumes for Ms. Shields and has her looking variously like Celebrity Barbie and Carmen Miranda, appears to have had more fun than anyone else connected with this production. Ms. Shields, who performs gamely and is not to blame for the film's listlessness, sensibly treats this more as a modeling assignment

than an acting job. Also on hand, though not able to rise above the film's dull and scenery-logged adventure plot, are Timothy Dalton as the terminally dashing Basil St. John and Diana Scarwid as Libby Lips, Brenda's archrival in the reporting game. Viewers who are not won over by Brenda's incessant costume changes will probably not warm to Libby, who in one scene bribes a man with her garter belt to scoop Brenda on an important story.

How important? Vintage comic strip aficionados will easily guess. The survival of the free world depends upon it.

•

"Brenda Starr" is rated PG (Parental guidance suggested). It includes mild expletives ("Shoot!" "Blast!") and even milder sexual situations.

1992 Ap 19, 46:1

The Playboys

Directed by Gillies Mackinnon; written by Shane Connaughton and Kerry Crabbe; director of photography, Jack Conroy; edited by Humphery Dixon; production designer, Andy Harris; produced by William P. Cartlidge and Simon Perry; released by the Samuel Goldwyn Company. Running time: 114 minutes. This film has no rating.

Hegarty	Albert Finney
Tom	Aidan Quinn
Tara	Robin Wright
Freddie	Milo O'Shea
Malone	Alan Devlin
Brigid	Niamh Cusack
Cassidy	Ian McElhinney
Rachel	Stella McCusker
Denzil	Niall Buggy
Vonnie	Anna Livia Ryan
Mick	Adrian Dunbar
Ryan (John Joe)	Lorcan Cranitch

By JANET MASLIN

"A woman, a baby and a mystery man for a father," as one villager puts it: those are the elements that drive a small Irish town to distraction. The year is 1957 and the woman, Tara Maguire (Robin Wright), is uncommonly strong and beautiful by the standard of that time or any other. At the start of "The Playboys," a lovely and enveloping new film about Tara and her neighbors, Tara gives birth to an illegitimate son. The townspeople's response is for the most part narrow-minded and petty, but "The Playboys" is anything but small.

Enchanting and lyrical, superbly picturésque, "The Playboys" (which opens today) is another reminder that Irish cinema is suddenly enjoying something of a golden age. The screenwriter Shane Connaughton, an Oscar nominee for "My Left Foot," comes from the tiny, quaint village where the film was made, Redhills in County Cavan, and has summoned up the villagers' lives with sly and affectionate attention to detail. From the too inquisitive priest to the watchful children, from Irish Republican Army smugglers to farmers desperately concerned about sick cattle, the residents and their troubles, loves and jealousies are duly noted. All these ingredients serve to bear out one character's haunting thought that "if the passion of the people could be bottled, we could all of us sail to the moon."

•

Drawing upon childhood memories, Mr. Connaughton (who wrote the screenplay with Kerry Crabbe) has

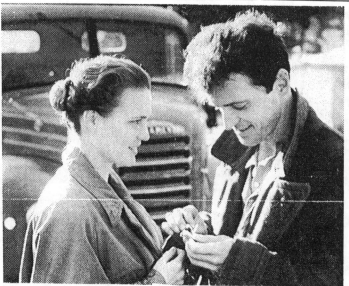

The Samuel Goldwyn Company
Robin Wright and Aidan Quinn in a scene from "The Playboys."

also introduced a colorful band of outsiders: the Playboys, a flea-bitten theatrical troupe visiting town for a single week and temporarily breathing new fun and promise into this remote place. Among the Playboys is Tom (Aidan Quinn), a dashing actor who immediately sets his sights on Tara and would have better luck with her were it not for Tara's fiercely independent streak. Another obstacle to romance exists in the form of Sgt. Brendan Hegarty (Albert Finney), the local constable, who devotes more than reasonable attention to Tara. The dangerous, glowering policeman clings desperately to his equilibrium, but in Tara's presence he becomes quite mad with love.

As directed by Gillies Mackinnon, "The Playboys" unfolds at a leisurely pace and weaves its magic out of gentle touches rather than grand passions. Much of the enjoyment comes from simply observing a fine cast in a beautiful setting. The film's principal surprise is Ms. Wright, previously most memorable (in "The Princess Bride" and "State of Grace") for her delicate looks but this time creating an impression of great sturdiness and backbone. Since much of the plot revolves around men vying for Tara's attention, the performance needs to justify their intense interest. Ms. Wright's does that easily.

•

Mr. Finney, looking puffy and ravaged in the role of a man who has lost much of himself to drink (and whose obsessive interest in Tara somehow offers him the chance of redemption), brings a furious, buried intensity to Hegarty's longing. The role is subtle and mysterious, and Mr. Finney plays it with uncommon grace. Mr. Quinn, in the more conventional role of a brash young charmer, is every bit as dashing as the material requires him to be, even when delivering such fanciful outbursts as "Ah, Freddie, we're only dreamin'!" Milo O'Shea, as Freddie, the theatrical impresario, very nearly steals the film in a smallish role.

As the principal Playboy, Mr. O'Shea's Freddie Fitzgerald is often seen in direct opposition to Father Malone (Alan Devlin), the priest encouraging Tara to confess and repent her sins. In Father Malone's eyes, the actors' spirited vaudeville is as much

an affront to decency as Tara is. The film, accepting these modest polarities among country folk circa 1957 (and acknowledging, with the arrival of rock-and-roll and television in town, that the world will soon change drastically), has great fun with the actors' relatively innocent sense of mischief.

Whether stealing chickens or stealing ideas, the Playboys remain cheerfully resourceful at all times. A viewing of "Gone With the Wind" in the town's movie theater abruptly sends Freddie into blackface and a dress (since he is too old to play Rhett Butler) for that evening's performance, in which the burning of Atlanta is staged as a sort of musical comedy number. Handsome Tom lands the starring role, even though he has a notoriously hard time remembering his lines. "To be quite honest, honey, I don't give a tuppenny damn," he says during the performance's climactic scene.

The rest of the time, "The Playboys" gets things right.

The relatively innocent mischief of country folk in 1957.

1992 Ap 22, C15:1

Cold Moon

Directed by Patrick Bouchitey; screenplay by Mr. Bouchitey and Jacky Berroyer, based on short stories by Charles Bukowski (in French with English subtitles); director of photography, Jean-Jacques Bouhon; edited by Florence Bon; music by Didier Lockwood; produced by Luc Besson and Andrée Martinez. At the Walter Reade Theater, 165 West 65th Street. Running time: 92 minutes. This film has no rating.

Simon	Jean-François Stevenin
Dédé	Patrick Bouchitey
Gérard	Jean-Pierre Bisson
Nadine	Laura Favali
Aunt Suzanne	Marie Mergey
The Whore	Sylvana de Faria
The Blonde	Consuelo de Haviland
Cacahuète	Karim Nouar

"Cold Moon"
Patrick Bouchitey in "Cold Moon."

Little Girl	Clémentine Nicolini
The Tramp	Dominique Colignon Maurin
Jean-Loup	Patrick Fierry
The Cop	Pierrick Charpentier

By VINCENT CANBY

Patrick Bouchitey's "Cold Moon" ("Lune Froide"), the French film opening today at the Walter Reade Theater, is less a drama about alienation than a small gray spectacle that pictures alienation in starkly poetic terms that become editorial comment.

Two 40-ish layabouts, Dédé (Mr. Bouchitey) and Simon (Jean-François Stevenin), spend their days wandering around the industrial debris of an unidentified port city. When first seen, they are idling away the time at an otherwise deserted beach. Simon, the short, stocky, more romantic one, lies on the sand, his shirt open, feeling the warmth of the sun. Dédé walks along the shore, singing a refrain about masturbation, followed by a mangy female dog.

They drink beer, watch television and occasionally pick up women, including a corpse that, as a prank, they steal from the morgue without knowing either the sex or the condition of the body. It is a measure of their disconnection from the world that Simon falls seriously in love with this chilly not-yet-stiff representation of what had once been a living woman.

"Cold Moon" was adapted by Jacky Berroyer and Mr. Bouchitey from two short stories, "The Copulating Mermaid of Venice" and "Trouble With the Battery," both by Charles Bukowski, the California poet laureate of the post-Beat Generation. It's a very different kind of film from "Barfly," which Barbet Schroeder made in California in 1987 from a screenplay by Mr. Bukowski.

Though grim and sometimes close to stomach turning, "Barfly" is essentially a comedy. There is a kind of upside-down nobility about its skidrow characters, especially the alcoholic-ex-boxer played by Mickey Rourke in the performance of his career. Mr. Schroeder accepts the Bukowski characters on their own terms, with something of their own self-deprecating humor.

•

Mr. Bouchitey's approach is more solemn and theoretical. "Cold Moon" is often difficult to watch, not because it is so rough, which it often is, but

because there is never any doubt about the film's intended existential significance. Dédé, Simon and the others are important only for what they represent. Mr. Bouchitey turns them into characters viewed from a sightseeing bus.

The movie's black-and-white photography also emphasizes this sense of distance. Squalid images have a beauty that's unrelated to their content.

Mr. Stevenin gives a good legitimate performance as the well-meaning but baffled Simon. He stays within the film's frame, which Mr. Bouchitey does not. His is a broad, busy performance. He laughs all the time, pops his eyes and is seldom quiet. If he isn't talking, he's humming.

Then, too, there are his teeth, all perfectly capped and gleaming. Dédé is aimless. He has to steal gasoline for his car and never has a pack of his own cigarettes. Yet, at some point in the recent past, he had the money and the resolve to spend a great deal of time with his dentist.

1992 Ap 22, C17:1

Tetsuo
The Iron Man

Written directed and edited by Shinya Tsukamoto, (in Japanese with English subtitles); director of photography, Mr. Tsukamoto and Kei Fujiwara; music by Chu Ishikawa; produced by Kaijyu Theater; released by Original Cinema. At Film Forum 1, 209 West Houston Street. Running time: 67 minutes. This film has no rating.

Salaryman	Tomoroh Taguchi
Girlfriend	Kei Fujiwara
Woman in Glasses	Nobu Kanaoko
Metals Fetishist	Shinya Tsukamoto
Doctor	Naomasa Musaka
Tramp	Renji Ishibashi

Drum Struck

Directed by Greg Nickson; written and produced by Mr. Nickson, Guy Nickson and Markus Greiner; edited by Greg Nickson and Mr. Greiner; music by Perma-Buzz; released by Original Cinema. At Film Forum 1, 209 West Houston Street. Running time: 25 minutes. This film has no rating.

With: Anthony Bevilacqua, Markus Greiner, Lia Nickson, Richard Nickson, Julie Jordan, Guy Nickson, Brigid Murphy, Bob McHale, Joel Nickson, Dean Qualandri, Paul Santori, Bucky Gonzalez, Michael Greenberg, Story Mann and Gizmo.

By STEPHEN HOLDEN

Early in Shinya Tsukamoto's film "Tetsuo: The Iron Man," a character identified only as a metals fetishist (Mr. Tsukamoto) scours a junkyard, slices open his thigh and sticks a piece of scrap metal into the wound. Gasping in ecstatic agony, he lurches into the street where he is nearly run over by a car driven by a white-collar worker called the Salaryman (Tomoroh Taguchi).

While shaving the next morning, the Salaryman notices a metal spike growing out one cheek. It is the first sign of his gradual transformation from 'a human being into a walking metal scrapheap of rusty metal plates, dangling cables and a rotating metal drill that extends from his groin.

The 67-minute black-and-white film, which opened today at Film Forum 1 in Manhattan on a double bill with Greg Nickson's shorter but equally eccentric film, "Drum Struck," suggests a David Cronenberg fantasy reimagined as the cinematic equivalent of grungy industrial

rock music. With its hyperkinetic pacing and wildly contorted acting, it also suggests a live-action imitation of the kind of Japanese science-fiction cartoon in which there's a visual explosion every 10 seconds.

•

"Iron Man" makes little sense as a story, but it is driven by a perverse sense of humor. As the Salaryman's transformation proceeds, it becomes increasingly hard for him to differentiate between his waking state and nightmares in which he is attacked by machinery. The more metallic he grows, the more his mind becomes a tape loop that keeps rewinding the same fragment of soft-core pornography being played on his television set. In the film's funniest sequence, he tries to protect his live-in girlfriend from his metallicized lust by barricading himself in the bathroom.

Eventually, the fetishist and the Salaryman face off against each other, in an abandoned factory in which the two merge into a two-headed metal creature determined to transform the rest of human race into a creaking, rusty metallic monsters.

•

Mr. Nickson's "Drum Struck" shares some of the metal rock attitudes of "Iron Man." The film depicts in slam-bang cartoon style the violent rivalry between two rock drummers in and around a warehouse inhabited by an eccentric group of musicians and pets. They include a woman who sings a blues song about "letting your linen hang low" and a dog with a taste for newly severed heads.

The appeal of both "Iron Man" and "Drum Struck" should be limited to aficionados of weird genre films.

1992 Ap 22, C17:1

A Midnight Clear

Written and directed by Keith Gordon, based on the novel by William Wharton; director of photography, Tom Richmond; edited by Donald Brochu; music by Mark Isham; production designer, David Nichols; produced by Dale Pollock and Bill Borden; released by Interstar. Running time: 107 minutes. This film is rated R.

Bud Miller	Peter Berg
Mel Avakian	Kevin Dillon
Stan Shutzer	Arye Gross
Will Knott	Ethan Hawke
Mother Wilkins	Gary Sinise
Father Mundy	Frank Whaley
Major Griffin	John C. McGinley
Lieutenant Ware	Larry Joshua
German Soldier	Curt Lowens
Janice	Rachel Griffin
Morrie	Tim Shoemaker

By VINCENT CANBY

THE place is the Ardennes Forest, somewhere near the French-German border in December 1944, when World War II is lurching toward its climax in Europe. This particular landscape is untouched. The fighting is still elsewhere.

The trees are heavy with snow, but even the whiteness looks dark. The light is feeble and withdrawn; there's no longer any intensity to it. Seen in the center of a broad clearing in the woods is an apparently abandoned country house, elegant but not quite a chateau. Nearby is the weathered stone figure of a martyred Christian saint, its severed head held to its chest like a chalice, evoking thoughts of sacrifice, salvation and life everlasting.

Interstar Releasing

Ethan Hawke

With these arresting images behind the opening credits, Keith Gordon, a young man who has made only one other film as a writer and a director, introduces "A Midnight Clear," his very fine screen adaptation of William Wharton's 1982 novel of war remembered as surreal muddle.

The film begins abruptly: Will Knott (Ethan Hawke), the baby-faced 19-year-old sergeant of a severely abbreviated intelligence squad, watches with horror as his pal, Mother Wilkins (Gary Sinise), goes suddenly mad. Mother climbs out of their fox hole, throws away his rifle and, taking off his clothes as he runs, heads into the forest.

There being no one to see Will leave his post, he runs after Mother, carefully retrieving the discarded government property as he goes, finally coming upon the naked soldier kneeling in a shallow stream, unsure what to do next. Will talks Mother out of the water, hands him his gear and offers to put him up for a Section 8 discharge. Mother is uncheered. He points out that it wouldn't work since only Will was witness to his crazy behavior.

They return to the squad and the war.

•

The members of Will's squad were picked for this special intelligence and reconnaissance assignment because of their high I.Q.'s. They may be bright, but that hasn't prevented the squad from losing half of its 12 original men.

In the course of the attrition, Will was made sergeant, perhaps because he was less rude to the officers than any of the squad's other survivors. It's not a responsibility he welcomes.

His men are a commonplace crew but not, as in so many American war movies, a comprehensive demographic cross section. Both Mother Wilkins, so nicknamed because he is compulsively fastidious, and Father Mundy (Frank Whaley), a seminary dropout, are in their mid-20's, older than the others and, in their own minds anyway, disconnected from the business of war. The remaining three soldiers, Bud Miller (Peter Berg), Mel Avakian (Kevin Dillon) and Stan Shutzer (Arye Gross), are in their late teens or early 20's. They're still in the process of defining themselves, but in a world without definitions.

As he is in the novel, Will is the voice of the film, which is told in the first person as he relives the events of

that year-end in the Ardennes. The squad is sent out to occupy the house seen in the film's opening sequence, to scout enemy movements in an area that remains no man's land. They are to stay one week and if possible take a prisoner.

•

Strange things happen even before they reach their destination. Coming around a bend in the road, they find the frozen bodies of two soldiers, one American, one German, propped up and leaning together as if struck dead in the ecstasy of dancing. The squad members are outraged by this grotesque joke. Later, as they are settling into the life at the house, they hear what sounds like laughter.

The next day on their perimeter Shutzer builds a snowman in Hitler's image and, using twigs, or, out an obscene message suggesting what should be done with the Führer. That night they hear German voices reading the message phonetically, followed by a phrase that Shutzer, who speaks Yiddish, deciphers as German for "sleep well."

In the course of a patrol, Will and two of his men discover the German outpost, an unguarded, unpainted wooden hut in a gulley. They watch with fascination as the soldiers, a small group of old men and boys, go about their tasks of chopping wood and policing their territory. The Americans withdraw without initiating action.

The following day three members of the American squad come up a hill to find themselves in the gun-sights of their German neighbors. The Americans raise their hands to surrender. The Germans walk away. Shutzer thinks that perhaps the Germans are trying to effect some kind of meeting. Mother, who spends most of the time alone in the attic, doesn't want to hear such nonsense. "I don't like this kind of war," he says. "I prefer to keep out of their way until we fight."

•

"A Midnight Clear" recalls the often told story about a Christmas Eve in the trenches during World War I. At midnight, so the story goes, Allied and German soldiers met in the middle of no man's land to sing carols and toast each other's health. "A Midnight Clear" expresses something of the same longing, but without the greeting-card sentiment.

The film is seriously angry. From time to time it comes close to losing its way, but even a possibly superfluous flashback to the squad's last night before shipping out is redeemed by the discipline of the film making.

Mr. Gordon is the actor ("Dressed to Kill," "Back to School," among others) who wrote and directed the independently made "Chocolate War" (1989). "A Midnight Clear" would seem to indicate that he has had far more experience. His adaptation of the Wharton novel is remarkably faithful without seeming literary. He doesn't go for easy wisecracks or for speeches that tell us what we're supposed to be seeing. He has distilled the novel effortlessly. As far as I can tell, he has made only one change, a character's name, which, in the book, is all too heavily ironic.

Equally impressive is the quality of the physical production, made on location last winter in and around Park City, Utah. As photographed by Tom Richmond, "A Midnight Clear" looks gorgeous without being pretty. It's anything but. The somber lighting suggests wet boots, cold feet, stale rations and a state of mind in which sleeplessness induces visions.

The dominant performances are those of Mr. Sinise (Tom Joad in the recent Broadway production of "The Grapes of Wrath"), Mr. Hawke (the neurotically shy student in "Dead Poets Society") and Mr. Gross, who plays the Jewish soldier, the only member of the squad who can communicate with the ragtag German outfit.

"A Midnight Clear" is so solidly constructed that it can even accommodate two characters who would wreck a lesser film: a broadly ridiculous and evil commanding officer (John C. McGinley) and the kind of sad young woman (Rachel Griffin), once beloved in soapy American literature, who "gives" herself to strangers, surrogates for the man she loved and lost.

In "A Midnight Clear," just about everything works.

•

"A Midnight Clear" is rated R (Under 17 requires accompanying parent or adult guardian). It has some scenes of piercing violence and carnage, as well as a lot of vulgar language.

1992 Ap 24, C1:3

Passed Away

Written and directed by Charlie Peters; director of photography, Arthur Albert; edited by Harry Keramidas; music by Richard Gibbs; production designer, Catherine Hardwicke; produced by Larry Brezner and Timothy Marx; released by Buena Vista Pictures Distribution. Running time: 96 minutes. This film is rated PG-13.

Johnny Scanlan	Bob Hoskins
Jack Scanlan	Jack Warden
Frank Scanlan	William Petersen
B. J.	Diana Bellamy
Froggie	Don Brockett
Aunt Maureen	Helen Lloyd Breed
Mrs. Finch	Patricia O'Connell
Mrs. Cassidy	Sally Gracie
Mrs. Richfield	Ruth Jaroslow
Aunt Sissy	Alice Eisner
Mary Scanlan	Maureen Stapleton
Terry Scanlan	Pamela Reed
Boyd Pinter	Tim Curry
Carmine Syracusa	Louis Mustillo
Louise	Ann Shea
Peter Syracusa	Peter Riegert
Sam Scanlan	Tristan Tait
Amy Scanlan	Blair Brown
Megan Scanlan	Sara Rule
Denise Scanlan	Deborah Rush
Cassie Slocombe	Nancy Travis
Nora Scanlan	Frances McDormand

By JANET MASLIN

"Passed Away," an affectionate comedy written and directed by Charlie Peters, uses a wake and a funeral as the occasion for highlighting the conflicts within a large Irish family. Though the large cast is impressive and the results are sometimes ruefully funny, audiences are less likely to appreciate Mr. Peters's artistry than his insistence upon whistling past the grave.

The dead patriarch is Jack Scanlan (Jack Warden), whose warm presence in the film's opening scenes makes his demise harder to take than it otherwise would be. It does not help that Mr. Peters, previously known as the screenwriter of films including "Paternity" and "Three Men and a Little Lady," kills Jack off with a heart attack at a surprise party in his honor. When the Scanlan children are told of their father's death, their grief is meant to seem real, and yet the film insists on a blithe, breezy tone throughout. That it works even a little

is remarkably lucky, under the circumstances.

The two things Mr. Peters has done best are to give the story's various quarrels a touch of real family friction and to cast the film with many actors who are savvy and substantial, never glib. Bob Hoskins, as Johnny Scanlan, is believably treated like an overgrown boy by his father, Jack, in the film's opening scenes, and is later coddled by his equally big-hearted mother, played by the supremely comforting Maureen Stapleton. "You're my oldest now, Johnny," she says tremulously, upon learning of her husband's death. With perfect deadpan timing, Mr. Hoskins's Johnny reminds her that that is nothing new.

•

Jack's quarrelsome siblings include his self-centered brother, Frank (William Petersen), whom their own mother describes as "thick as a brick" but good looking; his sister Terry (Pamela Reed), who is the family's rebellious New York sophisticate, and another sister, Nora (Frances McDormand), a fiery nun who works in Central America, describes herself as a liberation theologian and sneers at any signs of middle-class materialism, particularly where Terry is concerned. "Just think of it as accessorizing," she snaps, when Terry says she is going off to choose their father's headstone.

Also in the large cast are Peter Riegert, amiably funny as the mortuary cosmetologist who still carries a torch for Terry and who puts so much rouge on Jack that the dead man is unrecognizable; Tim Curry as the reluctant ex-husband dragged to the funeral by Terry (since she wants to hide the divorce from her family); an underused Blair Brown as Johnny's very patient wife, and Louis Mustillo as the funeral director who exhorts, "Well, let's get the great man a great casket!" There are a variety of good small performances like Mr. Mustillo's, and there are only a few misfires. Nancy Travis, as a mystery woman whose presence is meant to lend a bit of heat to the proceedings, is a glamorous but coy mistake.

Mr. Peters fares best when coaxing the film along gently without the contrived and ill-developed minor subplots that eventually arise. One character thinks of leaving his wife; another rekindles an old flame; the nun hides an illegal immigrant and brings investigators from the Immigration and Naturalization Service into the midst of the extended Scanlan wake. At moments like these, "Passed Away" would have benefited from a looser and less strenuous story line. Robert Altman's masterly chaos in the equally populous and family-minded "A Wedding" comes to mind.

"Passed Away" does occasionally have some loopy moments of its own. "If he shot the sheriff but didn't shoot the deputy," Ms. Stapleton muses, apropos of nothing, "who did?"

•

"Passed Away" is rated PG-13 (Parents strongly cautioned). It includes brief sexual situations, mild profanity and an episode depicting childbirth.

1992 Ap 24, C8:1

Little Noises

Directed by Jane Spencer; screenplay by Ms. Spencer and Jon Zeiderman, based on a story by Ms. Spencer and Anthony Brito; director of photography, Makoto Watanabe; edited by Ernie Fritz; music by Kurt Hoffman and Fritz Van Orden; production designer, Charles Lagola; produced by Michael Spielberg and Brad M. Gilbert; released by Monument Pictures. At the Cinema Village 12th Street, 22 East 12th Street, Manhattan. Running time: 80 minutes. This film has no rating.

Joey Kremple	Crispin Glover
Stella Winslow	Tatum O'Neal
Aunt Shirley	Carole Shelley

Only someone close to the production might know whether "Little Noises," the first feature directed by Jane Spencer, is inept, unrealized or some combination of both. Whatever the reason, the film is an astonishingly inert comedy about an untalented young New York writer and his pals. Its only distinguishing feature is that a mature Tatum O'Neal appears in it, just barely, along with Crispin Glover, whose dreadfully mannered performance may be an attempt to fill the void. The film opens today at the Cinema Village 12th Street.

VINCENT CANBY

1992 Ap 24, C8:6

White Sands

Directed by Roger Donaldson; written by Daniel Pyne; director of photography, Peter Menzies Jr.; edited by Nicholas Beauman; music by Patrick O'Hearn; production designer, John Graysmark; produced by William Sackheim and Scott Rudin; released by Warner Brothers. Running time: 102 minutes. This film is rated R.

Ray Dolezal	Willem Dafoe
Lane Bodine	Mary Elizabeth Mastrantonio
Gorman Lennox	Mickey Rourke
Greg Meeker	Sam Jackson
Bert Gibson	M. Emmet Walsh
Flynn	James Rebhorn
Noreen	Maura Tierney
Roz	Beth Grant
Ben	Alexander Nicksay
Delmar Blackwater	Fredrick Lopez
Ruiz	Miguel Sandoval
Demott	John Lafayette
Kleinman	Ken Thorley
Casanov	Jack Kehler

By VINCENT CANBY

Roger Donaldson's "White Sands" is set entirely in the vast painterly landscapes of the American Southwest, but it means to be a suspense thriller reflecting the scaled-down undercover realities of the post-cold-war era. In fact, it's almost as difficult to follow as the politics of the federation that replaced the Union of Soviet Socialist Republics, and as difficult to remember as that federation's official name.

The film, written by Daniel Pyne, begins well: the body of a well-dressed man, an apparent suicide, is found in the ruins of an Indian village in a remote corner of New Mexico. In the man's hand is a gun; beside him is a briefcase containing $500,000 in $100 bills. If the man is truly a suicide, why did he travel so far to do the deed? Why no suicide note? But if it was murder, why did the killer leave the money?

These are the questions the local sheriff, Ray Dolezal (Willem Dafoe), asks himself and, with the help of the garrulous old coroner (M. Emmet Walsh), starts to answer. Ray stands by as the coroner performs the autopsy. "He must have had his last lunch at a salad bar," the coroner says, just before retrieving a piece of partly

digested paper with a telephone number on it.

With this telephone number, Ray, whose job is otherwise pretty boring, sets out to solve the puzzle. To this end he adopts the identity of the dead man. In no time flat, he finds himself in partnership with Gorman Lennox (Mickey Rourke), an arms dealer with an unreliable temper, and being romanced by Lane Bodine (Mary Elizabeth Mastrantonio), a rich and beautiful young woman who raises money for what are vaguely identified as liberal Latin-American causes.

•

Lane doesn't squeal on Ray, though she's aware he's not the man he says he is. Ray also finds himself pursued by two different pairs of agents from the Federal Bureau of Investigation. The United States military is involved and, possibly, even the Central Intelligence Agency, if not in an official capacity. What begins as a puzzle and turns into a mystery finally sinks into utter confusion.

Yet it is always quite photogenic confusion, the penultimate sequence being played out in New Mexico's brilliantly white gypsum dune fields, which look like masses of refined cocaine. Cocaine is a substance that often crops up in such movies, though not (I think) in "White Sands." It's necessary to hedge that statement since, toward the end of the movie, there are so many twists and reversals that anything is possible.

Mr. Donaldson gets some attractive performances from his leading players, as well as from some of the supporting actors, especially from Mr. Walsh and a young woman named Maura Tierney, who appears briefly as the lover of the dead man. Yet the director, who somehow made the complex plot of "No Way Out" comprehensible, allows "White Sands" to get buried under its own revelations.

Could it be that Mr. Donaldson modified Mr. Pyne's screenplay to serve the actors during the shooting, leaving little time for explanations? When the explanations do come, they are delivered at such speed, and with such lack of emphasis, that the audience is left behind. Or was Mr. Donaldson actually trying to clarify the screenplay? In one way and another, "White Sands" raises more questions than it can hope to answer.

•

"White Sands," which has been rated R (Under 17 requires accompanying parent or adult guardian), has some violence, partial nudity and vulgar language.

1992 Ap 24, C18:1

Highway 61

Directed by Bruce McDonald; screenplay by Don McKellar; director of photography, Miroslaw Baszak; music by Nash the Slash; produced by Colin Brunton and Mr. McDonald; released by Skouras Pictures. At the Angelika Film Center, 18 West Houston Street, Manhattan. Running time: 102 minutes. This film is rated R.

Jackie Bangs	Valerie Buhagiar
Pokey Jones	Don McKellar
Mr. Skin	Earl Pastko
Mr. Watson	Peter Breck
Otto	Art Bergmann
Customs Agent No. 1	Jello Biafra
Customs Agent No. 2	Hadley Obodiac
Motorcycle Gang Leader	Tav Falco
Margo	Tracy Wright
Claude	Johnny Askwith
Funeral Director	Namir Khan
Jeffrey the Corpse	Steve Fall

By STEPHEN HOLDEN

Pokey Jones (Don McKellar) and Jackie Bangs (Valerie Buhagiar), traveling companions who transport a coffin from Canada to New Orleans atop the roof of Pokey's car, are one of the more intriguing couples to be paired in a modern road movie.

An innocent lad who secretly practices the trumpet, Pokey makes his living cutting hair in a bleak little northern Canadian town named Pickerel Falls. Until the day a body turns up in a bathtub in the backyard of his shop, his life seems to be on a permanently dreary treadmill. Jackie, a fugitive rock roadie who has absconded with her band's stash of drugs, coincidentally turns up in the same little town at the same moment. On a whim, she claims to be the dead man's sister, hides the drugs on his body and persuades the local authorities to let her return the body to New Orleans for burial. Pokey impulsively seizes his opportunity to turn his back on Pickerel Falls and volunteers to be the chauffeur.

Their adventures on the road from Minneapolis to New Orleans form the heart of "Highway 61," which opens today at the Angelika Film Center. Like the 1965 Bob Dylan album "Highway 61 Revisited," which was an obvious inspiration, the movie offers a surreal carnival vision of America as a land of freaks, hustlers, outlaws and fools. In their rush southward, the pair is pursued by a mysterious con man named Mr. Skin (Earl Pastko), who is convinced he is the incarnation of Satan and wants the body of the dead man for himself.

•

"Highway 61" is the second collaboration of Bruce McDonald, a Canadian director, and Mr. McKellar, a screenwriter and Toronto-based actor who also plays Pokey. Their 1989 film, "Roadkill," won the best-film award at the 1989 Toronto Film Festival. The new film should enhance their reputation.

What the team has concocted with "Highway 61" is a phantasmagoric comedy that unfurls with the lunatic unpredictability of one of Mr. Dylan's lengthier mid-1960's ballads. Each of the pair's adventures becomes a stanza in a cinematic ballad of the open road that embraces a lot of rock-and-roll imagery.

The first in the gallery of oddball characters they meet is a fiercely patriotic American Customs official (Jello Biafra) who demands with trembling emotion, "Why should I invite you into my home?" Later they barge into the lives of the Watsons, a would-be stage father and his three tone-deaf young daughters whom he has groomed into a wobbly vocal trio that he takes around the country. Outside of Memphis, they visit a reclusive rock star and his wife who live in a Graceland-like mansion and invite their guests to roam the halls shooting the chickens they will eat for dinner.

Along the way, Pokey loses his virginity in a church graveyard during a pouring rainstorm. Jackie, who has an outlaw streak, has no qualms about stealing whatever is necessary for their survival.

•

Almost by the very nature of its rambling form, "Highway 61" is a movie that doesn't know how to end. It is much too smart and droll to do away with its protagonists in an apocalyptic blast of violence. But before it finally peters out in New Orleans, the film offers an amusingly off-center vision of a land in which everyone marches giddily to the beat of his own drum without really paying attention to anyone else.

The most memorable satiric set piece involves a Bingo game that a crowd of dour, polite churchgoers watches in silent resentment as Mr. Skin wins game after game and insults them. But "Highway 61" also includes some tableaux, including Pokey's encounter with a menacing motorcycle gang, that feel too forced to convey a convincing flavor of Americana seen through a surreal lens.

The film's wide-eyed sense of wonder owes a great deal to Mr. McKellar's Pokey, a stubborn dreamer who is awestruck at the sight of Mr. Dylan's childhood home and for whom the very words Memphis and New Orleans conjure an Olympian musical mythology. Ms. Buhagiar is almost as fine as a well-seasoned rock-and-roll woman who knows how to live by her wits.

•

"Highway 61" is rated R (Under 17 requires accompanying parent or adult guardian). It includes some strong language, flashes of nudity and a sex scene.

1992 Ap 24, C19:1

Year Of The Comet

Directed by Peter Yates; written by William Goldman; director of photography, Roger Pratt; edited by Ray Lovejoy; music by Hummie Mann; production designer, Anthony Pratt; produced by Mr. Yates and Nigel Wooll; released by Columbia Pictures. Running time: 91 minutes. This film is rated PG-13.

Margaret Harwood	Penelope Ann Miller
Oliver Plexico	Tim Daly
Philippe	Louis Jourdan
Nico	Art Malik
Sir Mason Harwood	Ian Richardson
Ian	Ian McNeice
Richard Harwood	Timothy Bentinck
Landlady	Julia McCarthy
Doctor Roget	Jacques Mathou

By JANET MASLIN

William Goldman's screenplay for "Year of the Comet" has the charming élan of an old-fashioned caper story, the sort that inevitably concludes (as this one does) on the French Riviera. Mr. Goldman throws together a pert young wine expert named Maggie Harwood (Penelope Ann Miller), a handsome, wisecracking trouble-shooter named Oliver Plexico (Tim Daly) and a bottle of wine dating back to Napoleon (Lafite, 1811) to create a scenic and romantic escapade.

This sort of material calls for a higher gloss than Peter Yates's direction ever supplies, so the dialogue and plot development are often more fun than the production. (The story line is sheer nonsense even by caper-movie standards, but Mr. Goldman does an energetic job of coaxing it along.) "Year of the Comet" is mostly breezy and entertaining even under these circumstances, but it's clear that both the casting and the direction could have had more spark.

Ms. Miller and Mr. Daly spend most of the film together, sharing one bedroom scene, numerous quarrels and a few impassioned declarations. Still, not much seems to go on between them. Ms. Miller, as the wine expert who discovers the valuable Lafite, is too often cranky and frail, especially in comparison to the more robust Mr. Daly, who is meant to recall the young Robert Redford and really does. The resemblance, as Mr. Daly comfortably delivers the same kind of funny, self-deprecating dialogue Mr. Goldman wrote for Mr. Redford and Paul Newman in "Butch Cassidy and the Sundance Kid," goes well beyond the mustache.

•

The story moves from London, where the Harwood family's wine business is located, to Scotland, where Mr. Yates fails to get much of a tingle even out of his two leads being stalked through dense fog in the middle of Loch Ness. (The film's action scenes can be so clumsily staged that a sequence in which Oliver supposedly hangs off the side of a building calls attention to its own special effects.)

Later on, after they cross paths with wine thieves and with a debonair villain (Louis Jourdan) in search of a mysterious chemical formula, they wind up renting a motorcycle and pursuing their enemies through the south of France. Maggie complains about the mode of transportation. "Are you kidding?" retorts Oliver. "The French Riviera in July? We're lucky we're not *running* after them."

The small talk is often amusingly small, as with Oliver's complaints about his back ailments. ("I can hit all the people I want," he says, as Maggie hauls the giant wine bottle. "I'm just not supposed to lift things.") Only occasionally does it takes a sophomoric turn, making the principals sound more like schoolmates than lovers. Maggie: "Is it your beauty or your charm that makes you so irresistible?" Oliver: "Uh, 60-40 charm."

•

"Year of the Comet" is rated PG-13 (Parents strongly cautioned). It includes one very brief bedroom scene and mild profanity.

1992 Ap 25, 17:1

Company Business

Written and directed by Nicholas Meyer; director of photography, Gerry Fisher; edited by Ronald Roose; music by Michael Kamen; production designer, Ken Adam; produced by Steven-Charles Jaffe; released by Metro-Goldwyn-Mayer Communication Company. Running time: 98 minutes. This film is rated PG-13.

Sam Boyd	Gene Hackman
Pyotr Grushenko	Mikhail Baryshnikov
Elliot Jaffe	Kurtwood Smith
Colonel Grissom	Terry O'Quinn
Mike Flinn	Daniel Von Bargen
Grigory Golitsin	Oleg Rudnick
Natasha Grimaud	Geraldine Danon
Faisal	Nadim Sawalha

By VINCENT CANBY

"You're both dinosaurs," a comparatively neutral observer tells the two bewildered former cold war spies in Nicholas Meyer's new espionage melodrama, "Company Business." They are Sam Boyd (Gene Hackman), an American, and Pyotr Grushenko (Mikhail Baryshnikov), a Russian, who have joined forces to flee the coordinated wrath of the Central Intelligence Agency and the K.G.B.

The neutral observer fails to notice that if the two men are dinosaurs, then their adventure must be antediluvian.

Though "Company Business," which opened here yesterday, is slickly acted and photographed, it has the monotonous one-two-three, one-two-three tempo of a waltz that begins in Fort Worth and lumbers on to Washington, Berlin and Paris.

The long-retired Sam is brought back by the C.I.A., the "company" of the title, to effect the swap of a Russian prisoner, Pyotr, for an American U-2 pilot still held in Moscow.

Things inevitably go wrong. It's not giving anything away to reveal that the C.I.A. isn't up to any good, dealing, as it is, with money provided by a Colombian drug cartel. Sam and Pyotr quickly realize that each is the other's best friend.

The movie has a funny scene involving a Saudi Arabian arms merchant in Berlin, a rather superfluous scene set in a Berlin drag bar, a small shootout on the top of the Eiffel Tower in Paris. Mr. Hackman, who has played this role before, and Mr. Baryshnikov, who hasn't, are both sturdy if a little tired. Under the direction of Mr. Meyer, who also wrote the screenplay, the film makes sense without ever being surprising.

•

"Company Business," which has been rated PG-13 (Some material may be unsuitable for those under 13), includes some vulgar language and violence.

1992 Ap 25, 17:1

FILM VIEW/Stephen Jay Gould

Say It Ain't So, 'Babe': Myth Confronts Reality

OLDER NATIONS CAN CONvert the heroes of their antiquity into true gods, fully freed from the quotidian reality of their actual lives. Newcomers like the United States must construct their legends from recent historical figures — and mythology must then compete with memory and documentation. We record this ambivalence by allowing such people to serve in two distinct roles — Honest Abe the source of moral instruction to generations of schoolchildren, and Lincoln the country lawyer turned President.

No one, from the most revered statesman to the most feared outlaw, has surpassed Babe Ruth as an American folk hero. Japanese soldiers shouted "to hell with Babe Ruth" as they engaged our men on various Pacific Islands. And an Englishman, forced to respond to an American's taunt of "To hell with the King" during a barroom argument, could only retaliate, with majestic equality: "To hell with Babe Ruth." The Babe, to cite a cliché of stunning accuracy in this case, was "larger than life" in all ways — from his physical size, to his appetites (food and women), to his ac-

complishments (his 54 home runs in 1920 exceeded the total of every other *team* in the league).

This irreconcilable combination of myth and humanity makes the life of a legend particularly hard to capture in film or biography. Babe Ruth, once

Once again, Babe Ruth has been cheated. Surely the task of capturing him is not impossible.

served so badly by William Bendix in a 1948 film that appeared just before Ruth's death, has been sorely cheated again. The task is surely not impossible; Gary Cooper triumphed as Lou Gehrig, in a moving, if somewhat maudlin, performance in "The Pride of the Yankees" — with Babe Ruth, playing himself in a supporting role, as a fine addition to the cast.

"The Babe" chose to follow the most vulgar, cardboard, clichéd version of myth, and ignored both the richness of humanity and the beauty of legend in its subtler and laudable meaning. I do not complain with the prissy fastidiousness of an academic touting a highfalutin theory about veracity, or of a baseball aficionado who takes pious and egotistical delight in uncovering every trivial departure from fact (though I am — and proudly — both a professor and a lifelong Yankee fan). I accept without question the right,

even the necessity, for some fictionalization in historical films. (In my own domain, I love "Inherit the Wind" as drama, even though the script is grossly inaccurate, in a studied and purposeful way, as an account of the Scopes trial.)

For example, I don't mind that "The Babe" epitomizes Ruth's relations with his fellow players by pretending that one central friendship, with the third baseman Jumping Joe Dugan, pervaded his entire career, for such focusing makes good drama. (Dugan was not with Ruth during his early days in Boston. They became close when Dugan joined the Yankees in 1922, but Dugan left New York after the 1928 season, and therefore missed the last six years of Ruth's Yankee career.)

■

Rather, "The Babe" suffers because its fabric of inaccuracy has a common theme and purpose — one that patronizes us and cheapens its maximally fascinating subject. This man of so many facets becomes one-dimensional, no richness of texture and therefore no capacity to win our hearts (however much the dripping sentimentality of contrived events may temporarily exercise our tear ducts). His accomplishments become so bizarre that no one with a modicum of knowledge about the game — a category including most Americans — could possibly credit the absurdity. Ruth did not hit an infield pop so high that he had circled the bases for a home run before it landed — a ludicrous claim that must make any fan laugh in derision. He did, however, twice reach third base on towering

Movie Still Archives

William Bendix portrayed the Sultan of Swat in "The Babe Ruth Story" (1948), which appeared just before Ruth's death.

pops that landed in front of outfielders, just behind the base paths. What is wrong with the reality in this case?

Even the accurate bits are usually transposed in time to produce a web of maddening anachronism that fatally dilutes a temporal setting otherwise meticulously constructed. I ended up feeling wrenched from history. Nicknames and identifying features of maturity are attributed to entire careers, and we lose the flow of a lifetime. Ruth is depicted as a home-run machine from the start. If we were not shown one quick shot of Ruth on the mound, we would never know that he was exclusively a pitcher during his first four seasons in Boston, with a maximum of four homers in 1915. Why throw away the most truly amazing point about Ruth's career — that he was the best left-handed pitcher in baseball and would probably have made the Hall of Fame as a pitcher even if he had never learned to hit.

Ruth is portrayed as bloated and gargantuan from boyhood, but he was firm and trim during his first seasons, and his nickname at his Baltimore reform school was not Fatso. He did not make his famous comment about earning more than the President — "Why not, I had a better year than he did" — while receiving peanuts during his early Boston career but rather (if he said it at all) as a well-paid Yankee contrasting himself

with an inept Herbert Hoover. Lou Gehrig was not called Iron Horse in his first season, before setting a record for consecutive games that earned him that epithet.

If the accurate bits are falsely arrayed, the fabrications are even more disturbing in their common theme of reducing such a multifaceted life to a single dimension of saccharine sentimentality. "The Babe" wheels out every Washington's cherry tree of canonical Ruthian lore, and even manages to embellish the old clichés.

Just two examples. George Ruth Sr. takes his young son to St. Mary's Industrial School and abandons him forever. We are told that he never saw his parents again. We are even given the impression that he never left the schoolgrounds until his "parole" at age 20 to join the Baltimore Orioles. (The locked gate swings open and the Babe stares in amazement at the outside world.)

In fact, Babe was in and out of the school, spending the intervening time with his parents. His mother died young, but he remained on decent, if strained, terms with his father. George Sr. gave his underage son permission to marry, and then threw a party for the newlyweds in the apartment above his saloon. Ruth used his share of the 1915 World Series money to set up his dad in a new saloon — and he worked behind the bar with his father all that winter.

Universal Pictures

John Goodman as Babe Ruth—A rich and contradictory figure, an icon who deserves a nonexploitative film.

The movie's treatment of legend numero uno is even more manipulative. In the usual version, he visits a seriously ill (or dying) boy named Johnny Sylvester in the hospital and promises to hit a homer for him the next day. (In some versions, he makes Johnny promise to get well in return.) In "The Babe," poor Johnny is so ill that he cannot talk at all. When Ruth makes his promise, Johnny holds up *two* fingers — and the Babe delivers with a second homer in his last at-bat.

(In his standard biography of Ruth's life, Robert Creamer states, in an oft-quoted account, that the real Johnny was badly hurt in a fall from a horse. A family friend got Ruth to autograph a ball and delivered it to Johnny along with Ruth's promise to hit a home run in the 1926 World Series. Ruth hit four homers in the series and did pay Johnny a visit afterward. The next spring, Johnny's uncle approached Ruth to thank him. Ruth, whose inability to remember names was truly legendary, replied, "Glad to do it. How is Johnny?" When the uncle left, Ruth turned to his cronies and said, "Now who the hell is Johnny Sylvester?")

The film then exaggerates the legend even more. In 1935, fat, 40 and washed up, Ruth spent a pathetic partial season with the Boston Braves. But he did have one great day when he hit three homers in a single game. (The last one, following a cliché that has become canonical in

Only a quick shot suggests that Babe Ruth was exclusively a pitcher early in his career.

baseball movies since "The Natural," unrolls in slow motion — as does Ruth's most famous homer: the "called shot" in he 1932 World Series, another dubious tale.) To construct a simplistic story of the Babe leaving with dignity, the film then shows him striding over to the Braves' owner (who had hoodwinked him into playing with a phony promise that he could manage the team the next season), throwing his hat on the ground in contempt and then walking into the dugout for that final stroll into the dark corridor of his future.

And now, who should follow him into the dugout but — you guessed it — Johnny Sylvester, grown up! He gives Babe the autographed ball back, saying that it had once brought him luck, a commodity that Ruth now needs himself. Babe looks at Johnny and says with simple dignity: "Johnny, I'm gone." (Chalk up yet another transposition. In a true and poignant tale, Joe Dugan visited Babe in the hospital when he was dying of cancer. They drank a beer, and Ruth then said, "Joe, I'm gone." The two men then cried together.)

I know that this is an age of 15-second sound bites, and that movies are a medium of mass entertainment. So perhaps this is what the public wants; perhaps we the people deserve no more. I do not believe this pessimistic and cynical judgment. I acknowledge the obvious fact that mass markets will accept and embrace pap when offered nothing else. But complex films of genuine merit can also be great commercial successes. Doesn't so rich and contradictory a man as Babe Ruth, a figure so central in American history, finally deserve a nonexploitative film? Don't America's serious baseball fans, who number in the tens of millions and who pay good money to see movies, merit an honorable version of their chief icon and hero?

I offer an incident as proof that veracity has both virtue and mass appeal. When I saw "The Babe" in Boston, two young men sat behind me, whispering intelligent baseball commentary throughout. As we left, one said to the other: "Gee, I didn't know that Ruth hit a homer in his last at-bat. But now I'm awfully confused. Everyone knows that Ted Williams hit one his last time up. If the Babe did the same, especially if it was the last of three in one game, why don't we ever hear about it?"

They, in their naïveté, had never considered the hypothesis that a film might distort. I turned and told them that Ruth had played for another week or two after the three-homer game, and had not left with such power of dignity. They thanked me for relieving their confusion. Do we not all deserve the truth, especially when drama does not suffer (and may gain in reclaiming humanity from cardboard). After all, a man even greater than Babe Ruth or the King of England once told truth might make us free.

1992 Ap 26, II:15:1

FILM VIEW/Caryn James

What Gives 'White Men' Its Spring?

FORGET ABOUT "HOOK." THE TRUE STORY OF "Peter Pan: The Later Years" is "White Men Can't Jump," the hit film about two guys who leap through the air and don't wanna grow up. The Wendys who love them tell these overgrown boys to settle down and get jobs, as any self-respecting mother figure would.

Depicting heroes who are pop-culture Peter Pans is a basic part of the film's appeal, though the message is not overt or even intentional. "White Men" is, above all, a swift, gutsy entertainment about two playground basketball hustlers who defy racial stereotypes. As Billy, Woody Harrelson says flat-out that the hip-hopping black players see him as a "geeky white guy." He turns out to be the all-American con man masquerading as an innocent.

Wesley Snipes plays Sidney, a fast-mouthed, egocentric black man with a gold chain around his neck and an unshakable belief that "white people can't *hear*" Jimi Hendrix. Sidney uses the streetwise stereotype to give attitude but along the way smashes the common image of the absent black father. He is a loyal family man with a wife and son to support, and basketball hustling puts food on the table.

The writer and director Ron Shelton is shrewd enough to handle these ticklish themes with the lightest touch. But, like pop hits in any genre, "White Men" breezily captures the pulse of the times. The film is politically correct in its attack on stereotypes, but rude enough in its humor so that no one feels preached at; it echoes both political correctness and the anti-P.C. backlash.

This film also proves that Mr. Shelton's 1988 baseball movie, "Bull Durham," was no fluke hit. He has created a savvy, repeatable formula: treat the audience like adults while admitting that, whether the game is baseball, basketball or a television quiz show, grown-ups still want to be kids. "White Men" makes playing games seem like a career option — an appealing fantasy at any age.

Of course, much of the success of "White Men" has to do with its fast and funny surface, not its hidden meaning.

Ron Shelton's hit relies on a combination of political correctness and rude humor.

The ads showing the stars with the names "Wesley" and "Woody" over them suggest the personal appeal of the actors and their characters. Mr. Harrelson owes his popularity to the television phenomenon "Cheers," and Mr. Snipes is well known from the films "Jungle Fever" and "New Jack City." Billy and Sidney seem real because of the frank way they acknowledge stereotypes even as they subvert them.

"You remind me of one of the dudes from 'The Brady Bunch,' " Sidney tells Billy, and before the film ends black characters have called him every white-bread name they can think of, from Cindy Brady to Martha Graham to Opie. Billy cuts deeper when he angrily asks Sidney how many family dinners his gold chain cost. These two are different from most movie heroes. They are not perfect, and they live in a believable world where racial clichés exist.

On the surface, though, theirs is a jock world, and "White Men" might seem like the kind of macho movie that doesn't usually reach female audiences. But 20th Century Fox's surveys reveal that the film is appealing to both male and female viewers. Obviously, any film as successful as

"White Men," which was No. 1 for a while and is still strong a month after its release, appeals to more than one group.

Sports fans appreciate the rough-edged, realistic basketball scenes (I have that on good authority); but the sports scenes also make sense to someone with only the vaguest sense of how and why the ball goes through the hoop (that's the part I'm sure of).

Much of its allure to non-basketball-fans is the comic-romantic subplot. Rosie Perez plays Billy's girlfriend, Gloria, as a hilarious pop-culture heroine. Gloria is a former disco queen who dreams of appearing on "Jeopardy!" and spends her days cramming her head with categories of information like: foods that begin with the letter Q.

Neil Leifer/20th Century Fox

Woody Harrelson and Wesley Snipes in "White Men Can't Jump"—Unlikely movie heroes.

But like Sidney's wife, Rhonda (Tyra Ferrell), Gloria has an annoying tendency to play mama. Rhonda nags Sidney to get a job so they can buy a house. Gloria blows up at the way Billy keeps gambling away their money. These are reasonable enough reactions, even if they do fall back on the childhood truism that girls mature faster than boys. But why do the women get together and find a compromise when Billy and Sidney have a fight? Their feistiness masks the fact that they are like mothers rolling their eyes and saying, "Now, now, boys, play nice."

As Billy tells Gloria, "Men's rules are very simple: if you win, you win; if you lose, you lose" — not a bad description of boys at play. Gloria has a much more complicated take on things and explains that sometimes winning is losing, losing is winning, coming out even is really losing or some other combination of the above. "I hate it when you talk like that," Billy says.

It is no compliment to say the women are more levelheaded than the men here, when they function mainly as maternal clichés, despite Gloria's comic charm.

The women provide one of the sneakier messages in "White Men Can't Jump," though: boys do have to grow up. Billy and Sidney figure out that playground ball is not a career option after all. Mr. Shelton really has it every possible way in a movie that is political but not about politics, that is and is not about basketball, that is both deeper and more lighthearted than its Peter Pan heroes suggest. □

1992 Ap 26, II:15:5

Raspad

Directed by Mikhail Belikov; screenplay by Mr. Belikov and Oleg Prihodko, (in Russian with English subtitles); directors of photography, Vasily Trushkovsky and Aleksandr Shagaev; edited by Tatyana Magalias; music by Igor Stentcuk; production designer, Inna Bichenkova; produced by Mikhail Kostiukovsky; released by MK2 Productions USA. At the Eighth Street Playhouse, 52 West Eighth Street. Running time: 103 minutes. This film has no rating.

Aleksandr Zhuravlev	Sergei Shakurov
Lyudmila Zhuravleva	Tatyana Kochemasova
Senior Zhuravlev	Stanislav Stankevich
Anatoly Stepanovich	Georgi Drozd
Valery	Aleksei Cerebriakov
Lyuba	Marina Mogilevskaya
Shurik	Aleksei Gorbunov

Ignati	Anatoly Groshevoy
Kolka	Nikita Buldovsky
Mariya	Natalya Plohotniuk
Valentin Ivanovich	Nikolai Docenko
Dimitri Stepanovich	Valery Sheptekita
Nurse Lida	Valentina Masenko
Dimka	Taracik Mikitenko
Osip Lukich	Vladimir Olekceenko
Lyudmila's friend	Olga Kuznetcova

By VINCENT CANBY

"Raspad," the Russian-language film, opening today at the Eighth Street Playhouse, is a big, sprawling, awkward but nearly always riveting attempt to re-create the 1986 nuclear disaster at Chernobyl and to see it as

a metaphor for the collapse of moral values in the social-political system that produced it. Raspad is Russian for collapse or deterioration.

Mikhail Belikov, the film's Ukrainian director, got more metaphor for his rubles than he originally intended. The film was made with Government approval in 1989-90, before the actual breakup of the Soviet Union. Because "Raspad" is both about big events and a result of them, it has an interest that goes well beyond its sometimes impressive cinematic dimensions.

Its private story is the erosion of trust between Aleksandr, a journalist, and his wife, Lyudmila, when he returns to Kiev after an assignment in Greece. On the night of his arrival, following a convivial reunion of family and friends, Aleksandr receives an anonymous letter telling him that Lyudmila is having an affair with their friend Shurik, an influential member of the Communist Party.

When Aleksandr shows the letter to Lyudmila, she sighs as if she'd expected it. The letter, she says, is obviously from her father, who came by the apartment one day when Shurik was there and who misunderstood a perfectly commonplace situation. Aleksandr and Lyudmila don't fight. Each automatically accommodates diminished expectations of the other.

Intersecting with these domestic scenes, which are written and acted with great economy and wit, are the events taking place 70 miles away at the Chernobyl nuclear facility.

In the early morning hours of April 26, 1986, in the course of tests, the No. 4 reactor exploded. This was the start of the defining accident of the nuclear age, the meltdown and fire that spread radioactive material around the world with a toll that is still beyond measure.

Though President Mikhail S. Gorbachev was not to acknowledge the disaster on television until 18 days after the initial explosion, Aleksandr and the people of Kiev are almost immediately aware that something is wrong.

The sounds of sirens are heard. Motorcades of fire engines and ambulances are seen leaving the city. The camera cuts away from Aleksandr and his family to pick up Aleksandr's friend, Anatoly, a doctor at Chernobyl. The scope of the film broadens to include vignettes that are interwoven with the initial story. One is about a small boy who becomes separated from his mother during the evacuation of a town near Chernobyl. Another is about newlyweds who are caught in the chaos of the general exodus.

The film pays no attention to conventional narrative form. It has a mind of its own, which is all to the good. What begins as the story of one man and one family turns into a kind of fresco depicting the end of civilization. Mr. Belikov makes no attempt to show the initial disaster at Chernobyl, though the film is there soon after.

•

In the days that follow, the Communist Party denies any major problems. Kiev television devotes its coverage to more sports events. Preparations for May Day celebrations continue. At the airport, though, a long line of black limousines deposits the families of party officials seeking to leave the area.

A number of scenes haunt the memory: An exhausted doctor sits in his examining room with the nude corpse of one of the first Chernobyl victims. He smokes, drinks from a bottle, then gets up and rolls the body off the table onto a plastic winding

sheet. A brass band plays jolly songs on a bus packed with refugees. At one point there is a series of stunning aerial shots taken from a helicopter as it flies over what has become the forbidden zone. The fields, woods and cities look perfectly normal except that they are empty.

The film's separate pieces are not always well integrated, but that's part of its effectiveness. "Raspad" is rough and angry. It's about a world in which everything is fraudulent: happy marriages, filial loyalty, modern technology, governments that are empowered to serve the interests of the people.

Early in "Raspad," before Chernobyl has entered anyone's consciousness, when Aleksandr is driving away from the Kiev station, the camera catches sight of a car in the background bouncing away from a collision, its hood flying up as it jumps a curb onto the sidewalk.

In retrospect, the bizarre image of this anonymous, suddenly neutralized automobile sets the tone for everything that follows, including the event that has been called the most expensive accident in human history.

1992 Ap 29, C15:1

Leaving Normal

Directed by Edward Zwick; written by Edward Solomon; director of photography, Ralf Bode; edited by Victor Du Bois; music by W. G. Snuffy Walden; production designer, Patricia Norris; produced by Lindsay Doran; released by Universal Pictures. Running time: 110 minutes. This film is rated R.

Marianne	Meg Tilly
Darly	Christine Lahti
66	Patrika Darbo
Harry	Lenny Von Dohlen
Leon	Maury Chaykin
Kurt	Brett Cullen
Walt	James Gammon
Emily	Eve Gordon
Rich	James Eckhouse
Marshall	Lachlan Murdoch
Sarah	Robyn Simons
Nuqaq	Ken Angel
Clyde	Darrell Dennis
Izuzu Mother	Barbara Russell
Izuzu Judy	Ahnee Boyce
Dave	Marc Levy
Spicy	Peter Anderson

By JANET MASLIN

In the prologue to "Leaving Normal," a van carrying a family suddenly takes leave of the blacktop and flies off into a starry, special-effects sky. The surreal, exuberant escape promised by that image is something this film obviously aspires to but never manages to achieve.

In a star-crossed coincidence of the sort "Leaving Normal" might otherwise celebrate, this story of two runaway women has appeared in the shadow of the much better "Thelma and Louise," which robs the new film of even novelty value and necessitates unflattering comparisons. Credibility is an immediate problem, even for a film whose fondness for the fanciful is apparent at every turn. Not even the initial meeting between Darly (Christine Lahti), a hard-boiled cocktail waitress with a wardrobe that leans toward leopard spots and leather, and Marianne (Meg Tilly), an abused wife on the run from her husband, has an honest ring. The two cross paths at a bus stop in the middle of the night in a town called Normal; Marianne cries; Darly tentatively comforts her. This is all it takes to send two new acquaintances off into the heart of road-movie America, romping and squabbling and making

up as if their friendship went back many years.

The cute, facile aspects of the story are surprising in a film directed by Ed Zwick, whose direction of "Glory" and whose contributions to the television series "Thirtysomething" had a much greater grip on reality. This time, directing from a screenplay by Edward Solomon (who co-wrote the "Bill and Ted" films), Mr. Zwick declares his film's fancifulness at every turn. The characters are reduced to caricature whenever possible, with even the film's most attention-getting minor characters limited by the silliness of their roles. (Patrika Darbo has a memorable turn as a plump waitress known as 66, which is somehow short for Cecilia, who lives in a trailer almost entirely covered in flocked, flowered fabric.)

•

Even a simple matter like the bus trip Marianne takes at the beginning of the story is embellished with a needlessly adorable flourish. (Marianne pours out her tale of woe to a seat mate who is continually-changing into different people, more in the manner of a rock video than a dramatic narrative.) The attempt to make a running joke out of the word "flan" (something Marianne has not heard of, though her abusive husband expects her to make it for dinner) is similarly thin. Later on, when Marianne blossoms after finding her way to a beautiful spot in Alaska, her new job at a hardware store is rendered in similarly broad strokes. "Happy hardware!" Marianne insists on declaring gaily, to any store customer she happens to meet on the street.

Ms. Lahti continues to be an actress who can breathe life into even the sketchiest material. She succeeds in making Darly a big, generous-hearted character who holds the interest even in situations that seem utterly contrived. Ms. Tilly, who seems to spend much of her time either weeping profusely or beaming her radiant, feline smile, is a lot less substantial and a lot more noticeably false. Actors in smaller roles (Lenny Von Dohlen as a trucker who cries while reading "The Grapes of Wrath" and is thus a natural match for Marianne, Maury Chaykin as his lecherous uncle) do what they can with the material's uncertain blend of jokiness and drama. Too many times, the characters appear to be arguing their hearts out over matters of either too much substance (i.e. Darly's terrible secret, Marianne's history of abuse) or none at all.

•

"Leaving Normal," leads its characters across the American West, through Canada and up to Alaska, where the part-Eskimo Darly (another of the film's unlikely touches) means to make a new start. The scenery is beautiful, even when augmented by patently artificial rainbows and northern lights in the nighttime sky.

•

"Leaving Normal" is rated R (Under 17 requires accompanying parent or adult guardian). It includes profanity and sexual situations.

1992 Ap 29, C17:1

A Woman's Tale

Directed by Paul Cox; screenplay by Mr. Cox and Barry Dickins; director of photography, Nino Martinetti; edited by Russell Hurley; music by Paul Grabowsky; production designer, Neil Angwin; produced by Mr. Cox and Samantha Naidu; released by Orion Classics. At the 57th Street Playhouse, 110 West 57th Street. Running time: 94 minutes. This film is rated PG-13.

Martha	Sheila Florance
Anna (Malinka)	Gosia Dobrowolska
Billy	Norman Kaye
Jonathan	Chris Haywood
Miss Inchley	Myrtle Woods
Peter	Ernest Gray
Billy's daughter	Monica Maughan
Billy's son-in-law	Max Gillies

By JANET MASLIN

"I'm very old and a little bit sick, but I love life and I love young people!" That gallant half-truth comes from the central figure in "A Woman's Tale," Martha (Sheila Florance), who is in fact much more ill than she lets on. In Paul Cox's new film about Martha, Miss Florance is quite literally a haunting presence. Playing a character whose history and attitudes are modeled on her own, Miss Florance was dying of cancer when this film was made. She died just after accepting the Australian Film Institute's best-actress award for this performance.

"A Woman's Tale" is purely a showcase for this eager, loquacious actress, who bears a visual resemblance to Lillian Hellman and delivers tart, opinionated monologues to everyone she meets. The film unfolds gently as the camera follows Martha through her daily routine, stopping for her encounters with various friends and neighbors who listen gratefully to her many pronouncements. Martha has advice for everyone, from the prostitute on the corner to a sobbing woman who telephones a radio talk show. Theatrically outspoken at any opportunity, Martha even lectures a restaurant proprietor who asks her to observe a no-smoking rule. "I smoke because I love it!" she exclaims defiantly. "Can you understand that?"

•

Mr. Cox's obvious affection for his subject (whom he knew for 30 years before writing this screenplay about her life) can be a bit suffocating, since he seldom allows the audience to discover her intelligence and spirit on its own. The film, which opened yesterday at the 57th Street Playhouse, is a shade too relentless in its adulation. But Miss Florance's indomitable energy is impressive, as is her courage, and the film is finally an affecting tribute to her affirmative outlook. "Your mother is a woman of imagination and spirit," one of the film's characters tells Martha's son, "and that's what's keeping her alive."

Martha lives alone, except for the canary she has named Jesus, in an apartment filled with memorabilia celebrating a rich, varied life. She gladly lends the place to her pretty young nurse, Anna (Gosia Dobrowolska), who is having an affair with a married man, since Martha is a firm believer in romance. In fact, when Anna reports that another patient, an elderly neighbor of Martha's named Billy (Norman Kaye), has tried to fondle her breast, Martha chides the young woman for being uncooperative. "Why didn't you let him?" she snaps. "He'll be dead soon. What's the difference?"

Martha's tenderness toward Billy is one of the film's most affecting elements, and also one of its more graceful ways of depicting the realities of illness and advanced age. Billy's living room has tacitly become a sickroom — there are medicine bottles on the mantelpiece — and he requires Martha's help for middle-of-the-night trips to the bathroom. Martha is as quietly considerate with Billy as she is exuberantly outspoken with the film's other characters, and only once does she correct him sharply, when he drifts off into memories of having been an officer in wartime. "I know that, but what are you now?" Martha asks.

•

Martha's own wartime memories are terrible, involving the death of her baby daughter during a bombing raid, and they emerge during her most impassioned monologue. Too talky for real pathos much of the time, "A Woman's Tale" can also become abruptly solemn and moving. Merely by depicting Martha at home in her bathtub, surveying her wizened body and then preparing quietly for bed, Mr. Cox generates more feeling than he does in endless encounters with Martha's acquaintances.

"Beauty in life may come from makeup or clothing, but for beauty in death you have to fall back on character," Martha says at one point. In its better moments, "A Woman's Tale" is indeed what Mr. Cox must have intended: a vivid embodiment of that thought.

1992 Ap 30, C16:6

Cabbies and Their Fares, As Seen by Jim Jarmusch

"Night on Earth" was shown as part of last year's New York Film Festival. Following are excerpts from Vincent Canby's review, which appeared in The New York Times on Oct. 4, 1991. The film, which is partly in English and has English subtitles in three foreign segments, opens today in Manhattan.

The first image in "Night on Earth," Jim Jarmusch's delirious new comedy, is important: that of universal darkness in the center of which is a rotating sphere of brilliant blue overlaid by wisps of white.

As the camera approaches, the wisps of white turn into cloud formations so beloved by forecasters as "weather systems." Familiar oceans and seas appear, also land masses that are as yet undivided by and unclaimed for national aspiration.

Although the movie is composed of five different stories, rooted in turn in the realities of Los Angeles, New York, Paris, Rome and Helsinki, "Night on Earth" seems always to keep the alien's distance, as if part of its mind remained forever fixed in outer space.

That is the consistent, comic method of Mr. Jarmusch's films, from "Stranger Than Paradise" through "Down by Law," "Mystery Train" and now "Night on Earth," his most effervescent work to date.

•

Although "Night on Earth" is exceptionally funny, it is no less bleak than those earlier movies. The often bright colors in which it has been photographed, and the laughter it prompts, are a kind of cloud cover for the film's secret nature.

In "Night on Earth" Mr. Jarmusch explores a primal urban relationship, that of man and taxi driver, in situations in which woman is sometimes man and sometimes driver. The cab itself is the world temporarily shared. It's also a distinctive cocoon (each taxi in the film has its own special purr or knock) from which one of the parties will emerge, if not changed, then at least shaken up or, in one case, no more sure where he is than when he got into the cab.

The movie opens at the Los Angeles airport on the night that Corky (Winona Ryder), a very young cabdriver with a single dream and a mouth full of bubble gum, picks up Victoria Snelling (Gena Rowlands), a chic casting agent. Victoria is so high-powered that you might think her capable of raising Mars with the cellular telephone she uses.

In the course of their drive to Beverly Hills, Victoria, whom Corky sarcastically calls "Mom," admits to having night blindness. Corky wonders if that comes with age. Something about Corky's no-nonsense hold on life inspires Victoria to think she has found a new star.

This story leads into the New York segment, in which, late on a cold winter night, YoYo (Giancarlo Esposito), an exuberant, loquacious young man, is trying desperately to find a taxi that will take him from Manhattan to Brooklyn. At long last a yellow cab lurches to a halt beside him.

At the wheel is Helmut (Armin Mueller-Stahl), a smiling, suspiciously eager East German refugee who has yet to learn how to drive properly. After a couple of false starts and a lot of dickering, YoYo climbs into the driver's seat and they take off. Helmut sits beside him as the delighted passenger and student of American manners.

In their journey toward the borough that only the dead know, they are joined by Angela (Rosie Perez), YoYo's highly opinionated sister-in-law, whom they happen to pass on a lonely East Village street. The conjunction of YoYo, Helmut and Angela is deft and hilarious, a liberating delight.

•

The Paris interlude is also funny but shadowed with melancholy. The night isn't going well for a handsome young cabby from the Ivory Coast (Isaach de Bankolé). He fights with, and then kicks out, two arrogant black African diplomats with the fancy manners of white colonials.

He then picks up a young blind Frenchwoman (Béatrice Dalle), who grumpily mistakes his curiosity as attempts to be patronizing. His questions are direct, without guile, when he brings up the subject of sex and what it must be like to make love with someone one cannot see. Even here she somehow manages to squelch him. The night ends as badly as it began.

It's also a rotten night for the Roman cabdriver, played by the irre-

Taxi drivers from the world over, and not a Travis Bickle in the bunch.

pressible Robert Benigni, who was one of the stars of "Down by Law." His passenger is a priest (Paolo Bonacelli), a tired old fellow who wants only a little peace and quiet, not wisecracks, nor, finally, the driver's confession.

The concluding Helsinki segment is most characteristic of the spine of Mr. Jarmusch's work, best represented by "Stranger Than Paradise." This is a rueful tale for 4 A.M., about a night of drinking with the boys until you can't stand up, when your physical state has finally attained an awfulness that matches your chances in life.

With this, his fourth commercially released feature, Mr. Jarmusch again demonstrates his mastery of comedy of the oblique.

He seems to see his characters through a telescope while attending to their talk with some kind of long-range listening device. Everything that is seen and heard is vivid and particular, but decidedly foreign. Meanings are elusive. Themes can be supplied by others.

"Night on Earth" transforms the commonplace into something haunting, mysterious and newly true.

•

"Night on Earth" is rated R (Under 17 requires accompanying parent or adult guardian). It includes vulgar language.

1992 My 1, C10:5

Who Shot Patakango?

Directed by Robert Brooks; written and edited by Mr. Brooks and Halle Brooks; director of photography, Mr. Brooks; released by Castle Hill Productions. At the Sutton, Third Avenue and 57th Street, Manhattan. Running time: 102 minutes. This film is rated R.

Bic Bickham	David Knight
Devlin Moran	Sandra Bullock
Mark Bickham	Kevin Otto
Cougar	Aaron Ingram
Patakango	Brad Randall

By VINCENT CANBY

"Who Shot Patakango?" means to be a fond look back to what it was like to be in the senior class at Alexander Hamilton Vocational School in Brooklyn in 1957. Yet the film, the first feature by Robert and Halle Brooks, a husband-and-wife team, is so amateurishly conceived that it's difficult even to look at the screen.

The Brookses have made documentaries, industrial films and commercials, which are very different from fiction. "Who Shot Patakango?" is efficiently if antiseptically photographed, but the Brookses don't have a clue about how to write characters and shape a screenplay.

The movie, directed by Mr. Brooks, who was also his own cameraman, is a random collection of jokey anec-

David Knight

dotes about five boys who, though seniors, seem somewhat more aged than their general dimness of mind explains. The leader of the group is Bic, who is handsome enough to be a model and less lively than an 8-by-10 glossy.

In the course of the film, Bic and his friends become involved in some mild gang scrapes, play gags on one another, steal dimes from parking meters and take part in a staged reading of "Julius Caesar," for which they wear sheets tied over their clothes. Bic also meets and falls in love with a Sarah Lawrence girl, who finds him to be the man of her dreams. Throughout the film, there are references to a school talent show, and at the end Bic's group sings a song at the show.

That's it.

No anecdote leads logically to the next. Characters are introduced, then dropped. Plausibility doesn't exist. The movie reflects a time when violence and racial tensions were comparatively rare, although even that reflection is unconvincing as either comedy or drama. "Who Shot Patakango?" is a seriously deprived work.

The film opens today at the Sutton.

•

"Who Shot Patakango?" is rated R (Under 17 requires accompanying parent or adult guardian). It includes some nudity and strong language.

1992 My 1, C10:5

All the Vermeers in New York

Written, directed, edited and photographed by Jon Jost; music by Jon A. English; produced by Henry S. Rosenthal; released by Strand Releasing in association with Complex Corporation and American Playhouse Theatrical Films. At the Cinema Village 12th Street, 22 East 12th Street, Manhattan. Running time: 87 minutes. This film has no rating.

Anna	Emmanuelle Chaulet
Nicole	Katherine Bean
Felicity	Grace Phillips
Ariel Ainsworth	Laurel Lee Kiefer
Gracie Mansion	Herself
Gordon	Gordon Joseph Weiss
Mark	Stephen Lack
Max	Roger Ruffin

By VINCENT CANBY

Most film makers pretend to be anonymous. Even when their methods and concerns are familiar, they hide behind or within the events and the characters on the screen. Not Jon Jost, long identified with the American avant-garde. His new work, "All the Vermeers in New York," opens today at the Cinema Village 12th Street.

Although "All the Vermeers in New York" is not exactly obscure, and although it proceeds in the chronological order of a conventional narrative

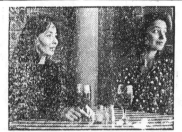

Complex Corporation

Emmanuelle Chaulet, left, and Grace Phillips

film, Mr. Jost is very much its most important character. He seems to talk directly to the audience as if he were standing just outside the film frame. He doesn't hector the audience; he nudges it. He tweaks its sensibilities by interrupting expectations that would be slavishly fulfilled in any other movie. Sometimes the effect is provocative and funny. At other times it's like being locked in a room with a raconteur who won't shut up, and whose asides are not always as illuminating as they are intended to be.

•

At the center of the film, though less important than the time, place and milieu they represent, are three people: Mark (Stephen Lack), a youngish Wall Street wheeler-dealer with an increasingly desperate passion for the work of the 17th-century Dutch painter Vermeer; Anna (Emmanuelle Chaulet), a pretty, unfocused, rather chilly would-be actress from France, and Anna's roommate, Felicity (Grace Phillips), also pretty, aimless, very rich and a half-hearted supporter of liberal causes.

One afternoon, in the Metropolitan Museum of Art, Mark observes Anna as she observes his favorite Vermeer, a portrait of a pensive young woman gazing out from the canvas. Struck by Anna's resemblance to the woman in the picture, which is not all that pronounced, Mark begins to pursue her. He pays no attention to her lack of enthusiasm and rudeness. He sees in her something of the healing serenity he associates with Vermeer. She sees him as a convenience and borrows $3,000.

If "All the Vermeers in New York" could be said to have a story, that would be it. Mr. Jost, though, is less interested in what happens next than in creating his own portrait of a loveless, barren world in which art, Vermeer in this case, represents a last vestige of humanism.

The film is alternately too explicit and too vague. It's one of the film's more obvious ironies that Mark, the exhausted stockbroker, is obsessed with art, while a young painter, introduced early in the film, is obsessed with money. At Anna's insistence, Mark takes her to the top of the World Trade Center. The view enchants her. He says: "I hate it up here. It's like being dead." For him it's just another reminder of how small and worthless people are in the contemporary scheme of things.

Mark and Anna are only part of the film's texture, which is occasionally enriched and often blurred by Mr. Jost's mannerisms. He has what amounts to a floor fetish. It seems that whenever in doubt about what to do next, he pans across the surface of a marble, parquet or conventional wooden floor, each highly polished and often being walked across by women's feet, sometimes bare of shoes and socks or stockings.

If two people are talking, he may photograph the scene by focusing exclusively on one of the participants. This creates a certain amount of tension, but to no particular effect. The camera will continue to stare at a space after it has been vacated. These images are frequently beautiful and soothing in themselves but, in spite of Mr. Jost's silent orders from offscreen, the audience may be reluctant to connect them to the film's other reality.

Although Mark, Anna and Felicity are, with purpose, obliquely characterized, they still remain more interesting than a consideration of a parquet floor, or a long, quite graceful camera movement around the columns of a great Wall Street lobby.

To enjoy "All the Vermeers in New York," you must accept it on Mr. Jost's severely structured terms.

1992 My 1, C13:1

The Linguini Incident

Directed by Richard Shepard; written by Mr. Shepard and Tamar Brott; director of photography, Robert Yeoman; edited by Sonya Polonski; music by Thomas Newman; production designer, Marcia Hinds-Johnson; produced by Arnold Orgolini; released by Academy Entertainment. Running time: 99 minutes. This film is rated R.

Lucy	Rosanna Arquette
Monte	David Bowie
Vivian	Eszter Balint
Dante	André Gregory
Cecil	Buck Henry
Miracle	Viveca Lindfors
Jeanette	Marlee Matlin
Tony Orlando	Eloy Casados
Oliver	Michael Bonnabel

By JANET MASLIN

"The Linguini Incident" trumpets its eccentricity with its title and casting, as well as in every other way it can. When a film's most down-to-earth actor is David Bowie, that film is clearly determined to stay off the beaten track.

In this case, the first-time director Richard Shepard (working from a screenplay he wrote with Tamar Brott) locates the center of his offbeat universe in a desperately hip restaurant called Dali (with appropriate décor, including a melting clock). The casual animosity among owners, staff and patrons (whom one

Academy Entertainment

Rosanna Arquette

waitress describes as "trend-sucking leeches") provides this cheerfully bizarre comedy with all the energy it needs.

•

Mr. Bowie, looking elegantly sunken and sounding wonderfully debonair, plays Monte, the new English bartender in this establishment. Monte causes an immediate flurry among the waitresses (whose uniforms involve metallic go-go dresses and flip hairdos) by proposing marriage to as many of them as he can persuade to listen. His principal target is Lucy (Rosanna Arquette), who uses Lucy the Ethereal as her stage name and is the flakiest of all the waitresses — no small accomplishment. Lucy's particular quirk is absorbing everything she can about Mr. and Mrs. Harry Houdini, and imitating the former with an arrangement of noose, leg irons and handcuffs that she keeps at home.

What does linguine have to do with any of this? Less than nothing, but then "The Linguini Incident" is not a film to worry about small details, except for those it finds unusually droll. Among the latter are the "ultimate self-defense bra" devised by Vivian (Eszter Balint), Lucy's friend and confidante, and the "disgusting hair pretzel" that is a mandatory accessory for Jeanette (Marlee Matlin), the restaurant cashier, who manages to swear colorfully in sign language at this and other job-related annoyances. Jeanette's complaints about her hairpiece fall on the heedless ears of Dante (André Gregory) and Cecil (Buck Henry), the smiling, slave-driving owners who give their employees hilarious pep talks and not much else. Ms. Brott, the co-screenwriter, once worked in a fashionable Manhattan restaurant and can consider that score nicely settled.

•

The casting, which is as much of a statement as this film has to make, also finds Viveca Lindfors playing a mysterious store proprietor who happens to have Mrs. Houdini's wedding ring for sale. Diverse as the actors are, they all seem to share Mr. Shepard's idea of what constitutes enlightened mischief, and to spread as much of it as possible. Typical of the film's many capricious thoughts is one from Mr. Gregory's Dante as he muses on a bet he has with Mr. Bowie's Monte. Perhaps if Monte loses he should have plastic surgery and be made to look just like Dante, Dante suggests. After all, he has always wanted an identical twin.

Mr. Bowie makes himself an amusingly level-headed presence, and Ms. Balint is scene-stealingly good as the hapless inventor who turns hold-up woman in the film's later stages. Her Vivian proves no more successful at this than at anything else, even when waving a gun at Dali's surprised customers and staff. "Honey, I hope you have a reservation," one of them says. At that, Vivian wisely drops the robbery scheme and claims to be a performance artist living in the East Village.

•

"The Linguini Incident" is rated R (Under 17 requires accompanying parent or adult guardian). It includes mild profanity and one brief sexual situation.

1992 My 1, C15:1

K2

Directed by Franc Roddam; screenplay by Patrick Meyers and Scott Roberts, based on the play by Mr. Meyers; director of photography, Gabriel Beristain; edited by Sean Barton; music by Chaz Jenkel; production designer, Andrew Sanders; produced by Jonathan Taplin, Marilyn Weiner and Tim Van Rellim. Released by Paramount Pictures. Running time: 104 minutes. This film is rated R.

Taylor Brooks	Michael Biehn
Harold Jamison	Matt Craven
Phillip Claiborne	Raymond J. Barry
Dallas Woolf	Luca Bercovici
Jacki Metcalfe	Patricia Charbonneau
Cindy Jamison	Julia Nickson-Soul
Takane Shimuzu	Hiroshi Fujioka
Malik Khan	Jamal Shah

By VINCENT CANBY

After about 80 minutes, "K2," Franc Roddam's screen version of Patrick Meyers's 1983 Broadway play, arrives at the point at which the play starts: Taylor and Harold, coming down from a successful ascent of K2, the world's second highest peak, have a nearly fatal accident. They become marooned on a mountain ledge, halfway between real life and life ever after, in a situation that tests their loyalty to each other, their skills as mountain climbers and their commitment to existence.

The two-man play, which runs about 95 minutes, is something of a tour de force, a densely packed, hair-raising drama in which character is revealed through extraordinary event. The movie is a windy big-screen adventure that doesn't get under way even when vestiges of the play do appear. There seems to be very little of the play left.

Mr. Roddam's film is something other. It's one of those movies in which a perilous, comparatively arcane passion, here mountain-climbing (though it could as easily be bull-fighting, deep-sea diving or snake-charming), becomes an excuse for some picturesque thrills and mystical talk about the siren sound of danger.

•

The film introduces Taylor (Michael Biehn) and Harold (Matt Craven) in their ordinary lives in Seattle. Taylor is a smooth, arrogant, self-assured assistant district attorney by day and, at night, a remarkably successful womanizer. Harold is a sober, successful, happily married physicist. As their personalities complement each other, they also share a love of the sport.

Or, as Harold tries to explain about the exhilaration that comes with mountain-climbing: "I feel the truth of my life. I have to have that."

•

In the course of an expedition in Alaska, Taylor and Harold befriend Phillip Claiborne (Raymond J. Barry), a billionaire climber, and the

Majestic Films International
Michael Biehn and Matt Craven

members of his team, who are preparing for the ascent of K2, in northern Kashmir. Though K2, at 28,250 feet, is not quite as tall as Everest (29,028 feet), it is regarded as the far tougher, more demanding climb. Taylor and Harold eventually make the team.

Mr. Meyers is credited as one of the two writers of the script, but the film's concerns and quality of imagination have very little to do with his play. The new characters are drab, their thoughts routine. The movie doesn't even make much of the clichés it introduces, such as the rivalry between Taylor and another Seattle lawyer who is a member of the Claiborne team.

"K2," which was filmed on mountain locations in Canada and Pakistan, has some stunning if isolated sequences of physical daring, including the ascent of a sheer rock face, an avalanche and an accident in which two climbers slip and fall down what appears to be several hundred feet of nearly perpendicular mountain ice.

Both Mr. Biehn and Mr. Craven work hard but without success to bring life to their watered-down roles. The action doesn't quite carry the film, but it prevents boredom from setting in for too long.

•

"K2" is rated R (Under 17 requires accompanying parent or adult guardian). It includes vulgar language and accidents that maim and kill.

1992 My 1, C16:1

FILM VIEW/Caryn James

This 'Deli' Thrives On Its Blender

WITH ITS GRACEFUL BUT SHAMELESS slapstick humor, "Delicatessen" is the closest thing to an impossible genre: a silent film with sound. That paradox merely hints at all the warring elements blended together in this strange and inventive French cult film, which has crossed over to mainstream success. Crossbreeding genres is this movie's wise esthetic premise.

The cockeyed story is set in a post-nuclear future, but the scene looks amazingly like the aftermath of World War II, from the bombed-out buildings to the women's 1940's fashions. The central characters live in an isolated apartment building covered in a murky brown smog. For these survivors, cannibalism is a political choice. The butcher who owns the ground-floor deli takes what meat he can get, which usually means sacrificing a recently hired handyman; a vegetarian underground group tries to thwart him.

■

Meanwhile, the butcher's accident-prone daughter falls in love with every new piece of meat he hires. One tenant sets up hilarious Rube Goldberg-inspired contraptions in futile attempts to commit suicide. And the only person who has no trouble finding food is the man who lives in a cellar teeming with frogs and snails. "My dear Hercules," he says to the escargot he's about to swallow, "every man for himself." It would be hard to find a darker and goofier film than this, or one that so smoothly combines black comedy with sight gags inspired by cartoons and silent-film comedians.

The film's hybrid nature is so pronounced that the most apt descriptions are themselves crossbreeds: if "The Cook, the Thief, His Wife and Her Lover" were remade starring the Simpsons; if David Lynch were possessed by the ghost of Charlie Chaplin; if the Coen brothers were set loose in Euro Disneyland — these are the odd couplings that might produce a film like "Delicatessen."

Because its mélange of borrowed and contradictory elements has been received with wild enthusiasm abroad, the film was already in danger of being oversold by the time it opened in the United States last month. A first film co-directed by Jean-Pierre Jeunet and Marc Caro — two Frenchmen with backgrounds in animation, experimental videos and television commercials — it has been running for more than a year in Paris and recently won three Césars (the French Oscars) for best first film, screenplay and editing. Early this year, it was the No. 1 film in England. It was given a midnight showing at the New York Film Festival last fall, and

since its release in the United States has done solid, though not blockbuster, business.

"Delicatessen" is too slight to live up to the inflated expectations raised by its European success; it is clever, but not radically new. The movie's debts to Terry Gilliam's futuristic "Brazil" are evident. For whatever marketing value it is worth, Mr. Gilliam has let his name be used as a "presenter" of "Delicatessen," as in "Terry Gilliam presents."

And at times the film becomes too whimsical for its own good. Its hero, the latest of the endangered handymen, is a

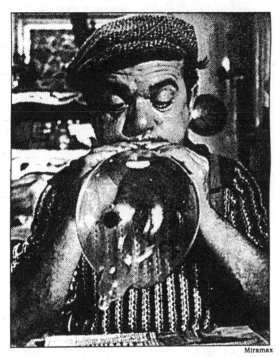

Miramax

Ticky Holgado in "Delicatessen"—A cockeyed story from France that elevates borrowing to an art form.

circus clown who ran away after his partner was kidnapped and eaten. The partner, it turns out, was a monkey, and the tiny red hat the clown carries along as a memento is more bathetic than comic.

Despite these minor flaws, as the film meanders from one set piece to another it makes good use of its directors' experience with short video forms. Like commercials and music videos, "Delicatessen" relies on visual flair and quickly paced mini-stories.

There is a vestige of a plot, in which Julie, the butcher's daughter, and Louison, the clown, fall in love. She tries to save him from becoming dinner. But the story is never as important as the film's atmosphere, physical humor and throwaway jokes. Julie takes off her glasses for a date with Louison and accidentally serves him soporific herbs instead of tea. They play romantic duets; she on the cello and he on the musical saw. Louison's character is one long visual gag, from his oversized clown shoes to an all-too-appropriate joke in which he puts a cleaver on his head. At a crucial point, a bathroom is flooded to the ceiling with water and used as a lethal weapon. Throughout, the characters wear expressions that range from deadpan to slightly baffled — theirs is a classic approach borrowed from cartoons and silent movies.

Given the determined silliness of "Delicatessen," it may be stretching things too far to say that the film's success in France owes something to the story's wartime allegory. But it is true that when Julie needs help in saving Louison, she goes to the Troglodistes, the vegetarian guerrilla fighters who live in the sewers and wear wet suits and miners' lanterns. This is one underground resistance group that truly exists underground. The film's unmistakable World War II design and cross-section of good and venal citizens evokes decades of French movies about the postwar period, with its legacy of heroes and collaborators. Even if the effect is subliminal, that history must resonate more strongly in France than anywhere else.

The film's broad success takes it beyond nationalism, of course, and suggests an international future for its directors. Having elevated borrowing to an art form in "Delicatessen," they would be fools to abandon the crossbreeding that has

worked so well. They have told countless interviewers on two continents that their next film will be a cross between "Pinocchio," "The Night of the Hunter" and Fritz Lang's "M." □

1992 My 3, II:13:4

Folks

Directed by Ted Kotcheff; written by Robert Klane; director of photography, Larry Pizer; edited by Joan E. Chapman; music by Michel Colombier; production designer, William J. Creber; produced by Victor Drai; released by 20th Century Fox. Running time: 109 minutes. This film is rated PG-13.

Jon Aldrich	Tom Selleck
Harry Aldrich	Don Ameche
Mildred Aldrich	Anne Jackson
Arlene Aldrich	Christine Ebersole
Audrey Aldrich	Wendy Crewson
Fred	Robert Pastorelli
Ed	Michael Murphy
Kevin	Kevin Timothy Chevalia
Maggie	Margaret Murphy
Jerry	Joseph Miller
Steve	T. J. Parish
Howard	John McCormack
Another Trader	Peter Burns
Chicago Taxi Driver	Jon Favreau
Gail	Jackye Roberts

By JANET MASLIN

Tom Selleck gets hurt a lot in "Folks," possibly more than might have been intended. Among the many painful pratfalls this actor must endure in the role of Jon Aldrich, a Chicago stockbroker suddenly trying to cope with his aging parents, is one bad fall that costs him a toe and a testicle. It's not easy to fathom how Mr. Selleck or any other actor could have read this far in Robert Klane's screenplay and still decided to go full steam ahead.

"Folks," which opened on Friday, is a comedy about something even less funny than the lost-testicle misadventure. It addresses the lighter side of Alzheimer's disease, with Don Ameche playing Jon's dazed, forgetful father as if he were a wonderful figure of fun. Jon has supposedly not seen his parents in many years, but the story sends him from Chicago to Florida to help them after his mother becomes ill, which allows the film a chance to find dubious humor among the shuffleboard set. "Look, do you mind?" says one of two old men playing that game when Jon gets in his way. "We're trying to finish the game while we're still alive."

Even deadlier than this, if possible, is the film's eventual get-rich-quick scheme for Jon, which involves engineering a fatal accident for his parents so he can collect on their life-insurance policies. The idea has actually been suggested by Jon's mother, played by Anne Jackson, who seems to be saying meekly "We never meant to be a burden" in several different scenes. "Folks," directed by Ted Kotcheff, actually intends to spin a funny routine out of how Jon's parents deliberately drive off into traffic trying to cause an accident, and do cause the demolition of many other cars.

●

Mr. Klane is best known as the screenwriter of "Where's Poppa?" and he may be aspiring to comparably dark humor. But "Folks" tries to be tender and vicious simultaneously, and that makes for an impossible mix. A more mean-spiritedly funny actor might have carried this material better, but Mr. Selleck strives for the cuddly rather than the caustic. Mr. Ameche, mugging furiously, af-

fects a jaw-jutting blank look and even props his chin on Mr. Selleck's shoulder occasionally for quasi-comic effect.

The film's only effectively tough performer is Christine Ebersole, playing Jon's grasping, unpleasant sister with garish verve. Also in the film are Michael Murphy as a Federal Bureau of Investigation agent and Wendy Crewson as Jon's sugary wife.

●

"Folks" is rated PG-13 (Parents strongly cautioned). It includes mild profanity.

1992 My 4, C15:1

Split Second

Directed by Tony Maylam; written by Gary Scott Thompson; director of photography, Clive Tickner; edited by Dan Rae; music by Stephen Parsons and Francis Haines; production designer, Chris Edwards; produced by Laura Gregory; released by Interstar. Running time: 90 minutes. This film is rated R.

Stone	Rutger Hauer
Michelle	Kim Cattrall
Durkin	Neil Duncan
The Rat Catcher	Michael J. Pollard
Thrasher	Alun Armstrong
Paulsen	Pete Postlethwaite
Jay Jay	Ian Dury
Robin	Roberta Eaton
O'Donnell	Tony Steedman
Foster	Steven Hartley
Tiffany	Sarah Stockbridge
Drunk	Colin Skeaping
Forensic Expert	Ken Bones
Nick (the Bar Man)	Dave Duffy

By STEPHEN HOLDEN

London in the year 2008 is a dank hellhole aswarm with rats and is severely flooded because of global warming and torrential rains. The soggy environment has spawned a killer who rips out the hearts of his victims, eats them and leaves elaborate astrological clues to his whereabouts.

Enter Stone (Rutger Hauer), the creature's would-be nemesis. Three years earlier, his police partner was murdered by the beast. Partly out of guilt for having taken up with his former partner's wife, Michelle (Kim Cattrall), Stone lives only to track down and exterminate the thing.

"Split Second," which opened on Friday, follows the efforts by Stone and his squeamish new partner (Neil Duncan) to end the terror. Before sputtering to a predictable ending, this clammy, blood-soaked thriller directed by Tony Maylam finds the pair staking out a sleazy strip club and rummaging through a morgue. Eventually they face down their enemy in a dripping, rat-infested subway tunnel.

●

Within the genre of supernatural thrillers, "Split Second' is fairly dull. Mr. Hauer's Stone is an expressionless, unsympathetic lug who grunts his lines in a near monotone that sometimes becomes unintelligble in the movie's muffled soundtrack. The film is so desperate to create tingles

that poor Miss Cattrall has to endure two protracted nude scenes — one in a shower, the other in a bathtub — in which she is menaced. Neither is especially spine-tingling.

•

"Split Second" is rated R (Under 17 requires accompanying parent or adult guardian). It has nudity, strong language and lots of gore.

1992 My 4, C15:1

Just Like in the Movies

Written and directed by Bram Towbin; director of photography, Peter Fernberger; edited by Jay Keuper; music by John Hill; production designer, Marek Dobrowolski; produced by Alon Kasha; released by Cabriolet Films. At the Quad Cinema, 34 West 13th Street, Manhattan. Running time: 90 minutes. This film is rated R.

Ryan Legrand............................Jay O. Sanders
Tura Erikson.....................Katherine Borowitz
Dean Erickson..................................Alan Ruck
Vernon Jackson...........................Michael Jeter
John Zanasco..............................Mark Margolis
Carter Legrand............................Alex Vincent
Alice..Lauren Thompson

By STEPHEN HOLDEN

A morose romantic comedy of unusual integrity, "Just Like in the Movies" aspires to be more than another up-to-date sitcom about the travails of being a lonely grown-up in search of a mate. Its central character, Ryan Legrand (Jay O. Sanders), is a divorced private investigator who specializes in gathering evidence of spousal infidelity. And despite his rugged good looks, he is no Mr. Right.

With his bohemian sidekick, Dean (Alan Ruck), Ryan spends hours each week hidden in a van with a video camera ready to roll when an adulterous couple shows up. The darkest scenes in the film, now playing at the Quad Cinema, are the moments when Ryan dispassionately presents his clients with the evidence they have hired him to gather, and he watches as they crumple when put face to face with the bitter truth.

It slowly becomes clear that Ryan, beneath his bluff, hail-fellow exterior, is quite unstable. His troubles begin when he subscribes to a video dating service and meets Tura Erikson (Katherine Borowitz), an impulsive free spirit who, he complains, "doesn't know where Vermont is." The two quickly become attached, but their relationship begins to come apart when Ryan displays a streak of irrational jealousy. After Tura breaks off their relationship, he tortures himself by using the same surveillance techniques on her that he employs for his clients.

Ryan's bottled-up anger doesn't reveal itself only in his relationship with Tura. On outings with his young son (Alex Vincent), he is also prone to inappropriate explosions of impatience.

•

"Just Like in the Movies," which was written and directed by Bram Towbin, is an odd piece of work because it seems to wander in several directions at once without settling into a particular niche. While the tone of the dialogue and the style of acting suggest an offbeat sitcom, the events of the story point toward melodrama. Yet no truly violent eruptions take place.

The movie also includes several set pieces that veer toward social satire. Two party scenes — a poolside gathering on eastern Long Island and a promotional event in Manhattan — paint a bleak, nasty picture of sophisticated New York social life. In the film's most audacious scene, Ryan and Dean embark on a disastrous double date that reaches its nadir in a place where Ryan forces a terrified young woman to stand in a cage and submit to a game of automated batting practice.

"Just Like in the Movies" is as quirky as the character of Ryan. Although Mr. Sanders tries to make him as likable as possible, he emerges as a wounded lost soul and a bad risk. The movie seems to uphold the motto "You are what you do." All the years spent spying on others and gathering evidence have curdled something in Ryan's soul and left him a bitter voyeur of his own emotionally empty life.

•

"Just Like in the Movies" is rated R (Under 17 requires accompanying parent or adult guardian). It includes strong language and adult situations.

1992 My 4, C15:1

Caroline Leaf
An Animated Life

A compilation of nine animated film directed by Caroline Leaf. At Film Forum 1, 209 West Houston Street. Running time: 74 minutes. This film has no rating.

By CARYN JAMES

Caroline Leaf has been labeled an animator, for lack of a better word. But there is nothing Saturday-morning cartoonish about the visual daring and variety of her work: adaptations of "Peter and the Wolf" and Kafka's "Metamorphosis" created in lines and shadows made of sand; "The Owl and the Pussycat," set to Stravinsky's music, with live actors in oversized masks; "The Street," a funny and emotionally stirring version of a Mordecai Richler story about a boy waiting for his grandmother to die. Each frame of "The Street" was painted on glass and photographed, so that it resembles a vibrant watercolor brought to life.

These and five other short works have been strung together to create "Caroline Leaf: An Animated Life," which opens today at Film Forum. Covering the first 23 years of Ms. Leaf's still-flourishing career, it is an uneven but often exciting introduction.

•

Ms. Leaf, an American who has lived in Canada since 1970, turns up on screen here in "Interview," a film made with her friend and fellow animator Veronika Soul in 1979. Shown in still photographs, live action and animation, the women describe themselves and their work. Ms. Leaf appears as a soft-spoken, conventionally pretty young woman — no one's idea of an artist on the avant-garde edge — who turns out to be her own best critic. She says her work is "like finger painting on glass," but admits the result would be more powerful "if I didn't hide from life."

Her work has the rich playfulness of finger painting, no matter what techniques she tries out. The sand animation, made from forming sand figures on glass and filming them, resemble some kind of magical

shape-shifting, as shadows form and reform fluidly into new scenes.

But this sepia vision isn't enough to capture the tone of "The Metamorphosis." Ms. Leaf seems to be illustrating the story, not reimagining the terror of a man turned into a beetle — which only shows that you can't hide from life and do justice to Kafka. Too often she settles for such eloquent but facile illustrations.

•

At her best, though, Ms. Leaf combines visual elegance with a deep, humane narrative. She infuses "The Street" with humor and sorrow as she tells the story of the sick grandma who won't die, forcing the hero to share a room with his sister until the old woman gives up the ghost. The thoroughly natural voices of the boy and his family blend perfectly with the soft, warm look of the film. Ms. Leaf is directing actors as well as paintbrushes here.

And in "Two Sisters," she invents a bizarre, haunting tale that might be an intellectual's version of "Whatever Happened to Baby Jane." Two sisters live on a deserted island. One is a famous author with a devastating secret; the other cares for her and lives through her. By etching her figures directly onto the film, Ms. Leaf created the look of a dark woodcut that glows with an eerie, beautiful green light. The figures are heavy and stylized, with distorted features, and seem inspired by Picasso. Made just last year, "Two Sisters" suggests that Caroline Leaf may have entered a stunning new phase of her art.

1992 My 6, C18:3

At Cannes, a Sense of Déjà Vu as Hollywood Elbows In

By JANET MASLIN

CANNES, France

ACROSS the street from the Palais des Festivals, the vast convention center at which the 45th Cannes International Film Festival began yesterday, it is possible to buy an oil painting of Scarlett O'Hara and Rhett Butler embracing against the backdrop of a burning Tara (not Atlanta), with Rhett sporting an unfamiliar-looking gun holster at his waist. The same art gallery also displays oils of Harrison Ford (looking rakish with an Indiana Jones-style bullwhip coiled around his neck) and Humphrey Bogart (parting grimly from Ingrid Bergman). For those who prefer their movie imagery on a more symbolic level, another painting depicts a chrome banana halfway unzipped to reveal a nasty-looking chrome dagger inside.

Whatever this may say about the tastes of art lovers basking too long in the Mediterranean sunshine,

it's a clear indication of Hollywood's overpowering influence on the international film world. Even stronger evidence can be found inside the Palais itself, where this year's festival will feature an even more highly visible American presence than usual. And American films have won the Palme d'Or, this festival's highest honor, the last three years.

Déjà vu may be a French phrase, but it is given newly American meaning by the presence of "Basic Instinct," "The Player" and "Howards End" in competition, not to mention Sidney Lumet's "Stranger Among Us," David Lynch's "Twin Peaks: Fire Walk With Me," Gary Sinise's "Of Mice and Men," Hal Hartley's "Simple Men" and Ron Howard's "Far and Away." Mr. Howard's Irish epic, which stars Tom Cruise and Nicole Kidman, is not in competition but will be the festival's closing feature next Monday.

Not surprisingly, at a time when complaints about American cultural imperialism are commonly heard

in France, this sort of cultural lineup is guaranteed to provoke snappishness in some quarters. As one writer remarked, handicapping the competitors for an international film journal, " 'Basic Instinct' has about as much chance of winning the Palme d'Or as it does of being turned into a ride at Euro Disney."

Certainly "Basic Instinct" plays strangely in this setting, as evidenced by the problems of translating its

American slang into French subtitles for last night's gala screening. The screenplay's 31 stab wounds became 31 blessures profondes, and ice pick was pic à glace; phrases like les practices Sado-Maso and cow-boy also found their way onto the screen. So did less than a minute's worth of censored material, the difference between the film's original NC-17 version and the one later released in the United States with an R rating. Sev-

eral seconds' worth of this restored material made the film's opening sequence, a stabbing during sex, substantially more gruesome than before.

It was clear at the "Basic Instinct" news conference that no underlying malaise about an American-dominated festival would be expressed in the form of hostile questions. Michael Douglas was asked how he felt about being treated as a love object. Sharon Stone, showing up at midday in a tiny black dress with a beaded sunflower over each breast, was able to de-

In subtitles, harsh 'stab wounds' turn into elegant 'blessures profondes.'

scribe the sexy sadist she plays in the film as "the most profoundly moving character that I've ever been offered." The Dutch-born director, Paul Verhoeven, referred to protests against the film by American gay groups as "just a storm in a glass of water," which seemed to mean "tempest in a teapot." Mr. Verhoeven was actually asked whether it signified anything that the sports car featured prominently in his film was a Lotus. "We couldn't afford the Ferrari," he said.

Ms. Stone and her co-star Jeanne Tripplehorn were asked to say something about Marlene Dietrich, who died on Wednesday at the age of 90, as was virtually everyone else who could talk into a microphone here yesterday. Jamie Lee Curtis, one of the jurors, was once engaged to Dietrich's grandson and actually had something relevant to say. It was universally noted that Dietrich, whose exquisite likeness in a portrait from "Shanghai Express" is the symbol of this year's festival, had died at an eerie moment as far as the festival was concerned. "For me, stars never die," proclaimed the gallant Gérard Depardieu, the head of the jury this year.

The other jurors are the directors John Boorman, Pedro Almodóvar, Lester James Peries and Nana Djordjadze; the cinematographer Carlo di Palma; the producer René Cleitman; the critic Serge Toubiana, and the screenwriter Joële van Effenterre. They were asked at another hard-hitting news conference whether they liked one another and said yes. As to how they would deliberate, Mr. Depardieu shook his Christopher Columbus-length hair and shrugged. "All you really have to do is follow your own heartbeat," he said.

Among the other films to shown in the main competition are Pavel Lungin's "Luna Park" and Vitaly Kanevsky's "Independent Life." Those two directors were significant newcomers two years ago (with "Taxi Blues" and "Freeze, Die, Come to Life," respectively), but then Cannes is the kind of place where new blood becomes old guard very quickly. Also of note are the "Best Intentions," by Bille August, who made "Pelle the Conqueror," and out-of-competition screenings of Quentin Tarantino's "Reservoir Dogs" and Darrell James Roodt's "Sarafina."

That this will be an especially peculiar festival was made clear at the

opening-night ceremony, where the onlookers lining the Croisette, Cannes's flower-lined seaside boulevard, divided their attention between familiar French figures like Johnny Hallyday and more unexpected ones, like Julie Andrews (whose husband, Blake Edwards, is being honored this year) and Spike Lee (a sure-fire winner-to-be). The fans, looking for excitement wherever they could find it, shrieked even at the sight of Jean-Claude Van Damme ("Kickboxer"), but the mood seldom exceeded the polite. Onstage in the Palais, an international assortment of producers was presented with awards, then surrounded by an amazing collection of flowers and bathing beauties. That made for a decorative tableau, but the accessory of choice is clearly the black Rolls-Royce convertible, left casually on the street with its top down. Three of these were outside the Palais as the opening-night ceremony began. Perhaps all three were still there when it was over.

1992 My 8, C1:2

November Days

Produced and directed by Marcel Ophuls (in German with English subtitles); director of photography, Peter Boultwood; edited by Sophie Brunet, Albert Jurgenson and Catherine Zins. At the Loews Village VII, Third Avenue and 11th Street, Manhattan, as part of the 1992 Human Rights Watch Film Festival. Running time: 129 minutes. This film has no rating.

With: Bärbel Bohley, Barbara Brecht-Schall, Werner Fischer, Stefan Hermlin, Pastor Uwe Hollmer, Egon Krenz, Michael Kühnen, Kurt Masur, Walter Momper, Thomas Montag, Heiner Müller, Günther Schabowski, Markus Wolf and others.

By VINCENT CANBY

Toward the end of "November Days," Marcel Ophuls's fine, wide-ranging documentary about the reunification of Germany, there is an uncharacteristic moment when the person being interviewed turns on his interviewer, Mr. Ophuls, and seems to stop him cold.

Until that moment, the film maker has received almost fawning respect from his subjects, especially from those former Communist Party officials who governed the German Democratic Republic and presided over its collapse. Not from Kurt Masur, though.

Mr. Masur, the new music director of the New York Philharmonic, has been the music director of the Leipzig Gewandhaus Orchestra since 1970. Though one of East Germany's most prized cultural figures, he played a leading part in the 1989 liberalization movement, only to become the victim of a later backlash when it was suggested that his liberal politics were opportunistic.

The charges did not stick, but they appear to be in Mr. Ophuls's mind when he asks the conductor if he feels betrayed by the former regime that once was his employer. Mr. Masur's response is chilly. He tells the film maker that he sees no need to answer such questions put "in your ironic and superficial way." He says, "You just want your story."

It's a tough, specific, unpleasant exchange in a film that, made during and shortly after the events it is considering, is no less effective for being often generalized and impressionistic.

With Mr. Ophuls in attendance to answer the audience's questions, "November Days" will be shown tonight at 6:30 at the Loews Village Theater VII to open the 1992 Human Rights Watch Film Festival. "November Days" will be presented

Marcel Ophuls takes his camera on the interview trail again.

three more times in the course of the festival.

Because of legal problems with the German interests that control the worldwide film rights, "November Days," which was shot on film, is being exhibited here in the video version that was presented by the BBC. Big-screen video is never the perfect way to see a theatrical film, but the format does little to diminish the impact of "November Days."

This new work is quite unlike Mr. Ophuls's monumental "Sorrow and the Pity" and "Hotel Terminus: The Life and Times of Klaus Barbie," both of which look back to the Nazi Occupation of France during World War II. Those films have the advantage of time's perspective and, indeed, they are as much about the effect of time as about the events they recall. The fine-grain images of film suit the subject: extraordinary and terrible events recollected in comparative tranquillity.

"November Days" is about initial impressions, expectations and apprehensions. It's an attempt to record the contradictory readings of a particular series of events as they are happening. It is contemporary history and, as such, the grainy video images reinforce the sense of immediacy.

More than in any other of his films that have been shown here, Mr. Ophuls is an on-screen presence in "November Days," probing, sometimes needling his subjects, occasionally offering a personal response. At one point he notes that he was lucky that his father (the noted German director Max Ophuls) fled west from Nazi Germany and not east.

Implied is his uncertainty about how he might have behaved if, like his old friend Barbara Brecht-Schall, the daughter of the German playwright Bertolt Brecht, he had been brought up in East Germany. The two reminisce about their childhoods in Hollywood during the war, before she returned to East Germany with her father in 1949.

She insists that she remained nonpolitical throughout the Communist era, saying that the only dealings she had with the regime were connected with the business of her father's theater company, the celebrated Berliner Ensemble. Old friends or not, Mr. Ophuls doesn't hesitate to punctuate that statement with a clip showing her socializing with Erich Honecker, who was the head of the East German Communist Party from 1971 until his forced resignation in 1989.

Mr. Ophuls's taste for irony and sarcasm is also evident in interviews with Markus Wolf, the former head of the East German secret police; Egon Krenz, former general secretary of the Communist Party, and Günther Schabowski, a former party leader and member of the Politburo. A lot of

Egon Krenz

these people are obviously self-serving, but there are some who, while admitting the failures of the Communist regime, insist that those failures do not necessarily mean the attempt was wrong.

One of his subjects suggests, sadly, that East Germans equate freedom with money, and then asks Mr. Ophuls what he would prescribe as a substitute for the former East German state. The director says that all Germans should be able to choose their way of life "like anyone else." It's a rather flat, limp response from someone who has been pushing everyone else to answer his questions directly and in detail.

That Mr. Ophuls has not seen fit to edit himself from the material, in this way to adopt a bogus anonymity, is to his credit and to the advantage of "November Days." Behind all of his reporting there are references to the personal memoir that fuels the passion to see and hear and, with luck, to comprehend.

1992 My 8, C8:1

Incident at Oglala

Directed by Michael Apted; director of photography, Maryse Alberti; edited by Susanne Rostock; music by John Trudell and Jackson Browne; produced by Arthur Chobanian; released by Miramax Films. Running time: 93 minutes. This film is rated PG.

Narrated by Robert Redford.

By JANET MASLIN

John Trudell, the American Indian spokesman and organizer, appears as an actor in Michael Apted's "Thunderheart," playing a firebrand suspected of murdering a Federal Bureau of Investigation agent. Mr. Trudell also appears in "Incident at Oglala," Mr. Apted's documentary on the same subject, and the difference is instructive. Mr. Trudell's fervent, angry manner is similar in both films. But it is "Incident at Oglala" that displays a photograph of this man's wife and children. They were killed (along with his mother-in-law) in a fire of suspicious origin, a fire that Mr. Trudell regards as directly linked to his political outspokenness.

"Thunderheart" made highly dramatic use of Mr. Trudell's furious, adamant demeanor; the quieter "Incident at Oglala" is the film that explains it. This straightforward, meticulous documentary offers a detailed account of the violent events that led to the murders of two F.B.I. agents in Oglala, S.D., in 1975, and the subsequent investigation that found Leonard Peltier guilty of the killings.

At the very least, "Incident at Oglala" persuasively points to gaping holes in the case made against Mr. Peltier, who is serving his 16th year in prison and continues to petition the court for a new trial. At most, when

Leonard Peltier

viewed as a companion piece to "Thunderheart," it offers some insight into the different possibilities afforded by the documentary and dramatic formats, differences that Mr. Apted has explored with considerable skill.

On its own, "Incident at Oglala" unfolds in a simple and often arid style, sometimes using visual representations of vital evidence in a manner that recalls "The Thin Blue Line." As narrated by Robert Redford, who is also the film's executive producer, it chiefly strives to make sense of the conflicting testimony of various figures in the case, and to consider the larger context in which the murders took place.

With interviewees ranging from members of the American Indian Movement to the F.B.I. agent in charge of the investigation, the film covers a wide area, but its focus remains clear. Mr. Apted establishes trouble between progressive and traditional elements within the Indian community, and supplies evidence that seems to attest to the violent acts of the so-called GOON squad (for Guardians of the Oglala Nation), led by Richard Wilson, who opposed the American Indian Movement's activities and who died in 1990.

After examining this volatile situation, the film moves on to the murders in question, with testimony from Darrelle (Dino) Butler and Bob Robideau, who were tried for the murders separately from Mr. Peltier and acquitted. "It would have been easy to die here that day, and it was a lot harder to go on living," one of them says.

Having established much confusion about what actually happened to the F.B.I. agents, Mr. Apted moves on to the evidence against Mr. Peltier and shows it to be questionable. "I didn't know what Leonard looked like until I met him in the courtroom," says Myrtle Poor Bear, who was falsely identified as Mr. Peltier's girlfriend and whose testimony led to his extradition from Canada. Using contradictory visual images of a truck and a gun that figured prominently in the case, the film also emphasizes the unreliability of other crucial evidence.

A thorough exploration of this material could easily stop there, but "Incident at Oglala" is filled with possibilities that lent themselves to Mr. Apted's fictional version. The GOON squad's activities, established here through victims' accounts and old photographs of Mr. Wilson, were more effectively dramatized in

"Thunderheart," as was the F.B.I. agents' side of the story. (Working in the realm of fiction, Mr. Apted apparently felt free to give this part of the tale a more satisfying ending.) The element of mysticism that is freely expressed in "Thunderheart" is felt more tacitly in "Incident at Oglala," through rapturous aerial views of the South Dakota terrain and through the chanting, rhythmic musical accompaniment supervised by Mr. Trudell and Jackson Browne.

Of these two films, "Thunderheart" is the broader and more far-reaching. But "Incident at Oglala" achieves what it set out to do, not only in Mr. Peltier's behalf but also in that of his people.

●

"Incident at Oglala" is rated PG (Parental guidance suggested). It includes mild profanity.

1992 My 8, C15:1

The Favor, the Watch and the Very Big Fish

Written and directed by Ben Lewin, based on the short story "Rue St.-Sulpice," by Marcel Aymé; director of photography, Bernard Zitzermann; edited by John Grover; music by Larghetto Music and Les Films Ariane; produced by Michelle De Broca and Simon Perry; released by Trimark Pictures. Running time: 89 minutes. This film is rated R.

Louis Aubinard	Bob Hoskins
Pianist	Jeff Goldblum
Sybil	Natasha Richardson
Norbert	Michel Blanc
Charles	Jacques Villeret
Elizabeth	Angela Pleasence
Zalman	Jean-Pierre Cassel
Grandfather	Samuel Chaimovitch
Violinist	Sacha Vikouloff
Mother Superior	Claudine Mavros
Bishop	Carlos Kloster
Prostitute	Yvonne Constant
Charles's Mother	Martine Ferrière

By VINCENT CANBY

"The Favor, the Watch and the Very Big Fish" is an exhausting, aggressively eccentric comedy about a photographer of devotional pictures, an innocent actress who provides the moaning and groaning for porn-film soundtracks and a pianist who comes to believe he is Jesus.

The setting is a fairy-tale Paris that is more easily reproduced on a Hollywood sound stage than in the real city where this film was made. The multi-national cast of actors, all of whom are supposed to be French, is headed by Bob Hoskins as the photographer, Natasha Richardson as the actress and Jeff Goldblum as the mad savior. Michel Blanc, who really is French, appears in a supporting role.

It's easy to see how Ben Lewin, the Polish-born, Australian-bred writer and director, was able to collect such a talented crew. His screenplay, based on a Marcel Aymé short story, has just enough funny lines and situations to inspire the hope that somehow everything will work out. It doesn't. Those lines and situations remain, but they are like mirages in a desert. They lead the audience on, only to disappoint.

Everyone works hard, and everyone has a brief moment when laughter is achieved. Mr. Hoskins's comes early when, trying to photograph a tableau featuring St. Francis of Assisi, he is driven to a near-breakdown by a goat that refuses to take direc-

Bob Hoskins, left, and Jeff Goldblum.

tion. Miss Richardson is funny for the intensity she brings to her dubbing work. Mr. Goldblum's character, though certifiably nuts from the start, goes over the edge when, through an unlikely accident in a park, he is convinced he has performed a miracle.

Though the film is comparatively short, it seems to play longer than its unwieldy and not terribly clever title. The screenplay is full of barren patches, the director's sensibility more doggedly persistent than comic. The real-life Paris settings don't have much connection to the principal players, who look like tourists.

Mr. Blanc, best remembered as the frail love object in Bertrand Blier's "Ménage," has little to do here, but even that is more than is required of his equally gifted French colleagues, Jean-Pierre Cassel and Yvonne Constant. They play bit parts.

●

"The Favor, the Watch and the Very Big Fish," which has been rated R (Under 17 requires accompanying parent or adult guardian), has some sexual situations and vulgar language.

1992 My 8, C15:3

Poison Ivy

Directed by Katt Shea; written by Ms. Shea and Andy Ruben; director of photography, Phedon Papamichael; edited by Gina Mittleman; music by Aaron Davies; production designer, Virginia Lee; produced by Mr. Ruben; released by New Line Cinema. Running time: 92 minutes. This film is rated R.

Cooper	Sara Gilbert
Ivy	Drew Barrymore
Darryl	Tom Skerritt
Georgie	Cheryl Ladd
Bob	Alan Stock
Isabelle	Jeanne Sakata
Kid	E. J. Moore
Another Kid	J. B. Quon
Guy No. 1	Leonardo Dicaprio
Man In Car	Michael Goldner
Tiny	Charley Hayward
Old Man	Tim Winters
James	Billy Charles Kane
Man on Screen	Tony Ervolina

By JANET MASLIN

Home-wrecking remains mostly the province of female movie characters, perhaps because it involves such subtle skills. "Poison Ivy" is the latest thriller about a sexy, scheming blond interloper who singles out an ostensibly happy nuclear family and, just for fun, sets her sights on destroying the whole household.

Ivy (Drew Barrymore), an older and much worldlier Lolita, can accomplish this using nothing more than clever, intuitive seductiveness and a keen grasp of each family member's private weakness. That makes "Poison Ivy" a B movie with a vengeance, one that offers a wickedly feminine (though hardly feminist) view of nominally happy family life and its failings.

"I mean, I never knew anyone who looked that much like a slut," recalls glum, introverted Sylvie Cooper (Sara Gilbert), who first meets the girl she nicknames Ivy when they both get into trouble at school. (The nickname comes from the tattoo on Ivy's thigh.) Ivy, who has no stable family of her own, quickly attaches herself to this wealthy, neglected daughter of a preoccupied television executive (Tom Skerritt) and a beautiful, bedridden woman who is slowly dying of emphysema (Cheryl Ladd). And Ivy begins playing upon the weaknesses of each of these unhappy people.

Sylvie, known as Cooper, is more than happy to let the glamorous, troublemaking Ivy take over her life. Soon Ivy has moved into the Cooper home and developed an eerie rapport with her friend's ailing mother, Georgie, a rapport that conveniently involves borrowing the sick woman' clothes. "Energy never dies; it jus changes form," Ivy tries to say con solingly, as she talks about death with her friend's mother, played with an effective edginess by Ms. Ladd "Yeah, well, you see whether you're ready to change forms when you're 38 years old," Georgie snaps back, but still the two seem to have developed some kind of kinship.

Ivy burrows even more deeply into the psyche of Darryl (Mr. Skerritt), whose concerns about his career and the prospect of losing his wife make him an ideal target for this teenager's many talents. In one of the film's more startling scenes, Darryl encounters Ivy in the middle of the night, when he happens not to have his toupee on, and finds her almost diabolically comforting; she tells him soothingly that she likes him better without the artifice, and he seems deeply relieved at that thought. Another sequence finds Ivy seducing Darryl on a rainy day atop the hood of his expensive car, in an image that ably conveys the film's sultry, insinuating power.

Katt Shea, who directed and co-wrote "Poison Ivy," displays a gleeful enthusiasm for the B-movie genre to which her film essentially belongs, as well as a grasp of the form's more delicate possibilities. "Poison Ivy" never resorts to overt malice when something more quietly sinister will do. In addition to exploiting the menacing possibilities of her film's basic situation, Ms. Shea also finds ways to look at the underlying causes of her characters' anomie, which are observed rather than discussed directly. Among the Coopers, materialism matters greatly and no love is unconditional, not even the family dog's. Incidentally, he too is eventually caught up in Ivy's spell.

After her long and well-publicized burnout period, Ms. Barrymore is an actress again, and quite a sly one in this coquettish role. (The resemblance to Sue Lyon's Lolita is pointedly underscored in at least one scene, but Ms. Barrymore brings her own brand of toughness to the type.) Providing a strong contrast to Ivy's tactics is Ms. Gilbert's sulkier, more introverted Cooper, whose gratitude at having found a new friend eventually blossoms into something more troubling. Trouble is Ivy's middle name.

●

"Poison Ivy" is rated R (Under 17 requires accompanying parent or adult guardian). It includes sexual situations and profanity.

1992 My 8, C16:3

Wild Orchid 2
Two Shades of Blue

Written and directed by Zalman King; director of photography, Mark Reshovcsky; edited by Marc Grossman and James Gavin; music by George Clinton; production designer, Richard Amend; produced by David Saunders and Rafael Eisenman; distributed by Vision International. Running time: 107 minutes. This film is rated R.

Blue........................Nina Siemaszko
Elle...........................Wendy Hughes
Josh..............................Brent Fraser
Sully..............................Robert Davi
Ham.............................Tom Skerritt
Jules......................Joe Dallesandro
Senator............Christopher McDonald
Mona............................Liane Curtis

By STEPHEN HOLDEN

It is 1958 somewhere in California, and the cry of a muted trumpet curls through a sepia haze. In this grungy, twilight world, Ham (Tom Skerritt), an itinerant jazz musician, and his teen-age daughter, Blue (Nina Siemaszko), travel from town to town as Ham weaves his moody trumpet magic in nearly pitch-black clubs. Like Chet Baker, on whom he is obviously modeled, Ham is also a heroin addict. And one night when he is too sick from withdrawal to perform, Blue, who is as practical as she is attractive, sells her body to the club owner (Joe Dallesandro) in order to pay for her father's drugs.

These atmospheric opening scenes of the West Coast jazz life are the most captivating moments in "Wild Orchid 2: Two Shades of Blue," Zalman King's latest fusion of soft-core and art-film esthetics. The movie follows the tradition of such earlier King movies as "9½ Weeks" and the original "Wild Orchid," which were modestly successful in the United States while doing blockbuster business overseas. There is every reason to expect that "Wild Orchid 2," which tells of Blue's descent into prostitution after her father's violent death, will follow the same pattern.

The orphaned, destitute teen-ager is taken under the wing of Elle (Wendy Hughes), an icy madam who persuades her to work in her elegant suburban brothel. Beginning with a scene of Blue's brutal initiation into Elle's world in the men's room of a chic restaurant, the movie loses any semblance of reality and becomes a high-gloss peep show with a romantic sheen and a nasty undertone of violence.

Triumph

Nina Siemaszko

The romance focuses on Josh (Brent Fraser), a handsome teenager Blue met by chance shortly before her father's death and about whom she fantasizes while going about her daily erotic chores. The film's most poignant moment comes when Josh is brought to Elle's mansion by his father to lose his virginity and the young man chooses Blue, whom he does not recognize behind a geisha disguise. They meet again, when Blue runs away and tries to lead a normal teen-age life.

The erotic ambiance of "Wild Orchid 2" has little to do with explicit sex and everything to do with fantasy. Most of the scenarios in which Blue and her fellow sex workers are asked to participate involve some form of bondage and ritualized violence. The ugliest one, which prompts Blue to flee the brothel, occurs when she is sent to the home of a Senator (Christopher McDonald, obviously chosen for his physical resemblance to John F. Kennedy), who wants to film her being gang-raped by a group of his friends.

Miss Siemaszko, the 22-year-old actress who plays Blue, brings a surprising integrity to the role. Babyfaced, with blond curls, a cleft chin, fiercely penetrating brown eyes, and a clear, calm speaking voice, she projects a mixture of feistiness and vulnerability that recalls the younger Jodie Foster. Miss Hughes, a respected Australian actress who is best known to American audiences for her work in "Careful, He Might Hear You," gives a finely modulated portrayal of Elle, a role that would also seem tailor-made for Faye Dunaway.

Even though he has some impossible dialogue, Mr. Fraser epitomizes the sort of precocious pre-hippie teenager who has read "On the Road" and is waiting for the 60's youth culture to explode. The performances of Robert Davi, who plays Elle's slightly sinister chauffeur and Blue's protector, and Mr. Skerritt, as her volatile father, also shine through the murk.

"Wild Orchid 2" clearly wants to do more than merely titillate, but it has only the faintest idea of what it wants to say and of how to say it.

•

"Wild Orchid 2: Two Shades of Blue" is rated R (Under 17 requires accompanying parent or adult guardian). It has nudity, explicit sex and some strong language.

1992 My 8, C17:2

A Soviet Family
That's Close, *Very* Close

"Adam's Rib" was shown as part of last year's New York Film Festival. Following are excerpts from Janet Maslin's review, which appeared in The New York Times on Sept. 21, 1991. The film, in Russian with English subtitles, opened yesterday at the Lincoln Plaza Cinema, Broadway and 63d Street in Manhattan.

If ever there was a good argument for family life in close quarters it is "Adam's Rib," a wonderfully wry Soviet comedy about three generations of women living in nerve-jangling proximity to one another. Sharing a bathroom, some clothes, some onerous chores and a lot more intimacy than any of them bargained for, the heroines of this story manage to make the best of a desperately claustrophobic situation.

Presiding over it all is the silent figure of a matriarch (Yelena Bogdanova), who lies paralyzed in one corner of the apartment while her daughter and two granddaughters bustle frantically about. The director, Vyacheslav Krishtofovich, eloquently moves his film from the everyday to something much larger by beginning with this silent old woman's memories of a warm family life that is long gone.

The baby of those memories is now 49-year-old Nina (Inna Churikova), the twice-married, beleaguered, very funny mother of both Lida (Svetlana Ryabova), a beautiful office worker trapped in an unhappy affair with her boss, and Nastya (Masha Golubkina), an outspoken 15-year-old who every morning seems to have spirited away a different one of Lida's belongings. Watching these three characters ricochet wildly off one another as they prepare for work each day, arguing bitterly about whose job it is to change grandma's bedpan, is akin to observing some mad scientist's non-working model for nuclear fission.

Even the subject of anti-Semitism, improbably enough, becomes grist for the film's sly and very Soviet humor. So does the Soviet economy, where the smaller a bathing suit is the more it costs.

The undercurrent of hardship in "Adam's Rib" makes its humor that much more welcome. Mr. Krishtofovich also underscores the essential generosity of his characters, however sorely it is often put to the test. At the end of this small and enormously likable film, all of the women have been united in a heartening show of solidarity and in the certainty that their dynasty will endure.

1992 My 9, 17:2

Crisscross

Directed by Chris Menges; screenplay by Scott Sommer, based on his novella; director of photography, Ivan Strasburg; edited by Tony Lawson; music by Trevor Jones; production designer, Crispian Sallis; produced by Anthea Sylbert and Robin Forman; released by Metro-Goldwyn-Mayer. Running time: 100 minutes. This film is rated R.

Tracy Cross.........................Goldie Hawn
Joe...Arliss Howard
Emmett................................James Gammon
Chris Cross..............................David Arnott
John Cross..........................Keith Carradine
Jetty..J. C. Quinn
Louis.......................................Steve Buscemi
Blacky..................................Paul Calderon
Oakley.............................Cathryn dePrume
Kelly.................................Nada Despotovich
Blondie.................David Anthony Marshall
Shelly.............................Deirdre O'Connell
Monica......................Anna Levine Thomson
Snyder.......................................Neil Giuntoli
Termina.................................Christy Martin
Buggs................................Damian Vantriglia
Cruz...Derrick Velez
Harvey...................................Frank Military
Connie..John Nesci

By CARYN JAMES

Goldie Hawn does not giggle or act bubble-headed once in "Crisscross." She is thoroughly restrained and convincing as Tracy Cross, a divorced mother raising her 12-year-old son, Chris, in a seedy Florida hotel in 1969. That is just the first of many surprises in a film that offers a deeply touching and tough-minded treatment of motherhood and adolescence.

Seen largely from Chris's point of view, the story is as understated as his admission that he has "a screwed-up life." Things are so messed up in this hard-scrabble family that Chris has two jobs in addition to his paper route. And while Tracy keeps her day job as the Eden Hotel's waitress, at her night job she has moved on from bartending to stripping in a local dive. She'll make five times as much money, but doesn't want her son to find out.

The story is an open invitation to the kind of upbeat inspirational sentiments that hackneyed movies are made of. But Scott Sommer's script and Chris Menges's direction avoid every pitfall. Like Mr. Menges's last film, "A World Apart," this is the story of parents who make desperately wrong choices with all the best intentions. The film doesn't flinch from the pain and anger those decisions inflict on the family.

Chris, baffled when he overhears a reference to "Tracy's new act," sneaks into the club one night. As the camera cuts back and forth between the determined mother and her confused son, it is impossible to guess who is in more pain. The scene is never lurid, but is profoundly troubling.

•

The actors evoke enormous sympathy for people who are trying hard to survive and make sense out of the emotional conflicts of their lives. Chris's father is so traumatized by his service in Vietnam that he has abandoned his family and retreated to the shelter of a monastery where he works as a gardener. In that brief and implausible role, Keith Carradine creates the compelling image of a gaunt, haunted man barely able to help himself, much less the son who needs him so much.

As Tracy's love interest, Arliss Howard is just as mysterious and effective as he needs to be. But it is David Arnott, as Chris, who carries this film. With a voice that seems just about to crack into adolescence, Chris is intelligent and poignant, but still a quickly maturing kid.

The film's flaws are minor. It relies so heavily on Chris's voice-overs that it becomes a touch too literary. And Mr. Menges has a mercifully short attention span for the 1960's atmosphere, which includes watching the moon landing on black-and-white television. Those scenes don't need to be here at all.

But when it counts, "Crisscross" makes all the right moves, including an ending that is both optimistic and realistic. And Goldie Hawn, whose company produced this film, shows that she can stop being a bubblehead any time she wants.

•

"Crisscross" is rated R. (Under 17 requires accompanying parent or adult guardian.) It includes scenes of drug use and some brief flashes of nudity.

1992 My 9, 17:5

FILM VIEW/Caryn James

One Director, Two Routes
To American Indian Travail

THE MURDER MYSTERY "THUN-
derheart" and the documentary
"Incident at Oglala" feature dra-
matic aerial shots in which the cam-
era swoops down and glides across
the vast Badlands of South Dakota. The
scenes, filmed on the Pine Ridge Indian Res-
ervation, are remarkably similar. But this is
no case of plagiarism, unless you count a di-
rector borrowing from himself. Michael Ap-
ted is behind both films, which offer fictional
and nonfictional versions of the same story —
the exploitation of American Indians by the
United States Government in the 1970's, with
effects that reach into the present.

The fictional version speaks eloquently to
the heart, while the documentary makes a co-
gent appeal to the mind; but the films did not
start out as neat companion pieces. Mr. Ap-
ted was already shooting "Oglala" when he
agreed to direct "Thunderheart." Acclaimed
for documentaries such as the recent "35
Up" and fiction films such as "Coal Miner's
Daughter," Mr. Apted was a more natural
choice for this material than any Englishman
might seem. His sense of texture and his abil-
ity to capture characters at revealing mo-
ments of crisis infuse both of his current
films.

Miramax

*An American Indian Movement supporter in "Incident at Oglala"—
Crosscurrents between a fictional version for the heart and a
documentary for the mind.*

When "Thunderheart" and "Oglala" are
viewed back-to-back, though, their crosscur-
rents make them even more powerful than
either would be alone. And they highlight two
ways in which politics goes to the movies.

"Oglala" is a straightforward and convinc-
ing documentary, which examines the case of
Leonard Peltier, an American Indian who
has been in prison for 16 years for the mur-
der of two F.B.I agents. The agents died in a
shootout with members of the militant Amer-
ican Indian Movement on the Pine Ridge
Reservation in 1975.

◼

The Peltier case is a complicated tangle in-
volving extradition from Canada, a trial and
several unsuccessful appeals (including one
pending). But the film's basic argument is
simple. Mr. Peltier did not receive a fair tri-
al, the film says, because the United States
Government manufactured evidence harm-
ful to him, withheld evidence that might sup-
port him, and threatened and manipulated
witnesses into testifying against him.

The purpose of "Oglala" is bluntly politi-
cal. As it marshals documents and inter-
views people on both sides of the case, it aims
to win Mr. Peltier his freedom, or at least a
new trial.

One obvious tactic is to give Mr. Peltier
such high visibility that the Government will
be embarrassed into reconsidering his case.
In that attempt, "Oglala" benefits immea-
surably from the star aura of Robert Red-
ford, who narrates the film and is its execu-
tive producer. Without the Redford name, it
is doubtful that such an uncommercial tale
would be taking up valuable space on movie
screens.

Some of those interviewed are extraordi-
nary. John Trudell, once the national spokes-
man for the American Indian Movement, is
articulate and vehement as he describes his
generation, "caught between the past and the

> ## Michael Apted has done the unusual, examining the same material in a documentary and in a feature film set in South Dakota.

future in a culture that wants to deny us a
present." But ultimately too many talking
heads dissipate the tension in the film.

One way to enliven the documentary's
sometimes slow, complicated proceedings is
to watch it after the more powerful and ac-
cessible "Thunderheart," which brings the
ideas behind both films to dramatic life.
While "Oglala" is a polemic with star back-
ing, "Thunderheart" is entertainment with a
social conscience. And the fiction film's poli-
tics become much clearer when seen in the
factual light of "Oglala."

Though John Fusco's script is original, the
film states that it is "inspired by events in
the 1970's on several reservations." Two fic-
tional F.B.I. agents (not based on those killed
at Pine Ridge) are sent to a reservation to in-
vestigate an Indian's murder. One agent is a
by-the-book career man, Frank Coutelle
(Sam Shepard); the other is a young man
who chooses to ignore his part-Indian ances-
try, Ray Levoi (Val Kilmer).

Levoi is the hero of "Thunderheart," for he
enters the reservation believing he is part of

a white man's world and leaves having discovered the beauty and importance of his Indian heritage. The film establishes the primacy of Indian values with a strong visual gesture at the start. Indians from the past, in traditional dress, dance in a circle on the empty plain and slowly fade away, vanishing into thin air. The scene portrays the beauty and loss of American Indian traditions more viscerally than all the words in "Oglala."

Like Levoi, Coutelle is a fictional type, meant to represent the sort of bureaucratic, distrusted F.B.I. agents who are challenged in "Oglala." And Graham Greene, as a tribal policeman named Walter Crow Horse, has the best scenes as another representative type. He is the savvy Indian who treasures his heritage yet finds ways to make it live in the modern world.

But while "Thunderheart" is a swift, engaging suspense movie, its strength comes from its factual backbone. The real-life American Indian Movement (A.I.M.) is depicted here as the Aboriginal Rights Movement (A.R.M.). Fred Ward, as a corrupt tribal leader called Jack Milton, evokes the late Dick Wilson, tribal leader of the Pine Ridge Reservation at the time of the shootout. Both Milton and Wilson were backed by vigilantes; in real life, Wilson's thugs were unabashedly called the G.O.O.N. squad, for Guardians of the Oglala Nation.

And John Trudell, so easy to remember from "Oglala," becomes the most visible link between the two films. He turns up in "Thunderheart" as the fictional character Jimmy Looks Twice, an A.R.M. member whom the F.B.I. agents believe is the murderer. Pursued and framed by the F.B.I., Jimmy Looks Twice combines an echo of Leonard Peltier with the real-life Jimmy Eagle, the young Indian the F.B.I. agents were following on the day of the Pine Ridge shootout. Mr. Trudell's intensity on camera is effective in both films, and for anyone who has seen "Oglala," his presence in "Thunderheart" adds legitimacy to the fiction.

Similarly, the fictional Maggie Eagle Bear (Sheila Tousey), whose home is shot at and whose small son is wounded by A.R.M.'s enemies, echoes a story told by a woman in "Oglala," a story that is not unique. Her house was shot at and her son wounded, as if they were in a real-life movie.

This episode is doubly disturbing no matter which film is seen first. For anyone who has witnessed the scene of the little boy being shot in "Thunderheart," the interview in "Oglala" comes painfully to life. And if the viewer has already heard the mother in "Oglala" describe the actual event, the dramatized scene in "Thunderheart" becomes almost unbearably strong.

Such illuminating moments in the two films are countless and often small, but they add up to a large point. "Oglala" affirms the truth behind "Thunderheart," just as "Thunderheart" enhances the emotional power of "Oglala."

Meanwhile, Oliver Stone has dropped his plans, started years ago, to make a feature based on the Peltier case. The two current films have left the field too crowded, at least commercially. But in artistic and political terms, "Thunderheart" and "Oglala" suggest there is always room for other views if they enhance what is already there. □

1992 My 10, II:22:1

Cannes Loves Altman's Mockery of Filmdom

By JANET MASLIN

Special to The New York Times

CANNES, France, May 10 — There were posturing and schmoozing and power-breakfasting to be seen here over the weekend, and some of those things actually took place off the screen. The rest were on view in "The Player," which thoroughly enchanted the Cannes audience even as it lacerated much of what that audience holds dear. Shown only three days into the Cannes International Film Festival, "The Player" was cheered for its dead-on satire and its irreverence, both of which give it the earmarks of a possible winner. The fact that the director, Robert Altman, publicly expressed his disapproval of organized competitions among artists probably only heightened his chances of winding up with a major prize at this one.

Although "The Player" speaks a universal language, some of it was inevitably lost in translation. The film's running gag about brands of bottled water seldom turned up in the subtitles. And of course Mr. Altman's famous fondness for overlapping dialogue could not be adequately conveyed. However, the festival audience had its own eye for interesting details, buzzing more about minor players like the director Sydney Pollack than about movie-star walk-ons like Cher. The audience was particularly startled by the film's jokes about newspaper headlines like the one about a mud slide in Chile that is described by Peter Gallagher, playing an ambitious movie executive, as good material for the director John Boorman. (Mr. Boorman happens to be on the Cannes jury this year.)

Even greater frissons were caused by the film's references to a gas-chamber execution and to the beating of Rodney King. "It seems to me that if we were able to anticipate both of those events, George Bush and the American Government should have been able to anticipate them as well," Mr. Altman said firmly at his news conference. He also described Hollywood executives as being so short-sighted that "they only worry about making enough money to fill their own swimming pools until they get fired." He faltered only once during the session, when faced with a reporter from Iceland, a country that is regularly made fun of in his film. Only momentarily flustered, Mr. Altman stuck to his film's contention that "Iceland is green and Greenland is icy."

A few hours later, marveling over the bouillabaisse at a famous seaside restaurant, the novelist and screenwriter Michael Tolkin remembered what the Cannes festival had conjured up for him when he was a young art-house film fan. "This is the fantasy you punish yourself for having," said Mr. Tolkin, who was here for the first time. It was Mr. Tolkin who originally evoked "The Bicycle Thief" in his novel "The Player" (it is briefly glimpsed in Mr. Altman's film) as a throwback to the golden age of the Eurpoean art film, and "because it is unbelievably sentimental and painfully true at the same time, which is a combination that's been lost." As for his collaboration with Mr. Altman, whose style is much looser than the writer's hard-edged prose, Mr. Tolkin said the upshot was that the director "wound up knowing more about how the characters felt about each other, and I knew more about how they felt about themselves."

Both the writer and the director remarked upon the fact that the film "The Player" includes not a single reference to an agent, apparently because Mr. Altman preferred not to give agents the satisfaction of being brought to mind. However, Mr. Tolkin is working on a novel about an agent, which he said he expects to finish soon after returning to California. "This looks like home," said his wife as she gazed wistfully out at the ocean. "Except our pool isn't this big, Wendy," Mr. Tolkin said.

Reuters

Robert Altman, left, director of "The Player," with Whoopi Goldberg and Tim Robbins in Cannes.

Merchant-Ivory's Soirée

As "The Player" began one of its main promotional events on Saturday night — a candle-lighted, paparazzi-ringed gala on the beachfront deck of the Carlton Inter-Continental Hotel — this festival took on the otherworldly glamour for which it is so well known. An even more dazzling photo opportunity came along the next day at a villa a short distance outside town. The party there was in honor of Ismail Merchant and James Ivory, who have a lot to live up to in the villa department. Sure enough, they had found a small chateau and a large formal garden well worthy of their.

Casanova returns, at least in a movie, but he may not get as far as America.

"Howards End," which was shown in competition today.

"Queen Victoria spent a weekend here," Mr. Merchant remarked as he mingled among reporters and cast members, serving lentils he had cooked himself. It turned out that the lentils would have to be cooked again in New York, since Mr. Merchant had been filmed in the kitchen by a crew from "60 Minutes" and the shot hadn't come out right. Later on, as television crews cornered Mr. Merchant, Mr. Ivory and Vanessa Redgrave in various sections of the rose garden, Samuel West, the young actor who plays Leonard Bast in "Howards End," recalled that the film makers had sent him home to inquire whether his mother wanted to be in the film. His mother is Prunella Scales, who said yes and appears as Aunt Juley.

Miss Redgrave was roundly complimented on her performance and asked if she would continue her auspicious association with the Merchant-Ivory team. "Yes, you bet I will," she said.

Lessons for Casanova

There are other films in the festival, of course, but thus far the tidal waves of enthusiasm remain out at sea. The two Russian-language films shown in the main competition, Vitaly Kanevsky's "Independent Life" and Pavel Lungin's "Luna Park," share a

raw, muscular, elliptical style that often lacks narrative continuity, and makes up for its vagueness with brute force. Each of these films attests to its director's talent and vision, but neither is coherent enough to have taken the festival by storm. On the tamer end of the spectrum is the lightweight, charming costume drama "The Return of Casanova," directed by Édouard Niermans and drolly co-written by the director and Jean-Claude Carrière, about events that teach the aging great lover some essential lessons.

This film is no deeper than the creases in the handsome brow of Alain Delon, who plays the title role most elegantly despite a waist-length wig and whose similarity to the figure he plays has been breathlessly noted by the French press. "The Return of Casanova" is attractive and entertaining, but in the current climate for film distribution, that may not be enough. American distributors looking for foreign films here sound all too mindful of the narrow range of foreign films that American audiences will accept.

A director belittles contests, helping his chances for a prize.

Dan Talbot of New Yorker Films said he remained sanguine and was adding three screens at his Lincoln Plaza Cinemas in Manhattan to prove the point. The influential Mr. Talbot, who likens his wide-ranging cinematic interest to stamp collecting, was on a schedule of four or five films a day and said he planned to see certain films purely out of curiosity about the geographical regions from which they come. Sounding more cautious was Bingham Ray of the California-based October Films, the much smaller company that is currently distributing the comic, well-observed Russian film "Adam's Rib." October Films is at Cannes this year hoping to acquire one particular American independent film, which he preferred not to identify, that was well received at an earlier festival.

1992 My 11, C9:1

A Political Prisoner's Quest for an Apology

"Locked-Up Time" was shown as part of last year's New York Film Festival. Following are excerpts from Caryn James's review, which appeared in The New York Times on Sept. 29, 1991. The film, in German with English subtitles, opened yesterday at the Walter Reade Theater, 165 West 65th Street in Manhattan.

In 1984, Sibylle Schönemann and her husband, both film makers frustrated by restrictions on their work, asked the East German Government for exit visas. The next thing they knew, they had been arrested on

charges that were never made clear to them. Ms. Schönemann spent a year as a political prisoner, then was put directly onto a bus for the West. Her husband, who received a slightly longer sentence, and their two children were sent after her, with only a few suitcases of belongings.

"Locked-Up Time," Ms. Schönemann's extraordinary documentary about that experience, begins with another bus on the highway, but this time the director is traveling in the opposite direction. In 1990, after the Berlin wall had come down, she returned to the East. She says she want-

ed to confront the past, but the film is more remarkable for the way Ms. Schönemann confronts the individuals responsible for her arrest and imprisonment. This deft and chilling film has the style of a personal excursion into history and the urgency of a moment when history is still inchoate.

Because it was shot in black and white, the documentary carries an aura of the past. This technique creates a strong, ironic tension. As Ms. Schönemann tracks down her prison warden, the man who interrogated her, the lawyer who failed her and the judge who convicted her, the film suggests that their experiences are far too fresh to be reacted to with anything like detachment or remorse. For them, the past is still the present.

●

Ms. Schönemann eases into these interviews, beginning in the yard of a woman who lives near the prison. The director climbs to the top of a tree she saw from her cell window, while the neighbor says she had no idea political prisoners were being held there. The film maker moves on to the woman who was her jailer. She smiles and says she remembers Ms. Schönemann, as if they were old friends.

●

But when Ms. Schönemann asks why a letter from her husband was withheld for six weeks, the warden pulls a book of rules off the shelf to show that she didn't break any.

Ms. Schönemann's method is to be calm and restrained rather than confrontational. She seems to want understanding, if not an outright apology, from the people she questions. That, it turns out, is asking too much too soon.

Most often, she lets her questions fill in the details about what happened. Although this technique adds a bit of confusion that is intensified by the translation from German, it is an effective, nonpolemical approach. "Locked-Up Time" is an eloquent film that shows what an abstraction like "politics" did to one woman and her family.

1992 My 11, C10:3

The Waterdance

Directed by Neal Jimenez and Michael Steinberg; written by Mr. Jimenez; director of photography, Mark Plummer; edited by Jeff Freeman; music by Michael Convertino; production designer, Robert Ziembicki; produced by Gale Anne Hurd and Marie Cantin; released by the Samuel Goldwyn Company. Running time: 106 minutes. This film is rated R.

Joel Garcia	Eric Stoltz
Anna	Helen Hunt
Lés	William Allen Young
Man in electronic wheelchair	James Roach
Rosa	Elizabeth Peña
Mr. Gibson	Henry Harris
Victor	Tony Genaro
Victor's wife	Eva Rodriguez
Victor's sons	Erick Vigil and Edgar Rodriguez
Victor's daughter	Angelica Castell
Bloss	William Forsythe
Pat	Grace Zabriskie
Raymond Hill	Wesley Snipes
Alice	Kimberly Scott
Vernon	Casey Stengal
Cheryl Lynn	Susan Gibney
Candy	Elizabeth Dennehy
Rachel Hill	Fay Hauser

By VINCENT CANBY

In 1984 Neal Jimenez, the screenwriter ("The River's Edge," "Something for the Boys"), was left with his

legs permanently paralyzed after breaking his neck on a camping trip. Now he has written and co-directed, with Michael Steinberg, "The Waterdance," a good, tightly constructed film about the kind of intense physical and psychological therapy that he himself went through during long months at a rehabilitation center.

It's easy to understand why "The Waterdance" was named the audience's favorite film at the Sundance Film Festival in January. Though small in scale, it is big in feelings expressed with genuine passion and a lot of gutsy humor. Also, because of the kind of movie it is, there's never much doubt that these paraplegics will somehow come through. "The Waterdance," set mostly in a hospital ward, is occasionally harrowing, but it doesn't mean to expose anything except the human spirit's capacity to triumph over adversity.

The excellent cast is headed by Eric Stoltz, Wesley Snipes and William Forsythe. Mr. Stoltz is Joel Garcia, Mr. Jimenez's surrogate, a young but already successful writer who, at the time of his accident, was involved in a serious affair with Anna (Helen Hunt), married, unfortunately, to someone else. Though Joel's origins are Hispanic, he doesn't look it and pays little attention to ethnic roots.

●

One of the contradictions of Mr. Stoltz's career is that he made his biggest splash in "Mask," but he was disguised under so many prosthetic devices that audiences could never be sure of recognizing him again. There will be no such problem after "The Waterdance." It's a fine, self-assured, carefully measured performance that is the conscience of the film.

Mr. Forsythe plays Bloss, a beefy, bigoted white biker who hates black, Hispanic and Asian people, which gives him a lot to complain about since the ward is so demographically balanced. It's one of the film's funnier touches that Bloss, the would-be social outlaw, is about the only patient whose mother is a steady, doting visitor.

Mr. Snipes, who can also be seen currently in "White Men Can't Jump," has the film's richest role and wastes none of it. He is Raymond Hill, a quick-witted, fast-talking, womanizing young black man who, in the course of the therapy, must acknowledge the accumulation of emotional debts owed to his no-longer sympathetic wife (Fay Hauser).

Mr. Jimenez's screenplay is so packed with incident and so cannily paced that it has the somewhat breathless feeling of a certain genre of upbeat Broadway play. It's not dishonest, but there is a such a symmetry to it that the revelations, confrontations and resolutions become predictable. Yet the dialogue and the performances surprise even when the story does not.

There is a moving and doomily funny sequence in which Raymond suddenly explodes in hopeless fury during a group discussion about the sexual possibilities available to paraplegics. Raymond focuses his anger on the particular practices suggested by the discussion leader. He says he's shocked, but it's the life forever denied him that prompts the outburst. These sexual adjustments are pursued further in an inevitably sad encounter between Joel and Anna in a motel room.

The film's subsidiary characters are as finely drawn as the major ones. Ms. Hunt's Anna is a woman of unusual sensibility but not unlimited

Samuel Goldwyn Company

Eric Stoltz in "The Waterdance." The film, written by Neal Jimenez, was inspired by an accident that left his legs permanently paralyzed.

patience. Also good are Elizabeth Peña and William Allen Young as the ward nurses, and Grace Zabriskie as Bloss's chatty mother.

The exact significance of the title is not spelled out, but it apparently alludes to the miraculous self-assurance required of these paraplegics if they are to survive and keep their sanity: it's like dancing on water. The film is notable as much for all the bathos it manages to avoid as for its consistent common sense and seriously good humor.

•

"The Waterdance" is rated R (Under 17 requires accompanying parent or adult guardian). It has vulgar language, sexual situations and partial nudity.

1992 My 13, C13:1

At Cannes, Tim Robbins Proves a Double Threat

By JANET MASLIN

Special to The New York Times

CANNES, France, May 12 — Tim Robbins is courtly and unassuming, and in spite of that he is suddenly at the red-hot center of this year's Cannes International Film Festival. Mr. Robbins would stand out here even if he were nothing more than a strong contender for the best-actor award, which he is for his performance as the smooth-talking Hollywood executive Griffin Mill in "The Player." But today he emerged as a directorial talent as well. "Bob Roberts," the political satire that he wrote, directed and stars in, is the first new title here to touch off that current of surprise, chatter and excitement known on film-festival circuits as the buzz.

Mr. Robbins's fiendishly funny film is obviously an idea whose time has come. Constructed as a mock documentary, it is a "This Is Spinal Tap" for the political arena, with flashes of Robert Altman's television series "Tanner '88" thrown in for good measure. Not for nothing has Mr. Altman been touting Mr. Robbins as a new director to be reckoned with, a recommendation that counts for a lot more than the standard hyperbole that is heard in this hype-crazy setting. It became clear at this morning's screening that Mr. Robbins, in simultaneously embodying the slick soullessness of both Hollywood and electoral politics, is truly the man of the hour.

Bob Roberts, a "poet, folk singer, businessman and senatorial candidate," is a wonderful invention. Brought up on a commune, he has gladly rejected his parents' hippie ideals to become a sanctimonious right-wing singer and songwriter whose favorite subjects are Godlessness and welfare abuse. Bob has preserved little more of his 60's forebears than the guitar playing and the super-sincere manner, but he does occasionally recast familiar images of Bob Dylan to fit a 90's mind-set. Bob Roberts's version of the famous film clip of Dylan illustrating his "Subterranean Homesick Blues" lyric with flash cards is a "Wall Street Rap," complete with female dancers in white shirts and businesslike neckties. Among Bob's yuppie mottos are

"This Land Is My Land" and "The Times Are Changin' Back."

"Bob Roberts" has wicked humor, and it also has teeth. Seen along the Pennsylvania campaign trail is a stunningly mean-spirited Bob Roberts television commercial meant to smear Bob's venerable rival Brickley Paiste (played by Gore Vidal), who tries to discuss serious issues but is tarred for his supposed dalliance with a 16-year-old girl. The fact that Bob's associates, part of a group calling itself Broken Dove, have been accused of channeling funds meant to house the homeless into airplanes for private enterprise does not even attract media attention. The film also skewers the bubble-headed telecasters — with names like Chip and Tawna (played in cameo appearances by Peter Gallagher, Pamela Reed, James Spader and Susan Sarandon) — whose happy-talk approach to the news winds up helping Bob in his rise to power. Bob's fortunes are ultimately helped by a political ploy so sneaky it sets a new standard for dirty tricks.

Mr. Robbins, who is 33, the son of a real folk singer (Gil Robbins of the Highwaymen) and the father of two boys, a 3-year-old and an 8-day-old (who are at home with their mother, Ms. Sarandon), worked for five years on what was originally a screenplay about a businessman and singer before he came up with such an inspired bit of political chicanery. "I wanted to think of it before somebody did it for real," Mr. Robbins said.

From Fan to Fan Material

If Mr. Robbins's sudden arrival in the limelight shows it is possible to be discovered here without having been exactly unknown, Hal Hartley further proves the point. Mr. Hartley's two earlier features, "The Unbelievable Truth" and "Trust," have won him a devoted following. But that following will grow much larger thanks to "Simple Men," the darkly funny and meticulously spare comedy that was shown here yesterday. Sitting unobtrusively at a beachfront restaurant this afternoon, Mr. Hartley was interruped by an autograph-seeking fan, which reminded him of the time he tried to shake the hand of a "huge inspiration," Wim Wenders, at the New York Film Festival a decade ago.

A lot has changed for him since then, and some of it literally changed overnight. Last night he and his actors were delighted by the festival audience's response to their droll, minimalist road movie, and were marveling at the elaborate protocol of a black-tie screening at the Palais des Festivals. Today, Mr. Hartley tried to order plain water and wound up with Evian, which perhaps puts him a shade closer to Hollywood than he used to be. He remains a determined outsider, but the sleek, handsome friends who act in his films have had to join the Screen Actors Guild. "Great," Mr. Hartley said. "So now they have a dental plan."

A Change of Scene

With the kind of irony so familiar here that it barely attracts notice, the party celebrating the film version of "Sarafina!" was held aboard an elegant yacht anchored in the Cannes Marina. The film, a rousing and finally quite moving version of the musical starring Whoopi Goldberg, is about oppression in South Africa, but the only sign of hardship at the party was a large pile of expensive loafers

on deck: the yacht, which belongs to David Bowie, has cream-colored carpeting, and the invitations specified no shoes.

So perhaps it was only natural that the dinner for Jonathan Demme and his cousin Robert Castle, who is a priest in Harlem and the subject of Mr. Demme's documentary "Cousin Bobby," was also held in an extravagant spot. "Everyone should have a night like this," Mr. Demme said, and his cousin, whose street sermons are heard in this moving, intimate family portrait, readily agreed.

Mr. Demme came here in 1986 with "Something Wild." and remembers having been asked halfhearted questions about that film. This year, as an Oscar winner, he attracted such a crowd of onlookers on the Carlton terrace while trying to conduct a private conversation that he was forced to go somewhere else.

Celebrating the Festival

A delegation from the Museum of Modern Art held a celebration on Monday in honor of the museum's Cannes retrospective, which will run from June 19 through Oct. 22 to mark the festival's 45th anniversary. Titles like "L'Avventura," "Divorce Italian Style," "My Night at Maud's" and "Never on Sunday," which are among the many films that will be shown, have at least as much to do with Cannes's inimitable flavor as do starlets, scenery and sun.

1992 My 13, C13:5

The Importance of Being Earnest

Directed by Kurt Baker; screen adaption by Peters Andrews and Mr. Baker, based on the play by Oscar Wilde; director of photography, Mark Angell; edited by Tracy Alexander; music by Roger Hamilton Spotts; produced by Nancy Carter Crow; released by Eclectic Concepts and Paco Global. At the Anthology Film Archives, 32 Second Avenue, at Second Street. Running time: 126 minutes. This film is rated G.

Lane	Obba Babatunde
Gwendolyn	Chris Calloway
Butler	Sylvester Hayes
Dr. Chausible	Brock Peters
Algernon	Wren T. Brown
Cecily	Lanei Chapman
Merriman	Barbara Isaacs
Miss Prism	C. C. H. Pounder
Lady Bracknell	Ann Weldon

By STEPHEN HOLDEN

By pushing the concept of nontraditional movie casting toward its outer limits, Kurt Baker's all-black film version of Oscar Wilde's "Importance of Being Earnest" deserves credit for breaking new ground. The film, which opened today at Anthology Film Archives, features a distinguished cast that includes Obba Babatunde as Lane, Daryl Roach as Jack, Wren T. Brown as Algernon, Chris Calloway as Gwendolyn, Lanei Chapman as Cecily and Ann Weldon as Lady Bracknell.

Although the setting has been moved up to the present, Wilde's epigrammatic dialogue has been left largely intact. The most obvious contemporary references come from the mouth of Lady Bracknell, who disapproves of rap music while lauding jazz. One scene is set on a patio alongside a very contemporary swimming pool, and the wardrobes are very up to date.

Technically, alas, the film is just one step more sophisticated than a

crude home movie. The colors are bleached, and the actors' voices sound as though they had been picked up by a single microphone placed at a distance. The precision of Wilde's apercus is severely blunted in the general drone of the soundtrack, and several times the light string quartet music by Roger Hamilton Spotts obscures the speakers.

In this version, the story is still set in London and its environs, yet none of the actors even attempt an English accent. Instead, the ensemble vocal style might be described as a caricature of generic hoity-toitiness, with the la-di-da cadences accompanied by stiff, affected body language. Much of the time, the actors stand around in small groups looking painfully self-conscious and at a loss as to what to do with their hands.

•

The actor who fares the best under these impossible circumstances is Brock Peters, who as Dr. Chausible exudes a crisp, no-nonsense regality. The performer who brings the most intriguing inflections to a famous role is Ms. Weldon, whose Lady Bracknell huffs all her lines like a disapproving small-town church lady.

1992 My 14, C20:4

Les 1,001 Mystères of the Cannes Film Festival

By JANET MASLIN

Special to The New York Times

CANNES, France, May 14 — There is no real looking glass through which one passes upon arriving here, but the effects can be felt just the same. Certainly they are effects that Alice would understand. A television set tuned to an English-language channel at night will be speaking French by morning. A banana in a kiosk on the Croisette costs $5. A mailbox in the festival's press headquarters could be opened with a key in previous years, but it has been outfitted with a magnetic sensing device that uses the journalist's ID card. So now it doesn't open at all.

The contents (which must be removed each day through the back of the box by a head-shaking French official) are a pound or two of junk mail, but wastebaskets do not exist. Traffic flows smoothly in front of the Palais des Festivals, but it flows four lanes deep in alternating directions, which makes it miraculous that so many live, unhurt pedestrians have successfully crammed themselves into the area. The carpet lining the main stairway of the Palais adds a ceremonial element, plus some additional confusion: some days it is red and some days it is blue.

The same degree of chaos surrounds the films themselves, which are often strangely translated. (The dialogue for the Russian film "An Independent Life," Vitaly Kanevsky's autobiographical glimpse of a harsh, unhappy boyhood, was read by a chipper English-accented interpreter and filled with expressions like "sweetie-pie.") The screenings of these films are heralded and discussed by a number of mistake-filled local publications. One of these identified a photograph of the mother and son in "The Long Day Closes," Terence Davies's smoothly precious autobiographical film about his Liverpool childhood, as something from "Beauty and the Beast." Another referred to "The late Maria Schneider" as a star of Mehdi Charef's tiresomely brooding "Au Pays des Juliets," which would have been a big surprise to anyone who saw Miss Schneider at her news conference the day the film was shown.

Strange things happen in such an atmosphere, and certain films suffer in the process. "El Sol del Membrillo" by Victor Erice (director of "The Spirit of the Beehive") is one of the most contemplatively beautiful works in the festival, but its subject creates a problem, at least in this setting. "El Sol del Membrillo" happens to be a 2-hour-20-minute film about an artist painting a still life of a quince.

The stampede out of the press screening said nothing about the merits of Mr. Erice's supremely meticulous direction and everything about the frantic pace of this event. The tranquillity required for appreciating such a film is out of the question. It is also probably true that comparisons to "La Belle Noiseuse," which was shown here last year, are inevitable; that four-hour film was also about an artist, but it paid considerable attention to the artist's beautiful nude model. ("'La Belle Noiseuse' was a Western compared to this one," said a distributor who preferred to remain anonymous.) "It makes 'La Belle Noiseuse' sound like 'Stagecoach,'" said somebody else, on an entirely different occasion.

The longest film in this year's festival runs only three hours, but it was conceived as a four-hour television drama. It is "Best Intentions," written by Ingmar Bergman as an account of his parents' lives involving faith, love, class positions and marital strife, and directed by Bille August ("Pelle the Conqueror") in a blandly pretty public television style. There is an awful lot of starched white linen in "Best Intentions," and not nearly enough of the force and mystery of Mr. Bergman's own direction.

Audience Problems

Sidney Lumet is here on a near-kamikaze mission, screening "A Stranger Among Us" for what is bound to be an unreceptive crowd. Giving the full Hollywood Treatment to a story about Hasidic Jews (with Melanie Griffith playing a smart-talking police detective who disguises herself as a Hasidic woman in order to solve a crime), Mr. Lumet's new film had major popularity problems at this morning's press screening. The audience booed — viewers are not shy about expressing ill will here — and the questions at the news conference were similarly unfriendly. "Did you get the feeling this might already have been done by Peter Weir in 'Witness?'" somebody asked. And that was only the opening question.

Later, as he laid out his tuxedo and prepared for what might be a rocky evening, Mr. Lumet was quite unperturbed. Neither his star nor his subject is a sure thing with European audiences, and one way or the other, this festival showing will make the film better known. Perhaps having first come to Cannes 30 years ago when the cast members of his film "Long Day's Journey Into Night" were given a collective prize, gave him a sense of perspective. "Listen," he said, "if it gets a bad kickoff, that's the gamble you take."

Badoit and Other Bubbles

At the Hôtel du Cap in Cap d'Antibes, the protected spot where Hollywood's heaviest hitters escape the festival's hubbub, the lunch-time scene was right out of "The Player." Several of the studio types satirized by Robert Altman's film were on the premises, and lunch was a two-water affair (Badoit with bubbles, Évian without). In the lobby, the management had actually sidelined an individual thought to be stalking a movie executive. And Mr. Altman, much as he hates the Hollywood establishment, was also there. That's probably right out of "The Player" too.

A studio head told of having done a very smart thing: he called the producer of a highly praised independent film and announced that the film made him ashamed of his own output. Several days later, the producer called back for a further discussion. The result: a probable strange-bedfellows collaboration that promises creative freedom for the artists, cachet for the studio and great benefits for both sides.

The talk turned to another producer, this one formerly responsible for big-budget action films. He had bailed out of his company with a large settlement just before the business went bad and has since produced an adventure film on a smaller scale. Just as he was being praised for his probity, he arrived on an enormous yacht complete with its own swimming pool and casino, and walked into the restaurant wielding a cellular phone and a cigar. Hollywood has its own way of thinking small.

Some Recession Effects

Despite that kind of high rolling, the recession has come to Cannes, too. Gone but not forgotten are the airplanes that used to buzz the beach at midday advertising new films. The Christopher Columbus galleon erected on the Croisette is only a mini-model, and a far cry from the Roman Polanski "Pirates" ship that spent so many years here. There are fewer posters and billboards than usual to deface the big hotels and the boulevards. So Cannes looks a little more like an ordinary place. But nothing could be further from the truth.

1992 My 15, C3:1

Johanna d'Arc of Mongolia

Written, directed and photographed by Ulrike Ottinger (in German, French and Mongolian with English subtitles); edited by Dörte Völz; music, Wilhelm Dieter Siebert; production design, Ms. Ottinger and Peter Bausch. An Ulrike Ottinger production with Popular Film, ZDF and La Sept, released by Women Make Movies. At Le Cinématographe, 15 Vandam Street in Manhattan, as part of the Women Make Movies film series. Running time: 165 minutes. This film has no rating.

Women Make Movies

Ines Sastre, left, and Xu Re Huar

Lady Windemere	Delphine Seyrig
Giovanna	Ines Sastre
Ulun Iga	Xu Re Huar
Frau Müller-Vohwinkel	Irm Hermann
Fanny Ziegfield	Gillian Scalici
Mickey Katz	Peter Kern
Colonel Muravjev	Nougzar Aharia
Aloysha	Christoph Eichhorn

The Kalinka Sisters
Jacintha, Else Nabu and Sevembike Elibary

By CARYN JAMES

Riding camels, a band of Mongol women crosses the desert. These warriors bear large bows and arrows, and they are dressed to kill, in long shimmering robes of pastel green, vivid rose or royal blue. But they don't mean any harm. They simply stop the Trans-Mongolian railroad on its tracks, abduct seven foreign women, and take them on an adventure that is part anthropological study, part fancy costume party.

"Johanna d'Arc of Mongolia," which opens today at Le Cinématographe, is a witty, matriarchal, multicultural epic, running 2 hours and 45 minutes. It was written, directed and sumptuously photographed in Mongolia by the Ulrike Ottinger, a German who is usually regarded as a "difficult" avant-garde film maker. But while "Johanna d'Arc" is eccentric, it is also perfectly accessible, as long as a few missing narrative threads and lapses of logic don't bother you.

On its journey from West to East, this 1989 film mirrors Western and Eastern storytelling forms. The first hour is a deft, detailed comedy of manners that takes place entirely on the train. Lady Windemere, played by the French actress Delphine Seyrig in her last role (she died in 1990), is the film's centerpiece. Her private car is filled with framed icons, velvet furniture, Chinese vases; Lady Windemere herself is delicately beautiful enough to be one more objet d'art. But she is also generous, intellectually curious and, most useful of all, an amateur ethnographer who speaks Mongolian.

Her fellow travelers include two middle-class tourists, a German tied to her Baedeker and a Broadway singer named Fanny Ziegfield. A young woman named Giovanna, with a Walkman and a backpack, travels in a car cramped with peasants, their children and geese.

The director is at her playful best in upsetting the clichés of strangers on a train. The English subtitles distract attention from one comic, mythic touch: Lady Windemere and Giovanna speak French, while the German and American characters speak German, and no one seems to need any translation.

•

The women get to know each other in the dining car, where they are entertained by the Kalinka Sisters, a trio that combines retro-40's taste

with Muzak style. They also meet the only significant male character, Mickey Katz, an obese, heavily rouged singer who wears an ermine-trimmed yarmulke and orders a whole swan among his countless dinner courses. He is less buffoonish and more dislikable than the director seems to realize. But he serves a purpose, singing an effectively funny version of "Toot-Toot-Tootsie" before he disappears from this women's world.

When the Mongol band carries off the women (for some never-explained reason), the film's style changes drastically. It becomes slow, ritualistic, Eastern. The director places the audience in the position of her characters, who have been taken out of ordinary time and place and dropped into this exotic culture. A

messenger recites the history of the Mongol princess who leads the group; a shaman chants and dances around a fire; the earth magically swells and cracks open above an underground shrine.

Despite some magical touches and great visual beauty, this section is too anthropological and solemn. Seyrig provides a wise presence, but she can't mask the fact that tourism has replaced drama on screen. When a Mongol princess becomes infatuated with Giovanna, renaming her Johanna, the most perceptible change is in the young woman's wardrobe. Johanna begins wearing an elaborately embroidered vest and fur hat.

"Johanna d'Arc" turns into a travelogue. But few travelogues are this rich, ambitious and unusual.

1992 My 15, C8:1

Cabeza de Vaca's Journey To 16th-Century Mexico

"Cabeza de Vaca" was shown as part of last year's New Directors/ New Films series. Following are excerpts from Vincent Canby's review, which appeared in The New York Times on March 23, 1991. The film — in Spanish with English subtitles — opens today at the Village East Cinema, Second Avenue and 12th Street in Manhattan.

•

Nicolas Echevarria's "Cabeza de Vaca" is a historical film that can probably be best appreciated by those who already know the story of the 16th-century Spanish explorer Álvar Núñez Cabeza de Vaca. The style of the Mexican film is sometimes straightforward, sometimes pageant-like and sometimes hallucinatory. It's not especially difficult to follow, though it is less informative than evocative of times and events unknown.

Cabeza de Vaca, whose dates are approximately 1490 to 1557, was a member of an expedition that set out from Spain for the New World in 1527 under the command of Panfilo de Narvaez. After losing their ship off what is now Tampa Bay, the members of the expedition went their separate ways.

Cabeza de Vaca and a small group of men apparently sailed on a makeshift barge westward to the Texas coast, where, in 1528, they came under Indian attack. Most of the party was killed or captured.

•

This was the beginning of the remarkable overland journey for which Cabeza de Vaca is known. It ended in 1536 with his arrival at the Spanish camp at Culiacan on the Pacific coast of Mexico.

"Cabeza de Vaca" is a road movie set in a time before there were roads. In the eight years of what becomes a kind of pilgrimage, Cabeza de Vaca (Juan Diego) lives with various Indian tribes, alternately as a slave and as a shaman with great healing powers. As he teaches his captors, he is taught by them.

Mr. Echevarria's previous films have all been documentaries, which is possibly the reason that "Cabeza de Vaca" is most effective when it

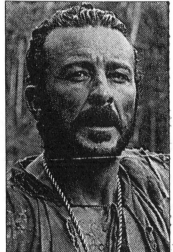

Concorde

Juan Diego

observes people and events at an impartial remove. Yet so little attempt is made to fix time and place that confusion arises. There seem to be mountains on the coast of Florida, and Texas would appear to be only a stone's throw from the Pacific coast of Mexico.

Though Mr. Diego tends to act broadly, Cabeza de Vaca remains an unknown, chilly character. The camera does little to reflect the man's state of mind, except during what are obviously dreams, illustrated in conventional movielike ways.

"Cabeza de Vaca" is a small, generalized evocation of an epic subject.

1992 My 15, C8:5

The Good Woman of Bangkok

Director, producer and director of photography, Dennis O'Rourke; editor, Tim Litchfield; released by Roxie Releasing. At the Cinema Village 12th Street, 22 East 12th Street, Manhattan. Running time: 82 minutes. This film has no rating.

Featuring: Yaiwalak Chonchanakun (Aoi)

By VINCENT CANBY

"The Good Woman of Bangkok," Dennis O'Rourke's comparatively austere documentary feature opening today at the Cinema Village 12th Street, is about a pretty 25-year-old Thai prostitute named Yaiwalak Chonchanakun, called Aoi. In addition to being the subject of the film, Aoi was the 43-year-old Mr. O'Rourke's paid lover during its production. The result of this collaboration is a very personal, complex movie, the nature of which changes as one watches it.

"The Good Woman of Bangkok" is possibly more of a horror story than Mr. O'Rourke realizes: a mixture of willful naïveté, good intentions and post-colonial exploitation. Behind it all is a middle-aged white man's randiness, which comes to look as careless as it is selfish. The director describes his work as "documentary fiction," not because AIDS is never mentioned but because he has shifted the chronology of some of the events in an effort to give the film dramatic shape.

Mr. O'Rourke, an Australian film maker, explains at the start that after his marriage broke up, he went to Bangkok to have sex and to make a documentary about the life of a prostitute. He succeeded in both, though, in many ways, "The Good Woman of Bangkok" is less about Aoi than about the man who made it. By extension, it's also about the way in which the rich countries of the world treat those a lot less well off.

•

Mr. O'Rourke remains an off-screen voice throughout, asking questions of Aoi, her friends and members of her family, and receiving answers that, in one way and another, his respondents know he wants to hear. That doesn't necessarily mean that the answers are untrue, only that the truth is as elusive as the heart of "The Good Woman of Bangkok."

The film's production stories suggest that Mr. O'Rourke and Aoi had a real love affair, but there is little evidence of love on the screen. Aoi seems far beyond the point where love has any meaning. She is barely able to tolerate the camera, which is operated by Mr. O'Rourke, who is, after all, just another of her customers. When she says, "I hate men," it is said less in anger than in complete despair. Her "all men lie and cheat" is a statement of fact.

Aoi's story would appear to be typical. Born in a small village in northeast Thailand, she married young and was abandoned by her husband even before their only child was born. She became the sole support of her mother, father, brothers and sisters after her father was arrested for making bootleg alcohol and lost the family farm. Since prostitution was not only the easiest but also about the only way, she was drawn to Bangkok's booming red light district.

•

What is infinitely sad is Aoi's view of herself. "You are the sky and I am the ground," she tells the film maker. "I am just trash." Mr. O'Rourke's response is bifocal. Even as he studies her as a representative type, he is moved by Aoi's specific problems. When he offers to buy her a rice farm so she can retire from the trade, she answers, "If you want to help me, that is up to you, but don't expect anything in return."

At the end of the film, there is a screen note reporting that Mr. O'Rourke did, in fact, buy the farm

but that one year later, when he returned to Bangkok, Aoi was back in town working in a massage parlor. "It's my fate," he says she told him.

That gives "The Good Woman of Bangkok" dramatic shape, but it's a distortion of the facts that Mr. O'Rourke makes no attempt to hide. He did buy her a farm, but he bought it during the film's production. Though that doesn't alter the film's portrait of Bangkok's sex business, it does alter the truth of the Aoi character, as presented on the screen. Mr. O'Rourke's answer to that is to call his film documentary fiction.

•

"The Good Woman of Bangkok" clearly acknowledges (and satirizes) its contradictory impulses when Mr. O'Rourke talks to an Australian sailor who, as happy as a kid in a candy store, looks on the bright side of prostitution in Bangkok.

"What we do helps them," the sailor says with a big grin on his face. "Hopefully, Thai women won't have to do this much longer." His idea seems to be that once prostitution has built up the Thai economy, women will be able to move on to other less degrading pursuits. Meanwhile, who is he to stand in the way of their liberation?

1992 My 15, C13:1

Lethal Weapon 3

Directed by Richard Donner; screenplay by Jeffrey Boam and Robert Mark Kamen, based on a story by Mr. Boam; director of photography, Jan De Bont; edited by Robert Brown and Battle Davis; music by Michael Kamen, Eric Clapton and David Sanborn; production designer, James Spencer; produced by Mr. Donner, Joel Silver, Steve Perry and Jennie Lew Tugend; released by Warner Brothers. Running time: 118 minutes. This film is rated R.

Martin Riggs	Mel Gibson
Roger Murtaugh	Danny Glover
Leo Getz	Joe Pesci
Jack Travis	Stuart Wilson
Lorna Cole	Rene Russo
Trish Murtaugh	Darlene Love
Rianne Murtaugh	Traci Wolfe
Nick Murtaugh	Damon Hines
Carrie Murtaugh	Ebonie Smith
Capt. Murphy	Steve Kahan
Dr. Stephanie Woods	Mary Ellen Trainor

By VINCENT CANBY

Richard Donner's "Lethal Weapon 3" opens when Detective Sgts. Martin Riggs (Mel Gibson) and Roger Murtaugh (Danny Glover), the Los Angeles Police Department's two most tireless cutups, accidentally blow up a building while trying to defuse a car bomb. It ends when they burn down a housing project that, in real life, was an unfinished memento of the savings-and-loan debacle in Lancaster, Calif.

In between, Riggs and Murtaugh become involved in a comic armored-car heist and more or less stumble across a vicious former cop, Jack Travis (Stuart Wilson), who's now running an underground supermarket dealing in stolen guns, armor-piercing bullets and drugs.

The family-oriented Murtaugh is looking forward to retirement in six days' time, which seems unlikely in view of the popularity of the "Lethal Weapon" movies. But now even Riggs is growing up in his own way. He finds the woman of his dreams in Lorna Cole (Rene Russo), a detective as crazily fearless as he is. The two fall in love as, shedding a shirt here, a pair of pants there, they turn each

other on by showing off their battle scars.

•

In the first "Lethal Weapon," released in 1987, it was the manic Riggs who was suicidal. Now it's the film itself that seems bent on self-destruction, as if in a torment of grief over the end of the heedless 1980's, an age that could more easily accommodate the grandly inconsequential adventures of Riggs and Murtaugh.

"Lethal Weapon 3" isn't that much worse than the two earlier films, though the gags quickly wear thin and the back-and-forth banter is now so fast-paced that the overlapping dialogue may be more unintelligible than intended. Mr. Gibson looks tired and has every right to. The movie isn't going anywhere, but it goes in circles at top speed. "Lethal Weapon 3" is a pretty good imitation of its predecessors.

The problem is that the times are changing, and they're changing so quickly that "Lethal Weapon 3" seems out of date.

The film is fantasy. The building that is destroyed in the opening sequence is actually the Orlando, Fla., City Hall, which was set for demolition anyway. The cars that explode, the bodies that are blown apart and the tons of glass that shatter are all tricks. The audience knows that. Yet the film's release so close to the recent Los Angeles riots doesn't help to make it seem like a barrel of laughs.

•

This is especially true when Riggs and Murtaugh, temporarily demoted to foot patrol, relieve their boredom by taking out their guns and terrorizing a pedestrian they catch jaywalking. What is even more out of touch is the film's overall attitude.

"Lethal Weapon 3" gets all weepy about the friendship of Riggs and Murtaugh. O.K. It takes sentimental note of the fact that we live in an age in which innocent young men (one black, one white) may be struck down in their prime. Fine.

At the same time, though, through the very expensive technical virtuosity of its special effects, it celebrates a luxurious kind of destruction and disorder that can only appear mindless amid today's realities and scaled-down expectations. "Lethal Weapon 3" goes beyond escapism into the territory of collective death wish.

Mr. Gibson and Mr. Glover are good actors. They work hard, as does Joe Pesci, the money-launderer from "Lethal Weapon 2," who returns here as a hyperventilating real-estate agent with a crush on cops. He is funnier than his material. Ms. Russo is attractive and somewhat intimidating as a woman who only comes to life as a karate chopper. The film's most interesting performance is given by Mr. Wilson as the sadistic ex-cop. His ruthlessness has a personal dimension missing from the rest of the movie.

Jeffrey Boam and Robert Mark Kamen are credited with writing the screenplay, though they might as easily have described it over a couple of beers.

If and when "Lethal Weapon 4" arrives, we'll know for sure that there is life after death.

•

"Lethal Weapon 3," which has been rated R (Under 17 requires accompanying parent or adult guardian), includes lots of simulated violence, some partial nudity, sexual situations and vulgar language.

1992 My 15, C16:3

FILM VIEW/Janet Maslin

On the Beach at Cannes With the American Force

CANNES, France

S THIS BEAUTIFUL BEACHFRONT A playground or a battlefield? It may be both. The Cannes International Film Festival, the world's most glittering trade convention, appears to be at an important turning point this year, one that may have serious long-term effects on film makers of the future. At issue is the Americanization of this influential festival and the simultaneous disappearance of almost all the film world's old guard. Perhaps Cannes is simply filling a vacuum by incorporating such a high percentage of American work. Or it could be helping to perpetuate that vacuum by overlooking more modest, less showy talents from other parts of the world.

The year that brought Euro Disneyland is not the best year for a calm discussion of this question. And this Cannes festival, which happens to be the 45th, did not begin on a neutral note. By choosing "Basic Instinct" as its opening attraction, the festival appeared to be casting its lot with the most lurid aspects of Hollywood exploitation. It hardly helped that the opening-night ceremony featured a tribute to movie producers, as performed by a bevy of bathing-suited, banana-eating models. The French press had a field day with discussions of bad taste both on and off the screen.

Only part of this furor is really fair.

The American films being shown here represent a wide range of creative attitudes and financial arrangements, from Hal Hartley's small-scale, droll, unmistakably independent "Simple Men" to the splashy, big-studio "Basic Instinct." This lineup also includes works as varied as "A Stranger Among Us" (directed by Sidney Lumet), "Twin Peaks: Fire Walk With Me" (a prequel directed by David Lynch) and (in the side-festival known as the Directors' Fortnight) two films directed by American actors, Tim Robbins's "Bob Roberts" and John Turturro's "Mac." But these films share no common factor except nationality. It's worth noting that Mr. Hartley made his whole film for less than the $3 million cost of the "Basic Instinct" screenplay.

But not everyone here regards Paul Verhoeven's sultry, violent "Basic Instinct" as the essence of evil. It has been doing land-office business in Paris since it opened there last week, joining hits by American film makers as varied as Jonathan Demme, Steven Spielberg and John Cassavetes on the box-office charts. (Cassavetes's work has been revived partly through the auspices of Gérard Depardieu.) "The screenwriter and the director of 'Basic Instinct' are very clever," says Gilles Jacob, the festival's director and the driving artistic force behind its selec-

Are American films at this year's festival filling a temporary vacuum or are they shutting out deserving talent?

tions, by way of explaining its presence here. "I like this feeling of not only auteur films in Cannes."

In the opinion of Harvey Weinstein, co-chairman of the highly visible independent distributor Miramax Films, "Gilles Jacob has got the world stage. If 'Basic Instinct' keeps the glare of the Cannes film festival going so that the work of first-time directors is also highlighted, then I'm all for 'Basic Instinct.' " In the past, the difficulty of attracting high-visibility Hollywood features in springtime prompted talk of moving the festival to fall or winter, but Mr. Jacob now says happily that such thoughts have been "postponed very seriously" for at least two years.

In any case, it does seem that the problem of American cultural imperialism is less clear-cut than it appears. The very concept can be misleading. Peter Hoffman (the former chief executive officer of Carolco and the head of a new company planning to bring more American films to remote corners of the globe) points out: "There are little villages in the deepest part of India, and they're in there with a black-and-white TV set and videocassette watching 'E.T.' "

■

Ubiquitous as such symbols of American culture are, they may not be entirely American. These days, the nationalities of films have as much to do with financing as with artists' geographical origins. And if there is one thing festivalgoers here agree on, it is denouncing the soulless international co-production that has no identity of its own. "Maybe the American thing is purer," suggests Mr. Jacob, pointing out that most of the films

Associated Press

The actress Sharon Stone and the director Paul Verhoeven in Cannes, where the international festival opened with their sultry, violent thriller "Basic Instinct."

grosses for "Wayne's World." "You mean you haven't seen 'Wayne's World'?" Robert Altman asked facetiously at his news conference for "The Player" last weekend. "Oh, you should. It's a biggie." ☐

1992 My 17, II:15:1

FILM VIEW/Caryn James

Bite vs. Bark Or 'Beethoven' Vs. 'Ferngully'

IF YOU WERE 6 YEARS OLD, WHAT would you rather see? A rain forest fairy who talks gently about "the magic powers of the web of life" or a big sloppy dog who comes in from the rain, shakes his fur and gets your dad all wet?

Somehow, the makers of "Ferngully: The Last Rain Forest," an environmentally correct cartoon, got the answer wrong. And the people behind "Beethoven," the story of a St. Bernard who destroys the carpets and torments the father of a typical suburban family, are making dog jokes all the way to the bank.

"Beethoven" is turning into this season's "Home Alone," a surprise hit that children want to see over and over. The film was No. 3 at the box office last week, more than a month after it opened. And, an even bigger surprise, it has enough energetic charm to keep parents' attention focused on the screen instead of on the hundred other things they could be doing. Given a story that sounds

Why is a comedy about a slobbering dog outdrawing a sincere cartoon about saving the rain forest?

hopelessly stupid, stale and desperate, "Beethoven" is much more enjoyable than it has any right to be.

No one will ever call this film original, but originality is not high on a list of children's demands. "Beethoven" tugs all the right strings, in a manner strangely reminiscent of "Home Alone." It is savvy about kids' troubles, from being ignored by a parent to being picked on by school bullies or having a crush on a cute guy who might not know your name. The film is sentimental but not gooey. Most important, its cartoonish bad guys offer villainy without any true danger and are vanquished by a non-adult hero; whether it's Macaulay Culkin the boy or Beethoven the dog, the star is not a man.

The echoes of "Home Alone" are easy to explain. One of the screenwriters is Amy

here have complex financial backgrounds. There is Japanese money in "Far and Away," Ron Howard's epic about Irish immigrants. Financing for "Simple Men" is partly British, and French financing is involved in a film as seemingly American as "Of Mice and Men," Gary Sinise's version of the John Steinbeck novel.

The real question concerns not the biggest, paparazzi-pleasing hallmarks of the festival but rather its capacity for bringing forth new talent. Suddenly the legends and the mainstays have vanished, leaving room for a new generation, the one Mr. Jacob describes optimistically as "the new New Wave." Two years ago, Akira Kurosawa, Federico Fellini and Jean-Luc Godard were represented here. But this year even their immediate successors, from countries like Germany, Japan and Australia, are not to be found.

So it is encouraging to find Mr. Jacob singling out film makers like Mr. Hartley, the Coen brothers and Spike Lee as the wave of the future, along with an international list of contenders, including Jane Campion, Aki Kaurismaki, Emir Kusturica, Zhang Yimou and Luc Besson. Wherever the new blood comes from, it had better come along soon.

Meanwhile, the archway in front of the Carlton Hotel that once advertised the James Bond series now touts the $100-plus million

Bruce McBroom/Universal City Studios

*The St. Bernard and Charles Grodin in "Beethoven"—
It tugs all the right strings.*

Holden Jones, a director and a writer of "Mystic Pizza." But her elusive colleague, Edmond Dantes, is the power behind the film. Edmond Dantes is the fictional Count of Monte Cristo, and lurking beneath the pseudonym is none other than John Hughes, who wrote and produced "Home Alone." He left a script for "Beethoven" behind when he parted ways with Universal Pictures, and their deal was that the Hughes identity would be concealed. Secrecy being one of the biggest jokes in Hollywood, of course, published rumors and off-the-record confirmations abound. It is an open secret that "Beethoven" and "Home Alone" share the same creator.

Still, "Beethoven" has its own appeal for children. Here, the dog is the perfect parent. After the puppy Beethoven escapes dognappers, he wanders into the very family that needs him the most. George Newton (Charles Grodin) is the kind of anal-retentive father who gets his three children up at 7 on Saturday morning, on principle. Mr. Grodin fearlessly ignores the standard actors' advice about never working with dogs and children, and provides much of the adult appeal of "Beethoven." He underplays his comic scenes where another actor would have been mugging furiously, but he still lets on that George is a softy underneath it all.

■

Beethoven has the warmer personality, though. The dog does some stupid pet tricks

like drinking from the goldfish bowl, but he also helps the Newtons' adolescent daughter meet that cute boy, scares the bullies away from their son and saves their youngest daughter when she falls into a swimming pool. Even in the near-drowning scene, it is clear that Beethoven will come to the rescue instantly. The film's comic tone promises everything will turn out all right, largely because of its cartoonish danger.

When George is in the backyard, about to sign a business deal with a sinister yuppie couple, Beethoven wraps his leash around the couple's chairs and runs. Like live cartoons, they are pulled along the sidewalk, then propelled through the air still sitting in their chairs, until they land safely next door. The patio table drops neatly in front of them.

An evil veterinarian (Dean Jones) and his two nasty accomplices seem less human than Cruella DeVil. And when young Ted Newton drives the family station wagon into the vet's hideout, a table full of multicolored hypodermic needles is turned over. The needles whiz through the air in perfect formation, the way cartoon arrows do, before landing neatly in the doctor's chest. And the sign outside George's business is cartoonish, too. The logo of Newton's Air Fresheners is a giant nose.

Why "Beethoven" works is no mystery, but there is one large question left about the film.

Who is responsible for sneaking in its insidious social message? In the world of this film, fathers are distracted tyrants and mothers should not work. When the little girl falls into the pool, a neglectful babysitter is nearby. Mom has been working in the family business for exactly one day, and her reaction to the accident is to say she had better stay home with the children from now on. (Dad is treated like a cold-hearted idiot for suggesting that all they need is a better babysitter.) The volatile message is like a rotten apple dropped into a bag of Halloween candy.

"Ferngully," at least, parades its preaching, even if the message comes wrapped in new-age mumbo jumbo. The teen-age human hero falls for the teen-age fairy Crysta and carves her name on a tree. She puts his hand on the bark and scolds, "Can't you feel its pain?" It's a fine idea for children to respect the feelings of trees. But it is easier for them to identify with a sloppy St. Bernard. □

1992 My 17, II:22:1

FILM VIEW/Vincent Canby

Time Was Dietrich's Most Ardent Lover

"**M**ARLENE DIETRICH IS A PROFESSIONAL," Alfred Hitchcock once said. "She's a professional actress, a professional wardrober, a professional lighting technician...." Hitchcock knew his subject well, having directed her in "Stage Fright" (1950), in which she introduced one of her favorite cabaret songs, "The Laziest Girl in Town." Dietrich was a professional just-about-everything.

Even before the British astrophysicist Stephen Hawking, the incomparable Marlene understood the nature of time and used this knowledge to create a legend that, eventually, became as good as fact.

The stories from Paris reporting her death on May 6 said with journalistic authority that she was 90 years old, which is as ridiculous as the persistent rumors that she was

20th Century Fox

*Zak and Crysta in "Ferngully"—A message wrapped
in new-age mumbo jumbo.*

Photographs by Movie Still Archives

Dietrich in "The Devil Is a Woman" (1935)—The keeper of her own flame.

once a little girl. Dietrich's life spanned most of this century, and her active career, six decades; yet it's not easily proven that at any point she was young. She certainly was never old.

Dietrich knew, if only intuitively, that when there is no beginning or end, the concept of time becomes meaningless. Thus her career has no easily defined start and nothing that, with certitude, can be called a finale. Her career seems to have accumulated in the collective conscious, as if it were some kind of force of nature that had always existed but only recently been identified.

Time gets turned upside down in any consideration of Dietrich. The German-made "Blue Angel," her memorable first film for her mentor Josef von Sternberg, opened in New

The incomparable star used the years to create a legend that eventually became as good as fact.

York in December 1930, one month after her second Sternberg collaboration, the equally memorable "Morocco," which was her first Hollywood film. And both of these followed the release here of such early German productions as "Manon Lescaut" (1926) and "Three Loves" (1929), for which the anonymous New York Times critic cited her "rare Garbo-esque beauty."

Dietrich didn't burst onto the scene. She eased on, more or less the way she was to ease off, her final appearance being not an appearance at all but her quarrelsome off-screen voice in Maximilian Schell's remarkable documentary, "Marlene" (1986). The voice is sometimes thick, but in it there is the tenacity of the woman who always was, and remains today, the keeper of her own flame.

Though her American career was launched as an attempt to cash in on the popularity of M-G-M's Garbo, Diet-

rich went on to become a public personality who bore about as much relationship to Garbo as Mae West did to Dietrich. Her career tactics shifted through the years; the kind of movies she made became more varied, though the singular Dietrich persona was only enriched.

In the mid-30's she was among a number of top Hollywood stars to be called "box-office poison" by Photoplay Magazine. She turned away from the sort of grandly photographed madonna/whore dramas and spectacles directed by Sternberg, first to comedies, including two for Ernst Lubitsch, "Desire" (1936) and "Angel" (1937), and one for George Marshall, "Destry Rides Again" (1939). These led to a series of blue-collar action melodramas in which she played good-time women with names like Bijou and Cherry and Josie and was fought over by George Raft, John Wayne and Randolph Scott.

Beginning in the late 1950's there were also a series of hugely successful appearances in cabarets and one-woman Broadway shows. With the planes of her face as dramatic as ever, Dietrich looked stunning on the stage, neither young nor old, wearing a sheer sequined gown that cost, it was always reported, $30,000. Her control of the audience, achieved as much by what the audience brought to her as by what she brought to them, was such that she could accurately pencil in standing ovations before a performance.

According to one of her associates, at least part of the reason for her dazzling figure was a tip-to-toe flesh-colored bodystocking with the tensile strength of steel. Artifice was her fine art.

At the steadfast center of this career was the public personality initially shaped by Sternberg. Though Dietrich dominated 20th-century show business more than any other woman, the public personality was a product of 19th-century Anglo-Saxon attitudes toward women. Like Carmen and Violetta, the Dietrich character was heartless, loose, proudly independent and, when loving, loving on her own terms. Only at

a time when women were in bondage to motherhood, genteel manners and domestic servitude could the Dietrich temptress hold such fascination. There is no equivalent today, nor can there be in this liberated age.

Dietrich was always less erotic than a representation of idealized eroticism. When one looks at her films now, it's difficult to imagine that her characters actually have sex or, if they do, that they have it in any conventional mom-and-pop or even hooker-and-john way. Sternberg's emphasis on Dietrich-as-icon resulted in films that became increasingly elegant and, sexually speaking, theoretical. The films are gorgeous to look at, cinematically exhilarating and a bit arid.

Other actresses played this symbolic role, including the magnificent but comparatively limited Garbo. Had Dietrich stayed with Sternberg, her career might have ended about the same time as Gar-

Dietrich in Paris during the 1940's.

bo's. Yet that speculation ignores the character of the real Marlene Dietrich, who learned from Sternberg and, when the time came, took command of her life. The Dietrich we see on the screen doesn't change that much, but the wit, intelligence, independent spirit and talent seem to become more clearly evident.

How much of this was a real woman and how much of it was sleight of Dietrich's hand, I've no idea. My own perceptions of the screen Dietrich changed as my awareness of the off-screen personality increased. It was difficult to be alive in the 40's and 50's and not be aware that this was a woman with a strong mind of her own, who was fondly called Kraut by Ernest Hemingway and who, though she had a husband, apparently didn't hesitate to have affairs with whomever she wanted at her own convenience.

When the time came, she was canny enough to embrace her notoriety as a grandmother, which simply put her dominant glamour image in bold relief. One of the first times I felt jealousy as an adult was the day I learned that she had made chicken soup, and delivered it herself, to one of my former

schoolmates, a recently published first novelist temporarily ailing. Who needs Pulitzers?

Though she thought Fritz Lang, who directed the underrated "Rancho Notorious" (1952), was "a monster," she said of Orson Welles that "people should cross themselves when they speak of him." She adored, and was adored by, men and women of substance.

Noël Coward brought down the house with his Las Vegas act in the 1950's when he sang his own lyrics to Cole Porter's "Let's Do It": "Louella Parsons can't quite do it/ 'Cause she's so highly strung/ Marlene might do it/ But she's far too young."

It is this Dietrich one sees in Billy Wilder's chef d'oeuvre, "A Foreign Affair" (1948), playing the temptress of her career. The role is the wife of a former Nazi big shot surviving in the honeycombed ruins of Berlin by romancing a rather silly American Army officer. The film, which is mercilessly satiric, is full of Mr. Wilder's own melancholy feelings about Germany, defined as much through the brilliant Dietrich performance as by the Wilder-Charles Brackett screenplay.

This is the Dietrich who plays, for smashing effect, a most uncharacteristic role in Mr. Wilder's "Witness for the Prosecution" (1958). It is the same woman who, standing in a spotlight at the center of the Lunt-Fontanne Theater in 1967, earned bravos singing the lines, "Just Molly and me/ And baby makes three," in her own concept of what constitutes "My Blue Heaven."

Only Dietrich. No one else comes near. □

1992 My 17, II:22:3

Lament At Cannes: Rarities Are Rare

By JANET MASLIN

Special to The New York Times

CANNES, France, May 17 — The consensus among those who came here to buy and sell newly discovered films is that this has been a better year for long lunches at Cannes than for anything else. Only a few previously unknown works are being fought over, among them Baz Luhrmann's "Strictly Ballroom," an appealingly offbeat Australian comedy with an unusually well-developed sense of kitsch.

In better times "Strictly Ballroom," which was shown in the middle-range subsection of the Cannes International Film Festival known as Un Certain Regard, would still attract attention. But the present furor

says at least as much about film buyers' desperation here as about this particular film and its long-term prospects. Meanwhile, the price of distribution rights for "Strictly Ballroom" has reportedly shot up significantly during the course of the festival. And a lawyer representing the film's production company has been abruptly summoned from Los Angeles, in case a deal is in the offing.

Traffickers in the newly discovered find very little to buy or sell.

Aside from this and a few other blips on the radar screen, business in the marketplace for independent films here has been extremely slow. The temperature of the main competition has proven equally tepid, despite the recent emergence of a couple of superb, highly personal films that may well be honored at Monday's closing-night awards ceremony. Foremost is "Léolo," Jean-Claude Lauzon's earthy, fanciful portrait of a nascent artist, a Canadian boy who would prefer to be Italian and whose writing is meant to free him from the misery of life in a fleshy, demented family. Today's screening made it clear the bawdy yet beautifully reflective "Léolo" is a crowd-pleaser. It also established that Mr. Lauzon, though a strikingly original film maker, was surely familiar with "Portnoy's Complaint."

Equally successful was Gianni Amelio's "Ladro di Bambini" or "The Stolen Children," the spare, precise story of a shy Italian carabiniere assigned to escort two sullen children to an orphanage. As in Mr. Amelio's "Open Doors," which was shown here two years ago, the humanity of the characters is seen in marked contrast to the impersonal legal system that alters their lives. Mr. Amelio, whose compassionate simplicity carries strong echoes of Italian Neo-Realism, was refreshingly blunt when asked at his news conference how he felt about being the only important representative of Italian cinema at the festival. He did not wish to be seen as a cultural ambassador, he said, but he knew that his film was very strong. It is.

•

Also strong, but for all the wrong reasons, was the disastrous "Twin Peaks: Fire Walk With Me," David Lynch's much-vaunted prequel to his successful television series. It was hard to say whether the film played worse to "Twin Peaks" fans, who already knew more than enough about the death of Laura Palmer, or to anyone happening onto this impenetrable material for the first time. Either way, Mr. Lynch's taste for brain-dead grotesque has lost its novelty, and it now appears more pathologically unpleasant than cinematically bold.

This overlong (well over two hours), empty film is not helped by the absence of most of the television show's most popular characters, like those played by Kyle MacLachlan (who is seen only briefly) and Sherilyn Fenn (who is elsewhere at the festival, with John Malkovich in Gary Sinise's highly scenic version of "Of Mice and Men"). At his news conference, Mr. Lynch had the good sense to

bring along Angelo Badalamenti, whose music is the only remaining aspect of "Twin Peaks" that has much appeal.

Also shown here recently were "Hyènes," Djibril Diop Mambety's warm and lively Senegalese version of Friedrich Dürrenmatt's play "The Visit," and "The Sentinel" by Arnaud Destlechin, a French film dismissed as "snobbish" by a notable French cinéaste who certainly knows what snobbish means. Half an hour into "The Sentinel," the hero, a diplomat's

Those prowling for rarities might better have stayed in their lairs.

son returning to France after many years in Germany, finds a shrunken head in his suitcase. Others might overreact to such a discovery, but this character merely registers exasperation, as if to indicate that he is having a very bad day.

•

The presence of "The Sentinel" as one of two weak French films in the main competition indicates that French film makers are now as reluctant as many of their Hollywood counterparts to risk the potentially catty fallout of a festival screening. New films by Roman Polanski and Jean-Jacques Beineix are among those reportedly ready for release but not available for Cannes.

In light of this year's peculiar lineup, no one hazards anything but the most reckless guesses as to what may win awards tomorrow evening. "Howards End" and "The Player" remain popular, but so does anti-American sentiment (though "Howards End" is nominally an English entry here, because it has English financing). And there is the pettiness factor to consider. Could Alain Delon, who stars in "The Return of Casanova," be a sentimental favorite in the best actor's category? Gérard Depardieu, who is the head of the jury this year, "hates him and would never vote for him," declares someone who knows them both. Is the Spanish film "El Sol del Membrillo," an exquisitely meticulous work about an artist painting a still life, a possible winner? "You must be joking," says another source. "Don't forget that Pedro Almodóvar is on the jury and he would never let that kind of a Spanish film win. He will not let 'Howards End' win, either."

•

Immune to any speculation about what the jurors may do are, of course, the jurors themselves. "My schmooze factor is down to zero," said Jamie Lee Curtis, who is honor-bound not to discuss anything more specific than, say, her capacity for avoiding being pestered on the streets here. ("I walk so fast I'm 15 or 20 feet away before people know it's me.") Ms. Curtis sat at a poolside table at a hotel bar, deftly fielding a drunken fan and an amateur photographer, commenting only on the rigors of spending so much time being passive, considering others' work, when she normally concentrates on work of her own.

She has been swimming laps in this same pool at dawn, when it is deserted, which is one good way of staying

sane in the midst of jury duty. Some here are bound to speculate about the jurors' sanity no matter what their deliberations yield Monday evening.

1992 My 18, C13:6

The Enchantment

Directed by Shunichi Nagasaki; screenplay by Goro Nakajima, (in Japanese with English subtitles); director of photography, Makoto Watanabe; edited by Yoshiyuki Okuhara; music by Satoshi Kadokura; produced by Toshiro Kamata, Kei Sasaki and Shinya Kawai; released by Herald Ace/Nippon Herald Films. At the Joseph Papp Public Theater, 425 Lafayette Street, Manhattan. Running time: 109 minutes. This film has no rating.

Sotomura..................................Masao Kusakari
Miyako........................Kumiko Akiyoshi
Harumi..............................Kiwako Harada

By VINCENT CANBY

"The Enchantment," a Japanese film opening today at the Joseph Papp Public Theater, is a richly romantic melodrama that would seem to suggest that schizophrenia is the common cold of contemporary Tokyo. Yet it is a work of such self-assured style and acerbic humor that it also suggests that Shunichi Nagasaki, the man who directed it, could be one of Japan's more promising new film makers.

The title is appropriate. "The Enchantment" is a hip, dark fairy tale for movie Freudians, about a passion so all-consuming that it has the power to transform reality for the object of that passion. In its particulars, "The Enchantment" recalls those lush Hollywood melodramas of the 1950's in which women suffer dreadfully, sometimes to the point of permanent psychological damage, in a world in which nothing matters except love.

Though the central character is Sotomura (Masao Kusakari), a handsome, urbane psychiatrist, the focus of the film is Miyako (Kumiko Akiyoshi), the shy beauty who arrives at the doctor's office late one afternoon without an appointment. She wants to talk about her jealous lover, a woman named Kimie, who has begun to beat her. When Sotomura asks if she's afraid of Kimie, Miyako says that she's more afraid of not loving her.

It's not long before the doctor's interest is something more than professional. Miyako has the manner of a woman too pure and sensitive for this world. She flinches when a light is turned on. Sotomura feels he has to protect her. The day after Miyako's first visit, he receives a call from Kimie threatening him if he sees her lover again. There's even reason to suspect that Kimie is capable of murder.

Sotomura becomes casual toward Harumi (Kiwako Harada), the young woman he lives with, and eventually pays for his interest in Miyako by being badly knifed by her. It is only the first (and not the most surprising) of the film's succession of revelations that Miyako and Kimie are the same person.

Mr. Nagasaki takes this vivid and rather rare case history and turns it into a surprisingly entertaining, haunted love story in which Sotomura becomes the spellbound observer. In the threesome that develops toward the end, Sotomura finds himself in more or less the same role as the director of a film: he can make certain things happen, but he can't order the outcome.

"The Enchantment" looks elegant without being ornate. It's not a film of

Masao Kusakari, top, and Kumiko Akiyoshi in "The Enchantment."

Public Theater

fancy décor, costumes and camera movements. Mr. Nagasaki's style is spare, reasonable, even when the events are charged with melodrama. That he is also a director with a good deal of wit is demonstrated in the film's central seduction sequence. This begins in a sedate French restaurant, moves to a bar for after-dinner drinks and ends, some hours later, after both parties have accidently fallen into Tokyo Bay.

Mr. Nagasaki, who will be 36 years old next month, made "The Enchantment" in 1989.

1992 My 20, C15:3

Once Upon a Time in China

Directed by Tsui Hark; screenplay by Mr. Hark, Yuen Kai-chi and Leung Yiu-ming; music by James Wong; produced by Raymond Chow; released by Golden Harvest. In Cantonese with Chinese and English subtitles. At Film Forum 1, 209 West Houston Street, SoHo. Running time: 112 minutes. This film has no rating.

Wong Fei-hung	Jet Li
Leung Foon	Yuen Biao
Buck Teeth Sol	Jacky Cheung
Aunt Yee	Rosamund Kwan
Porky Lang	Kent Cheng

By STEPHEN HOLDEN

The kung fu fighting sequences in Tsui Hark's "Once Upon a Time in China" are more than just balletic displays of martial-arts prowess. They are extended acrobatic fantasies in which Wong Fei-hung (Jet Li), an invincible figure from modern Chinese folklore, executes whooshing Superman leaps and in one scene turns an umbrella into a miraculous combination of sword, shield, parachute and human-meat hook.

In the film's most spectacular duel, he and an adversary face each other across a scaffold of entangled ladders, which they treat as a kind of seesaw, flinging each other high into the air and landing securely after double somersaults. Despite the frantic activity, the combat is strangely

nonviolent. As in other films of the kung fu genre, the haphazard synchronization of sped-up blows, which often seem to avoid landing on flesh, with the soundtrack's thuds and slaps creates an eerie sense of discontinuity.

In "Once Upon a Time in China," which is at the Film Forum, these aerial ballets are presented as nostalgic set pieces in a witty, extravagantly picturesque homage to Sergio Leone. It is the late 19th century, and China's coastal cities are aswarm with Western visitors. Some are Jesuit missionaries who march through the streets, singing Handel's "Hallelujah" Chorus. Others deal in slave-running and opium. With them they bring firearms, against which even the most dextrous kung fu fighter is helpless. Among other things, "Once Upon in a China" is a stylized lament for the end of the era of clean fighting.

●

Beyond being a paragon of martial-arts purity, Wong, who runs a medical clinic, is a symbol of an older, traditional way of life that colonialism is corrupting. The film takes some witty digs at the culture of the Western intruders. Moments before a French restaurant is thoroughly trashed in a free-for-all scuffle, a Chinese man gazing at the immaculate knife-and-fork table settings wonders why there are so many swords and daggers.

The film has a big streak of comedy. Two of the most prominent among Wong Fei-hung's disciples are farcical incompetents appropriately nicknamed Buck Teeth Sol (Jacky Cheung) and Porky Lang (Kent Cheng). Wong is also amorously pursued by his Aunt Yee (Rosamund Kwan), who has recently returned to China from the West because, as she puts it, "there were no people I want to see." Yee, who is not his blood relative, becomes a magnet for trouble and requires several last-minute rescues.

●

With its pageantry and battle scenes and its Hong Kong-style version of spaghetti-western music, "Once Upon a Time in China" is an unabashedly gaudy film. Its storytell-

ing is episodic to the point of seeming disconnected as characters appear out of the blue, take center stage and then recede into the background. Whenever it's time for a duel, the story screeches to a halt so that Wong can put on another leisurely demonstration of what it means to be a kung fu Superman.

1992 My 21, C16:5

Alien 3

Directed by David Fincher; screenplay by David Giler, Walter Hill and Larry Ferguson, based on a story by Vincent Ward and characters created by Dan O'Bannon and Ronald Shusett; director of photography, Alex Thomson; edited by Terry Rawlings; music by Elliot Goldenthal; production designer, Norman Reynolds; produced by Gordon Carroll, Mr. Giler and Mr. Hill; released by 20th Century Fox. Running time, 135 minutes. This film is rated R.

Ripley	Sigourney Weaver
Dillon	Charles S. Dutton
Clemens	Charles Dance
Golic	Paul McGann
Andrews	Brian Glover
Aaron	Ralph Brown
Morse	Danny Webb
Rains	Christopher John Fields
Junior	Holt McCallany

By VINCENT CANBY

IT'S apparent during the opening credits of "Alien 3" that this is going to be a movie for the generation that finds the computer friendly. Those of us born before 1975 can't possibly comprehend all of the introductory information that goes clicking across the on-screen television monitor, spelling out time, place and imminent crises with the relentlessness of a speed-reading exam.

The information is also so understated that only someone who speaks computer language realizes that life, as we know it, is about to crash. Yet again. What the computer generation knows, and the rest of us don't, is that this information isn't really necessary or especially relevant. Logic is out. Visceral sensation is the point.

Unlike "Alien" (1979) and "Aliens" (1986), the new film, directed by David Fincher, puts no great emphasis on futuristic technology. "Alien 3" belongs to that branch of fantasy comics, best exemplified by the "Road Warrior" movies, in which the iron and space ages meet for dizzy results.

As "Alien 3" begins, a spaceship headed back to Earth suffers unidentified flight difficulties. "Stasis interrupted" is the way the television monitor announces it. Aboard the

ship, snugly unconscious in their sleep pods, are Officer Ripley (Sigourney Weaver) and the other survivors of the dreadful battle that ended the 1986 movie. By the time the opening credits have finished, the spaceship has crashed on Fiorina 161 and Ripley, wiser and heaven knows how much older, is the only person left alive.

Fiorina 161 is a planet, but we never see much of it. Clearly, though, it is a place where the sun doesn't shine. The outside temperature hovers in the neighborhood of 40 degrees below zero. Formerly a maximum-security prison, Fiorina 161 has been decommissioned and is now home to 25 of society's worst rejects, former prisoners who have elected to remain on the planet to live lives of edgy atonement. They are members of what is called "an apocalyptic millennarian fundamentalist Christian sect." Whatever they are, they obey their own commandments.

They're a rude, obscene and dirty lot. The place is so infested with lice that the first thing demanded of Ripley is that she shave her head. The men don't take kindly to the arrival of a beautiful if exhausted young woman. Inevitably there is an attempted gang rape, from which Ripley is saved by Dillon (Charles S. Dutton), the planet's unofficial chaplain.

It's not one of the prisoners who initiates the film's only successful sexual encounter. It is Ripley. Straightforward, liberated woman that she is, she propositions, and is accepted by, Clemens (Charles Dance), the planet doctor and a man with a past.

As Ripley gets to know the guys and awaits a rescue ship, she slowly becomes aware that, just possibly, one of the aliens she fought earlier has somehow arrived on Fiorina 161 with her. A pet dog is murdered in a ghastly way. "What sort of animal would do this to a dog?" someone asks. Then, prisoners start disappearing.

●

Pretty soon, it's all-out mobilization on planet Fiorina 161, which seems to be about the size of a suburban high-school gymnasium with a catacomb-like basement. Ripley and her new comrades are at a disadvantage. There are no weapons on Fiorina 161, not even flashlights. All they have is fire and their wits.

Matters aren't helped when poor Ripley learns that she is carrying a little alien inside her, and no ordinary alien but a queen, capable of producing thousands of eggs. How the little stranger got there remains a mystery, though Ripley thinks it must have happened while she was in her

It's back and it's got a terrible disposition — Sigourney Weaver as Ripley faces a killer from another planet.

Officer Ripley is expecting a little stranger. Much stranger!

script is sometimes intentionally funny. Ms. Weaver has a brisk, no-nonsense approach to the material. She never betrays it, but she also never suggests that the movie is anything more than a haunted-house movie for the space age. She has a way of spreading her intelligence around, upgrading everything in her vicinity.

The production is dourly handsome, with great, chunky, dimly lighted sets that suggest dungeons out of the Middle Ages. They are actually so dark that sometimes it's not easy to know who is doing what to whom. Blood looks black, which may not be all bad. The alien is seen in glimpses, but it's seen often enough so that it seems to be nothing worse than a large, dark sticky lobster claw with a terrible disposition.

•

In addition to Ms. Weaver's Ripley, only two characters are defined to any extent: Mr. Dance's doctor and Mr. Dutton's unofficial chaplain. Lance Henriksen, who played Ripley's faithful android in "Aliens," appears again briefly, mostly in separate pieces.

Mr. Fincher, who has directed music videos for Madonna, Billy Idol and others, doesn't waste time trying to make things plausible. His direction of "Alien 3" suggests that he grew up reading instructions on how to program VCR's. He knows that most explanations, like directions, are incomprehensible, and thus irrelevant.

•

"Alien 3," which has been rated R (Under 17 requires accompanying parent or adult guardian), includes vulgar language, mock violence and sexual situations.

1992 My 22, C1:1

Frida Kahlo
A Ribbon Around a Bomb

Directed and edited by Ken Mandel; based on the play by Abraham Oceransky; director of photography, Jeff Hurst; music by John Bryant and Frank Hames; produced by Mr. Hurst, Mr. Mandel and Cora Cardona; a Roxie release. At Le Cinématographe, 15 Vandam Street, SoHo. Running time: 71 minutes. This film has no rating.

Performed by: Cora Cardona, Quigley Provost and Costa Caglage.

By CARYN JAMES

An hour is hardly enough time to do justice to the passionate life and art of Frida Kahlo, the Mexican painter who seems about to jump off the canvases of her vibrant, fantastic self-portraits. Even more than her accessible art, Kahlo's explosive ex-

Frida Kahlo in a self-portrait.

istence has made her something of a pop icon in recent years. That well-documented life is the subject of "Frida Kahlo: A Ribbon Around a Bomb," a part-documentary, part-performance film that opens today at Le Cinématographe.

When Kahlo was 18 years old, her abdomen was pierced by a piece of metal in a trolley accident, causing her to suffer endless pain and many operations until her death in 1954 at the age of 47. She married the painter Diego Rivera twice, and endured endless betrayals by him, including an affair with her sister. She retaliated with love affairs of her own, with both men and women. Throughout all this she painted a stream of self-portraits that splashed her psychology and emotions across the canvas in blunt symbols that are both primitive and surreal: a naked Kahlo bleeds profusely in a hospital bed that seems to float in space; several portraits show Rivera's face painted on Kahlo's forehead.

The director Ken Mandel takes a scattershot approach to this material. He weaves together interviews with people who knew Kahlo, several photographs and films of her, and many shots of her most familiar paintings. Most successfully, he includes excerpts of a theater piece by Abraham Oceransky called "The Diary of Frida Kahlo," presented by Teatro Dallas.

•

The documentary sections are extremely weak, because Kahlo's associates are not sufficiently identified, their often spurious opinions not put in any context. Surely the bloodiness of Kahlo's paintings cannot be traced simply to her one-time ambition to study medicine, as an interview subject claims.

But the dramatized episodes, based on Kahlo's diaries, are surprisingly effective. Most of this theater piece is a monologue performed by Cora Cardona, sometimes joined by Quigley Provost as a younger Kahlo. Ms. Cardona does not imitate Kahlo so much as bring the depths of that volcanic, tortured personality to life. Depicting Kahlo's reaction to her accident, she wraps a large chain around her leg and reveals both pain and astonishing strength as she says: "I am not dead. I am not sick. I am only broken."

Still, the film, whose subtitle comes from André Breton's description of Kahlo's art, is likely to be too shallow

for anyone who knows her story and too sketchy for anyone unfamiliar with it. Ms. Cardona's trenchant performance hints at how illuminating this film might have been.

1992 My 22, C10:1

Far and Away

Directed by Ron Howard; screenplay by Bob Dolman, based on a story he and Mr. Howard wrote; director of photography, Mikael Salomon; edited by Michael Hill and Daniel Hanley; music by John Williams; production designers, Jack T. Collis and Allan Cameron; produced by Brian Grazer and Mr. Howard; released by Universal. Running time: 138 minutes. This film is rated PG-13.

Joseph	Tom Cruise
Shannon	Nicole Kidman
Stephen	Thomas Gibson
Christie	Robert Prosky
Nora Christie	Barbara Babcock
Danty Duff	Cyril Cusack
Molly Kay	Eileen Pollock
Kelly	Colm Meaney
Dermody	Douglas Gillison

By CARYN JAMES

"Far and Away" is being sold as a big, old-fashioned movie event, an epic shot on giant-sized 70-millimeter film, sweeping across two continents. It even has a genuine movie star, Tom Cruise, as a 19th-century Irish tenant farmer named Joseph Donelly, who finds love and land in America.

Well, the film does have a lot of crowd scenes and wide shots of scenery, so it's big. And the story is determinedly old-fashioned. When Joseph runs off to Boston with Shannon Christie, a rich landowner's daughter (Nicole Kidman), they masquerade as and actually live like brother and sister. You can't get more old-fashioned than that. But this film is as much an epic event as sitting at home watching television, an activity that seeing "Far and Away" greatly resembles.

The lush green landscape of Ireland is shot in the picturesque manner of an Irish Spring soap commer-

Phillip Caruso

Tom Cruise

cial. Joseph and Shannon's episodic journey from Ireland to Boston to Oklahoma offers fewer surprises than a mediocre mini-series. And though the film turns into a rousing western during its Oklahoma scenes, it feels so familiar that Pa and Hoss and Little Joe might come galloping

into sight any minute. Despite the movie's ambitious scope, there are small-sized imaginations at work here.

•

The problem is not Mr. Cruise or his now-and-then Irish accent. He is an appealing presence and a powerful actor in films like "Rainman" and "Born on the Fourth of July." But what can he do with scenes like this? At his father's deathbed, Joseph hears the older man say, "Without land a man is nothing," and he vows in response, "I'll work my own land someday, Da."

Ron Howard, who directed "Far and Away" and conceived the story with its screenwriter, Bob Dolman, is faithful to every cliché lurking beneath Joseph's promise. The camera rises over the dead man's body as his soul escapes, then swoops across the green hills and out to sea, trying to look grand for no particular purpose.

Soon Joseph stumbles across Shannon, his true love. In these early scenes, Ms. Kidman is wonderfully feisty and comic. Joseph trespasses on the Christie estate and she stabs him with a pitchfork. When he is recuperating, she takes a gleeful peek at the most intimate (off-camera) part of his anatomy, suggesting strong romantic-comic possibilities. She airily says, "I'm running away because I'm modern," and invites Joseph to come along as her servant.

But her high spirits and the film's energy disappear when she loses her money in Boston. Shannon plucks chickens, Joseph becomes a boxer, they chastely share a room in a whorehouse and consort with stock characters like the ward boss. They are a likable enough pair, but their predictable adventures are a snooze.

Of course nothing will stop them from their dream of Oklahoma, not even a mawkish Christmas scene that ends with blood on the blatantly fake snow and that causes their temporary separation.

That's when Joseph gets advice from his dead Da, whose disembodied voice reminds him, "Without land a man is nothing." With an ease only

Phillip Caruso/"Far and Away"

On the Run Nicole Kidman plays a wealthy Irish landlord's daughter who runs off to the United States with a poor tenant farmer (Tom Cruise) in "Far and Away."

movie heroes can manage, he jumps off a train in the middle of nowhere nd' is suddenly in Oklahoma. Scores of covered wagons and horses race across the land, toppling over one another, creating the kind of visual excitement the film desperately needs. But by then, in the last half-hour of this 2-hour-18-minute film, the real race is toward the story's suspenseless end.

In previous films like "Parenthood" and "Backdraft," Mr. Howard has created commercial hits by following a similar formula: give the audience something as comfortable and unsurprising as its own living rooms. This time the concept of TV-for-a-very-big-screen comes out silly.

•

"Far and Away" is rated PG-13 (Parents strongly cautioned). It includes some violence, particularly in the boxing scenes.

1992 My 22, C10:5

The Stranger

Written and directed by Satyajit Ray (in Bengali with English subtitles); director of photography, Barun Raha; edited by Dulal Dutt; music by Ray; production designer, Ashoke Bose. At the Walter Reade Theater, 165 West 65th Street, Manhattan. Running time 100 minutes. This film has no rating.

Sudhindra Bose	Deepankar De
Anila Bose	Mamata Shankar
Satyaki	Bikram Bhattacharya
Manomohan Mitra	Utpal Dutt
Prithwish	Dhritiman Chatterji
Ranjan Rakshit	Rabi Ghosh
Chhanda Rakshit	Subrata Chatterji

By VINCENT CANBY

Satyajit Ray's last film, "The Stranger," opening today at the Walter Reade Theater, is a fitting grace note to the career of the great Indian film maker, who died last month, just short of his 71st birthday. "The Stranger" is a small, gentle, exquisitely realized comedy about, among other things, family loyalties and trust in a world in which traditions have been devalued.

The film, written and directed by Ray, has the shapeliness and some of the mystery of a parable. One morning a letter arrives at the perfectly ordered upper-middle-class household of Sudhindra Bose. It is for his wife, Anila. "Ah," says Sudhindra in English, "a massive missive."

His good spirits disappear when he hears that the letter is from Anila's long-lost uncle, Manomohan, who left home in 1955 and hasn't been heard from since 1968. Manomohan writes with a somewhat majestic air, "I have finished my travels in the West." He says he is returning to Calcutta and wants to spend a week with his niece.

•

Sudhindra, who doesn't otherwise appear to be unusually suspicious, immediately suggests that the letter could be from an imposter, someone out to borrow money or even to steal their valuable antique bronzes. Sudhindra's small son is ecstatic at the prospect of the visit: "A fake great uncle!" Anila says they have to take the man in. Traditional Indian hospitality demands that they receive him.

"The Stranger" is a kind of elegiac "Man Who Came to Dinner." Manomohan arrives and settles in, to the delight of the little boy, the confusion of Anila and the increasing suspicions of her husband. One of the more dis-

concerting things about the aging uncle is that he is completely aware of their discomfort, which both amuses and saddens him.

He charms the boy with tales of his travels in Europe, the American West and Machu Picchu in South America. He explains the difference between solar and lunar eclipses. He seems to know the answers to the mysteries of the universe. For Sudhindra's benefit, he produces his passport with his name and picture. Anila is convinced of his identity but Sudhindra remains skeptical.

In a series of beautifully observed (and acted) encounters, including one in which Manomohan is rudely cross-examined by a journalist friend of the family, he slowly turns the tables on Anila's suspicious husband. When Manomohan finally leaves, this time to check out Australia, he has forever changed the lives of Sudhindra, Anila and the boy, Satyaki.

•

The name of the boy suggests that Ray may be recalling some incident from his own childhood. Maybe not. Yet "The Stranger" has about it an air of enchantment, of a story out of the past, repeatedly retold and embellished through time. Manomohan, played with immense wit by Utpal Dutt, is a boy's idealized great-uncle, someone who has been nearly everywhere, seen nearly everything and has the freedom to keep on going. As he passes through this household he transforms the boy's mother and father into better parents. More important, he teaches the boy to question life, to pursue his own independent course and finally to respect the past.

"The Stranger" doesn't necessarily change one's perception of Ray's career. It doesn't compete with the great films — the Apu trilogy, "Charulata," "Distant Thunder" and "The Chess Players." Yet it couldn't have been made by any other film maker. "The Stranger" is a sweet and enriching dividend.

1992 My 22, C13:1

Zentropa

Directed by Lars von Trier; screenplay by Mr. von Trier and Niels Vorsel (in English and German with English subtitles); directors of photography, Henning Bendtsen, Jean-Paul Meurisse and Edward Klosinsky; edited by Herve Schneid; music by Joakim Holbek; produced by Peter Aalbaek Jensen and Bo Christensen; released by Miramax Films. At the Angelika Film Center, 18 West Houston Street, Manhattan. Running time: 107 minutes. This film has no rating.

Narrator	Max von Sydow
Leopold Kessler	Jean-Marc Barr
Katharina Hartmann	Barbara Sukowa
Lawrence Hartmann	Udo Kier
Uncle Kessler	Ernst-Hugo Jaregard
Pater	Erik Mork
Max Hartmann	Jorgen Reenberg
Siggy	Henning Jensen
Colonel Harris	Eddie Constantin

By STEPHEN HOLDEN

"Zentropa" may well be the first feature film that literally attempts to hypnotize the audience into appreciation. During its opening sequence, a narrator (Max von Sydow) whose voice is as soothing as it is authoritative, suggests that viewers sink "still deeper into Europa" as he slowly counts from 1 to 10 while railroad tracks flash by on the screen.

Periodically during the film, which opens today at the Angelika Film

Center, Mr. von Sydow returns like the voice of God (and of Lars von Trier, the Danish film maker who directed and, with Niels Vorsel, co-wrote "Zentropa") to push the narrative forward. Sometimes he even directly addresses the film's improbable main character, Leopold Kessler (Jean-Marc Barr). It is 1945, and Leopold, a German-American pacifist, has traveled to Germany to help the country rebuild from the ashes of World War II. Or as he puts it, "It's time to show the country a little kindness."

With the help of an uncle (Ernst-Hugo Jaregard), Leopold finds work as a sleeping-car conductor for a giant railway complex called Zentropa. On his first night on the job, he is summoned into the cabin of a beautiful woman, Katharina Hartmann (Barbara Sukowa), who turns out to be the daughter of the Zentropa's owner. A romance develops, and Leopold finds himself used as a pawn in a web of intrigue that involves pro-Nazi terrorists known as werewolves.

Although the actual story of "Zentropa" is the stuff of an ordinary thriller, that plot is the only conventional aspect of a film that is an almost impudently flashy and knowing exercise in post-modern cinematic expressionism. "Zentropa" is set in the 1940's, but its vision of a defeated Germany suggests a futuristic nightmare in which stony-faced crowds move somnambulistically through a bleak, wintry landscape strewn with rubble. In a film that is crowded with strikingly desolate visual set pieces, perhaps the eeriest is a scene in which Leopold attends a midnight Christmas Mass in the shell of a bombed-out cathedral in the falling snow. The atmosphere of the scene suggests a a Wagnerian ceremony of zombies.

•

"Zentropa" is so self-conscious in making reference to film history that it is a virtual grab-bag of familiar moods and clever allusions. They range from Fritz Lang's "Metropo-

Prestige Films

Aftermath Jean-Marc Barr stars in "Zentropa" as an American of German descent who finds himself enmeshed in the chaos and politics of Germany just after World War II.

lis" (the crowd scenes, the tangled railroad technology) to Alfred Hitchcock's "Vertigo" (Joakim Holbek's emotionally tortured score, which practically quotes from Bernard Herrmann's music for "Vertigo"). The director is also fearless in showing off his cinematic know-how. Although shot mostly in murky black-and-white, in moments of high drama, "Zentropa" sometimes bleeds and at other times bursts into color. At other moments, only one object is shown in color in an otherwise black-and-white frame.

The selective use of color enhances the deliberately artificial look of a film that uses such techniques as back projection, superimposition and distortion and magnification of images. The director's anything-for-a-reaction visual esthetic makes the entire film seem to be as much a bravura cinematic collage as a narrative. "Zentropa" also develops several very flashy visual leitmotifs. One interweaves images of the railway company's real trains, which are fairly shabby, with a glamorous electric train set in the back of the Hartmann home. The director is also fascinated with images of people filmed underwater.

Beneath all its high-flown effects, "Zentropa" is at heart a sarcastic comic meditation about cinematic myth-making and the relationships between Hollywood, Europe and World War II. If at the beginning of the film Leopold looks like a potential movie hero, he never accumulates any stature. The character that emerges is a weak, altruistic cipher and credulous dupe who is prone to panic when he needs to keep his head.

It is the ambiguous and fascinating Katharina, powerfully played by Miss Sukowa, who expresses the closest thing to a moral vision the film offers when she tells Leopold that everybody on the train "has killed and betrayed hundreds of times just to survive." He is the only criminal aboard, she asserts. His crime, the movie suggests, is nothing more than a case of hopeless, quintessentially American naïveté.

1992 My 22, C14:1

Encino Man

Directed by Les Mayfield; screenplay by Shawn Schepps, based on a story she wrote with George Zaloom; director of photography, Robert Brinkmann; edited by Eric Sears; music by J. Peter Robinson; production designer, James Allen; produced by Mr Zaloom; released by Hollywood Pictures. Running time: 98 minutes. This film is rated PG.

Dave Morgan	Sean Astin
Link	Brendan Fraser
Stoney Brown	Pauly Shore
Robyn Sweeney	Megan Ward
Ella	Robin Tunney
Matt	Michael DeLuise
Phil	Patrick Van Horn
Will	Dalton Jones
Mr. Brush	Rick Ducommun
Kim	Jonathan Quan
Mrs. Morgan	Mariette Hartley
Mr. Morgan	Richard Masur

By CARYN JAMES

Here is a simple quiz to gauge whether you should even think about seeing "Encino Man." Do the phrases "He's dope" and "She's buff" seem like compliments or insults to you? If they sound like insults, you might as well put on your reading glasses and curl up with a copy of "Modern Maturity" or a video of "Thirtysome-

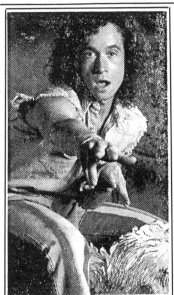

Luke Wynne/Buena Vista Pictures

Back to the Future Pauly Shore stars in "Encino Man" as a California high shool student who discovers a frozen cave man while excavating a backyard pool.

thing." This film isn't likely to play well with anyone who has strayed very far from the age of 15 or the vicinity of a high school.

It is the story of a Cro-Magnon guy who goes from frozen fossil to prom king in just a few days. Dave (Sean Astin) is clean-cut and geeky, searching for popularity by digging a swimming pool in his backyard. His best friend, Stoney, has a tangle of hair, a headband, neo-60's clothes, a hiccupy manner of speech and a chillin' vocabulary impenetrable to parents.

That is, he is played by Pauly Shore as a millimeter away from the comedian's persona on MTV's "Totally Pauly."

When Dave unearths a caveman frozen inside a glacier, the friends thaw him out, clean him up and pass him off as Linkovitch Chomofsky, an exchange student from Estonia. With his tousled hair, hightops and wideeyed stare, he turns into the coolest guy at Encino High. He dances around the halls and turns into a perfect hip-hopper without even trying. He makes primitive cave drawings on a computer. Brendan Fraser plays Link as an endearing caveman, suggesting some of the guileless charm of Tom Hanks.

•

But the real question is whether Dave and Stoney and Link are worthy heirs to Bill and Ted or Wayne and Garth. Not really. "Bill and Ted's Excellent Adventure" was a novelty when it came out, and "Wayne's World" has a manic edge. But while Pauly Shore has a following, too much of "Encino Man" might have come from a Hollywood cookie cutter. Link takes driving lessons, turning corners on two wheels while the nerdy instructor yells, "Stop that car, young man." Isn't that joke from the Pleistocene Era?

When Stoney explains that Milk Duds belong to one of the four major food groups, the dairy group, that's about as funny as things get. For a film that prides itself on throwing around Pauly-isms like fully (meaning yes), and grindage (food), "Encino Man" is surprisingly not buff (cool).

•

"Encino Man" is rated PG (Parental guidance suggested). It includes drinking.

1992 My 22, C15:1

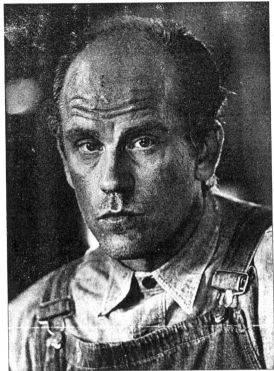

M-G-M

John Malkovich in "Of Mice and Men"—Movie directors are beginning to read.

FILM VIEW/Janet Maslin

Godzilla, Sharon and 'X' Meet in the Kaleidoscope

CANNES, France

RANDOM THOUGHTS ARE THE only thoughts left to anyone who has spent two sleepless weeks here, making feverish, futile attempts to keep up with the dozens of films that are shown every day. Here are a few of those free-floating observations, conveying a hint of how dizzying, exhilarating and unimaginably petty the Cannes International Film Festival can be:

"Please don't think I'm becoming an egomaniac, because I *am*": a remark by a suddenly world-famous participant in one of the festival's best-liked films.

"The main activity of Cannes is envy": an accurate observation by someone who has known great success here, but happens to be out of the limelight this time.

■

"Nice, but it won't make a dime": casual comment overheard at the end of a black-tie screening of a film that was greeted with a five-minute standing ovation. Enthusiasm at Cannes can be much wilder than it would be

anywhere else. The regrettable thing is that the speaker was probably right.

"Adult education has taken off in America, and some of our movie directors are even beginning to read": John Malkovich, who plays Lennie to Gary Sinise's George in Mr. Sinise's film version of John Steinbeck's "Of Mice and Men." He was responding to a typically weightless question about why at least two forthcoming American films (the other is Martin Scorsese's adaptation of "The Age of Innocence," by Edith Wharton) are based on important American novels.

Typically bizarre plot synopsis: "Two men, tired and dirty, walk along a dirt road toward a ranch. A magnificent blue sky and rolling countryside provide breathtaking scenery, but little comfort to the two itinerant laborers just trying to get by in the California of 1930." This was the official festival précis for "Of Mice and Men."

"Who knows? Everyone likes to stretch his outer limits!": Tom Cruise, answering a local reporter's question about whether he would like to direct someday. Mr. Cruise, at his own news conference, was actually asked to define his idea of romance and tell what kind of toothpaste he uses.

"Thanks so much for all your help. We couldn't have done it without you": gift card being composed at the Hermès boutique in Cannes to accompany a scarf for someone who must have helped implement a business deal. (Film distribution rights for various regions are bought and sold here.) Gifts like this must have been rare this year, since the consensus was that business was unusually flat. Tim Robbins's wicked political satire, "Bob Roberts," and the enjoyably arch Australian comedy "Strictly Ballroom" were among the festival's few sleepers.

"Twice as much, at least. And maybe $100 million": knowledgeable guesses as to just how much prices in Cannes increase for the festival's two-week run, and what that period brings the city of Cannes in total revenues. The source of these estimates, a French film maker very well versed in the ways of the

festival, makes a point of going to nearby Nice to buy his Champagne.

"Little green men from outer space! You can tell your son about it when he's born": a line from the refreshing Japanese monster movie "Godzilla vs. King Ghidorah," seemingly one of the more out-of-the-way selections in the unofficial marketplace that accompanies the official selections being shown

What adjectives befit the Cannes festival? Try: dizzying, exhilarating and unimaginably petty. And its main activity is envy.

here. There were only 14 people at the screening, but 3 of us turned out to know one another. Escapism in the face of three or four or five other screenings a day can become desperately important.

Incidentally, the scene in question is supposed to take place in the South Pacific in 1944, just before Godzilla is awakened from his underwater sleep by a team of time-traveling scientists. The person being addressed is a young man called Major Spielberg.

The most meaningless spectacle to be seen here during two weeks' worth of wall-to-wall television coverage: Sharon Stone picking up her luggage at the Nice airport.

The unlikeliest musical selection played by a dance band: "Beauty and the Beast." Naturally, Disney threw the party.

The most urgently needed implement: scissors. Almost every film seen here was significantly overlong, and that perception was not simply a function of audience fatigue. Gilles Jacob, the festival's director, observed that few film makers today are content to show an actor walking up a single step if they can show an entire flight of stairs.

Most tasteless touch (a tie): the ad for a porn remake of "The Blue Angel" promised to outdo Marlene Dietrich, an idea embarrassingly timed to coincide with Dietrich's death and patently absurd anyhow. Equally obnoxious was the leering at a barely covered Tom Cruise in "Far and Away," not to mention the film's various witticisms about the star's good looks and great virility.

∎

The festival's major discoveries, within the main competition: "Leolo," Jean-Claude Lauzon's funny, fearless, genuinely poetic portrait of a young French-Canadian boy seeking to escape his monstrous family life through art and dreams. Also "The Stolen Children," Gianni Amelio's bracingly pure and humane story of an Italian soldier on a journey with two abandoned children. And "El Sol del Membrillo," Victor Erice's very slow but exquisitely serene Spanish film about a still-life painter.

Accessory of choice: the "Malcolm X" baseball cap, black with a white X and visible on everyone from Spike Lee's associates to elderly Japanese film financiers. Mr. Lee himself was sometimes spotted in black tie (obligatory for official nighttime screenings), but he appeared to have been doing the true work of the festival, doubtless participating in meetings and conferences needed to keep an expensive project like "Malcolm X" internationally visible. The hat is a sign of

both this forthcoming film's built-in cachet and the energy level already connected with its marketing.

The reason we came here: It was inadvertently illustrated by Abel Ferrara, whose lurid, down-and-dirty approach to film making ("Fear City," "The King of New York") makes him a marginal figure with cautious American audiences. He is better treated here, and better understood. Sitting in a cafe one evening, Mr. Ferrara was approached by three avid French film students. They claimed to have seen his new "Bad Lieutenant," about a drug-addicted policeman (Harvey Kietel) investigating the rape of a beautiful young nun, several times. They asked him to sign a film magazine they had published. They showed him an article about himself and one about John Cassavetes, another of their heroes.

Then, summoning up their courage, they asked Mr. Ferrara to describe his film-making philosophy. In another context that might have seemed ridiculous, but here it made perfect sense.

"Just keep rockin', just keep shootin'," Mr. Ferrara said nonchalantly. To remain active is the real point of this gaudy exercise for any film maker. Lest we forget. □

1992 My 24, II:9:1

Cousin Bobby

Directed by Jonathan Demme; edited by David Greenwald; music by Anton Sanko; produced by Edward Saxon; released by Cinevista. At the Joseph Papp Public Theater, 425 Lafayette Street, Manhattan. Running time: 70 minutes. This film has no rating.

By JANET MASLIN

THE fact that Jonathan Demme had not seen his cousin the Rev. Robert Castle in 30-odd years is not sufficient to explain "Cousin Bobby," Mr. Demme's documentary account of his cousin's life. Plenty of people have long-lost relatives, and not all of those relatives' stories belong on film. But something special was at work here: a true meeting of the minds, which the film captures effortlessly, and a remarkable family trait both cousins share. Both Mr. Demme, the Academy Award-winning director, and Father Castle, the priest in charge at St. Mary's Episcopal

The Rev. Robert Castle, the subject of Jonathan Demme's documentary.

Church in Harlem, are avid enthusiasts, and both are fueled by an idealism that elevates "Cousin Bobby" well beyond the home-movie realm.

It seems fitting that Mr. Demme, in one scene, wears a shirt displaying a map of the world. As the major director with Hollywood's most exotic résumé, Mr. Demme has explored an enormous range of interests, making a collection of films bound together by the film maker's sheer fascination with his subjects rather than by any unifying themes.

His features are as different as the meticulously chilling "The Silence of the Lambs" and the antic, dreamlike "Something Wild"; his documentaries range from one of the best and most ingenious rock concert films, Talking Heads' "Stop Making Sense," to a simple, riveting treatment of Spalding Gray's "Swimming to Cambodia" and the political essay "Haiti Dreams of Democracy." "Cousin Bobby," an hourlong film made with what proves to be deceptive nonchalance, shares with these other projects an unwavering intensity and strong sense of purpose. Most important, it shows off Mr. Demme's unusual ability to draw audiences close to the subjects he embraces.

"Cousin Bobby," which opens today at the Joseph Papp Public Theater, gets to know Father Castle the way anyone might explore a new acquaintance: gradually, casually, in a circular rather than linear fashion. Seemingly at random, the film supplies old photographs, relatives' reminiscences and scenes of the priest among his parishioners. The film quickly establishes that he has carved out an unusual role for himself within this Harlem congregation, and searches through his background to explain that aspect of his character. From the film's seemingly random observations — that Bobby's father, Mr. Demme's great-Uncle Willy, once bowled a 300 game — to its scorching political invective, "Cousin Bobby" eventually assembles a moving and fully formed portrait.

Father Castle's view of racial politics in America seems to surprise even some of his black parishioners, and the film recounts the ways his radical stance has brought him both satisfaction and trouble. In his Jersey City parish in the 1960's, he was closely involved with the Black Panthers and was particularly influenced by the late Isaiah Rowley, one of the people to whom "Cousin Bobby" is dedicated. Without exploring Father Castle's politics in great detail, the film does visit with his first wife, who recalls the couple's four children asking, "How much is the bail, Mom?," on one of the various times the priest was in jail.

Father Castle himself remembers being told by his Bishop, "Bob, there should be a job for you here in the Diocese of Newark, but there isn't." This prompted a move to Vermont in 1970, where the Castles planned to run a general store. Instead, Father Castle was again drawn to the church, and eventually he returned to the New York area, setting up St. Mary's as a kind of all-purpose community service center for its parishioners. Father Castle is seen doing everything from holding mail for neighbors who are in jail or missing to railing against drugs, poor living conditions and a huge pothole in the middle of the street. The film becomes so intimate with his concerns that the news of this pothole's being repaired becomes a major triumph.

As they stroll together through the settings that shaped Father Castle's life, from the Harlem street corner where he delivers a sermon to the Vermont hillside where one of his sons is buried, the director and the priest share a developing bond that is captured on film. They attend a family reunion; they visit the house where they last saw each other; they share impressions, sometimes terribly moving ones, about relatives who are now gone.

By the time the viewer hears the poignant story of Father Castle's final encounter with his father, and learns the priest's thoughts on his faith and the possibility of an afterlife, the film has achieved a rare degree of intimacy. There's a lot to be learned from the apparent guilelessness with which that intimacy is developed, and the precise modulation of topic, tone and background music used to construct this studiously unself-conscious style.

"Cousin Bobby," handsomely shot by several cinematographers including Ernest Dickerson, concludes on a stark, sobering note with archival scenes of the fiery damage caused by American race riots in the 1960's and bracing sounds of rap "Edutainment" by KRS-1, comparing ancient Greek and Egyptian cultures and stressing the importance of black history. This final touch, eerily timed in light of recent events, fits perfectly with the film's presentation of Father Castle's ideals.

It also suits Mr. Demme's larger mandate in making this film, since it was commissioned by an independent Spanish production company making a series "On Shooting Reality." Reality is seldom found onscreen these days, but it is alive and well here.

1992 My 29, C1:4

Sister Act

Directed by Emile Ardolino; written by Joseph Howard; director of photography, Adam Greenberg; edited by Richard Halsey; music by Marc Shaiman; production designer, Jackson DeGovia; produced by Teri Schwartz; released by Touchstone Pictures. Running time: 96 minutes.

Deloris	Whoopi Goldberg
Mother Superior	Maggie Smith
Sister Mary Patrick	Kathy Najimy
Sister Mary Robert	Wendy Makkena
Sister Mary Lazarus	Mary Wickes
Vince LaRocca	Harvey Keitel

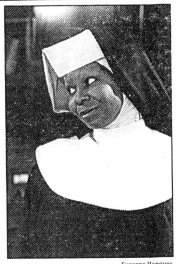

Suzanne Hanover

Whoopi Goldberg in "Sister Act."

Eddie Souther	Bill Nunn
Joey	Robert Miranda
Willy	Richard Portnow
Sister Alma	Rose Parenti
Bishop O'Hara	Joseph Maher

By JANET MASLIN

The main lesson of "Sister Act," the sugary farce featuring Whoopi Goldberg as a lounge singer hiding out in a convent, is that many girl-group hits of the 1960's were even more divine than many of us originally realized. The film's chief comic invention is that Ms. Goldberg's Deloris Van Cartier, enlisted as the convent's new choirmaster, can teach nuns to sing slightly modified versions of songs like "My Guy" (now "My God") and "I Will Follow Him" and thus attract hordes of extra churchgoers, who love this hip and tuneful approach to religious music. Apparently no one connected with "Sister Act" has ever heard a gospel choir.

Originally intended as a vehicle for Bette Midler, "Sister Act" has been retooled in a way that only partly suits Ms. Goldberg's broadly demonstrative comic style. When Deloris, on the run from the married mobster (Harvey Keitel) with whom she has been having an affair, is sent to the convent by an obliging police detective (Bill Nunn, who gives the only easygoing performance in the movie) she is scorned by the Mother Superior (Maggie Smith), who disdains her loud clothes and vulgar manners. Scenes that might have played as mere snobbery with Ms. Midler now have a hint of racism, which might have been dispelled if the film had addressed it head on.

The fact that Deloris is the only black nun in the convent is not even mentioned descriptively. When a dozen nuns are loose in a gambling casino and Deloris is being frantically hunted among all the habits, no one thinks to cite her race as an identifying detail. That would not matter if it didn't indicate a larger unreality in "Sister Act," which offers the kind of cute, synthetic uplift usually found in television commercials and casts its nun characters as walking sight gags rather than real people. The actresses who stand out — Kathy Najimy as a plump, too-perky nun with a comically bad singing voice, Wendy Makkena as a shy novice who turns out to be a real belter, and Mary Wickes as an older character who

sounds as if she's half-nun, half-marine — are likeable, but they seem to be advertising rather than acting.

●

Ms. Goldberg starts out with some tough talk, but this turns out to be one of her ultra-lovable roles. It can be predicted that her Deloris will complain bitterly about the convent's food and early wake-up call, that she will bungle the prayers ("Through the power vested in me I pronounce us ready to eat") and that she will eventually develop a soft spot for the women she once scornfully described as "penguins."

It can be predicted that Miss Smith's Mother Superior will become an old softy, too. It can probably even be predicted that the convent will become famous enough to wind up on the covers of national magazines. Paul Rudnick, who wrote the original screenplay, tried to remove his name from this slick, contrived and not very funny version, which is now credited to him under the pseudonym Joseph Howard.

"Sister Act" was screened on Wednesday night for an audience of 300 nuns who found a lot of it funny, especially a closing gag about the Pope. Secular audiences aren't likely to be so charitable.

●

"Sister Act" is rated PG (Parental guidance suggested). It includes one brief sexual situation, mild violence and mild profanity.

1992 My 29, C10:1

Pepi, Luci, Bom

Directed and written by Pedro Almodóvar (in Spanish with English subtitles); director of photography, Paco Femenia; edited by Pepe Salcedo; released by Cinevista. At Angelika Film Center, Mercer and Houston Streets, SoHo, Manhattan. Running time: 80 minutes. This film has no rating.

Pepi	Carmen Maura
Policeman	Félix Rotaeta
Bom	Olvido Gara
Luci	Eva Siva

By JANET MASLIN

It would have taken more than foresight, and not much less than X-ray vision, to detect the promise of Pedro Almodóvar's subsequent success within "Pepi, Luci, Bom," a rough, unfunny comedy made in 1980. Most notable for its bathroom jokes, humorous rape scenes and abysmal home-movie cinematography, this reputation-dimming mess finally opens in New York today at the Angelika Film Center.

Spanish critics at the time described the film as being "like a healthy, well-intentioned sock on the nose" (Tele-Express) and praised Mr. Almodóvar as "a stubbornly passionate defender of substandard movies" (El Periódico), maintaining that this one "upturns with true daring the most respected taboos of our ridiculous society" (El País). Only in the context of an exceptionally taboo-ridden culture could this film's scatological silliness be construed as bold.

The director's daring is limited to shock value of a very adolescent variety, and to plot turns that are better described than seen. A bearded lady tries to improve her marriage to a voyeur by shaving her facial hair; a nightclub holds a contest measuring

Carmen Maura

the penises of various volunteers; a 40-year-old masochistic housewife becomes enthralled with a surly 16-year-old punk rocker, who first captivates the housewife by urinating on her. The film's overall messiness is such that the members of this odd couple, Luci (Eva Siva) and Bom (Olvido Gara), appear to be approximately the same age.

●

Only Carmen Maura, as the boundlessly energetic Pepi, provides any of the spark associated with Mr. Almodóvar's later work. This film, which was also known as "Pepi, Luci, Bom and Other Girls on the Heap," can most euphemistically be seen as a faint blueprint for "Women on the Verge of a Nervous Breakdown," in which Miss Maura starred.

Miss Maura's role, which perfectly exemplifies the film's anything-for-attention spirit, is that of an heiress who becomes hellbent on revenge after a loutish policeman rapes her and takes her virginity, which she was planning to sell for a good price. Later on, rallying from this setback, she becomes an advertising executive who tries to dream up new products. A doll that sweats and menstruates is supposed to be one of her cleverest inventions, second only to underwear that doubles as a sexual aid. Mr. Almodóvar's celebrated wit had a long way to go when he came up with any of this.

1992 My 29, C10:5

Diary of a Hit Man

Directed by Roy London; screenplay by Kenneth Pressman, based on his play "Insider's Price"; director of photography, Yuri Sokol; edited by Brian Smedley-Aston; music by Michel Colombier; production designer, Stephen Hendrickson; produced by Amin Q. Chaudhri; released by Vision International. At Worldwide Cinemas, 340 West 50th Street. Running time: 91 minutes. This film is rated R.

Dekker	Forest Whitaker
Jain	Sherilyn Fenn
Kiki	Sharon Stone
Zidzyk	Lewis Smith
Shandy	James Belushi
Koenig	Seymour Cassel
Shiela	Lois Chiles
Dr. Jamison	John Bedford-Lloyd

By STEPHEN HOLDEN

In "Diary of a Hit Man," Forest Whitaker, an actor best remembered for his portrayal of Charlie Parker in

Clint Eastwood's film "Bird," has the impossible role of Dekker, a hired killer who suddenly develops pangs of conscience. One day he is a cold-blooded murderer, the next a slobbering, tear-stained mess who bawls, "How am I supposed to live?"

Dekker's crisis of conscience comes after a commodities trader (Lewis Smith), a yuppie caricature who is beyond monstrous, hires him to kill his wife, Jain (Sherilyn Fenn), and her baby for $40,000. The carrying out of the assignment turns into farce as the victim's slatternly sister, Kiki (Sharon Stone), shows up and Jain, a forlorn agoraphobe and failed cheerleader, tries to seduce Dekker in a rah-rah strip act.

●

Mr. Whitaker does what he can to make this preposterous role believable by playing Dekker as an eccentric roly-poly tough guy. It is one of several ambitious performances in the film, which is the first feature to be directed by Roy London, a respected acting coach who was an original member of Joseph Chaikin's Open Theater.

But the most thoughtful acting in the world couldn't compensate for the chasms of credibility in Kenneth Pressman's screenplay, which introduces and then abandons three subplots. The film, which opens today at Worldwide Cinemas, clumsily attempts to avoid an offscreen narration by having Dekker mumble history over a pay phone into an answering machine. The 90-minute message is hopelessly garbled.

"Diary of a Hit Man" is rated 'R' (Under 17 requires accompanying parent or adult guardian). It includes brief nudity and strong language.

1992 My 29, C10:5

The Silk Road

Directed by Junya Sato; screenplay by Tsuyoshi Yoshida and Mr. Sato, based on an original story by Yasushi Inoue (in Japanese with English subtitles); produced by Atsushi Takeda, Yuzo Irie, Yoshihiro Yuki, Ma Wang Liang and Masahiro Sato; released by Trimark Pictures. At the Quad Cinema, 13th Street, west of Third Avenue, Manhattan. Running time: 126 minutes. This film is rated PG-13.

Zhao Xingde	Koichi Sato
Zhu Wangli	Toshiyuki Nishida
Li Yuanhao	Tsunehiko Watase
Weichi Kuang	Daijiro Harada
Tsao Yanhui	Takahiro Tamura
Tsurpia	Anna Nakagawa
Woman of Xixia	Yoshiko Mita

By STEPHEN HOLDEN

Whenever "The Silk Road," a lavish but somewhat muddled epic of life in 11th-century China, doesn't know what else to do, the camera draws back for one more spectacular aerial shot of warring tribes thundering on one another on horseback across the desert.

The film, a Chinese-Japanese co-production directed by Junya Sato, is an Asian variant of American swashbucklers like "Ivanhoe," and has an eye toward educating as well as entertaining. The story is framed with a pompous-sounding historical narration explaining that "The Silk Road" takes its title from the name of the ancient trading route later followed by Marco Polo. The action is set in the general area of Dun Huang, a desert city that was the last Chinese outpost on the route.

Adapted from a novel by Yasushi Inoue, the film imagines events that might have created what came to be known as the Thousand Buddha Caves. It was at this site not far from the city where an enormous trove of Buddhist icons and scrolls in several languages was discovered in 1900.

The events are seen through the eyes of Zhao Xingde (Koichi Sato), a young scholar who manages, conveniently, to be on the scene wherever the action is. His adventures begin when he joins a caravan of traders that is soon attacked by a band of Chinese mercenaries whose general (Toshiyuki Nishida) recognizes his intelligence and makes him a kind of military protégé. The film becomes a very far-fetched love story when Zhao rescues Tsurpia (Anna Nakagawa), a princess from an enemy tribe, and tries to hide her from battle.

●

Melodrama follows melodrama as the star-crossed lovers attempt to flee. Then they are forcibly separated. Tsurpia is betrothed to Li Yuanhao (Tsunehiko Watase), the evil ruler of Xixia, a warlike desert nation on the empire's border. In the film's penultimate action sequences, Li's forces attack and destroy Dun Huang, while Zhao arranges for the safe removal of the treasures that will be discovered nearly 900 years later.

"The Silk Road," which opens today at the Quad Cinema, is loaded with pageantry and has some stirring battle sequences, but its human dramas have little resonance. The love scenes look like uncomfortable imitations of stagy tableaux from 1950's Hollywood adventure films, but with the emotional faucets turned off.

The biggest problem is the film's protagonist, who is depicted as a wide-eyed cipher who behaves more like a studious witness to history than a passionate participant in events, which, as told through the subtitles, are hard to follow.

●

"The Silk Road" is rated PG-13 (Parents strongly cautioned). Although quite violent, it is not terribly gory, and it includes a mild sex scene.

1992 My 29, C13:1

Cold Heaven

Directed by Nicolas Roeg; screenplay by Allan Scott, based on a novel by Brian Moore; director of photography, Francis Kenny; edited by Tony Lawson; music by Stanley Myers; production designer, Steve Legler; produced by Mr. Scott and Jonathan D. Krane; released by the Hemdale Pictures Corporation. Running time: 103 minutes. This film is rated R.

Marie Davenport	Theresa Russell
Dr. Alex Davenport	Mark Harmon
Daniel Corvin	James Russo
Sister Martha	Talia Shire
Father Niles	Will Patton
Monsignor Cassidy	Richard Bradford

By JANET MASLIN

It appears at first as if Nicolas Roeg may be on promisingly familiar territory with "Cold Heaven," which concerns a married couple whose travels to a foreign land are infused with menace and dread. These were the underpinnings of "Don't Look Now," the unforgettably eerie 1973 thriller that remains Mr. Roeg's best work. They are also factors in the novel by Brian Moore on which "Cold Heaven" is based.

Mr. Moore's book, which has been adapted for the screen by Allan Scott,

revolves around the bizarre accident that befalls Dr. Alex Davenport (Mark Harmon), who is vacationing in Nice, France, with his wife, Marie (Theresa Russell). An excursion on a paddle boat in coastal waters (the setting has been changed to Mexico for the film) leads to a ghastly mishap, and Marie is told by doctors that her husband is dead. She is asked to view his body and she does, which makes it all the more surprising when that body disappears the next morning.

Decisive evidence — like a discarded hospital smock in the wastebasket in Marie's hotel room — suggests that Alex has not died after all, and that he has returned to exact some sort of retribution. In light of that, Marie's guilt becomes overwhelming. Just before the accident, Marie had planned to tell him she was having an affair with Daniel (James Russo), another doctor and another married man.

●

This beginning is promising, especially for someone with Mr. Roeg's flair for swirling intimations of eroticism, danger and mysticism into an insinuating blend. But "Cold Heaven" proves to be surprisingly graceless and literal, especially when faced with the questions of faith that are raised in Mr. Moore's book. Marie had seen a religious vision a year earlier, one that links her fate to a religious retreat in Carmel, Calif. Alex's accident revives this vision, while also sending Marie into paranoid fantasies and what she comes to regard as a personal battle with God.

On film, this translates as vague voice-over mutterings from Ms. Russell and a ghoulish confusion surrounding Mr. Harmon, who is seldom fully dead or alive after the opening mishap. The screenplay, often tongue-tied and dilatory, rarely manages to articulate the film's central concerns. "I don't really know how to begin," Ms. Russell says typically, as the story unfolds slowly and with a great deal of stalling. Ms. Russell is expected to carry too much of the film single-handedly, and too often displays a whiny, petulant manner ill-suited to the film's supposed obsession with spiritual matters.

Mr. Roeg's direction is peculiarly blunt and uncomplicated, except on those occasions when he can edit groups of turbulent images — memories of the accident, a thunderstorm, swaying rosaries, crashing religious icons — into some semblance of even greater turmoil. Most of the time the film looks and sounds drab, thanks particularly to hand-held-camera work and to the bland motel-room interiors in which much of the story unfolds. The ending is especially weak, as the film builds toward a visionary episode that winds up looking absurd. "It's incredible! It's incredible!" exclaims a priest who is a witness. Miracles may beggar the imagination, but they still deserve a better response than that.

"Cold Heaven" is rated R (Under 17 requires accompanying parent or adult guardian). It includes brief nudity, some violence and sexual situations.

1992 My 29, C15:1

Critic's Choice

A '53 Classic
By Allégret

Yves Allégret belonged to the paternal generation of film makers the French New Wave rebelled against. Gérard Philipe was known as the French James Dean. And Jean-Paul Sartre needs no introduction, except as the unlikely author of the story on which Allégret's 1953 film "The Proud Ones" was based.

Sartre's story "L'Amour Redempteur" ("Love the Redeemer") was resituated from China to Mexico, where the film was shot. Philipe was cast as a drunken, defrocked Parisian doctor. And the result was a bizarre combination of melodrama, existential redemption and star presence.

The film, in French with English subtitles, opens today at Film Forum 2 (209 West Houston Street, SoHo) under the banner "Martin Scorsese Presents," part of the director's project to restore and re-release neglected movies. "The Proud Ones" (released here originally as "The Proud and the Beautiful") is a powerful artifact of the 1950's, worth rediscovering.

Michèle Morgan plays a bored, languorous French tourist stranded in a sweltering town in Mexico after her husband dies of meningitis. She is attracted to and repelled by Philipe, whose handsome features and sexual magnetism shine through the layers of dirt on his face and clothes. As surely as if they were Sartre and Simone de Beauvoir gone wild in the noonday sun, these two flirt, squabble, fight the meningitis epidemic (submitting to immense hypodermic needles) and redeem each other's lives before falling into each other's arms.

Allégret's slow, steady camera work seems old-fashioned today. So does the sight of Morgan lying on a bed in her bra and slip. But "The Proud Ones" also includes the creepy vision of the town church used as a hospital, where dying peasants lie beneath large, ornate statues and crucifixes. Allégret, who died in 1987, knew how to find the art in melodrama. *CARYN JAMES*

1992 My 29, C17:1

Painting the Town

Directed by Andrew Behar; director of photography, Hamid Shams; edited by Sara Sackner and Mr. Behar; music by Peter Fish; production designer and producer, Ms. Sackner. At the Walter Reade Theater, 165 West 65th Street, Manhattan. Running time: 80 minutes. This film has no rating.

With: Richard Osterweil.

By STEPHEN HOLDEN

"Why did I come to New York?" muses Richard Osterweil, a painter and notorious party crasher, in the opening moments of Andrew Behar's documentary film, "Painting the Town." "Well, I came here for the same reason most people do, though they will not admit it. I came to see celebrities and to spy on celebrities."

There is certainly much truth in Mr. Osterweil's description of the allure of big-city glamour. The difference between him and everybody else is that he has refused to settle for the vicarious pleasures of the society columns. By scouring the newspapers, forging invitations, adopting disguises and accents, and exercising sheer chutzpah, he has succeeded in attending many of New York's grander social events over the last two decades without an invitation.

In "Painting the Town," Mr. Behar's sympathetic documentary portrait, Mr. Osterweil emerges as an impish, voluble storyteller and voyeur who cheerfully admits to being just a tad nutty.

The film, which opened a one-week engagement yesterday at the Walter Reade Theater, is an extended interview filmed mostly at Mr. Osterweil's home where he is surrounded by his own paintings. For the most part, he is disarmingly unpretentious about his hobby and his art, which are closely related. Many of his pop-art canvases imagine the artistic and social elite of earlier decades mingling in Proustian settings.

Because he has had little success as a painter, Mr. Osterweil has had to support himself as a cab driver and coatroom attendant. He takes the subway to most of the events he crashes and claims to subsist on a $6-a-day food budget. That diet, of course, is augmented by all the fancy food he eats at the events he crashes and that he takes a bitchy pleasure in evaluating.

Mr. Osterweil is a fund of trivial but amusing anecdotes. One of his favorite gate-crashing tricks has been to have his friends pose as paparazzi to intimidate the security as he arrives at an event. At one celebrity funeral, he created a stir disguised as a mysterious Greta Garbo-like mourner in sunglasses, kerchief and lipstick.

As lighthearted as most of Mr. Osterweil's vignettes may be, the portrait is touched with pathos and a hint of ghoulishness. He is especially fond of funerals, and among the many celebrity memorials he has attended have been those for Richard Rodgers and Andy Warhol, and a New York ceremony for Mao Zedong.

There is something desperately forlorn in Mr. Osterweil's explanation for his affection for funerals.

"I see them as events, each one marking the end of a life that is history," he reflects. "I'm grabbing at different points of history and hanging onto it."

1992 My 30, 13:1

Some Serious Singing in the Shower

"The Adjuster" was shown as part of last year's New York Film Festival. Following are excerpts from Janet Maslin's review, which appeared in The New York Times on Sept. 26, 1991. The film opened yesterday at Lincoln Plaza Cinemas, Broadway and 63d Street, Manhattan.

Atom Egoyan, the director of "The Adjuster," takes quiet glee in laying out the individual elements of his film as if they were clues in a detective story or pieces of a puzzle. Mr. Egoyan finds even greater satisfaction in the off-balance, mischievously witty way in which those pieces finally fit together.

With an approach like this, it isn't likely — or even necessary — that the final effect will be as fascinating as the deadpan, perfectly controlled manner in which the film maker permits information to be released. What matters is that Mr. Egoyan directs with utter confidence in a style that grows more polished and accessible with each new effort, and is unmistakably his own.

A fire scene. A screening room. A motel. A subway car, on which a rich woman makes herself available to a sobbing and thankful derelict. A brand-new house in the absolute middle of nowhere. These are some of the ingredients with which Mr. Egoyan, in typically solemn and elliptical fashion, allows "The Adjuster" to begin. Only gradually does the connective tissue begin to appear. The screening room is where Hera (the beautiful Arsinée Khanjian, who is this director's frequent leading lady and also his wife) works as a censor. The fire scene is where her husband, Noah (Elias Koteas), the insurance adjuster of the title, comforts a new client in a manner that is not entirely reassuring.

•

Noah makes house calls here not only for sexual purposes (at one point he discusses itemization and deductions while in the heat of passion) but also to study photographic evidence by which he reconstructs the value of his clients' past lives. "Was this a purebred?" he somberly asks two gay men who have lost their dog. "This is your bedroom?" he inquires studiously when one of these men provocatively hands over a set of sexually explicit photographs. "These don't show too much of the background."

The mournful music and the autumnal tone of "The Adjuster" allow Mr. Egoyan, a Cairo-born film maker of Armenian descent who now works in Canada, to incorporate all manner of mythological references, strange parallels and even terrible puns into the film's seemingly serious mood. "I've had people with warts covering their entire soles," says a doctor who removes one from Hera's foot. The film also pays fairly serious attention to the question why people sing in the shower.

That substance remains secondary to intriguing style here is borne out by the film's seemingly humorous listing of alphabetical categories of censorship from A through H. In fact, these guidelines, from the Ontario Board of Classification, are real. But in the blithely skewed context of Mr. Egoyan's film, they are made to seem otherwise.

1992 My 30, 13:1

Sandinistas in Retrospect

"Pictures From a Revolution" was shown as part of last year's New York Film Festival. Following are excerpts from Vincent Canby's review, which appeared in The New York Times on Oct. 5, 1991. The film — in Spanish and English with English subtitles — opened Thursday at the Joseph Papp Public Theater, 425 Lafayette Street, at Astor Place, in Manhattan.

•

"Pictures From a Revolution" is a somber meditation on what sometimes looks like the futility of all social struggle. It's a report on Nicaragua today, recorded by Susan Meiselas, an American photographer who covered the Sandinista revolution, its victory and its collapse.

The film was jointly produced, directed and edited by Ms. Meiselas, Richard P. Rogers and Alfred Guzzetti, who also collaborated on "Risk: The Story of a Nicaraguan Family" (1984-85).

In "Pictures From a Revolution," Ms. Meiselas talks to a number of the people she photographed earlier at the height of the battle against the Somoza regime, during the early months of victory and then during the Sandinista Government's long war against the United States-backed contras.

Ms. Meiselas narrates the film and makes no secret of her own belief in the Sandinista cause. Yet she and her collaborators have made a fine film that transcends partisanship. "Pictures From a Revolution" is as much about the perspectives of history as it is about specific people in particular events.

Ms. Meiselas's own testimony is crucial to the film's effectiveness. She remembers that many people who worked for the Sandinista victory dropped away after victory was won: "Nothing moved fast enough. Nothing changed." One man speaks of the gulf that developed between the people who fought the war and the people who governed after the victory.

Ms. Meiselas recalls acts of heroism and moments of terrible fright. There was one time when she endangered herself and the people who were hiding her to take a picture that later turned out to convey nothing of the situation it represented.

The Nicaragua that Ms. Meiselas and her collaborators see is exhausted. She says that she lost a dream, but that "the Nicaraguans lost much more."

"Pictures From a Revolution" is serious and moving film reportage.

1992 My 30, 13:4

FILM VIEW/Caryn James

Sequels Battle Monsters, Villains and Burnout

TRYING TO DEFUSE A bomb set to go off in seconds, Mel Gibson tells his partner something as deep and profound as anything else in "Lethal Weapon 3." He looks down at the tangle of red and blue wires and says: "Oh, no. More plastic than Cher." For a while he and Danny Glover debate which wire to cut, two detectives doing a perfect Abbott and Costello routine, but soon the inevitable happens. A building explodes in a gargantuan fire burst and, from that big-bang opening on, "Lethal Weapon 3" never slows down as it mixes droll comedy and relentless action.

There's no need to look for messages or high art or even a plot here, but the film follows an unbeatable formula for commercial success. In its first weekend, it took in $33.2 million, making it the second-biggest opening in history, just behind "Batman." The major explosion at the start reveals the movie's simple, cautious strategy: pump up the volume and give the audience what it wants, only more.

That's not as easy as it sounds. Films like "Look Who's Talking Too" and "The Two Jakes" prove that major hits can spawn major-flop sequels. And maintaining the original film's energy and liveliness through a third episode is even trickier, as this summer's "3" movies show. "Lethal Weapon 3" played it safe, with stunning results on screen and at the box office. "Alien 3" took admirable risks but might be sorry. Though it is more daring than "Lethal Weapon 3," it is also uneven and less entertaining. In its opening weekend, "Alien 3" could not dislodge "Lethal Weapon" from the No. 1 spot.

Sigourney Weaver's shaved head in "Alien 3" is only the most conspicuous difference between this movie and its predecessors. The latest installment is extremely dark, both in its subject and its intense, shadowy look.

Ms. Weaver, playing the alien-haunted Ellen Ripley, crashes onto a planet inhabited by prisoners turned religious fanatics. As the doctor played by Charles Dance explains, the sect is some form of "apocalyptic millenarian Christian fundamentalism." Oh. So when does the alien get here?

An adventurous sequel has to take a new direction without forgetting what worked in the first place. And in the midst of its claustrophobic darkness, "Alien 3" loses sight of the creature, which doesn't appear nearly often enough. When it does, it looks a little like E. T. on steroids.

On its own, "Alien 3" is an intriguing, cultish science-fiction movie. But it also has to live in the shadow of Ridley Scott's jump-out-of-your-seat "Alien" (1979) and James Cameron's high-tech, tough-mama "Aliens" (1986). "Alien 3" tones down the action and tries to replace it with thorny

Remember 'The Two Jakes'? So do the makers of 'Lethal Weapon 3' and 'Alien 3.'

but vague moral questions, like: Is it better to live with an alien in your stomach or to die trying to save the world?

◼

The best scenes bring to mind the wit and flair of "Aliens." After she has sex with the doctor, Ripley casually says, "You have a bar code on the back of your head." He answers with perfect, deadpan sincerity, "That does deserve an explanation, but I don't think now is the moment." And the film includes some magnificent action sequences. The camera zooms at an impossibly fast speed through the brown, murky tunnels of the prison. But before long it seems as though the prison population (a steadily decreasing group) is being chased down those same old tunnels again and again.

It would be too easy to blame all this on David Fincher, the 28-year-old, first-time director; he's just partly responsible. The film was one of those difficult projects that chewed up at least one other director (Vincent Ward, who never started shooting) and more than a half-dozen writers. But the stylishly existential "Alien 3" is also of a piece with Mr. Fincher's "Express Yourself" video for Madonna, in which giant gears, chains and slave-labor are a fashion statement.

There is no reason why the ambitious "Alien 3" could not have been a smashing entertainment. But there may be some connection between the high-energy escapist success of "Lethal Weapon 3" and the fact that its only ambition is to top itself.

Of course, topping "Lethal Weapon 2" means coming up with something more inventive than a bomb stuck under a toilet (and therefore under Mr.

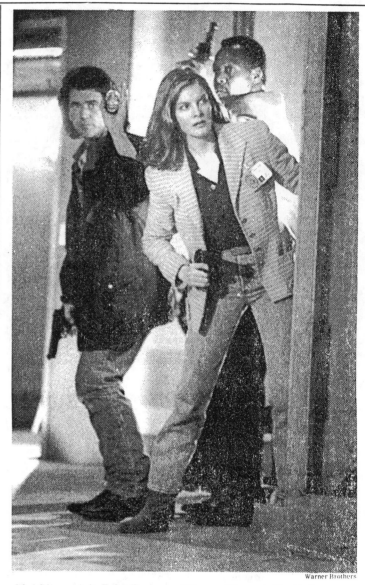

Warner Brothers

Mel Gibson, left, Rene Russo and Danny Glover in "Lethal Weapon 3"—The best formula since Butch and Sundance.

Glover) — a funny scene, but we're not talking about visionary moments. And though "Lethal Weapon 3" may be the least inventive in the series, that still makes it very good. Mr. Gibson, Mr. Glover and Richard Donner, who has directed all three "Lethal Weapons," have concocted the best action-buddy-comedy formula since "Butch Cassidy and the Sundance Kid."

Mr. Glover is the family man supposedly heading toward retirement. Mr. Gibson is his manic partner, a cute version of all three Stooges, who happens to be as indestructible as the Terminator.

He compares scars with a glamorous, karate-kicking detective (Rene Russo). Then they go off to blow away bad guys together. Mr. Gibson takes flying leaps over cars and crashes through several floors of a house under construction. These characters are not quite tethered to reality, which means that every car chase, shootout and explosion can be a lark, an occasion for one-liners.

Joe Pesci, who returns from "Lethal Weapon 2" as the fast-talking Leo Getz, is this film's mascot. He is a walking visual joke with spiky,

bleached-blond hair and nothing much to do. He's irrelevant, but so is the plot about a corrupt ex-cop and stolen guns. "Lethal Weapon 3" is composed of dozens of such isolated elements — like Leo, familiar but slightly altered — that add up to a fluent whole.

The movie only goes wrong when it tries to be serious, introducing the idea of teen-agers with guns, a subject the film is not nearly equipped to handle. And this script certainly wouldn't address the irony of an action film preaching against street violence. A film that does that might as well ask existential questions about aliens. ▸ ☐

1992 My 31, II:20:4

Wisecracks

Directed by Gail Singer; directors of photography, Zoe Dirse and Bob Fresco; edited by Gordon McClellan; music by Maribeth Solomon; produced by Ms. Singer and Signe Johansson in association with Studio D of the National Film Board of Canada, Telefilm Canada and the Ontario Film Development Corporation; released by Alliance International. At Film Forum 1, 209 West Houston Street, SoHo. Running time: 90 minutes. This film has no rating.

With: The Alexander Sisters, JoAnne Astrow, Joy Behar, Maria Callous, the Clichettes, Dreenagh Darrell, Ellen DeGeneres, Phyllis Diller, Faking It Three, Whoopi Goldberg, Dorothy Hart, Geri Jewell, Jenny Jones, Maxine Lapiduss, Jenny Lecoat, Emily Levine, Paula Poundstone, Sandra Shamas, Carrie Snow, Pam Stone, Deborah Theaker, Robin Tyler, Kem Wayans, Lotus Weinstock

By JANET MASLIN

How do female stand-up comics differ from their male counterparts? What does comedy mean to them? How do they feel about their audiences and about being able to make those audiences laugh? These not altogether burning questions are addressed by Gail Singer's "Wisecracks," a full-length documentary that is noticeably bigger than its subject. Still, Ms. Singer manages to offer an interesting overview, not to mention scattered moments of insight and humor.

The two dozen comics who are featured here constitute a wide range of talents and attitudes. Not surprisingly, some are much more adroit than others, both on and off the stage. Analyzing their art is not the normal purview of many of them, and the film is seldom selective enough in choosing which of their conversational comments to include. A remark like "Because laughter is such an affirmative thing, it's never a negative thing" contributes little to anyone's understanding of what comedy is and why it matters.

The film, which opened yesterday at the Film Forum, would have worked better with less meandering commentary and more sharp juxtapositions of performance clips, since certain themes emerge repeatedly from stage acts that are seen. Female comics do tend to joke more scathingly about matters of beauty and self-esteem than their male counterparts, and to sound more self-deprecating in the process. Maxine Lapiduss, one of the funnier performers

'A gasket is $150. But "a gasket, honey," is $250.'

seen here, offers her impersonation of a fashion model whirling around implausibly to face the camera, and Sandra Shamas tries to imagine how anyone could strike a back-wrenching Cosmo Girl pose in any real-life situation. Kim Wayans describes having a Muslim boyfriend who insists on imposing his own ideas of beauty, and on changing her name.

Women's magazines are, not surprisingly, a major satirical subject for these humorists. One tries to act out 10 tips on how to appear sexually available, trying several of them at the same time. Another chirps: "Feeling fat, girls? Just try this simple test: slip yourself down between the wall and the radiator." And another brings up the subject of so-called female problems, wondering what the phrase means: "You can't parallel park? You can't get credit?" Though this is some of the funniest material Ms. Singer includes, the real anger behind it comes through loud and clear.

•

Needless to say, the male of the species is also a popular target with female humorists. "There was a sign that said Wet Floor, so he did," one says. "He asked me to mother him, so I spit on a hanky and wiped his face," says Jenny Jones, whose smooth delivery is shown off to particularly good advantage. Emily Levine, discussing the contemptuous attitudes of male garage mechanics toward female customers, says "I know what a gasket is — a gasket is $150. But 'a gasket, honey' is $250." On the less funny, more militant end of the spectrum are three women dressed in naked man suits, doing a far from clever pantomime.

The film works better in allowing viewers to observe the full range of women's approaches to comedy, with occasional quick glimpses of pioneers from Mae West to Eve Arden to Gracie Allen. (Among present-day female comics whose work is included, Roseanne Arnold and Lily Tomlin are conspicuous for their absence.) Only rarely do its conversational interludes provide information of comparable interest.

Much of the film's best thoughts on comedy come, perhaps surprisingly, from Phyllis Diller, who can articulate exactly the kind of theater and lighting arrangements that show her off to best advantage, and who discusses the difference between comic actresses, comediennes and bona fide comics. The first group, she explains, is the one that includes Lucille Ball and Carol Burnett, actresses working with scripted material or sketches. In the second category, she cites Carol Channing as someone performing lighter humorous material, sometimes with the accompaniment of singers and dancers. Finally there are the women, like those seen here, who come up with their own material and work alone onstage, with all the risk and excitement and exposure that implies. "Now we're talking hard core!" exclaims Ms. Diller, with the glee and pride that bind all of this film's participants together.

1992 Je 4, C17:1

Patriot Games

Directed by Phillip Noyce; screenplay by W. Peter Iliff and Donald Stewart, based on the novel by Tom Clancy; director of photography, Donald M. McAlpine; edited by Neil Travis; music by James Horner; production designer, Joseph Nemec 3d; produced by Mace Neufeld and Robert Rehme; released by Paramount Pictures. Running time: 113 minutes. This film is rated R.

Jack Ryan	Harrison Ford
Cathy Ryan	Anne Archer
Kevin O'Donnell	Patrick Bergin
Sean Miller	Sean Bean
Sally Ryan	Thora Birch
Lord Holmes	James Fox
Robby Jackson	Samuel L. Jackson
Annette	Polly Walker
Adm. James Greer	James Earl Jones
Paddy O'Neil	Richard Harris

By JANET MASLIN

THE Queen of England owes a debt of gratitude to the makers of "Patriot Games," the sleek film adaptation of Tom Clancy's best-selling paranoid thriller. Their version of this story is so intelligently streamlined that it has the good grace to leave the Queen alone.

In Mr. Clancy's original, which revolves around a plot against the Prince of Wales and his young family, the heroic ex-C.I.A. agent Jack Ryan foils the attackers and becomes an instant celebrity on English television. For his trouble, he is not only knighted but also thanked ad nauseam by Her Majesty. So the Queen visits Jack's bedside and makes Jack and Cathy Ryan house guests at Buckingham Palace, gushing about the adorableness of the couple's little daughter, Sally. The Queen's husband treats Jack like a new chum. Their son, the Prince, listens gratefully to Jack's friendly advice about how to solve his marital problems and how to be more of a man. "We must see more of each other," the Prince declares. By the end of the novel, Jack has saved the Prince's life yet again and feels comfortable addressing him as "pal."

It is some measure of this film's good sense and relative probity that one generic royal cousin (played wryly by James Fox) has now been substituted for the book's improbable lineup of Ryan admirers. Much of the small talk and hubris has been excised from "Patriot Games," leaving just the bare bones of Mr. Clancy's political tug of war. On one side stand Jack, the sanctity of the American family and the remarkable ability of the C.I.A. to influence international events with the help of highest-tech surveillance gimmickry. On the other stand Irish terrorists who, in the absence of the kinds of coldwar villains who populated Mr. Clancy's "Hunt for Red October," are the author's best exemplars of the forces of anarchy and evil. Or at least they'll have to do.

Unlike the heartier "Hunt for Red October," which was directed by John McTiernan, "Patriot Games" takes a pensive, moody view of the intrigue in which Jack becomes embroiled. As directed by Phillip Noyce, an Australian, it has more in common with Mr. Noyce's meticulous, brooding thriller "Dead Calm" than with the earlier Clancy-based spy story. Mr. Noyce's approach is quite elegant (thanks in large part to Donald M. McAlpine's decorous cinematography and James Horner's mournfully lovely score), even if that some-

times seems peculiar in light of his material. The cool, sophisticated staging of a car chase through rush-hour traffic amounts to a cinematic oxymoron.

"Patriot Games" delivers the best possible version of a tale that boils down to nothing but gamesmanship, as its title implies. Except for a minor casting problem on the home front (Anne Archer, as Cathy, has become much too familiar in the role of the warm, ruefully sexy spouse), it concentrates on the string of elaborately staged ambushes that are this story's main attraction. For all its polish and its apparent global span, the film never really moves beyond the hollow question of whether the Ryan family will survive each new threat to life and limb. "You get him, Jack," snaps the once-serene Cathy, after an Irish terrorist makes a threatening call to the Ryan home. "I don't care what you have to do — just get him."

From the attempted strike at the royals near Buckingham Palace to a two-pronged attack on the Ryans after they return to Maryland, the film moves chillingly toward one last, watery showdown that recalls the ending of Martin Scorsese's recent "Cape Fear." Lodged somewhere in mid-story is a remarkable and emblematic sequence in which coffee-drinking C.I.A. analysts, dressed in business suits, stand quietly watching abstract computer images. The eerily beautiful scenes shown on the monitor represent the flaming destruction of a terrorist training camp halfway around the world.

•

Despite its many violent episodes, the film remains bloodless. Perhaps that can be traced to Mr. Clancy's fascination with technology, and to his way of treating human characters only slightly less methodically than he treats machines. The Ryans are so generically happy, and the terrorists so generically bad, that it's a wonder Mr. Noyce can create any real tension or surprise. But he has cast the villainous roles particularly well; the fierce-looking Sean Bean is outstandingly good as Ryan's main antagonist, and Patrick Bergin brings the right air of calculation to the terrorist mastermind he plays. Several of the film's main sequences, like an encounter between Mr. Bean's Sean Miller and David Threlfall as the police inspector who has been his captor, derive their horror from the looks of pure loathing that these terrorists bestow upon their prey.

Mr. Ford's restrained performance is just right for this chilly atmosphere, and he even brings some earnestness to the happy-family scenes, which are otherwise saccharine. He makes a more plausible Jack Ryan than Alec Baldwin did in the earlier film, partly because this screenplay (by W. Peter Iliff and Donald Stewart) is less obsessed with technical jargon and high-tech toys. The devices that are used here — an antennalike video camera that can creep under closed doors to do its spying, or the satellite technology that can scan a terrorist training camp from somewhere in space — are gratifyingly unobtrusive. One exception is the infrared goggles that are critical to the story's final showdown, and wind up recalling "The Silence of the Lambs."

"Patriot Games" can be as readily watched for its subtext as for its main events. From the sign marking "Hanover Street" (one of Mr. Ford's earlier credits) to the portrait of John F.

Kennedy on the wall at C.I.A. head-quarters, marginalia often takes on unexpected prominence. One bit of trivia worth noting is that the authen-tic look of the Ryans' waterfront homestead on Chesapeake Bay was achieved only by digging up and later replanting 17 palm trees. This visual embodiment of Ryans' wholesome, traditional values is quite synthetic, and was shot in California.

•

"Patriot Games" is rated R (Under 17 requires accompanying parent or adult guardian). It includes violence and sexual situations.

1992 Je 5, C1:1

Monster in a Box

Directed by Nick Broomfield; written and performed by Spalding Gray; director of photography, Michael Coulter; edited by Graham Hutchings; music by Laurie Anderson; production designer, Ray Oxley; produced by Jon Blair and Renee Shafransky; released by Fine Line Features. At Lincoln Plaza Cinemas, 63d Street and Broadway. Running time: 88 minutes. This film is rated PG-13.

By VINCENT CANBY

At the very beginning of his splendid new monologue film, "Monster in a Box," opening today at the Lincoln Plaza Cinemas, Spalding Gray sets the record straight. Sitting at a table on an otherwise bare stage, as he did in his earlier "Swimming to Cambodia," he tries to clear up any questions about the title of this new film. He doesn't want people to worry about the meaning.

He holds up the 1,900-page manuscript of his autobiographical novel, "Impossible Vacation," on which he has been working for four years, and the box in which he totes it around. "This is the box," he says. "This is the monster in it."

So far, so good, until late in the performance. It's then that Mr. Gray recalls returning home from a Mexican vacation in 1967, when he was 26 years old, to learn that his mother had committed suicide. It was not a complete surprise. He spent much of his youth, he tells us, trying to help his mother through long periods of severe depression, times when she might suddenly ask him: "How shall I do it, dear? How shall I do it? Shall I do it in the garage with the car?"

Paula Court/New Line Cinema
Spalding Gray

On his return from Mexico, all that was left of his mother was ashes in an urn, which was kept in a box by his father's bed.

Beloved and mourned, the monster in the box trailed an umbilical cord that seems to have stretched around the world several times without snapping.

•

Mr. Gray, a one-man cast of tens, now recalls how he coped with writing "Impossible Vacation" (edited down to the comparatively slim 228-page novel published last month by Alfred A. Knopf), which was also a way with coping with the unthinkable. I've not read "Impossible Vacation," but it's difficult to believe that it could carry quite the same impact as "Monster in a Box."

These meticulously crafted performance pieces belong in a category all their own. "Monster in a Box" is theater. It is film. It gives the impression of having the density of literature that is more often read than listened to.

Mr. Gray is a master of oral story-telling, an art that began to wane with Gutenberg's invention of the printing press in the 15th century, although it's still practiced with vigor here and there in libraries and at folk festivals, and often in primitive societies.

That a one-man performance piece can remain so vivid on the screen, which has a way of embalming even action films with casts of thousands and spectacular special effects, is a testament both to Mr. Gray's singular talents and to the elasticity of movies.

•

Like "Swimming to Cambodia," the new film is sly and funny and dead-on serious, full of the kind of particular details that separate the poet from the journalist, all of which are delivered with what might be called committed skepticism. As a storyteller, Mr. Gray paces his material so skillfully that he never allows the pathos to blunt the satiric edge.

Whether you take the monster in the box to be his novel or his mother is not especially important. The film is an exhilarating free-form roller-coaster ride through the mind of a man whose curiosity remains undiminished, even when acute anxiety prompts him to bark like a dog during a screening at the Museum of Modern Art.

The form of the narrative seems simple and straightforward but is, in fact, incredibly complex. Chronology comes and goes. One story suggests another before the first is completed. Mr. Gray loops back to pick up earlier subjects and again becomes side-tracked. In the course of "Monster in a Box," Mr. Gray, the first-person narrator, often recounts the adventures of a third-person hero, Brewster North, the Gray surrogate at the center of his novel.

There are hilarious tales about Mr. Gray's adventures at a Moscow film festival in the company of his girlfriend, Renee, about his first California earthquake, about his various power lunches with Hollywood agents. Says one very important talent broker, "We all hope you're not one of those artists that's afraid to make money."

•

At one point he is commissioned by the Mark Taper Forum in Los Angeles to find and interview people who have nothing to do with the film industry. It's not easy. Everybody, in-cluding the supermarket check-out clerk, has a screenplay in the works. He's also not helped by the young woman assigned to help him in his search.

They don't walk around Los Angeles. They drive. His assistant, he says, had "a 35-mile-an-hour consciousness." That is, "she simply perceived nothing on her retinas below 35 miles an hour. She had been on wheels since the day she was born."

He talks about performing in the Lincoln Center Theater production of "Our Town." In what is possibly the film's strangest, most melancholy and most comic sequence, he tells about going to Nicaragua disguised as a member of a left-wing fact-finding commission to gather material for a film.

Although at one point he stands to act out a recollection of a catastrophic moment during a performance of "Our Town," most of the film is shot with Mr. Gray sitting down. It's not exactly a feast for the eyes, but then it's not a soporific either. Nick Broomfield, the director, sometimes chooses to cut between close-ups and medium-shots at awkward moments, but the intrusions serve to relieve the otherwise static nature of the enterprise, which is actually not a bad idea. It's like stretching one's legs. Also helpful are the occasional sound effects and Laurie Anderson's sparely employed musical score.

Even if you saw "Monster in a Box" when it was performed onstage in New York in 1990-91, you may want to see it again. The exact nature of Mr. Gray's art cannot be fully comprehended at one viewing. If you haven't seen it yet, a treat awaits.

•

"Monster in a Box" is rated PG-13 (Parents strongly cautioned). It has some rude language.

1992 Je 5, C6:4

For Sasha

Directed by Alexandre Arcady; screenplay by Mr. Arcady and Daniel Saint Hamont with the collaboration of Antoine Lacomblez (in French with English subtitles); director of photography, Robert Alazraki; edited by Martine Barraque; music by Philippe Sarde; produced by Mr. Arcady and Diane Kurys; released by MK2 Productions USA. Running time: 115 minutes. This film has no rating.

Laura	Sophie Marceau
Sasha	Richard Berry
Paul	Fabien Orcier
Simon	Niels Dubost
Michel	Frederic Quiring
Dan Chemtov	Jean-Claude De Goros
David Malka	Gerard Darmon
Madame Malka	Emmanuelle Riva
Myriam	Shlomit Cohen
Judith	Yael Abecassis
Steve	Amit Goret
The Maskir	Nissam Dau
Shoshana	Ayelet Zorer
The Colonel	Ezra Kafri
Salomon	Amit Doron
Teacher	Tali Atzmon

By STEPHEN HOLDEN

Alexandre Arcady's intermittently stirring film, "For Sasha," aspires to be something like the "Dr. Zhivago" of the Arab-Israeli war in 1967. The movie, which opens today, teems with characters who are vital and attractive and whose personal dramas are given an extra romantic weight by Philippe Sarde's overripe symphonic score.

The movie, which is set on an Israeli kibbutz just below the Golan Heights, portrays a utopian community where hard work and lofty dreams have turned the desert landscape into a bountiful Eden. The camera lingers sensuously over deep blue skies and golden sunsets and on the shining faces of the people who have brought about this transformation.

Sasha (Richard Berry), the heroic title character, is a 40-ish philosophy professor who has left his comfortable teaching job in Paris to become an Israeli farmer and soldier. Laura (Sophie Marceau), who lives with him, is a beautiful and gifted 19-year-old violinist who forsook a promising musical career to go with him.

Moments before the war breaks out, Laura is visited by three young men who were students of Sasha's and part of the couple's Parisian circle. Michel (Frederic Quiring), Simon (Niels Dubost) and Paul (Fabien Orcier) are each half in love with Laura and also somewhat in awe of their former teacher. The reunion eventually stirs painful memories of a sixth member of their group, Myriam (Shlomit Cohen), who committed suicide.

•

"For Sasha" is a movie that aims high. It wants to be a sweeping historical epic that touches on still-simmering political issues like Palestinian settlement. At the same time, it tries to explore a tangle of unresolved relationships among complicated people that were formed years before the movie begins. Partly for lack of time, these dual ambitions don't harmonize very well.

The movie is at its panoramic best when depicting a kibbutz way of life that is simultaneously idyllic and imperiled. Its scenes of the communal peace suddenly shattered by Syrian shelling have an almost surreal clarity and sharpness in their timing, and they shock one in remembering how every paradise is conditional.

The eruption of full-scale war is sweepingly evoked by the interweaving of old news clips with battle scenes tinted yellow to give them the look of a vintage documentary. On several occasions the director uses voice-over narration by a character to push the story forward.

Within this visually splendid canvas, however, the personal connections among the principals remain too sketchy. Of these, the relationship

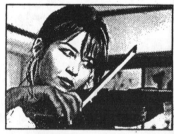

Sophie Marceau

between Sasha and Laura, which has its stormy moments, is the most fully realized. Miss Marceau's Laura is an entrancing mixture of youthful volatility, brash self-assurance, and unself-conscious sexiness. Mr. Berry's Sasha exudes nobility and wisdom but reveals enough insecurity, along with a streak of hot-bloodedness, to keep him from seeming too perfect.

•

Although the actors who play the three visitors each give appealingly natural performances, the screenplay spends more time looking at them as tourists than in exploring their psyches, and they remain insuf-

ficiently differentiated. The film's biggest mistake is in waiting until the movie is more than half over to bring in the mysterious Myriam. And when she appears, it is in an overly contrived home-movie flashback.

With all its flaws, "For Sasha" is still immensely likable. Its characters are smart, idealistic, passionate people who are living their lives to the fullest. Along with having a confident, warm-blooded sensuality, the film expresses a touching faith in the conjunction of significant world events and larger-than-life romantic love.

1992 Je 5, C13:1

Beautiful Dreamers

Written and directed by John Kent Harrison; director of photography, Francois Protat; edited by Ron Wisman; music by Lawrence Shragge; produced by Michael Maclear and Martin Walters; released by the Hemdale Pictures Corporation. Running time: 107 minutes. This film is rated PG.

Dr. Maurice Bucke	Colm Feore
Walt Whitman	Rip Torn
Jessie Bucke	Wendel Meldrum
Mollie Jessop	Sheila McCarthy
The Rev. Haines	Colin Fox
Dr. Lett	David Gardner
Leonard	Tom McCamus
Agatha Haines	Barbara Gordon
Birdie Bucke	Marsha Moreau
Dr. John Burgess	Albert Schultz
Wallace	Angelo Rizacos
John Carver	Gordon Masten
John Freeman	Gerry Quigley
The Hon. Timothy Pardee	Roland Hewgill

By STEPHEN HOLDEN

The opening scenes of "Beautiful Dreamers" offer a harsh reminder of some of the more benighted aspects of Victorian culture. In a London, Ontario, mental hospital, a patient who has been compulsively masturbating is brutally shackled to a chair to prevent him from touching himself. At a medical convention in Philadelphia, one doctor smugly demonstrates a crude electrical shock treatment for catatonia, and another passes around a jar of ovaries while delivering a solemn discourse about how their removal will cure "nymphomania and moral insanity."

It is at this gathering that Dr. Maurice Bucke (Colm Feore), the young Canadian physician who runs the London asylum, first meets the American poet Walt Whitman (Rip Torn). Both are outraged at the inhumanity being flaunted in the name of medical progress. After visiting Whitman's home and meeting his mentally disturbed brother, Eddie, whom the poet treats playfully instead of with fear and loathing, Dr. Bucke invites Whitman to Canada for an extended visit.

"Beautiful Dreamers" chronicles Whitman's profound influence on Bucke, who would become his official biographer, Bucke's wife, Jessie (Wendel Meldrum), and his mental patients. On one level, the film is the love story of Whitman and Bucke, who had a passionate but platonic relationship in which the doctor almost literally worshiped at the poet's feet. On a different level, its story is a sort of 1880 version of "One Flew Over the Cuckoo's Nest" in which Bucke becomes convinced that what the mentally afflicted need instead of punishment and ostracism is music and outdoor sports.

•

The story pits Whitman and Bucke and a few nervous allies against the upright Victorian townspeople who are scandalized by the presence in

Hemdale Pictures
Rip Torn and Colm Feore

their midst of a poet whose notorious "Leaves of Grass" was banned in Boston. Leading the conservative forces is a local minister (Colin Fox) who rails from his pulpit about how "bad literature and evil companions" go together. At one point, it is darkly suggested that the doctor himself is on the verge of losing his mind.

"Beautiful Dreamers" is the first feature to be written and directed by John Kent Harrison, who happens to be a native of London, Ontario. The film, which flows in a stately "Masterpiece Theater" style, becomes progressively mellower as it goes along. What begins as a hard-headed look at Victorian narrow-mindedness has turned mushy by the time of the story's dramatic showdown, an improbable cricket game that pits the stuffy local gentry against the "loons," as they are nicknamed. In these scenes, the film becomes giddily sentimental and resorts to such hackneyed tactics as making a life-or-death drama out of whether somebody can catch a ball.

The film, which opened today at the Tower East and Village East Theaters, is very well acted. Rip Torn's Whitman is a fierce and fearless renegade of considerable charm and humor who gazes out from behind a pile of whiskers with a flinty acuity softened by a deeper kindness. Mr. Torn's portrayal plays down the elegiac aspect of Whitman's literary voice. He is a gruff, robust celebrant of life who enjoys bellowing Verdi arias at the top of his lungs in the middle of the woods.

Without overdramatizing the doctor's inner conflicts, Mr. Feore's Bucke suggests a continual struggle between a Victorian propriety and fiery iconoclasm. Ms. Meldrum's Jessie has to undergo a more dramatic change of heart. From a neurotic wife who leaves the table when Whitman insists on picking up his asparagus instead of cutting it into tiny pieces, she changes overnight into someone who proudly bathes naked in a lake with the two men.

•

"Beautiful Dreamers" is rated PG (Parental guidance suggested). There is one brief nude scene.

1992 Je 5, C15:1

Class Act

Directed by Randall Miller; screenplay by John Semper and Cynthia Friedlob, based on the story by Michael Swerdlick and Wayne Rice and Richard Brenne; director of photography, Francis Kenny; edited by John F. Burnett; music by Vassal Benford; production designer, David L. Snyder; produced by MaynellThomas and Todd Black; released by Warner Brothers. Running time: 98 minutes. This film is rated PG-13.

Duncan	Christopher (Kid) Reid
Blade	Christopher (Play) Martin
Jail Guard	Andre Rosey Brown

Warner Brothers
Christopher (Play) Martin, left, and Christopher (Kid) Reid in "Class Act."

Duncan's Dad	Meshach Taylor
Duncan's Mom	Mariann Aalda
Blade's Mom	Loretta Devine
Parole Officer Reichert	Rick Ducommun
Dr. Oppenheimer	Tony Simotes
Prison Guard	Scott Jensen
Janitor	Jack (The Rapper) Gibson
Principal Kratz	Raye Birk
Miss Joanne Simpson	Rhea Perlman
Latin Student	Graham Galloway
Rashid	Gabe Green
Teacher	Philip Perlman
Popsicle	Doug E. Doug
Damita	Alysia Rogers

By JANET MASLIN

The story is familiar, thanks to dozens of lily-white high school comedies along the same lines. But the setting and casting are different, and therein lies the fun. In "Class Act," Kid 'n' Play (the stars of "House Party"), engage in a mistaken-identity farce that casts Christopher (Kid) Reid, the nervous one with the mile-high fade hairdo, as a classic nerd named Duncan. Meanwhile, his tougher partner, Christopher (Play) Martin, appears as Blade, who has the kind of rap sheet that makes both teachers and bullies quake when he appears.

The joke here is that Blade and Duncan's school records are accidentally switched, and that each gets a taste of the other's medicine. And the

film's sight gags go well beyond Kid's coiffure, which Play converts into mini-dreadlocks in an attempt to make his stand-in look a little more streetwise. (He also gives Kid his removable gold tooth.) One of the better visual gags concerns the layout of the school itself. As "Duncan," who is supposed to have a 4.0 average and perfect S.A.T. scores, the school-hating Play finds himself escorted into a hidden classroom decorated with classical busts, and resonating with the sounds of Gregorian chants.

Meanwhile Kid, mistaken for a hoodlum, is thrown into a hellhole with the school's hardest cases, which lets him quail in a comical way, something he does to good effect. The rest of the cast includes a funny assortment of bullies (led by Lamont Johnson), mixed-up teachers (among them Rhea Perlman), sidekicks (Doug E. Doug) and potential girl-friends (chiefly Alysia Rogers), who manage to see through the confusion and wind up with the right mates.

As directed by Randall Miller, the movie doesn't aspire to much more than cartoonish verve, but Kid 'n' Play easily hold it together. Their comic timing is right, and their humor manages to be both traditional and current. (An argument about whether one of them is "deaf" or "def" unfolds in the best "Who's on first?" fashion.) The film easily incorporates a crowd-pleasing rap and dance episode featuring both of them, and it meanders only when taking on anything more complicated. A chase sequence through a wax museum only confuses matters by becoming too crowded, and temporarily losing track of the stars.

Also in "Class Act" are Meshach Taylor and Mariann Aalda as Kid's ultrabourgeois parents, who patiently listen to his various excuses. ("Dad, we've been through this before," he says about that hairdo. "I'm just expressing myself aerodynamically.") One of the film's funnier episodes has these bewildered parents roundly insulted by the straight-talking Play. Considerably less amusing is a running gag whereby the parents, not used to having their newly hip son referred to as a "homey," become terrified that he may be gay. The rest of "Class Act" is much more benign.

•

"Class Act" is rated PG-13 (Parents strongly cautioned). It includes sexual references and rude language.

1992 Je 5, C17:1

FILM VIEW/Caryn James

Movies Turn Convent Life Upside Down

SOME OF US ARE SUCKERS FOR nun jokes: they're cheap, they're easy, they're irresistible. It isn't necessary to have lived through parochial school to be a connoisseur of nun jokes, but it helps. So for the benefit of the parochially deprived who might not

have the advantage of my comic education — having been taught first grade by Sister Gregory, a wizened woman with steel-gray hair and a malfunctioning hearing aid — here are the two basic categories of nun humor: sister as unworldly innocent and sister as repressed storm trooper. The first category is kinder, beloved by good Catholics and non-Catholics alike. The storm-trooper category is usually favored by Sister Gregory's students and other lapsed Catholics. It's tougher but makes for a much better movie.

The new Whoopi Goldberg film, "Sister Act," is one long, sugary nun joke. Ms. Goldberg plays Deloris Van Cartier, a Diana Ross wannabe who witnesses a murder committed by her married mobster boyfriend (Harvey Keitel). She hides out in a convent where the sisters are so relentlessly upbeat that they make "The Singing Nun" and "The Flying Nun" look like Lucrezia Borgia.

The stern but well-meaning Mother Superior (Maggie Smith) warns Deloris that the convent is not a sorority house, which proves how little she knows her own nuns. These sisters eat together in the dining hall, live in tiny dorm rooms and one night sneak out to a biker bar. Unlike real college women, though, all they want to do is save souls and dance to the jukebox, with each other. For a real guilty pleasure they gather in the kitchen at night to eat illicit ice cream.

■

Kathy Najimy plays a plump nun able to laugh after every sentence she utters. This is the nun-as-child approach, and the only thing that saves "Sister Act" from drowning in its own treacle is the inspired casting of Ms. Goldberg.

As she did in "Ghost," she takes an otherwise unwatchable film and turns it into a comedy that is sometimes very funny. With more energy than the watered-down script deserves, she glides over its most horrendous moments. After she puts on an extremely old-fashioned nun's habit, she actually has to look in the mirror and recite the most stale sister joke of all. "Look at me!" she yells. "I'm a penguin."

Occasionally, she is allowed an acerbic line. When she is given the alias Sister Mary Clarence, she asks, "Like in Clarence Williams 3d in 'Mod Squad'?" That, as it happens, is the only pointed racial reference. Her conspicuousness in this fictional convent has nothing to do with color and everything to do with Whoopi Goldberg's persona. When she was last seen on screen, she was casually twirling a tampon in the air as a tough-talking cop in Robert Altman's film "The Player," a role much closer to her usual irreverent comedy than to anything in a cloister. The very idea of her in a convent is the film's first and funniest nun joke and goes a long way.

So does the cheerful use of old pop and Motown songs when Sister Mary Clarence takes over the choir. Changing the words of "My Guy" to "My God" is hokey. But when you see a lineup of nuns using hand gestures patented by the Supremes, the cheerful oddness of the scene has to be funny. Dumb and obvious, but irresistibly funny.

"Sister Act" is a fish-out-of-water comedy dressed in a nun's costume. But that formula has been used to create a more satiric breed of nun joke, in earlier films that also send misfit characters to hide in a convent.

In Pedro Almodóvar's amusing 1984 black comedy, "Dark Habits," a nightclub singer who has accidentally given her boyfriend a drug overdose finds sanctuary at a convent populated by Sister Rat of the Sewers, who happens to be a pornographer; Sister Manure, an acid-head, and other nuns happily dedicated to secret vices. No ice cream here.

Films about nuns draw upon a fondness for nun jokes: they're easy and irresistible.

"Nuns on the Run" is a genial 1990 comedy written and directed by Jonathan Lynn (the director of this year's hit "My Cousin Vinny"). The humor is irreverent and the nuns are human. Eric Idle and Robbie Coltrane play gangsters who hide from the mob in a convent, pretending to be Sister Euphemia and Sister Inviolata. Part of the plot turns on a genuine nun who drinks and has gambled away much of the convent's money playing the horses.

Of course, men passing for sisters adds a different twist. And it must be said that Mr. Coltrane (England's version of John Candy) gets the film's major laughs because he is so convincing as Sister Inviolata. He borrows the gambling nun's clothes and becomes a more credible sister than Whoopi Goldberg.

■

Realism is sometimes subjective, though. The most convincing screen nun for me is a minor character in "Sister Act." An organist with an erratic hearing aid, she would seem like a contrived character to anyone not in my first-grade class.

So while the goody-goody "Sister Act" did not send me back to church, it did inspire me to call my parents. Why was a deaf old nun teaching 6-year-olds, I wondered. Didn't the P.T.A. ever think to buy her a new hearing aid?

Mom reminded me that in those ancient days no one criticized nuns. All anyone ever said about Sister Gregory was: "God bless her. She's so smart, she can read lips." Not one line in "Sister Act" is as funny or as true as that.　　　□

1992 Je 7, II:13:1

Suzanne Hanover/Touchstone Pictures

Wendy Makkena, left, Kathy Najimy and Whoopi Goldberg in "Sister Act."

Lost Prophet

Director, producer, editor and director of photography, Michael de Avila; written by Mr. de Avila, Drew Morone, Larry O'Neil and Shannon Goldman; music by TRF Music Libraries; released by Rockville Pictures. Le Cinématographe, 15 Vandam Street, SoHo. Running time: 75 minutes. This film is not rated.

Jim ...Jim Burton
KymZandra Huston
Real Estate Agent and Mick Prophet
...Drew Morone
KidJames Tucker
Kid's BrotherSteven Tucker
Park PatrolmanShannon Goldman
Punk No.1Larry O'Neil
Punk No.2Christian Urich
Punk No.3Sophia Ramos

BY STEPHEN HOLDEN

Michael de Avila's "Lost Prophet" is an arty, low-budget horror fantasy that doesn't attempt to be shocking or scary in a conventional way. The movie, which opens today at Le Cinématographe in SoHo, inaugurates the theater's showcase of young film makers, First Film/First Chance. In following the wanderings of a disoriented young man who grows progressively more agitated, it tries to induce in the audience a childlike emotional state that is equal parts fear and wonder.

As played by Jim Burton, an unshaven actor with frightened, burning eyes, the character is a sort of grown-up wild child adrift in the countryside who finds his way to a castlelike resort hotel that has been shuttered for the season. Various oddball characters wander around the premises. They include three sinister punks who drink themselves into oblivion, a woman who spouts mystical Indian lore, a foul-mouthed young boy and a fiendish character antagonist named Mick Prophet (Drew Morone).

The black-and-white film, which looks quite handsome for a low-budget production, is essentially a manipulation of cinematic mood that, as the central character appears to come apart, shifts in attitude from anxious curiosity into terror. By the end of the film it is hard to know whether the demon that the character battles is real or imaginary. Among the movies to which it alludes are "The Shining," "Psycho" and "Repulsion."

A director's note describes "Lost Prophet" as "a portraiture of the dream state, a manipulated represen-

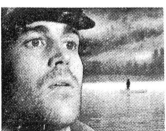

Rockville Pictures

Jim Burton

tation of consciousness, breaking away from the world as we know it to arrive at a time and place we have never been."

That's overstating it. In its most effective moments, "Lost Prophet" succeeds as a mood piece evoking childhood memories of feeling alone in a strange old house where unnameable dangers lurk in every shadow and behind every creaking door.

1992 Je 8, C16:1

Housesitter

Directed by Frank Oz; screenplay by Mark Stein, based on the story by Mr. Stein and Brian Grazer; director of photography, John A. Alonzo; edited by John Jympson; music by Miles Goodman; production designer, Ida Random; produced by Mr. Grazer; released by Universal Pictures. Running time: 102 minutes. This film is rated PG.

DavisSteve Martin
GwenGoldie Hawn
BeckyDana Delany
Edna DavisJulie Harris
George DavisDonald Moffat
MartyPeter MacNicol
RalphRichard B. Shull
MaryLaurel Cronin
MosebyRoy Cooper
Father LiptonChristopher Durang

By VINCENT CANBY

IF, as some skeptics suggest, there is hidden, somewhere deep below Central Park, one mammoth kitchen that prepares the food for every Chinese restaurant in New York, it now seems possible that Hollywood might have its own secret megaworkshop for the assembly-line manufacture of movie comedies. Why else would they all taste so much alike and vanish from memory even before they're over?

To be sure, the comedies have different titles and are distributed by different companies. Some are passably funny. Yet they all share a surpassing blandness and an almost patriotic need to uphold middle-class values, as observed not in the world in which we live, but in generations of television sitcoms that, with time, have created their own values. These comedies can't even be easily enjoyed as escapist entertainment. They are so out of touch that they effectively deny any reality one would wish to escape from.

Such a comedy is "Housesitter," a cardboard vehicle in which Steve Martin and Goldie Hawn ride up front, doing what each does with great talent and occasional vigor, and a lot of very able character actors sit in the back, kibitzing and adding local color. The director is Frank Oz, the man responsible for Mr. Martin's falling-down-funny "Dirty Rotten Scoundrels" and the formidably eccentric charmer "Little Shop of Horrors."

"Housesitter" is neither rude nor shocking, nor is it quite the romantic comedy it aspires to be, although that is its form. It's about Newton Davis (Mr. Martin), a feckless Boston architect, and Gwen (Ms. Hawn), the waitress he meets one night in a Hungarian restaurant and beds for lack of anything better to do.

The next morning, after Newton departed without even leaving a note, Gwen takes off for Dobbs Mill, the picture-postcard-pretty (and fictional) New England village where Newton was born and brought up. The night before, Newton told her about building a dream house there for his childhood sweetheart, who turned him down.

Gwen, longing for her own Norman Rockwell house and her own Norman Rockwell family, is such an expert fantasist that after moving in, she cons everyone with her stories of how she and Newton met and were secretly married. Some of her lies are, indeed, seductive whoppers. Among the people she enchants along the way are Newton's parents (Donald Moffat and Julie Harris), his one-time girlfriend (Dana Delany), and the boss of his architectural firm (Roy Cooper).

When Newton suddenly arrives in Dobbs Mill to sell the house, Gwen has so complicated his relations with everybody that he must go along with the charade until they can find a feasible way to extricate themselves.

This might have made a first-class farce or even a sweet romantic comedy except that the screenplay, written by Mark Stein from a story by him and Brian Grazer, the film's producer, has the manner of something in desperate need of additional rewrites. Individual lines are often funny, and small bits of business evoke smiles. There's a good satirical Martin moment when he must sing "Too-ra-loo-ra-loo-ra" in front of a room full of weepy friends.

Yet too much of the film seems unfinished. Almost every four scenes could be condensed into one. The comedy doesn't build to any climax. It just rolls on, with Ms. Hawn doggedly working to create some sense of oddball fun. The characters, as written, are as flimsy as Newton's dream house, which, even though based on a House Beautiful award-winning design, looks less habitable than a billboard. Even its brand-new furnishings are tacky.

That's also the feeling of the entire film. The public personalities of Mr. Martin and Ms. Hawn aren't easily scaled down to fit the silly ambitions of the screenplay. They're both terrifically engaging performers, but each has far more sophistication than the movie knows what to do with. Ms. Delany's role is also amorphous. She's not quite the other woman. She's not especially endearing. She's less a character than a basic function of the plot.

The same goes for Ms. Harris, Mr. Moffat and Peter MacNicol, who plays Newton's office pal. Two supporting actors do prompt a couple of bursts of real laughter: Richard B. Shull, appearing as the Boston vagrant whom Gwen hires to masquerade as her father, and Christopher Durang, the playwright, who appears briefly as a smiling clergyman with a cliché for almost any occasion.

"Housesitter" was shot on location in Boston and, as a stand-in for Dobbs Mill, Concord and Cohasset, Mass. Only a comedy of this slapdash sort could succeed in making some of its

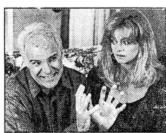

Kerry Hayes/Universal

Steve Martin and Goldie Hawn

lovely real-life settings look both fake and rather drab.

•

"Housesitter," which has been rated PG (Parental guidance suggested), has some mildly vulgar language.

1992 Je 12, C1:4

Aces: Iron Eagle III

Directed by John Glen; written by Kevin Elders; based on characters created by Mr. Elders and Sidney J. Furie; director of photography, Alec Mills; edited by Bernard Gribble; music by Harry Manfredini; production designer, Robb Wilson King; produced by Ron Samuels and Stan Neufeld; released by Seven Arts. Running time: 98 minutes. This film is rated R.

ChappyLouis Gossett Jr.
AnnaRachel McLish
KleissPaul Freeman
LeichmanHorst Buchholz
PalmerChristopher Cazenove
HorikoshiSonny Chiba
StockmanFred Dalton Thompson
SimmsMitchell Ryan
DoyleRob Estes
AmesJ. E. Freeman
CrawfordTom Bower
Tee VeePhill Lewis

By JANET MASLIN

"Aces: Iron Eagle III" is an action film for anyone who thinks women look good toting machine guns, or that "ordnance" is a word easily used in conversation. As directed by John Glen, who is best known for his James Bond films, it takes a no-nonsense approach to stern dialogue and military maneuvers.

It also stretches noticeably to incorporate Rachel McLish, a glamorous body builder, into an otherwise ultramasculine story. Ms. McLish may struggle with even the simplest dialogue ("She's gone to stay with friends for a few days"), but she otherwise gets right into the spirit of things. When menaced by a would-be rapist, for instance, she manages to knee him in the groin and knife him in the throat simultaneously. "Aces" isn't outstandingly violent, but it clearly feels that gestures like those deserve to be applauded.

Louis Gossett Jr. returns as the trusty Chappy Sinclair, who keeps busy flying at air shows until the discovery of a Peruvian cocaine ring in a remote village galvanizes him and his aging cronies into action. Avenging the death of a comrade, they borrow a fleet of World War II vintage airplanes to raid the village, and inadvertently come into conflict with the fellow Air Force officer who is the story's chief villain. He ascribes his treachery to the Pentagon's decision to close an air base.

The actors playing Chappy's flying buddies, and trading remarks like "in our day it used to be the man, not the machine," are a genial if unremarkable bunch. Horst Buchholz, Christopher Cazenove and Sonny Chiba share Mr. Gossett's four-square acting style, and are later joined by Phill Lewis, as a ghetto teen-ager who provides some semblance of comic relief. Notwithstanding this character's references to Sylvester Stallone, Pee-wee Herman and Eddie Murphy, the film does its best to speak some sort of universal language.

•

"Aces: Iron Eagle III" is rated R (Under 17 requires accompanying parent or adult guardian). It includes occasional violence.

1992 Je 13, 16:4

The Inland Sea

Directed by Lucille Carra; written and narrated by Donald Richie (in English and Japanese with English subtitles), based on his book "The Inland Sea;" director of photography, Hiro Narita; edited by Brian Cotnoir; music by Toru Takemitsu; produced by Ms. Carra and Mr. Cotnoir; released by Films Inc./Voyager Company. At Film Forum 1, 209 West Houston Street, SoHo. Running time: 56 minutes. This film is not rated.

Unknown Soldiers

Written, produced, directed and edited by Veronika Soul (in English and Japanese with English subtitles); music by Andre Vincelli. Running time: 40 minutes. This film is not rated.

WITH: Go Riju, Yosuke Irifune and Tony Rayns.

By VINCENT CANBY

In Lucille Carra's all too short, invigorating new film, "The Inland Sea," as in the Donald Richie travel memoir on which it is based, there are two inland seas: the "nearly land-locked, lakelike body of water bounded by three of Japan's four major islands," which is the vanishing heart of ancient Japan, and the somewhat less well-known sea of the author's own inner self.

Mr. Richie, a novelist, essayist and film historian who has lived in Japan for much of the last 46 years, is present in the film mostly as the unseen first-person narrator. He is looking for "the real Japan," he says, not the Japan of the economic miracle but the Japan of which he has seen only glimpses in Tokyo.

As the camera moves from one island to the next in search of what Mr. Richie calls "the originals," he

The steep steps of a Shinto shrine are a revealing clue.

observes, speculates and confides. On occasion he is transported by a transient beauty that can't be pickled in time, not even by the motion-picture camera. The real Japan remains elusive but, in the course of this fascinating and deceptively serene journey, Mr. Richie discovers reflections of himself in the people he meets and in his own reactions to them.

The 56-minute "Inland Sea" opens today at the Film Forum. Accompanying it is Veronika Soul's "Unknown Soldiers," a 40-minute collage largely of children's recollections of wartime Japan. The fractured form and somewhat blunt point of "Unknown Soldiers" emphasize the almost 19th-century sensibility that informs "The Inland Sea."

•

Mr. Richie's book, published in 1971 and still in print, is of a breadth and richness that underscore the inadequacy of categorizing it as a travel book. "The Inland Sea" recalls Rebecca West's "Black Lamb and Grey Falcon" about Yugoslavia, though it doesn't really resemble the West classic at all. Yet in both books the minutely observed details of a particular time and place are only the initial excuse for what becomes, at last, a meditation on the meaning of history and the peculiarities of civilization.

There is probably no way that any film could do justice to the scope of the Richie book, which is as much an interior monologue as it is a record of things seen and heard. Ms. Carra's film provides a lovely, seriously tactful setting for selected ruminations of this American expatriate, who is nothing if not self-aware: "I live in this country as the water insect lives in the pond, skating across the surface, not so much unmindful as incapable of seeing the depths."

He may not see the depths, but he at least has a good idea where they are.

Of all the place names mentioned in the film, few will be familiar to most Americans, possibly only Hiroshima. The camera sees, in passing, the shell of the building below the spot where the atomic bomb is said to have detonated. Around it is a modern city, emblematic of the new Japan. Says the narrator, "Life is too strong to keep memory green."

The film otherwise avoids the usual, and nearly everything the camera finds prompts contemplation. There is a visit to a small island's Shinto shrine, not an especially noteworthy one but, Mr. Richie finds, worth talking about. Shinto shrines often are on heights. "The steps lead straight into the sky and are always steep. It is work to reach such a shrine. The faithful must arrive puffing, gasping, the senses reeling. This is as it should be. One arrives as though new born, helpless, vulnerable."

•

He is delighted by the city of Takamatsu on the big island of Shikoku, especially by Takamatsu's open plazas, gardens and arcades. Most Japanese, he tells us, would say they are too busy to waste time, but "Takamatsu openly admits the Japanese fondness for strolling." Wandering through Takamatsu prompts him to consider the place of coffee shops in Japanese life. Coffee shops specialize. There is the coffee shop where one can hear Schoenberg, another where there are always copies of Vogue, still another that once was the only place in Japan where he could find The Partisan Review.

He recalls meetings with fishermen, with schoolgirls, with an old woman who has been delivering papers for 53 years, with an island man who loves Audrey Hepburn movies. He finds himself in a leper colony on one of the most beautiful islands in the Inland Sea: "Lepers are often sent to beautiful places, as if in compensation for the ugliness of the disease."

Mr. Richie generalizes, but with insight and wit. One of the secrets of the Japanese, he says, is that they are a sea people not defined by ancient castles or modern cities. "The longest lasting totalitarian state in history" has changed this. The Japanese have lost what he describes as the Elizabethan character still surviving in pockets of islanders around the Inland Sea.

•

There are great shots of cats, comments on the occasional boredom of travel ("Sex is the ideal souvenir"), and a visit to a private Buddhist temple constructed by a former munitions manufacturer: "When kitsch becomes this grand, it becomes art, like the Albert Memorial."

The film's images and Ms. Carra's use of them superbly serve the Richie subtext, which is that everything we see is passing out of existence, being devoured here as elsewhere by the needs of a different world. The tone,

though, is not dour. It is matter of fact and from time to time exuberant. Or as the narrator says in the course of his passage from one island to the next: "I am happy because I am suddenly whole and know who I am. I am a man sitting in a boat looking at a landscape."

Mr. Richie comes on briefly in the black-and-white sequences that end the film, appearing as a neatly dressed man going about his business in Tokyo. He looks to be in all ways

anonymous but, like everything else in "The Inland Sea," this coda has a point.

It suddenly reminds us how little can ever be known simply by the looks of things. "The Inland Sea" has been made vivid less by Hiro Narita's superb color cinematography than by the mind of the man who wrote and narrates it. In this way, the film gives Mr. Richie back his privacy.

1992 Je 17, C13:1

Batman Returns

Directed by Tim Burton; screenplay by Daniel Waters, story by Mr. Waters and Sam Hamm, based upon Batman Characters created by Bob Kane and published by DC Comics; director of photography, Stefan Czapsky; edited by Chris Lebenzon; music by Danny Elfman; production designer, Bo Welch; produced by Denise Di Novi and Mr. Burton; released by Warner Brothers. Running time: 125 minutes. This film is rated PG-13.

Bruce Wayne/Batman	Michael Keaton
The Penguin/Oscar Cobblepot	Danny DeVito

Catwoman/Selina Kyle	Michelle Pfeiffer
Max Shreck	Christopher Walken
Alfred	Michael Gough
Commissioner Gordon	Pat Hingle
Mayor of Gotham City	Michael Murphy
Organ Grinder	Vincent Schiavelli
Jen	Jan Hooks
Ice Princess	Cristi Conaway
Chip Shreck	Andrew Bryniarski
Josh	Steve Witting
The Penguin's Father	Paul Reubens
The Penguin's Mother	Diane Salinger

By JANET MASLIN

"ATMAN" was an exceptionally hard act to follow, and that's no compliment. It says less about the first film's dark ingenuity than about its sour, cynical spirit and its taste for smirking sadism, qualities that dimmed the urgency for a return visit to Gotham City and its trouble-plagued citizenry. Yet the status of "Batman" as one of Hollywood's biggest commercial triumphs only compounded the sequel problem, creating pressure to re-activate this money machine at any cost. The prospect of a new "Batman" installment — "Batman Returns" opens today at more than 2,600 theaters nationwide — has thus been more inevitable than welcome.

Under these circumstances, the director Tim Burton has wisely switched gears, re-inventing the mood and manner of "Batman" so fearlessly that he steps out of his own film's murky shadow. Mr. Burton's new "Batman Returns" is as sprightly as its predecessor was sluggish, and it succeeds in banishing much of the dourness and tedium that made the first film such an ordeal. Indeed, allowing for a ceiling on viewers' interest as to just what can transpire between cartoon characters like Batman and the Penguin, "Batman Returns" is often an unexpectedly droll creation. It stands as evidence that movie properties, like this story's enchantingly mixed-up Catwoman, really can have multiple lives.

Drawing upon the fairy-tale spirit of his more free-wheeling fables — "Edward Scissorhands," "Beetlejuice," "Pee-wee's Big Adventure" — Mr. Burton creates a wicked world of misfits, all of them rendered with the mixture of horror, sympathy and playfulness that has become this director's hallmark. More so than Jack Nicholson's mockingly vicious Joker in the earlier film, this story's miscreants have colorful clinical histories. So intensely does Mr. Burton render his villains' tender psyches, in fact, that the upright hero Bruce Wayne, a.k.a. Batman (Michael Keaton), is easily overlooked amid all the toys and troublemakers that surround him. This Batman, with motives and magical powers that are never made interesting, is at best a cipher and at worst a black hole. The blandness of Batman (through no fault of Mr. Keaton, who plays the character with appropriate earnestness) is symptomatic of this material's main shortcoming: almost nothing about it makes sense or particularly matters. Primarily a visual artist, Mr. Burton is often casual about plot considerations, which means that audiences watching his films are set adrift as if in dreams. And the characters' thoughts and motives are half-forgotten before the film is over. Costumes, attitudes, gadgets and the great ingenuity of Bo Welch's dazzling production design will linger in the mind long after the actual story of "Batman Returns" becomes a blur.

Because the film's predominant motif is that of wounded individuals re-inventing themselves as wily villains, its most memorable episodes are early ones explaining each main character's transformation. Beginning wittily with the troubled infancy of the Penguin — as parents, Diane Salinger and a monocled Paul Reubens are seen throwing their offspring into a sewer, where he floats away to grow up among the birds —

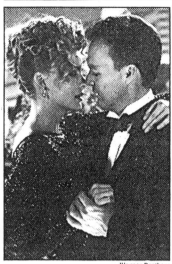

Warner Brothers

Michelle Pfeiffer and Michael Keaton in "Batman Returns."

the film moves on to the beleaguered secretary Selina Kyle (Michelle Pfeiffer) and her own peculiar evolution.

Mousy and lonely — Selina habitually calls out "Honey, I'm home," then reminds herself that she isn't married — this secretary is treated contemptuously by Max Shreck (Christopher Walken), a wealthy industrialist with the arrogance to throw uncooperative employees out windows. "How can you be so mean to someone so meaningless?" Selina wails. But Max hurts her anyway, and only the efforts of a team of alley cats bring her back to life. Saved, like the Penguin, by the magic of the animal world, Selina metamorphoses thrillingly into Catwoman, in a sequence that ranks with the most captivating moments Ms. Pfeiffer has spent on screen. Fully inhabiting this vixenish character, she turns Catwoman into a fierce, seductive embodiment of her earlier dissatisfaction. "Life's a bitch," she slyly declares. "Now so am I."

Systematically destroying her past, Selina smashes the bric-a-brac, demolishes the dollhouse and spray-paints the cute clothes, emerging from the ruins of her earlier life as a wonderfully sultry and diffident creature in a skin-tight, gleaming black wetsuit. There will be viewers drawn to "Batman Returns" largely for the chance of watching Ms. Pfeiffer strike this pose, and they won't be sorry. But there is at least as much personality to the performance as there is visual appeal, as evidenced by the bored, feline drawl with which she delivers her best lines. "Oh, please," she yawns later, when propositioned by the eager, Humpty Dumpty-shaped Penguin (Danny DeVito). "I wouldn't touch you to scratch you."

"Batman Returns" is at its best in this introductory stage, and in the halting courtship that develops between Batman and Catwoman when they aren't matching wits in black battle regalia. It is weakest in a long, drawn-out finale that only emphasizes Mr. Burton's relative lack of interest in ordinary action sequences. This ending will make audiences wish it were not a Hollywood truism that films as expensive and ambitious as "Batman Returns" need be more than two hours long.

Mr. Welch's production design, which is much sleeker and brighter than the brooding, oppressive look Anton Furst created for the earlier film, is only one of the behind-the-scenes contributions that have set this Batman saga on a different course. Stefan Czapsky's crisp cinematography gives a lively look even to the film's subterranean settings, and does a lot to keep the Felliniesque clown extras (one of Mr. Burton's needless excesses) from lapsing into the grotesque. And Daniel Waters, who wrote "Heathers," gives this screenplay a sharper edge than the earlier film's string of dull taunts and insults. "They wouldn't put me on a pedestal, so I'm laying 'em on a slab!" declares the fiendish Penguin, after Max Shreck's attempts to make him Mayor of Gotham City have gone awry. "Not a lot of reflective surfaces down in the sewer, huh?" asks an

image consultant assigned to the Penguin's campaign, at which the Penguin tries to bite off his nose.

•

Mr. DeVito deserves particular credit for conveying verve through the Penguin's feature-obscuring makeup, and for managing to seem charming even when drooling black ink. Mr. Walken, wonderfully debonair, would have been villain enough for any story, and is certainly one of the bright spots of this one. "I don't know what you want," this smooth businessman declares when he meets a mortal enemy, "but I know that I can get it for you with a minimum of fuss."

"Batman Returns" includes enough trickery to attract children's interest. But a cartoonish spirit and a taste for toys do not make it a children's film. Parents should take into account the film's nightmarish setting, its characters' mean-spirited sparring and the fact that children are abandoned, kidnapped and threatened with murder during the course of the story.

•

"Batman Returns" is rated PG-13 (Parents srtongly cautioned). That merely reflects its dialogue, which prefers double-entendres to actual profanity, and its occasionally ugly violence.

1992 Je 19, C1:1

The Hairdresser's Husband

Directed by Patrice Leconte; screenplay by Mr. Leconte and Claude Klotz (in French with English subtitles), based on a story by Mr. Leconte; director of photography, Eduardo Serra; edited by Joelle Hache; music by Michael Nyman; produced by Thierry de Ganay; released by Triton Pictures. At Lincoln Plaza Cinemas, 63d Street and Broadway, Manhattan. Running time: 84 minutes. This film has no rating.

Antoine	Jean Rochefort
Mathilde	Anna Galiena
Antoine's father	Roland Bertin
Agopian	Maurice Chevit
Morvoisieux	Philippe Clevenot
Mr. Chardon	Jacques Mathou
Gay Customer	Claude Aufaure
Donecker	Albert Delpy
12-year-old Antoine	Henry Hocking
Morvoisieux's son-in-law	Ticky Holgado
Adopted child's mother	Michele Laroque
Madame Shaeffer	Anne-Marie Pisani

By JANET MASLIN

Patrice Leconte gives "The Hairdresser's Husband" the same obsessive intensity he brought to "Monsieur Hire," but beyond that these two films have precious little in common. Working with the Georges Simenon thriller that was the basis for his elegant 1989 tale of erotic longing, Mr. Leconte constructed a tragic, symmetrical film graced with superb understatement and an eloquently plain visual style. This time, he takes a similar tack with material so flimsy that it borders on sheer silliness. Relentlessly contemplative, "The Hairdresser's Husband" is simply about one man's lifelong enjoyment of having women cut his hair.

The perfumes, the lotions, the trickling shampoo water, the close physical contact: these may be pleasant sensations, but there's a limit to how deeply they can be explored, at least by someone whose interests are as myopic as Mr. Leconte's appear here. Describing his film (which he co-wrote with Claude Klotz) as "this story that might have been about me," he imagines a hero named Antoine whose whole life has seemingly revolved around barbershop erotica. Not even by incorporating customers who debate the existence of God during their haircuts can Mr. Leconte give this idea any weight.

Finding no detail too trivial to include in Antoine's sensual reminiscences — this narrator refers repeatedly to the scratchiness of a pompon-trimmed woolen bathing suit his mother made him wear — the film attempts to find some meaning in the hero's search for contentment with a scissors-wielding mate. As a boy, Antoine (Henry Hocking) is seen delighting in the attentions of the plump Madame Schaeffer (Anne-Marie Pisani), whose uniform gaps conveniently at the bosom and whose suicide is remembered by her young customer chiefly as an opportunity to look up her dress. On more than one occasion in the film, Antoine wistfully contemplates a woman's death as if it were primarily important as a learning experience for him.

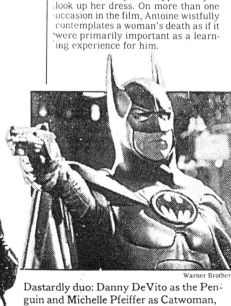

Warner Brothers

Dastardly duo: Danny DeVito as the Penguin and Michelle Pfeiffer as Catwoman, archenemies of Michael Keaton's Batman.

.. Forty years pass, somehow. Now Antoine is a shy, somber-looking man played by Jean Rochefort (who has perhaps fared better collaborating with Mr. Leconte on a couple of comedies in the past). The adult Antoine is thrilled beyond reason when he finds the warmly accommodating Mathilde (Anna Galiena) running a tiny barbershop, and he blurts out a marriage proposal during his first haircut. It takes three weeks for his hair to grow in enough for him to return and get an answer.

Mathilde and Antoine do marry, and they share what is supposed to be a life of pure claustrophobic bliss. Neither they nor the film often ventures outside the tiny confines of the barbershop (even the wedding takes place there, with Mathilde stopping to trim a customer's beard in the middle of the reception). They make love — quite chastely, considering the film's tireless attention to eroticism — right there in the shop, though its storefront window is without curtains. They indulge in one mad bender, playfully drinking brightly colored aftershave. And they quarrel once, after Mathilde says something admiring about a movie star and Antoine calls the star a dummy. "That was our only fight, but it froze the blood in my veins," Antoine recalls.

Although it is at one point suggested that Antoine may paint the ceiling, he is almost entirely idle, preferring to sit back and enjoy watching his wife minister to the occasional customer. Sometimes, at moments that seem especially awkward, he enjoys fondling Mathilde while the customer conveniently has his eyes closed. At other moments, he may break the solemnity of the shop's mood by bursting into the spontaneous Arab dancing he has enjoyed since boyhood. Within the film's artificially finite barbershop setting, such eccentricities become even more contrived than they have to be.

Mr. Leconte has filmed "The Hairdresser's Husband," which opens today at the Lincoln Plaza, with more skill than he conceived it. But the film's precise, thoughtful visual style

becomes a constant reproach to its insubstantial subject. Once again, this director is greatly helped by the music of Michael Nyman, whose scores have also been so valuable in films by Peter Greenaway. As it did in "Monsieur Hire," the music intrudes eloquently to express the characters' nameless yearnings. This time, those passions are a lot more interesting than the people themselves.

1992 Je 19, C11:1

Life on the Edge

Directed by Andrew Yates; written by Mark Edens; directors of photography, Tom Fraser and Nick Von Sternberg; edited by Armen Minasian; music by Mike Garson; production designer, Amy Van Tries; produced by Eric Ligwald, Miriam Preissel and Mr. Yates; released by Festival Entertainment. At Quad Cinema, 34 West 13th Street, Greenwich Village. Running time: 88 minutes. This film is not rated.

Ray Nelson	Jeff Perry
Karen Nelson	Jennifer Holmes
Tim	Ken Stoddard
Terry	Michael Tulin
Mike	Roger Callard

Their best friends won't tell them, but Andrew Yates, the director, and Mark Edens, the writer, must be told anyway: their first feature film, a comedy titled "Life on the Edge," is inept and unfunny to the point of being terrible.

It's about some eccentric Los Angeles types caught in a hillside house after an earthquake, the long-promised "big one." There are gags about adultery, plastic surgery, "channeling," homosexuality, cocaine, bungee jumping (called skywalking in the film), hidden gold and childbirth. The performances suit the material and Mr. Yates's direction of it.

"Life on the Edge" opens today at the Quad Cinema.

VINCENT CANBY

1992 Je 19, C11:1

FILM VIEW/Caryn James

Miss Piggy Snares Her Man at Last

EVEN BEFORE THE AVALANCHE of negative reviews, "Housesitter" had a bad reputation. Friends who had seen the film early described it in terms that ranged from the kindly "It's sort of dull" to the more pointed "If you're going to write about it, why don't you talk about the decline of comedy?" So the best way to say this is just to spit it out: I loved it.

Steve Martin is at his best as a straitlaced architect driven to loony behavior by love. Goldie Hawn is blithely likable as the scatterbrain who invades his house and his life. And the director Frank Oz — whose films include the hilarious "Dirty Rotten Scoundrels" and the dud "What About Bob?" but who will forever be beloved as the voice of Miss Piggy — has turned a totally nonsensical story into a charmingly nonsensical comedy.

Mr. Martin, as the architect named Newt, has been spurned by Becky (Dana Delany), a woman so staid she wears preppy plaid

shorts and knee socks. During a one-night stand with Gwen, a waitress played by Ms. Hawn, Newt tells her about the house he had built for Becky, which now stands empty in his small New England hometown.

Soon Gwen sneaks into the house, pretends to be Newt's wife and goes furniture shopping with his mother. He decides to play along because Becky suddenly sees him as a potential husband.

This lunatic premise makes as much sense as adopting a baby leopard, and the expectations it sets up may account for many of the negative reactions to "Housesitter." The story is designed to evoke words like "screwball," "madcap" and other hallowed terms from the 1930's and 40's that it can't possibly live up to. The movie's producer, Brian Grazer, has even described it as "a 90's update of those films."

So audiences walk in, expecting Steve Martin and Goldie Hawn to be Cary Grant and Katharine Hepburn. They are not. They are Kermit and Miss Piggy. That is meant as a compliment.

■

The comparison comes to mind only because of Mr. Oz, of course; but think of Piggy having dropped some serious weight, and it makes sense.

Like Kermit, Newt is a smart, sweet, regular guy who bumbles around a little too much for his own good. Like Piggy, Gwen is the apparently ditsy but strong-willed blonde who knows exactly what, or rather whom, she wants. She will employ any scheme, the more fantastic the better, to get him. Like Muppets, these two are cartoonish exaggerations of basic human foibles, and their silliness is endearing as long as you don't expect them to behave like real people.

"Housesitter" signals from the start that it will be less attached to reality than most romantic comedies. "It's like something out of a fairy tale," Becky says when she sees the house that Newt built, gift-wrapped with a huge red ribbon. Then she dumps him, upsetting every fairy-tale expectation and setting the film on the skewed path ahead.

Even their town, Dobbs Mill, is an exaggeration of the picture-book-perfect New England village. There are pretty fall colors on the trees and clapboard houses and a town square, and in the background are not one but two white church steeples. By subtly overstating the idyllic small-town features and by undermining the fairy-tale elements, the film sets itself up as a sophisticated, parodic version of traditional romantic comedies.

In fact, the movie's predictable romance and its tangled plot are less important than the inspired storytelling that increasingly takes over its characters. Gwen begins with

Kerry Hayes/Universal City Studios

Steve Martin and Goldie Hawn in "Housesitter"—The film's director, Frank Oz, has turned a totally nonsensical story into a charmingly nonsensical comedy.

one whopper about being married to Newt, then spins out a wildly funny story about their whirlwind courtship, which involves a tragic accident, doctors and gauze.

Newt matches her by making their fictitious marriage miserable. He invents his wife's infidelity with an old boyfriend named Boomer, and in a flash she leaps into the story and defends herself, yelling, "Boomer was just a one-nighter!"

If these scenes had been played with any

In 'Housesitter,' Goldie Hawn and Steve Martin aren't Hepburn and Grant. They're the Muppets.

self-conscious effort, they would have been unbearable. But both stars dance gracefully through them. The entire film takes its cue from Mr. Martin's most consistent comic persona: that of a serious man acting straight-faced in a ridiculous situation.

As a stand-up comedian, he spoke matter-of-factly while wearing an arrow on his head. In one of his funniest films, "The Man With Two Brains," he is convincingly, passionately in love with a detached brain in a scientific laboratory. He and Ms. Hawn romp through "Housesitter" in much the same spirit.

That attitude is carried to its crazed limits in the film's comic centerpiece. At a party, Newt is forced to sing "Too-ra-loo-ra-loo-ra" to his father. In one of Gwen's stories, he had once brought tears to the older man's eyes with that song, and now he has to do it again, but for the first time. Mr. Martin puts a mawkish expression on his face, glides around the room, stretches out the words of the song and uses exaggerated sentiment to hilarious effect. Like the town with two church steeples or the man with two brains, Newt plays it straight and funny at the same time.

The rest of "Housesitter" never quite matches the giddy level of that scene. But its ever-wilder stories and Muppet-like characters are engaging, even if the material doesn't resemble that of a screwball classic. Maybe "Housesitter" is not for madcap comedy fans. Maybe it's for people who have been waiting for Steve Martin to sing again (it's been more than a decade since his hit song, "King Tut") and for people who knew that eventually Miss Piggy would find a way to get her frog.

1992 Je 21, II:19:1

L'Élégant Criminel

Directed by Francis Girod; screenplay (in French with English subtitles) by George Conchon and Mr. Girod; director of photography, Bruno De Keyzer; music by Laurent Petitgirard; produced by Ariel Zeitoun; released by RKO Pictures. Cinema Village 12th Street, 12th Street between University and Fifth Avenue. Running time: 120 minutes. This film is not rated.

Pierre Lacenaire Daniel Auteuil
Allard Jean Poiret
Princess Ida Marie-Armelle DeGuy
Hermine Maiwenn Le Besco
Arago Jacques Weber
Avril Patrick Pineau
Lusignan Samuel Labarthe
Lacenaire's father François Perier
Lacenaire's mother Geneviève Casile

By VINCENT CANBY

"L'Élégant Criminel," opening today at the Cinema Village 12th Street, recalls the career of a colorful 19th-century French scoundrel apparently better known in France than in this country. According to some sources,

RKO Pictures

Daniel Auteuil in a scene from "L'Élégant Criminel."

Pierre Lacenaire, who was guillotined on Jan. 9, 1836, was one of Dostoyevsky's inspirations for the character of Raskolnikov in "Crime and Punishment."

Yet the film's Lacenaire, played with a good deal of nasty humor and dash by Daniel Auteuil, seems rather lighter of weight, more conscious of his brief celebrity, than Raskolnikov would ever have been. He seems more like a very rough sketch for Charlie Chaplin's Monsieur Verdoux. As thinking murderers go, Lacenaire is a dilettante, though an entertaining one.

"L'Élégant Criminel," directed by Francis Girod, who collaborated on the screenplay with George Conchon, opens with Lacenaire in prison, writing his memoirs as he awaits execution. When he has a free moment, he grants audiences to adoring members of the beau monde, aristocrats, phrenologists, artists and writers, including Prosper Mérimée, all drawn by his witty performance during his trial.

Among other things, Lacenaire has demanded as his right a sentence of death by guillotine.

Possibly only George Bernard Shaw could do justice to the film's conception of Lacenaire as a furious skeptic with a gift for turning conventional wisdom inside out. Neither Mr. Girod nor Mr. Conchon is up to that task. Their screenplay tries to be both a high comedy and a serious examination of the psychological forces that shaped Lacenaire's misanthropy. It's not really satisfying as either.

Instead it's an enjoyably slapdash portrait of a man with a big grudge against society, but whose crimes look rather petty and badly thought out. The film jumps around in time from Lacenaire's execution to his childhood, to an early imprisonment for fraud and, finally, to his trial for the murder of a pawnbroker and his wife.

He seems to blame all his troubles on a mother who did not love him enough, and on a rich father who understood him too well, predicting at one point that his son would die by the guillotine. His relations with women are so hobbled that he can get satisfaction only through rape or by being with whores. As an alternative he carries on an affair with Avril (Patrick Pineau), a fellow thief and murderer whom he meets in prison.

Just before they are executed, Lacenaire explains his life to Avril. He

has, he says, been in the process of committing suicide ever since he was born. "I wish you hadn't included me," says Avril. In attempting to cover so much ground, the movie inevitably leaves much unexplained. Important characters are introduced but never fully identified, including a young woman who may or may not be Lacenaire's daughter.

There also is no real buildup to Lacenaire's statement, just before his death, that he repents, not his crimes but having deprived himself of a career as a writer. For those of us who had never heard of Lacenaire before this movie, much less of his memoirs, this statement means little.

Mr. Auteuil, best remembered here as the slow-witted Ugolin in "Jean de Florette" and "Manon of the Spring," gives an intelligent, seriously comic performance as the monomaniacal Lacenaire. The film's period details also are attractive. "L'Élégant Criminel" is so good in some ways that it prompts the wish that it were better.

1992 Je 24, C18:3

Amoral, Unfeeling And Adrift

"Satan" was shown as part of the recent New Directors/New Films series. Following are excerpts from Janet Maslin's review, which appeared in The New York Times on March 28, 1992. The film opens today at the Walter Reade Theater, 165 West 65th Street, at Lincoln Center.

In the Russian film "Satan," the devil is a delicately handsome young man whose murderous opportunism is too easy to understand. While the film registers shock at its protagonist's absolute amorality, it also presents him as part of a bitterly divided and pessimistic culture. The world of "Satan" is one in which nothing really works, and therefore anything goes. "Where's our motherland?" one character asks, looking at a map of the Soviet Union that is upside down (the film was made in 1990). "At the bottom," another character replies.

"Satan," directed with a keen eye for detail and an unnerving matter-of-factness by Viktor Aristov, tells of the impassively good-looking Vitaly (Sergei Kuprianov), who at the beginning of the film cheerfully offers a bike ride to a preadolescent schoolgirl. They ride together for a while, singing, and then Vitaly pulls off into a deserted area and kills the child for no apparent reason.

Possibly more shocking than the crime is the fact that Vitaly next goes to discuss it with his grandfather, who has been a party to Vitaly's plans. Since kidnapping was the real motive, and since the little girl was the daughter of Vitaly's married lover Alyona (Svetlana Bragarnik), the grandfather understandably questions the extreme nature of Vitaly's act. Had he been in Vitaly's place, he says casually, he would only have

kidnapped the child and hidden her in a shed.

"Satan" divides itself between the particulars of Vitaly's unsettled existence and the extreme anguish of Alyona, whose unspecified job makes her something of a Soviet V.I.P. Vitaly's nominal reason for devising his scheme has been to extort some of the cash Alyona keeps hidden in her relatively comfortable apartment. Vitaly himself lives as a boarder with a number of other people in a crowded, grimy household where there are clusters of empty liquor bottles beside mattresses on the floor. A drifter, he has been dismissed from many jobs and makes his chief occupation the manipulation and exploitation of friends.

Vitaly's behavior is carefully placed within the context of a society coming apart at the seams. Although Vitaly is the film's nominal center, Alyona becomes an equally compelling figure, thanks to Miss Bragarnik's fierce and commanding performance; the scenes depicting her grief are almost unbearably painful to watch. "Satan" arrives at a remarkable resolution in a sequence that finds Alyona seeing her lover Vitaly for the first time during the story and telling him about her daughter's abduction. As she goes on, she begins to realize that she is speaking to her child's killer. The characters in Mr. Aristov's cool, clinical "Satan" find themselves face to face with the unthinkable in many ways.

1992 Je 24, C18:6

This Summer's Movies Give Literacy a Rest

By VINCENT CANBY

I'T'S not easy to evoke "Wayne's World," either the delirious five-minute accumulations of non sequiturs that became a weekly segment on "Saturday Night Live," or the spin-off, Penelope Spheeris's sweetly mad theatrical film that, according to the latest Variety, has so far earned $117,592,110 in the United States and Canada.

"Wayne's World," about two aging young men and their public-access television show, is not only one of the biggest hits of the summer season, but it's also a seminal entertainment. It somehow manages to celebrate the new style of nearly illiterate movie that it is simultaneously sending up. Or, as someone in the movie describes the public-access television show within, "I think it's two chimps on a davenport in a basement."

Nothing really happens in the film. Wayne (Mike Myers) and Garth (Dana Carvey), teen-age suburbia's idea of cool made manifest, are approached by a big-time television operator who promises them national exposure for their show, but at the expense of their artistic integrity. They refuse and, after they hang out, pick up girls and attend an Alice Cooper concert, the movie ends, not once but three or four times. Not being able to make up its mind how happy the ending should be, the movie offers some alternatives.

"Wayne's World" was, in fact, written (with a good deal of wit by Mr. Myers, Bonnie Turner and Terry Turner), but it pretends to be tongued-tied and spontaneous. It is very funny in short, disconnected takes. "Garth," says Wayne to his love-sick pal, "marriage is punishment for shoplifting in some countries." More important, the film makes a comic virtue of the same kind of slapdash approach to film structure that is accidentally built into most of the other big releases of the summer.

Consider Tim Burton's "Batman Returns," a movie that displays more comic imagination than any other big-budget fantasy in years, or at least since "Dick Tracy." Beginning with its priceless pre-credit sequence, in which the newly born Penguin is abandoned by his tony, martini-drinking parents, the film's first hour or so is a very dark, magically funny live-action cartoon.

It is full of privileged moments: the trashing of Gotham City's Christmas tree-lighting ceremony, set in a vicious parody of Rockefeller Center; Michelle Pfeiffer's death and resurrection as a kitten-with-a-whip called Catwoman, and the fast-talk of Gotham City's wheeler-dealer (Christopher Walken), a character that seems to have been inspired in part by Donald Trump, as he promotes a power plant of questionable necessity: "Give the Constitution a rest — it's Christmas."

Yet, about three-quarters of the way through, "Batman Returns" loses its way among the spectacular sets and special effects. Daniel Waters, who wrote the screenplay, is certainly literate. He comes up with a lot of hilarious dialogue, characters and bits of business, but his inventions are finally nullified by what amounts to an utter disregard for the story. There's a lot of sound and light at the climax of "Batman Returns." Also, complete confusion. The movie seems to forget its plot and to end like so many pop songs, simply by fading toward silence.

I've no idea who's responsible for this letdown: the writer, the director, the producers, or some combination of same. I'm not even sure that it is a letdown for most of the people who will see the movie. It's possible that audiences today do not necessarily expect the clearly defined beginning, middle and end that heretofore have shaped movie narratives. In this era of sequels, movies stop without ending — they don't have to. The story will resume next year. Further, since television makes it possible for us to live in a virtually nonstop continuum of entertainment, we make fewer demands on the individual segments.

Writers have never been at the head of the Hollywood pecking order, but this summer they seem to be even farther back in the line. Hollywood courts some writers like Shane Black ("Lethal Weapon," "The Last Boy Scout") and Joe Eszterhas ("Basic

Instinct"), but most appear to be scarcely tolerated.

One indication of their low estate may be the amount of space devoted

Hollywood film writing, never really an art, is now barely a craft.

to their biographies in the production notes given to reviewers. Mark Stein, the man who wrote Frank Oz's "Housesitter," is identified by a single sentence. Joseph Howard, credited with having written "Sister Act," is not even mentioned, and no wonder: Joseph Howard is a pseudonym.

Whatever the reason, the quality of the writing in this summer's movies has not been great. With the exception of "Batman Returns," "Wayne's World" and perhaps Paul Verhoeven's "Basic Instinct," which is riveting largely because of its mile-wide mean streak, bland is big in major motion pictures.

If "Housesitter" disappoints, it's not only because Steve Martin is choosing to play it lovable again, but also because the screenplay, like the Martin character, is so mild and tentative. Nothing seems to drive it forward. It's a succession of ideas for scenes. Billy Wilder and Preston Sturges had a way of constructing their comedies so tightly that everything that happens seems both inevitable and surprising. In "Housesitter," it's only inevitable.

"Sister Act" can be welcomed as being Whoopi Goldberg's first big hit comedy. Yet there's something both slightly bigoted and out-of-date about the way the film works.

It places the black Ms. Goldberg, playing a second-rate lounge singer who has witnessed a mob killing, in protective custody in an all-white convent whose nuns are retreads out of "The Bells of St. Mary's" and "The Trouble With Angels" (which wasn't super when Rosalind Russell did it). Emile Ardolino, the director, updates the language and the action a bit, but not grossly. His is a firmly middle-of-the-road comic sensibility. At one point he has Ms. Goldberg teach the choir how to sing a sort of white-gospel version of "My Guy," meaning Jesus. "Sister Act" soothes in a sticky way. Bring back "Nuns on the Run."

In his splendid one-man movie "Monster in a Box," Spalding Gray jokes about the difficulty of finding anyone in Los Angeles who is not writing a screenplay. But what is the lure? It must be money, or maybe fame. It certainly cannot be the creation of singular character, dialogue and story, which might once have been the impulse.

When you watch Richard Donner's "Lethal Weapon 3," you realize how much movie writing has had to adjust to accommodate contemporary audience tastes. Jeffrey Boam and Robert Mark Kamen don't write new characters, but new material for characters originally created by Shane Black.

In addition, they must write material for those characters to play in concert with the action, which is bigger and more expensive than ever. Mel Gibson and Danny Glover. The action is so improbable and so difficult to shoot that it seems inconceiv-

Suzanne Tenner/Paramount
Mike Myers in "Wayne's World."

able the writers could even have dreamed of it without the initial co-operation of the special-effects people. That's writing?

It is today and it pays off at the box office, as Phillip Noyce's "Patriot Games" also demonstrates. This film, written by Peter Iliff and Donald Stewart, is all plot. The public personalities of Harrison Ford, Anne Archer, Sean Bean and Richard Harris supply what characterization is needed. The screenplay is a blueprint for the action sequences, which come along at such predictable intervals that you know exactly when to go for popcorn without missing anything.

●

The most oddball of the big summer movies may also turn out to be one of the summer's bigger flops, which is too bad. Ron Howard's "Far and Away" means well. It's supposed to be a nice old-fashioned romance with both comic and melodramatic peaks. Unfortunately, neither Mr. Howard nor Bob Dolman, who collaborated on the screenplay, has any idea how to create that kind of film.

They aren't exactly illiterate. They can manufacture a lot of plot. They can write coherent if rather perfunctory dialogue, which Tom Cruise, their megastar, delivers with a reasonable and coherent Irish brogue. But the movie has no sweep. It's a series of small encounters against big landscapes. The members of the paying audience with which I saw it giggled loudly when the movie tried to persuade us that Mr. Cruise was dying. They could recognize a popcorn moment when they saw it.

"Far and Away" (an immediately forgettable title) more or less begins with Mr. Cruise, a poor Irish tenant farmer, and Nicole Kidman, the daughter of rich Irish Protestants, setting off for the New World in 1892 to claim their destinies and land in the American West. Yet most of the movie is set in Boston. It ends with the Oklahoma land rush, which is the point at which it might have started.

The film makers even flub the romance. Mr. Cruise and Ms. Kidman, who are married in real life, are not especially winning as lovers, though they are attractive and funny as grudging partners who come to respect each other.

Never mind, it will probably play better on the VCR. Maybe in the very near future.

In addition to "Batman Returns," you still have a chance to catch Rob

ert Altman's witty, blackish Hollywood satire, "The Player," written with great style and literacy by Michael Tolkin, and Jim Jarmusch's "Night on Earth." Two other small, terrifically intelligent dramas that don't try to knock your socks off: Neal Jiminez's "Waterdance" and Keith Gordon's "Midnight Clear."

If you doubt your own literacy, you might test yourself by looking in on Zhang Yimou's "Raise the Red Lantern." This tale of the life of a concubine in pre-revolutionary China is extraordinarily beautiful, spare and chilling, but it's in Chinese. It won't mean anything if you can't read the subtitles.

1992 Je 26, C1:3

Unlawful Entry

Directed by Jonathan Kaplan; screenplay by Lewis Colick; story by Mr. Colick, George D. Putnam and John Katchmer; director of photography, Jamie Anderson; edited by Curtiss Clayton; music by James Horner; production designer, Lawrence G. Paull; produced by Charles Gordon; released by 20th Century Fox. Running time: 110 minutes. This film is rated R.

Michael Carr	Kurt Russell
Officer Pete Davis	Ray Liotta
Karen Carr	Madeleine Stowe
Officer Roy Cole	Roger E. Mosley
Roger Graham	Ken Lerner
Penny	Deborah Offner
Jerome Lurie	Carmen Argenziano
Captain Hayes	Andy Romano
Ernie Pike	Johnny Ray McGhee
Leon	Dino Anello

By JANET MASLIN

After Michael and Karen Carr (Kurt Russell and Madeleine Stowe) are frightened in their home by a menacing burglar, they are grateful to the police officer who comes to their rescue. Too grateful, as a matter of fact. Pete Davis (Ray Liotta) has barely arrived at the crime scene before he is warmly accepted by both Michael, who is impressed with Pete's skill and daring, and Karen, who is impressed for more basic reasons. There are obvious impediments to a friendship between these three, not least of them the way Pete looks at Karen. But for a while those obstacles are conveniently ignored.

Michael and Karen can be described as comfortable, economically and otherwise. But Pete appears deeply uneasy. Merely being in the presence of this successful entrepreneur and his glamorous wife makes Pete fidget, as does the sight of their well-appointed home. But he is disarmed by their eagerness, and so he talks about his private life with Karen. And he provides some vicarious excitement for the sedate, law-abiding Michael by taking him out for a Los Angeles police officer's night on the town.

This evening culminates in Pete's accidentally catching Michael's burglar and offering Michael the opportunity to beat the man senseless, which Michael nervously refuses. "I already know what I would do," Pete snaps to Michael, while glaring at the terrified culprit. "I just wondered about a civilized guy like you."

●

This exchange in "Unlawful Entry" — along with the subsequent sight of Pete attacking his prisoner — is enough to make Michael rethink his position vis-à-vis Pete, and decide all bets are off. But Pete has a mind of his own. More important, he also has

complete access to the Carr household, since he has helped to install its new burglar alarm. Soon Pete begins making a serious nuisance of himself, dropping by the house unexpectedly and trying various tricks to ruin Michael's career and reputation.

In a scene that provides the film with its most startling paranoid vision, this policeman actually appears with a flashlight in the Carr bedroom while Karen and Michael are making love. "I'm as embarrassed about this as you are," he says, although that hardly appears to be the case. After this, Pete's assaults on the couple quickly escalate to new degrees of fiendishness, which seem intended to prod Michael out of his nice-guy behavior and into something a bit more primal. The film culminates furiously in a showdown proving that the veneer of civilization is paper-thin, and that the fancy-looking fixtures in the Carr kitchen and bathroom are easy to break.

●

"Unlawful Entry" was directed by Jonathan Kaplan ("The Accused," "Heart Like a Wheel"). Mr. Kaplan's intelligence and economy are gratifyingly apparent, but his approach remains level-headed and long after the material (from a screenplay by Lewis Colick) has gone berserk. The film looks seriously at its police officer's frustration and his potential for abuse of power, but it is less successful in getting under the three principals' skins. The characters are seldom spontaneous or lifelike enough to justify their having stepped into this messy situation.

Compared with the cop, a robber is a godsend.

Karen, though seemingly drawn to Pete and deeply curious about him, is played with a bland, unimpassioned solemnity by Ms. Stowe. Mr. Russell makes Michael more believable than that, but the character of a beleaguered businessman — whose biggest dream at the time the story takes place is of building an elaborate rock club — isn't terribly sympathetic.

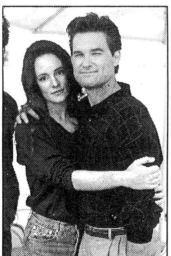

Ron Batzdorff/20th Century Fox

Madeleine Stowe and Kurt Russell in "Unlawful Entry."

Only Mr. Liotta finds much complexity in his role, and gives a performance with a dangerous edge. But even in Pete's case the story moves slowly. It's an hour and a half before Pete's heavily foreshadowed dark side has really come to light.

"Unlawful Entry" manages to be more gripping than it is convincing, thanks to the story's inevitable movement toward a violent showdown. The film is also helped by James Horner's brooding score, and by a few good supporting performances. Roger E. Mosley is powerfully effective as Pete's watchful partner, the character who knows best what a wild card this polite-sounding policeman really is. And Ken Lerner is convincingly worried as the lawyer Michael needs more and more urgently as the film moves on. Appearing briefly and providing mild comic relief is Deborah Offner, as Karen's single friend Penny, who has no trouble understanding Pete's appeal. Gazing wistfully at this policeman's handcuffs, she asks, "Think I could get him to use those on me?"

●

"Unlawful Entry" is rated R (Under 17 requires accompanying parent or adult guardian). It includes violence, brief nudity and sexual situations.

1992 Je 26, C10:4

Branford Marsalis: The Music Tells You

Directed by D. A. Pennebaker and Chris Hegedus; edited by Mr. Pennebaker, Ms. Hegedus and Erez Laufer; produced by Frazer Pennebaker; Steve Berkowitz and Ann Marie Wilkins, executive producers; released by Pennebaker Associates Inc. At the Joseph Papp Public Theater, 425 Lafayette Street, Greenwich Village. Running time: 60 minutes. This film is not rated.

Featuring the Branford Marsalis Trio: Mr. Marsalis, Robert Hurst and Jeff (Tain) Watts

By JANET MASLIN

"Branford Marsalis: The Music Tells You" is an appreciative, hour-long documentary portrait of the jazz saxophonist, directed by D. A. Pennebaker and Chris Hegedus in typically simple, penetrating style. Seen mostly while on the road, Mr. Marsalis is revealed as an uncommonly articulate musician with distinct ideas about his work in particular and jazz in general. "You don't play what you feel," he says, during the discussion from which the film's title is taken. "There's only freedom in structure, my man. There's no freedom in freedom."

As someone who can readily discuss jazz polyrhythms — as he does during a visit to the class of his former teacher, Prof. David Baker at Indiana University — Mr. Marsalis would make a stimulating documentary subject even if he did not also contemplate the larger context for this music. "The difference between them and us," he says about jazz pioneers like Charlie Parker and their hopes for a music that could bring about social justice and racial equality, "is we know that's not going to happen."

Also on the subject of race, Mr. Marsalis eloquently describes his annoyance at a French listener's comment that his music must be making an angry racial statement: "The nerve of him to think for a second that when I'm creating the most unbeliev-

Timothy White/Columbia

Branford Marsalis

ably complicated music in the history of the world, I'm thinking" about anyone else's agenda. The film's musical interludes, especially the long one that concludes it, confirm the impression that Mr. Marsalis's work is light years beyond the realm of the simple statement.

Branford Marsalis contemplates his music and the world of jazz.

"Hope we didn't confuse you too much," he jokingly tells his audience at the end of that intricate selection. "See you later," he says at the start of another. The music heard here is indeed as absorbing and complex as that implies. And Mr. Marsalis points out that it is more demanding and less profitable than more popular musical forms. "How to make a million dollars playing jazz: well, first you start with two million," jokes one of his band members. "The Music Tells You" makes no reference to Mr. Marsalis's new job as musical director of the "Tonight" show.

"The Music Tells You" opens today at the Joseph Papp Public Theater and is headed for home video release at some later date. Its matter-of-fact style and frequent close-ups are well suited to the small screen.

1992 Je 26, C12:6

FILM VIEW/Caryn James

'Batman Returns' With Ills and Angst

THE STORY WAS SAD AND LUrid, and if it had happened in New York City it would have been a natural for late-night television news. "Abandoned baby found alive in sewer! Details at 11!" The anchorwoman would shake her head ever so slightly after reading this heartbreaking report. In a follow-up, politicians would bemoan the lack of family values, and a child psychiatrist would foresee severe identity problems.

Lucky for us it didn't happen here. It happened in Gotham City, the fun-house mirror version of New York that is the setting of "Batman Returns."

The season's biggest movie (its recordbreaking opening weekend brought in $46.5 million) starts with an eerie, irreverent sequence. The wealthy Mr. and Mrs. Cobblepot, the ultimate dysfunctional parents, push a baby carriage with baby inside into the river. Thirty-three years later, the Penguin surfaces from the sewers. He is a white-faced man with flipper hands, a beaky nose and a definite penguinlike shape.

As impossible as alligators in the sewers, perhaps. But the episode is a skewed line away from the lost-baby stories that tabloids and television stations adore.

"Batman Returns" goes on to engage, tongue-in-cheek, the trendiest social topics. Dysfunctional families, politics, feminism, the media, self-esteem, toxic waste — the

Warner Brothers

Danny DeVito as the Penguin—To Gotham City, he is an enigma, like Ross Perot.

film makes fun of them all. With the sneakiness and impact of a sucker punch, this wildly witty and inventive adventure taps into the confused Zeitgeist of the moment.

The Penguin runs for mayor, with the help of image consultants. A mousy secretary, fed up with her demeaning sexist boss, turns into the female avenger, Catwoman. True to its comic-book roots, the film is cartoonish, but no more so than reality.

Politics, feminism, self-esteem, toxic waste, media — Tim Burton's film makes fun of them all.

In real life, the Vice President chastises Murphy Brown for her morals. Bill Clinton plays the sax on "Arsenio Hall." Though "Batman Returns" is fiction, it's not much stranger than truth.

In this film, as in life, chaos rules and images don't quite come clean. Catwoman is confused, but so is feminism. The Penguin is an enigma, but so is Ross Perot. A tabloid headline in the film blares: "Penguin — Man or Myth? Or Something Worse?" Substitute "Perot" for Penguin, and you're probably in touch with tomorrow's big story.

■

"Batman Returns" is, of course, a movie, not a message. And as a film, it is far superior to its 1989 predecessor, also directed by Tim Burton. The strength of "Batman" was Jack Nicholson's luscious, irredeemable Joker, but its weakness was all those blurred-together scenes of the Batmobile racing around.

In "Batman Returns," the perfectly cast villains run the show, and they are a catalogue of social and emotional problems. Danny DeVito is a wonderfully mixed-up Penguin, deprived of his upper-crust birthright, who tries to take over Gotham with the help of a ruthless industrialist named Max Shreck (Christopher Walken). Michelle Pfeiffer is a sympathetic mess as the lonely, bedraggled secretary, Selina Kyle, and an absolute hoot when she turns into the sexy, ambitious Catwoman. No offense to Michael Keaton, but this movie is better than the earlier one because the humorless Bruce Wayne and his alter ego, the armor-plated Batman, just aren't around as much.

"Batman Returns" resembles an elaborate amusement park ride, and Bo Welch's playful production design deliberately evokes that fun-house image. Gotham Plaza, with its oversized Christmas tree and gargantuan statues, is Rockefeller Plaza as it might appear in some demented Disneyland. In the dank, blue-green, penguin-infested sewers, the Penguin rides in a large yellow duck from an abandoned theme park ride.

In this film, all Gotham is a theme park, and the theme is the real world of urban blight and personal chaos. If Gotham is a funhouse mirror held up to New York, the plot and characters are comic but astute reflections of the times.

■

The movie is filled with sharp satirical jabs at politics. Behind the Penguin's jokey mayoral campaign is the dark truth that money and image are everything.

"We're both perceived as monsters," the Penguin tells Shreck. "But you're a well-re-

spected monster and I — to date — am not."
The Penguin wants to change not his soul but his image.

He has found the right evil cohort. Though Shreck is a murderer and a toxic polluter, he is known as a friend of the city. At the lighting of the Gotham Plaza Christmas tree, he modestly tells the crowd he is not Santa Claus. Well, it was Paul Tsongas's most memorable line, and Shreck is obviously not above stealing from his betters.

Soon Shreck's image consultants go to work on the Penguin and prove that no transformation is impossible in politics. Here is a candidate who appears before his first supporters eating a whole, raw fish. The film's bleak attitude taps into the current skepticism about political insiders.

Reflecting society just as truly, the movie's treatment of feminism is a jumble. Is Catwoman a feminist heroine or a villainess? The last time a movie provoked those questions it was "Thelma and Louise." Catwoman is even more dangerous, if only because she has nine lives.

"I'm afraid we haven't properly housebroken Miss Kyle," Shreck says when his secretary fumbles around the office. That line alone justifies a lot of revenge.

And at first, Catwoman's intentions seem good. She sews herself a cat outfit and gets out of the house. For her first crime-fighting feat she pulls a man away from a woman he is attacking, but that is just the first blow for feminism. Next she yells at the victim for making it so easy. "Always waiting for a Batman to save you," she cries with scowling derision. "I am Catwoman. Hear me roar." (Millions of "Batman" fans are too young to know that she is laughing at Helen Reddy's 1972 feminist pop-anthem, "I am woman. Hear me roar." Meowing feminists weren't on the agenda back then.)

■

But Catwoman sometimes uses her gender as an excuse. During a tough physical fight with Batman, she whines when she hits the ground, "How could you? I'm a woman." Catwoman's feminism is the same as her toughness; it's genuine, though she cheats a little. Even without consulting Gloria Steinem's best-seller "Revolution From Within," though, she has found a cure for low self-esteem. Becoming Catwoman will do it every time.

Catwoman still has that nagging identity problem: secretary by day,

Catwoman's feminism is the same as her toughness; it's genuine, though she cheats a bit.

whip-wielding avenger by night. But her problem is nothing next to the Penguin's. As he searches for his lost parents, he claims he wants only to know himself. Yet at some point he must have looked for the child inside and found the penguin equivalent of a feral child. In a wicked twist on "The Elephant Man," he discovers who he is and cries, "I am not a human being! I am an animal!" That's what we love and recognize about the film's villains: they are totally maladjusted, like everyone in the real world.

Viewers may go to "Batman Returns" seeking adventure. They will find that the film's best and funniest surprise is "Batman: The Zeitgeist."

1992 Je 28, II:11:1

Last Date
Eric Dolphy

Directed by Hans Hylkema; screenplay by Mr. Hylkema assisted by Thierry Bruneau; edited by Ot Louw; produced by Marian Brouwer; Deen van der Zaken, director of photography; Luk Brefeld, camera assistant; Piotr van Dijk and Lukas Boeke, sound. At Film Forum 2, 209 West Houston Street, SoHo. Running time: 92 minutes. This film has no rating.

By JON PARELES

On June 2, 1964, Eric Dolphy played bass clarinet, alto saxophone and flute with a trio of Dutch musicians for a Netherlands radio show called "Jazz Magazine." Most of the time, the show's sessions were broadcast live and were not recorded; Dolphy's set was taped because he was leaving before the day of the show. It was fortuitous. On June 29 he died in Berlin after collapsing onstage; the doctors assumed that the black American jazz musician was on drugs. But Dolphy had slipped into a diabetic coma, and without treatment he never regained consciousness. The Dutch recordings became his album "Last Date."

The radio sessions were photographed but not filmed, so Hans Hylkema's documentary "Last Date — Eric Dolphy," which will be shown today and tomorrow at the Film Forum 2 as part of the JVC Jazz Festival, becomes a tease. Although it is a kind of biography of Dolphy, its unstated and perhaps unintentional subject is the relation of Europeans to jazz, as perennial fans and inevitable outsiders, hearing a mythic America that they distrust and long for. The manager of the Berlin nightclub Tangente, who didn't understand until it was too late why Dolphy was wolfing down ice cream and Coca-Cola, says: "I thought he's a black musician, and so he'll be on drugs. I was tolerant, but. . . ."

The film follows Thierry Bruneau, who is writing a Dolphy biography, to the places Dolphy lived, where neighbors and colleagues are interviewed; it shows streets and bridges and black children playing as if congratulating itself on its authenticity. The film also returns repeatedly to the Dutch musicians who played with Dolphy. The pianist, Misha Mengelberg, apparently still bears a grudge that Dolphy called him lazy for the trouble he was having with the complex music; the drummer, Han Bennink, is still in awe.

●

A portrait of Dolphy does emerge. He was a "practiceaholic," one colleague said, and he wanted to be the first black musician in the Los Angeles Philharmonic. During a spell without work in New York, he lived on white beans, bags of them in his closet, but he'd also buy groceries for unemployed musicians. And he loved the sounds of birds, which turned up in his improvisations.

"Last Date" grows frustrating as the film details reactions to Dolphy — like a Dutch bass clarinetist trying to recreate a Dolphy solo — rather than showing the musician himself. In a few astonishing sequences, filmed the night that Dolphy told Charles Mingus he was leaving the bassist's group to stay in Europe, Mingus alternately abuses and commends Dolphy; the documentary then cuts away from the music. If that footage exists at greater length, it would be far more illuminating than the film's arty shots of hands taking apart a saxophone and nestling it in its case.

As it stands, "Last Date" only shows snippets of Dolphy performing until the closing credits. Behind the list of European and American names, the subject of the documentary finally has his own say.

1992 Je 29, C16:5

A League of Their Own

Directed by Penny Marshall; screenplay by Lowell Ganz and Babaloo Mandel; based on a story by Kim Wilson and Kelly Candaele; director of photography, Miroslav Ondricek; edited by George Bowers; music by Hans Zimmer; production designer, Bill Groom; produced by Robert Greenhut and Elliot Abbott; released by Columbia Pictures. Running time: 124 minutes. This film is rated PG.

Jimmy Dugan	Tom Hanks
Dottie Hinson	Geena Davis
Kit Keller	Lori Petty
Mae Mordabito	Madonna
Doris Murphy	Rosie O'Donnell
Marla Hooch	Megan Cavanagh
Betty Horn	Tracy Reiner
Evelyn Gardner	Bitty Schram
Shirley Baker	Ann Cusack
Helen Haley	Anne Elizabeth Ramsay
Ellen Sue Gotlander	Freddie Simpson
Alice Gaspers	Renee Coleman
'a Lowenstein	David Strathairn
Walter Harvey	Garry Marshall
Ernie Capadino	Jon Lovitz
Bob Hinson	Bill Pullman

By VINCENT CANBY

In 1943 at the height of World War II, when women well over voting age could still be called girls, Philip K. Wrigley, of the Chicago Cubs, and other prominent baseball figures got together to form the nonprofit All American Girls Professional Baseball League. It was a stopgap idea. Its aim: to fill the vacuum if, as seemed possible, the major league clubs lost too many of their players to the armed services.

As things turned out, the major leagues never had to shut down, but the women's league survived until 1954.

Taking this footnote to baseball history, the director, Penny Marshall, and the screenwriters, Lowell Ganz and Babaloo Mandel, have made "A League of Their Own," which must be as rare as a day in August when the sky is clear, the humidity low and the temperature hovers in the mid-70's.

Though big of budget, "A League of Their Own" is one of the year's most cheerful, most relaxed, most easily enjoyable comedies. It's a serious film that's lighter than air, a very funny movie that manages to score a few points for feminism in passing.

●

The film's focus is the Rockford (Ill.) Peaches, one of the four clubs that made up the league in its problematical first season. As imagined by Ms. Marshall and her associates, the Peaches are a gallant and somewhat rum crew.

Their star: Dottie Hinson (Geena Davis), a crackerjack catcher and a dependable hitter who is so beautiful that she winds up on the cover of Life magazine. On the mound is Dottie's younger sister Kit (Lori Petty). She has a terrific arm but tends to go to pieces when at bat. It's a sibling thing — she gets rattled by Dottie's advice and can't resist swinging at the high ones. Keeping things lively in center field is pint-size Mae Mordabito (Madonna), informally known as All the Way Mae, who finds pro-baseball preferable to taxi dancing.

Coaching the Peaches, at first with great reluctance, is Jimmy Dugan (Tom Hanks), a former major league hero disabled by booze and unreliable knees. Jimmy is a tobacco-chewing slob with his own manner of expressing himself. He's a guy who doesn't hesitate to urinate in front of his players in their locker room. During their disastrous first game, he lounges in the dugout, snoozing in rye-induced oblivion.

Though "A League of Their Own" is an ensemble piece, meaning that each performer relates to and enriches the others, Mr. Hanks is first among the equals. His Jimmy Dugan is a priceless, very graceful eccentric. With his work here, there can be no doubt that Mr. Hanks is now one of Hollywood's most accomplished and self-assured actors. Having put on weight for the role, he even looks jowly and over-the-hill.

●

While the women on the field are knocking themselves out to achieve fame and glory in a league that embraces just three Midwestern states, the film never strains to get a laugh or make a point. It adopts a summer pace as it follows Dottie, Kit, Mae and their teammates from what is, in effect, boot camp to the league's first world series, in which the Peaches face the Racine (Wis.) Belles.

The players' training includes not only practice on the field, but also intense sessions at a charm school where they are drilled in table manners, dress, makeup, posture and general deportment. In addition to public apathy, the league's backers have to overcome furious editorials warning against the threatened "masculinization" of the players.

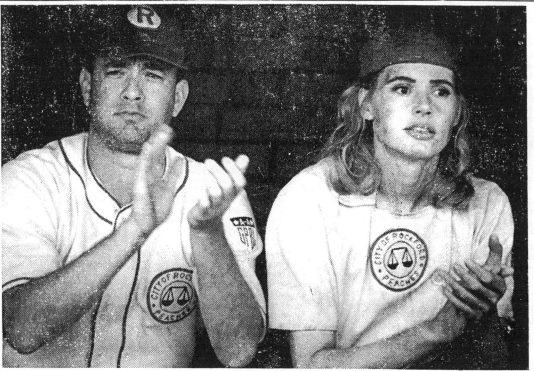

Columbia Pictures

Tom Hanks and Geena Davis cheering their team on in a scene from "A League of Their Own."

Mr. Ganz and Mr. Mandel, whose earlier collaborations include the screenplays for "City Slickers" and "Splash," have written a dozen rich roles, which Ms. Marshall has filled with a dream cast. Ms. Davis, who reportedly arrived on the set well after her colleagues had been practicing, comes across as a no-nonsense ball player, which reflects Dottie's no-nonsense approach to her career in the women's league. Dottie hasn't any intention of staying with the game when her husband returns from overseas.

She's a Peach with attitude. When a teen-age boy comes on to her ("What say we get in the back of the car and you make a man of me?"), her reply is, "What say I smack you around?" She doesn't have the last word, though. His wistful answer: "Can't we do both?"

Not since "Desperately Seeking Susan" has Madonna had a role that fits her public personality as well as Mae, an opinionated, operational fighter who's not about to pay too much attention to training rules when it comes to men. It's not a big role, but it is choice.

The film's most unexpected performance is that of Ms. Petty. She has true comic radiance as an awestruck, loving younger sister who would often like to murder the paragon to whom she's so closely related. It's a performance that could shape her career.

•

Among the excellent supporting players are Rosie O'Donnell, as Madonna's sidekick and a former dance hall bouncer; Megan Cavanagh, a heavy heavy-hitter from rural Colorado who's too shy even to smile so that anyone will notice; Garry Marshall (the director's brother and a director in his own right), who plays the fictional equivalent to Philip K. Wrigley (the character manufactures candy bars, not gum), and Bill Pullman, as Dottie's soldier-husband.

On-screen too short a time is Jon Lovitz, formerly of "Saturday Night Live," who plays Ernie Capadino, the

weary talent scout for the new league. As he delivers his finds to their training center, Ernie says: "Hey, cowgirls, see the grass? Don't eat it."

"A League of Their Own" has its share of obligatory lines. At a sentimental moment, Jimmy Dugan must say, "There's no crying in baseball." He must also define the game for the women: "Baseball is what gets inside you. It's what lights you up."

"A League of Their Own" is so good that it can accommodate such stuff and still leave one admiring its skill, humor and all-American enthusiasm.

•

"A League of Their Own," which has been rated PG (Parental guidance suggested), has some mildly vulgar jokes and language.

1992 Jl 1, C13:4

Boomerang

Directed by Reginald Hudlin; screenplay by Barry W. Blaustein and David Sheffield; story by Mr. Murphy; director of photography, Woody Omens; edited by Earl Watson; music by Marcus Miller; production designer, Jane Musky; produced by Brian Grazer and Warrington Hudlin; executive producer, Mark Lipsky; released by Paramount Pictures. Running time: 118 minutes. This film is rated R.

Marcus Graham	Eddie Murphy
Jacqueline	Robin Givens
Angela	Halle Berry
Gerard	David Alan Grier
Tyler	Martin Lawrence
Strangé	Grace Jones
Nelson	Geoffrey Holder
Lady Eloise	Eartha Kitt
Bony T.	Chris Rock
Yvonne	Tisha Campbell
Christie	Lela Rochon
Todd	John Canada Terrell
Mr. Jackson	John Witherspoon
Mrs. Jackson	Bebe Drake-Massey

By JANET MASLIN

Marcus Graham, the main character in "Boomerang," is a suave, ladykilling executive who can send flow-

ers to seven different girlfriends, each with a note saying, "Thinking only of you." Marcus is so picky about women that he secretly inspects their feet for imperfections, and is appalled if their toenail polish happens to be chipped. There's a short name for a man like this, and it's not Eddie Murphy. But Mr. Murphy happens to be playing this role, so Marcus becomes a lot more likable than he deserves to be.

The presence of the dapper, dressed-for-success Mr. Murphy also locates "Boomerang" in a strangely retrograde Fantasyland. The star may wear an earring and sound savvy, but he inhabits an improbably glamorous corporate universe that comes straight out of the Rock Hudson-Doris Day 50's. Though all the principals in "Boomerang" are black, with only a few white extras used occasionally for comic relief, the film's ideas about business and prosperity remain weirdly dated even as its sexual attitudes strive for something new.

Picture Elvis with an earring and a briefcase, living in a world whose racial stereotypes have been deliberately reversed, and you have some notion of how Mr. Murphy's Marcus appears in the film's opening scenes. Warmly greeted by every single woman in his high-gloss headquarters, Marcus smirks his way through a day job as a cosmetics marketing executive and seduces a long list of female conquests by night. Hooting would be in order if anyone other than Mr. Murphy were attempting this, but he manages to make the character's smugness at least halfway funny, especially when it gives him an opportunity to fast-talk his way out of trouble. Fast-talking is still what the newly smooth, fashionable and lovestruck Mr. Murphy does best.

The joke here is that Marcus is knocked for a loop once he meets a female executive who is even more vain and sexually predatory than he is. And once again casting saves the day. Robin Givens, as Marcus's gorgeous and commanding colleague

Jacqueline, gives great appeal to a potentially unsavory character. And she holds her own with Mr. Murphy in those scenes that involve them in an elaborate form of sexual role reversal. In one such episode, Marcus tries to boast about his cooking while Jacqueline asks if she can watch a Knicks game during dinner. In another, after visiting Marcus for a quick sexual encounter, Jacqueline compliments him on his prowess and then leaves, saying: "I'll call you tomorrow, O.K.? Get some sleep."

•

The funniest parts of this uneven, ostentatiously upscale comedy are those that find Mr. Murphy's Marcus adopting the behavior of a sexually insecure woman. Indeed, his brush with Jacqueline soon has him muttering things like "What happened to caring and sharing and commitment?" Mr. Murphy's intuitive mimicry can be devastatingly apt on such occasions, even though the humor comes from little more than the reversal of clichés. The screenplay never gets beyond the fact that they *are* clichés, and as such could have been greatly improved upon.

Except in those welcome moments when Mr. Murphy sounds like he may be ad-libbing, the dialogue usually sounds stilted, and at times it has some strange lapses. In a clothing store, an encounter that Marcus and his two best friends have with a white salesman appears headed for an incisive putdown, especially after this salesman insults these potential customers by mistaking them for thieves. But instead of setting up some bon mot for Mr. Murphy, the screenplay merely has him scare the man and leave the store. The scene winds up incomplete and vaguely hostile, which gives it no place in a film that otherwise pays no attention to social reality. One character's joking remark in another language — "That's Korean for 'I'm sorry I shot you but I thought you were robbing my store'" — is virtually the film's only other nod to the world beyond its cloistered brand of escapism.

The film's omissions are less egregious than the excesses devised for some of its minor characters, notably Grace Jones as the sort of celebrity who warrants having her name attached to a brand of perfume. It's a safe bet that every single review of "Boomerang," including this one, will use the word "vulgar" to describe what Ms. Jones does here. (One of her tamer gestures involves looking around a restaurant and loudly pointing out those diners she thinks are gay.) Eartha Kitt, as the aging cosmetics queen whom Marcus sleeps with in hopes of improving his career opportunities, is similarly scary, although in her case the effect is more game and less forced. Ms. Kitt appears to have landed in this film straight out of a "Star Trek" episode, but she shows an enjoyable awareness of her own impact. And she is well used as the first of Marcus's many comeuppances here.

•

As directed by Reginald Hudlin, who generally makes a graceful transition from the smaller scale of "House Party" to this film's showy excesses, "Boomerang" intermingles its risqué gambits with a peculiar squeaky-clean streak. David Alan Grier, as Gerard, one of Marcus's two best friends (the other is the very funny Martin Lawrence, as a more militant type who complains that billiards is a racist game "because the white ball drives the black ball completely off the table"), is paired with

FILM VIEW/Janet Maslin

A 'League' Where Eddie Can't Play

I T'S WELL KNOWN THAT A FILM'S HISTORICAL time frame has absolutely nothing to do with how contemporary that film may feel. But that point is seldom illustrated as clearly as it was last week with the simultaneous arrival of "Boomerang," a seemingly ultramodern corporate comedy that actually belongs somewhere back in the mid-1950's, and "A League of Their Own," the 1940's baseball story that couldn't be more charmingly up to date.

"Boomerang" incorporates present-day elements like the vision of a slick, prosperous black middle class and the insistence on obnoxious sexual candor (the film includes no real nudity, but Grace Jones makes a point of dropping her underwear on two different occasions). Despite those timely touches, "Boomerang" summons up a quaintly idealized world of swanky offices, cavalier bachelors and admiring females, with only one brief shot of a condom wrapper to suggest that life is no longer so carefree.

■

The idea of a cute role reversal — making Eddie Murphy's boastful ladies' man fall madly in love with Robin Givens's gorgeous, ruthless executive, who is even more predatory than he is — does nothing to make the premise less rusty. This film's brassy flaunting of money, power and sex appeal would appear naïve no matter who wore the pants, as they used to say.

If "Boomerang" is full of clichés about the sexes, then "A League of Their Own" is full of comparable surprises. Rarely are feminist attitudes handled as breezily and entertainingly as they are here. And seldom, even in baseball movies, do so many clever touches come out of left field. The director, Penny Marshall, has cast the principal roles entirely against type, and the results are wonderfully unexpected. Disguising the voluptuous Geena Davis as a tomboyish, no-nonsense country girl makes her appear all the more showstopping because she isn't trying.

The usually genial Tom Hanks is used here hilariously as an overweight, surly boor, a manager who complains: "Girls are to sleep with after the game, not to coach *during* the game!" Mr. Hanks's funniest scene finds him drunkenly kissing the team's prim chaperone by accident, then recoiling in horror and snapping, "By the way, I loved you in 'The Wizard of Oz.'" It would be hard to imagine any of this — the kiss, the wisecrack, the boozy stupor — in any of Mr. Hanks's earlier films, but it works here because it's so perfectly unexpected. So is the warm but not effusive direction by Ms. Marshall herself, whose mile-wide sentimental streak (as displayed in her earlier "Awakenings") is well under control.

And then there's Madonna — or is there? Her familiar attention-getting tactics are nowhere in evidence, except in those scenes that affectionately mock her familiar image. As the team's irrepressible tramp, Madonna is seen emerging from a confessional followed by a priest in a cold sweat ("That's the second time he's dropped the Bible since she's been in there," one teammate remarks). She is also given the chance to say, "Hi, my name's Mae, and that's more than a name — it's an attitude." Madonna's Mae is even mocked when she suggests it might be good for business if she let her uniform become unbuttoned on the ball field. "You think there are men in this country who ain't seen your bosoms?" a colleague asks her in disbelief.

None of this is allowed to upstage the film's ensemble spirit. And indeed, the smartest thing Madonna does here is to make herself a small, very funny part of an overall scheme. That scheme, clearly bigger than any of the film's appealing individual characters, treats the fun, freedom and unexpected social progress experienced by these women as a form of heroism. The idea works because Ms. Marshall and

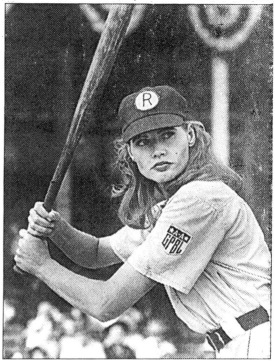

Columbia Pictures

Geena Davis in "A League of Their Own"—The 1940's story is charmingly up to date. "Boomerang," with Eddie Murphy, belongs back in the mid-1950's.

the screenwriters, Lowell Ganz and Babaloo Mandel, are never preachy about it, and because they bring real tenderness to the telling of this story.

It may be hard to imagine a film whose most deeply felt moment comes with the embrace of two suburban-looking matrons. But "A League of Their Own" invests that particular encounter, which comes late in the story, with remarkable emotion. The director's decision to use real elderly women, instead of fresh young actresses who have been artificially aged by makeup, adds immeasurably to the poignancy of the scene. It also underscores the fact that this blithe comedy is quite serious in what it has to say about gutsy, pioneering women and their accomplishments.

Making its points with an enchantingly light touch, the film satirizes male hecklers at the stadium, like the one who nastily simpers, "Better look out, I might break a nail." (He soon gets hit by a "stray" pitch.) The lure of marriage and motherhood is treated no more charitably, with one woman on the team actually going after a bratty child with a baseball bat. And a male talent scout is made to look shortsighted for trying to pass over a woman who's a great player but homely. ("You know General Omar Bradley?" the scout asks. "Well, there's too strong a resemblance.")

The film has fun with the media's idiotic treatment of these athletes. "She's also an expert coffee maker," a newsreel comments about one of them. But the coffee makers, figuratively speaking, can be found in "Boomerang." The heroines are here. []

1992 Jl 12, II:11:5

Echoes From a Somber Empire

Directed by Werner Herzog; edited by Rainer Standke and Thomas Balkenkol; music by Michael Kreihsl; produced by Galeshka Moravioff and Mr. Herzog; in French and English with English subtitles; released by New Yorker Films. Film Forum 1, 209 West Houston Street. Running time: 91 minutes. This film has no rating.

WITH: Michael Goldsmith

By JANET MASLIN

The man on television denies the charges against him with great indignation, even though he has been accused of cannibalism and there are strong indications the stories are true. A great many citizens will swear that Jean-Bédel Bokassa, the deposed Emperor Bokassa I of the Central African Republic, did indeed eat his countrymen and that he maimed and murdered others in comparably horrifying ways. The oversize refrigerator and oven in his quarters have long since been abandoned, but they are reminders of the Bokassa regime and its bloodthirsty ways.

The people of the Central African Republic no longer see much of Bo-

Werner Herzog's film "Echoes From a Somber Empire" includes scenes of the 1977 coronation of Jean-Bédel Bokassa, left, as Emperor of the Central African Republic. Seated beside Bokassa was his Empress.

Film Forum

By JANET MASLIN

AUDIENCES watching "A Stranger Among Us," the latest film directed by Sidney Lumet, must try to believe that Melanie Griffith is Emily Eden, a street-smart New York City police detective who makes remarks like "you wouldn't *believe* the things that I've seen" and "we were puttin' down some perps, and one of them stuck him with a blade."

They will also have to believe that in the line of duty it becomes absolutely necessary for Emily to go to Brooklyn and infiltrate the Hasidic Jewish community that is this film's real focus. A new hair color, a chaster wardrobe and endless pointers on this group and its customs are required before Emily can complete her assignment and catch a killer.

It is also inevitable, if not exactly essential, that Emily attract the attention of a devout, modest young man named Ariel (Eric Thal), the son of the sect's spiritual leader. "He is to Jewish learning what Mozart is to music," another character says of Ariel, who will succeed his father one day. The tentative, forbidden romance that promises to spring up between Ariel and Emily is only one of the reasons Variety has dubbed this film "Vitness," which is the perfect one-word description.

Although the premises of this film and of "Witness" are indeed similar, the parallel goes only so far. The world of the Hasidim in Borough Park is less prettily exotic than that of the Amish in rural Pennsylvania, a fact not lost on Disney's Hollywood Pictures division as it tries to market "A Stranger Among Us" in mystifying ways. Printed ads for the film offer no clue to its real subject, showing only a huge likeness of Melanie Griffith and tiny, shadowy figures that have no identifying features. This might as well be a representation of the famous "Twilight Zone" episode in which Agnes Moorehead battled tiny space invaders as that of a film trying earnestly to stimulate interest in Jewish precepts and traditions. But the seriousness of "A Stranger Among Us" is compromised from the start, since the otherwise articulate and lively screenplay by Robert J. Avrech makes too many concessions to Hollywood clichés. The film's guided tour of Hasidic life is eclipsed by an overlay of pulp storytelling, from the trumped-up murder plot to the problems Emily is having

kassa since he is incommunicado (with a death sentence commuted to life imprisonment) in a tiny cell. Nor was he at the disposal of Werner Herzog. So Mr. Herzog's haunting documentary "Echoes From a Somber Empire," which opens today at the Film Forum, must work obliquely to summon images of this eccentric, benighted ruler and the damage he left behind.

The mad legacy of Bokassa in the Central African Republic.

Bokassa's absence turns out to be oddly helpful to Mr. Herzog, who characteristically finds more in the mystery of Bokassa than he does in the actual man. Unlike Barbet Schroeder's 1974 "General Idi Amin Dada," which allowed the despot to reveal himself devastatingly before the camera, this restrained film prefers to wander through the memories and artifacts left over from a tyrant's reign. Its post-mortem on the Bokassa years is conducted by Michael Goldsmith, a journalist whose dignified bearing and quiet manner correspond well with the film's reflective tone. Mr. Goldsmith's memories are colored by the fact that he himself was once tortured and imprisoned by Bokassa, an experience that the film conveys by showing a foot slowly crushing a pair of glasses.

•

Mr. Goldsmith, who eventually tells of how Bokassa broke his glasses in just that way, was jailed as a South African spy. This came about after an article he wrote about Bokassa's coronation was accidentally garbled during its telex transmission, and a vigi-

lant Bokassa loyalist thought the message might be in code. The capriciousness of this mistake is representative of many Bokassa gestures, as his victims reveal in interviews. One tells how a boy who lent one of Bokassa's wives a bicycle was ordered executed by the jealous Emperor. David Dacko, who was President of his country before and after the Bokassa episode (Bokassa seized power in 1966 and was deposed in 1979), says it was possible either to be told to get lost or to be beaten to death for the same transgression, depending on the Emperor's mood.

And a woman who resisted Bokassa's sexual advances, only to find herself and her whole family thrown into prison, recalls having finally decided to accept Bokassa's proposition for the sake of her kin. "Oh, but I have forgotten about them," he reportedly said about the incarcerated relatives. "I shall send for them immediately."

Mr. Herzog's film, which unfolds in a circular manner and at a stately pace, first follows Mr. Goldsmith to the French chateau where Bokassa lived in exile during the 1980's before voluntarily returning to the Central African Republic to face a trial. (Upon leaving France, he complained bitterly about not having farmland, telling the television cameras: "What can I do here in the way of cultivation or breeding? Nothing!")

•

At the chateau are one of Bokassa's wives, a few of his 54 children (who run wild and are often arrested, their stepmother reports) and endless relics of Bokassa's bizarre ideas of glory. Much of his ceremonial regalia had a Napoleonic flavor, as did his dynastic notion of dressing a kindergarten-age Crown Prince in military uniform and white gloves. The film includes mesmerizing scenes of the Emperor's coronation, which appears to have been the purest expression of Bokassa's self-image, from the diamond and ermine trappings to the golden eagle-shaped throne. Mr. Herzog sees beyond the demented

grandeur to the bored, dazed expressions on the wife and children forced to lend themselves to such strange pageantry.

Throughout "Echoes From a Somber Empire," Mr. Herzog's camera tacitly absorbs the madness of the Bokassa legacy and at times transforms that madness into mesmerizing visions. A statue of the dictator lies rusting in the weeds ("Do you know who it is?" Mr. Goldsmith asks some nearby children) and a monkey smokes a cigarette with unnerving intensity in the ruins of the Emperor's private zoo. Mr. Goldsmith's nightmare of a world inundated by orange crabs is illustrated quite literally, in eerily brilliant colors. And the thought of a monstrous and unstoppable plague lingers in the memory long after Bokassa has faded.

1992 Jl 15, C15:3

A Stranger Among Us

Directed by Sidney Lumet; written by Robert J. Avrech; director of photography, Andrzej Bartkowiak; edited by Andrew Mondshein; music by Jerry Bock; production designer, Philip Rosenberg; produced by Steve Golin, Sigurjon Sighvatsson and Howard Rosenman; executive producers, Sandy Gallin and Carol Baum; released by Hollywood Pictures. Running time: 109 minutes. This film is rated PG-13.

Emily Eden	Melanie Griffith
Ariel	Eric Thal
Levine	John Pankow
Mara	Tracy Pollan
Rebbe	Lee Richardson
Leah	Mia Sara
Nick	Jamey Sheridan
Yaakov	Jake Weber
Mendel	Ro'ee Levi
Mr. Klausman	David Rosenbaum
Mrs. Klausman	Ruth Vool
Lieut. Oliver	David Margulies
Detective Tedford	Ed Rogers 3d
Detective Marden	Maurice Schell

S. Karin Epstein

Melanie Griffith

with her injured partner and beau (Jamey Sheridan). And the Hasidic characters, though vividly rendered, are diminished by the kind of sweeping generosity that makes each one a wise, kindly paragon. You'd have to visit Santa's workshop to find another community as sunny and cooperative as this one.

"You people really *care* about each other!" Emily declares in astonishment as she begins to appreciate the film's rosy vision of Hasidic life. As Andrzej Bartkowiak's cinematography bathes the characters in a golden glow and Jerry Bock's score gives the soundtrack a jaunty klezmer sound, the film dutifully explores everything from bread-baking for the Sabbath feast to funeral customs to the number of knots in the fringes of a prayer shawl. Emily's friendly guides, Ariel and his demure sister, Leah (Mia Sara, giving a disarmingly sweet performance), offer colorful bits of information whenever possible, and so does their father (Lee Richardson), who as rebbe is the group's patriarchal authority figure. It requires another great stretch of the imagination to believe that the rebbe would take the tough, profane, flirtatious Emily under his wing.

•

Since "A Stranger Among Us" is the work of Mr. Lumet, it has been made with the kind of technical assurance that should have dispelled more of its problems. As this seasoned director provides yet another slice of New York life, the film abounds with small, sharp characterizations and lively contrasts. Even a car chase and shoot-out in the diamond district of Manhattan, however weary it is conceptually, has been lent a degree of verve by Mr. Lumet's staging and Andrew Mondshein's brisk editing. But the film makers' proficiency is overpowered by their piety and by their tendency to sugarcoat the material.

Allowing for the improbability of their attraction (and for a romance that is automatically dead-ended by their situation), Ms. Griffith and the newcomer Mr. Thal still manage to develop a rapport. Ms. Griffith blusters and wisecracks her way through some of the story's most awkward junctures, and Mr. Thal very nearly becomes a rabbinical scholar with sex appeal. John Pankow provides comic relief as Emily's police department sidekick, and Tracy Pollan registers despair as the sweetheart of the murdered man, while Ro'ee Levi has a couple of amusing moments as Emily's secret admirer. The extremely farfetched solution to the murder mystery is not helped by a shrill, over-the-top performance from the perpetrator.

The Borough Park scenes in "A Stranger Among Us" were shot in Ridgewood, Queens, which has been painstakingly modified to resemble the Hasidim's home territory. It would countermand all the film's lessons about the seclusion and spirituality of Hasidic life if this group had made itself party to the filming.

•

"A Stranger Among Us" is rated PG-13 (Parents strongly cautioned). It includes mild profanity and several sexual references.

1992 Jl 17, C1:3

One False Move

Directed by Carl Franklin; screenplay by Billy Bob Thornton and Tom Epperson; director of photography, James L. Carter; edited by Carole Kravetz; music by Peter Haycock and Derek Holt; produced by Jesse Beaton and Ben Myron; executive producers, Miles A. Copeland 3d, Paul Colichman and Harold Welb; released by IRS Releasing. Film Forum 1, 209 West Houston Street, SoHo. Running time: 105 minutes. This film is rated R.

Dale (Hurricane) Dixon	Bill Paxton
Fantasia (Lila)	Cynda Williams
Ray Malcolm	Billy Bob Thornton
Pluto	Michael Beach

By JANET MASLIN

Carl Franklin's first feature, "One False Move," says as much about where Mr. Franklin is headed as about where he has been. Although he works within the idiom of a conventional crime story, telling of three violent drug dealers running from the law, Mr. Franklin delivers the kind of symmetry, surprise and detail that easily transcend the limits of the genre. It's clear that this new film maker could work well with other types of material and on a much more ambitious plane. Thanks to the thoughtfulness and promise he displays this time, he undoubtedly will.

Too bad it would be unfair to describe the closing image of "One False Move," since this film's resolution lifts it so far above ordinary film noir fatalism. Despair, terrible irony and the sudden chance of redemption combine to end the story on a wrenching, altogether satisfying note.

This conclusion is light-years away from the ugly episode with which the film begins: three deceptively mild-mannered desperadoes terrorize people at a party, then butcher their

Despair joins irony and a chance at redemption.

victims. The viciousness of the attack and the banality of the motive — drugs and money — threaten to consign "One False Move" to the realm of mindless exploitation.

•

But something is different. The criminals are an unusual bunch. Fan-

IRS
Bill Paxton

tasia (Cynda Williams), the soft-voiced beauty who served as a decoy, has a more complex conscience than might be expected. Pluto (Michael Beach), the stony mastermind of the operation, combines the look of a polite accountant with an incongruous taste for savagery. Ray (Billy Bob Thornton, who wrote the screenplay with Tom Epperson) is Fantasia's lover and a mouthpiece with a mad-dog temper, but his ability to intimidate the other two is not all it seems. The racial makeup of the group is equally unexpected: Pluto is black, Ray is white, Fantasia (who had a black mother and a white father) somewhere in between.

These three travel from Los Angeles back to Star City, Ark., where they plan to touch base with relatives. The film seems to expand along the way. Mr. Franklin, carefully balancing and manipulating his cast's racial makeup, sets up a parallel threesome in the form of a white Southern sheriff, Dale (Hurricane) Dixon (Bill Paxton), and a team of detectives from Los Angeles, one black, one white, who quietly ridicule Dale and his folksy ways. Dale does not need this extra pressure. He is already so tightly wound that he defiantly leaves a $10 bill at a coffee shop to pay a $12 check. The film is about what happens when these opposing forces — Ray, Pluto, Dale and the constantly surprising Fantasia, who was once a Star City small-town girl named Lila — finally collide.

Mr. Franklin's measured pacing and James L. Carter's meticulous cinematography give "One False Move" a clear, bold, angular look reminiscent of many other nouveau noir films, especially "Blood Simple," the one that put the Coen brothers on the map. But the acting style here is warmer and less self-conscious than that implies. Ms. Williams carries a large part of the narrative burden and makes the gentle-sounding, deadly Lila a riveting modern counterpart to the familiar good-bad noir heroine. Mr. Paxton captures all Dale's regret about his past and uncertainty about his future. Both Mr. Beach and Mr. Thornton convey great menace with a minimum of effort.

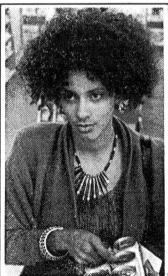

I.R.S. Releasing

On the Road Cynda Williams stars in "One False Move," which tracks three violent outlaws from Los Angeles to Arkansas, where a small-town sheriff awaits them.

Of particular note in "One False Move," which opens today at the Film Forum, are a tense, well-staged encounter between the runaways and a highway patrolman in a convenience store, and the reunion of Lila and her brother in the perfect Hitchcockian setting, a crossroads beside an open field. That scene, like symmetries involving children in "One False Move" and even the conspicuous use of whippoorwill calls as harbingers, points to a director who knows the effects he wants and knows precisely how to achieve them.

•

"One False Move" is rated R (Under 17 requires accompanying parent or adult guardian). It includes violence and profanity.

1992 Jl 17, C6:1

Honey, I Blew Up the Kid

Directed by Randal Kleiser; screenplay by Thom Eberhardt, Peter Elbling and Garry Goodrow; story by Mr. Goodrow; based on characters created by Stuart Gordon, Brian Yuzna and Ed Naha; director of photography, John Hora; edited by Michael A. Stevenson and Harry Hitner; music by Bruce Broughton; production designer, Leslie Dilley; produced by Dawn Steel and Edward S. Feldman; released by Walt Disney Pictures. Running time: 89 minutes. This film is rated PG.

Wayne	Rick Moranis
Diane	Marcia Strassman
Nick	Robert Oliveri
Adam	Daniel and Joshua Shalikar
Amy Szalinski	Amy O'Neill
Clifford Sterling	Lloyd Bridges
Hendrickson	John Shea
Mandy	Keri Russell
Marshall Brooks	Ron Canada
Capt. Ed Myerson	Michael Milhoan
Terence Wheeler	Gregory Sierra
Constance Winters	Leslie Neale
Nosy Neighbors	Julia Sweeney and Linda Carlson
Lab Technicians	Lisa Mende and John Paragon
Smitty	Ken Tobey

By STEPHEN HOLDEN

In the most spectacular sequence of "Honey, I Blew Up the Kid," a gurgling 2½-year-old boy who has soared to 112 feet clomps through the glittering heart of Las Vegas clutching a car he thinks is a toy. Reaching the Hard Rock Cafe, which is topped by a giant neon guitar, he plucks the sign from its moorings and idly strums it while soldiers in an Army helicopter try to shoot him with tranquilizers.

The movie is the inevitable sequel to the 1989 Disney blockbuster "Honey, I Shrunk the Kids." If the new film doesn't exude quite as much fairy-tale magic as the original, it is still a thoroughly entertaining family romp.

This cheery comic nightmare about a suburban child who has suddenly been turned into Godzilla offers all sorts of offhanded advice about how to deal with a child in his "terrible 2's." When coaxing your restless child to fall asleep, the movie advises, mild deception is the best strategy. Don't say, "It's time for your nap." By the age of 2½, your child should be familiar enough with the word "nap" to sense pressure, and will resist. Just trust that your cracked falsetto version of "Twinkle, Twinkle, Little Star," which has lulled him to sleep in the past, can still do the trick. The film also suggests that a 2-year-old child will follow an ice-cream truck anywhere.

"Honey, I Blew Up the Kid" revisits the zany world of Wayne Szalinski

Richard Foreman

Rick Moranis

(Rick Moranis), the eccentric inventor of Rube Goldberg-style contraptions equipped with laser beams that rearrange matter in the most astounding ways. In the original movie, one of Wayne's gizmos, when hit with a stray baseball, accidentally shrinks his son and daughter and two neighborhood children to under a quarter of an inch. With the help of the family dog, Quark, who reappears in the sequel, they make their way back to the house across a lawn that must be navigated like a perilous jungle.

By the time of the sequel, several years have passed. The Szalinskis have moved to a Las Vegas suburb, where Wayne works for a laboratory that has bought his latest still unperfected idea, an electromagnetic ray that can enlarge objects. The Szalins-

On the bright side, he's a sure bet for a basketball scholarship.

kis now have a third child: 2½-year-old Adam (played by twin brothers, Daniel and Joshua Shalikar), who is a handful even at normal size.

One day, Wayne recklessly takes his sons to the laboratory, where he decides to try to enlarge Adam's stuffed bunny. While Wayne isn't looking, the child goes to rescue his toy and is accidentally zapped. Hours later, while watching television, he starts to grow at an alarming rate, shooting up to seven feet tall and creating havoc. It is not long before he is too big for the house.

Although "Honey, I Blew Up the Kid" has a different director (Randal Kleiser) and different screenwriters (Thom Eberhardt, Peter Elbling and Garry Goodrow) from the original movie, it retains much of the first film's easygoing charm. A lot of that appeal is rooted in the characters. Wayne and his eldest son, Nick (Robert Oliveri), who has now reached adolescence, are science nuts with hearts of gold and their heads in the clouds. For this movie, Wayne has taken to wearing a preposterous, gadget-covered helmet, which at the flick of a switch performs all sorts of daily tasks, including shaving. Nick is a sensitive nerd who pines after

Mandy (Keri Russell), a self-assured teen-ager who comes to baby-sit for Adam just after he has suddenly shot up in height and who has to be forcibly restrained until her panic subsides.

Once again, much of the fun derives from distortions of perspective. When Adam is wielding the car like a toy, he doesn't realize that his brother and his baby-sitter are passengers. When he puts it in his pocket, they find themselves strewn among ordinary objects of gigantic proportions, including a crayon and a grotesquely oversize raisin.

If the new film's special effects are much grander than those of the original, the sequel offers nothing quite so wondrous as the first film's scenes of the tiny children taming a red ant with giant cookie crumbs, then harnessing the creature and trying to ride it to safety. "Honey, I Blew Up the Kid" is also burdened with an unnecessary subplot in which Wayne's ruthless boss (John Shea) exploits the situation to try to take over the laboratory.

But the film's most critical casting choice, of the Shalikar twins, is a complete success. With reddish curls and wide blue eyes that glint with an unfocused urge for mischief, the character is a charmer. When the 112-foot-tall child goes into a brief, tearful pout in the center of Las Vegas, it is small wonder that the panic-stricken spectators pause to shed a few empathetic tears with the lost, lovable boy.

●

"Honey, I Blew Up the Kid" is rated PG (Parental Guidance Suggested). Scenes of the giant toddler might frighten young children.

1992 Jl 17, C6:5

The Paris Of Rohmer's 'Springtime'

"A Tale of Springtime" was shown as part of the 1990 New York Film Festival. Following are excerpts from Vincent Canby's review, which appeared in The New York Times on Sept. 25, 1990. The film, in French with English subtitles, opens today at the Lincoln Plaza, Broadway at 63d Street, Manhattan.

The Paris inhabited by Eric Rohmer's characters never prompts thoughts about architecture, color or light. No picturesque bistros, no chestnut trees in blossom, no Seine, no landmarks. It is an endless stretch of those unremarkable neighborhoods one drives through on the way into the city from the airport.

If, as in his new comedy, "A Tale of Springtime" ("Conte de Printemps"), there is a brief glimpse of the dome of Sacre-Coeur, it seems accidental. Much more to his point is the functionally modern facade of the Lycée Jacques Brel. Mr. Rohmer's Paris is utterly banal.

Yet it's also a setting in which unexpected encounters can be as potentially momentous as those in any enchanted forest.

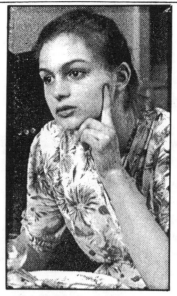

Changing Places Eloise Bennett stars in "A Tale of Springtime," about a daughter who tries to replace her father's mistress with a woman she meets at a party.

"A Tale of Springtime" begins with just such a meeting, between Jeanne (Anne Teyssèdre) and Natacha (Florence Darel).

They are at a party at which each seems superfluous. Or, as the academic Jeanne puts it, she feels as if she were wearing Gyges's ring, which, Plato wrote, renders the wearer invisible.

Jeanne, a tall, beautiful, self-assured young woman, teaches philosophy at the Lycée. She has come to the party only because she doesn't want to be alone in the apartment of her lover, Mathieu, who is out of town.

Natacha, a music student, came to the party with her lover, a journalist, who had to leave suddenly. Although she doesn't look much younger than Jeanne, Natacha dresses and behaves like a willful teen-ager. She gives the impression of being big and rawboned. As it turns out, she is also one of those girls who, in Mr. Rohmer's fiction, are obsessed by the need to organize other people's lives.

Very early in "A Tale of Springtime," even earlier, possibly, than Mr. Rohmer intends, it is clear that Natacha has latched onto Jeanne as a replacement for Eve (Eloïse Bennett), her father's young mistress, whom Natacha loathes.

Natacha schemes to bring her father, Igor (Hugues Quester), and Jeanne together. When Igor, Eve, Jeanne and Natacha have dinner, Natacha counts on Jeanne to upstage Eve, who was also a philosophy major. Natacha is not disappointed when Jeanne points out that there is an important difference between transcendentalism and transcendency.

This sort of delicate, informed combat has been great fun in other Rohmer films, but the balance is so off in "A Tale of Springtime" that the audience is likely to be pulling for the pretty but officious Eve, instead of worrying about Natacha. The problem with the film is Natacha, both as the role is written by Mr. Rohmer and as she is played by Miss Darel. There isn't an ounce of humor in the bossy Natacha. She's such a heavy presence that the movie takes off only when she is not on screen, which isn't often.

"A Tale of Springtime" is the first in what Mr. Rohmer plans to be his "Tales of the Four Seasons," a new series that is not to be confused with his "Six Moral Tales" or his "Comedies and Proverbs."

If that isn't clear, it may be because with a couple of exceptions, almost any Rohmer comedy might fit into any of the writer and director's preset categories. But for whatever reason he differentiates between the series, the films themselves represent a singular contribution to the cinema of high comedy.

Mr. Rohmer's films look like no one else's. They are direct and clean, the movie equivalent to prose that dispenses with adjectives and adverbs. They cut with swiftness from one scene to the next. Character, mood, emotional concerns and social context are defined with an efficiency that recalls movie making of the 1930's and 40's.

Although "A Tale of Springtime" has a serious built-in flaw, it's still a pleasure to watch Mr. Rohmer at work. The way, for example, he introduces Jeanne at the beginning of the film in several sequences without dialogue, when her entire character is reflected by the look of two very different apartments.

Miss Teyssèdre, Mr. Quester and Miss Bennett are a very attractive trio of Rohmer prototypes. Yet it is a further indication that something is not working properly in "A Tale of Springtime" when the actors seem familiar though being seen for the first time.

In fact, it is the characters who are making return appearances, but without the engaging, self-deceiving idiosyncrasies that usually distinguish the director's work.

1992 Jl 17, C10:6

Man Trouble

Directed by Bob Rafelson; written by Carole Eastman; director of photography, Stephen H. Burum; edited by William Steinkamp; music by Georges Delerue; production designer, Mel Bourne; produced by Bruce Gilbert and Carole Eastman; released by 20th-Century Fox. Running time: 100 minutes. This film is rated PG-13.

Harry Bliss	Jack Nicholson
Joan Spruance	Ellen Barkin
Redmond Layls	Harry Dean Stanton
Andy Ellerman	Beverly D'Angelo
Eddy Revere	Michael McKean
Laurence Moncrief	Saul Rubinek
June Huff	Viveka Davis
Helen Dextra	Veronica Cartwright
Lewie Duart	David Clennon
Detective Melvenos	John Kapelos
Adele Bliss	Lauren Tom
Lee MacGreevy	Paul Mazursky
Butch Gable	Gary Graham
Socorro	Betty Carvalho
Talk Show Host	Mark J. Goodman

By JANET MASLIN

Not much about "Man Trouble," a sad mess of a romantic comedy directed by Bob Rafelson, written by Carole Eastman and starring Jack Nicholson, suggests that these three collaborated on one of the most haunting and representative films of another day. The memory of "Five Easy Pieces," plus a few moments in which Mr. Nicholson cuts loose despite the halfheartedness of what surrounds him, are all that mark "Man Trouble" as a film with a distinguished pedigree.

Mr. Nicholson and Ellen Barkin play Harry Bliss, a dog trainer who's down on his luck, and Joan Spruance, an opera singer who (according to the production notes, if not to the film) is

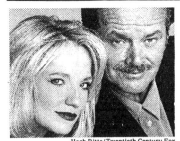

Herb Ritts/Twentieth Century Fox
Ellen Barkin and Jack Nicholson

in some way "trying to find her voice." There is visual evidence to prove that they spent time together while the film was being made, but in effect the two performances seem to come from different continents. Ms. Barkin, looking uncharacteristically pert and affecting a stilted, ladylike speaking voice, seems particularly uneasy. Even Mr. Nicholson's rare gift for managing to behave comfortably under any circumstances is put to the test.

Mr. Rafelson makes surprisingly ineffectual use of Mr. Nicholson at times. During the course of one typically unfunny subplot, which has Harry and an Asian wife he calls Iwo Jima undergoing marriage counseling, Harry is told by the therapist: "Just take her by the hand, Harry. Look at her. Just communicate." At the very least, this would seem to be the opening for some priceless mugging by Mr. Nicholson, but there is barely a close-up; the scene just fizzles.

Mr. Nicholson, sporting a mustache and a wardrobe to make that mustache curl, has better luck with dialogue that is tailor-made for his sly delivery. But lines like "She's got hands like a hula dancer" and "Here we have the dog's arsenal, so to speak" (when showing off a guard dog's teeth) can't offset the film's embarrassingly weak sense of humor. Repeated jokes about an oversexed dog making overtures to Ms. Barkin and a Hispanic housekeeper are about as funny as "Man Trouble" ever gets.

•

The frantic, empty plot has Joan terrified by a crime-filled Los Angeles and taking refuge in her sister's house, where Harry is eventually hired to help protect her. These two, both gun-shy about romance, gradually overcome their reservations. ("It's so hard to pioneer in this area," says Joan, as she and Harry venture into a sexual encounter.) Meanwhile, many minor characters figure in mysterious attempts to harm Joan and her sister (Beverly d'Angelo), who has written a tell-all book about a billionaire businessman. It's indicative that Harry Dean Stanton has been cast likably but implausibly as the billionaire, who has heart trouble, and that the film makes jokes about heart transplant donors.

Also in "Man Trouble," and mostly bogged down by the film's joyless approach to comedy, are Michael McKean, David Clennon and Veronica Cartwright as two of Joan's fellow musicians; Saul Rubinek as an amusingly slick lawyer, and Paul Mazursky as a dog dealer who has business difficulties with Harry. A film that can't find much deadpan wit in a scene pairing Mr. Mazursky and Mr. Nicholson is indeed a study in missed opportunities.

"Man Trouble" is rated PG-13. It includes mild profanity and discreet sexual situations.

1992 Jl 18, 18:4

Afraid of the Dark

Directed by Mark Peploe; screenplay by Mr. Peploe and Frederick Seidel; director of photography, Bruno de Keyzer; edited by Scott Thomas; music by Jason Osborn; production designer, Caroline Amies; produced by Simon Bosanquet; released by Fine Line Features. Running time: 92 minutes. This film is rated R.

Frank	James Fox
Miriam	Fanny Ardant
Tony Dalton	Paul McGann
Rose	Clare Holman
Dan Burns	Robert Stephens
Lucy Trent	Susan Woolridge
Lucas	Ben Keyworth

By JANET MASLIN

Mark Peploe's chilling, meticulous "Afraid of the Dark" begins by introducing a quiet London neighborhood that is filled with menace. This dangerous world is seen through the eyes of Lucas (Ben Keyworth), an impassive and very peculiar young boy. His mother (Fanny Ardant) and her friends are blind women, all of them menaced by a vicious slasher. His father (James Fox) is the policeman in charge of apprehending this fiend. "Don't rob a bank or I'll have to put you behind bars," the father says jovially to his son.

The neighbors are a sinister lot, many of them men overtly threatening to the blind women. Those women fascinate Lucas because they are in such obvious peril, and because he is powerless to help them. Well into the film, Lucas watches in horror as the beautiful Rose (Clare Holman) is sexually exploited and then slashed by a man who pretends to be a baby photographer. The backdrop of this man's studio has a heavenly motif, with cherubs that contrast violently with the truth about him.

•

It is at this point that Mr. Peploe, who directed and co-wrote (with Frederick Seidel) "Afraid of the Dark," does something shocking: he reveals that the first half of his film has been a deception. Nothing and no one is what it has appeared to be, not even the neighborhood's favorite dog. Certainly Lucas, whose imagination has shaped the whole first section of the film, is not what he has seemed. When the real identities and circumstances of the film's various characters are abruptly revealed, they be-

Simon Mein
Ben Keyworth

come an oblique tribute to the depths of Lucas's anxieties, and a not-so-indirect tribute to Dr. Freud.

"Afraid of the Dark" is in fact a precise, playfully macabre exploration of this young boy's unexpressed terrors and resentments. It revolves around eyesight, which becomes important not only as the focus of Lucas's fears, but also as a metaphor for empowerment, which is the truly central issue in this Oedipal drama. The specifics of Lucas's distortions are clever, and for the audience's sake they are best not revealed here. But they present an intricate, textbook-ready psychological profile of a pre-adolescent boy grappling with sexuality and jealousy, terrified that his yearnings will bring him physical harm.

"The bad man is different in every story, isn't he?" says the man (Paul McGann) who appeared to be the razor-wielding photographer in Lucas's fantasy, and who is later revealed to play an entirely different role in the boy's life. He is talking about Lucas's Spiderman toy, one of many minor artifacts — like eyeglasses, knitting needles, cemetery markers — that are paid keen attention by Mr. Peploe's direction and Bruno de Keyzer's cinematography. "Not really," Lucas answers. "He just looks different." The film experiments with its own brand of mutability in characters' names, occupations and relations to one another, all the while trying to identity the same underlying truths about Lucas's life.

Exquisitely myopic, "Afraid of the Dark" is in some ways as self-absorbed and narrow as Lucas's nightmares. The sleepwalking quality of some of the acting is distractingly cool, with the sloe-eyed young Mr. Keyworth looking deliberately expressionless during much of the film and Miss Ardant sounding even more strangely remote than her role warrants. Rather than bring his audience into intimate proximity with the characters, Mr. Peploe sometimes seems to be viewing his principals through a microscope, with clinical detachment rather than concern. Since the characters are essentially unreal, that may well be his point. But it limits the film to the realm of ingenious gamesmanship rather than expanding it to the broader range of art and experience.

•

"Afraid of the Dark" is rated R (Under 17 requires accompanying parent or adult guardian). It includes violence and nudity.

1992 Jl 24, C7:1

Mo' Money

Directed by Peter Macdonald; written by Damon Wayans; director of photography, Don Burgess; edited by Hubert C. de La Bouillerie; music by Jay Gruska, Jimmy Jam and Terry Lewis; production designer, William Arnold; produced by Michael Rachmil; released by Columbia Pictures. Running time: 97 minutes. This film is rated R.

Johnny Stewart	Damon Wayans
Amber Evans	Stacey Dash
Lieut. Raymond Walsh	Joe Santos
Keith Heading	John Diehl
Tom Dilton	Harry J. Lennix
Seymour Stewart	Marlon Wayans
Chris Fields	Mark Beltzman
Eddie	Quincy Wong
Lloyd	Kevin Casey
Businessman	Larry Brandenburg
Rock	Garfield
Charlotte	Almayvonne
Ted Forrest	Dick Butler
Kid	Matt Doherty

By JANET MASLIN

Sometimes it looks in "Mo' Money" as if Damon Wayans may be picking up where Eddie Murphy left off. Just as Mr. Murphy has, he plays a smart, wily interloper in a high-powered world. The big credit card company where Mr. Wayans's Johnny Stewart accidentally lands a job is loaded with comical, stereotypical sketches of various climbers. And Mr. Wayans, who wrote the screenplay, eagerly exploits them all.

From the bland white personnel officer with nervous tics (which Johnny can't help imitating) to the upwardly mobile black executive who notes that "ain't" is ungrammatical, the film supplies countless caricatures for its star to react against. And unlike Mr. Murphy (who put himself in the winner's seat with his own corporate comedy, "Boomerang") Mr. Wayans appears ready to take chances. His own character, a scruffy street hustler, can be both good-hearted and dishonest, particularly when faced with the prospect of impressing a pretty co-worker (Stacey Dash) with the help of credit card fraud. But some of the humor in "Mo' Money" has a mean-spirited edge. And only in isolated moments is it as funny as its own title.

The film would have been helped by more directorial spark than is supplied by Peter Macdonald, who is effectively stumped by the screenplay's split personality. Some of the material is played as comedy, with Mr. Wayans doing whatever quick impression (a junkie, a lunatic, a gay man having a spat with his lover) suits the occasion. But a lot of the film hinges on some intrigue involving a corporate swindle, and neither the scheme nor the villains are compelling. Mr. Wayans himself has a gentle delivery that gets lost in action sequences, and is much better served by irreverent humor.

Also in the film are Marlon Wayans, who looks a lot like his brother and makes a lively sidekick. "Johnny, a job ain't nothin' but work," he counsels rather memorably. And Almayvonne does more than might be expected with the unflattering role of Charlotte, a predatory co-worker who sets her sights on Johnny.

Columbia Pictures Industries
"Mo' Money," starring Damon Wayans, offers a smart, wily interloper in a high-powered world.

Trivia note: The kiss-off line of choice for gun-toting killers is currently "Are we having fun?" So the last version of that same thought — "This time it's personal" — is obsolete.

•

"Mo' Money" is rated R (Under 17 requires accompanying parent or adult guardian). It includes violence, profanity and sexual references.

1992 Jl 25, 15:1

Affengeil

Written, directed and produced by Rosa von Praunheim (in German and English with English subtitles); edited by Mike Shepard; music by Maran Gosov and Thomas Marquard; released by First Run Features. Cinema Village 12th Street, between University Place and Fifth Avenue, Greenwich Village. Running time: 87 minutes. This film is not rated.

WITH: Lotti Huber, Rosa von Praunheim, Helga Sloop, Gertrud Mischwitzky, Thomas Woischnig, Hans Peter Schwade and Frank Schafer.

By STEPHEN HOLDEN

Lotti Huber, the subject of Rosa von Praunheim's eccentric documentary film "Affengeil," exudes a remarkable vitality for a woman in her late 70's. A German equivalent of one of Andy Warhol's superstars, she was discovered more than a decade ago by Mr. von Praunheim, a well-regarded experimental film maker who cast her in his movie "Our Corpses Are Still Alive." More recently, she portrayed Anita Berber, a nude dancer who scandalized Weimar Germany, in his film "Anita, Dances of Vice."

A flamboyant figure in large hoop earrings, dramatic makeup and hair worn in huge unkempt shocks, Miss Huber bears a striking resemblance to the transvestite actor Divine. Although she expresses a sunny, live-and-let-live attitude, she is also clearly someone who is used to being in control, and "Affengeil" includes scenes of a fight between the film maker and his subject, in which he accuses her of trying to take over his movie. She, in turn, argues that since it is her life that is being shown, she is entitled to that control.

•

The quarrel seems almost a staged effort by Mr. von Praunheim to deconstruct the very biography he is filming. Another strategy is to compete with Miss Huber for attention. In

several scenes, he is shown pelting his subject with nosy sexual questions while the two of them lie side by side in bed with the film maker posing like a pouty gigolo. In another scene, their roles are reversed, and Miss Huber interviews Mr. von Praunheim's mother about her son's homosexuality.

Between this bickering and role-playing, Miss Huber's life story unfolds jerkily in interviews that use subtitles only part of the time. As Miss Huber tells it, she was born in Kiel in northwestern Germany and fell in love at the age of 16 with the son of the Lord Mayor of her hometown. Because she was Jewish, he was arrested and shot by the Nazis, and she was thrown into a concentration camp, from which she escaped. At 27, according to her account, she moved to Palestine, where she developed a successful career as an exotic dancer.

She later opened and operated a hotel and restaurant in Cyprus, some-

A director lets his subject battle him for control of a documentary.

thing she says was unheard of for a woman to do in that time and place. When she eventually returned to Berlin, she established a charm school, and she later spent several years demonstrating products in a department store. In one scene, she is shown teaching belly-dancing to middle-aged women.

Miss Huber is a proud survivor of the Holocaust, and the film, which opened yesterday at the Cinema Village 12th Street in Greenwich Village, touches darkly on the resurgence of Nazism in Germany. It also shows her being saluted from her window by marchers in a gay pride parade.

With its scratchy sound track and bleached-out color, the film is not always easy to follow. It also doesn't clearly indicate Miss Huber's exact place in contemporary German show business. For all its quirks of technique and sensibility, however, the portrait is a deeply affectionate one.

1992 Jl 25, 15:4

FILM VIEW/Janet Maslin
Summer Movies Sniff the Political Winds

LONG BEFORE THE MOVIE WORLD takes an overtly political turn in September with the arrival of "Bob Roberts," Tim Robbins's hilarious mock documentary about a Pennsylvania Senatorial campaign, politics will have already made its presence felt on the screen. Even some of this summer's most mindless commercial releases have managed, deliberately or otherwise, to indicate a strong political undercurrent. Sure, every summer brings us some version of the thrillers and police adventures and fish-out-of-water comedies we've been seeing this year.

But it's not every season that so thoroughly enforces the relatively conservative ideas of mainstream Americana, family values and law and order, L.A.P.D.-style, that are now on the screen.

"Unlawful Entry," the thriller about a Los Angeles policeman who oversteps the law in his pursuit of a great-looking woman he meets on the job, shows him making an unannounced middle-of-the-night raid on the woman's bedroom as she and her husband make love. This vision, representing the ultimate in police-state paranoia, would seem to indicate the film's liberal bias, but by the end, the story has turned around to advocate vigilante justice.

Such leanings are embodied more cheerfully by America's favorite live-action comedy team, Murtagh (Danny Glover) and Riggs (Mel Gibson). These two Los Angeles cops blast their way through "Lethal Weapon 3," a movie in which some citizen invariably seems to be asking for free advice about law and order, vigilante-style. They playfully threaten a passer-by who has been merely jaywalking and make fun of victims who aren't in a position to talk back. (Riggs jokingly offers to read one suspect his rights after that suspect has already been knocked unconscious.) Whatever their antics, Murtagh and Riggs operate in a trouble-filled universe where trigger-happy police behavior is made to look like common sense. Were it not for the easy charm and great rapport of these two actors, all the "Lethal Weapon" movies, and especially this one, would raise a lot more hackles than they have.

"Patriot Games," based on Tom Clancy's novel, could have been expected to sound a note of political paranoia in view of the background of Jack Ryan, the story's C.I.A. man who becomes a target for Irish terrorists after he happens to save the life of a member of the British royal family. This film's admiring view of the C.I.A.'s surveillance methods, military tactics and defensive posture are in keeping with both Mr. Clancy's writing and with the conventions of any political thriller.

■

This cool, stylish thriller has almost reached the pitch of a "Straw Dogs" by the time Jack finds himself fighting savagely to keep invaders away from his home and hearth. And Jack's once-peaceable wife, the very model of smiling decorousness in the film's early scenes, is snarling "I don't care what you have to do to get him — just get him" before the film is over.

Of course, a law-and-order response to

It's not every season that so thoroughly enforces so many conservative ideas. This one is heavy on law and order and conformity.

danger is fundamental to countless thrillers. And that response has often been exploited viciously, as in the Charles Bronson "Death Wish" series of the 70's and 80's and its many imitators. But those films trumpeted their political attitudes aggressively, while a "Patriot Games" or "Unlawful Entry" merely makes more tacit assumptions about what sort of behavior viewers might admire. Indeed, "Unlawful Entry" leaps from quiet in-

Warner Brothers · Suzanne Hanover/Touchstone Pictures

any Americans seem to endorse the vigilante values of "Lethal Weapon 3," ith Mel Gibson, left, and the wholesomeness of "Sister Act," with Richard ortnow, Whoopi Goldberg and Robert Miranda.

dignation over a policeman's lawlessness to a bloody ending in which the film's protagonist, a placid yuppie type played by Kurt Russell, is finally persuaded to pick up a gun and kill someone. Mysteriously, the film moves beyond condemnation of the renegade officer and applauds the homeowner's comparably bloodthirsty behavior.

This season's thrillers and action films look varied in comparison to the comedies, which almost always trade on the same premise. It's that fish-out-of-water concept, so beloved by formula-minded screenwriters: a (singer, caveman, stupid kid, eccentric barmaid, incompetent lawyer from Brooklyn) tries to become a (nun, high school student, smart kid, suburban housewife, successful lawyer in a Southern courtroom) and learns the obligatory lessons about (friendship, understanding, our differences being smaller than they seem) along the way. Box-office figures for most of the films that employ this gambit ("Sister Act," "Encino Man," "Class Act," "Housesitter" and, last spring, "My Cousin Vinny," to name a few) will attest to the fact that it's an approach audiences never tire of.

But what the current crop of fish-out-of-water comedies really emphasize, in the end, is fitting in. Characters who start out as miscreants or outsiders step into settings as squeaky-clean as a convent ("Sister Act") or suburbia ("Housesitter") and wind up liking what they see.

Though "Sister Act" doesn't dare suggest that Whoopi Goldberg's character will remain a nun when the story is over, it does come close. It's a lot easier to believe that she will retain the wholesome values she picked up during the course of the film than to believe that she'll return to being a lounge singer and mobster's mistress, as she was in the first place.

Even in "Class Act," where a delinquent and an A-student are forced to change places, both boys have been thoroughly tamed and socialized by the time the movie is over.

In the dispiriting and synthetic-feeling "Housesitter," the oddball bohemian and liar whom Goldie Hawn portrays at the film's outset is thoroughly overhauled. She is cleaned up and made to fit into a middle-American mold. She chooses, for reasons that never really make sense, to step into an unoccupied suburban house and instantly appropriate the décor, husband, in-laws and friends that make her appear to be a pillar of the community. And this complacent comedy goes well beyond appreciating the trappings and the corresponding "family values" that turn Ms. Hawn's character into a solid citizen. It also suggests, perhaps unwittingly,

that life in America's mainstream can be completely artificial, and can be successfully bought, copied and otherwise simulated in less than a week.

■

When movies embrace conventionality as warmly as these comedies do, or present violent images that steer viewers toward a law-and-order response to crime, they may be reflecting authentic shifts in American attitudes. As such they have as legitimate a role in the political process as any other form of reportage. This summer, for whatever reason, audiences are more freely admiring heroes who seek their own forms of justice in a violent society. And they are appreciating outsiders who ultimately decide that they're tired of being fish out of water and would prefer the middle of the road. Large numbers of Americans are now endorsing those attitudes at the box office. In November, will they do the same thing at the polls? ☐

1992 Jl 26, II:9:1

Mom and Dad Save the World

Directed by Greg Beeman; written by Chris Matheson and Ed Solomon; director of photography, Jacques Haitkin; music by Jerry Goldsmith; production designer, Craig Stearns; produced by Michael Phillips; released by Warner Brothers. Running time: 87 minutes. This film is rated PG.

Marge Nelson	Teri Garr
Dick Nelson	Jeffrey Jones
Tod Spengo	Jon Lovitz
Raff	Eric Idle
Sibor	Wallace Shawn
Sirk	Dwier Brown
Semage	Kathy Ireland
General Afir	Thalmus Rasulala

By STEPHEN HOLDEN

"Nice little planet you have here," says Marge Nelson (Teri Garr) to Tod Spengo (Jon Lovitz), the intergalactic despot who has whisked her to his tiny kingdom somewhere in outer space to become his wife.

"It's not the size of your planet, it's how you use it," the vain, nasty emperor snaps back defensively.

Such smart-aleck exchanges are mostly what pass for humor in "Mom and Dad Save the World," which opened at local theaters on Friday. The film, which was directed by Greg Beeman with a screenplay by Chris Matheson and Ed Solomon (the duo responsible for "Bill and Ted's Excellent Adventure"), is one of those comedies that might sound like a zany hoot when pitched to a movie studio but that in execution emerges virtually laugh-free.

Admittedly, the pitch sounds promising. Suppose that a mad Caligula from a distant planet falls inexplicably in love with a California housewife while spying on earth and transports her and her husband to his kingdom in the family station wagon. Suppose that the planet has a large population of squeaking anthropomorphic creatures that look like rejects from the "Star Wars" drawing boards. Suppose that the sets resemble a deliberately tacky parody of low-budget biblical and science-fiction movies of the 1950's. And suppose that the rebel forces have the pretty faces and bodies of California beach folk but are so stupid that they keep blowing themselves up with their own weapons, hand grenades on which are written the words "pick me up."

What might sound amusing in theory has been directed by Mr. Beeman in a clunking mechanical style that is utterly lacking in playfulness or warmth. Ms. Garr and Jeffrey Jones, who play the Nelsons, are engaging comic actors, but the film views their characters and their suburban way of life with a snooty condescension that leaves Ms. Garr seeming half-frozen and Mr. Jones looking perpetually frazzled.

Mr. Lovitz, from "Saturday Night Live," in his first starring film role, is even more seriously undermined by the screenplay's mean-spiritedness. The character is a whining, one-dimensional brat who struts about in ludicrous Napoleonic plumage and pantaloons and spends much of his time trying on grotesque hairpieces. The actors Eric Idle and Wallace Shawn are also ill used, with Mr. Shawn's homely face the butt of a gratuitously nasty visual joke.

A comedy that banks much of its humor on pointing its finger derisively and crying "Stupid" had better have a few smart jokes to justify its attitude. All told "Mom and Dad Save the World" has maybe one and a half.

●

"Mom and Dad Save the World" is rated PG (Parental guidance suggested). It has some mildly off-color jokes.

1992 Jl 27, C18:4

Gas Food Lodging

Written and directed by Allison Anders, based on the novel "Don't Look and It Won't Hurt," by Richard Peck; director of photography, Dean Lent; edited by Tracy S. Granger; produced by Daniel Hassid, Seth M. Willenson and William Ewart; released by IRS Releasing Corporation. At Film Forum, 209 West Houston Street, SoHo. Running time: 102 minutes. This film is rated R.

Nora	Brooke Adams
Trudi	Ione Skye
Shade	Fairuza Balk
John Evans	James Brolin
Dank	Robert Knepper
Hamlet	David Lansbury
Darius	Donovan Leitch
Javier	Jacob Vargas

By JANET MASLIN

THE Film Forum has brought more excitement to moviegoing in the past two weeks than Hollywood has delivered all summer. The theater's second fine sleeper in a row, after Carl Franklin's "One False Move," is Allison Anders's debut feature "Gas Food Lodging," a look at three vibrant, restless women in a dusty Western town.

Imagine "The Last Picture Show" shot in color and shaped by a rueful feminine perspective, in a place where women are hopelessly anchored while the men drift through like tumbleweed. The becalmed town of Laramie, N.M., is the setting in which Nora (Brooke Adams), a hard-working waitress with a knowing, generous grin, has tried to bring up her two unruly daughters.

The older one, Trudi (Ione Skye), has turned defiantly trampy by the time the film begins, trying hard to hurt her mother while inflicting even greater pain upon herself. The younger and more hopeful girl, Shade (Fairuza Balk), loses herself in campy Mexican movie romances that tell her something about noble, long-suffering women in a cruel world.

The father in this family is long gone, and the mother and daughters spend too much time in indirect efforts to replace him. Trudi, an angry bombshell played with enormous delicacy and openness by Ms. Skye, falls miserably at drowning her sorrows with the town's loutish teen-age boys. Nora has had her own share of dead-end encounters, enough to prompt one of her daughters to shout "I think you just hate men," though that is clearly not the whole story.

Shade, thinking that finding a mate for her mother may offer some sort of family panacea, actually arranges a blind date (in an extremely funny dinner scene staged in the family's cramped mobile home) between Nora and a man with whom she has already had a long, deflating affair. Each of the three principals has learned the hard way that Laramie is a small town. Although the self-sufficiency of its heroines is always apparent, "Gas Food Lodging" pivots upon the arrival of various male strangers on this desolate scene. Although Ms. Anders (whose screenplay is based on a novel by Richard Peck) has to rely twice on introducing characters when one finds another crying, the meetings are felicitous and the tears very easy to understand. But "Gas Food Lodging" takes a wry, upbeat view of its principals, despite the enormous obstacles that face them and despite the absurdity of their plight. The fact that Shade is sweet on a boy who wishes she were more like Olivia Newton-John, or that Nora can stagger out of her trailer at dawn and bump into a possible Mr. Right, only heightens these women's justly whimsical view of the world.

Ms. Anders keeps her film expertly balanced between quiet despair and a sense of the miraculous, as manifested by the big, open skies and glorious sunrises and sunsets (with cinematography by Dean Lent) that punctuate the story.

When Trudi experiences a transforming romance with a sincere English geologist (Robert Knepper) who is passing through town, the consummation of the affair is staged unforgettably in a cave shimmering with eerie blue light.

Shade's burgeoning friendship with a shy Mexican boy (Jacob Vargas) takes an unexpected turn when his mother, who is deaf, motions for the couple to join her in an impromptu modern dance. At that particular moment the film overworks its sense of wonder, but most of the time Ms. Anders's instincts are uncannily right. "Gas Food Lodging" is a big film in a small setting, a keenly observed character study of women who don't know their own strength. The film shows how they find that strength and heal old wounds, discovering great reserves of grace and hope in the process.

There is nothing traditionally uplifting here, nor any cause for getting out one's handkerchief (at least until the story's closing moments); Ms. Anders directs in a spare, laconic style that keeps the material from degenerating into soap opera. But there are subtly etched characters, effortlessly fine performances, and a moving story that is not easily forgotten.

Also in "Gas Food Lodging," playing a small but crucial role, is James Brolin, who perfectly embodies the kinds of hopes and disappointments this story is all about.

Donovan Leitch, Ms. Skye's brother, appears as one of the landmarks in Shade's life, a window dresser with a taste for peculiar pop artifacts. A pair of psychedelic platform shoes that turn up prominently in a couple of scenes could easily have belonged to Mr. Leitch's namesake and father.

●

"Gas Food Lodging" is rated R (Under 17 requires accompanying parent or adult guardian). It includes nudity, mild profanity and sexual situations.

1992 Jl 31, C1:1

Father

Directed by John Power; written by Tony Cavanaugh and Graham Hartley; director of photography, Dan Burstall; edited by Kerry Regan; music by Peter Best; production designer, Phil Peters; produced by Damien Parer, Paul Douglas Barron, Mr. Cavanaugh and Mr. Hartley. At the Quad Cinema, 13th Street between Fifth Avenue and Avenue of the Americas, Greenwich Village. Running time: 90 minutes. This film is not rated.

Joe Mueller	Max von Sydow
Anne Winton	Carol Drinkwater
Iya Zetnick	Julia Blake
Bobby Winton	Steven Jacobs
Rebecca Winton	Simone Robertson
Amy Winton	Kahli Sneddon
Paul Jamieson	Nicholas Bell
George Coleman	Tim Robertson

By CARYN JAMES

A gentle, respectable old man is accused of having been a Nazi war criminal. At first his grown daughter fiercely believes he is a victim of mistaken identity, but eventually she wonders whether her beloved father is hiding unfathomable depths of evil. Does this story sound familiar? It is the exact plot shared by "Music Box," Costa-Gavras's 1989 film, and "Father," an Australian film made at about the same time. "Father" opens today at the Quad.

With Max von Sydow as the father and Carol Drinkwater as the daughter, the Australian film is more earnest and less slick than "Music Box," which featured Jessica Lange, Armin Mueller-Stahl and a richer visual style. But it is just as shallow, blending questions about guilt and evil with pedestrian family melodrama.

Here the daughter receives an anonymous phone call telling her that if she watches a particular tabloid-television show she will learn the truth about her father, Joe Mueller. On television, Joe's aged face appears superimposed over that of a young man in a Nazi uniform. A woman says she was 12 when she watched him murder her family, then smile and shoot her, too. She has spent nearly 50 years trying to bring this man to justice, and she is now certain she has found him.

●

As that sneak attack suggests, "Father" favors dramatic twists over subdued, realistic scenes. The daughter is especially burdened with trite lines. "Nothing I do is ever quite good enough for you, is it?" she yells after trying to help her father escape from the police.

Mr. von Sydow's presence can justify almost any film, but there is only one way to play this role: just as Mr. Mueller-Stahl did in "Music Box," with an ambiguous look of distress

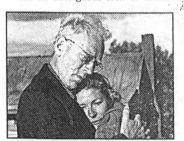

Max von Sydow and Carol Drinkwater in a scene from "Father."

that could signal guilt or unjust accusation.

The most intriguing figure is scarcely explored. Joe's accuser is a pathetic-looking woman who might, or might not, have lost her emotional stability during her lifelong quest for vengeance.

The film reaches toward some powerful questions: Is everyone capable of barbarism during a war? How can someone prove he is innocent if a television report labels him guilty? But it settles for a neat, forced ending. "Father" is not a lurid film; it is just inadequate to the deep and painful story it tries to tell.

1992 Jl 31, C5:5

Death Becomes Her

Directed by Robert Zemeckis; written by Martin Donovan and David Koepp; director of photography, Dean Cundey; edited by Arthur Schmidt; music by Alan Silvestri; production designer, Rick Carter; produced by Steve Starkey and Mr. Zemeckis; released by Universal Pictures. Running time: 105 minutes. This film is rated PG-13.

Madeline Ashton	Meryl Streep
Dr. Ernest Menville	Bruce Willis
Helen Sharp	Goldie Hawn
Lisle	Isabella Rossellini
Chagall	Ian Ogilvy
Dakota	Adam Storke
Rose	Nancy Fish
Doctor	Sydney Pollack

By JANET MASLIN

Nowhere do movie characters defy the laws of the physical universe as gleefully as they do in Robert Zemeckis's films. From Marty McFly's time travel in the "Back to the Future" trilogy to Jessica Rabbit's close encounters with real flesh and blood in "Who Framed Roger Rabbit," Mr. Zemeckis's creations escape the ordinary every chance they get. Even so, this director's latest film manages to find a new frontier as it takes two glamour girls one step beyond the world of collagen shots and chemical peels. With inexorable logic, "Death Becomes Her" pushes Beverly Hills's beautiful people over the edge, and into the land of the living dead.

Well, why not? The premise for "Death Becomes Her" is at least as funny as a corpse, and often a lot more so. It suggests that Madeline Ashton (Meryl Streep), an over-the-hill star first seen in a ghastly Broadway production number ("Can you believe that, a musical version of 'Sweet Bird of Youth'?"), could be no worse off than she already is. Not even without a pulse.

Meryl Streep and Goldie Hawn match wits amid the special effects.

And it suggests that death can be achieved in small, expensive doses. Shot through with an eternal-youth serum that will keep her uncannily attractive (if a bit brittle), Madeline is conveniently impervious to real injury by the time her milquetoast husband, Dr. Ernest Menville (Bruce

Meryl Streep

Deana Newcomb

Willis), screws up the nerve to throw her down a flight of stairs. All it takes is a coat of spray paint and an upbeat attitude to give Madeline what might, under less confusing circumstances, be called a new lease on life.

•

When a film barges headlong onto such thin ice, it had better have the brazenness to go all the way. "Death Becomes Her" dares to invent a world of spectacular self-interest and populate that world with two fabulous harridans (Ms. Streep and Goldie Hawn) giving wonderfully spirited performances. But in spite of that, it remains surprisingly tame. A lot of the problem arises from simple — and inexplicable — lapses in the screenplay. If you're going to stage a party filled with dead celebrities (Marilyn, Andy, Elvis, etc.), better think of something for them to say.

As written by Martin Donovan and David Koepp, "Death Becomes Her" is wildly uneven, sometimes as wicked as a fashion-minded fairy tale and at other times unaccountably coarse and flat. Although the familiar jauntiness and energy of Mr. Zemeckis's direction are always there, the viewer has too many occasions to wonder why those fine qualities aren't somewhere else.

Too often, material that could have been acidly funny is merely allowed to make the audience queasy, especially when it comes to the ghoulish special effects used to prove that Madeline Ashton and her arch-rival, Helen Sharp (Ms. Hawn), are really dead. Yes, it is now technically possible, through the magic of morphing, to show Ms. Streep with her head twisted on backward, her neck arched at an impossible angle. And it's possible to depict Ms. Hawn, after she has been shot through the abdomen, with a cheery expression and a hole right through her middle. It may be possible, but it isn't funny, and it isn't even essential to the film's point. The wildest extremes of "Death Becomes Her" seem to have come about for the sake of special effects, not for the sake of the story.

•

The film works best when it simply lets its two heroines match wits, since both actresses seem to be reveling in the down-and-dirty aspects of these witchy roles. Obviously, Ms. Streep has never been afraid of taking chances. But this time, in a role that more or less starts out where her comic turn in "She-Devil" left off, she outdoes even herself, daring to look ridiculous or pitiable in some scenes and rising to wonderfully silly heights of Hollywood chic in others. The costumes, by Joanna Johnston, are every bit as drop-dead as the material requires.

Ms. Hawn, charmingly spiteful as the romantic rival who has vowed revenge against Madeline for stealing her fiancé, has a similarly high time. The effects used to make Ms. Hawn's Helen, pre-youth serum, look as if she has gained a hundred pounds on an all ice-cream diet are truly amazing. So is the transformation that renders her svelte, gorgeous and ready to steal back Dr. Menville, although Mr. Willis's mild performance makes him the least lively part of the equation. But even after the love of Dr. Menville fades on all sides ("Could you just not breathe?" Madeline hisses at him), his capacity as mortician to the stars makes him essential to the upkeep of the two gorgeous dead women in his life. "What if it fades?" they ask. "What if it chips? What if it rains? Will he come back for touch-ups?"

Also in "Death Becomes Her," and providing an unexpected bright spot, is an uncredited Sydney Pollack as a doctor at L'Hospital Beverly Hills who is greatly nonplussed when he discovers Madeline Ashton's unusual symptoms. Isabella Rossellini appears at a more Gothic moment, playing the sorceress who supplies the potion and holding court over a household of well-trained Dobermans and handsome slaves. Ms. Rossellini's scenes are staged as if the film makers had suddenly decided to play their story straight, without any hint of a satirical spark. For a comedy as chancy as this one, that kind of mistake is fatal.

•

"Death Becomes Her" is rated PG-13 (Parents strongly cautioned). It includes partial nudity, mild violence, and special effects that will startle small children.

1992 Jl 31, C8:1

Buffy the Vampire Slayer

Directed by Fran Rubel Kuzui; written by Joss Whedon; director of photography, James Hayman; edited by Camilla Toniolo and Jill Savitt; music by Carter Burwell; production designer, Lawrence Miller; produced by Kaz Kuzui and Howard Rosenman; released by 20th Century Fox. Running time: 98 minutes. This film is rated PG-13.

Buffy	Kristy Swanson
Merrick	Donald Sutherland
Amilyn	Paul Reubens
Lothos	Rutger Hauer
Pike	Luke Perry
Jennifer	Michelle Abrams
Kimberly	Hilary Swank
Nicole	Paris Vaughan
Buffy's Mom	Candy Clark
Coach	Mark DeCarlo

By JANET MASLIN

Those who look for political import in prom-queen movies may be interested to note that Buffy (Kristy Swanson), the cheerleading, bubble-headed heroine of the blithe teen-age comedy "Buffy the Vampire Slayer," kicks and backflips her way to martial-arts mastery before the story is over. As for other things worth noticing, you may be too old to appreciate one of this film's main selling points if you're distracted by its efforts to enhance Luke Perry's hair.

Luckily, there are better reasons for watching "Buffy the Vampire Slayer," a slight, good-humored film that's a lot more painless than might have been expected. Ms. Swanson's funny, deadpan delivery holds the

Kristy Swanson

Ron Phillp.

story together reasonably well, as does the state-of-the-art Val-speak that constitutes most of Buffy's dialogue. (The screenplay, uneven but bright, is by Joss Whedon.) "Excuse me for not knowing about El Salvador — like I'm ever going to Spain *anyway*," sniffs Buffy at the mall. "I can't believe I'm in a graveyard hunting for vampires with a strange man," she whines later, *"on a school night."*

Buffy, we learn, had a special gift for killing vampires when she lived an earlier life in Europe, during the Dark Ages. (A title gives the film's main setting as "Southern California: the Lite Ages.") Nowadays, her ambitions are more modest. "All I want to do is graduate high school, go to Europe, marry Christian Slater and die," she says at one point. About career goals, she says: "I'm going to be a buyer. . . . I don't know, it's just a job I heard of, sounded pretty cool."

•

The very thin plot describes what happens after Donald Sutherland, as a kind of cosmic coach, makes Buffy understand her mission and trains her to do battle with a latter-day vampire squad. These spooks are led by Rutger Hauer, who indeed looks ghoulish, and Paul (Pee-wee Herman) Reubens, who seems to be greatly enjoying the malevolent possibilities of his role. "Kill him a lot," he hisses, about a potential victim. "I'm fine," says Buffy, after he greets her nastily, "but you're obviously having a bad hair day."

The film, directed breezily by Fran Rubel Kuzui, slows down to make room for some mugging from Mr. Perry, who plays potential vampire bait and is better at being studiously cute than really acting. It also loses speed during Buffy's transformation into a pompon-waving woman warrior. Her conversion may be commendable, but it's a shame to see her drop the princessy mannerisms that make her early scenes so amusing, especially as they are seconded by a giddy Greek chorus of Valley Girlfriends (Michele Abrams, Hilary Swank and the funny, voluptuous Paris Vaughan). "The earth's in terrible shape, we could all die!" one of them wails when discussing whether an ecological theme might be right for the senior dance. "Besides, Sting's doing it." When Buffy chimes in about the ozone layer during this discussion, it is only to announce "Yeah, we've got to get rid of that."

•

Just as the higher-energy "Wayne's World" did, "Buffy the Vampire Slayer" aims for a teen-age audience but occasionally offers a broad wink at what it sees. This film also includes a few minor characters worth mentioning, like the psycho-babbling coach (Mark DeCarlo) who tells his basketball players to think:

"I *am* a person. I have a right to the ball." Candy Clark appears too briefly as the jewelry-jangling mother who cries out "Kiss noise!" as she bids Buffy goodbye.

•

"Buffy the Vampire Slayer" is rated PG-13 (Parents strongly cautioned). It includes very mild violence and profanity.

1992 Jl 31, C8:5

En Toute Innocence

Directed by Alain Jessua; written (in French with English subtitles) by D. Roulet, L. Béraud and A. Jessua; director of photography, Jean Rabier; edited by Hélène Plémiannikov; music by Michel Portal; produced by Mr. Jessua; released by Cine Qua Non. At Cinema Village, Third Avenue at 12th Street, Greenwich Village. Running time: 100 minutes. This film is not rated.

Paul	Michel Serrault
Catherine	Nathalie Baye
Thomas	François Dunoyer
Clémence	Suzanne Flon
Didier	Bernard Fresson

By STEPHEN HOLDEN

In its first half-hour, "En Toute Innocence" ("In All Innocence") promises to be one of those delicious bittersweet comedies about extra-marital hanky-panky among the bourgeoisie for which the French have long been celebrated. But half-way along, the film, which was directed by Alain Jessua and stars Michel Serrault and Nathalie Baye, begins to toy uncomfortably with the idea of becoming a thriller. In the last half-hour, it finally makes the leap from sophisticated comedy into Alfred Hitchcock-style suspense, and then fizzles out in a flurry of plot developments that are as preposterous as they are hastily introduced.

"En Toute Innocence," which opens today at Cinema Village, is set mostly at a sumptuous estate near Saint-Émilion, looks at the prosperous Duchesne family, whose members run a successful architectural firm. All is well until Paul (Mr. Serrault), the firm's founder and pater-familias, accidentally catches his daughter-in-law, Catherine (Miss Baye), in flagrante delicto with Didier (Bernard Fresson), the firm's brilliant young assistant. Paul drives off in a fury and minutes later has a nearly fatal accident that leaves him in a wheelchair and temporarily unable to speak.

While recovering at home, Paul is lovingly attended by his son, Thomas (François Dunoyer), and his housekeeper, Clémence (Suzanne Flon), while being warily observed by Catherine. When Catherine makes a reconciliatory overture, he rebuffs her angrily, and she declares war. Their relationship becomes an increasingly

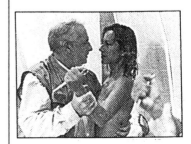

Michel Serrault and Nathalie Baye

sinister cat-and-mouse game after Paul is nearly drowned when his motorized wheelchair mysteriously accelerates and plunges him into a river. After he becomes violently ill from some tainted food Catherine has served, Paul becomes convinced that she is trying to kill him. One of his weapons is silence. Even after regaining his speech, he feigns muteness to everyone except his housekeeper.

•

With its sensuous atmosphere of sunlight and flowers, and its smart, attractive characters dining luxuriously on the lawn of the estate, "En Toute Innocence" seduces the audience into thinking it is a lot more intelligent than the film turns out be. Enhancing this aura of smartness is the Duchesnes' mania for gadgets. They are constantly toying with all things mechanical, from lawn sprinklers to lighting fixtures, and the firm's latest triumph is a model for a revolving solar-heated mansion. Paul is such an avid mountain climber that while still unable to walk, he practices scaling heights with a rig that lifts and lowers him from his wheelchair.

As dramatized by Mr. Serrault and Miss Baye, Paul and Catherine's psychological duel is a sustained and delightful tease. Has the sulky, glaring Paul succumbed to a case of posttraumatic paranoia? Or are his suspicions justified? The mercurial Catherine is the sort of juicy role that Jeanne Moreau might have played in the 1960's, and Miss Baye carries it off with relish and subtlety. One minute, she seems the smiling embodiment of familial solicitude; the next, she is eyeing Paul with a cold, hawkish scrutiny that chills the blood. Even though the film sees the world through Paul's eyes, "En Toute Innocence" belongs entirely to Miss Baye.

1992 JI 31, C14:3

Deep Blues

Directed by Robert Mugge; written by Robert Palmer; director of photography, Erich Roland; edited by Mr. Mugge; produced by Eileen Gregory and John Stewart; released by Tara Releasing. Running time: 91 minutes. At the Walter Reade Theater, Lincoln Center. This film is unrated.

WITH: Robert Palmer, Dave A. Stewart, Junior Kimbrough, Roosevelt (Booba) Barnes, Wade Walton, Big Jack Johnson, Lonnie Pitchford.

By STEPHEN HOLDEN

In the conventional view of American pop history, genres have succeeded one another in a relentless parade of stylistic and technological innovations, each rendering the sounds of the preceding era obsolete. But as Robert Mugge's documentary film "Deep Blues" shows, things are seldom that orderly. An expert, guided tour of those areas of the Deep South where old-time blues music flourishes, the film visits backwoods juke joints and urban honky-tonks where the music, often performed with antiquated technology, lives on as an everyday expression of people's lives.

"Deep Blues," which opens today at the Walter Reade Theater, credits David A. Stewart of Eurythmics, the English rock duo, as executive producer. Early in the film, Mr. Stewart, looking saturnine and slightly foppish, presents himself as an admiring blues student eager to go on a field

Axel Kutsner

Big Jack Johnson

trip. His mild-mannered, shaggy-haired guide is Robert Palmer, a former chief pop-music critic for The New York Times and the author of "Deep Blues" (Viking Penguin, 1981), a musical and cultural history of the Mississippi Delta.

Mr. Palmer, who wrote and narrated the film, shepherds his student through various locations around the Deep South until Mr. Stewart has to leave to keep previous commitments. But even after he departs, the expedition continues.

•

The trip begins in Memphis on Beale Street, the city's legendary blues quarter, which has been refurbished into a tourist attraction. Here, the pair visit a store that sells mysterious herbal concoctions, with names like Mojo Hand, which have found their way into blues lore.

The journey then dips into the hill country of northern Mississippi for visits with several musicians, each of whom has a strikingly different style. Among the first is Jessie Mae Hemphill, a fine country-blues singer, whose fife-and-drum trio bridges 19th-century band music and 20th-century blues.

Junior Kimbrough, a local blues legend who has never been recorded, is shown playing in a juke joint in Holly Springs, Miss. And at a club in Greenville, Miss., a blues hub that was once a notorious trouble spot, Roosevelt (Booba) Barnes, a flamboyantly outfitted musician, picks his guitar with his teeth. Nowhere do the blues seem more alive than in Clarksville, Miss., where Wade Walton, a barber and part-time bluesman, recalls cutting the hair of Sonny Boy Williamson, Ike Turner and Howlin' Wolf, and where Big Jack Johnson, a driver for Shell Oil, is shown playing in a local lounge.

Lonnie Pitchford, one of the youngest musicians in the film, is its prime exemplar of how the Delta blues is perpetuated. First he demonstrates the diddley bow, a single strand of wire tacked to a barn door and plucked with a pick. Then he takes his guitar and performs a Robert Johnson song taught to him by Johnson's stepson, Robert Junior Lockwood.

Johnson is the patron saint of "Deep Blues." Mr. Palmer tells how he and other blues musicians believed that mastery of the form could be obtained only by selling one's soul to the devil. But in early blues lore, he adds, the devil wasn't regarded as the incarnation of evil, but as a trickster

related to a spirit in the Yoruba religion of Nigeria.

In his analysis, Mr. Palmer brings in everything from the music's African origins to the quality of soil in the Mississippi Delta to the sociology of the region. Although the blues came from the bottom of American's social hierarchy, he observes, spiritually it aimed high. Just how high is suggested by Mr. Pitchford's performance of a Johnson song whose title, "If I Had Possession Over Judgment Day," says it all.

1992 JI 31, C14:3

Enchanted April

Directed by Mike Newell; written by Peter Barnes; director of photography, Rex Maidment; edited by Dick Allen; music by Richard and Rodney Bennett; production designer, Malcolm Thorton; produced by Ann Scott; released by Miramax Films. Running time: 93 minutes. This film is rated PG.

Lottie Wilkins	Josie Lawrence
Rose Arbuthnot	Miranda Richardson
Mrs. Fisher	Joan Plowright
Lady Caroline Dester	Polly Walker
Mellersh Wilkins	Alfred Molina
Frederick Arbuthnot	Jim Broadbent
George Briggs	Michael Kitchen

By JANET MASLIN

"Enchanted April" revolves around the appealing notion that a trip to Italy, specifically to a medieval castle with a glorious view of the surrounding countryside, will cure any ills. The voyagers are four colorfully incompatible Englishwomen who all discover, to their delight, that travel can indeed be a broadening experience. Each has changed visibly for the better by the time this soothing, picturesque film arrives at what is quite literally a rosy ending.

"Enchanted April" was directed by Mike Newell ("Dance With a Stranger") and based on a 1922 novel by Elizabeth von Armin. But it actually unfolds on what has come to be thought of as Merchant-Ivory-Forster territory. The ladies are well bred, the scenery is lovely and the dialogue is polished and polite. It helps that the same villa in Portofino where Miss von Armin wrote the novel has been used to fine effect as the film's principal setting.

•

The principals here are the tremulous Lottie (Josie Lawrence) and the meek, saddened Rose (Miranda Richardson), who are cowed by overbearing husbands and join forces to answer a newspaper advertisement offering the castle for rent. Wisteria and sunshine are the main selling points mentioned in the ad; the film similarly depends on those attractions, but it also has a welcome element of wit. Joan Plowright, uproariously funny as Mrs. Fisher, a commanding older woman who becomes Rose and Lottie's unlikely roommate, booms through the film dropping the names of literary eminences she once knew through the connections of her distinguished father. "Dear Alfred Tennyson, who pulled my pigtails and said they were too long!" she says, in a typical comment.

Miss Plowright's indignant hauteur makes for the film's most amusing moments. "No, I didn't, and I didn't know Shakespeare and Chaucer either!" she snaps when one of her exasperated roommates asks if she happened to know Keats. The starchiness of her presence contrasts very well with that of the scene-stealing Polly Walker, who plays a serene

Miramax

Polly Walker

beauty badly in need of respite from the attentions of male admirers. "You won't be able to mention the name of a single person I know," this socialite tells the others, as she explains why she wants to make the trip.

Miss Walker, who also plays a terrorist femme fatale in "Patriot Games," makes a mesmerizing impression as she holds her own against Miss Plowright without seeming remotely ruffled. When someone tartly advises that she make the most of her allure, she purrs, "I've been making the most of it ever since I can remember." Miss Richardson, miles away from her grittier performance as Ruth Ellis in "Dance With a Stranger," is at the quiet center of this story and radiates a peaceful air. Miss Lawrence, a comedian on British television, overplays her character's fussiness and has the unenviable job of pronouncing the castle "a tub of love" once the vacationers' various mates have begun to appear.

•

Alfred Molina and Jim Broadbent behave sportingly, under the circumstances. Both are made figures of fun as they play Lottie's and Rose's respective husbands, a penny-pinching businessman and an author of racy books. ("Theodora the Slave Princess" is his work in progress.) Mr. Newell's early depictions of these two are obvious and unkind (tight close-ups of Mr. Molina smacking his lips as he eats), but even the husbands are allowed to mellow during the course of this revitalizing tale.

And they provide the inspiration for Mrs. Fisher's most memorable bon mot. "In my day, husbands and beds were never spoken of in the same breath," she says contemptuously when one of the other women asks about sleeping accommodations for her spouse. "Husbands were taken seriously as the only real obstacles to sin."

•

"Enchanted April" is rated PG (Parental guidance suggested). It includes mild profanity.

1992 JI 31, C15:1

Bebe's Kids

Directed by Bruce Smith; written by Reginald Hudlin based on the characters created by Robin Harris; edited by Lynne Southerland; music by John Barnes; production designer, Fred Cline; produced by Willard Carroll and Thomas L. Wilhite; executive producers, Reginald and Warrington Hudlin; released by Paramount Pictures. Running time: 74 minutes.

WITH: the voices of: Faizon Love, Vanessa Bell Calloway, Wayne Collins, Jonell Green, Marques Houston, Tone Loc, Nell Carter.

By CARYN JAMES

"Bebe's Kids" is calling itself "animation with an attitude," which is a half-smart idea. Attitude is what gives this movie its appeal, but the animation was a desperate afterthought.

The original idea was to build a story around the actor and comedian Robin Harris and characters he created in his stand-up act: mischievous kids he describes as "up at 4 in the morning drinking coffee and taking No Doz." After Mr. Harris died of a heart attack, the executive producers of "Bebe's Kids," Reginald and Warrington Hudlin, turned to animation.

The movie's in-your-face but good-at-heart attitude owes a lot to the Hudlin brothers, especially to Reginald Hudlin's script. The Hudlins are also behind the current, transformation-of-Eddie-Murphy movie, "Boomerang." More to the point, they created the teen-age, hip-hop hit "House Party." "Bebe's Kids" sets itself up as a "House Party" for the grammar-school set, but it is not nearly as fresh or lively.

The character Robin falls for Jamika, a woman who has a well-behaved little boy. When Robin shows up to take them to a theme park called Funworld, he gets the bad news that Jamika is babysitting her friend Bebe's three neglected monsters. The funniest is PeeWee, a baby in smelly diapers whose gravelly voice belongs to the rapper Tone Loc. It's an obvious joke, but it works.

Set loose in Funworld, the four kids should have sent the film off into frenzied chaos. But the animation is tame — it uses bright blocks of color, but limited movement that suggests a limited budget — so the movie plods along. Similar stories like "Home Alone" and "House Party" move three times as fast.

"Bebe's Kids" does have irreverence going for it. Robin yells at Bebe's son Kahlil, "I'm gonna beat the black off you and you'll be whiter than Michael Jackson!"

It also has a cute, kiddy, hip-hop score (including a bouncy rap track about freedom) and a social message about caring for children like Bebe's. But the film isn't as much fun as it should have been, or might have been if Mr. Harris's brash presence had been live on screen.

•

"Bebe's Kids" is rated PG-13 (Parents strongly cautioned). It includes rude language.

1992 Ag 1, 16:6

Dream Deceivers
The Story Behind James Vance vs. Judas Priest

Produced and directed by David Van Taylor; edited by Mona Davis; music by Judas Priest; released by First Run Features/Tapestry International. At Film Forum 1, 209 West Houston Street. Running time: 60 minutes. This film has no rating

The Red Bridge

Directed by Geneviève Mersch, (in French and Luxembourgeois with English subtitles); released by First Run Features. At Film Forum 1, 209 West Houston Street. Running time: 21 minutes. This film has no rating.

Associated Press
Rob Halford of Judas Priest testifying against the accusation that lyrics from a song by the group provoked the attempted suicide of a fan. The 1985 incident inspired the film "Dream Deceivers."

By JANET MASLIN

The unusual arrangement through which "Dream Deceivers" had a simultaneous theatrical premiere at the Film Forum and a television showing on Channel 13 this week emphasizes the importance of format for documentary film makers. Good documentaries often go from theatrical showings to television (as Marlon Riggs's "Color Adjustment" did). And occasionally they take the opposite route ("Heart of Darkness: A Film Maker's Apocalypse" was seen by cable viewers well before its theatrical release). More often, the film makers must choose between television's larger audience and the keener attention that will be given a film shown in a theater.

"Dream Deceivers," directed by David Van Taylor, is an hourlong work shot on videotape, which would seem to make television its most appropriate context. But the material is so overpowering, and the videotape creates such painful intimacy, that the coziness of the small screen may not do it justice. In any case, at the Film Forum "Dream Deceivers" has been wittily paired with "The Red Bridge," a matter-of-fact look at a tiny village in Luxembourg that has the bad luck to be a favorite spot for suicidal jumpers.

But it is "Dream Deceivers" that will rivet the attention, as it presents a terrible story of mixed signals and wasted lives. In 1985, Raymond Belknap and James Vance, both fans of the heavy-metal band Judas Priest, shot themselves with a 12-gauge shotgun. Mr. Belknap died and Mr. Vance, who shot himself in the face, was left horribly disfigured. Their parents, in a subsequent lawsuit, maintained that subliminal messages in Judas Priest's recordings induced the two boys to take this drastic action. "I

didn't really perceive that as a really meaningful, deep lyric," says Rob Halford, a member of the band, about one of the tracks in question.

The band members are present in court during the trial that figures

A harsh story of mixed signals and wasted lives.

prominently in the film, but it is clear that their role is unimportant. Hardly anyone heard here — with the very significant exceptions of the boys' mothers and their lawyers — seriously believes that heavy metal was the source of Raymond and James's troubles. A grim tale of alcoholism, physical abuse, divorce and indifference emerges from the testimony, along with the fact that Ray's sister, who is no heavy-metal fan, has attempted suicide twice. James, filling out a questionnaire at a place where he received counseling and treatment, listed his favorite leisure activity as "doing drugs."

At the time the film was made, James could speak for himself, however agonizingly; his facial injuries were so severe that his remarks are accompanied by subtitles. (James later died, under mysterious circumstances. His scenes in the film, heartbreaking and grotesque, will be very difficult for some viewers to watch.) Accompanied by his mother, Phyllis, who sits placidly beside him, James talks of Judas Priest in a way that makes it clear his heavy-metal obsession was directed mainly at his mother. "He said 'looking now the music would almost drive me crazy,'" Mrs. Vance piously recalls. "Drive *you* crazy," amends her son.

•

Mrs. Vance is seen talking with her minister, who says, "The thing I appreciate about you, Phyllis, is that you don't deceive yourself." Evidence to the contrary is provided in court, where Mrs. Vance endures some difficult moments. Dressed with girlish propriety in a flowered dress with a middy-blouse collar, she listens to stories of her husband's drinking and gambling, to the news that James's longest period of sobriety in five years lasted only two weeks. She tells of her son's inability to hold any job, however menial, for more than a few days. She acknowledges uneasily that she characterized James as "obnoxious" and "a punk" in her deposition. She seems not have any idea of the depths of her son's unhappiness. "Doesn't 'antisocial' mean you have no friends?" she asks at one point.

Mrs. Vance talks of family trips to Knotts Berry Farm and Disneyland, of her fondness for the Singing Nun. (The members of Judas Priest have a hard time remaining stony-faced over that one.) James's stepfather, describing himself as "strict but not overstrict," calmly discusses the last time he remembers hitting James with his fist.

And James himself summarizes this story most succinctly and most pitiably when he says: "We weren't looking for an easy way out. We honestly thought there was something better." "Dream Deceivers," in exploring the misery of these boys' lives, ultimately understands too well how they came to that conclusion.

•

"The Red Bridge," directed by Geneviève Mersch, takes an utterly calm view of an equally bleak situation, that of a village whose citizens must habitually look upward to make sure no one is jumping off the bridge overhead. A road sign, picturing a bridge and a falling person, attests to the seriousness of the problem. But the residents, seen at communal dances and flanked by dishes and doll collections, have learned to speak matter-of-factly about the unspeakable things they see. "I saw one who fell like a ball," says a child. "Even if they look all right," says an older resident, "inside there is always something broken."

1992 Ag 6, C15:4

Unforgiven

Directed and produced by Clint Eastwood; written by David Webb Peoples; director of photography, Jack N. Green; edited by Joel Cox; music by Lennie Niehaus; production designer, Henry Bumstead; released by Warner Brothers. Running time: 130 minutes. This film is rated R.

Bill Munny	Clint Eastwood
Little Bill Daggett	Gene Hackman
Ned Logan	Morgan Freeman
English Bob	Richard Harris

Schofield Kid	Jaimz Woolvett
W. W. Beauchamp	Saul Rubinek
Strawberry Alice	Frances Fisher
Delilah Fitzgerald	Anna Thomson
Quick Mike	David Mucci
Davey Bunting	Rob Campbell
Skinny Dubois	Anthony James
Little Sue	Tara Dawn Frederick
Silky	Beverley Elliott
Faith	Liisa Repo-Martell
Crow Creek Kate	Josie Smith
Will Munny	Shane Meier
Penny Munny	Aline Levasseur

By VINCENT CANBY

TIME has been good to Clint Eastwood. If possible, he looks even taller, leaner and more mysteriously possessed than he did in Sergio Leone's seminal "Fistful of Dollars" a quarter of a century ago. The years haven't softened him. They have given him the presence of some fierce force of nature, which may be why the landscapes of the mythic, late 19th-century West become him, never more so than in his new "Unforgiven."

As written by David Webb Peoples and directed by Mr. Eastwood, "Unforgiven" is a most entertaining western that pays homage to the great tradition of movie westerns while surreptitiously expressing a certain amount of skepticism. Mr. Eastwood has learned a lot from his mentors, including the great Don Siegel

Bounty hunter: Clint Eastwood as Bill Munny, a hog farmer with a violent past.

Warner Brothers

Warner Brothers
Richard Harris in "Unforgiven."

("Two Mules for Sister Sara" and "The Beguiled," among others), a director with no patience for sentimentality.

The time is the 1880's. The principal setting is Big Whiskey, a forlorn hamlet in that vast American no-man's land of high plains edged by mountains, somewhere between St. Louis and San Francisco but not on any map.

Late one night a couple of cowboys are on the second floor of the saloon with the girls. Suddenly one of the cowboys whips out his knife and slashes the face of Delilah, the prostitute he's with. It seems that she made a rude comment about his anatomy. Instead of arresting the cowboys, Little Bill Daggett, the sheriff, allows them to get off with the understanding that they hand over six horses to the saloon keeper.

Strawberry Alice, the victim's best friend, is outraged. "We may be whores," she says, "but we aren't horses." Alice, Delilah and the other girls pool their savings and offer a bounty of $1,000 to anybody who will murder the cowboys.

Thus "Unforgiven" becomes an epic about the revenge of whores. It's not sending up the women. Rather it's equating Old Western codes of honor with the handful of men who set out to collect the bounty, motivated in varying degrees by economic necessity, greed and half-baked notions of glory.

Chief among the bounty hunters is the aging Bill Munny (Mr. Eastwood), a widower trying to support his two young children on an unsuccessful hog farm. Munny has been keeping to himself in recent years. He's still trying to live down his notorious career as a gun-crazy outlaw, a man who used to shoot women, children — anybody — just for the hell of it.

There is something creepy about him now, especially about the way he keeps harping on how his wife "saved" him, his distaste for violence and his need to be true to his pledge never to pick up a gun again. He has something of the manner of the mild-mannered clerk who comes into the office on Monday morning and shoots everyone in sight.

When a young fellow who styles himself the Schofield Kid (Jaimz Woolvett) asks Munny to join him to win the bounty, Munny at first refuses. Then he changes his mind, apparently because he is desperately hard up, but with Munny you can't be sure. Along the way to Big Whiskey, they are joined by Ned Logan (Morgan Freeman), who rode with Munny in the outlaw days and appears to trust him.

Also en route to Big Whiskey for the same purpose is English Bob (Richard Harris). He's a dandyish former outlaw who, when first seen, is aboard a train, reading about the assassination of President James A. Garfield and explaining to anyone who will listen why America would be better off with a king. His admiring companion is W. W. Beauchamp (Saul Rubinek), whom English Bob introduces as "my biographer," the author of a penny dreadful about the outlaw titled "The Duke of Death."

•

Little Bill Daggett (Gene Hackman) is ready for the bounty hunters as they arrive in Big Whiskey. He immediately spots English Bob as he gets off the stagecoach, gives him a sadistic beating and throws him in jail. Mr. Harris, who has a tendency to overpower his roles, has never been finer, funnier or more restrained than he is as English Bob, whom Daggett insists on calling "the Duck of Death."

Things turn far darker with the arrival of Munny, Ned and the Schofield Kid. Daggett suspects their purpose but is unable to prove anything. Just to let them know who runs Big Whiskey, Daggett beats up Munny as savagely as he has English Bob, but Munny appears to ask for it. Bleeding and only partly conscious, he crawls out of the saloon and into a muddy gutter.

It is a measure of how the film works that Munny's almost Christ-like acceptance of his beating is one of the film's scariest moments. There is a madness inside him waiting to emerge, but where and when? "Unforgiven," which has no relation to "The Unforgiven," the 1960 John Huston western, never quite fulfills the expectations it so carefully sets up. It doesn't exactly deny them, but the bloody confrontations that end the film appear to be purposely muted, more effective theoretically than dramatically.

This, I suspect, is a calculated risk. Mr. Eastwood doesn't play it safe as a director, but there are times in "Unforgiven," as in his jazz epic, "Bird," that the sheer scope of the narrative seems to overwhelm him. It's not easy cramming so much information into a comparatively limited amount of time. Toward the end of "Bird," he didn't seem to be telling the story of Charlie Parker as much as letting it unravel. That doesn't happen in "Unforgiven," but the tone, so self-assured to begin with, becomes loaded with qualifications.

•

The film looks great, full of broad chilly landscapes and skies that are sometimes as heavy with portents as those in something by El Greco. It's corny but it works.

Photographed by Jack N. Green, who was the camera operator for Bruce Surtees, Mr. Eastwood's cinematographer for "Pale Rider," "Unforgiven" favors the kind of backlighting that can add a sense of desolation and menace to even the most conventional moments. Seen against a bright background, faces turned to the camera are so hidden in shadow that they aren't immediately recognizable. It is a storyteller's gesture for the audience's benefit, since the other characters within the scene would not be so disadvantaged.

The cast is splendid, though some of the actors have more to do than others, including Mr. Freeman, whose role is not especially demanding. Mr. Hackman delights as Sheriff Daggett: no more Mr. Good Guy. Also worthy of particular note are Mr. Woolvett, who makes his feature film debut as the unreliable Schofield Kid; Mr. Rubinek as a city journalist out of his element out West, and Frances Fisher as Strawberry Alice, a woman who doesn't know when to shut up.

Yet the center of attention, from the moment he rises up out of a hog pen until the darkest fade-out in western movie history, is Mr. Eastwood. This is his richest, most satisfying performance since the underrated, politically lunatic "Heartbreak Ridge." There's no one like him.

•

"Unforgiven" is rated R (Under 17 requires accompanying parent or adult guardian). It has a lot of violence, vulgar language and some sexual situations.

1992 Ag 7, C1:1

Raising Cain

Written and directed by Brian De Palma; director of photography, Stephen H. Burum; edited by Paul Hirsch, Bonnie Koehler and Robert Dalva; music by Pino Donaggio; production designer, Doug Kraner; produced by Gale Anne Hurd; released by Universal Pictures. Running time: 95 minutes. This film is rated R.

Carter/Cain/Dr. Nix/Josh/Margo	
	John Lithgow
Jenny	Lolita Davidovich
Jack	Steven Bauer
Dr. Waldheim	Frances Sternhagen
Lieutenant Terri	Gregg Henry
Sergeant Cally	Tom Bower
Sarah	Mel Harris
Karen	Teri Austin
Nan	Gabrielle Carteris
Mack	Barton Heyman
Amy	Amanda Pombo
Emma	Kathleen Callan

By JANET MASLIN

A peaceful playground. A pleasant day. And two parents making small talk as they watch their children and then share a ride home. Dr. Carter Nix (John Lithgow), a child psychiatrist taking time off from his work to help bring up his daughter, engages a female friend in small talk about the legitimacy of conducting psychological studies on small children. The conversation starts innocently, but within moments — during the course of an edgy, sustained driving shot executed with bravura ease — it turns hostile enough to make Carter sneeze. Even worse, it makes Carter commit murder.

Bounding back gamely from "The Bonfire of the Vanities," Brian De Palma has vigorously returned to fa-

miliar ground. "Raising Cain," a delirious thriller starring John Lithgow as a man with at least three more personalities than he really needs, finds Mr. De Palma creating spellbinding, beautifully executed images that often make practically no sense. Working with an exhilarating sense of freedom, he seems to care not in the least what any of it really means. The results are playful, lively and no less unstrung than Dr. Carter Nix himself.

In his early days, Mr. De Palma sometimes labored to make his neo-Hitchcockian thrillers appear reasonable. This time that kind of strain is gone. So is the need to compare Mr. De Palma's latest psychological mystery, which he both wrote and directed, with any films other than his own. Less grisly and more mischievous than "Body Double," infused with the kind of free-floating menace that colored "The Fury," "Raising Cain" is best watched as a series of overlapping scenarios that may or may not be taking place in the real world. By the time it reaches its greatest feverishness, the film has featured a tussle involving three characters. One is real, one probably imaginary and one may actually be dead. At that point, it's hard to know for sure.

•

The Cain to whom the title refers is Carter's vicious alter ego, who likes to appear whenever a violent crime is in the wind. (This time, Mr. De Palma dispenses with the power drills and keeps the violence implicit and off screen.) Frequently shooting Cain from disturbing, tilted angles, Mr. De Palma may be promising to provide some kind of stylistic compass, but the film is often too caught up in its own craziness to keep track of that. Risky as it sounds, "Raising Cain" is enjoyable precisely because it makes the most of its own lunacy and stays so far out on a limb.

The fact that "Raising Cain" is beautifully made is, of course, another attraction. The film offers no warning as to when Mr. De Palma will launch into a spectacular tracking shot (a stunning one involving Frances Sternhagen goes on for about five minutes) or spin out a multi-tiered, slow-motion operatic showdown. The cinematographer Stephen H. Burum, whose several other films for Mr. De Palma include "The Untouchables," gives "Raising Cain" a crisp, handsome look that helps to ground its fanciful story in some sort of reality. As it means to, the film has the strange, perfect clarity of a dream.

Some of "Raising Cain" really does consist of dream sequences, although of course Mr. De Palma has fun by failing to specify where they begin and end. Carter has his own set of hallucinations, involving Cain's evil aphorisms ("The cat's in the bag, and the bag is in the river") and Carter's attempts to shake off very persistent childhood demons.

•

Carter's wife, Jenny (Lolita Davidovich), is confused in her own right once her former lover Jack (Steven Bauer) makes an unexpected appearance on the scene. Jenny's purchase of two clocks, one for Jack and one for Carter, affords the director many opportunities to play tricks upon the audience, as do Jenny's sexual reveries about Jack. These sequences, also startlingly photographed, have a way of featuring Carter lurking somewhere in the back of Jenny's mind.

Mr. Lithgow has a field day with an indescribably loony role, one that amounts to an open invitation for scenery-chewing excess; instead, this subtle, careful actor stays very much in control. Even in a woman's black wig, barefoot and wearing a raincoat, Mr. Lithgow manages to seem remarkably restrained. Miss Sternhagen also stands out as someone who is very much on the film's peculiar wavelength, although by the time she appears, fairly late in the story, it has all gone well over the edge. It is she, as someone who knew Carter and his even crazier father (also played by Mr. Lithgow), who reveals that their early troubles were once the basis for a television mini-series. That's one of the few things in "Raising Cain" that makes perfect sense.

•

"Raising Cain" is rated R (Under 17 requires accompanying parent oradult guardian). It includes profanity, sexual situations and implicit violence.

1992 Ag 7, C5:1

3 Ninjas

Directed by Jon Turteltaub; screenplay by Edward Emanuel, based on a story by Kenny Kim; director of photography, Richard Michalak; edited by David Rennie; music by Rick Marvin; production designer, Kirk Petruccelli; produced by Martha Chang; released by Touchstone Pictures. Running time: 85 minutes. This film is rated PG.

Grandpa	Victor Wong
Rocky	Michael Treanor
Colt	Max Elliott Slade
Tum Tum	Chad Power
Snyder	Rand Kingsley

By STEPHEN HOLDEN

Take a half-pint imitation of "Home Alone," fuse it with a Bruce Lee martial-arts fantasy, and frost it with a thick sugarcoating of Walt Disney-style comic cheer, and you have "3 Ninjas," the story of three young brothers trained in the martial arts who foil the schemes of an evil arms smuggler named Snyder (Rand Kingsley).

Rocky (Michael Treanor), Colt (Max Elliott Slade) and Tum Tum (Chad Power), sons of an F.B.I. agent, have been trained as ninjas by their indefatigably spry grandfather (Victor Wong). Grandpa, as he is known, also seems to possess magical powers. Early in the film, he vanishes in a flash, only to be discovered seconds later perched high in a tree.

His pupils are as fearless and invincible as he. When some demented gun-toting surfers are sent by Snyder to the boys' house to kidnap them, their counterinsurgency is a balletic tour de force of lightning maneuvers augmented by household items ranging from jellybeans to a powerful laxative.

•

The film can't seem to make up its mind whether it wants to be a comedy, a fantasy or an adventure film. Mr. Kingsley's villain gnashes his teeth and snorts, "I love being the bad guy." Those who displease him are threatened with the tearing out of a heart or liver. The character ends up being neither scary nor funny, while the boys are so busy demonstrating their superhuman skills that no personalities emerge.

Beneath all the excitement, the message that "3 Ninjas" conveys is anything but reassuring. Cute as they are, Rocky, Colt and Tum Tum live only to practice martial arts. Not yet adolescent, they have been programmed by their cheery Grandpa into being a robotic team of leaping and spinning lethal weapons.

•

"3 Ninjas" is rated PG (Parental Guidance Suggested). It has very little blood but a lot of violence.

1992 Ag 7, C5:1

Mistress

Directed by Barry Primus; screenplay by Mr. Primus and J. F. Lawton, based on a story by Mr. Primus; director of photography, Sven Kirsten; edited by Steven Weisberg; music by Galt MacDermot; production designer, Phil Peters; produced by Meir Teper and Robert De Niro; released by Rainbow/TriBeCa. Running time: 109 minutes. This film is rated R.

Marvin Landisman	Robert Wuhl
Jack Roth	Martin Landau
Stuart Stratland	Jace Alexander
Evan M. Wright	Robert De Niro
Rachel Landisman	Laurie Metcalf
George Lieberhoff	Eli Wallach
Carmine Rasso	Danny Aiello
Beverly Dumont	Sheryl Lee Ralph
Patricia Riley	Jean Smart
Peggy Pauline	Tuesday Knight
Warren Zell	Christopher Walken
Ernest Borgnine	Himself
Hans	Vasek C. Simek
Stagehand	Tomas R. Voth
Shelby's Waitress	Mary Mercier

By STEPHEN HOLDEN

In the opening scene of "Mistress," Barry Primus's deliciously spiky satire of life on the fringes of the movie business, Marvin Landisman (Robert Wuhl), a failed screenwriter and director, sits in his darkened Los Angeles apartment morosely studying Jean Renoir's film classic, "Grand Illusion." His cinematic reverie is interrupted by a phone call from Jack Roth (Martin Landau), a once-successful producer reduced to grasping at straws. Jack excitedly tells Marvin he has found a possible backer to finance a movie from an abandoned screenplay of Marvin's, which he has just re-read and insists is "more timely than ever."

"The Darkness and the Light," the property that Jack hopes to revive, isn't just any old screenplay, but a project that consumed five years of Marvin's life and that represents his heart and soul. The project, the story of a misunderstood artist who commits suicide, would have made it to the screen but for an act of God that is

Rainbow/Tribeca
Robert De Niro in "Mistress"

revealed in flashbacks toward the end the film.

The would-be producer, George Lieberhoff (Eli Wallach), turns out to be a canny old clockmaker who is looking for a vehicle for his girlfriend, Peggy Pauline (Tuesday Knight), an aspiring actress and pop singer with no discernible talent. At her audition, she squeaks out something called "I'm a Sex Goddess" in a wilted Betty Boop voice.

•

George becomes the first of three producers whom Jack lines up to put money into the project. The two others, Carmine Rasso (Danny Aiello) and Evan Wright (Robert De Niro), both successful businessmen, also turn out to have girlfriends with movie-star ambitions.

Carmine's lover, Patricia Riley (Jean Smart), is a would-be comedian and recovering alcoholic who is even more desperate for marriage than for fame. Evan's mistress, Beverly Dumont (Sheryl Lee Ralph), is the only one of the three women with any acting talent. Imperious and demanding, she knows exactly what she wants and skillfully manipulates her slick, know-it-all lover by playing on his sexual jealousy. The story builds to a climactic deal-signing party at which the three girlfriends suspiciously rub elbows while the producers loudly haggle over points.

"Mistress" portrays a Hollywood ethos that is as merrily duplicitous as the worlds of "The Player," "Scenes From the Class Struggle in Beverly Hills" and "Shampoo." What it lacks is those films' sensuous sheen of glamour. In "Mistress," the real estate is not nearly as fancy. Gold jewelry has replaced European double-breasted suits as a status symbol. And instead of taking place at Le Dome, power lunches are held at a glorified diner where Jack tries to impress his associates by ordering a harried waitress to "tell the chef to really heap the shrimp on the salad."

Jack has an obnoxious sidekick, Stuart Stratland (Jace Alexander), a conceited young film school graduate who comes up with a glib new concept every few minutes. He and Marvin become instant antagonists.

•

The first feature film to be directed by Mr. Primus, an actor who has appeared in some 30 films, "Mistress" is mercilessly evenhanded in dealing out its satirical barbs. Out of all the characters, Marvin is probably treated the worst. A humorless idealist who screams and yells about every change that is inflicted on his screenplay, he still capitulates to every outrageous demand, in the hope that the movie will somehow get made. Periodically, Marvin's wife, Rachel (Laurie Metcalf), telephones from New York, where she is raising the money to open an imitation Los Angeles restaurant whose ads will advise, "Bring your sunglasses."

The screenplay by Mr. Primus and J. F. Lawton is filled with insiders' jokes that give the movie an extra ring of truth. In trying to pitch a story about an artist who commits suicide, Jack and Marvin wind up comparing the film to "Terms of Endearment." They insist that the main character, though suicidal, will still be as likably kooky as Jack Nicholson in that film.

"Mistress" abounds with sharp comic performances that never stray into caricature or sentimentality. Mr. De Niro, one of the producers of "Mistress," is particularly impressive as the slick, eagle-eyed owner of a string of tennis clubs who exerts total con-

troi over everyone except for the crafty Beverly. Mr. Aiello, as his less successful friend, is appealing as a blubbering dolt who knows much less about the world than he assumes. Mr. Landau uses his huge blue eyes to project a blend of frazzled fanaticism and sad-eyed vacancy. Ms. Ralph and Mr. Wallach give strong, uncompromising portrayals of tough operators who know exactly what they want and won't settle for less.

Ernest Borgnine makes a cameo appearance as himself. Jack and Marvin spot the actor as he is leaving a supermarket and rush at him as though he were a superstar who could be the answer to their prayers. Their crazed response amusingly illustrates the desperate, self-abasing extremes to which these characters will go to hold on to the grand illusion that they are bona fide Hollywood film makers.

•

"Mistress" is rated R (Under 17 requires accompanying parent or adult guardian). It includes some strong language and adult situations.

1992 Ag 7, C16:3

No Fear, No Die

Directed by Claire Denis; screenplay by Miss Denis and Jean-Pol Fargeau (in French with English subtitles); director of photography, Pascal Marti; cinematography by Agnès Godard; edited by Dominique Auvray; music by Abdullah Ibrahim. At the Walter Reade Theater, 165 West 65th Street, Upper West Side, Manhattan. Running time: 97 minutes. This film has no rating.

Dah	Isaach de Bankolé
Jocelyn	Alex Descas
Pierre Ardennes	Jean-Claude Brialy
Toni	Solveig Dommartin
Michel	Christopher Buchholz

By CARYN JAMES

On the surface, the rough-edged style and down-and-out characters of Claire Denis's second feature, "No Fear, No Die," make this film seem radically different from her exquisitely beautiful, fluid "Chocolat." But "No Fear" is about much more than its small-time heroes: two black immigrants in France who train and sell birds for illegal cockfights. As she did in the 1988 "Chocolat," the partly autobiographical story of a French girl growing up in Cameroon, in "No Fear" Miss Denis shows how the details of daily life carry the weight of a whole lifetime, even a culture. This film is exquisite in its own tough-minded way.

"No Fear, No Die," released in France in 1990, will be shown today through Tuesday at the Walter Reade Theater as part of the Film Society of Lincoln Center's series "Eurobeat: Blacks in European Cinema."

At the start, Dah, an African from Benin, and Jocelyn, a man from the French West Indies, decide to make some quick cash by staging cockfights for Pierre (Jean-Claude Brialy), who has created an arena in the basement of his roadside restaurant.

•

Dah, who takes care of the business end, seems to be angrier and more explosive. He is played by Isaach de Bankolé, who was the servant Protée in "Chocolat" and the Paris cabdriver in Jim Jarmusch's current "Night on Earth." In all three of these roles Mr. de Bankolé is exceptional. With a glance he not only suggests suppressed rage, but also hints at the

complex cultural and racial prejudices behind it.

It is Jocelyn who trains the cocks and gets in touch with Pierre, who knew Jocelyn's mother in the Antilles. Though he seems simpler, Jocelyn turns out to be the more troubled character, and Alex Descas plays him with perfect subtlety. He is the true star and center of the film.

Miss Denis does not rush her story, and at first it appears there may not be one at all. Pierre gives Dah and Jocelyn a small, squalid room, where they eat, sleep and train the roosters. Jocelyn spends his days lavishing attention on the birds, and the film captures these scenes in affectionate detail. Jocelyn trains them as if they were prizefighters, feeding them vitamins, exercising their wings, gently clipping their feathers with small scissors before the fight. It takes some time before his identification with his birds comes to seem an unhealthy substitute for a sane life.

Though Miss Denis's influences range from Jean-Luc Godard at his most lucid to the African tradition of non-narrative storytelling, the style of "No Fear" is her own. The handheld camera work (by Agnès Godard, no relation to Jean-Luc) and intentional choppiness are as much a reflection of Dah and Jocelyn's scrappy lives as the gracefulness of "Chocolat" mirrored the false calm in a colonized country. Dah and Jocelyn's room is blue-tinged and claustrophobic, while the basement arena is dim and dank, the restaurant by the highway garishly bright.

•

Eventually, as in "Chocolat," the surface of this world explodes with the force of repressed passions and cultural conflict. Pierre cuts Dah and Jocelyn's share of the money, and says to Jocelyn: "Just like your mother. Good in bed but born to lose. If you weren't so black, I'd think you might be my son."

Jocelyn is losing his equilibrium, feeling so sexually frustrated that he becomes obsessed with Pierre's wife, Toni (Solveig Dommartin). His barely controlled feelings are expressed in extraordinary visual images, in the increasingly intimate way he dances with a strange woman at a bar, or the sudden impulse to dance with a rooster. When he finally snaps, it is not with any melodramatic wrench of the story line, but with a sense that violence and tragedy are born from the accumulation of small daily dramas.

The film shows the cockfights (and a final disclaimer that no animals were mistreated) in just enough detail to suggest the violent emotions that are projected on the birds. But the great triumph of all Miss Denis's work is that her characters are never reduced to mere cultural symbols.

There are some weak elements in "No Fear." Toni seems dull, though she is meant to be indiscriminately provocative to men. And Pierre has a grown son who, atypically for Miss Denis, seems to exist only because he must move the plot at a crucial moment. While this film is not as perfectly wrought as "Chocolat," it is just what one might expect from Claire Denis after all: the work of a daring, accomplished, unpredictable artist.

1992 Ag 7, C16:5

Whispers in the Dark

Directed and written by Christopher Crowe; director of photography, Michael Chapman; edited by Bill Pankow; music by Thomas Newman; production designer, John Jay Moore; produced by Michael S. Bregman and Martin Bregman; released by Paramount Pictures. Running time: 102 minutes. This film is rated R.

Dr. Ann Hecker	Annabella Sciorra
Doug McDowell	Jamey Sheridan
Detective Morgenstern	Anthony LaPaglia
Dr. Sarah Green	Jill Clayburgh
Fast Johnny C	John Leguizamo
Eve Abergray	Deborah Unger
Dr. Leo Green	Alan Alda
Paul	Anthony Heald

By CARYN JAMES

"Whispers in the Dark" is the latest in the bumper crop of shrinks-in-distress movies. Playing a psychiatrist named Ann Hecker, Annabella Sciorra sets out to find an exciting new sex life, admit she is angry at her dead father and, by the way, avoid being murdered. No matter what Freud said about there being no accidents, this unsexy, unsuspenseful thriller cannot be what the writer and first-time director Christopher Crowe really wanted.

We see only two of Ann's patients, and she isn't doing either of them any good. Johnny C (John Leguizamo) is a hot young painter with a violent streak and a fantasy that he is from another planet. Eve (Deborah Unger) is a beautiful gallery owner who likes to tell the doc about her sexual experiences with a mystery man, who usually ties her wrists to an overhead pipe in a basement.

Ann dreams about these bondage stories, finding them so provocative and disturbing that she goes back into therapy herself. A better reason to get help might be that she has an R-rated, art-directed unconscious; her dreams are shown, complete with strategically placed sheets and shadows.

Early in the film, Ann gets a quick cure. She falls in love with a gentle guy named Doug (Jamey Sheridan), then discovers he is Eve's mystery-bondage man.

But enough about sex. On to murder. Eve is found naked, a noose around her neck, hanging from a beam in her gallery. Is the killer Johnny? Is it Doug? And why does Doug want to take Ann home to mother instead of tying her up? Mr. Crowe's ludicrous script and bland direction can't generate much suspense about those questions.

Anthony LaPaglia is a police detective who tries to bully Ann into turning over her confidential notes about patients. Alan Alda is a psychiatrist who agrees to treat Ann even though they are close friends. Both actors deserve better lines. "Oh, come on," Mr. Alda has to say with a straight face. "A bright psychopath can fool anybody." Jill Clayburgh as Mr. Alda's wife has nothing to do. And Ms. Sciorra, last seen hiring the baby sitter from hell in "The Hand That Rocks the Cradle," is even less believable as the addlebrained Ann.

In its worst moments, "Whispers in the Dark" is exploitative, with the detective flashing gruesome photos of tortured women at Ann. More often, it is so loopy it should have been played for laughs.

•

"Whispers in the Dark" is rated R. It includes nudity, violence, a scene of near-torture and photos of mutilated bodies.

1992 Ag 7, C17:1

London Kills Me

Written and directed by Hanif Kureishi; director of photography, Ed Lachman; edited by Jon Gregory; music by Charlie Gillett; production designer, Stuart Walker; produced by Tim Bevan; released by Fine Line Features. Running time: 105 minutes. This film is rated R.

Clint	Justin Chadwick
Best Friend	Steven Mackintosh
Sylvie	Emer McCourt
Dr. Bubba	Roshan Seth
Headley	Fiona Shaw
Hemingway	Brad Dourif

By VINCENT CANBY

"London Kills Me" is about the lives of a group of young London druggies and pushers toward the end of the Thatcher era. Clint is a pusher who wants to get a straight job. His best friend aspires to an association with the mob. Sylvie, a pretty addict, sort of loves both the men but not enough to kick the habit. In various combinations, they wander around Portobello Road, and on one special day they take a trip to the country.

The English film is the first to be directed as well as written by Hanif Kureishi, the hugely gifted playwright and novelist who wrote the screenplays for "My Beautiful Laundrette" and "Sammy and Rosie Get Laid." The kindest thing to say about "London Kills Me" is that Stephen Frears, who directed Mr. Kureishi's first two scripts, might have persuaded the writer to shape this very raw material to make some dramatic or even political point.

"London Kills Me" now plays as if Mr. Kureishi had filmed his notebook. It's an accumulation of ideas for characters and scenes that remain undeveloped and without focus. The film demands more forbearance than most audiences are inclined to give such a slack endeavor. Even the actors are off-putting, which may be another result of the director's lack of experience.

Of far more interest than the film is the new Penguin paperback "London Kills Me." It contains Mr. Kureishi's three produced screenplays and four essays, including one, "The Rainbow Sign," in which he remembers growing up in an increasingly racist England as the son of a Pakistani father and an English mother. He's not yet a film director, but he's a first-rate writer.

•

"London Kills Me" is rated R (Under 17 requires accompanying parent or adult guardian). It includes vulgar language and sexual situations.

1992 Ag 7, C19:1

FILM VIEW/Caryn James

'Intentions' That Don't Go Astray

"The Magic Lantern," Viking, 1988

Erik and Karin Bergman, who were models for the couple in the film—Poignantly unable to be happy.

THERE IS NOTHING REMARKABLE ABOUT the fact that Ingmar Bergman spent a lifetime feeling angry at his stern, controlling parents. But the way he has come to terms with their memories is an extraordinary tale, on artistic and personal terms. In writing "The Best Intentions," a tough-minded yet generous depiction of his parents' tortured courtship and early marriage, Mr. Bergman has turned the ghosts of the real Karin and Erik Bergman into the slightly fictional Anna and Henrik Bergman. They are complex, stubborn, well-meaning people who share a heartbreaking inability to be happy no matter what they try.

Mr. Bergman himself is a benevolent ghost hovering over this film, directed with poetry and fidelity by Bille August. The child that Anna is expecting at the end of the story, in 1918, is Ingmar. More important, the film's unsentimental view of emotions is definitely his, though he is more compassionate than ever before. It is easy to believe Mr. Bergman's remark, in a magazine interview with his Swedish publisher, about how writing the screenplay changed his attitude toward his parents. "After this," he said, "every form of reproach, blame, bitterness or even vague feeling that they have messed up my life is gone forever from my mind."

■

"The Best Intentions" (which has been playing in New York for a month and is gradually opening around the country) is not pseudo-Bergman. It is a legacy from the 74-year-old director, who stopped making films after the autobiographical "Fanny and Alexander" in 1982. Alexander's childhood reflects the director's own, and he has no mercy for that film's nightmarishly strict stepfather, the clergyman who represented Mr. Bergman's own unbending father. But in "Fanny and Alexander" there is also joy in the extravagant Christmas celebration and sympathy for the beautiful, misguided mother who only wanted the best for her children.

The consoling memories in "Fanny and Alexander" point toward "The Best Intentions," which is about three generations' worth of forgiveness. In the first scene, Henrik (Samuel Fröler), a poor divinity student, is called to see his paternal grandfather. His dying grandmother regrets her unkindness to Henrik and his mother, the grandfather says. Henrik refuses to visit her, saying, "Tell her she deserved her life and death. She will never have my forgiveness."

In his autobiography, "The Magic Lantern," Mr. Bergman recalls a similar scene, in which he rejected his mother's pleas to visit his father in the hospital. Mr. Bergman has experienced Henrik's brutal honesty; he makes no excuses for it. And like Mr. Bergman, who was reconciled with his parents before they died, Henrik will learn something about compromise.

When he falls in love with Anna Akerblom (Pernilla Au-

Ingmar Bergman is a benevolent ghost hovering over 'The Best Intentions.'

gust), the pampered daughter of a bourgeois family, Anna's mother is certain the marriage will be a catastrophe. She sends Henrik away and later destroys a letter Anna tries to send him. One of the horrifying truths that emerges in "The Best Intentions" is that Mrs. Akerblom is not a monster. She is wrong in her interference, but quite simply right in foreseeing a disastrous marriage. That Mr. Bergman can extend sympathy to such wrongheaded behavior is a great and gen-

erous gesture, one that allows him to create characters of astonishing depth.

Bille August's fluent, unfussy style is certainly influenced by aspects of Mr. Bergman's. Mr. August's 1988 film, "Pelle the Conqueror," is a languorous tale of a poor 19th-century drunken farmer and his precious, impressionable son. Though it is beautifully photographed, this potentially treacly story is shaped by a Bergmanesque toughness. When he invited Mr. August to direct "The Best Intentions," Mr. Bergman chose someone who could interpret his vision without imitating it.

Mr. August's visual poetry and Mr. Bergman's dialogue combine with stunning richness. When Mrs. Akerblom tells her daughter that Henrik is still engaged to another woman, Anna stubbornly refuses to break down. Her pain seems more intense for being repressed. As Anna faces the camera, her mother stands behind her, looking at her daughter's back as she leaves the room; only then does one tear fall down Anna's impassive face. "I'll never forgive this," she says, and her cruelly truthful mother wonders, "Whom won't you forgive? Is it me you'll never forgive? Or life, perhaps? Or God?"

Mr. August and the actors have fulfilled the spirit of Mr. Bergman's script in ways that go beyond dialogue. During their engagement, Henrik and Anna have an explosive, hateful argument and can envision a miserable marriage. The film moves directly from this scene to the wedding — allowing no time for comfort or calmness — and they marry with expressions that are knowing and wary. They look as if they were condemning themselves to an unhappiness they cannot avoid or resist, any more than they can resist each other.

The film's single, relatively minor flaw is the pacing of its last hour. "The Best Intentions" was filmed in two forms — a six-hour television version and the three-hour theatrical version. The second half of the film deals with the early days of the Bergman marriage, in a cold, poor parish. It includes extraordinary scenes — Anna sitting dejected and lonely in her shabby kitchen — but events are sometimes blunt and telescoped, suggesting traces of the missing three hours.

Still, Mr. Bergman's uncompromising honesty remains to the last scene. Anna and Henrik, deciding to patch together their ruptured marriage, look at each other from separate park benches. "Will we be able to forgive each other?" she asks. It is a question neither dares to answer. "The Best Intentions" is Mr. Bergman's deep, forgiving, unsentimental response. □

1992 Ag 9, II:13:5

Cup Final

Directed by Eran Riklis; screenplay by Eyal Halfon, based on an idea by Mr. Riklis, in English, Arabic and Hebrew with English subtitles; director of photography, Amnon Salomon; edited by Anal Lubarsky; music by Raviv Gazil; produced by Michael Sharfshtein; released by First Run Features. At Film Forum 1, 209 West Houston Street, SoHo. Running time: 107 minutes. This film has no rating.

Cohen.. Moshe Ivgi
Ziad.. Muhamad Bacri
Omar .. Suheil Haddad
With: Sailm Dau, Basam Zuamut, Yuseff Abu Warda, Gasan Abbss, Sharon Alexander and Johnny Arbid.

By STEPHEN HOLDEN

War and sports are activities in which passions run high and competition is fierce. Both involve similar sorts of physical and mental training, and both yield heroes. Yet making war is generally regarded as the expression of humanity's basest drives, while international sports events are haloed in a mystique of Olympian nobility.

The similarities and contradictions between the two are milked for all they are worth in Eran Riklis's splen-

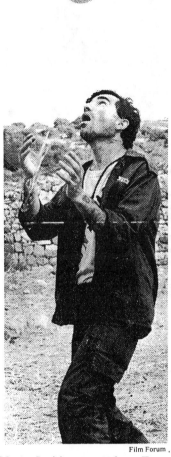

Moshe Ivgi in a scene from Eran Riklis's film "Cup Final."

did antiwar film, "Cup Final," which opens today at Film Forum 1. Set in Lebanon in June 1982, the film follows the fortunes of Cohen (Moshe Ivgi), an Israeli Army reservist who is captured by a retreating eight-man unit of Palestinian soldiers during Israel's invasion of Lebanon.

Coincidentally, the World Cup soccer games are in progress in Spain. Cohen, who is an avid soccer fan, still carries his tickets for the games. As the party makes its way through the war-ravaged Lebanese landscape toward Beirut, where the Palestinians hope to ransom Cohen, the men sporadically follow the events in Spain on radio and television. As it happens, the Palestine Liberation Organization leader, Ziad (Muhamad Bacri), and Cohen are both passionate supporters of the Italian soccer team. If they are enemies in one cause, the film stresses, they are allies in another.

•

As "Cup Final" makes disturbingly clear, the emotions that the games stir up in the soldiers are almost identical to their soldierly loyalties, and the comparison makes their deadly struggles seem like a game that has gone tragically out of control. The film is so eager to make its points that it occasionally becomes ham-fisted. The worst lapse is a scene in an amusement arcade crammed with video games and a pool table, where a friendly billiards match turns ugly and is forced to take on a bogus allegorical weight.

These excesses are only minor flaws in a film whose depiction of

modern warfare has a harsh documentary reality. When violence erupts, it is usually a sneak attack that flares up out of nowhere, turning a deceptively tranquil setting into a howling firestorm. Subsiding as quickly as they begin, these eruptions leave a human carnage that is all the more horrifying for seeming so random.

The presence of the media adds a surreal layer. Radio and television announcers in several languages are overheard describing the games in the same cool tones with which they report on the invasion. After awhile the television snippets of the games match live-from-the-front war reporting.

•

The film's greatest strength is its extraordinary ensemble acting. As Cohen is transported across the country's scarred terrain, he develops increasingly warm relations with several of his captors, most notably Ziad. Their friendship almost seems to override politics until brutal reminders of the war suddenly divide them. Cohen makes several desperate sprints toward freedom, but by the end of the film, he is so near to being a comrade in arms with his captors that his escape attempts seem almost like a recurrent comic shtick.

"Cup Final" is scrupulously evenhanded in giving both sides their political say, with Cohen and Ziad emerging as equally sympathetic characters. Mr. Ivgi's sad-eyed, shaggy-browed Cohen is an endearing everyman whose movements carry a twinge of rueful comedy. Mr. Bacri's proud, hawkish Ziad is a hardened soldier whose war experience hasn't left him callous.

At the end of "Cup Final," as the exhausted men try one by one to cross a fortified highway into a city they believe holds some sort of deliverance, one realizes how far away from a sporting event the war has brought them. Even for those fortunate enough to cross the deadly finish line, there will be no prizes waiting.

1992 Ag 12, C13:1

Diggstown

Directed by Michael Ritchie; screenplay by Steven McKay, based on the novel "The Diggstown Ringers" by Leonard Wise; director of photography, Gerry Fisher; edited by Don Zimmerman; music by James Newton Howard; production designer, Steve Hendrickson; produced by Robert Schaffel and Youssef Vahabzadeh; released by MGM. Running time: 97 minutes. This film is rated R.

Gabriel Caine James Woods
Honey Roy Palmer Louis Gossett Jr.
John Gillon Bruce Dern
Fitz ... Oliver Platt
Emily Forrester Heather Graham
Wolf Forrester Randall (Tex) Cobb

By VINCENT CANBY

NOT since "Smile" and "Semi-Tough," both released in the mid-1970's, has Michael Ritchie directed anything quite as entertaining as "Diggstown," a funny and vulgar fable about con artists so cynical that signs of simple skepticism can be taken for religious epiphanies. Adapted by Steven McKay from a novel by Leonard Wise, "Diggstown" is rough and improbable, its plotting sometimes opaque; yet it moves with such speed and cheerful nerviness that it's almost as irresistible as its fast-talking hero is reputed to be.

He is Gabriel Kane (James Woods) who, when first seen, is preparing for his release from Winfield Prison, somewhere in Georgia, where he has spent three years for selling Old Masters painted with acrylics. Gabe hasn't been wasting his time inside. He has accumulated a $50,000 nest egg by arranging bare-knuckle fights and taking bets, and, as a profitable antiestablishment sideline, custom-designing escape routes for other cons.

Gabe himself has not been tempted to make a premature exit. He intends to leave with all legal requirements having been met. The reason: he has a plan for a scam that will make him a multi-millionaire. He doesn't want anything to prevent him from being able to enjoy his success when, as he is sure, it falls into his lap.

The scam takes him to Diggstown, a small Georgia town that seems to be as fantastic as Brigadoon but far less benign. Gabe has learned of the place through his cellmate. Halfway between nowhere and nowhere, Diggstown looks like any other sleepy, utterly corrupt speed-trap, but it's different. It's the center for what's known as cash fighting, epic boxing matches that are supervised by no one except the high rollers who arrange and bet on them. They aren't the kind of matches that are recorded in the almanacs.

Gabe's intended mark is John Gillon (Bruce Dern), the soft-spoken, politely menacing Mr. Big of Diggstown, who came into his position some years before as a result of a legendary bout that is still spoken about in hushed, somewhat embarrassed tones. Everybody knows that the bout was crooked, but not to what degree. Gabe and Gillon are perfectly matched in their sparring outside the ring.

More or less in the middle is Honey Roy Palmer (Louis Gossett Jr.), the pal whom Gabe brings to Diggstown to fight any 10 opponents Gillon puts up against him in a 24-hour period. Gabe and Roy have played this game before, but never for the stakes that accumulate this time. The initial bets are comparatively picayune, but before the 24 hours are up, even Diggstown is up for grabs.

Gillon cannot figure out Gabe's angle at the beginning. Roy wouldn't seem to be the most promising fighter. He's in good shape, but he is 48 years old and hasn't had a recorded match since 1972. Long before this new fight gets started, each side is tampering with the other's game plan.

•

"Diggstown" is acted with immense style by Mr. Woods, Mr. Dern and Mr. Gossett, as well as by some members of the supporting cast. These include Oliver Platt, who plays a card-sharp and pool hustler, the decoy Gabe sends into Diggstown to set up the scam, and Heather Graham, best remembered as the unhappy Nadine in "Drugstore Cowboy," who somehow manages to be memorable in a movie that scarcely recognizes women.

"Diggstown" isn't overtly chauvinist, but it exemplifies a kind of macho fiction that is usually no less tawdry than the male characters it tries to canonize. Like Don Siegel's "Escape From Alcatraz" and Robert Aldrich's "Emperor of the North Pole" and "All the Marbles," this new film somehow transcends its rather parochial roots to become a first-rate work of legitimate if eccentric order.

That doesn't mean it's perfect. Women may well be put off by it. The heart of the movie is a series of brutal and hilarious ring confrontations that send up the kind of heart-rending nonsense the "Rocky" films trade in. (Mr. McKay's next produced screenplay, it's reported, will be Sylvester Stallone's "Rambo IV.")

A high-stakes scam, with sparring outside the ring and in.

The opening exposition is complete confusion. The scam is set up so fast that not until the film's end can one be sure exactly how it is meant to operate. Though memorable, Ms. Graham's character seems to have fallen off a Greyhound bus en route to another film location. The movie isn't sure what to do with her, but she is necessary to the plot.

The macho behavior of the characters carries over into the method of the film itself. It has a way of running headlong into situations it never completely resolves. Yet in an unexpected way, that is part of the movie's appeal. Like Mr. Woods's Gabe, a tireless operator, "Diggstown" is a lot cannier than its sometimes rather slapdash manners would seem to indicate.

•

"Diggstown," which has been rated R (Under 17 requires accompanying parent or adult guardian), has vulgar language, brutality and sexual situations.

1992 Ag 14, C1:1

Johnny Suede

Written and directed by Tom DiCillo; director of photography, Joe DeSalvo; edited by Geraldine Peroni; music by Jim Farmer; production designer, Patricia Woodbridge; produced by Yoram Mandel and Ruth Walburger; released by Miramax Films. At the Angelika Film Center, 18 West Houston Street, Greenwich Village. Running time: 97 minutes. This film is rated R.

Johnny Suede Brad Pitt
Deke ... Calvin Levels
Freak Storm .. Nick Cave
Slick Wilfredo Giovanni Clark
Darlette ... Alison Moir
Flip Doubt Peter McRobbie
Mrs. Fontaine Tina Louise
Fred Business Michael Mulheren
Yvonne Catherine Keener

By VINCENT CANBY

Tom DiCillo, who photographed Jim Jarmusch's classic "Stranger Than Paradise," now makes his own debut as a writer and a director with "Johnny Suede," a comedy so lazily hip and so laid back that it often seems to be asleep. When it stirs, which is now and then, it exhibits a sweetly embarrassed charm, as if apologizing for causing a commotion, no matter how unobtrusive.

The movie, which opens today at the Angelika Film Center, is set in a large city that has no visible center and where time seems to have stopped in 1961. Johnny Suede (Brad Pitt) longs to be a teen-age idol like

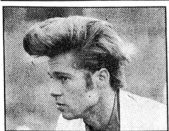

Brad Pitt

Miramax Films

Ricky Nelson. He has a pair of black suede shoes, an impressive pompadour, a guitar and some pals who will play backup for him. Yet he doesn't have much talent or drive.

His adventures, all small ones, involve Darlette (Alison Moir), who is startlingly beautiful and writes terrible poetry; Darlette's equally beautiful mother (Tina Louise), who has eyes for Johnny; Deke (Calvin Levels), his best friend, and most important of all, Yvonne (Catherine Keener), a schoolteacher Johnny falls in love with (to his disgust), even though she doesn't use eye liner.

•

Mr. DiCillo never quite finds the right tone for his comedy, whose images come and go on the screen like daydreams. There are a few genuinely funny moments, as when Deke tries to persuade Johnny to consider the pros and cons of living with Yvonne. Although "Johnny Suede" is as ephemeral as smoke, somehow it is very good to its cast members, all of whom are attractively off the wall.

Mr. Pitt, who played the unreliable hitchhiker in "Thelma and Louise," seems to be a genuine movie personality with some of the characteristics of a young Jack Nicholson. Ms. Keener would also seem to be a very promising new screen presence, and Mr. Levels takes a small number of not hilarious lines and makes them both comic and, for a brief moment, important.

Something is going on in "Johnny Suede," though what is anybody's guess.

•

"Johnny Suede" is rated R (Under 17 requires accompanying parent or adult guardian). It includes partial nudity, sexual situations and some vulgar language.

1992 Ag 14, C5:5

Single White Female

Directed and produced by Barbet Schroeder; screenplay by Don Roos, based on the novel 'SWF Seeks Same" by John Lutz; director of photography, Luciano Tovoli; edited by Lee Percy; music by Howard Shore; production designer, Milena Canonero; released by Columbia Pictures. Running time: 107 minutes. This film is rated R.

Allison Jones	Bridget Fonda
Hedra Carlson	Jennifer Jason Leigh
Sam Rawson	Steven Weber
Graham Knox	Peter Friedman
Mitchell Myerson	Stephen Tobolowsky

By VINCENT CANBY

Allison Jones (Bridget Fonda) has everything needed to live the good life in Manhattan. She's smart, pretty and aggressive. She has her own computer programming business and a great Upper West Side apartment, which not only has two bedrooms, parquet floors and high ceilings, but also is rent controlled.

When Alli breaks up with her boy-friend, Sam Rawson (Steven Weber), because he has been two-timing her with his ex-wife, Alli never thinks of moving into a smaller place. Like many Manhattanites, she can't afford to move. Instead, she advertises for a roommate and finds Hedra Carlson (Jennifer Jason Leigh), who appears to be as perfect as everything else in Alli's life, with the notable exception of Sam.

Hedy presents herself as someone who likes nothing better than doing for others. She's self-effacing to the point of frumpiness, though she could be as pretty as Alli. With no particular aim in life, she works at a Rizzoli bookstore and soon comes to focus all her attentions on Alli, who is delighted at first.

Hedy takes up the space that Sam once occupied. Hedy also cooks, cleans, buys a dog for Alli and is there to watch late-night television movies with her. Little by little, though, Alli realizes that Hedy is beginning to emulate her with scary adoration. The last straw is when Hedy emerges from the beauty parlor with her hair cut and dyed to look so much like Alli's that the two could be identical twins.

•

Taking this situation, Barbet Schroeder, the director, and Don Roos, who adapted his screenplay from a novel by John Lutz, have made "Single White Female," a psychological thriller far classier than — but essentially not very different from — "The Hand That Rocks the Cradle." It's another situation that would never have come to pass if someone had just checked the references.

Anyone who associates "Single White Female" with Ingmar Bergman's "Persona" has to be kidding. Mr. Schroeder ("Barfly," "Reversal of Fortune") is a director of terrific intelligence and wit. Yet the journey made by Alli and Hedy in "Single White Female" has more to do with stiletto heels as weapons and the use of guns than it does with serious considerations of identity.

"Single White Female" is Mr. Schroeder's bid to compete in the mass market, and there's no reason he shouldn't succeed. The film is smooth, entertaining and believably sophisticated. It has far more sound psychological underpinnings than other movies of its type. In Alli and Hedy it has two characters whose complexity supports the breathless melodramatics that climax the film. The willful and somewhat spoiled Alli doesn't quite invite Hedy's obsessive devotion, but it takes her a long time to recognize its fatally inconvenient power.

Both actresses are exceptionally good. Ms. Fonda's Alli has a breezy self-sufficiency that's most appealing, though it fails her when it comes to men, particularly to Sam, a nice guy who can't help being a pig.

Ms. Leigh continues to astonish. It's difficult to recognize in the lunatic Hedy the same woman who played the innocent hooker in "Miami Blues" and the frail, lost Tralala in "Last Exit to Brooklyn." She's become one of our most stunning character actresses before looking old enough to vote.

Mr. Weber and Peter Friedman, who plays Alli's gay upstairs neighbor, do well in rather colorless sup-

Bridget Fonda

Columbia Pictures

porting roles. The most interesting male in the film is Stephen Tobolowsky, who gives an aggressively rude and funny performance as one of Alli's demanding clients. He gets a good deal more than he asks for in one of the film's series of twists that are both politically and socially correct.

What Roman Polanski did for the Dakota in "Rosemary's Baby," Mr. Schroeder attempts to do for the Ansonia, the old great Beaux-Arts pile at the corner of Broadway and 73d Street on the Upper West Side, which stands in for Alli's rent-controlled apartment house. If the Ansonia doesn't have quite the impact, it's not because the building is any less photogenic, but because "Single White Female" doesn't rely on creepy effects to the same extent as the Polanski film.

•

"Single White Female," which has been rated R (Under 17 requires accompanying parent or adult guardian), has violence, partial nudity, sexual situations and vulgar language.

1992 Ag 14, C8:1

Using Death As a Means Of Rebellion

"The Living End" was shown as part of the 1992 New Directors/New Films series. Following are excerpts from Janet Maslin's review, which appeared in The New York Times on April 3. The film opens today at the Angelika Film Center, 18 West Houston Street, in Manhattan.

Black humor doesn't get much darker than "The Living End," the story of two H.I.V.-positive young men who manage to turn potential tragedy into a desperate, uproarious celebration of their new-found nihilistic freedom. Doing himself a great disservice, the writer and director Gregg Araki labels his work "an irresponsible movie" when in fact it has the power of honesty and originality, as well as the weight of legitimate frustration. Miraculously, it also has a buoyant, mischievous spirit that transcends any hint of gloom.

Mr. Araki has managed to make even morbidity seem intrinsically droll, from a character's remark that this is "the first day of the rest of my life" to the slogan "Choose Death" on a bumper sticker. Suddenly, in this film's fun-house universe, even the simplest of platitudes looks mad. Normal life ceases to exist for this film's two main characters as soon as they receive their bad news. And the passion that develops between them, however playful it appears, is truly a matter of life or death.

Wearing his cinematic influences on his sleeve, Mr. Araki acknowledges film makers including Jean-Luc Godard, Andy Warhol and Derek Jarman during the course of his story, and he stages that story with a mock nonchalance reminiscent of Jim Jarmusch or Gus Van Sant. Even the offhanded "Sorry" with which a doctor tells Jon (Craig Gilmore) that he has tested H.I.V.-positive is given an absurdly downbeat, casual spin.

•

In that context, the film's outbursts of violence seem no less bizarre than its tiny proprieties. And its crime spree is presented as an understandable response to AIDS-induced rage. Like "Thelma and Louise," which it resembles on a more modest and desperate scale, "The Living End" uses crime as a way of extricating its characters from everyday society, and not as an occasion for passing moral judgment on their behavior. Getting out is what matters, not getting even.

Soon after Jon receives his diagnosis, he encounters a handsome hustler named Luke (Mike Dytri), whose more raucous exploits have been separately detailed early in the film. Luke even witnesses a murder, an event staged with the type of cartoonish exaggeration that Mr. Araki succeeds in making unexpectedly droll. Compared with the more conventional Jon, Luke seems a real rebel, but the two soon overcome their differences to begin a fervent love affair. When they begin having sex, Jon forces himself to acknowledge his recent diagnosis, but Luke's response is typically cool. "Welcome to the club, partner," he whispers.

Mr. Araki gets a lot of mileage out of the cultural climate from which Jon, a film critic, has emerged. "You know what they say: Those that can't do, teach; and those that can't teach get 25 cents a word to rip other people's work to shreds," he explains when Luke visits his apartment, which is filled with carefully selected movie posters. The film easily shifts between dry asides and observations of a more solemn kind. "The generation before us had all the fun," says one of the film's handsome, 20-ish heroes. "And we get to pick up the tab."

The ragged humor of "The Living End" wears thinner as the characters discuss sex, death and the afterlife and begin to come face to face with their fate. Mr. Araki, for all his playfulness, fully grasps his heroes' situation, and he does not presume to invent an easy escape. Rudely funny as it is about most things, "The Living End" doesn't trivialize AIDS in any way. What it does instead is give vibrant, angry substance to the phrase "till death do us part."

1992 Ag 14, C8:6

La Discrète

Directed by Christian Vincent; screenplay (in French with English subtitles) by Mr. Vincent and Jean-Pierre Ronssin; director of photography, Romain Winding; edited by François Ceppi; music by Jay Gottlieb; produced by Alain Rocca; released by MK2 Productions, U.S.A. At the Lincoln Plaza Cinemas, Broadway at 63d Street, Manhattan. Running time: 95 minutes. This film has no rating.

Antoine......................................Fabrice Luchini
Catherine....................................Judith Henry
Jean...Maurice Garrel
Solange...Marie Bunel

By STEPHEN HOLDEN

Antoine (Fabrice Luchini), the narrator and protagonist of "La Discrète," is a far less appealing character than either he or Christian Vincent, the film's director and co-author, might imagine. Skinny and nervous, with blazing, buggy eyes and a penchant for rattling on excitedly about historical trivia, Antoine is presented as a sophisticated ladies' man who can usually have his pick of women.

The film takes its title from a piece of that trivia. Upper-class women of the 17th century, he says, adorned themselves with artificial beauty marks to attract male attention. The marks had names that were based on where they were placed. On the chin, it was called La Discrète. When Antoine meets Catherine (Judith Henry), who has a mole on her chin, it becomes his nickname for her.

•

Cocky as he is, Antoine doesn't always win at the game of love. In the first scene of the film, which opens today at the Lincoln Plaza Cinemas, he prepares to break up with his current lover, Solange (Marie Bunel), but she beats him to it by returning to Paris with a new boyfriend after an out-of-town trip and coldly dumping Antoine when he surprises her at the railroad station.

His pride stung, Antoine confides his desire for revenge to his friend Jean (Maurice Garrel), a wizened publisher and rare-book collector. Jean proposes an experiment that could conceivably help Antoine make the leap from parliamentary speechwriter to more serious literary pursuits. Together they concoct a scheme in which he will advertise for a female typist under 25, make her fall in love with him, then break up with her after their first sexual encounter. Antoine is to keep a detailed diary of his campaign, which Jean will publish as their joint revenge against the opposite sex.

Catherine, Antoine's unwitting prey, turns out to be a self-possessed young woman with brown saucer eyes and a Mona Lisa smile. Even though Antoine says he finds her revolting, the plan goes forward, with Antoine letting Jean dictate his every move. Although resistant at first, Catherine begins to melt. The film

MK2 Productions
Judith Henry

closely follows their dates at a cafe, at the movies and at a swank bar where Catherine becomes sweetly tipsy. Eventually, the story takes a nasty twist, with the bitter old book collector brutally pulling the strings.

As a film maker, Mr. Vincent has been compared with Eric Rohmer, for good reason. "La Discrète," like the typical Rohmer film, gazes fixedly on the nuances of supposedly civilized behavior to uncover a less-than-civilized moral universe. With its crisp musical soundtrack that uses piano pieces by Schubert and Scarlatti and its brownish-hued vision of contemporary Paris, the film feels like a formal, slightly musty chamber piece.

•

The interior world that it meticulously uncovers is a meanly duplicitous one. If Antoine, with his glib tongue and seductive ways, is presented as a sort of urban Parisian everyman, he is a pretty poor excuse of a man, for he is weak, self-deluded, vindictive and blindly sexist.

Catherine is something else. A woman without airs, she is emotionally direct to the point of curtness, but never cruel. In Miss Henry's enchanting portrayal, she emerges as an accidental, uncalculating femme fatale whose waifish charm recalls the young Glynis Johns or Giulietta Masina, but without their childlike vulnerability.

In a conversation with Antoine, Catherine casually regales him with stories of her sexual adventures while working in England as an au pair. The most revealing tale recalls a brief foray into prostitution, during which Catherine discovered that all the customers had to be treated like babies.

With his huge but fragile ego and his fantasy of himself as a brainy, swashbuckling soldier in the war between the sexes, Antoine is a sophisticated baby. If Catherine is far too good for him, she is also too good-hearted to know it.

1992 Ag 14, C13:1

Stay Tuned

Directed by Peter Hyams; screenplay by Tom S. Parker and Jim Jennewein, based on a story by Mr. Parker, Mr. Jinnewein and Richard Siegel; director of photography, Mr. Hyams; edited by Peter E. Berger; music by Bruce Broughton; production designer, Philip Harrison; produced by James G. Robinson and Arne Schmidt; released by Warner Brothers. Running time: 90 minutes. This film is rated PG-13.

Roy Knable....................................John Ritter
Helen Knable..............................Pam Dawber
Spike...Jeffrey Jones
Crowley..Eugene Levy
Darryl Knable...............................David Tom
Diane Knable..........................Heather McComb
Rap Artists...................................Salt-n-Pepa

By STEPHEN HOLDEN

"Stay Tuned" takes a nifty satiric concept — a Hadean video world run by a devil who kidnaps couch potatoes and puts them into programs in which they die — and reduces it to a mild-mannered suburban comedy with little bite.

The film, which opened yesterday, follows the adventures of Roy and Helen Knable (John Ritter and Pam Dawber), who are sucked into their satellite dish after Roy signs a contract with a Mr. Spike (Jeffrey Jones), later revealed to be "the Mephistopheles of the cathode ray." From their backyard the couple find

Bob Akester/Morgan Creek
Jeffrey Jones

themselves plopped into a sadistic game show called "You Can't Win," in which a wrong answer to an embarrassing personal question results in ejection into a pit of vipers.

Leaping by remote control from program to program on the 666-channel receiver, they find themselves attacked by wolves in "Northern Overexposure" and menaced by gangsters in a 40's film-noir spoof, among many other perils. If they can survive for 24 hours, they learn, they will be returned to their normal lives.

•

As it happens Darryl (David Tom), one of their two children, is an electronics whiz. When he catches on to what has happened, he puts his ingenuity to work to get them back.

"Stay Tuned," which was directed by Peter Hyams with a screenplay by Tom S. Parker and Jim Jennewein, is a cleverly plotted movie that offers ample opportunity for spoofing anything and everything that can be found on television. Unfortunately,

most of its takeoffs — of a black-and-white gangster film, a spaghetti western and a period swashbuckler — show no feel for genre and no genuine wit.

The film is a bit more on target in its takeoffs of actual television shows. One of the cleverer moments is a "Wayne's Underworld" segment of "Saturday Night Dead," in which chortling adolescents in ghoulish masks bash Roy in the head with the camera that is actually filming him.

Only two sketches suggest what the film might have been. The first is a cartoon created by the noted animator Chuck Jones, in which the Knables are turned into mice menaced by a nearly indestructible feline called RoboCat. The second finds Roy in drag pursued by the devil in an elaborate music video by the female rap duo Salt-n-Pepa. Adding an extra zany touch is the fact that in the middle of the chase the "mute" on the remote control is accidentally pressed.

Mr. Ritter and Miss Dawber don't have much to do in the movie except be frantic. But Mr. Jones's devil is an amusing caricature. With his creepy grins, arching eyebrows and stifled fits of apoplexy when things don't go his way, he suggests a sneaky television executive gone bonkers from all the competitive pressure.

•

"Stay Tuned," which has been rated PG-13 (Parental Guidance Suggested), has a few slightly off-color jokes.

1992 Ag 15, 14:5

FILM VIEW/Janet Maslin

Whose Life Is It, Anyway?

FORGET CAT BURGLARS. MUGgers and bank robbers are equally passé. The cleverest thieves on screen right now are after something subtler than money, something not easily carried off in the dead of night. The prize in many current films is someone else's peace of mind, whether it is co-opted through delicate treachery or stolen outright by a brazen impersonator. Quicker than you can say "Vertigo" or "Persona," the movies have filled up with identity-snatching bandits who have uncanny abilities to invade the privacy of their prey.

The means for this kind of psychic crime may vary, and the tone can be sinister or comic. But the attempt to borrow a target's best attributes remains essentially the same, whether the thief is copying someone's appearance, stealing a lover or invading a home. The latest example, and a film whose villain attacks on all three of the above-mentioned fronts, is "Single White Female," in which the small, vaguely dangerous Hedra Carlson (Jennifer Jason Leigh) does all in her considerable power to steal the identity of her willowy roommate, Allison Jones (Bridget Fonda). Then there's "Basic Instinct," which makes such a point of how badly Beth (Jeanne Tripplehorn) wants to become Catherine (Sharon Stone) that this identity-lifting subplot obscures the solution to its murder mystery. (Still wondering who did it? Look at the printout on Catherine's computer when she finishes her novel.)

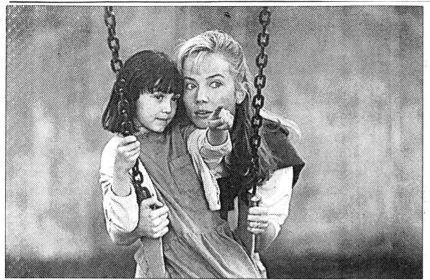

Matthew McVay/Buena Vista Pictures

Madeline Zima and Rebecca De Mornay in "The Hand That Rocks the Cradle"—The nasty nanny sets out to make her employer miserable.

In these cases, imitation is construed as flattery. Or outright fondness, as in "What About Bob?," when Bill Murray becomes so smitten with his psychiatrist that he tries to make the doctor's family his own. Or loathing, as in "The Hand That Rocks the Cradle."

Personality theft is never easy to justify in dramatic terms. Would a grieving widow really go to the trouble of taking up a whole new career just to undermine the woman she hates, as Rebecca De Mornay does in "The Hand That Rocks the Cradle"?

■

Probably not. But personality-theft plots often amount to nothing more than malevolent fun for both film maker and bandit. As a nanny, Ms. De Mornay has an awfully good time spilling perfume on the best dress of her employer (Annabella Sciorra) or making her feel as if she is losing her family. And though a rogue cop would be unlikely to try to steal another man's beautiful wife as persistently as Ray Liotta does in "Unlawful Entry," that film enjoys making the hero feel that his home might be invaded at any moment.

Even a man who has at least five personalities, as John Lithgow does playing a gleefully deranged child psychologist in Brian DePalma's "Raising Cain," can allow four of them to revel in the idea of driving the fifth — the quiet, polite Dr. Carter Nix — completely crazy. The wayward teen-ager portrayed by Drew Barrymore in "Poison Ivy" claims to need love and attention, but she seems to be stealing her best friend's family (and seducing the father) mostly as a lark.

Personality theft affords great opportunities for such mischief, not to mention the kinds of insidious visual tricks that "Single White Female" employs. Elegantly directed by Barbet Schroeder ("Reversal of Fortune"), with a production design by Milena Canonero of such ravaged urban beauty that it suggests "Last Tango in Paris" on the Upper West Side, "Single White Female" introduces Allie and Hedy as opposites. They meet, as the title suggests, through a real estate ad. (The original title of John Lutz's novel, "SWF Seeks Same," has been purged of its discriminatory overtones.) The poised Allie is momentarily on the rebound from an unfaithful boyfriend, and she hopes mousy, grateful Hedy will help her feel less lonely.

Allie's motives are easily fathomed. And the film, to its credit, tries to make sense of Hedy's, too. A phone call home brings hints of a troubled childhood. Old snapshots offer a few clues. But it would require in-depth psychoanalysis to explain why Hedy would feel moved to adopt her new friend's exact hairdo and secretly copy her clothes. (Similarly, without compromising its sunny mood and making its heroine sound deranged, "Housesitter" cannot begin to explain why Goldie Hawn's character would change identities on impulse and appropriate someone else's house, parents and friends.)

Villains these days invade their victims' privacy, stealing identities, lovers and peace of mind.

There *have* been films that approached some understanding of identity-stealing characters without compromising their entertainment value (David Cronenberg's eerily brilliant "Dead Ringers," in which one twin brother overpowers the other). "Single White Female" doesn't have that depth, but its superficial details are so well chosen that they say a lot about the principals' underlying thoughts. Ms. Fonda and Ms. Leigh, cleverly cast, move in and out of a close physical resemblance that is entirely a fiction of the movie's (Ms. Fonda is a head taller, with much sleeker features) but is superbly controlled by Mr. Schroeder. And the resemblance is exploited in powerfully insinuating ways. A scene in which Hedy sexually co-opts Allie's boyfriend revolves around his partial awareness that he is being tricked, as Hedy makes his willingness part of her power.

At times "Single White Female" recalls one of the great New York identity-theft movies, "Rosemary's Baby," in which a young bride finds herself controlled by a coven of witches, and even the apartment building seems a party to the crime. In any such story there are a couple of constants: watch out for living quarters where the walls have ears, and never trust a roommate who looks too good to be true. He or she may wind up borrowing a lot more than your umbrella. ☐

1992 Ag 16, II:15:1

Lombard's Recipe: Take Hauteur and Chic, Add Madcap Comedy, and Stir

By VINCENT CANBY

THE initial setting in Howard Hawks's "Twentieth Century" (1934) is a bare Broadway stage where Oscar Jaffe (John Barrymore), a theater impresario deferentially called "sire" by his press agent, is taking the first day of rehearsals of his new production. The show is a ghastly romance set in an antebellum South

Photofest

Screen equals: John Barrymore and Carole Lombard in the 1934 comedy "Twentieth Century."

whose fictional apogee would be reached a few years later in "Gone With the Wind." The air is thick with out-of-state "Ah-declares" and "you-alls."

. Oscar is having difficulty with his latest discovery, an ex-lingerie model née Mildred Plotka (Carole Lombard), whom he has newly christened Lily Garland. Eager and ambitious but painfully shy, Lily isn't screaming the way Oscar demands when she hears that her daddy has shot her lover dead on the front lawn. Her best attempt is a tentative "eek." Oscar, a Krakatoa waiting to erupt, is gentle and avuncular.

"That kind of acting," he says, "is for pins in a basement."

He urges her to let herself go, but the "eeks" only become more self-conscious. Finally, at the moment that Lily is again required to scream, Oscar picks up a hatpin only a little smaller than a rail spike. With the authority of Zeus letting go a thunderbolt, he directs it at her rear end.

As Lily bellows the surprised fury of an impaled mother elephant, Carole Lombard roars into the collective consciousness as the grandest, most skilled, most uninhibited American comic actress of her day, and of any day since. At the same time, "Twentieth Century" is on its way to becoming the most delectable American film farce ever made or, at least, the first among a trio of equals that would include Ernst Lubitsch's "To Be or Not to Be" (1942) and Billy Wilder's "Some Like It Hot" (1959).

Just how much the dazzling Lombard contributed to both "Twentieth Century" and "To Be or Not to Be" can be seen in "Nothing Sacred: Silver Screenings With Carole Lombard," the not-to-be-missed 10-day retrospective organized by the Film Society of Lincoln Center. It begins today at the Walter Reade Theater.

The opening attraction? "Twentieth Century." It will be half of a double bill today and tomorrow with another of Lombard's 1934 films, "Bolero," a rather elegant studio pot-boiler, directed by Wesley Ruggles, in which George Raft receives top billing.

Lombard was — is — a phenomenon. With her strong, almost classical features, her pale blond hair and sleek figure, she is downright gorgeous but capable, on cue, of looking and sounding like a fishwife. The voice is alternately soothing and abrasive. She can call hogs if necessary. Satin evening gowns, worn without bras and fitted to the skin of her hips, give her a sensuousness that is often seriously, uproariously compromised by full-bodied, unladylike laughter.

Even at her most chic, playing characters of monumental egos, Lombard gives the impression of being the least vain of actresses. She's someone who might compete in the frosty icon department with Garbo, Dietrich and Crawford, except that she can't keep a straight face. She's a woman with a low tolerance for institutional fraud. When, with the best of intentions, she goes for the gold in so-called serious drama, something seems not right, as when she plays the heroic English nurse in "Vigil in the Night" (1940), directed by George Stevens.

Having been nominated for an Oscar for her performance as the manic Irene Bullock in the classic screwball comedy "My Man Godfrey" (1936), and having lost to Luise Rainer of "The Great Ziegfeld," Lombard was convinced that she stood another chance with "Vigil in the Night." She wasn't even nominated, probably for the wrong reasons. The film was released early in the year and wasn't a big box-office hit.

•

More to the point: though she is quite good in "Vigil in the Night," she is an actress who is least convincing when she is trying to scale herself down to the solemn proportions of missionary denial and sacrifice. She is much better in her other 1940 film, Garson Kanin's adaptation of Sidney Howard's "They Knew What They Wanted." The film itself is a piece of cheese, not helped by Charles Laugh-

The gorgeous actress could sound, on cue, like a fishwife.

ton's hammy performance as a Napa Valley grape farmer or by a ludicrously moral ending dictated by the Production Code. The rural environment doesn't suit her talent, but Lombard has a tough, breezy authenticity as Laughton's mail-order bride.

Watching her play more or less straight drama is to see a great actress working at half speed. It throws her off her pace. One result is her inability in "Vigil in the Night" to deliver conviction to the ripe line "Our war never ends. You can't sign a peace treaty with disease." The expectation is that she will screw her tongue into the corner of her mouth, as she does every time she tells a whopper in "True Confession," a not-quite-successful 1937 screwball comedy in which she appears as a pathological liar.

Playing sincere in "Vigil in the Night" and "Made for Each Other" (1939), a decent but contrived domestic drama in which she co-stars with James Stewart, Lombard seems faux naïve. Thus reined in, she suggests an aspiring 14-year-old about to deliver Portia's "quality of mercy" speech. She is an actress whose intelligence is fully expressed only in comedy.

The Lombard career is an odd one. She was born in 1908, made her first film as a child actress in 1921 and later had a short run as a Mack Sennett bathing beauty. She didn't really move into the major studios until 1928, just as talkies were coming in. Between 1928 and her death in January 1942 in an airplane crash, she appeared in 45 features, often as the star. She probably survived more dreadful movies than any other major actress of her time.

Several of these are included in the Walter Reade retrospective, though now they have a certain historical interest: "Supernatural" (1933), a tepid horror film in which she plays a society girl possessed by the soul of a convicted murderer; "Lady by Choice" (1934), a flabby follow-up to Frank Capra's 1933 hit "Lady for a Day," and "Fools for Scandal" (1938), a comedy-with-music (two songs) to accommodate her European co-star, Fernand Gravet, whose Hollywood career was not long.

Of far more interest in the retrospective are those classy if uncharacteristic Lombard romantic dramas that were considered in their day to be far more prestigious than her comedies: "Made for Each Other" and "In Name Only" (1939), both directed by John Cromwell. "In Name Only" presents the curious spectacle of Lombard and Cary Grant, two of the most accomplished comic performers of their time, playing a sudsy wife-versus-mistress triangle in upper-middle-class Connecticut.

•

Not included in the retrospective are "No Man of Her Own" (Wesley Ruggles, 1932), by all reports a minor film but the only time she played opposite Clark Gable, whom she would later marry, and "My Man Godfrey" (Gregory La Cava), one of her most fondly remembered hits, in which she plays opposite her ex-husband, the incomparable William Powell. The film society's apparent reason for not including "Godfrey" is that the film is shown so frequently on television and is available on video.

The absence of "Godfrey" is unfortunate in any summation of the Lombard career. It is one of the richest films in the screwball tradition so closely associated with life in Depression America. It also shows Lombard to be the equal of Irene Dunne and Claudette Colbert as the much-beloved, madcap screwball heroine.

If there's any doubt about this, check out the retrospective's showings of "Hands Across the Table" (1935), directed by Mitchell Leisen, in which Lombard, co-starring with Fred MacMurray, plays a manicurist out to catch a rich husband; "The Princess Comes Across" (1936, directed by William K. Howard, also with MacMurray and notable for Lombard's marvelous imitation of Greta Garbo; "Nothing Sacred" (1937), with Fredric March, written by Ben Hecht and directed by William Wellman, about a scheming young woman from Vermont who makes her fortune by saying she's dying of radium poisoning, and, a must-see, "Mr. and Mrs. Smith" (1941), written by Norman Krasna and directed by Alfred Hitchcock.

This is one of the most underrated comedies of its time, largely ignored by the critics and the public because Hitchcock was not expected to make a screwball comedy. Yet it's one of Lombard's best and, as is always the case in her successful films, she has a leading man who is her psychic match, Robert Montgomery.

"My Man Godfrey" is also missed for the way it demonstrates the differences between screwball comedy and the kind of pure farce so gloriously defined by "Twentieth Century" and "To Be or Not to Be." Screwball comedy is, even if indirectly, a product of the political, social and economic conditions of the times. Great farce is something else. It takes place as if in a glass bubble floating through space, detached from earthly

laws of gravity and conventional systems of rewards and punishments.

It's not necessary to know anything about the Broadway theater of the 1930's to respond to the delirious, hermetically sealed world of "Twentieth Century," evoked by the brilliant script by Ben Hecht and Charles MacArthur, and by Hawks's magical direction. The film tells you all you need to know to appreciate the hilarious love-hate relationship of Oscar Jaffe and Lily Garland. The main setting is the crackerjack train speeding from Chicago to New York with Oscar, Lily and a most enchanting crew of oddballs, including two bewildered cast members of the Oberammergau Passion Play.

"To Be or Not to Be," written by Edwin Justus Mayer, is set in Nazi-occupied Poland but is just as far removed from reality as "Twentieth Century," which was the reason Lubitsch was roundly criticized at the time of its release in 1942. It, too, is about self-absorbed theater folk, mainly Joseph and Maria Tura (Jack Benny and Lombard), ham actors supreme who somehow manage to outwit the entire German Army before they are done. Though the Mel Brooks-Anne Bancroft remake is al-

Alfred Hitchcock is the unlikely director of one funny feature.

most as fine, the Lubitsch-Benny-Lombard original is about as close to heaven as movie farces ever get.

•

In each of her classic films, Lombard plays opposite an actor who is her screen equal. Barrymore's performance in "Twentieth Century" forever transformed her talents. Otherwise untrained, Lombard learned a lot from Barrymore. He gave her insight into a comic method that goes beyond screwball to farce and that would be evident later in everything she did. It's especially apparent in her work with Powell, Montgomery and even Benny, whose performance in "To Be or Not to Be" is completely unexpected of a radio comedian, even a great one.

Lombard never became a figure of camp, perhaps because she wasn't around long enough, though I doubt that's the reason. Rather, I suspect, it's because she obviously was too passionate and too committed as a woman of ordinary appetites. She never stands alone in her films, like Garbo, Dietrich and Crawford. She was never a queen bee. If the actor isn't up to her measure when he starts out with her, he quickly learns the ropes, as did MacMurray, with whom she played in four films.

It would be chauvinist to say that Lombard needs a man. It's rather more accurate to say that, given the opportunity, she responds to men. She likes them. Lombard in her films seems complete only with a man, which is why there is such a magnificently daffy human face on even her most over-the-top comedies. Yet she's never subservient to the man. She is his equal.

If the man doesn't understand, then like Oscar Jaffe, he may have a num-

ber of large precious objects hurled at his head with the accuracy of a Dizzy Dean. Lombard is simultaneously of this earth and divine.

1992 Ag 21, C1:1

A Brief History of Time

Directed by Errol Morris; based on the book by Stephen Hawking; directors of photography, John Bailey and Stefan Czapsky; edited by Brad Fuller; music by Philip Glass; production designer, Ted Bafaloukos; produced by David Hickman; released by Triton Pictures. At Lincoln Plaza Cinemas, Broadway at 63d Street. Running time: 80 minutes. This film has no rating.

By VINCENT CANBY

Help is at hand for everyone who, like me, plunked down $18.95 to buy Stephen Hawking's "Brief History of Time" only to realize, upon reaching page 11, that not a word had sunk in after page 5. "A Brief History of Time" has been its own black hole. It not only swallowed up enough of the curious to keep it on the best-seller lists for 100 weeks. It also seems to have prevented any reader from emerging to sound the alarm: brief the volume is, but also dangerously dense.

Errol Morris, a director of documentaries ("The Thin Blue Line," "Gates of Heaven"), has come to the rescue of everyone who feels some-

A bit of the history of Stephen Hawking, too.

how inadequate for failing to mush on to the last page. Inspired by the book and working with the English physicist's cooperation, Mr. Morris has now made a film with the same alluring title. It opens today at the Lincoln Plaza Cinemas.

This "Brief History of Time" has its impenetrable moments, but it is also something of a delight. It functions both as an introduction to the work by Mr. Hawking and his associ-

Triton Pictures
Prof. Stephen Hawking in the film "A Brief History of Time."

ates in their search for a unified theory of physics, and as a most engaging portrait of him, the members of his family, his friends and colleagues. They are variously serious, funny, brilliant, caustic and, from time to time, eccentric in a way that evokes memories of more than one novel about England's academe.

•

Mr. Hawking's own story would be enough for any single film. A bright but lazy student, he was diagnosed as having amyotrophic lateral sclerosis (known as Lou Gehrig's disease in the United States) shortly after he went to Cambridge in the mid-1960's to work on his Ph.D. in theoretical physics. The illness, which is progressive and incurable, has now left him almost completely paralyzed. After a bout of pneumonia and a tracheotomy, he talks through a computer whose commands activate a voice synthesizer.

The film integrates Mr. Hawking's personal story with the story of his work on the unified theory, including his increasing ability to focus his mental energies while losing so much of his physical freedom. His mother speaks of the effect of the illness on his work, and of luck, something her son might associate with the random behavior of particles. "Everybody has disasters," she says, "and yet some people disappear and are never seen again."

•

The film moves easily among its dozens of interviews. This is surprisingly lively stuff, whether his sister is recalling Mr. Hawking's passion for board games and his mother is saying that board games are just a substitute for life, or his colleagues are attempting to explain the value of Mr. Hawking's work, his breakthroughs and his mistakes. Little by little some inkling of what the book is all about comes through, though certain terms (event horizons, singularities, imaginary time) still are not easily grasped.

•

There are moments when Mr. Hawking and his colleagues sound a bit like characters in a revue sketch from "Beyond the Fringe." "I was thinking about black holes as I got into bed one night in 1970, shortly after the birth of my daughter Lucy." This is Mr. Hawking's way of intro-

ducing an insight he had about the behavior of collapsing stars and what might happen should they collide.

Later he recalls having made a proposal to an associate that "time and space are finite in extent, but they don't have any boundary or edge." He likens it to the earth's surface, which is finite in area though without boundaries. He then adds something that sounds very much like a physicist's joke: "In all my travels I have not managed to fall off the edge of the world."

A number of the Hawking theories are illustrated by beautifully executed graphics. Yet ideas seem less important to the film than being in the presence of agile minds at work, talking, speculating, theorizing, searching, questioning. "A Brief History of Time" is a kind of adventure that seldom reaches the screen, and it's a tonic.

1992 Ag 21, C3:1

Clearcut

Directed by Richard Bugajski; screenplay by Rob Forsyth, based on the novel "A Dream Like Mine," by M. T. Kelly; director of photography, François Protat; edited by Michael Rea; music by Shane Harvey; production designer, Perri Gorrar; produced by Stephen J. Roth and Ian McDougal; released by Northern Arts Entertainment. At the Gramercy, 23d Street and Lexington Avenue, Manhattan. Running time: 98 minutes. This film is rated R.

Arthur	Graham Greene
Peter	Ron Lea
Bud	Michael Hogan
Wilf	Floyd Red Crow Westerman
Eugene	Raoul Trujillo
Louise	Rebecca Jenkins
Tom Starbuck	Tom Jackson

By STEPHEN HOLDEN

An aerial view of a forest in northern Canada devastated by the lumber industry "looks like the moon on a bad day," one character in the film "Clearcut" says. To another observer, the same sight "looks like money."

Those remarks define the bitter regional war that ignites this Canadian film, which opens today at the Gramercy Theater. As the movie begins, a local lumber company that is the area's economic wellspring has just won a legal skirmish against an Indian tribe whose sacred ground has been violated by a road used to truck timber from the forest to the mill. Peter (Ron Lea), the big-city lawyer for the Indians' cause, arrives in time to witness a bloody battle between the police and the Indians, who are trying to prevent the company's logging trucks from entering their territory.

"Clearcut," adapted from M. T. Kelly's novel "A Dream Like Mine," soon shifts from a political drama into a thriller with a supernatural edge. As a gesture of solidarity with his clients, the lawyer takes part in an Indian sweat lodge ceremony, during which he has hallucinations of blood oozing from trees and other grisly visions. Soon after, he meets Arthur (Graham Greene), an arrogant young Indian-rights advocate with an ominous gleam in his eye and a lust for violent revenge.

•

Peter, who underestimates the ferocity of Arthur's rage, becomes a reluctant accessory to kidnapping when the Indian grabs the mill's manager, Bud Rickets (Michael Hogan), at a gas station and takes him hostage. Peter changes from unwilling

collaborator to hostage after Arthur transports them by canoe across a lake into a virgin wilderness.

The bulk of "Clearcut" concentrates on the prisoners' desperate struggle for survival at the hands of a vengeful sadist with magical powers. Arthur knows how to hone the end of a stick and spear a fish with a single thrust into the water. He also possesses second sight. And since he has the ability to be in more than one place at the same time, escape is all but impossible.

Things become increasingly dire as the three make their way through the wilderness. One morning Peter awakens to find Arthur meticulously flaying one of Bud's legs. When he protests the torture, Arthur replies that what he is doing is no worse than the conduct of American soldiers who used to play catch with the breasts of Navajo women. Ultimately Peter, who has always eschewed violence, is driven to fight for his life.

•

"Clearcut" suggests a low-budget Canadian answer to "Deliverance," but heavily streaked with mysticism and environmental politics. Although the film never comes out and says it, Arthur is actually an Indian trickster spirit conjured into human form by Peter's anger. Also known as Wisakedjak, he is the same bloodthirsty spirit who is described to Peter during the sweat lodge ceremony by Wilf (Floyd Red Crow Westerman), the tribe's wise, long-suffering chief.

The film, directed by Richard Bugajski, is scrupulously fair to its characters and the issues they represent. Arthur radiates the glamour of a survivalist who is so perfectly attuned to nature that he moves through the wilderness with the confidence of a god. But he also kidnaps, tortures and kills with the casual ease of the most dangerous movie psychopaths. In Mr. Greene's riveting portrayal, he exudes a sinister, slightly comic buoyancy.

Mr. Hogan's burly mill-manager is considerably more sympathetic than Mr. Lea's lawyer. A rugged outdoorsman who is as fiery in his way as Arthur, he argues forcefully that closing the mill would destroy the livelihood of thousands.

Even if Peter is on the side of the angels, as the film seems to suggest, he is a weak-willed do-gooder who doesn't really understand the people whose rights he is championing. His forced journey into the wilderness is his initiation into a spiritual authenticity.

These strong, beautifully balanced performances infuse what is essentially an adventure movie with gripping psychological undercurrents. The deepest character is the tribe's chief, a man of few words whom Mr. Westerman imbues with an anguished benignity. All-knowing yet powerless to change the course of events, this elder is the film's grieving spiritual guide.

•

"Clearcut" is rated R (Under 17 requires accompanying parent or adult guardian). It includes strong language, violence and a graphic scene of torture.

1992 Ag 21, C9:1

Wax, or the Discovery of Television Among the Bees

Written, produced and directed by David Blair; director of photography, Mark Kaplan; edited by Florence Ormezzano; music by Beo Morales and Brooks Williams; released by Jasmine T. Films. At Papp Public Theater, 425 Lafayette Street, Manhattan. Running time: 85 minutes. This film has no rating.

Jacob Maker	David Blair
Melissa Maker	Meg Savlov
Allelle Zillah	Florence Ormezzano
James (Hive) Maker	William Burroughs

By STEPHEN HOLDEN

David Blair's "Wax, or the Discovery of Television Among the Bees" is so obsessed with looking and sounding like nothing that has come before that it defies the conventional wisdom that movies should be clear and well focused. Set in the vicinity of Alamogordo, N.M., with some of its more striking scenes filmed in the Carlsbad Caverns, the movie reimagines the world as it might be perceived through the blurred eyesight of a bee.

That world is a surreal video dreamscape in which visual phenomena are continually metamorphosing in ways that used to be described as psychedelic. In scenes shot in the New Mexico desert, the landscape unfolds like a shivering mirage, with the images of faces and mountains furling and dissolving like pictures on a flag in the wind. A bomb-sight grid becomes a honeycomb that becomes a map of the brain. The letters of a riddle float in the air and rearrange themselves into another slogan that seems to answer the first riddle. "Wax" goes so far as to imagine an alternative alphabet used to communicate by the spirits of the dead.

The story of "Wax," which opens today at the Papp Public Theater, is almost impossible to describe. It is narrated by a character named Jacob Maker (Mr. Blair), who designs gunsight displays at a flight-simulation factory in New Mexico. Jacob also keeps a hive of very unusual bees that were taken to Europe from Mesopotamia by his grandfather between the wars. Through the film maker's witty use of archival material, Jacob's family history in the 20th century is told as a sort of pseudo-documentary on the development of photography and its relation to the occult.

•

Maintaining a dispassionate, scientific tone, Jacob methodically expands this family history into a fantastic story of time travel, reincarnation and communion with the dead that conflates science fiction, biblical myth and entomology into a convoluted fable. The tale, among other things, is a multi-generational family saga as it might be imagined by a cyberpunk novelist. It flashes all the way back to the story of Cain and Abel and the Tower of Babel and forward to the narrator's own death, birth and rebirth in an act violence.

It all begins when Jacob starts experiencing an eerie communication with his bees. Before long, he begins suffering mysterious blackouts. During one, the bees drill a hole in the side of his head and insert a television whose supernatural images begin controlling his movements.

Propelled on a journey into the desert, he visits the site where the first nuclear bomb was tested, and eventually he ventures below the earth into a radiant underworld where the bees are preparing new bodies for the dead. Ultimately he is instructed to commit a murder in Iraq.

The character of Jacob involves a visual double-entendre. As he wanders about the desert in a beekeeping outfit that looks virtually indistinguishable from a space suit, he suggests a refugee from "2001: A Space Odyssey." That film is one of many to which "Wax" pays homage, although it looks a lot more like a movie by Jim Jarmusch than one by Stanley Kubrick. With its shifting, alternative realities, "Wax" might also be described as an electronic video answer to "Total Recall" with the weirdness multiplied exponentially.

•

What should help make the film a cult favorite is the intricate design of Mr. Blair's story. Eccentric as it is, the fable has a rigorous interior logic that puzzle aficionados should enjoy deciphering. Beyond that, "Wax" reverberates with implications about the relationship between video and the modern world.

There is a sense in which we have all had televisions implanted in our heads. And those sets broadcast television's version of reality. Who really knows what those endless reruns are doing to us?

1992 Ag 21, C10:1

The Ox

Directed by Sven Nykvist; screenplay (Swedish with English subtitles) by Mr. Nykvist and Lasse Summanen; by Mr. Summanen; cinematography by Dan Myhrman; produced by Jean Doumanian, Sweetland Films AB; released by Castle Hill Productions and First Run Features. Running time: 91 minutes. This film has no rating.

Helga	Stellan Skarsgard
Elfrida	Ewa Froling
Svenning	Lennart Hjulstrom
The Vicar	Max von Sydow
Maria	Liv Ullmann
Flyckt	Bjorn Granath
Silver	Erland Josephson

By VINCENT CANBY

"The Ox," directed by Sven Nykvist, best known for his work as Ingmar Bergman's cinematographer, is a solemn tale of betrayal and reconciliation set in rural Sweden in the 1860's, when drought and famine prompted a tidal wave of immigration to America.

The screenplay, written by Mr. Nykvist and Lasse Summanen and said to be based on a true story, is about an archetypal poor farmer who slaughters his neighbor's ox to feed his hungry wife and baby daughter. When the farmer is eventually caught, he's sentenced to life imprisonment. In a twist at the film's end, the pardoned farmer must forgive his wife as his neighbor has forgiven him.

•

There is a kind of biblical simplicity and inevitability to the story that Mr. Nykvist makes ponderous with Dan Myhrman's all-too-beautiful camerawork. The individual images are sometimes stunning. The lighting often suggests the work of Vermeer. Yet after a while this self-conscious beauty seems more admirable than stimulating. It also seems to deny the very real hardships these bewildered people must endure. As a drama,

"The Ox" has all the impact of a series of pretty sunsets.

The cast is headed by Stellan Skarsgard and Ewa Froling as the farm couple, while such Bergman stars as Max von Sydow, Liv Ullmann and Erland Josephson appear in supporting roles.

1992 Ag 21, C10:5

Rapid Fire

Directed by Dwight H. Little; screenplay by Alan McElroy; based on a story by Mr. McElroy and Cindy Cirile; director of photography, Ric Waite; edited by Gib Jaffe; music by Christopher Young; production designer, Ron Foreman; produced by Robert Lawrence; released by 20th Century Fox. Running time: 96 minutes. This film is rated R.

Jake Lo	Brandon Lee
Mace Ryan	Powers Boothe
Antonio Serrano	Nick Mancuso
Agent Stuart	Raymond J. Barry
Karla Withers	Kate Hodge
Kinman Tau	Tzi Ma

By STEPHEN HOLDEN

If a list were compiled of movies that destroyed the most glass, "Rapid Fire" would probably rank near the top. During its nonstop mayhem, several glass walls are shattered, and the film's star, Brandon Lee, guns his motorcycle through a window.

Mr. Lee, son of the action star Bruce Lee, who died in 1973, plays Jake Lo, an indestructible college student and martial-arts virtuoso. The movie is shameless in exploiting the father-son connection to try to make the star, who exudes a bored, dead-eyed cool, seem sympathetic.

•

Jake teams up with Mace Ryan (Powers Boothe), a hardened but still idealistic older policeman (and near dead ringer for the late actor John Ireland) to fight the Mafia. Mace becomes a surrogate for Jake's dead father, a Chinese freedom fighter who, in a clumsy flashback, is shown being shot to death in Tiananmen Square before his son's eyes.

Lithe and smooth-skinned, with a face so chiseled he seems to be sucking in his cheeks, Mr. Lee projects the slick, sulky arrogance of a Beverly Hills brat. That patina of cynicism may be one reason "Rapid Fire," in the few moments it pauses to catch its breath, delivers its clunking dialogue in tones that are desperately tongue-in-cheek.

The story pits Jake, Mace and Karla Withers (Kate Hodge), a beautiful and tough-talking young policewoman, against the Italian and Chinese gangs that are warring for control of the Chicago heroin trade. Many ugly ethnic and racial epithets are swapped. And when people are wounded, for some reason they usually bleed from the nose and mouth.

•

"Rapid Fire" is rated R (Under 17 requires accompanying parent or adult guardian). It includes strong language and nonstop violence.

1992 Ag 21, C11:

Light Sleeper

Written and directed by Paul Schrader; director of photography, Ed Lachman; edited by Kristina Boden; music by Michael Been; production designer, Richard Hornung; produced by Linda Reisman; released by Fine Line Features. Running time: 103 minutes. This film is rated R.

John LeTour	Willem Dafoe
Ann	Susan Sarandon
Marianne	Dana Delany
Robert	David Clennon
Teresa	Mary Beth Hurt

By VINCENT CANBY

Paul Schrader's "Light Sleeper" is about the mid-life crisis of a decent, exceptionally responsible Manhattan drug dealer. John LeTour (Willem Dafoe) is the sort of man who will make a special delivery to a customer in need at the emergency room of St. Luke's Hospital. When he thinks another customer is using too much, John refuses to sell. Later, when that same customer seems to be going around the bend, John recommends a first-rate rehab center in Minnesota and calls the customer's brother to come help.

They don't make dealers like John anymore. Nor do film makers with credits to equal Mr. Schrader's ("The Comfort of Strangers" and "Patty Hearst," among others) often bring forth movies as ponderously fuzzy-minded as "Light Sleeper," which he both wrote and directed.

At its best, "Light Sleeper" is merely theoretical. Most of the time, though, it is artificial and laughably unbelievable. Even the dark, gritty Manhattan locations don't add authenticity.

John, just 40 years old, feels that he's at a turning point. He's a good, resourceful supplier, but he no longer gets satisfaction as he whips around New York wheeling and dealing. He's a former drug user himself, although nothing about him suggests that he's ever done anything stronger than Miller Lite. Now, because his boss, Ann (Susan Sarandon), is giving up the drug business to manufacture and sell her own line of herbal cosmetics, John has to think of his own future.

Then fate and the screenwriter step in. John runs into Marianne (Dana Delany), with whom he had a long and stormy affair when both were addicts. Marianne is now straight and wants no part of John, who clearly makes her talk funny. "You were an encyclopedia of suicidal fantasies," she tells him, without further explanation. The movie becomes more and more peculiar until there's a shoot-out and a resurrection as remarkable as anything in a film not adapted from the Bible.

A pushy pusher tries to be his brother's keeper.

"Light Sleeper" manages to be simultaneously uninflected and melodramatic, its narrative prompting neither intellectual nor emotional response. John is full of quirks (he keeps a journal) and wisdom (heard as narration on the soundtrack) that bend the mind. "When a dealer keeps a diary, it's time to quit," he confides at one point. It might also be time to quit when a dealer starts recommending rehab centers, but he doesn't think of that.

The actors don't have a very rich time of it. The material is dim, humorless and arid. This is especially true for Ms. Sarandon, an actress with a lot to give when a film treats her right. Mr. Dafoe's John is a sort of contemporary no-cal substitute for the character the actor played in Martin Scorsese's "Last Temptation of Christ," written by Mr. Schrader. John doesn't have anybody up there to talk to, but he does heed the advice of a psychic. What paltry times we live in.

•

"Light Sleeper" is rated R (Under 17 requires accompanying parent or adult guardian). It has violence, sexual situations and vulgar language.

1992 Ag 21, C12:5

Little Nemo
Adventures in Slumberland

Directed by Masami Hata and William T. Hurtz; concept for the screen by Ray Bradbury; screenplay by Chris Columbus and Richard Outten; story by Jean Mobius Giraud and Yutaka Fujioka; based on the comic strip by Winsor McCay; director of photography, Hajime Hasegawa; edited by Takeshi Seyama; music by Thomas Chase and Steve Rucker; produced by Yutaka Fujioka; released by Hemdale Pictures Corporation. Running time: 85 minutes. This film is rated G.

Nemo	Gabriel Damon
Flip	Mickey Rooney
Professor Genius	Rene Auberjonois
Icarus	Danny Mann
Princess Camille	Laura Mooney
King Morpheus	Bernard Erhard
Nightmare King	William E. Martin

By STEPHEN HOLDEN

The title character of "Little Nemo: Adventures in Slumberland," a captivating animated feature, is a perky, wide-eyed boy whose nighttime dreams are so tumultuous that he sometimes wakes up on the floor beside his bed. One night when the circus is in town, four clowns with cone hats appear at his bedroom window with a professor who summons him to visit King Morpheus in Slumberland. He has been chosen, the professor explains, to be the official playmate of the king's daughter, Princess Camille.

Accompanied by his pet squirrel, Icarus, the little boy boards a turn-of-the-century showboat attached to a dirigible and sails through the sky to Slumberland. On their way, they bypass Nightmare Land, which spins in the heavens like a lump of coal, discharging lightning and thunder. Their destination turns out to be a Christmasy, pink-turreted toy land of happy people and circusy pleasures.

The princess, though initially disapproving of Nemo for appearing in pajamas, quickly warms to him. Morpheus reveals himself as a jolly Santa Claus-like fellow who shares the boy's passion for electric trains. He names Nemo his heir and presents him with a royal scepter and a golden key that opens all doors to the kingdom. One door, however, he must never unlock.

•

Nemo is tricked into taking a peek behind the forbidden door by Flip, a cigar-chomping con artist and the kingdom's resident pariah, who wears a bright-red suit and rides around on a black crow. Once the door has opened, amorphous demons pour into the palace where they overwhelm the king and whisk him to Nightmare Land. Nemo bravely as-

Hemdale Pictures

Little Nemo

sumes responsibility for the catastrophe, and with Camille and Flip, and armed with the magic scepter, he steals into the evil kingdom to rescue Morpheus, who is held prisoner by the ghoulish Nightmare King. Their journey becomes a "Wizard of Oz"-like odyssey.

•

The movie, conceived by Ray Bradbury and directed by Masami Hata and William T. Hurtz, is based on Winsor McCay's "Little Nemo," one of the first comic strips published in America. The film retains the original comic strip's turn-of-the-century ambiance. Nemo's home is festooned with vintage model planes and dirigibles, and the characters, who are as elegantly drawn as the most memorable Disney creations, look as though they had stepped out of an early 20th-century storybook.

As animated fairy tales go, "Little Nemo" is remarkable not only for the elegance of its pictorial design, but also for the calm benignity of its mood. Although the film has scenes of combat, its battles have none of the pow, bam and splat of an ordinary cartoon. The warring forces are more spiritual than physical. When the nightmare spirits attack, they gather and swirl like a vaporous oil slick that smothers its victims with an animated representation of fear and despair.

The trickster figure of Flip is an interestingly ambiguous bad guy. Although he has a Mephistophelean side, at heart he is a mischief-maker and rebel who is driven more by curiosity and an impulse to be contrary than by an urge to do harm.

The voices matching the characters are well chosen. Gabriel Damon makes an agreeable, not too squeaky Nemo. Rene Auberjonois is the professor, Laura Mooney the princess and Bernard Erhard the kindly Morpheus. The most evocative portrayal is Mickey Rooney's Flip. Over the years, Mr. Rooney has played everything from Andy Hardy, the epitome of 1940's teen-age ingenuousness, to the emcee of a burlesque show in the Broadway show "Sugar Babies." In his Flip, the two extremes meet and merge in a way that makes perfect sense.

1992 Ag 21, C13:1

Christopher Columbus: The Discovery

Directed by John Glen; screenplay by John Briley, Cary Bates and Mario Puzo, based on the story by Mr. Puzo; director of photography, Alec Mills; edited by Matthew Glen; music by Cliff Eidelman; production designer, Gil Parrondo; produced by Ilya Salkind; released by Warner Brothers. Running time: 122 minutes. This film is rated PG-13.

Christopher Columbus	George Corraface
Torquemada	Marlon Brando
King Ferdinand	Tom Selleck
Queen Isabella	Rachel Ward
Martin Pinzón	Robert Davi
Beatriz	Catherine Zeta Jones
Harana	Oliver Cotton

By VINCENT CANBY

"Christopher Columbus: The Discovery," produced by the same wags who brought us "Superman: The Movie" and "Santa Claus: The Movie," is not quite a nonstop hoot, but it is pretty funny far more often than it intends to be. It opened in theaters here yesterday.

Surprisingly little is known about Columbus and his life. Yet the film makers' imaginations seem to have fallen over the edge when they place Tomás de Torquemada, Spain's most notorious inquisitor, on the quay at the departing Niña, Pinta and Santa María. Torquemada? Shouldn't he be pulling out the fingernails of heretics instead of attending bon voyage parties?

This Torquemada could have dropped in from a lost Jerry Lewis movie. He doesn't look quite real. Though he is strangely familiar, it's not easy to recognize him. Then you have it: the nearly round, evilly smiling face is that of the man in the moon. A spitting image, really. The effect is emphasized by the fact that the head seems unattached to the body below it. It's as if the face of the man in the moon had been perched on a great gray cassock, which serves as a sort of mobile plinth.

Another shock is to come. The actor playing Torquemada turns out to be the great Marlon Brando. Torquemada doesn't have a great deal to do with Columbus's epic voyage of 1492, but he was a significant force of his time. In consideration of this, and of the salary Mr. Brando was receiving to play a bit role in an early sequence, the producers probably thought it was little enough to ask that Mr. Brando also appear for a couple of minutes in a seaside crowd scene.

"Christopher Columbus: The Discovery" is that kind of movie: expensive, sloppy and, at its most ambitious, a frail reminder of the Warner Brothers swashbucklers that Michael Curtiz used to turn out with Errol Flynn. The French-born George Corraface, who resembles a robust, healthy Al Pacino, plays Columbus as a fellow who smiles a lot, has a set of extremely white teeth, enchants the ladies and is handy with a sword.

The team-written screenplay, directed by John Glen and credited to John Briley and Cary Bates and Mario Puzo (the last two conjunctions are apparently called for by their contracts), cannot sustain the film's swashbuckling aspirations. A certain amount of historical scene-setting is necessary, all of which is dead wood. Tom Selleck and Rachel Ward, who appear as Ferdinand and Isabella, behave like a couple who have become separated from their Mardi Gras float.

The film preserves, but never enlivens, all those gestures so dear to old-time Hollywood costume dramas: people sweeping into and out of throne rooms, kissing royal rings and unrolling parchments that are of more interest to them than to us.

"Christopher Columbus: The Discovery" is concerned only with Columbus's first remarkable voyage. Yet the depiction is perfunctory and sort of hurried, in part because of all those throne-room scenes and of others showing Columbus romancing a very pretty young woman to whom he later compares the Santa María ("a bit top-heavy and too narrow in the beam").

"Christopher Columbus: The Discovery," which has been rated PG-13 (Parents strongly cautioned), includes partial nudity.

1992 Ag 22, 11:1

Storyville

Directed by Mark Frost; screenplay by Mr. Frost and Lee Reynolds; based on the novel "The Juryman" by Frank Galbally and Robert Macklin; director of photography, Ron Garcia; edited by B. J. Sears; music by Carter Burwell; production designer, Richard Hoover; produced by David Roe and Edward R. Pressman; released by 20th Century Fox. Running time: 112 minutes. This film is rated R.

Cray Fowler	James Spader
Natalie Tate	Joanne Whalley-Kilmer
Clifford Fowler	Jason Robards
Lee	Charlotte Lewis
Nathan LeFleur	Michael Warren
Michael Trevallian	Michael Parks
Pudge Herman	Chuck McCann
Theotis Washington	Chino Fats Williams
Charlie Sumpter	Woody Strode
Abe Choate	Charlie Haid

By VINCENT CANBY

"Storyville" is the kind of enjoyably overstuffed Deep South melodrama that Hollywood turned out in the 1950's and 60's, sometimes based on works by William Faulkner. The provenance of "Storyville" is not that high-toned — it is said to have "evolved" from an Australian novel, "The Juryman," by Frank Galbally and Robert Macklin. The film is apparently something quite different.

Set in and around contemporary New Orleans, "Storyville" is about politics, lust, greed, oil leases, murder and closeted skeletons crying to get out. More particularly, it's about Cray Fowler (James Spader), the scion of a nouveau riche family, a young lawyer who is running for Congress both because it's expected of him and because he has nothing better to do.

Cray wouldn't seem to be an ideal candidate for any elected office. His family values are questionable. He's separated from his birdbrained wife (Justine Arlin), and he has been carrying on an edgy affair with Natalie Tate (Joanne Whalley-Kilmer), an assistant district attorney. Yet when propositioned, he doesn't hesitate to have an overnight fling with Lee (Charlotte Lewis), a mysterious young woman whose motives are as suspect as her beauty is obvious. Cray is later stunned when he receives a copy of a steamy video tape of himself and Lee performing in her hot tub.

The guy is monumentally naïve, but he carries within him an unexpected streak of decency and an untapped liberal political conscience. These surface when Lee is suddenly charged with the murder of her father, a former colonel in the South Vietnamese Army who for years has been acting as his unwilling daughter's pimp.

Am I going too fast? So far the plot is as clear as bouillon. Before the film is over, it's become the sort of ragout that has to be cut with a knife.

•

While running for office, Cray also manages to act as Lee's defense attorney at the trial in which Natalie represents the state. At the same time he has reopened the investigation into his father's suicide some years earlier, thought to be connected to valuable oil leases acquired generations before by his grandfather.

•

Keeping an eye over everything is Cray's craggy old Uncle Clifford (Jason Robards), who may or may not be as nice as he seems. "Down here," he tells Cray, "the past isn't dead. It's not even the past." Living in her own world is Cray's Southern belle of a mom (Piper Laurie), who can't even be trusted to say grace without making a meal of it. Would you be shocked to learn that she drinks? At no point in the film is there any hint of incest, but that may have been left on the cutting room floor.

Mr. Frost's work as David Lynch's collaborator on "Twin Peaks" is evident in almost every frame of "Storyville," though the new film is far less of a tease than the television series, a good deal shorter and much more fun.

For all of its paperback melodramatics, "Storyville" looks terrific. A great physical production, with fine camera work by Ron Garcia, can go a long way to persuade audiences to accept outrageous coincidences and final revelations that are not entirely clear. The locations in New Orleans and in the Louisiana bayou country, often rain swept, are eerily beautiful. A political fund-raiser held on the lawn of a great old mansion is simultaneously contemporary and evocative of a 1930's way of life and thought: There aren't many black faces in the crowd.

Even more important than the film's look are the casting and what appears to be the director's remarkable way with his actors. Mr. Spader may have won prizes for "Sex, Lies and Videotape" but he comes of age as an actor in "Storyville." The performance is clean, uncluttered and often funny, without sidestepping the material. He responds especially well to Mr. Robards, pro that he is, and Ms. Whalley-Kilmer, an actress who is always as good as we remember Debra Winger to have been.

•

The film is packed with character roles performed with enthusiasm by, among others, Michael Warren, Michael Parks, Chuck McCann, Chino Fats Williams and Woody Strode.

The "Storyville" title seems to be a reference both to New Orleans's pre-World War I red-light district and to a present-day disco, which, in this film's fervid imagination, looks like a seamy version of something you might find in a theme park for the entire family.

Patti Perret/20th Century Fox
Jason Robards, right, and James Spader play an uncle and nephew in "Storyville."

"Storyville," which has been rated R (Under 17 requires accompanying parent or adult guardian), has sexual situations, violence and vulgar language.

1992 Ag 26, C13:3

Wild Wheels

Produced, directed and edited by Harrod Blank; directors of photography, Paul Cope, Mr. Blank and Les Blank; released by Tara Releasing. Film Forum, 209 West Houston Street, SoHo. Running time: 64 minutes. This film has no rating.

Drive-In Blues

Directed by Jan Krawitz; director of photography, Thomas Ott; released by Direct Cinema Ltd. Film Forum, 209 West Houston Street, SoHo. Running time: 28 minutes. This film has no rating.

By STEPHEN HOLDEN

Just about anything that can be done to an automobile to turn it into a garish art object is on display in "Wild Wheels," Harrod Blank's witty cinematic survey of American car art. Depending on one's tastes, one could come away with a yen to possess any of the more than 40 vehicles that are proudly paraded through the movie, which opened today at Film Forum 1.

Hippie nostalgists might covet either of the film's two psychedelic buses: Lisa Law's Silver, or the original converted school bus, nicknamed Further, that toted the writer Ken Kesey and his Merry Pranksters around in the 1960's. Christian fundamentalists could choose between W. C. Rice's Cross Car (a pickup truck that carries a giant cross) and H. L. Gandy's Jesus Truck (a pickup truck covered with pictures of Jesus). Equestrians should be drawn to Ron Snow's Coltmobile, a Buick Skylark studded with miniature horses.

•

But the most visually compelling cars are the motorized realizations of eccentric personal visions that have no social or religious references. The most elaborate, in terms of care and maintenance is Gene Pool's Grass Car. Its creator demonstrates how he coats his car with an industrial adhesive, sprinkles grass seed on it, and carefully tends it until it becomes a full-grown lawn that he enjoys showing off while driving around in his hometown, Kansas City.

The funniest vehicles, Albert Guibarra's Hippomobile and Larry Fuente's Cowasaki are cars that have been transformed into motorized beasts guaranteed to cause rubbernecking. Mr. Guibarra's brass-plated hippopotamus, placed over the body of a 1971 Mustang convertible, mechanically urinates. Mr. Fuente also designed the Mad Cad, a 1965 Coupe de Ville festooned with thousands of beads and rhinestones. With footprints running across its body and an ornithological sculpture atop its roof. The Mad Cad has a stylishly jazzy design that contrasts sharply with many of the other cars, which are indiscriminately plastered with junk.

The sleekest cars are Bob Corbett and Renee Sherrer's Mirrormobile, an Oldsmobile stuck with thousands of pieces of mirror, and Eric Staller's Lightmobile, a Volkswagen Beetle strung with 1,400 lights that a computer flashes into 25 different programs.

Although the film presents car art as an American folk art movement, most of the designers of these ostentatious vehicles don't think in terms of art-world recognition. They are ordinary people who just crave attention or who see the form as a novel way of advertising a particular product'or idea.

Mr.' Blank filmed "Wild Wheels" on the road, while driving his own flamboyantly decorated Volkswagen Beetle across the United States. More than an artistic survey, the film is an engaging travelogue peopled with a somewhat bizarre cross-section of American types.

Jan Krawitz's "Drive-In Blues," which shares the bill, is a short, dry history of the rise and decline of the movie drive-in, from the early 1930's to the present. The film's interweaving of vintage movie ads with shots of decaying structures should provoke a twinge of nostalgia for the demise of the 1950's "passion pit." But it also devotes far too much time to recording the monotonous reminiscences of veteran drive-in movie proprietors.

1992 Ag 26, C15:1

Ah, to Live And Fight In Brooklyn!

"Laws of Gravity" was shown as part of the 1992 New Directors/New Films series. Following are excerpts from Vincent Canby's review, which appeared in The New York Times on March 21. The film opens today at the Waverly Theater, 323 Avenue of the Americas, at Third Street, Greenwich Village.

Nick Gomez makes an impressive debut as the writer and director of his first feature, " Laws of Gravity," a vividly acted and extremely well photographed tale of three days and nights on the Brooklyn streets.

At the center of "Laws of Gravity" is the friendship of the comparatively settled Jimmy (Peter Greene), who is married and makes ends meet by petty thievery, and his sidekick, Jon (Adam Trese) a good-looking younger man with no great amount of brains and a dangerously short temper.

The film is also about Jimmy's wife, Denise (Edie Falco), who has a good deal of common sense but not much chance to exercise it, and Celia (Arabella Field), Jon's pretty girlfriend, so infatuated that she forgives him all, even after he brutally beats her. To Celia beatings are the price a woman pays to be with the man of her dreams. Such barren dreams.

The star of "Laws of Gravity" is Jean de Segonzac's remarkably sensitive hand-held camera, which attends to Jimmy, Jon, Denise and Celia like a neighborhood groupie. The camera tags along from early morning until late at night, studying them in close-up, sometimes pulling back for an appreciative medium shot.

It watches Jimmy and Jon as they steal the contents of an unlocked van. It stands by as they haggle with street-corner customers and behaves, it seems, like a lookout for cops. It hangs out with them at the corner bar. It goes along on a family picnic in the park where, not unexpectedly, there is a fight.

The coming together of any two or more of Mr. Gomez's characters sooner or later leads to a physical confrontation. Though their streets are open and they are nominally free, Jimmy, Jon and their friends wear the threadbare coats of caged creatures. The fights they so readily invite somehow reassure them. The fights give them identity, importance and a momentary sense of direction.

1992 Ag 26, C18:6

Via Appia

Written and directed by Jochen Hick; director of photography, Peter Christian Neumann; edited by Claudia Vogeler; music by Charly Schoppner; produced by Norbert Friedlander; released by Strand Releasing International. At Eighth Street Playhouse, 52 West Eighth Street. In German, with English subtitles. Running time: 90 minutes. This film has no rating.

Frank	Peter Senner
Jose	Guilherme de Padua
Director	Yves Jansen
Lucia	Margarita Schmidt
Sergio	Jose Carlos Berenguer
Ulieno	Gustavo Motta
Mario	Luiz Kleber

By VINCENT CANBY

Jochen Hick's "Via Appia," the German movie that opened yesterday at the Eighth Street Playhouse, is a fiction film in the form of a documentary, supposedly being the record of one man's search for the Rio de Janeiro hustler who gave him AIDS. It is melancholy and dour and not always easy to follow. It is also uncompromising in the way it refuses to moralize about the obsessions of its doomed protagonist.

He is Frank (Peter Senner), a former Lufthansa steward who goes back to Rio from Germany with a film crew to look for Mario (Luiz Kleber), a young man with whom he had a one-night stand. Before Mario departed the morning after, he left a message scrawled in soap on the bathroom mirror: "Welcome to the AIDS Club."

Frank's motives are never stated, though he doesn't seek revenge. Since he appears to have been exceedingly promiscuous, he could have picked up the virus in any number of encounters, but Frank is not much of a thinker. The film also presents him as something of a voyeur, the kind of man for whom sex has meaning only after the fact, as in the series of Polaroid snaps he takes of his partners and later puts up on the walls of his room in Germany.

Frank and his director (Yves Jansen) hire a fast-talking hustler named José (Guilherme de Padua) to help them find Mario, who seems always to have just left whenever they arrive. "Via Appia," the nickname of a Rio district where male prostitutes hang out, becomes a grim guided tour of the city's gay subculture, its bars, discos, streets and a beach known as the AIDS farm.

The documentary-within-the-film format justifies this material, including a lot of nudity and one brief hardcore porn sequence, but it doesn't accommodate any revelation that would give shape to such chilly fiction. Frank remains almost as mysterious as Mario. He appears never to comprehend that now he too is a victim of his own kind of late-20th-century colonial exploitation.

That may be the film's uninflected point. "Via Appia" is not a pretty picture, but it doesn't ask for sympathy. It is firmly, aggressively unapologetic.

Mr. Hick, who directed from his own screenplay, made the film on a shoestring, and it shows. The images often are so dark that it's impossible to recognize characters. English subtitles, which translate the German and Portuguese dialogue, would also be helpful for the English dialogue, frequently incomprehensible because of the fuzziness of the soundtrack.

1992 Ag 27, C16:5

Honeymoon in Vegas

Written and directed by Andrew Bergman; director of photography, William A. Fraker; edited by Barry Malkin; music by David Newman; production designer, William A. Elliott; produced by Mike Lobell; released by Columbia Pictures. Running time: 96 minutes. This film is rated PG-13.

Tommy	James Caan
Jack	Nicolas Cage
Betsy and Donna	Sarah Jessica Parker
Mahi	Pat Morita
Johnny Sandwich	Johnny Williams
Sally Molars	John Capodice
Bea Singer	Anne Bancroft
Sidney Tomashefsky	Robert Costanzo
Orman	Peter Boyle

By VINCENT CANBY

Andrew Bergman has been getting his act together for some time, beginning, in the minds of most of us, when he wrote the story for "Blazing Saddles" and was a member of the platoon of comic talents who collaborated on its screenplay. He also wrote "The In-Laws," and wrote and directed "So Fine" and "The Freshman."

Now, with "Honeymoon in Vegas," which he wrote and directed, Mr. Bergman arrives in the very big time. "Honeymoon in Vegas" is a virtually nonstop scream of benign delirium, pop entertainment as revivifying as anything you're likely to see this year. It's a romantic farce in which the explosion of the epically

"Via Appia"

Guilherme de Padua, left, and Peter Senner in "Via Appia."

earnest and funny central situation creates shock waves that leave no person or thing untouched. Even the film's bit players and extras are funny.

Jack Singer (Nicolas Cage) is a nice, normal Manhattan private eye except for one problem. Around his neck he wears an umbilical cord tied in a hangman's knot. Bea Singer (Anne Bancroft), his mother, did not slip quietly into the night. In the film's precredit sequence, Bea, on her deathbed, gives his hand a bone-crushing squeeze and demands that he promise never to marry. "No one could ever love you like I love you," she says, then goes into instant rigor mortis.

•

Four years later Jack is still haunted by his promise. One morning he tells Betsy (Sarah Jessica Parker), his longtime girlfriend, that he has again dreamed about his mother. Betsy asks if she was naked. Says Jack: "I only had one dream about her when she was naked, and she was vacuuming. It wasn't about sex. It was about cleanliness."

Jessica thinks it's time she and Jack move their relationship to a new plateau, that is, marriage, but he remains reluctant. Jack agrees only when Jessica threatens to walk out of his life. On the spur of the moment they fly off to Las Vegas to take vows and play the slots. By chance they arrive during a convention of Elvis impersonators.

Las Vegas is always gaudy and photogenic, but Mr. Bergman's vision is something new. It's a folksy Fellini daydream in which the Elvis Presleys come in all sizes, ages, shapes and colors. As Elvis music drenches the soundtrack, the King's would-be lookalikes line up at the reservations desk, sidle through the gaming rooms and appear on stage at the supper club, including one who is 5 years old. The motley crowd of Elvises is not only funny in itself, but it also defines the engagingly lunatic environment in which so many commonplace things can go so wildly wrong.

There is very little superfluous material in Mr. Bergman's screenplay. It also has three uncommonly reso-

Gamma LaMana

Sarah Jessica Parker and Nicolas Cage in "Honeymoon in Vegas."

Twin Peaks
Fire Walk With Me

Directed by David Lynch; written by Mr. Lynch and Robert Engels; director of photography, Ron Garcia; edited by Mary Sweeney; music by Angelo Badalamenti; production designer, Patricia Norris; produced by Gregg Fienberg; released by New Line Cinema. Running time: 134 minutes. This film is rated R.

Laura Palmer...................Sheryl Lee
Leland Palmer Ray Wise
Special Agent Dale Cooper Kyle MacLachlan
Special Agent Chester Desmond. Chris Isaak
Donna Hayward.............................Moira Kelly
Carl Rodd.........................Harry Dean Stanton
Phillip Jeffries..............................David Bowie

By VINCENT CANBY

Everything about David Lynch's "Twin Peaks: Fire Walk With Me" is a deception. It's not the worst movie ever made; it just seems to be. Its 134 minutes induce a state of simulated brain death, an effect as easily attained in half the time by staring at the blinking lights on a Christmas tree.

The film, which opened yesterday, was put together for hard-core fans of the "Twin Peaks" television series, that is, for people so crackers over the show that they will pretend they don't know who killed Laura Palmer. Most others, including those who don't care, won't go to see the movie anyway.

Having already told the story of Laura Palmer's decline and fall in flashbacks, Mr. Lynch and Robert Engels, who collaborated with him on the screenplay, now elect to tell the same story more or less chronologically. Some characters from the tele-

vision series appear in the film. Many do not. There are also a lot of new characters. The presence of some may be justified by the fact that they are phantoms, though of whose mind is never clear.

The awful truth about "Fire Walk With Me" is that Mr. Lynch is again plumbing the modest depths of the same kind of surrealism that looked fresher and funnier in his first film, "Eraserhead." Characters are introduced and disappear for no special reason, not even mystical. It seems more likely that actors of the caliber of Kieffer Sutherland and David Bowie could spend only a limited amount of time on the picture, and that Mr. Lynch accommodated them and himself by introducing into the script intimations of the occult. He can't get off the hook that easily.

At one point he would certify his surrealist credentials by showing a quick image of a white horse standing patiently in Laura Palmer's living room. This could be a quote from something by Luis Buñuel, but it would make as much sense inserted into a segment of "Golden Girls."

The director's imagination is on hold in "Fire Walk With Me." The film starts off with the murder of Teresa Banks (Pamela Gidley), a young woman whose death foretells the fate of Laura Palmer, the beautiful high-school student who, as played Sheryl Lee, looks to be approaching her mid-30's. Poor cocaine-sniffing Laura never learned how to just say no.

At the film's beginning, Mr. Lynch makes a large cameo appearance as

nant central characters. In addition to the resourceful but faint-hearted Jack and the delicately iron-willed Betsy, there is Tommy Korman (James Caan), a tough, high-rolling mob figure who's also an incurable romantic. He still mourns his beloved wife, Donna.

Tommy watches with sorrow as people bake in the sun around a Las Vegas hotel pool. They remind him of Donna, who died of skin cancer. "She lay there all day," he says, his eyes becoming misty, "with her Sidney Sheldon novels and her coconut oil. The doctor said she had skin like a reptile."

When Tommy sees Betsy beside the pool, he is astonished by her resemblance to Donna. It's almost eerie. Being a man of action, he immediately schemes to meet and eventually to marry her. The unsuspecting Jack is asked to join a "hospitality" poker game with Tommy as host. Not eager to run immediately to the wedding chapel, Jack accepts the invitation to play cards for a couple of carefree hours, at the end of which, to settle a $65,000 marker, Betsy is turned over to Tommy for a platonic weekend.

•

Mr. Caan is hilarious as a sentimental mug who would hate to break kneecaps in his pursuit of the second great love of his life. In Hawaii, where he flies with Betsy to woo her, Tommy becomes poetic. "If I were a medieval knight," he says, "I would have jostled for you." "Jousted," says Betsy. "I mean," he says, "we're up there with Romeo and Juliet, George and Gracie, all the big ones."

Mr. Caan has genuine charm as well as impeccable comic timing.

This is the best work he's ever done, which would include his Oscar-nominated performance in "The Godfather." Ms. Parker, who turned a small role in "L.A. Story" into one of that film's few major assets, is super as a young woman who behaves sanely without somehow losing her great good humor. Mr. Cage is usually an actor who tries to demonstrate that more is more. Not this time. He plays Jack straight, without mannerisms. It's a beautifully disciplined performance that makes possible all of the film's peripheral dividends.

"Honeymoon in Vegas" is full of riveting subsidiary characters who might steal the attention in a less firmly constructed comedy. There's Sidney Tomashefsky (Robert Costanzo), a blue-collar guy who's sure that his frumpy wife is having an affair with Mike Tyson. The most priceless is possibly Orman (Peter Boyle), a Hawaiian tribal chief who, on meeting Jack, asks boldly, "Am I attractive to you?" The chief's great passion is Broadway musical comedy. When last seen, he's singing "Bali Ha'i" with innovative arm gestures.

The film's climactic sequence involves a swarm of Elvis impersonators sky-diving over Las Vegas at night, all wearing sequined jump suits and shades, with flares attached to their boots. It's a coup de cinéma to equal the helicopter attack in "Apocalypse Now," but without the guilt feelings. As Jack is set gloriously free, so is the audience for "Honeymoon in Vegas."

•

"Honeymoon in Vegas," which has been rated PG-13 (Parents strongly cautioned), includes some vulgar language and sexual situations.

1992 Ag 28, C8:5

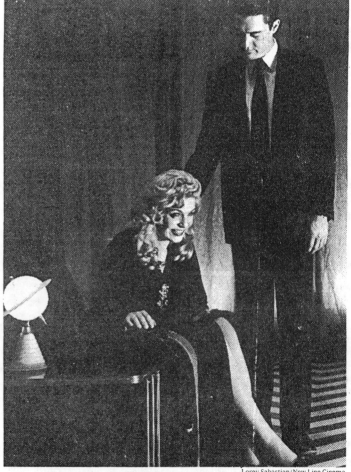

Lorey Sabastian/New Line Cinema

Sheryl Lee and Kyle MacLachlan in a scene from David Lynch's film "Twin Peaks: Fire Walk With Me," based on the television series.

a F.B.I. agent who shouts a lot because he's deaf, and who sees in the death of Teresa Banks intimations of civilization's mortality. He assigns to the case two oddball agents, played by Mr. Sutherland and Chris Isaak, who vanish early on, to be replaced by good old Special Agent Dale Cooper (Kyle MacLachlan), who seems to be visiting this movie on his day off from the production of another.

Harry Dean Stanton comes on a couple of times as the bewildered manager of the Fat Trout Motor Court, not far from the town of Twin Peaks. Most of the movie is occupied by showing Laura's increasing hysteria as she tries to score more cocaine, to pacify her various boyfriends and to make sense of obscene daymares involving her dad (Ray Wise).

Because of the director's repeated use of long, lingering lap-dissolves, in which the images of one scene remain on the screen beneath the images of the succeeding scene, the film appears to be an undifferentiated mess of story lines and hallucinations. There's no reason to care which is which. Even Mr. Lynch's eccentric touches become boring. The jokes are stillborn.

"Fire Walk With Me" glazes the eyes and the mind.

•

"Fire Walk With Me," which has been rated R (Under 17 requires accompanying parent or adult guardian), has partial nudity, sexual situations and vulgar language.

1992 Ag 29, 11:1

Pet Sematary Two

Directed by Mary Lambert; written by Richard Outten; director of photography, Russell Carpenter; edited by Tom Finan; music by Mark Governor; production designer, Michelle Minch; produced by Ralph S. Singleton; released by Paramount Pictures. Running time: 102 minutes. This film is rated R.

Jeff Matthews	Edward Furlong
Chase Matthews	Anthony Edwards
Sheriff Gus Gilbert	Clancy Brown
Renee Hallow	Darlanne Fluegel
Clyde	Jared Rushton
Amanda Gilbert	Lisa Waltz
Marjorie Hargrove	Sarah Trigger
Drew Gilbert	Jason McGuire

By STEPHEN HOLDEN

In the infinitely vengeful world of Stephen King, a snake lurks under every rock, and that's only if you're lucky. If you venture into places where it says "Keep Out," far worse things are likely to pop up, and they're a lot harder to get rid of than snakes.

In "Pet Sematary Two," the sequel to the successful 1989 horror film adapted by Mr. King from his best-selling novel, "Pet Sematary," those nearly indestructible pests are the corpses of dead animals and people interred in an ancient Indian burial ground. The sequel, which opened yesterday, tells the story of Chase Matthews (Anthony Edwards), a Los Angeles veterinarian, and his 13-year-old son Jeff (Edward Furlong), who move back to his mother's hometown of Ludlow, Me., after a family tragedy. In the movie's opening sequence, Jeff witnesses the hideous accidental electrocution of his beloved actress-mother Renee (Darlanne Fluegel) while she is making a horror film.

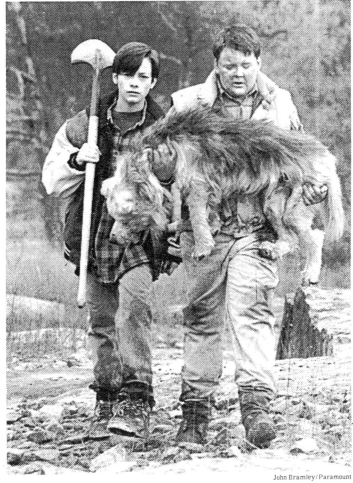

John Bramley/Paramount

Edward Furlong, left, and Jason McGuire in "Pet Sematary Two."

At the local junior high school, Jeff befriends a chubby classmate, Drew (Jason McGuire), whose sadistic stepfather Gus (Clancy Brown) is the local sheriff. Gus also happens to have been Renee's high school boyfriend. The chain of horror begins when Gus shoots his stepson's pet dog, Zowie, and the two boys bury the corpse in the cemetery.

Richard Outten, the screenwriter who replaced Mr. King for the sequel, is clearly well steeped in the author's symbolic world, since "Pet Sematary Two" roils with Freudian subtext rendered as grinning nightmarish horror. The cruel stepfather and the voracious mother are only the two most obvious negative figures who lunge from beyond the grave to try to destroy children who are already wounded enough to have a melancholy streak.

•

Mary Lambert, who directed the original "Pet Sematary," has returned for the sequel, which, like its forerunner, is much better at special effects than at creating characters or telling a coherent story. Ms. Lambert made her reputation directing Madonna's music videos, and the new film has the garish theatrical look and pumpingly precise rhythms of an extravagantly produced heavy-metal video. Most of many shock scenes are above average in impact and suspense, with the scenes of the resurrected, red-eyed Zowie going for people's throats especially gruesome. Also notable is a highway crash involving a truckload of potatoes.

Except for Mr. Brown's supermacho Gus, who even before he becomes one of the living dead seems to have a very nasty chip on his shoulder, the grown-up characters are wooden and distant. Ms. Lambert fares better with the film's younger actors. Jared Rushton, who plays the leering class

A class bully who outbullies all his fictional precursors.

bully who torments Jeff, exudes an almost phosphorescent repellence. In the role of Jeff, Mr. Furlong, who is familiar from the movie "Terminator 2: Judgment Day," projects a glowering surliness that darkens the movie's already grim psychological perspective.

•

"Pet Sematary Two" is rated R (under 17 requires accompanying parent or adult guardian). It has graphic violence and strong language.

1992 Ag 29, 14:4

Freddie as F.R.O.7

Written and directed by Jon Acevski; produced by Mr. Acevski and Norman Priggen; released by Miramax Films. Running time: 90 minutes. This film is rated PG.

Freddie	Ben Kingsley
Daffers	Jenny Agutter
Nessie	Phyllis Logan
Scotty/First Aide/Royal Coachman	
	John Sessions
Messina	Billie Whitelaw
El Supremo	Brian Blessed
Trilby	Jonathan Pryce

By STEPHEN HOLDEN

One lesson that the creators of animated features never seem to grasp is that simpler is better. An excess of plot and mythical baggage, along with a needless freneticism, helped sink "Rock-a-Doodle" and "An American Tail: Fievel Goes West," two of the year's more elaborate cartoon features. The same confused overreaching undermines Jon Acevski's "Freddie as F.R.O.7," which opened nationally on Friday.

The movie, which bills itself as the most ambitious animated film ever to come out of Britain, is a convoluted adventure story that swirls classic fairy-tale mythology together with modern pop-cultural iconography into an unwieldy hodgepodge. Its characters include a wicked queen out of "Snow White and the Seven Dwarfs" and her nephew, Freddie, a former prince she has turned into a frog after drowning his father. Freddie, who has just barely eluded his aunt's murderous schemes, grows up to become a celebrated detective, F.R.O.7 (shades of James Bond), whose mannerisms recall Hercule Poirot fused with Inspector Clouzot.

When Freddie comes of age, the wicked queen, Messina, is married to El Supremo, a world-class bully whose henchmen march in goose step and wear swastikalike Z's on their helmets. El Supremo, whose headquarters are on an island off the Scottish coast, plans to conquer the world, starting with England. In the first phase of his plan, he demoralizes the country by using magic rays to steal its most beloved monuments, including Buckingham Palace, Stonehenge and the Tower of London, secreting them in his underground island fortress. When the British Government is unable to solve the crimes, Freddie is called in from France to try to crack the case.

Although it's conceivable that a witty, self-consciously post-modern statement could have been devised by combining the myth of the frog prince with crypto-Nazis, the Pink Panther and James Bond, these elements clumsily bump into one another in a futile search for coherence. Instead of enhancing the story's mythical resonance, the pop cultural references undermine it. And except for relentlessly overstressing the joke of having an animated frog represent a French detective, the dialogue is devoid of wit.

With its handsome storybook design, the film at least looks expensive. But despite the quality of its drawing, it conveys very little visual energy. The timid action sequences have no punch. The film's casting of voices also feels deeply wrong. Ben Kingsley, who plays Freddie, speaks his role in what sounds like a deliberate impersonation of Maurice Chevalier. The tone is far too urbane and devil-may-care for a character whose mission is to smite evil and gain a stolen kingdom.

"Freddie as F.R.0.7" is rated PG (Parental guidance suggested). It has a few mild sexual references.

1992 S 1, C11:1

Bob Roberts

Written and directed by Tim Robbins; director of photography, Jean Lepine; edited by Lisa Churgin; music by David Robbins; songs by David and Tim Robbins; production designer, Richard Hoover; produced by Forrest Murray; released by Paramount Pictures with Miramax Films. Running time: 102 minutes. This film is rated R.

Bob Roberts	Tim Robbins
Bugs Raplin	Giancarlo Esposito
Chet MacGregor	Ray Wise
Delores Perrigrew	Rebecca Jenkins
Franklin Dockett	Harry J. Lennix
Clark Anderson	John Ottavino
Bart Mackleroony	Robert Stanton
Lukas Hart 3d	Alan Rickman
Senator Brickley Paiste	Gore Vidal
Terry Manchester	Brian Murray
News Anchor	Susan Sarandon
News Anchor	James Spader
News Anchor	Pamela Reed
News Anchor	Fred Ward
TV Host	John Cusack

By VINCENT CANBY

"**B**OB ROBERTS," written and directed by Tim Robbins, who also plays the title role, is a very funny, sometimes prescient satire of American politics, and of the comparatively small, voting portion of the electorate that makes a Bob Roberts phenomenon possible. Recent events haven't completely overtaken the movie, but they do indicate just how wild a satire must be these days to remain on the cutting edge of the outrageous.

In the person of Mr. Robbins, whose performance is a career-defining achievement, Bob Roberts is a smoothly ingratiating, guitar-playing businessman, a self-made millionaire who wants to be the next United States Senator from Pennsylvania. He's good-looking, but in the way of a familiar television personality, not of a major movie star. His charisma doesn't intimidate.

He's young, healthy and sincere. More important, he appropriates gestures and language associated with 1960's protest movements and uses them in the cause of his own brand of 1990's right-wing rabble-rousing. He calls himself a "rebel conservative." He's the kind of guy who answers a young fan's letter by cautioning her not

A rabble-rousing Tim Robbins takes on an amused Gore Vidal.

to do crack, adding, "It's a ghetto drug."

When Bob strums his guitar and sings such upbeat numbers as "My Land," "Times Are Changin' Back" and

"Wall Street Rap," he is selling family values and patriotism and assuring his supporters that, in effect, it's their duty to "take, make and win by any means," even if they can't. Among other things, Bob understands the appeal of an ultra-conservative political and economic policy even to those who have nothing: anticipating the day when they do have it all, they want to make sure they will be able to keep it.

"Bob Roberts" takes the form of a documentary being made about the candidate's campaign from its opening days until its eventful close, through the election itself and its aftermath. Driving through the state in his caravan called the Pride, he speaks and sings at fund-raisers and rallies and attends a beauty contest where the young woman with a ribbon identifying her as Miss Three Mile Island becomes one of the film's sight gags. He's fawned on by some of the news media, insulted by others, called a savior by his supporters and a cryptofascist by the disenchanted.

Interviewed from time to time in the course of Bob's campaign, and seen on one occasion attempting to debate the issues with him, is the liberal incumbent whose seat Bob covets. Senator Brickley Paiste is a patrician fellow whose breeding, wit and political intelligence are tested by Bob's money, razzle-dazzle public shows, dirty tricks and supermarket charm.

As played by Gore Vidal, the novelist, essayist, political commentator and sometime aspirant to political office, Brickley Paiste is the film's conscience and most articulate voice. Mr. Vidal performs on-screen much as he does in print. His manner is one of detached amusement combined with feigned shock that the world has somehow come to this ghastly pass. Without him "Bob Roberts" would be no more than an exceptionally clever, feature-length revue sketch.

The film's mock-documentary form, which echoes two classic comedies, Woody Allen's "Take the Money and Run" and Rob Reiner's "This Is Spinal Tap," can't easily accommodate the sort of melodrama and conspiracies with which Mr. Robbins begins to load the movie toward the end. It's not only because the melodrama and the conspiracies are a little far-fetched. It's also because no documentary film maker who was privy to such explosive information could have kept it under wraps for very long. If he had, he certainly wouldn't have finished his movie quite as gently as Terry Manchester (Brian Murray), the director of the film-within, finishes this one.

It can be argued that the documentary form is not to be taken too seriously, that it's only a narrative device, but Mr. Robbins can't decently enjoy all the advantages of the form without acknowledging the limitations.

A documentary is the record of the way people and events look and sound. It is a collection of surfaces that can reveal interior truths. Almost everything one needs to know about this candidate can be found in the mundane details Terry Manchester records for his film. Bob is so charming and plausible that his supporters probably couldn't care less that he did not work his way through college, as he says, but, as his mother says, forged her name to a check to pay his tuition.

"Bob Roberts" works best when it is most documentary-like. Jean Le-

Sam Jones

Tim Robbins

pine's use of the hand-held camera is wizardly, creating a sense of mounting hysteria as it captures the candidate and his handlers at public functions and in those small private moments that no film maker can ever anticipate.

The movie is terrific when it attends to reportorial detail, to the behavior of people, to the found incident, to campaign decisions relating to print and television commercials, and especially to Bob's repertory of campaign songs. These are alternately foot-stomping battle cries for fatcats or cautionary, lunatic-fringe dirges, all written, in fact, by Mr. Robbins and his older brother David.

Mr. Robbins has learned a lot from Robert Altman, who directed him in "The Player" and whose "Nashville" and "Tanner '88" would seem to have influenced both the spirit and the style of "Bob Roberts." The new film's soundtrack is layered with as much information as the images.

With one exception, the movie is beautifully cast, from the featured roles (Giancarlo Esposito, Ray Wise) to the bits in which Susan Sarandon, James Spader, Pamela Reed, Fred Ward and John Cusack, among others, appear as some of the television anchors and hosts who deal with the Bob Roberts phenomenon.

The exception is Alan Rickman as Lukas Hart 3d, the chief architect of Bob's campaign. Mr. Rickman is not a subtle actor. The minute he comes on the screen, he is so arrogant, shifty and Mephistophelean that it seems likely someone would have checked out his connections before it actually happens.

With "Bob Roberts," Mr. Robbins emerges as a formidable triple-threat man. There's a big imagination at work here. The movie sometimes overstates its case, but the music-making, success-oriented Bob represents an authentic American political tradition. Our politics has always been entertainment. Think of the crowds that came out for the Lincoln-Douglas debates. It's just that the entertainment has declined a bit in quality and, with television, become pervasive in ways to numb the thought processes.

●

"Bob Roberts," which has been rated R (Under 17 requires accompanying parent or adult guardian), has vulgar language and some violence.

1992 S 4, C1:1

The Tune

Produced and directed by Bill Plympton; story by Mr. Plympton, Maureen McElheron and P. C. Vey; edited by Merril Stern; music by Ms. McElheron; released by October Films. At the Quad Cinema, 34 West 13th Street, Greenwich Village. Running time: 72 minutes. This film has no rating.

Del	Daniel Neiden
Didi	Maureen McElheron
Mayor, Mr. Mega and Mrs. Mega	Marty Nelson
Dot	Emily Bindiger

The Wiseone, Surfer, Tango Dancer and Note Chris Hoffman

By STEPHEN HOLDEN

Del, the nerdy carrot-topped songwriter who is the protagonist of Bill Plympton's delightful animated feature "The Tune," is shown in the movie's opening sequence trying desperately to come up with a rhyme for the line "My love for you is equal to." Dozens of possibilities present themselves, from "a worn-out shoe" to "day-old stew" to "a big cow moo." It's no wonder that Mr. Mega, the ferocious music publishing honcho for whom Del toils, threatens to fire him if he doesn't come up with a hit in 47 minutes.

"The Tune," which opens today at the Quad Cinema, follows Del's adventures after he takes the wrong exit from a cloverleaf and finds himself stranded in Flooby Nooby, a strange farming town he has never heard of. It is there that Del, gently shepherded around by the town's folksy mayor, begins learning how to write songs that come from people's lives instead of a rhyming dictionary.

If the basic story of "The Tune" is almost too simple to bother relating, Mr. Plympton, one of the country's most admired creators of animated shorts, has fleshed it out with a continually inventive and witty series of tangents. Animated with 30,000 ink and watercolor drawings, the movie effuses a jaunty surrealistic magic of a sort that the folks at Disney, with all their resources, have probably never even thought of.

●

One of the first lessons Del learns in Flooby Nooby is that perspective is everything. Objects that intimidate him are gigantic. When he's less fearful, they shrink to almost nothing. That's why, from moment to moment, things are always changing in size and shape.

In search of career guidance, Del meets a riddle-spouting guru whose bald head metamorphoses into a zoo full of animal heads. Another character he happens upon is a bloated hound dog and Elvis impersonator who sings "Dig My Do," a "Jailhouse Rock"-style ode to his own hair. As he groans out the song, a succession of hilarious hairpieces sprout on his head.

Visiting the hellish Lovesick Hotel, Del is taken on a tour of its suites by a maniacal bellhop. Among the accommodations are the medicinal suite, whose occupant takes pills that stretch him into wild shapes, and the music room, where guests are forced to listen to the sound of chalk on a blackboard. As he leaves the hotel, a cabdriver without a nose serenades him with a country-blues song about a two-timing pink proboscis.

When Del eventually arrives for his appointment with Mr. Mega, he finally has more to offer than worn-out shoes and day-old stews. But it isn't

Contortionist-inhabitants of the town of Flooby Nooby in "The Tune."

An Early Technical Triumph

"Limite" was shown as part of the 1979 New Directors/New Films series. Following are excerpts from Janet Maslin's review, which appeared in The New York Times on April 21, 1979. This silent film opens today at the Joseph Papp Public Theater, 425 Lafayette Street in Manhattan.

"Limite," first released in 1931, was directed by a Brazilian, Mario Peixoto. Though relatively obscure, the film received praise from Sergei Eisenstein. "Limite" is feverishly beautiful and desperately ambitious, even when it isn't clear.

Mr. Peixoto anticipated in "Limite" a great many camera movements that have since become commonplace, and the air of discovery is one of the things that keeps "Limite" exciting. His camera zooms in on a subject even if that means zooming out of focus, or executes a dizzyingly, precarious 360-degree whirl. He shoots up at his actors from such a low angle that a telephone pole appears to hover over them, or devotes long sections of the film exclusively to the players' feet. His choices are flashy, impetuous and never less than interesting.

•

However, "Limite" is of more technical than dramatic importance. Beginning with two women and a man adrift in an open boat, and following each of them through more-or-less imaginary adventures on land, the narrative is elusive at best. Despair is evidently meant to be the overriding sentiment, but despair is easily upstaged by the glorious Brazilian scenery. It's hard to share the misery of a woman contemplating suicide when the bay into which she may jump shimmers exquisitely and is bounded by a spectacular mountainside.

Mr. Peixoto appears briefly near the end of the film, sitting mysteriously in a graveyard and announcing something — on one of the few title cards — about leprosy. He is gaunt, intense looking and faintly diabolical, as befits the author of so solemn and furious a first effort.

1992 S 4, C11:1

Out on a Limb

Directed by Francis Veber; written by Daniel Goldin and Joshua Goldin; director of photography, Donald E. Thorin; edited by Glenn Farr; music by Van Dyke Parks; production designer, Stephen Marsh; produced by Michael Hertzberg; released by Universal Pictures. Running time: 83 minutes. This film is rated PG.

Bill	Matthew Broderick
Matt/Peter	Jeffrey Jones
Sally	Heidi Kling
Jim Jr.	John C. Reilly
Ann	Marian Mercer
Darren	Larry Hankin
Buchenwald	David Margulies
Marci	Courtney Peldon
Jim Sr.	Michael Monks

By STEPHEN HOLDEN

Hollywood movies tend to be so formulaic that a reviewer can usually deduce why even the most unfortunate turkeys got made. But not always. The reasoning behind "Out on a Limb," a frantically unfunny new comedy starring Matthew Broderick, seems impenetrable. The movie, which opened yesterday, follows the farcical misadventures of Bill Campbell (Mr. Broderick) a young financial whiz whose imaginative kid sister becomes convinced that her stepfather is a criminal and coaxes her brother to come home when he should be in Mexico closing a deal.

On the way home to Buzzsaw, a tiny logging community in northern California, Bill is kidnapped by a redheaded woman with a gun (Heidi Kling), who abandons him on a roadside without his clothes. Rescued by two beer-guzzling brothers, both named Jim, and both with I.Q.'s well under 50, he eventually finds his way to the house, clad in a scarecrow's rags. As it turns out, his stepfather, Peter (Jeffrey Jones), has an identical twin brother, Matt (Mr. Jones), who has just appeared intent on revenge for serving a 15-year prison sentence for a crime Peter committed. The film doesn't make nearly enough hay out of the comedy of mistaken identity once Matt steps into Peter's shoes.

"Out on a Limb," which was directed by Francis Veber from a screenplay by Daniel and Joshua Goldin (who happen to be twins), has several amusing moments, all involving the fraternal backwoods idiots who toot around the countryside in a dilapidated stationwagon, perpetually drunk. The funniest bit involves a dead man whom they transport to a local bar in the belief that he is simply a little more sozzled than they.

But during far too much of the film, people chase one another through the northern Pacific landscape on foot and in cars waving guns. In the role of

Elliott Marks/Universal Pictures

Up a Tree
Matthew Broderick stars in "Out on a Limb," Francis Veber's comedy about a successful young man whose focused approach to life is totally upset when he goes to the aid of his mother and sister in a remote logging town.

until he and his sweetheart, Didi, swear their love in the midst of crisis that he comes up with an honest tear-jerker that melts the heart of the music mogul, who pronounces it a gold mine.

•

For all its pleasures, "The Tune" has its choppy moments. Because Mr. Plympton financed the movie, two sections of it — "The Wiseman" and "Push Comes to Shove" — were released as short films to generate money. Both are bravura exercises, but they impede the flow of a story that too often seems like a strung-together series of shorts with no relation except their visual style. The movie's 10 songs offer a decent pastiche of styles, from Elvis Presley's to the Beach Boys' to Tammy Wynette's, but none quite match the wit of the drawings.

1992 S 4, C3:1

Woman Demon Human

Directed by Huang Shuqin; directors of photography, Xia Lixing and Ji Hongsheng; music by Yang Mao; produced by Shanghai Film Studio. In Mandarin with English subtitles. At the Joseph Papp Public Theater, 425 Lafayette Street, Greenwich Village. Running time: 106 minutes. This film has no rating.

Qiu Yun (adult)	Xu Shouli
Qiu Yun (teen-ager)	Gong Lin
Qiu Yun (child)	Wang Feifei
The Father	Li Baotian

By VINCENT CANBY

Everything about "Woman Demon Human" is odd and perhaps unnecessarily opaque. Its meanings appear fitfully, like the flashes of color that indicate the presence of carp in a murky pond, the depth of which is anybody's guess. The 1987 Chinese film, which opens today at the Joseph Papp Public Theater, has barely adequate English subtitles.

"Woman Demon Human" is the story of Qiu Yun, the daughter of two

traveling actors, who grows up to be a star in a national theater company. Though uncommonly pretty, Qiu Yun becomes known for her male roles, especially for her performance as Zhong Kui, the king of the ghosts, in a play that is apparently a classic. Zhong Kui is a benign demon who devotes himself to the search for a good husband for his sister.

"Woman Demon Human," which was directed by a woman, Huang Shuqin, appears to have a number of things on its mind, including the role of women in life as well as in theater, and the effect of a somewhat bent childhood on the adult Qiu Yun. It is not an accident, it seems, that her most famous role is the one for which her father was best known in the provinces.

•

Early in the film, when she is a little girl, Qiu Yun is abandoned by her mother. This happens shortly after she finds her mother with a lover in a haystack. As Qiu Yun grows up, she longs for love but inevitably gives herself to the wrong man. Her first lover has a wife and four children. The man she marries is a gambler. Meanwhile, on the stage, she can express herself only in male roles. Freud appears to have seeped through the Great Wall of China.

Although "Woman Demon Human" refers to the Cultural Revolution in dialogue, nothing of that tumultuous time is shown. The world in which Qiu Yun lives is the sealed environment of the theater. The film is most effective when it is showing something of Qiu Yun's theatrical training (in martial arts, dance and makeup, among other things) or presenting material from various productions.

The private story is commonplace. There's even a scene in which Qiu Yun, who wants to abandon the stage at one point, has to be reminded by her father how much she would miss the greasepaint and the applause. Her true love is theater.

Hokum's magic spell is everywhere.

1992 S 4, C11:1

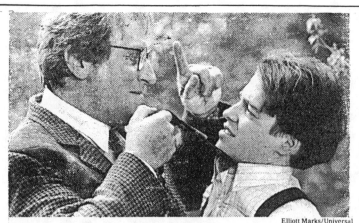

Elliott Marks/Universal

Jeffrey Jones, left and Matthew Broderick in "Out on a Limb."

the twins, Mr. Jones, a usually reliable comic actor, has little to do except dash around in a continuous fit of rage. Mr. Broderick, whose comic performances tend to be too cute for comfort, doesn't even bring his customary shtick to the role of Bill. He seems wide-eyed, vacant and slightly frazzled.

"Out on a Limb" is rated PG (*Parental guidance suggested*). *It has some profanity.*

1992 S 5, 15:1

John Lurie and the Lounge Lizards Live in Berlin 1991

Directed by Garret Linn; edited by Caleb Oglesby; produced by Valerie Goodman and Taku Nishimae; released by Telecom Japan International. Walter Reade Theater, 165 West 65th Street, Upper West Side. Running time: 102 minutes. This film has no rating.

Featuring John Lurie and the Lounge Lizards: John Lurie, Michael Blake, Steven Bernstein, Jane Scarpantoni, Bryan Carrott, Michele Navazio, Billy Martin, Oren Bloedow, and Grant Calvin Weston.

By STEPHEN HOLDEN

Three-quarters of the way into Garret Linn's engaging concert film, "John Lurie and the Lounge Lizards Live in Berlin," the leader of the nine-member band puts down his alto saxophone to relate a surreal vignette. A man wakes up in a white room that he doesn't recognize, peers in a mirror and decides his lips are so thin that he ought to try collagen treatments. When his wife walks in, he is disappointed to find that she looks so dowdy, but he realizes he loves her, and they both start laughing so hard at a secret joke that they collapse onto the carpet. The man impulsively apologizes to his wife for his meager sexual endowment. She says it's all right, but asks him if it is the reason he has massacred so many people.

At this point, Mr. Lurie does a lurching little dance while making moans and groans that suggest primitive attempts at speech. The story ends when the man's wife asks, "Why are you so stupid, dear?" and he replies, "Because I'm the President of the United States."

Muttered in a deadpan growl, Mr. Lurie's unfunny, sophomoric vignette embodies an attitude of snide hipness that sneaks around the edges of the Lounge Lizards' fashionably eclectic music. Where does the band's supercool attitude end and its passion for music begin? Mr. Lurie's attitudinizing sometimes makes it hard to tell.

Mr. Linn's cinematic portrait of the Lounge Lizards in a 1991 performance at Quartier Latin, a popular Berlin nightclub, however, makes the most positive case for the band whose music was once labeled fake jazz. The concert's 12 songs are superbly recorded. And as a musically sensitive concert film ought to do, "Live in Berlin," which opens a 17-performance engagement today at the Walter Reade Theater, visually underlines the structures and expressive qualities of the pieces being played.

The film's close-up portraits of individuals soloing or playing in duos and in trios also points up the superior technical skills of each member. The close-ups show how musical elements as dissimilar as Billy Martin's sizzling African-influenced percussion and Jane Scarpantoni's texturally abrasive, almost hornlike cello, contribute to an ensemble style that is rooted in diversity.

A typical Lounge Lizards piece, if there is such a thing, begins with Mr. Lurie and Michael Blake's trilling

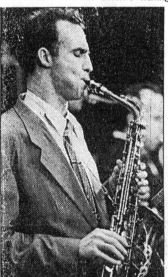

Film Society of Lincoln Center

Overseas Gig John Lurie leads the way in "John Lurie and the Lounge Lizards Live in Berlin," Garrett Linn's chronicle of four consecutive concerts by the band.

saxophones, which are soon joined by Steven Bernstein's silvery trumpet in a Minimalist, Steve Reich-like theme. Before long it is interrupted by a blast of percussion and drums that take it in an African-pop direction.

From there on, abrupt stylistic crosscurrents regularly arrive to keep changing the piece's stylistic focus. Sooner or later, everything from a cacophonous post-bop freneticism to echoes of a hard-boiled film-noir romanticism, to a tilting jazz-inflected rhythm-and-blues is brought in. The continual dynamic changes and churning sense of musical drama give each piece the feel of an adventure story jam-packed with action and spiced with a high-tension romantic interlude or two.

It is all as stylishly bohemian (1980's-style) as the studiedly frayed glamour of Mr. Lurie's pallid, slicked-back, suit-with-skinny-tie look. And like Mr. Lurie's little stories, it all feels somehow deeply disingenuous.

1992 S 9, C14:5

Brother's Keeper

Produced, directed and edited by Joe Berlinger and Bruce Sinofsky; director of photography, Douglas Cooper; music by Jay Ungar and Molly Mason; released by Creative Thinking International Ltd. Film Forum, 209 West Houston Street, SoHo. Running time: 104 minutes. This film has no rating.

By VINCENT CANBY

On June 6, 1990, William Ward, 64 years old, was found dead in the bed he had shared for most of his life with his brother, Adelbert, 59, known as Delbert, in the unheated shack on the upstate New York dairy farm where they lived with their brothers Roscoe, 70, and Lyman, 62. Bill suffered from several ailments, and the death was originally thought to have been the result of natural causes. An autopsy then suggested that there had been foul play.

After his interrogation by the state police, Delbert signed a confession to the effect that he had smothered Bill in his sleep in a mercy killing that had been sanctioned by the three surviving brothers. Until then the semiliterate brothers, always called "the Ward boys" in spite of their ages, were regarded as harmless eccentrics. With their long beards, unkempt hair and disregard for personal hygiene, the brothers didn't have many friends in nearby Munnsville (pop. 499). "The smell might get the best of you," one woman reports. The Ward boys kept to themselves.

Yet when Delbert was arrested, his cousins, neighbors and even those

The neighbors say one brother was another's keeper, not his killer.

Madison County people who didn't personally know him rose up to unite in his defense. Within a few of hours of the announcement of his arrest, they had collected the $10,000 needed for his bail. Their common belief was that the Delbert they knew, if only from a distance, was incapable of murder. There also was the conviction that Delbert had no idea what he was signing when he put his name to the confession.

Further, there was something like territorial pride at work: the Ward boys might be oddballs, but they were Munnsville oddballs. It was all right for people in Munnsville to make fun of them, but woe to the outsiders who assumed that intimacy. Early in the case, two New York film makers began to record the developments as they occurred. The result is "Brother's Keeper," the superb documentary opening today at the Film Forum.

Produced, directed and edited by Joe Berlinger and Bruce Sinofsky. "Brother's Keeper" is not only the story of Delbert's arrest, the long months leading up to his trial and the trial itself. It's also about his family and about the community that found its identity by supporting him. It's a

Derek Berg/Creative Thinking International

Lyman Ward on the upstate New York dairy farm where he lives with his brothers, in "Brother's Keeper."

rich slice of Americana that would seem to belong to an earlier, pre-television era, except that television comes to play a large part in Delbert's story. It's also about an aspect of life in rural America that's seldom seen by people who drive through it, and seldom if ever glimpsed in movies.

•

Mr. Berlinger, Mr. Sinofsky and Douglas Cooper, the cameraman, start at the story's center and work out from there. They begin with portraits of the brothers as they go about their chores on the farm, and as they sit around their filthy, cluttered two-room house, sometimes talking, often not saying much at all. The focus becomes wider as the film makers talk to cousins and neighbors, including the man who came over shortly after Bill was found dead, and who reports that at 6 A.M., the body "was kind of cool, not cold, and his arm sort of flipsy."

There are interviews with members of the state police, with the people responsible for the prosecution, and with Ralph A. Cognetti, the Syracuse lawyer hired to defend Delbert. The film makers attend a noisy, convivial community dinner and square dance organized by the Delbert Ward Defense Fund. The affair also attracts television reporters who are seen giving their on-camera reports even as Delbert, no longer the recluse he once was and now something of a local celebrity, is happily do-si-doing in the background.

The case turns into a media event. Connie Chung comes to Munnsville. Mr. Cognetti speaks to a large school-room full of Delbert's supporters, telling them that he worries that Delbert will lose his plausibility if he becomes too fond of the limelight. Delbert demonstrates for the camera how the state police demonstrated to him how he had smothered Bill. The prosecution suggests that Bill was murdered as a result of an incestuous relationship between the brothers.

•

Yet nothing fazes Delbert's supporters, a number of whom are as surprisingly articulate as they are staunch. The camera pulls further and further back until, by the end, "Brother's Keeper" is a remarkably rich portrait of a man in the context of his family, his community, the law and even the seasons.

The film inevitably raises more questions than it answers. Are the individual Ward boys genuinely slow-witted or, until this event, have they

The Wards kept to themselves until the 4 of them became just 3.

been hampered by their isolation and lack of formal schooling? To what extent, if any, was the case against Delbert trumped up? And to what extent was his community's increasing support a result of the media attention?

Like fine fiction, "Brother's Keeper" does not supply easy answers. It haunts the mind in the speculation it prompts.

1992 S 9, C15:3

Sneakers

Directed by Phil Alden Robinson; written by Lawrence Lasker, Walter F. Parkes and Mr. Robinson; director of photography, John Lindley; edited by Tom Rolf; music by James Horner; production designer, Patrizia von Brandenstein; produced by Mr. Parkes and Mr. Lasker; released by Universal Pictures. Running time: 125 minutes. This film is rated PG-13.

Bishop	Robert Redford
Crease	Sidney Poitier
Young Bishop	Gery Hershberger
Whistler	David Strathairn
Mother	Dan Aykroyd
Carl	River Phoenix
Gregor	George Hearn
Dick Gordon	Timothy Busfield
Liz	Mary McDonnell
Cosmo	Ben Kingsley
Young Cosmo	Jojo Marr

By VINCENT CANBY

"Sneakers" looks like a movie that just surfaced after being buried alive for 20 years. It's an atrophied version of a kind of caper movie that was so beloved in the early 1970's, starring Robert Redford and Sidney Poitier, both of whom were very big back then, though they now appear embarrassed to be imitating their youthful selves in such creaky fashion.

Mr. Redford even says at one point, "We're getting too old for this," as if to disarm criticism. Instead the line calls attention to all of the other ways in which time has overtaken the movie, directed by Phil Alden Robinson ("Field of Dreams") and written by him with Lawrence Lasker and Walter F. Parkes. Mr. Lasker and Mr. Parkes are the team that wrote the somewhat funnier and timelier "War Games" (1983), which also made use of computer mythology.

At the center of this caper is a little black box, one of those magical instruments on which mad doctors pin their hopes for world domination. In fact, it looks like a telephone answering machine, but it can instantaneously break any computer code

that a company, industry or nation might use to guard its secrets.

Mr. Redford plays Dan Bishop, who was a notorious computer hacker in his undergraduate days in the 1960's. In the film's opening sequence, the youthful Dan, played by Gary Hershberger (who looks remarkably like Mr. Redford), and his pal Cosmo (Jojo Marr) are seen as they break into the computers of the rich to provide money for the poor. Dan manages to escape a raid on their lab, but Cosmo winds up doing prison time.

•

Dan has since gone more or less straight and now runs a company that tests security systems for large corporations. Mr. Poitier appears as one of his associates, a 20-year C.I.A. man cashiered, it's said, because of a personality conflict.

Theirs is pretty much an all-star gang, the other members being played by Dan Aykroyd, River Phoenix and David Strathairn. Playing Dan's nemesis is Ben Kingsley, who shows up as the adult Cosmo, who not only looks entirely different but also speaks with a strange mid-Atlantic accent. Dan and Cosmo, once pals, now engage in series of a bitter and violent confrontations for possession of the little black box.

"Sneakers" is jokey without being funny, breathless without creating suspense, in part because of the feeble plot. Any 11-year-old film buff will be ahead of its revelations. The characters are more often described by the dialogue than they are defined by what they do. The two exceptions are the fellows played by Mr. Strathairn, who is blind and has developed phenomenal hearing skills, and Mr. Phoenix, who is easily identifiable because he is so much younger than anyone else in the movie.

The performances are generally quite bad. Among other things that date "Sneakers" is its abiding faith in technology. Everything in the movie works perfectly, the fancy electronic

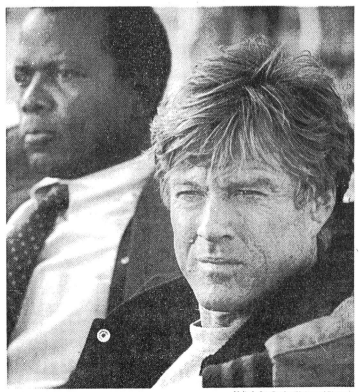

Melinda Sue Gordon/Universal Pictures

Sidney Poitier and Robert Redford in a scene from "Sneakers."

surveillance equipment, the voice-identifiers, the computers, the little black box. Nothing crashes except the movie.

•

"Sneakers" is rated PG-13 (Parents strongly cautioned). It has some vulgar language and sexual situations.

1992 S 9, C18:3

The Man Without a World

Written, produced and directed by Eleanor Antin; director of photography, Rich Wargo; edited by Lynn Burnstan; music by Charlie Morrow and Lee Erwin; released by Milestone Films. At Village East, Second Avenue and 12th Street. Running time: 98 minutes. This film has no rating.

Zevi	Pier Marton
Rukheleh	Christine Berry
Sooreleh	Anna Henriques
Ballerina	Eleanor Antin
Strong Man	Nicolai Lennox
Gypsy	Sabato Fiorello
Magician	James Scott Kerwin
Rukheleh's mother	Marcia Goodman
Rukheleh's father	Sargun A. Tont
Zevi's mother	Luba Talpalatsky

By STEPHEN HOLDEN

Eleanor Antin, the creator of "The Man Without a World," is a film maker and performance artist who goes to extraordinary lengths to explore artistic issues involving history, identity and authenticity. In the 1970's, she invented an exotic alter ego named Eleanora Antinova, an aging black American ballerina who once danced in Diaghilev's Ballets Russes. Eventually, Ms. Antin published a book that described what it was like to live in the world as a fictional character for whose portrayal she went around New York wearing tan makeup and a gray wig.

Yevgeny Antinov, the fictional avant-garde director of "The Man Without a World," is a spinoff from the Antinova character. This exiled Russian silent-film director was supposedly the lover of the ballerina who starred in his 38-minute silent film, "The Last Night of Rasputin." That movie, billed as a lost masterpiece rediscovered in the era of glasnost, was shown in museums around the country in the late 1980's with its make-believe star often on hand to introduce the screenings. "The Man Without a World," which opened today at the Village East, is supposed to be a sequel to "The Last Night of Rasputin" in that it is the first feature-length Antinov film to have come to light.

•

A preamble to this silent sequel, which Ms. Antin wittily bills as "the latest post-modernist classic by the famous imaginary director," gives the biography of the director, who fled the Soviet Union for Cracow, Poland, in 1927 after "The Last Night of Rasputin" offended Stalin. There he met a couple of entrepreneurs who persuaded him to make a movie about shtetl life for the American nostalgia market. But because he insisted on putting political commentary into the work, his backers withdrew their support and took the film out of circulation before it was shown in America. Until its rediscovery, it was thought to have disappeared in the Holocaust.

The cinematic oddity that Ms. Antin has concocted doesn't nearly live up to the fake hoopla necessary to explain its existence. A melodrama

with broad comic touches, the movie is a reasonably skillful parody of a Yiddish silent film set in a Polish village in the early 20th century. The main characters are Rukheleh (Christine Berry), a merchant's daughter, and Zevi (Pier Marton), an impoverished Yiddish poet who impregnates her and eventually marries her in a ceremony that ends in bloodshed.

But before the wedding can take place, many obstacles must be overcome. They include Rukheleh's parents, who insist that she marry the local butcher, and a gypsy dancer (Ms. Antin) who seduces the young poet. A subplot follows the misfortunes of Zevi's younger sister Sooreleh (Anna Henriques), who has been mute and crazy since she was gangraped as girl. Kidnapped by religious fanatics, Sooreleh is subjected to a ritual exorcism.

•

The film's politics are in scenes in a local cafe where Zevi hangs out and listens to socialists, anarchists and Zionists heatedly debate world affairs.

Even though "The Man Without a World" has subtitles between its scenes, it is not the easiest film to follow. And for all its hand-wringing melodrama, it is quite dull. The film's acting is as uneven as its ever-changing visual momentum. Ms. Berry and Mr. Marton are completely devoid of the sort of physical magnetism that makes silent-film acting interesting. Perhaps the worst impediment to enjoyment of the film is Charlie Morrow's dreary, obtrusive score, which is played by the noted movie theater organist and composer of silent-film music Lee Erwin. Heavy-handedly illustrative, the music has no life of its own.

In the context of Ms. Antin's performance-art career, "The Man Without a World" may be an impressive esthetic exercise. But it is also a film that forgot to be entertaining.

1992 S 9, C18:4

Wind

Directed by Carroll Ballard; screenplay by Rudy Wurlitzer and Mac Gudgeon; based on a story by Jeff Benjamin, Roger Vaughan and Kimball Livingston; director of photography, John Toll; edited by Michael Chandler; music by Basil Poledouris; production designer, Laurence Eastwood; produced by Mata Yamamoto and Tom Luddy; released by Tri-Star Pictures. Running time: 126 minutes. This film is rated PG-13.

Will Parker	Matthew Modine
Kate Bass	Jennifer Grey
Morgan Weld	Cliff Robertson
Jack Neville	Jack Thompson
Joe Heiser	Stellan Skarsgard
Abigail Weld	Rebecca Miller
Charley Moore	Ned Vaughn

By VINCENT CANBY

Carroll Ballard's "Wind" is an irresistible end-of-summer dividend that extends the season indefinitely. It's a bracing fable about those grand 12-meter yachts and their crews that compete for the America's Cup, the oldest and most prestigious of international sailing trophies. Though called the Hundred Guinea Cup when it was originally offered in England in 1851, it was renamed that year for the boat that won the first race. Since then, except for one brief period in the 1980's when Australian sailors took the prize, the cup has remained in American hands.

"Many things have happened to the cup in the last 140 years. What was once the sport of aristocrats and millionaires (Harold Sterling Vanderbilt won the cup three times in the 1930's) is now the sport of syndicates. The race is big business. Only associations of the well-heeled can afford the huge cost of building the boats. Their design has become as high-tech as that of supersonic aircraft. Even their specifications have changed.

In 1989, the 12-meter classification was replaced by a new one called the International America's Cup Class, which, it is said, allows the yachts to be longer and lighter and to carry more sail, thus to be faster.

"Wind," which is fiction suggested by fact, doesn't bother itself too much with such details, although it seems to be embracing a sort of transition period between the old 12-meter yachts and those of the new class. That's the impression given when, near the film's breathtaking finale, one of the competitors breaks out a mammoth spinnaker informally called the "whupper," for the sudden, impressive "whup" sound it makes when it catches the wind.

•

Purists may object to the ways "Wind" oversimplifies the business of big-yacht sailing. The film foreshortens the years spent on the design and building of the boats and the training of their crews. Television coverage of the last two America's Cup competitions gave armchair sailors a better idea of the technical complexity of today's racing than the film offers.

Yet "Wind" does something else. Mr. Ballard, who earlier directed "The Black Stallion" and "Never Cry Wolf," and John Toll, the masterly cinematographer, give the audience a real sense of the heady excitement, primal joy and serenity of ocean sailing, even during big-stakes competitions. It's a high that transcends all physical sensations of fatigue, cold, wet and especially noise. The sea is anything but silent when one of these great sleek hulls is sailing close to the wind on a day of serious wind and chop.

Although "Wind" seems to have originated as a vague idea about the America's Cup, the screenplay by Rudy Wurlitzer and Mac Gudgeon is more than just serviceable. It's hip, feather-light and sweet-natured. It's about four demonstrably bright young people who, somewhat in the tradition of Mickey and Judy wanting to put on a show, decide to design and build their own boat to win back the America's Cup, recently lost to an Australian crew. They build their

The business of big-time sailing yields to the human drama.

boat not in a barn, but in an airplane hangar on the salt flats of Utah.

The head of the group is Will Parker (Matthew Modine), the American helmsman and tactician responsible for the United States' defeat, who now wants to reclaim the cup. His companions are Kate Bass (Jennifer Grey), his former girlfriend and Will's equal as a sailor; Joe Heiser (Stellan Skarsgard), Kate's new lover, who is also a whiz when it comes to boat design, and Abigail Weld (Rebecca Miller), the bored and slightly nutty daughter of the millionaire Newport, R.I., yachtsman who was Will's skipper in the race with the Australians.

•

Cliff Robertson appears as Morgan Weld, Abigail's father, and Jack Thompson is Jack Neville, the Australian skipper with whom Will competes in the spectacular races that give the film its poetic heart. There is an almost magical simplicity to the narrative. A lot of relevant material is dealt with off screen: the financing of the new boat, and the trials and early races leading up to the climactic competitions that end the film off western Australia.

Tri-Star
Matthew Modine is out to reclaim the America's Cup in "Wind."

"Wind" has something of the manner of teen-age adventure fiction, but it is played by adults with recognizable passion and genuine humor. Will, Kate, Joe and Abigail are a most engaging crew of eccentrics. Mr. Modine, Ms. Grey, Mr. Skarsgard and Ms. Miller are a collective delight, never quite behaving in ways prescribed by conventional fiction. The characters' love lives are sloppy, disordered variations on the ideal. Mr. Modine's Will still loves Kate but, hoping to get their help, he blithely accepts her living arrangements with Joe six months after she has left him. Will puts first things first.

The other three are equally unpredictable. Kate is an amused but independent, no-nonsense type. Joe, who plays the cello to relax, is forever unsurprised. Abigail is a rich, abandoned brat who is about to do the right thing.

•

"Wind" is not commonplace movie making. The sailing sequences, including one short, very funny race off Newport involving the kind of small boats you and I might sail, surpass anything I've ever seen on the screen. There are collisions at sea, wrecked spinnakers and freak accidents, like the one during a race when a sailor finds himself hanging upside down from the mast as the other boat gains. These things exhilarate as they threaten to stop the heart.

The end is euphoria.

•

"Wind," which has been rated PG-13 (Parents strongly cautioned), has some vulgar language and mildly suggestive sexual situations.

1992 S 11, C3:1

A Crime Of the 20's In the Garb Of Today

"Swoon" was shown as part of this year's New Directors/New Films series. Following are excerpts from Janet Maslin's review, which appeared in The New York Times on March 27. The film opens today at the Lincoln Plaza, Broadway at 63d Street, Upper West Side.

In "Swoon," his wildly audacious debut feature about the 1924 kidnapping and murder committed by Nathan (Babe) Leopold Jr. and Richard (Dickie) Loeb, Tom Kalin challenges his audience's every assumption about this story, and quite a few assumptions the viewer may never have made. Mr. Kalin's objective is to fracture any familiar notions and prejudices that have been incorporated into this much-studied story.

Removing all elements of the usual, and sometimes deliberately interjecting jarringly incongruous touches to disrupt the ordinary, Mr. Kalin insists that his viewers reinvent the atmosphere that contributed to this enormously public 1924 crime.

The greatest success of "Swoon" lies in its power to dismantle ideas

into a ball and bounced, blown into a balloon and flown, and eventually tossed into a wastebasket. The film's juxtaposition of an animated figure and photorealistic setting give the antics an almost three-dimensional sense of space.

1992 S 17, C22:1

Husbands and Wives

Written and directed by Woody Allen; director of photography, Carlo Di Palma; edited by Susan E. Morse; production designer, Santo Loquasto; produced by Jack Rollins and Charles H. Joffe; released by Tri-Star Pictures. Running time: 107 minutes. This film is rated R.

Gabe Roth	Woody Allen
Judy Roth	Mia Farrow
Sally	Judy Davis
Jack	Sydney Pollack
Rain	Juliette Lewis
Michael	Liam Neeson
Sam	Lysette Anthony
Judy's ex-husband	Benno C. Schmidt Jr.
Shawn Grainger	Christi Conaway
Paul	Timothy Jerome
Rain's analyst	Ron Rifkin
Rain's mother	Blythe Danner
Rain's father	Brian McConnachie

By VINCENT CANBY

WELL, then, what about the movie? Woody Allen's "Husbands and Wives" is a very fine, sometimes brutal comedy about a small group of contemporary New Yorkers, each an edgy, self-analyzing achiever who goes through life without much joy, but who finds a certain number of cracked satisfactions along the way.

The film is Mr. Allen's uproarious answer to Ingmar Bergman's far more solemn but no less bleak "Scenes From a Marriage." It's also an ensemble piece acted to loopy perfection by a remarkable cast headed by Judy Davis, Sydney Pollack, Mia Farrow, Juliette Lewis, Liam Neeson and Mr. Allen, who's also the writer, director and ringmaster, as well as his own best friend.

Brian Hamill

Woody Allen

In a crunch, Mr. Allen comes through for himself.

With "Husbands and Wives" he has made a movie that's so strong, wise and exhilarating that it should be able to weather the chaos of accusations, gossip, public statements and dirty jokes attending its release. Whether this was the right time to open "Husbands and Wives" nobody yet knows, although the kind of attention being given to the very noisy split of Mr. Allen and Ms. Farrow has never sold tickets in the past.

People with insatiable appetites for the lubricious details of scandal are not the most loyal moviegoers. The sort of information they want is supplied by newspapers, magazines and television. They demand facts, or their loose facsimiles.

A movie, after all, is fiction, and with fiction you can never be sure what really happened. Or, as a bright student of creative writing says in "Husbands and Wives," writing (meaning fiction) "is just a trick."

Or is it? That's the question that haunts this new movie and sometimes clouds the screen. If "Husbands and Wives" were less of an achievement, it might be impossible to watch. It's sorrowful enough without real life butting in.

"Husbands and Wives" is actually scenes from two marriages, one on the rocks as the film begins, the other in a kind of stasis, set in a uniformly upscale Manhattan where the apartments are big, book-lined and comfortable, the corporate suites ultramodern, the halls of academe ivied and the restaurants quiet enough to permit sustained conversation. The characters all work at endeavors that are immensely profitable, prestigious or celebrated (as with fame).

Gabe Roth (Mr. Allen) is a novelist and short-story writer who teaches at Columbia. He and Judy (Mia Farrow), an editor at an art magazine, have been married for 10 years. Their best friends are Jack (Mr. Pollack), a successful businessman who is an epically clumsy, impotent philanderer, and Sally (Ms. Davis), whose work for the Landmarks Preservation Commission does not fill the void left by her bored husband.

●

In the film's stunning opening sequence Jack and Sally arrive at the Roths' apartment on their way out to dinner. In the course of a single extended take, which has the appearance of something shot by the hand-held camera of a documentary film maker, Jack and Sally cheerfully announce that they are separating, and then stand by as the camera tries to keep up with the donnybrook that follows.

Gabe and Judy are shocked. Judy goes from shock to fury. She's ready to throw something. Gabe tells her mildly that it isn't their business. "Of course it's our business!" Judy yells. She works herself into a first-rate tantrum and disappears into the bedroom. "Please don't not support us," Sally says. Jack looks embarrassed for his friends.

"Husbands and Wives" follows the moral muddles and emotional crises of Jack, Sally, Judy and Gabe over the next year and a half as the friends fight, schmooze, separate, take lovers and, in a way, reconcile. The film's form is freer than anything Mr. Allen has attempted in the past, although it's more successful for what it achieves than for its consistency.

At the beginning, "Husbands and Wives" appears to be some kind of simulated cinéma vérité. All of the characters, usually alone but sometimes in couples, take time out to be interviewed by the off-screen director of what one assumes to be the film-within. The testimony, as heartbreaking as it is hilarious, is interrupted by jump cuts within close-ups, as if the editor were eliminating the repetitions and nonessential information.

Yet there are other times when the audience is clearly watching things that no film maker would be allowed to photograph. The movie becomes a narrative presented by an omniscient observer. This form (could it be Mr. Allen in a post-modern mode?) disturbs, but it works for sometimes devastating results. Carlo Di Palma is the brilliant cinematographer. "Husbands and Wives" goes beneath the surface of things in a way few movies ever do. The story spins dizzily on.

●

Mr. Pollack's human, klutzy Jack realizes his dream: he moves in with his much younger aerobics instructor, Sam (Lysette Anthony), whom Gabe labels a cocktail waitress. Jack admits that she's not Simone de Beauvoir. She's a vibrant young beauty who is into health and astrology, and who talks too much at parties with his older friends. Sometimes Jack loses a serious temper.

Judy introduces Sally to Michael (Mr. Neeson), a young, good-looking, intensely sincere editor who wants very much to be married. Judy, who fancies Michael herself, is not pleased that Michael falls for Sally, while Sally makes him miserable.

Sally must be one of the most endearingly impossible characters Mr. Allen has ever written, and Ms. Davis nearly purloins the film. If Michael asks Sally how she liked their dinner, she says that she loved it, that it was superb, but that she'd like to teach the chef how to make a proper Alfredo sauce. She tells him the Mahler symphony was divine, but the second movement too slow. Michael kisses her. Sally responds, then breaks away. "Metabolically," she says, "it's not my rhythm."

Ms. Farrow's Judy is also a rich and contradictory character. Her former husband, one of the film-within's peripheral witnesses (played by the former president of Yale University, Benno C. Schmidt Jr.), describes her

Brian Hamill

Mia Farrow

with lethal accuracy as "passive-aggressive." She's someone with a will of steel who pretends to be helpless. Yet she is also the one character in the film who seems to have her eyes open, if sometimes with a vengeance.

In the early scenes, she whines to Gabe about wanting a child. He points

Woody Allen casts his keen vision on the rhythms of relationships.

out that she already has a daughter from her first marriage. Aren't she and he enough as they are? She says no. He accuses her of the worst kind of deceit, of telling him that she's using a diaphragm when she isn't. Later, when he says that he's changed his mind about a baby, she refuses. "This is crazy," Gabe says. "I'm urging you to have a baby I don't even want!" Judy leaps at him in rage. Her point has been made.

In the meantime, Gabe has been seeing one of his students, Rain (Juliette Lewis), a pretty, uncommonly self-possessed would-be writer, named by her mother for Rainer Maria Rilke. Rain sets about to seduce Gabe, who has always been drawn to what he describes as "kamikaze women" — that is, women who "crash into you," possibly to take you down in flames with them.

Rain's 21st-birthday party at her family's penthouse becomes a major romantic moment for Gabe. There's a grandly operatic thunderstorm. The lights go out. Candles are lighted. The wine is vintage stuff. Gabe and Rain are alone. She asks him to kiss her on the mouth. "Why is it," he says, "that I'm hearing $50,000 worth of psychotherapy dialing 911?"

Fact? Fiction? Fantasy? Who cares? This sort of material is better analyzed by the critical biographer than by either the gossip columnist or the film critic. What is far more disturbing (because of current events) is the role Mr. Allen has given Ms. Farrow, that of a woman who is both tenacious and unforgiving. Judy gets what she wants. Ms. Farrow is funny and more than a little frightening. The performance is superb. Yet the role now seems mean-spirited. This Judy is a waif with claws. A year ago, no one would have seen anything except the fiction. Today, that's not possible.

●

"Husbands and Wives" — the entire Allen canon, for that matter — represents a kind of personal cinema for which there is no precedent in modern American movies. Even our best directors are herd animals. Mr. Allen is a rogue: he travels alone. This species is not unknown in Europe. Consider Federico Fellini and "8½" and "City of Women." Or François Truffaut and the devastating "La Peau Douce," made at a time when his own marriage was in difficulty. "La Peau Douce" is about a husband whose jealous wife calmly blows his head off with a shotgun. The man had been unfaithful but, the film seems to ask, does infidelity really deserve this? Truffaut photographed much of that film in his own apartment.

"Husbands and Wives" is the 13th collaboration of Mr. Allen and Ms.

Farrow and, it must be assumed, the last. Too bad, we say, but, as Ms. Farrow's Judy tells Gabe in the film, life is change. Like life, all relationships have their beginnings, middles and ends. Not to recognize that natural law is to attempt to stop the planets.

As it plays today, "Husbands and Wives" may appear self-serving. Mr. Allen's Gabe is the one who suffers most. In the film's poignant last scene, played to the film-within's interviewer, Gabe says, "I blew it," then, at the very end: "Can I go? Is this over?"

•

"Husbands and Wives," which has been rated R (Under 17 requires accompanying parent or adult guardian), has vulgar language and sexual situations.

1992 S 18, C1:1

Singles

Written and directed by Cameron Crowe; director of photography, Ueli Steiger; edited by Richard Chew; music by Paul Westerberg; production designer, Stephen Lineweaver; produced by Richard Hashimoto and Mr. Crowe; released by Warner Brothers. Running time: 99 minutes. This film is rated PG-13.

Janet Livermore	Bridget Fonda
Steve Dunne	Campbell Scott
Linda Powell	Kyra Sedgwick
Debbie Hunt	Sheila Kelley
David Bailey	Jim True
Cliff Poncier	Matt Dillon
Dr. Jamison	Bill Pullman
Luiz	Camilo Gallardo
Jamie	Peter Horton
Xavier McDaniel	Himself
Brian	Tim Burton

By JANET MASLIN

"Does everybody go through this?" asks a voice heard at the end of "Singles," Cameron Crowe's buoyant, utterly charming look at a small sample of Seattle's young, unmarried population. "Nah," comes the answer. "I think just us."

Since that is so patently untrue, and since "Singles" speaks so wryly to all the fun and trouble of being newly independent in one's early 20's, Mr. Crowe has a lot to work with. He also has an uncanny ear for the ways in which hip, humorous, vastly likable young characters might express themselves, with a jokey casualness that's a lot more substantial than it sounds.

Mr. Crowe (who wrote "Fast Times at Ridgemont High" and directed "Say Anything") has an exceptional ability to enjoy such characters without a trace of condescension. Unopened Champagne, half-eaten birthday cake, duck sauce and pantyhose: Mr. Crowe understands exactly what kind of person might have these things (and not much else) in her refrigerator.

The items in question belong to Janet Livermore, played by Bridget Fonda as an utter heartbreaker whose luck with men is inexplicably awful. An aspiring architect with a waitressing job, Janet is unaccountably stuck on Cliff Poncier (Matt Dillon), a hilariously talentless rock musician first seen lounging on Jimi Hendrix's grave. Cliff, who has to concentrate very hard on the simplest concepts, can and often does point to his band's popularity in Belgium to offset their miserable status in Seattle. (Mr. Crowe, once known as the boy wonder of Rolling Stone mag-

Bridget Fonda

azine, concocts a review so blistering that Cliff's fellow band members are afraid to read it aloud in Cliff's presence.)

Cliff, Janet and several of the film's other principals are neighbors living in the same apartment building. But Linda (Kyra Sedgwick) is proud of having a place of her own, and a parking space to go with it. Gadgets like garage-door openers, telephones and answering machines take on a totemic importance under these circumstances. (Giving someone an extra garage-door opener becomes an important romantic gesture, as well as the basis for one of Mr. Crowe's better sight gags.) As the film begins, Linda is seen risking this once too often with a man named Luiz (Camilo Gallardo), who claims to be on his way back to Spain. "If I married him, he could live in this country and I'd always have someone to go out with," Linda muses to a friend.

But Linda, an environmentalist, has become shell-shocked by the time she meets Steve (Campbell Scott), who is studying traffic patterns for the Seattle Department of Transportation. Only reluctantly does she agree to accompany him on a quasi-date, during which they drink water and discuss the Exxon oil spill. Details like these are perfectly observed, as is the Seattle club scene that provides background music and occasional settings for the story. (The soundtrack is relied upon too heavily, but Paul Westerberg of the Replacements provides an irresistible theme song.)

Much of "Singles" is structured as short takes and obvious gags, which give a sitcom flavor to material that is actually much more delicate than that. A running joke about a sneeze turns out to say something real about one character's emotional requirements, and it allows one love affair to be resolved on a charming note. Even the punch lines have their serious side, as when one of the principals speaks dismissively of casual sex ("It's lethal, it's over") and nearly drives several others out of the room.

"Singles" is crammed with funny marginal touches, from a safe-sex party ("Come as your favorite contraceptive") to the minor characters' colorful affectations ("I live my life like a French movie," says one young man, whose mind is actually on collecting 20 phone numbers to store in his high-tech watch.) Among the more memorable cameo appear-

ances here are those of the basketball star Xavier McDaniel (who gives Steve some very personal advice) and Peter Horton (who turns up as his "Thirtysomething" character, and soon has two roommates fighting over him). The marginal-looking film maker who agrees to make a dating-service video for $20, and is described as "only like the next Martin Scorseez," is Tim Burton.

Also in "Singles," and furthering the feeling that this film's characters are real and completely irresistible, are Sheila Kelley as the only single who is dead set on being married, Jim True as that would-be French movie hero, and Bill Pullman as a doctor who does breast-implant surgery, which becomes a matter of importance to Janet for a while. It's typical of "Singles" that this episode turns out a bit unexpectedly, that its lightweight tone is deceptive, and that audiences will be sorry to see it end.

•

"Singles" is rated PG-13 (Parents strongly cautioned). It includes profanity and discreet sexual situations.

1992 S 18, C3:4

Sarafina!

Directed by Darrell James Roodt; written by William Nicholson and Mbongeni Ngema; director of photography, Mark Vicente; edited by Peter Hollywood, Sarah Thomas and David Heitner; music by Stanley Myers; production designer, David Barkham; produced by Anant Singh; released by Miramax Films. Running time: 96 minutes. This film is rated PG-13.

Sarafina	Leleti Khumalo
Mary Masembuko	Whoopi Goldberg
Angelina	Miriam Makeba
School Principal	John Kani
Crocodile	Dumisani Dlamini
Sabela	Mbongeni Ngema
Guitar	Sipho Kunene

By JANET MASLIN

"Sarafina!" would seem to be a musical exceptionally well suited to the screen, where its subject can be depicted rather than merely imagined. It's clear from the opening number of this energetic, impassioned film version that Soweto — presented ironically with its name spelled out across the landscape, as in the "Hollywood" sign — is the essence of the story, not merely its background.

It's also clear that a tougher, more realistic "Sarafina!" means a film at war with itself, as it tries to reconcile "Fame"-style high spirits with the misery of its characters' lives. It's no small accomplishment on the part of Darrell James Roodt, the director of this vibrant film adaptation, that "Sarafina!" remains a forceful mixture of celebration and fury much of the way through.

Reflecting a strong music-video influence in its snappily edited dance numbers (which incorporate fantasy elements like a mock Oscar for its heroine), the film also has a sharply realistic strain. Its galvanizing opening images of young men on the run at dawn turn out to prefigure the firebombing of the high school that is central to the story. This school is a home away from home for both Sarafina (Leleti Khumalo), the lovely young girl who dreams of changing her world, and Mary (Whoopi Goldberg), the noble teacher who is the film's principal repository of wisdom. "Like they say, if you want to find a way, you must first know where you're going," Mary says.

Although Ms. Goldberg serves an inspirational purpose in the film and does this movingly (despite a laboriously achieved South African accent), the film never wavers from its focus on Sarafina. The radiant Ms. Khumalo, for whom that fake Oscar may be no joke, is both a fine actress and a mesmerizing beauty.

As she travels from the shanties of Soweto to the comfortable Johannesburg house where her mother (played with immense dignity by Miriam Makeba) works as a maid, Sarafina remains a remarkably free spirit. Her anger rises during the course of the story, but she somehow retains her teasing egotism and her insistence on becoming a star. Sarafina dreams of portraying Nelson Mandela and speaks reverently to a picture of this leader, voicing her hopes that he will be freed from prison (an aspect that certainly dates the material). A closing title announcing Mr. Mandela's release seems admirable but misplaced, since the only viewers for whom it can have news value are those still unaware that Woody and Mia are having family problems.

Vigorous and affecting as it is in its early stages, when the issue of freedom is still an abstraction, "Sarafina!" turns increasingly grim and violent when it addresses the real and tangible injustice in its characters' lives. The silencing of a brave teacher, the burning to death of a hated policeman, the reprisals that follow and a dramatic re-staging of the Soweto riots make the film's early musical energy a dim memory. Mr. Roodt's final attempt to reprise that upbeat mood, with a jarringly edited closing dance number, comes not long after Sarafina has been tortured by South African policemen.

This film's presentation of such violence is painfully credible, certainly more so than comparable moments in "Cry Freedom" and other big-budget dramatizations. Only within the context of "Sarafina!" and its fiercely affirmative energy does such bloodshed become ill conceived.

•

"Sarafina!" is rated PG-13 (Parents strongly cautioned). It includes some graphic violence.

1992 S 18, C16:6

Jumpin' at the Boneyard

Written and directed by Jeff Stanzler; director of photography, Lloyd Goldfine; edited by Christopher Tellefsen; music by Steve Postel; production designer, Caroline Wallner; produced by Nina R. Sadowsky and Mr. Goldfine; released by 20th Century Fox. Running time: 107 minutes. This film is rated R.

Manny	Tim Roth
Danny	Alexis Arquette
Jeanette	Danitra Vance
Mr. Simpson	Samuel L. Jackson
Mom	Kathleen Chalfant
Cathy	Elizabeth Bracco
Derek	Jeffrey Wright

By VINCENT CANBY

"Jumpin' at the Boneyard," Jeff Stanzler's first feature, is a small, grim, sometimes brutal drama about two brothers from the Bronx, each of whom is equally dispossessed but in different ways.

Manny (Tim Roth) is divorced, out of work and in deep depression. The only thing that keeps him going is hatred for his recently deceased father and adoration of his mother.

Andrew Moore

Tim Roth and Alexis Arquette.

Danny (Alexis Arquette), the younger brother, is a crack addict. He's sick and fearful of everything and everybody, sustained at life's edge by his girlfriend, Jeanette (Danitra Vance), who supplies their two habits by working as a hooker.

The brothers are reunited after three years when Danny and Jeanette, thinking that Manny is at work, break into his apartment to rob it. Manny nearly beats his brother senseless before he decides that they should go see their mother. When she's not at home, they drive to the cemetery to visit the grave of their father.

Thus begins a 24-hour odyssey during which the brothers explore the emptiness of their present lives as they walk through the remains of their old Bronx neighborhood, once white, now black. They are not only strangers there, but also enemies. They are briefly befriended by the black man (Samuel L. Jackson) who runs the youth club, and who allows Danny to take a shower. Manny decides he can reclaim his own life by somehow getting Danny into a drug rehab program.

"Jumpin' at the Boneyard" looks authentic. It's acted with immense technical skill by Mr. Roth, an English actor who has been seen in films by Mike Leigh and Stephen Frears. Here he sounds as if he had never been out of the Bronx. Mr. Arquette, who appeared as the transvestite Georgette in "Last Exit to Brooklyn," is a scary zombie who might like to be saved if it weren't so difficult. Ms. Vance, who isn't around that long, gives a good, vivid performance as the only uninhibited character in the film.

Yet there is something soft at the center of "Jumpin' at the Boneyard" in spite of all of its carefully simulated squalor, the intensity of Mr. Roth's bravura work and the apparent nihilism of the narrative. It is evident in both Mr. Stanzler's screenplay, whose characters are not entirely credible on their own terms, and especially in his directorial choices.

"Jumpin' at the Boneyard" is one of those movies in which the characters mean exactly what they say. Manny and Danny are utterly realistic without being surprising for a minute. The camera doesn't observe them from a distance, so as to allow the audience to think for itself. The camera has the effect of asking for sympathy. It's too well meaning, as if aware of its social mission. This is the opposite of the effect of the current "Laws of Gravity," Nick Gomez's astonishing first feature, which deals not with drug addiction but with blue-collar lives no less barren.

●

"Jumpin' at the Boneyard," which as been rated R (Under 17 requires accompanying parent or adult guardian), has a lot of obscene language, some brutality, nudity and sexual references.

1992 S 18, C18:5

School Ties

Directed by Robert Mandel; written by Dick Wolf and Darryl Ponicsan; director of photography, Freddie Francis; edited by Jerry Greenberg and Jaqueline Cambas; music by Maurice Jarre; production designer, Jeannine Claudia Oppewall; produced by Stanley R. Jaffe and Sherry Lansing; released by Paramount Pictures. Running time: 109 minutes. This film is rated PG-13.
David GreeneBrendan Fraser
Charlie DillonMatt Damon
Chris ReeceChris O'Donnell
Rip Van KeltRandall Batinkoff
McGivernAndrew Lowery
Jack ConnorsCole Hauser
Sally Wheeler..................................Amy Locane
Cleary...Zeljko Ivanek
Coach McDevitt.............................Kevin Tighe
Alan Greene ..Ed Lauter

By JANET MASLIN

In "School Ties," a tale of anti-Semitism geared to the "Dead Poets Society" crowd, the film's Jewish hero quietly removes the gold Star of David that he wears around his neck and hides it in a box of Band-Aids. In a drama like this, the worst-case scenario would have a classmate later skinning his knee and reaching for the Band-Aids, thus letting the cat out of the bag.

At least that doesn't happen. Though much of "School Ties" follows a predictable path, this film does manage a few surprises, particularly those surrounding David Greene (Brendan Fraser), the story's exemplary hero. David is smart, handsome and the star of the school's football team. This means he is not the sort to behave philosophically once he experiences religious discrimination at a prestigious New England prep school during the mid-1950's. Indeed, David's habit of grabbing, berating or otherwise challenging anyone who insults him gives "School Ties" a muscular quality not usually found in films about this subject. It hardly hurts that the director, Robert Mandel, stages one of David's most significant brawls with his classmates in a communal shower.

Mr. Fraser, who played the subverbal title role in "Encino Man," emerges from the primordial slime of that film as a very appealing leading man. Cast this time as an intelligent, well-groomed hunk, Mr. Fraser makes David believable even when the film seems to indicate otherwise. David's home life in Scranton, Pa., is presented ludicrously, as he fights off anti-Semitic bikers who look like male models. David's father is seen only briefly and is played by Ed Lauter, surely one of the last actors an audience might expect to hear speaking Yiddish. Later on, David recalls watching two strangers foraging for tin cans in a garbage dump and hearing his father say, "Davy, it's an honest living."

●

Without having made a plausible case for either David's working-class background or his Jewish roots, the film sends him to a snobbish New England boys' school on a football scholarship. "Is there anything you can't eat?" asks the coach (Kevin Tighe) when David arrives. "Just play your cards close to the vest, that's my advice," this coach continues, with the same sledgehammer delicacy. "Don't tell people more than they need to know."

So David stands by, looking chagrined, while his new classmates crack anti-Semitic jokes and speculate about their own futures at Ivy League colleges. (Each one has a family mandate to follow his ancestors' footsteps at Harvard, Princeton

or Yale.) "I wouldn't go to Harvard if you paid me," one teases another. "All those Jews and Communists," he adds. Another classmate chimes in, "Yeah, and that's just the faculty."

The film, which gets its ethnic and economic snobbery mixed up, imagines that David's relative poverty would cause no problems in this setting; only his Jewish lineage, when it is finally made public, becomes a source of trouble. Meanwhile, David has picked up the expected accouterments of a pretty blond girlfriend (Amy Locane) whose religious tolerance goes no deeper than her pageboy hairdo and a bigoted friend (Matt Damon) whose prejudice masks his fears about his own inadequacies.

The screenplay, by Dick Wolf and Darryl Ponicsan, occasionally presents David with interesting and slightly unexpected dilemmas. What does he do about the fact that an important game falls on Rosh ha-Shanah, a day when Jewish law prohibits anyone from playing quarterback? The film's ending also has the potential for presenting David with a significant ethical question, and leads to a mildly surprising resolution.

"School Ties" has a leafy, genteel look that is somehow less than convincing, perhaps because the hairdos are too tidy and the resemblances to other prep-school stories too clear. Some good young actors, including Randall Batinkoff as the football-team captain and Chris O'Donnell in a standard nice-guy role, do what they can to enliven these surroundings. So does Zeljko Ivanek, gleefully overplaying the role of a bow-tie-wearing sadist who teaches French.

●

"School Ties" is rated PG-13 (Parents strongly cautioned). It includes mild profanity and discreet nudity.

1992 S 18, C19:1

Captain Ron

Directed by Thom Eberhardt; written by John Dwyer and Mr. Eberhardt; director of photography, Daryn Okada; edited by Tina Hirsch; music by Nicholas Pike; production designer, William F. Matthews; produced by David Permut and Paige Simpson; released by Touchstone Pictures. Running time: 104 minutes. This film is rated PG-13.
Captain Ron................................... Kurt Russell
Martin Harvey.............................. Martin Short
Katherine Harvey.................. Mary Kay Place
Caroline Harvey.......................... Meadow Sisto
Benjamin Harvey............Benjamin Salisbury

By VINCENT CANBY

"Captain Ron" looks like the pilot film for an unsold sitcom. It is about

Kurt Russell

an average yuppie family from Chicago, the broken-down boat they inherit in the Caribbean, and the colorful, one-eyed skipper who takes command of their boat and their lives. They have adventures that could possibly fill two 30-minute episodes with the help of a laugh-track.

The cast is headed by Kurt Russell as the skipper, who talks like Long John Silver; Martin Short and Mary Kay Place, who play the dad and mom (he's a harried business executive, she's an interior decorator), and Meadow Sisto and Benjamin Salisbury, who appear as their wise-cracking children. Thom Eberhardt directed the screenplay he wrote with John Dwyer. Though the film could not have been too inexpensive to produce on its Puerto Rican locations, it manages to seem threadbare, mostly because of the lack of a comic imagination.

●

Among other things, "Captain Ron" features fictitious Caribbean islands with jokey names (St. Pomme de Terre, St. Haag), the expected landlubber-at-sea gags (people falling overboard, anchors dropped without being secured to the boat), and some contemporary pirates (anti-Castro Cuban guerrillas who hijack the boat). By the end, the family, which had been on the edge of being dysfunctional, has bonded.

The scenery is pretty but the movie never makes one wish to be in it. Mr. Russell, a good, reliable actor, prompts a few smiles as the raffish, impossibly self-assured sailor who is always half tight. Mr. Short and Ms. Place also are attractive in spite of the dim material. Two 58-foot ketches stand in for the family's boat, first seen in nearly terminal disrepair and then miraculously spruced up. They are quite fine.

●

"Captain Ron" is rated PG-13 (Parents strongly cautioned). It has some vulgar language and mildly suggestive sexual situations.

1992 S 18, C23:1

Flashbacks of a Festivalgoer

By VINCENT CANBY

HALCYON NIGHTS, AND SOME NOT SO, AT THE annual New York Film Festival. When it opens Friday, the festival will be celebrating 30 years at the same Lincoln Center stand. In that time, Rainer Werner Fassbinder has come and gone. Akira Kur-

osawa, who already had a full body of work behind him in 1963, continues to add to it today. François Truffaut is dead, but Jean-Luc Godard, who has had more films at the festival than any other director (16 features, plus 5 short films), goes on.

In the 30 years before that first New York festival, technicians invented 'scopes to make movies bigger and wider. Stereo sound was introduced. The great three-strip Technicolor process achieved something close to perfection. Since 1963, three-

Remembering the delights of movies of the last 30 years (not to mention the lethargy).

strip Technicolor has been abandoned — too expensive, and color photography has been so improved that today a negative can fade to magenta before a film has finished its first run.

As television has profoundly altered our political processes in these three decades, video has transformed the business and art of movies. Theaters have multiplied and shrunk. The movies they show have become portable. "Lawrence of Arabia" fits into a hip pocket. Almost anybody can afford to buy "Gone With the Wind" to screen at will and use as a doorstop.

Though fashions in clothes recur with the regularity of the tides, the manners, language and expectations of the people who wear them are far different today than in 1963. It used to be that four-letter words could shock simply by appearing in print. A mother was a mom and not a euphemism. A small boy might have reasonably assumed that, due to something in the water, only women in France and Sweden grew bare breasts.

When the New York Film Festival set up shop, American movies were still paying lip service to the puritanical notions in the old Production Code. Hollywood film makers were doing their damnedest to find ways to get around the prohibitions,

sometimes brilliantly. But only in foreign movies could men and women sleep together and even make love.

American movie critics used to rave about the cinematic genius of Carl Dreyer, Satyajit Ray and Kurosawa, but the movies that kept the so-called art houses open in 1963 were more likely to be sexy melodramas and comedies starring Brigitte Bardot, Gina Lollobrigida and their spin-offs. In ideal circumstances, the foreign-language art-house movie was both a work of some substance and a frank approach to behavior not yet allowed in American films.

That American audiences were less interested in the art of foreign films than in other kinds of display seems to be certified by the decline in film imports in recent years. Once the American film was liberated in 1968, when the Code was replaced by the rating system, Hollywood could match the yardage of naked flesh from abroad, with the extra added attraction of explicit violence, which had never much appealed to overseas movie makers.

For this reason, the New York Film Festival is probably of greater service today than it was 30 years ago. Along with the cavernous film palaces, the art houses have gone, as well as the movies they used to show. At Loew's 84th Street, you aren't likely to stumble across the latest discovery from Iran or a film that, according to the forthcoming festival's ad, "pushes even Romanian cynicism past the limit."

It's been a busy 30 years of cinema at Lincoln Center: a total of nearly 800 movies, a continuum of other people's dreams, most of which are now forgotten. It was a happy coincidence that the festival came into being at the time it did, thus to be able to

celebrate all but one of 10 great films that marked the Golden Age of the incomparable Luis Buñuel. Only "Viridiana" (1962) came out too soon.

Yet as vividly as I remember the hysterically deadpan delights of Buñuel's "Exterminating Angel," the opening night attraction in 1963, I also re-experience the lethargy inspired by Marguerite Duras's "Nathalie Granger" in 1972.

The lyrically surreal Buñuel comedy is about a group of dinner party guests who find themselves mysteriously unable to leave their hosts at the end of the evening. "Nathalie Granger" achieves the same effect

Stacey P. Morgan for The New York Times

Warhol's poster for the 1967 New York Film Festival.

through intentionally inconsequential talk and minimal action. It paralyzes the will, which is not an entirely unpleasant sensation. It's like going under anesthesia. One stares at the exit sign to stay awake. The red letters lose their shape and sequence to form the sinuous silhouettes of mythical beasts. The body's extremities tingle. Sleep beckons ever more insistently. Then someone less susceptible, sitting three rows away, stands up saying, "To hell with it," and stomps out. The spell is broken.

■

As a writer, Duras creates narratives with prose that has been pared down to the essentials. Her novels are spare, yet packed. She is a major artist and an original voice. As such, her experiments in film command attention, though writing and movie making don't really have much in common. Richard Roud, the program director through the 1987 festival, gave her that attention, five times.

Taking such notice is one of the festival's continuing obligations, also met by the showing of Norman Mailer's entertaining precinct improvisation, "Beyond the Law," in 1968, and Susan Sontag's somewhat less gripping "Duet for Cannibals" in 1969. Occasionally these crossover attempts pay off handsomely, as they did in 1987 when the festival presented the playwright David Mamet's superb first film as a writer-director, "House of Games."

My fondest memories of the New York festival are not of the hot tickets, such as Bernardo Bertolucci's "Last Tango in Paris" in 1972 and Godard's "Hail Mary" in 1985 (when furious nuns formed picket lines at Lincoln Center), but of the discovery of extraordinary films for which there was no hype, or for which the advance word was dead wrong. I think especially of the afternoon in 1971 when I arrived at Alice Tully Hall for the press screening of Terrence Malick's "Badlands," about which I knew nothing.

■

As I was on my way into the auditorium, one of the festival aides waved at me and said, making a pained expression, "I don't envy you this one." His wasn't a lengthy review, but it was enough to throw me off course for about eight minutes, after which it was apparent that we were watching the work of a new film maker completely in control of his mind, manner and talent. "Badlands" is not a nice movie. It's about a gun-crazy teen-age killer who briefly terrorizes a large section of the country's heartland. It's also a deceptively dispassionate portrait of an America in which actions seem magically to be relieved of all consequences. Among other things, "Badlands" is a political movie.

I think, too, of the way that Roud force-fed all of us on Godard in the early years. Godard is irascible. He is an acquired taste, but he's also the most original, innovative and seriously ambitious film maker of his generation. This only became clear over the years in which Roud pushed our faces into "Bande à Part" (1964), "Alphaville" (1965), "Two or Three

Things I Know About Her" (1968) and all of the others.

Most film makers would pawn birthrights to be able to please the public. Godard has always been willing to infuriate and offend, lay audiences as well as nuns. There was the night in 1972 when, as the curtain raiser for his latest feature, "Tout Va Bien," with Jane Fonda, the festival showed "Letter to Jane," a 45-minute

Over 30 years, nearly 800 movies have played at the festival.

film in which Godard and his codirector, Jean-Pierre Gorin, ridicule a news photograph of Fonda taken during a trip to North Vietnam.

■

The members of the audience became as angrily restless as I have ever seen them at the festival. If it had been a 42d Street movie theater, it would have been seat-slashing time. At Lincoln Center, some people walked out. Others stamped feet and began to boo, though not because they were feeling sorry for Fonda, who was, after all, the star of "Tout Va Bien." "Letter to Jane" is one of those Godard efforts in which the screen often goes black for long periods of time, when the same point is repeated more often than is absolutely necessary and when the dialectic appears to devour itself, leading to total incoherence.

Without the New York festival, I'm not sure Godard would ever have been recognized. In much the same way the festival supported Godard and Buñuel, it kept the public's attention focused on Ray, Truffaut, Bertolucci, Fassbinder, Maurice Pialat, Werner Herzog, Andrzej Wajda, Eric Rohmer and Krzysztof Zanussi. These film makers were Roud's passions, a number of which came to be shared by film aficionados who would otherwise have remained untouched.

It's still too early in the tenure of Richard Peña, who succeeded Roud as program director, to identify the ways in which his personal biases will influence and lead the members of the festival's selection committees. There has been an increasing number of films from Latin America and Asia in the last several years, though whether this has to do with policy or availability is anybody's guess. There also have been some notable discoveries since 1988, Peña's first festival, particularly films by Aki Kaurismaki, Jane Campion and Mike Leigh.

Yet there is the danger that, at 30, the festival will begin to slip into comfortable, self-satisfied middle age, doing the correct political thing in its selections while avoiding those films that can make audiences hoot with rage and boo the way Godard's once did. Each year there are rumors about the worthy films that did not get into the festival for one reason or another.

I'm haunted by one title in particular that never made it, Federico Fel-

lini's self-revealing "Intervista," made several years ago. It's a staged documentary in which the maestro, accompanied by some Japanese journalists and Marcello Mastroianni, more or less pushes his way into Anita Ekberg's house. According to the film, Ekberg, who co-starred with Mastroianni in "La Dolce Vita," doesn't want to be photographed. She doesn't like the way she looks — she's put on weight.

Fellini persists. The result is moving and funny and less unkind than it sounds. It's also instant memorabilia, a footnote to some glorious cinema history. The film was finally seen here earlier this year in a restrospective of Italian films. "Intervista" would have been a natural for the festival. The Lincoln Center Film Society honored Fellini at its annual gala in 1985. Its festival has never shown a single Fellini film. □

1992 S 20, II:1:1

Mr. Saturday Night

Directed by Billy Crystal; screenplay by Mr. Crystal, Lowell Ganz and Babaloo Mandel; director of photography, Don Peterman; edited by Kent Beyda; music by Marc Shaiman; production designer, Albert Brenner; produced by Mr. Crystal and Peter Schindler; released by Columbia Pictures. Running time: 110 minutes. This film is rated R.

Buddy Young Jr. Billy Crystal
Stan Yankelman David Paymer
Elaine ... Julie Warner
Annie ... Helen Hunt
Susan .. Mary Mara
Phil Gussman Jerry Orbach
Larry Meyerson Ron Silver
Mom ... Sage Allen
Jerry Lewis .. Himself
Ed Sullivan ... Will Jordan
Gene ... Jackie Gayle
Freddie ... Carl Ballantine
Joey .. Slappy White

By JANET MASLIN

"Mr. Saturday Night" starts out by letting the audience know exactly what, or whom, it is up against: Buddy Young Jr., a corrosively funny stand-up comic who will stop at nothing for the sake of a laugh. Buddy's brand of humor is so emphatically in-your-face that he feels equally free deriding close relatives ("my daughter, the paper cut") and total strangers ("I'd like to show you something that you probably haven't seen in a very long time: your feet"). Nasty as Buddy is, it's hard to resist him. Besides, he's already his own worst enemy.

Billy Crystal, who directed "Mr. Saturday Night" and co-wrote it (with Lowell Ganz and Babaloo Mandel), knows a great deal about this character. He can pinpoint everything from Buddy's mother's cooking (the basis for a vivid title sequence by Saul and Elaine Bass, complete with cabbage stuffing) to his choice in latter-day loungewear (a Nipsey Russell-Joey Bishop Pro-Am sweatsuit). Having fine-tuned his performance as Buddy for nearly a decade on television, Mr. Crystal makes the man instantly recognizable, and often scathingly funny, as a Borscht Belt-style comic whose flair for wisecracks has wildly distorted every other aspect of his life.

Comedy comes first for Buddy, way ahead of friends, family and peace of mind (his or anyone else's). In the process of carving out a niche in nightclubs and on television, Buddy

Bruce McBroom/Castle Rock Entertainment
Billy Crystal ages 40 years as the star of "Mr. Saturday Night."

has made a sideline out of humiliating his brother, Stan (David Paymer), who is his long-suffering manager. ("Stan, let's each do what we do best, huh?" Buddy bellows in one scene. "I'll tell the jokes, you get me a sandwich.") Stan knows best how out of control Buddy's wisecracks can be, and that they are somehow laced with real affection. "What if they take us to the orphanage and the big kids beat us up?" Buddy asks his brother when the two are old men, after Buddy has just finished making jokes — of course — at their mother's funeral.

Buddy also largely ignores his wife, Elaine (Julie Warner, who like the other principals ages 40 years behind too-heavy makeup, and is noticeable only during several warm scenes of Buddy's courtship). And he has scared and embarrassed his daughter privately while loudly singing her praises on stage. When she refused to be part of the show, Buddy had no qualms about hiring another little girl to replace her.

"Mr. Saturday Night" sets forth all these bitterly funny facts about Buddy's ruthlessness in the form of a detailed, static portrait. The film works best when it simply relies on Mr. Crystal to purse his lips with a faint distaste, wield his cigar as if it were a precision instrument and bring Buddy resoundingly to life. (There is more than a little of Alan King in Buddy's onstage delivery.) Where it falters is in trying to foist a dramatic shape onto the story of a man who has not changed much since childhood, probably never will, and is certainly no candidate for a last-minute change of heart.

The encounters between Buddy and Stan are deftly acted by Mr. Crystal and Mr. Paymer, but they develop a lulling sameness. So do many of Buddy's angry outbursts and his various attempts to sabotage his own career. As might be expected, a man of Buddy's scabrous personal style is bound to encounter professional difficulties, which are described here in amusing detail. From television stardom in the 50's to a present-day job doing commercials for leak-proof undergarments, Buddy has consistently — and

somewhat repetitively — shot himself in the foot.

●

The film attempts some insight into Buddy's psyche with a boyhood scene that has him transforming the good-humored, family-minded gags into crueler versions that work with an audience of strangers. And later, as it cuts between Buddy's professional prime and his years of borderline employment, it links his nastiness to self-doubt. (When he is approached by a pert and potentially helpful young agent, played by Helen Hunt, Buddy brands her "an embryo in a dress.") But these insights are narrow, and they are further diminished by the way in which Mr. Crystal's direction, which is mostly very serviceable, can become broad. A close-up of flabby maternal arms, as young Buddy makes his relatives literally quake with laughter, is no more helpful than another in which the camera seems to have gone down Buddy's throat.

"Mr. Saturday Night" is best watched from riff to riff, as it offers intermittent but clear evidence of just how funny Mr. Crystal can be. Like Robin Williams, he remains more of an energy source than an actor, but that can make for irresistible moments. Among these are an improvised-sounding exchange with Jerry Lewis at the Friar's Club ("You and Dean broke up?" Buddy gasps in mock amazement), and a session with that young, daughter-like agent in which he describes certain high points of his career. "I once punched Joan Baez in the mouth at a peace rally," insists the aged Buddy. "She started it!"

Auditioning frantically for a hot Hollywood director (Ron Silver, definitely looking the part), Buddy also offers some of his typically lethal observations about life. "As Mrs. Einstein said to her husband, Albert," Buddy snaps, "what the hell do you know?"

●

"Mr. Saturday Night" is rated R (Under 17 requires accompanying parent or adult guardian). It includes profanity.

1992 S 23, C13:4

Together Alone

Written, directed and produced by P. J. Castellaneta; director of photography, David Dechant; edited by Maria Lee and Mr. Castellaneta; music by Wayne Alabardo; released by Frameline. At Film Forum 1, 209 West Houston Street, South Village. Running time: 87 minutes. This film has no rating.

Blond Bryan Todd Stites
Brunette Brian Terry Curry

By VINCENT CANBY

Bryan (Todd Stites) is blond and gay. The dark-haired Brian (Terry Curry) describes himself as bisexual. They meet in a bar one night, go back to Bryan's place, have unsafe sex, sleep for a little while and then wake up to get to know each other. P. J. Castellaneta's "Together Alone" is the record of their discoveries.

The film, opening today at the Film Forum, is an earnest, carefully choreographed dialogue, set entirely in one room, in which the two young men debate their conflicting values, recall key events in their lives and slowly, reluctantly reveal themselves. They talk about sexual identity, role-playing, homosexual and heterosexual relationships, the gay liberation movement, feminism, loneliness and Emily Dickinson. Giving a desperate edge to everything that's said is the possibility of AIDS.

The film is no gay version of "My Dinner With André." Mr. Castellaneta, who produced, wrote and directed "Together Alone," hasn't created two characters of a brilliance to match the real-life Wallace Shawn and André Gregory. There is little evidence of irony or wit in his film. Yet on a shoestring budget of $7,000, Mr. Castellaneta has made a film that speaks to its time.

Why was the sex unsafe? Bryan, who says that this was his first sexual adventure in a long time, initially blames Brian for not having insisted on taking precautions. Brian refuses to say whether or not he has tested positive. The way in which Bryan pursues the topic eventually leads to the suspicion that he might have infected Brian. Brian says that AIDS is not something he likes to think about. If it happens, it happens — that's his way of dealing with AIDS. Bryan is appalled, but he too was a willing participant in the night's encounter.

●

When Bryan ridicules Brian's claims of being bisexual, Brian expresses impatience with "militant drag queens" who insist on dragging everyone out of the closet. "People shouldn't be so obsessed by labels," he says. Bryan points out that it was the militant drag queens who led the gay revolution.

"Together Alone" defines political positions, social questions and emotional dilemmas with brisk efficiency. Considering the film's claustrophobic nature, Mr. Castellaneta, David Dechant, his cameraman, and the two actors keep things moving.

Frameline
Todd Stites, left, and Terry Curry

The film's poetic aspirations are not as effectively realized. That Bryan and Brian are different aspects of the same personality is not only reflected in their names but also in their having had the same dream while they slept on this night.

By the film's end, it's apparent Bryan is both lonelier and stronger than Brian. He doesn't fool himself about the way things are. At the same time he is a romantic. ("I like to think that every time you do the right thing, you become a little better.") Brian, leading his double life, appears headed for disaster.

Though schematic, "Together Alone" is articulate and to the point.

1992 S 23, C18:4

The Last of the Mohicans

Directed by Michael Mann; screenplay by Mr. Mann and Christopher Crowe, based on the novel by James Fenimore Cooper and the screenplay by Philip Dunne; director of photography, Dante Spinotti; edited by Dov Hoenig and Arthur Schmidt; music by Trevor Jones and Randy Edelman; production designer, Wolf Kroeger; produced by Mr. Mann and Hunt Lowry; released by 20th Century Fox. Running time: 110 minutes. This film is rated R.

Hawkeye	Daniel Day-Lewis
Cora	Madeleine Stowe
Chingachgook	Russell Means
Uncas	Eric Schweig
Alice	Jodhi May
Heyward	Steven Waddington
Magua	Wes Studi
Colonel Munro	Maurice Roëves
General Montcalm	Patrice Chéreau
John Cameron	Terry Kinney

By JANET MASLIN

"Come, friends," a scout says typically in James Fenimore Cooper's novel "The Last of the Mohicans." "Let us move our station, and in such a fashion, too, as will throw the cunning of a Mingo on a wrong scent, or our scalps will be drying in the wind in front of Montcalm's marquee, ag'in this hour tomorrow."

Modern readers who find "The Last of the Mohicans" heavy sledding will be glad to know they are not alone. "Cooper's word-sense was singularly dull," Mark Twain wrote in his famous essay "Fenimore Cooper's Literary Offenses." And: "If

Cooper had any real knowledge of Nature's ways of doing things, he had a most delicate art in concealing the fact." And: "It would be very difficult to find a really clever 'situation' in Cooper's books, and still more difficult to find one of any kind which he has failed to render absurd by his handling of it."

The question of the hour, therefore, is why this most stupefying of American classics has now been brought back to the screen. Even in its 1936 version, which starred Randolph Scott, "The Last of the Mohicans" was thought to be badly dated, and so stodgy it required considerable modification to allow its hero and heroine a genteel kiss. Think of "Robin Hood," "Dances With Wolves," thrilling scenery and Daniel Day-Lewis running bare-chested through the forest if you want to grasp the real impetus behind this latest Cooper revival.

Actually, these are not bad reasons to have made the handsome, swashbuckling, peculiarly prescient epic that "The Last of the Mohicans" has now become. Drawing upon the novel with merciful selectivity, and adding such a contemporary flavor that the film's woodsmen often have a laid-back air, Michael Mann has directed a sultrier and more pointedly responsible version of this story. The film makers may have done a better job of making their own tomahawks and rebuilding Fort William Henry than of breathing sense into their material, but the results are still riveting. A movie whose crew included a mountaineer, several "greensmen" and a meteorologist is a movie with a keen sense of natural spectacle.

Mr. Mann, who wrote the screenplay with Christopher Crowe (drawing from the earlier movie as well as the novel), is not great on the who-does-what-to-whom aspects of this story. The facts remain hazy, which is probably just as well. All the audience need know is that the year is 1757, the French and the English are at war in North America, various American Indian tribes have aligned themselves with the combatants, and the world as any of these forces knows it is about to change forever.

At the center of this conflict is a haunting frontiersman whose identity, in this version, is so clouded that he doesn't explain or really name himself until the final reel. He is Natty Bumppo, or Hawkeye, the

adopted son of the Mohican named Chingachgook (whom Twain insisted on calling "Chicago"). On screen, Hawkeye is defined less by what he has to say — not much — than by the viscerally powerful presence of Mr. Day-Lewis, whose fierce and graceful body language speaks much louder than words. Does Mr. Day-Lewis have the wherewithal to give this figure a matinee-idol magnetism? What a silly question.

Teamed with Mr. Day-Lewis in a romantic subplot that would have made Cooper blush is the beautiful Madeleine Stowe, whose fine-boned features and long, flowing hair make for some stunning two-shots with her co-star. Good looks are a specialty with Mr. Mann (the creator of "Miami Vice"), whether it comes to actors or landscapes. So his "Last of the Mohicans" features some superb tableaux, particularly in the adventure episodes that give the film an added clarity during its second half. A terrifying ambush, a desperate escape into a waterfall and a tragic mountaintop showdown give the film its moments of high drama.

Earlier, during some ambitious maneuvers involving French and British soldiers, the film is harder to follow. The prodigious energy that has gone into historical detail is overshadowed by Mr. Mann's uncertain staging, which often obscures the emphasis of busy, complicated scenes. Showmanship and editing rhythm are difficult qualities to define, but they are often best understood by their very absence. "The Last of the Mohicans" is often choppy when it aspires to real sweep, with only a swelling score to supply what should have been achieved through editing and staging.

The film seems meant to be watched as closely for its background detail — beadwork, tattoos, uniforms, weapons, canoes, peculiarly Irish-sounding music — as for its central action. It can also be watched for its enlightened and uncommonly interesting treatment of the story's Indian characters, who are played by American Indian actors. Among these, Wes Studi makes the most formidable impression as Magua, the kind of tough and treacherous villain who would be at home in any tale of war and deceit. Russell Means, a co-founder of the American Indian Movement, brings a quiet strength to the role of Chingachgook.

Also featured prominently in this intelligently acted spectacle are Steven Waddington as Maj. Duncan Heyward, the British officer who becomes Hawkeye's rival for the attention of Cora (Ms. Stowe). Playing Cora's sister, as these two well-bred Englishwomen attempt their dangerous journey through enemy-filled forests, is Jodhi May, who has some remarkable moments late in the story.

Dominating every scene, and greatly missed whenever he happens to be off-camera, is Mr. Day-Lewis, who understands Hawkeye as a living, breathing American artifact and plays him with all the brooding energy that requires. It's to the credit of Mr. Day-Lewis's performance that a character best known for his tracking skills and derring-do will now be thought of, first and foremost, as a hot-blooded leading man.

●

"The Last of the Mohicans" is rated R (Under 17 requires accompanying parent or adult guardian). It includes discreet sexual situations and considerable violence.

1992 S 25, C3:1

Danzón

Directed by María Novaro; screenplay (in Spanish with English subtitles) by Ms. Novaro and Beatriz Novaro; director of photography, Rodrigo García; edited by Ms. Novaro and Nelson Rodríguez; produced by Jorge Sanchez; released by Sony Pictures Classics. At the Lincoln Plaza Cinemas, Broadway and 63d Street, Upper West Side. Running time: 103 minutes. This film is rated PG-13.

Julia	María Rojo
Dona Ti	Carmen Salinas
La Colorada	Blanca Guerra
Susy	Tito Vasconcelos
Rubén	Victor Vasconcelos
Silvia	Margarita Isabel
Carmelo	Daniel Rergis

By JANET MASLIN

María Novaro's "Danzón," an unusual work of Mexican feminism opening today at the Lincoln Plaza Cinemas, is the gentle and earnest story of one woman's voyage of self-discovery. It concerns Julia (María Rojo), a telephone operator in Mexico City whose principal joy is the form of ballroom dancing for which the film is named. Julia and her dance partner, Carmelo (Daniel Rergis), have been meeting weekly for six years, which is the full extent of their relationship when Carmelo mysteriously disappears. Julia sets out to find him and manages, in the process, to find herself.

Julia's journey, which is slowly and sensitively rendered, plays a bit like the Good Housekeeping version of a Pedro Almodóvar story. It takes her to a seedy hotel inhabited by prostitutes and to the Veracruz waterfront among the sailors, where she wanders the docks in a red dress. It also makes her a new friend in the form of Susy (Tito Vasconcelos), a transvestite entertainer, with whom Julia patiently practices her dancing although neither of them is sure who ought to lead.

Julia's yearning for Carmelo, a man about whom she knows practically nothing, remains undimmed during these adventures. Thinking Carmelo may have gone to sea, she visits ships with names like Pure Illusions and Lost Love, and at one point even sends Carmelo a letter in a bottle. Even when a boat called See Me and Suffer turns out to have a handsome young skipper, Julia still has Carmelo on her mind. But by the film's ending, on a note that is fitting but anticlimactic, she can be seen to have deepened her romantic outlook into something more real.

●

Miss Rojo's performance is simple and believable. And it has an unexpected sweetness in scenes that could easily have been played in a campier, more outrageous manner. The film also has an element of realism as it describes Julia's drab workaday life (she shares dormitory-like living quarters with two friends and her own teen-age daughter) and the harried existence of Veracruz's prostitutes. Miss Rojo's scenes with Mr. Vasconcelos give the film an unexpected warmth, as do the lilting Mexican love songs that float through the soundtrack.

"Danzón" is very much in keeping with the courtly dance for which it is named, and for which Julia and Carmelo have won many prizes. The film's several scenes of crowded ballrooms reveal polite, mostly elderly couples as they go through the stiffly gracious motions of this formal dance. The mood is staid, and yet these couples' very devotion to the

Frank Connor
Madeleine Stowe and Daniel Day-Lewis in "The Last of the Mohicans."

dance, and presumably to one another, has a quiet eloquence. In its modest way, "Danzón" has that eloquence, too.

•

"Danzón" is rated PG-13 (Parents strongly cautioned). It includes some sexual situations.

1992 S 25, C6:5

Innocent Blood

Directed by John Landis; written by Michael Wolk; director of photography, Mac Ahlberg; edited by Dale Beldin; music by Ira Newborn; production designer, Richard Sawyer; produced by Lee Rich and Leslie Belzberg; released by Warner Brothers. Running time: 115 minutes. This film is rated R.

Marie	Anne Parillaud
Lenny	David Proval
Gilly	Rocco Sisto
Tony	Chazz Palminteri
Joe Gennaro	Anthony LaPaglia
Sal (the Shark) Macelli	Robert Loggia
Emmanuel Bergman	Don Rickles
Count Dracula	Christopher Lee

By JANET MASLIN

When a foreign actress makes the kind of impression Anne Parillaud made in "La Femme Nikita," she is likely to find herself fielding American movie offers. So there is always the danger that she will wind up in something like John Landis's "Innocent Blood." Mr. Landis's latest overlong, overproduced spectacle finds this elegant beauty playing a blood-soaked, red-eyed vampire. Her voice is sometimes electronically altered à la "The Exorcist," just to add an extra element of fun.

In much the same spirit, there's the scene in which Miss Parillaud handcuffs her arms behind her back as the prelude to a sexual encounter. No less tasteful is the initial nude shot of the actress as she makes vampire jokes by candlelight, referring to her potential victims as "food." Meanwhile, on a comparably droll note, Robert Loggia's Mafia kingpin is seen beating a colleague to death with a toaster oven during the film's first 10 minutes. This scene, like most of the movie, is played as if it were amusing. In France, where Miss Parillaud is best remembered for her César-winning performance as a chic hit-woman in an evening dress, rest assured that no one will be laughing.

For the former femme Nikita, a new role as a sort of swinging bat.

"Innocent Blood," which could easily have been titled "A French Vampire in Pittsburgh" in homage to one of Mr. Landis's earlier triumphs, is even more dependent on gruesome special effects than "An American Werewolf in London" was, and is a lot less imaginative. Miss Parillaud's status as a vampire is never explained. Mr. Loggia, as the gangster who becomes her principal nemesis through a series of dark and pointless encounters, does little besides curse and scream. He does this even after he is murdered horribly and returns

Warner Brothers

Anne Parillaud

from the dead coated with liver-spotted mud.

After he and many of the minor players become vampires themselves, they sport the same gleaming special-effects eyes and do odd things like sleep in meat lockers. Don Rickles, in a small and extremely thankless role, goes this one better by disintegrating into hideous, smoking cinders while Mr. Landis has the temerity to play "Strangers on a Train" on a television screen. It isn't smart to offer the viewer glimpses of a great film during this one.

Michael Wolk's screenplay runs to dialogue like "I'm gonna eat your face like a chicken" and "I'm gonna grind you down to blood and screams." Though neither of these threats is made good on, the film does include one innovative action scene in which the same man is struck by both a car and a bus. Also memorable is the autopsy room in which Mr. Landis, never one to risk understatement, provides four or five fully visible, partly dissected corpses when none would have sufficed.

Miss Parillaud, who is also given a nice-guy love interest in the form of Anthony LaPaglia (hence the affectionate use of handcuffs), gets through the film looking beautiful but rather dazed. Her attitude is all too easy to understand.

•

"Innocent Blood" is rated R (Under 17 requires accompanying parent or adult guardian). It includes nudity; extreme, sickening violence, and endless obscenities.

1992 S 25, C6:5

The Refrigerator

Written and directed by Nicholas A. E. Jacobs; director of photography, Paul Gibson; edited by P. J. Pesce, Suzanne Pillsbury, Christopher Oldcorn and Mr. Jacobs; music by Don Peterkofsky, Chris Burke and Adam Roth; production designer, Therese Deprez; produced by Mr. Oldcorn; released by Avenue D Films Ltd. At the Village East, Second Avenue and 12th Street, Manhattan. Running time: 86 minutes. This film has no rating.

Steve Bateman	David Simonds
Eileen Bateman	Julia McNeal
Juan the Plumber	Angel Caban
Eileen's Mother	Nena Segal
Paolo the Plumber's Assistant	Jaime Rojo
Young Eileen	Michelle DeCosta

By STEPHEN HOLDEN

"The Refrigerator" is not the first film in which an inanimate object embarks on a lethal rampage against humanity, but in its crude way it is one of the most amusing. Written and directed by Nicholas A. E. Jacobs and shot on the Lower East Side of Manhattan on a minuscule budget, the comic horror film is set mostly in a tenement apartment dominated by a battered old Norge refrigerator that is quite literally from hell.

From the moment Steve and Eileen Bateman, a young married couple fresh from Ohio with big city dreams, move into their grubby apartment, there are ominous growlings from the kitchen. The refrigerator door has a way of opening itself a crack, out of which pours a ghastly sulfurous light. Sometimes the appliance spontaneously defrosts onto the floor, depositing what look suspiciously like rivers of blood.

When Eileen opens the door, she never knows what she'll discover. Sometimes it is the usual breakfast items. At other times, it is a horrifying childhood memory of her mother holding a butcher's knife to her own chest and threatening suicide.

•

The appliance also begins transforming Steve from an eager young businessman into a yuppie monster. When he opens the door, he is liable to find his tyrannical boss leering out at him from behind a milk carton and spurring his meaner ambitions. Steve's actual office is one of the least hospitable work places ever to be shown on a screen. The place is plastered with framed placards bearing creepy slogans like "Look your best — every eye is a camera."

The longer the Batemans live in the apartment, the surlier their refrigerator becomes. One day while Eileen is out of the house, it attacks and devours a plumber's assistant. The apartment's previous tenants, Eileen eventually learns, disappeared without a trace.

The movie, which opens today at the Village East, is a lot funnier when focusing on the refrigerator than when satirizing New York life. David Simonds and Julia McNeal, who play the Batemans, have been directed to play their roles as over-the-top cartoon caricatures. Their performances, like the rest of the cast's acting, seem desperate and amateurish. And the film's scenes of the couple mocked by the hostile Hispanic neighbors shamelessly indulge in negative stereotyping that no amount of maniacal good humor can redeem.

1992 S 25, C16:6

Olivier, Olivier

Written and directed by Agnieszka Holland (in French with English subtitles); director of photography, Bernard Zitzermann; edited by Isabelle Lorente; production designers, Hélène Bourgy and Benoît Clemenceau; produced by Marie-Laure Reyre; released by Sony Pictures Classics. At Alice Tully Hall (7:30 P.M.) and Avery Fisher Hall (9 P.M.) tonight, as part of the 30th New York Film Festival. Running time: 110 minutes. This film has no rating.

Dr. Duval	François Cluzet
Elisabeth Duval	Brigitte Roüan
Olivier (teen-ager)	Grégoire Colin
Nadine (teen-ager)	Marina Golovine
Inspector Druot	Jean-François Stevenin
Marcel	Frederick Quiring
Olivier (young)	Emmanuel Morozof
Nadine (young)	Faye Gatteau

By VINCENT CANBY

Agnieszka Holland, who wrote and directed last year's popular "Europa, Europa," is in a far less somber mood with her new "Olivier, Olivier," the entertaining, initially sunny, very spooky opening attraction of the 30th New York Film Festival at Lincoln Center. The film will be shown tonight at 7:30 at Alice Tully Hall and at 9 at Avery Fisher Hall.

"Olivier, Olivier" is a perverse kind of idyll, set not far from Paris in a countryside where quaint old farmhouses are still affordable, wheatfields are golden and children can be raised with a freedom no longer possible amid the congestion and crime of polluted cities.

Serge Duval (François Cluzet), a veterinarian, and Elisabeth (Brigitte Roüan) have two children, Nadine (Faye Gatteau), who is about 11 years old, and Olivier (Emmanuel Morozof), 9. At first the lives of the Duvals appear to be serene. The children seem to be especially compatible. The bright, impressionable Olivier looks up to Nadine, whose imagination dominates his. Yet something is slightly off. There's an edginess to their relationship.

•

Their beautiful and otherwise sensitive mother spoils the boy outrageously. When she puts the children to bed, she sits beside him and sings, and then goes in to give Nadine a perfunctory kiss. Elisabeth is not cold to Nadine, but it's clear that she's obsessed by the boy in a way that excludes her daughter. Nadine doesn't complain. She can't: she shares the obsession. When Olivier is kicked out of their parents' bed, he crawls in with her.

This is more or less the introduction to "Olivier, Olivier," which is about what happens to the Duvals after their beloved Olivier disappears. Like Red Riding Hood, he is sent off one day to take some food to his grandmother and is never seen again. Search parties are sent out. Days pass. No clues. The boy has been swallowed up. The police are convinced that he's run away.

In the months that follow, Elisabeth goes into a decline. She's always had a way of slipping into bizarre trancelike states during which she appears to have tuned into another world. Those moments come more frequently. She grieves and looks for scapegoats. Sometimes she blames Serge, sometimes Nadine. Serge, at the end of his rope, accepts a job in Chad. Elisabeth and Nadine refuse to go with him.

Six years later, Olivier (Grégoire Colin) turns up, if reluctantly. Inspector Druot (Jean-François Stevenin), who originally handled the case, comes upon a sarcastic, all-too-knowing Paris street hustler who he's convinced is Olivier. Though the boy claims not to remember his childhood, Elisabeth identifies him as her son. She takes him home the same day that Serge returns from Chad. Serge and the now mature Nadine (Marina Golovine) are skeptical. The adored Olivier remains enigmatic.

Is he or isn't he?

•

"Olivier, Olivier" was apparently inspired by a story that Ms. Holland read in the French press. Though she does eventually provide answers, she's less interested in them than in the curious relationships within this one French family, whose members

are never quite as commonplace as they first seemed. As it proceeds, the film exposes a mare's-nest of tangled feelings and repressed passions below the surface of mostly polite behavior.

Yet "Olivier, Olivier" is less a Freudian nightmare than a fairy tale that remains mysterious even after the mysteries are answered. That's what so good about it. The characters are more complex, more interesting, than the singular events that come to shape their lives, which presents something of a problem. The story that inspired "Olivier, Olivier" finally seems inadequate for the movie that Ms. Holland made. The ending, which I assume was dictated by the actual events, has the effect of undercutting the film maker's imagination.

Unlike the German-language "Europa, Europa," whose scale was epic, the French-language "Olivier, Olivier" is small, intense, introverted and, it would seem, far more personal. The movie is at its best when it's not paying attention to anything except Ms. Holland's fantasies.

There's an extraordinary scene in which the grown-up Nadine, who emerges as the film's most arresting character, turns on her mother and calls her a bimbo for the way she has abased herself in front of the recently returned Serge and Olivier. Mother and daughter fight, but they always reconcile. In this family, forgiveness is asked and wounds are healed.

•

In another scene, which sends the film into a brief, delirious orbit, Nadine casually demonstrates for Olivier the telekinetic powers she developed during the years he was missing. Nadine is not like Stephen King's Carrie; she's not into mass mayhem. She rattles tables and breaks glasses as her way of dealing with anger.

The grown-up Olivier is also a ruefully funny sort. After turning tricks on the streets of Paris, he finds life in the country a pleasant rest. The food is good, the air clean. He genuinely likes Nadine, even her disbelief in him. It could be that the uncertainty now surrounding him gives him a stature that makes up for those years in which Nadine dominated his childhood.

As dysfunctional families go, the Duvals get along unusually well.

Sony Pictures Classics Release

Brigitte Roüan, left, and Emmanuel Morozof as mother and son.

Even the love of Serge and Elisabeth survives their long years of separation.

In addition to writing and directing her own films, Ms. Holland has also written or contributed to some of the finest films directed by the Polish master Andrzej Wajda, among them "A Love in Germany" and "Man of Marble." She continues to grow as her own director. "Olivier, Olivier" is not only far more adventurous than "Europa, Europa," but it also reveals a gift for serious humor that's brand new in her work.

"Olivier, Olivier" will go into commercial release here early next year. Sharing the program with it at Lincoln Center tonight is "Omnibus," Sam Karmann's funny eight-minute French short about a man who wants desperately to get off an express train before the destination listed in the timetable. Wait for the punch line.

1992 S 25, C34:1

Taking The Pulse

PETS OR MEAT: THE RETURN TO FLINT, directed by Michael Moore; edited by Jay Freund; produced by Mr. Moore and Lydia Dean Pilcher. Running time: 24 minutes. This film has no rating. These films are at Alice Tully Hall, as part of the 30th New York Film Festival.
SEEN FROM ELSEWHERE, directed by Denya Arcand; screenplay by Paule Baillargeon (in French with English subtitles); director of photography, Paul Sarossy; produced by Denise Robert. Running time: 25 minutes. This film has no rating. With: Domini Blythe, Remy Girard, Paule Ballargeon, Raoul Trujillo, Guylaine Saint-Onge, John Gilbert.
A SENSE OF HISTORY, directed by Mike Leigh; screenplay by Jim Broadbent; director of photography, Dick Pope; music by Carl Davis; produced by Simon Channing-Williams; released by October Films. Running time: 25 minutes. This film has no rating. With: Jim Broadbent.

By VINCENT CANBY

Three superb short films by Mike Leigh of England, Denys Arcand of Canada and Michael Moore of the United States make up the program titled "Taking the Pulse," which will be shown at the New York Film Festival today at 4 P.M. and midnight. Because they probably won't be presented anywhere else in this same combination, you may want to check

Film Society of Lincoln Center

Michael Moore revisiting Rhonda Britton and her rabbits in his new short film, "Pets or Meat: The Return to Flint."

if there are any seats left for the program. The films don't have much in common, but seeing three such decisively idiosyncratic works together has a way of raising the spirits.

Mr. Moore's 23-minute contribution, "Pets or Meat: The Return to Flint," is a sort of "Roger and Me 2." It's an engagingly tatterdemalion sequel to his 1989 hit documentary in which he examined the sad state of Flint, Mich., after mass layoffs by General Motors, and some of the ways in which private citizens and public boosters were coping.

Since Mr. Moore last visited Flint with a camera crew, things have continued to change, meaning that they've gotten worse, even for Roger Smith, the G.M. chairman whom the film maker unsuccessfully tried to interview earlier. Mr. Moore says that Mr. Smith, after resigning from G.M., had his pension package reduced by $100,000.

From time to time throughout "Pets or Meat," the folksy film maker toys with the idea of sending the former executive a check to make up the difference. He could afford it: his profits from "Roger and Me" reportedly allowed him to set up a $250,000 foundation to help independent film makers and social action groups. According to the new film, Mr. Moore also paid two years' rent to each person shown being evicted in "Roger and Me." Now and then social satire pays off.

•

"Pets or Meat" takes its title from the sign outside the house of Rhonda Britton, the woman who was selling rabbits in "Roger and Me." She is now bankrupt but unbowed. She works at K-Mart and has expanded her in-home business by adding a line of rats and mice, sold as food for pet snakes. One not-great shot: a python engorging a rabbit the size of a small dog.

Other characters make return visits, including Fred Ross, the deputy

seen evicting destitute tenants in the earlier film. Now Mr. Ross also works as a repo man, that is, as a repossessor of automobiles. Not all business in Flint is down. Employment is up at the unemployment office. Sales of home security systems and guns have risen because of the increase in crime.

Wearing his G.M. cap squarely on his head, looking quizzical and never surprised, Mr. Moore wanders through this landscape like Tocqueville disguised as a late 20th-century Middle American hayseed. For those who can't get to Lincoln Center today, PBS television stations are scheduled to show both "Pets or Meat" and "Roger and Me" on Monday night.

•

Mr. Arcand's 25-minute "Seen From Elsewhere" is a segment from a new Canadian anthology feature titled "Montreal Vu Par..." Whatever the rest of the film is like, Mr. Arcand's contribution is delicious, an older woman's ecstatic, alarmingly frank recollection of a love affair she had many years ago in Montreal.

Attending a boring diplomatic reception in a Latin American capital, where each succeeding guest has a worse horror story to tell about the provincial manners and morals of French Canadians, the woman is prompted to recall Montreal as the scene of the great love affair of her life. Her surprised husband stands by as she delights the women around her with the explicit details of an escapade conducted during a World Health Organization conference, amid a very snowy weekend and exploding mailboxes, among other things.

The film, beautifully written by Paule Baillargeon, who also appears in a small role, recalls the wit and élan of Mr. Arcand's "Decline of American Civilization" (1986).

•

The high point of the program is Mike Leigh's "Sense of History," a

one-character film that is not, strictly speaking, a Mike Leigh film at all. Mr. Leigh did not write the script, as he usually does. Instead, he sort of presides over it, seeing that all goes well. The true auteur of "A Sense of History" is Jim Broadbent, the 40-ish English actor and wizard, who conceived and wrote the screenplay and plays the portly, 70-ish 23d Earl of Leete.

In the course of a 25-minute monologue, the Earl takes his unseen interviewer on a tour of the 900-year-old Leete estate, chatting all the while about his family, his politics, his marriages and the skeletons in his closet. It's a merciless and sometimes hilarious portrait of the aristocracy, though the Earl is far from being a twit. He's a bigoted, arrogant, lethal weapon of privilege. Yet for all of his faults he is almost likable. He's certainly credible.

The performance of Mr. Broadbent is as remarkably rich as his screenplay, a capsule history of Britain from the landing of William the Conqueror through World War II and beyond. The Earl tells the interviewer that he could not, in all good conscience, take up arms against Hitler, though that doesn't mean he approved of everything Hitler stood for. The Earl believes in land, class, civil order and, as he says with a sweeping gesture, "keeping the bastards out."

Mr. Broadbent will be remembered for his performance as the husband in Mr. Leigh's "Life Is Sweet." To appreciate his extraordinary physical transformation for "A Sense of History," you might want to see him in Neil Jordan's "Crying Game," also being shown at the festival today. In that film he plays a character about 30 years younger and 40 pounds lighter than the garrulous old Earl.

"A Sense of History" is an exemplary work.

1992 S 26, 11:4

Autumn Moon

Directed by Clara Law; screenplay (in English and Cantonese with English subtitles) and editing by Fong Ling Ching; director of photography, Tony Leung; music by Lau Yee Tat, Tats; produced by Ms. Law and Fong Ling Ching. At Alice Tully Hall, as part of the 30th New York Film Festival. Running time: 108 minutes. This film has no rating.

Tokio	Masatoshi Nagase
Wai	Li Pui Wai
Grandmother	Choi Siu Wan
Miki	Maki Kiuchi
Boyfriend	Sun Ching Hung

By STEPHEN HOLDEN

Hong Kong, with its modern skyscrapers soaring over a misty harbor framed by a spectacular mountain backdrop, is one of the most photogenic cities in the world. And it has never looked more imposingly spiffy than in Clara Law's gorgeous "Autumn Moon," which the New York Film Festival is presenting tomorrow at 1:30 P.M. and Monday at 9:15 P.M. at Alice Tully Hall.

But in Miss Law's elegiac comedy, the city also symbolizes a modern world in which technology and popular culture have all but erased cultural traditions that are centuries old. In aerial shots of the city's skyscrapers, parks and beltways, Hong Kong could be any modern metropolis. The young people adrift in this environment tote expensive cameras and film equipment, eat at McDonald's and drop the names of pop stars. As they wander around, conversing in a careful, slightly broken English, they exude

an uneasy melancholia that, given their ages, seems premature.

Tokio (Masatoshi Nagase), the film's world-weary young protagonist, has come to Hong Kong from Japan, looking for good restaurants, he says. When he first meets Wai (Li Pui Wai), a 15-year-old girl who lives with her aged grandmother, he is fishing in a harbor that seems unlikely to yield much of anything. In an early conversation, he regales her with the prices of everything from his camera to his underwear. When Wai worries that in Canada, where her parents have recently moved, no one will have heard of Madonna, he assures her: "Don't worry. Madonna is everywhere."

The character is also an intrepid Lothario. While in Hong Kong, he begins an affair with Miki (Maki Kiuchi), the sister of a woman he seduced and coldly dropped. Divorced and a bit older than Tokio, Miki is flawlessly beautiful, yet she keeps referring to her wrinkles and evinces a pathetic gratitude for his attentions. Tokio also encourages Wai to ask a young classmate whom she fancies out on a date. When they meet, all he can talk about are his plans to go to America and make a fortune as a computer-wise nuclear physicist.

"Autumn Moon" is more concerned with ways of looking at the world than with telling a dramatic story. Although visually magnificent, it is not especially deep or emotionally involving. Like the city itself, the characters are in transition, caught in a cultural void between East and West. Visually, the film alternates between lingering shots of the city

Film Society of Lincoln Center
Masatoshi Nagase

and its environs, all photographed with an exquisite eye for composition, and the more constricted, bluish pictures of the same scenes as viewed through the lens of Tokio's movie camera.

•

When the characters, who seem to be perpetually at loose ends in a city that is almost empty of people, have nothing better to do, they interview one another. Beneath his suave exterior, Tokio reveals himself as a nihilist. His greatest fear, he tearfully admits, is that life is worthless.

The traditions that the modern world is sweeping away are represented by Wai's 80-year-old grandmother. The ailing old woman cooks traditional meals that seem exotic to Tokio when Wai takes him home for dinner. She also practices daily devotions in front of a Buddhist shrine in her apartment. The fading old ways are ultimately symbolized by a mid-autumn ceremony involving bamboo-and-paper lanterns that are set on fire and floated out on the water.

That ceremony is re-enacted by the young people in "Autumn Moon," but using plastic and light bulbs. As their electric lanterns drift away from the

shore to an explosion of fireworks, one senses that a way of life is being inexorably washed out to sea with nothing to replace it.

1992 S 26, 12:1

The Crying Game

Directed by Neil Jordan; screenplay by Mr. Jordan; director of photography, Ian Wilson; edited by Kant Pan; music by Anne Dudley; production designer, Jim Clay; produced by Stephen Woolley; released by Miramax Films. At Alice Tully Hall, as part of the 30th New York Film Festival. Running time: 112 minutes. This film has no rating.

Jody	Forest Whitaker
Jude	Miranda Richardson
Fergus	Stephen Rea
Maguire	Adrian Dunbar
Tinker	Breffini McKenna
Eddie	Joe Savino
Tommy	Birdie Sweeney
Dil	Jaye Davidson
Jane	Andre Bernard
Col	Jim Broadbent
Dave	Ralph Brown

By VINCENT CANBY

Neil Jordan, the Irish writer and director of "The Company of Wolves" (1985), "Mona Lisa" (1986) and "The Miracle" (1991), is one of a kind. He makes melodramas that are often very funny, fantasies that are common-sensical and moral fables that are perverse. At heart, he is a madly unreconstructed romantic. In his view, the power of love can work miracles of a kind that would send Freud back to his own couch.

All of these things are evident in Mr. Jordan's elegant new film, "The Crying Game," which will be shown at the New York Film Festival tonight at 9:30 and tomorrow at 4:15 P.M.

When the film's subplots, all of which are germane, are stripped away, "The Crying Game" becomes a tale of a love that couldn't be but proudly is, although even this love could be a substitute for another love that never quite was.

If I sound vague, it's partly because the film's producers have pleaded with reviewers not to reveal important plot twists, and partly because Mr. Jordan's screenplay reveals itself as if it were an onion being peeled. The nubbin of onion remaining at the end is important only as a memory of the initially unviolated bulb. More from me you will not get.

•

The love story that dominates the film is about Fergus (Stephen Rea), a sweet-tempered, naïve Irish Republican Army terrorist, and Dil (Jaye Davidson), the snappy, almost beautiful London hair stylist who captures his heart. Fergus is living in England under an assumed name after a botched kidnapping in Northern Ireland. He's lonely and haunted by the events that forced him into exile.

Dil is like no one he's ever met before. Wearing a tight spangled dress and earrings that look like Christmas tree ornaments, she drinks margaritas and flirts with no thought of what her political responsibilities might be. When she gets up on the stage at her favorite pub, the Metro Bar, and sings the film's title song, Fergus is hooked. Dil is glamorous, witty and capable of a depth of love that Fergus has never known before.

Their idyll is short-lived. His past and her present surface in a manner to tear them apart. Fergus's former comrades show up in London and,

Miramax
Miranda Richardson

threatening harm to the unsuspecting Dil, force Fergus to participate in one last job, the assassination of an English judge.

The film's penultimate sequence is as bloody and brutal as the extended opening sequences set in Northern Ireland, as Fergus, assigned to guard an I.R.A. hostage, first begins to understand "the war" in human terms. Yet for all its sorrowful realism, "The Crying Game" believes in the kind of redemption not often seen in movies since the 1930's and 40's. At times the film comes close to trash, or at least camp, but it's saved by the rare sensibility of Mr. Jordan, who isn't frivolous.

•

"The Crying Game" is full of masks. Fergus and Dil wear them, as do the people who have shaped Fergus in Ireland, including his I.R.A. girlfriend, Jude (Miranda Richardson), and the English soldier (Forest Whitaker) he comes to know in Northern Ireland. The biggest mask is that worn by the film itself, which pretends to be about the love affair of Fergus and Dil, although it really has more esoteric matters on its mind: the strength of political commitment and the role-playing of life's fugitives.

The film is exceptionally well acted by Mr. Rea in a big, very complex role, and by some of the subsidiary players, including Jim Broadbent, the writer and star of Mike Leigh's "Sense of History," (part of "Taking the Pulse," reviewed on page 11), as the Metro bartender who functions as the matchmaker for Fergus and Dil. There are times when Mr. Whitaker's English accent sounds post-synchronized, but the performance is good.

Mr. Jordan's screenplay could have done without the cautionary tale about the frog that agreed to ferry the scorpion to the other side of the river, which is told twice, but is otherwise both efficient and ingenious. The physical production is as lush as the film's romantic longings.

1992 S 26, 12:4

Strictly Ballroom

Directed by Baz Luhrmann; screenplay by Mr. Luhrmann and Andrew Bovell, based on the play by Mr. Luhrmann and Craig Pearce; director of photography, Steve Mason; edited by Jill Bilcock; music by David Hirschfelder; production designer, Catherine Martin; produced by Tristram Miall; released by Miramax. At Alice Tully Hall, as part of the 30th New York Film Festival. Running time: 94 minutes. This film has no rating.

Scott Hastings	Paul Mercurio
Fran	Tara Morice
Barry Fife	Bill Hunter
Shirley Hastings	Pat Thomson
Liz Holt	Gia Carides
Les Kendall	Peter Whitford
Doug Hastings	Barry Otto
Ken Railings	John Hannan

Tina Sparkle	Sonia Kruger-Tayler
Charm Leachman	Kris McQuade
Wayne Burns	Pip Mushin
Vanessa Cronin	Leonie Page
Rico	Antonio Vargas
Ya Ya	Armonia Benedito

By JANET MASLIN

Inside the bright, brassy confines of an Australian dance palace, a kitschy melodrama unfolds. It is the story of Scott (Paul Mercurio), a contender for the Pan-Pacific dance trophy who may suddenly have sabotaged his chances by daring to do steps of his own, and Fran (Tara Morice), the homely, spunky girl who dreams of becoming Scott's partner. It is a tale of scheming for the trophy, of a corrupt contest official (who hawks his own educational video, titled "Dance to Win"), and of Scott's ambitious parents, who hope their son's triumph can make up for their own broken dreams.

Baz Luhrmann's Australian film "Strictly Ballroom" is, in short, pure corn. But it's corn that has been overlaid with a buoyant veneer of spangles and marabou, and with a tireless sense of fun. (The film's outrageously glittery get-ups, according to production notes, "exhausted Australia's supply of Austrian diamantes, which were used on everything from costumes to fingernails," and the film makers no doubt made a dent in supplies of hair mousse and peroxide, too.) Though none of it can be taken more than half-seriously, "Strictly Ballroom" tells an enjoyably hokey story with flair. Those who wonder whether Fran will be beautiful once she takes off her glasses are not approaching Mr. Luhrmann's material with the lightheartedness it deserves.

"Strictly Ballroom," one of the only films to emerge from this year's Cannes Film Festival as a potential crowd-pleaser, laughs at its own silliness while trying to raise that silliness to a fever pitch. What saves the film from campy overkill is the enjoyable predictability of its central love story, which is played more or less earnestly. Mr. Mercurio, a talented dancer (he is also a choreographer) and a straightforward actor, makes Scott's growing interest in Fran as plausible as his determination to be his own man. Miss Morice succeeds in blossoming, with suitable miraculousness, from a plain Jane into a dance-hall revelation.

The metaphorical aspects of the story are not easy to miss. Scott is pressured by his elders to conform to the rules and to dance with the partner they have chosen ("It's an answer to our prayers!" exclaims his mother, when told of Scott's potential partnership with the popular blonde named Tina Sparkle). Fran must at first defy her own relatives, who are Spanish and highly suspicious of Scott and all he stands for. They also turn out to be talented flamenco dancers (Fran's father is played by the dancer Antonio Vargas), and eventually they like Scott enough to teach him their secrets. This is the kind of film in which Fran's grandmother can magically produce a flamenco dress at a crucial moment, exclaiming, "I brought this just in case!"

Despite its gleefully flashy dramatic style, "Strictly Ballroom" is less visually appealing than it might be, with its sometimes drab cinematography punctuated by needlessly broad fish-eye shots of various oddball characters. But Mr. Luhrmann knows exactly how he wants this film to look, as he demonstrated in a rooftop rehearsal sequence between Scott and Fran, positioning them before a gleaming red Coca-Cola billboard and beneath rows of socks drying on clotheslines.

Of particular appeal is a brief, jokey flashback sequence telling how Scott's pushy mother (Pat Thomson) and timid father (Barry Otto) became the way they are. Mr. Luhrmann, whose idea for the film started out as a student workshop production and who has made the very most of its low-budget look, presents this vignette ingeniously, with the kind of energy and cleverness money can't buy.

"Strictly Ballroom" will be shown today at 6:30 P.M. and tomorrow at 9:30 P.M. as part of the New York Film Festival.

1992 S 26, 12:5

And Life Goes On

Directed by Abbas Kiarostami (in Farsi with English subtitles); screenplay by Mr. Kiarostami; director of photography, Homayun Piever; edited by Changiz Sayyad and Mr. Kiarostami; produced by Ali-Reza Zarrin. At Alice Tully Hall, as part of the 30th New York Film Festival. Running time: 91 minutes. This film has no rating.

The Father	Farhad Kheradmand
The Son	Pooya Pievar
WITH: The people of Quokar and Poshteh	

BY STEPHEN HOLDEN

The fragility of civilization is something that most of us prefer not to think about until something like Hurricane Andrew comes along to show how an overwhelming force of nature can reduce a community to Stone Age living conditions.

In "And Life Goes On," that catastrophe is a devastating earthquake in the north of Iran. The Iranian director Abbas Kiarostami, accompanied by his young son, drives into the area only a day or two after the quake. Although his ostensible goal is to find out what happened to some young actors who live in the area and who once worked with him, his real quest seems to be the gleaning of as much spectacular post-quake film as possible.

The film, which is being shown this afternoon and tomorrow evening at Alice Tully Hall, is a visually gripping travelogue in which the more the director is thwarted, the more his journey acquires metaphoric weight.

At first he braves nightmarish traffic jams brought on by the relief effort. When he eventually resorts to dusty side roads whose destinations are uncertain, there is the fear that he will run out of gas and find himself stranded in a semi-wilderness without resources. Most of the people he asks for directions along the way seem too dazed to be of any help. The deeper he travels into the region, the more devastation he finds.

•

The most impressive sights in a film that continually contrasts the vastness of the landscape with the smallness of individuals are its panoramic shots of mountainsides cleft by giant seams. In one scene, the director's tiny car is shown from a distance crawling along the top of a hill where it is halted by a gaping crevice that runs all the way down the side.

When he finally reaches the heart of the earthquake area, the film begins to explore the impact of the catastrophe on people's lives. No tears are shed, since everyone is too busy digging through the mountains of rubble to have time for grief.

For the most part, those he interviews demonstrate a remarkable resilience, along with a deep-seated fatalism. Some speak almost casually of losing whole families. The explanation that is offered again and again is that it was God's will.

One young man seems almost jubilant about the tragedy because it enabled him to marry his fiancée long before he otherwise would have. He no longer must adhere to the custom of first having to gain the approval of dozens of relatives because most of them perished. In one town, the major priority is the repair of a television antenna in time for the inhabitants to watch the World Cup soccer matches.

Life indeed does go on.

1992 S 26, 13:1

Benny's Video

Directed and screenplay by Michael Haneke, (in German with English subtitles); director of photography, Christian Berger; edited by Marie Homolkova; music by Johann Sebastian Bach; production designer, Christoph Kanter; produced by Veit Heiduschka and Bernard Lang. At Alice Tully Hall, as part of the 30th New York Film Festival. Running time: 105 minutes. This film has no rating.

Benny	Arno Frisch
Mother	Angela Winkler
Father	Ulrich Mühe
Young girl	Ingrid Stassner

By STEPHEN HOLDEN

The title character of "Benny's Video," a portrait of a 14-year-old electronics nut in present-day Vienna, lives in a sort of televised hall of mirrors. Although the boy's bedroom window faces the street outside his apartment building, he prefers to take in the view through one of several video monitors positioned around the room. Benny's television is almost never turned off. Its relentless parade of violent images remains a visual backdrop even while he does his homework to blasting heavy metal music.

In his spare time, Benny sits in his room dispassionately flicking among channels and editing his own home videos. His latest creation, shot on his parents' farm, shows the stunning of a pig before slaughter. Alone in his room, Benny replays the scene over and over with the detached absorption of someone analyzing a new and improved system of torture.

One day after school Benny meets a strange girl his own age and brings her back to his apartment. After showing her his latest video, he hands her the stun gun he stole from the farm and invites her to shoot him in the stomach. "Coward!" he sneers, when she refuses. She in turn gives him the gun and dares him to shoot her. He does, and her terrible screams are so alarming that in panic he shoots her in the head. Naturally he has taped the homicide. Before deciding what to do with her body, he calmly replays this latest episode of life in video.

"Benny's Video," which the New York Film Festival is showing tonight and tomorrow evening at Alice Tully Hall, was written and directed by the Austrian film maker Michael Haneke. His vision of an affluent, postindustrial environment so dominated by video and computers that people have lost touch with their feelings is bone-chilling, even though it also seems glib. Every image in the

Film Society of Lincoln Center

Arno Frisch

film is chosen to underscore its themes. Benny and his parents live in a building that seems indistinguishable from a giant, immaculately kept office tower. Inside an apartment that is polished to the point of sterility, the dining room wall is plastered with Pop Art posters.

Benny's parents (Angela Winkler and Ulrich Mühe), both of whom work, are tastefully attired, tight-lipped careerists obsessed with money and social reputation. When Benny impulsively gets a skinhead haircut, his father grimly asks whom he was trying to impress. Both parents are moral weaklings. Once they learn of their son's crime, their initial horror is almost immediately replaced by a frantic desire to cover it up.

The film makes strong, if heavy-handed, points about the confusing effects of television violence. Moments before killing the girl, Benny dismisses most of the gore shown on television as only "ketchup and plastic." Ultimately the film suggests that the generation reared on video is more comfortable viewing life as a television show than as a flesh-and-blood world. Even when Benny and his mother go to the Middle East, the boy is too busy recording the sights and sounds in his video camera to be a spontaneous participant. His vision is a kind of icy electronic surveillance.

What gives the film a chilly authenticity is the creepy performance of Arno Frisch in the title role. Cool and unsmiling, with a dark inscrutable gaze, his Benny is the apotheosis of what the author George W. S. Trow has called "the cold child," or an unfeeling young person whose detachment and short attention span have been molded by television. Or in other words, Mr. Trow adds, "A sadist."

1992 S 28, C14:1

Léolo

Written and directed by Jean-Claude Lauzon (in French with English subtitles); director of photography, Guy Dufaux; edited by Michel Arcand; produced by Lyse Lafontaine and Aimée Danis; released by Fine Line Features. At Alice Tully Hall, as part of the 30th New York Film Festival. Running time: 105 minutes. This film has no rating.

Léolo	Maxime Collin
Mother	Ginette Reno
Grandfather	Julien Guiomar
The Word Tamer	Pierre Bourgault
Fernand	Yves Montmarquette
Father	Roland Blouin
Bianca	Giuditta del Vecchio
Psychiatrist	Andrée Lachapelle
Career adviser	Denys Arcand
Teacher	Germain Houde
Fernand's enemy	Lorne Brass
Rita	Geneviève Samson
Nanette	Marie-Hélène Montpetit
Narrator	Gilbert Sicotte

Allah Tantou

Directed by David Archer; (in French and English with some voice-overs); director of photography, Anne Mustelier; edited by Anne Guerin Castell; music by Lumumba Marrouf r. Achkar and François Corea; produced by Diesel and David Achkar and Edmée Milot. At Alice Tully Hall. Running time: 60 minutes. This film has no rating.

By STEPHEN HOLDEN

There are some remarkable similarities between "Lumumba: Death of a Prophet" and "Allah Tantou," two documentaries, each relating to the African independence movement, that the New York Film Festival is presenting today at 6:15 P.M. in Alice Tully Hall.

Each film is about an hour long. Each tries its best to reconstruct a portrait of a heroic if shadowy figure who was executed under cloudy circumstances by political enemies many years ago. In the absence of extensive documentary material, Raoul Peck, who made "Lumumba," and David Achkar, who created "Allah Tantou," have boldly inserted themselves into their films. In both, the frustrating search for the truth becomes as significant as any facts they uncover.

Patrice Lumumba, the subject of Mr. Peck's documentary, spearheaded the movement that led to independence for the Belgian Congo (now Zaire) in 1960. Appointed Prime Minister, he formed a coalition Cabinet with Belgian and Congolese leaders. But his denunciation of the white power structure, which he accused of planning to keep the black population stupid" while treating it well, precipitated widespread violence and led to an exodus of Europeans, the secession of copper-rich Katanga Province and a civil war. President Joseph Casavubu removed Lumumba from power, and he was imprisoned for civil disobedience.

Mobutu Sese Seko, who became resident in 1965 and still is, arranged for Lumumba to be delivered to his political enemies in Katanga Province, where he and his followers are believed to have been tortured and killed in early 1961. Their bodies were never recovered.

Mr. Peck's film weaves fragments of old newsreels with interviews with Belgian leaders and with Lumumba's daughter Julianna. Much of the film deals with the frustrations of making the documentary. President Mobutu refused to be interviewed, and Mr. Peck was told that if he flew to Zaire he would be greeted by the secret service. He decided against the trip. He was also hindered in his project, he says, by the prohibitive fees for using excerpts from old newsreels.

People recalling Lumumba in the film repeatedly speak of his power. He is remembered as the "the Elvis Presley of African politics" and called a lion, a giant and a prophet. From what little is shown of Lumumba, he does seem both serious and charismatic. But finally not enough of him is shown for any sense of his personal style to register indelibly.

•

"Allah Tantou" is David Achkar's memoir of his father, Marolf Achkar, a Guinean diplomat who represented his country at the United Nations. Under the dictatorship of Sékou Touré, who ruled the country from 1958 until his death in 1984, paranoia reigned. Achkar was one of the thousands of suspected traitors who are said to have been arrested on false

charges and tortured. The director was 8 years old when his father was imprisoned.

During much of "Allah Tantou," the director is shown ritually reliving what he imagines his father's experience in solitary confinement to have been, based on his letters from prison. The often harrowing scenes are interwoven with flashes of better times in home movies and film clips of the diplomat at the United Nations.

The narration, much of which is presumably based on the father's letters, depicts a spiritual metamorphosis that accompanied his physical degradation. At the same time, the film provides a sketchy political history of Guinea under Touré, who in 1970 apparently conceived the idea of a "permanent conspiracy" against him. That decision left Achkar little hope of someday being freed.

In 1971, after three years of grueling captivity in which he lost most of his eyesight, he was executed. The son was not officially informed of his father's death until 1985.

1992 S 30, C18:3

The Oak

Written and directed by Lucian Pintilie, based on the novel "Balanta" by Ion Baiesu, (in Romanian with English subtitles); director of photography, Doru Mitran; edited by Victorita Nae; production designer, Calin Papura; produced by Eliane Stutterheim, Sylvain Bursztejn and Mr. Pintilie; released by MK2/U.S.A. At Alice Tully Hall, as part of the 30th New York Film Festival. Running time: 105 minutes. This film has no rating.

Nela	Maia Morgenstern
Mitica	Razvan Vasilescu
The Mayor	Victor Rebengiuc
Country Priest	Dorel Visan
Priest's Wife	Mariana Mihut
Lawyer	Dan Condurache
Nela's Father	Virgil Andriescu
Nela's Mother	Leopoldina Balanuta
Butusina	Matei Alexandru
Priest on the train	Gheorghe Visu
Mitica's assistant	Magda Catone
Titi	Ionel Mahailescu

By VINCENT CANBY

"The Oak," being shown at the New York Film Festival today at 9:30 P.M. and on Saturday at 6:15 P.M., is a good festival choice. It represents Romania, a country whose films don't often turn up here. The world it evokes is completely alien to contemporary American experience. Though sometimes baffling, it is never boring. To feel your way through it is like the exploration of a house of horrors in an amusement park in space. You can't be sure which way is up.

"The Oak" is the work of Lucian Pintilie, a Romanian film maker who has spent most of the last 20 years in exile, earning a formidable reputation as a director of innovative theatrical productions in France, Britain and the United States. This film, a French-Romanian co-production, is Mr. Pintilie's reaction to the 1989 collapse of the Communist regime in his country and his expectations for the future. It begins as a nightmare and ends with a vague expectation of the break of day.

The time is apparently prior to the overthrow of Nicolae Ceausescu in 1989. Among other things, "The Oak" is about the spiritual journey of Nela, a young schoolteacher, after the death of her father, a former big shot in the secret police, though you wouldn't know that he had ever been powerful from the opening scenes.

The two are living in epic squalor in a tiny flat in a Bucharest housing

project. The place is a mess of unwashed dishes, soiled sheets and small mountains of cigarette butts. Nela and her father lie in bed, a 16-millimeter movie projector between them, watching home movies of a happier time: a small girl at her birthday party, running around and aiming a toy gun at guests, who dutifully topple over for her amusement.

Nela at first seems completely opaque. She reacts to her father's death as if he had been a lover. She's so possessive that she won't let her sister into the flat. When she tries to donate her father's organs, she's told by a doctor that it's too late, that they've already deteriorated. The medical school has no use for the cadaver because there are no refrigerators. Nela has the body cremated and for the rest of the movie carries the ashes with her in a Nescafé jar.

In the course of "The Oak," Nela accepts a job outside Bucharest, is gang-raped en route to the assignment, learns that her father was something less than a hero and meets a man who is, in his way, just as offthe wall as she is. He is Mitica, a cheerfully sardonic doctor whose relations with the regime are not good. He refuses to follow protocol and insists on taking care of a patient whom the regime would like to see die.

Though Nela's is a spiritual journey, Mr. Pintilie dramatizes it in the bitter ways of social satire. The movie has the tempo of cabaret theater. It is wildly grotesque, shocking and sometimes very funny. The details are vivid. The authorities are alternately fearful, blundering and good-hearted. At one point Nela and Mitica go camping, only to wake up in the night to find themselves in the middle of a target range. Late in the film, as Nela and Mitica reach some kind of understanding, Mr. Pintilie seems to suggest that there is still hope for Romania, though it's not just around the corner.

The two central roles are exceptionally well played by Maia Morgenstern (Nela) and Razvan Vasilescu (Mitica). She has the manner and force of a young Anna Magnani. He is an actor who can't help being seriously comic. That the movie doesn't always make sense to the English-speaking audience may be more of a reflection on the subtitles than on the original text of the film itself.

1992 O 1, C13:1

Dream of Light

Directed by Victor Erice; screenplay by Mr. Erice and Antonio López García (in Spanish with English subtitles); director of photography, Javier Aguirresarobe and Angel Luis Fernández; edited by Juan Ignacio San Mateo; music by Pascal Gaigne; produced by María Moreno with the participation of Euskal Media and Igeldo Zine Produkzioak. At Alice Tully Hall, as part of the 30th New York Film Festival. Running time: 139 minutes. This film has no rating.

WITH: Antonio López García, María Moreno, Enrique Gran, José Carrtero, María López García, Carmen López García, Elisa Ruíz, Amalia Avia, Lucio Muñoz, Esperanza Parada, Julio López Fernández, Janusz Pietrziak, Marek Domagala, Grzegorz Ponikwia, Fan Xiao Ming and Yan Sheng Dong.

By JANET MASLIN

As one of the people seen in Victor Erice's "Dream of Light" (none of them are actors) finally wonders, "How can such a small tree bear so much fruit?" The same question

might be asked about this quiet, meticulous and supremely simple film, which concentrates exclusively on the process whereby a painter, Antonio López García, works on a still life of the above-mentioned tree. Mr. Erice's method is modest, yet his film manages to achieve a mesmerizing intensity. The purity and breadth of this meticulous study are all the more gratifying in view of its unprepossessing style.

For nearly two and a half hours, Mr. López García is seen working patiently on his project, observing and painting a small tree that stands in his Madrid backyard. Mr. López

García is most emphatically not in a hurry. Neither is Mr. Erice, whose tranquil pace appears to be set by his subject. So the film watches serenely as Mr. López García arrives home with his canvas, stretches it out and nails it to a frame. He is then seen looking long and hard at the tree itself, which he later dots with a series of unexplained white markings. A string with a weight attached is tied to the foliage, and a horizontal line is drawn along the backyard wall.

•

The camera watches as this exceptionally precise artist drives stakes into the ground at two exact spots in which he plans to keep his feet during the painting process. It sees him locate the perfect center of the blank canvas on which he plans to work. Most of these details are observed in silence, which lends a surprising degree of suspense to the whole undertaking. Not until late in the film, when asked casually about his marking system by a couple of visitors, does Mr. López García happen to explain what the white spots on the leaves are for. "The best part is being close to the tree," he also confides to someone who asks about his work.

The Film Society of Lincoln Center

Antonio López García in Victor Erice's "Dream of Light."

Every day, as the film takes the form of a journal, Mr. López García is seen venturing into his backyard to carry his creative efforts one step further And the process behind the painting, a process that is entirely mysterious as the film begins, is made progressively clearer as the work moves along. Meanwhile, Mr. Erice begins incorporating gentle, amiable glimpses of Mr. López García's friends and fellow artists, who do not act but simply drop by to witness the proceedings. Through these visits, and through small talk on subjects ranging from Mr. López García's art school days to his thoughts about Michelangelo, Mr. Erice (director of "The Spirit of the Beehive") can be seen creating his own affectionate portrait to parallel the one taking shape on screen.

"Dream of Light" (the Spanish title, "El Sol del Membrillo," translates more directly as "The Quince-Tree Sun") should be watched appreciatively and peacefully, in keeping with the tranquillity of the material. In its own minimalist way it becomes a thoughtful, delicate inquiry into the essence of the artistic process, and a tribute to the beauty and mutability of nature. Mr. Erice's film is much bigger than it may appear to be. It is also, like its subject, undeniably one of a kind.

"Dream of Light" will be shown today at 6 P.M. and Saturday at 11:30 A.M. as part of the New York Film Festival.

1992 O 1, C17:1

Of Mice and Men

Directed by Gary Sinise; screenplay by Horton Foote, based on the novel by John Steinbeck; director of photography, Kenneth MacMillan; edited by Robert L. Sinise; music by Mark Isham; production design, David Gropman; produced by Russ Smith and Gary Sinise; released by Metro-Goldwyn-Mayer Inc. Running time: 110 minutes. This film is rated PG-13.

Lennie	John Malkovich
George	Gary Sinise
Candy	Ray Walston
Curley	Casey Siemaszko
Curley's Wife	Sherilyn Fenn
Slim	John Terry
Carlson	Richard Riehle
Whitt	Alexis Arquette
Crooks	Joe Morton
The Boss	Noble Willingham

By VINCENT CANBY

Lennie is a gentle giant of a man with the mental capacities of an 8-year-old. He loves to fondle soft things, like mice, puppies and rabbits, even a small piece of velvet. His friend George has brains enough for two. Together they ride the freights through Depression America, working as hired hands and dreaming of the day when they can buy their own spread. The trouble is that whenever they settle into a good place, where they might save some money, Lennie gets into trouble and they have to move on. Sometimes just ahead of a posse.

"Of Mice and Men," John Steinbeck's haunting 1937 novella about these two now-legendary bindle stiffs, has withstood time's ravages with remarkable ease. The prose is too rock-hard to age and so clean and spare that it remains outside fashion. The new film adaptation, directed by Gary Sinise and written by Horton Foote, remains faithful in almost every way to the stark Steinbeck tale. Yet this "Of Mice and Men," starring

Mr. Sinise as George and John Malkovich as Lennie, emphasizes something in the original work that never before seemed of foremost importance: "Of Mice and Men" is a mournful, distantly heard lament for the loss of American innocence.

This has always been in the Steinbeck novella, but it is the dominant mood of the film, which is gorgeous in the idealized way of beauty remembered. The wheat fields are golden, the skies blinding blue. There is a stylized perfection about the seediness of the run-down Tyler ranch, where George and Lennie find work at the beginning of the film. The hired hands work all day in 90-degree heat, and though they mop their brows, they don't seem to sweat.

This "Of Mice and Men" doesn't mean to be either realistic or melodramatic, that is, in the manner of Lewis Milestone's far darker 1940 adaptation. In that black-and-white film, Burgess Meredith played George, Lon Chaney Jr. was Lennie and Betty Field sashayed around the ranch as the tarty young woman who brings disaster to George and Lennie. The Milestone film, made in the midst of the Great Depression, did not take the long view.

Mr. Sinise's "Of Mice and Men" is a recollection of a simpler way of life that was swept aside by the realities of the Depression and all the momentous social changes that followed. In particular it's about the relationship of George and Lennie, which is not all that simple. George is father, mother and brother to Lennie. The two men are a mismatched couple, making do with what fate has dealt them.

Early in the story it seems as if they finally are going to realize the dream of their own spread. The one-handed Candy (Ray Walston), who has $400 saved up, offers to throw in with them. It's almost enough to swing the deal. Then Curley's wife (Sherilyn Fenn), who remains unnamed in the film as in the novel, butts in. Her husband is the ranch owner's cocky, mean-tempered son. She doesn't set out to cause trouble, but she's bored on the ranch. When Lennie accidentally crushes Curley's hand in a fight, his wife becomes attracted to the big, simple-minded fellow.

Possibly in keeping with the film's elegiac mood, the character of Curley's wife has been toned down into a lonely cipher. She's no longer the heavily madeup plot function she is in the book. She's sort of sweet and none too bright, which is politically correct. She is, after all, the only woman featured in the film. Yet her moral redemption also removes a lot of the potential for drama.

The movie's most flamboyant effect is Mr. Malkovich's performance as Lennie. I've no idea how it was done, but Mr. Malkovich does look

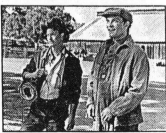

Andrew Cooper

Gary Sinise, left, and John Malkovich in "Of Mice and Men."

huge. Everything about the performance has been intelligently thought out, from the physical size he somehow has attained to his manner of speaking, which is slow and tortured without being grotesque. The actor's intelligence, however, shows through. It's the kind of performance that might be far more effective on stage than it is in front of the movie camera, which gets too close. Playing dumb is not easy.

That the performance works as well as it does is largely because the rest of the film is equally theoretical. Mr. Sinise, who played George to Mr. Malkovich's Lennie on the stage in 1980, gives a strong self-effacing performance, matching his work as the film's director. The supporting roles are all well cast, the script is good and the physical production first rate.

Yet for all its evident talent, "Of Mice and Men" is not very exciting. It could be that looking back at Lennie and George with the perspective of time robs them of their urgency. There's no surprise left.

"Of Mice and Men" is rated PG-13 (Parents strongly cautioned). It has some violence and vulgar language.

1992 O 2, C5:4

A Fine Romance

Directed by Gene Saks; screenplay by Ronald Harwood, based on the play "Tchin Tchin," by François Billetdoux; director of photography, Franco Di Giacomo; edited by Richard Nord and Anna Poscetti; music by Pino Donaggio; produced by Arturo La Pegna; released by Castle Hill Productions. Running time: 83 minutes. This film is rated PG-13.

Pamela Picquet	Julie Andrews
Cesareo Gramaldi	Marcello Mastroianni
Bobby Picquet	Ian Fitzgibbon
Marcel	Jean-Pierre Castaldi
Dr. Noiret	Jean-Jacques Dulon
Miss Knudson	Maria Machado
Dr. Picquet	Jean-Michel Cannone
Marguerite Gramaldi	Catherine Jarret

By STEPHEN HOLDEN

The chief pleasures to be found in "A Fine Romance," a strained romantic comedy starring Julie Andrews and Marcello Mastroianni, come from watching two indomitable troupers go through familiar paces with an obvious relish.

Set in Paris, which has rarely looked more appetizing, the film portrays the highly improbable romance between two people who meet after their spouses have fallen in love and run off together. Pamela Picquet, the prim English do-gooder abruptly abandoned by her doctor husband, is just the kind of modern-day Mary Poppins role that has always been a cinch for Miss Andrews. Cesareo Gramaldi, whose wife has run off with Pamela's husband, is also a quintessential Mastroianni role. Continually tipsy and slobberingly sentimental, the character is also a charmer who indulges his emotions and appetites as enthusiastically as Pamela represses hers.

When the pair first meet in a restaurant to formulate a joint plan of action for winning back their mates, Cesareo, to Pamela's disgust, disintegrates in a pool of whisky. But with Cesareo leading the way, they eventually warm to each other. And in her do-gooder's zeal, Pamela even drags Cesareo to a luxurious health spa where liquor and almost every other pleasure one might name are strictly

forbidden. Their stay is predictably a fiasco.

•

"A Fine Romance" was directed by Gene Saks, who has oversee many of Neil Simon's comedies bot on Broadway and in the movies. He has neatly stacked the scenes in Ronald Harwood's screenplay as thoug they were set pieces in a Simon comedy. There is a comic sketch in fancy restaurant, another in the spa and another in a sumptuously appointed country inn. Mr. Mastroianni has a grand solo turn baying drunkenly in the wee small hours under the windows of the building that he believes houses his faithless wife an her lover.

As amiable as the performance are, what sinks "A Fine Romance" is the screenplay's complete absence of jokes. In scene after scene, the potential for madcap farce is efficiently set up but never developed. Such promising subsidiary characters as Pamela's whiny yuppie son, Bobby (Ian Fitzgibbon), who wears headphone to family meals, are introduced but not exploited for their obvious comic potential. The only joke that lands is the final twist in a story that until the very last moment is entirely predictable.

•

"A Fine Romance" is rated PG-1 (Parents strongly cautioned). It includes adult situations and brief nudity.

1992 O 2, C10:

The Story of Qiu Ju

Directed by Zhang Yimou; screenplay by Liu Heng, based on the novel "The Wan Family's Lawsuit" by Chen Yuan Bin (in Mandarin with English subtitles); director of photography, Chi Xiao Ling and Yu Xiao Qun; edited by Du Yuan; music by Zhao Ji Ping. At Alice Tully Hall, as part of the 30th New York Film Festival. Running time: 100 minutes. This film has no rating.

WITH: Gong Li, Lei Lao Sheng, Liu Pei Qi, G Zhi Jun, Ye Jun and Yang Liu Xia.

By JANET MASLIN

Zhang Yimou is the superb Chinese film maker whose life sounds like the stuff of legend (he is said to have "sold his blood to buy his first camera") and whose rural historical dramas (among them "Raise the Red Lantern" and "Ju Dou") would be accessible in any part of the globe Now in "The Story of Qiu Ju," which will be shown at the New York Film Festival tonight at 6:15 and on Sunday at 9:30 P.M., Mr. Zhang has attempted something more modern and no less fascinating. With the simplicity of a folk tale or a fable, he tells of a farmer's wife and her search for justice, and in the process he provides a remarkably detailed view of contemporary Chinese life.

Sony Picture Classics

Gong Li

The principal performers in "The Story of Qui Ju" are professional actors, most notably Gong Li, who again emerges as a figure of astonishing fortitude. But this film's background figures are real people, caught unawares by Mr. Zhang's cameras as they travel and congregate in public settings. Without diminishing the film's dramatic interest, this realistic backdrop gives the film a documentary aspect, which is presented no less elegantly than the spare, historical details of the director's earlier films. Once again, it is Mr. Zhang's keen and universal view of human nature that raises his work far above its own visual beauty and into the realm of timeless storytelling.

"The Story of Qui Ju" is, for Mr. Zhang, exceptionally down to earth. It tells of a very simple problem. The pregnant Qui Ju (played by Gong Li) is incensed because her husband, Qinglai, has been kicked in the groin by a man named Wang, who is the head of the small village in which they all live. Qui Ju wants to know exactly what happened; she wants justice, and she is not shy about saying so. "If we can't fix your plumbing, we're stuck with the single-child policy for good," she grouses to Qinglai as she pulls him in a cart so he can visit a local doctor. The doctor, when first seen, is splitting logs with a hatchet instead of treating patients.

Slowly but surely the film carries the stubborn Qui Ju up the ladder of Chinese justice as she enlists ever-higher authorities to help her right this wrong. A local official, the smiling and compromise-minded Officer Li, initially suggests a monetary settlement to cover Qinglai's medical bills. He also advises the principals of the case: "I want both of you to do some self-criticism. Is that clear?" But Wang, who is gallingly amused by Qui Ju's outrage, merely throws the financial settlement at her in cash, expecting her to retrieve it. "For each one you pick up," he says, with a smile, "you bow your head to me."

Needless to say, Qui Ju will have none of this. So she embarks on arduous journeys to see different officials, journeys that the film records with impressive attention to detail. In rural contemporary China, the viewer learns, a pregnant woman may travel sidesaddle on someone else' bicycle over icy roads if she wants badly to get to town. She may also haul a wagon filled with chili peppers if she thinks that can influence her case. Mr. Zhang, incidentally, still has a fine eye for the fastidious beauty of Chinese peasant customs. The simple farm dwellings of Qiu Ju's village are festooned with spectacular garlands of drying peppers and corn.

•

As Qui Ju travels to ever more modern settings, the film overflows with interesting information. In town, the viewer can see how certain Western images, like pinups of Arnold Schwarzenegger, have infiltrated the indigenous culture. The film also observes Qiu Ju's reactions to such things as dishonest taxi drivers (the taxi is actually a bicycle-driven wagon) and loud, printed leggings.

Along the way, it also notes the behavior of public officials toward a woman of Qiu Ju's beauty and persistence, and it underscores some of the more basic inequities of Chinese life. The original fight between Wang and Qinglai had to do with Qinglai's impugning his rival's virility, since Wang is the father of four girls. "He

cannot have sons, so he takes his frustrations out on us," a public letter-writer maintains on Qiu Ju's behalf. Though Qiu Ju is clearly the strongest character in this story (and Gong Li plays her as a real force of nature), she has no trouble with the thought that sons are preferable to daughters.

"The Story of Qui Ju" manages to weave its dramatic spell while providing a clear, detailed picture of the way China works. From the petty graft at a cheap urban hotel (the rate is higher for those who want a receipt) to the way enemies, enmeshed in a bitter legal dispute, still sit down amicably to a meal of noodle soup, the film offers close and witty observations about Chinese daily life. The story's last moments, giving it an ending O. Henry would have appreciated, provide as much wisdom about Chinese hospitality and Chinese justice as what has come before.

"The Story of Qui Ju" reaffirms Zhang Yimou's stature as storyteller and sociologist extraordinaire, and as a visual artist of exceptional delicacy and insight.

1992 O 2, C12:1

Correction

A movie review in Weekend yesterday about "The Story of Qiu Ju" at the New York Film Festival rendered the name of the title character incorrectly in some references. She is Qiu Ju.

1992 O 3, 2:5

A Tale of Winter

Written and directed by Eric Rohmer; director of photography, Luc Pagès; edited by Mary Stephen; music by Sébastien Erms; produced by Margaret Menegoz. At Alice Tully Hall, as part of the 30th New York Film Festival. Running time: 114 minutes. This film has no rating.

Félicié	Charlotte Véry
Charles	Frédéric Van Den Driessche
Maxence	Michel Voletti
Loïc	Hervé Furic
Élise	Ava Loraschi
The Mother	Christiane Desbois
The Sister	Rosette
The Brother-in-Law	Jean-Luc Revol
Edwige	Haydée Caillot
Quentin	Jean-Claude Biette
Dora	Marie Rivière

By VINCENT CANBY

No matter how Eric Rohmer classifies his films, whether as Moral Tales, Comedies and Proverbs or Tales of the Four Seasons, which is the title of his current cycle, each film comes down to the same thing: a most singular woman. She is always young, usually very pretty, sometimes beautiful, with a capacity to enchant that is equaled only by her maddeningly stubborn, sometimes wayward pursuit of destiny as she sees it.

This has been true since the 1969 release of "My Night at Maud's," the French director's first hit in this country. It is still true of "A Tale of Winter," his second installment in Tales of the Four Seasons, which he initiated recently with "A Tale of Springtime." "A Tale of Winter" will be shown at the New York Film Festival tonight at 9:15 and on Sunday at 1:30 P.M. Though the Rohmer films' methods and obsessions are now familiar, their particular details are always new.

"A Tale of Winter" is about Félicié (Charlotte Véry) who, in an idyllic opening credit montage, is seen on a holiday at the seashore in the middle of a passionate affair with a young man who turns out to be Charles (Frédéric Van Den Driessche). By the end of the credits, Félicié and Charles are at the railroad station saying goodbye. She gives him her address. He says he is between addresses and will write her when he settles.

It is five years later when "A Tale of Winter" actually begins. Félicié, a hairdresser, has a sweet 4-year-old daughter, Élise (Ava Loraschi), and no Charles. In the excitement of parting at the station, she gave him the wrong address. Did he ever try to contact her? She is sure that he did. In the meantime she is delighted to have his child and has gone blithely on with her life.

At this juncture Félicié has two suitors, Maxence (Michel Voletti), a handsome man who owns a string of beauty salons and whom she finds sexually attractive, and Loïc (Hervé Furic), a librarian who excites her mind but whose admiration bores her a bit. In the weeks before New Year's, Félicié is pushed into deciding between Max and Loïc. First she feels that she has to marry Max, if only because he has left his wife for her. When she backs out of that commitment, after moving with him to Nevers, she begins to consider Loïc in a new light.

Through all of these indecisions she has always been open and aboveboard about her loyalty to the vanished Charles. She continues to expect that sometime, somewhere, they will meet again and resume what she serenely believes was the love of a lifetime for each.

Like all of Mr. Rohmer's films, "A Tale of Winter" is a madly romantic comedy about people who think they are most rational but who are often self-deluding. Sometimes, like Félicié, they have the mysterious gift of intuition. At one point Félicié, an agnostic, tells Loïc about a kind of epiphany she had in the Nevers cathedral. "I didn't think," she says. "I saw my thoughts." Which was when she decided that she could not share her life with Max.

•

At least part of the comic appeal of Mr. Rohmer's work is the complete confidence, clarity and decisiveness with which he dramatizes the utter confusion of his emotionally besieged heroines. Félicié is no egghead, by her own admission, though she delights Loïc by spontaneously coming out with pensées that echo Pascal, with insights about reincarnation that suggest Plato. She doesn't read, but she does use her brain.

In the course of "A Tale of Winter" Félicié and Loïc attend a production of Shakespeare's "Winter's Tale," whose magical reconciliation scene proves to be a portent. The film's reconciliation scene is completely unexpected, uncomfortable, very funny and, finally, ambiguous. There are limits beyond which Mr. Rohmer will not allow his romantic imagination to roam.

Ms. Véry takes her place in the long line of actresses who have realized Mr. Rohmer's dreams over the last 30 years, many never to be seen here again. She is lovely, fresh and young, as all his actresses are. He grows older. His admirers grow older. His vision of youth does not age.

1992 O 2, C12:6

Mr. Baseball

Directed by Fred Schepisi; screenplay by Gary Ross, Kevin Wade and Monte Merrick, based on a story by Theo Pelletier and John Junkerman; director of photography, Ian Baker; edited by Peter Honess; music by Jerry Goldsmith; production designer, Ted Haworth; produced by Mr. Schepisi, Doug Claybourne and Robert Newmyer. released by Universal Pictures. Running time: 100 minutes. This film is rated PG-13.

Jack Elliot	Tom Selleck
Uchiyama	Ken Takakura
Hiroko Uchiyama	Aya Takanashi
Max (Hammer) Dubois	Dennis Haysbert
Yoji Nishimura	Toshi Shioya
Toshi Yamashita	Kohsuke Toyohara

By JANET MASLIN

When the former New York Yankee slugger Jack Elliot (Tom Selleck) first arrives in Japan, his body language says it all. A head taller than anyone he meets, Jack has to duck constantly, which does not always save him from walking into doorjambs. He also has to wince a lot when confronted by local customs he finds baffling, or when discovering how creatively his words are being translated into Japanese. When Jack gives a newspaper interview and speaks of his new coach in typically surly style, his words come out: "I will gladly strive to shed all my old disgusting ways of laziness and become my best under his guidance."

The character of Jack, whose being sent to Japan is the impetus for "Mr. Baseball," provides Mr. Selleck with something unusual: a movie role that actually suits his talents. Mr. Selleck's easygoing, self-deprecating manner works particularly well when he lets himself look silly, as he often does here. (One early scene, in the United States, finds him waking up in what looks like a sorority house with a baby-blue stuffed animal over his head.) And the plot of "Mr. Baseball" prevents this genial actor from seeming colorless, since it gives him a great deal to react to once Jack reaches Japan.

The real point of the film, of course, is to contrast Japanese and American modes of behavior, a comparison that seldom works to Jack's advantage.

Although it has been suggested that "Mr. Baseball," a film made by Universal Pictures after that studio came under Japanese ownership, has been somehow soft-pedaled, the finished version shows no signs of ever having been a hard-hitting satire. It is instead a light and sometimes ruefully funny comedy, replete with lively wisecracks (the screenplay is by Gary Ross, Kevin Wade and Monte Merrick) and fueled by Mr. Selleck's enjoyable performance.

•

Best in its early stages, when the effects of culture shock on Jack are still fairly broad, the film eventually dissolves into more standard plot maneuvers; Jack winds up romantically involved with a young Japanese businesswoman (Aya Takanashi) who proves to be the daughter of his disapproving coach (Ken Takakura). The ending certainly smacks of compromise, since this is not a film willing to think seriously about Japanese attitudes toward an interracial romance. But by that point the film has long since lost its modest sting.

"Mr. Baseball" gets off to a funny start with its look at Jack's disastrous career with the Yankees. He knows what it is to run afoul of the fans. "And the kids that used to worship you — now they just make goat noises and run away," he tells a fellow player, seeming to speak with

considerable authority. Jack is also losing ground with his agent, who tells him that his commercial endorsements for a lawnmower company are in jeopardy. Later on, Jack will learn that the rookie of whom he was so jealous is having his Nike commercial directed by Spike Lee.

When Jack is told, by a couple of tobacco-spitting managers, that he must go to Japan, he does not feel inclined to accentuate the positive. Instead, he views his new home with deep suspicion, and does his best to make fun of Japanese attitudes. When handed business cards by bowing Japanese acquaintants, Jack dishes out baseball cards in return. When singled out as an American star (he becomes known as "Mr. Besuboru"), he responds irritably and complains loudly about his situation. "It's like being a black guy back home, only there's less of us," says a teammate (Dennis Haysbert), who happens to be black, and who has a considerably better attitude.

Some of the film's crass American characters, like Jack's ponytailed agent, are allowed to become caricatures. And there is a trace of hostility in the way one of Jack's teammates refers to him as "white trash". The film also makes room for the occasional lecture, as when Jack complains about what he calls "the Japanese way — shut up and take it." In response, he is told: "Sometimes acceptance and cooperation are strengths also." There's a lesson there; but, to the film's credit, that lesson is not allowed to surface very often.

●

"Mr. Baseball" is rated PG-13 (Parents strongly cautioned). It includes profanity, partial nudity and discreet sexual situations.

1992 O 2, C14:6

The Mighty Ducks

Directed by Stephen Herek; screenplay by Steven Brill; director of photography, Thomas Del Ruth; edited by Larry Bock and John F. Link; music by David Newman; production designer, Randy Ser; produced by Jon Avnet, Jordan Kerner, Lynn Morgan and Martin Huberty; released by Walt Disney Pictures. Running time: 100 minutes. This film is rated PG.

Gordon Bombay	Emilio Estevez
Hans	Joss Ackland
Coach Reilly	Lane Smith
Casey Conway	Heidi Kling
The Boss	Josef Sommer

By JANET MASLIN

"The Mighty Ducks," a family-minded comedy about a reluctant coach and a rotten hockey team, is certainly better than its title. But it's not in a league with "The Bad News Bears," an obvious model for this story of how one surly grown-up (Emilio Estevez) and a bunch of poorly behaved kids can help build one another's character, and also — not so coincidentally — embark on a winning streak.

Part of the impetus behind "The Mighty Ducks" is to show how Gordon Bombay, the obnoxious yuppie lawyer played by Mr. Estevez, abandons the victory-crazy attitude that has given him a vanity license plate reading "JUSTWIN." After Gordon is arrested for driving under the influence, he is sentenced to do community service with peewee hockey players. He then undergoes the predict-

Deborah Croswell

Emilio Estevez

able change of heart. Adopting a philosophy best described as McZen ("concentration, not strength," he advises his players, prompting one of them to mention "The Karate Kid"), Gordon renounces the cutthroat thinking of his courtroom days.

"We may win, we may not," he tells one boy during an all-important game. "But that doesn't matter, Charlie. What matters is that we're here." The film is remarkably oblivious to the fact that if the team weren't hell-bent on a championship, young moviegoers would be significantly less interested in its adventures.

●

"The Mighty Ducks," with a screenplay by Steven Brill, takes a solidly by-the-numbers approach to all the expected breakthroughs the team experiences. When Gordon, who was himself a hockey player as a boy, decides to skate again, the film gives him a wise old mentor (Joss Ackland) and a solitary skating scene at dawn. When the Ducks receive enough financing to allow them to buy first-class hockey equipment, there is a frolicsome scene in a sporting goods store, complete with a shot of the cash register and its total.

Some of these episodes have an unduly nasty edge, as when bullies taunt the Ducks or the Ducks try out their new skates by knocking down shoppers at a mall. But what's missing from the film, even during its most rambunctious moments, is a distinct personality. Mr. Estevez gives a low-keyed, likable performance, but like the Ducks themselves, he lacks color. The film's young actors appear to have been chosen more for size (too fat, too tall, etc.) and ethnic mix than for distinct character traits.

As directed by Stephen Herek, "The Mighty Ducks" moves energetically but lacks the enjoyable quirkiness of "Bill and Ted's Excellent Adventure," which Mr. Herek also directed. The overly pat screenplay includes occasional amusing wisecracks but resorts to such tactics as supplying a childhood wrong for Gordon to right and a friendly single mother (Heidi Kling) to make the team scenes more interesting. The screenplay also includes duck jokes, which wear thin almost immediately. Mr. Estevez is asked not only to rally the troops with a cry of "Look, it's time to play smart hockey — Duck hockey!," but also to quack angrily at Josef Sommer, who appears briefly as his boss.

Among the film's other duckisms are a hockey maneuver that has the boys skating in a flying V, as if migrating, and Gordon's defiant claim about a rival team. "They know that if they mess with one duck, they gotta mess with the whole flock!" he says, sustaining a straight-faced expression that is nothing short of a miracle.

"The Mighty Ducks" is rated PG ("Parental guidance suggested"). It includes rude language.

1992 O 2, C18:1

Hero

Directed by Stephen Frears; screenplay by David Webb Peoples, based on a story by Laura Ziskin and Alvin Sargent, and Mr. Peoples; director of photography, Oliver Stapleton; edited by Mick Audsley; music by George Fenton; production designer, Dennis Gassner; produced by Ms. Ziskin; released by Columbia Pictures. Running time: 112 minutes. This film is rated PG-13.

Bernie Laplante	Dustin Hoffman
Gale Gayley	Geena Davis
John Bubber	Andy Garcia
Evelyn	Joan Cusack
Donna O'Day	Susie Cusack

By VINCENT CANBY

"Hero" is a big, expensive-looking, quite harmless Hollywood comedy that is finally far more enjoyable than it has any right to be, largely because of Dustin Hoffman, Andy Garcia and Geena Davis, but most of all because of Ms. Davis, though not for the expected reasons.

There's nothing wrong with her performance as a beautiful, high-powered television news personality. She's good. Yet what really counts is her angularly comic presence. She's as cheering and surprising as the sight of a very tall lollipop careering around on Rollerblades. It's Ms. Davis who pulls together the various elements of a screenplay whose complicated mechanics keep slowing down what should be the fun.

"Hero," directed by Stephen Frears from an original screenplay by David Webb Peoples, seems to have begun with a high-profile story concept, that is, with the sort of plot that can be told in a single sentence. Then something happened, possibly during a large number of story conferences.

At the beginning, "Hero" is exclusively about Bernie Laplante (Mr. Hoffman), a tireless but none-too-successful con artist who often looks and sounds like Ratso Rizzo, 20-odd years after "Midnight Cowboy." Bernie has served in Vietnam, been in and out of one marriage, and fathered a son. When first seen in "Hero," he's in court, where he's being found guilty of selling stolen property. He's also stealing money from the purse of his public defender.

●

The high-profile concept that apparently prompted the film takes a long time to appear. Bernie is driving across town one night during a thunderstorm when he chances upon a just-crashed commercial airliner. Against his better judgment, he goes into the flaming wreckage to save the passengers, including Gale Gayley (Ms. Davis). By the time the police and firefighters arrive, Bernie's job is done. He leaves without identifying himself.

"Hero" is also about John Bubber (Andy Garcia), a down-and-out Vietnam veteran, who takes credit for Bernie's heroism when Gale starts a television campaign to find "the angel of Flight 104." John is not much better than Bernie at heart, but the lure of the $1 million reward is too much for him. The paradox: by pretending to be a hero, John actually becomes one. Shaved, shined and dressed in a new wardrobe, John not only looks like a hero, but he also behaves like one.

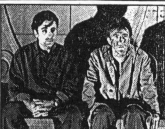

Murray Close/Columbia Pictures

Andy Garcia, left, and Dustin Hoffman in "Hero."

He's humble. He's handsome. He makes people feel good about themselves. As in old Frank Capra movies, a flawed common man is recognized as the populist savior for whom the world has been waiting these thousands of years. Poor John almost goes to pieces guarding his terrible truth. He can't even tell the gorgeous Gale, who falls in love with him.

●

Mr. Hoffman is terrific when he doesn't have to move the creaky story forward. The performance is big and complex, but it's at a remove from the rest of the film. Mr. Garcia's John Bubber is funny and intense, a very reasonable facsimile of a Capra character. Ms. Davis has something of the gutsy spirit of what would be the Jean Arthur role.

Neither Mr. Frears ("The Grifters," "Dangerous Liaisons," "My Beautiful Laundrette") nor Mr. Peoples, who wrote the screenplay for "Unforgiven," appears to have a natural bent for this sort of comedy. They let every scene and every gag run on too long. Nothing is condensed. There's even too great a profusion of legitimately comic supporting characters who, by getting on and off fast, often seem funnier than the stars. Joan Cusack is super as Mr. Hoffman's harried ex-wife, and her real-life sister, Susie Cusack, is a joy as Mr. Hoffman's earnest if inexperienced public defender.

"Hero" has its moments of high good humor, but they are so spread out, and the pacing is so laborious, that watching the film too often seems like work.

●

"Hero," which has been rated PG-13 (Parents strongly cautioned), has vulgar language and sexual situations.

1992 O 2, C20:6

In the Soup

Directed by Alexandre Rockwell; screenplay by Mr. Rockwell and Tim Kissell; director of photography, Phil Parmet; edited by Dana Congdon; music by Mader; production designer, Mark Friedberg; produced by Jim Stark and Hank Blumenthal; released by Triton Pictures. At Alice Tully Hall, as part of the 30th New York Film Festival. Running time: 93 minutes. This film has no rating.

Adolpho	Steve Buscemi
Joe	Seymour Cassel
Angelica	Jennifer Beals
Dang	Pat Moya
Skippy	Will Patton
Old Man	Sully Boyar
Louis Bafardi	Steven Randazzo
Frank Bafardi	Francesco Messina
Monty	Jim Jarmusch
Barbara	Carol Kane
Gregoire	Stanley Tucci
Guy	Rockets Redglare
Jackie	Elizabeth Bracco

By JANET MASLIN

In his arch, furiously clever "In the Soup," Alexandre Rockwell tackle

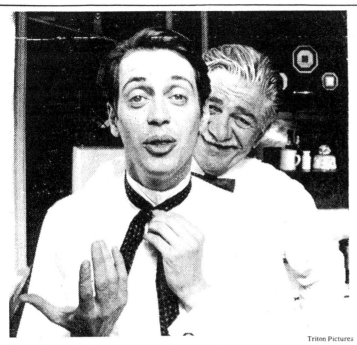

Steve Buscemi, foreground, and Seymour Cassel in "In the Soup."

the subject most readily available to any up-and-coming film maker: the difficulty of getting a film made. Beyond this, there is nothing pat or ordinary about "In the Soup," which won the prize for best dramatic feature at the Sundance Film Festival this year and a well-deserved best-actor award for Seymour Cassel. Mr. Cassel, in a hilarious turn as a mischievous, big-hearted gangster and potential movie producer, is less an actor here than a one-man show.

Mr. Rockwell has transformed his potentially myopic subject into a wild grab bag of offbeat characters and deadpan comic effects, and in the process made a dryly funny film of exceptional visual beauty. The crystal-clear black-and-white look of Phil Parmet's cinematography gives a helpfully austere look to scenes that otherwise might go over the top.

Take, for instance, the film's opening glimpse of its hero, Adolpho Rollo (played by Steve Buscemi, whose perpetually horror-stricken expression is perfectly in tune with the film's brand of humor). Adolpho introduces himself by telling the audience: "My father died the day I was born. I was raised by Fyodor Dostoevsky and Friedrich Nietzsche." At this, Mr. Rockwell offers a glimpse of the threesome at a kitchen table, an image greatly helped by the film's spare, velvety look and its studied nonchalance.

•

According to his own account, Adolpho is anything but casual about wanting to make his film. Trapped in a Manhattan tenement where the rent is overdue and the landlord's hoodlum friends bring a doo-wop sound to their demands for money, Adolpho dreams of becoming successful — so successful that this building will be a stop for tour buses some day. As a first step, he takes a newspaper ad offering to sell "one epic 500-page film script."

And he finds a taker: a lovable gangster named Joe (Mr. Cassel), who declares, "I've decided I want it to be an important part of my life." Regardless of whether that is true, Joe wants to take Adolpho under his wing. Their scenes together have

an irresistibly funny tenderness, since Joe has other conspicuous love interests and, when with Adolpho, is such an unlikely romantic. The little things — like waking up Adolpho by nibbling his ear, or coyly saying things like, "Don't say you don't remember" — wind up meaning a lot.

Still smart enough to remain suspicious of Joe's sweet talk, Adolpho is hopelessly in love with Angelica (Jennifer Beals), the Hispanic waitress who lives next door. Angelica is unfriendly and also unfortunate, since she managed to marry a Frenchman for his green card. ("I'm stupid. Is that a crime?") Also figuring in the film's large, eccentric cast are Pat Moya as Joe's hyperactive girlfriend, named Dang, and Will Patton as Skippy, Joe's hemophiliac brother. Always seen bleeding slightly from one scratch or another, occasionally bursting into inappropriate song ("The Little Drummer Boy" during a non-Christmas drive to New Jersey), Skippy brings an undeniable air of menace to the proceedings.

•

Jim Jarmusch, whose dry wit is one of many obvious influences on Mr. Rockwell (John Cassavetes is another, making Mr. Cassel's appearance a kind of homage), turns up as a seedy television producer. He sees Adolpho as "a young Don Knotts" and somehow persuades him to appear on "The Naked Truth," an interview show conducted au naturel. (Carol Kane, as the co-producer, claims to see Adolpho more as the Gary Cooper type.) Sully Boyer has a memorably poignant scene as an old man who, once Joe and Adolpho have begun experimenting with criminal forms of fund-raising, finds the two of them in his house in the middle of the night and treats them like old friends.

Although "In the Soup" has a deliberate story line, it plays more as a series of anecdotes, in part because the story is so diffidently told. The film's energy and humor are most sharply focused around Mr. Cassel's scene-stealing antics and around the young would-be film maker's artistic aspirations. Another fine moment has Adolpho proudly unveiling a black-and-white home movie starring his

mother as an angel. ("Here she goes into the doorway where the guy sees his past and future all at the same moment.") Adolpho, who keeps a poster from a film by the Russian director Andrei Tarkovsky prominently displayed in his apartment, sees the influence of Renoir and Godard on this material. Joe sees "The Honeymooners."

"In the Soup," a droll, self-conscious fable with an unexpected heart of gold, can be seen tonight at midnight and tomorrow at 7 P.M. as part of the New York Film Festival. Its commercial run begins Oct. 23 at the Angelica Film Center, Mercer and Houston Streets, and at Cinema 2, Broadway at 66th Street.

1992 O 3, 13:2

Stone

Directed by Aleksandr Sokurov; screenplay by Yuri Arabov (in Russian with English subtitles); director of photography, Aleksandr Burov; edited by Leda Semenova; produced by Yuri Torokhov. At Alice Tully Hall, as part of the 30th New York Film Festival. Running time: 88 minutes. This film has no rating.

WITH: Leonid Mozgovoy and Pyotr Aleksandrov.

By VINCENT CANBY

"Stone" isn't the best way to get to know Aleksandr Sokurov, a Russian director still comparatively new to American audiences. "Stone" is best seen as a kind of footnote to "Save and Protect," his 1989 Siberian variation on "Madame Bovary," and the other films presented in the Sokurov retrospective at the Walter Reade Theater in January.

The new film, which will be shown at the New York Film Festival today at 3:45 P.M., is a severely obscure meditation on pre-revolutionary Russia in the form of an encounter between a ghost from the past and the ghost's present-day guardian. In fact, the two characters seem to be the shade of Anton Chekhov and the young man who tends a Chekhov museum in the Crimea, though that is never made explicit.

A lot of other things remain inexplicit, at least in part because the black-and-white photography is mostly so medium-gray that the images are not easily understood. There's no way of telling how much of this is intentional. The old man, who resembles photographs of Chekhov, wanders through the museum like someone who has been a long time away. He seeks the familiar touch of a piece of furniture. He plays the old piano. He makes doctor-sounding comments, telling the young man that he needs to eat more iron. At one point he states flatly: "Tolstoy was wrong. A patch of land is too little."

The young man doesn't have much in the house to feed his guest, but they make do with what's at hand. They drink ink as their table wine. The old man puts on his evening clothes, as if preparing for the opera. Toward the end they walk across the chilly hills.

Mr. Sokurov occasionally uses an anamorphic, or squeeze, lens, though he doesn't unsqueeze the images for the finished film, thus creating the same effect one sometimes sees in the opening credit sequences in videos of CinemaScope movies. Everything looks tall and skinny. There are other times when the dimness of the images prompts one to wonder whether the characters within the film have the same difficulty seeing

each other, or whether this is just a poetic effect.

This print of "Stone" asks more questions than maybe even Mr. Sokurov intended.

1992 O 3, 18:1

Hyenas

Written and directed by Djibril Diop Mambety, adapted from Friedrich Dürrenmatt's play "The Visit" (in Wolof with English subtitles); director of photography, Matthias Kälin; edited by Loredana Cristelli; music by Wasis Diop; produced by Pierre-Alain Meier and Alain Rozanes. At Alice Tully Hall, as part of the 30th New York Film Festival. Running time: 110 minutes. This film has no rating.

Dramaan Drameh	Mansour Diouf
Linguère Ramatou	Ami Diakhate
The Mayor	Mahouredia Gueye
The Teacher	Issa Ramagelissa Samb
Toko	Kaoru Egushi
Gaana	Djibril Diop Mambety
An Amazon	Hanny Tchelley
The Head of Protocol	Omar Ba
The Priest	Calgou Fall
The Doctor	Abdoulaye Diop

By STEPHEN HOLDEN

Anyone can be bought if the price is right. That is the message of Friedrich Dürrenmatt's viciously misanthropic drama "The Visit," in which a woman buys an entire town in order to wreak revenge on the lover who betrayed her decades earlier. In "Hyenas," Djibril Diop Mambety's pungent film adaptation of the story, the setting has been moved from Europe to Africa.

Although the film by the Senegalese director keeps the outlines of the Dürrenmatt play intact, the change of locale lends the tale a new political dimension. The vengeance that the richest woman in the world brings to the dusty African village of her birth is an avalanche of irresistible Western paraphernalia that will certainly eradicate the area's tribal culture.

The desert town of Colobane is so destitute that in the movie's opening scene its ramshackle city hall is repossessed. Its social center is a scantily stocked market run by its most popular resident, Dramaan Drameh (Mansour Diouf), a jolly white-bearded grocer who keeps his cronies happy by doling out glasses of cheap wine.

The village would probably go on wasting away on the fringe of the Sahara were it not for the triumphal return of Linguère Ramatou (Ami Diakhate), a woman who left the town in disgrace 30 years earlier. Linguère, who was Dramaan's lover at the time, has mysteriously emerged as the world's richest woman. The townspeople, hoping that she will end their poverty, fall over themselves to offer her a welcome-home banquet.

Though Dramaan is married, he woos Linguère obsequiously, ignoring the fact that she is now a stone-faced hag with a prosthetic leg and hand. At the height of the celebration, she announces that she intends to donate "one hundred thousand millions to the town." But there is a catch. She produces witnesses who swear that 30 years ago Dramaan paid them to testify that they had slept with her so he could deny the paternity of her unborn child. Before the town can get its reward, Dramaan must pay with his life.

Deeply insulted, the townspeople at first side with the grocer. But as greed eats away at their souls, their mood slowly shifts. The men in the town soon begin sporting fashionable yellow shoes from Burkina Faso.

Truckloads of electric fans, air- conditioners, refrigerators and television sets arrive.

The more spoiled the townspeople become, the more luxuries they insist that Dramaan sell them on credit. In the film's most surreal moment, Linguère imports a carnival complete with a ferris wheel, fireworks and ads for Pepsi posted everywhere. The town goes delirious with the cheap thrills.

"Hyenas," which will be shown at Alice Tully Hall tonight at 9 and tomorrow at 4:15 P.M. as part of the New York Film Festival, inflects the grim drama with an edge of carnival humor. That may explain why the central performances are not very gripping. Ami Diakhate's Linguère, though imposingly grotesque, is

something less than the fearsome apotheosis of revenge. And when she declaims the play's key lines — "The world made a whore of me; I want to turn the world into a whorehouse" — they ring slightly flat. Mr. Diouf's Dramaan behaves more like a victimized village idiot than the African equivalent of a petit bourgeois storekeeper betrayed by his friends as well as by every social institution, from the justice system to the church.

But even done so lightly, the film still carries a sting. And its symbolism is enriched by frequent shots of fiery-eyed hyenas restlessly stalking the outskirts of the town like evil spirits alert to the scent of decay.

1992 O 3, 18:4

FILM VIEW/Janet Maslin
Make a Date With Love

FOR DATING COUPLES WHO would like to see their hopes and fears reflected on the screen, here's a recommendation. Go see a double feature of Cameron Crowe's "Singles" and Woody Allen's "Husbands and Wives" and telescope 20 or 30 years' worth of romantic travails into one eye-opening evening.

Mr. Crowe is not Mr. Allen — his film is much lighter and bouncier — but the connection between the two films is real. Their formats are similar, and to a surprising extent they have the same matters in mind. The differences are those of age, outlook and experience, which brings up another recommendation: see these films in what may seem to be reverse order, with the middle-aged "Husbands and Wives" first. That way, the ebullient "Singles" can send you home humming its theme song ("Dyslexic Heart," by Paul Westerberg of the Replacements — catchy but markedly different from Mr. Allen's favorite, Gershwin). If you end the evening with the terminal despair of "Husbands and Wives," you may find yourself wanting to break up other things, too.

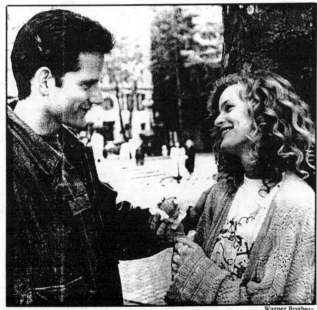

Warner Brothers

Campbell Scott and Kyra Sedgwick in "Singles"—In Cameron Crowe's film, the search for love is a risky business.

The generational gap between these two films can be summed up with a single article of clothing. Plaid flannel shirts look great on the pert, hopeful twentysomething women who wear them around Seattle in "Singles," women who drink water on dates and have jobs like environmentalist or coffee house waitress. But the same shirts look dowdy in "Husbands and Wives" on Mia Farrow's Judy, who is two decades older, well established, unhappily married (though she doesn't yet know it) and living in New York.

Each of these films, incidentally, has its distinct sense of urban chic, whether expressed through posters and slogans on the sets of "Singles" or the more upscale, rarefied décor of "Husbands and Wives." Each film is highly selective about such backdrops, using only the well-chosen minor players and precise details that its director wants the audience to see.

Each film is also set up as a quasi documentary, so that characters can tell the camera things they won't tell one another. And each follows a handful of well-defined characters who brood endlessly about the difficulties of romantic love. But the ones in "Singles" have only begun casting about for some kind of permanence. ("Somewhere around 25," observes Bridget Fonda's enchanting "Singles" character, "bizarre becomes immature.") Their long-married counterparts in Mr. Allen's film are so ready to sever do-

'Singles' and 'Husbands and Wives' add up to a long night's journey into romance.

mestic ties that when they wind up together (as one couple manages to do), this does not constitute a happy ending.

In "Husbands and Wives," Mr. Allen plays a famous writer named Gabe, one of whose short stories is entitled "The Gray Hat." "Giving up one's hopes, compromising one's dreams is like putting on a gray hat," quotes Rain (Juliette Lewis), the young student who expresses her admiration for Gabe's work by trying to seduce him. Gray hats are everywhere in "Husbands and Wives," as the characters drink too much, tell half-truths and occasionally lash out at one another. "You use sex to express every emotion except love," Judy tells Gabe angrily during one of their many quarrels.

"Singles" is set well before the gray hat stage, but compromise is still an issue. In their first attempts to settle down, its characters have to decide just how badly they want to accommodate one another. A funny, deceptively casual subplot involving Ms. Fonda has her contemplating a breast enlargement operation to please her not-quite-boyfriend, the hilariously dim rock musician played by Matt Dillon. Real concerns about her identity and self-worth are not obscured by the ostensible silliness of the episode.

"Singles" is serious in understanding how scary and tempting the idea of change for change's sake can be, especially during one's 20's, and how much newly independent young people both want and fear commitment. "Don't do this to me; don't make me remember this chili dog forever!" wails one of the film's heroines, when her nervous suitor suddenly proposes marriage.

A couple of decades later, in "Husbands and Wives," new experience is no longer

easy, and it has thus become wildly desirable. So the two long-married couples in the film yearn for adventure, no matter what the cost. Mr. Allen has a lot of fun with the way Sydney Pollack's guilty, henpecked husband finds happiness with a bubble-brained blond aerobics instructor. ("I *flip* over couscous!" declares Lysette Anthony, very amusing in this role, when it is suggested she have dinner in a Mexican restaurant.) If Mr. Allen's film is ever successfully separated from the media furor that surrounds it, it will be seen as a thoughtful exploration of why smart, enlightened, self-aware men in their 50's — men like Mr. Allen and so many of his fellow cultural heroes — begin behaving as they do.

Meanwhile, at Mr. Crowe's stage of the game, optimism has not died. And it remains as unexpectedly funny as it is when handled by Mr. Allen. "Being alone — there's a certain dignity to it," muses Ms. Fonda's newly separated character, as she suns herself on her roof. The detail is not overemphasized, but in fact, she has brought her telephone outdoors with her, just in case. In the world of "Singles," where a dating video made by a would-be film maker includes a quick parody of the "Psycho" shower scene, the search for love is a risky business. In "Husbands and Wives," the stakes are higher and the risks different, but some things never change. □

1992 O 4, II:9:1

FILM VIEW/Caryn James

Inside 'Hero,' A 1930's Heart Vs. a 90's Brain

THERE IS A MORAL TO THE MOVie "Hero," which Andy Garcia eventually blurts out. He plays John Bubber, a homeless man who takes credit for rescuing dozens of people from a plane crash. The rescue was, in fact, performed by a petty thief named Bernie LaPlante (Dustin Hoffman), going against every impulse in his misanthropic little body. But a television reporter, Gale Gayley (Geena Davis), believes that Bubber pulled her from the burning plane. She makes him a media star, showing how heroes can be made from telegenic looks and sound bites.

If "Hero" had stopped there, it would have been a bitterly funny satire. But Bubber performs his own courageous act, which leads to the moral of his story. "I think we're all heroes if you catch us at the right moment," he tells the television cameras. What a soothing sentiment. How totally unconvincing, for there is a more realistic lesson in "Hero." Bernie tells his young son at the movie's end: you can't believe what you see on television.

In one of Mr. Hoffman's best and most natural performances, Bernie is a relentless thief, a congenital liar, a man whose goodness is so deeply buried no one has seen it in years. He's great because he maintains his cynicism while everyone around him is getting starry-eyed and stupid.

Stephen Frears's film is always lively and often shrewd, but in the end "Hero" is at war with itself. The movie's Capraesque heart is locked in battle with its cynical, contemporary brain. That the brain is more believable proves how tough it is to transport a heartening 30's ethos into the skeptical 90's.

In Stephen Frears's film, a Capraesque spirit is locked in battle with a cynical view of the world.

With Bubber's rags-to-riches story and the film's sense that ordinary people can save the world, "Hero" desperately tries to keep Frank Capra's spirit alive. Though there is a hint of the 1944 Preston Sturges comedy "Hail the Conquering Hero" in Bubber's character of a poseur-hero, the allusions to Capra are specific and frequent.

As in "Meet John Doe" (1941), where a radio mogul helps Gary Cooper pose as a grassroots political savior, this film exposes how the media create fraudulent idols. Cooper's John Doe threatens to jump off the ledge of a building. "Hero" has several potential ledge jumpers — not a popular 90's mode of self-destruction, but a favorite 30's and 40's cliché.

Most important, the Geena Davis character is essentially the same one played by Barbara Stanwyck in "Meet John Doe" and Jean Arthur in "Mr. Deeds Goes to Town" (1936).

Murray Close/Columbia Pictures

Andy Garcia as John Bubber in "Hero"—From rags to riches.

All three women are tough reporters who discover they are softhearted after all.

At the start, Gale Gayley is so competitive that, as she is carried to an ambulance after the plane crash, she yells to her colleague: "It's my story! I did the research!" Later, inspired by Bubber, she ends up crying on the job and telling her boss (Chevy Chase in a wry performance) that she's quitting. He responds that she has always been "a cream puff," and the least she can do is be a professional cream puff. In the movie's scheme of things, this is meant as a compliment.

These old-fashioned touches are charming — newspaper headlines swirl on the screen, and "The Man I Love" becomes Bubber's soundtrack signature — but they are as convincing as a tough cream puff. And they are at odds with Bernie's up-to-the-minute dourness. Bubber and the softhearted Gale appeal to what viewers want to believe. But Bernie and the hardhearted Gale speak to the pervasive cynicism of this social moment. That skepticism is symbolized by television news.

Television news is an easy target, but "Hero" attacks it with deadly satirical force. The realistic part of Gale's character is the reporter who watches a suicide and asks her cameraman, "Did you get that?" Next she wonders, "Did I say that?," a comment that hints at her cream-puff heart. But she second-guesses herself much too quickly, suggesting how the film forces its themes. Her first reaction is the one that sticks.

Her colleagues represent television at its worst. The cameraman, who talks to himself in pompous terms about every camera angle, is proud to film the suicide and say, "I got it!" Mr. Chase and Stephen Tobolowsky, as the station manager, care about ratings and money, not news or truth. They are buffoons whose spiritual father is not Edward R. Murrow or the demagogue from "Meet John Doe"; it's Ted Baxter.

And the coverage of the plane crash recreates television news at its most literal and ludicrous. The mystery rescuer becomes known as "The Angel of Flight 104." On screen he is shown as a silhouette with a question mark appearing over his figure. After Bubber is discovered, the station reenacts the crash. Its promo promises: "See the real-life participants. No makeup! No actors! This is the real thing! Thursday night. Channel 4. Be there!" How far is this from "reality television" as we know it?

Given the sharpness of this satire, it is easy to agree with Bernie's life lesson: don't believe these guys. It is harder to buy Gale's words to Bubber: "You're making us better human beings, less cynical, more open." When Jean Arthur and Barbara Stanwyck go mushy, they are bathed in nostalgia. You don't have to be a hardhearted Hannah to find this statement mawkish and incredible when it comes from a contemporary heroine. Bubber has walked out of a Frank Capra movie, which is why he seems strained. Bernie has walked out of life. His story isn't the pretty one. It's the one that sounds true. ☐

1992 O 4, II:9:4

FILM VIEW/Walter Goodman

In Mamet's World, You Are How You Speak

WORDS, WORDS, words. In life they are the weapons of poets and con artists; in the plays and movies of David Mamet, they are measures of character too, replacing the high-mindedness and moral fiber by which heroes of fiction are customarily measured. Heroic actions do not abound in the Mametian world, populated by hustlers trying to make a buck by their wits, where love-thy-neighbor is not high on anybody's agenda. Here a man is judged by his spiel, and in none of Mr. Mamet's works does language figure more resoundingly than in "Glengarry Glen Ross," the 1984 Pulitzer Prize-winning play that has now been turned into a movie, slyly subtitled "A Story for Everyone Who Works for a Living," with a screenplay by Mr. Mamet.

The plot is skeletal: four peddlers of dubious properties in Florida and Arizona, under pressure from the unseen boss known collectively as Mitch and Murray, are scrambling for suckers. None of these hustlers — Ricky Roma, the star salesman (played by Al Pacino); Shelley Levene, a sometime star who has fallen on hard times (Jack Lemmon); the scheming Dave Moss (Ed Harris), or the dullish George Aaronow (Alan Arkin) — are role models for the young.

A contest is under way: a Cadillac Seville goes to the salesman who closes the biggest deals. Second prize, a set of steak knives. Third prize, you're fired. But the audience does not have to wait for any sales figures to be posted to calculate the quality of the men in the office. Their language tells it all.

Mr. Mamet has added one more character to the movie version, Blake, a high-powered emissary of Mitch and Murray who starts the action off with a nasty do-or-be-done-to tirade to the beset salesmen. His function is to turn up the pressure and, not incidentally, to cue in the movie audience on the local lingo, particularly the meaning of the "leads" that are so crucial to the plot. They are the names and telephone numbers of the most promising marks and are doled out as rewards for high sales.

Blake has the eloquence of the bully; his idea of the rewards of salesmanship is his expensive wristwatch. Moss is a good talker, but his grievances become tedious: "Ninety percent of our sale, we're paying to the *office* for the *leads*." Aaronow's language, imitative and a little stupid, stamps him as a loser.

The more interesting Levene is trapped in the tricks he mastered long ago. Now and then he bursts forth with a plaintive aria that evokes the persuader he once was and, alas, what he has become: "He's going to have a 'sales' contest . . . you know what our sales contest used to be? *Money*. A *fortune*. Money lying on the

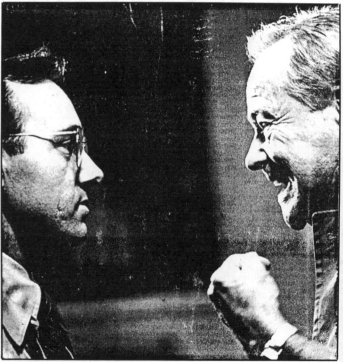

Kevin Spacey, left, and Jack Lemmon in the new David Mamet film "Glengarry Glen Ross," based on Mr Mamet's 1984 Pulitzer Prize-winning play—The poetry of con men, the insight of instinct.

ground. Murray? When was the last time *he* went on a sit? Sales contest. It's *laughable*. It's cold out there now, John. It's tight. Money is *tight*. This ain't '65. It ain't. It just ain't. See? See?" It is bravura marinated in pathos.

Roma is the virtuoso in residence. His big sell scene erupts in a Chinese restaurant, favorite watering place of the group, where he is coming on cold to one James Lingk (played by Jonathan Pryce) who probably just dropped in for a bite, and bite he does. Roma's soliloquy is not chop suey. The words flow and flow from some deep and mystifying source, odd bits of reflection, confession, philosophy, nonsense, apparently meandering yet picking up speed as he approaches the objective, climaxing in a rush to the close. It is delirium, hallucination, gibberish, yet perfectly targeted on the susceptible Lingk and capable, as delivered by Al Pacino, of hypnotizing an audience.

'Glengarry Glen Ross' comes to the screen as a battle of words and attitude.

Quoting at length from Mamet is difficult in a family newspaper, but here is Roma moving toward the kill: "A guy comes up to you, you make a call, you send in a brochure, it doesn't matter, 'There're these *properties* I'd like for you to see.' What does it mean? What you *want* it to mean." Pause. "Money?" Pause. "If that's what it signifies to you. Security?" Pause. "Comfort?" Pause. "All it is is THINGS THAT HAPPEN TO YOU." Pause. "That's all it is. How are they different?" Pause. "Some poor newly married guy gets run down by a cab. Some *busboy* wins the lottery." Pause. "All it is, it's a carnival. What's special . . . what *draws* us?" Pause. "We're all different." Pause. "We're not the same." Pause. "We are not the same."

This is in another sphere from the rote cons of the lesser practitioners, whose repertory consists mainly of posing as big-wheel operators from out of town with a once-in-a-lifetime opportunity for lucky you if you will sign up this very minute. Does Roma believe what he is saying? Does he even understand it? Is he any more in control of his words than a poet in the throes of inspiration? What wonder that the impressionable Lingk, whom Roma spots as the sort of fellow who probably reads romantic verse in the bathroom, should feel guilty when his wife forces him to back out. It's the act of a craven philistine. He has failed Roma by allowing mundane good sense to spoil the poetry of the deal.

Compared to the staccato rhythms and zigzag logic of Ricky Roma, the speeches of Willy Loman, the most famous salesman of stage and screen, tend to be high-flown and earthbound. Loman is no doubt the more realistic figure, more like Levene, who can be

persuasive, up to a point. But if it's a memorable con you're after, the obsessed Roma is the man. When Loman is rejected, he grows depressed and desperate. When Roma is rejected, he flies higher.

Here he is tapping into the worries of the apologetic Lingk, who is under, absolute orders from his wife to cancel the deal: "*Forget* the deal, Jimmy." Pause. "*Forget* the deal . . . you know me. The deal's *dead*. Am I talking about the *deal*? That's *over*. Please. Let's talk about *you*. Come on. come on." Pause "Come on, Jim." Pause. "I want to *tell* you something. Your life is your own. You have a contract with your wife. You have certain things you do *jointly*, you have a *bond* there . . . and there are *other* things. Those things are yours. You needn't feel *ashamed*, you needn't feel that you're being *untrue* . . . or that she would abandon you if she knew. This is *your* life." Pause. "Yes. Now I want to *talk* to you because you're obviously upset and that *concerns* me. Now let's go. Right now."

This is not just hype; it is rich in the insight of instinct. Quite possibly Roma even believes he is offering therapy to the needy. Lingk recites words of resistance, but beneath them is a craving to play, and Roma caresses that craving. The Roma-Mamet italics get at you. Listen to this man long enough and you'll wind up with a few acres of Florida swamp.

By the special standards of "Glengarry Glen Ross," Ricky Roma is the hero. There's no competition. Compare him to Williamson, the office manager (played by Kevin Spacey), the closest thing in the play to a normal businessman and the least likable character in a not particularly likable sample. Williamson, who was never a salesman and may have gotten his job because he was somebody's cousin, has no language at all. A big sentence for him is "My job is to marshal those leads." No language, no imagination, no sense of mission, no character. Can Mamet be saying that America's Romas and Levenes talk a zestier English than those to the language born, hence are better people?

■

Williamson is no mensch. He is so maladroit that he messes up a smooth and funny spur-of-the-moment vaudeville skit that Roma and Levene improvise to keep Lingk from doing what good sense demands. Yet Williamson is tough and shrewd and vengeful enough to endure. That is on Roma's mind when he ruminates to Levene, also known as The Machine, "It's not a world of men, Machine . . . it's a world of clock watchers, bureaucrats, office-holders . . ." In their grubby little office, as in classier precincts, the system weighs upon the creative individual.

Since there are no strictly honest characters in "Glengarry Glen Ross," the work's message, if it has one, has nothing to do with whether honesty pays in business. If you like, the message can be that business itself, anyhow the real-estate game, makes honesty impossible, that property, as Proudhon proclaimed, is theft. But the more forceful and original message lies in the language, in

the esthetics of salesmanship, the adventure of inspiration, the poetry of the good con and the wayward genius of the artist. □

1992 O 4, II:24:3

La Sentinelle

Directed by Arnaud Desplechin; screenplay by Mr. Desplechin with Emmanuel Salinger, Noémie Lvovsky and Pascale Ferran (in French with English subtitles); director of photography, Caroline Qampetier; edited by François Gedigier; music by Marc Oliver Sommer; produced by Mr. Desplechin. At Alice Tully Hall, as part of the 30th New York Film Festival. Running time 144 minutes. This film has no rating.

Mathias	Emmanuel Salinger
Jean-Jacques	Thibault de Montalembert
Bleicher	Jean-Louis Richard
Nathalie	Valérie Dreville
Marie	Marianne Denicourt
Varins	Jean-Luc Boutté
William	Bruno Todeschini
Macaigne	Philippe Duclos
Pamiat, the Russian	Laszlo Szabo
Claude	Emmanuelle Devor

BY STEPHEN HOLDEN

Anyone who believes that Americans have a monopoly on conspiracy theories should see the French director Arnaud Desplechin's intricately constructed film, "La Sentinelle." In the movie, which might be described as a medical thriller, a brain that turns out to be symbolic of cold-war mentality is meticulously dissected and analyzed on a laboratory table by a student of forensic medicine.

Without giving away too much, it should suffice to say that among other revelations about the recently ended cold war is the suggestion that it was a cloak-and-dagger game played with boyish relish by participants on both sides of the Iron Curtain. That idea is hinted at in an early scene in which a lecturer describes the meeting at which Churchill and Stalin sat down together and in a matter of minutes blithely carved up eastern Europe.

"La Sentinelle," which the New York Film Festival is presenting tonight at 6 P.M. and tomorrow at 9 P.M. at Alice Tully Hall, follows the present day travails, both scientific and romantic, of Mathias Barillet (Emmanuel Salinger), a glum young student who moves from Germany to France to attend medical school. In the film's opening scene, Mathias, who is about to leave for Paris, pays a farewell visit to the grave of his father, who was once a border sentinel in Aachen, Germany.

●

Aboard the train, he and his friend Jean-Jacques (Thibault de Montalembert), an employee of the French Foreign Office, are visited by customs officials. Although Jean-Jacques passes the inspection, Mathias finds himself taken at gunpoint to the customs car where he is grilled by a sinister double-agent type named Bleicher (Jean-Louis Richard). But after a search of his luggage reveals nothing unusual, Mathias is allowed to continue.

In his Paris hotel, however, Mathias finds a strange parcel in one of his suitcases. Opening it up, he discovers the shrunken head of a middle-aged man. Deeply shaken, he decides to keep his discovery a secret, and over the following weeks he begins surreptitiously testing samples of the head in his medical school laboratory. His quest for information quickly mounts into an obsession. He discovers that the head has Russian dental work but

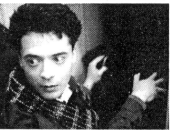

Film Society of Lincoln Center

Emmanuel Salinger in a scene from "La Sentinelle."

was shrunk by a technique commonly used by Indians in Sumatra.

The director, who also co-wrote the screenplay, extends the cold-war analogies of people divided by nationality, religion and sex to Mathias's touchy interpersonal relationships. Mathias decides to share an apartment with William (Bruno Todeschini) a colleague of Jean-Jacques's who is sleeping with Jean-Jacques's girlfriend Nathalie (Valérie Dreville). William is so insistent on guarding his own space in the apartment that the door between their bedrooms almost becomes a kind of checkpoint.

Also on hand is Mathias's sister Marie (Marianne Denicourt), a singer with a small opera company run by Jean-Jacques's boss Varins (Jean-Luc Boutté). An elegant and mysterious figure, Varins has the power to decide if the company will visit Russia.

●

The relations among everyone in the circle, in which Mathias finds himself an outsider, are edgy. As Mathias goes about his life, his dealings with people have a quality of strained diplomatic negotiations.

Although the thriller aspect "La Sentinelle" doesn't quite add up, the film is still an absorbing, psychologically resonant portrait of French student life. As directed by Mr. Desplechin, the attractive young cast hardly seems to be acting. Mr. Salinger's Mathias portrayal is a wonderfully subtle depiction of a man divided by his desire to be in a group and his deeper loner's instincts. Among the film's most delightful moments are scenes of the opera company at work and play. The laboratory scenes, though graphic, don't rub the audience's faces too insistently in clinical detail.

"La Sentinelle" is both an epitaph for the cold war and a reflection of it. It also wonders seriously about the psychological ramifications of a united Europe.

1992 O 5, C14:3

Avant-Garde Visions

SIDE/WALK/SHUTTLE, directed by Ernie Gehr. These films are at Alice Tully Hall, as part of the 30th New York Film Festival. Running time: 40 minutes. This film has no rating.

JOHN FIVE, directed by James Herbert, with John Cory, Noah Ray and Poppy Z. Brite. Running time: 25 minutes. This film has no rating.

SHORT FUSE, directed by Warren Sonbert. Running time: 37 minutes. This film has no rating.

By STEPHEN HOLDEN

Although their styles and moods are dissimilar, all three films in the New York Film Festival's program

"Avant-Garde Visions," at 9 tonight at Alice Tully Hall, exalt the physical world in ways that delight the eye.

Ernie Gehr's "Side/Walk/Shuttle," the most abstract and pictorially intriguing of the three films, depicts San Francisco as a semi-abstract cityscape viewed from upside down, sideways and overhead, with a soundtrack that fades in and out. His 40-minute film interweaves conventional views of the city with long sustained shots from carefully arranged perspectives in which the constantly moving camera slides slowly down the sides of buildings against whose facades the streets below form shifting abstract patterns.

The visual effects, which are analogous to the imagined sense of movement one gets when looking into the windows of a moving train through the windows of a stationary one, are delightfully disorienting. In some scenes, cars seem to crawl backward along the sides of a high-rise. In others, an apartment tower slowly plunges head first into the bay, which can easily be confused with the sky. Many of the shifting tableaux have an exquisite sense of design.

The soundtrack is a sequence of aural takes on the city that give the pictures a moody undertone. The sounds range from undifferentiated crowd noises to the hubbub of a take-out food counter, to the song a solitary worker sings to himself.

•

James Herbert's "John Five" celebrates the naked body as fixedly as "Side/Walk/Shuttle" contemplates urban geometry. This film maker's search for classical beauty concentrates on the naked body of John Cory, an androgynously handsome

Playing havoc with the usual notions of reality.

young man who is shown posing and frisking about with another young man and with a woman.

Alternating between color and black and white, the film moves in sensuous fits and starts, freezing for a split second on favorite moments, then continuing what has the feel of a passionate erotic dance between the film maker and his subject.

In the black-and-white sequences, Mr. Herbert explores the ability of film to be as texturally rich as the most carefully prepared and printed still photographs. Many of the color sequences aspire to the coloristic depth and chiaroscuro of paintings, with the subjects assuming positions that suggest classical poses in paintings by Caravaggio and Ingres, among others, but without actually imitating them.

In its sexual attitudes, the film rhapsodizes a playful polymorphous sensuality.

•

If Warren Sonbert's "Short Fuse," superficially seems like the happiest film of the three, an undercurrent of rage seeps through the cracks of its ebullient surface. Like Mr. Sonbert's earlier films, "Short Fuse" at first seems to be a random selection of film clips celebrating the diversity and liveliness of a world in which almost everybody is hard at play. Surfers, a basketball game, parades, hang-gliders, amusement park rides, Las Vegas casinos and all kinds of fun

are shown. A wonderfully diverse soundtrack includes the opening movement of Prokofiev's First Piano Concerto, the Platters' version of "Ebb Tide," Richard Rodgers's "Victory at Sea" music, Glenn Miller's "There'll Be Bluebirds Over the White Cliffs of Dover" and Laura Branigan's disco hit "Gloria."

But not all is frolic and joy. There are vintage film clips of air and sea battles from World War II. And idyllic shots of male couples are countered with shots of violent demonstrations in San Francisco against the police by the AIDS protest group Act Up.

If the film expresses its political rage almost subliminally, the point is not lost. In contrasting the winning of World War II with the fight against AIDS, it asks why the same extraordinary teamwork isn't being used in the war that hasn't been won.

1992 O 5, C14:4

Les Amants du Pont Neuf

Written and directed by Léos Carax, (in French with English subtitles); director of photography, Jean-Yves Escoffier; edited by Nelly Quettier; produced by Christian Fechner. At Alice Tully Hall, as part of the 30th New York Film Festival. Running time: 125 minutes. This film has no rating.

Michèle	Juliette Binoche
Alex	Denis Lavant
Hans	Klaus-Michael Grüber

By VINCENT CANBY

Alex (Denis Lavant) is a sad young wino and vagrant with the kind of lopsided, expressionless face that suggests he might be simple-minded. He lives on the Pont Neuf, the oldest and most beautiful bridge in Paris, which has become a secret home to clochards, or bums, while closed for extensive repairs. From time to time he wanders out into the world of the committed to make a few francs by giving sidewalk fire-eating shows.

Michèle (Juliette Binoche), who is going blind, is a street artist and, like Alex, determinedly homeless. One day she makes her way to the Pont Neuf and settles in with her bags, boxes and portfolio of sketches. Hans (Klaus-Michael Grüber), the elderly, self-appointed guardian of the bridge's clochards, resents Michèle's intrusion. Alex falls hopelessly in love with her.

The story of their affair, "Les Amants du Pont Neuf" ("Lovers of the Pont Neuf"), written and directed by Léos Carax, must be one of the most extravagant and delirious follies perpetrated on French soil since Marie-Antoinette played the milkmaid at the Petit Trianon. Never has so much money been spent so heedlessly at the whim of so few.

"Les Amants du Pont Neuf" will be shown at the New York Film Festival today at 6 P.M. and tomorrow at 9:30 P.M.

•

For pure cockeyed romanticism, you have to go back to Jacques Demy's "Umbrellas of Cherbourg" to match Mr. Carax's film. Yet its romance, which is actually a sentimental mélange of realism and surrealism, is no match for the film's architecture. "Les Amants du Pont Neuf" is not a musical, but if it were, it would be the kind you would leave, as

Abel Green of Variety once said, humming the sets.

To make this huge plywood cream puff of a movie, Mr. Carax and Michel Vandestien, his art director, rebuilt a sizable portion of the city outside Paris. In the middle of farmland they constructed the Pont Neuf, the familiar facades along the 14th-century quays on the Left Bank, the Samaritaine department store on the Right Bank, and that portion of the Île de la Cité, in the middle of the Seine, where the bridge crosses the island to set off the Square of the Vert Gallant, the garden at the island's western tip dominated by the equestrian statue of Henri IV.

As achievements in art direction go, this faux Paris outranks the ancient Rome built for "The Fall of the Roman Empire," the Moscow for "Doctor Zhivago," the Atlanta for "Gone With the Wind" and all of the planet Mars for "Total Recall." Though it doesn't look quite real, being rather emptier than is the real Paris in summer, it looks real enough to match occasional shots of the original, and it perfectly suits the film's elaborately stylized fancies.

It also allows Mr. Carax to stage a dazzling sound-and-light show that is pretty much the climax of the film, if a long time before the film finds its fey way to the end.

•

The occasion is the grand finale of the celebrations marking the bicentennial of the fall of the Bastille. As magnificent skyrockets explode over Paris, Alex and Michèle dance in wine-soaked ecstasy on the bridge and then climb onto the rump of Henry IV's great bronze horse to fire a pistol into the air. Later Alex is at the wheel of a stolen speedboat while Michèle water-skis behind, amid a waterfall-like cascade of silvery sparklers on either side of the Seine. Such coups de cinéma justify themselves.

This is just as well, since the tale at the center of the film is not easy to stomach unless you have a high tolerance for whimsy. Poor Michèle, who has run away from an upper-middle-class home because of her impending blindness, finds a few weeks of escape in the company of the adoring Alex. They make some money by scamming unsuspecting men sitting alone at sidewalk cafes, which allows them to have a brief holiday at the seashore.

Life intervenes in a manner too arch to mention. Michèle goes back to her home in St. Cloud. Alex gets into a scrape with the law. Years pass. More should not be revealed, except that at the end the film introduces a fine old Seine barge that suggests the one in Jean Vigo's romantic classic "L'Atalante."

"Les Amants du Pont Neuf" always stands a little apart from the innocence it pretends to be extolling. Yet that distance doesn't make it seem any less absurd, or anything more than a movie inspired primarily by other movies. Except for the very real triumph of the artifice of its principal set, "Les Amants du Pont Neuf" is more exhausting than entertaining.

1992 O 6, C16:1

Feed

Directed and produced by Kevin Rafferty and James Ridgeway; edited by Sarah Durham and Mr. Rafferty; released by Original Cinema. At Film Forum 1, 209 West Houston Street, South Village. Running time: 76 minutes. This film has no rating.

By JANET MASLIN

"Feed," a compendium of candid glimpses at this year's Presidential candidates, is as cruel a film as you may ever see. The contenders are caught unawares, some during seemingly private moments just before their televised satellite feeds are scheduled to begin. This is the time for throat-clearing, for smile-practicing, for working on the handclasps or upbeat gazes or other reassuring touches that make up a public demeanor. "Feed" observes these studied politicians both before and after they become their familiar selves.

The result is a revealing look at these specific candidates and the political process itself, at least as it manifests itself on television. This film, like C-Span's "Road to the White House" series, presents the Andy Warhol version of campaign posturing. Some minor but fascinating aspect of a candidate's nature is inevitably exposed when that candidate is shown glad-handing strangers or struggling to understand the quirks of high-tech equipment that doesn't work (Senator Bob Kerrey trying to answer questions posed by an interviewer he cannot hear). Jerry Brown, viewers of "Feed" learn, is a guy who can pick a fight over whether his necktie looks straight.

This film's spy tactics are at their most merciless in using the warm-up material that precedes live broadcasts. President Bush is seen sitting looking vacant for a very long time; Gov. Bill Clinton coughs badly and curses himself for getting teary-eyed; Ross Perot tells what he thinks is a corker of a racy story. Anyone, it might be argued, could be made to look foolish in such a context, and the glimpses seen here appear deliberately unkind. They are riveting in spite of that, and so are the film's campaign sequences, which are fairer since most of them take place in public. One quality worth studying is how a candidate responds to endless petty ambushes along the campaign trail.

"Feed," which opens today at Film Forum, exposes reactions that range from testiness to good humor. Bill Clinton runs the full gamut of those responses when he is cornered by a man who grills him on his abortion-rights stand in highly personal terms, asking, "How many abortions have you caused yourself?" Mr. Clinton, only momentarily taken aback, stares his questioner in the eye and answers: "None. Zee-ro." At this, his antagonist laughs and promises to vote for Mr. Clinton because he is a good sport.

Skill in parrying hostile questioners is most apparent when the candidates are seen at close range with inquisitive strangers, as they often are here. Paul Tsongas, who remains good-humored and self-possessed each time he is seen, must field a hostile questioner who wonders if the candidate knows the price of a gallon of milk. At this, the candidate compliments his antagonist for having asked a good question and gives a low estimate, at which the man in the audience wants to know where the Senator does his shopping. Mr. Tsongas' quick reflexes are even better demonstrated by

the stir created when Sam Donaldson of ABC shows up in the small auditorium where the candidate is being grilled by voters. "Just remember one thing," he tells this small, star-struck crowd. "I came to see you. He came to see *me*."

•

"Feed," which was directed by Kevin Rafferty (the co-director of "Atomic Cafe") and James Ridgeway (the Washington correspondent for The Village Voice), not only looks closely at the candidates but also captures certain peculiarities of television-minded campaigning. Pat Buchanan's supporters, waving placards for the camera, have the same avid intensity ascribed to the candidate's fans in the film "Bob Roberts." A bewildered Jerry Brown is seen trying to talk about the global village to a roomful of college students who have never heard of Marshall McLuhan. (The only time Mr. Brown really lights up is when being told by a reporter about a book filled with quotable political anecdotes. "It would take you from here to California," the reporter tells a very interested Mr. Brown.)

Reporters themselves are sometimes caught in the camera's unflinching eye. In the film's most telling effort to account for why television-style politicking can be so empty, two journalists are caught unawares during a video feed. They are heard bad-mouthing various candidates and discussing a speech that one of them thinks had major news value. "Well, we probably had Louie cover it," the other reporter says with an indifference that will no doubt give way to keen on-the-air enthusiasm once they know the camera is working.

1992 O 7, C15:1

Careful

Directed, edited and photographed by Guy Maddin; screenplay by George Toles and Mr. Maddin, based on a story by Mr. Toles; music by John McCulloch; produced by Greg Klymkiw and Tracy Traeger. At Alice Tully Hall, as part of the 30th New York Film Festival. Running time: 100 minutes. This film has no rating.

Grigorss	Kyle McCulloch
Zenaida	Gosia Dobrowolska
Klara	Sarah Neville
Johann	Brent Neale
Count Knotgers	Paul Cox
Herr Trotta	Victor Cowie
Blind Ghost	Michael O'Sullivan
Franz	Vince Rimmer
Sigleinde	Katya Gardner
Frau Teacher	Jackie Burroughs

By STEPHEN HOLDEN

"Children, heed the warnings of your parents: peril awaits the incautious wayfarer and strews grief where laughter once played!" intones a narrator in the prologue of Guy Maddin's amusing film "Careful."

That pompous voice belongs to Herr Trotta (Victor Cowie), a scientific expert on the cause-and-effect relation between sound and avalanches. It's a subject the character ought to know well. For like everyone else in "Careful," he lives in Tolzbad, an Alpine community of apple-cheeked villagers whose scrubbed faces belie a Freudian wasp's nest of incestuous desire and sibling rivalry. Life in Tolzbad is so precarious, that even the cries of wild geese could unleash a snowy apocalypse.

"Careful" is the third full-length movie by Mr. Maddin, an eccentric Canadian film maker who achieved cult status with his two earlier films, "Archangel" and "Tales From the Gimli Hospital." Both were tongue-in-cheek spoofs of early talkies that caught the look and sound of a bygone era while telling virtually impenetrable stories. Although "Careful," showing at the New York Film Festival at Alice Tully Hall at 6:45 tonight and at 9 P.M. on Sunday, shares some of those films' obsessions, it is by far Mr. Maddin's most polished and coherent work.

From its portentous between-scenes titles to the way the director bathes whole scenes in garish oranges and blues, "Careful" is one long and amusing pun on German Expressionistic film imagery, Freudian psychology and quasi-Wagnerian storytelling, all carried to absurdist lengths. The plot concentrates on a star-crossed family of four. Zenaida (Gosia Dobrowolska), the beautiful widow of an oafish swan feeder, tends a home she shares with her three sons, Johann (Brent Neale), Grigorss (Kyle McCulloch) and Franz (Vince Rimmer).

While Johann and Grigorss are model sons who attend the same training school for butlers, Franz, who reminds Zenaida of her hated dead husband, is kept prisoner in the attic. Now and then, her husband's blind ghost (Michael O'Sullivan) appears to urge Franz to take action.

The family's orderly little world begins to crumble when Johann, who has just become engaged to Klara (Sarah Neville), one of Herr Trotta's two daughters, has an incestuous dream about his mother. Suddenly mad with forbidden passion, he drugs his mother, slits open her bodice and places his lips on her breast. Then in a paroxysm of guilt, he sears his mouth with hot coals, cuts off several fingers and leaps off a precipice.

•

That's just the beginning of the sexual Sturm und Drang that rises in the characters like an avalanche from within. The screenplay by Mr. Maddin and George Toles, who thought up the story, is filled with stilted speeches about duty, honor, virtue, shame and toilet training. Proclamations of love are written in bright purple. "Your eyes are so blue," Johann declares to his fiancée. "You're as fresh and sound as a rose." This all builds to a ludicrous snow-filled Liebestod that rings with stilted oratory.

The movie's biggest strength is its knowing burlesques of antiquated cinematic techniques. Although "Careful" hardly tries to look exactly like an old movie, it uses the visual textures and rhythms of old-time movie making to caricature a particular cultural mindset.

The film's biggest weakness is its acting. Most of the players, including Mr. McCulloch, the director's regular leading man, go about their chores with an amateurish enthusiasm that gives the movie a homemade quality. If the central performances in "Careful" approached the earnest intensity of some of its early-1930's inspirations, the movie would probably be twice as funny.

1992 O 7, C20:3

Zebrahead

Written and directed by Anthony Drazan; director of photography, Maryse Alberti; edited by Elizabeth Kling; music by Taj Mahal; production designer, Naomi Shohan; produced by Jeff Dowd, Charles Mitchell and William F. Willett; released by Sony Pictures Entertainment/Triumph Releasing Corporation. At Alice Tully Hall, as part of the 30th New York Film Festival. Running time: 100 minutes. This film is rated R.

Zach	Michael Rapaport
Nikki	N'Bushe Wright
Dee	DeShonn Castle
Nut	Ron Johnson
Richard	Ray Sharkey
Saul	Martin Priest
Otis	Paul Butler
Marlene	Candy Ann Brown
Diane	Helen Shaver
Dominic	Kevin Corrigan
Dominic's Mother	Lois Bendler
Mr. Cimino	Dan Ziskie
Mrs. Wilson	Marsha Florence
Michelle	Shula Van Buren
Angel	Bobby Joe Travis
Al	Abdul Hassan Sharif

By JANET MASLIN

By an accident of fate, Zach (Michael Rapaport) happens to be white. But everything about Zach's interests and attitudes ties him to black culture, from the way he talks and walks to the friends he has made at a Detroit high school. Zach takes for granted the right to will himself part of a cultural tradition other than his own.

At the beginning of "Zebrahead," Zach is seen taking racial harmony very much for granted. He is best friends with a black classmate named Dee (DeShonn Castle) and on close terms with Dee's family. Quiet but forceful, he conducts himself with a loner's intensity that transcends racial stereotypes. The film, written and directed by Anthony Drazan, shows what happens when Zach falls in love with a beautiful black girl named Nikki (N'Bushe Wright), who is new to his high school. Once this happens, he quickly finds out whether his friends' and relatives' open-mindedness matches his own.

The answer will not come as a surprise. Neither does much else about "Zebrahead," despite the superficial boldness with which the film attacks its subject. Though Zach comes from a long line of hipsters who run a music store, for instance — there is a lot of talk among the film's white characters about their love of black music — his scenes with his father (Ray Sharkey) and grandfather (Martin Priest) are remarkably conventional at their core. When Zach asks about the meaning of love, his father, a preening roué who boasts to his son about his sexual conquests, actually answers: "Love? That's a horse of a different color."

•

Too many of the film's principals wind up talking and acting as if they carried placards. ("He's a good kid, but he's white," says a relative of Dee and Nikki, who happen to be cousins. "And she's black, and this is America," says another.) So the real strength of "Zebrahead" ought to be its slice-of-life view of the community in which the story takes place. The film is at its best in observing the friends and classmates who complain about Zach and Nikki's romance, but its high school atmosphere still seems peculiarly staid. The volatile atmosphere described in the screenplay is not matched by Mr. Drazan's straightforward direction.

"Zebrahead" returns several times to the sight of a backyard so oil-or gasoline-soaked that it can be made to burst into flame. Yet there is nothing particularly fiery about either the image or the way Mr. Drazan uses it, since his film is otherwise so literal and plain. The cinematography by Maryse Alberti is similarly placid, good enough on its own terms but not much use in raising the film's energy level. Soundtrack music by Taj Mahal is effective but noticeably underused.

•

In the absence of the usual teen-movie pyrotechnics, "Zebrahead" has a quiet, stagy style, more like a 1950's teleplay with a social conscience than a stormy present-day tale of racial strife. Its major sources of energy are the actors themselves, most of whom rise above the film's otherwise calm mood. Mr. Rapaport gives a terse, peculiar performance that becomes quite compelling, though casting makes him more a fish out of water than he needs to be. (It's impossible to believe that Mr. Sharkey's swaggering Richard is father to the tough, withdrawn Zach.) Ms. Wright, in a warm and natural performance, ably conveys Nikki's confusion about her interracial romance.

The film's assortment of school-yard staples includes Ron Johnson as Nut, the tough guy who resents Zach's overtures to a woman Nut also admires; Bobby Joe Travis as a silent, worried crackhead; and Abdul Hassan Sharif as a more militant classmate whose objections to Zach are on ideological grounds. "Zebrahead" is also convincing in its depiction of the black principals' families, who are dismayed not only by Zach's presence but by their discovery of their own prejudices.

"Zebrahead," which can be seen at 9:45 tonight and at 12:30 P.M. Saturday in the New York Film Festival (and opens commercially on Oct. 23), is an uneasy blend of hot-blooded subject and antiseptic style. Only late in the story, when the inevitable violence has erupted, does the film achieve a fleeting touch of tragic grace.

•

"Zebrahead" is rated R (Under 17 requires accompanying parent or adult guardian). It includes profanity and sexual situations.

1992 O 8, C17:5

Idiot

Directed by Mani Kaul; screenplay by Anrup Singh, based on the novel "The Idiot" by Fyodor Dostoyevsky (in Hindi with English subtitles); director of photography, Piyush Shah; edited by Lalitha Krishna; music by D. Wood and Vikram Joglekar. At Alice Tully Hall, as part of the 30th New York Film Festival. Running time: 165 minutes. This film has no rating.

Prince Miskin	Ayub Khan Din
Pavan Raghujan	Shah Rukh Khan
Nastassya Mukhopadhyaya	Mita Vashisth
Amba Mehta	Navjot Hansra
Mathew	Vasudeo Bhatt
Ganesh	Deepak Mahan
Colonel	Babulal Bora
Leelavati Mehta	Meenakshi Goswami
Mr. Mehta	Zul Vellani
Shapit	Amritlal Thulai

By STEPHEN HOLDEN

The Indian director Mani Kaul is no stranger to the New York Film Festival, which is showing his nearly three-hour adaptation of Dostoyevsky's novel "The Idiot" at 6 tonight at

Alice Tully Hall. Two years ago the festival presented "Siddheshwari," his biography of an Indian singer as part of its "Avant-Garde Visions" program. And in 1983, it showed "Dhrupad," his documentary about a form of Indian classical music. Both films were praised for their production skills.

"Idiot" should not win Mr. Kaul any new admirers. A low-budget production that was apparently made for television, it turns a literary masterpiece into a numbing soap opera as incoherent as it is technically crude. Although the setting has been moved from 19th-century St. Petersburg to contemporary Bombay, Anup Singh, who wrote the screenplay, has neglected to give the story a modern Indian cultural or political context. As a result, references from the book to such things as a liberal movement that could destroy the country are simply mystifying.

Mr. Singh's adaptation desperately tries to cram as much of the novel's plot as it can into the film's interminable 165 minutes. Even so, substantial chunks of the story have been omitted, so what happens on the screen often makes no sense at all.

As Prince Miskin, the novel's central character, Ayub Khan Din wanders through the film like a fleshy wooden soldier with a pained, beseeching look on his face. Sauntering in and out of the camera's range, often looking as though they were pushed from behind, the mediocre cast delivers the dialogue, some of which has been lifted straight from the novel, as just so much irritable prattle. In all the deadening talk, the author's ideas get left by the wayside.

1992 O 8, C21:4

A River Runs Through It

Directed by Robert Redford; screenplay by Richard Friedenberg, based on the story by Norman Maclean; director of photography, Philippe Rousselot; edited by Lynzee Klingman and Robert Estrin; music by Mark Isham; production designer, Jon Hutman; produced by Mr. Redford, Patrick Markey, Annick Smith, William Kittredge and Barbara Maltby; released by Columbia Pictures. Running time: 123 minutes. This film is rated PG.

Norman Maclean.................Craig Sheffer
Paul Maclean..........................Brad Pitt
Mr. Maclean.....................Tom Skerritt
Mrs. Maclean................Brenda Blethyn
Jessie Burns.......................Emily Lloyd
Rawhide...........................Susan Traylor

By JANET MASLIN

"**I**T is those we live with and love and should know who elude us," Norman Maclean's father tells him in "A River Runs Through It," a mesmerizing family memoir fueled by sense of place, force of memory and love of nature. On the page and now on the screen, this tale of the author's youth in Montana is told obliquely, attempting to fathom a stern father and a reckless younger brother by capturing the vigorous masculine rituals they shared.

These are men for whom the physical is inseparably entwined with the spiritual, men for whom both aspects of life are best appreciated knee-deep in a rushing river on a glorious day. Fly-fishing became Mr. Maclean's

Joel Snyder

Brad Pitt

way of expressing all that was unspoken and mysterious about the people he loved best. It also worked on the page in a manner not easily transposed to another medium. Between the novella's well-known first sentence ("In our family, there was no clear line between religion and fly-fishing") and its elegiac last line ("I am haunted by waters"), "A River Runs Through It" circled gracefully among the landmarks of Mr. Maclean's early years without violating the distant perfection of those memories.

It's easy to recognize Robert Redford's reverent film version of this beautifully spare novella as a labor of love. While the film is more lavish than Mr. Maclean's story, and hence less commandingly precise, it radiates much the same seriousness of purpose. The same thoughts embraced by Mr. Maclean — of family and history, of the unbridgeable distances between men, of a wild natural landscape as a pathway to spiritual grace — are ably reflected on the screen.

What is different is the way those ideas are woven together. Mr. Redford's film is more a homage to its source material than a work of comparable emotion or breadth. Mr. Maclean's idiosyncratic storytelling followed no linear pattern, but the film (with a screenplay by Richard Friedenberg) has rearranged scenes in chronological order and thus lost some magic right away.

The events the author described in "A River Runs Through It" do not build upon one another in a conventionally dramatic manner. Instead they reconstruct remembered people and places with the gradualness of a jigsaw puzzle being assembled one piece at a time. The sense of slow discovery in this creates its own brand of suspense, but on the screen it has been replaced by a loose series of handsome tableaux and a diminished urgency.

As directed by Mr. Redford and ravishingly photographed by Philippe Rousselot, "A River Runs Through It" has both prettiness and a distinctly masculine outlook. The two brothers on whom the film centers, quiet and scholarly Norman Maclean (Craig Sheffer) and the wilder, more magnetic Paul (Brad Pitt), have a fistfight in their kitchen early in this story and accidentally knock their mother down. The story's attention to male bonding is such that the two

boys remain frozen, glaring at each other, with neither one bothering to help their timid mother (Brenda Blethyn) off the floor.

In this atmosphere, manly toughness has an element of the taciturn, at least in the household presided over by the Maclean boys' father, a stern Presbyterian minister (Tom Skerritt). Unless he joins his sons in the fly-fishing rituals that bring them closer together, he has painfully little to say. Teaching writing to his boys early in the story, the pastor's only advice — applied repeatedly to the same writing efforts — is "half as long." Mr. Redford's film, which moves at a stately pace and runs more than two hours, would itself have benefited from following that suggestion to some degree.

"It was a world with dew still on it, more touched by wonder and possibility than any I have since known," says Mr. Redford, who gives the film a strong narrator's voice as he recites stirring passages from the novella. At its simple and intermittent best, this film truly captures the feeling thus described. When the action goes indoors and gives way to overcostumed extras and genteel small talk, that sense of wonder is quickly lost, but the outdoor scenes retain their purity. It is never hard to understand what Mr. Redford means his film to celebrate.

As a director of actors, Mr. Redford leaves an uncanny imprint. His own acting style is evident not only in the halting, thoughtful manner of Mr. Skerritt (whose role would have suited the director beautifully), but also in Mr. Pitt's irresistible star turn. With his hair dyed blond, Mr. Pitt sports an easy, confident grin that masks a quiet reticence, and he makes himself so like the young Robert Redford that the effect is astonishing. The performance strikes a cleverly familiar chord without being derivative. Mr. Pitt has star quality of his own.

Much of the other acting in the film is sturdy and dutiful at best. Mr. Sheffer cannot do much with a Norman Maclean who becomes more passive than he was on the page. The women in the film are unfortunately silly, either as maternal caricatures or as the dumpling ingénue played by Emily Lloyd (in a performance that recalls Elizabeth McGovern's in Mr. Redford's "Ordinary People"). Miss Lloyd's Jessie was Norman's seldom-seen wife in the novella, but the film has made her his sweetheart and invented a tedious string of courtship scenes that slow the action. Among the actresses, only Susan Traylor, as a surly barfly, has some lively moments.

The tragedy that ends "A River Runs Through It" is meant to seem born out of recklessness, but this decorous film never develops a reckless streak. To convey the requisite danger, Mr. Redford falls back on so much foreshadowing that even the fish must sense trouble. On the page, this story ends abruptly with an incident of violence and a transcendent acknowledgment of affirmation and loss. On film, "A River Runs Through It" remains eye-catching and contemplative without reaching that higher plane.

•

"A River Runs Through It" is rated PG (Parental guidance suggested). It includes mild profanity, brief nudity and implicit violence.

1992 O 9, C1:3

Johnny Stecchino

Directed by Roberto Benigni; screenplay by Mr. Benigni and Vincenzo Cerami (in Italian with English subtitles); director of photography, Giuseppe Lanci; edited by Nino Baragli; music by Evan Lurie; produced by Mario and Vittorio Cecchi Gori; released by New Line Cinema. At 68th Street Playhouse, at Third Avenue, Upper East Side. Running time: 100 minutes. This film is rated R.

Dante/Johnny.....................Roberto Benigni
Maria.............................Nicoletta Braschi
D'Agata..............................Paolo Bonacelli
Cozzamara....................Ignazio Pappalardo

By VINCENT CANBY

Roberto Benigni, one of Italy's most popular comic actors, has been creeping up on American audiences with a certain amount of self-effacing stealth. He was first seen here as the bewildered tourist who finds true love in the Louisiana bayous in Jim Jarmusch's "Down by Law," then as the gabby, hilariously unobservant Roman cab driver in Mr. Jarmusch's "Night on Earth."

With the opening of "Johnny Stecchino" (Johnny Toothpick) today at the 68th Street Playhouse, Mr. Benigni reveals himself to Americans as the triple-threat phenomenon for which he is so beloved on his home grounds. He's all over the place in "Johnny Stecchino," an engagingly loose, very Italian comedy, which he wrote (with Vincenzo Cerami) and directed, and in which he stars in a dual role. If the film seems somewhat less breathless in New York than it does in Rome, it may be because reading English subtitles keeps interrupting the mad flow of sound and image.

In "Johnny Stecchino," Mr. Benigni plays Dante, a woefully innocent if duplicitous Roman who drives a school bus, and the title character, Dante's lookalike, a Sicilian mob boss who has gone into hiding after squealing on his associates. Nicoletta Braschi costars as Maria, the wife of Johnny Stecchino, who sets up the school bus driver for a mob hit, to allow her and Johnny to escape to Argentina.

New Line Cinema

Pursuit Roberto Benigni wrote, stars in and directed "Johnny Stecchino," an Italian comedy of mistaken identity about a mild-mannered bus driver targeted to be killed.

Mr. Benigni's Dante is a classic comic character. His skinny physique and mild expression give no indication of the passions that rage within. Only the bobbing of his Adam's apple hints at his feelings. He is always a gentleman. Women confide in him and then go off with someone else. Until he meets the alluring Maria, Dante has expressed himself in altogether harmless ways, like faking an insurance claim and stealing bananas with sleight-of-hand worthy of a magician.

Most of "Johnny Stecchino" is set in Palermo, where Maria has invited Dante to pursue what he fondly believes to be their great romance. The film is an anthology of comedy routines that can be worked out when the antecedents of pronouns are confused and when identities are mistaken.

Dante's troubles in Palermo begin when he becomes the unaware target of a mob assassination at just the moment he's stealing a banana from a sidewalk display. He knows that he has broken the law, but does the theft of a banana require that much gunfire? When he catches Maria's uncle snorting a line of cocaine, the old thug tells him it is powder used for the treatment of diabetes. Later that night, at a grand reception, Dante helpfully offers cocaine to Palermo's most prominent sufferer of diabetes, the local cardinal.

Mr. Benigni's Johnny is not a character to equal his Dante. Johnny goes into maudlin despair every time someone mentions his mother, but he's otherwise a fairly colorless mafioso. There is a fine moment near the end when the two men, both drawn to the kitchen by hunger in the middle of the night, briefly meet and enact the gag in which one pretends to be the mirror image of the other.

"Johnny Stecchino," reportedly one of the biggest moneymaking films in Italian box-office history, offers clowning of a broad kind that has little to do with Mr. Benigni's performances for Mr. Jarmusch. The new film is like a Bob Hope comedy from the 1940's. It's fun, energetic and easy to take. Never for a minute does it betray the immense amount of skill required to get a laugh, or even a smile, from a properly timed double take.

Miss Braschi, the benign Circe of the bayous in "Down by Law" and the beautiful, enigmatic Italian tourist in Mr. Jarmusch's "Mystery Train," is here playing Jane Russell to Mr. Benigni's Hope. Though her role is essentially a plot function, she has her own cool, very funny way of functioning.

•

"Johnny Stecchino," which has been rated R (Under 17 requires accompanying parent or adult guardian), has some vulgar language and sexual situations.

1992 O 9, C8:5

Breaking the Rules

Directed by Neal Israel; written by Paul W. Shapiro; director of photography, James Hayman; edited by Tom Walls; music by David Kitay; production designer, Donald Light-Harris; produced by Jonathan D. Krane and Kent Bateman; released by Miramax Films. Running time: 100 minutes. This film is rated PG-13.

Phil Stepler	Jason Bateman
Gene Michaels	C. Thomas Howell
Rob Konigsberg	Jonathan Silverman
Mary Klingsmith	Annie Potts
Mr. Stepler	Kent Bateman
Young Phil	Shawn Phelan
Young Gene	Jackey Vinson
Young Rob	Marty Belafsky

By STEPHEN HOLDEN

In the prologue to "Breaking the Rules," Neal Israel's tear-jerker about the reunion of three childhood pals, one of whom is dying of a rare leukemia, the film flashes back to 1982, when they were growing up in the suburbs of Cleveland. Phil, the daredevil prankster of the trio, has conceived an initiation in which he and his best friends, Gene and Rob, must take a spin in a Laundromat washing machine. Once they've completed the ritual, they dub themselves the Chosen Ones. Their theme song is a wobbly a cappella version of the Miracles' early-60's hit "You Really Got a Hold on Me."

In a movie as formulaic as "Breaking the Rules," it almost goes without saying that Phil (Jason Bateman), the trio's spark plug, is the one who is dying. A decade after the washing-machine incident, he engineers the reunion of the Chosen Ones by inviting them to a bogus engagement party. Things are tense, since Gene (C. Thomas Howell) once stole Rob's girlfriend and the two haven't spoken since. But incredibly, Phil persuades them to drop everything and join him on a cross-country jaunt to Los Angeles. Phil's one dream before dying, he says, is to be a contestant on "Jeopardy."

"Breaking the Rules" tries desperately to avoid seeming pat by making the journey a series of madcap adventures. One night, while camping outdoors, they meet a big brown bear. Later on the trip, when they are menaced by some rednecks in a roadhouse, Phil saves them with his party trick of literally breathing fire. At a skating rink, Rob, who is Jewish, succumbs to the wiles of a fundamentalist Christian who has turned her bathtub into a baptismal font. The film's quirkiest character is Mary (Annie Potts), a saintly kook and self-proclaimed artist who impulsively gives up her job as a waitress in a crummy Missouri restaurant to join the cross-country odyssey.

•

Although "Breaking the Rules" has its diverting moments, almost nothing in the film rings true. And for a road movie, it is woefully lacking in a panoramic vision of the land being crossed. Most of the time, the focus remains tightly fixed on the characters, especially Phil, who is fading fast as the journey proceeds. But for all the time spent, the audience really doesn't get to know any of them very well.

Under the circumstances, the actors do the best they can to distinguish the Chosen Ones' personalities. Mr. Bateman is appealing as brave, foolhardy Phil who tries to choke back his fears of dying. But Mr. Howell's snippy Gene and Jonathan Silverman's soulful Rob are not so focused. As a free-spirited angel, Ms. Potts has her charmingly daffy moments, but she cannot entirely unsweeten a role that in Paul W. Shapiro's screenplay emerges as chokingly saccharine.

•

"Breaking the Rules" is rated PG-13 (Parents strongly cautioned). It has some strong language and adult situations.

1992 O 9, C10:6

Under Siege

Directed by Andrew Davis; written by J. F. Lawton; director of photography, Frank Tidy; edited by Robert Ferretti; music by Gary Chang; production designer, Bill Kenney; produced by Arnon Milchan, Steven Seagal, Steven Reuther, Jack B. Bernstein and Peter MacGregor-Scott; released by Warner Brothers. Running time: 120 minutes. This film is rated R.

Casey Ryback	Steven Seagal
William Strannix	Tommy Lee Jones
Commander Krill	Gary Busey
Jordan Tate	Erika Eleniak
Captain Adams	Patrick O'Neal

By VINCENT CANBY

The intoxicating premise of "Under Siege," the new Steven Seagal action movie, is that 30 men, disguised as caterers and as the members of a rock combo, accompanied by the Playmate of July 1989 as a sort of front, could seize the great United States battleship Missouri at sea. Once firmly in charge, they stand ready to nuke Honolulu while conducting sales, via a cellular telephone, of the ship's other nuclear-tipped Tomahawk missiles to the highest bidders on three continents.

The mind reels, as well it should. Here is a movie to make "The Hunt for Red October" look as soberly conceived as "Potemkin." Yet "Under Siege," directed by Andrew Davis and written by J. F. Lawton, is just lunatic enough to keep you watching the screen while snorting in uncertain derision. The movie alternately prompts awe and out-of-control laughter, but who is sending up whom? A clue: J. F. Lawton, who wrote the screenplay, collaborated with Barry Primus on the script for the very funny "Mistress."

From the elegant opening shots of American warships at sea, you might think that the producers received a certain amount of cooperation from the United States Defense Department, but apparently they didn't. The Missouri used in the film is the battleship Alabama, decommissioned and permanently moored in Mobile Bay. The other ships are beautifully constructed models. The film looks very official.

Early on, in newsreel clips, President and Mrs. Bush appear in "Under Siege" as they attend a ceremony aboard the Missouri at Pearl Harbor, shortly before the film's Mighty Mo takes off on its final voyage home for decommissioning. It's during this trip that everything goes so danged wrong.

From Mr. Bush's brief remarks, and from all of Mr. Seagal's lordly performance, it seems clear that the two men share more than just an affection for the gallant old ship on whose decks the Japanese surrendered at the end of World War II. "Under Siege" is a movie that exalts the talents of America's covert operatives. Mr. Seagal plays a cook aboard the Missouri who is actually a one-man army, a former member of the Navy Seals. The madman in charge of the piracy (Tommy Lee Jones) is a former operative who has gone bonkers in a major way.

"Under Siege" is as seriously paranoid and as red-white-and-blue patriotic as "Rambo." Yet there would be no plot for "Under Siege" if the system that is supposed to control American operatives were not so full of holes. This may be meant as realism.

As wild as the premise is, "Under Siege" is almost guiltily enjoyable. To accept the movie, you must buy the notion that, on the pretext of giving the Missouri's captain a surprise birthday party, the ship's executive office would have a lot of caterers, musicians and a topless dancer flown out to the ship by helicopter. Once there, the interlopers get everyone drunk and then start murdering.

Mr. Seagal's cook, who looks as if he has licked too many cake pans, goes through the film slashing, chopping, shooting and maiming and, in one instance, putting a knife directly into another man's skull. The body count for which he alone is responsible seems higher than the number of low-lifes who came aboard the ship in the first place. Yet since so much of the movie is played for laughs, this could be another joke.

Mr. Jones has a lot of fun as the mad brains of the hijacking operation. Gary Busey, who appears as the treasonous executive officer, also gives a broad performance, which includes a sequence in which he wears drag. Erika Eleniak, who actually does look like a Playboy centerfold, adds a sexy note to the carnage. There's one moment so stunning that it seems almost avant-garde: Ms. Eleniak, having fallen asleep inside the cake from which she was to emerge topless, wakes up, stands up and starts singing to a wardroom that's empty except for the corpses.

•

"Under Siege," which has been rated R (Under 17 requires accompanying parent or adult guardian), has a lot of explicit violence, vulgar language and some partial nudity.

1992 O 9, C12:1

Alberto Express

Directed by Arthur Joffe; screenplay by Mr. Joffe and Jean-Louis Benoit with the collaboration of Christian Billette, based on an original story by Mr. Joffe (in French and Italian with English subtitles); director of photography, Philippe Welt; editor, Marie Castro-Brechignac; music by Angélique and Jean-Claude Nachon; produced by Maurice Bernart; released by MK2 Productions U.S.A. Running time: 90 minutes. This film has no rating.

Alberto	Sergio Castellitto
Alberto's Father	Nino Manfredi

Miramax

On the Road Annie Potts stars in "Breaking the Rules," about three friends who go on a cross-country journey before settling down.

MK2 Productions

Sergio Castellitto

Clara	Marie Trintignant
Conductor	Marco Messeri
Baroness	Jeanne Moreau
Man in Debt	Michel Aumont
Juliette	Eugenia Marruzzo
Young Alberto	Thomas Langmann
Black Man	Dennis Goldson
Waiter	Roland Amstutz
Train Engineer	Dominique Pinon
Alberto's Grandfather	Nanni Tamma

By JANET MASLIN

The first and only funny scene in "Alberto Express" finds the story's hero, at the age of 15, confronted by a father who pleasantly produces an adding machine and a mountain of bills. The father, played with comic serenity by Nino Manfredi, has kept track of every last diaper and school-book he ever had to buy for his son, and would now like Alberto to pay back a total of more than 30 million lire. He assures his son helpfully that there is no hurry. Alberto need not repay his debt until he himself is ready to have a child.

Cut to Alberto (Sergio Castellitto), now grown up and living in Paris, married to a wife named Juliette (Eugenia Marruzzo) who is due to have a baby the next day. A broke, panicky Alberto abandons his sleeping wife and hops aboard a train to Rome, hoping to solve his family problem once and for all.

•

If anyone in "Alberto Express" belongs on a train it is Mr. Manfredi, whose performance as a railway employee in "Bread and Chocolate" had all the charm this film sorely lacks. The unappealing Alberto is seen through an endless array of contrived episodes, which supposedly hinge on his efforts to raise money. He meets a rich old man who will pay him to have sex with the man's beautiful young wife. He encounters a former girlfriend (Marie Trintignant) and steals money from her purse. The actresses playing young women who are unaccountably smitten with the nervous, sweaty Alberto all look like interchangeable fashion models, which does little to make the film any funnier or more likely.

Jeanne Moreau, giving a pay-the-rent-caliber performance, appears briefly as an aging baroness who has been virtually mummified in her search for eternal youth, and who provides one of the screenplay's typically toothless insights: "The most complicated things always work out

in the end." Even more wince-worthy is the film's presentation of a gay black American tourist who wears a diamond in his front tooth and declares: "Europe is such an exotic continent!"

Arthur Joffe's direction is most noteworthy for allowing Mr. Castellitto infinite room for mugging and overreacting, and for bungling the few sight gags that the film attempts. These include a funny-as-a-corpse visit with Alberto's dead ancestors and a scene that shows patrons in the dining car suddenly sporting red antennae, in sympathy with the lobster Alberto is about to eat.

"Alberto Express" opens today in Manhattan at the Angelika Film Center (18 West Houston Street) and the Art East Cinema (First Avenue at 61st Street), where it will be preceded by Sam Karmann's "Omnibus," the short that accompanied "Olivier, Olivier" on the opening night of the current New York Film Festival.

1992 O 9, C12:5

La Vie de Bohème

Written, produced and directed by Aki Kaurismaki, based on the novel "Scènes de la Vie de Bohème" by Henri Murger (in pidgin French with English subtitles); director of photography, Timo Salminen; edited by Veikko Aaltonen; production designer, John Ebden. At Alice Tully Hall, as part of the 30th New York Film Festival. Running time: 100 minutes. This film has no rating.

Rodolfo	Matti Pellonpaa
Mimi	Evelyne Didi
Marcel	André Wilms
Schaunard	Kari Vaananen
Musette	Christine Murillo
Blancheron	Jean-Pierre Léaud
Baudelaire	Laika
Barman	Carlos Salgado
Henri Bernard	Alexis Nitzer
Mme. Bernard	Sylvie van den Elsen
Hugo	Gilles Charmant
Lady at shop	Dominique Marcas
Gassot	Samuel Fuller
Francis	Jean-Paul Wenzel
Gentleman	Louis Malle

By VINCENT CANBY

From the look and manner of his films, Aki Kaurismaki would seem to be like the "Li'l Abner" character who walks the earth shadowed by a small dark cloud. The cloud follows him with the fidelity of a severely depressed hound dog. It's almost affectionate. Yet the cloud isn't big enough to block out the sun completely, and life lived in the penumbra can sometimes be astonishingly rich.

Well, if not rich, then not so poor, though melancholy.

•

Such is the world of Mr. Kaurismaki's singular comedies, the latest being "La Vie de Bohème," the Finnish film maker's coolly funny, laid back, very free update of the same Henri Murger novel that inspired Puccini's opera "La Bohème." As Mr. Kaurismaki puts it in the production notes, the film is his way of rescuing Murger's work from the bourgeois fancies of the composer. In other words: à bas Puccini!

"La Vie de Bohème" will be shown at the New York Film Festival at 9:15 tonight and at 3 P.M. tomorrow.

Mr. Kaurismaki carries with him a sense of foreboding that is forever at war with his natural exuberance. Though filmed in Paris, his "Vie de Bohème" takes place in a city that somehow looks like the forgotten fringes of Helsinki. No matter what

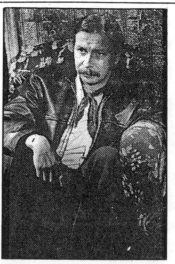

Matti Pellonpaa as Rodolfo in a scene from "La Vie de Bohème."

the season is said to be in the movie, it always seems to be that time of year when winter is on the edge of spring but won't give way to it, and when chill and damp are the order of existence.

As he rediscovers the milieu of the Murger original, Mr. Kaurismaki reinvents the identities of the Murger characters, all of whom now appear to be approaching middle age. Rodolfo (Matti Pellonpaa), a dour, unsmiling man, is an obsessed Albanian artist living in Paris without the proper papers. Marcel (André Wilms) looks like a truck driver whose license has been revoked, possibly for D.W.I. When first met, Marcel is having his 21-act play rejected because he refuses to cut even a semicolon. Also intensely committed to his art is the always scowling Schaunard (Kari Vaananen), a composer in the midst of creating something he calls "The Influence of Blue on Art."

The women in their lives, the tubercular Mimi (Evelyne Didi) and the commonsensical Musette (Christine Murillo), exist solely in the dimly reflected light of the men they love.

In his "Leningrad Cowboys Go America," about the world's worst polka band and its disastrous road tour through the United States and Mexico, Mr. Kaurismaki couldn't help but tip his hand about the film's comic intentions: there's no way that a bunch of deadpan polka-band players will seem anything but funny. The film maker is working with much more ambiguously comic material in "La Vie de Bohème," in which Rodolfo, Marcel and Schaunard often seem no less mad than the polka players, though their concerns are completely serious.

In the course of "La Vie de Bohème," Rodolfo receives a sizable commission to paint the portrait of a man (Jean-Pierre Léaud) who is about to become a collector, and Marcel is hired by a crabby publisher, played by Samuel Fuller, the American director, to edit a special issue of a magazine called the Girdle of Eris. How they ever carry out their commissions is difficult to see, even though the artists in the film don't have to sing as well as drink.

At one point Marcel, possibly after he has been fired for printing his play in the Girdle of Eris, states flatly, in lines that send up the opera's libretto: "We make child's play of all misfortunes. We don't get depressed."

Mr. Kaurismaki's joke is that his Marcel, Rodolfo and Schaunard are already so depressed that there's no place for them to go but up.

•

The cast includes two veterans of Mr. Kaurismaki's earlier films, Mr. Pellonpaa and Mr. Vaananen, and Mr. Wilms, a French actor, who is so suitably hard faced and gloomy that it's a surprise to learn he is not from the Kaurismaki stock company. Mr. Léaud, suddenly looking like a man who has reached his comfortable middle years, is exceptionally good in a small but importantly comic role. The portrait that eventually results from his commission to Rodolfo actually suggests Picasso's portrait of Gertrude Stein.

Mr. Kaurismaki has shot some of his films in color, but black and white suits the blunt temperament of "La Vie de Bohème." Here is a fine, deceptively querulous comedy that mocks the conventions of art and romantic love while, at the same time, exalting them as the only means of salvation. Make no mistake about it: Mr. Kaurismaki is an original, one of the cinema's most distinctive and idiosyncratic new artists, and possibly one of the most serious.

1992 O 9, C14:1

Man Bites Dog

Directed and produced by Rémy Belvaux, André Bonzel and Benoît Poelvoorde; screenplay by Mr. Belvaux, Mr. Bonzel, Mr. Poelvoorde and Vincent Tavier, based on an idea by Mr. Belvaux (in French with English subtitles); director of photography, Mr. Bonzel; edited by Eric Dardill and Mr. Belvaux; music by Jean-Marc Chenut; released by Roxy. At Alice Tully Hall, as part of the 30th New York Film Festival. Running time: 95 minutes. This film has no rating.

Ben	Benoît Poelvoorde
Ben's Mother	Jacqueline Poelvoorde Pappaert
Ben's Grandmother	Nelly Pappaert
Ben's Grandfather	Hector Pappaert
Jenny	Jenny Drye
Malou	Malou Madou
Boby	Willy Vanderbroeck
Mamie Tromblon	Rachel Deman
Reporter	Rémy Belvaux
Cameraman	André Bonzel

By STEPHEN HOLDEN

How can "Man Bites Dog" affect the escalating level of violence in the movies and on television? Is it part of the problem or the solution? Or is it merely a sensationalistic cinematic prank unworthy of serious discussion? Such debate is likely to be stirred up by the Belgian movie's New York Film Festival screenings this evening at 6:15 and tomorrow at midnight in Alice Tully Hall.

Two things can safely be said about this pseudo-documentary of a serial killer, which won the International Critics' Prize earlier this year at the Cannes Film Festival. The film, directed and co-written by its three young producers, who also appear in it, is jam-packed with graphic violence. And its gun-toting, speed-rapping subject, Ben (Benoît Poelvoorde), has the edgy charisma of James Woods in one of his more maniacal star turns.

In the film's opening moments, Ben is shown accosting a woman in a railway car, forcing her into a compartment and biting at her coat like a mad dog. The sequence is funny in a Dadaist sort of way. Moments later, Ben is exuberantly explaining to the

camera how much weight in water human corpses of different ages are likely to take on when thrown off a bridge.

A complete exhibitionist, he boasts of being nicknamed "the octopus" for his ability to wiggle so many different parts of his body independently of one another, and offers a demonstration. He has no qualms about being filmed throwing up in a restaurant after ingesting some tainted mussels. To the accompaniment of mock-pastoral fantasy sequences, he proudly recites his own ghastly romantic verses.

•

But the character is also casually, viciously racist and xenophobic. One of his first murders is of a black night watchman, whose trousers he unzips while titteringly inspecting the size of the man's genitals. Ben murders both for sport and for money. Forcing his way into an old woman's apartment on the pretext of doing a television interview about loneliness and old age, he puts a gun to her head, screams, "Granny snuff!" and scares her to death. He knew he wouldn't have to shoot, he boasts afterward, because on entering her apartment, he spied her heart medication. Seconds later, he has plucked her life savings from under a mattress and gleefully waved them at the camera.

As the killing spree intensifies, it becomes clear that the two-man camera crew attending Ben at all times is not about to step in and stop the violence. In fact, they are active collaborators who help prepare the action. More than that, it is their mere presence that incites him to new levels of virtuosic savagery. When Ben methodically slaughters a well-to-do couple and their little boy in their suburban home, at his instruction the sound man obligingly moves in to record the crunch of a neck being broken. The film's most disturbing scene graphically depicts a rape as well as a double murder.

"Man Bites Dog," which was filmed in grainy black-and-white and has the jerky momentum of cinéma-vérité, is a grisly sick joke of a film that some will find funny, others simply appalling. On one level, it is an in-joke about movie making, since one reason given for Ben's rampage is the need to steal enough money to make the documentary.

•

On another level, the film satirizes real-life television shows that purport to take viewers into the thick of the action. It suggests how profoundly the presence of the camera affects events, and thumbs its nose at the very notion of documentary objectivity. In one of the film's most blatant bits of satire, a film crew member shot in the line of duty is mawkishly eulogized by his surviving partner.

"Man Bites Dog" is not the only selection in this year's film festival to find a causal relationship between television and movie violence and real-life homicide. The Austrian film "Benny's Video" explores similar notions with an icy elegance that is the stylistic opposite of the semi-improvised freneticism of "Man Bites Dog."

Although "Benny's Video" pushes its pessimism a bit too insistently, it is the more resonant of the two films. "Man Bites Dog," by contrast, gets carried away with its own cleverness. It makes the audience the butt of a nasty practical joke.

1992 O 9, C14:5

1492
Conquest of Paradise

Directed by Ridley Scott; written by Roselyne Bosch; director of photography, Adrian Biddle; edited by Willian Anderson and Françoise Bonnot; music by Vangelis; production designer, Norman Spencer; produced by Mr. Scott, Mark Boyman, Ms. Bosch, Pere Fages and Alain Goldman; released by Paramount Pictures. Running time: 152 minutes. This film is rated PG-13.

Columbus	Gérard Depardieu
Sánchez	Armand Assante
Queen Isabel	Sigourney Weaver
Marchena	Fernando Rey
Moxica	Michael Wincott
Santangel	Frank Langella
Bobadilla	Mark Margolis
Brother Buyl	John Heffernan

By VINCENT CANBY

Much in the way that the mind and motives of Christopher Columbus continue to elude historians, the drama of his life continues to baffle those who would make coherent movies about him. First there was Ilya and Alexander Salkind's "Christopher Columbus: The Discovery," the inadvertently funny swashbuckler seen here in August. Now comes the far more ambitious "1492: Conquest of Paradise," directed by Ridley Scott, written by Roselyne Bosch, and starring Gérard Depardieu as a very intense, conflicted Columbus, caught midway between the known world of historical facts and the film makers' imaginations.

The film, which actually begins some years before 1492 and ends some years later, starts off with a lot of solemn and quite conventionally effective scene-setting as Columbus's son and biographer, Fernando, recalls his father, the dreamer of impossible dreams. "I want to travel all over the seas," the father tells the young Fernando as they stand in handsome profile gazing toward the western horizon. "I want to get behind the weather."

Approximately 45 minutes and several throne-room scenes later, Columbus sets sail from Spain on the voyage that would end in what some

Paramount Pictures

Obsessed Gérard Depardieu plays Christopher Columbus in Ridley Scott's version of how the explorer found an earthly paradise "which became his hell."

call the great discovery of the New World and others ridicule as the cruel invasion of a world that had always been there. The film that follows is a decent, if primitive sort of recap of Columbus's four voyages (condensed into two), his initial triumphs, his disgrace and his final neglect as others receive credit for his accomplishments.

"1492" is not a terrible film. Yet because it is without any guiding point of view, it is a lot less interesting than the elaborate physical production that has been given it. Only a very great writer could do justice to all the themes the Columbus story suggests. Ms. Bosch may be a very good researcher, but she's not a very great writer. She can't even squeeze in many relevant facts, much less define the relevance of those she does include.

With the great hulking figure of Mr. Depardieu at its center, the movie at least has the presence of an actor who can suggest passions that the screenplay never pursues with any consistency. At the beginning of "1492," this Columbus is both a dreamer of unknown worlds and the hustler he had to be to secure backing for his first voyage. Later, as his colony in Hispaniola is besieged by angry Indians and sabotaged by jealous countrymen, he is suddenly revealed to be a Utopian.

"You treat Indians as the equals of Europeans," says one disgusted colleague. "What do you want?"

Answers Columbus, "I want a new world." The movie would seem to agree that the Spaniards treated the Indians badly right from the start, but Columbus's complicity is ignored. He's as shocked as the Indians.

As the movie goes relentlessly on, and as Mr. Scott more and more frequently fills the air with rain, mist, fog, smoke or dandelion fluff, dramatic invention runs out. With his dreams of wealth and fame collapsing, all Columbus can say is, "Nobody ever said this would be easy."

That line appears to be an original inspiration, which can't be said of Columbus's pep talk to his men the night they threaten mutiny on the first voyage: "In time they will talk about the courage of the men who crossed this ocean, and then you can say, 'I was on the Niña,' 'I was on the Pinta,' 'I was on the Santa María.' " Did Ms. Bosch find something in the archives in Seville to suggest that Shakespeare cribbed Henry V's St. Crispin's Day speech from Columbus?

The members of the supporting cast have even less to work with than Mr. Depardieu. Sigourney Weaver is surprisingly effective as Isabel. She plays straight and true and looks regal, even when having to say, at the end, "The New World is a disaster." Armand Assante, Fernando Rey, Frank Langella and John Heffernan are among the familiar faces that from time to time peer out around the historical personages.

The most riveting supporting actors both play bad guys. Michael Wincott, wearing his hair long in 1960's, hippie style, appears as the young Spaniard who precipitates the revolt in Hispaniola. Mark Margolis is similarly impressive as the Spanish noble who shows up in Hispaniola to give Columbus his walking (sailing) papers back to Spain.

The scenery is impressive, including some of Spain's grandest old palaces and cathedrals. The film's other principal location was Costa Rica, which passes not only for all of the various islands Columbus visited, but

also for Palos, the small Spanish port from which Columbus sailed on his first voyage. It's a very pretty little port, if somewhat tropical for Spain.

The special effects are also good, especially a hurricane that sweeps down on Columbus at one point as if it were the hand of God, though just what God might be thinking remains as fuzzy as the ideas of the film makers. Vangelis, the composer, supplies the music, which often suggests the upbeat theme he wrote for "Chariots of Fire."

•

The film "1492," which has been rated PG-13 (Parents strongly cautioned), shows heretics being burned at the stake and scenes of bloody battle and mayhem.

1992 O 9, C21:1

Night and the City

Directed by Irwin Winkler; screenplay by Richard Price, taken from Jules Dessin's 1950 film, which was based on the novel by Gerald Kersh; director of photography, Tak Fujimoto; edited by David Brenner; music by James Newton Howard; production designer, Peter Larkin; produced by Jane Rosenthal, Mr. Winkler and Rob Cowan; released by 20th Century Fox. At Avery Fisher Hall, as part of the 30th New York Film Festival. Running time: 103 minutes. This film is rated R.

Harry Fabian	Robert De Niro
Helen Nassaros	Jessica Lange
Phil Nassaros	Cliff Gorman
Al Grossman	Jack Warden
Ira (Boom Boom) Grossman	Alan King
Peck	Eli Wallach
Tommy Tessler	Barry Primus
Resnick	Gene Kirkwood
Regis Philbin	Himself
Joy Philbin	Herself
Doctor	Richard Price

By JANET MASLIN

In "Night and the City," which will be shown at 9 P.M. tomorrow as the closing feature of the New York Film Festival, the glad-handing New York lawyer Harry Fabian (Robert De Niro) is seen making enemies all over town. Harry's career as an ambulance-chaser has understandably

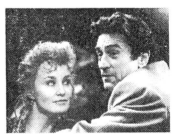

20th Century Fox

Jessica Lange and Robert De Niro

left a string of irate clients in its wake, as has his habit of borrowing money he has only the faintest intention of repaying. The film's intermittent glimpses of Harry's methods leave no doubt as to why he has a raft of problems hanging over him. On one occasion, trying to sound honest, he swears upon his goldfish's eyes.

For others this modus operandi may be irritating, but for Harry it is mostly a game. "You wanna take a walk in the park?" he cheerfully advises one guilty-looking client. "Leave the baseball bat at home." To another, a potential plaintiff who has physical injuries but says he feels all right, Harry counsels: "You wanna make some money? You feel terrible."

Harry believes in making the best of any opportunity that comes his

way, whether it means phoning accident victims he finds in the newspaper or having an affair with a woman whose husband is putatively Harry's pal. But as "Night and the City" begins, Harry's gambits are sounding a little tired. The fun of running endless scams is wearing thin.

•

"Night and the City," with Richard Price's screenplay taken from Jules Dassin's 1950 film, which was itself based on Gerald Kersh's novel, finds Harry at a turning point. He is on the verge of trying something serious and leaving the petty hustling behind. As directed by Irwin Winkler, "Night and the City" is colorfully acted and refreshingly free of all the moody clichés such a story might be expected to thrive on. But it is also saddled with overly busy direction that sometimes interferes with the dialogue, making Mr. Price's long, perversely elegant conversational riffs hard to hear.

Street sounds and pop songs, overlapping voices and actors who talk while on the run: all these elements get in the way of sharp, funny language that deserves to come through without interference. The problem is compounded by Mr. Price's way of burying plot points within feverish monologues, so that the narrative importance of some scenes is too easily missed. The film's plot hinges on such an intricate train of small related developments that each of them needs to be crystal clear.

That said, "Night in the City," which opens commercially on Friday, is still a lively, gripping foray into the urban landscape that is home base for Harry and the starting-off point for his schemes. This world is rude. (An automated cash machine is more polite than any of the film's human characters, even if it is telling Harry that his account is overdrawn.) But it is a place of unlimited opportunity, and neither the film nor Harry ever loses the appealing optimism that allows them to see big chances at every turn. As played with manic intensity by Mr. De Niro, Harry is a motor-mouthed self-promoter who is aptly described by Helen (Jessica Lange) as "just like an arrow looking for a target."

•

The ruefully gorgeous Helen, married to a wary bartender named Phil (Cliff Gorman), has come to regard Harry with the film's trademark mixture of realism and romance. "Night and the City" imagines a vibrant, seductive Manhattan where it's possible to have sex outdoors at dawn, but even under the spell of such magic Helen never loses sight of Harry's less seductive qualities. Neither does Phil, who glares suspiciously at Harry whenever Harry visits the bar. Other fixtures in this well-cast film are Alan King as a dauntingly powerful fight promoter and Jack Warden as his estranged brother; Regis Philbin as himself (amusingly turned into the embodiment of Harry's big-time dreams), and Eli Wallach as a knowing loan shark. "Harry, I like you, but I'm such a last resort," he counsels when Harry needs money. "Don't be so desperate."

Mr. Winkler draws fine supporting performances out of these actors (Mr. King and Mr. Warden are especially effective), and finds real warmth in the bond between Helen and Harry, which seems made of attraction, friendship and opportunism in equal parts. Mr. De Niro, though sometimes straining to make Harry's antic delivery sound lifelike, creates a full and affecting character.

Ms. Lange's knowing, physically striking performance is also used well. One of the film's greatest assets is Tak Fujimoto's deep-hued cinematography, which gives allure to Manhattan night spots and pure verve to the parade of dives Harry haunts by day.

A world of endless scams is rude but full of opportunity and optimism.

Mr. Price, in adapting the original material to his own dazzling contemporary style, has provided a great deal of the urban irony that works so well for him in his novels (among them the bravura "Clockers). He understands perfectly the kind of woman who would soothingly offer a man breakfast, then dial a coffee shop to have it sent over. He also understands the humor of turning Mr. De Niro's Harry, in one of the film's funniest scenes, into a star-struck pest at Elaine's. Some of Mr. Price's throwaway lines are so good that it's an outright pity to find them thrown away. Viewers may wish the film would simply slow down and let them listen.

•

"Night and the City" is rated R (Under 17 requires accompanying parent or adult guardian). It includes profanity and sexual situations.

1992 O 10, 11:3

Delivered Vacant

Produced, directed, filmed and edited by Nora Jacobson. At Alice Tully Hall, as part of the 30th New York Film Festival. Running time: 110 minutes. This film has no rating.

By VINCENT CANBY

Nora Jacobson's "Delivered Vacant," showing at the New York Film Festival today at 6 P.M., is a big, long, ungainly documentary about the gentrification of Hoboken. Though not neat, it is a fine, rich film, a large lode of raw material accumulated by Ms. Jacobson over an eight-year period beginning in 1984.

That's when young upwardly mobile New Yorkers, having discovered Hoboken's charms and comparatively cheap rents, began moving across the river in droves, and when property owners and land developers jumped in to reap the profits. The result was an upscale feeding frenzy. The first victims: Hoboken's long-time blue-collar residents, the newer immigrant families from Latin America and the Indian subcontinent, and the elderly pensioners, mostly retired merchant seamen and railroad men, who filled the city's rooming houses.

•

Ms. Jacobson documents the changing Hoboken character with a concern that is always very polite, in part because she is supposed to be an impartial observer and in part because, being herself a new arrival, she is a player in the story she is telling. "Delivered Vacant" is a story of greed, hope, political action, bewilderment, free enterprise, idealism

Film Society of Lincoln Center

A graffiti artist identifying buildings in Hoboken where families once lived, in Nora Jacobson's documentary "Delivered Vacant."

and rampant opportunism. A lot of colorful characters pass in front of Ms. Jacobson's camera.

There's Tom Vezetti, who walked Hoboken's streets glad-handing the citizens ("Your charming personality is exceeded only by your outward appearance") to be elected Mayor in 1985, largely on promises to find housing for the city's increasingly squeezed underclasses. There are speculators who buy out tenants, refurbish the buildings and then sell the units as condominiums.

The tactics of some are sleazy. Others are just unmindful, like the well-dressed young man who speaks with disgust of the smells and the deplorable conditions of the old rooming houses he acquires. At least one pair of speculators, whom Ms. Jacobson calls "the lovable developers and patrons of the arts," contributed money toward the production of "Delivered Vacant."

Looking on, at first with amusement and then with fear, are the pre-boom residents. Says one woman: "I don't understand what people want with condominiums. Maybe an elevator?" She's even more puzzled when told that the condos don't necessarily have elevators. Nobody has told her about tax writeoffs or the easy commute to Manhattan.

•

The yuppies are a varied lot. "We sort of like ethnic communities," says

one, "but not when they're falling apart or noisy." Others make conscious attempts to fit into the community. One young couple continues on up the ladder, leaving Hoboken at the end of the movie for life in an affluent suburb. Another couple, having established Hoboken as home, are now thinking about acquiring a weekend place at the shore.

The rising value of the real estate prompts a lot of ugly scenes. Buildings are torched, some say by owners desperate to evict low-rent tenants, others say by disgruntled pre-boom residents. Politically and socially committed citizens form committees to promote legislation to protect those who are being evicted. Yuppie residents form tenant committees to protect their rights.

"Delivered Vacant" is shaped by the events it records, which is why one gets the feeling near the end that the original victims of gentrification have been forgotten. Ms. Jacobson revisits a few, but time has moved on. Most of these people have moved or died.

In the way of drama that satisfies, time wounds all heels. By the 1990's many of the developers, earlier seen wheeling and dealing with such enthusiasm, have gone bust, their properties sold at auction. "Delivered Vacant" is something of an urban epic.

1992 O 10, 13:1

FILM VIEW/Caryn James

Wading Through Blood To the Festival's Heart

TO SURVIVE ANY FILM FESTIval, it helps to have strong eyes. To make it through the 30th New York Film Festival, which closes tonight at Lincoln Center, it helped to have a strong stomach. I found this out the hard way.

My screening schedule was a fluke, but the message it sent was not. Here is a brief diary

of what I came to think of as the end-of-the-world film festival.

Monday: Neil Jordan's "Crying Game." In this story of love and I.R.A. terrorists, a major character is smashed by a truck. Lesser killings follow. As movie violence goes, I've seen worse.

Tuesday: "Benny's Video." The adolescent Benny picks up a girl and kills her in his bedroom, with his video camera running. The film's director, Michael Haneke, likes to replay the girl's blood-chilling screams. I can take it; I'm a pro.

Wednesday: "Man Bites Dog." In this mock documentary, a camera crew tags along with a friendly murderer, filming his crimes — a little old lady is shot, a man and woman are disemboweled — in detail that is unbearably gruesome even in black and white. The film's Belgian directors (Rémy Belvaux, André Bonzel and Benoit Poelvoorde) have said they want audiences to think about the connection between violence and the media. I think I am the test case: if I don't belt somebody on my out of the screening room, it will prove that there *is* no connection between violence on film and in life.

Thursday: My luck has to change. The fes-

Shallow murder-and-mayhem movies revealed a lot about the 30th New York Film Festival.

tival's opening-night feature, Agnieszka Holland's "Olivier, Olivier," can't be morbidly depressing. It turns out to include a missing boy, child molestation and, yes, a murder. My friends are immediately suspicious of any movie I have to see.

Thank goodness it would be another week before I got to "La Sentinelle," the French director Arnaud Desplechin's first film, in which a medical student discovers a dried, severed head in his luggage and dissects it. By comparison, the Canadian Jean-Claude Lauzon's "Léolo," in which the young hero tries to hang his grandfather in the bathtub, seems positively whimsical.

Coincidence aside, something is going on here. I don't think the answer is that the festival's program committee has suddenly descended into mass depression, though its audiences might.

Violence is obviously a preoccupation of film makers around the world. What disappoints about these films is that their creators' thinking about murder doesn't go very deep.

On the level of visual style and narrative pull, all these works are accomplished, even if they are not masterpieces. But as different as they are stylistically, ranging from the ever-darkening psychological development of "Olivier" to the brash assault of "Man Bites Dog," none examines the impulse toward violence. "Benny's Video" and "Man Bites Dog" simply assume the connection between video and killing, and as a result seem more emotionally hollow and less trenchant as social criticism than the directors intended.

Even the richest of them, "Olivier," subjects the viewer to a harrowing final hour without offering enough understanding or emotional impact to justify the ordeal. The effect is to make a viewer walk out thinking: Why did you put me through this?

Mansour Diouf, top, with an unidentified man in "Hyenas"; and Jacqueline Poelvoorde-Pappaert and Benoit Poelvoorde in "Man Bites Dog"— The good and the gruesome.

Hype and Hypability

The shallowness of the murder-and-mayhem films reflects the pool of films from which the festival committee had to choose. The word from many of this year's major festivals was dismal: Cannes was too narrowly American, Berlin unexciting, Montreal and Toronto blah. Doing the best it could in a weak year, the New York Film Festival was loaded with intriguing but slight works that might not have made it against tougher competition.

"The Crying Game" contains some elements from Mr. Jordan's gritty, realistic "Mona Lisa" and others from his dark fairy tale, "The Company of Wolves." A surprise twist in "The Crying Game" links these two styles but also splits the film in half, changing it from a story of political terrorism to a farcical sex comedy. It's a daring shift, one that Mr. Jordan can't quite get away with.

Other choices, including some younger directors' films, like "La Sentinelle," "Léolo" and "Strictly Ballroom," might have fit more comfortably in the New Directors/New Films festival.

The Australian Baz Luhrman's deft "Strictly Ballroom" at least has the advantage of being cheerful. It's "Dirty Dancing" set in Australia, without Patrick Swayze or sex. In this garishly funny romance, a ballroom dancer named Scott breaks free to invent his own steps and, on his way to the triumphant big dance competition, carries along a plain-to-pretty love interest named Fran. The film is no more than cute, but the crowds here loved it, as they had in Cannes and Toronto.

Oddly, one of the festival's few genuine discoveries came with little hype and a presentation that didn't do it justice. Though Clara Law's "Autumn Moon" is the fifth film by the 36-year-old director from Hong Kong, she is virtually unknown in this country. The festival program's description of "Autumn Moon" as Ozu meets Jarmusch was the kiss of death, because the mention of the great Japanese director Ozu seems a code word for slow and boring.

But "Autumn Moon," the story of a 15-year-old girl in Hong Kong and a young Japanese man who becomes her friend, is delicate and witty, deadpan and wise. Wai (Li Pui Wai) has been left in Hong Kong with her granny while her family has gone to Canada to plan for their immigration. She speaks Cantonese and a smattering of English.

Tokio (Masatoshi Nagase, who played the Japanese Elvis-lover in

Jim Jarmusch's "Mystery Train"), arrives armed with his video camera, speaking Japanese and a smattering of English, too. As their friendship sweetly develops, Miss Law tackles complex questions with an astuteness that few film makers in this festival display: cultural dislocation, video as a substitute for true emotion, the way the generational bonds in families are breaking down.

To state those themes makes "Autumn Moon" sound heavy-handed, but its virtue is its subtlety. Tokio wants to go to Wai's favorite restaurant; the film cuts to a scene of them at McDonald's. On paper, this sounds like a bad joke, but on screen it is a wonderful moment of visual comedy as the two characters sit side by side, munching hamburgers, with slightly puzzled expressions on their faces. Miss Law is a real find.

Multiculturalism Goes To the Movies

As Richard Peña's tenure as program director develops, the festival continues to give multiculturalism a good name and to mix works by newcomers with those of established directors.

"La Vie de Bohème" is a contemporary retelling of the classic story told in the irresistibly droll style of the Finnish film maker Aki Kaurismaki. This may not be his breakout film, but it is a lovely addition to his career and the festival, which has supported his work for several years.

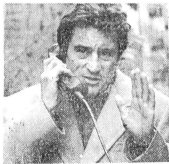

Louis Goldman/20th Century Fox

Robert De Niro as an ambulance-chasing lawyer in "Night and the City."

The festival has also supported the work of Zhang Yimou, having shown "Red Sorghum" and "Ju Dou." His new "Story of Qiu Ju" is his most accessible ever. The tale of a pregnant woman who relentlessly seeks justice after the village chief kicks her husband in the testicles may well be Mr. Zhang's breakout when it is released commercially early next year. The director himself admitted it was the first of his films designed to make people laugh.

And some films from unlikely places turned out to be among the festival's best. The Romanian director Lucian Pintilie's rich and absorbing film "The Oak" moves deftly from a young woman's personal story — mourning her father's death — to a detailed view of political repression and underground resistance. Even if the political nuances are difficult for most American audiences to grasp, this is a work full of artistic and social revelations.

"Hyenas," a wry social comedy from Senegal, is improbably but beautifully transposed from Friedrich Dürrenmatt's German-lan-

As different as the violent films are, none examines the impulse toward murder.

guage play about a rich woman who returns to her home village determined to buy herself revenge.

What Is Romance, Especially in France?

Two of the French films in this year's festival offer wildly different views of romance. Leos Carax is a director in his early 30's who was heavily influenced by the New Wave. His fifth film, "Les Amants du Pont Neuf," is a romance so intently weird and unsavory it makes the hardhearted "Breathless" seem sappy. Juliette Binoche, wearing an eye patch, and Denis Lavant, wearing a cast on his foot and dirt on his body, are street people who become lovers. Mr. Carax means their story to be a triumph of romance, but the studied performances turn it into an anthropological study of dysfunctional personality and thwarted circumstance.

"A Tale of Winter," though, is one of Eric Rohmer's most extravagantly romantic and masterly works. It is easy to say, "Another year, another Rohmer," but this one — about a young woman who loses track of her lover, has his child and remains convinced that he will return — is as charming and magical as the director's classic works. Telling such an unlikely, old-fashioned story is almost a radical act right now, and pulling it off is much more difficult than the ageless Mr. Rohmer makes it seem.

It's in the Festival, But Is It Art?

If anyone doubts that being included in the film festival carries artistic weight and prestige, think about what the festival's context does to the closing film, Irwin Winkler's "Night and the City." An updated version of Jules Dassin's 1950 B-movie, it features a smart screenplay by Richard Price, a colorful but gritty vision of New York photographed by Tak Fujimoto and two immensely enjoyable performances. Robert De Niro plays a highenergy, crooked lawyer trying to make it to the big time as a boxing promoter. He doesn't want to go straight; he just wants to make more money being crooked. Jessica Lange's performance is more subdued, but every bit as good. She is poignant as the tough but loving woman who believes in him.

Watch "Night and the City" as just another commercial film (opening Friday), and it seems like a good, entertaining movie. Part of its charm is its lack of pretension. But put it in

the film festival, and suddenly the work seems loaded with an artistic weight it can't bear. Including it in the festival is an everybody-wins proposition for those involved. Mr. Winkler, who was a producer for years but who got middling reviews for the first film he directed, "Guilty by Suspicion," gains artistic respectability. Mr. De Niro's fledgling company, TriBeCa Productions, gets a boost. And the festival gets a glitzy closing film.

"Night and the City" may not be art, but it doesn't disgrace the festival. In fact, there is only one film that seems a disgraceful inclusion, the absolute low point: the outrageously overhyped "Zebrahead." This story of an interracial high school, by the first-time director Anthony Drazan, is no better than a made-for-television movie. Its themes are preachy and its acting often amateurish.

Anything is better than a mediocrity like "Zebrahead," even in a year when the choices were less than dazzling. ☐

1992 O 11, II:11:1

The Public Eye

Written and directed by Howard Franklin; director of photography, Peter Suschitzky; edited by Evan Lottman; music by Mark Isham; production designer, Marcia Hinds-Johnson; produced by Sue Baden-Powell; released by Universal Pictures. Running time: 99 minutes. This film is rated R.

Leon Bernstein	Joe Pesci
Kay Levitz	Barbara Hershey
Danny the Doorman	Jared Harris
Sal	Stanley Tucci
Arthur Nabler	Jerry Adler
Spoleto	Dominic Chianese
Farinelli	Richard Foronjy
Officer O'Brien	Richard Riehle
Conklin	Gerry Becker
Older Agent	Bob Gunton
Federal Watchman	Peter Maloney

By VINCENT CANBY

In "The Public Eye," set in 1942, Joe Pesci appears as a nervy, rude freelance photographer, Leon Bern-

stein, who's called Bernzy or the Great Bernzini by the editors and the cops with whom he deals. Bernzy has a way of arriving at the scene of a crime even before the police.

Armed with a Speed Graphic, the pockets of his trench coat bulging with flashbulbs and film, Bernzy roams nighttime Manhattan in search of the right subject. His specialties: mob rub-outs, tenement fires, celebrities caught off guard, servicemen and their girlfriends necking in doorways, automobile accidents, suicides and the anonymous faces of the sidewalk lookers-on. In his photographs these people speak.

Bernzy has an eye for detail. If the gunned-down body hasn't fallen to the pavement in a way that tells the story, he rearranges the pose, sometimes pushing the guy's hat into the frame. "People like to see the hat," he says.

His gift is to be able to freeze moments of hysteria, despair and loneliness into black-and-white images of arresting immediacy. Bernzy's tabloid pictures are vulgar, sensational and occasionally unforgettable.

Howard Franklin, who wrote and directed "The Public Eye," hasn't quite figured out how to dramatize the essence of a man as peculiarly gifted and obsessed as Bernzy, but at least he has created a rich character, whom Mr. Pesci plays with a furious, sweaty kind of authenticity.

Mr. Franklin seems to have been inspired by the life and work of the great Weegee, Arthur Fellig, whose photographs of New York in the 1940's defined the city for natives as well as those who had never seen it. Weegee's nickname, a corruption of Ouija, as in Ouija board, was apparently a reference to his uncanny way of turning up where the action was. Bernzy's dream in "The Public Eye" is to shoot a mob massacre not seconds after the victims have been turned into corpses, but as it happens.

Yet that's just part of the story of "The Public Eye," which tries to be both a 1940's film noir and a story about an artist's search for recognition. Bernzy wants a one-man show at the Museum of Modern Art. He thinks it's time his photographs were collected and published between hard

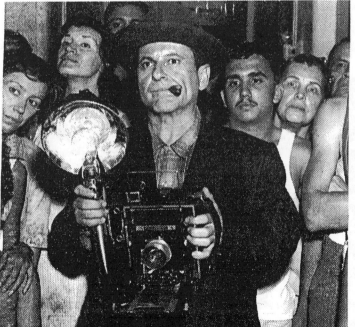

Universal City Studios

Joe Pesci as a freelance photographer in "The Public Eye."

covers. He's also carrying on like a private eye, uncovering a scandal that involves both mob and Government figures in the black-market sale of gasoline ration stamps.

Bernzy is drawn into this mess by the beautiful, mysterious Kay Levitz (Barbara Hershey), who has inherited a Manhattan establishment like the Stork Club from her much older, recently deceased husband. When a man who is clearly a racketeer shows up one night to declare himself her partner, Kay seeks out Bernzy, sometimes known as photographer to the mob, to find out what's going on.

•

"The Public Eye" never quite takes off, either as romantic melodrama or as a consideration of one very eccentric man's means of self-expression. The facts are there, but they never add up to much. The psychology is rudimentary. Mr. Pesci's Bernzy is presented as a fellow who can see the world only in terms of the black-and-white pictures he takes. He protects his feelings behind the camera lens. That is, until he meets Kay.

This most tentative love story is not helped by the lack of sparks between the two people who play the lovers. For whatever reason, Mr. Pesci and Ms. Hershey were never made for each other. It doesn't help that Kay seems to make contact with Bernzy only when the script calls for her to admire his work as an artist. The movie strains too hard for too little effect and concludes with a sequence whose only sense is vaguely poetic.

Several members of the supporting cast stand out: Jared Harris, as the menacing, ambiguously motivated doorman at Kay's swank club; Stanley Tucci, as a mob stoolie, and Jerry Adler, who plays the only person Bernzy can trust.

"The Public Eye" was shot on location in Cincinnati, Chicago and Los Angeles, although it looks as authentic as the Chrysler Building, which goes to show (the Mayor's Office on Film, Theater and Broadcasting might note) that New York is not indispensable to movie makers.

Mr. Franklin shows the audience a lot of examples of work by Weegee and his contemporaries, including Weegee's classic shot made at the opening of the Metropolitan Opera in 1948: the arrival of Mrs. George Washington Kavanaugh and Lady Peel, two smiling grandes dames cloaked in ermine. Weegee studies them, front view and in full figure, as they in turn are studied by a skeptical bag lady, standing at the side and seen in profile.

Weegee's work is full of such double whammies. The movie's only double whammy is Mr. Pesci's demonstration of his own talent and the driven character he creates.

•

"The Public Eye," which has been rated R (Under 17 requires accompanying parent or adult guardian), has explicit violence and vulgar language.

1992 O 14, C17:1

Simple Men

Written and directed by Hal Hartley; director of photography, Michael Spiller; edited by Steve Hamilton; music by Ned Rifle; production designer, Dan Ouellette; produced by Ted Hope and Mr. Hartley; released by Fine Line Features. Running time: 105 minutes. This film is rated R.

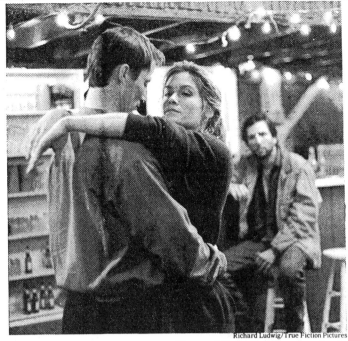

Richard Ludwig/True Fiction Pictures

Robert Burke dancing with Karen Sillas as Martin Donovan watches in a scene from Hal Hartley's new comedy, "Simple Men."

Bill McCabe	Robert Burke
Dennis McCabe	William Sage
Kate	Karen Sillas
Elina	Elina Löwensohn
Martin	Martin Donovan
Mike	Mark Chandler Bailey
Vic	Chris Cooke
Ned Rifle	Jeffrey Howard
Kim	Holly Marie Combs
Jack	Joe Stevens
Sheriff	Damian Young
Mom (Meg)	Marietta Marich
Dad	John Alexander MacKay
Mary	Bethany Wright

By VINCENT CANBY

At the center of Hal Hartley's new comedy, "Simple Men," are the two McCabe brothers, Bill (Robert Burke), in his mid-20's, and Dennis (William Sage), a few years younger. Bill, as square-jawed as the face atop a suit in a Calvin Klein ad, is first met as he is being dumped by his girlfriend just after they have successfully completed a robbery. Dennis, equally square of jaw, is a bookish type, home from college.

Meeting by accident, the brothers decide to search for their long-lost father, who they have reason to suspect is somewhere within the 516 area code on Long Island. Their father, known as "the radical shortstop," is a former big-league baseball player who became notorious in the 1960's for bombing the Pentagon. Bill hates his father. Dennis wants to get to know him.

So begins "Simple Men," in which Bill and Dennis take off for Long Island to meet, in passing, a depressed motorcyclist, a cigarette-smoking nun who, when last seen, is wrestling in the street with a policeman, and two enigmatic women, one of whom is a pretty epileptic whose looks prompt memories of Anna Karina.

•

"Simple Men," Mr. Hartley's third feature, is even less about real life than was his amusingly diffident "Trust," his second film, released last year. "Simple Men" is mannered in the terrifically knowing way of someone who has looked too long at the movies of others, especially, in this case, at the movies and mannerisms of Jean-Luc Godard, with particular emphasis on "A Woman Is a Woman," starring Ms. Karina.

There is more to "Simple Men" than these references to Mr. Godard, but they provide the film with its most conspicuous moments.

Art can be quoted, as Mr. Godard and his New Wave colleagues were all too fond of doing, but it can't be reinvented. Art recycled, as Mr. Hartley seems to be doing here when he is most successful, tends to become merely fashion.

The characters in Mr. Godard's greatest films, no matter how mindless they may be within the film frame, have a wit, a humor and a spontaneity that completely belie their deadpan expressions and their parroting of clichés. The people in "Simple Men" are functions of a long shaggy-dog story, composed of purposely flat dialogue that, from time to time, leads to a purposely flat punch line.

Consider a scene in which Bill and Dennis are spending the night in an abandoned Long Island store. Dennis: "Go to sleep." Bill: "I can't sleep." Dennis: "What?" Bill: "I'm in pain. I have a broken heart. I was betrayed by the woman I love." Dennis: "Who? Mom?" What has often been called Mr. Hartley's gift for quirky dialogue here sounds like his own mild inspirations combined with lumps of unrefined ore from the writer's notebook of overheard conversations.

•

"Simple Men" was independently made on a comparatively modest budget and looks very handsome. Mr. Hartley and his cinematographer, Michael Spiller, appear to have learned a lot from Raoul Coutard, Mr. Godard's favorite cameraman for years. The opening holdup scene is photographed against a wall painted a deep, lush red, which seems the Hartley equivalent to the deep, rich blue that is a kind of hallmark of many Godard films.

Other backgrounds are artfully divided between light and dark, white and unusual shades of brown, gray or

what have you. It's not easy to pay attention to the foreground when the décor is so chic. The movie is a decorator's dream. Mr. Hartley also has at least one long, lazy Godardian pan shot from right to left and back. The film's camera movements are as stylized as the characters' behavior, and as precious as Mr. Hartley's response to his own muse.

"Simple Men" is all technique, which is possibly a proper subject for a movie at a time when there are how-to videos for everything from self-analysis and childbirth to the building of a greenhouse. Technique of this rigorous kind is also a way of masking all thought, even all commitment to anything except the making of more movies. It's exhausting.

•

"Simple Men," which has been rated R (Under 17 requires accompanying parent or adult guardian), has some vulgar language.

1992 O 14, C22:1

Deadly Currents

Directed by Simcha Jacobovici; director of photography, Mark MacKay; edited by Steve Weslak; music by Stephen Price; produced by Mr. Jacobovici, Elliot Halpern and Ric Esther Bienstock; released by Alliance. Running time: 115 minutes. This film has no rating.

By STEPHEN HOLDEN

In a prologue to "Deadly Currents," Simcha Jacobovici's disquieting documentary study of the Israeli-Palestinian conflict, a written history tracing the region's ethnic and political strife back several millennia is scrolled up the screen. Since biblical times, it suggests, nothing has essentially changed. And although many intelligent and articulate people on both sides offer a range of political perspectives, the cumulative view seems to be that barring a miracle, the conflict is irresolvable because it is built into history.

But if "Deadly Currents," which opens today, is pessimistic, it at least struggles to be balanced. And as documentaries go, it offers an elegantly interwoven sequence of words and images that concentrate on the human face of the conflict. The film has no narrator or central character. Yet certain figures emerge as symbolic touchstones.

One is Lieut. Kobi Motiv, a soldier for Israel's defense forces and a "Rambo" admirer, who is matter-of-fact, if a bit regretful, about the lethal aspects of his job. Another is Juliano Mor, a muscular Tel Aviv street performer whose father is Palestinian and whose mother is Israeli. Periodically, he is shown doing a one-man street performance in which he squeezes a toy that makes shrill, anguished squeals while shooting colored paint over his body and then collapses. As often as not, his ritual self-mutilation provokes hostility from passers-by.

Mr. Mor is not the only artist in the film whose work deals with the conflict. Politically pointed pop music from both sides is heard. An excerpt from a dramatically militant piece by the Israeli choreographer Amir Kolban and his Tamar Dance Company is contrasted with a depiction of war staged by Hayan Yacoub, a Palestinian theater director in Jerusalem. Both these excerpts are intercut with film of actual street fighting.

One of the most film's most insistent themes is television's influence on public opinion. There is much complaining by Israelis about how they are portrayed as child-killers when rock-throwing Palestinian youths are slain in self-defense. The film takes pains to show just how dangerous those youths are and how readily their parents allow them to practice their crude but effective form of revolt.

"Deadly Currents" also gives equal time to the victims of the conflict. On one side is the grieving family of Hamad Ardah, a martyr of the uprisings known as the intifada, and on the other, Shim Navon, a victim of the Palestinian rebellion, who was grotesquely disfigured by a Molotov cocktail.

Throughout the film, Israeli and Palestinian academics and politicians offer a range of perspectives on the conflict. They devote many more words to analyzing the problem than to proposing practical solutions. There is little talk about the possibility of two coexisting states. Ultimately, the film's pessimistic tone derives not so much from what comes out of the mouths of leaders and experts, but from the feelings expressed by men and women in the street.

The general attitude of the Palestinian people seems to be that Jews should clear out of the area altogether. The Israelis, especially new settlers on the West Bank, have no intentions of giving up anything. For both sides, it comes down to a deeply held conviction that the disputed territory is a holy land to which one side, and nobody else, is entitled.

1992 O 16, C8:5

Candyman

Written and directed by Bernard Rose, based on "The Forbidden" by Clive Barker; director of photography, Anthony B. Richmond; edited by Dan Rae; music by Philip Glass; production designer, Jane Ann Stewart; produced by Steve Golin, Sigurjon Sighvatsson and Alan Poul; released by Tri-Star. Running time: 101 minutes. This film is rated R.

Helen Lyle	Virginia Madsen
Candyman	Tony Todd
Trevor Lyle	Xander Berkeley
Bernadette Walsh	Kasi Lemmons
Anne-Marie McCoy	Vanessa Williams
Archie Walsh	Bernard Rose

By JANET MASLIN

Too many tales of the supernatural allow occult goings-on to take a garden-variety turn. But the imagination of Clive Barker is authentically strange. In "Candyman," adapted by Bernard Rose from the Barker novel "The Forbidden," the horror unfolds inside a housing project and plays out provocatively against a backdrop of racial injustice. For those who find this approach too unconventional, the Candyman of the title also has a reassuringly familiar hook where his hand ought to be. Using this, he slashes victims with suitable abandon.

After a perfunctory prologue involving careless, sexy teen-agers (any horror-film stalker's favorite prey), "Candyman" settles upon a Chicago academic named Helen Lyle (Virginia Madsen) as its heroine of choice. A doctoral candidate whose studies lead her to the Candyman legend, Helen begins her own hands-on research into the story of this mysterious killer. She learns that Candyman (Tony Todd), a black man

in a fashionably long coat who can be summoned by repeating his name five times into a mirror, was once the victim of a terrible crime and has been seeking his own form of justice ever since. His ashes are scattered at Cabrini Green, the Chicago housing project where much of the action takes place.

●

Mr. Rose, very partial to secret gateways into the netherworld, also gives Candyman a surprisingly soft touch. His gambits run toward "sweets to the sweet" and "be my victim," and his taste runs toward Helen once she begins stirring up the memory of his past, through a series of suspensefully staged investigative episodes. That Helen goes from the halls of academe to a lunatic asylum during the course of the story says nothing to disparage her sleuthing talents.

"Candyman" is set up as an elaborate campfire story. More than once, it is said that what someone witnessed turned his or her hair white from shock. The film also has its share of novel touches, from the cute young student who dotes too much on Helen's husband (Xander Berkeley) to the fellow academics who view Candyman's crimes as a form of urban folklore. There is also an offbeat resolution to the tale, one that suggests there will soon be a new Candyperson in town.

The story's unusually high interest in social issues is furthered by the contrast between Helen's genteel condominium (which turns out to have a secret history as public housing) and the rougher atmosphere of Cabrini Green. At the latter, Vanessa Williams appears effectively as a young mother fighting to raise her baby against impossible obstacles, some of which emanate from the great beyond. The film's spooky atmosphere is accentuated by Anthony B. Richmond's cinematography and Philip Glass's score.

Ms. Madsen's performance is a lot more enterprising than what the material requires; the same can be said for Mr. Rose's direction. Mr. Todd sounds suitably ominous when oozing lines like "the pain, I can assure you, will be exquisite." Late in the story, both stars are required to play a kiss scene involving mouthfuls of bees. (Bees loom large in Candyman's troubled history.) Whatever these actors were paid, it wasn't enough.

●

"Candyman" is rated R (Under 17 requires accompanying parent or adult guardian). It includes nudity, graphic violence and miscellaneous horror effects not suitable for children.

1992 O 16, C10:5

South-Central

Written and directed by Steve Anderson, based on the book "Crips" by Donald Bakeer; director of photography, Charlie Lieberman; edited by Steve Nevius; music by Tim Truman; production designers, David Brian Miller and Marina Kieser; produced by Janet Yang, William B. Steakley and Mr. Anderson; released by Warner Brothers. Running time: 99 minutes. This film is rated R.

Bobby	Glenn Plummer
Ray Ray	Byron Keith Minns
Carole	LaRita Shelby
Ali	Carl Lumbly
Bear	Lexie D. Bigham
Loco	Vincent Craig Dupree
Baby Jimmie	Allan and Alvin Hatcher
Older Jimmie	Christian Coleman

Central Productions

Glenn Plummer, left, and Christian Coleman in "South-Central."

By JANET MASLIN

Although "South-Central" is about gangs, drugs, mindless violence and the paucity of father figures for young black men, the style of the film is distinctly dated. In setting forth the story of Bobby (Glenn Plummer), who joins a gang and spends much of his life in jail before coming to his senses, "South-Central" plays more like an exploitative potboiler than a civics lesson. Only late in the film, thanks to a sobering of tone and Mr. Plummer's credible performance, does the story develop any real impact. Too much of what has come before takes the form of empty posturing and seething; wide-eyed rants for the benefit of the camera.

"South-Central," written and directed by Steve Anderson, begins with the sight of Bobby being released from a year's imprisonment and immediately being reunited with his buddies, who belong to a gang called the Deuce. As set forth by Ray Ray (Byron Keith Minns), a friend of Bobby's with the ambition to become Mr. Big, the gang's purposes are simple. "Gangs have gotten to be the strongest force on the streets of L.A.," he says. "So we have to be the strongest gang." Each Deuce member is instructed to sell drugs without using the merchandise, and to wear an identifying black heart tattoo beneath his left eye.

Bobby has mixed feelings about a life of crime because he loves Jimmie, the baby he has fathered by Carole (LaRita Shelby), the quintessential drug-addicted tramp. Meeting Jimmie for the first time when he is released from jail, Bobby takes over caring for the child and is determined to bring him up right, until fate intervenes. Bobby is caught up in another crime. (The film, based on the book "Crips" by Donald Bakeer, whose experience of the Los Angeles ghetto is firsthand, includes the interesting fact that a potato can be used as a silencer on a gun.) And Bobby winds up spending his son's formative years away from the boy and back behind bars.

Years pass. Bobby comes home again. Carole is still hooked on PCP but still around. (The film has an odd sentimental streak.) And Jimmie, coached by Ray Ray in the ways of car-radio theft, is on the verge of going bad. The last and best part of the film concentrates on Bobby's jail-

house rebirth under the tutelage of a fellow prisoner (Carl Lumbly) and his efforts to save his son.

A lot of "South-Central" has a cartoonish broadness, but its final plea for parental responsibility comes through loud and clear. It would have come through even more strongly without the unconvincing swaggering that dominates the story. The sordidness that surrounds Bobby may not be factually exaggerated, but Mr. Anderson elicits performances that are way over the top. Sending Carole to visit her critically ill son in a skintight red dress with black bra showing says more about the film's brand of social realism than about the parental neglect it means to address.

Mr. Plummer's quiet performance is mercifully free of such showiness, and in the end it is honest and touching. More of the film could have played that way without the overheated excesses of its lurid, outmoded style.

●

"South-Central" is rated R (Under 17 requires accompanying parent or adult guardian). It includes violence, profanity and sexual situations.

1992 O 16, C13:1

Consenting Adults

Directed by Alan J. Pakula; written by Matthew Chapman; director of photography, Stephen Goldblatt; edited by Sam O'Steen; music by Michael Small; production designer, Carol Spier; produced by Mr. Pakula, David Permut and Katie Jacobs; released by Hollywood Pictures. Running time: 95 minutes. This film is rated R.

Richard Parker	Kevin Kline
Priscilla Parker	
	Mary Elizabeth Mastrantonio
Eddy Otis	Kevin Spacey
Kay Otis	Rebecca Miller
David Duttonville	Forest Whitaker
George Gordon	E. G. Marshall

By JANET MASLIN

In "Consenting Adults," Richard and Priscilla Parker (Kevin Kline and Mary Elizabeth Mastrantonio) live in a brand-new house with a second-floor study that directly overlooks the neighbors' Jacuzzi. This becomes an important point once Eddy and Kay Otis (Kevin Spacey and Rebecca Miller) move in next door. Eddy, who makes his entrance roaring out of a moving van on his motorcycle, is clearly the showier of the two. But it is Kay who gets Richard's attention. It's also Kay who likes the Jacuzzi and Kay, no doubt, who is careless about the window shades.

Richard, whose workaday existence can be summed up by the facts that he writes jingles for a living and that his wife falls asleep reading

Jurgen Vollmer

Kevin Kline, left, Kevin Spacey and Mary Elizabeth Mastrantonio in "Consenting Adults."

magazines, is knocked for a loop by the Otises' more flamboyant lives. Eddy boasts about his expensive toys and says things like "without money, you shrivel up." Eddy also taunts Richard for being so timid, once the two couples become instant best friends. When the Parkers are first invited over to the Otis house for a drink, they find themselves in a candlelit, Mephisto-red interior (the production design is not subtle) listening to Kay sing torch songs. The Parkers sense they are in over their heads.

It isn't long before Eddy begins dropping hints about mate-swapping. He doesn't get far with Priscilla, who reveals that she has never been unfaithful to Richard ("I guess I'm kind of old-fashioned that way"). But he piques Richard's interest when he asks whether the Parkers ever make love in the middle of the night when they're half-asleep, and wonders what would happen if Eddy and Richard surreptitiously changed places some evening. "Would they know the difference?" Eddy asks about his and Richard's wives. "And would they mind?"

●

"Consenting Adults," with a screenplay by Matthew Chapman, can be described only up until the point when Richard apprehensively takes Eddy up on this offer. A sinuous bedroom long-shot divides the film in half, and what happens afterward should remain a surprise. Suffice it to say that if the early, antiseptic-looking part of the film makes it an unlikely project for Alan J. Pakula, the second half makes it clear what the director of "Presumed Innocent" is doing here. It turns out that Eddy, who has been goading Richard to take risks and make life more interesting, has been following his own advice.

The devilish neighbors of "Consenting Adults" are no more plausible than any of the demon nannies or spouses or school friends who have lately become movie fixtures. If anything, this film's characters are even more far-fetched than most, since the annoyingly bland production design and peculiarly abrupt editing rob them of any possible complexity. Still, watching the plot unfold remains fun, if only for its "Can you top this?" brand of craziness. Eddy in particular, played by Mr. Spacey as the life of the party, is a ludicrous caricature but helps to keep matters interesting.

Mr. Kline is saddled with a reactive role too much of the time, but he manages to generate plenty of sympathy for the shell-shocked Richard, especially during the latter half of the story. Ms. Mastrantonio, appealing as always, has a lot less to work with. (The sexism of the film's premise goes without saying, but the screenplay compounds this by virtually ignoring the wives' side of the sexual equation.) Ms. Miller performs more than adequately, but her role would have required real star power to command much attention. Forest Whitaker has some gently fine moments as a man with a reason for believing Richard Parker's version of events when nobody else does, not even his lawyer (E. G. Marshall).

●

Mr. Pakula succeeds in holding the interest, but he can't make this story go further than skin-deep. Mr. Chapman's screenplay concentrates too much on plot contrivance and not enough on credible, cliché-free dialogue. The film's Southern settings are made to look dismayingly bland, and even if this is the point it has been unduly exaggerated. The squeaky-

clean Atlanta suburb where the story begins condescends visually to the characters even before the screenplay can begin trivializing them in other ways.

Several early scenes find Eddy and Richard testing their manhood by sharing various athletic rituals, like bicycling and jogging. While doing the former, Eddy plays chicken with an oncoming truck, which seems an excessive way of establishing his reckless nature. And the two men are seen running in a long, bouncy shot that follows them so closely the viewer is made dizzy. Such distractions wouldn't be needed if the characters had more to say.

●

"Consenting Adults" is rated R (Under 17 requires accompanying parent or adult guardian). It includes violence, nudity, sexual suggestiveness and mild profanity.

1992 O 16, C14:5

American Fabulous

Directed, edited and produced by Reno Dakota; written by Jeffrey Strouth; released by First Run Features. At the Joseph Papp Public Theater, 425 Lafayette Street, Greenwich Village. Running time: 105 minutes. This film has no rating.

WITH: Jeffrey Strouth.

By STEPHEN HOLDEN

Before dying of AIDS in June at the age of 33, Jeffrey Strouth, the subject of Reno Dakota's documentary portrait "American Fabulous," lived several lifetimes' worth of frenetic adventure. Proudly and flamboyantly gay, Strouth also learned how to tell, and perhaps how to embellish, a good yarn.

"American Fabulous," which opens today at the Joseph Papp Public Theater, is a crudely edited autobiographical monologue that was videotaped two years ago in the back of a 1957 Cadillac while driving around in Strouth's native territory, southern Ohio. Although growing up gay in small-town America must have had its traumas, in Strouth's recollections the experience becomes a grotesquely funny personal odyssey whose pungency is enhanced by the twangy lilt of his delivery.

●

Strouth's insistently comic tone only partly camouflages the pain and desperation of his short, frenzied life. His horror stories of his father, a brutal, alcoholic man and sometime Elvis impersonator, are capped by his memory of the time Strouth tried to asphyxiate his father with bleach fumes. When Strouth, at the age of 14, was sent to live with his father in Fort Lauderdale, Fla., he was left alone for weeks at a time and was forced into prostitution to feed himself. Characteristically, Strouth claims to have rather enjoyed turning tricks.

Beginning with Miss Earl, a toothless transvestite who was his first gay friend, Strouth's memoir is peopled with the kind of larger-than-life eccentrics one often finds in Southern Gothic fiction. One of many outrageous stories he tells on himself is of accidentally running a car out of control, while high on drugs and booze, into the apartment of a 400-pound drag queen and burning the place down.

His most elaborate story details a cross-country hitchhiking jaunt that he and a friend made, carrying a little

dog and a caged bird. In his most harrowing tale, he recalls being dumped naked at a highway rest stop in the middle of Utah after escaping possible death at the hands of a psychopath. Rescued by the police, he was held in jail for two days, forgotten, without food or water. Later, he was taken under the wing of the Salvation Army and washed dishes to raise the money to return east.

Strouth, who had always dreamed of being some kind of star, eventually wound up in New York, dressed as a caterpillar in a display case in the fashionable early-1980's nightclub Area, and sleeping in a friend's car in his costume to keep warm. When he finally found an apartment, his roommates were drug dealers for whom he played "nurse," administering everybody's daily heroin fixes, including his own.

The same streak of defiant eccentricity that colors Strouth's adventures on the road extends to his narrative's rare moments of outright sentiment. He describes in exquisite detail the funeral he arranged for his troubled younger sister after she committed suicide. For the event, he bought her a white Victorian gown, redid her makeup and strewed the casket with flower petals to make her look like an angel.

"American Fabulous" offers an indelible portrait not only of Strouth, but also of a type he represents, which might be described as a tough Southern queen who takes no prisoners. Impossible in some ways, endearing in others, he emerges as a flaming creature who was well worth memorializing.

1992 O 16, C14:5

FILM VIEW/Caryn James

Redford Lands the Big One

ERE ARE TWO THINGS I never thought I'd say: I like a movie about fly fishing, and Robert Redford has directed one of the most ambitious, accomplished films of the year. "A River Runs Through It," Mr. Redford's beautiful and deeply felt new movie, puts him in an entirely new category as a film maker.

The earlier films he directed, "Ordinary People" (1980) and "The Milagro Beanfield War" (1988), were competent but never hinted that there was a genuine artistic vision behind them. Now they seem like apprentice work for "A River Runs Through It," a film whose subtlety and grace disguise the fact that this is an artistically risky project.

Mr. Redford had to succeed big or not at all, because the story sounds sugary enough to make your teeth ache. Early in this century, two brothers and their Presbyterian-minister father learn about love, understanding and how fishing the Big Blackfoot River of Montana brings you closer to God. The word boring is bound to crop up about a film that tries to prove that fly fishing is next to

godliness. And though the photography is exquisite — the powerful, sun-kissed river is surrounded by lush green hills — pretty pictures only take you so far.

But don't fall asleep yet. Like Norman Maclean's autobiographical story, on which it is based, the film is filled with thorny contradictions. Mr. Redford depicts the emotions of people unable to express the depth of their feelings. He creates an unsentimental film about a past that is ripe for cheap nostalgia. And one of his main characters is a man who is never meant to be understood at all. Anyone who expects this film to be simple-minded and simple-hearted is coming from the wrong direction.

Though Mr. Redford does not appear in the movie, his voice is heard throughout as that of the unseen narrator, Norman Maclean, an old man looking back at his life. The story begins in 1910, when Norman and his younger brother, Paul, are boys. This is a family in which their fond but stern father (Tom Skerritt) insists that everyone sit at the table until Paul finishes his oatmeal; the small boy stares at the congealing mess in his bowl for hours.

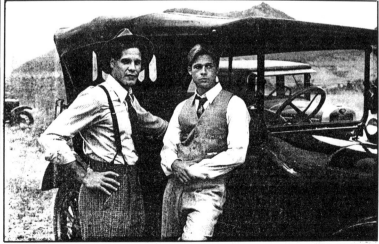

Columbia Pictures

Craig Sheffer and Brad Pitt in "A River Runs Through It"—The film triumphs over a story that sounds sugary enough to cause a toothache.

But the minister is also an expert fly fisherman who teaches his sons to be reverent about the miracles of the natural world. "In our family there was no clear line between religion and fly fishing," Mr. Redford says, his narration perfectly balancing the wit and sincerity of the opening line from Norman Maclean's 1976 novella. Throughout the film, the fishing scenes — don't worry, they are not long or about bait — create

Don't think you have to love fish to appreciate 'A River Runs Through It.'

the sense that each man is at one with nature but is quite separate from the other people in this family where emotions are rarely expressed.

As a young man, Norman (Craig Sheffer) is the studious, dark-haired one, who returns home after years at Dartmouth to find that the golden-haired Paul (Brad Pitt) has become a reporter. Mr. Pitt looks astonishingly like the young Robert Redford, with the same mischievous grin and crinkly smile. The resemblance probably has less to do with the director's ego than with Mr. Pitt's charismatic presence and ability to project Paul's glamorous aura so powerfully.

Paul is equally blessed and tortured. He is distant from his family but has an evident deep love for them; he is charming and bright but also a hard drinker, a gambler, a brawler. He is at peace only when fishing, in the place where he discovered a profound affection for nature.

For too long in the film, Paul seems an alluring but underwritten character, whose demons are never explained or explored. Only at the end does it become clear that he is meant to be a beautiful mystery. Paul is an enigma to viewers because Norman — and it is his story to tell, after all — cannot understand him any better than we can. Finally, their father preaches a sermon that sums up the meaning of the film: "It is those we love and should know who elude us. But we can

The actor has learned well from his earlier outings as a director.

still love them. We can love completely without complete understanding."

It would have helped if the narration had hinted at this mystery sooner. There are lines in the book ("It is a shame I do not understand him.") that would have accomplished that easily enough. Such foreshadowing on screen risks becoming too blunt; as it is, the film errs on the side of subtlety.

Still, this flaw doesn't overwhelm what is lively and heartfelt about the film. It doesn't upset the lovely balance Mr. Redford achieves in rendering his characters' contradictions.

He has learned well from his earlier works. "Ordinary People" was supposedly about repressed emotions. In fact, the story of an unemotional family's delayed reaction to a young man's death had characters emoting all over the place. The farmers in "The Milagro Beanfield War" felt a spiritual connection to nature, but that kinship seemed abstract, proclaimed instead of dramatized. But "A River Runs Through It" makes the Macleans' unexpressed emotions and religious affinity with the natural world moving and believable.

By the time the film arrives at its lyrical, elegiac end, it has earned all the feeling that comes pouring out. Mr. Redford's narration is staightforward and calm, allowing the poetry of Norman Maclean's written words to carry the emotion: "Eventually, all things merge into one, and a river runs through it." At last the Sundance Kid has grown up. □

1992 O 18, II:13:1

face than to give him a coy, beautiful Queen Isabella (Sigourney Weaver) to authorize his mission — and to turn Columbus into Gérard Depardieu, an actor who clearly appreciates feminine attention wherever he finds it?

It took a lot more than tomahawks to make a box-office success of "The Last of the Mohicans," that's for sure. What it took was the inclusion of heartthrob elements, plus a strain of modern-day silliness, in a story not previously known for its sex appeal. The reviewer for this newspaper who teasingly complained, in 1936, that the Randolph Scott version of "The Last of the Mohicans" had been made to include a chaste kiss had no idea that James Fenimore Cooper's stodgy Hawkeye would ever become matinee-idol material. Now Mr. Day-Lewis, teamed smolderingly with the beautiful Madeleine Stowe, brings serious chemistry to a role that seemingly had no romantic potential at all.

So "The Last of the Mohicans," thanks to two great-looking, mane-tossing leads who set off sparks merely by staring at each other, offers a lot more natural beauty than rushing waterfalls and unspoiled forests. But those forests are important, since they introduce another part of Hollywood's current formula for historical hindsight. Both "The Last of the Mohicans" and "1492" are politically correct enough to pay attention to the level of the unspoiled tree canopy (very high) and emphasize hints of eco-tragedy to come. And each of these films makes a point of modernizing its hero in ways that present-day audiences can be trusted to understand.

This just-like-us thinking — the common but ridiculous notion that celebrities or tabloid victims or unhappy members of the British royal family are at heart like you and me — is a staple of much modern-day historical fiction. But it reaches new heights of zaniness in the image of a drawling, laid-back Hawkeye, who at times seems positively Californian (at one point in the film, this former loner is seen amiably visiting with a cabinful of affectionate friends). It gets even crazier in the pulpy writing of "1492," which, according to an opening title, is set against the backdrop of "a ruthless inquisition that persecuted men for daring to dream." Surely they had a better way of putting it back in Columbus's day.

"1492," an unnaturally stiff and talky epic for the director Ridley Scott, presents a Columbus who is no less sensitive than the revamped Hawkeye, and who at one point is even seen in a dropped-waist red dress (on a man with Mr. Depardieu's physique, this is not flattering). Indeed, the language of the screenplay often borders on bodice-ripping romantic silliness, as when an eager-to-sail-around-the-world Columbus is cautioned: "You must learn to control your passion." At this, of course, an indignant Columbus answers: "Passion is something one cannot control!" Such dialogue can be heard so readily on any soap opera that it sounds crazily out of tune with history.

Daniel Day-Lewis—It's good to have a mane to toss.

FILM VIEW/Janet Maslin

Hunks Help To Sell History

HOLLYWOOD HAS LATELY REVIVED ITS INterest in historical pageantry, and the insurance policy is the longhaired leading man. What better way to attract the dating crowd to, say, the French and Indian War than to provide the sight of Daniel Day-Lewis in form-fitting buckskin? What better way to send Columbus to the New World with a smile on his

"1492" is so terribly earnest that its two and a half hours contain only a few memorable howlers. (Columbus being told that Amerigo Vespucci has discovered the mainland in the New World: "I hope you're not too disappointed." Columbus being cheered up during a particularly trying part of his adventure: "No one ever expected this to be easy, Christopher.") But this brand of prettified, oversimplified history reaches a pinnacle during its certifiable Big Moment — the

Hawkeye and Columbus market sex appeal.

one that finds the explorer setting foot for the very first time on what will be known as North American soil.

The music swells. (Vangelis's score for this film often sounds like his music for "Chariots of Fire.") The feet are seen in close-up. Columbus moves in exalted slow motion. And the whole image virtually invites viewers to share the Columbus experience. (It is simply a miracle that neither the screenplay nor the film's ads thought to put it that way.) Yet if you had to name the top-10 unimaginable epiphanies of world history, surely Columbus's at that precise moment would make the list. No film can begin to capture an event of that intensity, even if this one feels obligated to try.

No, the closest "1492" can come to inviting true audience identification is by presenting a movie-star conquistador whose face and feelings seem conveniently familiar. When Mr. Depardieu, whose star turn works much less comfortably than Mr. Day-Lewis's, sits gazing at the horizon with an orange in his hand, he declares fervently to his young son: "It's round, like this — round!" This may not work as drama, but it does work as a teaching aid, just as Mr. Depardieu's very presence helps bring the geography lesson to life. And if it is not precisely true that the discoverer of America was a longhaired hunk, well, isn't it pretty to think so? []

1992 O 18, II:13:5

Russia on Analyst's Couch

"Interpretation of Dreams" was shown as part of the 1991 New Directors/New Films series. Following are excerpts from Vincent Canby's review, which appeared in The New York Times on March 30, 1991. The film opens today at Film Forum 1, 209 West Houston Street, South Village.

In Andrei Zagdansky's "Interpretation of Dreams," a short (50-minute), interesting and difficult Russian film, an entire country is put on the couch to be analyzed by the film maker using Sigmund Freud as his guide. Mr. Zagdansky juxtaposes

quotes from Freud, which are read on the soundtrack, and the history of the Soviet Union as captured in vintage newsreels and other old films.

The tone is that of an enlightened skeptic; the manner, witty. The film attempts to come to terms with a time that now seems to have been seriously neurotic, if not worse. The English subtitles fly by at a fairly relentless pace, which makes the film almost as exhausting as it is provocative.

1992 O 21, C20:1

The Panama Deception

Directed by Barbara Trent; written and edited by David Kasper; music by Chuck Wild; produced by Ms. Trent, Mr. Kasper, Nico Panigutti and Joanne Doroshow; released by Empowerment Project. Village East Cinema, Second Avenue at 12th Street, Manhattan. Running time: 94 minutes. This film is not rated.

Narrated by Elizabeth Montgomery; English voice-overs by Abraham Alvarez, Carlos Cantu, Diviana Ingravallo, Alma Martinez, Lou Diamond Phillips, Tony Plana, Rose Portillo, Lucy Rodriguez and Carmen Zapata.

By VINCENT CANBY

"The Panama Deception," opening today at the Village East Cinema, is a tough, provocative, highly opinionated and slickly produced documentary, an answer to the official United States Government line about the 1989 invasion of Panama.

Barbara Trent, the film's director; David Kasper, the writer and editor, and their colleagues say the principal purpose of the invasion was not to liberate Panama from the control of a ruthless dictator and to bring Gen. Manuel Antonio Noriega to trial on drug charges. Rather, they say, it was to destabilize the country and destroy Panama's Defense Forces, creating a situation that would allow the United States to renegotiate the treaties, signed by President Jimmy Carter, under which the canal is to be turned over to the Panamanians by the year 2000.

The film is full of witnesses: policy makers, official spokesmen, politicians, informed observers, flunkies, historians and ordinary folk, many of them Panamanian victims of the war that, the film points out, was covered by the American news organizations almost entirely in terms that served

official United States interests. This is hardly a scoop, but it's something that needs repeating for Americans who judge the importance of everything that happens in the rest of the world, whether it's a war or the Olympics, from the hometown point of view.

"The Panama Deception" puts the 1989 invasion in a historical context, presenting it as a continuation of the policies by which the United States first acquired rights over what would become the Panama Canal Zone under President Theodore Roosevelt. The film sees the actions of President Bush and his Administration as no less high-handed but possibly even more sorrowful in the light of what is supposed to be a better informed, more liberal age.

•

Included are interviews with Gen. Maxwell R. Thurman, the commander of the invasion, and President Guillermo Endara of Panama, and with outspoken critics of the invasion, including Representative Charles B. Rangel, Democrat of New York, and Ramsey Clark, the former United States Attorney General. In addition to the material shot specifically for the film, "The Panama Deception" also presents much material shot during and after the invasion but not widely seen before. Ms. Trent makes much use of irony, for example, by juxtaposing a Panamanian politician's statements about peace and democracy with shots dramatizing the fearful toll war takes on civilians, most of them poor. It's easily done but still effective.

"The Panama Deception" is very canny film making. Its images are moving in themselves and beautifully edited. It really doesn't need a lot of Elizabeth Montgomery's instructive narration, which constantly tells the audience what it's supposed to think. The pictures and the testimony do quite well on their own.

1992 O 23, C10:5

The Whole Truth

Directed by Dan Cohen and Jonathan Smythe; written by Mr. Cohen; director of photography, Dennis Michaels; edited by Rick Derby; music by Bill Grabowski; produced by Richard Bree; released by Cinevista. Quad Cinema, 34 West 13th Street. Running time: 85 minutes. This film is not rated.

Vanessa	Dyan Kane
Dan	Dan Cohen
Judge	Jim Willig
Olivia	Pat Lemay
Paul	Paul Kahane

By JANET MASLIN

"The Whole Truth," a hard-working comedy with a homemade flavor, is about love and Lancaster, Pa., not necessarily in that order. Shot in Lancaster with a distinctively low-gloss look, it presents the lovelorn Dan (played by Dan Cohen, who also wrote and co-directed the film, and is its executive producer). The flimsy setup sends Dan to court to defend himself against harassment charges brought by Vanessa (Dyan Kane), an ex-date who now considers Dan a nuisance.

With their debate moderated by a gavel-swinging judge, the two litigants present conflicting versions of their brief romance. Dan, a sometime nightclub comic who sells magicians' supplies ("the rabbits got into the

flash powder," he complains), tends to have the rosier memories. He recalls his own amorous efforts as charming, while Vanessa characterizes him as a relentless pest.

Dan's scenes of a first date find him wowing Vanessa with his comedy act. But in Vanessa's version, the nightclub's other patrons watch Dan with stone-faced disbelief, and the man sitting beside her exclaims, "What a jerk!" Dan remembers a serious cinéaste's discussion of his videotape collection, with Vanessa remarking on a Rohmer film; Vanessa recalls noticing Dan's copies of "Deathsport" and "Truck Stop Women." "Oh, yeah," Vanessa remembers saying irritably about Dan's beloved uncut version of "Touch of Evil." "I saw the cut version. It was still too long."

•

"The Whole Truth," which opens today at the Quad Cinema in Greenwich Village, may itself wind up in somebody's video collection some day. Its charms are real, even if Mr. Cohen (and his co-director, Jonathan Smythe) too often allow them to wear thin. The film's modest humor, which sometimes suggests very early Woody Allen and at other points recalls Albert Brooks's "Defending Your Life," has a needlessly overindulged tendency to turn cute. "The Whole Truth" is billed as "a comedy romantic," for instance, when "romantic comedy" would easily have sufficed. And the directors should have resisted the temptation to have courtroom spectators comment on the action.

Mr. Cohen's hangdog, self-deprecating presence can be quietly funny, and is well suited to the film's high-amateur style. Cast members look like real Lancaster natives, and settings are artlessly down to earth. The film's stabs at eccentricity — Dan's golf-playing mother, his efforts to pester Vanessa with mash notes disguised as junk mail — work as often as they misfire.

Among the better touches in Mr. Cohen's offbeat, promising material are Dan's dating service video, in which he traces the role of the clothes hanger for artists including Michelangelo and Picasso, and his attempts to reassure Vanessa about love and trust. "You don't have to trust me to love me," he insists. "Just don't loan me money."

1992 O 23, C10:5

Pure Country

Directed by Christopher Cain; written by Rex McGee; director of photography, Richard Bowen; edited by Jack Hofstra; music by Steve Dorff; production designer, Jeffrey Howard; produced by Jerry Weintraub; released by Warner Brothers. Running time: 112 minutes. This film is rated PG.

Dusty Wyatt Chandler	George Strait
Lula Rogers	Lesley Ann Warren
Harley Tucker	Isabel Glasser
Buddy Jackson	Kyle Chandler
Earl Blackstock	John Doe
Ernest Tucker	Rory Calhoun
Grandma Ivy Chandler	Molly McClure
Tim Tucker	James Terry McIlvain
J. W. Tucker	Toby Metcalf

By JANET MASLIN

It's lonely at the top. Success is a misery for Dusty, a ponytailed country-music star so famous he doesn't need a last name. The screaming fans and the fancy stage lighting have lost their appeal. So has Dusty's man-

Ron Phillips

George Strait

ager, Lula (Lesley Ann Warren), who wears too much leather and screeches things like "Cute guys like you who sing are a dime a dozen." So at the start of "Pure Country," Dusty decides to get a haircut, escape his fame and rediscover the simple life.

"I'm tired of all the smoke and the lights," declares Dusty, played by the singer George Strait with a monotone and a wooden grin, in a performance that is all cowboy hat. "It ain't me." So he embarks on a search for his simpler self, the kind of voyage also attempted (a lot more successfully) by John Mellencamp in his recent "Falling From Grace." For Dusty, this means going miraculously unrecognized in a small-town coffee shop and meeting a nice girl at a honkytonk, then finding himself trapped in a parking-lot brawl. See "Thelma and Louise" for a much livelier take on similar scenes.

As directed listlessly by Christopher Cain, "Pure Country" lacks even the enjoyable chutzpah of a vanity production, preferring a somnolent seriousness about Dusty and his problems. The resulting film is, as one of its characters could easily have said, slower 'n molasses. Too much of it depends on the magnetism of Mr. Strait, who peers into the camera sheepishly and never seems the superstar he is supposed to be. The Strait songs on the soundtrack sound pleasant enough, but never catch fire.

•

"Pure Country," which in no way lives up to its title, also features Isabel Glasser as the hearty rodeo queen who rescues Dusty (known as Wyatt in his nice-guy incarnation) from a life of empty glitter, and a nearly unrecognizable Rory Calhoun as her crusty father. Molly McClure plays the knowing Grandma who advises Dusty: "There are no answers. Only the search." Rex McGee's screenplay is all on a par with that.

Among the film's few scenes to command any attention are the concert shot in which a camera hurtles frighteningly toward Dusty from the back of a huge indoor stadium, and a rodeo scene in which a lone rider circles an arena to the tune of "America the Beautiful," with the inspirational mood impaired by advertising posters plastered all over the walls.

•

"Pure Country" is rated PG (Parental guidance suggested). It includes very mild profanity.

1992 O 23, C13:1

Reservoir Dogs

Written and directed by Quentin Tarantino; director of photography, Andrzej Sekula; edited by Sally Menke; production designer, David Wasco; produced by Lawrence Bender; released by Miramax Films. Running time: 99 minutes. This film is rated R.

Mr. White	Harvey Keitel
Mr. Orange	Tim Roth
Mr. Blonde	Michael Madsen
Nice Guy Eddie	Chris Penn
Mr. Pink	Steve Buscemi
Joe Cabot	Lawrence Tierney
Holdaway	Randy Brooks
Marvin Nash	Kirk Baltz
Mr. Blue	Eddie Bunker
Mr. Brown	Quentin Tarantino

By VINCENT CANBY

It's been an unusually good year for the discovery of first-rate new American film directors: Barry Primus ("Mistress"), Nick Gomez ("Laws of Gravity"), Allison Anders ("Gas Food Lodging") and Carl Franklin ("One False Move"), among others. Now add to the list the name of Quentin Tarantino, the young writer and director of "Reservoir Dogs," a small, modestly budgeted crime movie of sometimes dazzling cinematic pyrotechnics and over-the-top dramatic energy. It may also be one of the most aggressively brutal movies since Sam Peckinpah's "Straw Dogs."

"Reservoir Dogs" is about a Los Angeles jewelry store robbery masterminded by a tough old mob figure named Joe Cabot (Lawrence Tierney). The principal characters are introduced in an extended precredit sequence in which the thieves are seen relaxing over lunch sometime before the job.

The camera looks on with the indifference of a waitress who expects no tip. One guy holds forth on the meaning of the lyrics of popular songs, with special emphasis on the oeuvre of Madonna. His discoveries are no more profound than those of academe, but his obscene jargon, which disgusts some of his colleagues, is refreshingly blunt and more comprehensible than any deconstructionist's. It's a brilliant scene-setter.

•

Cut to the initial postcredit sequence, just after the heist has been carried out and two of the hoods, played by Harvey Keitel and Tim Roth, are fleeing the scene. Mr. Keitel is at the wheel of the car while Mr. Roth lies across the back seat, bleeding badly and clutching his stomach as if to hold in the organs. Something obviously went wrong. One of the hoods became panicky during the holdup and began shooting. It's also apparent that the police had been tipped off. Mr. Roth begs to be taken to a hospital, or just dumped somewhere near a hospital, but Mr. Keitel refuses. They go on to the warehouse where the gang members were to meet according to the original plan.

Though all of the film's contemporary action takes place inside this warehouse, "Reservoir Dogs" cuts back and forth in time with neat efficiency to dramatize the origins of this soured caper. One of the elements of old Joe's plan was the anonymity of the men he hired for the job, to protect them from one another and from the police.

To this end he gave them noms de crime (Mr. White, Mr. Pink, Mr. Orange and so on), which especially offends the man dubbed Mr. Pink, who thinks it makes him sound like a sissy. In the course of the film, some of the men do reveal their real

Miramax Films

Tim Roth

names; which leads to a certain amount of confusion for the audience when the men are talking about characters who are off screen.

•

Though small in physical scope, "Reservoir Dogs" is immensely complicated in its structure, which for the most part works with breathtaking effect. Mr. Tarantino uses chapter headings ("Mr. Blonde," "Mr. Orange," etc.) to introduce the flashbacks, which burden the film with literary affectations it doesn't need. Yet the flashbacks themselves never have the effect of interrupting the flow of the action. Mr. Tarantino not only can write superb dialogue, but he also has a firm grasp of narrative construction. The audience learns the identity of the squealer about midway through, but the effect is to increase tension rather than diminish it.

"Reservoir Dogs" moves swiftly and with complete confidence toward a climax that matches "Hamlet's" both in terms of the body count and the sudden, unexpected just desserts. It's a seriously wild ending, and though far from upbeat, it satisfies. Its dimensions are not exactly those of Greek tragedy. "Reservoir Dogs" is skeptically contemporary. Mr. Tarantino has a fervid imagination, but he also has the strength and talent to control it.

•

Like "Glengarry Glen Ross," another virtually all-male production, "Reservoir Dogs" features a cast of splendid actors, all of whom contribute equally to the final effect. Among the most prominent: Mr. Keitel, whose moral dilemma gives the film its ultimate meaning; Steve Buscemi, as the fellow who has thought long about the messages in Madonna's songs; Mr. Roth, the English actor who gives another amazing performance as a strictly American type; Chris Penn, as Mr. Tierney's son and heir; Michael Madsen, as a seemingly sane ex-con who isn't, and Mr. Tierney, who more or less presides over the movie.

The film also marks the American debut of Andrzej Sekula, the Polish-born director of photography. Mr. Sekula's work here is of an order to catapult him immediately into the front ranks. One of the principal reasons the film works so well is the sense of give-and-take that is possible only when two or more actors share the same image. Mr. Sekula and Mr. Tarantino have not been brainwashed

by television movies. They don't depend on close-ups. "Reservoir Dogs" takes a longer view.

Pay heed: "Reservoir Dogs" is as violent as any movie you are likely to see this year, but though it's not always easy to watch, it has a point.

•

"Reservoir Dogs" is rated R (Under 17 requires accompanying parent or adult guardian). It has a great deal of obscene language and scenes of explicit brutality, including one in which a policeman who is tied to a chair is attacked by a man with a razor.

1992 O 23, C14:1

The Professional

Directed by Osamu Dezaki; English-language dialogue written and directed by Greg Snegoff; based on the graphic novels by Takao Saito; director of photography, Hirokata Takahashi; edited by Mitsuo Tsurubuchi; music by Toshiyuki Omori; produced by Yutaka Fujioka, Mataichiro Yamamoto and Nobuo Inada; adaptation produced and directed by Carl Macek; released by Streamline Pictures. Cinema Village Third Avenue, 100 Third Avenue, at 13th Street. Running time: 95 minutes. This film is not rated.

Voices:

Golgo 13	Greg Snegoff
Leonard Dawson	Michael McConnohie
Bragan	Mike Reynolds
Laura	Edie Mirman
Cindy	Joyce Kurtz
Rita	Diane Michelle
Pablo	Kerrigan Mahan
Garvin	David Povall
Jefferson	Ed Mannix

By JANET MASLIN

"The Professional," which opens today at the Cinema Village Third Avenue, is a Japanese animated film whose comic-book tawdriness would be just as well served by witless live action. In this lurid mélange of violence and soft-core sex, animation makes it possible to pay close attention to a bullet entering a villain's forehead or to other similarly piquant touches. But the animators' delicacy is wasted on a crude, idiotic story.

Based on the graphic novels (comics) by Takao Saito, and directed by Osamu Dezaki, "The Professional" tells of a ruthless hit man who is wildly popular with women. Perfunctory about both sex and violence, it involves the dull Duke Togo, also known as Golgo 13, in an array of alternating shootouts and trysts. The women, who lure Duke into sexual encounters every 15 minutes or so, all have the same statuesque shape and propensity for moaning and sweating. Their dialogue ("I've waited for you to pull my trigger, lovingly and softly") is embarrassing even by comic-book standards.

The violence here is equally mindless, even if it pits Duke against a ruthless American tycoon who supposedly masterminded President Kennedy's assassination. And the look is relatively nondescript, even if the settings include South America and Malibu. Though the film seems to consider its locations exotic, and though it pays attention to supposedly authentic details like an Esso sign, "The Professional" has little real color. The occasional fanciness of Mr. Dezaki's direction, which at times simulates flashy editing effects, is no substitute for real style.

Fanciers of animated violence may appreciate the slashing (with a giant hook) and eye-gouging that can be seen here. Even more egregious is a

Streamline Pictures

A scene from the animated feature "The Professional."

scene in which the story's villain, as part of a business arrangement, agrees to let his son's widow be raped by a grinning, yellow-eyed giant. The film depicts this episode enthusiastically while pretending to find it lamentable.

1992 O 23, C14:5

Dr. Giggles

Directed by Manny Coto; written by Mr. Coto and Graeme Whifler; director of photography, Robert Draper; edited by Debra Neil; music by Brian May; production designer, Bill Malley; produced by Stuart M. Besser; released by Universal Pictures. Running time: 93 minutes. This film is rated R.

Dr. Evan Rendell	Larry Drake
Jennifer Campbell	Holly Marie Combs
Tom Campbell	Cliff De Young
Max Anderson	Glenn Quinn
Officer Joe Reitz	Keith Diamond
Officer Hank Magruder	Richard Bradford
Tamara	Michelle Johnson
Dr. Chamberlain	John Vickery
Elaine Henderson	Nancy Fish
Coreen	Sara Melson

By VINCENT CANBY

"Dr. Giggles" is a horror film about a pudgy, mad, very general practitioner (Larry Drake) who is inclined to giggle in moments of stress, which are frequent. After escaping from an asylum, he returns to his hometown to kill everybody in one seemingly endless night. The job is not as difficult as it might seem: his victims have very small brainpans. Nobody ever turns on a light, looks behind a door or walks home in the company of someone else.

The screenplay is stitched together from variations on clichés used by or about the medical community. As the mad doctor removes a bullet from his own stomach, he chortles, "Physician, heal thyself." At another point, just before strangling a victim, he announces: "Reflexes normal. Now let's check the blood pressure." A few minutes later, he observes, while affecting great surprise, "Either you're dead or my watch has stopped." So it goes as the bodies accumulate.

"Dr. Giggles" opened here yesterday at a number of theaters, including the National Twin, where the noon show was plagued by quality-conscious gremlins. Throughout the opening portion of the program (five trailers and the first reel of the feature) the screen curtains rhythmical-

ly opened and closed, apparently of their own accord. It was as if some benign supernatural force were trying to prevent this jokey movie from ever being seen. Eventually the forces of evil triumphed.

●

"Dr. Giggles," which has been rated R (Under 17 requires accompanying parent or adult guardian), has lots of simulated violence and gore.

1992 O 24, 16:4

Frozen Assets

Directed by George Miller; written by Don Klein and Tom Kartozian; directors of photography, Ron LaToure and Geza Sinkovics; edited by Larry Bock; music by Michael Tavera; production designers, Deborah Raymond and Dorian Vernacchio; produced by Mr. Klein; released by RKO Pictures Distribution. Quad Cinema, 34 West 13th Street. Running time: 96 minutes. This film is rated PG-13.

Dr. Grace Murdock	Shelley Long
Zach Shepard	Corbin Bernsen
Newton Patterson	Larry Miller
Mrs. Patterson	Dody Goodman
J. F. Hughes	Matt Clark
Zach's Mother	Jeanne Cooper
McTaggert	Paul Sand
Gloria the Madam	Gloria Camden
Peaches	Teri Copley

By STEPHEN HOLDEN

When Zach Shepard (Corbin Bernsen), a dumb junior executive from a big Los Angeles bank, is sent to run one of its branches in northwestern Oregon, he hasn't a clue that the place is really a sperm bank and not a financial institution. This makes for many smirking double-entendres when he first encounters its straitlaced young manager, Dr. Grace Murdock (Shelley Long).

An ultimate male chauvinist, Zach conceives the notion of increasing the bank's deposits by holding a stud-of-the-year contest, its $100,000 winner being the entrant with the highest sperm count. At a packed-to-the-rafters pep rally in the high school, teen-age cheerleaders shout the do's and don'ts for increasing one's count. One of the do's is sexual abstinence, and when business drops precipitately at the brothel, the angry prostitutes picket the bank until they are hired as "nurses."

"Frozen Assets," which opened yesterday, was directed by George Miller and written by Don Klein and Tom Kartozian. It is the sort of frantic comedy that builds up a certain maniacal energy by trying to top itself in bad taste and ludicrous plot twists every few minutes. Heading a long list of absurdities is the notion that Grace could ever develop a crush on Zach, who is a walking dictionary of sexist put-downs.

For Mr. Bernsen, who looks puffy and uncomfortable and demonstrates little aptitude for comedy, the film is big step down from "L.A. Law." For Ms. Long it augurs worse. It is the kind of role that signals the last-ditch stand of a fading career. Only the comedian Larry Miller, as an escaped mental patient who becomes Zach's right-hand man, survives the fiasco by acting like a somewhat tamer Jonathan Winters. His character dreams in animated cartoons.

●

This film is rated PG-13 (Parents strongly cautioned). It is filled with off-color humor.

1992 O 24, 16:4

Venice/Venice

Written and directed by Henry Jaglom; director of photography, Hanania Baer; music by Marshall Barer and David Colin Ross; produced by Judith Wolinsky; released by Rainbow Film Company. Running time: 108 minutes. This film has no rating.

Jeanne	Nelly Alard
Dean	Henry Jaglom
Carlotta	Suzanne Bertish
Peggy	Melissa Leo
Eve	Daphna Kastner
Dylan	David Duchovny
Stephanie	Diane Salinger
Dennis	Zack Norman
Mark	Marshall Barer
John Landis	Himself

By JANET MASLIN

Henry Jaglom knows exactly what his critics think of him, and in "Venice/Venice" he tries to beat them to the punch. Brazenly casting himself as a revered American film maker ("I am very much a maverick in America") at the Venice Film Festival, he holds court in restaurants and at poolside while giving interviews about his oeuvre. But he also allows a beautiful French journalist named Jeanne (Nelly Alard) to point out that "people accuse you of looking at your bellybutton." Those who single out that aspect of Mr. Jaglom's work in other films (among them "Eating," "Tracks" and "New Year's Day") are not about to miss it this time.

Mr. Jaglom looks at his bellybutton, figuratively speaking, with such tireless intensity that the act takes on a certain fascination. He is also willing to devote vast attention to the many talkative, vulnerable-sounding women who crop up in his films, women who gaze warmly into the camera and voice their innermost thoughts on a specific subject, in this case movie romance. One says, "I just expected that I would be taken care of and life would be beautiful." Another wonders why her life is not more like "The Philadelphia Story." Mr. Jaglom's specialty is creating the perfect climate in which such thoughts can be expressed.

●

In "Eating," when many women spoke passionately (and humorously) on subjects like the comparative virtues of sex and baked potatoes, their various hang-ups about food managed to occupy center stage. This time that position is firmly held by Mr. Jaglom himself, as he conveys the rush of flattery that surrounds any well-received film maker at a festival and moves on to address age-old questions about illusion and reality. "Life is not a movie," says the ad copy for "Venice/Venice"; "Life is not an illusion ... or vice versa." Go no further unless you find that making marginal sense.

"Venice/Venice," which opens today, certainly does all it can to contradict the thought that life and films are separate. Miss Allard, who has a warmly inviting smile and an admiring demeanor, plays a reporter who is greatly impressed by Mr. Jaglom's film director, Dean — and in fact Miss Allard has made a documentary film ("On the Tracks of a Film maker") about the Jaglom career. The whole film festival ambiance that is captured here has a documentary flavor, with only the use of a pseudonym for Mr. Jaglom seeming to suggest a fictional component. Among the few touches that call attention to artifice are the way Dean glad-hands the director John Landis, who is a juror, and a scene in which Dean asks Jeanne to quit arguing with him in

front of festival spectators, who he thinks may be watching his every move. The film would have benefited from a bit more in this ironic vein.

●

Although it initially hints at "Player"-like satirical possibilities, with a behind-the-scenes view of one film maker's wheeling and dealing, "Venice/Venice" proves extremely ear-

Henry Jaglom looks inward and spoofs himself at the same time.

nest. It shows Jeanne falling head over heels for Dean, who takes her for gondola rides and listens to her thoughts about the cosmos. "If you touch one thing in the universe, it affects all the other things," Jeanne muses. "You're very beautiful, you know that?" says Dean, who speaks Jeanne's language. "But that can be an illusion, too."

Mr. Jaglom happens to be a terrific listener, both behind and in front of the camera. He gazes encouragingly at any woman who speaks to him, which may be why so many of the fleeting interviewees appear so exhilarated and eager to please. Still, it may be more than the traffic will bear for Mr. Jaglom to have made a film in which a beautiful acolyte follows him from Venice, Italy, where he is surrounded by one set of admirers and hangers-on, to Venice, Calif., where he has another. The title indicating this change of locale is superfluous, since the move offers the audience a rare chance to figure something out on its own.

●

"Venice/Venice" is wildly self-indulgent, and the director seems to know that. He also knows that his work, however protracted and rambling, is not dull. The self-serving aspect of Mr. Jaglom's work is balanced by a real craving for some brand of candor, or at least a taste for capturing spontaneity on screen. "It seems to me that a movie only exists once you have the images," Dean tells an interviewer, sounding a shade ridiculous but making what for Mr. Jaglom is an honest point. Like John Cassavetes and Robert Altman, whose respective fury and wit he cannot begin to equal, Mr. Jaglom serves as a kind of divining rod for emotional candor, and sometimes he gets what he is after.

There are limits, however. It's hard to imagine another director who, at a casting call for an actress to play his wife in his next movie, would ask aspirants: "Can you see me as the father of your children?" Mr. Jaglom has that particular brand of Hollywood artistry to himself.

1992 O 28, C20:5

A Day In October

Directed by Kenneth Madsen; screenplay by Damian F. Slattery; director of photography, Henning Kristiansen; edited by Nicolas Gaster; music by Jens Lysdal and Adam Gorgoni; production designer, Sven Wichmann; produced by Just Betzer and Philippe Rivier; released by Castle Hill Productions. Running time: 103 minutes. This film is rated PG-13.

Niels Jensen	D. B. Sweeney
Sara Kublitz	Kelly Wolf
Emma Kublitz	Tovah Feldshuh
Solomon Kublitz	Daniel Benzali
Larsen	Ole Lemmeke
Arne	Kim Romer
Kurt	Anders Peter Bro
Willy	Lars Oluf Larsen

By STEPHEN HOLDEN

Kenneth Madsen's film "A Day in October" treats one of the more heroic chapters of World War II, the Danes' rescue of most of their Jewish population during the Nazi occupation, as an inspirational history lesson in the guise of a thriller. But the film is so intent on commemorating noble deeds by decent people that it is not very suspenseful. Its attitude is also one of restrained self-congratulation. The Danish characters are all unambiguously wonderful, while its German officer (Ole Lemmeke) is a familiar cartoon of Nazi evil.

Set in the fall of 1943, "A Day in October" follows the painful awakening of the Kublitzes, a Jewish family in Copenhagen, to the full extent of the Nazi peril. Solomon Kublitz (Daniel Benzali), the head of the household, is a nervous bookkeeper who believes that he and his wife, Emma (Tovah Feldshuh), and daughter, Sara (Kelly Wolf), should try to wait out the occupation. It is only when Sara impulsively brings home Niels Jensen (D. B. Sweeney), a wounded Danish freedom fighter, that Solomon begins facing reality.

No sooner has Niels been nursed back to health than he sets about persuading Solomon to plant a bomb in the factory where he works. Solomon's conversion from frightened mouse to underground terrorist is the psychological crux of the drama. And although Mr. Benzali's portrayal of a security-obsessed bookkeeper is full and detailed, the film throws away its only chance to dramatize an agonizing moral dilemma by rushing through it.

From there, "A Day in October," which opens locally today, turns into a mechanical cat-and-mouse game, as the Kublitzes flee their home and join other Jewish families at a seacoast hideaway where they wait to be transported to Sweden. Along the way, Niels and Sara also fall in love.

For a war film, "A Day in October" is remarkably lacking in kinetic drive. Its action sequences are so perfunctory that at times the camera seems to be turning away as though it would be too much trouble to make them exciting. Damian F. Slattery's screenplay has a similarly too-cautious attitude. The dialogue has the sound of a plot outline being laboriously turned into speech.

Except for Solomon, none of the characters come to life. All that is shown about Niels is his fervent dedication to the cause. As portrayed by Mr. Sweeney, a talented young actor given to dramatic understatement, the character exudes a slack-jawed innocence so unreadable that you eventually begin to question his intelligence.

"A Day in October" is rated PG-13 (Parents strongly cautioned). It includes adult themes and situations.

1992 O 28, C20:5

The Lover

Directed by Jean-Jacques Annaud; screenplay by Mr. Annaud and Gérard Brach, from the novel by Marguerite Duras; director of photography, Robert Fraisse; edited by Noëlle Boisson; music by Gabriel Yared; production designer, Thanh At Hoang; produced by Claude Berri and Timothy Burrill; released by Metro-Goldwyn-Mayer Inc. Fine Arts Theater, 4 West 58th Street, Manhattan. Running time: 103 minutes. This film is rated R.

Young Girl	Jane March
Chinese Man	Tony Leung
Mother	Frédérique Meininger
Elder Brother	Arnaud Giovaninetti
Younger Brother	Melvil Poupaud
Hélène Lagonelle	Lisa Faulkner
Chinese Man's Father	Xiem Mang
Narrated by Jeanne Moreau	

By VINCENT CANBY

"The Lover" ("L'Amant"), Marguerite Duras's best-selling French novel, would not seem to be the ideal subject for a film, especially not for an English-language French film, directed by Jean-Jacques Annaud ("The Name of the Rose," "The Bear") and shot on a very big budget on location in Vietnam.

"The Lover" isn't exactly "Apocalypse Now." It's Miss Duras's slim self-searching memoir about a love affair she had when she was 15½ years old, a French schoolgirl in Saigon in 1929, with a rich Chinese man of 27. The novel is an interior monologue so sparely written that the characters aren't even named. The girl is the Girl, the man the Man, mother the Mother and her two brothers the Older Brother and the Younger Brother.

Even the love affair, a series of alternately diffident and passionate couplings in a room in Saigon's Chinese quarter, is not quite what it seems. It is more an expression of the girl's loathing for her doomed mother, her bullying older brother and her bleak life than it is an expression of love for the man she has sex with. The novel is also about colonialism turned upside down. Though young, pretty and white, the girl is dependent on the man for his money, his consuming love and his knowledge of the world of sexual politics she is about to enter.

The novel is almost without incident. It's both delicate and hard as nails. Not the easiest sort of material to adapt. Yet the film that Mr. Annaud and his producer, Claude Berri, have made is something of a triumph. It's tough, clear-eyed, utterly unsentimental, produced lavishly but with such discipline that the exotic locale never gets in the way of the minutely detailed drama at the center.

"The Lover," opening today at the Fine Arts, is the elegiac, barbed recollection of one very particular young woman's growing up, of her initial timidity expressed as incredible rudeness and of her increasing preoccupation with the power she realizes she now possesses. The awareness that love had anything to do with the relationship comes late.

The screenplay, written by Gérard Brach and Mr. Annaud, is a remarkably good one. It sticks closely to the structure of the Duras novel and even to the literary tone, which the film doesn't try to hide but, instead, exploits in the soundtrack narration spoken by Jeanne Moreau. The rich husky Moreau voice perfectly calls up the image of the aging Duras, sitting at her desk as she writes, remembering her youthful prettiness and virtually the exact moment at which that prettiness vanished, seemingly overnight, leaving, in her words, "a destroyed face."

•

Jane March, a young English model, makes her acting debut in the central role of the girl. It's still too soon to tell whether she's a great or even a good actress, but she is wonderful here. Wearing a sleeveless sack of an old silk dress and her adored hat (a man's fedora), her hair in pigtails and her lips caked with the brilliant red lipstick she puts on when out of her mother's sight, Ms. March looks remarkably like the photographs of the young Duras. Possibly for reasons of taste, the film increases the girl's age from 15½ to 18.

Whatever her years, Ms. March is still a nymphet beauty. The girl she plays with such seeming effortlessness is pathetically inexperienced but also coldly focused, approaching her first adult sexual relationship with a clinical curiosity that both fascinates and baffles the man.

Equally good is Tony Leung, the handsome Hong Kong actor who plays the lover, the son of a Chinese businessman from the north whose fortune comes from real estate. Having recently returned from Paris, where he dropped out of school, the Man has the manners of a Parisian playboy but with none of playboy's self-assurance. He dresses impeccably, rides around Saigon in a shiny black, chauffeur-driven limousine, but his hand shakes almost out of control when he lights a cigarette the first time he meets her. She is standing by the rail on a crowded ferry boat crossing the Mekong River.

That first afternoon he offers to give her a ride back to Saigon, so that she can escape the bus she had been

Marguerite Duras's youthful memories of a steamy Saigon.

riding. She accepts. They scarcely speak in the car during the drive, but their hands touch. She looks out the window, away from him. He looks out the other window. The next day he waits in his limousine in the street by her school. When she comes out, she walks directly to the car and they go to the room in the Chinese quarter. That is the beginning.

Though "The Lover" hasn't much time to characterize the girl's family, enough is sketched in to give a sense of what her mother and brothers are like. They are poverty-stricken, loveless colonials living frugally in a society in which they're supposed to be dominant, at the top of the heap. On a rare day they seem to enjoy each other. Mostly they are bitter and fearful. This is what the girl means to escape.

•

In the room in the Chinese quarter she is tender to the man when they make love. Afterward she might say without emotion that she doesn't much like Chinese. He retaliates. He tells her that he couldn't even marry her now if he wanted to: she's no longer a virgin.

He sometimes takes her out to expensive dinners with her mother and brothers, who gorge themselves on food, get drunk and never speak to him. They accept the relationship because the man gives the girl money. The fact that she might be in love with him never enters their minds. He is, after all, Chinese.

From the beginning of the affair both the girl and the man have known it was not to last. She is due to go back to Paris. He is betrothed to a proper Chinese girl. The awareness of the limited duration of their relationship has seemed to relieve them of any responsibilities, to have guaranteed them against awkward commitments. Yet the end is not what either expected.

Mr. Annaud demonstrates real authority in his treatment of this material. The film stays within its prescribed bounds. It is so beautifully controlled that even the love scenes, though steamily photographed, have a kind of innocence about them. Like the girl, the film has a way of standing just a little outside everything it sees, considering, recording the details, reserving judgment. The final effect is unexpectedly sad, but in a way that has nothing to do with pity.

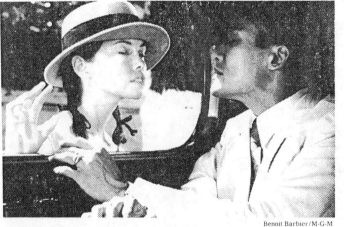

Benoit Barbier/M-G-M

Passion Jane March and Tony Leung star in "The Lover," Jean-Jacques Annaud's film adaptation of the Marguerite Duras novel. Set in French Indochina during the 1920's, the story centers on a schoolgirl's sensual affair with a mysterious, wealthy man.

Through the voice of Miss Moreau, the Duras presence is never forgotten. "The Lover" is a very good movie.

●

"The Lover," which has been rated R (Under 17 requires accompanying parent or adult guardian), has a lot of nudity and scenes of simulated sexual intercourse.

1992 O 30, C5:1

My New Gun

Written and directed by Stacy Cochran; director of photography, Ed Lachman; edited by Camilla Toniolo; music by Pat Irwin; production designer, Tony Corbett; produced by Michael Flynn and Lydia Dean Pilcher; released by I.R.S Media. Running time: 99 minutes. This film has no rating.

Debbie	Diane Lane
Skippy	James Le Gros
Gerald	Stephen Collins
Kimmy	Tess Harper
Andrew	Bill Raymond
Irwin	Bruce Altman
Myra	Maddie Corman

By JANET MASLIN

Debbie Bender (Diane Lane) looks perplexed. Something about her marriage to an indifferent radiologist named Gerald (Stephen Collins) and her life in a featureless New Jersey town house isn't quite working out. Debbie isn't the type to dwell on this, but she can't help noticing that life may be passing her by. It is at this point that a miracle appears, in the form of the small, dainty handgun, which Gerald wants Debbie to keep in her night table drawer.

Across the street, in an identical dwelling, lives one of the world's great liars. Skippy (James Le Gros) is also something of a romantic, having become so smitten with Debbie that he can hear her cry out in alarm (when she dreams that the gun fires accidentally) in the middle of the night. Skippy, who will eventually be pronounced "a fishy guy" for doing things like paying for a magazine with a $100 bill, doesn't say much, and never truly gets around to explaining himself. But he understands Debbie better than she understands herself, and he is ready to become the instrument of her salvation.

These are the elements of "My New Gun," a delectably wry slice of suburban life from a new director, Stacy Cochran, whose sympathy for her subject greatly humanizes an otherwise deadpan style. As imagined by Ms. Cochran and played with perfect bewilderment by the enormously appealing Ms. Lane, Debbie is a lot more than the mad-housewife caricature she might have been. Repeated insults by her husband ("You back in the Valley of the Dolls, Deb?") do not annoy Debbie as much as they could. She seems to have her mind on something bigger, something that becomes clearer as the film lets her inch toward a getaway.

"My New Gun" has such a keen sense of setting and character that its actual plot seems almost an afterthought. More could have happened here, and should have. But Ms. Cochran succeeds in holding the attention with the general arc of Debbie's transformation, and with a wealth of clever details and deft camera moves. Ed Lachman's cinematography has a bright, mischievous verve, and the mood is compounded by Pat Irwin's jaunty score.

As screenwriter, Ms. Cochran certainly knows her territory; she knows the kind of man who thinks a new Gore-Tex windbreaker is a good topic of conversation, and she knows why that man's wife would be sick of him. Yet "My New Gun" is not a series of potshots at familiar targets. Ms. Cochran also understands that the kind of bland, anonymous setting in which her characters live can be full of wonderful surprises.

It is telling (and tacitly amusing) that the Benders's mock-tasteful household and Skippy's more eccentric place were actually shot in the same setting (for Skippy's domestic scenes, the living room is redone with red linoleum, a Ping-Pong table and conga drums). This points not only to Ms. Cochran's low-budget resourcefulness but also to her knack for making a few well-chosen props say a lot about the people around them. Sometimes the props don't even need to be visible to be funny, as when an injured Gerald is told that blood was spilled in the Bender family car. "I knew we shouldn't have gotten mocha seats," he wails.

Ms. Cochran fares even better with live actors than with inanimate objects, drawing a hilariously obtuse caricature out of Mr. Collins and a delightfully sly, hangdog manner from Mr. Le Gros. His Skippy has an uncanny way of sounding timid while making outrageous demands. "You don't have another one, do you?" he shyly asks Debbie, after he has stolen her gun for reasons he does not altogether explain. Gerald's irritable assessment of Skippy as a "Satan-worshiping junkie" seems to miss something seriously cunning in Skippy's nature.

Also in "My New Gun" are Tess Harper as Skippy's suitably peculiar mother, a country singer of some renown. ("You know, my brother had a bunch of your records," an admirer tells her. "He was a big fan. He's dead now.") Bruce Altman plays Gerald's best friend, another radiologist, and Maddie Corman is especially funny as his wide-eyed, baby fiancée; it is this couple's romantic plan to buy both gun and engagement ring that convinces Gerald that there is something amorous about a firearm. The film finally points to a sneakier assessment of the gun and its near-magical way of empowering Debbie and setting her free.

1992 O 30, C10:1

Close to Eden

Directed by Nikita Mikhalkov; screenplay by Rustam Ibragimbekov, based on an original idea by Mr. Mikhalkov and a story by Mr. Mikhalkov and Mr. Ibragimbekov; director of photography, Villenn Kaluta; edited by Joelle Hache; music by Eduard Artemyev; production designer, Aleksei Levchenko; released by Miramax Films. Lincoln Plaza Cinema, Broadway at 63d Street. Running time: 106 minutes. This film has no rating.

Pagma	Badema
Gombo	Bayaertu
Sergei	Vladimir Gostukhin
Grandma	Babushka
Marina	Larisa Kuznetsova

By VINCENT CANBY

Nikita Mikhalkov's "Close to Eden," opening today at the Lincoln Plaza Cinema, is a fiction film that looks very much like anthropology. Shot in Inner Mongolia, the movie centers on the friendship of Sergei, a boisterous, outgoing Russian truck driver, and Gombo, the Mongolian farmer who saves Sergei after he falls asleep and drives into a lake.

The film is equally divided between its fictional story, which is about Gombo's wish to have another child, though the Chinese Government forbids Mongols to have more than three, and its documentary concern, which is to show the world what life in Mongolia is like today. Mr. Mikhalkov's fear is that the unspoiled beauty of the Mongolian steppes is about to be swept away by the civilization that men like Sergei are bringing to one of the last vast underpopulated regions of the world.

●

The Russian director, whose earlier films include "Slave of Love" and "Dark Eyes," works well with his cast, most of them Mongolian actors, but the events are small. Very small. Gombo goes into town to buy the condoms his wife has told him about, then loses his nerve when he finds that the clerks in the Government store are women. Returning home with a television set, Gombo has a terrible vision in which Genghis Khan and his hordes sweep down on him to destroy the dread appliance.

"Close to Eden," which was named best picture at the 1991 Venice Film Festival, is handsomely photographed but extremely mild entertainment.

1992 O 30, C10:5

Waterland

Directed by Stephen Gyllenhaal; screenplay by Peter Prince, based on the novel by Graham Swift; director of photography, Robert Elswit; edited by Lesley Walker; music by Carter Burwell; production designer, Hugo Luczyc-Wyhowski; produced by Katy McGuinness and Patrick Cassavetti; released by Fine Line Features. Running time: 95 minutes. This film is rated R.

Tom Crick	Jeremy Irons
Mary Crick	Sinead Cusack
Young Tom	Grant Warnock
Young Mary	Lena Headey

By JANET MASLIN

"Waterland" is a ghost story told by the ghost himself, a gaunt, ravaged Englishman whose wounds go almost unimaginably deep. Tom Crick (Jeremy Irons) has the haunted look of a man desperate to escape the past, and the paradoxical occupation (as high school history teacher) of someone who never can. Day after day, Tom stands before his students and ignores the usual syllabus to tell tales of love, madness and murder, stories about his own life and the lives of his ancestors. He must try to stare down these memories in order to escape their overwhelming weight, a hopeless yet supremely poignant endeavor.

And not a terribly cinematic one, at least not under ordinary circumstances. Graham Swift's idiosyncratic 1983 novel, set in the Fen country in East Anglia and swooping erratically through 200 years of personal and regional history, is about as elusive and unfilmable as a book can be. Yet Stephen Gyllenhaal, who directed this imaginative adaptation, and Peter Prince, who wrote the screenplay, have seen beyond the unwieldiness of their material and sought to preserve only its essential episodes, weaving them together into a fearlessly eccentric film of haunting depth. With its dark sexual secrets and peculiar symmetries, its obsessive and unre-

lenting pull toward the past, "Waterland" is more likely to remind the viewer of Faulkner's prose than of anything on film.

The task of conveying these things succinctly is so daunting that "Waterland" would never work without a unifying central performance of such agonizing power. With a dazed, frightened expression and the keen sense that his life is coming undone, Mr. Irons's Tom becomes a rivetingly sad figure, and a sharp focus for the film's many reveries. Most of these concern Mary (Sinead Cusack), the wife who stands on the brink of madness and threatens constantly to rupture a very fragile status quo. "Once upon a time," Mr. Swift writes of Tom and Mary as adolescents, "there was a future history teacher and a future history teacher's wife for whom things went wrong, so — since you cannot dispose of the past, since things must be — they had to make do."

They make do only barely as the film begins, with Mary telling Tom she is pregnant even though he knows this cannot be. (In the bed, these two are in their mid-50's, which makes Mary's claim even more startling.) These present-day scenes are set for no clear reason in Pittsburgh, but the story's many glimpses of Tom and Mary as teen-agers return them to the flat, featureless Fens. Tom's observation that this land is essentially water can serve as a metaphor for his larger uncertainty, and a sign of the place's fairy-tale strangeness. This a story in which a witch and a magical elixir can somehow shape the course of ordinary-looking lives.

●

Sex is another and more important force in the lives of young Tom and Mary, played with eagerness and delicacy by Grand Warnock and Lena Headey. The film's earthy anecdotes about Tom and Mary's initial attraction to one another, and the jealousy that attraction creates among friends and relatives, fuels the vivid flashbacks through which the film pieces together the past. The story's sexual undercurrents are enduringly strange, from the parallels between Mary's fertility in adolescence and in middle age to a scene in which a young boy sneaks an eel into Mary's underwear. The accumulated effect of these episodes is to make it clear that Tom is in no way overreacting by coming unstrung.

"I think that in one's life there can be more than one ending," Tom says. "It's been like that in mine." "Waterland" is able to recognize the tragedy in this without universalizing it, so that the film remains deliberately idiosyncratic and small. Some of its more gimmicky efforts to encapsulate its difficult material needlessly underscore that smallness, particularly the device whereby Tom takes his Pittsburgh students time-traveling to scenes right out of his English boyhood, as if this were a class outing. Even then, Mr. Irons's remarkable gravity dispels any sense of the frivolous or the fanciful.

"Waterland," which also features Ethan Hawke and John Heard as two of the story's uneasily Americanized characters, relies on Robert Elswit's cinematography to make its flat coastal scenery as eerie and singular as the characters who inhabit it.

"Waterland" opens today at the Lincoln Plaza Cinemas, on one of three brand-new screens there. These theaters will double the Lincoln Plaza's capacity to help prevent the art-

house film from becoming an endangered species. "Waterland" inaugurates this fine new theater on an auspicious note.

•

"Waterland" is rated R (Under 17 requires accompanying parent or adult guardian). It includes nudity and sexual situations.

1992 O 30, C14:6

Van Gogh

Direction and screenplay by Maurice Pialat; directors of photography, Emmanuel Machuel, Gilles Henri and Jacques Loiseleux; edited by Yann Dedet and Nathalie Hubert; production designer Edith Vesperini; produced by Daniel Toscan du Plantier; released by Sony Pictures Classics. Lincoln Plaza Cinema, Broadway at 63d Street. Running time: 155 minutes. This film is rated R.

Vincent van Gogh Jacques Dutronc
Marguerite Gachet............. Alexandra London
Dr. Gachet Gérard Sety
Theo van Gogh Bernard Le Coq
Jo ... Corinne Bourdon

By VINCENT CANBY

After Maurice Pialat's "Van Gogh" was shown at the Cannes International Film Festival in 1991, some members of the audience emerged feeling vaguely cheated and disoriented. "What happened to his ear?" one woman asked her friend. She might have more properly wondered, "What didn't happen to his ear?" All sensational reports to the contrary, Vincent van Gogh did not cut his ear entirely off. He took some nasty swipes at it.

As if to wipe away the myths, Mr. Pialat, the French director who was himself a painter for a number of years, has made "Van Gogh," opening today at the Lincoln Plaza Cinema. Forget all of the hysterical melodrama of "Lust for Life." This "Van Gogh" is an almost serene consideration of the remarkably productive final two months in the artist's life, ending on the day of his death, July 29, 1890, two days after he suffered a self-inflicted gunshot wound.

•

In Mr. Pialat's revisionist's view, van Gogh couldn't possibly have turned out paintings of such consistent vigor, and at such a pace, if he had been the depressed lunatic he is most often supposed to have been. His film's Vincent, played with seriousness but without solemnity by Jacques Dutronc, is a man who works very hard, and who no longer has the time or the constitution for out-of-control debauchery. He is plagued by headaches and by fears of the return of the bouts of madness that earlier sent him into the asylum. Yet he is not a madman.

"Van Gogh" is almost anti-dramatic. The film opens with Vincent's arrival at Auvers-sur-Oise, a picturesque village north of Paris that has been a favorite with painters for some time. His contact there is Dr. Gachet (Gérard Sety), a wonderfully eccentric medical man who admires painters and, as a result, already has a house stuffed with the work of Cézanne, Pisarro and Renoir, among others.

Dr. Gachet has promised Vincent's brother Theo (Bernard Le Coq) and Theo's wife, Jo (Corinne Bourdon), to look after him. For a time, Vincent and the doctor are fast friends. Gachet understands Vincent's work and sees him as taking painting in an entirely new direction. Vincent does portraits of the doctor and one of his daughter, Marguerite (Alexandra London), at the piano, a work later to be known as "Mlle. Gachet at the Piano."

Mr. Pialat mostly avoids this sort of "See It Now" approach to art history in the making, but no movie about a great painter can avoid it completely. When Vincent returns from a long day in the field, there are bound to be questions about what he has under his arm. Could it be "The Plain at Auvers"? Or maybe "The Plain of Auvers Under a Stormy Sky"? At one point toward the end, Marguerite follows Vincent to Paris where she, Vincent and Theo wind up having a very sporting night on the town, a sequence in which Toulouse-Lautrec shows up and Mr. Pialat presents a few discreet quotes from the work of other painters of the day.

Most of the time, "Van Gogh" is a leisurely, roomy sort of movie, about Vincent's daily life in Auvers, his boisterous, convivial reunions with Theo and Jo over long outdoor lunches at the Gachets', and the occasional picnics with other artists and their models who have come up from Paris for the day.

Mr. Pialat also suggests that Vincent has an affair with Marguerite when she throws herself at him. It's a schoolgirl's crush on her part. Vincent accepts her without committing himself. In the film, this is what leads to his break with her father and, perhaps, hastens his suicide.

"Van Gogh" is a good, quiet, rigorous film, made with intelligence and acted with earnest conviction. It looks lovely, but never makes the mistake of equating a real-life view with what finally appears on Vincent's canvas. "Van Gogh" doesn't shake its head over Vincent's sad fate. It accepts him as he appears to accept himself, without tears, and with only a moderate amount of fury directed at the forces that have yet to recognize him.

•

"Van Gogh," which has been rated R (under 17 requires accompanying parent or adult guardian), features some partial nudity and some sexual situations.

1992 O 30, C16:5

Critic's Choice

Godard's Video Works

Mention Jean-Luc Godard and the response is likely to be idle curiosity or jaded boredom. With the exception of "Hail Mary," the 1985 film that annoyed the Vatican with its modern retelling of the Virgin birth, the New Wave master hasn't created a stir in two decades.

But there is new evidence that the steep decline of Mr. Godard's career may be a myth. "Jean-Luc Godard: Son et Image, 1974-1991" is a monthlong series of 30 films and videos beginning today at the Museum of Modern Art (information: 212-708-9480). The series title comes from "Sonimage," the production company Mr. Godard founded in 1974 when he began to work seriously in video, and it is the perfect name for work that gives equal weight to sound, image, words on the screen, overlapping photographs and the forceful presence of the director, who hovers over each project whether he is on screen or not.

One of the best recent works will be shown tonight at 6 in Titus Theater 2 at the museum. "Histoire(s) du Cinéma," translated as "(His)stories of Cinema," offers two parts of a projected eight-part series made for French television (shown here with English subtitles). This is no historical survey, but a dazzling essay that is emotionally stirring, intellectually rigorous and often playful.

Mr. Godard positions himself on screen at the typewriter, puffing a cigar, appearing throughout the 100 minutes of the video like a ringmaster orchestrating the flow of overlapping images. His sense of order is associative, as he moves from Jean Renoir to Jean Cocteau to Jean Vigo, with the word Jean written on the screen at one point. Here is the Godard who still loves the movies.

Mr. Godard was to have introduced tonight's screening of "Histoire(s) du Cinéma" and of his 1991 film "Germany Year 90 Nine Zero" (to be shown at 6:30 tonight in Titus Theater I, in French with English subtitles). But the other day he canceled; he is reshooting scenes from his new film, starring Gérard Depardieu, a work whose title must sum up feelings around the museum right now: "Hélas Pour Moi," or "Alas for Me."

CARYN JAMES

1992 O 30, C16:5

Rampage

Written and directed by William Friedkin based on the novel by William P. Wood; director of photography, Robert D. Yeoman; edited by Jere Huggins; music by Ennio Morricone; production designer, Buddy Cone; produced by David Salven; released by Miramax Films. Running time: 97 minutes. This film is rated R.

Anthony Frazer........................Michael Biehn
Charles Reece...........................Alex McArthur
Albert Morse............................Nicholas Campbel
Kate Frazer...........Deborah Van Valkenburgh
Dr. Keddie.....................................John Harkins
Mel Sanderson...............................Art Lafleur
Judge McKinseyBilly Greenbush
Gene Tippetts.................Royce D. Applegate

By JANET MASLIN

William Friedkin's chillingly effective "Rampage" begins with the sight of a killer preparing to commit his crimes. Charles Reece (Alex McArthur), a handsome, wide-eyed man with a disarming smile, buys a gun at a store and answers jovially when the seller asks an obligatory question about whether Charles has been in a mental hospital ("Let me think. No"). He selects a house at random, surprises the white-haired woman who answers the door, then shoots three people, going on to carve up two of them with a kitchen knife. These events are left largely implicit, with the bloodshed offscreen, but the full scope of their grisliness is allowed to sink in.

In presenting this murderous spree, which goes on to include a mother and young son from another household, Mr. Friedkin's method is as systematic as Reece's. He works briskly and efficiently to lay out the details of a case based on a real story. And he does so without the shroud of moral ambiguity that is sometimes made to surround crime stories as extreme as this. "Rampage," while offering discreet exposition about the murders and their aftermath, also becomes a tirade against a judicial system that would spare someone like Reece by deeming him criminally insane.

•

The focus of the film's polemical attack against the insanity defense (and its argument in favor of the death penalty for a killer whose acts are so gruesome and deliberate) is Anthony Frazer (Michael Biehn), a liberal district attorney who must question his own attitudes during the course of his investigation. The film tries to equate the fact that Frazer and his wife (Deborah Van Valkenburgh) have recently lost their daughter with Frazer's raw feelings about the Reece case as it unfolds.

Mr. Friedkin's horrifyingly matter-of-fact account is powerful enough to be persuasive even without that sentimental aspect of the story. "Rampage" (which was made in 1987 by the De Laurentiis Entertainment Group and had its release delayed by that company's bankruptcy proceedings) devotes half its time to the

Sony Pictures Classics

At the End Jacques Dutronc portrays the artist in "Van Gogh." Maurice Pialat's film deals with Van Gogh's relationships with family and friends during the final 67 days of his life, in the spring of 1890, when he settled in the town of Auvers-sur-Oise and painted many of his finest works.

courtroom maneuvers that shape Reece's defense and to the psychiatrists who maintain that his murderous acts were instinctive rather than willful.

The film presents these psychiatrists as motivated by self-interest, and allows their arguments to be theoretically applied to Nazi war criminals, who could be considered insane rather than culpable if held to the same standard. At one point during the courtroom proceedings, it asks the jury and the audience to experience three long minutes of silence. ("This is how long it took for just one of them to die," Frazer says.) It is not necessary to share the film's political views to feel that it makes a cogent and disturbing case.

"Rampage" has a no-frills, realistic look that serves its subject well, and it avoids an exploitative tone. That is fortunate, since the material is so potentially lurid that it needs no further stylistic amplification. The performances are in keeping with the generally forceful, if sometimes colorless, approach. Mr. McArthur is particularly spooky as a man who explains in the most straightforward terms that he must kill and mutilate others for the sake of his own physical well-being. "Everything I did was justified," he says, about crimes that apparently culminated in his drinking his victims' blood. "I had to do it. It was all up to me."

Mr. Biehn, a gentler actor than the usual hard-hitting district attorney type, begins on a mild note but succeeds in conveying great outrage as the story builds. Royce D. Applegate is memorable for his brief, utterly believable appearance as an ordinary husband and father who has the dreadful luck to have Charles Reece for a next-door neighbor.

●

"Rampage" is rated R (Under 17 requires accompanying parent or adult guardian). It includes gory details and a great deal of material that would be disturbing for children.

1992 O 30, C27:1

The Quarrel

Directed by Eli Cohen; screenplay by David Brandes, based on the story by Chaim Kovler, adapted for the stage by Joseph Telushkin; produced by Mr. Brandes and Kim Todd; released by Honey and Apple Film Corporation. At the Film Forum 1, 209 West Houston Street, South Village. Running time: 88 minutes. This film has no rating.

Hersh Rasseyner Saul Rubinek
Chaim Kovler............................. R. H. Thomson

By STEPHEN HOLDEN

"The Quarrel," Eli Cohen's film adaptation of a short story by the Yiddish writer Chaim Grade, is commendable simply for having the temerity to grapple with serious ideas in a form not usually given to intellectual discourse. During much of its 88 minutes, an Orthodox rabbi and a non-religious Jewish poet, fervently carry on the age-old argument about reason versus faith. What gives their debate an anguished urgency is the shadow of the Holocaust, which each has survived bearing a heavy load of guilt.

The film, which opens today at Film Forum 1, is set in Montreal in 1948. One morning, Chaim Kovler (R. H. Thomson), a New York poet

visiting Canada, runs across a group of Orthodox Jews in a park practicing a Rosh ha-Shanah ritual. In the crowd, he is astonished to discover Hersh Rasseyner (Saul Rubinek), a childhood friend from Poland, who he assumed had died in the Holocaust. Best friends 15 years earlier, they parted bitterly when Chaim forsook the religious life to become a writer. Having lost their families, both have started new lives in North America.

Within minutes of their reunion, the two have picked up the quarrel that estranged them 15 years earlier. During a leisurely walk that is interrupted by a sudden downpour, they harangue each other with arguments for and against religious faith and its value in the light of the Holocaust.

●

Their discussion boils down to a very familiar moral dialogue. The poet maintains that nothing could possibly justify God's allowing six million of His "chosen people," including a million children, to die. Guided by their reason and their realization of a common good, he insists, people will help one another. The rabbi argues that if there is no master of the universe, who's to say that Hitler did anything wrong? He even suggests that the Holocaust was God's punishment for Jews' assimilation into European culture.

The arguments are balanced to give both sides equal weight. And enough of the characters' personal baggage is brought in to invest the confrontation with some psychological resonance.

But if "The Quarrel" is fair to its characters, its screenplay by David Brandes has a clunking oratorical ring that neither Mr. Rubinek nor Mr. Thomson can transcend. Instead of the spontaneous resumption of a passionate debate, the dialogue sounds like a collection of carefully prepared speeches stitched together with minimal small talk. And both performances seem somewhat cramped.

●

Unlike Louis Malle's "My Dinner With André," a film with which "The Quarrel" is likely to be compared, the two main characters do not emerge as quirky individuals speaking in their own personal vernacular, but as earnest mouthpieces for carefully predigested ideas.

The confrontation has been gussied up with some heavy-handed visual symbolism. A policeman on horseback, filmed in a menacing way, suggests a flashback of the Nazi persecution. And when, at the end of the film, the two old friends take divergent paths and become lost, the heavy-handedness turns sentimental. The most shameless moment comes when the two spontaneously break into a song and dance from their student days and find themselves applauded by bystanders. At moments like these, "The Quarrel" ceases to be serious and turns to mush.

1992 N 4, C22:4

Correction

A film review yesterday about "The Quarrel" at Film Forum 1, on West Houston Street, misidentified the author of the short story upon which the film is based. He is Chaim Grade. (Chaim Kovler is a character in the film.)

1992 N 5, A2:6

Slight Smile for Rat Poison

"The Match Factory Girl" was shown as part of the 1990 New York Film Festival. Following are excerpts from Caryn James's review, which appeared in The New York Times on Oct. 3, 1990. The film, in Finnish with English subtitles, opened yesterday at the Lincoln Plaza Cinema, Broadway at 63d Street.

For Aki Kaurismaki, being laconical and deadpan is high art. The downtrodden heroine of "The Match Factory Girl" spends most of the film looking pathetic and sad with excellent cause. But a glimmer of a smile crosses her face when she dilutes rat poison in water, for reasons the audience will soon discover. The film is a magnificent conclusion to a trilogy about Finnish working-class heroes that includes "Shadows in Paradise" and "Ariel." This virtuosic work is heartbreaking until it turns outrageously funny.

●

The film begins with a log in a factory and follows the stages by which wood emerges as a box of matches. At the end of this long mechanical chain is a pair of hands hovering over a conveyor belt, making certain the mailing labels are stuck securely on the boxes. The hands belong to Iris, a wan blonde with circles under her eyes whose life

threatens to remain as mundane and sterile as her job.

She pays rent to sleep on the couch in the apartment of her mother and stepfather, who do little more than eat and smoke. She puts on blue eyeshadow, goes to a dance and at the end of the evening is the only woman left sitting against the wall. And in a small act of heroism, she defies her parents and takes part of her paycheck to buy a cheap-looking redflowered dress in which she is finally asked to dance.

●

As Iris, Kati Outinen has a slight, angelic smile as she rests her head on this strange man's shoulder. Her beautiful, unsentimental performance is all the more remarkable because so far Iris has not said a word on camera. No one, in fact, says very much in this film. Music and noise are everywhere, but dialogue is a luxury in Mr. Kaurismaki's spare esthetic.

Iris is no saint; she sleeps with the stranger that night and later finds herself in the kind of mess that makes her want to poison ratty humans. And the more rebellious she becomes, the more Mr. Kaurismaki provokes viewers to cheer her antisocial behavior.

The director's style is ruthlessly pared down, every scene edited to its core, every lingering shot of an empty room used to good effect. Yet Mr. Kaurismaki's buoyant energy fends off any hint of a mannered or minimalist approach. He keeps viewers trailing after him by unsettling every expectation.

1992 N 5, C18:5

Choice Snippets Sell Big Films

By JANET MASLIN

"**N**O one can see what Jennifer saw," intones an announcer, as Uma Thurman glides across the screen. "No one can imagine what Jennifer felt." Now it just so happens that Ms. Thurman plays Helena, not Jennifer, in "Jennifer 8," the thriller whose trailer we are discussing. And Jennifer's thoughts and feelings are rather beside the point, since Jennifer is a never-seen character who is dead. Furthermore, this trailer's two-minute intimation of a steamy, suspenseful crime drama is a lot more feverish than the actual two-hour-and-seven-minute "Jennifer 8" (review on C6) happens to be.

Never mind: when it comes to trailers (movie parlance for coming attractions), accuracy is not the issue. Salesmanship is, and the onset of the Christmas movie season finds the hard sell in full flower. Fierce seasonal competition forces trailer makers to cram as many big moments as possible into very brief promotional vehicles, all of them competing for an audience that is bound to be suspicious after such an uninspired movie year. Outrageous claims, misleading images, false promises, seductive little lies — did anyone think these things were now behind us? Election Day may be over, but the Christmas blitz has only just begun.

Certainly, movie trailers can announce major triumphs on the horizon. And under the best of circumstances (like Robin Williams's wild-man sales pitch for Barry Levinson's "Toys"), they can be great fun in their own right. For some weary viewers, they may even serve as substitutes for seeing the complete film. The

"That's right! This entire wheatfield is in one building!" Robin Williams declares in his wild sales pitch for the movie "Toys."

real movie sometimes comes as a letdown after one has seen its major plot developments, biggest moments and best zingers compressed into something resembling a mega-sound-bite.

The foremost rule of trailer-making is simple: take what you have and run with it. If you have Eddie Murphy playing a wisecracking fake Congressman in "The Distinguished Gentleman," accentuate the wisecrack. If you have "Dracula," with a staggering array of strange effects, then bare every fang. If you have Mr. Williams, simply stick him in a field and let him say absolutely anything that comes into his head.

"That's right! This entire wheatfield is in *one building!*" Mr. Williams declares on behalf of "Toys," which has the hands-down best trailer of the season. "I'll be back — wind me," he mutters as "The Toy-minator" a moment later. In another of several separate takes patched wittily together, he explains that "studio executives, in their great insight, said 'You got a movie about toys, what's a good time to bring it out? Rosh ha-Shanah? No — Christmas!' Sure beats the hell out of Groundhog Day."

This took a star of Mr. Williams's one-of-a-kind talent, and it also took nerve. Most trailers play it much safer, like the "Home Alone 2" spots that emphasize Macaulay Culkin's trademark scream-take and the ability of the story's villains, played by Joe Pesci and Daniel Stern, to fake ever more cartoonishly exaggerated pratfalls. "Don't you know a kid always wins against two idiots?" Mr. Culkin asks in the trailer, thus summing up the film's probably foolproof appeal. At the very least, the "Home Alone 2" spot identifies its target audience and touts itself as a cinematic brand name.

•

Some of the selling points of this season's most ambitious films have an impact that transcends advertising. In the case of a "Malcolm X" or a "Hoffa," highlighting a familiar star's impersonation of a historical figure is a main goal of the trailer, along with conveying some of the

film's epic sweep. These films can afford to take the high road. So the "Malcolm X" trailer establishes Spike Lee's new film as a major event, interspersing huge crowd scenes with snippets of Denzel Washington's uncanny-looking performance. With only a few well-chosen lines of dialogue — "Do you know where you came from?" "That's too much power for one man to have" — the trailer signals both the stature of its subject and the drama of its story.

The "Hoffa" ad concentrates more heavily on a stellar performance, letting the camera linger on a Jack Nicholson who looks newly square-jawed and swaggering for this role. A rueful glimpse of Danny DeVito, who directed the film and also acts in it, suggests that "Hoffa" will have, its share of entertainment value, too. Judging from the trailer alone — never a smart thing to do — "Hoffa" appears to have exceptional star power. But Mr. Nicholson will be competing against himself in "A Few Good Men," which also stars Tom Cruise and Demi Moore and has the season's best storytelling trailer.

Coming attractions for "A Few Good Men" simply signal a strong cast and a courtroom drama, but in this case that's enough. (The director is Rob Reiner, but in trailers these days the director rarely gets much attention.) When it comes to encapsulating a film's whole plot in a two-minute trailer, moderation is most important. It is used brilliantly in a nearly silent two-minute encapsulation of "Lorenzo's Oil," which seems to tell a heart-tugging story of parents who take science into their own hands to save a sick child.

There's a fine line between providing tantalizing information, as the "Lorenzo's Oil" and "A Few Good Men" spots do, and resorting to overkill. Mel Gibson's whole life seems to flash before the audience's eyes in the trailer for "Forever Young," which shows him falling in love, losing his sweetheart, being cryogenically frozen and moving 50 years into the future, where he meets Jamie Lee Curtis and, apparently, his old flame, too. Audiences may well find the fin-

ished film superfluous to such a full synopsis. And anyone who saw last year's "Late for Dinner" might recognize a lot of the plot.

Sometimes, familiarity is actually the point. The trailer for Kenneth Branagh's "Peter's Friends" suggests an English version of "The Big Chill," complete with house party, old pals and rock songs (even one by Bruce Springsteen) on the sound-track. "Used People," emphasizing a zany all-star cast including Shirley MacLaine, Jessica Tandy and Marcello Mastroianni, plays like "Fried Green Magnolias" (a composite I once arrived at by mistake). "Scent of a Woman" establishes a blind, curmudgeonly Al Pacino and a nice young man to help him. The trailer says "Rain Man" even if the finished film winds up saying something else.

•

Perhaps the optimum combination for any trailer is that of the three magic S's: sex, story and stars. Ads for "The Bodyguard" attempt this by presenting two attractive leads, Kevin Costner and Whitney Houston, and an employment situation that has brought them together. The trailer hints, economically but clearly, that he has been hired to protect her, that they will somehow become romantically involved, and that a hit soundtrack album is in the offing.

"The Bodyguard" gets high marks in the trailer department, but it is outshone by the one for "Damage," which presents a torrid, forbidden affair between an urbane Englishman and his son's girlfriend. Aside from a tantalizing synopsis and an apt descriptive line ("a story of ecstasy and obsession"), this trailer makes the most of its stars' credentials. Jeremy Irons's Academy Award is mentioned, as are the performances of Juliette Binoche in "The Unbearable Lightness of Being" and Miranda Richardson in "Enchanted April." The name of the director, Louis Malle, further establishes this film's prestige.

When a film is so clearly a sure thing, its trailer may as well say so,

The approach that works for "Damage" is equally successful for the animated "Aladdin" (with which "Damage" otherwise has absolutely nothing in common). Disney's trailer pushes all the right buttons, from mentioning "The Little Mermaid" and "Beauty and the Beast" to the Academy Awards won by Alan Mencken, the composer. All this, plus glimpses of the film's colorful characters and snippets of its by-now-obligatory big production number, certifies "Aladdin" as the real thing in the minds of Disney devotees.

Of course, any and all of these trailers may turn out to be seriously misleading. But you'd have to go see the finished film to find that out. And once that happens, the trailer has already done its job.

1992 N 6, C1:1

Becoming Colette

Directed by Danny Huston; written by Ruth Graham; director of photography, Wolfgang Treu; music by John Scott; produced by Heinz Bibo; released by Castle Hill Productions. Sutton Theater, 205 East 57th Street. Running time: 97 minutes. This film has no rating.

Willy Villars...............Klaus Maria Brandauer
Colette...................................Mathilda May
PolaireVirginia Madsen
Chapo...Paul Rhys
AlbertJohn van Dreelen
Captain.......................Jean-Pierre Aumont
SidoLucienne Hamon
CreditorGeorg Tryphon

By VINCENT CANBY

Danny Huston's "Becoming Colette" purports to be the story of how Sidonie-Gabrielle Colette, an innocent country lass with a fervid imagination, grew up to be the worldly-wise grande dame of French letters known simply as Colette. The film, which opens today at the Sutton, is not quite a nonstop scream but, in its determinedly flatfooted way, it's as saucy a piece of movie baggage as has turned up in two or three decades.

Francois Duhamel

The trailer for "Hoffa" concentrates heavily on a stellar performance, letting the camera linger on a newly square-jawed Jack Nicholson.

It's almost as if Mr. Huston, who was born in 1962, a son of the great John Huston, were re-inventing a movie genre that had all but disappeared by the time his voice changed. "Becoming Colette" is one of those heavily filtered soft-core porn flicks that the French used to export to us in the 1950's and 60's, before the old Production Code was junked.

•

According to the screenplay by Ruth Graham, revised by Burt Weinshanker, the young Colette (Mathilda May) is just waiting to be ravished when Henri Gauthier-Villars (Klaus Maria Brandauer), a Parisian writer and publisher known as Willy, arrives to do some business with her father. Willy sweeps her off her tiny feet and marries her. On their return to Paris, virtually before she has unpacked, he arranges a threesome with his great and good friend Polaire (Virginia Madsen), a performer at the Moulin Rouge.

Colette is surprised but not really outraged. She does what Willy expects of her. Also, as she has been doing all her life, she jots everything down in one of her notebooks, in which she identifies herself as Claudine.

When Willy comes upon her notebook by chance, he is entranced. He puts his own name to the manuscript and publishes it. An étoile is born or, to put it another way, a star is née. The film's English-language dialogue is laced with French words, but never more than one per sentence. Mr. Huston and his associates don't want to burden the audience too much.

Willy treats Colette badly. He pushes her into a relationship with Polaire, then is furious when the two women fall in love on their own. This happens in a prettily photographed sequence that begins as one woman blows smoke into the mouth of the avid other. The last straw for Colette is when Willy promises her that she will play Claudine in a stage adaptation of her stories, but then gives the role to Polaire. The once-innocent wife rebels, thus becoming Colette.

•

It could be argued that Colette's Claudine stories invite the sort of soft-core porn methods Mr. Huston uses here, but the stories also have a wit and wisdom that is nowhere to be recognized in "Becoming Colette."

The movie is much more interested in naked flesh, including Ms. May's left breast, which, for reasons never made clear, is seen far more often than her right. The dialogue often sounds like something lifted from the inter-titles of the 1921 silent version of "The Three Musketeers." Among the whoppers: "Surely you jest, monsieur." Then, too, there is the film's big Moulin Rouge production number, a song sung by Polaire that includes that old French endearment "tootsie-wootsie."

"Becoming Colette" bears no relation to Mr. Huston's very stylish "Mr. North" (1988), which was shot more or less in collaboration with his bedridden father. This one looks to have been made in a certain amount of confusion. Ms. Madsen, who is married to the director, gives the film's only good performance. Ms. May looks great without clothes. Mr. Brandauer is charmless although he smiles a lot.

•

A solemn note at the end of the movie reports that after Colette left

Castle Hill Productions

Klaus Maria Brandauer, left, and Mathilda May in a scene from "Becoming Colette."

Willy she became the first woman to be awarded the Legion of Honor and that in 1958, four years after her death at the age of 81, the film based on her novel "Gigi" received nine Academy Awards. That's to put things in the proper perspective.

1992 N 6, C6:1

Jennifer 8

Written and directed by Bruce Robinson; director of photography, Conrad L. Hall; edited by Conrad Buff; music by Christopher Young; production designer, Richard MacDonald; produced by Gary Lucchesi and David Wimbury; released by Paramount Pictures. Running time: 127 minutes. This film is rated R.

John Berlin	Andy Garcia
Helena Robertson	Uma Thurman
Freddy Ross	Lance Henriksen
Margie Ross	Kathy Baker
John Taylor	Graham Beckel
Citrine	Kevin Conway
St. Anne	John Malkovich

By JANET MASLIN

Andy Garcia has a profile to recall Barrymore's, which is as good a reason as any to watch "Jennifer 8," in which he steps up to a starring role. As Detective John Berlin, Mr. Garcia smolders his way through this story of a serial killer, a beautiful blind witness (Uma Thurman) and a footloose detective trying to make his way in a new town. Professionalism is not necessarily John Berlin's strongest suit. "I'll tell you what," he says to Helena, the blind girl. "If I promise to stop being a cop, will you promise to stop being a witness?"

Most detective thrillers keep an eye toward the extracurricular, but in "Jennifer 8" this tendency goes unusually far. The writer and director Bruce Robinson, who also directed "How to Get Ahead in Advertising" and "Withnail and I," seems strongly drawn to his supporting characters and their colorful lives. Sometimes this can go too far: the fact that Berlin's boss (Kevin Conway) sports a scraggly beard and likes to paint by numbers probably reveals more about him than any audience wants to know. Still, Mr. Robinson has created a lively array of small-town figures in northern California, and given them stories that stretch beyond the limits of a suspense plot.

•

This is a lucky thing, since the film's mystery eventually proves to be its weakest element. Though Mr. Robinson begins on a note that seems brutal even for this genre — a severed hand covered with old noodles, found at a garbage dump — he quickly abandons any taste for such un-

Jack Rowand

Uma Thurman and Andy Garcia in a scene from "Jennifer 8."

pleasantness. Indeed, the film's subsequent gentleness can be downright bizarre, or at least precedent-setting. This may be the only thriller in which a blind woman is stalked by a killer in an abandoned house, cornered by him, and then given a warning and allowed to go free.

Just as the plot softens during "Jennifer 8," so, too, does John Berlin. Initially displaying great deductive skills, he can figure out what a pattern of tiny scars on the hand means. But he later becomes significantly slower on the uptake. Increasing attention is paid to Mr. Garcia's ability to hold the film together through sheer force of personality, which is not always an easy task. This actor has a quiet appeal that is put to the test by the film's own quiet stretches, which may be why he occasionally bursts into flashes of hoarse, unexpected rage. The star, while skilled and eminently watchable, sometimes winds up being overshadowed by those around him.

It doesn't help that Ms. Thurman, playing Helena on a wan, neurasthenic note, seldom summons the requisite passion once Helena and John have begun an affair. During the latter part of the film, when much of John's energy is devoted to protecting Helena, his actions are made to seem more purposeless than they should. This leads to a denouement that is nothing if not bewildering, especially since "Jennifer 8" begins on such a hardboiled note. (Incidentally, the title is a kind of John Doe reference to the serial killer's string of victims, most of whom are never even discussed during the story.)

Among the attention-getting supporting characters are Kathy Baker and Lance Henriksen as the long-lost friends who have helped John land this new job after the breakup of his marriage; Ms. Baker gushes convincingly over the new arrival while Mr. Henriksen, as her husband, becomes John's sidekick and mentor on the job. John Malkovich has an utterly scene-stealing turn as the interrogator who grills Berlin once he himself has become a crime suspect. Mr. Malkovich's sly, languid confidence is so absolute that it upstages the less solid characters who surround him.

One of the most surprising things about "Jennifer 8," a strikingly atmospheric film even when not an entirely convincing one, is a running time that is in excess of two hours. Losing 20 minutes would almost certainly have heightened the film's sense of purpose, which is sometimes in danger of drifting away. Conrad Hall's evocative cinematography, which accentuates the damp, forbidding climate in which the story takes place, is especially helpful in keeping this otherwise rambling thriller on track.

"Jennifer 8" is rated R (Under 17 requires accompanying parent or adult guardian). It includes nudity, profanity and a few brief ghoulish touches.

1992 N 6, C6:2

The Efficiency Expert

Directed by Mark Joffe; screenplay by Max Dann and Andrew Knight; director of photography, Ellery Ryan; edited by Nick Beauman; production designer, Chris Kennedy; produced by Richard Brennan and Timothy White; released by Miramax Films. Running time: 85 minutes. This film is rated PG.

Wallace	Anthony Hopkins
Mr. Ball	Alwyn Kurts
Cheryl	Rebecca Rigg
Kim	Russell Crowe
Caroline	Angela Punch McGregor
Carey	Ben Mendelsohn
Wendy	Toni Collette

By VINCENT CANBY

After his first tour of Ball's, a small factory in Melbourne, Australia, that has been turning out casual footwear for 30 years, Wallace (Anthony Hopkins), a tough-minded efficiency expert, is almost in despair. It's the sort of place where the employees gather to sign a sentimental going-away card for a fellow who is leaving after three weeks. The men in the engineering shop spend more time worrying about a toy-car race than their jobs. The women, who sew the moccasins and pastel bunny slippers for which Ball's is known, favor long lunches that turn into tea breaks.

•

The appalled Wallace says when he arrives home that night, "It's like visiting my grandfather's house and finding it full of people."

The new Australian comedy titled "The Efficiency Expert" tries very hard to be daffy, and succeeds about half the time. In its own meandering way, it vaguely recalls the classic 1960 Boulting Brothers satire "I'm All Right, Jack," in part because it also deals with a confrontation between labor and management, and in part because "The Efficiency Expert" also takes place in the 1960's. There seems to be no special reason for setting "The Efficiency Expert" 30 years ago except that the comedy, like Ball's, is just slightly out of date.

The film is yet another demonstration of how a happy community of eccentric little people triumph over, and finally even convert, the forces of darkness, in this case Wallace, a man so dedicated to his job that he's forgotten how to live. Neither the screenplay, written by Max Dann and Andrew Knight, nor Mark Joffe's direction is inspired, but the film has its peripheral rewards.

Chief among them is Mr. Hopkins's absolutely straight, rock-hard comic performance, which never for a min-

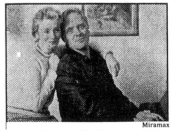

Miramax

Angela Punch McGregor and Anthony Hopkins.

ute betrays his awareness that the film is supposed to be funny. There also are a number of randomly giddy lines ("I met her a couple of weeks ago," says the factory Romeo to his pal. "I ran over her cat."), and the presence of Alwyn Kurts, the veteran Australian actor who plays Mr. Ball.

Mr. Kurts, who has the face of a worried bloodhound, is a very engaging performer, especially in scenes with Mr. Hopkins that usually end with the older man's suffering some new humiliation. "The Efficiency Expert" prompts benign smiles more often than outright laughter.

•

"The Efficiency Expert," which has been rated PG (Parental guidance suggested), includes some mildly vulgar language.

1992 N 6, C8:1

Playboy Enterprises Inc., 1992
Hugh M. Hefner

Hugh Hefner
Once Upon a Time

Directed by Robert Heath; written by Mr. Heath, Gary H. Grossman and Michael Gross; edited by Mr. Gross; music by Charlotte Lansberg, Reeves Gabrels and Tom Dube; produced by Mr. Grossman and Mr. Heath; released by I.R.S. Releasing. At Loew's Festival Theater, 6 West 57 Street. Running time: 91 minutes. This film has no rating.

Narrated by James Coburn.

By JANET MASLIN

The documentary "Hugh Hefner: Once Upon a Time" works nicely as a Rorschach test. There are those who will find it an appreciative portrait of Playboy's founding father as pioneer, libertarian and social critic, a man "with a castle for a home and a dream for a life." There are also those who will find it a tale of eerie isolation and weird excess, revealing the spiritual emptiness in a life of full-time fun. (Comments like "Hef was having this great time playing pinball" are often heard.)

For the latter group, this film from Lynch-Frost Productions appears to be taking place in some lonely, oversexed outpost of "Twin Peaks." Slow-motion glimpses of Mr. Hefner (seen in interviews, old photographs and elaborate home movies) seem to emanate from somewhere underwater, thanks partly to music recalling Angelo Badalamenti's "Twin Peaks" score. And the subject's own comments about his life reinforce the sleepwalking sensation, as when Mr. Hefner describes his 1985 medical emergency — a stroke — as "a stroke of luck."

Even the narration, which is read portentously by James Coburn, sounds a strange note somewhere between unctuousness and eulogy. "His days are now spent in reflection and remembrance, enjoying a life that only few could imagine," Mr. Coburn solemnly intones. Images of the once-carefree Playboy Mansion West, now filled with children's toys and family memorabilia (a "Kim and Hef" champagne glass celebrating Mr. Hefner's 1989 marriage to that year's Playmate of the Year, Kimberly Conrad, and a framed photograph of the happy couple in pajamas), seem equally unreal. "The Playboy Mansion has become a home, not for a playboy and his playmates, but for a husband and his family," Mr. Coburn grandly explains. Mr. Hefner speaks of "the golden years of autumn" and observes, "I don't think I could have

gotten here without having taken that other trip."

The other trip, as the film points out, was an extremely long and public one. As directed by Robert Heath, this documentary takes a straightforward, chronological approach to its subject's story, doing its best to explain how Hugh Hefner, the Chicago-born son of conservative Protestant parents, transformed himself into the world-famous hedonist known as Hef. Early influences, like the standoffishness of his parents and the pain of discovering that his fiancée had had an affair, are seen to have led to the development of the much-vaunted Playboy Philosophy.

Mr. Hefner is seen, in a photograph from the early days of his magazine, working beside a set of files on subjects like "Sex in Early Judaism" and "Womanization and Feminism." The film works so hard to emphasize Mr. Hefner's depth, and the fact that Playboy really could be read for its articles, that it even works in a clip of the Rev. Dr. Martin Luther King's "I have a dream" speech. (King and Justice William O. Douglas are among those cited as Playboy authors.) The aura of seriousness is even allowed to extend to the Playboy Clubs and their Bunnies, with Keith Hefner, Hef's brother, earnestly explaining the invention of the Bunny Dip, a graceful motion for delivering drinks off a tray. "It was stylized and kind of special and rather balletic," Keith Hefner says with obvious pride.

At these and many other moments, "Hugh Hefner: Once Upon a Time" is more vanity production than fairy tale. But it is still perversely interesting for its mixture of deliberate and accidental-looking revelations. Among the many scenes of Mr. Hefner's ostentatious partying, the staged quality is underscored by the very presence of the camera, which casts all the revelry in a self-conscious light. "Well, excuse me, I didn't see you come in," Mr. Hefner says with strained gaiety to the camera, while dancing for an early Playboy television show.

The film presents many luminaries who were drawn to the festive Playboy spirit. Lenny Bruce brandishes a champagne bottle; Jules Feiffer and Dick Gregory are among those who speak admiringly of Mr. Hefner as a host. Several ex-Bunnies speak of Playboy parties as a great adventure, and if any of them felt otherwise, they are not heard from. (Neither are

many potentially interesting interviewees, like Mr. Hefner's first wife.) A brief clip of Susan Brownmiller and unattractive, bra-burning feminists takes care of any critical point of view.

Sad episodes in Mr. Hefner's life, like the drug investigation that led to the suicide of his assistant and the

Retracing the steps to the Playboy mansion.

murder of Dorothy Stratten, the Playmate, are presented as gently as possible. This film avoids anything resembling an unflattering tone, yet it seems most caustic when it glows. "He was like the President," recalls an ex-girlfriend, Barbi Benton, about the receptions she and Hef would receive when landing at an airport in the Big Bunny, a large black airplane equipped with disco, bed and shower. His wife recalls: "When I met him I remember thinking there were going to be a lot of naked women around. And there were."

Mr. Hefner, who seems to have had at least as great a passion for being photographed with beautiful, acquiescent women as for the women themselves, reveals himself most fully through his own words. How many consorts has he shared the Playboy Philosophy with after all these years? "Many hundreds, probably more than a thousand," he says bashfully. "But for me it's never been a matter of quantity."

1992 N 6, C10:3

Flirting

Written and directed by John Duigan; director of photography, Geoff Burton; edited by Robert Gibson; production designer, Roger Ford; produced by George Miller, Doug Mitchell and Terry Hayes; released by The Samuel Goldwyn Company. At the Carnegie Hall Cinemas, Seventh Avenue at 57th Street, midtown. Running time: 100 minutes. This film has no rating.

Danny Embling	Noah Taylor
Thandiwe Adjewa	Thandie Newton
Nicola Radcliffe	Nicole Kidman
Gilby Fryer	Bartholomew Rose
Jock Blair	Felix Nobis
Baka Bourke	Josh Picker
Slag Green	Kiri Paramore
Christopher Laidlaw	Marc Gray
Colin Proudfoot	Greg Palmer
Cheddar Fedderson	Joshua Marshall
Possum Piper	David Wieland
Pup Pierdon	Craig Black
Greg Gilmore	Leslie Hill

By VINCENT CANBY

John Duigan's "Flirting" is the second low-key, easy-to-take installment in the Australian film maker's projected trilogy about the coming of age of Danny Embling (Noah Taylor), the sensitive young fellow introduced in "The Year My Voice Broke," released four years ago. The new film opens today at the Carnegie Hall Cinemas.

In "Flirting," set in 1965, Danny has been packed off to a fairly fancy boarding school where life is no easier than it was at home. As he notes on the soundtrack, there is no privacy at the school: "You're surrounded 24 hours a day. Either you become a herd animal or you dig a cave deep inside your head" in which to hide.

Samuel Goldwyn Company
Thandie Newton, right, and Noah Taylor in "Flirting."

Danny is still a very idealized odd-kid-out. He reads Sartre. When he has to assume a fake identity, he calls himself Camus.

"Flirting" is mostly about Danny's first, very tentative love affair, with Thandiwe (Thandie Newton), who attends the girls' boarding school just across the lake. Thandiwe is bright, funny and exceptionally pretty, though being from Uganda and black, she feels disconnected from the small world around her, much as Danny does for much fuzzier reasons.

In spite of the pressures on Danny and Thandiwe, their lives and their groping affair go along with remarkably few serious problems. They are able to meet at dances, and then during rehearsals for a play that is being put on as a co-production by the two schools. The teachers at both schools are strict, but they seem never to realize that students frequently make night voyages across the lake in rowboats to visit one another.

There is a kind of painless calm about "Flirting." The film is simultaneously attractive and just a little dull. Mr. Duigan avoids melodrama, which is all to the good. Yet his gift for the acutely observed commonplace detail is neither strong nor original enough to transform the movie into something comparable to so many similar, better films.

The best things about "Flirting" are the performances. Ms. Newton is delightful as Thandiwe, who is far more sophisticated than Danny and wise enough never to let him know it. Mr. Taylor is also good, although the troubled Danny is not an easy character to play. He's virtually the generic artist-as-a-young-man. Nicole Kidman appears in a supporting role as one of Thandiwe's older classmates, who is less of a snob than she first appears.

Mr. Duigan has announced that Mr. Taylor will again play Danny in the trilogy's final film, which is to be set in Paris but won't be made until his star grows a bit older. It seems likely that Danny will finally emerge as a writer, a painter or maybe even a film maker. It's a cinch he won't be on his way up in the world of international banking.

1992 N 6, C13:1

Passenger 57

Directed by Kevin Hooks; screenplay by David Loughery and Dan Gordon; director of photography, Mark Irwin; edited by Richard Nord; music by Stanley Clarke; production designer, Jaymes Hinkle; produced by Lee Rich, Dan Paulson, Dylan Sellers and Robert J. Anderson; released by Warner Brothers. Running time: 90 minutes. This film is rated R.

John Cutter	Wesley Snipe
Charles Rane	Bruce Payne
Sly Delvecchio	Tom Sizemore
Marti Slayton	Alex Datcher
Stuart Ramsey	Bruce Greenwood

BY STEPHEN HOLDEN

Watching "Passenger 57," a film that wants to establish Wesley Snipes as the coolest action hero this side of Steven Seagal, is like taking a ride on a sleekly designed roller coaster. There are lots of oohs and ahs in this nasty shoot-'em-up story of a psychopathic terrorist who hijacks a jumbo jet. But beneath the thrill-by-numbers surface of the film, nothing makes much sense.

Mr. Snipes plays John Cutter, an airline security expert with martial-arts training who happens to take the same flight as Charles Rane (Bruce Payne), an English terrorist and mass murderer being taken to Los Angeles in handcuffs by the F.B.I. Somehow or other, a whole gang of Rane's evil accomplices, including a bogus flight attendant, has managed to board the plane. It is up to Mr. Snipes, who is in the lavatory when the hijackers take over the flight, to save the day.

•

"Passenger 57" explodes into action in a spectacular opening sequence in which Rane, who is about to undergo plastic surgery, tries to evade a SWAT team by leaping through a hospital window. Here and throughout the film, Kevin Hooks, who directed, shows a masterly skill at plunging the viewer into the heart of the action and pumping up adrenaline. In one of the most exciting sequences, Mr. Snipes leaps from a speeding police car onto the landing gear of a departing jet and pulls himself into the aircraft, which is seconds away from becoming airborne, and immediately plunges into a life-or-death battle with a terrorist thug.

Adding tension to the film is an undercurrent of racial antagonism. Early in the flight, a dithering old lady who is seated next to Cutter mistakes him for Arsenio Hall. In an angrier mode, the movie evokes the Rodney G. King beating when Cutter is abused by a racist Southern sheriff and his henchmen after the jet is forced to land at a tiny Louisiana airstrip. The sexual interest that Cutter and Rane share for a spirited young flight attendant (Alex Datcher) is also depicted as a coded racial battle.

As an action hero, Mr. Snipes belongs to the school that plays it cool and tongue-in-cheek. Consistently underplaying his part, he strolls through the role with a glint in his eye that seems to acknowledge that the movie is really a live-action cartoon. Mr. Payne brings a similar tongue-in-cheek humor to the psychopathic fiend. In a clever cosmetic stroke, the handsome actor has been demonized with a subtly jaundiced skin tone that suggests his entire system is flooded with bile.

•

"Passenger 57" is rated R (Under 17 requires accompanying parent or adult guardian). It has many scenes of extreme violence.

1992 N 6, C14:5

Fathers and Sons

Written and directed by Paul Mones; director of photography, Ron Fortunato; edited by Janice Keuhnelian; music by Mason Darling; production designer, Eve Cauley; produced by Jon Kilik; released by Pacific Pictures. Running time: 100 minutes. This film is rated

Pacific Pictures

Jeff Goldblum

Max	Jeff Goldblum
Ed	Rory Cochrane
Smiley	Mitchell Marchand
Kyle	Famke Janssen
Lisa	Natasha Gregson Wagner
Judy	Ellen Greene
Marshall	Samuel L. Jackson
Lois	Joie Lee
Miss Athena	Rosanna Arquette
Shore Killer	Michael Disend

By JANET MASLIN

"Fathers and Sons" is actually about only one father — Max Fish (Jeff Goldblum), a former bad-boy movie director now living in modest circumstances on the Jersey Shore — and one son (Rory Cochrane). Beyond that, it is in no way succinct. As written and directed by Paul Mones, this is the torpid, myopic story of two brooding loners in a cute setting, to which the film pays unhelpfully rapt attention. "Things change; things remain the same," says the teen-age son, Ed, as the camera lingers lovingly on a bleak shot of the beach.

Mr. Mones, who manages to incorporate both a dead fish (get it?) and a fortuneteller (Rosanna Arquette, mincing showily in a needless role) into his film, has described "Fathers and Sons" as "a tapestry" and "a fugue." He also boils down his original inspiration to this: "ED FISH. Sixteen-year-old kid sits on the porch. Large, liquid eyes." Around this vision, the film maker has constructed a strained story of Max's efforts to cope with his son's growing independence while also getting back on his own two feet. The death of Max's wife has reminded Max that he must strive to be a better, simpler person, which is why he has turned his back on film making and the big city.

Max now operates a shop called Fish Books, appears in local theater (starring in a production of "Don Quixote" that has Quixote ending up in a straitjacket) and runs. During a road race, he meets a pretty young woman who illustrates the film's hubris problem. As she later puts it, "When you told me your name was Max Fish, I didn't know you were *that* Max Fish."

She also tells him she is a member of Alcoholics Anonymous, which is one of the few times this soft-edged film strikes a nerve. "Fathers and Sons" really rises to the subject of substance abuse, with a sequence that crosscuts Ed's drug experimentation with Max's efforts to resist drinking.

Mr. Goldblum brings gentleness and intensity to a character who might otherwise be entirely insufferable, and he mercifully shrugs off exaggerated claims of Max's former greatness. Mr. Cochrane is asked mostly to react to his co-star's fatherly entreaties, and does this plausibly, if not with any great fire.

The supporting cast includes Natasha Gregson Wagner as a carelessly seductive friend of Ed's and Joie Lee, Ellen Greene and Samuel L. Jackson as members of Max's self-consciously chummy theatrical set. Ms. Lee, best known for appearances in films by her brother Spike manages to be lively and appealing even in the film's most forced one-big-happy-family scenes.

"Fathers and Sons," which opens today, has a subplot about a mysterious author (Michael Disend) who — it is clear from the moment we first seem him lurking — is a hunted figure known as the Shore Killer. In this film, even the Shore Killer talks more than he should.

•

"Fathers and Sons" is rated R (Under 17 requires accompanying parent or adult guardian). It includes mild profanity and sexual situations.

1992 N 6, C17:1

FILM VIEW/Caryn James

'Nashville': Political Prescience

ROBERT ALTMAN'S "NASHVILLE" MAY BE the perfect follow-up to the strangest Presidential campaign in recent memory. When the film appeared in 1975, it seemed anchored in its own political moment, a time far different from the 90's. Watergate, the Nixon resignation and the war in Vietnam were last year's news instead of history. But the film's mix of cynicism and hope is so eerily pertinent today that watching it again is a revelation — about politics and about art.

"Nashville" has just opened at the Film Forum in its original wide-screen format. It is also available on video, in a version that cuts off some of the action on the sides of the screen and so loses something of the film's epic scope. That loss matters, because the film is, above all, a rich, savvy, entertaining epic of Americana. It was never a political tract.

As its two dozen characters wander through Nashville, bumping into one another, each reveals something about the American drive for success: Ronee Blakley is the country-and-western star who has an emotional breakdown on stage; Henry Gibson is the power-hungry singer who represents old Nashville; Keith Carradine barely takes time to breathe between women; Geraldine Chaplin, who identifies herself only as "Opal from the BBC," wanders around gathering material for a documentary about the city.

The Altman style — overlapping dialogue, multiple plots, wide shots that suggest all of life is theater — has never been put to more effectve use. Even after this year's critical and commercial hit "The Player," even measured against his early masterpieces, "M*A*S*H" (1970) and "McCabe and Mrs. Miller" (1971), "Nashville" still seems the director's shrewdest, liveliest movie.

■

But its political attitude is the most fascinating aspect of "Nashville" today. A viewer might expect the film to be loaded with dated references; it is not. There are only a few, glancing allusions to 1970's politics. Keith Carradine makes a casual remark to a soldier that reflects the anti-military feeling of the period: "You kill anybody this week?" One background song mentions Watergate and gasoline shortages.

And that lack of specificity is the key to the film's artistic success and political relevance. Mr. Altman taps into a deeper sense of disillusionment with politics. He creates a third-party candidate for President who captures the country's imagination. He takes it as a given that politics and show biz are hopelessly intermingled. His fictional campaign is not so far from the one we have just lived through.

That does not mean that Mr. Altman and his collaborators — the screenwriter Joan Tewkesbury and a cast that often created dialogue for their characters — were prophets. Rather, the film's prescience about the 90's suggests how little the political landscape has changed in 17 years.

The movie's third-party Presidential candidate, Hal Phillip Walker, is never seen, though his voice is heard coming from the speaker of a van that drives through the city. The folksy rhetoric, no-nonsense attitude and twangy voice might belong to Dana Carvey doing his flawless impression of Ross Perot. "What we need first and foremost is a common-sense approach," says Walker. "Nothing complicated."

Walker also warns, "If the chairman of the board or the president of your company had been running your business the way Washington has been running our business, you'd be asking a lot of questions." And Howard K. Smith, in a television commentary in "Nashville," says what commentators have repeated endlessly about Mr. Perot: "Hal Phillip Walker is in a way a mystery man, out of nowhere with a handful of students and scarcely any pros." It is possible to make too much of the Perot factor in "Nashville." After all, Walker was not a billionaire. But when Mr. Altman recognized the appeal of a grass-roots, independent candidate, he discerned a political attitude that has only become more pronounced.

He did the same with Michael Murphy's character, John Triplette, the political handler and television strategist. Triplette comes from Los Angeles to Nashville to set up a musi-

Paramount Pictures

Geraldine Chaplin as Opal in "Nashville"—The director Robert Altman saw a lot back in 1975.

cal benefit for Walker, to be syndicated nationally on television. He is a ubiquitous type today.

If "Nashville" seems dated at all, it is in the relative lack of emphasis on television and politics. Compare it to a film it has influenced, Tim Robbins's "Bob Roberts," and you can see how public awareness of the media's role in politics has grown. In Mr. Robbins's film, the candidate's television image is a central feature, shown in satires of political ads and news reports that are the movie's funniest scenes.

The BBC documentarian who trails Bob Roberts may owe something to Opal, though he is not a ditz. Her character would have made more sense if Mr. Altman had included a scene he later cut, in which she admits she does not work for the BBC. As a fraud, Opal would have offered another acerbic comment on the media. People fall all over themselves to be interviewed by this airhead.

Still, Mr. Altman saw a lot for 1975. He recognized that the New South was beginning to rise, that country music was moving toward the mainstream. And he ends "Nashville" with a scene that is still chilling. After an assassination at the music rally, the crowd is united and restored by singing: "You may say that I ain't free/ But it don't worry me."

The ending demonstrates the wondrously effective mix of hope and disillusionment that characterizes both "Nashville" and the 1992 Presidential campaign, in which calls for change collided with skeptical news analyses of political commercials. Tapping into that deep current of Americana is how "Nashville" became a great, enduring movie. □

1992 N 8, II:13:5

Aladdin

Directed by John Musker and Ron Clements; screenplay by Mr. Clements, Mr. Musker, Ted Elliott and Terry Rossio; editor, H. Lee Peterson; music, Alan Menken; lyrics, Howard Ashman/Tim Rice; production designer, R. S. Vander Wende; produced by Mr. Musker, Mr. Clements, Donald W. Ernst and Amy Pell; presented by Walt Disney Pictures; distributed by Buena Vista Pictures. Running time: 90 minutes. This film is rated G.

Voices:
Aladdin....................Scott Weinger/Brad Kane
GenieRobin Williams
JasmineLinda Larkin/Lea Salonga
Jafar....................Jonathan Freeman
Abu.............................Frank Welker
Iago.........................Gilbert Gottfried
Sultan.........................Douglas Seale

By JANET MASLIN

"Master, I hear and obey," said the Genie in the storybook version of "Aladdin," and his comments seldom went further than that. For an exercise in contrast, consider the dizzying, elastic miracle wrought by Robin Williams, Walt Disney Pictures' bravura animators and the Oscar-winning songwriting team of Alan Menken and Howard Ashman in "Aladdin," the studio's latest effort to send the standards for animated children's films into the stratosphere.

It may be nothing new to find Mr. Williams, who provides the voice of a big blue Genie with a manic streak, working in a wildly changeable vein. But here are animators who can actually keep up with him. Thanks to them, the Genie is given a visual correlative to the rapid-fire Williams wit, so that kaleidoscopic visions of Groucho Marx, Arnold Schwarzenegger, William F. Buckley Jr., Travis Bickle and dozens of other characters flash frantically across the screen to accompany the star's speedy delivery. Much of this occurs to the tune of "Friend Like Me," a cake-walking, show-stopping musical number with the mischievous wit that has been a hallmark of Disney's animated triumphs.

If the makers of "Aladdin" had their own magic lamp, it's easy to guess what they might wish for: another classic that crosses generational lines as successfully as "Beauty and the Beast" did, and moves as seamlessly from start to finish. "Aladdin" is not quite that, but it comes as close as may have been possible without a genie's help. The fundamentals here go beyond first-rate: animation both gorgeous and thoughtful, several wonderful songs and a wealth of funny minor figures on the sidelines, practicing foolproof Disney tricks. (Even a flying Oriental rug is able to frolic, sulk and move its thumb, which has evolved out of a tassel.) Only when it comes to the basics of the story line does "Aladdin" encounter any difficulties.

●

It may date back to the early 18th century, but the "Aladdin" story has a 1980's ring. Here is the ultimate get-rich-quick tale of an idle boy (a cute, raffish thief in Disney's modified version) who has the good luck to be designated the only person able to retrieve a magic, Genie-filled lamp from a subterranean cave. Once in possession of the lamp, the original Aladdin goes to work improving his fortunes. He acquires slaves, loot and an extravagant dowry so as to win the hand of a princess, eventually ordering the Genie to build them a palatial home. Even in the movie version, this hero, who has been made more boyish and remains unmarried, dreamily tells his pet monkey: "Some day,

Walt Disney Company

The character Abu in the Disney animated feature "Aladdin."

Abu, things are going to change. We'll be rich, live in a palace and never have any troubles at all."

Compared with the sounder underpinnings of "The Little Mermaid" and especially of "Beauty and the Beast," this has an unfortunately shallow ring, as do the two teen-age types on whom the story is centered. The blandly intrepid Aladdin (with the speaking voice of Scott Weinger) and the sloe-eyed Princess Jasmine (Linda Larkin), a nymph in harem pants, use words like "fabulous" and "amazing" to express unremarkable thoughts. (Jasmine's main concern is deciding whom she will marry.) Luckily, they are surrounded by an overpowering array of secondary characters who make the film's sidelines much more interesting than its supposed center. The scene-stealing monkey Abu (with noises supplied by Frank Welker) is a particular treat, as when he jealously mimics the Princess or otherwise comments on Aladdin's adventures.

As directed by John Musker and Ron Clements (the "Little Mermaid" team), "Aladdin" is a shade less smoothly paced than its recent predecessors. An opening number, "Arabian Nights," gets the film off to a grand start but ends sooner than viewers will wish. A sample lyric by the irreplaceable Mr. Ashman, who died of AIDS before completing this film's score:

Oh I come from a land,
From a faraway place,
Where the caravan camels roam.
Where they cut off your ear
If they don't like your face.
It's barbaric, but hey, it's home.

A lot of early exposition time is also used to explain the chicanery of Jafar (voice by Jonathan Freeman), the Sultan's evil vizier, whose chilling, bony features suggest a composite of Nancy Reagan (the animators have mentioned this as a deliberate reference, along with a more pointed one to Conrad Veidt in "The Thief of Bagdad") and Captain Hook. It's a long time before Mr. Williams's Genie makes his arrival, and some of the film's early moments — notably Aladdin's descent into a daunting, computer-animated cave — are on the scary side. But this "Aladdin" has so much in its favor that these drawbacks are truly minor. When it comes to Disney animators and children's films, this remains certain: nobody does it better.

What will children make of a film whose main attraction — the Genie himself — has such obvious parent appeal? They needn't know precisely what Mr. Williams is evoking to understand how funny he is. And the crazily antic pacing of the Genie's outbursts will be utterly familiar to small viewers, even if they can't identify a lightning-fast evocation of "The

Ed Sullivan Show." What will come through clearly to audiences of any age is the breathless euphoria of Mr. Williams's free associations, in which no subject is off-limits, not even Disney itself.

When Aladdin promises the Genie his freedom, the Genie mutters "Yeah, right" and turns into a nose-growing Pinocchio. Late in the story, the Genie cries out: "Aladdin! You've just won the heart of the Princess! What're you going to do next?" And the Genie even alludes to the centerpiece numbers of Disney's last two animated films by flashing an "Applause" sign after he sings "Friend Like Me," an heir apparent to the applause-getting "Under the Sea" (from "The Little Mermaid") and "Be Our Guest" (from "Beauty and the Beast"). "Aladdin" actually has two of these sensationally playful songs, the other being "Prince Ali," in which Abu the monkey becomes Abu the elephant, and Aladdin struts his stuff on a grand scale.

Half the film's lyrics are by Tim Rice ("Evita" and "Jesus Christ Superstar"), whose style is so much more conventional than Mr. Ashman's that the difference is instantly apparent. But the collaboration between Mr. Rice and Mr. Menken has produced a lilting ballad, "A Whole New World," that provides the film with a pretty interlude. The soaring voice of Jasmine in this duet is provided by Lea Salonga, who sings with Brad Kane (as Aladdin) and offers more evidence of just how shrewdly this film has been put together.

Of special note are the warm, dark tones of the film's color palette and its playful allusions to Al Hirschfeld's drawings (in the many curving, seamless shapes of the Genie) and to Erté's designs (in the angular chic of Jafar). Among the many animators who made stellar contributions here, particular mention must be made of Randy Cartwright, who has nothing more to work with than a flying carpet, and turns it into a charming new fixture in Disney's Anthropomorphic Hall of Fame.

This film is rated G (General audiences).

1992 N 11, C15:3

Traces of Red

Directed by Andy Wolk; written by Jim Piddock; director of photography, Tim Suhrtedt; edited by Trudy Ship; music by Graeme Revell; production designers, Dan Bishop and Dianna Freas; produced by David V. Picker and Mark Gordon; released by the Samuel Goldwyn Company. Running time: 105 minutes. This film is rated R.

Jack Dobson James Belushi
Ellen Schofield Lorraine Bracco
Steve Frayn Tony Goldwyn
Michael Dobson William Russ
Morgan Cassidy Michelle Joyner
Lieut. J. C. Hooks Joe Lisi

By STEPHEN HOLDEN

"Traces of Red" is a contemporary film noir that begins on such a clunky note that it doesn't begin to find its footing until about a third of the way through. That note is sounded by James Belushi as Jack Dobson, a rambling police detective in Palm Beach, Fla., who in the film's opening scene is shot. In a monotonous voice-over narration, Jack announces that he will recount the events that led to his shooting. He starts off by observ-

Frank Connor/Samuel Goldwyn Company

Whodunit Lorraine Bracco portrays a Palm Beach socialite in "Traces of Red."

ing that in Palm Beach everyone has three lives: "public, private and secret."

The film, which was directed by Andy Wolk and written by Jim Piddock, goes to extravagant, ultimately ludicrous extremes to create a complex and unpredictable web of lust, deception and murder that involves five major characters and any number of subsidiary figures. It has a satisfying double-trick ending.

At the center of the drama are Jack and his older brother, Michael (William Russ), who is running for Congress. Tony Goldwyn is Steve Frayn, Jack's iron-pumping, womanizing police partner. Faye Grant is Steve's jealous wife, Beth. And Lorraine Bracco plays Ellen Schofield, a rich Palm Beach widow and former flight attendant who seduces both police officers. Ms. Bracco's diction is so full of deses, doses and dems and her body language so graceless that her portrayal of a bored femme fatale is close to comedy.

The story, which involves the serial murders of three women, also has several bizarre little twists that are almost impossible to swallow. Early on, the film, which opened locally yesterday, assumes potentially "Psycho"-like overtones when it is revealed that Jack was sexually abused by his first-grade teacher who went to prison for her crimes. The movie takes a side trip to Key West, where Jack and Steve try to locate her son.

But as clumsy as it can get and as flat as its dialogue often sounds, "Traces of Red" succeeds in stirring up some adrenaline and in painting a fairly rich picture of Palm Beach as an opulent cesspool of sleaze baking in the Florida sun. As the film slowly gathers steam, nasty suspicions surround all the major characters. Mr. Goldwyn, in particular, skillfully trades on the aura he exuded in "Ghost": the friend and loyal sidekick who may be too good be true. As an aspiring politician, Mr. Russ makes his character's very solidity seem like grounds for suspicion of any number of abominable acts.

The film's biggest liability is Mr. Belushi, an actor who, try as he might, is incapable of projecting anything beyond an affable blandness. Neither sensual, nor threatening, nor kinetic, and without a sense of personal style, he is a neutral presence who commands neither sympathy nor dread.

"Traces of Red" is rated R (Under 17 requires accompanying parent or adult guardian). It has some nudity, strong language, and violence.

1992 N 12, C22:1

Bram Stoker's 'Dracula'

Directed by Francis Ford Coppola; screenplay by James V. Hart, based on the novel by Bram Stoker; director of photography, Michael Ballhaus; edited by Nicholas C. Smith, Glen Scantlebury and Anne Goursaud; music by Wojciech Kilar; production designer, Thomas Sanders; produced by Mr. Coppola, Fred Fuchs and Charles Mulvehill; released by Columbia Pictures. Running time: 130 minutes. This film is rated R.

Dracula Gary Oldman
Mina Murray/Elisabeta Winona Ryder
Professor Van Helsing Anthony Hopkins
Jonathan Harker Keanu Reeves
Dr. Jack Seward Richard E. Grant
Lord Arthur Holmwood Cary Elwes
Quincey P. Morris Bill Campbell
Lucy Westenra Sadie Foster
R. M. Renfield Tom Waits
Dracula's Brides .. Monica Bellucci, Michaela Bercu and Florina Kendrick
Mr. Hawkins Jay Robinson

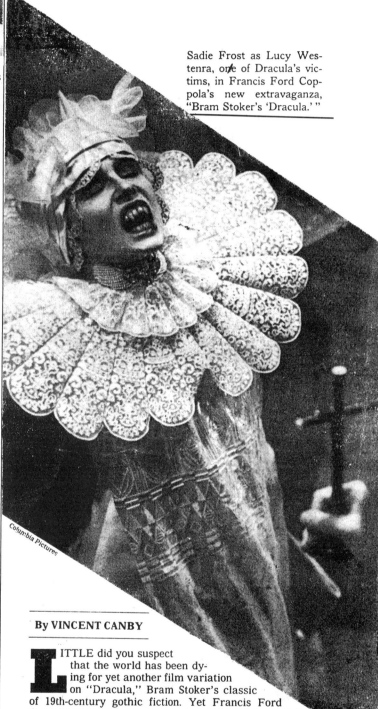

Columbia Pictures

Sadie Frost as Lucy Westenra, one of Dracula's victims, in Francis Ford Coppola's new extravaganza, "Bram Stoker's 'Dracula.' "

By VINCENT CANBY

LITTLE did you suspect that the world has been dying for yet another film variation on "Dracula," Bram Stoker's classic of 19th-century gothic fiction. Yet Francis Ford Coppola's new extravaganza, suitably titled "Bram Stoker's 'Dracula' " to separate it from all others, is such a dizzy tour of movie-making forces that it comes close to overwhelming all reasonable doubts.

Taking James V. Hart's unusually faithful screen adaptation of the novel, Mr. Coppola has created his own wild dream of a movie, which looks as if it required a special pact with the Treasury Department to finance. With its gorgeous sets and costumes, its hallucinogenic special effects and mad montages that recall the original grandeur of Abel Gance's "Napoleon," this "Dracula" transcends camp to become a testimonial to the glories of film making as an end in itself.

463

That's all very well and good, you might say, but shouldn't movies, even Dracula movies, be about something?

Not necessarily. This "Dracula" is most easily enjoyed if you don't search too hard for meanings, at least for those that go beyond the idea that the Stoker novel is really about Victorian England's fear of unleashed female sexuality. Interpretations

can be fun, but
they are also mis-
leading. "Nosferatu,"
F. W. Murnau's unauthorized
1922 adaptation of the Stoker novel,
is a silent-screen classic, but it is seen by
many to be anti-Semitic. Tod Browning's 1931
"Dracula," starring Bela Lugosi, is about nothing
whatsoever. It's watchable today mostly as a footnote to

the career of the man who also made "Freaks" and "The Devil Doll."

Mr. Coppola's version looks like something that he might have imagined nearly 30 years ago, when he wrote and directed his first film, "Dementia 13," a tepid black-and-white horror movie made for about $12 and change. "Dracula" has the nervy enthusiasm of the work of a precocious film student who has magically acquired a master's command of his craft. It's surprising, entertaining and always just a little too much.

Though set mostly in 1897 London and Transylvania, Mr. Hart's screenplay covers not only what's in the original novel but also what Stoker saw fit to omit.

This includes the film's vivid pre-credit sequence in Transylvania shortly after Constaninople's fall to the Turks in 1462. Dracula (Gary Oldman), the bravest knight in all Transylvania, goes mad with grief when his young wife, Elisabeta (Winona Ryder), tricked into suicide by the fiendish Turks, is denied a Christian burial. The young count curses God and stabs the sacred cross, which begins to bleed the first of the buckets of stage blood with which this film is awash. It's never clear just how or why Dracula's vampirism results from this outrage, but dramatic coherence isn't as important as style.

Mr. Oldman's Dracula comes in all sizes and shapes. When first seen

after the opening credits, he is an ancient, bloodless fellow welcoming Jonathan Harker (Keanu Reeves), a young English solicitor who has come to Transylvania to help the old count in his plans to move to London. At another time he is a hairy incubus who ravishes a London society girl in a magnificent Victorian garden in the middle of the night. He also appears as the Devil, as a wolf, as a lizard, as mist. Most important, he turns up as a reincarnated, dandyish version of his younger self.

That is when he's in London, courting the innocent Mina (Miss Ryder), Jonathan Harker's fiancée, who, by chance, is the reincarnated, long-dead Elisabeta. They meet on a London street in broad daylight. The movie doesn't devote a lot of time to the laws governing vampires and vampirism, but it does point out that the notion that vampires can't stand the light of day is poppycock. It also seems that there are times when a holy cross is of no more use against an attacking vampire than a rolled-up umbrella.

•

The narrative of the film, like that of the novel, defies rational synopsis but, in addition to Jonathan, Mina and, of course, the thirsty count, it also involves Mina's best friend, Lucy Westenra (Sadie Frost), an early and quite willing victim of the count in

London. She's the sort of Victorian maiden who owns a copy of Sir Richard Francis Burton's privately printed English translation of the "Arabian Nights," unexpurgated and illustrated.

There's also the brilliant if eccentric Prof. Abraham Van Helsing (Anthony Hopkins), the noted vampire specialist, who is called in when it's clear to Lucy's doctor that his patient's failing health is something more than chronic flu. Tom Waits appears as Renfield, the solicitor who goes out to Transylvania before Jonathan and returns quite out of his mind with an insatiable appetite for insects. •

The movie proceeds in the feverish manner of one of Dracula's victims just before he crosses over into the land of the undead. Nights seldom fall that a great storm doesn't erupt. One scene is never completed before another begins, necessitating lots of crosscutting between various simultaneous actions. In this way Mr. Coppola finds equivalents to unhinged minds without ever losing his own.

When the very proper Jonathan, trying to get some sleep in the castle, is seduced by Dracula's undead brides, they surface up through the mattress, bare-breasted and ravenous. Catching his brides feeding on his guest, Dracula is furious. "That man is mine," he says, luring the women away with the gift of a peasant baby. It's as if Mr. Coppola were saying: "You want a horror film? You got a horror film."

In the film's most Gance-like montage, covering Dracula's journey to London during yet another storm, the movie crosscuts between Dracula as he changes into some new being, Lucy's being sexually attacked in her garden while Mina watches, and the crazy Renfield in his lunatic asylum. Coherence is beguiled, temporarily anyway.

The film's most brilliant invention is an eerie sequence set in a London nickelodeon where, don't ask me why, Mina is suddenly stalked by a wolf, which, at Dracula's direction, becomes a docile, loving puppy. It's amazing how long Mr. Coppola can keep this up.

The principal actors are all fine. Mr. Oldman, Ms. Ryder, Mr. Hopkins, Mr. Reeves and Ms. Frost, a new and very bright-eyed actress, behave with a grace and an affectation that fits the time. The anachronisms are not glaring. Among Mr. Coppola's other colleagues who deserve special mention are Michael Ballhaus, the cinematographer; Thomas Sanders, the production designer, and Eiko Ishioka, who designed the fantastic costumes.

In a movie of such over-the-top frenzy and opulence, however, performances and people do not stand out as much as the kaleidoscopic results. This movie was imagined, written and directed, then somehow engineered into being as if it were one long, uninterrupted special effect.

For the most part Mr. Coppola avoids camp humor, though Grand Guignol jokes are in order. "You mean you're going to conduct a post-mortem?" someone says tearfully of a vampire victim, as if to suggest that the victim has already suffered enough. "Not exactly," says Van Helsing. "I just want to cut off the head and take out the heart."

•

"Dracula" works well as long as it remains a show. Late in the narrative, possibly to give it some kind of philosophical basis, the director sort

of nudges the audience to make analogies between AIDS and vampirism. The film is full of close-ups of horrible things seen so closely that you can't be sure of their exact identity, but there's no doubt about the shots of what are intended to be blood cells. It's not funny. According to the gospel of Bram Stoker, only divine intervention can save Dracula's victims.

One safer way to interpret "Dracula" is to say that it's about a man disconnected from the world on which he remains dependent. That also has appeared to be the director's problem for some time. After "Apocalypse Now," everything Mr. Coppola touched seemed a bit puny, either light of weight or more technically innovative than emotionally involving. With "Dracula" it's apparent that Mr. Coppola's talent and exuberance survive.

•

"Bram Stoker's 'Dracula'" is rated R (Under 17 requires accompanying parent or adult guardian). It has lots of blood, violence, female nudity and sexual situations.

1992 N 13, C1:3

Tous les Matins du Monde

Directed by Alain Corneau; screenplay by Pascal Quignard and Mr. Corneau, based on the novel by Mr. Quignard (in French with English subtitles); director of photography, Yves Angelo; edited by Marie-Josèphe Yoyotte; music arranged and performed by Jordi Savall; produced by Jean-Louis Livi; released by October Films. Lincoln Plaza Cinemas, Broadway at 63d Street, Manhattan. Running time 114 minutes. This film has no rating.

Sainte Colombe	Jean-Pierre Marielle
Marin Marais	Gérard Depardieu
Madeleine	Anne Brochet
Young Marin Marais	Guillaume Depardieu
Mme. de Sainte Colombe	Caroline Sihol
Toinette	Carole Richert
Young Madeleine	Violaine Lacroix
Young Toinette	Nadège Téron
Guignotte	Myriam Boyer
Abbé Mathieu	Jean-Claude Dreyfus
Chabonnières	Yves Lambrecht
Baugin	Michel Bouquet
De Bures	Jean-Marie Poirer

By JANET MASLIN

Taking his cue from his subject — a Baroque composer and violist da gamba known only for his reticence and the mournful beauty of his music — the French film maker Alain Corneau has fashioned a reserved and elegant portrait colored by dark, romantic longing. Where the film embroiders the sketchy biography of the 17th-century musician called Monsieur de Sainte Colombe (even his first name is unknown, as are the dates of his birth and death), it remains utterly true to the spirit of his work. Music is so effectively used, and so central to the film, that "Tous les Matins du Monde," a big hit in France and a winner of seven French Césars last year, has since prompted its own Baroque music revival.

That his film creates such interest without pedantry is a credit to Mr. Corneau's measured, thoughtful approach to his unusual subject. Not truly a biography of Sainte Colombe, "Tous les Matins du Monde" is a series of vignettes framed with painterly precision, combined to create some sense of the man's mysticism and his utter dedication to art. Even the major part of the film that involves Sainte Colombe's family furthers these ideas, since the death of the composer's wife infuses

Winona Ryder as Mina and Gary Oldman as Dracula.
Columbia Pictures

his music with such elegiac power. Sainte Colombe's two daughters, who study music with him, intensify the link between love and artistry. And one of those daughters arrives, through music, at a tragedy of her own.

•

The interloper and catalyst in the pastoral, beautifully evoked Sainte Colombe household is Marin Marais, the protégé who would go on to become a court composer at Versailles and a man as celebrated as Sainte Colombe was private. Marais is first seen, in a shot devised for calculating shock value, as a bloated, bewigged Gérard Depardieu, speaking haltingly of his mentor and weeping with the force of his memories. The film then flashes backward to the spring of 1660, when Sainte Colombe (Jean-Pierre Marielle) learns of his wife's death and the direction of his music is changed forever.

The film's austere style is well suited to celebrating Sainte Colombe's obsessive dedication. The camera quietly observes him as he arranges for a small, simple cottage to be built near the family's grander quarters, so that he can isolate himself for marathon sessions devoted only to art.

The specifics of these scenes — the glass of wine, the utter solitude, the lovely, curved lines of the composer's instrument — are observed meticulously by Mr. Corneau. So are the household rituals of the two Sainte Colombe daughters, Madeleine and Toinette, who wear costumes out of a Vermeer painting as they practice their music and perform simple chores. That Sainte Colombe once locks his children in the cellar and forgets to release them is perfectly consistent with this film's rigid, self-absorbed central figure.

"It was said he could imitate the full range of the human voice, from a young woman's sigh to an old man's sob, from Henry IV's battle cry to a child's sleeping breath," Mr. Depardieu says as he narrates this story. Brilliance like that is what prompts the young Marais to seek out Sainte Colombe as a mentor. The boyish Marais is played by tall, blond Guillaume Depardieu, Gérard's son, who has an uncomplicated handsomeness very different from his father's looks and whose manner is considerably less intense.

But the younger Mr. Depardieu combines a wounded, wary gaze with obvious sexual confidence, which makes him well suited to play the man who brings discord to the Sainte Colombe household. Marais also becomes a sounding board as the fiercely exacting Sainte Colombe becomes his contemptuous teacher. "You make music! You're not a musician," the older man says scathingly as the young Marais tries haplessly to please him. Marais's covert love affair with the sad-eyed, lovely Madeleine (Anne Brochet) helps to compensate for her father's stinging remarks.

The film makes a slightly awkward transition from this slender young Marais to the one, played by Depardieu père, whom Madeleine describes as "marvelously beribboned and fat." He appears, in the late stages of the story, for an anguished encounter with Madeleine and a climactic effort to discover Sainte Colombe's musical secrets. It's not every film that can build, with genuine suspense, to a philosophical discussion of music and its meaning.

October Films

Jean-Pierre Marielle, left, and Gérard Depardieu in a scene from "Tous les Matins du Monde."

There is a danger of preciousness within the rarefied atmosphere of "Tous les Matins du Monde" (a title that, in context, means something like "each day dawns but once"). And Mr. Corneau occasionally gives in, as when he lets the young Marais remark that "Life, to be sweet, must be cruel" or sound unduly literary. ("The Seine was bright with sunlight.") The film also lacks narrative momentum at times, when the screenplay by Mr. Corneau and Pascal Quignard (on whose novel it is based) revels too fully in art-filled ambiance, which is in abundant supply. Corinne Jorry's spare, elegant costumes contribute greatly to the lofty mood.

Miss Brochet, who co-starred with the senior Depardieu in "Cyrano de Bergerac," gives a radiant performance remarkable for its expressiveness and gravity. Carole Richert, as her younger sister, is equally well cast in a smaller role. The senior Mr. Depardieu once again displays his willingness to take extreme chances and his ability to invest potentially dry characters with unexpectedly complex passions. The stern, dignified Mr. Marielle makes Sainte Colombe a perfect visual equivalent for the stately score.

•

"Tous les Matins du Monde" is unrated. It includes sexually explicit language, sexual situations and graphic nudity.

1992 N 13, C3:4

Damned in the U.S.A.

Directed by Paul Yule; produced by Mr. Yule and Jonathan Stack; edited by John Street; released by Diusa Films. At Quad Cinema, 34 West 13th Street, Greenwich Village. Running time: 76 minutes. This film has no rating.

With: Judge David Albanese, Dennis Barrie, Luther Campbell, Senator Alfonse M. D'Amato, Representative Thomas J. Downey, James Ford, Charles Freeman, Christie Hefner, Senator Jesse Helms, Senator Gordon Humphrey, Harry Lunn, Norma Ramos, Peter Reed, Joe Reilly, Andres Serrano, Jimmy Tingle, the Rev. Donald Wildmon and Philip Yenawine.

By VINCENT CANBY

"Damned in the U.S.A.," opening today at the Quad Cinema in Greenwich Village, was originally made as a television documentary for England's Channel 4, being a report on the state of the arts in this country with special emphasis on pornography and censorship. The news peg was the Cincinnati obscenity trial involving the exhibition of explicit sexual photographs, taken by Robert Mapplethorpe, at the Contemporary Arts Center there.

Having completed their film and shown it here at the Margaret Mead Film Festival in September 1991, Paul Yule, the director, and Jonathan Stack, his co-producer, were sued by the Rev. Donald Wildmon, of the American Family Association, who sought to enjoin the film's release in this country. In this way the film makers became a part of the story they set out to cover. In this way, too, it seems, the film gained a notoriety that led to a theatrical release it might not otherwise have obtained.

"Damned in the U.S.A." is a comprehensive recap of the conflicting views that led to the Mapplethorpe trial, but it won't be especially revealing to anyone who followed the news coverage of the trial. After being interviewed by the film makers, Mr. Wildmon, a strong conservative, objected to being in a movie that shows some of the things he's fighting against. He eventually lost the case, and might better not have started it.

Mr. Wildmon does not look ridiculous in the film, though he is certainly opinionated. The film is much rougher on the other conservative spokesmen, especially Senators Jesse Helms of North Carolina and Alfonse M. D'Amato of New York, whose thoughts about the National Endowment for the Arts are well known.

A lot of "Damned in the U.S.A." looks like padding. Between interviews and a tour of the empty Cincinnati courtroom, conducted by Judge David Albanese, who presided at the trial, there are comments by Jimmy Tingle, a comedian whose barbs are suitably caustic but not in the Lenny Bruce league. The film's most articulate interviewees are Philip Yenawine, the director of education for the Museum of Modern Art, Christie Hefner, chairman of Playboy Enterprises, and Norma Ramos, representing Women Against Pornography.

"Damned in the U.S.A." may look sharper on the small television screen.

1992 N 13, C11:1

Love Potion No. 9

Written, produced and directed by Dale Launer, inspired by the song by Jerry Leiber and Mike Stoller; director of photography, William Wages; edited by Suzanne Pettit; music by Jed Leiber; production designer, Linda Pearl; released by 20th Century Fox. Running time: 96 minutes. This film is rated R.

Paul	Tate Donovan
Diane	Sandra Bullock
Marisa	Mary Mara
Gary	Dale Midkiff
Sally	Hillary Bailey Smith
Prince Geoffrey	Dylan Baker
Palm Reader	Anne Bancroft

By VINCENT CANBY

Dale Launer, the man who wrote the hilarious "Ruthless People," "Dirty Rotten Scoundrels" and "My Cousin Vinny," makes his debut as what Hollywood calls a "hyphenate" (writer and director) with "Love Potion No. 9," the kind of comedy you can outrun at a walk. Given the premise, which is said to be inspired by the song by Jerry Leiber and Mike Stoller, virtually everything that happens can be predicted from the opening frame.

•

The situation is this: Paul (Tate Donovan), a shy biochemist, and Diane (Sandra Bullock), an animal

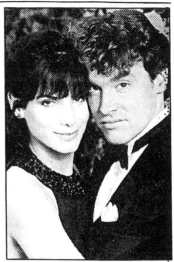

Robert Isenberg

Tate Donovan, right, and Sandra Bullock in "Love Potion No. 9."

psychologist who is also shy, find themselves in possession of a love potion that works on chimpanzees. They agree to test it out on themselves, though not together. Would you believe that Paul becomes an exhausted Lothario? Would you believe that Prince Geoffrey of England (Dylan Baker), who looks like a somewhat taller, handsomer Prince Charles, proposes to Diane? Would you believe that true love is elsewhere, but not too far away?

Mr. Launer's writing credits indicate that he's a very funny man, but "Love Potion No. 9" suggests that he needs a collaborator to tell him when the jokes don't work. He also needs a funnier story in which to plant them. "Love Potion No. 9," which refers not to the original potion but to its antidote, has a decent young cast, some mild smiles and a lot of gags that lie on the floor like pennies not worth picking up.

The only real laugh is provided by Anne Bancroft as the Gypsy palm reader who deals in love potions. That laugh comes when, looking into Paul's hand, she frowns, spits into it and rubs it with a cloth as if to clean her glasses. It's not really a joke, more like a bit of business, but in "Love Potion No. 9," it's the equivalent to the stateroom scene in "A Night at the Opera."

•

"Love Potion No. 9," which has been rated R (Under 17 requires accompanying parent or adult guardian), has a lot of vulgar language and some sexual situations.

1992 N 13, C12:5

Aventis

Direction and screenplay by Vicente Aranda, based on the story by Juan Marsé (in Spanish with English subtitles); director of photography, Juan Amorós; edited by Teresa Font; music by José Nieto; produced by Enrique Viciano. Joseph Papp Public Theater, 425 Lafayette Street, Greenwich Village. Running time: 120 minutes. This film has no rating.

Menchu/Ramona/Aurora Nin	Victoria Abril
Java	Jorge Sanz
Marcos	Antonio Banderas
Conrado Galán	Javier Gurruchaga
Fusam	Guillermo Montesinos
Taylor	Ferrán Rañe
Palau	Lluís Homar
Nadal	Joan Miralles
Sendra	Carlos Tristancho
Sarnita	Juan Diego Botto

By STEPHEN HOLDEN

In Barcelona in the early 1940's, adolescents whose parents were too poor to buy them toys used to entertain themselves by sitting around in groups and telling stories, explains the prologue for Vicente Aranda's film "Aventis" ("Stories"). Their tales typically interwove current events, neighborhood gossip and fantasy into surreal little scenarios, infused with sex and high adventure, in which the line between real and imagined events often blurred.

In "Aventis," the Spanish film maker has pieced together some of those stories to create a complex and haunting portrait of his country's psyche during the harsh early years of the Franco regime. Although the film is set mostly in 1940, it jumps forward to 1970 when two of the characters turn up in a mortuary. It has a final scene, set in the present, that suggests how events of 50 years earlier can still cast long, if pale, shadows.

The film follows the lives of several groups of people living in the Gracia area of Barcelona. Its interlocking vignettes evoke the period as romantically remembered by the teen-age boys who meet regularly in a desolate lot where the local anarchists have buried their weapons. The boys' leader, Java (Jorge Sanz), is an older teen-ager who earns money from a local madam by having kinky sex with her prostitutes for high-paying voyeurs.

•

One of her regular clients is Conrado Galán (Javier Gurruchaga), a well-to-do man who uses a wheelchair. A sinister symbol of sexual repression, Conrado also directs the neighborhood teen-agers in religious pageants staged in a seedy local theater. Unbeknownst to Conrado, in their off hours the boys use the theater's basement storeroom to stage "rehearsals," in which they tie up and interrogate the girls from a local orphanage. In one ritual, they try to glean information on the whereabouts of Aurora Nin (Victoria Abril), a former director of the orphanage who has become a prostitute and changed her name to Ramona.

Java, too, is searching for Aurora. Before the war, she was the girlfriend of his older brother, Marcos (Antonio Banderas), an anarchist who spends most of his time hidden behind a brick wall in his grandmother's junk shop.

The other characters include a group of anarchists and Marxists, who meet secretly to plan ways of carrying on their terrorist activities, and Menchu (Miss Abril), the flamboyant, blond-wigged mistress of a local black marketeer.

•

"Aventis" is not the easiest film to follow because it is structured like a dramatic collage in which bits and pieces of the past flash by like scenes in the fever dream of an adolescent boy. As the film abruptly segues from one story to another, the pieces only gradually begin to gel into a broader portrait of a community struggling to survive an oppressive, Puritanical fascism.

The director has lighted the film so that the impoverished, war-torn district of the city seems like a magical place holding all sorts of secrets and forbidden pleasures. The film is suffused with an unapologetic prurience that treats adolescent sexual curios-

Victoria Abril and Antonio Banderas in "Aventis."

ity as a quasi-religious mystique, and the scenes of the rehearsals exude an intoxicated erotic glow. Clearly, for Mr. Aranda, as for his more famous film-making compatriot, Pedro Almodóvar, sexual openness is a precious badge of artistic freedom.

Mr. Sanz and Miss Abril, the two most prominent actors in "Aventis," also co-starred in Mr. Aranda's steamy film noir, "Lovers," which won praise when it was shown in March at the New Directors/New Films series. And in "Aventis," Mr. Sanz, who suggests a more punkish Spanish answer to the young Alain Delon, is magnetic as a calloused, streetwise youth living by his wits.

Miss Abril, who has starred in most of Mr. Aranda's films since the mid-1970's, plays both Aurora and Menchu. Although virtually unrecognizable as she slips between the two, she brings to both roles a tempestuous headstrong passion that suggests the earthiness of Anna Magnani fused with the steel will of Faye Dunaway, to create a commandingly volatile force field.

•

"Aventis" opens a four-week festival of 20 films — "Spanish Eyes: Visions From Post-Franco Spain 1975-1990" — at the Joseph Papp Public Theater, 425 Lafayette Street. Mostly American premieres, they reflect the new freedom in Spain after 40 years of dictatorship and artistic censorship. All films are in Spanish with English subtitles. Information: (212) 598-7171.

1992 N 13, C15:1

The Giving

Written and directed by Eames Demetrios; director of photography, Antonio Soriano; edited by Bruce Barrow and Nancy Richardson; music by Stephen James Taylor; production designers, Diane Romine Clark and Lee Shane; produced by Tim Disney, Cevin Cathell and Mr. Demetrios; released by Northern Arts Entertainment. At Quad Cinema, 13th Street, west of Fifth Avenue, Greenwich Village. Running time: 100 minutes. This film has no rating.

Jeremiah Pollock	Kevin Kildow
Gregor	Lee Hampton
Graffiti Painter	Flo Hawkins
Stefan	James Asher-Salt
Gale	Stephen Hornyak
The Boss	Paul Boesing
Yurgen	Michael McGee
Tiffany	Satya Cyprian

By JANET MASLIN

"The Giving," Eames Demetrios's aggressively earnest film about a Los Angeles yuppie who changes his life to help the homeless, is literally and figuratively in black and white. Shot in the stagy, soliloquy-filled style of a student film, it presents the tremulous white banker Jeremiah Pollock

Kevin Kildow and Satya Cyprian

(Kevin Kildow) and the caustic black firebrand named Gregor (Lee Hampton), who regards Jeremiah's charitable efforts with suspicion. The arguments between Jeremiah and Gregor's radicalized band of street people have a stubbornly polemical flavor. Watching Jeremiah being forced to rethink his notions of generosity suggests what it might have been like to spend an hour and a half being browbeaten by the Symbionese Liberation Army.

When Jeremiah donates $10,000 to a mission house at a black-tie auction, his gesture is greeted with disbelief by his fellow bankers and with scorn by the homeless themselves. "Anyone can write a check, but it takes a brave man to see us as human," Gregor eventually announces, dripping contempt. (A female friend of Gregor's actually spits at Jeremiah rather than take his money.) Gregor, an idealist who keeps bees in a car engine and dreams of creating an urban farming project with a community of friends, eventually so overpowers Jeremiah that Jeremiah's car is filled with hay and turned into a chicken coop.

This self-flagellating and highly symbolic tale is told in a stilted manner, so that its theatrical tone is never subordinated to real drama. Many of the performers are either homeless or mentally ill, but even they are made to sound false somehow. Mr. Demetrios's most intrusive devices, like the many soliloquies or a scene in which the bankers castigating Jeremiah become cardboard cutouts of themselves, suggest narrative problems that should have been solved in plainer ways.

"The Giving" obviously means well, just as Jeremiah does. But its protracted struggle seems seriously contrived (despite Mr. Hampton's efforts to make Gregor a three-dimensional figure) and even dated. The film begins to seem a genuine throwback to the radicalism of the 1960's when it moves past the thought that Jeremiah's gifts of his own money are somehow reprehensible. When he concocts a scheme to allow the homeless to rob the bank he once worked for, widely publicizing the access codes for cash machines among street people, he at last assumes the status of an anti-establishment folk hero.

1992 N 13, C17:1

Malcolm X

Directed by Spike Lee; screenplay by Arnold Perl and Mr. Lee, based on the book "The Autobiography of Malcolm X" as told to Alex Haley; director of photography, Ernest Dickerson; edited by Barry Alexander Brown; music by Terence Blanchard; production designer, Wynn Thomas; produced by Marvin Worth, Mr. Lee, Monty Ross, Jon Kilik and Preston Holmes; released by Warner Brothers. Running time: 199 minutes. This film is rated PG-13.

Malcolm X	Denzel Washington
Betty Shabazz	Angela Bassett
Elijah Muhammad	Al Freeman Jr.
West Indian Archie	Delroy Lindo
Baines	Albert Hall
Shorty	Spike Lee
Laura	Theresa Randle
Sophia	Kate Vernon
Louise Little	Lonette McKee
Earl Little	Tommy Hollis
Brother Earl	James McDaniel
Sidney	Ernest Thompson
Benjamin 2X	Jean LaMarre
Speaker No. 1	Bobby Seale
Speaker No. 2	Al Sharpton
Chaplain Gill	Christopher Plummer
Miss Dunne	Karen Allen
Captain Green	Peter Boyle
Judge	William Kunstler

By VINCENT CANBY

Malcolm X lived a dozen different lives, each in its way a defining aspect of the black American experience from nightmare to dream. There was never any in-between for the man who was initially called Malcolm Little, the son of a Nebraska preacher, and who, when he died, was known by his Muslim name, El-Hajj Malik El-Shabazz. Malcolm traveled far, through many incarnations to become as much admired as he was feared as the black liberation movement's most militant spokesman and unrelenting conscience.

Malcolm was already something of a myth when he was assassinated at the Audubon Ballroom in New York on Feb. 21, 1965, just three months short of his 40th birthday. The publication later that year of "The Autobiography of Malcolm X," his remarkably vivid testament written with Alex Haley, eventually consolidated his position as a great American folk hero, someone whose life speaks with uncanny pertinence to succeeding generations, white as well as black.

Taking the autobiography and a screenplay by Arnold Perl that was begun more than 20 years ago (Perl died in 1971), Spike Lee has attempted the impossible and almost brought it off. His new "Malcolm X" is not exactly the equal, or even the equivalent, of the book, but it's an ambitious, tough, seriously considered biographical film that, with honor, eludes easy characterization.

•

"Malcolm X" will offend many people for all the wrong reasons. It is neither so inflammatory as Mr. Lee's statements about it would have you believe nor so comforting as might be wished by those who would call a halt to speculation concerning Malcolm's murder. It is full of color and exuberance as it tells of life on the streets in Boston and New York, but it grows increasingly austere when Malcolm is arrested for theft and sent to prison, where he finds his life's mission. The movie becomes proper, well mannered and somber, like Malcolm's dark suits and narrow ties, as it dramatizes his rise in the Nation of Islam, founded by Elijah Muhammad.

Mr. Lee treats the Nation of Islam and its black separatist teachings seriously and, just as seriously, Malcolm's disillusionment when Elijah Muhammad's fondness for pretty young secretaries is revealed. When, after his split from the Nation of Islam, Malcolm goes on his pilgrimage to Mecca, the film celebrates his new insight into racial brotherhood, which makes his assassination all the more sorrowful.

In the film's view, a god has been recognized, then lost.

Mr. Lee means for "Malcolm X" to be an epic, and it is in its concerns and its physical scope. In Denzel

David Lee/Warner Bros.

Denzel Washington addressing Harlem residents outside the Apollo Theater in Spike Lee's "Malcolm X."

Washington it also has a fine actor who does for "Malcolm X" what Ben Kingsley did for "Gandhi." Mr. Washington not only looks the part, but he also has the psychological heft, the intelligence and the reserve to give the film the dramatic excitement that isn't always apparent in the screenplay.

This isn't a grave fault, nor is it singular. Biographical films, except those about romantic figures long since dead like "Lawrence of Arabia," carry with them responsibilities that tend to inhibit. Mr. Lee has not been inhibited so much as simultaneously awe struck and hard pressed.

•

"Malcolm X" is frank about what it sees as the murder conspiracy, which involves a combination of people representing the Nation of Islam and the Federal Bureau of Investigation. Yet n trying to cover Malcolm's life from his boyhood to his death, it sometimes seems more breathlessly desperate han cogently revealing.

The movie picks up Malcolm's story in the 1940's on his arrival in wartime Boston as a bright but square teen-ager from rural Michigan. Malcolm eagerly falls in with the wrong crowd, initially represented by Shorty (Mr. Lee), a street hustler who shows him how to dress (a pearl gray zoot suit) and introduces him to he fast set at the Roseland Ballroom. Malcolm learns how to Lindy and how o wheel and deal. He discovers women and drugs. In addition to his attachment to Laura (Theresa Randle), a sweet young black woman, he evelops a far steamier liaison with a

thrill-seeking young white woman, Sophia, played by Kate Vernon, who looks a lot like Carroll Baker in her "Baby Doll" days.

As the film moves forward from the 40's, it suffers spasms of flashbacks to Malcolm's childhood in Nebraska and Michigan. These are so fragmented that they may mean nothing to anyone who hasn't read the autobiography. They also don't do justice to the early experiences themselves, especially to Malcolm's time in a white foster home where he excelled in school and was encouraged by well-meaning adults who did not hesitate to refer to him as a "nigger."

•

Mr. Lee is very good in his handling of individual sequences, but until very near the end, "Malcolm X" fails to acquire the momentum that makes everything that happens seem inevitable. The film goes on and on in a kind of reverential narrative monotone.

The story of Malcolm X is fraught with pitfalls for any movie maker. Mr. Lee is creating a film about a man he admires for an audience that includes those who have a direct interest in the story, those who may not have an interest but know the details intimately and those who know nothing or only parts of the story. It's a tricky situation for anyone committed to both art and historical truth.

Mr. Lee's method is almost self-effacing. He never appears to stand between the material and the audience. He himself does not preach.

There are no carefully inserted speeches designed to tell the audience what it should think. He lets Malcolm speak and act for himself. The moments of confrontational melodrama, something for which Mr. Lee has a particular gift, are quite consciously underplayed.

In this era of aggressive anti-intellectualism, the film's most controversial subtext might not even be recognized: Malcolm's increasing awareness of the importance of language in his struggle to raise black consciousness. Vaguely articulated feelings aren't enough. Ideas can be expressed only through a command of words.

•

Before Mr. Lee came to the "Malcolm X" project, other people had worked on it. In addition to Perl's screenplay, there were adaptations by James Baldwin, David Mamet, Calder Willingham, David Bradley and Charles Fuller. In retrospect, it's easy to see what their difficulties might have been.

•

Though the autobiography is full of characters and incidents, they are only peripheral to the larger story of Malcolm's awkward journey toward intellectual and spiritual enlightenment. Then too, Malcolm's life ended before the journey could be said to have been completed. This is not the sort of thing movies accommodate with ease.

"Malcolm X" never bursts with the free-flowing energy of the director's

own fiction, but that's a reflection of the genre, the subject and Mr. Lee's sense of mission. Though the film is being promoted with all sorts of merchandise on the order of T-shirts and baseball caps, the one item that promotes it best is the new book, "By Any Means Necessary: The Trials and Tribulations of the Making of 'Malcolm X,' " by Mr. Lee with Ralph Wiley, published by Hyperion.

In addition to the screenplay, the book has an extensive report on the research Mr. Lee did before starting the production. Among the people he interviewed was the Rev. Louis Farrakhan, who succeeded Elijah Muhammad as the head of the Nation of Islam. It was apparently a polite encounter, but Mr. Lee remains sharp, skeptical and uninhibited. He's not a reporter to let anyone else have the last word. It's this sort liveliness that is most missed in the film.

•

The real triumph of "Malcolm X" is that Mr. Lee was able to make it at all. As photographed by Ernest Dickerson and designed by Wynn Thomas, the movie looks as authentic as any David Lean epic. The large cast of featured players, including Al Freeman Jr., who plays Elijah Muhammad, and Angela Barrett, who plays Malcolm's wife, Betty Shabazz, is supplemented by, among others, Al Sharpton, Christopher Plummer, Bobby Seale, William Kunstler and Peter Boyle in cameo roles.

Nelson Mandela, photographed in Soweto, appears at the end to speak a kind of benediction.

•

"Malcolm X" is rated PG-13 (Parents strongly cautioned). It has vulgar language and some violence.

1992 N 18, C19:3

To Render a Life

Director of photography and directed by Ross Spears; written by Silvia Kersusan; produced by Mr. Spears and Ms. Kersusan; released by the James Agee Film Project. Film Forum 1, 209 West Houston Street, South Village. Running time: 88 minutes. This film has no rating.

WITH: The Glass family, Robert Coles, Frederick Wiseman, Howell Raines and Jonathan Yardley.

By JANET MASLIN

Ross Spears's "To Render a Life" is a documentary made in the long shadow of "Let Us Now Praise Famous Men," the indelible record of Southern sharecroppers' lives created by James Agee and Walker Evans during the Great Depression. In ways deliberate and otherwise, Mr. Spears raises interesting questions about his predecessors' methods and his own.

Among the many things for which "Let Us Now Praise Famous Men" is so vividly remembered are its stark contrasts: between the utter simplicity of Evans's photographs and the extravagance of Agee's descriptive prose, between the haunting dignity of these subjects and the harshness of their lives. The difference between two distinguished, worldly visitors — "a spy, traveling as a journalist," Agee called himself — and the unself-conscious rural people they befriended and studied is another sharp one.

In "To Render a Life," which opens today at Film Forum 1, Mr. Spears adds yet another layer of comparison: between the original work and his attempt to reinvent it for the

present day. Using live-action color film in place of Evans's evocative black and white, interviewing subjects whose casual conversation replaces the earlier sharecroppers' silent eloquence, Mr. Spears records the life of a poor white family in rural Virginia. How different are the hardships of the Glass family from those recorded in "Let Us Now Praise Famous Men"? And how much of the difference depends on different technology, varying perspective or an artist's manipulative methods?

•

Mr. Spears's two-faceted film tries to consider these matters while also creating its own set of portraits. The format is ambitious; it is also extremely limiting, since it so often invokes the earlier work as a model and point of reference. Curiously, Mr. Spears allows lively criticism of Agee's outlook while simultaneously trying hard to make it his own. The critic Jonathan Yardley expresses the opinion that "Let Us Now Praise Famous Men" is "seriously, badly overwritten," while the documentary film maker Frederick Wiseman describes the book's inherent narcissism. "I thought it was about some sharecroppers in Alabama, but I may be wrong," Mr. Wiseman says dryly.

Mr. Wiseman also cogently discusses the ways in which any documentary study makes manipulative choices. Meanwhile, Robert Coles is seen lecturing about "Let Us Now Praise Famous Men" to his students at Harvard. In the end, no one disputes the assessment of another interviewee: "I think that once you read that book, the effect never stops." Certainly it has not stopped for Mr. Spears, who started a James Agee Film Project nearly 20 years ago and made an Academy Award-nominated documentary, "Agee," in 1981.

As enlightening as the discussion of Agee's work is, this film becomes much more revealing through its attempts at mimicry. The closer it comes to Agee and Evans's territory, the more strongly it underscores the artifice in their seemingly straightforward work. Simply by being filmed in color and allowed to walk

and talk for themselves, the Glasses do not resemble the piercing still-life portraits Evans composed. (There is more of the Agee-Evans ethos in Barbara Kopple's films about striking coal miners and meatpackers than there is here.) Not even the detritus of the Glasses' lives — plastic flowers, a rotting baseball, an abandoned pill bottle — has the poetic severity of "Let Us Now Praise Famous Men."

•

Mr. Spears is extremely lucky in having found Alice Glass, the motherly dynamo who holds this family together and provides his film with a powerful focus. This matriarch is presented as a formidable and impressively stalwart figure, though she would have been better served by a less slavish format. (Mr. Agee's words are even imposed, in voice-over, on the Glass family's domestic routine.) Alice Glass, a big, hard-working woman with a gap-toothed smile, is seen cooking, washing, tending chickens and killing rattlesnakes, while the camera lingers on such telling details as insects crawling on the family's food. Alice's good cheer, remarkable as it is, seems even more so in comparison with the gaunt, unsmiling figures Evans photographed.

Obea Glass, Alice's husband, has worked for 30 years as a furniture restorer and once joined forces with his wife to build the rough-hewn house in which they live. Late in the film, when Mr. Spears cites Alice's failing health, he notes that the Glasses have no health insurance or disability benefits, and that they have never received help from Federal, state or local social services agencies. That the film makers received several grants, including one from the National Endowment for the Humanities, is only one of the many paradoxes that color "To Render a Life."

Mr. Spears and Silvia Kersusan, the screenwriter, are well aware of the inequities inherent in such work. In light of that, their own perseverance deserves praise. The purpose of such work is best expressed by James Hubbard, a photographer who focuses on the homeless (in a spirit very like Evans's) and who talks of

turning his camera on people being evicted from their homes. He describes both his own unease and that of his subjects, and speaks of their surprising willingness to allow such painful moments to be recorded.

Gradually, he says, "they would all recognize that maybe a photograph would change things for other people."

1992 N 18, C23:1

Home Alone 2
Lost in New York

Directed by Chris Columbus; written and produced by John Hughes, based on characters created by Mr. Hughes; director of photography, Julio Macat; edited by Raja Gosnell; music by John Williams; production designer, Sandy Veneziano; released by 20th Century Fox. Running time: 120 minutes. This film is rated PG.

Kevin	Macaulay Culkin
Harry	Joe Pesci
Marv	Daniel Stern
Kate	Catherine O'Hara
Peter	John Heard
Buzz	Devin Ratray
Concierge	Tim Curry
Pigeon Lady	Brenda Fricker
Mr. Duncan	Eddie Bracken
Desk Clerk	Dana Ivey
Fuller	Kieran Culkin

By JANET MASLIN

IF "Home Alone 2," the by-the-numbers sequel to the third-biggest hit in movie history, is viewed as a learning experience, its first lesson is that originality is a dangerous thing. Its second, aimed at any child who ever dreamed of drinking Coca-Cola out of a Champagne glass, is that malicious mischief can be construed as no-fault fun. Its third, and most interesting, inadvertent notion is that time does not stand still, no matter how profitable it might be to think otherwise. Between this film and its seemingly very similar predecessor, there is all the difference in the world.

"Home Alone" became a hit by speaking to secret wishes any child could understand: the desire for independence, the novelty of feeling empowered, the triumph of defending one's castle against invading hordes, or at least against two cartoonish bozos. No one could have predicted that these messages would come through quite so loud and clear, or be presented as so much fun.

And no one could have suggested, even in an age of slavish sequels, that the formula be replicated outright this time. So "Home Alone" moves to New York City, and does its best both to ignore and exploit this change of scene. But it also changes direction in another way: a film bursting with enthusiasm for a fresh, appealing fantasy has been replaced by one most eager to maintain the status quo.

This film's only real show of ingenuity comes with its explanation of how Kevin McCallister (of course played by the one-boy box-office phenomenon, Macaulay Culkin) gets to New York in the first place. In establishing this, it actually toys with the audience's expectation of a carbon copy. Once again, the McCallister clan is seen getting ready for a vacation from their outsized suburban dream house, which was a small but significant factor in the first film's fantasy appeal.

Once again, an alarm clock fails. And once again Kevin is threatened with the possibility of sleeping in the attic, where he was left behind last time. After thus nudging viewers in the ribs, the film makers — the director Chris Columbus and the writer and mastermind John Hughes — let Kevin get as far as the airport, where a man wearing clothes like Kevin's father's accidentally leads the boy astray. It takes only a few more wild coincidences to land the film's wide-

John Danehy/Film Forum

The Glass family of Virginia in Ross Spears's film "To Render a Life."

eyed hero in Manhattan, a setting that is treated by "Home Alone 2" as a holiday gift. It's a long time since a film regarded New York with the wide-eyed, touristy wonder that is evident here.

The mood is as buoyant as it was the first time, and the story of Kevin's big-city adventures is certainly fun. But there's a difference between watching a previously unknown child actor finagle his way past a grocery clerk and seeing Mr. Culkin, this nation's most stellar little boy, booking himself a hotel suite and a white stretch limousine. The ante is raised when this boy's once-precocious confidence begins to seem like second nature, and when he moves on from the job of defending his parents' house to spending their money.

A plot twist that has Kevin carrying his father's credit card en route to the airplane expedites the boy's big plans, as does his use of a tape recorder to lower his voice during telephone calls; that's how he makes travel plans. Look for similar tape recorders in toy stores as part of what will surely be the season's second biggest movie-merchandising coup (after "X"), and don't worry about missing the point. Much of "Home Alone 2" takes place in a toy store.

•

But this film's home away from home is the Plaza Hotel, plugged so tirelessly that the screenplay works in an 800 number for reservations and a walk-on by Donald Trump. That setting is well used and well populated, thanks to a suspicious hotel staff led by Tim Curry, whose droll disapproval is transformed by Kevin's imagination into a seasonally Grinch-like vision. Rob Schneider and Dana Ivey give the film some lively comic moments by falling for Kevin's stupid-grown-up tricks.

Those tricks are so similar to the first film's antics that some viewers may blink in disbelief. Again, Kevin tape-records movie dialogue from television and uses it to scare intruders; again, he constructs a dummy that casts an adult-looking silhouette. And again he matches wits, if that is the word, with the two hapless burglars who stalked him last time: Harry (Joe Pesci) and Marv (Daniel Stern), the two most birdbrained adult males who ever figured in a little boy's daydream. Once again, Kevin subjects Harry and Marv to terrible tortures in the name of fun.

But Kevin does not happen to be defending his home this time. Indeed, the setup is so awkward that the boy and his pursuers wind up running from the Plaza to West 95th Street, just so they can play out the film's long-awaited endgame in an empty brownstone. It is here that Kevin throws bricks off the roof onto Marv's forehead, puts a staple through

Marv's nose, sets Harry's hair on fire (in a stunt that turns particularly dangerous when Harry soaks his head in a kerosene-filled toilet), inflicts a series of spine-cracking injuries and otherwise works out his aggressive whims.

•

Many children will find this funny, and many parents will not. It's much more violent than the first film's comparable set of dirty tricks. And Kevin, removed from his embattled home, seems much more cavalier, possibly even meaner than his bullying older brother, Buzz (Devin Ratray).

"Home Alone 2" may be lazily conceived, but it is staged with a sense of occasion and a lot of holiday cheer. The return of Mr. Culkin in this role is irresistible, even if this utterly natural comic actor has been given little new to do. Mr. Pesci and Mr. Stern bring great gusto to their characters' stupidity, to the point where they are far funnier just walking and talking than they are being hurt. Catherine O'Hara and John Heard give amusing reprises of their earlier roles as Kevin's parents, and do some memorable squirming when asked to explain their child-losing mishap to the police. Kieran Culkin, playing Kevin's pesky little brother, is a reminder that this is a family to be reckoned with. And a snowy-haired Eddie Bracken fills much of the film's sentimentality quota as a toy mogul who loves to help sick children.

A sense of déjà vu? At first, no doubt, but then you see the differences.

The rest of that quota is taken care of by the estimable Brenda Fricker, who won an Oscar as the mother in "My Left Foot" and brings surprising grace and stature to the role of a pigeon lady in Central Park. As an echo of the lonely old man played by Roberts Blossom in the first film, this character would be the most shameless element in this one; that is, if bits of John Williams's score didn't sound like "The Nutcracker," too.

•

"Home Alone 2" is rated PG (Parental guidance suggested). It includes mild profanity and considerable violence.

1992 N 20, C1:1

"All About Eve" (1950), from which it passed into the public domain, better recognized as the happy hunting ground where one man's wit gains immortality as another man's cliché.

The time is at hand to rediscover the line, the film and the mind behind them: "All About Eve" starts a special one-week engagement today at the Film Forum. It's the opening attraction in a five-week retrospective devoted to the man who began his career in the 1920's writing intertitles for silent films ("The Mysterious Dr. Fu Manchu"), won his first Oscar nomination in 1931 (as one of the two writers of "Skippy") and produced a string of M-G-M hits, including "The Philadelphia Story" (1940), before he became the Oscar-winning writer and director of his own films.

At the age of 83, Mr. Mankiewicz deserves all the salutes he can accumulate, as much for his endurance in a lunatic discipline as for the stinging skepticism, the reassuring common sense, the élan and the immense technical virtuosity of his work.

When you go to see "All About Eve," and you should unless chained to a bedpost, you will come upon a kind of cinema for which there is no exact equivalent in any of the other arts. Because Mr. Mankiewicz has always possessed a singular gift for humane, well-rounded, literate dialogue, his work has often, if carelessly, been equated with the legitimate theater's well-made drawing-room comedy.

Yet the great Mankiewicz films are more than theater; they also have the scope of novels. This is due, at least in part, to his free use of sound-track narration and flashbacks, which provide his films with a richness of narrative context not possible in the theater. As demonstrated by "All About Eve," "A Letter to Three Wives" (1949) and even "Suddenly Last Summer" (1959), among others, Mr. Mankiewicz is a master of flashbacks.

How he does it, I'm not quite sure; possibly through his sheer talent as a storytell-

Bette Davis in "All About Eve," which opens a Mankiewicz film retrospective.

40 Years of Cinematic Magic

By VINCENT CANBY

"**F**ASTEN your seat belts. It's going to be a bumpy night." The line has now been so thoroughly absorbed into the collective subconscious that many people no longer remember its origins: the mind of Joseph L. Mankiewicz, who wrote it in the screenplay of

er. Yet one's heart never sinks in a Mankiewicz film when the camera moves slowly in to announce a slippage in time. Flashbacks slow most movies; they lend force and psychological complexity to Mankiewicz films, which are neither bogus theater nor bogus literature: that is, Hollywood-style comic books. They are movies in a most fully realized form. They have their own identity. Jean-Luc Godard wasn't far off the mark when, writing about the adaptation of Graham Greene's "Quiet American" of 1957, he called Mr. Mankiewicz "the most intelligent man in all contemporary cinema."

In addition to the acknowledged classics, the Film Forum retrospective includes films that represent the entire Mankiewicz career, with the exception of the silent movies. Bruce Goldstein, who programmed the show with Mr. Mankiewicz's advice and cooperation, has chosen well. Nothing of importance has been left out, from Mr. Mankiewicz's first credit as a writer and director, "Dragonwyck" (1946) — a good though not spectacular period piece produced by his mentor, Ernst Lubitsch — through "Sleuth" (1972), starring Laurence Olivier and Michael Caine. "Sleuth" is one of the two most rewarding whodunits ever made (the other being Billy Wilder's "Witness for the Prosecution"). It's also in a class by itself as the most exuberant whodunit ever made.

Representing Mr. Mankiewicz's early work as writer is W. C. Fields's magnificent throw-away farce, "Million Dollar Legs" (1932), in which Fields appears as the president of Klopstokia, a small European country where all the girls are named Angela and all the boys are George. Fields is hilarious, but so are his cohorts, Hugh Herbert, Andy Clyde, Billy Gilbert and Ben Turpin. The woeful Turpin skulks through the film as an undercover agent, a cloak held up to his face, which is completely covered except for his severely crossed eyes.

•

The retrospective even features the film that Mr. Mankiewicz would prefer to forget, the original, uncut, four-hours-and-three-minutes version of "Cleopatra," which will be shown on one day only, Dec. 20. For those with the stamina to sit it out, "Cleopatra" may be something of a surprise. It's a lot less lugubrious than was generally admitted at the time of its release. It's a gorgeous spectacle, and in Rex Harrison, whom Mr. Mankiewicz once called his Stradivarius, it has a Julius Caesar who carries Mr. Mankiewicz's neo-Shavian comedy as long as he is on the screen.

What it doesn't have is a neo-Shavian Cleopatra. Elizabeth Taylor, so good in "Suddenly Last Summer," looks and sounds like one of her own handmaidens. She's a drag. Yet the film would never have been made if she hadn't been in it, which, of course, is Hollywood.

Although Mankiewicz films are often about the emotional crises of women, who may be as exalted as Cleopatra or as common as Linda Darnell's exaltingly funny Lora May Hollingsway in "A Letter to Three Wives," they are best remembered for the brilliant work of their male stars. The only important exception is Bette Davis's once-in-a-lifetime performance as Margo Channing in "All About Eve." She's the one actress who comes close to the measure of Harrison in "Cleopatra," "The Ghost and Mrs. Muir" (1947) and "The Hon-

ey Pot" (1967); of James Mason in "Five Fingers" (1952) and "Julius Caesar" (1953); of Cary Grant in "People Will Talk" (1951), and of Olivier and Mr. Caine in "Sleuth."

Harrison and Mason both seem bred to define the particular world of Mankiewicz cinema. Each stars in one of the retrospective's two major discoveries: Harrison as the shade of a turn-of-the-century English sea captain in "The Ghost and Mrs. Muir"; Mason as the traitorous valet of the English ambassador to Turkey in "Five Fingers."

A synopsis of "The Ghost and Mrs. Muir" doesn't sound promising: a cantankerous, recently deceased mariner courts a lonely, very-much-alive English widow (Gene Tierney), from her young womanhood to her grave. Harrison's substance, Miss Tierney's toothy beauty and sweetness and Mr. Mankiewicz's stylish direction transform corner-pub suds into vintage froth. "Five Fingers" is even better; in fact, it's a must-see. Though written by Michael Wilson, the film sounds like Mankiewicz and plays like Mankiewicz in an uncharacteristic Hitchcockian mode.

Based on a true story, "Five Fingers" is about a perfectly mannered, perfectly corrupt fellow who, in 1944, sells Germany's Nazi Government all of England's top secrets, including the plans for the invasion of Normandy. The secret of Mason's very funny and moving performance is not charm, but wit. As he goes about his avaricious scheme, which has nothing to do with ideology, Mason, as a valet, has thought of everything. He's a lowly servant who seems at long last to have found his place in life as a rascal. The audience appreciates that. It pulls for him to succeed.

In the end he's undone, not by counter-intelligence but by the old European class system, which, like avarice, has nothing to do with national origins, boundaries or loyalties. Almost as good as Mason is Danielle Darrieux, who plays an impoverished Polish countess sitting out the war in Ankara. Asked by a German suitor why she left occupied Warsaw, she answers: "Bombs were falling. I felt I was in the way."

•

The gift for language is central to the success of both "All About Eve," the definitive comedy about the Broadway theater, and "A Letter to Three Wives," the definitive comedy about suburban manners and mores in post-World War II America. The gift can't quite carry "People Will Talk," although Mr. Mankiewicz provides Cary Grant with one smashingly funny, beautifully choreographed scene in which he turns the tables on some would-be witch-hunters in academe. The gift all but sinks "The Barefoot Contessa" (1954), when Mr. Mankiewicz's language seems to become a kind of all-consuming blob. It takes on a life of its own and will not stop.

That film, about a tragic, goddesslike movie star (Ava Gardner) who moves among the dregs of the international set, is fun to listen to until the story goes one way and plausibility another. Consider this: an honorable Italian count (Rossano Brazzi), madly in love, waits until his wedding night to announce to his bride (Miss Gardner) that "about the only thing left undestroyed" by a war wound "is my heart." He walks into their bedroom, says his piece, turns on his heel and departs. He might have suggested a game of rummy.

It's not a scene that would work even if the fellow had admitted he was gay, which appears to be the truth behind the war wound. The scene is out of touch in a way that seldom happens in Mr. Mankiewicz's cinema. He knows how people think, feel and talk. Thelma Ritter, the meta-cleaning woman in "A Letter to Three Wives," tells the producer of a hugely successful radio soap opera: "You know what I like about your show? Even with the vacuum on, I can understand it."

Mr. Mankiewicz's almost unholy articulateness has also served to deflect attention from another gift of equal importance: his amplitude of feeling as a film maker, expressed in the technical choices he makes while shooting.

•

Mr. Mankiewicz likes to maintain a discreet distance from his characters. When he doesn't have to use close-ups, he avoids them. Watch "All About Eve" and see how often there are at least two, sometimes three or even four characters in a single frame. In reality, this is more than a technical decision. It's a way of looking at life. Mr. Mankiewicz's films are obsessed with society, with the interplay of characters within particular social units.

His great films appear to be uncommonly rich because they are full of unexpected information. They are packed with details that don't exist in most movies, in which the camera, like a spectator at a tennis match, seems to turn back and forth from one close-up to another. Close-ups keep everything on a one-on-one basis. There are no reactions to reaction. In a close-up, even a surreptitious glance becomes overstated. Medium

Linda Darnell, Ann Sothern and Jeanne Crain in the Joseph Mankiewicz film "A Letter to Three Wives."

and long shots, in which the characters are seen at the same time, are expressions of generosity, initially toward the characters and, through them, to the actors playing the roles.

This amplitude of feeling is consistent throughout the film. It's evident in the fine, uncluttered adaptation of Shakespeare's "Julius Caesar," which has the immediacy of crisp journalism. It's also there in "All About Eve," which, in addition to being a satire of a supremely funny sort, is as romantic as any movie ever made.

•

The years that followed the filming of "Cleopatra" were troubled ones for Mr. Mankiewicz. He watched as his ambitious "Cleopatra," conceived in haste and initially planned as two features, was cut to one feature of more than four hours, then subsequently pared down each week until it seemed it was being re-edited by every individual theater manager who played it. He said it was being turned into "banjo picks."

It was at that time that Mr. Mankiewicz, with some rue, described himself as "the oldest whore on the block." This was a reference to the fact that he had willingly taken on the job of saving a doomed production, started by others, because of the huge amount of money he received. He finally recovered his self-esteem, but it wasn't easy. This retrospective, while entertaining us, should reassure him. The oldest whore on the block indeed. He doesn't even have a heart of gold. It's pure film.

1992 N 20, C1:3

1991: The Year Punk Broke

Directed, edited and photographed by Dave Markey; released by Tara Releasing. At the Angelika Film Center, Mercer and Houston Streets, Greenwich Village. Running time: 99 minutes. This film has no rating.

WITH: Sonic Youth, Nirvana, Dinosaur Jr., Babes in Toyland, Gumball and the Ramones.

By JON PARELES

Way back in the summer of 1991, Sonic Youth and Dinosaur Jr. were collegiate cult favorites, while Nirvana, Gumball and Babes in Toyland were among dozens of largely unknown independent rock bands. Just over a year later, Nirvana has sold four million albums, teen-age girls crowd Sonic Youth's concerts and record companies are betting heavily on bands that would have been dismissed a year ago as just too noisy.

Sonic Youth and other bands toured European rock festivals for two weeks that summer, and Dave Markey's film "1991: The Year Punk Broke" documents their last season as insider idols. It also captures the raucous, disheveled, self-mocking, noncommittal and ironically triumphant alternative-rock pose. The music is a squall, turning feedback and distortion into both assault and victory cry, sometimes tuneful, sometimes just a blare. And the musicians work hard to prove they don't take themselves too seriously. "Our audience is expanding," says Thurston Moore of Sonic Youth. "My mind is turning into a fine gelatinous ball of pepper."

•

The film has all the regular ingredients of a tour documentary: shaky

hand-held camerawork, backstage high jinks (Kim Gordon of Sonic Youth applies lipstick and mascara to Kurt Cobain of Nirvana), uncomprehending interviewers, wary tourism and unpolished live performances.

But the principals have all seen "Gimme Shelter" and "This Is Spinal Tap" and "Woodstock," and they know better than to appear too earnest. Musicians undercut themselves, knocking over equipment and fellow band members, turning backstage scenes into parodies of Madonna's "Truth or Dare." Mr. Markey's direction follows suit, breaking up razzle-dazzle performance montages with shots of a bratwurst vendor or a spinning beer bottle. Still, those who wonder how Sonic Youth produces its huge clangor can glimpse, through the quick cuts and wayward pans, the many ways the band abuses its guitars.

The film is for insiders; the bands don't try to endear themselves, even to their own audiences. Yet there's no holding back the power of the music, which will give fans a pleasing jolt and grate mercilessly on others.

1992 N 20, C5:1

Texas Tenor
The Illinois Jacquet Story

Directed by Arthur Elgort; director of photography, Morten Sandtroen; edited by Paula Heredia; produced by Ronit Avneri; released by Rhapsody Films. At Village East Cinema, Second Avenue and 12th Street, East Village. Running time: 81 minutes. This film has no rating.

WITH: Illinois Jacquet, Walter Blanding Jr., Arnett Cobb, Wild Bill Davis, Ron Della Chiesa, Dorothy Donegan, Dan Frank, Harry (Sweets) Edison, Dizzy Gillespie, John Grimes, Lionel Hampton, Al Hibbler, Milt Hinton, Mona Hinton, Matthew Hong, Javon Jackson, Jonah Jones, Emilo Lyons, Dan Morgenstern, Cecil Payne, Bob Porter, Sonny Rollins, John Simon, Buddy Tate and Clark Terry.

By PETER WATROUS

"Texas Tenor: The Illinois Jacquet Story" starts out with a close-up of something fuzzy and spends the rest of its 81 minutes stylishly using close-ups and blurred shots to produce a modernist documentary. The fuzz turns out to be the chin of the tenor saxophonist Illinois Jacquet; the rest of the opening scene is close-ups of lips, reeds and mouthpiece. Filmed in black and white from 1988 to 1990, Mr. Jacquet at various times fills a third of the screen, sometimes less, his skin tone light against the coal-black background. Sometimes he takes over half the screen, and a huge portion of the screen always remains coal black, contrasting detail against nothingness. This is a documentary with style.

Directed by the fashion photographer Arthur Elgort and shot by the cinematographer Morten Sandtroen, it has so much style that the narrative portions make much less sense than the plentiful, gorgeous and seemingly improvised scenes, in which the visual sensibility matches the music without cliché. Mr. Elgort is a visual sensualist, content with building meaning out of blurs and abstractions. Mr. Jacquet, who leads what is probably the most commercial big band in jazz, is purely a musical sensualist. Music is intrinsically abstract, and the two men are clearly made for each other.

The documentary places Mr. Jacquet in all sorts of traditional jazz

Rhapsody Films

Illinois Jacquet

documentary positions. He is seen having his hair done for a show at the Blue Note in Greenwich Village in 1988. The camera intercuts scenes from the waiting audience; a hand slips from a wine glass, and there's Mr. Jacquet, improvising on his own "Louisiana Blues." It might as well be 1939, and the anachronistic tone is no accident; the film celebrates the past.

Mr. Jacquet, who can dispense bromides with the best of them, is seen in a series of talking-head shots. (Some of his better lines: "I play to open up my freedom. Things that have happened to me in the South, you let things out that you never know could come out.") He drives around in his Lincoln Continental in St. Albans, Queens, the middle-class black neighborhood to which he and a host of other jazz musicians migrated. He is seen in Paris, buying a hat, and at Harvard, rehearsing a student big band.

The film goes into Mr. Jacquet's finest — or most popular — moment, when he created his improvisation on "Flying Home" as part of the Lionel Hampton band, ushering in rhythm-and-blues and the honking tenor saxophonist. Various jazz luminaries, including Mr. Hampton, Dizzy Gillespie, Clark Terry and Sonny Rollins, dutifully comment. And there's a half-hearted attempt at covering the biographical details of his life.

All of this is less than essential. The film captures one of jazz's great audience-hounds in action, somebody who clearly loves performing. Mr. Jacquet sings a bit, does a little tap-dancing and plays some extraordinary improvisations, in which his brutal tenor saxophone contrasts with the smooth fabric of the big band. The documentary, in its fixation with abstraction and close-ups, reproduces the shiny, ecstatic moments of orchestral jazz as well as any film made, its beauty and rounded shapes and sharp punctuations, the delirium and sensuality of performance, the congregational ecstasy. John Grimes, a musician in Mr. Jacquet's band, says in an interview, "I don't know anybody who gets to the people better than Jacquet," and the movie shows that as well.

1992 N 20, C5:1

Intervista

Written and directed by Federico Fellini, (in Italian with English subtitles); director of photography, Tonino Delli Colli; edited by Nino Baragli; music by Nicola Piovani with a tribute to Nino Rota; production designer, Danilo Donati; produced by Ibrahim Moussa and Michel Vieyte; presented by Martin Scorsese and Julian Schlossberg; released by Castle Hill Productions. Lincoln Plaza Cinema, Broadway at 63d Street. Running time: 108 minutes. This film has no rating.

The Reporter........................Sergio Rubini
The Assistant.........................Maurizio Mein
The Wife..Lara Wendel

Castle Hill Productions

Marcello Mastroianni in Federico Fellini's "Intervista."

The Star...Paola Liguori
The Vestal Virgin....................Nadia Ottaviani
The Girl...............................Antonella Ponziani
With Anita Ekberg and Marcello Mastroianni as themselves.

By VINCENT CANBY

Federico Fellini's "Intervista" (Interview) can be described as an impromptu fiction, a mock documentary or simply a divertissement. There are some who have suggested that it's just something Fellini turned out when he had nothing better to do, as if the cinema master had become a Sunday painter.

In whatever way you classify "Intervista," it is an enchanting work, a logical extension of all the films that have gone before it, and one of the unequivocal delights of the current season. The 1987 film, ignored by American distributors until now, opens today at the Lincoln Plaza Cinema under auspices of Martin Scorsese and Julian Schlossberg, the English version (meaning the excellent subtitles, I assume) supervised by Paul Mazursky and Leon Capitanos.

Apparently conceived as a tribute to the Cinecitta Studios in Rome, which has been Fellini's base throughout his career, "Intervista" is a magical mixture of recollection, parody, memoir, satire, self-examination and joyous fatansy. With Fellini himself as the master of ceremonies, the film is an uproarious celebration of the studio community: actors, actresses, bit players, make-up artists, scene painters, publicity agents, technicians, hangers-on and gate-crashers.

Fellini cherishes them all. They are his life's permanent entourage. An assistant director speaks an impassioned monologue about the heroism of those who stay assistant directors throughout their careers, instead of seeking fame as directors in their own right. He's clearly stating Fellini's thoughts when he says it's like remaining an adolescent forever.

•

"Intervista" begins when a Japanese television crew arrives at the studio a day early to be able to watch Fellini as he starts a new film, which is said to be an adaptation of Kafka's "Amerika." "We open with the standard dream of flying," Fellini explains. "You must have the same dream in Japan."

He introduces the visitors to his producer. "Tell me," says the pretty Japanese interviewer, "how do you and your producer feel about each other?" Responds the maestro pleasantly, "It's total mutual mistrust." When asked how he regards Cinecitta, Fellini says that it is his fortress, "or maybe an alibi." Cinecitta is the most seductive theme park in the world.

On meeting a young reporter (Sergio Rubini) who has come to interview a great star, Fellini remembers the first time he ever came onto the lot, also to interview a great star. As the audience watches, Fellini turns Mr. Rubini into his younger self, instructing the make-up people to add a large pimple to the reporter's nose, just to make sure he feels slightly uncomfortable.

"Intervista" then slips into Fellini's memory as enacted by Mr. Rubini and Paola Liguori, who plays the actress whose beauty dazzles the Fellini surrogate. The reporter asks her if she knows Tiepolo. "No," says the languorous star. "I doubt that one can know everybody."

Fellini is talking business in his second-floor Cinecitta office when Marcello Mastroianni, dressed as Mandrake the Magician, appears outside the window. He sort of floats up from the street, standing on a mechanical platform. The actor explains that he is shooting a commercial downstairs. The expansive Fellini decides that he, Mastroianni and the Fellini entourage should take the rest of the day off and go to the country. In the middle of the motorcade, which has become instantly available, Fellini shares the back seat of a car with Mr. Mastroianni, who refuses to put out his cigarette. Explains the coughing actor, "I can't breathe without smoking."

The goal of the motorcade is the Villa Pandora, Anita Ekberg's handsome house outside Rome. "Intervista" reunites the stars of "La Dolce Vita" nearly 30 years after the film was made. Miss Ekberg and Mr. Mastroianni hug and kiss, then stare at each other. It's an uncomfortable moment. She has put on a lot of weight. Suddenly his age shows. Each denies that the other has changed. With the flick of his magician's cane, Mandrake/Mastroianni calls up the clip from "La Dolce Vita" in which their two beautiful younger selves frolic in the Fountain of Trevi.

•

In the same way that the film plays fantasy against reality, it plays one era against another, youth against age, the illusion offered by one movie image against the illusion of a later one. Both illusions are fixed, but time, being merciless, recognizes neither. Time will not be appeased.

Fellini has great fun choosing the ways in which he disguises the ravages of time and amends the laws of the natural world. In "Intervista," as in "Amarcord," "8½" and all the others, he brings brief order to chaos. Within Cinecitta he can do anything.

"Intervista" is a divertissement, but no ordinary one. In its own seemingly off-hand manner, it's a cosmic joke.

1992 N 20, C10:1

The Most Beautiful Night

Directed by Manuel Gutiérrez Aragón; screenplay by Mr. Gutiérrez Aragón and Luis Megino (in Spanish with English subtitles); director of photography, Carlos Suárez; edited by José Salcedo; produced by Mr. Megino. At the Joseph Papp Public Theater, 425 Lafayette Street, Greenwich Village. Running time: 81 minutes. This film has no rating.

Federico	José Sacristán
Elena	Victoria Abril
Bibi	Bibi Andersen
Luis	Fernando Fernán Gómez
Oscar	Oscar Ladoire

By STEPHEN HOLDEN

Manuel Gutiérrez Aragón's film "The Most Beautiful Night" should reinforce the impression that sex in the cinema of post-Franco Spain is different from the sex in movies that come from anywhere else in the world. As portrayed in the films of Pedro Almodóvar, Vicente Aranda and others, it is usually tempestuous, often fraught with hysteria and surprisingly androgynous. This devil-may-care flaunting of eroticism suggests a head-on collision between traditional Roman Catholic notions of propriety and the rebellious spirit of a cinema still giddy from its liberation after years of oppression and censorship.

"The Most Beautiful Night," made in 1984, is a dizzy bedroom farce about Federico (José Sacristán), a television executive whose life is a parody of the sexual double standard. Despite his own dalliances, Federico becomes obsessively jealous of his wife, Elena (Victoria Abril), after his mistress, Bibi (Bibi Andersen), dispenses some innocent observations on female behavior.

Bibi, who has a leading role in a much-troubled television production of a play called "The Night of Don Juan," informs Federico that when a woman sighs and stares at the night sky, it is a sure sign she is in love. Returning home, Federico finds his wife, Elena, in exactly that mood, and he is instantly convinced that she is having an affair. Elena, although faithful to her husband, is sexually starved. Even after she practically rapes him' on the floor, it doesn't occur to him that all she really wants is some of what he has been giving to Bibi.

Adding a mischievous twist to the film is the fact that Miss Andersen, who in Spain is a well-known transsexual (and who is not to be confused with the star in many of Ingmar Bergman's films), towers over Mr. Sacristán. In their first love scene, she casually picks him up, marches across the room and throws him down on the bed.

•

The film becomes nuttier and more out of control as it goes along. Federico implores Oscar (Oscar Ladoire), the director of the play, to try to seduce Elena to pry information from her about her lover. Complicating matters is a threatened technicians' strike that would further escalate the cost of a production that has already gone way over budget and has yet to find a suitable Don Juan.

Federico's boss, Luis (Fernando Fernán Gómez), soon joins the fray, and it isn't long before Federico suspects him of being Elena's lover. Luis, however, is an astronomy buff who, until he sets eyes on Bibi, cares more about the cosmos than about love. A comet that reappears every hundred years is about to pass across

the Madrid sky, and he is desperately eager to observe it through a telescope.

"The Most Beautiful Night," which plays through Wednesday at the Joseph Papp Public Theater as part of the "Spanish Eyes" series, doesn't make much sense and has no real ending. But it is still fun to watch, and its warm-blooded "Midsummer Night's Dream" atmosphere leaves a pleasant erotic buzz.

The performances have a giddy vivacity. Mr. Sacristán's Federico, at once stern and maniacal, weirdly suggests the actor Sam Waterston with Richard Pryor's wild, panic-stricken eyes.

Miss Abril and Miss Andersen are polar opposites. Miss Abril radiates an intense, smoldering, barely contained sensuality that the foolish male characters refuse to recognize. They are all agog over Bibi, the flamboyant giantess whom Miss Andersen imbues with a twinkling sense of amusement. As Bibi gazes down at her present and would-be lovers, there is a sense that she doesn't need anybody. She is her own special creation, a sexual law unto herself.

1992 N 20, C10:5

Bad Lieutenant

Directed by Abel Ferrara; written by Zoe Lund and Mr. Ferrara; director of photography, Ken Kelsch; edited by Anthony Redman; music by Joe Delia; production designer, Charles Lagola; produced by Edward R. Pressman, Mary Kane and Randall Sabusawa; released by Aries Film Releasing. Running time: 98 minutes. This film is rated NC-17.

Lieutenant	Harvey Keitel
Lieutenant's Son	Brian McElroy
Lieutenant's Son No.2	Frankie Acciario
Lieutenant's Wife	Peggy Gormley
Lieutenant's Daughter	Stella Keitel
Bat Cop	Victor Argo
Cop 1	Paul Calderone
Cop 2	Leonard Thomas
Nun	Frankie Thorn

By JANET MASLIN

When Abel Ferrara calls something bad, better believe it: he means business. Mr. Ferrara, whose gleefully down-and-dirty films include "Fear City" and "King of New York," has used his latest, "Bad Lieutenant," as a form of personal one-upmanship. He has come up with his own brand of supersleaze, in a film that would seem outrageously unforgivably lurid if it were not also somehow perfectly sincere.

In inventing the corrupt police officer of the title, this director is not thinking of the sort who fixes parking tickets. He's imagining a crack addict who'll yell "Police business!" to empty a tenement hallway so he can make his drug buy. Mr. Ferrara is inventing a law officer who, confronted with the sight of a robbery in progress, runs to a pay phone to call his bookie with a bet on a Mets game.

As played by Harvey Keitel, the eponymous (and otherwise nameless) Bad Lieutenant is so far gone he initially seems funny. Here, after all, is a cop so jaded he frightens suspects at the scene of a crime. Here's a man who can give an appreciative once-over to a well-built female corpse, and whose idea of a romantic evening is two hookers, slow dance music and a blood alcohol level that would fell a horse. The film's depiction of the lieutenant's badness reaches an over-the-top epiphany in a long, rambling scene that shows Mr. Keitel sexually

intimidating two women, whom he suspects of a minor driving infraction. One of Mr. Ferrara's directorial frissons at such a moment is to have the cooperation of one of these trampy-looking women, whom the Lieutenant orders to simulate a sexual act, impeded by the fact that she is chewing gum.

It goes without saying that Mr. Ferrara's work has a polarizing effect. One condition of his cult status is that his films give as much offense as possible (without resorting to much violence) and make no attempt to find the middle of the road. Viewers with little tolerance for over-the-top sensationalism will this time be even further put off than they might have been by Mr. Ferrara's tamer efforts, since the subject is the rape of an extremely pretty nun. The director is not shy about either the details of the assault or the nun's extreme piety in its aftermath. He may mean to switch gears when he moves from a sordid rape scene to the nun's forgiveness of "those boys, those sad, raging boys," but in fact the note of excess is much the same.

The Lieutenant eventually finds his saving grace through the nun's ordeal. Mr. Ferrara has his saving graces, too, the chief one being raw talent, which he continues to display while telling even the most farfetched story. Imagine a Martin Scorsese who had chosen to make nothing but B movies and you may have some idea of what Mr. Ferrara can be capable of. Imagine a series of long, improvised-sounding behavioral meltdowns and you get some notion of what happens when "Bad Lieutenant" goes off the tracks.

•

The results may be uneven, but they certainly aren't dull. "Bad Lieutenant" uses a long string of vivid New York locations without often retracing its steps, and presents a brutal, knowing look at the city's seamy side. A take-it-or-leave-it attitude toward mainstream audiences also gives the film a distinct independent streak. Even its frequent excesses can have a certain panache when viewed with suitable open-mindedness, though such tolerance is not always easily achieved. When Jesus Christ appears to a hallucinating Lieutenant late in the story, even He displays a hip-tilting posture and has swagger to spare.

Mr. Keitel gives the Lieutenant's role his all, which is sometimes more than it requires. At its best, the performance conveys a lost, sardonic character in real pain; at other times, Mr. Keitel's Lieutenant is too stonily silent to evoke much feeling. Also appearing briefly as part of the film's large cast is Zoe Lund, the co-screenwriter, who plays a bleary-eyed, stick-thin drug addict and espouses the sentiment that best defines the film's tortured characters. "We gotta eat away at ourselves until there's nothing left except appetite," she says.

Mr. Ferrara's own appetite for sensationalism remains untempered. Even at his most reckless, he continues to indulge it with a lively, low-down version of high style.

•

"Bad Lieutenant" is rated NC-17 (No one under 17 admitted). It includes nudity, profanity and countless situations that make it unsuitable for children.

1992 N 20, C15:1

FILM VIEW/Caryn James

Dangerous Liaisons Are All the Rage

A MAN'S DEEP, ROMANTIC VOICE says, "I have crossed oceans of time to find you." What woman could resist such a line? And who would have thought he meant it literally? Gary Oldman, as the lovelorn vampire in "Bram Stoker's Dracula," has traveled four centuries to discover Mina (Winona Ryder), the reincarnation of his beloved wife. His romantic obsession gives new meaning to the idea of mating for life. It also captures the essence of Francis Ford Coppola's enjoyable, excessive version of the vampire myth.

This "Dracula" is so rococo — overwrought with miles of jewel-colored costumes, gallons of movie blood and go-for-broke performances — that it takes a powerful essence to emerge at all. And it has one, perfectly expressed in the film's advertising tag line, "Love Never Dies."

Such obsessive love is an idea as ageless as a vampire, but it is newly fashionable. In Louis Malle's "Damage," Jeremy Irons plays a middle-aged man who falls uncontrollably, tragically, in love with his son's fiancée. (The film will have its premiere tomorrow at a benefit for the Walter Reade Theater at Lincoln Center and will open commercially on Dec. 16.)

In Tom Kalin's long-playing "Swoon," the Leopold and Loeb case is retold as a love story in which crime comes from passion; Leopold would do anything for his cherished Loeb, even commit a murder. And coming in December is "Forever Young," in which Mel Gibson decides he cannot live without the woman he loves, and has himself frozen. "Time waits for no man," that film's ad line says, "but true love waits forever." In other words, "Love never dies," though the passion portrayed in the current movies usually results in somebody's bodily death.

No one would call this realism. In life, an uncontrollable affair is likely to be sad, murky, sordid, whether it's Woody Allen falling for his lover's daughter or Sol Wachtler, the chief judge in New York State, being arrested for threatening the mistress who dumped him. Movies raise the stakes as they race toward the surreal and melodramatic. As far as we know, vampirism hasn't been a factor in any celebrity romance lately. But these movies and headlines are alluring because they reveal forbidden impulses — feelings or actions that most people might consider for a guilty moment or fantasize about for hours, but never put into practice.

A man who is obsessed for four centuries, of course, makes Glenn Close stalking Michael Douglas in "Fatal Attraction" look like a victim of puppy love. But there is a more crucial difference. "Fatal Attraction" was about a crazily twisted affair based on lust. The current obsession movies are about glorious, irresistible, destructive true loves, where the depth of feeling and loss of reason are so intense they become lethal.

The movies also share a moody atmosphere, with "Dracula" the most far-flung. Mr. Coppola's film owes more to "Beauty and the Beast" — the fairy tale and the 1946 Cocteau film — than it does to Bela Lugosi. Its old-movie echoes come from lush romances like "Wuthering Heights" and "Gone

With the Wind" rather than horror flicks.

In one romantic scene, Mina and Dracula — disguised as Prince Vlad, man-about-town in 19th-century London — embrace as dozens of candles glow in the background. Her red gown and loose hair, and the way he leans over her, visually evoke the famous moment

Obsessive love is an idea as ageless as a vampire. But with 'Bram Stoker's Dracula' and 'Damage,' it is newly fashionable.

in "Gone With the Wind" when Rhett carries Scarlett up the staircase to their bedroom.

In that same scene in "Dracula," Mina cries, and her tears turn to diamonds, like the heroine who cries diamond tears in Cocteau's "Beauty and the Beast." And when Mina writes a "Dear John" letter, or a "Dear Vlad" letter, the handsome prince shape-shifts and becomes an animal-faced beast.

She loves him anyway, which is the most original twist in this "Dracula." Eroticism in vampire stories is nothing new. Max Schreck leans over the heroine's bed in F. W. Murnau's silent "Nosferatu" (1922) and Klaus Kinski similarly sinks his fangs into Isabelle Adjani's neck in Werner Herzog's 1979 remake, "Nosferatu the Vampyre." But never before has a major-movie Dracula had so willing or romantic a bride. "I love you,"

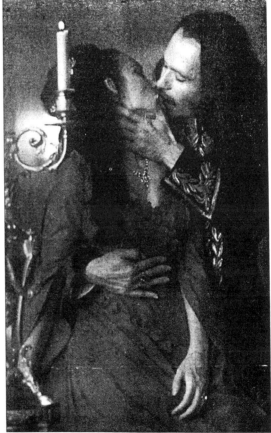

Ralph Nelson/20th Century Fox

Winona Ryder and Gary Oldman, madly in love in "Bram Stoker's Dracula."

Mina says as she prepares to kiss the blood off Dracula's chest. "God forgive me, I do."

She'll pay the price for this love that is beyond control or restraint. So will the hero of "Damage," a story that actually believes in love at first sight. Jeremy Irons and Juliette Binoche look into each other's eyes and are lost. Nothing else matters, not his wife, not the betrayed son-and-fiancé.

Though the Irons character is a Member of Parliament, the family betrayal rather than the fall of a public man is the tragedy in "Damage." This is much more the Woody Allen story than the Sol Wachtler case, but the particulars are less important than the uncontrollable passion that runs through all these movie and real-life scenarios. The theme was expressed most succinctly by Mr. Allen, who explained his off-screen love for Soon-Yi Farrow Previn with a now-notorious statement: "The heart wants what it wants. There's no logic to those things." There is also no safety to them, which is part of the enticement of forbidden love. Relegated to the movie screen, they are defanged.

The very title of "Swoon" makes it clear that logic and control have no place in love and desire. The lush black-and-white photography creates a hothouse atmosphere, so the movie's social themes are inseparable from its swoony, romantic esthetic. Mr. Kalin unearths the homophobic and anti-Semitic pressures that shaped Leopold and Loeb and contributed to the social and criminal judgments against them. And though "Swoon" does not excuse the characters' murder of a young boy, it suggests there was something grand about their unshakable love for each other.

■

Compare "Swoon" or "Damage" with "The Lover," another film that seems to be about erotic obsession, and the difference becomes clear. The teen-age girl and the wealthy Chinese man who fall into a forbidden affair in "The Lover" are always supremely conscious of what they are doing. She is, at first, positively cold-blooded about the way she is using him for his money. Reluctantly, she realizes she cares for him. He, true to his social station and his duty, leaves her in her dusty village at the end. The erotic force between them is strong, but their passion is not obsessive or uncontrollable. Such detachment on screen is rare right now.

It is easy to see every new romantic twist as a reaction to the age of AIDS, but maybe it is impossible to exaggerate the effects of AIDS on life and art. Certainly movies about obsessive love reflect a shifting focus, away from the casual, unromantic lust that dominated the days of the sexual revolution, and toward romance and monogamy. Any way you look at it, these films imply, it's dangerous to be a fool for love. □

1992 N 22, II:13:1

The Bodyguard

Directed by Mick Jackson; written by Lawrence Kasdan; director of photography, Andrew Dunn; edited by Richard A. Harris and Donn Cambern; music by Alan Silvestri; production designer, Jeffrey Beecroft; produced by Mr. Kasdan, Jim Wilson and Kevin Costner; released by Warner Brothers. Running time: 130 minutes. This film is rated R.

Frank Farmer	Kevin Costner
Rachel Marron	Whitney Houston
Sy Spector	Gary Kemp
Devaney	Bill Cobbs
Herb Farmer	Ralph Waite
Portman	Tomas Arana
Nicki	Michele Lamar Richards
Tony	Mike Starr
Henry	Christopher Birt
Fletcher	DeVaughn Nixon
Ray Court	Gerry Bamman
Minella	Joe Urla
Dan	Tony Pierce
Klingman	Charles Keating
Oscar Host	Robert Wuhl
Debbie Reynolds	Herself

By JANET MASLIN

Deep inside the vague, unfocused excesses of "The Bodyguard," the tale of a buttoned-down security agent hired to protect a glamorous pop star, there lurks the potential for a compelling film noir. Frank Farmer (Kevin Costner), the bodyguard of the title, could have been a loner in a last-chance profession, terminally

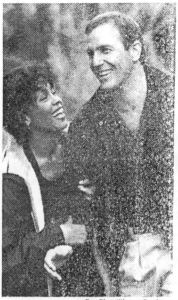

Ben Glass/Warner Brothers

Whitney Houston and Kevin Costner star in "The Bodyguard."

alienated from his own past. Rachel Marron (Whitney Houston), the glittery singer, could have been drawn tantalizingly as both treacherous vixen and damsel in distress. Rachel could have been dangerously ready to confuse Frank's brand of peace and protection with love. Frank could have fallen, and fallen hard.

And Rachel's household of hangers-on could have provided a full supply of trouble. On the surface, all her minions — including a sly publicity agent (Gary Kemp), a senior aide (Bill Cobbs), an oafish security chief (Mike Starr) and a music executive who is also Rachel's sister (Michele Lamar Richards), toady ceaselessly and devote body and soul to insuring Rachel's happiness. But at least one of them also wants her dead.

As written by Lawrence Kasdan in the mid-1970's, well before his "Body Heat" days, "The Bodyguard" could have capitalized on a mood of mystery and on the dark elements within each principal character. Handled thus, it might have made a lean romantic thriller instead of the long, sprawling semi-travelogue it has become. Mick Jackson, the director of "L.A. Story," has placed the emphasis on the least interesting aspect of this material: the pampered existence of Hollywood royalty, as manifested by countless swimming-pool shots and much attention to grandiose architecture. (The home of William Randolph Hearst and Marion Davies is used prominently.) While this is worth something in terms of pure voyeurism, it seldom does much to advance the film's slender story.

●

The viewer quickly discovers that Frank Farmer has a tragic flaw: as a Secret Service agent, he was otherwise engaged (actually, at his mother's funeral) on the day President Ronald Reagan was shot and has never forgiven himself for this "lapse." Unaccountably, a sense of failure has led Frank to highly paid work in the private sector, which leaves his Secret Service friends feeling very jealous indeed.

As the film begins, Frank is hired to guard Rachel, who has received death threats, so he must spend long hours visiting her mansion and watching her concert act. In one such appearance, with Rachel dressed in metal as a kind of Mrs. Ben Hur,

Frank becomes so apprehensive about the fans that he uses a fire extinguisher to keep them peaceful. It is from this sort of trumped-up action scene, interspersed with palmy glimpses of Rachel's privileged existence, that the film has been patched together.

Romantic sparks between Frank and Rachel would have disguised much of the clumsiness, but those sparks are minimal. Sporting the close-cropped haircut he must have had in grade school, Mr. Costner plays Frank in the extremely muted, colorless style that befits Frank's job description. A similar restraint translated wonderfully into slow-burning sexual tension when Mr. Costner appeared in "No Way Out," but this time the effect is more wan. And as Frank, he spends a lot of time looking more watchful than the film's events really warrant.

●

Ms. Houston, looking great and displaying the best set of teeth in movies, does better with Rachel's imperious side than with her gentler scenes. Her character's self-absorption may be lifelike, but it doesn't do much for a love story. Two long hours and 10 minutes after this tale begins, Rachel and Frank seem no closer than seatmates on a long bus trip. It takes a dizzying 360-degree shot of them embracing, plus the swelling of the hitbound soundtrack, to suggest any passion.

"The Bodyguard" kills time with some memorably transparent gambits, like a startling leap from Miami to the snows near Lake Tahoe (where Ralph Waite ambles into the film as Frank's father) and a painfully poor facsimile of Academy Awards night. It also pauses, though only briefly, for a couple of perfunctory love scenes between Rachel and Frank. Unreal as these scenes seem anyhow, they are further undercut by the film's failure even to notice that this is an interracial romance. Strangely enough, "The Bodyguard" comes from Warner Brothers, the studio that just released "Malcolm X."

The sidelines of "The Bodyguard" are enlivened by Mr. Kasdan's occasionally deft zingers (including the perfect rejoinder to a party pickup line), by moments when Mr. Costner's wariness takes on some dramatic edge and by supporting performances geared to a film noir sensibility. Mr. Kemp, a sinister star of "The Krays," and Ms. Richards are particularly strong reminders of what might have been.

●

"The Bodyguard" is rated R (Under 17 requires accompanying parent or adult guardian). It includes discreet sexual situations, mild profanity and slight violence.

1992 N 25, C9:5

Political Ideology and Love

"The Crying Game" was shown as part of the New York Film Festival this autumn. Following are excerpts from Vincent Canby's review, which appeared in The New York Times on Sept. 26.

●

Neil Jordan, the Irish writer and director, makes melodramas that are

often very funny, fantasies that are common-sensical and moral fables that are perverse. At heart, he is a madly unreconstructed romantic. In his view, the power of love can work miracles of a kind that would send Freud back to his own couch.

All these things are evident in Mr. Jordan's elegant new film, "The Crying Game," a tale of a love that couldn't be but proudly is, although even this love could be a substitute for another love that never quite was.

If I sound vague, it's partly because the film's producers have pleaded with reviewers not to reveal important plot twists, and partly because Mr. Jordan's screenplay reveals itself as if it were an onion being peeled. The nubbin of onion remaining at the end is important only as a memory of the initially unviolated bulb. More from me you will not get.

The love story that dominates the film is about Fergus (Stephen Rea), a sweet-tempered, naïve Irish Republican Army terrorist, and Dil (Jaye Davidson), the snappy, almost beautiful London hair stylist who captures his heart. Fergus is living in England under an assumed name after a botched kidnapping in Northern Ireland. He's lonely and haunted by the events that forced him into exile.

Dil is like no one he's ever met before. Wearing a tight spangled dress and earrings that look like Christmas-tree ornaments, she drinks margaritas and flirts with no thought of what her political responsibilities might be. When she gets up on the stage at her favorite pub, the Metro Bar, and sings the film's title

song, Fergus is hooked. Dil is glamorous, witty and capable of a depth of love that Fergus has never known.

•

Their idyll is short-lived. His past and her present surface in a manner to tear them apart. Fergus's former comrades show up in London and, threatening harm to the unsuspecting Dil, force Fergus to participate in one last job, the assassination of an English judge.

The film's penultimate sequence is as bloody and brutal as the extended opening sequences set in Northern Ireland, as Fergus, assigned to guard an I.R.A. hostage, first begins to understand "the war" in human terms. Yet for all its sorrowful realism, "The Crying Game" believes in the kind of redemption not often seen in movies since the 1930's and 40's. At times the film comes close to trash, or at least camp, but it's saved by the rare sensibility of Mr. Jordan, who isn't frivolous.

"The Crying Game" is full of masks. Fergus and Dil wear them, as do the people who have shaped Fergus in Ireland, including his I.R.A. girlfriend, Jude (Miranda Richardson), and the English soldier (Forest Whitaker) he comes to know in Northern Ireland. The biggest mask is that worn by the film itself, which pretends to be about the love affair of Fergus and Dil, although it really has more esoteric matters on its mind: the strength of political commitment and the role-playing of life's fugitives.

1992 N 25, C10:1

FILM VIEW/Caryn James

Keeping Grown-Ups Pacified

THERE IS A MAGICAL MOMENT FOR ADULTS in Disney's new "Aladdin." The giant blue genie escapes from the bottle and — what a relief — turns out to be Robin Williams. He doesn't look like Robin Williams, but he acts and sounds exactly like him at his most manic, which is to say, at his best. He jumps in and out of characters and voices with delirious speed: he's Groucho Marx, Jack Nicholson, Arnold Schwarzenegger, Ed Sullivan. He parodies game shows and talk shows. The magic of this shape-shifting genie is not lost on small children, though his dead-on impression of William F. Buckley Jr. probably is.

Mr. Williams does more than hold together "Aladdin," an elaborate but uneven version of the classic story. He relieves the boredom for adults and even makes it possible to recommend the film for unaccompanied grown-ups. His performance is a prime example of the Rocky-and-Bullwinkle Syndrome, that well-known but still vital approach in which topical allusions whiz over children's heads without diminishing their interest in the adventure. Five-year-olds, who presumably have never seen "Taxi Driver," will not be in the dark when the genie asks in his De Niro voice, "Are you lookin' at me? Did you rub my lamp?"

■

Creating a movie that will keep children from squirming is one thing; making a family film that will keep parents

from fidgeting is another. This season's major children's movies, "Aladdin" and "Home Alone 2: Lost in New York," keep both groups alert most of the time, though achieving that requires the balance of a tightrope walker.

For "Aladdin," the danger is dullness for both adults and children. Aladdin and the princess he loves look and sound as bland as characters on Saturday morning cartoons. Inanimate objects, animals and other magical creatures are left to carry the show. Happily, they are up to it. The magic carpet, whose tassels turn into hands and feet, has almost as much personality as Aladdin. Abu, Aladdin's mischievous pet monkey, is just as adorable when he turns into an elephant. But Mr. Williams's genie is the most fun and the most emotionally moving. His wish to be free is more poignant than Aladdin's puppy love; he makes this point wistfully, without preaching to children or pandering to adults.

As long as the genie is on screen (most of the film), "Aladdin" avoids the dreaded pitfall of boredom. But there is another deadly trap in children's movies: the tendency to create tacked-on scenes that have "Moral Lesson! Are You Parents Happy Now?" written all over them. "Home Alone 2" falls into this trap in one conspicuous episode.

Overall, this raucous, funny movie sucessfully follows the first law of sequels: be the same, only different. The se-

Walt Disney Pictures

The genie as Jack Nicholson in "Aladdin"—
Providing laughs for adults, adventure for children.

quel is even more cartoonish than the original, with Kevin (Macaulay Culkin) on the loose in New York, pursued by the world's stupidest burglars, Harry and Marv (Joe Pesci and Daniel Stern). Like Wile E. Coyote, these villains are so bounce-back indestructible that when their noses are actually smashed to the side, they just push them back in place.

There is also more sentimentality in the sequel, most of it surprisingly effective. In the original, Kevin and the grumpy old neighbor played by Roberts Blossom learned about the importance of family. In the black-comedy world of "Home Alone," this seemed like a tacked-on disclaimer flashing the words "MORALLY NUTRITIOUS" across the screen for the benefit of parents. How many children asked to see "Home Alone" again because they loved that tender scene in the church?

■

"Home Alone 2" has even more moral lessons, but Mr. Culkin handles most of them with such a light, savvy touch that he takes the Sunday-school curse off them. In a toy store, he has a sweet conversation with the owner, played by Eddie Bracken, and donates $20 to a children's hospital. Kevin undercuts the scene's saccharine quality by saying he'd probably use the money for something that would rot his body and mind anyway. That's how to be sweet and savvy at once.

But when Kevin has a heart-to-heart chat with the pigeon lady (Brenda Fricker), a homeless woman who feeds the birds in Central Park, the film loses its balance. Suddenly this 10-year-old has the wisdom of Solomon, as he advises the pigeon lady to trust people and to risk caring about someone.

She is afraid of having her heart broken, so Kevin tells her the parable of the roller blades.

He once had a great new pair of roller blades, he says, but was afraid he would ruin them if he wore then outside. (Does this sound like the daredevil Kevin we know?) Then he outgrew them. "Maybe your heart is like my roller blades," he tells her. If you don't use it, what good is it? Kevin is an extremely smart kid, but where did this speech come from?

And where did the idea come from? Teaching children that it's bad to steal or that it's good to give money to people who need it makes sense. Somehow, telling them to take a chance on love doesn't have the right childhood ring to it. The tone of this scene is weirdly off-kilter and adult, and has nothing to do with the era of broken families and untrusting children. This is a jarring episode aimed at parents.

The scene doesn't sink "Home Alone 2," though it may test children's patience. And it illustrates the danger of pandering to adults as well as kids. The Solomonic Kevin is less appealing, less realistic and less wise than the one who says, "Don't you know a kid always wins against two idiots?" □

1992 N 29, II:11:5

Daddy and the Muscle Academy

Written and directed by Ilppo Pohjola, (in English and Finnish with English subtitles); director of photography, Kjell Lagerroos; produced by Kari Paljakka and Alvaro Pardo. At Film Forum 1, 209 West Houston Street, South Village. Running time: 55 minutes. This film has no rating.

Time Expired

Written, directed and edited by Danny Leiner; director of photography, Randy Drummond; produced by Whitney Ransick; released by Zeitgeist Films. At Film Forum 1, 209 West Houston Street, South Village. Running time: 29 minutes. This film has no rating.

Ruby John Leguizamo
Bobby Bob Gosse
Ginny Edie Falco
Bert Mark Bailey
Mom Flo Miller

By JANET MASLIN

Tom of Finland is a household name in households well-equipped with biker gear and leather regalia. And "Daddy and the Muscle Academy," a documentary by the Finnish film maker Ilppo Pohjola, attests to the dedication of Tom's fans. As a legendary purveyor of gay erotica, one whose work (in the words of one interviewee heard here) is "almost a blueprint for the appearance of gay men in the latter part of the 20th century," Tom exerted a palpable influence on both fashion and fantasy. This 55-minute film, opening today at the Film Forum, tries to explain why.

The film spends most of its time studying Tom's drawings, analyzing the elements of Tom's mystique. The explicit nature of his art made it imperative that Tom, who died last year at the age of 71, work under a pseudonym, as he did. ("The sad thing about the name is that I don't represent Finland," says Tom, who appears here mostly as a talking head. "It's a more personal thing.")

From his early Norman Rockwell period, in which he favored images like a smiling youth dancing with a rosy-cheeked sailor, Tom moved on toward the idealized erotic images for which he is best known. Friendly, muscular, wasp-waisted men share many forms of sex and companionship, always in a spirit of affectionate ease. The film presents hundreds of these drawings, each more acrobatically and anatomically miraculous than the last.

Beyond providing a showcase for Tom's trademark-worthy version of the pinup, a sort of pornographic gay equivalent of the Vargas girl, Mr. Pohjola attempts some minor analysis. It is pointed out that Tom's men favor boots, sideburns, mustaches and motorcycle caps; it is noted that they often smile engagingly even when busy with the strenuous business of group sex. It is observed, most provocatively, that Tom's fascination with military and particularly fascist iconography (swastikas appear in some of his work) becomes an effort to sexualize images of power. But this thought is not seriously pursued. The film's analytical and biographical aspects are regrettably shallow and are easily overshadowed by the raw specifics of Tom's erotic art.

Least successful when he attempts to provide a context for this retrospective, Mr. Pohjola resorts to overlapping conversations, shadowy scenes of men stroking and oiling well-muscled bodies, glibly redundant titles ("Tom's Uniforms," "Tom's Gestures," "Tom's Name," etc.) and miscellaneous fashion statements. "I dress like this because I know I feel good in it, and I look good in it," says a man who likes leather. Naturally, Madonna is also mentioned, though only in passing. ("No matter how hard I try, I can't make them appealing," Tom says about trying to draw women.)

The film is at its most myopic in allowing one of Tom's business associates to talk of cataloguing his drawings and setting up a Tom of Finland museum. There are also anonymous cries of "I am a Tom's man!" and glimpses of a badge featuring Tom's insignia, a penis with wings. Tom's fans know who they are and may share this documentary's adulatory outlook. For other viewers, the film maker's approach is too limited to cast much light.

•

On the same bill is Danny Leiner's "Time Expired," a lively 29-minute short about a married man with serious roommate problems. When Bobby (Bob Gosse) leaves jail and returns home to his wife and mother, he is followed by a spitfire named Ruby, who was his cellmate and still wants to be the woman in his life. "We consummated," Ruby proudly announces to Bobby's wife, Ginny (Edie Falco), once the inevitable domestic quarrel is under way.

As Ruby, John Leguizamo sports varied wigs and bright red fingernails, stamping fearlessly into the life

of an ex-lover and refusing to take no for an answer. Mr. Leguizamo, the star of "Mambo Mouth" and "Spic-o-Rama," further proves his comic versatility. And Mr. Leiner makes the most of his characters' understandable malaise.

1992 D 2, C18:4

The Distinguished Gentleman

Directed by Jonathan Lynn; screenplay by Marty Kaplan, based on a story by Mr. Kaplan and Jonathan Reynolds; director of photography, Gabriel Beristain; edited by Tony Lombardo and Barry B. Leirer; music by Randy Edelman; production designer, Leslie Dilley; produced by Leonard Goldberg and Michael Peyser; released by Hollywood Pictures. Running time: 105 minutes. This film is rated R.

Thomas Jefferson Johnson Eddie Murphy
Dick Dodge Lane Smith
Miss Loretta Sheryl Lee Ralph
Olaf Andersen Joe Don Baker
Celia Kirby Victoria Rowell
Arthur Reinhardt Grant Shaud
Terry Corrigan Kevin McCarthy
Elijah Hawkins Charles S. Dutton
Armando Victor Rivers
Van Dyke Sonny Jim Gaines
Zeke Bridges Noble Willingham
Jeff Johnson James Garner
Kimberly Sarah Carson

By VINCENT CANBY

WHEN first seen in "The Distinguished Gentleman," Thomas Jefferson Johnson (Eddie Murphy) is making his way through a crowd of well-heeled Floridians at a political fund-raiser. His is the only black face in an otherwise pink and white sea of earnest contributors. In quick succession he is taken for, or passes himself off as, a waiter, a guest, an F.B.I. agent. In fact he is a small-time con artist whose most successful scam to date has been a phone-sex service: Girls of Many Nations (1-800-555-NATO), the point of which is to obtain the names and addresses of johns to be shaken down at a later date.

Thomas's initial brush with politics is instructive. It opens his eyes to the rewards of big-time scamming in what's sometimes called the political arena. Before you have time to note the mechanics of the film, which moves with the speed and the purpose of a game of three-card monte, Thomas has got himself elected to the House of Representatives. Among his freshman colleagues: a television weather forecaster and a former football player of some regional fame.

Thomas is a junior member of Congress, but it takes him no more than four days to secure an appointment to the prestigious House Power and Industry Committee, where the pay-offs are large and nonstop. Thomas is on his way.

As written by Marty Kaplan and directed by Jonathan Lynn, the sly Englishman responsible for "My Cousin Vinny" and "Nuns on the Run," "The Distinguished Gentleman" is an easy, breezy romp of a movie, a low comedy of highly entertaining order. As it tells of the meteoric rise (and magical salvation of) Thomas Jefferson Johnson, the film even manages to kid the flimsy comic conventions it so carefully observes.

Eddie Murphy is Representative Thomas Jefferson Johnson in "The Distinguished Gentleman."

"The Distinguished Gentleman" isn't to be confused with Frank Capra's "Mr. Smith Goes to Washington," though the leading characters in both films share a nominal fondness for the same Founding Father. That fondness is supposed to be sincere in the Capra classic. In "The Distinguished Gentleman," it's the basis for a succession of jokes. The new movie owes nothing to Capra and everything to Mr. Murphy's earlier days on "Saturday Night Live" as one of television's greatest revue artists. Though it has a coherent narrative and continuing characters, "The Distinguished Gentleman" has the random, off-the-wall charm of a series of black-out sketches: short, often manic dramatic inventions in which reason is turned inside out and no pieties are safe. Take the montage in which Thomas and his aides, the same crew that helped him run his phone-sex business, start a telephone campaign to persuade the right Washington people that Thomas should be on the Power and Industry Committee.

Mr. Murphy's Thomas is a genius on the telephone, as easily adopting the vocal inflections of a clenched-jaw Connecticut accent as those of a fellow who sounds as if he were the ghost of the Rev. Dr. Martin Luther King Jr. Mr. Murphy's Yiddish accent isn't great but, in these loose and scatterbrained circumstances, it will do.

There is something contagious as well as hilarious about Thomas's delight when, once he's in the Washington swing, he becomes the recipient of so many perks. He listens sympathetically as a lobbyist tells him that automatic weapons have been given a bad rap. But even Thomas is surprised when, sharing a blind with some M16-carrying duck hunters, only one bird is bagged. Thomas's comment: "It must have had a heart attack."

•

The star is surrounded by a group of equally inventive and tireless sup-

porting actors. Sheryl Lee Ralph, memorably funny as Robert De Niro's outspoken mistress in "Mistress," is a joy as Loretta, Thomas's helpful cousin who works as the entire stable of telephone sweethearts for his phone-sex business. Lane Smith, the courtly prosecuting attorney in "My Cousin Vinny," plays the crooked chairman of the Power and

A far cry from Capra: pieties are for puncturing.

Industry Committee. He's a white politician who recognizes the value in Thomas's widest, toothiest, most unthreatening grin, which is pretty much the reason Thomas is allowed to sit on the committee.

Joe Don Baker, Kevin McCarthy and Grant Shaud appear as some of the other less than noble political types. Sarah Carson doesn't have a large role, but she is not easily forgotten as the beautiful, frosty young white woman who more than lives up to her job description ("consummate public servant"). Victoria Rowell plays the sweetly committed young black woman who threatens to make Thomas into an honest man.

"The Distinguished Gentleman" is not as subversive as Mr. Murphy's recent "Boomerang." In that film, you remember, he plays an unrepentant male chauvinist in a yuppie world as exclusively black as it is exclusively white in almost every other movie. "The Distinguished Gentleman" isn't quite as adventurous, and certainly not as romantic. Instead, it reflects a mostly integrated world, much like the one that television sitcoms see all around them, though few sitcoms have the wit or edge Mr. Lynn brings to this movie.

•

"The Distinguished Gentleman," which has been rated R (Under 17 requires accompanying parent or adult guardian), has a lot of vulgar language and some sexual situations.

1992 D 4, C1:4

Critic's Choice

Thriller That Runs Deep

No one who's seen "The Crying Game" would dispute that it is, quite literally, amazing. Neil Jordan's romantic thriller is a brilliant original, one that expands an initially simple suspense story into a dizzying exploration of sex, loyalty, betrayal and unexpected love.

Beautifully acted by an unusual cast, it features Stephen Rea as an uncommonly gentle I.R.A. operative, Miranda Richardson as his partner, Forest Whitaker as a fearful hostage and Jaye Davidson as the hostage's coolly alluring girlfriend. Whatever else you

may say about "The Crying Game" — and it's a dazzling conversation piece — this much is guaranteed: you will be talking about Jaye Davidson's extraordinary performance on the way home.

Mr. Jordan directs with both passion and precision. He turns a tale of intrigue into a complex, challenging love story no viewer will soon forget. The film's distributors have asked those writing about "The Crying Game" to avoid spoiling it by describing too much of the story, and so far that's worked, but it won't last forever. Do yourself a favor and see this fine, startling film before the cat's out of the bag.

JANET MASLIN

1992 D 4, C3:5

El Bosque Animado

Directed by José Luis Cuerda; screenplay by Rafael Azcona, based on the novel by Wenceslao Fernández Flórez, (in Spanish with English subtitles); director of photography, Xabier Aguirresarobe; edited by Juan Ignacio San Mateo; music by José Nieto; produced by Classic Films Produccion S.A. At the Joseph Papp Public Theater, 425 Lafayette Street, at Astor Place, East Village. Running time: 10 minutes. This film has no rating.

Malvis	Alfredo Landa
Gerardo	Fernando Valverde
Hermelinda	Alejandra Grepi
Juanita Arruallo	Encarna Paso
Fiz Cotovelo	Miguel Rellán
Mrs. d'Abondo	Paca Gabaldón
Mr. d'Abondo	Fernando Rey

By VINCENT CANBY

Opening a special one-week engagement today at the Joseph Papp Public Theater is "El Bosque Animado" ("The Enchanted Forest"), José Luis Cuerda's bittersweet fantasy set in Galicia in northwest Spain in the 1920's. Though the presentation is part of the Public Theater's current retrospective, "Spanish Eyes: Visions of Post-Franco Spain, 1975-1990," the 1987 film doesn't reveal any startling changes. It celebrates not political liberation but the enduring character of the Spanish peasant, his passions, biases, superstitions, strengths and weaknesses.

"El Bosque Animado" is not exactly an inflammatory political statement. It's a series of interlocking tales about mercilessly picturesque characters who live in or near the forest of the film's title. There's gentle Gerardo, a poor well-digger whose wooden leg is so much shorter than his real one that he limps grotesquely and has trouble attracting women. Malvis is a would-be bandit who scares nobody. There are also a lonely ghost; a beautiful, overworked kitchen maid; a witch, and some rich landowners.

It could be that one should possess some knowledge of Galician folklore to fully appreciate "El Bosque Animado," or that one should know the Wenceslao Fernández Flórez novel on which the screenplay is based. It is otherwise not much of a delight. The ever-reliable Fernando Rey appears in a small role. Some of the other actors give credible performances, but the fellow who plays the failed bandit overacts without shame.

1992 D 4, C8:6

Love Field

Directed by Jonathan Kaplan; written by Don Roos; director of photography, Ralf Bode; edited by Jane Kurson; music by Jerry Goldsmith; production designer, Mark Freeborn; produced by Sarah Pillsbury and Midge Sanford; released by Orion Pictures. Running time: 104 minutes. At the New York Twin, Second Avenue at 66th Street, Manhattan. This film is rated PG-13.

Lurene Hallett	Michelle Pfeiffer
Paul Cater	Dennis Haysbert
Jonell	Stephanie McFadden
Ray Hallett	Brian Kerwin
Mrs. Enright	Louise Latham
Mrs. Heisenbuttal	Peggy Rea
Hazel	Beth Grant

By JANET MASLIN

"Love Field," a gentle, involving film about interracial friendship, begins with a very broad stroke in the form of Lurene Hallett (Michelle Pfeiffer), a blond bombshell who feels a special psychic bond with Jacqueline Kennedy. The year is 1963, the President has just been assassinated and Lurene feels duty bound to take the bus from Dallas to Washington to attend the funeral. "What I want is to go to that rotunda and file past that caisson or cortège or whatever it is and pay my respects," Lurene says, savoring the important-sounding words that make her think she has a mission.

For Lurene, feeling closely involved in this national tragedy amounts to a kind of character trait. Defining herself visibly in terms of Mrs. Kennedy's appeal, she boards the bus wearing a homemade lavender suit in the Kennedy style and sporting a bouffant hairdo that happens to be platinum blond. "Love Field," which opens today at the New York Twin, takes its title from the Dallas airport where Lurene turns up, early in the story, to catch a glimpse of the Presidential plane.

A character this flamboyant would risk sinking any film. But Ms. Pfeiffer, again demonstrating that she is as subtle and surprising as she is beautiful, plays Lurene with remarkable grace. Her only problem, if you could call it that, is looking like a cross between the young Mrs. Kennedy and the Marilyn Monroe of "The Misfits." It isn't easy to believe that a pastel vision like Ms. Pfeiffer's Lurene could pass through so many sleepy Southern towns without causing more of a stir.

•

Lurene does get a rise out of Paul Cater (Dennis Haysbert), a fellow passenger on the bus, but she commands his attention for the wrong reasons. A quiet, serious black man traveling with a little girl (Stephanie McFadden), whom he introduces as Jonell, his daughter, Paul has little patience for the chattery Lurene, who insists on befriending him.

Lurene's sweetness is real, but her self-image includes a bit too much of Lady Bountiful. When she insists on telling Paul that President Kennedy "did a lot for the Negro," Paul particularly bristles. "Hey, you want this?" he asks dryly, offering Lurene a magazine. "I'm finished with it. It's got lots of pictures."

As the film progresses, Lurene persists in finding ways of attaching herself to Paul and Jonell. Jonathan Kaplan ("The Accused"), a director capable of uncommonly delicate treatment of difficult issues, carefully conveys the context in which this friendship is formed.

Adgar W. Cowans

Michelle Pfeiffer

This modest film actually covers a lot of ground, touching on the racial and sexual attitudes of its time while also filling in the particulars of its characters' earlier lives. Lurene's unhappy marriage clearly has a lot to do with her eagerness to reinvent herself in such dramatic ways. Paul's constant watchfulness around white Southerners and his occasional angry outbursts at Lurene's unwitting gaucheness on the subject of race are also carefully drawn.

Lurene identifies with Jackie, but she looks a bit like Marilyn.

So are the limits placed on friendship between a black man and a white woman in rural Southern society. When Paul comforts Lurene by touching her arm, a white woman looks on disapprovingly. When Lurene is ostentatiously nice to Paul at a bus station, a black woman registers similar dismay. And when these two finally give in to temptation, there is a long pause before anything happens. The camera watches both Paul and Lurene think things over before they kiss.

•

As written by Don Roos (who also wrote "Single White Female"), "Love Field" brings remarkably few preconceptions to the telling of its understated story. The characters transcend stereotypes, but what really matters is the actors' ability to breathe these people to life. Mr. Haysbert is warm, sturdy and impressive in conveying Paul's mixture of exasperation and attraction to Lurene. Ms. Pfeiffer has a much showier role. Once again, she manages to be quietly spectacular, revealing the ways Lurene's inner desperation contributes to her outward gaiety. "I just kind of ran it together: don't know why!" she exclaims nervously, trying to explain how she got that name out of her original Louise Irene.

"Love Field" is finally a shade too polite. It moves cautiously in developing its central relationship, perhaps

as a reflection of the restrictive world in which the characters live. But that world is outstandingly well evoked through the series of quiet, desolate, Southern settings through which Paul and Lurene pass.

At a remote farmhouse, an elderly white woman (Louise Latham) harbors these two once they become fugitives, and displays a grudging awareness that the world is changing. And in another small town, when Lurene tries to tell a black mechanic of President Kennedy's good deeds regarding racial equality, the man says: "Take a look around, ma'am. Look like he done much here?"

•

"Love Field" is rated PG-13 (Parents strongly cautioned). It includes brief violence, mild sexual suggestiveness and slight profanity.

1992 D 11, C6:3

Night and Day

Directed by Chantal Akerman; written by Ms. Akerman and Pascal Bonitzer (in French, with English subtitles); camera, Jean-Claude Neckelbrouck, Pierre Gordower, Bernard Delville and Olivier Dessalles; edited by Francine Sandberg and Camille Bordes-Resnais; music by Marc Herouet; produced by Pierre Wallon and Marilyn Watelet. At the Joseph Papp Public Theater, 425 Lafayette Street, East Village. Running time: 90 minutes. This film has no rating.

Julie .. Guilaine Londez
Jack Thomas Langmann
Joseph François Negret

By VINCENT CANBY

Love as a terrifically intense if farcical learning experience is the subtext of Chantal Akerman's "Night and Day," an elegant and stylish new French comedy that's as subversively funny as its two very young lovers are self-absorbed and humorless. The film, opening today at the Joseph Papp Public Theater, is the Belgian-born Ms. Akerman's post-modern take on "Jules and Jim," with a little bit of "The Captain's Paradise" thrown in.

Julie (Guilaine Londez) is not conventionally pretty: her hair is sort of stringy and her nose is too big for the rest of her face. Yet she has a great body that expresses feelings not easily articulated in speech. At the beginning of "Night and Day," Julie and Jack (Thomas Langmann), a skinny taxi driver who never smiles, are living only for each other in a large, sparsely furnished flat in the vicinity of the Boulevard Sebastopol on the Right Bank of Paris.

It is summer. It is hot. They spend their days mostly naked, either on or in the vicinity of their bed. They are at that stage of passion when the rest of the world doesn't exist and, indeed, they only seem to exist when in actual physical contact with each other.

International Film Circuit
Guilaine Londez and Thomas Langmann in "Night and Day."

When Jack goes to work at night, Julie leaves the flat to walk around Paris until dawn, thinking only of his return.

The lovers are baffled that other people would choose to fill up their lives with television, telephones, babies, families, friends. When Julie or Jack makes some practical suggestion relating to real life, the other will respond, "Next year." They inhabit a high plateau of ecstatic stasis.

•

One evening Jack introduces Julie to Joseph (François Negret), who drives his cab during the day and looks as skinny, lonely and intense as Jack. The two men could be blood brothers. After Jack drives off on his night shift, Julie and Joseph start to walk and talk. Within an hour, they are in a hotel room making love. When Joseph suggests that she might want to give up Jack, Julie is surprised. She loves them both, she says, and their work schedules make it a nearly perfect arrangement.

Life goes on, but not quite as it was before. Julie gets no sleep. She starts missing dates. Joseph frets about playing second fiddle to Jack. Jack senses that Julie is not quite as obsessed with him as before. Julie knows that something drastic must be done when each man in turn starts mouthing the same cant to her.

In the same way, the method of "Night and Day" becomes apparent only with time. The film begins in a severely restricted, very stylized space (the flat shared by Julie and Jack), then gradually moves out into the recognizable world, a place inhabited by people who have more on their minds than all-consuming romantic love and nonstop sexual fulfillment. The movie is astonishingly handsome without looking frivolous.

"Night and Day" is a small, seriously comic extravaganza.

1992 D 11, C10:6

The Muppet Christmas Carol

Directed by Brian Henson; written by Jerry Juhl, after the story by Charles Dickens; director of photography, John Fenner; edited by Michael Jablow; score by Miles Goodman; songs by Paul Williams; production designer, Val Strazovec; produced by Mr. Henson and Martin G. Baker; released by Walt Disney Pictures and Jim Henson Productions. Running time: 120 minutes. This film is rated G.

Scrooge Michael Caine
VOICES OF:
The Great Gonzo/Robert Marley Dave Goelz
Kermit the Frog/Rizzo the Rat
Steve Whitmire
Tiny Tim Cratchit/Jacob Marley
Jerry Nelson
Miss Piggy/Fozzie Bear Frank Oz

By JANET MASLIN

"The Muppet Christmas Carol" is not one of those clever children's films that keep adult escorts from gazing longingly at the exit signs. What you expect — Muppets — is pretty much what you get. There's no great show of wit or tunefulness here, and the ingenious cross-generational touches are fairly rare. But there is a lively kiddie version of the Dickens tale, one that very young viewers ought to understand.

Michael Caine stars as Scrooge, playing the role enthusiastically and well. (It can't have been easy to smile tearfully and sing "wherever you find

Jim Henson Productions
Yule Tidings
The Great Gonzo, as Charles Dickens, joins Miss Piggy and Kermit the Frog in "The Muppet Christmas Carol."

love it feels like Christmas" in the midst of a Muppet crowd.) But when this film's target audience watches the opening credits, don't be surprised if Fozzie Bear gets a bigger hand than any grown-up could. The Muppets, undertaking their first major acting assignment, are so scene-stealing that when they turn up within the familiar story they assume the status of celebrity guests. The Great Gonzo narrates the film as Charles Dickens, and that suspiciously green-looking Bob Cratchit is Kermit the Frog.

There's some degree of suspense in wondering whether Mrs. Cratchit, who does not appear until late in the film, will be played by you-know-who. Miss Piggy (who is of course here) deserves to turn up in a Muppet "Madame Bovary" some day, but that's another story. In this one, some fancy special effects are also used to heighten the audience appeal of the original material, so that Scrooge flies à la Superman when he returns to his childhood with the Ghost of Christmas Past. As many past generations have known, the story works just fine without such tricks. But this version strives to be elaborate, even in the design of its ghosts: Christmas Past is a small, eerie, wide-eyed nymph and Christmas Present a chortling giant.

Jim Henson Production
Michael Caine and Kermit the Frog, in "The Muppet Christmas Carol" from Walt Disney.

Songs for this musical version of Dickens's cautionary tale have been provided by Paul Williams. But the music is seldom memorable, and the labored lyrics may go over young audiences' heads. (A lonely life "paints you with indifference like a lady paints with rouge," Mr. Williams writes, trying to rhyme "Scrooge"). Much of the music is also on the saccharine side, but little children should like that reasonably well, just as they enjoy crowd scenes featuring Muppet vegetables and other talking toys. Val Strazovec's production design offers a droll collection of snowy English rooftops and atmospheric street scenes.

"The Muppet Christmas Carol" was co-produced and capably directed by Brian Henson, whose supervision of puppetry and special effects keeps the film on a par with earlier Muppet efforts. The screenplay, by Jerry Juhl, is less inventive, but then it must cope with the challenge of retelling Dickens in terms that will register with young children. In this regard the film does work well, bringing home the story's impact and reinforcing its central message. Even if it takes two dancing black-and-white Muppet Marleys, a passel of quill-wielding rats as Scrooge's office clerks and a collection of young frogs and pigs in the Cratchit household, this "Christmas Carol" makes a clear case for kindness and successfully warms the heart.

1992 D 11, C12:6

A Few Good Men

Directed by Rob Reiner; written by Aaron Sorkin, based on his play; director of photography, Robert Richardson; edited by Robert Leighton; music by Marc Shaiman; production designer, J. Michael Riva; produced by David Brown, Mr. Reiner and Andrew Scheinman; released by Columbia Pictures and Castle Rock Entertainment. Running time: 140 minutes. This film is rated R.

Lieut. (j.g.) Daniel Kaffee Tom Cruise
Col. Nathan R. Jessep Jack Nicholson
Lieut. Comdr. JoAnne Galloway Demi Moore
Capt. Jack Ross Kevin Bacon
Lieut. Jonathan Kendrick . Kiefer Sutherland
Lieut. Sam Weinberg Kevin Pollak
Pfc. Louden Downey James Marshall
Lieut. Col. Matthew Markinson J. T. Walsh
Dr. Stone Christopher Guest
Judge Randolph J. A. Preston
Lieut. Dave Spradling Matt Craven
Lance Cpl. Harold W. Dawson
Wolfgang Bodison
Pfc. William T. Santiago Michael DeLorenzo

By VINCENT CANBY

The role doesn't have to be big, but if it's good, and if the actor playing it is great, the results can be magically transforming. Witness Jack Nicholson's vicious, funny, superbly reptilian turn in Rob Reiner's entertaining "A Few Good Men," adapted by Aaron Sorkin from his hit Broadway courtroom drama.

Mr. Nicholson doesn't steal the film, which would mean that he somehow separates himself from everybody else in it. Rather, in the course of only a handful of scenes, he seems to suffuse the entire production, giving it a weight, density and point that might not otherwise be apparent.

The role, beautifully written, is made to Mr. Nicholson's order. It's that of Col. Nathan R. Jessep of the United States Marine Corps, a tough, bigoted Vietnam veteran, a career officer shaped by decades of cold-war politics. By chance, Jessep is stationed in that last corner of the earth

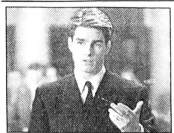

Sidney Baldwin

Tom Cruise

where the cold war goes on as if there were no yesterday.

He's the commander of the marines stationed at the American naval base on the southwestern coast of Cuba at Guantánamo Bay, on a small bit of arid real estate protecting one of the best anchorages in the western Atlantic, a legacy of the Spanish-American War. It's there that the United States and Cuba, separated by barbed wire and command posts, have continued to co-exist through the Bay of Pigs invasion, the great missile crisis and a continuing, crippling economic embargo, in one of the strangest examples of symbiosis to be found in all of international relations.

This geographic fact becomes a central image in the film adaptation, which gracefully opens up the story of a military court-martial without allowing the tension to evaporate. There are times when the movie seems to force-feed the audience essential information, and when the audience might well wonder whether the emotional crises of the defense lawyers really are of more interest than the fates of the two men on trial.

Yet such things are built into the structure and nature of the drama, which is less about the workings of the military than about the mechanics of this particular inquiry. The story is this: in the course of what appears to be a hazing incident at Guantánamo, a Marine private has died, apparently poisoned by the rag stuffed into his throat before his mouth was taped. Two enlisted men are charged with the murder. As often happens during proceedings of this sort, the victim and the men on trial become less important than the politics surrounding the case.

The Marine Corps would like to wrap it up as quickly and efficiently as possible. To this end, a hot-shot young naval lawyer, Lieut. (j.g.) Daniel Kaffee (Tom Cruise), is assigned to the defense with the understanding that he'll persuade the defendants to accept a plea bargain. Also assigned to the defense is Lieut. Comdr. Jo-Anne Galloway (Demi Moore), who acts as Kaffee's conscience, eventually persuading him that there is a strong possibility that the two enlisted men were, in fact, acting on orders from their officers.

The investigation, initially undertaken by Kaffee with some reluctance, uncovers the fact that the victim, Pfc. William T. Santiago (Michael DeLorenzo), had for some time been trying to transfer out of his unit. Also, that he had ignored both the Marine Corps code and its chain of command. He had written letters to Washington offering to testify that he had witnessed an incident in which a member of his unit had arbitrarily fired on a Cuban watchtower near the base.

As the investigation continues, Kaffee and Galloway, who clearly never go to the movies, read a book or spend much time talking to career service

personnel, are surprised to discover a kind of military mind that, to them, seems prehistoric. The two defendants at first behave like automatons. Pfc. Louden Downey (James Marshall) is so taciturn that he seems seriously retarded. His co-defendant and spokesman, Lance Cpl. Harold W. Dawson (Wolfgang Bodison), refuses all offers of help. He will stoically accept whatever punishment is meted out. The two men simply parrot the Marines' code of fidelity to unit, corps, God and country.

On a fact-finding trip to Guantánamo, Kaffee, Galloway and their assistant Lieut. Sam Weinberg (Kevin Pollak) have their first brush with Jessep at a scary lunch, during which the colonel cheerfully lies through his teeth. For Galloway's benefit, he also describes the special kind of high one can get when having sex with a superior officer. According to Jessep, that's one of the few benefits of an integrated service.

•

"A Few Good Men" doesn't pack the surprises of "Witness for the Prosecution," nor does it probe very deeply into the psyche of men who exercise the power of dictators in a society that congratulates itself on its freedoms. It's no "Full-Metal Jacket." "A Few Good Men" recalls something of "The Caine Mutiny Court Martial," though it is most troubling not for the questions it raises, but for the casual way it finally treats its two lost, utterly bewildered defendants.

The screenplay is a good one, directed with care and acted, for the most part, with terrific conviction. Among the supporting players who do exceptional work are Kiefer Sutherland, as a Marine officer who is a Jessep in the making; J. T. Walsh, as an officer fatally flawed by conscience; Kevin Bacon, who appears as the military prosecutor, and Mr. Bodison, a new young actor whose performance as the more prominent defendant gives the film its melancholy shock value.

Mr. Cruise, Ms. Moore and Mr. Pollak are perfectly adequate in less flashy roles, which, unlike the others, appear to have been constructed to keep the plot moving right along. They have to play it comparatively straight, which must be maddening when the actors around them are having such a colorful time.

Mr. Nicholson is in his own league. His Jessep is both a joy to watch because of the actor's skill, and an explanation of why the United States base at Guantánamo Bay, whatever its military value, continues to exist. "A Few Good Men" is a big commercial entertainment of unusually satisfying order.

•

"A Few Good Men," which has been rated R (Under 17 requires accompanying parent or adult guardian), has a lot of vulgar language and some violence.

1992 D 11, C20:1

Is a Cinematic New Wave Cresting?

By JANET MASLIN

WHILE THE HOLLYWOOD studios spent much of 1992 churning out the most forgettable home video fodder in recent memory, a funny thing was happening out on the fringes. American independent film makers enjoyed an exhilaratingly good year, marked by receptive audiences, critical encouragement and the promise of even better things to come.

Why did we see such a confluence of impressive new talent? Maybe it was just coincidence. It may even have signaled the emergence of yet another cinematic new wave.

To some extent, the arrival of promising new American directors goes in cycles. And the studios have a lot to do with setting the conditions in which those cycles can occur. A corporate penchant for risk taking, in the years after the unexpected box-office success of "Easy Rider" in 1969, helped bring forth or encourage an astonishing array of new names. Martin Scorsese, Robert Altman, Woody Allen, Francis Ford Coppola, Paul Mazursky, Steven Spielberg and George Lucas all established their reputations in the late 60's and early 70's, when marginal-seeming young film makers captured and revitalized Hollywood's mainstream.

While there is not yet reason to think that the current wave is on a par with that one, it is still very visible — and there is ample evidence of its impact. Several of this year's best American independently made films — "The Waterdance," co-directed by Neal Jimenez and Michael Steinberg; Carl Franklin's "One False Move"; Allison Anders's "Gas Food Lodg-

Cineville

Fairuza Balk and Ione Skye in "Gas Food Lodging"—As well acted and entertaining as anything the major studios had to offer.

479

ing" — must surely have given more conventional film makers pause. Made uncompromisingly, and on a shoestring, they were as well acted and entertaining as anything the studios had to offer.

Several others — Gregg Araki's "Living End" and Tom Kalin's "Swoon," Quentin Tarantino's superviolent yet droll "Reservoir Dogs," Tim Robbins's sharply satirical "Bob Roberts," Julie Dash's poetically

For American independent film makers, this was an exhilaratingly good year.

evocative "Daughters of the Dust" — refreshingly dispensed with the something-for-everyone blandness of big-studio efforts. These films succeeded in frankly singling out specific audiences by race, politics or general outlook and showing those audiences characters they wanted to see. Even some of the year's more uneven or self-absorbed independents took chances that would be out of the question in mainstream Hollywood.

"Commerce has overwhelmed art, which is why Hollywood movies aren't as good as they used to be," says Jeffrey Katzenberg, the chairman of Walt Disney

Pictures, by way of explaining the independents' new surge. "The process has been corrupted. It is too much about money and not enough about good entertainment." Noting the disappearance of many smaller film companies, the ones known as mini-majors, Mr. Katzenberg points to a gap between film making as "guerrilla warfare, meaning three guys with a camera strapped on their back" and "megablockbuster Hollywood productions."

Disney's 1992 roster included the flatly generic "Straight Talk," "The Mighty Ducks" and "Sister Act," but there will be future projects by formidable independent types, among them Merchant-Ivory ("Howards End"), Bill Duke ("A Rage in Harlem") and Wayne Wang ("Chan Is Missing").

■

This change of direction appears to be part of a broader shift. The way has been paved by a group of now-established film makers whose work is distinctly independent — including Spike Lee, Steven Soderbergh, John Sayles, Jim Jarmusch, Gus Van Sant Jr. and the Coen brothers. Critically or commercially, they have attained the kind of stature that makes the studios take notice. And a parallel show of force among documentary film makers — with films like "Roger and Me," "Paris Is Burning," "Brother's Keeper," "Hearts of Darkness" and "35 Up" — has similarly focused attention on the growing commercial viability of independent film makers.

So has the increasing importance of the Sundance Film Festival each winter, which brings to light many films that subsequently find a measure of box-office success; it was here

that "Sex, Lies and Videotape" first emerged. (Last year, "The Waterdance" and Alexandre Rockwell's "In the Soup" were highly visible there.)

Sundance doesn't simply bring exposure to pre-existing independent efforts; it may also help to bring an added professionalism to the films being shown. According to Harvey Weinstein, co-chairman of Miramax Films (a major force in distributing independent films), young film mak-

The vitality of young American directors has coincided with a decline in foreign films.

ers are becoming more cognizant of the opportunities this showcase provides. "It's not like they can just go make a home movie," he says. "The stakes are a little higher, now that there's a forum for it. This really is a world stage."

Something else has helped pave the way for the independents' success in finding an audience. Foreign films have, in general, experienced a decline in quality that coincides with the new vitality of young American film makers. Says Mr. Weinstein, who notes that he has heard complaints about subtitles from young viewers: "American independents may be more appealing to a generation that listens to radio and watches TV, where reading is maybe eighth on the list."

Also, the corporate thinking that has drained the life out of Hollywood has had a similarly dulling effect on some foreign efforts. When a high-gloss, violent thriller like "La Femme Nikita" is one of the most prominent French films in recent years, the appeal of movies that are small, quirky and substantial only grows.

Karen Cooper, who runs the Film Forum in lower Manhattan and has consistently showcased American independents, speaks of the audience's sophistication, a term once more commonly applied to the audience for foreign films. She also ascribes some of the popularity of these to their "particularization of experience," which is infinitely harder to find in Hollywood product. "There are food stores that sell just pasta and clothing stores that sell just black," she said. "Films can do that, too, when they aren't just looking for the lowest common denominator."

When the Film Forum showed "Daughters of the Dust" early this year, there was an overwhelming response from viewers attracted by Ms. Dash's lovely, ruminative glimpses of

a turn-of-the-century Gullah family in the Carolina Sea Islands. Hollywood may have brought forth "The Color Purple," but it could never have produced anything as idiosyncratic as "Daughters of the Dust."

■

Whatever else these new film makers will accomplish, they are helping to forge a path others can follow. Every time a "One False Move" appears out of nowhere to attract viewers and impress critics, nowhere picks up an added cachet. And every film festival that is dominated by an unexpected hit like "The Waterdance" (in Sundance) or "Bob Roberts" (in Cannes) makes viewers that much readier to expect the unexpected.

For those left terminally disaffected by formula film making, expecting the unexpected is indeed a happy prospect. This year has brought the good news that the free-spirited, try-anything film is alive and well. Even better, it has a future. □

1992 D 13, II:1:2

FILM VIEW/Caryn James

What's Under The Tree? Stiffs And Hoods

TWO YEARS AGO, THE BIG movie that opened on Christmas Day was a cheerful extravaganza, "The Godfather, Part III." Well, it *was* about a family. And the Corleones are always sitting around eating a lot, so maybe it wasn't such an odd holiday choice, except for the back-stabbing and shooting and dead people.

Last year's holiday season brought that lovable gangster in "Bugsy." And the tradition goes on. This year you're getting Jimmy Hoffa for Christmas. Coming up are movies filled with bloodshed, betrayal and music — something for everyone, from the tiniest incipient Mafioso to the most corrupt patriarch.

Movie makers will tell you there are valid commercial reasons for this. The holiday season is a major filmgoing period, and the end of the year is the cutoff date for Oscar contention. On the theory that the typical Academy Award voter has the memory of a flea, the best, most dramatic movies are usually released at Christmastime.

What's a softhearted viewer to do? Why not rise to the occasion and put your own holiday spin on the story of a presumably-dead teamster? Here are some viewing tips, ways to turn this year's Christmas films into holiday fun.

"Hoffa"
(Opening Christmas Day)

Think of Jack Nicholson's Jimmy Hoffa as Santa, bringing cheer to thousands of little teamsters. Don't ask about his mob connections. Instead, focus on Danny DeVito as Hoffa's helpful elf and sidekick, Bobby, always ready to do Santa's bidding — sending threatening messages, lending Santa his gun. Off-season, Santa and Bobby go to the joint instead of the North Pole, but that's just geography.

Watch for the film's tender family scenes. In one, Hoffa's granddaughter waves bye-bye as gramps goes off to prison. In another, Hoffa visits Robert Kennedy and tells him what he can do with his brother.

If you look carefully, holiday trappings are everywhere: in the snowy scenery (convenient for an arsonist who rolls in the snow after getting too close to his work); in the gift-wrapped package that Bobby delivers for Hoffa. (Don't worry. Santa won't send *you* dismembered body parts.)

"Trespass"
(Opening Christmas Day)

This story of an inner-city gang and corrupt firemen is such a perfect holiday movie that it was actually saved for Christmas. Originally called "The Looters," it was scheduled to open over the summer, but that seemed

like an incendiary idea after the Los Angeles riots. Then it was pushed ahead to February 1993, before someone recognized its holiday spirit.

The rappers Ice Cube and Ice-T star as gang members in East St. Louis, Ill. When two firemen from Arkansas arrive in search of hidden gold (think frankincense and myrrh, too), they cross the gang members and are trapped in a burned-out fac-

Remember when Christmas movies meant Santa Claus and angels? Ho, ho, ho! Are you out of it!

tory. Directed by Walter Hill, known for slick adventures like "48 Hours," the movie promises a gigantic special-effects finale in which the factory explodes.

But don't ignore the story's deeper meaning. Press material for the film calls it "a contemporary retelling of man's age-old quest for riches." Well, who hasn't thought, at one time

or another, "Christmas is about loot"? Just make sure to lock up the presents before you head for the theater.

"Damage"
(Opening Dec. 23)

This almost became the first Christmas movie rated NC-17 (no one under 17 admitted), which would have made it tough to think of as an outing for the tots. The director, Louis Malle, trimmed a few steamy seconds to qualify for an R rating, but there is still plenty of family activity on screen, as Jeremy Irons falls into an obsessive sexual relationship with his son's fiancée. In one family-dinner scene, knowing glances pass between Mr. Irons's character, Stephen Fleming, and the young woman, played by Juliette Binoche. Think of the Christmas surprise in store for Stephen's son and wife.

"Indochine"
(Opening Dec. 24)

Here is a family story much like "Damage," but from the mom's point of view and with guerrilla insurrection thrown in for good measure. Against the backdrop of French colonial Indochina, Catherine Deneueve and her adopted daughter fall in love with the same man. When it's time to sit down to the Christmas goose, "Indochine" might lead to one of those sentimental dinner-time discussions every family loves: What were the

French doing in Indochina? How did that lead to the United States involvement in the Vietnam War? Has Catherine Deneuve had a facelift?

■

There is alternative Christmas programming, too. Some good-guy films are sneaking into town this week, a step ahead of the holiday-movie thugs. In "Leap of Faith," Steve Martin experiences a miracle. In "Forever Young," Mel Gibson wakes up after being frozen for 50 years and finds true love. With their inspirational themes, these films seem hopelessly out of sync with the season's movie spirit. But if it helps make the mood more Christmasy, think of Steve Martin as a crime boss who experiences a miracle. □

1992 D 13, II:20:5

Passion Fish

Written, directed and edited by John Sayles; director of photography, Roger Deakins; music by Mason Daring; production design by Dan Bishop and Dianna Freas; produced by Sarah Green and Maggie Renzi; released by Miramax. Running time: 136 minutes. This film is rated R.

May-Alice	Mary McDonnell
Dawn/Rhonda	Angela Bassett
Chantelle	Alfre Woodard
Ti-Marie	Nora Dunn
Rennie	David Strathairn
Kim	Sheila Kelley
Sugar	Vondie Curtis-Hall
Reeves	Leo Burmester
Drushka	Marianne Muellerleile

By JANET MASLIN

May-Alice (Mary McDonnell) was on her way to a leg-waxing appointment when her life changed forever. Hit by a car as she got out of a taxicab in New York City, May-Alice was left permanently paralyzed. She formerly worked as a soap-opera actress, but nothing she simulated on television can match the drama her real life now offers. She is seen in a hospital, waking up to the daunting facts of her new life, as John Sayles's "Passion Fish" begins.

Stunned at first, May-Alice soon develops a caustically bitter way of dealing with her frustration. She keeps to herself and drinks too much. She remains angry and proud. She mocks those who try to help her and, even more mercilessly, she mocks herself. "It's important that we have clean walls," she snaps at one of the many nurses she employs briefly,

A soap-opera actress loses her world, then finds a richer one.

then fires or scares away. "I'll be climbing them soon."

When solicitous old friends come to visit, after May-Alice has relocated to her girlhood home in Louisiana, she is even worse. "Didn't we always say, 'I wonder how May-Alice is going to end up?' " asks one chatty, thoughtless matron who drops by. May-Alice stares, drilling holes into her guest's

empty head. "Well, now you know," she flatly replies.

●

"Passion Fish," a film much less precious than its title (which refers to a Cajun superstition about finding love), is about the spiritual rebirth that finally occurs within May-Alice. It's also about the strong, sympathetic helpmate who makes such regeneration possible. The right nurse finally comes along in the person of Chantelle (Alfre Woodard), who is only slightly cowed by May-Alice's insults and has had enough troubles of her own to understand her employer's mean streak.

As played memorably by Ms. Woodard, a quietly voluptuous actress who conveys vast inner strength, Chantelle is willing to help May-Alice only on her own terms, thus providing the kind of toughness and back talk her patient desperately needs. "Have you been doing this long?" May-Alice asks Chantelle curtly during their job interview. "No," Chantelle answers. "You?"

If this situation sounds fraught with the danger of sentimentality, it certainly is. But Mr. Sayles's writing and direction are refreshingly blunt, going over the top only when taking cheap shots at some of May-Alice's tiresome old friends. Though the story is essentially house-bound, set in the soothing Louisiana household as May-Alice gradually re-establishes herself there, it manages to introduce a varied stream of visitors. Collectively, they keep the film moving and prevent it from looking inward to a stultifying degree.

●

"Passion Fish" was also edited by Mr. Sayles, who adopts a leisurely pace and often slows down to emphasize the seductive charm of Cajun culture. His film is warmly appealing, played with subtlety and intelligence by both its stars. But like many of this season's releases, "Passion Fish" is needlessly long. With a two-and-a-quarter-hour running time, this essentially modest film often seems to be luxuriating in the story of Chantelle and May-Alice rather than making sure that story gets told.

Also in "Passion Fish," and well matched with Ms. McDonnell's touchingly stubborn May-Alice, is David Strathairn as a Louisiana native who looked good to her as a teen-ager, and looks even better now that he is a father of five. Mr. Strathairn appears in two of the film's more magical sequences, a dream that restores May-Alice to her earlier, sexually adventurous self and an all-day boat ride through the bayou that becomes a larger sort of journey. In these sequences, Mr. Strathairn's handsome, down-to-earth Rennie serves as both a reminder of everyday reality and a secret avenue of escape.

Also contributing mightily to the Southern charm of "Passion Fish" are Vondie Curtis-Hall as the rural blacksmith who somehow persuaded the wary Chantelle to let down her guard, and Leo Burmester as the wayward, tippling uncle in two-toned shoes, a colorful sine qua non in such a story. Sheila Kelley and Angela Bassett (Betty Shabazz in "Malcolm X") have some good moments as a couple of soap opera queens from May-Alice's past.

●

Equally helpful, on a different note, is Marianne Muellerleile as the scari-

Sony Pictures Classics

Catherine Deneuve and Lin Dan Pham in "Indochine"—For the holidays, guerrilla insurrection and a family feud.

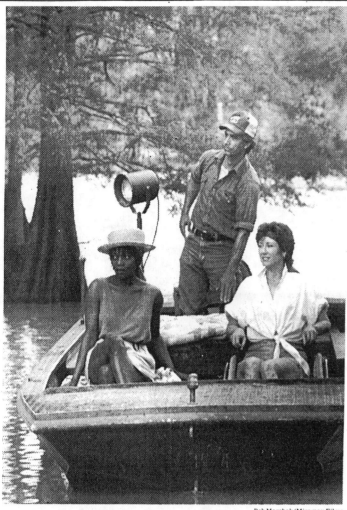

Bob Marshak/Miramax Films

Alfre Woodard, left, David Strathairn and Mary McDonnell in a scene from John Sayles's new film, "Passion Fish."

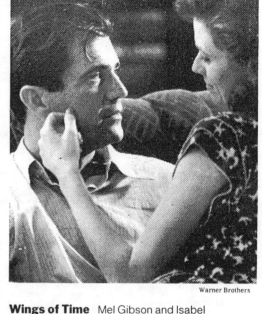

Warner Brothers

Wings of Time Mel Gibson and Isabel Glasser star in "Forever Young," Steve Miner's romantic drama about a test pilot who is transported from 1939 to the present and gets a second chance to declare his love for the woman he left behind.

est and most exacting in a long parade of unlucky nurses. The nurses' scenes are edited together in a funny, bad-audition type montage, during which one particularly pesty nurse insists on grilling May-Alice about other stars (with character names, like Raven and Dominique), whom she presumably knows from other soaps. "There's not like a room where they store us all between shows," May-Alice replies in exasperation.

"Passion Fish" opened yesterday at the 68th Street Playhouse, where it will play for the one-week run necessary for Academy Award eligibility. Its gentle manner contrasts nicely with the hot air of many higher-powered Christmas releases.

•

This film is rated R (Under 17 requires accompanying parent or adult guardian). It has profanity, sexual references and sexual situations.

1992 D 14, C16:1

Forever Young

Directed by Steve Miner; written by Jeffrey Abrams; director of photography, Russell Boyd; edited by Jon Poll; music by Jerry Goldsmith; production designer, Gregg Fonseca; produced by Bruce Davey; released by Warner Brothers. Running time: 104 minutes. This film is rated PG.

Daniel	Mel Gibson
Claire	Jamie Lee Curtis
Nat	Elijah Wood
Helen	Isabel Glasser

Harry	George Wendt
Cameron	Joe Morton
John	Nicolas Surovy
Wilcox	David Marshall Grant
Felix	Robert Hy Gorman
Susan Finley	Millie Slavin
Steven	Michael Goorjian
Alice	Veronica Lauren
Alice's Father	Art LaFleur
Fred	Eric Pierpoint
Gate M.P.	Walt Goggins
Debbie	Amanda Foreman
Blanche	Karla Tamburrelli

By VINCENT CANBY

"Forever Young" has the manner of something that was made in the kind of perfect vacuum that can be achieved only in a Hollywood bell jar. Here's a romantic comedy in which Mel Gibson plays a pre-World War II test pilot who, accidently defrosted after spending more than half a century in a cryogenic capsule, learns about life and love in 1992.

When first seen in 1939, Daniel McCormick (Mr. Gibson) seems to have the world in the palm of his hand. He's not only at the top of his class as a flier, but he's also in love with and loved by an ideal woman, Helen (Isabel Glasser), a successful magazine photographer. Daniel has one small failing: marriage scares him, though for no reason more special than that the story requires it.

When Helen is suddenly run over in the street and declared brain dead, the distraught Daniel volunteers to be the first human guinea pig in a cryogenic experiment. After all, he's not going anyplace, nor is Helen. He ac-

cepts his deep-freeze willingly. What with one thing and another, including World War II, he's forgotten until two small boys of the 1990's come upon his abandoned but still icy crypt in a warehouse. It's at this point that "Forever Young," which has been unraveling for some time, really starts.

Written by Jeffrey Abrams ("Regarding Henry") and directed by Steve Miner, "Forever Young" has nothing much to do with anything except the movie conventions of an earlier time when near-fatal accidents, wild coincidences and miraculous resurrections were the way life was lived on the silver screen. Plausibility is not important in this sort of movie; everything depends on the charm, style and verve with which it's played.

This is Mr. Gibson's department. He passes through "Forever Young" with the self-assurance of a Hollywood star of the great studio era, someone who in good pictures and bad remains magically and consistently his own idealized self. Mr. Gibson is good enough to give the film substance, making "Forever Young" far easier to sit through than it has any right to be.

Jamie Lee Curtis also is attractive as Claire, the gutsy 1990's woman who befriends Daniel and with whom he has a brief flirtation, almost forgetting his still strong commitment to the memory of the brain-dead Helen. I shouldn't reveal more about the plot except to emphasize that, brain death aside, it is a romantic comedy.

This is not always apparent while one is watching the film. Though "Forever Young" initially would have you believe that Daniel and Helen share some kind of transforming passion, Helen is forgotten for much of the running time. The heart is earnestly warmed instead by Daniel's friendship with Claire's 11-year-old son, Nat (Elijah Wood), whom he teaches to fly. There are also some obligatory Rip Van Winkle gags

about Daniel's reaction to television, telephone answering machines and such.

"Forever Young" looks to be very much a star vehicle. Because of that, it may not be fair to blame either the writer or director for its lack of narrative focus. The star is the center of everything. The physical production is handsome and elaborate, but nothing deflects attention from Mr. Gibson for any length of time, not even Ms. Curtis. Ms. Glasser is not around long enough to establish her own screen presence. Even George Wendt, the formidably funny "Cheers" star, who plays the inventor of Daniel's deep-freeze chamber, does not make much of an impression.

The only thing that gives Mr. Gibson competition is a great Billie Holiday recording of the Ray Noble standard "The Very Thought of You." Daniel and Helen consider it their song. It later turns up as a favorite of Claire in 1992. Lady Day was not exactly a household name in 1939. That Daniel and Helen should have cherished her then lends them more class and character than anything else in the movie.

•

"Forever Young" is rated PG (Parental guidance suggested). It has some mildly vulgar language.

1992 D 16, C17:1

Used People

Directed by Beeban Kidron; screenplay by Todd Graff; director of photogarphy, David Watkin; edited by John Tintori; music by Rachel Portman; production designer, Stuart Wurtzel; produced by Peggy Rajski; released by 20th Century Fox. Running time: 115 minutes. This film is rated PG-13.

Pearl	Shirley MacLaine
Joe	Marcello Mastroianni
Jack	Bob Dishy
Young Bibby	Emma Tammi
Young Norma	Asia Vieira
Uncle Harry	Lee Wallace

Kathy Bates, left, and Shirley MacLaine in "Used People."

20th Century Fox

Uncle Normy	Louis Guss
Bibby	Kathy Bates
Mark	Gil Filar
Rhonda	Maia Filar
Uncle Al	Irving Metzman
Swee' Pea	Matthew Branton
Bill the Jeweler	David Gow
Norma	Marcia Gay Harden
Freida	Jessica Tandy
Becky	Sylvia Sidney
Aunt Lonnie	Doris Roberts
Aunt Ruthie	Helen Hanft
Cousin Matthew	Jeremy Tracz
Cousin Stevie	Stuart Stone

By JANET MASLIN

Why would anyone not under duress want to spend time with a loud, obnoxious family eager to discuss body odor, toilets and Tupperware? "Used People" makes the dubious assumption that these are funny grotesques, and that within their earthy platitudes lies some kind of reassuring candor. ("Even cheap borscht is a blessing for the toothless." "When you got a humpback, why spend money on a nose job?")

In fact the grotesque far outweighs the funny, emphasized as it is by shellacked hairdos, deliberately awful costumes (the year is 1969) and crude conversation. "Not too spicy, we're Jewish," warns Shirley MacLaine as Pearl Berman, a recent widow who seems to be getting free advice from every last person in Queens, and who herself is criticizing someone else's cooking. "We take gas very seriously."

•

Pearl's grief over the loss of her husband (Bob Dishy) is established in a funeral sequence that has her relatives fighting over which parkway to take to the cemetery. The film's brand of wit is thus established, along with its notion of compassion. ("You wanna sit here alone like a dog the rest of your life?" Pearl's sister-in-law demands.) Its idea of romance appears soon afterward in the form of Joe Meledandri (Marcello Mastroianni), a courtly Italian who mysteriously pops up to woo Pearl. Joe's brand of charm consists of weirdly inappropriate references (he quotes both Shakespeare and Herbert Hoover) and talk of travel, which brings a faraway look to his eye. Under these circumstances, Mr. Mastroianni's faraway look can be construed as wishful thinking.

Mr. Mastroianni has mastered English well enough to deliver lines like "Bibby! Bibby! The air-conditioner — is it still broken?" But he is hardly well used in a film that, as directed by Beeban Kidron ("Antonia

and Jane"), makes an international issue out of an Italian-Jewish courtship. It also slathers the ethnic equivalent of corn onto every sentimental scene. When Pearl and Joe finally kiss, they stand in a wading pool cheered on by the mah-jongg set. Behind them is a large billboard advertising salami.

Some of the appeal here ought to be in the casting, which suggests a Jewish "Moonstruck" plus an attempted "Fried Green Tomatoes"-"Steel Magnolias" class reunion. Kathy Bates, who this time appears as Jessica Tandy's granddaughter (and Ms. MacLaine's daughter) is one of the few cast members to play a believable character, thanks to endless talk about her weight, her sibling rivalry and her divorce.

Marcia Gay Harden, as Ms. Bates's sister, has the cute quirk of dressing up as famous movie stars. She appears variously, and with decreasingly droll effect, as Faye Dunaway, Barbra Streisand and Marilyn Monroe. The film's most bizarre episode has her re-enacting Anne Bancroft's role in "The Graduate" in order to stage a seduction, then handcuffing her prey (Joe Pantoliano) and torturing him with hot candle wax.

Ms. Tandy and Sylvia Sidney fare best as two wisecrack-trading old friends. But not even Ms. Tandy can find much charm in a line like: "Who're you? You Cousin Minnie's kid, the gimp?" The screenplay, by Todd Graff, places way too much faith in the comic power of such locutions.

•

"Used People" is rated PG-13. It includes profanity and one sexual situation.

1992 D 16, C23:3

The Short and Funnies

At the Film Forum 1, 209 West Houston Street, South Village. Total running time: 80 minutes. These films are not rated.

MONA'S PETS, written, produced and directed by John David Allen; director of photography, Doug Smith; production designer, Cynthia Morton; with Mary Ann Hagan as Ramona, Taylor St. Clair as Mom, and Joel McGinnis and Michael Ogletree as Ramona's brothers. Running time: 32 minutes.

HAIRWAY TO THE STARS, written and directed by David O. Russell; with William Hickey and Julie Follansbee. Running time: 12 minutes.

EDSVILLE, directed by Alan Marr; written by Stuart Clow, Mr. Marr and James O'Regan; produced by Mr. O'Regan. Running time: 14 minutes.

DER SUPER, written and directed by Tobias Meinecke, based on an original story by Will Eisner (in German with English subtitles); with Erich Bar as the super and Natalia Bitnar as Rosy. Running time: 12 minutes.

THE BIG SNIT, written, directed and animated by Richard Condie; produced by the National Film Board of Canada. Running time 10 minutes.

By STEPHEN HOLDEN

The title character of John David Allen's short film "Mona's Pets" is a punkish young woman who paints her fingernails black, twists her hair into spiky antlers and speaks in surly pronouncements. In the opening scene, she walks out on her boyfriend and goes home to the suburbs to live with her mother.

Mom (Taylor St. Clair) already has a hard enough time bringing up Mona's younger brothers, Bobby and Jimmy (Joel McGinnis and Michael Ogletree), two squabbling hellions on the verge of adolescence. No sooner has Mona begun unpacking than the tidy little house becomes infested with cockroaches that she has brought from the city.

"Mona's Pets," which opens today at Film Forum 1, is the longest and best of the five short comic films that have been collected on a program called "The Short and Funnies," which plays through Dec. 29. The film might be described as a domestic horror comedy in which the monsters are ordinary cockroaches, filmed in twitching, glistening close-up as they slither in and out of appliances and turn up, like nasty Crackerjack surprises, in the oddest places.

Despite its surreal touches, the film offers an amusing, believable portrait of a thoroughly dysfunctional family forced into tentative togetherness by a rapidly multiplying army of invading pests.

•

A similar mixture of Surrealism, dark humor and satire informs the program's other films. In David O. Russell's wildly imaginative 1989 film, "Hairway to the Stars," a woman on the eve of her 50th wedding

anniversary has her hair done in a beauty salon. As the lid on the dryer descends over her, she imagines a rocket launching her into a series of fantasies of the seductive power of her new coiffure. In her most grandiose dreams, she is the belle of the ball in a 1940's musical and also Bette Davis in "The Letter." Although the film jams too many images into its 12 minutes, it has a giddy, lilting exuberance.

Tobias Meinecke's 1985 film, "Der Super," which was adapted from a short novel by Will Eisner, is a deadpan parody of German Expressionism. Erich Bar portrays Scuggs, the incredibly porcine and disfigured superintendent of a tenement whose inhabitants hate him. His fate is sealed when a tenant's treacherous 10-year-old niece offers to expose herself to him for money. The only film that doesn't comfortably blend with the others on the program, "Der Super" has the feel of a prelude to a longer work.

On the lighter side are Alan Marr's "Edsville" and Richard Condie's "The Big Snit." In "Edsville" a yuppie couple on their way to an auction find themselves nearly trapped in a village where everyone from the minister to the members of motorcycle gang talk and gesticulate like caricatures of Ed Sullivan. The 14-minute film ends just as the joke begins to run out of steam.

Although "The Big Snit," is the program's only animated segment, it fits right into the concept. Created by Mr. Condie, a Canadian film maker, its central characters are a long-married couple whose simmering resentments erupt during a Scrabble game. Unbeknownst to them, nuclear war has broken out, and while the world outside their door panics (they think the turmoil is just a parade), they go on with their fight.

Neatly and without sentimentalizing, "The Big Snit" suggests that all wars, be they domestic spats or global catastrophes, are the peevish clashes of parties who have been cooped up together too long and have fallen out of sorts.

1992 D 16, C30:3

Toys

Directed by Barry Levinson; written by Valerie Curtin and Mr. Levinson; director of photography, Adam Greenberg; edited by Stu Linder; music by Hans Zimmer and Trevor Horn; production designer, Ferdinando Scarfiotti; produced by Mr. Levinson, Mark Johnson, Charles Newirth and Peter Giuliano; released by 20th Century Fox. Running time: 110 minutes. This film is rated PG-13.

Leslie Zevo	Robin Williams
General Zevo	Michael Gambon
Alsatia Zevo	Joan Cusack
Gwen Tyler	Robin Wright
Patrick Zevo	LL Cool J
Kenneth Zevo	Donald O'Connor
Owen Owens	Arthur Malet
Old General Zevo	Jack Warden

By VINCENT CANBY

BARRY LEVINSON'S "Toys" is a magnificent mess, a chaotic fantasy set in a brilliantly vivid, Surreal landscape that recalls the paintings of Magritte and the pop-up illustrations in children's books. Dada is also evoked, though less consistently. "Toys" dazzles the eye even as the mind goes numb attending to the narrative, which is about the apocalyptic battle for control of Zevo Toys, where whimsy is said to be a tradition but is more like a curse.

Here is a nonmusical "Babes in Toyland" crossed with "Dr. Strangelove," a danceless "Nutcracker" that suggests "Paradise Lost," yet plays as if it were the nightmare of a child of 4. "Toys" is supposed to be spontaneous and fun, but it has a drearily self-impor-

tant message stolen from a bumper sticker: War is hazardous to children and other living things.

It's impossible to tell for whom this movie was made.

Very young children would seem to be the target audience, though they won't have a clue as to what's going on. Their adult companions will be driven to dreamless slumber. Masochistic film students may possibly respond. The confusions of "Toys" are so many that they appear intentional, as if arcane truths were to be discovered somewhere within.

Just before ailing old Kenneth Zevo (Donald O'Connor) dies, he entrusts the family toy company to his brother, the mad General Zevo (Michael Gambon), whose life has been without purpose since the end of the cold war. Thus passed over are Leslie (Robin Williams) and Alsatia Zevo (Joan Cusack), Kenneth's children, both of whom acknowledge that they are too innocent to run the factory that is their world.

Leslie spends his days moving happily around the assembly lines where smiling workers put together dolls, stuffed animals and the kinds of harmless toys that kids drop out of car windows. He is especially fond of novelties made for joke stores: water glasses that drip, fake deviled eggs and blobs of plastic in the shape of what the movie genteelly calls dog poop. At one point he demonstrates a spectacular smoking jacket, which is a jacket that emits smoke.

Alsatia is more interested in paper dolls, and wears clothes that are fixed to her body as if they were paper-doll outfits. At the end of the day, Leslie and Alsatia go home to their pretty pop-up Victorian mansion, set among a series of vast green, treeless hills, where Alsatia sleeps in what looks to be a golden sarcophagus shaped like a duck.

Meanwhile, the general sets about to turn Zevo Toys into a high-tech armaments plant. His inspiration: the cool reflexes displayed by little boys playing the kinds of video war games that Zevo has firmly refused to manufacture. The general's idea is to revolutionize war by the development of miniature, nuclear-equipped airplanes, rockets and whatnot that any child could operate by remote control.

It takes Leslie and Alsatia some time to realize that things aren't what they used to be at Zevo Toys. Trusted employees are being let go, including the lady who used to paint lips on alligators. The general hires storm troopers to protect his private laboratories. His curiosity piqued, Leslie sneaks into the general's workshop one day to discover the awful truth: a huge collection of vile video games and war toys. Leslie's reaction: "My God, F. A. O. Schwarzkopf!"

War soon erupts at Zevo Toys as the forces of heaven, led by Leslie and Alsatia, take on those of hell, the general's mechanized, computerized toys, which initially massacre the teddy bears, dolls and novelties that Leslie throws into the struggle. It's just one of the many contradictions of "Toys" that the film, which is antiwar, comes to life only in this spectacular if muddled confrontation. In the context of a movie that makes such a big thing of innocence, the mayhem of the battle is pretty strong stuff, especially when a principal character is decapitated.

•

There are, in fact, a number of wars going on in this antiwar movie. The most apparent is the struggle between the brilliant imagination of Ferdinando Scarfiotti, the production designer, and the banal, fake-innocent conceits of Mr. Levinson, who directed the movie and wrote the screenplay with Valerie Curtin. Though Mr. Scarfiotti is reported to have used Dada as an inspiration for the film's look, nothing in the script has much to do with Dada's resolute antipathy to reason. "Toys" doesn't exalt randomness. It is the victim of it. The film has no consistent vision. Even worse, it's not very funny. Leslie, Alsatia and their friends laugh more often than the audience does.

Mr. Williams seems peculiarly subdued. His monologues in "Good Morning, Vietnam" have far more to do with the exuberant iconoclasm of Dada than does anything in "Toys." He has the occasional rude line, but he spends most of the film behaving with immense politeness, which is apparently to be equated with innocence.

There's also something fatally wrongheaded about the film's attempts to equate Leslie's humane impulses with the sorts of toys that for perfectly good reason, would bore most children today. No adult of a certain age can have forgotten how quickly the windup toy always ran down. Though war toys aren't great, "Toys" sometimes gives the impression that it would like to disinvent everything that's battery-operated and remote-controlled.

While "Toys" means to celebrate the benign paternalism of Zevo Toys before the maniacal general takes over, it presents a far scarier picture of assembly-line labor than anything in "Modern Times." Beneath giant plaster heads of pastel-colored animals, the Zevo workers go about their tasks with the blank expressions of people who have been lobotomized and then had smiles surgically fixed to their faces.

•

It takes time to get the full measure of the film's failure. Not since

Robin Williams

"The Cabinet of Dr. Caligari" has there been a movie set in such a stylish, hermetically sealed environment, calling up a world where absolutely nothing is real. The effect is sort of pleasant for a while, like being in a weightless state. Eventually, though, whimsy takes over, nausea threatens and patience runs out.

Mr. Gambon ("The Singing Detective") has fun as the mad general, but it's a role that Mr. Williams might have done equally well, and with some of the mania that "Toys" so desperately lacks. The only two performers who come out of this film unscathed are Robin Wright, who plays Leslie's sweetly dippy girlfriend, and LL Cool J, the rap performer, who appears as the white general's black son. The screenplay offers no explanation for this color difference, which becomes one of its few good jokes.

Mr. Levinson reportedly hoped to direct "Toys" years ago as his first film, but good fortune kept getting in the way as he went on to direct "Diner," "Tin Men," "Good Morning, Vietnam," "Rain Man" and "Bugsy," among other hits.

His luck finally ran out.

•

"Toys" is rated PG-13 (Parents strongly cautioned). It includes some vulgar language and simulated violence.

1992 D 18, C1:3

Critic's Choice

Cartoon Creations With Silent Sentiments

Before Mickey Mouse was a gleam in Walt Disney's eye, Oswald the Lucky Rabbit was a gleam in Walt Disney's eye. A rambunctious, accident-prone creature who liked to take off his foot and kiss it for luck, Oswald became the hero of a popular series of cartoon shorts. When it turned out, in 1928, that the producer of the Oswald series owned the rights to the character, Disney set out on his own.

The rabbit's floppy ears were rounded (the better to make Mouseketeer hats one day), his puffy tail became long and skinny, and faster than anyone could say "Magic Kingdom" there was Mickey. Within months, Mickey starred in his own silent cartoon, "Plane Crazy," tousling his hair to look like Lindbergh's and giving a plane ride to Minnie.

Oswald-the-Mickey-Look-Alike and "Plane Crazy" are two of the rare and happy surprises in "Disney in Wonderland: The Silent Cartoons of Walt Disney, a series that will be shown at the American Museum of the Moving Image. Running from tomorrow through Jan. 3, the series will present first-rate prints of 58 shorts, from Disney's earliest silents in 1922 through a few Mickey Mouse sound cartoons of the 1930's.

The silent films will be presented at the museum, 35th Avenue at 36th Street in Astoria, Queens, with piano accompaniment. Museum admission is $5 ($4 for those over 65 and $2.50 for children); screenings are an additional $2. Screening times this weekend: tomorrow and Sunday, 2 and 4 P.M. Information: (718) 784-0077. Travel directions: (718) 784-4777.

The most enchanting and unusual films here are from Disney's silent "Alice" series, in which a real little girl steps into a cartoon world. In the first, "Alice's Wonderland" (1923), the girl visits Walt Disney in his studio. That night, she dreams herself into an animated world, where she rides a cartoon elephant in a circus parade of ostriches, donkeys and top-hatted dogs.

One of the best Alice shorts is included in the opening program, a collection called "Scary Tales and Adventures." In "Alice's Spooky Adventure" (1924), the heroine wanders into a haunted house, where ghosts and black cats sing and dance. Whenever there is singing in the silents, musical notes fly through the air. And the animated dancing is quite impressive for its time. Though nothing ever moves in the background of these early works, the animation is advanced enough for a friendly cat to kiss Alice's hand.

And, familiar though he is, some of Mickey's cartoons are revelations as well. "The Mad Doctor," a sound film from 1933, is genuinely frightening, with Pluto kidnapped by a crazed scientist who wants to experiment on him.

By 1936, just a year before "Snow White," Disney had become a sophisticated animator, and in "Thru the Mirror," his enduring style is recognizable. Mickey dreams himself into Lewis Carroll's Wonderland, where playing cards, telephones, chairs and radios are alive. It is a short distance from Mickey in Wonder-

The Walt Disney Company
A detail of a 1924 film poster for "Alice's Spooky Adventure."

land to the animated carpet in the current "Aladdin." But whatever historical interest these early cartoons hold, they are first of all funny, charming and timeless.

CARYN JAMES

1992 D 18, C3:5

Leap of Faith

Directed by Richard Pearce; written by Janus Cercone; director of photography, Matthew F. Leonetti; edited by Don Zimmerman; music by Cliff Eidelman; production designer, Patrizia von Brandenstein; produced by Michael Manheim and David V. Picker; released by Paramount Pictures. Running time: 108 minutes. This film is rated PG-13.

Jonas Nightengale	Steve Martin
Jane	Debra Winger
Marva	Lolita Davidovich
Will	Liam Neeson
Boyd	Lukas Haas
Hoover	Meat Loaf
Matt	Philip Seymour Hoffman
Tiny	M. C. Gainey
Georgette	La Chanze
Ornella	Delores Hall
Lucille	Albertina Walker
Titus	John Toles-Bey
Ricky	Ricky Dillard

By JANET MASLIN

It is a tacit seasonal tradition that smaller, more interesting films arriving in December are often trampled in the all-star holiday stampede. It would be too bad if that happened to "Leap of Faith," the lively story of an Elmer Gantry for the computer age.

Well acted and amusingly told, featuring a fine performance by Steve Martin in the central role, this tale ultimately switches gears and takes a deeply serious turn. "If I get the job done, what difference does it make?" Mr. Martin's Rev. Jonas Nightengale, a bogus faith healer, asks twice during the story. The second answer he receives sums up the film's fundamental message: "It makes all the difference in the world."

"Leap of Faith" begins by pointing out that Jonas is a person of real talent. Sweet-talking a highway patrolman out of giving him a ticket, Jonas instinctively guesses where the man's vulnerabilities lie and exploits those weaknesses brilliantly. He likes to perform such feats with the help of Jane (Debra Winger), the clever manager who gives Jonas constant back talk and runs every aspect of his traveling road show.

Jane even feeds Jonas helpful information using an earpiece and a radio transmitter. This preacher might well be able to wow audiences on his own, but it helps to have Jane studying a floor plan of the faithful, telling him exactly where to find the heavy drinker, the pregnant teenager, the worker who has just been laid off or the farmer who is desperate for rain. That way Jonas, who leaps and skips and works the stage like a rock star, can shout all the appropriate "Halleluljahs!" and dazzle listeners with his intuition.

Jonas's large entourage ordinarily plays good-size cities. But when a bus breaks down, the group is forced to stay in a small, impoverished Kansas town. As the flimflam operation rolls into tiny Rustwater, the soundtrack offers exactly the right musical accompaniment: "Sit Down, You're Rockin' the Boat" from "Guys and Dolls," the song about a con artist getting his comeuppance from the faithful, as performed in a lilting reggae version by Don Henley. The film is full of similarly small, perfect touches, and never makes the mistake of calling attention to them.

●

As directed with care and intelligence by Richard Pearce ("The Long Walk Home," "Country"), "Leap of Faith" turns cynicism into a peculiar virtue. This is demonstrated in a wonderful montage that shows Jonas's "Miracles and Wonders" road show setting up in Rustwater after Jane, who is the group's resident charmer, has sweet-talked a permit out of the local sheriff (Liam Neeson). In this montage, all the con artists' tricks are revealed: a full supply of crutches and wheelchairs, a system for tipping off Jonas about the audience, a life-size statue of Jesus passed around by roadies as if it were a prop in a rock show.

Yet amid all this activity something miraculous really does begin to happen. Mr. Pearce spins together an inspiring sequence as the tent rises up, the show comes together, the gospel choir rehearses gloriously as the singers stand simply by the side of the road. At this moment, the audience can simultaneously feel the dual strengths of faith and doubt just as surely as Jonas can. It is thus prepared for the crisis of confidence upon which this story, like any "Rainmaker"-type tale, must eventually hinge.

Mr. Martin's performance, surprisingly jaunty under the circumstances, is as remarkable for its restraint as for its energy. The temptation to reduce Jonas's slickness to broad parody is gracefully avoided; so is the immense maudlin potential of any tale in which the con man comes to sympathize with the little people and regret the error of his ways. Rolling into town unabashedly in a T-shirt, cowboy hat and gold chain, Mr. Martin's Jonas is a model of self-assurance, and the public be damned. "Always look better than they do," he jokes, while getting dressed for a show.

As "Leap of Faith" slowly closes in on Jonas's spiritual crisis, it heads for trouble. In conventional Hollywood terms, at least, there is no way to embrace this film's ultimate outlook without losing part of the audience along the way. To its credit, this film sticks to its convictions and ignores that worry, at the expense of a happy-ending payoff or a clear resolution. Yet the attempt to take the central question of faith seriously becomes gratifying in its own, much quieter way.

●

As written colorfully by Janus Cercone, "Leap of Faith" includes a number of potentially sentimental subplots, including one involving a pretty waitress (Lolita Davidovich) and her disabled brother (Lukas Haas, so well cast that he and Ms. Davidovich seem to share a family resemblance). Jonas dispenses with any weepy aspects of this situation by snappishly calling the boy "Tiny Tim," and takes a similarly caustic attitude throughout the movie. Another subplot, linking Ms. Winger's Jane to Mr. Neeson's sheriff, also risks turning sticky. But Ms. Winger, very well matched as a pal of Mr. Martin's, ably adopts the glib, self-protecting banter that gets these phony healers through the day. Even as the sarcasm falls away later in the story, and even when surrounded by a shower of miraculous butterflies (one of the few fancy effects used), Ms. Winger's Jane remains appealingly direct.

From its small-town coffee shop to its "I Am Saved" T-shirts, "Leap of Faith" has the right look for the story it means to tell. Immense support is provided by the Angels of Mercy, the real-life singers (including La Chanze, Delores Hall and Albertina Walker) who do a beautiful job of playing Jonas's gospel choir.

"Leap of Faith" is rated PG-13 (Parents strongly cautioned). It includes mild profanity.

1992 D 18, C14:1

FILM VIEW/Caryn James

Retro Hunks: They're Tough, But Oh So Gentle

"YOU DÓN'T LOOK LIKE A bodyguard," Whitney Houston tells Kevin Costner when they meet in their new hit movie, giving the first hint that this film is seriously out of touch with reality. He looks exactly like a bodyguard, trained in the Secret Service, which is probably where he picked up that conservative gray suit, white shirt and narrow black tie. A laconic authority figure who would die to protect the woman he loves, the hero of "The Bodyguard" was conceived by Lawrence Kasdan 17 years ago with Steve McQueen in mind. That — along with the geekiest haircut this side of basic training — helps explain why the character seems to have walked out of the past.

In "Forever Young," Mel Gibson *does* walk out of the past. In 1939, he is a brave test pilot, so despondent when the woman he loves is hopelessly injured that he volunteers to be frozen as part of a top-secret experiment. He is defrosted in 1992 without losing a trace of his boyish good looks and proves that a 30's man is perfect for the 90's — protective of women but gentle enough to cry, an eternal romantic who is also handy at home repairs.

Who are these guys, and how did they get here? They're handsome. They're old-fashioned. They're Mel and Kev, the retro hunks.

Mel Gibson and Kevin Costner are also two of Hollywood's most successful actors, and when stars with such sure commercial instincts cast themselves as old-style romantic heroes — in movies that could have been made, with the tiniest changes, in the soapy Hollywood of the 1940's — something is in the air. Their new-old male image may reflect several currents, from an anti-feminist backlash to the worn-out status of 80's yuppies.

Mr. Costner, the politically enlightened hero of "Dances With Wolves" and the swashbuckler in "Robin Hood: Prince of Thieves," has been playing with macho images for a while now. But the most trendsetting heroes lately have been Terminators, Lethal Weapons and other cartoonish types. Just when you think it's time for realistic characters, along comes the retro hunk, evoking the safety and familiarity of the past.

The films' backward-looking formulas mirror this desire for security. As Frank Farmer, the bodyguard, one of Mr. Costner's first moves is to rescue Rachel, the pop star played by Ms. Houston, from a stageful of trampling fans. Like some romantic cavalier, he carries her away in his arms.

Frank, a muddled character, also owes something to John Wayne and Gary Cooper. Attacked by a bigger, stupider bodyguard in

Warner Brothers

*Kevin Costner in "The Bodyguard"—
In its outdated, pre-AIDS ethos, love
means safety and security.*

Rachel's kitchen, Frank wins a wordless
knife fight and then says, "I don't want to
talk about this again."

And after they make love, Rachel says to
him, "I've never felt this safe before." The
professional bodyguard comes to his senses
and tells her, "I can't protect you this way."
They may sound like a condom commercial,
but they are invoking an outdated, pre-AIDS
movie ethos: love means safety and security,
even more than sex appeal.

This attitude makes "The Bodyguard" so-
cially pertinent, but that doesn't mean it's a
good movie. It is obvious and laughable, espe-
cially when Frank's motivation is revealed.
He feels guilty because he was at his moth-
er's funeral, rather than at his Secret Service
job, the day Ronald Reagan was shot.

Much of the film's popularity seems driven
by Ms. Houston's hit single, "I Will Always
Love You." The commercial success of "The
Bodyguard" is also a tribute to star power
and traditional movie conventions — a defi-
nite retrograde enticement.

"Forever Young" is a more enjoyable
movie, because it shamelessly evokes the
sentimentality and nostalgic appeal of 40's
weepers. It doesn't strain to be anything
other than a fluffy romance, and though the
details are updated for the 90's, no one plays
around with the basic formula: boy loves
girl, boy loses girl, boy and girl and audience
get choked up at the end.

As Daniel, Mr. Gibson is suave in his 1930's
flight jacket and talks like a hero from yes-
terday. When he practices his marriage pro-
posal, he begins: "Gosh, you usually get my
thoughts before I do, so you probably know
what I'm going to say." Only a man from an
earlier era could get away with using "gosh"
in a romantic conversation, but it has a
quaint charm here.

In their new movies, Mel Gibson and Kevin Costner show that an old-fashioned guy is perfect for the 90's.

Daniel is no wimp in the present, either. He
saves Jamie Lee Curtis from an attack by a
former boyfriend, making moves that are
quite effective even if he does begin by
putting up his dukes like an old-time boxer.

"Forever Young" also plays off its star's
appeal with more wit than "The Bodyguard."

Warner Brothers

Mel Gibson in "Forever Young"—Protective of women but not afraid to cry.

When Daniel needs a young woman at the records office to help him track down a friend, he puts his hand over hers and looks into her eyes. He is un-self-conscious; she melts and promises him anything. He is, after all, Mel Gibson, movie star. The movie works as exquisitely sappy escapism — an escape to a more heroic era with a more innocent romantic sensibility.

These retro hunks are not alone. "The Last of the Mohicans" depends on a similar old-fashioned appeal, as the handsome, romantic hero played by Daniel Day-Lewis rescues his love from Indians. Of course, he lives in the 18th century, so he has a good excuse.

In any era, there is no disguising who these men are. As the two little boys who unfreeze Daniel yell when they see him walking around, "It's the dead guy!" Contemporary sex and romance only get more complicated. The movies respond by breathing life into dead guys from a seemingly simpler age. ☐

1992 D 20, II:26:1

Scent Of A Woman

Directed and produced by Martin Brest; screenplay by Bo Goldman; director of photography, Donald E. Thorin; edited by William Steinkamp, Michael Tronick and Harvey Rosenstock; music by Thomas Newman; production designer, Angelo Graham; released by Universal Pictures. Running time: 149 minutes. This film is rated R.

Lieut. Col. Frank Slade	Al Pacino
Charlie Simms	Chris O'Donnell
Mr. Trask	James Rebhorn
Donna	Gabrielle Anwar
George Willis Jr.	Philip S. Hoffman
W. R. Slade	Richard Venture
Randy	Bradley Whitford
Gretchen	Rochelle Oliver
Gail	Margaret Eginton
Garry	Tom Riis Farrell
Harry Havemeyer	Nicholas Sadler
Trent Potter	Todd Louiso
Jimmy Jameson	Matt Smith
Manny	Gene Canfield
Christine Downes	Frances Conroy
Mrs. Hunsaker	June Squibb

By JANET MASLIN

"Scent of a Woman," a glorified father-son buddy film with a needlessly sensitive title, offers Al Pacino the kind of opportunity actors dream about. As Lieut. Col. Frank Slade, a corrosively bitter military man who has been blinded (quite literally) by his own stupidity, Mr. Pacino roars through this story with show-stopping intensity.

Bo Goldman's screenplay provides him with a string of indelible wisecracks, and Martin Brest's direction allows room for the character to be developed at great length. Mr. Pacino's contribution, in the sort of role for which Oscar nominations were made, is to remind viewers that a great American actor is too seldom on the screen.

As in "Rain Man," another effort to reveal a star's great versatility through the eyes of a nice young man, this film juxtaposes a flamboyant performance and a quieter foil. The latter is Charlie Simms (Chris O'Donnell), a scholarship student at a snobbish New England prep school who takes on the job of minding Colonel Slade over Thanksgiving vacation. The colonel lives, somewhat dismally, with a niece and her family, whom he often compares to the Flintstones. When the colonel meets Charlie, he is no less charitable about prep school students, calling them "a bunch of runny-nosed snots in tweed jackets, all studying to be George Bush."

Having hired Charlie and arranged an introduction, the niece leaves town, doing her best to allay Charlie's worries. "The man grows on you," she insists. "By Sunday night you'll be best friends." The bad thing about "Scent of a Woman" is that there is a certain inevitability to that promise, and it takes about two and a half hours to play itself out.

The good thing is that the principals and film makers make the absolute most of a conventional opportunity. They succeed in turning a relatively contrived situation into a terrific showcase for Mr. Pacino's talents. They also breathe life into certain hoary dramatic notions, like the thought that any lonely, angry man can be turned into a kindly father figure by the right surrogate son. An equally familiar note is sounded by a subplot at the prep school, which has the poor, honest Charlie threatened with expulsion if he refuses to turn in some rich, spoiled classmates for their bad behavior. This standard plot twist was also the basis for "School Ties," in which Mr. O'Donnell also appeared.

Luckily, it is possible to enjoy "Scent of a Woman" without caring

Myles Aronowitz/Universal Pictures.
Al Pacino in "Scent of a Woman."

about the contortions Mr. Goldman's screenplay must go through in finding links between Charlie and the colonel. Besides, Mr. Pacino has a way of explosively dispelling any doubt. From the moment he first appears, sitting in a darkened room blasting insults at the hapless Charlie, he seems to take up all of the story's dramatic space. Frank's voice, the only weapon he has left, becomes so formidable that even watching him speak becomes an adventure. Bellowing invective, letting his body rise and swell with each new pronouncement, Frank intones like a Southern radio announcer as he tests Charlie's mettle. "Don't shrug, you imbecile, I'm blind," he barks, using his disability to make Charlie even more uncomfortable. "Save your body language for the bimbae."

•

It develops that Frank has a plan: instead of staying home, he wants to visit the Waldorf-Astoria for one last fling, and he wants Charlie as his guide. This leads the film into a series of separate New York adventures, which would seem disconnected were it not for the gusto Mr. Pacino brings to them all. A visit to his brother brings Frank's nastiness to a new high. ("Let's surprise him," he says eagerly to Charlie. "Give that fat heart of his an attack.")

A chance meeting with a beautiful young woman who smells like soap and water — Frank prides himself on noticing such things, and takes this as a measure of his lust for life — leads the blind man into a flamboyant tango. Later on, a long episode finds Frank and Charlie test driving a new Ferrari through the streets of New York City, with Frank at the wheel. "You can dance the tango and drive a Ferrari better than anyone I've ever seen," Charlie insists later, during another semi-separate episode, in which Frank waves a gun and threatens suicide. "You've never seen anyone do either," Frank snaps in return.

Mr. Brest makes surprisingly little effort to link these chapters in his story, letting Mr. Pacino's stentorian singsong provide most of the glue. Only occasionally, when it allows itself to become speechy, does the film jeopardize its enjoyably meandering style. Instead of letting his characters' exploits unfold so slowly, Mr. Brest could well have created the impression of greater coherence by simply picking up the pace, revealing the straightforward hour-and-50-minute film that lurks inside this longer one. The film's ending, a contrived occasion for some spectacular grandstanding from Mr. Pacino, is greeted with pumped-up applause that underscores the film's essential predictability.

Mr. O'Donnell has the tough job of weathering every "Ha!" or "Hoowah!" from Mr. Pacino without jeopardizing his role as straight man, and he does this stalwartly. Only a master of straight-faced delivery could handle Charlie's sincere side, as when he confounds Frank with one of Mr. Goldman's few nonsparkling observations: "You're not bad. You're just in pain."

•

"Scent of a Woman" is rated R (Under 17 requires accompanying parent or adult guardian). It includes sexual references and off-color language.

1992 D 23, C9:1

Damage

Directed by Louis Malle; screenplay by David Hare, adapted from the novel by Josephine Hart; director of photography, Peter Biziou; edited by John Bloom; music by Zbigniew Preisner; production designer, Brian Morris; produced by Mr. Malle, Vincent Malle and Simon Relph; released by New Line Cinema. Running time: 111 minutes. This film is rated R.

Dr. Stephen Fleming	Jeremy Irons
Anna Barton	Juliette Binoche
Ingrid	Miranda Richardson
Martyn	Rupert Graves
Edward Lloyd	Ian Bannen
Elizabeth Prideaux	Leslie Caron
Peter Wetzler	Peter Stormare
Sally	Gemma Clark
Donald Lyndsaymp	Julian Fellows

By JANET MASLIN

There are no words in "Damage," Louis Malle's elegant film version of Josephine Hart's slender, soapy novel of sexual obsession, to explain what happens when Dr. Stephen Fleming (Jeremy Irons) and Anna Barton (Juliette Binoche) meet. The setting is an otherwise boring party. The encounter seems random, though the two have reason to cross paths: Anna happens to be the new girlfriend of Martyn (Rupert Graves), Stephen's son.

The chemistry is so intense that an affair begins immediately, for reasons that the film simply takes for granted. Stephen has been seen staring wistfully around the house, showing only perfunctory interest in his unobjectionable wife (Miranda Richardson) and precocious daughter. The much bolder Anna is presented as one of those fearlessly honest sexual beings, the sort who make more sense in the imagination than they do in the flesh. On the simplest level, the two make a handsome couple, with Ms. Binoche's serene, chiseled features and Mr. Irons's ability to look great with a walking stick and a Labrador retriever. It's not possible to watch him without thinking of the word debonair.

The affair begins with what is supposed to be pure heat, in a deliberately wordless phase. Unfortunately, this does not last. In the throes of passion, Stephen is soon reduced to moaning "Who are you?" at his mysterious lover. (Anna's type of answer to that, on the page, is "I am what you desire.") And Anna's dialogue, in a screenplay filled with conversational lapses one might drive a truck through, is limited to lines like: "You must never worry. I'll always be there." No amount of love-goddess behavior can survive small talk like that.

•

It's important to appreciate the high-"Dynasty" tone of this material. The screenplay, adapted by David Hare, tells the sort of story in which when two male strangers meet for the first time, they immediately begin talking about Anna's love life. Ms. Hart herself wrote a brief but verbose book mixing high-flown philosophical musings with mundane conversation, a bodice-ripper on a lofty note. In the film, this tone is best captured by Leslie Caron, who turns up briefly (in the blindingly bright wardrobe of a soap-opera guest star) as Anna's mother. Her manner is suitably regal as she talks about — what else? — Anna's love life.

Not even a film maker of Mr. Malle's intelligence and taste can make this stilted story add up. The only ingredient that can make sense of "Damage" is the obvious one: outright eroticism, of the sort that pre-

sumably got the film its original NC-17 rating. Seldom have a film maker's complaints about having to trim his work to suit the Motion Picture Association of America's ratings board (which has since awarded "Damage" an R) seemed more reasonable, since without its full sexual component this tale is robbed of its best energy source. However, there is reason to suppose that even in its slightly more complete version, "Damage" would lack heat.

Mr. Malle made a far more erotic film about mother-son incest (the incomparable "Murmur of the Heart") than he has about the strenuous couplings depicted here. It must be noted that the film's sexual episodes are very strange. The staging is so arduous that the actors never appear comfortable or unself-conscious, which would seem to be two prerequisites for making their encounters work. On the simplest level, they often knock into things, and are forced into painfully awkward postures. One bout finds them seeming to be experiencing simultaneous seizures while attempting a difficult yoga position. Another has them leaning upright against an open door, which moves when they do. One particularly memorable event finds Ms. Binoche, however briefly, sitting on top of a stove.

Some of this appears to be a simple case of trying too hard, as when Mr. Irons nibbles Ms. Binoche's back as she tries to crawl away. In any case, the actors behave in a manner that is gallant but perplexed. The beautiful Ms. Binoche has the difficult task of embodying too much mystery, so that after two hours she has come to seem surprisingly ordinary. Mr. Irons is asked to look wounded and questing so often that the role approaches the absurd, though this actor's immense dignity carries him through. During the course of the story, as a wayward husband and Member of Parliament, he does have the chance to deliver one of the all-time great excuses: "I've got to go to the House and vote."

One of the film's quiet pleasures is the way it looks, which is often an improvement on how it sounds. The décor is flawlessly appealing and quite detailed, carrying the principals from one beautifully appointed setting to another. Brian Morris's production design and Milena Canonero's costumes often serve as a welcome distraction from the main action. This rarefied visual beauty, all wood paneling and interesting art and fresh flowers, does a lot to elevate behavior that wouldn't work in a less refined atmosphere.

Miranda Richardson's credible performance as Ingrid, Stephen's thoroughly correct wife, culminates in a violent outburst that gives the film some spark, not to mention a much-needed reality check. Mr. Graves, as Martyn, plays his role just as it's written, which means his character never seems to have much connection with the others. The father-son passions on which the story ultimately hinges make particularly little sense when the actors playing father and son seem barely to have met.

"Damage" is rated R. It includes nudity (much of it discreet) and graphic sexual situations.

1992 D 23, C13:1

Indochine

Directed by Régis Wargnier; screenplay (in French with English subtitles) by Eric Orsenna, Louis Gardel, Catherine Cohen and Mr. Wargnier; director of photography, François Catonné; music by Patrick Doyle; produced by Eric Heumann and Jean Labadie; released by Sony Pictures Classics. At the Lincoln Plaza Cinemas, Broadway and 63d Street. Running time: 155 minutes. This film is rated PG-13.

Éliane	Catherine Deneuve
Jean-Baptiste	Vincent Perez
Camille	Linh Dan Pham
Guy	Jean Yanne
Yvette	Dominique Blanc

WITH: Carlo Brandt, Mai Chau, Alain Fromager, Chu Hung, Jean-Baptiste Huynh, Gérard Lartigau, Hubert Saint-Macary, Henri Marteau, Thibault de Montalembert, Andrzej Seweryn, Eric Nguyen, Nhu Quynh, Tien Tho, Thi Hoe Tranh Huu Trieu, Nguyen Lan Trung and Trinh Van Thinh.

By VINCENT CANBY

Catherine Deneuve reigns in "Indochine." That is, she presides over its second-rate fiction with the manner of an empress who knows her powers are constitutionally limited but who continues to take her duties seriously. She can't change the course of the film, but her lofty presence keeps it from flying apart. She plays Éliane who, when first met in 1930, divides her time between a mansion near Saigon and a successful rubber plantation, which she oversees with (sometimes for) her widowed father.

Miss Deneuve has her work cut out for her, since the new French film, made on location at great expense and with attention to historical accuracy, intends to be nothing less than epic. "Indochine" is the story of the last 25 years of French rule in Indochina as reflected by the events in Éliane's life. The subject is potentially rich, but the screenplay, whomped up by three screenwriters in collaboration with Régis Wargnier, the director, has neither the conviction of

fact, the sense of revelation found in good fiction, nor the fun of trashy literature.

In 1930 Éliane enjoys all the perks that accrue to the dominant class in a smoothly functioning colonial society. Though French by birth, she has never seen France. She was born and reared in Indochina, which she considers as much her home as it is for the anonymous laborers who work on her plantation. Éliane is not as bigoted as some French. She is bringing up Camille (Linh Dan Pham) as her own daughter. The pretty teen-ager, an Annamese princess, was adopted by Éliane after her parents — Éliane's best friends — were killed in an accident.

Since Éliane is France to a large extent, it's not surprising that her life falls apart more or less in concert with French colonial rule, and that her heartbreak and (dare I say?) her hopes parallel those of France itself. She's sorely tried, both as an adoring mother and as the conscience of a great European nation.

Camille has been betrothed since childhood to Tanh (Eric Nguyen), a well-born Vietnamese fellow whom she likes but does not love. She shatters her adoptive mother by falling madly in love with Jean-Baptiste (Vincent Perez), a handsome, mostly uncharacterized French naval officer, who had once been Éliane's lover.

Éliane puts her foot down, but Camille runs off to join Jean-Baptiste at the remote outpost to which Éliane has arranged that he be sent. It's the beginning of the end for both the motherland and Éliane. I'm not giving away one-tenth of what happens in the movie by reporting that the feckless Tanh turns out to be a sort of Vietnamese Scarlet Pimpernel, a dedicated, recklessly brave Vietnamese freedom fighter and Communist.

Camille, too, is politicized, becoming known as "the red princess" for her underground activities. When last heard from in 1954, she's at the table in Geneva, a member of the Indochinese committee negotiating independence from France.

It's not easy for any movie, even one running for 2 hours and 35 minutes, to cover so much time and history and still maintain its coherence as drama. Though Éliane is the film's focal point, she is not Scarlett O'Hara. Éliane has her weaknesses: she falls in love with the wrong man, and she occasionally seeks solace in a pipe of opium. Yet she's not so much a character as a beautiful, somewhat frosty icon, like the statue of Marianne, the official symbol of the French Republic for which Miss Deneuve's likeness was used in 1985.

Without seeming to age a day from 1930 to 1954, Miss Deneuve moves through "Indochine" more as an observer than as a participant. Her Éliane/Marianne is not an embodiment of the ideals of the French Revolution, but a representation of the kind of chic associated with Coco Chanel and Yves Saint Laurent.

She looks ravishing from start to finish. She's supremely unruffled when a man with a nosebleed attempts to make love to her. Not a hair is out of place as she beats a worker for attempting to run away from the plantation. She's not a particular woman but an abstraction as she tells the victim, "Do you think I like beating my children?"

In spite of all that, Miss Deneuve lends the movie a lot of her own instinctive intelligence. Behind the movie-star facade, a real actress is at work. It's not her regal beauty but the force of her personality that carries the viewer through a choppy screenplay not always easy to follow. It may be that the film has been re-edited for

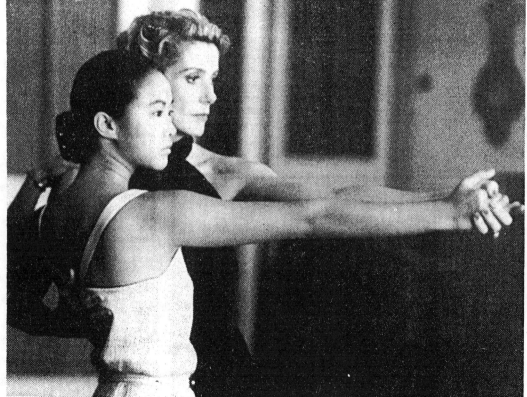

Sony Pictures Entertainment Inc.

Linh Dan Pham and Catherine Deneuve in "Indochine," a love story set amid the fall of French rule in Asia.

its American release, but whatever the reason, characters seem to disappear before their time, or to appear on screen without having been properly introduced. In the etiquette of cinema, this is called rude editing. There also are times when the soundtrack music hails an emotional crescendo that only it recognizes.

Aside from Miss Deneuve's performance, the only one worth noting is that of Jean Yanne, whose acting style has become increasingly self-important and busy since the early 1970's when he appeared in two fine Claude Chabrol films, "This Man Must Die" and "Le Boucher." Here he plays the head of the French security police in Saigon, a jaded functionary who half-heartedly courts Éliane while wearily going about his brutal job.

"Indochine" offers the audience much more history and many more views of the Vietnamese landscape than can be seen in "The Lover," Jean-Jacques Annaud's fine, laconic screen adaptation of the Marguerite Duras novel, also set in Vietnam in the 1930's. Yet "The Lover" evokes subtle truths about colonial relationships that are effectively buried in the epic fanciness of "Indochine."

•

"Indochine," which has been rated PG-13 (under 13 strongly cautioned), has scenes of violence.

1992 D 24, C9:1

Hoffa

Directed by Danny DeVito; written by David Mamet; director of photography, Stephen H. Burum; edited by Lynzee Klingman and Ronald Roose; music by David Newman; production designer, Ida Random; produced by Edward R. Pressman, Mr. DeVito and Caldecot Chubb; released by 20th Century Fox. Running time: 110 minutes. This film is rated R.

James R. Hoffa	Jack Nicholson
Bobby Ciaro	Danny DeVito
Carol D'Allesandro	Armand Assante
Frank Fitzsimmons	J. T. Walsh
Pete Connelly	John C. Reilly
Young Kid	Frank Whaley
Robert Kennedy	Kevin Anderson
Red Bennett	John P. Ryan
Billy Flynn	Robert Prosky
Jo Hoffa	Natalija Nogulich
Hoffa's Attorney	Nicholas Pryor

By VINCENT CANBY

IN his 1960 book, "The Enemy Within," Robert F. Kennedy, soon to be the Attorney General of the United States, wrote about his first face-to-face meeting with the man he had sworn to send to prison, James R. Hoffa, the powerful president of the International Brotherhood of Teamsters. Kennedy was surprised by how short the labor leader was, "only five feet five and a half."

Anyone who knows anything about Hoffa's rise and fall will be similarly surprised by how much he's grown in "Hoffa," the riveting, almost impressionistic new film biography, written with mean brilliance by David Mamet and directed by Danny DeVito in a splashy style best described as Las Vegas Empire.

The film not only presents a Jimmy Hoffa with the beefed-up physical dimensions of Jack Nicholson, who gives a gigantic powerhouse of a performance, but it also effectively rearranges the hierarchy of American heroes as it's understood in the 1990's.

Many people may be uncomfortably surprised.

"Hoffa" sees Kennedy, who was assassinated in 1968 in the middle of his campaign for the Democratic Presidential nomination, as he was perceived by Hoffa: a whiny, aggressive, Harvard-educated rich kid desperate for publicity, ready to use fair means and foul to trap Hoffa, and no match at all for Hoffa in their furious verbal confrontations.

Mr. DeVito and Mr. Mamet don't whitewash Hoffa, but they seem almost nonjudgmental about him. By omission they appear to sanction a complicated, very dubious, if colorful, character. In the context of most commercial movies today, which insist on explaining too much or repeating the obvious at seemingly endless length, "Hoffa" remains cool and detached, not unlike Mr. DeVito's very funny, very dark comedy, "The War of the Roses." Yet "Hoffa" is not a comedy. It is a take on history.

It's a serious consideration of the career of a man whose gift for the expedient and personally profitable alliance was the near-equal of Talleyrand's. Hoffa's ties to the Mafia not only cost the rank-and-file teamsters millions of dollars but also set a pattern for corruption that tainted the entire labor movement. His is a quintessentially American story, for only in America did Big Labor become a big business to rival Big Business.

•

"Hoffa" is a remarkable movie, an original and vivid cinematic work, but is that enough? I think it is. Others will have legitimate objections to the ways the film operates.

Mr. DeVito and Mr. Mamet stay at a discreet distance from Hoffa, neither sentimentalizing him nor attempting to analyze him beyond his own automatic defense that you have to do it unto others before others do it unto you. Without comment, and in very general terms, they document Hoffa's evolution from small-time labor reformer to big-time labor racketeer, master shakedown artist and influence-peddler, and friend to mobsters of frightening moment.

The tale is told in a series of flashbacks from the last day of Hoffa's life. On July 30, 1975, Hoffa disappeared forever, having been shot, according to some reports, his body placed inside an automobile compactor, the remains then buried in a location that no one yet has discovered.

The movie opens as the nervous, exhausted Jimmy, accompanied by his trusted factotum and pal, a fictitious character named Bobby Ciaro (Mr. DeVito), waits in the back seat of a Cadillac in the parking lot of a roadhouse near Detroit. Jimmy has an appointment with a long-time Mafia associate who, he hopes, will support him in his attempts to win back his place as the teamsters' president. Convicted of jury-tampering and sent to jail in 1967, Jimmy was paroled in

Part fact, part fiction, but a quintessentially American story.

1971 on the condition that he remain out of union politics until 1980. It's not a condition he has ever taken seriously.

The recollections that are the body of the film are not Jimmy's, but the adoring, busy Bobby's. Bobby can't sit still. He paces around the parking lot, goes into the roadhouse to make phone calls, returns with paper cups of coffee for Jimmy, reminisces a bit, gets out of the car again and paces.

Bobby frets over Jimmy's situation, recalling his first meeting with the vital, energetic Jimmy in the depressed 1930's when, one night on the road, Jimmy invited himself into the cab of his truck and attempted to recruit him for the teamsters. Jimmy was then something of an idealist. As the long day passes in the parking lot, Bobby chronologically remembers his way through Jimmy's career:

their days as members of a teamster goon squad, torching a company that failed to recognize the union; Jimmy's success in a brutal confrontation with police while organizing the Railway Transport workers, and his introduction to the Mafia in the person of (the fictitious) Carol D'Allesandro (Armand Assante). He's the film's representation of the forces that provided much of the pressure and muscle that made possible Hoffa's rise within the teamsters' union.

In one of the film's more bizarre inventions, Bobby remembers a crucial hunting trip during which D'Allesandro outlines the ways Jimmy might manipulate the teamsters' pension fund to make loans to the mob and enrich all concerned, with the exception of the membership. As the two men are signing an agreement on the back of a hunting license, Bobby, not a natural hunter, spots a sluggish deer, takes out his pistol and shoots it between the eyes.

•

Although Bobby's memory is fond, "Hoffa" sees all impassively, with a shrug that seems to ask, "Well, what can you do about it?" This gives "Hoffa" a bitterly skeptical edge that is rare in American movies. It forces viewers to make up their own minds, something that can be immensely disorienting as well as rewarding. The film suggests there are times when you have to think for yourself.

A more reasonable objection to the movie is the way it necessarily foreshortens history, simplifies events, and either ignores important real-life characters or reinvents them as composites. This is dramatic license, but dramatic license often seriously distorts, which is not easily acceptable when the subject is as rich and significant as the Jimmy Hoffa story.

The movie notes in passing, but doesn't appear to understand, Hoffa's real achievement in negotiating the precedent-setting National Master Freight Agreement, guaranteeing teamsters uniform wage and benefit conditions across the country. The movie also doesn't begin to suggest the profound complexity of Hoffa's connections to the mob, his relations to his wife and family, and the teamsters' connections to the Government. A lot has been left out, which is unfortunate, since the snarl of these relationships is what seems finally to have done him in.

The great thing about "Hoffa" is that it doesn't pretend to be a docudrama or anything like it. It's not a

King of corruption: Jack Nicholson as Jimmy Hoffa.

François Duhamel

François Duhamel

Danny DeVito in "Hoffa."

vulgarized rip-off of Costa-Gavras movies, reduced to the exploitation of the latest case of murder, kidnapping or child molestation, or a briefly notorious domestic disagreement. "Hoffa" is an original work of fiction, based on fact, conceived with imagination and a consistent point-of view.

•

In addition to Mr. Assante and Mr. DeVito, the excellent supporting cast includes J. T. Walsh as Hoffa's colleague and successor, Frank Fitzsimmons; John C. Reilly as a protégé who squeals on Hoffa; Natalija Nogulich, briefly seen as Jimmy's wife; Kevin Anderson as Robert Kennedy; Frank Whaley as a young man befriended by Bobby in the course of the day in the roadhouse parking lot, and Robert Prosky as another early associate of Jimmy.

Mr. DeVito's direction is full of extravagant gestures that seem entirely in keeping with Bobby's highly colored memories of life with Jimmy. There are a number of grand overhead shots, as if the camera were in the position of a gaudy casino chandelier, whether it's a scene of Jimmy in prison or a panoramic view of union men fighting scabs. At the same time, Mr. DeVito knows when to use closeups, that is, to reveal character rather than to punctuate dialogue. When the director shows a remembered explosion and fire, they have the huge proportions of something reported in a tall story told late at night in a favorite bar.

Mr. Nicholson has altered his looks, voice and speech to evoke Hoffa, but the performance is composed less of superficial tricks than of the actor's crafty intelligence and conviction. The performance is spookily compelling without being sympathetic for a minute. Unlike Norman Jewison's "F.I.S.T." (1978), an underrated Sylvester Stallone movie about a Hoffa-like character, the new film doesn't mourn Jimmy's lost innocence. "Hoffa" is a tough movie about American life. It hasn't time for tears.

•

"Hoffa," which has been rated R (Under 17 requires accompanying parent or adult guardian), is full of obscene language and violence.

1992 D 25, C1:1

Chaplin

Directed by Richard Attenborough; screenplay by William Boyd, Bryan Forbes and William Goldman, based on "My Autobiography," by Charles Chaplin and "Chaplin: His Life and Art," by David Robinson; director of photography, Sven Nykvist; edited by Anne V. Coates; music by John Barry; production designer, Stuart Craig; produced by Mr. Attenborough, Mario Kassar and Terence Clegg; released by Tri-Star Pictures. Running time: 142 minutes. This film is rated PG-13.

Charlie Chaplin	Robert Downey Jr.
Hannah Chaplin	Geraldine Chaplin
Charlie Age 5	Hugh Downer
Charlie Age 14	Tom Bradford
Sydney Chaplin	Paul Rhys
Fred Karno	John Thaw
Hetty Kelly/Oona O'Neill	Moira Kelly
George Hayden	Anthony Hopkins
Stan Laurel	Matthew Cottle
Mack Sennett	Dan Aykroyd
Mabel Normand	Marisa Tomei
Edna Purviance	Penelope Ann Miller
Douglas Fairbanks	Kevin Kline
J. Edgar Hoover	Kevin Dunn
Paulette Goddard	Diane Lane
Joan Barry	Nancy Travis
Lawyer Scott	James Woods

Tri-Star Pictures

Geraldine Chaplin and Robert Downey Jr. in a scene from "Chaplin."

By VINCENT CANBY

"Chaplin," the screen biography of Charlie Chaplin, is the film you might have seen in your fearful mind's eye when it was announced as the next project for Richard Attenborough, the English director of "Oh! What a Lovely War," "Young Winston" and "Gandhi."

"Chaplin" is thorough. It begins when Charlie is 5 in a London music hall and plows through the rest of his life, ending shortly before his death in Vevey, Switzerland, on Christmas Day 1977, at the age of 88.

Based on two books, Chaplin's "My Autobiography" and David Robinson's scholarly, very complete "Chaplin: His Life and Art," the film is dutiful. Though slow of pace, it is so hurried that the best it can do to cover the material is to identify significant characters and eras and keep moving. It is terrifically appreciative, extremely long and has two welcome surprises.

The first is Robert Downey Jr. He is good and persuasive as the adult Charlie when the material allows, and close to brilliant when he does some of Charlie's early vaudeville and film sketches. His slapstick routines are graceful, witty and, most important, really funny. The other surprise is Geraldine Chaplin, Chaplin's eldest child by his last wife, Oona O'Neill. She's splendid playing her own grandmother, Hannah Chaplin, whose slide into madness provides the movie with its only emotional weight.

"Chaplin" is otherwise rather like the autobiography: windy, courtly, full of names and dates but never terribly revealing about either the film maker's life or his art. In view of the fact that the autobiography was harshly criticized for its superficiality, the narrative device employed by the screenplay is so idiotic as to seem self-destructive. The conceit used to introduce the film's flashbacks is to have the aging Charlie, while working on the book in Vevey, discussing the manuscript with his editor, a fictional character named George Hayden (Anthony Hopkins).

It's as if George had already had a peek at the book's reviews. He's likely to say something like: "Charlie, you haven't told us much about your father. Why is that?" To which Charlie might say, "I didn't like him." End of topic. Or, "Tell me, Charlie, when did you actually start work on 'The Great Dictator'?," which serves to introduce a quick clip that demonstrates not much of anything. It's merely a reminder of what the audience is missing.

George's comments are also politely used to shovel in information, as in this unlikely expostulation: "My God, Charlie, you weren't even 30. You had your own studio. You were the most famous man in the world. Couldn't you slow down?"

With the exception of the moving episodes involving Ms. Chaplin, the film makers never transform Charlie's life into significant drama. Chaplin had an unusually long and productive life. It was often tumultuous, what with his recurring problems with wives and other women, but (and the film bears this out) he was the kind of man who could lose himself entirely in his work. One suspects that the tumult was far harder on the

people in his immediate vicinity than on him.

Geraldine Chaplin plays her own grandmother, who went mad.

Chaplin's childhood was deeply troubled but, early on, he achieved phenomenal success and the status of a major artist, which he hung onto until he died, along with his money and the rights to virtually all of his films. The movie tries very hard to whip up dramatic momentum when J. Edgar Hoover and the Federal Bureau of Investigation go after Charlie.

Hoover, convinced that Chaplin's loosely defined left-wing politics were a danger to the country, tried to discredit him. There was first the scandal involving the young, mentally unstable Joan Barry, who was somehow goaded into filing a paternity suit against Chaplin. When that failed to dim Chaplin's career, Hoover pursued his attacks by suggesting that Chaplin was either a card-carrying Communist or a fellow traveler. This was all by innuendo and finally successful, which is understandable considering the political climate of the country in the late 1940's and early 50's. After Chaplin and Oona O'Neill sailed to Europe in 1952, his re-entry permit (he was a British citizen still) was revoked.

This is a vile chapter in American history but, though Chaplin lived ever afterward in European exile, he seems also to have enjoyed the happiest and most serene days of his life, married to a woman he loved deeply and with whom he had eight children. He directed two more films ("A King in New York" and "A Countess From Hong Kong"), supervised the successful reissue of several of his earlier films and, in 1972, made a triumphant return to this country to receive a special Academy Award. Buster Keaton should have had such a life.

It's difficult to tell what Mr. Attenborough thought to be the purpose of "Chaplin." The film is certainly not a critical biography. It adds nothing to one's understanding of the man's work. Several times Mr. Attenborough tries to portray events in Chaplin's life as if they were from Chaplin films (sequences featuring a lot of running around and pratfalls, shot with a speeded-up camera). These results are witless and embarrassing.

•

The production, photographed by Sven Nykvist, is handsome and dull. Among the many familiar actors who come and go are Dan Aykroyd (who plays Mack Sennett), Paul Rhys (Chaplin's brother, Sydney), Marisa Tomei (Mabel Normand), Kevin Kline (Douglas Fairbanks), Penelope Ann Miller (Edna Purviance) and Diane Lane (Paulette Goddard). Another of Mr. Attenborough's conceits is to have Moira Kelly, as a London chorus girl beloved by Charlie, and who dies in the great influenza epidemic of 1918, return to the film as Oona O'Neill. The effect is lost, though, since both characters are so bland that you might not recognize the trick without having carefully read the cast list.

Mr. Downey and Ms. Chaplin give the movie what class it has.

"Chaplin" is to serious biography, even to Mr. Attenborough's "Gandhi," what unfortified cornflakes are to real food. It's slick packaging around what is mostly warm air.

•

"Chaplin," which has been rated PG-13 (Parents strongly cautioned), has some female nudity.

1992 D 25, C3:1

Peter's Friends

Produced and directed by Kenneth Branagh; written by Rita Rudner and Martin Bergman; director of photography, Roger Lanser; edited by Andrew Marcus; production designer, Tim Harvey; released by Samuel Goldwyn Company. Running time: 102 minutes. This film has no rating.

Roger	Hugh Laurie
Mary	Imelda Staunton
Peter	Stephen Fry
Maggie	Emma Thompson
Andrew	Kenneth Branagh
Sarah	Alphonsia Emmanuel
Carol	Rita Rudner
Vera	Phyllida Law
Paul	Alex Lowe
Brian	Tony Slattery

By JANET MASLIN

"Peter's Friends," a cheerfully derivative comedy about a group of old friends enjoying a house-party reunion, borrows so blatantly from "The Big Chill" that it takes a while to realize this film has some life of its own. Once again, the principals are brought together to reconsider the courses of their lives. Once again, these decisions are made to the tune of an ebullient rock soundtrack. Once again, thoughts of mortality lend substance to what otherwise would look like lighthearted fun.

The setting this time is a grand English manor house, which Peter (Stephen Fry) has recently inherited in one of the film's more conspicuous coming-of-age touches. A decade earlier, the principals were college chums joining forces to stage a giddy New Year's Eve musical revue. But they are now at a more serious stage in their lives.

Maggie (Emma Thompson) is desperately lonely, and determined to do something about it. Roger and Mary (Hugh Laurie and Imelda Staunton) are recovering from the loss of a child. Sarah (Alphonsia Emmanuel) has embarked on one too many ill-considered affairs, this one with Brian (Tony Slattery), a married actor. Brian's biggest dramatic accomplishment is feigning interest in what others have to say.

Kenneth Branagh, who produced and directed the film, also appears as Andrew, who once aspired to be a serious playwright and. is now best known as the creator of an American sitcom. Appearing as Carol, his brassy American wife, is Rita Rudner, who wrote the screenplay with her husband, Martin Bergman, and all but steals the film. "Did you ever see 'Upstairs, Downstairs?'" Carol worriedly asks Peter's cook, who has somehow failed to jump at her orders the way they do back in Hollywood.

Arriving with a load of exercise equipment and a Rodeo Drive wardrobe that is a comedy act all by itself, Ms. Rudner's Carol makes no bones about not fitting in with her husband's English friends. Looking around the manor, she denies that a house of

Clive Coote

Kenneth Branagh

hers in Bel Air was vulgar, saying, "It was just like this, only everything was brand new." Inspecting her room, she complains to Peter about the lack of a television set, only to learn there are none anywhere in the house. "That's all right, I'll read," she says bravely. "Does anyone have a book?"

As the foil to such a flamboyant character, Mr. Branagh has a lot to work with. "If we stay together five years, I get free hair transplants and she gets a new set of breasts," he tells Peter, while discussing the likely longevity of the marriage. "So then she'll have four?" Peter asks. "No, her agent gets one," Andrew answers.

•

Although "Peter's Friends" eventually sounds a note of gravity, and although it addresses AIDS more directly than many films have, it remains a lightweight entertainment, enjoyable mostly for the fun of hearing arch, skillful actors deliver droll remarks. Mr. Branagh's direction is blithe and serviceable without having any particular hallmarks, save perhaps an appreciation of the talent he has assembled. If the film didn't have two vulgar show-biz characters to make fun of, it would have a lot less verve.

Ms. Thompson is once again a delight, fidgeting nervously in shapeless smocks until Ms. Rudner's Carol says, "You are a very pretty girl, yes, but you make Mother Teresa look like a hooker." As Maggie, she is so insecure that she leaves Polaroids of herself all over her apartment for the benefit of her cat, who apparently couldn't care less. Maggie's desire to win over Peter is only one of the romantic currents that keep the film more or less in motion. Another subplot has to do with the promiscuity of Sarah, of whom Andrew says: "You know those mice that go round on wheels? Imagine one wearing a tight leather skirt." "Peter's Friends," sunny and superficial, works best on the level of quips like that.

1992 D 25, C8:6

Trespass

Directed by Walter Hill; written by Bob Gale and Robert Zemeckis; director of photography, Lloyd Ahern; edited by Freeman Davies; music by Ry Cooder; production designer, Jon Hutman; produced by Neil Canton; released by Universal Pictures. Running time: 104 minutes. This film is rated R.

Vince	Bill Paxton
King James	Ice-T
Don	William Sadler
Savon	Ice Cube
Bradlee	Art Evans

By VINCENT CANBY

"Trespass" is an outlandishly melodramatic, all-male morality fa-

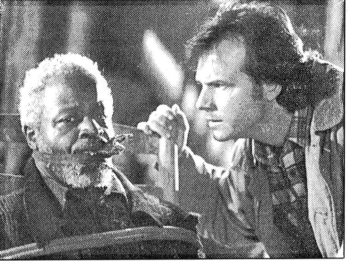
Sam Emerson/University City Pictures

At Odds Art Evans, left, plays a squatter and Bill Paxton a fireman in Walter Hill's thriller "Trespass," about an encounter between two rural firemen and local criminals. The action takes place amid a hunt for stolen gold in a tenement in East St. Louis, Ill.

ble about two white firemen from Arkansas who go hunting for buried treasure in an abandoned, exceptionally photogenic factory in East St. Louis, Ill. In the course of their search, they are discovered by the members of a gang of black hoodlums who, thinking the off-duty firefighters are on-duty policemen, set out to capture and murder them. Most of the violent cat-and-mouse game takes place inside the factory within one day that seems 96 hours long.

The movie was written by Bob Gale and Robert Zemeckis, best known for the "Back to the Future" comedies, and directed by Walter Hill ("Southern Comfort," "The Driver," "48 Hours"), whose hand has never been heavier. The cast is headed by Bill Paxton and William Sadler, who play the firemen (one good guy and one bad guy), and Ice-T and Ice Cube, the rap performers who appear as the two principal gang members. Art Evans gives the film's most interesting performance as a homeless black man who lives in the factory and whose routine is disturbed by the warring interlopers.

That Mr. Gale and Mr. Zemeckis are very funny writers is nowhere apparent in "Trespass." With the exception of a running gag about the gangsters' use of cellular telephones, the film is singularly humorless. Though full of the kind of simulated violence achieved by special-effects artists, it's not too heavy on suspense. Everything in the screenplay seems arbitrary, including the firefighting jobs assigned to the two would-be treasure-seekers. They could as easily be magazine salesmen or amateur songwriters.

•

The movie also never makes clear the crimes of choice of this particular gang, though drugs would seem to be obvious. Ice-T and Ice Cube may be ravaging rappers on records and television, but they seem to be especially lightweight presences in "Trespass," less menacing than attitudinizing. They both adopt fixed frowns and use a lot racial epithets, but their favorite 12-letter obscenity now sounds like an endearment. In particular, Ice Cube appears to have been denatured, possibly because he's been denied recourse to the crotch-clutching gesture that best

defines the politics of his music videos.

Mr. Hill has difficulty filling the running time. There is much creeping around litter-filled corridors, stairwells, chimneys and air shafts. Hostages are taken. Every now and then a fierce gunfight breaks out, at which point the film's sound levels are turned up to awaken the drowsy.

•

"Trespass," which has been rated R (Under 17 requires accompanying parent or adult guardian), has a lot of obscene language and violence.

1992 D 25, C18:5

Lorenzo's Oil

Directed by George Miller; written by Nick Enright and Mr. Miller; director of photography, John Seale; edited by Richard Francis-Bruce, Marcus D'Arcy and Lee Smith; production designer, Kristi Zea; produced by Doug Mitchell and Mr. Miller; released by Universal. Running time: 140 minutes. This film is rated PG-13.

Augusto Odone	Nick Nolte
Michaela Odone	Susan Sarandon
Professor Nikolais	Peter Ustinov
Deirdre Murphy	Kathleen Wilhoite
Doctor Judalon	Gerry Bamman
Wendy Gimble	Margo Martindale
Ellard Muscatine	James Rebhorn
Loretta Muscatine	Ann Hearn
Omouri	Maduka Steady

By JANET MASLIN

"Lorenzo's Oil" is the tough-minded, completely gripping story of Augusto and Michaela Odone, parents who responded magnificently after receiving the worst conceivable news about their child. At 5, Lorenzo Odone began exhibiting symptoms of what would soon be diagnosed as adrenoleukodystrophy, a rare and invariably fatal disease. The Odones were essentially told that the best they could do would be to make Lorenzo's last days comfortable. They were told that he would die within two years.

The Odones found that prognosis unacceptable. And, amazingly, they did something to change it. This economist and linguist set out to educate themselves to tackle a complex medical mystery, and take on the slow-

Mikki Ansin/Universal

Susan Sarandon, Zack O'Malley Greenburg, center, and Nick Nolte in a scene from "Lorenzo's Oil," a new film directed by George Miller.

moving medical establishment in the process. On their own, they undertook the job of determining what, if anything, would keep their son alive.

"Lorenzo's Oil" is not the maudlin television-movie version of such a tale. There are no false miracles; there are no self-congratulatory triumphs; there is no smiling through anyone's tears. As directed by George Miller, the former physician whose unusual résumé includes "The Witches of Eastwick" and "Mad Max," this film has an appealingly brisk, unsentimental style and a rare ability to compress and convey detailed medical data. It also displays tremendous compassion for all three Odones and what they have been through.

•

There is no small talk in "Lorenzo's Oil"; there isn't time. Mr. Miller hurtles forward so quickly, in fact, that Lorenzo's adventurous early years are seen only as cinematic snapshots of happier, less complicated days. Beginning with a prologue showing the family living in Africa, the film moves to Washington, where Michaela (Susan Sarandon) is given the first telltale sign: a teacher's account of Lorenzo's disruptive behavior in school. Typically protective of her son, Michaela sniffs that the boy must have been provoked.

The family's house is a few doors down from Lorenzo's school, and the children seem to fly out the door in joyous, healthy flocks. (House, school and a medical library seen later have all been convincingly created for the film.) This becomes increasingly painful as Lorenzo, played as a confident, precocious child by Zack O'Malley Greenburg and several other young actors, begins falling into decline. He tumbles off his bike, has unaccountable tantrums and tips over the family's Christmas tree. Using swift editing and vigorous camera movements, Mr. Miller frames these episodes with shock and foreboding, as if "Lorenzo's Oil" were a horror movie, which in a sense it is.

He also lingers on expressive two-shots of Augusto (Nick Nolte) and Michaela as they absorb each new piece of bad news, giving the film a true heart-in-the-throat intensity. As Michaela, Ms. Sarandon movingly combines private terror with cold fury. Her huge, expressive eyes have never seemed more full of feeling as she plays a stubborn, ferocious mother who snaps bitterly at those who thwart her, and crusades tirelessly in behalf of her son. Mr. Nolte is so skillful that he actually seems Italian, despite strong physical evidence to the contrary. At one point he even conducts a domestic argument complete with hand-waving, shouting dialogue that has to be subtitled.

•

It is Mr. Nolte's Augusto who becomes the family's researcher, beginning with a sequence in which he visits a medical library after the diagnosis has been made. The film achieves maximum effectiveness here by letting terrible words out of medical texts: "blindness," "dementia," "death" literally swim before Augusto's eyes. Later on, he becomes so frequent a visitor to the library that he is seen wearing house slippers while he studies. Mr. Miller resorts to all manner of instructional aids — graphs, flow charts, models of fatty-acid molecules made from paper clips — to convey what Augusto has learned.

As the Odones are seen encountering other parents who face ALD (as the disease is known), "Lorenzo's Oil" effectively raises the issues surrounding AIDS research as well. Desperate for time, the Odones are eager to try experimental treatments for Lorenzo, but are told by other ALD parents that it is more decorous to wait until such measures are approved by doctors. Peter Ustinov, used effectively as a doctor irritated by the Odones' haste, represents the maddeningly cautious view that no treatment can be tried until it has been discussed, financed and duly tested.

In response, the Odones are seen organizing their own medical symposium and doing the remarkable detective work that leads to the title discovery, a miraculous substance that is mostly olive oil. "I am not a scientist," Augusto says angrily, when challenged about the oil. "I am a father. And nobody can tell me what dressing I can put on my kid's salad, O.K.?"

•

Only once during "Lorenzo's Oil" do Mr. Nolte and Ms. Sarandon, who both give hugely affecting performances, actually register the enormity of their ordeal. Late in the story, Augusto forces Michaela to think about how much damage has actually been sustained by Lorenzo, who by then can no longer communicate with his parents at all. "Do you ever think," asks Augusto, posing a terrible question, "that maybe all this trouble has been for somebody else's kid?" The film's coda provides an impressive but wrenching answer.

The persuasiveness of "Lorenzo's Oil" is greatly enhanced by Kristi Zea's lively, inviting production design, and by the various young actors who create glimpses of Lorenzo's harrowing experience. Also notable are Kathleen Wilhoite as Michaela's sister, who shares the genetic destiny of carrying ALD and goes to great lengths to hold the family together, and Margo Martindale as an ALD parent who shares the Odones' independent spirit. Don Suddaby, playing himself as the English research chemist who helped to devise the vital ingredient for the Odones' formula, also makes an invaluable contribution on screen.

•

"Lorenzo's Oil" is rated PG-13 (Parents strongly cautioned). It includes mild profanity.

1992 D 30, C7:3

The Golden Stallion

Directed by William Witney; produced b Republic Pictures; Released by Kit Parke Films. Film Forum 1, 209 West Housto Street, South Village. Running time: 67 min utes. This film has no rating.

Roy Rogers..Himse
Stormy Billings Dale Evan

Roy Rogers: King of the Cowboys

Written and directed by Thys Ockersen; d rector of photography, Peter Brugman; m sic by the Sons of the Pioneers, Roy Roger Dale Evans, Roy Rogers Jr. and Emm Smith; produced by Kees Ryninks. At Fil Forum 1, 209 West Houston Street, Sou Village. Running time: 80 minutes. This fil has no rating.

By STEPHEN HOLDEN

The appeal of Roy Rogers, Holly wood's second most popular singin cowboy after Gene Autry, was no limited to North America. An earl scene in the Dutch film maker Thy Ockersen's documentary film "Ro Rogers: King of the Cowboys," show an Amsterdam movie theate crammed with children who are thor oughly caught up in a subtitled Rog ers horse opera.

The film maker cheerfully admit that as a boy he, too, was smitten b the Rogers mystique. He even ap pears briefly in a cowboy neckerchie and wide-brim hat, riding a stic horse the way he used to as a child.

•

That spirit of playful homage pe vades the movie, which opened toda at Film Forum 1 on a double bill wit "The Golden Stallion," a typical Rog ers film from 1949. The likable straightforward documentary fo lows Mr. Ockersen from the Nether lands to the United States as h tracks down and eventually meets hi idol in the Roy Rogers Museum i Victorville, Calif. His travels are reg ularly interspersed with previews o

Roy Rogers and Trigger

Film Forum

coming attractions and short excerpts from Rogers movies. Along the way Mr. Ockersen drops in on a Roy Rogers festival in Portsmouth, Ohio. He also interviews assorted relatives and associates who all seem to agree that Mr. Rogers is a nice guy and was a dream to work with.

They include William Witney, who directed many of the films that the star made for Republic Pictures. Although the director praises Mr. Rogers's horsemanship, he reserves his most glowing compliments for the horse Trigger, who, by all accounts, lived up to his marquee billing as "the smartest horse in the movies." Mr. Ockersen also speaks with Roy Rogers Jr., who has a career singing his father's songs with a latter-day incarnation of the Sons of the Pioneers.

The portrait that emerges of the star, who is now 80, suggests someone who is not unlike the laconic cowboy hero he played on screen. Born in Cincinnati, Mr. Rogers, whose original name was Leonard Slye, made the first of his 91 feature films in 1938. At the peak of his career he averaged seven films a year. These B-movie westerns typically ran a little over an hour, and each took several weeks to crank out. With the arrival of television, he went on to film more than 100 half-hour episodes of a regular series.

•

When the director eventually meets his idol in the museum that bears his name, the star seems as modest and dignified — and ultimately as enigmatic — as he appeared in his movies. "I had no acting lessons — I just played myself," he recalls and speaks softly about God. Then his wife, Dale Evans, with whom he was first paired in 1944 in "The Cowboy and the Senorita," arrives.

As garrulous as her husband is reticent, she coaxes him into joining her in their favorite song from a Roy Rogers film, "The Lights of Old Santa Fe." At the end they exchange a kiss, which is something that they weren't allowed to do in their movies because, as Miss Evans explains, "Kids didn't like kissing." Trigger is in the museum too, stuffed but looking very lifelike.

1992 D 30, C12:3

Il Portaborse

Directed by Daniele Luchetti; written by Sandro Petraglia, Stefano Rulli and Mr. Luchetti, (in Italian with English subtitles), based on a story by Franco Bernini and Angelo Pasquini; director of photography, Alessandro Pesci; edited by Mirco Garrone; music by Dario Lucantoni; production designers, Giancarlo Basili and Leonardo Scarpa; released by Titanus Distribution. Joseph Papp Public Theater, 425 Lafayette Street, East Village. Running time: 93 minutes. This film has no rating.

Luciano Sandulli	Silvio Orlando
Cesare Botero	Nanni Moretti
Francesco Sanna	Giulio Brogi
Juliette	Anne Roussel
Irene	Angela Finocchiaro
Sebastiano Tramonti	Graziano Giusti

By STEPHEN HOLDEN

The ghost of Benito Mussolini haunts "Il Portaborse," a satirical comedy about the ascent of a crypto-Fascist Italian politician with a telegenic face and the conscience of a sewer rat.

The rise of this fascinating monster, Cesare Botero (played by Nanni Moretti), is followed through the eyes of Luciano Sandulli (Silvio Orlando), an Italian literature teacher and professional ghostwriter who is sucked into Botero's inner circle. Money is the lure. Even with the extra money earned from ghostwriting novels and political columns, Luciano still can't afford repairs on a grand country home whose ceiling rains plaster on his head while he works.

One day Luciano is visited by representatives of Botero, Italy's high-powered Minister of Finance. Whisked to their boss's inner sanctum, Luciano is pressed into accepting a job as a speechwriter for the minister's embattled re-election campaign.

Botero, who cultivates an image of a progressive-minded smoothie with

Silvio Orlando and Anne Roussel in a scene from "Il Portaborse."

a picture-perfect family, is a different character behind the scenes. A control freak with an explosive temper, he tyrannizes his staff and encourages his henchmen to rough up demonstrators who would mar his public appearances. Luciano also discovers that Botero is thoroughly corrupt. The minister, who portrays himself as a forward-looking civil servant, in private ridicules modern politics as "grotesque" and arrogantly compares himself to a feudal baron.

As Botero's pet, Luciano becomes the recipient of favors. A new sports car appears in his driveway, his house is fixed up, and his fiancée, Irene (Angela Finocchiaro), suddenly lands a better teaching job. Juliette (Anne Roussel), a beautiful assistant to the minister, makes it clear to Luciano that she is also available for him.

If "Il Portaborse," which opened today at the Joseph Papp Public Theater, is an ominous political fable, the tone is almost perversely lighthearted. And the film, a French-Italian production directed by Daniele Luchetti, lacks any of the thriller elements that would be de rigueur in a Hollywood movie about political corruption. Even in its darkest moments, "Il Portaborse" never loses its attitude of cheery cynicism. It goes so far as to suggest that in Italy it is fairly easy to carry off a gigantic voting fraud, whether through paper ballots or computers.

•

Because the film, which created a minor storm when it was shown at the Cannes Film Festival in 1991, seems to allude to contemporary figures in Italian politics, American audiences will feel a sense of dislocation. It also doesn't help that the movie lacks even a rudimentary explanation of the Italian political system.

"Il Portaborse" is quite well acted. Mr. Orlando's Luciano is a blank, faintly comic figure whose one pathetic gesture of nobility is to try to secure a pension from Botero for an impoverished but distinguished poet he reveres. But the film really belongs to Mr. Moretti, whose portrait of a power-hungry megalomaniac is notable for the way it captures the chameleonlike temperament of someone who can transform himself from a thundercloud into a font of sweetness and charm in the blink of an eye.

1992 D 31, C18:1

Film/1992

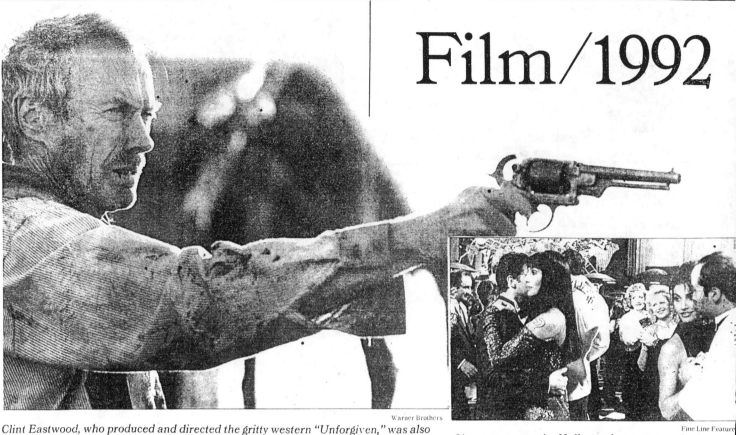

Warner Brothers

Clint Eastwood, who produced and directed the gritty western "Unforgiven," was also the movie's star.

Fine Line Feature

Cher was among the Hollywood partygoers who turned up in Robert Altman's film "The Player," a satirical loo at the movie industry.

VINCENT CANBY

Let's Hear It for Clint and Jack And Also Welcome a Few Newcomers

Incumbent Icon Clint Eastwood, the director, star and enduring cinematic spirit of "Unforgiven." Icon-Elect: Jack Nicholson ("A Few Good Men," "Hoffa").

Ring in the New Welcome the directors of memorable first features: Allison Anders ("Gas Food Lodging"), Carl Franklin ("One False Move"), Nick Gomez ("Laws of Gravity"), Barry Primus ("Mistress"), Tim Robbins ("Bob Roberts"), Quentin Tarantino ("Reservoir Dogs").

But Don't Forget the Old Orson Welles's "Othello," Federico Fellini's "8½" and Joseph L. Mankiewicz's "All About Eve," presented at the Film Forum, and Howard Hawks's "Twentieth Century," the highlight of the Walter Reade Theater's Carole Lombard retrospective.

Stop Her Before She Kills Again This may have been the Year of the Woman, but she's on a rampage: Sharon Stone ("Basic Instinct"), Kim Basinger ("Final Analysis"), Rebecca De Mornay ("The Hand That Rocks the Cradle") and Jennifer Jason Leigh ("Single White Female").

Once Brilliant Star Turns Into Black Hole The year's most thoroughly obscured actor: Whatsisname, the fellow who plays the title role in "Batman Returns."

Best Drama, Best Comedy Woody Allen's "Husbands and Wives." (Most Subver-

sive Comedy: Aki Kaurismaki's Finnish chef d'oeuvre, "The Match Factory Girl.")

Best Film Adaptation of an American Play "Glengarry Glen Ross," David Mamet's screen reworking of his drama, directed by James Foley.

Why Francis Ford Coppola Must Envy Spike Lee Mr. Coppola, who has all of the talent in the world, has nothing much to say though he has great fun saying it (in "Bram Stoker's Dracula"), while the equally talented Mr. Lee ("Malcolm X") has so much on his mind that he can't seem to make movies fast enough.

Actresses to Watch Come Oscar Time Emma Thompson ("Howards End"), Judy Davis ("Husbands and Wives"), Michelle Pfeiffer ("Batman Returns").

Winner of the 1992 "Heaven's Gate" Total Confusion Award Barry Levinson's "Toys."

Worst Box-Office Hit "Sister Act." (Best Box-Office Flop: Carroll Ballard's "Wind.")

JANET MASLIN

Kicking Around Hollywood And Rating the Ratings

Silly Ratings Three major misfires: "Home Alone 2" (a sadistic PG), "Batman Returns" (PG-13, nice for the tie-in toy market but not representative of the film's double-entendres and mean-spirited mood) and "Basic Instinct" (if this is an R-worthy thriller, Sharon Stone is Santa Claus).

Derrick Santini/Orion Classics

Emma Thompson in the Merchant-Ivory production of "Howards End."

Sidney Baldwin/Castle Rock Entertainment

Jack Nicholson in Rob Reiner's courtroom drama, "A Few Good Men."

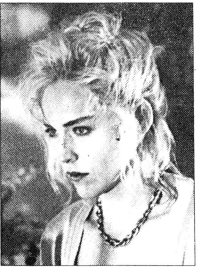

Tri-Star Pictures

Sharon Stone as the femme fatale in Paul Verhoeven's "Basic Instinct."

A Deadlier New Strain of Femme Fatale Sharon Stone and her various weapons, the vengeance-minded Kati Outinen in Aki Kaurismaki's "Match Factory Girl," Meryl Streep and Goldie Hawn stretching the limits of self-improvement in "Death Becomes Her." Special breed of femme fatale: Jaye Davidson's one-of-a-kind performance in "The Crying Game."

Home Video Alert "Far and Away," "The Power of One," "Memoirs of an Invisible Man," "Gladiator," "Straight Talk," "Year of the Comet" and "Man Trouble" are part of the Hollywood effluvia that will wash up on unsuspecting VCR's long after 1992 is gone.

Strong Satire On the subjects of Hollywood ("The Player," "Mistress") and politics ("Bob Roberts").

Strange Bedfellows Malcolm X and the Baroque composer known only as Monsieur de Sainte-Colombe, subjects of the year's most surprising screen biographies, "Malcolm X" and "Tous les Matins du Monde." Both films are surprising for many reasons, not least the fact that they actually exist.

Proof That There Are Limits to Prurient Interest The weak box-office performance of "Husbands and Wives," a troubling work but also one of Woody Allen's best films. Possible explanation of the public's reluctance: Mr. Allen's "Shadows and Fog," released several months earlier.

Global Warming Crowd-pleasing films from Ireland ("The Playboys," "Hear My Song") and China ("Raise the Red Lantern") change the shape of the foreign film market. Thanks to Aki Kaurismaki, frozen Finland looks equally hot.

Racial Harmony A major topic in many films this year, handled most successfully when dealt with head-on. Better tough talk ("Malcolm X," "White Men Can't Jump") or well-observed characters ("One False Move," "Love Field") than no talk at all ("Sister Act," "The Bodyguard"). Even "Lethal Weapon 3" managed to be smart about this.

C A R Y N J A M E S

Are Actors the Best Directors? (And Should Columbus Sue?)

Women Who Kill Too Much Sharon Stone as the bisexual writer whose motto is "an icepick under every bed" in "Basic Instinct," and Rebecca De Mornay as the murderous nanny hired without references in "The Hand That Rocks the Cradle." Stupid movies, big bucks.

Foreign Riches Dazzling films from the Chinese director Zhang Yimou: "Raise the Red Lantern," an opulent soap opera about a man with four wives, and "The Story of Qiu Ju" (shown at the New York Film Festival), the witty story of a peasant woman's search for justice.

Biggest Flub The silly Kevin Costner-Whitney Houston thriller, "The Bodyguard," reenacts the Academy Awards ceremony and shows celebs parading into the building — *at night*.

She Should Have Stayed Home Sigourney Weaver leaves the planet one time too many in the dark, dull "Alien 3."

Tri-Star Pictures

Robert Downey Jr. in the title role of Richard Attenborough's "Chaplin."

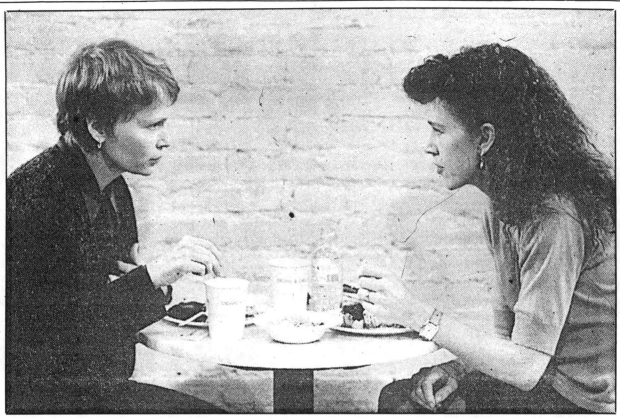

Brian Hamill/Photoreporters

Mia Farrow and Judy Davis appeared in the comedy-drama "Husbands and Wives," written and directed by Woody Allen.

**When Bad Movies Happen to Good
Actors** Jack Nicholson's freshest perform-
ance in years redeems the incoherent "Hof-
fa"; Robert Downey Jr. seems miraculously
real in the plodding "Chaplin."

**Oscar Prediction — The All-Actors
Race for Best Director** Clint Eastwood
for "Unforgiven," Robert Redford for "A
River Runs Through It;" Rob Reiner for "A
Few Good Men," Danny DeVito for "Hoffa,"
Richard Attenborough for "Chaplin." How
can the Academy resist?

**Best Film That Never Found Its
Audience** Bille August's "Best Intentions,"
from Ingmar Bergman's script about his
parents' disastrous marriage. Intelligent and
emotionally rich, but three hours long and
sad, it failed at the box office faster than the
Bergman marriage went sour.

Best Film That Found Its Audience
"Howards End," the greatest Merchant-Ivo-
ry-Jhabvala collaboration yet, captured the
exquisite undercurrents of E. M. Forster's
Edwardian novel. Intelligent and emotionally
rich, *and* it had great furniture. A hit.

Tough Guy of the Year Harvey Keitel
creates the year's most wrenching, believ-
able thugs in two daring independent films,
as the robber with a heart in Quentin Taran-
tino's "Reservoir Dogs" and the depraved
cop in Abel Ferrara's "Bad Lieutenant."

He Should Have Stayed Home "Chris-
topher Columbus: The Discovery" and
"1492: Conquest of Paradise" offer a revi-
sionist view — Columbus as box-office poi-
son.

1992 D 27, II:9:1

For a Change, Popular Films Win Top Prizes at Sundance

By CARYN JAMES

Special to The New York Times

PARK CITY, Utah, Jan. 26 —
Someone must have told the Sun-
dance Film Festival to lighten up. At
the awards ceremony on Saturday
night that concluded this festival of
independent films — more noted for
their sincerity than their wit — the
major prizes in the drama competi-
tion went to two of the most popular
and accessible works in competition.

The jury prize, awarded by a panel
of four judges, went to "In the Soup,"
an artsy but crowd-pleasing little
black-and-white comedy about a
struggling film maker and an aging
con man. The audience award, a bet-
ter gauge of a film's commercial
prospects because it is selected by
viewers' ballots, went to "The Water-
dance," an autobiographical story of
a paraplegic whose tragedy is laced
with sharp, engaging humor. Last
year's festival was criticized for be-
ing too esoteric. This year, Sundance
came back with a surprising ability to
laugh, sometimes at itself.

The tone was set by the host of the
awards, Spalding Gray, whose new
film, "Monster in a Box," had its
United States premiere at Sundance
on Saturday afternoon. Rarely has a
Sundance audience laughed as loudly
as it did at the film, a faithful but
successfully cinematic version of the
popular monologue he presented Off
Broadway. And never has the awards
ceremony had such a refreshingly
irreverent host.

Among the first myths Mr. Gr
addressed in his introduction at t
awards ceremony was the idea th
Sundance is held at Sundanc
Though the festival is sponsored l
Robert Redford's Sundance Institu
it is actually held in Park City, a 4
minute drive away from the ski i
sort where the institute is.

Even artsiness is tempered by the crowd-pleasing factor.

"I pictured pine trees and snow a
dancing in the sun," Mr. Gray said
his low-key, deadpan manner.
thought I would be at Bob's place
arrived to find this tacky, tacky fro
tier town, like a combination of A
tralia, Alaska and Poland."

•

The remarks went over well w
the denizens of Hollywood and N
York who had descended in mass
during the last days of this 10-d
festival here. Agents, producers,
rectors and a handful of stars
among them Sean Penn, Fa
Dunaway, John Cusack and E
Stoltz — were spotted on quaint
Main Street, where the ghost of Ga
Cooper might appear for a "Hi
Noon" shoot-out. As one actor put

"Don't get me started on the restaurants here. I wanted breakfast and the hotel sent me to a place called the Grub Steak. I'm a vegetarian. Everything here has a name like the Macho Cow." For the record, the Grub Steak is a real restaurant. The Macho Cow is not.

When Mr. Gray got to the awards, there were few surprises. Both "In the Soup" and "The Waterdance" were hugely popular with audiences and received positive critical reaction.

"In the Soup" stars Steve Buscemi as a New York film maker so desperate for money that he places a newspaper ad offering his epic script for sale. He is lured into a life of petty crime by a high-spirited crook named Joe, played by Seymour Cassel. Mr. Cassel, a long-respected actor in John Cassavetes's films, received a special jury prize for his performance: an emotional homage from a festival dominated by younger film makers to a veteran of the independent movement.

With its meandering style and ironic, downtown sensibility, "In the Soup" is vaguely reminiscent of a Jim Jarmusch movie. (Mr. Jarmusch makes a brief appearance in it.) And it comes with a perfect, even clichéd, Sundance story behind it. It was written and directed by Alexandre Rockwell, a 35-year-old New York film maker who was a protégé of Cassavetes and Sam Fuller. Mr. Rockwell's three previous features have been well received in Europe but have not been released in the United States. "In the Soup" came to Sundance without a distributor, though major distributors have been talking to the film maker since he arrived here, and it barely made it into the competition because the programmers had seen only unsatisfactory rough cuts until the last minute.

Financing for "In the Soup" fell through two days before Mr. Rockwell was to have begun shooting. When his producer finally arranged new backing, the money came from Italy, Germany, France, Spain and Japan. "Not a dime came from America," Mr. Rockwell said, pointing out the oddity of this film's winning an award for American independent film. Made for an astonishingly low $800,000, the film was shot in color film but processed to be shown in black and white. It can be developed in color for foreign theatrical and video release, but Mr. Rockwell said he would not release a color version in the United States.

The judges for the drama competition were Callie Khouri, the screenwriter of "Thelma and Louise"; Beth, the independent film maker; Bill Duke, the actor and director of "A Rage in Harlem," and David Ansen, film critic for Newsweek. The judges agreed that the award could have gone to any of a handful of films, including "The Waterdance." But as Ms. Khouri said after the awards ceremony, "In the spirit of this festival, we wanted to help a film maker who needed a break."

"The Waterdance" already has a distributor lined up. The Samuel Goldwyn Company announced during the festival that it would release the film, probably in the summer. But the film can use the boost from Sundance because of its tricky, darkly humorous tone.

It was written by Neal Jimenez (the writer of "River's Edge" and a writer of "For the Boys"), who was paralyzed in an accident and now uses a wheelchair. Mr. Jimenez and Michael Steinberg co-directed the film, a decision that was made because Mr. Jimenez said he felt he did not have the stamina to do the film himself.

Eric Stoltz stars as the fictional version of Mr. Jimenez in a story that traces his emotional adjustment to paralysis. The film wisely avoids mawkishness, but a tragi-comedy about paralysis will need all the help it can get. The black humor is, in fact, one great strength of the character and the film.

•

The audience award in the other category, for documentaries, went to "Brother's Keeper," directed by Joe Berlinger and Bruce Sinofsky. It is a cinéma vérité approach to the story of four eccentric, uneducated brothers, dairy farmers in Munnsville, N.Y. Delbert Ward was tried for the murder of his brother Bill, who died in the bed the two shared in their ramshackle house. The film, an early and obvious favorite for this award, has been approached by theatrical distributors and will eventually be shown on "American Playhouse" on PBS.

The documentary jury unanimously decided to give the award to two films: "A Brief History of Time," directed by Errol Morris ("The Thin Blue Line"), which is partly a biography of the astrophysicist Dr. Stephen W. Hawking and partly an explication of Dr. Hawking's best-selling book of the same name, and "Finding Christa," by Camille Billops and James Hatch, the story of Ms. Billops's search to find the daughter she gave up for adoption nearly 30 years ago. The decision to split the award addressed one of the thorniest problems for this festival: how to compare a slickly produced multi-million-dollar production by a well-known director like Mr. Morris with a small, personal film made for under $100,000 like Ms. Billops's and Mr. Hatch's. The documentary judges were the film makers Stephanie Black, William Greaves and Isaac Julien and the critic Bérénice Reynaud.

Several out-of-competition works arrived at Sundance with the film makers trying to position them for strong openings. Among the best was Paul Schrader's "Light Sleeper," starring Willem Dafoe as a drug dealer suffering a dark weekend of the soul. Among the weakest were two first films directed by respected writers: "Storyville," directed by Mark Frost, co-creator of "Twin Peaks," and "London Kills Me," directed by Hanif Kureishi, the screenwriter of "My Beautiful Laundrette." Sometimes Sundance promotes new careers. Sometimes it just brings bad news.

1992 Ja 27, C17:4

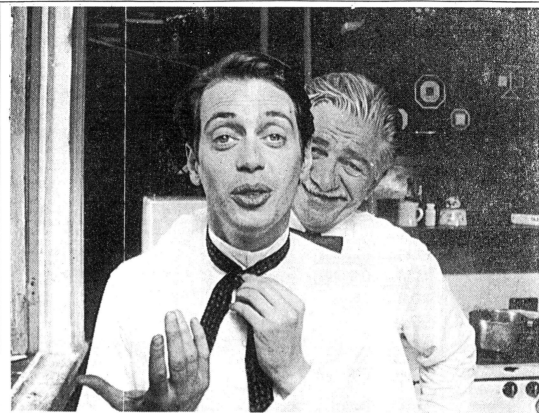

Cacous Films

Steve Buscemi, left, and Seymour Cassel in "In the Soup," which won the Sundance Film Festival jury prize.

A festival loosens up and learns to laugh, sometimes at itself.

Swedish Film Is No. 1 at Cannes; Tim Robbins Wins Acting Prize

By JANET MASLIN

Special to The New York Times

CANNES, France, May 18 — "The Best Intentions," a three-hour Swedish film based on a screenplay by Ingmar Bergman about his parents' courtship and marriage, tonight was awarded the Palme d'Or, the highest honor at the Cannes International Film Festival. Directed by Bille August, who won an Oscar in 1989 for "Pelle the Conqueror," the film stars Pernilla August, who was voted best actress. "I'd like to send a thank you to Sweden to Ingmar Bergman, who wrote this wonderful part for me and then of course to my director, who also helped me — my husband," Mrs. August said at the ceremony.

"The Best Intentions," which was shown in Sweden as a six-hour television series, is one of the more straightforward and less adventurous films to have been shown here. Reception to the news of its winning the Palme d'Or was distinctly lukewarm, in contrast to the wave of enthusiasm greeting the choice of Gianni Amelio's "Stolen Children" as winner of the Grand Jury Prize, or runner-up. Mr. Amelio appeared on stage at the Palais des Festivals with the adult actor and two children who constitute virtually the entire cast of his beautifully spare and humane film.

Acting Prize Was Foreseen

Tim Robbins, who stars as the soulless movie executive Griffin Mill in "The Player," was voted best actor, a popular choice that was not entirely a surprise. Mr. Robbins, who left here

Bille August, director of "The Best Intentions," which won the Palme d'Or at the Cannes International Film Festival yesterday, and Pernilla August, his wife, who was named best actress for her performance in the film.

Agence France-Presse

several days ago, had left a statement offering thanks to "the entire festival for encouraging American films made outside of the mainstream" and to his "partner in crime, Susan Sarandon, and her three angels, who helped me keep Griffin Mill out of our home." Mr. Robbins's speech was read by Robert Altman, who only moments earlier had received the best director award the same film.

Though "The Player" and "Howards End" were early favorites here, each received what could be construed as a consolation prize. Cannes juries have a way of making up special awards to solve deliberation problems, and in this case they created the festival's 45th-anniversary award, which was given to "Howards End." Another compromise accompanied the Jury Prize, which is a notch below the Grand Jury Prize. This year it was divided between "El Sol del Membrillo," Victor Erite's Spanish film about a painter at work on a still life, and "An Independent Life," Vitaly Kanevsky's second installment in his autobiographical account of a harsh Russian boyhood. "Merci" was all Mr. Kanevsky said tonight.

The Caméra d'Or, which goes to the best first-time director, was given to John Turturro, whose film "Mac" was part of the Directors' Fortnight section of the festival. Mr. Turturro is well known here, having been last year's choice as best actor for his performance in the Palme d'Or winner "Barton Fink." It was also pointed out at the awards ceremony that "Strictly Ballroom," the charmingly eccentric Australian comedy that has been quite popular here, came in a close second for the Caméra d'Or. Among the other prizes was a technical award that went to the Argentine director Fernando Solanas for "The Voyage."

The awards ceremony unfolded in typically bewildering festival fashion, with celebrity guests serving as scroll holders while the various jurors announced who the winners were. Scroll holders, who included the French actresses Irène Jacob, Isabelle Huppert and Brigitte Fossey, were often appropriately paired with their jury counterparts: Victoria Abril, for example, joined forces with Pedro Almodóvar, her frequent director.

The presentation of the Palme d'Or was a collaborative effort by Gérard Depardieu, the president of the jury, and Tom Cruise, the star of "Far and Away," which drew mild hoots at last night's press screening and was shown out of competition as tonight's closing selection. Even in a place that thrives on wild contrasts, it would be hard to imagine a stranger twosome.

1992 My 19, C13:4

Critics' Circle Votes 'The Player' Best Film

"The Player," Robert Altman's satirical film depicting a supremely amoral Hollywood, was voted the best film of 1992 yesterday by the New York Film Critics' Circle. Mr. Altman was named best director. The 27-member group, voting its 58th annual film awards, also cited "The Player" for best cinematography; Jean Lepine was the director of photography.

Denzel Washington was voted best actor for his performance in "Malcolm X," playing the title character through the many stages of his spiritual evolution. Emma Thompson was named best actress for her role as the astute heroine of "Howards End." Miranda Richardson was voted best supporting actress for roles in three films: "The Crying Game," "Damage" and "Enchanted April." Gene Hackman received the best supporting actor award for "Unforgiven," the film that was runner-up in both best film and best-director categories.

"The Crying Game" was cited for best screenplay. "Raise the Red Lantern," the only first-ballot winner, was voted best foreign film. "Brother's Keeper" was chosen as best doc-

umentary. And Allison Anders was cited as best new director for "Gas Food Lodging."

Robert Altman's tale of an amoral Hollywood is honored.

The awards will be presented on Jan. 17 at a ceremony in the Pegasus Suite of the Rainbow Room in Rockefeller Center. The group's chairman is Marshall Fine, entertainment columnist for Gannett Suburban Newspapers.

1992 D 18, C3:1

Film Critics' Society Honors 'Unforgiven'

"Unforgiven," the epic, ruminative western that represented a high point in the career of Clint Eastwood, its star and director, was voted the best

film of 1992 by the National Society of Film Critics yesterday.

The 35-member group of critics from New York, Los Angeles, Boston, Chicago and other cities, also voted Mr. Eastwood best director. The film's screenplay, by David Webb Peoples, was also cited, as was Gene Hackman's supporting performance as a corrupt sheriff.

Stephen Rea was voted best actor for his performance as a reluctant Irish Republican Army terrorist in "The Crying Game." Emma Thompson was voted best actress for playing the spirited, intellectual heroine of "Howards End." Judy Davis was voted best supporting actress for "Husbands and Wives," in which she played an archneurotic woman newly separated from her spouse. "Raise the Red Lantern" was voted best foreign film and cited for its cinematography.

The prize for best documentary, awarded by the 25 group members who voted yesterday, went to "American Dream," Barbara Kopple's impassioned study of the Hormel meatpackers' strike. "Another Girl, Another Planet," an experimental film by Michael Almereyda, was cited "for expanding the possibilities of experimental film making."

The group dedicated its 1992 awards to the memory of Stephen Harvey, a former film critic for Inquiry magazine and a curator of the film department at the Museum of Modern Art. Mr. Harvey, a biographer of Vincente Minnelli, also wrote movingly about the effects of AIDS on gay culture. He died of AIDS on Friday.

1993 Ja 4, C14:3

All Is Glittery And a Bit Odd At Golden Globes

By BERNARD WEINRAUB

Special to The New York Times

HOLLYWOOD, Jan. 24 — Tom Cruise was nervous. Emma Thompson's feet hurt. Al Pacino said he felt "out of control." And Gene Hackman was in a bad mood, and grumbled that he'd rather be home.

Despite all this Hollywood angst, the 50th annual Golden Globe awards on Saturday night turned out to be the glitziest and zaniest event of the new year.

No event, including the Academy Awards, attracts so many stars and executives. And no event quite captures the sometimes surreal nature of Hollywood culture and the bizarre relationship between the movie world and the press.

"Actually, it's like high school, a show-business prom," said Jay Leno, standing in the mobbed lobby of the Beverly Hilton Hotel in Beverly Hills as Jack Nicholson strode past and fans screamed. Asked if he was being nominated for any award, Mr. Leno rolled his eyes.

"I'm lucky I have a job," he said.

'Very Unreal'

Several feet away, Robert Altman, the director, threaded past fans clutching pieces of paper seeking autographs of the stars. Mr. Altman's film, "The Player," a scathing portrait of Hollywood, was nominated for several awards.

"I feel like I'm in my own movie," he said. "Very unreal." He laughed. "Actually I came here to see Pia Zadora."

The Golden Globes, which were televised live on TBS, are given by the Hollywood Foreign Press Association. Within Hollywood, the awards are significant because this group of 87 foreign journalists, some of them freelancers who actually own boutiques or don't write very much, have often been predictive about the Academy Awards. The Oscars will be announced on March 29.

The major awards on Saturday carried one significant surprise. "Scent of a Woman," starring Al Pacino, was named best picture in the drama category. (Mr. Pacino as well

"I feel out of control," said Al Pacino at the 50th annual Golden Globe awards on Saturday.

Photographs by Agence France-Presse

Emma Thompson won a Golden Globe award for best actress for her role in "Howards End."

as Bo Goldman, the movie's screenwriter, also won awards.) The film, which opened to mixed reviews and which deals with a friendship between a blind former Army officer and a prep school student, unexpectedly defeated such movies as "Unforgiven," "Howards End," "The Crying Game" and "A Few Good Men." ("The Player" won in the best musical or comedy lineup.)

Privately, Hollywood executives may scoff a bit at the foreign press association — "an odd, motley group," said one studio executive — but virtually everyone in town takes the awards seriously.

Why?

Because careers ebb and flow in Hollywood, awards ceremonies are a prime source of validation, even more than box office receipts for a new film. And the Golden Globes have grown enormously popular not only because they cover the television as well as film industries, but also be-

cause the group hands out so many prizes to so many stars. (Unlike the Academy Awards, the Golden Globes have one category of prizes for best drama and another category for best musical or comedy.)

Journalists give standing ovations and ask stars to pose with them.

"They try to spread them out," said one top studio executive, who spoke only on condition of anonymity. "Unlike the Academy Awards, this is actually a low-pressure event," he said. "People sit around a table and have a good time. It's a good party. You're kind of obliged to take it seriously."

The Hollywood crowd is also obliged to take the scores of celebrity journalists from the United States and, for that matter, all over the world, quite seriously, too. And the Golden Globes, even more than the Oscars, afford a glimpse into the often strange symbiosis between journalists in Hollywood and the people they cover.

Many journalists seemed infatuated with the stars who trooped into a press room after they won awards. As Clint Eastwood, who won best director in the drama category for "Unforgiven," walked into a press area to answer questions from television and other reporters, he was actually given a standing ovation. Several journalists stood and cheered when Miss Thompson, who won for "Howards End," and Mr. Pacino, walked into the press room. ("I feel out of control," said Mr. Pacino).

Stars obliged journalists who asked to pose with them for photographs. Lauren Bacall, who was given an honorary award, was asked by one journalist, "When you look back on your wonderful career, what are the highlights?"

She winced. "Bogie," she said after a moment.

When John Goodman, who won an award for his role in "Roseanne" was asked a similar question, he replied, "This is weird."

'It's Such a Hollywood Thing'

At times, the numerous awards seemed, curiously, almost secondary to the hoopla surrounding the Golden Globes. It seemed resonant of old Hollywood, or perhaps the dark Hollywood of Nathanael West's "Day of the Locust."

"It's such a Hollywood thing," said Mr. Cruise, who nearly caused pandemonium among fans and journalists when he arrived. His wife, the actress Nicole Kidman, seemed startled.

Ms. Kidman said: "It's nice to hear public reaction. You thrive on it, but you don't look forward to it." She gazed around. "The crowds: you start to shake. It's nerve-racking. Tom starts to shake. I start to shake."

Close by, Miss Thompson, ebullient and friendly, threaded past television cameras. "Whoa, this is a wingding," she said, seemingly amazed. "Darling, I've never felt like a movie star. It's the one thing I'm not. I keep trying to make sure my tights don't fall down."

Associated Press

Clint Eastwood, who was named best director in the drama category for "Unforgiven," arrived at the awards with his co-star Frances Fisher.

Robin Williams's Contribution

Robin Williams, who practically stole the show later in the evening, stood before a television interviewer and engaged in a brief stream-of-consciousness performance about the Clinton Administration's first crisis. "Hey Zoë, remember the words: 'green card,' 'green card,' " he said. Suddenly he sputtered: "Keep the Quayle alive!"

Then an MTV interviewer, Randy Kagan, grabbed Mr. Eastwood. "Can you you do me a favor," Mr. Kagan said, "and just say hello to Alan Kagan. He's my father. It is, believe me, an honor." Mr. Eastwood obliged.

The awards themselves covered, almost deliberately, a broad range that seemed intended to please almost everyone. "Roseanne" won several top television prizes, as did "I'll Fly Away," "Northern Exposure" and the mini-series based on the career of Frank Sinatra.

Joan Plowright won two prizes, as a supporting actress in "Enchanted April" and for her role in the HBO drama "Stalin." Mr. Eastwood won as best director for "Unforgiven," "Indochine" won best foreign film and "Aladdin" was given some awards for its songs.

Mr. Hackman's dour mood lifted when he won best supporting actor for his role in "Unforgiven." As he entered a hotel ballroom at the start of the evening, the actor was asked if he had been to previous Golden Globes ceremonies.

"Too many times," he replied tartly.

Did he enjoy them? "Not particularly," he said. "I'd rather be home."

Later, Mr. Hackman said happily that he had lost a $100 bet with a television reporter. Mr. Hackman bet he would lose the nomination.

'The Best Party in Town'

By evening's end, the tempo and the party atmosphere picked up.

"We pride ourselves on being the best party in town, and it is," said Marianne Ruuth, a long-time executive with the Hollywood Foreign Press Association. She writes for journals such as Le Figaro in France, as well as publications in Sweden and Portugal, she said.

She said the organization was scrupulous in making sure its members were bona fide journalists. There have been various reports that some Golden Globe members supplemented their incomes in other ways, by owning boutiques or being waiters, for example. Miss Ruuth said she was unaware of this, but even if it were the case, it would make little difference.

"There's nothing wrong with being a waiter," she said. "Andy Garcia, the actor, used to be a waiter here at the Beverly Hilton. He once actually served at the Golden Globes. Isn't that something?"

1993 Ja 25, C11:5

Eastwood Gets Directors Guild Prize

BEVERLY HILLS, Calif., March 7 (AP) — Clint Eastwood won the top award from the Directors Guild of America on Saturday for his dark and violent western "Unforgiven."

The guild's choice for best director has almost always coincided with that of the Motion Picture Academy. In the 45-year history of the Directors Guild award, only three winners as best director have not gone on to win the Oscar.

The Academy Awards will be presented on March 29.

Clint Eastwood after winning the top award from the Directors Guild of America on Saturday for his western movie "Unforgiven."

Reuters

"I'm not a blabbermouth and I'm not going to start now," Mr. Eastwood said in a short acceptance speech in Beverly Hills hours after the award was announced. "I can't tell you how proud I am to be a member of this guild."

Mr. Eastwood had been the heavy favorite to win the award, followed by Neil Jordan for the agile and offbeat thriller "The Crying Game."

The other nominees were Robert Altman for "The Player," the brutal sendup of Hollywood and murder; Rob Reiner for his adaptation of the military courtroom drama "A Few Good Men," and James Ivory, who directed "Howards End," adapted from the E. M. Forster novel. Only Mr. Reiner has not been nominated for an Oscar as best director.

The guild's D. W. Griffith Award, an honorary prize for lifetime achievement, was given this year to Sidney Lumet.

1993 Mr 8, C16:1

Liliana Nieto del Rio for The New York Times

Emma Thompson signing an autograph before the awards ceremony on Saturday sponsored by independent film makers.

As Low-Key as Hollywood Allows

By BERNARD WEINRAUB

Special to The New York Times

HOLLYWOOD, March 28 — Forget that other event taking place on Monday night at the Dorothy Chandler Pavilion.

"*This* is the event that counts, not the Academy Awards," Tom Rothman, the president of production at Samuel Goldwyn Pictures, said half-jokingly on Saturday afternoon, wandering beneath an enormous and packed tent beside the beach in Santa Monica.

The Talk of Hollywood

"Monday night you'll see the glitter and polish," he said.

As for what was offered in Santa Monica, he said: "Look around. It's younger, it's more integrated and it's certainly hipper."

He looked up startled. "There's Joan Chen," he said. "And she's had her head shaved!"

The annual awards ceremony of the independent feature-film movement — which was only a small event a few years ago — held its biggest and certainly hippest show on Saturday when more than 1,200 people honored independent films. These films are cheaper and more provocative and not the by-the-numbers comedies, remakes and violent buddy movies churned out by most of the studios.

Harvey Keitel, who won the award for best actor for his role in "The Bad Lieutenant," said in an interview as he walked into the tent: "The independent-film movement is growing because of the power of the stories that are being told and the way they're being told, with passion and spirit and sacrifice. You look at the people running the studios and you can only ask: What are their values?

What do they want? What do they aspire to?

"I don't know. Are they making films that deal with the conflicts we all face in our lives? No! I think audiences are saying, 'Enough already.'"

The awards ceremony — which is always held the weekend before the Oscars — is sponsored by Independent Feature Project/West, the largest nonprofit group of independent film makers in the nation, with more than 2,000 members. The peculiarly California-titled Independent Spirit Awards ceremony, the eighth, is intended to be a deliberate counterpoint to the Academy Awards. But this year the line between the two awards shows seemed to blur.

There were plenty of movie stars wandering around the tent and sitting down to lunch for the long afternoon of prizes and some eye-rolling speeches. Although jeans and casual clothes were the order of the day, there were enough expensive leather and black outfits to finance a few small independent films or two.

And the cast of characters was definitely glittery: such performers as Denzel Washington, Emma Thompson, Danny Glover, Miranda Richardson, Billy Baldwin, Marisa Tomei, Andie MacDowell, Willem Dafoe, Jeff Bridges, Peter Gallagher, Juliette Lewis, Keanu Reaves, Forest Whitaker and Laura Dern schmoozed, gossiped and waved at one another.

"Sure, it's fun to get all dressed up and go to the Academy Awards on Monday night but, frankly, it's a little more fun to wear jeans and no tie to the independent film awards," said Sid Ganis, the executive vice president of Columbia Studios and one of the few studio executives to show up. "This is the heart and soul of the business. This is where the George

Lucases and the Francis Coppolas began. This is what it's all about."

At the ceremonies, Neil Jordan, the director and author of "The Crying Game," delivered the keynote speech, and Ismail Merchant and James Ivory were given the John Cassavetes Award for their years of film making, including "Howards End."

And the fact that the Academy of Motion Picture Arts and Sciences had nominated three independently made films — "The Crying Game," "Howards End" and "The Player" — for major awards was not lost on the independent film makers.

What's Gaudy and What's Not

Buck Henry, the perennial master of ceremonies, wearing a khaki army-style jacket, was characteristically acerbic. "As they assemble in their gaudy palaces," he said of the Hollywood establishment at the Academy Awards, "we gather here, holding high our torch of self-righteousness."

Mr. Henry also brought down the house when he began discussing Harvey and Bob Weinstein, the brothers who own Miramax Films, a major independent film maker and distributor. The brothers have a reputation for being daring producers, but also temperamental and tightfisted. Mr. Henry called them the Kray brothers of the movie business, after the strange English underworld twins.

Bob Weinstein buried his face on the table.

The mood was not entirely light. Jonathan Wacks, a producer and director who is the chairman of the independent-film group, drew applause when he attacked the way films were rated, saying, "By what weird moral calculus are these decisions arrived at?" He called the ratings board "an arbitrary and dictatorial group" and cited bizarre cases of film makers compelled to barter various semi-nude shots of men and women to get ratings that would insure wide distribution of movies.

The top awards went to "The Player," as best picture; "The Waterdance" as best first feature, and for best screenplay; Carl Franklin as best director for "One False Move"; "The Crying Game" as best foreign film; Fairuza Balk as best actress, in "Gas Food Lodging," and Steve Buscemi as best supporting actor, in "Reservoir Dogs."

Alfre Woodard, the actress, delivered perhaps the most elegant brief speech when she won best supporting actress for "Passion Fish."

With a smile, she said: "I don't only consider you guys my peers, I consider you my people. I thank you on behalf of real actors everywhere. You provided a space for me to work when I first walked into this maze."

1993 Mr 29, C13:4

The Night Oscar Paid Some Attention to Women

By JANET MASLIN

When last seen at the end of the Academy Awards telecast on Mon-

day night on ABC, Oscar was still looking sleek and undraped, despite the show's persistent efforts to put him in a dress. Dedicating itself noisily to the Year of the Woman, this

Billy Crystal arriving astride a giant Oscar onstage at the Dorothy Chandler Pavilion in Los Angeles to begin his duties as the host of the Academy Awards. The statue was pulled by Jack Palance, whose speech accepting last year's award for best supporting actor was punctuated by pushups.

year's show missed no opportunity to emphasize Hollywood's feminine side, no matter how misconceived that opportunity might be. There was, for instance, a quickie tribute to "93 winners or nominees written or co-written by women." But as luminaries were seen entering the Dorothy Chandler Pavilion, the background music was "Thank Heaven for Little Girls."

The show was determined to honor women as sanctimoniously as possible, provided it could retain the usual quota of dancing girls. (A writhing-cheesecake presentation of the Oscar-winning song from "Aladdin" suggested that the film's teen-age lovers had wandered into a bordello.) And the prevailing tone of condescension was established early on. "Women have always made vital contributions to movies," intoned the academy's president, Robert Rehme, who pointed out that this year 36 women were nominated in 12 categories. "That's not equality yet, but it's progress," he insisted as the audience offered weak applause.

Homage to feminism, followed by the usual dancing girls.

Moments later, Geena Davis made a more tangible womanly contribution in low-cut black velvet, reeling off what sounded like a new version of the Girl Scout credo as she described what women supposedly do in Hollywood ("To shoot from the hip, to ease and uplift ...") Mock-feminist lip service would later yield the suggestion that movies were like children. (Female editors "nurtured, nourished and shaped" their work, it was said.) And it brought forth a Liza Minnelli musical number that was an instant camp classic. "Women have taken a brand new position/They'll pilot your plane or repair your transmission," lip-synched a grinning Ms. Minnelli, flanked by hapless chorus

boys. "Hillary will lead the way!" the awful song continued.

•

Poor Billy Crystal. Swamped by self-righteous sentiments, gazing into a sea of red AIDS ribbons (now so obligatory at Hollywood functions that their size, position and glitter content have become fashion statements) and lavender ones (protesting urban violence), fielding preachy political asides from various Oscar presenters and recipients, Mr. Crystal had precious little to joke about this year. Not even Jack Palance, who made an entrance hauling the host astride a giant Oscar, could inject a note of levity. But Mr. Crystal did introduce him by saying, "Please welcome your new Supreme Court justice, ladies and gentlemen."

A joke about Mr. Palance's siring many children was recycled from the last Oscar show. And the host, while still the hero of the evening, was reduced to kidding about plastic surgery, Roseanne and Tom Arnold's temper, and Kim Basinger's legal troubles. Mr. Crystal fared best when the subject was gender-bending, saying Jack Nicholson's front-row presence made him feel like a Laker Girl and identifying one of the elegantly dressed women on stage as Salman Rushdie. "Those eyes, those thighs, surprise! It's 'The Crying Game,'" he sang as part of his ever-foolproof musical medley.

Three and a half hours later, it was hard to remember that Mr. Crystal had started off the evening on a such a high note. The show, produced by Gilbert Cates, sank badly under the weight of its self-importance, which was not leavened by much of the small talk that can make Oscar night fun. Many of the presenters appeared singly, eliminating the chance of any colorful banter.

And the evening was as notable for its absentees as for those who appeared. All 10 names on Variety's recent list of stars best able to guarantee a profitable opening weekend over the last seven years — Eddie Murphy, Arnold Schwarzenegger, Sigourney Weaver, Michael Keaton, Bill Murray, Mel Gibson, Harrison Ford, Tom Cruise, Julia Roberts and Michael J. Fox — were otherwise engaged.

Meanwhile, Oscar the feminist was too short-sighted to think of Lillian Gish, Helen Hayes or Marlene Dietrich, to name several recently departed actresses who might have lent this Year of the Woman show greater range. (The evening's early montage of women's roles by Lynne Littman did provide a quick, delightful overview.) Audrey Hepburn, a posthumous recipient of the Jean Hersholt Humanitarian Award, was remembered very movingly with the help of candid video clips that showed her visiting African children. In contrast, Elizabeth Taylor (another Hersholt award winner, for her AIDS work) appeared in full film-star regalia, sans ribbon, and said: "I call upon you to draw from the depths of your being to prove that we are a human race."

Another honoree was Federico Fellini, who was said by Marcello Mastroianni (a co-presenter with Sophia Loren) to have introduced the word "Fellini-esky" into the language. Giving one of the evening's most memorable acceptance speeches, Mr. Fellini said succinctly: "I really did not expect it. Or perhaps I did, but not before another 25 years. Is better now."

Clint Eastwood gave another of the night's better speeches by saying: "In the year of the woman, the greatest woman on the planet is here tonight. That's my mother, Ruth." Barbra Streisand, one of several presenters who looked smashing in simple black gowns (Jodie Foster was an-

other), sounded an extremely welcome note after being introduced as "the woman who directed 'The Prince of Tides.'" "That's nice," she said, "but I look forward to the time when tributes like this will no longer be necessary."

•

The evening's biggest waste of talent: Sharon Stone, relegated to presenting technical awards and doing most of that job off camera. Its most debonair presenters: Dustin Hoffman, who recalled "The Graduate" by asking Anne Bancroft, "Are you trying to seduce me?" and Ms. Bancroft, who answered dryly, "Not anymore." Its wittiest costume: Nell Carter's celery-colored harem pants and fez, to suit her rendition of "Friend Like Me" from "Aladdin." Ms. Carter's jubilant performance made a lot more sense than Plácido Domingo's earnest number from "The Mambo Kings."

Biggest fashion problem: where to put your red ribbon if, like Catherine Deneuve, you are mostly covered in marabou. Biggest etiquette lapse: Barbara Trent's habit of applauding her own statements as she browbeat the audience while accepting an Oscar for best documentary. Craziest thought: Richard Gere's notion that he could beam a message about Tibet to Deng Xiaoping, whom he envisioned watching the Oscar show surrounded by his children and grandchildren. Beaming Oscar-related messages is a dangerous precedent. This year's show left viewers wanting to beam a few messages of their own.

The Oscar Winners

Film: "Unforgiven"
Director: Clint Eastwood, for "Unforgiven"
Actor: Al Pacino, "Scent of a Woman"
Actress: Emma Thompson, "Howards End"
Supporting Actor: Gene Hackman, "Unforgiven"
Supporting Actress: Marisa Tomei, "My Cousin Vinny"
Foreign-Language Film: "Indochine," France
Original Screenplay: "The Crying Game" (Neil Jordan)

Adapted Screenplay: "Howards End" (Ruth Prawer Jhabvala)
Cinematography: "A River Runs Through It" (Philippe Rousselot)
Film Editing: "Unforgiven" (Joel Cox)
Original Score: "Aladdin" (Alan Menken)
Original Song: "Whole New World" from "Aladdin" (music, Alan Menken; lyrics, Tim Rice)
Art Direction: "Howards End" (art direction, Luciana Arrighi; set decoration, Ian Whittaker)

Costume Design: "Bram Stoker's 'Dracula' " (Eiko Ishioka)

Makeup: "Bram Stoker's 'Dracula' " (Greg Cannom, Michele Burke, Matthew W. Mungle)

Visual Effects: "Death Becomes Her" (Ken Ralston, Doug Chiang, Doug Smythe, Tom Woodruff Jr.)

Sound: "The Last of the Mohicans" (Chris Jenkins, Doug Hemphill, Mark Smith, Simon Kaye)

Sound Effects Editing: "Bram Stoker's 'Dracula' " (Tom C. McCarthy and David E. Stone)

Documentary Feature: "The Panama Deception" (Barbara Trent and David Kasper, producers)

Documentary Short Subject: "Educating Peter" Thomas C. Goodwin and Gerardine Wurzburg, producers)

Short Film, Live: "Omnibus" (Sam Karmann)

Short Film, Animated: "Mona Lisa Descending a Staircase" (Joan C. Gratz)

Honorary Award: Federico Fellini, in recognition of his cinematic accomplishments.

Jean Hersholt Humanitarian Awards: Audrey Hepburn (posthumously), for her work as Unicef's roving ambassador to the world's children,

and Elizabeth Taylor, for her work in the fight against AIDS.

Academy Award of Merit (technical): Chadwell O'Connor for development of the fluid-damped camera head.

Gordon E. Sawyer Award (technical): Erich Kaestner for technical contributions to the motion picture industry.

1993 Mr 31, C15:1

502

INDEX

Index

This index covers all the reviews included in this volume. It is divided into three sections: Titles, Personal Names, and Corporate Names.

Citations in this index are by year, month, day, section of newspaper (if applicable), page, and column; for example, 1992 Ja 5, II:13:1. Since the reviews appear in chronological order, the date is the key locator. The citations also serve to locate the reviews in bound volumes and microfilm editions of The Times.

In the citations, months are abbreviated as follows:

Ja - January	My - May	S - September
F - February	Je - June	O - October
Mr - March	Jl - July	N - November
Ap - April	Ag - August	D - December

TITLE INDEX

All films reviewed are listed alphabetically. Articles that begin titles are inverted. Titles that begin with a number are alphabetized as though the number was spelled out. Whenever possible, foreign films are entered under both the English and foreign-language titles. Films reviewed more than once and films with identical titles are given separate listings.

PERSONAL NAMES INDEX

All persons included in the reviews are listed alphabetically, last name first. Their function in the film is listed in parentheses: Screenwriter, Director, Producer, Cinematographer, Composer, Original Author, Narrator. Other functions (such as Editor, Production Designer, etc.) are listed as Miscellaneous. Where no such qualifier appears, the person was a performer (actor, actress, singer, dancer, musician). A person with multiple functions will have multiple entries.

Names beginning with Mc are alphabetized as if spelled Mac. Names beginning with St. are alphabetized as if spelled Saint. Entries under each name are by title of film, in chronological order.

CORPORATE NAME INDEX

All corporate bodies and performance groups mentioned in reviews as involved in the production or distribution of the film or in some other function connected with it are listed here alphabetically. Names that begin with a personal name are inverted (e.g., Goldwyn, Samuel, Company). The function of the organization is given in parentheses as Prod. (for Producer), Dist. (for Distributor), or Misc. (for Miscellaneous). A company that has more than one function is listed twice.

Entries under each name are by title of film, in chronological order.

D

E

F

G

H

J

K

I

L

M

N

O

P

Q

R

S

T

U

V

W

Y

Z

A

Aalda, Mariann
Class Act 1992,Je 5,C17:1
Aaltonen, Veikko (Miscellaneous)
Vie de Boheme, La 1992,O 9,C14:1
Abarbanell, Judith
Uncle Moses 1991,N 21,C18:4
Abatantuono, Diego
Mediterraneo 1992,Mr 22,48:4
Abbott, Bruce
Bride of Re-Animator 1991,F 22,C17:1
Abbott, Elliot (Producer)
League of Their Own, A 1992,Jl 1,C13:4
Abbott, Steve (Producer)
Blame It on the Bellboy 1992,Mr 6,C10:6
Abbss, Gasan
Cup Final 1992,Ag 12,C13:1
Abdallah, Rabia Ben
Halfaouine 1991,Mr 15,C1:4
Abecassis, Yael
For Sasha 1992,Je 5,C13:1
Abello, Jorge (Miscellaneous)
Adorable Lies 1992,Mr 27,C8:5
Abildgard, Bertel
Birthday Trip, The 1991,Mr 26,C14:3
Abrahams, Jim (Director)
Hot Shots! 1991,Jl 31,C11:2
Abrahams, Jim (Screenwriter)
Hot Shots! 1991,Jl 31,C11:2
Abrahamsen, Christer (Producer)
Shadow of the Raven, The 1991,Jl 13,12:1
Abramowsky, Klaus
Europa, Europa 1991,Je 28,C10:1
Abrams, Jeffrey (Screenwriter)
Regarding Henry 1991,Jl 10,C13:3
Regarding Henry 1991,Jl 14,II:9:5
Regarding Henry 1991,Ag 11,II:18:1
Forever Young 1992,D 16,C17:1
Abrams, Michelle
Buffy the Vampire Slayer 1992,Jl 31,C8:5
Abrams, Peter (Producer)
Point Break 1991,Jl 12,C12:6
Abrham, Josef
End of Old Times, The 1992,Ja 10,C12:6
Abril, Victoria
High Heels 1991,D 20,C20:6
Lovers 1992,Mr 25,C18:5
Aventis (Stories) 1992,N 13,C15:1
Most Beautiful Night, The 1992,N 20,C10:5
Acciario, Frankie
Bad Lieutenant 1992,N 20,C15:1
Accorncro, Roberto
Peaceful Air of the West 1991,Mr 20,C12:5
Acevski, Jon (Director)
Freddie as F.R.O.7 1992,S 1,C11:1
Acevski, Jon (Producer)
Freddie as F.R.O.7 1992,S 1,C11:1
Acevski, Jon (Screenwriter)
Freddie as F.R.O.7 1992,S 1,C11:1
Achkar, David (Producer)
Allah Tantou 1992,S 30,C18:3
Achkar, Diesel (Producer)
Allah Tantou 1992,S 30,C18:3
Achkar, Lumumba Marrouf, Jr. (Composer)
Allah Tantou 1992,S 30,C18:3
Acker, Kathy
Golden Boat, The 1991,Je 22,12:4
Ackerman, Tom (Cinematographer)
True Identity 1991,Ag 23,C16:1
Ackland, Joss
Object of Beauty, The 1991,Ap 12,C14:4
Bill and Ted's Bogus Journey 1991,Jl 19,C10:1
Mighty Ducks, The 1992,O 2,C18:1
Acs, Janos
Memoirs of a River 1992,Mr 20,C15:1
Acs, Miklos
Where 1991,S 6,C13:1
Adam, Ken (Miscellaneous)
Doctor, The 1991,Jl 24,C11:1
Company Business 1992,Ap 25,17:1
Adams, Brandon
People Under the Stairs, The 1991,N 2,17:1
Adams, Brooke
Gas Food Lodging 1992,Jl 31,C1:1

Adams, Geoff (Producer)
Complex World 1992,Ap 10,C14:5
Adams, John (Composer)
Cabinet of Dr. Ramirez, The 1992,Ja 23,C15:4
Adams, Kim
Ted and Venus 1991,D 20,C23:1
Adams, Mason
Toy Soldiers 1991,Ap 26,C15:1
Adams, Tony (Producer)
Switch 1991,My 10,C13:1
Adamson, Barry (Composer)
Delusion 1991,Je 7,C12:6
Addams, Charles (Miscellaneous)
Addams Family, The 1991,N 22,C1:1
Adefarasin, Remi (Cinematographer)
Truly, Madly, Deeply 1991,My 3,C11:1
Adler, Jerry
Public Eye, The 1992,O 14,C17:1
Adouani, Mustapha
Halfaouine 1991,Mr 15,C1:4
Adrien, Gilles (Screenwriter)
Delicatessen 1991,O 5,14:3
Agede-Nissen, Harald (Miscellaneous)
Shipwrecked 1991,Mr 1,C6:1
Aginsky, Yasha (Miscellaneous)
Forever Activists 1991,Je 14,C10:4
Aginsky, Yasha (Screenwriter)
Forever Activists 1991,Je 14,C10:4
Aguirresarobe, Javier (Cinematographer)
Dream of Light (Sol del Membrillo, El) 1992,O 1,C17:1
Bosque Animado, El (Enchanted Forest, The) 1992,D 4,C8:6
Agustin, Jose (Screenwriter)
City of the Blind (Ciudad de Ciegos) 1992,Ap 4,17:5
Agutter, Jenny
Freddie as F.R.O.7 1992,S 1,C11:1
Aharia, Nougzar
Johanna d'Arc of Mongolia 1992,My 15,C8:1
Ahern, Lloyd (Cinematographer)
Trespass 1992,D 25,C18:5
Ahern, Tim
Hearing Voices 1991,N 15,C11:1
Aherne, Michael
Commitments, The 1991,Ag 14,C11:1
Ahlberg, Mac (Cinematographer)
Oscar 1991,Ap 26,C10:5
Innocent Blood 1992,S 25,C6:5
Ai Jing
Five Girls and a Rope 1992,Mr 22,48:1
Aiello, Danny
Once Around 1991,Ja 18,C12:4
Once Around 1991,Ja 27,II:1:1
Hudson Hawk 1991,My 24,C8:4
Hudson Hawk 1991,Ag 18,II:11:5
29th Street 1991,N 1,C14:1
Ruby 1992,Mr 27,C1:3
Mistress 1992,Ag 7,C16:3
Aiello, Rick
29th Street 1991,N 1,C14:1
Akasegawa, Genpei (Screenwriter)
Rikyu 1991,Ja 18,C8:1
Akerman, Chantal (Director)
Window Shopping 1992,Ap 17,C13:1
Night and Day 1992,D 11,C10:6
Akerman, Chantal (Screenwriter)
Window Shopping 1992,Ap 17,C13:1
Night and Day 1992,D 11,C10:6
Akers, George (Miscellaneous)
Crossing the Line 1991,Ag 9,C11:1
Edward II 1992,Mr 20,C16:3
Akins, Claude
Falling from Grace 1992,F 21,C16:5
Akiyoshi, Kumiko
Enchantment, The 1992,My 20,C15:3
Akutagawa, Ryunosuke (Original Author)
Iron Maze 1991,N 1,C13:1
Alabardo, Wayne (Composer)
Together Alone 1992,S 23,C18:4
Alard, Nelly
Eating 1991,My 3,C8:1
Venice/Venice 1992,O 28,C20:5
Alazraki, Robert (Cinematographer)
My Father's Glory (Gloire de Mon Pere, Le) 1991,Je 21,C10:5
For Sasha 1992,Je 5,C13:1
Albam, Evan (Miscellaneous)
Begotten 1991,Je 5,C23:1

Albanese, David
Damned in the U.S.A. 1992,N 13,C11:1
Albani, Romano (Cinematographer)
Sleazy Uncle, The 1991,F 22,C10:5
Albano, Captain Lou
Complex World 1992,Ap 10,C14:5
Albert, Arthur (Cinematographer)
Passed Away 1992,Ap 24,C8:1
Albert, Eddie
Brenda Starr 1992,Ap 19,46:1
Alberti, Gigio
Mediterraneo 1992,Mr 22,48:4
Alberti, Maryse (Cinematographer)
H-2 Worker 1991,F 15,C17:1
Poison 1991,Ap 5,C8:3
Incident at Oglala 1992,My 8,C15:1
Zebrahead 1992,O 8,C17:5
Alcaine, Jose Luis (Cinematographer)
Ay, Carmela! 1991,F 8,C8:5
Lovers 1992,Mr 25,C18:5
Alcazar, Damian
Woman of the Port (Mujer del Puerto, La) 1991,S 27,C5:1
Alda, Alan
Whispers in the Dark 1992,Ag 7,C17:1
Aldredge, Tom
What About Bob? 1991,My 17,C15:1
Other People's Money 1991,O 18,C10:3
Alejandro, Edesio (Composer)
Adorable Lies 1992,Mr 27,C8:5
Alekan, Henri
Other Eye, The 1991,S 25,C17:1
Alekan, Henri (Cinematographer)
Berlin Jerusalem 1991,Mr 8,C16:6
Aleksandrov, Pyotr
Second Circle, The 1992,Ja 2,C15:1
Stone 1992,O 3,18:1
Alekseyeva, Margarita
Satan 1992,Mr 28,18:1
Alexander, Jace
Mistress 1992,Ag 7,C16:3
Alexander, Jane (Narrator)
Building Bombs 1991,O 12,20:3
Alexander, Scott (Screenwriter)
Problem Child 2 1991,Jl 5,C6:1
Alexander, Sharon
Cup Final 1992,Ag 12,C13:1
Alexander, Spike
Brain Donors 1992,Ap 18,11:1
Alexander, Tracy (Miscellaneous)
Importance of Being Earnest, The 1992,My 14,C20:4
Alexandru, Matei
Oak, The 1992,O 1,C13:1
Allegret, Yves (Director)
Proud Ones, The (Proud and the Beautiful, The) 1992,My 29,C17:1
Allen, Dede (Miscellaneous)
Addams Family, The 1991,N 22,C1:1
Allen, Dick (Miscellaneous)
Enchanted April 1992,Jl 31,C15:1
Allen, James (Miscellaneous)
Encino Man 1992,My 22,C15:1
Allen, John David (Director)
Mona's Pets (Short and Funnies, The) 1992,D 16,C30:3
Allen, John David (Producer)
Mona's Pets (Short and Funnies, The) 1992,D 16,C30:3
Allen, John David (Screenwriter)
Mona's Pets (Short and Funnies, The) 1992,D 16,C30:3
Allen, Karen
Sweet Talker 1991,My 12,42:5
Sweet Talker 1991,Je 2,II:25:1
Malcolm X 1992,N 18,C19:3
Allen, Keith
Small Time 1991,N 8,C11:1
Allen, Mikki
Regarding Henry 1991,Jl 10,C13:3
Allen, Sage
Mr. Saturday Night 1992,S 23,C13:4
Allen, Woody
Scenes from a Mall 1991,F 22,C19:1
Scenes from a Mall 1991,F 24,II:11:5
Shadows and Fog 1992,Mr 20,C6:1
Husbands and Wives 1992,S 18,C1:1
Husbands and Wives 1992,O 4,II:9:1

Allen, Woody (Director)
Alice 1991,Ja 15,C11:3
Shadows and Fog 1992,Mr 20,C6:1
Husbands and Wives 1992,S 18,C1:1
Husbands and Wives 1992,O 4,II:9:1
Allen, Woody (Screenwriter)
Alice 1991,Ja 15,C11:3
Shadows and Fog 1992,Mr 20,C6:1
Husbands and Wives 1992,S 18,C1:1
Husbands and Wives 1992,O 4,II:9:1
Allman, Gregg
Rush 1991,D 22,56:4
Almayvonne
Mo' Money 1992,Jl 25,15:1
Almendros, Nestor (Cinematographer)
Billy Bathgate 1991,N 1,C1:1
Almodovar, Agustin (Producer)
High Heels 1991,D 20,C20:6
Almodovar, Pedro (Director)
High Heels 1991,D 20,C20:6
High Heels 1992,Ja 12,II:11:5
Pepi, Luci, Bom (Pepi, Luci, Bom and Other Girls on
the Heap) 1992,My 29,C10:5
Dark Habits 1992,Je 7,II:13:1
Almodovar, Pedro (Screenwriter)
High Heels 1991,D 20,C20:6
Pepi, Luci, Bom (Pepi, Luci, Bom and Other Girls on
the Heap) 1992,My 29,C10:5
Alonso, Maria Conchita
McBain 1991,S 23,C15:1
Alonzo, John A. (Cinematographer)
Housesitter 1992,Je 12,C1:4
. Cool World 1992,Jl 11,12:3
Alt, Chris
Famine Within, The 1991,Jl 17,C13:1
Altaraz, Naomi
Double Edge 1992,S 30,C18:3
Altman, Bruce
Regarding Henry 1991,Jl 10,C13:3
Glengarry Glen Ross 1992,S 30,C15:3
My New Gun 1992,O 30,C10:1
Altman, John (Composer)
Hear My Song 1992,Ja 19,48:1
Altman, Robert (Director)
Player, The 1992,Ap 10,C16:1
Player, The 1992,My 11,C9:1
Nashville 1992,N 8,II:13:5
Altman, Stephen (Miscellaneous)
Player, The 1992,Ap 10,C16:1
Alvarado, Trini
American Blue Note 1991,Mr 29,C12:1
Babe, The 1992,Ap 17,C8:1
Alvarez, Abraham
Panama Deception, The 1992,O 23,C10:5
Alvarez, Lucia (Composer)
Woman of the Port (Mujer del Puerto, La) 1991,S
27,C5:1
Ambrose, David (Screenwriter)
Year of the Gun 1991,N 1,C10:6
Ameche, Don
Oscar 1991,Ap 26,C10:5
Folks! 1992,My 4,C15:1
Amelio, Gianni (Director)
Open Doors 1991,Mr 8,C15:1
Ladro di Bambini, Il (Stolen Children, The) 1992,My
18,C13:6
Amend, Kate (Miscellaneous)
Legends 1991,Mr 17,68:5
Amend, Richard (Miscellaneous)
Wild Orchid 2: Two Shades of Blue 1992,My
8,C17:2
Amendola, Claudio
Forever Mary 1991,Ap 19,C11:1
Ames, Christopher (Screenwriter)
Class Action 1991,Mr 15,C20:4
Amick, Madchen
Sleepwalkers 1992,Ap 11,18:1
Amico, Robert F.
Small Time 1991,N 8,C11:1
Amicucci, Gianfranco (Miscellaneous)
Sleazy Uncle, The 1991,F 22,C10:5
Amies, Caroline (Miscellaneous)
Crossing the Line 1991,Ag 9,C11:1
Afraid of the Dark 1992,Jl 24,C7:1
Amitay, Jonathan (Director)
Nukie Takes a Valium 1991,O 12,20:3
Ammerlaan, Harry (Miscellaneous)
Voyeur 1991,Ag 2,C9:1

Ammon, Beat
Little Stiff, A 1991,Mr 16,16:3
Ammon, Ruth (Miscellaneous)
Strictly Business 1991,N 8,C13:3
Amoros, Juan (Cinematographer)
Aventis (Stories) 1992,N 13,C15:1
Amritraj, Ashok (Producer)
Popcorn 1991,F 1,C6:5
Double Impact 1991,Ag 9,C8:5
Amstutz, Roland
Alberto Express 1992,O 9,C12:5
Amzallag, Pierre
Ciel de Paris, Le 1992,Mr 29,48:2
Anciano, Dominic (Producer)
Reflecting Skin, The 1991,Je 28,C9:1
Anders, Allison (Director)
Gas Food Lodging 1992,Jl 31,C1:1
Gas Food Lodging 1992,D 13,II:1:2
Anders, Allison (Screenwriter)
Gas Food Lodging 1992,Jl 31,C1:1
Andersen, Bibi
Most Beautiful Night, The 1992,N 20,C10:5
Anderson, Adisa
Daughters of the Dust 1992,Ja 16,C19:1
Anderson, David (Producer)
Alan and Naomi 1992,Ja 31,C8:5
Anderson, Dion
Dying Young 1991,Je 21,C10:1
Anderson, Jamie (Cinematographer)
Unlawful Entry 1992,Je 26,C10:4
Anderson, Kevin
Sleeping with the Enemy 1991,F 8,C10:1
Liebestraum 1991,S 13,C6:1
Hoffa 1992,D 25,C1:1
Anderson, Laurie (Composer)
Monster in a Box 1992,Je 5,C6:4
Anderson, Peter
Leaving Normal 1992,Ap 29,C17:1
Anderson, Robert J. (Producer)
Passenger 57 1992,N 6,C14:5
Anderson, Robin (Director)
Black Harvest 1992,Ap 4,17:1
Anderson, Robin (Miscellaneous)
Black Harvest 1992,Ap 4,17:1
Anderson, Robin (Producer)
Black Harvest 1992,Ap 4,17:1
Anderson, Stanley
He Said, She Said 1991,F 22,C17:1
Anderson, Steve (Director)
South-Central 1992,O 16,C13:1
Anderson, Steve (Producer)
South-Central 1992,O 16,C13:1
Anderson, Steve (Screenwriter)
South-Central 1992,O 16,C13:1
Anderson, William (Miscellaneous)
At Play in the Fields of the Lord 1991,D 6,C8:1
1492: Conquest of Paradise 1992,O 9,C21:1
Andreasi, Felice
Story of Boys and Girls, The 1991,Mr 28,C12:1
Andrews, Julie
Fine Romance, A 1992,O 2,C10:6
Andrews, Peters (Screenwriter)
Importance of Being Earnest, The 1992,My 14,C20:4
Andriescu, Virgil
Oak, The 1992,O 1,C13:1
Andrus, Mark (Screenwriter)
Late for Dinner 1991,S 20,C6:5
Anello, Dino
Unlawful Entry 1992,Je 26,C10:4
Angel, Ken
Leaving Normal 1992,Ap 29,C17:1
Angell, Mark (Cinematographer)
Importance of Being Earnest, The 1992,My 14,C20:4
Angelo, Yves (Cinematographer)
Tous les Matins du Monde 1992,N 13,C3:4
Angelopoulos, Theo (Director)
Suspended Step of the Stork, The 1991,S 23,C15:1
Angelopoulos, Theo (Producer)
Suspended Step of the Stork, The 1991,S 23,C15:1
Angelopoulos, Theo (Screenwriter)
Suspended Step of the Stork, The 1991,S 23,C15:1
Anglade, Jean-Hugues
Femme Nikita, La 1991,Mr 8,C10:1
Angus, David
Hours and Times, The 1992,Ap 3,C10:1
Angwin, Neil (Miscellaneous)
Woman's Tale, A 1992,Ap 30,C16:6

Anholt, Christien
Reunion 1991,Mr 15,C16:6
Ann-Margret
Newsies 1992,Ap 8,C22:3
Annaud, Jean-Jacques (Director)
Lover, The 1992,O 30,C5:1
Annaud, Jean-Jacques (Screenwriter)
Lover, The 1992,O 30,C5:1
Anne, Alicia
Bikini Island 1991,Jl 27,16:3
Ansley, Zachary
Princes in Exile 1991,F 22,C12:5
Anthony, Lysette
Husbands and Wives 1992,S 18,C1:1
Husbands and Wives 1992,O 4,II:9:1
Antin, Eleanor
Man Without a World, The 1992,S 9,C18:4
Antin, Eleanor (Director)
Man Without a World, The 1992,S 9,C18:4
Antin, Eleanor (Producer)
Man Without a World, The 1992,S 9,C18:4
Antin, Eleanor (Screenwriter)
Man Without a World, The 1992,S 9,C18:4
Anwar, Gabrielle
If Looks Could Kill 1991,Mr 19,C12:5
Wild Hearts Can't Be Broken 1991,My 24,C16:6
Scent of a Woman 1992,D 23,C9:1
Anwar, Tariq (Miscellaneous)
Under Suspicion 1992,F 28,C10:1
Anzell, Hy
Crossing the Bridge 1992,S 11,C12:1
Applegate, Christina
Don't Tell Mom the Babysitter's Dead 1991,Je
7,C19:1
Applegate, Royce D.
Rampage 1992,O 30,C27:1
Apted, Michael (Director)
Class Action 1991,Mr 15,C20:4
35 Up 1992,Ja 15,C13:5
35 Up 1992,F 16,II:13:5
Thunderheart 1992,Ap 3,C12:1
Thunderheart 1992,My 10,II:22:1
Incident at Oglala 1992,My 10,II:22:1
Incident at Oglala 1992,My 8,C15:1
Apted, Michael (Producer)
35 Up 1992,Ja 15,C13:5
Aquino, Amy
Alan and Naomi 1992,Ja 31,C8:5
Arabov, Yuri (Screenwriter)
Second Circle, The 1992,Ja 2,C15:1
Save and Protect 1992,Jl 10,C14:5
Stone 1992,O 3,18:1
Araki, Gregg (Cinematographer)
Living End, The 1992,Ap 3,C1:1
Araki, Gregg (Director)
Living End, The 1992,Ja 23,C15:4
Living End, The 1992,Ap 3,C1:1
Living End, The 1992,Ag 14,C8:6
Living End, The 1992,D 13,II:1:2
Araki, Gregg (Miscellaneous)
Living End, The 1992,Ap 3,C1:1
Araki, Gregg (Screenwriter)
Living End, The 1992,Ap 3,C1:1
Living End, The 1992,Ag 14,C8:6
Arama, Shimon (Producer)
Eminent Domain 1991,Ap 12,C13:4
Arana, Tomas
Bodyguard, The 1992,N 25,C9:5
Aranda, Vicente (Director)
Lovers 1992,Mr 25,C18:5
Aventis (Stories) 1992,N 13,C15:1
Aranda, Vicente (Screenwriter)
Lovers 1992,Mr 25,C18:5
Aventis (Stories) 1992,N 13,C15:1
Aranguiz, Manuel
Paper Wedding, A 1991,Je 21,C8:1
Aranha, Ray
City of Hope 1991,O 11,C19:1
Arbid, Johnny
Cup Final 1992,Ag 12,C13:1
Arbogast, Thierry (Cinematographer)
Femme Nikita, La 1991,Mr 8,C10:1
Arbona, Gilles
Belle Noiseuse, La 1991,O 2,C17:5
Arcady, Alexandre (Director)
For Sasha 1992,Je 5,C13:1
Arcady, Alexandre (Producer)
For Sasha 1992,Je 5,C13:1

Behar, Joy
Wisecracks 1992,Je 4,C17:1
Behrens, Sam
American Blue Note 1991,Mr 29,C12:1
And You Thought Your Parents Were Weird 1991,N 15,C13:1
Beilke-Lau, Ankie
Leo Sonnyboy 1991,Mr 16,16:4
Belafonte, Harry
Player, The 1992,Ap 10,C16:1
Belafsky, Marty
Newsies 1992,Ap 8,C22:3
Breaking the Rules 1992,O 9,C10:6
Beldin, Dale (Miscellaneous)
Oscar 1991,Ap 26,C10:5
Innocent Blood 1992,S 25,C6:5
Belikov, Mikhail (Director)
Raspad 1992,Ap 29,C15:1
Belikov, Mikhail (Screenwriter)
Raspad 1992,Ap 29,C15:1
Belkin, Ann
Double Edge 1992,S 30,C18:3
Bell, Dan
Wayne's World 1992,F 14,C15:1
Bell, Nicholas
Father 1992,Jl 31,C5:5
Bell, Tom
Prospero's Books 1991,S 28,9:1
Let Him Have It 1991,D 6,C24:1
Bellamy, Diana
Passed Away 1992,Ap 24,C8:1
Beller, Hava Kohav (Director)
Restless Conscience, The 1992,F 7,C15:1
Beller, Hava Kohav (Producer)
Restless Conscience, The 1992,F 7,C15:1
Beller, Hava Kohav (Screenwriter)
Restless Conscience, The 1992,F 7,C15:1
Bellinhausen, Hermann (Screenwriter)
City of the Blind (Ciudad de Ciegos) 1992,Ap 4,17:5
Bellino, Clara
Steal America 1992,Ap 3,C24:5
Bellman, Gina
Secret Friends 1992,F 14,C10:1
Bellucci, Monica
Bram Stoker's "Dracula" 1992,N 13,C1:3
Belmondo, Jean-Paul
Mississippi Mermaid (Sirene du Mississippi, La) 1992,Ap 5,II:17:5
Belnavis, Christian
Rapture, The 1991,S 30,C14:4
Beloff, Zoe (Cinematographer)
Home Less Home 1991,Mr 22,C8:5
Beltzman, Mark
Mo' Money 1992,Jl 25,15:1
Belushi, James
Only the Lonely 1991,My 24,C10:6
Curly Sue 1991,O 25,C15:1
Curly Sue 1991,N 3,II:22:1
Once Upon a Crime 1992,Mr 7,20:4
Diary of a Hit Man 1992,My 29,C10:5
Traces of Red 1992,N 12,C22:1
Belvaux, Lucas
Madame Bovary 1991,D 25,13:1
Belvaux, Remy
Man Bites Dog 1992,O 9,C14:5
Belvaux, Remy (Director)
Man Bites Dog 1992,O 9,C14:5
Belvaux, Remy (Miscellaneous)
Man Bites Dog 1992,O 9,C14:5
Belvaux, Remy (Producer)
Man Bites Dog 1992,O 9,C14:5
Belvaux, Remy (Screenwriter)
Man Bites Dog 1992,O 9,C14:5
Belzberg, Leslie (Producer)
Oscar 1991,Ap 26,C10:5
Innocent Blood 1992,S 25,C6:5
Bena, Michael (Director)
Ciel de Paris, Le 1992,Mr 29,48:2
Bena, Michael (Screenwriter)
Ciel de Paris, Le 1992,Mr 29,48:2
Ben Ami, Yoram (Producer)
Stone Cold 1991,My 18,16:3
Benard, Joao Pedro (Producer)
Alex 1992,Mr 24,C15:3
Benard, Maurice
Ruby 1992,Mr 27,C1:3
Bender, Jack (Director)
Child's Play 3 1991,Ag 30,C11:3

Bender, Joel (Director)
Rich Girl 1991,My 4,15:1
Bender, Lawrence (Producer)
Reservoir Dogs 1992,O 23,C14:1
Benderson, Bruce (Screenwriter)
My Father Is Coming 1991,N 22,C12:5
Bendler, Lois
Zebrahead 1992,O 8,C17:5
Bendsen, Rikke
Memories of a Marriage 1991,Ja 28,C20:3
Bendtsen, Henning (Cinematographer)
Zentropa 1992,My 22,C14:1
Benedito, Armonia
Strictly Ballroom 1992,S 26,12:5
Benford, Vassal (Composer)
House Party 2 1991,O 23,C17:1
Class Act 1992,Je 5,C17:1
Benhamou, Luc (Cinematographer)
Window Shopping 1992,Ap 17,C13:1
Benigni, Roberto
Night on Earth 1991,O 4,C1:3
Night on Earth 1992,My 1,C10:5
Johnny Stecchino 1992,O 9,C8:5
Benigni, Roberto (Director)
Johnny Stecchino 1992,O 9,C8:5
Benigni, Roberto (Screenwriter)
Johnny Stecchino 1992,O 9,C8:5
Benigno, Francesco
Forever Mary 1991,Ap 19,C11:1
Bening, Annette
Grifters, The 1991,Ja 25,C13:1
Guilty by Suspicion 1991,Mr 15,C12:1
Regarding Henry 1991,Jl 10,C13:3
Regarding Henry 1991,Jl 14,II:9:5
Bugsy 1991,D 13,C12:1
Bugsy 1991,D 22,II:22:1
Benjamin, Jeff (Miscellaneous)
Wind 1992,S 11,C3:1
Benjamin, Mark (Cinematographer)
Blowback 1991,Ag 9,C13:1
Benn, Harry (Producer)
Kafka 1991,D 4,C21:1
Bennett, Charles C. (Miscellaneous)
New Jack City 1991,Mr 8,C15:1
McBain 1991,S 23,C15:1
Bennett, Eloise
Tale of Springtime, A (Conte de Printemps) 1992,Jl 17,C10:6
Bennett, James (Composer)
Poison 1991,Ap 5,C8:3
Swoon 1992,Mr 27,C8:1
Bennett, Joseph
Howards End 1992,Mr 13,C1:3
Bennett, Parker (Screenwriter)
Mystery Date 1991,Ag 16,C9:1
Bennett, Richard Rodney (Composer)
Enchanted April 1992,Jl 31,C15:1
Bennink, Han
Last Date: Eric Dolphy 1992,Je 29,C16:5
Benny, Jack
To Be or Not to Be 1992,Ag 21,C1:1
Benoist, Marie-Sidonie
Jacquot de Nantes 1991,S 25,C16:3
Benoit, Jean-Louis (Screenwriter)
Alberto Express 1992,O 9,C12:5
Benoit-Fresco, Francoise (Miscellaneous)
Inspector Lavardin 1991,D 26,C13:1
Benson, Laura
Amelia Lopes O'Neill 1991,S 21,12:3
Benson, Ray (Composer)
Never Leave Nevada 1991,Ap 28,60:5
Benson, Robby
Beauty and the Beast 1991,N 13,C17:4
Bentinck, Timothy
Year of the Comet 1992,Ap 25,17:1
Bentivoglio, Fabrizio
Peaceful Air of the West 1991,Mr 20,C12:5
Benton, Barbi
Hugh Hefner: Once Upon a Time 1992,N 6,C10:3
Benton, Robert (Director)
Billy Bathgate 1991,N 1,C1:1
Billy Bathgate 1991,N 3,II:13:4
Benvenuti, Leo (Screenwriter)
Sleazy Uncle, The 1991,F 22,C10:5
Benzali, Daniel
Day in October, A 1992,O 28,C20:5

Beraud, L. (Screenwriter)
En Toute Innocence (In All Innocence) 1992,Jl 31,C14:3
Bercovici, Luca
K2 1992,My 1,C16:1
Bercu, Michaela
Bram Stoker's "Dracula" 1992,N 13,C1:3
Beremeny, Geza (Director)
Age, An 1991,Mr 24,64:1
Berenbaum, Michael (Miscellaneous)
Misplaced 1991,Mr 1,C9:1
Berenger, Tom
Shattered 1991,O 11,C24:3
At Play in the Fields of the Lord 1991,D 6,C8:1
At Play in the Fields of the Lord 1992,Ja 19,II:13:5
Berenguer, Jose Carlos
Via Appia 1992,Ag 27,C16:5
Berens, Harold
Hear My Song 1992,Ja 19,48:1
Beresford, Bruce (Director)
Mister Johnson 1991,Mr 22,C13:1
Black Robe 1991,O 30,C15:2
Black Robe 1991,N 17,II:24:2
Berg, Peter
Crooked Hearts 1991,S 6,C13:1
Late for Dinner 1991,S 20,C6:5
Midnight Clear, A 1992,Ap 24,C1:3
Bergen, Frances
Eating 1991,My 3,C8:1
Berger, Christian (Cinematographer)
Benny's Video 1992,S 28,C14:1
Berger, Peter E. (Miscellaneous)
Dead Again 1991,Ag 23,C1:3
All I Want for Christmas 1991,N 8,C14:1
Stay Tuned 1992,Ag 15,14:5
Berger, Robert (Miscellaneous)
Final Analysis 1992,F 7,C8:1
Bergin, Patrick
Sleeping with the Enemy 1991,F 8,C10:1
Love Crimes 1992,Ja 26,43:5
Love Crimes 1992,F 9,II:13:1
Patriot Games 1992,Je 5,C1:1
Bergman, Andrew (Director)
Honeymoon in Vegas 1992,Ag 28,C8:5
Bergman, Andrew (Screenwriter)
Soapdish 1991,My 31,C10:1
Honeymoon in Vegas 1992,Ag 28,C8:5
Bergman, Ingmar (Screenwriter)
Best Intentions, The 1992,Jl 10,C10:5
Best Intentions, The 1992,Ag 9,II:13:5
Bergman, Jeff
Box Office Bunny 1991,F 9,12:4
Bergman, Martin (Screenwriter)
Peter's Friends 1992,D 25,C8:6
Bergmann, Art
Highway 61 1992,Ap 24,C19:1
Beristain, Gabriel (Cinematographer)
K2 1992,My 1,C16:1
Distinguished Gentleman, The 1992,D 4,C1:4
Berkeley, Michael (Composer)
Twenty-One 1991,O 4,C10:6
Berkeley, Xander
Candyman 1992,O 16,C10:5
Berkowitz, Steve (Producer)
Branford Marsalis: The Music Tells You 1992,Je 26,C12:6
Berliner, Alan (Director)
Intimate Stranger 1991,O 3,C21:1
Berlinger, Joe (Director)
Brother's Keeper 1992,S 9,C15:3
Berlinger, Joe (Miscellaneous)
Brother's Keeper 1992,S 9,C15:3
Berlinger, Joe (Producer)
Brother's Keeper 1992,S 9,C15:3
Berlioz, Hector (Composer)
Architecture of Doom, The 1991,O 30,C14:4
Berman, Richard C. (Producer)
December 1991,D 6,C8:5
Bernaola, Carmelo A. (Composer)
Wait for Me in Heaven (Esperame en el Cielo) 1991,Ja 30,C10:5
Bernard, Andre
Crying Game, The 1992,S 26,12:4
Bernard, Jeremie
Jacquot de Nantes 1991,S 25,C16:3
Bernard, Marie (Composer)
Strangers in Good Company 1991,My 10,C8:1

Brault, Sylvain (Cinematographer)
Paper Wedding, A 1991,Je 21,C8:1
Braunstein, Alan
Dead Ringer 1991,Jl 17,C14:5
Brave, Sarah
Thunderheart 1992,Ap 3,C12:1
Brazzi, Rossano
Barefoot Contessa, The 1992,N 20,C1:3
Brecht-Schall, Barbara
November Days 1992,My 8,C8:1
Breck, Peter
Highway 61 1992,Ap 24,C19:1
Breckman, Andy (Screenwriter)
True Identity 1991,Ag 23,C16:1
Bree, Richard (Producer)
Whole Truth, The 1992,O 23,C10:5
Breed, Helen Lloyd
Passed Away 1992,Ap 24,C8:1
Brefeld, Luk (Miscellaneous)
Last Date: Eric Dolphy 1992,Je 29,C16:5
Bregman, Martin (Producer)
Whispers in the Dark 1992,Ag 7,C17:1
Bregman, Michael S. (Producer)
Whispers in the Dark 1992,Ag 7,C17:1
Brennan, Richard (Producer)
Efficiency Expert, The 1992,N 6,C8:1
Brenne, Richard (Miscellaneous)
Class Act 1992,Je 5,C17:1
Brenner, Albert (Miscellaneous)
Backdraft 1991,My 24,C14:6
Frankie and Johnny 1991,O 11,C1:1
Mr. Saturday Night 1992,S 23,C13:4
Brenner, David (Miscellaneous)
Doors, The 1991,Mr 1,C1:1
Night and the City 1992,O 10,11:3
Brenner, Dori
For the Boys 1991,N 22,C12:1
Brero, Elide
Fallen from Heaven 1991,Mr 18,C12:3
Brest, Martin (Director)
Scent of a Woman 1992,D 23,C9:1
Brest, Martin (Producer)
Scent of a Woman 1992,D 23,C9:1
Bretherton, Monica (Miscellaneous)
Laws of Gravity 1992,Mr 21,18:1
Brezner, Larry (Producer)
Passed Away 1992,Ap 24,C8:1
Brialy, Jean-Claude
Inspector Lavardin 1991,D 26,C13:1
No Fear, No Die 1992,Ag 7,C16:5
Briat, Guillaume
Amour, L' 1991,Mr 15,C1:4
Brick, Richard (Producer)
Hangin' with the Homeboys 1991,My 24,C12:6
Brickman, Marshall (Screenwriter)
For the Boys 1991,N 22,C12:1
Bricmont, Wendy Greene (Miscellaneous)
My Girl 1991,N 27,C15:1
Bridges, Jeff
Fisher King, The 1991,S 20,C10:4
Fisher King, The 1991,S 22,II:13:1
Fisher King, The 1991,N 3,II:22:1
Bridges, Lloyd
Hot Shots! 1991,Jl 31,C11:2
Honey, I Blew Up the Kid 1992,Jl 17,C6:5
Briley, John (Screenwriter)
Christopher Columbus: The Discovery 1992,Ag 22,11:1
Brill, Steven (Screenwriter)
Mighty Ducks, The 1992,O 2,C18:1
Brimble, Nick
Robin Hood: Prince of Thieves 1991,Je 14,C1:4
Bringleson, Mark
Lawnmower Man, The 1992,Mr 7,20:1
Brinkmann, Robert (Cinematographer)
Shout 1991,O 4,C21:3
Encino Man 1992,My 22,C15:1
Brisbin, David (Miscellaneous)
Crooked Hearts 1991,S 6,C13:1
My Own Private Idaho 1991,S 27,C5:1
Ruby 1992,Mr 27,C1:3
Brite, Poppy Z.
John Five (Avant-Garde Visions) 1992,O 5,C14:4
Brito, Anthony (Miscellaneous)
Little Noises 1992,Ap 24,C8:6
Britton, Rhonda
Pets or Meat: The Return to Flint (Taking the Pulse) 1992,S 26,11:4

Bro, Anders Peter
Day in October, A 1992,O 28,C20:5
Broadbent, Jim
Life Is Sweet 1991,O 25,C10:1
Enchanted April 1992,Jl 31,C15:1
Crying Game, The 1992,S 26,12:4
Sense of History, A (Taking the Pulse) 1992,S 26,11:4
Broadbent, Jim (Screenwriter)
Sense of History, A (Taking the Pulse) 1992,S 26,11:4
Brochet, Anne
Maison Assassinee, La (Murdered House, The) 1991,O 25,C10:5
Tous les Matins du Monde 1992,N 13,C3:4
Brochu, Donald (Miscellaneous)
Midnight Clear, A 1992,Ap 24,C1:3
Brockett, Don
Passed Away 1992,Ap 24,C8:1
Brocksmith, Roy
Bill and Ted's Bogus Journey 1991,Jl 19,C10:1
Broderick, Beth
1,000 Pieces of Gold 1991,S 27,C10:4
Broderick, Matthew
Out on a Limb 1992,S 5,15:1
Brodie, Bill (Miscellaneous)
Body Parts 1991,Ag 3,9:1
Brodsky, Jack (Producer)
King Ralph 1991,F 15,C10:3
Brody, Adrien
Boy Who Cried Bitch, The 1991,O 11,C17:1
Brogi, Giulio
Portaborse, Il 1992,D 31,C18:1
Brolin, James
Ted and Venus 1991,D 20,C23:1
Gas Food Lodging 1992,Jl 31,C1:1
Bromfield, Valri
Nothing But Trouble 1991,F 16,16:5
Bronsky, Brick
Class of Nuke 'Em High Part 2: Subhumanoid Meltdown 1991,Ap 12,C13:1
Bronson, Charles
Indian Runner, The 1991,S 20,C6:1
Bronstein, David
My Father Is Coming 1991,N 22,C12:5
Brooks, Albert
Defending Your Life 1991,Mr 22,C12:1
Defending Your Life 1991,Ap 21,II:13:5
Brooks, Albert (Director)
Defending Your Life 1991,Mr 22,C12:1
Defending Your Life 1991,Ap 21,II:13:5
Brooks, Albert (Screenwriter)
Defending Your Life 1991,Mr 22,C12:1
Brooks, Halle (Miscellaneous)
Who Shot Patakango? 1992,My 1,C10:5
Brooks, Halle (Producer)
Who Shot Patakango? 1992,My 1,C10:5
Brooks, Halle (Screenwriter)
Who Shot Patakango? 1992,My 1,C10:5
Brooks, Mel
Life Stinks 1991,My 17,C1:1
Life Stinks 1991,Jl 26,C19:1
Life Stinks 1991,Ag 11,II:18:1
Brooks, Mel (Director)
Life Stinks 1991,My 17,C1:1
Life Stinks 1991,Jl 26,C19:1
Life Stinks 1991,Ag 11,II:18:1
Brooks, Mel (Producer)
Life Stinks 1991,Jl 26,C19:1
Brooks, Mel (Screenwriter)
Life Stinks 1991,My 17,C1:1
Life Stinks 1991,Jl 26,C19:1
Brooks, Randy
Reservoir Dogs 1992,O 23,C14:1
Brooks, Robert (Cinematographer)
Who Shot Patakango? 1992,My 1,C10:5
Brooks, Robert (Director)
Who Shot Patakango? 1992,My 1,C10:5
Brooks, Robert (Miscellaneous)
Who Shot Patakango? 1992,My 1,C10:5
Brooks, Robert (Screenwriter)
Who Shot Patakango? 1992,My 1,C10:5
Broomfield, Nick (Director)
Dark Obsession 1991,Je 7,C10:1
Monster in a Box 1992,Je 5,C6:4
Brosnan, Pierce
Mister Johnson 1991,Mr 22,C13:1
Lawnmower Man, The 1992,Mr 7,20:1

Brott, Tamar (Screenwriter)
Linguini Incident, The 1992,My 1,C15:1
Broughton, Bruce (Composer)
All I Want for Christmas 1991,N 8,C14:1
Honey, I Blew Up the Kid 1992,Jl 17,C6:5
Stay Tuned 1992,Ag 15,14:5
Brouwer, Marian (Producer)
Last Date: Eric Dolphy 1992,Je 29,C16:5
Brown, Andre Rosey
Class Act 1992,Je 5,C17:1
Brown, Barry Alexander (Miscellaneous)
Malcolm X 1992,N 18,C19:3
Brown, Blair
Passed Away 1992,Ap 24,C8:1
Brown, Bryan
FX2: The Deadly Art of Illusion 1991,My 10,C8:5
Sweet Talker 1991,My 12,42:5
Sweet Talker 1991,Je 2,II:25:1
Prisoners of the Sun 1991,Jl 19,C12:1
Blame It on the Bellboy 1992,Mr 6,C10:6
Brown, Bryan (Miscellaneous)
Sweet Talker 1991,My 12,42:5
Brown, Candy Ann
Zebrahead 1992,O 8,C17:5
Brown, Carolyn
Cage/Cunningham 1991,D 5,C20:1
Brown, Christopher
Replay 1992,Mr 31,C16:1
Brown, Clancy
Ambition 1991,Je 1,16:3
Pet Sematary Two 1992,Ag 29,14:4
Brown, David (Producer)
Player, The 1992,Ap 10,C16:1
Few Good Men, A 1992,D 11,C20:1
Brown, Derek (Miscellaneous)
Young Soul Rebels 1991,D 6,C21:1
Brown, Dwier
Cutting Edge, The 1992,Mr 27,C21:1
Mom and Dad Save the World 1992,Jl 27,C18:4
Brown, Georg Stanford
House Party 2 1991,O 23,C17:1
Brown, Gerard (Screenwriter)
Juice 1992,Ja 17,C10:1
Brown, John
Strip Jack Naked 1991,Je 8,16:5
Brown, Julie
Shakes the Clown 1992,Mr 13,C13:1
Brown, O. Nicholas (Miscellaneous)
City Slickers 1991,Je 7,C18:5
Sleepwalkers 1992,Ap 11,18:1
Brown, Ralph
Impromptu 1991,Ap 12,C10:5
Dark Obsession 1991,Je 7,C10:1
Alien 3 1992,My 22,C1:1
Crying Game, The 1992,S 26,12:4
Brown, Robert (Miscellaneous)
Dying Young 1991,Je 21,C10:1
Lethal Weapon 3 1992,My 15,C16:3
Brown, Robert Latham (Producer)
Child's Play 3 1991,Ag 30,C11:3
Brown, Wren T.
Importance of Being Earnest, The 1992,My 14,C20:4
Browne, Jackson (Composer)
Incident at Oglala 1992,My 8,C15:1
Brozhovskaya, Inna (Miscellaneous)
Adam's Rib 1991,S 21,12:5
Brubaker, James D. (Producer)
Brain Donors 1992,Ap 18,11:1
Bruce, Brenda
Antonia and Jane 1991,O 26,13:1
Bruce, Cheryl Lynn
Daughters of the Dust 1992,Ja 16,C19:1
Bruce, Lenny
Hugh Hefner: Once Upon a Time 1992,N 6,C10:3
Bruckheimer, Bonnie (Producer)
For the Boys 1991,N 22,C12:1
Bruel, Dirk (Cinematographer)
Sirup 1991,Mr 30,10:4
Bruel, Patrick
Maison Assassinee, La (Murdered House, The) 1991,O 25,C10:5
Brugman, Peter (Cinematographer)
Roy Rogers: King of the Cowboys 1992,D 30,C12:3
Bruneau, Thierry (Screenwriter)
Last Date: Eric Dolphy 1992,Je 29,C16:5
Brunet, Sophie (Miscellaneous)
November Days 1992,My 8,C8:1

Cage/Cunningham 1991,D 13,C37:1
Cage, Nicolas
Honeymoon in Vegas 1992,Ag 28,C8:5
Caggeine, J.
Slacker 1991,Mr 22,C8:1
Caglage, Costa
Frida Kahlo: A Ribbon Around a Bomb 1992,My 22,C10:1
Caillot, Haydee
Tale of Winter, A 1992,O 2,C12:6
Cain, Christopher (Director)
Pure Country 1992,O 23,C13:1
Cain, Roger (Miscellaneous)
Shipwrecked 1991,Mr 1,C6:1
Caine, Michael
Noises Off 1992,Mr 20,C10:1
Sleuth 1992,N 20,C1:3
Muppet Christmas Carol, The 1992,D 11,C12:6
Caine, Sari
June Roses 1992,Mr 24,C15:3
Cairns, Don
Blowback 1991,Ag 9,C13:1
Calderon, Luis Fernando (Miscellaneous)
Rodrigo D: No Future 1991,Ja 11,C10:5
Calderon, Paul
Crisscross 1992,My 9,17:5
Bad Lieutenant 1992,N 20,C15:1
Caldwell, H. H. (Miscellaneous)
Lucky Star 1991,N 1,C8:1
Calfa, Don
Chopper Chicks in Zombietown 1991,My 10,C15:5
Calhoun, Rory
Pure Country 1992,O 23,C13:1
Call, R. D.
Other People's Money 1991,O 18,C10:3
Callahan, Gene (Miscellaneous)
Man in the Moon, The 1991,O 4,C13:1
Callan, Kathleen
Raising Cain 1992,Ag 7,C5:1
Callard, Roger
Life on the Edge 1992,Je 19,C11:1
Callous, Maria
Wisecracks 1992,Je 4,C17:1
Callow, Simon (Director)
Ballad of the Sad Cafe, The 1991,Mr 28,C11:1
Calloway, Chris
Importance of Being Earnest, The 1992,My 14,C20:4
Calloway, Vanessa Bell
Bebe's Kids 1992,Ag 1,16:6
Calypso Rose
One Hand Don't Clap 1991,Ag 28,C13:1
Camara, Seni
Seni's Children 1992,Mr 20,C14:5
Cambas, Jacqueline (Miscellaneous)
Frankie and Johnny 1991,O 11,C1:1
School Ties 1992,S 18,C19:1
Cambern, Donn (Miscellaneous)
Butcher's Wife, The 1991,O 25,C24:1
Bodyguard, The 1992,N 25,C9:5
Camden, Gloria
Frozen Assets 1992,O 24,16:4
Cameron, Allan (Miscellaneous)
Far and Away 1992,My 22,C10:5
Cameron, James (Director)
Terminator 2: Judgment Day 1991,Jl 3,C11:5
Terminator 2: Judgment Day 1991,Jl 14,II:9:1
Cameron, James (Producer)
Terminator 2: Judgment Day 1991,Jl 3,C11:5
Cameron, James (Screenwriter)
Terminator 2: Judgment Day 1991,Jl 3,C11:5
Terminator 2: Judgment Day 1991,Jl 14,II:9:1
Campanella, Juan Jose (Director)
Boy Who Cried Bitch, The 1991,O 11,C17:1
Campbell, Bill
Rocketeer, The 1991,Je 21,C1:3
Bram Stoker's "Dracula" 1992,N 13,C1:3
Campbell, Diane (Producer)
Never Leave Nevada 1991,Ap 28,60:5
Campbell, Glen
Rock-a-Doodle 1992,Ap 3,C13:1
Campbell, J. Kenneth
Flight of the Intruder 1991,Ja 18,C19:1
Campbell, John (Cinematographer)
My Own Private Idaho 1991,S 27,C5:1
Campbell, Julia
Livin' Large 1991,S 20,C15:1
Campbell, Luther
Damned in the U.S.A. 1992,N 13,C11:1

Campbell, Malcolm (Miscellaneous)
Nothing But Trouble 1991,F 16,16:5
Wayne's World 1992,F 14,C15:1
Brain Donors 1992,Ap 18,11:1
Campbell, Martin (Director)
Defenseless 1991,Ag 23,C8:1
Campbell, Nicholas
Naked Lunch 1991,D 27,C1:3
Rampage 1992,O 30,C27:1
Campbell, Paul
Lunatic, The 1992,F 7,C14:5
Campbell, Rob
Unforgiven 1992,Ag 7,C1:1
Campbell, Tisha
House Party 2 1991,O 23,C17:1
Boomerang 1992,Jl 1,C18:1
Campell, Sally (Miscellaneous)
Until the End of the World 1991,D 25,18:5
Campion, Anna (Director)
Audition 1991,Mr 28,C12:1
Campion, Jane
Audition 1991,Mr 28,C12:1
Campion, Jane (Director)
Angel at My Table, An 1991,My 21,C15:1
Angel at My Table, An 1991,Je 16,II:11:5
Campo, Sabeline
Madame Bovary 1991,D 25,13:1
Canada, Ron
Honey, I Blew Up the Kid 1992,Jl 17,C6:5
Candaele, Kelly (Miscellaneous)
League of Their Own, A 1992,Jl 1,C13:4
Candib, Richard (Miscellaneous)
Rich Girl 1991,My 4,15:1
American Me 1992,Mr 13,C6:5
Candy, John
Nothing But Trouble 1991,F 16,16:5
Career Opportunities 1991,Mr 31,38:1
Only the Lonely 1991,My 24,C10:6
Only the Lonely 1991,Je 2,II:15:1
Delirious 1991,Ag 9,C12:4
Once Upon a Crime 1992,Mr 7,20:4
Canfield, Gene
Boy Who Cried Bitch, The 1991,O 11,C17:1
Scent of a Woman 1992,D 23,C9:1
Cannon, Bruce (Miscellaneous)
End of Innocence, The 1991,Ja 18,C17:1
Boyz 'n the Hood 1991,Jl 12,C1:1
Cannon, Dyan
End of Innocence, The 1991,Ja 18,C17:1
Cannon, Dyan (Director)
End of Innocence, The 1991,Ja 18,C17:1
Cannon, Dyan (Screenwriter)
End of Innocence, The 1991,Ja 18,C17:1
Cannon, Vince (Producer)
End of Innocence, The 1991,Ja 18,C17:1
Cannone, Jean-Michel
Fine Romance, A 1992,O 2,C10:6
Canonero, Milena (Miscellaneous)
Single White Female 1992,Ag 14,C8:1
Damage 1992,D 23,C13:1
Canova, Diana
Bruce Diet, The 1992,Ap 15,C19:1
Cantin, Marie (Producer)
Waterdance, The 1992,My 13,C13:1
Canton, Neil (Producer)
Trespass 1992,D 25,C18:5
Cantu, Carlos
Panama Deception, The 1992,O 23,C10:5
Cao Cuifeng
Raise the Red Lantern 1992,Mr 20,C18:1
Capitanos, Leon (Miscellaneous)
Intervista 1992,N 20,C10:1
Caplan, Elliot (Director)
Cage/Cunningham 1991,D 5,C20:1
Cage/Cunningham 1991,D 13,C37:1
Caplan, Elliot (Miscellaneous)
Cage/Cunningham 1991,D 5,C20:1
Capodice, John
Hard Way, The 1991,Mr 8,C8:1
Honeymoon in Vegas 1992,Ag 28,C8:5
Capotorto, Carl
Men of Respect 1991,Ja 18,C1:1
American Blue Note 1991,Mr 29,C12:1
Cappello, Frank (Screenwriter)
Suburban Commando 1991,O 6,56:3
Capra, Bernt (Director)
Mindwalk 1992,Ap 8,C17:1

Capra, Fritjof (Original Author)
Mindwalk 1992,Ap 8,C17:1
Capra, Fritjof (Screenwriter)
Mindwalk 1992,Ap 8,C17:1
Capshaw, Kate
My Heroes Have Always Been Cowboys 1991,Mr 22,C14:5
Carax, Leos (Director)
Amants du Pont Neuf, Les (Lovers of the Pont Neuf) 1992,O 6,C16:1
Amants du Pont Neuf, Les 1992,O 11,II:11:1
Carax, Leos (Screenwriter)
Amants du Pont Neuf, Les (Lovers of the Pont Neuf) 1992,O 6,C16:1
Carbutt, Adrian James (Composer)
Strip Jack Naked 1991,Je 8,16:5
Carbutt, Adrian James (Miscellaneous)
Strip Jack Naked 1991,Je 8,16:5
Cardinal, Tantoo
Black Robe 1991,O 30,C15:2
Cardinale, Claudia
Rocco and His Brothers 1991,S 21,12:1
Rocco and His Brothers 1992,Ja 24,C8:1
Cardona, Cora
Frida Kahlo: A Ribbon Around a Bomb 1992,My 22,C10:1
Cardona, Cora (Producer)
Frida Kahlo: A Ribbon Around a Bomb 1992,My 22,C10:1
Carey, Amy (Miscellaneous)
Daughters of the Dust 1992,Ja 16,C19:1
Carey, Peter (Screenwriter)
Until the End of the World 1991,D 25,18:5
Carhart, John, 3d
There's Nothing Out There 1992,Ja 22,C20:4
Carhart, Timothy
Thelma and Louise 1991,My 24,C1:1
Carides, Gia
Strictly Ballroom 1992,S 26,12:5
Caridi, Carmine
Ruby 1992,Mr 27,C1:3
Carlen, Catherine
Chopper Chicks in Zombietown 1991,My 10,C15:5
Carlin, George
Bill and Ted's Bogus Journey 1991,Jl 19,C10:1
Prince of Tides, The 1991,D 25,13:3
Carlson, Linda
Honey, I Blew Up the Kid 1992,Jl 17,C6:5
Carmody, Don (Producer)
Hitman, The 1991,O 27,51:5
Carmody, Don (Screenwriter)
Hitman, The 1991,O 27,51:5
Carmody, Jaqueline (Miscellaneous)
Hitman, The 1991,O 27,51:5
Carney, Charles (Screenwriter)
Box Office Bunny 1991,F 9,12:4
Carnochan, John (Miscellaneous)
Beauty and the Beast 1991,N 13,C17:4
Caro, Marc (Director)
Delicatessen 1991,O 5,14:3
Delicatessen 1992,Ap 5,53:2
Delicatessen 1992,My 3,II:13:4
Caro, Marc (Screenwriter)
Delicatessen 1991,O 5,14:3
Caron, Leslie
Damage 1992,D 23,C13:1
Carp, Jean-Philippe (Miscellaneous)
Delicatessen 1991,O 5,14:3
Carpenter, John (Director)
Memoirs of an Invisible Man 1992,F 28,C17:1
Carpenter, Ken
Hellraiser III: Hell on Earth 1992,S 12,14:3
Carpenter, Russell (Cinematographer)
Perfect Weapon, The 1991,Mr 16,16:5
Lawnmower Man, The 1992,Mr 7,20:1
Pet Sematary Two 1992,Ag 29,14:4
Carra, Lucille (Director)
Inland Sea, The 1992,Je 17,C13:1
Carra, Lucille (Producer)
Inland Sea, The 1992,Je 17,C13:1
Carradine, David
Roadside Prophets 1992,Mr 27,C10:1
Carradine, Keith
Ballad of the Sad Cafe, The 1991,Mr 28,C11:1
Street of No Return 1991,Ag 2,C6:1
Crisscross 1992,My 9,17:5
Nashville 1992,N 8,II:13:5

Chandler, Michael (Miscellaneous)
Amazon 1992,F 28,C8:5
Wind 1992,S 11,C3:1
Chang, Eileen (Original Author)
Rouge of the North 1991,D 6,C24:5
Chang, Gary (Composer)
Under Siege 1992,O 9,C12:1
Chang, Martha (Producer)
3 Ninjas 1992,Ag 7,C5:1
Chang, Peter (Composer)
Rouge of the North 1991,D 6,C24:5
Chang Shih
Five Girls and a Rope 1992,Mr 22,48:1
Chang, Shwu-Fen
Song of the Exile 1991,Mr 15,C21:1
Chang Suk-ping, William (Miscellaneous)
Days of Being Wild 1991,Mr 23,12:3
Chang Ying
Five Girls and a Rope 1992,Mr 22,48:1
Channing, Stockard
Meet the Applegates 1991,F 1,C6:1
Channing-Williams, Simon (Producer)
Life Is Sweet 1991,O 25,C10:1
Sense of History, A (Taking the Pulse) 1992,S 26,11:4
Chao, Rosalind
1,000 Pieces of Gold 1991,S 27,C10:4
Chaplin, Charles (Original Author)
Chaplin 1992,D 25,C3:1
Chaplin, Geraldine
Nashville 1992,N 8,II:13:5
Chaplin 1992,D 25,C3:1
Chapman, David (Miscellaneous)
This Is My Life 1992,F 21,C8:1
Chapman, Joan (Miscellaneous)
Mannequin Two: On the Move 1991,My 19,50:3
Folks! 1992,My 4,C15:1
Chapman, Lanei
Importance of Being Earnest, The 1992,My 14,C20:4
Chapman, Matthew (Screenwriter)
Consenting Adults 1992,O 16,C14:5
Chapman, Michael (Cinematographer)
Doc Hollywood 1991,Ag 2,C8:5
Whispers in the Dark 1992,Ag 7,C17:1
Chapman, Ron (Cinematographer)
Class of Nuke 'Em High Part 2: Subhumanoid Meltdown 1991,Ap 12,C13:1
Chapuis, Dominique (Cinematographer)
Outremer 1991,Mr 27,C15:1
Charbonneau, Jay
Complex World 1992,Ap 10,C14:5
Charbonneau, Patricia
K2 1992,My 1,C16:1
Charles, David
Julia Has Two Lovers 1991,Mr 24,64:1
Charles, Josh
Don't Tell Mom the Babysitter's Dead 1991,Je 7,C19:1
Crossing the Bridge 1992,S 11,C12:1
Charles, Keith
Drop Dead Fred 1991,My 24,C8:1
Charmant, Gilles
Vie de Boheme, La 1992,O 9,C14:1
Charolais, Pascale (Miscellaneous)
Captive of the Desert, The (Captive du Desert, La) 1991,Mr 21,C20:3
Charpentier, Pierrick
Cold Moon (Lune Froide) 1992,Ap 22,C17:1
Charraborty, Lily
Branches of the Tree, The 1992,Ap 17,C15:3
Charters, Rodney (Cinematographer)
Sleepwalkers 1992,Ap 11,18:1
Chartoff, Robert (Producer)
Straight Talk 1992,Ap 3,C17:1
Chase, Chevy
Nothing But Trouble 1991,F 16,16:5
Memoirs of an Invisible Man 1992,F 28,C17:1
Hero 1992,O 4,II:9:4
Chase, Thomas (Composer)
Little Nemo: Adventures in Slumberland 1992,Ag 21,C13:1
Chasnoff, Debra (Director)
Deadly Deception: General Electric, Nuclear Weapons and Our Environment 1991,O 12,20:3
Chasnoff, Debra (Producer)
Deadly Deception: General Electric, Nuclear Weapons and Our Environment 1991,O 12,20:3

Chatiliez, Etienne (Director)
Tatie Danielle 1991,My 17,C8:1
Tatie Danielle 1991,Je 2,II:15:1
Tatie Danielle 1991,Jl 5,C3:6
Chattaway, Jay (Composer)
Rich Girl 1991,My 4,15:1
Chatterjee, Soumitra
Branches of the Tree, The 1992,Ap 17,C15:3
Chatterji, Dhritiman
Stranger, The 1992,My 22,C13:1
Chatterji, Subrata
Stranger, The 1992,My 22,C13:1
Chatwin, Bruce (Miscellaneous)
On the Black Hill 1991,Ag 16,C8:1
Chau, Francois
Teen-Age Mutant Ninja Turtles II: The Secret of the Ooze 1991,Mr 22,C1:3
Chau, Mai
Indochine 1992,D 24,C9:1
Chaudhri, Amin Q. (Producer)
Diary of a Hit Man 1992,My 29,C10:5
Chaulet, Emmanuelle
All the Vermeers in New York 1992,My 1,C13:1
Chaykin, Maury
Adjuster, The 1991,S 26,C18:5
Leaving Normal 1992,Ap 29,C17:1
Chayko, Belinda (Director)
Swimming 1991,Mr 27,C15:1
Chelsom, Peter (Director)
Hear My Song 1992,Ja 19,48:1
Chelsom, Peter (Miscellaneous)
Hear My Song 1992,Ja 19,48:1
Chelsom, Peter (Screenwriter)
Hear My Song 1992,Ja 19,48:1
Chelton, Tsilla
Tatie Danielle 1991,My 17,C8:1
Tatie Danielle 1991,Je 2,II:15:1
Tatie Danielle 1991,Jl 5,C3:6
Chen Chun-sung (Producer)
Rouge of the North 1991,D 6,C24:5
Chen Kaige (Director)
Life on a String 1991,S 29,54:5
Life on a String 1992,Ja 10,C16:6
Chen Kaige (Screenwriter)
Life on a String 1991,S 29,54:5
Chen Po-wen (Miscellaneous)
Rouge of the North 1991,D 6,C24:5
Chen, Yang (Composer)
Song of the Exile 1991,Mr 15,C21:1
Chen Yuan Bin (Original Author)
Story of Qiu Ju, The 1992,O 2,C12:1
Cheng, Kent
Once Upon a Time in China 1992,My 21,C16:5
Chenut, Jean-Marc (Composer)
Man Bites Dog 1992,O 9,C14:5
Cher
Player, The 1992,My 11,C9:1
Chereau, Patrice
Last of the Mohicans, The 1992,S 25,C3:1
Cherednik, Aleksandr
Save and Protect 1992,Jl 10,C14:5
Chester, Craig
Swoon 1992,Mr 27,C8:1
Swoon 1992,S 11,C8:6
Chestnut, Morris
Boyz 'n the Hood 1991,Jl 12,C1:1
Cheung Hok-yau, Jackie. See Cheung, Jackie
Cheung, Jackie
Days of Being Wild 1991,Mr 23,12:3
Once Upon a Time in China 1992,My 21,C16:5
Cheung Kwok-wing, Leslie
Days of Being Wild 1991,Mr 23,12:3
Cheung, Maggie
Song of the Exile 1991,Mr 15,C21:1
Days of Being Wild 1991,Mr 23,12:3
Cheung Man-yuk, Maggie. See Cheung, Maggie
Chevalia, Kevin Timothy
Folks! 1992,My 4,C15:1
Chevit, Maurice
Hairdresser's Husband, The 1992,Je 19,C11:1
Chew, Richard (Miscellaneous)
Late for Dinner 1991,S 20,C6:5
Singles 1992,S 18,C3:4
Chi Xiao Ling (Cinematographer)
Story of Qiu Ju, The 1992,O 2,C12:1
Chianese, Dominic
Public Eye, The 1992,O 14,C17:1

Chiao, Roy
Shadow of China 1991,Mr 10,58:5
Chiba, Sonny
Aces: Iron Eagle III 1992,Je 13,16:4
Chijona, Gerardo (Director)
Adorable Lies 1992,Mr 27,C8:5
Chijona, Gerardo (Miscellaneous)
Adorable Lies 1992,Mr 27,C8:5
Chiles, Lois
Diary of a Hit Man 1992,My 29,C10:5
Chin, Michael (Cinematographer)
In the Shadow of the Stars 1991,Ag 14,C15:1
Chinn, Lori Tan
Glengarry Glen Ross 1992,S 30,C15:3
Chitty, Alison (Miscellaneous)
Life Is Sweet 1991,O 25,C10:1
Chiu Fu-Sheng (Producer)
Raise the Red Lantern 1992,Mr 20,C18:1
Chlumecky, Jiri (Composer)
Time of the Servants 1991,Mr 19,C12:3
Chlumsky, Anna
My Girl 1991,N 27,C15:1
My Girl 1991,D 1,II:11:1
Chobanian, Arthur (Producer)
Incident at Oglala 1992,My 8,C15:1
Choi Siu Wan
Autumn Moon 1992,S 26,12:1
Chonchanakun, Yaiwalak (Aoi)
Good Woman of Bangkok, The 1992,My 15,C13:1
Chong, Rae Dawn
Borrower, The 1991,O 18,C12:3
Amazon 1992,F 28,C8:5
Chong, Tommy
Ferngully: The Last Rain Forest 1992,Ap 10,C10:5
Chou, Nai-Chung (Producer)
Song of the Exile 1991,Mr 15,C21:1
Choudhury, Sarita
Mississippi Masala 1992,F 5,C15:1
Chow Chi-liang (Miscellaneous)
Rouge of the North 1991,D 6,C24:5
Chow, Raymond (Producer)
Once Upon a Time in China 1992,My 21,C16:5
Chow Yun-Fat
Killer, The 1991,Ap 12,C11:1
Chowdhry, Ranjit
Mississippi Masala 1992,F 5,C15:1
Chowdhury, Santu
City of Joy 1992,Ap 15,C15:1
Christensen, Bo (Producer)
Zentropa 1992,My 22,C14:1
Christensen, Martha (Original Author)
Memories of a Marriage 1991,Ja 28,C20:3
Christinat, Esther
Leo Sonnyboy 1991,Mr 16,16:4
Christopher, Lynn (Miscellaneous)
Ted and Venus 1991,D 20,C23:1
Chrysikou, Dora
Suspended Step of the Stork, The 1991,S 23,C15:1
Chu Kong
Killer, The 1991,Ap 12,C11:1
Chubb, Caldecot (Producer)
Hoffa 1992,D 25,C1:1
Chung Chi-Man (Cinematographer)
Song of the Exile 1991,Mr 15,C21:1
Chung, Shyro
Young Soul Rebels 1991,D 6,C21:1
"Chupadora," Eli Machuca
Cabeza de Vaca 1991,Mr 23,12:6
Churgin, Lisa (Miscellaneous)
Closet Land 1991,Mr 7,C18:3
Bob Roberts 1992,S 4,C1:1
Churikova, Inna
Adam's Rib 1991,S 21,12:5
Adam's Rib 1992,My 9,17:2
Chvatal, Cindy (Producer)
Hard Promises 1992,Ja 31,C12:6
Chylkova, Ivana
Time of the Servants 1991,Mr 19,C12:3
Ciamaca, Julien
My Father's Glory (Gloire de Mon Pere, Le) 1991,Je 21,C10:5
My Mother's Castle 1991,Jl 26,C6:1
Cibulkova, Vilma
Time of the Servants 1991,Mr 19,C12:3
Ciccolella, Jude
Glengarry Glen Ross 1992,S 30,C15:3
Cicekoglu, Feride (Screenwriter)
Journey of Hope 1991,Ap 26,C13:1

Collett, Ellen (Producer)
Deceived 1991,S 27,C8:5
Collette, Toni
Efficiency Expert, The 1992,N 6,C8:1
Collette, Yann
Maison Assassinee, La (Murdered House, The)
1991,O 25,C10:5
Collier, James F. (Director)
China Cry 1991,My 3,C9:1
Collier, James F. (Screenwriter)
China Cry 1991,My 3,C9:1
Collier, Maggie
Prince of Tides, The 1991,D 25,13:3
Collin, Maxime
Leolo 1992,S 29,C11:1
Collins, Kevin
Garden, The 1991,Ja 17,C16:5
Edward II 1992,Mr 20,C16:3
Collins, Patricia
Adjuster, The 1991,S 26,C18:5
Collins, Pauline
City of Joy 1992,Ap 15,C15:1
Collins, Stephen
My New Gun 1992,O 30,C10:1
Collins, Wayne
Bebe's Kids 1992,Ag 1,16:6
Collis, Jack T. (Miscellaneous)
Flight of the Intruder 1991,Ja 18,C19:1
Far and Away 1992,My 22,C10:5
Collis, Peter (Cinematographer)
Body Beautiful, The 1991,O 3,C21:1
Collister, Peter (Cinematographer)
Livin' Large 1991,S 20,C15:1
Collver, Mark
There's Nothing Out There 1992,Ja 22,C20:4
Colombier, Michel (Composer)
New Jack City 1991,Mr 8,C15:1
Room in Town, A (Chambre en Ville, Une) 1991,S
28,11:5
Strictly Business 1991,N 8,C13:3
Folks! 1992,My 4,C15:1
Diary of a Hit Man 1992,My 29,C10:5
Colpaert, Carl (Director)
Delusion 1991,Je 7,C12:6
Colpaert, Carl (Screenwriter)
Delusion 1991,Je 7,C12:6
Colton, Chevi
June Roses 1992,Mr 24,C15:3
Coltrane, Robbie
Perfectly Normal 1991,F 15,C14:5
Pope Must Die(t), The 1991,Ag 30,C10:3
Triple Bogey on a Par 5 Hole 1992,Mr 21,13:4
Nuns on the Run 1992,Je 7,II:13:1
Columbus, Chris (Director)
Only the Lonely 1991,My 24,C10:6
Only the Lonely 1991,Je 2,II:15:1
Home Alone 2: Lost in New York 1992,N 20,C1:1
Columbus, Chris (Screenwriter)
Only the Lonely 1991,My 24,C10:6
Only the Lonely 1991,Je 2,II:15:1
Little Nemo: Adventures in Slumberland 1992,Ag
21,C13:1
Combs, Holly Marie
Simple Men 1992,O 14,C22:1
Dr. Giggles 1992,O 24,16:4
Combs, Jeffrey
Bride of Re-Animator 1991,F 22,C17:1
Comfort, Bob (Screenwriter)
Dogfight 1991,S 13,C13:1
Dogfight 1991,S 15,II:13:5
Conaway, Cristi
Batman Returns 1992,Je 19,C1:1
Husbands and Wives 1992,S 18,C1:1
Conchon, George (Screenwriter)
Elegant Criminel, L' 1992,Je 24,C18:3
Condie, Richard (Director)
Big Snit, The (Short and Funnies, The) 1992,D
16,C30:3
Condie, Richard (Miscellaneous)
Big Snit, The (Short and Funnies, The) 1992,D
16,C30:3
Condie, Richard (Screenwriter)
Big Snit, The (Short and Funnies, The) 1992,D
16,C30:3
Condon, Bill (Screenwriter)
FX2: The Deadly Art of Illusion 1991,My 10,C8:5
Condurache, Dan
Oak, The 1992,O 1,C13:1

Cone, Buddy (Miscellaneous)
Rampage 1992,O 30,C27:1
Congdon, Dana (Miscellaneous)
Triple Bogey on a Par 5 Hole 1992,Mr 21,13:4
In the Soup 1992,O 3,13:2
Connaughton, Shane (Screenwriter)
Playboys, The 1992,Ap 22,C15:1
Connell, David (Cinematographer)
Neverending Story II, The: The Next Chapter 1991,F
9,12:4
Connell, Michael (Miscellaneous)
Lunatic, The 1992,F 7,C14:5
Connelly, Jennifer
Career Opportunities 1991,Mr 31,38:1
Rocketeer, The 1991,Je 21,C1:3
Connery, Sean
Russia House, The 1991,Ja 27,II:1:1
Medicine Man 1992,F 7,C13:1
Connick, Harry, Jr.
Little Man Tate 1991,O 9,C17:4
Connolly, Billy
Crossing the Line 1991,Ag 9,C11:1
Connolly, Bob (Cinematographer)
Black Harvest 1992,Ap 4,17:1
Connolly, Bob (Director)
Black Harvest 1992,Ap 4,17:1
Connolly, Bob (Miscellaneous)
Black Harvest 1992,Ap 4,17:1
Connolly, Bob (Producer)
Black Harvest 1992,Ap 4,17:1
Connolly, Kevin
Alan and Naomi 1992,Ja 31,C8:5
Conrad, Joseph
Newsies 1992,Ap 8,C22:3
Conroy, Frances
Scent of a Woman 1992,D 23,C9:1
Conroy, Jack (Cinematographer)
Playboys, The 1992,Ap 22,C15:1
Conroy, Pat (Original Author)
Prince of Tides, The 1991,D 25,13:3
Prince of Tides, The 1992,F 23,II:13:1
Prince of Tides, The 1992,F 28,C1:1
Conroy, Pat (Screenwriter)
Prince of Tides, The 1991,D 25,13:3
Constant, Yvonne
Favor, the Watch, and the Very Big Fish, The
1992,My 8,C15:3
Constantine, Eddie
Zentropa 1992,My 22,C14:1
Constantini, Brian
Talking to Strangers 1991,D 27,C12:6
Conte, Mark (Miscellaneous)
Lionheart 1991,Ja 11,C8:4
Double Impact 1991,Ag 9,C8:5
Stop! Or My Mom Will Shoot 1992,F 21,C8:5
Conti, Bill (Composer)
Necessary Roughness 1991,S 27,C21:3
Year of the Gun 1991,N 1,C10:6
Conti, Ugo
Mediterraneo 1992,Mr 22,48:4
Convertino, Michael (Composer)
End of Innocence, The 1991,Ja 18,C17:1
Doctor, The 1991,Jl 24,C11:1
Waterdance, The 1992,My 13,C13:1
Conway, Kevin
One Good Cop 1991,My 3,C13:1
Rambling Rose 1991,S 20,C12:4
Jennifer 8 1992,N 6,C6:2
Cooder, Ry (Composer)
Trespass 1992,D 25,C18:5
Coogan, Keith
Book of Love 1991,F 1,C10:6
Toy Soldiers 1991,Ap 26,C15:1
Don't Tell Mom the Babysitter's Dead 1991,Je
7,C19:1
Cook, Gerry
Heck with Hollywood!, The 1991,O 9,C15:1
Cook, Roger
Garden, The 1991,Ja 17,C16:5
Cooke, Chris
Simple Men 1992,O 14,C22:1
Cookson, Tony (Director)
And You Thought Your Parents Were Weird 1991,N
15,C13:1
Cookson, Tony (Screenwriter)
And You Thought Your Parents Were Weird 1991,N
15,C13:1

Coolidge, Martha (Director)
Rambling Rose 1991,S 20,C12:4
Rambling Rose 1992,F 9,II:13:1
Coonce, Cole (Composer)
Living End, The 1992,Ap 3,C1:1
Coonts, Stephen (Original Author)
Flight of the Intruder 1991,Ja 18,C19:1
Cooper, Alice
Freddy's Dead: The Final Nightmare 1991,S 14,11:4
Wayne's World 1992,F 14,C15:1
Wayne's World 1992,Je 26,C1:3
Cooper, Barry Michael (Screenwriter)
New Jack City 1991,Mr 8,C15:1
Cooper, Cami
Meet the Applegates 1991,F 1,C6:1
Cooper, Chris
Guilty by Suspicion 1991,Mr 15,C12:1
1,000 Pieces of Gold 1991,S 27,C10:4
To the Moon, Alice 1991,O 2,C19:1
Cooper, Douglas (Cinematographer)
Brother's Keeper 1992,S 9,C15:3
Cooper, James Fenimore (Original Author)
Last of the Mohicans, The 1992,S 25,C3:1
Last of the Mohicans, The 1992,O 18,II:13:5
Cooper, Jeanne
Frozen Assets 1992,O 24,16:4
Cooper, Jeremy
Reflecting Skin, The 1991,Je 28,C9:1
Cooper, Robert (Producer)
Truly, Madly, Deeply 1991,My 3,C11:1
Cooper, Roy
Housesitter 1992,Je 12,C1:4
Copans, Sylvain
Cross My Heart 1991,Ap 5,C18:5
Cope, Paul (Cinematographer)
Wild Wheels 1992,Ag 26,C15:1
Copeland, Miles A., 3d (Producer)
One False Move 1992,Jl 17,C6:1
Copes, Leslie
Little Stiff, A 1991,Mr 16,16:3
Copley, Teri
Frozen Assets 1992,O 24,16:4
Coppard, William (Producer)
Cheap Shots 1991,N 15,C11:1
Coppola, Eleanor (Miscellaneous)
Hearts of Darkness: A Film Maker's Apocalypse
1991,N 27,C9:1
Coppola, Francis Ford
Hearts of Darkness: A Film Maker's Apocalypse
1991,N 27,C9:1
Coppola, Francis Ford (Director)
Bram Stoker's "Dracula" 1992,N 13,C1:3
Bram Stoker's "Dracula" 1992,N 22,II:13:1
Coppola, Francis Ford (Producer)
Bram Stoker's "Dracula" 1992,N 13,C1:3
Coppola, Sam
Bruce Diet, The 1992,Ap 15,C19:1
Corbeil, Normand (Composer)
Princes in Exile 1991,F 22,C12:5
Corbett, Toby (Miscellaneous)
Iron Maze 1991,N 1,C13:1
My New Gun 1992,O 30,C10:1
Corea, Francois (Composer)
Allah Tantou 1992,S 30,C18:3
Corenblith, Michael (Miscellaneous)
He Said, She Said 1991,F 22,C17:1
Cool World 1992,Jl 11,12:3
Corey, Dorian
Paris Is Burning 1991,Mr 13,C13:1
Corman, Maddie
My New Gun 1992,O 30,C10:1
Corman, Roger
Silence of the Lambs, The 1991,F 14,C17:1
Corman, Roger (Producer)
In the Heat of Passion 1992,Ja 24,C12:5
Cormio, Claudio (Miscellaneous)
Peaceful Air of the West 1991,Mr 20,C12:5
Corneau, Alain (Director)
Tous les Matins du Monde 1992,N 13,C3:4
Corneau, Alain (Screenwriter)
Tous les Matins du Monde 1992,N 13,C3:4
Cornel, Dennis
Where 1991,S 6,C13:1
Cornfeld, Stuart (Producer)
Kafka 1991,D 4,C21:1
Corraface, Georges
Not Without My Daughter 1991,Ja 11,C8:1

Man Trouble 1992,Jl 18,18:4

Delgado, Evelio (Producer)
Adorable Lies 1992,Mr 27,C8:5

Delia, Joe (Composer)
Bad Lieutenant 1992,N 20,C15:1

Della Chiesa, Ron
Texas Tenor: The Illinois Jacquet Story 1992,N 20,C5:1

Dellentash, Alfred (Miscellaneous)
Dead Ringer 1991,Jl 17,C14:5

Dellentash, Alfred (Producer)
Dead Ringer 1991,Jl 17,C14:5

Delli Colli, Tonino (Cinematographer)
Intervista 1992,N 20,C10:1

Delmare, Victorien
My Mother's Castle 1991,Jl 26,C6:1

Delon, Alain
Rocco and His Brothers 1991,S 21,12:1
Rocco and His Brothers 1992,Ja 24,C8:1
Return of Casanova, The 1992,My 11,C9:1

DeLorenzo, Michael
Few Good Men, A 1992,D 11,C20:1

Delpeut, Peter (Director)
Lyrical Nitrate 1991,O 11,C10:1

Delpeut, Peter (Screenwriter)
Lyrical Nitrate 1991,O 11,C10:1

Delpy, Albert
Hairdresser's Husband, The 1992,Je 19,C11:1

Delpy, Julie
Europa, Europa 1991,Je 28,C10:1
Voyager 1992,Ja 31,C6:1
Voyager 1992,F 23,II:13:5

Del Rosario, Linda (Miscellaneous)
Adjuster, The 1991,S 26,C18:5

Del Ruth, Thomas (Cinematographer)
Kuffs 1992,Ja 10,C16:6
Mighty Ducks, The 1992,O 2,C18:1

del Sol, Laura
Amelia Lopes O'Neill 1991,S 21,12:3

DeLuca, Michael (Screenwriter)
Freddy's Dead: The Final Nightmare 1991,S 14,11:4

De Luca, Rudy
Life Stinks 1991,Jl 26,C19:1

De Luca, Rudy (Screenwriter)
Life Stinks 1991,Jl 26,C19:1

DeLuise, Dom
American Tail, An: Fievel Goes West 1991,N 22,C21:1

DeLuise, Michael
Wayne's World 1992,F 14,C15:1
Encino Man 1992,My 22,C15:1

de Luze, Herve (Miscellaneous)
Uranus 1991,Ag 23,C15:1

Delve, David
Dark Obsession 1991,Je 7,C10:1

del Vecchio, Giuditta
Leolo 1992,S 29,C11:1

Delville, Bernard (Cinematographer)
Night and Day 1992,D 11,C10:6

Deman, Rachel
Man Bites Dog 1992,O 9,C14:5

de Maupassant, Guy (Original Author)
Woman of the Port (Mujer del Puerto, La) 1991,S 27,C5:1
Golden Braid 1991,D 20,C20:6

de Medeiros, Maria
Meeting Venus 1991,N 15,C1:3
Alex 1992,Mr 24,C15:3

De Meo, Paul (Miscellaneous)
Rocketeer, The 1991,Je 21,C1:3

De Meo, Paul (Screenwriter)
Rocketeer, The 1991,Je 21,C1:3

Demers, Gloria (Screenwriter)
Strangers in Good Company 1991,My 10,C8:1

Demetrios, Eames (Director)
Giving, The 1992,N 13,C17:1

Demetrios, Eames (Producer)
Giving, The 1992,N 13,C17:1

Demetrios, Eames (Screenwriter)
Giving, The 1992,N 13,C17:1

Deming, Peter (Cinematographer)
Book of Love 1991,F 1,C10:6
Drop Dead Fred 1991,My 24,C8:1
My Cousin Vinny 1992,Mr 13,C6:1

Demirel, Fusun
Heart of Glass, A 1992,Mr 21,18:4

Demme, Jonathan
Cousin Bobby 1992,My 29,C1:4

Demme, Jonathan (Director)
Silence of the Lambs, The 1991,F 14,C17:1
Silence of the Lambs, The 1991,F 17,II:11:5
Silence of the Lambs, The 1991,Mr 10,II:1:1
Cousin Bobby 1992,My 29,C1:4

de Montalembert, Thibault
Sentinelle, La 1992,O 5,C14:3
Indochine 1992,D 24,C9:1

De Mornay, Rebecca
Backdraft 1991,My 24,C14:6
Hand That Rocks the Cradle, The 1992,Ja 10,C8:1
Hand That Rocks the Cradle, The 1992,F 2,II:13:5
Hand That Rocks the Cradle, The 1992,Ag 16,II:15:1

Dempsey, Donna
Begotten 1991,Je 5,C23:1

Dempsey, Patrick
Run 1991,F 1,C15:1
Mobsters 1991,Jl 26,C18:4

Dempsey, Shawna
We're Talking Vulva 1991,Jl 17,C13:1

Dempsey, Shawna (Director)
We're Talking Vulva 1991,Jl 17,C13:1

Dempsey, Shawna (Producer)
We're Talking Vulva 1991,Jl 17,C13:1

Demy, Jacques
Jacquot de Nantes 1991,S 25,C16:3

Demy, Jacques (Director)
Room in Town, A (Chambre en Ville, Une) 1991,S 28,11:5

Demy, Jacques (Screenwriter)
Room in Town, A (Chambre en Ville, Une) 1991,S 28,11:5

Deneuve, Catherine
Mississippi Mermaid (Sirene du Mississippi, La) 1992,Ap 5,II:17:5
Indochine 1992,D 13,II:20:5
Indochine 1992,D 24,C9:1

Denicourt, Marianne
Belle Noiseuse, La 1991,O 2,C17:5
Sentinelle, La 1992,O 5,C14:3

De Niro, Robert
1900 1991,F 1,C1:1
Guilty by Suspicion 1991,Mr 15,C12:1
Backdraft 1991,My 24,C14:6
Cape Fear 1991,N 13,C17:1
Cape Fear 1992,Ja 26,II:11:1
Mistress 1992,Ag 7,C16:3
Night and the City 1992,O 10,11:3
Night and the City 1992,O 11,II:11:1

De Niro, Robert (Producer)
Thunderheart 1992,Ap 3,C12:1
Mistress 1992,Ag 7,C16:3

Denis, Claire (Director)
No Fear, No Die 1992,Ag 7,C16:5

Denis, Claire (Screenwriter)
No Fear, No Die 1992,Ag 7,C16:5

Denisenko, Taras V.
Guard, The (Karaul) 1991,Mr 24,64:1

Denisova, Tamara (Miscellaneous)
Guard, The (Karaul) 1991,Mr 24,64:1

Dennehy, Brian
FX2: The Deadly Art of Illusion 1991,My 10,C8:5
Gladiator 1992,Mr 6,C17:1

Dennehy, Elizabeth
Waterdance, The 1992,My 13,C13:1

Dennen, Barry
Liquid Dreams 1992,Ap 15,C19:1

Denner, Charles
Window Shopping 1992,Ap 17,C13:1

Dennis, Darrell
Leaving Normal 1992,Ap 29,C17:1

Dennis, Sandy
Indian Runner, The 1991,S 20,C6:1

Dennis, Yvette
Home Less Home 1991,Mr 22,C8:5

Denny, Jon S. (Producer)
Object of Beauty, The 1991,Ap 12,C14:4

Densham, Pen (Miscellaneous)
Robin Hood: Prince of Thieves 1991,Je 14,C1:4

Densham, Pen (Producer)
Backdraft 1991,My 24,C14:6
Robin Hood: Prince of Thieves 1991,Je 14,C1:4

Densham, Pen (Screenwriter)
Robin Hood: Prince of Thieves 1991,Je 14,C1:4

Densmore, John
Doors, The 1991,Mr 1,C1:1

Denys, Marek (Miscellaneous)
Inventory 1991,S 24,C13:2

de Padua, Guilherme
Via Appia 1992,Ag 27,C16:5

De Palma, Brian (Director)
Raising Cain 1992,Ag 7,C5:1
Raising Cain 1992,Ag 16,II:15:1

De Palma, Brian (Screenwriter)
Raising Cain 1992,Ag 7,C5:1

de Palma, Rossy
Don Juan, My Love 1991,Jl 12,C10:5

Depardieu, Gerard
1900 1991,F 1,C1:1
Green Card 1991,Mr 3,II:11:1
Uranus 1991,Ag 23,C15:1
1492: Conquest of Paradise 1992,O 9,C21:1
1492 1992,O 18,II:13:5
Tous les Matins du Monde 1992,N 13,C3:4

Depardieu, Guillaume
Tous les Matins du Monde 1992,N 13,C3:4

Depardon, Raymond (Cinematographer)
Captive of the Desert, The (Captive du Desert, La) 1991,Mr 21,C20:3

Depardon, Raymond (Director)
Captive of the Desert, The (Captive du Desert, La) 1991,Mr 21,C20:3

de Paul, Darin
Phantom of the Opera, The 1991,Je 8,16:1

Deprez, Therese (Miscellaneous)
Swoon 1992,Mr 27,C8:1
Refrigerator, The 1992,S 25,C16:6

dePrume, Cathryn
Crisscross 1992,My 9,17:5

Depusse, Jean
Inspector Lavardin 1991,D 26,C13:1

Derby, Rick (Miscellaneous)
Whole Truth, The 1992,O 23,C10:5

Deren, Nancy (Miscellaneous)
Boy Who Cried Bitch, The 1991,O 11,C17:1

Dern, Bruce
Diggstown 1992,Ag 14,C1:1

Dern, Laura
Rambling Rose 1991,S 20,C12:4
Rambling Rose 1992,F 9,II:13:1

de Sade, Marquis (Original Author)
Marquis 1991,Jl 3,C12:5

de St. Pere, Helene
Winter in Lisbon, The 1992,Mr 9,C15:5

DeSalvo, Joe (Cinematographer)
Triple Bogey on a Par 5 Hole 1992,Mr 21,13:4
Johnny Suede 1992,Ag 14,C5:5

DeSando, Anthony
New Jack City 1991,Mr 8,C15:1

Desarthe, Gerard
Uranus 1991,Ag 23,C15:1

Desbois, Christiane
Tale of Winter, A 1992,O 2,C12:6

Descas, Alex
No Fear, No Die 1992,Ag 7,C16:5

Descy, Rohanne
Liquid Dreams 1992,Ap 15,C19:1

de Segonzac, Jean (Cinematographer)
Little Vicious, A 1991,My 23,C14:3
Laws of Gravity 1992,Mr 21,18:1
Laws of Gravity 1992,Ag 26,C18:6

DeSoto, Rosana
Star Trek VI: The Undiscovered Country 1991,D 6,C1:1

de Souza, Steven E. (Screenwriter)
Hudson Hawk 1991,My 24,C8:4
Ricochet 1991,O 5,12:6

Desplechin, Arnaud (Director)
Sentinel, The 1992,My 18,C13:6
Sentinelle, La 1992,O 5,C14:3

Desplechin, Arnaud (Producer)
Sentinelle, La 1992,O 5,C14:3

Desplechin, Arnaud (Screenwriter)
Sentinelle, La 1992,O 5,C14:3

Despotovich, Nada
Crisscross 1992,My 9,17:5

Dessalles, Olivier (Cinematographer)
Night and Day 1992,D 11,C10:6

Detmers, Maruschka
Mambo Kings, The 1992,F 28,C8:1

Deutch, Howard (Director)
Article 99 1992,Mr 13,C10:1

Devers, Claire (Director)
Noir et Blanc 1991,My 25,14:5

de Villepoix, Brigitte
Jacquot de Nantes 1991,S 25,C16:3

D'Onofrio, Vincent
Dying Young 1991,Je 21,C10:1
Naked Tango 1991,Ag 23,C19:1
Crooked Hearts 1991,S 6,C13:1
Player, The 1992,Ap 10,C16:1
Donoghue, Mary Agnes (Director)
Paradise 1991,S 18,C16:3
Donoghue, Mary Agnes (Miscellaneous)
Deceived 1991,S 27,C8:5
Donoghue, Mary Agnes (Screenwriter)
Paradise 1991,S 18,C16:3
Deceived 1991,S 27,C8:5
Donohoe, Amanda
Dark Obsession 1991,Je 7,C10:1
Paper Mask 1992,F 28,C19:1
Donovan, Arlene (Producer)
Billy Bathgate 1991,N 1,C1:1
Donovan, Martin
Julia Has Two Lovers 1991,Mr 24,64:1
Trust 1991,Jl 26,C16:5
Simple Men 1992,O 14,C22:1
Donovan, Martin (Screenwriter)
Death Becomes Her 1992,Jl 31,C8:1
Donovan, Tate
Love Potion No. 9 1992,N 13,C12:5
Doohan, James
Star Trek VI: The Undiscovered Country 1991,D
6,C1:1
Dooley, Paul
Shakes the Clown 1992,Mr 13,C13:1
Doran, Lindsay (Producer)
Dead Again 1991,Ag 23,C1:3
Leaving Normal 1992,Ap 29,C17:1
Dorff, Stephen
Power of One, The 1992,Mr 27,C20:5
Dorff, Steve (Composer)
Pure Country 1992,O 23,C13:1
Doris, Pierre
Outremer 1991,Mr 27,C15:1
Dornhelm, Robert (Director)
Requiem for Dominic 1991,Ap 19,C17:1
Doron, Amit
For Sasha 1992,Je 5,C13:1
Doroshow, Joanne (Producer)
Panama Deception, The 1992,O 23,C10:5
Dostie, Alain (Cinematographer)
Perfectly Normal 1991,F 15,C14:5
Dostoyevsky, Fyodor (Original Author)
Idiot 1992,O 8,C21:4
Dotrice, Roy
Suburban Commando 1991,O 6,56:3
Cutting Edge, The 1992,Mr 27,C21:1
Doublier, Francis (Cinematographer)
Opening the 19th Century: 1986 (Avant-Garde
Visions) 1991,O 1,C13:1
Doug, Doug E.
Hangin' with the Homeboys 1991,My 24,C12:6
Class Act 1992,Je 5,C17:1
Douglas, Alan (Producer)
Jimi Hendrix at the Isle of Wight 1991,Jl 4,C9:1
Douglas, Clare (Miscellaneous)
Secret Friends 1992,F 14,C10:1
Douglas, David (Cinematographer)
At the Max 1991,N 22,C15:1
Douglas, Kirk
Spartacus 1991,Ap 26,C6:4
Oscar 1991,Ap 26,C10:5
Ace in the Hole 1991,My 10,C1:1
Douglas, Michael
Shining Through 1992,Ja 31,C8:5
Shining Through 1992,F 23,II:13:1
Shining Through 1992,F 28,C1:1
Basic Instinct 1992,Mr 20,C8:1
Basic Instinct 1992,My 8,C1:2
Douglass, Maureen
Body Beautiful, The 1991,O 3,C21:1
Dougnac, Marie-Laure
Delicatessen 1991,O 5,14:3
Delicatessen 1992,Ap 5,53:2
Doumanian, Jean (Producer)
Ox, The 1992,Ag 21,C10:5
Dourif, Brad
Jungle Fever 1991,Je 7,C1:2
Body Parts 1991,Ag 3,9:1
Child's Play 3 1991,Ag 30,C11:3
London Kills Me 1992,Ag 7,C19:1
Dowaki, Hiroshi (Cinematographer)
Black Lizard 1991,S 18,C13:1

Dowd, Jeff (Producer)
Zebrahead 1992,O 8,C17:5
Dowding, Jon (Miscellaneous)
Return to the Blue Lagoon 1991,Ag 2,C12:1
Downer, Hugh
Chaplin 1992,D 25,C3:1
Downey, Keith (Miscellaneous)
Bikini Island 1991,Jl 27,16:3
Downey, Robert (Director)
Too Much Sun 1991,Ja 25,C8:5
Downey, Robert (Screenwriter)
Too Much Sun 1991,Ja 25,C8:5
Downey, Robert, Jr.
Too Much Sun 1991,Ja 25,C8:5
Soapdish 1991,My 31,C10:1
Chaplin 1992,D 25,C3:1
Downey, Thomas J.
Damned in the U.S.A. 1992,N 13,C11:1
Doyle, Christopher (Cinematographer)
Days of Being Wild 1991,Mr 23,12:3
Doyle, Maria
Commitments, The 1991,Ag 14,C11:1
Doyle, Patrick (Composer)
Shipwrecked 1991,Mr 1,C6:1
Dead Again 1991,Ag 23,C1:3
Indochine 1992,D 24,C9:1
Doyle, Roddy (Original Author)
Commitments, The 1991,Ag 14,C11:1
Doyle, Roddy (Screenwriter)
Commitments, The 1991,Ag 14,C11:1
Doyle, Tony
Secret Friends 1992,F 14,C10:1
Doyle-Murray, Brian
Wayne's World 1992,F 14,C15:1
Dozoretz, Wendy (Producer)
Deceived 1991,S 27,C8:5
D'Pella, Pamella
Ted and Venus 1991,D 20,C23:1
Drabla, Valda Z.
Swoon 1992,Mr 27,C8:1
Dragoti, Stan (Director)
Necessary Roughness 1991,S 27,C21:3
Drai, Victor (Producer)
Folks! 1992,My 4,C15:1
Drake, Claudia
Detour 1992,Jl 3,C8:1
Drake, Larry
Dr. Giggles 1992,O 24,16:4
Drake-Massey, Bebe
Boomerang 1992,Jl 1,C18:1
Draper, Robert (Cinematographer)
Dr. Giggles 1992,O 24,16:4
Drazan, Anthony (Director)
Zebrahead 1992,O 8,C17:5
Zebrahead 1992,O 11,II:11:1
Drazan, Anthony (Screenwriter)
Zebrahead 1992,O 8,C17:5
Dremann, Beau
Book of Love 1991,F 1,C10:6
Dreville, Valerie
Sentinelle, La 1992,O 5,C14:3
Dreyfus, Jean-Claude
Delicatessen 1991,O 5,14:3
Delicatessen 1992,Ap 5,53:2
Tous les Matins du Monde 1992,N 13,C3:4
Dreyfuss, Richard
Once Around 1991,Ja 18,C12:4
Once Around 1991,Ja 27,II:1:1
Rosencrantz and Guildenstern Are Dead 1991,F
8,C14:6
What About Bob? 1991,My 17,C15:1
Drinkwater, Carol
Father 1992,Jl 31,C5:5
Driss, Mohamed
Halfaouine 1991,Mr 15,C1:4
Drouot, Pierre (Producer)
Toto the Hero (Toto le Heros) 1991,S 21,11:1
Drozd, Georgi
Raspad 1992,Ap 29,C15:1
Druet, Soo
Robin Hood: Prince of Thieves 1991,Je 14,C1:4
Drum, Julius
Thunderheart 1992,Ap 3,C12:1
Drummond, Randy (Cinematographer)
Time Expired 1992,D 2,C18:4
Drummond, Reana E.
Straight Out of Brooklyn 1991,My 22,C11:5

Drye, Jenny
Man Bites Dog 1992,O 9,C14:5
Du Yuan (Miscellaneous)
Raise the Red Lantern 1992,Mr 20,C18:1
Story of Qiu Ju, The 1992,O 2,C12:1
Dube, Tom (Composer)
Hugh Hefner: Once Upon a Time 1992,N 6,C10:3
Dubin, Jay (Director)
Dice Rules 1991,My 18,15:5
Dubin, Mitchell (Cinematographer)
Meet the Applegates 1991,F 1,C6:1
Dublet, Daniel
Jacquot de Nantes 1991,S 25,C16:3
Du Bois, Victor (Miscellaneous)
Leaving Normal 1992,Ap 29,C17:1
Dubost, Niels
Ciel de Paris, Le 1992,Mr 29,48:2
For Sasha 1992,Je 5,C13:1
Dubrow, Donna (Producer)
Medicine Man 1992,F 7,C13:1
Duchene, Deborah
Perfectly Normal 1991,F 15,C14:5
Duchovny, David
Julia Has Two Lovers 1991,Mr 24,64:1
Rapture, The 1991,S 30,C14:4
Ruby 1992,Mr 27,C1:3
Beethoven 1992,Ap 3,C18:1
Venice/Venice 1992,O 28,C20:5
Duclos, Philippe
Sentinelle, La 1992,O 5,C14:3
Ducommun, Rick
Encino Man 1992,My 22,C15:1
Class Act 1992,Je 5,C17:1
Dudley, Anne (Composer)
Miracle, The 1991,Jl 3,C12:1
Crying Game, The 1992,S 26,12:4
Dudman, Christopher (Director)
Blackwater Summer 1991,Mr 22,C8:5
Dufaux, Guy (Cinematographer)
Pin 1991,D 4,C28:1
Leolo 1992,S 29,C11:1
Duff, Howard
Too Much Sun 1991,Ja 25,C8:5
Duffett, Nicola
Howards End 1992,Mr 13,C1:3
Duffin, Philip (Miscellaneous)
Bride of Re-Animator 1991,F 22,C17:1
Duffy, Dave
Split Second 1992,My 4,C15:1
Dufour, Bernard
Belle Noiseuse, La 1991,O 2,C17:5
Dugal, Rejean
Pin 1991,D 4,C28:1
Dugan, Dennis (Director)
Brain Donors 1992,Ap 18,11:1
Duggins, Harry (Miscellaneous)
Begotten 1991,Je 5,C23:1
Dugied, Jacques (Miscellaneous)
My Mother's Castle 1991,Jl 26,C6:1
Duhamel, Antoine (Composer)
Daddy Nostalgia 1991,Ap 12,C10:1
Duigan, John (Director)
Flirting 1992,N 6,C13:1
Duigan, John (Screenwriter)
Flirting 1992,N 6,C13:1
Duke, Bill
Street of No Return 1991,Ag 2,C6:1
Duke, Bill (Director)
Rage in Harlem, A 1991,My 3,C14:1
Deep Cover 1992,Ap 15,C19:4
Duke, Patty
Prelude to a Kiss 1992,Jl 10,C10:1
Dulon, Jean-Jacques
Fine Romance, A 1992,O 2,C10:6
Dumeniaud, Pierre-Francois
Inspector Lavardin 1991,D 26,C13:1
Dun, Dennis
1,000 Pieces of Gold 1991,S 27,C10:4
Dunaway, Faye
Double Edge 1992,S 30,C18:3
Dunbar, Adrian
Hear My Song 1992,Ja 19,48:1
Playboys, The 1992,Ap 22,C15:1
Crying Game, The 1992,S 26,12:4
Dunbar, Adrian (Screenwriter)
Hear My Song 1992,Ja 19,48:1
Duncan, Lindsay
Reflecting Skin, The 1991,Je 28,C9:1

Body Parts 1991,Ag 3,9:1
Duncan, Neil
Split Second 1992,My 4,C15:1
Duncan, Sandy
Rock-a-Doodle 1992,Ap 3,C13:1
Dundara, David
Jungle Fever 1991,Je 7,C1:2
Dunlop, Charles (Miscellaneous)
Princes in Exile 1991,F 22,C12:5
Dunn, Andrew (Cinematographer)
L.A. Story 1991,F 8,C8:1
Blame It on the Bellboy 1992,Mr 6,C10:6
Bodyguard, The 1992,N 25,C9:5
Dunn, Kevin
Only the Lonely 1991,My 24,C10:6
Hot Shots! 1991,Jl 31,C11:2
Chaplin 1992,D 25,C3:1
Dunn, Nora
Passion Fish 1992,D 14,C16:1
Dunne, Griffin
Once Around 1991,Ja 18,C12:4
My Girl 1991,N 27,C15:1
Straight Talk 1992,Ap 3,C17:1
Dunne, Griffin (Producer)
Once Around 1991,Ja 18,C12:4
Dunne, Philip (Miscellaneous)
Last of the Mohicans, The 1992,S 25,C3:1
Dunning, John (Producer)
Princes in Exile 1991,F 22,C12:5
Dunoyer, Francois
En Toute Innocence (In All Innocence) 1992,Jl
31,C14:3
du Plantier, Daniel Toscan (Producer)
Korczak 1991,Ap 12,C8:1
Van Gogh 1992,O 30,C16:5
DuPois, Starletta
Convicts 1991,D 6,C14:6
Dupree, Paris
Paris Is Burning 1991,Mr 13,C13:1
Dupree, Vincent Craig
South-Central 1992,O 16,C13:1
Du Prez, John (Composer)
Teen-Age Mutant Ninja Turtles II: The Secret of the
Ooze 1991,Mr 22,C1:3
Mystery Date 1991,Ag 16,C9:1
Durane, Olga
Peaceful Air of the West 1991,Mr 20,C12:5
Durang, Christopher
Butcher's Wife, The 1991,O 25,C24:1
Housesitter 1992,Je 12,C1:4
Duras, Marguerite (Director)
Nathalie Granger 1992,S 20,II:1:1
Duras, Marguerite (Original Author)
Lover, The 1992,O 30,C5:1
Durham, Sarah (Miscellaneous)
Feed 1992,O 7,C15:1
Duringer, Annemarie
Shadow of Angels 1992,Mr 6,C15:1
Durning, Charles
V. I. Warshawski 1991,Jl 26,C1:3
V. I. Warshawski 1991,Ag 4,II:7:5
Brenda Starr 1992,Ap 19,46:1
Durr, Jason
Young Soul Rebels 1991,D 6,C21:1
Durrenmatt, Friedrich (Original Author)
Hyenas 1992,O 3,18:4
Hyenas 1992,O 11,II:11:1
Dury, Ian
Split Second 1992,My 4,C15:1
Duthie, Michael J. (Miscellaneous)
Universal Soldier 1992,Jl 10,C17:1
Dutronc, Jacques
Van Gogh 1991,My 20,C11:4
Van Gogh 1992,O 30,C16:5
Dutt, Dulal (Miscellaneous)
Branches of the Tree, The 1992,Ap 17,C15:3
Stranger, The 1992,My 22,C13:1
Dutt, Utpal
Stranger, The 1992,My 22,C13:1
Dutta, Kavery (Director)
One Hand Don't Clap 1991,Ag 28,C13:1
Dutta, Kavery (Miscellaneous)
One Hand Don't Clap 1991,Ag 28,C13:1
Dutta, Kavery (Producer)
One Hand Don't Clap 1991,Ag 28,C13:1
Dutton, Charles S.
Mississippi Masala 1992,F 5,C15:1
Alien 3 1992,My 22,C1:1

Distinguished Gentleman, The 1992,D 4,C1:4
Duvall, Robert
Rambling Rose 1991,S 20,C12:4
Hearts of Darkness: A Film Maker's Apocalypse
1991,N 27,C9:1
Convicts 1991,D 6,C14:6
Newsies 1992,Ap 8,C22:3
Duvall, Shelley
Suburban Commando 1991,O 6,56:3
Duvall, Wayne
Final Approach 1992,Mr 13,C8:4
Dwyer, John (Screenwriter)
Captain Ron 1992,S 18,C23:1
Dye, John
Perfect Weapon, The 1991,Mr 16,16:5
Dytri, Mike
Living End, The 1992,Ap 3,C1:1
Living End, The 1992,Ag 14,C8:6
Dzhigarkhanian, Armen
City Zero 1991,Mr 22,C14:1
Dzundza, George
Butcher's Wife, The 1991,O 25,C24:1
Basic Instinct 1992,Mr 20,C8:1

E

Eads, Paul (Miscellaneous)
End of Innocence, The 1991,Ja 18,C17:1
Eareckson, J. K. (Producer)
Talking to Strangers 1991,D 27,C12:6
Eastman, Brian (Producer)
Under Suspicion 1992,F 28,C10:1
Eastman, Carole (Producer)
Man Trouble 1992,Jl 18,18:4
Eastman, Carole (Screenwriter)
Man Trouble 1992,Jl 18,18:4
Eastman, Kevin (Miscellaneous)
Teen-Age Mutant Ninja Turtles II: The Secret of the
Ooze 1991,Mr 22,C1:3
Eastwood, Clint
Unforgiven 1992,Ag 7,C1:1
Eastwood, Clint (Director)
Unforgiven 1992,Ag 7,C1:1
Eastwood, Clint (Producer)
Unforgiven 1992,Ag 7,C1:1
Eastwood, Laurence (Miscellaneous)
Wind 1992,S 11,C3:1
Eaton, Roberta
Split Second 1992,My 4,C15:1
Eatwell, Brian (Miscellaneous)
White Dog 1991,Jl 12,C8:1
Eban, Abba
Double Edge 1992,S 30,C18:3
Ebden, John (Miscellaneous)
Pope Must Die(t), The 1991,Ag 30,C10:3
Vie de Boheme, La 1992,O 9,C14:1
Eberhardt, Thom (Director)
Captain Ron 1992,S 18,C23:1
Eberhardt, Thom (Screenwriter)
All I Want for Christmas 1991,N 8,C14:1
Honey, I Blew Up the Kid 1992,Jl 17,C6:5
Captain Ron 1992,S 18,C23:1
Ebersole, Christine
Folks! 1992,My 4,C15:1
Eberts, Jake (Producer)
City of Joy 1992,Ap 15,C15:1
Eccleston, Chris
Let Him Have It 1991,D 6,C24:1
Echanove, Alonso
Woman of the Port (Mujer del Puerto, La) 1991,S
27,C5:1
Echevarria, Nicolas (Director)
Cabeza de Vaca 1991,Mr 23,12:6
Cabeza de Vaca 1992,My 15,C8:5
Echevarria, Nicolas (Screenwriter)
Cabeza de Vaca 1991,Mr 23,12:6
Eckert, Andrea
Weininger's Last Night 1991,Ag 1,C14:4
Eckhaus, Gwen
Vanishing, The 1991,Ja 25,C8:1
Eckhouse, James
Leaving Normal 1992,Ap 29,C17:1
Edel, Alfred
My Father Is Coming 1991,N 22,C12:5

Edelman, Randy (Composer)
Drop Dead Fred 1991,My 24,C8:1
V. I. Warshawski 1991,Jl 26,C1:3
Shout 1991,O 4,C21:3
My Cousin Vinny 1992,Mr 13,C6:1
Beethoven 1992,Ap 3,C18:1
Last of the Mohicans, The 1992,S 25,C3:1
Distinguished Gentleman, The 1992,D 4,C1:4
Edens, Mark (Screenwriter)
Life on the Edge 1992,Je 19,C11:1
Edison, Harry (Sweets)
Texas Tenor: The Illinois Jacquet Story 1992,N
20,C5:1
Edney, Beatie
Mister Johnson 1991,Mr 22,C13:1
Edson, Richard
Crossing the Bridge 1992,S 11,C12:1
Edwards, Anthony
Top Gun 1991,Ja 23,C11:1
Pet Sematary Two 1992,Ag 29,14:4
Edwards, Blake (Director)
Switch 1991,My 10,C13:1
Edwards, Blake (Screenwriter)
Switch 1991,My 10,C13:1
Edwards, Chris (Miscellaneous)
Split Second 1992,My 4,C15:1
Edwards, Eric Alan (Cinematographer)
My Own Private Idaho 1991,S 27,C5:1
Edwards, Jason
Drowning by Numbers 1991,Ap 26,C8:1
Edwards, Luke
Guilty by Suspicion 1991,Mr 15,C12:1
Newsies 1992,Ap 8,C22:3
Edwards, Vaughan (Miscellaneous)
Rosencrantz and Guildenstern Are Dead 1991,F
8,C14:6
Egan, Aeryk
Book of Love 1991,F 1,C10:6
Eggby, David (Cinematographer)
Warlock 1991,Mr 30,11:4
Harley Davidson and the Marlboro Man 1991,Ag
24,16:6
Egholdm, Sverri
Atlantic Rhapsody: 52 Scenes from Torshavn
1991,Mr 30,11:1
Eginton, Margaret
Scent of a Woman 1992,D 23,C9:1
Egoyan, Atom (Director)
Adjuster, The 1991,S 26,C18:5
Adjuster, The 1992,My 30,13:1
Egoyan, Atom (Screenwriter)
Adjuster, The 1991,S 26,C18:5
Egushi, Kaoru
Hyenas 1992,O 3,18:4
Ehlers, Corky (Miscellaneous)
Harley Davidson and the Marlboro Man 1991,Ag
24,16:6
Eichhorn, Christoph
Johanna d'Arc of Mongolia 1992,My 15,C8:1
Eide, Hugin (Producer)
Atlantic Rhapsody: 52 Scenes from Torshavn
1991,Mr 30,11:1
Eidelman, Cliff (Composer)
Delirious 1991,Ag 9,C12:4
Star Trek VI: The Undiscovered Country 1991,D
6,C1:1
Christopher Columbus: The Discovery 1992,Ag
22,11:1
Leap of Faith 1992,D 18,C14:1
Einhorn, Richard (Composer)
Closet Land 1991,Mr 7,C18:3
Eisenman, Rafael (Producer)
Wild Orchid 2: Two Shades of Blue 1992,My
8,C17:2
Eisenstein, Sergei (Director)
Alexander Nevsky 1991,N 10,II:13:1
Eisman, David W. (Producer)
Naked Tango 1991,Ag 23,C19:1
Eisner, Alice
Passed Away 1992,Ap 24,C8:1
Eisner, Will (Original Author)
Super, Der (Short and Funnies, The) 1992,D
16,C30:3
Ekberg, Anita
Intervista 1992,S 20,II:1:1
Intervista 1992,N 20,C10:1
Elam, Jack
Suburban Commando 1991,O 6,56:3

Elbling, Peter (Screenwriter)
 Honey, I Blew Up the Kid 1992,Jl 17,C6:5
Elders, Kevin (Miscellaneous)
 Aces: Iron Eagle III 1992,Je 13,16:4
Elders, Kevin (Screenwriter)
 Aces: Iron Eagle III 1992,Je 13,16:4
Eldridge, William (Composer)
 Pictures from a Revolution 1991,O 5,11:4
Elehwany, Laurice (Screenwriter)
 My Girl 1991,N 27,C15:1
Elek, Judit (Director)
 Memoirs of a River 1992,Mr 20,C15:1
Elek, Judit (Screenwriter)
 Memoirs of a River 1992,Mr 20,C15:1
Eleniak, Erika
 Under Siege 1992,O 9,C12:1
Elfman, Danny (Composer)
 Article 99 1992,Mr 13,C10:1
 Batman Returns 1992,Je 19,C1:1
Elgear, Sandra (Director)
 Voices from the Front 1992,Mr 18,C15:1
Elgear, Sandra (Miscellaneous)
 Voices from the Front 1992,Mr 18,C15:1
Elgear, Sandra (Producer)
 Voices from the Front 1992,Mr 18,C15:1
Elgort, Arthur (Director)
 Texas Tenor: The Illinois Jacquet Story 1992,N
 20,C5:1
Elibary, Sevembike
 Johanna d'Arc of Mongolia 1992,My 15,C8:1
Eliezer, Jose Roberto (Cinematographer)
 Exposure 1991,N 1,C12:6
Elizondo, Hector
 Necessary Roughness 1991,S 27,C21:3
 Frankie and Johnny 1991,O 11,C1:1
 Final Approach 1992,Mr 13,C8:4
Ellen, Cliff
 Proof 1992,Mr 20,C20:1
Ellen, Lesley (Director)
 Tender, Slender and Tall 1991,O 4,C8:5
Elliot, Paul (Cinematographer)
 My Girl 1991,N 27,C15:1
Elliot, Robert (Screenwriter)
 Rich Girl 1991,My 4,15:1
Elliott, Beverley
 Unforgiven 1992,Ag 7,C1:1
Elliott, Denholm
 Toy Soldiers 1991,Ap 26,C15:1
 Noises Off 1992,Mr 20,C10:1
Elliott, Paul (Cinematographer)
 And You Thought Your Parents Were Weird 1991,N
 15,C13:1
Elliott, Sam
 Rush 1991,D 22,56:4
Elliott, Ted (Screenwriter)
 Aladdin 1992,N 11,C15:3
Elliott, William A. (Miscellaneous)
 Hot Shots! 1991,Jl 31,C11:2
 Honeymoon in Vegas 1992,Ag 28,C8:5
Ellis, Michael (Miscellaneous)
 Impromptu 1991,Ap 12,C10:5
 Blame It on the Bellboy 1992,Mr 6,C10:6
Elmes, Frederick (Cinematographer)
 Night on Earth 1991,O 4,C1:3
Elorza, Jose (Composer)
 City of the Blind (Ciudad de Ciegos) 1992,Ap 4,17:5
Elswit, Robert (Cinematographer)
 Hand That Rocks the Cradle, The 1992,Ja 10,C8:1
 Waterland 1992,O 30,C14:6
Elwes, Cary
 Hot Shots! 1991,Jl 31,C11:2
 Bram Stoker's "Dracula" 1992,N 13,C1:3
Elwes, Cassian (Producer)
 Dark Backward, The 1991,Jl 26,C18:4
Emanuel, Edward (Screenwriter)
 3 Ninjas 1992,Ag 7,C5:1
Emmanuel, Alphonsia
 Under Suspicion 1992,F 28,C10:1
 Peter's Friends 1992,D 25,C8:6
Emmerich, Roland (Director)
 Universal Soldier 1992,Jl 10,C17:1
Endre, Lena
 Best Intentions, The 1992,Jl 10,C10:5
Engels, Robert (Screenwriter)
 Twin Peaks: Fire Walk with Me 1992,Ag 29,11:1
English, Jon A. (Composer)
 All the Vermeers in New York 1992,My 1,C13:1

Englund, Robert
 Freddy's Dead: The Final Nightmare 1991,S 14,11:4
Enoki, Takaaki
 Heaven and Earth 1991,Mr 1,C10:4
Enright, Nick (Screenwriter)
 Lorenzo's Oil 1992,D 30,C7:3
Ephron, Delia (Screenwriter)
 This Is My Life 1992,F 21,C8:1
Ephron, Nora (Director)
 This Is My Life 1992,F 21,C8:1
 This Is My Life 1992,F 23,II:13:1
 This Is My Life 1992,F 28,C1:1
Ephron, Nora (Screenwriter)
 This Is My Life 1992,F 21,C8:1
 This Is My Life 1992,F 28,C1:1
Epperson, Tom (Screenwriter)
 One False Move 1992,Jl 17,C6:1
Epps, Omar
 Juice 1992,Ja 17,C10:1
 Juice 1992,Ja 22,C13:2
Epstein, Mitch (Miscellaneous)
 Mississippi Masala 1992,F 5,C15:1
Erbe, Kathryn
 What About Bob? 1991,My 17,C15:1
Erhard, Bernard
 Little Nemo: Adventures in Slumberland 1992,Ag
 21,C13:1
Erice, Victor (Director)
 Sol del Membrillo, El 1992,My 15,C3:1
 Dream of Light (Sol del Membrillo, El) 1992,O
 1,C17:1
Erice, Victor (Screenwriter)
 Dream of Light (Sol del Membrillo, El) 1992,O
 1,C17:1
Eriksen, Skule (Miscellaneous)
 Children of Nature 1992,Ap 2,C18:3
Erkal, Genco
 Heart of Glass, A 1992,Mr 21,18:4
Ermey, R. Lee
 Toy Soldiers 1991,Ap 26,C15:1
Erms, Sebastien (Composer)
 Tale of Winter, A 1992,O 2,C12:6
Ernst, Donald W. (Producer)
 Aladdin 1992,N 11,C15:3
Ernst, Laura
 Too Much Sun 1991,Ja 25,C8:5
Ernst, Laura (Screenwriter)
 Too Much Sun 1991,Ja 25,C8:5
Ersoy, Ersen
 Heart of Glass, A 1992,Mr 21,18:4
Ervolina, Tony
 Poison Ivy 1992,My 8,C16:3
Erwin, Lee
 Man Without a World, The 1992,S 9,C18:4
Escoffier, Jean-Yves (Cinematographer)
 Amants du Pont Neuf, Les (Lovers of the Pont Neuf)
 1992,O 6,C16:1
Escorel, Eduardo (Miscellaneous)
 Earth Entranced (Terra em Transe) 1991,O 5,14:5
Escorel, Lauro (Cinematographer)
 At Play in the Fields of the Lord 1991,D 6,C8:1
Esposito, Giancarlo
 Harley Davidson and the Marlboro Man 1991,Ag
 24,16:6
 Night on Earth 1991,O 4,C1:3
 Night on Earth 1992,My 1,C10:5
 Bob Roberts 1992,S 4,C1:1
Estes, Rob
 Aces: Iron Eagle III 1992,Je 13,16:4
Estevez, Emilio
 Freejack 1992,Ja 18,17:5
 Mighty Ducks, The 1992,O 2,C18:1
Estevez, Ramon
 Cadence 1991,Mr 15,C18:5
Estrin, Robert (Miscellaneous)
 River Runs Through It, A 1992,O 9,C1:3
Eszterhas, Joe (Screenwriter)
 Basic Instinct 1992,Mr 20,C8:1
Etienne, Anne-Marie (Miscellaneous)
 Every Other Weekend 1991,Je 19,C12:3
Etzler, Miroslav
 Time of the Servants 1991,Mr 19,C12:3
Evans, Art
 Trespass 1992,D 25,C18:5
Evans, Bruce A. (Director)
 Kuffs 1992,Ja 10,C16:6
Evans, Bruce A. (Screenwriter)
 Kuffs 1992,Ja 10,C16:6

Evans, Dale
 Golden Stallion, The 1992,D 30,C12:3
Evans, Dale (Miscellaneous)
 Roy Rogers: King of the Cowboys 1992,D 30,C12:3
Evans, David Mickey (Screenwriter)
 Radio Flyer 1992,F 21,C16:1
Evans, Josh
 Doors, The 1991,Mr 1,C1:1
 Ricochet 1991,O 5,12:6
Evans, Kate (Miscellaneous)
 Antonia and Jane 1991,O 26,13:1
Evans, Lois
 Talking to Strangers 1991,D 27,C12:6
Evans, Troy
 Article 99 1992,Mr 13,C10:1
Everett, Gimel (Producer)
 Lawnmower Man, The 1992,Mr 7,20:1
Everett, Gimel (Screenwriter)
 Lawnmower Man, The 1992,Mr 7,20:1
Everett, Rupert
 Comfort of Strangers, The 1991,Mr 29,C6:1
 Comfort of Strangers, The 1991,Ap 7,II:13:5
Ewart, William (Producer)
 Gas Food Lodging 1992,Jl 31,C1:1
Eyre, D. M., Jr. (Screenwriter)
 Pastime 1991,Ag 23,C13:1
Eysturoy, Erling
 Atlantic Rhapsody: 52 Scenes from Torshavn
 1991,Mr 30,11:1
Eziashi, Maynard
 Mister Johnson 1991,Mr 22,C13:1
 Twenty-One 1991,O 4,C10:6

F

Faber, George (Producer)
 Antonia and Jane 1991,O 26,13:1
Fabian, Francoise
 Reunion 1991,Mr 15,C16:6
Fabre, Jean-Marc (Cinematographer)
 Ciel de Paris, Le 1992,Mr 29,48:2
Faerber, Peter
 Weininger's Last Night 1991,Ag 1,C14:4
Fagan, Ronald J. (Miscellaneous)
 Return to the Blue Lagoon 1991,Ag 2,C12:1
Fages, Pere (Producer)
 1492: Conquest of Paradise 1992,O 9,C21:1
Fahey, Jeff
 Body Parts 1991,Ag 3,9:1
 Iron Maze 1991,N 1,C13:1
 Lawnmower Man, The 1992,Mr 7,20:1
Faiman, Peter (Director)
 Dutch 1991,Jl 19,C13:1
Faiman, Peter (Producer)
 Ferngully: The Last Rain Forest 1992,Ap 10,C10:5
Fakir, Amina
 Chameleon Street 1991,Ap 24,C11:3
Falck-Ytter, O. V. (Original Author)
 Shipwrecked 1991,Mr 1,C6:1
Falco, Edie
 Trust 1991,Jl 26,C16:5
 Laws of Gravity 1992,Mr 21,18:1
 Laws of Gravity 1992,Ag 26,C18:6
 Time Expired 1992,D 2,C18:4
Falco, Tav
 Highway 61 1992,Ap 24,C19:1
Falkenberg, David
 Archangel 1991,Jl 19,C12:6
Fall, Calgou
 Hyenas 1992,O 3,18:4
Fall, Steve
 Highway 61 1992,Ap 24,C19:1
Fallon, David (Screenwriter)
 White Fang 1991,Ja 18,C16:3
Falstein, Bruce (Miscellaneous)
 Phantom of the Opera, The 1991,Je 8,16:1
Faltermeyer, Harold (Composer)
 Kuffs 1992,Ja 10,C16:6
Fan Kung Ming (Miscellaneous)
 Killer, The 1991,Ap 12,C11:1
Fan Xiao Ming
 Dream of Light (Sol del Membrillo, El) 1992,O
 1,C17:1
Fann, Al
 Frankie and Johnny 1991,O 11,C1:1

Fansten, Jacques (Director)
Cross My Heart 1991,Ap 5,C18:5
Fansten, Jacques (Producer)
Cross My Heart 1991,Ap 5,C18:5
Fansten, Jacques (Screenwriter)
Cross My Heart 1991,Ap 5,C18:5
Fantastichini, Ennio
Open Doors 1991,Mr 8,C15:1
Station, The (Stazione, La) 1992,Ja 3,C6:1
Farber, Viola
Cage/Cunningham 1991,D 5,C20:1
Fardoulis, Monique (Miscellaneous)
Madame Bovary 1991,D 25,13:1
Inspector Lavardin 1991,D 26,C13:1
Fargas, Antonio
Whore 1991,O 4,C15:1
Borrower, The 1991,O 18,C12:3
Fargeau, Jean-Pol (Screenwriter)
No Fear, No Die 1992,Ag 7,C16:5
Faria, Nico (Miscellaneous)
Exposure 1991,N 1,C12:6
Farina, Dennis
Men of Respect 1991,Ja 18,C1:1
Farley, Lindley (Director)
Boss of the Ballet (Young Black Cinema) 1992,F
29,17:1
Farmer, Jim (Composer)
Johnny Suede 1992,Ag 14,C5:5
Farocki, Harun (Director)
Images of the World and the Inscription of War
1991,N 13,C16:6
Farocki, Harun (Screenwriter)
Images of the World and the Inscription of War
1991,N 13,C16:6
Farr, Glenn (Miscellaneous)
Career Opportunities 1991,Mr 31,38:1
Shattered 1991,O 11,C24:3
Out on a Limb 1992,S 5,15:1
Farrell, Charles
Lucky Star 1991,N 1,C8:1
Farrell, Terry
Hellraiser III: Hell on Earth 1992,S 12,14:3
Farrell, Tom Riis
Scent of a Woman 1992,D 23,C9:1
Farrior, William
Home Less Home 1991,Mr 22,C8:5
Farrow, Mia
Alice 1991,Ja 15,C11:3
Shadows and Fog 1992,Mr 20,C6:1
Husbands and Wives 1992,S 18,C1:1
Husbands and Wives 1992,O 4,II:9:1
Farruggia, Colette (Miscellaneous)
Cross My Heart 1991,Ap 5,C18:5
Fassbinder, Rainer Werner
Shadow of Angels 1992,Mr 6,C15:1
Fassbinder, Rainer Werner (Original Author)
Shadow of Angels 1992,Mr 6,C15:1
Fassbinder, Rainer Werner (Screenwriter)
Shadow of Angels 1992,Mr 6,C15:1
Fast, Howard (Original Author)
Spartacus 1991,Ap 26,C6:4
Fatoba, Femi
Mister Johnson 1991,Mr 22,C13:1
Fattori, Antonella
Peaceful Air of the West 1991,Mr 20,C12:5
Faucon, Philippe (Director)
Amour, L' 1991,Mr 15,C1:4
Faucon, Philippe (Screenwriter)
Amour, L' 1991,Mr 15,C1:4
Faudet, Etienne (Cinematographer)
Marquis 1991,Jl 3,C12:5
Faulkner, Lisa
Lover, The 1992,O 30,C5:1
Favali, Laura
Cold Moon (Lune Froide) 1992,Ap 22,C17:1
Favreau, Jon
Folks! 1992,My 4,C15:1
Fayed, Dodi (Producer)
FX2: The Deadly Art of Illusion 1991,My 10,C8:5
Fechner, Christian (Producer)
Amants du Pont Neuf, Les (Lovers of the Pont Neuf)
1992,O 6,C16:1
Fechner, Eberhard (Director)
Comedian Harmonists, The 1991,Ap 5,C18:5
Fechner, Eberhard (Screenwriter)
Comedian Harmonists, The 1991,Ap 5,C18:5

Fegan, Jorge
Woman of the Port (Mujer del Puerto, La) 1991,S
27,C5:1
Fehr, Kaja (Miscellaneous)
29th Street 1991,N 1,C14:1
Feiffer, Jules
Hugh Hefner: Once Upon a Time 1992,N 6,C10:3
Feldman, Edward S. (Producer)
Honey, I Blew Up the Kid 1992,Jl 17,C6:5
Feldman, Jack (Miscellaneous)
Newsies 1992,Ap 8,C22:3
Feldman, John (Director)
Alligator Eyes 1991,F 15,C15:1
Feldman, John (Miscellaneous)
Alligator Eyes 1991,F 15,C15:1
Feldman, John (Producer)
Alligator Eyes 1991,F 15,C15:1
Feldman, John (Screenwriter)
Alligator Eyes 1991,F 15,C15:1
Feldshuh, Tovah
Day in October, A 1992,O 28,C20:5
Fellini, Federico (Director)
Intervista 1992,S 20,II:1:1
Intervista 1992,N 20,C10:1
Fellini, Federico (Screenwriter)
Intervista 1992,N 20,C10:1
Fellner, Eric (Producer)
Liebestraum 1991,S 13,C6:1
Fellows, Julian
Damage 1992,D 23,C13:1
Felperlaan, Marc (Cinematographer)
Voyeur 1991,Ag 2,C9:1
Felsberg, Ulrich (Producer)
Notebook on Cities and Clothes 1991,O 25,C17:1
Femenia, Paco (Cinematographer)
Pepi, Luci, Bom (Pepi, Luci, Bom and Other Girls on
the Heap) 1992,My 29,C10:5
Fenn, Sherilyn
Ruby 1992,Mr 27,C1:3
Diary of a Hit Man 1992,My 29,C10:5
Of Mice and Men 1992,O 2,C5:4
Fenn, Suzanne (Miscellaneous)
Rapture, The 1991,S 30,C14:4
Fenner, John (Cinematographer)
Muppet Christmas Carol, The 1992,D 11,C12:6
Fenton, George (Composer)
Fisher King, The 1991,S 20,C10:4
Final Analysis 1992,F 7,C8:1
Hero 1992,O 2,C20:6
Fenton, Simon
Power of One, The 1992,Mr 27,C20:5
Feore, Colm
Beautiful Dreamers 1992,Je 5,C15:1
Ferguson, Larry (Screenwriter)
Alien 3 1992,My 22,C1:1
Ferguson, Scott
Small Time 1991,N 8,C11:1
Fergusson, Karen
Angel at My Table, An 1991,My 21,C15:1
Fernandes, Joao (Cinematographer)
Hitman, The 1991,O 27,51:5
Fernandez, Angel Luis (Cinematographer)
Dream of Light (Sol del Membrillo, El) 1992,O
1,C17:1
Fernandez, Claudia
City of the Blind (Ciudad de Ciegos) 1992,Ap 4,17:5
Fernandez, Evelina
American Me 1992,Mr 13,C6:5
Fernandez, Juan
Liquid Dreams 1992,Ap 15,C19:1
Fernandez, Maria
Home Less Home 1991,Mr 22,C8:5
Fernandez, Tony
Laws of Gravity 1992,Mr 21,18:1
Fernandez Florez, Wenceslao (Original Author)
Bosque Animado, El (Enchanted Forest, The)
1992,D 4,C8:6
Fernan Gomez, Fernando
Most Beautiful Night, The 1992,N 20,C10:5
Fernberger, Peter (Cinematographer)
Just Like in the Movies 1992,My 4,C15:1
Ferran, Pascale (Screenwriter)
Sentinelle, La 1992,O 5,C14:3
Ferrandis, Antonio
Extramuros 1991,Je 28,C10:5
Ferrara, Abel (Director)
Bad Lieutenant 1992,N 20,C15:1

Ferrara, Abel (Screenwriter)
Bad Lieutenant 1992,N 20,C15:1
Ferrell, Tyra
Jungle Fever 1991,Je 7,C1:2
Boyz 'n the Hood 1991,Jl 12,C1:1
White Men Can't Jump 1992,Mr 27,C22:4
White Men Can't Jump 1992,Ap 26,II:15:5
Ferreol, Andrea
Sleazy Uncle, The 1991,F 22,C10:5
Street of No Return 1991,Ag 2,C6:1
Ferreri, Marco (Director)
Carne (Flesh) 1991,My 15,C11:1
Ferrero, Martin
Oscar 1991,Ap 26,C10:5
Stop! Or My Mom Will Shoot 1992,F 21,C8:5
Ferretti, Dante (Miscellaneous)
Sleazy Uncle, The 1991,F 22,C10:5
Ferretti, Robert A. (Miscellaneous)
Out for Justice 1991,Ap 13,12:4
Under Siege 1992,O 9,C12:1
Ferriere, Martine
Favor, the Watch, and the Very Big Fish, The
1992,My 8,C15:3
Ferris, Michael (Miscellaneous)
Into the Sun 1992,Ja 31,C10:6
Ferris, Michael (Screenwriter)
Into the Sun 1992,Ja 31,C10:6
Feug, Tien
Song of the Exile 1991,Mr 15,C21:1
Fevrier, Laurence
Tatie Danielle 1991,My 17,C8:1
Fichter, Rick (Cinematographer)
Bride of Re-Animator 1991,F 22,C17:1
Fiedel, Brad (Composer)
Terminator 2: Judgment Day 1991,Jl 3,C11:5
Gladiator 1992,Mr 6,C17:1
Straight Talk 1992,Ap 3,C17:1
Fiedler, John (Producer)
Mortal Thoughts 1991,Ap 19,C15:1
Field, Arabella
Laws of Gravity 1992,Mr 21,18:1
Laws of Gravity 1992,Ag 26,C18:6
Field, Chelsea
Harley Davidson and the Marlboro Man 1991,Ag
24,16:6
Last Boy Scout, The 1991,D 13,C14:6
Field, Sally
Not Without My Daughter 1991,Ja 11,C8:1
Not Without My Daughter 1991,Ja 27,II:1:1
Soapdish 1991,My 31,C10:1
Field, Sally (Producer)
Dying Young 1991,Je 21,C10:1
Field, Shirley-Anne
Hear My Song 1992,Ja 19,48:1
Field, Ted (Producer)
Class Action 1991,Mr 15,C20:4
Cutting Edge, The 1992,Mr 27,C21:1
Fields, Christopher John
Alien 3 1992,My 22,C1:1
Fields, Matthew
Newsies 1992,Ap 8,C22:3
Fields, Michael (Director)
Bright Angel 1991,Je 14,C6:1
Fields, W. C.
Million Dollar Legs 1992,N 20,C1:3
Fienberg, Gregg (Producer)
Twin Peaks: Fire Walk with Me 1992,Ag 29,11:1
Fierberg, Steven (Cinematographer)
29th Street 1991,N 1,C14:1
Fierry, Patrick
Cold Moon (Lune Froide) 1992,Ap 22,C17:1
Fieschi, Jacques (Screenwriter)
Every Other Weekend 1991,Je 19,C12:3
Figgis, Mike (Composer)
Liebestraum 1991,S 13,C6:1
Figgis, Mike (Director)
Liebestraum 1991,S 13,C6:1
Liebestraum 1991,O 13,II:21:1
Figgis, Mike (Screenwriter)
Liebestraum 1991,S 13,C6:1
Figueroa, Eddie
Blowback 1991,Ag 9,C13:1
Filar, Gil
Used People 1992,D 16,C23:3
Filar, Maia
Used People 1992,D 16,C23:3
Filatov, Leonid
City Zero 1991,Mr 22,C14:1

Filho, Jardel
Earth Entranced (Terra em Transe) 1991,O 5,14:5
Filleul, Peter (Composer)
Sweet Talker 1991,My 12,42:5
Finan, Tom (Miscellaneous)
Pet Sematary Two 1992,Ag 29,14:4
Finch, Mark
Living End, The 1992,Ap 3,C1:1
Fincher, David (Director)
Alien 3 1992,My 22,C1:1
Alien 3 1992,My 31,II:20:4
Fine, Travis
Child's Play 3 1991,Ag 30,C11:3
Finfer, David (Miscellaneous)
Defending Your Life 1991,Mr 22,C12:1
Warlock 1991,Mr 30,11:4
Bill and Ted's Bogus Journey 1991,Jl 19,C10:1
Fingleton, Anthony (Screenwriter)
Drop Dead Fred 1991,My 24,C8:1
Finnegan, Dave
Commitments, The 1991,Ag 14,C11:1
Finnell, Michael (Producer)
Deceived 1991,S 27,C8:5
Newsies 1992,Ap 8,C22:3
Finney, Albert
Playboys, The 1992,Ap 22,C15:1
Finocchiaro, Angela
Portaborse, Il 1992,D 31,C18:1
Fiorello, Sabato
Man Without a World, The 1992,S 9,C18:4
Fiorentino, Linda
Queens Logic 1991,F 1,C13:1
Fire, Richard (Screenwriter)
Borrower, The 1991,O 18,C12:3
Firestone, Daren
Scenes from a Mall 1991,F 22,C19:1
Firestone, Diane (Producer)
Liquid Dreams 1992,Ap 15,C19:1
Fischer, Werner
November Days 1992,My 8,C8:1
Fischer-Hansen, Andreas (Cinematographer)
Atlantic Rhapsody: 52 Scenes from Torshavn
1991,Mr 30,11:1
Fish, Nancy
Death Becomes Her 1992,Jl 31,C8:1
Dr. Giggles 1992,O 24,16:4
Fish, Peter (Composer)
Painting the Town 1992,My 30,13:1
Fishburne, Larry
Cadence 1991,Mr 15,C18:5
Class Action 1991,Mr 15,C20:4
Boyz 'n the Hood 1991,Jl 12,C1:1
Deep Cover 1992,Ap 15,C19:4
Fisher, Carrie
Drop Dead Fred 1991,My 24,C8:1
Soapdish 1991,My 31,C10:1
This Is My Life 1992,F 21,C8:1
Fisher, Christopher
Steal America 1992,Ap 3,C24:5
Fisher, Frances
Unforgiven 1992,Ag 7,C1:1
Fisher, Gerry (Cinematographer)
Company Business 1992,Ap 25,17:1
Diggstown 1992,Ag 14,C1:1
Fisher, Morgan (Composer)
Twilight of the Cockroaches 1991,Mr 29,C14:4
Fisher, Tricia Leigh
Book of Love 1991,F 1,C10:6
Fitzgerald, Michael (Producer)
Mister Johnson 1991,Mr 22,C13:1
Fitzgerald, Tara
Hear My Song 1992,Ja 19,48:1
Fitzgibbon, Ian
Fine Romance, A 1992,O 2,C10:6
Fix, Paul
Lucky Star 1991,N 1,C8:1
Flagg, Fannie (Original Author)
Fried Green Tomatoes 1991,D 27,C3:1
Fried Green Tomatoes 1992,F 28,C1:1
Flagg, Fannie (Screenwriter)
Fried Green Tomatoes 1991,D 27,C3:1
Flaherty, Lanny
Ballad of the Sad Cafe, The 1991,Mr 28,C11:1
Flaksman, Alberto (Producer)
Exposure 1991,N 1,C12:6
Flamand, Thierry (Miscellaneous)
Until the End of the World 1991,D 25,18:5

Flaubert, Gustave (Original Author)
Madame Bovary 1991,D 25,13:1
Madame Bovary 1992,F 9,II:13:1
Save and Protect 1992,Jl 10,C14:5
Flaum, Seth (Miscellaneous)
Shout 1991,O 4,C21:3
Flea
My Own Private Idaho 1991,S 27,C5:1
Flender, Rodman (Director)
In the Heat of Passion 1992,Ja 24,C12:5
Flender, Rodman (Producer)
In the Heat of Passion 1992,Ja 24,C12:5
Flender, Rodman (Screenwriter)
In the Heat of Passion 1992,Ja 24,C12:5
Flinn, Denny Martin (Screenwriter)
Star Trek VI: The Undiscovered Country 1991,D
6,C1:1
Flon, Suzanne
En Toute Innocence (In All Innocence) 1992,Jl
31,C14:3
Florance, Sheila
Woman's Tale, A 1992,Ap 30,C16:6
Florence, Marsha
Zebrahead 1992,O 8,C17:5
Flores, Claudia
There's Nothing Out There 1992,Ja 22,C20:4
Flores, Dolores
Flaming Creatures (Avant-Garde Visions) 1991,O
1,C13:1
Flores, Jose
Cabeza de Vaca 1991,Mr 23,12:6
Floria, Holly
Bikini Island 1991,Jl 27,16:3
Fluegel, Darlanne
Pet Sematary Two 1992,Ag 29,14:4
Flynn, Colleen
Late for Dinner 1991,S 20,C6:5
Flynn, Jerome
Edward II 1992,Mr 20,C16:3
Flynn, John (Director)
Out for Justice 1991,Ap 13,12:4
Flynn, Kimberly
Revolution 1991,N 15,C8:4
Flynn, Michael (Producer)
My New Gun 1992,O 30,C10:1
Focas, Spiros
Rocco and His Brothers 1991,S 21,12:1
Rocco and His Brothers 1992,Ja 24,C8:1
Foegelle, Dan (Miscellaneous)
Julia Has Two Lovers 1991,Mr 24,64:1
Foldes, Mathieu (Composer)
Outremer 1991,Mr 27,C15:1
Foldes, Pierre (Composer)
Outremer 1991,Mr 27,C15:1
Foley, James (Director)
Glengarry Glen Ross 1992,S 30,C15:3
Folk, Robert (Composer)
Neverending Story II, The: The Next Chapter 1991,F
9,12:4
Toy Soldiers 1991,Ap 26,C15:1
Rock-a-Doodle 1992,Ap 3,C13:1
Follansbee, Julie
Hairway to the Stars (Short and Funnies, The)
1992,D 16,C30:3
Follows, Megan
Termini Station 1991,My 31,C14:5
Fonda, Bridget
Doc Hollywood 1991,Ag 2,C8:5
Iron Maze 1991,N 1,C13:1
Single White Female 1992,Ag 14,C8:1
Single White Female 1992,Ag 16,II:15:1
Singles 1992,S 18,C3:4
Singles 1992,O 4,II:9:1
Fong Ling Ching (Miscellaneous)
Autumn Moon 1992,S 26,12:1
Fong Ling Ching (Producer)
Autumn Moon 1992,S 26,12:1
Fong Ling Ching (Screenwriter)
Autumn Moon 1992,S 26,12:1
Fonseca, Gregg (Miscellaneous)
Shattered 1991,O 11,C24:3
Wayne's World 1992,F 14,C15:1
Gladiator 1992,Mr 6,C17:1
Forever Young 1992,D 16,C17:1
Fonseca, Rubem (Original Author)
Exposure 1991,N 1,C12:6
Fonseca, Rubem (Screenwriter)
Exposure 1991,N 1,C12:6

Font, Teresa (Miscellaneous)
Lovers 1992,Mr 25,C18:5
Aventis (Stories) 1992,N 13,C15:1
Foote, Horton (Original Author)
Convicts 1991,D 6,C14:6
Foote, Horton (Screenwriter)
Convicts 1991,D 6,C14:6
Of Mice and Men 1992,O 2,C5:4
Foppa, Julia Solorzano (Producer)
Cabeza de Vaca 1991,Mr 23,12:6
Forbes, Bryan (Screenwriter)
Chaplin 1992,D 25,C3:1
Ford, David W. (Miscellaneous)
Pastime 1991,Ag 23,C13:1
Ford, Harrison
Regarding Henry 1991,Jl 10,C13:3
Regarding Henry 1991,Jl 14,II:9:5
Regarding Henry 1991,Ag 11,II:18:1
Regarding Henry 1991,Ag 18,II:11:5
Patriot Games 1992,Je 5,C1:1
Patriot Games 1992,Je 26,C1:3
Ford, James
Damned in the U.S.A. 1992,N 13,C11:1
Ford, Richard (Original Author)
Bright Angel 1991,Je 14,C6:1
Ford, Richard (Screenwriter)
Bright Angel 1991,Je 14,C6:1
Ford, Roger (Miscellaneous)
Flirting 1992,N 6,C13:1
Foreman, Amanda
Forever Young 1992,D 16,C17:1
Foreman, Ron (Miscellaneous)
Rapid Fire 1992,Ag 21,C11:1
Forgach, Andras (Screenwriter)
Shadow on the Snow 1992,Mr 31,C16:1
Forman, Robin (Producer)
Crisscross 1992,My 9,17:5
Foronjy, Richard
Public Eye, The 1992,O 14,C17:1
Forrest, Frederic
Hearts of Darkness: A Film Maker's Apocalypse
1991,N 27,C9:1
Forristal, Susan
L.A. Story 1991,F 8,C8:1
Forster, E. M. (Original Author)
Where Angels Fear to Tread 1992,F 28,C1:1
Where Angels Fear to Tread 1992,F 28,C12:1
Howards End 1992,Mr 13,C1:3
Where Angels Fear to Tread 1992,Mr 22,II:11:1
Howards End 1992,Mr 22,II:11:1
Forster, Robert
29th Street 1991,N 1,C14:1
Forsyte, Joey (Cinematographer)
American Blue Note 1991,Mr 29,C12:1
Forsyth, Rob (Screenwriter)
Clearcut 1992,Ag 21,C9:1
Forsythe, William
Out for Justice 1991,Ap 13,12:4
Stone Cold 1991,My 18,16:3
American Me 1992,Mr 13,C6:5
Waterdance, The 1992,My 13,C13:1
Fortunato, Ron (Cinematographer)
Fathers and Sons 1992,N 6,C17:1
Foss, Bob (Screenwriter)
Shipwrecked 1991,Mr 1,C6:1
Foster, David (Composer)
One Good Cop 1991,My 3,C13:1
Foster, Gloria
City of Hope 1991,O 11,C19:1
Foster, Jodie
Silence of the Lambs, The 1991,F 14,C17:1
Silence of the Lambs, The 1991,F 17,II:11:5
Silence of the Lambs, The 1991,Mr 10,II:1:1
Little Man Tate 1991,O 9,C17:4
Little Man Tate 1991,N 3,II:22:1
Shadows and Fog 1992,Mr 20,C6:1
Foster, Jodie (Director)
Little Man Tate 1991,O 9,C17:4
Little Man Tate 1991,N 3,II:22:1
Foster, John R. (Cinematographer)
Resident Alien 1991,O 18,C10:6
Foster, Richard
Talking to Strangers 1991,D 27,C12:6
Fourastier, Marc
Ciel de Paris, Le 1992,Mr 29,48:2
Fowler, Bernard
At the Max 1991,N 22,C15:1

Fulweiler, John
Puerto Rican Mambo (Not a Musical), The 1992,Mr 22,48:4
Funk, Bob
At the Max 1991,N 22,C15:1
Funk, Mason M. (Screenwriter)
Winter in Lisbon, The 1992,Mr 9,C15:5
Furic, Herve
Tale of Winter, A 1992,O 2,C12:6
Furie, Sidney J. (Director)
Taking of Beverly Hills, The 1991,O 13,68:5
Ladybugs 1992,Mr 28,17:1
Furie, Sidney J. (Miscellaneous)
Aces: Iron Eagle III 1992,Je 13,16:4
Furlong, Edward
Terminator 2: Judgment Day 1991,Jl 3,C11:5
Terminator 2: Judgment Day 1991,Jl 14,II:9:1
Pet Sematary Two 1992,Ag 29,14:4
Furness, Deborah-Lee
Voyager 1992,Ja 31,C6:1
Fusco, John (Producer)
Thunderheart 1992,Ap 3,C12:1
Babe, The 1992,Ap 17,C8:1
Fusco, John (Screenwriter)
Thunderheart 1992,Ap 3,C12:1
Babe, The 1992,Ap 17,C8:1
Thunderheart 1992,My 10,II:22:1
Fuzzy (Composer)
Memories of a Marriage 1991,Ja 28,C20:3
Fyfe, Jim
Kiss Before Dying, A 1991,Ap 26,C12:6

G

G., Kenny (Composer)
Traffic Jam 1992,Mr 20,C20:4
Gabaldon, Paca
Bosque Animado, El (Enchanted Forest, The) 1992,D 4,C8:6
Gable, June
Brenda Starr 1992,Ap 19,46:1
Gabor, Zsa Zsa
Naked Gun 2 1/2: The Smell of Fear 1991,Je 28,C8:1
Gabrels, Reeves (Composer)
Hugh Hefner: Once Upon a Time 1992,N 6,C10:3
Gage, Patricia
Perfectly Normal 1991,F 15,C14:5
Gagne, Jacques (Miscellaneous)
Paper Wedding, A 1991,Je 21,C8:1
Gagulaschvili, Arkady (Composer)
Satan 1992,Mr 28,18:1
Gaigne, Pascal (Composer)
Dream of Light (Sol del Membrillo, El) 1992,O 1,C17:1
Gaines, Sonny Jim
Distinguished Gentleman, The 1992,D 4,C1:4
Gainey, M. C.
Leap of Faith 1992,D 18,C14:1
Gaitan, Svetlana
Hey, You Wild Geese 1992,Ap 2,C20:5
Galabru, Michel
Uranus 1991,Ag 23,C15:1
Galbally, Frank (Original Author)
Storyville 1992,Ag 26,C13:3
Gale, Bob (Screenwriter)
Trespass 1992,D 25,C18:5
Gale, Charles (Screenwriter)
Guilty as Charged 1992,Ja 29,C17:1
Gale, Randolph (Producer)
Guilty as Charged 1992,Ja 29,C17:1
Galiardo, Juan Luis
Don Juan, My Love 1991,Jl 12,C10:5
Galiardo, Lou
June Roses 1992,Mr 24,C15:3
Galiena, Anna
Hairdresser's Husband, The 1992,Je 19,C11:1
Gallacher, Frank
Proof 1992,Mr 20,C20:1
Gallagher, Bronagh
Commitments, The 1991,Ag 14,C11:1
Gallagher, Dorothy
Complex World 1992,Ap 10,C14:5
Gallagher, Peter
Late for Dinner 1991,S 20,C6:5
Cabinet of Dr. Ramirez, The 1992,Ja 23,C15:4

Player, The 1992,Ap 10,C16:1
Player, The 1992,My 11,C9:1
Bob Roberts 1992,My 13,C13:5
Galland, Philippe
Outremer 1991,Mr 27,C15:1
Overseas (Outremer) 1991,N 8,C25:1
Gallardo, Camilo
Singles 1992,S 18,C3:4
Gallego, Jackson Idrian
Rodrigo D: No Future 1991,Ja 11,C10:5
Gallin, Sandy (Producer)
Stranger Among Us, A 1992,Jl 17,C1:3
Gallo, George (Director)
29th Street 1991,N 1,C14:1
Gallo, George (Screenwriter)
29th Street 1991,N 1,C14:1
Gallo, Vincent
Alex 1992,Mr 24,C15:3
Galloway, Graham
Class Act 1992,Je 5,C17:1
Gam, Giulia
Exposure 1991,N 1,C12:6
Gambon, Michael
Mobsters 1991,Jl 26,C18:4
Toys 1992,D 18,C1:3
Gambrill, Linda
Lunatic, The 1992,F 7,C14:5
Gammon, James
Leaving Normal 1992,Ap 29,C17:1
Crisscross 1992,My 9,17:5
Ganassini, Daria (Miscellaneous)
Story of Boys and Girls, The 1991,Mr 28,C12:1
Gannon, Ben (Producer)
Sweet Talker 1991,My 12,42:5
Gantzler, Peter
Birthday Trip, The 1991,Mr 26,C14:3
Ganz, Armin (Miscellaneous)
Kuffs 1992,Ja 10,C16:6
Love Crimes 1992,Ja 26,43:5
Ganz, Bruno
Children of Nature 1992,Ap 2,C18:3
Ganz, Bruno (Narrator)
Architecture of Doom, The 1991,O 30,C14:4
Ganz, Lowell (Screenwriter)
City Slickers 1991,Je 7,C18:5
League of Their Own, A 1992,Jl 1,C13:4
League of Their Own, A 1992,Jl 12,II:11:5
Mr. Saturday Night 1992,S 23,C13:4
Gara, Olvido
Pepi, Luci, Bom (Pepi, Luci, Bom and Other Girls on the Heap) 1992,My 29,C10:5
Garcia, Andy
Dead Again 1991,Ag 23,C1:3
Hero 1992,O 2,C20:6
Hero 1992,O 4,II:9:4
Jennifer 8 1992,N 6,C6:2
Garcia, Gerardo (Composer)
Adorable Lies 1992,Mr 27,C8:5
Garcia, Luis Alberto
Adorable Lies 1992,Mr 27,C8:5
Garcia, Nicole
Outremer 1991,Mr 27,C15:1
Overseas (Outremer) 1991,N 8,C25:1
Garcia, Nicole (Director)
Every Other Weekend 1991,Je 19,C12:3
Garcia, Nicole (Screenwriter)
Every Other Weekend 1991,Je 19,C12:3
Garcia, Rodrigo (Cinematographer)
Danzon 1992,S 25,C6:5
Garcia, Ron (Cinematographer)
Storyville 1992,Ag 26,C13:3
Twin Peaks: Fire Walk with Me 1992,Ag 29,11:1
Garcia Diego, Paz Alicia (Screenwriter)
Woman of the Port (Mujer del Puerto, La) 1991,S 27,C5:1
City of the Blind (Ciudad de Ciegos) 1992,Ap 4,17:5
Garcia Marquez, Gabriel (Miscellaneous)
Fable of the Beautiful Pigeon Fancier, The 1991,Mr 1,C6:4
Garcia Marquez, Gabriel (Screenwriter)
Fable of the Beautiful Pigeon Fancier, The 1991,Mr 1,C6:4
Garcin, Henri
Every Other Weekend 1991,Je 19,C12:3
Voyeur 1991,Ag 2,C9:1
Gardel, Louis (Screenwriter)
Indochine 1992,D 24,C9:1

Gardenia, Vincent
Super, The 1991,O 4,C10:1
Gardner, Ava
Barefoot Contessa, The 1992,N 20,C1:3
Gardner, David
Making of "Monsters," The (Avant-Garde Visions) 1991,O 1,C13:1
Beautiful Dreamers 1992,Je 5,C15:1
Gardner, Katya
Careful 1992,O 7,C20:3
Gardner, Lynn
On the Black Hill 1991,Ag 16,C8:1
Gardos, Eva (Miscellaneous)
Paradise 1991,S 18,C16:3
Garfield
Mo' Money 1992,Jl 25,15:1
Garin, Aleksandr
Inner Circle, The 1991,D 25,20:1
Garneau, Constance
Strangers in Good Company 1991,My 10,C8:1
Garner, James
Distinguished Gentleman, The 1992,D 4,C1:4
Garr, Teri
Mom and Dad Save the World 1992,Jl 27,C18:4
Garrard, Robert (Cinematographer)
Blast 'Em 1992,Jl 1,C18:3
Garrel, Maurice
Discrete, La 1992,Ag 14,C13:1
Garrett, W. O. (Miscellaneous)
Chopper Chicks in Zombietown 1991,My 10,C15:5
Garris, Cynthia
Sleepwalkers 1992,Ap 11,18:1
Garris, Mick (Director)
Sleepwalkers 1992,Ap 11,18:1
Garrison, Jim (Original Author)
J.F.K. 1991,D 20,C1:1
Garrison, Miranda (Miscellaneous)
Naked Gun 2 1/2: The Smell of Fear 1991,Je 28,C8:1
Garrity, Joseph T. (Miscellaneous)
Drop Dead Fred 1991,My 24,C8:1
My Girl 1991,N 27,C15:1
Garrone, Mirco (Miscellaneous)
Portaborse, Il 1992,D 31,C18:1
Garson, Mike (Composer)
Life on the Edge 1992,Je 19,C11:1
Garson, Willie
Ruby 1992,Mr 27,C1:3
Gartside, Kate
Close My Eyes 1992,F 21,C12:6
Garwood, Norman (Miscellaneous)
Hook 1991,D 11,C17:3
Gary, Romain (Original Author)
White Dog 1991,Jl 12,C8:1
Gasnold, Barbara (Miscellaneous)
Truly, Madly, Deeply 1991,My 3,C11:1
Gaspar, Sandor
Memoirs of a River 1992,Mr 20,C15:1
Gassman, Vittorio
Sleazy Uncle, The 1991,F 22,C10:5
Gassner, Dennis (Miscellaneous)
Barton Fink 1991,Ag 21,C11:1
Bugsy 1991,D 13,C12:1
Hero 1992,O 2,C20:6
Gassols, Carlos
Fallen from Heaven 1991,Mr 18,C12:3
Gassot, Charles (Producer)
Tatie Danielle 1991,My 17,C8:1
Gaster, Nicolas (Miscellaneous)
Rosencrantz and Guildenstern Are Dead 1991,F 8,C14:6
Day in October, A 1992,O 28,C20:5
Gates, Henry Louis, Jr.
Color Adjustment 1992,Ja 29,C15:1
Gatta, Stephen
Hearing Voices 1991,N 15,C11:1
Gatteau, Faye
Olivier, Olivier 1992,S 25,C34:1
Gaudette, Claude (Composer)
American Me 1992,Mr 13,C6:5
Gaup, Nils (Director)
Shipwrecked 1991,Mr 1,C6:1
Gaup, Nils (Screenwriter)
Shipwrecked 1991,Mr 1,C6:1
Gavin, James (Miscellaneous)
Wild Orchid 2: Two Shades of Blue 1992,My 8,C17:2
Gavin, John
Spartacus 1991,Ap 26,C6:4

Gitai, Amos (Director)
Berlin Jerusalem 1991,Mr 8,C16:6
Gitai, Amos (Screenwriter)
Berlin Jerusalem 1991,Mr 8,C16:6
Giuliano, Peter (Producer)
Toys 1992,D 18,C1:3
Giuntoli, Neil
Crisscross 1992,My 9,17:5
Giurato, Blasco (Cinematographer)
Everybody's Fine (Stanno Tutti Bene) 1991,My
31,C12:6
Year of the Gun 1991,N 1,C10:6
Giusti, Graziano
Portaborse, Il 1992,D 31,C18:1
Givens, Robin
Rage in Harlem, A 1991,My 3,C14:1
Boomerang 1992,Jl 1,C18:1
Boomerang 1992,Jl 12,II:11:5
Gizmo
Drum Struck 1992,Ap 22,C17:1
Glaser, Paul M. (Director)
Cutting Edge, The 1992,Mr 27,C21:1
Glaser, Stephanie
Leo Sonnyboy 1991,Mr 16,16:4
Glass, Alice
To Render a Life 1992,N 18,C23:1
Glass, Obea
To Render a Life 1992,N 18,C23:1
Glass, Philip (Composer)
Mindwalk 1992,Ap 8,C17:1
Brief History of Time, A 1992,Ag 21,C3:1
Candyman 1992,O 16,C10:5
Glasser, Isabel
Pure Country 1992,O 23,C13:1
Forever Young 1992,D 16,C17:1
Glasser, Phillip
American Tail, An: Fievel Goes West 1991,N
22,C21:1
Gleason, Joanna
FX2: The Deadly Art of Illusion 1991,My 10,C8:5
Gleason, Paul
Rich Girl 1991,My 4,15:1
Gleizer, Michele
Europa, Europa 1991,Je 28,C10:1
Glen, John (Director)
Aces: Iron Eagle III 1992,Je 13,16:4
Christopher Columbus: The Discovery 1992,Ag
22,11:1
Glen, Matthew (Miscellaneous)
Christopher Columbus: The Discovery 1992,Ag
22,11:1
Glenn, Pierre-William (Cinematographer)
Street of No Return 1991,Ag 2,C6:1
Glenn, Scott
Silence of the Lambs, The 1991,F 14,C17:1
My Heroes Have Always Been Cowboys 1991,Mr
22,C14:5
Backdraft 1991,My 24,C14:6
Glennon, James (Cinematographer)
December 1991,D 6,C8:5
Glickenhaus, James (Director)
McBain 1991,S 23,C15:1
Glickenhaus, James (Screenwriter)
McBain 1991,S 23,C15:1
Glimcher, Arne (Director)
Mambo Kings, The 1992,F 28,C1:1
Mambo Kings, The 1992,F 28,C8:1
Glimcher, Arne (Producer)
Mambo Kings, The 1992,F 28,C8:1
Glover, Brian
Kafka 1991,D 4,C21:1
Alien 3 1992,My 22,C1:1
Glover, Crispin
Doors, The 1991,Mr 1,C1:1
Little Noises 1992,Ap 24,C8:6
Glover, Danny
Flight of the Intruder 1991,Ja 18,C19:1
Rage in Harlem, A 1991,My 3,C14:1
Pure Luck 1991,Ag 9,C15:1
Pure Luck 1991,Ag 18,II:11:5
Grand Canyon 1991,D 25,18:1
Lethal Weapon 3 1992,My 15,C16:3
Lethal Weapon 3 1992,My 31,II:20:4
Lethal Weapon 3 1992,Je 26,C1:3
Lethal Weapon 3 1992,Jl 26,II:9:1
Glynn, Carlin
Convicts 1991,D 6,C14:6

Gnadinger, Mathias
Leo Sonnyboy 1991,Mr 16,16:4
Journey of Hope 1991,Ap 26,C13:1
Gobert, Boy
Shadow of Angels 1992,Mr 6,C15:1
Goch, Gary (Producer)
Popcorn 1991,F 1,C6:5
Godard, Agnes (Cinematographer)
Jacquot de Nantes 1991,S 25,C16:3
No Fear, No Die 1992,Ag 7,C16:5
Godard, Jean-Luc (Director)
Letter to Jane 1992,S 20,II:1:1
Histoire(s) du Cinema 1992,O 30,C16:5
Goddard, Keith (Cinematographer)
Twenty-One 1991,O 4,C10:6
Goded, Ángel (Cinematographer)
Woman of the Port (Mujer del Puerto, La) 1991,S
27,C5:1
Godet, Thomas
Toto the Hero (Toto le Heros) 1991,S 21,11:1
Toto the Hero (Toto le Heros) 1992,Mr 6,C12:1
Goelz, Dave
Muppet Christmas Carol, The 1992,D 11,C12:6
Goerdeler, Dr. Carl
Restless Conscience, The 1992,F 7,C15:1
Goethals, Angela
V. I. Warshawski 1991,Jl 26,C1:3
Triple Bogey on a Par 5 Hole 1992,Mr 21,13:4
Goetz, Peter Michael
My Girl 1991,N 27,C15:1
Goetz, Scot
Living End, The 1992,Ap 3,C1:1
Goetzman, Gary (Miscellaneous)
Queens Logic 1991,F 1,C13:1
Goggins, Walt
Forever Young 1992,D 16,C17:1
Gokcer, Deniz
Heart of Glass, A 1992,Mr 21,18:4
Goldberg, Leonard (Producer)
Sleeping with the Enemy 1991,F 8,C10:1
Distinguished Gentleman, The 1992,D 4,C1:4
Goldberg, Rubin
Uncle Moses 1991,N 21,C18:4
Goldberg, Whoopi
Long Walk Home, The 1991,F 3,II:13:5
Soapdish 1991,My 31,C10:1
House Party 2 1991,O 23,C17:1
Player, The 1992,Ap 10,C16:1
Player, The 1992,My 11,C9:1
Sister Act 1992,My 29,C10:1
Wisecracks 1992,Je 4,C17:1
Sister Act 1992,Je 7,II:13:1
Sister Act 1992,Je 26,C1:3
Sister Act 1992,Jl 26,II:9:1
Sarafina! 1992,S 18,C16:6
Goldblatt, Mark (Miscellaneous)
Terminator 2: Judgment Day 1991,Jl 3,C11:5
Last Boy Scout, The 1991,D 13,C14:6
Goldblatt, Stephen (Cinematographer)
For the Boys 1991,N 22,C12:1
Prince of Tides, The 1991,D 25,13:3
Consenting Adults 1992,O 16,C14:5
Goldblum, Jeff
Deep Cover 1992,Ap 15,C19:4
Favor, the Watch, and the Very Big Fish, The
1992,My 8,C15:3
Fathers and Sons 1992,N 6,C17:1
Golden, Annie
Strictly Business 1991,N 8,C13:3
Goldenthal, Elliot (Composer)
Alien 3 1992,My 22,C1:1
Goldfield, Debra (Miscellaneous)
Cool as Ice 1991,O 19,12:6
Goldfine, Lloyd (Cinematographer)
Jumpin' at the Boneyard 1992,S 18,C18:5
Goldfine, Lloyd (Producer)
Jumpin' at the Boneyard 1992,S 18,C18:5
Goldin, Daniel (Screenwriter)
Out on a Limb 1992,S 5,15:1
Goldin, Joshua (Screenwriter)
Out on a Limb 1992,S 5,15:1
Goldin, Sidney (Director)
Uncle Moses 1991,N 21,C18:4
Goldman, Alain (Producer)
1492: Conquest of Paradise 1992,O 9,C21:1
Goldman, Bo (Screenwriter)
Scent of a Woman 1992,D 23,C9:1

Goldman, Gary (Producer)
Rock-a-Doodle 1992,Ap 3,C13:1
Goldman, Shannon
Lost Prophet 1992,Je 8,C16:1
Goldman, Shannon (Screenwriter)
Lost Prophet 1992,Je 8,C16:1
Goldman, William (Screenwriter)
Memoirs of an Invisible Man 1992,F 28,C17:1
Year of the Comet 1992,Ap 25,17:1
Chaplin 1992,D 25,C3:1
Goldner, Michael
Poison Ivy 1992,My 8,C16:3
Goldovskaya, Marina (Cinematographer)
Solovki Power 1991,Ja 2,C10:5
Goldovskaya, Marina (Director)
Solovki Power 1991,Ja 2,C10:5
Goldring, Danny
Babe, The 1992,Ap 17,C8:1
Goldsmith, Jerry (Composer)
Not Without My Daughter 1991,Ja 11,C8:1
Sleeping with the Enemy 1991,F 8,C10:1
Warlock 1991,Mr 30,11:4
Medicine Man 1992,F 7,C13:1
Basic Instinct 1992,Mr 20,C8:1
Mom and Dad Save the World 1992,Jl 27,C18:4
Mr. Baseball 1992,O 2,C14:6
Love Field 1992,D 11,C6:3
Forever Young 1992,D 16,C17:1
Goldsmith, Martin (Screenwriter)
Detour 1992,Jl 3,C8:1
Goldsmith, Michael
Echoes from a Somber Empire 1992,Jl 15,C15:3
Goldson, Dennis
Alberto Express 1992,O 9,C12:5
Goldstein, Scott D. (Director)
Ambition 1991,Je 1,16:3
Goldstein, Scott D. (Miscellaneous)
Ambition 1991,Je 1,16:3
Goldthwait, Bobcat
Shakes the Clown 1992,Mr 13,C13:1
Goldthwait, Bobcat (Director)
Shakes the Clown 1992,Mr 13,C13:1
Goldthwait, Bobcat (Screenwriter)
Shakes the Clown 1992,Mr 13,C13:1
Goldwyn, Tony
Kuffs 1992,Ja 10,C16:6
Traces of Red 1992,N 12,C22:1
Golia, Vinny (Composer)
Blood and Concrete 1991,S 13,C9:1
Golin, Steve (Producer)
Ruby 1992,Mr 27,C1:3
Stranger Among Us, A 1992,Jl 17,C1:3
Candyman 1992,O 16,C10:5
Golino, Valeria
Hot Shots! 1991,Jl 31,C11:2
Indian Runner, The 1991,S 20,C6:1
Year of the Gun 1991,N 1,C10:6
Golovine, Marina
Olivier, Olivier 1992,S 25,C34:1
Golubkina, Masha
Adam's Rib 1991,S 21,12:5
Adam's Rib 1992,My 9,17:2
Gomez, Andres Vicente (Producer)
Ay, Carmela! 1991,F 8,C8:5
Gomez, Nick (Director)
Laws of Gravity 1992,Mr 21,18:1
Laws of Gravity 1992,Ag 26,C18:6
Gomez, Nick (Miscellaneous)
Trust 1991,Jl 26,C16:5
Gomez, Nick (Screenwriter)
Laws of Gravity 1992,Mr 21,18:1
Laws of Gravity 1992,Ag 26,C18:6
Gondre, Jean Francis (Cinematographer)
Winter in Lisbon, The 1992,Mr 9,C15:5
Gong Li
Ju Dou 1991,Mr 17,68:1
Raise the Red Lantern 1992,Mr 20,C18:1
Woman Demon Human 1992,S 4,C11:1
Story of Qiu Ju, The 1992,O 2,C12:1
Gonzalez, Bucky
Drum Struck 1992,Ap 22,C17:1
Goodall, Caroline
Hook 1991,D 11,C17:3
Goodhill, Dean (Miscellaneous)
All I Want for Christmas 1991,N 8,C14:1
Gooding, Cuba, Jr.
Boyz 'n the Hood 1991,Jl 12,C1:1
Gladiator 1992,Mr 6,C17:1

Goodis, David (Original Author)
Street of No Return 1991,Ag 2,C6:1
Goodman, Dody
Cool as Ice 1991,O 19,12:6
Frozen Assets 1992,O 24,16:4
Goodman, Joel (Miscellaneous)
House Party 2 1991,O 23,C17:1
Goodman, John
King Ralph 1991,F 15,C10:3
Barton Fink 1991,My 20,C11:4
Barton Fink 1991,Ag 21,C11:1
Babe, The 1992,Ap 17,C8:1
Babe, The 1992,Ap 26,II:15:1
Goodman, Julia
Twenty-One 1991,O 4,C10:6
Goodman, Marcia
Man Without a World, The 1992,S 9,C18:4
Goodman, Mark J.
Man Trouble 1992,Jl 18,18:4
Goodman, Miles (Composer)
He Said, She Said 1991,F 22,C17:1
What About Bob? 1991,My 17,C15:1
Super, The 1991,O 4,C10:1
Housesitter 1992,Je 12,C1:4
Muppet Christmas Carol, The 1992,D 11,C12:6
Goodman, Valerie (Producer)
John Lurie and the Lounge Lizards Live in Berlin
1991 1992,S 9,C14:5
Goodrich, Frances (Screenwriter)
Father of the Bride 1991,D 20,C17:1
Goodridge, George (Miscellaneous)
Alan and Naomi 1992,Ja 31,C8:5
Goodrow, Garry (Miscellaneous)
Honey, I Blew Up the Kid 1992,Jl 17,C6:5
Goodrow, Garry (Screenwriter)
Honey, I Blew Up the Kid 1992,Jl 17,C6:5
Goorjian, Michael
Forever Young 1992,D 16,C17:1
Gorbunov, Aleksei
Raspad 1992,Ap 29,C15:1
Gordean, William (Miscellaneous)
Delirious 1991,Ag 9,C12:4
Gordon, Barbara
Beautiful Dreamers 1992,Je 5,C15:1
Gordon, Bryan (Director)
Career Opportunities 1991,Mr 31,38:1
Gordon, Charles (Producer)
Rocketeer, The 1991,Je 21,C1:3
Unlawful Entry 1992,Je 26,C10:4
Gordon, Dan (Screenwriter)
Passenger 57 1992,N 6,C14:5
Gordon, Don
Borrower, The 1991,O 18,C12:3
Gordon, Eve
Paradise 1991,S 18,C16:3
Leaving Normal 1992,Ap 29,C17:1
Gordon, Keith (Director)
Midnight Clear, A 1992,Ap 24,C1:3
Gordon, Keith (Screenwriter)
Midnight Clear, A 1992,Ap 24,C1:3
Gordon, Kim
1991: The Year Punk Broke 1992,N 20,C5:1
Gordon, Lawrence (Producer)
Rocketeer, The 1991,Je 21,C1:3
Gordon, Mark (Producer)
Traces of Red 1992,N 12,C22:1
Gordon, Pam
Borrower, The 1991,O 18,C12:3
Gordon, Robert (Director)
All Day and All Night: Memories from Beale Street
Musicians 1991,Mr 15,C1:4
Gordon, Stuart (Miscellaneous)
Honey, I Blew Up the Kid 1992,Jl 17,C6:5
Gordower, Pierre (Cinematographer)
Night and Day 1992,D 11,C10:6
Gore, Michael (Composer)
Defending Your Life 1991,Mr 22,C12:1
Butcher's Wife, The 1991,O 25,C24:1
Goren, Amit
For Sasha 1992,Je 5,C13:1
Goren, Amit (Director)
Cage, The (Echoes of Conflict) 1991,Ap 10,C16:3
Gorgoni, Adam (Composer)
Day in October, A 1992,O 28,C20:5
Gorin, Jean-Pierre (Director)
Letter to Jane 1992,S 20,II:1:1
Gorman, Cliff
Night and the City 1992,O 10,11:3

Gorman, Robert Hy
Don't Tell Mom the Babysitter's Dead 1991,Je
7,C19:1
Forever Young 1992,D 16,C17:1
Gormley, Peggy
Bad Lieutenant 1992,N 20,C15:1
Goroschnikova, Valentina (Producer)
Satan 1992,Mr 28,18:1
Gorrar, Perri (Miscellaneous)
Clearcut 1992,Ag 21,C9:1
Gorton, Assheton (Miscellaneous)
For the Boys 1991,N 22,C12:1
Gosnell, Raja (Miscellaneous)
Only the Lonely 1991,My 24,C10:6
Home Alone 2: Lost in New York 1992,N 20,C1:1
Gosov, Maran (Composer)
Affengeil 1992,Jl 25,15:4
Gosse, Bob
Time Expired 1992,D 2,C18:4
Gosse, Bob (Producer)
Laws of Gravity 1992,Mr 21,18:1
Gossett, Louis, Jr.
Toy Soldiers 1991,Ap 26,C15:1
Aces: Iron Eagle III 1992,Je 13,16:4
Diggstown 1992,Ag 14,C1:1
Gostukhin, Vladimir
Close to Eden 1992,O 30,C10:5
Goswami, Meenakshi
Idiot 1992,O 8,C21:4
Gottfried, Gilbert
Problem Child 2 1991,Jl 5,C6:1
Aladdin 1992,N 11,C15:3
Gottfried, Howard (Producer)
Suburban Commando 1991,O 6,56:3
Gottli, Michael
Archangel 1991,Jl 19,C12:6
Gottlieb, Jay (Composer)
Discrete, La 1992,Ag 14,C13:1
Gough, Michael
Batman Returns 1992,Je 19,C1:1
Gould, Elliott
Bugsy 1991,D 13,C12:1
Gould, Heywood (Director)
One Good Cop 1991,My 3,C13:1
Gould, Heywood (Screenwriter)
One Good Cop 1991,My 3,C13:1
Gould, Jason
Prince of Tides, The 1991,D 25,13:3
Goulet, Robert
Naked Gun 2 1/2: The Smell of Fear 1991,Je 28,C8:1
Goursaud, Anne (Miscellaneous)
Bram Stoker's "Dracula" 1992,N 13,C1:3
Gouttman, Delphine
Cross My Heart 1991,Ap 5,C18:5
Gouze-Renal, Christine (Producer)
Room in Town, A (Chambre en Ville, Une) 1991,S
28,11:5
Governor, Mark (Composer)
Pet Sematary Two 1992,Ag 29,14:4
Gow, David
Used People 1992,D 16,C23:3
Graber, Jody
Garden, The 1991,Ja 17,C16:5
Edward II 1992,Mr 20,C16:3
Grabowski, Bill (Composer)
Whole Truth, The 1992,O 23,C10:5
Grabowsky, Paul (Composer)
Woman's Tale, A 1992,Ap 30,C16:6
Graceli-Salgado, Rosa (Miscellaneous)
Don Juan, My Love 1991,Jl 12,C10:5
Gracie, Sally
Passed Away 1992,Ap 24,C8:1
Gracindo, Paulo
Earth Entranced (Terra em Transe) 1991,O 5,14:5
Grade, Chaim (Original Author)
Quarrel, The 1992,N 4,C22:4
Graff, Ilene
Ladybugs 1992,Mr 28,17:1
Graff, Todd (Screenwriter)
Used People 1992,D 16,C23:3
Graham, Angelo (Miscellaneous)
Delirious 1991,Ag 9,C12:4
Scent of a Woman 1992,D 23,C9:1
Graham, Bill
Bugsy 1991,D 13,C12:1
Graham, Bill (Producer)
Doors, The 1991,Mr 1,C1:1

Graham, Gary
Man Trouble 1992,Jl 18,18:4
Graham, Heather
Shout 1991,O 4,C21:3
Guilty as Charged 1992,Ja 29,C17:1
Diggstown 1992,Ag 14,C1:1
Graham, Ruth (Screenwriter)
Becoming Colette 1992,N 6,C6:1
Graham, William A. (Director)
Return to the Blue Lagoon 1991,Ag 2,C12:1
Graham, William A. (Producer)
Return to the Blue Lagoon 1991,Ag 2,C12:1
Grais, Michael (Producer)
Sleepwalkers 1992,Ap 11,18:1
Grais, Michael (Screenwriter)
Cool World 1992,Jl 11,12:3
Gran, Enrique
Dream of Light (Sol del Membrillo, El) 1992,O
1,C17:1
Granath, Bjorn
Ox, The 1992,Ag 21,C10:5
Granger, Derek (Producer)
Where Angels Fear to Tread 1992,F 28,C12:1
Where Angels Fear to Tread 1992,Mr 22,II:11:1
Granger, Derek (Screenwriter)
Where Angels Fear to Tread 1992,F 28,C12:1
Granger, Toby Scott
Rock-a-Doodle 1992,Ap 3,C13:1
Granger, Tracy S. (Miscellaneous)
Gas Food Lodging 1992,Jl 31,C1:1
Grant, Beth
White Sands 1992,Ap 24,C18:1
Love Field 1992,D 11,C6:3
Grant, Cary
People Will Talk 1992,N 20,C1:3
Grant, David Marshall
Strictly Business 1991,N 8,C13:3
Forever Young 1992,D 16,C17:1
Grant, Faye
Traces of Red 1992,N 12,C22:1
Grant, Hugh
Impromptu 1991,Ap 12,C10:5
Crossing the Line 1991,Ag 9,C11:1
Grant, Lee
Defending Your Life 1991,Mr 22,C12:1
Grant, Richard E.
L.A. Story 1991,F 8,C8:1
Warlock 1991,Mr 30,11:4
Hudson Hawk 1991,My 24,C8:4
Player, The 1992,Ap 10,C16:1
Bram Stoker's "Dracula" 1992,N 13,C1:3
Grant, Salim
Hitman, The 1991,O 27,51:5
Grant, Vince
Rapture, The 1991,S 30,C14:4
Grass, Steve (Cinematographer)
Into the Sun 1992,Ja 31,C10:6
Grasten, Regner (Producer)
Birthday Trip, The 1991,Mr 26,C14:3
Graulau, Mary Lou
My Father Is Coming 1991,N 22,C12:5
Graves, Rupert
Where Angels Fear to Tread 1992,F 28,C12:1
Where Angels Fear to Tread 1992,Mr 22,II:11:1
Damage 1992,D 23,C13:1
Gray, Ernest
Woman's Tale, A 1992,Ap 30,C16:6
Gray, Marc
Flirting 1992,N 6,C13:1
Gray, Spalding
Straight Talk 1992,Ap 3,C17:1
Monster in a Box 1992,Je 5,C6:4
Monster in a Box 1992,Je 26,C1:3
Gray, Spalding (Screenwriter)
Monster in a Box 1992,Je 5,C6:4
Gray, Thomas K. (Producer)
Teen-Age Mutant Ninja Turtles II: The Secret of the
Ooze 1991,Mr 22,C1:3
Graysmark, John (Miscellaneous)
Robin Hood: Prince of Thieves 1991,Je 14,C1:4
White Sands 1992,Ap 24,C18:1
Grazer, Brian (Miscellaneous)
Housesitter 1992,Je 12,C1:4
Grazer, Brian (Producer)
My Girl 1991,N 27,C15:1
Far and Away 1992,My 22,C10:5
Housesitter 1992,Je 12,C1:4
Housesitter 1992,Je 21,II:19:1

Boomerang 1992,Jl 1,C18:1
Grazioli, Irene
Mediterraneo 1992,Mr 22,48:4
Greatrex, Richard (Cinematographer)
Lunatic, The 1992,F 7,C14:5
Green, Bruce (Miscellaneous)
Doctor, The 1991,Jl 24,C11:1
Green, Gabe
Class Act 1992,Je 5,C17:1
Green, Jack N. (Cinematographer)
Deceived 1991,S 27,C8:5
Love Crimes 1992,Ja 26,43:5
Unforgiven 1992,Ag 7,C1:1
Green, Jonell
Bebe's Kids 1992,Ag 1,16:6
Green, Sarah (Producer)
City of Hope 1991,O 11,C19:1
Passion Fish 1992,D 14,C16:1
Greenaway, Peter (Director)
Drowning by Numbers 1991,Ap 26,C8:1
Prospero's Books 1991,My 26,II:9:2
Prospero's Books 1991,S 28,9:1
Prospero's Books 1991,O 6,II:13:5
Prospero's Books 1991,N 15,C15:1
Greenaway, Peter (Screenwriter)
Drowning by Numbers 1991,Ap 26,C8:1
Prospero's Books 1991,S 28,9:1
Greenberg, Adam (Cinematographer)
Terminator 2: Judgment Day 1991,Jl 3,C11:5
Sister Act 1992,My 29,C10:1
Toys 1992,D 18,C1:3
Greenberg, Jerry (Miscellaneous)
For the Boys 1991,N 22,C12:1
School Ties 1992,S 18,C19:1
Greenberg, Michael
Drum Struck 1992,Ap 22,C17:1
Greenberg, Robbie (Cinematographer)
All I Want for Christmas 1991,N 8,C14:1
Greenblatt, Shon
Freddy's Dead: The Final Nightmare 1991,S 14,11:4
Greenburg, Zack O'Malley
Lorenzo's Oil 1992,D 30,C7:3
Greenbury, Chris (Miscellaneous)
Naked Gun 2 1/2: The Smell of Fear 1991,Je 28,C8:1
Greenbush, Billy
Rampage 1992,O 30,C27:1
Greene, Ellen
Stepping Out 1991,O 4,C26:4
Rock-a-Doodle 1992,Ap 3,C13:1
Fathers and Sons 1992,N 6,C17:1
Greene, Graham
Dances with Wolves 1991,Ja 13,II:13:5
Dances with Wolves 1991,F 24,II:11:1
Thunderheart 1992,Ap 3,C12:1
Thunderheart 1992,My 10,II:22:1
Clearcut 1992,Ag 21,C9:1
Greene, Michael
Eve of Destruction 1991,Ja 19,22:6
In the Heat of Passion 1992,Ja 24,C12:5
Greene, Peter
Laws of Gravity 1992,Mr 21,18:1
Laws of Gravity 1992,Ag 26,C18:6
Greenhut, Robert (Producer)
League of Their Own, A 1992,Jl 1,C13:4
Greenwald, David (Miscellaneous)
Cousin Bobby 1992,My 29,C1:4
Greenwood, Bruce
Passenger 57 1992,N 6,C14:5
Greer, Michael (Miscellaneous)
Hearts of Darkness: A Film Maker's Apocalypse
1991,N 27,C9:1
Gregoire, Richard (Composer)
Perfectly Normal 1991,F 15,C14:5
Gregorio, Rose
City of Hope 1991,O 11,C19:1
Gregory, Andre
Linguini Incident, The 1992,My 1,C15:1
Gregory, Constantine
Shadow of China 1991,Mr 10,58:5
Gregory, Dick
Hugh Hefner: Once Upon a Time 1992,N 6,C10:3
Gregory, Eileen (Producer)
Deep Blues 1992,Jl 31,C14:3
Gregory, Jon (Miscellaneous)
Life Is Sweet 1991,O 25,C10:1
London Kills Me 1992,Ag 7,C19:1
Gregory, Laura (Producer)
Split Second 1992,My 4,C15:1

Gregory, Marina
Eating 1991,My 3,C8:1
Gregson, Richard (Screenwriter)
Eminent Domain 1991,Ap 12,C13:4
Greiner, Markus
Drum Struck 1992,Ap 22,C17:1
Greiner, Markus (Miscellaneous)
Drum Struck 1992,Ap 22,C17:1
Greiner, Markus (Producer)
Drum Struck 1992,Ap 22,C17:1
Greiner, Markus (Screenwriter)
Drum Struck 1992,Ap 22,C17:1
Greisman, Alan (Producer)
Soapdish 1991,My 31,C10:1
Grenier, Zach
Liebestraum 1991,S 13,C6:1
Grepi, Alejandra
Bosque Animado, El (Enchanted Forest, The)
1992,D 4,C8:6
Grey, Gloria
Lucky Star 1991,N 1,C8:1
Grey, Jennifer
Wind 1992,S 11,C3:1
Grey, Joel
Kafka 1991,D 4,C21:1
Greyson, John (Director)
Making of "Monsters," The (Avant-Garde Visions)
1991,O 1,C13:1
Greyson, John (Screenwriter)
Making of "Monsters," The (Avant-Garde Visions)
1991,O 1,C13:1
Greytak, Sharon (Director)
Hearing Voices 1991,N 15,C11:1
Greytak, Sharon (Producer)
Hearing Voices 1991,N 15,C11:1
Greytak, Sharon (Screenwriter)
Hearing Voices 1991,N 15,C11:1
Gribble, Bernard (Miscellaneous)
White Dog 1991,Jl 12,C8:1
Aces: Iron Eagle III 1992,Je 13,16:4
Gribble, Mike (Producer)
Spike and Mike's Festival of Animation 1992,S
17,C22:1
Grieco, Richard
If Looks Could Kill 1991,Mr 19,C12:5
Mobsters 1991,Jl 26,C18:4
Grier, David Alan
Boomerang 1992,Jl 1,C18:1
Grier, Pam
Bill and Ted's Bogus Journey 1991,Jl 19,C10:1
Grieve, Andrew (Director)
On the Black Hill 1991,Ag 16,C8:1
Grieve, Andrew (Screenwriter)
On the Black Hill 1991,Ag 16,C8:1
Grifasi, Joe
City of Hope 1991,O 11,C19:1
Griffin, George (Director)
New Fangled 1991,O 5,14:3
Griffin, Rachel
Midnight Clear, A 1992,Ap 24,C1:3
Griffith, Melanie
Working Girl 1991,Ja 20,II:1:2
Paradise 1991,S 18,C16:3
Paradise 1991,O 13,II:21:1
Shining Through 1992,Ja 31,C8:5
Shining Through 1992,F 23,II:13:1
Shining Through 1992,F 28,C1:1
Stranger Among Us, A 1992,Jl 17,C1:3
Griffiths, Keith (Producer)
Rehearsals for Extinct Anatomies 1991,Mr 27,C15:1
Comb, The 1991,O 11,C10:1
Griffiths, Richard
King Ralph 1991,F 15,C10:3
Naked Gun 2 1/2: The Smell of Fear 1991,Je 28,C8:1
Blame It on the Bellboy 1992,Mr 6,C10:6
Griffiths, Susan
Legends 1991,Mr 17,68:5
Legends 1991,Mr 17,II:13:5
Grillo, Michael (Producer)
Defending Your Life 1991,Mr 22,C12:1
Grand Canyon 1991,D 25,18:1
Grimaldi, Alberto (Producer)
1900 1991,F 1,C1:1
Grimaldi, Aurelio (Miscellaneous)
Forever Mary 1991,Ap 19,C11:1
Grimaldi, Aurelio (Original Author)
Forever Mary 1991,Ap 19,C11:1

Grimes, John
Texas Tenor: The Illinois Jacquet Story 1992,N
20,C5:1
Grimwood, Unity
Hours and Times, The 1992,Ap 3,C10:1
Grinberg, Gordon (Miscellaneous)
Class of Nuke 'Em High Part 2: Subhumanoid
Meltdown 1991,Ap 12,C13:1
Grise, Pierre (Producer)
Belle Noiseuse, La 1991,O 2,C17:5
Grodin, Charles
Beethoven 1992,Ap 3,C18:1
Beethoven 1992,Ap 17,C24:5
Beethoven 1992,My 17,II:22:1
Groom, Bill (Miscellaneous)
League of Their Own, A 1992,Jl 1,C13:4
Gropman, David (Miscellaneous)
Once Around 1991,Ja 18,C12:4
Cutting Edge, The 1992,Mr 27,C21:1
Of Mice and Men 1992,O 2,C5:4
Groshevoy, Anatoly
Raspad 1992,Ap 29,C15:1
Gross, Arye
Matter of Degrees, A 1991,S 13,C9:4
For the Boys 1991,N 22,C12:1
Shaking the Tree 1992,Mr 13,C8:1
Midnight Clear, A 1992,Ap 24,C1:3
Gross, Charles (Composer)
Another You 1991,Jl 27,16:3
Gross, Edan
And You Thought Your Parents Were Weird 1991,N
15,C13:1
Gross, Michael
Cool as Ice 1991,O 19,12:6
Alan and Naomi 1992,Ja 31,C8:5
Gross, Michael (Miscellaneous)
Hugh Hefner: Once Upon a Time 1992,N 6,C10:3
Gross, Michael (Screenwriter)
Hugh Hefner: Once Upon a Time 1992,N 6,C10:3
Gross, Michael C. (Producer)
Stop! Or My Mom Will Shoot 1992,F 21,C8:5
Beethoven 1992,Ap 3,C18:1
Grossman, Gary H. (Producer)
Hugh Hefner: Once Upon a Time 1992,N 6,C10:3
Grossman, Gary H. (Screenwriter)
Hugh Hefner: Once Upon a Time 1992,N 6,C10:3
Grossman, Marc (Miscellaneous)
Wild Orchid 2: Two Shades of Blue 1992,My
8,C17:2
Grover, John (Miscellaneous)
Favor, the Watch, and the Very Big Fish, The
1992,My 8,C15:3
Growling Tiger
One Hand Don't Clap 1991,Ag 28,C13:1
Gruault, Jean (Screenwriter)
Window Shopping 1992,Ap 17,C13:1
Gruber, Klaus-Michael
Amants du Pont Neuf, Les (Lovers of the Pont Neuf)
1992,O 6,C16:1
Grusin, Dave (Composer)
For the Boys 1991,N 22,C12:1
Gruska, Jay (Composer)
Mo' Money 1992,Jl 25,15:1
Gruskoff, Michael (Producer)
Article 99 1992,Mr 13,C10:1
Prelude to a Kiss 1992,Jl 10,C10:1
Gruszynski, Alexander (Cinematographer)
Stone Cold 1991,My 18,16:3
Gruz, Ken
Talking to Strangers 1991,D 27,C12:6
Gu Changwei (Cinematographer)
Life on a String 1991,S 29,54:5
Guarnieri, Ennio (Cinematographer)
Inner Circle, The 1991,D 25,20:1
Guastaferro, Vincent
Homicide 1991,O 6,56:1
Guay, Richard (Producer)
Dogfight 1991,S 13,C13:1
Gubern, Roman (Screenwriter)
Wait for Me in Heaven (Esperame en el Cielo)
1991,Ja 30,C10:5
Gudejko, Jerzy
Double Life of Veronique, The 1991,D 8,II:13:4
Gudgeon, Mac (Screenwriter)
Wind 1992,S 11,C3:1
Gudmundss, Einar Mar (Screenwriter)
Children of Nature 1992,Ap 2,C18:3

H

Hatcher, Teri
Straight Talk 1992,Ap 3,C17:1
Hattensen, Kim (Cinematographer)
Birthday Trip, The 1991,Mr 26,C14:3
Hattori, Katsuhisa (Composer)
Fist of the North Star 1991,N 15,C8:1
Hauer, Rutger
Split Second 1992,My 4,C15:1
Buffy the Vampire Slayer 1992,Jl 31,C8:5
Haugland, Aage
Sirup 1991,Mr 30,10:4
Hauser, Cole
School Ties 1992,S 18,C19:1
Hauser, Fay
Waterdance, The 1992,My 13,C13:1
Hausermann, Ruedi (Composer)
Leo Sonnyboy 1991,Mr 16,16:4
Hausman, Michael (Producer)
Homicide 1991,O 6,56:1
Hausman, Shawn (Miscellaneous)
Too Much Sun 1991,Ja 25,C8:5
Hawke, Ethan
White Fang 1991,Ja 18,C16:3
Mystery Date 1991,Ag 16,C9:1
Midnight Clear, A 1992,Ap 24,C1:3
Waterland 1992,O 30,C14:6
Hawking, Stephen
Brief History of Time, A 1992,Ag 21,C3:1
Hawking, Stephen (Original Author)
Brief History of Time, A 1992,Ag 21,C3:1
Hawkins, Diana (Miscellaneous)
Chaplin 1992,D 25,C3:1
Hawkins, Flo
Giving, The 1992,N 13,C17:1
Hawkins, Screamin' Jay
Rage in Harlem, A 1991,My 3,C14:1
Hawks, Howard (Director)
Twentieth Century 1992,Ag 21,C1:1
Hawn, Goldie
Deceived 1991,S 27,C8:5
Crisscross 1992,My 9,17:5
Housesitter 1992,Je 12,C1:4
Housesitter 1992,Je 21,II:19:1
Housesitter 1992,Jl 26,II:9:1
Death Becomes Her 1992,Jl 31,C8:1
Housesitter 1992,Ag 16,II:15:1
Haworth, Ted (Miscellaneous)
Mr. Baseball 1992,O 2,C14:6
Haycock, Peter (Composer)
One False Move 1992,Jl 17,C6:1
Hayden, Sterling
1900 1991,F 1,C1:1
Terror in a Texas Town 1991,My 17,C16:4
Hayes, Sylvester
Importance of Being Earnest, The 1992,My 14,C20:4
Hayes, Terry (Producer)
Flirting 1992,N 6,C13:1
Hayman, James (Cinematographer)
Iron and Silk 1991,F 15,C12:5
Buffy the Vampire Slayer 1992,Jl 31,C8:5
Breaking the Rules 1992,O 9,C10:6
Haynes, Loren
Eve of Destruction 1991,Ja 19,22:6
Haynes, Todd (Director)
Poison 1991,Ap 5,C8:3
Poison 1991,Ap 14,II:15:1
Haynes, Todd (Miscellaneous)
Poison 1991,Ap 5,C8:3
Haynes, Todd (Screenwriter)
Poison 1991,Ap 5,C8:3
Haynie, Jim
Too Much Sun 1991,Ja 25,C8:5
Sleepwalkers 1992,Ap 11,18:1
Haysbert, Dennis
Mr. Baseball 1992,O 2,C14:6
Love Field 1992,D 11,C6:3
Hayward, Charley
Poison Ivy 1992,My 8,C16:3
Hayward, David
1,000 Pieces of Gold 1991,S 27,C10:4
Haywood, Chris
Sweet Talker 1991,My 12,42:5
Golden Braid 1991,D 20,C20:6
Woman's Tale, A 1992,Ap 30,C16:6
Hazard, John (Cinematographer)
Thank You and Good Night 1992,Ja 29,C20:4
He Caifei
Raise the Red Lantern 1992,Mr 20,C18:1

Headey, Lena
Waterland 1992,O 30,C14:6
Headly, Glenne
Mortal Thoughts 1991,Ap 19,C15:1
Heald, Anthony
Silence of the Lambs, The 1991,F 14,C17:1
Whispers in the Dark 1992,Ag 7,C17:1
Healy, Dorian
Young Soul Rebels 1991,D 6,C21:1
Heard, John
End of Innocence, The 1991,Ja 18,C17:1
Rambling Rose 1991,S 20,C12:4
Deceived 1991,S 27,C8:5
Radio Flyer 1992,F 21,C16:1
Gladiator 1992,Mr 6,C17:1
Mindwalk 1992,Ap 8,C17:1
Waterland 1992,O 30,C14:6
Home Alone 2: Lost in New York 1992,N 20,C1:1
Hearn, Ann
Lorenzo's Oil 1992,D 30,C7:3
Hearn, George
Sneakers 1992,S 9,C18:3
Hearne, Vicki
Little Vicious, A 1991,My 23,C14:3
Heath, Robert (Director)
Hugh Hefner: Once Upon a Time 1992,N 6,C10:3
Heath, Robert (Producer)
Hugh Hefner: Once Upon a Time 1992,N 6,C10:3
Heath, Robert (Screenwriter)
Hugh Hefner: Once Upon a Time 1992,N 6,C10:3
Heaton, Patricia
Beethoven 1992,Ap 3,C18:1
Hebb, Brian R. R. (Cinematographer)
Termini Station 1991,My 31,C14:5
Hecht, Arno
At the Max 1991,N 22,C15:1
Hecht, Ben (Screenwriter)
Twentieth Century 1992,Ag 21,C1:1
Hedaya, Dan
Addams Family, The 1991,N 22,C1:1
Heer, Johanna (Cinematographer)
Other Eye, The 1991,S 25,C17:1
Heer, Johanna (Director)
Other Eye, The 1991,S 25,C17:1
Heer, Johanna (Miscellaneous)
Other Eye, The 1991,S 25,C17:1
Heer, Johanna (Screenwriter)
Other Eye, The 1991,S 25,C17:1
Heffernan, John
1492: Conquest of Paradise 1992,O 9,C21:1
Hefner, Christie
Damned in the U.S.A. 1992,N 13,C11:1
Hefner, Hugh M.
Hugh Hefner: Once Upon a Time 1992,N 6,C10:3
Hefner, Keith
Hugh Hefner: Once Upon a Time 1992,N 6,C10:3
Hegedus, Chris (Director)
Branford Marsalis: The Music Tells You 1992,Je 26,C12:6
Hegedus, Chris (Miscellaneous)
Branford Marsalis: The Music Tells You 1992,Je 26,C12:6
Hegner, Isabel (Director)
Eye to Eye 1992,F 19,C15:1
Heiduschka, Veit (Producer)
Weininger's Last Night 1991,Ag 1,C14:4
Benny's Video 1992,S 28,C14:1
Heim, Alan (Miscellaneous)
Billy Bathgate 1991,N 1,C1:1
Heindriksdottir, Hjordis
Atlantic Rhapsody: 52 Scenes from Torshavn 1991,Mr 30,11:1
Heinl, Bernd (Cinematographer)
My Heroes Have Always Been Cowboys 1991,Mr 22,C14:5
Suburban Commando 1991,O 6,56:3
Heinze, Thomas
Voyager 1992,Ja 31,C6:1
Heinz-Schafer, Karl (Composer)
Street of No Return 1991,Ag 2,C6:1
Heitner, David (Miscellaneous)
Sarafina! 1992,S 18,C16:6
Held, Ingrid
Maison Assassinee, La (Murdered House, The) 1991,O 25,C10:5
Helfrich, Mark (Miscellaneous)
Rich Girl 1991,My 4,15:1
Stone Cold 1991,My 18,16:3

Last Boy Scout, The 1991,D 13,C14:6
Helgenberger, Marg
Crooked Hearts 1991,S 6,C13:1
Heller, Gus (Director)
Night Movie (Echoes of Conflict) 1991,Ap 10,C16:3
Heller, Paul M. (Producer)
Lunatic, The 1992,F 7,C14:5
Heller, Zoe (Screenwriter)
Twenty-One 1991,O 4,C10:6
Helms, Jesse
Damned in the U.S.A. 1992,N 13,C11:1
Helmsdal, Mikkjal
Atlantic Rhapsody: 52 Scenes from Torshavn 1991,Mr 30,11:1
Helmuth, Frits
Memories of a Marriage 1991,Ja 28,C20:3
Helmuth, Mikael
Memories of a Marriage 1991,Ja 28,C20:3
Helppie-Shipley, Kathleen (Producer)
Box Office Bunny 1991,F 9,12:4
Hemblen, David
Adjuster, The 1991,S 26,C18:5
Hemingway, Mariel
Delirious 1991,Ag 9,C12:4
Falling from Grace 1992,F 21,C16:5
Hemphill, Jessie Mae
Deep Blues 1992,Jl 31,C14:3
Henderson, Florence
Shakes the Clown 1992,Mr 13,C13:1
Henderson, Graham (Producer)
Taking of Beverly Hills, The 1991,O 13,68:5
Henderson, Robert (Miscellaneous)
Borrower, The 1991,O 18,C12:3
Hendrickson, Stephen (Miscellaneous)
Diary of a Hit Man 1992,My 29,C10:5
Diggstown 1992,Ag 14,C1:1
Hendrix, Jimi
Jimi Hendrix at the Isle of Wight 1991,Jl 4,C9:1
Henner, Marilu
L.A. Story 1991,F 8,C8:1
Noises Off 1992,Mr 20,C10:1
Henri, Gilles (Cinematographer)
Van Gogh 1992,O 30,C16:5
Henriksen, Lance
Stone Cold 1991,My 18,16:3
Alien 3 1992,My 22,C1:1
Jennifer 8 1992,N 6,C6:2
Henriques, Anna
Man Without a World, The 1992,S 9,C18:4
Henry, Buck
Defending Your Life 1991,Mr 22,C12:1
Player, The 1992,Ap 10,C16:1
Linguini Incident, The 1992,My 1,C15:1
Henry, David Lee (Screenwriter)
Out for Justice 1991,Ap 13,12:4
Henry, Gregg
Raising Cain 1992,Ag 7,C5:1
Henry, Judith
Discrete, La 1992,Ag 14,C13:1
Henry, Lenny
True Identity 1991,Ag 23,C16:1
Henry, Sue
Bruce Diet, The 1992,Ap 15,C19:1
Henshaw, Jere (Producer)
Harley Davidson and the Marlboro Man 1991,Ag 24,16:6
Henson, Brian (Director)
Muppet Christmas Carol, The 1992,D 11,C12:6
Henson, Brian (Producer)
Muppet Christmas Carol, The 1992,D 11,C12:6
Heraut, Barbara (Miscellaneous)
Requiem for Dominic 1991,Ap 19,C17:1
Herbert, Hugh
Million Dollar Legs 1992,N 20,C1:3
Herbert, James (Director)
John Five (Avant-Garde Visions) 1992,O 5,C14:4
Heredia, Paula (Miscellaneous)
Finding Christa 1992,Mr 24,C15:3
Texas Tenor: The Illinois Jacquet Story 1992,N 20,C5:1
Herek, Stephen (Director)
Don't Tell Mom the Babysitter's Dead 1991,Je 7,C19:1
Mighty Ducks, The 1992,O 2,C18:1
Herman, Mark (Director)
Blame It on the Bellboy 1992,Mr 6,C10:6
Herman, Mark (Screenwriter)
Blame It on the Bellboy 1992,Mr 6,C10:6

Hermann, Irm
Johanna d'Arc of Mongolia 1992,My 15,C8:1
Hermlin, Stefan
November Days 1992,My 8,C8:1
Hernandez, Angel (Director)
Phantom of the Opera, The 1991,Je 8,16:1
Hernandez, Oscar
Rodrigo D: No Future 1991,Ja 11,C10:5
Hernandez, Sergio
Amelia Lopes O'Neill 1991,S 21,12:3
Hernandez (Caifanes), Saul
City of the Blind (Ciudad de Ciegos) 1992,Ap 4,17:5
Herouet, Marc (Composer)
Window Shopping 1992,Ap 17,C13:1
Night and Day 1992,D 11,C10:6
Herrier, Mark (Director)
Popcorn 1991,F 1,C6:5
Herrington, Rowdy (Director)
Gladiator 1992,Mr 6,C17:1
Herrmann, Bernard (Composer)
Cape Fear 1991,N 13,C17:1
Cape Fear 1992,Ja 26,II:11:1
Herron, Cindy
Juice 1992,Ja 17,C10:1
Hersch, Kathie (Producer)
Thank You and Good Night 1992,Ja 29,C20:4
Hershberger, Ed (Cinematographer)
There's Nothing Out There 1992,Ja 22,C20:4
Hershberger, Gery
Sneakers 1992,S 9,C18:3
Hershey, Barbara
Defenseless 1991,Ag 23,C8:1
Public Eye, The 1992,O 14,C17:1
Herskovic, Patricia (Producer)
Toy Soldiers 1991,Ap 26,C15:1
Hertzberg, Michael (Producer)
Out on a Limb 1992,S 5,15:1
Hertzberg, Paul (Producer)
Where the Day Takes You 1992,S 11,C14:5
Herz, Michael (Producer)
Class of Nuke 'Em High Part 2: Subhumanoid
Meltdown 1991,Ap 12,C13:1
Herzberg, Ilona (Producer)
Iron Maze 1991,N 1,C13:1
Herzog, Werner (Director)
Herdsmen of the Sun 1991,My 8,C11:4
Echoes from a Somber Empire 1992,Jl 15,C15:3
Herzog, Werner (Producer)
Echoes from a Somber Empire 1992,Jl 15,C15:3
Hess, Oliver G. (Producer)
Into the Sun 1992,Ja 31,C10:6
Hetenyi, Pal
Memoirs of a River 1992,Mr 20,C15:1
Heumann, Eric (Producer)
Indochine 1992,D 24,C9:1
Hewgill, Roland
Beautiful Dreamers 1992,Je 5,C15:1
Hewitt, Pete (Director)
Bill and Ted's Bogus Journey 1991,Jl 19,C10:1
Hewlett, David
Pin 1991,D 4,C28:1
Heyman, Barton
Raising Cain 1992,Ag 7,C5:1
Heyman, David (Producer)
Juice 1992,Ja 17,C10:1
Hiatt, Vicki (Miscellaneous)
Double Edge 1992,S 30,C18:3
Hibbler, Al
Texas Tenor: The Illinois Jacquet Story 1992,N
20,C5:1
Hick, Jochen (Director)
Via Appia 1992,Ag 27,C16:5
Hick, Jochen (Screenwriter)
Via Appia 1992,Ag 27,C16:5
Hickenlooper, George (Director)
Hearts of Darkness: A Film Maker's Apocalypse
1991,N 27,C9:1
Hickenlooper, George (Screenwriter)
Hearts of Darkness: A Film Maker's Apocalypse
1991,N 27,C9:1
Hickey, William
Hairway to the Stars (Short and Funnies, The)
1992,D 16,C30:3
Hickman, David (Producer)
Brief History of Time, A 1992,Ag 21,C3:1
Hickox, Anthony (Director)
Hellraiser III: Hell on Earth 1992,S 12,14:3

Hickox, James D. R. (Miscellaneous)
Hellraiser III: Hell on Earth 1992,S 12,14:3
Hicks, Barbara
Howards End 1992,Mr 13,C1:3
Hicks, Greg (Miscellaneous)
Last Boy Scout, The 1991,D 13,C14:6
Hicks, James (Miscellaneous)
Defenseless 1991,Ag 23,C8:1
Hicks, James (Screenwriter)
Defenseless 1991,Ag 23,C8:1
Hides, Bernard (Miscellaneous)
Prisoners of the Sun 1991,Jl 19,C12:1
Higgins, Douglas
Hitman, The 1991,O 27,51:5
Highsmith, Patricia (Original Author)
Cry of the Owl, The (Cri du Hibou, Le) 1991,O
16,C19:1
Hijuelos, Oscar (Original Author)
Mambo Kings, The 1992,F 28,C1:1
Mambo Kings, The 1992,F 28,C8:1
Hill, Bernard
Drowning by Numbers 1991,Ap 26,C8:1
Hill, Debra (Producer)
Fisher King, The 1991,S 20,C10:4
Hill, Dennis M. (Miscellaneous)
My Heroes Have Always Been Cowboys 1991,Mr
22,C14:5
Another You 1991,Jl 27,16:3
Hill, John (Composer)
Just Like in the Movies 1992,My 4,C15:1
Hill, Leslie
Flirting 1992,N 6,C13:1
Hill, Michael (Miscellaneous)
Backdraft 1991,My 24,C14:6
Far and Away 1992,My 22,C10:5
Hill, Steven
Billy Bathgate 1991,N 1,C1:1
Billy Bathgate 1991,N 3,II:13:4
Hill, Walter (Director)
Trespass 1992,D 13,II:20:5
Trespass 1992,D 25,C18:5
Hill, Walter (Producer)
Alien 3 1992,My 22,C1:1
Hill, Walter (Screenwriter)
Alien 3 1992,My 22,C1:1
Hiller, Arthur (Director)
Babe, The 1992,Ap 17,C8:1
Hilliker, Katherine (Miscellaneous)
Lucky Star 1991,N 1,C8:1
Hilmarsson, Hilmar Orn (Composer)
Children of Nature 1992,Ap 2,C18:3
Himes, Chester (Original Author)
Rage in Harlem, A 1991,My 3,C14:1
Himmelman, Peter (Composer)
Crossing the Bridge 1992,S 11,C12:1
Hinds-Johnson, Marcia (Miscellaneous)
Bright Angel 1991,Je 14,C6:1
Paradise 1991,S 18,C16:3
Linguini Incident, The 1992,My 1,C15:1
Public Eye, The 1992,O 14,C17:1
Hines, Damon
Lethal Weapon 3 1992,My 15,C16:3
Hines, David (Original Author)
Whore 1991,O 4,C15:1
Whore 1992,F 9,II:13:1
Hines, Gregory
Eve of Destruction 1991,Ja 19,22:6
Rage in Harlem, A 1991,My 3,C14:1
Hingle, Pat
Grifters, The 1991,Ja 25,C13:1
Batman Returns 1992,Je 19,C1:1
Hinkle, Jaymes (Miscellaneous)
Passenger 57 1992,N 6,C14:5
Hinson, Rick (Miscellaneous)
December 1991,D 6,C8:5
Hinton, Milt
Texas Tenor: The Illinois Jacquet Story 1992,N
20,C5:1
Hinton, Mona
Texas Tenor: The Illinois Jacquet Story 1992,N
20,C5:1
Hirsch, Paul (Miscellaneous)
Dutch 1991,Jl 19,C13:1
Raising Cain 1992,Ag 7,C5:1
Hirsch, Tina (Miscellaneous)
Delirious 1991,Ag 9,C12:4
Mystery Date 1991,Ag 16,C9:1
Captain Ron 1992,S 18,C23:1

Hirschfelder, David (Composer)
Strictly Ballroom 1992,S 26,12:5
Hirschhorn, Joel (Composer)
China Cry 1991,My 3,C9:1
Hirsh, T. Robin (Cinematographer)
Forever Activists 1991,Je 14,C10:4
Hirst, Michael (Screenwriter)
Ballad of the Sad Cafe, The 1991,Mr 28,C11:1
Meeting Venus 1991,N 15,C1:3
Hirtz, Dagmar (Miscellaneous)
Voyager 1992,Ja 31,C6:1
Hitchcock, Michael (Screenwriter)
Where the Day Takes You 1992,S 11,C14:5
Hitner, Harry (Miscellaneous)
Honey, I Blew Up the Kid 1992,Jl 17,C6:5
Hjulstrom, Lennart
Ox, The 1992,Ag 21,C10:5
Ho, A. Kitman (Producer)
Doors, The 1991,Mr 1,C1:1
J.F.K. 1991,D 20,C1:1
Hoag, Judith
Matter of Degrees, A 1991,S 13,C9:4
Hoang, Thanh At (Miscellaneous)
Lover, The 1992,O 30,C5:1
Hobbs, Christopher (Miscellaneous)
Edward II 1992,Mr 20,C16:3
Hockey, J.
Slacker 1991,Mr 22,C8:1
Hockey, S.
Slacker 1991,Mr 22,C8:1
Hocking, Henry
Hairdresser's Husband, The 1992,Je 19,C11:1
Hockney, David
Day on the Grand Canal with the Emperor of China,
A 1992,Mr 20,C14:5
Hodge, Douglas
Dark Obsession 1991,Je 7,C10:1
Hodge, Kate
Rapid Fire 1992,Ag 21,C11:1
Hoenig, Dov (Miscellaneous)
Last of the Mohicans, The 1992,S 25,C3:1
Hoffer, William (Original Author)
Not Without My Daughter 1991,Ja 11,C8:1
Hoffman, Chris
Tune, The 1992,S 4,C3:1
Hoffman, Dustin
Billy Bathgate 1991,N 1,C1:1
Billy Bathgate 1991,N 3,II:13:4
Hook 1991,D 11,C17:3
Hook 1991,D 22,II:23:1
Hero 1992,O 2,C20:6
Hero 1992,O 4,II:9:4
Hoffman, Irving
Letter to Harvey Milk, A 1991,Je 14,C10:4
Hoffman, Kurt (Composer)
Little Noises 1992,Ap 24,C8:6
Hoffman, Michael (Director)
Soapdish 1991,My 31,C10:1
Hoffman, Phil
Triple Bogey on a Par 5 Hole 1992,Mr 21,13:4
Hoffman, Philip S.
Leap of Faith 1992,D 18,C14:1
Scent of a Woman 1992,D 23,C9:1
Hoffmann, Deborah (Miscellaneous)
Color Adjustment 1992,Ja 29,C15:1
Hoffmann, Gaby
This Is My Life 1992,F 21,C8:1
Hofschneider, Marco
Europa, Europa 1991,Je 28,C10:1
Hofschneider, Rene
Europa, Europa 1991,Je 28,C10:1
Hofstra, Jack (Miscellaneous)
Run 1991,F 1,C15:1
Super, The 1991,O 4,C10:1
Pure Country 1992,O 23,C13:1
Hogan, Hulk
Suburban Commando 1991,O 6,56:3
Hogan, Michael
Clearcut 1992,Ag 21,C9:1
Hohlfeld, Brian (Screenwriter)
He Said, She Said 1991,F 22,C17:1
Hojmark-Jensen, Pernille
Sirup 1991,Mr 30,10:4
Holbek, Joakim (Composer)
Zentropa 1992,My 22,C14:1
Holden, Frankie J.
Proof 1992,Mr 20,C20:1

Holden, Winifred
Strangers in Good Company 1991,My 10,C8:1
Holder, Geoffrey
Boomerang 1992,Jl 1,C18:1
Holdridge, Lee (Composer)
Pastime 1991,Ag 23,C13:1
Holgado, Ticky
Delicatessen 1991,O 5,14:3
Delicatessen 1992,My 3,II:13:4
Hairdresser's Husband, The 1992,Je 19,C11:1
Holland, Agnieszka (Director)
Europa, Europa 1991,Je 28,C10:1
Olivier, Olivier 1992,S 25,C34:1
Holland, Agnieszka (Screenwriter)
Korczak 1991,Ap 12,C8:1
Europa, Europa 1991,Je 28,C10:1
Olivier, Olivier 1992,S 25,C34:1
Holland, Deborah (Composer)
December 1991,D 6,C8:5
Holland, Rodney (Miscellaneous)
Dark Obsession 1991,Je 7,C10:1
Holland, Simon (Miscellaneous)
King Ralph 1991,F 15,C10:3
Where Angels Fear to Tread 1992,F 28,C12:1
Hollis, Tommy
Malcolm X 1992,N 18,C19:3
Hollmer, Pastor Uwe
November Days 1992,My 8,C8:1
Hollyn, Norman (Miscellaneous)
Meet the Applegates 1991,F 1,C6:1
Hollywood, Peter (Miscellaneous)
Neverending Story II, The: The Next Chapter 1991,F 9,12:4
Sarafina! 1992,S 18,C16:6
Holm, Ian
Kafka 1991,D 4,C21:1
Naked Lunch 1991,D 27,C1:3
Holman, Clare
Let Him Have It 1991,D 6,C24:1
Afraid of the Dark 1992,Jl 24,C7:1
Holman, Stephen
Living End, The 1992,Ap 3,C1:1
Holmes, Christopher (Miscellaneous)
Livin' Large 1991,S 20,C15:1
Holmes, Jennifer
Life on the Edge 1992,Je 19,C11:1
Holmes, Peggy (Miscellaneous)
Newsies 1992,Ap 8,C22:3
Holmes, Preston (Producer)
Malcolm X 1992,N 18,C19:3
Holst, Per (Producer)
Sirup 1991,Mr 30,10:4
Holt, Derek (Composer)
One False Move 1992,Jl 17,C6:1
Holt, Sandrine
Black Robe 1991,O 30,C15:2
Holubova, Eva
Time of the Servants 1991,Mr 19,C12:3
Holzbog, Arabella
Stone Cold 1991,My 18,16:3
Homar, Lluis
Aventis (Stories) 1992,N 13,C15:1
Homo, Charlie
Steal America 1992,Ap 3,C24:5
Homolkova, Marie (Miscellaneous)
Weininger's Last Night 1991,Ag 1,C14:4
Benny's Video 1992,S 28,C14:1
Honda, Ishiro (Miscellaneous)
Rhapsody in August 1991,My 19,II:13:1
Honegger, Andreas (Producer)
Lumumba: Death of a Prophet 1992,S 30,C18:3
Honess, Peter (Miscellaneous)
Ricochet 1991,O 5,12:6
Mr. Baseball 1992,O 2,C14:6
Hong, James
Perfect Weapon, The 1991,Mr 16,16:5
Hong, Matthew
Texas Tenor: The Illinois Jacquet Story 1992,N 20,C5:1
Hooks, Jan
Batman Returns 1992,Je 19,C1:1
Hooks, Kevin (Director)
Strictly Business 1991,N 8,C13:3
Passenger 57 1992,N 6,C14:5
Hool, Lance (Producer)
Pure Luck 1991,Ag 9,C15:1
Hootkins, William
Hear My Song 1992,Ja 19,48:1

Hoover, Richard (Miscellaneous)
Storyville 1992,Ag 26,C13:3
Bob Roberts 1992,S 4,C1:1
Hope, Richard
Antonia and Jane 1991,O 26,13:1
Hope, Ted (Producer)
Simple Men 1992,O 14,C22:1
Hopkins, Anthony
Silence of the Lambs, The 1991,F 14,C17:1
Silence of the Lambs, The 1991,F 17,II:11:5
Silence of the Lambs, The 1991,Mr 10,II:1:1
Spartacus 1991,Ap 26,C6:4
Freejack 1992,Ja 18,17:5
Howards End 1992,Mr 13,C1:3
Howards End 1992,Mr 22,II:11:1
Efficiency Expert, The 1992,N 6,C8:1
Bram Stoker's "Dracula" 1992,N 13,C1:3
Chaplin 1992,D 25,C3:1
Hopkins, Billy (Miscellaneous)
Doors, The 1991,Mr 1,C1:1
Hopkins, Jermaine
Juice 1992,Ja 17,C10:1
Hopper, Dennis
Superstar: The Life and Times of Andy Warhol 1991,F 22,C8:1
Indian Runner, The 1991,S 20,C6:1
Hearts of Darkness: A Film Maker's Apocalypse 1991,N 27,C9:1
Hora, John (Cinematographer)
Honey, I Blew Up the Kid 1992,Jl 17,C6:5
Horak, Jan-Christopher
Other Eye, The 1991,S 25,C17:1
Hordern, Michael
Dark Obsession 1991,Je 7,C10:1
Horn, Ivan
Birthday Trip, The 1991,Mr 26,C14:3
Horn, Trevor (Composer)
Toys 1992,D 18,C1:3
Hornaday, Jeffrey (Director)
Shout 1991,O 4,C21:3
Horner, James (Composer)
Once Around 1991,Ja 18,C12:4
Class Action 1991,Mr 15,C20:4
My Heroes Have Always Been Cowboys 1991,Mr 22,C14:5
Rocketeer, The 1991,Je 21,C1:3
American Tail, An: Fievel Goes West 1991,N 22,C21:1
Thunderheart 1992,Ap 3,C12:1
Patriot Games 1992,Je 5,C1:1
Unlawful Entry 1992,Je 26,C10:4
Sneakers 1992,S 9,C18:3
Hornung, Richard (Miscellaneous)
Light Sleeper 1992,Ag 21,C12:5
Hornyak, Stephen
Giving, The 1992,N 13,C17:1
Horovitz, Adam
Roadside Prophets 1992,Mr 27,C10:1
Horowitz, Ephraim (Producer)
Men of Respect 1991,Ja 18,C1:1
Horowitz, Jordan (Screenwriter)
Alan and Naomi 1992,Ja 31,C8:5
Horrocks, Jane
Life Is Sweet 1991,O 25,C10:1
Horton, Kim (Miscellaneous)
35 Up 1992,Ja 15,C13:5
Horton, Peter
Singles 1992,S 18,C3:4
Hoskins, Bob
Shattered 1991,O 11,C24:3
Hook 1991,D 11,C17:3
Hook 1991,D 22,II:23:1
Inner Circle, The 1991,D 25,20:1
Passed Away 1992,Ap 24,C8:1
Favor, the Watch, and the Very Big Fish, The 1992,My 8,C15:3
Hoskins, Dan (Director)
Chopper Chicks in Zombietown 1991,My 10,C15:5
Hoskins, Dan (Screenwriter)
Chopper Chicks in Zombietown 1991,My 10,C15:5
Hosoda, Tamiyo (Cinematographer)
Fist of the North Star 1991,N 15,C8:1
Houck, Byron (Cinematographer)
Sherlock Jr. 1991,D 27,C1:1
Houde, Germain
Leolo 1992,S 29,C11:1
House, Lynda (Producer)
Proof 1992,Mr 20,C20:1

Houston, Marques
Bebe's Kids 1992,Ag 1,16:6
Houston, Whitney
Bodyguard, The 1992,N 6,C1:1
Bodyguard, The 1992,N 25,C9:5
Bodyguard, The 1992,D 20,II:26:1
Hoven, Adrian
Shadow of Angels 1992,Mr 6,C15:1
Hovmand, Inger
Sirup 1991,Mr 30,10:4
Howard, Arliss
Ruby 1992,Mr 27,C1:3
Crisscross 1992,My 9,17:5
Howard, James Newton (Composer)
King Ralph 1991,F 15,C10:3
Guilty by Suspicion 1991,Mr 15,C12:1
Dying Young 1991,Je 21,C10:1
Man in the Moon, The 1991,O 4,C13:1
My Girl 1991,N 27,C15:1
Prince of Tides, The 1991,D 25,13:3
Grand Canyon 1991,D 25,18:1
Diggstown 1992,Ag 14,C1:1
Glengarry Glen Ross 1992,S 30,C15:3
Night and the City 1992,O 10,11:3
Howard, Jeffrey
Simple Men 1992,O 14,C22:1
Howard, Jeffrey (Miscellaneous)
Pure Country 1992,O 23,C13:1
Howard, Joseph (Screenwriter)
Sister Act 1992,My 29,C10:1
Howard, Karin (Screenwriter)
Neverending Story II, The: The Next Chapter 1991,F 9,12:4
Howard, Ron (Director)
Backdraft 1991,My 24,C14:6
Backdraft 1991,Je 30,II:11:5
Far and Away 1992,My 22,C10:5
Far and Away 1992,Je 26,C1:3
Howard, Ron (Miscellaneous)
Far and Away 1992,My 22,C10:5
Howard, Ron (Producer)
Far and Away 1992,My 22,C10:5
Howard, Ron (Screenwriter)
Far and Away 1992,Je 26,C1:3
Howard, Sidney (Original Author)
They Knew What They Wanted 1992,Ag 21,C1:1
Howarth, Jennifer (Producer)
On the Black Hill 1991,Ag 16,C8:1
Blame It on the Bellboy 1992,Mr 6,C10:6
Howe, Jenny
Truly, Madly, Deeply 1991,My 3,C11:1
Howell, C. Thomas
Breaking the Rules 1992,O 9,C10:6
Hrabal, Bohumil (Original Author)
Larks on a String 1991,F 13,C14:4
Hrabal, Bohumil (Screenwriter)
Larks on a String 1991,F 13,C14:4
Hrusinsky, Rudolf
Larks on a String 1991,F 13,C14:4
Hsia Wen-shi
Rouge of the North 1991,D 6,C24:5
Hsiao-I
Rouge of the North 1991,D 6,C24:5
Hsu Ming
Rouge of the North 1991,D 6,C24:5
Hu, Marcus (Producer)
Living End, The 1992,Ap 3,C1:1
Huang Lei
Life on a String 1991,S 29,54:5
Life on a String 1992,Ja 10,C16:6
Huang Shuqin (Director)
Woman Demon Human 1992,S 4,C11:1
Huang, Yih-Shun (Miscellaneous)
Song of the Exile 1991,Mr 15,C21:1
Huar, Xu Re
Johanna d'Arc of Mongolia 1992,My 15,C8:1
Hubbard, James
To Render a Life 1992,N 18,C23:1
Hubbert, Cork
Ballad of the Sad Cafe, The 1991,Mr 28,C11:1
Huber, Lotti
Affengeil 1992,Jl 25,15:4
Hubert, Nathalie (Miscellaneous)
Van Gogh 1992,O 30,C16:5
Huberty, Martin (Producer)
Mighty Ducks, The 1992,O 2,C18:1
Hubschmid, Edi (Producer)
Leo Sonnyboy 1991,Mr 16,16:4

Irie, Yuzo (Producer)
Silk Road, The 1992,My 29,C13:1
Irifune, Yosuke
Unknown Soldiers 1992,Je 17,C13:1
Irons, Jeremy
Kafka 1991,D 4,C21:1
Kafka 1992,Ja 26,II:11:1
Waterland 1992,O 30,C14:6
Damage 1992,N 6,C1:1
Damage 1992,N 22,II:13:1
Damage 1992,D 13,II:20:5
Damage 1992,D 23,C13:1
Ironside, Michael
McBain 1991,S 23,C15:1
Irvin, John (Director)
Eminent Domain 1991,Ap 12,C13:4
Irvin, Sam (Director)
Guilty as Charged 1992,Ja 29,C17:1
Irving, Amy
American Tail, An: Fievel Goes West 1991,N 22,C21:1
Irwin, Bill
Scenes from a Mall 1991,F 22,C19:1
Stepping Out 1991,O 4,C26:4
Irwin, Mark (Cinematographer)
Passenger 57 1992,N 6,C14:5
Irwin, Pat (Composer)
My New Gun 1992,O 30,C10:1
Isaacs, Barbara
Importance of Being Earnest, The 1992,My 14,C20:4
Isaacs, David (Screenwriter)
Mannequin Two: On the Move 1991,My 19,50:3
Isaacs, Susan (Original Author)
Shining Through 1992,Ja 31,C8:5
Shining Through 1992,F 28,C1:1
Isaak, Chris
Twin Peaks: Fire Walk with Me 1992,Ag 29,11:1
Isaaks, Levie (Cinematographer)
Rich Girl 1991,My 4,15:1
Isabel, Margarita
Danzon 1992,S 25,C6:5
Isaki, Mitsunori
Yen Family, The 1991,Ag 21,C13:1
Rhapsody in August 1991,D 20,C22:4
Isham, Mark (Composer)
Mortal Thoughts 1991,Ap 19,C15:1
Point Break 1991,Jl 12,C12:6
Crooked Hearts 1991,S 6,C13:1
Little Man Tate 1991,O 9,C17:4
Billy Bathgate 1991,N 1,C1:1
Midnight Clear, A 1992,Ap 24,C1:3
Cool World 1992,Jl 11,12:3
Of Mice and Men 1992,O 2,C5:4
River Runs Through It, A 1992,O 9,C1:3
Public Eye, The 1992,O 14,C17:1
Ishibashi, Renji
Tetsuo: The Iron Man 1992,Ap 22,C17:1
Ishikawa, Chu (Composer)
Tetsuo: The Iron Man 1992,Ap 22,C17:1
Ishioka, Eiko (Miscellaneous)
Closet Land 1991,Mr 7,C18:3
Bram Stoker's "Dracula" 1992,N 13,C1:3
Ishiyama, Ritsuo
Swimming with Tears 1992,Mr 22,49:1
Ison, Tara (Screenwriter)
Don't Tell Mom the Babysitter's Dead 1991,Je 7,C19:1
Israel, Betsy (Screenwriter)
Mannequin Two: On the Move 1991,My 19,50:3
Israel, Neal (Director)
Breaking the Rules 1992,O 9,C10:6
Isshiki, Nobuyuki (Screenwriter)
Yen Family, The 1991,Ag 21,C13:1
Ito, Binpachi
Heaven and Earth 1991,Mr 1,C10:4
Ito, Seikou (Original Author)
No Life King 1991,S 22,58:5
Ito, Tomonori
Swimming with Tears 1992,Mr 22,49:1
Itoh, Yukiko (Miscellaneous)
Robot Carnival 1991,Mr 15,C14:5
Ittsusei, Ogato
No Life King 1991,S 22,58:5
Ivanek, Zeljko
School Ties 1992,S 18,C19:1
Ivens, Joris
Tale of the Wind, A 1991,Ja 25,C14:6

Ivens, Joris (Director)
Tale of the Wind, A 1991,Ja 25,C14:6
Ives, Burl
White Dog 1991,Jl 12,C8:1
Ivey, Dana
Home Alone 2: Lost in New York 1992,N 20,C1:1
Ivgi, Moshe
Cup Final 1992,Ag 12,C13:1
Ivory, James (Director)
Howards End 1992,Mr 13,C1:3
Howards End 1992,Mr 22,II:11:1
Iwasaki, Hiromi
Yen Family, The 1991,Ag 21,C13:1
Ixa, Mohamed
Captive of the Desert, The (Captive du Desert, La) 1991,Mr 21,C20:3
Iyitanir, Galip (Miscellaneous)
Journey of Hope 1991,Ap 26,C13:1

J

Jablow, Michael (Miscellaneous)
Marrying Man, The 1991,Ap 5,C6:1
Muppet Christmas Carol, The 1992,D 11,C12:6
Jacintha
Johanna d'Arc of Mongolia 1992,My 15,C8:1
Jackee
Ladybugs 1992,Mr 28,17:1
Jackness, Andrew (Miscellaneous)
Prelude to a Kiss 1992,Jl 10,C10:1
Jackson, Anne
Folks! 1992,My 4,C15:1
Jackson, Gemma (Miscellaneous)
Miracle, The 1991,Jl 3,C12:1
Blame It on the Bellboy 1992,Mr 6,C10:6
Jackson, George (Director)
House Party 2 1991,O 23,C17:1
Jackson, George (Producer)
New Jack City 1991,Mr 8,C15:1
House Party 2 1991,O 23,C17:1
Jackson, Javon
Texas Tenor: The Illinois Jacquet Story 1992,N 20,C5:1
Jackson, Joe (Composer)
Queens Logic 1991,F 1,C13:1
Jackson, John M.
Eve of Destruction 1991,Ja 19,22:6
Career Opportunities 1991,Mr 31,38:1
Jackson, Mick (Director)
L.A. Story 1991,F 8,C8:1
Bodyguard, The 1992,N 25,C9:5
Jackson, Mike (Miscellaneous)
Love Crimes 1992,Ja 26,43:5
Jackson, Samuel L.
Jungle Fever 1991,My 17,C1:1
Jungle Fever 1991,Je 7,C1:2
Strictly Business 1991,N 8,C13:3
Juice 1992,Ja 17,C10:1
White Sands 1992,Ap 24,C18:1
Patriot Games 1992,Je 5,C1:1
Jumpin' at the Boneyard 1992,S 18,C18:5
Fathers and Sons 1992,N 6,C17:1
Jackson, Shorty
Tender, Slender and Tall 1991,O 4,C8:5
Jackson, Tom
Clearcut 1992,Ag 21,C9:1
Jacob, Catherine
Tatie Danielle 1991,My 17,C8:1
Jacob, Irene
Double Life of Veronique, The 1991,My 26,II:9:2
Double Life of Veronique, The 1991,Je 9,II:15:1
Double Life of Veronique, The 1991,S 20,C18:4
Double Life of Veronique, The 1991,D 8,II:13:4
Jacobi, Derek
Dead Again 1991,Ag 23,C1:3
Jacobovici, Simcha (Director)
Deadly Currents 1992,O 16,C8:5
Jacobovici, Simcha (Producer)
Deadly Currents 1992,O 16,C8:5
Jacobs, Katie (Producer)
Consenting Adults 1992,O 16,C14:5
Jacobs, Ken (Composer)
Opening the 19th Century: 1986 (Avant-Garde Visions) 1991,O 1,C13:1

Jacobs, Ken (Director)
Opening the 19th Century: 1986 (Avant-Garde Visions) 1991,O 1,C13:1
Jacobs, Ken (Miscellaneous)
Opening the 19th Century: 1986 (Avant-Garde Visions) 1991,O 1,C13:1
Jacobs, Ken (Screenwriter)
Opening the 19th Century: 1986 (Avant-Garde Visions) 1991,O 1,C13:1
Jacobs, Nicholas A. E. (Director)
Refrigerator, The 1992,S 25,C16:6
Jacobs, Nicholas A. E. (Miscellaneous)
Refrigerator, The 1992,S 25,C16:6
Jacobs, Nicholas A. E. (Screenwriter)
Refrigerator, The 1992,S 25,C16:6
Jacobs, Steven
Father 1992,Jl 31,C5:5
Jacobsen, John M. (Producer)
Shipwrecked 1991,Mr 1,C6:1
Jacobson, Dean
Child's Play 3 1991,Ag 30,C11:3
Jacobson, Nora (Cinematographer)
Delivered Vacant 1992,O 10,13:1
Jacobson, Nora (Director)
Delivered Vacant 1992,O 10,13:1
Jacobson, Nora (Miscellaneous)
Delivered Vacant 1992,O 10,13:1
Jacobson, Nora (Producer)
Delivered Vacant 1992,O 10,13:1
Jacoby, Bobby
Meet the Applegates 1991,F 1,C6:1
Jacquet, Illinois
Texas Tenor: The Illinois Jacquet Story 1992,N 20,C5:1
Jafa, Arthur (Cinematographer)
Daughters of the Dust 1992,Ja 16,C19:1
Jafa, Arthur (Producer)
Daughters of the Dust 1992,Ja 16,C19:1
Jaffe, Gib (Miscellaneous)
Rapid Fire 1992,Ag 21,C11:1
Jaffe, Stanley R. (Producer)
School Ties 1992,S 18,C19:1
Jaffe, Steven-Charles (Producer)
Star Trek VI: The Undiscovered Country 1991,D 6,C1:1
Company Business 1992,Ap 25,17:1
Jagger, Mick
At the Max 1991,N 22,C15:1
Freejack 1992,Ja 18,17:5
Jaglom, Henry
Venice/Venice 1992,O 28,C20:5
Jaglom, Henry (Director)
Eating 1991,My 3,C8:1
Venice/Venice 1992,O 28,C20:5
Jaglom, Henry (Miscellaneous)
Eating 1991,My 3,C8:1
Jaglom, Henry (Screenwriter)
Eating 1991,My 3,C8:1
Venice/Venice 1992,O 28,C20:5
Jakub, Lisa
Rambling Rose 1991,S 20,C12:4
James, Anthony
Unforgiven 1992,Ag 7,C1:1
James, Brion
Player, The 1992,Ap 10,C16:1
James, Hawthorne
Five Heartbeats, The 1991,Mr 29,C14:3
James, Henry (Original Author)
Green Room, The 1992,Ap 5,II:17:5
James, Jocelyn (Miscellaneous)
Dark Obsession 1991,Je 7,C10:1
James, Lee Ving
Taking of Beverly Hills, The 1991,O 13,68:5
James, M.
Slacker 1991,Mr 22,C8:1
James, Peter (Cinematographer)
Mister Johnson 1991,Mr 22,C13:1
Black Robe 1991,O 30,C15:2
James, Steve
McBain 1991,S 23,C15:1
Jamison, Peter (Miscellaneous)
Point Break 1991,Jl 12,C12:6
Jancso, Nyika (Cinematographer)
Where 1991,S 6,C13:1
Janda, Krystyna
Inventory 1991,S 24,C13:2
Janek, Tonicka (Miscellaneous)
Restless Conscience, The 1992,F 7,C15:1

Janisch, Attila (Director)
　Shadow on the Snow 1992,Mr 31,C16:1
Jankowski, Leszek (Composer)
　Rehearsals for Extinct Anatomies 1991,Mr 27,C15:1
Jans, Aleric (Composer)
　Homicide 1991,O 6,56:1
Jansen, Janus Billeskov (Miscellaneous)
　Best Intentions, The 1992,Jl 10,C10:5
Jansen, Yves
　Via Appia 1992,Ag 27,C16:5
Janssen, Famke
　Fathers and Sons 1992,N 6,C17:1
Japhet, Julie
　Amour, L' 1991,Mr 15,C1:4
Jaregard, Ernst-Hugo
　Zentropa 1992,My 22,C14:1
Jarman, Derek (Cinematographer)
　Garden, The 1991,Ja 17,C16:5
Jarman, Derek (Director)
　Garden, The 1991,Ja 17,C16:5
　Edward II 1992,Mr 20,C16:3
Jarman, Derek (Screenwriter)
　Garden, The 1991,Ja 17,C16:5
　Edward II 1992,Mr 20,C16:3
Jarmusch, Jim
　Golden Boat, The 1991,Je 22,12:4
　In the Soup 1992,O 3,13:2
Jarmusch, Jim (Director)
　Night on Earth 1991,O 4,C1:3
　Night on Earth 1992,My 1,C10:5
Jarmusch, Jim (Producer)
　Night on Earth 1991,O 4,C1:3
Jarmusch, Jim (Screenwriter)
　Night on Earth 1991,O 4,C1:3
Jaroslow, Ruth
　Passed Away 1992,Ap 24,C8:1
Jarre, Maurice (Composer)
　Only the Lonely 1991,My 24,C10:6
　School Ties 1992,S 18,C19:1
Jarret, Catherine
　Fine Romance, A 1992,O 2,C10:6
Jarvenpaa, Sakke (Miscellaneous)
　Zombie and the Ghost Train 1991,O 4,C8:5
Jason, Jack (Screenwriter)
　Matter of Degrees, A 1991,S 13,C9:4
Jaynes, Roderick (Miscellaneous)
　Barton Fink 1991,Ag 21,C11:1
Jeavons, Colin
　Secret Friends 1992,F 14,C10:1
Jefferds, Vincent (Miscellaneous)
　Motorama 1992,Mr 28,18:5
Jefferson, Frank
　Adjuster, The 1991,S 26,C18:5
Jefford, Barbara
　Where Angels Fear to Tread 1992,F 28,C12:1
　Where Angels Fear to Tread 1992,Mr 22,II:11:1
Jenkel, Chaz (Composer)
　K2 1992,My 1,C16:1
Jenkins, Ken
　Crossing the Bridge 1992,S 11,C12:1
Jenkins, Michael (Director)
　Sweet Talker 1991,My 12,42:5
Jenkins, Rebecca
　Clearcut 1992,Ag 21,C9:1
　Bob Roberts 1992,S 4,C1:1
Jennewein, Jim (Miscellaneous)
　Stay Tuned 1992,Ag 15,14:5
Jennewein, Jim (Screenwriter)
　Stay Tuned 1992,Ag 15,14:5
Jennings, Will (Miscellaneous)
　American Tail, An: Fievel Goes West 1991,N
　　22,C21:1
Jensen, Birger Moller (Miscellaneous)
　Sirup 1991,Mr 30,10:4
Jensen, Henning
　Zentropa 1992,My 22,C14:1
Jensen, Johnny E. (Cinematographer)
　Rambling Rose 1991,S 20,C12:4
Jensen, Peter Aalbaek (Producer)
　Zentropa 1992,My 22,C14:1
Jensen, Scott
　Class Act 1992,Je 5,C17:1
Jerome, Timothy
　Husbands and Wives 1992,S 18,C1:1
Jessua, Alain (Director)
　En Toute Innocence (In All Innocence) 1992,Jl
　　31,C14:3

Jessua, Alain (Producer)
　En Toute Innocence (In All Innocence) 1992,Jl
　　31,C14:3
Jessua, Alain (Screenwriter)
　En Toute Innocence (In All Innocence) 1992,Jl
　　31,C14:3
Jet Li
　Once Upon a Time in China 1992,My 21,C16:5
Jeter, Michael
　Fisher King, The 1991,S 20,C10:4
　Just Like in the Movies 1992,My 4,C15:1
Jeunet, Jean-Pierre (Director)
　Delicatessen 1991,O 5,14:3
　Delicatessen 1992,Ap 5,53:2
　Delicatessen 1992,My 3,II:13:4
Jeunet, Jean-Pierre (Screenwriter)
　Delicatessen 1991,O 5,14:3
Jewell, Geri
　Wisecracks 1992,Je 4,C17:1
Jewison, Norman (Director)
　Other People's Money 1991,O 18,C10:3
Jewison, Norman (Producer)
　Other People's Money 1991,O 18,C10:3
Jhabvala, Ruth Prawer (Screenwriter)
　Howards End 1992,Mr 13,C1:3
　Howards End 1992,Mr 22,II:11:1
Ji Hongsheng (Cinematographer)
　Woman Demon Human 1992,S 4,C11:1
Jimenez, Neal (Director)
　Waterdance, The 1992,My 13,C13:1
　Waterdance, The 1992,D 13,II:1:2
Jimenez, Neal (Miscellaneous)
　For the Boys 1991,N 22,C12:1
Jimenez, Neal (Screenwriter)
　For the Boys 1991,N 22,C12:1
　Waterdance, The 1992,My 13,C13:1
Jimmy Jam (Composer)
　Mo' Money 1992,Jl 25,15:1
Jin Shuyuan
　Raise the Red Lantern 1992,Mr 20,C18:1
Jinno, Hiroaki (Screenwriter)
　No Life King 1991,S 22,58:5
Joanou, Phil (Director)
　Final Analysis 1992,F 7,C8:1
Joffe, Arthur (Director)
　Alberto Express 1992,O 9,C12:5
Joffe, Arthur (Miscellaneous)
　Alberto Express 1992,O 9,C12:5
Joffe, Arthur (Screenwriter)
　Alberto Express 1992,O 9,C12:5
Joffe, Charles H. (Producer)
　Shadows and Fog 1992,Mr 20,C6:1
　Husbands and Wives 1992,S 18,C1:1
Joffe, Mark (Director)
　Efficiency Expert, The 1992,N 6,C8:1
Joffe, Roland (Director)
　City of Joy 1992,Ap 15,C15:1
Joffe, Roland (Producer)
　City of Joy 1992,Ap 15,C15:1
Joglekar, Vikram (Composer)
　Idiot 1992,O 8,C21:4
Johansen, David
　Freejack 1992,Ja 18,17:5
Johansson, Lars (Cinematographer)
　Atlantic Rhapsody: 52 Scenes from Torshavn
　　1991,Mr 30,11:1
Johansson, Signe (Producer)
　Wisecracks 1992,Je 4,C17:1
Johnes, Alexandra
　Neverending Story II, The: The Next Chapter 1991,F
　　9,12:4
Johnke, Torben (Producer)
　Popcorn 1991,F 1,C6:5
Johns, Jasper
　Cage/Cunningham 1991,D 5,C20:1
Johnson, Anne-Marie
　True Identity 1991,Ag 23,C16:1
　Strictly Business 1991,N 8,C13:3
Johnson, Ashley
　Lionheart 1991,Ja 11,C8:4
Johnson, Ben
　My Heroes Have Always Been Cowboys 1991,Mr
　　22,C14:5
　Radio Flyer 1992,F 21,C16:1
Johnson, Big Jack
　Deep Blues 1992,Jl 31,C14:3
Johnson, Brad
　Flight of the Intruder 1991,Ja 18,C19:1

Johnson, Don
　Harley Davidson and the Marlboro Man 1991,Ag
　　24,16:6
　Paradise 1991,S 18,C16:3
　Paradise 1991,O 13,II:21:1
Johnson, Frank (Cinematographer)
　Taking of Beverly Hills, The 1991,O 13,68:5
Johnson, J. Randal (Screenwriter)
　Doors, The 1991,Mr 1,C1:1
Johnson, Karl
　Close My Eyes 1992,F 21,C12:6
Johnson, Lamont
　Class Act 1992,Je 5,C17:1
Johnson, Laura
　Opening Night 1991,My 17,C11:1
Johnson, Mark (Producer)
　Bugsy 1991,D 13,C12:1
　Toys 1992,D 18,C1:3
Johnson, Marques
　White Men Can't Jump 1992,Mr 27,C22:4
Johnson, Michelle
　Dr. Giggles 1992,O 24,16:4
Johnson, Richard (Miscellaneous)
　Stone Cold 1991,My 18,16:3
Johnson, Richard E. (Producer)
　Ambition 1991,Je 1,16:3
Johnson, Ron
　Zebrahead 1992,O 8,C17:5
Johnson, Sherry
　Bikini Island 1991,Jl 27,16:3
Johnson, Taborah
　Making of "Monsters," The (Avant-Garde Visions)
　　1991,O 1,C13:1
Johnston, Becky (Screenwriter)
　Prince of Tides, The 1991,D 25,13:3
Johnston, J. J.
　Homicide 1991,O 6,56:1
Johnston, Joanna (Miscellaneous)
　Death Becomes Her 1992,Jl 31,C8:1
Johnston, Joe (Director)
　Rocketeer, The 1991,Je 21,C1:3
Jolley, Stan (Miscellaneous)
　Dutch 1991,Jl 19,C13:1
Jones, Amy Holden (Screenwriter)
　Beethoven 1992,Ap 3,C18:1
　Beethoven 1992,My 17,II:22:1
Jones, Bryan (Miscellaneous)
　People Under the Stairs, The 1991,N 2,17:1
Jones, Catherine Zeta
　Christopher Columbus: The Discovery 1992,Ag
　　22,11:1
Jones, Claude Earl
　Bride of Re-Animator 1991,F 22,C17:1
Jones, Dalton
　Encino Man 1992,My 22,C15:1
Jones, Dean
　Other People's Money 1991,O 18,C10:3
　Beethoven 1992,Ap 3,C18:1
　Beethoven 1992,Ap 17,C24:5
　Beethoven 1992,My 17,II:22:1
Jones, Gemma
　On the Black Hill 1991,Ag 16,C8:1
Jones, Grace
　Boomerang 1992,Jl 1,C18:1
　Boomerang 1992,Jl 12,II:11:5
Jones, Gregory (Composer)
　Steal America 1992,Ap 3,C24:5
Jones, James Earl
　Convicts 1991,D 6,C14:6
　Patriot Games 1992,Je 5,C1:1
Jones, Jeffrey
　Mom and Dad Save the World 1992,Jl 27,C18:4
　Stay Tuned 1992,Ag 15,14:5
　Out on a Limb 1992,S 5,15:1
Jones, Jenny
　Wisecracks 1992,Je 4,C17:1
Jones, John Christopher
　Misplaced 1991,Mr 1,C9:1
　Bruce Diet, The 1992,Ap 15,C19:1
Jones, Jonah
　Texas Tenor: The Illinois Jacquet Story 1992,N
　　20,C5:1
Jones, Laura (Screenwriter)
　Angel at My Table, An 1991,Je 16,II:11:5
Jones, Loretha C. (Producer)
　Five Heartbeats, The 1991,Mr 29,C14:3
Jones, Neal
　Glengarry Glen Ross 1992,S 30,C15:3

Jones, Robert C. (Miscellaneous)
Heaven and Earth 1991,Mr 1,C10:4
Babe, The 1992,Ap 17,C8:1
Jones, Sophia
At the Max 1991,N 22,C15:1
Jones, Steven A. (Composer)
Borrower, The 1991,O 18,C12:3
Jones, Steven A. (Producer)
Borrower, The 1991,O 18,C12:3
Jones, Tommy Lee
J.F.K. 1991,D 20,C1:1
Under Siege 1992,O 9,C12:1
Jones, Trevor (Composer)
True Colors 1991,Mr 15,C19:1
Freejack 1992,Ja 18,17:5
Blame It on the Bellboy 1992,Mr 6,C10:6
Crisscross 1992,My 9,17:5
Last of the Mohicans, The 1992,S 25,C3:1
Jordan, Dennis
Talking to Strangers 1991,D 27,C12:6
Jordan, Julie
Drum Struck 1992,Ap 22,C17:1
Jordan, Neil (Director)
Miracle, The 1991,Jl 3,C12:1
Miracle, The 1991,Ag 2,C11:1
Crying Game, The 1992,S 26,12:4
Crying Game, The 1992,O 11,II:11:1
Crying Game, The 1992,N 25,C10:1
Crying Game, The 1992,D 4,C3:5
Jordan, Neil (Screenwriter)
Miracle, The 1991,Jl 3,C12:1
Miracle, The 1991,Ag 2,C11:1
Crying Game, The 1992,S 26,12:4
Crying Game, The 1992,N 25,C10:1
Jordan, Will
Mr. Saturday Night 1992,S 23,C13:4
Joseph, Allan R. J.
Thunderheart 1992,Ap 3,C12:1
Joseph, Karen (Miscellaneous)
Liquid Dreams 1992,Ap 15,C19:1
Joseph, Rudolph S.
Other Eye, The 1991,S 25,C17:1
Josephson, Erland
Prospero's Books 1991,S 28,9:1
Meeting Venus 1991,N 15,C1:3
Ox, The 1992,Ag 21,C10:5
Joshua, Larry
Midnight Clear, A 1992,Ap 24,C1:3
Jost, Jon (Cinematographer)
All the Vermeers in New York 1992,My 1,C13:1
Jost, Jon (Director)
All the Vermeers in New York 1992,My 1,C13:1
Jost, Jon (Miscellaneous)
All the Vermeers in New York 1992,My 1,C13:1
Jost, Jon (Screenwriter)
All the Vermeers in New York 1992,My 1,C13:1
Joubeaud, Edouard
Jacquot de Nantes 1991,S 25,C16:3
Jourdan, Louis
Year of the Comet 1992,Ap 25,17:1
Jovovich, Milla
Return to the Blue Lagoon 1991,Ag 2,C12:1
Kuffs 1992,Ja 10,C16:6
Joyner, Mario
Hangin' with the Homeboys 1991,My 24,C12:6
Joyner, Michelle
Traces of Red 1992,N 12,C22:1
Judson, Tom (Composer)
Revolution 1991,N 15,C8:4
Juhl, Jerry (Screenwriter)
Muppet Christmas Carol, The 1992,D 11,C12:6
Julia, Raul
Addams Family, The 1991,N 22,C1:1
Julien, Isaac (Director)
Young Soul Rebels 1991,D 6,C21:1
Julien, Isaac (Screenwriter)
Young Soul Rebels 1991,D 6,C21:1
Juliusson, Karl (Miscellaneous)
Shadow of the Raven, The 1991,Jl 13,12:1
Junkerman, John (Miscellaneous)
Mr. Baseball 1992,O 2,C14:6
Junkersdorf, Eberhard (Producer)
Voyager 1992,Ja 31,C6:1
Jur, Jeff (Cinematographer)
Ambition 1991,Je 1,16:3
Jurgenson, Albert (Miscellaneous)
November Days 1992,My 8,C8:1

Justman, Zuzana (Screenwriter)
Terezin Diary 1991,Ag 16,C11:3
Jympson, John (Miscellaneous)
King Ralph 1991,F 15,C10:3
Housesitter 1992,Je 12,C1:4

K

Kabalah, Johnny
Revolution 1991,N 15,C8:4
Kabdebo, Katalin (Miscellaneous)
Memoirs of a River 1992,Mr 20,C15:1
Kabler, Roger
Alligator Eyes 1991,F 15,C15:1
Kachyna, Karel (Director)
Ear, The 1992,Mr 25,C18:5
Kachyna, Karel (Screenwriter)
Ear, The 1992,Mr 25,C18:5
Kaczenski, Chester (Miscellaneous)
Toy Soldiers 1991,Ap 26,C15:1
Kadokawa, Haruki (Director)
Heaven and Earth 1991,Mr 1,C10:4
Kadokawa, Haruki (Screenwriter)
Heaven and Earth 1991,Mr 1,C10:4
Kadokura, Satoshi (Composer)
Enchantment, The 1992,My 20,C15:3
Kady, Charlotte
Daddy Nostalgia 1991,Ap 12,C10:1
Kafri, Ezra
For Sasha 1992,Je 5,C13:1
Kaga, Takeshi
Yen Family, The 1991,Ag 21,C13:1
Kahan, Marcy (Screenwriter)
Antonia and Jane 1991,O 26,13:1
Antonia and Jane 1991,N 8,C3:3
Kahan, Steve
Lethal Weapon 3 1992,My 15,C16:3
Kahane, Rabbi Meir
Double Edge 1992,S 30,C18:3
Kahane, Paul
Whole Truth, The 1992,O 23,C10:5
Kahane, Thomas (Composer)
Locked-Up Time 1991,S 29,54:3
Kahn, Cedric (Screenwriter)
Outremer 1991,Mr 27,C15:1
Kahn, Jeff (Director)
Revolution 1991,N 15,C8:4
Kahn, Jeff (Screenwriter)
Revolution 1991,N 15,C8:4
Kahn, Michael (Miscellaneous)
Toy Soldiers 1991,Ap 26,C15:1
Hook 1991,D 11,C17:3
Kahnert, Ray
Making of "Monsters," The (Avant-Garde Visions)
1991,O 1,C13:1
Kahraman, Erdal (Cinematographer)
Heart of Glass, A 1992,Mr 21,18:4
Kai Kit-wai (Miscellaneous)
Days of Being Wild 1991,Mr 23,12:3
Kain, Khalil
Juice 1992,Ja 17,C10:1
Kaionji, Chogoro (Original Author)
Heaven and Earth 1991,Mr 1,C10:4
Kalin, Matthias (Cinematographer)
Lumumba: Death of a Prophet 1992,S 30,C18:3
Hyenas 1992,O 3,18:4
Kalin, Tom (Director)
Swoon 1992,Ja 23,C15:4
Swoon 1992,Mr 27,C8:1
Swoon 1992,S 11,C8:6
Swoon 1992,N 22,II:13:1
Swoon 1992,D 13,II:1:2
Kalin, Tom (Miscellaneous)
Swoon 1992,Mr 27,C8:1
Kalin, Tom (Producer)
Swoon 1992,Mr 27,C8:1
Kalin, Tom (Screenwriter)
Swoon 1992,Mr 27,C8:1
Kalinowski, Waldemar (Miscellaneous)
Liebestraum 1991,S 13,C6:1
Kallberg, Kevin M. (Producer)
Into the Sun 1992,Ja 31,C10:6
Kalogeras, Savas (Cinematographer)
Princes in Exile 1991,F 22,C12:5

Kaluta, Villenn (Cinematographer)
Close to Eden 1992,O 30,C10:5
Kamata, Toshio (Screenwriter)
Heaven and Earth 1991,Mr 1,C10:4
Kamata, Toshiro (Producer)
Enchantment, The 1992,My 20,C15:3
Kamen, Michael (Composer)
Nothing But Trouble 1991,F 16,16:5
Hudson Hawk 1991,My 24,C8:4
Robin Hood: Prince of Thieves 1991,Je 14,C1:4
Last Boy Scout, The 1991,D 13,C14:6
Shining Through 1992,Ja 31,C8:5
Company Business 1992,Ap 25,17:1
Lethal Weapon 3 1992,My 15,C16:3
Kamen, Robert Mark (Miscellaneous)
Gladiator 1992,Mr 6,C17:1
Kamen, Robert Mark (Screenwriter)
Gladiator 1992,Mr 6,C17:1
Power of One, The 1992,Mr 27,C20:5
Lethal Weapon 3 1992,My 15,C16:3
Lethal Weapon 3 1992,Je 26,C1:3
Kaminski, Janusz (Cinematographer)
Cool as Ice 1991,O 19,12:6
Kamron
House Party 2 1991,O 23,C17:1
Kanan, Sean
Rich Girl 1991,My 4,15:1
Kanaoko, Nobu
Tetsuo: The Iron Man 1992,Ap 22,C17:1
Kane, Billy Charles
Poison Ivy 1992,My 8,C16:3
Kane, Bob (Miscellaneous)
Batman Returns 1992,Je 19,C1:1
Kane, Brad
Aladdin 1992,N 11,C15:3
Kane, Carol
Ted and Venus 1991,D 20,C23:1
In the Soup 1992,O 3,13:2
Kane, Dyan
Whole Truth, The 1992,O 23,C10:5
Kane, Ivana
Romeo and Julia 1992,F 14,C6:5
Kane, Mary (Producer)
Bad Lieutenant 1992,N 20,C15:1
Kanefsky, Rolfe (Director)
There's Nothing Out There 1992,Ja 22,C20:4
Kanefsky, Rolfe (Producer)
There's Nothing Out There 1992,Ja 22,C20:4
Kanefsky, Rolfe (Screenwriter)
There's Nothing Out There 1992,Ja 22,C20:4
Kanefsky, Victor (Miscellaneous)
There's Nothing Out There 1992,Ja 22,C20:4
Kanew, Jeff (Director)
V. I. Warshawski 1991,Jl 26,C1:3
Kani, John
Sarafina! 1992,S 18,C16:6
Kanin, Garson (Screenwriter)
They Knew What They Wanted 1992,Ag 21,C1:1
Kanter, Christoph (Miscellaneous)
Benny's Video 1992,S 28,C14:1
Kao-Chieh
Rouge of the North 1991,D 6,C24:5
Kapelos, John
Defenseless 1991,Ag 23,C8:1
Man Trouble 1992,Jl 18,18:4
Kaplan, Jonathan (Director)
Unlawful Entry 1992,Je 26,C10:4
Love Field 1992,D 11,C6:3
Kaplan, Mark (Cinematographer)
Wax, or the Discovery of Television Among the
Bees 1992,Ag 21,C10:1
Kaplan, Mark Allan (Miscellaneous)
Delusion 1991,Je 7,C12:6
Kaplan, Marty (Miscellaneous)
Distinguished Gentleman, The 1992,D 4,C1:4
Kaplan, Marty (Screenwriter)
Noises Off 1992,Mr 20,C10:1
Distinguished Gentleman, The 1992,D 4,C1:4
Karabatsos, Ron
Rich Girl 1991,My 4,15:1
29th Street 1991,N 1,C14:1
Karaindrou, Helena (Composer)
Suspended Step of the Stork, The 1991,S 23,C15:1
Karapiperis, Mikes (Miscellaneous)
Suspended Step of the Stork, The 1991,S 23,C15:1
Karasumaru, Setsuko
Twilight of the Cockroaches 1991,Mr 29,C14:4

Karaszewski, Larry (Screenwriter)
Problem Child 2 1991,Jl 5,C6:1
Karbelnikoff, Michael (Director)
Mobsters 1991,Jl 26,C18:4
Karmann, Sam (Director)
Omnibus 1992,S 25,C34:1
Karmitz, Martin (Producer)
Madame Bovary 1991,D 25,13:1
Inspector Lavardin 1991,D 26,C13:1
Karr, Gregory
Suspended Step of the Stork, The 1991,S 23,C15:1
Karsch, Andrew (Producer)
Prince of Tides, The 1991,D 25,13:3
Karson, Eric (Producer)
Lionheart 1991,Ja 11,C8:4
Kartozian, Tom (Screenwriter)
Frozen Assets 1992,O 24,16:4
Karyo, Tcheky
Femme Nikita, La 1991,Mr 8,C10:1
Exposure 1991,N 1,C12:6
Kasander, Kees (Producer)
Drowning by Numbers 1991,Ap 26,C8:1
Prospero's Books 1991,S 28,9:1
Kasdan, Lawrence (Director)
Grand Canyon 1991,D 25,18:1
Grand Canyon 1992,F 2,II:13:5
Kasdan, Lawrence (Producer)
Grand Canyon 1991,D 25,18:1
Bodyguard, The 1992,N 25,C9:5
Kasdan, Lawrence (Screenwriter)
Grand Canyon 1991,D 25,18:1
Bodyguard, The 1992,N 25,C9:5
Bodyguard, The 1992,D 20,II:26:1
Kasdan, Meg (Screenwriter)
Grand Canyon 1991,D 25,18:1
Kases, Karl (Cinematographer)
Mindwalk 1992,Ap 8,C17:1
Kasha, Al (Composer)
China Cry 1991,My 3,C9:1
Kasha, Alon (Producer)
Just Like in the Movies 1992,My 4,C15:1
Kasmer, Shelley
My Father Is Coming 1991,N 22,C12:5
Kasper, David (Miscellaneous)
Panama Deception, The 1992,O 23,C10:5
Kasper, David (Producer)
Panama Deception, The 1992,O 23,C10:5
Kasper, David (Screenwriter)
Panama Deception, The 1992,O 23,C10:5
Kassar, Mario (Producer)
Chaplin 1992,D 25,C3:1
Kastner, Daphna
Julia Has Two Lovers 1991,Mr 24,64:1
Eating 1991,My 3,C8:1
Venice/Venice 1992,O 28,C20:5
Kastner, Daphna (Miscellaneous)
Julia Has Two Lovers 1991,Mr 24,64:1
Kastner, Daphna (Screenwriter)
Julia Has Two Lovers 1991,Mr 24,64:1
Kasyanov, Andrei
Adam's Rib 1991,S 21,12:5
Katchmer, John (Miscellaneous)
Unlawful Entry 1992,Je 26,C10:4
Kates, Bernard
Babe, The 1992,Ap 17,C8:1
Katsouridis, Dinos (Cinematographer)
Quiet Days in August 1992,Mr 29,48:1
Katsouridis, Dinos (Miscellaneous)
Quiet Days in August 1992,Mr 29,48:1
Katsulas, Andreas
True Identity 1991,Ag 23,C16:1
Blame It on the Bellboy 1992,Mr 6,C10:6
Kauderer, Emilio (Composer)
Julia Has Two Lovers 1991,Mr 24,64:1
Kaufman, Kevin (Director)
Romeo and Julia 1992,F 14,C6:5
Kaufman, Kevin (Producer)
Romeo and Julia 1992,F 14,C6:5
Kaufman, Kevin (Screenwriter)
Romeo and Julia 1992,F 14,C6:5
Kaufman, Lloyd (Producer)
Class of Nuke 'Em High Part 2: Subhumanoid
Meltdown 1991,Ap 12,C13:1
Kaufman, Lloyd (Screenwriter)
Class of Nuke 'Em High Part 2: Subhumanoid
Meltdown 1991,Ap 12,C13:1
Kaul, Bhupender (Producer)
One Hand Don't Clap 1991,Ag 28,C13:1

Kaul, Mani (Director)
Idiot 1992,O 8,C21:4
Kaurismaki, Aki (Director)
Vie de Boheme, La 1992,O 9,C14:1
Vie de Boheme, La 1992,O 11,II:11:1
Match Factory Girl, The 1992,N 5,C18:5
Kaurismaki, Aki (Producer)
Vie de Boheme, La 1992,O 9,C14:1
Kaurismaki, Aki (Screenwriter)
Vie de Boheme, La 1992,O 9,C14:1
Kaurismaki, Mika (Director)
Zombie and the Ghost Train 1991,O 4,C8:5
Amazon 1992,F 28,C8:5
Kaurismaki, Mika (Miscellaneous)
Zombie and the Ghost Train 1991,O 4,C8:5
Kaurismaki, Mika (Producer)
Zombie and the Ghost Train 1991,O 4,C8:5
Amazon 1992,F 28,C8:5
Kaurismaki, Mika (Screenwriter)
Zombie and the Ghost Train 1991,O 4,C8:5
Amazon 1992,F 28,C8:5
Kavner, Julie
To the Moon, Alice 1991,O 2,C19:1
This Is My Life 1992,F 21,C8:1
This Is My Life 1992,F 23,II:13:1
This Is My Life 1992,F 28,C1:1
Kawai, Shinya (Producer)
Enchantment, The 1992,My 20,C15:3
Kawakami, Ei
Swimming with Tears 1992,Mr 22,49:1
Kawakami, Syujiro (Producer)
Swimming with Tears 1992,Mr 22,49:1
Kawano, Osami
Woman of the Port (Mujer del Puerto, La) 1991,S
27,C5:1
Kawarasaki, Choichiro
Rhapsody in August 1991,D 20,C22:4
Kawashima, Akimasa (Miscellaneous)
Traffic Jam 1992,Mr 20,C20:4
Kayashima, Narumi
Rhapsody in August 1991,D 20,C22:4
Kaye, Norman
Woman's Tale, A 1992,Ap 30,C16:6
Kazan, Lainie
29th Street 1991,N 1,C14:1
Kazan, Nicholas (Screenwriter)
Mobsters 1991,Jl 26,C18:4
Keating, Charles
Bodyguard, The 1992,N 25,C9:5
Keaton, Buster
Sherlock Jr. 1991,D 27,C1:1
Navigator, The 1991,D 27,C1:1
General, The 1991,D 27,C1:1
Film 1991,D 27,C1:1
Keaton, Buster (Director)
Sherlock Jr. 1991,D 27,C1:1
Navigator, The 1991,D 27,C1:1
General, The 1991,D 27,C1:1
Keaton, Diane
Father of the Bride 1991,D 20,C17:1
Keaton, Michael
One Good Cop 1991,My 3,C13:1
Batman Returns 1992,Je 19,C1:1
Batman Returns 1992,Je 28,II:11:1
Keener, Catherine
Johnny Suede 1992,Ag 14,C5:5
Kehler, Jack
White Sands 1992,Ap 24,C18:1
Keita, Balla Moussa
Finzan 1992,Mr 22,48:4
Keita, Oumar Namory
Finzan 1992,Mr 22,48:4
Keitel, Harvey
Mortal Thoughts 1991,Ap 19,C15:1
Thelma and Louise 1991,My 24,C1:1
Thelma and Louise 1991,Je 16,II:11:1
Bugsy 1991,D 13,C12:1
Reservoir Dogs 1992,Ja 23,C15:4
Sister Act 1992,My 29,C10:1
Sister Act 1992,Je 7,II:13:1
Reservoir Dogs 1992,O 23,C14:1
Bad Lieutenant 1992,N 20,C15:1
Keitel, Stella
Bad Lieutenant 1992,N 20,C15:1
Keith, Woody (Screenwriter)
Bride of Re-Animator 1991,F 22,C17:1
Keller, Madlyn DePaolo
June Roses 1992,Mr 24,C15:3

Keller, Sarah
Kiss Before Dying, A 1991,Ap 26,C12:6
Kelley, DeForest
Star Trek VI: The Undiscovered Country 1991,D
6,C1:1
Kelley, Sheila
Pure Luck 1991,Ag 9,C15:1
Singles 1992,S 18,C3:4
Passion Fish 1992,D 14,C16:1
Kellgren, Nina (Cinematographer)
Young Soul Rebels 1991,D 6,C21:1
Kellman, Barnet (Director)
Straight Talk 1992,Ap 3,C17:1
Kellogg, David (Director)
Cool as Ice 1991,O 19,12:6
Kelly, Carol
Terror in a Texas Town 1991,My 17,C16:4
Kelly, David Patrick
Cheap Shots 1991,N 15,C11:1
Kelly, M. T. (Original Author)
Clearcut 1992,Ag 21,C9:1
Kelly, Moira
Boy Who Cried Bitch, The 1991,O 11,C17:1
Cutting Edge, The 1992,Mr 27,C21:1
Twin Peaks: Fire Walk with Me 1992,Ag 29,11:1
Chaplin 1992,D 25,C3:1
Kelly, Nancy (Director)
1,000 Pieces of Gold 1991,S 27,C10:4
Kelly, Nancy (Producer)
1,000 Pieces of Gold 1991,S 27,C10:4
Kelly, Patricia (Miscellaneous)
Pictures from a Revolution 1991,O 5,11:4
Kelsch, Ken (Cinematographer)
Bad Lieutenant 1992,N 20,C15:1
Kemp, Gary
Bodyguard, The 1992,N 25,C9:5
Kempel, Arthur (Composer)
Double Impact 1991,Ag 9,C8:5
Kemper, Steven (Miscellaneous)
New Jack City 1991,Mr 8,C15:1
Kemper, Victor J. (Cinematographer)
FX2: The Deadly Art of Illusion 1991,My 10,C8:5
Another You 1991,Jl 27,16:3
Beethoven 1992,Ap 3,C18:1
Kempster, Victor (Miscellaneous)
J.F.K. 1991,D 20,C1:1
Kendrick, Florina
Bram Stoker's "Dracula" 1992,N 13,C1:3
Kennealy, Patricia
Doors, The 1991,Mr 1,C1:1
Kennedy, Burt (Director)
Suburban Commando 1991,O 6,56:3
Kennedy, Chris (Miscellaneous)
Efficiency Expert, The 1992,N 6,C8:1
Kennedy, George
Naked Gun 2 1/2: The Smell of Fear 1991,Je 28,C8:1
Kennedy, John F., Jr.
Matter of Degrees, A 1991,S 13,C9:4
Kennedy, Kathleen (Producer)
Hook 1991,D 11,C17:3
Kennedy, Patrick (Miscellaneous)
Queens Logic 1991,F 1,C13:1
Once Upon a Crime 1992,Mr 7,20:4
Kennedy, William P. (Original Author)
Toy Soldiers 1991,Ap 26,C15:1
Kenner, David
June Roses 1992,Mr 24,C15:3
Kenney, Bill (Miscellaneous)
Oscar 1991,Ap 26,C10:5
Under Siege 1992,O 9,C12:1
Kenny, Francis (Cinematographer)
New Jack City 1991,Mr 8,C15:1
House Party 2 1991,O 23,C17:1
Cold Heaven 1992,My 29,C15:1
Class Act 1992,Je 5,C17:1
Kenny, Tom
Shakes the Clown 1992,Mr 13,C13:1
Kensit, Patsy
Twenty-One 1991,O 4,C10:6
Blame It on the Bellboy 1992,Mr 6,C10:6
Kent, Debra (Producer)
Bruce Diet, The 1992,Ap 15,C19:1
Keogh, Alexia
Angel at My Table, An 1991,My 21,C15:1
Angel at My Table, An 1991,Je 16,II:11:5
Keramidas, Harry (Miscellaneous)
Passed Away 1992,Ap 24,C8:1

Kleiser, Randal (Director)
White Fang 1991,Ja 18,C16:3
Honey, I Blew Up the Kid 1992,Jl 17,C6:5
Klimek, Joe
Complex World 1992,Ap 10,C14:5
Kline, Kevin
Soapdish 1991,My 31,C10:1
Grand Canyon 1991,D 25,18:1
Consenting Adults 1992,O 16,C14:5
Chaplin 1992,D 25,C3:1
Kline, Richard (Cinematographer)
Double Impact 1991,Ag 9,C8:5
Kling, Elizabeth (Miscellaneous)
Men of Respect 1991,Ja 18,C1:1
Zebrahead 1992,O 8,C17:5
Kling, Heidi
Out on a Limb 1992,S 5,15:1
Mighty Ducks, The 1992,O 2,C18:1
Klingman, Lynzee (Miscellaneous)
Little Man Tate 1991,O 9,C17:4
River Runs Through It, A 1992,O 9,C1:3
Hoffa 1992,D 25,C1:1
Kloomok, Darren (Miscellaneous)
Boy Who Cried Bitch, The 1991,O 11,C17:1
Kloser, Harald (Composer)
Requiem for Dominic 1991,Ap 19,C17:1
Klosinsky, Edward (Cinematographer)
Zentropa 1992,My 22,C14:1
Kloster, Carlos
Favor, the Watch, and the Very Big Fish, The
1992,My 8,C15:3
Klotz, Claude (Screenwriter)
Hairdresser's Husband, The 1992,Je 19,C11:1
Kluger, Steve (Screenwriter)
Once Upon a Crime 1992,Mr 7,20:4
Klymkiw, Greg (Producer)
Archangel 1991,Jl 19,C12:6
Careful 1992,O 7,C20:3
Knatchbull, Philip (Producer)
Get Back 1991,O 25,C19:1
Kneiper, Jurgen (Composer)
Exposure 1991,N 1,C12:6
Knepper, Robert
Gas Food Lodging 1992,Jl 31,C1:1
Kneuer, Cameo
Final Approach 1992,Mr 13,C8:4
Knight, Andrew (Screenwriter)
Efficiency Expert, The 1992,N 6,C8:1
Knight, Darwin (Miscellaneous)
Phantom of the Opera, The 1991,Je 8,16:1
Knight, David
Who Shot Patakango? 1992,My 1,C10:5
Knight, Erik (Director)
Baobab (Young Black Cinema) 1992,F 29,17:1
Knight, Karen
Close My Eyes 1992,F 21,C12:6
Knight, Tuesday
Mistress 1992,Ag 7,C16:3
Knowland, Nic (Cinematographer)
Testimony 1991,D 18,C25:1
Kobayashi, Kaoru
Twilight of the Cockroaches 1991,Mr 29,C14:4
Kocak, Mevlut (Miscellaneous)
Heart of Glass, A 1992,Mr 21,18:4
Koch, Karen (Producer)
Rapture, The 1991,S 30,C14:4
Kochemasova, Tatyana
Raspad 1992,Ap 29,C15:1
Koehler, Bonnie (Miscellaneous)
Iron Maze 1991,N 1,C13:1
Hard Promises 1992,Ja 31,C12:6
Raising Cain 1992,Ag 7,C5:1
Koenekamp, Fred J. (Cinematographer)
Flight of the Intruder 1991,Ja 18,C19:1
Koenig, Walter
Star Trek VI: The Undiscovered Country 1991,D
6,C1:1
Koepp, David (Screenwriter)
Toy Soldiers 1991,Ap 26,C15:1
Death Becomes Her 1992,Jl 31,C8:1
Koherr, Bob
Romeo and Julia 1992,F 14,C6:5
Kohlmeier, Michael (Screenwriter)
Requiem for Dominic 1991,Ap 19,C17:1
Kohlund, Christian
Leo Sonnyboy 1991,Mr 16,16:4
Kohn, Yariv (Director)
Letter to Harvey Milk, A 1991,Je 14,C10:4

Kohn, Yariv (Producer)
Letter to Harvey Milk, A 1991,Je 14,C10:4
Kohn, Yariv (Screenwriter)
Letter to Harvey Milk, A 1991,Je 14,C10:4
Kokorian, Armen
Adjuster, The 1991,S 26,C18:5
Kolban, Amir
Deadly Currents 1992,O 16,C8:5
Kollek, Amos
Double Edge 1992,S 30,C18:3
Kollek, Amos (Director)
Double Edge 1992,S 30,C18:3
Kollek, Amos (Producer)
Double Edge 1992,S 30,C18:3
Kollek, Amos (Screenwriter)
Double Edge 1992,S 30,C18:3
Kollek, Teddy
Double Edge 1992,S 30,C18:3
Koller, Ingrid (Miscellaneous)
Requiem for Dominic 1991,Ap 19,C17:1
Weininger's Last Night 1991,Ag 1,C14:4
Koller, Xavier (Director)
Journey of Hope 1991,Ap 26,C13:1
Koller, Xavier (Screenwriter)
Journey of Hope 1991,Ap 26,C13:1
Kolodziejski, Krzystof (Screenwriter)
Birthday Trip, The 1991,Mr 26,C14:3
Kolsrud, Dan (Producer)
Memoirs of an Invisible Man 1992,F 28,C17:1
Koltai, Lajos (Cinematographer)
Mobsters 1991,Jl 26,C18:4
Meeting Venus 1991,N 15,C1:3
Koltay, Robert
Memoirs of a River 1992,Mr 20,C15:1
Kolvig, Lars (Producer)
Memories of a Marriage 1991,Ja 28,C20:3
Komorowska, Maja
Inventory 1991,S 24,C13:2
Komuro, Tetsuya (Composer)
Heaven and Earth 1991,Mr 1,C10:4
Konchalovsky, Andrei (Director)
Inner Circle, The 1991,D 25,20:1
Inner Circle, The 1992,Ja 19,II:13:5
Konchalovsky, Andrei (Screenwriter)
Inner Circle, The 1991,D 25,20:1
Kong Lin
Raise the Red Lantern 1992,Mr 20,C18:1
Konner, Lawrence (Miscellaneous)
Star Trek VI: The Undiscovered Country 1991,D
6,C1:1
Kopache, Thomas
Liebestraum 1991,S 13,C6:1
Kopelson, Arnold (Producer)
Out for Justice 1991,Ap 13,12:4
Koppel, Anders (Composer)
Birthday Trip, The 1991,Mr 26,C14:3
Kopple, Barbara (Director)
American Dream 1992,Mr 19,C16:6
Korda, David (Producer)
Shattered 1991,O 11,C24:3
Kore, Daki
Captive of the Desert, The (Captive du Desert, La)
1991,Mr 21,C20:3
Kore, Dobi
Captive of the Desert, The (Captive du Desert, La)
1991,Mr 21,C20:3
Kore, Isai
Captive of the Desert, The (Captive du Desert, La)
1991,Mr 21,C20:3
Kornis, Anna (Miscellaneous)
Shadow on the Snow 1992,Mr 31,C16:1
Korsmo, Charlie
What About Bob? 1991,My 17,C15:1
Doctor, The 1991,Jl 24,C11:1
Hook 1991,D 11,C17:3
Hook 1991,D 22,II:23:1
Kostiukovsky, Mikhail (Producer)
Raspad 1992,Ap 29,C15:1
Kotcheff, Ted (Director)
Folks! 1992,My 4,C15:1
Koteas, Elias
Adjuster, The 1991,S 26,C18:5
Adjuster, The 1991,S 26,C18:5
Adjuster, The 1992,My 30,13:1
Kotto, Yaphet
Freddy's Dead: The Final Nightmare 1991,S 14,11:4
Kotzwinkle, William (Original Author)
Book of Love 1991,F 1,C10:6

Kotzwinkle, William (Screenwriter)
Book of Love 1991,F 1,C10:6
Kouri, Pentti (Producer)
Amazon 1992,F 28,C8:5
Kourmarianou, Irene
Quiet Days in August 1992,Mr 29,48:1
Kovacs, Attila (Miscellaneous)
Where 1991,S 6,C13:1
Meeting Venus 1991,N 15,C1:3
Kovacs, Laszlo (Cinematographer)
Shattered 1991,O 11,C24:3
Radio Flyer 1992,F 21,C16:1
Kowalski, Lech (Director)
Rock Soup 1992,Ap 8,C22:3
Chico and the People 1992,Ap 8,C22:3
Kowalski, Lech (Miscellaneous)
Rock Soup 1992,Ap 8,C22:3
Kowalski, Lech (Producer)
Rock Soup 1992,Ap 8,C22:3
Kozak, Harley Jane
Necessary Roughness 1991,S 27,C21:3
Taking of Beverly Hills, The 1991,O 13,68:5
All I Want for Christmas 1991,N 8,C14:1
Kozlowski, Piotr
Korczak 1991,Ap 12,C8:1
Europa, Europa 1991,Je 28,C10:1
Kozoll, Michael (Miscellaneous)
Hard Way, The 1991,Mr 8,C8:1
Krabbe, Jeroen
Kafka 1991,D 4,C21:1
Prince of Tides, The 1991,D 25,13:3
Krabbe, Tim (Original Author)
Vanishing, The 1991,Ja 25,C8:1
Krabbe, Tim (Screenwriter)
Vanishing, The 1991,Ja 25,C8:1
Kraft, Robert (Composer)
Hudson Hawk 1991,My 24,C8:4
Kraft, Robert (Miscellaneous)
Hudson Hawk 1991,My 24,C8:4
Krahl, Hilde
Other Eye, The 1991,S 25,C17:1
Krakowski, Andrzej (Miscellaneous)
Eminent Domain 1991,Ap 12,C13:4
Krakowski, Andrzej (Screenwriter)
Eminent Domain 1991,Ap 12,C13:4
Krakowski, Jane
Stepping Out 1991,O 4,C26:4
Kramer, David H.
June Roses 1992,Mr 24,C15:3
Kramer, Hilton
Superstar: The Life and Times of Andy Warhol
1991,F 22,C8:1
Kramer, Richard (Screenwriter)
All I Want for Christmas 1991,N 8,C14:1
Krane, Jonathan D. (Producer)
Convicts 1991,D 6,C14:6
Cold Heaven 1992,My 29,C15:1
Breaking the Rules 1992,O 9,C10:6
Kraner, Doug (Miscellaneous)
Sleeping with the Enemy 1991,F 8,C10:1
Curly Sue 1991,O 25,C15:1
Raising Cain 1992,Ag 7,C5:1
Krause, Brian
Return to the Blue Lagoon 1991,Ag 2,C12:1
December 1991,D 6,C8:5
Sleepwalkers 1992,Ap 11,18:1
Kravetz, Carole (Miscellaneous)
December 1991,D 6,C8:5
One False Move 1992,Jl 17,C6:1
Krawitz, Jan (Director)
Drive-In Blues 1992,Ag 26,C15:1
Krbova, Ljoba
End of Old Times, The 1992,Ja 10,C12:6
Kreihsl, Michael (Composer)
Echoes from a Somber Empire 1992,Jl 15,C15:3
Krenz, Egon
November Days 1992,My 8,C8:1
Kreuzer, Lisa
Berlin Jerusalem 1991,Mr 8,C16:6
Krige, Alice
Sleepwalkers 1992,Ap 11,18:1
Krishna, Lalitha (Miscellaneous)
Idiot 1992,O 8,C21:4
Krishtofovich, Vyacheslav (Director)
Adam's Rib 1991,S 21,12:5
Adam's Rib 1992,My 9,17:2
Kristiansen, Henning (Cinematographer)
Day in October, A 1992,O 28,C20:5

Kristinsson, Ari (Cinematographer)
　Children of Nature 1992,Ap 2,C18:3
Kristjansdottir, Edda (Miscellaneous)
　Shadow of the Raven, The 1991,Jl 13,12:1
Kroeger, Wolf (Miscellaneous)
　Last of the Mohicans, The 1992,S 25,C3:1
Kroner, Josef
　Shadow on the Snow 1992,Mr 31,C16:1
Kroopf, Scott (Producer)
　Class Action 1991,Mr 15,C20:4
　Bill and Ted's Bogus Journey 1991,Jl 19,C10:1
　Paradise 1991,S 18,C16:3
Kroyer, Bill (Director)
　Ferngully: The Last Rain Forest 1992,Ap 10,C10:5
Kruger-Tayler, Sonia
　Strictly Ballroom 1992,S 26,12:5
Kubo, Naoko
　Homemade Movie 1991,Mr 26,C14:3
Kubrick, Stanley (Director)
　Spartacus 1991,Ap 26,C6:4
Kuenster, T. J. (Composer)
　Rock-a-Doodle 1992,Ap 3,C13:1
Kuhn, Beth (Miscellaneous)
　Misplaced 1991,Mr 1,C9:1
Kuhn, Toni (Cinematographer)
　Vanishing, The 1991,Ja 25,C8:1
Kuhnen, Michael
　November Days 1992,My 8,C8:1
Kunene, Sipho
　Sarafina! 1992,S 18,C16:6
Kunin, Vladimir (Screenwriter)
　Adam's Rib 1991,S 21,12:5
Kunstler, William
　Doors, The 1991,Mr 1,C1:1
　Malcolm X 1992,N 18,C19:3
Kuosmanen, Sakari
　Night on Earth 1991,O 4,C1:3
Kuprianov, Sergei
　Guard, The (Karaul) 1991,Mr 24,64:1
　Satan 1992,Mr 28,18:1
　Satan 1992,Je 24,C18:6
Kuras, Ellen (Cinematographer)
　Swoon 1992,Mr 27,C8:1
Kurchatkin, Anatoly (Original Author)
　Adam's Rib 1991,S 21,12:5
Kureishi, Hanif (Director)
　London Kills Me 1992,Ag 7,C19:1
Kureishi, Hanif (Screenwriter)
　London Kills Me 1992,Ag 7,C19:1
Kurita, Toyomichi (Cinematographer)
　Rage in Harlem, A 1991,My 3,C14:1
　Convicts 1991,D 6,C14:6
Kuroki, Hitomi
　Traffic Jam 1992,Mr 20,C20:4
Kurosawa, Akira (Director)
　Rhapsody in August 1991,My 19,II:13:1
　Rhapsody in August 1991,D 20,C22:4
Kurosawa, Akira (Screenwriter)
　Rhapsody in August 1991,My 19,II:13:1
　Rhapsody in August 1991,D 20,C22:4
Kurosawa, Hisao (Producer)
　Rhapsody in August 1991,D 20,C22:4
Kurotsuchi, Mitsuo (Director)
　Traffic Jam 1992,Mr 20,C20:4
Kurotsuchi, Mitsuo (Screenwriter)
　Traffic Jam 1992,Mr 20,C20:4
Kurson, Jane (Miscellaneous)
　Hot Shots! 1991,Jl 31,C11:2
　Love Field 1992,D 11,C6:3
Kurts, Alwyn
　Efficiency Expert, The 1992,N 6,C8:1
Kurtz, Joyce
　Professional, The 1992,O 23,C14:5
Kurtz, Michael
　Class of Nuke 'Em High Part 2: Subhumanoid
　　Meltdown 1991,Ap 12,C13:1
Kurys, Diane (Producer)
　For Sasha 1992,Je 5,C13:1
Kusakari, Masao
　Enchantment, The 1992,My 20,C15:3
Kuss, Richard
　Warlock 1991,Mr 30,11:4
Kut, Stefan (Miscellaneous)
　Final Approach 1992,Mr 13,C8:4
Kuznetcova, Olga
　Raspad 1992,Ap 29,C15:1
Kuznetsova, Larisa
　Close to Eden 1992,O 30,C10:5

Kuznetsova, Marina
　Hey, You Wild Geese 1992,Ap 2,C20:5
Kuzui, Fran Rubel (Director)
　Buffy the Vampire Slayer 1992,Jl 31,C8:5
Kuzui, Kaz (Producer)
　Buffy the Vampire Slayer 1992,Jl 31,C8:5
Kwan, Rosamund
　Once Upon a Time in China 1992,My 21,C16:5
Kwapis, Ken (Director)
　He Said, She Said 1991,F 22,C17:1
Kwei, James Y. (Miscellaneous)
　Iron and Silk 1991,F 15,C12:5

L

L.L. Cool J.
　Hard Way, The 1991,Mr 8,C8:1
　Toys 1992,D 18,C1:3
Labadie, Jean (Producer)
　Indochine 1992,D 24,C9:1
Labarthe, Samuel
　Elegant Criminel, L' 1992,Je 24,C18:3
Labeija, Pepper
　Paris Is Burning 1991,Mr 13,C13:1
LaBrie, Richard (Miscellaneous)
　Blood and Concrete 1991,S 13,C9:1
LaBrie, Richard (Producer)
　Blood and Concrete 1991,S 13,C9:1
LaBrie, Richard (Screenwriter)
　Blood and Concrete 1991,S 13,C9:1
Labuda, Marian
　Meeting Venus 1991,N 15,C1:3
　End of Old Times, The 1992,Ja 10,C12:6
La Cava, Gregory (Director)
　My Man Godfrey 1992,Ag 21,C1:1
La Chanze
　Leap of Faith 1992,D 18,C14:1
Lachapelle, Andree
　Leolo 1992,S 29,C11:1
Lachman, Ed (Cinematographer)
　Mississippi Masala 1992,F 5,C15:1
　London Kills Me 1992,Ag 7,C19:1
　Light Sleeper 1992,Ag 21,C12:5
　My New Gun 1992,O 30,C10:1
Lack, Stephen
　All the Vermeers in New York 1992,My 1,C13:1
Lacomblez, Antoine (Screenwriter)
　For Sasha 1992,Je 5,C13:1
Lacroix, Violaine
　Tous les Matins du Monde 1992,N 13,C3:4
Ladd, Cheryl
　Poison Ivy 1992,My 8,C16:3
Ladd, Diane
　Rambling Rose 1991,S 20,C12:4
　Rambling Rose 1992,F 9,II:13:1
Ladoire, Oscar
　Most Beautiful Night, The 1992,N 20,C10:5
Lafayette, John
　White Sands 1992,Ap 24,C18:1
Lafer, Suzy (Miscellaneous)
　Naked Gun 2 1/2: The Smell of Fear 1991,Je 28,C8:1
LaFleur, Art
　Rampage 1992,O 30,C27:1
　Forever Young 1992,D 16,C17:1
Lafont, Bernadette
　Inspector Lavardin 1991,D 26,C13:1
Lafontaine, Lyse (Producer)
　Leolo 1992,S 29,C11:1
La Frenais, Ian (Screenwriter)
　Commitments, The 1991,Ag 14,C11:1
Lagerroos, Kjell (Cinematographer)
　Daddy and the Muscle Academy 1992,D 2,C18:4
Lagola, Charles (Miscellaneous)
　American Blue Note 1991,Mr 29,C12:1
　Little Noises 1992,Ap 24,C8:6
　Bad Lieutenant 1992,N 20,C15:1
LaGravenese, Richard (Screenwriter)
　Fisher King, The 1991,S 20,C10:4
　Fisher King, The 1991,S 22,II:13:1
Laguna, Sylvie
　Delicatessen 1991,O 5,14:3
　Delicatessen 1992,Ap 5,53:2
Lahti, Christine
　Doctor, The 1991,Jl 24,C11:1
　Leaving Normal 1992,Ap 29,C17:1

Laika
　Vie de Boheme, La 1992,O 9,C14:1
Laing, Bob (Miscellaneous)
　Neverending Story II, The: The Next Chapter 1991,F
　　9,12:4
Laird, Peter (Miscellaneous)
　Teen-Age Mutant Ninja Turtles II: The Secret of the
　　Ooze 1991,Mr 22,C1:3
Lake, Ricki
　Where the Day Takes You 1992,S 11,C14:5
Lalinde, Rodrigo (Cinematographer)
　Rodrigo D: No Future 1991,Ja 11,C10:5
Lam, Nora (Original Author)
　China Cry 1991,My 3,C9:1
LaMarre, Jean
　Malcolm X 1992,N 18,C19:3
Lambert, Dennis (Composer)
　American Me 1992,Mr 13,C6:5
Lambert, Mary (Director)
　Pet Sematary Two 1992,Ag 29,14:4
Lambrecht, Yves
　Tous les Matins du Monde 1992,N 13,C3:4
Lamdo, Mao (Director)
　Robot Carnival 1991,Mr 15,C14:5
Lamont, Peter (Miscellaneous)
　Eve of Destruction 1991,Ja 19,22:6
　Taking of Beverly Hills, The 1991,O 13,68:5
Lampert, Zohra
　Opening Night 1991,My 17,C11:1
　Alan and Naomi 1992,Ja 31,C8:5
Lampreave, Chus
　Wait for Me in Heaven (Esperame en el Cielo)
　　1991,Ja 30,C10:5
Lancaster, Burt
　1900 1991,F 1,C1:1
Lanci, Giuseppe (Cinematographer)
　Johnny Stecchino 1992,O 9,C8:5
Landa, Alfredo
　Bosque Animado, El (Enchanted Forest, The)
　　1992,D 4,C8:6
Landau, Martin
　Mistress 1992,Ag 7,C16:3
Landau, Neil (Screenwriter)
　Don't Tell Mom the Babysitter's Dead 1991,Je
　　7,C19:1
Landis, John
　Venice/Venice 1992,O 28,C20:5
Landis, John (Director)
　Oscar 1991,Ap 26,C10:5
　Innocent Blood 1992,S 25,C6:5
Landon, Hal, Jr.
　Bill and Ted's Bogus Journey 1991,Jl 19,C10:1
Lane, Charles
　True Identity 1991,Ag 23,C16:1
Lane, Charles (Director)
　True Identity 1991,Ag 23,C16:1
Lane, Diane
　My New Gun 1992,O 30,C10:1
　Chaplin 1992,D 25,C3:1
Lane, Nathan
　He Said, She Said 1991,F 22,C17:1
　Frankie and Johnny 1991,O 11,C1:1
Lang, Bernard (Producer)
　Benny's Video 1992,S 28,C14:1
Lang, Stephen
　Hard Way, The 1991,Mr 8,C8:1
Lange, Anne
　Shadows and Fog 1992,Mr 20,C6:1
Lange, Jessica
　Cape Fear 1991,N 13,C17:1
　Cape Fear 1992,Ja 26,II:11:1
　Night and the City 1992,O 10,11:3
　Night and the City 1992,O 11,II:11:1
Langella, Frank
　True Identity 1991,Ag 23,C16:1
　1492: Conquest of Paradise 1992,O 9,C21:1
Langen, Todd W. (Screenwriter)
　Teen-Age Mutant Ninja Turtles II: The Secret of the
　　Ooze 1991,Mr 22,C1:3
Langer, A. J.
　People Under the Stairs, The 1991,N 2,17:1
Langlais, Randy (Producer)
　Love Crimes 1992,Ja 26,43:5
Langmann, Arlette (Screenwriter)
　Uranus 1991,Ag 23,C15:1
Langmann, Thomas
　Alberto Express 1992,O 9,C12:5
　Night and Day 1992,D 11,C10:6

557

Lansberg, Charlotte (Composer)
Hugh Hefner: Once Upon a Time 1992,N 6,C10:3
Lansbury, Angela
Beauty and the Beast 1991,N 13,C17:4
Lansbury, David
Gas Food Lodging 1992,Jl 31,C1:1
Lanser, Roger (Cinematographer)
Peter's Friends 1992,D 25,C8:6
Lansing, Sherry (Producer)
School Ties 1992,S 18,C19:1
Lantos, Robert (Producer)
Black Robe 1991,O 30,C15:2
LaPaglia, Anthony
He Said, She Said 1991,F 22,C17:1
One Good Cop 1991,My 3,C13:1
29th Street 1991,N 1,C14:1
Whispers in the Dark 1992,Ag 7,C17:1
Innocent Blood 1992,S 25,C6:5
La Pegna, Arturo (Producer)
Fine Romance, A 1992,O 2,C10:6
Lapicki, Andrzej
Inventory 1991,S 24,C13:2
Lapiduss, Maxine
Wisecracks 1992,Je 4,C17:1
Lapierre, Dominique (Original Author)
City of Joy 1992,Ap 15,C15:1
Lapine, James (Director)
Impromptu 1991,Ap 12,C10:5
Impromptu 1991,Je 16,II:11:5
Lapipe, Jean-Francois
Jacquot de Nantes 1991,S 25,C16:3
Larcher, Geoffrey (Miscellaneous)
Tatie Danielle 1991,My 17,C8:1
Larionov, Vsevolod
Inner Circle, The 1991,D 25,20:1
Larkin, Linda
Aladdin 1992,N 11,C15:3
Larkin, Peter (Miscellaneous)
Life Stinks 1991,Jl 26,C19:1
Night and the City 1992,O 10,11:3
Laroque, Michele
Hairdresser's Husband, The 1992,Je 19,C11:1
Larsen, Annabelle
Alligator Eyes 1991,F 15,C15:1
Larsen, Kenji (Director)
Shirt 1991,S 22,58:5
Larsen, Lars Oluf
Day in October, A 1992,O 28,C20:5
Lartigau, Gerard
Indochine 1992,D 24,C9:1
Lasker, Lawrence (Producer)
Sneakers 1992,S 9,C18:3
Lasker, Lawrence (Screenwriter)
Sneakers 1992,S 9,C18:3
Lassally, Walter (Cinematographer)
Ballad of the Sad Cafe, The 1991,Mr 28,C11:1
Lassick, Sydney
Cool as Ice 1991,O 19,12:6
Laston, Dan (Producer)
Chameleon Street 1991,Ap 24,C11:3
Laszlo, Andrew (Cinematographer)
Newsies 1992,Ap 8,C22:3
Latham, Louise
Love Field 1992,D 11,C6:3
Latorraca, Ney
Fable of the Beautiful Pigeon Fancier, The 1991,Mr 1,C6:4
LaToure, Ron (Cinematographer)
Frozen Assets 1992,O 24,16:4
Lau Chia-hua (Screenwriter)
Five Girls and a Rope 1992,Mr 22,48:1
Lau Kar-ling, Karina
Days of Being Wild 1991,Mr 23,12:3
Lau Tak-wah, Andy
Days of Being Wild 1991,Mr 23,12:3
Laub, Lindy (Miscellaneous)
For the Boys 1991,N 22,C12:1
Laub, Lindy (Screenwriter)
For the Boys 1991,N 22,C12:1
Laufer, Erez (Miscellaneous)
Branford Marsalis: The Music Tells You 1992,Je 26,C12:6
Laughton, Charles
Spartacus 1991,Ap 26,C6:4
They Knew What They Wanted 1992,Ag 21,C1:1
Launer, Dale (Director)
Love Potion No. 9 1992,N 13,C12:5

Launer, Dale (Producer)
My Cousin Vinny 1992,Mr 13,C6:1
Love Potion No. 9 1992,N 13,C12:5
Launer, Dale (Screenwriter)
My Cousin Vinny 1992,Mr 13,C6:1
Love Potion No. 9 1992,N 13,C12:5
Laure, Odette
Daddy Nostalgia 1991,Ap 12,C10:1
Lauren, Veronica
Forever Young 1992,D 16,C17:1
Laurence, Ashley
Hellraiser III: Hell on Earth 1992,S 12,14:3
Laurence, Gerald (Screenwriter)
Final Approach 1992,Mr 13,C8:4
Laurent, Christine (Screenwriter)
Belle Noiseuse, La 1991,O 2,C17:5
Laurie, Hugh
Peter's Friends 1992,D 25,C8:6
Laurie, Piper
Other People's Money 1991,O 18,C10:3
Storyville 1992,Ag 26,C13:3
Lauter, Ed
Rocketeer, The 1991,Je 21,C1:3
School Ties 1992,S 18,C19:1
Lautner, Georges (Director)
Maison Assassinee, La (Murdered House, The) 1991,O 25,C10:5
Lautner, Georges (Screenwriter)
Maison Assassinee, La (Murdered House, The) 1991,O 25,C10:5
Lauzon, Jean-Claude (Director)
Leolo 1992,My 18,C13:6
Leolo 1992,S 29,C11:1
Lauzon, Jean-Claude (Screenwriter)
Leolo 1992,S 29,C11:1
Lavant, Denis
Amants du Pont Neuf, Les (Lovers of the Pont Neuf) 1992,O 6,C16:1
Amants du Pont Neuf, Les 1992,O 11,II:11:1
Lavista, Mario (Composer)
Cabeza de Vaca 1991,Mr 23,12:6
Law, Clara (Director)
Autumn Moon 1992,S 26,12:1
Autumn Moon 1992,O 11,II:11:1
Law, Clara (Producer)
Autumn Moon 1992,S 26,12:1
Law, Lindsay (Producer)
Thank You and Good Night 1992,Ja 29,C20:4
Law, Phyllida
Peter's Friends 1992,D 25,C8:6
Lawaetz, Gudie (Screenwriter)
Berlin Jerusalem 1991,Mr 8,C16:6
Lawrence, Elizabeth
Sleeping with the Enemy 1991,F 8,C10:1
Lawrence, Josie
Enchanted April 1992,Jl 31,C15:1
Lawrence, Marc
Ruby 1992,Mr 27,C1:3
Lawrence, Martin
Boomerang 1992,Jl 1,C18:1
Lawrence, Robert (Producer)
Kiss Before Dying, A 1991,Ap 26,C12:6
Rapid Fire 1992,Ag 21,C11:1
Lawson, Tony (Miscellaneous)
Crisscross 1992,My 9,17:5
Cold Heaven 1992,My 29,C15:1
Lawton, J. F. (Screenwriter)
Mistress 1992,Ag 7,C16:3
Under Siege 1992,O 9,C12:1
Layton, Vernon (Cinematographer)
Under Suspicion 1992,F 28,C10:1
Lazar, Paul
29th Street 1991,N 1,C14:1
Lazare, Veronica
Berlin Jerusalem 1991,Mr 8,C16:6
Lazenberg, Christophe (Cinematographer)
Truth or Dare 1991,My 10,C1:3
Lea, Ron
Clearcut 1992,Ag 21,C9:1
Leacock, Robert (Cinematographer)
Truth or Dare 1991,My 10,C1:3
Leaf, Caroline (Director)
Caroline Leaf: An Animated Life 1992,My 6,C18:3
Leahy, Joe
Black Harvest 1992,Ap 4,17:1
Leao, Danuza
Earth Entranced (Terra em Transe) 1991,O 5,14:5

Leary, Timothy
Ted and Venus 1991,D 20,C23:1
Roadside Prophets 1992,Mr 27,C10:1
Leaud, Jean-Pierre
Two English Girls 1992,Ap 5,II:17:5
Vie de Boheme, La 1992,O 9,C14:1
Leavell, Chuck
At the Max 1991,N 22,C15:1
Lebenzon, Chris (Miscellaneous)
Hudson Hawk 1991,My 24,C8:4
Batman Returns 1992,Je 19,C1:1
Leber, Julius
Restless Conscience, The 1992,F 7,C15:1
Le Besco, Maiwenn
Elegant Criminel, L' 1992,Je 24,C18:3
Lebeshev, Pavel (Cinematographer)
Adam's Rib 1991,S 21,12:5
Lebowitz, Fran
Superstar: The Life and Times of Andy Warhol 1991,F 22,C8:1
Resident Alien 1991,O 18,C10:6
Lebreton, Fanny
Jacquot de Nantes 1991,S 25,C16:3
Lebrun, Danielle
Uranus 1991,Ag 23,C15:1
Lecoat, Jenny
Wisecracks 1992,Je 4,C17:1
Leconte, Patrice (Director)
Hairdresser's Husband, The 1992,Je 19,C11:1
Leconte, Patrice (Miscellaneous)
Hairdresser's Husband, The 1992,Je 19,C11:1
Leconte, Patrice (Screenwriter)
Hairdresser's Husband, The 1992,Je 19,C11:1
Le Coq, Bernard
Van Gogh 1992,O 30,C16:5
Lederer, Francis
Other Eye, The 1991,S 25,C17:1
Lee, Brandon
Showdown in Little Tokyo 1991,S 22,58:6
Rapid Fire 1992,Ag 21,C11:1
Lee, Chi-Hung
Song of the Exile 1991,Mr 15,C21:1
Lee, Christopher
Innocent Blood 1992,S 25,C6:5
Lee, Danny
Killer, The 1991,Ap 12,C11:1
Lee, Franne (Miscellaneous)
Dead Ringer 1991,Jl 17,C14:5
Lee, Joie
Fathers and Sons 1992,N 6,C17:1
Lee, Maria (Miscellaneous)
Together Alone 1992,S 23,C18:4
Lee, Sheryl
Twin Peaks: Fire Walk with Me 1992,Ag 29,11:1
Lee, Spencer
Garden, The 1991,Ja 17,C16:5
Lee, Spike
Jungle Fever 1991,My 17,C1:1
Jungle Fever 1991,Je 7,C1:2
Malcolm X 1992,N 18,C19:3
Lee, Spike (Director)
Jungle Fever 1991,My 17,C1:1
Jungle Fever 1991,Je 7,C1:2
Jungle Fever 1991,Je 23,II:20:1
She's Gotta Have It 1992,F 9,II:13:1
Malcolm X 1992,N 6,C1:1
Malcolm X 1992,N 18,C19:3
Lee, Spike (Producer)
Jungle Fever 1991,Je 7,C1:2
Malcolm X 1992,N 18,C19:3
Lee, Spike (Screenwriter)
Jungle Fever 1991,My 17,C1:1
Jungle Fever 1991,Je 7,C1:2
Malcolm X 1992,N 18,C19:3
Lee, Virginia (Miscellaneous)
Poison Ivy 1992,My 8,C16:3
Lee Yi-shu (Cinematographer)
Five Girls and a Rope 1992,Mr 22,48:1
Lee-Wilson, Pete
Garden, The 1991,Ja 17,C16:5
Le Gaf, Gaston
Bikini Island 1991,Jl 27,16:3
Legler, Steven (Miscellaneous)
Rage in Harlem, A 1991,My 3,C14:1
Cold Heaven 1992,My 29,C15:1
Le Gros, James
Point Break 1991,Jl 12,C12:6
Blood and Concrete 1991,S 13,C9:1

Lewis, Joseph H. (Director)
Terror in a Texas Town 1991,My 17,C16:4
Lewis, Juliette
Crooked Hearts 1991,S 6,C13:1
Cape Fear 1991,N 13,C17:1
Husbands and Wives 1992,S 18,C1:1
Husbands and Wives 1992,O 4,II:9:1
Lewis, Mark (Director)
Wonderful World of Dogs, The 1991,My 23,C14:3
Lewis, Mark (Screenwriter)
Wonderful World of Dogs, The 1991,My 23,C14:3
Lewis, Phill
Aces: Iron Eagle III 1992,Je 13,16:4
Lewis, Richard
Once Upon a Crime 1992,Mr 7,20:4
Lewis, Richard (Miscellaneous)
Whore 1991,O 4,C15:1
Lewis, Richard B. (Producer)
Backdraft 1991,My 24,C14:6
Robin Hood: Prince of Thieves 1991,Je 14,C1:4
Lewis, Terry (Composer)
Mo' Money 1992,Jl 25,15:1
Lewitt, Elliott (Producer)
Shadow of China 1991,Mr 10,58:5
L'Homme, Pierre (Cinematographer)
Voyager 1992,Ja 31,C6:1
Li Bao-Tian
Ju Dou 1991,Mr 17,68:1
Woman Demon Human 1992,S 4,C11:1
Li Pui Wai
Autumn Moon 1992,S 26,12:1
Autumn Moon 1992,O 11,II:11:1
Lichtenheld, Ted
Heck with Hollywood!, The 1991,O 9,C15:1
Lieberman, Charlie (Cinematographer)
South-Central 1992,O 16,C13:1
Lieberman, Robert (Director)
All I Want for Christmas 1991,N 8,C14:1
Liebig, Margaret
Finding Christa 1992,Mr 24,C15:3
Liechti, Hans (Cinematographer)
Leo Sonnyboy 1991,Mr 16,16:4
Lierras, Anibel
Laws of Gravity 1992,Mr 21,18:1
Lifford, Tina
Grand Canyon 1991,D 25,18:1
Light, Allie (Director)
In the Shadow of the Stars 1991,Ag 14,C15:1
Light, Allie (Miscellaneous)
In the Shadow of the Stars 1991,Ag 14,C15:1
Light, Allie (Producer)
In the Shadow of the Stars 1991,Ag 14,C15:1
Light-Harris, Donald (Miscellaneous)
Breaking the Rules 1992,O 9,C10:6
Liguori, Paola
Intervista 1992,N 20,C10:1
Lin, Deng-Fei (Producer)
Song of the Exile 1991,Mr 15,C21:1
Lin Mei-ling
Rouge of the North 1991,D 6,C24:5
Lin Tung-fei (Producer)
Rouge of the North 1991,D 6,C24:5
Linares, Aida
Regarding Henry 1991,Jl 10,C13:3
Lincovski, Cope
Naked Tango 1991,Ag 23,C19:1
Lind, Traci
Voyager 1992,Ja 31,C6:1
Lindenlaub, Karl Walter (Cinematographer)
Universal Soldier 1992,Jl 10,C17:1
Linder, Stu (Miscellaneous)
Toys 1992,D 18,C1:3
Lindfors, Viveca
Misplaced 1991,Mr 1,C9:1
Linguini Incident, The 1992,My 1,C15:1
Lindley, John (Cinematographer)
Sleeping with the Enemy 1991,F 8,C10:1
Father of the Bride 1991,D 20,C17:1
Sneakers 1992,S 9,C18:3
Lindo, Delroy
Hard Way, The 1991,Mr 8,C8:1
Bright Angel 1991,Je 14,C6:1
Malcolm X 1992,N 18,C19:3
Lindsay, Arto
Step Across the Border 1992,F 19,C15:1
Lindsay-Hogg, Michael (Director)
Object of Beauty, The 1991,Ap 12,C14:4

Lindsay-Hogg, Michael (Screenwriter)
Object of Beauty, The 1991,Ap 12,C14:4
Lineweaver, Stephen (Miscellaneous)
Singles 1992,S 18,C3:4
Ling, Barbara (Miscellaneous)
Doors, The 1991,Mr 1,C1:1
V. I. Warshawski 1991,Jl 26,C1:3
Fried Green Tomatoes 1991,D 27,C3:1
Link, John F. (Miscellaneous)
Hand That Rocks the Cradle, The 1992,Ja 10,C8:1
Mighty Ducks, The 1992,O 2,C18:1
Linklater, Richard
Slacker 1991,Mr 22,C8:1
Linklater, Richard (Director)
Slacker 1991,Mr 22,C8:1
Slacker 1991,Jl 5,C6:5
Linklater, Richard (Producer)
Slacker 1991,Mr 22,C8:1
Linklater, Richard (Screenwriter)
Slacker 1991,Mr 22,C8:1
Linn, Garret (Director)
John Lurie and the Lounge Lizards Live in Berlin
1991 1992,S 9,C14:5
Linn-Baker, Mark
Noises Off 1992,Mr 20,C10:1
Lio
Window Shopping 1992,Ap 17,C13:1
Liotard, Therese
My Father's Glory (Gloire de Mon Pere, Le) 1991,Je
21,C10:5
My Mother's Castle 1991,Jl 26,C6:1
Liotta, Ray
Article 99 1992,Mr 13,C10:1
Unlawful Entry 1992,Je 26,C10:4
Unlawful Entry 1992,Ag 16,II:15:1
Lipinski, Eugene
Perfectly Normal 1991,F 15,C14:5
Lipinski, Eugene (Screenwriter)
Perfectly Normal 1991,F 15,C14:5
Lipsky, Mark (Producer)
Boomerang 1992,Jl 1,C18:1
Lisi, Joe
Traces of Red 1992,N 12,C22:1
Lisova, Raisa (Miscellaneous)
Second Circle, The 1992,Ja 2,C15:1
Litchfield, Tim (Miscellaneous)
Good Woman of Bangkok, The 1992,My 15,C13:1
Lithgow, John
Ricochet 1991,O 5,12:6
At Play in the Fields of the Lord 1991,D 6,C8:1
Raising Cain 1992,Ag 7,C5:1
Raising Cain 1992,Ag 16,II:15:1
Litteral, Hollywood Paul
At the Max 1991,N 22,C15:1
Little, Dwight H. (Director)
Rapid Fire 1992,Ag 21,C11:1
Littleton, Carol (Miscellaneous)
Grand Canyon 1991,D 25,18:1
Litwak, Ezra (Screenwriter)
Butcher's Wife, The 1991,O 25,C24:1
Liu, Harrison
Black Robe 1991,N 17,II:24:2
Liu Heng (Screenwriter)
Story of Qiu Ju, The 1992,O 2,C12:1
Liu Pei Qi
Story of Qiu Ju, The 1992,O 2,C12:1
Liu Zhongyuan
Life on a String 1991,S 29,54:5
Life on a String 1992,Ja 10,C16:6
Liubomirova, Dobrina
City of the Blind (Ciudad de Ciegos) 1992,Ap 4,17:5
Lively, Gerry (Cinematographer)
Hellraiser III: Hell on Earth 1992,S 12,14:3
Livi, Jean-Louis (Producer)
Tous les Matins du Monde 1992,N 13,C3:4
Livingston, Jennie (Director)
Paris Is Burning 1991,Mr 13,C13:1
Livingston, Jennie (Producer)
Paris Is Burning 1991,Mr 13,C13:1
Livingston, Kimball (Miscellaneous)
Wind 1992,S 11,C3:1
Livingstone, Russell (Miscellaneous)
Where the Day Takes You 1992,S 11,C14:5
Lloyd, Christopher
Suburban Commando 1991,O 6,56:3
Addams Family, The 1991,N 22,C1:1
Lloyd, Emily
River Runs Through It, A 1992,O 9,C1:3

Lloyd, John J. (Miscellaneous)
Naked Gun 2 1/2: The Smell of Fear 1991,Je 28,C8:1
Brenda Starr 1992,Ap 19,46:1
Lloyd, Lauren (Producer)
Butcher's Wife, The 1991,O 25,C24:1
Lloyd, Walt (Cinematographer)
Kafka 1991,D 4,C21:1
Lobell, Mike (Producer)
Honeymoon in Vegas 1992,Ag 28,C8:5
Lo Bianco, Tony
City of Hope 1991,O 11,C19:1
Locane, Amy
School Ties 1992,S 18,C19:1
Lockhart, Robert (Composer)
On the Black Hill 1991,Ag 16,C8:1
Lockwood, Didier (Composer)
Cold Moon (Lune Froide) 1992,Ap 22,C17:1
Lockwood, Evan
Rambling Rose 1991,S 20,C12:4
Loewy, Ronny
Other Eye, The 1991,S 25,C17:1
Loftis, Norman (Director)
Small Time 1991,N 8,C11:1
Loftis, Norman (Miscellaneous)
Small Time 1991,N 8,C11:1
Loftis, Norman (Producer)
Small Time 1991,N 8,C11:1
Loftis, Norman (Screenwriter)
Small Time 1991,N 8,C11:1
Logan, Phyllis
Freddie as F.R.O.7 1992,S 1,C11:1
Logan, Ricky Dean
Freddy's Dead: The Final Nightmare 1991,S 14,11:4
Loganbill, Loren
Never Leave Nevada 1991,Ap 28,60:5
Loggia, Kristina
Chopper Chicks in Zombietown 1991,My 10,C15:5
Loggia, Robert
Marrying Man, The 1991,Ap 5,C6:1
Necessary Roughness 1991,S 27,C21:3
Gladiator 1992,Mr 6,C17:1
Innocent Blood 1992,S 25,C6:5
Logothetis, Ilias
Suspended Step of the Stork, The 1991,S 23,C15:1
Lohmann, Dietrich (Cinematographer)
Ted and Venus 1991,D 20,C23:1
Lohr, Aaron
Newsies 1992,Ap 8,C22:3
Loiseleux, Jacques (Cinematographer)
Van Gogh 1992,O 30,C16:5
Lom, Herbert
Pope Must Die(t), The 1991,Ag 30,C10:3
Lombard, Carole
Twentieth Century 1992,Ag 21,C1:1
Vigil in the Night 1992,Ag 21,C1:1
They Knew What They Wanted 1992,Ag 21,C1:1
My Man Godfrey 1992,Ag 21,C1:1
To Be or Not to Be 1992,Ag 21,C1:1
Lombard, Kevin (Cinematographer)
Undertow 1991,S 18,C16:3
Lombardi, Francisco J. (Director)
Fallen from Heaven 1991,Mr 18,C12:3
Lombardi, Francisco J. (Screenwriter)
Fallen from Heaven 1991,Mr 18,C12:3
Lombardi, John R.
Poison 1991,Ap 5,C8:3
Lombardo, Lou (Miscellaneous)
Other People's Money 1991,O 18,C10:3
Lombardo, Tony (Miscellaneous)
Hard Way, The 1991,Mr 8,C8:1
My Cousin Vinny 1992,Mr 13,C6:1
Distinguished Gentleman, The 1992,D 4,C1:4
Londez, Guilaine
Night and Day 1992,D 11,C10:6
London, Alexandra
Van Gogh 1992,O 30,C16:5
London, Andrew (Miscellaneous)
FX2: The Deadly Art of Illusion 1991,My 10,C8:5
London, Jack (Original Author)
White Fang 1991,Ja 18,C16:3
London, Jason
Man in the Moon, The 1991,O 4,C13:1
December 1991,D 6,C8:5
London, Melody (Miscellaneous)
Bright Angel 1991,Je 14,C6:1
London, Micheal B. (Producer)
Rich Girl 1991,My 4,15:1

London, Roy (Director)
 Diary of a Hit Man 1992,My 29,C10:5
Lone, John
 Shadow of China 1991,Mr 10,58:5
Long, Nia
 Boyz 'n the Hood 1991,Jl 12,C1:1
Long, Richard
 Stones and Flies: Richard Long in the Sahara
 1992,Mr 20,C14:5
Long, Shelley
 Frozen Assets 1992,O 24,16:4
Longworth, David
 Reflecting Skin, The 1991,Je 28,C9:1
Loof, Claus (Cinematographer)
 Memories of a Marriage 1991,Ja 28,C20:3
Lopert, Tanya
 Ciel de Paris, Le 1992,Mr 29,48:2
Lopez, Frederick
 White Sands 1992,Ap 24,C18:1
Lopez, Sal
 American Me 1992,Mr 13,C6:5
Lopez Fernandez, Julio
 Dream of Light (Sol del Membrillo, El) 1992,O
 1,C17:1
Lopez Garcia, Antonio
 Dream of Light (Sol del Membrillo, El) 1992,O
 1,C17:1
Lopez Garcia, Antonio (Screenwriter)
 Dream of Light (Sol del Membrillo, El) 1992,O
 1,C17:1
Lopez Garcia, Carmen
 Dream of Light (Sol del Membrillo, El) 1992,O
 1,C17:1
Lopez Garcia, Maria
 Dream of Light (Sol del Membrillo, El) 1992,O
 1,C17:1
Lopez Linares, J. L. (Cinematographer)
 Fallen from Heaven 1991,Mr 18,C12:3
Loquasto, Santo (Miscellaneous)
 Shadows and Fog 1992,Mr 20,C6:1
 Husbands and Wives 1992,S 18,C1:1
Loraschi, Ava
 Tale of Winter, A 1992,O 2,C12:6
Lord Kitchener
 One Hand Don't Clap 1991,Ag 28,C13:1
Lordon, Anne (Producer)
 Vanishing, The 1991,Ja 25,C8:1
Lord Pretender
 One Hand Don't Clap 1991,Ag 28,C13:1
Lorente, Isabelle (Miscellaneous)
 Europa, Europa 1991,Je 28,C10:1
 Olivier, Olivier 1992,S 25,C34:1
Loriaux, Fabienne
 Toto the Hero (Toto le Heros) 1991,S 21,11:1
 Toto the Hero (Toto le Heros) 1992,Mr 6,C12:1
Loridan, Marceline (Director)
 Tale of the Wind, A 1991,Ja 25,C14:6
Loschilin, Ivan (Screenwriter)
 Guard, The (Karaul) 1991,Mr 24,64:1
Lottman, Evan (Miscellaneous)
 Public Eye, The 1992,O 14,C17:1
Loughery, David (Screenwriter)
 Passenger 57 1992,N 6,C14:5
Louise, Tina
 Johnny Suede 1992,Ag 14,C5:5
Louiso, Todd
 Scent of a Woman 1992,D 23,C9:1
Louret, Guy
 Inspector Lavardin 1991,D 26,C13:1
Louw, Ot (Miscellaneous)
 Last Date: Eric Dolphy 1992,Je 29,C16:5
Louzil, Eric (Director)
 Class of Nuke 'Em High Part 2: Subhumanoid
 Meltdown 1991,Ap 12,C13:1
Louzil, Eric (Screenwriter)
 Class of Nuke 'Em High Part 2: Subhumanoid
 Meltdown 1991,Ap 12,C13:1
Love, Brett J. (Director)
 Emil & Fifi 1991,Mr 30,10:4
Love, Brett J. (Producer)
 Emil & Fifi 1991,Mr 30,10:4
Love, Brett J. (Screenwriter)
 Emil & Fifi 1991,Mr 30,10:4
Love, Darlene
 Lethal Weapon 3 1992,My 15,C16:3
Love, Faizon
 Bebe's Kids 1992,Ag 1,16:6

Lovecraft, H. P. (Original Author)
 Bride of Re-Animator 1991,F 22,C17:1
Lovejoy, Ray (Miscellaneous)
 Let Him Have It 1991,D 6,C24:1
 Year of the Comet 1992,Ap 25,17:1
Lovett, Lyle
 Player, The 1992,Ap 10,C16:1
Lovitz, Jon
 American Tail, An: Fievel Goes West 1991,N
 22,C21:1
 League of Their Own, A 1992,Jl 1,C13:4
 Mom and Dad Save the World 1992,Jl 27,C18:4
Lowe, Alex
 Peter's Friends 1992,D 25,C8:6
Lowe, Arvie, Jr.
 Newsies 1992,Ap 8,C22:3
Lowe, Lowell (Composer)
 Killer, The 1991,Ap 12,C11:1
Lowe, Rob
 Dark Backward, The 1991,Jl 26,C18:4
 Wayne's World 1992,F 14,C15:1
Lowens, Curt
 Midnight Clear, A 1992,Ap 24,C1:3
Lowensohn, Elina
 Simple Men 1992,O 14,C22:1
Lowery, Andrew
 School Ties 1992,S 18,C19:1
Lowitsch, Klaus
 Shadow of Angels 1992,Mr 6,C15:1
Lowry, Hunt (Producer)
 Career Opportunities 1991,Mr 31,38:1
 Only the Lonely 1991,My 24,C10:6
 Last of the Mohicans, The 1992,S 25,C3:1
Lu Yuan-chi
 Five Girls and a Rope 1992,Mr 22,48:1
Lubarsky, Anal (Miscellaneous)
 Cup Final 1992,Ag 12,C13:1
Lubitsch, Ernst (Director)
 Carmen 1991,N 10,II:13:1
 To Be or Not to Be 1992,Ag 21,C1:1
Lubtchansky, Nicole (Miscellaneous)
 Belle Noiseuse, La 1991,O 2,C17:5
Lubtchansky, William (Cinematographer)
 Every Other Weekend 1991,Je 19,C12:3
 Belle Noiseuse, La 1991,O 2,C17:5
Luca, Loes
 Voyeur 1991,Ag 2,C9:1
Lucantoni, Dario (Composer)
 Portaborse, Il 1992,D 31,C18:1
Lucarelli, Sir Ralph
 June Roses 1992,Mr 24,C15:3
Lucas, Craig (Original Author)
 Prelude to a Kiss 1992,Jl 10,C10:1
Lucas, Craig (Screenwriter)
 Prelude to a Kiss 1992,Jl 10,C10:1
Lucchesi, Gary (Producer)
 Jennifer 8 1992,N 6,C6:2
Luchetti, Daniele (Director)
 Portaborse, Il 1992,D 31,C18:1
Luchetti, Daniele (Screenwriter)
 Portaborse, Il 1992,D 31,C18:1
Luchini, Fabrice
 Discrete, La 1992,Ag 14,C13:1
Luczyc-Wyhowski, Hugo (Miscellaneous)
 Waterland 1992,O 30,C14:6
Luddy, Tom (Producer)
 Wind 1992,S 11,C3:1
Luft, Herbert G.
 Other Eye, The 1991,S 25,C17:1
Luhrmann, Baz (Director)
 Strictly Ballroom 1992,S 26,12:5
 Strictly Ballroom 1992,O 11,II:11:1
Luhrmann, Baz (Original Author)
 Strictly Ballroom 1992,S 26,12:5
Luhrmann, Baz (Screenwriter)
 Strictly Ballroom 1992,S 26,12:5
Lukesova, Jirina (Miscellaneous)
 Larks on a String 1991,F 13,C14:4
Lulli, Folco
 Wages of Fear, The (Salaire de la Peur, Le) 1991,O
 18,C8:3
Luly, Ann (Producer)
 Shakes the Clown 1992,Mr 13,C13:1
Lumbly, Carl
 South-Central 1992,O 16,C13:1
Lumet, Sidney (Director)
 Stranger Among Us, A 1992,Jl 17,C1:3

Luna, Ernesto
 Complex World 1992,Ap 10,C14:5
Lund, John
 Foreign Affair, A 1991,My 10,C1:1
Lund, Zoe
 Bad Lieutenant 1992,N 20,C15:1
Lund, Zoe (Screenwriter)
 Bad Lieutenant 1992,N 20,C15:1
Lundgren, Dolph
 Showdown in Little Tokyo 1991,S 22,58:6
 Universal Soldier 1992,Jl 10,C17:1
Lundquist, Christine
 In the Shadow of the Stars 1991,Ag 14,C15:1
Lungin, Pavel (Director)
 Taxi Blues 1991,Ja 18,C12:1
 Taxi Blues 1991,F 3,II:13:5
Lungin, Pavel (Screenwriter)
 Taxi Blues 1991,F 3,II:13:5
Lunn, Harry
 Damned in the U.S.A. 1992,N 13,C11:1
Lupo, Rich
 Complex World 1992,Ap 10,C14:5
Lupo, Rich (Producer)
 Complex World 1992,Ap 10,C14:5
Lupovitz, Dan (Producer)
 Late for Dinner 1991,S 20,C6:5
Lurie, Evan (Composer)
 Johnny Stecchino 1992,O 9,C8:5
Lurie, Jeffrey (Producer)
 V. I. Warshawski 1991,Jl 26,C1:3
Lurie, John
 John Lurie and the Lounge Lizards Live in Berlin
 1991 1992,S 9,C14:5
Lutz, John (Original Author)
 Single White Female 1992,Ag 14,C8:1
 Single White Female 1992,Ag 16,II:15:1
Lutzhoft, Asa
 Atlantic Rhapsody: 52 Scenes from Torshavn
 1991,Mr 30,11:1
Lvovsky, Noemie (Screenwriter)
 Sentinelle, La 1992,O 5,C14:3
Lynch, David (Director)
 Twin Peaks: Fire Walk with Me 1992,My 18,C13:6
 Twin Peaks: Fire Walk with Me 1992,Ag 29,11:1
Lynch, David (Screenwriter)
 Twin Peaks: Fire Walk with Me 1992,Ag 29,11:1
Lynch, John
 Edward II 1992,Mr 20,C16:3
Lynch, Kelly
 Curly Sue 1991,O 25,C15:1
Lynd, Laurie (Director)
 R.S.V.P. 1992,Ap 3,C10:1
Lynd, Laurie (Producer)
 Making of "Monsters," The (Avant-Garde Visions)
 1991,O 1,C13:1
Lynn, Jonathan (Director)
 My Cousin Vinny 1992,Mr 13,C6:1
 Nuns on the Run 1992,Je 7,II:13:1
 Distinguished Gentleman, The 1992,D 4,C1:4
Lynn, Jonathan (Screenwriter)
 Nuns on the Run 1992,Je 7,II:13:1
Lyons, Chester (Cinematographer)
 Lucky Star 1991,N 1,C8:1
Lyons, Emilo
 Texas Tenor: The Illinois Jacquet Story 1992,N
 20,C5:1
Lyons, James
 Poison 1991,Ap 5,C8:3
 Poison 1991,Ap 14,II:15:1
Lyons, James (Miscellaneous)
 Poison 1991,Ap 5,C8:3
Lysdal, Jens (Composer)
 Day in October, A 1992,O 28,C20:5
Lyssy, Rolf (Director)
 Leo Sonnyboy 1991,Mr 16,16:4
Lyssy, Rolf (Screenwriter)
 Leo Sonnyboy 1991,Mr 16,16:4

M

Ma Jingwu
 Raise the Red Lantern 1992,Mr 20,C18:1
Ma Ling
 Life on a String 1991,S 29,54:5

Ma, Tzi
Rapid Fire 1992,Ag 21,C11:1
Ma Wang Liang (Producer)
Silk Road, The 1992,My 29,C13:1
Maas, Dick (Producer)
Voyeur 1991,Ag 2,C9:1
McAlpine, Andrew (Miscellaneous)
Deceived 1991,S 27,C8:5
McAlpine, Don (Cinematographer)
Hard Way, The 1991,Mr 8,C8:1
Career Opportunities 1991,Mr 31,38:1
Medicine Man 1992,F 7,C13:1
Patriot Games 1992,Je 5,C1:1
McArdle, Tom (Miscellaneous)
Laws of Gravity 1992,Mr 21,18:1
McArthur, Alex
Rampage 1992,O 30,C27:1
MacArthur, Charles (Screenwriter)
Twentieth Century 1992,Ag 21,C1:1
Macat, Julio (Cinematographer)
Only the Lonely 1991,My 24,C10:6
Borrower, The 1991,O 18,C12:3
Home Alone 2: Lost in New York 1992,N 20,C1:1
McBeath, Tom
Run 1991,F 1,C15:1
McBride, Elizabeth (Miscellaneous)
Fried Green Tomatoes 1991,D 27,C3:1
McBride, Jesse
Triple Bogey on a Par 5 Hole 1992,Mr 21,13:4
McBride, Stephen (Screenwriter)
Edward II 1992,Mr 20,C16:3
McBroom, Lorelei
At the Max 1991,N 22,C15:1
McCallany, Holt
Alien 3 1992,My 22,C1:1
McCallum, David
Hear My Song 1992,Ja 19,48:1
McCamus, Tom
Beautiful Dreamers 1992,Je 5,C15:1
McCann, Chuck
Storyville 1992,Ag 26,C13:3
McCann, Donal
Miracle, The 1991,Jl 3,C12:1
Miracle, The 1991,Ag 2,C11:1
McCann, Sean
Run 1991,F 1,C15:1
McCarthy, Andrew
Year of the Gun 1991,N 1,C10:6
McCarthy, Julia
Year of the Comet 1992,Ap 25,17:1
McCarthy, Kevin
Final Approach 1992,Mr 13,C8:4
Distinguished Gentleman, The 1992,D 4,C1:4
McCarthy, Peter (Producer)
Roadside Prophets 1992,Mr 27,C10:1
McCarthy, Sheila
Stepping Out 1991,O 4,C26:4
Beautiful Dreamers 1992,Je 5,C15:1
McCartney, Linda
Get Back 1991,O 25,C19:1
McCartney, Paul
Get Back 1991,O 25,C19:1
McCarty, Bruce
Blowback 1991,Ag 9,C13:1
McCauley, James
Laws of Gravity 1992,Mr 21,18:1
McCay, Winsor (Miscellaneous)
Little Nemo: Adventures in Slumberland 1992,Ag 21,C13:1
Macchio, Ralph
Too Much Sun 1991,Ja 25,C8:5
My Cousin Vinny 1992,Mr 13,C6:1
McClellan, Gordon (Miscellaneous)
Termini Station 1991,My 31,C14:5
Wisecracks 1992,Je 4,C17:1
McClintock, Derrick Saldaan (Screenwriter)
Young Soul Rebels 1991,D 6,C21:1
McClure, Molly
Pure Country 1992,O 23,C13:1
McComb, Heather
Stay Tuned 1992,Ag 15,14:5
McConnachie, Brian
Husbands and Wives 1992,S 18,C1:1
McConnohie, Michael
Fist of the North Star 1991,N 15,C8:1
Professional, The 1992,O 23,C14:5
McCormack, John
Folks! 1992,My 4,C15:1

McCormick, Kevin (Producer)
Dying Young 1991,Je 21,C10:1
McCourt, Emer
London Kills Me 1992,Ag 7,C19:1
McCoy, Matt
Hand That Rocks the Cradle, The 1992,Ja 10,C8:1
McCray, Special K
Rush 1991,D 22,56:4
McCullers, Carson (Original Author)
Ballad of the Sad Cafe, The 1991,Mr 28,C11:1
McCulloch, John (Composer)
Careful 1992,O 7,C20:3
McCulloch, Kyle
Archangel 1991,Jl 19,C12:6
Careful 1992,O 7,C20:3
McCullough, Allen
Alligator Eyes 1991,F 15,C15:1
McCunn, Ruthanne Lum (Original Author)
1,000 Pieces of Gold 1991,S 27,C10:4
McCusker, Stella
Playboys, The 1992,Ap 22,C15:1
McDaniel, James
Strictly Business 1991,N 8,C13:3
Malcolm X 1992,N 18,C19:3
McDaniel, Xavier
Singles 1992,S 18,C3:4
MacDermot, Galt (Composer)
Mistress 1992,Ag 7,C16:3
McDermott, Carolyn
Puerto Rican Mambo (Not a Musical), The 1992,Mr 22,48:4
McDermott, Debra (Miscellaneous)
Naked Tango 1991,Ag 23,C19:1
Paradise 1991,S 18,C16:3
McDonald, Bruce (Director)
Highway 61 1992,Ap 24,C19:1
McDonald, Bruce (Producer)
Highway 61 1992,Ap 24,C19:1
McDonald, Christopher
Thelma and Louise 1991,My 24,C1:1
Dutch 1991,Jl 19,C13:1
Wild Orchid 2: Two Shades of Blue 1992,My 8,C17:2
MacDonald, Edmund
Detour 1992,Jl 3,C8:1
McDonald, Gary
Young Soul Rebels 1991,D 6,C21:1
MacDonald, John D. (Original Author)
Cape Fear 1991,N 13,C17:1
MacDonald, Philip
Garden, The 1991,Ja 17,C16:5
MacDonald, Richard (Miscellaneous)
Addams Family, The 1991,N 22,C1:1
Jennifer 8 1992,N 6,C6:2
McDonald, Robin
Hours and Times, The 1992,Ap 3,C10:1
MacDonald, Rodney (Miscellaneous)
Chopper Chicks in Zombietown 1991,My 10,C15:5
Macdonald, Peter (Director)
Mo' Money 1992,Jl 25,15:1
McDonnell, Mary
Dances with Wolves 1991,Ja 13,II:13:5
Dances with Wolves 1991,F 24,II:11:1
Grand Canyon 1991,D 25,18:1
Grand Canyon 1992,F 2,II:13:5
Sneakers 1992,S 9,C18:3
Passion Fish 1992,D 14,C16:1
McDormand, Frances
Butcher's Wife, The 1991,O 25,C24:1
Passed Away 1992,Ap 24,C8:1
McDougal, Ian (Producer)
Clearcut 1992,Ag 21,C9:1
MacDougall, Lee
Making of "Monsters," The (Avant-Garde Visions) 1991,O 1,C13:1
McDowell, Alex (Miscellaneous)
Lawnmower Man, The 1992,Mr 7,20:1
MacDowell, Andie
Green Card 1991,Mr 3,II:11:1
Object of Beauty, The 1991,Ap 12,C14:4
Hudson Hawk 1991,My 24,C8:4
McDowell, Malcolm
Assassin of the Czar 1991,My 11,11:4
Assassin of the Czar 1991,Je 9,II:15:1
Macek, Carl (Producer)
Professional, The 1992,O 23,C14:5
McElheron, Maureen
Tune, The 1992,S 4,C3:1

McElheron, Maureen (Composer)
Tune, The 1992,S 4,C3:1
McElheron, Maureen (Screenwriter)
Tune, The 1992,S 4,C3:1
McElhinney, Ian
Playboys, The 1992,Ap 22,C15:1
McElroy, Alan (Miscellaneous)
Rapid Fire 1992,Ag 21,C11:1
McElroy, Alan (Screenwriter)
Rapid Fire 1992,Ag 21,C11:1
McElroy, Brian
Bad Lieutenant 1992,N 20,C15:1
McElwee, Ross (Cinematographer)
Something to Do with the Wall 1991,Ap 3,C11:1
McElwee, Ross (Director)
Something to Do with the Wall 1991,Ap 3,C11:1
McElwee, Ross (Miscellaneous)
Something to Do with the Wall 1991,Ap 3,C11:1
McElwee, Ross (Producer)
Something to Do with the Wall 1991,Ap 3,C11:1
McElwee, Ross (Screenwriter)
Something to Do with the Wall 1991,Ap 3,C11:1
McEntee, Brian P. (Miscellaneous)
Beauty and the Beast 1991,N 13,C17:4
McEwan, Geraldine
Robin Hood: Prince of Thieves 1991,Je 14,C1:4
McEwan, Ian (Original Author)
Comfort of Strangers, The 1991,Mr 29,C6:1
Comfort of Strangers, The 1991,Ap 7,II:13:5
McFadden, Stephanie
Love Field 1992,D 11,C6:3
McGann, Mark
Let Him Have It 1991,D 6,C24:1
McGann, Paul
Paper Mask 1992,F 28,C19:1
Alien 3 1992,My 22,C1:1
Afraid of the Dark 1992,Jl 24,C7:1
McGavin, Darren
Blood and Concrete 1991,S 13,C9:1
McGee, Michael
Giving, The 1992,N 13,C17:1
McGee, Rex (Screenwriter)
Pure Country 1992,O 23,C13:1
McGhee, Johnny Ray
Unlawful Entry 1992,Je 26,C10:4
McGill, Bruce
My Cousin Vinny 1992,Mr 13,C6:1
McGill, Everett
People Under the Stairs, The 1991,N 2,17:1
McGillis, Kelly
Babe, The 1992,Ap 17,C8:1
McGinley, John C.
Point Break 1991,Jl 12,C12:6
Article 99 1992,Mr 13,C10:1
Midnight Clear, A 1992,Ap 24,C1:3
McGinnis, Joel
Mona's Pets (Short and Funnies, The) 1992,D 16,C30:3
McGrady, Michael
Babe, The 1992,Ap 17,C8:1
McGrath, Debra
Termini Station 1991,My 31,C14:5
McGrath, Martin (Cinematographer)
Proof 1992,Mr 20,C20:1
McGregor, Angela Punch
Efficiency Expert, The 1992,N 6,C8:1
MacGregor-Scott, Peter (Producer)
Under Siege 1992,O 9,C12:1
McGuinness, Katy (Producer)
Waterland 1992,O 30,C14:6
McGuinness, Patrick
Romeo and Julia 1992,F 14,C6:5
McGuire, Jason
Pet Sematary Two 1992,Ag 29,14:4
McGuire, Richard (Miscellaneous)
Rich Girl 1991,My 4,15:1
Machado, Maria
Fine Romance, A 1992,O 2,C10:6
McHale, Bob
Drum Struck 1992,Ap 22,C17:1
McHenry, Doug (Director)
House Party 2 1991,O 23,C17:1
McHenry, Doug (Producer)
New Jack City 1991,Mr 8,C15:1
House Party 2 1991,O 23,C17:1
Machuel, Emmanuel (Cinematographer)
Van Gogh 1992,O 30,C16:5

McHugh, David (Composer)
 Mannequin Two: On the Move 1991,My 19,50:3
 Prisoners of the Sun 1991,Jl 19,C12:1
McIlvain, James Terry
 Pure Country 1992,O 23,C13:1
McIlvanney, William (Original Author)
 Crossing the Line 1991,Ag 9,C11:1
McIlwaine, Ken (Miscellaneous)
 Cheap Shots 1991,N 15,C11:1
McIntosh, Robbie
 Get Back 1991,O 25,C19:1
Mackarov, Yuri (Miscellaneous)
 Interpretation of Dreams 1991,Mr 30,10:4
McKay, Craig (Miscellaneous)
 Silence of the Lambs, The 1991,F 14,C17:1
 Shining Through 1992,Ja 31,C8:5
MacKay, James (Producer)
 Garden, The 1991,Ja 17,C16:5
MacKay, John
 Alligator Eyes 1991,F 15,C15:1
 Regarding Henry 1991,Jl 10,C13:3
 Trust 1991,Jl 26,C16:5
 Simple Men 1992,O 14,C22:1
MacKay, Mark (Cinematographer)
 Deadly Currents 1992,O 16,C8:5
McKay, Steven (Screenwriter)
 Diggstown 1992,Ag 14,C1:1
McKean, Michael
 Book of Love 1991,F 1,C10:6
 True Identity 1991,Ag 23,C16:1
 Memoirs of an Invisible Man 1992,F 28,C17:1
 Man Trouble 1992,Jl 18,18:4
McKee, Lonette
 Jungle Fever 1991,Je 7,C1:2
 Malcolm X 1992,N 18,C19:3
McKellar, Don
 Adjuster, The 1991,S 26,C18:5
 Highway 61 1992,Ap 24,C19:1
McKellar, Don (Screenwriter)
 Highway 61 1992,Ap 24,C19:1
McKenna, Breffini
 Crying Game, The 1992,S 26,12:4
Mackenzie, John (Director)
 Ruby 1992,Mr 27,C1:3
McKeon, Nancy
 Where the Day Takes You 1992,S 11,C14:5
Mackie, Bob (Miscellaneous)
 Brenda Starr 1992,Ap 19,46:1
McKim, Erin
 Little Stiff, A 1991,Mr 16,16:3
McKim, Mike
 Little Stiff, A 1991,Mr 16,16:3
Mackinnon, Gillies (Director)
 Playboys, The 1992,Ap 22,C15:1
Mackintosh, Steven
 London Kills Me 1992,Ag 7,C19:1
Macklin, Robert (Original Author)
 Storyville 1992,Ag 26,C13:3
MacLachlan, Kyle
 Doors, The 1991,Mr 1,C1:1
 Twin Peaks: Fire Walk with Me 1992,My 18,C13:6
 Twin Peaks: Fire Walk with Me 1992,Ag 29,11:1
 Where the Day Takes You 1992,S 11,C14:5
McLain, Mary
 Alligator Eyes 1991,F 15,C15:1
MacLaine, Shirley
 Used People 1992,N 6,C1:1
 Used People 1992,D 16,C23:3
Maclean, Norman (Original Author)
 River Runs Through It, A 1992,O 9,C1:3
 River Runs Through It, A 1992,O 18,II:13:1
MacLean, Robert (Producer)
 Bright Angel 1991,Je 14,C6:1
Maclear, Michael (Producer)
 Beautiful Dreamers 1992,Je 5,C15:1
MacLiammoir, Micheal
 Othello 1992,Mr 6,C1:3
McLish, Rachel
 Aces: Iron Eagle III 1992,Je 13,16:4
MacMillan, Kenneth (Cinematographer)
 King Ralph 1991,F 15,C10:3
 Rush 1991,D 22,56:4
 Of Mice and Men 1992,O 2,C5:4
McMullen, Ken (Director)
 1867 1991,N 13,C16:6
McMurray, Sam
 L.A. Story 1991,F 8,C8:1
 Stone Cold 1991,My 18,16:3

McMurtry, Larry (Screenwriter)
 Falling from Grace 1992,F 21,C16:5
McNally, Terrence (Original Author)
 Frankie and Johnny 1991,O 11,C1:1
 Frankie and Johnny 1991,N 3,II:22:1
McNally, Terrence (Screenwriter)
 Frankie and Johnny 1991,O 11,C1:1
McNamara, Brian
 Mystery Date 1991,Ag 16,C9:1
McNaughton, John (Director)
 Henry: Portrait of a Serial Killer 1991,Mr 10,II:1:1
 Sex, Drugs, Rock & Roll 1991,S 13,C1:1
 Borrower, The 1991,O 18,C12:3
McNaughton, Robert (Composer)
 Borrower, The 1991,O 18,C12:3
McNeal, Julia
 Refrigerator, The 1992,S 25,C16:6
McNeice, Ian
 Year of the Comet 1992,Ap 25,17:1
McNichol, Kristy
 White Dog 1991,Jl 12,C8:1
MacNicol, Peter
 American Blue Note 1991,Mr 29,C12:1
 Hard Promises 1992,Ja 31,C12:6
 Housesitter 1992,Je 12,C1:4
McOsker, Kathleen
 Bikini Island 1991,Jl 27,16:3
McPherson, Don (Screenwriter)
 Crossing the Line 1991,Ag 9,C11:1
McPherson, John (Cinematographer)
 Bingo 1991,Ag 10,9:2
McQuade, Kris
 Strictly Ballroom 1992,S 26,12:5
MacRae, Michael
 Run 1991,F 1,C15:1
McRobbie, Peter
 Johnny Suede 1992,Ag 14,C5:5
McShane, Micheal
 Robin Hood: Prince of Thieves 1991,Je 14,C1:4
McTiernan, John (Director)
 Medicine Man 1992,F 7,C13:1
McVey, Beth
 Phantom of the Opera, The 1991,Je 8,16:1
Macy, William H.
 Homicide 1991,My 11,11:4
 Homicide 1991,O 6,56:1
Maddalena, Marianne (Producer)
 People Under the Stairs, The 1991,N 2,17:1
Madden, David (Producer)
 Eve of Destruction 1991,Ja 19,22:6
 Hand That Rocks the Cradle, The 1992,Ja 10,C8:1
Maddin, Guy (Cinematographer)
 Archangel 1991,Jl 19,C12:6
 Careful 1992,O 7,C20:3
Maddin, Guy (Director)
 Archangel 1991,Jl 19,C12:6
 Careful 1992,O 7,C20:3
Maddin, Guy (Miscellaneous)
 Archangel 1991,Jl 19,C12:6
 Careful 1992,O 7,C20:3
Maddin, Guy (Screenwriter)
 Archangel 1991,Jl 19,C12:6
 Careful 1992,O 7,C20:3
Mader (Composer)
 In the Soup 1992,O 3,13:2
Madonna
 Truth or Dare 1991,My 15,C11:1
 Truth or Dare 1991,My 10,C1:3
 Shadows and Fog 1992,Mr 20,C6:1
 League of Their Own, A 1992,Jl 1,C13:4
 League of Their Own, A 1992,Jl 12,II:11:5
Madou, Malou
 Man Bites Dog 1992,O 9,C14:5
Madsen, Kenneth (Director)
 Day in October, A 1992,O 28,C20:5
Madsen, Michael
 Doors, The 1991,Mr 1,C1:1
 Thelma and Louise 1991,My 24,C1:1
 Thelma and Louise 1991,Je 16,II:11:1
 Straight Talk 1992,Ap 3,C17:1
 Reservoir Dogs 1992,O 23,C14:1
Madsen, Virginia
 Candyman 1992,O 16,C10:5
 Becoming Colette 1992,N 6,C6:1
Mae, Yoshisuke (Producer)
 Rikyu 1991,Ja 18,C8:1
Maeda, Yonezo (Cinematographer)
 Heaven and Earth 1991,Mr 1,C10:4

Magalias, Tatyana (Miscellaneous)
 Raspad 1992,Ap 29,C15:1
Maganini, Elena (Miscellaneous)
 Sex, Drugs, Rock & Roll 1991,S 13,C1:1
 Borrower, The 1991,O 18,C12:3
Magnan, Pierre (Original Author)
 Maison Assassinee, La (Murdered House, The)
 1991,O 25,C10:5
Magnier, Claude (Original Author)
 Oscar 1991,Ap 26,C10:5
Maguire, Charles H. (Producer)
 Dead Again 1991,Ag 23,C1:3
Mahailescu, Ionel
 Oak, The 1992,O 1,C13:1
Mahal, Taj (Composer)
 Zebrahead 1992,O 8,C17:5
Mahan, Deepak
 Idiot 1992,O 8,C21:4
Mahan, Kerrigan
 Professional, The 1992,O 23,C14:5
Maher, Joseph
 Sister Act 1992,My 29,C10:1
Mahern, Michael (Screenwriter)
 Mobsters 1991,Jl 26,C18:4
Mahmoody, Betty (Original Author)
 Not Without My Daughter 1991,Ja 11,C8:1
Mahoney, John
 Barton Fink 1991,Ag 21,C11:1
 Article 99 1992,Mr 13,C10:1
Maidment, Rex (Cinematographer)
 Antonia and Jane 1991,O 26,13:1
 Enchanted April 1992,Jl 31,C15:1
Mairesse, Valerie
 Amelia Lopes O'Neill 1991,S 21,12:3
Makeba, Miriam
 Sarafina! 1992,S 18,C16:6
Makepeace, Anne (Screenwriter)
 1,000 Pieces of Gold 1991,S 27,C10:4
Makkena, Wendy
 Sister Act 1992,My 29,C10:1
 Sister Act 1992,Je 7,II:13:1
Malafronte, Victor
 Blast 'Em 1992,Jl 1,C18:3
Malavoy, Christophe
 Cry of the Owl, The (Cri du Hibou, Le) 1991,O
 16,C19:1
 Madame Bovary 1991,D 25,13:1
Malcolm X (Original Author)
 Malcolm X 1992,N 18,C19:3
Maldonado, Dominic
 Newsies 1992,Ap 8,C22:3
Malekzadeh, Firouz (Cinematographer)
 Runner, The 1991,Je 21,C5:1
Malet, Arthur
 Toys 1992,D 18,C1:3
Malherbe, Annet
 Voyeur 1991,Ag 2,C9:1
Malik, Art
 City of Joy 1992,Ap 15,C15:1
 Year of the Comet 1992,Ap 25,17:1
Malina, Judith
 Addams Family, The 1991,N 22,C1:1
Malinger, Ross
 Late for Dinner 1991,S 20,C6:5
Malkin, Barry (Miscellaneous)
 Honeymoon in Vegas 1992,Ag 28,C8:5
Malkin, Gary Remal (Composer)
 1,000 Pieces of Gold 1991,S 27,C10:4
Malkovich, John
 Queens Logic 1991,F 1,C13:1
 Object of Beauty, The 1991,Ap 12,C14:4
 Shadows and Fog 1992,Mr 20,C6:1
 Of Mice and Men 1992,O 2,C5:4
 Jennifer 8 1992,N 6,C6:2
Mall, Adolph
 Homicide 1991,O 6,56:1
Malle, Louis
 Vie de Boheme, La 1992,O 9,C14:1
Malle, Louis (Director)
 Damage 1992,N 6,C1:1
 Damage 1992,N 22,II:13:1
 Damage 1992,D 13,II:20:5
 Damage 1992,D 23,C13:1
Malle, Louis (Producer)
 Damage 1992,D 23,C13:1
Malle, Vincent (Producer)
 Damage 1992,D 23,C13:1

Malley, Bill (Miscellaneous)
Dr. Giggles 1992,O 24,16:4
Mallik, Ranjit
Branches of the Tree, The 1992,Ap 17,C15:3
Malm, Mona
Best Intentions, The 1992,Jl 10,C10:5
Malo, Rene (Producer)
Pin 1991,D 4,C28:1
Malone, Dorothy
Basic Instinct 1992,Mr 20,C8:1
Malone, Mark
Straight Out of Brooklyn 1991,My 22,C11:5
Malone, Patrick
Grand Canyon 1991,D 25,18:1
Maloney, Denis (Cinematographer)
Complex World 1992,Ap 10,C14:5
Maloney, Denis (Producer)
Complex World 1992,Ap 10,C14:5
Maloney, Michael
Truly, Madly, Deeply 1991,My 3,C11:1
Maloney, Peter
Public Eye, The 1992,O 14,C17:1
Malotschevski, Veniamin
Satan 1992,Mr 28,18:1
Maltby, Barbara (Producer)
River Runs Through It, A 1992,O 9,C1:3
Maman, Sidi Hadji
Captive of the Desert, The (Captive du Desert, La)
1991,Mr 21,C20:3
Mambety, Aziz Diop (Miscellaneous)
Touki-Bouki (Hyena's Voyage) 1991,F 15,C10:1
Mambety, Djibril Diop
Hyenas 1992,O 3,18:4
Mambety, Djibril Diop (Director)
Touki-Bouki (Hyena's Voyage) 1991,F 15,C10:1
Hyenas 1992,O 3,18:4
Mambety, Djibril Diop (Screenwriter)
Touki-Bouki (Hyena's Voyage) 1991,F 15,C10:1
Hyenas 1992,O 3,18:4
Mamet, David (Director)
Homicide 1991,My 11,11:4
Homicide 1991,O 6,56:1
Homicide 1991,O 6,II:13:5
Homicide 1991,O 20,II:17:5
Mamet, David (Original Author)
Glengarry Glen Ross 1992,S 30,C15:3
Glengarry Glen Ross 1992,O 4,II:24:3
Mamet, David (Screenwriter)
Homicide 1991,My 11,11:4
Homicide 1991,O 6,56:1
Homicide 1991,O 6,II:13:5
Homicide 1991,O 20,II:17:5
Glengarry Glen Ross 1992,S 30,C15:3
Glengarry Glen Ross 1992,O 4,II:24:3
Hoffa 1992,D 25,C1:1
Mamonov, Pyotr
Taxi Blues 1991,Ja 18,C12:1
Taxi Blues 1991,F 3,II:13:5
Mamou, Sabine (Miscellaneous)
Room in Town, A (Chambre en Ville, Une) 1991,S
28,11:5
Manchester, Melissa
For the Boys 1991,N 22,C12:1
Mancini, Don (Screenwriter)
Child's Play 3 1991,Ag 30,C11:3
Mancini, Henry (Composer)
Switch 1991,My 10,C13:1
Mancuso, Frank, Jr. (Producer)
He Said, She Said 1991,F 22,C17:1
Body Parts 1991,Ag 3,9:1
Cool World 1992,Jl 11,12:3
Mancuso, Nick
Rapid Fire 1992,Ag 21,C11:1
Mandel, Babaloo (Screenwriter)
City Slickers 1991,Je 7,C18:5
League of Their Own, A 1992,Jl 1,C13:4
League of Their Own, A 1992,Jl 12,II:11:5
Mr. Saturday Night 1992,S 23,C13:4
Mandel, Johnny (Composer)
Brenda Starr 1992,Ap 19,46:1
Mandel, Ken (Director)
Frida Kahlo: A Ribbon Around a Bomb 1992,My
22,C10:1
Mandel, Ken (Miscellaneous)
Frida Kahlo: A Ribbon Around a Bomb 1992,My
22,C10:1

Mandel, Ken (Producer)
Frida Kahlo: A Ribbon Around a Bomb 1992,My
22,C10:1
Mandel, Robert (Director)
School Ties 1992,S 18,C19:1
Mandel, Yoram (Producer)
Johnny Suede 1992,Ag 14,C5:5
Mandela, Nelson
Malcolm X 1992,N 18,C19:3
Mandylor, Costas
Mobsters 1991,Jl 26,C18:4
Manfredi, Nino
Alberto Express 1992,O 9,C12:5
Manfredini, Harry (Composer)
Aces: Iron Eagle III 1992,Je 13,16:4
Mang, Xiem
Lover, The 1992,O 30,C5:1
Manheim, Michael (Producer)
Leap of Faith 1992,D 18,C14:1
Manker, Paulus
Weininger's Last Night 1991,Ag 1,C14:4
Manker, Paulus (Director)
Weininger's Last Night 1991,Ag 1,C14:4
Manker, Paulus (Screenwriter)
Weininger's Last Night 1991,Ag 1,C14:4
Mankiewicz, Joseph L. (Director)
All About Eve 1992,N 20,C1:3
Cleopatra 1992,N 20,C1:3
Ghost and Mrs. Muir, The 1992,N 20,C1:3
Five Fingers 1992,N 20,C1:3
People Will Talk 1992,N 20,C1:3
Barefoot Contessa, The 1992,N 20,C1:3
Letter to Three Wives, A 1992,N 20,C1:3
Sleuth 1992,N 20,C1:3
Mankiewicz, Joseph L. (Screenwriter)
All About Eve 1992,N 20,C1:3
Cleopatra 1992,N 20,C1:3
People Will Talk 1992,N 20,C1:3
Barefoot Contessa, The 1992,N 20,C1:3
Letter to Three Wives, A 1992,N 20,C1:3
Million Dollar Legs 1992,N 20,C1:3
Mankiewicz, Tom (Director)
Delirious 1991,Ag 9,C12:4
Mann, Danny
Little Nemo: Adventures in Slumberland 1992,Ag
21,C13:1
Mann, Hummie (Composer)
Box Office Bunny 1991,F 9,12:4
Year of the Comet 1992,Ap 25,17:1
Mann, Michael (Director)
Last of the Mohicans, The 1992,S 25,C3:1
Mann, Michael (Producer)
Last of the Mohicans, The 1992,S 25,C3:1
Mann, Michael (Screenwriter)
Last of the Mohicans, The 1992,S 25,C3:1
Mann, Story
Drum Struck 1992,Ap 22,C17:1
Mannion, Sean (Miscellaneous)
Shaking the Tree 1992,Mr 13,C8:1
Mannix, Ed
Professional, The 1992,O 23,C14:5
Manojlovic, Miki
Every Other Weekend 1991,Je 19,C12:3
Manos, Mark (Director)
Liquid Dreams 1992,Ap 15,C19:1
Manos, Mark (Screenwriter)
Liquid Dreams 1992,Ap 15,C19:1
Mansbridge, John (Miscellaneous)
Stone Cold 1991,My 18,16:3
Mansfield, David (Composer)
Late for Dinner 1991,S 20,C6:5
Mansion, Gracie
All the Vermeers in New York 1992,My 1,C13:1
Mantegna, Joe
Alice 1991,Ja 15,C11:3
Queens Logic 1991,F 1,C13:1
Homicide 1991,My 11,11:4
Homicide 1991,O 6,56:1
Homicide 1991,O 20,II:17:5
Bugsy 1991,D 13,C12:1
Bugsy 1991,D 22,II:22:1
Mantel, Bronwen
Pin 1991,D 4,C28:1
Mara, Mary
Hard Way, The 1991,Mr 8,C8:1
Mr. Saturday Night 1992,S 23,C13:4
Love Potion No. 9 1992,N 13,C12:5

Marais, Jean
Beauty and the Beast 1992,Ap 17,C8:6
Marcas, Dominique
Vie de Boheme, La 1992,O 9,C14:1
Marceau, Sophie
For Sasha 1992,Je 5,C13:1
March, Jane
Lover, The 1992,O 30,C5:1
Marchand, Mitchell
Fathers and Sons 1992,N 6,C17:1
Marchand, Nancy
Brain Donors 1992,Ap 18,11:1
Marcovich, Carlos (Cinematographer)
City of the Blind (Ciudad de Ciegos) 1992,Ap 4,17:5
Marcucci, Stefano (Composer)
Sleazy Uncle, The 1991,F 22,C10:5
Marcus, Andrew (Miscellaneous)
Ballad of the Sad Cafe, The 1991,Mr 28,C11:1
Howards End 1992,Mr 13,C1:3
Peter's Friends 1992,D 25,C8:6
Marder, Marc (Composer)
True Identity 1991,Ag 23,C16:1
Marescotti, Ivano
Peaceful Air of the West 1991,Mr 20,C12:5
Margolis, Mark
Just Like in the Movies 1992,My 4,C15:1
1492: Conquest of Paradise 1992,O 9,C21:1
Margulies, David
Stranger Among Us, A 1992,Jl 17,C1:3
Out on a Limb 1992,S 5,15:1
Marich, Marietta
Simple Men 1992,O 14,C22:1
Marielle, Jean-Pierre
Uranus 1991,Ag 23,C15:1
Tous les Matins du Monde 1992,N 13,C3:4
Marignac, Martine (Producer)
Window Shopping 1992,Ap 17,C13:1
Marin, Cheech
Ferngully: The Last Rain Forest 1992,Ap 10,C10:5
Marini, Thom (Cinematographer)
Cheap Shots 1991,N 15,C11:1
Marion, Umberto (Screenwriter)
Station, The (Stazione, La) 1992,Ja 3,C6:1
Maris, Monica
Legends 1991,Mr 17,68:5
Mariscal, Silva
City of the Blind (Ciudad de Ciegos) 1992,Ap 4,17:5
Mark, Laurence (Producer)
True Colors 1991,Mr 15,C19:1
One Good Cop 1991,My 3,C13:1
Markaris, Petros (Screenwriter)
Suspended Step of the Stork, The 1991,S 23,C15:1
Markes, Anthony (Director)
Bikini Island 1991,Jl 27,16:3
Markes, Anthony (Producer)
Bikini Island 1991,Jl 27,16:3
Markey, Dave (Cinematographer)
1991: The Year Punk Broke 1992,N 20,C5:1
Markey, Dave (Director)
1991: The Year Punk Broke 1992,N 20,C5:1
Markey, Dave (Miscellaneous)
1991: The Year Punk Broke 1992,N 20,C5:1
Markey, Patrick (Producer)
River Runs Through It, A 1992,O 9,C1:3
Markman, Joel
Flaming Creatures (Avant-Garde Visions) 1991,O
1,C13:1
Marks, Alfred
Antonia and Jane 1991,O 26,13:1
Marks, Richard (Miscellaneous)
One Good Cop 1991,My 3,C13:1
Father of the Bride 1991,D 20,C17:1
Marlowe, Christopher (Original Author)
Edward II 1992,Mr 20,C16:3
Marmo, Malia Scotch (Screenwriter)
Once Around 1991,Ja 18,C12:4
Hook 1991,D 11,C17:3
Marodi, Nicolas
Cross My Heart 1991,Ap 5,C18:5
Maron, Philippe
Jacquot de Nantes 1991,S 25,C16:3
Marquard, Thomas (Composer)
Affengeil 1992,Jl 25,15:4
Marr, Alan (Director)
Edsville (Short and Funnies, The) 1992,D 16,C30:3
Marr, Alan (Screenwriter)
Edsville (Short and Funnies, The) 1992,D 16,C30:3

Last of the Mohicans, The 1992,S 25,C3:1
May, Mathilda
Naked Tango 1991,Ag 23,C19:1
Cry of the Owl, The (Cri du Hibou, Le) 1991,O 16,C19:1
Becoming Colette 1992,N 6,C6:1
Mayall, Rik
Drop Dead Fred 1991,My 24,C8:1
Mayer, Edwin Justus (Screenwriter)
To Be or Not to Be 1992,Ag 21,C1:1
Mayfield, Les (Director)
Encino Man 1992,My 22,C15:1
Mayfield, Les (Producer)
Hearts of Darkness: A Film Maker's Apocalypse 1991,N 27,C9:1
Maylam, Tony (Director)
Split Second 1992,My 4,C15:1
Mayo, Alfredo (Cinematographer)
High Heels 1991,D 20,C20:6
Mayson, Michael
Billy Turner's Secret 1991,Mr 16,16:3
Billy Turner's Secret (Young Black Cinema) 1992,F 29,17:1
Mayson, Michael (Director)
Billy Turner's Secret 1991,Mr 16,16:3
Billy Turner's Secret (Young Black Cinema) 1992,F 29,17:1
Mazan, Cecile
Love Without Pity (Monde sans Pitie, Une) 1991,My 31,C16:4
Mazar, Debi
Little Man Tate 1991,O 9,C17:4
Mazur, Paula (Producer)
Search for Signs of Intelligent Life in the Universe, The 1991,S 27,C8:1
Mazursky, Paul
Scenes from a Mall 1991,F 22,C19:1
Man Trouble 1992,Jl 18,18:4
Mazursky, Paul (Director)
Scenes from a Mall 1991,F 22,C19:1
Scenes from a Mall 1991,F 24,II:11:5
Mazursky, Paul (Miscellaneous)
Intervista 1992,N 20,C10:1
Mazursky, Paul (Producer)
Scenes from a Mall 1991,F 22,C19:1
Mazursky, Paul (Screenwriter)
Scenes from a Mall 1991,F 22,C19:1
Mazzello, Joseph
Radio Flyer 1992,F 21,C16:1
Mazziotti, Thomas
Undertow 1991,S 18,C16:3
Mazziotti, Thomas (Director)
Undertow 1991,S 18,C16:3
Mazziotti, Thomas (Producer)
Undertow 1991,S 18,C16:3
Mazziotti, Thomas (Screenwriter)
Undertow 1991,S 18,C16:3
Meaney, Colm
Far and Away 1992,My 22,C10:5
Means, Russell
Last of the Mohicans, The 1992,S 25,C3:1
Meat Loaf
Dead Ringer 1991,Jl 17,C14:5
Motorama 1992,Mr 28,18:5
Leap of Faith 1992,D 18,C14:1
Medak, Peter (Director)
Let Him Have It 1991,D 6,C24:1
Meddings, Cissy
Strangers in Good Company 1991,My 10,C8:1
Medjuck, Joe (Producer)
Stop! Or My Mom Will Shoot 1992,F 21,C8:5
Beethoven 1992,Ap 3,C18:1
Medoff, Mark (Screenwriter)
City of Joy 1992,Ap 15,C15:1
Meeks, Edith
Poison 1991,Ap 5,C8:3
Megino, Luis (Producer)
Most Beautiful Night, The 1992,N 20,C10:5
Megino, Luis (Screenwriter)
Most Beautiful Night, The 1992,N 20,C10:5
Meheux, Phil (Cinematographer)
Defenseless 1991,Ag 23,C8:1
Ruby 1992,Mr 27,C1:3
Meichsner, Dieter (Producer)
Comedian Harmonists, The 1991,Ap 5,C18:5
Meier, Dieter
Leo Sonnyboy 1991,Mr 16,16:4

Meier, Pierre-Alain (Producer)
Hyenas 1992,O 3,18:4
Meier, Shane
Unforgiven 1992,Ag 7,C1:1
Meieran, David (Director)
Voices from the Front 1992,Mr 18,C15:1
Meieran, David (Miscellaneous)
Voices from the Front 1992,Mr 18,C15:1
Meieran, David (Producer)
Voices from the Front 1992,Mr 18,C15:1
Meigs, Mary
Strangers in Good Company 1991,My 10,C8:1
Mein, Maurizio
Intervista 1992,N 20,C10:1
Meinecke, Tobias (Director)
Super, Der (Short and Funnies, The) 1992,D 16,C30:3
Meinecke, Tobias (Screenwriter)
Super, Der (Short and Funnies, The) 1992,D 16,C30:3
Meininger, Frederique
Lover, The 1992,O 30,C5:1
Meiselas, Susan (Director)
Pictures from a Revolution 1991,O 5,11:4
Pictures from a Revolution 1992,My 30,13:4
Meiselas, Susan (Miscellaneous)
Pictures from a Revolution 1992,My 30,13:4
Meiselas, Susan (Narrator)
Pictures from a Revolution 1992,My 30,13:4
Meiselas, Susan (Producer)
Pictures from a Revolution 1991,O 5,11:4
Pictures from a Revolution 1992,My 30,13:4
Meistrich, Larry (Producer)
Laws of Gravity 1992,Mr 21,18:1
Meitil, Heoin (Composer)
Atlantic Rhapsody: 52 Scenes from Torshavn 1991,Mr 30,11:1
Mekas, Jonas
Step Across the Border 1992,F 19,C15:1
Meldrum, Wendel
Beautiful Dreamers 1992,Je 5,C15:1
Melissa
City of the Blind (Ciudad de Ciegos) 1992,Ap 4,17:5
Mell, Randle
Grand Canyon 1991,D 25,18:1
Mellencamp, John
Falling from Grace 1992,F 21,C16:5
Mellencamp, John (Director)
Falling from Grace 1992,F 21,C16:5
Melnick, Daniel (Producer)
L.A. Story 1991,F 8,C8:1
Melnick, Mark (Miscellaneous)
Brenda Starr 1992,Ap 19,46:1
Melnick, Peter (Composer)
L.A. Story 1991,F 8,C8:1
Convicts 1991,D 6,C14:6
Melson, Sara
Dr. Giggles 1992,O 24,16:4
Mende, Lisa
Honey, I Blew Up the Kid 1992,Jl 17,C6:5
Mendelsohn, Ben
Efficiency Expert, The 1992,N 6,C8:1
Menegoz, Margaret (Producer)
Tale of Winter, A 1992,O 2,C12:6
Meneses, Ramiro
Rodrigo D: No Future 1991,Ja 11,C10:5
Mengelberg, Misha
Last Date: Eric Dolphy 1992,Je 29,C16:5
Menges, Chris (Director)
Crisscross 1992,My 9,17:5
Menke, Sally (Miscellaneous)
Reservoir Dogs 1992,O 23,C14:1
Menken, Alan (Composer)
Beauty and the Beast 1991,N 13,C17:4
Newsies 1992,Ap 8,C22:3
Aladdin 1992,N 6,C1:1
Aladdin 1992,N 11,C15:3
Mennenti, Emma (Miscellaneous)
Touki-Bouki (Hyena's Voyage) 1991,F 15,C10:1
Menshov, Vladimir
City Zero 1991,Mr 22,C14:1
Menzel, Jiri (Director)
Larks on a String 1991,F 13,C14:4
End of Old Times, The 1992,Ja 10,C12:6
Menzel, Jiri (Screenwriter)
Larks on a String 1991,F 13,C14:4
End of Old Times, The 1992,Ja 10,C12:6

Menzies, Peter, Jr. (Cinematographer)
White Sands 1992,Ap 24,C18:1
Mercer, Marian
Out on a Limb 1992,S 5,15:1
Mercero, Antonio (Director)
Wait for Me in Heaven (Esperame en el Cielo) 1991,Ja 30,C10:5
Don Juan, My Love 1991,Jl 12,C10:5
Mercero, Antonio (Screenwriter)
Wait for Me in Heaven (Esperame en el Cielo) 1991,Ja 30,C10:5
Don Juan, My Love 1991,Jl 12,C10:5
Merchant, Ismail (Producer)
Ballad of the Sad Cafe, The 1991,Mr 28,C11:1
Howards End 1992,Mr 13,C1:3
Howards End 1992,Mr 22,II:11:1
Merchant, Veronica
City of the Blind (Ciudad de Ciegos) 1992,Ap 4,17:5
Mercier, Mary
Mistress 1992,Ag 7,C16:3
Mercier, Patrice (Miscellaneous)
Double Life of Veronique, The 1991,S 20,C18:4
Mercure, Monique
Naked Lunch 1991,D 27,C1:3
Mercurio, Paul
Strictly Ballroom 1992,S 26,12:5
Mergey, Marie
Madame Bovary 1991,D 25,13:1
Cold Moon (Lune Froide) 1992,Ap 22,C17:1
Merhige, E. Elias (Cinematographer)
Begotten 1991,Je 5,C23:1
Merhige, E. Elias (Director)
Begotten 1991,Je 5,C23:1
Merhige, E. Elias (Miscellaneous)
Begotten 1991,Je 5,C23:1
Merhige, E. Elias (Producer)
Begotten 1991,Je 5,C23:1
Merhige, E. Elias (Screenwriter)
Begotten 1991,Je 5,C23:1
Merimee, Prosper (Original Author)
Carmen 1991,N 10,II:13:1
Merkerson, S. Epatha
Terminator 2: Judgment Day 1991,Jl 3,C11:5
Merlin, Joanna
Class Action 1991,Mr 15,C20:4
Meron, Neil (Producer)
If Looks Could Kill 1991,Mr 19,C12:5
Merrick, Monte (Screenwriter)
Mr. Baseball 1992,O 2,C14:6
Merrill, Dina
True Colors 1991,Mr 15,C19:1
Player, The 1992,Ap 10,C16:1
Merritt, Michael (Miscellaneous)
Homicide 1991,O 6,56:1
Mersch, Genevieve (Director)
Red Bridge, The 1992,Ag 6,C15:4
Mesgusch, Felix (Cinematographer)
Opening the 19th Century: 1986 (Avant-Garde Visions) 1991,O 1,C13:1
Messeri, Marco
Alberto Express 1992,O 9,C12:5
Messick, Dale (Miscellaneous)
Brenda Starr 1992,Ap 19,46:1
Messina, Francesco
In the Soup 1992,O 3,13:2
Meszaros, Istvan
Memoirs of a River 1992,Mr 20,C15:1
Metcalf, Laurie
Mistress 1992,Ag 7,C16:3
Metcalf, Toby
Pure Country 1992,O 23,C13:1
Metcalfe, Tim (Miscellaneous)
Iron Maze 1991,N 1,C13:1
Metcalfe, Tim (Screenwriter)
Iron Maze 1991,N 1,C13:1
Metzler, Jim
Delusion 1991,Je 7,C12:6
Metzman, Irving
Used People 1992,D 16,C23:3
Meurisse, Jean-Paul (Cinematographer)
Zentropa 1992,My 22,C14:1
Mewshaw, Michael (Original Author)
Year of the Gun 1991,N 1,C10:6
Meyer, Bess
Inner Circle, The 1991,D 25,20:1
Meyer, Breckin
Freddy's Dead: The Final Nightmare 1991,S 14,11:4

Meyer, Nicholas (Director)
Star Trek VI: The Undiscovered Country 1991,D 6,C1:1
Company Business 1992,Ap 25,17:1
Meyer, Nicholas (Screenwriter)
Star Trek VI: The Undiscovered Country 1991,D 6,C1:1
Company Business 1992,Ap 25,17:1
Meyers, Ari
Dutch 1991,Jl 19,C13:1
Meyers, Janet (Producer)
Closet Land 1991,Mr 7,C18:3
Meyers, Nancy (Producer)
Father of the Bride 1991,D 20,C17:1
Meyers, Nancy (Screenwriter)
Father of the Bride 1991,D 20,C17:1
Once Upon a Crime 1992,Mr 7,20:4
Meyers, Patrick (Original Author)
K2 1992,My 1,C16:1
Meyers, Patrick (Screenwriter)
K2 1992,My 1,C16:1
Meyjes, Menno (Miscellaneous)
Ricochet 1991,O 5,12:6
Miall, Tristram (Producer)
Strictly Ballroom 1992,S 26,12:5
Michael, Jordan Christopher
Motorama 1992,Mr 28,18:5
Michaels, Dennis (Cinematographer)
Whole Truth, The 1992,O 23,C10:5
Michaels, Joel B. (Producer)
Universal Soldier 1992,Jl 10,C17:1
Michaels, Lorne (Producer)
Wayne's World 1992,F 14,C15:1
Michalak, Richard (Cinematographer)
Guilty as Charged 1992,Ja 29,C17:1
3 Ninjas 1992,Ag 7,C5:1
Michaud, Cedric
Jacquot de Nantes 1991,S 25,C16:3
Micheaux, Oscar (Director)
God's Stepchildren 1991,F 8,C1:1
Michelle, Diane
Professional, The 1992,O 23,C14:5
Midkiff, Dale
Love Potion No. 9 1992,N 13,C12:5
Midler, Bette
Scenes from a Mall 1991,F 22,C19:1
Scenes from a Mall 1991,F 24,II:11:5
For the Boys 1991,N 22,C12:1
For the Boys 1992,Ja 19,II:13:5
For the Boys 1992,F 23,II:13:1
Midler, Bette (Producer)
For the Boys 1991,N 22,C12:1
Mighty Duke
One Hand Don't Clap 1991,Ag 28,C13:1
Mignot, Pierre (Cinematographer)
Straight for the Heart 1991,F 4,C14:1
Mihut, Mariana
Oak, The 1992,O 1,C13:1
Mikesch, Elfi (Cinematographer)
Alex 1992,Mr 24,C15:3
Mikhalkov, Nikita (Director)
Close to Eden 1992,O 30,C10:5
Mikhalkov, Nikita (Miscellaneous)
Close to Eden 1992,O 30,C10:5
Mikitenko, Taracik
Raspad 1992,Ap 29,C15:1
Mikuni, Rentaro
Rikyu 1991,Ja 18,C8:1
Milchan, Arnon (Producer)
Guilty by Suspicion 1991,Mr 15,C12:1
Mambo Kings, The 1992,F 28,C8:1
Power of One, The 1992,Mr 27,C20:5
Under Siege 1992,O 9,C12:1
Miles, Sylvia
Superstar: The Life and Times of Andy Warhol 1991,F 22,C8:1
Milhoan, Michael
Honey, I Blew Up the Kid 1992,Jl 17,C6:5
Milicevic, Djordje (Miscellaneous)
Gladiator 1992,Mr 6,C17:1
Military, Frank
Crisscross 1992,My 9,17:5
Milius, John
Hearts of Darkness: A Film Maker's Apocalypse 1991,N 27,C9:1
Milius, John (Director)
Flight of the Intruder 1991,Ja 18,C19:1

Millan, Victor
Terror in a Texas Town 1991,My 17,C16:4
Miller, David Brian (Miscellaneous)
South-Central 1992,O 16,C13:1
Miller, Don (Producer)
White Men Can't Jump 1992,Mr 27,C22:4
Miller, Flo
Time Expired 1992,D 2,C18:4
Miller, George (Director)
Neverending Story II, The: The Next Chapter 1991,F 9,12:4
Frozen Assets 1992,O 24,16:4
Lorenzo's Oil 1992,D 30,C7:3
Miller, George (Producer)
Flirting 1992,N 6,C13:1
Lorenzo's Oil 1992,D 30,C7:3
Miller, George (Screenwriter)
Lorenzo's Oil 1992,D 30,C7:3
Miller, Harry B., 3d (Miscellaneous)
Gladiator 1992,Mr 6,C17:1
Miller, Joseph
Folks! 1992,My 4,C15:1
Miller, Joshua
And You Thought Your Parents Were Weird 1991,N 15,C13:1
Miller, Larry
Necessary Roughness 1991,S 27,C21:3
Suburban Commando 1991,O 6,56:3
Frozen Assets 1992,O 24,16:4
Miller, Lawrence (Miscellaneous)
L.A. Story 1991,F 8,C8:1
Doc Hollywood 1991,Ag 2,C8:5
Buffy the Vampire Slayer 1992,Jl 31,C8:5
Miller, Marcus (Composer)
Boomerang 1992,Jl 1,C18:1
Miller, Michael C. (Cinematographer)
Small Time 1991,N 8,C11:1
Miller, Michael R. (Miscellaneous)
Medicine Man 1992,F 7,C13:1
Miller, Nolan (Miscellaneous)
Soapdish 1991,My 31,C10:1
All I Want for Christmas 1991,N 8,C14:1
Miller, Penelope Ann
Kindergarten Cop 1991,Ja 20,II:13:1
Other People's Money 1991,O 18,C10:3
Year of the Comet 1992,Ap 25,17:1
Chaplin 1992,D 25,C3:1
Miller, Randall (Director)
Class Act 1992,Je 5,C17:1
Miller, Randy (Composer)
Into the Sun 1992,Ja 31,C10:6
Hellraiser III: Hell on Earth 1992,S 12,14:3
Miller, Rebecca
Regarding Henry 1991,Jl 10,C13:3
Wind 1992,S 11,C3:1
Consenting Adults 1992,O 16,C14:5
Miller, Robert Ellis (Director)
Brenda Starr 1992,Ap 19,46:1
Miller, Terry
Bikini Island 1991,Jl 27,16:3
Milliken, Sue (Producer)
Black Robe 1991,O 30,C15:2
Mills, Alec (Cinematographer)
Aces: Iron Eagle III 1992,Je 13,16:4
Christopher Columbus: The Discovery 1992,Ag 22,11:1
Mills, Charles (Cinematographer)
Boyz 'n the Hood 1991,Jl 12,C1:1
Mills, Johnny
Garden, The 1991,Ja 17,C16:5
Milot, Edmee (Producer)
Allah Tantou 1992,S 30,C18:3
Milsome, Douglas (Cinematographer)
If Looks Could Kill 1991,Mr 19,C12:5
Robin Hood: Prince of Thieves 1991,Je 14,C1:4
Mims, Stephen (Director)
Aunt Hallie 1991,Mr 22,C8:1
Mimura, Hidefumi
Homemade Movie 1991,Mr 26,C14:3
Minasian, Armen (Miscellaneous)
Life on the Edge 1992,Je 19,C11:1
Minch, Michelle (Miscellaneous)
House Party 2 1991,O 23,C17:1
Pet Sematary Two 1992,Ag 29,14:4
Miner, Steve (Director)
Warlock 1991,Mr 30,11:4
Wild Hearts Can't Be Broken 1991,My 24,C16:6
Forever Young 1992,D 16,C17:1

Miner, Steve (Producer)
Warlock 1991,Mr 30,11:4
Minervini, Gianni (Producer)
Mediterraneo 1992,Mr 22,48:4
Minghella, Anthony (Director)
Truly, Madly, Deeply 1991,My 3,C11:1
Minghella, Anthony (Screenwriter)
Truly, Madly, Deeply 1991,My 3,C11:1
Mingus, Charles
Last Date: Eric Dolphy 1992,Je 29,C16:5
Minion, Joseph (Screenwriter)
Motorama 1992,Mr 28,18:5
Minna
Amazon 1992,F 28,C8:5
Minnelli, Liza
Stepping Out 1991,O 4,C26:4
Minns, Byron Keith
South-Central 1992,O 16,C13:1
Minns, Michele
Daddy Nostalgia 1991,Ap 12,C10:1
Minsky, Charles (Cinematographer)
Dutch 1991,Jl 19,C13:1
Minter, Kristin
Cool as Ice 1991,O 19,12:6
Miracle, Jay (Miscellaneous)
Hearts of Darkness: A Film Maker's Apocalypse 1991,N 27,C9:1
Miralles, Joan
Aventis (Stories) 1992,N 13,C15:1
Miranda, Robert
Sister Act 1992,My 29,C10:1
Sister Act 1992,Jl 26,II:9:1
Mirandolo, Vasco
Mediterraneo 1992,Mr 22,48:4
Mirkovich, Steve (Miscellaneous)
Flight of the Intruder 1991,Ja 18,C19:1
Teen-Age Mutant Ninja Turtles II: The Secret of the Ooze 1991,Mr 22,C1:3
Necessary Roughness 1991,S 27,C21:3
Cool World 1992,Jl 11,12:3
Mirman, Edie
Professional, The 1992,O 23,C14:5
Mirojnick, Ellen (Miscellaneous)
Basic Instinct 1992,Mr 20,C8:1
Mirren, Helen
Comfort of Strangers, The 1991,Mr 29,C6:1
Comfort of Strangers, The 1991,Ap 7,II:13:5
Where Angels Fear to Tread 1992,F 28,C12:1
Where Angels Fear to Tread 1992,Mr 22,II:11:1
Mischwitzky, Gertrud
Affengeil 1992,Jl 25,15:4
Mishima, Yukio
Black Lizard 1991,S 18,C13:1
Missel, Renee (Producer)
Defenseless 1991,Ag 23,C8:1
Mistysyn, Stacie
Princes in Exile 1991,F 22,C12:5
Mita, Yoshiko
Rikyu 1991,Ja 18,C8:1
Silk Road, The 1992,My 29,C13:1
Mitard, Julien
Jacquot de Nantes 1991,S 25,C16:3
Mitchell, Charles (Producer)
Zebrahead 1992,O 8,C17:5
Mitchell, Doug (Producer)
Flirting 1992,N 6,C13:1
Lorenzo's Oil 1992,D 30,C7:3
Mitchell, Eddy
Until the End of the World 1991,D 25,18:5
Mitchell, Eric
Triple Bogey on a Par 5 Hole 1992,Mr 21,13:4
Mitchell, Heather
Proof 1992,Mr 20,C20:1
Mitchell, John Cameron
Book of Love 1991,F 1,C10:6
Misplaced 1991,Mr 1,C9:1
Mitchell, Mitch
Jimi Hendrix at the Isle of Wight 1991,Jl 4,C9:1
Mitchell, Shareen
June Roses 1992,Mr 24,C15:3
Mitchum, Bentley
Man in the Moon, The 1991,O 4,C13:1
Mitchum, Robert
Cape Fear 1991,N 13,C17:1
Cape Fear 1992,Ja 26,II:11:1
Mithoff, Bob (Composer)
Class of Nuke 'Em High Part 2: Subhumanoid Meltdown 1991,Ap 12,C13:1

Mitler, Matt
Blowback 1991,Ag 9,C13:1
Mitran, Doru (Cinematographer)
Oak, The 1992,O 1,C13:1
Mitterer, Felix
Requiem for Dominic 1991,Ap 19,C17:1
Mitterer, Felix (Screenwriter)
Requiem for Dominic 1991,Ap 19,C17:1
Mittleman, Gina (Miscellaneous)
Poison Ivy 1992,My 8,C16:3
Miyazaki, Hayao (Director)
Castle of Cagliostro, The 1992,Jl 3,C10:6
Miyazaki, Hayao (Screenwriter)
Castle of Cagliostro, The 1992,Jl 3,C10:6
Model, Ben
Puerto Rican Mambo (Not a Musical), The 1992,Mr
22,48:4
Model, Ben (Director)
Puerto Rican Mambo (Not a Musical), The 1992,Mr
22,48:4
Model, Ben (Miscellaneous)
Puerto Rican Mambo (Not a Musical), The 1992,Mr
22,48:4
Model, Ben (Producer)
Puerto Rican Mambo (Not a Musical), The 1992,Mr
22,48:4
Modine, Matthew
Wind 1992,S 11,C3:1
Moffat, Donald
Class Action 1991,Mr 15,C20:4
Regarding Henry 1991,Jl 10,C13:3
Housesitter 1992,Je 12,C1:4
Moffat, Pam (Miscellaneous)
Liquid Dreams 1992,Ap 15,C19:1
Mogilevskaya, Marina
Raspad 1992,Ap 29,C15:1
Mohr, Birita
Atlantic Rhapsody: 52 Scenes from Torshavn
1991,Mr 30,11:1
Moir, Alison
Johnny Suede 1992,Ag 14,C5:5
Mokae, Zakes
Rage in Harlem, A 1991,My 3,C14:1
Doctor, The 1991,Jl 24,C11:1
Body Parts 1991,Ag 3,9:1
Mokri, Amir (Cinematographer)
Queens Logic 1991,F 1,C13:1
Whore 1991,O 4,C15:1
Freejack 1992,Ja 18,17:5
Moldrup, Grete (Miscellaneous)
Memories of a Marriage 1991,Ja 28,C20:3
Molen, Gerald R. (Producer)
Hook 1991,D 11,C17:3
Molina, Alfred
Not Without My Daughter 1991,Ja 11,C8:1
Not Without My Daughter 1991,Ja 27,II:1:1
Enchanted April 1992,Jl 31,C15:1
Momoi, Kaori
Yen Family, The 1991,Ag 21,C13:1
Momper, Walter
November Days 1992,My 8,C8:1
Monahan, Debi A.
Shattered 1991,O 11,C24:3
Mondshein, Andrew (Miscellaneous)
Once Around 1991,Ja 18,C12:4
Stranger Among Us, A 1992,Jl 17,C1:3
Mones, Paul (Director)
Fathers and Sons 1992,N 6,C17:1
Mones, Paul (Screenwriter)
Fathers and Sons 1992,N 6,C17:1
Monjauze, Liza
Steal America 1992,Ap 3,C24:5
Monks, Michael
Out on a Limb 1992,S 5,15:1
Monnier, Laurent
Jacquot de Nantes 1991,S 25,C16:3
Montag, Thomas
November Days 1992,My 8,C8:1
Montand, Yves
Wages of Fear, The (Salaire de la Peur, Le) 1991,O
18,C8:3
Monteiro da Silva, Elias
Medicine Man 1992,F 7,C13:1
Monteleone, Vincenzo (Screenwriter)
Mediterraneo 1992,Mr 22,48:4
Montell, Judith (Director)
Forever Activists 1991,Je 14,C10:4

Montell, Judith (Producer)
Forever Activists 1991,Je 14,C10:4
Montell, Judith (Screenwriter)
Forever Activists 1991,Je 14,C10:4
Montes, Emmanuel
Mindwalk 1992,Ap 8,C17:1
Montes, Osvaldo (Composer)
Straight for the Heart 1991,F 4,C14:1
Montes, Vira
American Me 1992,Mr 13,C6:5
Montesinos, Guillermo
Aventis (Stories) 1992,N 13,C15:1
Montgomery, Elizabeth (Narrator)
Panama Deception, The 1992,O 23,C10:5
Montgomery, Reggie
Hangin' with the Homeboys 1991,My 24,C12:6
Montiege, Olivier
Cross My Heart 1991,Ap 5,C18:5
Montini, Luigi
Mediterraneo 1992,Mr 22,48:4
Montmarquette, Yves
Leolo 1992,S 29,C11:1
Montoya, Alejandra
Woman of the Port (Mujer del Puerto, La) 1991,S
27,C5:1
Montpetit, Marie-Helene
Leolo 1992,S 29,C11:1
Mooney, Laura
Little Nemo: Adventures in Slumberland 1992,Ag
21,C13:1
Moore, Allen (Cinematographer)
Black Water 1991,My 8,C11:4
Moore, Allen (Director)
Black Water 1991,My 8,C11:4
Moore, Allen (Miscellaneous)
Black Water 1991,My 8,C11:4
Moore, Allen (Producer)
Black Water 1991,My 8,C11:4
Moore, Brian (Original Author)
Black Robe 1991,O 30,C15:2
Black Robe 1991,N 17,II:24:2
Cold Heaven 1992,My 29,C15:1
Moore, Brian (Screenwriter)
Black Robe 1991,O 30,C15:2
Black Robe 1991,N 17,II:24:2
Moore, Deborah Maria
Into the Sun 1992,Ja 31,C10:6
Moore, Demi
Nothing But Trouble 1991,F 16,16:5
Mortal Thoughts 1991,Ap 19,C15:1
Butcher's Wife, The 1991,O 25,C24:1
Few Good Men, A 1992,N 6,C1:1
Few Good Men, A 1992,D 11,C20:1
Moore, Dudley
Blame It on the Bellboy 1992,Mr 6,C10:6
Moore, E. J.
Poison Ivy 1992,My 8,C16:3
Moore, John Jay (Miscellaneous)
FX2: The Deadly Art of Illusion 1991,My 10,C8:5
Double Impact 1991,Ag 9,C8:5
Whispers in the Dark 1992,Ag 7,C17:1
Moore, Julianne
Hand That Rocks the Cradle, The 1992,Ja 10,C8:1
Moore, Kaycee
Daughters of the Dust 1992,Ja 16,C19:1
Moore, Michael
Pets or Meat: The Return to Flint (Taking the Pulse)
1992,S 26,11:4
Moore, Michael (Director)
Pets or Meat: The Return to Flint (Taking the Pulse)
1992,S 26,11:4
Moore, Michael (Miscellaneous)
Blood in the Face 1991,F 27,C11:1
Moore, Michael (Producer)
Pets or Meat: The Return to Flint (Taking the Pulse)
1992,S 26,11:4
Moore, Sheila
Reflecting Skin, The 1991,Je 28,C9:1
Moore, Simon (Director)
Under Suspicion 1992,F 28,C10:1
Moore, Simon (Screenwriter)
Under Suspicion 1992,F 28,C10:1
Moore, Thurston
1991: The Year Punk Broke 1992,N 20,C5:1
Moorhouse, Jocelyn (Director)
Proof 1992,Mr 20,C20:1
Moorhouse, Jocelyn (Screenwriter)
Proof 1992,Mr 20,C20:1

Mor, Juliano
Deadly Currents 1992,O 16,C8:5
Morahan, Christopher (Director)
Paper Mask 1992,F 28,C19:1
Morahan, Christopher (Producer)
Paper Mask 1992,F 28,C19:1
Morales, Beo (Composer)
Wax, or the Discovery of Television Among the
Bees 1992,Ag 21,C10:1
Morales, Esai
Naked Tango 1991,Ag 23,C19:1
Moran, Michael (Miscellaneous)
Undertow 1991,S 18,C16:3
Moranis, Rick
Honey, I Blew Up the Kid 1992,Jl 17,C6:5
Morano, Carl (Screenwriter)
Class of Nuke 'Em High Part 2: Subhumanoid
Meltdown 1991,Ap 12,C13:1
Moravioff, Galeshka (Producer)
Echoes from a Somber Empire 1992,Jl 15,C15:3
Moreau, Jeanne
Femme Nikita, La 1991,Mr 8,C10:1
Femme Nikita, La 1991,My 5,II:17:1
Anna Karamazova 1991,My 26,II:9:2
Suspended Step of the Stork, The 1991,S 23,C15:1
Until the End of the World 1991,D 25,18:5
Alberto Express 1992,O 9,C12:5
Moreau, Jeanne (Narrator)
Lover, The 1992,O 30,C5:1
Moreau, Marsha
Beautiful Dreamers 1992,Je 5,C15:1
Morehead, Elizabeth
Whore 1991,O 4,C15:1
Moreno, Maria
Dream of Light (Sol del Membrillo, El) 1992,O
1,C17:1
Moreno, Maria (Producer)
Dream of Light (Sol del Membrillo, El) 1992,O
1,C17:1
Moreno, Ruby
Swimming with Tears 1992,Mr 22,49:1
Moreno, Sergio
Hours and Times, The 1992,Ap 3,C10:1
Moretti, Nanni
Portaborse, Il 1992,D 31,C18:1
Morgan, Andre E. (Producer)
Ladybugs 1992,Mr 28,17:1
Morgan, Lynn (Producer)
Mighty Ducks, The 1992,O 2,C18:1
Morgan, Mark (Composer)
Where the Day Takes You 1992,S 11,C14:5
Morgan, Michele
Everybody's Fine (Stanno Tutti Bene) 1991,My
31,C12:6
Proud Ones, The (Proud and the Beautiful, The)
1992,My 29,C17:1
Morgan, W. T. (Director)
Matter of Degrees, A 1991,S 13,C9:4
Morgan, W. T. (Screenwriter)
Matter of Degrees, A 1991,S 13,C9:4
Morgan, Willard
Romeo and Julia 1992,F 14,C6:5
Morgenstern, Dan
Texas Tenor: The Illinois Jacquet Story 1992,N
20,C5:1
Morgenstern, Janusz (Producer)
Korczak 1991,Ap 12,C8:1
Morgenstern, Maia
Oak, The 1992,O 1,C13:1
Mori, Mark (Director)
Building Bombs 1991,O 12,20:3
Mori, Mark (Producer)
Building Bombs 1991,O 12,20:3
Mori, Mark (Screenwriter)
Building Bombs 1991,O 12,20:3
Moriarty, Cathy
Soapdish 1991,My 31,C10:1
Mambo Kings, The 1992,F 28,C8:1
Morice, Tara
Strictly Ballroom 1992,S 26,12:5
Morie, Hiroshi (Producer)
Rikyu 1991,Ja 18,C8:1
Morimoto, Kouji (Director)
Robot Carnival 1991,Mr 15,C14:5
Morita, Fujio (Cinematographer)
Rikyu 1991,Ja 18,C8:1
Morita, Pat
Honeymoon in Vegas 1992,Ag 28,C8:5

569

Myers, Mike (Screenwriter)
Wayne's World 1992,F 14,C15:1
Wayne's World 1992,Mr 8,II:15:1
Wayne's World 1992,Je 26,C1:3
Myers, Stanley (Composer)
Rosencrantz and Guildenstern Are Dead 1991,F
8,C14:6
Dark Obsession 1991,Je 7,C10:1
Iron Maze 1991,N 1,C13:1
Voyager 1992,Ja 31,C6:1
Cold Heaven 1992,My 29,C15:1
Sarafina! 1992,S 18,C16:6
Myhrman, Dan (Cinematographer)
Ox, The 1992,Ag 21,C10:5
Myron, Ben (Producer)
One False Move 1992,Jl 17,C6:1

N

N., Edward
Home Less Home 1991,Mr 22,C8:5
Nabu, Else
Johanna d'Arc of Mongolia 1992,My 15,C8:1
Nachon, Angelique (Composer)
Alberto Express 1992,O 9,C12:5
Nachon, Jean-Claude (Composer)
Alberto Express 1992,O 9,C12:5
Naderi, Amir (Director)
Runner, The 1991,Je 21,C5:1
Naderi, Amir (Screenwriter)
Runner, The 1991,Je 21,C5:1
Nae, Victorita (Miscellaneous)
Oak, The 1992,O 1,C13:1
Naff, Lycia
Chopper Chicks in Zombietown 1991,My 10,C15:5
Nagasaki, Shunichi (Director)
Enchantment, The 1992,My 20,C15:3
Nagase, Masatoshi
Autumn Moon 1992,S 26,12:1
Autumn Moon 1992,O 11,II:11:1
Nage, Mason (Miscellaneous)
Borrower, The 1991,O 18,C12:3
Nage, Mason (Screenwriter)
Borrower, The 1991,O 18,C12:3
Nagy, Erika
Hearing Voices 1991,N 15,C11:1
Naha, Ed (Miscellaneous)
Honey, I Blew Up the Kid 1992,Jl 17,C6:5
Nahyr, Maite
Meeting Venus 1991,N 15,C1:3
Naidu, Samantha (Producer)
Woman's Tale, A 1992,Ap 30,C16:6
Nair, Mira (Director)
Mississippi Masala 1992,F 5,C15:1
Nair, Mira (Producer)
Mississippi Masala 1992,F 5,C15:1
Najimy, Kathy
Soapdish 1991,My 31,C10:1
Sister Act 1992,My 29,C10:1
Sister Act 1992,Je 7,II:13:1
Nakagawa, Anna
Silk Road, The 1992,My 29,C13:1
Nakajima, Goro (Screenwriter)
Enchantment, The 1992,My 20,C15:3
Nakamura, Kichiemon
Rikyu 1991,Ja 18,C8:1
Nakamura, Takashi (Director)
Robot Carnival 1991,Mr 15,C14:5
Nakano, Desmond (Screenwriter)
American Me 1992,Mr 13,C6:5
Nanak, Gabor (Producer)
Shadow on the Snow 1992,Mr 31,C16:1
Nanty, Isabelle
Tatie Danielle 1991,My 17,C8:1
Narcejac, Thomas (Original Author)
Body Parts 1991,Ag 3,9:1
Nardi, Tony
Adjuster, The 1991,S 26,C18:5
Nardone, Robert (Miscellaneous)
Jacquot de Nantes 1991,S 25,C16:3
Narita, Hiro (Cinematographer)
Rocketeer, The 1991,Je 21,C1:3
Star Trek VI: The Undiscovered Country 1991,D
6,C1:1
Inland Sea, The 1992,Je 17,C13:1

Narusawa, Masashige (Screenwriter)
Black Lizard 1991,S 18,C13:1
Nash the Slash (Composer)
Highway 61 1992,Ap 24,C19:1
Nasikyan, Armen
Satan 1992,Mr 28,18:1
Natkin, Rick (Screenwriter)
Necessary Roughness 1991,S 27,C21:3
Taking of Beverly Hills, The 1991,O 13,68:5
Navarre, Yves (Original Author)
Straight for the Heart 1991,F 4,C14:1
Navarrete, Roberto
Amelia Lopes O'Neill 1991,S 21,12:3
Navarro, Guillermo (Cinematographer)
Cabeza de Vaca 1991,Mr 23,12:6
Navaud, Guillaume
Jacquot de Nantes 1991,S 25,C16:3
Navazio, Michele
John Lurie and the Lounge Lizards Live in Berlin
1991 1992,S 9,C14:5
Navon, Shim
Deadly Currents 1992,O 16,C8:5
Nazimova, Alla
Salome 1991,N 8,C1:1
Neal, Billie
Mortal Thoughts 1991,Ap 19,C15:1
Neal, Tom
Detour 1992,Jl 3,C8:1
Neale, Brent
Careful 1992,O 7,C20:3
Neale, Leslie
Honey, I Blew Up the Kid 1992,Jl 17,C6:5
Nealon, Kevin
All I Want for Christmas 1991,N 8,C14:1
Near, Holly
Dogfight 1991,S 13,C13:1
Nebenzal, Harold
Other Eye, The 1991,S 25,C17:1
Neckar, Vaclav
Larks on a String 1991,F 13,C14:4
Neckelbrouck, Jean-Claude (Cinematographer)
Night and Day 1992,D 11,C10:6
Nedd-Friendly, Priscilla (Miscellaneous)
Guilty by Suspicion 1991,Mr 15,C12:1
Doc Hollywood 1991,Ag 2,C8:5
Neely, Richard (Original Author)
Shattered 1991,O 11,C24:3
Neeson, Liam
Crossing the Line 1991,Ag 9,C11:1
Shining Through 1992,Ja 31,C8:5
Under Suspicion 1992,F 28,C10:1
Husbands and Wives 1992,S 18,C1:1
Leap of Faith 1992,D 18,C14:1
Negishi, Toshie
Rhapsody in August 1991,D 20,C22:4
Negret, Francois
Night and Day 1992,D 11,C10:6
Negrin, Michael (Cinematographer)
Dice Rules 1991,My 18,15:5
Negron, Taylor
Nothing But Trouble 1991,F 16,16:5
Last Boy Scout, The 1991,D 13,C14:6
Neiden, Daniel
Tune, The 1992,S 4,C3:1
Neil, Debra (Miscellaneous)
Fried Green Tomatoes 1991,D 27,C3:1
Dr. Giggles 1992,O 24,16:4
Neill, Sam
Until the End of the World 1991,D 25,18:5
Until the End of the World 1992,Ja 19,II:13:5
Memoirs of an Invisible Man 1992,F 28,C17:1
Nelligan, Kate
Frankie and Johnny 1991,O 11,C1:1
Prince of Tides, The 1991,D 25,13:3
Prince of Tides, The 1992,F 23,II:13:1
Shadows and Fog 1992,Mr 20,C6:1
Nelson, Ann
My Girl 1991,N 27,C15:1
Nelson, Bob
This Is My Life 1992,F 21,C8:1
Brain Donors 1992,Ap 18,11:1
Nelson, Ed
Brenda Starr 1992,Ap 19,46:1
Nelson, Jerry
Muppet Christmas Carol, The 1992,D 11,C12:6
Nelson, Jessie (Director)
To the Moon, Alice 1991,O 2,C19:1

Nelson, Jessie (Screenwriter)
To the Moon, Alice 1991,O 2,C19:1
Nelson, Judd
New Jack City 1991,Mr 8,C15:1
Dark Backward, The 1991,Jl 26,C18:4
Nelson, Marty
Tune, The 1992,S 4,C3:1
Nelson, Merritt
Trust 1991,Jl 26,C16:5
Nemec, Joseph, 3d (Miscellaneous)
Terminator 2: Judgment Day 1991,Jl 3,C11:5
Patriot Games 1992,Je 5,C1:1
Nemolyayev, Nikolai (Cinematographer)
City Zero 1991,Mr 22,C14:1
Nepomniaschy, Alex (Cinematographer)
End of Innocence, The 1991,Ja 18,C17:1
Nero, Franco
Amelia Lopes O'Neill 1991,S 21,12:3
Nesbitt, James
Hear My Song 1992,Ja 19,48:1
Nesci, John
Crisscross 1992,My 9,17:5
Netter, Gil (Producer)
Brain Donors 1992,Ap 18,11:1
Nettles, Laurie
Talking to Strangers 1991,D 27,C12:6
Neufeld, Mace (Producer)
Flight of the Intruder 1991,Ja 18,C19:1
Necessary Roughness 1991,S 27,C21:3
Patriot Games 1992,Je 5,C1:1
Neufeld, Stan (Producer)
Aces: Iron Eagle III 1992,Je 13,16:4
Neuman, Rivka
Berlin Jerusalem 1991,Mr 8,C16:6
Neumann, Peter Christian (Cinematographer)
Via Appia 1992,Ag 27,C16:5
Neuwirth, Bebe
Bugsy 1991,D 13,C12:1
Bugsy 1991,D 22,II:22:1
Neville, Sarah
Archangel 1991,Jl 19,C12:6
Careful 1992,O 7,C20:3
Nevius, Steve (Miscellaneous)
South-Central 1992,O 16,C13:1
New, Gary T. (Miscellaneous)
Into the Sun 1992,Ja 31,C10:6
New, Robert (Cinematographer)
Lionheart 1991,Ja 11,C8:4
Borrower, The 1991,O 18,C12:3
Newbern, George
Father of the Bride 1991,D 20,C17:1
Newberry, Norman (Miscellaneous)
Noises Off 1992,Mr 20,C10:1
Newborn, Ira (Composer)
Naked Gun 2 1/2: The Smell of Fear 1991,Je 28,C8:1
Brain Donors 1992,Ap 18,11:1
Innocent Blood 1992,S 25,C6:5
Newell, Mike (Director)
Enchanted April 1992,Jl 31,C15:1
Newirth, Charles (Producer)
Toys 1992,D 18,C1:3
Newman, Andrew Hill
Mannequin Two: On the Move 1991,My 19,50:3
Newman, David (Composer)
Meet the Applegates 1991,F 1,C6:1
Marrying Man, The 1991,Ap 5,C6:1
Don't Tell Mom the Babysitter's Dead 1991,Je
7,C19:1
Bill and Ted's Bogus Journey 1991,Jl 19,C10:1
Paradise 1991,S 18,C16:3
Other People's Money 1991,O 18,C10:3
Honeymoon in Vegas 1992,Ag 28,C8:5
Mighty Ducks, The 1992,O 2,C18:1
Hoffa 1992,D 25,C1:1
Newman, Laraine
Problem Child 2 1991,Jl 5,C6:1
Newman, Leslea (Original Author)
Letter to Harvey Milk, A 1991,Je 14,C10:4
Newman, Peter (Producer)
Dogfight 1991,S 13,C13:1
Newman, Thomas (Composer)
Career Opportunities 1991,Mr 31,38:1
Naked Tango 1991,Ag 23,C19:1
Deceived 1991,S 27,C8:5
Rapture, The 1991,S 30,C14:4
Fried Green Tomatoes 1991,D 27,C3:1
Player, The 1992,Ap 10,C16:1
Linguini Incident, The 1992,My 1,C15:1

Nyman, Michael (Composer)
Drowning by Numbers 1991,Ap 26,C8:1
Prospero's Books 1991,S 28,9:1
Hairdresser's Husband, The 1992,Je 19,C11:1

O

O'Bannon, Dan (Miscellaneous)
Alien 3 1992,My 22,C1:1
Obata, Toshishiro
Teen-Age Mutant Ninja Turtles II: The Secret of the Ooze 1991,Mr 22,C1:3
Oberer, Amy
All I Want for Christmas 1991,N 8,C14:1
Obodiac, Hadley
Highway 61 1992,Ap 24,C19:1
Obrecht, Philip (Miscellaneous)
Building Bombs 1991,O 12,20:3
O'Brien, Kevin
Warlock 1991,Mr 30,11:4
Obst, Lynda (Producer)
Fisher King, The 1991,S 20,C10:4
This Is My Life 1992,F 21,C8:1
Oceransky, Abraham (Original Author)
Frida Kahlo: A Ribbon Around a Bomb 1992,My 22,C10:1
Ochlan, P. J.
Little Man Tate 1991,O 9,C17:4
Ockersen, Thys (Director)
Roy Rogers: King of the Cowboys 1992,D 30,C12:3
Ockersen, Thys (Screenwriter)
Roy Rogers: King of the Cowboys 1992,D 30,C12:3
O'Connell, Deirdre
Misplaced 1991,Mr 1,C9:1
Pastime 1991,Ag 23,C13:1
Straight Talk 1992,Ap 3,C17:1
Crisscross 1992,My 9,17:5
O'Connell, Patricia
Passed Away 1992,Ap 24,C8:1
O'Connor, Donald
Toys 1992,D 18,C1:3
Odom, George T.
Straight Out of Brooklyn 1991,My 22,C11:5
O'Donnell, Anthony
Nuts in May 1992,Ap 10,C1:2
O'Donnell, Chris
Fried Green Tomatoes 1991,D 27,C3:1
School Ties 1992,S 18,C19:1
Scent of a Woman 1992,D 23,C9:1
O'Donnell, Rosie
League of Their Own, A 1992,Jl 1,C13:4
Offner, Deborah
Unlawful Entry 1992,Je 26,C10:4
Ogata, Naotoshi (Miscellaneous)
Robot Carnival 1991,Mr 15,C14:5
Ogier, Bulle
Paloma, La 1992,F 29,17:5
Ogilvy, Ian
Death Becomes Her 1992,Jl 31,C8:1
Oginski, Michal (Composer)
Shadow on the Snow 1992,Mr 31,C16:1
Oglesby, Caleb (Miscellaneous)
John Lurie and the Lounge Lizards Live in Berlin 1991 1992,S 9,C14:5
Ogletree, Michael
Mona's Pets (Short and Funnies, The) 1992,D 16,C30:3
O'Hagan, Colo Tavernier (Screenwriter)
Daddy Nostalgia 1991,Ap 12,C10:1
Ohana, Claudia
Fable of the Beautiful Pigeon Fancier, The 1991,Mr 1,C6:4
O'Hara, Catherine
Home Alone 2: Lost in New York 1992,N 20,C1:1
O'Hara, Jenny
Career Opportunities 1991,Mr 31,38:1
O'Hara, Maureen
Only the Lonely 1991,My 24,C10:6
Only the Lonely 1991,Je 2,II:15:1
O'Hara, Paige
Beauty and the Beast 1991,N 13,C17:4
O'Hearn, Patrick (Composer)
White Sands 1992,Ap 24,C18:1
Ohmori, Hidetoshi (Director)
Robot Carnival 1991,Mr 15,C14:5

Ohno, Yuuji (Composer)
Castle of Cagliostro, The 1992,Jl 3,C10:6
Ohtakara, Tomoko
Rhapsody in August 1991,D 20,C22:4
Ohtsuka, Yasuo (Cinematographer)
Castle of Cagliostro, The 1992,Jl 3,C10:6
Okada, Daryn (Cinematographer)
Wild Hearts Can't Be Broken 1991,My 24,C16:6
Captain Ron 1992,S 18,C23:1
Okada, Eiji
Traffic Jam 1992,Mr 20,C20:4
Okada, Yutaka (Producer)
Heaven and Earth 1991,Mr 1,C10:4
Traffic Jam 1992,Mr 20,C20:4
Okay, Yaman
Journey of Hope 1991,Ap 26,C13:1
Oken, Stuart (Producer)
Queens Logic 1991,F 1,C13:1
Impromptu 1991,Ap 12,C10:5
Freejack 1992,Ja 18,17:5
Okonedo, Sophie
Young Soul Rebels 1991,D 6,C21:1
Okuhara, Shigeru (Miscellaneous)
No Life King 1991,S 22,58:5
Okuhara, Yoshiyuki (Miscellaneous)
Enchantment, The 1992,My 20,C15:3
Okun, Charles (Producer)
Grand Canyon 1991,D 25,18:1
Olafsson, Egill
Shadow of the Raven, The 1991,Jl 13,12:1
Olanick, Anita
Julia Has Two Lovers 1991,Mr 24,64:1
Oldcorn, Christopher (Miscellaneous)
Refrigerator, The 1992,S 25,C16:6
Oldcorn, Christopher (Producer)
Refrigerator, The 1992,S 25,C16:6
Oldham, Will
1,000 Pieces of Gold 1991,S 27,C10:4
Oldman, Gary
Rosencrantz and Guildenstern Are Dead 1991,F 8,C14:6
J.F.K. 1991,D 20,C1:1
Meantime 1992,Ap 10,C1:2
Bram Stoker's "Dracula" 1992,N 13,C1:3
Bram Stoker's "Dracula" 1992,N 22,II:13:1
O'Leary, William
Hot Shots! 1991,Jl 31,C11:2
Olekceenko, Vladimir
Raspad 1992,Ap 29,C15:1
Olin, Ken
Queens Logic 1991,F 1,C13:1
Oliver, Allen
Complex World 1992,Ap 10,C14:5
Oliver, Michael
Problem Child 2 1991,Jl 5,C6:1
Oliver, Natalie
Mississippi Masala 1992,F 5,C15:1
Oliver, Rochelle
Scent of a Woman 1992,D 23,C9:1
Oliver, Tony
Fist of the North Star 1991,N 15,C8:1
Oliveri, Robert
Honey, I Blew Up the Kid 1992,Jl 17,C6:5
Olivier, Laurence
Spartacus 1991,Ap 26,C6:4
Sleuth 1992,N 20,C1:3
Olmos, Edward James
American Me 1992,Mr 13,C6:5
Olmos, Edward James (Director)
American Me 1992,Mr 13,C6:5
Olmos, Edward James (Producer)
American Me 1992,Mr 13,C6:5
Olsen, Dana (Screenwriter)
Memoirs of an Invisible Man 1992,F 28,C17:1
Olvis, William (Composer)
29th Street 1991,N 1,C14:1
O'Meara, C. Timothy (Miscellaneous)
Flight of the Intruder 1991,Ja 18,C19:1
V. I. Warshawski 1991,Jl 26,C1:3
Omens, Woody (Cinematographer)
Boomerang 1992,Jl 1,C18:1
Omori, Toshiyuki (Composer)
Professional, The 1992,O 23,C14:5
Ondricek, Miroslav (Cinematographer)
League of Their Own, A 1992,Jl 1,C13:4
O'Neal, Patrick
For the Boys 1991,N 22,C12:1
Under Siege 1992,O 9,C12:1

O'Neal, Tatum
Little Noises 1992,Ap 24,C8:6
O'Neil, Larry
Lost Prophet 1992,Je 8,C16:1
O'Neil, Larry (Screenwriter)
Lost Prophet 1992,Je 8,C16:1
O'Neill, Amy
Honey, I Blew Up the Kid 1992,Jl 17,C6:5
O'Neill, Ed
Dutch 1991,Jl 19,C13:1
O'Neill, Maggie
Under Suspicion 1992,F 28,C10:1
Onwurah, Madge
Body Beautiful, The 1991,O 3,C21:1
Onwurah, Ngozi (Director)
Body Beautiful, The 1991,O 3,C21:1
Onwurah, Ngozi (Screenwriter)
Body Beautiful, The 1991,O 3,C21:1
Ophuls, Marcel (Director)
November Days 1992,My 8,C8:1
Ophuls, Marcel (Producer)
November Days 1992,My 8,C8:1
Oppenheim, Jonathan (Miscellaneous)
Paris Is Burning 1991,Mr 13,C13:1
Bruce Diet, The 1992,Ap 15,C19:1
Oppewall, Jeannine Claudia (Miscellaneous)
School Ties 1992,S 18,C19:1
O'Quinn, Terry
Rocketeer, The 1991,Je 21,C1:3
Prisoners of the Sun 1991,Jl 19,C12:1
Pin 1991,D 4,C28:1
Cutting Edge, The 1992,Mr 27,C21:1
Company Business 1992,Ap 25,17:1
Orbach, Jerry
Out for Justice 1991,Ap 13,12:4
Delusion 1991,Je 7,C12:6
Delirious 1991,Ag 9,C12:4
Beauty and the Beast 1991,N 13,C17:4
Straight Talk 1992,Ap 3,C17:1
Universal Soldier 1992,Jl 10,C17:1
Mr. Saturday Night 1992,S 23,C13:4
Orbach, Ron
Love Crimes 1992,Ja 26,43:5
Orcier, Fabien
For Sasha 1992,Je 5,C13:1
O'Regan, James (Producer)
Edsville (Short and Funnies, The) 1992,D 16,C30:3
O'Regan, James (Screenwriter)
Edsville (Short and Funnies, The) 1992,D 16,C30:3
Orgolini, Arnold (Producer)
Linguini Incident, The 1992,My 1,C15:1
Oristrell, Joaquin (Screenwriter)
Don Juan, My Love 1991,Jl 12,C10:5
Orlando, Silvio
Portaborse, Il 1992,D 31,C18:1
Ormezzano, Florence
Wax, or the Discovery of Television Among the Bees 1992,Ag 21,C10:1
Ormezzano, Florence (Miscellaneous)
Wax, or the Discovery of Television Among the Bees 1992,Ag 21,C10:1
Ormieres, Jean-Luc (Producer)
Captive of the Desert, The (Captive du Desert, La) 1991,Mr 21,C20:3
Ornstein, Michael (Miscellaneous)
And You Thought Your Parents Were Weird 1991,N 15,C13:1
O'Ross, Ed
Universal Soldier 1992,Jl 10,C17:1
O'Rourke, Dennis (Cinematographer)
Good Woman of Bangkok, The 1992,My 15,C13:1
O'Rourke, Dennis (Director)
Good Woman of Bangkok, The 1992,My 15,C13:1
O'Rourke, Dennis (Producer)
Good Woman of Bangkok, The 1992,My 15,C13:1
Orsatti, Frank
Ruby 1992,Mr 27,C1:3
Orsatti, Silvana
City of the Blind (Ciudad de Ciegos) 1992,Ap 4,17:5
Orsenna, Eric (Screenwriter)
Indochine 1992,D 24,C9:1
Ortega, Chick
Until the End of the World 1991,D 25,18:5
Ortega, Kenny (Director)
Newsies 1992,Ap 8,C22:3
Ortega, Kenny (Miscellaneous)
Newsies 1992,Ap 8,C22:3

P

Parke, Sean
Steal America 1992,Ap 3,C24:5
Parker, Alan (Director)
Commitments, The 1991,Ag 14,C11:1
Commitments, The 1991,S 29,II:15:1
Parker, Bonnie
Antonia and Jane 1991,O 26,13:1
Parker, David (Cinematographer)
Pure Luck 1991,Ag 9,C15:1
Parker, Don LeRoy (Producer)
China Cry 1991,My 3,C9:1
Parker, Jameson
White Dog 1991,Jl 12,C8:1
Parker, Laurie (Producer)
My Own Private Idaho 1991,S 27,C5:1
Parker, Mary-Louise
Grand Canyon 1991,D 25,18:1
Fried Green Tomatoes 1991,D 27,C3:1
Fried Green Tomatoes 1992,F 23,II:13:1
Parker, Mike
My Own Private Idaho 1991,S 27,C5:1
Parker, Sarah Jessica
L.A. Story 1991,F 8,C8:1
L.A. Story 1991,F 24,II:11:5
Honeymoon in Vegas 1992,Ag 28,C8:5
Parker, Tom S. (Miscellaneous)
Stay Tuned 1992,Ag 15,14:5
Parker, Tom S. (Screenwriter)
Stay Tuned 1992,Ag 15,14:5
Parker, Trey
Newsies 1992,Ap 8,C22:3
Parkes, Walter F. (Producer)
Sneakers 1992,S 9,C18:3
Parkes, Walter F. (Screenwriter)
Sneakers 1992,S 9,C18:3
Parkinson, Michael (Miscellaneous)
Close My Eyes 1992,F 21,C12:6
Parks, Gerard
Adjuster, The 1991,S 26,C18:5
Parks, Michael
Storyville 1992,Ag 26,C13:3
Parks, Tom
Ladybugs 1992,Mr 28,17:1
Parks, Van Dyke (Composer)
Out on a Limb 1992,S 5,15:1
Parlor, Lonnie
Legends 1991,Mr 17,68:5
Parmet, Phil (Cinematographer)
In the Soup 1992,O 3,13:2
Parodi, Alejandro
Woman of the Port (Mujer del Puerto, La) 1991,S
27,C5:1
Parrondo, Gil (Miscellaneous)
Christopher Columbus: The Discovery 1992,Ag
22,11:1
Parsons, Stephen (Composer)
Split Second 1992,My 4,C15:1
Parton, Dolly
Straight Talk 1992,Ap 3,C17:1
Parton, Dolly (Composer)
Straight Talk 1992,Ap 3,C17:1
Pasco, Isabelle
Prospero's Books 1991,S 28,9:1
Paso, Encarna
Bosque Animado, El (Enchanted Forest, The)
1992,D 4,C8:6
Pasotti, Felicie
Every Other Weekend 1991,Je 19,C12:3
Pasquini, Angelo (Miscellaneous)
Portaborse, Il 1992,D 31,C18:1
Pass, Cyndi
Bikini Island 1991,Jl 27,16:3
Pastko, Earl
Highway 61 1992,Ap 24,C19:1
Pastor, Julian
Woman of the Port (Mujer del Puerto, La) 1991,S
27,C5:1
Pastorelli, Robert
Ferngully: The Last Rain Forest 1992,Ap 10,C10:5
Folks! 1992,My 4,C15:1
Paterson, Bill
Object of Beauty, The 1991,Ap 12,C14:4
Truly, Madly, Deeply 1991,My 3,C11:1
Patinkin, Mandy
True Colors 1991,Mr 15,C19:1
Impromptu 1991,Ap 12,C10:5
Doctor, The 1991,Jl 24,C11:1

Patou, Francoise
Ciel de Paris, Le 1992,Mr 29,48:2
Patric, Jason
Rush 1991,D 22,56:4
Patrick, Robert
Terminator 2: Judgment Day 1991,Jl 3,C11:5
Patterson, Chuck
Five Heartbeats, The 1991,Mr 29,C14:3
Patterson, Jay
McBain 1991,S 23,C15:1
Patton, Will
Bright Angel 1991,Je 14,C6:1
Rapture, The 1991,S 30,C14:4
Cold Heaven 1992,My 29,C15:1
In the Soup 1992,O 3,13:2
Paul, Don Michael
Rich Girl 1991,My 4,15:1
Paul, Don Michael (Screenwriter)
Harley Davidson and the Marlboro Man 1991,Ag
24,16:6
Paul, Nancy
V. I. Warshawski 1991,Jl 26,C1:3
Paul, Victoria (Miscellaneous)
Kuffs 1992,Ja 10,C16:6
My Cousin Vinny 1992,Mr 13,C6:1
Paull, Lawrence G. (Miscellaneous)
City Slickers 1991,Je 7,C18:5
Memoirs of an Invisible Man 1992,F 28,C17:1
Unlawful Entry 1992,Je 26,C10:4
Paulson, Dan (Producer)
Passenger 57 1992,N 6,C14:5
Pavel, Paul
Love Without Pity (Monde sans Pitie, Une) 1991,My
31,C16:4
Pavlaskova, Irene (Director)
Time of the Servants 1991,Mr 19,C12:3
Pavlaskova, Irene (Screenwriter)
Time of the Servants 1991,Mr 19,C12:3
Paxinou, Katina
Rocco and His Brothers 1991,S 21,12:1
Rocco and His Brothers 1992,Ja 24,C8:1
Paxton, Bill
Dark Backward, The 1991,Jl 26,C18:4
One False Move 1992,Jl 17,C6:1
Trespass 1992,D 25,C18:5
Paymer, David
City Slickers 1991,Je 7,C18:5
Mr. Saturday Night 1992,S 23,C13:4
Payne, Allen
New Jack City 1991,Mr 8,C15:1
Payne, Bruce
Passenger 57 1992,N 6,C14:5
Payne, Bruce Martyn
Switch 1991,My 10,C13:1
Payne, Cecil
Texas Tenor: The Illinois Jacquet Story 1992,N
20,C5:1
Payne, William Mosley (Screenwriter)
Livin' Large 1991,S 20,C15:1
Paynter, Robert (Cinematographer)
Get Back 1991,O 25,C19:1
Pays, Amanda
Exposure 1991,N 1,C12:6
Paz, Senel (Screenwriter)
Adorable Lies 1992,Mr 27,C8:5
Peake, Don (Composer)
People Under the Stairs, The 1991,N 2,17:1
Pearce, Craig (Original Author)
Strictly Ballroom 1992,S 26,12:5
Pearce, Richard (Director)
Leap of Faith 1992,D 18,C14:1
Pearl, Daniel (Cinematographer)
Truth or Dare 1991,My 10,C1:3
Pearl, Linda (Miscellaneous)
Love Potion No. 9 1992,N 13,C12:5
Peck, Bob
On the Black Hill 1991,Ag 16,C8:1
Peck, Cecilia
Ambition 1991,Je 1,16:3
Peck, Craig
There's Nothing Out There 1992,Ja 22,C20:4
Peck, Gregory
Other People's Money 1991,O 18,C10:3
Other People's Money 1991,N 3,II:22:1
Cape Fear 1991,N 13,C17:1
Cape Fear 1992,Ja 26,II:11:1
Peck, Raoul (Director)
Lumumba: Death of a Prophet 1992,S 30,C18:3

Peck, Raoul (Miscellaneous)
Lumumba: Death of a Prophet 1992,S 30,C18:3
Peck, Raoul (Producer)
Lumumba: Death of a Prophet 1992,S 30,C18:3
Peck, Richard (Original Author)
Gas Food Lodging 1992,Jl 31,C1:1
Peck, Ron (Cinematographer)
Strip Jack Naked 1991,Je 8,16:5
Peck, Ron (Director)
Strip Jack Naked 1991,Je 8,16:5
Peck, Ron (Miscellaneous)
Strip Jack Naked 1991,Je 8,16:5
Peck, Ron (Screenwriter)
Strip Jack Naked 1991,Je 8,16:5
Peck, Tony
Brenda Starr 1992,Ap 19,46:1
Pei Xiaonan (Miscellaneous)
Life on a String 1992,S 29,54:5
Peiser, Judy (Director)
All Day and All Night: Memories from Beale Street
Musicians 1991,Mr 15,C1:4
Peixoto, Mario
Limite 1992,S 4,C11:1
Peixoto, Mario (Director)
Limite 1992,S 4,C11:1
Peldon, Ashley
Drop Dead Fred 1991,My 24,C8:1
Peldon, Courtney
Out on a Limb 1992,S 5,15:1
Pelikan, Lisa
Lionheart 1991,Ja 11,C8:4
Return to the Blue Lagoon 1991,Ag 2,C12:1
Pell, Amy (Producer)
Aladdin 1992,N 11,C15:3
Pellegrino, Mark
Blood and Concrete 1991,S 13,C9:1
Pelletier, Andree (Screenwriter)
Paper Wedding, A 1991,Je 21,C8:1
Pelletier, Theo (Miscellaneous)
Mr. Baseball 1992,O 2,C14:6
Pellonpaa, Matti
Night on Earth 1991,O 4,C1:3
Zombie and the Ghost Train 1991,O 4,C8:5
Vie de Boheme, La 1992,O 9,C14:1
Peltier, Leonard
Incident at Oglala 1992,My 8,C15:1
Incident at Oglala 1992,My 10,II:22:1
Pemrick, Donald Paul (Producer)
December 1991,D 6,C8:5
Pena, Elizabeth
Waterdance, The 1992,My 13,C13:1
Pendleton, Austin
Ballad of the Sad Cafe, The 1991,Mr 28,C11:1
My Cousin Vinny 1992,Mr 13,C6:1
Penn, Chris
Reservoir Dogs 1992,O 23,C14:1
Penn, Sean (Director)
Indian Runner, The 1991,S 20,C6:1
Indian Runner, The 1991,S 29,II:15:1
Penn, Sean (Screenwriter)
Indian Runner, The 1991,S 20,C6:1
Pennebaker, D. A. (Director)
Branford Marsalis: The Music Tells You 1992,Je
26,C12:6
Pennebaker, D. A. (Miscellaneous)
Branford Marsalis: The Music Tells You 1992,Je
26,C12:6
Pennebaker, Frazer (Producer)
Branford Marsalis: The Music Tells You 1992,Je
26,C12:6
Penot, Jacques
Cry of the Owl, The (Cri du Hibou, Le) 1991,O
16,C19:1.
Pentti, Pauli (Miscellaneous)
Zombie and the Ghost Train 1991,O 4,C8:5
Penzel, Werner (Director)
Step Across the Border 1992,F 19,C15:1
Penzel, Werner (Screenwriter)
Step Across the Border 1992,F 19,C15:1
Penzer, Jean (Cinematographer)
Amelia Lopes O'Neill 1991,S 21,12:3
Room in Town, A (Chambre en Ville, Une) 1991,S
28,11:5
Peoples, David Webb (Miscellaneous)
Hero 1992,O 2,C20:6
Peoples, David Webb (Screenwriter)
Unforgiven 1992,Ag 7,C1:1
Hero 1992,O 2,C20:6

Piddock, Jim (Screenwriter)
Traces of Red 1992,N 12,C22:1
Pidgeon, Rebecca
Homicide 1991,O 6,56:1
Pieczka, Franciszek
Memoirs of a River 1992,Mr 20,C15:1
Pierce, Bradley Michael
Beauty and the Beast 1991,N 13,C17:4
Pierce, David
Little Man Tate 1991,O 9,C17:4
Pierce, Tony
Bodyguard, The 1992,N 25,C9:5
Pierce-Roberts, Tony (Cinematographer)
White Fang 1991,Ja 18,C16:3
Howards End 1992,Mr 13,C1:3
Pierpoint, Eric
Forever Young 1992,D 16,C17:1
Piesiewicz, Krzysztof (Screenwriter)
Double Life of Veronique, The 1991,S 20,C18:4
Pietrziak, Janusz
Dream of Light (Sol del Membrillo, El) 1992,O
1,C17:1
Pievar, Pooya
And Life Goes On 1992,S 26,13:1
Piever, Homayun (Cinematographer)
And Life Goes On 1992,S 26,13:1
Pike, Nicholas (Composer)
Sleepwalkers 1992,Ap 11,18:1
Captain Ron 1992,S 18,C23:1
Pilcher, Lydia Dean (Producer)
Pets or Meat: The Return to Flint (Taking the Pulse)
1992,S 26,11:4
My New Gun 1992,O 30,C10:1
Pilkington, Lorraine
Miracle, The 1991,Jl 3,C12:1
Miracle, The 1991,Ag 2,C11:1
Pillsbury, Sarah (Producer)
Love Field 1992,D 11,C6:3
Pillsbury, Suzanne (Miscellaneous)
Refrigerator, The 1992,S 25,C16:6
Pimentel, Vasco (Miscellaneous)
Alex 1992,Mr 24,C15:3
Pinchot, Bronson
Blame It on the Bellboy 1992,Mr 6,C10:6
Pineau, Patrick
Elegant Criminel, L' 1992,Je 24,C18:3
Pinon, Dominique
Delicatessen 1991,O 5,14:3
Delicatessen 1992,Ap 5,53:2
Alberto Express 1992,O 9,C12:5
Pinter, Harold (Screenwriter)
Reunion 1991,Mr 15,C16:6
Comfort of Strangers, The 1991,Mr 29,C6:1
Comfort of Strangers, The 1991,Ap 7,II:13:5
Pinter, Herbert (Miscellaneous)
Mister Johnson 1991,Mr 22,C13:1
Black Robe 1991,O 30,C15:2
Pintilie, Lucian (Director)
Oak, The 1992,O 1,C13:1
Oak, The 1992,O 11,II:11:1
Pintilie, Lucian (Producer)
Oak, The 1992,O 1,C13:1
Pintilie, Lucian (Screenwriter)
Oak, The 1992,O 1,C13:1
Piovani, Nicola (Composer)
Intervista 1992,N 20,C10:1
Piroue, Claude (Miscellaneous)
Mindwalk 1992,Ap 8,C17:1
Pisani, Anne-Marie
Hairdresser's Husband, The 1992,Je 19,C11:1
Pisoni, Edward (Miscellaneous)
Queens Logic 1991,F 1,C13:1
True Colors 1991,Mr 15,C19:1
Hand That Rocks the Cradle, The 1992,Ja 10,C8:1
Pitchford, Lonnie
Deep Blues 1992,Jl 31,C14:3
Pitoniak, Anne
V. I. Warshawski 1991,Ag 4,II:7:5
Pitt, Brad
Thelma and Louise 1991,My 24,C1:1
Thelma and Louise 1991,Je 16,II:11:1
Cool World 1992,Jl 11,12:3
Johnny Suede 1992,Ag 14,C5:5
River Runs Through It, A 1992,O 9,C1:3
River Runs Through It, A 1992,O 18,II:13:1
Pizer, Larry (Cinematographer)
Mannequin Two: On the Move 1991,My 19,50:3
Folks! 1992,My 4,C15:1

Place, Dale
Occupational Hazard (Young Black Cinema) 1992,F
29,17:1
Place, Mary Kay
Bright Angel 1991,Je 14,C6:1
Captain Ron 1992,S 18,C23:1
Placido, Michele
Forever Mary 1991,Ap 19,C11:1
Plana, Tony
One Good Cop 1991,My 3,C13:1
Panama Deception, The 1992,O 23,C10:5
Platt, Josefin
Weininger's Last Night 1991,Ag 1,C14:4
Platt, Oliver
Beethoven 1992,Ap 3,C18:1
Diggstown 1992,Ag 14,C1:1
Pleasence, Angela
Favor, the Watch, and the Very Big Fish, The
1992,My 8,C15:3
Pleasence, Donald
Shadows and Fog 1992,Mr 20,C6:1
Plemiannikov, Helene (Miscellaneous)
En Toute Innocence (In All Innocence) 1992,Jl
31,C14:3
Plenert, Thomas (Cinematographer)
Locked-Up Time 1991,S 29,54:3
Plimpton, George
Little Man Tate 1991,O 9,C17:4
Plohotniuk, Natalya
Raspad 1992,Ap 29,C15:1
Plowright, Joan
Drowning by Numbers 1991,Ap 26,C8:1
Enchanted April 1992,Jl 31,C15:1
Plummer, Amanda
Fisher King, The 1991,S 20,C10:4
Fisher King, The 1991,S 22,II:13:1
Freejack 1992,Ja 18,17:5
Plummer, Christopher
Star Trek VI: The Undiscovered Country 1991,D
6,C1:1
Rock-a-Doodle 1992,Ap 3,C13:1
Malcolm X 1992,N 18,C19:3
Plummer, Glenn
Pastime 1991,Ag 23,C13:1
South-Central 1992,O 16,C13:1
Plummer, Mark (Cinematographer)
Waterdance, The 1992,My 13,C13:1
Plympton, Bill (Director)
Tune, The 1992,S 4,C3:1
Plympton, Bill (Producer)
Tune, The 1992,S 4,C3:1
Plympton, Bill (Screenwriter)
Tune, The 1992,S 4,C3:1
Poe, Amos (Director)
Triple Bogey on a Par 5 Hole 1992,Mr 21,13:4
Poe, Amos (Producer)
Triple Bogey on a Par 5 Hole 1992,Mr 21,13:4
Poe, Amos (Screenwriter)
Triple Bogey on a Par 5 Hole 1992,Mr 21,13:4
Poelvoorde, Benoit
Man Bites Dog 1992,O 9,C14:5
Poelvoorde, Benoit (Director)
Man Bites Dog 1992,O 9,C14:5
Poelvoorde, Benoit (Producer)
Man Bites Dog 1992,O 9,C14:5
Poelvoorde, Benoit (Screenwriter)
Man Bites Dog 1992,O 9,C14:5
Pogue, Ken
Run 1991,F 1,C15:1
Pohjola, Ilppo (Director)
Daddy and the Muscle Academy 1992,D 2,C18:4
Pohjola, Ilppo (Screenwriter)
Daddy and the Muscle Academy 1992,D 2,C18:4
Poire, Alain (Producer)
My Father's Glory (Gloire de Mon Pere, Le) 1991,Je
21,C10:5
My Mother's Castle 1991,Jl 26,C6:1
Maison Assassinee, La (Murdered House, The)
1991,O 25,C10:5
Poirer, Jean-Marie
Tous les Matins du Monde 1992,N 13,C3:4
Poiret, Jean
Inspector Lavardin 1991,D 26,C13:1
Elegant Criminel, L' 1992,Je 24,C18:3
Poitier, Sidney
Sneakers 1992,S 9,C18:3
Polakow, Michael E. (Miscellaneous)
Cutting Edge, The 1992,Mr 27,C21:1

Polanah, Rui
Amazon 1992,F 28,C8:5
Poledouris, Basil (Composer)
Flight of the Intruder 1991,Ja 18,C19:1
White Fang 1991,Ja 18,C16:3
Return to the Blue Lagoon 1991,Ag 2,C12:1
Harley Davidson and the Marlboro Man 1991,Ag
24,16:6
Wind 1992,S 11,C3:1
Poletti, Victor
Meeting Venus 1991,N 15,C1:3
Poliakoff, Stephen (Director)
Close My Eyes 1992,F 21,C12:6
Poliakoff, Stephen (Screenwriter)
Close My Eyes 1992,F 21,C12:6
Poliker, Jaco
Because of That War 1991,Mr 8,C16:6
Poliker, Yehuda
Because of That War 1991,Mr 8,C16:6
Poliker, Yehuda (Composer)
Because of That War 1991,Mr 8,C16:6
Polito, Jon
Barton Fink 1991,Ag 21,C11:1
Polk, Mimi (Producer)
Thelma and Louise 1991,My 24,C1:1
Poll, Jon (Miscellaneous)
Wild Hearts Can't Be Broken 1991,My 24,C16:6
Forever Young 1992,D 16,C17:1
Poll, Martin (Producer)
My Heroes Have Always Been Cowboys 1991,Mr
22,C14:5
Pollack, Sydney
Player, The 1992,Ap 10,C16:1
Player, The 1992,My 11,C9:1
Death Becomes Her 1992,Jl 31,C8:1
Husbands and Wives 1992,S 18,C1:1
Husbands and Wives 1992,O 4,II:9:1
Pollak, Cheryl
Crossing the Bridge 1992,S 11,C12:1
Pollak, Kevin
L.A. Story 1991,F 8,C8:1
Ricochet 1991,O 5,12:6
Few Good Men, A 1992,D 11,C20:1
Pollan, Tracy
Stranger Among Us, A 1992,Jl 17,C1:3
Pollard, Michael J.
Split Second 1992,My 4,C15:1
Pollard, Sam (Miscellaneous)
Jungle Fever 1991,Je 7,C1:2
Juice 1992,Ja 17,C10:1
Pollarolo, Giovanna (Screenwriter)
Fallen from Heaven 1991,Mr 18,C12:3
Pollock, Dale (Producer)
Crooked Hearts 1991,S 6,C13:1
Midnight Clear, A 1992,Ap 24,C1:3
Pollock, Daniel
Proof 1992,Mr 20,C20:1
Pollock, Eileen
Far and Away 1992,My 22,C10:5
Polo, Teri
Mystery Date 1991,Ag 16,C9:1
Polonski, Sonya (Miscellaneous)
Linguini Incident, The 1992,My 1,C15:1
Pombo, Amanda
Raising Cain 1992,Ag 7,C5:1
Pomeroy, John (Producer)
Rock-a-Doodle 1992,Ap 3,C13:1
Pomykala, Dorota
Birthday Trip, The 1991,Mr 26,C14:3
Poncela, Eusebia
Winter in Lisbon, The 1992,Mr 9,C15:5
Ponicsan, Darryl (Screenwriter)
School Ties 1992,S 18,C19:1
Ponikwia, Grzegorz
Dream of Light (Sol del Membrillo, El) 1992,O
1,C17:1
Ponziani, Antonella
Intervista 1992,N 20,C10:1
Pool, Lea (Director)
Straight for the Heart 1991,F 4,C14:1
Pool, Lea (Screenwriter)
Straight for the Heart 1991,F 4,C14:1
Poole, Kelly
Bikini Island 1991,Jl 27,16:3
Poon Dik-wah
Days of Being Wild 1991,Mr 23,12:3
Poor Bear, Myrtle
Incident at Oglala 1992,My 8,C15:1

Q

Quade, John
And You Thought Your Parents Were Weird 1991,N 15,C13:1
Quagliata, Al
Poison 1991,Ap 5,C8:3
Qualandri, Dean
Drum Struck 1992,Ap 22,C17:1
Quan, Jonathan
Encino Man 1992,My 22,C15:1
Quaranta, Gianni (Miscellaneous)
Comfort of Strangers, The 1991,Mr 29,C6:1
Quarrington, Paul (Screenwriter)
Perfectly Normal 1991,F 15,C14:5
Quay, Stephen (Director)
Rehearsals for Extinct Anatomies 1991,Mr 27,C15:1
Comb, The 1991,O 11,C10:1
Quay, Timothy (Director)
Rehearsals for Extinct Anatomies 1991,Mr 27,C15:1
Comb, The 1991,O 11,C10:1
Queen Latifah
House Party 2 1991,O 23,C17:1
Juice 1992,Ja 17,C10:1
Quentin, Florence (Screenwriter)
Tatie Danielle 1991,My 17,C8:1
Quester, Hugues
Tale of Springtime, A (Conte de Printemps) 1992,Jl 17,C10:6
Quettier, Nelly (Miscellaneous)
Amants du Pont Neuf, Les (Lovers of the Pont Neuf) 1992,O 6,C16:1
Quigley, Gerry
Beautiful Dreamers 1992,Je 5,C15:1
Quigley, Tony (Composer)
Body Beautiful, The 1991,O 3,C21:1
Quignard, Pascal (Original Author)
Tous les Matins du Monde 1992,N 13,C3:4
Quignard, Pascal (Screenwriter)
Tous les Matins du Monde 1992,N 13,C3:4
Quilley, Dennis
Mister Johnson 1991,Mr 22,C13:1
Quinlan, Kathleen
Doors, The 1991,Mr 1,C1:1
Quinn, Aidan
At Play in the Fields of the Lord 1991,D 6,C8:1
Playboys, The 1992,Ap 22,C15:1
Quinn, Anthony
Jungle Fever 1991,My 17,C1:1
Only the Lonely 1991,My 24,C10:6
Jungle Fever 1991,Je 7,C1:2
Mobsters 1991,Jl 26,C18:4
Quinn, Declan (Cinematographer)
Blood and Concrete 1991,S 13,C9:1
Freddy's Dead: The Final Nightmare 1991,S 14,11:4
Quinn, Glenn
Dr. Giggles 1992,O 24,16:4
Quinn, J. C.
Babe, The 1992,Ap 17,C8:1
Crisscross 1992,My 9,17:5
Quiring, Frederick
For Sasha 1992,Je 5,C13:1
Olivier, Olivier 1992,S 25,C34:1
Quon, J. B.
Poison Ivy 1992,My 8,C16:3
Quynh, Nhu
Indochine 1992,D 24,C9:1

R

Raben, Peer (Composer)
Sirup 1991,Mr 30,10:4
Rabier, Jean (Cinematographer)
Cry of the Owl, The (Cri du Hibou, Le) 1991,O 16,C19:1
Madame Bovary 1991,D 25,13:1
Inspector Lavardin 1991,D 26,C13:1
En Toute Innocence (In All Innocence) 1992,Jl 31,C14:3
Rabinowitz, Jay (Miscellaneous)
Night on Earth 1991,O 4,C1:3
Rachini, Pasquale (Cinematographer)
Story of Boys and Girls, The 1991,Mr 28,C12:1
Rachmil, Michael (Producer)
L.A. Story 1991,F 8,C8:1
Mo' Money 1992,Jl 25,15:1

Rados, Antonia
Requiem for Dominic 1991,Ap 19,C17:1
Radot, Oliver (Miscellaneous)
Jacquot de Nantes 1991,S 25,C16:3
Rae, Dan (Miscellaneous)
Split Second 1992,My 4,C15:1
Candyman 1992,O 16,C10:5
Rafelson, Bob (Director)
Man Trouble 1992,Jl 18,18:4
Rafferty, Kevin (Cinematographer)
Blood in the Face 1991,F 27,C11:1
Rafferty, Kevin (Director)
Blood in the Face 1991,F 27,C11:1
Feed 1992,O 7,C15:1
Rafferty, Kevin (Miscellaneous)
Blood in the Face 1991,F 27,C11:1
Feed 1992,O 7,C15:1
Rafferty, Kevin (Producer)
Blood in the Face 1991,F 27,C11:1
Feed 1992,O 7,C15:1
Rafill, Stewart (Director)
Mannequin Two: On the Move 1991,My 19,50:3
Ragalyi, Elemer (Cinematographer)
Journey of Hope 1991,Ap 26,C13:1
Ragno, Joe
Babe, The 1992,Ap 17,C8:1
Ragsdale, William
Mannequin Two: On the Move 1991,My 19,50:3
Raha, Barun (Cinematographer)
Branches of the Tree, The 1992,Ap 17,C15:3
Stranger, The 1992,My 22,C13:1
Raines, Howell
To Render a Life 1992,N 18,C23:1
Rajski, Peggy (Producer)
Little Man Tate 1991,O 9,C17:4
Used People 1992,D 16,C23:3
Ralph, Sheryl Lee
Mistress 1992,Ag 7,C16:3
Distinguished Gentleman, The 1992,D 4,C1:4
Rambova, Nastacha (Miscellaneous)
Salome 1991,N 8,C1:1
Ramirez, Arcelia
City of the Blind (Ciudad de Ciegos) 1992,Ap 4,17:5
Ramos, Norma
Damned in the U.S.A. 1992,N 13,C11:1
Ramos, Sophia
Lost Prophet 1992,Je 8,C16:1
Rampo, Edogawa (Original Author)
Black Lizard 1991,S 18,C13:1
Ramsay, Anne Elizabeth
League of Their Own, A 1992,Jl 1,C13:4
Rand, Patrick (Miscellaneous)
In the Heat of Passion 1992,Ja 24,C12:5
Randall, Brad
Who Shot Patakango? 1992,My 1,C10:5
Randall, Ethan
Dutch 1991,Jl 19,C13:1
All I Want for Christmas 1991,N 8,C14:1
Randall-Cutler, Roger (Producer)
Commitments, The 1991,Ag 14,C11:1
Randazzo, Steven
In the Soup 1992,O 3,13:2
Randle, Theresa
Malcolm X 1992,N 18,C19:3
Randolph, John
Iron Maze 1991,N 1,C13:1
Randolph, Virginia L. (Miscellaneous)
Article 99 1992,Mr 13,C10:1
Random, Ida (Miscellaneous)
Defending Your Life 1991,Mr 22,C12:1
Housesitter 1992,Je 12,C1:4
Hoffa 1992,D 25,C1:1
Rane, Ferran
Aventis (Stories) 1992,N 13,C15:1
Ransick, Whitney (Producer)
Time Expired 1992,D 2,C18:4
Ranvaud, Don (Producer)
Life on a String 1991,S 29,54:5
Rapaport, Michael
Zebrahead 1992,O 8,C17:5
Rapley, Dale
Paper Mask 1992,F 28,C19:1
Rarick, Ken (Composer)
In the Heat of Passion 1992,Ja 24,C12:5
Rasche, David
Delirious 1991,Ag 9,C12:4
Bingo 1991,Ag 10,9:2

Rash, Steve (Director)
Queens Logic 1991,F 1,C13:1
Rasulala, Thalmus
Mom and Dad Save the World 1992,Jl 27,C18:4
Rath, Christopher
Phantom of the Opera, The 1991,Je 8,16:1
Rathery, Isabelle (Miscellaneous)
Exposure 1991,N 1,C12:6
Ratliff, Garette Patrick
Return to the Blue Lagoon 1991,Ag 2,C12:1
Ratray, Devin
Home Alone 2: Lost in New York 1992,N 20,C1:1
Rauschenberg, Robert
Cage/Cunningham 1991,D 5,C20:1
Cage/Cunningham 1991,D 13,C37:1
Ravarra, Gina
Steal America 1992,Ap 3,C24:5
Rawlings, Terry (Miscellaneous)
Not Without My Daughter 1991,Ja 11,C8:1
Alien 3 1992,My 22,C1:1
Rawlins, David (Miscellaneous)
Life Stinks 1991,Jl 26,C19:1
Ray, Noah
John Five (Avant-Garde Visions) 1992,O 5,C14:4
Ray, Satyajit
Stranger, The 1992,My 22,C13:1
Ray, Satyajit (Director)
Branches of the Tree, The 1992,Ap 17,C15:3
Stranger, The 1992,My 22,C13:1
Ray, Satyajit (Screenwriter)
Branches of the Tree, The 1992,Ap 17,C15:3
Stranger, The 1992,My 22,C13:1
Ray, Tim
Julia Has Two Lovers 1991,Mr 24,64:1
Raymond, Bill
City of Hope 1991,O 11,C19:1
My New Gun 1992,O 30,C10:1
Raymond, Deborah (Miscellaneous)
Frozen Assets 1992,O 24,16:4
Rayns, Tony
Unknown Soldiers 1992,Je 17,C13:1
Rea, Michael (Miscellaneous)
Clearcut 1992,Ag 21,C9:1
Rea, Peggy
Love Field 1992,D 11,C6:3
Rea, Stephen
Life Is Sweet 1991,O 25,C10:1
Crying Game, The 1992,S 26,12:4
Crying Game, The 1992,N 25,C10:1
Crying Game, The 1992,D 4,C3:5
Read, James
Love Crimes 1992,Ja 26,43:5
Reardon, Patrick (Miscellaneous)
Proof 1992,Mr 20,C20:1
Rebengiuc, Victor
Oak, The 1992,O 1,C13:1
Rebhorn, James
Regarding Henry 1991,Jl 10,C13:3
White Sands 1992,Ap 24,C18:1
Scent of a Woman 1992,D 23,C9:1
Lorenzo's Oil 1992,D 30,C7:3
Red, Eric (Director)
Body Parts 1991,Ag 3,9:1
Red, Eric (Screenwriter)
Body Parts 1991,Ag 3,9:1
Redford, Ian
Antonia and Jane 1991,O 26,13:1
Redford, Robert
Sneakers 1992,S 9,C18:3
Redford, Robert (Director)
River Runs Through It, A 1992,O 9,C1:3
River Runs Through It, A 1992,O 18,II:13:1
Redford, Robert (Narrator)
Incident at Oglala 1992,My 10,II:22:1
Incident at Oglala 1992,My 8,C15:1
River Runs Through It, A 1992,O 9,C1:3
River Runs Through It, A 1992,O 18,II:13:1
Redford, Robert (Producer)
Incident at Oglala 1992,My 8,C15:1
Incident at Oglala 1992,My 10,II:22:1
River Runs Through It, A 1992,O 9,C1:3
Redglare, Rockets
In the Soup 1992,O 3,13:2
Redgrave, Jemma
Howards End 1992,Mr 13,C1:3
Redgrave, Vanessa
Ballad of the Sad Cafe, The 1991,Mr 28,C11:1
Howards End 1992,Mr 13,C1:3

Richardson, Peter (Director)
Pope Must Die(t), The 1991,Ag 30,C10:3
Richardson, Peter (Screenwriter)
Pope Must Die(t), The 1991,Ag 30,C10:3
Richardson, Robert (Cinematographer)
Doors, The 1991,Mr 1,C1:1
City of Hope 1991,O 11,C19:1
J.F.K. 1991,D 20,C1:1
Few Good Men, A 1992,D 11,C20:1
Richens, Pete (Screenwriter)
Pope Must Die(t), The 1991,Ag 30,C10:3
Richert, Carole
Tous les Matins du Monde 1992,N 13,C3:4
Richert, William
My Own Private Idaho 1991,S 27,C5:1
Richie, Donald (Narrator)
Inland Sea, The 1992,Je 17,C13:1
Richie, Donald (Original Author)
Inland Sea, The 1992,Je 17,C13:1
Richie, Donald (Screenwriter)
Inland Sea, The 1992,Je 17,C13:1
Richmond, Anthony B. (Cinematographer)
Indian Runner, The 1991,S 20,C6:1
Candyman 1992,O 16,C10:5
Richmond, Branscombe
Taking of Beverly Hills, The 1991,O 13,68:5
Richmond, Tom (Cinematographer)
Pastime 1991,Ag 23,C13:1
Roadside Prophets 1992,Mr 27,C10:1
Midnight Clear, A 1992,Ap 24,C1:3
Richter, W. D. (Director)
Late for Dinner 1991,S 20,C6:5
Richter, W. D. (Producer)
Late for Dinner 1991,S 20,C6:5
Rickles, Don
Innocent Blood 1992,S 25,C6:5
Rickman, Alan
Closet Land 1991,Mr 7,C18:3
Truly, Madly, Deeply 1991,My 3,C11:1
Robin Hood: Prince of Thieves 1991,Je 14,C1:4
Close My Eyes 1992,F 21,C12:6
Bob Roberts 1992,S 4,C1:1
Ridgeway, James (Director)
Blood in the Face 1991,F 27,C11:1
Feed 1992,O 7,C15:1
Ridgeway, James (Miscellaneous)
Blood in the Face 1991,F 27,C11:1
Ridgeway, James (Producer)
Blood in the Face 1991,F 27,C11:1
Feed 1992,O 7,C15:1
Ridley, Philip (Director)
Reflecting Skin, The 1991,Je 28,C9:1
Ridley, Philip (Screenwriter)
Reflecting Skin, The 1991,Je 28,C9:1
Rieber, Arnold (Composer)
Small Time 1991,N 8,C11:1
Riegert, Peter
Oscar 1991,Ap 26,C10:5
Passed Away 1992,Ap 24,C8:1
Riehle, Richard
Prelude to a Kiss 1992,Jl 10,C10:1
Of Mice and Men 1992,O 2,C5:4
Public Eye, The 1992,O 14,C17:1
Rifkin, Adam (Director)
Dark Backward, The 1991,Jl 26,C18:4
Rifkin, Adam (Screenwriter)
Dark Backward, The 1991,Jl 26,C18:4
Rifkin, Ron
Husbands and Wives 1992,S 18,C1:1
Rifle, Ned (Composer)
Simple Men 1992,O 14,C22:1
Rigby, Terence
Testimony 1991,D 18,C25:1
Rigg, Rebecca
Efficiency Expert, The 1992,N 6,C8:1
Riggs, Marlon T. (Director)
Color Adjustment 1992,Ja 29,C15:1
Riggs, Marlon T. (Producer)
Color Adjustment 1992,Ja 29,C15:1
Riggs, Marlon T. (Screenwriter)
Color Adjustment 1992,Ja 29,C15:1
Riju, Go
Unknown Soldiers 1992,Je 17,C13:1
Riklis, Eran (Director)
Cup Final 1992,Ag 12,C13:1
Riklis, Eran (Miscellaneous)
Cup Final 1992,Ag 12,C13:1

Riley, Michael
Perfectly Normal 1991,F 15,C14:5
Riley, Terry (Composer)
Pictures from a Revolution 1991,O 5,11:4
Rimmer, Vince
Careful 1992,O 7,C20:3
Rincon, Rodney
Never Leave Nevada 1991,Ap 28,60:5
Rintels, David W. (Screenwriter)
Not Without My Daughter 1991,Ja 11,C8:1
Rippy, Leon
Universal Soldier 1992,Jl 10,C17:1
Ripstein, Arturo (Director)
Woman of the Port (Mujer del Puerto, La) 1991,S
27,C5:1
Risi, Marco (Director)
Forever Mary 1991,Ap 19,C11:1
Ritchie, Michael (Director)
Diggstown 1992,Ag 14,C1:1
Ritter, John
Problem Child 2 1991,Jl 5,C6:1
Noises Off 1992,Mr 20,C10:1
Stay Tuned 1992,Ag 15,14:5
Ritter, Thelma
Letter to Three Wives, A 1992,N 20,C1:3
Riva, Emmanuelle
For Sasha 1992,Je 5,C13:1
Riva, J. Michael (Miscellaneous)
Radio Flyer 1992,F 21,C16:1
Few Good Men, A 1992,D 11,C20:1
Rivarola, Carlos (Miscellaneous)
Naked Tango 1991,Ag 23,C19:1
Rivers, Victor
Distinguished Gentleman, The 1992,D 4,C1:4
Rivette, Jacques (Director)
Belle Noiseuse, La 1991,My 26,II:9:2
Belle Noiseuse, La 1991,O 2,C17:5
Rivette, Jacques (Screenwriter)
Belle Noiseuse, La 1991,O 2,C17:5
Rivier, Philippe (Producer)
Day in October, A 1992,O 28,C20:5
Riviere, Marie
Tale of Winter, A 1992,O 2,C12:6
Rizacos, Angelo
Beautiful Dreamers 1992,Je 5,C15:1
Rizzoli, Angelo (Producer)
Comfort of Strangers, The 1991,Mr 29,C6:1
Everybody's Fine (Stanno Tutti Bene) 1991,My
31,C12:6
Roach, Daryl
Importance of Being Earnest, The 1992,My 14,C20:4
Roach, James
Waterdance, The 1992,My 13,C13:1
Robards, Jason
Reunion 1991,Mr 15,C16:6
Storyville 1992,Ag 26,C13:3
Robbins, David (Composer)
Too Much Sun 1991,Ja 25,C8:5
Ted and Venus 1991,D 20,C23:1
Bob Roberts 1992,S 4,C1:1
Bob Roberts 1992,S 4,C1:1
Robbins, Matthew (Director)
Bingo 1991,Ag 10,9:2
Robbins, Richard (Composer)
Ballad of the Sad Cafe, The 1991,Mr 28,C11:1
Howards End 1992,Mr 13,C1:3
Robbins, Tim
Jungle Fever 1991,Je 7,C1:2
Player, The 1992,Ap 10,C16:1
Player, The 1992,My 11,C9:1
Bob Roberts 1992,My 13,C13:5
Bob Roberts 1992,S 4,C1:1
Robbins, Tim (Composer)
Bob Roberts 1992,S 4,C1:1
Robbins, Tim (Director)
Bob Roberts 1992,My 13,C13:5
Bob Roberts 1992,S 4,C1:1
Bob Roberts 1992,D 13,II:1:2
Robbins, Tim (Screenwriter)
Bob Roberts 1992,My 13,C13:5
Bob Roberts 1992,S 4,C1:1
Robert, Denise (Producer)
Straight for the Heart 1991,F 4,C14:1
Seen from Elsewhere (Taking the Pulse) 1992,S
26,11:4
Robert, Yves (Director)
My Father's Glory (Gloire de Mon Pere, Le) 1991,Je
21,C10:5

My Mother's Castle 1991,Jl 26,C6:1
Robert, Yves (Screenwriter)
My Father's Glory (Gloire de Mon Pere, Le) 1991,Je
21,C10:5
My Mother's Castle 1991,Jl 26,C6:1
Roberts, Conrad
Hard Way, The 1991,Mr 8,C8:1
Roberts, Doris
Used People 1992,D 16,C23:3
Roberts, Douglas
Rapture, The 1991,S 30,C14:4
Roberts, Eric
Final Analysis 1992,F 7,C8:1
Roberts, Francesca P.
Gladiator 1992,Mr 6,C17:1
Roberts, Jackye
Folks! 1992,My 4,C15:1
Roberts, Julia
Pretty Woman 1991,Ja 20,II:1:2
Sleeping with the Enemy 1991,F 8,C10:1
Sleeping with the Enemy 1991,F 17,II:11:5
Dying Young 1991,Je 21,C10:1
Dying Young 1991,Ag 11,II:18:1
Hook 1991,D 11,C17:3
Player, The 1992,Ap 10,C16:1
Roberts, Scott (Screenwriter)
K2 1992,My 1,C16:1
Roberts, Tony
Popcorn 1991,F 1,C6:5
Switch 1991,My 10,C13:1
Robertson, Cliff
Wild Hearts Can't Be Broken 1991,My 24,C16:6
Wind 1992,S 11,C3:1
Robertson, George R.
Deceived 1991,S 27,C8:5
Robertson, Simone
Father 1992,Jl 31,C5:5
Robertson, Tim
Father 1992,Jl 31,C5:5
Robideau, Bob
Incident at Oglala 1992,My 8,C15:1
Robie, Wendy
People Under the Stairs, The 1991,N 2,17:1
Robin, Helen (Producer)
Shadows and Fog 1992,Mr 20,C6:1
Robinson, Amy (Producer)
Once Around 1991,Ja 18,C12:4
Robinson, Bruce (Director)
Jennifer 8 1992,N 6,C6:2
Robinson, Bruce (Screenwriter)
Jennifer 8 1992,N 6,C6:2
Robinson, David (Original Author)
Chaplin 1992,D 25,C3:1
Robinson, J. Peter (Composer)
Wayne's World 1992,F 14,C15:1
Encino Man 1992,My 22,C15:1
Robinson, Jackson
Bikini Island 1991,Jl 27,16:3
Robinson, James G. (Producer)
Stay Tuned 1992,Ag 15,14:5
Robinson, Jay
Bram Stoker's "Dracula" 1992,N 13,C1:3
Robinson, Phil Alden (Director)
Sneakers 1992,S 9,18:3
Robinson, Phil Alden (Screenwriter)
Sneakers 1992,S 9,18:3
Robinson, Sally (Screenwriter)
Medicine Man 1992,F 7,C13:1
Robinson, Susan (Director)
Building Bombs 1991,O 12,20:3
Robinson, Susan (Producer)
Building Bombs 1991,O 12,20:3
Robinson, Susan (Screenwriter)
Building Bombs 1991,O 12,20:3
Robles, Mike
Puerto Rican Mambo (Not a Musical), The 1992,Mr
22,48:4
Roby, Teresa
Alex 1992,Mr 24,C15:3
Rocca, Alain (Producer)
Love Without Pity (Monde sans Pitie, Une) 1991,My
31,C16:4
Discrete, La 1992,Ag 14,C13:1
Rocco, Alex
Pope Must Die(t), The 1991,Ag 30,C10:3
Rocco, Marc (Director)
Where the Day Takes You 1992,S 11,C14:5

Rocco, Marc (Screenwriter)
Where the Day Takes You 1992,S 11,C14:5
Rocha, Enrique
City of the Blind (Ciudad de Ciegos) 1992,Ap 4,17:5
Rocha, Glauber (Director)
Earth Entranced (Terra em Transe) 1991,O 5,14:5
Rocha, Glauber (Screenwriter)
Earth Entranced (Terra em Transe) 1991,O 5,14:5
Rocha, Glauce
Earth Entranced (Terra em Transe) 1991,O 5,14:5
Rochant, Eric (Director)
Love Without Pity (Monde sans Pitie, Une) 1991,My 31,C16:4
Rochant, Eric (Screenwriter)
Love Without Pity (Monde sans Pitie, Une) 1991,My 31,C16:4
Roche, Catherine
Strangers in Good Company 1991,My 10,C8:1
Roche, Henri-Pierre (Original Author)
Two English Girls 1992,Ap 5,II:17:5
Rochefort, Jean
Hairdresser's Husband, The 1992,Je 19,C11:1
Rochon, Lela
Boomerang 1992,Jl 1,C18:1
Rock, Chris
New Jack City 1991,Mr 8,C15:1
Boomerang 1992,Jl 1,C18:1
Rocket, Charles
Delirious 1991,Ag 9,C12:4
Rockwell, Alexandre (Director)
In the Soup 1992,O 3,13:2
Rockwell, Alexandre (Screenwriter)
In the Soup 1992,O 3,13:2
Rockwell, Sam
Strictly Business 1991,N 8,C13:3
Rodallec, Yves (Cinematographer)
Maison Assassinee, La (Murdered House, The) 1991,O 25,C10:5
Roddam, Franc (Director)
K2 1992,My 1,C16:1
Rodde, Volker (Cinematographer)
Restless Conscience, The 1992,F 7,C15:1
Roddenberry, Gene (Miscellaneous)
Star Trek VI: The Undiscovered Country 1991,D 6,C1:1
Roden, Karel
Time of the Servants 1991,Mr 19,C12:3
Rodger, Struan
Dark Obsession 1991,Je 7,C10:1
Rodnova, Nadezhda
Second Circle, The 1992,Ja 2,C15:1
Rodriguez, Edgar
Waterdance, The 1992,My 13,C13:1
Rodriguez, Eva
Waterdance, The 1992,My 13,C13:1
Rodriguez, Lucy
Panama Deception, The 1992,O 23,C10:5
Rodriguez, Nelson (Miscellaneous)
Danzon 1992,S 25,C6:5
Roe, David (Producer)
Storyville 1992,Ag 26,C13:3
Roeg, Luc (Producer)
Let Him Have It 1991,D 6,C24:1
Roeg, Nicolas (Director)
Cold Heaven 1992,My 29,C15:1
Roel, Gabriela
City of the Blind (Ciudad de Ciegos) 1992,Ap 4,17:5
Roelfs, Jan (Miscellaneous)
Prospero's Books 1991,S 28,9:1
Roeves, Maurice
Last of the Mohicans, The 1992,S 25,C3:1
Roewe, Jay (Producer)
Truth or Dare 1991,My 10,C1:3
Rogers, Alva
Daughters of the Dust 1992,Ja 16,C19:1
Rogers, Alysia
Class Act 1992,Je 5,C17:1
Rogers, Cynthia (Miscellaneous)
Alligator Eyes 1991,F 15,C15:1
Rogers, Ed, 3d
Stranger Among Us, A 1992,Jl 17,C1:3
Rogers, Mimi
Rapture, The 1991,S 30,C14:4
Rapture, The 1991,O 13,II:13:5
Rapture, The 1992,F 9,II:13:1
Rogers, Richard P. (Cinematographer)
Pictures from a Revolution 1991,O 5,11:4

Rogers, Richard P. (Director)
Pictures from a Revolution 1991,O 5,11:4
Pictures from a Revolution 1992,My 30,13:4
Rogers, Richard P. (Miscellaneous)
Pictures from a Revolution 1992,My 30,13:4
Rogers, Richard P. (Producer)
Pictures from a Revolution 1991,O 5,11:4
Pictures from a Revolution 1992,My 30,13:4
Rogers, Roy
Golden Stallion, The 1992,D 30,C12:3
Rogers, Roy (Miscellaneous)
Roy Rogers: King of the Cowboys 1992,D 30,C12:3
Rogers, Roy, Jr. (Miscellaneous)
Roy Rogers: King of the Cowboys 1992,D 30,C12:3
Rogoschkin, Aleksandr (Director)
Guard, The (Karaul) 1991,Mr 24,64:1
Rogovoi, Vyacheslav
Save and Protect 1992,Jl 10,C14:5
Rogow, David (Miscellaneous)
Restless Conscience, The 1992,F 7,C15:1
Rohmer, Eric (Director)
Tale of Springtime, A (Conte de Printemps) 1992,Jl 17,C10:6
Tale of Winter, A 1992,O 2,C12:6
Tale of Winter, A 1992,O 11,II:11:1
Rohmer, Eric (Screenwriter)
Tale of Springtime, A (Conte de Printemps) 1992,Jl 17,C10:6
Tale of Winter, A 1992,O 2,C12:6
Roi, Tony
Legends 1991,Mr 17,68:5
Roizman, Owen (Cinematographer)
Addams Family, The 1991,N 22,C1:1
Grand Canyon 1991,D 25,18:1
Rojas, Manuel (Cinematographer)
Wait for Me in Heaven (Esperame en el Cielo) 1991,Ja 30,C10:5
Rojo, Jaime
Refrigerator, The 1992,S 25,C16:6
Rojo, Maria
Danzon 1992,S 25,C6:5
Roland, Erich (Cinematographer)
Deep Blues 1992,Jl 31,C14:3
Rolf, Tom (Miscellaneous)
Sneakers 1992,S 9,C18:3
Roling, Marcus (Screenwriter)
Class of Nuke 'Em High Part 2: Subhumanoid Meltdown 1991,Ap 12,C13:1
Rolland, Jean-Louis
Room in Town, A (Chambre en Ville, Une) 1991,S 28,11:5
Rolle, Esther
Color Adjustment 1992,Ja 29,C15:1
Rollin, Jean Marie
Love Without Pity (Monde sans Pitie, Une) 1991,My 31,C16:4
Rollins, Jack (Producer)
Shadows and Fog 1992,Mr 20,C6:1
Husbands and Wives 1992,S 18,C1:1
Rollins, Sonny
Texas Tenor: The Illinois Jacquet Story 1992,N 20,C5:1
Romano, Andy
Unlawful Entry 1992,Je 26,C10:4
Romer, Kim
Day in October, A 1992,O 28,C20:5
Rompel, James
Legends 1991,Mr 17,68:5
Ronssin, Jean-Pierre (Screenwriter)
Discrete, La 1992,Ag 14,C13:1
Roodt, Darrell James (Director)
Sarafina! 1992,S 18,C16:6
Rooker, Michael
J.F.K. 1991,D 20,C1:1
Rooney, Mickey
My Heroes Have Always Been Cowboys 1991,Mr 22,C14:5
Little Nemo: Adventures in Slumberland 1992,Ag 21,C13:1
Roos, Don (Screenwriter)
Single White Female 1992,Ag 14,C8:1
Love Field 1992,D 11,C6:3
Roose, Ronald (Miscellaneous)
Star Trek VI: The Undiscovered Country 1991,D 6,C1:1
Company Business 1992,Ap 25,17:1
Hoffa 1992,D 25,C1:1

Root, Antony (Producer)
Edward II 1992,Mr 20,C16:3
Ros, Philippe (Cinematographer)
Lumumba: Death of a Prophet 1992,S 30,C18:3
Rosario, Bert
Shattered 1991,O 11,C24:3
Rosato, Tony
Mystery Date 1991,Ag 16,C9:1
Rose, Anthony
Home Less Home 1991,Mr 22,C8:5
Rose, Bartholomew
Flirting 1992,N 6,C13:1
Rose, Bernard
Candyman 1992,O 16,C10:5
Rose, Bernard (Director)
Candyman 1992,O 16,C10:5
Rose, Bernard (Screenwriter)
Candyman 1992,O 16,C10:5
Rose, Gabrielle
Adjuster, The 1991,S 26,C18:5
Rose, Jamie
Chopper Chicks in Zombietown 1991,My 10,C15:5
Rosen, Charles (Miscellaneous)
Butcher's Wife, The 1991,O 25,C24:1
Stop! Or My Mom Will Shoot 1992,F 21,C8:5
Rosen, Lawrence (Composer)
Phantom of the Opera, The 1991,Je 8,16:1
Rosenbaum, David
Stranger Among Us, A 1992,Jl 17,C1:3
Rosenbaum, Ed, M.D. (Original Author)
Doctor, The 1991,Jl 24,C11:1
Rosenberg, Deborah (Miscellaneous)
Heck with Hollywood!, The 1991,O 9,C15:1
Rosenberg, Jeanne (Screenwriter)
White Fang 1991,Ja 18,C16:3
Rosenberg, John (Miscellaneous)
Mannequin Two: On the Move 1991,My 19,50:3
Rosenberg, Philip (Miscellaneous)
Other People's Money 1991,O 18,C10:3
Stranger Among Us, A 1992,Jl 17,C1:3
Rosenberg, Stuart (Director)
My Heroes Have Always Been Cowboys 1991,Mr 22,C14:5
Rosenblatt, Jay (Director)
Short of Breath 1991,Mr 21,C20:3
Rosenman, Howard (Producer)
Father of the Bride 1991,D 20,C17:1
Shining Through 1992,Ja 31,C8:5
Stranger Among Us, A 1992,Jl 17,C1:3
Buffy the Vampire Slayer 1992,Jl 31,C8:5
Rosenman, Leonard (Composer)
Ambition 1991,Je 1,16:3
Rosenstock, Harvey (Miscellaneous)
Curly Sue 1991,O 25,C15:1
Scent of a Woman 1992,D 23,C9:1
Rosenthal, Henry S. (Producer)
All the Vermeers in New York 1992,My 1,C13:1
Rosenthal, Jane (Producer)
Thunderheart 1992,Ap 3,C12:1
Night and the City 1992,O 10,11:3
Rosenthal, Mark (Miscellaneous)
Star Trek VI: The Undiscovered Country 1991,D 6,C1:1
Rosenthal, Sheila
Not Without My Daughter 1991,Ja 11,C8:1
Rosette
Tale of Winter, A 1992,O 2,C12:6
Rosnell, John (Cinematographer)
Straight Out of Brooklyn 1991,My 22,C11:5
Rosniak, Justin
Sweet Talker 1991,My 12,42:5
Ross, David Colin (Composer)
Venice/Venice 1992,O 28,C20:5
Ross, Fred
Pets or Meat: The Return to Flint (Taking the Pulse) 1992,S 26,11:4
Ross, Gary (Screenwriter)
Mr. Baseball 1992,O 2,C14:6
Ross, Gene
Babe, The 1992,Ap 17,C8:1
Ross, Herbert (Director)
True Colors 1991,Mr 15,C19:1
Ross, Herbert (Producer)
True Colors 1991,Mr 15,C19:1
Ross, Margery
Naked Gun 2 1/2: The Smell of Fear 1991,Je 28,C8:1
Ross, Monty (Producer)
Jungle Fever 1991,Je 7,C1:2

Malcolm X 1992,N 18,C19:3

Ross, William (Composer)
One Good Cop 1991,My 3,C13:1

Rossberg, Susana (Miscellaneous)
Toto the Hero (Toto le Heros) 1991,S 21,11:1

Rossellini, Isabella
Death Becomes Her 1992,Jl 31,C8:1

Rossen, Barry
Glengarry Glen Ross 1992,S 30,C15:3

Rossi, Leo
Too Much Sun 1991,Ja 25,C8:5

Rossio, Terry (Screenwriter)
Aladdin 1992,N 11,C15:3

Rostock, Susanne (Miscellaneous)
Incident at Oglala 1992,My 8,C15:1

Rostrup, Kaspar (Director)
Memories of a Marriage 1991,Ja 28,C20:3

Rostrup, Kaspar (Screenwriter)
Memories of a Marriage 1991,Ja 28,C20:3

Rota, Nino (Composer)
Rocco and His Brothers 1991,S 21,12:1
Rocco and His Brothers 1992,Ja 24,C8:1

Rota, Nino (Miscellaneous)
Intervista 1992,N 20,C10:1

Rotaeta, Felix
Pepi, Luci, Bom (Pepi, Luci, Bom and Other Girls on
the Heap) 1992,My 29,C10:5

Roth, Adam (Composer)
Refrigerator, The 1992,S 25,C16:6

Roth, Stephen J. (Producer)
Clearcut 1992,Ag 21,C9:1

Roth, Steve (Producer)
Mobsters 1991,Jl 26,C18:4
Gladiator 1992,Mr 6,C17:1

Roth, Tim
Rosencrantz and Guildenstern Are Dead 1991,F
8,C14:6
Jumpin' at the Boneyard 1992,Ja 23,C15:4
Reservoir Dogs 1992,Ja 23,C15:4
Jumpin' at the Boneyard 1992,S 18,C18:5
Reservoir Dogs 1992,O 23,C14:1

Rothman, John
Boy Who Cried Bitch, The 1991,O 11,C17:1

Rothman, Marion (Miscellaneous)
Memoirs of an Invisible Man 1992,F 28,C17:1

Rothstein, Richard (Screenwriter)
Universal Soldier 1992,Jl 10,C17:1

Rotter, Stephen A. (Miscellaneous)
True Colors 1991,Mr 15,C19:1
Prelude to a Kiss 1992,Jl 10,C10:1

Rotunno, Giuseppe (Cinematographer)
Regarding Henry 1991,Jl 10,C13:3
Rocco and His Brothers 1991,S 21,12:1
Once Upon a Crime 1992,Mr 7,20:4

Rouan, Brigitte
Outremer 1991,Mr 27,C15:1
Overseas (Outremer) 1991,N 8,C25:1
Olivier, Olivier 1992,S 25,C34:1

Rouan, Brigitte (Director)
Outremer 1991,Mr 27,C15:1
Overseas (Outremer) 1991,N 8,C25:1

Rouan, Brigitte (Screenwriter)
Outremer 1991,Mr 27,C15:1
Overseas (Outremer) 1991,N 8,C25:1

Rouaud, Cecilia
Cross My Heart 1991,Ap 5,C18:5

Roulet, Dominique (Miscellaneous)
Inspector Lavardin 1991,D 26,C13:1

Roulet, Dominique (Screenwriter)
Inspector Lavardin 1991,D 26,C13:1
En Toute Innocence (In All Innocence) 1992,Jl
31,C14:3

Rourke, Mickey
Harley Davidson and the Marlboro Man 1991,Ag
24,16:6
White Sands 1992,Ap 24,C18:1

Roussel, Anne
Portaborse, Il 1992,D 31,C18:1

Roussel, Marie-France
Room in Town, A (Chambre en Ville, Une) 1991,S
28,11:5

Roussel, Nathalie
My Father's Glory (Gloire de Mon Pere, Le) 1991,Je
21,C10:5
My Mother's Castle 1991,Jl 26,C6:1

Rousselot, Philippe (Cinematographer)
Miracle, The 1991,Jl 3,C12:1
River Runs Through It, A 1992,O 9,C1:3

Roven, Charles (Producer)
Final Analysis 1992,F 7,C8:1

Rowell, Victoria
Distinguished Gentleman, The 1992,D 4,C1:4

Rowland, Leesa
Class of Nuke 'Em High Part 2: Subhumanoid
Meltdown 1991,Ap 12,C13:1

Rowlands, Gena
Once Around 1991,Ja 18,C12:4
Opening Night 1991,My 17,C11:1
Night on Earth 1991,O 4,C1:3
Ted and Venus 1991,D 20,C23:1
Night on Earth 1992,My 1,C10:5

Rozanes, Alain (Producer)
Hyenas 1992,O 3,18:4

Rubell, Steve
Superstar: The Life and Times of Andy Warhol
1991,F 22,C8:1

Ruben, Andy (Producer)
Poison Ivy 1992,My 8,C16:3

Ruben, Andy (Screenwriter)
Poison Ivy 1992,My 8,C16:3

Ruben, Joseph (Director)
Sleeping with the Enemy 1991,F 8,C10:1

Ruben, Katt Shea (Director)
Poison Ivy 1992,Ja 23,C15:4

Rubes, Jan
Class Action 1991,Mr 15,C20:4
Deceived 1991,S 27,C8:5

Rubin, Jennifer
Too Much Sun 1991,Ja 25,C8:5
Delusion 1991,Je 7,C12:6

Rubinek, Saul
Man Trouble 1992,Jl 18,18:4
Unforgiven 1992,Ag 7,C1:1
Quarrel, The 1992,N 4,C22:4

Rubini, Sergio
Station, The (Stazione, La) 1992,Ja 3,C6:1
Intervista 1992,N 20,C10:1

Rubini, Sergio (Director)
Station, The (Stazione, La) 1992,Ja 3,C6:1

Rubini, Sergio (Screenwriter)
Station, The (Stazione, La) 1992,Ja 3,C6:1

Rubinstein, Arthur B. (Composer)
Hard Way, The 1991,Mr 8,C8:1

Rubinstein, Zelda
Guilty as Charged 1992,Ja 29,C17:1

Ruck, Alan
Just Like in the Movies 1992,My 4,C15:1

Rucker, Hal (Director)
Manic Denial 1991,O 12,20:3

Rucker, Steve (Composer)
Little Nemo: Adventures in Slumberland 1992,Ag
21,C13:1

Rudder, David
One Hand Don't Clap 1991,Ag 28,C13:1

Ruddy, Albert S. (Producer)
Ladybugs 1992,Mr 28,17:1

Rudin, Scott (Producer)
Regarding Henry 1991,Jl 10,C13:3
Little Man Tate 1991,O 9,C17:4
Addams Family, The 1991,N 22,C1:1
White Sands 1992,Ap 24,C18:1

Rudkin, David (Screenwriter)
Testimony 1991,D 18,C25:1

Rudner, Rita
Peter's Friends 1992,D 25,C8:6

Rudner, Rita (Screenwriter)
Peter's Friends 1992,D 25,C8:6

Rudnick, Oleg
Company Business 1992,Ap 25,17:1

Rudnick, Paul (Screenwriter)
Sister Act 1992,My 29,C10:1

Rudolf, Gene (Miscellaneous)
Out for Justice 1991,Ap 13,12:4

Rudolph, Alan (Director)
Mortal Thoughts 1991,Ap 19,C15:1

Ruehl, Mercedes
Another You 1991,Jl 27,16:3
Fisher King, The 1991,S 20,C10:4
Fisher King, The 1991,S 22,II:13:1

Ruffin, Roger
All the Vermeers in New York 1992,My 1,C13:1

Rufus
Delicatessen 1991,O 5,14:3
Delicatessen 1992,Ap 5,53:2

Rugoff, Edward (Producer)
Mannequin Two: On the Move 1991,My 19,50:3

Rugoff, Edward (Screenwriter)
Mannequin Two: On the Move 1991,My 19,50:3

Ruiz, Elisa
Dream of Light (Sol del Membrillo, El) 1992,O
1,C17:1

Ruiz, Nelson
Fallen from Heaven 1991,Mr 18,C12:3

Ruiz, Raul (Director)
Golden Boat, The 1991,Je 22,12:4

Ruiz, Raul (Screenwriter)
Amelia Lopes O'Neill 1991,S 21,12:3

Ruiz Anchia, Juan (Cinematographer)
Dying Young 1991,Je 21,C10:1
Naked Tango 1991,Ag 23,C19:1
Liebestraum 1991,S 13,C6:1
Glengarry Glen Ross 1992,S 30,C15:3

Rule, Sara
Passed Away 1992,Ap 24,C8:1

Rulli, Stefano (Screenwriter)
Forever Mary 1991,Ap 19,C11:1
Portaborse, Il 1992,D 31,C18:1

Rullier, Christian (Screenwriter)
Outremer 1991,Mr 27,C15:1

Runte, Terry (Screenwriter)
Mystery Date 1991,Ag 16,C9:1

Rupp, Sieghardt
Weininger's Last Night 1991,Ag 1,C14:4

Ruscio, Nina (Miscellaneous)
Cool as Ice 1991,O 19,12:6

Rush, Deborah
Passed Away 1992,Ap 24,C8:1

Rush, Sara
Talking to Strangers 1991,D 27,C12:6

Rushton, Jared
Pet Sematary Two 1992,Ag 29,14:4

Ruskin, Morris (Producer)
Glengarry Glen Ross 1992,S 30,C15:3

Russ, William
Pastime 1991,Ag 23,C13:1
Traces of Red 1992,N 12,C22:1

Russell, Barbara
Leaving Normal 1992,Ap 29,C17:1

Russell, David O. (Director)
Hairway to the Stars (Short and Funnies, The)
1992,D 16,C30:3

Russell, David O. (Screenwriter)
Hairway to the Stars (Short and Funnies, The)
1992,D 16,C30:3

Russell, Ken (Director)
Whore 1991,O 4,C15:1
Whore 1992,F 9,II:13:1

Russell, Ken (Screenwriter)
Whore 1991,O 4,C15:1
Whore 1992,F 9,II:13:1

Russell, Keri
Honey, I Blew Up the Kid 1992,Jl 17,C6:5

Russell, Kimberly
Hangin' with the Homeboys 1991,My 24,C12:6

Russell, Kurt
Backdraft 1991,My 24,C14:6
Unlawful Entry 1992,Je 26,C10:4
Unlawful Entry 1992,Jl 26,II:9:1
Captain Ron 1992,S 18,C23:1

Russell, T. E.
Toy Soldiers 1991,Ap 26,C15:1

Russell, Theresa
Whore 1991,O 4,C15:1
Kafka 1991,D 4,C21:1
Whore 1992,F 9,II:13:1
Cold Heaven 1992,My 29,C15:1

Russell, Ward (Cinematographer)
Last Boy Scout, The 1991,D 13,C14:6

Russell-Pavier, Nicholas (Composer)
Secret Friends 1992,F 14,C10:1

Russo, David E. (Composer)
Shaking the Tree 1992,Mr 13,C8:1

Russo, James
My Own Private Idaho 1991,S 27,C5:1
Cold Heaven 1992,My 29,C15:1

Russo, Rene
One Good Cop 1991,My 3,C13:1
Freejack 1992,Ja 18,17:5
Lethal Weapon 3 1992,My 15,C16:3
Lethal Weapon 3 1992,My 31,II:20:4

Rust, Henri (Miscellaneous)
Wages of Fear, The (Salaire de la Peur, Le) 1991,O
18,C8:3

San Giacomo, Laura
Once Around 1991,Ja 18,C12:4
Once Around 1991,Ja 27,II:1:1
Under Suspicion 1992,F 28,C10:1
Where the Day Takes You 1992,S 11,C14:5
Sanjay
Whore 1991,O 4,C15:1
Sanko, Anton (Composer)
Cousin Bobby 1992,My 29,C1:4
San Mateo, Juan Ignacio (Miscellaneous)
Dream of Light (Sol del Membrillo, El) 1992,O
1,C17:1
Bosque Animado, El (Enchanted Forest, The)
1992,D 4,C8:6
Sano, Shiro
Swimming with Tears 1992,Mr 22,49:1
Sanogo, Diarrah
Finzan 1992,Mr 22,48:4
Sanon, Barbara
Straight Out of Brooklyn 1991,My 22,C11:5
Santini, Bruno (Miscellaneous)
Ballad of the Sad Cafe, The 1991,Mr 28,C11:1
Santori, Paul
Drum Struck 1992,Ap 22,C17:1
Santos, Isabel
Adorable Lies 1992,Mr 27,C8:5
Santos, Jesus Fernandez (Original Author)
Extramuros 1991,Je 28,C10:5
Santos, Joe
Mo' Money 1992,Jl 25,15:1
Sanz, Jorge
Lovers 1992,Mr 25,C18:5
Aventis (Stories) 1992,N 13,C15:1
Sara, Mia
Stranger Among Us, A 1992,Jl 17,C1:3
Saraf, Irving (Director)
In the Shadow of the Stars 1991,Ag 14,C15:1
Saraf, Irving (Miscellaneous)
In the Shadow of the Stars 1991,Ag 14,C15:1
Saraf, Irving (Producer)
In the Shadow of the Stars 1991,Ag 14,C15:1
Sarafian, Richard
Bugsy 1991,D 13,C12:1
Ruby 1992,Mr 27,C1:3
Sarafinchan, Lillian (Miscellaneous)
Termini Station 1991,My 31,C14:5
Sarandon, Susan
White Palace 1991,Ja 20,II:1:2
Thelma and Louise 1991,My 24,C1:1
Thelma and Louise 1991,Je 16,II:11:1
Thelma and Louise 1991,Ag 18,II:11:5
Bob Roberts 1992,My 13,C13:5
Light Sleeper 1992,Ag 21,C12:5
Bob Roberts 1992,S 4,C1:1
Lorenzo's Oil 1992,D 30,C7:3
Sarde, Alain (Producer)
Every Other Weekend 1991,Je 19,C12:3
Sarde, Philippe (Composer)
Eve of Destruction 1991,Ja 19,22:6
Reunion 1991,Mr 15,C16:6
For Sasha 1992,Je 5,C13:1
Sarelle, Leilani
Basic Instinct 1992,Mr 20,C8:1
Sargent, Alvin (Miscellaneous)
What About Bob? 1991,My 17,C15:1
Hero 1992,O 2,C20:6
Sargent, Alvin (Screenwriter)
Other People's Money 1991,O 18,C10:3
Sarkisyan, Rose
Adjuster, The 1991,S 26,C18:5
Sarmiento, Valeria (Director)
Amelia Lopes O'Neill 1991,S 21,12:3
Sarmiento, Valeria (Screenwriter)
Amelia Lopes O'Neill 1991,S 21,12:3
Sarno, Hector V.
Lucky Star 1991,N 1,C8:1
Sarossy, Paul (Cinematographer)
Adjuster, The 1991,S 26,C18:5
Seen from Elsewhere (Taking the Pulse) 1992,S
26,11:4
Sartain, Gailard
Fried Green Tomatoes 1991,D 27,C3:1
Stop! Or My Mom Will Shoot 1992,F 21,C8:5
Sartre, Jean-Paul (Original Author)
Proud Ones, The (Proud and the Beautiful, The)
1992,My 29,C17:1
Sas, Tamas (Cinematographer)
Shadow on the Snow 1992,Mr 31,C16:1

Sasaki, Kei (Producer)
Enchantment, The 1992,My 20,C15:3
Sass, Jeffrey W. (Screenwriter)
Class of Nuke 'Em High Part 2: Subhumanoid
Meltdown 1991,Ap 12,C13:1
Sassone, Oley (Screenwriter)
Wild Hearts Can't Be Broken 1991,My 24,C16:6
Sastre, Ines
Johanna d'Arc of Mongolia 1992,My 15,C8:1
Satler, Renata
Where 1991,S 6,C13:1
Sato, Junya (Director)
Silk Road, The 1992,My 29,C13:1
Sato, Junya (Screenwriter)
Silk Road, The 1992,My 29,C13:1
Sato, Koichi
Shadow of China 1991,Mr 10,58:5
Silk Road, The 1992,My 29,C13:1
Sato, Masahiro (Producer)
Silk Road, The 1992,My 29,C13:1
Sato, Mineyo (Screenwriter)
Traffic Jam 1992,Mr 20,C20:4
Saunders, David (Producer)
Wild Orchid 2: Two Shades of Blue 1992,My
8,C17:2
Saunders, Derek (Screenwriter)
Deceived 1991,S 27,C8:5
Saura, Carlos (Director)
Ay, Carmela! 1991,F 8,C8:5
Savage, Ann
Detour 1992,Jl 3,C8:1
Savage, Pius
White Fang 1991,Ja 18,C16:3
Savall, Jordi
Tous les Matins du Monde 1992,N 13,C3:4
Savall, Jordi (Miscellaneous)
Tous les Matins du Monde 1992,N 13,C3:4
Savant, Doug
Shaking the Tree 1992,Mr 13,C8:1
Savident, John
Brain Donors 1992,Ap 18,11:1
Savino, Joe
Crying Game, The 1992,S 26,12:4
Savino, Joseph W. (Miscellaneous)
Queens Logic 1991,F 1,C13:1
Savitt, Jill (Miscellaneous)
Convicts 1991,D 6,C14:6
Buffy the Vampire Slayer 1992,Jl 31,C8:5
Savlov, Meg
Wax, or the Discovery of Television Among the
Bees 1992,Ag 21,C10:1
Savoca, Nancy (Director)
Dogfight 1991,S 13,C13:1
Dogfight 1991,S 15,II:13:5
Dogfight 1991,S 29,II:15:1
Sawalha, Nadim
Company Business 1992,Ap 25,17:1
Sawyer, Richard (Miscellaneous)
Child's Play 3 1991,Ag 30,C11:3
Innocent Blood 1992,S 25,C6:5
Sax (Maldita Vecindad)
City of the Blind (Ciudad de Ciegos) 1992,Ap 4,17:5
Saxon, Edward (Producer)
Silence of the Lambs, The 1991,F 14,C17:1
Cousin Bobby 1992,My 29,C1:4
Sayles, John
City of Hope 1991,O 11,C19:1
Straight Talk 1992,Ap 3,C17:1
Sayles, John (Director)
City of Hope 1991,O 11,C19:1
Passion Fish 1992,D 14,C16:1
Sayles, John (Miscellaneous)
City of Hope 1991,O 11,C19:1
Passion Fish 1992,D 14,C16:1
Sayles, John (Screenwriter)
City of Hope 1991,O 11,C19:1
Passion Fish 1992,D 14,C16:1
Sayyad, Changiz (Miscellaneous)
And Life Goes On 1992,S 26,13:1
Sazatornil, Jose
Wait for Me in Heaven (Esperame en el Cielo)
1991,Ja 30,C10:5
Sbragia, Mattia
Year of the Gun 1991,N 1,C10:6
Scacchi, Greta
Shattered 1991,O 11,C24:3
Player, The 1992,Ap 10,C16:1

Scales, Prunella
Howards End 1992,Mr 13,C1:3
Scalia, Pietro (Miscellaneous)
J.F.K. 1991,D 20,C1:1
Scalici, Gillian
Johanna d'Arc of Mongolia 1992,My 15,C8:1
Scandiuzzi, Gian-Carlo
Bugsy 1991,D 22,II:22:1
Scantlebury, Glen (Miscellaneous)
Bram Stoker's "Dracula" 1992,N 13,C1:3
Scantlebury, Glen (Screenwriter)
Steal America 1992,Ap 3,C24:5
Scarfe, Alan
Double Impact 1991,Ag 9,C8:5
Scarfiotti, Ferdinando (Miscellaneous)
Toys 1992,D 18,C1:3
Scarpa, Leonardo (Miscellaneous)
Portaborse, Il 1992,D 31,C18:1
Scarpantoni, Jane
John Lurie and the Lounge Lizards Live in Berlin
1991 1992,S 9,C14:5
Scarwid, Diana
Brenda Starr 1992,Ap 19,46:1
Schabowski, Gunther
November Days 1992,My 8,C8:1
Schaeffer, Rainer (Cinematographer)
Comedian Harmonists, The 1991,Ap 5,C18:5
Schaer, Martin (Cinematographer)
Restless Conscience, The 1992,F 7,C15:1
Schafer, Frank
Affengeil 1992,Jl 25,15:4
Schaffel, Robert (Producer)
Diggstown 1992,Ag 14,C1:1
Schallert, William
Dead Again 1991,O 13,II:21:1
House Party 2 1991,O 23,C17:1
Schamus, James (Producer)
Thank You and Good Night 1992,Ja 29,C20:4
Schanker, Larry (Composer)
American Blue Note 1991,Mr 29,C12:1
Schatzberg, Jerry (Director)
Reunion 1991,Mr 15,C16:6
Scheele, Henrik
Sirup 1991,Mr 30,10:4
Scheider, Roy
Russia House, The 1991,Ja 27,II:1:1
Naked Lunch 1991,D 27,C1:3
Scheinman, Andrew (Producer)
Few Good Men, A 1992,D 11,C20:1
Schell, Maurice
Stranger Among Us, A 1992,Jl 17,C1:3
Schellenberg, August
Black Robe 1991,O 30,C15:2
Black Robe 1991,N 17,II:24:2
Schepisi, Fred (Director)
Mr. Baseball 1992,O 2,C14:6
Schepisi, Fred (Producer)
Mr. Baseball 1992,O 2,C14:6
Schepps, Shawn (Miscellaneous)
Encino Man 1992,My 22,C15:1
Schepps, Shawn (Screenwriter)
Encino Man 1992,My 22,C15:1
Scherfig, Lone (Director)
Birthday Trip, The 1991,Mr 26,C14:3
Schiavelli, Vincent
Batman Returns 1992,Je 19,C1:1
Schierhorn, Paul (Composer)
Phantom of the Opera, The 1991,Je 8,16:1
Schiff, Paul (Producer)
My Cousin Vinny 1992,Mr 13,C6:1
Schifrin, Lalo (Composer)
FX2: The Deadly Art of Illusion 1991,My 10,C8:5
Schindler, Klaus
Toto the Hero (Toto le Heros) 1991,S 21,11:1
Toto the Hero 1991,O 6,II:13:5
Toto the Hero (Toto le Heros) 1992,Mr 6,C12:1
Schindler, Peter (Producer)
Mr. Saturday Night 1992,S 23,C13:4
Schink, Peter (Miscellaneous)
Dark Backward, The 1991,Jl 26,C18:4
Schipkova, Zhanna
Satan 1992,Mr 28,18:1
Schlachet, Daniel
Swoon 1992,Mr 27,C8:1
Swoon 1992,S 11,C8:6
Schlair, Doron (Cinematographer)
Hearing Voices 1991,N 15,C11:1
Rock Soup 1992,Ap 8,C22:3

Seltzer, David (Director)
Shining Through 1992,Ja 31,C8:5
Shining Through 1992,F 28,C1:1
Seltzer, David (Screenwriter)
Shining Through 1992,Ja 31,C8:5
Seltzer, Frank N. (Producer)
Terror in a Texas Town 1991,My 17,C16:4
Semel, Stephen (Miscellaneous)
Kuffs 1992,Ja 10,C16:6
Semenova, Leda (Miscellaneous)
Save and Protect 1992,Jl 10,C14:5
Stone 1992,O 3,18:1
Semler, Dean (Cinematographer)
City Slickers 1991,Je 7,C18:5
Power of One, The 1992,Mr 27,C20:5
Semper, John (Screenwriter)
Class Act 1992,Je 5,C17:1
Seneca, Joe
Mississippi Masala 1992,F 5,C15:1
Senia, Jean-Marie (Composer)
Cross My Heart 1991,Ap 5,C18:5
Senner, Peter
Via Appia 1992,Ag 27,C16:5
Sentier, Jean-Pierre
Maison Assassinee, La (Murdered House, The)
1991,O 25,C10:5
Seppala, Silu
Zombie and the Ghost Train 1991,O 4,C8:5
Ser, Randy (Miscellaneous)
Mighty Ducks, The 1992,O 2,C18:1
Serandrei, Mario (Miscellaneous)
Rocco and His Brothers 1991,S 21,12:1
Serna, Assumpta
Extramuros 1991,Je 28,C10:5
Serna, Pepe
American Me 1992,Mr 13,C6:5
Serra, Eduardo (Cinematographer)
Hairdresser's Husband, The 1992,Je 19,C11:1
Serra, Eric (Composer)
Femme Nikita, La 1991,Mr 8,C10:1
Serrano, Andres
Damned in the U.S.A. 1992,N 13,C11:1
Serrano, Nestor
Hangin' with the Homeboys 1991,My 24,C12:6
Brenda Starr 1992,Ap 19,46:1
Serrault, Michel
En Toute Innocence (In All Innocence) 1992,Jl
31,C14:3
Serreau, Joachim
Every Other Weekend 1991,Je 19,C12:3
Serzalov, Andrei
Guard, The (Karaul) 1991,Mr 24,64:1
Sesay, Mo
Young Soul Rebels 1991,D 6,C21:1
Sessions, John
Freddie as F.R.O.7 1992,S 1,C11:1
Seth, Roshan
Not Without My Daughter 1991,Ja 11,C8:1
Mississippi Masala 1992,F 5,C15:1
London Kills Me 1992,Ag 7,C19:1
Sety, Gerard
Van Gogh 1992,O 30,C16:5
Sewell, Rufus
Twenty-One 1991,O 4,C10:6
Seweryn, Andrzej
Indochine 1992,D 24,C9:1
Seyama, Takeshi (Miscellaneous)
Little Nemo: Adventures in Slumberland 1992,Ag
21,C13:1
Seydor, Paul (Miscellaneous)
White Men Can't Jump 1992,Mr 27,C22:4
Seyrig, Delphine
Window Shopping 1992,Ap 17,C13:1
Johanna d'Arc of Mongolia 1992,My 15,C8:1
Sezer, Serif
Heart of Glass, A 1992,Mr 21,18:4
Sfat, Dina
Fable of the Beautiful Pigeon Fancier, The 1991,Mr
1,C6:4
Shabari, Nabil
City of Joy 1992,Ap 15,C15:1
Shaber, David (Screenwriter)
Flight of the Intruder 1991,Ja 18,C19:1
Shad, Samantha (Screenwriter)
Class Action 1991,Mr 15,C20:4
Shadix, Glenn
Meet the Applegates 1991,F 1,C6:1
Sleepwalkers 1992,Ap 11,18:1

Shafransky, Renee (Producer)
Monster in a Box 1992,Je 5,C6:4
Shagaev, Aleksandr (Cinematographer)
Raspad 1992,Ap 29,C15:1
Shah, Ash R. (Producer)
Lionheart 1991,Ja 11,C8:4
Shah, Jamal
K2 1992,My 1,C16:1
Shah, Plyush (Cinematographer)
Idiot 1992,O 8,C21:4
Shaiman, Marc (Composer)
Scenes from a Mall 1991,F 22,C19:1
Addams Family, The 1991,N 22,C1:1
Sister Act 1992,My 29,C10:1
Mr. Saturday Night 1992,S 23,C13:4
Few Good Men, A 1992,D 11,C20:1
Shakespeare, William (Original Author)
Hamlet 1991,Ja 6,II:13:5
Prospero's Books 1991,S 28,9:1
Prospero's Books 1991,O 6,II:13:5
Prospero's Books 1991,N 15,C15:1
Othello 1992,Mr 6,C1:3
Shakhnazarov, Karen (Director)
City Zero 1991,Mr 22,C14:1
Shakhnazarov, Karen (Screenwriter)
City Zero 1991,Mr 22,C14:1
Shakur, Tupac
Juice 1992,Ja 17,C10:1
Juice 1992,Ja 22,C13:2
Shakurov, Sergei
Raspad 1992,Ap 29,C15:1
Shalhoub, Tony
Barton Fink 1991,Ag 21,C11:1
Shalikar, Daniel
Honey, I Blew Up the Kid 1992,Jl 17,C6:5
Shalikar, Joshua
Honey, I Blew Up the Kid 1992,Jl 17,C6:5
Shamas, Sandra
Wisecracks 1992,Je 4,C17:1
Shams, Hamid (Cinematographer)
Painting the Town 1992,My 30,13:1
Shane, Lee (Miscellaneous)
Giving, The 1992,N 13,C17:1
Shankar, Mamata
Branches of the Tree, The 1992,Ap 17,C15:3
Stranger, The 1992,My 22,C13:1
Shapiro, Allen (Producer)
Universal Soldier 1992,Jl 10,C17:1
Shapiro, Paul W. (Screenwriter)
Breaking the Rules 1992,O 9,C10:6
Sharfshtein, Michael (Producer)
Cup Final 1992,Ag 12,C13:1
Sharif, Abdul Hassan
Zebrahead 1992,O 8,C17:5
Sharkey, Ray
Zebrahead 1992,O 8,C17:5
Sharp, Lesley
Close My Eyes 1992,F 21,C12:6
Sharpton, Al
Malcolm X 1992,N 18,C19:3
Shatner, William
Star Trek VI: The Undiscovered Country 1991,D
6,C1:1
Shaud, Grant
Distinguished Gentleman, The 1992,D 4,C1:4
Shaver, Helen
Zebrahead 1992,O 8,C17:5
Shaw, Fiona
London Kills Me 1992,Ag 7,C19:1
Shaw, Stan
Fried Green Tomatoes 1991,D 27,C3:1
Shaw, Vinessa
Ladybugs 1992,Mr 28,17:1
Shawn, Wallace
Mom and Dad Save the World 1992,Jl 27,C18:4
Shaye, Robert (Director)
Book of Love 1991,F 1,C10:6
Shaye, Robert (Producer)
Freddy's Dead: The Final Nightmare 1991,S 14,11:4
Shbib, Bashar (Director)
Julia Has Two Lovers 1991,Mr 24,64:1
Shbib, Bashar (Miscellaneous)
Julia Has Two Lovers 1991,Mr 24,64:1
Shbib, Bashar (Producer)
Julia Has Two Lovers 1991,Mr 24,64:1
Shbib, Bashar (Screenwriter)
Julia Has Two Lovers 1991,Mr 24,64:1

Shea, Ann
Passed Away 1992,Ap 24,C8:1
Shea, John
Honey, I Blew Up the Kid 1992,Jl 17,C6:5
Shea, Katt (Director)
Poison Ivy 1992,My 8,C16:3
Shea, Katt (Screenwriter)
Poison Ivy 1992,My 8,C16:3
Shearer, Harry
Oscar 1991,Ap 26,C10:5
Pure Luck 1991,Ag 9,C15:1
Sheckley, Robert (Original Author)
Freejack 1992,Ja 18,17:5
Sheedy, Ally
Only the Lonely 1991,My 24,C10:6
Sheen, Charlie
Cadence 1991,Mr 15,C18:5
Hot Shots! 1991,Jl 31,C11:2
Sheen, Martin
Cadence 1991,Mr 15,C18:5
Hearts of Darkness: A Film Maker's Apocalypse
1991,N 27,C9:1
Sheen, Martin (Director)
Cadence 1991,Mr 15,C18:5
Sheffer, Craig
River Runs Through It, A 1992,O 9,C1:3
River Runs Through It, A 1992,O 18,II:13:1
Sheffer, Jonathan (Composer)
Pure Luck 1991,Ag 9,C15:1
Sheffield, David (Screenwriter)
Boomerang 1992,Jl 1,C18:1
Shelby, Carolyn (Screenwriter)
Class Action 1991,Mr 15,C20:4
Shelby, LaRita
South-Central 1992,O 16,C13:1
Sheldon, Greg (Miscellaneous)
Jimi Hendrix at the Isle of Wight 1991,Jl 4,C9:1
Shelley, Carole
Super, The 1991,O 4,C10:1
Little Noises 1992,Ap 24,C8:6
Shelly, Adrienne
Trust 1991,Jl 26,C16:5
Shelton, Ron (Director)
White Men Can't Jump 1992,Mr 27,C22:4
White Men Can't Jump 1992,Ap 26,II:15:5
Shelton, Ron (Screenwriter)
White Men Can't Jump 1992,Mr 27,C22:4
White Men Can't Jump 1992,Ap 26,II:15:5
Shepard, Mike (Miscellaneous)
Affengeil 1992,Jl 25,15:4
Shepard, Richard (Director)
Linguini Incident, The 1992,My 1,C15:1
Shepard, Richard (Screenwriter)
Linguini Incident, The 1992,My 1,C15:1
Shepard, Sam
Bright Angel 1991,Je 14,C6:1
Defenseless 1991,Ag 23,C8:1
Voyager 1992,Ja 31,C6:1
Voyager 1992,F 23,II:13:5
Thunderheart 1992,Ap 3,C12:1
Thunderheart 1992,My 10,II:22:1
Shepard, Shelby
Class of Nuke 'Em High Part 2: Subhumanoid
Meltdown 1991,Ap 12,C13:1
Shepherd, Cybill
Once Upon a Crime 1992,Mr 7,20:4
Shepherd, Jack
Twenty-One 1991,O 4,C10:6
Sheptekita, Valery
Raspad 1992,Ap 29,C15:1
Sheridan, Guillermo (Screenwriter)
Cabeza de Vaca 1991,Mr 23,12:6
Sheridan, Jamey
All I Want for Christmas 1991,N 8,C14:1
Stranger Among Us, A 1992,Jl 17,C1:3
Whispers in the Dark 1992,Ag 7,C17:1
Sheridan, Nicollette
Noises Off 1992,Mr 20,C10:1
Sherkow, Daniel A. (Producer)
Impromptu 1991,Ap 12,C10:5
Shi Tiesheng (Original Author)
Life on a String 1991,S 29,54:5
Shi Tiesheng (Screenwriter)
Life on a String 1992,Ja 10,C16:6
Shields, Brooke
Brenda Starr 1992,Ap 19,46:1
Shields, Nicholas
Princes in Exile 1991,F 22,C12:5

Sivas, Emin
Journey of Hope 1991,Ap 26,C13:1
Sizemore, Tom
Flight of the Intruder 1991,Ja 18,C19:1
Matter of Degrees, A 1991,S 13,C9:4
Passenger 57 1992,N 6,C14:5
Skaggs, Jimmie F.
1,000 Pieces of Gold 1991,S 27,C10:4
Skala, Lilia
Men of Respect 1991,Ja 18,C1:1
Skarsgard, Stellan
Ox, The 1992,Ag 21,C10:5
Wind 1992,S 11,C3:1
Skeaping, Colin
Split Second 1992,My 4,C15:1
Skerritt, Tom
Poison Ivy 1992,My 8,C16:3
Wild Orchid 2: Two Shades of Blue 1992,My
8,C17:2
River Runs Through It, A 1992,O 9,C1:3
River Runs Through It, A 1992,O 18,II:13:1
Skinner, Claire
Life Is Sweet 1991,O 25,C10:1
Sklar, Zachary (Screenwriter)
J.F.K. 1991,D 20,C1:1
Skulason, Helgi
Shadow of the Raven, The 1991,Jl 13,12:1
Skye, Ione
Mindwalk 1992,Ap 8,C17:1
Gas Food Lodging 1992,Jl 31,C1:1
Gas Food Lodging 1992,D 13,II:1:2
Slade, Max Elliott
To the Moon, Alice 1991,O 2,C19:1
3 Ninjas 1992,Ag 7,C5:1
Slate, Jeremy
Lawnmower Man, The 1992,Mr 7,20:1
Slater, Christian
Robin Hood: Prince of Thieves 1991,Je 14,C1:4
Mobsters 1991,Jl 26,C18:4
Star Trek VI: The Undiscovered Country 1991,D
6,C1:1
Kuffs 1992,Ja 10,C16:6
Ferngully: The Last Rain Forest 1992,Ap 10,C10:5
Where the Day Takes You 1992,S 11,C14:5
Slater, Helen
City Slickers 1991,Je 7,C18:5
Slattery, Damian F. (Screenwriter)
Day in October, A 1992,O 28,C20:5
Slattery, Tony
Peter's Friends 1992,D 25,C8:6
Slavin, Millie
Forever Young 1992,D 16,C17:1
Sloman, Roger
Nuts in May 1992,Ap 10,C1:2
Sloop, Helga
Affengeil 1992,Jl 25,15:4
Sluizer, George (Director)
Vanishing, The 1991,Ja 25,C8:1
Sluizer, George (Miscellaneous)
Vanishing, The 1991,Ja 25,C8:1
Sluizer, George (Producer)
Vanishing, The 1991,Ja 25,C8:1
Smal, Ewa (Miscellaneous)
Korczak 1991,Ap 12,C8:1
Europa, Europa 1991,Je 28,C10:1
Small, Michael (Composer)
Mobsters 1991,Jl 26,C18:4
Consenting Adults 1992,O 16,C14:5
Smart, Jean
Mistress 1992,Ag 7,C16:3
Smedley-Aston, Brian (Miscellaneous)
Diary of a Hit Man 1992,My 29,C10:5
Smestad, Stian
Shipwrecked 1991,Mr 1,C6:1
Smirnov, Aleksandr N.
Guard, The (Karaul) 1991,Mr 24,64:1
Smith, Annick (Producer)
River Runs Through It, A 1992,O 9,C1:3
Smith, Brooke
Silence of the Lambs, The 1991,F 14,C17:1
Smith, Bruce (Director)
Bebe's Kids 1992,Ag 1,16:6
Smith, Buck
Poison 1991,Ap 5,C8:3
Smith, Buffalo Bob
Problem Child 2 1991,Jl 5,C6:1
Smith, Charles Martin
Deep Cover 1992,Ap 15,C19:4

Smith, Craig
Blowback 1991,Ag 9,C13:1
Smith, Doug (Cinematographer)
Mona's Pets (Short and Funnies, The) 1992,D
16,C30:3
Smith, Ebonie
Lethal Weapon 3 1992,My 15,C16:3
Smith, Elliott
Termini Station 1991,My 31,C14:5
Smith, Emma (Miscellaneous)
Roy Rogers: King of the Cowboys 1992,D 30,C12:3
Smith, Hillary Bailey
Love Potion No. 9 1992,N 13,C12:5
Smith, Howard (Miscellaneous)
Point Break 1991,Jl 12,C12:6
Glengarry Glen Ross 1992,S 30,C15:3
Smith, Howard K.
Nashville 1992,N 8,II:13:5
Smith, Irby (Producer)
City Slickers 1991,Je 7,C18:5
Smith, Jack (Director)
Flaming Creatures (Avant-Garde Visions) 1991,O
1,C13:1
Smith, John Victor (Miscellaneous)
Get Back 1991,O 25,C19:1
Smith, Josie
Unforgiven 1992,Ag 7,C1:1
Smith, Kurtwood
Star Trek VI: The Undiscovered Country 1991,D
6,C1:1
Company Business 1992,Ap 25,17:1
Smith, Lane
My Cousin Vinny 1992,Mr 13,C6:1
Mighty Ducks, The 1992,O 2,C18:1
Distinguished Gentleman, The 1992,D 4,C1:4
Smith, Lee (Miscellaneous)
Lorenzo's Oil 1992,D 30,C7:3
Smith, Lewis
Diary of a Hit Man 1992,My 29,C10:5
Smith, Lionel Mark
Homicide 1991,O 6,56:1
Smith, Lois
Fried Green Tomatoes 1991,D 27,C3:1
Hard Promises 1992,Ja 31,C12:6
Smith, Madolyn
Super, The 1991,O 4,C10:1
Final Approach 1992,Mr 13,C8:4
Smith, Maggie
Hook 1991,D 11,C17:3
Sister Act 1992,My 29,C10:1
Sister Act 1992,Je 7,II:13:1
Smith, Matt
Scent of a Woman 1992,D 23,C9:1
Smith, Mel
Brain Donors 1992,Ap 18,11:1
Smith, Nicholas C. (Miscellaneous)
Love Crimes 1992,Ja 26,43:5
Bram Stoker's "Dracula" 1992,N 13,C1:3
Smith, Norman (Miscellaneous)
Dead Ringer 1991,Jl 17,C14:5
Smith, Roger Guenveur
Deep Cover 1992,Ap 15,C19:4
Smith, Roy Forge (Miscellaneous)
Teen-Age Mutant Ninja Turtles II: The Secret of the
Ooze 1991,Mr 22,C1:3
Warlock 1991,Mr 30,11:4
Smith, Russ (Producer)
Queens Logic 1991,F 1,C13:1
Of Mice and Men 1992,O 2,C5:4
Smith, Scott (Miscellaneous)
Mobsters 1991,Jl 26,C18:4
Smith, Will
Where the Day Takes You 1992,S 11,C14:5
Smith, William Cooper (Cinematographer)
Lucky Star 1991,N 1,C8:1
Smits, Jimmy
Switch 1991,My 10,C13:1
Smokler, Peter (Cinematographer)
Problem Child 2 1991,Jl 5,C6:1
Smythe, Jonathan (Director)
Whole Truth, The 1992,O 23,C10:5
Sneddon, Kahli
Father 1992,Jl 31,C5:5
Snegoff, Greg
Fist of the North Star 1991,N 15,C8:1
Professional, The 1992,O 23,C14:5
Snegoff, Greg (Miscellaneous)
Professional, The 1992,O 23,C14:5

Snegoff, Greg (Screenwriter)
Professional, The 1992,O 23,C14:5
Snider, Norman (Screenwriter)
Body Parts 1991,Ag 3,9:1
Snipes, Wesley
New Jack City 1991,Mr 8,C15:1
Jungle Fever 1991,My 17,C1:1
Jungle Fever 1991,Je 7,C1:2
Jungle Fever 1991,Je 23,II:20:1
White Men Can't Jump 1992,Mr 27,C22:4
White Men Can't Jump 1992,Ap 26,II:15:5
Waterdance, The 1992,My 13,C13:1
Passenger 57 1992,N 6,C14:5
Snow, Carrie
Wisecracks 1992,Je 4,C17:1
Snyder, Blake (Screenwriter)
Stop! Or My Mom Will Shoot 1992,F 21,C8:5
Snyder, David L. (Miscellaneous)
Bill and Ted's Bogus Journey 1991,Jl 19,C10:1
Class Act 1992,Je 5,C17:1
Snyder, Drew
Misplaced 1991,Mr 1,C9:1
Snyder, Maria (Producer)
Chopper Chicks in Zombietown 1991,My 10,C15:5
Snyder, Steven (Composer)
Complex World 1992,Ap 10,C14:5
Sobel, Curt (Composer)
Defenseless 1991,Ag 23,C8:1
Sobol, Joshua (Original Author)
Weininger's Last Night 1991,Ag 1,C14:4
Sobolev, Vyacheslav
Hey, You Wild Geese 1992,Ap 2,C20:5
Sochor, Hilde
Weininger's Last Night 1991,Ag 1,C14:4
Soderbergh, Steven (Director)
Kafka 1991,D 4,C21:1
Kafka 1992,Ja 26,II:11:1
Sofr, Jaromir (Cinematographer)
Larks on a String 1991,F 13,C14:4
End of Old Times, The 1992,Ja 10,C12:6
Sokol, Yuri (Cinematographer)
Diary of a Hit Man 1992,My 29,C10:5
Sokurov, Aleksandr (Director)
Second Circle, The 1992,Ja 2,C15:1
Save and Protect 1992,Jl 10,C14:5
Stone 1992,O 3,18:1
Soldini, Silvio (Director)
Peaceful Air of the West 1991,Mr 20,C12:5
Soldini, Silvio (Screenwriter)
Peaceful Air of the West 1991,Mr 20,C12:5
Solomon, Ed (Screenwriter)
Bill and Ted's Bogus Journey 1991,Jl 19,C10:1
Leaving Normal 1992,Ap 29,C17:1
Mom and Dad Save the World 1992,Jl 27,C18:4
Solomon, Lin (Producer)
Body Beautiful, The 1991,O 3,C21:1
Solomon, Maribeth (Composer)
Wisecracks 1992,Je 4,C17:1
Solonitsin, Anatoly
Andrei Rublev 1992,F 21,C10:6
Solovyev, Vladimir (Miscellaneous)
Second Circle, The 1992,Ja 2,C15:1
Solovyov, Viktor
Swan Lake: The Zone 1991,S 4,C13:1
Sommer, Josef
Mighty Ducks, The 1992,O 2,C18:1
Sommer, Marc Oliver (Composer)
Sentinelle, La 1992,O 5,C14:3
Sommer, Scott (Original Author)
Crisscross 1992,My 9,17:5
Sommer, Scott (Screenwriter)
Crisscross 1992,My 9,17:5
Sonbert, Warren (Director)
Short Fuse (Avant-Garde Visions) 1992,O 5,C14:4
Sonego, Rodolfo (Miscellaneous)
Once Upon a Crime 1992,Mr 7,20:4
Sonenberg, David (Miscellaneous)
Dead Ringer 1991,Jl 17,C14:5
Sonenberg, David (Producer)
Dead Ringer 1991,Jl 17,C14:5
Song, Magie
Living End, The 1992,Ap 3,C1:1
Sonkan, Macit
Heart of Glass, A 1992,Mr 21,18:4
Sonnenfeld, Barry (Director)
Addams Family, The 1991,N 22,C1:1
Soriano, Antonio (Cinematographer)
Giving, The 1992,N 13,C17:1

Stengal, Casey
Waterdance, The 1992,My 13,C13:1
Stenn, David (Screenwriter)
Cool as Ice 1991,O 19,12:6
Stentcuk, Igor (Composer)
Raspad 1992,Ap 29,C15:1
Stephen, Mary (Miscellaneous)
Tale of Winter, A 1992,O 2,C12:6
Stephens, Robert
Pope Must Die(t), The 1991,Ag 30,C10:3
Afraid of the Dark 1992,Jl 24,C7:1
Sterling, Scott (Director)
Natives 1992,Ap 4,17:1
Stern, Daniel
Home Alone 1991,Ja 20,II:13:1
City Slickers 1991,Je 7,C18:5
Home Alone 2 1992,N 6,C1:1
Home Alone 2: Lost in New York 1992,N 20,C1:1
Home Alone 2 1992,N 29,II:11:5
Stern, Merril (Miscellaneous)
Tune, The 1992,S 4,C3:1
Stern, Sandor (Director)
Pin 1991,D 4,C28:1
Stern, Sandor (Screenwriter)
Pin 1991,D 4,C28:1
Sterner, Jerry (Original Author)
Other People's Money 1991,O 18,C10:3
Sternhagen, Frances
Doc Hollywood 1991,Ag 2,C8:5
Raising Cain 1992,Ag 7,C5:1
Stevan, Robyn
Stepping Out 1991,O 4,C26:4
Stevenin, Jean-Francois
Cold Moon (Lune Froide) 1991,My 11,11:4
Room in Town, A (Chambre en Ville, Une) 1991,S 28,11:5
Cold Moon (Lune Froide) 1992,Ap 22,C17:1
Olivier, Olivier 1992,S 25,C34:1
Stevens, Dave (Original Author)
Rocketeer, The 1991,Je 21,C1:3
Stevens, David P. B.
Complex World 1992,Ap 10,C14:5
Stevens, Fisher
Mystery Date 1991,Ag 16,C9:1
Stevens, George (Director)
Vigil in the Night 1992,Ag 21,C1:1
Stevens, Joe
Simple Men 1992,O 14,C22:1
Stevens, Leslie (Screenwriter)
Return to the Blue Lagoon 1991,Ag 2,C12:1
Stevens, Robert (Cinematographer)
Naked Gun 2 1/2: The Smell of Fear 1991,Je 28,C8:1
Delirious 1991,Ag 9,C12:4
Stevenson, Cynthia
Player, The 1992,Ap 10,C16:1
Stevenson, Juliet
Drowning by Numbers 1991,Ap 26,C8:1
Truly, Madly, Deeply 1991,My 3,C11:1
Stevenson, Michael A. (Miscellaneous)
Honey, I Blew Up the Kid 1992,Jl 17,C6:5
Stevenson, Rick (Producer)
Crooked Hearts 1991,S 6,C13:1
Stevic, Ralph E. (Miscellaneous)
Final Approach 1992,Mr 13,C8:4
Stewart, Dave A.
Deep Blues 1992,Jl 31,C14:3
Stewart, David A. (Producer)
Deep Blues 1992,Jl 31,C14:3
Stewart, Donald (Screenwriter)
Patriot Games 1992,Je 5,C1:1
Patriot Games 1992,Je 26,C1:3
Stewart, James
American Tail, An: Fievel Goes West 1991,N 22,C21:1
Stewart, Jane Ann (Miscellaneous)
Candyman 1992,O 16,C10:5
Stewart, John (Producer)
Deep Blues 1992,Jl 31,C14:3
Stewart, Paul
Opening Night 1991,My 17,C11:1
Stiers, David Ogden
Doc Hollywood 1991,Ag 2,C8:5
Beauty and the Beast 1991,N 13,C17:4
Stiles, Shannon
Bikini Island 1991,Jl 27,16:3
Still, Aline
Love Without Pity (Monde sans Pitie, Une) 1991,My 31,C16:4

Stiller, Michael (Cinematographer)
Revolution 1991,N 15,C8:4
Sting
Resident Alien 1991,O 18,C10:6
Stinton, Colin
Homicide 1991,O 6,56:1
Stites, Todd
Together Alone 1992,S 23,C18:4
Stock, Alan
Poison Ivy 1992,My 8,C16:3
Stockbridge, Sarah
Split Second 1992,My 4,C15:1
Stockhausen, Markus
Berlin Jerusalem 1991,Mr 8,C16:6
Stockhausen, Markus (Composer)
Berlin Jerusalem 1991,Mr 8,C16:6
Stock-Poynton, Amy
Bill and Ted's Bogus Journey 1991,Jl 19,C10:1
Stockwell, Anne (Director)
High Road, Low Road 1991,Mr 16,16:4
Stockwell, Dean
Player, The 1992,Ap 10,C16:1
Stoddard, Ken
Life on the Edge 1992,Je 19,C11:1
Stoddart, John (Miscellaneous)
Sweet Talker 1991,My 12,42:5
Stoeffhaas, Jerry (Director)
Cheap Shots 1991,N 15,C11:1
Stoeffhaas, Jerry (Producer)
Cheap Shots 1991,N 15,C11:1
Stoeffhaas, Jerry (Screenwriter)
Cheap Shots 1991,N 15,C11:1
Stohl, Andras
Memoirs of a River 1992,Mr 20,C15:1
Stok, Witold (Cinematographer)
Close My Eyes 1992,F 21,C12:6
Stoker, Bram (Original Author)
Bram Stoker's "Dracula" 1992,N 13,C1:3
Stokes, Terry (Miscellaneous)
Book of Love 1991,F 1,C10:6
Suburban Commando 1991,O 6,56:3
Stoller, Mike (Miscellaneous)
Love Potion No. 9 1992,N 13,C12:5
Stollman, Sarah (Miscellaneous)
Poison 1991,Ap 5,C8:3
Stoltz, Eric
Waterdance, The 1992,My 13,C13:1
Stona, Winston
Lunatic, The 1992,F 7,C14:5
Stone, Danton
Once Around 1991,Ja 18,C12:4
Stone, Dee Wallace
Popcorn 1991,F 1,C6:5
Stone, Noreen (Screenwriter)
Brenda Starr 1992,Ap 19,46:1
Stone, Oliver (Director)
Doors, The 1991,Mr 1,C1:1
Doors, The 1991,Mr 17,II:13:5
Doors, The 1991,Mr 24,II:11:1
J.F.K. 1991,D 20,C1:1
J.F.K. 1992,Ja 5,II:13:5
J.F.K. 1992,Ja 19,II:13:5
Stone, Oliver (Producer)
J.F.K. 1991,D 20,C1:1
Stone, Oliver (Screenwriter)
Doors, The 1991,Mr 1,C1:1
J.F.K. 1991,D 20,C1:1
Stone, Pam
Wisecracks 1992,Je 4,C17:1
Stone, Sharon
He Said, She Said 1991,F 22,C17:1
Year of the Gun 1991,N 1,C10:6
Basic Instinct 1992,Mr 20,C8:1
Basic Instinct 1992,My 8,C1:2
Diary of a Hit Man 1992,My 29,C10:5
Basic Instinct 1992,Ag 16,II:15:1
Stone, Stuart
Used People 1992,D 16,C23:3
Stoppard, Tom (Director)
Rosencrantz and Guildenstern Are Dead 1991,F 8,C14:6
Stoppard, Tom (Original Author)
Rosencrantz and Guildenstern Are Dead 1991,F 8,C14:6
Stoppard, Tom (Screenwriter)
Rosencrantz and Guildenstern Are Dead 1991,F 8,C14:6
Billy Bathgate 1991,N 1,C1:1

Billy Bathgate 1991,N 3,II:13:4
Storaro, Vittorio (Cinematographer)
1900 1991,F 1,C1:1
Hearts of Darkness: A Film Maker's Apocalypse 1991,N 27,C9:1
Storke, Adam
Death Becomes Her 1992,Jl 31,C8:1
Stormare, Peter
Damage 1992,D 23,C13:1
Stothart, John (Miscellaneous)
Truly, Madly, Deeply 1991,My 3,C11:1
Stover, Garreth (Miscellaneous)
December 1991,D 6,C8:5
Stowe, Madeleine
Closet Land 1991,Mr 7,C18:3
Unlawful Entry 1992,Je 26,C10:4
Last of the Mohicans, The 1992,S 25,C3:1
Last of the Mohicans, The 1992,O 18,II:13:5
Straight, Beatrice
Deceived 1991,S 27,C8:5
Strain, Jim (Screenwriter)
Bingo 1991,Ag 10,9:2
Strait, George
Pure Country 1992,O 23,C13:1
Strasburg, Ivan (Cinematographer)
Crisscross 1992,My 9,17:5
Strassman, Marcia
And You Thought Your Parents Were Weird 1991,N 15,C13:1
Honey, I Blew Up the Kid 1992,Jl 17,C6:5
Strathairn, David
City of Hope 1991,O 11,C19:1
League of Their Own, A 1992,Jl 1,C13:4
Sneakers 1992,S 9,C18:3
Passion Fish 1992,D 14,C16:1
Strawn, C. J. (Miscellaneous)
Book of Love 1991,F 1,C10:6
Freddy's Dead: The Final Nightmare 1991,S 14,11:4
Strazovec, Val (Miscellaneous)
Muppet Christmas Carol, The 1992,D 11,C12:6
Streep, Meryl
Defending Your Life 1991,Mr 22,C12:1
Defending Your Life 1991,Ap 21,II:13:5
Death Becomes Her 1992,Jl 31,C8:1
Street, John (Miscellaneous)
Damned in the U.S.A. 1992,N 13,C11:1
Streisand, Barbra
Prince of Tides, The 1991,D 25,13:3
Prince of Tides, The 1992,F 23,II:13:1
Prince of Tides, The 1992,F 28,C1:1
Streisand, Barbra (Director)
Prince of Tides, The 1991,D 25,13:3
Prince of Tides, The 1992,F 23,II:13:1
Streisand, Barbra (Producer)
Prince of Tides, The 1991,D 25,13:3
Strick, Wesley (Miscellaneous)
Final Analysis 1992,F 7,C8:1
Strick, Wesley (Screenwriter)
Cape Fear 1991,N 13,C17:1
Final Analysis 1992,F 7,C8:1
Strickland, Gail
Man in the Moon, The 1991,O 4,C13:1
Strode, Woody
Storyville 1992,Ag 26,C13:3
Strong, Andrew
Commitments, The 1991,Ag 14,C11:1
Commitments, The 1991,S 29,II:15:1
Strouth, Jeffrey
American Fabulous 1992,O 16,C14:5
Strouth, Jeffrey (Screenwriter)
American Fabulous 1992,O 16,C14:5
Strouve, Georges (Cinematographer)
Jacquot de Nantes 1991,S 25,C16:3
Strozier, Henry
Talking to Strangers 1991,D 27,C12:6
Strucchi, Stefano (Miscellaneous)
Once Upon a Crime 1992,Mr 7,20:4
Struycken, Carel
Addams Family, The 1991,N 22,C1:1
Stuart, Hamish
Get Back 1991,O 25,C19:1
Stuart, John
Legends 1991,Mr 17,68:5
Legends 1991,Mr 17,II:13:5
Stubbs, Imogen
True Colors 1991,Mr 15,C19:1
Studi, Wes
Last of the Mohicans, The 1992,S 25,C3:1

Stumm, Michael
Golden Boat, The 1991,Je 22,12:4
Swoon 1992,Mr 27,C8:1
Sturridge, Charles (Director)
Where Angels Fear to Tread 1992,F 28,C12:1
Where Angels Fear to Tread 1992,Mr 22,II:11:1
Sturridge, Charles (Screenwriter)
Where Angels Fear to Tread 1992,F 28,C12:1
Sturup, Jens (Cinematographer)
June Roses 1992,Mr 24,C15:3
Stutterheim, Eliane (Producer)
Halfaouine 1991,Mr 15,C1:4
Oak, The 1992,O 1,C13:1
Su Tong (Original Author)
Raise the Red Lantern 1992,Mr 20,C18:1
Suarez, Carlos (Cinematographer)
Don Juan, My Love 1991,Jl 12,C10:5
Most Beautiful Night, The 1992,N 20,C10:5
Subramaniam, L. (Composer)
Mississippi Masala 1992,F 5,C15:1
Suchy, William (Screenwriter)
Building Bombs 1991,O 12,20:3
Suddaby, Don
Lorenzo's Oil 1992,D 30,C7:3
Sugiyama, Yukio (Cinematographer)
Robot Carnival 1991,Mr 15,C14:5
Suhrstedt, Tim (Cinematographer)
Don't Tell Mom the Babysitter's Dead 1991,Je 7,C19:1
Noises Off 1992,Mr 20,C10:1
Traces of Red 1992,N 12,C22:1
Sukowa, Barbara
Voyager 1992,Ja 31,C6:1
Zentropa 1992,My 22,C14:1
Sullivan, Brad
Prince of Tides, The 1991,D 25,13:3
Sullivan, Frank (Miscellaneous)
Terror in a Texas Town 1991,My 17,C16:4
Sullivan, Tim (Screenwriter)
Where Angels Fear to Tread 1992,F 28,C12:1
Sumen, Mauri (Composer)
Zombie and the Ghost Train 1991,O 4,C8:5
Summanen, Lasse (Miscellaneous)
Ox, The 1992,Ag 21,C10:5
Summanen, Lasse (Screenwriter)
Ox, The 1992,Ag 21,C10:5
Summers, Andy (Composer)
Motorama 1992,Mr 28,18:5
Summers, Cathleen (Producer)
Mystery Date 1991,Ag 16,C9:1
Sun Ching Hung
Autumn Moon 1992,S 26,12:1
Sun, Shirley (Director)
Iron and Silk 1991,F 15,C12:5
Sun, Shirley (Producer)
Iron and Silk 1991,F 15,C12:5
Sun, Shirley (Screenwriter)
Iron and Silk 1991,F 15,C12:5
Sun Xudong
Iron and Silk 1991,F 15,C12:5
Sunara, Igor (Cinematographer)
Misplaced 1991,Mr 1,C9:1
Suozzo, Mark (Composer)
Thank You and Good Night 1992,Ja 29,C20:4
Surer, Nur
Journey of Hope 1991,Ap 26,C13:1
Surovy, Nicolas
Forever Young 1992,D 16,C17:1
Surtees, Bruce (Cinematographer)
Run 1991,F 1,C15:1
White Dog 1991,Jl 12,C8:1
Super, The 1991,O 4,C10:1
Suschitzky, Peter (Cinematographer)
Naked Lunch 1991,D 27,C1:3
Public Eye, The 1992,O 14,C17:1
Sust, Jiri (Composer)
Larks on a String 1991,F 13,C14:4
End of Old Times, The 1992,Ja 10,C12:6
Sutherland, Donald
1900 1991,F 1,C1:1
Eminent Domain 1991,Ap 12,C13:4
Backdraft 1991,My 24,C14:6
J.F.K. 1991,D 20,C1:1
Buffy the Vampire Slayer 1992,Jl 31,C8:5
Sutherland, Kiefer
Article 99 1992,Mr 13,C10:1
Twin Peaks: Fire Walk with Me 1992,Ag 29,11:1
Few Good Men, A 1992,D 11,C20:1

Sutton, Dudley
Edward II 1992,Mr 20,C16:3
Suzuki, Akira (Miscellaneous)
Heaven and Earth 1991,Mr 1,C10:4
Suzuki, Masayuki
Swimming with Tears 1992,Mr 22,49:1
Suzuki, Mie
Rhapsody in August 1991,D 20,C22:4
Suzuki, Saeko
No Life King 1991,S 22,58:5
Svankmajer, Jan (Director)
Death of Stalinism in Bohemia, The 1991,F 13,C14:4
Svare, Steen
Birthday Trip, The 1991,Mr 26,C14:3
Sirup 1991,Mr 30,10:4
Svirgun, Yuri
Save and Protect 1992,Jl 10,C14:5
Swaab, Robert (Producer)
Voyeur 1991,Ag 2,C9:1
Swan, Bob
Babe, The 1992,Ap 17,C8:1
Swank, Hilary
Buffy the Vampire Slayer 1992,Jl 31,C8:5
Swanson, Kristy
Mannequin Two: On the Move 1991,My 19,50:3
Buffy the Vampire Slayer 1992,Jl 31,C8:5
Swartz, Steve
Never Leave Nevada 1991,Ap 28,60:5
Swartz, Steve (Director)
Never Leave Nevada 1991,Ap 28,60:5
Swartz, Steve (Screenwriter)
Never Leave Nevada 1991,Ap 28,60:5
Swayze, Patrick
Point Break 1991,Jl 12,C12:6
City of Joy 1992,Ap 15,C15:1
Sweeney, Birdie
Crying Game, The 1992,S 26,12:4
Sweeney, D. B.
Cutting Edge, The 1992,Mr 27,C21:1
Day in October, A 1992,O 28,C20:5
Sweeney, Julia
Honey, I Blew Up the Kid 1992,Jl 17,C6:5
Sweeney, Mary (Miscellaneous)
Twin Peaks: Fire Walk with Me 1992,Ag 29,11:1
Sweeney, Michelle
Strangers in Good Company 1991,My 10,C8:1
Swenson, Charles (Miscellaneous)
American Tail, An: Fievel Goes West 1991,N 22,C21:1
Swerdlick, Michael (Miscellaneous)
Class Act 1992,Je 5,C17:1
Swift, Graham (Original Author)
Waterland 1992,O 30,C14:6
Swimar, Barry (Producer)
Paris Is Burning 1991,Mr 13,C13:1
Swinson, David (Producer)
Roadside Prophets 1992,Mr 27,C10:1
Swinton, Tilda
Garden, The 1991,Ja 17,C16:5
Edward II 1992,Mr 20,C16:3
Sylbert, Anthea (Producer)
Crisscross 1992,My 9,17:5
Sylbert, Paul (Miscellaneous)
Career Opportunities 1991,Mr 31,38:1
Rush 1991,D 22,56:4
Prince of Tides, The 1991,D 25,13:3
Sylbert, Richard (Miscellaneous)
Mobsters 1991,Jl 26,C18:4
Sylvers, Jeremy
Child's Play 3 1991,Ag 30,C11:3
Symons, James (Miscellaneous)
Nothing But Trouble 1991,F 16,16:5
Naked Gun 2 1/2: The Smell of Fear 1991,Je 28,C8:1
Szabo, Gabor (Director)
Where 1991,S 6,C13:1
Szabo, Gabor (Producer)
Where 1991,S 6,C13:1
Szabo, Gabor (Screenwriter)
Where 1991,S 6,C13:1
Szabo, Istvan (Director)
Meeting Venus 1991,N 15,C1:3
Szabo, Istvan (Screenwriter)
Meeting Venus 1991,N 15,C1:3
Szabo, Laszlo
Sentinelle, La 1992,O 5,C14:3
Szanto, Annamaria (Miscellaneous)
Cool World 1992,Jl 11,12:3

Szczerbic, Michal (Miscellaneous)
Inventory 1991,S 24,C13:2
Szokoll, Carl
Other Eye, The 1991,S 25,C17:1
Szollosy, Andras (Composer)
Shadow on the Snow 1992,Mr 31,C16:1

T

Tabakov, Oleg
Inner Circle, The 1991,D 25,20:1
Tadeschi, Valeria Bruni
Story of Boys and Girls, The 1991,Mr 28,C12:1
Taga, Hidenori (Producer)
Twilight of the Cockroaches 1991,Mr 29,C14:4
Tagawa, Cary Hiroyuki
American Me 1992,Mr 13,C6:5
Tagg, Brian (Miscellaneous)
Whore 1991,O 4,C15:1
Taggart, Rita
Crossing the Bridge 1992,S 11,C12:1
Tagore, Sharmila
Mississippi Masala 1992,F 5,C15:1
Taguchi, Tomoroh
Tetsuo: The Iron Man 1992,Ap 22,C17:1
Taha, Fadi
Captive of the Desert, The (Captive du Desert, La) 1991,Mr 21,C20:3
Tait, Tristan
Passed Away 1992,Ap 24,C8:1
Takahashi, Hirokata (Cinematographer)
Professional, The 1992,O 23,C14:5
Takahisa, Susumu (Screenwriter)
Fist of the North Star 1991,N 15,C8:1
Takakura, Ken
Mr. Baseball 1992,O 2,C14:6
Takama, Kenji (Cinematographer)
Traffic Jam 1992,Mr 20,C20:4
Takanashi, Aya
Mr. Baseball 1992,O 2,C14:6
Takayama, Ryo
No Life King 1991,S 22,58:5
Takeda, Atsushi (Producer)
Silk Road, The 1992,My 29,C13:1
Takei, George
Prisoners of the Sun 1991,Jl 19,C12:1
Star Trek VI: The Undiscovered Country 1991,D 6,C1:1
Takemitsu, Toru (Composer)
Rikyu 1991,Ja 18,C8:1
Inland Sea, The 1992,Je 17,C13:1
Takita, Yojiri (Director)
Yen Family, The 1991,Ag 21,C13:1
Talalay, Rachel (Director)
Freddy's Dead: The Final Nightmare 1991,S 14,11:4
Talalay, Rachel (Miscellaneous)
Freddy's Dead: The Final Nightmare 1991,S 14,11:4
Talalay, Rachel (Producer)
Book of Love 1991,F 1,C10:6
Tally, Ted (Screenwriter)
Silence of the Lambs, The 1991,F 14,C17:1
Silence of the Lambs, The 1991,F 17,II:11:5
Talmadge, William (Producer)
Ted and Venus 1991,D 20,C23:1
Talpalatsky, Luba
Man Without a World, The 1992,S 9,C18:4
Tambor, Jeffrey
Life Stinks 1991,Jl 26,C19:1
Pastime 1991,Ag 23,C13:1
Brenda Starr 1992,Ap 19,46:1
Crossing the Bridge 1992,S 11,C12:1
Tamburrelli, Karla
Forever Young 1992,D 16,C17:1
Tamma, Nanni
Alberto Express 1992,O 9,C12:5
Tammi, Emma
Used People 1992,D 16,C23:3
Tamura, Takahiro
Silk Road, The 1992,My 29,C13:1
Tan, Fred (Director)
Rouge of the North 1991,D 6,C24:5
Tan, Fred (Screenwriter)
Rouge of the North 1991,D 6,C24:5
Tan, Philip
China Cry 1991,My 3,C9:1

Tanaka, Toru
Perfect Weapon, The 1991,Mr 16,16:5
Tancredi, Louis (Producer)
Boy Who Cried Bitch, The 1991,O 11,C17:1
Tandy, Jessica
Fried Green Tomatoes 1991,D 27,C3:1
Fried Green Tomatoes 1992,F 23,II:13:1
Used People 1992,N 6,C1:1
Used People 1992,D 16,C23:3
Tang, Rover (Producer)
Days of Being Wild 1991,Mr 23,12:3
Tani, Toshihiko (Miscellaneous)
Yen Family, The 1991,Ag 21,C13:1
Tanner, Peter (Miscellaneous)
Eminent Domain 1991,Ap 12,C13:4
Taplin, Jonathan (Producer)
Until the End of the World 1991,D 25,18:5
K2 1992,My 1,C16:1
Tarantino, Quentin
Reservoir Dogs 1992,O 23,C14:1
Tarantino, Quentin (Director)
Reservoir Dogs 1992,Ja 23,C15:4
Reservoir Dogs 1992,O 23,C14:1
Reservoir Dogs 1992,D 13,II:1:2
Tarantino, Quentin (Screenwriter)
Reservoir Dogs 1992,O 23,C14:1
Taraporevala, Sooni (Screenwriter)
Mississippi Masala 1992,F 5,C15:1
Tarkovsky, Andrei (Director)
Andrei Rublev 1992,F 21,C10:6
Tarlov, Mark (Producer)
Mortal Thoughts 1991,Ap 19,C15:1
Tashiro, Hirotaka (Director)
Swimming with Tears 1992,Mr 22,49:1
Tashiro, Hirotaka (Screenwriter)
Swimming with Tears 1992,Mr 22,49:1
Tass, Nadia (Director)
Pure Luck 1991,Ag 9,C15:1
Tat, Lau Yee (Composer)
Autumn Moon 1992,S 26,12:1
Tate, Buddy
Texas Tenor: The Illinois Jacquet Story 1992,N
20,C5:1
Tate, Caron
Talking to Strangers 1991,D 27,C12:6
Tattersall, Gale (Cinematographer)
Commitments, The 1991,Ag 14,C11:1
Taubner, Beth (Producer)
June Roses 1992,Mr 24,C15:3
Tavera, Michael (Composer)
Frozen Assets 1992,O 24,16:4
Tavernier, Bertrand (Director)
Daddy Nostalgia 1991,Ap 12,C10:1
Daddy Nostalgia 1991,Je 2,II:15:1
Tavier, Vincent (Screenwriter)
Man Bites Dog 1992,O 9,C14:5
Tavoularis, Alex (Miscellaneous)
Beethoven 1992,Ap 3,C18:1
Tavoularis, Dean (Miscellaneous)
Hearts of Darkness: A Film Maker's Apocalypse
1991,N 27,C9:1
Final Analysis 1992,F 7,C8:1
Taylor, Dub
Falling from Grace 1992,F 21,C16:5
Taylor, Edward (Screenwriter)
V. I. Warshawski 1991,Jl 26,C1:3
Taylor, Elizabeth
Cleopatra 1992,N 20,C1:3
Taylor, Lili
Bright Angel 1991,Je 14,C6:1
Dogfight 1991,S 13,C13:1
Dogfight 1991,S 15,II:13:5
Taylor, Meshach
Mannequin Two: On the Move 1991,My 19,50:3
Class Act 1992,Je 5,C17:1
Taylor, Noah
Flirting 1992,N 6,C13:1
Taylor, Ronnie (Cinematographer)
Popcorn 1991,F 1,C6:5
Taylor, Stephen James (Composer)
Giving, The 1992,N 13,C17:1
Taylor, Teresa
Slacker 1991,Mr 22,C8:1
Tchelley, Hanny
Hyenas 1992,O 3,18:4
Te Kanawa, Kiri
Meeting Venus 1991,N 15,C1:3

Telford, Robert S.
Ruby 1992,Mr 27,C1:3
Tellefsen, Christopher (Miscellaneous)
Revolution 1991,N 15,C8:4
Jumpin' at the Boneyard 1992,S 18,C18:5
Telushkin, Joseph (Original Author)
Quarrel, The 1992,N 4,C22:4
Temiz, Okay (Composer)
Heart of Glass, A 1992,Mr 21,18:4
Temple, Julien (Director)
At the Max 1991,N 22,C15:1
Temple, Julien (Miscellaneous)
At the Max 1991,N 22,C15:1
Tenenbaum, Nancy (Producer)
Rapture, The 1991,S 30,C14:4
Tennant, Victoria
L.A. Story 1991,F 8,C8:1
Tent, Kevin (Miscellaneous)
Guilty as Charged 1992,Ja 29,C17:1
Teper, Meir (Producer)
Mistress 1992,Ag 7,C16:3
Teron, Nadege
Tous les Matins du Monde 1992,N 13,C3:4
Terrell, John Canada
Boomerang 1992,Jl 1,C18:1
Terry, Clark
Texas Tenor: The Illinois Jacquet Story 1992,N
20,C5:1
Terry, John
Of Mice and Men 1992,O 2,C5:4
Terry, Nigel
Edward II 1992,Mr 20,C16:3
Ter Steege, Johanna
Vanishing, The 1991,Ja 25,C8:1
Meeting Venus 1991,N 15,C1:3
Teschner, Peter (Miscellaneous)
Bride of Re-Animator 1991,F 22,C17:1
Teshigahara, Hiroshi (Director)
Rikyu 1991,Ja 18,C8:1
Teshigahara, Hiroshi (Screenwriter)
Rikyu 1991,Ja 18,C8:1
Testori, Giovanni (Original Author)
Rocco and His Brothers 1991,S 21,12:1
Tewkesbury, Joan (Screenwriter)
Nashville 1992,N 8,II:13:5
Teyssedre, Anne
Tale of Springtime, A (Conte de Printemps) 1992,Jl
17,C10:6
Thal, Eric
Stranger Among Us, A 1992,Jl 17,C1:3
Thaw, John
Chaplin 1992,D 25,C3:1
Theaker, Deborah
Wisecracks 1992,Je 4,C17:1
Thevenet, Virginie
Cry of the Owl, The (Cri du Hibou, Le) 1991,O
16,C19:1
Thewlis, David
Life Is Sweet 1991,O 25,C10:1
Thicke, Alan
And You Thought Your Parents Were Weird 1991,N
15,C13:1
Thiel, Nick (Screenwriter)
White Fang 1991,Ja 18,C16:3
Shipwrecked 1991,Mr 1,C6:1
V. I. Warshawski 1991,Jl 26,C1:3
Thigpen, Lynne
Article 99 1992,Mr 13,C10:1
Thin Elk, Chief Ted
Thunderheart 1992,Ap 3,C12:1
Thinh, Trinh Van
Indochine 1992,D 24,C9:1
Thirard, Armand (Cinematographer)
Wages of Fear, The (Salaire de la Peur, Le) 1991,O
18,C8:3
Thire, Cecil
Fable of the Beautiful Pigeon Fancier, The 1991,Mr
1,C6:4
Tho, Tien
Indochine 1992,D 24,C9:1
Thomas, Christopher (Composer)
There's Nothing Out There 1992,Ja 22,C20:4
Thomas, Gordon A. (Miscellaneous)
Never Leave Nevada 1991,Ap 28,60:5
Thomas, Henry (Producer)
Get Back 1991,O 25,C19:1
Thomas, Jeremy (Producer)
Naked Lunch 1991,D 27,C1:3

Thomas, Jessie
My Own Private Idaho 1991,S 27,C5:1
Thomas, John (Cinematographer)
Bruce Diet, The 1992,Ap 15,C19:1
Thomas, Leonard
Bad Lieutenant 1992,N 20,C15:1
Thomas, Maynell (Producer)
Class Act 1992,Je 5,C17:1
Thomas, Ray (Miscellaneous)
Black Harvest 1992,Ap 4,17:1
Thomas, Rufus
All Day and All Night: Memories from Beale Street
Musicians 1991,Mr 15,C1:4
Thomas, Sarah (Miscellaneous)
Sarafina! 1992,S 18,C16:6
Thomas, Scott (Miscellaneous)
Reflecting Skin, The 1991,Je 28,C9:1
On the Black Hill 1991,Ag 16,C8:1
Afraid of the Dark 1992,Jl 24,C7:1
Thomas, Seth
Bikini Island 1991,Jl 27,16:3
Thomas, Tony (Producer)
Final Analysis 1992,F 7,C8:1
Thomas, Tressa
Five Heartbeats, The 1991,Mr 29,C14:3
Thomas, Wynn (Miscellaneous)
Five Heartbeats, The 1991,Mr 29,C14:3
Jungle Fever 1991,Je 7,C1:2
Malcolm X 1992,N 18,C19:3
Thompson, Brian
Lionheart 1991,Ja 11,C8:4
Ted and Venus 1991,D 20,C23:1
Thompson, Caroline (Screenwriter)
Addams Family, The 1991,N 22,C1:1
Thompson, Emma
Impromptu 1991,Ap 12,C10:5
Impromptu 1991,Je 16,II:11:5
Dead Again 1991,Ag 23,C1:3
Dead Again 1991,O 13,II:21:1
Howards End 1992,Mr 13,C1:3
Howards End 1992,Mr 22,II:11:1
Peter's Friends 1992,D 25,C8:6
Thompson, Ernest
Malcolm X 1992,N 18,C19:3
Thompson, Fred Dalton
Curly Sue 1991,O 25,C15:1
Thunderheart 1992,Ap 3,C12:1
Aces: Iron Eagle III 1992,Je 13,16:4
Thompson, Gary Scott (Screenwriter)
Split Second 1992,My 4,C15:1
Thompson, Jack
Wind 1992,S 11,C3:1
Thompson, Jim (Original Author)
Grifters, The 1991,Ja 25,C13:1
Thompson, Lauren
Just Like in the Movies 1992,My 4,C15:1
Thompson, Lea
Article 99 1992,Mr 13,C10:1
Thompson, Richard (Composer)
Sweet Talker 1991,My 12,42:5
Thompson, Sophie
Twenty-One 1991,O 4,C10:6
Thomson, Alex (Cinematographer)
Alien 3 1992,My 22,C1:1
Thomson, Anna
Crisscross 1992,My 9,17:5
Unforgiven 1992,Ag 7,C1:1
Thomson, Pat
Strictly Ballroom 1992,S 26,12:5
Thomson, R. H.
Quarrel, The 1992,N 4,C22:4
Thoolen, Gerard
Prospero's Books 1991,S 28,9:1
Thor, Cameron
Curly Sue 1991,O 25,C15:1
Thoren, Terry (Producer)
Third Animation Celebration, The 1991,Ja 18,C16:5
British Animation Invasion, The 1991,Mr 29,C12:4
23d International Tournee of Animation, The
1991,Ag 28,C11:1
National Film Board of Canada's Animation
Festival, The 1991,D 28,9:1
Fourth Animation Celebration, The: The Movie
1992,Ap 18,14:3
Thorin, Donald E. (Cinematographer)
Marrying Man, The 1991,Ap 5,C6:1
Out on a Limb 1992,S 5,15:1
Scent of a Woman 1992,D 23,C9:1

Trese, Adam
Laws of Gravity 1992,Mr 21,18:1
Laws of Gravity 1992,Ag 26,C18:6
Treton, Gilles
Every Other Weekend 1991,Je 19,C12:3
Treu, Wolfgang (Cinematographer)
Becoming Colette 1992,N 6,C6:1
Treut, Monika (Director)
My Father Is Coming 1991,N 22,C12:5
Treut, Monika (Producer)
My Father Is Coming 1991,N 22,C12:5
Treut, Monika (Screenwriter)
My Father Is Coming 1991,N 22,C12:5
Treves, Frederick
Paper Mask 1992,F 28,C19:1
Trevor, Richard (Miscellaneous)
Ruby 1992,Mr 27,C1:3
Trieu, Thi Hoe Tranh Huu
Indochine 1992,D 24,C9:1
Trigger, Sarah
Grand Canyon 1991,D 25,18:1
Pet Sematary Two 1992,Ag 29,14:4
Trintignant, Marie
Alberto Express 1992,O 9,C12:5
Tripplehorn, Jeanne
Basic Instinct 1992,Mr 20,C8:1
Basic Instinct 1992,My 8,C1:2
Basic Instinct 1992,Ag 16,II:15:1
Tristancho, Carlos
Aventis (Stories) 1992,N 13,C15:1
Tronc, Nicolas
Window Shopping 1992,Ap 17,C13:1
Tronick, Michael (Miscellaneous)
Hudson Hawk 1991,My 24,C8:4
Straight Talk 1992,Ap 3,C17:1
Scent of a Woman 1992,D 23,C9:1
Troum, Kenn
Teen-Age Mutant Ninja Turtles II: The Secret of the Ooze 1991,Mr 22,C1:3
Troupe, Tom
My Own Private Idaho 1991,S 27,C5:1
Trousdale, Gary (Director)
Beauty and the Beast 1991,N 13,C17:4
Truchot, Laurent (Miscellaneous)
Berlin Jerusalem 1991,Mr 8,C16:6
Trudell, John
Thunderheart 1992,Ap 3,C12:1
Incident at Oglala 1992,My 8,C15:1
Thunderheart 1992,My 10,II:22:1
Incident at Oglala 1992,My 10,II:22:1
Trudell, John (Composer)
Incident at Oglala 1992,My 8,C15:1
True, Jim
Singles 1992,S 18,C3:4
Truffaut, Francois
Green Room, The 1992,Ap 5,II:17:5
Truffaut, Francois (Director)
Mistons, Les 1992,Ap 5,II:17:5
Green Room, The 1992,Ap 5,II:17:5
Mississippi Mermaid (Sirene du Mississippi, La) 1992,Ap 5,II:17:5
Two English Girls 1992,Ap 5,II:17:5
Trujillo, Raoul
Adjuster, The 1991,S 26,C18:5
Clearcut 1992,Ag 21,C9:1
Seen from Elsewhere (Taking the Pulse) 1992,S 26,11:4
Truman, Tim (Composer)
South-Central 1992,O 16,C13:1
Trumbo, Dalton (Screenwriter)
Spartacus 1991,Ap 26,C6:4
Trump, Donald
Home Alone 2: Lost in New York 1992,N 20,C1:1
Trung, Nguyen Lan
Indochine 1992,D 24,C9:1
Truscello, Denise
Liquid Dreams 1992,Ap 15,C19:1
Trushkovsky, Vasily (Cinematographer)
Raspad 1992,Ap 29,C15:1
Trybala, Marzena
Korczak 1991,Ap 12,C8:1
Tryphon, Georg
Becoming Colette 1992,N 6,C6:1
Tsang, Kenneth
Killer, The 1991,Ap 12,C11:1
Tsao, Calvin (Miscellaneous)
Iron and Silk 1991,F 15,C12:5

Tsitsopoulos, Giannis (Miscellaneous)
Suspended Step of the Stork, The 1991,S 23,C15:1
Tsugawa, Masahiko
Heaven and Earth 1991,Mr 1,C10:4
Tsui, Jeanette Lin
Iron and Silk 1991,F 15,C12:5
Tsukamoto, Shinya
Tetsuo: The Iron Man 1992,Ap 22,C17:1
Tsukamoto, Shinya (Cinematographer)
Tetsuo: The Iron Man 1992,Ap 22,C17:1
Tsukamoto, Shinya (Director)
Tetsuo: The Iron Man 1992,Ap 22,C17:1
Tsukamoto, Shinya (Miscellaneous)
Tetsuo: The Iron Man 1992,Ap 22,C17:1
Tsukamoto, Shinya (Screenwriter)
Tetsuo: The Iron Man 1992,Ap 22,C17:1
Tsurubuchi, Mitsuo (Miscellaneous)
Professional, The 1992,O 23,C14:5
Tsurubuchi, Mototoshi (Miscellaneous)
Castle of Cagliostro, The 1992,Jl 3,C10:6
Tubbs, William
Wages of Fear, The (Salaire de la Peur, Le) 1991,O 18,C8:3
Tucci, Stanley
Men of Respect 1991,Ja 18,C1:1
Prelude to a Kiss 1992,Jl 10,C10:1
In the Soup 1992,O 3,13:2
Public Eye, The 1992,O 14,C17:1
Tucker, James
Lost Prophet 1992,Je 8,C16:1
Tucker, Steven
Lost Prophet 1992,Je 8,C16:1
Tuffarelli, Daniel
June Roses 1992,Mr 24,C15:3
Tuffarelli, Samantha
June Roses 1992,Mr 24,C15:3
Tugend, Jennie Lew (Producer)
Lethal Weapon 3 1992,My 15,C16:3
Tulin, Michael
Life on the Edge 1992,Je 19,C11:1
Tulliver, Barbara (Miscellaneous)
Homicide 1991,O 6,56:1
Tunney, Robin
Encino Man 1992,My 22,C15:1
Turco, Paige
Teen-Age Mutant Ninja Turtles II: The Secret of the Ooze 1991,Mr 22,C1:3
Turman, Glynn
Deep Cover 1992,Ap 15,C19:4
Turner, Bonnie (Screenwriter)
Wayne's World 1992,F 14,C15:1
Wayne's World 1992,Mr 8,II:15:1
Wayne's World 1992,Je 26,C1:3
Turner, George Jesse (Cinematographer)
35 Up 1992,Ja 15,C13:5
Turner, Kathleen
V. I. Warshawski 1991,Jl 26,C1:3
V. I. Warshawski 1991,Ag 4,II:7:5
Turner, Simon Fisher (Composer)
Garden, The 1991,Ja 17,C16:5
Edward II 1992,Mr 20,C16:3
Turner, Terry (Screenwriter)
Wayne's World 1992,F 14,C15:1
Wayne's World 1992,Mr 8,II:15:1
Wayne's World 1992,Je 26,C1:3
Turpin, Ben
Million Dollar Legs 1992,N 20,C1:3
Turrow, Randolf (Producer)
Ted and Venus 1991,D 20,C23:1
Turteltaub, Jon (Director)
3 Ninjas 1992,Ag 7,C5:1
Turturro, John
Men of Respect 1991,Ja 18,C1:1
Jungle Fever 1991,My 17,C1:1
Barton Fink 1991,My 20,C11:4
Jungle Fever 1991,Je 7,C1:2
Barton Fink 1991,Ag 21,C11:1
Barton Fink 1991,Ag 25,II:16:1
Brain Donors 1992,Ap 18,11:1
Twaine, Michael
Cheap Shots 1991,N 15,C11:1
Twohy, D. T. (Screenwriter)
Warlock 1991,Mr 30,11:4
Tyler, Robin
Wisecracks 1992,Je 4,C17:1
Tyson, Cicely
Fried Green Tomatoes 1991,D 27,C3:1

Tyson, Richard
Babe, The 1992,Ap 17,C8:1
Tyson, Thom (Producer)
End of Innocence, The 1991,Ja 18,C17:1
Tzudiker, Bob (Screenwriter)
Newsies 1992,Ap 8,C22:3

U

Udoff, Yale (Screenwriter)
Eve of Destruction 1991,Ja 19,22:6
Udvaros, Dorottya
Meeting Venus 1991,N 15,C1:3
Ueda, Masaharu (Cinematographer)
Rhapsody in August 1991,D 20,C22:4
Ueki, Hidenori (Producer)
Iron Maze 1991,N 1,C13:1
Ufland, Harry J. (Producer)
Not Without My Daughter 1991,Ja 11,C8:1
Ufland, Mary Jane (Producer)
Not Without My Daughter 1991,Ja 11,C8:1
Uhlen, Gisela
Toto the Hero (Toto le Heros) 1991,S 21,11:1
Uhlman, Fred (Original Author)
Reunion 1991,Mr 15,C16:6
Ujlaki, Denes
Shadow on the Snow 1992,Mr 31,C16:1
Ulfers, Erik (Miscellaneous)
Bruce Diet, The 1992,Ap 15,C19:1
Ullmann, Liv
Mindwalk 1992,Ap 8,C17:1
Ox, The 1992,Ag 21,C10:5
Ulmer, Edgar G. (Director)
Detour 1992,Jl 3,C8:1
Ultra Violet
Superstar: The Life and Times of Andy Warhol 1991,F 22,C8:1
Umbach, Martin
Neverending Story II, The: The Next Chapter 1991,F 9,12:4
Umetsu, Yasuomi (Director)
Robot Carnival 1991,Mr 15,C14:5
Umezu, Sakae
Swimming with Tears 1992,Mr 22,49:1
Underwood, Ron (Director)
City Slickers 1991,Je 7,C18:5
Ungar, Jay (Composer)
Brother's Keeper 1992,S 9,C15:3
Unger, Deborah
Whispers in the Dark 1992,Ag 7,C17:1
Unger, Matt (Screenwriter)
Class of Nuke 'Em High Part 2: Subhumanoid Meltdown 1991,Ap 12,C13:1
Urbaniak, Michael (Composer)
Misplaced 1991,Mr 1,C9:1
Urbini, Juan Jose (Miscellaneous)
Woman of the Port (Mujer del Puerto, La) 1991,S 27,C5:1
Ureles, Jeff (Director)
Cheap Shots 1991,N 15,C11:1
Ureles, Jeff (Producer)
Cheap Shots 1991,N 15,C11:1
Ureles, Jeff (Screenwriter)
Cheap Shots 1991,N 15,C11:1
Urich, Christian
Lost Prophet 1992,Je 8,C16:1
Urioste, Frank J. (Miscellaneous)
Basic Instinct 1992,Mr 20,C8:1
Urla, Joe
Bodyguard, The 1992,N 25,C9:5
Usami, Junya
Black Lizard 1991,S 18,C13:1
Usatova, Nina
Hey, You Wild Geese 1992,Ap 2,C20:5
Usov, Anatoly (Screenwriter)
Inner Circle, The 1991,D 25,20:1
Ustinov, Peter
Spartacus 1991,Ap 26,C6:4
Lorenzo's Oil 1992,D 30,C7:3
Utt, Kenneth (Producer)
Silence of the Lambs, The 1991,F 14,C17:1

V

Vaab, Robert
Save and Protect 1992,Jl 10,C14:5

Vaananen, Kari
Night on Earth 1991,O 4,C1:3
Amazon 1992,F 28,C8:5
Vie de Boheme, La 1992,O 9,C14:1

Vachon, Christine (Producer)
Poison 1991,Ap 5,C8:3
Swoon 1992,Mr 27,C8:1

Vadell, Jaime
Amelia Lopes O'Neill 1991,S 21,12:3

Vadim, Christian
Winter in Lisbon, The 1992,Mr 9,C15:5

Vahabzadeh, Yousef (Producer)
Diggstown 1992,Ag 14,C1:1

Vail, Bretton
Living End, The 1992,Ap 3,C1:1

Vajna, Andrew G. (Producer)
Medicine Man 1992,F 7,C13:1

Valcarcel, Horacio (Screenwriter)
Wait for Me in Heaven (Esperame en el Cielo)
1991,Ja 30,C10:5

Valdes, Julio (Cinematographer)
Adorable Lies 1992,Mr 27,C8:5

Valdes, Thais
Adorable Lies 1992,Mr 27,C8:5

Valentino, Rudolph
Four Horsemen of the Apocalypse, The 1991,N
8,C1:1

Valero, Sharrie
Talking to Strangers 1991,D 27,C12:6

Valier, Petra (Miscellaneous)
Famine Within, The 1991,Jl 17,C13:1

Valk, Kate
Golden Boat, The 1991,Je 22,12:4

Vallone, John (Miscellaneous)
Rambling Rose 1991,S 20,C12:4

Valverde, Fernando
Bosque Animado, El (Enchanted Forest, The)
1992,D 4,C8:6

Van Buren, Shula
Zebrahead 1992,O 8,C17:5

Vance, Danitra
Jumpin' at the Boneyard 1992,S 18,C18:5

Vance, James
Dream Deceivers: The Story Behind James Vance
vs. Judas Priest 1992,Ag 6,C15:4

Vance, James D. (Miscellaneous)
Babe, The 1992,Ap 17,C8:1

Vance, Kenny (Composer)
Hard Promises 1992,Ja 31,C12:6

Vance, Phyllis
Dream Deceivers: The Story Behind James Vance
vs. Judas Priest 1992,Ag 6,C15:4

Vance-Straker, Marilyn (Miscellaneous)
Rocketeer, The 1991,Je 21,C1:3

Van Citters, Darrell (Director)
Box Office Bunny 1991,F 9,12:4

Vancura, Vladislav (Original Author)
End of Old Times, The 1992,Ja 10,C12:6

Van Damme, Jean-Claude
Lionheart 1991,Ja 11,C8:4
Double Impact 1991,Ag 9,C8:5
Universal Soldier 1992,Jl 10,C17:1

Van Damme, Jean-Claude (Miscellaneous)
Lionheart 1991,Ja 11,C8:4

Van Damme, Jean-Claude (Producer)
Double Impact 1991,Ag 9,C8:5

Van Damme, Jean-Claude (Screenwriter)
Lionheart 1991,Ja 11,C8:4
Double Impact 1991,Ag 9,C8:5

Van Den Driessche, Frederic
Tale of Winter, A 1992,O 2,C12:6

van den Elsen, Sylvie
Vie de Boheme, La 1992,O 9,C14:1

van den Ende, Walther (Cinematographer)
Toto the Hero (Toto le Heros) 1991,S 21,11:1

Vanderbroeck, Willy
Man Bites Dog 1992,O 9,C14:5

Vander Wende, R. S. (Miscellaneous)
Aladdin 1992,N 11,C15:3

van der Zaken, Deen (Cinematographer)
Last Date: Eric Dolphy 1992,Je 29,C16:5

Van de Sande, Theo (Cinematographer)
Once Around 1991,Ja 18,C12:4
Body Parts 1991,Ag 3,9:1
Wayne's World 1992,F 14,C15:1

Vandestien, Michel (Miscellaneous)
Amants du Pont Neuf, Les (Lovers of the Pont Neuf)
1992,O 6,C16:1

van Dijk, Piotr (Miscellaneous)
Last Date: Eric Dolphy 1992,Je 29,C16:5

van Dongen, Hans (Miscellaneous)
Voyeur 1991,Ag 2,C9:1

van Dormael, Jaco (Director)
Toto the Hero (Toto le Heros) 1991,S 21,11:1
Toto the Hero 1991,O 6,II:13:5
Toto the Hero (Toto le Heros) 1992,Mr 6,C12:1

van Dormael, Jaco (Screenwriter)
Toto the Hero (Toto le Heros) 1991,S 21,11:1
Toto the Hero (Toto le Heros) 1992,Mr 6,C12:1

van Dreelen, John
Becoming Colette 1992,N 6,C6:1

Vane, Richard (Producer)
Dutch 1991,Jl 19,C13:1

Vanel, Charles
Wages of Fear, The (Salaire de la Peur, Le) 1991,O
18,C8:3

van Eyck, Peter
Wages of Fear, The (Salaire de la Peur, Le) 1991,O
18,C8:3

Vangelis (Composer)
1492: Conquest of Paradise 1992,O 9,C21:1
1492 1992,O 18,II:13:5

Van Horn, Patrick
Encino Man 1992,My 22,C15:1

Vanilla Ice
Cool as Ice 1991,O 19,12:6

Van Orden, Fritz (Composer)
Little Noises 1992,Ap 24,C8:6

van Os, Ben (Miscellaneous)
Prospero's Books 1991,S 28,9:1

Van Peebles, Mario
New Jack City 1991,Mr 8,C15:1

Van Peebles, Mario (Director)
New Jack City 1991,Mr 8,C15:1

Van Rellim, Tim (Producer)
K2 1992,My 1,C16:1

Van Runkle, Theadora (Miscellaneous)
Butcher's Wife, The 1991,O 25,C24:1

Van Sant, Gus, Jr. (Director)
My Own Private Idaho 1991,S 27,C5:1
My Own Private Idaho 1991,O 6,II:13:5

Van Sant, Gus, Jr. (Screenwriter)
My Own Private Idaho 1991,S 27,C5:1

Van Taylor, David (Director)
Dream Deceivers: The Story Behind James Vance
vs. Judas Priest 1992,Ag 6,C15:4

Van Taylor, David (Producer)
Dream Deceivers: The Story Behind James Vance
vs. Judas Priest 1992,Ag 6,C15:4

Van Tries, Amy (Miscellaneous)
Life on the Edge 1992,Je 19,C11:1

Vantriglia, Damian
Crisscross 1992,My 9,17:5

Van Valkenburgh, Deborah
Rampage 1992,O 30,C27:1

Van Voorst, Suzanne (Producer)
Lyrical Nitrate 1991,O 11,C10:1

VanWagenen, Sterling (Director)
Convicts 1991,D 6,C14:6
Alan and Naomi 1992,Ja 31,C8:5

van Warmerdam, Alex
Voyeur 1991,Ag 2,C9:1

van Warmerdam, Alex (Director)
Voyeur 1991,Ag 2,C9:1

van Warmerdam, Alex (Screenwriter)
Voyeur 1991,Ag 2,C9:1

van Warmerdam, Vincent (Composer)
Voyeur 1991,Ag 2,C9:1

Van Wijk, Joke (Miscellaneous)
Miracle, The 1991,Jl 3,C12:1

Varda, Agnes (Director)
Jacquot de Nantes 1991,S 25,C16:3

Varda, Agnes (Screenwriter)
Jacquot de Nantes 1991,S 25,C16:3

Vargas, Antonio
Strictly Ballroom 1992,S 26,12:5

Vargas, Jacob
Gas Food Lodging 1992,Jl 31,C1:1

Vargas, Valentina
Street of No Return 1991,Ag 2,C6:1

Varja, Olli (Cinematographer)
Zombie and the Ghost Train 1991,O 4,C8:5

Varley, Sarah-Jane
Double Impact 1991,Ag 9,C8:5

Vasconcellos, Ronaldo (Producer)
Whore 1991,O 4,C15:1

Vasconcelos, Nana (Composer)
Amazon 1992,F 28,C8:5

Vasconcelos, Tito
Danzon 1992,S 25,C6:5

Vasconcelos, Victor
Danzon 1992,S 25,C6:5

Vashisth, Mita
Idiot 1992,O 8,C21:4

Vasilescu, Razvan
Oak, The 1992,O 1,C13:1

Vasquez, Elsa (Screenwriter)
Rodrigo D: No Future 1991,Ja 11,C10:5

Vasquez, Joseph B. (Director)
Hangin' with the Homeboys 1991,My 24,C12:6

Vasquez, Joseph B. (Screenwriter)
Hangin' with the Homeboys 1991,My 24,C12:6

Vaughan, David (Screenwriter)
Cage/Cunningham 1991,D 5,C20:1
Cage/Cunningham 1991,D 13,C37:1

Vaughan, Paris
Buffy the Vampire Slayer 1992,Jl 31,C8:5

Vaughan, Roger (Miscellaneous)
Wind 1992,S 11,C3:1

Vaughn, Ned
Wind 1992,S 11,C3:1

Vawter, Ron
Swoon 1992,Mr 27,C8:1

Veber, Francis (Director)
Out on a Limb 1992,S 5,15:1

Vecindad, Maldita (Sax)
City of the Blind (Ciudad de Ciegos) 1992,Ap 4,17:5

Vega, Daniel (Miscellaneous)
Wait for Me in Heaven (Esperame en el Cielo)
1991,Ja 30,C10:5

Velez, Derrick
Crisscross 1992,My 9,17:5

Velez, Hector (Miscellaneous)
In the Heat of Passion 1992,Ja 24,C12:5

Vellani, Zul
Idiot 1992,O 8,C21:4

Veneziano, Sandy (Miscellaneous)
One Good Cop 1991,My 3,C13:1
Father of the Bride 1991,D 20,C17:1
Home Alone 2: Lost in New York 1992,N 20,C1:1

Vengos, Thanassis
Quiet Days in August 1992,Mr 29,48:1

Vennera, Chick
McBain 1991,S 23,C15:1

Venosta, Giovanni (Composer)
Peaceful Air of the West 1991,Mr 20,C12:5

Venture, Richard
Scent of a Woman 1992,D 23,C9:1

Verdu, Maribel
Lovers 1992,Mr 25,C18:5

Verhoeven, Paul (Director)
Basic Instinct 1992,Mr 20,C8:1
Basic Instinct 1992,My 8,C1:2

Verhoeven, Yves
Madame Bovary 1991,D 25,13:1

Verity, Peter (Miscellaneous)
Motorama 1992,Mr 28,18:5

Vernacchio, Dorian (Miscellaneous)
Frozen Assets 1992,O 24,16:4

Vernon, Kate
Malcolm X 1992,N 18,C19:3

Verro, Philippe (Miscellaneous)
Room in Town, A (Chambre en Ville, Une) 1991,S
28,11:5

Very, Charlotte
Tale of Winter, A 1992,O 2,C12:6

Vesely, Jiri (Composer)
Time of the Servants 1991,Mr 19,C12:3

Vesperini, Edith (Miscellaneous)
Van Gogh 1992,O 30,C16:5

Vey, P. C. (Screenwriter)
Tune, The 1992,S 4,C3:1

Vezetti, Tom
Delivered Vacant 1992,O 10,13:1

Viana, Zeliot (Producer)
Earth Entranced (Terra em Transe) 1991,O 5,14:5

Viard, Karin
Delicatessen 1991,O 5,14:3
Vicente, Mark (Cinematographer)
Sarafina! 1992,S 18,C16:6
Viciano, Enrique (Producer)
Aventis (Stories) 1992,N 13,C15:1
Vickery, John
Fist of the North Star 1991,N 15,C8:1
Dr. Giggles 1992,O 24,16:4
Victor, Mark (Producer)
Sleepwalkers 1992,Ap 11,18:1
Victor, Mark (Screenwriter)
Cool World 1992,Jl 11,12:3
Victoria, Christa
Finding Christa 1992,Mr 24,C15:3
Vidal, Gore
Bob Roberts 1992,My 13,C13:5
Bob Roberts 1992,S 4,C1:1
Viegas, Joao Alfredo (Producer)
Fable of the Beautiful Pigeon Fancier, The 1991,Mr
1,C6:4
Viegas, Manuela (Miscellaneous)
Alex 1992,Mr 24,C15:3
Vieira, Asia
Used People 1992,D 16,C23:3
Vierny, Sacha (Cinematographer)
Drowning by Numbers 1991,Ap 26,C8:1
Prospero's Books 1991,S 28,9:1
Vieyte, Michel (Producer)
Intervista 1992,N 20,C10:1
Viezzi, Adolphe (Producer)
Daddy Nostalgia 1991,Ap 12,C10:1
Vigdorschik, J. (Miscellaneous)
Satan 1992,Mr 28,18:1
Vigfusdottir, Klara Iris
Shadow of the Raven, The 1991,Jl 13,12:1
Vigil, Erick
Waterdance, The 1992,My 13,C13:1
Vikouloff, Sacha
Favor, the Watch, and the Very Big Fish, The
1992,My 8,C15:3
Villa-Lobos, Heitor (Composer)
Earth Entranced (Terra em Transe) 1991,O 5,14:5
Villalobos, Reynaldo (Cinematographer)
American Me 1992,Mr 13,C6:5
Villard, Tom
Popcorn 1991,F 1,C6:5
Villarreal, Daniel
American Me 1992,Mr 13,C6:5
Villarreal, Gerardo
Cabeza de Vaca 1991,Mr 23,12:6
Villaverde, Teresa (Director)
Alex 1992,Mr 24,C15:3
Villaverde, Teresa (Screenwriter)
Alex 1992,Mr 24,C15:3
Villeret, Jacques
Favor, the Watch, and the Very Big Fish, The
1992,My 8,C15:3
Vincelli, Andre (Composer)
Unknown Soldiers 1992,Je 17,C13:1
Vincent, Alex
Just Like in the Movies 1992,My 4,C15:1
Vincent, Christian (Director)
Discrete, La 1992,Ag 14,C13:1
Vincent, Christian (Screenwriter)
Discrete, La 1992,Ag 14,C13:1
Vincent, Frank
Jungle Fever 1991,Je 7,C1:2
Vincenzoni, Luciano (Miscellaneous)
Once Upon a Crime 1992,Mr 7,20:4
Vinokur, Semyon (Screenwriter)
Interpretation of Dreams 1991,Mr 30,10:4
Vinson, Jackey
Breaking the Rules 1992,O 9,C10:6
Vinyl, Kosmo (Miscellaneous)
Blowback 1991,Ag 9,C13:1
Virkler, Dennis (Miscellaneous)
Freejack 1992,Ja 18,17:5
Falling from Grace 1992,F 21,C16:5
Visan, Dorel
Oak, The 1992,O 1,C13:1
Visconti, Luchino (Director)
Rocco and His Brothers 1991,S 21,12:1
Rocco and His Brothers 1992,Ja 24,C8:1
Visconti, Luchino (Screenwriter)
Rocco and His Brothers 1991,S 21,12:1
Visu, Gheorghe
Oak, The 1992,O 1,C13:1

Viterelli, Joe
Ruby 1992,Mr 27,C1:3
Viva
Superstar: The Life and Times of Andy Warhol
1991,F 22,C8:1
Vogel, Nikolas
Requiem for Dominic 1991,Ap 19,C17:1
Vogeler, Claudia (Miscellaneous)
Via Appia 1992,Ag 27,C16:5
Vogler, Rudiger
Until the End of the World 1991,D 25,18:5
Voita, Michael
Straight for the Heart 1991,F 4,C14:1
Voletti, Michel
Tale of Winter, A 1992,O 2,C12:6
Volkov, Solomon (Miscellaneous)
Testimony 1991,D 18,C25:1
Volkova, Galina
Hey, You Wild Geese 1992,Ap 2,C20:5
Volonte, Gian Maria
Open Doors 1991,Mr 8,C15:1
Volter, Philippe
Double Life of Veronique, The 1991,S 20,C18:4
Voltinos, Thanassis (Screenwriter)
Suspended Step of the Stork, The 1991,S 23,C15:1
Volz, Dorte (Miscellaneous)
Johanna d'Arc of Mongolia 1992,My 15,C8:1
von Armin, Elizabeth (Original Author)
Enchanted April 1992,Jl 31,C15:1
Von Bargen, Daniel
Complex World 1992,Ap 10,C14:5
Company Business 1992,Ap 25,17:1
Von Brana, Jonathon
Legends 1991,Mr 17,68:5
Legends 1991,Mr 17,II:13:5
Von Brandenstein, Patrizia (Miscellaneous)
Billy Bathgate 1991,N 1,C1:1
Sneakers 1992,S 9,C18:3
Leap of Faith 1992,D 18,C14:1
von dem Bussche, Axel
Restless Conscience, The 1992,F 7,C15:1
von der Schulenburg, Count Fritz-Dietlof
Restless Conscience, The 1992,F 7,C15:1
Von Dohlen, Lenny
Leaving Normal 1992,Ap 29,C17:1
von Dohnanyi, Dr. Hans
Restless Conscience, The 1992,F 7,C15:1
von Dormael, Pierre (Composer)
Toto the Hero (Toto le Heros) 1991,S 21,11:1
von Hasperg, Ila (Miscellaneous)
Shadow of Angels 1992,Mr 6,C15:1
von Hofmannsthal, Hugo (Miscellaneous)
Rosenkavalier, Der 1991,N 10,II:13:1
von Kleist, Ewald-Heinrich
Restless Conscience, The 1992,F 7,C15:1
von Moltke, Count Helmuth James
Restless Conscience, The 1992,F 7,C15:1
von Praunheim, Rosa
Affengeil 1992,Jl 25,15:4
von Praunheim, Rosa (Director)
Affengeil 1992,Jl 25,15:4
von Praunheim, Rosa (Producer)
Affengeil 1992,Jl 25,15:4
von Praunheim, Rosa (Screenwriter)
Affengeil 1992,Jl 25,15:4
Von Sternberg, Nick (Cinematographer)
Life on the Edge 1992,Je 19,C11:1
von Sydow, Max
Kiss Before Dying, A 1991,Ap 26,C12:6
Until the End of the World 1991,D 25,18:5
Zentropa 1992,My 22,C14:1
Best Intentions, The 1992,Jl 10,C10:5
Father 1992,Jl 31,C5:5
Ox, The 1992,Ag 21,C10:5
von Tresckow, Maj. Gen. Henning
Restless Conscience, The 1992,F 7,C15:1
von Trier, Lars (Director)
Zentropa 1992,My 22,C14:1
von Trier, Lars (Screenwriter)
Zentropa 1992,My 22,C14:1
von Trott zu Solz, Adam
Restless Conscience, The 1992,F 7,C15:1
Vool, Ruth
Stranger Among Us, A 1992,Jl 17,C1:3
Voronzov, Yuri (Cinematographer)
Satan 1992,Mr 28,18:1
Vorsel, Niels (Screenwriter)
Zentropa 1992,My 22,C14:1

Voss, Birgit (Miscellaneous)
Weininger's Last Night 1991,Ag 1,C14:4
Voss, Kurt (Screenwriter)
Delusion 1991,Je 7,C12:6
Where the Day Takes You 1992,S 11,C14:5
Voth, Tomas R.
Mistress 1992,Ag 7,C16:3
Voulgaris, Pantelis (Director)
Quiet Days in August 1992,Mr 29,48:1
Voulgaris, Pantelis (Producer)
Quiet Days in August 1992,Mr 29,48:1
Voulgaris, Pantelis (Screenwriter)
Quiet Days in August 1992,Mr 29,48:1
Voyo
Lionheart 1991,Ja 11,C8:4
Vrienten, Henny (Composer)
Vanishing, The 1991,Ja 25,C8:1
Vuorinen, Esa (Cinematographer)
Shadow of the Raven, The 1991,Jl 13,12:1

W

Wachinke, Dobi
Captive of the Desert, The (Captive du Desert, La)
1991,Mr 21,C20:3
Wacks, Jonathan (Director)
Mystery Date 1991,Ag 16,C9:1
Waddell, Karen
Letter to Harvey Milk, A 1991,Je 14,C10:4
Waddington, Steven
Edward II 1992,Mr 20,C16:3
Last of the Mohicans, The 1992,S 25,C3:1
Wade, Kevin (Screenwriter)
True Colors 1991,Mr 15,C19:1
Mr. Baseball 1992,O 2,C14:6
Wade, Robert (Screenwriter)
Let Him Have It 1991,D 6,C24:1
Wages, William (Cinematographer)
Love Potion No. 9 1992,N 13,C12:5
Wagner, Jane (Original Author)
Search for Signs of Intelligent Life in the Universe,
The 1991,S 27,C8:1
Wagner, Jane (Screenwriter)
Search for Signs of Intelligent Life in the Universe,
The 1991,S 27,C8:1
Wagner, Lindsay
Ricochet 1991,O 5,12:6
Wagner, Natasha Gregson
Fathers and Sons 1992,N 6,C17:1
Wagner, Raymond (Producer)
Run 1991,F 1,C15:1
Wagner, Reinhardt (Composer)
Marquis 1991,Jl 3,C12:5
Wagner, Richard (Composer)
Architecture of Doom, The 1991,O 30,C14:4
Meeting Venus 1991,N 15,C1:3
Wahl, Ken
Taking of Beverly Hills, The 1991,O 13,68:5
Wahl-li, Atchi
Captive of the Desert, The (Captive du Desert, La)
1991,Mr 21,C20:3
Waite, Ralph
Bodyguard, The 1992,N 25,C9:5
Waite, Ric (Cinematographer)
Out for Justice 1991,Ap 13,12:4
Rapid Fire 1992,Ag 21,C11:1
Waites, T. G.
McBain 1991,S 23,C15:1
Waits, Tom
Queens Logic 1991,F 1,C13:1
At Play in the Fields of the Lord 1991,D 6,C8:1
Bram Stoker's "Dracula" 1992,N 13,C1:3
Waits, Tom (Composer)
Night on Earth 1991,O 4,C1:3
Wajda, Andrzej (Director)
Korczak 1991,Ap 12,C8:1
Walburger, Ruth (Producer)
Johnny Suede 1992,Ag 14,C5:5
Walden, W. G. Snuffy (Composer)
Leaving Normal 1992,Ap 29,C17:1
Walken, Christopher
Comfort of Strangers, The 1991,Mr 29,C6:1
Comfort of Strangers, The 1991,Ap 7,II:13:5
McBain 1991,S 23,C15:1
Batman Returns 1992,Je 19,C1:1

599

Wiseman, Frederick
To Render a Life 1992,N 18,C23:1
Wiseman, Frederick (Director)
Titicut Follies 1992,Mr 5,C21:3
Wisher, William (Screenwriter)
Terminator 2: Judgment Day 1991,Jl 3,C11:5
Wisman, Ron (Miscellaneous)
Beautiful Dreamers 1992,Je 5,C15:1
Witcher, Guy
Power of One, The 1992,Mr 27,C20:5
Witherspoon, John
Boomerang 1992,Jl 1,C18:1
Witherspoon, Reese
Man in the Moon, The 1991,O 4,C13:1
Witney, William
Roy Rogers: King of the Cowboys 1992,D 30,C12:3
Witney, William (Director)
Golden Stallion, The 1992,D 30,C12:3
Witt, Paul Junger (Producer)
Final Analysis 1992,F 7,C8:1
Witta, Jacques (Miscellaneous)
Double Life of Veronique, The 1991,S 20,C18:4
Witting, Steve
Batman Returns 1992,Je 19,C1:1
Woischnig, Thomas
Affengeil 1992,Jl 25,15:4
Wolf, Dick (Screenwriter)
School Ties 1992,S 18,C19:1
Wolf, Jeffrey (Miscellaneous)
McBain 1991,S 23,C15:1
Wolf, Kelly
Day in October, A 1992,O 28,C20:5
Wolf, Markus
November Days 1992,My 8,C8:1
Wolfe, Tom
Superstar: The Life and Times of Andy Warhol
1991,F 22,C8:1
Wolfe, Traci
Lethal Weapon 3 1992,My 15,C16:3
Wolinsky, Judith (Producer)
Eating 1991,My 3,C8:1
Venice/Venice 1992,O 28,C20:5
Wolitzer, Meg (Original Author)
This Is My Life 1992,F 21,C8:1
This Is My Life 1992,F 28,C1:1
Wolk, Andy (Director)
Traces of Red 1992,N 12,C22:1
Wolk, Michael (Screenwriter)
Innocent Blood 1992,S 25,C6:5
Wolkind, Jenny (Screenwriter)
Brenda Starr 1992,Ap 19,46:1
Wolpaw, James (Director)
Complex World 1992,Ap 10,C14:5
Wolpaw, James (Screenwriter)
Complex World 1992,Ap 10,C14:5
Wolsky, Albert (Miscellaneous)
Bugsy 1991,D 13,C12:1
Wonder, Stevie (Composer)
Jungle Fever 1991,My 17,C1:1
Jungle Fever 1991,Je 7,C1:2
Wong, B. D.
Mystery Date 1991,Ag 16,C9:1
Father of the Bride 1991,D 20,C17:1
Wong, James (Composer)
Once Upon a Time in China 1992,My 21,C16:5
Wong Kar-wai (Director)
Days of Being Wild 1991,Mr 23,12:3
Wong Kar-wai (Screenwriter)
Days of Being Wild 1991,Mr 23,12:3
Wong, Quincy
Mo' Money 1992,Jl 25,15:1
Wong, Russell
New Jack City 1991,Mr 8,C15:1
China Cry 1991,My 3,C9:1
Wong, Victor
3 Ninjas 1992,Ag 7,C5:1
Wong Wing Hang (Cinematographer)
Killer, The 1991,Ap 12,C11:1
Woo, John (Director)
Killer, The 1991,Ap 12,C11:1
Woo, John (Screenwriter)
Killer, The 1991,Ap 12,C11:1
Wood, Art (Composer)
In the Heat of Passion 1992,Ja 24,C12:5
Wood, D. (Composer)
Idiot 1992,O 8,C21:4
Wood, Deeanna
Home Less Home 1991,Mr 22,C8:5

Wood, Elijah
Paradise 1991,S 18,C16:3
Radio Flyer 1992,F 21,C16:1
Forever Young 1992,D 16,C17:1
Wood, Oliver (Cinematographer)
Bill and Ted's Bogus Journey 1991,Jl 19,C10:1
Mystery Date 1991,Ag 16,C9:1
Wood, Ron
At the Max 1991,N 22,C15:1
Wood, William P. (Original Author)
Rampage 1992,O 30,C27:1
Woodard, Alfre
Grand Canyon 1991,D 25,18:1
Passion Fish 1992,D 14,C16:1
Woodard, Charlayne
He Said, She Said 1991,F 22,C17:1
Woodbridge, Pamela (Miscellaneous)
Blood and Concrete 1991,S 13,C9:1
Shakes the Clown 1992,Mr 13,C13:1
Woodbridge, Patricia (Miscellaneous)
Johnny Suede 1992,Ag 14,C5:5
Woodlawn, Holly
Resident Alien 1991,O 18,C10:6
Woods, Carol
Stepping Out 1991,O 4,C26:4
Woods, James
Hard Way, The 1991,Mr 8,C8:1
Straight Talk 1992,Ap 3,C17:1
Diggstown 1992,Ag 14,C1:1
Chaplin 1992,D 25,C3:1
Woods, Justen
Prince of Tides, The 1992,F 23,II:13:1
Woods, Myrtle
Woman's Tale, A 1992,Ap 30,C16:6
Woodward, Edward
Mister Johnson 1991,Mr 22,C13:1
Wool, Abbe (Director)
Roadside Prophets 1992,Mr 27,C10:1
Wool, Abbe (Screenwriter)
Roadside Prophets 1992,Mr 27,C10:1
Wooldridge, Susan
Twenty-One 1991,O 4,C10:6
Afraid of the Dark 1992,Jl 24,C7:1
Wooley, Peter (Miscellaneous)
Pure Luck 1991,Ag 9,C15:1
Wooll, Nigel (Producer)
Year of the Comet 1992,Ap 25,17:1
Woolley, Stephen (Producer)
Rage in Harlem, A 1991,My 3,C14:1
Miracle, The 1991,Jl 3,C12:1
Crossing the Line 1991,Ag 9,C11:1
Pope Must Die(t), The 1991,Ag 30,C10:3
Crying Game, The 1992,S 26,12:4
Woolverton, Linda (Miscellaneous)
Beauty and the Beast 1991,N 13,C17:4
Woolvett, Jaimz
Unforgiven 1992,Ag 7,C1:1
Workman, Chuck (Director)
Superstar: The Life and Times of Andy Warhol
1991,F 22,C8:1
Workman, Chuck (Miscellaneous)
Superstar: The Life and Times of Andy Warhol
1991,F 22,C8:1
Workman, Chuck (Producer)
Superstar: The Life and Times of Andy Warhol
1991,F 22,C8:1
Workman, Chuck (Screenwriter)
Superstar: The Life and Times of Andy Warhol
1991,F 22,C8:1
Workman, Jimmy
Addams Family, The 1991,N 22,C1:1
Woronov, Mary
Warlock 1991,Mr 30,11:4
Motorama 1992,Mr 28,18:5
Living End, The 1992,Ap 3,C1:1
Worth, David (Cinematographer)
China Cry 1991,My 3,C9:1
Worth, Marvin (Producer)
Malcolm X 1992,N 18,C19:3
Worth, Nicholas
Blood and Concrete 1991,S 13,C9:1
Wozencraft, Kim (Original Author)
Rush 1991,D 22,56:4
Wray, Lindsay
Prince of Tides, The 1991,D 25,13:3
Wright, Amy
Deceived 1991,S 27,C8:5
Hard Promises 1992,Ja 31,C12:6

Wright, Bethany
Simple Men 1992,O 14,C22:1
Wright, Jeffrey
Jumpin' at the Boneyard 1992,S 18,C18:5
Wright, Jenny
Lawnmower Man, The 1992,Mr 7,20:1
Wright, John (Miscellaneous)
Teen-Age Mutant Ninja Turtles II: The Secret of the
Ooze 1991,Mr 22,C1:3
Necessary Roughness 1991,S 27,C21:3
Wright, Michael
Five Heartbeats, The 1991,Mr 29,C14:3
Wright, N'Bushe
Zebrahead 1992,O 8,C17:5
Wright, Robin
Playboys, The 1992,Ap 22,C15:1
Toys 1992,D 18,C1:3
Wright, Samuel
Boy Who Cried Bitch, The 1991,O 11,C17:1
Wright, Steven
Men of Respect 1991,Ja 18,C1:1
Wright, Thomas Lee (Miscellaneous)
New Jack City 1991,Mr 8,C15:1
Wright, Thomas Lee (Screenwriter)
New Jack City 1991,Mr 8,C15:1
Wright, Tracy
Highway 61 1992,Ap 24,C19:1
Wu Nien-Jen (Screenwriter)
Song of the Exile 1991,Mr 15,C21:1
Wu Pei-yu
Five Girls and a Rope 1992,Mr 22,48:1
Wu, Vivian
Iron and Silk 1991,F 15,C12:5
Shadow of China 1991,Mr 10,58:5
Wuhl, Robert
Mistress 1992,Ag 7,C16:3
Bodyguard, The 1992,N 25,C9:5
Wurlitzer, Rudy (Screenwriter)
Voyager 1992,Ja 31,C6:1
Voyager 1992,F 23,II:13:5
Wind 1992,S 11,C3:1
Wurtzel, Stuart (Miscellaneous)
Mambo Kings, The 1992,F 28,C8:1
Used People 1992,D 16,C23:3
Wyle, Noah
Crooked Hearts 1991,S 6,C13:1
Wyman, Bill
At the Max 1991,N 22,C15:1
Wyman, Brad (Producer)
Dark Backward, The 1991,Jl 26,C18:4
Wyner, Tom (Miscellaneous)
Fist of the North Star 1991,N 15,C8:1
Wyner, Tom (Screenwriter)
Fist of the North Star 1991,N 15,C8:1

X

Xhonneux, Henri (Director)
Marquis 1991,Jl 3,C12:5
Xhonneux, Henri (Screenwriter)
Marquis 1991,Jl 3,C12:5
Xia Lixing (Cinematographer)
Woman Demon Human 1992,S 4,C11:1
Xiao Mao (Screenwriter)
Five Girls and a Rope 1992,Mr 22,48:1
Xtravaganza, Venus
Paris Is Burning 1991,Mr 13,C13:1
Xu Qing
Life on a String 1991,S 29,54:5
Xu Shouli
Woman Demon Human 1992,S 4,C11:1

Y

Yacoe, Joseph (Cinematographer)
Motorama 1992,Mr 28,18:5
Yacoub, Hayan
Deadly Currents 1992,O 16,C8:5
Yagher, Kevin (Miscellaneous)
Meet the Applegates 1991,F 1,C6:1
Borrower, The 1991,O 18,C12:3

Z

A

Academy Entertainment (Dist.)
Linguini Incident, The 1992,My 1,C15:1
AGAV Films (Prod.)
Berlin Jerusalem 1991,Mr 8,C16:6
Agee, James, Film Project (Dist.)
To Render a Life 1992,N 18,C23:1
Albatros Produktion (Prod.)
Shadow of Angels 1992,Mr 6,C15:1
Alexander Sisters, The (Misc.)
Wisecracks 1992,Je 4,C17:1
Alliance International (Dist.)
Wisecracks 1992,Je 4,C17:1
Deadly Currents 1992,O 16,C8:5
American Playhouse Theatrical Films (Misc.)
All the Vermeers in New York 1992,My 1,C13:1
American Playhouse Theatrical Films (Prod.)
Thank You and Good Night 1992,Ja 29,C20:4
Angelika Films (Dist.)
Ballad of the Sad Cafe, The 1991,Mr 28,C11:1
Antarctic Pictures (Dist.)
Hours and Times, The 1992,Ap 3,C10:1
Argos Films, (Prod.)
Broadway by Light 1991,O 11,C10:1
Aries Films (Dist.)
Superstar: The Life and Times of Andy Warhol 1991,F 22,C8:1
Story of Boys and Girls, The 1991,Mr 28,C12:1
Station, The (Stazione, La) 1992,Ja 3,C6:1
Thank You and Good Night 1992,Ja 29,C20:4
Lovers 1992,Mr 25,C18:5
Bad Lieutenant 1992,N 20,C15:1
Artcofilm SA (Prod.)
Shadow of Angels 1992,Mr 6,C15:1
Australian Broadcasting Commission (Misc.)
Black Harvest 1992,Ap 4,17:1
Australian Film Commission (Misc.)
Black Harvest 1992,Ap 4,17:1
Avenue D Films Ltd. (Dist.)
Refrigerator, The 1992,S 25,C16:6
Avenue Pictures (Dist.)
Mister Johnson 1991,Mr 22,C13:1
Daddy Nostalgia 1991,Ap 12,C10:1
Sex, Drugs, Rock & Roll 1991,S 13,C1:1
Avenue Pictures (Misc.)
Object of Beauty, The 1991,Ap 12,C14:4

B

B.M.G. Films (Prod.)
Don Juan, My Love 1991,Jl 12,C10:5
Babes in Toyland (Misc.)
1991: The Year Punk Broke 1992,N 20,C5:1
Bad Tribe (Misc.)
We're Talking Vulva 1991,Jl 17,C13:1
Barrandov Film Studios (Prod.)
Time of the Servants 1991,Mr 19,C12:3
End of Old Times, The 1992,Ja 10,C12:6
Basilisk (Prod.)
Garden, The 1991,Ja 17,C16:5
BBC Films (Misc.)
Object of Beauty, The 1991,Ap 12,C14:4
Bedford Entertainment (Dist.)
Strangers in Good Company 1991,My 10,C8:1
Beijing Film Academy (Misc.)
Iron and Silk 1991,F 15,C12:5
Belbo Films (Prod.)
Cross My Heart 1991,Ap 5,C18:5
BFI Productions (Prod.)
Strip Jack Naked 1991,Je 8,16:5
On the Black Hill 1991,Ag 16,C8:1
Blair, L. W., Films (Dist.)
Straight for the Heart 1991,F 4,C14:1
Blowback Productions (Dist.)
Blowback 1991,Ag 9,C13:1
Bomb Squad (Misc.)
Juice 1992,Ja 17,C10:1
Boston Symphony Orchestra (Misc.)
Alexander Nevsky 1991,N 10,II:13:
Briarpatch Releasing Corporation (Dist.)
Secret Friends 1992,F 14,C10:1

British Screen Finance Ltd. (Prod.)
Garden, The 1991,Ja 17,C16:5
On the Black Hill 1991,Ag 16,C8:1
Bronze Eye (Prod.)
Poison 1991,Ap 5,C8:3
Buena Vista Pictures Distribution (Dist.)
Run 1991,F 1,C15:1
Marrying Man, The 1991,Ap 5,C6:1
One Good Cop 1991,My 3,C13:1
Wild Hearts Can't Be Broken 1991,My 24,C16:6
Doctor, The 1991,Jl 24,C11:1
V. I. Warshawski 1991,Jl 26,C1:3
Beauty and the Beast 1991,N 13,C17:4
Medicine Man 1992,F 7,C13:1
Blame It on the Bellboy 1992,Mr 6,C10:6
Passed Away 1992,Ap 24,C8:1
Aladdin 1992,N 11,C15:3

C

Cabriolet Films (Dist.)
Never Leave Nevada 1991,Ap 28,60:5
Amazon 1992,F 28,C8:5
Puerto Rican Mambo (Not a Musical), The 1992,Mr 22,48:4
Just Like in the Movies 1992,My 4,C15:1
California Newsreel (Dist.)
Finzan 1992,Mr 22,48:4
Canadian Broadcasting Corporation (Prod.)
Princes in Exile 1991,F 22,C12:5
Cannon Pictures (Dist.)
Borrower, The 1991,O 18,C12:3
Hitman, The 1991,O 27,51:5
Capitol Entertainment (Dist.)
Rikyu 1991,Ja 18,C8:1
Paper Wedding, A 1991,Je 21,C8:1
Capstone Films (Dist.)
Undertow 1991,S 18,C16:3
Castle Hill Productions (Dist.)
Alligator Eyes 1991,F 15,C15:1
Reunion 1991,Mr 15,C16:6
Strangers in Good Company 1991,My 10,C8:1
Iron Maze 1991,N 1,C13:1
Voyager 1992,Ja 31,C6:1
Close My Eyes 1992,F 21,C12:6
Paper Mask 1992,F 28,C19:1
Shaking the Tree 1992,Mr 13,C8:1
Who Shot Patakango? 1992,My 1,C10:5
Ox, The 1992,Ag 21,C10:5
Double Edge 1992,S 30,C18:3
Fine Romance, A 1992,O 2,C10:6
Day in October, A 1992,O 28,C20:5
Becoming Colette 1992,N 6,C6:1
Intervista 1992,N 20,C10:1
Castle Rock Entertainment (Dist.)
City Slickers 1991,Je 7,C18:5
Late for Dinner 1991,S 20,C6:5
Few Good Men, A 1992,D 11,C20:1
Catpics (Prod.)
Journey of Hope 1991,Ap 26,C13:1
A Center for Southern Folklore (Dist.)
All Day and All Night: Memories from Beale Street Musicians 1991,Mr 15,C1:4
Channel Four (Misc.)
Black Harvest 1992,Ap 4,17:1
Channel Four (Prod.)
Garden, The 1991,Ja 17,C16:5
On the Black Hill 1991,Ag 16,C8:1
Chanticleer Films (Prod.)
To the Moon, Alice 1991,O 2,C19:1
China Co-production Film Corporation (Misc.)
Iron and Silk 1991,F 15,C12:5
Cine Ballet (Dist.)
Swimming with Tears 1992,Mr 22,49:1
Cine Qua Non (Dist.)
Maison Assassinee, La (Murdered House, The) 1991,O 25,C10:5
En Toute Innocence (In All Innocence) 1992,Jl 31,C14:3
Cinecom Entertainment Group (Dist.)
Rosencrantz and Guildenstern Are Dead 1991,F 8,C14:6
Cinegrit (Dist.)
Touki-Bouki (Hyena's Voyage) 1991,F 15,C10:1

Cinema Art (Dist.)
Shadow of the Raven, The 1991,Jl 13,12:1
Cinema Esperanca International (Dist.)
Blast 'Em 1992,Jl 1,C18:3
Cinema Plus (Dist.)
Ricochet 1991,O 5,12:6
Cinema Plus (Prod.)
Don't Tell Mom the Babysitter's Dead 1991,Je 7,C19:1
Cinepix (Prod.)
Princes in Exile 1991,F 22,C12:5
Cinepool (Dist.)
Weininger's Last Night 1991,Ag 1,C14:4
Cinetel Films (Dist.)
Too Much Sun 1991,Ja 25,C8:5
Cineville, Inc. (Prod.)
Delusion 1991,Je 7,C12:6
Cinevista (Dist.)
Forever Mary 1991,Ap 19,C11:1
Black Lizard 1991,S 18,C13:1
Cousin Bobby 1992,My 29,C1:4
Pepi, Luci, Bom (Pepi, Luci, Bom and Other Girls on the Heap) 1992,My 29,C10:5
Whole Truth, The 1992,O 23,C10:5
Circle Releasing Corporation (Dist.)
Killer, The 1991,Ap 12,C11:1
Dark Obsession 1991,Je 7,C10:1
Barton Fink 1991,Ag 21,C11:1
Classic Films Produccion S.A. (Prod.)
Bosque Animado, El (Enchanted Forest, The) 1992,D 4,C8:6
Clichettes, The (Misc.)
Wisecracks 1992,Je 4,C17:1
Columbia Pictures (Dist.)
Men of Respect 1991,Ja 18,C1:1
Mortal Thoughts 1991,Ap 19,C15:1
Boyz 'n the Hood 1991,Jl 12,C1:1
Return to the Blue Lagoon 1991,Ag 2,C12:1
Double Impact 1991,Ag 9,C8:5
Taking of Beverly Hills, The 1991,O 13,68:5
My Girl 1991,N 27,C15:1
Inner Circle, The 1991,D 25,20:1
Prince of Tides, The 1991,D 25,13:3
Hard Promises 1992,Ja 31,C12:6
Falling from Grace 1992,F 21,C16:5
Radio Flyer 1992,F 21,C16:1
Under Suspicion 1992,F 28,C10:1
Gladiator 1992,Mr 6,C17:1
Sleepwalkers 1992,Ap 11,18:1
Year of the Comet 1992,Ap 25,17:1
League of Their Own, A 1992,Jl 1,C13:4
Mo' Money 1992,Jl 25,15:1
Single White Female 1992,Ag 14,C8:1
Honeymoon in Vegas 1992,Ag 28,C8:5
Mr. Saturday Night 1992,S 23,C13:4
Hero 1992,O 2,C20:6
River Runs Through It, A 1992,O 9,C1:3
Bram Stoker's "Dracula" 1992,N 13,C1:3
Few Good Men, A 1992,D 11,C20:1
Compania de Fomento Cinematografico (Focine) (Prod.)
Rodrigo D: No Future 1991,Ja 11,C10:5
Complex Corporation (Misc.)
All the Vermeers in New York 1992,My 1,C13:1
Concorde Pictures (Dist.)
In the Heat of Passion 1992,Ja 24,C12:5
Condor Productions (Prod.)
Journey of Hope 1991,Ap 26,C13:1
Connoisseur (Dist.)
Notebook on Cities and Clothes 1991,O 25,C17:1
Coralie Films (Dist.)
Alex 1992,Mr 24,C15:3
Courier Films (Dist.)
Wait for Me in Heaven (Esperame en el Cielo) 1991,Ja 30,C10:5
Creative Thinking International Ltd. (Dist.)
Brother's Keeper 1992,S 9,C15:3
Creative Union Chetverg Kievnauchfilm (Prod.)
Interpretation of Dreams 1991,Mr 30,10:4
Cunningham Dance Foundation, Inc. (Prod.)
Cage/Cunningham 1991,D 5,C20:1

P

Q

R

S

T

U

V

W

Curly Sue 1991,O 25,C15:1
Strictly Business 1991,N 8,C13:3
Meeting Venus 1991,N 15,C1:3
Last Boy Scout, The 1991,D 13,C14:6
Until the End of the World 1991,D 25,18:5
Final Analysis 1992,F 7,C8:1
Mambo Kings, The 1992,F 28,C8:1
Memoirs of an Invisible Man 1992,F 28,C17:1
Power of One, The 1992,Mr 27,C20:5
White Sands 1992,Ap 24,C18:1
Lethal Weapon 3 1992,My 15,C16:3
Class Act 1992,Je 5,C17:1
Batman Returns 1992,Je 19,C1:1
Mom and Dad Save the World 1992,Jl 27,C18:4
Unforgiven 1992,Ag 7,C1:1
Stay Tuned 1992,Ag 15,14:5
Christopher Columbus: The Discovery 1992,Ag 22,11:1
Singles 1992,S 18,C3:4
Innocent Blood 1992,S 25,C6:5
Under Siege 1992,O 9,C12:1
South-Central 1992,O 16,C13:1
Pure Country 1992,O 23,C13:1
Passenger 57 1992,N 6,C14:5

Malcolm X 1992,N 18,C19:3
Bodyguard, The 1992,N 25,C9:5
Forever Young 1992,D 16,C17:1
Water Bearer Films (Dist.)
Traffic Jam 1992,Mr 20,C20:4
Where Film (Prod.)
Where 1991,S 6,C13:1
Willenson, Seth M., Productions (Prod.)
Delusion 1991,Je 7,C12:6
Women Make Movies (Dist.)
Body Beautiful, The 1991,O 3,C21:1
Johanna d'Arc of Mongolia 1992,My 15,C8:1
World Artists (Dist.)
Window Shopping 1992,Ap 17,C13:1

X

Xanadu Films (Prod.)
Straight for the Heart 1991,F 4,C14:1

Z

ZDF (Prod.)
Garden, The 1991,Ja 17,C16:5
Johanna d'Arc of Mongolia 1992,My 15,C8:1
Zeitgeist Films (Dist.)
Oreos with Attitude 1991,Mr 17,68:5
Poison 1991,Ap 5,C8:3
We're Talking Vulva 1991,Jl 17,C13:1
Archangel 1991,Jl 19,C12:6
Swan Lake: The Zone 1991,S 4,C13:1
Comb, The 1991,O 11,C10:1
Lyrical Nitrate 1991,O 11,C10:1
Time Expired 1992,D 2,C18:4